D1314495

NEW DISCOVERIES AND PERSPECTIVES

IN THE

WORLD OF ART

UNDER THE AUSPICES
OF THE
FONDAZIONE GIORGIO CINI

IN COOPERATION WITH
JACK HERATY & ASSOCIATES, INC.
PALATINE, ILLINOIS

ENCYCLOPEDIA OF WORLD ART
VOLUME XVII/SUPPLEMENT II

61606

FULTON-MONTGOMERY COMMUNITY
COLLEGE LIBRARY

STAFF FOR THIS VOLUME
Editor in Chief — David Eggenberger
Editor — Susan Carroll
STAFF FOR JACK HERATY & ASSOCIATES, INC.
Administrative Director — Maria Jo Bruno
Assistant To Director — Deneen C. Kornacker
Production Manager — Wayne Campbell
Manufacturing Director — Ron Otterness

ENCYCLOPEDIA OF WORLD ART: Supplement II
Copyright © 1987 by Jack Heraty and Associates; 1978
by UNEDI, Rome (Italy). All Rights Reserved. No part
of this publication may be reproduced, stored in a
retrieval system, or transmitted, in any form or by any
means, electronic, mechanical, photocopying, record-
ing, or otherwise, without the prior written permission
of the publishers. Text Printed in USA. Bound by
Nicholstone Book Bindery.

Library of Congress Catalog Card Number: 87-080314

International Standard Book Number: 0-910081-01-8

TABLE OF CONTENTS

FOREWORD

Because the Encyclopedia of World Art was originally planned more as a review and a verification of the methodological disciplines than as an alphabetical repertoire of information, it is clear that it can and should be developed rather than simply supplemented and updated. The task was more difficult for contemporary art: in this field not only have there been important new contributions, but also radical changes in the object of the critical reflections. It was necessary to take into consideration the new currents that have rapidly followed one another in the last 20 years. It was also necessary to keep in mind the methodologies and the critical problems that brought about new perspectives and methods of evaluation and led to the discovery of new fields of perception.

Criticism has ceased to be a judgment a posterior of products that are specifically artistic in nature; it has rather been integrated into the cultural sphere itself, extending its limits to overturn the categorial distinction that formerly ruled between art and non-art. Typical, in this sense, is the case of "Kitsch," which "judging" criticism excluded from art but which criticism based on phenomena and signs cannot fail to consider as pertinent to the area of art.

The new criticism, which was formed simultaneously with the new concept of the artistic operation, could not fail to take into consideration the crisis in traditional technologies and the introduction of new technologies.

In the task of describing the simultaneous changing of aesthetic research and of critical functions, a different way of approaching art phenomena has been considered, often through overlapping perspectives combining the sociological and the structural approach. The result has been the emergence of problems that are completely new, especially in consideration of the contrast between urban and rural cultures.

The analysis of the attitude of the modern world toward the object-oriented universe of art could not fail to come up in this volume. The necessity of taking care of an art object (besorgen), not only as an individual experience but as a practice of society, is crucial to the current understanding and appreciation of an art object. Much of this study is devoted to the recent developments in the protection of the law, in cataloging, and in the creation of public institutions.

GIULIO CARLO ARGAN

INTRODUCTION

Any large encyclopedia has a need to be updated from time to time. This is especially true in the case of the original Italian work, *Enciclopedia Universale dell'Arte*, published in 15 volumes between 1958 and 1967 by the Institute for Cultural Collaboration under the patronage of the Giorgio Cini Foundation and issued in the United States by the McGraw-Hill Book Company of New York as the *Encyclopedia of World Art*. Such updating presented particular problems with complex and delicate facets, due to the special characteristics of the work.

What was required, in fact, was an overall treatment of the different aspects and problems of art covering all of history and mankind; also considered were the relationship of the visual arts with other forms of expression of the human spirit and with the form and make-up of society, as well as the history and theory of objective methodologies. The basic material was arranged in articles or monographic entries, each subject having its own particular theme (historic, geographic, typologic, iconographic, conceptual), in alphabetical order. This was done more to provide objectively, through a purely conventional order, the autonomy of different points of view, than to conform necessarily to the usual encyclopedic format.

It seems clear that the *Encyclopedia of World Art*, because of its adherence to its basic concepts, the scope and completeness of its research, the systematic investigation into individual aspects of the multi-level world of artistic creativity, and the richness of the illustrative documentation, represents a durable and unequalled compendium of thought, scientific elaboration, and cultural resonance. Any publication that may wish to enhance its discussions of art may refer to it with fruitful results. However, many advances have been made and new discoveries have been revealed; recent directions in production have changed, and certainly the development of critical orientations has taken a different course. In essence, then, an extensive array of data associated with the material in the original 15 volumes of the Encyclopedia must be brought up to date. Hence, in this sense and within these limits, we see the present volume as a necessary adjunct to our existing knowledge in this discipline.

Nevertheless, it was not the intention of the publishers nor of the editor for this to be merely a collection of analytical additions of notions and bibliographies to the entries of the *Encyclopedia of World Art*. Ignoring for the moment the difficulties of integration into the text, the indices, and the illustrations of the original work, this would have reduced its function to that of a modest reportorial appendix, destined to become immediately outdated and superseded by the continuous succession of other information, even during editorial preparation and the printing. It appeared more advantageous to summarize and insert into the general framework the substance of the progress of knowledge, methodology, and concepts realized in the intervening years in a unified, narrative treatment that should be considered not so much an "updating" as a "supplement" to the encyclopedia.

This volume has a continuity with the *Encyclopedia* and Supplement I (Vol. XVI), including the outside appearance. Nevertheless it can assume a value and autonomy of content of its own, inasmuch as it offers a general panorama of the more recent movements and present tendencies in the sphere of the history, the production, and the critique of art. As such, it addresses itself to the interests of those who know and use the *Encyclopedia of World Art* and also to a wider audience of readers, especially those sensitive to the problems and debates of contemporary culture.

As to the arrangement of the material in this volume, it seemed to be most suitable to divide the work into parts, chapters, and sections arranged in chronological and/or geographic order based on the historical and cultural settings of the material. Part I is dedicated to the origins of art and to the ancient world; Part II to the civilizations of the Asiatic East, considered in all their amplifications, and to those of the other continents outside Europe; Part III to the Middle Ages and the Modern Age through the 1800s; and Part IV to the art of the 1900s in connection with its present critical problems. Within this framework are presented the known data resulting from archaeological discoveries, restorations, comparisons, interpretative studies, and other sources, or, in the case of contemporary art, from the analysis of the new methods of composition. This has not been executed as a simple informational summary, or as one that aspires to the minute completeness of a catalogue. What has been attempted instead is to provide an essential and reasoned outline of the more important innovations, principally through their reflections in the arrangement of the material in the volume, rather than a critique of their meaning with regard to the progression of ideas relating to art. Thus, in the exposition of the facts the "historical" position is never separated from the "conceptual" precept. More specifically, in the last part the discussions of the methodological and theoretical problems, which are treated with particular thoroughness, involve the illustration and evaluation of the entire range of expressive research now in progress.

It is surely not necessary to emphasize that the treatment of the material was also intended to further the reader's knowledge of art commentary and international bibliography as much as possible, as was done in the *Encyclopedia*, including the contemplation of artistic facts as part of a universal whole. Rather, it has been attempted, as in the *Encyclopedia*, to give adequate importance to the discoveries and to the studies of those sectors that are

generally marginal to the "history of art" as conceived in the traditional European and Western eye: sectors that seem to win a position of ever more accentuated scientific and cultural importance, especially in the light of recent progress, as in the case of China for example.

The realization of such a program necessarily had to utilize contributions entrusted to different authors of proven competence in different fields, with the consultation and guidance of the work of scholars who, for the most part, had been a part of the direction of the *Encyclopedia Universale dell'Arte*, as they represented the surest guarantee of experience and continuity. These were, for Part I, Sabatino Moscati, Michelangelo Cagiano de Azevedo, and the undersigned; for Part II, Mario Bussagli and Vinigi Grottanelli, for Parts III and IV, Angiola Maria Romanini and Giulio Carlo Argan, with the cooperation of Silvana Macchioni. In some cases they also assisted directly in the preparation of the texts. The other contributors were designated by them from among the leading connoisseurs in their respective sectors, from the university and art criticism environments, for the most part Italian; however, illustrious foreign names are present whenever possible. The work of compilation was ably directed with particular dedication and ability by Gigliola Bonucci Caporali, who also is qualified by her experiences with the *Enciclopedia Universale dell'Arte*. In the final phase of the work the help of Silvana Macchioni was invaluable.

The compilation of the volume, which is more in the nature of brief essays than longer treatises, has been done in such a way as to avoid diminishing its utility as an instrument of reference. The following characteristics are in accordance with that goal:

a. general structure designed to facilitate consultation, with frequent subdivisions made in an opportune and coherent way, with corresponding titles, including paragraph and subparagraph titles in italics; summaries at the beginning of each part; and titles of the part and the chapter repeated at the top of the pages;

b. essential bibliography, providing as complete as possible a reference to the sources of the ideas reported in the text, laid out according to the scheme of the *Encyclopedia* and gathered as a rule at the end of each subchapter (in some cases at the end of the chapter);

c. bibliographic abbreviations substantially conforming to those of the *Encyclopedia*, but for convenience presented in full in a preliminary list;

d. references to the illustrations in the titles of the subchapters; and

e. names of the authors written out at the end of the respective texts (or after the bibliography if the subchapter or the chapter is by one author only).

Utilization of the volume is facilitated by the final indices, the first of which provides an alphabetized guide to the major historical and conceptual themes treated in the work and at the same time provides cross references to the corresponding entries in the *Encyclopedia*, which often represent a primary informative source for the subject. Some subjects are new to this volume and do not have a corresponding entry in the *Encyclopedia*. The second index is by author.

The remaining portion to be considered is the illustrative section. This consists exclusively of plates located separately from the text, comprising photographic reproductions of paintings, some of which are in color, and drawings. It is understood, but it is appropriate to emphasize, that the illustrations, as in the *Encyclopedia*, are a direct instrument of information and explanation—for many aspects an irreplaceable one; they are not merely examples to illustrate or integrate the text or to add aesthetic value. The order of the illustrations is the same as the order of the text, with headings at the top of the pages corresponding to the chapter titles. The description under each illustration contains references to the location, source, and state of conservation; to the nature of the material; and, wherever possible, to the dimensions, the cultural connections, or the dating of the things illustrated.

It is hoped that with this publication a work has been created that is of use to science and culture, even while recognizing the difficulties and the imperfections that are inevitable in an undertaking of such challenge. Of the efforts made in pursuing and attaining these goals, the highest recognition must be given not only to the compilers and to the scientific contributors, but to the editor and his offices and to all of the technical personnel that have helped in such a decisive way to transform this project into reality.

MASSIMO PALLOTTINO

EDITORIAL STAFF

Scientific advisory board: Giulio Carlo ARGAN, Professor of Modern Art History at the University of Rome (with the collaboration of Silvana Macchioni, assistant to the Department of Modern Art History of the University of Rome). — Mario BUSSAGLI, Professor of Art History of India and Central Asia at the University of Rome. — Michelangelo CAGIANO DE AZEVEDO, Professor of Archeology and Greek and Roman Art History at the Catholic University of Milan. — Vinigi GROTTANELLI, Professor of Ethnology at the University of Rome. — Sabatino MOSCATI, Professor of Semitic Philology at the University of Rome. — Massimo PALLOTTINO, Professor of Etruscan Studies and Italian Antiquities at the University of Rome. — Angiola Maria ROMANINI, Professor of Medieval Art History at the University of Rome.

Director : Massimo PALLOTTINO.

Editor : Gigliola BONUCCI CAPORALI, Researcher of the National Research Council. — *Co-editor* : Silvana MACCHIONI. – *Advisors to the editors* : Alessandra GIANFRANCESCHI and Massimo BONELLI.

ENGLISH TRANSLATION AND COORDINATION

Donald W. Abbott Kathleen M. Abbott
Stefania Malpighi Joseph T. Simone, Jr.

LIST OF CONTRIBUTORS

Martin ALMAGRO BASCH, Professor, University of Madrid; Director of the National Archeological Museum of Madrid

Alessandra ANTINORI CARDELLI, Rome

Franco BARBIERI, Professor of Medieval and Modern Art History, University of Macerata

Emilio BATTISTI, Professor of Architectural Composition, Politecnic di Milano, Milan

Luisa BECHERUCCI, formerly Superintendent and Director of the Uffizi Gallery of Florence; formerly Professor of Museology, University of Pisa

Antonio BELTRÁN, Dean of the School of Letters and Philosophy, University of Saragoza

Mirella BENTIVOGLIO, Visual Poet and Artist

Alberto BOATTO, Author, Rome

Massimo BONELLI, Rome

Mario BUSSAGLI, see Scientific Advisory Board

Antonio CADEI, Assistant Professor of History of Medieval Art, University of Rome

Michelangelo GAGIANO DE AZEVEDO, see Scientific Advisory Board

Fulvio CANCIANI, Visiting Professor of Archeology and History of Greek and Roman Art, University of Bari

Marco CHIARINI, Director of the Palatina Gallery, Pitti Palace, Florence

Pietro CLEMENTE, Assistant Professor of Literature and Popular Traditions, University of Siena

Daniela COCCHI, Istituto Italiano di Preistoria e Protostoria, Florence

Ercole CONTU, Professor of Sardinian Antiquities, University of Sassari

Mauro CRISTOFANI, Professor of Etruscan Studies, University of Siena

Loretta DEL FRANCIA, Scuola Orientale, Rome

Carlo DELLA CORTE, Journalist, Italian Radio and Television, Venice

Sergio DONADONI, Professor of Egyptology, University of Rome

Paul–Marie DUVAL, Professor of Archeology and History of Gaul, Collège de France, Paris

Andrea EMILIANI, Superintendent, Director of the Pinacoteca Nazionale of Bologna

Marcello FAGIOLO, Professor of Stylistic and Constructive Character of Monuments, University of Florence

Grazia Marina FALLA CASTELFRANCHI, University of Chieti

Oreste FERRARI, Director of the Istituto Centrale per il Catalogo e la Documentazione, Rome

Francesco GANDOLFO, Assistant Professor of Medieval Art History, University of Rome

Emilio GARRONI, Professor of Aesthetics, University of Rome

Renata LOMBARDO ARIOTI, Rome

Gianclaudio MACCHIERELLA, Assistant Professor of Medieval Art History, University of Rome

Corrado MALTESE, Professor of Medieval and Modern Art History, University of Genova

Paolo MARCONI, Assistant Professor of History of Architecture, University of Palermo

Paolo MATTHIAE, Professor of Archeology and Art History of the Ancient Middle East, University of Rome

Filiberto MENNA, Professor of Modern Art History, University of Salerno

Maria Grazia MESSINA, Istituto di Storia dell'Arte, University of Rome

Abraham A. MOLES, Professor, University of Strasbourg

Sabatino MOSCATI, see Scientific Advisory Board

Daniela PALAZZOLI, Professor of Theory and Method of Mass–Media, Accademia di Brera, Milan

Massimo PALLOTTINO, see Scientific Advisory Board

Paola PALLOTTINO, Bologna

Serenita PAPALDO, Director at the Istituto Centrale per il Catalogo e la Documentazione, Rome

Gianna PIANTONI, Inspector of the Galleria Nazionale di Arte Moderna, Rome

Antonio PINELLI, Professor of Art History, Accademia di Belle Arti, Rome

Nello PONENTE, Professor of Modern Art History, University of Rome

Massimo PRAMPOLINI, Istituto di Filosofia, University of Rome

Lionello PUPPI, Professor of History of Architecture and Urban Studies, University of Padova

Carlo Arturo QUINTAVALLE, Professor of Modern Art History, University of Parma

Pierre RESTANY, Art Critic, Paris

Angiola Maria ROMANINI, see Scientific Advisory Board

Orietta ROSSI PINELLI, Istituto di Storia dell'Arte, University of Rome

Italo SIGNORINI, Assistant Professor of Ethnology, University of Rome

Giorgio SIMONCINI, Assistant Professor of History of Architecture, Politecnico di Torino, Turin

Vincenzo STRIKA, Assistant Professor of History of Muslim Art, Istituto Universitario Orientale, Naples

Angelo TRIMARCO, Assistant Professor of History of Art Criticism, University of Salerno

Lucia VAGNETTI, Researcher of the Istituto di Studi Micenei ed Egeo–Anatolici, Consiglio Nazionale delle Ricerche, Rome

Mario VERDONE, Professor of History and Film Critic, University of Rome

Paola VERGARA CAFFARELLI MORTARI, Assistant Professor of History of Tibetan and Mongolian Art, Scuola Orientale, Rome

Pia VIVARELLI, Inspector of the Galleria Nazionale d'Arte Moderna, Rome

Marisa VOLPI ORLANDINI, Assistant Professor of History of Contemporary Art, University of Cagliari

xiii

PHOTOGRAPHIC SOURCES

AREZZO, Arch. Fot. Soprintendenza per i Beni
Architettonici e Ambientali
ASSISI, De Giovanni
ATHENS, American School of Classical Studies
National Museum
BAGHDAD, Deutsches Archaeologisches Institut
Iraqi Museum
BASEL, Horner
Museum für Völkerkunde u. Schweizer-
isches Museum für Volkskunde
Schulz
BERN, Historisches Museum
BOLOGNA, Istituto di Antichità Ravennati e Bizantine,
Università
Soprintendenza per i Beni Artistici e Storici
BOMBAY, Prince of Wales Museum
BROOKLYN (N.Y.), The Brooklyn Museum
CAIRO, Germanisches Archaeologisches Institut
CALCUTTA, Indian Museum
CORINTH, Museum
DAKAR, Musée de l'IFAN
DAMASCUS, National Museum
DARMSTADT, Landesmuseum
FIRENZE, Gab. Fot. Soprintendenza Archeologica
Gab. Fot. Soprintendenza per i Beni Artis-
tici e Storici
Graziosi
GENOVA, Gab. Fot. Soprintendenza Archeologica
HANIA, Museum
ISTAMBUL, Deutsches Archäeologisches Institut
KABUL, Museum
KARLSRUHE, Badisches Landesmuseum
LAGOS, Federal Department of Antiquities
LENINGRAD, Hermitage
LIMA, Bonavia
Guillém
LISBON, Museu de Etnologia
MADRID, Museo del Prado — see Italian list
MARBURG, Bildarchiv Photo Marburg
MEXICO CITY, Instituto Nacional de Antropología y
Historia
MILANO, Borromeo
Carrieri
Cassa di Risparmio delle Provincie
Lombarde
Fabbrica del Duomo
Gab. Fot. Soprintendenza Archeologica
UNEDI
MUNCHEN, Hirmer Photoarchiv

NAPOLI, Lab. Fot. della Soprintendenza Archeologica
NEW DELHI, Archaeological Survey of India
National Museum
NEW YORK, Clements
Metropolitan Museum of Art
Russell
Sonnabend Gallery
OTTAWA, National Gallery of Canada
OXFORD, Ashmolean Museum
PADOVA, Arch. Fot. Soprintendenza Archeologica delle
Venezie
PARIS, Musée des Arts Africains et Océaniens
PAVIA, Istituto di Storia dell'Arte, Università
PERUGIA, Soprintendenza per i Beni Architettonici,
Ambientali, Artistici e Storici dell'Umbria
REGGIO CALABRIA, Gab. Fot. Soprintendenza
Archeologica
ROMA, Antinori
Autenticolor
Bossaglia
Deutsches Archäeologisches Institut
Gab. Fot. Nazionale
Gab. Fot. Soprintendenza per i Beni Artis-
tici e Storici
Istituto di Storia dell'Arte, Università
La Medusa
Museo Nazionale di Arte Orientale
Museo di Palazzo Venezia
Museo Pigorini
Partito Repubblicano Italiano
Soprintendenza Archeologica
SALERNO, Gab. Fot. Soprintendenza Archeologica
TANJORE, Art Gallery
TAŠKENT, Art Museum
THESSALONIKI, Archaeological Museum
TEHERAN, Bastan Museum
TORINO, Testa
TOULOUSE, Yan
TRENTO, Museo Tridentino di Scienze Naturali
TRIER, Stadtbibliothek
TROYES, Musée des Beaux-Arts
VARESE, Panza di Biumo
VENEZIA, Gab. Fot. Soprintendenza per i Beni Artistici
e Storici
WASHINGTON, Dumbarton Oaks Coll.
Hawkins
ZARAGOZA, Photos–Coyne
ZÜRICH, Schweizerisches Landesmuseum

LIST OF ABBREVIATIONS

AAnz = Archäologischer Anzeiger, Berlin
AB = Art Bulletin, New York
AbhAKWiss = Abhandlungen der Bayerischen Akademie der Wissenschaften, München
AC = Archeologia Classica, Roma
ActHung = Acta Archaeologica Academiae Scientiarum Hungaricae
AE = Arte Español, Madrid
AEA = Archivo Español de Arqueología, Madrid
AIRN = Acta ad Archeologiam et Artium Historiam Pertinentia. Institutum Romanicum Norvegiae
AJA = American Journal of Archaeology, Baltimore
AM = Mitteilungen des deutschen archäologischen Instituts, Athenische Abteilung, Athen–Stuttgart
AmAnt = American Antiquity, Menasha (Wisc.)
AN = Art News, New York
AnzÖAk = Anzeiger der Österreichischen Akademie der Wissenschaften, Wien
AQ = Art Quarterly, Detroit
ARSI = Annual Report of the Smithsonian Institution, Bureau of Ethnology, Washington
ASAE = Annales du Service des Antiquités Egyptiennes, Le Caire
ASI = Archivio Storico Italiano, Firenze
AttiPontAcc = Atti della Pontificia Accademia Romana di Archeologia, Roma
AZ = Archäologische Zeitung, Berlin
BAC = Bulletin du Comité des Travaux Historiques et Scientifiques, Section d'Archéologie, Paris
BAEB = Bureau of American Ethnology, Bulletins, Washington
BAEO = Boletín de la Asociación Española de Orientalistas
BAFr = Bulletin de la Societé Nationale des Antiquaires de France, Paris
BArte = Bollettino d'Arte del Ministero della Pubblica Istruzione, Roma
BBA = Berliner Byzantinische Arbeiten
BCahA = Bibliothèque des Cahiers Archéologiques
BCH = Bulletin de Correspondance Hellénique, Paris
BICR = Bollettino dell'Istituto Centrale del Restauro, Roma
BIFAN = Bulletin de l'Institut Français d'Afrique Noire, Dakar
BIFAO = Bulletin de l'Institut Français d'Archéologie Orientale, Le Caire
BM = Burlington Magazine, London
BMC = British Museum, Catalogue of Greek Coins, London
BMed = Bulletin Medelhavsmuseet
BMFA = Museum of Fine Arts, Bulletin, Boston
BMFEA = Museum of Far–Eastern Antiquities, Bulletin, Stockholm
BMQ = The British Museum Quarterly, London
BSA = Annual of the British School at Athens, London
BSAC = Bulletin de la Societé d'Archéologie Copte
BSOAS = Bulletin of the School of Oriental and African Studies, London
CahArch = Cahiers Archéologiques, Paris
CahArt = Cahiers d'art, Paris

CAJ = Central Asiatic Journal, Wiesbaden
CEFEO = Cahiers de l'Ecole Française d'Extrême–Orient, Paris
CIO = Congrès International des Orientalistes
CPAM = Chinese Palace Museum
CRAIBL = Comptes Rendus de l'Académie des Inscriptions et Belles–Lettres, Paris
DK = Dresdener Kunstblätter
EAA = Enciclopedia dell'arte antica, Roma
EB = Encyclopaedia Britannica
Ench = Enchoria, Zeitschrift für Demotistik und Koptologie
EFEO = Ecole Française d'Extrême Orient
ERI = Edizioni Radio Italiana, Torino
ESC = Annales Economie, Sociologie, Culture
EUA = Enciclopedia Universale dell'Arte
FA = Fasti Archaeologici, Firenze
GBA = Gazette des Beaux–Arts, Paris
HJAS = Harvard Journal of Asiatic Studies, Cambridge, Mass.
IAAS = Institute of Archaeology, Academia Sinica
IAE = Internationales Archiv für Ethnographie, Leiden
IESS = International Encyclopedia of the Social Sciences
IFAN = Institut Français d'Afrique Noire, Dakar
INAH = Boletín del Instituto Nacional de Antropología y Historia de México
IPEK = Jahrbuch für prähistorische und ethnographische Kunst, Berlin
JabRGZK-Mainz = Jahrbuch der Römich-Germanischer Zentralkommission, Mainz
JARCE = Journal of the American Research Center in Egypt
JbAC = Jahrbuch für Antike und Christentum
JdI = Jahrbuch des deutschen archäologischen Instituts, Berlin
JEA = Journal of Egyptian Archaeology, London
JHS = Journal of Hellenic Studies, London
JRAS = Journal of the Royal Asiatic Society, London
JRS = Journal of Roman Studies, London
JSAcanistes = Journal de la Société des Africanistes, Paris
JSAm = Journal de la Société des Americanistes, Paris
MDA FA = Mémoires de la Délégation Archéologique Française en Afghanistan
MDAIK = Mitteilungen des Deutschen Archäologischen Instituts Abteilung Kairo
MdIK = Mitteilungen des Deutschen Instituts für ägyptische Altertumskunde in Kairo, Wiesbaden
MEFRA = Mélanges d'Archéologie et d'Histoire. Ecole Française de Rome
MemLinc = Memorie dell'Accademia dei Lincei, Roma
MGH = Monumenta Germaniae Historica, Berlin
MJBK = Münchner Jahrbuch der Bildenden Kunst
MM = Madrider Mitteilungen
MonPiot = Monuments et Mémoires publiés par l'Académie des Inscriptions et Belles Lettres, Fondation Eugène Piot
MPontAcc = Memorie della Pontificia Accademia Romana di Archeologia, Roma
NAC = Notiziario Arte Contemporanea

xv

NIFAN	=	Notes de l'Institut Français d'Afrique Noire, Dakar
NR	=	Numismatic Review, New York
NSc	=	Notizie degli scavi di antichità, Roma
OA	=	Oriens Antiquus
Öjh	=	Jahreshefte des österreichischen archäologischen Instituts, Wien
Or	=	Orientalia
RA	=	Revue Archéologique, Paris
RAA	=	Revue des Arts Asiatiques, Paris
RAC	=	Rivista di Archeologia Cristiana, Roma
RBK	=	Reallexicon zur Byzantinischen Kunst
RdE	=	Revue d'Egyptologie, Paris
REL	=	Revue des Études Latines, Paris
RPontAcc	=	Rendiconti della Pontificia Accademia Romana di Archeologia, Roma
RIASA	=	Rivista dell'Istituto Nazionale d'Archeologia e Storia dell'Arte, Roma

RM	=	Mitteilungen des deutschen archäologischen Instituts, Römische Abteilung, Berlin
RN	=	Revue Numismatique, Paris
RNA	=	Revista Nacional de Arquitectura, Madrid
RQ	=	Römische Quartalschrift für Christliches Altertumskunde und für Kirchengeschichte
RSO	=	Rivista degli Studi Orientali, Roma
RSP	=	Rivista di Scienze Preistoriche, Firenze
StE	=	Studi Etruschi, Firenze
USMB	=	United States National Museum, Bulletin, Washington
VFPA	=	Viking Fund Publications in Anthropology, New York
ZfE	=	Zeitschrift für Ethnologie, Berlin

For all other abbreviations used in this volume, generally those in common use and readily understandable, please consult the listings of the Encyclopedia of World Art.

PART I

THE ORIGINS OF ART AND THE ANCIENT WORLD

SUMMARY

FOREWORD: NEW TRENDS IN ARCHAEOLOGY

Recent archaeological research – not only at the level of theoretical writings – has broadened its spectrum of interest. Although the discipline's heuristic procedures were considered to be preparation for a knowledge of ancient art, today's idealistically-oriented "Kunstarchäologie," at least that which is founded on categories of "traditional" analyses of research on style, and its development in relation to the change in artistic form, has given way to new orientations in the sphere of human sciences. The goal of research has now become focused on the entire complex of man-made objects that connote a research unit, whether this be a building or a settlement. This is in order to obtain the data necessary for making a comparison with determined sociocultural models (a prevalent position among Anglo-Saxon scholars connected with the American functionalist anthropological school, and with A.L. Kroeber in particular) or with production methods (a position taken by Marxist archaeologists). This change is tied to the different approaches in methodology that have characterized the discipline in America – where archaeology and anthropology often coexist in the same university department – as well as those in Europe – where the tradition of humanistic study has placed archaeology in "Altertumwissenschaften" or, more rarely, into the orbit of historic-artistic disciplines. The deeper motivations of this phenomenon, which includes the adoption of European methods by American scholars, falls outside the realm of the present study.

The position of the so-called "New Archaeology" (particularly in the works of D.L. Clarke) begins with the acknowledgement that the fundamental procedures of the discipline, entrusted as it is to the intuitive skill of the individual, has so far avoided formalizing archaeological data in relation to the objective specificity of artifacts. On the contrary though, it is understood that analytical procedures make it possible, through the use of mathematical and informational instruments, to build up an entire hierarchy of entities, beginning with the common artifact and its specific attributes, and arriving at, through the establishment of synchronous events and associations, distinguishing the widest-ranging units, i.e., the culture, the cultural group, and the technological complex ("technocomplexe"). Analytical models provide for the approaches of an evolutionist, diffusionist, and functionalist position where the use of statistical and electronic computing procedures becomes indispensable. In this context, according to the needs of completeness, which the study of every culture requires, it is questionable to favor artifacts over artistic objects (considered only as sources of information quite apart from their expressive components). This obviously denotes a dependence on the heuristic, and at times aseptic, procedures of a certain school of American anthropology (as evinced by the writings of L.R. Bindford) and is in disagreement with the idealistic tradition of European research. Also in America, G. Kubler tries to react to this theoretical approach by vindicating the autonomy of the "life of forms" (as Focillon had defined it) while taking into account mathematical and linguistic procedures ("series and sequences"); this is done without verifying existing correlations – interferences – with other historical "series," leaving out those "traditional" problems tied to value or hierarchical judgments.

European science has quite recently, in the 1960s, introduced itself into this debate as a spearhead of "Kunstarchäologie," with an essay by R. Bianchi Bandinelli in which philological methods (including stylistic analysis) and historical interpretation were included in the "mirroring" ideological framework of Lukacsian derivation. In Italy, the ongoing debates among modern art historians, as well as anthropologists, has made it possible to develop themes relative to transitional periods, e.g., the formation of Roman art and the passage from Late Antiquity to the Middle Ages; or, relative to aspects of peripheral, subordinate, figurative cultures, e.g., Etrusco-Italic, in particular, in which the client/skilled-worker relationship was evidenced in regards to the appropriation of specific Hellenic cultural models – both ideological and figurative.

In Germany the validity of "structure research," stressed in a 1964 essay by F. Matz, seems to have lost its applicability today. The study of the representation of the human figure, understood as the symbolic ideal of beauty in a specific time and place, is considered a sort of "Kunstanthropologie" and, as such, a subsidiary means for arriving at the understanding of artistic form (E. Langlotz). On the other hand, once we have borrowed the idea of art as a system of signs from linguistics and semiotics (A. Borbein), the concept of "structure" (as Kaschnitz Weinberg insisted) would no longer single out eternal formal constants in historically objectified environments. Rather, it singles out the organization of the internal elements of a single or a group of works of art in a system that transforms and "generates" itself at different creative stages (as defined by Chomsky, with whom Francastel, for example, concurs). In brief, attention seems again turned towards the symbolic significance which artistic form takes on as a result of an immanent arrangement within historically determined creative forces, rather than, as in Italy, on

the historical significance that artistic production assumes as a manifestation of socially active groups in a dialectical sphere.

In France the prospects opened by the "New Archaeology" seem to have found the state of research more prepared for the aforementioned debate since recourse to epistemological references of linguistics and mathematics, especially in typological analysis, has been practiced for more than a decade. It is in any case by the milieu of the "Annales," always alert to progress in the field of human science, that the archaeology/anthropology relationship was pointed out as the theoretical crux of this type of research. Not without criticisms of the deductive procedures used by the "New Archaeology," this criticism had already been practiced in America (K. C. Chang). These problems, which had arisen in connection with prehistoric archaeology (or populations at the "anthropological" level), was popularized also in Italy in an attempt to apply the same methods to classical archaeology (A. Carandini). The sounder theoretical background possessed by Polish scholars of medieval archaeology made it possible, however, to refute the system worked out by Clarke, especially in regard to the degree of quantitative and qualitative truth of data and their interpretation, which changes according to the objective situation in which they are found (tomb-storeroom-settlement).

The situation of research in ancient art history seems, therefore, to have reached a crisis point: supporters of the "anthropological" school do not seem to have an orientation radically different from that of art historians. Having cleared the field of univocally dangerous interpretations (such as "Greek art as a religious phenomenon" à la Schefold) and of the introduction of aesthetic taste into the historical discourse, many levels are offered (for example by Ph. Bruneau) and at once the work of art becomes, as Bianchi Bandinelli writes, "a historical fact in itself, revealer of an acutal situation that would otherwise remain hidden." An approach of this kind, placed in a Marxist-derived "integral historicism" or "histoire totale" of the school of the Annales, regains for the method all the traditional heuristic procedures. The polyvalence of an artistic object, not only on the expressive, but also on the communicative plane, induces one to attempt all the systems of analysis, provided that one does not lose sight of the final objective of historical reconstruction. In this sense, attributionism, widely used in the study of figured ceramics (notwithstanding recent unreliable criticisms which excluded the most negative aspect of this procedure: "connoisseurship" of the mercantile type), still remains a necessary act of philology when other contextual data are lacking. On the other hand, an examination of the meaning of elements that emphasize content over form and of its transformation on a symbolic level (borrowed from the "iconological" school) tries to raise iconographical research from a purely philological antiquarian level. Considerations on the function of ancient artistic crafts has underlined the position of the artisan/artist: socially "free" in a colonial environment, but subjected to professional discipline and a series of conditioning processes imposed on him/her in the more complex system of the city/state. This system is one that consists of both a market, which takes advantage of intermediaries, and of a public building policy – an activity in which free labor and slave labor are independently inserted into economic history.

BIBLIOGRAPHY - *New Archaeology*: L.R. Bindford; Archaeology as Anthropology, American Antiquity, 28, 1962; J. Deetz, Invitation to Archaeology, New York, 1967; K.C. Chang, Rethinking Archaeology, New York, 1967; New Perspectives in Archaeology, edited by J.R. and L.R. Bindford, Chicago, 1968; K.C. Chang, Settlement Archaeology, Palo Alto, 1968; D.L. Clarke, Analytical Archaeology, London, 1968; Archéologie et calculateurs. Problèmes sémiologiques et mathématiques, Paris, 1970; J. C. Gardin, A propos de l'ouvrage de D.L. Clarke "Analytical Archaeology", RA, 1970, 1; R. Ginouvès, Archéographie, archéométrie, archéologie. Pour une informatique de l'archéologie gréco-romaine, RA, 1971, 1; Models in Archaeology, edited by D.L. Clarke, London, 1972; S. Cleuziou, J.P. Demoulle, Annie Schnapp, A. Schnapp, Rénouveaux des méthodes et théorie de l'archéologie, Annales ESC, 20, 1973; A. Schnapp, Archéologie, in Faire de l'histoire, Paris, 1974; J.C. Gardin, A propos de modèles en archéologie, RA, 1974, 2; S. Tabacyński, E. Plesczynska, O teoretycznych podstawach archeologii, Archeologia Polski, 19, 1974; A. Carandini, Archeologia e cultura materiale. Lavori senza gloria nell'antichità classica, Bari, 1975; Ph. Bruneau. Quarte propos sur l'archéologie nouvelle, BCH, 100, 1976; S. Tabaczyńsky, Cultura e culture nella problematica della ricerca archeologica, Archeologia medievale, 3, 1976.

Relationship between ethnoarchaeology and history of art: G. Kubler, The Shape of Time, New Haven, 1962; Primitive Art and Society, edited by A. Forge, London-New York, 1973; G. Kubler, History – or Anthropology – of Art?, Critical Inquiry, 1, 4, 1975 (trad. ital.: Prospettiva, 5, 1976; M. Cristofani, Storia dell'arte e acculturazione: le pitture tombali arcaiche di Tarquinia, Prospettiva, 7, 1976; G. Previtali, Introduzione a G. Kubler, La forma del tempo, Torino, 1976; S. Gruzinski, A. Rouveret, Histoire et acculturation dans le Mexique colonial et l'Italie méridionale avant la romanisation, Mélantiquité, 88, 1976.

Archaeology and history of art: R. Bianchi Bandinelli, Archeologia e cultura, Milano-Napoli, 1961; F. Matz, Strukturforschung und Archäologie, Studium generale, 17, 1964; G. von Kaschnitz Weinberg, Struttura, ricerche di, EAA, VII, 1966; Allgemeine Grundlagen der Archäologie, Handbuch der Archäologie, edited by U. Hausmann, München, 1969; A.H. Borbein, Gnomon, 44, 1972; R. Bianchi Bandinelli, Introduzione all'archeologia come storia dell'arte antica, Bari, 1975; Ph. Bruneau, Situation méthodologique de l'art antique, AntC, 44, 1975; E. Langlotz, Studien zur nordostgriechischen Kunst, Mainz, 1975.

Artistic work and crafts in the classical world: N. Himmelmann-Wildschütz, Ueber bildende Kunst in der homerischen Gesellschaft, Ak. der Wiss. und der Lit. in Mainz. Abhandlungen der geist-. und sozialwiss. Klasse, 7, Wiesbaden, 1969; T.B.L. Webster, Potter and Patron in classical Athens, London, 1972; B. d'Agostino, Appunti sulla funzione dell'artigianato nell'Occidente greco dall'VIII al IV sec. a.C., Economia e società della Magna Grecia (Atti XII Convegno di Studi sulla Magna Grecia), Napoli, 1973; G. Bodei Giglioni, Lavori pubblici e occupazione nell'antichità classica, Bologna, 1974; H. Lauter, Zur gesellschaftlichen Stellung des bildender Künstler in der griechischen Kunst, Erlangen, 1974; G. Colonna, Firme arcaiche di artefici nell'Italia centrale. RM, 82, 1975.

Archaeology in modern culture: N. Himmelmann, Utopische Vergangenheit. Archäologie und moderne Kultur, Berlin, 1976.

MAURO CRISTOFANI

PREHISTORY

THE GENESIS OF ART (PLATE 1a)

Even with the many new discoveries made recently, it still appears certain that figurative art appeared at a rather late period in the evolution of our species, during the Late Paleolithic period, towards the end of the last Ice Age, coming from those human forms known as "sapiens," to which modern man belongs.

The scarcity of information on discoveries of graphic or even sculptural artifacts found in the oldest deposits, dating back to the Mousterian Middle Paleolithic or even earlier cultural periods, do not allow us to speak of art in a "pre-sapiens" era. In fact, until now, the only artifacts found were: bone fragments and pebbles marked with parallel notches, found in Pre-Mousterian and Mousterian deposits, such as the bone covered with scrollwork found in Pech de l'Azé (Dordogne) in Acheulean layers; a stone with coarse hemispheric cavities, which covered one of the well-known Neanderthal burial places in La Ferrassie (Dordogne); marked bones from the same location; similar ones from La Quena (Charente), pebbles from Isturitz (Basses-Pyrenees); arabesques "a maccherone" drawn in clay in the caves of Pech-Merle (Cabreretz Lot), which caught the interest of the abbot H. Breuil, and others; in addition, a few fragments of ochre, possibly used for coloring, were found in several Mousterian deposits.

However, interest in this problem has been enthusiastically revived lately as a result of the studies done by P. Leonardi, which were based on the discovery of incisions made on pebbles and stone fragments, presumably intentionally, from the Mousterian layers of the Tagliente Shelter in the Lessini Mountains, near Verona. More evidence comes from France, particularly from pebbles found in Upper Paleolithic deposits in Terra Amata near Nice.

Up to this point we do not have any concrete evidence to support a possible pre-figurative origin of art ("pre-art" according to A. Leroi-Gourhan). Even the most ancient figurative examples found appear as expressions of a realism that display a remarkable level of technical and stylistic development. We may assume that any evidence that would link the first known manifestations of art to prefigurative graphic expressions has either been lost or has not yet been discovered. One can therefore accept the theories that liken the development of prehistoric art to that of children's art, or even more recent theories based on experiments carried out on young chimpanzees; these assume that in early men, as well as in apes, there is a potential aesthetic talent, displayed by marks and doodles, together with a certain interest in graphic forms and balance; in the hominoids this talent has developed into true forms of art. These are, of course, merely theories, and are not based on concrete evidence.

BIBLIOGRAPHY - P. Leonardi, Les incisions pré-leptolitiques du Riparo Tagliente (Vérone) et de Terra Amata (Nice) en relation au problème de la naissance de l'Art, Mem. Linc. Classe di Scienze fisiche, matematiche e naturali, s. VIII, XIII, fasc. 3, 1976, pp. 35-104

DANIELA COCCHI

GENERAL ISSUES IN PALEOLITHIC ART

Chronology — The abbot Henry Breuil's well-known outline of two parallel cycles has been modified several times by its author and has received harsh criticism of its organization, which appeared to be overly pragmatic, as shown by the discovery of the plaquettes of Parpalló in the Solutrean layers. This criticism began with Anette Laming, who replaced Breuil's parallelism of the cycles with a linear evolution in three stages, an early stage (the first phase of Breuil's Aurignacian-Perigordian cycle), an intermediate stage (the last stages of the above-mentioned cycle, and the first of the Solutrean-Magdalenian period) and a final stage (Magdalenian "polychromes"). André Leroi-Gourhan's ideas represented a revolution of thought. He developed a system with four periods: I, Aurignacian I-IV (c. 30,000 - 27,000 B.C.); II, Gravettian, up to the beginning of the Solutrean (c. 25,000 - 18,000); III, Solutrean and Early Magdalenian; IV, consisting of two phases, an early one with Magdalenian III and IV, and a recent one with Magdalenian V and VI (these last periods approximately between 20,000 and 10,000 B.C.). Seventy-eight percent of the prehistoric works of art, both cave paintings and figurines, correspond to style IV.

In Spain, F. Jordá followed Leroi-Gourhan's theories, but reduced to a minimum the number of paintings and engravings attributed to the Aurignacian-Perigordian period, classifying most of them in the Solutrean and early Magdalenian Cantabrian. Nevertheless, the stairshaped engravings in the cave of Conde (Tuñán, Asturias) are apparently Aurignacian, as well as other similar engravings that are covered by a layer of that period. Also similar are the still unpublished engravings of Cova Rosa (Ribadesella, Asturias) displaying a bird, the lines of the cave of Las Mestas (Trubia) and those in the entrance of the cave of La Venta de la Perra. However, the chronology of the so-called "polychromes" was changed by the fact that the entrance to the room of Altamira was closed in the Magdalenian III, and by the discovery of the cave of Tito Bustillo; this confirmed the dating of the deposits to the earlier period mentioned above.

P. Ucko and A. Rosenfeld believe that the art of the Upper Paleolithic period is as heterogeneous as the archeological cultures that accompany it, with great

diversity of techniques and conventions, so that the supposed evolution from the simplest to the most intricate appears to be false, and the 20,000 years duration of this period to be of great complexity.

J. Gonzáles Echegaray has attempted chronological precision based on statistical studies of the fauna represented, especially at Las Monedas and at Las Chimeneas de Puente Viesgo (Santander), while H. de Lumley has attempted to draw conclusions, for the purposes of dating, from the changes in proportions of the different parts of the bodies in the animals over succeeding time periods.

Significance of Paleolithic cave painting. — In the last few years the old hypotheses, which explained it with the concept of "art for art's sake," of *"sympathetic" magic*, and of totemism, or of the magic of the hunt and fertility, have not been completely abandoned. Nevertheless, new hypotheses have developed, and Leroi-Gourhan deserves the credit for a total critical revision through the inventory and the analysis of paintings and engravings in each cave and their arrangement; also the study of the distribution and frequency of animals, of signs, and of the rare representations of humans. The associated figures, complementary or opposed, refer to two main themes: one (A) of horses, with masculine significance, and the other (B) of bison, displaying bulls and women, of feminine significance; both occupy the central areas, since the caves appear to be divided into seven parts, each with a particular meaning. The first of these contain symbols, followed by communicating passages and entrances to side passages, clefts and alcoves; then a final area and the central part of the painted walls in the large galleries; finally, marginal areas of these and the insides of side passages, clefts and alcoves. The caves appear to be organized sanctuaries, while the juxtaposition, opposition, coupling or association of masculine or feminine symbols apply also to the signs located in a peripheric area, signifying male sexual organs (vertical lines, sticks, dots) and female sexual organs (shaped like ovals, circles, triangles and shields). The latter are more frequent in the central groups, the former in the entrances. Both Laming and Leroi-Gourhan believe that all the groups of animals and signs have a narrative value, and that the positioning of one figure over another establishes only a direct relation to these figures, and not an orderly succession. Consequently, the caves appear to have been painted according to a systematic plan and represent the organized world of the Paleolithic man. The wounds of the animals do not represent the magic of the hunt, but symbols, in which the button-hole has a feminine value and the javelins or the arrows a masculine one. In fact, there appears to have been a unified idea of fertility dominating everything, thus denying the purely religious significance or the idea of the magic of the hunt. The foregoing is principally from Laming, who rather believes in an order of social and other relations with the woman, who represents the universal principle of fertility, which always occupies the central areas.

According to Leroi-Gourhan, hands convey a feminine significance, given the fact that they are combined with masculine symbols, but they can also be related to hunting activity, as can be concluded from ethnographic comparisons. Dr. A. Sahly believes that the mutilated hands of Gargas indicate a sanctuary for the cure of diseases of the fingers.

Despite the great popularity of Leroi-Gourhan's research, severe criticisms of him have been made, based mainly on the pragmatism and the rigidity of his "ideal *scheme.*" Such a scheme is not applicable to all caves and the many exceptions end up compromising the validity of the theory. Accordingly, Ucko states that the main obstacle to understanding the meaning of Paleolithic art is our lack of knowledge in the use that the artists made of the cave, although it seems that a number of activities took place inside the caves, as is proven by footprints, some of which belong to children.

It is clear that animals were painted or engraved according to specific choices, even though the reasons might have been different for each cave. In this regard, Karl J. Narr and Hermann Mueller-Karpe supported a "commemorative" interpretation - based on Bauman's old idea that this art reflected the narration of hunting episodes - and believe that history, and not magic, should be taken into consideration, and that commemorated facts did actually happen. Abbot Glory, on the contrary, reproposes a magical interpretation by means of the cult of the "ongons."

Finally, the astronomical hypothesis should also be considered; according to this, the spots, lines, and other signs have a meaning related to the moon, the stars, the zodiac, and numbers. This hypothesis was perfected by Alexander Marshack.

It is significant that representations of landscapes or of any vegetal element never occur; this, together with the scarcity of the human figure, seems to indicate the need for a not so realistic interpretation.

It can be concluded that any rigid interpretation is valid only for a few paintings or engravings that can result, in general, from very different intentions, including the simply artistic and decorative one. More specifically, they can be the expression of totemism or magic, or of religious myths and traditions, or even of motivations completely unknown to us.

Geographic variations. — The recent discoveries stress our lack of knowledge of essential aspects of Paleolithic art, such as its extension, unity, and diversity; the centers of its origin and areas of diffusion; the formation and development of schools repeating its models and conventions; and the possibility that the differences and similarities among different centers reflect, on one side, regional and geographic factors and, on the other, temporal logicality. This issue has been pointed out by Paolo Graziosi, who defined what he then named the "Mediterranean province" (see below), a concept to be completed by considering the Spanish findings of Pedraza (Segovia), Los Casares and La Hoz (Guadalajara), Maltravieso (Cáceres), Reguerillo (Madrid), El Niño (Albacete), Penches and Ojo Guareña (Burgos), and Escoural (Portugal), which are quite distant from the Cantabrian centers.

Geographical continuity does not necessarily produce homogeneous cave painting, as there are at times close resemblances among very distant caves, while much closer caves are significantly different; an example is the similarity between Santimamiñe and Niaux or between Arenaza and Covalanas, while Fontanét, so close to Niaux, is different from it, as Cullalvera differs from the very close Covalanas or La Haza; this is true even if other than time factors are considered.

Another aspect to be redefined is that of the sanctuary closely connected with the darkness and the mystery of the depth of the caves. Leroi-Gourhan mentioned the external sanctuaries in Bourdeilles, Le Roc-de-Sers, Laussel, Cap Blanc, Commarque, La Magdeleine, Angles-sur l'Anglin and Mouthier; to these one should add Chufin (Santander), Coimbre (Asturias), and the well-known cases of Hornos de la Pena and Santimamiñe, all in Spain, and also El Niño, Atapuerca, and Venta de la Perra. This last group of Spanish engravings has nothing to do with the sculptured shelters in Dordogne and must be dated in a much earlier period, perhaps to the Aurignacian.

In Spain, from a geographical point of view, it is possible to identify a main area of paintings in the Cantabrian region, from the Bidascoa to the Asturias; a second area in the interior with fewer paintings, which borders on the eastern area of cave painting; and a third area, Mediterranean, in the provinces of Cadiz and Malaga, extending through painted or engraved plaques to the eastern coast.

Protection of cave paintings — In the last few years there has been a great awakening of interest in the conservation of caves containing artistic manifestations, resulting in their closing to the public. Unfortunately, in some cases serious damage had already taken place (such as at Lascaux); in other cases damage was done immediately after the discovery, such as at Fontanet or at the new galleries of Niaux. The situation of other caves has been studied, such as those of El Buxu, San Román de Candamo or Altamira; the "Santander Symposium" has taken into consideration the general measures that are required. In France, in the Ariège, under the direction of Jean Clottes, instruments to measure the changes in temperature and humidity and the changes caused by human presence have been installed at Niaux; these steps represent the maximum progress possible at this time.

BIBLIOGRAPHY - A. Leroi-Gourhan, Préhistoire de l'art Occidental, Paris, 1964, 2 ed., 1970; P. Ucko, A. Rosenfeld, L'art. paléolithique, Paris, 1966; K. J. Narr, Handbuch der Urgeschichte I, Berna, 1966; H. Müller-Karpe, Handbuch der Vorgeschichte I, Munich 1966.

Chronology: A. Laming-Emperaire, La signification de l'art rupestre paléolithique. Méthodes et applications, Paris, 1962; F. Jordá Cerda, Los comienzos del Paleolítico superior en Asturias, Anuario del Instituto de Estudios Atlánticos, Madrid-Las Palmas, 1969; Sobre los ciclos del arte rupestre cantábrico, Asociación Española para el progreso de las Ciencias. Congreso Luso-español, Madrid, 1964; A Beltrán, Novedades en el arte paleolítico español, XIII Congreso Nacional de Arqueología, Zaragoza, 1975; Los grabados de las cuevas de la Venta de Lapperra y sus problemas, Munibe, XXIII, 2-3, 1971; M. Almagro, M.A. Garcia Guinea, M. Berenguer, La época de las pinturas y esculturas policromas cuaternarias en relación con los yacimientos de las cuevas: rèvalorización del Magdaleniense III, Santander Symposium, Santander, 1972; J. Gonzales Echegaray, Sobre la datación de los santuarios paleolíticos, Simposio de Arte Rupestre, Barcelona, 1966-1968; Ñotas para el estudio cronológico del arte rupestre de la Cueva del Castillo, Santander Symposium, Santander, 1972; H.de Lumley, Proportions et construction dans l'art paléolithique: le Bison, Simposio Barcelona, cit.

Meaning: A. Laming-Emperaire, Art rupestre et organisation sociale, Santander Symposiun, cit.; Pour une nouvelle aproche des sociétés préhistoriques, Melanges... offerts a M. André Varagnac; A. Leroi-Gourhan, Considerations sur l'organisation spatiale des figures animales dans l'art parietal paléolithique, Santander Symposium, cit.; Les signes parietaux du Paléolithique Superieur franco-cantabrique, Simposio Barcelona, cit.; P. Casado, Los signos en el arte parietal paleolítico de la Península Iberica, Caesaraugusta, 37-38, 1973; Leroi-Gourhan, Les mains de Gargas. Essai pour une étude d'ensemble, Bulletin de la Société Prehistorique Francaise, LXIV, 1967; A. Sahly, Les mains mutilées dans l'art préhistorique, 1966; A. Glory, L'enigme de l'art quaternaire peutelle être resolue par la theorie du culte des "ongons"? Simposio Barcelona, cit.; A. Marschack, Notation dans les gravures du Paléolithique Supérieur: Nouvelles methodes d'analyse, Burdeos, 1970; The roots of civilisation: The cognitive beginnings of man's first art, symbol and notation, New York, 1972. On anthropomorphisms: Uçko-Rosenfeld, Anthropomorphic representations in Paleolithic Art, Santander Symposiun, cit.; W. Haensch, Die Paläolithischen Menschendarstellungen aus der Sicht der somatischen Anthropologie, Bonn, 1968.

Geographic variations: P. Graziosi, L'arte dell'antica età della pietra, Firenze, 1956; A. Beltrán, Nuevos descubrimientos, cit., and El arte rupestre del resto de la cornisa cantábrica, Santander, 1976; El problema de los santuarios exteriores paleolíticos en España, Santander, 1976.

Protection: J. Clottes, Quelques observations sur la conservation des grottes ornées, à propos de deux galeries magdaleniennes récemment découvertes en Ariège, Caesaraugusta, 37-38, Zaragoza, 1973-74. In "Santander Symposium" cit. ss. con trabajos de Garcia Lorenzo, Sarradet, G. Laporte and J. Fayard.

ANTONIO BELTRÁN

NEW DATA ON THE PALEOLITHIC FIGURATIVE WORLD, WITH PARTICULAR ATTENTION TO WESTERN EUROPE (PLATE 1b-c)

In the decade from 1960 to 1970, the patrimony of paleolithic art discoveries, and consequently the amount of material to be studied, was extraordinarily enriched, particularly in the classical areas of presence and distribution of these phenomena, which are so important in understanding the cultural developments of prehistoric mankind in Western Europe. The following review will point out the most relevant data in a progressive geographic order, from south-west to north-east, starting from the Iberian peninsula and France and continuing to the U.S.S.R., while Italy will be examined separately.

In the Basque province of Guipúzcoa, the discovery of Altxerri (Orio), made known in 1964 but studied only later, posed some problems regarding its content: an area of engravings displaying bison, goats, two reindeer, a fox, four fish, one anthropoid, and symbols; a double row of paintings and engravings with sixteen animals, bison, a goat, and a bull; another one with a bison; then six more bison, two horses, and three goats in another group; finally a horse, a bison, and reindeer; for Leroi-Gourhan all of the figures are of his style IV, while many engravings are apparently of the Solutrean period. The cave of Ekain (Cestona) was discovered in

1969 and contains one of the most beautiful group of paintings of horses in Paleolithic art. These can be placed in the Magdalenian III, within style IV of Leroi-Gourhan, as indicated by the proportions of the animals, very close to reality, by the double lines of the shoulders, and by the "M" in the ventral area; the horses are painted in so-called "polychromy" (which, in our opinion, does not really exist, since there are only two colors, whose different intensity, together with the tones of the wall, give the impression of several chromatic variations; this is true for the totality of the so-called polychromes). The figures are contemporary with the best black figures of Niaux (Magdalenian IV and V); to be noted are the parallel lines on the legs of the horses, which appear to be either donkeys or wild horses. The animals total thirty-three horses, ten bison, two bears, two deer, four goats, two fish, perhaps a rhinoceros (very unclear), and some signs; the colors are red and black, in straight or thick lines; the tones are even, giving at times a mottled and bicolored effect; the incisions are light.

In Biscay, in 1973, the cave of Arenaza (Galdames) was discovered, with a small room in which are ten figures in red, with a smooth coloring technique, as in Covalanas and in La Haza, together with some black lines; in a passageway are found a profile of a bull in red, also engraved, a deer painted by a dabbing technique, and the head of a bull, engraved. Although Leroi-Gourhan dates these in his style III, the early Magdalenian, based on the smeared areas painted over the area that had been done by dabbing, and which linked the spots, this technique could also be dated in the middle or final period of Breuil's Aurignacian-Perigordian cycle.

In the province of Santander, new paintings and engravings are constantly being discovered in caves that are already known, especially in the caves of Castillo (by E. Ripoll and others) and Las Chimeneas (Gonzáles Echegaray), and in others not yet published. In the cave of Cudon (Torrelavega), which has Aurignacian-Mousterian Cantabrian deposits, many engraved fragments were found at the bottom of the cavity. La Peña del Cuco (Castro Urdiales) and Cobrantes (Valle de Aras) were discovered in 1966, both with deer, goats, and other quadrupeds, the second showing what appears to be an anthropoid, all engraved. The cave of Chufin (Riclones), found in 1972, is of exceptional importance: it shows a complex of engravings in the vestibule, visible in natural light, of at least two different periods. Internally, it shows paintings in red and engravings representing horses of a very ancient appearance, very similar to the dabbing technique, together with an extraordinary collection of "tectiforms" and other signs; the paintings and deep engravings belong to the Aurignacian period.

The new findings in the Asturias show this area to have its own peculiarities. Still to be published is the cave of El Queso (Llonín), with an impressive and crowded collection of geometric symbols in red and occasionally in black; some engravings and a very few figurative representations, such as of goats and horses. The caves of Peñamellera Alta have engravings of vulvas and of a large bison, deeply incised, as well as deer, horses, a goat, and fish, done very lightly. The deep engravings may be very old, the lighter ones more recent and belonging to the Magdalenian III-IV. The cave of El

Trauno has deep lines and a net-like form, difficult to date although apparently very old, particularly in view of the subsequent finding of a fragment of assagai belonging to the early Magdalenien Cantabrian period. La Riera (Llanes) has a series of red colored spots or finger imprints, arranged in string-like rows; Herrerias, inadequately publicized up to 1972, has 22 symbols or groups of symbols, mostly in the form of a grille, which have been dated by Jordá between the Magdalenian IV and the Azilian. The problem of the red spots and of their dating in the Mesolithic period is still unresolved since it was first proposed by the Abbot Breuil at Niaux and other locations. Finally, there is a non-figurative engraving in the cave of Las Mestas (Las Regueras) that can be placed in the Aurignacian period.

One of the most extraordinary discoveries of cave paintings is that of Tito Bustillo (Ardines, Ribadesella) in 1968. Most of the paintings and engravings are composed in one room and its vestibule, while a selection of abstract symbols in red is to be found at the end of the final passageway. The most important animals are outside of the room; a dark red ox and a violet horse measuring 1.58 meters, are to be found there. Inside, there is a linear arrangement of deer and oxen formed in shades of black. These belong to the Magdalenian III-IV; on the large panel, in two shades of red and bordered in black, is a figure representing a horse, similar to those of La Pasiega, Le Portel, and Fontanet, and dated by Brueil at the end of the Aurignacian-Perigordian period. In the center, an exceptional collection of about twenty animals, parts of others, and numerous engravings; the entire wall is painted in red, possibly the preparation of a background, or perhaps the remains of paintings that were even older, or not clearly defined, as in the case of the ceiling of the main room of Altamira. The animals are essentially horses, reindeer, and other types of deer; noteworthy are a two-meter long reindeer and two horses in an even violet, outlined in black; in addition there is a horse's head in black and numerous tectiforms. At more than 500 meters from the main room, there are red symbols, spots, string-like forms, and a series of vulvas; some of these are almost realistically natural, while others show a degree of simplification. Positioned in time, these symbols should be associated with the red animals of La Lloseta, which is joined to the cave of Tito Bustillo by an almost inaccessible passageway containing line drawings of two deer and a horse. There is also an aggregation of red Aurignacian-Perigordian lines, another of the Magdalenian III-IV, with fine and wide lines in black; and the last, unless we consider these figures to be older (as will be necessary for those of Altamira), a bicolored grouping of large proportions of an even violet, outlined in black, of the Magdalenian V-VI.

Continuing with the recent discoveries in the Asturias, the cave of Las Pedroses (El Carmen, Ribadesella) must be noted. This cave, which has been given little notice, contains figures of deer or goats, and possibly a horse without the head, in an even red, together with numerous engravings. The Cova Rosa cave (Ribadesella), with a deeply cut engraving of a bird done in the same style as the figures in the cave of Conde (Tuñón), is similarly virtually unknown. The cave of Ania (Las Regueras), with a deposit dated between the Magdalenian Middle Cantabrian and the Azilian, was discovered in 1975. A painting of a bi-

colored bison can be seen in the vestibular area in natural light, done in red with a black outline, and also red patches and spots. This can be compared to the bicolored examples of Tito Bustillo already mentioned.

Many caves exist outside of the Cantabrian zone, throughout the peninsula, widely dispersed and without artistic unity – some already well-known, such as Penches and Atapueca (Burgos), El Reguerillo (Madrid), Los Casares and La Hoz (Guadalajara), La Pileta and the Andalusian grouping of Malaga and Cadiz. Nevertheless, new engravings and paintings have been discovered in many of these, while other caves have been discovered that enlarge the geographic area of the Spanish Paleolithic art. Such is the case of Ojo Guareña (Burgos), located in an extensive Karstic area; this Palomera cave has a room with black paintings that begin with a deer and continue with horses and bulls, a proboscidean, and various other animals; they reveal accentuated stylization, unusual forms, and numerous black triangles, which alternate with the figures. We may even ignore the style and the difficulties of dating, but they are without doubt Paleolithic paintings. At Penches (Oña, Burgos), new engravings have been discovered, though not yet published. In the cave of La Griega (Pedraza, Segovia), a fine engraved horse's head, very similar to that of Los Casares, was recently found. In this cave, and in that of La Hoz, we noted many more engravings than were originally made public in 1935. Still, in spite of their geographic closeness, we were not able to establish a connection with Levantine art. The same holds true for the cave of El Niño (Aina, Albacete), discovered in 1970, with seventeen paintings in vivid red, only 14 meters away from the entrance; they measure from 13 to 57 centimeters and portray deer and goats. Below the opening of the cave, and in the ravine, some remains of Levantine paintings have appeared, one of which seems to portray a warrior. Almagro Gorbea connects these paintings with the III period of Leroi-Gourhan, but they may be much earlier.

An anomolous and interesting discovery is that of the cave of La Moleta de Cartagena (Sierra del Montsiá, Tarragona), in 1964, which contained a black bull, positioned vertically, next to an archer of apparent levantine type. The bull appears to be of Graziosi's "Mediterranean" style, and Ripoll believes we could be dealing with a very old phase of levantine art, in which the human figure is portrayed in a stylized manner, while the bull continues the style of the Mediterranean Paleolithic art. The unusual geographic locations, in the south of Cataluña, raises some doubts about this interpretation.

Passing by the interesting caves of Maltravieso (Caceres) and Escoural (near Evora) – the former with new discoveries and the latter with an impressive collection of mutilated hands – the findings of Nerja (Malaga) are worthy of mention, with fish, possibly dolphins, various outline drawings, and a protrusion of the wall transformed by painted areas into an elephant's head. Also noteworthy is the recent discovery of the cave of El Toro (Malaga), that has lines of red color in the entrance, and as a central figure a headless bull, in dark red, and in the background two spots of the same color; the figure is in an archaic mode, although it is considered to be in style III of Leroi-Gourhan. New engravings have also been found at La Pileta, at least a

deer and a goat, and a study conducted by Lya Dams on the entire cave sector is under way.

Turning our attention from Spain to France; in addition to the important discoveries of Rouffignac (1956) and Villars (1958), we must mention the cleaning of the paintings of Font de Gaume, the studies of the engravings of La Marche and the publicizing of the little-known complex of Marsoulas. The author of this essay has made some discoveries and published his findings concerning the Le Poretel, Bédeilhac and Ussat-les-Eglises systems (important among these are the new bison of Bédeilhac and the arrangement of Ussat), while other researchers have published all of the findings of Pech Merle.

Items of significance at Niaux are new figures in the "Grand Dôme," finger marks, red club-shaped forms, lines, and two black horses, made public for the first time in 1969. In the same year the Cartailhac gallery was discovered, in which three painted horned goats are shown while fleeing; also a black bull (finished in red?) and a dorsal line of a bison, all drawn in very thin black lines. In 1970, the "réseau René Clastres" was found, featuring traces of human footprints, a weasel and horse in black, the dorsal line of a bison, an incomplete bison and another, partially covered by a stalagmite. In 1966 we discovered a black bison, noticeably faded, where the "Salon Noir" and the "Grande Galerie" meet. The figures in black are almost completely of the Magdalenian III–IV; the red figures pose some problems as they must be dated with the black ones when they are found together, and yet the ones in the deep gallery up to the terminal lake appear to be Early Azilian or Azilian. The black animals of the Dôme and the Cartailhac and Clastres galleries, together with some figures of the deep gallery and of I Marmi, may be of the late Magdalenian, based on comparisons that have been made with other artifacts.

The cave at Fontanet (Ornolac, Ussat-les-Bains), discovered in 1972, has been saved from destruction by closing it to the public. It contains several human handprints and footprints, both of children and adults; flintstones, numerous light engravings of bisons, some symbols, a cluster of two black bison, realistic human heads seen in profile, and a number of red spots. Another panel contains various vertical and horizontal lines, a feminine symbol, and five club-shaped forms. Facing this is a beautiful bicolored bison in an even red color bordered in black, as in other caves already mentioned. Most of the paintings can be dated in the Magdalenian IV, with the problem of the bicolored figures still to be fully resolved, although it is likely they are from an earlier period.

Some caves with prehistoric art have been found in the department of Lot, such as that of Pergousset (Bouziès-Bas), in 1964. This cave consists of a long passageway with engravings of style IV of Leroi-Gourhan; it features a goat, various groups of bison, a horse, a doe, vulvas, a man whose head has been replaced by a bison's tail, the head of an elk, and numerous symbols. The cave of Les Escabasses (Thémines), discovered in 1965, has about a dozen figures in black, some badly deteriorated, portraying horses, a bison, a goat, a reindeer, and a duck-like bird, similar to that of Labastide; vertical symbols are found throughout from the entrance to the end of the cave. All of this may correspond to Leroi-Gourhan style IV. The cave of Rou-

cador, at Thémines, was uncovered in 1961 but remains practically unknown because of the death of the Abbot Glory, who was studying it. It contains imprints of hands in the negative and small very fine-lined engravings; the hands, red or black, have long thin fingers. This chamber can be assigned to an early period; the animals are perhaps Leroi-Gourhan style II-III. Finally, the cave at Les Fieux (Miers, Lot), discovered in 1965, contains the strange portrayal of a goat, six hands in red and one in black, in the negative, and vertical lines with little dots.

The Derouine cave (Saulges, Mayenne), discovered in 1967, contains paintings of a mammoth, a horse, bison, a horse's head, and symbols in line and oval form, all in black, of Leroi-Gourhan style III.

In Dordogne, one should mention the cave of Sous-Grand-Lac (Meyrals), near Bernifal. It contains poorly conserved engravings, including one of a man with a rounded head, arms extended and with a long sexual organ; in a niche is a horse, in poor condition, and two symbols; in a nearby cavity, which has been called that of the Bison, a poorly conserved hand in red. La Forêt (Tursac), practically unknown before 1968, contains some symbols, a goat, and three reindeer or deer, and as many horses. The figures measure only 15 to 20 centimeters and are of the recent Leroi-Gourhan style IV.

Finally, the yet to be publicized cave of Massat in the Ariège deserves a mention, with its numerous light engravings, animals of many types, and anthropomorphic figures, copies of which have been shown by R. Gailli. At Ségries (Basses Alpes), an engraved bison was discovered in 1963 and given attention in 1968 by H. de Lumley, who dates it in the Leroi-Gourhan style IV. In the mountains of Foix, the Cave of the Horse has red lines and the engraving of a horse.

In West Germany one of the most extraordinary discoveries was that of Gönnersdorf (Coblenz), during the digs of 1968; located were a small number of bones and ivory of the Magdalenian V, eleven female statues (or remains thereof), and about 500 engraved segments of slate, in which stylized female forms predominate, but which also contain mammoths, horses, more rarely rhinoceros, oxen, a reindeer (?), a wolf, fish, and some non-figurative images. In the engravings of female figures protruding breasts and buttocks are portrayed while the head is missing, and in most instances the legs and arms as well. In many cases the women are grouped in twos or threes. Also from Germany the female figure of Nebra (Halle), as well as the two from Oelknitz in the Saal valley, must be mentioned. The chronology of many of these figures will be determined by the dates obtained with Carbon 14 by Willendorf, of 28,890 in layer 4 and 30,050 in the fifth, or that of 23,650 for the late Aurignacian of Dolni Vestonice.

In the U.S.S.R., there was a sensational discovery, in 1961, of a cave at Kapowa, with paintings in red of a mammoth, a rhinoceros, horses, and tectiforms; these have a close relationship with those of western Europe and can be considered Leroi-Gourhan style III or early style IV; interesting questions could be raised concerning the dating in the Azilian period of some of these symbols. Since then, no other discoveries have been made outside of those in Siberia. The engravings of the Angara River and those of Lena, Amur, and Tom must be attributed to the Mesolithic, the Neolithic, or the Bronze Age. It still remains difficult to determine a chronology for the elks studied by Okladnikov.

In regard to sculptures, we must mention the small female statue of Manpazier (Dordogna) and the studies on the overall Spanish Cantabrian area due to the efforts of I. Barandiaran and Maria S. Corchon. Ms. Corchon has dedicated herself particularly to the Asturian discoveries and to the pebble of La Colombière with many animals positioned one over the other.

BIBLIOGRAPHY - *Spain*: J.M. De Barandiarán, La Cueva de Altxerri y sus pinturas rupestres, Munibe, 16, 3-4, 1964; F. Fernandez Garcia, Una pintura paleolítica gigantesca de bisonte en la cueva de Altxerri (Guipúzcoa), IV Symposio de Prehistoria Peninsular, Pamplona, 1966. A. Beltrán, Avance al estudio de la cronología del arte parietal de la cueva de Altxerri, ibidem; La cueva de Altxerri y sus grabados y pinturas rupestres; aportación al problema del arte parietal solutrense, "Congresso dell'Unione internazionale delle scienze preistoriche e protostoriche."

Prague: 1966; Nota sobre la técnica de los grabados de Los Casares y Altxerri, Simposio de Barcelona, cit., M. C. Alcrudo, Nueva interpretación de una cabra grabada en la cueva de Altxerri, Estudios del Departamento de Prehistoria . . . de Zaragoza, I, 1972; J. M. De Barandiarán, J. Altuna, La cueva de Ekain y sus figuras rupestres, Munibe, XXI, 4, 1969; Raul Lion Valderrabano, El caballo en el arte cántabro-aquitano, Santander, 1971; J. M. Barandiarán, La cueva de Ekain, Guipuzcoa, España, IPEK, 1970-73, 23; I. Barandiarán, Representación de caballos en la cueva de Ekain, Estudios de Arqueología Alavesa, VI, Vitoria, 1974; M. Grande, Las pinturas prehistóricas de la cueva de Arenaza (Galdames), Revista Vizcaya, 34, 1972; E. Ripoll, La cueva de las Monedas en Puente Viesgo, Santander, Barcelona, 1972; M. A. Garcia Guinea, J. Gonzales Echegaray, Découverte de nouvelles representations d'art rupestre, dans la grotte de El Castillo, Bulletin de la Société Préhistorique de l'Ariège, XXI, 1966; Ripoll, Un palimsesto rupestre de la cueva del Castillo, Santander, Santander Symposium, cit.; La cueva de las Monedas en Puente Viesgo Santander, Barcelona, 1972; J. Gonzales Echegaray, Pinturas y grabados de la cueva de Las Chimeneas. Puente Viesgo, Santander, Barcelona, 1974; A. Begines, El yacimiento y los "macarroni" de la cueva de Cudon, La Prehistoire. Problèmes et tendences, Paris, 1968; M. A. Garcia Guinea, Los grabados de la cueva de la Peña del Cuco, en Castro Urdiales y de la cueva de Cobrantes (Valle de Aras), Santander, 1968; M. Almagro Basch, La cueva de Chufín, Bellas Artes, 73, IV; Las pinturas y grabados rupestres de la cueva de Chufin, Riclones (Santander), Trabajos de Prehistoria, 30, Madrid, 1973; J. A. Moure, G. Gil, Noticia preliminar sobre los nuevos yacimientos de arte rupestre descubiertos en Peñamellera Alta (Asturias), Trabajos de Prehistoria, 29, Madrid, 1972; M. Mallo Viesca, J. M. Diaz, Las pinturas de las cuevas de la Riera y de Balmori, Zephyrus, XXIII-XXIV, 1972-73; F. Jordá, M. Mallo, Las pinturas de la cueva de las Herrerías (Llanes, Asturias), Salamanca, 1972; M. R. Gonzales Morales, El grabado rupestre paleolítico de la cueva de las Mestas (Las Regueras), XIII Congreso Nacional de Arqueología, Zaragoza, 1975; M. Mallo Viesca, M. Perez, Primeras notas sobre el estudio de la cueva del Ramu y su comunicación con la Lloseta, Zephyrus, XIX-XX, 1968-69 (I nomi di Tito Bustillo = Ramue Lloseta = Maria); M. Berenguer, La pintura prehistórica de la cueva de Tito Bustillo, en Ardines (Ribadesella), Boletín de la Real Academia de la His-

toria, CLXIV, 1, 1969; tradotto in tedesco, Oviedo, 1971; A. Beltrán, M. Berenguer, L'art pariétal de la grotte de Tito Bustillo (Asturias), L'Anthropologie, 73, 7-8, 1969; Fr. F. Soria, Análisis estético de las pinturas prehistóricas de El Ramu (Ribadesella), Archivum, XIX, Oviedo, 1969; A. Beltrán, Las vulvas y otros signos rojos de la cueva de Tito Bustillo (Ardines, Ribadesella), Santander Symposium, cit.; F. Jordá, M. Mallo-M. Perez, Los grottes Pozo del Ramu et de la Lloseta, Prehistoire Ariegeoise, Bull. Soc. Preh. Ariège, 25, 1970; F. Jordá, Avance al estudio de la cueva de la Lloseta (Ardines, Ribadesella, Asturias), Oviedo, 1958; M. Berenguer, Arte en Asturias de la cueva de Candamo al palacio ramirense del Naranco, Oviedo, 1969; in Les Pedroses. Leroi-Gourhan, loc. cit. 2 ed.; F. Jordá, El arte rupestre paleolítico de la región cantábrica: nueva secuencia cultural, Prehistoric art of the Western Mediterranean and the Sahara, Chicago-Barcelona, 1964; F. Jordá, Los comienzos del pal. sup., cit.; Sobre ideomorfos de haces de líneas y animales sin cabeza, Valcamonica Symposium, Capo di Ponte, 1975; Per la grotta di Ania (Las Regueras) comunicazione inedita al Congresso nazionale di archeologia, di Vitoria, ottobre 1975, by J. M. Gómez de Tabanera, M. Perez and J. Cano; B. Osaba y Ruiz De Erenchun, J. L. Uribarri, El arte rupestre en Ojo Guareña: Sección de pinturas, Burgos, 1968. F. Jordá, Nuevas representaciones rupestres de Ojo Guareña, Burgos, Zephyrus, 19-20, 1968-69; M. Almagro Gorbea, La cueva del Niño (Albacete) y la cueva de la Griega (Segovia), Trabajos de Prehistoria, 28, Madrid, 1971; A. Beltrán, I. Barandiarán, Avance al estudio de las cuevas paleolíticas de La Hoz y Los Casares (Guadalajara), Excavaciones arqueológicas en España, 64, Madrid, 1968; M. Almagro Gorbea, La cueva del Niño (Ayna, prov. Albacete, España) un yacimiento con representaciones de arte rupestre de estilo paleolítico y levantino, IPEK, 1970-73, 23; Descubrimiento de una cueva con arte rupestre en la provincia de Albacete, Santander Symposium, cit.; E. Ripoll, Une peinture de type paléolithique sur le littoral méditerranéen de Tarragone (Espagne), Rivista di Scienze Preistoriche, XIX, 1964; Una pintura de tipo paleolítico en la Sierra del Montsiá (Tarragona) y su posible relación con los orígenes del arte levantino, Miscelánea en homenaje al abate Breuil, II, Barcelona, 1965; M. Farinha Dos Santos, Novas gravuras rupestres descobertas na Grota do Escoural, Revista de Guomarães, XXVII, 1967; S. Gimenez Reyna, La cueva de Nerja, Málaga, 1964; J. Fortea, M. Gimenez Gomez, La cueva del Toro. Nueva estación malagueña con arte paleolítico, "Zephyrus" XXIII-XXIV, 1972-73; J. A. Bullon, M. W. Loreto, Dos nuevas pinturas en la cueva de la Pileta, Monografias espeleológicas, 2, Málaga 1973.

France: M. Sarradet, Fontde Gaume en Perigord, Perigueux, 1969; L. Pales, Les gravures de la Marche, I, Felins et ours, Burdeos, 1969; A. Plenier, L'art de la grotte de Marsoulas, senza città e anno di edizione; A. Beltrán, R. Robert, J. Vezian, La cueva de Le Portel, Monografías Arqueológicas, I, Zaragoza, 1966. A. Beltrán, R. Robert, R. Gailli, La cueva de Bédeilhac, ibid., 2, 1967. A. Beltrán, La cueva de Ussat les Eglises..., ibid., 5, 1969; A. Lemozi, Ph. Renault, A. David, Pech Merle. Le Combe. Marcenac, Graz, 1969; A. Beltrán, R. Gailli, R. Robert, La cueva de Niaux, Monografías Arqueológicas, 16, Zaragoza, 1973. E. Schmidt, Remarques au sujet d'une représentation de bouquetin à Niaux, Bull. Soc. Preh. Ariège, XIX, 1964. R. Gailli, L. R. Nougier, R. Robert, L'art de la caverne de Niaux (compléments), ibid., XXIV, 1969; G. Aynie Clastres, Nouvelles découvertes dans la caverne de Niaux: le réseau René Clastres, ibid., XXV, 1970; E. Caralp, L. R. Nougier, R. Robert, L'intérêt archéologique du nouveau réseau René Clastres de la caverne de Niaux (Ariège), ibid. J.

Clottes, R. Simonnet, Quelques éléments nouveaux sur le réseau René Clastres de la caverne de Niaux, ibid., XXVII, 1972; and Le réseau René Clastres de la caverne de Niaux, Bulletin de la Société Prehistorique Française, 69, 1972; J. Delteil, P. Durbas, L. Wahl, Présentation de la galerie ornée de Fontanet (Ornolac, Ussat-Les-Bais, Ariège), Bull. Soc. Preh. Ariège, XXVII, 1972; Lorblanchet, Découverte de peintures et d'une gravure préhistorique dans la grotte des Escabasses (commune de Thémines, Lot), Bull. Soc. Preh. Fr., 7, 1965; A. Glory, La grotte de Roucadour, Bull. Soc. Preh. Franç., 1964; A. Glory, Nouvelles découvertes de dessins rupestres sur la Causse de Gramat, Lot, Bull. Soc. Preh. Franç., LXII, 3, 1965; R. Bouillon, Activités spéléologiques (grotte ornée de la Dérouine), Mayenne Sciences, 1967; A. Le Dren, A. Glory-Jardel, Grotte à gravures préhistoriques da La Foret, près Reignac, a Tursac (Dordogne), Congrès préhistoriques de France, XIV, Strasbourg, 1953; H. De Lumley, Le bison gravé de Ségriès. Moustiers-Ste. Maria, Bassin du Verdon (Basses-Alpes), Simposio Barcelona, cit.; R. Simonnet, Aperçu sur la préhistoire du rocher de Foix (Ariège). La grotte du Cheval et ses vestiges d'art pariétal, Bull. Soc. Preh. Franç., LXV, 1968.

Other territories: G. Bosinski, Der Magdalenien Fundplatz Feldkirchen-Gönnersdorf, Kr. Neuwied, Germania, 47, 1969; Magdalenien anthropomorphic figures at Gönnersdorf (Western Germany), Bollettino del Centro Camuno di Studi preistorici, 5, 1970; Drosler, Die Venus der Eiszeit, Leipzig, 1967; O. N. Bader, La caverne Kapovaia. Peinture paléolithique dans l'Oural Sud, "VI Congrès Int. UISPP," 1962; A. P. Okladnikow, Petrogliphi Angari (in russo), Moscú, 1966; Die Felsbilder am Angara-Pluss bei Irkutsk, Sibirien, IPEK, 1966-1969, 22; Die Felsbilder am Amur und den Ussuri, IPEK, 1970-73, 23.

Small sculpture: J. Clottes, E. Cerou, La statuette féminine de Monpazier (Dordogne), Bull. Soc. Preh. Franç., 67, 1970. J. Clottes, La découverte d'une statuette féminine Paleolithique a Monpazier (Dordogne), Bull. Soc. Preh. Ariège, XXVI, 1971. I. Barandiarán, El arte mueble del Paleolitico Cantábrico, Monografías Arqueológicas, 14, Zaragoza, 1973. M. S. Corchon, Notas en torno al arte mueble asturiano, Salamanca, 1971. H. L. Movius, Sh. Judson, The rock-shelter of La Colombière, Cambridge Mass., 1956. Sull'arte della Navarra: I. Barandiarán, Arte paleolítico en Navarra, Principe de Viana, 134-135, Pamplona, 1974.

ANTONIO BELTRÁN

PALEOLITHIC AND UPPER PALEOLITHIC IN ITALY:
THE MEDITERRANEAN PROVINCE (PLATE 1d)

The patrimony and knowledge of Paleolithic and Upper Paleolithic art in Italy, both of wall paintings and sculptures, has in the last few years been noticeably enriched by advances in investigative techniques.

The first known artistic manifestations in Italy are of the Upper Paleolithic period, contemporary to the flourishing of the Franco-Cantabrian art. As an example, bone engraving found in the Grotta Paglicci in the Gargano area, dated with carbon 14 techniques, goes back to about 21,000 B.C.. The connections to the Franco-Cantabrian art are evident and continue with the passing of time and cultures in cave painting as well as in sculpture. The Paleolithic sculptures found in Italy (up to now represented exclusively by female figurines) are in Franco-Cantabrian style, as are numerous examples of smaller incised works. Through these, we are

able to follow the evolution of a naturalistic art, similar to that which is found in France and Spain. It is possible that at one point the zoomorphic realism and certain geometric figures of Franco-Cantabrian art influenced the inorganic and abstract aspect of "Mediterranean" art (as defined by P. Graziosi). According to this scholar, the beginning and first development of Mediterranean art took place towards the end of the Paleolithic civilization, predominantly in southern areas. Some of its inorganic and stylized forms were passed on to the succeeding post-Paleolithic cultures, where they were to develop much further.

Let us begin by examining some of the more important discoveries of statuary art (for purposes of critical discussion; some works traditionally considered to be Paleolithic are included in this essay, even though they are known to be of a later period).

In the area of sculpture of human forms, some extremely interesting items have come to light: in the cave of the Venuses, near Parabita (Lecce), two female figurines have been found, 6 to 9 centimeters high and carved in bone. They clearly show the anatomical characteristics of Paleolithic "Venuses"; their arms are joined under the stomach, as in figurines from several deposits in the Soviet Union; in all other "Venuses" in western Europe the arms are folded over the breasts. These have been attributed to the Epigravettian period, as some of the cracks present on the surface were filled with traces of the Epigravettian sediment that made up the uppermost layers of deposits in the cave.

In the Gaban shelter (Trento), a female figurine was found at the bottom of a hole of the Mesolithic period. It is a 10.2 centimeters long bas-relief carving on a fragment of deer antler and represents a nude and erect woman, with her arms at her sides, her legs joined together with a deep split between them which spreads at the bottom suggesting the presence of feet. This figurine could be placed in the classical category of Paleolithic "Venuses," even though, compared to them, it shows a certain rigidity and hardness of its own, as, for example, in the position of the arms and the form and disposition of the legs, which neither end in points (as in a good part of the European statuettes) nor separate widely under the knee as in many of the Russian ones.

With regard to other Italian "Venuses" found in earlier excavations, it seems proper, in the absence of datings by means of stratification, to designate them to the Paleolithic era in general. This placement is based strictly upon characteristics of style; one exception being the Venus of Chiozza, for which the attribution to a Neolithic cultural phase now seems most probable. This is because it was found together with pebbles from a Holocene deposit in which a dwelling and sepulchres of the Neolithic era were later discovered. Therefore, anthropomorphic Paleolithic sculpture, and the cult of the mother goddess associated with it, would continue in Italy through the Mesolithic era (as evidenced by the figurine of the Gaban shelter) all the way into the Neolithic era, as indicated by the Venus of Chiozza.

In recent years, numerous bones and engraved stones have been discovered in deposits in Italy. Because of their conspicuous number, one can speak of the existence in Italy of two aspects of the Paleolithic graphic art, one associated with the Franco-Cantabrian, the other with the "Mediterranean province."

From the Tagliente shelter (Verona), unfortunately mixed with material from earlier excavations, comes a pebble engraved with the figure of an ibex. This is one of the most beautiful works of Italian Paleolithic art and has corresponding examples in the Franco-Cantabrian art. Also from the Tagliente shelter are two other pebbles with engravings of a feline and of a horse. A stone, found in a late Epigravettian layer, has figures of mammals engraved on both sides, though the portion of the figure depicted is limited to the hind legs. A stone with the figure of a bison, found in levels of the middle Epigravettian era, testifies to the previously undocumented presence of this animal in Italy in the Upper Paleolithic era. Rather recently, inside a sepulchre found in the shelter itself, two incised calcium rocks, also of the Epigravettian era, were found; noteworthy is the larger of the two stones, which has the figure of a lion engraved in profile. The drawing of the head, in a thin, decisive line, is natural in all details, such as the nose, ear, eye, mouth, and whiskers; however, the body is depicted in a rather tentative and schematic way.

In the small cave of Vado all'Arancio (Grosseto), engraved bones and a stone were found in late Epigravettian levels. The engravings are figures of animals, in a style that leans towards the Franco-Cantabrian. Among them, is one human profile, a head that is outstanding in its accuracy of details pertaining to eye, mouth, beard, and whiskers. It is a very realistic portrait that recalls the famous Magdalenian pictures of the cave of La Marche and of Lussac-les-Chateaux (Vienne).

The oldest manifestation of statuary art to be found in Italy has come to light in the Paglicci cave in the Gargano, and it is datable around 21,000 B.C. The artifacts that accompany it are analogous to others of the evolved French Gravettian period. The sculpture in question is the figure of an ibex, rather carefully done in its details, covered by a series of more or less parallel lines, and, over the lines, by a motif of chevrons. Mainly because of its archaic style it recalls the best Franco-Cantabrian works. The other figures of a horse and of deer found in the upper layers of the cave approach the full development of the Franco-Cantabrian style. Noteworthy is a hip bone of a horse, from the Epigravettian levels, that shows scratches on both its sides. On one side one can see the head of an ox, a smaller ox, and the profile of a fawn. The poverty of detail within the contour, the simplicity of the drawing, and the shape of the ox-horns facing the front all recall the style of the Mediterranean province. On the opposite side is the engraving of a stout-bodied horse, with legs in motion. Near it one can perceive the heads of two deer and part of the back of one deer; the details of the body are well evidenced and, together with the other engraved lines, they compete in creating clear chiaroscuro effects. Surrounding the group are numerous arrows, a few of which (those that are feathered) are of the same type as those scratched on the Perigordian pebbles of Colombière (Ain). Therefore, the style of these engravings would demonstrate that Epigravettian culture and traditional Franco-Cantabrian modules coexisted with other stylistic formulae in Italy. They established themselves, all the while slowly changing, with other abstract graphic manifestations to constitute the so-called Mediterranean artistic province. Also from the Epigravettian levels of Paglicci comes a bone which is engraved with a strange scene of a bird roosting while a serpent enters

the nest to devour the eggs. Near this scene is another bird, characterized by a long beak.

A very complete documentation of the Romanelli cave is now available to us, thus allowing a clear definition of the characteristics of the art of the cave and of the Mediterranean Province in general. Out of a total of 110 engraved stones gathered in the Romanellian layers, dated by carbon-14 to about 9850 B.C., only nine naturalistic figures are discernible; geometric or abstract designs predominate. The naturalistic figures, all zoomorphic (a bull, a feline, a probable fawn, a boar, three deer) are engraved in profile and in a very fine line. Only rarely are anatomical details shown within the contour; more often a checkerboard pattern and broken lines fill the inside of the perimeter. The geometric and abstract patterns are composed of broken lines, crosshatching, stripes, rows of straight and curved parallel lines, and figures resembling snakes or ribbons.

Between 1963 and 1966, in the Romanellian deposits of the Grotta del Cavallo (Cave of the Horse) near Santa Caterina di Nardo (Lecce), about a dozen engraved stones were found, some of them very large. Both naturalistic figures and abstract designs are present in varying quantities. A few of the stones have different graphic layers superimposed. They show representations of oxen that, for the simplicity of the design and for the characteristic form of the turned-forward horns are clearly of a Mediterranean style. They are not to be considered among the best works of this province, due to a certain rigidity of design and to the distortion and inaccuracy of certain parts of the body. A large ithyphallic human figure in a long tunic is noteworthy, though rather rigid, incomplete, and somewhat distorted. The geometric and abstract figures can be compared to those of the Romanelli cave; they include designs in the form of ribbons, ladders, and chevrons. Finally, the engravings of the Grotta del Cavallo offer a repertoire of subjects and of styles that are typical of the Mediterranean Province, especially of its most advanced period. In the area around the cave a chance discovery was made of a stone from the same Romanellian layers, possibly dug from inside the cave and later discarded by clandestine diggers. In addition to the geometric figures and to a figure of an ox in pure Mediterranean style, this stone presents the engraving of the partial profile of a horse. This profile could be considered in the Mediterranean style for the compactness of its representation. It also presents such realistic details that it could be deemed to be of the Franco-Cantabrian style.

Also important are the stone engravings of the Giovanna cave, near Syracuse, which come from levels of the final stages of the late Gravettian period. There are about 70 limestone blocks from this cave that have linear incisions of various types; the only naturalistic figure among them is a fragmented ox in Mediterranean style.

In the Romanellian levels of the Prazziche cave (Lecce), a rectangular fragment of a bone was found, with nine roundish spots in red ochre, a decoration that recalls that of Azilian pebbles.

In Arene Candide (Finale Ligure), at Praia a Mare (Cosenza) and at Levanzo (Egadi), pebbles have been found that are painted with geometric patterns or with simple, yet intentional, ochre spots. Some of the above mentioned pebbles are certainly of the Mesolithic culture.

Italian caves with Upper Paleolithic or Paleolithic wall paintings that are known of are about ten in number. Much difficulty has been encountered in the dating of these paintings. Except for the caves of Romito (Calabria) and of Caviglione at Balzi Rossi (Ventimiglia), where it is possible to establish a relation between the figures and the layers of the deposit, an approximate dating was reached only through an evaluation of comparative styles.

Most Italian Paleolithic wall paintings can be attributed to different periods in the development of Mediterranean art; for example, the cave of Cala Genovese on the island of Levanzo and the cave of Addaura, and that of Niscemi near Palermo. There are exceptions: the paintings of the Paglicci cave (Foggia), instead, seem to be linked in technique and style to Franco-Cantabrian art. In addition to positive red imprints of hands, the Paglicci paintings depict two complete figures of horses and traces of the back of another larger horse; details, such as eyes and nostrils, are clearly shown. As already mentioned, in technique and style these figures recall those of early Franco-Cantabrian art.

In Sicily, after the discovery of the now famous caves of Levanzo, of Addaura, and of Niscemi, numerous caves with wall incisions have been found along the coastal strip between Palermo and Trapani. Generally, these incisions consist of simple parallel, converging, or intersecting linear marks, similar to those of the Riparo del Romito, dated in the Upper Paleolithic age. Naturalistic figures of animals have been found in the Racchio cave (Trapani), in the small cave shelter of Za Minica (Palermo), and in the Puntali cave (Palermo). These figures recall similar ones in the Levanzo cave.

At the Riparo del Romito near Papasidero in Calabria there are two large incised rocks covered by Upper Paleolithic layers. They seem to have been engraved during the last phase of the Paleolithic era. They show, besides the recurrent figure of the bull, linear marks arranged in different directions, similar to those of the Sicilian caves and of Balzi Rossi.

In the cave of Aviglione, in the Balzi Rossi area, a naturalistic representation of a horse was recently found. This horse, crossed by incised vertical marks, recalls works from the Franco-Cantabrian area, such as those at Les Combarelles (Dordogne). The horse is crossed by deeply scratched vertical marks. We have frequently seen these linear marks, sometimes in isolation and other times over figures of animals. They seem to show that Paleolithic artists had the same interest for realism as for non-figurative graphic marks, in wall painting as well as in three-dimensional artifacts.

BIBLIOGRAPHY - O. Acanfora, Pittura dell'età preistorica, Soc. editr. libraria, Milano, 1960; O. Acanfora, Figurazioni inedite della Grotta Romanelli, B.P.I., 76, 1967; F. Biancofiore, Nuovi dipinti preistorici della Lucania, R.A., LII, 1965; E. Borzatti von Lowenstern, Oggetti romanelliani con testimonianze d'arte nella Grotta delle Prazziche (Novaglie, Lecce), R.S.P., XX, 1965; P. Graziosi, L'arte dell'antica età della pietra, Sansoni, Firenze, 1956; P. Graziosi, Levanzo - Pitture e incisioni, Sansoni, Firenze, 1962; P. Graziosi, Découverte de gravures rupestres de type paléolithique dans

l'Abri du Romito (Italie), L'Anthropologie, 66, 1962; P. Graziosi, Nuove osservazioni sulle incisioni rupestri della grotta Romito presso Papasidero, Magna Grecia, a. V, 7-8, luglio-agosto 1970; P. Graziosi, L'origine dell'arte, Atti del Colloquio internaz.: L'Origine dell'Uomo, Accademia Nazionale dei Lincei, a. CCCLXX, Roma, 1973; P. Graziosi, L'arte preistorica in Italia, Sansoni, Firenze, 1973; P. Leonardi, Bisonte graffito e incisioni lineari e geometriche del deposito epigravettiano del Riparo Tagliente nei Lessini (Verona), R.S.P., XXVII, 1972; A. Leroi-Gourhan, Préhistoire de l'art occidental, Mazenod, Paris, 1965; G. Mannino, Nuove incisioni rupestri scoperte in Sicilia, R.S.P., XVII, 1962; F. Mezzena, Oggetti d'arte mobiliare del Paleolitico scoperti al Riparo Tagliente in Valpantena (Verona), R.S.P., XIX, 1964; F. Mezzena, A. Palma di Cesnola, Oggetti d'arte mobiliare di età gravettiana ed epigravettiana nella Grotta Paglicci (Foggia), R.S.P., XXVII, 1972a; A. Palma di Cesnola, La scoperta di arte mobiliare romanelliana nella Grotta del Cavallo (Uluzzo, Lecce), R.S.P., XXVII, 1972; A. Radmilli, Le "Veneri" di Parabita, R.S.P., XXI, 1966; G. Vicino, Scoperta di incisioni rupestri paleolitiche ai Balzi Rossi, Rivista di Studi Liguri, XXXVIII, I, 1972; A. Vigliardi Micheli, Le incisioni su pietra romanelliane della Grotta del Cavallo (Uluzzo, Lecce), R.S.P., XXVII, 1972; F. Zorzi, Pitture parietali e oggetti d'arte mobiliare del Paleolitico scoperti nella Grotta Paglicci presso Rignano Garganico, R.S.P., XVII, 1962; F. Zorzi, Pitture parietali paleolitiche scoperte nella Grotta Paglicci presso Rignano Garganico, Memorie del Museo Civico di Storia Naturale di Verona, X, 1962.

DANIELA COCCHI

SCHEMATISM AND DECORATIVISM IN THE MESOLITHIC, THE NEOLITHIC AND THE BRONZE AGES (PLATES 2-4)

This topic has developed enormously as a result of recent discoveries. Much is still being evaluated, with the goal of fully understanding the evolution from paleolithic naturalistic art to the schematism and decorativism of the more recent prehistoric art.

Cave art in Eastern Spain. — The debate on Paleolithic dating of Spanish art of the Levant, supported by Breuil, Obermaier, and Bosch Gimpera, has been subdued as of late. Previous Mesolithic and Neolithic dating have gained some support. Jordá dated cave shelters in general at the end of the Bronze Age. Breuil, in a little known recording of 1960, responded to A. Sahly's questions expressing doubts upon hearing that the paintings of the Spanish Levant do not have any direct relation with Franco-Cantabrian paintings, except in the execution of the horns of deer and bulls. In this case, the execution is identical to that of the Perigordian style, and never of that of the Magdalenian style. Nevertheless, the overall concept of the drawings, seen in the shape of the hooves, is generally more Magdalenian than Perigordian. It seems that the source of the art of the Levant is an evolved Perigordian Franco-Cantabrian art, progressively influenced by Magdalenian or Solutrean-Magdalenian art. Bosch Gimpera, however, strongly supported his Paleolithic hypothesis up to his death, although he did not produce any new evidence. In numerous articles, Jordá, basing his arguments on the climate, the fauna, and the problems of the Mesolithic Age and of its art in Spain, concludes that the art of the Levant and schematic art came about

during the same period. Their roots, Jordá maintains, are in the agricultural and pastoral cultures of the eastern Mediterranean peoples. According to Jordá, the first artistic elements apparently arrived with the Neolithic invasions from Anatolia and Syria; the same that brought ceramics and the cultivation of grains to the Spanish Levant. These were followed by another invasion from Egypt and Palestine, which brought dolmens, villages, and undecorated ceramics. The art of the Levant and schematic art seem to have arisen during the Bronze Age, spreading to the Meseta in the III period. The Mesolithic dating, supported by M. Almagro, is defended — though slightly corrected — by Ripoll, who places its final periods in the Neolithic era. Personally, we believe that the art of the Levant is Mesolithic, with roots that go as far back as the Paleolithic, and its continuation lasting until the Neolithic time. It apparently began between 7000 and 6000 B.C. and ended around 1500 B.C. or shortly thereafter. Phase I (of Aurignacian-Perigordian tradition), contemporary to the Upper Paleolithic (6000 to 3500 B.C.), reached its apogee around 5000 B.C. It includes the large naturalistic bulls in La Araña, Minateda, and Cingle; the single deer in Val del Charco; the several deer in Calapatá; and the many geometric designs such as those below the figures in La Sarga, La Araña, and Cantos de la Visera. Phase II is characterized by a great number of deer and goats and the appearance of the human figure around 4000 B.C. (its best example is the central area in La Remigia). Phase III can be dated between 3500 and 2000 B.C. It is marked by a sense of motion in the figures and a move towards animal naturalism. Phase IV, between 2000 and 1200 B.C., sees a return to static figures, with the introduction of references to agriculture and to the domestication of animals.

The painted caves discovered since 1965, in which important new developments appeared, are the following: in the province of Terragona, at Ulldecona, ten cave shelters showing scenes of archers hunting deer, most of them in red with occasional figures in black. In the province of Lerida, at Os de Balaguer, one notes the discovery of a complex with mostly schematic representations and a few naturalistic quadrupeds. For the province of Terragona, we published a complete study of Val del Charco of the Agua Amarga. Ripoll published his studies of the caves of Santolea, and with it started the series "Monografie di Arte Rupestre" for the Prehistoric Institute of the Disputación of Barcelona. In Alcaine, La Cañada de Marco, with mixed stylized naturalistic and schematic figures, is viewed as part of the Alacón grouping. A new group of painted caves has been discovered in Sierra de Albarracín, near La Losilla. In the province of Castellón de La Plana, the shelters of Racó de Molero and Racó de Gasparo have been re-examined. In the ravine of Valltorta remains have been found above the shelter of La Saltadora. Among them is a representation of three men dancing, painted in black. In the province of Valencia, the paintings in Els Covarjos are still to be made known. In these paintings, four quadrupeds in red, with elongated heads like those of horses and with bodies of deer, are shown together with two archers. In the province of Alicante is the important complex of La Sarga (Alcoy); it contains beautiful deer, very few human figures, strange meandering lines, and schematic signs, possibly more ancient than the above mentioned deer and human figures. In

this province we have brought to public attention the site at Los Grajos (Cieza); here we find an interesting, and very schematic, scene of female dancers. We also made public the locations of La Cañaica del Calar and of Fuente de Sambuco; the first is comprised of deer in a fine style and a few men; the second of many stylized male figures and a bear. In the province of Cuenca is the unreported compound of Marmalo, near Villar del Humo, with bulls and schematic human figures. At Selva Pascuela we interpret the depicted scene of the breaking-in of a horse at a hunt with lasso. In the province of Albacete, one should add the new findings in the rich area of Nerpio to the few remains of representations of archers in the precipice of El Niño. In the area of Nerpio, the group of shelters of Solana de Las Covachas has not been extensively studied, while those of Torcal de las Bojadillas and Fuente del Sapo – whose figures are dated in our phases II and III – were first published in 1975. Finally, at Prado del Azogue (Aldeaquemada, Jaén) we verified that the paintings of goats were originally of deer, but were later repainted and shaped into the form of goats. Only through a short newspaper article did we learn of the schematic paintings, with a semi-naturalistic deer, at Santo Espiritu and Albalat de Tarouchers (Valencia). The shelters of Racó de Nando and Racó del Senallo are in the same region, at Riu de Moullar.

ANTONIO BELTRÁN

Italy: the revelation of Porto Badisco — The deep changes undergone by civilization in the Neolithic Age, with the advent of agricultural and pastoral cultures, are reflected in art. Paleolithic naturalism is slowly replaced by a semi-naturalistic, schematic, and abstract approach. In the Paleolithic Age, art was a relatively unified phenomenon in style, technique, and subject. In the Neolithic Age it differs from place to place and from epoch to epoch, producing manifestations that are isolated and characteristic of each specific culture. This eclecticism of post-Paleolithic art in Italy is perhaps due to the coming together in different periods of cultural elements of diverse origin and to the consequent affirmation and spreading of different civilizations.

The repertoire of Italian statuary art in the Neolithic and in the Bronze Age, compared to the same works of non-Italian Paleolithic or prehistoric art, is, in most cases, aesthetically quite modest. We have in our possession painted pebbles similar to Mesolithic ones. To be noted are those of Grotta delle Felci (Cave of the Ferns), on the island of Capri, in red ocher with schematic human figures and a stone from the Grotta dell'Orso (Cave of the Bear), at Sarteano (Siena), with oblique parallel bands. From the lake dwellings of Lagozza di Besnate, near Varese, come pebbles engraved with simple marks, straight or in a grid pattern.

Among the engravings on bone, the most important works are those found in the Gaban shelter, near Trento. During the excavations of 1972-1973, a fragment of a humerus of a ruminant animal was found in late Neolithic layers, covered by geometric engravings and one stylized human figure. A thin rectangular bone plaque was also found, with a complicated geometric pattern and two small holes, possibly for hanging. In 1974, a particularly interesting object was found in layers of the final Neolithic period. It is a 22 cm. long section of a human femur diaphysis, engraved with complicated geometric patterns, filed and smoothed in various places in such a way as to modify its original appearance. The internal cavity seemed to have a bearing on its use as an instrument. According to experiments made on the femur, it appears to be a wind instrument, created for the production of sounds. All three sides of the bone are carefully decorated with deep geometric engravings: triangles, rectangles, rhombuses, circles, notches, figures in the form of a wolf's teeth, chevrons, and one stylized human face. The geometric elements placed below the human face could represent the richly decorated gown or robe worn by the figure itself, as is recurrent in certain anthropomorphic steles of prehistoric Europe or in the "idolos placas" of Portuguese and Spanish megalithic cultures; in particular those of the Almerian culture. The geometric decorations engraved on the Neolithic objects in the Gaban shelter seem to have been influenced by the extreme art manifestations of the Italian and Balkan Upper Paleolithic, recalling the Mediterranean Province. We should not exclude, however, the possible relations with the Po Valley ceramic decoration of the Neolithic (the culture of vases with square openings in Chiozza, Rivoli, and Romagnano Loc) and with other Italian or non-Italian cultures (for example the culture of Danilo).

The anthropomorphic sculpture of the Neolithic and of more recent ages is very different from that of the Paleolithic. It does not seem to originate from a local culture. Judging from certain similarities with clay statuettes of the Balkanic and eastern Mediterranean areas, it appears to have originated from external influences and then developed into rather simple and coarse forms.

In Italy, clay statuettes of particular sculptural value are very rare; only one, found in the Neolithic village of Passo di Corvo, in the province of Foggia, has a special value for its expressiveness, realism, and precision of facial features. The others, found in Arene Candide, Grotta Pollera (Finale Ligure), Vho (Cremona), Rocca dei Rivoli (Verona), Ripoli (Teramo), and Lipari (Eolie Islands) appear rather coarse in both technique and form. A little more elaborate, compared to the others, are the two female statuettes recently found in Arene Candide and in Pollera. Two bone figures discovered in the Gaban shelter are worthy of note. The first, found in 1972 in early Neolithic layers, is a bi-dimensional female figurine, slightly more than 6 cm. long, decorated only on the lower part; the body is almost lozenge shaped, the legs, without feet, are joined together; there are no arms nor facial features. These statuettes have certain general qualities in schematic form reminescent of the "Venus" symbols of the Paleolithic Age, although the latter are characterized by highly detailed feminine features. The second statuette is a highly original piece: it is made out of the third inferior left molar of a boar, complete with its crown. Its root area has been scraped to obtain a surface characterized by protrusions and hollows, a headless female figure seen from the front. Precise carving, to make the anatomical features more prominent, gives the object a high degree of expressiveness. Though rather schematic, due to the original shape of the tooth from which it is made, this statuette can also be grouped with Paleolithic

figures. It shows similarities with other figurines, evident in the overall shape of the body and in the belt-like section around the waist crossed by parallel segments.

Stone statuettes conserve some Paleolithic archaism, such as in the case of the two Aeneolithic figures found in 1967 at Busoné in the area of Agrigento. They seem to represent the extreme simplification of the morphology of Paleolithic statuettes. The "Venus" found in Macomer, in the area of Nuoro, recalls the "Venus" of Savignano, though with less technical refinement. Other statuettes appear as the product of well-defined external influences, such as the marble sculptures found in Sardinia (Senorbì, Porto Ferro), which, for their sense of geometry and synthesis of form, seem to be almost exact copies of the marble statuettes of the Cyclades. Other sculptures, such as those found in Arnesano (Lecce), Cerno (Verona), and the Gaban shelter, seem to be part of the tradition of "owl" faced Mediterranean anthropomorphs, though they have other peculiar characteristics of their own.

As for zoomorphic sculpture, a three-dimensional head of a deer was also found in the Gaban shelter during the excavations of 1974. It was made out of a deer's hoof, by using the morphological features of the bone and adding only a few engraved marks to indicate the mouth, the nostrils, the wrinkles of the skin, and the muscles. The eyes were obtained in relief by slightly chipping away the bone surface. Even if we did not take into account that the natural shape of the bone determined the shape of this object, this naturalistic sculpture would show notable similarities with Franco-Cantabrian statuary art. A relationship with Franco-Cantabrian art is, in fact, still to be pointed out, as such art often used accidental natural formations that evoked particular images to reproduce, with few knowledgeable touches, realistic figures of fauna.

The known repertoire of anthropomorphic steles has been enriched by new elements found in recent years. The new findings are characterized by the same linearity and essentiality in the representation of the human figure and by the same realism of symbols and ornaments of the previously known steles.

One of the several interesting discoveries that took place in 1969 in Aosta was a conglomerate of megalithic constructions formed by cist tombs, menhirs, and geometrically decorated anthropomorphic steles, fixed between the late Neolithic and the beginning of the Bronze Age.

Cave paintings, both for their number and their peculiar qualities, represent the most notable manifestation of the late Italian prehistoric era. From the technical and the geographical points of view, one can distinguish two general areas: one, mostly northern, characterized by engravings, and the other, mostly southern, by paintings. These two groups are profoundly different, except for some morphological similarities in the details of single figures. For example, the dominant realism of the Alpine engravings contrasts with the symbolism and abstraction typical of the southern paintings. The origin of Italian cave art in these two areas of development is very difficult to determine: we can only affirm that they seem to have had different beginnings. The latest periods of Alpine engravings could be linked to the cave art of northern European countries, while southern mural painting seems related

in one way to Mesolithic naturalism, and in another to Upper Paleolithic schematism.

Southern paintings are concentrated in the Salentine peninsula (the cave of Porto Badisco and the Cosma cave) and in Sicily (Levanzo). The paintings of the Genovese cave, in the small island of Levanzo, number more than a hundred, all in black. They are characterized by a coarse naturalism that changes by degrees into more schematic and symbolic forms. This process is clearly visible in anthropomorphic figures. We can observe a progressive transformation from the realistic representations of the human figure to schematic figures and cross-shaped marks, similar to those of the cave art in the Iberian peninsula. There are also schematic representations of quadrupeds and fish, the most realistic interpretations of all; furthermore there are depictions of the so-called "en violon" idols found in Crete, the Cyclades Islands, Thessaly, Troy, and the Iberian peninsula: i.e., the Mother Goddess figure of the Mediterranean basin. These data allow us to suggest a time frame for the idols of Levanzo that is probably between the Neo-Aeneolithic and the early Bronze Age.

The most important collection of late prehistoric wall art in Europe, and particularly in Italy, is that of the Apulian cave of Porto Badisco, dated in the late prehistoric era and discovered in 1970. The presence of ceramics from the period between the middle Neolithic and the early Aeneolithic logically suggests the same chronological dating for the paintings found in the same cave. These paintings, distributed over the walls of the three main corridors of the cave, consist of about 60 groups, each one with dozens of figures, painted either in a black-brown substance, later identified as almost fossilized bat guano, or, less often, in red ocher. Figurative forms appear alongside abstract figures, sometimes within the same composition. The figurative forms consist of either semi-naturalistic or more-or-less schematic representations of men and animals, frequently together in hunting scenes. It is possible to establish some comparisons with similar figures of Spanish schematic painting, designated to the early Bronze Age or to a more remote period. In Porto Badisco as well as in the caves of Sierra Morena, for example, figures of men in the shape of a Φ are prevalent. Some hunting scenes might recall the "impressionism" of the art of the Levant.

However, abstract representations are the most numerous and constitute the main characteristics of art in the caves. There is a great variety of images. At times, it is possible to identify the prototypes of the abstract images by examining their different stages of realization. In particular, the human figure reaches, through successive transformations, apparently incomprehensible graphic expressions. For example, the anthropomorphic shape formed by two triangles attached at the vertex (known as "bi-triangular" or "hour-glass", and which is a common manifestation in schematic art all over the world) becomes progressively more geometric, altering the figure to such an extent that the arms become two triangles attached at the vertices. Short vertical segments represent the hair when placed above the triangle or the legs or genitals when placed below. By losing these appendices, the images become perfect Byzantine crosses. These cross-shaped figures can at times represent four anthropoids, each one formed by an arm of the cross. Transitional forms from more real-

istic figures support this interpretation. A figure with a triangular head and a tendency toward emphasizing curved lines, such as arms curling at the extremities, may be related to another figure in which even the arms and genitals become spirals or images appearing as a tangle of wavy lines. From this tangle we arrive at a simple spiral, which can be interpreted as a graphic synthesis of the human body. Finally, from the stylized figures with arms raised and joined above the head, positioned one over the other vertically, we reach a chain of purely geometric lozenges. There are indeed many abstract figures whose origins are difficult to definitively identify. These are shaped as stars, suns, arabesques, and s-shaped lines. For such a similar combination of realist and abstract drawings in the same location and at the same time, Porto Badisco seems to repeat the previously observed phenomenon of Upper Paleolithic art in the Mediterranean Province.

A new cave, Grotta Cosma, was discovered in 1970 a few kilometers away from Porto Badisco. In it, wall paintings similar to those of Porto Badisco were found, though in a lesser number. These consist of seminaturalistic men armed with bows, figures shaped as snakes, an s-shaped line, and a cross. In the cave of Tuppo dei Sassi (Potenza) a group of red paintings was discovered in 1965, consisting of figures of mammals and anthropoids during the hunt. These paintings are rather schematic and quite like certain paintings of Porto Badisco.

Cave engravings, generally widespread in Valcamonica, and less common in Valtellina, on Lake Garda, Liguria, and Piedmont, tend to be realistic, in the sense that they portray "real" objects, though still rather stylized and leaning toward schematism. Despite the fact that the actual object portrayed is at times difficult or even impossible to determine, one gets the impression that these engravings actually represent a concrete object, though its real meaning is not easy to grasp. Besides the above mentioned "realistic" figures, one also finds a series of forms shaped as crosses, crossbows, grids, etc., in the Ligurian and Piedmont areas.

In Valcamonica, 25,000 figures have thus far been reported; the oldest of which seem to date to the Neolithic, and the more recent to the Middle Ages. Recently, near Boario, some engravings representing deer were discovered; these may be from the oldest cultural period yet to be found in Valcamonica. Their style is clearly a kin to engravings that are among the earliest of Scandinavian cave art.

The engravings of Valtellina and Lake Garda seem to resemble many of the forms of Valcamonica. The engravings in Liguria are rather numerous. Many of them, thought to be prehistoric by their discoverers, now appear to belong to more recent history, and mainly to the Christian period. The cross-shaped figures are sometimes anthropomorphic representations, but often they represent the Christian cross itself. Piedmontese engravings also present problems in their chronological and cultural definitions. Their style and content are difficult to define: the cupels, for example, numerous in the graffiti, appear everywhere and in different periods. Cross-shaped designs are also frequent, some of them certainly of Christian origin.

Finally, we should not forget the engravings, sculptures, and funerary paintings in Sardinia that can be traced to the Aeneolithic cultures of the island. They consist of architectural motifs (frames, architraves, pilaster strips underlining doors or pillars, simulating false doors, frameworks of roofs, etc.) or geometric figures shaped as spirals, Vs, or hourglasses that fill the inner spaces and wall surfaces. Representations of bull's horns are frequent symbols of the divinity that protects the dead. Rather spectacular is the painted burial place of Mandra Antine (Sassari), decorated with bands curved at the extremities that seem to represent stylized horns and which include a false door and disk-shaped pendants. The ceiling is divided into rectangles outlined in red that seem to reproduce a main central beam and smaller beams, accompanied by spirals, semicircles, and bands.

DANIELA COCCHI

Other European and non-European discoveries. — In the last few years the number of discoveries and resulting publications on prehistoric Paleolithic art have been prolific; there have not been, however, sufficient and significant attempts at works of synthesis. In Spain, schematic paintings are found throughout the peninsula. This fact makes it possible for us to attempt a quick synthesis. We have worked out the following chronological basis: Spanish schematic art is a consequence of the cultural changes provoked by the arrival of searchers of metal from the Near East in a period when the peninsula was still in a Neolithic stage. This period does not appear to be prior to the IV millennium. The most ancient caves are located in the southern and south-eastern areas. The new art is not a continuation of the art of the Levant, even though one can recognize a schematic tendency in its last period. The new art spread all over the peninsula and was part of an artistic movement common to all of Europe and North Africa. It has, however, special characteristics in the region of Galicia and in the Canary Island that concerns the Spanish territory. The persistence of the new art created areas slow to change within the peninsula. These areas were foreign to the art of the Levant, which only accepted the new "metallurgical" ideas later, through commerce and occasional contacts. The end of this schematic art must be dated in the late Iron Age, after the penetration of the contributions of the Hallstattian people. Its disappearance is also due to the establishing of the art of colonizing peoples and of the Iberians from the coastal areas. The occurrence is similar in Portugal where, to the numerous well-known sites, another one with many engravings is added in the Tago Valley, and this extends as far as Alcantara, in Spain.

In France, the two most interesting groups of new discoveries are in the area of the East Pyrenees and in Olmetta-du-Cap, in northern Corsica.

In Central Europe, the engravings in Switzerland and Austria show a likeness to those of Northern Italy; they are essentially geometric, at least as far as rock art is concerned. The excavations of Lepenski-Vir, in the Danube valley, made an extraordinary contribution with a group of stone sculptures of the Meso-Neolithic Age. Interesting data have been gathered concerning funerary rituals related to those sculptures.

In Scandinavia, the area of engravings on horizontal rocks is widespread, reaching the borders of the Arctic cultures. A new method for the recording of complexes on a grid structure and for the study of their

chronology has been introduced. There are still many disagreements concerning the results of these studies, though the existence of very ancient centers remains generally accepted.

The complexes of the U.S.S.R., in both the European area and in Siberia, still pose a problem of dating, though most of the locations can be placed in the Mesolithic period or later. The previously mentioned studies by Okladnikov on the Siberian rivers supply the chronological information. A comprehensive exhibition offering an overall view of Russian prehistoric cave art was organized in 1975.

Probably one of the most important discoveries of the last few years is the cave of Çatal Höyük, in Turkey. This cave is notable for its mural paintings in red, one of which consists of a large bull surrounded by men. This painting has been associated with the art of the Spanish Levant, though without valid foundation, as it had been found at the site of Beldibi. In Turkey itself, numerous petrogliphs have been discovered. Those in the southwestern area present definite similarities to those of Armenia and Uzbekistan, thus showing a very interesting unity.

The Canary Islands have an unusual complex of engravings, found only at La Palma, El Hierro, Gran Canaria, and Lanzarote. These seem to have their origin in the Bronze Age and display accentuated differences in each island. The themes consist of figures of humans and animals of a recent era (only at Balos), spirals, labyrinths, and very complicated marks (La Palma and El Hierro), simple marks, ovals, circles, etc.; and "tifinagh" writings corresponding to the arrivals of the Berbers in recent times. The statuettes and pintaderas of Gran Canaria should also be mentioned. They are comparable to those of the eastern Mediterranean in the Neolithic Age and to the decorative paintings of Cueva Pintada, of Gáldar (Gran Canaria), and are typologically related to the Mediterranean models of the III millennium. The relationship between the petroglyphs of La Palma and the cults of water and the sun seems certain.

ANTONIO BELTRÁN

BIBLIOGRAPHY - *Spanish Levant. General problems*: The ultimate works of Bosch Gimpera: Chronologie de l'art levantin espagnol, Valcamonica Symposium (International d'art Préhistorique), Capo di Ponte, 1970; La chronologie de l'art rupestre seminaturaliste et schématique de la Péninsule Ibérique, La Préhistoire. Problèmes et tendences, Paris, 1968; F. Jordá, Notas para una revisión de la cronología del arte rupestre levantino, Zephyrus, XVII, 1966; Formas de vida económica en el arte rupestre levantino, ibid., XXV, 1974; Nello stesso senso, con argomenti contrari alla datazione mesolitica F. J. Fortea, Algunas aportaciones a los problemas del arte levantino, ibid.; il prof. Almagro ha espresso il suo pensiero in diversi articoli; El problema de la cronología del arte rupestre levantino español, Prehistoric Art of the Western Mediterranean and the Sahara, Barcelona, 1964; E. Ripoll, Cuestiones en torno a la cronología del arte rupestre postpaleolítico en la Península Ibérica, Simposio Barcelona, cit.; A. Beltrán, Arte rupestre levantino, Monografías Arqueológicas, 4, Zaragoza, 1968. Die Kronologie der Levantinische Kunst, IPEK, 1975; Superposiciones de pinturas en el arte rupestre levantino: Algunos problemas que plantean, XI Congreso Nacional de Arqueología, Zaragoza, 1970.

Individual discoveries: R. Viñas, R. Ten, J. Romeu y D. Miguel, Un nuevo conjunto de arte rupestre en Cataluña, comunicazione al Congresso di Vitoria, ottobre 1975. A. Beltrán, Avance al estudio de las pinturas rupestres levantinas de la provincia de Tarragona: estado de la cuestión, Miscelánea Sanchez Real, Boletín Arqueológico, LXVII-LXVIII, Tarragona, 1967-68; L. Diez Coronel, Nuevas pinturas rupestres y su protección en Os de Balaguer (Lérida), XIII Cong. Arq. Nac., Zaragoza, 1975; A. Beltrán, La cueva del Charco del agua amarca y sus pinturas levantinas, Monografías Arqueológicas, 7, Zaragoza, 1970; E. Ripoll, Los abrigos pintados de los alrededores de Santolea, Barcelona, 1961, y Pinturas rupestres de la Gasulla (Castellón), Barcelona, 1963; T. Ortego, Una nueva estación de arte rupestre en el término de Alcaine (Teruel), Simposio Barcelona, cit.; M. Almagro, Cuatro nuevos abrigos rupestres con pinturas en Albarracin, Teruel, 51, 1974; A. Beltrán, Nouveautés dans la peinture rupestre du Levant espagnol: El Racó de Gasparo et El Racó de Molero (Ares del Maestre, Castellón). Bull. Soc. Preh. Ariège, XX, 1965; Breve nota sobre un grabado rupestre en el Racó Molero, barranco de Gasulla (Castellón de la Plana), Ampurias, XXV, 1965; Sobre representaciones femeninas en el arte rupestre levantino, IX Cong. Nac. Arq., Zaragoza, 1966; A. Beltrán, Nota sobre el grupo de tres figuras negras del abrigo de La Saltadora en el barranco de la Valltorta (Castellón), Revista da Faculdade de Letras, Lisboa, 1965; E. Ripoll, Noticia sobre l'estudi de les pintures rupestres de "La Saltadora" (Barranco de La Valltorta, Castellón), Cuadernos de Arqueología e Historia de la Ciudad, Barcelona, 1970; Calcos de Alcacer en el S. I. P. de Valencia; A. Beltrán, Las pinturas rupestres prehistóricas de La Sarga (Alcoy), El Salt (Penáguila) y El Calvari (Bocairente), Valencia, 1974 (with V. Pascual); A. Beltrán, La cueva de los Grajos y sus pinturas rupestres en Cieza (Murcia), Mon. Arq., 6, Zaragoza, 1969; Los abrigos pintados de la Cañaíca del Calar y de la Fuente del Sabuco en el Sabinar (Murcia), Mon. Arq., 9, Zaragoza, 1972; A. Beltrán, Una escena bélica en el abrigo de la Fuente de Sabuco, XI Cong. Nac. Arq., Zaragoza, 1970; A. Beltrán, Sobre la pintura rupestre levantina de un caballo cazado a lazo del abrigo de Selva Pascuala en Villar del Humo, Cuenca, Homenaje Lacarra, Zaragoza, 1968; S. De Los Santos, B. Zornoza, Nuevas aportaciones de estaciones de la pintura rupestre levantina en la zona de Nerpio (Albacete), XIII Cong. Arq. Nac., Zaragoza, 1975; A. Beltrán, Las figuras naturalistas del prado del Azogue, en Aldequemada, Homenaje Canellas, Zaragoza, 1969; Las provincias, Valencia, 12 octubre 1974; A. Gonzales Prats, El complejo rupestre del Riu de Montllor, Zephyrus, XXV, 1974.

Italy: E. Anati, Civiltà preistorica in Valtellina, Sondrio, 1967; B. Bagolini, Aspetti figurativi ed elementi di decorazione nel Neolitico del Riparo Gaban (Trento), R.S.P., XXVII, 1972; G. Buchner, La stratigrafia dei livelli a ceramica ed i ciottoli dipinti antropomorfi della Grotta delle Felci, B.P.I., 64, 1954-55; L. Cardini, Dipinti schematici antropomorfi della Grotta Romanelli e su ciottoli dei livelli mesolitici della Caverna delle Arene Candide e della Grotta della Madonna a Praia a Mare, Atti della XIV Riunione scientifica dell'Ist. It. di Preistoria e Protostoria in Puglia 1970, Firenze, 1972; E. Contu, Tombe preistoriche dipinte e scolpite di Thiesi e Bessude, R.S.P. XIX, 1964; E. Contu, Nuovi petraglifi schematici della Sardegna, B.P.I., n.s. XVI, 74, 1965; E. Contu, I pagei con "corna sacrificali" plurime di Bradu (Oniferi, Nuoro), R.S.P., XXI, 1966; P. Graziosi, Le pitture preistoriche delle Grotte di Porto Badisco e S. Cesarea, Rend.

Lincei, VIII, XXVI, 1971; P. Graziosi, L'arte preistorica in Italia, Firenze, 1973.

Other European and non-European discoveries: L. Pericot, J. Galloway, A. Lommel, Prehistoric and Primitive Art, Londres, 1969; A Beltrán El problema de la cronología del arte rupestre esquemático español, Caesaraugusta, 39, 1975. P. Acosta, La pintura rupestre esquemática en España, Salamanca, 1968 y Representaciones de ídolos en la pintura rupestre esquemática española, Trabajos de Prehistoria, 1967. A Beltrán, Las pinturas esquemáticas de Lecina (Huesca), Monografías arqueológicas, 13, Zaragoza, 1972. E. Anati, Arte rupestre nelle regioni occidentali della Penisola Iberica, Capo di Ponte, 1968; M. Varela e altri, O complexo de arte rupestre do Tejo. Processos de levantamento, III Congreso Nac. Arq., Porto, 1974; M. A. Querol e altri, El complejo de arte rupestre del Tajo (Portugal), XIII Congr. Nac. Arq.; J. Abelanet, Les couples humaines dans l'art schématique des Pyrénées Orientales, IPEK, 1966-69; R. L. Grossjean, La Corse avant l'Histoire, Paris, 1966. A. Beltrán, Las pinturas esquemáticas de Olmetta du Cap (Córcega), en Mon. Arqs. 5, cit.; Ch. Zindel, Felszeichnungen auf Carschenna, Ur-Schweiz, XXVII, 1, Basilea, 1968; H. Liniger, Schalenbrauchtum und Felsgravuren in Zeit und Raum, Basler Beiträge zum Schalenstein-problem, 4-5, 1970. E. Burgstaller, Felsbilder in Osterreich, Linz, 1972; D. Srejovic, Lepenski Vir, Belgrado, 1969; La réligion de la culture de Lepenski Vir, Valcamonica Symposium, 1972, 1975; M. Gimbutas, Figurines of old Europe (6,500-3,500 B.C.), ibid.; V. Boroneant, Le caractère magique-religieux de l'art epipaléolithique du Sud-Ouest de la Roumanic, Valcamonica Symposium, 1972, 1975; E. Comsa, Tipologie et signification des figurines anthropomorphes néolitiques du territoire roumain, ibid.; G. Burenhult, The rock carvings of Götaland, Lund, 1973. A. Fredsjo, Rock Carvins Svenneby, Göteborg, 1971. A. Ohlmaris, P. Hasselroth, Hällristninger, Stockolm, 1966. G. Mandt Larsen, Bergbilder i Hordaland, Bergen, 1972. S. Mastrander, Oestfolds Jordbrukstninger Skjeberg, Trondheim, 1963 (fra altre pubblicazioni); M. Ksica, L'art rupestre en Union Sovietique, 1975; J. Mellart, Catal Hüyük. A neolithic town in Anatolia, Londres, 1967; M. Uyanik, Petroglyphs of South-Eastern Anatolia, Graz, 1974; A. Beltrán, Los grabados del barranco de Balos, Las Palmas, 1971; El arte rupestre canario y las relaciones atlánticas, Anuario de Estudios Atlánticos, Madrid, 1972; Consideraciones sobre el arte rupestre de las Islas Canarias, XII Cong. Nac. Arq., 1973; M. Hernandez, Grabados rupestres de Santo Domingo, Garafia, La Palma, Revista de Historia, XXXIII, 1970; Contribución a la carta arqueológica de la isla de la Palma, Anuario Estudios Atlánticos, Madrid, 1972; A. Beltrán, J.M. Alzola, La Cueva Pintada de Gáldar, Mon. Arq., 17, Zaragoza, 1974; A. Beltrán, Religion préhispanique aux Canaries: l'apport des gravures rupestres, Valcamonica Symposium, 72, 1975.

Antonio Beltrán and Daniela Cocchi

PREHISTORIC ART OF CENTRAL ASIA

Research into the earliest phases of human existence in north-central Asia has increased considerably in the past few years, thanks the advent of new methodologies and interpretations. This research, mainly oriented towards "typologic" exams and the analysis of the methods of preparation of lithic artifacts, has shown that many areas formerly believed to be completely free of items of historical interest do in fact offer interesting findings. For example, the Paleolithic deposits in the U.S.S.R. alone that are known today number more than one thousand. Other discoveries have been made in the Indo-Pakistani, Iranian, and Mongolian territories. These findings significantly modify our evaluation and knowledge of prehistoric Asia, a knowledge that, up to today, had gone relatively unaltered for a long period of time.

From the historic and artistic point of view, one of the most significant findings is the cave of Kapovaja, in the Autonomous Republic of Baskiria, near a big bend in the Belaja river. This cave has been known since 1760, mainly through the descriptions of P. O. Rytskov, but the richness and importance of its paintings have only been recognized in recent years. Kapovaja is of the same level of importance as the hundred and more caves known and studied in France and in Spain. In the western regions, a group of more than 20 realistic pictures has been found together with distinctly symbolic schematic ones. This system of integrating realistic forms with geometric symbols or stylized forms, noted by A. Leroi-Gourhan as being characteristic of European prehistoric art, is now acknowledged to be present in Asia as well. The naturalistic paintings of the Kapovaja cave are stylistically very close to those of Font-de-Gaume and of Altamira. Chromatically, though, they show a predominance of a light sanguine hue. The repertoire is modified by a figure representing a circular hut whose frame is composed of mammoth tusks. O. N. Bader, however, tends to date the most antique figures to the archaic style III of Leroi-Gourhan (i.e., around the XV millenium B.C.), though emphasizing certain technical and stylistic characteristics that make the Uralo-Asiatic cave unique in the context of Paleolithic painting; others he dates to the beginning of the classic style IV (around the XII millenium B.C.). Nevertheless, the relevant diversity in the stylized and in the figurative works of Kapovaja makes this dating doubtful, and in any event only approximate, though substantiated by the very close similarity of the schematic and symbolic designs. A. A. Formosov, with some justification, feels that all these paintings belong to the end of the Paleolithic era (IX millenium B.C. and the first half of the VIII millenium). Consequently the stylistic synchronism between Uralic images and those of western Europe has still to be proven.

On the other hand, if we keep in mind Leroi-Gourhan's method of calculating the statistical frequency of images, the percentages of distribution, and the other data gathered and elaborated by the French paleoethnologist in the 62 caves he examined, we still have much data to be considered. Even if Kapovaja offers us only 20 images (with several more still to be defined), it seems clear that the frequency of mammoths in those 20 images is far greater than in western Europe, where only 2 percent of several hundreds of images are of mammoths. In fact, more than one third of the images at Kapovaja represent a mammoth, giving to it, however, a physiognomy slightly different to that found in the West, with a more pronounced hump. At the same time these images are distributed throughout the entire area of the cave, while in the west up to 50 percent of the total of mammoth images is centered in the middle areas (grouped with wild oxen, bison, and horses). In the Uralic cave, on the other hand, the middle part has mainly figures of horses and rhinoceros; thus

the frequency of the mammoth seems to diminish right where it increases in the West. If one can judge from a single case and from a small amount of data, the highest frequency of mammoth seems to depend on a greater geographic presence of the animal, on its mystical value, and on its dual role of the dangerous animal and special and preferred game.

The mystical value of the mammoth is confirmed by a series of seemingly irrefutable facts. A mysterious construction discovered in Elissèevici, perhaps a sanctuary, contains an area marked off by mammoth skulls. The walls of the entrance way – a long trench-like walkway – are lined with long bones and ribs of mammoths. Various pre-historic burial places, both in the eastern and the western part of the Urals, show the bodies of the dead literally covered with mammoth skulls. The dwellings of the area – huts with either a round floor plan, or mixed round and square as in the settlements of Mal'ta – were built with a framework of long bones and tusks of mammoths and then covered with skins. The great number of bones, teeth, and tusks found in an enormous hut containing three hearths at Puškar could also indicate some special mystical value. In any case, it shows how essential the presence of mammoths was in the life of the Paleolithic hunters in the Euro-Asiatic area centered aound the Uralic chain.

Nevertheless, despite these differences with the Spanish and French situations, there is no doubt that the pictorial ensemble of Kapovaja is part of that unique episode in figurative production defined as Paleolithic art. This is a period of art that existed over an extremely long time, with pronounced technical modifications over the course of millenia, but with exceptional continuity in the repertoire of its images and markings. For example, the steatopygian "Venuses" of Kostenki I and Gagarino are not very different from those of Willendorf (the overall structure is identical). However, the artists of the settlement of Buret', on the upper stretches of the Angara, created a type of long-limbed female figurine, almost thread-like despite the fur mantle and hood, that is unknown in the Western world. All of this shows that a certain unity of artistic creation is not only determined by the environment (with reference to the typical fauna of that time) but also by a similarity of intent and set of values. Most important is the similarity in the symbolic and schematic markings. On the other hand, we not only are facing an isolated and in some ways anomalous pictorial cycle, but also a complex of converging data that, from Šiškin to the caves of Mongolia, outline, with their characteristic graffiti, a rather clear physiognomy of the Siberian and central Asiatic Paleolithic era. The settlements of Afontova Gora, Verkholenskja Gora (near Irkutsk), Ošurkovo, Niangi, Ust Kiakhta (on the Solenga), Mal'ta, Buret', Šiškin, and others testify, through their deposits and stratifications, to a rapid increase in the local population and a growing figurative activity (in graffiti, works in ivory and bone, and figurines in stone). It thus seems strange that for these periods there is only one relatively small pictorial cycle, almost isolated in an immense territory. According to certain researchers, Kapovaja may be the last pictorial exploit – in a geographic and perhaps chronological sense – of a unified cultural system that changed by progressing in time and by spreading out in area. But the explanation can be totally different, and perhaps connected with the relative scarcity of caves suitable for pictorial decorations, whatever the function of the pictorial images might be.

As for the graffiti in Mongolia, several are known to be quite recent in spite of the images of proboscideans that appear in them. The ambiguity of the very stylized images of the pachiderms is due to the shape of the animal itself, which doesn't seem to conform to that of the most familiar mammoths. The presence of the great Mongolian camel (later to become a source of great wealth for merchants and breeders) also creates some chronological perplexity. The continuation of Mongolian graffiti art and of its stylized works into a late period is important, because it allows us to reconstruct the wide distribution of a characteristic phenomenon, otherwise already indirectly confirmed by the paintings and by the Mesolithic graffiti of Turkmenia (pictures of the cave of Šakhta in Pamir, where hunting scenes with dogs appear) and of other locations.

The spreading of the figurative arts, together with the other data, seems to suggest a slow continuous influx of groups coming from the south, an immigration that is even more remarkable considering the scarcity of human life in such remote ages. It seems that the first cause of the movement is the withdrawal of the glacial fauna that followed the melting of the ice cover. Entire groups of hunters, specialized in large collective expeditions that aimed at isolating one or more individuals from a large herd, in order to kill with greater ease, weren't able to adapt to the changes of climate and game. Consequently they followed the withdrawal of reindeer, mammoths, giant deer, and the wooly rhinoceros, leaving behind groups that could more easily adapt to the new situation, such as those of Šakhta, who hunted mostly wild cattle. Then, people of the Cro-Magnon type infiltrated the taiga and became the much feared hunters of the Euro-Siberian forests. Hence the diffusion in a very extended area of "Europoid" populations (as revealed by skull measurements), a diffusion that was further increased by ensuing migrations. Measurements of skulls found at Mal'ta coincide perfectly with those of Kostenki I (near Voronež, on the Don) despite the enormous distance between the two settlements. Thus A. P. Okladnikov, who defined these groups as the bearers of a culture defined by him as "continental," suggested a possible connection with the Paleolithic populations of Western Europe. Yet the "Venuses" of Buret', relatively near Mal'ta, show broadheaded brachycephalic types, with a clearly flat nose and with oblique eyes. Therefore, they belong to a type that is Far-Eastern rather than Europoid. Other anatomical and osteological data confirm the coexistence and closeness of different races, in alternating waves and movements, that have imposing and lasting effects up to the historic era, and even up to very recent times.

For us, what counts is the importance of the Paleolithic tradition. This is more significant than it could be suspected, whatever the prime origin of the Asiatic figurative tendencies of the time may be. Vadim Elissèeff maintained that the culture so called "Neolithic of the forests" presents signs of evident continuity with preceding Paleolithic cultures. He defined the "mother cultures" as Solutreo-Magdalenian (the era to which the pictures of Kapovaja belong), even though he recognized the existence of an intermediate Mesolithic period. This period appears to have ended in the mil-

lenium between 4500 and 3500 B.C. A. P. Okladnikov, as well, emphasizes the continuity of the Paleolithic tradition in the art of the Neolithic tribes of Siberia. He points out the variety of different means of transition from the so-called Paleolithic naturalism (which was based on a particular way of seeing the represented animal, on a valid but elusive poetry, and on somewhat unclear mystical or religious facts) to the stylized, inorganic, or abstract forms of the Neolithic. At any rate, according to Okladnikov, an evident and aggressive realism is maintained, not only in western Siberia, but also in the region of the lower Amur and in the Ussuri and Bajkal basins. This is confirmed by several series of graffiti in Mongolia, all of fairly recent era. Outside north-central Asia, for a later period, we should not overlook Iranian asphalt vases, with stupendous ram's heads, the bodies of which are divided into two stylized profiles adorning the edges. It would then seem that, in light of the findings in the northern regions of Asia, the passage from organic forms to inorganic, stylized, or abstract forms of the Neolithic and Aeneolithic phases is not an inevitable nor an irreversible fact. It is better to speak of prevailing trends and of inter-changeable phenomenology rather than of fixed laws, expecially since similar phenomena are observed on other continents as well (for example, in Africa with the graffiti of the Sahara and the creations of the Bushmen, in America with the artifacts of the northern regions, and with others in Central America). The social stimuli that underlie these different phenomena are certainly diverse, but they seem to share the persistence of hunting and fishing as the essentially integrative or dominating activities of an economy that is based only in part on agriculture. It is certain, however, that rare but very beautiful realistic works of the Issakovo phase (3500-2500 B.C.), are due not only to the persistence of hunting and fishing as important activities of the Neolithic phase (and to the mystic aura attributed to certain animals), but also, finally, to the persistence of a desire for art, such as is typical of the Paleolithic era.

These are the elements that may have contributed directly and – more often – indirectly, to the formation of the figurative art of the nomadic people, and which amply justify the position taken by Georges Charrière and by M. Artamonov. Together with other researchers, and reassured by undoubted persistences such as steatopygian terracotta figurines of Turkestan, by continual examples of Paleolithic configurations in the art of the steppe, even in some conventional expressions such as figurines with several paws to show motion (much as in Giacomo Balla's "Dynamism of a Dog on a Leash"), they suggest a continuity over the millenia that is irrepressibly and unexpectedly realistic and would compete very favorably with the most-avant garde stylizations with a predominantly ornamental style. On the other hand, an interest in the images of animals (at least of certain species) is found continuously in the art of the steppe, which is to say the art of the nomadic people. These images, while different, are fairly close to those of the hunting people and particularly to those of the Paleolithic age. The "shamanistic" attitude in relation to religion and magic could have very ancient counterparts. One of these could, for example, be the "sorcerer" painted in the so-called sanctuary of the Pyrenean cave of Le Trois Frères. The "sorcerer" clearly has a semi-animalistic look, presumably due to a

mask he is wearing (provided that this is in fact the representation of a "sorcerer" and not of a mutant or hybrid being such as a werewolf). The research of A. Leroi-Gourhan into the frequency and the design of the animal figures in the prehistoric caves show a clear tendency to concentrate images of carnivores (bears and tigers) in the deepest zones of the caverns. In the Sino-Mongolian area, the image of bears and tigers have, since ancient times, been identified with the "demon of darkness" and the "power of the unknown." This may be a modified memory of very ancient traditions. It is a legitimate hypothesis, supported by the precise correspondence of the mystical value attributed to the bear in prehistoric rites, attested, for example, at the other end of Eurasia by the very well known Paleolithic altar characterized by five skulls of "ursus speleus" arranged "in quinquncem." As to the presumed persistence of a mystical value attributed to the reindeer, even in a recent age and well outside the area of its normal habitat, many specialists – among them K. Jettmar – reject it as uncertain. Due to the complexity and the importance of this problem, it will be worthwhile to summarize the important data, and also to give other data that may confirm a possible connection between the attested mysticism in the frozen kurgans of Pazyryk and the ancient world of the hunters of the tundra and the forest.

Numerous headpieces of horses found in these kurgans have simple ornaments in animalistic style. Two, coming from kurgan no. 5, appear to be formed in such a way as to "mask" the horse that wore them; they are of a griffon, covered with thin layers of gold, and of a reindeer. A third, coming from kurgan No. 2, has a complex composition: it is surmounted by a head of a goat, with a dove positioned between the two curved horns. G. Charrière associates it again to a legend and to a traditional ossetic background, explaining the dove as a symbol of one of the three souls of the dead horse and the goat as a codified symbol of a guide animal, with an evident reference to the qualities and functions of the dead horse. Jettmar, referring to the other two headpieces, discloses that the figurative contaminations and "combinations" that create the mythical fauna of the art of the steppe are too numerous to allow positive conclusions from the headpieces themselves. Nevertheless it appears clear that the men of Pazyryk gave a horse the ability to assume different identities for itself by means of these "masks" (which have also been found for other animals in other cultures of different eras), and it is evident that the two headpieces of kurgan no. 5 are different from all the others. While their funerary value is unquestioned, it appears also that the symbolism of the two "masks" is complementary. The griffon – whatever the origin of this mythical monster may be – is the custodian of the gold in the Siberian rivers, as is also stated in classical sources. This ruler of the air and of the darkness is balanced against and integrates the value of the reindeer, which is not merely an animal associated with the land or the herbivore of the traditions of the hunters of tundra and forest, but also has psychedelic values, recently brought to light by Levi-Strauss. It is associated with the use of "amanita muscaria," the mushroom from which the "soma" or "haoma" of the Indo-Iranian tradition is extracted. Consequently the two masked horses that guide the group of animals sacrificed in kurgan No. 5 and the soul

of the dead person to the afterlife show, in the symbols that are applied to them, values connected not only with the splendor and permanence of gold, but also with the different and distorted – but luminous – world created by the effects of psylocibin, the hallucinogenic substance contained in the mushroom referred to above. Nevertheless, the symbolic value of the reindeer is preserved also in very different surroundings in a world that must refer to the masked horse to remember this characteristic animal. This value appears enormously complex and is in part tied to a precise knowledge of its behavior, observed, if not used, in connection with the sacredness of specific hallucinogens. The hypothesis of the prolonged persistence of the image of the reindeer, although controversial and in some aspects obscure, leans on the horse masked as a reindeer and seems to maintain an unsuspected consistency, especially in its latest versions.

Without a doubt, a common element in a possible continuity of interests and values through the millennia is the hunt. With it, we must keep in mind the relationship that certain human groups kept with the animal world. To them, though in a different way, this world was the source of life. Obviously this relationship was different for the hunters of the Paleolithic era, for those (much later) of the forests, and for the various nomadic groups in different phases of evolution. It would be enough to say that the economy of cattle breeding, from which the social structure of all nomadic people was derived, has its origin in an insufficient agriculture. This insufficiency might be in spite of extraordinary efforts to increase the yield (as is indicated by the artificial canals carved in the rocks of the Altaic region) and determined by a constant increase in the population. We know that the nomadic economy did not originate, as was believed several decades ago, from a population of hunters, but was the creation of frustrated farmers faced with a clear choice. This situation was due, at least in part, to the inevitable competition between agriculture and cattle breeding which quickly flared up as soon as the two activities, on which the survival of a people depended, reached the maximum limit of reciprocal integration. The "clear choice" was to specialize in the breeding and in the use of animals (both in life and death), greatly increasing the possibility of a tolerable living, or to remain exposed to the uncertainties of a difficult survival at the edge of agricultural territories firmly in possession of more fortunate groups. The "early nomads" began in fact as refugees of an agricultural society that rejected them and forced them into activities that could be carried out in new territories unsuitable for agriculture. On the other hand, the economy of a nomadic people, which requires such effort on the part of the shepherd who must determine the proper ratio between the number of animals and of horses needed for their custody, also has the need for two other integrative activities: hunting and metal working. The need for the latter shows the enormous difference between the Paleolithic culture and the culture of a nomadic people. Nevertheless the relation between animal life and hunting, which again became essential, established particular analogies that are translatable into figurative forms that are at times similar and at times diverse.

It is appropriate to stress the importance of hunting for the nomads, in spite of the agricultural origin of breeding. Apart from the attraction that a nomadic economy exercised on the northern hunters, hunting traditionally proved itself useful in many other ways: for individual defense, for protection of the cattle and sheep from carnivores, as a means of recreation, as an opportunity for an individual's worth to be proven, as a preparation for war and for raids, as a means of integrating the people, as a way of giving variety to nourishment, and as an important means of obtaining items of value through barter. Furs represented an easily portable and durable good and were widely requested by the people of the settlements. Fur trade was almost monopolized by nomadic people and was widely used also for internal exchanges between groups or families. Recent sources from the time of Genghis Khan and documents concerning the Kingdom of the Golden Horde (which was considered an anomalous social structure, sustained by an also uneven economy) confirm the importance of fur trade. The tendency of people of nomadic origin to develop this trade (even in a later-stage, sedentary phase) is quite clear. To conclude, we have only to remember that the behavior of all nomadic people is always tied to hunting, even when faced with situations completely unrelated to the hunt. Many sources, both Western and Eastern, attest that the tactics of war of nomadic people come from the experience of collective hunting and, in a lesser way, from that of the individual hunt. This origin of war tactics becomes clear when Ghenghis Kahn organizes his military forces by adapting them to a strategy that predates the war of movement (if we can use this term "ante litteram"). This strategy also continued under his offspring and heirs, perfectly integrated sedentary rulers of the revived civilizations that they themselves had brought to the edge of total destruction.

Therefore, it should not come as a surprise if the animalistic art of the steppe, the highest expression of the nomadic style, is critically considered and clarified in light of its connection to the hunt. Nor should we be surprised at the success of the numerous and well-grounded hypotheses that refer to practices that extend infinitely longer than the usual time in art history and that can be measured in the scale of millenia. A specific interest for the animal as a living entity, filled with rationally elusive values and forces, and the mystique of the hunt (that is so clear in several Paleolithic figures), continuously resurface in the art of the steppes. But here the value of the animal image is prevailingly symbolic. It tends to transfer the power and the qualities of the animal symbolized (which may be frightening, is probably stronger, and is at any rate different) to the man who wears it, possibly as an ornament in belt buckles or pins. The animal in question is assimilated into a universal principle that can be outlined as follows: in herbivores, the main quality is that of fecundity; in carnivores (symbols of strength), the ability to dominate either in a controlling or a destructive manner; and in eagles or other birds of prey, the value of a supreme principle, representing the basic concept of the "sky" (the tängri of the Mongolians). This is very different from "the pursuit of effects" through sympathetic magic by the artists of the Paleolithic, even though the percentage of distribution and the frequency of the images painted in the caves hint at a marginally and partially similar set of values. It must be pointed out that – with the due reservation for the works in cloth and wood of Pazyryk

and for the Scythian art (deeply affected by the Greek world) – the animal image has more importance in the art of the steppe than in Paleolithic art, where the human figure, even though stylized, plays a central role.

Up to today, it has been impossible to verify clearly the prime origin of animal imagery in nomadic art. The persistence and survival of a very ancient tradition, mainly in the Mongolian area, and the undoubted contribution of the hunters of the forests (later grown into shepherds and breeders), must have had a bearing on the art of the steppe. Other sources of inspiration must also have had an impact on nomadic art, by introducing motifs of stylization of animals. There may have been two such sources: the so-called "Iranian" (from the territory eventually ruled by the Iranian people) and the Chinese. The material in which the artist of the steppe expresses himself most frequently is metal. It should be noted that for a long period of time groups coming from different cultures – sometimes related, sometimes independent – used geometric ornamentations, often in the form of spirals, for the decoration of metal objects. Such ornaments are connected to those of pottery production and are probably derived from the characteristic spiritual attitude of the producers of pottery, mostly from rural cultures. In this context of cultures, including the various "Andronovian" varieties and the bearers of the bronzes of Sui-yüan and of the region of the Horde (those which are, according to Max Loehr, before the XIII century B.C.), the geometrical style is exclusive, and it is in this same context that the animal motif breaks out. To clarify the origin of the phenomenon, which is connected with a profound modification of the entire culture, the study of nomadic metal working in its technical aspect can be of help.

At the beginning of the IV millenium B.C., a culture of Europoid gatherers, characterized by large oval habitations made of wood and stubble, established itself around the Aral. This group then expanded over hundreds of kilometers and met in the East with the microlithic industries of Sinkiang and Gobi, which were characterized by "miniaturized" but perfectly functional lithic tools. This culture of hunters and fishermen, the Kel'teminar, is not an isolated example. Here we are interested mostly because of its adaptability and its extension. Then, between 3100 and 2100 B.C., the Neolithic culture of Afanas'evo extended throughout most of the territory that we are examining, including the cultures already listed with the name of Tazabagjab (replacing Kel'teminar, expecially in the southeastern region of the Aral) and the Oriental cultures of Sujargan.

The culture of Afanas'evo shows a very wide area of expansion, originating in the high valleys of the Obi and the Enisej from a stationary people, possibly Europoid. The exchanges among the various cultural "facets" of the Afanas'evo group (as evidenced by the similarity between the burial rites, by the lithic tools, and by the technique and decoration of pottery) made the area in which they had expanded culturally almost homogenous. The cultural exchanges were carried out over long routes, often intersecting and interlaced, whatever the means of communication may have been. Furthermore they maintained contact and trade even with cultures not adjoining their own. Too, the present updated knowledge of the culture of Tripol'e (between the Dnieper and the lower Danube) and its variants

suggests again, in new terms, the problems of the spiral ribbon-shaped decorations and their presence in the early pre-historic cultures of the Chinese area, as well as of the expansion towards the east of the tombs in the form of graves.

The animalistic repertoire of the Tripol'e culture – in evolution since the IV millenium – tends to become richer in time, but appears to be more recent than the so-called "treasure" of Karbuna. This was discovered by accident in 1961 and consists of objects in copper, bone, hard stones, and marble. (Incidentally, among the findings, only about twenty anthropomorphic figurines in copper were discovered.) As for the cultures of the Afanas'evo group, their rudimentary agricultural basis, which did not have great possibilities of development, appears integrated by an increasing activity of domestic animal breeding. A new culture, known as Andronova (from a Siberian village near Ačinsk), already capable of working with metals, will use this relatively unified background and develop it further. Andronova maintained contacts with other Uralic-European cultures from Sejma to Gorbunova and extended itself from the Uralic region to the eastern basin of the Enisej, to Issīq-köl and to the middle stretches of the Amūdāryā.

As we can see, a tendency to evaluate in a unified way cultures that differ slightly among themselves, but which are basically similar, is now replacing the divided (and divisive) vision of the preceding stages of research. Consequently, a remarkable uniformity in the evolution between the cultures of Eastern Europe and those of the western region of central and northern Asia appears much clearer. With the culture of Andronova and its variants, metalsmithing appears to be in a period of rapid growth. This is the era of development of the tin mines of Kazahstan (very intense, as shown by the enormous movements of the metal gangues), as well as the development of copper and gold mines in the Altai. This demonstrates, therefore, the presence in the Andronovian society of specialized groups living off mining activity, a noticeable change in the society's economic and organizational structure. The number of remains of domestic animals found in the various sites, and also in the smaller settlements, shows that the raising of cattle, still an integrative activity of agriculture, had reached the stage that allowed the beginnings of nomadism. It is the first step toward the birth of the horseman-shepherd. The Andronovian cultures, in fact, succeeded in establishing an equilibrium between agriculture and breeding that seems quite miraculous. Outside of the limits set by these cultures, the two activities become antithetic and damaging to one another. As we have seen, the geometric orientation of the pottery decorations and that of the metal objects, often spiral shaped, confirm that the cultures gathering around Andronova followed the patterns, outlines, and style of rural cultures. Thus a wide Asiatic area faced the Aeneolithic period with a weaving of cultures, related or not, in which the taste for geometrical decoration was a reflection of the various attempts of an agricultural economy to be integrated with the raising of cattle.

Meanwhile, another exceptionally important occurrence has taken shape. A part of central Asia appears to be the area of the northernmost extension of a very wide-spread process of urbanization. This event was caused by the formation of large urban centers,

together with a rapid decline of the smaller surrounding settlements. These centers were invariably located on wide waterways and were thus considered "river civilizations." The stimulus that gave rise to this phenomenon came from the south, but expanded very rapidly whenever there were favorable conditions for the formation of large urban settlements. Besides Egypt, the central Asiatic urbanization seems to be connected to the rise of the large metropolises of Mesopotamia and of the Indo, but with pronounced differences. The III and IV stages of the Namazga culture are characterized by large urban settlements located in the Murgab valley (Turkmenistan) surrounded by walls with towers for defense and having dwellings with several rooms.

The culture that produced these cities is clearly agricultural, as for example the great villages of the Geoksjur culture and the urban centers of Hilmand in Afghanistan, Shahr-i-Sokhta, 75 hectares of area, and Mundigak, slightly less. The presence of examples of ancient urbanization in central Asia is a very recent discovery. The Russian teams deserve the credit for having rapidly determined the general layout, in collaboration with the Italian and French discoverers of the Afghan metropolises. Simplifying, we can say that a stimulus from the south produced significant signs of urbanization in Turkmenistan when the economic "surplus," accumulated through a flourishing agriculture, allowed the transition from a village to a large city. The village, as well, can have as intense a life and vitality as the large urban center, modifying its value and explaining, in a manner that is not too precise, the genesis of the urban centers. It is obvious that this ancient urbanization will leave in subsequent periods also a groundwork that will be relevant to the evolution of the area, attesting to the availability and favorable inclination, since very ancient times, for stationary life. In itself, this urbanization remains an isolated chapter of history, because of its sudden and quick end, presumably due to ecological reasons, as well as to a violent invasion from the east. At least for now, it is impossible to specify the exact identity of the protagonists, the causes, or the nature of this invasion. Another cultural component that interferes with our area of interest, and that appears relevant but of a totally different value, is the uninterrupted concatenation of spiral shaped motifs that started in Tripol'e, a culture between the Dnieper and the lower Danubé, and that most likely influenced even the decoration of the large funerary jars of the Chinese culture of Yang-shao.

The expansion of the culture of Tripol'e toward the east couples with the spreading of burials in gravelike tombs and appears as an element of importance in the evaluation of the genesis of protohistoric cultures in the Chinese area. Tripol'e, as well as Fat'janovo, Abaševo, and the cultures of west Kazahstan, initially worked only with copper, which was imported from the west, perhaps from the Balkans. It is possible that Tripol'e might be the matrix of the culture of Fat'janovo, which the Soviet scholars consider as a possible "barbaric" variation of some foreign metal-smithing culture. The culture of Abaševo, instead, had pure copper available, favored as it was by the geological structure of its territory of origin. These cultures, with the exception of Kazahstan, felt the effects of metal-working in central Europe.

Now that we have mentioned several important links between the earliest prehistoric world of Eastern Europe and the Central Asiatic area, and also the presence in this zone of the northernmost point of the earliest urbanization, it would be opportune to examine several technical aspects of the periods prior to nomadism, which can offer us a solid base for clarification and interpretation of other data. The techniques connected with the working of bronze accurately outline the complicated interlacing in the diffusion of cultures that covered a large portion of the Asiatic territory concerned, mingled in various ways with the genesis and the development of the art of the steppe. According to Soviet research, confirmed by the Institute of Metals of Stuttgart and by American specialists, the bronze alloys used in the Altai, and particularly in the territory of Minusinsk, are arsenious alloys. These are very similar to those known during the III millenium B.C. in the Caucasian regions (on both sides of the Caucasus Mountains) and are free of tin. Though the origin of these particular alloys is most likely Anatolian, it is the so-called culture of Majkop in the Kuban basin that was the source of its diffusion over a vast area that reached the Volga and the Dnieper basins and extended as far north as the 51st parallel. In most cases finished goods were distributed and circulated; at times ingots, also, were circulated. This is the reason that the figurative taste of Majkop and its repertoire came to reach the culture of Fat'janovo. Technically speaking, the alloys in question show a strong percentage of arsenic (from 2% - 10%) and from insignificant and perhaps casual amounts of nickel (around 0.01%) to an average that is very close to the maximum values (a little below 4.4%).

Around the middle of the II millenium B.C., the arsenious bronze market narrowed down and collapsed because of the availability of the standard bronze alloy (copper and tin, 70% and 30% respectively), which was competitive in quality and was brought by migration towards Eastern Europe by the Andronovian tribes. The origin of this alloy is certainly connected with the working of the tin mines of Kazahstan (of course only as much as regards the commercial area absorbing the tin coming from these mines). Its diffusion is so wide that the whole central Asiatic belt south of Semipalatinsk shows a quantity of different Andronovian cultures, all characterized by this kind of bronze. Confirming this metallurgical activity are deposits, "treasures," stamps or molds, raw materials, unfinished objects, and various tools that show the breadth and the vitality of the production, which was connected, as we have seen, with the working of the tin mines of Kazahstan.

Curiously, the territory of the Altai and the Minusinsk basin, even if relatively near the ancient mining territory of Kazahstan itself, are characterized by the use of arsenious bronze, as though there were a barrier to the influx of tin. It should be noted that the arsenious alloys are very close in composition to those of Kuban. This does not mean, however, that the alloy's derivation from Kuban is proven. On the other hand, even where the use of the copper and tin at one point started being used in bronze alloy, the arsenious alloys survived, for reasons that are not too clear. Nevertheless, in these territories metal working had a wide development, not only in quantity (most of the bronze of the steppe comes from the Altaic area) but also in technique.

Minusinsk was clearly the earliest culture that used iron, although, because of the high percentage of carbon present in the ore, it was a kind of cast iron. This metal was strictly used for blade handles or bronze points. The knowledge of iron does not actually bring about a real iron age in southern Siberia, at least not until a later period. This zone thus shows an autonomous development that is not influenced – possibly because of its isolation due to the orographic conformation of the territory – by the suggestions of Kazahstan. None-the-less, the culture of Sejma, which is much farther away in the Uralic area, does show the effects of this influence.

If we consider that the culture of Karasuk, from which almost the entire evolution of the art of the steppe in its first stages derives, used arsenious bronze rather than the tin alloy of Kazahstan, we should then discount as unlikely an influx from the south, which would include contributions from the tin regions. The hypothesis of Clurova that suggests searching in Iran for the source of the Karasuk style – that is, from the world of Luristan – seems untenable. This is a problem we will consider further on.

The evolution of Karasuk seems to fall within an area in which the Chinese metallurgy exerted a considerable influence. A continuous influx and exchange has in fact been confirmed, though in a later period. In both these zones, due to different phenomenological components, the exploitation of iron had a late development because of an anomalous preference for bronze. In China, the technique of working bronze rapidly reached levels that were very high, and indeed difficult to surpass, even today. The alloy is formed by copper, tin, lead, and, in very small and variable quantities, by other metals that are often contained in the metalliferous gangues from which the main components of the alloy itself were extracted. Yet the legendary Chinese tradition, both of the Tso-chüan and of the Shih-chi, recorded by the great historian Ssŭ-ma Ch'ien, speaks of a gift made of metal sent from the "lands of the nine shepherds" to a legendary Chinese emperor of the Hsia dynasty. Whether this is "the great Yü" – that is, the one who made China fertile and healthy again after the deluge – or rather his son, does not concern us at this point; instead, the suggestion of a western origin of metalworking from an area of shepherds is of great interest. In light of the composition of the Chinese alloy (apart from the very high technical level reached by Chinese workers since the beginning of the Shang dynasty), one can suppose that if ever there were such an influence, it must have come from Kazahstan and it must have coincided with the full development of its tin mines. If this is true, then from Sejma in the Urals to the China of the Shangs, the techniques of working metal and the trade of raw materials and finished products from Kazahstan acted as a stimulant in the evolution of very extensive areas and in the formation of the complex Chinese civilization. Yet, this technological advance in the end enormously complicated a problem that is essential to the understanding and evaluation of the art of the steppe.

BIBLIOGRAPHY - In. A. Zadneprovskij, Drevnezmledel'ceskaja kul'tura fergany. M.I.A. 118, Moskva-Leningrad, 1962; V. I. Sarianidi, Pamjatniki pozdngo Eneolita Jugosostocnoj turkmenii, Moskva-Leningrad, 1965; A. F. Ganjalin, Raskopi v 1959-1961 gg.na altyn-depe, Spvetskaja arkheologija, 4, 1977 (Namazza-tepe 4º); V. M. Masson, Protogorodskaja civilizacija juga srednej Azii – Sovetskaja arkheologija, 3, 1967 (Namazza-tepe, 4º, 5º); M. Tosi, Excavations at sharh-i sokhta, a chalcolitic settlement in the Iranian sistan. Preliminary rapport on the first Compaign, october-dicember 1967, East and West XVIII, 1-2, 1968; M. Tosi, Excavations at shahr-i sokhta. Preliminary Report on the second compaign, E. and W. XIX, 3-4, 1969; V. M. Masson, Raskopki na Altyn Depe v 1969 g., Askabad, 1970; I. T. Kruglikova and V. I. Sarianidi, Drevnjaja baktrija v svete movyh archeologiceskih atkrytik, Sovietskaja arkheologija, 4, 1971; V. I. Sarianidi, Raskopki tillja tepe, Moskva, 1971; V. M. Masson and V. I. Sarianidi, Central Asia southern turkmenia before the achaemenians, London, 1972; M. Tosi – C. C. Lamberg, Karlowsky – Shahr-i sokhta and tepe yahya: traks on the earliest history of the Iranian plateau, E. and W. XXIII, 1-2, 1973; V. M. Masson, V. I. Sarianidi, Sredneazjatskaja terrakota epokhi bronzy, Moskva, 1973; A. Askarov, Sapallitepa, Taskent, 1973; V. I. Sarianidi, Baktrija e epokhu bronzy, Sovetskaja archeologija, 4, 1974; V. M. Masson, Raskopki pogrebal'nogo Kompleksa na Altyn depe Sovetskaja Arkheologija 4, 1974; V. I. Sarianidi, Pecati – amulety Murgabskago stilja Sovetskaja Arkheologija 1, 1976; V. I. Sarianidi, Material'naja Kul'tura juznogo Turkmenistana v. period rannej bronzy – Pervobytnyj Turkmenistan, Askhabad, 1976; L. I. Al'baum, Balalyk Tepe, Taskent, 1960; A. N. D'jakonova, Documents of Khotanese Buddhist Iconography, A. As. XXIIIn, 1960; A. R. Hatani (e altri), The ancient Buddhist arts in Central Asia and Tunhuang, Monumenta Serindica, V, Kyoto, 1962; V. A. Siskin, Vataksa, Moskva, 1963; M. Bussagli, La peinture de l'Asie Centrale, Genève, 1963; Camilla V. Trever, Tête de semmurv en argent des collections de l'Ermitage, Itanica antiqua, IV, 1964; G. Frumkin, Archaeology in Soviet Central Asia – IV. Tadzhikistan Central Asian Review, vol. XII, 3, 1964; G. Frumkin, Archaeology in Soviet Central Asia – V. The deltas of the Oxus and Jaxartes: Khorezm and its Borderlands, Central Asian Review, vol. XIII, 1, 1965; G. Frumkin, Archaeology in Soviet Central Asia – VI. Uzbekistan, excluding Khorezm, Central Asian Review, XIII, 3, 1965; B. Rowland, Art along the Silk Road, Harvard Journal of Asiatic Studies, XXV, 1964-65; G. A. Pugacenkova, La sculpture de Khaltchayan, Iranica Antiqua, V, 1965; G. A. Pugacenkova, Des Problèmes de l'art de la Parthie du Nord et de la Bactriane du Nord, Huitième Congrès International d'Archéologie classique, Paris, 1965; T. Talbot Rice, Ancient Arts of Central Asia, London, 1965; G. A. Pugacenkova, Khalcajan, Taskent, 1966; G. Frumkin, Archaeology in Soviet Central Asia – VII. Turkmenistan-Central Asian Review, XIV, 1, 1966; Mission Paul Pelliot, Documents archéologiques publiés sous les auspices de l'Academie des Inscriptions et Belles Lettres sous la direction de Louis Hambis – I, Toumchouq; planches – II, Toumchouq; textes – III, Koutcha; planches, Paris, 1961-1964-1967; P. Bernard, Ai Khanum on the Oxus. A. Hellenistic City in Central Asia, Proceedings of the British Academy, LIII, 1967; R. E. Emmerick, Tibetan Texts Concerning Khotan, London, 1967; J. Rosenfield, The Bynastic Art of the Kushans, Berkeley – Los Angeles, 1967; A. Beleniskij, Asie Centrale, Genève, 1968; Sir Mortimer Wheeler, L'incendio di Persepoli, Milano, 1968: Papers on the date of Kaniska, edited by A. L. Bassham, Leiden, 1968; M. M. Hallade, Inde. Un Millénaire d'art bouddhique, Paris, 1968; B. A. Litvinskij, Kangjuisko sarmatskii far, Dusambe, 1968; E. Emmerick, Some khotanese Inscriptions on l'object d'Art, J.R.A.S., 1968; B. A. Litvinskij,

Archeology in Tradzikistan under Soviet Rule – East and West, XVIII, 1968; G. Frumkin, The Expansion of Buddhism as witnessed by Recent Archaeological Finds in Soviet Central Asia, Bibliotheca Orientalis, XXV, 1968; M. and Sh. Mostamindi, Nouvelles fouilles à Hadda (1966-1967) par l'Institut Afghan d'Archéologie, Arts Asiatiques XIX, 1969; G. Azarpay, Nine Inscribed Chorezmian Bowls, A. As. XXI, 1969; M. Taddei, Inde, Genève, 1970; B. A. Litvinskij, Outline History of Buddhism in Central Asia, Kushan Studies in U.R.S.S., Calcutta, 1970; B. Rowland, Zentralasien. Kunst der Welt: Die aussereuropäische Kulturen, Baden-Baden, 1970; Ph. Granoff, Tobatsu Bishamon. E. and W. XX, 1970; M. Bussagli, Culture e civiltà dell'Asia Centrale, Torino, 1970; A. M. Belenitski and B. J. Marshak, L'art de Piandjikent à la lumière des dernières fouilles (1958-1968), Arts Asiatiques, XXIII, 1971; B. A. Litvinskij – T. J. Zejmal, Adzina-Tepa. Architektura, Zivopis Sculptura, Moskva, 1971; N. Pugacenkova, Skulptura Chalcajana, Moskva, 1971; Chiara Silvi Antonini, Le pitture murali di Balalyk tepe, Annali dell'Istituto Orientale di Napoli, volume 3, 1971; P. Vergara Caffarelli, Proposte per una nuova cronologia e per un ulteriore esame critico dell'opera di Yu-ch'ih I-Seng – R.S.O., 1972; J. Williams, The iconography of Khotanese Painting. E. and W., XXIII, 1973; A. C. Lavagnino, Alcune note sulla «Musica di Kucha», Annali dell'Istituto Orientale di Napoli, vol. 33, 1973; B. Ja Staviskij, The capitals of Ancient Bactria, E. and W., XXIII, 1973; A. M. Beleniskij, Monumentalnoe iskusstvo Pendzikenta: Zivopis Skulptura, Moskva, 1973; Fouilles d'ai Khanoum I (Campagnes 1965, 66, 67, 68, M.D.A. F.A., vol. XXI-Rapport préliminaire publié sous la direction de Paul Bernard avec le concours de Raymond Desparmet, Jean Claude Gardin, Philippe Gouin, Albert de Lapparent, Marc La Beere, Georges Le Rider, Louis Robert, Rolf Stucki, Ed. Klincksieck, Paris, 1973; M. Taddei, Appunti sull'iconografia di alcune manifestazioni luminose dei Buddha. Gurarajamanjanika, Studi in onore di Giuseppe Pucci, Napoli, 1974; A. M. Quagliotti, Recensione a B. Rowland, Zentralasien, Baden-Baden, 1970, in R.S.O., 1975; Guitty Azarpay, Some Iranian Iconografic Formulae in Sogdian Painting, Iranica Antiqua, vol. XI, 1975; Francine Tissot, Remarques iconographiques à propos d'une tête de roi barbare du Ganghara, Arts Asiatiques, XXXII, 1976. See also M. Bussagli and others Architettura orientale, Milano-Venezia, 1973 (introduction).

MARIO BUSSAGLI

ART OF THE MIDDLE EAST

GENERAL OBSERVATIONS AND NEW ORIENTATIONS
ON THE ART OF THE ANCIENT MIDDLE (OR NEAR) EAST

Recent discoveries and studies have progressively underlined the quality of homogeneity found in the cultures of the Ancient Middle, or Near, East. This was not to deemphasize obviously independent information and data from individual areas, but rather to point out the organic connections and components of the Ancient Near East, with special regard to the concept of art and to art related problems. In this introduction, the major issues will be presented and explained in view of this recent and still on-going critical debate.

Unity and Variety. — The first issue we shall look at is that of the homogeneity of the area in question. It is now clear that this area can be characterized and distinguished as the first well-defined block of "advanced civilizations" ever to appear. With it came the phenomena that usually accompany advanced civilizations, namely urbanization and the creation of written language, which then lead to the beginning of historical documentation. In this sense, there was no breach of continuity within the Near East area. An interruption did occur, however, in other regions where for periods of time certain peoples did not have a written language, and therefore no history was recorded.

Specifically in the realm of art, the rise of advanced civilizations carries with it highly distinctive characteristics. Obviously, art existed even in prehistoric times; but then it was primarily used to enhance objects of common use, such as personal ornaments. Monumental art in the true sense was unknown in the past – as it is unknown in the present – to peoples still at the "ethnological" level. This is due to a lack of a sense of history at that level, and therefore to a lack of a sense of the need to commemorate through monuments, to create works that, for religious or political purposes, will be *lasting.*

The first well-defined block of advanced civilization known to history appears in the Ancient East. This block appears to be intrinsically consistent, when one considers the continuous relations that link the area's regions to one another. Evidently, this does not exclude individual characteristics and forms of civilization for individual domains. In the past, historical research in the field of art has been based on geographic division and boundaries on the one hand and on specific elements of the area's internal unity and variety on the other.

Geographically speaking, the term "Ancient East" by a confirmed and well-established tradition refers to the Near East. The common center of gravity and main attraction of peoples and their cultures is the eastern basin of the Mediterranean, which everyone sooner or later looked to, finding on its shores meeting places and ports of exchange. Outside of this area is the Iranian world, whose position is continuously shifting; sometimes leaning towards Mesopotamia, and other times towards India. In these past years, however, a series of discoveries, which we shall get to shortly, points to the communication of the Iranian world with the West.

On the opposite side of the Mediterranean basin, on the margins of the Ancient East, was the Aegean world. Relations between this world and Near Asia and Egypt are intense and constant, especially in the II millenium B.C. W. Stevenson Smith, the scholar who most thoroughly researched the relations between the Aegean and the Ancient Near East, has adopted the Aegean component as the central focus for his research. (We feel that this civilization has its roots in an area that is culturally different. Therefore, it would seem that a hypothesis should be sufficiently flexible so as to include the Aegean experience whenever it converges with the Ancient East, but that it still should differentiate the Aegean from the Near Eastern civilization.)

The region being examined in this study has been influenced by different peoples, whose contributions to civilization in general, and to art in particular, have been differently evaluated. J.A.H. Potratz, one of the greater scholars of the art of the Ancient Near East, pointed out that the diversity in character of Sumeric figurative art, as compared to Akkadian art, is determined by the "diversity of essential structures" between those two peoples. We do not share Potratz's opinion, which attributes to ethnic entities concepts that are too complex and varied and that can be worked out and justified only with great difficulty. In addition, there are the unquestionably varied facets of the ethnic situation in Mesopotamia, which act as the counterpart to the more homogenous ethnic situation of Egypt.

Examining diacritically the internal relations in the area, it is obvious that different eras bear different sets of information. There is no doubt that certain phases that are essential to the political, cultural, and artistic history of the area clearly point out and demonstrate the intrinsic links and basic unity of the Ancient East. Of primary importance is the formative period of history, from 4000 to 3000 B.C. That period coincides with the development of urbanization and of a written language: in simpler terms, with the development of an "advanced civilization."

In the past, Frankfort had already carefully gathered data on this period, pointing out the connection between Egypt and Mesopotamia, a connection based on artistic trends that shifted from the first region to the second. At present, the research on the IV Millenium Egyptian statuettes that were found in the Naqāda region reveals further similarities to Mesopotamian statuettes, so much so that certain specimens could easily be mistaken and incorrectly attributed. If one considers this new data in the light of previously known facts, one can see that the relations between the two great river valleys was stronger at the beginning of history than in the ensuing period.

Without a doubt, Mesopotamia played a major role in these relations. The diffusion of Mesopotamian art at the beginning of history is also indicated by other recent discoveries in central Iran. The cities that are currently being discovered in the Lut desert define the oneness of the events of urbanization, which characterize the beginning of the II millenium B.C., with evidence of a written language linked to Mesopotamia and an art, consisting of figurines and seals, which also clearly recall this area. At least two points are clearly defined by the research so far completed: one is the dispersion of the known Mesopotamian influence in the East, and the other is the discovery of a civilization that links the Near East and India. This is an important finding, necessary for the evaluation of locations and time frames of the formative period of history.

A subsequent period of particularly intense relations between the areas of the Ancient East is around the second half of the II millenium, when the mountain civilizations intervene from the north and the east and break the political and cultural dualism of Egypt and Mesopotamia. The area of Syria and Palestine acts as a nucleus; a variety of elements, balancing each other, develop around it and progress in a rather unstable, but essentially unchanged, manner for around three centuries. Recent research has clarified the elements of a circle of international relations of highly homogenous nature.

In a more specifically artistic framework, W. Stevenson Smith dedicated his essay of 1965 on the "interconnections" of the Ancient Near East to this period, directing other scholars to the Egyptian, Aegean, and Near Asian worlds. The focus of this study is Egypt, examined from its position in international relations, i.e., the actions it carried out beyond its borders and their resulting repercussions. Wall figurations in particular take on a special significance in this type of study, in agreement with the theory that monumental art becomes the symbol of the union of a world that was closely interrelated.

After sudden historical and cultural severances, the I millenium B.C. sees the political unification of the Ancient East; a partial joining under the Assyro-Babylonians, a complete one under the Persians. This historic fact does not automatically translate into an artistic one. Yet, it is obvious that the relations between the areas are more intense and so are those appearances of historic art which mark periods of greater unity. Nevertheless, emphasis should be placed not so much on the historic aspect of art, but rather on the condition of "koiné" and on the exterior assimilation that naturally accompanies the growing homogeneity of the Ancient East.

Phoenician art is perhaps the best example of these components. Influenced by many different areas, from Egypt to the Aegean to Mesopotamia, the Phoenicians assimilate and blend into their ornamental development varied artistic currents that are among the most ancient and valid. By then exporting their products to the West, they bring about a wide dissemination of the, by now, more and more important Oriental heritage.

This does not occur in a direct fashion. The characteristic phenomenon of orientalizing art brings to Greece, Etruria, and the entire West the mediated experience of the art of the ancient Near East. Without a basic homogeneity, these phenomena could not be explained. So there is an "a priori" and an "a posteriori" confirmation of the cohesion of the art of the Ancient East. This confirmation constitutes, even in the recognized difference of its components, the indispensable introduction to the present treatment of the matter.

The protagonists of art. — Today, the study of the crafts of different cultural areas and time periods presents a greater understanding of the events that occured in the Ancient East and defines the political and social positions in which they took place. It is clear that crafts are naturally linked to the development of autonomous cities and towns and that they constitute an essential component of the type of work of the city itself. Apparently, this did not happen only in the Ancient East; however, this area provides us with the earliest documentation of these types of activities.

Furthermore, it is clear that crafts develop in relation to royal courts and religious centers that are often connected to the courts. This connection to the courts gives rise to a qualitative difference in the craftmanship; it is conceivable that an artifact made for the political and religious authorities is different and superior in quality from that which is made for everyday life use. This distinction is particularly evident in the Ancient East, where an "elite" production, specifically made for royalty, appears even in the most ancient times.

How could the actual conditions of the artist in the Ancient East be described? Apparently, he was not free, and he served under political and religious powers. Nevertheless, what the attachment to the court demonstrates is not the inferior condition of the artist, but rather the integration of the artisan into the institutions of the palace and the temple. This integration reflects the important and essential duties assigned to the artisan: the duties of long term participation in the celebration of kings and gods. In conclusion, in the Ancient Near East one notices the first establishment of permanent relations between the receiver and the producer of art: a relation in which art reveals an evident and stable dignity.

Linked to the specialization of a craft and to the political-religious functions of its production are the new and emerging tendencies towards professional "secrecy." This secrecy had the purpose of safeguarding the accumulated patrimonies of knowledge and experience against possible competition. These patrimonies have a clearly religious, or rather a magical, connotation. At this point, the "advanced society" still displays its prehistoric heritage, in which the artisan is still in part a sorcerer who has specialized skills linked to the occult powers.

The connection between craft and religion, or rather the inclusion of craft in the religious sphere, is an essential element in the understanding of the art of the Ancient East. It is necessary to state, however, that in every period and in each country religion has played a major role in artistic production. Therefore, in the Ancient East these characteristics do not conflict with those of other periods. The fact is they are exclusive in the sense that, unlike other areas, profane art did not exist alongside sacred art. If a profane art did not develop contemporarily to a sacred art, it is because a "sense of sacredness" completely dominated the con-

ception of the universe, and it influenced art as well as all other facets of life.

In the Ancient Near East, political power openly received its investiture and legitimization from the supernatural world. In Egypt, statues were dedicated to divine beings and sovereigns, also considered gods. Art was influenced in a direct and constant manner by political forces, so that flourishing and declining periods of art corresponded to the various circumstances of the pharaonic institution. In Mesopotamia, the king was not a god, but his portrait and the portraits of his high officials were equally given as an offering to the gods in the temples. Art remained at a stately level and was conceived and developed in the framework of the court.

The monumentality of art which is characteristic of the ancient Eastern world is an integral aspect of the link between power and faith. Undoubtedly there is, together with monumentality, an intent to represent the qualities of stability and changelessness that are inherent to the divinity. Also present is the intent to remove anything that could possibly remind one of the limitedness of human labor, or anything that is in any way related to it. Concurrently, the surpassing of the "natural" dimensions brings us to another series of conditions, which will later be discussed in detail. These are antinaturalism and symbolism, i.e., the obvious abandonment of the natural appearance in favor of the portrayal of the superior force that exists in the hereafter.

The situation thus far described reveals a quality that is characteristic of Ancient Eastern art: anonymity. To know the name of the author of a work of art was the exception. (The same is somewhat true for literature, although we more often know the name of the scribe.) In other words, not much importance was given to the creative character of the artist, nor was the aspiration to originality and to personal and subjective creativity at all apparent. Like all artisans, the Ancient Near Eastern artist worked on a commission and had to adapt as much as possible to the models and avoid subjective interpretations.

The above described situation was not necessarily the same throughout the Near East. In Egypt, the court architect at times takes on so much importance that his name is forever remembered. This is what happened in the case of Imhotpe, who built the burial ground in Saqqāra for the Pharaoh Doser. His name – a rare and unprecedented occurrence – appears on the statue of the pharaoh and also on the wall of the so-called "unfinished pyramid." Imhotpe's figure is extremely complex, and his complexity raises several questions. Tradition celebrates him as a great architect. We know he was also a philosopher and a patron of writers, so much so that the tradition says he was offered the first drop of ink for his writing; in addition, he was thought to be a sorcerer, a god that heals, to whom shrines and temples had been dedicated. Any one of these skills may have granted him remembrance, and, with remembrance, immortality.

On the whole, the image of a collective and anonymous artisan working for church and state is valid. This image is the necessary introduction to the study of tradition and of its interaction with art, as well as to the duties that establish "genres." or categories of craftsmanship in art.

Tradition and "types". — Does the society of artisans thus far described present a conscious tendency towards innovation, and does it try to modify the criteria passed down by tradition? Does it express a will to create in an autonomous and original manner? If both questions are put in those terms, the answers can only be in the negative. To the collective and anonymous nature of the art one has to add its static nature, which is especially evident in certain periods and areas. The lack of innovative spontaneity, which is its negative component, finds its positive counterpart in the deliberate imitation of the ancient models, considered perfect and unsurpassable. This explains why, in art as well as in literature, it is difficult to outline a well-defined evolution. When we may do so, this evolution corresponds to a political and religious development, rather than to a strictly artistic one.

It is thus opportune to emphasize the binding functions imposed by traditional models, which are taken as examples, as an inspiration for subject matter and technical and stylistic choices. It is understood that the appearance of great artistic figures was not thwarted by the lack of recognition of the individual names and qualities of the artists. There is no doubt, however, that in the Ancient East the "nourishing veneration of the arts," of which Cicero will speak with regards to Greece, was not present.

The utmost respect for the past, and the tendency to consider it as an exclusive model, the tendency to imitate it and repeat it in concept as well as in realization, are attitudes characteristic of a civilization that is absolutist on the religious and political level. The adherence to models of an already achieved perfection reflects a conservative approach, a will to celebrate truths that have already been "realized" and to assert their continuity and stability. In the field of art, this posture is reflected not only by canonization, but also by archaic thinking and a reverence for the ancient.

It is understood that the basis for such an attitude is the lack of art theory and therefore of an awareness of the creative autonomy of art. Consequently, there is – and not only on an artistic level – a constant tendency to keep within the tradition and to produce works in agreement with the forms already in use. The artist forsakes his individuality; his tastes identify with those of the community, he considers the past as a model for the present.

Innovation in art that cannot be explained through intrinsic artistic factors can, as previously stated, be explained through political and religious ones. The most typical example is that of the revolution in el-Àmārna in Egypt. There, the modification and break-down of religious and political values had an immediate reflection in the ensuing modification and disintegration at the artistic level. Solemn and impersonal art became personal and wrought with feelings. Personalities and emotions were revealed through images, only to be again concealed with the restoration and the return to the ancient values.

Nevertheless, a final definition of "staticity" for Eastern art can be considered both valid and not valid at the same time. Static are the general, or at least the predominant, attitudes, such as the cult of tradition and the faith in a set of values that are by nature unchangeable. A problem in the aforementioned attitudes is that of stylistic evolution, an evolution that becomes evident when in-depth research is carried out. This can be seen both in the higher arts (for instance, in the case of Syr-

ian reliefs), and in the so-called minor arts (the case of the seals is an example). In seals in particular, there is often a development that is rapid enough to clearly mark the different phases of art history, phases which would otherwise not easily surface.

Also linked to the problem of tradition is that of "genres" or categories in which an artistic product may fall. Today, we are well aware of the debatability and inherent weakness of any subdivision of this type. However, considered in this particular historic context, the issue of categorizations and "genres" may not be so controversial. In the Ancient Near East, the cult of traditional designs falls into the relative schematization of "genres." Yet, this schematization is more significant when compared to other forms of categorizing applied to other eras and cultural areas.

Recent criticism, moreover, again recognizes the validity of this type of research. It points out that a typology is not necessarily a surpassed schematization that arbitrarily constrains the creative process into formal and restrictive limitations. A typology, rather, can indicate the conditions and the guidelines under which the creative process works and under which the local traditions are met. It also indicates the political, religious, economical, and theological facts which the artist cannot transcend.

In the Ancient East, the categories of figurative art were transmitted by the spreading of typologies from area to area, and, also, through the influence a particular typology had on iconography. The history of artistic motifs is therefore tied to the history of the "genres" in which they appear, often in an influencing relationship.

No less important than the ideological factors are the environmental ones. For example, the nature of the Anatolian environment favored mountain fortresses and rocky reliefs. But, above all, it was the materials employed that greatly influenced the solution of problems from area to area. In Mesopotamia, and particularly in the South, clay bricks prevailed, first shaped, then dried in the sun. These bricks were then used to build continuous and solid walls, with rare windows, in order not to weaken the bulk of the construction. There were no columns, or at least columns were not used for support; rather, wooden supports were generally employed.

In other regions, except for a brief period in northern Mesopotamia, stone was more commonly used. When columns are used for support, the presence of windows does not affect the sturdiness of a wall. Stone allows for a more flexible alternation of solid and open spaces. The differences between Mesopotamia and Egypt are clearly evident. In both cultures the sense and the desire for grandiosity was present. However, in Mesopotamia the lack of use of supporting columns inevitably made for cumbersome structures, whereas in Egypt the ample use of the column conferred grace and harmony to the buildings.

The functions of art. — The fundamental purpose of art stemmed from its typical palatial and templar nature, which enhanced its integration into society. Basically, it can be said that art served two distinctive, but interrelated, primary functions: one was to substitute for the person it represented, and the other was to celebrate the person and the events in which he or she is the protagonist or played a part.

In regard to the image as a substitute for the person, it should be pointed out that in the entire Ancient East a work of art was not a means of expression of the figurative world of art, but rather one of substitution for the real world. It therefore took on an autonomy of its own, an actual "otherness" the moment it was created. The question one poses is why was there this "doubling" of reality, this objectification and reconstruction of the image? Basically, that was to place the person portrayed under divine protection in the place where this protection is eternal – that is, in the temple. For the most part, Eastern art was therefore votive, but through the portrayal of a god it could also indicate the counterpart of a vow.

The considerations thus far presented show that for the people of ancient Egypt, and for those of Mesopotamia, statues always portrayed a specific person with whom the statue is identified. This concept is more clearly expressed in Egyptian art, where a statue was the object of special rituals. One example is the so-called "opening of the mouth" ritual, in which it was believed that the statue physically carried out ceremonies for the deceased. These were ceremonies the deceased could in reality not perform, but that nevertheless were a part of the afterlife, a life that was considered as real as the life on earth.

The votive purpose of a statue explains its location not only in the temple, but also (in the case of Egypt) in the tomb. This last statement contradicts the commemorative purpose of the statue, which we will see surfaces and establishes itself in the Ancient East. In Egypt, we find the custom of placing a statue in the "serdāb", a sacred room closed to the public and from which it was believed the statue could look out without being seen. In the serdāb, not only are the commemorative elements ignored, but they are also contradicted in that it is the statue that looks out at the visitor, not the visitor who looks at the statue.

The function of substitution explains the reason a statue often had a name written on it. The name was obviously not that of the artist, who remained anonymous. An artist's name could not have appeared on a statue, otherwise the artist himself would have been identified with the statue and therefore with the person represented. It was the name of the person portrayed who was in this way unequivocally placed under divine protection. Consequently, to erase the name on a statue would have meant to annul the existence of the person exemplified by the statue; to substitute the name would have meant to substitute the person.

Certain essential aspects of ancient Eastern figurative art are more clearly explained by defining the process through which art represents a person or creates a vicarious being. To this end, the artist must characterize the image, in order to have it carry out its assigned role. To define a person, an image must be marked to avoid any chance of future substitution and error. The bulk of the research by S. Moscati concentrates on the methods of characterization.

In the ancient Near East, the artist was in no way free to reproduce reality as he saw it. Aside from the conventions, schemes, and formal and stylistic principles by which he worked, he was conditioned by the goal of producing a work that was a substitute for the person. In order to do so, it was necessary to represent and characterize without possibility of error. Therefore,

the approach an artist had to follow was twofold: first, he had to reproduce according to the criteria of his surroundings; second, he had to verify the characterization and, when needed, to modify it in order to implement it. As for the means employed to execute a work of art, a determination was made by either collective or individual criteria; collective criteria were used to define groups, and individual to define persons. Intrinsic and extrinsic values were deemed to be of great importance in seeking authenticity and perfection in the created replica. The first case includes such things as clothing, signs, and ornaments, and the second physical qualities. Finally, there may have been non-physiognomic criteria (such as the dimension of the figure), as well as physiognomic criteria (the ones that relate to portraiture).

It must be noted that the need for characterization and individualization did not necessarily coincide with a physiognomic interest. This interest did exist, but in the Ancient East the complex reasoning involved between appearance and reality took place in a world where reality did not coincide with physiognomy. Rather, the notable difference between the two indicates that a characterization was not necessarily a "portrait," to the point that the elements involved in portraiture were basically of little importance. This becomes all the more interesting when one considers that the primary requirement of a work of art was to unequivocally portray a given person for the sake of "substitution."

Up to this point, we have said that art was aimed at representation. As we know, it also had the function of commemoration and, therefore, that of admonition. Commemoration of great events by means of works of art is without a doubt an essential feature of ancient Eastern society. The ruins of statues, of victory steles and obelisques, of great reliefs on temples and palaces are majestic and monumental, and still today impress all who come into contact with them.

We should therefore discuss commemorative art beyond all superficial impressions. We should concentrate on the causes and on the circumstances that determined the vigorous development of historic art in the Ancient East, and also on those causes which, in other times and areas, suppressed it. At the same time, one must research the true nature of this art and the magical and ritual context in which it was produced. There is a dialectic reciprocity between art that substitutes and art that commemorates; each one is implied in the other.

There is no doubt that historic art is a characteristic of "advanced civilizations." However, before closely examining the situation in the Ancient East, one should indicate that not all "advanced civilizations" create historic art, or at least do not create in the same way or to the same extent. Historic art is usually found in large, centralized states and in absolute monarchies, which see this type of art as a means of asserting their power and of implementing campaigns of propaganda and intimidation, internally and externally. Furthermore, historic art reflects a political awareness, which, in exalting power and glory, professes national continuity and places collective values above individual ones.

Turning to the grand phenomenon that historic art was in the Ancient East, one recognizes the unquestionable superiority of the cultures of the greater powers, of those with centralized and absolutist structures. One should also bear in mind the connection between an artisan and the court and that art was produced under a commission by a sovereign, as an expression of his or her ideals of ascendancy. Basically, because of its overall situation, one can say that the Ancient Near East was conducive to the development of historic art. However, there also are reservations. In addition to the positive developments, there were the negative ones, which came to be in times and areas where despotism did not prevail or did not take on the centralized nature of a great unitary state.

This is the case of Sumeric cities, whose situation anticipated that of the Greek city-states. This was also the case of Israel, where religious beliefs from the start prevented any development of figurative art and, therefore, of monumentality. Without going into too much detail, it is clear that the Ancient East was not uniform in all times and areas. One can say that where there was a lack of despotic and centralized power, historic art was of little importance. Nevertheless, the constants are such that the consideration of the area as a whole is not only justified, but highly appropriate.

The problem of ritual and magic in art still remains to be analyzed. In the Ancient East, the "secular" component that one frequently finds closely tied to historic art is missing. In reality, religious sensitivities may contradict news of the past. In order to have significance as a lasting testimony to past achievements, a work of art must specifically refer to a concrete, passing, and not-repeatable fact. A ritual or mythological depiction, by its own nature, places itself outside of "real time" into a cyclical repetitive time.

Certainly, the recognition of historicity in the art of the Ancient East is an essential critical point in the study of the region. The point is not to identify at all costs the artistic phases that could be considered exclusively "secular," but rather to define the phases in which a specific historic intention is present. These phases certainly do exist. In some, one can observe the predominance, though not explicitly depicted, of the "secular" aspects of an art that has generally leaned towards the transcendant.

Themes of representation. — As for the problem of the organic versus the abstract in the art of the Ancient East, one can say that it is an art which is, to a great extent, organic. If and when it moves towards the abstract, it is through the autonomous mode of ornamentation (which will be discussed later). Without a doubt, the real world offers art a large part of its subject matter, at least in its figurative components. The combination of the figurative components in the art of the Ancient East often surpasses and contradicts appearances. These border on what we might call the monstrous and the fantastic, although in the environment in which this art originates the monstrous and the fantastic represent reality.

Images are therefore based on elements that are for the most part natural. Interest in portraying the world as it is seen causes the elements to combine in forms that are not evident in nature, and, on the other hand, it causes the super-natural to integrate with the natural. For these reasons, one can say that rather than representing the world as it "appears," the Ancient East represents it as it "is." When, for example, the artist changes the size of a person according to his or her

importance, he clearly demonstrates the predominance of his "thinking" over his "seeing."

This device brings with it the subordination of the particular to the general. Only the necessity to identify the persons portrayed opposes this tendency, and it accomplishes this through non-physiognomical means. Aside from this magic, rather than aesthetic, need, the search for what is essential and stable (to the detriment of the ephemeral) determines a predominant tendency towards standardization and repetition. In Egypt and in Mesopotamia, art is not detail-oriented nor abstract; rather, it focuses on "types" and "genres."

This method was described by the American scholar Robert L. Scranton, who wrote regarding Egyptian art: "It is clear that it utilizes models with a fair degree of abstraction. In the conceptual form this is especially true with regard to the human figure, which almost always appears in a few limited poses, in a few typical costumes. This is also true for the activities represented. These activities, as we have observed, are almost unlimited in covering the entire gamut of human life, but an activity is never reproduced as a specific one – a specific feast, for example, on a given day, in a given place – but as a general activity." And elsewhere, regarding Mesopotamian art: "Once again, it is not the particulars of the phenomena that are real, but their spiritual, prototypical forms."

With these premises in mind, one can begin to analyze the subject matter starting from the models offered by experience, primarily from the human figure. It is, however, necessary to point out that there are specific "methods" of representation involved, and therefore stylistic patterns that recur. Generally speaking, anatomical observation is subordinate to idealization. Gestures and proportions do not aim to reproduce an appearance, but rather to affirm an idealized reality. They are not employed to record what is mutable, but to establish what is inmutable. Consequently, a human figure is not so much based on its actual appearance, as constructed and recreated according to stable laws and ideal principles.

The representation of animals is less confined by a canon than that of man. There is an unquestionable richness of zoomorphous themes in the Ancient East. One should point out that at least part of these fall into the framework of representation of the supernatural. Animal components are of primary importance in the depiction of the divine (in Egypt) and of the demonic. Plants appear frequently, but rarely as an autonomous description of the vegetable kingdom. The palm, the lotus, and the bullrush, schematized and stylized, offer the models for the decoration of columns and capitals in Egyptian art. In Mesopotamia, the palm tree appears as a component of the ancient, common motif of the sacred tree, the image of a supernatural reality. Therefore it is the object of full stylization, as exemplified by the winged gargoyles that tend to it.

One can, therefore, consider phytomorphous themes as a primary source of decorative and ornamental art, along with geometric motifs. Ornamentation is an essential component of ancient Eastern art, secondary only to stylization. Both thrived as a complement to the representation of visible reality and as a form of reducing it to geometric patterns. The predominance of ornamentation in the Ancient East indicates a limited interest in the actual appearance of things depicted and a willingness to modify, stylize, and rhythmically reproduce images.

As for the depiction of the non-visible, better yet, as for what is beyond the visible, deities, mythical figures, and demoniacal beings which are intermediaries between gods and man make up one of the main themes of ancient Eastern art. The combination of human and animal elements into a god or goddess characterizes the long course of Egyptian iconography, whereas in Mesopotamia an anthropomorphic view of the gods prevails. A series of attributes and symbols usually completes these iconographies, the variety of which can be surprising to us but was not to the world in which they belonged.

The beings that are intermediaries between the gods and man, which constitute the demonic world, have their own iconographies. In Egypt, these are generally composed of animal and of animal/human elements. In Mesopotamia, the combination of animal and human elements is never used for the depiction of gods, but is commonly employed in the depiction of demonic beings. Tied to the same theme, though not necessarily coinciding with it, is that of the grotesque and of the bizarre. The sphinx – a symbol of pharaonic power and therefore an expression of the divine – combines a human head with the body of a lion, and therefore inverts the usual relation of the Egyptian mixed creature. In Mesopotamia, in the same category are the winged bulls with human heads that are found on the side of portals, the winged genies with the head of man or of eagle that appear next to the sacred plants, and other motifs that hint at mystical and magical events.

Art scarcely tells us what these events were. Especially in Egypt, myths emerge from veiled allusions, from isolated images of protagonists outside of the context of the narrative or else in a limited or incomplete depiction of an event. Furthermore, mythical elements generally appear in connection with the ritual from which they most likely emerge. In Mesopotamia, the mythical world finds larger expression in art, though conditioned by the allusive, rather than narrative, character of this art and by its reduction to a single figure and a single scene. Small-scale art, especially engravings on cylindrical seals, is where, in Mesopotamia, mythical reality is primarily reflected.

When appearance is of little importance, the "coherence" between appearance and the non-visible reality is equally non-important. Symbolism then becomes an integral part of a figurative patrimony, without need of separation and autonomy. In Egypt, the prehistoric insignias of deities are in fact symbols, as are many ideograms, which, from their primitive function, naturally come to express a set of values that converges in those signs. In Mesopotamia insignias are generally the symbols of the gods and of royalty. These are not necessarily "combined" as in Egypt – such as the staff and the magic circle for the gods, the club and the brush hook for the gods and the kings. Finally, in Anatolia and in Palestine specific emblems are the royal arms, derived from the elaboration and stylization of the Egyptian scarab.

In short, the wide range of artistic themes in the Ancient East, with its natural and supernatural motifs, converges to indicate the predominance of the supernatural and of its inherent purpose on earth. At the same time, it is directed toward demonstrating that there is

no separation between natural and supernatural, in so far as the former is considered nothing more than the outward, partial appearance of the latter. In this context, it can be said that art ultimately is a "technique of relation with the supernatural," intended to depict human actions as eternal, to reproduce them in order to attain participation with magical powers in human affairs. It finally is a way to create a communion between images and the supernatural, similar to that which can be created between words and ritual.

Modes of representation. — Representation presents a set of problems that are essentially linked to the human figure central to an art that concentrates its expressive purposes on it. It should be made clear that the problem of anatomical accuracy is secondary. As has repeatedly been noted, naturalistic imitation is of little importance; of greater importance is a series of signs that, though allowing the identification of the person portrayed, tend to convey his or her particular and superior spirituality.

Of primary importance in the general phenomenon of idealization of the human form is geometric reduction, and, through it, the complete or partial simplification of the form within a geometric framework. This type of "conceptual realism" acts through the simplification and the regularization of natural forms as an expressive function, and therefore according to the rules of style. In sculpture, where this mode is clearly exemplified, masses appear distributed according to the principles of a solid form, predominantly a cube or a parallelepiped in Egypt, a cylinder or a cone in Mesopotamia. Geometric forms are models into which bodies are composed and adapted; an example of this is how the arms of Mesopotamian statutes are tightly joined at the bust.

Reflections of stylization are found in a series of designs relating to the treatment of the human figure and its gesturing. One should point out that ancient Eastern sculpture is predominantly presentative, rather than narrative, and therefore describes a state, rather than narrates an action. The presentation is ruled by the laws of frontality, whereby a figure is seen as being ideally divided by a vertical line that goes from the center of the forehead to the crotch, separating the body into two equal and symmetrical parts. This rule results in a "mirror" vision of the two sides of the body and greatly limits the possible poses.

Obviously, this does not mean that gestures were not derived from reality; it rather means that the singling out of a gesture, its isolation and passing down through time, developed into a symbol and convention beyond its primitive inspiration. Commonly found is therefore the figure seated on a throne, the age-old pose of royalty and divinity. The erect figure is also prominent, whether it be standing with hands joined in prayer, or walking, almost as if moving towards the viewer. Of these two types, the standing figure is prevalent in Mesopotamia and the walking one in Egypt.

Other positions have lesser relevance, such as those with the person kneeling or sitting cross-legged. It should be noted that a different scheme is employed with these figures – that of accentuating characteristic features to the detriment of non-characteristic ones. With this in mind, it should be remembered that the goal of identification and of characterization bestows "privilege" to the face over the body. In the Ancient East, the body is not the object of analysis comparable to that of Greece. The nude figure is in most cases avoided or its use limited, clothing is rigid, and drapery, which we will see highly developed in Greek art, is barely hinted at. This is due to the religious function of a statue rather than to an inadequate knowledge of anatomy.

As for facial details, the enlargement of the eye is the most frequent and outstanding element found. In fact, the lack of this feature in Mesopotamian art is considered an exception. There are other ways, in addition to the accentuation of certain details, to idealize the figure within the mold of his or her general gesturing. Among these, the stylization of the beard and of the hair and the draping of clothing are predominant, all straying from reality for their geometric symmetry.

Deformation, therefore, operates in the details, rather than in the figure as a whole, where a geometric leaning conditions the structure of the image into one of its most important features: that of proportion. This is a stylistic scheme which is still part of a geometric conception. In the figurative arts it takes on a modifying role, similar to the application of the rules which regulate the laws of metrics in poetry. It is understood that proportion is the result of the complex tendency to overcome appearance in favor of a reality that, is in itself perfect and therefore stable, balanced, and harmonious.

A matter of primary importance is that of perspective. One should be cognizant of the fact that the ancient Eastern world does not know the way to incorporate figures into space as we know it. It is evident that the modern awareness of perspective as a "symbolic form" is unknown in the art of the Ancient East. It is therefore appropriate to ask what standards are met by the arrangement of figures in space and by the placement of various constituents of the figure in ancient Eastern art.

A series of techniques makes each component essentially harmonious and is one of the most significant aspects of its homogeneity. The problem of representing a three-dimensional figure on a two-dimensional surface is solved by depicting the profile of the face, the frontal view of the eye and shoulders, a three-quarter view of the pelvis, and the profile of the limbs. The result is undoubtedly a distorted image, but, as mentioned previously, the ancient Eastern artist aims at reality, not at outward appearances. In this light, it is certain that the norms thus far presented, and their resulting choices, give to each part of the body the most simple and precise characterization.

In reality, the result of this process is a kind of "assemblage" of autonomous parts, each considered independently in its most significant and paradigmatic facet. It should be reiterated that a precise will determines this style. It would therefore be improper to consider this process the result of ignorance and error. As Ekrem Akurgal has written: "This is not in the least an 'incorrect' representation, but rather . . . the ideal portrayal of the human body. In the 'presentative' view of the human body it is not a matter of 'able to' or 'not able to' depict the human figure, but of 'wanting to' or 'not wanting to'." (E. Akurgal, 1966)

The process of "assemblage" is not only applied to individual figures, but also to combinations of figures and to the surrounding space. The need for clarity and

stability is better confirmed by a combination of traditional stereotypes than by the spontaneity of episodes. In this way, a line of prisoners becomes, in Egyptian as well as in Mesopotamian art, a succession of single, identical figures at regular intervals. This leads into ornamentation and to the repetition of identical scenes, because the schemes that constitute them are also identical even for events that take place in different times and places.

From what was said above, the presentative rather than the narrative nature of ancient Eastern art emerges noticeably. Let us consider, for example, the recurring theme of the Pharaoh who seizes the defeated enemy by the hair and beats him or her with a club. The historic intent of the depiction, and the reference to specific events and people, is certain. Nevertheless, that scheme is uniformly repeated in Egyptian art, so that, at first glance, one does not perceive the uniqueness of the person and of the event that were the inspiration for the narrative. A careful study then becomes necessary to determine if, how, and to what extent that scheme allows a definition of the event.

An outside, yet valid, tool towards that goal is the inscription that usually accompanies images. Regardless of their degree of uniformity the inscription allows for a differentiation and identification of events. In certain cases, the scheme appears to be characteristic of certain times, making images more readily identifiable. In this manner, the war steles that crop up in Mesopotamia in the age of Akkad not only characterize this well-known period, but also present substantial variety within the framework of the general theme. Not to be disregarded are the secondary occurrences of "updating." For example, in a portrayal of the pharaoh killing an enemy, the physical characteristics of the enemy may vary in relation to the specific episode.

Once the models have been established, the analysis of their use allows us to identify two recurring methods of narration. One is based upon a single and "culminating" scene, and the other upon several scenes. In the first instance, the most important and significant episode obviously represents the entire event, as is the case of the stele of Naram-Sin in Mesopotamia. The method of the "culminating scene" can serve a narrative purpose, yet the reduction of an event to a single episode, no matter how important, gives an allusive nature to the image that symbolizes it that in some ways transfigures the historicity of the event depicted.

The multi-scene method can either be implemented through a choice of the most significant facts in a discontinuous succession or as an intelligible succession of events in a continuous form. Examples of the first approach are the Egyptian table of Narmer and the Mesopotamian stele of Eannatum. The second is used in the great reliefs of Egyptian temples and palaces and in Mesopotamian palaces. In the first approach, because of the selection and relative autonomy of the images, a certain amount of inference and symbolism is necessary, while this is greatly reduced in the second case, where more happenings are tied together in narrative continuity.

One can say that the various methods of narration thus far presented appear in all ancient Eastern art, but not in the same manner in all time periods and areas. The changes they undergo can, and in fact do, constitute a significant criterion for historic differentiation. The single-scene and discontinuous multi-scene methods of narration are the most common in time and space, in the sense that they appear throughout the area, though with limited frequency. In contrast, the continuous multi-scenic narration has a specific line of development that is established at a relatively late date, but which prevails in intensity and breadth of diffusion.

In conclusion, historic narrative originates in Egypt, at the beginning of the New Kingdom, under the stimulus of the international situations of that time. From Egypt it extends to the Near East, by way of Syria and Palestine. Finally, through the Egyptian influence, Assyria develops its own narrative genre which quickly rises to a high and autonomous level of art. Once again, the artistic phenomena spread across the entire Ancient East and demonstrate that considering them in a unitary fashion is a necessity of modern historiography.

BIBLIOGRAPHY - R.L. Scranton, Aesthetic Aspects of Ancient Art, Chicago-London, 1964; W. Stevenson Smith, Interconnections in the Ancient Near East, New Haven-London, 1965; E. Akurgal, Orient und Okzident. Die Geburt der griechischen Kunst, Baden-Baden, 1966; S. Moscati, Apparenza e realtà nell'arte del Vicino Oriente antico (Memorie dell'Accad. Nazionale dei Lincei, VIII, vol. XVIII) Roma, 1975. W. Stevenson Smith, The Art and Architecture of Ancient Egypt, Harmondsworth, 1958. J.A.H. Potratz, Die Kunst des Alten Orient, Stuttgart, 1961; A. Moortgat, Die Kunst des Alten Mesopotamien, Köln, 1967. E. Akurgal, Die Kunst Anatoliens von Homer bis Alexander, Berlin, 1961. Per la Siria: P. Matthiae, Ars Syra, Roma, 1962. S. Moscati, Problematica della civilià fenicia, Roma, 1974; J.M. Blázquez, Tartessos y los orígines de la colonización fenicia en Occidente, Salamanca, 1975. M. Tosi, Shahr-i Sokhta, La parola del passato, CXLII-CXLIV, 1972; J.A. Boulain, L'Egypte avant les pyramides, Archeologia, LX, 1973; P. Amiet, La civilisation du désert de Lut, ibid. Sul fenomeno dell'orientalizzante: M.E. Aubet, Los marfiles orientalizantes de Praeneste, Barcelona, 1971. S. Moscati, Historical Art in the Ancient Near East, Roma, 1963. S. Donadoni, Appunti sul ritratto egiziano, Zeitschrift für Agyptische Sprache, XCVII, 1971. G. Fecht, Vom Wandel des Menschenbildes in der ägyptischen Rundplastik, Hildesheim, 1965; E. Strommenger, Die neuassyrische Rundskulptur, Berlin, 1970. J. Boese, Altmesopotamische Weihplatten, Berlin-New York, 1971. B. Hrouda, Die Kulturgeschichte des assyrischen Flachbildes, Bonn, 1965; E. Weidner, Die Reliefs der assyrischen Königc, l, Osnabrück, 1967. D. Homès Frédéricq, Les cachets mésopotamiens protohistoriques, Leyde, 1970.

SABATINO MOSCATI

CIVILIZATIONS OF THE MIDDLE (NEAR) EAST (PLATES 5-9)

The elements that have significant bearing on the study of the art of the ancient Middle (Near) East are the extension of areas and periods for which there is little documentation and the importance of archaeological findings that revolutionize thinking and implement knowledge that has long been considered conclusive. A substantial amount of critical judgment which developed from these factors proved to be unstable, even with regard to those segments of research that had long been widely accepted as valid. Currently, all findings

have to be constantly verified so that gaps in documentation can be taken into account and evaluated within the context of other information. Often, these gaps do not depend on an actual loss of material, but rather on archaeological exploration that is, by chance or by lack of scientific need, incomplete or totally non-existent. It is for this reason that, in recent years, archaeological research has had to review its outlook on the diffusion of urbanization in the Syrian area and toward the West in general. This research has brought about a broadening of knowledge of the so-called period of the "mountain people" in their final phase, especially in the north Syrian and Elamite areas. Recent data has also allowed the recovery of a valid image of the Urartian civilization of Eastern Anatolia in the first half of the I millenium B.C.

Early Dynastic Mesopotamia. — The central problem of the onset of the urban phenomenon in the Near East during the second half of the IV millenium B.C. has been researched on the basis of territorial division by R. C. McAdams. The goal of McAdams' research was to determine the development of the first urban groupings in the nodal regions of Uruk and in the surrounding areas and also to verify the dynamic relationship between the fluctuations of urban settlements and the frequency and intensity of agricultural allocation of villages.

Observation of superficial archaeological evidence has led to the belief that the continuous expansion of Uruk during the early historic period (c. 3500 - 2900 B.C.) took place at the expense of the surrounding villages, which progressively decreased in number during the entire expansion of Uruk urbanization, or until the period of Ğemdet Naşr (c. 3100 - 2900 B.C.). Parallel analyses, based on the exploration of readily identifiable settlements, have been carried out in areas adjacent to southern Mesopotamia, in the region of Ur and in Kiš, respectively north and south of Uruk. These explorations indicated that urbanization was late in starting and achieved fruition in the final stages of the Uruk period. Even in the period of Ğemdet Naşr (c. 3100-2900 B.C.) modalities of aggregation other than urban concentration, the typical movement of the Uruk area, have been noted. It is precisely this concentration, which would later produce the urbanization of Uruk, that points out the weakness of the hypothesis of overpopulation due to immigration from surrounding areas of poorly irrigated agriculture. The historic urbanization evolvement in southern Mesopotamia seems to be much more complex and less linear than believed, and required the use of various techniques of research and the adoption of numerous methodologies of theoretical approach in order to deal with its reality.

A new temple of the Uruk period was recently discovered during the study of the chronology of a series of sacred buildings in the cult area of Inanna. This temple is structurally similar to the usual "nave" and "transept" plan of the great early historic temples of Uruk, though it is significantly different in its lack of the traditional complex of alcoves. The new building, the so-called temple of the cone-shaped stones, is characterized by cone-shaped decorations in alabaster or red and black limestone tesserae that cover the structural nucleus of crude bricks. From the study of the building phases of the great temples in the sacred area of Inanna, it appears that an interest in open urban spaces emerged during the early historical period, though limited to the centers of political and religious power. This interest should be considered symptomatic of a social situation that based its decision-making on collective assembly-like institutions, whose existence was aknowledged in later mythological texts, but to which the urban structures of the early dynastic period (c. 2900 - 2340 B.C.) do not seem to have dedicated a specific area.

Several pieces of sculpture of uncertain origin, but certainly from the early historical period, have been recently found. These in part alter and in part confirm the course of development previously gathered from the first sculptural evidence. Apart from the problem of a possible influence by prehistoric clay and stone sculpture, the most notable new fact is the emergence of a statuary art peripheral to Mesopotamia. This art is essentially foreign to that of Mesopotamia in its formal structure, as is documented by a group of statuettes from the Shiraz region. Here, even though the combinatory technique is not entirely different from early Mesopotamian works, the formal solution – realized through the juxtaposition of geometric volumes and the superimposition of a decorative scheme – contrasts with that of contemporary Mesopotamian artifacts.

As is demonstrated by the bust of a prince of Uruk found in a Hellenistic earthenware jar and attributed with certainty to the Ğemdet Naşr period, the formal proto-historic outlook was based on a vigorous statuary sense of extraordinary coherence and purity. The surface of this torso, like those of well-known remains of animal statues from Uruk, defines the concreteness of the body masses with intense naturalistic tones and a slightly intellectual attitude.

The variety of the accomplishments of the Ğemdet Naşr period, often identified through certain technical deteriorations found in works thematically in the Uruk tradition rather than through individual characteristics, is revealed by pieces of statuary of unique iconographic conception and identity, as in the case of the bronze male figure wearing a headpiece with long, arched horns. This statuette, probably from Tellō, is conceived according to a system of correspondence of formal rhythms that result in the notable curvature of the footwear and the horns and in the well-defined surface of the waist, beard, and cloak.

In recent years, an attempt has been made to answer the many questions that arise from the interpretation of the Mesopotamian culture of the proto-dynastic period. This has been done through the excavations of several important centers of that period – in particular those of Nippur, Lagaš, and el-Hība by D. P. Hansen – and through an important critical re-evaluation of the artistic material of the pre-Sargonic period. An important part of early dynastic reliefs are the plaquettes with scenes of a ritualistic banquet found in the temple of Inanna in Nippur. Their chronology probably extends from the beginning of the second proto-dynastic period (c. 2750 - 2580 B.C.) to the central phase of the third proto-dynastic period (c. 2450 B.C.). Mostly concentrated in the former, they correspond to the so-called Mesilim style. The reliefs from the temples of Inanna, the first notable examples of early dynastic figurative art in the Mesilim style found in Nippur, are the work of a provincial school and most likely did not play a major role in the formation of proto-dynastic figurative tradition. This information is not without interest, as

the identification of primary centers in the elaboration of proto-dynastic culture is a fundamental goal of the study of the paleo-sumerian civilization of Mesopotamia.

The foundation upon which the chronology relative to the archaeological reconstruction of Mesopotamia is based is the exploration of the strata of apparently peripheral centers, such as Tell Asmar, Khafaje, and Tell Agrab. To this purpose, the succinct diachronical analysis of the ceramics of Nippur and the sculpture of el-Hība of the first proto-dynastic period is also of great value. It is precisely the initial proto-dynastic phases of a major center like Lagaš that have demonstrated – with their evolved themes of battles between heroes, wild beasts, and semi-divine beings – the provincialism of the contemporary sculpture of the Diyāla region, whose geometric arabesques belong to the style found in the Tigris area.

A significant contribution to the knowledge of proto-dynastic statuary art has been made in recent years by A. Parrot's exploration of two temples in Mari: the so-called sanctuaries of Ištarat and Ninnizaza. In the structure of one of the temples, the courtyard with alcoves and dedicated to a religious cult have been interpreted by A. Moogtat as a westernizing element datably in the beginning of the third proto-dynastic period. The large collection of limestone statuettes from the Mari temples integrates the already known documentation gathered from this important city of the middle Euphrates area. These statuettes, which predominantly repeat the models seen in Ešnunna, Assur, and Nippur, are of notable interest for their original stylistic solution to the composition of the face and for the unity of their production.

The synchronicism between one of the kings of Mari, mentioned in the dedications on several statues from the sacred buildings, and a king of Ebla, whose chronology is known, place these statuettes, here-to-fore attributed to the transitory phase between early dynastic periods II and III, in the decades immediately preceding Sargon of Akkad. This contemporaneity is essential for the stylistic classification of early dynastic art, since it questions the concept of the style of Imdugud Sukurru which has been thought to characterize this period of transition.

One should also include in the final phase of the proto-dynastic period the large nucleus of statuary production found in the ancient temple of Ištar in Assur. This new chronological attribution to the pre-Sargonic period for the artifacts found in the two temples of Ištarat and Ninnizaza allows for the appraisal of the problems relative to the role of the early Akkadian age. The Mari environment supposedly was culturally similar to that of Kiš and to Akkad in general, where the premises were established for the brilliant innovations that charaterize the flourishing of early Akkadian art in Mesopotamia in the III millenium B.C.

Traditionally, the rise of Sargon of Akkad around 2340 B.C. and the subjection of the Sumerian cities to the centralized power of the Akkadian dynasty mark the conclusion of the proto-dynastic culture of Mesopotamia. Though the weakness of the view which, on the basis of an Akkadian-Sumerian ethnic opposition, compares the static and abstract proto-dynastic forms to the fantastic and imaginative early Akkadian ones is by now generally acknowledged, it is often still believed that a fracture that opened in Mesopotamia at the time of Sargon of Akkad.

Too little is known of the proto-dynastic figurative culture of the final pre-Sargonic decades, especially in the area of Kiš, to thoroughly understand the historic roots of early Akkadian art. However, the analytical study of seals by R. M. Boehmer and the identification of technical-stylistic criteria which allow the differentiation between the three generations of the Akkadian dynasty have revealed a significant continuity between the sculpture of the late stages of the proto-dynastic period and that of the time of Sargon. In actuality, the kingdom of Sargon does not seem to be marked by substantial innovations in sculpture. The theme of the stele of the great king of Susa depicts an early dynastic offering having a motif which portrays vanquished enemies being held in large nets. In the posture of dignitaries that follow their ruler and in the subjective hierarchical enlargement of the ruler himself one is made aware of the likeness to scenes of more remote times.

It is rather in the course of the second generation of the Akkadian dynasty that important innovations are realized and readily discernable in some fragments of victory steles. In these, the individual assumes a new value and becomes the protagonist in war. The figurative transposition is accomplished through a series of individual duels that replace the traditional primitive compositions dominated by the collective anonymity of the Sumerian talange and the piles of fallen soldiers. A concrete sense of history that makes the individual its primary agent pervades the battle scenes of early Akkadian steles following Sargon. Individuals are shown performing specific acts instead of the collective types of the early dynastic militia, who repeated conventional gestural patterns. The static images of the compact and immobile armies and of the fallen warriors are replaced by scenes of individual battles of which the winner is not evident. The king does not tower over his dignitaries and soldiers, but rather can be recognized by his decorations and his slightly taller stature.

A new ideological position emerges, clearly hinted at in the early works of the Akkadian culture: man assumes the role of protagonist, no longer tied to the social function that the gods have destined him for, and, conscious of his identity, acts independently from it. The gods guide the fate of mortals through their moral judgment; the world is no longer a mirror of their celestial decisions, but rather the stage on which man realizes his destiny. A particular artistic vision corresponds to this ideological position, a vision that summarizes the mature proto-dynastic experiences in new formal and spatial solutions. In victory steles, at first gradually in the times of Sargon and Rimuš and then fully during Naramsin's reign, warriors are arranged in a space with dimensional depth, by virtue of a highly expressive plastic approach. In sculpture, and in particular during the period of Maništusu, the decorative pattern of early friezes is broken; the roles of the protagonists are stabilized in a band of figures, and the plastic substance of the bodies in movement is deepened. The artist's search is no longer polarized by the repetition of variations in which figures alternate in fixed and predetermined positions, but freely espouses different solutions for the composition of mythical battles.

In the time of Naramsin and Šarkališarri, when sculpture reaches its full development in the Akkadian style, the terms of artistic refinement are reversed; the traditional schemes are abandoned and the problem of space becomes pre-eminent. Employing heroes and semi-gods as protagonists, at times realized in their morphology, audacious thematic combinations are elaborated; in these the early Akkadian line is fully expanded as an instrument of spatial refinement.

This same refinement operates in statutary art, of which unfortunately too little has survived. The recent attempt by P. Amiet to recover and recompose the fragments that were found several decades ago at Susa, where they had been taken as booty, perhaps by the middle Elamite king Šutruknakhkhunte, indicates the traces of a refinement that must have been conducted by a school of artists coming from the same tradition; the so-called "imperial shop" of Akkad has been recognized in this school and tradition. It is conceivable that a large part of the statuary works and reliefs representing the kings of Akkad were produced in the imperial shop, including the fragments of the statues of Maništusu and Naramsin and the steles of Rimuš (?) and of Naramsin of Susa and of Pīr Husayn. An important chronological support is furnished by the lower part of a statue of diorite of Manistusu, in which the compact and unmoving early type of belt becomes a fullbodied and vibrant sash wrapped around the waist and the pyramidal structure of the bottom of the cloak is altered in its rigidity by the slight undulations of the fabric.

The period of Maništusu is when the coherent and tight refinement of the Akkad school accomplishes its most resolute steps toward a new concept of space, the most conspicuous fruits of which are born in the time of Naramsin and Sarkalisarri. The new ideological approach, already noted on the steles of Sargon, the irregular and anomolous structure of which makes one think of an "unfinished" typology in contrast to the patina and shine of the finished surface of the diorite, is significant but is barely felt in the steles of Naramsin of Susa. Here the king, the "Divine Namramsin", is the hero of the story; in front of him are the benevolent deities represented in the stars that sparkle in the mountain, but at a distance from the royal scene. The soldiers of Akkad, though anonymous in their march, are still discernable by their individuality as they overcome an enemy that is cast off from the sides of the mountain.

The process that guides the artists from the "royal shop" of Akkad to the mature approach of the time of Naramsin is the result of a formal refinement that starts from the analytical naturalism of the statuary art of Diyāla, defined by H. Frankfort as belonging to the early dynastic III period (c. 2580 – 2340 B.C.), and culminates in a synthetic naturalism found in the bronzed royal head of Ninive, correctly attributed by M.-Th. Barrelet to the period of Naramsin. In the head of Ninive, the paleo- Akkadian taste for an organic line synthesizes the fragmentary data gathered in an early investigation of the individual physiognomic elements with the intent of surpassing the geometric-abstract concept of the style of Mesilim (c. 2750 – 2600 B.C.). While the mature schools of Ešnunna, Ǧirsu, and Adab had the merit of tackling the study of natural reality and establishing the basis for the early Akkadian investigation, it is only the school of Akkad, founded as it was on a renewed concept of man, that made this research conscrete through an original artistic approach in works of the highest quality.

Early Syrian civilization and art: the revelation of Ebla. — Our historical perspective, restricted as it is by the limits of archaeological research and documentation, attributed the above-mentioned artistic vision specifically to the era of Akkad. Certainly, it was also part of a more extensive innovative movement. This may have had as protagonists several centers of western Asia, some distant from the more culturally fertile southern Mesopotamian area. This seems to be proven by the recent discoveries by P. Matthiae of the Royal Palace of Ebla, datable in the early Syrian Period IIA (c. 2400 - 2250 B.C.). Here, the recovery of valuable wood carvings from the palatial furniture, inlaid with minute tesserae of shell, has revealed the existence of an unsuspected artistic craftmanship in the period between 2300 and 2250 B.C. It appears to be the remote antecedent of the celebrated Syrian and Phoenician art of ivory carving of the I millenium B.C. It also appears to be the expression of an artistic culture solidly rooted in its own time, inspired by proto-dynastic themes. The rampant lions that face erect goats, the nude heroic figures that impale standing lions, the man-bulls with human faces and bovine ears, and the heroic figures that hold the chalice of the life-giving waters, though in a fragmentary state, more recent stages of the proto-dynastic age.

A series of unusual details in Mesopotamian contemporary shops also indicates the influence of early Syrian masters in the workmanship of the more traditional compositions. The image of a king in a layered cloak holding a scythe and certain remains of female figurines with ruffled tunic hems place these works in the initial decades of the XXIII century B.C. In them, one notices the surpassing of the early dynastic approach. These images are structured according to a rigid conception that, though not unlike other contemporary Akkadian works, expresses itself with more austere accents and without that freedom of imagination that is typical of the more advanced developments of the Akkadian school.

A group of imprints of cylindrical seals of the Royal Palace of Ebla that belonged to high officials of the first half of the XXIII century B.C. are the first sculptural evidence of paleo-Akkadian Syria. The early dynastic sphragistic themes are characterized by rampant lions that seize their prey, erect bulls that bite wild beasts in the throat, man-bulls that protect their flocks, male and female figures that defend the captured preys from the wild beasts, and gods that dominate wild beasts and hold pasture animals. All of these express, in a creative language largely Mesopotamian, a mythical content analogous to that of the early Sumerians, the fundamental elements of which are surely and properly proto-Syrian. The robust tractable substance of these ancient works from Ebla, which with expressionistic traits evidence the bodily structure of the figures more than the graphic thoroughness of the mature paleo-Akkadian naturalism, reveals itself to be a product of the same innovative style that inspired the shops of Akkad. At Ebla, the tendency to emphasize the flexibility of the mass is directed to the naturalistic reinterpretation of the turgid archaic Syrian decorations (P. Amiet) whose crowded ornate forms are a provincial version of the late proto-dynastic style of Mesopotamia.

The value of the discoveries at Ebla of material from the mature early Syrian period consists of the revelation of the genesis of an artistic tradition. This tradition, though seriously fragmented, passed on a series of autonomous elaborations of architectural and artistic forms to the cultures of Syria of the II and I millenium B.C. An important characteristic of the Royal Palace of Ebla is a large courtyard with tall columns that extend from the palace itself to the lower city. Inside the courtyard, to which the king had access through an ornate ceremonial stairway made of inlaid stone steps on perforated wooden panels, a wide podium was raised for public hearings. The eastern façade of this courtyard, onto which the portal of the palace opened, was preceded by a short stairway. This courtyard can be considered the origin of those palatial units that are preceded by a portico, both of the neo-Syrian citadels of the Aramaic era and of the middle-Syrian palaces of Ugarit and Alalah. In the last phase of the Syrian Royal Palace of Ebla, around 2350 B.C., the portico was closed on its sides by two doors that continued for a brief stretch on the façade along the line of columns and thus narrowed the width of the portico. This solution was probably dictated by construction needs, and it altered the original plan of the court, possibly tetraporticoed. The structure of the façade portico in the palace of Ebla during its last phase corresponds typologically to the so-called "bīt hilāni" of the neo-Hittite and Aramaic citadels, for which it may have been the model.

The concept of the audience court of Syrian Ebla presents aspects of originality that are in opposition to the Mesopotamian urbanistic concept. The open structure of the court of Ebla, mostly external to the palace and adjacent to it and the lower city, qualifies it as an urban space with public function. Although the erosion of the soil does not allow the verification of the architectural solution employed to actuate the transition to the lower city, the court certainly connected in an original manner the modest dwellings of the community to the monumental administrative quarters.

If it still cannot be affirmed that the fragmentation of the seat of government into individual palatial units, typical of the neo-Syrian citadels of the I millenium B.C., originates in an early Syrian concept, it may be said that the importance conferred to the external spaces of the palace in the Syrian approach is in clear opposition to the urbanistic trend of ancient Mesopotamia. This approach led to the incorporation of open spaces of public significance into the palatial area, which in historic cities – for example at Uruk – had a precise urbanistic positioning. In this sense early Syrian Ebla, though a politically centralized structure, adheres more faithfully to the older models of prehistoric Kiš. The palace of Tell Brāk, erected in northern Mesopotamia by Naramsin of Akkad around 2250 B.C., in a logical development of the Mesopotamian tradition, foreshadows the Palace of Mari, in spite of its use as a fortress and a warehouse in a frontier territory. In a way, this building represents the total denial of early Syrian ideals, as it is the result of a conceptual and historical tendency to systematically aggregate and incorporate open spaces into a palatial organism.

Neo-Sumerian art. — The concept of neo-Sumerian renaissance, which applies to the period of the so-called II dynasty of Laga (c. 2200 - 2120 B.C.) and to the III dynasty of Ur (c. 2115 - 2000 B.C.), is full of equivocations, since in the most accepted explanation it indicates only the re-emergence of values of the Mesopotamian culture after the political and economic collapse of the interlude of the Gutei. However, this concept often overshadows the decisive importance of the Sumerian ethnic component in what is considered by many a restoration against not only the Gutean barbarism but also the Akkadian innovations. The almost insurmountable difficulties in identifying the literary works attributable to the early dynastic period, in which the cultural gap with the neo-Sumerian works can be evaluated, is a hindrance to the determination of the reality of this renaissance. However, for that very reason the analysis of the artistic phenomena assumes a greater weight. Aside from rather inconclusive comparisons of style, which may associate the artistic works of the time of Gudea of Lagaš to the sculpture of early dynastic period III (c. 2580 - 2340 B.C.) – in particular to the so-called style of Anzu-Sud – there is certainly no conscious inspiration from the early dynastic works in the neo-Sumerian refinement.

On the contrary, any reference – at least from Gudea to Ur-Nammu – is actually more to the Akkadian political sphere, than to the remote early dynastic world. Starting with Šulgi this reference becomes explicit with the assumption by the kings of Ur of the titles of the Akkadian empire. In this sense, if the sculpture of Gudea and of Ur-ningirsu eloquently represent the continuity of the formal refinement of Lagaš, in the wake of the activities of the school of Akkad of the time of Naramsin and of Šarkališarri, the stele of Ur-Nammu from Ur is the only dated evidence of neo-Sumerian style.

Particularly important is the recent dating (A. Moortgat) of the cave relief of Darband-i-Gaur to the kingdom of Šulgi. It was previously held to be of the period of Naramsin, because of the evident compositive and iconographic analogies with the steles of Susa. Such antiquarian details as the long square beard and the hemispheric tiara with the high brim of the ruler determine an approximate dating to the III dynasty of Ur, and definitely after Ur-Nammu. Since the untitled relief celebrates a victory over the Lullubi, being sculpted on a rocky wall of a pass that joins the Mesopotamian plane with the country of that mountain people of western Iran, it is conceivable that either Šulgi or Šu-Sin could be the sovereign represented, since both had victories over the Lullubi. In any case, the attribution to a royal shop of the III dynasty of Ur would explain the classic clarity of the composed structure, the quiet vigor of the image, and the closed disposition of the forms – all elements typical of the neo-Sumerian idea. In this relief, as in the stele of Ur-Nammu, the spatial refinement of the stele of Naramsin, based as it was on a linear organic unity, is no longer current. The neo-Sumerian style, such as we see in the relief of Darband-i-Gaur, is without a doubt the direct origin of the sculpture and relief of the first two centuries of the II millenium B.C., the so-called period of the dynasties of Isin and Larsa.

The era of the Amorean dynasties: Mari. — The complex problem of the age of the Amorean dynasties (c. 2000 - 1595 B.C.), characterized by political fragmentation and cultural exchanges after the sacking of Ur by the Elamites, is being actively studied in the southern Mesopotamian area through the renewal of the

excavations at Larsa (A. Parrot and J. Margueron) and by the recently begun archaeological exploration of Isin (B. Hrouda). A noteworthy contribution to the knowledge of the architecture of the time is furnished by the recovery of the palaces of Sin-gašid (c. 1865 - 1833 B.C.) at Uruk, unfortunately incomplete, and of Nūr-Adad (c. 1865 - 1850 B.C.) at Larsa.

The palace at Larsa is particularly important for its unitary nature, unlike the larger example of administrative and residential buildings of the period of the Amorian dynasties, the so-called Zimrilim palace (c. 1782 - 1759 B.C.) at Mari. Although the walls of baked bricks attributed to Nūr-Adad are built on a deep base in crude bricks, it is impossible to determine if we are dealing with real foundations or the ruins of a pre-existing building whose layout has substantially been repeated. However, it is certain that the palace of Larsa follows a unitary design centered on a large quadrilateral courtyard with entrances at the corners; only one of the sides of the courtyard has an opening in the center of the perimetral structure. The complex of the quadrilateral courtyard and the two large longitudinal rooms flanking that side of the court is the spatial nucleus of the building; it is remarkably similar to the Palace of Ilušuilia at Ešnunna of the last years of the XXI century B.C.

The residence of Ešnunna apparently reproduces a floor plan, probably prepared by the architects of Ur, in a modestly provincial version. Ekhursag, the presumed residence of the kings of the III dynasty, did not follow this disposition, undoubtedly because of its rather particular function. The compact planimetric structure of the building of Ur and its tight coordination demonstrate that the monuments of the religious and administrative center of Ur set the standards for early Babylonian architecture. In some sectors, the planimetric structure of the palace of Larsa reveals aspects of a rational plan sustained by a clear definition of spaces that derives from the neo-Sumerian formulation of the period of Ur-Nammu and of Šulgi. In particular, these aspects are the tight fragmentation of storage spaces and the expansion of the dimensional data, both expressive modes of a spatiality that tends to detach itself from the classic neo-Sumerian idea and move towards the early Babylonian concept.

The ancient palace of Assur, recently dated to the early Akkadian period (A. Moortgat) on the basis of a cuneiform tablet found in the foundations of the building, presents an analagous setting of rooms, though only the understructure of the building has actually reached us. As the above mentioned stratigraphic date can be explained also if the building had been erected after the paleo-Akkadian period, the dating of the palace of Assur appears to be of the early Assyrian period. Even in the celebrated so-called palace of Zimrilim (c. 1782 - 1759 B.C.) the square courtyard of the building is conceived in relation to the two long rooms adjacent to one side. However, an axial and symmetrical orientation seems to indicate a particular development in a functional sense of the traditional planimetric disposition, for the first room is latitudinal with a central podium and frontal entrance, while the second is longitudinal with a side entrance.

The complex building of the palace of Mari, undoubtedly the result of enlargements and modifications over long periods of time, of which the only certain date is that of its destruction in 1759 B.C. by Hammurabi of Babylonia, has been put through a thorough re-examination of its most important decorative components (A. Moortgat) in order to arrive at the dating of its individual parts. This has confirmed the dating of the celebrated picture of the "investiture of Zimrilim" to the time of Zimrilim himself, in the last period of this palace's history. The agreement of the dates with the style confirms its execution in the time of Hammurabi — a time when official early Babylonian art turned its attention to the spatial relation of the individual parts of the figure.

Also at this time vigorous plastic tendencies are affirmed in paleo-Syrian art, notably in the glyptic of high officials and of the royal family of Mari, who were joined with close ties to the ambience of Aleppo. Also well-founded is the dating to the time of Šamši-Adad (c. 1814 - 1782 B.C.) of pictures done in an exquisite style, particularly one showing the sacrifice of a calf, which emphasize the borders of cloaks in a manner that appears festive in contrast with the austere immobility of the Mesopotamian cloaks. The more incisive aspects of style that characterize those pictures are to be related more with the activity of paleo-Syrian-inspired shops than with different periods of development of early Babylonian schools. It is less likely that the pictures in audience chamber 132, the two major scenes of sacrifice before the images of the goddess of war Ištar and the moon god Sin, are attributable to the neo-Sumerian period. There is a great distance between this picture and those of the sacrifice of the bull. The figures of the scene before the great gods are drawn with a firm and rigid line, their forms immobile, their contours enclosed by a solid line, undoubtedly derived from the neo-Sumerian style but not corresponding at all to the works in this style at Ur. In the sacrificial scenes with the bulls, there is an extraordinary sense of movement, with images of palpitating vividness, with cloak borders in motion in a vibrating, exquisite elegance of form. As noted by B. Hrouda, there are stratigraphic elements suggesting that the nucleus of the audience chamber and of the anterior court of the palace did not come after the era of the predecessor of Samsi-Adad I; therefore, these notable stylistic differences must be explained in the setting of the shops of various types at Mari between 1850 and 1760 B.C. In such a valuation, the pictures of the sacrificial scenes of the audience chambers must be interpreted as the work of the Mesopotamian school of the period of Larsa, in which the classic neo-Sumerian standards became frozen in an academic rigidity.

In the same way that different – and even opposing – tendencies of the period of the Amorean dynasties are joined in the pictorial culture of Mari, its architectural culture is also not an exemplary representative of Mesopotamian tendencies. Even though the typical Mesopotamian concept of the closed and centered structure is reflected in the large palace buildings, the design of the religious buildings was affected by early Syrian influences. Although very little is known of the early Babylonian architecture of the monumental centers in the large cities of southern Mesopotamia, the recent excavations at Larsa have revealed brief sections of a large courtyard of an important religious building, which could be the Ebabbar, one of the two most celebrated places of worship of the sun god Šamaš. The ruins of these structures found so far are important in

that they show an extraordinary plastic articulation of the surface of the walls, with motifs of compact vertical ribs with differentiated sections of the same style as the so-called rampart of Warad-Sin (c. 1834 - 1823 B.C.) of Larsa on the terrace of the *ziqqurat* of Ur.

A most notable example of religious architecture of the southern Mesopotamian tradition is the temple of Tell Rimah – the former Karana in the Assyrian area – that is a brilliant elaboration of the most austere neo-Sumerian models in the spirit of the early Babylonian spatial sensibility. Although the planimetric structure of the building mentioned is a reconstruction (D. Oates), the temple reflects the rational planning of the neo-Sumerians with a remarkable clarity of spatial articulation. Within the limits of the compact unity of the four-sided layout, the building is set on a rigidly axial central sector containing a fore-court, a courtyard, an ample antechamber, and a smaller room developed laterally and flanked by two vestries. To the sides of the central sector are two wings with rows of elongated rooms symmetrically positioned in a rigid order. If the spatial organization is based on neo-Sumerian standards, then the complex expression of the surfaces – with dense interlacing of the projections of the pillars, semi-columns, and pilaster strips, sometimes hidden in the shadow of the alcoves, as in the façade – reveal the early Babylonian awareness of this architecture.

The absence of any provincial tone in this remote early Syrian city of Karana suggests the work of Babylonian architects, who may have come from Assyria with Šamši-Adad I. This extraordinary Amorean prince, originally from Terqwa, was protagonist of the first important "Babylonianization" of Assyria, as proved by the introduction of the cult of Enlil. In the period immediately following Šamši-Adad I, under Aškur-Addu (whose residence at Karana is described in a letter of Mari), the palace of the third phase has, with the throne room, an axial structure centered on the wide room with a median alcove. This palace has a much more monumental plan than those of the two preceding phases, probably in relation to the acquired independence of Karana. The spatial organization of the last palace faithfully reproduces the planimetric structure of the neo-Sumerian sanctuaries, because of the influence of southern Mesopotamia. This is in contrast with the local tradition, which is represented by the forward parts of the palace having a throne room with a longitudinal plan and lateral access.

The period of the Amorean dynasties, though an era of intense cultural exchanges, is the epoch in which the fundamental elements of the early Syrian traditional architecture in north Syria are defined. This is done in full autonomy with respect to the contemporary Mesopotamian world. At Ebla, the center that dominated the Syrian area before giving way to Aleppo shortly before 1800 B.C., several temples are known. All of these are characterized by imposing perimetral structures and great height, with their compact, squared structures towering over the crowded, even rooftops of the city. The single-roomed temple, typical of the paleo-Syrian period, is characterized by the two large antas projecting from the façade. This same design on a more monumental scale is found in the Palestinian temples of Megiddo and Sichem, whose older parts were recently dated by G.E. Wright to the XVII century B.C. In both of these important sacred buildings, the façade is marked by two angular towers, which accent their soaring perspectives without altering the compact disposition of the buildings.

The Long Temple at Hazor, also of the XVII century B.C., is even more akin to the examples of Ebla. The largest of these, the so-called Temple D from the XX century or the beginning of the XIX century B.C., is divided into three parts – the longitudinal room, a latitudinal antechamber, and a small vestibule. The originality of the paleo-Syrian concept is exemplified by this temple. Its depth is increased, while the axiality still remains the central motif of this approach; the internal space is broken up, but the outer rooms emphasize the length of the main room, which ends in a deep alcove at the farthermost wall, where the cult is performed. The main characteristics of this temple – the separate area given to the performance of the cult, the axiality of the structure, the main room positioned longitudinally, the division of the internal spaces into three parts – are also found in one of the temples of Biblos, Building II, according to a recent interpretative hypothesis by P. Matthiae.

This temple at Biblos dates from roughly the same period as the temples of Ebla. Although at Biblos the walls are completely lost and only the foundations remain, some of their technical details indicate that the plan is similar to that of the great northern Syrian temple. Nevertheless the tradition of the longitudinal room in three-part temple buildings is not a standard element of the religious architecture of the Syrian-Palestinian area, where the tradition of the latitudinal room is well established. The rigid axiality and the total autonomy of the building within the context of the infrastructure of the religious organization are the stable elements of the architectural culture of the Syrian-Palestinian region.

An important example of a sacred building with a latitudinal room is the Temple of the Orthostats of Hazor, also founded in the XVII century B.C. It consists of a wide room with a deep alcove for the cult at one end, in front of which are two bases of columns. Their function was to reduce the excessive light of the room due to its flat roof covering. Before the main room an antechamber of the same width and of lesser depth was subdivided latitudinally into three smaller rooms. The Temple of the Orthostats of Hazor is not an isolated phenomenon, nor is it a southern variant of the Syrian-Palestinian area, as is a similar planimetric structure which exists in the temple of Alalah, dating from 1700 B.C. The temple with a latitudinal room with an antechamber is a monumental elaboration of a simple type with a wide room; this is attested to not only by the Temple of the Steles at Hazor, whose foundation nevertheless belongs to the XIV century B.C., but also by the Sacred Area of Megiddo. In one part of this area there are three temples with antas and a wide room whose foundation has been recently dated to the last centuries of the III millenium B.C. by K. M. Kenyon.

The paleo-Syrian civil architecture also conceived of the palace as a unit in itself, not easily enlarged through aggregation of other buildings, but potentially open to enlargement by further construction. This can be substantiated by the later palaces of Ugarit and Alalah, which belong to the Middle Syrian period (c. 1600 - 1200 B.C.). The discovery of the small palace of Tilmen Hüyük by U. B. Alkim and the still rather incomplete status of the exploration of the more exten-

sive palace of Ebla do not permit any definite conclusions. The typologies of the city gates testify eloquently to the autonomy of early Syrian architectural language. The monumental example of the south-west gate of Ebla furnishes a series of important data that seems to be the standard for most of the contemporary city gates of the Syrian-Palestinian area, from Alalah to Qatna to Hazor. The nucleus of the gate was formed by a planimetric disposition developed in depth consisting of two passages between three pairs of pillars. At times, as in fact at Ebla, these two portals were preceded on the outside by an extensive courtyard opening to the countryside, with a forward portal giving access to a single passage between two pairs of pillars. The monumental complex was covered on one of its two sides by an imposing rampart with a system of towers; the gates appear to have been surmounted by an arch and the structures by large orthostatic layers of basalt rocks and limestone.

In recent years, there has not been any noticeable improvement in our knowledge of the Mesopotamian art of the period of the Amorean dynasties. Only one statue of the sovereign of Larsa has come to light, and this unfortunately was rather mutilated. It conforms with the image of rigid conventionalism into which the classic neo-Sumerian concept of the period of Isin and Larsa seems to have fallen. An attempt by J. R. Kupper to arrive at a precise chronological definition of the rulers of Mari – limited usually to the period from the beginning of the II dynasty of Ur up to Yaggid-Lim (c. 1850 - 1835 B.C.) – tends to place the statuary of Idi-ilum, of Puzur-Ištar, and of the other rulers mainly in the period of Isin. Such an attempt, based on paleographic and historic arguments, furnishes hypotheses that fit in well with the approach to the artistic development of Mari, a city subject to the influence of paleo-Syrian style because of its western position. This inspiration resulted in the preference for agile forms, typical of the statuary art of Mari after Ištup-ilum. This agility of forms is stated with casual elegance in the rich wide bordered cloaks that create subtle linear graphic elements without interfering with the volumetric structure of the images (as in the contemporary statuary of Ešnunna).

To the XIX century B.C. belong the monumental sculptures of Ebla (P. Matthiae), which are the first important examples of the great paleo-Syrian art. Until just a few years ago, the beginnings of this art were attributed to the period between 1750 and 1600 B.C.; such a placement in time was based on several thin cylinders found in various collections. The more frequent monuments of Ebla were the typologically unusual sculptured basins with two receptacles; these were placed in the temples and decorated on three or four sides with ritual and mythical scenes. The structure of the basins seems to depend on rare analogous monuments of smaller dimensions of the early dynastic period of Nippur. They could, therefore, be a reoccurrence of an archaic type of Mesopotamian pre-Sargonic furniture found at the beginning of the period of the Amorean dynasties. The principal decorations of the basins are scenes of ritual banquets with the king and a high official or with the king and queen and a retinue of soldiers and servants. On one of the basins, the banquet scene is adjacent to one of pasture animals menaced by a lion.

The theme of the ritual banquet and its association with flocks of animals are characteristic of the iconography of the Mesopotamian style of the I dynasty of Ur. This style is associated with fertility cults, typical of the proto-dynastic religions and according to which nature is a world animated by divine powers who regulate its vital cycles. The mythical figures represented on the sides of the basins with the banquets and the flocks correspond to this archaic world of pre-Sargonic images. Thus the nude hero, seen frontally with his face framed by stylized curls and holding a fish in one hand, reveals his relation with the world of the waters under the earth, dominion of the god Enki. This relationship is frequently shown in late proto-dynastic sculpture by placing the hero among the waves on which the boat of Enki navigates.

In an image foreign to the Mesopotamian early dynastic tradition – a composite dragon with the body of a lion covered with scales, its wings raised, with the claws of an eagle, an erect angular tail, and the lion-like face baring his teeth with fertile liquid flowing from the jaws and tail – begins to appear in early Akkadian sculpture, almost certainly the fruit of proto-Syrian inspiration. A nude heroic figure with the head of a lion, holding two lion cubs from the hind legs and dominating the animals of the pasture, is evidently the survivor of an early Syrian creation, as this iconographic type was unknown to the Mesopotamian world. It was, however, attested to in the sculpture of Ebla in the age of the dynasty of Akadd. In the oldest basins of Ebla, of about 1850 B.C., roaring lions are frequently found in the form of furniture legs. Although it is difficult to define it with precision, the lion motif seems to have a meaning intrinsically connected to the use of basins in the cult, possibly related to the fertility value of the subterranean waters. It thus became a traditional element of the basins dedicated to the cult, such as in the later one of Hattuša.

The most recent of the Ebla basins, from around 1800 B.C., was decorated on four sides. A series of minor female divinities are represented frontally on the shorter sides and groups of male bearded figures perform ritual acts, probably connected to stipulation of a treaty, on one of the longer sides. It is possible that the female divinities are the guarantors of the treaty, while the bearded personages may be the dignitaries or the priests assigned to carry out the actions required for the execution of the treaty. According to B. Buchanan, this monument of early Syrian sculpture is particularly significant, as it marks the passage from the severe approach of the older basins – which may be dated to the final phase of the early Syrian period I (c. 2000 - 1800 B.C.) – to the mature art of the early Syrian period II (c. 1800 - 1600 B.C.). At that time, undoubtedly for political reasons, the output of art in Ebla is noticeably reduced, except for the cylindrical seals, as evidenced by imprints of extraordinary examples, belonging to high functionaries of the kingdom around 1725 B.C.

Almost nothing remains of the monumental art of the mature paleo-Syrian style, even from other cities. Recently, however, the critical re-examination by P. Matthiae of a fine fragment of upright relief of Karkenis – which has the figure of a prince with an ovoid tiara and a wide bordered cloak – has permitted the recovery of noteworthy remains of a more extensive

figurative complex from one of the major cities of the early Syrian artistic civilization. The relief of Karkemiš, from about 1750 B.C., is an example of classic paleo-Syrian art, in whose tradition several minor works can be placed, in a phase already clearly marked by linearistic tendencies. An example is the noteworthy bronze plaque of Hazor showing a walking dignitary in the style of a school that in the XVI century B.C. had inherited the paleo-Syrian artistic tradition.

If examples of stone sculptures of the paleo-Syrian artistic civilization are still elusive, bronze statuettes have been found in an important city of that period, Ugarit, on the northern coast of the eastern Mediterranean. Although they cannot be definitely dated by stratigraphic means, it is likely that they are from the final phase of the middle Syrian period (c. 1600 - 1200 B.C.). An example of highly prized workmanship is the so-called statuette of "Anat"; in this work the forms are modelled with subtle sensitivity in the style of the time, in an image that still conserves the austere lines of the classic period.

Although too little is yet known of the Anatolian figurative period of the first centuries of the II millenium B.C., notable progress has been made with the identification (N. Özgüç) of a series of seal imprints from Kaniš, the modern Kültepe. These seals, in great part from the second half of the XVIII century B.C., constitute a homogeneous group of glyptic examples of Anatolian manufacture. Their main theme can be referred to neo-Sumerian compositional solutions of predominantly paleo-Akkadian schemes, such as the bearded hero who tramples a lion, the god on the throne who raises the drinking chalice, the bearded hero holding the vase with the gushing waters. Other elements derive from the contemporary early Babylonian glyptic, such as the god of the tempest approaching a bull brandishing forked lightening bolts or man-bulls facing front holding the solar banner. Some minor motifs derive from the early Syrian figurative patrimony; this is the case with the small figures of atlases and the series of animal heads. Other secondary motifs, such as the vulture or the lion springing on the flock, are of the early Syrian world.

The antiquarian data of the early Anatolian glyptic of Kaniš presents most notable analogies with the culture of contemporary Ebla. Examples are the refined structure of the offertory tablets with central support and bull's hooves; the clothing seemingly in movement and stylized with tight oblique lines. Certainly Ebla and Kaniš were in close contact with each other. A fundamental originality distinguishes the Anatolian glyptics of Kültepe from those of contemporary early Syria in its taste for minute and rich design, which in certain pieces becomes a luxurious arabesque that dissolves the traditional feelings of composition. This not only occurs in the cylinders, in which secondary motifs emerge to overcome the dominance of the cult scenes, but also in the seals, in which the main theme of neo-Sumerian derivation conserves its substantial value. This is due to the insistent cross-hatching that appears throughout the images, exalting the predominance of the graphic elements in works whose most remarkable feature is their dense and tight composition.

The classic neo-Sumerian approach, which seems to have rationalized and blocked the fervent stimuli of the late Akkadian art by orienting that vivid liveliness in the direction of a quiet formalism, appears to have exhausted itself in the Mesopotamia of the period of Isin and Larsa in an ever more sterile attitude of closed conventionality. In the late phase of the period of Isin and Larsa, schools that assumed a critical attitude in relation to the formal patrimony of neo-Sumerian derivation existed in Assyria, in central Anatolia, and in northern Syria. They revealed a lively inventiveness in bending neo-Sumerian themes toward the dissolution of the classic form. This was achieved in different ways: through the alteration of the image plan, through a taste for the arabesque which transformed the figurative fabric into a dense pictorial structure, or finally through a more gradual refinement of naturalistic structuring of the image on the basis of a combination of plastic and linear experiences.

In a rather late age, probably in the time of Hammurabi of Babylon (c. 1792 - 1750 B.C.), an innovative current also became active in southern Mesopotamia. Though it worked along the lines of the neo-Sumerian tradition, it introduced an intense expressionistic tendency, still within the formal standards of the plastic structures of the period of Isin and Larsa. This was a refinement of great originality, one that we can just barely deduce from the little artistic evidence that has survived the destruction and sacking that ended the I dynasty of Babylonia (c. 1595 B.C.). It cannot be said with any certainty whether this current was properly Babylonian, as the king's head found in Susa, generally thought to be a portrait of Hammurabi and considered the most important evidence of the innovative style of the early Babylonian period, is still not validated. Nevertheless, in the two surviving reliefs of the great Babylonian king, it is possible to perceive the expressionistic refinement that is fostered through the reduction of conventions of design and the introduction of ways to overcome the rigidity of image of the period of Isin and Larsa. Working within the formal limits of neo-Sumerian derivation, the early Babylonian artists seem to have developed to the utmost degree – mainly in a tone of intimistic expressionism – the organic naturalism of the early Akkadian period.

The age of the Cassites and the Mitannians. — The destruction that put an end to the dynasties of Aleppo and Babylon around 1600 B.C. at the hand of Muršili I of Hatti caused one of the gravest interruptions ever in the flow of history of the ancient Near East. Serious crises occurred in the major centers of southern Mesopotamia, while in northern Syria the established settlements were abandoned or reduced to very modest dimensions. The material culture of the Mesopotamian area, as proved by observations made principally on the ceramics of Nippur (D. P. Hansen), suffered a severe interruption in its development. The emergence of the Cassites to political power in Babylon; the establishment of the powerful northern Mesopotamian state of Mitanni, prevalently of Hurrite population; and the gradual strengthening of power of the Hittites in Anatolia resulted in the period beginning around 1600 B.C. becoming known as the age of the mountain peoples. These peoples become the protagonists of a world of widened horizons, in which traditional predominances were overturned, or at least substantially changed.

It is in this world of profoundly shaken values that formal tendencies that do not have their roots in

the court tradition of paleo-Babylonian or paleo-Syrian art are affirmed. These tendencies are characterized by a narrative style of popular inspiration that, in different ways, seems to be a unifying element which traumatically affects the traditional schools, although the individual denominations that were given to these currents by modern historiography often have misleading ethnic references. The most relevant point that has been focused upon in recent investigations is that of the origin of these tendencies. In the Syrian and Mesopotamian areas, these tendencies were active around 1750 - 1700 B.C., as shown by stratigraphically dated evidence from Alalah (P. Matthiae) and by tablets dated in the early Babylonian period (B. Buchanan). The traditional designations of "Cassite" and of "Mitannian" for these glyptic styles would suggest that their origin is in the ethnic nuclei of northern Mesopotamia. However, the absence of documentation from these presumed areas of origin, as well as the early appearance of cultural nuances in important centers of early Syria and Babylon, suggest the opposite.

The period of the Amorean dynasties saw the emergence into the homogeneous and compact panorama of artistic schools – whose standards were still determined by the palace directives – of workshops of different inspirations and origins, tied to modes of expression of popular immediacy and not bound by tradition. The workshop is therefore to be associated with particular social situations of the same state organisms of the early Babylonian period. They reveal a stratification of expressive attitudes and the possibility of artistic accomplishments outside – and below – the dominating classes of administrators and priests.

It is these inclinations that, after 1600 B.C., result in the substitution of a popular style in place of the vision of the court schools, and this even at an official level. In the Mesopotamian world, in the middle Babylonian period (c. 1600 – 1000 B.C.), the problem of the human condition, of the destiny of man, of the fundamental injustice of his state, emerges in the literature. The antiquarian and iconographic classification of "kudurru" (U. Seidl), a typical monument of the Cassite era, on which are registered donations to specific funds, has permitted the verification of the actual detachment from early Babylonian expressive ideals in monumental art as well as in glyptic art (Th. Beran).

The Mesopotamian tradition is by now broken, the early Babylonian refinement is abandoned, and the schools of the Cassite era reconstruct the bases of definition for the new modes of artistic expression. The human figure is by now a volumetric mass, on whose undifferentiated surfaces are duly expended the details of geometrical brocades of the rich and heavy clothing that hides the corporeal essence. Divine images disappear, replaced by the abstract symbols that cover the reliefs, in homage perhaps to an ideology that seems to have lost direct contact with the divinity in the distressing conscience of the human state. The pictures of Dur Kurigalzu, the modern Aqar Quf, a capital of new Cassite foundation erected by Kurigalzu I (around 1400 B.C.), or possibly by Kurigalzu II (c. 1345 – 1324 B.C.), with the squared and massive forms of the figures enclosed in the heavy contours of the design contrast significantly with the elegant composite formulas of the early Babylonian paintings of Mari and show their full participation in the new middle Babylonian figurative concept.

In the spatial refinement of the small temple of Inanna at Uruk, that of the temple of Nin-gal, and also Edublalmakh at Ur, there are important new elements perceived: the use of the barrel vault, the isolation of the templar plan, and the accentuated ductility of the angles tend to show interest in different problems from those of the early Babylonian architectural civilization. It is no longer the scenographic complexes, subtly modulated, of the early Babylonian facades that polarize the attention; rather it is the internal spaces of the sacred area, created as a unit, that is the central issue of middle Babylonian architecture.

In the Syrian area, the raising of a popular style to the official level is unequivocally documented by the statue of Idrimi, a king of Alalah who ruled shortly after 1500 B.C. The contraction of natural dimensions and the flattening of the image that is typical of the ancient northern Mesopotamian and northern Syrian cult statuary, the expansion of the physiognomic elements into a substantial disintegration of the modules of early Syrian expressive relations, the presentation of the elements of drapery that were exalted in the plastic outlook of the great paleo-Syrian art – all are aspects of an innovative style that finds its counterpart in the contemporary glyptic production. Although various stylistic currents can be identified within this general tendency of style (R. Opificius), glyptic art in the middle Syrian period is characterized by a substantial consistency in northern Mesopotamia, northern Syria, and Palestine until about 1350 B.C., though some of its aspects did not reach certain centers of Palestine until much later.

In about 1350 B.C., and probably in relation to the recovery of political independence and to a general cultural reawakening, the Assyrian area is pervaded by an intense ferment that gave rise to the flourishing middle-Assyrian glyptic, from the XIV to the XII centuries B.C. The middle-Assyrian glyptic of Assur that recently came to light (U. Moortgat-Correns) confirms and defines the fundamental historic role that is attributed to this formative phase of the artistic culture, which may properly be called Assyrian.

Although there are serious gaps in the figurative material, the accomplishments of the great sculptural cycles of Assurnasirpal II (c. 883 – 859 B.C.) are the robust naturalistic refinement of the mature middle Assyrian art and the reestablishment of spatial investigation. It is not possible to determine the sources of this rebirth, which constitutes a decisive turning in the artistic history of the Near East, but it is certain that a typically Assyrian development is involved, a development which remains completely foreign to the rest of southern Mesopotamia. It is a profound and radical cultural upheaval that represents an intense change in the Assyrian world, possibly created in opposition to the Mitannian culture that dominated Assur for more than a century. The value of the individual, the sense of historic process, and the awareness of the significance of tradition seem to be the characteristic points of this cultural revolution, the Assyrian assimilation of a process affecting the contemporary Babylonian world.

In the Syrian-Palestinian area, the destruction that occurred around 1600 B.C. and the successive Mitannian dominance produced the court tradition of the Amorean principalities. The recent discoveries by

C. F. A. Schaeffer at Ugarit, the modern Rās Šamra, a center noteworthy for its vitality though not of great political importance, confirm the presence of external stimuli that acted negatively upon the unity of the artistic culture of the coastal region. Particularly significant is the ivory headboard of a bed with panels in relief that show figures of the mythical world. This headboard, notable for its pre-Amarnian elements, can be dated in the first quarter of the XIV century B.C. The extraordinary stylistic accomplishments of the reliefs undoubtedly result from a thorough study of the formal qualities of the art of the time of Amenophis III. These qualities were then applied to themes of middle-Syrian mythology, such as the frontal winged goddess identified as "Anat" with figures of two young princes nursing and a portrayal of a young royal couple embracing.

The ivory headboard of Ugarit reveals the activity of a workshop in Syria, and possibly in Ugarit, where craftsmen had thoroughly assimilated the lesson of the pre-Amarnian school. A highly original expressive solution is found in an admirable ivory head, adorned with inlaid gold and precious stones, also from Ugarit. The remains of a tall hairstyle and the traces of precious mountings suggest, according to H. Safadi, that the head in question is an image of the tempest god Hadad, usually represented wearing a high tiara with wide bull's horns at the top of the headpiece. The rather full lineaments and a certain softness of the lines that confer a sensual and enigmatic quality to the face have raised the possibility (H. Seyrig) that this may be a portrait of a woman. This head, which certainly portrays a member of the royal family, indicates that the major centers of Syria, after the crisis of the middle Syrian period, had fully recovered the techniques of expression and that this recovery had taken place through experiences essentially foreign to the early Syrian tradition and in the minor arts.

Ugarit holds a particular role among western Syrian centers due to the exceptional level of its artifacts, which were without a doubt from palace workshops. This is confirmed by the excavations (R. Hachmann) of Kamid el-Loz, the ancient Kumidi, a center of provincial Asian administration of Egypt. Here, a bronze statuette of a warrior god and an ivory figurine appear to be the work of a local craftman and present only the echo of the stylistic mode of other centers in the coastal area.

If a caesura seems to characterize the passage from the paleo-Syrian to the middle Syrian world in the figurative arts, continuity is characteristic of the architectural tradition of the same time. This quality is clearly evident in the peripheral centers of the Syrian and Palestinian areas during the late part of the paleo-Syrian period. An example of this is Hazor, a city in which all of the major temples of the time had gone through reconstruction without substantial modification at the beginning of the middle Syrian period. Although in southern Palestine during the first phase of the middle Syrian period there are evident traces of interference in the development of the paleo-Syrian architectural type of refinement, such as the temporary abandonment of the canon of axiality in temples such as the Ditch Temple of Lākīš, the stability and permanence of traditional elements is generally prevalent.

In northern Syria, the recent excavations at Emar, the modern Meskene (J. Margueron), at Tell Mumbaqat (W. Orthmann), and at Tell Fray (P. Matthiae), all in the valley of the Euphrates, reveal a series of temples with a long main cell, an axial entrance, and wide perimetral structures – all elements derived from the paleo-Syrian tradition. Typical of the middle Syrian era is the issue of the facade and of the parts of the building that are before the main cell. It is during this time that the standard of isometry of the early Syrian period is broken and that vestibules that substantially modify the spatial structure of a building are created. Two examples of this new approach are the temple of the Orthostats at Hazor, with a small vestibule, and the South Temple of Tell Fray, with a vestibule larger than the cell.

In sacred architecture, the middle Syrian style seems to operate according to stable typological elements, though a final assessment of this interpretation is premature given the excessive fragmentation of the documentation that has reached us. Still, the basis of this hypothesis is solid, as is demonstrated by the notable development of a typology for sanctuaries that differ from classic temples with axial configurations. These sanctuaries are complex buildings in which quadrangular and rectangular rooms with fixed furnishings for the cult are developed around a courtyard or a larger central cell. The first examples of this genre are the so-called Temple B2 and the Double Temple in area F at Hazor. The continuity of the tradition is explicitly documented in area F of Hazor, where in the XVI and XV centuries B.C. a more simple sacred building is built in place of the Double Temple; it has a central plan, consisting of a small square room surrounded by long rooms. The same planimetric disposition is found in a more recent temple, excavated not long ago in the citadel of 'Ammān by J. B. Hennessy. While the analogies between the temples of Hazor and of 'Ammān are most relevant, the contemporary Temple of Kamid el-Loz, though not completely excavated, reveals variations upon the planimetric theme of a central cell surrounded by elongated rooms. Two anomalies are present in the Temple of Kamid el-Loz with respect to the standard model: a projection on the side of the presumed entrance and the lack of peripheral rooms precisely on that side. Both might have stemmed from an attempted fusion of two clearly distinct typologies. The emerging portion in the facade is one of the documented means of treating the spatial problem of the facade of the late middle Syrian temples, mainly in the Palestinian area.

Important progress has been made in the furthering of our knowledge of the south-western Iranian area in the middle Elamite period through a systematic exploration of Tchoga Zanbil (R. Ghirshman). This is the ancient Dur Untaš, the residence founded by Untaš-napiriša (c. 1275 B.C.), one of the Elamite kings engaged in a political activity of intervention in southern Mesopotamia. The nucleus of Dur Untaš was the great "Ziqqurat" erected between two lines of walls. The internal walls had seven gates, the largest of which, the "Royal Gate," opened on the south-west side and gave access to the intermediate courtyards between the "Ziqqurat" and the outer wall. It was decorated with enamelled bricks and nails with enamelled heads inscribed with the name of Untaš-napiriša. On the same southwestern side, before the entrance to the "Ziqqurat," were two rows of offertory tablets in the shape of truncated pyramids, a well for sacrifices of animals, an installation for liquid offerings, and three large square altars in baked

brick. The entrance to the temple towers was guarded by pairs of animals; only a part of these, bulls with very agile looking bodies, have been reconstructed. On the south-west side of the "Ziqqurat" were different chapels for votive offerings, and near the temple towers were a variety of sacred complexes dedicated to the principal gods of the Elamite pantheon.

Extraordinarily well conserved is the "Ziqqurat," of which three out of the five terraces postulated in the reconstruction are still visible. According to R. Ghirshman, the terraces constituted homogeneous nuclei built from the base to the top and not by successive building-over of the single steps. Based on this same hypothesis, the two lower external terraces were the first to be constructed, followed by the upper terraces of the internal court. All of them had vertical facades, decorated with alcoves and pilaster strips, and had an access at the top through a steep set of stairs positioned on the central axis of the facade, which was only partially covered by short barrel vaults or by a succession of arches with radial shells.

A particular architectural character of the "Ziqqurat" of Tchoga Zanbil is a series of rooms dug into the lower terrace, with vaulted coverings and with an independent access through a stairway. The main point of interest of these rooms is that they had been duly plastered and then filled with bricks, probably in the same phase of erection as the upper inner terraces. It has been suggested that they had only been temporarily used as storerooms and that their real function was that of funerary chambers. This is one of the major arguments in favor of the view that the "Ziqqurat" of Tchoga Zanbil had never been completed. Although some elements of the architecture of Tchoga Zanbil, such as the alcoves with triple recess covered by an arch, are almost certainly foreign to the Mesopotamian tradition, it is difficult to define just which elements of this important monument are properly Elamite. This is because the contemporary monuments of southern Mesopotamia, such as the "Ziqqurat" of Dur Kurigalzu, are in an advanced state of deterioration; therefore it is extremely difficult to make adequate comparisons.

Nonetheless, there are several indications that the "Ziqqurat" of Dur Untaš differs substantially from the Babylonian models. It was conceptually inspired by the celebrated monumental typology of Mesopotamia, whose "Ziqqurat" of Ur-Nammu and of Šulgi at Ur were the first complete examples that have reached us. The verticality of the facades, the extension of the surface of the terraces, the substantial progressive reduction of the successive steps, and the incorporation of the steps in the nucleus of the brickwork of the terraces all seem to be elements that are foreign to the Mesopotamian workmanship. These conform to the "Ziqqurat" of Tchoga Zanbil that predominance of horizontal lines that is the opposite of the Mesopotamian concept, which constantly strove to underline the vertical thrust of the monument, though in different ways in different periods.

Notable new testimonies have been gathered concerning the grave events that put an end to numerous important settlements in the western area of the Near East around 1200 B.C.; in particular with regard to Emar, an important city on the Euphrates. The information is significant in that the date of the destruction of Emar can be determined to be around 1190 B.C. thanks to several inscriptions containing references to the kings of Karkemiš. This agrees with what had been previously deduced from archaeological observations, mainly at Alalah and at Ugarit on the Mediterranean coast.

Neo-Assyrian Art. - The recent advances in knowledge of the artistic culture of the first centuries of the I millenium B.C. have been quite revealing. The publication of the excavations completed since the last war at Nimrūd (M. E. L. Mallowan) provided a series of fundamental details on the monuments of a neo-Assyrian capital, Kalah, which, incidentally, had also been one of the first and most fruitful sites of Oriental archaeology in the 1840s. Deep probings in the Oriental sector of the Acropolis have confirmed the validity of the inscriptions of Assurnasirpal (c. 883-859 B.C.), according to which this great neo-Syrian king had established Kalah on the site of the ruins of a middle Assyrian city erected by Salmanassar I (1274 - 1245 B.C.). The works carried out by Assurnasirpal II, mainly in the first five years of his reign, defined the appearance of Kalah, with its trapezoidal plan dominated on the eastern side by a large acropolis that looked over the ancient bed of the Tigris. On the western side of the acropolis, coinciding with the outside walls of the city, was a gigantic terrace in stone that protected the unbaked bricks of the walls from the erosion of the river's waters. This terrace was admired by Xenophon after the destruction of the city in 612 B.C., when he passed through in 401 B.C. with the survivors of the Greek armies after the defeat at Cunassa on his march to the Black Sea.

Among the many monumental buildings of the acropolis of Nimrūd, where excavations have been resumed, the most important and the oldest is the northwest palace erected by Assurnasirpal II as his residence. Recent explorations have identified the restoration carried out by Salmanassar III (c. 858 - 825 B.C.) and by Šamši-Adad V (c. 824 - 810 B.C.), who also resided in that palace. After Šamši-Adad V the northwest palace was abandoned as a royal residence, but it continued for a long time as the seat of the royal chancellery and as a storage place for the tributes given to the Assyrian kings by their subjects. An inscription by Sargon II (c. 722-705 B.C.), written over yet another inscription by Assurnasirpal II, notes that the tributes paid to him by the king of Karkemiš were stored in the palace. The magnificent rooms of the receiving quarters were later used for purely administrative purposes. This is demonstrated by the fact that the palace had been partially stripped of its sculptural decoration in order to adorn other more recent residential buildings of the acropolis of Kalah, and also by the discovery of a group of official weights, inscribed with the name of Sennacherib (c. 705 - 681 B.C.) in the throne room itself. In the VII century B.C., after the residence of the great king had been transferred to Ninive, the ancient palace of Kalah was used as a peripheral administrative seat, though by then it was in a state of decay because of its partial abandonment.

The recent exploration of the northwest palace has resulted in the recovery of the northern wing of the facade; notable for a double series of rooms used as offices; of parts of the northeast wing; and of a sector of apartments in the southeast wing. Although extensive areas of this monumental complex, the earliest neo-Assyrian palace known to date, have been lost to the

erosion of the hill on which it was built, the general planimetric structure of the palace is clear.

The wide buttressed facade on the north side, erected before the temple of Ninurta and the "Ziq-qurat," had a complex main entrance; a wide courtyard surrounded by areas for administrators that opened onto the representation quarter, in the heart of which was a grand throne room; and a smaller internal court on whose southern side were the residential apartments. The organic and functional planimetric concept of the northwest palace of Assurnasirpal II apparently was the model for other residential buildings constructed by the Assyrian kings at Kalah and in other capitals of the empire. With minor variations, in large part concerning the representative quarters; and apparently connected more as formal motifs than as chronological developments (G. Turner), the formulation of the neo-Assyrian palace remained tied to the fundamental scheme of two courtyards connected by a nucleus of rooms around the throne room.

Another palace of Nimrūd of great constructive effort, the so-called Salmanassar Fort, presents notable variations with respect to the northwest palace due to the manner it which it was used. The immense palatial building erected on the southeast edge of the lower city, built by Salmanassar III, is mentioned in the later inscriptions of Asarhaddon (c. 680 - 663 B.C.), who made restorations, such as an 'ekalmasharti' (that is, an arsenal-palace). The building certainly had from its beginning the multiple functions of residence, arsenal, and parade grounds, as is revealed by its singular and grandiose structure. The palace was ringed on the northern and western sides by two thick curtains of turreted walls and to the east and north by the great city walls. Four extensive quadrangular courtyards were positioned in a square pattern, with two smaller trapezoidal courtyards, limited on the south by the city walls that ran at an angle to the palace. In the ample space of one of the four anterior courtyards, four more minor courtyards have been uncovered, separated by long rooms used as magazines.

All of the areas uncovered along the turreted walls and along the arms of the cross formed by the courtyards were reserved for the troops and, in a smaller measure, for the administration. The residential apartments were located in the southwest corner, while the complex of the areas of representation — with the usual disposition of the large throne room parallel to the inner side of the larger courtyard — was followed by other minor long rooms separating it from one of the internal courtyards. Access to the throne room, which is characterized in the Salmanassar Fort by particularly imposing dimensions, was from the grand courtyard, through two monumental portals that were flanked by imposing buttresses. The large and unusual number of rooms utilized for administrative purposes and as small independent residential units, with long rooms and a communicating service; the quantity of localities employed as magazines for arms and for tribute; the dimensions of the courtyards - in the largest of which, against normal practice, a royal throne was installed - all demonstrate with certainty that the building, perhaps much more than as a residence, must have been utilized for military purposes; mainly in relation to the preparation for the frequent and systematic campaigns of war undertaken annually by the Assyrian kings.

Recent exploration of the other large palaces of Nimrūd, all located on the acropolis, has not cleared up the many doubts resulting from the excavations done in the 1800s. Nevertheless, at the present state of the research, the northwest palace appears to have been abandoned as a residence by Adad-Nirāri III (c. 810 - 782 B.C.), who then constructed the palace immediately to the south of the northwest palace, in proximity to the western limit of the acropolis. The central palace of the ancient excavations was evidently the work of Tiglatpileser III (c. 745 - 727 B.C.).

In the southeast area of the acropolis, the problems of the origin of an important group of ivory figures discovered in the excavations of the 1800s have been partially resolved: these have traditionally, and in part incorrectly, been attributed to the southeast palace. From the recent exploration has emerged that which is described as the "Burnt Palace," in which nonetheless only the anterior sector of a wider palace can be recognized — a sector which apparently extended toward the south around a presumably internal courtyard, probably constructed by Sargon II (c. 721 - 705 B.C.). This may have occurred before the sovereign transferred his residence to the new city of Dūr Sarrukin, during the long preparatory works for the new royal building to the north of Ninive.

To the same period of Sargon II must be attributed the final phase of the Ezida, the building overlooking the "Burnt Palace," with the two flanking chapels of Nabu and Tašmetum. The Ezida, the most important and the best conserved of the temples of the acropolis of Kalah, has apparently been reconstructed and restored in the time of Sargon II on the ruins of an earlier sacred building, either of Assurnasirpal II or of Salmanassar III. The sanctuary, with its two chapels preceded by two courts, repeats a design that is perhaps typical of the temples of Nabu, as confirmed at Assur, at Dūr Šar-rukin, and, in provincial form, in a temple of Tell Halāf at the time when Guzana became the seat of the Assyrian government.

The neo-Assyrian artistic culture has been the object in recent years of some systematic studies (B. Hrouda, T. Madhloom) on the material cultures as reflected in the grand cycles of historic reliefs. From these systematic analyses useful - even if not decisive - indications are derived on the dating of some monuments and of cycles of controversial dating. Many details of the material culture and of the wall paintings of Till Barsip find their counterpart in the sculpted works of Tiglatpileser III and sometimes even in the Sargonic age at the end of the VIII century B.C. This led to a dating (B. Hrouda) of the ancient pictorial cycle of the provincial center on the Euphrates to Tiglatpileser III, as had been proposed in the original edition. Previously this had been attributed (A. Moortgat) to the "turtanu" Šamši-ilu, who governed between 780 and 752 B.C. A similar analysis has also resulted in the dating of the main group of ivories from the clandestine excavation of Ziwīya, in northwestern Iran, to the time of Sargon II. Considerations of an iconographic and stylistic character also indicate that the same group of ivories came to Ziwīya as a result of a sacking, but that they originated in an Assyrian workshop of the last decades of the VIII century B.C.

The recent excavations at Nimrūd have also furnished an extraordinary mass of ivories, of which a

significant number can be attributed to Assyrian schools (M. E. L. Mallowan). Discoveries were recently made of important fragments of ivory of the IX century B.C., belonging to the reign of Assurnasirpal II, or to that of Salmanassar III, made with the typical techniques of engraving. The theme of these panels is noteworthy, as it re-echoes the motifs of the great monumental art that exemplified Assurnasirpal II himself as well as the extraordinary accomplishments of the historical cycles in what has been defined as the epic-rythmic style.

Nevertheless, even in the time of Assurnasirpal II, plaquettes in bas-relief of very fine workmanship have been confirmed, with representations of the king shown in the act of drinking: these are from workshops certainly very close to the great maestros who decorated the rooms of the northwest palace. The images presented by these neo-Assyrian discoveries is unitary and homogeneous, even stylistically, to the formal world of contemporary historic relief. The wall reliefs from the recent excavation of Nimrūd have not provided any essential integration, even though they came down to us almost complete; however, noteworthy findings are a fragmentary statue of Salmanassar III - which it has been possible to reconstruct almost completely - and the royal podium of the throne room of the so-called Salmanassar Fort of that king. The podium in particular, with its frieze of tributaries rendering homage to the sovereign, is a precious testimony of Assyrian art during the historically important reign of Salmanassar III, but it is sadly lacking in documentation concerning historical wall reliefs.

Regarding the latter, the critical edition (R. D. Barnett) of all of the material existing in the British Museum in London, whether marble slabs and fragments or graphic reproductions and descriptions of reliefs that have been lost, contribute decisively to the accomplishments of an historic-artistic study of the neo-Assyrian monumental art, until now never undertaken. The attempted restitution of the slabs to their original position, as has been accomplished for the quite fragmentary complexes of the cycles of Tiglatpileser III of the central palace - which had been partly dismantled in ancient times - is of considerable importance, since it permits the reading of the works in their original context and the interpretation of scenes with references to the military campaigns mentioned in the annals. The data furnished are essential also in the dating of the works of the different reigns, on which may be implanted the historic chronology.

Neo-Hittite Art. - Some important centers of the artistic civilization of the Luvite and Aramaic kingdoms of southern Anatolia and of northern Syria, defined in the contemporary literature as "neo-Hittite," have been explored in recent years, with noteworthy results. Such is the case of 'Ayn Dara - according to some the ancient Kunalua - the major center of the kingdom of Ḥattina, designated in Aramaic with the name of Ūnqi (F. Seirafi). Other excavations had less satisfying results, due to the brevity of the excavations; as in the case of Tell Rifaat, almost certainly the ancient Arpad (M. V. Seton-Williams), the capital of the Aramaic state of Bît-Aguši in the region of Aleppo. 'Ayn Dara is an important center situated in a strategic position, with a high acropolis surrounded by a wide external ring of walls. On the acropolis was a large sacred enclosure, difficult to decipher or to reconstruct as it was quite ruined, but

which conserved notable remains of decorations of orthostatic slabs with extensive fragments of reliefs. These had mainly divine representations that seem to re-echo themes and manners of the latest Hittite imperial art, even if they do not seem to be before the IX century B.C.

A substantial increase in our knowledge of the architecture of two important centers of the northern Syrian area in the first centuries of the I millenium B.C. has resulted from the definitive publication of the reports of the excavations of Tell Ta'ynat in the region of 'Amq (R. C. Haines) and of Hama (E. Fugmann). Tell Ta'ynat was apparently an administrative center of some importance, judging from the three successive periods of adaptations and restorations undergone by the centraleastern area of the tell, where the public buildings were found. In the oldest phase, which is apparently of the IX century B.C., the larger palace was a "bīt ḫilāni" of classic type, with a facade with three columns and a tower with a stairway of four ramps; then a wide latitudinal room, and finally some smaller rooms in a third alignment. On one of the sides, nevertheless, a wide wing was added to the palace, subdivided into two sectors with rooms that are also articulated in three different alignments, but probably without porticos.

In front of the larger palace was a second "bīt hilāni" with a portico having two columns and a double line of smaller areas behind the large latitudinal room; a long ante-room, and a vestibule, with emerging antas flanking the two columns of a small portico. In a second phase, characterized by the extension in the fortifications at the gate to the citadel, the area of the wing of the first palace, quite enlarged, developed into a wide elevated terrace, limited by a wall that was buttressed toward the inside of the citadel. Access to the citadel was by a short stairway opening on to the square between the two palaces: the stairway itself then becoming the third side. In a third phase, the area between the two palaces was limited by the palace facades, a buttressed wall, and a IV wall of uniform surface, thus defining a rectangular square.

Also at Hama is the administrative center of the city destroyed by Sargon II in 720 B.C. This included a large palace of morphology analogous to the classic "bit halani" to the southwest; a monumental access gate to the "bit halani" to the southeast; and a small complex of structures, perhaps incomplete, to the west. This has been interpreted as either the ruins of a second gate or as a three-part temple (D. Ussishkin), but is most likely a treasury house. Particularly important is the palace that evidently had an entrance portico with three columns, recessed with respect to the facade of the building and characterized by thick buttresses that set off deep alcoves. The layout of the rooms is also different from the classic one of the "bit halani" inasmuch as the areas are arranged in two alignments in the larger part of the building, one external and one internal; access to the first of these is by one of the two lateral doors and to the second by the axial door of the portico. The second lateral door gives access into the smaller section of the building, where the rooms are also distributed in two alignments, set at right angles to the others. The Hama palace is a monument of singular and subtle coherence of proportions, projected on the basis of a system of metric ratios, to which corresponded a harmonious spatial equilibrium of volumes. An analagous and refined

system of metric ratios coordinated the disposition and the orientation of the three larger buildings of the citadel, in which the continuations of the axes of the gates intersect in the central part of the typical trapezoidal piazza.

The abundant and complex figurative documentation usually defined as "neo-Hittite" has recently been the object of a systematic study (W. Orthmann). This has emphasized the aspects of dependence of the artistic civilization of the II millenium B.C. in the Anatolian and Syrian areas and has also attempted a unitary classification on the basis of technique and stylistic considerations. An evaluation of the historic position of some cycles of reliefs has been attempted (P. Matthiae), as in the case of Karatepe, in the framework of the "neo-Hittite" artistic civilization, mainly in the elements of stylistic refinement identifiable in the complex. These reveal two distinct schools, one of archaic inspiration, the other sensitive to the stylistic tendencies of the last decades of the VIII century B.C.; the reliefs appear to be of that epoch, in spite of recent hypotheses of an earlier dating (D. Ussishkin).

Some pieces of statuary of this era were found by chance in northern Syria; among these the large statue of the sovereign of 'Ayn et-Tell, a section of Aleppo, has a considerable value, a precious and very rare testimony to the monumental art of Bît Aguši. The image expresses with efficacy and vigor, in its singularly flattened and compressed structure, the volumetric style of the "neo-Hittite" art and reveals how profoundly unitary the figurative concept of the major Syrian-Anatolian centers of the I millenium B.C. was. The excavations of Nimrūd have, furthermore, yielded a great number of ivories; for the most part these are of northern Syrian origin. Thus various pieces of the "Burnt Palace," clearly coming from the so-called W. K. Loftus group of the 19th-century excavations of the southeast palace, probably were made in central Syria; the hypothesis advanced, on incomplete data (R. D. Barnett), that Hama is the place of origin of this type of ivory seems very likely. The recent finding of the "Burnt Palace" confirms the independence of the workshops of the cities of inner Syria from the artistic craftmanship of Egyptian inspiration. Although one cannot really speak of a stylistic unity between the ivories and the monumental sculpture of Hama, the volumetric concept of the "neo-Hittite" art is not foreign to the refined but severe style of the engraving schools. This art, however, does not match the refined and exquisite quality of the engravers of the Asiatic workshops of Egyptianizing style, recently defined as "almost Egyptian" (M. E. L. Mallowan).

If it can be believed that the ivories of the "Burnt Palace" are from Hama, then the splendid collection of panels amassed in one of the storage rooms of the so-called Salmanassar Fort are certainly either from a workshop of Hattina (a state that flourished in the valley of 'Amq, the classic Antiochene) or from a school very close to the ambient of Tell Ta'ynat and of Sakçagözü, and thus open to Anatolian influence. Most of the ivory panels of the Salmanassar Fort are from headboards of beds or thrones; there are representations of a series of scenes of a hunt for wild bulls, four-winged genies, and standing soldiers or feminine figures holding flowering branches under a winged sun of typically Anatolian formulation. Among the less frequent themes are feminine figures seated on thrones, shown either with twisted branches of plants or preparing to consume food set out on an offertory table. All of the ivories are worked in relief; completely absent are techniques of inlaying or of perforated carving. A series of antiquarian and iconographic elements clearly reveals substantial analogies of these masterpieces of northern Syrian artisanship with Sakçagözï, the ambient responsible for the later reliefs during the last quarter of the VIII century B.C. Nevertheless, the great value and the workmanship of these works, and a certain satisfaction in the alteration of the standard iconographic designs, are not documented in the contemporary monumental art. The panels of the headboards of the Salmanassar Fort are works that testify to the supreme development of style of those northern Syrian centers that are very close to the Anatolian area, probably just in the last years of the VIII century B.C. Some remains of relief panels showing a wide use of inlays with colored stones were found in the Salmanassar Fort, together with many other fragments, often not easily identifiable in place or time. These ivories, stylistically quite close to the Samarian collection, are apparently of Phoenician origin; such an origin has been repeatedly claimed recently in summaries on the complex of artistic reproductions attributed for various reasons to the Phoenician schools (S. Moscati.)

Discoveries and problems of the northern area: Western Iranian and Urartu Civilization. - Another part of the Near East where considerable progress has been made in recent years is the northwestern Iranian area; nonetheless, the absence of reliable data on the ethnic and social status and the political order makes historic interpretation of the findings difficult. Thus the tombs dug into the Marlik hill in the valley formed by the sefi Rud on the coast of the Caspian Sea (E. O. Negahban), even though typologically quite modest, are notable for some rich furnishings; these apparently belonged to some leaders of the communities whose members were buried in the region or may have been the results of sackings. In any case, the pieces of major interest are very naturalistic glasses of irregular workmanship, apparently from that phase of vivid naturalistic art which is the middle Assyrian period (E. Porada), indicating a northern Iranian culture datable to the XII-XI century B.C. The glasses of Marlik are associated with precious objects coming from an area extending from the southwestern coastal region of the Caspian Sea to the region of Azerbajdzăn.

The archaeological site of major interest is without a doubt H̲asanlu, which is also the only center where the excavations (R. T. Dyson) have uncovered a unified monumental collection. The golden cup of H̲asanlu, with scenes of a Hurrite myth relating to the great celestial god Kumarbi and to the tempest god Tĕsup, are attributable to an earlier phase of the larger settlement of about the XII-XI century B.C. Iconographic elements having analogies with the bronzes of Luristan suggest that this fine cup may be the work of Iranian artisanship, created around 1100-1000 B.C.

The larger city of H̲asanlu is of a later time and appears to have been destroyed around 800 B.C. In that period the citadel was surrounded by a strong system of walls in unbaked bricks, reinforced by large towers and interspersed with smaller buttresses. The larger buildings had a portico in the facade reminiscent of the col-

onnades of the "bīt ḫilāni" of northern Syria, a shallow longitudinal room flanked by two small square areas, and a large longitudinal colonnaded room with three naves, a typical Iranian architectural motif. The large colonnaded rooms of the Achemide palaces probably depend on the tradition evidenced at Ḥasanlu, in which Iranian and Syrian elements are combined, seemingly a typical character of the northwestern Iranian area. It is possible that the intermediary between the cultures of northern Syria and the area of Ḥasanlu was eastern Anatolia, and in particular the Urartean world, which had close contacts with both these cultures, bordering it to the southwest and the southeast.

The artistic culture of Ḥasanlu reflects a variety of relationships and considerable contacts and a marked capacity to assimilate influences from local customs. Thus the glazed mural bricks with a man-like bull with bearded head fixed in the center bull seems to be an original elaboration of the bricks of the Assyrian palaces having nail heads in the center, in a version probably of Elamite derivation. Thus the silver chalice, of a typology similar to the glasses of Marlik and of Luristan, with a war scene of an archer on a chariot drawing a bow towards the soldiers who follow with a horse, is decorated according to the epic-narrative manner of the cycles of Assurnasirpal II. Thus only antiquarian elements and compositive data show a real point of contact between the Assyrian reliefs of the IX century B.C. and the northern Iranian chalice. Thus a 'rhyton' in the form of a horse's head, with others in the form of a goat's head, presents typological analogies with similar neo-Assyrian receptacles; there are also, more importantly, notable stylistic and technical points of agreement with Urartian objects from Altintepe and from Karmir Blur, particularly in the wavy rendition of the mane. Although the attribution to a particular ethnic group in the Ḥasanlu complex is rather difficult, the most likely hypothesis advanced is that it was a citadel of Mannei, in the region to the south of the lake of Urmia, where royal Assyrian inscriptions are found.

In recent years there have also been the beginnings of a scientific exploration of the area of Urartu, in eastern Anatolia, and of some important ancient centers of the region. The largest palace of the Urartian area excavated up to now is that of Erebuni, the modern Arin (K. L. Ohanesian); of its two courtyards that are surrounded by rooms, the public one, with a portico of wooden columns along its side, had an isolated temple with a single room on its western side and three rooms side-by-side on the eastern side, each with the same width on the side of the courtyard; these rooms had access to a large room, where the throne room has also been identified. Some internal indications confirm this hypothesis, such as the presence of two alcoves on the eastern side and, mainly, of the remains of a mural picture similar to that of the northwest palace of Kalah. Historically the typology of the throne room behind the antechambers, which communicates with the colonnaded courtyard, corresponds to the often more complex planimetric disposition found in Mesopotamia since the period of Larsa. Nevertheless, the predominant arrangement is of a central entrance from the courtyard to the first of the two usual large rooms of the representatives' quarters. The arrangement of two peripheral entrances as at Erebuni is also confirmed, as, for example, in the palace of Nūr-Adad at Larsa,

because of the second large room of the complex. The double entranceway with peripheral arrangement at the corners of the courtyard is the classic one of the large neo-Assyrian palaces; these do not have antechambers or direct passageways from the external courtyard to the throne room and are mainly characterized by the disposition of the entranceway at right angles to the axis of the room.

Among the other Urartian public buildings, Altintepe, whose dating is doubtful but which could be of the Achemenid era, had an ample room with six rows of three columns each. A smaller columned room was found in the palace of Giriktepe. The walls, with double recessed alcoves, and the entrances, where the motif of the re-entering was repeated, indicate a certain relation with the Mesopotamian area in general, and more probably with the neo-Assyrian, as well as possible relations with the presumed Mannean area of Ḥasanlu.

In the sacred architecture, some important monuments recently discovered have identified as a standard type of temple the single-roomed autonomous building surrounded by thick perimetral structures. This type of temple is already documented at Erebuni, to the west of the colonnaded courtyard in the chapel that was successively transformed into a "temple of fire" in the Achemenid period, when the courtyard of the palace was reduced to a fore-court of the sacred complex. A small temple of Anzavurtepe apparently had a structure very similar to the temple of Erebuni (K. Balkan). Here the small room is enclosed by very thick perimetral walls whose face, in unbaked bricks, rests on an imposing foundation erected with large square blocks, with angular towers whose sides project slightly from the line of the external walls; the room is inserted in a short courtyard that is also enclosed by thick structures.

This structure is also found at Altintepe in a more monumental conception. Here recent excavations (T. Özgüç) have uncovered a temple that, for the structure or for the proportions, appears quite like that of Rusahina, the modern Toprakkale, whose foundation goes back to Rusa I (c. 735 - 715 B.C.), or, more probably, to Rusa II (c. 685 - 645 B.C.). The temple of Altintepe, which is apparently of Argišti II (c. 715 - 685 B.C.) and is well conserved in its planimetric elements, presents the typical massive central room with angular towers, a podium on the internal wall at the far end, and a low bench around these internal walls. The room was positioned in a colonnaded courtyard with two entranceways: one with an axial access to the room, the other lateral and preceded by a wide vestibule flanked by two small symmetrical rooms. Although the short porticos in which the Urartian temples were positioned seem to be a specifically Urartian element, as at Altintepe, the type of temple with single room and thick perimetral walls is very probably the result of an earlier Syrian influence.

Of the Urartian administrative centers, the one that has furnished the most complete documentation is certainly Teišebaini, the modern Karmir Blur; its fortified citadel was defended by a second internal ring of towered walls reinforced with buttresses, and all of the northeast sector was reserved for laboratories and storerooms. The type of room most frequently found is of a narrow and elongated form, subdivided in three chronologically successive parts, not connected by courtyards.

The larger areas, with central pillars, were filled with provision jars, most of them fixed in the floor and connected to one another. The appearance of plaster fragments on the walls and the absence of any trace of internal pictures and the unusual narrow structure of the elongated rooms indicate the presence of a wider second floor given over to art work.

The excavations of Altintepe have furnished a good documentation of Urartian painting, adding to what is already known of the temple and the palace of Erebuni. The larger frieze of Altintepe was found on the walls of the colonnaded room and showed a close succession, from top to bottom, of long registers. Two of these were higher than the others; one shows felines passing between stylized trees of thin tapered trunks with leaves typical of conifers, the other has images of bulls kneeling on their front legs and winged sphinxes, separated by large ornamental panels. The smaller registers, of varied height, show rosettes, spires, stylized pomegranates, and small frontal divine feminine figures at the sides of schematized sacred plants. Many iconographic elements of this frieze are also found in the Urartian artistic culture of the neo-Assyrian area; examples are the ornamental panels with the crescent-shaped sides and the multiple central circle, the decorative design of kneeling bulls (even if the formal qualities of these figures are typically Urartian), and the motifs of the spires. Many elements, however, are typically Urartian in their design; examples are the pomegranates with internal concentric circles, the base with rectangular plaquettes, the three-pointed crown, the cylindrical head coverings lightly tapered below, the sphinxes with the low squared crowns and the wings extended along their lions' bodies, and torsos completely human, with the arms positioned in the ritual act of sprinkling water on the sacred plant.

The artistic style of Urartu, whose production has been systematically reexamined (M. N. van Loon), seems to be characterized by a noteworthy persistence of form, that from Argišti I (c. 786 - 764 B.C.) to Rusa III (c. 625 - 609 B.C.), does not undergo consistent evolution. The decoration for the shields in later periods has a more casual workmanship and the forms are much thinner. The surviving material Urartian figures belong in large part to the architectural arts and derive from that the prevalence of horizontal and vertical lines. An aspect of originality of the culture is given by its preference for composite forms, mostly of animals, as is the case of the eagle with four legs or the bull with the head of a bird of prey. The artistic culture of Urartu was evidently strongly influenced by the Hurrite figurative patrimony; even though such patrimony is not yet fully appraised, some iconographic analogies that tie the Hittite world with the Urartian world are derived from it. It is also probable that the isolated Urartian area has conserved, in a renovated artistic form, figures and images drawn from the early Syrian repertoire of mythical animals, among them several composite beings, which were then passed on to the Hurrite culture. Regarding the historic role of Urartian art, it is possible that some stylistic methods may have been derived from it and then transmitted to the art of the Medians; the accomplishments of the Achemenid period certainly drew frequent inspirations from it. The Urartian artistic culture, finally, besides contributing to the formation of the art of the Medians and the Persians, was apparently a fundamental intermediary for the passing on of ornamental designs and figurative concepts of the ancient Near East to the later Scythian art. This was essentially verified by the passing on of some decorative elements of accentuated stylization and with the creation of complex mixed beings; in them are carried out elementary zoomorphological concatenations, as the basis for the figurative metamorphoses that the Scythian art performed on the formal lexicon drawn from the world of early Asia.

BIBLIOGRAPHY. - K.M. Kenyon, Archaeology in the Holy Land, London, 1960; E. Strommenger, Das Menschenbild in der Altmesopotamischen Rundplastik von Mesilim bis Hammurapi: Baghdader Mitteilungen, 1, 1960, pp. 1-91; E. Akurgal, Die Kunst der Hethiter, München, 1961; P. Amiet, La glyptique mésopotamienne archaïque, Paris, 1961; R. Opificius, Das Altbabylonische Terrakottarelief, Berlin, 1961; J.A. H. Potratz, Die Kunst des Alten Orients, Stuttgart, 1961; R.D. Barnett, M. Falkner, The sculptures of Assur-nasir-apli II, Tiglathpileser III, Esarhaddon from the Central and southwest Palaces at Nimrūd, London, 1962; P. Matthiae, Ars Syra, Contributi alla storia dell'arte figurativa della Siria nel Bronzo Medio e Tardo, Roma, 1962; C.F.A. Schaeffer, Ugaritica IV, Paris, 1962; E. Strommenger, Fünf Jahrtausende Mesopotamien. Die Kunst von den Anfängen um 5000 v. Chr. bis zur Alexander dem Grossen, München, 1962; R. Ghirshman, Perse, Proto-Iraniens, Mèdes, Achéménides, Paris, 1963; P. Matthiae, Studi sui rilievi di Karatepe, Roma, 1963; S. Moscati, Historical Art in the Ancient Near East, Roma, 1963; K. Bittel, E. Heinrich, B. Hrouda, W. Nagel (ed.), Vorderasiatische Archäologie. Studien und Aufsätze A. Moortgat gewidmet, Berlin, 1964; M.J. Mellink (ed.), Dark Ages and Nomads c. 1000 B.C. Studies in Iranian and Anatolian Archaeology, Istanbul, 1964; W. Nagel, Djamdat Nasr-Kulturen und frühdynastische Buntkeramiker, Berlin, 1964; R. McC. Adams, Land behind Baghdad. A History of Settlement on the Diyala Plain, Chicago-London, 1965; R.M. Boehmer, Die Entwicklung der Glyptik während der Akkad-Zeit, Berlin, 1965; R.W. Ehrich (ed.), Chronologies in Old World Archaeology, Chicago-London, 1965; B. Hrouda, Die Kulturgeschichte des Assyrischen Flachbildes, Bonn, 1965; P. Matthiae and others, Missione archaeologica italiana in Siria. Rapporto preliminare della campagna 1964, Roma, 1965; N. Özgüç, The Anatolian Group of Cylinder Seal Impressions from Kültepe, Ankara, 1965; E. Porada, Ancient Iran. The Art of Pre-Islamic Times, London, 1965; W. Stevenson Smith, Interconnections in the Ancient Near East. A Study of the Relationships between the Arts of Egypt, the Aegean, and Western Asia, New Haven, 1965; E. Akurgal, Orient und Okzident. Die Geburt der Griechischen Kunst, Baden-Baden, 1966; P. Amiet, Elam, Auvers-sur-Oise, 1966; B. Buchanan, Catalogue of Ancient Near Eastern Seals in the Ashmolean Museum, I, Cylinder Seals, Oxford, 1966; M.N. van Loon, Urartian Art. Its Distinctive Traits in the Light of New Excavations, Istanbul, 1966; M.E.L. Mallowan, Nimrūd and Its Remains, I-III, London, 1966; P. Matthiae and others, Missione archaeologica italiana in Siria. Rapporto preliminare della campagna 1965 (Tell Mardikh), Roma, 1966; J. Mellaart, The Chalcolithic and Early Bronze Ages in the Near East and Anatolia, Beirut, 1966; H. J. Nissen, Zur Datierung des Königs-friedhofes von Ur, Bonn, 1966; T. Özgüç, Altintepe. Architectural Monuments and Wall Paintings, Ankara, 1966; R. Ghirshman, Tchoga Zanbil (Dur-Untash), I-II, Paris, 1966-1968; Th. Beran, Die Hethitische Glyptik von Boğazköy, I, Die Siegel

und Siegelabdrücke der Vor- und Althethitischen Perioden und die Siegel der Hethitischen Grosskönige, Berlin, 1967; D.E. McCown, R.C. Haines, D.P. Hansen, Nippur, I, Temple of Enlil, Scribal Quarter, and Soundings, Chicago, 1967; P. Delougaz, H. D. Hill, S. Lloyd, Private Houses and Graves in the Diyala Region, Chicago, 1967; P. Matthiae and others, Missione archaeologica italiana in Siria. Rapporto preliminare della campagna 1966 (Tell Mardikh), Roma, 1967; A. Moortgat, Die Kunst des Alten Mesopotamien, Köln, 1967; A. Moortgat, Tell Chuēra in Nordost-Syrien. Vorläufiger Bericht über die fünfte Grabungskampagne 1964, Wiesbaden, 1967; W. Nagel, Die Neuassyrischen Reliefstile unter Sanherib und Assurbanaplu, Berlin, 1967; J.J. Orchard, Ivories from Nimrud (1949-1963), I 2, Equestrian Bridle-Harness Ornaments, London, 1967; A. Parrot, Mission Archéologique de Mari, III, Les temples d'Ishtarat et de Ninnizaza, Paris, 1967; F. Schachermeyr, Ägäis und Orient. Die überseeischen Kulturbeziehungen von Kreta und Mykenai mit Ägypten der Levant und Kleinasien unter besonderer Berücksichtigung des 2. Jahrtausends v. Chr., Wien, 1967; E. Akurgal, Urartäische und Altiranische Kunstzentren, Ankara, 1968; G. Azarpay, Urartian Art and Artifacts. A Chronological Study, Berkeley-Los Angeles, 1968; M.-Th. Barrelet, Figurines et reliefs en terre cuite de la Mésopotamie antique, I, Paris, 1968; W. Nagel, Frühe Plastik aus Sumer und Westmakkan, Berlin, 1968; W. Nagel, E. Strommenger, Reichsakkadische Glyptik und Plastik im Rahmen der mesopotamisch-elamischen Geschichte; Berliner Jahrbuch für Vor- und Frühgeschichte, 8, 1968, pp. 137-206; N. Özgüç, Seals and Seal Impressions of Level Ib from Karum Kanish, Ankara, 1968; A. Parrot, Mission Archéologique de Mari, IV, Le "Trésor d'Ur," Paris, 1968; U. Seidl, Die Babylonischen Kudurru-Reliefs, Baghdader Mitteilungen, 4, 1968, pp. 7-220; P. Calmeyer, Datierbare Bronzen aus Luristan und Kirmanshah, Berlin, 1969; T. Özgüç, Altintepe, II, Tombs, Storehouse and Ivories, Ankara, 1969; H.T. Wright, The Administration of Rural Production in an Early Mesopotamian Town, Ann Arbor, 1969; K. Bittel, Hattusha. The Capital of the Hittites, New York, 1970; Th. A. Busink, Der Tempel von Jerusalem von Salomo bis Herodes. Eine archäologisch-historische Studie unter Berücksichtigung des Westsemitischen Tempelbaus, Leiden, 1970; R. Hachmann (ed.), Bericht über die Ergebnisse der Ausgrabungen in Kamid el-Loz. (Libanon) in den Jahren 1966 und 1967, Bonn, 1970; D. Homès-Frédéricq, Les cachets mésopotamiens protohistoriques, Leiden, 1970; T.A. Madhloom, The Chronology of Neo-Assyrian Art, London, 1970; M.E.L. Mallowan, L.G. Davies, Ivories from Nimrud (1949-1963), II, Ivories in Assyrian Style, London, 1970; E. Porada, Tchoga Zanbil (Dur-Untash), IV, La glyptique, Paris, 1970; E. Strommenger, Die Neuassyrische Rundskulptur, Berlin, 1970; J. Boese, Altmesopotamische Weihplatten. Eine Sumerische Denkmalsgattung des 3. Jahrtausends v. Chr., Berlin, 1971; C.A. Burney, D.M. Lang, The Peoples of the Hills. Ancient Ararat and Caucasus, London, 1971; R.C. Haines, Excavations in the Plain of Antioch, II, The Structural Remains of the Later Phases, Chicago, 1971; B. Hrouda, Vorderasien, I, Mesopotamien, Babylonien, Iran und Anatolien, München, 1971; K.M. Kenyon, The Royal Cities of the Old Testament, London, 1971; K.R. Maxwell-Hyslop, Western Asiatic Jewellery c. 3000-612 B.C., London, 1971; R. Naumann, Architektur Kleinasiens, 2. Aufl., Tübingen, 1971; W. Orthmann, Untersuchungen zur Späthethitischen Kunst, Bonn, 1971; R. McC. Adams, H.J. Nissen, The Uruk Countryside. The Natural Setting of Urban Societies, Chicago, 1972; P. Amiet, Glyptique susienne des origines à l'époque des Perses achéménides, I-II, Paris, 1972; U. Moortgat-Correns, Die Bildwerke vom Djebelet el Bēdā in ihrer räumlichen und zeitlichen Umwelt, Berlin, 1972; Y. Yadin, Hazor. The Head of All those Kingdoms, Joshua 11:10, London, 1972; P. Calmeyer, Reliefbronzen in Babylonischen Stil. Eine Westiranische Werkstatt des 10. Jhs. v. Chr., München, 1973; V. Karageorghis, Excavations in the Necropolis of Salamis, I-III, Nicosia, 1973; J. Thimme, Phönizische Elfenbeine, Möbelverzierungen des 9. Jhs. v. Chr. Eine Auswahl aus den Beständen des Badischen Landesmuseums, Karlsruhe, 1973; P. Garelli (ed.), Le Palais et la royauté (Archéologie et Civilisation). XIXme Rencontre Assyriologique Internationale, Paris, 1974; M.E.L. Mallowan, G. Herrmann, Ivories from Nimrud (1949-1963), III, Furniture from SW. 7 Fort Shalmaneser, London, 1974; C.L. Woolley, Ur Excavations, VI, The Buildings of the Third Dynasty, London-Philadelphia, 1974; R.D. Barnett, A Catalogue of the Nimrud Ivories with Other Examples of Ancient Near Eastern Ivories, 2nd Ed., London, 1975; P. Matthiae, Ebla nel periodo delle dinastie amorree e della dinastia di Akkad. Scoperte archaeologiche recenti a Tell Mardikh, Orientalia, 44, 1975, pp. 337-60; M.J. Mellink, J. Filip (ed.), Propyläen Kunstgeschichte, 13, Frühe Stufen der Kunst, Berlin, 1975; A. Moortgat, U. Moortgat-Correns, Tell Chuēra in Nordost-Syrien, Vorläufiger Bericht über die sechste Grabungskampagne 1973, Berlin, 1975; W. Orthmann (ed.), Propyläen Kunstgeschichte, 14, Der Alte Orient, Berlin, 1975; Le temple et le culte. Compte rendu de la XXme Rencontre Assyriologique Internationale, Istanbul, 1975; A. Moortgat, U. Moortgat-Correns, Tell Chuēra in Nordost-Syrien. Vorläufiger Bericht über die siebente Grabungskampagne 1974, Berlin, 1976.

Paolo Matthiae

EGYPTIAN CIVILIZATION (PLATES 10-15)

The length of the tradition of Egyptian archaeology and the number, richness, and rarity of its monuments is such that significant changes can occur in its evaluation over the course of several decades — the period covered in this updating. In the past few years, a series of circumstances has lead to the discovery of enough new information that a number of accepted theories can be corrected and the evolution of ancient figurative culture and its modern interpretation can be made clearer to us.

The Preservation of Nubia. - The great event that has dominated the Egyptian archaeological scene for a decade is the flooding of the Egyptian Nubia and part of the Sudanese Nubia as a consequence of the new dam in Aswan. The desire to save the most archaeological material possible from that region and to study as much of it as possible, all in a set amount of time and in an emergency situation, has had several significant results: the polarization of interest into a limited number of fields, the sharing of work areas by missions of various nationalities and cultural formations, the extensive presence of international organizations, the facing by archaeology of highly complex technological problems, and a scheduling of time that had rarely been found in archaeological projects, certainly never in Egypt nor in the classic world. The advantage of an in-depth excavation of a single archaeological site, and especially of an almost uninterrupted series of sites as it occurred in Nubia, is somewhat questionable. Too many things were seen in a study conducted within the framework of a well-defined archaeological and historical culture for

their significance to match the advantages of successive evaluations of the same type of finds over a greater period of time (and thus from different cultures), or from successive explorations in a unitary archaeological framework (such as is the Nubian); successive evaluations would have proposed a well defined subject of study, always consistent in its interpretation and continuously renewed from one generation of researchers to the next.

Whatever the theoretical objections may be against the rescue of Nubia, the fact remains that there was no other way to go about it and that, along with the negative points, there were also the positive ones; these derive from having considered the region to be explored as an immense whole area with unified historical problems and interpretations and summed up as such, not as a result of sporadic or partial research. Also significant is that the territory is to be thought of as an element of union between rather different experiences (from prehistoric studies to local ethnographic ones), whose cohesion must be proved by the scholar.

The experience of the planned work and the familiarity with the engineering aspects of the excavation are other positive factors of the Nubian campaign, and, moreover, with an even greater significance, the interest in surveying as a valuable means of archaeological research, whether it be carried out by geographic areas or by groupings of objects. The "rescue," with its unquestionable need for globality, has given new strength to Egyptian archaeological experiences; these have been too often weakened due to a preference for inscriptions and more clearly figurative forms of documentation (reliefs, paintings, statues), to the detriment of issues connected with architecture, with urban and environmental evaluation, and with the study of documentary material that is not "artistic."

The composition of the basin south of Aswan has also had further influence on the organization of archaeological research. From this basin comes the development of irrigation of the Egyptian valley, which probably resulted in converting desert-like areas into humid and arable regions. Thus a traditional element of the archaeological framework is changed; that which had made Egypt the country where the largest quantity of perishable materials (wood, pottery, papyrus) had been preserved for the longest period of time (from prehistoric times on). The agricultural destruction of ancient sites and materials, which had occurred to a great extent only in flood areas and which had accompanied and aided Egypt's economic recovery in the last century, is now being repeated in other areas that had remained more or less unscathed. Moreover, the electrification of the country due to the Aswan dam required major excavations for the towers of the power lines that extend from the north to the south of the country—excavations that more than once have been in archaeological areas.

The research, moreover, had to take into account a set of priorities that called for the first explorations to take place in areas most subject to radical change. In Egypt, as in other areas, this has resulted in the assistance being of an emergency nature. This is not a very suitable setting for archaeological research, but explains the motives behind certain choices and techniques. Another crucial element was the Israeli-Egyptian war, which closed off the entire valley to foreign excavation

missions from 1966 to 1975, the exceptions being the immediate Alexandrian hinterland and the regions of Memphis, Thebes, and Aswan. Thus there has been a concentration of varied missions in rather closely neighboring areas, and the experience of a "global" excavation, inaugurated in Nubia, has also occurred in territories that were of substantially smaller dimensions, but of critical importance to Egyptian history.

Once this is clear to the reader, it should be added that an "update" such as this is not a new version of Egyptian art history nor a list of everything that has been discovered in the meantime, but rather the illustration of several facts and problems that are especially significant. The explanation will be organized in chronological order based on the material rather than on the dates of discovery, even if a certain relationship may exist in the two cases (which will be so indicated).

Early dynastic phases. - Let us begin with the early dynastic period, noting that the research concerning the pre-historic era took place in Sudan, where the previous classifications were readopted and modified, by simplification of the denominations and by a greater interest in other prehistoric African cultures. Concerning early historic Egypt, the most important discoveries were made in two studies that took place in northern Egypt - one was carried out by Englishmen (Emery, Smith, Martin) in Saqqara, the other by the English at Buto and by Americans (Bothmer) at Mendes.

The first studies produced most remarkable and exciting results. Around the middle of this century a series of tombs made of unbaked clay, of large proportions and complex structure, was found in the northern necropolis of Saqqara. These had already been identified as the tombs of high officials of the royal administration of the first dynasties, leading to the belief that the tombs of the kings of these dynasties were also there. However, tombs of these sovereigns had already been discovered at Abydos during the last century. It is obvious that from our point of view either of the two sets of tombs should be considered cenotaphs, but it is likely that for ancient Egyptians both of them were "true" tombs, which repeated reality of a funerary experience in two important cemeteries—in one case, of the sovereign as king of the Delta, in the other as king of the Valley, according to the plan of double royalty on which the political structure of ancient Egypt was based. In the cemetery at Saqqara, a discovery was made of a fragment of a stone architrave with relief figures of resting lions. This came from the tomb of the probable bride of Der, the second king of Egypt, and it shows, in the earliest origins of Egyptian architecture, the use of stone for precious details and above all an interest in depiction as a complement to construction.

This concentration around the building of interests and meanings different from those of pure tectonic functionality is splendidly displayed in the tomb of King Wad. There is absolute precision in the design of the funerary apartment, a rectangle approximately 50 x 20 meters, with facades of niches, containing in the exact center a well that includes the apartment at various levels, including a series of storage rooms. The harmony between elements, the respect for axes and orthogonality, the play of bricks in building the niches and ledging by means of an even distribution—all display the technical joy of a planning capable of foresight and accomplishment. With this abstract architectural

neatness, a bench running along the perimeter of the entire monument offers much contrast. On this bench are portrayed almost 300 cow's heads in clay, all life-size, with real horns. These were both a guarantee of immortality and evidence of massacres - as are the 62 small tombs surrounding the royal tomb, most likely reserved for the escorts of the king in the after life. But the crowding together of these large heads, certainly at one time brightly colored, with the naturalistic emphasis of real horns, is exactly the opposite of detached constructive virtuosity and demonstrates the counterpoint between rationalizing intellect and actual worldly experience that is found in this monument in its earliest manifestation. The only worry, as is often the case, is that the discovery of such a meaningful and fragile monument also marks the start of its deterioration and eventual loss. Photographs taken of a monument at the time of its discovery often tell us much more than the monument itself, which may deteriorate rapidly after its discovery.

The most recent research at the necropolis of Saqqara has been guided by the desire to find the tomb of the most significant figure of primitive Egyptian history: Imhotpe, the architect of the step-shaped pyramid located nearby. Only time will tell whether the tomb will ever be found. The destruction of this tomb was already mourned in the literature of the feudal age (c. XXI century B.C.) as an example of the fraility of the human condition. In this connection, a region explored in Saqqara with an abundance of monuments of later periods linked to the cult of the mother of the Api bull and to the burials of ibis gave very important material for the study of the late periods, with inscriptions and papyrus in different languages - demotic, Greek, Carian, and Aramaic. These are matters that do not, however, interest us here, and though they add archaeological materials and provide new discoveries, they only marginally increase our knowledge of later Egyptian art history.

The approach to the Saqqara excavation, in the necropolis of a capital such as Memphis, reflects a very precise and traditional archaeological taste: the search for monuments and objects of a certain value to enrich the museums of art works and to add to the information of prevailing dynastic history. There is also a preference for regions - such as those in the desert - where succeeding generations have tampered with the monuments in a succession of destructions and reconstructions, but where, nevertheless, there was not a continual disintegration due to agricultural work, the greatest destroyer of historical ruins.

The other two projects in the area of archaic research just mentioned are conceived by an inspiration opposite that of Saqqara; because of this they represent an innovative attitude. Mendes and Buto are two cities in the delta where deposits of alluvial mud are thickest; they cover over many antiquities, and they also led to intense farming activity. The seepage of water, moreover, destroys what is usually rescued in Egypt, and there is little hope that excavations will yield those delicate and fragile remains that are typical of other Egyptian excavations.

Furthermore, while necropolises tend to spread out in surface areas, cities grow in one place, and stratigraphic excavation, so rarely used in Egypt, becomes essential for the interpretation of the ruins. If in those necropolises precious objects are theoretically taken out of use and kept in their original condition, in urban households everyday objects are used and passed from person to person, ending up in basements and storage areas. The simple distribution of the necropolises according to the importance of the owners of the tombs is set against the growth - or the waning - of the city, the specialization of its neighborhoods, and the application of structural criteria determined by the need for defense, by living together and trade, by the practicability of the roads, by administration, by religious observances, and so forth. A study of this nature attempts to grasp the reality of the constantly changing needs of day to day living. Aspects of economic and sociological research become very important; the small findings are grouped into larger series that take on meaning and importance (we only have to consider how much methodical study can yield and also the great number of ceramics of daily uses).

It is this change of archaeological methodology that was implied in the decision to excavate at Mendes and Buto. But this isn't all: the two cities are both well known as very important religious-mythological centers, continuously mentioned in the texts. It appears that Buto may have had the role of a primitive capital of the delta, in the northern half of Egypt, leaving traces also in the historical period of the ritual. To be able to obtain local documents of urban centers known only by tradition would mean being able to research the most ancient Egyptian history; making an attempt to understand how the "united kingdom" came to be, seeing how valid the traditional theories actually are, and studying the composition and the nature of political bodies (urban, not tribal) perceived behind the unitary monarchy that very quickly levelled them. As is clear, this is an ambitious approach. The project is still in the initial stages, as the excavation sites in the delta were the first ones to be closed as a result of the Egyptian-Israeli war. In both sites only an analysis of the higher levels had been started; however, they gave important indications of urbanism during the Roman era at Buto and the first stratographic clarifications at Mendes. The reopening of operations is anxiously awaited.

The Memphis Age. - Concerning archaeological ruins, this era is essentially typified by its most remarkable monument: the pyramid. At this point, an in-depth study was carried out by Maragione and Rinaldi, neither of whom were strictly Egyptologists or archaeologists. However, they handled all of the Memphian pyramids according to unitary criteria of measurement and publication, studying them carefully from an engineer's perspective in order to explain the rules followed by the ancient builder and analyzing the hypotheses of previous researchers on the essential basis of the practical possibility of technical implementation. We therefore have at our disposal an updated series of measurements, designs, and blueprints, which have led to many fundamental corrections.

Besides this already known precious work of precise definition, there have been several other important discoveries. One was the discovery associated with the excavations of Ahmed Fakhry at the pyramid of Snofru in Dahšūr and, most important, at its temple. Leaving aside the problems brought up by the architectural structures, over 1,400 fragments of wall reliefs and several royal statues dating to the IV dynasty were found

there. If we consider that this kingdom is the one emerging almost immediately after the realm which saw the creation of the stepped pyramid, and that in this period the conceptual revolution which replaced the vital "pathos" of the ancient era with the rational and mathematical observation of Memphian classicism begins, we can understand the significance of all this documentation. Thus it is important to have it properly restored and made available to scholars, enabling them to add this material to the very fine but limited material of this period. Unfortunately, this has not been the case, and very little can be deduced from the photographs of complete reliefs and from the examples of fragments of reliefs; thus the possibility of evaluation of the royal statues is not likely.

However, a discovery that occurred at the pyramid of Cheops had a different fate. Here, a large boat made of cedar was found, measuring over 30 meters by 3 meters. It was positioned in a dry dock in a cavity excavated in the desert stone near the funereal monument, covered with 42 blocks of limestone, each one weighing approximately 20 tons. The uniqueness of the finding lies, for the most part, in the condition of almost incredible freshness and soundness in which it was found. The restoration process was long, but it was possible to carry it out without structural damage by using the technical solutions that were used in the ancient Egyptian shipyards almost five thousand years ago.

What this ship actually was is a topic of much discussion. It is known that space was reserved for four more ships near the pyramid and that the possibility of ships being buried near the pyramids had previously been hypothesized—or, rather, confirmed. In this sense, the discovery was only a documented confirmation of its puzzling (but already known) use. What is truly new is the visual and tactile experience of a construction of this magnitude and of this technical complexity. This ship perfectly displays the forms we already know from models and paintings; they have tall florally decorated ends, on which there is an embossed imitation of a rope binding, and are equipped with large rudders (the rudder oar is over 5 meters long) and oars; the sides rise high above the waterline. It should not be thought that such a nautical structure does not have a concrete purpose; however, at the same time (and most important), it is an example of balance in composition, a study of the realization of a beautiful object. Technically the ship can be criticized for the elements that make its navigation less balanced and less smooth - even though it is river navigation; but the flattened tops of the bow and the stern and the exposure of such a large part of the body all emphasize the composition in which an experienced artisan can translate the stylistic traditions of his time, of careful analysis and precise harmony, into practical techniques. We have before us a marvelous example of the transfer of the more abstract formal culture to that of everyday life, more influenced by technical needs. Such an extraordinary piece was considered worthy of its own museum on the site where it was found. Thus an elevated cement and crystal container (architect Minissi) was erected near the pyramid of Cheops, apparently inspired by the presumed "solar" character of the ship. The ship is displayed in such a way that it appears to be suspended in mid-air, with the view of the keel seen more from below than from above. An object so concrete is therefore perceived as a magical and mythological vessel, testing its improbable balance on a celestial ocean rather than on a river.

A French effort (Lauer and Leclant) is also operating within the milieu of the Memphian civilization and has the task of excavating and studying the pyramids of Saqqāra. These are a group of monuments that are for the most part in poor condition, but which are very important for their ancient funerary texts. This work has led to additional knowledge of these texts, which were found on large fragments of stone that had fallen in the internal part of the tomb.

In addition to the philological work, the French mission enthusiastically undertook the study of architectural structures, and in particular systematically studied the high temple of the burial complex of King Tetis (the one located on the eastern wall of his pyramid). There were very modest remains of the front view left, but despite this the layout was successfully reconstructed. It is a rather complex building, containing within a very simple external wall very dissimilar elements apparently completely independent of one another. The layout of the building is in two parts, contained within external retaining walls and joined at right angles. One side is set against the pyramid and is hidden by its surrounding walls, while the other leans against this wall and appears as a building projecting from it. Between the two constructions, the first of which is the "private" sanctuary and the second the "public" one, the separation - and the connection - consists of a transversal corridor that extends the entire width of the building. The spaces included between these two exterior walls are used very differently. A series of entrances and courtyards occupies the central part of the internal area, while the area between this part and the surrounding wall is used for storerooms accessible by concealed doors. With this plan the utmost harmony is achieved between two opposite concepts of architecture: one is the solid block that is seen from the outside, the other the spaciousness that can be enjoyed from the interior.

Starting from the temples of the V dynasty, which already show the influence of the celebration of the cult, determining the axis of the complex (the entrances and courtyards just mentioned), a process developed whereby there was more and more use of neutral areas, which in the past were solid masses of blocks. The layout, which later became typical, achieved here a solution of maximum lightening with these useless solid blocks completely disappearing. It is significant, in fact, that the funereal temple of Pepis II (the last king of the dynasty begun by Tetis) exactly repeats this design. To progress further, it is necessary to completely change the architectural concept and to achieve the feeling of a basic internal-external relationship that would better blend together the internal layout and the exterior. This never happened in Egyptian architecture of the Memphian age. Other observations have been made regarding the temple, but perhaps the most memorable is that if the measurements are calculated in cubits (0.523 meters), the basic measurements are always in whole numbers. This would give us reason to believe that there was accurate designing involved before the beginning of the actual building on the site, and a very accurate execution of the design. This gives us an idea of the Egyptian manner of working, hostile to any improvised solution dictated by circumstance (or inspiration, as in other areas of figurative art).

But the results of these French excavations in Saqqāra are not only philological and architectural; from this area (the funereal temple of Pepis I) also comes a group of fragmented statues portraying bound prisoners, according to an ancient tradition already known of from preceding excavations. It may be wondered what these representations mean in Egyptian figurative culture. First of all, their complementary - or at least integrational - function must be evaluated in an architecture in which they convey a ritualistic and meaningful position, as this line of prisoners serves to honor the king (even if it does not seem probable that ritualistic manipulations were exercised on these prisoners, as was once believed). In the second place, it should be noticed that there is a desire to typify physical characteristics of cultures different from the Egyptian, in a research which is a combination of the identification of traditional styles (hair style, type of beard) and of somatic characteristics. The desire to express precise illustrative contents by a certain formal language is a beginning of the study of "individuality" of the image through physiognomical definition. Although these are still common to an entire class (Libyans, Africans, Asians), they nevertheless pose the problem of the differentiations of an ideal and universal prototype, which alerts one to a resulting serious expression. Finally, it is notable that these images are not, according to normal Egyptian practice, identifiable with individual people; rather, they portray in almost life size the characteristics of the small statues of servants and the like. Generally, these do not have names - but they are not needed as they are different from the majority of other statues, representing people who are "doing" something, rather than people who "are" someone, and they can be identified by their actions, not by their names.

Further understanding of Memphian art stems from the study of a famous series of sculptures dubiously interpreted thus far: the schist triad which decorated the valley temple of the pyramid of Mycerinus, the richest works of Memphian sculptures. Since this group represents the king with Hathor and with other deities from different provinces, it was believed that they represented in some way the gathering of the various administrative bodies around the deceased king; thus they derived from the depiction of geographical bodies personified as the bearer of offerings, as we find in the valley temple of Dahšūr. Consequently, a great part of it must have been lost, and originally they must have filled the entire courtyard, the only area large enough to contain it in its entirety. In all likelihood, it was possible to arrange in the original plan of the building the different whole or fragmented groups that were received. It is no longer necessary to postulate a crowding of hypothetical statues in an open air court; rather, there is an arrangement that places each group in two series of four chapels to the left and to the right of the front vestibule. These groups therefore become meaningful in their own right, and at the same time become an element of animation for the rooms in which they are located. The relationship between architecture and sculpture, a constant problem in Egyptian construction, has thus been enriched by a new case for the most ancient period.

Next to these studies, in this area that is Memphian by definition, there have also been notable exceptions. In this light, the excavations of the necropolis at Elephantine (Aswán Gharbi) (Edel) are not considered an exception. These were conducted with a philological spirit, and in any case they researched a provincial area already known from the German studies on the island of Elefantina itself. It can also be said of this excavation that it has a methodological drive. Elephantine was destroyed and rebuilt many times in the past. The temples that were built there served as the foundation and provided the material subsequently used to build new ones. There were no other possibilities but to build over the existing ruins, as the southern end of the island was limited by the river. Above all, missions of different origins and clandestine excavators had become intensely involved in the search for papyruses of the famous Jewish community that had lived in Elephantine during the Persian era, and, as often happens where papyruses were searched for, the excavations left the site in great disarray. The German excavations were conceived as a reorganization of this situation, and as the reconstruction of a particularly delicate and meaningful archaeological fabric of a settlement that has always been important, since it is the traditional boundary between Egypt and the Nubian world. In this case as well, the research in the city seems to have more meaning than the ancient exploration of the necropolis.

The excavations begun in 1969 have identified the surrounding wall of the city of the Ancient Kingdom, as well as several elements of fortification - including a door dating back to an even earlier age than the Memphian period. The most important discovery after the temple of Satis was of the method of stratification. To an original early historic temple built between tall massive rocks were added other buildings, which were built on top of it up to the Greek period, keeping a tie with the primitive sacred building on the base level by means of a well. In this type of excavation it is clear that the results cannot be immediately evaluated, and the same holds true for the first signs of discoveries of tombs of the governors of the Memphian age, found by Ahmed Fakhry in the oasis of Dakhla. Such discoveries outside of the court make the picture of the "classic" age much less clear by increasing those "provincial" characteristics (as, for example, the series of reliefs from Hemamiyye) that explain the passage to the figurative culture of the Middle Kingdom.

First intermediate era and the Middle Kingdom. - Research into these areas has had a privileged site in the last few years: Thebes, or more specifically the necropolis of Thebes. The richest, most varied and authoritative documentation of the art of the New Kingdom is found here, but the quantity of monuments found from this epoch has for the most part overshadowed their historic roots. This is true in part regarding the level of the materials found and in part in the perspective of the researchers, and it is on both levels that the change has occurred. The few remains of the older necropolis, which is of the Ancient Kingdom, had already been explored for some time in the region of Khokha; only recently has the tomb of Unis-'aukh been throughly explored and the findings published. The name, that of the last sovereign of the fifth dynasty, seems a guarantee of the dating. The walls, where they had been maintained, show what we would expect—that is, an analogous theme to that of the Memphian tombs and as well that more rustic, casual, and bloodstained appearance that we know to be from the province. It is what we will

find in the paintings that adorn another significant dated tomb at the other end of the feudal period, which belonged to Antef (Nr. 386) and which has been dug up by the Deutsches Archaeologisches Institut (Stock). This is found at "Asāsīf, the valley where the funerary temples of Deyr el-Bahrī were found. They were unfortunately covered by the numerous successive urbanistic manipulations of the region, but its original location is established in relation to the access route to the more ancient temple of Deyr el-Bahrī, that of Mentuhotpe Nebhepetrē, the sovereign whose name in fact appears on the tomb.

This building includes a large access court, at the end of which was a portico with pillars of quadrangular section, with the funerary chapel perpendicular to the center of it and built into the mountain. The portico (as for the nearby tomb of Dai, discovered in 1930 by the mission of the Metropolitan Museum) was adorned with paintings, the chapel with reliefs. Most of the decorations were lost, but it is possible to identify a series of themes of "Memphian" origin (the hunt with the harpoon in the cane thicket, the hunt with the net) next to others testifying to styles and interests: scenes of war with personages wearing unusual costumes, attacks on fortresses by archers, armed soldiers in boats, the wounded being carried off the field of battle. The narrative style becomes precise, probably alluding to specific facts even if they are not indicated as such. The artist does not only attempt the portrayal according to the conventional rules of what we would expect as tomb figures, but also the figurations substituting for biographic data. From the tomb also come fragments of a statue of a dead person, a little smaller than life-size. It is a sculpture in sandstone (an unusual, not very refined material); the contrast between the rather casual and almost swollen form and the details (eyes, eyebrows, cut of the mouth, tufts of hair), accurately rendered and described, is most curious.

On this background of provincial continuity between the Memphian era and the beginning of the Middle Kingdom, a series of funerary monuments of the family that had first given birth to the princes of the region, then the kings of Egypt, stands out. These are the tombs of the Antef at el-Tārif and of the monument of Mentuhotpe at Deyr el-Bahrī. It is natural that, as these are rather conspicuous monuments, they have been explored by many people over a long period of time. It is curious that while for Mentuhotpe there is a series of volumes and repeated investigations, there do not exist reports by the older excavators (Mariette, Petrie, perhaps Schiaparelli) for the tombs of the Antef. However, they did finally have an accurate investigation through the efforts of the Deutsches Archaeologisches Institut (Arnold); unfortunately, by that time, irreversible damage had already occurred through ancient excavations, successive settlements, public works, and the building of canals. The area where these funerary structures were situated is a kind of plateau at the edge of the now cultivated fields. Due to the enormity of the tomb, it was decided to excavate extensive areas, 100 meters and more wide, open toward the valley, with the Nile seen in the distance. On the far side there was a usable porticato, with pillars of square cross-section. This long facade of light and shade is that which in Arabic and in archaeological language is called a "saff"; this is a type of tomb that in Upper Egypt is

noted at el Ğebeleyn, at Mo'alla, and at Thebes itself. But here the immensity is obtained from the dimensions themselves, and also from the presence of additional tombs for family members, and perhaps for servants, along the two side walls of the court. Furthermore, it seems that the regal character of these sepulchers was reinforced by these pyramids in unbaked brick (originally with a stone covering), placed in the desert, behind the courtyard. Today only traces of the bases of such pyramids remain, and testimony of ancient archaeologists and travelers, in some cases all in agreement.

The precise inquiry into these three ambitiously regal tombs (even if, in some cases, they are only of princes), the study of the situation of each in relation to the others, and the observations of the ceramics gathered within them place these monuments in the framework of the others of the same time and place. This permits the study of the more unusual of these three, that of Mentuhotpe Nebhepetrē at Deyr el-Bahrī. This had been thoroughly studied by Naville at the start of the century, afterward by Winlock in the 1930s. But a meticulous resumption of the investigation on the part of, again, the Deutsches Archaeologisches Institut (Arnold) has made an accurate and methodical review of the previous solutions. Unfortunately, excavations intended as definitive, carried out more than once on this same location, in the end altered almost everything of historical value, thereby eliminating the possibility of comparisons on the terrain using new methods of reconstructive hypothesis (as was possible for many important Egyptian centers).

The complexity of the temple at Deyr el-Bahrī is well known; thus it is not necessary to reiterate its characteristics, unless to emphasize the motif of the flanking and multiple openings of the "saff," obtained artificially with the construction of porticos; these may be doubled, one over the other on two different levels of the building. In the new arrangement, the portico is positioned around a large area not otherwise usable; on this Naville had suggested the presence of a pyramid, but such a view was disclaimed by the most recent explorer, Arnold. Thus the relationship between Deyr el-Bahrī and el-Tārif is broken, as well as a point of support for the later practice of private tombs with pyramid. The mark of reality in the tomb, the connection with the form of the pyramid, is therefore omitted. And the monument is also impoverished, as it is limited to placing one parallelepiped on the other, originally unadorned and later with added porticos, in a structure with tapered stairways; these evidently allude (as "the pyramid with stairway" of Saqqāra) to the primordial tombs rising from the chaotic ocean to act as a bastion for the rising of the sun. The significance that Egyptian architecture must always have had is, therefore, perpetuated, but it is worth noting that the arguments against the old reconstruction are not all decisive and in favor of the new reconstruction from the more recent excavators - of which the merit of having resumed the vision of the royal funerary architecture of the XI dynasty at Thebes in an organic and global way is already notable.

The counterpart of this research should be, in a sense, that of the Spanish at Herakleopolis, the capital of the X dynasty from whom the XI gained its position. In effect, it was there that the ruins of a necropolis of the X dynasty were found, deeply buried and already in

the phreatic stratum. Because of technical complications this work was very difficult and went slowly, and in fact did not proceed at all during World War II. It was just resumed in the 1980s.

It is rather curious that the period of the Middle Kingdom, whose history and literary aspects have recently been thoroughly investigated, has not become richer in its archaeological connotations in the last few years. The most important observations for this epoch have been made regarding a culture that is not properly Egyptian, and is in fact opposed to the Egyptian culture: this is the so-called culture of "Group C" in Lower Nubia, which is the indigenous culture of the region to the south of the natural border of Egypt, during the period between the end of the Memphian era and the beginning of the New Kingdom. This culture has precise connotations and has been variously studied, dated, and qualified. It is to the credit of Bietak (who directed the Austrian excavations during the campaign to save the monuments) to have comprehensively and lucidly summarized the data at his disposal. He unified the terminology of the preceding explorations and thus put the material into logical order, noting the character of growth of the necropolises in successive rings, the central tombs usually being the earliest, the peripheral ones the more recent. With a splendid analysis, he has separated what is typical of "Group C" from that which is valid for the culture of "pan graves," which has been confused with the "Group C" more than once. It is the analytical study of the reactions and of the acceptances in the area of the tombs of "Group C" of the elements of the culture in the "pan graves," such as of that of Kerma or, indeed, of the Egyptian culture itself, that gives a solidity and flexibility to these investigations. Before Bietak, these remained an abstract design and were tied to typological approaches. The history of Nubia is enriched by this investigation, which lends authenticity and endorsement to a terrain hard to define, such as is an archaeology completely separated from written sources.

Bietak also must be credited with the discovery and the identification of another quite revolutionary complex of ruins in the delta at Tell el-Dab'a near Qantir, in the very heart of Egypt. These also are located a little outside of the Middle Kingdom, not only for chronological reasons (they are rather of the "Second Intermediate Period"), but more for the cultural milieu. Qantir, in the eastern delta, was an old problem of Egyptology since the time that observations on site (often determined by chance findings) by Egyptian Egyptologists had shown first the possibility, then the probability, that here, and not Tanis, was the location of first Avari and then PiRamesse. Previously the site was presumed to be Tanis, based on the excavations and the arguments of Montet.

The Austrian excavations had a limited duration (from 1966 to 1969), but have now been resumed. They are characterized by a technical rigor, unfortunately not frequent in Egypt, which has fully permitted the complete evaluation of the discoveries in a framework of a known stratigraphy, analyzed in the precise place where they were initially found (for the most part these were of modest quality). Thus it has been possible to reconstruct the history of the site up to the end of the Middle Kingdom at a fortified foundation dating from Amenemhēt I.

The vestiges of a settlement were found here, in which, together with Egyptian material, there are numerous remains of an Asiatic culture in the initial phases of the first Middle Bronze Age. This proves that an infiltration of human groups from Syria entered into the Egyptian life, assuming their customs and rites. This first settlement shows explicit signs of destruction (more than those to be expected of abandoned ruins), rather than touches of the Egyptian influence on a people who participated fully in the culture and the material of the second Middle Bronze Age; an Asiatic people who destroyed the older city and who were proud of its culture. Surviving from it are the houses, the tombs (often inside the houses), funerary complexes with areas used for the cult - and the material of daily use that came from the tombs. There are arms similar to those found in Syria and skeletons of horses, apparently those that were imported into Egypt from Asia in this epoch. One is, in summary, faced with the Hyksos, who reappear archaeologically, after so much has been said of them in recent years, and who show characteristics more Asiatic than what was generally thought. It is evident that this single ancient site represents an extreme case, given its position near the frontier. The reality of a Hyksos reign deep in Egyptian territory may have been different. But it is extremely important to capture the initial moments of cultural osmosis between Egypt and Syria that are characteristic of the New Kingdom, right at the geographic point where the contact took place. On a higher level, Asiatic elements continue, but the culture is impoverished. The Asians who had frequented the zone of the frontier remained there, but they were no longer the masters.

The New Kingdom.- The investigations and the discoveries of this period are varied and important. The fact that Thebes was the obligatory starting point for most of the foreign undertakings has given preeminence to an era that is fundamentally Thebian. However, it is less likely that discoveries in completely new areas can occur here. Thus the majority of the archaeological activity has rather been concentrated on a refinement of data and problems; this effort has been amply repaid. Works at Karnak and Luxor are also known, but more has been done across the Nile, in the region of Qurna where the necropolises are found. The great funerary temples have been - and are - the specific theme of activity, in particular that of Hašepsowe at Deyr el-Bahrī, the Ramesseus, and the temple of Sethos I. At Deyr el-Bahrī the Polish have undertaken the task of rechecking the old reconstructions and rebuilding the monuments, as much as it is possible. We will speak more later of this work, which has its problems. But it has had an unexpected consequence; during the thorough cleaning of the areas surrounding the temples a new terrace with pillars has appeared, to the south of the complex and before that of Mentuhotpe. It is dated to Tuthmosis III, the king who was overthrown by Hašepsowe as a child and regained the throne after her death. Thus is added another rustic temple to the same scenario in which we already knew two others; since this last one was constructed right after that on which it rests, it had been done by its architects with the precise task of joining it to the previous conspicuous monuments on which it had been built.

The other temple that is the object of particular care is the Ramesseus, which is one of the most original

of Egypt, rich in inscriptions and figurative values. The Documentation Center of the Antiquities Service of Egypt has undertaken the task of summarization; this task required a certain amount of excavational activity. Italian and Swiss scholars were engaged in the revision of the data of excavations done by Petrie for the temples (for the most part no longer existing) of Amenophis III, of Meneptah, and of Tuthmosis IV in the late 1970s. Their discoveries have a strictly technical character; their only originality is a listing of the Mycenean cities whose names were transcribed in hieroglyphics on the base of a statue of Amenophis III. This shows a remarkable knowledge of the routes of the Aegean and serves to remind us that the Egyptian world was more open to foreign countries than its ostentatious self-sufficiency would suggest.

Another large project in the region of the necropolis organized and guided by the Documentation Center (Des-roches Noblecourt) is the summarizing and copying of all of the hieratic graffiti that throughout the valleys of the desert had been written by workers, priests, and travellers. Even here the work was not entirely new, as collections of this type and of this material had been made before. What made this new, and gave it new value, was the method adopted and the richness of the sources. A complete renovation of the cartograph of the area was possible and the "banks" of graffiti were thus registered with a precise topography. To those previously indicated, many others have been added, and the names and the titles (sometimes the dates) permit the indication of routes in the desert and establish in which era or with what preference they had been used. These were not just idle exercises: with the help of these graffiti, it has been possible to reexamine movements of peoples in relation to certain specific works, as, for example, the transfer of mummies of the sovereigns, along with objects to be placed with them in the tombs, to the Valley of the Kings and their hiding place (the famous "cachette") at Deyr el-Bahrī during the XXI dynasty.

And finally, another important investigation was underway in the 1970s in the region of western Thebes by the American researchers (O'Connor and Kemp) at Malqata, a locality at the southern end of the area of the necropolises dating to Amenophis III. This area had been explored some years previous by researchers from the Metropolitan Museum of Art. In addition to the tomb in the Valley of the Kings and the funerary temple of which the colossuses of Memmon is the facade, the sovereign constructed a palace, or rather an extensive residential complex. Not only did the pharaoh live here with his family and his court, but also the principal offices of the kingdom, the storage rooms, and the structures required for the offices to function were located here as well. It was thus a new capital to which the sovereign withdrew after abandoning the traditional seat at the temple of Ammon on the eastern bank. He occupied in full liberty and without old conditioning a new terrain, using all the space that seemed proper. This was done with a grandiosity of dimensions that find their counterparts in the large dimensions of the funerary statues or the colonnades of Luxor. It is, after some well-defined example in the Memphian era, the first time that the taste for the colossal, that unjustly and superficially is portrayed as being innate in its art but that instead each time recalls very precise cultural

precedents (Ramesses II will consciously imitate Amenophis III, Ramesses III will compete allusively with Ramesses II and so on), is experienced in Egypt. However, the abandonment of the old residence and the construction of a new world is a precise antecedent for that which will be done, a few years later, by the son of Amenophis III, when he will leave Thebes for Tell el-'Amārna, constituting there a palatial grouping that in many respects recalls the experience of Malqata.

In Tell el-'Amārna, the most recent excavations rigorously explored the ruins of the ancient gate of the city and only touched on the palace. The excavations brought to light an enormous basin that was conceived at the same time as the city-palace; that basin is today a unique example for the study of the port installations. It was evidently joined to the Nile, which flows 3 kilometers away, and in its dimensions (about 2½ kilometers by 1 kilometer) take on the colossal tone of the projects of that time. The excavations have clearly shown the practical uses of the port. It connected with the rest of the world the palatial quarter of an empire that had relations with the Aegean and with Sudan by means of navigation and was used also for the transportation of tributes and construction materials. But in addition to these ostentatious and practical functions, it had another ritual and religious function. In the harbor basin a ceremony for the jubilee of the king took place (properly witnessed at Malqata), and the waters of this expanse are recalled in the inscriptions of the soverign as an allusion to the primordial waters from which the sun originated. Practical, urbanistic, economical, religious, and ritual elements mix together and are expressed in this work, which is to be explored specifically to respond to the questions posed by the above mentioned elements, though without much hope for spectacular discoveries.

Another monument associated with the same jubilee of Amenophis III, at a site quite far from Thebes (though perfectly Thebian in its concept), is the temple of Soleb, deep into Sudan. It has been studied with great care by an Italian and French mission (Schiff, Giorgini, and Robichon), which began the study of the construction with the precise intent of revealing its history. This is a temple built by just one king, to which no modifications or enlargements were ever made. It is therefore a unitary and coherent organism. Nevertheless, the relief of the apparent ruins and a painstaking excavation have permitted the identification of about 30 successive layers of pavement on soil that had been compressed and whitened with lime. These last are then dated according to the depth of the foundations of the walls in the system of their stratigraphy.

With what in some cases might be considered an excessive rigor, a stage by stage modification of the temple during its construction has been recorded. It is not to be considered complete only in its final version, but is rather to be seen as an uninterrupted sequence of solutions, each autonomously valid for a certain moment, but ready to be modified into another, with its own specific meaning. Even if the identification of the single moments may be modified, it is important that a temple so complex and grandiose as that of Soleb has originated in a dialectic process. It was a continuously ongoing accomplishment, and as such it should be studied. The study of the development of a building can be extremely revealing of the dynamic solutions an archi-

tect achieves in the process of building a structure and of interacting with the territory. The history of the successive forms that from Hašepsowe to Ramesses II had covered the temple of Buhen at Wādī Ḥalfa, is exemplary in this regard. But the analysis of Soleb shows that the plasticity of the plan can be put to advantage already at the time of the construction, without waiting for additions and the further building of later times.

Another significant discovery for this epoch is the identification at Rizeiqat - near Armant, and thus in the Thebian area - of a sanctuary of the god Sobk, imperfectly explored and thus difficult to interpret. From it came a life-size statuary group of Amenophis III, in a perfect state of conservation, and a statue of Sobk, with the head of a crocodile. The high value of the material (alabaster), and the refinement of the execution, make it one of the most significant finds of this age.

At Thebes, the most significant research regards the so-called "talātāt" of Eḥnaton; these are sandstone blocks of the dimensions of one cubit by one-half cubit. Their use began during the Thebian phase of the Armanian heresy; they were used to erect a series of sacred buildings to the new god Aton at Karnak. The radical approach of this age, the revolutionary spirit of their new typology, and the themes and forms of this time are clearly expressed with freshness and energy. The abandonment of Thebes by the king, and the subsequent reaction to his religious concepts, resulted in shortness of life for a group of monuments that had been hurriedly constructed in the first years of his reign. They were soon dismantled and used as a convenient source of building material, serving as foundations and filling material for successive enlargements of the temple of Ammon at Karnak.

Many of these blocks were left unattended for decades after they had been extracted and set aside during restorations and excavations in the temple; in successive moves the single blocks have suffered because of having been mixed with each other. It is likely that their use will one day allow us the reconstruction of quite large figurative complexes, but until now their study has been limited to the analysis of the stylistic qualities of a large series of details. Two different archaeological projects at Karnak have attempted to modify the situation and to recuperate archaeological material that has high artistic as well as documentary value. One of these is American; its goal is to make an inventory of the single blocks, and with the use of a computer determine the arrangement of the single pieces in a unitary context. This is a long-term project, and it will certainly produce noteworthy results; it will also serve to free the archaeologists from the sense of guilt derived from this abandoned material. The second project is of wider scope and involves the foundation of a Franco-Egyptian center for restorations. This would tie the research of the smaller blocks still contained in the structure of the walls of the temple (here we are speaking of the IX shrine of Karnak) with the rebuilding of unstable or fallen walls and the dismantling and consolidation of them. The "Armanian" material probably derives from a direct tearing down of other constructions, without excessive intermediate storage; furthermore, the taking apart of the shrine was carried out with documentary caution missing from similar undertakings in the past. The result is that as a new series of "talātāt" becomes

available, it is located with relative ease in figurative groupings, and thus identified within the extensive complexes of what was the prior "Amarnian" decoration. In spite of the many damages that might have taken place over a long and violent history, new and organic monuments have been recovered and have allowed us to evaluate not only the details, but also the tone and the quality, of Amarnian art in its first Thebian formulations. Its radical character was clearly evident in the immediate comparisons with the official monuments of the earlier eras, and it offered to the contemporary Egyptian the sense of the difference and breach of the tradition.

The discovery by the English, of the tomb of the Pharaoh Harmais at Saggāra, in the ruins of the Armanian era, is still to be evaluated. This tomb was opened in the last century, furnishing to various museums (among them that of Bologna) reliefs that are among the most beautiful of ancient Egypt. This discovery will permit a more precise dating within an architectural framework than has been possible until now.

There are, of course, many other activities of research, publication, and study of the monuments of the era and the milieu of Ramesses. But if all together they result in modifying more than one old belief, it would be difficult to give a symbolic case for this period. However, the age of Ramesses II is certainly a period of enormous artistic richness, perhaps one of the richest in ancient Egypt, because of the coexistence of various attitudes and expressive point of views.

Late eras and discoveries in Nubia. - It can be said that the riches of the recent age have been looked at with renewed sympathy and sensitivity in a series of excavations by Italians, Germans, Austrians, and Belgians. A series of clarifications has occurred of the monuments of the Menphite necropolis (Bresciani), but the most complex and unitarily significant nucleus is that of the Thebian necropolis of 'Asāsīf. The name of the locality itself is a plural of "'asifiyah," which indicates a special type of tomb located above ground and having a sunken courtyard that is open to the sky. We already had extensive information on such tombs; what had been published earlier were mainly the reliefs and the inscriptions that decorated the walls, with special attention, rather more explicit, for the descriptive contents than for their formal qualities.

The origin of the "'asifiyah" is the grand tomb-temple of Mentemhet, who during the Ethiopian period ruled Thebes and who at 'Asāsīf, under Deyr el-Bahrī, raised his monument as an imposing construction in unbaked bricks. The "'asifiyah" was imitated by a series of high functionaries of the Saitic era, who were connected with the local court of the "divine worshipper of Ammon," in a line of tombs along the access way to the temple of Hašepsowe. If the parts below ground level of some have been rather well preserved, in general the raised part has been lost.

The example that is being studied by the mission from the University of Rome, the tomb of Šošenq, reunites in paradigmatic form characteristics that are found elsewhere only in traces and therefore has considerable importance. The building consists of a foursided structure in unbaked bricks having an access on one of the short sides. The portal opens onto a courtyard that was originally tree-lined, closed at the far end by a second and central portal, which is in fact a false portal,

opening onto only a small area. The passage to the second courtyard is through a modest off-centered door in the outside walls to the south. This is not merely by chance; the second courtyard is divided roughly into two halves along the principal axis of the funerary temple, and the apparently secondary door is in turn central with regard to the southern half of the second courtyard. The southern half, rather, is lowered more than 6 meters from the base level and constitutes a porticoed and open element which can be observed from above, but to which access is not possible except through an independent system of structures (portal, descending stairway, underground antechamber) positioned on the outside of the building on its northern side.

This summary description shows the richness and the structural imagination that breaks with the ancient rigid axial design, using certain aspects of it but also adopting surprise solutions of a refined ambivalence, such as the subterranean courtyard that has two different values, according to the system in which one imagines it to be inserted. It can be either an adventurous view from above of a courtyard with balausters, or it can be the luminous center of a series of underground rooms. This complexity of architectural language is enriched by a studied use of archaic constructive elements, which give to the outer walls the aspect of an early dynastic building, inserted however into completely modern elements, as the portal equal to that of the contemporary temples shows. Thus we have a "quotation," certainly with its specific meaning. To the imaginative composition of the building is added an overburdening of elements of cultural significance, whether antiquarian or religious. With regard to this, many other discoveries of the Saitic, Persian, and Ptolemaic eras have a value that is more antiquarian than historic-artistic. But the importance of the excavation of the Roman cities of the delta (the later levels of Mendes and of Buto, the Polish excavations at Athribis and at Alexandria) should not be underestimated. These have been carried out with great attentiveness to the urbanistic implications of the centers explored. Here the lack of integration between residential and industrial quarters is notable. One can also recognize the identifiable design at Antinoe as analogous to that of Athribis.

Before concluding this review, one has to mention a chapter of art history that, if not strictly Egyptian, is at least of the Nile, and which has been the subject of increased interest in the last few years. This concerns the artistic products that, parallel to the Ptolemaic and Roman period of Egypt, came into existence in northern Sudan, around the capital city of Meroe.

The most important complex recently excavated in Meroe is that of the temple of the Lion at Musawwarāt el-Sofre, studied by the East Germans (Hintze). It has been particularly fruitful inasmuch as it is a building that was destroyed by an earthquake, and the recovery of which has been almost complete. But more important than the single excavations was the desire of a more methodical investigation into the chronology, the typological characteristics, and the social and organizational life. These are aspects that have involved mainly the French (Leclant), the Americans (Adams, Shinnie, Trigger), and the Germans (Hintze, Wenig). At first glance these aspects are not specifically pertinent to archaeology, but one has to keep in mind that this useful mass of documentation falls in the category of mate-

rial civilization: in this case, any textual documentation is of little use, for the almost complete unintelligibility of Meroitic. This, by itself, gives an indication of the degree of interdependence of the problems. In any case, archaeology, however formalistic, cannot avoid placing a work within its cultural, social, and economic structure, without which the full comprehension of an artistic and historical phenomenon is impossible.

Meroitic art has thus appeared more closely related to pharaonic and also Ptolemaic modules. Its much emphasized "Indian" character, which seemed to enlarge its cultural horizons, has appeared to be untenable under a more stringent analysis. The study of Meroitic art is still in a period of recognition; already some elements of identification of a special figurative civilization begin to appear, with strong accents on production pieces (ceramics, in example). Even in the rare cases of statues and of reliefs of large dimensions, what one feels most valid and vital is the mass of details, the faithful renderings of the costumes and jewels, of these components that characterize rather than portray only general composition. It could be said that it is the sum of the smallest and most elemental units which were of utmost interest to the Meroitic artist. Following closely the chronological developments of the material known, the relation between the Meroitic world and that of the civilization of "Group X," manifested in Lower Nubia a little before the introduction of Christianity in the region by Justinian, appears more clearly. The English excavation at Qasr Ibrim (Plumley), the Roman Primis, the only Nubian center to remain above the waters of Lake Nasser, confirms this passage and furnishes precious material for dating the moments of the passing from one civilization of the region to another.

Final considerations: techniques of excavation, conservation, restorations, exhibits.- This rather extensive review of activities and discoveries does not have the character of a methodic examination; this can be left to the reports that are furnished at close intervals on the archaeological discoveries in Egypt and in Sudan (Leclant, Burri) and that allow a rapid look at the time frame of the events.

The picture nonetheless would be even more incomplete without some observations of a more general integrative character than have been made so far. It is evident that a shift of interest from "history of art" to archaeology (i.e., history) took place in the study of ancient Egypt. The renewed interest in ceramics is symbolic of this shift. The abundance of written documentation in all epochs and for all locations has made it relatively easy to date the Egyptian complexes and associated material. Up to the 1970s, though, there had been a lack of use for that purpose of the abundant Egyptian ceramic material, which is often dated with extreme certainty and which can be characterized through a series of very accurate elements. Changes were first noted in regard to late Nubian and Meroitic material; the person who gave us the first systematic organization is a scholar from another field of research, Adams, an historic ethnologist. The impulse to study Egyptian material came from the discovery of vases dated to the tombs of Antef at el-Tārif. Thus a process of investigations begun in the 1970s brought about the constitution of a scientific organism for the study of the Egyptian ceramics.

In another field, but with a similar spirit, proof of this documentary taste for history is the "harvest" of Egyptian ruins outside Egypt, which came about in a sudden explosion of interest. These are often represented by materials of equivocal formal quality, but which testify to a cultural fact as important as the contacts made by the classic Western world with an Orient that was the master of the religious life: the formation of a terrain in which a new spiritual experience would easily germinate. The "pastiche," the imitation which until a few decades ago scandalized the Egyptologist, is more acceptable today in that it has more historic relevancy.

In a sense, one encounters the opposite attitude at Kalābsa, where the work of dismantling has uncovered the ancient surface of rock, allowing a determination of the necessary measurements for the reconstruction. An in-depth study of such traces and an interpretation of the relations between the parts of the building involved have brought the architect who studied them to recognize, in this building of Augustean age situated on the far line of the tropics, the proportions described and hoped for at the same time in Rome by none other than Vitruvius.

Another example of this way of looking at monuments is the interest in the reconstruction of the factual, environmental, and climatic situations in which to locate the material in order to give it its full significance. Even in this case, Nubia, where various groups have worked under pressure for years, has been exemplary. Here the rebuilding of the dynamics of successive settlements were carried out, such as at Trigger, as well as the accurate early climactic and paleographic investigations that Vercouter has had done to locate the fort of Mirğissa.

But the experience of saving the Nubian monuments has been formative also for other aspects. The serious practical problems inherent in the moving of the temples has brought technicians from other fields to the site to collaborate with archaeologists. Surveys have been made through aerial photography; engineers have assumed responsibilities for new works; restorers have come to consolidate and to remove mural pictures; geologists have investigated the nature of the soil; chemists have come up with the most appropriate substances for the impressions of inscriptions or the rebuilding of the blocks. As can sometimes occur in these circumstances, the new technology did not influence the direction of the works; this has remained in the hands of the archaeologists; but these have in turn assumed a new familiarity with the engineering mentality and a trust in the possibilities of other methods, in conjunction with philological and historical research.

The most momentous happenings certainly have been those of the moving of the Nubian temples, today synthesized in the two exemplary cases of Abū Simbel and Kalābsa. The first is a complex of rural temples of particular historical and monumental significance; probably the most distinctive of the architecture of the time of Ramesses. The complex has been moved higher, in the same locality, maintaining the same relationship between the single monuments, and recreating the surrounding areas to differ as little as possible from the original. For Kalābsa the situation is quite different: this is an important temple of the Roman era, dismantled at the expense of the Federal Republic of Germany, of the Deutsches Archaeologisches Institut (Stock, Siegler), and that was then reconstructed in another site by the new Aswan Dam (New Kalābsa). Nearby, other formerly dismantled and rebuilt temples have been located, grouped in an artificial association.

A similar case is that of two other locations of Nubia, where the remaining temples recovered from what is now the bottom of Lake Nasser will be united in an "Oasis of Temples" that is still under construction. This second system of construction is dictated by practical necessities, and the temples will be seen in a way which is not altogether different from how works of art are seen in museums, shorn of their functional originality and improverished of their vitality, though better preserved. And here it is appropriate to recall the latest case of a move now underway (1975): that of the monuments of the island of Philae, which were destined to be immersed into the Nile, to the near and higher island of Agilikia. The move was patterned after that of Abū Simbel, with a similar care taken to faithfully keep the relation between the individual buildings and between the complex and its environs; but where at Abūsimbel the move was unavoidable, for Philae it was technically possible to have saved the island in its original position. The decision to substitute a perfect (and perhaps improved) copy for an original seems in contrast with that respect for history that we have said is characteristic of recent archaeological Egyptology.

New technologies have made their presence felt in archaeology in Egypt: from the new emphasis on cartography to electromagnetic surveys (useful where the archaeologists were in charge of the operations, such as at Mirğissa; less so where technicians were in charge). But another valuable accomplishment of the Nubian experiment was the beginnings of a wide scale practice of performing restoration as a necessary complement to excavations; excavation-restoration is becoming the ideal model of archaeological activity, even in official recommendations. Where such activity is particularly desirable is in the region of the Thebian necropolis: after their discovery, the tombs suffered under the attacks of the climate, of tourism, and of vandals. An organized rescue operation must be planned before the general worsening of the situation makes cooperative intervention at all of the menaced areas impossible.

There are now cases of re-examination of tombs that have been known for some time, such as the tomb of Tanuna with its very beautiful paintings by a Swiss mission from Basel. There are those who are restoring the excavations that they make to a certain level of comprehensiveness and of stability, as is being done by the Italians and the Austrians at 'Asāsif. In addition there are many who are ambitiously redoing the older restorations, such as the Poles at Deyr el-Bahrī.

These various projects all have in common a desire to leave to the future the clearest documentation possible of the work that has been done, which cannot properly be testified to by reproductions and by publications, as unfortunately is often the case for the older excavations. Nevertheless it should be noted that the methods used in these undertakings are not all the same: if we take a region as compact as 'Asāsif, we encounter three different "styles." The Poles at Dar el-Bahri - given also the most particular monumentality of the complex, which carries a considerable responsibility - are carrying out a responsible reconstruction; they

have even reopened the ancient cave used by Hašep-sowe to obtain materials worthy of her. The Austrians, a little further south, have reconstructed large walls on the ancient foundations, using unbaked bricks (the material originally used), to a such a height as to reveal all of the richness of the layout of the building in its entirety. The Italians, excavating the tomb of Šošenq, only tried to consolidate the compromised structures and to construct supports to replace in their original position the fragments found fallen or out of place; for this they used construction materials different from the original, without restoring missing parts or elements. It is clear that here we have three different concepts of restoration, one spectacular, one educational, and one conservative: we could hope that different cultural experiences would not introduce elements of discrep-ancy in a unitary archaeological fabric - but I rather think that this variety is the best method for interpreta-tion of monuments for the future, as each plan for resto-ration will show details that have been lost.

In addition to these problems there is the issue of the preservation and exposition of the Egyptian archaeological material in the countries that have had the more abundant wealth; first of all Egypt itself, and then the Sudan. Egypt has a central museum - first at Bulacco, then at Ǧiza, and finally at Cairo itself - where the products of excavations were gathered in display rooms. The arrival at Cairo of the treasure of Tat'anẖamūn upset the equilibrium of the museum, which was already too crowded with exhibits and could not absorb all of the new items. The continuing arrivals were inserted at random in the empty spaces of the show cases and for the most part ended up in storage.

The coup-de-grace was the state of war, with the eventuality of a partial evacuation and the problems that arose of special protection for the works of art. The question of moving the museum had to be faced, and various solutions were proposed. At the same time, the opportunity arose to decentralize the material. In place of a comprehensive collection that levels and depreci-ates what it should preserve, a well planned series of local museums located with the documents *in situ* would revalue even modest archaeological findings. This is what began to happen. There is such a museum at Minia, another at Mallawi for the region of Hermo-polis, at Kom Ušim for Fayyūm, and others are in prep-aration. Some of these museums have special characteristics: the museum of the boats of Cheops, which is a spectacle in itself, and that of Luxor, which contains a collection of masterpieces - including an entire wall reconstructed of the "talātāt" of Karnak - rather than Thebian documentary material. It is per-haps the only place in Egypt today where one can view an Egyptian work of art in the ideal conditions of light, spacing, and distance. One may hope that a museum with a more pronounced educational purpose will be placed next to it. The new Museum of Khartoum should be noted as an example of singular clarity in this regard. With the simplest and almost ascetic methods, it centers all on the visual account of the successive civilizations of ancient Sudan; single pieces are exhibited, but are also interrelated quite well with their surroundings. And all of this is done without obvious emphasis of any kind.

Finally, a word on the travelling exhibits of arti-facts that move from one city to another; this system,

while having great potential for good, unfortunately is not yet clear and sophisticated enough to fully promote understanding and appreciation. In 1961 there was an exhibit of "5000 years of Egyptian art." This exhibit was of little value as an aid to critical comprehension, as can be surmised from the title itself. Little different is the case of those showings of the treasures of Tut'anẖamūn that have excited crowds of Japanese, French, English, and Russians and that were openly intended as a means of collecting funds for archaeological undertakings in Egypt; these clearly could not have been useful in fur-thering knowledge of the material exhibited. The cere-monies of "Sound and Light" shows at Ǧiza and at Karnak had a similar character and resulted in tumultu-ous and hurried excavations (1973). Fortunately, how-ever, certain exhibits were successful in leading to a better understanding of monuments that are normally difficult to see. Others displayed items that were widely dispersed and thus difficult to appreciate in their total-ity (such as the exhibit of Eẖnaton at Hamburg in 1965). However, these exhibitions were especially help-ful when the articles were hard to interpret and une-qualled in innovation and preservation. Among these, the exhibitions at the Brooklyn Museum, organized by Bothmer for the statuary of recent eras and for the Amarnian statuary, were true critical and historical enrichments, definitely more important than many excavations. The Paris exhibit of Ramesses II in 1976 gathered significant material that covered all aspects of the epoch considered.

The selection of this material, which in some ways may seem arbitrary or at least partisan, has deter-mined new aspects of the Egyptian archaeology, but it is always difficult to say unequivocally and precisely what is new in a field. The new discoveries are not so much a listing of facts as a slight adjusting to new requirements of all knowledge, both old and new, not only documen-tary but also interpretative. A real updating, to be coherent and correct, should thus involve nothing less that a rewriting of the history of Egyptian art.

BIBLIOGRAPHY - F. Wendorf (ed.), The Prehistory of Nubia, 2 vol., Dallas, 1968; W. Emery, Archaic Egypt, London, 1969; Idem., Great Tombs of the First Dynasty (Excavations at Saqqara I-II-III), 3 vol., Le Caire, 1949-1958; J. Ph. Lauer, Sur le dualisme de la monarchie égyptienne et son expression architecturale sous les premières dynasties, BIFAO, LV, 1956; W. Emery, Preliminary Report on the Exca-vations at North Saqqara, 1964-1965, JEA, LV, 1965; Id. 1965-1966, JEA, LII, 1966; Id., 1968, JEA, LV, 1969; Id., 1968-1969, JEA, LVI, 1970; Id., 1969-1970, JEA, LVII, 1971; G.T. Martin, Excavations in the Sacred Animals Necropolis at North Saqqara 1971-1972, JEA, LIX, 1973; Id., 1972-1973; JEA, LX, 1974; M. V. Seton Williams, The Tell el Fara'in Expedition 1968, JEA, LV, 1969; D. Charlesworth, Tell el Fara'in: The Industrial Site, 1968; JEA, LV, 1969; Id. The Tell el Fara'in Excavations, 1968, JEA, LVI 1900; D. P. Hansen, The Excavations at Tell el Ruba, JARCE, VI, 1967; C.L. Sogher, Inscriptions from Tell el Ruba, o.c.; F.L. Och-senschlager, The Excavations at Tell Timai, o.c.; D.P. Hansen, Mendes 1964, JARCE, VI, 1965; V. Maragioglio, C. Rinaldi, L'architettura delle piramidi menfite, 7 vol., Torino-Rapallo, 1963-1970; Ahmed Fakheti, The Monuments of Snefru at Dahshur, 3 vol., Cairo, 1959; J. Ph. Lauer, Remarques sur la planification de la construction de la grande pyramide,

BIFAO, LXXIII, 1973; J. Černy, A note on the recently discovered boat of Cheops, JEA, XLI, 1955; Abdelmoneim Abu Bakr, Ahmed Y. Mustafa, The Funerary Boat of Khufu, Beitr. zu äg. Bauforsch. u. Altert. XII, 1971; B. Landström, Ships of the Pharaohs, London, 1970; J. Ph. Lauer et J. Leclant, Le temple haut du complexe funéraire du Roi Teti (Miss. Arch. de Saqqarah, I), Le Caire, 1972. J. Ph. Lauer, J. Leclant, Découverte de statues de prisonniers au temple de la Pyramide de Pépi I, RdE, XXI, 1969; W. Wood, A Reconstitution of the Triads of King Mycerinus, JEA, LV, 1974; E. Edel, Die Felsengräber der Qubbet el Hawa bei Assuan, Wiesbaden, 1967-1971; W. Kaiser and others, Stadt und Tempel von Elephantine. Erster Grabungsbericht, MDIK, XXVI, 1970; Id. Zweiter Grabungsbericht, MDIK, XXVII 1971; Id., Dritter Grabungsbericht, MDIK, XXIX, 1973; Id., Vierter Grabungsbericht, MDIK, XXX, 1974; Id., Fünfter Grabungsbericht, MDIK, XXXI, 1975; Moh. Saleh Aly, Three Old-Kingdom Tombs at Thebes, Mainz, 1977. D. Arnold and J. Settgast, Erster Vorbericht über die vom Deutschen Archäologischen Institut Kairo im Asasif unternommenen Arbeiten (1. u. 2. Kampagne), MDIK, XX, 1965; Id., Zweiter Vorbericht. usw. (3.Kampagne), MDIK, XXXI, 1966; D. Arnold, Bericht über die vom Deutschen Archäologischen Institut Kairo in Mntwhtp Tempel und in El Târif unternommenen Arbeiten, MDIK, XXVIII, 1972, n. 15 sgg.; Id., Bericht über die vom Deut. Arch. Inst. Kairo im Winter 1972-73 in El Târif durchgefuhrten Arbeiten, MDIK, XXIV, 1973; Id., Bericht über die vom Deut. Arch. Inst. Kairo im Winter 1972-73 in El Târif durchgefuhrten Arbeiten, MDIK, XXX, 1974; A. Arnold, Der Tempel des Königs Mentuhotep von Deir el-Bahari, I. Architektur und Deutung; II. Die Reliefs des Sanktuars, Mainz, 1974. J. Lopez, Rapport préliminaire sur les fouilles d'Héracléopolis, OA, XIII, 1974; S. Roccati, I testi dei sarcofagi di Eracleapoli, o.c.; M. Bietak, Studien zur Chronologie der nubischen C Gruppe. Ein Beitrag zur Frühgeschichte Unternubiens zwischen 2200 und 1550 vor Chr. (Öst. Ak. Wiss. Denkschr. 97), Wien, 1968. M. Bietak, Vorläufiger Bericht über die erste und zweite Kampagne der österreichischen Ausgrabungen auf Tell Ed-Dab'a im Ostdelta Ägyptens (1966, 1967), MDIK, XXIII, 1968; Id., Vorläufiger Bericht über die dritte Kampagne usw. (1968), MDIK, XXVI, 1970; J. Lipinska, Name and History of the Sanctuaries built by Tuthmosis III at Deir el Bahri, JEA, LIII, 1970; Id., The architectural design of the temple of Tuthmosis III at Deir el Bahari, MDIK, XXV, 1969; Id., The Granite Doorway of the Temple of Tuthmosis III at Deir el Bahari. Studies on Reconstruction, Etudes et Travaux, II, 1968; E. Dabrowska Smektala, Coffins found in the Area of the Temple of Tuthmosis III at Deir el Bahari, BIFAO, LXVI, 1968; K.A. Kitchen, Theban Topographical Lists, Old and New, Orientalia, XXXIV, 1965; E. Edel, Die Ortsnamenlisten aus dem Totentempel Amenophis III, Bonn, 1966. Aa. Vv., Graffiti de la Montagne Thébaine, vol. I-IV, Le Caire, 1970. B. Kemp, D. O'Connor, An Ancient Nile Harbour. University Museum Excavations at the «Birket Habu», The International Journal of Nautic Archaeology and Underwater Exploration, III, 1974; M. Schiff Giorgini, Soleb Campagnes 1961-63, Kush XII, 1964, M. Schiff Giorgini, C. Robichon, J. Leclant, Soleb, vol. I-II, Firenze, 1965-1971. H. S. K. Bakry, The discovery of a temple of Sobk in upper Egypt, MDIK, XXVII, 1971; Ramadan Saad, New Light on Akhenaten's Temple at Thebes, MDIK, XXII, 1967; J. Lauffray, S. Sauneron, La création d'un centre franco-égyptien pour l'étude des temples de Karnak, Kemi, XVIII, 1968; J. Lauffray, Nouvelles découvertes par la centre franco-égyptien d'étude des temples de Karnak, CRAIBL, 1968; J.D. Cooney, Amarna Reliefs from Hermopolis in American Collections,

The Brooklyn Museum, 1965; M. Bietak, Theben West (Luqsor). Vorbericht über die ersten vier Grabungskampagnen (1969-1971) (Stzb. Öst. Ak. Wiss., 278 Bd 4Abt.), Wien, 1972; S. Donadoni and others Relazione preliminare sulla II campagna dï scavo nella tomba di Šešonq all'Asasif (1971) in OA, VI, 1973; L. Dabrowski, La topographie d'Athribis à l'époque romaine, ASAE, LVII, 1962; K. Michalowski, Les fouilles polonaises à Tell Atrib (Saison 1961), ASAE, LVIII, 1964; P. L. Shinnie, Meroe, London, 1967; F. Hintze, Die Inscriften des Löwentempels von Musawwarat es Sufra, Berlin, 1962; Id., Musawwarat es Sufra. Vorbericht über die Ausgrabungen des Instituts für Ägyptologie der Humboldt Universität zu Berlin, 1963 bis 1966, Wissenschaftiliche Zeitschrift der Humboldt Universität zu Berlin, XVII, 1968; I progressi della disciplina son da seguire su Meroitic Newsletter, rivista a carattere privato pubblicata da J. Leclant e B. R. Trigger. Un insieme di relazioni, edite solo per i partecipanti al congresso, è stata presentata a una sottosezione del congresso degli Orientalisti tenutasi a Parigi nel luglio del 1973. I. Hofman, Die Kulturen des Niltals von Aswan bis Sennar. Vom Mesolithikum bis zum Ende christlichen Epoche, Hamburg, 1967; W. Y. Adams, Continuity and Change in Nubian Cultural History, Sudan Notes and Records, XLVIII 1967; B. R. Trigger, The Royal Tombs at Qustul and Balana and their Meroitic antecedents, JEA, LV, 1969; J.M. Plumley, Qasr Ibrim 1963-64, JEA, L, 1964; Id., 1966, JEA, LII, 1966; Id., 1968, JEA, LVI, 1970; W. H. C. Freud, The Podium Site at Qasr Ibrim, JEA, LX, 1974; (Fouilles en Egypte et au Soudan), 1952, and under the editorship of C. Burri, Bollettino d'informazione della sezione archaeologica dell'istituto Italiano di cultura del Cairo, dal 1964. Un gruppo di ricerche ceramiche è stato costituito al Cairo nel 1973 con la collaborazione di vari istituti archaeologici. Da segnalare: W. Y. Adams, Progress Report on Nubian Pottery. I. The native Wares. II. The imported Wares, Lexington, 1968 (a diffusione privata. Ne è prevista la pubblicazione in Kush, XV e XVI); D. Arnold, Weiteres zur Keramik von el-Tarif, MDIK, XXVIII, 1972; J. Leclant, Notes sur la propagation des cultes et monuments égyptiens en Occident, à l'époque impériale, BIFAO, LV, 1958; J. Leclant et G. Clerc, Inventaire bibliographique des Isiaca (IBIS). Répertoire analytique des travaux relatifs à la diffusion des cultes isiaques (1949-1969), Leiden, 1972; E. Iversen, Obelisks in Exile, 2 vol., Copenhagen, 1968-1972; K.C. Siegler, Kalabsha. Architektur und Baugeschichte des Tempels, Berlin, 1970 (= DIK, Arch. Ver. I). W. Kaiser, Bericht über eine archäologische-geologische Felduntersuchung in Ober- und Mittelägypten, MDIK, XVII, 1967; K. W. Butzer, Archäologische Fundstelle Ober- und Mittelägyptens in ihre geologischen Landschaft, MDIK, XVII, 1961; K. W. Butzer, C. L. Hansen, Desert and River in Nubia. Geomorphology and Prehistoric Environments at the Aswan Reservoir, Madison and London (University of Wisconsin Press), 1968; B. G. Trigger, History and Settlement in Lower Nubia, New Haven, 1965. C. Desroches Noblecourt, G. Gersten, Die Welt rettet Abu Simbel, Wien-Berlin, 1968; H. Stock, G.G. Siegler, Kalabsha, der grösste Tempel Nubiens und das Abenteuer seiner Rettung, Wiesbaden, 1964. Hesse in J. Vercoutter and others, Mirgissa, I, Paris, 1970 (nell'opera l'aspetto tecnico é assai sottolineato anche per quanto riguarda geografia e geologia). J. Lipinska, Preliminary Report on the Reconstruction Works of the Temple of Hatshepsut at Deir el-Bahari During the Season 1964-65, ASAE, LX, 1968; L. Dabrowski, Temple de Hatchepsout à Deir el-Bahari, 3 Terrasse. Projet de la reconstruction du mur ouest de la cour, Etudes et Trav. III, 1968; E. Dabrowska-Smekatala, Remarks on the Restoration of the Eastern Wall on the 3rd Terrace of Hatshepsut Temple, Etudes et

Travaux, II, 1968; L. Dabrowski, The Main Hypostyle Hall of the Temple of Hatshepsut at Deir el-Bahari, JEA, LVI, 1970; B.V. Bothmer, Egyptian Sculpture of the Late Period, The Brooklyn Museum, New York, 1960; C. Aldred, Akhenaten and Nefertiti, The Brooklyn Museum, New York, 1973; L'Egypte avant les Pyramides (Exp. au Grand Palais 29 mai - 3 sep. 1973), Paris, 1973. Ramsès le Grand, Galéries nationales du Grand Palais, Paris, 1976 (Catalogo della Mostra).

Sergio Donadoni

THE CLASSIC WORLD

The Aegean: new discoveries on Minoan-Mycenaean Art. - Our knowledge of Minoan-Mycenaean civilization has greatly expanded with the archaeological research of the past 15 years. The deciphering of Linear B writing as a very archaic form of the Greek language has in fact given this research a new lift, directing it towards the explanation of specific matters, especially the following: the chronology and modality of the first establishment of Indo-European speaking peoples in the Aegean world; the genesis of Mycenaean civilization; the relationship between Minoan and Mycenaean civilizations; the role of outlying cultural areas (the first of which being the Cyclades); and the passage from the Bronze Age to the Iron Age with all the related problems of continuity and establishment of new cultural aspects.

a) *Crete.* - Special care was given to the research on pre-palatial culture, both by the systematic study of its individual aspects and by new excavations, of which the most important is that of the village of Myrtos, near Ierapetra. This village can be dated back in its entirety to the II ancient Minoan period, which has supplied abundant and varied information on the everyday life and on the economy of the III millenium B.C. Light has also been shed on other aspects of the pre-palatial period by the exploration of many tholos tombs, which are concentrated mainly in the Messara area, but which are also found in other areas of Crete. Among these the tombs of Lebena and Archanes are important because of their many finds and the chronological issues.

One very complex and debated issue is that of the complete chronology of the pre-palatial period, which is based on some imported Egyptian pieces, many of uncertain date, and also on the new radio carbon dating techniques. These techniques give a dating for the beginning of pre-palatial culture of between 3000 and 2700 B.C., although further studies and additional radio carbon dating may give a more accurate result.

Besides the chronological questions, there are new results concerning the early palatial period, especially at Phaistos and Mallia. The continuing Italian excavations at Phaistos have confirmed the extraordinary artistic vitality of the Cretan civilization of the first palaces, which brought a newness and a decorative variety to the Kamares style virtually unique in the early Mediterranean world. Ever since the first appearance of the Kamares style, red and black decorative motifs with small polychromatic markings appear on the black bottoms of the vases. These motifs, inspired by plant life and, less often, animal life, appear around the outside of cups, pots, jars, and amphoras with a decorative freedom that continuously creates new compositions. With the passage of time the Cretan potter becomes a little less creative, choosing a more limited repertoire of motifs, combining them with confidence and good taste to the different ceramic forms. This same taste and variety are once again found in contemporary Cretan glyptic, of which there is a unique display in the more than 5,000 earthenware pieces recovered in Phaistos. These date back to the first early palatial phase and were produced with seals of widely varied decoration, often closely related to the Eastern repertoire.

The excavation of the new Zakro palace on the far eastern part of the island, entirely constructed during the neo-palatial age, has made an important contribution to the knowledge of the new palace. The intensive research carried out in the eastern portion of Crete has revealed that these regions as well were part of the flowering of Minoan civilization; a palatial center is believed to be at éHania. On the other hand, the western regions of Crete were significant in the post-palatial age as well. The numerous painted sarcophagi recovered in the Armeni necropolis, near Rhethymnon, showing hunting scenes, represent a style and a decorative repertoire substantially different from the ones known thus far, although provincial in some aspects; they open a new chapter in the history of late Minoan art.

It is known that Minoan civilization had considerable influence beyond the shores of the island. We now know that it was also very advanced, as demonstrated by the excavations on the island of Kythira, where an actual Minoan foundation dating back to the pre-palatial age was recovered.

b) *The Cyclades: the pictorial revelation of Thera.* - The excavations directed by Marinatos since late 1967 on the island of Thera have perhaps supplied the most surprising results of all the research carried out in the Aegean. The prehistoric town of Akrotiri was in fact buried towards the end of the XVI century B.C. by a thick layer of pumice from an erupting volcano; underneath it were conserved an unprecedented number of houses, frescoes, and household furnishings. The inhabitants had time to escape, taking with them precious objects and other easily transportable objects; however, the architectural remains, the paintings, and the furnishings left behind reveal a rich and sophisticated civilization with a significant Minoan quality, though with Cycladic characteristics.

The small portion of the site excavated thus far consists of houses of several stories, connected by streets and squares. Many of these houses were decorated with well preserved frescoes. From the artistic viewpoint, the frescoes, although not yet critically studied, reveal a greatly advanced school of painting; it is much less analytical and rigid than the Cretan school, with a very ample figurative repertoire. The human figure is depicted in acts of daily life (the fisherman), play (young boxers), or religion (the priestess) and is often displayed in very precise physiognomic detail, as in one fragment of a fresco that appears to portray an African man. One of the favorite sources of inspiration of the painters of Thera is nature. In the famous "springtime" fresco, which covered three walls of a room, single and paired swallows fly around bushes of lilies blossoming on multicolored mountain tops, depicted according to the Minoan conventions. In this fresco a decorative scanning of space prevails, while in a small frieze discovered very recently there is for the first time a realistic representation of a landscape; on the shores of a winding river, bordered by palm trees, both real and mythical animals are depicted gracefully running after each other.

However, among all the frescoes of Thera, the one which can be considered the most innovative is a long frieze painted in a miniaturized style, depicting on one side a fleet of ships crossing the sea between two cities and on the other a naval battle with the landing of warriors armed with huge shields and wearing helmets with boar tusks. We have here a painting with a histori-

cal subject, a painting that reveals a way of describing events and people that is completely different from the rigid and solemn way of contemporary Eastern painting. The human body is freely portrayed in different poses, and land and sea backgrounds are enlivened by scenes such as a lion chasing after a herd of deer or dolphins freely swimming around ships.

The quantity, the state of preservation, and often the quality of the frescoes found make Thera the cornerstone for the study of ancient painting and allow for a better understanding of the intrinsic character of Aegean civilization and its cultural autonomy from the Eastern world.

Another excavation in the Cyclades that has furnished important results is that of Agia Irini on the island of Keos, an urban center of the Bronze Age, where a temple-like building was discovered with large terra-cotta statues inside of women dressed in the characteristic Minoan clothing that leaves the breasts uncovered. These statues are slightly smaller than life-size and reveal the existence of an Aegean monumental sculpture that was previously unknown.

c) *Continental Greece and the Mycenaean civilization.* - Many studies have contributed to clarifying the problem of the first appearance of Indo-European peoples in the Greek peninsula. The only possible cultural interruption during the Bronze Age which could be linked to the arrival of new peoples is during the Ancient Helladic III, the period which thus coincides with the arrival of human groups who gave rise to the complex phenomenon of Mycenaean civilization. We now have much information on the beginning of Mycenaean civilization, but it is limited to the tombs. The most important new finding was from the excavation of the B circle of Mycene, consisting of 26 cist and ditch tombs which probably contained the remains of the first rulers of the citadel of Mycene. The B circle is older in part than the A circle, its contents displaying characteristics that are almost completely Middle Helladic; it is here that the first evidence of Mycenaean wealth was found.

Many excavations have supplied materials that date back to the flourishing period of Mycenaean civilization - the XV and XIV centuries B.C. In addition to the significant collection of materials from the necropolis, we also have the results of the studies of palatial centers such as Mycenaea, Tyrins, Pylos, Gla, Yolkos, and, most important, Thebes, where many Eastern seals and exquisitely crafted Mycenaean gold pieces were discovered in a new wing of the palace of Kadmos, as well as a number of small paintings in Linear B.

In Boeotia, near Tanagra, there was an exploration of a Mycenaean necropolis made up of chamber tombs containing a large number of sarcophagi with painted scenes of mourning. In addition to being very important from the artistic-historic perspective of painting, they give a new insight of the Mycenaean funerary ritual.

The later stages of the Bronze Age are well-illustrated by the exemplary stratigraphic excavation of Lefkandi in Eubea, by that of Teichos Dimaion in Achaïa, and by the necropolis of Perati in Attica of the Mycenaean III C age, whose materials often reveal extensive relations between the Mycenaean world and continental European cultures.

Because of this and other material, the causes of the fall of Mycenaea and the importance that should be given to the tradition of the Doric invasion are still under discussion. The present belief is now leaning towards internal causes having brought about the final crisis of Mycenaean civilization, as well as the slow passage of several of its cultural elements to the geometric world through the so-called "dark ages."

Lucia Vagnetti

The central-western Mediterranean: Corsica and Sardinia. - The knowledge of the artistic expression of the islands of the central-western Mediterranean for the more recent prehistoric stages, as well as for the beginnings of the historic era, does not significantly change due to the discoveries of recent years. Their culture is noticeable different due to their isolation; nevertheless, they have in common the effects of a substantial delay in the prehistoric forms, particularly megalithic; an accentuated specialization; and influences coming from the Aegean world of the Bronze Age and the reflections of the civilizations of the Phoenician and Greek colonists, modified by the local traditions, needs, and tastes. These phenomena are more characteristic of Sardinia, Corsica, and the Balearic Islands than either the Maltese archipelago, isolated and in a deteriorated state after the great flourishing of the Neolithic and the first Iron Age, or Sicily, which was increasingly more attracted to the phenomena of the Italian region and deprived of its own megalithic experience.

The extraordinary revelation of architectural and figurative manifestation in Corsica, for which we can thank R. Grosjean and his assistants, has led to further research and discoveries - in the now famous center of Filitose, in the Cauria plateau, and especially in Palaggin in the township of Sartena. It was here that in 1965 and shortly thereafter numerous new steles were recovered, partially anthropomorphic, with several that represent warriors carrying arms similar to those of the small Sardinian sculptures. It has also led to an attempt at chronological classification and historical interpretation which is still going on. A megalithic culture of neolithic tradition can be perceived, developing mainly during the first Iron Age and reaching its full expression in the first half of the II millennium B.C. From it will emerge a new kind of civilization, particularly in the southwestern region of the island, characterized by monuments similar to the Sardinian nuraghes and the Balearic talayots; they are known as "torreano" as they come from the architectural complex of Torre, near Portovecchio. This transformation was attributed to the penetration of the Mediterranean currents of the Late Bronze Age. The parallel with the nuraghic civilization of Sardinia is nevertheless obvious, chronologically as well (from the middle of the II millennium B.C. to the first centuries of the I millennium B.C.). The production of the menhir statues, which originated in the megalithic circles, continues with an increasingly obvious evolution from the primitive aniconism to the accentuation of anthropomorphic characteristics. The figurative steles, of heroic or funereal significance, often appear arranged in grandiose alignment and probably belonged to sanctuaries.

Corsican statuary and semi-statuary has been linked for some time to Lunigiana statuary in Ligurian

circles, and there has been increased scholarly interest in it through research, publications, exhibits, and conventions. But links to Sardinia have now also been found, not only iconographic but also of material and proportions.

The most sensational news we have received from the paleo-Sardinian world is the discovery in an indigenous sanctuary of the Sinis peninsula, near Cabras, of many fragments of huge sandstone statues of warriors; they are in the costume and what appears to be the pose of the well-known bronze nuraghic figurines. G. Lilliu, in calling attention to this discovery, has revealed the rigorous and cutting geometric essentiality of their style, especially reminiscent of the bronze statuary of the Uta-Abini group. But there is an echoing of the style of the small local stone statuettes of neolithic tradition, naturally much enlarged. It can therefore be said that in Sardinia, parallel to the development of the menhir or thick stone in a partially iconic sense, and similar and parallel to that of Corsica - of which a typical example is the inscribed pillar with a human face in San Pietro di Golgo near Baunei (Nuoro) - coexists and develops in the late Nuraghic Age—that is, at the beginning of the I millennium (according to Lilliu in the VIII century B.C.). This is an authentic original production of statuary whose importance cannot be overemphasized and is proof of the emergence of a figurative monumental art also in the "barbarian" territories of the western Mediterranean. This was until now a completely unknown fact.

MASSIMO PALLOTTINO

The Nuraghic bronze sculpture has been greatly enriched in recent years through numerous discoveries or new emphasis on known items. It is interesting that the locations of these new discoveries are not only in Sardinia, but also in Etruria. In the meantime, the progress of the studies has been significant: in fact, in addition to the monumental work by G. Lilliu ("Sculptures of Nuraghic Sardinia," Verona, 1966) there were also contributions by M. Pallottino, S. Ferri, and E. Contu.

In this way, there has been a clarification of both internal and external relations of this very interesting and prolific production of bronze statuettes. There appears to be confirmation of the main division between two styles (until now intermingled): one of geometric inspiration, expressed in rigid and severe shapes, and one displaying loose and popular forms. These should also be considered in relation to the derivation from other techniques: wood sculpture for the former, and clay and wax sculpture for the latter. Elements of extrainsular origin are manifestations of Greek "geometric" and the integration between "geometric" and "oriental" concepts of Etruria. Traces of Luristanian art and of figurative motifs of Urartu can also be perceived; however, they may have been acquired. In the second style, instead, in addition to generic references to a type of artistic Mediterranean "koine," specific elements of Syrian-Phoenician-Cypriot origin were found. However, all these contributions do not significantly affect the originality of the works.

Concerning the significance of the bronze statuettes - it seems clearer than ever that they are not idols or divine figures, but rather votive offerings that portray the offering itself, or the grace received or requested, or the postulant. The latter is characterized by hairstyle, clothing, weapons, etc., but no individual physiognomic or psychological marking is present.

Important among the recent discoveries for their chronological value and relationship with other civilizations are the discoveries of Grotta Pirosu (Santadi, Cagliari) (tripod of Cypriot tradition of the second half of the IX century B.C., the beginning of the VIII century B.C.), of Cavalupo (Vulci) (end of IX, first half of VIII centuries B.C.), of late nuraghic of Nuraghe su Igante (Uri, Sassari) (VI century B.C.), of the Punic fortress of Monte Sirai (Carbonia, Cagliari) (VII - VI centuries B.C.), and of the Greek sanctuary of Gravisca (Tarquinia) (end of VII, beginning of VI centuries B.C.).

ERCOLE CONTU

BIBLIOGRAPHY - *Minoan-Mycenaean Civilization and Art*: R. Hutchinson, Prehistoric Crete, Harmondsworth, 1962; P. Demargne, Naissance de l'art grec, Paris, 1964; W. Taylour, The Mycenaeans, London, 1964; E. Vermeule, Greece in the Bronze Age, Chicago, 1964; L. Palmer, Mycenaeans and Minoans, London, 1965, L.A. Stella, La civiltà micenea nei documenti contemporanei, Roma, 1965; F. Matz, Kreta, Mykene, Troja, Stuttgart, 1965; N. Platon, Crète, Genève, 1965; G.E. Mylonas, Mycenae and the Mycenaean Age, Princeton, 1966; A.E. Samuel, The Mycenaeans in History, Englewood Cliffs, 1966; R.A. Higgins, Minoan and Mycenaean Art, London, 1967; S. Alexiou, Minoan Civilization, Heraklion, 1969; M.I. Finley, Early Greece: the Bronze and Archaic Age, London, 1970; K. Branigan, The foundations of Palatial Crete, London, 1970; K. Branigan, The Tombs of Mesara, London, 1970; S. Hood, The Minoans, London, 1971; H.G. Buchholz-V. Karageorghis, Altägäis und Altkypros, Tübingen, 1971; C. Renfrew, The Emergence of Civilisation. The Cyclades and the Aegean in the Third Millennium B.C., London, 1972; S. Marinatos-M. Hirmer, Kreta, Thera und das Mykenische Hellas, München, 1973; P. Faure, La vie quotidienne en Crète au temps de Minos, Paris, 1973; Aa. Vv., History of the Hellenic World, Prehistory and Protohistory, London, 1974; P. Faure, La vie quotidienne en Grèce au temps de la guerre de Troie, 1250 av. J.C., Paris, 1975. P. Ålin, Das Ende der mykenischen Fundstatten auf dem griechischen Festland, Lund, 1962; V.R. d'A. Desborough, The Last Mycenaeans and their successors, Oxford, 1964; R. Carpenter, Discontinuity in Greek Civilization, Cambridge, 1966; C. G. Styrenius, Submycenaean Studies, Lund, 1967; A.M. Snodgrass, The Dark Age of Greece, Edinburgh, 1971; V.R. d'A. Desborough, The Greek Dark Ages, London, 1972; R.A. Crossland-A. Birchall, Bronze Age Migrations in the Aegean, London, 1973. A.J.B. Wace-F. Stubbings, A Companion to Homer, London, 1962; F. Matz (ed.), Archaeologia Homerica (fascicoli separati dal 1967); J. Bouzek, Homerisches Griechenland, Praha, 1969. W. Graham, The palaces of Crete, Princeton, 1962; N. Scoufopoulos, Mycenaean Citadels, Göteborg, 1970; J. W. Shaw, Minoan Architecture: materials and techniques, AS Atene, XLIX, 1971; A.D. Lacy, Greek Pottery in the Bronze Age, London, 1967; A. Zois, Der Kamares Stil, Werden und Wesen, Tübingen, 1968; J. L. Benson, Horse, Bird and Man. The Origins of Greek Painting, Amherst, 1970. D. Levi, L'archivio delle cretule a Festòs, AS Atene, XXXV-XXXVI, 1957-58; V.E.G. Kenna, Cretan Seals, Oxford, 1961; F. Matz (ed.), Corpus der minoischen und mykenischen Siegel, I; II, 1; II, 5; IV; VII; VIII; IX; XII, München 1964-1972 (in continuazione). P. Warren, Minoan

Stone Vases, Cambridge, 1969. H.W. Catling, Cypriote Bronzework in the Mycenaean World, Oxford, 1964; K. Branigan, Aegean Metalwork of the Early and Middle Bronze Age, Oxford, 1974. D. Levi, Recent Excavations at Phaistos, Lund, 1964; M. R. Popham-L. H. Sackett, Excavations at Lefkandi, Euboea, 1964-1966, London, 1968; S. Iakovidis, I-III, Athenai, 1969-70; S. Marinatos, Excavations at Thera, I-VII, Athenai, 1969-1976; N. Platon, Zakros. The Discovery of a lost Palace of Ancient Crete, New York, 1971; S.A. Immerwahr, The Neolithic and Bronze Ages, The Athenian Agora, XIII, Princeton, 1971; P. Warren, Myrtos, London, 1972; J.N. Coldstream-G.L. Huxley, Kythera, London, 1972; S. Symeonoglou, Kadmeia, I, Göteborg, 1973; E. Slenczka, Figürlich Bemalte mykenische Keramik aus Tiryns, Tiryns VII, Mainz, 1974; C.W. Blegen et al., The Palace of Nestor at Pylos in Western Messenia, I-III, Princeton, 1966-1973; S. Stucchi, Il Giardino delle Esperidi e le tappe della conoscenza greca della costa cirenaica, in Cirene e la Grecia, Quaderni di archaeologia della Libia, 8, Roma, 1976; J. Luce, Thera and the Devastation of Minoan Crete: a new Interpretation of the Evidence, Am. Jour. of Arch., LXXX, 1976.

Central-western Mediterranean: *Corsica*: R. Grosjean, La Corse avant l'histoire, Paris, Klincksiech, 1966; G. Lilliu, Rapports entre la culture torréenne et les aspects culturels pré- et protonuragiques de Sardaigne, in Actes du VIIIe Congrès prèhistorique de France, Aiaccio, 1966; R. Grosjean, La Préhistoire. La protohistoire, in Histoire de la Corse, Toulouse, Privat, 1971; R. Grosjean, Diorama de la civilisation torréenne corse, in Mélanges d'études corses, Aix-en-Provence, 1971; R. Grosjean, Les alignements de Pagliaiu (Sartène, Corse), in Bulletin de la Société prehistorique française, LXIX, 2, 1972; Sites préhistoriques et protohistoriques de l'Ile de Corse (IXe Congrès intern. des sciences préhistoriques et protohistoriques), Nice, 1976.

Central-Western Mediterranean: *Sardinia*: G. Lilliu, Dal «betilo» aniconico alla statuaria nuragica, Sassari, Gallizzi, 1977. Oltre all'opera citata del Lilliu (ivi a p. 480 la più recente bibliografia): M. Pallottino, Etruria e Urartu, in A.C., IX, 1957; G. Lilliu, Sarda, Arte, in E.A.A., VII, 1966; M. T. Falconi Amorelli, Tomba villanoviana con bronzetto nuragico, in A.C., XVIII, 1, 1966; E. Contu, R.S.P., XVIII, 1963; Ibid., XIX, 1964; p. 317; Ibid., XXIX, 1, 1974, E. Contu, in Sardegna, Electa Editrice, Torino, 1969; G. Lilliu (Gravisca), N. Sc., 1971, 1, G. Lilliu, Civiltà dei Sardi dal Neolitico all'Età dei Nuraghi, ERI, Torino, 1972; F. Barreca, La Sardegna fenicia e punica, Chiarella, Sassari, 1974, E. Contu, La Sardegna dell'Età Nuragica, in Popoli e Civiltà dell'Italia Antica, III, 1974; G. Lilliu, Tripode bronzeo di tradizione cipriota dalla Grotta Pirosu-Su Benatzu di Santadi (Cagliari), in Estudios dedicados al Prof. Dr. Luis Pericot, Universidad de Barcelona, 1973; F. Lo Schiavo, St. E., XLII, 1974; G. Lilliu, Antichità nuragiche nella Diocesi di Ales, nel volume La Diocesi di Ales-Usellus-Terralba - Aspetti e valori, STEF, Cagliari, 1975; Id., Un giallo del secolo XIX in Sardegna (gli idoli sardo-fenici), St. S., XXIII, 1975, parte I.

Lucia Vagnetti,

Massimo Pallottino and

Ercole Contu

GREEK ART (PLATES 19-23)

It is not an easy task to give an account of the discoveries in Greek art that occurred in the 1960s and 1970s. Some of considerable importance have occurred without receiving the attention they merited. Adding to the difficulty, the archaeological bibliography has become more complex and confusing. Furthermore, presentations of the entire world of Greek art, or of parts of it, have become widespread, and in them personal convictions of individual authors are often presented as factual.

Perhaps the most exciting event of the period 1965 to 1975 is the discovery of the famous city of Sibari, in an area discovered by U. Zanotti Bianco in 1932. Excavations have revealed a settlement of the Hellenistic-Roman age, with traces of the ancient dwellings and samples of artifacts such as pottery and architectural fragments from different eras.

Early geometric and geometric. - Knowledge of these periods has grown recently and the chronology has become firmer; dates for the later periods proposed by H.G.G. Payne have been confirmed. The proto-geometric appears as a cultural type found throughout Greece and on the coast of Asia Minor; it is characterized by the reaction of a sub-Mycenaean tradition, rather more consistent with the Attican stimuli than had been believed. One of the more significant findings is the tomb of Lefkandi in Eubea, in which was found a figurine of a centaur, the earliest representation found to date of this mythical creature of Greek art. It is a very thin statuette, executed in late Mycenaean crafts fashion and iconographically close to Cypriot models. It thus documents the persistence of relations with other and far countries during these little known centuries. Contacts with the Near East were more intense during the IX century, in the middle geometric era, with the sudden appearance in Athens of gold jewelry executed with extraordinary levels of technique such as filigree and granulation; this proved not only the importing of precious materials but also the acquisition of the techniques necessary to work them.

The historical framework now becomes notably well defined. In the first half of the VIII century B.C., and perhaps already at the end of the IX, Greeks of the Cyclades, of Eubea, and of Attica are present on the coasts of Syria and Phoenicia, with single-story dwellings (Al Mina, Sukas). By no later than 750 B.C, Euboean colonies had been established in the west at Pithecusa, with contacts having already been made for some time to the coasts of Campania and of southern Etruria. At the end of the VIII century, the settlement of Lefkandi was destroyed, perhaps in connection with the Lelantine war between Halcis and Eretria. The findings made there present a rather complete picture of the Euboean ceramic production, suggesting that the workshop of the Cesnola crater, which is generally thought to have been located in Nasso, was more likely at Euboea. The excavations at Andros, in the Zagora area, have revealed geometric settlement of short duration, showing many connections with Euboea, thus confirming the domination of Andros and other islands of the Cyclades by Eretria (Strabo: X 1, 10).

In the late geometric ceramics, particularly of Attica, Argolis, and Boeotia, workshops and masters are recognized, thus presenting a well-defined picture of its development, from which the innovative force of the master of Dipylon shows clearly. Particular attention has been given to the geometric art from an iconographic and iconological point of view, thus revealing

the connections with the art of the Near East and the effective independence of the manifestations. The continuity of an iconographic tradition with the Mycenaean world (Benson) instead appears questionable, mainly for the hiatus between the late geometric figurative explosion and the late Bronze Age.

Also in the field of bronze and terra-cotta sculpture, particularly well documented in the sanctuaries, different groups can be distinguished, but the differing results suggested by the individual workshops reveal a margin of approximation still well below that reached by the ceramics. An accurate analysis of the geometric depictions has revealed the descriptive, analytical character; the sculpture particularly uses constant formulas, of almost hieroglyphic values, similar to the Homeric phraseology, which alter the figure according to various viewpoints.

More uncertain is the meaning of the figurations, even if the grand funerary and battle scenes are referred with good arguments to real life. The appearances of mythological representations in the late geometric art is still under discussion, and this is due to the typical character of the iconography and for an often excessively schematic approach to the problem. It would seem more realistic to say that a representation can also assume mythological content through the insertion of characteristic elements, such as the Aktorion-Molion twins.

Chronological conclusions are still rather discordant for certain classes of objects, such as bronze tripods. Concerning these, one of the more lucid summaries is to be found in the volume of B. Schweitzer dedicated to geometric art; the conclusions of the author, who favors later dating, give a beginning around 800 B.C. These conclusions are to be reconsidered as a result of the discovery of a form of fusion by tripod leg in a proto-geometric context at Lefkandi. The gold bands of Attica with animal friezes are by now securely documented at the first half of the VIII century B.C. (Kynosarges, tomb 19), but the origin of the matrices - too few to hypothesize an "orientalizing geometric" style - is still controversial: certain hypotheses suggest the eastern Aegean, others the Near East.

The Eastern-type art of the VII century B.C. - The Easternizing art of the Greek world by now appears to be inserted in a better-defined historic context, due in part to a more detailed knowledge of the situation in the Near East - Cyprus, Phoenicia, Syria, Assyria, Urartu, Phrygia, Iran. In ceramics, the Easternizing style is elaborated through the modification of Eastern stimuli, which occur with noticeable differences in various cities. For example, Corinth seems chronologically more advanced, while Athens, at this point more noted for the monumental production of the Keramikos necropolis, retreats into a splendid isolation. In the Greek-Oriental milieu, regional variations in the apparent uniformity of the "style of the wild goat" can be perceived, even if their precise locations are not known; the production of Samos nevertheless seems to distinguish itself for its inspiration and originality, while in the centers of the Aeolians the style is less certain, the design more awkward and angular. The excavations of Thasos and Neapolis (the modern Kavala) have contributed to clearing up in part the situation of the Cycladian schools; the "apple-tree" vases are almost certainly to be attributed to Paros, while the "nesiotic linear" (island

linear), which appears to have a connection with Phrygian ceramics, remains of uncertain origin. Crete shows close relations with the Near East, particularly Syria and Phoenicia, in the assimilation of Oriental practices and rites, as evidenced in vases used in religious observances, such as the one in which the liquid flows from a lion's protome.

In the West, a colonial Greek line emerges, which confidently modifies proto-Corinthian and Cycladian models (Megara Hyblaea, Metapontum, Pithecusa).

The richness of the figurative culture of Crete and of the Cyclades is also seen from numerous "pithoi" decorated in relief. The pertinence of the "Boeothic" pithoi to the Cycladian milieu is now certain, due to the discoveries of Tenos, which are from the VIII century B.C. These are monumental works, consisting of spirited figurines whose actions are depicted with great throughness ("pithos" with "Ilioupersis" at Mykonos). The artistic physiognomy of Sparta has been notably enriched through the discovery and publicizing of some "pithoi" in relief, decorated with processions of carts and hunting and battle scenes, from the end of the VII and the first years of the VI century B.C.

Of great importance for the Orientalizing culture is toreutics, but here the situation is rather more fluid than in ceramics, given the continuing uncertainty in the classification of Oriental products. The role played by Cyprus is still difficult to evaluate; among the more remarkable discoveries are the bronze cauldrons found in tomb no. 79 of Salamis, one with protomes of wrought mermaids and protomes of cast griffons. Perhaps some of the bronzes found in the cave of Ida on Crete are to be considered in relation with this island, produced in a city in which different cultural influences, some coming from as far as Iran, are intermingled. At Olympia the presence of protomes of mermaids, griffons, and lions on the same cauldron is at last proven; the truncated conical "hypokrateria" in laminated bronze were apparently produced in the same workshops. The various components find their counterparts in the late Hittite and Urartean cultural ambiences; the location of the workshops is still uncertain.

The most disconcerting new information is the discovery at Olympia, and to a greater extent at Arkades in Pediada, of a series of Cretan defensive arms, armor, and helmets; some of them with graphic inscriptions. They belong for the most part to the second half of the VII century B.C. and are decorated with probable mythological scenes, animals, and monsters, with a fantastic exuberance and a preference for sinuous and elastic lines, quite in contrast with the bronzes of Ida. Even the already significant series of the bronze plates has been enriched as a result of new discoveries in the sanctuary of Hermes at Kato Syme.

A much debated problem is that of the beginnings of the monumental sculpture, not only for the involvements with the Orient but also for the participation of the various cities of the Greek world. The insistence of the ancient tradition of the name of the Cretan Dedalus is confirmed in any case in the great statue of Astritsi, also in the first half of the VII century B.C.; this statue, and another of smaller dimensions found at Gortina, both of them incomplete, were of two separate parts; they throw new light on a probable passage of Diodorus (I 98,5 etc.) that recalls also the derivation of certain systems of proportion of the Egyptian art. On

the other hand, the participation of the regions of the Greek-Oriental world in the modification of monumental sculptures has clearly resulted from the systematic publication of the sculptures of Samos. The proposed dating to the VII century B.C. of the Archaios Naos on the Acropolis of Athens with its architectural ornamentation would involve a profound revision in the ancient Attica sculpture.

A field in which the documentation has noticeably increased of late is architecture. One of the more surprising discoveries is an apsed "oikos" at Eretria, also dating to the VIII century B.C., dedicated to Apollo Daphnephoros. Formed of a wooden framework that supported walls of twigs, it is a suggestive confirmation of the house of laurel that Pausanias (X 5,9) recalls as the first temple to the god at Delphi. For a certain period the "oikos" coexisted with a "Hekatompados" of an apsed floorplan, to which in the VII century B.C. a rectangular temple with peristyle succeeded. The order of this temple is uncertain, though it recalls the proto-Ionic Heraion of Samos.

Of exceptional importance is the publicizing of the temple of Poseidon at Isthmia, also in the first half of the VII century B.C., the earliest Doric temple of which enough is conserved to allow a reconstruction: the main room is 100 feet long, with steps and a peristyle of 7 by 19 columns, with a width-to-length ratio of 1:3. The walls of the nave, in porous blocks, were externally defined by semipillars and decorated both on the outside and the inside with paintings, of which minute fragments remain. Columns and architraves were apparently of wood, the roof in four sloping surfaces. The hypothetical first Heraion of Olympia has disappeared: the temple, which did not have predecessors, foresaw the peristyle in the original project; the room was divided into three naves by two rows of columns, to which corresponded semipillars against the walls. For the origin of the Ionic order, the excavations of the temple of Athena at Smirne, destroyed about 600 A.D. by Alyattes, is very important; it had a podium in a very accurate polygonal shape, bases or capitals of columns with crowns of leaves, and, to the sides of the access ramp, guardian lions of late Hittite tradition.

The Archaic art of the VI century B.C.- In spite of the intense excavations and the abundant bibliography, our knowledge of art history after the VII century B.C. is rather uneven. In the field of ceramic studies, the posthumous publication of the Paralipomena of J. D. Beazley makes a conspicuous addition to the monumental classification that this scholar has made of Attican ceramics. At the end of the proto-Attican era, the Artist of the Chimera and the Artist of Nettos are considered a single personality; the first representing the younger, more exuberant phase, the second depicting the maturation of the same artist. At the other extreme of the Attican production, the Lysippides artist and the Andokides artist, who collaborated on bilingual vases, are confirmed as two distinct personalities.

Among the Attican vases recently discovered, or newly publicized, is the "deinos" at the British Museum, signed by Sophilos, portraying the marriage of Peleus and Thetis; another representation of the same myth, also by Sophilos, was already known through some fragments of the Acropolis. The finding that caused the most excitement in the early 1970s was from the end of the VI century B.C. and uses the technique of the red figures; this is the chalice bowl signed by the vase-painter Euphronius and by the pottery-maker Euxytheos, showing Hypnos and Thanatos carrying the body of Sarpedote. This vase mysteriously ended up in the collection of the Metropolitan Museum of New York. More than for its quality, which is high but not exceptional, the piece is to be remembered for having brought the dramatic problem of the care of the Italian artistic patrimony to the attention of the often distracted public opinion.

A series of detailed investigations has contributed to clearing up various problems in the history of the archaic ceramics and in the relations between the various schools. Relations between the artists of the Siana type cups and the lesser masters appear closer than they had seemed, as the circulation of iconographics and decorative schemes shows. The Laconian pottery painting is known for its richness and complexity; personalities such as the Artist of Naukratis are justly considered among the greatest of the VI century B.C. In other ways the taking up of discarded theories, without plausible historical reasons, is clearly a regression: for example, the attribution of the Halcidic vases to a Greek island workshop, one of the most visible cases of an arbitrary attribution (CVA, Munich 6).

In the field of sculpture, different findings have shown the critical insufficiency of the traditional concept of the school, inadequate in a historical situation that was probably more characterized by itinerant masters: the differences that are perceived between works found in the same localities are often quite pronounced. Only in relatively isolated regions such as Boeotia can one follow the coherent development of local schools.

The Greek-Oriental world shows a certain homogeneity, with internal differences that are still elusive. The sculptures of the Didymaion - finally removed from the awkward alignment along the access way and restored to the inside of the sanctuary - show the total independence from the Eastern models that occurred during the VI century B.C.; their position in the Greek-Oriental sculptural milieu is described, however, by means of critically ambiguous concepts such as mass and dimension. Only the island of Samos appears to distinguish itself through a wider variety of types and a more secure treatment of drapery.

The situation of Attica and the Cyclades is uncertain, principally after the discovery of a "kouros" and a "kore" of marble at Merenda, the ancient Myrrhinous. The "kore" belongs to a previously known base, on which can be read its name, Phrasikleia, and the signature of the artist, Aristion of Paros (IG. 12 1014; L. H. Jeffrey, BSA. 57, 1962, 138, no. 46). The figure, datable to the middle of the VI century B.C., is solidly structured, with a compact drapery of linear folds, and can be considered part of the tradition of the goddess of Berlin, while the head recalls that of the "kouros" of Volomandra. The "kouros" is by a different artist, even though stylistically very similar; if it is the work of the master of the "kore" of Lyon, as has been suggested, the position of the latter in the scope of Attican sculpture becomes more definable. The fact remains, however, that the Cycladic traits in the works of Aristion are more attenuated than would have been expected. Reconstructions of works of the masters of archaic sculptures is still difficult and uneven, due in part to the

discontinuity of the documentation, unlike the case of ceramics.

A finding made in Crete should be noted: two "Kore" and a "kouros," without the head, and a seated sphinx with an Ionic capital. The eclecticism of these works brings up the problem of the formation of a local school at Cyrene, and therefore that of sculpture in the colonial Greek world of the West. The "kore" are similar to the production of Samos, while the head of the sphinx is reminiscent of sculptures of Egina and Athens. The variety of the cultural components is all the more evident from the two plates found at Selinunte, which can be added to the series of the "small metopes": one, with three female deities, has "Doric" parts, almost Dedalic; the other, with the extraordinary representation of a quadriga in perspective, with the outside horses rampant, seems to reveal some of the Ionic style. In such uncertainty, the sphinx recently found at Corinth should at least dispel the doubts on the pertinence of the "kouros" of Tenea to Corinthian art. A remarkable large bronze statue of Zeus found at Ugento, one of only a small number of such statues, is perhaps evidence of the art of Taranto from the end of the VI century. From the beginning of the same century is a winged female bust from Olympia, executed in the archaic technique of the "sphyrelaton."

An improvement has been made in the dating of the late Archaic period: an attentive reading of literary sources has dated the sculpture of the west facade of Alcmeonides at Delphi to the years after 514/513 B.C., while the treasure of the Athenians seems to belong to the years immediately successive to the battle of Marathon.

In the field of Archaic architecture, much knowledge has been gained through re-discoveries or more thorough publicizing of complexes that were already known. Ruins with vivid coloring have come to light in the temple of Aphaia at Egina that are complete enough to allow a reconstruction, though in part hypothetical. The temple of Apollo at Didyma turned out to be a key monument of Ionic architecture. Its plan is derived in part from that of the Heraion of Rhoikos at Samos and in part from the Artemision of Ephesus and develops an original concept that includes a sekos in an adyton ipetrale, while the epistyle bears a frieze of animals and, at the corners are protomes in the shape of gargons. Studies of the temple of Apollo at Naxos and of the architectural elements employed in the medieval fortress of Paros have allowed us to define the characteristics of the architecture of the Cyclades in the Archaic period. A number of buildings at Delphi have been attributed to this school: the treasures of Massalia, Cnidus, Klazomenai, Siphnos, and the Doric treasure in the "temenos" of Athena at Marmaria. Recurring characteristics of Cycladic architecture are the doors with monolithic jambs, the skirting-board molding of the walls, the frieze above the architrave, the spiral truss; of these many will be important in the formation of the Ionian-Attican orders of the V century B.C.

To the little that is known of the Ionic order in the West is now added a monumental temple from the end of the VI century B.C., never finished, uncovered at Syracuse a short distance from the Doric Athenaion, and a temple at Metapontum, probably from the first half of the V century B.C., both still under study.

The Syracuse temple is peripteral, probably composed of 6 columns by 18 columns; the bases, with spiral fluting, are similar to those of the Heraion of Samos, while the columns, with sharp-edged fluting, were destined to be "caelatae" in the lower part, as were those of Artemision at Ephesus. At Himera, above the famous Doric temple, another temple with a single elongated room has been discovered, perhaps in four parts (B), with rich architectural terra-cottas placed over a more modest ancient "oikos" (A); a little to the north was another building (C), perhaps a sacellum with an uncovered atrium, from as early as the beginning of the V century B.C. At Metapontum the foundations of two Doric temples have been completely uncovered. One, dedicated to Apollo, with a peristasis of 8 by 18 columns with a double row in front, recalls temple C of Selinunte; the other, a Heraion, placed over a previously incomplete building, appears to consist of a room with walls having Doric semi-columns on the outside. The Olympieion of Agrigento may have been modeled after it.

In the VI century B.C. temples could still be of extreme simplicity: at Hios the temple of Athena at Emporion was a simple "oikos" with flat roof, without any architectural ornamentation, having an altar near the base of the statue of the cult, according to a custom from remote times.

In a more specifically topographic site, traces of the ancient settlement at Tocra, the former Taucheira, were discovered in Cirenaica, where the Roman settlement was already known: probably these were the remains of votive offerings, very rich in Archaic pottery, dating from the period of the foundation of the colony.

In the VI century B.C., contacts with the Eastern world continued to be lively; it is this period that saw the beginning of the diffusion of Greek cultural elements, because of different historical reasons, that reached its maximum intensity with Hellenism. In the new Achemenid capital, Pasargade, the presence of Greek artisans can be seen in architectural details and in the techniques of working stone; the use of Ionic "kymation" is evident even in the tomb of Cyrus.

New perspectives on the art of the classical period: the V century B.C.- The imbalances that were encountered in the VI century B.C. increase in the V and the IV; this is all the more embarrassing in that this is the classic period, so important for the study of ancient art history, which has contributed in many ways to the formation of the modern European style. These two centuries are often treated together; in reality the differences in the artistic and social fields are rather marked and in the IV century the first signs of Hellenism mature.

The Attican ceramics are enriched by the addition of several pieces of highest quality: the amphora of the Artist of Berlin at Basel, with the solemn late-Archaic Athena, and Heracles, already done in a severe style; the cup with the bottom in white, by the Artist of Pistoxenos at Delphi, portraying Apollo with a crow, of very pure marking. In Italy, at Paestum, a tomb with a coffin has been discovered, painted in the late Archaic style; it is known as "the tomb of the diver" from the scene represented on the cover, probably scatological. It has a banquet scene on the sides. A comparison with the painted Etruscan tombs of the same era shows a notable

divergence in spirit and in style; nonetheless, this is still a provincial work and does not reach the level of the better Attican ceramics. An impression of the great Greek paintings, irretrievably lost, is conserved in places that are really outside the Greek world, in the painted tombs of Lycia. A tomb at Elmali (Kizilbel), also from the end of the VI century B.C., is probably the work of artists of Ionia and recalls the paintings of a house at Gordion; it has several rows of friezes representing hunts, warriors, and a decapitated Medusa from whose neck emerge Pegasus and Chrysaor. Another tomb of the same locality (Karaburun II) with battle scenes, an "ekphora," and the dead king on a throne and at a symposium, is from the beginning of the V century B.C.; in this tomb stylistic and iconographic elements of Greek and Achaemenid origin are joined.

The concept of the school, revealed as ambiguous in the VI century B.C., is still such in the V century. Even the sculptures of Olympia, the complex that is fundamental to the comprehension of the severe style, have not yet found a satisfactory framework; an attempt has been made to explain them as the casual result of a meeting of several masters who are independent and with different backgrounds. The documentation of the severe style in Sicily is enriched by a marble torso of a warrior, of high quality, perhaps a pedimental ornament, found in Agrigento, but its relation with the ineffable personality of Pythagoras is not certain.

The activity of publication has continued without pause, and complexes of fundamental importance, such as the face and the metopes of the Parthenon, are at last accessible to everyone, with all the related documentation. It is symptomatic, however, that the more controversial problems are still those that have occupied generations of scholars and that new discoveries, instead of moving towards a solution, complicate by making the uncertainty even more evident. The awkward bronze "kouros" of Piraeus is symbolic in this regard; previously considered as either an original late-Archaic or a work of the V century B.C. in Archaic style, it is now deemed to be a neo-Attican work. The doubts on the authenticity of the throne of Boston would seem to have finally been dispelled, thanks to an examination of naturalistic character of the marble, but the uncertainty of the setting - V century B.C. or the first half of the imperial era - has not been overcome. At least the problem of the "Leukothea" Albani finds its stylistic and iconographic counterpart in a funerary stele of Ikaria, sculpted by a Parian artist.

A certain progressive convergence of opinions is seen in the various attempts to reconstruct the shield of the Pheidian Parthenos, and it may be that a satisfactory reconstruction of the eastern face of the Parthenon has finally been achieved; this is done by grouping the almost frontal figure of Zeus seated on a rock in the center, an aesthetically convincing solution that takes into consideration the markings on the floor as well as the iconographic documentation. If we turn, however, to the analysis of the different masters of the V century B.C., the situation is attenuated in all its uncertainty. Exemplary in this regard is the matter of the four Amazons. In the early 1970s the belief had been gaining that the Mattei type should be attributed to Pheidias, the capitoline type to Polikleitos, the Sciarra type to Kresalis, and the Doria Pamphili type to Phradmon. According to a recent and unsupported hypothesis, only the capitoline type is of the V century; the Mattei type would be at the end of the IV century, and the others of the Augustean age: this is an example of how imprecise is the picture of the late-Hellenistic and imperial classicism.

To this period another work has been attributed: the bronze "Apollo" from Piombino, now at the Louvre, commonly considered an original of the V century B.C. But the renewed proposal to attribute the capitoline type to Pheidias, based on a new collection of literary sources and monuments, is very suggestive. The personality of the Argive Phradmon is enriched, at least, by the epigraphic testimony of one of his sculptures, the portrait of the priestess Charite; the identification with the type of Lysimachos is suggestive but not demonstrable. In spite of many doubts a positive factor is the reconstruction of the statue of the Nemesis of Ramnunte, the work of Agorakritos, based on numerous identified fragments in the museums of London and Athens; the reconstruction also has the merit of disproving the Aphrodite Doria Pamphili as a supposed replica of the Nemesis, confirmed nevertheless as pertinent to the Agorakritos circle. The characteristic minute and nervous hand of the master can be seen even from the drapery of the statue, which will be a cornerstone for the study of the post-Phidian art.

The other key figure in the comprehension of the sculpture of the second half of the V century B.C. is still Polikleitos, both for the works directly identified with him and for the "crux" represented by problems of the canon. The problem of the sculpture of Polikleitos is in the positioning of the figure in space by ponderation and the limbs projecting out or to the rear. In this sense the "quadratum" of the passage of Pliny (Nat. Hist. XXXIV 56), rather than a term derived from the rhethorical language, as had always been supposed, would seem to be tied to a bidimensional, classicist concept of the statuary; a valuation better understood in the milieu of late-Hellenistic classicism and of the first empire rather than of the post-Lysippean Hellenism. An indirect confirmation of this interpretation comes from attempts to reconstruct the system of Polikleitean proportions on the basis of minute measurements conducted on copies of a statue; from them different units of measure are derived, but with no relation to each other. This also ignores the fact that the copies of a statue, inasmuch as they are the expression of style of a particular historical moment, do not have an immediate documentary value; however, the study of the dating of the copies of the Roman era is still at its beginnings.

The two bronze statues of armed nude men, found in the sea at Riace near Reggio Calabria, will be of enormous interest for the history of classical art if they are proved to be originals of the V century B.C.; the scarcity of information and the limited facts made available to date have not yet allowed a proper evaluation.

Excavations have contributed in a decisive manner to the solution of some problems of Athenian topography and architecture, and the topography of the city has been the subject of exhaustive publications. In the Agora, immediately to the north of the stoa of Zeus, the Basileios stoa has been identified; a simple Doric portico dating from the end of the VI century B.C., to which were later added two projecting lateral portions. Of the poikile stoa the approximate site is known, as well as

various architectural elements, allowing a reconstruction of a Doric portico with a row of Ionic columns on the inside. Judging from the blocks used in the walls, which have numerous nail holes, the famous paintings appear to have been panels rather than frescoes.

Even in the study of architecture the "cruces" are not lacking, the most visible of these being the Parthenon and the temple of Apollo at Bassai. The phases of the Parthenon and their dating are controversial, even after painstaking research; for the building of the Periclean age, against all evidence, Pheidias has been claimed as the architect rather than Iktinos and Kallikrates. As for the temple of Bassai, a step towards solving this problem has perhaps been made by recognizing the double interaxis as a unit of measure, while the plan is made rational by moving the nave by a half interaxis; the dating, already moved ahead by more than half a century, seems to be concentrated in the years following the peace of Nicea (421 B.C.).

The continuing question of the nave of the temple of Segesta has finally been resolved in the most obvious of ways — by identifying the foundation trench of the nave and also some of the blocks of its walls.

Italiot ceramics - The situation today is rather more elaborate due to the efforts of A. D. Trendall. A discovery of exceptional importance for the proto-Italiot ceramics has been made in a tomb at Policoro, the ancient Eraclea. The compound is datable to the end of the V century B.C. and consists of vases by the artists of Amykos, Kreusas, and the Carneades and by a pottery maker, previously unknown, who has been called the Artist of Policoro; the subjects, rather varied, are mainly drawn from the tragedies of Euripides. The discovery proves the existence of respectable workshops at Ereclea and is important for the chronological relationship between some of the more important personalities of the proto-Italiot painting and also for the connections that can be perceived between the Lucanian and the Tarentine production.

The production of the Artist of Amykos is identified more clearly: the later vases attributed to this artist have been revealed rather as the work of another master, the Artist of Palermo. This artist was technically highly competent, with notable graphic capacity, principally in the detail, although somewhat uncertain in the larger compositions.

While the view of the Apulian production has remained substantially unchanged, the situations in Campania, Lucania, and Sicily are now more clear. At the origin of the Campanian, Pestian, and Sicilian productions are the Artists of the Chessboard and of Dirce, who descend from Attican painters of the Midian circle. They seem to have been active in Sicily, perhaps at Syracuse; their schools then seem to have expanded in various directions. In Sicily some vases of large dimensions are from the first half of the IV century B.C.; they are mainly chalices, ornamented with elaborate mythological scenes, and are particularly close to the contemporary Attican production of the best quality, such as the chalices portraying Odysseos and Maron and the death of Hyppolitos that were found at Lipari. That the larger paintings were done using models is evident from the preference for complicated draping of the figures and from the heads being foreshortened or in perspective.

Most of the Italiot production seems to have begun, however, around 340 B.C., after the Timoleontean restoration. Three main groups have been recognized: Lentini-Manfria, Etna, and Lipari; common to all is the preference for forms such as the lekane, the Skyphoid Pyxis, "Iekythos" for female subjects of a general or a Dionysian type and the common use of polychromy. Vases of the phlyakes are also found, such as a chalice of Lentini. The polychrome is particularly vivid on the vases of the Lipari group, from the end of the IV century B.C., decorated almost exclusively with Nikai and female figures. Siciliot production, as opposed to that of the schools at Paestum, Lucania, and Campania, maintains a decent quantity until the end, which apparently was around 300 B.C.; in the III century B.C., production of ornamented vases continues, with tendrils and geometric patterns on a dark background, a local variation of the Gnathia style.

Sculpture and architecture of the IV century B.C. - In the sculpture of the IV century B.C., two fixed points are the temple of Asklepios at Epidarus (380/370 B.C.) and the sarcophagus of Alexandria (after 312 B.C.). Some of the more interesting results will probably come out of the study and the reconstruction of the already known complexes, such as the sculptures of the temple of Asklepios at Epidaurus or the Mausoleum of Halicarnassus, to which new parts are continuously being added. The sculptures of the two facades of the temple of Asklepios - the battle of the Amazons and "Ilioupersis" - present divergent stylistic characters and reveal little of the style of Timotheos, showing how the "typoi" (if these are in fact models of the facades) are to be understood in a rather indirect sense. The central akroteria consisted of two figures of Nikai; Nikai were also used as lateral akroteria on the temple of Artemis.

Attempts to connect the known personalities from literary sources with the types of statues documented have been pursued, sometimes with great precision and with an attentive consideration given to the bases that have survived. The results, however, are widely discordant and often disappointing, both for the ambiguity of the sources and for the objective difficulties in identifying single personalities in a series of works known exclusively from copies done in the Roman era. The school of Polikleitos seems be distinguished for a preference for athletic figures and paradoxically for a relative independence from the three-dimensional conquests of the master; the reasons for this are to be sought in the general approach to sculpture in the IV century B.C.

The embarassment that comes from this situation, and its substantial equivocation, is evident when one attempts to compare originals, such as the bronze Athena and Artemis found at Piraeus, with the "kouros" already mentioned. Thus the temptation to connect the works to the great names is too strong: Athena has been attributed to Euphranor or identified with a statue of Kephisodotos at Piraeus cited by Pliny (Nat. Hist. XXXIV 74) and Pausanias (I 1,3); however, the latter hypothesis is improbable, as the bronzes must have been hidden at the time of the sack of Scylla. In the current situation, a different approach from the strictly philological one of a reexamination of literary sources seems more promising; better would be the consideration of the proper setting of phenomena as historical representations and the origins of portraiture. These are

complex problems that are to be met keeping in mind the purchaser-artist relations and the connections with the Near East.

The historical representations originate as proud affirmations of the single work ("pinax" of the architect Mandrokles of Samos, the creator of the bridge over the Bosphorus for Darius) or as a dedication of the "polis," with normative value, leveller of the individual restored to his function as citizen; the realistic representation of an historic episode, even with all its programmatic implications, is confirmed only at the end of the IV century B.C. The battle of Alexandria, conserved in the mosaic of the house of the Faun at Pompeii, probably is based on a painting of Philoxenos of Eretria; it is the first historical painting in which a descriptive intent is evident, as well as a commemorative one, in the realism - tactical as well - of the battle.

An analogous phenomenon is that of the portrait: the Tyrannicides in the Agora of Athens are honorary statues, of a model citizen rather than of an exceptional personage. The historical requirements for the formation of realistic portraits are verified in the IV century B.C. with the growing secularization of culture and the crisis in the "polis"; the beginnings, however, can already be found in the V century B.C. in the private sphere and in the outlying areas of the Greek world. The portrait of Temistocles, before the middle of the V century, will be the one dedicated privately by the Athenian state in the sanctuary of Artemis Aristoboule, or the public one erected to him in the Agora of Magnesia, which had been given to him by the king of Persia - in both cases an individual in conflict with the norms of the "polis." It is certainly not by chance that some of the earliest portraits in a physiognomic sense are found on the coins minted at the end of the V century B.C. by Persian satraps in Asia Minor. The same tension between realistic intent and exemplary image is found in the IV century B.C., comparing two portraits of Socrates, a private one, perhaps from the beginning of the century, and one that is a work of Lysippos, offered in propitiation to the "polis." A bronze head of extraordinary quality, representing an old man with a long beard in the subtle tones characteristic of the beginning of the IV century B.C., has recently been found in the sea at Porticello in the Strait of Messina.

The most notable contribution to the sculpture of the IV century B.C. comes not from Greece, but from a region such as Lycia, in which Greek artists were apparently active for some time in the service of the local dynasties and contributed to the formation of an indigenous school that was strongly Hellenized. At Kadyanda a funerary monument from the beginning of the IV century B.C., of the traditional Lycean type and already well known, has been graphically recomposed. The most notable discovery was, however, at Limyra, where a monumental tomb has been found from the second quarter of the IV century B.C., perhaps from the local dynasty of Pericles. The building, amphiprostyle, was ornamented on the sides with a frieze representing the "ekophora" and a procession of horsemen; it had caryatids in place of columns and, as akroteria, Perseus with the head of Medusa, and two running Gorgons.

The statues of the V century B.C. are three-dimensional bodies positioned in space, which maintain their independence even if part of a group: the observer can move around freely and communicate directly. In the IV century B.C. the relationship with the observer becomes more subtle and indirect, and the space in which the figure is inserted becomes itself an object of representation: this leads an observer to study the statue from a certain distance, concentrating the possible points of view over a wider field. If several statues are united to form a group, it is to be considered as a whole and the viewer is kept on the outside; thus one side of the figure is considered as secondary, destined not to be seen. The new concept of the group, no longer additive, thus positions the figures in an area isolated from the surrounding world. Thus an illusionistic concept is added to the "ingenuous" three-dimensionality of the V century B.C., which had found its most complete expression in the "doryphoros" of Polikleitos; it is exemplified in the "apoxyomenos" of Lysippos and will be manifested in all its evidence in the early Hellenism. It is just this complete adhesion to the ways of the IV century B.C. that suggests the recognition of Hermes of Olympia as a work of Praxiteles surpassing the vicious cycle of technical and stylistic character that were founded on the presupposition of the reciprocal validity.

A splendid bronze cup with Dyonisian scenes of the late IV century B.C., found at Derveni, is still practically unpublicized and brings up again the problem of identifying the centers of production of the bronze and the gold found in northern Greece and in the Balkans.

The architecture of Argolides in the IV and III centuries B.C. presents some peculiar characteristics that allow us to speak of a local school. Perhaps some tendencies common to the Hellenistic era are to be ascribed to it, such as the use of Corinthian capitals, semicolumns, and the preference for the long, thin Doric columns. At Epidaurus an Ionic temple (L) has been reconstructed, perhaps of the III century B.C. if not actually of advanced Hellenism, notable for its layout: it is hexastyle pseudo-peripteral, with Corinthian columns inside against the walls. Another Peloponnesian temple, of Zeus at Nemea, has been exhaustively publicized: with its plan of 6 by 12 columns and the cella without opisthodomos, it is connected to a frontal view that will be developed in a Hellenistic architectural stage setting. The affinity with the earliest temple of Athena Alea at Tegea can be explained by the community of tradition rather than by attributing it to the same builders.

Of considerable interest are the new studies and research on the temple of Artemis at Ephesus, reconstructed after the fire set by Herostratos in 356 B.C. The new building, substantially the same as the preceding one, rose on a podium 13 steps high, with the level of the "sekos" ipetrale, for cult reasons, remaining as before. In the new reconstruction, only the front side, the west, was topped by a pediment, while the rear face had a sloping roof. Some details, however, are debatable: the "geison" between two rows of ovuli, reconstructed by analogy with the altar, and the positioning of the ornamented cylindrical drums at the top of the columns. In front of the temple rose a monumental altar in the form of a porticoed court of Ionic order, on a high socle open towards the west; in the socle was inserted a frieze, with a plaque portraying an amazon of Sciarra type (recently attributed to the Augustean age). For the construction and the ornamentation, the altar constitutes a precedent for those of Pergamon, Magnesia, and Priene. An interesting example of provincial Doric architecture is a small temple of Megara Hyblaea from

the end of the IV century B.C.; in Asia Minor the Ionic temple of Hemitheia at Kastabos demonstrates the assimilation of Doric conventions.

Hellenism. - The uncertainties in the study of the classic era have been noted. In Hellenism the situation is still more confused, due to the scarcity of chronological reference points, the poorness of the documents, and the problems posed by the new discoveries. The spreading of the Greek culture becomes extensive even in the far territories; a Hellenistic "koinè" spreads throughout central and southern Italy, probably through the cities of Magna Grecia, particularly Taranto. Monuments such as the painted tomb of Giglioli of Tarquinia are the provincial reflection of the Macedonian ceremonial art.

In the field of painting and mosaics, the new discoveries are limited mostly to the edition or the re-edition of monuments that are already known; this is the case of Delos, Pella, and Vergina. The great Hellenistic painting is irretrievably lost, the vase painting is gone; all that remains are the reflections in mosaics and the paintings of the Roman era.

Documentation of the sculpture is more abundant, but with enormous gaps and uncertainties. The period of the late Hellenistic classicism often becomes a comfortable refuge for problematic works, its artistic valuation is varying - and this can't be explained by the particular style of an era - first-class works such as the prototype of Niobe with her daughter are casually moved from the end of the IV century B.C. (Kunzl) to the I century B.C. (Weber). Only in specialized fields, such as ceramics, does an effective increase in knowledge follow from an increase in the material available.

The points of reference for the study of the beginnings of Hellenism are still the Tyche of Antioch, the work of Eutychides, from the beginning of the III century B.C., and the great votive offering of Attalos I at Pergamon, perhaps by Epigonos, datable to 230/220 B.C. and conserved in copies of the Roman era. The former continues tendencies already manifested in the sculpture of the IV century B.C., causing the observer to continuously change his point of observation, almost reaching an isolation in space that allows it to be seen from all sides; in the latter the composition is wider, with the view from the back being clearly secondary. Between these extremes are the originals of works such as the child strangling the goose - if it is by Boethos, it probably is not by the same artist who signed the Eros Enagonios of Mahdia, much later - and the girl of Anzio, although its chronology has again been questioned. The historical consistency of the Bythinian Doidalsas has also been doubted; the original of Aphrodite bathing is, however, definitely a work of the middle of the III century.

The reconstruction proposed by A. Schober for the votive offering of Attalos I, on the round base in front of the temple of Athena Polias, having the Ludovisi group in the center and surrounded by four fallen soldiers, must be abandoned: such a composition is only found in the modern era and clearly shows the equivocal character of the baroque concept when applied to ancient art. The "greater offering" consisted probably of a series of figures aligned on a long rectangular base, of which some inscribed blocks have survived, perhaps in the southern part of the "temenos" of Athena Polias. The figures of the "lesser offering" - Galatians, Persians, Amazons - take some ideas from the "greater offering," but simplified and constrained to forced poses. The displacement of the viewpoint is also noticeably reduced, almost coinciding with the frontal view, which will finally be reached in the late Hellenism. The frontal view, a composition that deliberately leans toward the sentimental effect, treats the "lesser offering" in common with the originals of the famous group of Pasquini and that of Achilles and Pentesilea; the latter has recently been restored to its original appearance and probably dates from the second half of the II century B.C.

In the field of portraiture, a detailed study of the coins of the Hellenistic kingdoms between 220 and 160 B.C. will lead to a revision of the iconography of the different dynasties. The relief with the triumph of Homer, signed by Archelaos of Triene, is from the second half of the II century B.C., probably around the years 130 to 120 B.C. The Muses that are represented there eclectically take up the late-Hellenistic prototypes of different cycles; the identification of one of these with the Muses of Philiskos of Rhodes, noted by Pliny, is somewhat in doubt.

The most debated problem of the late-Hellenistic sculpture in the last few years is that of the groupings found in the cave of Tiberius at Sperlonga; as one of these has the signature of the Rhodian sculptors Hagesandros, Apollodoros, and Athanodoros, already known as the authors of the group of Laocoon; the discussion in the end involved the latter as well. On the other hand, the recent restoration of the Laocoon has reopened the problem of its dating - no longer bound by the genealogy reconstructed by Ch. Blinkenberg, found to be in error. The variation in the proposed dating - from the altar of Pergamon to the age of the Flavii - is very wide and shows how generic our knowledge of Hellenistic art in its contradictory manifestations is. In the particular case of Sperlonga, a judgment is made even more difficult by the fact that, in spite of the number of bibliographies and a publication that would seem to be definitive, the ongoing restoration work can still provide some surprises. The problem has multiple aspects: the chronological relationship between the various groups, the dating of the sculptures, and whether the sculptures are originals or copies. From a reexaminations of the geneologies of the Rhodian sculptors, the possible datings seem to be the end of the II or the first half of the I century B.C.; however, the study of the replicas suggests that none of the groups in question seems to be a prototype. The Laocoon group, notwithstanding the considerable modifications made during restoration, seems to be set against an imaginary background; the same setting in seen also in the group of the blinding of Polyphemos. A greater problem is the reconstruction of the group of Scylla and of the ship, on which are the signatures of the artists. The setting of the prototype in the proper framework thus returns to criteria of a stylistic character: in this way, the attribution of the Rhodian sculptures to the second half of the II century B.C. now seems the most probable. An interesting element of the sculptures of Sperlonga is their exposition in a cave, with a taste for the mingling of art and nature that is characteristic of the Rhodian culture of the Hellenistic age and, at another level, shows itself in the creation of a type of park.

Other centers, such as Samos, present rather a less defined aspect. Retrospective currents of the late Hellenism remain to be dealt with; the indiscriminate attribution of very different works, which for various reasons present problems - such as the "kouros" of Piombino or the Amazon of Sciarra - result in causing more confusion in an already uncertain period. Recently a systematic treatment has been undertaken for the nude male figure, showing how different types of works are already freely combined at the end of the II century B.C.; in this context the Farnese "anadoumenos" is revealed as a variant of the Polikleitean "diadoumenos," perhaps of the I century B.C. The bronze "kouros" of Piraeus may be a retrospective work; the throne of the priest of Dionysius in the theater of Athens, commonly believed to be neo-Attican, seems rather to be a work of the fourth century A.D.

One of the Hellenistic monuments of controversial dating is the Doric temple of Athena at Troy, for which extreme datings have been proposed, from the III to the I century B.C., with diametrically opposed valuations of its architecture and the sculptural ornamentation. This doubt at least seems to be by now resolved, and in favor of the higher dating. An accurate examination of the architecture has brought out the rational, almost schematic, characters that place it in the evolution from the temple of Nemea to the temple of Athena Polias at Pergamon. Even the metopes find a correspondence in works of early Hellenism and seem to be a lesser, almost provincial, version of the Rhodian art.

One of the localities in which excavations have been resumed is Knidos. An identification of the temple in which the famous statue of Aphrodite was placed has been proposed in a "monopteros" of this site, based on a comparison with a Doric "monopteros" in the Villa Adriana of Tivoli, where a copy of the Venus of Knidos had been found; the building seems later than the IV century B.C., however, and the identification has some problems. At Xanthos, in Lycia, the sanctuary of Latona is being excavated; among other things an Ionic temple (A) from the end of the III century B.C. has been identified, with a peristasis of 6 by 11 columns, and a Doric temple (B), also with a peristasis of 6 by 11 columns, of the first half of the II century B.C.; in the latter the cella is a mosaic with an arch, a quiver, and a lyre, an obvious reference to Artemis and Apollo.

A major new Hellenistic palace has been added to those already known, an imposing example at Demetriade, brought to light by an excavation on the site in which the Agora had been supposed. The plan is that already known of Pella and Vergina, with a rectangular porticoed court around which are set the various rooms.

Knowledge of Hellenism in central Asia, limited until now to what has been learned from coinage and a few portraits, has expanded recently as a result of an exceptional discovery: Ai Khanum - whose original name is unknown - a city of Bactriana on the Amudarya, on the territory of present-day Afghanistan. The city, although in wider dimensions, reveals its Greek matrix in the general layout and in the individual buildings, among which a gymnasium and a "heroon," probably dedicated to the ekista. The most spectacular complex is a porticoed court, from which one reachs a hypostyle room with Corinthian columns; its destination - palace or Agora - is still uncertain. A temple with a square floor plan and external walls containing niches is more of a Mesopotamian type, thus showing a composite culture of the colonies. Due to the scarcity of stones, the sculptures were mostly in clay and stucco; the external layer is often separated from the center by a covering of cloth, which prevented a too rapid drying that would have wrinkled the surface. The same technique is found in many sculptures in stucco in central Asia, thereby demonstrating a knowledge of the style and iconography of the Greek world. Ai Khanum is thus revealed as a fundamental element for understanding the cultures of Asia, from Parthia to Gandhāra, and also was the foundation for the successive kingdom of Kusāna. A more modest Hellenistic settlement has been identified at Failaka, an island in the Persian Gulf. An invasion of nomad populations at the end of the II century B.C. provoked the collapse of the Greek states in those far regions.

BIBLIOGRAPHY - *General works.* E. Akurgal, Orient und Okzident. Die Geburt der griechischen Kunst, Baden-Baden, 1966; P.E. Arias, L'arte della Grecia, Torino, 1967; B. Ashmole, Architect and sculptor in classical Greece, London, 1972; G. Becatti, L'arte dell'età classica, Firenze, 1971; J. Boardman, Greek art, London, 1964; J. Boardman, J. Dörig, W. Fuchs, M. Hirmer, Die griechische Kunst, München, 1966; J. Carter, The beginnings of narrative art in the Greek geometric period, BSA, LXVII, 1972; J. Charbonneaux, R. Martin, F. Villard, Grèce archaïque (620-480 av. J.-C.), Paris, 1968; J. Charbonneaux, R. Martin, F. Villard, Grèce classique (480-330 av. J.-C.), Paris, 1969; J. Charbonneaux, R. Martin, F. Villard, Grèce hellénistique (330-50 av. J.-C.), Paris, 1970; P. Demargne, Naissance de l'art grec, Paris, 1964; V.R. d'A. Desborough, The Greek dark ages, London, 1972; K. Fittschen, Untersuchungen zum Beginn der Sagendarstellungen bei den Griechen, Berlin, 1969; W. Gauer, Weihgeschenke aus den Perserkriegen, Ist. Mitt., Beih. 2, Tübingen, 1968; Ch. M. Havelock, Hellenistic art, London, 1971; T. Hölscher, Griechische Historienbilder des 5. und 4. Jhs. v. Chr., Würzburg, 1973; E. Homann Wedeking, Das archaische Griechenland, Baden-Baden, 1966; J. Kleine, Untersuchungen zur Chronologie der attischen Kunst von Peisistratos bis Themistokles, Ist. Mitt. Beih. 8, Tübingen, 1973; N.M. Kontoleon, Aspects de la Grèce prèclassique, Paris, 1970; E. Langlotz, L'arte della Magna Grecia. Arte greca in Italia meridionale e Sicilia, Roma, 1968; E. Langlotz, Studien zur nordostgriechischen Kunst, Mainz, 1975; H. Lauter, Kunst und Landschaft, ein Beitrag zum rhodischen Hellenismus, Ant. Kunst, XV, 1972; K. Papaioannou, Griechische Kunst, Freiburg-Basel-Wien, 1972; H. Philipp, Tektonon daidala. Der bildende Künstler und sein Werk im vorplatonischen Schriftum, Berlin, 1968; P.J. Riis, Sūkās I. The north-east sanctuary and the first settling of Greeks in Syria and Palestina, København, 1970; M. Robertson, A History of Greek Art, Cambridge, 1975; K. Schefold, Klassisches Griechenland, Baden-Baden, 1965; K. Schefold, Die Griechen und ihre Nachbarn, Berlin, 1967; B. Schweitzer, Die geometrische Kunst Griechenlands, Köln, 1969; A. M. Snodgrass, The dark age of Greece, Edinburgh, 1971; H. von Steuben, Frühe Sagendarstellungen in Korinth und Athen, Berlin, 1968; T.B.L. Webster, Hellenistic Art, London, 1967.

Architecture. P. Auberson, Temple d'Apollon Daphnéphoros. Eretria, fouilles et recherches, I, Berne, 1968; A. Bammer, Die Architektur des jüngeren Artemision von Ephesos, Wiesbaden, 1972; A. Bammer, Der Altar des jüngeren Artemision von Ephesos, AAnz., 1968; H. Bauer,

Korinthische Kapitelle des 4. und 3. Jhs. v. Chr., AM, 3, Beih., Berlin, 1973; O. Broneer, Temple of Poseidon, Isthmia I, Princeton, 1971; J.M. Cook, W.H. Plommer, The santuary of Hemithea at Kastabos, Cambridge, 1966; H. Drerup, Griechische Baukunst in geometrischer Zeit, Archaeol. homerica, III O, Göttingen, 1969; G. V. Gentili, Il grande tempio ionico di Siracusa, Palladio, XVII, 1967; A. Giuliano, Urbanistica delle cittàgreche, Milano, 1966; G. Gruben, Die Tempel der Griechen, München, 1976; G. Gruben, Kykladische Architektur, Münchner Jb, XXIII, 1972; B. H. Hill, The temple of Zeus at Nemea, Princeton, 1966; H. Lauter, Ptolemais in Libyen. Ein Beitrag zur Baukunst Alexandrias, JdI, LXXXVI, 1971; G. Lavas, Altgriechisches Temenos. Baukörper und Raumbildung, Basel, 1974; G. Roux, L'architecture de l'Argolide aux IVᵉet IIIᵉ siècles av. J.-C., Paris, 1961; W. Höpfner, Zum Entwurf des Athena-Tempels in Ilion, AM, LXXXIV, 1969; A. Mallwitz, Olympia und seine Bauten, München, 1972; D. Ohly, E.L. Schwandner, Aegina, Aphaia-Tempel II, AAnz., 1971; A. K. Orlandos, Les matériaux de construction et la technique architecturale des anciens grecs, I, Paris, 1966; U. Pannuti, Il tempio di Apollo Epikourios a Bassai (Phigalia). Storia, struttura e problemi, MemLinc, XVI, 1971; H. Schläger, Beobachtungen am Tempel von Segesta, RM, LXXV, 1968; G. Vallet, F. Villard, Mégara Hyblaea 4, le temple du IVᵉ siècle, Mél., suppl. 1, Paris, 1966; D. Wesenberg, Kapitelle und Basen, Bonner Jb, Beih. 32, Düsseldorf, 1971.

Sculpture. Sh. Adam, The technique of Greek sculpture in the archaic and classical periods, BSA, suppl. 3, London, 1967; D. Arnold, Die Polykletnachfolge, JdI, Erg. H. 25, Berlin, 1969; E. Berger, Der neue Amazonenkopf im Basler Antikenmuseum, ein Beitrag zur hellenistischen Achill-Penthesilea-Gruppe, Gestalt und Geschichte, Festschrift K. Schefold, Ant. Kunst, Beih. 4, Bern, 1967; E. Berger, Die Geburt der Athena im Ostgiebel des Parthenon, Basel, 1974; I. Beyer, Die Datierung der grossen Reliefgiebel des Alten Athenatempels der Akropolis. Mit einem Beitrag von F. Preisshofen, AAnz., 1977; H. Biesantz, Die thessalischen Grabreliefs. Studien zur nordgriechischen Kunst, Mainz, 1965; P.C. Bol, Die Skulpturen des Schiffsfundes von Antikythera, AM, 2. Beih., Berlin, 1972; A.H. Borbein, Die griechische Statue des 4. Jhs. v. Chr. Formanaltische Untersuchungen zur Kunst der Nachklassik, JdI, LXXXVIII, 1973; J. Borchhardt, G. Neumann, Dynastische Grabanlagen von Kadyanda, AAnz., 1968; J. Borchhardt, Epichorische, gräkopersich beeinflusste Reliefs in Kilikien, Ist. Mitt., XVIII, 1968; J. Borchhardt, Die Bauskulpturen des Heroons von Limyra, das Grabmal des lykischen Königs Perikles, Ist. Forsch., XXXII, Berlin, 1976; F. Brommer, Die Skulpturen der Parthenon-Giebel, Mainz, 1963; F. Brommer, Die Methopen des Parthenon, Mainz, 1967; B. R. Brown, Anticlassicism in Greek sculpture of the IV century B.C., New York, 1973; W.A.P. Childer, Prolegomena to a lycian chronology: the Nereids monument from Xanthos, Opusc. Rom., IX, 1973; F. Coarelli, Sperlonga e Tiberio, Dialoghi di Archeol., VII, 1973, B. Conticello, B. Andreae, Die Skulpturen von Sperlonga, Antike Plastik, XIV, Berlin, 1974; M.-Th. Couilloud, Les monuments funéraires de Rhénée, Explor. archéol. de Délos, XXX, Paris, 1974; C. Davaras, Die Statue aus Astritsi, Ant. Kunst, Beih. 8, Bern, 1972; E. De Miro, Il guerriero di Agrigento e la scultura di stile severo in Sicilia, Cronache di archeol. e storia dell'arte, VII, 1968; V. R. d'A. Desborough, R. V. Nicholls, M. Popham, A euboean centaur, BSA, LXV, 1970; G. I. Despinis, Ein neues Werk des Damophon, AAnz., 1966; W. Deyhle, Meisterfragen der archaischen Plastik Attikas, AM, LXXXIV, 1969; J. Ducat,

Les kouroi du Ptoion, Paris, 1971; J. Frel, Sculpteurs attiques de la fin du 5ème et du 4ème siècle, Listy Filologické, XC, 1967; J. Frel, The sculptor to the kouros from Myrrhinous, Athens Ann. of archaeology, VI, 1973; B. Freyer-Schauenburg, Elfenbeine aus dem samischen Heraion. Figürliches, Gefässe und Siegel, Hamburg, 1966; B. Freyer-Schauenburg, Bildwerke der archaischen Zeit und des strengen Stils, Samos, XI, Berlin, 1974; W. Fuchs, Die Skulptur der Griechen, München, 1969; W. Gauer, Die griechischen Bildnisse der klassischen Zeit als politische und persönliche Denkmäler, JdI, LXXXIII, 1968; V. von Graeve, Der Alexandersarkophag und seine Werkstatt, Ist. Forsch., XXVIII, Berlin, 1970; E.B. Harrison, Archaic and Archaistic Sculpture. The Athenian Agora, XI, Princeton, 1965; E.B. Harrison, Athena and Athens in the east pediment of the Parthenon, AJA, LXXI, 1967; W.D. Heilmeyer, Frühe olympische Tonfiguren, Olymp. Forsch., VII, Berlin, 1972; H.-V. Hermann, Werkstätten geometrischer Bronzoplastik JdI, LXXXII, 1964; F. Hiller, Formgeschichtliche Untersuchungen zur griechischen Statue des späten 5. Jhs. v. Chr., Mainz, 1971; H. Hiller, Ionische Grabreliefs der ersten Hälfte des 5. Jahrhunderts v. Chr., Ist. Mitt., Beih., 12, Tübingen, 1975; N. Himmelmann Wildschütz, Bemerkungen zur geometrischen Plastik, Berlin, 1964; R. Horn, Hellenistische Bildwerke aus Samos, Samos, XII, Berlin, 1972; H. Jucker, Zur Heliosmetope aus Ilion, AAnz., 1969; E. Künzl, Frühhellenistische Gruppen, Köln, 1968; E. Künzl, Die Kelten des Epigonos von Pergamon, Würzburg 1971; H. Kyrieleis, Bildnisse der Ptolomäer, Berlin, 1975; S. Lagona, Pitagora di Reggio, Cronache di archeol, e storia dell'arte, VI, 1967; H. Lauter, Zur Chronologie römischer Kopien nach Originalen des V. Jhs., Bonn, 1966; A. Linfert, Von Polyklet zu Lysipp. Polyklets Schule und ihr Verhältnis zu Skopas von Paros, Freiburg, 1966; A. Linfert, Der Meister der "kauernden Aphrodite,"AM, LXXXIV, 1969; A. Linfert, Kunstzentren hellenistischer Zeit, Wiesbaden, 1976; Th. Lorenz, Polyklet, Wiesbaden, 1972; M. Maass, Die Prohedrie des Dionysostheaters in Athen, München, 1972; E. L. Marangou, Lakonische Elfenbein- und Beinschnitzerein, Tübingen, 1969; D. Metzler, Porträt und Gesellschaft, Ueber die Entstehung des griechischen Porträts in der Klassik, Münster, 1971; P. Moreno, Testimonianze per la teoria artistica di Lisippo, Treviso, 1974; P. Moreno, Lisippo I, Bari, 1974; J. G. Pedley, The archaic favissa at Cyrene, AJA, LXXV, 1971; D. Pinkwart, Das Relief des Archelaos von Priene und die "Musen des Philiskos", Kallmünz, 1965; G. M. A. Richter, The portraits of the Greeks, London, 1965 (suppl., London, 1972); G.M.A. Richter, Korai, archaic Greek maidens, London, 1968; G.M.A. Richter, Kouroi, archaic Greek youths, London-New York, 1970, G. Rizza, V. Santa Maria Scrinari, Il santuario sull'acropoli di Gortina, I, Roma, 1968; B. Schlörb, Untersuchungen zur Bildhauergeneration nach Phidias, Waldsassen, 1964; B. Schlörb, Timotheos, JdI, Erg. H. 22, Berlin, 1965; K. Schefold, Die Athena des Piräus, Ant. Kunst, 14, 1971, E. Simon, T. Hölscher, Die Amazonenschlacht auf dem Schild der Athena Parthenos, AM, XCI, 1976; B. Sismondo Ridgway, The bronze Apollo from Piombino in the Louvre, Antike Plastik, VII, Berlin, 1967; B. Sismondo Ridgway, The severe style in Greek sculpture, Princeton, 1970; B. Sismondo Ridgway, A story of five Amazons, AJA, LXXVIII, 1974; H von Steuben, Der Kanon des Polyklet. Doryphoros und Amazone, Tübingen, 1973; V.M. Strocka, Piräusreliefs und Parthenonschild. Versuch einer Wiederherstellung der Amazonomachie des Phidias, Bochum, 1967; K. Tuchelt, Die archaischen Skulpturen von Didyma. Beiträge zur griechischen Plastik in Kleinasien, Ist. Forsch., XXVII, Berlin, 1970; V. Tusa, Due nuove metope

arcaiche da Selinunte, AC, XXI, 1969; K. Wallenstein, Korinthische Plastik des 7. und 6. Jhs. v. Chr., Bonn, 1971; M. Weber, Die Amazonen von Ephesos, JdI, XCI, 1976; D. White, The Cyrene Sphinx, its capital and its column, AJA, LXXV, 1971; D. Willers, Zu den Anfängen der archaistischen Plastik in Griechenland, AM, 4 Beih., Berlin, 1975; W. J. Young, B. Ashmole, The Boston Relief and the Ludovisi Throne, BMFA, 66, 1968; P. Zanker, Klassizistische Statuen. Studien zur Veränderung des Kunstgeschmacks in der römischen Kaiserzeit, Mainz, 1974; F. Zevi, Tre iscrizioni con firme di artisti greci, Rend. Pont. Acc., XLII, 1969-70.

Paintings, ceramics, mosaics. G. Ahlberg, Fighting on land and sea in Greek geometric art, Stockholm, 1971; G. Ahlberg, Prothesis and ekphora in Greek geometric art, Göteborg, 1971; P.E. Arias, Storia della ceramica di età arcaica, classica ed ellenistica e della pittura di età arcaica e classica, Torino, 1963; P.E. Arias, Il grande cratere di Euphronios di New York, Ann. Scuola Normale di Pisa, serie Ill, 3, 1973; J.D. Beazley, Paralipomena, additions to attic black-figure vase-painters and to attic red-figure vase-painters, Oxford, 1971; J. L. Benson, Horse, bird and man. The origins of Greek painting, Amherst, 1970; J. Boardman, Attic black figure vases. A handbook, London, 1974; J. Boardman, Athenian red figure vases, the archaic period, London, 1975; F. Brommer, Vasenlisten zur griechischen Heldensage, Marburg, 1974; Ph. Bruneau, Les mosaïques, Explor. archéol. de Délos, XXIX, Paris, 1972; D. Callipolitis-Feytmans, Deux coupes à figure noires du Musée National d'Athènes, Revue archéol., 1972; J.N. Coldstream, Greek geometric pottery, London, 1968; J.N. Coldstream, The Cesnola Painter, a change of address, Bull. Inst. of Class. Stud., XVIII, 1971; R. Hampe, Kreitsche Löwenschale des siebten Jhs. v. Chr. SbHeidelberg, 1969, 2; P. Kahane, Ikonologische Untersuchungen zur griechischgeometrischen Kunst. Der Cesnola-Krater aus Kourion im Metr. Mus., Ant. Kunst, XVI, 1973; N.M. Kontoleon, Die frühgriechische Reliefkunst, 1969; K. Kübler, Die Nekropole des späten 8. bis frühen 6. Jhs., Kerameikos, VI, 2, Berlin, 1970; D. C. Kurtz, Athenian white lekythoi, patterns and painters, Oxford, 1975; M. J. Mellink, Notes on Anatolian wall painting, Mél. Mansel I, Ankara, 1974; P. Moreno, Il realismo nella pittura greca del IV sec, B.C., RIASA, XIII-XIV, 1964-65; M. Napoli, La tomba del tuffatore. La scoperta della grande pittura greca, Bari, 1970; D. Papastamos, Melische Amphoren, Münster, 1970; C.M. Robertson, Greek mosaics, JHS, LXXXV, 1965; A. Ruckert, Frühe Keramik Böotiens, Ant. Kunst, Beih. 10, Bern, 1976; J. Schäfer, Hellenistische Keramik aus Pergamon, Berlin, 1968; K. Schauenburg, Zu attischen Kleinmeisterschalen, AAnz., 1974; E. Simon, Die griechischen Vasen, München, 1976; C.M. Stibbe, Lakonische Vasenmaler des 6. Jhs. v. Chr., Amsterdam, 1972; A.D. Trendall, The red-figured vases of Lucania, Campania and Sicily, Oxford, 1967; A. D. Trendall, First Suppl., Bull. Inst. of Class. Stud., suppl. XXVI, London, 1970; A. D. Trendall, Second Suppl., Bull. Inst. of Class. Stud., suppl. XXXI, London, 1973; G. Vallet, F. Villard, Mégara Hyblaea 2, la céramique archaïque, Mél., suppl. 1, Paris, 1964; H. Walter, Frühe samische Gefässe. Chronologie und Lanschaftsstile ostgriechischer Gefässe, Samos, V, Berlin, 1968; E. Walter-Karydi, Samische Gerässe des 6. Jhs. v. Chr., Samos, VI, 1, Berlin, 1973.

Miscellaneous. F. Canciani, Bronzi orientali e orientalizzanti a Creta nell'VIII e VII sec. B.C., Roma, 1970; H.-V. Herrmann, Die Kessel del orientalisierenden Zeit I, Olymp. Forsch., VI, Berlin, 1966; H. Hoffmann, Early Cretan Armorers, Mainz, 1972; M. Weber, Die geometrischen Dreifusskessel. Fragen zur Chronologie der Gattungen und deren Herstellungszentren, AM, LXXXVI, 1971; J. Boardman, Archaic Greek gems, London, 1968; Ch. Boeringer, Zur Chronologie mittelhellenistischer Münzserien 220-160 v. Chr., Berlin, 1972; H. A. Cahn, Knidos. Die Münzen des 6. und des 5. Jhs. v. Chr., Berlin, 1970; C.M. Kraay, M. Hirmer, Greek Coins, London, 1966; M. Mitchiner, Indo-Greek and Indo-Scythian coinage I-IX, London, 1975-76. P. Bernard, Fouilles d'Aï Khanoum, I, Paris, 1973; P. Leriche, Aï Khanoum, un rempart hellénistique en Asie centrale, Revue Archéol., 1974; C. Nylander, Ionians in Pasargade. Studies in old Persian architecture, Uppsala, 1970; D. Schlumberger, Der hellenisierte Orient. Die griechische und nichtgriechische Kunst ausserhalb des Mittelmeerraumes, Baden-Baden, 1969. J.A. Bundgaard, The excavations of the Athenian Acropolis 1882-1890. The original drawings edited from the papers of G. Kawerau, København, 1974; T. L. Shear, Jr., The stoa basileios, Hesperia, XL, 1971, p. 243 (per la datazione: J. P. Michaud, BCH, XCLVIII, 1974; p. 592), L. Shoe Merritt, The stoa poikile, Hesperia, XXXIX, 1970; E. L. Smithson, The tomb of a rich Athenian lady, ca. 850 B.C., Hesperia, XXXVII, 1968; J. Travlos, Bildlexikon zur Topographie des antiken Athens, Tübingen, 1971; A. Tschira, Untersuchungen im Süden des Parthenon, JdI, LXXXVII, 1972; - J. Boardman, Excavations in Chios 1952-55, Greek Emporio, BSA, suppl. 6, Oxford, 1967. I.C. Love, Excavations at Knidos, AJA, LXXIV, 1970; LXXVI, 1972; V. Milojčič, D. Theocharis (ed.), Demetrias I, Bonn, 1976; G. Daux, BCH, LXXXVII, 1963; P. Auberson, Le reconstruction du Daphnéprorćoion d'Erétrie, Ant. Kunst, XVII, 1974; A. Adriani, Himera, I, campagne di scavo 1963-65, Roma, 1970. G. Buchner, Pithecusa; scavi e scoperte 1966-71, Atti dell'XI Convegno di studi sulla Magna Grecia, Taranto, 1971 (Napoli 1974); M. R. Popham, L.H. Sackett, Excavations at Lefkandi, Euboea 1964-66, London, 1968. D. Adamesteanu, La Basilicata antica, storia e monumenti, Cava dei Tirreni, 1974; D. Adamesteanu, D. Mertens, A. De Siena, Metaponto: santuario di Apollo - tempio D (tempio ionico), rapporto preliminare, BArte, 1975; A.H.S. Megaw, Archaeol. Reports, 1965-66, p. 9 fig. 12. G. Foti, Relitti di navi greche e romane nei mari della Calabria, Calabria turismo, IV, 1973; V. Karageorghis, Excavations in the necropolis of Salamis, III, Nicosia, 1973; F.G. Rainey, C.M. Lerici, The search for Sybaris, 1960-65, Roma, 1967; NSc, 1969, I suppl.; 1970, III suppl.; 1972, suppl.; Atti Mem. Soc. Magna Grecia, 13-14, 1972-73. E. Akurgal, Ancient civilizations and ruins of Turkey, Ankara, 1973; J. Boardman, J. Hayes, Excavations at Tocra 1963-65, the archaic deposits, BSA, suppl. 4, Oxford, 1966; J. Boardman, J. Hayes, The archaic deposits II and later deposits, BSA, suppl. 10, Oxford, 1973. N. Degrassi, BArte, XLIX, 1964, 392. H. Metzger et al. Fouilles du Létoon de Xanthos, Revue Archéol., 1974; A. Cambitoglu, Zagora, excavation season 1967; study season 1968-9, Sydney, 1971; J.P. Descouedres, Zagora auf der Insel Andros: eine eretrische Kolonie?, Ant. Kunst, XVI, 1973;

FULVIO CANCIANI

PRE-ROMAN ITALY AND EUROPE (PLATES 24-27)

The problem of relations between native civilizations and "peripheral" territories. - The old controversy on the originality of Etruscan art - or of Italic art in general - with respect to Greek art no longer appears pertinent in the current historical debate. It was formerly considered as part of the dialectic opposition

between classic and anti-classic (or "primitive'), or in terms of the conflict between "structures" (G. Kaschnitz-Weinberg), as was held in the first half of the 20th century. This controversy now appears to have been superseded by an increasingly rigorous evaluation of the facts in relation to the differences between different periods, social classes, and functions of artistic works. In view of new discoveries, the recent tendencies towards a reassertion of Greek supremacy must be verified again through more thorough study; this is necessary both in a relative sense - the importance of Greece with respect to "peripheral" cultures (including non-Hellenic Italy) - and in an absolute sense - the superiority of Greek form as "organic" rather than "abstract" (R. Bianchi Bandinelli).

The problem is to be considered in a much wider and different perspective from that of traditional critical postures. It is not limited to Greece, but concerns the relations of civilizations having creative and expansive ability with territories that are less advanced or culturally receptive; nor does it regard only figurative expression separately from its religious, social, and economic premises and conditions. It considers rather the entire range of material and spiritual culture, such as we know it from the archaeological evidence. We are referring to the contrast of the precociously and intensely innovative Near East and the Eastern Mediterranean with continental Europe and the central western Mediterranean. Their contacts date back to prehistoric times and continue to the Roman period, with a constant influence from south to north and from east to west. In Italy, we can speak of commercial and cultural penetration, and possibly Eastern colonization, as early as the Neolithic and Bronze Ages, culminating in the presence of Mycenaean civilization on the southern coasts of the peninsula, in Sicily, and even on the Tyrrhenian Sea. The general movement continued with the Phoenician and Greek colonizations of historic times, with the spread of the geometric style and "easternizing" civilization, then with the massive and uninterrupted influx of imports, of inspirations, and of Archaic, Classic, and Hellenistic Greek stimuli. Similar phenomena are noted - less intense as the distance from the centers of diffusion is greater - on the coast of northern Africa, on the Iberian peninsula, in southern France, and even in central Europe, as shown by the discovery of Vix in Burgundy and of Heuneburg in Bavaria. Thus the view that these countries, considered "peripheral" by Boethius, were in fact influenced by the Eastern and Greek world now seems more justified.

New documents and new directions of research in Etruscan-art. - During these past few years there has been intense development in research, discoveries, and publications on civilizations of ancient Italy before the Roman Empire; this has considerably expanded and even revolutionized our knowledge on their artistic productivity. Presented here in summary form is a critical survey of the most important discoveries.

It is important to note that Italy of the first millenium B.C. - that is, during the same period as the Greek Archaic, Classic, and Hellenistic civilizations - acquired ever more decisively an autonomous and significant character within the general framework of ancient art history. In a way, Italy appears to have been in a mid-position between the cultural sources of the eastern Mediterranean and the "peripheral" receiving

areas of the western Mediterranean and Europe; its Greek colonies, and Etruria also, within certain limits, participated in this primary creative function. Italy received iconographic models, techniques, and styles; reworked them; and retransmitted them. Naturally, the perspectives differ according to the time and the place; most obvious is the inequality of the more intense, precocious, and original developments of Hellenized southern Italy and the territories on the Tyrrhenian coast (Etruria, Latium, Campania) compared with the slow and secondary processes of the inland part of the peninsula, the Adriatic coast, and northern Italy. Nevertheless, recent discoveries seem to reveal unexpected displays of vitality and finesse in the figurative works of the Italic peoples of the north-central areas. They seem to show the existence of reciprocal influences that led to unitary tendencies of a pan-Italic nature, beginning in the V and IV centuries B.C. This occurred through a process of gradual assimilation and levelling, and included not only all of non-Hellenic Italy - Tyrrhenian, Adriatic, and northern Italy - but also the Greek colonies.

Thus the dichotomous classification of the whole of the artistic phenomena of pre-Roman Italy into "Etruscan art" and "Italic art," still used in two articles in the *"Enciclopedia dell'Arte Antica Classica e Orientale,"* should now be considered outdated. This classification was based in part on ethno-linguistic criteria and grouped experiences of very different origins and characteristics under the sole label of "Italic." In the same way, we must now consider unsatisfactory the isolated consideration of the "Etruscan art" as a separate theme. Such an approach was traditionally held in many monographic publications, including those of J. Martha, the classic repertoires of P. Ducati and of G. Q. Giglioli, and the more recent syntheses of P. J. Riis, R. Bloch, T. Dohrn, and G. A. Mansuelli. In this perspective are some areas that are difficult to define, which transcend the idea of a rigidly defined nationality. Examples are the architecture and the fine templar decorations common to Etruria, Latium, and Campania since the VI century B.C.; the bronze votive works that extended from Etruria through all of central Italy, and the funerary paintings with a similarity in the concept of background (although with variety of expression) that reached as far as Apulia.

It is clear that the most important event in the critical approach of this era is the new awareness of the need to study and evaluate the art of the peoples of ancient Italy as a whole, rather than individually. This view is found in the current tendency to reconsider the history of pre-Roman Italy as "Italic history," in the sense of U. von Wilamowitz, and in isolated but significant precedents such as the concept of "Italic art," including Etruria and Rome itself, hinted at by C. Anti in 1930 and by Ch.-Cl. van Essen in 1960. A summary of considerations of this nature in the art field was attempted by this author in the article "Etruscan-Italic centers" in the *Encyclopedia of World Art*, later republished separately (1971). But the same need has essentially been proposed in the work *Les Etrusques et l'Italie avant Rome* by R. Bianchi Bandinelli and A. Giuliano in the Gallimard collection (1973).

The results of the discoveries and the studies of the period 1965-1975 may be summarized in a series of themes in which new perspectives are given, or present

knowledge is added to and further developed. First of all is the proto-history, the culture of the Iron Age. In this field the activity of Italian and foreign archaeologists has never been more intense, either quantitatively or qualitatively. There have been profitable explorations throughout the territory of Italy, as well as considered critical assessments, all working in two principal directions: chronological investigations - mostly using the methods and plans of the school of H. Muller-Karpe and R. Peroni, even if these have not yet found universal acceptance - and a comprehensive interpretation of the sociological and ideological factors of the single cultural emergences. The development of research in Latium, where proto-historical necropolises have been discovered at Decima, Lavinio, La Rustica, and Gabii, among others, has been given more urgency by the continuing expansion in the construction of modern buildings and roads around Rome. These discoveries have excited new interest in the origins of Rome, already a subject of much interest in historical circles. In addition, an extensive program is underway to publish studies on both the old and the new excavations of the sites and burial grounds of the Iron Age in Italy. Naturally, the effect of the determination of urbanistic, architectural, and decorative facts has been felt.

With regard to the latter proposal, significant knowledge has been gained of the earliest known occurrence of artistic civilization of the Etruscan-Italic world that is comparable to the experiences of the Orient and of the Aegean; this development is the "easternizing" style. In the study of the archaeological complexes of the VII century B.C., it is mainly its earlier phases that are widely known, as shown by the systematic treatment of J. Strom; examples are the Castellani Tomb of Palestrina, restored and exhibited in Rome and Paris, and the two tombs of princes at Pontecagnano near Salerno, masterfully published by B. D'Agostino. There has been a growing interest in the Etruscan-Corinthian painted ceramics of the recent Easternization, mainly due to the efforts of G. Colonna and J. Szilagyi.

Our knowledge of the Archaic Etruscan civilization is continuously growing due to new data. The American and Swedish excavations at Poggio Civitate near Murlo (Siena), and Acquarossa near Ferento (Viterbo), allow us to clarify the origins of the clay ornamentation on buildings since the VII century B.C. in relation to similar works of the Greek world; however, there have been differing opinions on the dating of the earlier pieces of Poggio Civitate. In Rome the discoveries of the Archaic temple of Boario Forum (S. Omobono) have been published and discussed; they are considered to be proof of a high level of development of the Archaic city under the Greek and Etruscan influence. The level of development in the painting is documented by the numerous additional discoveries of new tombs at Tarquinia, by M. Moretti. The variety of styles and the similarity to the art of Asiatic Ionia attest to the complex intermingling in the activities of the Greek artists and their apprentices in the Etruscan cities. This is more evident since the surprising discovery of painted tombs in Anatolia. Specific works have been written on other classes of monuments: sculptures in marble (rarely seen, according to Adren), bronzes, vases of red clay, ivories, and scarabaeuses, among others.

Concerning the art of the Classic and Hellenistic periods, some important clarifications have been made about noted and even famous monuments, which had not been sufficiently studied previously. In particular the funerary sculpture of Chiusi (M. Cristofani), the statue of Mars at Todi (on which F. Roncalli has written an exemplary work, attributing it to the Orvieto area), the small urns of Volterra (F.-H. Pairault, M. Cristofani, and others), and the Orator (T. Dohrn). It is of interest that definitive evaluations have been made of certain Etruscan treasures conserved in the Archaeological Museum of Florence as a result of studies and restorations carried out following the floods of 1966.

Outside of Etruria, there has been an intensification of the research and the discoveries in the necropolises of Paestum. It was here that the remarkable painted coffin, known as "the Diver" was found; this is a unique example of Greek colonial painting of the first half of the V century B.C. and has notable similarities with the late Archaic and protoclassic Etruscan funerary paintings. An immense collection of Lucanian paintings of the IV century B.C., of the Hellenistic age, was also found here by the late M. Napoli; they are now being studied. Our knowledge of the cultural and artistic fruits of the original inhabitants of the Basilicata is richer and more thorough. This is particularly true with regard to the following: the by now famous Daunian center of Melfi (D. Adamesteanu, G. Tocco); the anthropomorphous and stylized steles of Siponto (S. Ferri); the late Villanovian and Easternizing culture of Verucchio in Romagna (of which the publication by G. V. Gentili is awaited); and the more recent Venetian artistic culture, represented especially by the stylized steles of Padua (G. Fogolari, A. Prosdocimi). Many of these new items are described in their proper setting in the general work *Popoli e civiltà dell'Italia antica*, in several volumes.

Finally, we must not overlook the value of the intensive and effective cooperation between scholars and young researchers of various nations, with the interchange of ideas, meetings, and conferences (including those promoted by the Istituto di Studi Etruschi e Italici). In addition, there was the preparation of new museums and the reorganization of old ones (Civitavecchia, Vulci, Grosseto, Siena, Marzabotto, Pontecagnano, Matera, Melfi, Chieti, Adria), and the great increase in the number of archaeological exhibits, with catalogs that were true scientific manuals.

<div style="text-align:right">MASSIMO PALLOTTINO</div>

Continental Europe: a) The Iberians. - Iberian art was discovered only towards the end of the 19th century and at the beginning of the 20th century. Between 1903 and 1915, the first researchers to study this artistic cycle - the last of the great artistic and cultural cycles of the Mediterranean to be recognized - attempted to connect it to the Mycenaean art that had so impressed archaeologists and prehistorians of that period with its richness and its originality. After 1915, the continuous new discoveries showed the contemperaneity of the Iberian art with the Greek, and it was in the Greek sculpture, toreutic art, and ceramics that the inspirations for Iberian art were sought. Only incidentally were Etruscan parallelisms and influences noted and accepted or rejected according to the different researchers; however, it had always been accepted that the Etruscan culture had contributed to the Iberian.

Due to the different evaluations of Iberian art, its dating has been continuously shifting. Initially the Iberian art was dated towards the end of the second millenium B.C. Later, the finding of Greek ceramics of the V century B.C. and in Iberian deposits moved the chronology of this artistic cycle forward, a cycle seen as a provincial projection of the Greek art. More radical in the "modernization" of Iberian art were the judgments made between 1934 and 1943 by different authors. Thus Garcia y Bellido, who had long supported the Greek derivation of Iberian art, changed his views as a result of a study he made in 1943 of the "Lady of Elche," one of the most famous Iberian sculptures. Thereafter he vigorously supported:

> a complete change in the accepted concept concerning the origins of Iberian art; this art - mainly sculpture and ceramics - had instead developed during the Roman republican era and the beginnings of the empire, and responded not to Greek, but to Roman, or possibly Italic, influences; these, combined with the indigenous background, resulted in an art and a culture that can best be defined as Iberian-Roman rather than Iberian.

In the past year, these judgments have influenced many on the evaluations of the Iberian art and culture. Thus J. Maluquer, in his monographic study on the Iberian writings, maintains that they began after the V century B.C.; he has even held that the earliest Iberian inscriptions, known as "tartessie," which appeared in the southwest of the peninsula, are "probably of the III or even of the II century B.C."

The many discoveries show the fertility and the originality of the Iberian artists and a new outlook on the themes, the chronology, and the aesthetic currents of the Iberian art. We now know that the Iberians created a monumental architecture with full reliefs and sculptures and that a rich and perfect toreutic art was developed, as well as ornamental painting for the decoration of the walls and the cinerary urns and for the coloring of statues. The Iberian ceramics more than anything show a noteworthy and spontaneous agility of design and an originality in the creation of forms.

Evidence from recent discoveries of sculptures, bronzes, and architectural ruins, mainly those of Pozo Moro (Albacete) and Mogente (Valencia), show that Iberian art had its origins in the influences of the Easternizing world; these influences were also felt by Greek and Etruscan art. Supporting this conclusion are many objects that have been found, such as fibulae, arrowheads, shields cut in the form of a V, "thymiateria" of bronze, ceramics, and many others. And it originated with the cultural currents that brought into Iberia works of art of different quality, including works from Phoenicia, Cyprus, and even Egypt, starting in the VIII century B.C.

There is convincing evidence of the influence of these Easternizing currents on architecture and ornamental sculpture in the exclusively Iberian deposit of Pozo Moro. This was discovered and excavated recently by Almagro Gorbea and is still being studied. There is no evidence of any parallelism with the classic Greek art as a source of inspiration: neither in the iconography - gods with two heads devouring human sacrifices, offered by beings with heads of horses - nor in the aesthetics with which these works have been conceived. We must rather look to northern Syria, Asia Minor, and the neo-Hittite area for the correct interpretations and attribute to these areas the source of inspiration of other famous Iberian sculptures - the "Bicha de Balazote," griffons, sphinxes, and, most important, the numerous funerary lions. The earliest of these are of clear Syrian-Hittite inspiration and not Greek, as has been claimed. Furthermore, we now know that the lions that first appeared during the formative period of Greek art were of neo-Hittite influence.

The spear-shaped ears of the Iberian lions are worked on the inside in the neo-Hittite manner; recent studies have identified other characteristics that are similarly derived from that area - for example, the geometric working of the mane, the almond shaped eyes, the canines in accentuated cubic relief with the gums visible, the slightly open mouth, the upper lip pulled back and the tongue out, and the typological evolution of the claws of neo-Hittite type. Similarly, as we know from the small Egyptian and Syrian-Phoenician bronzes discovered recently in Spain, the Iberian toreutica originated before Greek works became the principal inspiration of the Iberian bronze artists.

The formation of the rich Iberian ceramic art was similarly influenced by Phoenician and Cypriot works brought into Iberia with the Phoenician colonizers, starting in the VIII century B.C. Vases from Rhodes and Chalcidian, as well as from other centers of Asia Minor along the commercial routes that from the VII century B.C. were inherited by Phocaea, also appeared very soon.

Other evidence that leads us to the same conclusion are the earlier fibulae, the bronze waistband clasps, and mainly the semi-syllabic Iberian writings of Oriental origin. Thus Iberian art is now considered as part of that Easternizing "koinè" that reigned in all of the Mediterranean from the IX to the VI century B.C., before the formation of the "national" art of the Greeks, Etruscans, Iberians, and Carthaginians. These created their own particular form of artistic expression during the period from the VII to the IV century B.C. Subsequently the Greek influence increased a little at a time, imposing the sensitivity and techniques of Hellenism. This was the basis of the general unification that reached all regions of the Mediterranean with the Roman conquest; the conquest began very early in Spain, in 219 B.C., with the landing of the Scipios at Ampurias and was completed by Augustus in 19 B.C. With the Roman Empire, a Romanized Hellenism was imposed, suffocating the first great artistic cycle of Spanish history, whose roots have been so surprisingly pointed out by the most recent discoveries.

MARTIN ALMAGRO

b) The Celts. - Several new discoveries of Celtic art works deserve to be mentioned. A discovery of gold jewelry and bronze objects made at Reinheim (Saarland) in 1954 has recently been cataloged. Gold necklaces of great beauty were found in 1962 at Erstfeld (Uri, Switzerland) - buried underground in an Alpine valley - and also in Great Britain at Ken Hill (Snettisham, Norfolk) and Ipswich (Suffolk). The excavations of the fortification at Manching (Bavaria) have yielded important material from the I century B.C., in particular painted ceramics. Celtic objects (circular necklaces and

bronze fibulae) have been found for the first time in sites in Greece and Asia Minor. Finally, two important findings of votive offerings made by invalids at the Sanctuary of the Fountains of Senna (Côte-d'Or) and at Chamalières (Puy-de Dôme) show the survival of the Gallic tradition in wood sculpture into the first century A.D., and demonstrate this form of art in general in ancient times.

Since 1958, several new studies have appeared that add significantly to our knowledge of different areas of Celtic art. The analysis of the characteristics of the art of La Tene has supported the definitions given by Jacobsthal, while emphasizing the importance of sculpture since the earliest period. It has become necessary to study objects as part of a series, as well as studying only the principal pieces in an isolated manner. The publication of archaeological material for the different regions has raised hopes that some day it will be possible to distinguish regional styles. Coinage has been recognized as one of the most important manifestations of the Celtic art. The definition of styles given by Jacobsthal — quite varied — has been made more precise. The purpose of the geometric design has been clarified, especially those designs executed with a compass. Also published is the furniture from different regions that Jacobsthal was unable to include in his larger work. On the one hand the unity of the ancient Celtic art and of the spirit of La Tène throughout Europe has been confirmed, on the other the wider areas have been better defined: the continental center (from Gaul to Bohemia), the Atlantic islands, and the Danubian border territories.

The numerous and important contemporary publications on Celtic art are listed in the bibliography.

PAUL-MARIE DUVAL

c) Illirians and Tracian-Getian. - To complete the picture of the European populations that had arisen with their own original cultures at the same time as the classic world, we must consider the Danubian and Balkan areas; here the ancient ethnology had grouped the Illirians in the west with the Tracians and the Geti (or Dacians) towards the east. An intense research activity by Yugoslavian, Albanian, Bulgarian, and Rumanian scholars since 1950 has revealed the more significant aspects of the artistic production of these peoples. These are mainly arms, furnishings, and embossed gold and silver jewelry. The jewelry has ornamental and figured designs, in which many factors are combined in different ways, according to place and period: local geometric traditions; massive Greek influences from the south; Greek-Scythian inspirations from the east; and elements of great similarity and common development with the central European Celtic area, especially in the compact and decorative stylization of the reliefs and in the curvilinear design. These are impeccably documented by the famous "treasures" of Vratza, Stara Zagora, Letnitsa, and Loukovit in Bulgaria and of Agighiol in Rumania. In the last few years, besides the continuing excavations in many localities, there has been a great increase in historical art publications specifically devoted to these areas. A tendency to summarize the old and the new discoveries at the level of critical evaluation has been shown by the intensification of national and international gatherings and conventions - promoted principally by the Associazione internazionale di studi del sud-est europeo - and by the preparation of grand exhibitions, such as "Illirians and Dacians" presented at Belgrade and at Cluj and the "Tracian treasures" exhibition that toured several European capitals.

MASSIMO PALLOTTINO

BIBLIOGRAPHY - *Etruscan - Italian Art*: Problems and general works: M. Pallottino, L'Italia preromana, in Sources archéologiques de la civilisation européenne (Colloque international, Mamaïa, Roumanie, 1968), Bucarest, 1968; M. Pallottino, Sul concetto di storia italica, in Mélanges offerts à J. Heurgon, Rome, Ecole Francaise, 1976; M. Pallottino, Civiltà artistica etrusco-italica, Firenze, Sansoni, 1971; R. Bianchi Bandinelli, A. Giulliano, Les Etrusques et l'Italie avant Rome, Paris, Gallimard; Milan, Rizzoli, 1973; Popoli e civiltà dell'Italia antica, Roma, Biblioteca di Storia Patria, vol. II-V, 1974-1976.

Other recent publicatious dealing only with monuments: M. Moretti, Nuovi monumenti della pittura etrusca, Milano, Lerici, 1966; T. Dohrn, Der Arringatore, Berlin, Mann, 1968; R.D. Gempeler, Die etruskischen Kanopen, Einsiedeln, n.d.; G. Colonna, Bronzi votivi umbro-sabellici, I, Firenze, Sansoni, 1970; J. Strøm, Problems Concerning the Origin and Early Development of the Etruscan Orientalizing Style, Odense University Press, 1971; F. Roncalli, Il « Marte » di Todi, Memorie della Pontificia Accademia Romana di archaeologia, XI, 2, 1973; S. Ferri, M. L. Nava, Stele daunie, Manfredonia, 1974; M. Cristofani, Statue-cinerario chiusine di età classica, Roma, G. Bretschneider, 1974; A. Hus, Les bronzes etrusques, Bruxelles, Coll. Latomus, 1975; M. Cristofani et al., Corpus delle urne etrusche di età ellenistica. Urne Volterrane, I, Firenze, Centro DI, 1975; Civiltà del Lazio primitive (Catalogo della Mostra), Roma, 1976.

Continental Europe: a) Iberian Art: M. Almagro, Las raices del Arte Ibérico, Papeles de Arqueologià. 50 Aniversario. Valencia, 1974, (contains bibliographies collected by topic) A. Garcia y Bellido, La Dama de Elche y el conjunto de piezas reingresadas en España en 1941, Madrid, 1943; Idem, La Escultura ibérica. Algunos problemas de arte y cronología, A.E. de Arq., tomo XVI, Madrid, 1943. On more recent discoveries: M. Almagro Gorbea, Pozo Moro. Una nueva joya del arte ibérico, Bellas Artes, n. 28, 1973; Las excavaciones de Pozo Moro, Congreso Nacional de Arqueología de Huelva, 1973; idem, Pozo Moro. Anatolische Würzeln Iberischen Kunst, X International Congréss of Classical Archaeology, Ankara-Ismir, 1973; idem, El monumento de Pozo Moro el problema de las raices orientales del arte ibérico, Congreso Luso Español para el Progreso de las Ciencias, Cádiz, 1974. On the formation of "national" arts in the West: P. Demargne, El nacimiento del Arte Griego, Editorial Aguilar, Madrid, 1964, ch. X, ch. XI; Ekren Akurgal, The Birth of Greek Art, Londres, 1966; idem, Die Kunst der Hethiter, Munich, 1961; J. Nisette Godfroid, Contribution à l'étude de l'influence du lion néo-hittite sur la constitution du type léonin dans l'art grec orientalisant, Archéologie Classique, 41, 1972;

b) Celtic Art: General studies: A. Varagnac-Gabrielle Fabre, L'Art gaulois, Paris, 1956; Kunst und Kultur der Kelten, Austellung in Allerheiligen, Schaffhausen, 1957; T. Powell, The Celts, London, 1958; J. Moreau, Die Welt der Kelten, Stuttgart, 1958; C. Fox, Pattern and Purpose - A. Survey of Early Celtic Art in Britain, Cardiff, 1958; P.-M. Duval, Celtica Arte, in Enciclopedia dell'Arte antica, Roma, 1954; J. Filip, Celtic Civilization and its Heritage, Praha, 2d

ed., 1976; P.-M. Duval, L'Art des Celtes et la Gaule, Art de France, 4, 1964; R. Joffroy, L'Art des Celtes, in Les Celtes et les Germains à L'époque Païenne, Paris, 1965; J.-J. Hatt, Sculptures gauloises, Esquisse d'une évolution de la sculpture en Gaule depuis le VIᵉ siècle avant J.-C. jusqu'au IVᵉ siècle après J.-C., Paris, 1966; T. Powell, L'Art préhistorique, Paris, 1967; N. Sandars, Prehistoric Art in Europe, Baltimore, 1968; J.-J. Hatt and Danièle Gourevitch, Celtes, in Enciclopedia Universalis, 4, Paris, 1968; F. Benoît, Art et Dieux de la Gaule, Paris-Grenoble, 1969; J. V. S. Megaw, Art of the European Iron Age - A. Study of the Elusive Image, Bath, 1970; S. Piggott, Early Celtic Art, catalogo dell'esposizione Edimburgo-Londra 1971, Edinburgh, 1971; P. MacCana, Celtic Mythology, London 1970; A. Grenier, Les Gaulois, Paris, 1970; P.-M. Duval, Les Styles de l'art celtique occidental - Terminologie et chronologie, in Actes du VIIᵉ Congrès International des Sciences préhistoriques et protohistoriques, Prague 1966, Prague, 1971, pp. 812-817; J. Finlay, Celtic Art. An Introduction, Park Ridge (New Jersey), 1973; M. Mellink and J. Filip, Die La Tène - Zeit. Keltische Kunst, in Frühe Stufen der Kunst, Berlin, 1974; P.-M. Duval and Ch. Hawkes, Celtic Art in Ancient Europe. Five Protohistoric Centuries. L'Art Celtique en Europe protohistorique: débuts, développements, styles. Proceedings of the Colloquy held in 1972 at the Oxford Maison Française, London, 1976. Studies of a regional character: Françoise Henry, Art Irlandais, Dublin, 1954; Ilona Hunyady, Kelták a Kárpátmedencében. Leletanyag (Les Celtes dans le Bassin des Carpathes. Répertoire des lieux et des trouvailles), Budapest, 1957; Janina Rosen-Przeworska, Les Recherches sur la civilisation celtique en Pologne, in Revue archéologique, 1962, II and 1963, I; R. Lantier, Art celtique et Art ibérique, in A Pedro Bosch-Gimpera in el Septuagesimo aniversario de su nacimiento, Mexico, 1963; L. Alcock, Celtic Archaeology and Art, in Celtic Studies in Wales, A Survey, Cardiff, 1963; V. Zirra, Un cimitir celtic in Nord-Vestul României. Ciumesti I, Baia Mare, 1967; J. Todorovič, Kelti u Jugoistočnoj Evropi. Die Kelten in Süd-Ost Europa, Beograd, 1968; Z. Wozniak, Osa dnictwo Celtykie w Polsca, Wroclaw, 1970; M. Szabó, Sur les traces des Celtes en Hongrie, Budapest, 1971; D. Bretz-Mahler, La Civilisation de La Tène en Champagne. Le Faciès Marnien, XXIII Supplemento a Gallia, Paris, 1971; V. Zirra, Beiträge zur Kenntnis des Keltischen La Tène in Rumänien, in Dacia, XV, 1972; M. Szabó, Celtic Art and History in the Carpathian Basin, in Acta Archaeologica Academiae Scientiarium Hungaricae, XXIV, 1972; F. Schwappach, Frühkeltischen Ornament zwischen Marne, Rhein und Moldau, in Bonner Jahrbücher, 173, 1973; F. Maier, Keltische Altertümer in Griechenland, in Germania, 1973; R. Bianchi Bandinelli-A. Guiliano, Les Etrusques et l'Italie avant Rome. De la Protohistoire à la Guerre Sociale, Collezione l'Univers des Formes, Paris, 1973; p. 59; V. Zirra, Nouveaux points de vue sur Les Celtes et leur civilisation en Roumanie, in Actes du IVᵉ Congrès International d'Etudes Celtiques, Rennes 1971, II, Paris, 1973; B. Cunliffe, Iron Age Communities in Britain. An account of England, Scotland and Wales from the seventh century B.C. until the Roman Conquest, London-Boston, 1974; Z. Wozniak, Wschodrieze Kultury Laténskiej (Les confins orientaux de la Civilisation de La Tène), Wroclaw, 1974; J. Todorovic, Skordisci. Istorija i Kultura (The Skordisci, History and Culture), Novi Sad-Beograd, 1974; W. Drack, Die Eisenzeit, Ur- and Frühgeschichtliche Archäologie der Schweiz, Basel, 1974; The Celts in Central Europe, Székesfehérvár, Bulletin du Musée Roi, Saint-Etienne, 1975; V. Kruta, L'Art Celtique en Bohême. Les parures métalliques du Vᵉ au IIᵉ siècle avant notre ère, Paris, 1975. Studies stressing materials and techniques: N. Rybot, Armorican Art. A view and enlarged Edition of the Article published in the Bulletin of the Société Jersiaise, Jersey, 1952; R. Clarke, The Early Iron Age Treasure from Snettisham, Norfolk, Cambridge, 1954; E. Haevernick, Die Glasarmringe und Ringperlen der Mittelund Spälatènezeit auf dem europäischer Festland, Bonn, 1960; F. Maier, Zur bemalten Spätlatène Keramik in Mitteleuropa, in Germania, 41, 1963; J. Keller, Das Keltische Fürstengrab von Reinheim, Mainz, 1965; R. Lantier, Le bois dans l'industrie et l'art des Celtes, Revue archéologique du Centre, V, 1966; L. Lengyel, Le Secret des Celtes (d'après les monnaies), Forcalquier, 1969; F. Schwapach, Stempelverzierte Keramik von Armorica, in Festschrift W. Deha, Fundeberichte aus Hessen, Bonn, 1969; M. Rusu, Das Keltische Fürstengrab von Ciumesti in Rümanien, in 50. Bericht der Römisch - Germanischen Kommission 1969; W. Krämer-F. Schubert, Einführung und Fundstellen übersicht, in Die Ausgrabungen in Manching, Wiesbaden, 1970; J.-M. de Navarro, The Finds from The Site of La Tène. The Scabbards and the Swords found in them, I-II, London, 1972; J. Brailsford et Stapley, The Ipswich Torcs, in Proceedings of The Prehistoric Society, 38, 1972; P.-M. Duval, L'Art des monnaies gauloises, in Competes Rendus de l'Académie des Inscriptions, 1972; Les Celtes, Collezione l'Univers des Formes, Paris, 1976.

c) Illirian and Tracian - Getian Art: R. Florescu, L'art des Daces, Bucharest 1969; D. Berciu, Arte traco-getică, Bucharest 1970; Epoque préhistorique et protohistorique en Yougoslavie, Recherches et résultats (VIII Congrès Intern. des Sciences Préhistoriques et Protohistoriques), Belgrade, 1971; Iliri si Daci - Illyres et Daces (Catalogo della Mostra), Belgrade-Cluj, 1972; Thracian Treasures from Bulgaria (Catalogo della Mostra), London, British Museum, 1972.

MASSIMO PALLOTTINO, MARTIN ALMAGRO AND PAUL-MARIE DUVAL

ROME AND LATE ANTIQUITY (PLATES 28-32)

Roman art: Critical problems. - The concept of "Roman art" is still unclear and is in fact constantly changing; answers have not yet been found to the problems it has raised. Is this due to insufficient research, inadequate evidence, or the manner in which questions have been formulated? The constantly changing answers are, at any rate, more about the adjective "Roman" than about the word "art." Is this art ethnically Roman or culturally Roman? Is it Roman only in that it developed in an age that was dominated by Rome?

The critics tend to isolate a real Roman component. Some see this in the artistic works created by order of politically significant persons or groups; others see it in a following of the popular tastes or, in Rome, of the plebeian; finally, some view the Roman character in some particular characteristics of certain artistic or artisan works.

The position of H. Kaler is typical; he sees the characteristics of Roman art as a strict adherence to reality and to the period and geographical location. Ch. Picard connects the artistic product to the social psychology of the Roman people: this is a step forward, though rather general. R. Bianchi Bandinelli, on the other hand, takes a completely different view and looks at the middle Italic ethnic groups from which the Roman "plebeians" descended - that is, the Roman people in a strict sense - and how they reacted to the Hellenistic culture, both of Greece and of Magna Grecia; he

feels that they turned to art more as the thing to do rather than from conviction.

The unevenness of form, the indifference to the effects of space, an "eclectic" style that accepts the most varied experiences and condenses them into a single composite work without giving thought to the underlying reasons - these are the characteristics of the "plebeian" (Roman) reaction, as opposed to the Hellenistic. Conspicuous examples are the sarcophagus of L. Cornelius Scipio Barbatus, the frieze of the Arch of Augustus at Susa, the funerary relief of Amiternum, the funerary monument of C. Lusius Storax of Chieti, and so on.

These same characteristics were noted by R. Bianchi Bandinelli, although to a much lesser degree, even in those works commissioned by members of the political and financial social classes; these classes, which Mansuelli considered to be "cultured," were intent on absorbing as much Greek culture as possible. Examples of works in this category are the so-called altar of Domitius Enobarbus and the Ara Pacis (Altar of Peace); in the latter, a more austere Greek exterior aspect covers up plebeian inflections.

The building uncovered beneath the Capitolium of Brescia, of the late republican era, could clarify the "provincial" position with respect to the Roman models, if only we were sure that this was in fact a religious building; this is not at all certain, in view of the peculiarities of its structures. However, the wall paintings, both on panels and painted directly on the walls, are of refined quality, different from what is generally encountered in other cities; an example is the house at Herculaneum with the Tuscan portico.

The plebeian tradition, furthermore, resurfaced toward the end of the Roman empire, when the classic culture weakened due to the breakdown in the imperial administrative unity; in the provinces, particularly in the east, artistic forms developed reflecting various ethnic and cultural groups.

The investigations of Bianchi Bandinelli concentrated on sculptures and painting and ignored architecture. This he considered to have a separate development with a large degree of autonomy, free from the Hellenistic models. In this sense the lightness of structure of the Roman-Piceno sanctuary of Monterinaldo shows how the standards of the Greek temple were weakened through a conscious alteration of the proportioned ratios. The question remains whether this is a "plebeian' reaction, a "cultured" one, or even a reaction of "power groups.

A recent reexamination of the "Ephebus" of Magdalensberg (Wunsche) suggests a stimulating alternative in answer to this question, examining the Roman artistic position of the I century B.C. and the first decades of the following century.

There was an attitude in Rome itself that was contrary to the eclecticism and the disjointedness of the local artistic production which readily accepted the imposed Hellenistic models. This pose was found in the senatorial and patrician spheres; both in the artists and in those who commissioned the works. Though sometimes superficial, this feeling suggested "interpretation" of the Hellenistic elements, a "Latin version" of the Hellenistic culture. The "Ephebus" of Magdalensberg is among a series of works from the "lychnouchoi" of Pompeii to the type derived from the ephebe of Antikythira that is related to the Roman production of

Pasiteles, Stephanos, and M. Cossutius Menelaos—that is, to the flourishing of artistic production that ends in the Tiberian age.

The Greek teaching, seen from a more properly Attican and neo-classic (the so-called neo-Atticism) viewpoint, leads also to works such as the "Campania" reliefs; of these, important new plates have been found in the Roman forum (Plate 28). Their clear academic sculpturing, and their conventional coloring so rich in timbre, made this a work of reconstruction using as a model a world that was not its own, but which it had acquired and added to its own culture. This it did through those literary patterns that were the basis of the art criticism of the time and that were the key to the interpretation of a work of art.

Discoveries and restorations of monumental systems. - In the most important current excavation of a Roman city in Italy, at Luni (Liguria), confirmations of the positions of recent critique have been made through the art and artifacts that have been found. A great variety in architectural solutions has been revealed for public and other buildings, previously conceived as following rather fixed structural practices. Some of these buildings have lasted for long periods of time without significant alterations or improper restorations; that which was still useful was left untouched even if no longer in style. A good example of this is the so-called "hall" constructed at the time of the second colonial founding of the city, at the beginning of the Augustan age. In an area marked off by a series of bases supporting marble vases, which had been made over into fountains, was a room with a relief containing a splendid portrait of young Augustus (Plate 29); it was done in a richly colored Hellenistic style, very different from the neo-Attican formalism usually found in these portraits. Coins found embedded in the floor confirm that the area was still in use in the V century A.D. in its original appearance, unaltered by restorations.

It should be noted that the Hellenistic figurative culture at Luni was not received through Rome, but directly from Greece, due to the maritime relations with that country. The same thing was noted in the areas surrounding Marseilles and Provence in general, leading some of the more conventional experts to modify previously accepted datings of some monuments, dating them in relation to the Roman monuments rather than considering the direct relations with Greece. Examples are the arches at Orange and Vienne, or even the arch at Saint-Remy. This reasoning is also true for other regions of Gaul, where the influence of Provence made itself felt directly. This is proved by certain wooden votive sculptures of Clermont-Ferrand, including particularly significant figures I have seen of a pilgrim, a horse, and a matron, in which the Greek inspiration appears first hand and not indirectly; these figures also show traces of Celtic tradition. Hellenistic culture showing Roman influence is evident in some portraits in the typical Julian-Claudian style; this also is significant.

The identification proposed recently for the Capitolium of Brescia as a building for the imperial cult, at least for part of the building, is more significant for the history of that cult than for the history of art. However, the recovery of the seat of the Augustan cult at Miseno has yielded many sculptures of great interest; the statues of Vespasian and Titus are the earliest known representing the emperors in nude, heroic poses,

with the body shaped in the manner of the classic works and the head executed in the tradition of the Hellenistic portraiture (Plate 29). A portrait of Vespasian found at Ecija (Seville), by contrast, has a tighter and more compact rendering and a much more accentuated sculptural sense, quite different from the official portraits of Rome.

Also from Miseno, and in fact from the same complex, is an equestrian statue in bronze, unfortunately quite fragmented. The original face of Domitian has been replaced by a very fine face of Nerva; this was apparently done by Domitian's successors in order to remove all reminders of him. The equestrian statue may have been patterned after the famous "equus Domitiani" of the Roman Forum, or it may even be a copy in reduced scale; comparison with representations on coins supports this possibility. That statue, for the same reasons as for those at Miseno, was purposely destroyed.

Reinforcement work on the Trajan arch at Benevento has permitted a thorough study of its structure and its sculptures. The inside of the arch is made up of fill material from destroyed buildings, which had been haphazardly discarded. Statues of Trajan and Plotinus formerly surmounted the arch and large fragments of these were found in the immediate vicinity. A smooth pedestal gave a soaring quality to the monument. A small eagle's head inserted in one of the historical panels, with no apparent relationship to the context, appears to be an identifying mark of the sculptor; his name could have been Aquila, Aquilinus, Aquilius, or the like. He was apparently one of the sculptors who worked with Apollodorus of Damascus, now accepted as the creator of the Trajan complex in Rome. Apollodorus was very likely the sculptor of two panels of the arch at Benevento that are markedly different from the others and stylistically superior; they are definitely contemporary.

Austrian excavations at Ephesus have made decisive contributions to the knowledge of art history of the second century A.D. A severely fragmented ivory relief was found in a room of a house perched on the slopes of the Panacir Dag, with scenes of the Dacian wars of Trajan in the main panels. These scenes were separated by pilaster strips and completed by provincial figures in high relief; two figurative friezes were positioned above and below the historic panels. The friezes are similar to those of the Arch of Titus, and the provincial panels to those of the Hadrianeum of Rome inaugurated in 145 A.D. However, they cannot be simply fitted in as missing links in a chronological or typographical series; one must look at the whole in order to understand even the Trajan column or the Aurelian relief of the fountain of Celsus at Ephesus. The method used here of narrating through images is identical to that of the Trajan column; this is seen in certain special details, such as the empty space left between Trajan and the figures surrounding him, so as to emphasize the personality of the emperor, and also the rhythmic alternation of groups of men and then of animals. The two monuments are culturally similar, even though the techniques of carving ivory are quite different from those of sculpture in marble. In ivory, the artist must emphasize graphically almost as he would when working in stucco. It is clear that the cultural thread of figurative art passes through these very refined artisan workshops, leading to the Trajan forum in Rome and also to the relief of the Celsus

fountain in Ephesus itself. The tradition of Pergamon continues in these works, as in the great sarcophagi of Asia Minor, well into the third century A.D. This is shown by the Campanian sarcophagus of L. Valerius Valerianus, prefect of Mesopotamia and Osroene, which cannot have been in existence prior to 250 A.D.; it is a "descendant" of the sarcophagus of Melfi, which is dated to about 170 A.D. For the latter it appears that the villa from which it came has been identified.

Clearly Hellenistic in tradition is the great "palace" currently being excavated by a Polish archaeological mission at Nea Papkos on Cyprus; a rich series of rooms is arranged in a multiplicity of orthogonal axial relationships, with their focal point in a grandiose central courtyard. In an area of the palace was a sculpture gallery, comprising works of the second century A.D. and copies of classic works, demonstrating an interest for the past that is typical of the nostalgic and lethargic classicism of the initial Antonine periods.

An important work at Zagwan, in Tunisia, on the opposite side of the Mediterranean, is the channeling of the waters of a spring to supply the public works of Carthage (Plate 29); it was probably begun under Hadrian and completed no later that 162 A.D., when the great Antoninian baths of the city were activated. This work contains elements typical of Hadrian's academism, especially in the façade of the sacellum of the waters. It also shows a clear Near-Eastern and Hellenistic imprint in the construction of a wide semicircular portico right in the mountainside; it is almost as though the rocks become architectural elements of the structure, which is then linked to the aqueduct leading off from the complex into a series of spans extending all the way to the coast. Our perspective of the building is from outside, but, as is true for so many Roman constructions, it was designed to be seen from the inside and to blend into the view of the surroundings. Unfortunately, the relationship between the building and its surroundings, and between the outside and the inside, has not yet received adequate attention, not only for the Roman world, but also for the classic world in general. Also from the same period and the same area is the great portico of Apamea and its decorative work, done over about two centuries later.

Of the same period and geographic area is the seat of the Augustan cult at Miseno; this was restored in the Antoninian period, but was completely destroyed by a violent earthquake only a few years later. Its provincial interpretation of the Hellenistic and Near Eastern culture appears evident, even paradigmatic. There is a lessening of the sense of perspective, with more emphasis on the volumetric relation between the different architectural elements, and on the volumes enclosed by the buildings with respect to the surface area they cover. There are also overabundant decorative works, as exemplified by the facade of the sacellum - where ritual banquets were held - with the medallion containing portraits of the donors, in very high relief and with deep undercutting, and winged Victories filling the angles of the tympanum.

Aspects of figurative style. - A break from the official style and a profound rethinking of the classic tradition occurred at the time of the Antonines, leading to the cultural interruption of the tetrarchian period. Evidence of this has been found in the last decade in the study of certain decorative sculptures of Parma, in a

mosaic discovered at Elis in Greece, and in two portraits of Alexander Severus (Alexianus). One of these, in Naples, is well known and has been closely studied; the other, from Rhyakia in Macedonia, is of recent discovery (Plate 30).

In Parma, a homogeneous group of fragments from the architectural decoration of an important Roman monument has been found in the fill material used during the Middle Ages in the embankment of the Po River. This find has led to a study of the activities of the Po Valley workshops. Some cities were flourishing because of the trade resulting from a road through the Appenines connecting the port of Luni with Parma in the Po Valley. At the same time, though, others were in decline due to the first incursions of the barbarians.

In the Elis mosaic, the well-known figurative subject of Apollo and the Muses, so dear to the funerary theme, is portrayed in an unusual manner; the figures are shown on a wheel, with only enough of the features shown to allow recognition and with the lyre of Apollo as the hub, suggesting a rhythmic dance of the Muses around their god. The stillness of the representations on the sarcophagi is thus broken, as is the conventional figurativeness that presented the "dramatis personae" to the viewer in a meaningless rigidity; in its place there is the suggestion of rotative movement that the interpretation of the viewer will transform into a dance of the Muses around Apollo, divinely immobile.

The colossal nude statue of Alexander Severus in a heroic pose, located in the National Museum in Naples, is in reality of Elagabalus; as for the Diocletian of Miseno, also there, the *damnatio memoriae* has resulted in substituting a different face for the face of the person in disfavor. In this case it was the face of Alexander Severus, a rather swollen and colorless sculpture, of an officially approved sort. In contrast, the vigorous sculpture of the bronze portrait of Rhyakia (Plate 30), on exhibit in the Museum of Thessaloniki, is a fresh and lively work. If it had its precursors in heads of figures in battle scenes on sarcophagi or in portraits on the Aurelian column, it nonetheless contains elements of newness in the clean surfaces of the cheeks, the well-defined hair, and the simple vividness of the beard. These help to explain the artistic facts of the arch of Thessaloniki and of so many other figurative styles of the fourth, fifth, and sixth centuries. Certain Justinian interpretations, even in mosaic, have their cultural roots in works such as these and in the bronze portrait of Julia Mamea of the acropolis of Sparta. Greece returned to the limelight, reworking its glorious artistic tradition in such a way as to render it new and up-to-date and productive: the Hellenism of the second century, and in particular of the workshops of Asia Minor, found in Greece - and especially in Macedonia - promoted its relaunching in the Byzantine world; but this also is a theme little faced by art criticism.

Architectural structures and articulations: Towards a new methodology? - What has been said up to now is true not only for painting and for sculpture, but even more so for architecture; the historical and artistic studies made to date in this field need to be done again with a new methodology, one that is still just barely perceived.

An example is that of the central building at Lambaesis, which has been known by different names, such as the honorary arch and Torhalle; its real name and function were finally revealed when the inscription of dedication was reconstructed. This building is called the "groma" (a surveying instrument), as it was constructed on the site where the groma was placed at the time of the initial survey of the area. The lower part has the form of a tetrapylon, above there is a large open area, whose purpose is not known, but which in some way could be connected with the name of the building. The date of the inscription, 267-268 A.D., places the edifice at the time of Gallienus and recalls the first structure at that site a century and a half earlier. From this identification it follows that the "typological" examination of the buildings is to be reappraised and that one should consider the single architectural components that make up the monuments, rather than the models of "arch," "villa," or "praetorium."

Let us look at the villas. Their standard plan changes totally in the course of the third century; thus one cannot speak of one or more typologies of the villas of the first through the fourth centuries, but of a category of luxurious country villas. These villas had a composition and an arrangement of parts that varied over time, even before the variations due to the geographical displacements; however, the characteristic element of the central courtyard - or series of courtyards - remained. But the disposition of the rooms surrounding the courtyards changed, in a way that they were for the most part no longer positioned on the main axis of the villa. There was rather an arrangement on smaller mutually perpendicular axes - with an insistent but broken rhythm - of rooms open to the sky, courtyards, and living areas, arranged in groups with their own spatial rhythms.

The difference appears evident if we examine the African villas of Zlite, or, even better, of Silin, comparing them with those studied in Gaul, either before or after the fateful year of 276 A.D. that saw the first uprisings of the Germanic populations within the Roman Empire. The older large villas tend to extend themselves in the facade probably because of that interest that the Roman had for the open view, for the panorama. In the villas after the middle of the third century, there is a general closing in of the rooms on the courtyards, whether they are of representation or for living areas, using a procedure parallel to that long noted by Becatti in the Ostian houses of the IV century; the workshops and even the porticoes of the walkways face inward, with walls that are closed towards the outside, allowing the rooms to breathe only through the gardens, courtyards, or internal light wells. Another characteristic of these villas is the presence of long internal porticoes, at Laonquette in Gaul as at Piazza Armerina in Sicily. This is an architectural structure that is not peculiar to the villas, having been found in other secular and public buildings, contemporary and later; examples are the baths of Skolastikia at Ephesus, the ardica of Santa Croce at Ravenna, and, in a certain sense, those of San Vitale.

The villa of Montmaurin in Gaul could appear to be an exception, with its rooms apparently arranged on courtyards along a median axis of the building, if the large semicircular portico of the entrance were not to lead us into error; this was added later to protect the reconstructed sanctuary of the waters, formerly located at some distance and destroyed at the beginning of the IV century A.D. Except for this addition, the arrange-

ment of the rooms of this villa is typical of the buildings of the IV century.

This complexity in the internal arrangement is common to every category of building, rather than one type being derived from another; it is a general cultural acquisition. This is proved by the castrum of Palmyra, with its praetorium of monumental scale, and the palace of Diocletian at Split, now that careful investigations have partially brought the original structures to light. The positioning of polygonal or circular buildings with a central axis, sometimes connected to buildings of longitudinal axis, is within rectangular spaces, having relative proportions approaching the ideal. But the disposition of the internal structures is on axes with varied relations among themselves. We are dealing with the arrangement of the other parts of the palaces of the late empire, such as that of Thessaloniki, or, even more so, of Constantinople.

Complex arrangements appear also in the religious buildings; this is true not only for ecclesiastical and baptistry buildings, but also adjoining buildings connected to the ecclesiastical life of the city, whether diocesan or not. Unfortunately, in this sector, the investigation is for now limited to the eastern part of the empire.

Christian buildings. - In the 1970s many monuments of Christian architecture were given new attention. Even if they have always been excavated with the proper care, their historical and chronological identification sometimes turns out to be difficult.

Among the most significant monuments are those of Milan, and in particular Santa Tecla and the Baptistry. They demonstrate the very high quality of the architecture of the Po Valley in the second half of the IV century; from there - especially with the Baptistry, using themes and motifs from the Baptistry of Rome - this high quality was spread out in a wide cultural range, with the metropolitan church of Mediolanum as its epicenter.

The "rotunda" of the Pinian Palace is the baptistry of a church that is not yet excavated and which was in turn transformed into a church itself; this is a typical example of a Christian cult building built over a grandiose Roman villa. Another imposing baptistry is that of Canosa, whose architectural structure has been accurately dated because of the presence of numerous roofing tiles with the name of the bishop Sabino. At Canosa itself, because of the type of cement used to consolidate the walls (alluvial material), it is no longer possible to reconstruct the history of S. Leucio, with its interesting layout, central axis, and double concentric apses. This is probably a martyrium, even if the studies made of the octagon of Antioch, where the cathedral of the city has been identified, cannot be used as a confirmation of this. Rather, the contribution of the building culture of the Greek Church to the historic development of the religious buildings following the rediscovery of the basilical complexes should be studied more thoroughly. Among these I will name only those of Nea Anchialos and Amphipolis for their richness and complexity. While in the West there are no groups of basilicas, except the infrequent cases of double cathedrals, this phenomenon appears frequent and distinctive in Greece and in the Orient.

A complex that has been much studied is that of Anastasis at Jerusalem. The samplings conducted by P.

Corbo in the so-called "Rotunda" have clarified how the Holy Sepulchre was positioned, enveloped in a building in a sort of wide vaulted apse; this apse adjoined a flat facade opening on the portico of Golgotha. Completely new and distinctive architectural solutions were employed, in accordance with the instructions given by Constantine to the bishop Makarios; his complex had to surpass all others then existing in its diversity, the disposition of the buildings, and its richness. It is a fact to be kept in mind by anyone wishing to study the history of the late Archaic art.

The excavations made in the cities of Pamphylia have brought to light numerous architectural works. A basilical and episcopal complex was uncovered at Side, consisting of a very large building of the V century that included a church, martyriums, living areas for the clergy, private chapel, hall, triconch, and garden. A series of more ancient buildings was found at Perga, generally of Severian style, restored and modified in the IV and V centuries A.D. Among these were the great gate of the city with a rich internal propylaeum with statues of pagan deities in Archaic and Classic style, a nymph with imperial statues, a propylaeum with imperial statues and statues of local personages, and a "macellum" later transformed into a Byzantine church with cupola.

It is interesting that virtually all of the restored buildings are of the Severian period: apparently the style of the end of the second and the start of the third century was still very popular in the IV and V centuries. The trend is not isolated; it is also found at Leptis Magna, in the Severian basilica, where buildings in late style are found. Its Severian ornamentation has recently been the subject of a new critical study.

Architectural and mosaic decorations. - All of the buildings mentioned above have rich internal ornamentation; the mosaics of the buildings of the East, and also those in the West that are derived from them - such as those of central Italy on the Adriatic and, in particular, Ravenna and Aquileia - are especially luxurious. Floors with marble slabs of differing dimensions and form appear throughout the western-central Po Valley, accompanying the wall ornamentations of marble panels, either real or imitated in paintings; a conspicuous example of this has been found at Ostia in a building outside of the Marina port. Marble floors exist also in the Greek basilicas, such as in Kraneion at Corinth, which, incidentally, is not prior to 500 A.D. The little church of Troia of Setubal is interesting as an example that shows the spreading of wall decoration - or its pictorial surrogate - throughout the West. It proves the existence of a previous history of such ornamentation in later barbarian churches in the Iberian peninsula; an example is San Julian de los Prados (although this has certain provincial limitations).

The rich internal decoration of the buildings brings our discussion back to the mosaics. At Noto, on the Tellaro in Sicily, a villa has been identified that seems to have a mosaic decoration at least equal to that of Piazza Armerina. It has not yet been excavated, and only a little information and a few photographs have been made public. It seems to be dated after 360 A.D. perhaps even after the earthquake of 365. Themes and motifs noted also at Piazza Armerina appear in its mosaics, but are developed with a more elaborate and refined technique. The finding prolongs the discussion on the determination of where, figuratively and chrono-

logically, the Sicilian mosaics are to be placed. This is part of a larger discussion of mosaics from other areas as well, which can lead to more knowledge on the gradual migrations of artists toward Constantinople as different areas were occupied by the barbarians. Another villa has been found near Patti containing mosaics from a few decades earlier, and this is still being studied. The number of those luxurious villas confirms the fact that they belonged to senatorial families rather than to imperial landowners. Outside of Sicily, the rich mosaic decoration of the villa of Desenzano on Lake Garda must be mentioned; the villa seems to have also been used by the early Christians.

Other mosaics on which research has been carried out, including technical research, are those of the Rotunda of St. George at Thessaloniki. These mosaics date from the time the building was transformed from an imperial mausoleum into a Palatine church at the end of the fourth century. A clearer knowledge of mosaics has been gained by these studies; designs of some of the lost mosaics have also been recovered.

The use of mosaics continues into the V century throughout what had been the classic world, as is proven by the floors of Heraklea Lyncestis. However, when we now speak of the Eastern world it is accepted practice to refer to these manifestations as Byzantine art, and for the Western world as barbarian art or art of the high middle ages.

Minor late-ancient art. - The barbaric invasions have led to findings of silver treasure troves, although rare and sporadic, which were hidden in moments of danger and then forgotten. Among these, a quite remarkable recovery was recently made at Kaiseraugust in Switzerland; it was probably hidden in the second half of the fourth century and was composed of numerous plates irregularly decorated (Plate 31). While there are no problems of dating or milieu for the objects in this find, the discussions on the finding of Canoscio and on the authenticity of some of its inscriptions are still going on. Finally, a silver capsella for relics from the IV century found in Halkidiki at Nea Herakleia, is of a well known typology that is much diffused, even in the upper Adriatic regions. A very similar one has recently been acquired by the Bayerisches National Museum of Munich: it is exhibited in Room I but has not yet been catalogued. It is said to be from Thessaloniki: with what has previously been noted, this suggests the existence in that area of a center of production of these objects, perhaps in Thessalonik itself.

Finally to be noted is the return to Alexandria of the Ambrosian Iliad, which is a real reference point for the study of the late antique art.

The recent restoration of the monumental catacombs of San Gennaro in Naples has brought out the very high quality of many paintings and of certain mosaics, which were from as late as the tenth century. Thus the late Roman artistic production is seen to be connected to that of the early middle ages in a precise continuation of tendencies, or even of schools, at least in the culturally well defined area of Campania.

In the area of the so-called minor arts are to be remembered the printed medallions for application to pitchers, flasks, etc. They make up a category of objects that has been little studied, except for the votive flasks of the Anastasis or the sanctuary of St. Menna. Their scenes are therefore of great iconographic interest. They were widely used in every sector, mainly for what we would call "propaganda" - that is, the spreading of ideas by means of images. A very popular theme was that of the death of a hero in the defense of ancient ideals; for example, the death of Hector on the Gallic medallion of Felix. Even more openly political are the two medallions on the flask found at Gavardo, now conserved in the local town hall; one representing the myth of Hercules and Exion and the other the Indian triumph of Bacchus. In the latter, the image of a Roman emperor is substituted for the figure of the god, with the inscription "Liber in Deum" - that is, "Bacchus against God" - with a clear allusion to the religious conflicts of the last part of the IV century.

BIBLIOGRAPHY - R. Bianchi Bandinelli, Roma: L'arte romana al centro del potere, Milano, 1969; R. Bianchi Bandinelli, Roma: la fine dell'arte antica, Roma, 1970; R. Bianchi Bandinelli, M. Torelli, L'arte della antichità classica: Etruria - Roma, Torino, 1976; Ch. Picard, L'art romain, Paris, 1963; H. Kaehler, Rom und sein Imperium, Baden-Baden, 1963; C. Vermeule, Roman Imperial Art in Greece and Asia Minor, Cambridge, Mass., 1963. M. Manni, Le pitture della casa del colonnato tuscanico, Mon. Pitt. Ant. III, II Ercolano, Roma, 1974. A. Blanck, Scavi in Italia Centrale, AAnz, 1970; H. Gabelmann, Das Kapitolium von Brescia, in Jhb GZ Museum, Mainz, 18, 1971; R. Wuensche, Der Junglinge vom Magdalensberg, in Festscht. L. Dussler, München-Berlin, 1972; G. Carettoni, Nuova serie di lastre fittili 'Campana', in Barte, 58, 1973; A. Frova et al. Scavi di Luni, Roma, 1973; P. Mingazzini, La decorazione dell'arco di Orange, in RM. 75, 1968; C. Vatin, Circonscription d'Auvergne, in Gallia, 27, 1969; Cl. Pourset, Circonscription d'Auvergne, in Gallia, 31, 1973; N. Degrassi, Il c.d. Capitolium di Brescia, in Atti Congr. Centenario del Capitolium di Brescia; A. De Franciscis, Il sacello degli Augustali a Miseno, in Atti decimo convegno Magna Grecia, Taranto, 1970; C. Fernandez-Chicharro, Hallazgo de un retrate de Vespasiano de Ecija in MM, 1973; M. Rotili, L'arco di Traiano a Benevento, Roma, 1973 H. Vetters, Forschungen in Ephesos, in AnzÖAkWien, 1972, 1973, F. Eichler, Zum Partherdenckmal in Ephesos, in ÖJh., Bh, 49, 1971; V.M. Strocka, Funde aus Italien, AAnz, 1971; V. Karageorghis, Chronique des fouilles à Chypre, in BCH, 100, 1976; F. Rakob, Der römischen Quellenheiligtum bei Zaghouan in Tunesien, AAnz, 1969; Colloque Apamée de Syrie, Musées Royaux du Cinquantenaire, Bruxelles, 1969. M.P. Rossignani, La decorazione architettonica romana in Parma, Roma, 1975. G. Papathanassopoulos, Mosaik mit Apollon und die Musen, in Arch. Ann. Ather., 21, 1969; K. Fittischen; p. Zanken, Die Kolossalstatue des Severus Alexander in Neapel, AAnz, 1970; D. Pandermalis, Ein Bildnis des Severus Alexander in Thessaloniki, AAnz, 1972; F. Michaud, Chronique des fouilles, in BCH, 95, 1971; Kolbe, Die Inschrift am Torbau der Principia im Legionslager von Lambaesis, in RM, 81, 1974; F. Rakob, S. Storz, Die Principia des roemischen Legionslager von Lambaesis, ibid.; F. Salza Prini Ricotti, Le ville romane del Silin, in RendPontAcc., 43, 1970-71; J. Lauffrey, J. Sehreyesk, N. Dupré, Les établissements et les villas romaines de Lalonquette, in Gallia, 31, 1973; G. Fouet, La villa gallo-romaine de Montmaurin, in Gallia, supp. 20, 1963; G. Fouet, Le sanctuaire des eaux de la "Hillie" à Montmaurin, in Gallia, 30, 1972; V.A. Daszewski, Les fouilles polonaises à Palmyre, in Annales Archèologiques Arabes-Syriennes, 22, 1972; N. Duval, Palais et fortresses en Yugoslavie, in BAFr, 1971; E. Toth, Late antique imperial

palace in Savaria, in Acta Arch. Ac. Sc. Hungar., 25, 1973; M. Cagiano de Azevedo, I palazzi imperiali tardoantichi, in Atti XVI Congr. Storia dell'Architettura, Grecia, 1969, J. and T. Marasovic, Der Palast der Diokletian, Wien, 1969; G. Waurik, Untersuchungen zur Lage der römischen Kaisergräbe in der Zeit von Augustus bis Constantin, in JabRGZK-Mainz, 20, 1973; M. Malaspina, Saggio sugli episcopia nella pars orientis dell'impero, in Contributi dell'Ist. di Archeologia della Università Cattolica del S. Cuore, 5, 1975, M. Mirabella Roberti, La cattedrale antica di Milano e il suo battistero, in Arte Lombarda, VIII, 1963; M. Mirabella Roberti, Il battistero della Cattedrale, in Studi e ricerche sul territorio della Provincia di Milano, Milano, 1968; M. Cagiano de Azevedo, La cultura artistica di S. Ambrogio, in Ambrosius, Atti del Conv. Int. per il VII cent. della elezione di S. A., Milano, 1976; M. Pelliccioni, Le nuove scoperte sulle origini del battistero lateranense, in MPontAcc, 12, 1973. M. Mirabella Roberti, Ancora sulla rotonda di Palazzo Piniano, in Insula Fulcheria, 7, 1968; R. Moreno Cassano, Il battistero di S. Giovanni a Canosa, in Puglia Paleocristiana, Bari, 1970; G. M. Castelfranchi Falla, Le principali fasi architettoniche del San Leucio di Canosa di Puglia, in Commentarii, 69, 1974; F. W. Deichmann, Das Oktagon von Antiocheia: Heroon, Martyrium, Palastkirche oder Kathedale?, in Byz. Zeitschrift, 65, 1972; P.J. Lazaridis, Anaskaphai Neas Anchialos, in Praktikà, 1972; E. Stikas, Anaskaphai Amphipoleos, in Praktikà, 1971; J. P. Michaud, Chronique des fouilles, in BCH, 97, 1973; V. Corbo, La basilica del Santo Sepolcro a Gerusalemme, in Liber annuus 19, 1969; C. Coüasnon, The church of the Holy Sepulchre in Jerusalem, London, 1974; M. Cagiano de Azevedo, Prìncipi committenti di opere d'arte, in Atti XXII sett. sull'Alto Medioevo, Spoleto, 1974; G. Becatti, Edificio con opus sectile fuori porta Marina, Scavi di Ostia, VI, Roma, 1969. F. de Almeida, F. L. de Matos, Frescos de la 'capela visigótica" de Troia, Setúbal, in Acta III Congr. Nac. Arq., Coimbra, 1970; G. Voza, archaeologia nella Sicilia sud-orientale, Siracusa, 1973; A. Di Vita, La villa di Piazza Armerina e Parte musiva in Sicilia, in Kokalos, 18-19 1972-73; Atti del III Congr. Int. di Studi sulla Sicilia Antica; F. Canciani, Un mosaico da Marsala con i busti delle stagioni, in Cronache di archaeologia, X, 1971; M. Mirabella Roberti, Architetture del IV secolo nell'Italia Padana, in RPontAcc, H. Torp, Mosaikkene i St-Georg-Rotunden i Thessaloniki, Oslo, 1963; A. Grabar, A propos des mosaïques de la coupole de Saint-Georges à Thessaloniki, in CahArch, 17, 1967; A.M. Mansel, Bericht über Ausgrabungen in Pamphilien in den Jahren 1957-1972, in AA, 1975; M. Floriani Squarciapino, Le sculture del Foro Severiano di Leptis Magna, Roma, 1974. G. Tomasevic, Une mosaïque du Vème siècle de Heraklea Lynkestis, in Atti VIII Congr. Int. Arch. Cristiana, Barcelona, 1969; H. W. Istinsky, Der spaetroemische Silberschatsfund von Kaiseraugst, in AbhAkWiss. Mainz, 1971, n. 5; W.F. Volbach, Il tesoro di Canoscio, in Atti Il Conv. Studi Umbri, Gubbio, 1965; M. Cagiano de Azevedo, Le opere d'arte nei bottini di guerra, in Atti XV sett. studio sull'Alto Medioevo, Spoleto, 1967 (1968), M. Michaelidis, Argyra lipsanothiki tou Mouseiou Thessalonikis, in Arch. Ann. Ath., 2, 1969; G. Cuscito, I reliquiari paleocristiani di Pola, in Atti e Mem. Soc. Istr. St. Patria, 20-21, 1972-73; G. Cavallo, Considerazioni di un paleografo per la data e l'origine della 'Iliade Ambrosiana", in Dial. archaeologia, VII, 1973, R. Bianchi Bandinelli, Conclusioni di uno storico dell'arte antica sulla origine e la composizione della Iliade Ambrosiana, ibid., U. Fasola, Le catacombe di S. Gennaro a Capodimonte, Roma, 1974. A. Audin, A. Bruhl, Le médaillon de la mort d'Hector, in Gallia, 26, 1968 M.J. Vermaseren, Liber in Deum, Leiden, 1976.

MICHELANGELO CAGIANO DE AZEVEDO

THE ASIATIC WORLD AND BARBARIAN EUROPE

THE ART OF THE STEPPES (PLATE 33 a, b)

The so-called "triptych" of the steppes - the animalistic art of the Scythians to the west, of the Altai Mountains and of Siberia in the center, and of the Ordos desert to the east - is mainly dependent on the so-called "problem of Karasuk," that culture that we have already touched on and which takes its name from a tributary of the Enisei. Its beginning must go back to the XII or XI century B.C. - although Kiselev, in his fundamental work on Siberian archaeology, believed it was as early as the XIV century B.C. - and it lasted until about 700 B.C. This culture was characterized by a remarkable agricultural activity, as shown by traces of an extensive system of artificial canals and by a large number of graves; it presents indisputable evidence of commercial and other relations with the Chinese world (Shang dynasty period of Anyang). The bronze tools of the Karasuk culture extend over a broad range, with hundreds of tombs at Minusinsk and in southern Siberia, and include arms and agricultural instruments; the animalistic motif is developed in typically Karasukian forms. For this reason, Karasuk is considered one of the principle sources of the animalistic style.

While M. P. Grjaznov and Clenova herself (who differs from Grjaznov in various points, including the dating) consider Karasuk as an evolutionary stage from the preceding culture of Andronovo, a tendency has developed to consider Karasuk as the product of a migratory movement coming from Mongolia. K. Jettmar and E. A. Novgorodova agree with this theory, although for different reasons. Novgorodova, through the use of a statistical method of comparison of ornamental objects, has determined that peoples migrating from the southeast and settling in the upper basin of the Enisei coexisted, but did not mix, with "aboriginal" groups; these groups - who had possibly migrated from the north - were of the culture of Afanas'evo and of Andronovo. The theory that the culture of Karasuk had a single point of origin seems clearly outdated; this is supported by the statistical and mathematical studies of the Russian scholar, which clearly show a subdivision into at least 10 different significant types. On the other hand, the exact definition of the character of the Karasuk culture leads automatically to its comparison (and differentiation) with the preceding phases; however, it is undeniable that there is a total absence of any connection between the migrated groups and those pre-existing, even if some continuity exists in the ceramic sector.

The migratory drive we referred to appears to have its origin in Mongolia and, according to Jettmar, the real center of origin of the Karasuk culture should be looked for in that area; the apparently Siberian aspect should not lead to the wrong conclusions. If we remember that N. L. Clenova held that the origin of the Karasuk culture was almost certainly in the older phases of the bronze age in Luristan (area of Zagros, in Iran), this is without question a radical change in thinking. The technological index, nonetheless, is in contrast with all of these theories. The presence and the persistence of arsenious alloys makes a complete derivation from the east less probable; however, the theory of a center of propagation in the Mongolian area, with a vector of migration directed to the west, is still valid. The theory of the Luristanian origin is improbable, for chronological and other reasons; the dating of the bronzes of Luristan is, for various reasons, still not clear (even if the proposals of Roman Ghirshman, which would be unfavorable to Clenova, remain basically valid); furthermore, migrations from the Iranian territory towards the north and east seem unlikely.

There is no doubt that there was a connection between the ancient cultures that developed in the territories of the Soviet republics of Central Asia and those of northern Iran. For example, a relationship between Tepe Hisar and Zaman Baba (in the oasis of Buhara) has been determined, where urban structures and architectural forms analogous to those of the Iranian center have been found. On the other hand, in the so-called "treasure" of Kalk, in Fergana, which may be composed entirely of imported objects, a bronze pin of a cow shown licking its calf and being milked by a woman is analogous in subject, composition, and style with similar objects of Tepe Hisar. Other examples may be found in the production and decoration of earthenware. According to V. M. Masson and V. I. Sarianidi, these reveal a succession of different cultural waves from the south, occurring over a long period of time, and especially for Turkmenistan.

At times the migrations appear to have been uneventful and peaceful, at other times they brought significant cultural contributions of different types. The local sequence presents moments of connection both with Iran and, seemingly, with the civilization of the Indus. There were also the calcolithic phases (Namazga I and II) and a possible period of exclusive Iranian interference; in this period, different groups arrived bringing a particular ceramic that characterized the culture of the oasis of Geoksjur, whose source of inspiration seems to be found in the south of Iran.

The elements characterizing the relationship between the cultures of the Iranian area, of Central Asia, and of the Indus are mainly either of a geometric type or are representations of human figures. The animal images of the Iranian world (goats and predatory cats, probably identifiable with the cheetah) have a lesser capacity for expansion. In the area of Beluchistan, where it can still be recognized, it is found to be profoundly modified in stylization and setting; in the civilization of the Indus, outside of the earthenware production - and therefore having different scopes and values - the animalistic images make a qualitative leap, assuming a much better defined and complete appearance that reveals a totally different psychological attitude.

Even though there is a relationship between the figurative art of Central Asia and other regions, and there are certainly influences from Central-Asiatic sources, the point of origin of animalistic art still remains to be identified. It is of course true that all of the cultures that have been studied, without exception, portray animals in their art. The portrayals of Central Asia, whether they are stylized or realistic, painted on vases of terra-cotta or worked as statuettes in full round, are nevertheless images with a decorative spirit very different from what would be suggested by the psychology of the nomad, a hunter par excellence.

The works of the steppes are, in fact, inevitably conditioned by the characteristic ties that unite the hunter-shepherd to the animal world, but which are

almost foreign to the life of the farmer, unless on a different level. On the other hand, a large amount of data shows that there were exchanges, contacts, and correlations forming a system of interconnections much more complicated than had been supposed. For example, the formal characteristics of the Scythian-like creations of Pazyryk, the diffusion of the motif of the deer in "flying gallop" studied by Clenova, and the recent excavations in the Fergana (eastern Uzbekistan) carried out by Ju. A. Zadneprovskij, give us a rather complete picture of this complexity. The first of these will be covered shortly. With regard to the motif of the deer, the work of Clenova (1963) shows that the earliest example is documented in the treasure of Ziwija (Kurdistan), datable to around the VII century B.C. It is closely related to similar creations of the Crimea and of the coast of the Black Sea (the Pontide of the classic sources), which are clearly Scythian and datable to the VI century B.C.

The observations of Clenova tend to confirm the probable monogenesis of the type studied, whose earliest figurations are unquestionably western, and in fact Scythian. The spreading of this motif, if the chronologies adopted are exact, was very rapid. The image appears in the area of Minusinsk in the V century B.C. and in the Ordos (further east) definitely in the V century and possibly in the VI. Furthermore, the earliest images, whether they were of the Ordos or of Minusinsk, are those that resemble most closely the original Scythian scheme and its modulations - essentially, two intermediate aspects and one that is transitional with respect to the more eastern works. This is an indirect confirmation of the possible connection between the western regions, the Altaic area, and the Ordosic area, a connection that could also be confirmed by comparing the use of bronze alloys rich in arsenic in these same locations. Thus the Scythian art, in its earliest phases, would assume an importance relevant in the genesis of the art of the steppes.

In contrast, the copper and bronze tools found in the excavations of Fergana (Cust) have revealed types of knives that are unknown in Central Asia, but which seemingly are local reworkings of the knives of Karasuk, whether they originated in Central Asia or were imported from China (a single exception is found of a blade made of iron). A tenuous relationship can be seen in their derivation with those found in the area, generally going from the north toward the southwest; this area crosses a portion of the territories of diffusion of the bronze-tin alloys derived from the mining and metallurgical activities of Kazakhstan. The studies of E. E. Kuzmina (1966) on the metallurgical typology and techniques of Russian Turkestan confirm that a substantial percentage of the knives found in these zones, miniaturized as well, are derived from Karasuk. If we add to this the known fact that the characteristic motif of the goats with the horns joined at the nape was also adopted by the founders of Luristan in the Iranian area (although with a different stylization, more coherent and linear), we have a complete picture of the expansive force, and of the capacity for affirmation, of the works of Karasuk, at least along one of the directions of propagation. The studies made by K. Jettmar (1971), which follow a personal line of interpretation supported by technological data, confirm what has just been described; they touch on the accentuated decorative tendency of the founders

of Kazakhstan, a tendency he feels is not in tune with the art of the steppes as he conceives it to be.

We can see that the problem of the origins of the art of the steppes and of its component parts is exceptionally complex. In general, the current tendencies underline the importance of the Ordosic area in the formation of the animalistic style of Karasuk, both for itself and as a mediator of the Chinese influences, whether Shang or Chou; consequently, this area is also important for the successive phase of Tagar, whose importance to the art of the steppes has long been recognized, and in fact is the central part of the so-called "triptych" of the steppes (Ordos, Tagar, Scythia). The value of the Caucasian production as a source of influence has become much greater due to the additional technological data, to more precise knowledge of the ties to other metallurgical centers with a great capacity for expansion (Luristan and especially Urartu), and, of course, of the characteristics of style that distinguish it and give it its nature. This is all the more true in that the Scythian art appears suddenly, already formed, as the typical Scythian motifs of the treasure of Ziwija demonstrate, mixed with others of different kinds of values.

In reality, the essential problem today is that of the exact definition of the style of the steppes (or rather the identification of the various stylistic modulations of the art of the steppes) and what constitutes the nature and the value of this phenomenon.

MARIO BUSSAGLI

CONTACTS WITH THE WEST AND THE FORMATION OF THE BARBARIAN STYLE (PLATE 33 c, d)

The critics are in agreement that the animalistic style possesses undoubted originality and that it constitutes a unique, grandiose, and, in a way, enraptured production. Some consider the real authentic art of the steppes to have been only in the initial periods of full maturity of the nomad societies in an economic and social sense. Consequently, the art of the Huns of Attila, which many do not recognize, would not be included in this definition, having occurred in a later period. Such an assertion, while true in part, has some limitations and, for various reasons, should be accepted cautiously and interpreted with considerable elasticity; this in spite of the authority of its supporters, ranging from Grjaznov to Jettmar, although along different lines.

The remarkable persistence and the capacity for diffusion of some characteristic figurative motifs of the art of the steppes is not only unexpected but undeniable (even if sporadic). This is demonstrated in the Romanesque art of Europe in many ways: Scythian motifs are found in paws that terminate in a ring, used for figures of eagles - for example, at St. Antimo near Montalcino - or of other animals of prey, or for four-footed game animals. Chinese motifs are found in the funerary flies and the locusts of the Merovingian art; other examples, more general, but unmistakable, are the contorted animals, recurrent in the sculptural ornamentation in the churches of the Abruzzi (and elsewhere) of the 11th century A.D.

The acceptance by Western cultures of certain forms created by the nomads is clear, in spite of the

distances between them - not only in the mentality and the type of life of these nomads and of their artists, but also in the distance from the generating sources, the ancient Chinese world, of some of the forms passed on by the nomads to the other side of Central Asia. From a historic point of view, this transmission of forms can be explained by the barbarian invasions, the events that put groups of nomadic origin in opposition to the dual Roman empire or to the Germanic populations, and the sometimes intense diplomatic relations that Byzantium maintained with the "barbarian" peoples of the east and the north. The populations of northern Europe also participated in these "transmissions" in different and sometimes unclear forms; the stylized animalistic motif assumed different values according to the cultural situation and the evolutionary phase in which the inhabitants of Scandinavia and Iceland found themselves. An indirect route - deserving further study - is the Islamic, responsible for the presence in Europe of central Asiatic reminiscences, originating in the cities of the caravan routes of the south. In any case this is a delicate and difficult field of investigation that must be gone into more thoroughly in the future.

However, the analysis of the psychological and emotional systems, as well as the style, that led to the adoption and the assimilation of the animalistic motifs on the part of the different peoples and cultures of the West is much more complex. Lacking a proper overall explanation, especially since each motif has its own particular story, we can only note the incursion of Central Asiatic forms into the style and symbology of the European West. These forms came mostly from the nomads, but there are exceptions, such as the two-headed serpent; they established themselves due to the appeal of their fantasy and also for the traces of their original values, transformed through a complicated system of iconological adaptation.

The criticism by most of the researchers of the supposed limitations in the art of the steppes is along two converging lines. The first of these is historical and does not limit the period when the nomadic societies came to full maturity; this maturity was conventionally considered to have been in epochs that are now known to be too recent. For example, the height of the political expansion of the nomads occurred with the Mongols in the 13th century A.D., while the influence of the art of the steppes on the Tibetan world and society can be attributed to the Karluk Turks of the ninth and tenth centuries A.D. The second line - including the internal variations - requires a considerable dedication on the part of scholars; the relationships and the persistencies that continuously formed (with reminiscences, echoes, modifications, and transformations) even outside the Central-Asiatic area are intricate and difficult to decipher. This area, in any case, remains a rich source of motifs, solutions, and expressions that are both typical and of a style that is capable of making its presence felt over many centuries.

Based on the preceding insights, the relationship between the nomadic production and the art of the High Middle Ages in Europe is undeniable; some motifs, in fact, persisted even into very late periods. It is also clear that this presence of "barbarian" reminiscences from Asia came both directly, through movements of peoples who came from the East (or who had contracts with the East, direct or through intermediaries), and indirectly, through other lines of contact and trade that were based on economic and commercial factors (including the military mercenaries). However, the acceptance of the motifs - undoubtedly "barbarian" if they are judged by the standard of surviving classicism or according to the aesthetics of the Byzantium and Ravenna - indicates an enormous force of affirmation and a cultural space adaptable to favor it. In a sense, barbarian Europe, even with an economy totally different from that of the nomads, becomes an area in which the dominant ethnic groups appear more receptive to the figurative experience of the nomads, through osmosis and adaptation, than they are to the immense artistic patrimony of their own new domains. Salin, for example, reveals that the contribution of the art of the steppes to the Merovingian animalistic figurations is certainly preponderant, much superior even to the Germanic contributions. Further, for historical reasons that are not always very clear, this contribution appears not only continuous, but at the same time strongly characterized and characterizing.

Salin had a vision of the art of the steppes that we may define as "all-inclusive," in the sense that among the bearers of the animalistic style of the steppes he includes both some Indo-European peoples (Scythians and related, Sarmatian, pseudo-Cimmerians) and those who could be classified as Huns. This is in contrast with Jettmar, who, as we have noted, limits the art of the steppes to a definite period of development of the nomadic society and to the products of particular ethnic groups. Independently from the technical observations on the metallurgy, which followed his work by several years, Salin wrote:

> It appears that the animalistic art of the Sarmatians - that which interests us the most - entered into Europe from two sources. The first, located in the Koban and on the Bosphorus, appears to have originated only the "birds' heads" so often seen in the gold products of the Goths, and, more generally, in those of the Merovingians of the fifth and sixth centuries. The second, found on the Don and in Siberia, excels in the animalistic reproduction.

The French scholar cites, as an example, the famous belt ornament of Majkop, and he recalls many others from Siberia.

This second center of propagation, besides having a realism of unquestioned originality, shows a great taste for composition; if not of extremely high quality, it is at least clearly ornamental. In it the animal is contracted and stylized. Sometimes its extremities extend and become wider, or parts of other animals are attached. For example, the body of a deer may be connected to that of a griffon or to the head of an eagle devouring a ram's head. According to Salin, it is not difficult to find tendencies of this type among the Merovingian compositions, although they may be considerably attenuated and somewhat indistinct. He further believes - and we cannot fail to agree with him - that the animalistic images of the Merovingians, in principle, are often marginal, even if they have come from a rather involved historical background based on the early relations of the Celts with the Scythians, the Sarmatians, and the Hellenized Asiatics of Asia Minor. The subsequent contact with the Avars and the Lombards - as a

result of the migrations - contributed to increasing the frequency of the animals in this most unusual repertoire; these were mainly heads of birds and animals, either monstrous or real, and complete figures that adhered quite closely to nature.

Nevertheless, since the seventh century, the animals most commonly represented by the Merovingian goldsmiths were the dragon, in its different aspects, and a semi-fantastic being, completely deformed. In general, the animal images of the seventh century are almost always unreal, as the predominant tendency was that of making the animal into a monster. This monstrous and fantastic fauna adapts easily into the Christian iconography, with an obvious modification of its symbolic value. For some figures, these come to be associated with values and animalistic symbols that were already Christian, although from different sources (not always clear), having long been found on sarcophagi. These figures were: the dove, representing the soul of the faithful in the fullness of his celestial ecstasy; the peacock, symbol of immortality; the fish, although in the Merovingian art it was not always a Christian symbol; the lamb; and the deer, which had varied implications.

The deer, the radiant animal of Scythian art, spread as a symbol to very wide areas, almost always being associated with an aspiration for immortality. Sometimes it was the protector of the departed, other times it was their guide in the journey beyond the tomb; it also could be the custodian of the drink of immortality, from which it also drank. Salin reveals that in the ambience of the Merovingian art it is not easy to distinguish between the "Christianized" interpretations of this animal and those that have a different value, especially since the motif is relatively scarce. The deer is in fact often replaced by the horse, which assumes certain of its values.

The horse may have represented an idea or a psychic projection of the particular bond between the man and the horse. The horse thus came to assume a vast range of different values, through a continual process of assimilation and dissimilation with the horseman, until it assumed a sort of duality presumably unknown outside of western Europe. It could be seen either as the necessary companion of the one who combats Evil (and the monsters, imagined as an emanation of Evil), the protagonist of the infernal hunt (in which the horseman is pulled along by the beast); or it could be seen as a symbolic and unrestrainable vehicle of the destructive forces. For these reasons the Merovingian images of horses are essentially natural, even if stylized. They may recall certain corresponding figures created by the founders of the Ordos, using very different techniques; some were done in damascene, some in forms that are more distinct and substantial, in full round, although flat through a functional adaptation. Certain equine figures, with the body covered by small circles representing solar symbols, are related to the winged horse (frequent in the small perforated wheels of the seventh century and as a recurrent motif in buckles of the entire Gallic area). It is not possible, however, to determine with certainty the original source of this variation, which is celebrated and persistent in the mythical art of all of Eurasia (although it is almost certainly Mesopotamian). Similarly, the bull, and even more the fish, have their connections - sometimes forgotten or simply ignored - with Far-Eastern values, if they were not from

Central-Asia itself; in any case, they at least came by way of central Asia.

We must not forget the ornate "ichthyomorphous" of the Benedictines, used as a descriptive element, suggested perhaps by the spreading of the motif. In China, for example, the fish represents the watery element, fertility (derived from the water), untiring vigilance (as it never closes its eyes), a charm for long life. These same values seem to persist in the use of this symbol in Merovingian times. Naturally, this does not exclude the use of the fish as the traditional Christian symbol (ichthos); thus the exact definition of the value - when a clarifying context is missing - is difficult, if not impossible, to determine. In any case, it is known that the figurative repertoire of medieval European art traceable to the barbarian invasions is characterized by motifs that are unequivocally connected with the Far East and with the art of the steppes. H. Kuhn, for example, numbers at least 63 examples of small metal objects representing flies or larvae of locusts; some of these works are of considerable interest for the history of the goldsmith's art. Two-thirds of these finds were made in Soviet and Hungarian territory, but those found in the rest of Europe are equally significant; the larva of the locust (or the complete insect) represents, in China, since the time of the Shang dynasty, a sign of indistinct asexuality that can have a dual result, and therefore symbolizes the beginning of the universe. The assimilation of Christ - through a sort of derived symbolism - is very clear. Concerning the fly, the Chinese custom of putting flies made of iron into the mouths of the deceased, in the Han dynasty, should not be overlooked; this evidently had the purpose of assuring the flight of the soul into the next life.

Therefore, the repertoire of motifs of indisputably Central-Asian or Far-Eastern derivation is not insubstantial; this swells to an even greater volume if we include the eagles that are stylized in forms recalling those of the Ordos and the birds' heads with curved beak (as for birds of prey). Certainly they are closer to the Caucasian and Scythian type than they are to the eagles of the classical tradition. This is valid even if we ignore the use of the isolated eagle's head. The motif of the bird of prey is persistently seen in ornamental use, portrayed on buckles or other objects of personal use. The monster being shown looking to the rear, sometimes covered with disks, and the animal contorted into the form of the letter S are also motifs of Central-Asian derivation; in the final analysis, they are in fact characteristic of this derivation, no less than the triple figures inscribed in circles or on pierced plates - more or less in curved lines - that can be connected to the Scythian decorative style. Other motifs can be either more complex (figures with four heads) or simpler (as the "palindrome" serpentine beings with a head at each end of their bodies); very clear examples of these are found in the mural paintings of Kuca. Motifs of this type in the inventory of the high Middle Ages show a style that can be defined as Scythian-Sarmatian, but the contribution of the Huns must still be considered.

The art of the Huns of Attila has acquired a more precise physiognomy after the research of Otto J. Maenchen Helfen (1973), which was unfortunately interrupted by his death. This research was not limited to the historical phenomenology and to the examination of a unending series of sources; rather, it put into evi-

dence, indirectly, at least two series of problems associated with the artistic activity of the Huns. The necessary prerequisite to successfully complete such a work was the recognition of the exact significance of the findings attributable with certainty to the Huns. This was done with the characteristic caution and with the colossal erudition of this most discerning Austrian scholar. The evidence proves a marked preference for the polychrome, with mountings of colored glass, hard and semi-precious stones, and occasionally precious stones, closely positioned; it also shows, at least in a general line, that the source of inspiration of the works of the Huns is more likely to be Kazakhstan and the Ordos than the Scythians. Glass and garnets are the materials preferred for the mounting; they are often shaped in geometric forms (triangles, rhombuses, rectangles), but sometimes in other forms (rounded, convex, ellipsoidal). These materials were usually worked into gold strips or mounted on bronze supports covered by thin layers of gold (for the diadems, in open rings). The forms in question are very similar to those found in Kazakhstan (diadems with ornamental conical bells at Qara Agac and a supply of necklaces and earrings from the same location). On the whole the findings from the Huns appear richer and more characterized than we might have expected. It is true that the jewelry of the Huns is composite and has various origins. An example is the gold enameled pendant, with garnets, from Wolfsheim, a finding of 1870, now in Wiesbaden; the name of the Sasanide sovereign Ardasir I, founder of the dynasty, is inscribed in pehlevi characters on the reverse.

The jewelry of the Huns was in part accumulated through tributes and trading, but it would be a serious error to consider the style of the Huns as eclectic. We should say rather that this people - who are in many ways still mysterious - appears tied to that which W. F. Volbach, speaking of the barbarian art of Europe, calls the "colored style." On the other hand the genesis of the taste and of the "style" of the Huns, manifested in a vast production and subject to wide variations in quality, can be connected with the so-called "Sarmatian" style, the last phase of the art of the steppes. The Soviet expression of the "Hunnish-Sarmatian phase" is by now overused, but it nonetheless retains some validity; this phase includes a vast phenomenology which would also include the rich production of Pazyryk.

With regard to this last locality, the works of Pazyryk, as a whole, appear prevalently tied to the zoomorphic and plant-like compositions. In these it is possible to capture a vivid reflection of stylized Scythian-like forms and also of the Achaemenid art; at times this reflection is precise and unequivocal, although it may be adapted to local style, while at other times it is more vague. Objects of Achaemenid production have survived; obtained through gift or trade, they were miraculously preserved in the ice of the Kurgan tombs. These tombs have become famous for their fortuitous transformation into frozen depositories. An important example is the great carpet that is, without doubt, the oldest Persian carpet that has yet come down to us.

The problem of the stylistic and iconographic relations identifiable in the art of Pazyryk is greatly expanded if one takes into account several factors: the possible connections with the so-called treasure of Oxus; the specific local characterizations (for example the tattooing of the chief fallen in battle, preserved through very expert work of mummification, then buried in Kurgan no. 2); the relations that the repertoire of Pazyryk maintains both with the Scythian world and - most important - with the phase of Tagar and with the stylization of the Ordos, two of the principle "focuses" of the art of the steppes. One of the principle motifs of the characteristic repertoire of the steppes - the animal contorted in the shape of the letter S that some call the "contortionist" - occurs in splendid and very clear form, included even in the tattoos of the chief mentioned above; this motif remains, modulated through innumerable variations, as a reminder of the influence of the art of the steppes, continuing up to a much later era.

The "contortionist" animal, discretely included in the Romanesque decorative art until the eleventh and twelfth centuries, survives - as an isolated fact - even in the "Battle of San Romano" of Paolo Uccello. This happening has already been mentioned. It is worth noting that the figurative production of Pazyryk is generally considered to be from the V-IV century B.C., although some researchers have lowered this to an era between the III and the I century B.C. Though Pazyryk is the principal example, and in addition has survived in an excellent condition of preservation, the figurative production is not limited to the group of the Kurgan or to the area of Pazyryk. The components that form it can still be identified, through the well-known research of S. V. Kiselev, as derived from Tagar (or at least from its latest phase); however, they have been modified by the addition of considerable Scythian contributions and of others that are, at least in part, of "Sarmatian" derivation, or even Central Asian.

In this last component the inventions and the tendencies of the Saka and the Massageti groups have a conspicuous part. The importance and the variety in the production of Pazyryk is constantly becoming more complete through minute analysis, comparative research, and technological clarifications. For us, whatever the fundamental parts of this art may be, it is very important to note that scenes on the fabric of Pazyryk already appear with human figures, done splendidly in colored and embroidered felt. The slow flourishing of the human image - or, if preferred, the slow infiltration of a figurative symbol where the representation of animal beings was almost exclusive - appears clear, if we consider, for example, the human images in the late Scythian art, dominated by a very strong Greek element through the presence of Greek goldsmiths (working in what they considered a "barbarian" world, but which was certainly very attractive from an economic point of view) and the funerary masks of the culture of Tastyk (a composite culture, limited to an area on the upper Enisei, and contemporary with Pazyryk and the last phase of Tagar - for some, a local variant of the Tagarian current).

In different forms, and with different values, the human figure ultimately spreads to the entire area of the steppes: from the tomb of Noin Ula (constructed for the princes of Hsiung-nu) at Pazyryk, from the creations of the Saka and of the Sarmatian groups, to the art of the Attilan Huns. Aside from the fact that the highest quality works of the Huns were influenced by the style of the nearby Sarmatians, with its preference for perforations and the mounting of jewelry and with the goldsmiths taking their inspiration from the "colored style," the

works of the Huns show the not infrequent human figures together with figures of stylized and fantastic animals. It is clear that the appearance and the diffusion of the human image in the art of the steppe - especially in objects intended for personal ornamentation - imply modification of the mystical ties that united man with the animals. This partly justifies the reservations of Grjaznov and of Jettmar, made less definite by the fact that the stylization of the animal figures proceeds according to traditional design.

The introduction of the human figure, in any case, became inevitable after the consolidation of the individual conscience among the nomads and because of their contacts with the surrounding sedentary civilizations. In prevalence, the flow of suggestions was influenced by the precarious equilibria in which the nomads were the oppressors, or at least in a position to cause trouble, as well as by encounters where blood was shed. Naturally, the internal interchange between nomad groups evolving in different cultural directions played an important part in the modification; some, as the Sarmatians and the Saka, were to "crystallize" easily into complex state organizations when they left the area of the steppes to dominate agricultural regions.

To conclude, it should be noted that the contact with the sedentary civilizations that were adjoining them, and adversary to them, had a clear effect, not only on the cultural evolution, but on the entire social fabric of the affected nomad groups. The economical connection, and the particular accomplishment of this connection, played an extremely important part in the type of evolution accomplished. For example, the Hsiung-nu group was exposed to a process of assimilation into the Chinese civilization; the Chinese believed they would be able to succeed in attenuating the offensive power of their formidable enemies through this adaptation. Later, the same thing happened for the T'uchueh.

The Huns of Attila were not subjected to conditioning of this sort, aside from the use of the Hunnish units that served as mercenaries with the Romans in pre-Attilan times. Nevertheless - to judge from the classic testimonies - the transformation of the customs and the Hunnish uses, in the few decades of their clashes with the two Roman empires, seems much more rapid and radical. The phenomenon may be explained not only through the close contacts that the Huns continuously had with the Germanic populations they dominated, but also in relation to the nature of the tributes paid to the Huns by the Romans. The Huns in fact, received great amounts of precious coins (gold and silver). The ease of circulation of the coins, together with the greater capillarity of its diffusion, affected the social unity of the Huns in such a way as to eliminate, in less than a century, many of the outstanding characteristics of the nomad societies: Attila came to live in a great wooden pavilion, furnished, so to speak, with barbarian style and luxury. The transformation of the Hsiung-nu came more slowly; a major factor was that the tributes from the Chinese were paid in silks and precious objects, which did not circulate easily, normally going into treasure stores held by those who were in power. This naturally limited the rapidity of reaction and of adaptation in the mass of the subjects. In any case, the Chinese were interested only in assimilating the chiefs into the Chinese culture, considering this method relatively economical and very effective.

None of this excludes the persistence of autonomous attitudes in the field of figurative art. That the Huns had a particular style is shown by the forms - particularly functional - of some offensive arms (for example, the protective helmets), by the type of some ornaments, and by particular manufactured products, such as the famous cauldrons with the handles in the shape of mushrooms. All of this is sufficient to prove that the Huns were not only capable of exercising an extensive and original metallurgical activity and that their foundries succeeded in utilizing different metals (from bronze to the "alloys" of copper and red cuprite, as the technical analyses gathered by O. Maenchen Helfen demonstrate), but also that they were, at least, one of the intermediaries in the formation of the "barbarian" colored style referred to by Volbach. It is clear, however, that the assertions by A. N. Bernstam (1951) regarding the possibility of the Gothic style being connected to the Huns, and to the part they played in the diffusion of the "colored" style, are exaggerations.

Even though the role of the Huns as intermediary in the diffusion of the Central-Asian and Far-Eastern motifs was recognized, the extent, or better the significance, of this intermediary role still remains to be determined; it is of course true that in the transmission to the West practically every connection with the ancient world of the hunters is completely lost, as the barbarian goldsmiths of Europe were unable to assimilate it. They had a much greater interest in the stylizations, the fantastic deformations, the symbolic values connected with particular forms we have spoken of; once accepted by the Western world, possibly at the price of a profound change in meaning, they would be passed on even to the decorative-symbolic repertoire of the Romanesque art.

Concerning the Hunnish cauldrons with the mushroom-shaped handles, it would be useful to briefly consider the complex problem they present. O. Maenchen Helfen has noted the presence of complete examples, as well as fragments, at the Catalauni Fields in Czechoslovakia (at Benesov near Opava), in Upper Silesia, in Hungary (at least four large whole examples), in Romania (southwestern regions of the Oltenia), in Moldavia, and in the Ukraine (Dniepropetrovsk). They even appear outside Europe in Asian territories: near Perm, in the autonomous republic of Komi, in the northern Altaic area, in other regions of Siberia, in Kazakhstan, in the Kirgizija (33 examples), and in the ancient Chorasmia. Cauldrons of this type, easily recognizable for the cylindrical-conical form with a hemispheric base and, at times, with flared supports, can also be found portrayed in incisions on the rocks in the area of Minusinsk. One of these (from the Pisannaya Gora) clearly shows a ritual ceremony carried out by two men.

It is true that the rough manufacture of many examples seems to contrast with their intended use in rituals; considering the size of many of the best and most important examples, it is certain, however, that they were intended to serve for collective uses. The studies made of the values of these cauldrons have shown a connection with water, as a certain number of these (statistically very high) have been found on the banks of lakes, rivers, and streams and on the edges of marshes. Some of them seem to have been intentionally buried in the sand of the shores, but incisions in the rock at Minusinsk show a precise association between the cauldrons and the life of groups of humans and

animals that formed the settlement represented on them. It is possible that the cauldrons themselves served for collective rites at the moment of the transhumance and return, as held both by E. Ju. Spasskaia, cited by Maenchen Helfen, and Joachim Werner, although on different bases. The most significant parts of the cauldrons themselves are certainly the handles.

The recent studies on the origin of Soma and on the use as a hallucinogen of the amanita muscaria carried out by R. Gordon Wasson ("Soma, Divine Mushroom of Immortality," New York, 1968) offer a plausible explanation to the very widespread collective use of these cauldrons; they were certainly used for sacred purposes, but were also in use by the common people. They were an important adjunct to the preparation of the intoxicating liquid that came to be used on special occasions by this or that tribal group, or even by the community as a whole. A rite of this kind was not unusual for the nomads of the steppes, since the use of inhalations of semi-roasted "cannabis indica" has been definitely proved by the tent-type inhalers found in the kurgans of Pazyryk. The seeds of Indian hemp were also in use, semi-roasted on rocks in special ovens, actually portable bronze vases that were heated over an open fire.

The hypothesis that I propose here for the first time appears sufficiently solid and could explain - among other things - the incisive and fanciful aspect of many creations of the art of the steppes: that the inspirations were produced by hallucinogens of considerable potency. This meshes perfectly with the diffusion of the bronze vases with the mushroom-shaped handles and with the finding of the "Scythian" inhalers of Pazyryk. With regard to these inhalers, Georges Charriere (1971) considers the possibility of the drug as the source of inspiration for the artistic activity of the Pazyryk groups, even if he appears to limit the use of the drug itself mainly to a sort of funerary consolation, perhaps dangerous, but effective. For comparison, Charriere refers to the experiences of Theophile Gautier with camphor. Aside from the uncertain foundation of the comparison, the problem of figurative inspiration obtained with the use of hallucinogens is very widespread and almost unfathomable. In the actual state of our knowledge, this problem seems to involve directly the users of the vases with the mushroom handles, and therefore the Attilan Huns; however, it also touchs works of art that are foreign to the area of the steppes— for example, some Central-Asian pictorial images. In any case, this problem opens to us a very extensive field of research. If it is possible to seriously enter into this field, it is probable that it will provide some notable surprises; it could prove to be responsible for the so-called colored style, derived indirectly from the "Sarmatian" style of the Central-Asian regions of the south.

BIBLIOGRAPHY - Some works preceding 1963 are cited that have much interest for the subjects covered in this treatise. The others are chosen from among the more recent works that have made relevant contributions to the series of problems that we have confronted here. In the treatise of the art of the steppes, and of the echoes that it caused in medieval European art, the results of studies financed by the Consiglio Nazionale delle Ricerche and directed by the author have been utilized.

E. Salin, La Civilisation mérovingienne d'après les sépultures, les textes et le laboratoire, Paris, 1949-1959, 4 vol.; E. Salin, Sur les influences orientales dans la France de l'Est à l'époque mérovingienne, Revue archéologique de l'Est et du Centre-est, I, 1950; J. Werner, Beiträge zur Archäologie des Attila Reiches, Bayerische Akademie der Wissenschaften - Philosophich-historische Klasse, Abhandlung, Neue Folge 38A, München, 1956; E.D. Phillips, The Agrippaei of Herodotus, Artibus Asiae, XXIII, 2, 1960; E. D. Phillips, New Light on the Ancient History of the Eurasian Steppe, American Journal of Archaeology, 61, 1961, A. Leroi-Gourhan, Sur une méthode d'étude de l'art pariétal paléolitique, "Bericht über der V Internationalen Kongress für Vor- und Frühgeschichte. Hamburg 1958," Berlin, 1961; S. J. Rudenko, Sibiriskaja Kollektsija Petra I. - Arkhaeologija S.S.S.R. Akad. Nauk S.S.S.R., Moskva-Leningrad, 1962; Ts. Doržsuren, Raskopki mogil khunnu V gorakh Noinula na r. Chunigol (1954-57). In Mongol'skii arkheologicheskii sbornik, Moskva, 1962; D. Frossard, Décors mérovingiens des bijoux et des sarcophages de plâtre - Arts de France, III, 1963; A.K. Abetekov & Ju.D. Barudzin, Sako-usnun'skie pamjatniki Talasskoï doliny, In Arkheologicheskie pamjatniki, Talasskoï doliny, Firenze, 1963; G. Annibaldi and J. Werner, Ostgotische Funde aus Acquasanta (prov. Ascoli Piceno), Germania, 41/2, Berlin, 1963; Françoise Henry, L'art irlandais, Paris, 1963-64, 3 vol.; L. Van Den Berghe, Le necropole de Khūrvīn, Istambūl, 1964; K. Jettmar, Die Frühen Steppenvölker, Baden-Baden, 1964; N. L. Členova, Karasukskaja Kul'tura V Južnoi Sibiri, tomo I, Materialy po drevnej istorii Sibiri, Ulan Ude, 1964; O. N. Bader, La caverne kapovaïa, peinture paleolitique. (Kapovaja pešera), Moskva, 1965; H. Schlunk, Die Auseinandersetzung des christlichen und des islamischen Kunst . . . bis zum Jahre 1000, Settimane di studio del centro italiano di studi sull'alto medioevo, Spoleto, 1965; A. Leroi-Gourhan, Préhistoire de l'Art Occidental, Paris, 1965; E. E. Kuz'mina, Metalličeskie izdelija eneolita i bronzobogo veka V srednii Azii, Arkheologija S.S.S.R., V, 1966; K. Jettmar, Mittelasien und Sibirien in vortürkischer Zeit, Handbuch der Orientalistik, I, 5, 5, Leiden-Köln, 1966; K. Jettmar, Geschichte Mittelasiens, Handbhuch der Orientalistik, 1966, I/5/V; E. N. Cern'ikh, Istorija drevneisei metallurgii vostošnoi Europi, Akademija Arkheologii, Moskva, 1966; Peter J. Ucko and Andrée Rosenfeld, Arte paleolitica, Milano, 1967; A. P. Okladnikov, Utro iskusstva, Leningrad, 1967; K. Jettmar, Art of the Steppes, New York, 1967; J. Erdely - C. Dorjsüren, D. Navan, Results of the Mongolian - Hungarian Archaelogical Expeditions, 1961-1964, Acta Archaelogica Hungarica, 19-3-4 (1967); P. Daffinà, L'immigrazione dei Saka nella Drangiana, Roma, Is. M.E.O., 1967; T. Cuyler Young Jr., The Iran Migration into the Zagros, Iran. Journal of the British Institute of Persian Studies, vol. V, 1967, J. Hubert, J. Porcher, W. F. Volbach, L'Europe des invasions, Paris, 1967. Trad. italiana, L'Europa delle invasioni barbariche, Milano, 1968; A.M. Mandel'štam, Pamjatniki epokhi bronzii v južnom Tadžikistane, Akademija Nauk S.S.S.R. Material'y i issledovanija 145, Leningrad, 1968; G. Herrmann, Lapis Lazuli: the Early Phases of its Trade, Iraq, XXX, 1968; N. Gryaznov, Sibeérie du Sud, Genève, 1968; R. D. Barnett, The Art of Bactria and the Treasure of Oxus, Iranica Antiqua, VIII, 1968; M. I. Artamonov, Treasures from Scythian tombs, London, 1969; M. I. Artamonov, The Splendor of Scythian Art, New York-Washington, 1969; S. I. Rudenko, Frozen tombs of Siberia: the Pazyryk Burials of Iron-Age Horsemen, Berkeley and Los Angeles, 1970; E. A. Novgoroda, Central'naja Azija i karasukskaja problema, Akad. Nauk S.S.S.R., Moskva, 1970; G. Charrière, L'art barbare scythe, Paris, 1971; V. Sarianidi, Southern

Turkmenia and Northern Iran, Ties and Differences in very Ancient Times, E. and W., 21, 1971, V. I. Sariandi, The Lapis Lazuli Route in the Ancient East, Archaeology, XXIV, 1971, B. A. Litvinskij, Drevnie koševniki "Kr'isi mira", Akademija Nauk S.S.S.R., Moskva, 1972; L.N. Gumilev, Hunnu, Moskva, 1960. Traduzione italiana: Gli Unni, Torino, Einaudi, 1972. (Si riferisce agli Hsiung-nu); V. M. Masson & I. Sarianidi Central Asia, Turkmenia before the Achaemenids, London, 1972; K. Jettmar, Die steppenkulturen und die Indoiranier des Plateaus, Iranica Antiqua, IX, 1972; K. Jettmar, The Karasuk culture and its South Eastern affinities, B.M.F.E.A., n. 22, 1956; L. B. Bartucz, Anthropologische Beiträge zur I und II periode der Sarmatenzeit in Ungarn, Acta Archaeologica Hungaria, 13-1-4, 1961; C. C. Lamberg-Karlovsky and M. Tosi, Shahr-i Sokhta and Tepe Yahya: Tracks on the earliest history of the Iranian plateau, E. and W., 23, 1973; Otto J. Maenchen-Helfen, The world of the Huns, Studies in their history and culture. Edited by Max Knight, University of California Press, Berkeley, Los Angeles, London, 1973; C. Gatsie, "Siberian" Gold collected by Peter the Great: the Gagarin Gift., A. As. XXXVII, 1975.

MARIO BUSSAGLI

PART II

THE ORIENT AND OTHER NON-EUROPEAN CIVILIZATIONS

SUMMARY

ISLAM

GENERAL

Introduction. — Aesthetics and General Characteristics. — Sociology.

ARCHITECTURE AND TOWN PLANNING (PLATES 34-41)

Religious Architecture. — Civil Architecture. — Town Planning.

PICTORIAL AND MINOR ARTS (PLATES 41-43)

Painting and Sculpture. — Minor Arts.

INDIA AND CENTRAL ASIA

ARTISTIC PHENOMENA OF THE INDIAN SUBCONTINENT TO THE PENETRATION OF ISLAM (PLATES 44-50)

CENTRAL ASIA AND GANDHARA (PLATES 51-59)

The Autonomy of Central Asian Art: a) The Controversy; b) Adzina Tepe; c) The New Criticism and Its Implications. — The Aesthetic of Light: Aspects of Codification. — The Proto-urban Civilizations of the South. The Proto-states. — Ai Khanum. Greek Urbanism in Battriana. — Koj-Krylgan-kola. — The Arts of Gandhara: a) Expansion into Central Asia; b) The Problem of Khalchayan; c) The Rotating Prospective; d) The Precedence of Bharhut; e) Value and Evolution in the Art of Gandhara; f) Discoveries in the Swat Valley and at Hadda. — The Problem of Bamyan and The Taste for Gigantism. — Tumsuq. — The Khotanese and Chorasmiana Areas. — From Livat Fonduistan to Tumsuq and Tepe Sardar: A New Problem. — New Critical Perspectives. — West Central Asia and Its Painting: a) Toprak-Kala; b) Balalyk-Tepe; c) Varalka; d) Other Centers of Pictorial Documentation: Afrasiab; e) Discoveries at Pjandzijkent; f) Other Discoveries. — The Eastern Zones of Central Asia.

EASTERN ASIA

CHINA (PLATES 60-71)

Introduction — Proto-historic Period. — Shang Period (circa 16th to 11th century B.C.). — Chou Dynasty (circa 11th century to 221 B.C.). — Ch'in and Han Dynasties 221 B.C. - 220 A.D.). — Period of the Three Reigns: the Ch'in and the North and South Dynasties (220 - 589 A.D.). — Sui and T'ang Dynasties (581 - 907 A.D.). — The Five Dynasties (907 - 960 A.D.) and the Liao Dynasty (916 - 1125 A.D.). — Sung Dynasty (960 - 1279). — Yuan Dynasty (1279 - 1368). — Ming Dynasty (1368 - 1644). — Ch'ing Dynasty (1644 - 1912). — Contemporary Period.

TIBET (PLATE 72)

Prehistory and Protohistory. — Architecture. — Painting. — Sculpture. — Handicrafts.

JAPAN (PLATE 73)

Introduction. — Prehistory and Protohistory. — The Asuka and Nara Periods (552 - 794 A.D.). — Heian Period (794 - 1185). — Kamakura (1185 - 1333) and Muromachi (1333 - 1573) Periods. — Momoyama Period (1573 - 1614). — Edo Period (1615 - 1868). — Modern and Contemporary Period.

SOUTHEAST ASIA (PLATE 74)

The Pre- and Protohistoric Phases. — The Historical Phase.

NATIVE CIVILIZATIONS OF AMERICA

NORTH AMERICA

THE ARCTIC

MIDDLE AMERICA (PLATES 75-78)

CENTRAL AMERICA

SOUTH AMERICA (PLATES 79-80)

Columbia. - Ecuador. — Venezuela. — Culture of the Andes. — Tropical Forests.

AFRICA AND OCEANIA

SIGNIFICANCE OF PRIMITIVE ART

Consideration of the Definition. — Significance and Interpretations.

ART OF BLACK AFRICA (PLATES 81-89)

Recent studies of Negro Art: a) Growth in interest; b) New orientations and techniques of study; c) Characteristics of Negro esthetics; d) The artist and style; e) Stylistic classification. — Archaeological research: a) The impetus of archaeological research; b) Saharan rock art; c) The Sao culture: recent discoveries; d) The art of Nok related to other cultures; e) The naturalism of Ife; f) Parallel derivations of the Yoruba style and that of Benin from the art of Ife; g) cultures of the lower Niger: the excavations of Igbo-Ukwu; h) Pre-Islamic cultures of the upper Niger: the terra-cottas of Djenne; i) Archaeological research in central and southern Africa. — Stylistic research and analysis: a) Influence of Islam on Sudanese art; b) Similar stylistics in the art of Mandingo influence; c) Stylistic origin of the "Afro Portuguese" ivories.

ART OF OCEANIA (PLATES 90-91)

Historic research as the foundation for the study of stylistic differences. — Mythological contents and stylistic typologies. — Stylistic comparisons: relationships and concordances. — The problem of stylistic origin in New Zealand.

ISLAM

Introduction. — For a "new science" such as Islamic art, the years since 1960 represent a period of great and productive activity. Above all, the vast and diligent contribution of Arab, Persian, and especially Turkish scholars should be noted. This included not only the study of written documents and monuments but also the more complex subject of archaeological excavations. This work, although often imperfect and contradictory, is so considerable that Islam and Islamic art can no longer be ignored. Alongside the archaeological activity is the organizational one which sees to the establishment of the Office of Antiquity, and similar institutions, even in countries like Saudi Arabia which are traditionally against Western institutions. The responsibility for the religious monuments, although dependent at least nominally on the Management of Antiquity, comes under the "waqfs" (charitable foundations). These do not carry out archaeological work but take care of the conservation and maintenance of the religious monuments. Apart from the Management of Antiquity, excavations are carried out by individual universities. Attempts at international cooperation also exist.

Foreign missions, however, remain at the head of the archaeological enterprise with their epicenter in the Near East, especially in Syria, Jordan, and Lebanon. In Iraq, where predominantly pre-Islamic interests converge, they have had significant, though only a few, archaeological finds such as the discovery of the "Dar al-imarah" (governor's palace) at Kufa. In Syria, the main excavated sites are, Qasr al-Hayr al-Sarqi, Gebel Seis, Rusafa, and Raqqa; in Jordan, Khirbet al-Mafgar; and in Lebanon, Angar. In Persia, the most important excavations are those of Siraf on the Persian Gulf, and in Algeria, L. Golvin has brought to light the palaces of Ziriti and Asir. The largest contribution to the history of art has been made in the Mosque section, although the hypothesis that its origins date back to the court room are somewhat doubted today. The studies on "mihrab" and "minbar" have also had a substantial revival. The "city" has been studied as an essential part of civilization, both from its city planning and, what is more important, from its sociological aspect. The research has opened a new frontier in the studies of Islamic art and, even if certain conclusions have still to be confirmed in areas which until now have been little explored, there is no doubt that the spreading interest has brought about a new phase in the study of the relationship between East and West.

The work of "rediscovering" of the Islamic museum inheritance has continued. This is an area which is particularly active in the United States as well as in other countries - as can be seen from the catalogue of U. Monneret de Villard in Italy. Even in the Islamic countries, the laws on antiques prompt this kind of initiative. The point of all this activity is still extremely difficult. It is worth remembering that the Islamic artistic phenomenon has lasted from the eighth century and covers an area from Spain to India to central Russian Asia.

Returning to the section in the previous edition of this Encyclopedia, in many cases still valid, let us try to give a global vision of the discoveries and the new facts which have emerged recently. We should bear in mind that Islam is an essentially religious fact and therefore ours will be an essentially "Islamic" contribution, based, in accordance with the character of the Encyclopedia, on essentially archaeological information commonly overlooked by traditional Islamism. We will give less importance to the "minor arts," as they are more difficult to characterize, emphasizing instead the latest information on the aspects which have greater adherence to the Islamic "view of the world." We have formed a total picture of the aesthetics and the sociology of Islamic art as has not been seen before. This is because it is the result of a continuous synthesis and the first attempts at an evaluation of Islamic Art using modern criteria. We have given an introduction of the general characteristics, having taken into consideration the latest theories. These have, in certain cases, profoundly modified the traditional impression of Islam — and of Islamic art, which in a certain sense reflects it.

Aesthetics and General Characteristics. – Islam is the religion founded by Mohammed in the seventh century A.D. and is widespread throughout a large part of Africa and the Near and Middle East. However, Islam also indicates the way of life in these countries in their legal, artistic, and literary aspects. In fact, as a theocratic institution, Islam tends to permeate and control the entire political, social, and cultural life. As indicated in recent studies (Graber, Stika), when this is carried to an extreme it excludes anything not foreseen by the law. A first consequence of this is that no secular art should exist in Islam, at least in the sense of a separation between religious and profane art which exists in the West, with a few notable exceptions, and is tolerated by Christianity. However, the prime font of Muslim rights, the Koran, rarely expresses opinions on the subject; instead, it is during the interminable speeches of Hadith (sayings attributed to the Prophet) that a standpoint begins to be seen. Even this, however, is badly defined, except in the case of paintings and sculptures.

The absence of clear legal indication must not, however, deceive us as to the nature of the areas not regulated by divine law. In fact, if you take the disapproval of the Prophet and the first Moslem generations

for any form of luxury and add it to the prohibition to represent human forms, it follows that perhaps the only artistic manifestation considered necessary was the mosque and perhaps the Dar al-imarah, the administrative palace attached to it. Theoretically, therefore, all the remaining art should be considered non-religious and therefore non "Islamic." Naturally, such an extreme interpretation is rarely found in the story of Islam. Indeed, with the cultural development of the Moslem population, there has been more tendency to compromise. The term "Islamic art" is therefore questionable for a large part of the artistic works from Moslem countries because only certain categories of buildings can be considered strictly "Islamic." The remaining work should be divided, in turn, into "profane" art and "secular" art according to whether it is work for which there is no legal probibition or whether it is work which has been specifically prohibited. We have therefore three large subdivisions: "religious" art, which includes mosques, theological schools ("madrasa"), and, by extension, mausoleums, badly tolerated initially, but later becoming common place; "profane" art, including palaces, bathing places, and caravanseries; and lastly "secular" art which includes painting, sculpture, and the Ommayad, Persian, and Indian Miniatures. These not only ignored the fact that it was prohibited to represent the human form but even added pornographic representations, artistically displayed.

In outlining the communal elements of this immense subject, it would be best to distinguish architecture from decorative art and figurative art. In the first, the unity of the building and its functionality maintain a relative symmetry. However, in decorative art and with the art of the miniature this is totally missing. Rather, it is normal for the artist to work in such a way that the various elements are in contrast with a coordinated vision and suggest the completion of the representation as a whole.

Characters of "centrality" are already evident in the mosque of Damascus, but are very much more accentuated in the Persian and Ottoman mosque as well, of course, as in the mausoleum. This desire for symmetry is sometimes found even in civil structures, like palaces and houses, but later additions and variations have somewhat taken away the centrality which once existed. These characters are found in the Alhambra, in the Topkapi Sarayi of Istanbul.

Among the general characteristics of architecture one should not forget the tendency to "flatten" buildings which clearly prevailed. This leads to the construction of buildings of only one or two floors. Yemenite civil architecture can be pointed out as an exception to this concept. On the other hand, in some cases the low structure of the building could be due to the fragility of the material which would not allow a higher structure. It is always necessary to remember this fact because similar conditions produce similar solutions, and elsewhere, like Turkey, where excellent construction stones exist, Islamic art was able to express itself in high and solid buildings. The relationship between architecture and decorative art is generally resolved differently than it is in classical art. Often, in the latter, it is the bearing structure itself which becomes involved in the decoration. In Islamic art, the decoration is applied to the walls. It is only in the Selgugide period that a different procedure appears where the wall bricks are placed in

such a way as to simulate an interwoven geometric pattern. Later, ceramic tiles were used in decoration and this practice is still present today in various countries.

Epigraphic decoration continued to have great importance. Its use also increased as a result of the opposition to human representation which was strictly observed in religious buildings. Epigraphic designs, added to the inside and outside of the building, contributed to the unity of the building. Dispersion and "horror vacui" are fundamental characteristics of figurative and decorative art. The first of these principles favors any element - which is in contrast to "centrality" and to "organicity." The walls of a room could quite well be decorated with different designs, and in turn these could be elaborated differently from each other, without the artist making any attempt at a coordinated effect. If he should, despite himself, happen to arrive at this effect, he would deliberately add some form of contrast almost in order to avoid a concrete and definitive sense to the scene.

The "horror vacui," the completely filled surfaces, is present almost everywhere in Moslem art. But recent studies tend to place the phenomenon in a larger medieval context in which Moslem art is correctly portrayed. The partial results of this are the bidimensional and "flat" perspectives. The first, by removing the sense of depth, tends to accentuate the "bird's eye view" perspective and to expand the scene. The second offers cubistic solutions, tending to represent also the outsides and the insides of the building. Both aspects concur, however, with the "filled surfaces" idea. One fact is certain: they do not derive from a primitive vision of art, from a lack of depth in artistic realization, as suggested by various scholars. It would otherwise be unthinkable that the Arab contribution to the much debated subject of optical perspective in the Middle Ages was greatly utilized by the 16th century writers. The Islamic "horror vacui" is a result of a conscious desire to fill entire surfaces, the essential aesthetic principle derived from art which has conditioned the development of Islamic art. But the pattern of its application is the result of the combination of social and religious awareness and of the organizational aspects of the artistic production.

Another fundamental aspect of the civilization, and therefore of Islamic art, is its "democracy." Distinctions do not exist between "major art" (architecture, painting, sculpture) and "minor arts" as in the West. Vital aspects of the antique art of the court, like the throne, find little prominence in Moslem art, nor do the "hierarchic" perspectives or other values of Western art. The position of man with respect to divinity, that of an "abd" (slave or servant), has certainly contributed to diminish human actions, and art reacts with representations in which man is treated like any other decorative element.

The Islamic aesthetics have been studied very little and therefore are not well defined. To the normal difficulties of this science must be added those particular to Islam, derived both from the divine nature of the Islamic legislation which appears to exclude any secular culture and by the problems involved in defining an art which has existed from the 14th century and is widespread over a vast area which extends from India to Spain. This explains the fragmentary and often contradictory character of information up until now and the

almost total absence of a specifically Moslem contribution. Apart from a few allusions in various places, the study of Islamic aesthetics started when Probst-Biraben, in the Acts of the XIV Congress of the Orientalists, published his "Essays on the Philosophy of the Arabesque." Although the study essentially examines decorative art, there is no doubt that it contains elements which are applicable to the whole of Moslem art. The arabesque is the ornamental translation of mystic Islamic thought because it inspires and retains the idea of extension and it flatters the power instinct. Massignon follows Probst-Biraben's philosphy when he affirms that the arabesque is the endless search for the unity which is God. He does not, however, maintain that this is a method for satisfying the power instinct, but rather that it comes from a negation of a full geometric form, like the circle and the straight line, avoiding the representation of the unity, which is only of God. Later, Massignon returned to the subject with an attempt to apply the aesthetics of Plotinus particularly to the miniature. Since the subject must disappear into the object one arrives at a pictorial Pantheism in which each being is seen as a divine manifestation. Massignon is also responsible for the hypothesis that the Persian Miniature reflects a tension toward light, in the sense described in Manichaeism, to which he attributes the greatest importance in the formation of the Iranian-Islamic paintings.

As can be seen, Massignon, from a specifically religious point of view, introduces the question of the contributions of Sufism to the evolution of the Moslem miniature. According to Binyon, Persian painting comes halfway between the West and China. In the first, man is at the center of the composition; in the second, man becomes a figure subjected to nature; here the importance of the landscape arises. From the West, the Persian miniature has derived the tendency to put man as the principal theme. Unlike classical art, however, the individualism of the human figure is mitigated by Sufism, in which the being comes to form a kind of "mirror" of the Unique Being, therefore a sort of mystic Panthesim. Binyon also attributes great importance to the mystic. Bronstein, developing the themes of Probst-Biraben and of Massignon, observed that the fundamental characteristic of the Persian miniature is the movement from the center to the edge. In this way, single elements can be positioned independently from each other. Lamm, however, has stressed the greater homogeneity of Islamic art in respect to European art, due essentially to its religious background. All the same, he denies that the sayings on art attributed to Mohammed have had any great importance. While developing the ideas of Massignon, he attempts to reconcile them with those of Probst-Biraben: as reality is unstable, the art which derives from it is necessarily abstract, and since, for a Moslem, the most direct revelation of God is logic and mathematics, geometry becomes the principal stimulus of Islamic art. Another element suggested by Lamm is the "democracy" of Moslem art which, by reconciling the simplicity of the whole with the attention to detail, can be understood by everyone, cultured and ignorant.

Also Diez, although elaborating on the subject of Islamic art as a whole, has mainly dealt with the aesthetics of the miniature. Classifying art on the ideas of Coellen, he defines Oriental art as "mechanistic" and "collectivistic," as opposed to the classical world, defined as "organic" and "personal." According to the mechanistic definition, the individual is part of space built according to mathematical principles because, in Islamic art, man in relationship to God is conceived as a being, not as an individual. In the magical conception of life, existence is conceived as an undefined totality.

Passing on to another classification, Diez defines "cubism" as the spatial conception corresponding to the mechanistic principle. He comments that the proximity of the Persian miniature to the cubistic values is such that it suppresses the anatomic composition. Other classifications are those between the "static" style and the "dynamic" style. The Infinite is the basis of existence and this is the basis of the Infinite. Two cosmologies follow, the first having as its focal point the quality of the two principles, the second their identity. Moslem art, for religious reasons, comes under the static style. Nevertheless, Diez questions whether mysticism, understood as a dynamic principle of the religion, would have been able to initiate a different phase. Diez responds negatively, offering in evidence the Oriental conservativeness. The bi-dimensionality of the "horror vacui" perspective is attributed to religious motives, specifically to the submission of man to divine will. These ideas open the way to the "expressionistic" definition of Islamic art which, utilizing the Plotinian aesthetics, firmly puts it in the Middle Ages. This has not escaped the notice of Talbot Rice, who unfortunately limited his research to the miniatures of the Baghdad school.

R. Ettinghausen also perceived the importance of religion, but his treatment is not without sociological implications when he underlines the humble base on which Islamic art has developed, the opposition of the Prophet, and its roots in servile manual work. His contribution is important for three reasons: for laying the foundations for the "contrast" theory which was later developed by Camón Aznar; for bringing to light a realistic component to the Moslem figurative art; and for having examined the aesthetic ideas of al-Ghazzali. On the first point, Ettinghausen confirms that from the point of view of Moslem aesthetics, decorative art negates form. The contribution of al-Ghazzali to the knowledge of Moslem aesthetics does not add much to common medieval aesthetics. The most interesting aspect is the "sixth sense" defined as "soul," through which it is possible to grasp "Beauty." This sense is also called "heart," "spirit," "reason." It is evident that this "sense" has common traits with the current ones on subjective aesthetics which in the West start after the Renaissance and culminate in the partial elimination of the object-subject dualism that we find in Kant's philosophy. Al-Ghazzali, however, follows in the tradition of Aristotle when he speaks of perfection inherent in each thing. A work of art is conceived as something "dismantleable" in its components, each of which has its own particular beauty. The total beauty is the "sum" of the component beauties — beauty which, however, will be lacking if any one of the elements is defective.

With Camón Aznar the question is more complex, even though predominantly directed towards the Islamic art of Spain and North Africa. Every artistic rhythm is based on equilibrium or on its non-existence, which is the case with Islamic art. Rhythm based on deliberation requires a naturalistic motive; its repetition causes abstraction. Bi-dimensionalism brings a density

to the figure, because, not having the third dimension, the spaces left free naturally remain empty. But the most important element emphasized by Camón Aznar is "contrast." This theme had already been expressed by Ettinghausen, but the full definition is that of the Spanish scholar. This is also because Ettinghausen took into consideration only certain objects of zoomorphic form, concluding that Islamic decorative art was in contrast to the object form. For Camón Aznar the "contrast" appears whenever a solution of continuity is formed that needs to be safeguarded and by reaction the artist requires contrary signs. He therefore includes not only decorative art, but all the arts.

In architecture, the contrast is due to the fact that the Islamic monuments rarely spring up suddenly, but are rather the result of a series of epochs like the Alhambra. From here comes the humility of Islamic art. The decorative illusions comes from the necessity to mask the poverty of inspiration, and in this context Camón Aznar, exaggerating, speaks of "the conscience of deception." This subject is part of a larger one — the use of bricks to contribute to anonomity which, as expressed by Ettinghausen, would have indicated the temporariness of existence. In certain cases, these observations may even be true, but generalization is arbitrary. The use of bricks was often due to the scarcity of stone or due to sociological and commercial factors such as the practicality, or the lightness of weight. Roman architecture used them very frequently, however.

We are not even in agreement with the assumption that Islamic art had only been receptive, elaborating in a superficial and decorative way on the work of others. There are original works in existence which have been widely copied, both in the Orient and in the West, and are undoubtedly of Moslem roots. Camón Aznar has interesting deductions with regard to the "horror vacui," which is interpreted as a consequence of the Islamic cosmic vision. In classical art there is an objective reference and a three dimensional perspective strengthened by the scenic vision which, by suggesting a hierarchy of values based on distance, builds an organic vision. Instead, in Islamic art, the artistic forms become elaborated through mental processes and developed according to geometric rules. In this way, the empty spaces, which unlike classical art do not have the scope of vitalizing the designs, become to the Moslems inert zones representing death. In effect, the worry of death is less present for a Moslem than it is for a Christian, who lives, whenever in mortal sin, under the fear of eternal damnation. Camón Aznar evidently arrived at his conclusions because of the preconception of the claimed superficiality of the Islamic civilization. Moslems would avoid the worry of death because of a lack of any profound or critical attitude towards the great problems of life. To us, a generalization of this kind appears extremely dangerous or at least debatable.

The views of Burckhart, although conditioned exclusively by religion, are among some of the most interesting. Islamic art is defined in the unity of God, a concrete conception, but indefinable and therefore abstract. From here we come to the abstraction of Moslem art and its "objectivity" as opposed to the "subjectivity" seen in Renaissance art. The first consequence: by avoiding the "subjective" character, Islamic art will be more restful and contemplative, fascinated by the apparent world but detached from it - in a word, infan-

tile and without problems. The second consequence: lacking an "organic" ideal of reality, it lacks also the possibility of putting this reality into a superior idealistic order. Therefore unity as a principle is non-existent and art will become disorganic, founded on attention to detail more than on the unity of the whole. In addition it will lack, or almost lack, the emotional "subjective" contribution, and thus it will be "impersonal" and incapable of translating the organistic ideals. Within the limits of a "religious" interpretation of Islamic art, these observations can be considered accurate. Based upon the contributions of Probst-Biraben and of Massignon, Burckhart arrived at an apt synthesis of all that applies to the influence of the religion on Islamic art; the problem is that part of these same results can be conditioned by historical and sociological motives.

G. Marçais has defined the problem at two different times. On the first occasion, with reference to the representation of human forms, he refuted the failure of Moslem art to create unitarian works. In the second, he claimed, instead, that this unity is maintained by the great influence of epigraphy and the Koran. Looking closer, however, it only appears that this is a contrast. The French scholar merely wanted to contradict the organistic aspects in Moslem art, as defined by Diez, where an epigraphic band which encircles a mosque does not add any organic aspect to an art which remains substantially "mechanistic" or, even more correctly, "cubistic." The French scholars are to be thanked, too, for emphasizing the scarcity of foundation for attributing the entire responsibility for the lack of development in Moslem art to religion. On the other hand, the proposed solution that attributes the origin and development of Moslem art to the affinity with other Semitic people and includes once again the general theory of Islam as being non-iconistic also seems debatable. This is because in different political and sociological conditions, as well as different religions, the Semitic people knew how to create particularly significant sculptural works. The arguments of Marçais can be considered valid, apart from a few reservations on the above and other points. He wished only to oppose the widespread hypothesis of a totally dispersive Moslem art. Nevertheless, we cannot see how his theories can be applied to the miniature, which, except in rare cases, has developed with very different principles.

These are the main hypotheses on Moslem aesthetics. In conclusion, we must first of all point out that, unlike the other civilizations, Islam has been unable to express a unitarian art in which man has a creative role. Although the above theories are debatable, they contain many truths on the limits placed by religion on free human initiative, including the autonomous development of the artist. We believe, however, that many limits attributed to the religion in this way are also due, and in certain cases predominantly, to historical and sociological factors in which religion had a totally subordinate role. We should therefore speak of "secular" aesthetics and of "Moslem" aesthetics, a matter of which the Moslem people were unaware and which is difficult for us to resolve.

Sociology. – The relationship between art and society has rarely been faced in Islamic art, the study of which even today is entrusted to those studying predominantly humanistic manifestations of art. The first question is that of the applicability, or not, of the

Western theories to the Islamic society. As noted in Europe and America, the sociological studies permeated the artistic studies to such an extent that not only the individuality of the artist has been negated but also the autonomy of pure aesthetics, considered merely an expressive language varying from epoch to epoch and from country to country, like, for example, religion.

This type of study has not yet appeared in the field of Moslem art, except perhaps in an occasional and inconclusive form, — for example, in the penetrating study of certain miniatures of Grabar, attributed to the 13th century. However, the efforts of sociologists and economists such as Goitein have been considerable. These, while analyzing difficult and unpublished documents, have given a well defined although as yet incomplete picture of the question of the method of production. This includes artistic production, still little studied in relationship to the sociology of Moslem art, which as a science remains non-existent. The only sector in which there was significant progress was in the organization of the work. But on the whole, there is no shortage of elements, though gleaned from completely different types of books, to allow us to identify certain essential characters.

One of the basic aspects is the anonymity, or at least the extremely scarce importance, given to the artist. One needs to wait practically until the 16th century before strong personalities, such as the Turkish architect Sinan and the Persian painter Bihzad, begin to surface. Previously, the artist was either unknown or was known only by name. The reason for this scarcity of knowledge can be found both in the religion and in the position of the artist in what were, as they are called today, the "social classes" of the time. It is interesting that Islam, as far as a global view and an attitude towards art is concerned, tends on one side to diminish the individualism and on the other to put men at the same level.

This does not, however, authorize us to attribute the Islamic anonymity to an ideological explanation. If this were the case, it should be extended to culture as a whole and this does not happen; for example, in literature the individuality of poets and writers is prominent. The explanation, therefore, is clearly sociological. The poet and the writer, once they had broken away from the tribal bonds, lived primarily in the shadow of the patrons of art and literature and the literary circles. The artist, on the other hand, was bound to a job, handed down from father to son; he was often illiterate, and as a result "major" literature felt no need to remember him. The real culture was poetry, completed by prose with its group of writers on religious science. This, in the scale of values, held first place.

The position of the artist was much lower, even though a distinction was made between the architect, the painter, and the decorator. Monnaret de Villard has emphasized how the structure of the work in the initial period was the same as that of the Byzantine and Sasanian period. But Arab literature, jealous of its traditions, has only passed on to us the name of the supervisor of the works, while that of the architect remains unknown. The explanation should evidently be looked for in the different religions of the workers, at that time still Christians or Zoroastrians. A definite change is seen in the Abbasid period, perhaps due to the great number of conversions. The architects here are known

to us right from the beginning with the foundation of Baghdad. Later, in the time of Harun al Rasid, the name of the architect will be rendered eternal, together with that of the Caliph, at the works of the great mosques. As a consequence, the architect will also have had a relative success in the literature of the time.

It is also normal to know the names of the artists in bronze and ceramic art. This is generally due to the fact that their signatures are inscribed on the works themselves. It is, however, impossible to reconstruct a description of the artist from a signature alone. This work appears in the late Ommayad period but developed extensively in the Fatamid period in which there are groups of works attributed to the same ceramic expert.

The distinction between "major arts" and "minor arts," frequent in the West, had no importance in Islamic art until modern times. In fact, on a value scale, it is sometimes the second one which is considered more important, such as calligraphy. This was one of the few arts accepted by Islam, because it adorned the Arab letters in which the Koran was written. Calligraphy remained, for some time, the dominant figure in Book Art. It was only in the period of Timur that miniatures became so popular, that they came to be depicted independently. Gradually, their work became one of the more important cultural factors, bringing a better economy and consequently the possibility to choose, and transfer to, a more convenient location. Grube is not wrong when he observes that a style does not necessarily belong to a certain city, because the artists moved frequently from place to place - more so than did the work. This also shows that the organization of the work was not strictly corporative, although various indications make one think that a very similar method of work had existed for a long time. Many doubts have been raised recently on the existence of corporations in Islam. This was particularly true after the publication of important documents on behalf of Goitein and an Oxford discourse on the Islamic city (Hourani-Stern, "The Islamic City," Oxford, 1970). In the latter they totally negated their existence despite the fact that, at least for a later period, precise data exists. At the head of the organizations there was a mu'allim (in Persian "ustadh"), followed by his "Khalifah," and then lastly the apprentice "muta 'allim" (in Persian "shagird"). Each type of job had its own "corporation," together with its own traditions and rules. These were often in the form of statutes ("dustur") which had to be observed by each associate. When the organization assumed a religious character, above everyone there was a "naqib." Discipline was exercised by a "muhtasib," a religious functionary, who was attached to the government and who was, among other things, responsible for supervising the customs.

Book art, very expensive because it was produced by many artists (calligraphers, miniaturists, and book binders), was aimed at a very limited market because of illiteracy, and therefore became an art of the elite, linked to the courts. In this aspect, our knowledge increases after the 16th century. We have news of Chardin on Isfahan, the capital of Sah 'Abbas, of Qazi, Ahmad, and of other Persian authors. Judging also from recent studies, however, an exact reconstruction of the organizations is still impossible. The dependence on the courts was such that Book Art adheres to specific themes and is subjected to the wishes of the sovereign.

According to some scholars, this could be considered as an act of good will by the latter. Perhaps this is exaggerated when one thinks of the great regard held for paintings in India, Persia, and Turkey and for the freedom of movement which was only occasionally prevented. But it is these links with the court which make the affirmation of the artist possible; a fact which even literature, although only occasionally, begins to accept.

This process certainly echoes the esteem held by the West for the artist. Plehanov sees in this a typical example of "play" and of "art as the illegitimate daughter of work," whereas Goldman sees it as another typical example of coherence with a social group. A similar situation, although directed toward a utilitarian end, can be found in the architecture of the 16th century and later. In Istanbul, the head architect ("mimar basi") is a government functionary who supervises the First and Second Architects ("ser-mimar" and "mimar-i sani") who, in turn, are in charge of the inspectors and workers. The "mimar basi" is responsible for all the buildings, both those ordered by the sovereign and his viziers and those under the charge of the charitable foundations; in effect all the town planning alterations fall under his jurisdiction. He himself, however, is under the responsibility of the court and consequently of the sovereign. This situation did not, however, impede the rise of great architects such as the greatest Islamic builder Sinan, who was restudied by Stratton.

The patrons of the works of art are sovereigns and princes, wealthy court personalities, dignitaries, and members of the royal family, sometime female. The figure of the merchant only appears in a second period with the introduction of the middle classes. The work could be financed directly or indirectly through the "waqfs." It is these charitable foundations, financed privately, whose income is used for a large variety of both religious and humanitarian aims. This includes the construction and maintenance of buildings, payment of personnel, help to orphans, and the maintenance of pigeons. In order to stress the importance of these institutions it is enough to remember that entire markets and apartments, financed by huge estates, were linked to the "waqfs," whose importance had, until modern times, been a determining factor in the economy of Moslem countries. This range of interests, conditioned by a statutory document, will not be the last cause of the static state of a large part of Moslem art. This will remain undeveloped until the advent of profound historical and political change and the emergence of strong artistic personalities.

BIBLIOGRAPHY - *General Works*: Index Islamicus, Cambridge (edited by J.D. Pearson, 1958); K.A.C. Creswell, A Bibliography of the Architecture, Arts and Crafts of Islam to 1st January 1960 (The American University of Cairo Press), Cairo, 1961; K.A.C. Creswell, Early Muslim Architecture (2 vols.), Oxford, 1969; A. Godard, L'art de l'Iran, Paris, 1962; D. Talbot Rice, Islamic Art, London, 1965; U. Monneret de Villard, Introduzione allo studio dell'archeologia islamica, Venezia, 1966; G. von Grunebaum, Classical Islam, Chicago, 1970; G. von Grunebaum, The Sources of Islamic Civilization, in Der Islam, 46, 1970; D.-J. Sourdel, La civilization de l'Islam classique, Paris, 1968; O. Aslanapa, Turkish Art and Architecture, London, 1971; M. Dimand, L'art de l'Islam, Paris, 1971; R. Ettinghausen, From Byzantium to Sasanian Iran and the Islamic World, Leyden, 1972; J. Sourdel-Thominc-B. Spuler, Die Kunst des Islam, Berlin, 1973; O. Grabar, The Formation of Islamic Art, New Haven-London, 1973.

Aesthetics and General Characteristics: L. Massignon, Les méthodes artistiques des peuples de l'Islam, Syria, 1921; E. Diez, A Stylistic Analysis of Islamic Art, in Ars Islamica, 1936 and 1938; R. Ettinghausen, The Character of Islamic Art, in The Arab Heritage, Princeton, 1944; R. Ettinghausen, Interaction and Integration in Islamic Art, in Unity and Variety in Muslim Civilization, 1955; R. Ettinghausen, al-Ghazzālī on Beauty, Art and Thought, in Studies in Honour of A.K. Coomaraswamy, Zürich, 1948; G. Burckhart, The Spirit of Islamic Art, in The Islamic Quarterly, 4, 1954; J. Camón Aznar, Temas de estetica musulmana, in Revista del Instituto Egipcio de Estudios Islámicos (en Madrid), 2, 1954; Mehmet Aga-Oglu, Remarks on the Character of Islamic Art, in The Art Bulletin, 36, 1954; G. Marçais, Remarques sur l'esthétique musulmane, Alger, 1957; Ismā'īl R.-al-Fārūqī, Misconceptions of the nature of Islamic Art, in Islam and the Modern Age, I, 1970; Ismā'īl R.-al-Fārūqī, On the Nature of Work in Islamic Art, in Islam and the Modern Age, 2, 1970; Sayyid Husein Nasr, The Significance of the Void in Art and Architecture of Islam, in Islamic Quarterly, 1973; V. Strika, Note introduttive a un'estetica islamica, in Rendiconti (Accademia dei Lincei), 1973; I. R.-al-Fārūqī, Islām and Art, in Studia Islamica, 1973.

Sociology: R. Brunschwig, Urbanisme médiéval et droit musulman, in Revue Études islamiques, XV, 1947; L. Gardet, La cité musulmane, Paris, 1954; L. Mayer, Islamic Architects and their Works, Génève, 1956; R. Mantran, Istambul dans la seconde moitié du XVIIᵉ siècle, Paris, 1962; S.D. Goitein, Studies in Islamic History and Institutions, Leyden, 1966; I.M. Lapidus, Muslim Cities in the Later Middle Ages, Harvard, 1967; Munīr ad-dīn Ahmad, Muslim Education and the Scholar Social Status up to 5th Century of the Muslim Era in the Light of Ta'rīkh Baghdād, Zurich, 1968; A.H. Hourani-S. M. Stern, The Islamic City, Oxford, 1970. For information on the "waqf," see G. Busson de Jaussens, Les waqfs dans l'Islam contemporain, Revue des Études islamiques, 1951.

VINCENZO STRIKA

ARCHITECTURE AND TOWN PLANNING (PLATES 34-41)

Religious architecture. — The mosques are the buildings studied the most frequently. The principal trend that emerged in the 1970s is the partial abandonment of the hypothesis that the origins of the mosque date back to the court room. Instead, there is now a cautious return to the forum mosque and to its relationship with the synagogue and an ever clearer distinction between the congregational mosques and the minor mosques. There is an increasing doubt as to the influence exercised by the House of the Prophet at Medina, the first meeting place of the growing Islamic community. How much influence this building really had on the formation of the mosque is difficult to establish. Certain coincidences have emerged from analyses of the facts, but they have perhaps been exaggerated by certain scholars. These are the covered areas where the Prophet prayed and the courtyard. These characteristics corresponded so well to the needs of the following evolution that they can be found almost everywhere.

The next stage was established by the Iranian mosques constructed by the Arabs in the period of the conquests during which the first Moslem cities, Basra and Kufa, were founded. The study of these has been intensified by Iranian scholars. Here we see the first signs of the mosque which will not be without repercussions in the following evolution. It is also in Iraq that the narrow correlation between the congregational mosque and "Dar al-imarah" or the "Government Palace" appears. The separation of these, even though it came about in Mesopotamia, signalled a new Islamic phase. The first mosques were only "outlines," — that is to say that they were not enclosed. In fact the historian, al-Buadhuri, wrote that at Basra, the canes indicating the boundaries of the area of the mosque were moved from time to time. This signifies that the mosque was not always to be found at the same place, nor probably was it always the same size. We are in an extremely primitive phase in which simplicity and "democracy" can already be seen. The latter will be one of the elements which most clearly characterizes the following evolution.

At first, the Omayyad period had no architectural plan, and it is only with the re-unification of the empire by Marwan I and Abd-al-Malik that significant monuments, such as the Dome of the Rock at Jerusalem and the Great Mosque of Damascus, can be seen. The first, erected on the site on which the Prophet is said to have made his journey to heaven, has been especially studied by Monneret de Villard and O. Grabar. While elaborating on the documentation of Creswell, they stressed the Byzantine and Persian components of the construction. This showed, for the first time in Moslem art, the international element of the building. Here Central Asian elements could clearly be seen in the arrangement of the cupolas.

Monneret de Villard is also to be credited with the confirmation that the Dome of the Rock, as part of an architectural complex together with the al-Aqsà mosque, was modelled on the Christian complexes. The most important of these is the Knight Hospitallier of St. John of Jerusalem of the Holy Sepulchre: the Rotonda of the Anastatis, the atrium, and the basilica. This theory was not in contrast to the studies of Stern. Stern emphasized the close relationship of the Abbasid building with the mosque of Walid I which had emerged in the restoration work. O. Grabar has demonstrated, through a precise analysis of written sources, that the Dome of the Rock was erected for symbolic reasons with the purpose of perpetuating a sacred place, not only for the Moslems, but also for the Jews and the Christians, both communities being in possession of important religions.

Even the Great Mosque of Damascus was constructed on the site of a pre-existent building, namely the temple of Zeus Damasceno. Part of this building was occupied by the Basilica of St. Giovanni. The controversy on the identification of the latter with the mosque of al-Walid can be considered as concluded. However, the stand taken by Ibn Asakir on the common use of the pre-existent building by Christians and Moslems could contain some truths as they were the two religions still in the "dialogue" phase. As shown by I. Golvin, it is the Great Mosque of Damascus, rather than the Dome of the Rock, which appears as the more original work today. Moreover, it corresponds to the Omayyad ideology, which on one side is intent on conserving the democracy of the origins and of the moralists, and on the other is penetrated by the supreme function of power. A clear indication of the latter is the transept which links the mosque to the Caliph's palace behind the building. Also evident, however, are the "democratic" components found in the courtyard, a typically agoral square where the faithful discuss politics, poetry, and religion — a place for meetings, walks, business, but also for theological discussions. They were like the later Abbasid mosques in Mesopatamia. As indicated by Monneret de Villard, the buildings that mainly bring to mind the Damascene mosque are the classical ones of Kremna and Smirne. They themselves recall the temple with the large court which has a very old tradition, especially in Mesopotamia and southern Arabia.

The harrowing events of the late Omayyad period provoked the move of the capital to Harran. Here, the excavations of D.S. Rice have clarified certain aspects of the mosques of Marwan II which confirmed the close relationship with the mosque of Damascus. An interesting field of research has opened in Iran where A. Dietrich, although confined to the limits of an analysis of written matter, has been able to study a series of mosques which are important both from the town planning and the sociological aspects. There were mosques for Arabs, others for "mawali" (clients), for various occupations, etc. Still at the sociological level, the "masgid" type of minor mosque emerged in the Omayyad period. These are distinguishable from the "masgid al-gami," which were destined for a greater scope. The Siro-Palestinians "badiyah" offer us ample study material for this extremely interesting socio-religious aspect of the time, even if the distinction between one type and another is not clear. The Omayyad "masgid" could, in fact, be part of the palace, as at Minyah; appendixed to it, as at Angar and Khirbet al-Margar; or even separated from it, as at Qastal, and Qasr al-Hallabat. These mosques were generally at the dispositon of all the inhabitants of the "badiyah." However, one type linked to a single family nucleus is that which we find at Gebel Seis, Khirbet al-Mafgar, and especially Qasr el-Tuba.

All these examples are clearly contrary to the views expressed by J. Sauvaget on the origins of the mosque dated to the Palatine court room ("La mosqué omayyade de Mèdine," Paris, 1947). This thesis, after a short period of great popularity, can be considered superseded by the studies of Stern and Golvin and Strika. These studies, while accepting some of the aspects of the thesis of Sauvaget, have returned to the hypothesis of the mosque as being unrelated to the court room. This is particularly evident in at least two cases. First, in the Msattà castle the mosque, situated near the entrance, is clearly separated from the court room situated in the center of the residential part. Secondly, the "Sar al-imarah" of al-Kufa possesses a court room which is clearly different from the mosque. As can be seen, the Omayyad period has laid the bases for the successive evolution. To this belongs not only the type of mosque with naves running parallel to the bottom wall as at Damascus, but also that of a perpendicular nave similar to the al-Aqsa mosque at Jerusalem. The latter type was destined for an even greater development.

In what we can define as the classical period of the Islamic civilization (eighth to tenth century) the most important phase occurred in Mesopotamia. Here the Great Mosque is a clear development of the temples with the large courts. An example of this from the fourth century can be seen at Hatra. The Great Mosque of al-Mansur in the city rotunda of Baghdad recaptures the close affinity between "masgid al-gami" and the Government Palace seen at Damascus, al-Kufa, and Wasit. In the significant symbolism of the "rotunda," the mosque appeared at the center of the complex. The expansion of Baghdad provoked other "masgid al-gami," like that of ar-Rusafa and of Qasr. The latter of these was probably on the site of the current caliph's mosque from a distant era. All the mosques of Baghdad of the classical period have been lost. To have an idea of their plan and functionality one needs to go to the ninth century.

In this period, in the north of Baghdad, Samarra and then al-Ga 'fariyyah were founded. The most stately forms of the Abassid art can be found here. These are the only examples which are still more or less intact today. According to Golvin, their origin should be investigated in antique Mesopotamian temples. In the Great Mosque of Simarra the absence of any suggestion of the court is accentuated by the very separation of the building from the residential area of the caliph. Nor is there a large central nave. The conception of space is still dominated by the "sahn," which emerges as the real central figure of the monument. With respect to the Omayyad mosques, one should note the piers which alternate with the columns. Also the semicircular towers along the walls seem to give a defensive character to the building. These towers are, however, in reality an echo of the Sasanide architecture, an incomprehensible loan, in which it is not difficult to detect also an Omayyad attitude.

A similar consideration can be made for the Great Mosque of Abu Dulaf built by al-Muta-wakkil at al-Ga 'fariyyah, its new capital. Here there is an enormous courtyard and a relatively small prayer room. The naves are perpendicular to the wall at the bottom, but the one in the center, unlike Samarra, is slightly larger than the others. An interesting particular, unique in Mesopotamia, is given by two of the parallel naves, which together with the central one form a T figure. This became very popular in North Africa. Excavations and restoration work have shown that the outside walls were flanked by external arcades which together with the numerous doorways contributed to, and accentuated, the character of the courtyard of the Abbasid mosque. Also in Mesopotamia are the type of minor mosques which we have seen spring up in the Omayyad period.

The most conspicuous example is given by the mosque situated on the inside of Ukhaydir castle. The great palaces of Samarra, the Gausaq al-Khaqani and the Balkuwara, all had this minor type of mosque. The influence of the "masgid al-gami," created in this period in Mesopotamia, is also noticeable in Egypt. Here, in the ninth century, in the Tulunid period, the Great Mosque of Ahmad ibn Tulun is founded at al-Qata. The prayer room consists of naves parallel to the bottom wall with the roof supported by brick pillars. Behind the mosque the "Dar al-imarah" could be found. The development of the studies in the West of Islam are particu-larly noteworthy. The Great Mosque at Qairawan has been particularly studied by A. Lézine. In the 836 A.D. plan, the influence of the mosque of Medina has been detected in the restorations of Walid I. This influence appears to predominate also in other places. However, the Great Mosque of Cordova in its spaciousness and in the use of the horseshoe shaped arch shows a great deal of affinity with the local tradition. Both reflect different needs from those which we have met in the Syrian and Mesopotamian mosques. When far away from large Islamic theological centers, they have more of a religious character and less that of a discussion center.

A similar consideration can be seen in the Persian mosques. The oldest we have seen is that of Damghan, which presents the usual layout of parallel naves with sustaining pillars. In the suburbs of Balkh a mosque has been found, and publicized, by L. Golombek. It is of great interest for two reasons. First, because it demonstrates, in its decoration and stucco, the diffusion of the Samarra style and also the inverse path, from Central Asia to Mesopotamia. Second, the structure of small cupolas gives a further variant of the minor "masgid." This we have already seen in the Omayyad period. In this particular case the structure became so widespread throughout North Africa that it was claimed to be of local origin. In Persia, as also revealed recently by R. Ettinghausen, the development of the mosque bears the influence of the traditional architectural view. This was sometimes seen in nearby Mesopotamia in the system of support, derived from the Achaemenid "apadana." This system consisted of pillars which supported the roof without intermediate arches. This system is found in the mosque of Kufa, as well as that of al-Mansur at Baghdad until the reconstruction of al-Mu'tadid. The spiral mosque will remain unseen in Mesopotamia. This originates from the "chehar-taq" which, in Persia, is situated in the most important and significant place in the mosque — in front of the "mihrab." Mosques of this last type are found in Persia from much older times, as demonstrated by the "masgid-i gum ah" at Ardistan and Barsyan. Although these later became courtyarded mosques with one or four "iwan," they maintained the altar of fire in front of the "mihrab."

This natural affiliation of the religious Moslem building with the Iranian one is accentuated by the "iwan" mosque. This type is widespread, especially in Khurasan, where it is sometimes situated at the side of the courtyard in accordance with the Iranian penchant of confronting two elements with a central one of a different type. The typical Persian mosque has four "iwan." This, rather than being functional, was due to the necessity to emphasize a national artistic program which was different from the Mesopotamian one. This is an affirmation of the Iranian supremacy, to which two factors are not strangers: the influence of the "madras," the functions of which often coincide with that of the mosque; and the loss, on the part of the latter, of the agoral significance which it would previously have had. "Madras" mosques, at this point, are structural buildings for the conservation of that finality which the closure of the "igtihad" put as an accomplished value.

At the same time as the eastern regions of Islam, North African and Spanish Moslems developed a compatible art, sensitive to the proper traditions. This was

demonstrated by Lézine in recent studies on the developments in the Orient. This Oriental study is perhaps the most interesting in the work of this learned Frenchman. He was able to place some of the principal Maghrebini monuments in a different perspective than that suggested by Marçais and Croswell. As a result, the story of the Great Mosque of Mahdiyya has been totally renovated, suggesting also favorable indications for the development of the Fatimid art in Egypt. It needs to be stressed that Egypt, by being positioned equidistant from them, had links not only with both Eastern and Western Islam, but also with the Christian world. This was all re-elaborated in a national context. The Fatimid Dynasty, which for nearly two centuries governed the country, was fascinated by the Iranian Shi'ite, but equally open to the North African art from which it originates. The following are wonderful monuments of synthesis: the al-Azhar mosque, open even today; the al-Hakim mosque, widely modified and enlarged, not being used, but recently restored; and the little mosque of al-Aqmar in which, for the first time in Egypt, stalactites appear.

The most notable of these mosques is perhaps that of al-Hakim. This follows the model of the Great Mosque of Ibn Tulun, which except for the naves placed perpendicular to the "mihrab" reflects classic Abassid art. The Fatimid tradition is the basis of the Mameluke art in which, among other things, a notable international element triumphs. Also, as elsewhere in the Islamic world, the madras-tomb sanctuary together with the mosque can be seen. The local tradition continued even after the country fell to the Ottoman domination in 1517. It will only be later in the ninth century, with the mosque of Muhammad 'Ali, that we will have an important religious structure of significant interest.

The development of the studies on the Ottoman mosque were particularly notable in the period 1965 - 1975, especially in the evaluation and clarification of the information on the various phases of development of Ottoman art. These have shown the limits of the Byzantine influence and the value and originality of the Turkish Baroque. Even before the Constantinople conquest, the religious Ottoman architecture, with its preference for a central plan with the "flat" cupola, had already been developed in Anatolic monuments. The portico in front of the mosque appears to have had a similar diffusion. The addition of a great architect such as Sinan and his school cannot help but seal up one source of Byzantine information.

The principal character of Ottoman religious art is the enormous emphasis centered on the mosque, although inserted into a complex of buildings of which it forms a part. The relationship between the minor constructions and the mosque is, however, of a different nature than that which comes about, for example, in the Shi'ite sanctuaries of Iran. In fact, in these sanctuaries the mosque forms a whole with the principal building. Instead, in Ottoman art we get a more open effect in which the buildings alternate with roads and open spaces sometimes follow layouts which were not declared as specific town planning programs. This program is already evident at Bursa, in the buildings which have risen up around the mosque of Ilderim Bayazid, but it is best seen in the imperial architecture of Istanbul. The evolution of the mosque from its primitive idea of the courtyard is particularly evident in the

mosque with the small cupolas. This is realized, to its maximum effect, in the Ulu-Gami of Bursa: it is evident in its planimetry and spacial concept that there is a lack of correlation not only with the art of the court but also with the form for contact between sovereign and community.

The mosque with the small cupolas, not anticipating any preferential areas, conforms to the democratic ideology of its origins. This even applied at a different period in the Islamic history when the Islamic sovereign, no longer a caliph nor a religious or political leader, had no further contact with the people. The reasons for this development need to be investigated not as a variation in the Moslem sovereignty concept, which has remained fundamentally the same, but rather as the crystallization of dogma and of the Islamic moral code, which corresponds to the increase of the mystique, a unique dynamic religious form, and a series of building alternatives to the mosque including the "madras" and the "tekiyah." The mosque with the small cupolas would rarely be expressed in enormous forms, but would continue its existence of physical contact with the people in a series of small mosques spread throughout other regions of the Moslem world, such as Libya, where it could rise up independently. All the same, the minor Ottoman mosques remained linked to the fundamental concept of an ambience where one cupola is or is not flanked by semi-cupolas, the whole unity preceded by a portico which itself has cupolas.

Of the numerous possibilities created in the various regions more or less linked to the Ottoman Empire, the Iraqi mosque is of particular interest. Studies on this have been reinstituted following the pioneer studies of Sarre and Herzfeld. Having lost its position as the center of the Islamic world, Iraq now gravitated, politically and culturally, towards Persia or towards Turkey. The destruction of almost all of the oldest antiques in Baghdad and the surrounding regions is the result of the building materials used. These were generally bricks of poor resistance.

In northern Mossul, the use of stone resulted in the preservation of many buildings. This factor, together with historical circumstances, has caused different results in the two cities. At Mossul, the mosque of the Ottoman period, including numerous reconstructions of previous buildings, reflects faithfully enough the Anatolic mosque which has a centrality in the cupola and a very tall minaret. Perhaps it was impossible to construct the minaret in material of little resistance, similar to the brick. In Baghdad, the religious architecture is subject to continuous and consuming restoration work which has not failed to profoundly alter the buildings. It is still possible, however, to recognize two components, the Persian and the Ottoman. The mosque of the antique Abbasid capital has been influenced by both these components. South Iraq participates finally in an architectural view which opens on the Indian Ocean, participating together with Southern Arabia both in the African Moslem influence and in the Indian tradition.

A new chapter in Ottoman art was initiated in the 18th century with the association of the Western techniques with the Moslem space conception. This period, which will see the wane of Turkish military power, has given us works of great interest, such as the Nusretiye mosque, and the Nur-u Osmaniye mosque.

Looking closely, however, the European influence does not alter the fundamental structure. That which essentially changes is the decoration. In the Turkish Baroque, there is no lack of Indian elements - the four small cupolas at the corners — or even Maghrebin - the arch in a horse-shoe shape. Both are in the Nur-u Osmaniye, demonstrating an open-mindedness towards other Islamic countries.

The support for the "madras," the institute of religious studies which suddenly appeared around the 10th to 11th century, is essentially linked to the Islamic creative decadence and consequently to a reactionary and conservatory impulse. It is not by chance that this appears when the caliphate had lost a major part of his effective power. This power controlled matters of dogma and moral. In Islam, with the end of the "igtihad" or speculative theology, a fulfilled and definitive value can be recognized. The issue of the "madras," therefore, is two-fold. It is artistic, as far as the origins of the architectural forms and the general plan are concerned, but it is also religious and sociological in the relationship between form and function.

There are three theories regarding the origins of the plan: Van Berchem's, which declares it Syrian; Creswell's which puts its origin in Egypt; and Godard's, already anticipated by other Iranian scholars, which gives its origin as Khurasan. All three theories, as demonstrated in recent studies (Grabar, Ettinghausen), can easily be attacked when confronted with archaeological evidence. In fact it has emerged that various types of monuments of the cruciform plan were diffused throughout an extremely vast area, approximately from east Persia to the Near East. They are so frequent in this latter zone, both in Pagan and Christian monuments, as to indicate that the same cruciform form which appears frequently for a certain period in the architecture of the Abbasid court could originate from Near-Eastern Siro-Mesopotamian traditions. This hypothesis is confirmed by the discovery of the "Dar al-imarah" of al-Kufa, in which the tendency can already be seen to construct the courtyard with four principal areas at the sides, even though differing from the classic "iwan." One cannot neglect any eventual influence of the Christian cruciform buildings whose origins can be found in the Palace of Assur. It appears that this type must have been much more widespread. It could surface as a local tradition since the Central-Asian Palace of Nissa proved to be of a different type. In any case, the appearance of the cruciform plan in the "madras" is connected closely to its function, and as such can claim an autonomous development. The "madras" will progressively take over from the mosque a large part of its previous function. It will also substitute for the mosque in the prestige of the citizens.

Two periods can be distinguished in the evolution of the "madras": one, the first, in which the building corresponds to the political program of protection for which it was created, and the second, in which the "madrasa" becomes a body annexed to the mosque with more modest functions and therefore artistically less important. Of the numerous "madrasa" erected in the first period, only the Mustansiriyya at Baghdad remains. This survived the Mongol conquest of the city and has lasted, with changing events and functions, until this day. The building was erected by the Caliph al-Mustansir, at a time of artistic revival of the antique

Abbasid city. Recent studies, carried out by Arab scholars, have described its history and the complex economic situation which surrounded the building. The "madras," inaugurated in 1233, was soon endowed with a library, a hospital, a bathing place, a "Dar al-Qur'an" (presently being excavated), and even a famous clock, prestigious because of its advanced technique for that time. Being the center of the town's cultural life, as the Al-Mansur mosque had been, it was customary that the sovereigns should visit it. The Mustansiriyya, first changed into "Mawlawi-khaneh," then into a caravansery and customs, was restored in the 1960s.

After the Mustansiriyya, which had conserved its distinction for a long time, the institute of the "madras" in the end coincided with the mosque. This is particularly evident in the mosque of Sultan Hasan, a Mameluke building with four "iwan," destined also for scholastic use. Its original significance has gradually been lost. Numerous more "madras" were built and were sometimes connected to the mosque in the complex arrangement of the "waqfiyyat." These were, however, in subordinate positions to the mosque. The mosque will reestablish its supremacy, now temporarily shaken, as soon as the modern world places the traditional teachings alongside the Occidental methods. All the same, the "madras," although having lost much of its importance, remains a center of study still alive in the conscience of the Islamic people. This is demonstrated by the theological university of al-Azhar at Cairo, the Qarawiyyin at Fez, and the faculty at Baghdad, which still today offer traditional teaching freed from some archaic methods.

The third Islamic religious building which rose to artistic value is the mausoleum. Actually, as Graber observes, this was opposed by Islamic officials who, in the most extreme way, condemned every sepulchral monument. The destruction of the sepulchral cupolas is well-known, and not only those operated in Arabia by the Wahhabita movement were affected. The destruction originates from a saying of the Prophet, which was apparently scrupulously observed. This subject, already confronted by various Muslims, has been supported recently by certain studies offering a fundamental contribution. O. Grabar has tried to clarify the complex chronology of the first centuries. G. Fehervari has analized the relationship between the "mihrab" and sepulchral "cippus" which could clarify various queries concerning this subject.

Both of these works, due to their nature and their diverse objects, have common basic problems in the sense that they tend to resolve the relationship between an abstract theory and the necessity of a tangible symbol. In the mosque, the first Islamic sepulchral cippo could have been erected for the Prophet himself and the mihrab, possibly to commemorate his death. We know nothing, however, as to the aspect of this tombal stone, nor those places eventually appearing on the site of the sepulchre of the first caliphs. This is particularly significant in the case of the Omayyad caliphs, who are generally noted for their liberality in the interpretations of Islamic rules. With the advent of the Abbasids we have more certain news. Outside the walls of the rotunda the "maqabir Quraysh" — that is, the tombs of the Quraishits, soon spring up. It appears that the first to be buried here was Ga'far ibri al-Mansur, the son of the founder of the city. Yaqut, in fact, recalls a Quabbat

Ga'far and says that his was the first tomb to be built. The term "qubba," even though it has other meanings, is normally translated as cupola. Therefore we have every reason to believe that it refers to a mausoleum. The maqabir Quraysh remained the principal Abbasid necropolis until 1285, when the Mongols destroyed a great part of the civic monuments. Of the numerous mausoleums, only the sanctuary of al-Kazimiyyah remains today. Here two "Imam" shi'ites are buried whose origins date back to the Abbasid era but which have been repeatedly enlarged and restored in the following periods.

In a similar period, other mausoleums sprang up in Iraq and Persia. These also developed into sanctuaries, but of a much simpler type. The mass diffusion of mausoleums, however, belongs to the late Abbasid period. Both the East and the West participated. Although the East has preserved all the most important monuments, North Africa has also contributed with such famous buildings as the mausoleum of the Saudi Arabians at Marrakech. This is a monumental transfiguration of the long tradition of the local Marabouts. However, the greatest stimula is attributed to the Selguqids. The studies on this subject have received a new impetus at the hands of E. Esin who, elaborating on the documentation of Diez and others, has reproposed the theory, already negated by Monneret de Villard, that its origin goes back to the tents of the Central-Asian and Siberian nomads, but in the specific case extended through the pre-Islamic funeral monuments ("kurgan"). In the wake of the mausoleum of Isma'il il Samanade at Bukhara, of which Ettinghausen has recently stressed the affinity with "chehar-taq" and with Qabus ibn Vashmgir in the Gurgan, a series of similar buildings spread throughout the Selguqid world.

Of the mausoleums slowly becoming known, two appear today to be fundamental, even if subject to undeniable modifications. The "zodiacal," perhaps the less old of the two, reproposes the Iranian cosmic vision in its plan. The second, the beehive style, is not without increasing significant influence. It perhaps goes back to the antique "Ziqqurat" whose tradition has, for a long time, remained alive in Mesopotamian art. This is shown by the minaret in the mosques of Samarra and Abu Dulaf. The presence of a cosmic component in a monument like the mausoleum should not cause surprise when considering the enormous importance of astronomy and astrology in the Moslem world. It had already appeared towards the end of the Omayyad period following the Mesopotamian, Iranian, Greek, and Indian traditions. Writers and philosophers, such as al-Gahiz, al-Farabi, and Avicenna, were extremely against it while others, including al-Kindi, were favorable. This high-level cultural component alongside the popular tradition caused a form of magic to enter into Islamic art right from the beginning. The "seal of Solomon" (the six pointed star) appeared at the end of inscriptions from the Omayyad period. It remains extremely common even today, either at the beginning or the end of sepulchral epigraphs. Sometimes the modification, not very well understood by the Moslems, is of the "School of David" (five points). Both of these motives show up, on a large scale, in the most assorted contexts, such as to exclude a uniquely decorative significance.

It is not difficult to understand the popularity of the zodiacal mosque. This also because in the Selguqid period there was a renewal of interest in astronomy and astrology which brought about the foundation of related institutes and much popularity of various sections, such as numismatics. The zodiacal layout will not, however, be unique and will, in any case, be subject to numerous modifications which not infrequently removed every symbolic significance from the building. Recently D. Stronach and T. C. Young have publicized certain 11th century Demavand and Kharaqan mausoleums. The influence of the mausoleum of Bukhara can be seen in the geometric brick decoration.

As far as the beehive type mausoleum is concerned, its existence is documented in Mesopotamia and in West Persia from the 12th century onwards. An earlier date can be excluded because the famous tomb of Baghdad, attributed to Sitta Subaida, the wife of Harun al-Rasid, and thus towards the end of the 8th century or the beginning of the 9th century, belongs, in reality, at the end of the 12th century and was built, as shown in recent studies, by the mother of the Caliph al-Nasir, Zumurrud Khatun. Buildings of this type are, consequently, common over a relatively vast area, but with the epicenter in central Mesopotamia. This judgment is also based on the fact that this type was seen persistently until a relatively late era. This is demonstrated to us by an example of the flattened perspective at Baghdad in the time of Suleiman the Magnificent. At Samarcanda, the short-lived capital of Tamerlano, the tradition of the Gur-i Mir, the tomb of the Conqueror, is present in the two Timurid mausoleums, recently publicized by the Pugacenkova.

Apart from these types there are numerous variations. The most common of these is that of the quadrangular, round, or polygonal shape surmounted by a "flat" cupola. This type of mausoleum is found frequently, especially in Ottoman art. Apart from this type, a more complex and monumental type can be found in the Moslem architecture. This, in fact, surpasses the concept of the mausoleum even though it still remains the fundamental element. It is a building which we can more or less call a sanctuary. It is predominantly Shi'ite, judging from the importance assumed by the tomb of the shi'ite imam. These structures are very difficult to study, since even the faithful are legally precluded from them. Generally, they are quadrangular mausoleums with a sepulchral room in the center, surrounded by an ambulatory with one or two domes. As one can see, it was a plan which was suitable to walking around the tomb, a characteristic part of the Moslem pilgrimage. The nature of the mausoleum and the economic privileges caused various buildings to spring up around the actual mausoleum such as mosques, madras, orphanages, and retreats. The faithful, whose corpses were often transported from other Moslem countries, were buried in the various areas around the courtyard. Buildings of this type can be found at Nagaf, Karbali, Kazimayni, near Baghdad, Mashad, and Qum. The structures of these, in their current form, are based on the primary form of the 16th century when the Safawid dynasty came to power in Persia. This dynasty started a national restoration program in which Shi'ism became the recognized religion of the state.

The characteristic elements of the mosque are the mihrab, the minbar, the maqsura, and the minaret.

They have all been repeatedly studied recently, with sometimes controversial results. The results, however, have contributed to a better definition of the related problems. At the head of the discussions was, and partly still is, the theory which Sauvaget proposes. Sauvaget suggests that the origins of the mosque date back to the Palatine court room, in the sense that it actually was a "court room." Consequently, the mihrab becomes interpreted as the apse of the throne. The throne is identified with the minbar. The maqsura becomes an open area for particular decision making. This theory put the Islamic ideology of the first centuries in a crisis and indicates that the Omayyads had a ritual similar to that of the Byzantine and the Sasanide. This theory has been supported by distinguished scholars, including Bettini and Schacht. It has, however, been contested by Stern, by Golvin, and by the writers who have stressed the impossibility of generalizing certain isolated phenomena, as shown by Sauvaget. There has, therefore, been a cautious return to the hypothesis that the original mosques were meeting places for the Islamic community. Nevertheless, the works of Sauvaget on the mihrab stimulated successive research.

Given the worthlessness of the mihrab in indicating the direction of Mecca, from the fact that it is the entire bottom wall which absolves this function, the studies have turned mainly to the various sgnificances of its limits and its symbolism. On the first aspect, the research of Serjeant is of particular interest. While elaborating on the question of South Arabia, he has reached the conclusion that the mihrab was a columnar structure in the pre-Islamic period which was transformed into the maqsura in the Omayyad period. The implication derives from the proximity of the mihrab to the maqsura. The hypothesis is nevertheless partially contradicted both by archaeological and written sources. Other scholars, including Golvin and the writer, have attempted to define a symbolic significance in the mihrab, especially in Selguqid period, in relation to the prayer room, often defined as the "threshold," where the mihrab becomes the "door" which leads the believer to the way of salvation. The recent work of Fehervari on the relationship between the mihrab and the tombal stone is extremely interesting, particularly in its reference to their origins.

This scholar maintains that the mihrab is derived from the necessity to recall, in the mosque, the place where the prophet was buried. He was the first to lead the prayers of the faithful. The first mihrab would have appeared on the site of the tombal stone in memory of the Prophet. This hypothesis was confirmed by the large diffusion, indeed a little late, of the flat mihrab on which it is based. Without going fully into this theory, it proposes, once again, a symbolic significance. The diversity of the problem seems to emerge from the current phase. This cannot be resolved with a unique formula because the significance of the mihrab, like its form, has changed from epoch to epoch and from country to country. The minbar, the Islamic pulpit, which Sauvaget's theory was interpreted as "throne," has not aroused as much interest. The studies by Monneret de Villard and Lambert on the relationship to the elder's throne in the synagogue should be noted. So should Schacht's astute study on the "mobile" minbar in certain African mosques which were examined in order to obtain further elements to support Sauvaget's theory.

We must, however, perceive that the first minbar is present in the Great Mosque of Abu Dulaf (ninth century), near Samarra, where it is positioned next to the mihrab. This fact would not appear to identify it with the apse of the throne.

Even the studies on the minbar seem to be extremely complex, both for the scarcity of archaeological evidence which has come to light and for the absence of a close connection between written and archaeological sources. There has not, however, been any lack of noteworthy studies which have better defined the historic development of the minbar. The current work of Golvin on the mosque and its principal elements should be mentioned. The maqsurah, the gallery which encloses the mihrab and the minbar, was included in the theory of Sauvaget, as was the area that was found behind the curtain ('higab'), placed in front of the apse of the throne. Golvin observes that no historical evidence exists, by ancient authors, which backs this hypothesis. Even then in this case one returns to the idea, documented considerably by ancient authorities, of an erect structure under the protection of the caliph or governor, owed to Mu'awiya or Marwan I. This, nonetheless, does not exclude its occasional use as a court room. The successive evolution would, however, be in favor of this second function, often in relationship to the judge or the governor.

The maqsura in the Great Mosque of Damascus seems to have had a particular function - that of an area for teaching law. This was pointed out by Ibn Gubayr, but dates back to a preceding period. We should note, finally, that it was not only that the Abbasid mosques simply did not possess any structures of this type, but that the pillars were so close together that it would have been very difficult for them ever to have existed.

The studies on the minaret have also sustained a radical change of ideas. Above all, the idea that the minaret originally had only one function, to call the faithful to prayer, has been superseded. The minaret of the Qairawan mosque, pointed out by Lézine as being similar to the Salakta lighthouse, has been used for military purposes. On the other hand, a symbolic significance is evident for two reasons. Firstly, because we have news of the town-crier who walked the streets calling the faithful to their prayers and additionally to any meeting, political or otherwise, which was held in the mosque. Secondly, because the extent of the inhabited area around the mosque is such that the muezzin could only be heard within a very limited range. This is evident at least at Samarra. On the other hand, the minarets (or towers) were used by the hermits, as also indicated by the ethmology of the "sauma," one of the terms commonly in use originally. The use, however, of 'manar', "sign indicating the street" but also "place where the fire burns," seems to indicate the origin of the minaret as going back to the Sasanid fire towers. With the passing of time, these functions were lost and the current ones remained.

Civil architecture. – Of the civil buildings, those studied the most in the period which is of interest to us are the "qasr," a term which can be translated as castle or palace. Progress was also made in the study of baths and caravansaries.

Chronologically, the "qasr" is the first to appear, its appearance being linked to the Omayyad period or,

more precisely, to the "badiyah" Siro-Palestinians. There has been much controversy in connection with this work, because various scholars have maintained that the Omayyads preferred to build in the desert in memory of the original site (see E. Kuhnel, "Islam"). Later studies, carried out on literary sources and especially on archaeological evidence which has been confirmed by recent excavations, have shown that the Omayyad "qasr" was merely the main building of one of the agricultural establishments - as was the Roman villa in its time.

The credit for this clarification goes to various scholars, including Monneret de Villard. He had already indicated the fundamental aspects, which the archaeological finding have amply confirmed, in a posthumous book. The disagreement had arisen because the abandonment of the irrigation works after the fall of the Omayyads had transformed the cultivated land into what is now desert. There exists above all a type which originates from the adaptation of pre-existing works, such as the Roman one and the Ghassanide Qastal and Qasr at Hallibat. These first works, in which the Arab contribution is not clear, are followed by others which although stylistically linked to the earlier ones are not without original elements - the Castle of Minyah near the Lake of Tiberiade, Gebel Seis (Usais) in Syria, and Angar in Libya. The latter one is also important at a city-planning level, and its castle, situated inside the boundaries, is one of the best examples of this type. At Gebel Seis, one of the most important rural Omayyad installations, excavations are being carried out which have defined more clearly the main building and some minor constructions. The castle, attributed to Walid I, has two floors with an internal courtyard and lateral arcades. The complex suggests a close affinity with the Omayyad castles, especially with regard to the system of the living quarters. The little arches in the shape of horseshoes on the balustrades are very interesting.

The most interesting buildings, however, belong to the late Omayyad period, during which extremely interesting works appear, such as Khirbet al-Mafgar, Qasr al-Hayr al-Gharbi, and Msatta. These have practically revolutionized the entire concept of Omayyad art. These complexes, in fact, even though they are linked to previous works, are subject to extremely varied influences, which only the expansion of the Islamic state could have justified. Grabar was not wrong when he recognized Central Asian elements in the decoration. The communal characteristics of the Omayyad castle are its inclusion in an agricultural establishment; the quadrangular plan with internal courtyards, surrounded sometimes by arcades; and the external walls flanked by circular towers at the corners and semicircular ones at the sides. The buildings generally are of two levels, and sometimes, as at Khirbet al-Mafgar and Qasr al-Hayr al-Gharbi, together with the caliphates of Hisam, the reception area and the residence of the owner are above the entrance, as in the Roman villas. The possibility of Roman influence is an extremely complex problem, because a similar plan existed in the pre-Islamic Syrian villas, and it is not certain that they had any Occidental origin. We can make similar reflections on the controversial question of the origins of the circular and semicircular towers which are part of a still greater controversy on the relationship between East and West, a problem which has been seen from a subjective point of view without considering the relation between form and function.

Another unresolved problem is that of the prevalence of the "bayt," an apartment of five or more rooms, the center one being the reception room. The origins of this habitation have been indicated by Sauvaget as being in classical architecture. Others, like Creswell, have detected a strong resemblance to similar types of Syrian residences, while Monneret de Villard, even in this case, has produced the most comprehensive documentation. We can add that the "bayt" in its basic form was largely in use at the Vigil of Islam in the Qasr Kharana and at Qastal in Jordan. The influence of the Omayyad "qasr" has probably been exaggerated, especially in the case of Frederick II's castle in Sicily. On the other hand, the Mesopotamian works could have been perceived in the local traditions, which were indicated together with the Persian one as being the main source of the Omayyad castle. After the foundation of Baghdad, we have news of various works of this kind but generally referring to buildings of a very different type, like the famous Qasr al-Khuld on the edge of the Tigris. Iranian scholars have carried out a systematic study of these works which, although lost, indicate the greatness of the Abbasid capital. The leader among these was the Dar al-khilafah, of which unfortunately only the location is known, but is said by the Arab reporters of the time to be surrounded by a wall, inside of which there were various buildings, palaces, pavilions, and mosques, among which was the "qasr," that is, the castle, probably the Qasr Hasani, which was the initial nucleus of the complex in the time of al-Ma' mun.

The study of the Dar al-imarah, the "government palace," has been completely renewed. This is situated in the immediate vicinity of the mosque which, in the case of the capital, coincided in origin with the palaces of the caliphs, such as the "Khadra" at Damascus and the "Bab adh-dhahab" at Baghdad. Ancient literature shows us how the Dar al-imarah was seen consistently in the congregational mosques and thus was present in all the main centers. It is, however, only with the excavations of Kufa that its true characteristics emerge. The building situated behind the mosque was rectangular and came within a larger boundary connected with the mosque. Inside, there was a complex series of rooms of various types and sizes situated around a central courtyard. The court room was like a basilica with a cupola shaped area at the end, of certain Persian derivation.

In the same place one can find the "bayts." These are different from the Omayyad ones. The building, in its general form, can be dated in the Omayyad period, but a large number of them go back to the Abbasid period. The Dar al-imarah at Kufa, with its axis with four main rooms opening onto a courtyard, can be considered as a landmark, even in the controversial area of the cruciform plan, which is seen often in various buildings until the complete acceptance of the mosque with four "iwan." Certain scholars, like Godard, attributed this latter type of mosque to Khurasan. Other scholars, however, were less certain. Its presence in the eighth century in one of the most important cities of Mesopotamia shows a Near-Oriental origin closer to the Christian buildings than to the Partheon ones of the cruciform design, bathing places, and Sirio-Palestinian tombs prevalent at the Vigil of Islam. The building at the side of the mosque in the larger area of Qasr al-Hayr

al-Sarqi could be of the more modest Dar al-imarah. However, the excavations by O. Grabar have not been published in their entirety as yet, so we are unable to form definitive conclusions about it for the time being.

A palace from the time of Harun al-Rasid has been excavated at Raqqa by Syrian archaeologists. In its plan and general design it is arranged more in the Syrian than the Mesopotomian tradition. The palace has living quarters, courtyards, and gardens. The principal entrance extends into the garden, which perhaps was added in a later epoch. The reception area consists of a courtyard ("cour d'office") with arcades on three sides. There are less signs of the court than in other palaces, because the building is more a villa than a caliph's palace. The living quarters, which are completely separate, are Iranian in style and thus open onto the respective courtyards.

The palace of Raqqa introduces us to the heart of Abbasid civil architecture and demonstrates that it was much more varied than the excavations of Samarra had lead us to believe. The Gausaq al-Khaqani and the Balkuwara of this city are the greatest examples of classic Abbasid architecture. Both are separated from the Great Mosque and have a cruciform court room in the central part. At the sides of the court room, grouped around the courtyard, are the living quarters. The imperial Abbasid art makes its influence felt in a large part of the region which, either in a direct or a symbolic manner, recognized the Caliph of Baghdad. The influence of Ukhaidir, the mysterious Abbasid palace near Samarra, is evident in the palace of Ziridi, recently excavated, at Asir. The building, which is apparently from the tenth century, is one of the rectangular types with a central courtyard and four minor courtyards. The entrance is between two rectangular towers. In front of it is situated the court room. The whole building has a distinct military quality, as was required at the time in which it was built. There are two factors of particular interest: first that it had abandoned the system of circular or semicircular towers which, for example, were present in the "ribat" of Susa and attributed to the influence of the Omayyads; and secondly, that the defense of the building is entrusted to quadrangular towers - as seen in many North African military buildings of the Byzantine time.

Progress in the study of East Islamic palaces has been scarce. Instead, there has been a certain re-awakening of interest in the housing which often borders the princely palaces. This type of residence became much more common with the establishment of the middle classes which, from the 16th century onwards - following the enormous development of exchanges between the Far East and Europe - brought ever increasing power to the merchant classes. Markets, bathing places, and caravansaries are built in Waqf, under the name of a great merchant whose residence, separated from the production area, has an internal courtyard with two floors, in stone or bricks and wood. Wood is also used for columns and capitals. At Diyarbakir in Turkey, a palace from the late Selguqid period has been excavated. From its cruciform shape and internal courtyards it reveals the presence of the Samarian and Ghaznavid tradition.

The studies of the Ottoman palaces have also had a new impetus, starting from the Topkapi Sarayi from which various details have been clarified, especially with reference to the Turkish Baroque, which show an ever increasing mixture of interests with European styles. As a result we have large windows, golden ceilings, and clearly Baroque floral motifs. This style, which is present in the works of Selim III at Tokapi Sarayi, withstood a mutation of its decorative exuberance in palaces such as the Solmabahce and Beylerbay, in which the influence of the Central European neo-classicism is evident.

Although never having reached the size or complexity of the Roman bathing places, the baths, as shown in recent studies, are one of the most interesting aspects of the Islamic civilization. The reason for their diffusion should be looked for both in the climate and in the religion. Islam, in fact, prescribes and recommends personal hygiene, ablutions before prayers, and a complete bath after the sex act as a religious duty. The Arabs, however, both from the desert and from Higaz, did not know this type of building, which only began to be appreciated in the conquered countries. It appears that Mohammed himself, despite frequent visits to Syria, had never entered a bathing establishment prior to his prophetic mission. We may add that the aversion continued until even later, and it was only with the Omayyads that the prejudices were eventually overcome. Not, however, without opposition, if it is true that one of the components in the prohibition of the representation of the human form was to be found in the sometimes licentious scenes represented in the baths. The moralists also evidently condemned places where they were found - the baths being considered an aspect of a corrupt society. To this should be added the fact that the Arabs and the Semitic people in general had an aversion for undressing.

The first cities that were founded by the Arabs do not seem to have been furnished with baths, and it is only with the Omayyads that they begin to become established. It is very probable that their appearance was facilitated by the Roman and Byzantine baths which were widespread in the Byzantine territory passed on to the Moslems, such as the thermal baths of Brad, Sergilla, and Babisqa in Syria which clearly preceded the Omayyad baths. This is clearly seen in the small castle of Amra in Jordan, which consists of an amusement room and baths. The first was interpreted until now as a court room. Recent research, based on written sources and the comparative study of similar monuments, brings to mind a "maglis al-ahwah." The baths are laid out in the same way as the Roman baths, with its typical sections: apodyterium, tepidarium, and calidarium. The frigidarium, however, is missing.

As a type of building, the Qusayr Amra does not seem to be an isolated phenomenon. Quite apart from the Abdah and Ruhaibah baths, whose dates in Islamic architecture are somewhat doubtful, we have very similar baths in Hammam as-Sarakh, not far from Qasr al-Hallabat, with which it was probably connected by an agricultural establishment. The fact remains that both Qusayr Amra and Hamman as-Sarakh remain unique of their kind in the Omayyad period and as such claim, despite certain controversy on the former, a date before the later installations. This is suggested also by the frescoes and the inscriptions.

At Angar in Lebanon, one of the most interesting recent finds is the bath inside the city limits, near one of its gates. The columned room and the thermal plan at

Khirbet al-Mafgar precede the important Omayyad "badiyah" excavated by Hamilton, which reaffirms its attribution to Walid II. The baths were the only part of the complex to be finished, which suggests their autonomous use, independent of the residential palace. Apart from being the largest thermal complex which we unearthed until today, it is, at least until the Mameluke period, one of the rare examples of a bathing place furnished with a frigadarium. It is clear that this is not a public establishment because, despite the very large side room, the private nature of the baths is emphasized by the "diwan," with an apse at one end, whose function could only have been to repose before or after the owner's bath. There is no doubt as to the dates of the monuments - which are put in the late Omayyad period. The name of the owner, however, remains obscure, although Hisam and Walid II appear to be the most probable. In any case, the royal character of the monument has been reaffirmed recently by Ettinghausen, who foresees also possible relationships with the Sassanid aulic architecture.

Baths of somewhat more minor proportions than those at Khirbet al-Mafgar have been discovered also in the "badiyah" of Qasr al-Hayr al-Gharbi in Syria. The same type of building has come to light in the recent excavations of Qasr al-Hayr. Little is known, however, of the baths in Mesopotamia, although Arab authors record that in Baghdad there were numerous baths. In about 993 there were 1,500 - one for every 200 houses. There is more information for the period after the 11th century. In Cairo, the older baths originate from the Fatimid epoch and, although they have been repeatedly restored, they should have conserved the original disposition. In these, the derivation from the Roman baths, already seen in the Omayyad baths, is evident. The dome shaped vestibule consists of a vast room to which there is access from an elbow shaped entrance. In the center there is a fountain and there are benches along the sides. This room connects to an apodyterium, from which one can pass to another room, the so called "bayt al-awwal," with a tepid temperature (the tepidarium). Then comes the calidarium, in Arabic "bayt al-hararah," and then the area with the stoves, the "maghtas," which is more or less the laconicum, and finally the room for soaping. In the various areas the cruciform and octagonal forms prevail. By the 14th century a certain tendency towards monumentality is manifested, as seen in Hamman Tambali, which, however, never reached the complexity of the most important Roman baths.

Similar characteristics may be found in Persia, where the most important baths are perhaps those of Haggi Sayyid Husayn at Kasan, connected to the market of the same name. A greater independence from the Roman baths is perhaps found in the Ottoman baths. In the baths of Mohammed Pascia at Istanbul, erected in 1466, we find more or less the same separations. However, thanks to the famous architect Sinan, we see in the more famous one of Haseki Hurrem, also at Istanbul, baths for men and those for the women united in one vast building, harmonized in its two parts and symmetrical. Corresponding to the two high domes of the respective vestibules, there are two minor domes in the central area over the two calidarium, following the plan of centrality, and the "iwan" at the sides. The basis of these buildings was perpetuated to the present age in numerous minor buildings, which are gradually disappearing in favor of modern ones.

The caravansary, or "khan," is one of the most characteristic buildings of Islamic art. Their success was probably due to motives of security but also, as the studies on Moslem economics have shown, in the corporative organizations of the Moslem economy, in the "waqf" property, and in the complex system around which the production method and Islamic commerce levitate. The oldest caravansaries belong to the Omayyad period, or more precisely to the "badiyah" of Qasr al-Hayr al-Gharbi and Qasr al-Hayr al-Sarqi which have been studied recently. The latter, although interpreted as a residential building, was probably also a large warehouse.

These caravansaries were still extremely simple - quadrangular shaped with central courtyards around which are grouped the service areas. The best buildings of the Selguqid period are found in the Anatolic Peninsula. Recently studied by Erdmann, they are perhaps of extremely varied types, but concur in the design, which is predominantly quadrangular with an internal courtyard with a facade which, modelled on the mosques, is very elaborate. Sometimes in Persia the caravansaries assume the octagonal shape, as at Hib-i Bad of the Safawid period. Generally, however, it is quadrangular in form with four "iwans" - like the ones recently studied at Bisutun. Between the rooms attached to the outside wall and those overlooking the courtyard there is a passageway which goes around the four sides and serves to isolate the stables. Generally, there was only one entrance, for security reasons. However, the caravansaries of the late Ottoman period reflect, in certain cases, the Omayyad model of rooms around the courtyard. Some, like Khan al-Mushahidah and Khan Mahmudiyyah near Baghdad, were studied by Herzfeld. Another, Khan Firman, was studied during the recent work of the cataloguing of city monuments. However, on the whole the Iraqi caravansaries, situated in one part along the road which connected Mesopotamia with Khu-rasan and in the other part on the road which connected the Persian Gulf to the Mediterranean, have still been studied very little. This is true, also, for similar buildings of the other Moslem countries.

Town Planning. – Islam, like every large civilization, had need of a city in order to establish itself. This statement was resumed in the recent meeting at Oxford by G. Marçais. The most sensational fact emerging from the meeting, the absence of any guilds in the Islamic world, applies more to sociology than to city planning, but some aspects, such as the studies on Baghdad and Samarra, contain specific contributions to the subject. Together with these contributions are numerous studies, sometimes limited to a single subject, sometimes dedicated to a vast number of subjects, as seen in R. Montran's book on Istanbul in the Golden Age. The most remarkable fact, following careful excavation campaigns, is the emergence at Angar and Qasr al-Hayr al-Sarqi of entire town-planning complexes from the Omayyad period.

Although the ancient Near East has a great town-planning tradition, the first cities founded by the Arabs owed little to the earlier pre-Islamic period which made itself felt in a more advanced phase. One of these was a military encampment in which one cannot speak of a town-planning design but which, as seen in recent stud-

ies, already indicated certain fundamental traits of Islamic cities. The mosque is, in fact, the dominating element and its characteristic "piazza" - a place for community meetings - is also evident. This fact has been documented for Basr, built in about 637 A.D., and for al-Kufa, built in about 638, the studies of which have been revived by Salih Ahmad al-Ali and Kazim al-Ganabi respectively. It has also been noted at Fustat, built by the conqueror of Egypt Amr ibn al-As, and recently excavated by G. T. Scanlon, and also at Qairawan in Tunis, built by Uqbahn ibn Nafi.

It has also been confirmed that these first urban agglomerates, in the distribution of habitable land, tended to conserve the subdivisions of the various tribes and their respective clans. In fact, Arab reporters describe these encampments as divided into separate quarters for each tribe. The nature of this tribal migration provides us with a sense of an Arab conquest which is often seen as a movement for reaching more fertile land.

Basca is famous for having possessed one of the oldest Islamic baths, the construction of which, without doubt, was facilitated by the hydraulic installations of the city. Al-kufa, which is similar in character, has been greatly studied by Massignon and has also, luckily, been the site of recent archaeological excavations. The city was originally an agglomeration of huts which in 643 were built with earth. It is only during the governorship of Zi-yad ibn Abiki that they became terra-cotta habitations. According to Arab historians, 15 "manahig" (tent alignments) were lined up on the habitable area - each for a different tribe. Additionally, there was a main road in which it is not difficult to recognize the main road which joined the caravan routes of the city. But the center of city life was situated in the Great Mosque and in the Dar al-imarah to which it was connected. The west side of the latter was preceeded by a "mastaba," which should be interpreted as a platform, of Persian origin, which opened onto the square. The surrounding area was built up by the merchants ("suq") and it only acquired a roof, and then only sometimes, in the time of the Governor Khalid al-Qasri. The historian Tabari adds that their construction was sometimes an imitation of the mosques. This brings to mind the covered markets which, for climatic reasons, have a long tradition in the Near East. Kufa faithfully reproduces the basic characteristics of the ancient city: a network of roads with a main route which passes through the city center where the mosque, the administrative center, and the market are found.

The transfer of the capital in Syria contributed to the expansion of the spiritual horizons of the Arabs, who were able to confront it with a rich town-planning tradition, without doubt in a better way than the Mesopotamian cities, which were generally erected in brick. Although based largely on local influence, the Islamic mark has remained evident. Thus, at Damascus, the study of which was continued by N. Elisseef in the previously mentioned Oxford meeting, we see the Government Palace arise behind the Great Mosque in the time of Mu'awiyah. It is logical to think that during Walid I's work the palace was modified to form a single complex with the mosque. The mosque would remain the city center for some time, favored also as a result of the absence of a real and proper city piazza.

Angar and Qasr al-Hayr al-Sarqi are of great interest for Moslem city planning, being places which were excavated recently with extremely interesting, though not yet conclusive, results. Angar, in Lebanon, is attributed to the caliphate of Walid I. It is a vast rectangular area, the walls of which are reinforced by semicircular towers at the sides and circular towers at the corners. Access to the area was via four doors which were connected to each other by two roads, thus dividing the rectangle into four equal parts. In the center was the tetrapylon, and next to the northern door were the baths. To complete the idea of a city of Hellenistic derivation, the two roads were flanked by colonnades. Being a city chosen at the whim of an Islamic sovereign, Angar could not be without the buildings which we have recalled. In fact, the mosque is situated at the caliphal palace in one of the rectangles formed by the roads crossing in such a way as to form a complex similar to the Dar al-imarah mosque which we have seen elsewhere.

With respect to the Roman and Hellenistic cities, where the main buildings are found in the pulsating center of the city life, the palace-mosque complex in Angar is in a relatively subordinate position. To find anything similar one needs to go back to the new city of Antioch built on the Orontes in about 280 A.D. It was, however, circular in shape. The nature of Angar, although deeply rooted in city planning, will remain tied to the Omayyad "badiyat," but without becoming either an agricultural establishment or even a true and proper city. The agricultural character of Qasr al-Hayr al-Sarqi has been confirmed by the excavations. The larger boundaries have clearly revealed its "city" character even if only within the limits of a large "badiyah." Various residential groups are in fact present, whose basic center is made up of a complex ("bayt"), which, however, is more complicated and comfortable than elsewhere. Next to the mosque there was a building which perhaps was a small Dar al-imarah. To the north are the baths, and nearby there are some presses. The smaller area has provisionally been interpreted as a "khan." The transfer of the capital in Mesopotamia did not at first cause any city-planning programs, and it is only with the founding of Baghdad that Abbasid city planning started.

The studies of al-Mansur's rotunda have been revived, especially by Salih Amnad al-Ali and J. Lassner, and in its turn the aspect of the future capital was clarified, with important results also in the Islamic sector. On the eve of its foundation the area was populated by a group of smaller centers which would gradually be incorporated into the city, and the rotunda would emerge as the citadel of this residential nucleus. The results were remarkable, especially in the clarification of the position of the mosque in relation to the caliphal palace and its extensions - often in detriment to the latter. This was also because, to stabilize the situation, the city expanded beyond the rotunda on each side of the banks of the Tigris.

It has only just become appropriate to mention this expansion, which was studied by various Iraqi authors and by Lassner. We must remember, above all, that it did not have a planned character, neither for the population, which at its peak seems to have reached one million inhabitants, nor for the evolution of the caliphate which, on one side, brought about a rapid decen-

tralization of the administrative center in respect to the mosque and, on the other, in the period of decadence removed every possibility of political intervention by the caliph with the masses. However, in both phases, the importance of the mosque remained intact. In fact, it is actually in Baghdad, the recognized center of classic Islam, that its evolution can be better defined.

Having lost a large part of the political significance which it had at the beginning, the mosque remained the building where Islamic dogma was elaborated, not always with peaceful discussions; the center where the great Moslem lawyers and reformists preached and taught; and, finally, the place where the caliph intervened in the subjects under discussion - in the presence of a multitude of the faithful. Thus the "piazza" character of the mosque is confirmed, but also the mosque as a business center and, one might even say, as the secular cultural center, because there is news that in the Great Mosque of al-Mansur there was a weekly meeting of poets. On the other hand, in certain cases the mosque is the place where justice is administered. It was also used as a place to repose and stroll when there was nowhere else suitable.

The expansion of Baghdad automatically resulted in more mosques, all more or less of the same "piazza" type, although it would be unreasonable to make additional comparisons other than those with the antique piazzas. Perhaps the only monumental characteristic in the Middle Ages can be found at Samarra, the new capital which was founded to the north of Baghdad in about 836. Baghdad, as stressed in the study by I. M. Rogers, represented a new phase in Islamic city planning in the sense that it was part of a process of dynastic maturation which, in the foundation of new cities, attempted to express itself with strength.

The foundation, or at least the partial construction, of al-Qadisiyyah by al-Mu'tasim was carried out in the ninth century. It was abandoned before its completion. One can see, even today, a vast octagonal boundary with numerous doors and flanked by towers. Al-Mu'tasin also founded Samarra, some buildings of which were erected or completed by al-Mutawakkil, although he preferred to build another capital, al-Ga 'farriyyah. Of these much more important cities, the most notable is Samarra which, unlike Baghdad, is surrounded by a quadrangular boundary of enormously large proportions. The Great Mosque is no longer connected to the caliph's palace, but appears completely separated from it, indicating that it was a building where the caliph rarely appeared. At the time his arrival was accompanied by solemn manifestations, although different in type from the Byzantine and Persian complex ceremonies. The caliphal palace, Gausaq al-Khaqani, is situated a long way away. Its huge entrance overlooked the Tigris in a particularly attractive part of the river. The three "iwan" type central fornices bring to mind the Roman Triumphal Arch, with a function which perhaps was similar to the Taq-i Kisra of Ctesifonte. It is difficult, however, to recognize the identity of the latter, both because the proportions are more modest and because in the middle of winter the river lapped much too closely to the door. Behind stretched walks and gardens, baths, an underground area for the summer, the room of the throne, and the harem.

Analyzing this complex from a town-planning level, one cannot help but notice one of the rules of Islamic art - that is, the placing of all the elements in an asymmetrical way, moderated by the directional axis including the main entrance and the entrance to the throne room, but evident in the general design. At Samarra a love of gardens is apparent. "Garden" is the word used to interpret little lakes and artificial canals. Garden art had been continued by the Islamic people from an extremely old pre-Islamic tradition, which was perpetuated, although in a weaker form, until the eve of Islam. Its development in Moslem art should be attributed not only to climatic reasons, but also to religious ones, the garden being considered the terrestrial image of Paradise. Their origins come from the Omayyad period. The "hayr" which we find at Qasr al-Hayr al-Sarqi and al-Gharbi, as well as at Khirbet al-Mafgar, should be understood in that sense. However, at the end of the Abbasid period, the word was subject to an evolution, in the sense that it came to mean "animal enclosure" or "hunting park." A "hayr" of this type existed also at Samarra.

Similar considerations can be made for the other large residential complex of Samarra, known as al-Balkuwara and erected for a son of al-Mutawakkil. This latter caliph was responsible not only for the completion of various Samarrian buildings, but also for the foundation of a new capital to the north of Samarra, al-Ga fariyyah - the caliphal palace of which has not yet been excavated, but which was destined to a very short life. With the death of al-Mutawakkil, in fact, the caliphs returned first to Samarra and then with al-Mu'tadid to Baghdad, which was to remain the capital until the fall of the Abbasids in 1258. The architecture of strength became weakened in this period, but with the decadence of the aristocratic Arab component, nominally in power, a cosmopolitan commercial class was established. The disparity of class provoked "union" movements, from which perhaps guilds developed.

Sociological research on this period of great social transformation has yet to be carried out, but it is certain that this period laid the basis for the great commercial development of the Islamic city in later centuries. This development will be characterized not only and naturally by the traditional buildings, but also by the ever expanding "suq." These, as observed by Monneret de Villard, were not true markets, but indicated a specific sector of them dedicated to a particular merchandise or job, linking precisely with the late-antique city-planning phenomenon of the Roman world. The caravansaries, in Arab "khan," would be constructed next to the markets, within the cities in order to store, in a safe place, the transit merchandise and also that which was waiting to be sold. In the second case, the caravansary often assumed the denomination of "Qaysariyya," probably from the later "caesareium," even if the Arab term specifically indicates a warehouse for precious merchandise. The baths, in Arab "hamman," were often erected near the markets, while the mosque gradually lost its character of propeller-like center of city life, losing most of the functions which it had had previously and remaining only a religious building.

There was no lack of town-planning creations, however, that were built simply at the desire of a sovereign, such as Madinat al-Zahra, the short-lived capital

of Abd al-Rahman III, the study of which has been continued by K. Brisch. The area of the city consisted of a rectangle of 1,500 x 700 meters. The buildings were arranged at least along three terraces, but it lacked the axial symmetry which characterized the palaces of Samarra of the previous century. It consisted rather of a group of single units, each with a courtyard, like the later complex of al-Hambra at Granada. In the tenth century, al-Qahirah (Cairo) was built next to al-Fustat, which had been built in the period of the conquests, and to Al Qat'i, built in the ninth century by Ibn Tulun, promotor in both cities of buildings of notable town-planning interest such as the hospital of al-Askar and the aqueduct of al-Basatin, from which a nilemeter is conserved. Cairo was built by the Fatimides, who erected famous monuments on the model of their first capital, al-Mahdiyya, in Tunis whose order of fortress has been again underlined by Lézine. At the time of Badr al-Gamali al-Guyus, during the Fatimide dominion, the city was encircled by a wall, of which certain pieces and famous doors remain today. These last buildings are evidence of the relationship with the military art of the Crusaders.

The changes in the Selguqid period were few but a flourishing economy was seen. In the Mongoloid period, Sam, the large suburbs built by Ghazan near Tabriz should be especially remembered, as should Sultaniya, the new capital of Olgeitu. In the Timurid period the capital of Tamerlano, Samarcanda, was famous for a certain period of time. A good part of the Samarcanda ruins have been restored today, causing new interest. The 16th century sees the birth or the development of great empires: the Ottoman, whose expansion covered a great part of the Near East as well as North Africa excluding Morocco; the Safawid empire, its rival, inheritor of a great civilization; and lastly the Mogul, empire whose eclecticism reveals the fundamental Indo-Iranian influence. From the town-planning point of view, this phase of Islam turned itself into flourishing city planning of notable importance which, although taking its origins from the Islamic and national tradition, responded, first with diffidence and later with ever increasing satisfaction, to Western influence.

The research of greatest interest is that on the Ottoman Empire, which spread its influence in the countries that directly or indirectly recognized its supremacy. In this way one can define certain fundamental aspects of one type of city that is widespread in the Near East and in the Balanic peninsula up until the impact with the modern world. In the administrative center there is the contrast between a religious center dominated by the congregational mosque ("ulu-gami") on the one side; and, on the other side, a commercial center, with a basic building, often extremely large and constructed by the "bedestan," around which the market ("çarsi") developed. This market, for climatic and security reasons, gradually became covered. A market could also rise up around the mosque, supplied by the "waqf" of the mosque and assuming the name of "arasta." A city could possess many "khan" and "arasta," but only one "bedestan," which was the center of affairs, the market and warehouse all in one.

On the town-planning level, the principal group is made up of religious buildings. Already Mehmed II, the Conqueror, had built the omonim mosque in Istanbul at the center of a palace surrounded by four "madras" as well as various buildings and his tomb. At Adrianopoli, Bayazid furnished the city center with such charitable works as an imaret (a house of rest for the poor) and a "tabkhaneh" (a hostel for travelers). We can make similar comments on the Suleymanye complex, which is, perhaps, the most important of this type. Elsewhere, as at Adrianopoli, around the Selimiye and in the complex of Sikollu Mehmed Pascia at Istanbul - recently restudied by D. Kuban - an unusual symmetry seems to prevail, perhaps due to the eternal latent Western element at this extreme edge of the Moslem world. Every important city and chief town in the provinces is endowed with complexes of this type, whose principal center is always the mosque, but unlike the first centuries, it is no longer the agoral center of the city, but rather a religious building. The buildings nearby also had a religious character, unified by the "waqf" system, which become the authentic propeller of the economic city life, conditioning the development and the principal characteristics.

The change in city planning in Persia is linked especially to the figure of Sah 'Abbas the Great who, in the reconstruction of Isfahan, drew from both the Iranian and the Islamic traditions. The studies on city planning have been renewed in the course of recent restoration work, especially as a result of the work of Galdieri. In effect, Isfahan is still the city of an Oriental dictator without the democratic contribution of Mohammed and the Arab tribes. The city of Sah 'Abbas was built near the medieval city. Two principal axes, an avenue and a long river, divided the habitation into four sections, in each of which resided a different community. On the north-east side was the Moslem city with the fortress and the Governor's palace. The general layout was dominated by two basic elements: the main avenue and the Maidan-i Sah. A design is suggested which is common to Near-East city planning, but the tree-lined avenue, instead of crossing the city as did the city caravan routes or opening into a central square, finished at the entrance of the residential area of the sovereign. The Maidan-i Sah, instead of being the community meeting place and the point of contact between the community and the sovereign, was conceived only for his own pleasure.

In its planimetry, Isfahan remains a "jewel" of Islamic city planning, which explains the renewal of interest. Its beauty is seen in the harmony between buildings and gardens and the austere plan of the Maidan-i Sah, the "king's piazza," surrounded by monuments such as the Great Mosque, the Mosque of the King, the Mosque of Shaikh Lutf Allah, the commercial center, and the Ali Kapu, the "high door" which, following the ancient significance of the door, gave access to the king's residence, the administrative center, the site of embassies, and belvedere all together. From the central arch of the "high door" a road began that went to the ruler's palaces. As can be seen, it was a city-planning concept of "strength," made graceful by Persian taste for the picturesque, the equilibrium within itself particularly and the harmony between the green of the gardens and the water of the canals.

These elements can also be found in the best Indo-Moslem town-planning manifestations. India possessed a very old town-planning tradition to which the Western influence was not foreign. The city is the result

of two principal elements - the Iranian-Moslem and the local. These two traditions sometimes became intermingled reciprocally, due also to anthropological factors, such as the presence of Persian and Indian workmen. An international eclecticism developed also in India. At first this was restricted to Moslem countries, but later became more open to the West. Unfortunately, however, large parts of the Mogul buildings, including their town-planning arrangements, have been lost. Fathpur Sikri, although it cannot really be considered a city, has conserved a good part of its monuments, the study of which has been continued. The Hindu contribution is prevalent in the decoration and the Iranian in the architecture. The arrangement of the buildings is more picturesque than rational and a unified and, as we have said, eclectic concept dominates.

BIBLIOGRAPHY - *Religious Architecture*: J. Sauvaget, La mosquée omeyyade de Médine, Paris, 1947; E. Lambert, La synagogue de Doura-Europos et les origines de la mosquée, in Semitica, III, 1950; H. Stern, Les origines de la mosquée à l'occasion d'un livre de J. Sauvaget, in Syria; R. Serjeant, Mihrâb, in Bulletin of the School of Oriental Studies, XXIII, 1960; H. Stern, Recherches sur la mosquée al-Aqsà, in Ars Orientalis, 5, 1963; A. Lézine, Mahdiya, Paris, 1965; A. Lézine, Architecture de l'Ifriqiya, Paris, 1966; O. Grabar, The Earliest Commemorative Structures, in Ars Orientalis, 6, 1966; L. Golvin, Essai sur l'architecture religieuse musulmane, Généralités, Paris, 1970; L. Golvin, L'art religieux des umayyades de Syrie, Paris, 1971; L. Golvin, L'art religieux des grands "Abbâsides et des Aghlâbides, Paris, 1974; D. Whitehouse, Excavations at Sīrâf, in Iran, 6, 1966; J. Sourdel, Mosquée et madrasah, in Cahiers de civilization médiévale, 13, 1970; G. Goodwin, A History of Ottoman Architecture, London, 1971; V. Strika, La grande moschea di Damasco e l'ideologia ommiade, in Annali di Ca' Foscari, 1972; V. Strika, Caratteri della moschea irachena dalle origini al X secolo, in Rendiconti (Accademia dei Lincei), 1973; Sa'd Mâhir Muhammad, Mashhad al-imâm 'Alì fî Nağaf, Cairo (n. d.).

Civil Architecture: S. Bettini, Il castello di Mshatta in Transgiordania nell'ambito dell'arte di "potenza" tardoantica, in Anthemon (written in honor di C. Anti), 1955, R.W. Hamilton, Khirbat al-Mafjar, Oxford, 1959; M. Chehab, The Umayyad Palace at Andjar, in Ars Orientalis, IV, 1963; K. Erdmann, Anatolische Karavanseray, Berlin, 1961; K. Brisch, Djebel Seis, in Annales archéologiques de Syrie, XIII, 1963; K. Erdmann, in Mitteinlungen der Deutsches Archäologisches Institut Abteilung, Kairo, 1963 and 1965; O. Grabar, Umayyad Palace and the 'Abbâsid Revolution, in Studia Islamica, 1963; O. Grabar, Qaṣr al-Hayr ash-Sharqī, in Les Annales archéologiques arabes-syriennes, XVI, 1968; O. Grabar, Three Seasons of Excavations, in Ars Orientalis, 1971; K. Brisch, Die Fenstergitter der Hauptmoschee von Cordoba, Berlin, 1966; A. Lézine, Mahdiyah, Paris, 1965; A. Lézine, Architecture de l'Ifriqiyah, Paris, 1966; A. Lézine, Notes d'archéologie ifriqiyenne, in Revue des Études islamiques, 35, 1967; L. Golvin, Recherches archéologiques à la qal'ah des Banū Hammâd, Paris, 1965; L. Golvin, Le palais de Zīrī Ashīr, in Ars Orientalis, 6, 1966; R.W. Hamilton, Who built Khirbat al-Mafjar?, in Levant (Journal of the British School of Archaeology in Jerusalem), I, 1969; J. Sauvaget, Châteaux ommeyades de Syrie, in Revue des Études islamiques, 35, 1967; J. Revault, Palais et demeures de Tunis, Paris 1967; V. Strika, Origini e primi sviluppi dell'architettura civile musulmana, Venezia (Ca' Foscari), 1968.

Town Planning: Sâlih al-'Alt, at Tanzīmāt al-iğtimāiyyah wa 'l-iqtisâdiyyah fî'l Basrah, Baghdâd, 1955; G. Deverdunan, Marrâkesh des origines à 1912, 2 vols., Rabât, 1959-1966; Kâzim al-Ğanabī, Madīnat al-Kūfah, Baghdâd, 1967; J. Alariage, Cairo, London, 1969; E. Galdieri. Two building phases of the time of Shâh 'Abbâs, in East and West, 20, 1970; E. Galdieri, Isfahân: Mašgid-i Ğum'ah, Roma, 1972; J. Lassner, The Topography of Baghdâd in the Early Middle Ages, Detroit, 1970; 'Abd el-'Azīz Daoulatli, Tunis sous les Hafsides, Tunis, 1976; A. H. Hourani-S. M. Stern, The Islamic City, Oxford, 1971.

VINCENZO STRIKA

PICTORIAL AND MINOR ARTS (PLATES 41-43)

Painting and sculpture. — The assertion of painting and sculpture in Islamic countries should be connected to the strength of local tradition and to the weakening of religious sensitivity in certain periods, which, when coinciding, gave rise to great artistic schools, such as the ones in Persia and India for miniatures.

The fundamental features that emerged were bidimensionalism, which is the absence of "plasticity," and chiaroscuro, in which, as observed by Graber, painting and sculpture often played a role that is prevalently decorative, both thus contributing to "horror vacui." The essence of these works, hardly assimilated by Islam, remained alien to the masses, belonging rather to the cultural elite close to the courts and later to the rich merchant class. Another feature was the lack of elaboration received by these works in the framework of Moslem art, wherein one can easily break down the elements which have merged into it.

One can already speak of painting and sculpture in the Omayyad period as revealed by the paintings of Qusayr 'Amra in Jordan and especially by the paintings and sculptures of Qasr al'Hary al'Gharbī and Khirbet al'Mafğar. Studies in this sector have been resumed by Graber, who has extended possible influences to Central Asia. Other scholars have underlined the Hellenistic component, which in a climate of relative tolerance was able to resurface in Syria and Palestine. The Byzantine elements still predominate over Qusayr 'Amra's painting, particularly in the "late-Syrian" factor studied by R. Ettinghausen and defined as "realism." Yet certain constituents are present which could qualify as a "Renaissance" of Hellenistic motifs abandoned in the Byzantine age, such as, for example, the "nude." Though still at the beginning, these studies have been able to reveal the breadth of Omayyad art. Research by the scholar Grignaschi on unpublished sources has extended the phenomenon of this art to the entire culture of the period.

Similar deliberations can be made on paintings by Qasr al'Hayr al'Gharbī and Khirbet al' Mafğar. Of particular significance for the former is the Gea fresco of late-Hellenistic origin, contrasted by the knight's fresco of a Parthian-Iranic origin. The latter is responsible for architectural representations which are also connected to similar pagan representations of late antiquity. One should always attribute to Khirbet al-

Mafgar the enormous development of mosaic art, which reaches its maximum splendor in the baths. The apsis of diwan constitutes the most important mosaic of Omayyad art. In the representation of a tree at the center of the scene, having on one side a lion hunting a gazelle, one can detect Iranian-Mesopotamian influences. The same representation displays also a realistic handling of the theme belonging to a Byzantine dimension. The details of the tree indicate a specific connection to pre-Islamic, particularly Christian, Syrian-Palestinian art.

Studies on Omayyad mosaic art have been resumed by Monneret de Villard, who, referring to the Dome of the Cliff and to the great mosque of Damascus, has provided the most comprehensive documentation on the origin of these mosaics. At the same time, Ch. Kessler has dedicated an interesting study to the Qusayr 'Amra mosaics in which geometric decoration prevails. The development of mosaics in the Omayyad epoch becomes more significant in view of its total decadence in subsequent periods. Only recently, in Turkey, have interesting mosaic floors come to light in the Diyarbakir palace. Following the Omayyad period, painting also began to decline, but this decline was more fictitious than real because, aside from the Samarra paintings long since published, literary sources give us ample proof of their continuity. Frescoes decorated the Egyptian and Turkish baths, while in Laškari Bāzār fragments have been discovered representing the sultan's guards. This evidence, along with literary information, gives us an idea of the importance of painting during this period.

Also evident is the blossoming of this art during the Fatimid epoch, an example being the miniatures recently published by Grube (see Minor Arts), as well as the more famous paintings on the ceiling of the Capella Palatina in Palermo studied by Monneret de Villard. While the Mongul and Timurid periods witnessed the rise of a great school of miniature, particularly in the regions of eastern Iran, one can talk of painting which deals extensively with complex and important subjects only during the Safawid, Moghul, and Ottoman epochs which witnessed the rise of a miniature independent from the text — that is, at the limits of painting.

A very interesting development of portraits and frescoes, which up to now has been paid little attention, is the evolution of Islamic painting after its encounter with Western painting. Such contacts seem to have taken place at first in India, particularly during the Ğahāngīr period, when tridimensional perspective was introduced on a large scale. Tridimensional perspective coexisted with hierarchical perspective, while the flat space perspective was slightly set aside. A similar phenomenon, always at the edge between painting and miniature, took place in Persia through the works of Muhammad (Paolo) Zaman, in whose regard Grube has recently published a few floral representations rendered in naturalistic terms with an anatomic dexterity typical of Western influence. In the meanwhile Turkey availed itself of Gentile Bellini's work, having invited, also, Michelangelo himself.

A sign of growing interest in this sector is the recent work by S. J. Falk on Qāğar paintings. Falk's work brings out the individuality of the artist as well as the choice of his themes, which dealt generally with court subjects (often in the form of portraits), dancers, and musicians, a more or less accurate reflection of life in those times. The evolutionary process apart from purely illustrative themes seems therefore complete. In this regard, European influence is also a main contributor as made particularly evident by the perspective. Contact with the West may have taken away part of the exotic charm of Moslem painting, but by no means did it subject Moslem painting to Western principles. As in other fields, we are dealing with the adaptation of Western design to the Moslem genius. The same considerations apply to modern painting in which European-educated Moslem artists carrying a well-established native tradition participate. Sa'd at-Ta'i and Ğawād Salīm, both Iraqis, are examples.

The first rise of Moslem culture corresponds also to the Omayyad period. The "Hadith," which forbids any representation casting a shadow, is well known. The Hadith can be interpreted as a total prohibition of sculpture. The attitude of Islam may derive from this precept, since in Moslem countries sculpture never fulfilled itself entirely, but remained a decorative element. This tendency is evident already in Sasanid sculpture and to a certain extent in the Byzantine and Indian. Among the sculptures of the Omayyad period the statutes of the Caliph stand out at Qasr al-Hayr al-Gharbī and at Khirbet al-Mafğar. These statues are of clear Iranian derivation in their iconography and costume, but in other aspects they belong to a broader Oriental tradition. Unfortunately the prohibition of human representation severed at its birth any iconographic development of the sovereign who later appeared only rarely on coins. This lasted until the Moghul and Ottoman periods, during which time the sovereign reappeared. Safawid painting did, however, preserve a certain discretion in this regard. As in painting, the Omayyad sculpture also contains many Hellenic elements, such as the goddess Atargatis in Qasr al-Hayr al-Gharbī, knights and people whose pose and costumes point to a clear classic derivation occasionally abandoned by Byzantine art.

In the period properly known as 'abbasid sculpture declined rapidly, notwithstanding occasional reports from written sources, among which one must indicate also those pertaining to Omayyad Spain. Instead, a new era opened up through the Selguqidians, a people originating in Central Asia with a long sculptural tradition. However, even in this case the Selguqidians did not go over the limits of plastic art, more or less emphasized. More commonly we can refer to their art as bas-reliefs, such as those recently published by D. Talbot Rice belonging to the Metropolitan Museum of Art in New York, the Worcester Art Museum in Massachusetts, and the Walters Gallery of Baltimore. Interesting in this aspect are certain sculptures by Ghanzi, described by Bombaci, displayed at the Kabul Museum and representing Indian and Selguqid influence. A bas-relief of remarkable interest could be found until 1917 over the Talisman Gate in Baghdad, one of the few remaining examples of Selguqid art in the ancient Abbasid capital. The bas-relief displays a sovereign on the throne between two dragons. According to certain sources, the sovereign represents the caliph, while to others he represents any Selguqid sovereign, because the iconography is patterned after a widespread design, both in the miniatures and in the metallic objects.

Studies pertaining to Indo-Islamic culture have had a new impetus. This culture was widespread in the Moghul period. Central Asian sentiments, Sasanid and Selguqid influence coexist in a series of currents properly separated by Goetz. These currents stand next to the pure Indian tradition, which is particularly evident in its representation of elephants or horses and less so in human representations. Interesting also are the groups connected to regional schools such as the Deccanese and Gugarati. These works of art are so clearly individualistic that one is apt to think of schools which operated independently from each other. In fact, perfect assimilation among the different schools was rather rare.

In the Near East, sculpture became very rare after the Selguqid period until a certain reawakening in our time, though in the shadow of painting. Also in this sector, the most prominent school seems to be the Iraqi.

Minor arts. — Particular emphasis has been given to minor arts in Moslem art due to their intrinsic value and to their having been considered the first Islamic works of art to have been appreciated in the West. Dating and tracing their origin is one of the most difficult tasks because each piece requires separate and unique analysis.

Many works have been published since 1960, though no new clamorous facts have emerged. These works have shed light on minor arts and have added to what has been disclosed by earlier works. The best known findings can be attributed to distinguished scholars such as Stchoukine and his younger colleagues Grube and Grabar. Of particular importance is the publication of miniatures belonging to the oldest period. These miniatures partially made up for the rarefaction of painting in the period following the Omayyad age, confirming at the same time the continuity of Hellenistic tradition regarded as a decisive component of Islamic civilization in its first centuries. These characteristics are evident in the miniatures of the "Book of the Fixed Stars," whose study has been taken up again by Wellesz and which is considered one of the most ancient works on Islamic bookbinding art. The description of each constellation is followed by a catalogue of stars listed according to the Tolemaic order. The iconography of the figures shows a clear link with Islamic painting in general, as well as with the artistic traditions which by merging have contributed to its formation.

Similar considerations can be made for certain very old miniatures coming from Egypt, particularly from Fustāt, recently published by Grube. Next to the late-classic traditions of Omayyad art, the premises of Fatimid art seem already evident. Very little has come down to us from Fatimid painting aside from the paintings of the Palatine chapel in Palermo, considered a reflection of Egyptian painting. In the representation of the elephant (in which Grube has recognized the "mahmal" of the Mecca pilgrimage) the preference for animal representation is likewise evident. Such an inclination shows also in Fatimid ceramics and reached its zenith in a few centuries in the famous "Manafi al-hayawān" miniatures of Ibn Bukhtyaśū. Grube is also responsible for publishing two ancient manuscripts: the "Medical Matter" by Discoride, translated in Baghdad in the ninth century but illustrated two centuries later, and the Kitāb al-Baitara. In both cases the text and

perhaps even the miniatures themselves may be referring to the original Greek. This constitutes, therefore, a bridge between two civilizations which in the final analysis seems to constitute one of the starting points for studies of this type.

Grabar and Ettinghausen agree that the appearance of the Mongols in the Islamic world not only conferred a new dimension to the scene, but it also changed the artistic themes. These themes change with a greater ease from a simple illustrated message of narrated facts to themes of a heroic nature and, one may add, of a Mongol world outlook devoid of religious or cultural prejudices and with a willingness to assimilate everything. Of this key period in the history of Islamic miniatures, the most important studies have come down to us from material gathered by the Library of Tubingen and from Topkapi Sarayi Muzesi. The latter is an inexhaustible source for the study of unpublished Islamic works.

One of the most interesting manuscripts, the "Ğāmy 'al-Tawārīkh," of which three versions exist, has been reviewed by G. Inal, who has demonstrated the interdependence among the three versions. Meanwhile, M. S. Ipsiruğlu, who has analyzed extremely interesting material, has provided a fine synthesis based on unpublished sources from available material. Studies of Timurid miniatures have been the object of interesting reviews, particularly by Grube, whose works cover also the later Safarid and Ottoman period. Of particular importance is the publication of the "Siyar-i Nabi," by Coll. Spencer, attributed to the second half of the 16th century and portraying the events from the creation of man to the life of the Prophet Mohammad, from whom it takes its title. An overview, full of original cues, on the origins of Turco-Ottoman miniature is owed to Esin Atil.

Concerning Safawid painting, perhaps the major credit goes to Welch, who published the entire "Sahnama" by Houghton, commissioned at the time of Shah Ismail but completed during the reign of Shah Tahmasp, from whom it takes its name. This is a monumental work that gives a fresh perspective to the study of Safawid painting and draws from the heritage of previous periods, though endowing this heritage with a grace of its own. Also remarkable is the resumption of studies covering the later period, as demonstrated by the Sah-nama of the end of the 17th century, reviewed by Robinson, who confirms the strong European influence on Persian miniature after the 16th century.

Even the study of ceramics has added a new impetus. In addition to archaeological excavations, which have provided ample information, the best results have come down to us from the gradual and sometimes systematic rediscovery of Western museums and private collections that, especially in the United States but also in Europe, have increased our knowledge. For the most ancient period, the Gebel Seis and Rusafa excavations have brought to light a few fragments of considerable interest which, added to the already available material, complete the picture of Omayyad ceramics, confirming its total independence from pre-Islamic ceramics schools. In regard to the so-called Samarra ceramics, a new development is the discovery of money coined at Samarra during the tenth century. Such a discovery could push up by a century the dates of the material published by Sarre and

Herzfeld, who based their theory on the premise that Samarra had been inhabited only from 836 to 883 A.D.

Of particular interest is the development of studies on Samarkand ceramics, of which a few works have been published that have given a new impetus to research. Bolshakov's works are especially noteworthy for having concentrated mainly on inscriptions, considered the basic decorative element of these pieces. Tashhodiev is another scholar who has contributed a quite interesting synthesis on this subject. Bolshakov's and Tashhodiev's studies belong to a Central-Asian dimension of Moslem art which is recently attracting renewed interest. The traits of Nisapur ceramics, though already known through the 1934 - 1937 American excavations, have only recently been distinguished from Samarkand ceramics through the work of Wilkinson. Equally important is the research effort carried out by Soviet scholars such as Maysuradze, who has dedicated himself to Afrasiyab material, later described in the volume dealing with the entire excavation activities. This ceramic shows considerable ties to local schools wherein a clear Islamic imprint is nevertheless undeniable, in technique as well as in decoration.

Scanty information has come out of Egypt, where the al-Fustāt excavations have nevertheless yielded considerable data in various sectors — for example, statuettes. These statuettes have been classified as toys, yet in the framework of a most ancient tradition they could have served a different function. For his part Grube has emphasized the survival of pre-Islamic tradition, which therefore confirms also in Egypt's case the "nationalistic" character of the Islamic art that flourished there. Of particular interest are the fragments in polished metal that have been brought to the surface in Algeria during the excavation of the Aal'al of the Banu Hammad. In fact, pieces have been found which prove how this technique, which seems limited to the brief Samarrian period, had continued up to the 12th century.

Excavations at the port of Siraf in the Persian Gulf have produced many fragments made with the technique of scribbling. It is likely that Islamic ceramics, which showed up later in excavations in Kenya and Tanzania, were exported from this port. Selguqid ceramics enriched itself through the publication of various pieces, some of which are of remarkable interest, particularly through the publication of all ceramic pieces belonging to the Barlow collection. These ceramics were already known to scholars, yet only through the recent work of G. Fehervari have they been portrayed in their entirety, even though fundamental studies pertaining to the Selguqid period are still credited to Kuhnel and Ettinghausen. Grube has provided new elements for dating Raqqa ceramics, yet the major contribution of this versatile scholar is his work on Timurid ceramics, which until now had been insufficiently studied. Grube's work has confirmed the composite character of the art which flourished in lands conquered by Tamerlan. In particular, the Chinese imprint shows up in these ceramics, more so than it does in the miniatures. In the vast field of Ottoman ceramics, the most important discoveries have occurred during the Iznik excavations. These findings have solved the enigma of the origin of the so-called Mileto ceramics, which have been divided by O. Aslanapa in various group types, often revealing Persian and Chinese influences. Particular attention should be paid to Ottoman ceramics, whose study has been resumed by U. Scerrato in his filing of Moslem works in Italy.

Studies on bronze and other metal objects have received impetus almost exclusively from museum research. Among the new pieces we point out the al-Malik al-Aziz studied in Naples by U. Scerrato in the course of his research on Islamic art. The work, dedicated to Saladin's nephew, can be traced to the city of Aleppo in the first half of the 13th century. The decoration consists of alternates of six circular medallions and as many of an octagonal form. Portrayed are scenes of conjugal life, drinkers, harp players, and dancers. The piece belongs to a long series of analogous works in which a certain mannerism is present that characterizes the late Selguqid periods and the period which preceded the Mongul and Ilkhamid production. Of particular significance is the Kevorkian ewer, probably the oldest silver inlaid work made in Syria. Scerrato is also credited for cataloguing various pieces in Afghanistan and in museums and private collections in Italy.

Studies of well-known works are also proceeding in the United States, one example being the famous Freer Canteen: the pilgrims' bottle with Christian representations whose study has been resumed by L. T. Schneider. In the meanwhile Grube, in an essay on Timurid decorative arts, has emphasized how certain characters of the Selguqid period seem to have been abandoned on account of a greater stylization of motifs, while the human figure, which predominated in the Selguqid and post-Selguqid periods, almost entirely disappeared. Abstraction prevailed, and sometimes there was a gratifying return to Kufic inscriptions, which during the Selguqid period had been assigned to the same level of the "naskhi." Chinese influence is particularly evident in precious metalwork and in the treatment of jade. For the perspective which it opens, Grube's and Scerrato's contributions should be considered among the best studies to have appeared in recent times on the world of Islamic metalwork.

Research in other sectors of minor arts has also been marked by substantial progress. First of all, we should be reminded of the ivories, which so far have received little attention, but two fundamental studies have been published about these. Beckwith's study deals with Spanish ivories. Kuhnel's essay constitutes the most complete listing of ivories containing examples of great interest, particularly his critique on various art centers such as Spain, Egypt, and Portugal, the latter possessing a well-defined group. We are dealing with a patrimony, often belonging to churches and art collections that before now had not been studied in its entirety. The controversial study on Omayyad ivories has been resumed by H. Stern. Concerning textile arts, the fundamental studies are still Serjeant's ("Ars Islamica," September 1940) and Wiet's ("Soreries persanes," Cairo, 1948). Regarding silk of the Buid period, a new essay has appeared in the supplement to the "Survey of Persian Art" co-authored by Kuhnel and Shepherd, who have been able to solve various problems. Works have also been published on Persian carpets.

BIBLIOGRAPHY - *Painting and Sculpture*: R. Ettinghausen, La peinture arabe, Lausanne, 1962; V. Strika, La formazione dell'iconografia del califfo nell'arte ommyyade, in Ann. Ist. Universitario Orientale di Napoli, 1964; H.

Goetz, Indo-Islamic Figural Sculpture, in Ars Orientalis, 1963; E. Baer, A Group of Seljuk Figural Reliefs, in Oriens, 20, 1967; D. Talbot Rice, Some Reflexions aroused by four Seljūkid Stucco Statues, in Anatolica, 1968; S. J. Falk, Qajar Paintings, London, 1972.

Minor Arts: K. Erdmann, Oriental Carpets, New York, 1960; K. Erdmann, Neuere Untersuchungen für Frage der Kairener Teppiche, in Ars Orientalis, 1961; D. Guest and R. Ettinghausen, The Iconography of a Kāshān Luster Plate, in Ars Orientalis, 1961; R. Ettinghausen, La peinture arabe, Lausanne, 1962; E. Grube, Studies in the Surviving and Continuity of Pre-Muslim Traditions in Egyptian Islamic Art, in Journal of the American Research Center in Egypt, I, 1962; E. Grube, Miniature islamiche, Venezia, 1962; E. Kühnel, Islamische Kleinkunst, Braunschwig, 1963; E. Grube, Three Miniatures from Fustāt, in Ars Orientalis, 1963; G. Inal, Some Miniatures from the Jāmi at-tawārīkh in the Topkapi Museum, in Ars Orientalis, 1963; K. Erdmann, Neue Arbeiten zur turkischen Keramik, in Ars Orientalis, 1963; R. Schnyder, Tulunidische Lüsterfayence, in Ars Orientalis, 1963; I. Stchoukine, Les peintures des manuscrits safavī de 1502 à 1587, Paris, 1959; I. Sīchonkim, Les peintures des manuscrits de Shāh 'Abbās I à la fin des Safavis, Paris, 1964; O. Grabar, A Newly Discovered manuscript of the maqāmāt of Harīrī, in Ars Orientalis, 1963; B. Gray, La peinture persane, Lausanne, 1965; U. Scerrato, Oggetti metallici di età islamica in Afghanistan, Annali Ist. Univ. Or. di Napoli, 1964; E. Grube, The Siyar-i Nabī of the Spencer Collection in the New York Public Library, in Atti II Congresso Inter. di Arte turca, Napoli, 1965; Studies in Islamic Art and Architecture in Honour of Prof. K. A. C. Creswell, London, 1965; O. Aslanapa, Turkische Fliesen und Keramik in Anatolien, Istanbul, 1966; Arabszkie nadpisi na polivnoj Keramike, in Epigrafika vostoka, 1958-1967; A. Invernizzi, Museo civico di Torino, Torino, 1966; U. Scerrato, Metalli islamici, Milano, 1966; U. Scerrato, Arte islamica a Napoli, Napoli, 1966; S. S. Tashkhodzhaev, Khudazhestvennaia keramika Samarkanda, Tashkent, 1967; E. J. Grube, The Classical Style in Islamic Painting, New York, 1968; Afrasyab (pubblicazione della spedizione archeologica), Tashkent, 1969; G. T. Scanlon, Ancillary Dating Material from Fustat, in Ars Orientalis, 1968; W. B. Kubiak, Medieval Ceramic Oil Lampes from Fustat, in Ars Orientalis, 1970; E. Kühnel, Die islamischen Elfenbeinskulturen, Berlin, 1971; E. Grube, Islamic Paintings from the 11th to the 18th Century in the Coll. H. P. Kraus, New York, 1972; M. S. Ipsiroğlu Seray-Alhen, Wiesbaden, 1963; M.S. Ipsiroglu, Das Bild im Islam, Wien-München, 1971; D. Talbot Rice, Islamic Painting, 1971; R. Ettinghausen, Islamic Art in the Metropolitan Museum of Art (various contributors), New York, 1972; S. Cary Welch, Il libro dei Re (Lo Shāh - Nāmeh di Shāh Tahmasp), New York, 1972; C. K. Wilkinson, Nīshāpūr. Pottery of the Early Islamic Period, New York (n.d.); C. K. Wilkinson, Iranian Ceramics, New York, 1963; G. Fehervari, Islamic Pottery (Barlow Coll.), London, 1973; E. Grube, Islamic Pottery of the Eighth to the Fifteenth Century in the Keir Collection, Oxford, 1976.

VINCENZO STRIKA

INDIA AND CENTRAL ASIA

In order to follow more easily the relations between the different regions and schools, the entire sub-continent of India is treated here as a whole. (Ancient and modern political divisions are disregarded.) It is a fact that the figurative experience of this area still remains on the outskirts of historic-artistic research and cultural interests. Naturally, specialized studies, well known works, iconography, and iconologic researches abound. New problems surface, and the points of view of the scholars and specialists slowly change. They give higher value to attitudes of thought and critical and exacting concepts which had been neglected or misvalued in the past. However, it cannot be said that the art of the Indian world has really won the aesthetic appreciation of the international world that is interested, directly or indirectly, in figurative phenomena. It is rare, in overall works and in widely conceived critical research, that one can find references to India corresponding to the quantity and quality of its production. Artistic expressions, both Asian and from other continents, have had, and have, better luck.

This unjust lack of acknowledgement of Indian art is partly due to facts intrinsic to its own nature. As far as the Western world is concerned, the problems of approach to Indian art mainly depend on a diversity - overcome with difficulty by many - of intentions, of means of expression, and of values. In clearer terms, both the will of the art of the Indian artists - i.e., the rationalizing aspect of their creative commitment - and their taste - i.e., the psychological aspect that subtends both their commitment and their choices - are distant and not easily grasped or appreciated by those who are interested in art but not at a specialized level in this specific field. Disregarding some cases of naive enthusiasm and sometimes personal psychological reasons, the art works of India (the term meaning, as we said, the sub-continent) do not attract the attention of Western art lovers that they deserve.

The difficulties of approach reside first of all in the very nature itself of what we could define as "Indianness," that is, the essence of the infinite number of cultures that have followed and flanked each other in the sub-continent and that have left behind stratifications and heritages which remained vital for a great deal of time. As far as the most widely spread and well-known forms are concerned, the exasperating recurrent symbolism, the difficulty of reading and understanding contents and iconographies, and their inclusion in a world that does not differentiate between sacred and profane and that as a consequence strongly disconcerts the spectator creates a state of uneasiness. As a result, the forms and compositions, which are aesthetically splendid and very close to certain modern art and taste trends, remain without a great following. No one denies that many Indian art works are well known and listed among the great art treasures of mankind, but the sporadic acknowledgement of indisputable value does not coincide with the general appreciation of a multiform activity that lasted for five thousand years.

Western criticism - especially beyond the specialists' limited circle - hesitates to confront, in depth, the amount of problems that the immense figurative wealth of the Indian world could submit to its attention. The difficulties amount to obstacles of an idealogical character that end up imposing limitations and fixed perspectives which are not always suited to form a substantial basis for critical analysis. Various authors, among whom many are of Marxist or Marxian inspiration, voluntarily restrict their investigations to the chronological examination of Indian figurative evolution. They consider this section of art history as one in which, correctly, but simplistically, each work must be placed in the precise moment and exact area of its discovery. This process is extremely useful. It becomes limiting, however, if one passes over too agilely the religious meaning and the values of the work itself. This often crosses into parapsychologic or psychotronic fields from which the work directly or indirectly derives.

There is no doubt, as some critics affirm, that the real physiognomy of this or that trend becomes outlined and specified with much greater certainty by the more common production (even the "series production," as stated by Maurizio Taddei) than by undetermined masterpieces. By limiting the research too much, by reducing it to a simple definition of the figurative facts - which are linked together and seen in relation to the social and economic ambient that produce them (not easily reconstructed) - there is a risk of admitting that the modern scholar, especially the Western one, finds himself without the critical means necessary for a deeper evaluation. This brings us to positions of extreme negation which can be connected to Hockeimer and to the doctrines limiting research capabilities only to what has been "lived." The nearly total anonymity of the Indian artists and the existence of collective labor organizations - starting from the "sreni," the corporations - favor an evaluation based only and exclusively on the non-selected mass of figurative products.

It must be recognized that, following such a principle, it is possible to show an amount of technical, chronological, and comparative data - of not negligible relevance - which would otherwise easily escape notice. Nevertheless, other aspects remain obscure. It is probably in these last that some of the essential values that cannot be ignored remain. The direct, and also critical, relationship between figurative production and the society that produces it is not always easily definable, due to the many historical and chronological uncertainties. However, if an accont is taken of the religious zeal that subtends every human action in the entire area of the sub-continent, it will be possible to indicate two fundamental points. The first is that the relation connecting the creation of the work of art to the surrounding socio-

economic situation is not entirely negative. Apparently, temples, monuments, and religious works, as well as all the representative works connected to regality and ruling "elites," can resemble a forced superstructure which did not take into account the people's real needs. It was made possible by more or less oppressive regimes which addressed the economic and labor values towards illusive ideas of the sacrum which could have been otherwise better employed.

It should be noted that as far as the first category of works is concerned, a circulation of wealth was re-established around the holy centers. This involved not only the guilds and artists employed in the construction but also those who, in substantial numbers, exploited the notoriety of the holy center in order to create around it. Semi-permanent maintenance, comfort, and hospitality services for the visitors and also small factories producing ex-vota, souveniers, and sacred material, were established. Wider and more complex interactions and exchanges took place, excluding too easy a simplification. There is no doubt that the historical evaluation of the entire Indian area is constantly on the move under the colors of a despotism (the typical Asian despotism) often changing, modulated in different ways, but still offensive.

This does not exclude the fact that the entire population, regardless of social level or political and economic power, had religious interest as a common denominator. This was so entrenched and so deeply felt as to constitute a second existence which was superior, in the hold it exerted, even to the grievous social conditions.

The second information concerns the so-called "series production" and the problem of analogies. The comparison between images and form or similar compositions - when the level of quality is clearly superior to the rough crafts - and the ensuing reduction to "series," is not always safe ground. Consequently, in a determined sample of works - for example, a series of bronzes representing the same divinity, in nearly the same postures and with the same attributes - some of them, if carefully examined, affect the spectator or user in different ways from others. These effects are obviously linked to the artist's different powers of expression.

It is clear that particular and serious reasons exist, among them a sure and ready image identification, that induce the artisans into following definite iconographic schemes. These are often prescribed by the texts, giving form to works which are nearly analogous and more or less similar, if not semi-identical, to each other. However, it is equally clear that in works of this kind (strictly dependent upon the descriptions in the texts) the artist's personality, his expressive power, the feeling with which he molds his material (which cannot be gauged) may succeed in freeing them and achieving dissimilar results within an apparent likeness. We cannot even approximately know what the original effect of these works might have been on the audience for whom they were created, except for some literary hints that are only recently beginning to be appreciated. However, we can recognize notable differences in feeling and imagination, in spite of the often dull adherence to the texts' prescriptions.

The differences are such, however, as to allow the artists a considerable margin of freedom and autonomy which can partly influence the valuation "by whole series" of the Indian figurative creations. All this remains valid even if the relative tendency of repetition, helped by the obligation to follow faithfully the literary descriptions, is undoubtedly much greater in India than in other Asian artistic cultures. We keep in mind that any comparison with the West could not possibly be established. The "series" really covers the presence of a code of expression developed (with the aid of a dense network of sub-codes) in order to express values born of a complex religious viewpoint, in diagram-like form, which is mainly anthropomorphic. When the emotional element fully dominates the code, then the resulting image is an authentic work of art and definitely emerges from the "series."

In the opposite case, the figure is more sign than image, although the contents to which the code is grafted are for the greater part derived from meditative values and experiences. The "sign," once the code sustaining and forming it is deciphered, opens horizons to the conscious thought of the user, different from those that can be experimented with through empiric consciousness and knowledge.

In conclusion, if more or less acute Marxist or Marxian criticism can at times, even with its unavoidable simplifications and limitations, show particular aspects of the figurative evolution in the Indian area - perhaps isolating and illuminating certain constants of this same evolution which otherwise would be missed - it does not mean that by changing the critic's point of view one cannot have other constants and a wider, and for the greater part equally certain, evaluation. The main problem of the best Marxist inspired critics is that of establishing to what point the constants, as they become identified, do or do not adhere to the country's social reality, or up to what point are they nothing but artful survivals with no remaining capacity to impress. The problem becomes extremely complex from a broader point of view, taking into account both psychology and religious values, historic evolution in a wide sense, and the socio-economic evolution on which the sub-continent's artistic blossoming partly depends. There is no doubt, in fact, that the whole of "Indianity" feels the religious phenomenon as a reality, insuppressible and necessary, on which the work of art must focus primarily. Subordinately, in order to circulate them, it must materialize and clarify (by visualizing them) the concepts and values essential to the religious. Another duty of the work of art is that of conserving these same values. Values which do not appear as a forced superstructure, but as live and vital thought from which the entire existence of the human masses that move and succeed each other in the territory of the sub-continent draw inspiration, even if that freedom firmly rejects the forced pre-eminence of any type of orthodoxy.

Indian piety is without doubt "sui generis." Although extremely vivacious and refined, it presents rigorously national aspects to such an extent that it can be compared more to a philosophical speculation than to a theological construction, in spite of the myriad myths and divinities it gives rise to. This rationalism, which in some cases is conducive to an exaltation of the non-being and to extreme relativism, automatically rejects the pressure exerted by history's anguish and reduces the strength of those forms of ecclesiastical power which will find limited space within Buddhism

and its ecumenic community. We must remember that in Indian thought the religious man has reached the highest point in life's scale in the universe. Even the gods obey him — gods who, if one rises towards a higher vision, are simple mortals too. Their existence has dimensions that are inconceivable to man, but nevertheless has the same end. However, human teachers of Buddhism and Janism, later deified by assimilation with the law preached to them, are nothing but men who, thanks to their intuition and intelligence, have succeeded in unveiling the deep reasons of universal evil and, with a superhuman effort, have shown them to man. As a consequence, excluding the soteriologic superstructures created to help man's weakness, these exceptionally intuitive and intellectual beings, once their worldly life is concluded, disappear from existence and become totally incapable of assisting their followers in any way. These followers can then only find shelter in their teachings and their own faith, while struggling towards a means of leaving life's cycle and of becoming dispersed in the Absolute. This system of thought, broken up into an infinite number of currents and tendencies and sectarian groups of dissenting communities, is permeated by a deeply felt relativism and by reflections that insist upon the intrinsic smallness of the human being. Such a way of thinking easily and deeply disconcerts anybody who comes into contact with the immense mass of forms that derive directly - in a more or less contradictory way - from the fermenting of a thought. This thought is very acute and vivacious but, in the end, very distant from the basic points of other traditions, especially Western ones.

We have described these difficulties, even from a methodological approach, since Indian art is, from some aspects, a page which stands alone in the Euro-Asian figurative production context. We can, therefore, immediately point out that the spectator, in spite of multiple, even well-known, research and publications, finds enormous obstacles in the comprehension and aesthetic appreciation of the forms and symbols employed with coherency and skill by the often anonymous Indian artists.

In spite of the prevalence and confusion of essentially anthropomorphic images, it is never easy to understand why Durga must have ten arms, Siva four faces and four arms, Brahma four heads and several arms, without counting the innumerable variants that concern this or that deity. The fact that Buddha may have an Apollo-like countenance or be a Central-Asiatic barbarian with a drooping moustache and that Visnu may be represented by a boar's head or even by a giant boar does not facilitate the approach of the observer. The observer is a stranger in the world of shapes and symbols through which religious values, myths, monstrous tales, or serene legends express themselves.

The "code," already discussed, remains indecipherable. In fact, the limit that separates the significant sign from the image created to substantiate aesthetic values, composite rhythms, and stylistic intentions is never clear. One suspects that an enormous effort by the observer is necessary in order to understand the centuries-old image before appreciating them. So this immense collection of very complex and often mysterious images shuns entirely naturalistic balances in order to pursue values that are really inexpressible except by convention. The convention has given, and continues to give, rise to curiosity and interest, essentially connected only to its exotic strangeness.

Yet, it would suffice to observe the rigorous coherency of the symbolic expression and the relation which these symbols, abstractly considered, obligatorially interweave with the figurative expression that receives and develops them. But this is not enough! Apart from some ornamental images and certain panels composed with a prevailing didactic and instructive purpose, the Indian religious work of art is never the product of simple aesthetic research. At the highest degree of its appreciation, it becomes an irreplaceable support for mystic meditation based on the most advanced techniques. The cultural image, for example, is neither a commemorative image nor, even less, a simple object of adoration. It is, first of all, a true and proper design of metaphysical values perfectly legible to those who know the language of symbols, attributes, gestures, and positions. This design may be "read," but it can also be meditated through yoga techniques by the worshipper, who finds in it the indispensable support for an evocation of the god or goddess within his own heart. Not without reason are these images called dhyana (that is, the same word that indicates meditation) within both Hinduism and Buddhism.

These same images, developed in color - in metal or in stone, are, in their turn, born of an evocative experience, either directly or, more often, through the descriptions of the texts that codify and divulge endlessly repeated ecstatic experiences. Consequently, many cultural images of the Indian world (particularly medieval India) have a double value. They are born of an evocative meditation that creates their archetype drawing. Above all, the language is in the position of the hands, of the gestures and the postures, often connected with dancing. They become sacred objects based on the will and choice of the craftsman who creates them. Their purpose is to serve as support to a further evocative meditation that can show the observor's spirit. This is already absorbed into the meditative state called samadhi, certain inherent values in the represented and contemplated deity. There is no doubt that on a totally different plane to that of normal aesthetic experience, and outside any sentimental emotion, the same image serves specific purposes. This is due to its characteristics as a structure that can be compared to a real and true chart of sacred values. It is created with finalistic intentions that consider the aesthetic component from a clarifying and incisive, but secondary, point of view. The purpose, in fact, is one of leading the onlooker to a spiritual condition in which contact with the sacred may be achieved without intermediate means.

A mind, well-versed in the meditative techniques and easily projected towards higher metaphysical planes, will often completely transcend the limited reality and the particular teaching offered by the image-diagram. This kind of phenomena are neither rare nor casual. Produced by careful preparation in the field of meditative techniques, they compel the art critic, who has neglected this amount of differing values for some time, to consider a notable part of the Indian figurative production as though it were meant to achieve specific purposes even though not always measurable in their existence, intensity, and abundance. It is, therefore, clear that with respect to Indian iconography, particularly the Hindustani, one undergoes an unusual evolu-

tion in following these lines of thought. This is also because it sets purposes that are not inconstant and fortuitous (as may happen in works created for magical ends), but fixed and recurrent in relation to the onlooker's meditative preparation and, in any case, completely extraneous to the limitedly rational mentality of a great part of mankind. Along these lines, it is also evident that the interest in the expression of feelings - obviously variable - of the represented figure loses importance and yields its place to the expression of the essential character of both human and divine personages. From here originates the typically Indian force of expressing in the reproductions of the sovereigns the essence of regality (rather than the sovereignty and the specific individuality of this or that sovereign), the feminity - or, better still, the eternal womanliness - in the figures of women, the heroic essence of the warrior, the mysticism of the saint, and so on. All of this derives from the key concept of the pictures seen as charts of values and in another way from the valuation of the human body seen as an ornamental element.

Interest in Indian erotic art, which became rather unwholesome during the 1960s, draws the scholars' attention to the figurative research concerning the sexual charge bursting forth from some feminine erotic images, even when in attitudes of rest or toilet. In other cases the subject, studied and exasperated, concerns first of all the couple (mithuna), represented also or only in sexual union, independent of the personality of the components, which are simply male and female without any individual qualification other than that of a simple physical beauty. In the end, what counts is their sexually qualifying anatomic structure and the relation to human beauty accepted by the Indians. The relatively recent studies by A. Boner, supported by the examination of technical manuscripts - discovered by chance and carefully studied - including a patient search for other parallel and integrative texts - have revealed the existence of a coherent and continuous effort to "geometrize" the composition in the available space. In fact, the characters in certain scenes - even very well known ones - draw, with the inclination of the bodies, with the gestures and posture of the arms and legs, and with the inclination of the head, more or less simple geometric figures. From these were formed the characteristic effect of the compositions themselves, the rhythm and the stasis of the motions, the prominence, greater or smaller, of this or of that figure. Wisely exploited, this "geometrizing of the composite space" is one of the fundamental characteristics of Hindustani story-telling - edifying plastic art. It finds, in its turn, some relation to the so-called psychologic perspective, pointed out by Jeanine Auboyer, predominant in the pictorial compositons of Ajanta.

When completing the list of reasons that have emerged over the last few years to explain the Indian artists' lack of interest in catching the expressive reflexes of the face — the fleeting flash of moods, perhaps the dominating expression of the eyes which are in India the mirror of the soul — one must not forget a typical argument that, albeit Buddhist, is valid for the whole of India. Buddha's body, prior to and after the Illumination, remains anatomically the same. But the Master who with his intelligence has conquered the Truth that permits victory over pain and death is no longer the same. Instead, he can be assimilated into the

Law he himself discovered and preached. Consequently he may, in a way, be deified. This is respecting, however, the limitations mentioned earlier. The artist, if he wishes to express the great worth of Buddha, must make recourse to symbolic means, to signs of accepted and traditional importance that clarify the real significance of the anthropomorphous image with the same precision with which they were expressed, through symbolic diagrams, at the time of the iconless schools. The images of the historic Buddha, those of the Buddhas of the past, and obviously those of the supreme Buddhas (or primeval ones) epitomize the Universe's essence and remain, substantially, diagrammatic. This is true, even when Subuti, developing the theory of the prajna (that is, of Buddhist knowledge), established that everything is an illusion except the Law derived from the Illumination and when Nagarjuna, the commentator, distinguishes between the life and the physical body of Buddha on one side and on the other his real substance, infinite and indefinable, which he calls dharmakaya (the body of the Law).

It is therefore clear, even if the specialists have arrived at a full and rational realization only in the last few years, that an unsurmountable abyss separates the Indian sub-continent's religious pictures from the major part of those of other religions. The inconvenience of the methodological approach and the difficulty in obtaining an easy appreciation, even simply intuitive, from the more or less prepared spectators originate from the very particular nature of the Indian figurative production. In fact, the work cannot be valued only by the more or less artificial parameters entrusted to stylistic analyses, to historical settings, and to the simple form accumulated over centuries and decades. A complete evaluation must in fact keep account, in a systematic way yet to be discovered, of the impressive value and the effectiveness of the work of art itself, previously an extremely precise reading of its diagrammatic indications. Moreover, one must keep in mind that it often has an evocative function far more excessive than could be obtained in works limiting their appeal to a simple sentimental sphere.

In the majority of cases, Indian works of art remain works which have specific functions in a field outside everyday reality. This does not mean that the art is not valid and appreciated also on the formal side. At least in appearance it should be of negligible value but it often radiates clearly above and apart from the gratification which, from a Westerner's point of view, is not always easy to put aside. Consequently, Indian art is proceeding towards a new and different evaluation which will break that strange insulation of which it still appears to be a victim. Although aware that Indian speculation about aesthetics places figurative art creations on a lower plane - almost that of a craft (because it is particularly interested in poetry and the theater) - modern criticism no longer neglects the possibility of associating plastic and pictoral creations with philosophical thought concerning aesthetics.

Indian aesthetic doctrines have always distinguished between human creations and nature's creations. Snakuka, for example, warns us that the images created by the artists imitate reality so as to make it recognizable, but, in themselves, they are simple images which cannot be defined - neither true nor false. They are images which detach themselves from the concept of

reality and non-reality because they withdraw from the world of nature from which, nevertheless, the artists draw their intuitions and observations. Although it may appear incredible, Indian thought has dealt with the aesthetic question by developing extremely coherent and systematic doctrinary speculations which precede the corresponding research carried out in our civilization by many centuries - I would say a millennium. Figurative art offers only rare examples to Indian philosophical reflections. The analysis is substantially based on literature and the theater. Nevertheless, one of the oldest texts on the subject, the "Dhammasamgani" - which dates back to the II or perhaps to the III century B.C. and which is therefore contemporary to the great Aniconic Buddhist schools of Bharhut and Sanci, together with the "Atthasalini" of Buddhaghosa (the greatest interpreter of the pali texts of Ceylonese Buddhism) - also bases its systematic investigation into the activities of human spirits upon various examples drawn from paintings. Buddhaghosa, for example, remarks that conscious desires easily change into the will to act. In the painter's spirit, the creative impulse first exists in the desire, and then in the will, to create. This turns into a process in which the subject or the contents are supplied by the picture, while the material form is reached from the clever use, dictated by technique, of lines and colors. Yet the spirit, continuously active, receives new impulses during the production of work so that it finishes by unconsciously altering the original intuition. Consequently, the work of art is a direct and immediate reflection of the intellect's creative activity. It remains a spiritual fact realized in a material form. The Buddhist interpreter identifies this phenomenom of normally unconscious, but sometimes conscious, modifications with the entire creative activity of what one could define as the intuitive spirit. He also considers that the works of art which derive from it are simply accidental translations of his activity. The desire to create — that is, the creative urge - supported by technique which chooses lines, masses, and colors in order to develop the imagined vision in a concrete form, takes the shape of an apparent antithesis between the activity of the spirit, which is always alert, and the stillness of the created work.

Indian thought - which lacks a specific word to signify beauty, but which talks of "supa" (that is, of form) and which considers this form as susceptible to various degrees of perfection - knows perfectly well that there are no rules to obtain the perfect form and that it can take infinite and very different aspects. This concept is explicitly stated by Sukracarya in his "Sukranitisara." Here, he perceives the uselessness of all research into the proportional canons of harmonic beauty. The aesthetic theories of medieval India (those of Dandin, Bhatta Lollata, Sri Sankuka, and Bhatta Nayaka) deal instead with the problem of "rasa" — i.e., the spectator's conditions of awareness, which have as their base the "energy" and the "taste" of the feeling expressed in the work of art and which represent the real object of the aesthetic research. The definitions of "rasa" are, each time, quite different. Dandin considers it a particular way of feeling, intensified by various kinds of external elements (in the example of a drama, by the plot, the script, the scenography, the actors). For Bhatta Nayaka, the "rasa" is a pleasure which is foreign to everyday life, a universally felt pleasure, generalized

in an outside space and time, a pleasure which rarely interrupts the course of the "samsara," the continuous cycle of births and deaths to which each living being is bound. In this way, the "rasa" becomes pleasure, bliss, and rest. The refinement of an aesthetic conscience is not a means nor, we would say, a cultural event, but a target to be achieved, very similar to a mystic experience. It can be considered a real source of enlightenment, a particular and autonomous condition of being. Abhinavagupta speaks of purification through aesthetic enjoyment and of drawing near to cosmic consciousness — that is, to a state of awareness that encompasses the present, the past, and also the future of mankind. The validity of the work resides, in part, in accepting neither temporal nor spatial conditioning (and therefore, we could add with our language, it must be valid and appreciable also in other cultures). As can be seen, Indian aesthetic speculation is very close to certain positions which the West has only recently reached in the field of philosophic reflection on artistic activity. The main task of figurative production in the Indian subcontinent is that of giving form to what cannot have form because it is practically inexpressible.

This does not alter the fact that the giant effort by these unknown Indian artists remains tied to life's tide, to nature-created forms, and to the balances of surrounding reality. They may have been modulated, fused, and harmonized in different and fanciful ways, but they were always based upon the reality of the world which they knew was deceptive, yet without ever striving for languages abstract or extraneous to the realm of perception and reason. Also, when it made use of inspirations derived from paranormal experiences, all Indian art remained anchored to the Being and its problems. If for nothing else, it strove to concretize into comprehensible and unchanging truth that supreme, mysterious, and eternal Being which distributes life and death.

The valuation of Indian art must therefore keep account of its purposes, of the means and sources of inspiration available, which only in the last few years are being valued at their correct worth. This explains, as mentioned at the beginning, the difficulty of a methodical approach and the tendency to reject a multiple experience, which is somehow inconvenient because it is not always supported by an easy comprehension of the purposes and contents that subtend the figurative creation. From this preliminary approach stage, which finally tends to offer a purely Indian point of view, a more accurate valuation of an immense number of works can be made. In this way it will be easier to pass on to a program of more constructive studies and to retrieve the Indian aesthetic experience for that sector of history that concerns itself with man's artistic activity.

Artistic production is present in the first phase of Indian evolution, or, better, of human evolution in the Indian sub-continent. An autonomous culture has been identified in the Madras area, but this is certainly connected with the one called Oldowana by L.S.B. Leakey and is characteristic of East Africa (a fact which raises a long series of problems). Apart from this, we find ourselves confronted only with problems of tools, stone-carving techniques, and rare specimens of nearly useless fragments of wall paintings which are, however, very much later and of uncertain date. Nevertheless, the attempt goes onto reconstruct the physiognomy of the Indian sub-continent with regard to the human popula-

tion in the various epochs that precede the better-known periods.

The many rock carvings, in spite of opinions current until a short time ago, have been definitely assigned to a very late period, and some even to the period that shortly precedes the birth of the second great Indian national empire, the Gupta Empire.

The northern protohistoric cultures were organized in villages which manufactured ceramics. They lived off agriculture and developed wide commercial links also with very distant lands. They represent the necessary premise for the development of a more complex civilization. Culturally, they are the origin of a continuous interchange with the world of protohistoric cultures which flourished in the Iranian area. In fact, the most recent research shows that this contact with Anau, Tepe Siyalk, and Tepe Hisar is much more relevant than at first imagined, even if, from a figurative point of view, the substantial autonomy of the Beluchistan and Indian cultures remains confirmed. This autonomy appears not only in the splendid vascular paintings, but also in the elegant shape of the vases. Due to their lack of cohesion and their becoming lost in a myriad of small centers (of high culture even if apparently illiterate), all these cultures formed a kind of protohistoric "Greece." As in classical Greece, the major villages, although under autonomous and different cultures, ended by joining together on the basis of a relative interterritorial unity. If, in the comparison with classical Greece, the sense of opposition to the foreign "barbarians" was lacking it was because here the sense of isolation was missing.

Apart from the Kot Diji phenomenon, which seems to point to an intermediate evolutionary phase situated in the Indus Valley, between the Indus civilization (which we shall talk about shortly) and the northern village cultures, it should be noted that the protohistoric world of northern India suddenly produced some very great metropolises.

Kot Diji offers ceramics of an earlier type to that of the Indus, which presents very strong similarities to that of Beluchistan and which could be datable to 2800 - 2700 B.C. It already had a vast citadel which dominated the city and which was fortified by great defensive walls made of crude bricks and rough stones. About 400 years after its foundation, Kot Diji was razed to the ground by war. In some ways the way for advent of the urbanization which followed had been prepared, even if the birth of the great metropolises remained unexpected.

The most important aspect of the Indus civilization is centered on urban studies and their problems, solved by avant guard solutions unique in so distant an epoch. In fact, great coeval and correlated cities, of recent discovery, grew up in Turkmenistan, on the River Tedzent (Namazga-Tepe and other centers), and in Afghanistan (Mundigak and Shahr-i-Sokhta on the River Hilmand). The economies sustaining these cities are very different and less complex than the ones that produced the Indus Valley civilization. The activism of these proto-civilizations is remarkable, so much so that the cultures of the Afghan centers of the Hilmand reached the eastern coasts of the Arab peninsula, but even this is not comparable to the civilization called "of the Indus." The difference in level is shown by the lesser rationality of the urban structure (which is still, at times, grand), by the narrower productive specialization, and by the absence of writing.

However, the Turkmen-Afghan phenomenon, which later links up with the evolution of ancient Margiana, takes away from the Indus civilization its characteristic isolation, which appeared to be a detached and unexpected creation within a territory in contact only with areas characterized by village cultures.

The Indus metropolises are structures of exceptional interest within a vast urbanization phenomenon which covered enormous territories and which revealed a remarkable productivity which brought about the replacement of the tiny villages with large and prosperous cities. In Turkmenistan, the metropolitan phase is followed by a breaking-up of the great cities due, among other things, to ecologic factors; i.e., man's survival in these cities was made impossible owing to altered hygienic conditions resulting from the accumulation of garbage. In the Indus civilization, owing to the sewers and the river's drainage capacity, this phenomenon did not occur, even if the civilization's end was determined, as we shall see further on, by other ecologic factors (deforestization and ensuing floods). These problems, although different, have some aspects in common. This very recent reorganization of the Indus civilization did not take anything away from the character of the great metropolises.

What is most important in the first Indian civilization is the town as a whole, in its perfect agreement with an incredibly modern rationalism and in its simple appearance. The monument, in the real sense, is missing, be it sacred or profane, and the search is exiguous for variations in the taste and in the conception of the single architectonic unit, probably in conformity with the social class (or better still, in accordance with the productive specialization) of the inhabitants.

The urbanization of the area over which the culture or civilization of the Indus extends appears in isolated patches with an exasperated activism and rationality. In the urban structure it is possible to perceive a hierarchy-based social ladder, perhaps subject to an oligarchic power, which probably had its seat in the thickly walled citadels. The high technical quality is made evident by the planning and organization of the public services. The people's incredible vitality and energy is seen in the continual rebuilding of the towns destroyed by the floods and in the construction of the port at Lothal. Lothal, today, is inland due to modifications in the coastal profile. At the time, the port facilities included a large dry-dock made of fired bricks, 200 meters long, 35 meters wide, and fitted with locks and loading platforms.

Important variations in the valuation of the Indus civilization depend upon examinations effected in two sectors. The first sector concerns the end of this civilization, which cannot only be attributed to the Aryan invasion, which in any case only contributed by wiping-out its last surviving traces. The very wide use of fired bricks and the continuous cutting down of the forests to feed the furnaces drastically modified the water situation in the Indus Valley. The floods became more destructive and frequent, slowly reducing the slope of the riverbed. The riverbed was already affected by bradyseism and was pushing the coastal profile forward. Insecurity owing to the floods and the unhealthiness of the ambient wore out the recovery capacities of

this civilization. This, the Aryans eventually managed to overcome. In fact, the connection between this primordial phase in the Indian civilization and what follows runs along a psychological link between archaic beliefs and vanished customs. The beliefs and customs later come to the surface here and there.

The second sector concerns the research in deciphering and interpreting the writing and the language of this same civilization. With the help of computers, attempts have been made to interpret the three hundred symbols of an unknown writing recurrent in slightly more than two thousand inscriptions. These were mostly engraved on the so-called soaptone seals decorated with real and fantastic figures. After the original effort by a group of Russian researchers (1964) most of the studies were carried out by the Finnish staff of the Scandinavian Institute for Aryan Studies in Copenhagen.

The Russians and the Finns began with the probable presupposition that the language used was related to Dravidian. Having stated in advance that the research was based on symbols that certainly belong to a unique writing and that there was no risk of entrusting false unrelated values to the computer, it should be pointed out that not all the scholars agreed with the results nor even with the premise, hypothetical, of a Dravidian language. Apart from the indirect confirmation of the skull remains which reveal the presence of Dravidian-like populations in the Indus Valley and the survival of a dialect - Brahui - of Dravidian type in Beluchistan, it must be recognized that the logical conclusion that follows the deciphering proposal is very solid and that the results appear satisfying enough. In any case, the continuation of the research will certainly lead to new views and a definite determination of some characteristics of the Indus civilization and its people. If the deciphering is correct, we would have proof of a religious feeling hinged on a male deity similar to Rudra, called Murugan (that is, "the Young"), well-known to the Dravidian population of the southern part of the peninsula.

The clash with the Indo-European invaders (who called themselves Arya, i.e., nobles) produced intermediate survival forms at village and small town levels. The brick building was abandoned in favor of other simpler techniques, particularly those using wood. At the same time, the Aryans, once settled in the Punjab regions, almost certainly had to change their social organizations, which were based on specialized classes that were not real social classes, but rather labor and functionary divisions. It is more than probable that a sovereign was elected by the tribal chieftains' council, somebody responsible for the whole population and its activities, even if organizational forms along republican lines survived for a long time. There is no doubt that in this period the tribal divisions survived as well. Judging from a celebrated text, the "Manavadharmasastra" — i.e., the Code of the Laws of Manu — we now have the first formation of the castes - called "Varna" (color).

This caste system was far less rigid, mainly because it appears to be without that inflexible "incommunicability" that characterizes the system in more recent history. A first division - which is clearly based on religion - exists between those who, being "initiates," are twice born to this life (they are called "Dvija") and the others who, although they feel the religious calling, are not initiates. To the first group belong, of course, the priestly classes and also the beings who are "born" to regality through complex ceremonies and who, for this reason, are equally dvija. From there derived the development of regalia, royal symbols and attributes according to political necessity, as shown in all the Indian religious iconography, from Buddhism to Hinduism.

However, during the whole of the Vedic phase (the settlement phase of the Indo-European groups in the western area of the sub-continent), even if the literary production was of a very high quality, it is known that there were no sacred buildings other than sacrificial altars. These altars were built following very strict rules that even specified dimensions, forms, and number of bricks. The temple is no longer of interest because it is no longer required by the ritual — only an open space is needed.

The urban centers, which emerged only from the more recent excavations, are small, poor, and without any building plan. The building technique used mud or unfired brick walls or walls sandwiched between two layers of knotted canes. Hastinapura in the Meerut district, in Utter Pradesh, is a typical example. Its first phase goes - according to B. B. Lal - from 1100 B.C. to 800 B.C. when the locality was abandoned following a flood. This was also mentioned by the "Mahabharata." The art production is quite poor and consists of fired clay figurines of uncertain use. This would lead us to believe that the "towns" of this period were only enlarged villages, rougher and with an infinitely lower vitality than those of the ancient Beluchistan villages.

The religious and cultural crisis of the VI century B.C., with the birth of Buddhism and other philosophic-religious currents, marks a profound change characterized, from the archaeological point of view, by black polished ceramics (the Northern Black Polished Ware) with elaborate and elegant vase forms and a wide diffusion and also by a rough currency (the so-called "punch-marked" coins).

At this point some of the big, crude villages began to turn into real towns as well as cultural centers — for instance, Taxila in the northwest. Almost certainly ancient Taxila did maintain a particular self-government of its own, even during the Achaemenid domination. Other towns, such as Charsadda, a short distance from Peshawar, appear fortified. Sir Mortimer Wheeler identified in the moat of Charsadda, protected by an earthwork lined with unfired bricks, the fortified complex that taxed so greatly Alexander's armies in 327 B.C.

Just as important, from an architectural point of view, are the octagonal structures made from great square blocks at Ujjain in the Madhya Pradesh which must presumably be pre-Mauryan and the great external wall of Rajagrha (the capital city of Magada before it was succeeded by Paliputra) which is many miles long and which is certainly pre-Mauryan. In spite of the scarcity of data concerning the phase preceding Alexander's invasion, it has been possible to define with greater precision the figurative physiognomy of the Indian area from the arrival of the Aryans to the birth of the first great Indian national empire: that of the Mauryans.

The Indian metropolises have by now disappeared in the mist of centuries. When they reappear - in the modern era - they will present themselves, initially,

as quarries of "fired" material (bricks) to be exploited as ballast for the English railways in the north.

The towns return to life again with different purposes and intentions, because now they have particular religious and symbolic functions, so, like the building materials, they assume sacred values. The sacrifice that the earth, taken away from cultivation and life, must fulfill in order to bear the weight of man-built edifices is always present in the architect's mind. The erection of a temple began with choosing a favorable site and then chasing away all demons, ghosts, and gods other than those to whom the temple would be consecrated. Following this the earth was placated with the "Vastusamana" rite. This was meant to establish a favorable relation between the creative force of the earth and the human work that had to rise up on it. A form of relation between architecture and nature, but based upon the invisible forces of an almost magic world rather than upon an aesthetic harmony which was not ignored entirely.

However, the town, the palace, and - above all - the religious buildings obey a basic motive: the building of a symbolically expressed magic-religious "center."As such, the town established a relationship between the inhabitants, even the occasional ones, and the Universe's harmony. Seen as the "axis mundi," the same towns became the focal point of the celestial world, of the terrestrial one, and even of the suitably appeased infernal one. The theoretical plans conform especially to a similar concept both when they are square (the square is the perfect form and is the perfection in order) or rectuangular (with the main streets forming a rhomboid) or when they describe equally geometric forms, but apparently less suitable for the purpose (such as circular, semicircular, triangular). The purpose, however, is always the same: to condense the earth's magic forces and to convert them into a supporting base for man's cohabitation or into a kind of magical breath that is in unison with the cosmic breath.

All this can be deduced from the technical texts, and it is certainly the theoretical basis of many foundations that were later changed by successive alterations. On the other hand the grammarian Panini (who lived between the IV and the III century B.C.) pointed out an internal organization of the city which distinguished the residential buildings, the royal shops, the council rooms (or meeting rooms), the sites for the spectacles, and the commercial areas. If one must judge from Taxila and the results of the excavations that have been carried out there, we do not find either a great wealth of buildings, notwithstanding the presence of expensive drainage systems, or precise town planning. In spite of the theoretical intentions, registered also by Panini, the Indian town, although searching for presuppositions of magical harmony, will often be chaotic in its development. This is even more surprising for Taxila, which enjoyed an advantageous position because it was the central junction of the great caravan route which led up to Bactra in Afghanistan, and its culture was open to a strong westernization.

In a slightly later period, Megasthenes, Seleukos's ambassador to the first Mauryan emperor, Chandragupta, speaks of the Mauryan capital city Pataliputra (todays Patna) in terms of great admiration, considering it superior to Iranian towns. Apart from the audience hall in the palace, which numbered at least 80 columns over three meters high, and apart from the traces of entrenched fortifications and the remains of an isolated pillar, the ancient Pataliputra of Chandragupta and Megasthenes does not seem to have been an exceptional model of urban planning. The grid-like town plans and the divisions of the quarters by productive specialization, characteristic of the Indus civilization, remain isolated, as a by now conclusive autonomous experience.

Not taking into account the discovery in Afghanistan of the Ashoka edicts, composed in fluent and elegant Greek, there is very little of interest in the entire Mauryan period. It should be noted, however, still in the architectural field, that a particular problem appears in this age which is important in the successive development of Indian art. During the reign of Ashoka, the last of the great Mauryans, a certain type of architectural building technique begins: that of carved rock. This technique is very characteristic of India and a subject of much discussion.

This same period is, above all, noted for the "stambha." These symbolic pillars, decorated with figures and animals, were recently described with great accuracy as being the axis between the cosmic waters and the skies' blazing light. This seems to confirm its value as a magical center.

In the Indian world it is necessary to make a distinction between properly built architecture - inaccurately called "open-air" architecture - and that "carved" in the cliffs, which is often really dug out of the rocky banks. In reality, the rock carved architecture, which usually imitates the "normal" buildings, is a pseudo-architecture. It is a way of obtaining space without having to face problems of static, which are substantially solved by the rock's cohesion. Nevertheless, this pseudo-architecture is brought to life by symbolic values which are sustained by a near-instinctive relation within the Indian world between the Sacred and the Earth. This is due to the fact that the sacred buildings become a participating element of earth's life which envelops and encloses and, at the same time, offers its own space.

The study of cliff-carved architecture has become deeper during the last few years. As a result, it is now considered the traditional figurative expression of India. It also had much success outside India where this culture reached by way of the Buddhist religion and where this particular architectural form could be realized with a certain ease, as for example the Chinese Sinkiang and in some other areas of China. In the Indian area the first example is provided by the four "caves" in the Barabar Hills (Bihar). These are approximately contemporary as two of them were commissioned by Ashoka. One bears a dedicatory inscription to the 12th anniversary of his coronation, which is to say it dates from 256 B.C. The other two, at the latest, may be attributed to his grandson Dasaratha, even if for some this attribution is without foundation.

So far these first examples of works realized in the cliffs imitate the elements of built architecture. The lack of external space is corrected with small facades which become quite complicated during the medieval period, yet without achieving more satisfying results. A good example of this is the Lomás rsi caitya in the Barabar Hills. Here the minute facade, characteristic and graceful, decorates the only entrance with a false "kudu" arch. This type of arch was widely used by the

Indian architects and has a horseshoe shape. It adapts perfectly to the small facade, which is given a pleasant ornamental effect by a few carvings and a splitting of planes. It seems to have been inserted like embroidery into the smooth side of the low cliff structure, rounded and stretching, emerging from the ground like a body surfacing from the waters.

The cave of Sudama, which dates from the 12th year of Ashoka's reign, was built for the ajivika (for a particular religious sect) and has an apse in the form of a hut. It is, in fact, built to a circular plan. The side closing the main room is convex. This is definitely connected with the aesthetic initiation rites and is an exceptional achievement showing the relationship between wooden and cliff constructions (or also built ones).

The architecture extracted from the caves by exploiting a technique which could be totally autonomous still uses pillars, molding, and vaulting which derive from real architectonic constructions. Obviously, in this case, the reproductions in the rock of these same elements have no static nor supporting functions. Their only purpose is to deceive the visitor's eye. They are, therefore, concessions to an already established and deep-rooted taste. One can deduce that the cave architecture is derived from the built one. This is confirmed also by the fact that the architecture "carved" in the cliffs imitates both the external form of the temples and the limited internal space.

The Indian architect more or less sculptured the projected temple like a monolith, creating both the external and the internal space by the removal of the superfluous material. In these cases, more numerous than one can imagine, the connection between architecture and ornamented modelling appears evident and indisputable. When it is said that this type of temple is "sculptured" in the cliffs, besides the precise meaning of the expression referring to the building technique, it also implies closer cohesion between the architectonic mass, the ornamentation, and the figures completing it.

Apart from the stupa and the Haibak complex in Afghanistan, which had to take rather exceptional symbolic values within the Buddhist tradition, the "sculptured" architectural system has no echoes of great originality outside India. It seems to have already reached Afghanistan by the fourth or fifth century A.D. This demonstrates that it is not necessary to wait for later epochs in order to consider this type of architecture as established. As far as Haibak is concerned, it should be pointed out immediately that recent research has given a greater historical-artistic importance to this complex. Sited in the Khulm Valley and formed by a monastery in a cave excavated from the rock, it is constructed to an unusual plan alluding to classical times (Ionic semi-columns) and Iranian-Sasanidi, but using the carved rock technique. There is also a stupa or stupa dome, surmounted by a "harmika." This is the traditional terrace which, unusually in this case, is cell-shaped and obtained by circular excavation. The dome was then surrounded by a trench and, being monolithic, is without the consecrating foundation deposit. If it is true, as it appears, that the trench was filled with water, we would be faced with a different symbolism of the stupa in question. In this case, it would be bound more to the Earth-Ocean system than to the Cosmos symbolic configuration through a symbolic-ornamental association between rock and water — a kind of liquid architecture which made the stupa at least partially visible by transparency.

Disregarding the Haibak problem, which belongs to a much later period, we can point out that the Mauryan phase, which continued for a long time, contains various elements which will be developed in different ways during the successive phases of Indian art. For example, from the characteristic form of the Persepolitan capitals which surmount the so-called isolated pillars of Ashoka will derive the "pillow"-like capitals, the characteristic Amalaka, much used in later Indian architecture. The Amalaka really served as a term for some types of temple — called precisely Amalaka temples. At the same time, the relation between the various building materials - which in this phase sees the triumph of polished stone - seems to symbolize the interdependence between the various building methods. What counts is the pattern, with its symbolic values. Wood, brick, and stone are of the same interest, even if each time there is a marked preference for one or the other of these materials. This preference depended upon economic, organizational, and ambiental factors and, obviously, also upon external suggestions, as in the case of the Iranian influence on the Mauryans. This was probably connected with an Iranian cultural expansion defined as posthumous — i.e., following and as a result of the Achaemenid Empire which was destroyed by Alexander the Great.

However, this relative indifference to the material used implies the affirmation of values and scale of values which do not always coincide with those adopted elsewhere. Besides the fact that architecture, although requiring an exceptional preparation of the architect-builder (as pointed out by the "Manasara," one of the most important technical texts), is never considered among the greater arts, owing to the sheer weight of the material used, it is also necessary to re-examine the long duration concept which is implicit in the Western valuation of building science and has become an essential requirement. Although popular in the Vedic period, Indian wooden architecture was not made to last and, in fact, has not left any trace. This is due to the unavoidable decay of the material used. The effects of this style can be seen in later periods. For religious and prestige reasons, longer lasting materials were used for important sacred works. Yet wooden architecture has lasted for a long time in some regions, ranging from Kashmir to Nepal and to Bhutan. Elsewhere too, wood on its own or together with other materials has certainly been used much more widely than would appear from the few examples available. This is confirmed by literary evidence, even in those extraneous to India such as Chinese pilgrims. It is enough to think of the famous stups of Kaniska (at Sahji-Ki-Dheri, near Peshawar), considered as India's highest tower. It reached 90 meters thanks to its wooden superstructure which achieved this exceptional height, more than doubling that of the brick-built base.

The problem becomes complicated when one bears in mind the fact that - especially within the limits of Buddhism - certain buildings could have been erected in order to gain merit. In this case the work, considered a sort of votive offering, was valued exclusively for the intention and the sacrifice (both in terms of money and labor) developed in its realization. Really, it was a no-return investment which could also be destroyed as

soon as it was completed, because its function ceased as a donation and votive offering. If the created work is finite and its duration has no importance, it is easy to explain the so-called "expedient techniques" which use low quality materials and permit quick construction without excessive involvement in matters such as static problems which were solved in approximate and precarious ways. Part of the Buddhist constructions of the northwest area and Afghanistan are inspired by these criteria, and they are very often formed by miniaturized buildings (votive stupa) which betray, even in their dimensions, this simple votive value. Perhaps this is because they were destined to be replaced, in the same space, by another different or similar offering after the first one had been demolished. This does not alter the fact that various monuments bear votive dedications by sovereigns, officials, and merchants who financed and cared for their buildings in order to "gain merit" and confirm their faith.

In conclusion, the examination of materials used emphasizes an unsuspected aspect of Indian architectonic psychology, especially Buddhist, which should not be overvalued, but which reveals an aspect of great importance for the full understanding of Indian architecture and the figurative arts in general.

The most recent criticism extracts from this particular psychological attitude a reason for reflecting on the relation that binds artistic creation to the relativistic relation as it is described in detail in many Buddhist and, naturally, Hindu myths. The same concept of space, seen as the only unchanging reality, as it appears in various philosophic schools, and the speculation on the eternity of the flow of time have reacted on the concept of "duration" in the architectonic field. It should be kept in mind that where great works are concerned, and particularly those permeated with sacred values, everything tends to revert to normality in the valuation used by the greater part of artistic civilizations. It is obvious that the architecture carved from the rock contains a concept of duration. We could define this as accentuated and emphasized, but the purpose that subtends these creations is above all symbolically sacred with clear intentions of duration and with references to the earth's essence in its strongest aspect — that is, the rock.

The component which we could re-connect with political history and celebrative and worldly achievement is always very reduced, as confirmed by the fact that the architects are generally unknown.

So far we have listed new angles and particular perspectives which contribute to a more exact valuation of the Indian figurative phenomena. Among these we have underlined some which confirm the difficulty in valuing correctly the effect the figurative arts had on the sub-continent. This valuation can be based on methods which concentrate attention only on specific aspects and phenomena or which examine and emphasize only certain aspects of the complex kaleidoscopic life of the generations that followed each other in that territory. Any method may give results, may clear certain aspects and succeed in opening new perspectives, but synthetic vision with some possibility of enlivening Indian art's great adventure in its infinite modulations and in its infinite episodes must, before all, begin from the deepest possible comprehension of the same phenomena. This should be seen and gauged with the same meter as

the world which produced them. Minimum distortions are compatible with the wider problem of historic reconstruction considered from a general point of view. The essential lesson learned from the studies and research carried out during the 1960s is that unusual analyses and isolated methods are no longer sufficient. A different and greater effort at comprehending such things as the structure of figurative space may save the Indian experience from universal criticism. This will widen the view on man's capacities and "artistic will."

Investigations into the periods following the origins of Indian art also contribute to this work, which I consider preliminary and indispensable to more valid syntheses. Obviously, accuracy and corrections of importance are not lacking. As more light is shed on the pre-Mauryan period (which until recently was above all centered on Alexander the Great) the following period also shapes into a more defined physiognomy. With the Shunga dynasty (185 B.C. - 75 B.C. approximately), which originated from a military plot (the last Mauryan was murdered by his chief general), perhaps the result of a political situation which had become precarious due to external pressures, there is a considerable increase in artistic activity which is no longer a prerogative of the sovereigns and their religious commitment.

The first of the Shunga sovereigns, Pusyamitra (the murderer general) is represented in the Buddhist texts as a very harsh persecutor of the Law and its followers. It is certain that he was an orthodox Brahmin. Nevertheless, once the initial settlement phase was over, Buddhist art flourished widely during this dynasty. The figurative production, as a whole, tends to assume uniform stylistic characteristics, without those considerable differences which divided the works of greater importance from the lesser artisan productions of the preceding period.

This phenomenon is particularly evident in the earthenware, especially from the Shunga period, which is of excellent workmanship and seems moreover to be inspired by profane subjects. There is no doubt that one is confronted by a modification which corresponds to a wider diffusion of culture and to a levelling of taste toward forms which had been or were being transformed into stone. As a consequence the phenomenon, although appearing important, can be somewhat minimized by that part of the figurative production which has not survived, but which, according to many signs, appears much wider and more important than the little surviving material. It is unquestionable that the social transformation which took place in the Shunga phase must have been very deep.

It is possible to conclude that the change in the figurative taste in this phase is certainly consequent to the new social organization and to the economic development of the area ruled by these sovereigns, but also to the religious progress of Buddhism. The great monuments of the Buddhist aniconico schools belong to this phase, which expressed the presence of Buddha in their narrative compositions by symbols instead of by anthropomorphous images. This was done for reasons of clarity and expressive precision rather than because of a specific prohibition.

The more ancient and artistically important stupa are those of Bharhut and Sanci in Madhya Pradesh. As far as development goes they certainly belong to the Shunga phase. The semi-spherical shaped

stupa of the Bharhut probably date from the Mauryan period, even if it is thought that they might be earlier. The same can be said about n. 2 of the Sanci stupa, which could be older than the Bharhut one, but it is impossible to prove it. The fact that the central body of these two monuments belongs to the Mauryan period is not extraordinary if one remembers that tradition attributes the erection of a number of these characteristic monuments to Ashoka.

What counts most is the artistically important part of the stupa, which is the circuit ("Vedika") that fixes the boundary of the sacred area that surrounds the monument, which is entered through swinging portals called "tarana." Two Brahmin inscriptions allow us to date the building of the circuit to the Shunga epoch. It imitates the same wooden structures, transforming them into stone. It is very rich in sculptures and presents synthetic but clear compositions in their narrative purpose. At the same time it gives particular importance to numerous images of minor deities - male and female - which are connected with the folk cults of the "Yaksa," the "Yaksini," and the "Naga" (the serpent kings), and perhaps even a few "devata," which are the most complex venerations of Buddha.

The exact date of the Bharhut vedika still escapes us, but W. Spink's investigations indicate a date of around 100 B.C., which as the research progresses appears even more probable. The stylistic appearance of Bharhut is undoubtedly complex. Besides certain recurrences of Achaemenid or Iranian styles, it is very rich in perspective and spatial problems. The isolated figures and the compositions are inserted into a "compressed" space between two very close planes, and the scarcity of depth (or height) reacts upon this effect. These are compositions which, by falsifying the depth of field, manage to convey the illusion of really circular compositions, strongly detached from reality, but extremely clear. On the other hand, Maria Spagnoli's reseach (1970) brought to light unusual features of perspective and composition in the Bharhut art. The authoress points out among other things the presence of amorphous research (that is, "trompe l'oeil") in some panels of the Bharhut vedika and, in particular, in the one in the Calcutta Indian Museum representing the "Visvantara-jataka."

In this specific case an illusory method is used, maintaining the maximum possible visibility of the images in relation to the onlooker's movement. The clever use of perspective in order to obtain this visibility is clearly suggested in the "pradaksina" rite — that is, the circumambulation of the stupa, evidently extended also to the external enclosure or vedika. Given the flat relief, use is made of calculated deformations of the profiles, the positions of the limbs, and the clothing in order to obtain such an effect. This undertaking appears extremely difficult because the artist is working on flat figures, within a representation based on the laws of perspective which clearly recall those of ancient stone sculptures from the Near East.

It is extremely important to be aware of both the antiquity of this illusory research and its application in straight panels (without curvature) where profiles, positions, raised planes, and slight deceptions are exploited.

In fact it appears clear that these first attempts constitute a precedent of exceptional value for what will happen, with much greater frequency and with more complex technical means, in Gandhara's art. These multiple visions, these optical illusions which strive to give the fullest enjoyment to the onlooker, all within a field of vision as near as possible to 180 degrees, is undoubtedly a creation of India. The optical and illusive technique used in the Greek world must have had some influence on this method, although the result was far removed from the Greek-Hellenistic one. This does not alter the fact that the circular form of the stupa, the enclosures, and the padaksina rite made the artists sensitive to a problem which is practically non-existent in the Western world. As pointed out by P. Francastel, figurative space and the search for perspective do not really reflect the Universe or nature, but only the human society that inhabits this same natural Universe.

Especially when referring to Gandhara, I proposed that this perspective-deceptive amorphous technique be defined with the expression "rotating perspective," because the composition seems to revolve upon its central axis following the onlooker's movement and, sometimes, inserting other secondary effects into this main one. Although accepted by some, this definition seems unpleasant to others who prefer the term "scenographic perspective." I shall take the liberty of remarking that this second definition leads to misunderstanding, mainly because theatrical scenography is centered upon the spectator remaining stationary and facing the scene, while in our case the image follows the compulsive motion of the onlooker.

M. Spagnoli pointed out the presence of effects similar to rotating perspective in some of the great figures (e.g., Culakoka devata, Kuvera yaksa, Gamgita Yaksa) carved on square section pillars. These images are above all meant to establish perspective-psychological bonds with those of the adjacent sides, but we shall return to this subject shortly when we talk of the Gandhara school.

Instead, we can immediately extend the area that is artistically relevant and vital to India in this period. Besides the Jaggayyapeta relief which represents a Cakravartin sovereign (that is, a universal sovereign) together with his royal insignia (this is now chronologically related to the Bharhut works and to the 2nd Sanci stupa, although it may be slightly later), remarkable importance has been acquired by both the sculpture from the Bhaja cave (southeast of Bombay) and the sculpture from the Pitalkhora cave in Maharastra. The date of this still varies, but seems to be between the II century B.C. and an imprecise date not much later than 100 B.C.

One of the Pitalkhora works, an "Atlantean" Yaksa which is produced in the round and can be seen in the New Delhi Museum, bears an inscription stating that, although it is in stone, it is the work of a goldsmith (Kanhadasa), which confirms, if it had been necessary, that artisans specializing in other techniques (goldsmiths, ivory carvers) undertook stone carving for religious reasons.

Regarding the "Great stupa" of Sanci and stupa number 3, it should be noted that they were erected with the contributions of many donors (as confirmed by the Brahmin inscriptions), at least as far as the vedika and the swing-doors are concerned. The Great Stupa's torana are just as rich and important from the stylistic point of view if only for the splendid Yaksini in the "salabhanjika" posture (meaning that one of the arms is raised to grasp a nearby tree branch), realized in the

round, which forms oblique connections between the vertical supports and the first of the horizontal ones of the torana. These figures mark a turning point in Indian sculpture, and they are among the ones most appealing to Western taste. The date proposed for these works by W. Spink is the second half of the first century A.D., and even if favorably accepted it seems too late and implies complex comparisons with other works found in the northwest of the peninsula. This date can be considered as an alternative to the one, perhaps more probable, which anticipates the work by a century.

Similarly, the group of four statues (of different origins) representing two Yaksa and two Yaksi are now considered to originate from the first century A.D. M. Taddei (1972) is not convinced by the Parkham Yaksa (Mathura Archaeological Museum), which could be likened to the Bharhut reliefs. In any case these images show a remarkable complaisance in the representation of the human figure, which some people interpret as a spreading of anthropomorphism.

For Ananda Coomaraswamy, who did not have the benefit of present day chronological details and who, given the times, had a more than justified nationalistic sentiment - and today, for Maurizio Taddei, with his Marxist background supported by a solid historical preparation - this interest in the human figure, shown in the above-mentioned statues and others, would be at the origin of the anthropomorphic representation of Buddha produced almost contemporarily by the so-called Mathura school and by that of Gandhara. As it is clear that the transition of Buddha's representation by symbols to the anthropomorphous one is an essential turning point for all Buddhist art, which was later diffused over more than half of India, it is convenient to linger over it for a moment.

The representation by symbols which are derived from the Vedic and Brahmin worlds, commonly accepted and easily read, is the most precise representation possible of the evasive mass of values concentrated in Buddha, the human teacher. These values were immediately assimilated as the Law, discovered and preached by him, which is in reality the Law that rules the life of the Universe. Although a worker of miracles, Buddha is not in a position to help his followers, having by now passed on to another plane. The anthropomorphous representations of Mathura and Gandhara strive, by different means, to characterize the image so as to make it correspond as near as possible to the conventional, abstract implications of the symbols. That is to say that the artists try to blend into one figure different, and not easily expressed, values. Therefore it is useless to discuss whether the priority of the anthropomorphous figure belongs to one school or another. It is also certain that the figures of the Yaksa, and generally the whole of Indian anthropomorphism, which is very different from the Greek, are at the base of the Mathuraean image. Anyhow, it does not seem logical or reasonable to relate the birth of anthropomorphism (which was preceded by groups of symbols which suggest an invisible human presence seated on the royal throne) and the consequent rarefaction of the symbolic representation, with a deep modification of political ideology.

Regality and power, becoming more "good natured," would also sweeten and humanize the vision of Buddha who, as a consequence, could finally be represented in human form. Having stated that Buddha's regality is an "analogic" form for expressing the Law's sovereignty over the entire Universe, and having also stated that the relations between Buddhism and royal power could not always be excellent, for no other reason than the fact that Buddhism not only did not accept castes, but was substantially ecumenical; it is difficult to see in what way the Shunga, or the following dynasties' regality might have been more "good-natured" than that of Ashoka.

Do not forget that Ashoka - a complex and in some ways misunderstood figure - did not think in terms of people, but of individuals, and extended his interest to all forms of life. He, in fact, considered himself as an example to other men (Kandahar bilingual edict); he granted 25 general amnesties in 26 years of his reign (5th edict), and it seems from recent studies that he might even have abolished the death penalty, certainly humanizing some of the lesser penalities to limits reached again only recently.

Because of the known separation of Buddhism from political life, there is no reason to connect Buddha and his image to the ideology of royal power. This separation, however, lasted for a long time even outside the Indian area (except for lapses and episodes which would be of no interest here) and was particularly clear during the first centuries.

It should be remembered that Buddhism was a revolutionary religion, contrary to castes and their privileges, capable of giving a greater spiritual value to women (who could be part of the "samgha," even if on a lower plane), and, moreover, accused by many of materialism. The Buddhists, in fact, are often defined as "nastika" (from na-asti – does not exist), especially because they denied the Vedas' authority.

Internal strife, schisms, very serious conspiracies, and an infinite network of personal and group interests were all obstacles which clashed with Buddha's organizational effort. He wanted to introduce a clarity of conscience capable of explaining the negative aspects of existence, and especially of human existence, in a tumultuous world. These obstacles brought Buddha to a separation from his community to which he returned, alone, shortly before his death, which occurred on the voyage to Kusinagara.

If a class existed which could find support in Buddhism and which was certainly in favor of it, it was the merchant class, as is evident from the texts. This was a class which was above all in favor of the new religion because it "severed" the bonds opposing free trade which had been imposed by traditional order. An ideology binding Buddhism to royal power through an interexchange (organized community - royal power) has no logic in it. Nor can one misunderstand the later representations of Buddha and of the Bodhisattva, seen in their glorious appearance, since they are clad in royal vestments, but only in order to clarify their metaphysical value as Masters of the Universe, as is evident from dozens of texts (see Paul Mus, Le Buddha Paré).

Above all there is no reason to consider a greater "good-humoredness" of the ruling power, neither with the Shunga (orthodox Brahmins and later followers of Bhagavata), under whom aniconism flourished, nor even less with the invading foreigners, the Yavana - skeptics and in any case intensely Greek, even if interested in Buddhist thought - nor with the destroying Saka

nor the Pahlava (the Parthians of India), equally harsh and connected to the feudal aristocracy, warlike and landowning.

As regards the Kusana, who were responsible for the flourishing of Gandhara's art in the stone phase, they can be considered tolerant toward Buddhism and had, perhaps, a remarkable interest in this religion. This was true especially during the period of Kaniska the Great, but Kusana regality was undoubtedly bound to values extraneous to Buddhism and based upon a strongly felt dynastic cult (confirmed by the temple of Surh Katal and the other small temple at Mat near Mathura) and shrouded in different and worldly values (the victories of Kaniska I in the Surh Kurtal temple, and the presence of Victory, deified, on the coins). According to Buddhist legend the conquering wars brought about Kaniska's murder - suffocated in a carpet - by his own soldiers, who did not relish the idea of conquering also the "North," which would mean an expedition into Central Asia. It does not look as though Kaniska's power was exactly good-humored, and, examined carefully, the various versions of the inscription about the repairs of Surh Kurtal cast the emperor into a circle quite inaccessible not only to his subjects, but also to the highest state officials. In short, the forced application of an explanatory plan on a politico-ideological base onto historical data that do not support it is harmful to the basic ideology and to its correct application in other more favorable fields.

Anyhow, resuming the examination of the new perspectives and the discoveries matured during the 1960s, it will be opportune to omit, in this section dedicated to India, the very rich field of Gandhara art which appears as an independent phenomenon, equally connected with India's figurative world and with that of Central Asia. However, historically this field is connected much more with the latter than to the world of Indian state structures, so that for reasons of clarity it is more convenient to discuss it in the part dedicated to Central Asia.

The epoch of the invasions brought the settlement of various Saka groups in Indian territory. One of these groups, known by the name Ksahanata (i.e., of "satraps"), conquered the Maharastra. Nahapana, the greatest of these satraps, extended his territory during the years of his reign (circa 119 - 124 A.D.), but at the expense of another important dynasty, that of the Satavahana, until his defeat in 124 A.D. by Satavahana Gautamiputra. The Satavahana territory was also threatened by the expansive strength of the Ujjain satraps, but this was later brought to an end by matrimonial alliances. What is certain is that Gautamiputra Satavahana's inscription, celebrating the victory over the Ksaharata, claims that he "has destroyed the Ksaharata, the Saka, the Yavana and the Pahlava has humbled the pride of the warriors and protected the interests of the Brahmins, has prevented the mixing of castes." Now, in practice, Gautamiputra did not destroy anything, as he says, but it appears clear from the inscription that the Ksaharata, as foreigners, assimilated themselves into the ksatriya caste and that Gautamiputra is of the Brahmin caste, and this tended to eliminate the slackening of the barriers between the castes, preventing or at least reducing the ensuing mixing of the members of one with those of the other. Therefore, the Ksaharata environment, their satrap and authoritarian organization remaining as it was, were being molded to different social necessities. These were of a kind prompted both by the military and warlike aspect of their state and by the specific intention of helping exchanges and trade, toning down the hindrance imposed by the caste system.

The most recent research on the monuments which belong to this period lowers the date of the Caityagrha of Karla, making it earlier, which is demonstrated by the more elaborate columns of the Caityagrha of Kondane and of Bhaja, which belong to the same style. Without being able to confirm, for the time being, the chronology of these monuments, it must be pointed out that Bhaja was more directly affected by the wooden productions, while Kondane was already further away from this tradition and Karla further still, even if the distance in time between these three works cannot be too great.

Karla was founded by a banker (Bhutapala of Vaijayanti) and very probably dates back to about 120 A.D. This can be deduced from the wealth of data from the inscriptions, which concern the Satrap Nahapana, a nephew of his, and some followers (see M. Taddei, 1972). Given the political line taken by the Ksaharata, it is evident that they had every interest in supporting Buddhism (which, as we have seen, encouraged trade and hindered the caste system), this being also due to their position as foreigners. In fact, in spite of a contrary attitude which was really inclined towards strengthening the caste separation, for the Ksaharata the classist prevalence of the trade-based categories must have had extreme importance, keeping in mind that the caste structure and the classist divisions do not always coincide nor have identical origins.

On the other hand, contrasting with the ostentatious orthodoxy of the Hindu social organization, the diffusion of an opinion which, theoretically at least, rejected caste division, which Buddhism did, offered foreign sovereigns an easy way of "inserting" themselves into a social structure which was strictly closed to those who did not belong to it. The Ksaharata's action, therefore, developed along two lines: a) that of ostentatious acceptance of a system which could have turned against them, or b) the support of disjointed thought which helped the softening of the system itself at the point of maximum interest to the sovereigns.

It is, however, certain that under the Ksaharata an important aspect of society is revealed by the selfsame inscriptions. In these the Yavana — i.e., the "foreigners," who in this case are obviously not Greek, but Saka), the "locals," and members of the royal family all appear on the same plane, with the sole exception of the sovereign (called Ksatrapa, and later Mahaksatrapa, as his title). However, in the Karla complex, formed not only by the caityaqrha, but also from various monasteries and monastic buildings, can be seen stupendous figures of couples carved in stone, exaggeratedly sensual, but extremely stimulating and powerful. We could say that they represent another page of Indian sculpture. A page which on one part is connected to the Mathura school and on the other is a prelude to further developments.

Particularly important, and in a sense linked to the works of the Ksaharata world, are the Satavahara productions, whose highest artistic expression can be identified in the Amaravati stupa, which is certainly

connected with Gautamiputra Satavahana's son, called Vasisthiputra Sri Pulumayi (130 - 158 A.D.). It has been discovered that this great stupa had unusual forms and dimensions. The diameter of the drum, which supported the dome (full), was about 50 meters. Being 1.80 meters high, it had, in correspondence to the external enclosure entrances, four platforms distinguished by five adjacent pillars. The swing-doors have disappeared, and it has taken on a more harmonious aspect which can be deduced from the remains of the stupa itself and from the images which have been more clearly interpreted through recent investigations.

The characteristic reliefs represent the highest peak of Buddhist narrative art or of Indian art in general. Here the artist was pleased to exploit particular spaces (e.g., the circular medallions) and at the same time tries to introduce the sensation of time. This result is obtained by the simultaneous representation of two or more different moments and is without doubt of great interest, also because it qualifies the sculptor's search for what could be defined as "cinema de pierre."

Alaravati with Bhattiprolu, Gantasala, Gummididurru, and other centers, or monuments, is by now divided, thanks to Barrett's studies, into four phases. The first three are characteristic of these centers, while the fourth phase is substantially represented by Nagarjunakonda. Here the lengthening of the figures and the stylizing of the folds, which have classical origins even if mediated through the Gandhara, are quite different from the other phases. The discovery of a relief (presently in Boston) carved on both sides because it was used twice is of remarkable importance because on one side it carried the representation of a stupa of the phase typical of the late period of Amaravati, while on the other side we find the remains of an illustration of the Bodhisattva bathing in the Nairanjare before the Illumination.

From this the following points can be deduced:
(1) Following alterations on the buildings the panels were used again according to Gandhara custom;
(2) There is a similarity between the bathing scene (the older of the two) and the Sanci compositions;
(3) Not only for the stylistic resemblances offered by the panel, but also for other reasons, it seems possible that the celebrated Begram ivories belong to the Satavahana school rather than to that of Mathura as has been maintained by Ph. Stern's French school.

Obviously this is a possibility that has not yet acquired the character of certainty or, at least, of strong probability. If the hypothesis is correct it is not without weight because, among other things, it demonstrates a strong capacity for expansion in the Satavahana school. As far as the rest is concerned, the Amaravati school and the connected centers continue to attract the attention of scholars for the freshness of style and for the audacious methods adopted in the narration, in the composition, and in the perspective. Although considered one of the greatest achievements of Indian sculpture, it cannot be said that it has been deeply studied, especially as regards the problems of perspective, except for the by now classical, but old, work by M. M. Hallade and Barrett's research, which should be expanded. Even in the Mathura school that was in competition with the Gandhara school in the creation of the anthropomorphous image of Buddha about which we have already spoken, there is no important new criticism.

Today, one can ascertain, on one side, a very pronounced stylistic component, which is clearly Indian, but on the other some of the signs point to a foreign influence, that is to say Kusana, since Mathura, the City of the Gods, was their winter capital. The Kusana taste triumphs in the paintings of the rulers in the Mat sanctuary near Mathusa, which, as we said before, was a dynastic sanctuary. This demonstrates that the Kusana did not want to abandon their traditional propensities for a style which could be described as Iranian as it seems to be of a Central-Asian type, even if they found themselves in a world in which the figurative expression searched for entirely different values. The Kusanas' will to oppose and to differ in respect to the taste of the groups they ruled is still debatable.

The Mathura art is not only Buddhist, although it was quite important for Buddhism, if for nothing else than for having created the image of the so-called "Kapardin" Buddha — that is the one with the spiral-shaped or, better still, snail-like usisa. Important Jaina sculptures represent the Mahavira of the Jaina, recognizable by the characteristic sign (srivatsa) which distinguishes him. Sometimes the Jaina sign or the Vishnu sign are to be found on figures which have perhaps been used to represent Buddhist images.

Mathura, although having been for a long time the object of particularly important studies concerning the iconography and the symbolic values of various works, has not been the object of overall research which is complete, analytically exhaustive, and capable of offering a synthesis which establishes the exact position of this school within Indian art. We can point out, nevertheless, thanks to C. Sivaramamurti, the presence of the remarkable connections of some images, both to particular aspects of life and to very well-known literary works. The value that subtends these connections is the value of exasperated femininity: often it is that of the prostitute. The so-called Yaksi of the Bhutesar balustrade are, in reality, great female figures sitting on crouching "gana" and surmounted by pairs of lovers, shown from the waist up standing on a slightly jutting balcony. In spite of their semi-divine quality they look like courtesans, both for their dress and hairstyles and also for other details. One, for example, looks as though she might be offering a cup of wine (decorated with the Jaina sign) to the couple above, while in her right hand she is holding a bunch of mango buds. She is undoubtedly a prostitute in her position as a cup-bearer for the couple above, and the flowers reveal the time of year as being summer.

Similar remarks can be made about the Yaksa who holds a parrot on her left shoulder and the bird's cage with her right hand, or about the other figure who is seen adjusting her large and valuable metallic necklace. A deep sensuality dominates these figures, with their opulent and liberated forms, perhaps reflecting the world of the Kusana where, according to Bardesane's testimony, the women enjoyed a position of freedom and superiority quite "sui generis." The inner side of the square pillars of the Bhutesar vedika presents, in contrast, schematic and very original descriptions of Buddha's jataka (episodes from his previous lives), among the most well-known but also among the most fantastic. The simple thickness of the vedika's pillars separates the external world from the sacredness of the holy area surrounding the stupa faced by the Jataka panels. But

the external world, its sensuality and exaltation of life and love notwithstanding, is dominated by a particular religiosity, albeit of a lower degree because there is no doubt it is being expressed with semi-divine ornamental figures which crown Buddha's presence (expressed by the stupa itself).

A notable part of the Mathura sculpture is of Jaina inspiration. The penetration of the south by the northern schools (Gandhara and Mathura) which fell within the area of Kusana domination (which obviously express, for a substantial part, Kusana culture) today appears greater than was at first thought. Some unresolved chronological problems notwithstanding, the irradiation from the northwest over the Rajasthan regions is proved by the Swedish Rangmahal diggings, which have brought to light traces of an expansion that took place at the time of the Kusana themselves. Similar proof of this irradiation - perhaps posthumous and perhaps only connected to a production of artisan type, even if of a high quality - is found in the Mirpur Khass pottery, which also presents modifications of classical motives, but already adapted to Kusana or Gandhara taste. These certainly belong to the Gupta period and now attract the attention of the specialists, being evidence of the irradiation phenomenon besides the stylistic fractioning of the so-called "classicality" of the Gupta epoch.

The Devnimori complex at Gujarat also belongs to the Gupta phase. Recently excavated and datable to the fourth or fifth century, it consits of a stupa and a monastery. The modelled decoration assumes notions and motives similar to Mirpur Khass. Among other things in the two localities, some decorative details of the architecture clearly date back to Gandhara sources of inspiration. The pseudo-Corinthian capitals, characteristic of the Gandhara are re-interpreted here and organized according to another taste, quite different, which tends to rearrange and break them up along with other architectonic forms, by the use of vegetable "capriccios" which, in this specific case, may give the impression of a search towards an increase in vegetable ornamentation in order to reduce the importance of still recognizable foreign styles. It is certain that this taste subtends a still unexplained phenomenon of social transformation.

Besides this, the sculptures of Samalaji, a locality very near to that of the Devnimori diggings, showed Gandhar reminiscences in a Hindu modelling typical of Gujarat, as demonstrated by Umakant P. Shah. The problem of the chronologies remains open, however. Shah is right in fixing a date corresponding to the Gupta beginnings (or perhaps to the Ksatrapa end) for the Samalaji sculptures, but we should think about a persistence (rather than rebirth) of the northern influences in Gujarat, while the Gupta models already flourished along different lines and also in Mathura. In this case, even if the uncertain presence of Mirpur Khass is defined as sure in respect to Devnimori, which is denied by various scholars, proof would be available of an irradiation from the north which was received by a certainly more engaged and higher level Hindu production (such as the Samalaji statutes) than that of the other two centers mentioned and which is, instead, Buddhist. Otherwise, in order to build a line of coherent development (even if separated from that of the great Gupta centers), it would be necessary to lower the date of at least a part of the Samalaji sculptures or to imagine a strong quality and difference in the cultural level of the Samalaji artists (who in any case show a greater freedom of action) in relation to that of the other centers, as though it concerned entirely different cultures - besides being of a different level - even if they have as a common denominator only the relation with vague sources of common inspiration identifiable in the Kusana epoch with Gandhara and Mathura traditions.

As far as the Gupta phase is concerned, the particular valuation of the period as "classical," in the Indian sense, of Indian culture, and therefore also of Indian art, is the object of hesitations if not of contestations. It is considered that the positive valuation of the Gupta phase is tied to a storiography which depends - more or less directly - on political interests, the initial roots of which could be recognized in British imperalism's characteristic position at the beginning of the century. However, within the limits of possible objectiveness and referring to data of that epoch, the following should be pointed out: the Gupta, not a noble dynasty, made an alliance, by way of matrimonial policy, with the Licchavi group, tenaciously attached to a republican-type of political-sociological tradition, and managed to create a cosmopolitan society and a homogenous economy balanced in both trade and agriculture.

The end of the economic crisis of the third century reacts upon this conjecture (which bounces from China to the Roman Empire and was the first Euro-Asian economic crisis of which a historical record exists), the resumption of trade with the West, an undoubtedly determining factor for the Gupta trade balance, and, finally, the diminished importance of the Brahmins and the ksatriya, determined by the ruling group's selfsame origin.

Without undue force an unexpected balance was achieved between the three fundamental life values of the ancient Indian traditional scale - that is, the "dharma" (religious law and moral rule), the "artha" (economic and political power), and the "karma" (that is the pleasure of the senses, love, and the quality of life).

It was the epoch of the prevalence of sanscrit over prakrti, while literature and the visual arts, helped by the expansion of Buddhism in the process of conquering the remotest Asian countries, react in an exceptionally important measure - but yet to be determined - upon other civilizations. Under the Gupta, Asanga and Vasubhandu wrote their works, which formed for centuries the basis of Buddhist thought, while the Vedanta was born and some of its principal texts were elaborated.

Fa-hsien, a Chinese pilgrim, was amazed when he discovered that torture did not exist, neither as punishment nor as a means of police investigation, while the death penalty seems to have been replaced by exile.

The very original administrative organization was divided into large provinces, with two orders of sub-divisions within them, which determined a collective cooperation which involved "bourgeois" state officials (bankers, merchants) and guild representatives. The essential opposition existed between town and country inhabitants, as in ancient Greece and in some aspects of medieval Italy.

Between the fourth and fifth centuries Vatsyayana Mallanaga elaborated the Kamasutra, which

was aimed at the town inhabitants (the nagaraka), on account of this counter-position. It is very difficult to gauge the amplitude of the reflections this classic of erotic literature exerted on any number of first class literary works, so it must have reacted upon the physiognomy and the structure of the personages that enliven the holy scenes in some of the Ajanta caves.

As far as the peasant class (which cannot be considered as a "class" in the modern sense, but which equally remains a reserve of labor and a wealth-producing mass) is concerned, it would be absurd to seek a united struggling conscience. Also, the slackening of the Brahmin and nobles' power undoubtedly helped the personal interests of its members. In clearer terms, keeping account of the very wide monetary circulation, without precedent in the peninsula; of the banking activity (which involved also the Buddhist community both through its members and its centers); and of mercantile traffic, there is no doubt that the Gupta phase is characterized by a rapid structuralization, wide and deep, which formed a balance in which the social dynamism (constantly unsuppressible) was contained with a relative absence of tension even if the village ceased to be the true social horizon, if the middle class assumed a cosmopolitan outlook, and if a form of urbanization existed favored by the economic development and by a greater social mobility connected to the nature of the Gupta (obviously against the caste system).

These were situations which should have been able to introduce very different forms of evolution, but which were stopped by the Gupta crisis. They were worn down by the commercial competition with the southern regions, who were too late in moving in the same way as their northern adversaries, and by the pressure from the foreigners from the north - the mysterious Huna - against whom the Gupta exhausted their riches and military strength in a defense that was nearly mortal both for themselves and for their defeated enemies. Today a political judgment becomes distorted and erroneous when it comes to putting into order the mosaic of documents and events of a past so distant and so different from a cultural point of view.

Consequently, the valuation of Gupta art has turned out to be the expression of the most balanced moment in Indian history, without any effort or connection of interests, but for simple objectivity. Within human limits it was perfectly in proportion and comparable with other contemporaries outside Indian territory and appears extremely progressive and substantially anti-feudal, at least in the sense that anti-feudalism would have in the West and already had in Iran. The key to the Gupta works lies in this fact, even if a lot of details are still to be determined.

Today's critics have little else to offer on this argument, except analytic research and, at times, important connections. Artistic research has made a place for itself partly by depending on the study of such technical texts as "Visnudharmottara Purana, Silparatna, Abhilasitarthacintamani, Samaranganasutradhara, Narada, and Silpasastra, but mostly by recovering, evaluating, and making history out of earlier pictorial works which were unknown and ignored due to neglect and deterioration until they create a different history of Indian painting. Naturally, apart from the study of the miniatures from the Muslim period, this refers to wall-paintings, as there is no documentation of those on wood panels or other material (which the technical texts call "phalaka" or "patta") nor for works on canvas (pata), of which there is only literary evidence.

The wall-paintings are nearly all of religious subjects, and the greatest interest and attention is focused on those of the Ajanta caves, which are superior in terms of quality and duration (many centuries), and on the Ceylonese murals, against which an absurd and useless protest has been made which was extremely destructive.

As these places provide an excellent basis of research for the study of wall-painting techniques, it has also helped the study of the technical texts, which has progressed notably. These texts, generally known by the name "Silpasastra," present difficulties in interpretation. Written for the "silpin," they are a collection of texts which were passed on by word of mouth for a long time; consequently they contain a lot of slang expressions and mistakes in grammar and syntax. The terms used, derived from the technical jargon in use among the laborers, are often obscure and can cause misunderstanding and confusion which at times become real puzzles or riddles.

It should be remembered here that the "silpin" were neither ordinary artisans nor real artists (using the expression in its Western sense), since the word appears too involved on a cultural level. The most suitable term for translating this expression is "craftsman," because it does not limit the creative and expressive capacity of some of them. It should also be remembered that the technical texts were mainly concerned with wall-paintings, even to the point of reducing the treatment of every other pictorial display to brief occasional outlines, and show the desire to "facilitate" the execution of the wall-paintings, which were greatly appreciated by the people, especially where it concerned paintings in religious surroundings. These paintings could be realized by entire groups of specialists (given the expanse and proportions) and were far more tied to economic factors than individual paintings were. This type of pictorial composition could be situated in the temples, in the palaces (with a reduced contact with the public), and in the art galleries - named in the "citrasala" texts, but of which no trace remains.

The use of real plaster, called "sudhalepa" in the texts (that is, "caustic lime wash"), is the last phase, which calls for a very complex levelling and polishing operation. It can be seen how longlasting and surprisingly strong this preparation is even when, as happened at Sigiriya, it is exposed to centuries of tropical rain.

Considerable research has been carried out for reasons of conservation and restoration on the preparation both of the rough first coat of plaster, constantly treated with molasses which functioned as an adhesive, and the successive coat of plaster. This was also formed of strongly adhesive material made from vegetable extracts, mixtures made with long animal fibers (horse hair) or vegetable fibers (straw, coconut), and reinforced with glue made from buffalo hides, diluted in hot water.

The difficulty in ascertaining the exact values of the terminology used in the various technical texts has not allowed a great deal of work to be carried out on this subject, even if the chemical analyses of the plaster samples demonstrate the connection between reality and theoretical teaching by way of a curious collaboration between chemistry and linguistics.

The Indian wall-paintings are, in practice, very close to the "dry fresco" in the Italy renaissance terminology. It is based, above all, on the design and on the outline ("rupabheda" — that is, "delimitation of the form" by way of the outline), but does not ignore the effect of light and shade.

The iconometry, confirmed by the texts, is a theoretical iconometry conceived by a frontal image and without movement: so much so that the "six measures" described by the Talamana includes as the sixth measure that of the height measured with a plumb-line which splits the figure into two symmetrical halves, standing, with arms extended and close to the body. All this does not exclude an equally practical iconometry derived, in various ways, from this basic theory and usable for moving or foreshortened figures.

On the other hand, the theoretic image must be considered as an indivisible unit: if it were considered separately it would remain an isolated unit incapable of adapting to the necessities of the composition. Therefore, it can assume values and harmony only on the basis of a series of modifications which connect and coordinate it to the other parts. In practice, it is evident that it leaves plenty of space to the artist's inventiveness. Some of the texts, starting with one of the best known, the Visnudharmottara, make a great effort to arrange the balance and the positions. Their obligation is to establish a clear contrast between the visible part (considered in the light) and the receding part (considered in shadow) and to establish a precise proportion between one and the other. The theoretic system assumes a succession of movements at intervals like a series of photograms, but always rigid.

In the effort of arranging the passage from the forehead to the profile three intermediate, graduated positions must be passed through, which with the two extreme positions (forehead and profile) form an organic complex, called Mukhyasthanani, which in the field of 180 degrees (from right to left of the profile, passing over the frontal image) forms a symmetrical scale of nine positions.

The division of the field of vision represented as an image rotating on its own axis for 180 degrees will have, as we shall see when discussing Gandhara, a notable effect on the plastic composition. This will be modified in order to obtain a prolonged visual validity on the part of the viewer who completes the pradaksina — that is, the ritual circumambulation around the stupa, the drum of which is decorated and adorned with edifying panels of a narrative character. There is no doubt that the technical texts rely on an artful visual plan (very far from the infinite variety that can be found in nature) formulated on illustrations in which the plumb-line plays an important part (rigid, symmetrical, and sitting figures). However, the sense of perspective and, therefore, the pictorial space follows a constant law, formulated by the silpin, on the basis of which it is possible to understand a large part of the form and pictorial structure of the Indian world.

The principle, or law, in question is called Ksayavrddhi, which means "reduction" (ksaya) and "growth" (vrddhi). The reduction regards the receding part, in the foreshortening of figures. The growth regards the part which is easily seen, considered in terms of light, which tends to take a proportionately dominant role. Apart from the numerous exceptions,

due to the craftsmen, the ksayavrddhi principle is particularly observed in the cultural images and, when it concerns Buddhist art, most of all for Buddha himself, who, generally, acts as the central pivot of the represented scene.

Originating from a tendency towards the industrialization of figurative art, this principle constitutes a simplifying background, linked to the various ways of creating pictorial space and resolving the problems of movement and foreshortening. One of the texts - the Silparatna - not only passes over descriptive particulars which in other similar texts are described minutely, but adds: "All this must be carried out according to the painter's personal inspiration ("svabuddhitah"). It is obvious that the use of color intervenes in the solution of foreshortening and movement problems, sometimes with very curious effects, both when the points are exposed to the light and lightened with white, and also when it arbitrarily resolves the variations in light and shade which should derive from gestures or movements, with unexpected chromatic effects.

The Ajanta paintings are a clamorous example of this freedom of interpretation. It is true that these compositions are full of detail and figures, so much so that all the cave walls are covered with images. But, as observed by Jeanine Auboyer, a psychological perspective exists in these compositions in which the viewer's eye is "guided" from one group of figures to another by way of gestures and designs of barely perceptible depth of field, and in the end the viewer is able to understand the whole story as narrated by the painting and at the same time link it up with the one next to it in a continual visual communication.

As pointed out by Maurizio Taddei, the fact that in the most valuable works "everything is transferred to grand surroundings, where the Bodhisattva are no longer the pensive Siddharth of Gandhara or those of the tumultuous gestures of Armaravati, but refined young men so that the beauty of the forms seems to incline more toward the Karmasutra arts than to reflections on human suffering." The same author adds that the novelty of "classical" India lies in this search for a balance (entrusted to personal freedom and choice) in morality, the search for self-realization, and the pleasure of the senses. This refers to both the India of the Gupta and, in the specific case of Ajanta art, in the area dominated by the Vatakata who were politically connected with the Gupta, but culturally independent, or at least, within the limits appropos to this period.

As far as can be seen the Vatakata were more oriented toward a revival of Hinduism, but were still attached to religious currents alien to Brahmin orthodoxy. This was so for reasons of tolerance (brought about by the numbers and the power of the Buddhist groups) and also because of financial interests, since the stiffening of the orthodox Brahmin attitudes would without a doubt have produced unsupportable limits to the commercial activity with consequential drastic reductions in the volume of trade. The idea of castes and the impossibility of maintaining free contacts not only with populations who did not recognize the caste system, but also between different castes within the system, would certainly have been harmful to commercial expansion. Furthermore, it should be noted that that the Gupta were not of noble caste and had no real interest in a triumphant revival of Hindu orthodoxy. Not only

that, but they still celebrated, for prestige reasons, the asvamedha, the sacifice of horses, a practice also carried on by the Vatakata, but for different reasons.

The pictures that adorn the Sigiriya Rock in Ceylon are considerably different from the ones at Ajanta. After liberation from their Indian rulers, brought about by the Ceylonese chief Dhatusena (460 A.D.), the kingdom came to an end 18 years later because of the revolt by one of his sons who murdered him. The new king, whose name was Kassapa (Kasyapa), turned the great Sigiriya Rock into the center of an imposing and impregnable fortified complex. He moved the capital here also, driven by magic-symbolic reasons. In fact, in the architectonic context of the immense fortress, the rock represents Mount Kailasa, so that the whole thing came to assume the value of a cosmogram with Shiva's sacred mountain at its center in relation to the identification of Kassapa with Kuvera, the god of Indian wealth who had considerable connections not only with Shiva but also with war. The images of Sigiriya, spacious and strongly sensual, carried out with a clear preference for red over the other colors, seem more restful and simple than the crowded compositions at Ajanta. Therefore, we can say that for modern critics, Sigiriya (or that which remains) is part of a parameter to contrast with the psychological perspective characteristic of Ajanta and its subtleties. At times, the subtleties exceed the limits of optical tricks and, more often, effect a programmed stimulation, especially regarding the reading system (with guided and graduated perception at the time of examination). This was of such significance that the techniques were widely adopted by the Ajanta artists.

The fundamental character of the paintings by Sigiriya is to eliminate the wall on which they lie. Even if they are brought to life by images that clearly suggest the presence of the third dimension, the artist limits himself to establishing a surface (both chromatic and figurative) characterized by depth and self-contained vibrations which recall the earthly world with a refined and elegant sensuality, but without being either the continuation of it or depending upon it. Therefore, the figures stand out in abstract dimensions, very close to that of normal existence, but without any natural or logical relation to it. It is a space brought to life by mental images, with a highly developed sense of beauty and sensuality. From a psychological point of view, these images are also real perceptions, suggested and produced by the craftman's imagination, which would appear to have a life of its own. Sigiriya's pictures are immediately appreciable without any difficulty as he is expressing a dream with implied mythical values that are part of the sacred and religious world, and all the art of this period moves between these two extremes.

The surviving works from the Bagh caves in western Malva are considered true Gupta art and are the only pictorial testimony from the central-north area. It is not difficult to link the fifth and sixth century pictures of the later Ajanta caves to some of the oldest existing sculpted works at Ellora, Aurangabad, and Elephanta. As revealed by the Indian critic C. Shivamamurti, a unity of taste and figurative research will be found due to the culture and sensitivity of Vakataka and to the society which it brings to life.

There is no doubt that an overflowing aestheticism goes side by side with religious feeling. Moreover, this refined aestheticism which supports elements that are alien to religion in the end changes the instructive message which the works by Vakataka intended to transmit.

The works from the Bagh caves, unfortunately badly conserved, are also inspired by Buddhism. They are similar in technique to those from Ajanta and date from the second half of the sixth century. Nevertheless, they are somewhat different in spirit and style. The form is more compact and the contours are stronger and without affectation. As far as can be seen from the restored remains they incline towards a dignified, but conventional academicism which eliminates that sense of mystery and joie de vivre which was found at Ajanta. Although devoid of what could be called interior vision, they are still very effective. However, the practical and merchant-like spirit of the Gupta, which seems to tone down the expressive capacity, is indeed in evidence.

The Badami pictures, dated around 578 A.D., are Vishnuite and are connected with the Calukya dynasty. This is proved by an inscription of the Regent Mangalesa who, apart from other things, describes the temple and specifies the order of worship which had to be observed there. Only fragments remain of the rich pictorial decorations explicitly mentioned in the inscription. It is a very serious loss as the surviving Badani paintings appear self-contained and isolated. The sculptural intention is evident, but the changes in tone - in the light and shade - are extremely soft and subtle. The proportions between the figure's head and the width of the shoulders, together with the slenderness of the body, increases the effect of a quest for interior values. This is unusual in India, where the psychological aspect of the person is generally suggested by shapes and conventional indications, while the contours, which are very soft, differ from the heavy outlines of Ajanta, and even more from those of Bagh.

The subjects of the surviving fragments have been identified by Shivaramamurti. In the biggest of them Indra is represented in his palace, enjoying the celestial music and admiring the apsara Urvasi. This divine dancer, who according to a hymn by Rgveda is loved by Pururava, a man who in order to follow the gods succeeds in becoming a demi-god, or, more precisely, a gangharva.

The second fragment honors the defunct king Kirtvarman I with all the affection his brother - the regent awaiting his son's coming of age - could impress on the artists.

Among the minor fragments we find a pair of Vidyadharas, demi-gods who could be better defined as celestial magicians, mysterious beings who inhabit a village among the Himalayan peaks.

Also at Ellora, in the 12 southern caves to be more exact, vast and important pictorial cycles should have existed, but of these no trace remains. In the middle of the rocky descent, where the religious monuments that make this place famous were excavated, the celebrated Kailasa, constructed by the Rastrakuta, is a splendid example of architecture carved entirely from the rock and flanked by Brahmin caves, two of which, numbers 21 and 14, have traces of paintings. The work was started by Krsna I, who reigned from 756 to around 772 or 773, and was continued under his instruction. The pictorial fragments conserved on the ceiling and on the architraves of the western door are the parts most

important to us. The ceiling has been painted at least twice, perhaps even three times, and at least two centuries passed between the first and the last application.

The oldest layer, with Vidyadharas and "gana" (i.e., dwarves) flying through the clouds, presents us with a divine being riding on a mythological monster (this is Sardula, who has feline connections) and worshipping a divinity which is, unfortunately, no longer visible. The modelled and life-like shapes of Ajanta and Badami have disappeared. The expression, more linear and much flatter, emphasizes the contours, which seem to take on a life of their own. The attempt to attain form is more or less infrequent, it does not create coherent illusive effects and seems less important than the attempt at elegance and light decoration. It is not easy to determine the origin or the inspirational source of this style, which is completely foreign to the lines developed at Ajanta. In general, similarities can only be found with the sculptures of Rastrakuta and with those from the minor southern states. However, again at Ellora, the same style can be found in cave 32 north of the Kailasa where there are five Jaina caves. I refer to the big panel which represents Shiva dancing in the clouds, in front of a divinity (Brahma?) who is clasping an apsara (dancer), while another female figure, two gana, and a male figure complete the composition. Apart from the color scheme which favors red and greenish colors, it has a curious spaciousness. Shiva is seen from behind. It is a highly decorated work.

The paintings of southern India show a notable richness and variety of style, although fragmentally documented and with substantially incomplete works which have been restored by cleaning and refurbishing. In the southeastern regions the fragments of paintings from the Kailasa of Kancipuram and from the Vaikuntaperumal in the same area, and those from Panamalai (Talagirisvara) and Sittannavasal in the extreme southeast show a great variety of figurative attitudes. In the painting which represents Shiva with Uma, the god of war, the colors are very clear, and although rather damaged it is still sufficiently visible. In the Kailasa of Kancipuram the colors become liquid, brilliant and extraordinarily delicate, as in the figure of Parvati, pictured under a large parasol, which adorns one of the walls of Shiva's temple at Panamalai.

Sivaramamurti suggests a link between this figure and the Parvati from the atrium in the Kailasa at Kancipuram. The style is similar but the effect is completely different because of the chromatic delicacy of the picture.

The Jaina caves at Sittannavasal, dated around 850 A.D., are beautifully decorated, with the continuous repetition of a floral theme (lotus buds) which fills the space. One of the paintings on the ceiling of the cave's veranda represents village life concentrated around the water-well. Whatever the real significance of the composition may be, the apparent aspect is simple and extremely poetic.

There is no doubt that the surviving compositions from Sittannavasal are of great interest and of unexpected importance as far as the fresco technique is concerned.

The paintings from Shiva's temple at Tanjor are equally important and more easily appreciable. This temple, called Rajarajesvara, is a Vimana, 60 meters high; it was finished towards 1010 A.D. and had fabulous endowments which permitted gold hangings and splendid bronze decorations. Paintings can be found in the darkest rooms around the central sanctuary, some of which are relatively late (17th and 18th century), but others are of the same period as the temple's construction, even though others were painted over later. They are Shivaite pictures which were brought to light with great difficulty after a great amount of work. Some of them are dedicated to the life of one of the 63 poet-saints who were responsible for the rebirth and renewal of Shivaism in southern India - with a tremendous emotional reaction on the part of the masses - in the period between the 7th and 9th centuries.

Naturally, these works show many images of Shiva, with exceptional effect, and the paintings of Rajarajesvara represent a whole complex still to be studied. Their technique, which is unique in the whole of India, is that of "fresco buono," which denotes the use of mineral pigments dissolved in various solvents, but above all in watery solutions, which were applied on to fresh plaster without adhesives. A few retouches were applied afterwards when dry. However, the technical ability of the Tanjor painters was notable. They were able to obtain effects of relief and volume by shading the colors, but with graduations and methods very different from those used later in the West. The style is similar to that found again in the bronzes of the same period. Among other things Rajarajesvara is an expression of the glory and the political, military, and above all, the naval strength of the great Chola sovereign Rajaraja I (985 - 1014), conqueror of Ceylon, the Laccadives, and the Maldives. Rajaraja can be considered the founder of the Chola thalassocracy - the greatest expression of the Tamil races who searched the seas for the source of an economic balance which Islamic pressure from the north had tended to alter.

With regard to the relations between the regal power and the subject masses, a superficial centralization is revealed, placed above the confederate conspiracy of the local and provincial powers. This meant that the figurative expression of the Chola is also connected to a collective consent, despite the sovereign's commands to the city and the provinces that they should supply spices, precious metals, and craftsmen both for the building and for the maintenance of the temples.

Fragments of pictures that, in their synthetic inspiration, present interesting ways of expressing movement are to be found in the other temple of Brihadisvara at Tanjor. A second cycle of paintings of the same period but still to be uncovered are to be found in the second hall. It now remains to consider only the complex of paintings at Lapaksi, where a big temple dedicated to Shiva grew up. This temple was built by two brothers, Viraima and Virupanna, and was situated near the fortress.

We are now in another epoch (towards 1540) and in a different environment, that of the kingdom of Vijayanagar, which is desperately trying to alleviate the pressure of the surrounding Muslim sultans and particularly that of the Bahani of northern Deccan. The king at this time was Acyuta Devaraja, who was described by Nicolò, Count of Chioggia, as a splendid king, deeply religious and with nationalistic ideals. The paintings on the ceiling of the rooms surrounding the temple's central sanctuary must have an exceptional value, and they

bring to mind suggestions for the subsequent evolution of the miniature.

This pictorial complex is dominated by a characteristic taste, so refined as to appear really sophisticated. Suggestive and balanced, it ignores the problems of light and shade and of relief and the volume is limited to mere suggestion. It is the triumph of formal beauty, even if the formal element itself satisfies its whims in the movement of the figures, in the ornate materials, the clothes, and the arrangement of the cushions. Again, it betrays that interest in animal life and feminine beauty which is shown with great efficiency in the grace of the faces and is characteristic of Eternal India. The solution to the foreshortening of the faces is modified by the pre-Mogul mode of the miniature, a tradition having been affirmed for a long time. With the partial decline of the Vijayanagar kingdom, resulting from the defeat of Talikota in 1565, the peak reached in the works of Lepaksi becomes a memory connected with a glorious past. We find survivals in some later murals (17th century) which demonstrate the slow decline of artistic inspiration. Nevertheless, two essential facts can be ascertained. The first is the relative importance assumed by the Vijayanagar style in the formation of the really Indian components of the Deccan miniatures. The second is a modified, but important, survival of this style in the temple and palace murals at Cochin in Travancore (that is, Kerala). The Mattanceri palace cycle, which dates back to the beginning of the 18th century, of Krsnaita inspiration, presents a very unusual color scheme, in which red and green predominate with accompaniments of white and yellow. Instead of using the "pastel-like" colors characteristic of the period found in many Indian miniature compositions, the pictures of episodes in the life of Krsna take on unexpected forms. They are greatly condensed, but with broad concessions to grace in the female faces; they seem to have derived from the style of Vijayanagar, but reveal a difference which is unfamilar to Indian tradition.

If comparisons with the West were permitted, I would say that the Cochin pictures have, in the area of Indian painting, a place similar to that of James Ensor in the sphere of European painting of his time. To be more precise (if only with borrowed words for lack of better ones), it seems that the Cochin artists presented expressive and compositive values relatively similar to those used by the surrealists. Certainly today it is no longer possible to consider the creative capacity of 18th century India at a standstill. It will take the Battle of Paniput (1761) and the end of the Maratha expansion to determine a brusque and real conclusion.

In India, architecture, together with sculpture and the minor arts, was considered an inferior activity and not of the "great arts" of the traditional hierarchy. Poetry, theater, dancing, painting, and music were the forms considered capable of reaching the highest peaks of human expression, and consequently they were the ones philosophic reflection concentrated on. Yet architects were required to have a vast knowledge in a variety of different fields including empiric notions of geology, geometry, psychology, and traditionalist knowledge. The latter was a cross between judicial knowledge, non-codified as it was routine, and other notions regarding the habits, technical methods, and certain ethnic and other organized groups' attitude towards work.

The reason for the theoretical exclusion of architecture from the category of major arts is because it implicates a vast technical component and requires a notable body of workers, occupied for a long time in hard work, all of which excludes the immediacy of realization; the architect was detached from the actual building work, being involved in technical texts, geomantic regulations, religious problems, and, naturally, the material to be used, as well as the techniques available. In other words, the final result could be distorted in respect to the original idea, caused by difficulties unrelated to the designer's intent.

This regards structures which had a particular function, judging from the religious architecture; this was without doubt the most important and was founded on sacred and ritual values that had to be followed and made clear at any cost and by fixed and precise rules. The construction of a building - referring to those of the so-called "classical" period of Indian culture and to those before the above stated period - became a liturgical operation. It follows that the search for an emotional effect (that is, explained in the correct terminology, the fulfillment of the rasa, precise argument for aesthetic research) was theoretically excluded from any architectural creation. It is clear that this theoretic position, in reality, appears to have been surmountable and surmounted, and the buildings became less valid for this.

Today, it is pointed out that the great architectural works were generally appreciated, but at times the difficult and complicated "readings" of the symbolic-religious values contained in them were not taken fully into consideration. The comparison between the buildings and the mountains is frequent - considering the dimensions of the buildings - while the observations of the Culavamsa (a Ceylonese work in Pali) is remembered for the description of the Polonnaruva ruins as resembing old men, who with the passing of time bend over even further towards the ground. This same text also speaks of constructions that bring "pleasure to the eyes, with their rising up in stone or brick." This last affirmation is particularly important because it demonstrates a strong sense of volume and space together with the full capacity of appreciation for ruins — that is, as casual results of uncontrollable happenings, with a fundamentally different spirit to that which permits the "reading" of symbolic values in a religious construction and deducing the meanings expressed in code. The political sense of the Ceylonese text is not lost. Similar observations can be found in other literary texts which try to express the greatness of certain temples by unexpected comparisons or bold metaphors. It is not a matter of unceasing comparisons or observations, but altogether they reveal something which has been neglected up to now, and it is thanks to C. Sivaramamurti that this has been brought to light. This could be described as an aesthetic sensitivity, similar to that of the West (and not only the West), which had seemed supressed by the prevalence of symbolic values linked together in the form of diagrams.

In practice, the critical position of the Ceylonese texts follows along the same lines as Dandin, one of the rasa theorists, who considers the rasa itself as a state of mind, a sentiment intensified by the combination of different elements, but substantially normal; one that

can be perceived (and expressed in the literary forms of which we spoke) even when it is suggested by forms which result from casual facts.

Let us also say that, outside the continual succession of engravings, reliefs, and etchings that produce tricks of light and shade not unknown to the Baroque period, the enormous dimensions of the temples are seen as artful "concretions" of the earth that appear to raise themselves up, with man's help, towards the heavens. This is a way of expressing the mystical impulse that, being typically Indian, is of value and of universal understanding.

The old problem of architecture extracted from the rock - with or without external space - is still one of the key points of Western evaluation of Indian art. We have already mentioned this fact in principle, but we will try to develop it here. Architecture or not? If the static problems are resolved by the cohesion of the rock (therefore it is more a "sui generais" architecture), the excavation of the rock and the digging out of a space deeper than the visible surface of the projecting walls is a symbolic gesture and has a particular value. In fact, it alludes to the re-entry into the earth, to the effort of explaining the continual presence of the sacred, even inside the rock and anywhere that the existence and the being can be found; even where life could not exist if not as brute matter. The impetus towards the heavens, to the temple - the mountain which indicates the magic-religious axis (and the center) of the Universe - is matched by the penetration into the earth and the rock which is a sign of unitarian sacred valuation. Given these assumptions and their aims, given the character of the digging and construction operation, which was similar in many ways to the magic operation or religious ritual which, in India, transcends the strength of the gods, the excavation builds a consecrated space full of religious values with a series of operations that tend to imitate the general appearance, evidently traditional, of the properly built architectural structures (that is to say, the free-standing structures).

However, the carved architectures have an entirely different value. In this case the building is the equivalent of an enormous sculpture which represents, and is, a temple. The most classic example, and at the same time most relevant from an aescetic point of view, is the famous Kailasanatha at Ellora. This was built by the Kings of Ratrakuta and was completed towards the end of the seventh century. They were at the center of a series of constructions dug out of a wall of rock more than a kilometer long. At Kalugumalai, in southern India, there is a magnificent chapel built in the time of the Kings of Pandya and dedicated to Shiva.

Kailasanatha was a pilgrim center (tirtha) of incomparable splendor. After the desecration by the Muslims under the command of Aurangzeb, the orthodox Muslim emperor who was the last of the great Moguls, its splendor was dimmed, but not completely, as it is still an important religious center. It grew up in the middle of a long expanse of religious buildings dug out in the form of grottoes (Buddhist, Jaina, Hindu) and represents, together with the ratha (temples in the form of wagons) at Mahabalipuram, a real architectural problem. In fact, to have been able to excavate, by the removal of material and therefore by "reduction," a complex of this type and plan is a tremendous undertaking which required exceptionally precise and unusual methods. It was a most accurate execution and a most incredible job. This work is a monolithic structure, made to last as long as the rock, absolutely without additions, connections, or applications in stone or brick.

The Kailasanatha, as a technical wonder, is no doubt exceptional and enhanced the architects' satisfaction in the creation of these difficult works of outstanding aesthetic value. The work was carried out under Krishna I of the Rashrakuta and imitates the Virupaksa Temple at Pattadakal - a work constructed by a southern architect called Gundaya who worked for the Calukya sovereigns. Many of these architects became well-known as a consequence of the fame won by their ability.

Therefore this form of construction is true architecture, even if the result in its simplest form - as in the ratha at Mahabalipuram - is nearer to giant sculptures with an architectural theme. Nevertheless, seeing these works, and in particular the great Temple at Ellora, it is difficult to find suitable words of appropriate admiration even though the process is clearly contrary to architectural principles used in this "extraction" from the rock.

A few years ago A. Volwahsen proposed the expression "antitectonic architecture" or "reductive." For us the expression "incised architecture" or "sculptured architecture" could be equally valid. Whichever expression is used, the value of the techno-organizational process can never be underlined enough; the process completely upsets the constructive system and, above all, results in construction by "extracting" or "digging out" by way of a gigantic cut and, therefore, by a "reduction" that eliminates the superfluous material.

However, we can agree with Volwahsen when he says "Nothing can better reveal our incredible poverty, when we are confronted by this vast "antitectonic" phenomena, of the absolute lack of an appropriate technical language."

The truth is that Indian architecture can only be valued on the basis of the culture that produced it and that it offers universal values, suggestions, and feelings capable of fascinating even those who are not Indian. As I have written elsewhere, "the measure and intensity of these impressive buildings change as a consequence of habits, of rulers, and are fixed by values that are in keeping with the different cultures which appear from time to time."

In any case, what seems certain to me is the extreme difference that separates the Hindu aesthetic vision from that of the Buddhists and the Jainas. For the Hindu the search for truth is directed towards an activity which is both creative and distinctive and which is hinged on an energy expressed in terms of divine dominion, absolute and unchangeable. The search is directed towards an ideal of peace and serenity in which human standards prevail. This search does not go beyond the individual and his destiny. It does not have the life of the universes as a parameter, but remains connected to the person and the community. This was seen by the Hindus as restoring a tolerable and practical relation between men and all living things.

This does not exclude the fact that the great Indian sacred works were the result of a particular social situation in which the gigantic force of entire generations was centered. Some of these were detrimental to

other works which the religious and free spirit of Indian culture felt to be less urgent and necessary. There was no real choice. Instead there was an inclination that could be called "programmed," if one could use such a modern term, to make a thrust towards the Absolute - essential to Indian religion. This would weaken the negative reality of the social situation, eliminating practical interests and the will to act. Those who were disinterested in the passing of history could at the same time react to life's agony through faith in the continual rebirth or final extinction in the Buddhist Nirvana.

In both these cases the certainty of rebirth subdued the instinctive terror of death, making life less miserable for a people crushed by insuperable and oppressive governments. The authentic choice, free and respected, was that of religious belief. That is to say, it was the key which permitted everyone to understand and evaluate the mystery of life, man's limits and the importance of individual destiny.

These are the ideas and values reflected in the field of figurative art and above all in architecture. This, together with other elements, decided the forms and effects which would not even be imaginable in other civilizations. Perhaps it is possible to define the basic stimulus which produces these same forms, by taking into consideration some aspects, essential in my opinion, of the Indian figurative reality. The great architectonic structures, whatever they might be and whatever the spatial compound (only internal, only external, or complete) were above all prakti — that is, "nature" — not only because they tended to harmonize with nature, because they alluded, symbolically, to a nature sublimated by a deep desire to harmonize the work with the rhythm of universal light, but also because they were deeply rooted in civilization, in the Indian, in the world that man had created and in which the thread of his existence unwound. They were prakti because prakti is, after all, the collective unconscious of the Indian people.

On the other hand, if every architectonic Indian structure - constructed or dug out of the rock - were considered a "center" (the technical texts are explicit about this) and if, also, every city was considered by the same standard so that the "axis mundi' passed through its principle temple or royal palace (in the theoretic plans), there is no need to wonder that - on the basis of the collective unconscious and by the automatic acceptance of particular values - a semiotic code can be worked out. This code is born of a net-like complex of sub-codes, but once formulated permits the values that subtend them and that are condensed into the work of art to be ostensibly restored. The representation of the center was the dominant motive in the architecture and town planning. For the latter the motive itself recurs constantly in all the theoretic plans of the city: when they had a square form (the square - the perfect form - is a symbol of the ordered World, of the perfection in the order organized around its center, indicated by the meeting of the diagonals) and when they had a circular form, in the rectangular plans (with the principal roads describing a rhomboid), and also in the semi-circular or triangular ones.

The value is substantially unique, and it is this same value that expresses the Buddhist or Jaina stupas, the great sikhara temples (that is, with pointed arches) or "vimana" (with a high pyramid-like roof) and others. Do not be surprised if the whole construction obeys an expressive code formed not only by form, proportions, and various other particulars, but also by images and ornaments and by the material used.

For the user of these coded expressions, formed by a number of expressive marks, the essential value appears immediately clear. All in all he is asked to collaborate responsibly in reading the minute particulars of the semantic context (which nearly always searches for the graphic clarity of a complex diagram) so that he overcomes the most subtle passages, reduces to units the many connections of the incomplete meanings, chooses the right course of reading, and considers more than one at a time, and that he does not get tired of reading, but, repeating it in different ways, reaches fully and, if possible, irreversibly, the complete value of the modulation which that determined architectonic "diagram" continues to transmit. The emotional contact is not thrown away but, repeats itself clearly even in the execution of the particulars; but as a final analysis, Indian art, especially when from the post-classical phase, whether architecture, sculpture, or painting, tends to transform itself into a text that is offered to the viewer in a way that would satisfy the demands of a continual communication; it is articulated in various ways (or channels) so as to seem valid and efficient in different historical and psychological circumstances, without ever altering the essential value that it subtends.

Perhaps this is the fundamental constant of Indian figurative research, from the "rotating" perspectives of Bharhut and Gandhara up to the schematic diagrams of the low-reliefs and the bronze images of the post-classical phase. The difficulty in making comparisons between the codified aspect of the work and the emotional one, between the programmed and the prepared effect and the unexpected in which the viewer reacts on his own account, overcoming the limits required by the author so as to enlarge or distort the sphere of the meanings included in the diagram, is part of the reason that Indian art has not been completely appreciated so far. India, which produced sanscrit, the perfect language, anticipated by two thousand or more years certain premises on structuring most difficult to interpret and read if one does not have a sufficient knowledge of the semantic values which this expresses in code. It is not hard, however, to bring back the appreciation of Indian art and the diffusion of its values to the fortune and development of the semiotic method, which so far has touched it only marginally.

BIBLIOGRAPHY - H. Goetz, Five Thousand Years of Indian Art, 2d ed., London, 1964; J. Auboyer, Introduction à l'étude de l'art de l'Inde, Roma, 1965; H. Sarkar, Studies in Early Buddhist Architecture of India, Delhi, 1966; Ph. Rawson, Indian Sculpture, London-New York, 1966; W. Spink, Ajanta's Chronology: The Problem of Cave Eleven, Ars Orientalis, VII, 1968; M. Hallade, Inde. Un millénaire d'art bouddhique, Paris, 1968; H. Goetz, Studies in the History and Art of Kashmir and the Indian Himalaya, Wiesbaden, 1969; A. Volwahsen, Living Architecture: India, London, 1969; M. Bussagli, India, in Architettura Orientale (a cura dello stesso), Milano-Venezia, 1971; M. Taddei, Inde, Archeologia Mundi, Genève, 1971; M. Bussagli - C. Sivaramamurti, 5000 Years of

Indian Art, New York (1971); M. Taddei, India antica, Milano, 1972.

MARIO BUSSAGLI

CENTRAL ASIA AND GANDHARA (PLATES 51-59)

The cultural features of so-called "Central Asia," have tended, with time, to be understood as extending beyond the geographical territory of Central Asia itself. The term "Central Asia" as used in this text corresponds to the term "Haute Asia," even though our main concern is with the southern area crossed by the grand caravan routes. The reason for this terminology is revealed in the intricate network of analogies, repetitions, and sources which link this area with those adjoining it and sometimes with more distant locations. The cultural characteristics of the Central Asian world appear to incorporate those of other regions, especially in certain periods, most often in the oldest eras. These connections substantially transform the traditional view of Central Asian figurative phenomenology and its relative evaluation. The nature of the relationships is not always clear. This has prompted a renewed interest in the problem of originality and autonomy in the development of Central Asian art. Periods which until now have received little notice, as well as certain phenomenon and some of the better known phases and facts, are being readdressed by scholars. Even the character of contemporary Chinese Sinkiang Buddhist painting has been reassessed. This is a field which had been thoroughly studied, having been part of the historical discourse for about 80 years. Studies done in the last decade have been divided on the subject. This has put a strain on the field as scholars take their sides in opposing and contradictory camps.

The discussion of the period which saw the expansion and flowering of Buddhism (roughly from the third to the ninth centuries A.D.) deals with the originality and autonomous evolution of Central Asian art. Almost paradoxically, however, some scholars have questioned the very existence and coherence of any art form which can properly be called Central Asian.

The autonomy of central Asian art: a) The controversy. – In 1963, M. Bussagli recognized an independence and inventive capacity in Central Asian painting which was able to respond to the Iranian world as a source of inspiration. This was as true for the Oriental regions as it was for the West. Against this contentious evaluation, B. Rowland wrote a long review ("Art Along the Silk Roads," *Harvard Journal of Asiatic Studies*, XXV, 1964-65) in which he judged the eastern and western art of Central Asia as " . . . an extension of forms and motifs of Sassanian and classic origin, with some slight admixture of Indian elements." The result of this would simply be an " . . . infiltration of Iranian, Indian and classical elements that combine to form a provincial, synthetic reflexion of all these sources." Various Soviet scholars have repeatedly reacted against this assessment. The first and foremost was B. A. Litvinskij (for example, in *Sovetskaja Archeologija*, 1967, 3, and in *East and West*, 18-1-2, 1968, as well as in "Outline History of Buddhism in Central Asia," *International Conference on the Culture of the Kushan Period*, Dushanbe, 1968).

B. Rowland, in his volume *"Zentralasien" Kunst der Welt* (Baden-Baden, 1970), seemed inclined to allow some major concessions even though this book closely followed the long review mentioned above. He continued, however, to insist on his unconventional preference for the expression "Indo-Iranian art" as a reference to "Central Asian art." He did admit that one could correctly speak of Central Asian styles in reference to the oasis of Kuca (which itself refers to the two main archaeological centers of Qizil and Qumtura). This admission certainly goes beyond the limits the American scholar meant to propose. Nothing was said about the presence of any strong analogies or, additionally, any images stylistically analogous to those of Kuceane, from Tumsuq, an important site located still further west on the northern silk route.

Regarding the eastern section of Central Asia, Roland notes with reason but rather superficially that it is impossible to speak of any single pictorial style. However, the greater part of new findings over the last few years have been in the region of ancient Sogdiana. This means that within the milieu of a complex society the ability existed to convert the local language into the *lingua franca* of the textile merchants used on the transcontinental caravan route which reached into Siberia and Mongolia. One recalls that the script of the Uiguri Turks and the Mongolian alphabet derived, successively, from the alphabet of this civilization. The alphabet of old Sogdiana itself evolved indirectly from the Aramaic alphabet.

As all scholars agree, the entire pictorial production of this crucial region displays enormous differences, not only from one center to another, but also at the peripheries of some of these centers. The differences are obvious even without taking into account stylistic diversity resulting from different periods or the personality and handwork of different craftsmen. Pjandzikent, Afrasiab, Varaksa, and Balalyk-tepe all display autonomous styles even if there are some important connections between them. Subject matter in the surviving paintings varies considerably. Profane subjects (epic, fantasy, or commemorative) as well as religious themes have been discovered. Some of the religious subjects were based on local beliefs, while others derived from doctrines of foreign thought. Identification of subject matter is often problematic, as is the case for the 47 figures in Room 14 of Balalyk-tepe. A ceremonial banquet is depicted, but it cannot be ascertained whether it is of a profane nature (Al'baum proposes a wedding banquet), a religious funeral (an idea held by Chiara Silvi Antonini in her scholarly work of 1972), a pre-orgy meal, or some other type of banquet. The rite could be a Mithratic one honoring the deceased, a celebration of the New Year, or some other type of celebration. Whatever it may be, it is clear that the Balalyk style is, for the most part, an independent one. There is also secondary documentation of other styles in the same location. The documentation is ample, but not very useful. It is possible that the styles were not contemporaneous.

Such a large range of styles can be documented and verified also at Pjandzikent. This is especially clear in the diversity between the Varaska fantasy/celebration pictures which display a relative naturalism, the historical/commemorative Afrasiab works, and the enigmatic Balalyk-tepe paintings. This does not prove a continuous or servile dependency on nearby Iranian centers.

Iconographic and stylistic indications emerge which appear relatively coherent, at least in the more impressive works. The very existence of a mural depicting the Roman wolf with the twins or the entire legend of Romulus and Remus is enough evidence to accept the existence of foreign iconographic sources. These are assimilated and adapted with customary inventiveness. There is a painting, discovered by N. Negmatov in the northernmost part of Tadzikistan which, as G. Frumkin notes (A.A. 1977), was an exceptional discovery. Negmatov made a serious study of the painting. This is the area from which Bundzikat emerged as the capital of an important empire (Ustrusana) before being destroyed by Arabs. The painting can be dated to the eighth or ninth century A.D. As poignantly noted by G. Frumkin ("The Expansion of Buddhism as Witnessed by Recent Archaeological Finds in Soviet Central Asia," *Bibliotheca Orientalis XXV*, 1968), Buddhist influence extends even further that previously thought.

One must exempt from this expansion a large area bordering Afghanistan containing the Buddhist centers and monuments of Termez, Airtam, Karatepe, as well as the more distant Giaur-Kala, near Merv (a town already fortified and flourishing in the first and second centuries A.D.). These locations signal the accepted western limits of Buddhist presence in this area. However, various important Buddhist temples and chapels discovered in Soviet Central Asia belong to the southernmost zone of the Kirgizija and the Fergana. This means that while the principal conduit of religion ran from India to China, it was the marginal regions which brought with them diverse religious elements even while dominated by Buddhism. In general terms, many of these monuments belong to a later era than most of the Buddhist sites in the Amu-darya region. This area bordered, or belonged to, Battriana, which was to the north, on the other side of the river. This indicates that, as a consequence of a complex historical evolution which has not yet been reconstructed, Buddhist expansion had some effect on obscure zones concurrent with a moment of crisis in the expansion of Buddhism which may be an effect of the renewal of Hinduism in India. These new constellations had to adapt themselves to a new social base and taste which departed substantially from the models and motives predominant in the principal surrounding areas.

The specific conditions of Buddhist influence on these and other centers still remains to be determined. Identification is also required for the different components which could respond to a local pictorial language that had been adopted from Buddhism. Inevitable distortions of certain iconographic conventions would result from the modification of symbolic values. Iconological changes would be unavoidable in the process of transposing signs and symbols from one area of culture to another. The new elements could, necessarily, only be adopted into cultural climates not culturally neutral, but open to the influence of Buddhism, even if it was at a late date.

Beyond these observations, the facts of interchange in the East must also be examined. For example, stylistic and iconographic elements flowed from the Pjandzikent area towards Kuca. Besides this, we find compositions with figures depicted flanking one another "in procession" which resemble compositions from Ravenna and Byzantine art (for example, the procession of the Virgin and the Martyrs in S. Apollinaire). The processional arrangement is found in the "musicians" of Pjandzikent and in the "Donating Knights" (perhaps they are princes) from Qizil (the Cave of the 17 Swordsmen). There are probably other examples in the Turfan region. It is certain that a particular attitude or style in the evolution of Pjandzikent made its effects felt on some of the painting of Qizil. Its impact is seen specifically in the "non-continuous" style which plainly appears in the Qizil mural representing the "Dance of the Queen Candraprabha." Other, minor elements borrowed from Pjandzikent are also found more to the East. Kuca probably mediated in this transmission, but only on the northern caravan route.

The essential problem in the evaluation of Central Asian figurative painting is that of dating. This is always a preliminary problem. Unfortunately, it is a problem which can be resolved only on the basis of uncertain and confused facts. In practice, the dating of many works or groups of works is made by comparisons and suppositions which depend on the few secure facts we have. The known facts connect to the unknown ones in various ways.

Until now, the same uncertainty has characterized the chronology problem presented by Gandhara art, and along with it the serious and crucial problem of the dating of Kaniska. The 1960 Congress of London, the subsequent publication of its acts in 1968, and the reviews of the volume by Alexander Coburn Soper and Paolo Daffinà shed no definitive light on the problem. However, they reevaluated the evidence for Chinese sources, proposing the highly probable date of 110-140 A.D. This information reduced the influence of the famous "romisch-kusanisches Mischmedaillon" which had been studied by Robert Gobel in 1963. It also undercut some of the conclusions advanced by E. V. Zeymal at the Dusambe Conference and those set forth in his book, published in 1970 in Calcutta. The Soviet scholar's field of study, to which he made great contributions, was the correspondence between the Roman currency system and that of Kusana. The various attempts to construct a relative chronology by comparing the stratified dates of the most recent excavations have not been satisfactory. The study of Central Asian art and that of Gandhara continues to be based on uncertain foundations. This is disturbing in that the discourse may appear implausible to scholars specializing in other areas of archaeology.

b) Adzina Tepe. — A series of important facts which have gained credence in the last few years is offered by the large Buddhist center at Adzina Tepe. Characterized by the presence of a colossal statue of the Dying Buddha, Adzina Tepe was a center of great vitality and notable importance. Situated in Tadzikistan, southeast of Dusambe, it is considered by B. A. Litvinskij and his collaborators as the fullest expression of an entire school or style, undoubtedly of considerable brilliance, which they call "Tukharistan Culture." This identification clarifies part of the problem offered by the western Central Asian region. It also documents, in a precise way, particular Central Asian contributions to the formation and evolution of Islamic art. Ernst J. Grube (1968) anticipated the existence of these contri-

butions, although he came at the problem from a different point of view, limiting himself to painting.

Adzina Tepe seems to have reached its most brilliant flowering between the middle of the seventh and eighth century A.D.; at least to judge from the local currency. The form of their coins closely followed, with some necessary variations, those used in Samarkand during the same period. The city is characterized by the remarkable size of a statue of the Dying Buddha which belongs to the beginning of the period. It was discovered in 1966. It is somewhat longer than 12 meters, while the central Buddha must have been 4 meters high, to judge from the dimensions of the surviving head.

The Adzina Tepe complex had two parts. The first, comprising the sanctuary, is situated to the northwest with an enclosed stupa (vedika) in the center of the courtyard. The second section (the sangharama) has four deep iwans which open onto an internal courtyard. The architectural configuration allowed Litvinskij to conclude that Adzina Tepe offers a point of departure for the design of madrasa architecture which would become a typical Muslim model that would last for almost a century. He also offers arguments considering the form of Buddhist monasteries (whether this one or others yet to be discovered) as the historical origin of the madrasa itself. W. W. Barthold had already hypothesized the origin of the madrasa arrangement as stemming from the Turkharistan area during the Samanid period. However, Barthold did not have any archaeological documentation available. The pictorial documentation offered by Adzina Tepe is itself remarkable, although qualitatively inferior to paintings from Balalyk-tepe or Pjandzikent. However, one may find the effort to represent the "externalization" of the Buddha's body with masses of images filling unreal cosmic space unusually distinguished.

The documentation offered by Adzina Tepe demonstrates the vitality of Buddhist art in Transoxiana, even in the later periods. It is similarly to be linked to the presence of Turkish elements in the region. This flowering is somewhat disconcerting because it occurred at the point that the Sassanian empire was already in its downfall. This affirms the supremacy of the Oriental T'uchüeh (Turks) over those from the West in the area which concerns us (the Kapagan Kaga, 692 - 716 A.D.). They initiated the grand Tibetan expansion (665) in the eastern part of Central Asia, which would spread into China, whose presence in Central Asia would be eliminated by a coalition of Arabs and Turks. The coalition was promoted by the Karlik, a group of Turks different from the T-uchüeh. Even more important is the fact that the Arabs, in 652 A.D., subdued the surviving eftaliti principalities of Herat and Bagdis, together with the southern part of Tu-ho-lo (the Chinese word for Tukharistan), which then comprised Balh. In a certain sense, the conditions allowing Ai Khanum to flourish and survive are exceptional, even if they are destructive. Events left large spaces within the network of its history. The intervals allowed certain facts and objects to survive.

c) The new criticism and its implications. – It is difficult to make connections between artistic developments and historical/political events with no precise recorded facts for single locations. On the other hand, neither does our knowledge proceed steadily. Some areas and particular periods have been more thoroughly studied and appear clearer, while others seem truly enigmatic. Relying on the observations of A. M. Beleniskij, Litvinskij has asserted that it is not impossible to sufficiently detail the internal evolution of some centers. For example, Beleniskij recognized that Pjandzikent offers a perfect model of the urban Asian center as it was in the early middle ages (between the 5th century and the second half of the 8th century A.D.). It is representative by virtue of the fact that the city center (the Muslim "saahrustan") was not reserved for the upper classes and their servants, but was open to craftsmen (even to crafts industry) and commercial groups. This did not prevent the co-existence of suburbs (in Arabic "rabad") since before the pre-Arabian era. In any case, city life in centers such as Pjandzikent, Varahsa, Balalyk-tepe, and others sometimes endured until quite late — i.e., the end of the 8th century. They presaged the form of city life that would develop in Islamic centers from the 11th to the 13th centuries A.D., before the Mongolian invasions. Similar phenomenon also occurred in other religious centers in different areas. Tepe Sardar, near Gazni, is one such example.

With so many questions left, notwithstanding the success of excavations and the difficulty of stabilizing precise connections between one school and another, it can be said that Central Asia had an important impact on the formation of Islamic art. As a whole, Central Asian art displays an extensive and rich vocabulary of pictorial representations. It expanded to represent (or, rather, "communicate," or transmit) a variety of subjects which were mostly, but not exclusively religious. The elements in this vocabulary were already present elsewhere in literary or figurative formats. Sometimes they existed in both. The art involves not only choices and creative capacity within internal development, but also the search for pre-existent external, or foreign, so-called "sources" of inspiration.

This region will be considered as a whole to facilitate discussion. However, it is actually split into schools, currents, phases, and centers, right up to the divergencies which ensue from the elusive traces of the personalities which enliven them. (Artists were almost always anonymous, with the notable exceptions of Tita from Miran and of Visa, two Khotanese workers from China.) At certain times, this area interacted with the foreign areas surrounding it, leaving strong traces that extended from China to Tibet and from Kashmir to Fondukistan. In the web of relations within an area comprising almost a quarter of Asia, the paths of exchange and simple transmission interact and become entangled in ways which have not yet been discerned. The art is primarily religious, chiefly inspired by Buddhism. But there is local domination by one or another of the major schools (or vehicles) besides those of Manichaeism, Christianity, Nestorianism, or Sivaism (which occurred less frequently and may be part of local cults derived from the mountains). The presence of southern Iranian religions within various locations obviously has diverse origins relative to traditional sources because they are differently adapted to new cultural situations.

This is what happened to the Rustam Cycle from Pjandzikent. The pan-Iranian hero, celebrated by Firdusi, is quite different in the fragments of the Sodigiana epic than the more splendid Iranian version. It should be remembered that originally Rustam was a hero of the Saka culture. The problem of discussing the

formation of figural languages in Central Asia is further complicated when the works assume a commemorative/ornamental character, as at Varahsa, or a magical/fantastic nature, as seen in the "Donating Knights" from Qizil. These works tend toward portrait-like detail, almost otherworldy, because their painted world is far from the reality of the spectator's world.

Central Asian figuration does not intend to "transmit" entirely new content when its source is one of the main religious tendencies flowing into their area. There is an obligation to remain true to subjects which are already realized and codified elsewhere. Artistic creativity is both limited and sustained by previously established orders. However, even if "models of content" existed elsewhere which attempted to exhibit certain values, the artistic aspirations of Central Asian artists clearly rested on ideal and still nonexistent models. It is logical to infer that each culture had its own idea of the "propriety" of different forms and thus emphasized values neglected or nonexistent in the inspirational source. Beyond the pursuit of emotional and sensory effects which appeared in many works, their situation was not necessarily different from that which Saint Giovanni Damasceno referred to in the eighth century A.D. when he said that images are "for the uneducated, and books for those who know how to read." (This coincides with the affirmation found in the 1335 "Brief on Art" which was a "Constitution" for Sienese painters.) Saint Giovanni adds that, "they [images] are for sight what words are for the hearing." It is likely that Central Asian artists, like those referred to by Saint Giovanni, felt themselves and their work burdened by a certain "ideographic" moment of expression. However, the subjects which inspired them and affected their activity assumed, with various conventional aspects, forms intended to indicate divine presence. That is, they asserted an imagined reality, intangible and inexplicable. Content was substantially beyond any sensible confirmation. It had to be altered and modified in order to be clear and persuasive (this could be called edification). These features must have been obtained through a "transcription" quite different from the original when one considers them in their function as an inspirational source. To render the works legible to the culture by creating the necessary "propriety," new values had to be developed and introduced. The "cultural" references had to be re-organized and modified. From time to time, according to the epoch, location, and dominant religious trend, the so-called propriety of images underwent variations and changes which are revealed in painterly features and media: iconography, symbolism, composition, color, and space. These changes occur in media ranging from painted murals or small canvasses, fabric, wood, stucco, gesso, bronze, stone, and other famous techniques.

Due to a proclivity for lively fantasy, the connotations lending value and significance to the images tend to be continually modified. Change from the original code continues to shift noticeably further in order to transmit new values, effects, and sensations to the viewer. The artist's work is to realize his mental images and, if possible, to augment his ability to transmit (or "communicate") the specific religious content he is treating. However, the artist must inevitably honor the legibility of the theme and its fundamental values as they appeared within the original source. The principal problem is to transpose a stable theme onto a different cultural plane. The correct inflection must be created which can respond to a culture's unique "proprieties," even though those inflections might not be relevant in another environment.

It cannot be denied that for all of southern Central Asian the confluence and concurrence of figurative impulses and influences stem from numbers of the major civilizations in Eurasia. This is manifested in the degree to which variations on influences are displayed and the sequence of prevalent cultural trends (which come in waves) consequent to individual historical events. That associations and dominance can often be outlined does not deny the positive value of any endeavor. The question is one of continual transposition (in quite different terms) of the expressive characteristics and cultural values already within another culture's tradition.

The new figurative language that arises through this process is often authentic and original. While freely translated, the new images remain vaguely bonded to the old values. They offer the spectator a certain set of spiritual qualities that differ from the original ones, but are no less important. Consequently, the yardstick used to measure the autonomy of a pictorial language in the Central Asian world must be sought in the organization of expressive codes and the supporting structure of subcodes. Of course, this exempts the poetry existent in any work which is obviously inconstant.

The "macroscopic" search for the function of the subject does not enter into codification, whether that be the Meditating Buddha, The Light, The Parinirvana, Nestorian Palm Sunday, or some Manichean theme. Subjects are consolidated in the Central Asian world because mental images are sought that are capable of expanding to encompass new themes and symbolic ideas which are elsewhere neglected or ignored. It is no wonder that the Central Asian artist solved the problem of transferring one subject from within a unique cultural "continuum" to another, quite different, one, by creating new expressive codes. They exploited the rich cultural patrimony offered by nearby areas, choosing from among them the "syntactical signs," graphic methods, and techniques for rendering space. At times adaptation and blending meant simply stripping original values from already codified forms and giving them ones responding to the new context. Integration and adaptation, in rapport with the new forms, created autonomous codification with undeniable effects, offering certain possibilities.

It is clear, however, that the truly valid works within the vast production of Central Asia were, and remain, those which distinguish themselves above all by their internal coherence. The stabilized organization and harmonic expression of values which they contain and transmit make such works worth considerable attention. In the search for aesthetic value, there is no doubt that the recognition of motifs originating from outside of southern Central Asia can be of great historical interest. Moreover, they can excite a certain emotion in the researchers themselves, although this is of secondary importance.

If all this is valid from an aesthetic point of view, it is important to remember that the discourse changes when a systematic semiological approach is taken. The presence, direct or indirect, of classic inscriptions from

Indian or Iranian art, which display all the variations, such as the appearance of Chinese inscriptions, is no longer seen as an indication of a vague influx whose value, range, or intensity is difficult to gauge. Instead, it is a sign of a choice which foreign workers had reason to make corresponding to local expressive needs. The inscriptions themselves are syntactical signs used, with or without modification, in order to codify a continual "transmission" destined to satisfy the psalm-singing crowd of the faithful and thus surrendered to change, becoming buried in the sand or in crumbling grottos due to the events of history.

Every Central Asian work, no matter what the era or style, is always an extract from a precisely and coherently articulated discourse, using mixed "words" of various origins in new and unusual combinations. The extract has, in each case, a value according to its system, its rigorous coherence, and its ability to exhibit values which were, and remain, solidly local. This is not to deny than many of these extracts are not universally appreciable. The polemic is exhausted in the affirmation that, because the figurative confluences are so extensive, one can speak neither of eclecticism nor of hybrids nor even amalgamation. In its stylistic diversity, Central Asian figural language is always an autonomous and coherent language in its infinite forms in as much as it is enriched by foreign extractions. It is a vigorous codification perfectly adapted to explain, with the necessary efficiency and flexibility, mental images and intuitions that might not be expressed similarly elsewhere. The codes often owe their particular adaptations to clumsy reading of texts. This consists of much more than the simple Indo-Iranian meeting which Rowland proposes. He forgets the enormous force of coherence and expressive elements that continually surface in extant works.

The cultural autonomy of a unified Central Asia crossed by the grand transcontinental silk and gold routes is proved by the extraordinarily complex quality of its linguistic system. Indo-European languages were used in the southern "Kentum" group. Their language was closer to Celtic and Latin than to Sanskrit or Iranian. Their presence coincides, very generally, with the extension of the metropolitan territories of the two major city-states Kuca and Agni. To these can be added an Islamic-Oriental language spoken at Kasgar, at Murtuq, and at Tunsuq (called Kanchaka). Khotanese, Sogdiana, and the so-called "Battrian" or "eteo-tochario," written in Greek characters, were also spoken, as well as the language of the Chorasmia, who were bloodily wiped out by Arabs.

The Central Asian world thus appears to be characterized by an exceptional variety of linguistic structures within very close quarters. They often mingled with one another in areas of expansion. At times these interactions were characterized by different evolutionary processes in which the vitality of the language itself is reflected as well as historical events. Other languages beyond those just noted existed. Some have been lost or are not yet distinguishable from those under discussion nor in their relation to the Chinese Buddhist pilgrims who crossed the area on their way to India (see M. Bussagli, "Letterature Indoeuropee dell' "Asia Centrale" in *Storia delle Letterature d'Oriente*, vol. III, Torino, 1969). Thus the total picture reveals the existence of different populations, all destined to disappear

when the Turks moved into the territory, although the civilizations survived under the new rulers.

Jealous custodians of their own distinctive character, the Central Asian artists maintained a notable autonomy in a variety of expressive means and styles, including the pictorial field. The continued variation of iconographic language is due to many factors: the continual intervention of other cultures with figurative traditions (from both near and far); the competition between the numerous religious currents; diversity in sacred and profane representations; and the succession of different populations. So many factors amply justify variations in iconography, from the choice of colors to the means of spatial depiction, which has its own semiotic and structural importance. For these reasons, Central Asia is a phenomenon "sui generis" — autonomous, and all the more rich in values for it. General characteristics of considerable interest are recognizable, some of which can be charted historically.

In the pictorial area, the general tendency is a passage from the illusionistic relief to progressively flatter images, advancing ever nearer to an Arabian painting style. Contour lines of figures are sometimes transformed to the point of becoming solid and emphatic things in themselves. These outlines can be adapted to delimit figures in the same way chromatic dissonance is used. Contours are sometimes thin and delicate, like ornamental details. The ornamental use of outline is found equally in the East and the West, but with different inflections. In the East, the use of contour seems near to the Chinese style, which at times uses a double, narrow outline. This is a technical device serving to emphasize the most important figures while remaining extremely delicate — almost evanescent.

The plastic arts too, generally pass from strong structures (imprinted or etched, but vigorously volumetric) to an attenuated and refined volume. This can lead to stylization that is more emphatic than caricatural. Sensitivity to plastic volumes is maintained. It is possible that this evolution involves an interchange of diverse interests, somewhat mystic and at times mannered in the first case; curiously ironic in the second.

Pictorial compositions, especially those arguably linked to Buddhism, generally lean towards the use of abstract spaces. It is space that at the same time seems both near and far from that within which the spectator moves, lives, and works. Inspirational intentions differ from those of Buddhism. Their function is basically narrative, edifying, or even commemorative. Taking the spectator into account, there is a search for psychologically effective composition.

Buddhist images and composition, stemming from India, attempt to create a fusion between the spectator and the object observed. They tend to favor and, if possible, produce an identification between the spectator's consciousness and the form in which the divinity or sacred scene is rendered. The assertions "nadevo devam yajet" (or arcayet), or "he who is not God does not adore God," or even "devo bhutva devam yajet," "To adore God it is necessary to become God," invite reflection on the image that should induce in the spectator a state of identification that, according to his acme, is an ecstatic trance (samadhi). Such a trance overcomes the distinction between the knower and the known.

The state of *samadhi* notoriously begins with a concentrated attention which, in the Indian world, can

be pictorially induced through so-called "psychological perspective." The French scholar Jeanine Auboyer has identified this type of perspective in paintings from Ajanta as well as in several Buddhist paintings from Central Asia. The gaze of the user (or knowledgable spectator) is guided to a particular reading through the depiction of illusionistic architectural spaces inserted into the various scenes. These are mostly lateral, perspectival visions with parallel or reverse vanishing points. The outlines, gestures, positions, dimensions of the figures, color contrasts, and every other detail are organized so as to slowly draw the eye toward the center of the composition. This guarantees an attentive and thorough reading. The gaze is then driven toward the periphery, which gradually diminishes (thus, this can be called evaporating fusion). The periphery ambiguously belongs to the composition in its entirety. This perspective, or, rather, this typical method of arrangement, is prompted by the will to make the user reflect on every detail within the composition. Attention is also drawn to the middle of the composition, where figures in an almost oval arrangement profoundly emphasize the central or principal image they surround.

The aesthetic of light: aspects of codification.— If, in the end, all Central Asian painting is analogous to Indian works, even if differing traditions, social environments, and identification of evocative techniques are taken into account, it is also certain that Central Asian religion includes components unknown in the Indian world — at least, they are concealed in confusing forms which are not systematic and which are almost embrionic. The figural transcription of these components originally arose from a certain "aesthetic of light" which is revealed in various forms and styles. S. Taki has reconstructed the theoretical base of this aesthetic, beginning with the impression it had in the mystic speculation on light. These deliberations are found in such texts as the Saddharmapun-darikasutra and Suvhavativyuha and the Amidista cycle, beginning with the Sukhavativyuha which deals with the Supreme Buddha of the West, Amitabha Amitayuh — that is, the "Supreme Buddha of the Infinite Light" and of the "Infinite Life," who is, in a certain sense, the personification of the essence of the tangible world. We can also add Candragarbhasutra and Suryarbhasutra, dedicated, respectively, to the moon and the sun, because they contain within them, as does Suvarnprabhasa (the sutra of the golden splendor), different signs alluding to a certain sanctity from Khotan, which was the major political and caravan center in Central Asia.

Without forgetting that Buddhism had originally absorbed the suggestions concerning mystical light from seers and Brahmans, it is noteworthy that the iconography relative to photic values developed particularly in the Gandhara school — that is to say, in the northwest of the peninsula and the Afghanistan area. This puts it in an area of direct contact with the Central Asian works, whether through the paths of the silk and gold caravans or through the route of the Swat which followed the valley of the "Omonimo" river which outlets very near Khotan. Iconography from Gandhara recalls the symbolism of light in various ways. This can be seen in the choice of preferred scenes (for example, the miracle of Sravasti), or in the symbolism of flames rising from the shoulders which recurs in the above mentioned miracle. It is used to explain the divine regality of the Kusana sovereigns or their *hvarnah*, which is quite unlike the true Iranian tradition. As well, halos are used as an indication of luminance that is sure to have Western origins.

It is clear that within the Central Asian world there was a strong insistence on light symbolism. This reflects not only a cultural fact which surely includes astrological components, but discloses signs of the same evolution investing all Buddhist thought. The reflection of mystical light was progressively accentuated through the elaboration of certain episodes from the life of Buddha as well as apochryphal stories about him in which he is the "Supreme Buddha" or the "Buddha of Meditation." Also, Amitabha/Amitayuh, who reigned over the splendid paradise (Pure Land) of the West, and the other supreme Tathagata are associated with luminosity. According to G. Tucci, one of the oldest Tantra (so judged by E. Conze), the Guhyasamaja Tantra (also called the Tathagataguhyaka), reveals a system in which the primordial principle, the sole reality and the ontological origin of all things, is not only considered the supreme God, but is assimilated into a principle of luminosity. This principle (which the scholar Candrakirti called Vajradhara) projects beyond itself the five tathagata (Supreme Buddha). Through them he does his earthly work and allows the minds of humans to realize him. Moreover, the five tathagata appear as his very shape (skanda). They, too, are considered luminous elements. So much so that Maharatha (literally, "the grand gem"), or, rather, the very existence of the universe, expressed in terms of splendor, must be prepared for through meditation. Thus, Maharatha is called "pancavarna," which means "five colors." In order to comprehend these terms, one must understand the ability of the mind to imagine a cosmology that moves from "a white, cold and immobile light" which produces a vibration (ksobha, or spanda) that then refracts into five different colors. From these derive all phenomenon of reality. Or rather, they derive from the Tathagata which is the basis of the translation in terms of illusory and evocative materialization of thought that is made of the same substance, material, and energy as that of the universe.

Speculations of this type cannot help but leave traces in images, especially in pictorial ones. But translating mystic photism and the evocative and intellectual experience it produces into figurative terms poses serious problems. Among these is the rendering of luminous irradiation, which must imply the presence of the mystic light surrounding the body of Buddha or, rather, his own luminescent essence. The unreal thoughts and mystic experiences resulting from meditation must be expressed through a code which can represent the essence of that imagined reality or meditative experience. This code must be accessible to viewers simply looking, not involved in focused meditation. Translation of this reality or experience into complex symbols can be expressed, for example, with the flames rising from the shoulders. This was already used at Gandhara, where they served to express a particular theme, i.e., the enchanted regality of the Kusana sovereigns. The oval mandoral or large, multi-colored disk behind the Buddha is a radiant cloud, alluding to the luminous halo surrounding his image. Polychromy refers to the refraction of the white light originally in the five centers which the Guhysamaja Tantra and other texts mention.

The abundance of sinuously curved lines, pressed into "S" shapes and then continuing, refer to the waves of mystic light. Here the idea is abbreviated into a diagrammatic expression. The same curved lines appear in the stylized treatment of fine hairs and the "usnisa," lending expression and evocative qualities to the physiognomy of the Buddha's head. It also alludes to (and this word has a precise significance in the context of the expressive effort) the trancendant luminosity of the Buddha's head.

Persistent research seeking to explain the range of values connected with mystic photism indicates profound changes of the image from its character within the classical Indian tradition. The attention given to the spectator, as in the Ajanta paintings, is indirectly connected to the experience of Indian theatrical scene painting. The separation between quotidian reality and the narrative reality on stage depends on the spectator's psychic effort. Analysis of the characters and details constituting the scene has a reflexive description which overturns the entire scene - to judge by its edifying content - to a level that is (or better, would like to be) outside real time ("in illo tempore"). Through theater, a fantastic or imagined story is presented.

In Central Asian art, the compositions which most clearly exhibit an involvement with mystical photism are of a completely different nature. Their function is substantially suggestive, such that they can generate effects. But these are only available at a certain level of psychic meditation. Images connected with mystic photism use signs (in Sanskrit, "laksana," "minitta," "samjna") to explain a superior sign (anna in pail, in Sanskrit, "ajna") which is indicative of the supreme psychic state. This power is inherent within the image and, in a certain sense, is connected with the power and the very consciousness of the portrayed motif. This last fact explains, through the code employed, the particular state and grade of value of a figure, but it explains it only in the most descriptive way possible (the way the spectator would be cognizant of it). It does not simplify the explanation in those diagrammatic terms which would aid the spectator in the retrieval of the psychic values inherent in the representation.

Therefore, at least as regards mural painting, one looks to the codes connected with expression as they exist in the attempt to instill certain feelings and emotions in the spectator. The motive is to offer the spectator a thorough demonstration of a mystical experience. This would necessarily be allusive, being ineffable and finally, inexpressible. The demonstration must be a support for meditation, useful for repeated and diverse yoga practices. Independent of the expressive codes used, the approach to the divine does not diverge from that found in Byzantine art, at Ravenna, or in Russian icons. With their gold backgrounds, these works announce not only a pervasive mystic photism, but also an unreal, timeless atmosphere. Any contingency or relativity is extraneous. Although with a different focus, the rigid rows of "princes" or "Donating Knights" of Kuca recall the procession of the Virgin and the Martyrs from S. Appolinaire in Classe in Ravenna. The attitudes of their bodies and faces are similar to those in the Christian works in compositional effect and rhythm of flanking figures.

In conclusion, for a conspicuous part of Central Asian painting from the East and West, it is legitimate to speak of a motivation originating in a true aesthetic of light. The aesthetic is similarly responsible for numerous other solutions. For example, stucco modelling is used to obtain light and shade effects through strong contrasts in folds and agitated lines. According to the movements of the sun, this lends vitality to the faces. At the same time, it indicates a general interest in light and shadow as inherent elements in a plastic structure. The polychromy of the pictorial composition rests on conventional codes of luminosity, but heightened color effects are also sought. Without the interest in light and color suggested by photic speculation, color effects and efforts to use relief to obtain vigorous contrasts of light and shade would perhaps not have occurred.

Given the enormity of the task limiting investigation, the question arises whether it is possible, at this point, to speak of a simple meeting of foreign currents, variously distributed amalgamations, or overlapping that could have been rather casual. The response is absolutely negative. The pictorial phenomena of the Central Asian artistic world must be evaluated only on a basis of differences. This allows not only the investigation of works of true merit and the extensive fragmentation into schools, tendencies, and styles, but also the succession of stages. Co-existence and interchange with the subsequent transformation of semantic codes (which were themselves the result of long processes of elaboration) are based on principles of choice that are never as simple as one might think. The semantic logic - which has yet to be properly analyzed - supporting the works which interest us is indisputably autonomous and unmistakable essentially because the culture's activity is anguished and complex. It would be sufficient to ignore the qualities of images as they are associated with theater to more clearly demonstrate visions of metaphysical luminosity moved to a level quite unlike the diagrammatic and meditative schematizations to which medieval Indian art turned. These diagrammatic representations demonstrate that the gupta memories of each current (Irano-gupta or Sassanian-gupta, to use the old classifications of the French archaeological school) have a value quite unlike the simple, automatic juxtaposition of iconographic influences stemming from two of the great figurative civilizations.

A position that should strenuously be avoided is a view that Central Asia works depends on this or that foreign representational trend. The art of Central Asia is indisputably autonomous. As such, it is in the perfect position to interact with the surrounding world, like a stream of emissions, which can be explained through a language capable of producing unexpected results. Central Asian art succeeded in overcoming the stamina of a persistent Chinese traditionalism (not only in areas at the borders, as, for example, Tun-huang clearly demonstrates), while even at the earliest time conditioned by Tibetan Buddhist art. This renders almost absurd the hypothesis of an effect on the life of Iranian art, even if the scarcity of documents and difficulties of interpretation render it troublesome to discern the existence and nature of this hypothetical effect. Perhaps, with excessive caution, we will consider it only as a possible position to take in the current state of research.

The proto-urban civilizations of the south. The proto-states. – Among the major cultural phenomena that concern the Central Asian regions, the first is the

extremely early urbanization of the area south of Turkmenia. The existence of a clearly configured proto-urban civilization has been recently discovered, although its particulars have not yet been examined. According to the Soviet scholars, the inhabited zone was in the lowlands, easily accessible from the Kopet-Dagh range which is in close proximity to the Tedzent river. There was an enormous programmed urbanization effort which reached its zenith in the first part of the so-called Namazge V period (2200 - 1800 B.C. according to the proposed date). Cities such as Altin-tepe and Namazge-tepe extended over ten and twelve acres, respectively. They had fortified city walls, palaces, temples, and monumental constructions. There are traces of a substantial commercial trade which extended all the way to Mesopotamia, Badakshan, and the Indo valley. Along with these metropolises, which were certainly animated by extremely profitable artisan activity, there were minor centers such as Hapuz-tepe and Ulug-tepe (covering two and a half acres). Six very small villages completed the settlement. Eighty percent of the population was concentrated in the two major cities. In the later phase of the period (1800 - 1600 B.C.), the situation changed rapidly. There was a dramatic reduction in the dimensions of the two major centers. In the successive phase (Namazga VI, 1600 - 1000 B.C.), one of the large centers, Altin-tepe, and one of the medium sized, Hapuz-tepe, were completely abandoned. A part of Tedzent became practically uninhabited. Namazga-tepe was reduced to a village of just five acres. Other newly formed centers with areas rarely exceeding 15,000 square meters gradually faded as they became more obscure. There is evidence for a concurrent population movement toward the East, the motive for which has not yet been discovered.

Notwithstanding the problems, it seems definitely assured that the growing population settled in numbers of small villages. It may be that the experiments with urbanization were impaired by fundamental deficiencies, contradictions, and an exhaustion of productive capacity. The alternative solution was the establishment of complexes of smaller villages located in the area of the Murgab valley (north of Merv), close to Battriana. It is certain, however, that Turkmeno villages appeared in Uzebekistan, to the north of the Amu-darya, in the northern plains of Afghanistan. Unexpectedly, there was no period of decadence in the craft and technological productions of these villages. They sustained the same level of quality in terracotta and metals. Nor was there a decline in the efficiency of the artificial irrigation systems. If the point can be made without pushing it too far, the facts suggest that the villages were collective organizations, in confederate form. In any case, we can project two helpful events to explain the situation. The first is the unexpected urban expansion toward the north, reaching (it was thought until now) into the most northernly point within the Central Asian territory until it exhausted itself. The second phenomenon involved the rejection of centralization and the resultant dispersion of the growing population into a scattering of villages. The cultures of these villages did not regress in relation to urban culture. In fact, there are signs of technical progression. Hygienic problems, such as the difficulty of getting rid of waste and infestations of insects and mice, must have played a part in the population dissemination. In terms of this hypothesis,

the tremendous quantity of egg shells found in the excavations at Shahr-i Sokhta, can be attributed to the birds who came to live on the rubbish heaps, attracted by the inexhaustible supply of insects. Humans would catch the birds - the hunters and their nest.

Agricultural production is an auxiliary component of the dispersion. The organization into smaller villages would grant each a larger amount of tillable soil than available before the workers left the centralized towns. The search for more fertile soil for hunting and crops was a renewed burden for these developing towns. Naturally, the palaces and division of the city into specialized quarters disappeared. Emphasis on sacred buildings assumed a new character, which has not yet become clear to us. It was certainly not monumental, however. The ziggurat on the left side of Altin-tepe can serve as comparison.

The effort to urbanization that lasted in Turkmenia for almost half a millennium (from about 2200 to 1800 B.C.) eventually gave in to a much more extensive wave of urbanization. Except for certain isolated spots, the new movement extended into an enormous territory which, excepting the classic zones of the so-called Antique Orient (from Mesopotamia to Syria, to Elam, and even Egypt), comprised the metropolis of the Indo valley and the large Afghan centers on the Hilmand (Mundigak and Shar-i Kakhta). It even had repercussion on the coastal strip and on the immediate hinterland of the Oman peninsula. But the Turkmena evolution, perhaps conditioned by the insufficient water supply of the Tadzent (the river that served as both hydraulic supply and refuse dump), followed an evolutionary curve that was able to avoid the effects of deforestation on the environment in a fight against persistent attrition. They did not consider the life model of the grand centers to be at all irreversible. Current research being carried out by various Soviet scholars and the Italian Raffaele Biscione proposes evidence for the greater hygienic safety of the small villages (or the restricted and isolated centers). Eventual outbreaks of epidemics and the spread of disease undoubtedly had less impact. As Biscione has noted, Turkmeno activity is oriented toward fragmentation into small parts and, we add, toward a broad communication organization between the different centers which united in the struggle survive.

There are numerous problems presented by the relationships between the marginal areas of Western Central Asia, the Iranian world, and Beluchistan. Thus, in discussing the possible movements of inspirational sources in terms of the phenomena of the art of the Steppes, we shall begin with this zone where there was interchange with cultures developing in the Iranian territory. We do not intend to take up again the problems of the andronovian cultures (so called because of the predominant one, or at least the one most well known). Instead, we will address a series of discoveries and interpretive hypotheses that have some direct or indirect reflections in figurative evolution. In particular, in the plains of the Vahs and Kizyl-Su, as well as in the Kafirnigan valley (all tributaries of Piandz), there are immense tomb complexes with sepulchres and catacombs of various types. The strong analogies between the clay burial urns in these tombs and the urns of Namazga VI, from Mundigak V and VI (in Afghanistan), and other works from the late bronze age in Iran

indicates a pre-agricultural population drive moving from the West (Turkmenistan) and the South sometime around 1500 B.C. B. A. Litvinskij thinks this drive superseded the preceding culture (called Kurgan Tjube) in the Vahs valley because this culture shows conspicuous analogies with the first bronze era of the Steppes.

Unfortunately, the investigation becomes complicated because the first expansion towards the West seems to have reached into the Swat valley, leaving notable traces in its wake. This was noted by Litvinskij and by E. E. Kuz'mina in other research that would have liked to have demonstrated the existence of analogies between the cultures of the Biskent and Swat valleys. The Swat culture must have been put to an end consequent to a different drive. This culture seems to be characterized by a certain painted ceramic which spread into Margiana and Battriana, reaching the south of Fergana and those areas which would become the original site of Parthia. The characteristic pre-agricultural culture with Turkmena origins survived, in part, in the north of Battriana. They remained in contact, except when interrupted by other settlements within the Namazga-tepe area. These movements were completely separate from Indo-European movements and can be related only in an indirect way.

No archaeological proof exists to sustain these facts. That the halt of the Turkmenistan drive was due to the painted ceramic industry is a very attractive hypothesis, but it is only a hypothesis. It is, however, certain that this interweaving of different drives within such a large territory would optimally explain the great variety of tendencies and local characteristics, whether referring to origins or ethnic and cultural foundations. Looking at the situation as a whole, we find less homogeneity than expected had there been only a singular movement. With a clear understanding of the limits of archaeological documentation, E. E. Kuz'mina has already remarked on this fact. Chiara Silvi Antonini made the same observation, but with a different view of the drives, differentiating between their natures and their vivacity. Also, the excavations carried out by A. M. Mandel'stam in the Biskent valley and the Kafirnigan have brought to light other objects connected to the metal productions of the Steppes, at least to judge by the style. It can be deduced that the interaction between the drives, including the Indo-European drives but in a different way, did not break the bond with nomadic cultures. It seems certain that the culture in the Vahs valley was not interested in occupying only Battriana but expanded north into Kazakhstan and a part of Western Siberia.

The primordial drives might also have stopped or exhausted themselves, but their cultural effects also spread into the regions which would be absolutely dominated by nomads. Of some importance are the discoveries coming from the valley of Surhan Darya (South Uzbekistan), which has shown itself to be an area of great archaeological interest. Of exceptional distinction are the excavations carried out in the area of Sapallitepe. The buildings, ceramics, and especially the ornaments and toilette articles are remarkable. They have been dated to 1700 to 1500 B.C. The same objects have been discovered in numerous centers that had contact with the culture in question, including Biskent in southern Tadzikistan and a myriad of minor centers. The site of Dasly III (dated to the middle of the second millennium B.C.) exhibits a monumental building on a round ground plan with a diameter exceeding 100 meters. It is not improbable that Koj-krylgan-kala derives from buildings of this type. Of equal importance is the discovery, made in 1966 by Maurizio Tosi, of the so-called "Treasure of Fullol" found south of Baglan, in Afghanistan. The "treasure" contains gold and silver cups that display a persistence of archaic motifs similar to those on Geoksiur ceramics and other ceramics (motifs such as the buffalo are certainly from a later period). The representation of buffalos recalls Cretan designs (Minoan art) or, perhaps, Mesopotamian illustrations.

It should not be forgotten that the Tazabagjab culture (1500 - 1000 B.C.) is a particular "facies" of the andronoviane culture present in the south of Aral. This seems to coincide with the exhaustion of the tin mines in Kazahstan (from which derived the bronze/tin alloy used in the art of the Steppes). They must have been a sedentary people given the character of mining work. The origins of this population could be connected with the spread of the Vahs culture into the zone. B. A. Litvinskij, among others, considers this culture as one of the most important in the evolution of the entire southwest Central Asian area. He thinks that, among other things, it was the springboard (exceptionally interesting for its historical and sociological implications) through which Margiana entered into the sphere of the politics of Battriana.

In fact, while at Tazabagjab the culture designated as Sujargan prospered through the diffusion of bronze/tin alloy, the so-called Jaz tepe culture was developing in Margiana. This was a sedentary culture, linked to the evolution of lower Murgab by the use of artificial irrigation canals. The Battriana area was marked by a culture which M. M. D'jakonov named "Kobadiana." It appears to have been partially autonomous. It can be assigned a date around the VI century B.C. The excavations of T. I. Zeimal, conducted at Baldai Tepe, in the Vahs valley, indirectly confirm that the Kobadiana culture developed at a time corresponding, at least in part, to the era when the "kingdom" of Battriana was still independent from the Acheamedian emperor (who would make of it a satrapy). Litvinskij has claimed that this was the same epoch in which Battriana was defined as the "beauty" of Avesta (first "fargad" of Videvdat). Archaeological facts provide evidence for a rapid development in the surrounding area, beyond Margiana, in parts of Battriana and the original territory of the Parthia.

We shall attempt to resume and discuss this with clarity, in a simplified manner. These developments formed a cultural "facies" with an organizational structure that can already be considered a state. This arrangement subsequently extended to the east even while being transformed, as occurred in Chorasmia, due to influences from the nomadic cultures. In fact, while the cultures of Margiana and Battriana had artificial irrigation until sometime after 700 B.C., the Chorasmiana area exemplifies a passage toward a certain amount of political consistency only in the so-called "villages with inhabited walls." This refers to the "thousand cities" of antique tradition.

This state structure had to be a federal one or, if one prefers, it was a confederation of small, rather isolated centers which cultivated exchange between agricultural communities and animal breeders. S. Tolstoy

thinks it was a true state, although, for now, there is no written documentation. V. M. Masson opposes this, asserting instead that, according to available sources, the first Chorasmiano sovereign was the King Pharasman in the IV century B.C. Whatever the case may be, it is certain that the artificial irrigation system of the "villages of inhabited walls" could not survive without a unified organization. The villages in question were fortified with walls often 20 to 25 meters thick. The habitations were within these walls. The walls enclosed areas ranging from 70,000 to 85,000 square meters. They were intended to contain herds of animals that evidently had to be protected in fortified spaces. As the culture became sedentary, the economy of breeding required interaction with agricultural communities. This integration, very difficult to create, set the citizens of the villages with inhabited walls against the masses of nomads from the east and the north, who formed a constraining frontier that presumed solidarity and unity between the various centers. Alexander the Great thus had reason on his campaign against India to convert some of these centers into Greco/Macedonian fortresses to protect the sides and back of the region from nomadic intervention.

The equilibrium between the pastoral, sedentary, and the agricultural villages, which was difficult to maintain, was dependent on artificial irrigation. This required technical and organizational skills for the maintenance of canals and for driving animals to free pastures (which meant moving large herds of animals). These skills could be had only through a unified organization that was more or less centralized. Tolstoy thinks it would not be possible to separate the artificial irrigation system and the relative canalization from the existence of a powerful center, even if, in this specific case, it would not have had to have been centralized or totally dispotic. Karl Wittfogel thinks it would have had to have been centralized, as he proposes in his book *Oriental Despotism: A Comparative Study of Total Power* (2nd ed., Yale University Press, 1959). His book has been widely criticized, but it still has some interesting elements. (For a synthesis of the polemic and divergent opinions that takes into account only syntological research, see Gianni Sofri, "Il Modo di Produzione Asiatico," *Storia di una Controversia Marxista*, Torino, Einaudi, 1969.)

Turning his attention to Margiana and Battriana, Masson does not depend on archaeological data as much as he leans on Ctesias, who regards Battriana as an archaic state (see V. M. Masson, "Drevnezemledel'ceskaja kul'tura Margiani," Materiali i issledovanija po archeologii S.S. S.R., Moskva-Leningrad, 1959). Masson also leans on Mede sources. Diodero Siculo readdressed Ctesias, which has been amply studied by R. Frye, (*The Heritage of Persia*, London, 1962). He confronts the problem of the Mede expansion toward the east. However, apart from the complications which would derive from placing the problem of the Medo empire in this context, he diverges from the opinions expressed by V. M. Masson (see also V. M. Masson and V.I. Sarianidi, *Central Asia: Turkmenia before the Acheamenids*, London, 1972) on the importance these regions would have had in determining the evolution of the eastern Central Asian regions. This also points out the fact that Margiana presents, contemporaneously with the first formative and expansive phases of the Medi empire, a cultural "facies" developed to the point that presupposes a very particular productive and social level able to support and shape it. The presence of a complex organization and strong cohesiveness is, in reality, a necessary presupposition. It is very probable that if they had a strongly unified confederation within which a strong central power developed, even if the various centers could have formed a pseudo-feudalistic system, which would have given power to local nobles, this allowed the partitioning of land.

In conclusion, a conspicuous part of the southern area of West Central Asia saw the birth of autonomous "proto-states," which were subsequently absorbed (in a way that has yet to be determined) into the satrapy of the Achaemenid empire. The serious question of the Medi empire, its eastern expansion and organization into large territorial subdivisions (from which the Acheamenid satrapy derived, although its extension was relatively minor), can not be dealt with here.

However, the problem of the "treasure" thought to be from the Oxus (the Amu-Darya, which can be written Amu Dar'ja) is a fascinating one. It seems important to note that Paolo Daffinà, in his 1975-1976 university course, asserted that it was probable, or at least possible, that at the time of Ciassare (624-535 B.C.) the Mede empire could have extended to the Kabul valley. This agrees with I. M. D'jakonov's opinion, voiced in this famous book *Istorija Midii* (1956). The so-called treasure of Oxus is recorded as being discovered in 1877 near Kunduz in Battriana. It supposedly underwent various romantic adventures. It must have derived from a temple treasury, as R. D. Barnett (1968) proposed, following the thought of Roman Ghirshman (1965). They assert it was dedicated to Anahita, which is a conceivable attribution. However, the materials of the treasure are not all from the same time period. It is certain that only a part of the treasure is pre-Achaemenid, but there is no way to ascertain where the most important and oldest pieces were made. One can recognize certain traces of a taste that is often connected to autonomous models, thus suggesting possible connections with the art of the Steppes from the so-called "unnosarmatica" phase and the "colored" style. The connection is not yet clear from a historical perspective.

Ai Khanum. Greek urbanism in Battriana. —
Besides the Achaemenid expansion which reached various Central Asian nomadic centers and which is particularly evidenced at Pazyryk, the Central Asian phenomena shows itself to be entranced with the spread of Hellenism and the introduction of Western motifs, indirectly, to the whole southern zone. The spread of Hellenism is due, in a large part, to the Greek persistence in Battriana and the grecization of the Afghan area. It is more deeply rooted and tenacious than previously thought, appearing responsible for a series of fascinating developments. D. Schlumberger, in what was an innovative proposal at the time, examined the descendancy of "non-Mediterranean" Hellenistic art. He gave a principal role to so-called Gandhara art. The end result of his research was a list of schools, currents, and Asian sites that clearly exhibited Hellenistic influence in pictorial production. Even without the list, he would have been able to see the consistency within Cen-

tral Asia through additional material and new perspectives.

One of the most important of these new components is the archaeological discoveries at Ai Khanum. It was a Hellenistic city that emerged under Alexander the Great or one of his immediate successors. The real name was ignored, and it has thus come to be known by the name of its current topographical site. When it was discovered in 1963 by D. Schlumberger and Marc Le Berre, it did not seem particularly noteworthy. However, the facts began to be revealed by the work done in 1965 by the French expedition directed by Paul Bernard. Ai Khanum was a large city, situated on a strip of land in an angle that was well protected by the Amudarya and its small tributary. There was a true acropolis situated high on an almost triangular plain that is about a kilometer and a half long. Within the acropolis there was a citadel rising above the middle section of the plain, forming the final defense for the city. The acropolis and the citadel were both fortified. So, too, the lower part of the city was protected by strong fortifications, especially the side running between the two rivers. A large moat and a high wall reinforced by large towers were situated on a rectangular ground plan. Each outside face of the wall is 20 meters long, barring any access to the city. One door and one passage over the moat are the only openings to the outside. Another door, open to the smaller river, has been swept away by more than two millennia of floods and alluvial deposits. A long, straight street ran parallel to the front, rising above the plain where the acropolis stands, crossing the entire lower city. Near the street there is a semicircular cavity which suggests the inevitable presence of a theater. Further down the street, on the opposite side, almost in the center of the inhabited area of the lower city, there is an oblong depression which must have been the stadium. In the northern part of the lower city, on the side not protected by the rivers, there do not seem to have been any living quarters. It is probable that this area served as a sanctuary for refugees from the inland region, along with their herds of animals. The analogy with the cities of inhabited walls is apparent, but the city is clearly Greek, even if adapted to local requirements. Between the public buildings there is a vast rectangular courtyard with a portico and a hypostyle atrium formed by 18 Irano/Corinthian columns. This must have been the agora. It was made of bricks, stone pilasters, and corinthian columns. Strong color effects were sought. The ornamental elements were vigorously colored. There was a complex of statues of which fragments remain, some still showing traces of flesh colored paint.

In the northern area there was a gymnasium dedicated to Hermes and Hercules, the divine symbols of intelligence and strength. There is an epigraph which demonstrates that the culture was distinctly Greek, and education followed a generally Western scheme. Not far from the agora, there is a sanctuary dedicated to some important personage. It may have commemorated the founder of the town. To judge from an inscription found in the city, this person was called Cinea, but he is not otherwise noted. The inscription itself is comprised of two distinct elegies which are rather archaic. They refer to a certain Clearco, whose name was engraved in the "temenos" of Cinea for bringing the Delphic precepts which he had copied at Delphi. The tenacity of Greek culture and the attachment to one's own land of origin are very clear in these men who are 5,000 kilometers away from the city which they mysteriously declare to be the center of the earth. A sculpture of an official or priest has survived. He is rather old, shown wearing a fastened cloak with his head (separated from the body) sporting a diadem, demonstrating how Hellenistic taste, techniques, and ways of living persisted even in these extreme limits of the world. The inscriptions, from an epigraphic point of view, seem to come from the III century B.C., but it is accepted that it was altered at least three times since then, putting the date of the city's emergence in the IV century.

It is certain that Ai Khanum, whatever its original name, remained a profoundly Greek city, notwithstanding local adaptations and Persian contributions, which were not negligible, but actually quite revealing. These adaptations are interesting from the urbanistic point of view for the way two completely different concepts - the Greek polis and the system based on the villages with inhabited walls - are juxtaposed. Although they seem antithetical, here they are fused into a functional unit, owing to the adaptability of Hellenism. In regard to Ai Khanum, Mortimer Wheeler argues that elements of interaction (which he calls "hybrids") have not been given a full evaluation and remain "secondary" considerations relative to Hellenistic diffusion. There is a presupposition about the presence of Greek priests, philosophers, and artists. Using given facts to gauge the magnitude of Hellenization, Wheeler asserts that the stamps on wine and oil jugs prove the existence of the "agoranomoi" (market supervisors) at Ai Khanum as well as in the Greek cities of the Black Sea or the Near East.

Ai Khanum (whether or not it was called Alexandria of Oxus, as P. Bernard has concluded) serves as exceptional and incontestible documentation of Hellenistic penetration into Battriana. Without noting here the controversial problem of a possible Greek presence in Battriana during the Achaemenid period - the XII satrapy would have been a deportation zone for Greeks rebelling against the king - it should be declared instead that the Hellenistic foundation to which Ai Khanum belonged had a precise and documentable endurance in the Battriana area. It appeared in the Kusana phase, affecting the art of this crucial period. The Corinthian capitals at Ai Khanum, the almost contemporary ones from Muncak-tepe, and the two from Old Termez are not only very similar, but prove to be the model for the other 33 extant capitals. But these were produced in the eras of the Kusana, Baglan, and Termez (late Kusana phase), from the sites of Ajrtam and Hatyn-Rabat (a center very close to Termez), as well as those from Sahrinau and Saksanohur.

This kind of prolonged chain of relations is not limited to the Battriana area. It extends, chronologically, far beyond the limits designated by local development and, geographically, it invests the entire area encompassed by the artistic currents of Gandhara. Without losing the "Corinthian" character the capitals were significantly modified. Perhaps this was a consequence of contact with the Roman world. This does not deny that a certain percent of these so-called Indo-Corinthian capitals appear recognizably similar to the Battrian model. It must be noted that these connections - the basis for which has not yet been studied - could

possibly provide important dates for a chronology relative to the art of Gandhara.

At about the same time that the French uncovered Ai Khanum, B. A. Litvinskij brought to light Sakanohuv, a notable complex of constructions in a Greco/Battrian style. Therefore, as the Soviet scholar has pointed out, in the southern part of contemporary Tadgikistan there was a center analogous to the Afghan center. Thus, it can be considered as the Transoxianian counterpart of Ai Khanum. Among other things, this extends the "Battrian" area notably beyond the Oxus. Thus, we are presented with a new problem: the Greco/Battrian cultural diffusion beyond the confines of the area dominated by the Greco/Battrian. G. Frumkin recently addressed these questions (L'Art Ancien de L'Asie Central Soviétique," *Arts Asiatiques*, XXXIII, 1977). He suggests that future excavations might reveal surprising information. He refers to those excavations conducted by Krulikove at Dal'verzin Tepe in Uzevekistan where strange mural paintings have been found. The murals are evidently of a late date but were quite unexpected discoveries.

Koj-Krylgan-Kala. — Moving beyond the Hellenistic component to a cultural ground in the VII-V centuries B.C., there was a renewed appearance of sedentary farmers who, having exhausted the fertility of the otherwise desert land with artificial irrigation, relocated to large fortresses. This movement began in the IV century B.C., and was completed by the end of the III century. They occupied the fortresses of Dzanbas-kala and Koj-krylgan-kala as well as other, minor centers. Koj-krylgan-kala was a circular construction about which we have some clear knowledge. It was a fortified center as well as a dynastic sanctuary and probably had attachments to astral cults. There is a temple or a tomb for the K'ang-chü sovereigns, who were part of a unique culture which is reflected in the state organization constituting Ancient Khwarezm, or at least the lower basin of the Amu-darya, and a part of Sogdiana.

The construction, exceptional for its dimensions, was surrounded by a wide moat. An enormous complex of fortifications protected the only door. Access was gained only after going through a "chicane" - a zigzagged passage with thick walls. The passage was protected by a large, rectangular outpost which had arrow-slits. There were two lateral towers that projected out, in the shape of a horseshoe. These could be defended from above with missiles. There were battle towers in a position to defend from behind. The outside ring, with eight reinforced towers standing outside the door defense, had a diameter of 87 meters. The inner battle towers, which were also circular, were 42 meters in diameter. The circle outside the walls - 7 meters thick - with its battlement towers on square plans, was inhabited, directly evoking the villages with wall dwellings. This displays the true tenacity of this model; it had the capacity to impress, in different ways, city organizations — be they Hellenistic, as at Ai Khanum, or the well fortified temple/mausoleum of the K'ang-chü sovereigns. The same system is found in the walls of Dzanbas-kala and elsewhere.

Historically, Koj-krylgan-kala was destroyed sometime around the first century A.D. Probably the destruction occurred at the time that Khwarezm was incorporated into the Kusana empire. Through this act, the Kusana intended to end the power of the K'ang-chü and eliminate the magical power of the reigning dynasty. Karl Jettmar thinks, in addition, that the temple of Surh Kutal, in Afghanistan, which was a Kusana dynasty sanctuary related to a fire cult, was raised in opposition to the sanctuary temple of the K'ang-chü. The Kusana eventually destroyed that temple. According to S. P. Tolstov and B. J. Vajnberg (1967) Koj-krylgan-kala had a cultural resurgence that lasted until the fourth century A.D. before its total destruction. From the artistic point of view, Koj-krylgan-kala is of enormous interest for its configuration, with many vaulted crypts, the techniques used, and the attempts after aesthetic effects. That it was ever a cultural or religious center, truly open to the masses, is dubious. Secondary local finds — for example, some of the terracottas — are highly refined.

In conclusion, while large, Hellenistic type cities flourished (along with strong Iranian and local elements), at the same time, and in close proximity, there were centers created by autonomous cultures which evolved refined architectural techniques and other skills. These centers, among others, are characterized by circular ground plans (as at Ecbatana and certain Parthian cities). It was assuredly the ground plan of Assyrian military encampments. S. Tolstov has rediscovered these circular ground plans in other Aval centers which are connected among themselves by common funereal rites of cremation and ties to astral cults. Interchange between different cultures, all with strong characteristics, is not only evident, but seems constant and almost inevitable. The current state of our knowledge makes Dasly III seem the prototypical Central Asian construction by dint of its circular ground plan. It is significantly older and larger than Koj-krylgan-kala. In the realm of figuration, the prevalence of Hellenistic tastes and designs, where they are manifested, seem instinctive additions. This produces a new problem of determining the influence that the diffusion and vitality of Greco/Battrian art had on the interesting centers such as Khalchayan in Transoxiana (southern Uzbekestan), and finally on the enigmatic and immense phenomenon of so-called Gandharan art.

The arts of Gandhara (Kandahar): a) expansion into central Asia. — The spread of Hellenistic figurative components is connected with the expansion of Buddhism along the grand caravan route advancing towards China. P. Daffinà (1975) denied the existence of any conclusive proof for Buddhist penetration into the Tarim basin or Margiana prior to the second century A.D., the indisputable date for the great Kusana expansion into the oasis of the southern caravan route. Buddhist expansion in this period brought with it figurative manifestations of a Gandharian variety. In the time of Kaniska the Victorious, the image of the Buddha with "himations" was already so diffused that it appeared on this sovereign's coins with a Greek inscription.

The beginning of the Kaniska empire can be placed between the beginning and the middle of the second century A.D. It is highly improbable that in the years between 130 and 140 A.D. the Kusana empire was connected with the Saka era. P. Daffinà has demonstrated this. However, two important inscriptions have been discovered that undermine the ingenious and brilliant logic which led him to decide on 144 A.D. as the

first year of the Kaniska empire, even though his date is not far from the true one. Daffinà's hypothesis, leaning toward the decade indicated, seems well founded and almost indisputable. All of this offers only a vague chronology, but at least it gives us a *terminus ante quem* after which Buddhist aniconic art must have been spread which cannot be separated from the first flowering of Gandhara. This is also true in the case of anthropomorphic images of the Buddha, which can be attributed to the Mathura school, winter capital for the Kusana.

That the Gandharian expansion in Central Asia had broad and rich effects is demonstrated by the mural pictures of Miran (east of Niya, on the southern path of the caravan route about 300 kilometers from the ancient confines of China). These are among the few surviving paintings from the school. They were found far from the actual area of expansion and the school to which they belong. Characterized by a precise iconography these pictures, signed "Tita," can be reunited, especially in terms of the Buddha image with his enormous *usnisa*, with certain sculptures held in various museums, above all, that in Pesavar. These sculptures are characterized not only by iconographic elements that reappear at Miran but also by illusionistic space which constructs a particular kind of rotating perspective in a search for anamorphic effects. This will be discussed more fully below. The pictorial patrimony of the Gandhara school is thus somewhat enriched. Beyond a new painting from Hadda, which can be added to those already noted, and the painting from Butkara, a cycle of murals still partially conserved around the edges has been discovered at Tepe Sardar. Although of considerable importance, the cycle has not yet been published.

The expansion of the Gandharan current in Central Asia is undoubtedly connected to the military and political growth of the Kusana. J. M. Rosenfield's brilliant book (1967) demonstrates the relations connecting part of the Gandharan current with the world and culture of the Kusana. This is accompanied by a series of observations that shed considerable light on the era of Kaniska the Victorious, as well as anticipating the serious crisis immediately following his reign. It is certain that the moment of Kusana expansion into the territory under discussion saw the development of a stylistic/iconographic language. This artistic basis characterized the first phase of Central Asian figural evolution within a large expanse that, reaching into the East, encompassed the entire Tarim basin. This refers to all the centers located on the silk caravan route, those on the southern track as well as the northern. Before going into the characteristics of the background, it is necessary to consider the problem offered by Khalchayan sculpture and other related schools. These will be investigated from both an archaeological and a stylistic point of view.

b) The problem of Khalchayan. — Khalchayan

is located on the right bank of the Surkhan Dar'ja in southern Uzbekistan. The site offers many ruins of fortifications and a palace complex of extreme interest because the central part of the facade is open, like an iwan, but supported by large wooden columns resting on a stone base. It seems that this formation signals the ulterio archetype, or absolutely a genuine and original model for what would become one of the most characteristic architectural aspects of Islam. This confirms the Central Asian origin for the iwan. The palace complex firmly attests in plan and construction technique the preponderance of deeply local traditions, even if many of the ornamental elements appear, instead, to have foreign origins: Iranian on the one hand, Hellenistic on the other. Ornamental forms used include acanthus leaves, friezes of crows and ribbons (in Achaemedian and Parthian form), moldings, and cornices. The inside of the pseudo-iwan and the adjoining audience room were decorated with mural paintings and statues.

Only traces remain of the murals. They are often faded, especially the ornamental friezes, but it is not impossible to recognize large pictorial compositions in which figures appear. The ethnicity and sex of the figures are defined. The composition alludes to an ideal presence of nobles of foreign birth. The statues on the other hand, were first refined in clay, roughly modeled and outlined before being committed to definitive form in blocks. Images were both in high relief (the compositions applied to the walls) and in the round. The central panel represents a regal scene showing what was probably the king and queen, flanked by the court. The other two panels represent, respectively, a cavalcade with horsemen shooting arrows (south side) and some sort of procession (north side). Above the central panel there are three divinities (a Victory, a Mithra, and a bearded figure which has not been identified).

Clearly subordinate to the architecture, even in the proportions, which are carefully calculated, the images that decorated the audience hall (in the pseudo-iwan only four statues were found) display the search for unique perspective effects. Placed three meters high, in respect to the floor, the figures are employed in a perspective foreshortening that gives the impression of images advancing out from the wall toward the spectator. Above all, the horsemen seem to leap in a gallop onto the guests standing below. The sculptures may have been polychrome to reinforce the effect, even if the coloration appears to be used to accent the expression of faces and the volume of the figures visible from a distance (given the height of three meters from the floor and considering the movement of the spectator), and especially from below. The system used to obtain the effect was to make the lower part of each image in bas-relief with further projections provided until the top of the head is reached. Thus, the heads are cut away from the walls; the distortion was used to accentuate the effect of detachment, the heads leaning out toward the floor below.

The search after perspective is even more important because it preludes others in the same field, specifically from the Gandhara school. One keeps in mind that the talented critic G. A. Pugacenkova, who was also the fortunate discoverer of Khalchayan, notes not only a strong Hellenistic component in the sculpture of Khalchayan, but dates the whole complex, with great probability, to the I century B.C. He gives this date keeping in mind the images representing the mysterious Heraus, a personage among the very first of the Kusana sovereigns, who is known only from his coins that are datable to the second half of the I century B.C. There is no doubt that at least two Khalchayan rulers closely resemble the monetary portraits of Heraus (who is the first Kusana sovereign to stamp his own coins).

Pugacenkova establishes the date for the end of the locale to between the third and fourth centuries A.D., for reasons that, in our opinion, are not clear. Moreover, he advances the hypothesis that Khalchayan could have been the residence of Heraus (with the same caution and honesty which distinguishes him) and concludes in attributing to the locale in question an intermediate position between Greco/Battrian sculpture and the more authentic sculpture of the grand Kusana (which is found, other than at Surh Kutal, at Ajrtan and Termez). To these examples one can add the famous works from Mat, near Mathura, which offer firm agreement with Pugacenkova on the fact that the presumed Indian component he anticipated could also be a spurious component or at least not clearly or genuinely Indian.

What is indisputable is that in a very ancient epoch, for as important a monumental complex as Khalchayan, unknown artists sought perspective and anamorphic effects with the objective of making sculpted decoration more impressive for a regal audience hall. If one considers the present state of facts received from excavations (campaigns from 1959 to 1963) and the fundamental work of Pugacenkova (1966 and 1971) into the argument, the importance of the Khalchayan discovery is obvious. Not only does it represent an important juncture in our knowledge of Central Asian art and the related problem of Gandhara, but this discovery has yet to show all of its possible implications due to the wealth of material and lack of time.

It has already been established that the term "Gandhara" is one of convenience, almost conventional, justified only by the fact that the region of Gandhara is, without doubt, one of the richest in works produced in the Omonima school. It is also acknowledged that the classic "Hellenistic" component (as well as "Roman") is a characteristic distinction - so much so that one still speaks of Greco/Buddhist art, or even Greco/Roman/Buddhist art - but is not the only component. In any case, the art of Gandhara is included, if only as a preeminent and, so to say, disruptive phenomenon among those figurative currents that D. Schlumberger defined as "non Mediterranean descendents of Hellenistic art." Beyond an ancient Greco/Iranian presence - which can also be seen at Ai Khanum, where it alludes to the possibility of fusions between different tendencies - the arts of Gandhara are also characterized by the presence of anticlassical elements and figurative solutions. They are similar, but not identical, with those that can be found in Parthian art. These anticlassical solutions (rigid, frontal images and processional dispositions) seem ascribable to a taste dominating under the grand Kusana in the period beginning with Kaniska the Victorious. Later they make only negligible appearances as stone sculpture was replaced by stucco.

This replacement is accompanied by a Hellenist revival of a kind of impressionistic style (which is commonly defined, perhaps with greater correctness, by the term "sketchy") which is inseparable from a romantic and sentimental component that includes many representations of episodes from the life of Buddha. This is obviously in inexplicable contrast with the very essence of the Buddhist teachings. In fact, this last observation tends, by its nature, to reduce the sentimental values within extremely diminished limits in an effort to annul them. It is worth noting, however, that the diffusion in Mahayana (one of the three main Buddhist currents) give exceptional prominence to the figure of Bodhisattva. He is, in reality, a living contradiction, as C. Pensa has demonstrated. Having reached Illumination, Bodhisattva renounced Everlasting Life and the tranquility of Nirvana to stay on the earth. He was inspired by a feeling of compassion for men (karuna). This was a feeling that he would have been able to overcome. Yet he existed among men, serving as an intermediary between the level of man, with his passions, and the Nirvana, created by the Buddha.

In turning to the relationship of interventions between Khalchayan and the school of Gandhara, it is seen that the presence of stylistic elements and Hellenistic figuration at Khalchayan is part of a search for illusionistic effects (of perspective and anamorphic). This could be of classic origins, given the studies of optics done in the West and their application to the figurative arts (for architecture, I remember most of all "De Architectura" by Vitruvius, III and VI, Damiano, ed. Berlin, 1897). In our case, a nearly similar phenomenon seems affirmed by Pliny, N.H. XXXIV (a passage almost certainly derived, according to S. Stucchi (1952-1954), from Zenocrates of Athens), which, referring to Mirone, maintains: "Primus hi [meaning Mirone] multiplicasse veritatem videtu." "Multiplicare veritatem" certainly alludes to the multiplicity of possible different visions on the part of the spectator, in whom the images maintain the maximal probability. One can cite, as confirmation, Quintilian (Inst. Or. II) who, speaking of the discobolus by the same Mirone, says, "in voltu [var. in vultu] mille species." The thousand aspects of the face are those obtained with "multiplicare veritatem."

c) "Rotating perspective". — I have had various opportunities to accent the presence, in Gandharan creations, of compositions or narrative panels in which the construction of figurative spaces through perspective devices are evident. They are used to maintain the force of the image - for the eye of the spectator - as long as possible. One must bear in mind that these panels decorated the barrel of the stupa. They were designed for contemplation by the spectator while engaged in pradaksina (the rite of circumambulation around the stupa). As a consequence, the panels were placed high in relation to the spectator. This allowed viewing to last as long as possible for the spectators moving and walking around the stupa at a lower level. The rigorous measurements made by Anna Maria Di Pascale on a small but significant selection of sculptures belonging to the Museo Nazionale di Arte Orientale in Rome confirm the use of different solutions to obtain their effects. The measurements deny that distortion was due to the attachment of figures to the background. This is to say that distortions were partly unintentional. Chiefly, this is seen in the convex arrangements of the images forming the first and principal level of the scene (which is almost always the same thing). Each figure stands out from the background plane with progressively greater projection until the maximum projection of somewhere between three and six millimeters is reached. The average extension of the panel itself oscillates somewhere in the area of 30 cm. Successive figures curl in toward the background, at times until they sink beyond the theoretical background, being left with negative dimension rel-

ative to it. The increase in projection progresses from right to left (pradaksina is done clockwise) with reduction. At times this is emphasized and abrupt in the second part of the panel. Regarding the length of the base of the scene (between 26 and 35 cm), the increase in projection concerns a major feature - at times in a very perceptible way - of how much space would be left empty due to the reduction. Going back to the horizontal arrangement of the figures and entering the maximum projection of the figures themselves into a system of longitudes measured in centimeters (corresponding to the length of the panel and the reciprocal distance of the personages) and ordinates measured in millimeters (the maximum projection and the dislocation of the median axis by each figure) the system describes an irregular curve. In reduction it gives the impression of a sharp drop.

By means of this inquiry into illusion and perspective, the spectator in motion is offered an incalculable multiplicity of visions. These are all contained within an arc smaller than 180°; the actual angle is still close to this number. The figurative space of the compositions is designed, undoubtedly, in terms of the myth of pradaksina, with a precise objective. In fact, it tends to enlarge the reception of the message contained in the panel (and transmitted from it) to the maximum possible limits. Thus one makes an indisputable effort to "multiplicare veritatem." Since the system itself is conceived in terms of a rotational movement (completed by the person using it), the system itself can be called "rotating perspective," but we can also propose the wording "foretica cycle." One important series of distortions, otherwise inexplicable, of the stone Gandhara images themselves is fully justified by the effort to construct spatial and compositional structures employing this "rotating perspective." On the other hand, it appears clear that the search for these optically illusionistic effects had antecedents in the perspectival structure (illusionistic, in a different way) of Khalchayan sculpture itself. This demonstrates the existence of a search for optical effects in sculpture occurring even before the flowering of Gandharan art proper, if the date proposed by Pugacenkova is, as I believe, accurate.

d) The precedence of Bharhut. — It must be further noted that Maria Spagnoli (1971) has observed the presence of analogous searches even in some bas-reliefs from Bharhut (for example, the Visvantara-jataka on a segment of the vedika from the stupa that is conserved in the Calcutta Indian Museum). In this case, the intentions of the anonymous artists are perfectly analogous to those recognizable in Gandhara works, even if, for Bharhut, one discusses the decoration of the vedika (that is, an element of foreign manufacture, and, in this specific case, of a panel put in a high place), rather than the decoration of the barrel of the stupa. It is clear that a vast movement, with the same will to achieve optical and illusionary effects and the stimulus offered by perspective, unite Khalchayan, Bharhut, and Gandhara. Diverse figurative manifestations which change according to the epoch, locality, cultural base, and subjects represented use analogous expressive methods to confer impressive and aggressive values on their creations. The problem offered by these complex manifestations is not only historical/artistic, and not

only invested in the creation of a figurative space "sui generis" and the value, already discussed, of perspective (which remains a symbolic form, but, for the case in question, seems strictly tied to sociological values - an opinion held by Francastel), but overflows into the area of the theory of communication. One notes that for two of the figurative manifestations taken into examination the source of inspiration is Buddhism with its unique rituals, although these same manifestations give particular weight to the circular movement of the spectator.

There is no doubt, in fact, that, whether it be at Bharhut or Gandhara, the devotional rite of circumambulation itself determined the solutions adopted. For Khalchayan, instead, optical effects are used to obtain aggressive and psychologically intimidating effects. Visitors are put in an enclosed, delimited space. Movements that are usually possible become rather restricted. It is, thus, even easier to willingly submit to the experience with the disconcerting effect of imaginary and impending presences. In an historical sense, the optical/illusionary effect recurring in the art of Gandhara, with the precedence of Khalchayan, is a key element in determining the force of Hellenistic influx and the capacity for adaptation and transformation that the attitudes of the Gandharan artists displayed. In fact, in the classic world there is nothing truly similar, perhaps because it lacked the force of necessity, tied to the pradaksina rite. Additionally, technical knowledge and observations in the field of optic effects almost certainly have Western origins. (This is not to say indisputably, if we adhere to available and documented knowledge.) This is especially important for Bharhut, where the classical component was nonexistent and the conception of figurative space was modified in terms of a autonomous taste. Since this was exceptionally different from a Western taste, the presence of solutions that, as much as they seem so, cannot have had Greco/Hellenistic origins, is exceptional and fascinating. In concrete application, the complex of figurative knowledge, stemming from a Greco/Hellenistic origin, appears prematurely at Bharhut (in the Sunga epoch) in regard to the more abundant diffusion and applications in the art of Gandhara. Furthermore, it is used by the artists explaining themselves with an autonomous figurative language. There is a tendency toward two dimensions, infused with reflections of Achaemedian art. The objective is the attainment of those optical/perspective effects the Gandhara school also developed in three dimensions which much more accentuated and much closer to major Greco/Hellenistic works. In order to transfer foreign, illusionary notions, means, and perceptions to work with completely different volumetric foundations, the artists of Bharhut must have made a genuine effort to adaptation while inserting into their expressive language - coherent and rigorous – the gist of a foreign experience. In the area of figuration, this world was almost an antithesis to that which they had created. In every case, the indisputable (and photographically documentable) presence of this particular perspective at Bharhut remains enigmatic.

e) Value and evolution in the art of Gandhara. — Since Gandhara was the arena with the capacity to delineate principal value changes, it comes to our attention that the modern vision of

Gandhara tends, in the first place, to underline the autonomy and the indisputable "personality" that makes it a broad expressive system, mostly inspired by Buddhism (but also by other religions, for example, Scivaism and the religion of Iran). This system is not only strongly characterized, thus rendering it unmistakable, but it had the capacity to exercise influence within a wide radius, then comprising all those flooding into Central Asia. Thus the art conventionally called "from Gandhara" is, in the first place, itself, even if it developed in a vigorous way under the great Kusana, thus appearing, in part, as an expression of taste and culture of the Kusana. It also appeared to re-enter the framework of figurative currents derived from Hellenism. Gandhara's involvement with this phenomenon is assuredly broader than might ever have been thought were it not for the innovative determinations made by D. Sclumberger. As well, as Maurizio Taddei (1972) has intelligently pointed out, one cannot search for precedents for Gandhara art only in Greco/Battrian art. It is sure even that Hellenism Scythian/Parthian had significant weight in the configuration of its physiognomy and the gold monetization of the Kusana, in part exemplified by Roman money which was clearly opposed to the exclusively silver monetization of the Parthians. This demonstrates that the Kusana themselves looked with much greater interest to the Roman Mediterranean than to the bordering Parthian world which was commercially little adapted (because of its use of greedy and selfish economic means) to encourage a broad development of traffic which, in any case, would have been moving toward more distant territories in their search for a more open society than that of the Roman Imperial empire. Taddei notes that these "commercial relations" undoubtedly represent — in both his and my opinion — the conducting line along which was disposed the rich "classical morphology of Gandhara."

Even if the presence of classic elements is indisputable and preeminent, there does not seem to be any clear alternative between Greek and Roman inflections. Thus, what is important are the reasons and the character of the choices made by the Gandhara artists. Such a positive result — beyond those already achieved or available through traditional study of iconography, which is more developed today — could also have been reached using a semiotic method that, for now, was utilized in preliminary research (published and not published). It seems a promising approach, at least within the limits of symbolic language and iconographic solutions adopted into the scope of Gandharan art.

Additionally, there is no doubt that, at least for several works from Gandhara, much older dates must be given than previously thought. Regarding several images from Butkara in the Swat valley, Taddei has observed unusually prominent analogies with productions of the Ganges area — for example, with the Yaksa of Patna, which are currently dated to the first half of the I century B.C. At the same time he cites the "Gandharian" lid with lotus flower decorations, which are found again in Tall-i-Takht Takht of Pasargade (see D. Stronach, 1964 and 1965), or, in the context that it arises, as first origins, in 280 B.C. (terminus post quem). The lid, which can be compared with other, similar objects from Taxila and Charsadda, seems to be proto-Gandharan, of Sythian/Parthian manufacture. It could be properly dated to the II century B.C., according to the

probable date confirmed by the research of K. Walton Dobbins (1973). These rediscovered objects, inspired by an undoubted classicism (indisputably) whether in the fifth stratum of Sirkap (Toilet-tray in green shale), which is now datable to between 60 and 50 B.C., or whether in the fourth stratum of Saikan-Dheri, which entered its downfall in c. 75 B.C. C. K. W. Dobbins, who presents in his works many observations of considerable interest, concluded by specifying that the examination of works coming from stratified excavations and their comparison indicated the presence of a long period of production during which the school of Gandhara used as materials skyblue shale, a green variety (a clay), and a very dark shale. Throughout the period, a rigid stylistic coherence was maintained.

The period in question is datable, very generally to the beginning of the I century B.C. until c. 200 A.D. It was preceded by a brief "experimental" phase or, better, attempts. Apart from some arguable dates, we can affirm that Dobbins pinpointed the chronological great flowering of the Kusana epoch. This uncertainty still remains about the date that Kaniska acceded to the throne and it firmly asserts that the phase of preparation could have been much longer. D. Faccenna - who excavated and studied the entire complex of the Butkara stupa - recognized the origins of the stupa in question as springing from Asoka (and in fact the stupa is called Dharmarajika in an inscription that is characteristic of the Asoka foundation). The second phase, materially encompassing the structure belonging to the first, displays in its configuration, and above all in its cylindrical base, all the characters of archetypal Gandharan art. This phase is datable to between the end of the II century B.C. and the principality of I. The third phase is clearly mature Gandharan, datable to the beginning of our era (or just before). The fourth phase is clearly Kusanian.

Notwithstanding the prevalence of stylistic unity in the Kusana epoch, the possible existence of separate schools or workshops, or even of preferred currents, should not be neglected. Neither should the indisputable effects of conflict between classicizing and anticlassicizing expressions go unnoted. Dobbins' research is limited exclusively to works from excavations with great stratification. In consequence, he provides indications of general trends that have exceptions, particularly when he deals with peripheral zones, even if they are of exceptional interest, like the valley of the Swat. Where the continual recutting of sculpted panels has quashed any hopes of determining a relative chronology.

f) Discoveries in the Swat Valley and at Hadda. — If these are the most important facts concerning the productions of Gandhara, it is also important not to neglect the Italian excavations in the Swat valley that have uncovered an enormous amount of material. The material appears stylistically diverse and exhibits some representations of subjects which are not found in the greater part of productions from other places in the Gandhara. Some of the motifs can be considered new for example, the Poligar divinity with the characteristic many-pointed crown. Some works are stylistically exceptional for the ornamental importance assumed by the drapery, which shows sharp and narrow folds. The cloth is transformed into a decorative motif

through the folds wholly permeating the area. There is resonance of this usage in the lines used to represent hair on top of the head. Even the conception of space is exceptional. It is conceived as horizontally receding lateral planes in a kind of false reverse perspective.

A note of extraordinary importance is offered by the Afghan excavations in the Hadda zone (the site of Tepe-Shutur), where a large Buddhist monastery has been uncovered. Here, around the major stupa - located in the court of the monastery itself - one finds 31 minor stupa, belonging to two distinct groups. The first of these is datable to before the middle of the fourth century A.D., while the second seems to be concentrated in the 20 years between 380 and 400 A.D. This date is supported by coins that were also discovered. The pseudo-Corinthian capitals that decorate the first group of stupa have one or two rows of acanthus leaves. The central points of these fold back on themselves, making a "curl" between the two sides. This is a type characteristic of Ai Khanum and Termez. Through intermediate passages, it ended up at Hadda in the terracotta phase, demonstrating the vitality of the Battrian solution. In the second group of stupa the motif is ignored; the central sections of the leaves rise to the right towards the top, where they are cut off.

A notable number of good quality sculptures show the Buddha, always seated, in the Indian manner, and the Bodhisattva present. But the most prestigious discovery was that of a large cell, on an almost square plan (2.90 x 2.40 meters), where the conversion of Naga Gopala was represented. This was a myth traditionally localized in this zone. Images are presented totally in the round or in strong relief. Found in the large cell are compositions characterized by illusionistic effects that create an environment. In a different sphere these compositions could recall other types of effects. The episode represented occurs deep underwater, in the fountain where Naga lived. In the center there was a Buddha accompanied by the inevitable Vajrapani and surrounded by about a dozen other characters. Of these, only six have survived, on a good part of the walls. The walls themselves are intermittently covered with sinuous waves that, at times curl up into spirals, alluding to whirlpools. Large lotus flowers, a whole school of fish, and water monsters (one with two heads, perhaps representing the evil forces of the deep) completed the decoration. Apart from the very fine quality of the work and the extraordinary fantasy with which the personages are represented (among these, the head of Naga survives, with animal-like teeth), the cell must have truly given the impression of an episode occurring underneath the water. There was a search for optical and other effects that were realized with rare efficacy. The representation of wet clothes on moving bodies is very impressive. The clothing looks wet, flattened by the weight of the water.

This representation of a sacred episode in a watery environment surely alludes to the "sovereignty" the Buddha has over all the universe, even in the waters of the deep. This might have had a psychological inspiration. There may be a connection with the monolithic stupa in Haibak, Afghanistan, which was probably meant to be surrounded by water. This has been discussed in the section on India. Something similar, but refering to a water cult of Zarafsan, is found at Pjandzikent, in an iwan of the 2nd temple, within the so-called Sahristan. There is a wall decoration in stucco,

which extends for most of the length of the frieze. It is animated by Tritons, marine monsters, makara (or something similar and certainly derived from Indian motifs of the makara), and fish. It reproduces, with a fairly efficacious stylization, an underwater environment, where a feminine aquatic creature appears holding a small architectural model. Although she appears above the frieze, she is an integral part of it.

To return to Hadda, there is a picture fragment that bears the lovely head of a youth with a thick mustache. It is painted in ochre colors. It is impressive for the rapidity and sureness of handling as well as the very abbreviated style. From the historical point of view, the new excavations in the Hadda zone confirm the destructive actions of the Ephthalite, even if the testimony of Hsüan-tsang, the famous Chinese Buddhist pilgrim, demonstrates that he was, on the whole, less radical than had been thought when research was begun in this zone. It is, however, certain that the iconoclastic frenzy of the invaders infuriated the religious body. It is also certain that the entire complex was burned. The great damage produced also has grave results for modern archaeologists and historians of art. However, the quality of the works and the vivacity of the classical-Hellenistic component, maintained until the last phase throughout the complex, makes the rediscovery of Tepe Shutur an important point of reference (I would say it is even a parameter) in the evaluation of the stucco phase in Gandharan art.

The problem of Bamiyan and the taste for gigantism. — In his book, already mentioned, Rowland emphasized the importance that the center of Bamiyan had in terms of diffusion of motifs and schemes, actually from Gandhara, within the Central Asian territory. It seems to me, without at all belittling the importance of Bamiyan, that the mediation of diffusion occurring as currents passed through the Swat valley must not be neglected. I still maintain the same hypothesis that the Gandhara paintings must be considered products of a school, notwithstanding the existence, already noted by Sir Aurel Stein, of certain analogies with the Parthian pictures of Dura Europus and Coptic/Alexandrine productions. It does not seem possible to me to separate this pictorial cycle from the sphere in which the sculptures from the Mardan collection, now in the Pesavar Museum, were born.

These sculptures originate precisely from the Swat valley. They demonstrate certain congruencies, like the enormous usnisa of Buddha or the same perspective structure that, in its way, recalls the effects sought in Khalchayan. Today conception of Miran as a type of "unicum" is secure, while the dating of Bamiyan must certainly be pushed back by quite a bit, because the colossal Buddha of 53 meters appears to date from the third century A.D., rather than the fifth century. This significantly revises the perception of the entirety, when one considers the function exercised by this important cultural and caravan center within the figurative equilibrium of Central Asia. In fact, today Bamiyan can also be seen as a source of diffusion and modification of Gandharan schemes, at least in terms of iconographic and stylistic solutions in the plastic arts. Bamiyan also appears as a documentary whole of quite

different values in terms of the surviving pictures (which are now being restored).

It is indisputable, however, that Bamiyan offers us the best extant testimony on the tendency to gigantism in the sculpted image of the Buddha. It is a testimony that, absolutely, makes this statue of 53 meters the largest in the world. At the same time it should be noted that the enormous size of this existing image, made in stone with very complex technical devices, is realized in a most difficult form and condition. This means that, if the images are reinserted into the scope of Gandharan art, it becomes apparent that the phenomena of "gigantism" - undoubtedly determined by the symbolism of proportion - has origins in the same school that created, by using wooden scaffolding, the "highest tower in all of Jumbudvipa," according to the expression used by Chinese pilgrims in reference to the stupa of Kaniska. The tendency to giganticism, confirmed in the Commagene, was already present since the second century A.D. in Margiana. The Buddhist chapel of Giaur Kala (the Antioch of Margiana), with its enormous, red stupa, conserved the head of a large Buddha. It is 72 cm high, which means the entire statue would have measured around 5 meters. It was recovered and correctly encased in a wall when the statue collapsed, sometime between the fifth and sixth centuries.

Apart from the proof that Buddhist expansion had already reached the Merv region in the ancient epoch, it appears clear that the tendency to giganticism which culminated at Bamiyan and was already active in the Kusana epoch was the derivation of other enormous images. Examples include the Dying Buddha at Adzina Tepe (650 - 750 A.D.), which was 12 meters long. This in turn recalled the large Dying Buddha from Polonnaruva (Ceylon), the seven meter tall Buddha from Kakrak (fifth - sixth centuries A.D.), and still others, such as that from Tepe Sardar.

Tumsuq. — Bamiyan played an independent role in the artistic evolution of Central Asia. The paintings flanking the various images of the Buddha can only partially be connected to the Gandhara school (as always with deviations, partially reworked, perhaps due to the influx of late Western influence). Their esoteric symbolism is as ambiguous and enigmatic as is their provenance. It seems acceptable that the Gandharan diffusion in Central Asia was much broader than had been thought. This is attested to not only by Miran paintings that - it bears repeating - constituted a "unicum," nor by the Gandharan works rediscovered at Turfan (at the extreme east on the northern track of the caravan route). As noted by Albert von Le Coq, these works probably had some influence on local westernized creations.

It is sure that the area of Gandharan infiltration, intense and vital, clearly extended to Tumsuq. Discovered by Paul Pelliot, the site is located to the west of Kuca. It has been perceptively and exhaustively studied by the staff of L. Hambis. Correspondences with the Gandhara school are, in fact, clearly apparent in a part of the plastic productions of Tumsuq. These are exhibited in their stucco works and the so-called technique of "ripiego." The site was destroyed by a fire in the tenth century, perhaps at the time of the Muslim conquest. Colored sculpture was widely used, while painting

seems to have been less prevalent. The artisans used mostly poor materials due to the almost total lack of stone that could be worked with a chisel. They chiefly molded terracotta, clay pressed onto a skeleton or framework of wood or panels of bound straw, gesso, and, more rarely, stucco.

One notes that Madeleine Hallade - without excluding the economic factors which would have encouraged the spread of these techniques due to the probable exhaustion of the shale quarries - reconnected the flowering of plasters in the art of Gandhara (second phase) to the intrinsic malleable quality of the material. It is much better adapted than stone to render a Hellenistic, sketchy impressionism, which corresponded to the tastes of the time. The observation, in part at least, is valid also for Tumsuq where, later, under the Chinese domination of the T'ang, only two plastic techniques dominated: that of working in clay mixed with minced straw and that using shreds of rope and silk soaked in lacquer. The "moldability" of these artificial materials is obvious even if different elements were emphasized in different works. The derivation of Tumsuq works from the Gandharan world is clear for a period of about two centuries. Subsequently, the figures follow a progression similar to that of Indian art, even if there often remain perceptible Gandharan traces.

The Khotanese and Chorasmiana areas. — The persistence of the Gandharan matrix is much more tenacious in Khotan. The use of the stupa as a celebrative and votive object, some characteristics in the plans of various monastic complexes, the type of mural decoration, and the adoption of themes and ornamental motifs from Gandhara reconfirm the facts of a renowned persistence that continues beyond the fifth century. There are also echoes of the Greek/Roman/Buddhist world. Thus, the presence of Buddhas flanking the large stupa of Ravaq (a locale very near Khotan) demonstrate, in their stylized drapery, an undoubted affinity with analogous solutions in Hadda. However, at Yotkan, busts of musicians placed in niches continue to recall, with strong modifications, motifs preferred in the first epoch of the Gandhara school (from Ajrtam to Bamiran). The small figures in terracotta from Yotkan, exceedingly numerous, often seem reminiscent of a taste from Sogdiana and Chorasmia (that is, the western Central Asian regions), without which it would be impossible to delineate whatever succession of phases or tastes. One notes that Yotkan survived at least for a century after the Muslim conquest. For reasons impossible to determine, the center was abandoned almost suddenly.

More to the east, at Niya, the scarce remains of mural figures present motifs of a Gandharan type (floral ornament). This is the site of the discovery of the famous seal of Athena Promachos, shown armed with lightning. It is, perhaps, of Western classical make. In any case, it is firmly connected with a more refined Hellenistic taste. It is not easy to establish the epoch in which such objects as the Athena Promachos were made in Central Asia. It is certain that, for a brief period, the Kusana empire included within its own confines all of Chorasmia (Khwarezm). Nevertheless, the effects of the domination, followed by a phase that was predominantly cultural rather than political, were not such as to

introduce the Gandhara style directly into the Chorasmiana area, which remained autonomous. It developed effects dependant on strong relief, satisfied with a heavy impressionism. This reveals an effort to express a rigid majesty and to attain an idealization of local regality. The results are not so different from forms found in the lower Roman empire. The charismatic perspective used to represent the already divinized emperor is handled in a way which is also determined by the search for the "colossal."

On the other hand, it is not difficult to perceive, in the alabaster heads from Afghanistan, discovered at Toprak-kala (third and fourth centuries A.D.), reminders of figurative conventions already in use in the West. For example, there is the colossal statue representing Commagene. In clearer terms, while the presence of Gandharan influence is noticeable and indisputable, it is not easy to determine just what is properly derived as inspiration from this source. This is not to exclude, in fact, the knowledge of other sources of inspiration that themselves belong to so-called "non-Mediterranean" Hellenism. Nor does it deny the "possible" presence of Western contributions, although such an impact would be unusual. However, the more than probable classical/Syrian component that would be able to insert itself in Manichaean works should not be forgotten. The persistence of contacts with the West is attested to, among other ways, by the bronze statuette of Saint Peter which was copied from a large Roman bronze. It was discovered at Carsadda and immediately lost. Only photographs remain of it. Some Ephthalite tribes were converted to Catholicism (fifth to seventh centuries). Their request for a bishop to be sent from Rome confirms this. These conversions can explain the phenomenon of the presence of the Saint Peter bronze. This firmly asserts that contacts with the Roman/Byzantine West are never completely interrupted.

From Fondukistan to Tumsuq and Tepe Sardar: A new problem. — The problem of the Buddhist monastery from Fondukistan, which was discovered in 1937 and probably dates to around the seventh century A.D., has become more complex in the last years. The characteristic style of Fondukistan presents iconographic elements which surely derive from India. Inscriptions appear that at times seem Iranian and at times conform to distinctly Central Asian modes. There are analogies within the tenuous extension of images in the so-called third style of Pjandzikent. Given the growth in our knowledge stemming from objects uncovered at the site, today the Fondukistan style can no longer be separated from that of Tumsuq in certain phases. As well, there are some more minor connections with some works from other centers in the Tarim basin and Soviet Central Asia. An even closer correspondence, mostly stylistic but also iconographic, is found in the works from Tepe Sardar, which is in the area of Gazni, in Afghanistan. Some works are extraordinarily similar to those from Tumsuq and Fondukistan. The excavations of the Italian archaeological Mission at Tepe Sardar determined that this ancient and sacred site seems to have been in full flower in the years immediately preceding the Muslim invasion. Taking the situation as a whole, it appears verifiable, as M. Taddei has observed, that the cultural area of "Central Asia"

extends far beyond the territory of Central Asia itself, penetrating into the entire northern zone of Afghanistan. It was here that the union occurred with a nearby cultural area, but even closer, in terms of its actual geographic position, to the Gandharan traditions. This encompasses the region going from Kabul and Hund (on the Indo, near Attock) to Kashmir and the Swat valley. Positioned between two different worlds, even if there were some similarities and contacts, this is an intermediate zone. In practice, it serves as a pivot point and junction, far from the zone of interference, often showing impulses not wholly autonomous.

The stylistic connections which put Fondukistan side to side with either Tumsuq or Tepe Sardar confer on Fondukistan itself the value of a local and homogeneous expression. Quality is very high, emerging from a broader foundation that presents obvious common characteristics, drawing Tumsuq near to Tepe Sardar and including Fondukistan itself. It is nevertheless seen that each particular stylistic and iconographic element common to all three centers presents different inflections and appears with different symptoms and frequencies. This demonstrates a notable variation in valuational vision in terms of common influences. The art of Fondukistan emerges (and takes shape) in a sphere of common foundation, for its extreme finesse, that at times becomes almost mannered and extenuated, as well as the type of iconographic and compositional solutions adopted. They are above all the result of the profound re-elaboration of an Indian component and of another, Iranian component.

This language separates itself, in various ways, from the relevant search for expression in the surrounding world. Thus, the human figure, even if it represents a divinity, becomes an ornamental element and is used as such. As it is a possible point of inspiration, one notes that analogous figurative value is not unknown in India. Nevertheless, in the Fondukistan works the ornamental exploitation of the human image is not only accented in formal expression, but is sought and developed into an elegant manner of representation. When inserted into religious compositions they assume a particular duty, meant to present the subject in a summary and emblematic manner. In clearer terms, we can say that the painting and sculpture of Fondukistan are constantly permeated by a decorative schematization that translates both a different "vision" of the represented subject and a profound modification of the method by which edifying content is "transmitted" to the spectator.

In the pictorial arena, classic examples of this manner of expression are the two divinities of the Sun and the Moon, discovered in 1936. This is especially true if one considers the stylized figures which surround them. In the sculptural field, the two Naga (Nanda and Upandada) that emerge at the base of the lotus flower stem (which represents the axis of the world) are an even clearer example of this decorative sensibility that, in this specific case, is emphasized by the curving divergence of the bodies. A similar motif, realized with different stylistic approaches and with numerous figures, is found also at Tepe Sardar. This site, for which the excavations are all but complete, displays a succession of stylistic phases that seem to derive from a period that can perhaps be connected with Khalchayan and, thus, with the Kusana epoch until a much later epoch. (A fragment of a terracotta head with tall, conical headgear

has been related by M. Taddei, director of the Tepe Sardar excavation, to the head from Dal'verzin Tepa in Uzbekistan, c. second century A.D.) This is confirmed by the images from Durga Mahisasuramardini, from which we know the body of a buffalo-demon killed by the Goddess. Standing on a pedestal, the body of the animal is highly stylized. It is realized with a sensibility that is certainly foreign to India.

Another example is the stupendous, gigantic head of the Goddess (64 cm tall) characterized by the third eye on her forehead, refined treatment of the masses of capillaries, and an enigmatic smile. The moderate disfigurements the group has undergone in the course of the centuries has left the group intact. The theme of the Goddess killing the demon is a common iconographic scheme, but the quality of the Tepe Sarda group is truly exceptional. Probably datable to the eighth century, the group belonged, as Taddei observed, to a phase in which the synchronism between elements and religious motifs of Hinduism and Buddhism announced the growing crisis for the latter. This does not exclude that in the handling of the Goddess's face, as in that of a Lokapala covered with a clearly Central Asian helmet, the stylistic and sinuous handling of the arched eyebrows exemplifies a particular physiognomic vision. Even though there are precedents in Ajanta painting of the fifth century, this head is definitely autonomous and unmistakable.

Other images from Tepe Sardar present, at least, a giant Buddha, which seems able to be a portrait, to judge from several fragments. It displays a light, sketchy quality with no interest in violent movement of the folds nor for any strong physiognomic characterization. L. Hambis organized and studied the great amount of material acquired on Paul Pallio's expedition. As much as at Tumsuq (or Toqquzsarai), a picture arises of the center as a monastic complex made of unbaked brick. It was destroyed by a large fire. Causing even further damage was the establishment of a Muslim cemetery on the site. The center flourished between the fourth and the seventh centuries. There was a large court with a stupa, many sanctuaries, and monastic constructions from various periods. With a facade of 300 meters, the complex rose without any order or homogeneity. The richness of the plastic decoration in unbaked earth appears evident, even though a great amount of material has been lost. The passage from the Gandharan style to a more clearly Central Asian one is extremely evident. The decorations are always heavier than those of Fondukistan even though there are some analogies in the volumetric scheme of bodies and faces. Here, they are often stockier.

Tumsuq, however, displays a notable variety of iconographic solutions and expressive experiments in consequence of a rather chaotic evolution. Balanced, harmonic, and elegant images are side by side with others tending decisively to the grotesque. Some decorative faces with flattened and expansive volumes meet with others that are plastically dense and almost closed, especially the images of demons with hair of flames. However, the scarce pictorial fragments, of which the most important is that in Berlin, confirm a relative resemblance with Kuca works. There are also considerable differences. At Tumsuq, greater care is taken with details, in the sense of miniaturization. There is a more accentuated search for effects of "iridescent" light, which has a symbolic character.

The problem thus remains an open one of which direction the influxes and influences ran which animated the unified base created by Tumsuq, Fondukistan, and Tepe Sardar. This is dependent on the possibility that it is possible to suppose the existence of any unified matrix. It is a problem which, in the current situation, can appear better resolved presupposing a "descent" from Central Asia towards the south, with variable adjustments from center to center. There is an analogous position to that accented here, but one that cannot take into account Tepe Sardar and ties with Tumsuq. Barring reinterpretation, the works from Fondukistan definitely confirm and amplify the idea of a primarily Central Asian derivation. This is a view which has been widely expressed by B. A. Litvinskij and T. Zeymal in their volume dedicated to Adzina Tepe, published in Moscow in 1971. The two authors broadly confirm the hypothesis which I expressed in "La Peinture de L'Asie Centrale," published in 1963.

New critical perspectives. — To conclude, in our opinion iconographic elements of clear common ancestry assume, from time to time, modulations and a desire for significantly different effects. This is due to small and, apparently, secondary variations that instead end in modifying the basis of motif values which were graphically similar within their sphere of origin. There is differentiation both in plastic situations, which differ in terms of volume, and pictorial ones, differing in the use of line and color. There are substantial variations in composition. A vast geographical area extending substantially into bordering confines thus comes to be connected with Central Asia. It is correctly said, in critical examination, that this introduced a conspicuous series of archaeological documents significant for figurative quality and historical interest. In practice, this area becomes inseparable from the Central Asian figurative evolution, amplifying the magnificence of this artistic phenomenon, which has been identified for less than a century. With time, stylistic variety and historical importance is extended and sketched out little by little. With good reason, today the arts of Central Asia can be placed next to the principal figurative expressions of the continent.

The first expeditions between the end of the 19th century and the beginning of World War I searched in the Taklamakan zone for traces of older Turkish empires. There was no expectation that either the existence or the complexity of local, autonomous, pre-Turkish, or Turkicized cultures would be discovered. Analogously, extensive Soviet investigations have shown, in an unforseen manner, the amplitude of extension and the intensity of the figurative Central Asian phenomena. It is understood today that Central Asian phenomenon exist in an extremely vast territory. Until a few years ago, this dominant fact was almost totally ignored. The art of Central Asia, with its innumerable modulations and minute fragmentation, has become, therefore, a large entry on the page of the universal history of art. This has fundamentally and profoundly modified the historical/artistic physiognomy of all Asia art and, in a specific way, that of the Buddhist currents concerning a large part of the continent.

A very extensive body of works is rendered more interesting by the convergence, within itself, of different components having variable degrees of intensity. These serve as sources of stimulus and information for the taste and inspiration of numerous diverse local populations. This serves as proof of a capacity for autonomy, renewal, and a particular creative genius. Foreign components, independent of local re-elaboration and the indisputable inventive autonomy, are always the same in all zones, even if they vary in breadth and intensity. Consequently, for all of Central Asia, we can observe the succession of the three principal waves of foreign influence.

The first was a semi-classical type which moved from the Hellenized Greco/Battrian world and the Indo/Greco, thus assuming the aspect of a bivalent dialectic contrasting the classic with the anticlassic. This occurred in the Kusana epoch. Greco/Buddhist art of Gandhara had, in fact, effects of not negligible value even outside the area politically and culturally dominated by the Kusana empire.

The second phase, divisible into different periods and sectors, saw the prevalence of a taste that, at least in part, had an Iranian source and was a consequence of the Sassanian expansion towards the east. This phase is the most complex and controversial, not only because it is difficult to distinguish between local autonomous creations (from the regions that came to be called Exterior Iran or Turan) and those that instead derive from the actual area of Iran, but also because this tendency is mixed in various ways with Indian components that arrive in the Central Asian area along with the progressive success of Buddhism. This Indo/Iranian wave assumes vitality both for evident correspondences of taste and habits and for the persistence of anti-classical reminiscences of an Iranian type, which had already infiltrated by the Kusana epoch (the anticlassical expressions in Parthian art are not very different from those of the Kusana). As well, there was the vast work of mediation carried out by a people of Iranian birth, as, for example, the Sogdianians. This wave not only concerns the reigns and the city-states already existing, but also other, different populations reaching the Central Asian area following enigmatic movements that, in some cases, must have assumed the character of true migrations. Later, this current met with contributions from the Chinese of the T'ang period, provoking the birth of a new style and particular iconographies, above all among the Uiguri. This was the Turkish population that, in the eighth century, made Turfan their cultural center. They became the heirs and carriers of a Central Asian civilization created by an Indo-European people.

The third cultural and artistic wave of prominence is undoubtedly Chinese. It moved toward the east, following an economic and military expansion of the empire. It reached and just touched the extreme western limits of the Taklmaka desert area. Their traces are evident in an area reaching from Kuca to Tumsuq and beyond. It did not, instead, touch the western regions, evidently for historical reasons (it was not part of the Chinese expansion). However, some figurative document may one day reveal such a tenuous Chinese reminiscence.

If these are, very generally, the three principal currents from which the foreign inscriptions observed in Central Asia derive, it is obvious that other expressive elements (symbolic, iconographic, and compositional) change, as has been emphasized, in different ways. Iconographic richness and the expressive capacity of the currents and schools flowering in the same area are allowed to prosper. But that which appears clearest from the totality is that the figurative phenomenon of Central Asia is a phenomenon existing within itself "sui generis." On a tormented and anguished historical base in fact, prevalently foreign cultural currents on a religious base are inserted into the culture. As such, these currents search for expressions of edifying value in relation both to their universalizing tendency (ecumenical) and their missionary duty (so to speak), as well as their will to sustain themselves for the true faithful and make the assertion that the community is autonomous and individualized.

The principle of concretization is apparent in the entire phenomenon. Contents are given new forms and are continually adapted. These contents are already recorded and in a large part fixed. Modulation of these and their expressive capacity in rapport with the modification of the fabric of local culture is subject to sudden variations in consequence of historical evolution. In clearer terms, Central Asian expression is animated by a creative spirit that attempts to adopt, and improve, the methods and influences used. The represented subject is less important than its local function in defining the cultural content and evading a descent into the vague and inarticulate. At the same time, and above all in relation to iconography, there exists a continual and focused effort to overcome foreign conventions in order to obtain stimuli which are locally more effective. This is done by exploiting different interferences.

It is useless to say, or, better, to confirm yet again, that critical judgment is limited to single works of art. Their emotional load, stylistic coherence, and the poetics cement together iconographic elements deriving from different influences and sources. In semiotic terms, these appear as pseudonegotiators connected among themselves in order to obtain programmed stimuli.

From this derives not only the search for luminous effects through conventional iridescence and stylized forms connected with "the aesthetic of light" characterized by Central Asian painting, especially in the eastern area, but also the genesis of a long series of different figurative and symbolic devices that characterize and differentiate Central Asian productions, especially in painting.

It is, however, certain that these forms, created from the overlapping of different interferences, from the actual continuation of choices and rejections, in a incessant effort of re-elaboration, adaptation, and differentiation (with respect to the models and archetypes from which they derive) are undoubtedly new expressions of a cultural content. These are predominantly foreign, assimilated, but also reinterpreted and adapted from a changeable Central Asian world that is charged with spiritual and psychological needs notably different from those recognizable in the regions where "sources" of information are localized. The difference is such that, in the changing social historical situation, various Central Asian zones can, at their time, become "sources" of inspiration for the same areas that had contributed to the formation of Central Asian expression. Products of the interweaving of economic and political forces in

delicate equilibrium, which is almost always precarious, Central Asian figuration is animated by autonomous speculative attitudes (even if orthodox in appearance) of movements of religious thought -- also sectarian -- not always easily reconstructible. It is the result of processes and historical facts of enormous interest for their exceptional complexity. There is no doubt that such results were not only autonomous and original, but also singularly vital. This definitively resolves the problem of autonomy and the historical value (not only artistic) of the different figurative currents classifiable as Central Asian.

West central Asia and its painting. — With respect to the ensembles of perspectives which have emerged in the last few years, we can add an ample series of observations. The pictorial patrimony of the western regions, thanks to the research of the Soviets, has been enormously enlarged until reaching a comparable consistency with the eastern area and, above all, its importance has been established.

a) Toprak-kala. - The difficulty of dating painting from the west remains rather grave. In general lines, it can be established that the most ancient paintings are those from Toprak-kala, datable to the third century A.D. with a fair margin of probability. The paintings come from a large castle with three towers (occupying 11,000 m) that was the official residence of the Khwarezm sovereigns and was completely abandoned in the fourth century. In particular, the paintings come from the major room (300 m) where, at least in regards to the statuary, there are identifiable reminiscences of Commagene next to others clearly Gandharan (even if the political domain of the Kusana was completely over and had been for some time). Very different from Miran, these fragmented pictures merit a comparative analysis and technical investigation. It is not impossible that in the Toprak-kala works there are echoes of a taste from the Steppes, in which case they would have a greater value from the historical point of view.

b) Balalyk-tepe. - Among the large pictorial cycles, those of Balalyk-tepe are considered the oldest, at least according to the date proposed by the discoverer, L. Al'baum, who would date the Uzbeco castle and the picture series to the fifth century. The paintings exhibit 47 figures engaged in a symbolic banquet. This is the most significant characteristic of the paintings. Chiara Silvi Antonini has, however, advanced various doubts regarding Al'baum's dating, which she would lower by a century or a bit more. The change, which seems more than acceptable, is supported by the Soviets B. I. Marsak and B. A. Litvinskij (letter to the authoress and the author (10/8/1977; the new date was also recorded by G. Frumkin). It seems all but irrelevant especially when one considers that it occupies a space in time which corresponds to a radical change of the historical situation. Balalyk-tepe remained equally the product of solidly individualistic artists. But the presumed Ephthalite (the military elite dominating in Uzbekistan during the fifth century) component disappeared and was substituted for by a Turkish component.

In reality, even the dating can remain, perhaps for an excess of prudence, "sub udice" (and Al'baum,

though appreciating the observations of the Italian scholar on the chronology he proposed, seems to maintain some reservations). It is not possible not to agree with what is written in conclusion by Silvi Antonini: "Balalyk-tepe is the product of a culture with a character that is essentially local," but this definition of local is acceptable if one attributes to the word "a matter much wider and complex than that which the Soviet scholar (in principle) maintains." Because by "local" is meant "the results of a synthesis process between indigenous traditions and local influences of the most diverse sort, all converging in out regions in the same decades: logical consequence of singularly rapid historical alternations and it still remains today to be profoundly illuminated." This clearly coincides with what we have previously affirmed.

As much as for the analysis of the rapport between Balalyk-tepe and other centers (from Pjandzikent to Bamiyan), we can note that the exceedingly vast field of investigations, opened by the Soviets and the Italians, is much more enigmatic than expected. It can offer surprises and signs signalling the uncertainty of what meaning should be attributed to an entire pictorial cycle. That the scene represented here is a banquet is obvious. Whether the banquet is funereal (evidently ritualistic), referring to the festival of the dead, as Silvi thinks, or has some other, different connection with the fire cult, or, instead, the explanation of its meaning should be sought in another type of rite (perhaps connected with intoxication) is, in the end, not at all relevant. It serves within the development of an iconographic and contextual base common to the various art centers of Ancient Sogdiana and the surrounding Central Asian areas. The efforts of Al'baum, A. Ju. Jakubovskij, and Silvi; the discovery of Adzina-Tepe (seventh and eighth centuries) by B. A. Litvinskij and the connections he observed between the Buddhist paintings from that site and those from Balalyk-tepe — all these constitute only attempts to reconstruct the enormous plot of contacts, interferences, influences, and relations which have always animated the artistic evolution of Central Asia.

c) Varaksa. - Next to Balalyk-tepe, which is one of the most visible examples of non-Buddhist art, the increasingly important pictorial cycle from Varaksa must be considered. To give the cycle its full due, it must be critically approached from within the framework of Soviet Central Asian painting. The paintings come from a feudal domain centered in the Oasis of Buhara. The pictorial complex presents symbolic/decorative motifs such as those from "The Red Room" where men on elephants fight with pairs of animals. Some of the animals are fantastic, while others derive from existing fauna. However, they are all of arbitrary, gigantic proportions, serving as they do in the context of a decorative composition.

The important fact in regard to these animals is their stylization. It can be compared with several artistic solutions in the art of the Steppes. The decorative sensibility reflected in the wings of the fantastic animals, who uniformly cover the red background of "The Red Room" from Varaksa, is found again at the same site in wings of imaginary beings from "The Room of the Griffins." These cannot be separated from analogous solutions used almost a millennium previously in figures from Pazyryk. There, the figures were drawn on

felt; they have been restored to us thanks to the Kurgan ices of Pazyryk.

Whatever the significance and symbolic value the Varaska paintings might have, it is obvious that they are inspired by a taste that differs notably from a traditional Iranian style. (This is meant to include all the modulations which actually derive from Parthian and Sassanian art.) This taste seems to put down its roots, or at least a part of them, in distant Scythian ground. Confirmation of this is found in the fantastic compositions from Pazyryk. These are the only murals showing real affinities with the Varaska figures. While at Pazyryk a slightly different tone can be discerned and different methods are used, the paintings from both sites show their measure of frivolous whimsy. As at Varaska, the Pazyryk paintings put exceptionally naturalistic images (even though these may be stylized) side by side with numerous and diverse fantasies that, in their elegant deformities, reveal a way of imagining the surreal. This occurs within the sphere of the so-called "zootassie," and it is absolutely analogous to that at Varaska. It would not be relevant to speak of more or less direct derivations in this situation, but it is clear that this affiliation could not have been coincidental, even though the historical connecting links are missing. Tamara Talbot Rice was the first to note the correspondence. She did it almost incidentally in V. S. Siskin's guide book. Varaska, Balalyk-tepe, and Pjandzikent form the Grand Triptych of Soviet Central Asian painting. The Varaska cycle allows us to recognize a particularly clear Scythian component, perhaps even clearer than other Sogdiana centers will allow.

d) Other centers of pictorial documentation: Afrasiab. – We have spoken of a Soviet Central Asian. pictorial triptych, but actually we should speak of a polyptych. Along with the large centers we have already noted, which are of equal importance and fame, Afrasiab must be discussed. It is the oldest Samarkand culture, notable for its very interesting series of high quality wall murals. They can probably be dated to the seventh or eighth century, meaning that they were created not long after the Varaska cycle (seventh century). These dates stand, even though the castle and architectural complex of Afrasiab must have been constructed in the fifth century. At that time, Afrasiab was already the capital of an important kingdom. At least a part of the paintings show a clear historical/celebratory character. V. A. Siskin has already extensively studied the first pictorial cycle. It has been thoroughly published together with the series by L. J. Al'baum (Zivopis Afrsiaba, Taskent, 1975). The painting runs a length of about 11 meters or a bit more. From an inscription, in Sodiano, written on one of the figure's clothing, we know that the composition represents the embassy dispatching the sovereign of a small principality (Chagnian) who held the pompous title of "Turanshah," to the sovereign of Afrasiab. In the presentation of the ambassador, his respect for the sovereign and the state he rules is very clearly expressed. The ambassador is depicted on his journey, at times on a horse and at other times on a camel. His assignment is to present a royal princess who has been promised to the son of the Afrasiab sovereign, or perhaps to the sovereign himself. The princess is shown riding a richly saddled elephant. She is accompanied by gift-bearers, rare animals, and ladies of the court. The highly decorative assembly depicts excep-

tional luxury and splendor. The gift-bearers' grab and the saddle-cloths on the animals are adorned with motifs common to the Sassanian decorative repertoire and often include pearl medallions. Among the motifs appear the "Senmurv," the typical Persian fantastic animal, and a bird with a garland in its beak. These probably refer to the contemporary situation, alluding to imported cloth. In any case, it is useless to think of local symbolic values or to construct an interpretative system from this deduction. It is wiser to think of the paintings as illustrations confined within a sphere of representational fashion rather than search for symbolic/religious derivations which are not otherwise expressed in the Sassanian world. Besides, the entire decorative repertoire of cloth would favor considerations of genre. However, the style of this composition is rather calligraphic — it gives those decorative effects sought to the entire design. The composition, being a historical subject and thus inspired by celebrative criteria, is a substantially decorative scene. It follows an easy and elegant rhythm which is not unknown in other western Central Asian works.

Other than this celebration design, which is on the south wall of the room, there are also other paintings. On the north wall there is a complicated hunting scene (on the east side of the wall). The continuity between the two compositions is indicated by the figures. For instance, there is a boatman tying the anchor rope to a rock that serves as the mooring bitt. The boatman and the rock appear in the margins of the pictorial space occupied by horsemen and the beasts from the hunt, although these appear dispersed in the other composition. Al'baum maintains that the two parts form a unity, but the narrative links are not clear. The artist, however, created a very specific figurative space using skillful solutions, although they are somewhat unconstrained.

This unconstraint is subsequently accentuated in the pictorial cycle on the west wall. Here we find a scene with donators and dignitaries paying hommage to the Afrasiab sovereign. They are representatives from Cast (Ancient Termez), a Turkish potentate. On the opposite (eastern) wall there is a scene of enigmatic interpretation. It depicts a woman (?) being dragged by a swimming buffalo. She holds his tail with two hands. The lively stylization of the waves, which form whirlpools, recalls the analogous solutions at Hadda, Pjandzijkent, and Kuca (The Cave of the Navigators). Several strange figurative solutions merit some basic study, but this will be impossible until the cycle is restored and better understood.

However, I would like to mention, to conclude this brief examination of the Afrasiab mural paintings, that B. Rowland (in his last volume which appeared, unfortunately, posthumously) had already understood the characteristic spatial constructions of the Afrasiab paintings. There is not only the conventional vertical perspective, with overlapping planes, but figures flanked next to each other. This is not a processional arrangement, because there is too much distance between each pair of figures. In fact, each figure had a portion of autonomous space allotted to it. The figures are seen in three-quarter view and are, at times, arranged with foreshortening that alternates left and right. This suggests the idea of depth, one that is undoubtedly artificial, but at the same time very sugges-

tive. It is an obvious characteristic of the paintings, and it is strongly distinguished. It is undeniable that the cycle holds value for the history of Central Asian painting.

e) Discoveries at Pjandzijkent. – Without excluding relationships and connections, the most recent discoveries made at Pjandzijkent confirm the stylistic autonomy of the site. They also accentuate the importance of wooden sculpture, presented as a figurative expression in an almost impressionistic style. This resulted from a concordance between technical details, such as the use of large, deep incisions, and the desire to actualize an abbreviated and contracted stylization which would be both pleasing and efficacious. Altogether the new discoveries put the sculptural compositions in stucco in a new light. Landscapes and underwater subjects are represented. In terms of painting, they confirm the importance of epic subjects. Along with the exploits of Rustam, the war against the Amazons is also celebrated. These are classical motifs which filtered into the Iranian world and remained lively until the seventh century.

Other, apparently epic, motifs have no concommitants in any of the surviving literature and perhaps belong to lost traditions. The pictures do not only illustrate epic and religious themes, but some motifs derive, in fact, from popular stories that must have been circulated within a large part of Eurasia. The source which would have inspired these stories was the famous Indian *Pancatantra*. There existed at least a partial translation of this in Sogdiano, which probably derived in turn from the version in Pahlavi made by Cosroe I, "Khalila and Dimna" (that is, the first book of the *Pancatantra*). He also translated Aesop's fables, which even had unexpected echoes in Sogdiana. As A. M. Beleniskij has observed, even in the field of popularized inspiration (from fables) local sources play their part, probably tied to orally transmitted traditions. This makes it practically impossible to recognize the exact value of an illustrated story. Besides, the Soviet scholar has shown that, whatever their specific significance may be, the scenes can also appear as genre scenes that reflect, in general lines, the daily life of the upper classes. Common and frequent events are depicted, including fights, hunts, games, banquets. It is sure that what has been recovered is only a very minor part of an artistic richness that has been lost and was, probably, the production of a true and proper local school for either painting or wooden sculpture. Given the genre productions, which are vast and multiformed even in the little that has survived, it is impossible to think of the productions as the results of limited activity by a few specialists.

On the other hand, there is no doubt that the school of Pjandzijkent had extensive relations with semi-contemporaneous schools which have already been discussed. There was a web of interactions and counter reactions between Pjandzijkent and other centers: from Varaska to Afrasiab to Balalyk-tepe and other centers that, for now, appear more minor and are excluded for lack of space. At their own time each of these artistic cultures put down their deepest roots in ancient cultural stratifications which had been amply extended. They shared reflections of other cultural evolutions. While distance between centers varied in the geographical sense, within these zones there were direct or indirect convergencies. This evolutionary mechanism continues its motion, albeit it be in different ways, in the progressive consolidation of the will to art and local tastes. This continued as long as the Arab/Islamic advances did not quash the historical evolutions of these regions and, in a large part, those on the fringe of a totally different process. It is clear, however, that the grand splendor of Sogdiana art coincides with the historical phase that saw the Sogdiana merchants standing as masters (almost absolute) of Central Asian commerce, both internal and transcontinental.

f) Other discoveries. – B. A. Litvinskij has brought to light in Kalai-Kafirnigan (that is, at Tokkuz-Kala, 80 km southwest of Dusnabe in northern Tadzikistan) a monument connected with the fire cult (Zarathrusism). It was, at a later date, decorated in sculpted wood when it was transformed into an aristocratic home with an adjacent Buddhist temple. In the latter, the walls of the corridor set aside for strolling are covered with magnificent pictures, still partially conserved. In the top band we find a triad with a Buddha seated on a throne of lotus and two Bodhisattva. Each figure is enclosed in a mandorla or a halo and can be compared to some paintings of the East (for example, with the triad of Chadalik published by A. Stein in Serinkia). Underneath, there is a procession moving towards the right with noblewomen, monks, and youths who are, however, seated and of smaller proportions. The figures are in three-quarter view, turned to the right, but their legs are seen from the front. They wear Kusana type footwear. The ensemble is comparable, for style and quality, with Balalyk-tepe, and it is certainly among the most important cycles in Central Asia. The sculpture from the site recalls that of Fondukistan. The site has important repercussions it terms of determining Central Asian contributions to Islamic architecture.

Litvinskij himself uncovered a governor's palace at Kafir-Kala, in the Vaks valley. It has a Buddhist chapel decorated with paintings analogous to those at Adzina-tepe. Unfortunately, only fragments remain of the chapel paintings. L. I. Al'baum found in Termez a new Kusana monastery (Fajaz-tepe) with stupendous pictures comparable to those at Miran. There is also sculpture of superior quality.

My thanks go to Prof. Litvinskij for having informed me of these exceptionally interesting discoveries and for having provided facts on those still unpublished.

The eastern zones of Central Asia. — French researchers have done the most work on the eastern regions of Central Asia, concentrating on the unpublished material from P. Pelliot's expedition. The materials are quite impressive, and they are accompanied by a revealing and important photographic documentation which has also not been published. The accurate analysis of the works from Tumsuq (with extensive comparison material) has opened new perspectives on the evaluation of the center. (These new perspectives have been, in part, utilized in this essay.) It has also offered a great deal of precision for both the stylistic and iconographic fields. The latter is preferred, with reason, by the French school. The immense implications of the work that has been done have not yet been taken advantage of, but offer a promising prospective for the future. Analogously, for Kuca and its region (the location of

Duldur-Aqur and Subasi) painted murals of notable importance have been presented which were previously almost wholly unknown. There are also objects (reliquaries), products of art and craftsmen, and others concerning daily life. In this case also, the perspective has been amplified and, due to some problems, only now is this precious material being prepared. An example of one of the paintings, notwithstanding their fragmentary state, displays a stylistic and compositional integrity that appears new, almost a testimony of a tendency (or, perhaps of artist's hands), not documented elsewhere.

Among the other centers, making an exception for Tun-huang, which is practically in China, Khotan has attracted much interest, whether from the iconographic point of view (acknowledging a legend with local gradations about the Princess of Silk) or from the point of view that Khotan also had importance in the evolution of Chinese art. Paola Vergara Caffarelli not only corrected the surnames of the two great Khotanese painters (of regal birth) who worked in T'ang, China, but she precisely defined the rapport of parentage that connected the two. This has the result of conferring on the Khotanese school of the Yü-ch'ih (almost always incorrectly transcribed Wei chi'ih, and known as such) a major enlargement of the chronological limits. It also supports an identification of a constant rethinking of Khotanese iconography, forms, themes, and motifs which had much greater echoes than previously thought in the formation of the T'ang pictorial style. As a consequence, the entire figurative "Koinè" extended, in the seventh and eighth centuries, into all of the extreme Orient, bringing with it an observable Khotanese component. This reappeared at Yü-ch'ih I-seng and, with its major ally and teacher Yü-ch'ih P'o-chih-na, arrived in China at the end of the Sui dynasty, perhaps in 615 A.D. The "koinè" phenomenon was noted for its strange and exotic Buddhist painting and its abbreviated fantasy, demonstrated even in round paintings. Of the two Yü-ch'ih (the name corresponds to the Khotanese Visa, that is, Victorious), I-seng is undoubtedly the largest and attracts the most critical interest from contemporary and past Chinese scholars — so much so that it has come to be considered among the greatest, becoming a touchstone celebrated by local artists. Vergara's work has opened a new perspective on the entirety of Khotanese art.

In the iconographic field, the ample research of Joanna Williams produced significant precision, even on problems that were controversial until the discoveries made by Sir A. Stein. Among other things, she also verified the breadth of the cult of the God of Silk (perhaps to be connected with Mahesvara). This confirms other *propedeutici* and gives, together with other facts, a religious aspect to Khotanese mercantilism. The archaeological discoveries made by the Chinese specialists, especially in the Turfan caves, have reawakened an interest in the eastern area - even the extreme eastern area - of Central Asia. Infinite problems still remain, both iconographic and stylistic. These comprise an enormous field of research which is to researchers of today and tomorrow.

This confirms the attempts made in this entire essay to demonstrate and put in clear evidence that the arts of Central Asia hold exceptional historical interest beyond their artistic value.

BIBLIOGRAPHY - This bibliography supplements the sources on ancient Asia cited in Part I with special emphasis on early urbanization. M. Bussagli, in volumes of M. M. Bussagli and others, Architettura orientale, Milano-Venezia, 1973. A. Zadneprovskij, Drevnežmledel'ceskaja kul'tura Fergany, M.I.A., 118, Moskva-Leningrad, 1962; V. I. Sarianidi, Pamjatniki pozdngo encolita jugo-sostočnoj Turkmenii, Moskva-Leningrad, 1965; A. F. Ganjalin, Raskopki v 1959-1961 gg.na Altyn-depe, Sovetskaja arkheologija, 4, 1967 (Namazgatepe); V.M. Masson, Protogorodskaja ěivilizaěija juga srednej Azii, Sovetskaja arkheologija, 3, 1967 (Namazga-tepe); M. Tosi, Excavations at Shahr-i Sokhta, a chalcolitic settlement in the Iranian Sistan. Preliminary Report on the first Campaign, October-December 1967, East and West, XVIII, 1968; M. Tosi, Excavations at Shahr-i Sokhta. Preliminary Report on the second Campaign, E. and W., XIX, 1969; V. M. Masson, Raskopki na Altyn-depe v 1969 g., Askabad, 1970; I.T. Kruglikova and V.I. Sarianidi, Drevnjaja Baktrija v svete novyh arkheologiceskih atkrytik, Sovetskaja arkheologija, 4, 1971; V. I. Sarianidi, Raskopki Tillja-tepe, Moskva, 1971; V. M. Masson and V. I. Sarianidi, Central Asia, southern Turkmenia before the Achaemenians, London, 1972; M. Tosi-C.C. Lamberg-Karlowsky, Shahr-i Sokhta and Tepe Yahya: Traks on the earliest History of the Iranian Plateau, E. and W. XXIII, 1973; V. M. Masson - V. I. Sarianidi, Sredneazjatiskaja terrakota epokhi bronzy, Moskva 1973; A. Askarov, Sapallitepa, Taskent, 1973; V. I. Sarianidi, Baktrija v epokhi bronzy, Sovetskaja arkheologija, 4, 1974; V. M. Masson, Raskopki pogrebal'nogo Kompleksa na Altyn-depe, Sovetskaja Arkheologija, 4, 1974; V. I. Sarianidi, Pecati - amulety Murgabskago stilja, Sovetskaja Arkheologija, 1, 1976; V. I. Sarianidi, Material'naja Kul'tura južnogo Turkmenistana v. period rannej' bronzy, Pervobytnyj Turkmenistan, Askhabad, 1976. The twelfth issue of the Corriere dell' UNESCO (Dec. 1976) is dedicated to the Scythian world. It contains various articles by Boris P. Piotrovski, Ivan Artemenko, Mikhail P. Griaznov and others.

Central Asia: S. Stucchi, Nota introduttiva sulle correzioni ottiche nell'arte greca fino a Mirone, Annuario della scuola archeologica di Atene e delle missioni italiane in Oriente, N. S., 1952-54; L. I. Al'baum, Balalyk Tepe, Taškent, 1960; A. N. D'Jakonova, Documents of Khotanese Buddhist Iconography, A. As. XXIII, 1960; A. R. Hotani and others, The ancient Buddhist arts in Central Asia and Tun-huang, Monumenta Serindica, V, Kyoto, 1962; V. A. Šiškin, Varakša, Moskva, 1963; M. Bussagli, La peinture de l'Asie Centrale, Genève, 1963; Camilla V. Trever, Tête de semmurv en argent des collections de l'Ermitage, Iranica antiqua, IV, 1964; G. Frumkin, Archaeology in Soviet Central Asia - IV. Tadzhikistan, Central Asian Review, vol. XII, 3, 1964; G. Frumkin, Archaeology in Soviet Central Asia - V. The deltas of the Oxus and Jaxartes: Khorezm and its Borderlands, Central Asian Review, vol. XIII, 1, 1965; G. Frumkin, Archaeology in Soviet Central Asia - VI. Uzbekistan, excluding Khorezm, Central Asian Review, XIII, 3, 1965; B. Rowland, Art along the Silk Road, Harvard Journal of Asiatic Studies, XXV, 1964-65; G.A. Pugačenkova, La sculpture de Khaltchayan, Iranica Antiqua, V, 1965; G. A. Pugačenkova, Des Probèmes de l'art de la Parthie du Nord et de la Bactriane du Nord, Huitième Congrès International d'Archéologie classique, Paris, 1965; T. Talbot Rice, Ancient Arts of Central Asia, London, 1965; G. A. Pugačenkova, Khalčajan, Taškent, 1966; Sir Mortimer Wheeler, Gandhāra Art. A Note on the Present Position, in Le rayonnement des civilisations grécque et romaine sur les cultures périphériques (VIII Congrès Intern. d'Archéologie classique, Paris, 1963), Paris, 1965; G. Frumkin, Archaeology in

Soviet Central Asia - VII. Turkmenistan, Central Asian Review, XIV, 1, 1966; Mission Paul Pelliot, Documents archéologiques publiés sous les auspices de l'Académie des Inscriptions et Belles Lettres sous la direction de Louis Hambis - I, Toumchouq; planches - II, Toumchouq; textes - III, Koutcha; planches, Paris, 1961-1964-1967; P. Bernard, Ai Khanum on the Oxus. A Hellenistic City in Central Asia, Proceedings of the British Academy, LIII, 1967; R. E. Emmerick, Tibetan Texts Concerning Khotan, London, 1967; J. Rosenfield, The Dynastic Art of the Kushans, Berkeley-Los Angeles, 1967; A. Beleniskij, Asie Centrale, Genève, 1968; Sir Mortimer Wheeler, L'incendio di Persepoli, Milano, 1968 ("Flames over Persepolis," New York, 1968); Papers on the date of Kaniska, edited by A. L. Bassham, Leiden, 1968; M. M. Hallade, Inde. Un Millénaire d'art bouddhique, Paris, 1968; B. A. Litvinskij, Kangjuisko sarmatskii Far, Dušambe, 1968; E. Emmerick, Some Khotanese Inscriptions on objects of Art, J.R.A.S., 1968; B. A. Litvinskij, Archaeology in Tadžikistan under Soviet Rule, East and West, XVIII, 1968; G. Frumkin, The Expansion of Buddhism as Witnessed by Recent Archaeological Finds in Soviet Central Asia, Bibliotheca Orientalis, XXV, 1968; Ernst J. Grube, The Classical Style in Islamic Painting, Edizioni Oriens (Venezia), 1968 (citing some influences of Central Asia on Islamic art); M. and Sh. Mostamindi, Nouvelles fouilles à Haddā (1966-1967) par l'Institut Afghan d'Archéologie, Arts Asiatiques, XIX, 1969; G. Azarpay, Nine Inscribed Chorezmian Bowls, A. As. XXI, 1969; M. Taddei, Inde, Genève, 1971; B. A. Litvinskij, Outline History of Buddhism in Central Asia. Kushan Studies in U.R.S.S., Calcutta, 1970; B. Rowland, Zentralasien. Kunst der Welt; Die aussereuropaische Kulturen, Baden-Baden, 1970; Ph. Granoff, Tobatsu Bishamon, E. W., XX, 1970; M. Bussagli, Culture e civiltà dell'Asia Centrale, Torino, 1970; M. Mariottini Spagnoli, Relationship between the Perspective and compositional Structure of the Bhārhut Sculptures and Gandharan Art, East and West, vol. XX, 3, 1970; A. M. Belenitski and B. J. Marshak, L'art de Piandjikent à la lumière des dernières fouilles (1958-1968), Arts Asiatiques, XXIII, 1971; B. A. Litvinskij and T. J. Zejmal, Adžina-Tepa, Architektura, Živopiš, Sculptura, Moskva, 1971; N. Pugačenkova, Skulptura Khalčajana, Moskva, 1971; Chiara Silvi Antonini, Le pitture murali di Balalyk Tepe, Annali dell'Istituto Orientale di Napoli, volume 3, 1971; P. Vergara Caffarelli, Proposte per una nuova cronologia e per un ulteriore esame critico dell'opera di Yu-ch'ih I-Seng, R.S.O. 1972; B.A. Litvinskij, Drevnie kočevniki na "Kryši mira" Moskva, 1972; J. Williams, The iconography of Khotanese Painting, East and West, 23, 1973; A.C. Lavagnino, Alcune note sulla "Musica di Kuchā", Annali dell'Istituto Orientale di Napoli, vol. 33, 1973; B. Ja Staviskij, The Capitals of Ancient Bactria, E. and W., 1973; A.M. Beleniskij, Monumentalnoe iskusstvo Pendžikenta: Zivopiš Skulptura, Moskva, 1973; Fouilles d'Ai Khanoum I (Campagnes 1965, 66, 67, 68), M.D.A. F.A., vol. XXI, Rapport préliminaire publié sous la direction de Paul Bernard avec le concours de Raymond Desparmet, Jean Claude Gardin, Philippe Gouin, Albert de Lapparent, Marc Le Berre, Georges Le Rider, Louis Robert, Rolf Stucki, Ed. Klincksieck, Paris, 1973; K. Walton Dobbins, Gandharan Art from Stratified Excavations, East and West, N.S., vol. XXIII, 1973; C. Silvi Antonini, More about Swât and Central Asia, East and West, 1973; M. Taddei, Appunti sull'iconografia di alcune manifestazioni luminose dei Buddha. Gururajamanjarika, Studi in onore di Giuseppe Tucci, Napoli, 1974; A.M. Quagliotti, Recensione a B. Rowland, Zentralasien, Baden-Baden, 1970, in R.S.O. 1975; Guitty Azarpay, Some Iranian Iconographic Formulae in Sogdian Painting, Iranica Antiqua, vol. XI, 1975; Hans Christoph Ackermann, Narrative stone reliefs from Gandhāra in the Victoria and Albert Museum in London, Roma, Is MEO, 1975; P. Daffinà, Sulla più antica diffusione del Buddhismo nella Serindia e nell'Iran orientale, in "Monumentum H.S. Nyberg", I; Acta Iranica, Téhéran-Liège, 1975; Francine Tissot, Remarques iconographiques à propos d'une tête de roi barbare du Gandhaāra, Arts Asiatiques, XXXII, 1976; E.E. Kuz'mina, The "Bactrian Mirage" and the Archaeological Reality. On the Problem of the Formation of North Bactrian Culture, East and West, vol. XXVI, 1976; G. Frumkin, L'art ancien de l'Asie centrale soviétique, Arts Asiatiques, vol. XXXIII, 1977.

MARIO BUSSAGLI

EASTERN ASIA

CHINA (PLATES 60-71)

Introduction. — The most recent sinological studies, including those in the historical and artistic fields, have demonstrated a considerable interest in the influences of outside interference on the evolutionary progression of the Chinese culture. These studies underline the lack of validity of the past historiographic tradition, which often considered China as the center of a "monostylistic civilization" undergoing slow evolution. This research, performed on some of the most representative periods, also shows a close relationship between artistic production and the political, social, and religious events of a zone or of a period. The reexaminations of the art of the Yuan period by Sherman Lee and Wai-kam Ho in 1968, by M. Medley in 1974, by J. Cahill in 1976, and by the publications of the National Museum of T'ai-pei delve more deeply into the study of the multiform characteristics resulting from the encounter of the Mongolian with the traditional Chinese cultural components.

Beurdeley's 1971 study is also valid, although it employs a completely different approach, namely the examination of the work of a Western artist (Giuseppe Castiglione) who has adopted some fundamental features of Chinese artistic expression. His multiform work can be useful in a certain way in clarifying the most peculiar characteristics. Furthermore, all of the attempts to define in historical and artistic terms the relation between China and the other countries of the Far East, particularly Korea and Japan, appear useful in determining a better interpretation of the Chinese artistic language. Research on the extent of the Chinese infuence in the various periods and on the national constants of each country's culture, done by Swann in 1963, Sherman Lee in 1964, W. Watson in 1971, and P. Rowson in 1973, is definitely useful in defining the extent and the limits of the Chinese acculturation effect on neighboring countries, especially in the most ancient eras. This research also helps to reveal peculiar characteristics emerging from each period in the history of Chinese art, often by way of the reflections of them found in the Korean and Japanese artistic productions. An example of this is the southern Chinese sculptural styles from the period of the North and South dynasties which A. Soper (1960) was able to define in their fundamental characteristics, mainly through several Japanese creations of the Asuka and Nara eras. This stylistic denotation subsequently found a partial confirmation with the numerous sculptures uncovered in the Wan-fo Temple excavations near Ch'eng-tu.

Given the problem posed by the vast and differentiated Chinese production, there is a lack of recent work that can reveal in a detailed manner the extent of the actual revolutions and innovations in the artistic field, especially in light of the new archaeological discoveries and the modern theories of aesthetic interpretation.

An historical-sociological study covering the entire span of Chinese cultural development was made by B. Smith and Weng Wang-go in 1973. The vastness of the subject matter forced them to limit themselves to the most salient elements, often condensing an entire period in a few sentences. P. Wheatley's 1971 reconstruction of the characteristics and origins of the first Chinese urbanization, though much more restricted in the subject matter and time span that it covers, is a good example of an adequate treatment of the information pertaining to the archaeological excavations and sources. It sheds new light on the genesis of the Chinese cultural and artistic world, thus providing valid starting points that may lead to future interesting developments in the field of research.

Moreover, contemporary Chinese archaeologists have provided several solutions concerning historical evolution in relation to the data furnished by scientific findings. The Archaeological Institute of Peking has proposed a periodical division of Chinese social evolution according to three different levels, having limits defined by the identification of economic models with differentiated historical periods. The first level, called the "primitive society" (Yuan shih), includes the Paleolithic and Neolithic periods (500,000 B.C. - the second millennium) and is characterized by an egalitarian culture. This is documented for the Neolithic period by the tombs, which have an equal type of furnishing, and the similar habitations, from which only one larger building can be differentiated, the so-called "clan house." Essentially it is impossible to establish whether this structure served as the residence of a leader, which would thus point to a stratified type of society. However, the uniformity of the tombs, each having the same type of furnishings, tends to confirm the hypothesis advanced by the Chinese scholars.

The next period, the "slave society" (Nu-li), includes the legendary Hsia dynasty, the Shang dynasty, and the first Chou dynasties (second millennium B.C. - 475 B.C.) and represents for the Chinese scholars a type of class-conscious pyramidal society in which slavery was practiced. The diversified urban settlements of various zones, different types of habitations presumably linked to the social rank of the inhabitants, and, above all, the monumental tombs of the kings and princes containing numerous skeletons of human sacrifice victims clearly demonstrate the presence of distinct class divisions.

Under the name "feudal society" (Feng-chien) are classified the successive dynastic periods from the era of the warring states to the Ch'ing empire (475 B.C. - 1840 A.D.). Even if this time division presents obvious limitations, given the occurrence of numerous historical, sociological, and political variations in the course of the centuries (as reflected in such studies as J. Genet's (1972) which continue to present more and more evidence of the fundamental "variations"), it is certain that feudalism of various forms was present in China up until the last century as a power held by the nobility, the

bureaucracy, or the military, delegated by a central government with wide discretionary power. The numerous discoveries and excavations uncovered today by the People's Republic of China, of which precise documentation has been furnished (after the pause from 1966 to 1972 due to the Cultural Revolution) in the specialized periodicals Wen-wu, K'ao-ku, and K'ao-ku Hsueh-pao and in various publications printed in Western languages and edited in Peking, will continue to shed light on the multiform and differentiated aspects of the Chinese artistic language and antedate several "variations." Mao's well-known teaching "make the past useful to the present" provided the impetus for the organization of a system of museums such as the Neolithic museum of Pan-p'o ts'un and for the excavation of ancient monumental complexes such as the Han tombs of Man-ch'eng in the Hopei region and those of Ma-wang-tui in the Hunan region. This strong interest in archaeology in China, although reflecting predominantly ideological objectives, will undoubtedly provide a renewed stimulus for further significant research.

At the same time, studies carried out in Japan, primarily on the abundant collections of Chinese art objects conserved in the country since the most ancient periods, are useful in clarifying the peculiar characteristics of a production or of a period that have had little documentation up until now. The work of S. Matsubara and Yuzo Sugimura and the numerous articles by T. Nagahiro, T. Mitsugi, A. Fujieda, Mino Yutaka, Yonezawa Yoshiho, and Umehara Sueji, along with others, represent valid contributions toward the comprehension of the Chinese artistic phenomenology.

Also, the examination of the extraordinary imperial collection assembled by the Chinese emperors of the successive dynasties and largely conserved in Taiwan has enabled the team of art historians at the National Museum to prepare excellent monographs on the production, especially pictorial, of artists, schools, and entire periods that are often as yet totally unknown.

Both the Eastern and the Western scholars seek to trace more precisely the line of Chinese cultural and artistic evolution and to identify the various "facies" closely associated with a tendency, zone, or period. This will permit the reintegration of an artistic production, school, author, or single work into the proper historic moment through research of the technical and stylistic means used in their production and the social, religious, and political structures that have conditioned their production. These relationships are at times extremely difficult to define due to the presence, since the most ancient times, of a strongly traditional and eclectic aesthetic attitude in China which permitted within the production of one period, or even often one artist, the coexistence of very diverse styles, especially in painting. This constant search for diversified pictorial expression explains the extreme modernness of some Chinese paintings. This ancient experimentation with aesthetic themes, compositions, and techniques led to solutions that are similar to those that have been reached in the West only in the most recent eras.

Elsewhere we have indicated by way of hypothesis (P. Mortari Vergara Caffarelli, 1973) several corresponding lines of artistic development from a formal and constructive point of view between European and Chinese architecture. Although this attempt is weakened by its schematism and Eurocentrism, it nevertheless definitively refutes the monostylistic viewpoint suggested by the majority of the critics associated with Chinese architecture with its proposal of a distinct, differentiated trend for each principal historical period. It is not a question of attributing to Chinese artistic evolution the same characteristics of the Western evolution, but to define in universally comprehensible terms the "variations" of the principal artistic codes corresponding to the different historical moments. Going beyond the rigidity and arbitrariness that are inherent in every classification, the system used up to the present day by the greater part of Western and Eastern sinologists, especially in relation to the figurative arts — namely, of conferring a stylistic connotation to every principal dynastic period that determines a particular socio-political change — is in our opinion still valid. It is only a matter of attributing to such periods a more precise and descriptive connotation. Watson's 1974 work attempted to go beyond the historical-dynastic scheme by establishing three different categories of artistic innovation more or less evident in all Chinese figurative art: the "hieratic," the "realistic," and the "decorative" styles. It was necessary for him to also establish the different times of emergence of the styles within a framework of historical development. The period ranging from the Bronze Age to the Han empire corresponds to the "hieratic" style; the "realistic" style corresponds to the period from the Han empire to the first Sung emperors, and the "decorative" style was assigned to the centuries ranging from the later Sung emperors to the fall of the Chinese empire.

The undoubted validity of the penetrating analysis by this English sinologist constitutes an important contribution to the definition of the universal values of the Chinese tradition which transcends limitations of time and place to create interesting analogies with the artistic development of the West. Along these lines one could continue to seek not only a more circumstantial individuation of the artistic codes and the more differentiated stylistic moments of the history of Chinese art, but also to find a more exact definition of some universal values of art that will enable persons totally unacquainted with the Far Eastern pictorial codes to at least partially comprehend, for example, the message of a Chinese landscape.

An examination of a production that is known in the West as "chinoiseries," created exclusively for exportation, is also useful in determining that which the Chinese artisans and artists considered universally comprehensible in their artistic language. The studies of M. Beurdeley (1969), C. L. Crossman (1972), and D. Sanctuary Howard (1973) concerning the definition and characterization of this phenomenon in relation to its numerous differentiations, schools, population centers, and, above all, ceramics, are helpful in clarifying the importance of this exchange and acquisition of new cultural and figurative patrimonies by very different civilizations.

A similar example, though on a different level and in a completely different field, is verified in the work of well-known architects such as F. L. Wright, O. Wagner, G. Rietveld, and Mies van der Rohe, whose work employed structural and planimetric solutions derived from Far Eastern architecture. This subject was examined by W. Blazer in his 1975 work.

Much less easily definable, though undoubtedly equally interesting, are the Chinese cultural influences in the Pacific region. Despite a 1967 symposium held on the subject along with successive studies, the problem of the influence of ancient Chinese art on the figurations of Oceania and pre-Columbus America still remains open to various interpretations. There must also be a reevaluation of the relationship between the Chinese civilization and Southeast Asia, which was until recent years considered an expansion zone of the Chinese and Indian cultures, at least in regard to its origins. In the light of recent discoveries (the Ban Chiang civilization in Thailand), this region has assumed more of a protagonistic role in the genesis of Asian civilizations. However, one of the greatest interests of modern aesthetic speculation on Chinese art centers on the research of several original circumstances that could be defined as "constants" if the term had not come to assume the connotation of fixity, which is impossible to attribute to artistic phenomena seen from an historical perspective.

The ever more numerous studies done on the definition and importance of calligraphic art in the various periods is very useful in elucidating the Chinese aesthetic attitude from an iconological standpoint. The pictographic origin of this writing has actually been proposed by various Chinese archaeologists. According to Kuo Mo-jo, before the use of pictograms, "indicative marks" (chih-shih) were used in the Neolithic ceramics in the form of probable tribal markings, which precede by about 2,000 years the documented pictographic writing of the Shang period. Ju Keng also proposes that several marks that appear on the late Shang (Yin) and Chou bronzes occupy an intermediate position between the "indicative" pictograms and symbols.

However, the writing soon acquired an aesthetic value beyond its exclusively symbolic and ritual function. T. Y. Ecke, with his interesting 1971 calligraphy study dealing with the period from its origins to the Ch'ing era, along with such other scholars as Ch'en Chih-mai (1966), E. Grinstead (1970), A. Giuganino (1973), T. C. Lai (1973), and M. Sullivan (1975) have sought, from various perspectives, to pinpoint the importance that a particular conception of the mark and its harmonic, rhythmic, and symbolic characters had in Chinese artistic creation. In fact, it has been asserted that painting was originally none other than the development of archaic writing. The aesthetic validity of the ideogram is still significantly evident, if one considers that calligraphy is still taught in the elementary schools of the People's Republic of China and that there are centers specializing exclusively in the creation and sale of calligraphic works.

B. Smith rightly maintained in 1975 that "the Chinese use symbols as illustration, decoration and communication . . . and sometimes it is difficult to distinguish the line of demarcation between the art of writing and the art of painting, because that which appears to be a realistic painting often presents a philosophical concept, and Chinese calligraphy implies subtle visual experiences."

A further clarification of the phenomenology of Chinese aesthetics is also provided by numerous studies on the ancient treatise writers and critics by Soper and Acker, P. Ryckmans (1970), S. Bush (1971), J. O. Caswell (1972), G. Goepper (1973), Kiyohiko Munakata

(1974), as well as others. In fact, through the translations and the commentaries from the vast number of Chinese treatises one can gain a greater understanding of the "will of art" and of the criteria of aesthetic evaluation of the Chinese civilization that are still implied in many artistic creations, even though they may have been altered and diversified by new acquisitions.

Proto-historic Period. – The new excavations permitted the gradual definition of some of the stages of the great Neolithic revolution that began primarily in the large plain of the Yellow River. The different dating systems place its origin 12,000, 8,000, or 7,000 years ago, lasting till the second millennium before Christ. Traces of this period can be found in the principal cultures in almost all the regions of China, although often they have been mixed with other influences. The archaeologists of the People's Republic have recently announced the discovery of more than 5,000 Neolithic sites and the systematic excavation of approximately 200.

The enormous amount of material and data has by degrees led to, and will continue to lead to, revisions and corrections of the preceding theories on the protohistory of China. As regards the Yang-shao or the painted ceramic culture, which appears to be the most ancient and of which the principal centers are in the Honan and the Shensi regions, it has been further established that this culture expanded into more marginal regions such as the Shansi, the Hopei, the Orosica zone, and the Kansu. In fact, several Western and Eastern scholars have proposed to have recognized a particular cultural "facies" named "Kansu Yang-shao" which corresponds to this latter region. On the other hand, it has not yet been possible to verify and document in an unquestionable manner the genesis and first phases of the Yang-shao culture, despite the interesting hypotheses formulated by the Chinese archaeologist Chand Kwang-chih in 1963. However, it appears that the theories regarding the lack of continuity in the passage between the ceramic and bronze cultures are acquiring more validity. As Watson rightly pointed out in 1974, the evolution of several decorative motifs of the Yang-shao culture, such as the well-known fish that through successive modifications became a pure sequence of geometric figures, approaches in its last stage the schematization characteristics of the style of the bronze decorations, further substantiating the hypothesis proposed by the Chinese archaeologists, and by now accepted by the majority of scholars, of a genesis or an application of the Bronze art having predominately local characteristics.

Also within the sphere of the Yang-shao culture, resulting from the systematic excavation of the Pan-p'o site in the Shensi, which was inhabited during intermittent periods between 5,000 and 2,000 B.C., it has been possible to trace an evolutionary trail of the various habitational solutions, not only of the farmers and animal breeders, but also of the hunters and fishermen who knew how to weave hemp and later silk. In his preliminary study of 1975 Yang Hung-hsun pointed out the most important phases of this development. The most ancient stage seems to have been the pit hut, which was 2 meters deep and covered with branches and straw. This was followed by the round or square hut with walls of tree trunks and clay, covered by branches and straw and dug about one and a half feet below

ground. However, the central hearth was placed in a shallower position. As M. Sullivan hypothesizes, such a structure follows the model of the primitive yurt or tent, though being of more solid materials, and perhaps is even related to the more ancient dugouts and caves excavated in the earth with regard to the curved interior space. We then pass to habitations having a tendency toward a more rectangular shape, often at ground level, with the entrance on the longest side and a deeply recessed hearth. The pavement is often divided in two different areas of different levels; this same division will be frequently encountered in the historical period, in which the raised part functions as a seat or bed.

One can even more clearly recognize in this Neolithic architecture further elements that will later form part of the Chinese architectural code of the historic period and that will also demonstrate the cultural continuity between the Neolithic and the Bronze Age. In fact, several constants of urban planning have already been codified, such as the custom of encircling the settlement with a wall and placing the largest building, the so-called "clan house," at the center of the complex. Other constants of a more strict architectural and planimetric sense are the preferred use of the northern side for the entrance, or the longest side in the case of rectangular buildings, often with the facade facing south. Constants of a more structural nature are the use of wood beams and pillars for the bearing framework and walls composed of a mixture of straw and clay. The prevalent roof covering is another lexical element that will be present in the successive Chinese architectural language.

It is also possible to recognize in the ceramic production several characteristic elements that will have interesting future developments. The use of a clearly demonstrable type of primitive paint-brush, especially shown in the Kansu production, and the emphasis on the line viewed in its calligraphic perfection are already evident in the Yang-shao painted ceramics. The decorative motifs are almost always geometrical and abstract, but sometimes also realistic and animalistic. Several symbolic figurations include the skeleton, the capital "T," the ritual masks (perhaps of shamans), and the symbolism of ancient animism cults having a probable ancestral character. C. Hentze proposed in 1967 several interesting interpretations of the ceramic figurations that parallel other primitive civilizations, as, for example, the "genealogical tree" formed by the stylized bodies of ancestors. In fact, one can ascertain that none of the representations has merely an "aesthetic" significance, but that all of them tend to symbolically express cultural values.

The relationship is not yet entirely clear between the Yang-shao production and the other great ceramic culture of the Neolithic, the Lung-shan, which seems to have had its center in the eastern regions, especially in the Shantung. This type of ceramic was black, smooth, decorated with ribs, and thrown on a wheel. The presence in the same strata of the two types of production, painted and black, in several sites such as Pao-t'ou-ts'un in the Shantung, together with a more crude type of grey crockery with rope imprints, has led the archaeologist Chang Kwang-chih to hypothesize the existence of a third culture that he calls Lungshanoide. It is his opinion that this culture was not only a transition phase between the Yang-shao and the Lung-shan, but that it

represents one of the most important eras of the late Chinese Neolithic period, that of the fusion and assimilation of more cultures with each other.

A further clarification of the sequence of the Neolithic civilizations is that proposed by Hsia Nai, and later by Lan Hsin-wen in 1973, which asserts that the excavations executed in several sites in the Kansu show evidence of the Ch'i-chia-p'ing culture, characterized by a grey, turned ceramic representing a "facies" in which copper ornaments and utensils are present. This culture followed the Yang-shao and was contemporaneous to the Lung-shan and not, as Andersson has proposed, one of the most ancient cultures.

This hypothesis has been confirmed by carbon 14 dating analyses of several Neolithic sites in the K'ao-ku region (1972, nos.1, 5), according to which the principal settlements of Pan-p'o date back to 4115 B.C., plus or minus 110 years, and 3890 B.C., plus or minus 105 years, while the Ch'i-chia-p'ing settlement was dated at 1725 B.C., plus or minus 95 years.

There has also been a further demonstration of the survival of Neolithic cultures in the southern regions, even in the periods succeeding the development of the bronze art in northern China. Yang-shao types of ceramics have been uncovered in the Szechwan region and in Taiwan, while the Neolithic sites of the An-hui, the Kiangsu, and the Kiangsi regions, although having some Yang-shao elements, seem more closely related to the Lung-shan culture, and in the later strata present decoration and printed impressions of the type used in the white ceramics of the late Shang.

Further ties are evident between the range of the late Neolithic period in China and the successive historic civilizations. Some of these are a developed sense of life associated with an agricultural-based economy and a high degree of artisan specialization, animist and shamanist types of religious beliefs, and a cult of the dead which is evidenced by the lavish furnishings of the tombs. Also, the adoption of artistic techniques and typologies (vase forms, brush use, jade workmanship) demonstrates a widespread presence of prototypes of the successive evolutionary path of Chinese artistic expression.

Shang Period (circa XVI century B.C. *- circa XI century* B.C.*).* – Unfortunately, none of the Neolithic cultures that have been discovered so far seems to show a relation to the events reported in the ancient historiography, which speaks of a series of mythical emperors. These cultural heroes purportedly discovered agriculture, the harnessing of water from the rivers, and the use of metals and ideographic writing. Not even the first Hsia dynasty, which lasted from 2205 to 1766 B.C., or from the XXI century B.C. to the XVI century B.C., according to the traditional and the more recent chronologies, respectively, can be substantiated by archaeological discoveries. However, some sites have been identified in the western Honan region that, though not yet excavated, presumably belong to the first period of the Shang dynasty, and that, perhaps, according to the Chinese archaeologists, also include remains of the mythical Hsia period in the lower strata. This should provide the answer to one of the most important questions regarding the origins of Chinese history. In fact, although the Hsia proto-ideogram appears in the bone oracles of the late Shang period, it doesn't appear to be used in reference to a dynasty. Hence, the proposal of

several Western scholars that the Hsia examples are only a literary invention of the Chou dynasties used to justify the expulsion of the Shangs (the usurpers of the first dynasty) cannot be definitively refuted.

A response is therefore expected from future systematic excavations which can shed more light on the evolution and the transition between the Neolithic cultures and the bronze civilization. In a parallel way, these excavations will be able to greatly clarify the origin of what is by now considered the most documented phase of the first period of the Shang civilization. The most important Shang remains have been uncovered near Ch'eng-chou in the Hunan region. This served as the seat of the dynasty's capital until 1400 B.C. or, according to the traditional dating, until 1300 B.C. Documentation of this includes the ancient Ao, recorded from the "Bamboo Annals" and the "Shih-ch'i" and initiated around 1500 B.C. by the tenth Shang king, Chung Ting. The archaeologist Fang Yu-sheng in 1965 proposed the identification of Po, which according to the Chinese annals was the capital of the first Shang king, Ch'eng T'ang, and was located at Erh-li t'ou in the district of Yen-shih in the Honan region. The abundance of the evidence definitely suggests that it was an important center. The presence of a bronze foundry, numerous types of ceramics having the same forms later adopted by the bronzes (chia, ku, chueh), and several imprinted marks on the vases which prelude a primitive form of writing can confirm this hypothesis.

However, it is at Ch'eng-chou that the first — or, better yet, the middle — Shang civilization has left the most important traces up till now. It is possible to recognize distinct characteristics in the architecture, in the bronze production, and in the glyptics which distinguish this phase from the following An-yang phase and demonstrate the important cultural acquisitions that differentiate this period from the bronze and Neolithic periods. The remains of the tamped earth surrounding wall, with a diameter measuring 2 by 1.7 km and a basic section of 20 m length, reveal a quadrangular structure which later becomes conventional in successive periods. A small number of shallow terracings of tamped earth (hang-t'u) used for building foundations are evident, which were totally absent in the proto-historic period. It may be possible that their ancient prototypes are the primitive ritual altars. These terracings became very important in successive periods in the structural economy of buildings. The presence of Neolithic-type habitations, with rectangular foundations ranging from 3 by 1.5 meters to 16 by 7.5 meters and a floor often dug about a half meter below ground, suggests that the elevation on a platform served to distinguish buildings which had important political or religious value.

Above all, it is the great number of bronze ritual receptacles of various shapes and sizes that reveals the high level of creative ability reached by the artisans of Ch'eng-chou. The problem of establishing a chronology of stylistic evolution of the abundant bronze production that characterizes the period of the first dynasty still occupies the prominent sinologists. B. Karlgreen's proposals, based on a stylistic analysis of the various decorative motifs (Styles A, B, C), have been countered by Max Loehr's "overall vision" (1956), which attempts to create a more narrow chronology on the basis of the progressive perfecting of technique and embellishment (An-yang I-IV). Actually, a large part of the brilliant stylistic and technical analyses of these two sinologists has remained valid to this day, after being revised by the 1968 studies of the same Max Loehr. The discoveries of Ch'eng-chou have enabled Watson (1974), among others, to clearly define two principal phases in the Shang bronze production: the period in which Ch'eng-chou was the capital and the successive An-yang period.

In fact, the bronzes of Ch'eng-chou have a less varied typology, and the shapes are often more rudimental, such as the chueh drinking-goblets that are shorter and more ungainly than those uncovered at An-yang or that have a flat bottom, less thickness, and are lacking handles. As to the decoration, the design is less complex and the "t'ao-t'ieh," the famous animal mask without jaws, often is portrayed alone or combined with a more realistic type of animal, such as a turtle, while its body, rendered with two lateral appendages closely connected to the facial mask, is represented in a more schematic manner than in subsequent periods. All of the decorative motifs of a geometric, zoomorphic, or symbolic type, with the exception of the protruding eye of the "t'ao-t'ieh," are more or less of the same scheme and are clearly subdivided into different levels.

The most recent discoveries have led to new conclusions, which also include those related to forging techniques. Due to the presence of numerous terra cotta molds and suture lines in several examples, it is possible to state that in this period and especially in the late Shang period the bronzes were forged in various separate pieces, which were then soldered together. In fact, as M. Bussagli asserted in 1966, one can now rule out the possibility that the ancient bronzes were cast with the so-called "lost wax" method, which had been supposed in the past due to the great perfection reached in such works. The chemical and spectrographic analyses, along with the analysis of the fabrication techniques, such as those carried out by N. Barnard in 1961 and by R. G. Gattens in 1969 on the Freer Gallery collection, have been very useful in clarifying the evolutionary line of the bronze production. Although limited in the number of examples examined, this latter research has further elucidated the variation of the percentage of the metals of the bronze alloy according to the various eras and the type of object forged and the recognition of restorations, imitations, and unauthentic glazings. Also examined were diverse types of decorating techniques that in a certain way limited and determined the decoration.

Analogous methods applied to the recently uncovered bronzes of Ch'eng-chou should shed further light on the problem of the first bronze production in China and its relation to the more ancient production of the Middle East, Russia, and Siberia. It is certain, however, that the typology of the vases having a symbolic-graphic type of decoration remains for the most part strictly Chinese, having its roots in the forms and the ornamentation of the Neolithic ceramics from Yang-shao to Lung-shan, as Hentze and Watson, as well as others, have emphasized.

The well-known bone oracles, which were used for divination, together with the inscriptions on the Shang bronzes, remain some of the most direct sources from which a verification can be made of the variation between the Ch'eng-chou and the An-yang phases. Of lesser number are the Ch'eng-chou bone oracles, which seem to be composed of scapulas of pigs and sheep, and

the examples with ideograms are very rare, while in the following An-yang period there is a preference for turtle shells, and its deposit has revealed many inscriptions.

The Chinese archaeologists indicate that the most ancient proto-porcelain discovery was also found at Ch'eng-chou, a "tsun" type of wine vase with a yellow-brown glazing and decorations imprinted by rope or stamp in grey ceramic of the Neolithic period. The art of working with jade, of which many examples have been found at Ch'eng-chou, was also developed from the ancient Neolithic prototypes, and several types show definite connections with the utensils and the ornamental and ritual objects of the ptoto-historic period. Other objects that are present are long knives (ko), saucers, small perforated animal figures (turtles and birds) that were probably used as pendants, and a perforated saucer called "hsuan-chi" with a denticulation on the edge that has been suggested to have been used as an astronomic instrument.

According to the "Bamboo Annals," the movement of the capital to An-yang did not occur immediately after the abandonment of Ch'eng-chou, but after the occupation of three other capitals (Hsiang, Pi, and Yen) whose locations still have not been well-identified. It appears that this movement coincided with a seizure of more power on the part of the Shang dynasties. The importance of this dynasty is documented by the increased number and variety of the archaeological findings, along with the greater degree of technical skill associated with all of them, whether strictly artisan (bronzes, ceramics, jades) or more monumental (such as tombs and large buildings). The city was surrounded by a tamped earth wall with doors surmounted by guard towers, and in the residential area the more important buildings of the "ceremonial center" (temples and palaces) were raised on podiums, obvious prototypes of the "tien" (the module, the basic construction of all the subsequent Chinese architecture). The "tien" has a bearing structure of wooden columns (chu) whose stone bases lightly retract from the edge of the tamped earth terracing (hang-t'u). These columns define a structure having an axial symmetry and arranged according to the cardinal points, with entrance steps at the center of one of the longest walls. Only the roof coverings conserve an archaic aspect, since no trace of tiles has been found, but according to the bearing structure that has been reconstructed by Shih Chang-ju, the purlins, placed in parallel lines that slope to the peak, had developed the same flexible tendency that would later occur with the tile roof coverings.

The monumentality ascribed to the organization of a number of "tiens" according to an axial line seems to have already been present at An-yang, except that the bases of the various structures tend to be aligned following an east-west plan with an entrance to the east. This occurred most often in the northern section of the ceremonial area, which came to be considered by Chinese archaeologists as the residence of the ruling family. This sacral east-west guiding principle is probably related to a solar cult, and it was used as a guiding principle on into the historic eras in many other zones of Asia, such as India and Tibet. Perhaps in this period, in particular cases, it continued to have a value equivalent to the north-south directive, which subsequently became "canonic" and appears to have predominated in the funeral complexes.

Several buildings with a central courtyard appear to represent the prototypes of the characteristic "quadrangular facility" that appeared in later eras. Together with the monumental buildings, which clearly demonstrate the great social and economic inequality between the various classes, habitations of a Neolithic type that were dug below ground level have been discovered. It is evident that the classes had already been specifically defined in their functions and duties - the king and the nobles governed and waged war; the artisans created manufactured articles; the farmers performed agricultural work; and the slaves were assigned the most humble and toilsome tasks. A certain mobility was perhaps present in the social system. At least that is what the ancient texts suggest when they refer to slaves that had become ministers of the king.

The large royal necropolis near An-yang, which was excavated for the most part by Chinese archaeologists from 1968 to 1971, still appears to provide the most striking evidence of the great power and wealth of the Shang kings. The structures are monumental and have abundant furnishings, and numerous human and animal victims were sacrificed and buried along with the dignitaries. These tombs reveal even more clearly than the habitations the magical-religious significance that the Shangs attributed to the orientation of a manufactured article, in this case a hypogean chamber, and to the access ramps, which reflected a harmonic relation between the macrocosm and the microcosm.

The sepulcher was then covered with earth and perhaps levelled to the surrounding ground. Actually, no trace has been found of particular elements that would reveal externally the presence of the tombs, unless one accepts Hentze's 1967 hypothesis which proposed that such a levelling was carried out by the Chou invaders to destroy any trace of the Shang necropoli. A further proof of the expansion of the culture of the Shang dynasties from their centers in the Honan into such neighboring regions as the Shantung is provided by the monumental sepulcher excavated by Chinese archaeologists in 1966 at Yi-tu, which contained 48 sacrificed human victims along with numerous furnishings.

The recent findings of examples of bronze vases in the Anhwei, Hopei, Hupei, and Shansi regions and the singular "ting" (ritual food vase) along with a human mask from the Hunan region found at Ninghsiang demonstrate the extent of the acculturation phenomena that the Shang dynasty instilled in a large part of the Chinese territory. These bronzes attest to the high degree of technical ability that the artisans of the An-yang period had attained. The shapes were perfected and enriched by new models, such as the "kuang" (wine vase in the form of a sauce-boat) and the "kuei" (food vase similar to a bowl with handles), demonstrating a higher level of perfection in the consistency, elegance, and movement of the contour line, often accentuated by a dentil-shaped projecting profile. The decoration is not the almost flat type employed in the Ch'eng-chou vases. It appears to have produced in bronze a technique that had been used for ceramics or wood. There was a greater awareness of the technical possibilities offered by metal. The decoration in pronounced relief indicates a clean break with the ancient traditional processes.

The welds of various sections of the vase become thicker because of the greater projection of the embellishment, and they tend to become axes of symmetry

around which the decoration of the vase is arranged. Lei-wens (spiral-shaped designs) fill the background, giving the entire receptacle a pleasing sense of movement and animation. Multiple t'ao-t'ieh masks and k'uei dragons fill a large part of the surface and are elevated at various levels. The t'ao-t'ieh mask loses its structural compactness and its parts become spaced out to fill the interstices of the lei-wen and other geometric designs. These elements, along with such animalistic figurations as eyes, horns, or snouts, animatedly stand out from the contour of the vase, often becoming this same contour line, as in the cases of the kuang lid or the vases having an animalistic form.

The typical plasticity of the mature Shang art is also present in the stone sculpture and the jades (birds, fish, tigers, and buffalo) which attest to the high level of technical skill, the richness of the figurative language, and the expressive power of the Shang artisans. An equal perfection is found in the ceramic production; the exceptional white proto-porcelains of An-yang with printed geometric decorations and animalistic decorations in relief constitute, as M. Sullivan states, a unique episode in the history of Chinese ceramics. But despite the numerous archaeological findings and the information furnished by the bone oracles (more than 10,000 pieces with about 5,000 different characters that represent the first evolutionary stage of the Chinese ideogram, already using the modern reading system of vertical lines from left to right), there are still many problems of the social, religious, cultural, and artistic life of the Shangs that remain to be resolved by further discoveries and acquisitions.

It has not been possible to determine in a thorough manner the political organization of the Shang reign, and the relation of this presumed proto-feudal organization with the aristocratic families, such as the Chou, of the surrounding regions. Neither can we adequately clarify all the aspects of the type of religion practiced. The remaining traces include a cult of the dead, human sacrifice, haruspices used in interpreting the bone oracles, and a great number of magical, symbolic, and mythical figurations ranging from the t'ao-t'ieh and the jade disks to the animalistic images, perhaps of a totemic or apotropaic character.

Chou Dynasty (circa XI century B.C. *- 221* B.C.*).* – It appears that we must revise, at least in part, the traditional view that held that the Chou, semi-barbarian lords of a frontier area, after the conquest of their ancient rulers the Shang developed more progressive cultural and artistic models than those possessed by the Shang. The excavations carried out in the Chou settlements of the pre-dynastic period demonstrate in many locations a direct succession from the Neolithic culture of the Lungshanoide type of the Chou culture. P. Wheatley's hypothesis thus appears to be relevant: "Either the first Chou were only a Lungshanoide type of Neolithic group somewhat influenced by the assimilation of the best characteristics of the Shang culture, or they had already developed one of the regional Lungshanoide traditions, to the extent that they must be classified as a civilization evolving in a parallel manner to the Shang civilization."

Furthermore, as N. Barnard has noted, the Chou bronzes, even including those preceeding the complete conquest of the Shang territory, have engraved inscriptions of a considerable length that are finer and more complex than the Shang bronzes. This presupposes a level of culture equal to, if not greater, than the Shang, at least in regard to written communication. Further excavations and findings will have to establish in what measure the cultural and artistic components of the western Chou date back to the pre-dynastic period and which ones were developed from their own civilization. Today one might concur with Chang Kwang-chih's 1963 proposal that "the conquest did not cause a greater discontinuity than that which could be ascribed to the normal development of the civilizations of the Yellow River."

It is certain, however, that in this long dynastic period, the longest ever ascribed to a reigning Chinese family, several cultural and artistic constants had been established that were to constitute a fixed point of reference for the successive historical periods. In fact, during the Chou dynasty, and above all in the next period, characteristics emerge that point to an agricultural economy on a national scale, with a feudal type of political organization. Also, the "100 schools" of the philosophers formed the speculative background of the future Chinese culture. As C. Hentze correctly states (1967), during the time of the first Chou emperors a process of cultural secularization began, and it would also have consequences in the artistic field. This evolution is also documented by the above bronze inscriptions, in which allusions to political and personal success begin to prevail over inscriptions of a magical-religious sort used by the Shang dynasties. This same writing loses part of its hieratic function through successive simplifications and becomes more predominately practical and celebrative. This represents the new philosophic attitude that breaks away from the irrational, and its expression will culminate with the Confucian theory, which paves the way for a more organic and realistic artistic production.

The development of urban planning, communication methods, transportation, irrigation, and metallurgic techniques facilitated the transfer of power to a new aristocracy composed of bureaucrats, intellectuals, warriors, and landholders, creating the framework for the process of national unification.

Obviously, it is impossible to cover in a unitary manner this long period, in the course of which many profound political and social changes took place. The traditional subdivisions, accepted even by the modern Chinese historians, still appear to be valid and applicable to a certain extent to the evolutionary development of the artistic production. These include the Western Chou period (circa XI century B.C. - 770 B.C.) and the Eastern Chou period subdivided in the era of the Spring and Fall Annals (770 - 475 B.C.) and the period of the Warrior States (475 - 221 B.C.).

The Western Chou emperors moved the center of their power westward into the Shensi region, conquering several western zones that had resisted the Shang penetration, though the feudal territories under their direct control were no more extensive than those of the Shang emperors.

Many settlements of this period have been examined. The most significant of these so far has been Ch'eng-tzzu-yai, yelding information that permits one to reconstruct the form of the urban structure. This settlement was the capital of the vassal state of T'an and was located near Chi-nan in the Shantung province. In several areas it was built over a preceding village of the

Lungshanoide period. The tamped earth surrounding wall was more or less rectangular in shape. The best preserved were the north and west walls, which had a height of about 3 meters and a thickness of 6 to 10 meters at the base. The excavation of the wall has permitted not only a study of the construction techniques, but also a determination of the wall remains of the Neolithic period that were incorporated in some of its sections.

The archaeological research underway at Chang-chia-p'o, near Sian, where the first Chou capital, Feng, was located, has uncovered two basic types of habitations. One is a rectangular structure dug slightly below ground, and the other is round and more deeply recessed below ground, with a tamped earth floor and a bearing structure composed of wood columns. These appear to be of the same type as the pre-dynastic habitations, although they are of a larger dimension.

The most interesting discovery is a water well that perhaps is the most ancient example in China. Cheng Te-k'un states that "one could reasonably presume that the Chou people invented the well in the Far East." Another innovation that can probably be ascribed to this period is the use of tile roof coverings. Numerous examples of these tiles have been found in many settlements of the Western Chou people, such as those discovered near K'e-sheng-chuang, Li-chia-ts'un, and Ch'en-chia-ts'un. They are considerably dense and must have been baked at a high temperature. Two types have been found; one is wider and flat with a hint of a curve, and the other is of a semi-cylindrical shape. Already in this period there was use of the same construction design that successive historical periods employed, with flat tiles arranged in parallel lines that covered the entire surface and semi-cylindrical tiles placed over the joints.

Apart from an examination of the evidence, one can infer from the sources that the major Chou settlements were above all ceremonial, administrative, and military centers, where artisans also resided and produced useful objects in bronze, jade, and ceramics for the dominant class, while the argicultural villages often continued to fabricate rudimentary utensils in stone, bone, and ceramics. Although not verifiable for the preceding period, there is evidence that the Chou emperors sought to locate settlements in proximity to main transportation routes. It appears that there was an increase in the number of urban centers, not only in the central and western regions, but also beyond the Chou territorial borders.

The large number of Western Chou sepulchers, among which nearly 400 belonging to the vast necropolis near Lo-yang have been recently found, show a certain continuity with the Shang tradition as regards the wooden structure of the quadrangular hypogean chamber. A sacrificed dog was often placed at the bottom; this resembles the Shang custom of placing a dog in foundations. Human sacrificial rites were still performed, as evidenced by the recently excavated tombs at Luiliho (Feng shan), but they were much less frequent. However, one does not find the large stairs in the tombs typical of the monumental Shang sepulchers. The diversity of the dimensions of these complexes and the richness of the furnishings clearly demonstrate an ever greater social stratification within the Chou society. The common people used simple small tombs, while the wealthiest classes enlarged the hypogean chamber, orientating it according to the ancient geomantic and cosmological rules and constructing long access ramps (which did not exceed two in number). Horses and carts were buried in nearby graves.

Further information on the Western Chou civilization has been provided by the inscriptions found on the sacrificial and funerary bronzes. For example, as Kuo Mojo suggests, from a group of bronzes uncovered at Chang-chia-p'o near Sian in 1965, one can conclude that the custom of mourning for three years was not yet in use (perhaps this was suggested later by Confucius himself), and one can determine the type of calendar used, the use of hereditary succession for high offices, and the nomenclature of several bronze receptacles.

There is evidence that the bronzes of this era had taken on a pronounced social function. These objects were created to commemorate a promotion in rank or a meritorious deed of an important personage and were collected as treasures to increase a family's patrimony. The dedicatory inscriptions were instrumental in W. C. Kane's proposal (1973) of a certain stylistic differentiation between several bronzes of the late An-yang period and those of the first Chou emperors. For example, the yu vases (wine receptacles) demonstrate definite changes in the subject of the inscriptions and a typology for which the examples before and after the Chou conquest can be distinguished. The simple S-shape profile of the Shang yu is now transformed into a more complex and undulated "silhouette" in which the curved lid becomes more elaborate with the addition of small lips.

Then, beginning with the fifth Chou emperor, Mu-wang (947 - 928 B.C.), this type of vase appears to deteriorate into an object having an increasingly squared and squat profile and whose static and flat form has almost completely lost the elegant and dynamic contour of the preceding examples.

It is also very interesting to note that in the Shang bronze production of Ch'eng-chou Kane also sees two different stylistic directions that later have separate, contemporaneous developments in the bronzes of the last An-yang period and in the pre-dynastic Chou bronzes. These then will follow a consistent style found in the Western Chou bronzes. In addition, from the lines and the highly "baroque" decoration of several vases from the last Shang period, Watson (1974) recognized the first sign of a northwestern or Chou influence on the pre-dynastic era.

It appears that by now it is an accepted fact that the Chou conquest brought several changes in the bronzes, both in decoration and in typology. The overall vision of the design becomes more important than the detail, and the technique of filling the background with "lei-wen" gradually disappears. The shape becomes more varied and less symmetrical, and in the best examples it manifests an exceptional sense of power and mass.

According to R. G. Gettens, these changes reflect a decline in the technical skills from the Shang to the Chou artisans. One could more easily agree with Watson that these changes are not merely the result of a deterioration of technique, but reflect a particular change in the arrangement of decoration in space, in the sense of a greater movement and freedom of the design.

This is actually the first circumspect affirmation of realism, which leads to the loss of meaning of certain

magical-religious values (verifiable in the geometric rendering and the disaggregation in an ornamental way of the ancient mythical and symbolic animal forms) and the gradual use of more real and vivid subjects. It is also possible to recognize the first signs of a simplification and transformation of several typically Chinese motifs, probably due to the influence of the stylization typical of the nomads of the steppes.

As Mino Yutaka correctly observes (1975), the glazed ceramics of the Western Chou period seemed to have suffered from the competition of the bronzes, and they often imitate the bronzes in form and decoration without assuming their own characteristics. However, from a technical point of view, as Hsia Nai noted in 1959, the so-called proto-porcelain level had been reached, and the work was baked at high temperatures. In the X century B.C. tombs discovered at P'u-tu-ts'un, near the Western Chou capital, vases were discovered that were decorated with horizontal fluting and covered with a bluish-gray glaze that was very different from the glaze used by the Shangs. In fact, Cheng Te-k'un's (1963) hypothesis, which links the end of this typical Shang production with the conquest of the capital near An-yang and the dispersion of artisans who created the white ceramics, is still valid. It appears instead that the discovery of glass, which occurred around the IX century B.C., was a technique acquired by the Western Chous, perhaps from the Western world. This is documented by the numerous pearls discovered primarily in the tombs located near the royal capitals in the Sian area.

The invasion by the "western barbarians," who sacked the flourishing capital, compelled the Chou dynasties in 770 B.C. to take refuge near Lo-yang, in a region in which the principal Shang centers were located. Their loss of power was clearly reflected in the artistic field, and one notices a decline of the official art and the affirmation of several provincial styles. It is not difficult to recognize elements extraneous to the Chinese artistic tradition belonging to the "animalistic art" of the nomadic invaders. At the same time one notices, starting around the VIII century B.C., a spread in the use of iron tools and weapons that will lead to new technical advancements in craftsmanship and agriculture.

We must reexamine the role that the Indochinese world has had regarding China's acquisition of iron workmanship. Evidence of iron work has been documented at Ban-Chiang in Thailand that dates back approximately to the last half of the II century B.C., and one can further hypothesize that iron could have been widespread first in the southern zones of China, starting between the VI and the V centuries B.C. As L. Lanciotti (1974) has pointed out, recent excavations show that the Wu and Yueh reigns still used bronze between the VI and V centuries B.C. In any case, one could hypothesize that the southern territories made a fundamental contribution to Chinese metallurgy, and the whole question of the historical-artistic connections between the Chou reign and the southern territories must be reconsidered.

In the Lo-yang region, the Chou emperors built two capitals. The first, Wang-ch'eng, was the capital of 12 sovereigns, and only toward the end of the Ch'un-ch'iu period (Springs and Falls) was the government moved to Ch'eng-chou, where it remained until the end of the Chan-kuo period (Warring States). Information

on the Eastern Chou can be gleaned not only from the numerous excavations carried out by Chinese archaeologists, but also from the historical texts that have reached us, in which detailed codification of a precise architectural and urban-planning lexicon is present. Chou-li was very clear in his description of the "ideal capital": it is formed by a "square with sides measuring 9 li [4.5 kilometers], with 3 doors per side; also 9 streets running longitudinally and 9 streets running transversely, all large enough to permit the passage of 9 carts. The ancestral temple is on the left, and the altar of the earth is on the right, facing the court, behind the market square." This is evidence of the greater complexity and functionalism of the Chou center in respect to the Shang center. This center was considered a valid model for all the successive designs of the imperial capitals, although it is impossible to define with certainty the time of its formulation, given the uncertainty surrounding the dating of the editions of the Chou texts.

In the Book of Cantos one finds clear references to the orientation given to the urban planimetry arranged according to the four cardinal points and to the close connection that was postulated between the cosmologic world and the city that symbolically recreates it and constitutes its center. The Shih Ching, along with other texts, also ascribe to this era the diffusion of the typical courtyard system, which used various multiples of the primitive building module, the t'ien, to form quadrangular courtyards having an axial and specular tendency. These centuries gave rise to the establishment of the "classical" constants that would characterize Chinese architecture and urban monumentality. These constants denote planar-volumetric solutions that are truly symmetrical, perspective and axial, and they are the typical expression of a rigidly hierarchical and stratified social structure.

All of the patrimony of laws concerning the organization and the use of living space was integrated with inordinate consistency by sumptuary regulations which served to regulate the size, structure, and decoration of each complex according to the corresponding social rank of the inhabitants.

However, the archaeological remains do not attest to an exact application of this differentiated and complex codification, above all in the field of the urban complex. According to the recent reconstructions by Ch'en Kung-jo, the capital Wang-ch'eng (whose excavations were begun about 1960) presents a rather irregular form of urban planning - largely a square with sides of about 3,000 meters, but having indentations and projections. There appears to be some validity in P. Wheatley's hypothesis, which regards the walls of the latest Han city as being the seat of the directional center, which in effect occupies the center of the quadrilateral city and uses the wall of the imperial palace for its surrounding wall.

This phenomenon is analogous to the one that will be encountered in the relationship between the Ch'ang-an of the T'ang and the later city of the Ming. But it is in the remains of the Ch'ao state capital near Han-tan (Hopei, 386 - 228 B.C.) that one finds a clear reconstruction of the north-south axis inside the quadrangular surrounding wall, with sides oriented according to the cardinal points, and a series of platforms in "hang-t'u" that represent the podiums of the larger buildings, ranging from about 3 to 10 meters in

height. The vicinity of the most important complex on the southern side of the wall shows, however, a localization that is strongly divergent from the canonical orientation. Other capitals of the feudal states of the Eastern Chou period, those of the Chin and Yen states (to cite only two of the numerous settlements of this period excavated by Chinese archaeologists), also present highly irregular complexes, quite different from the Chou-li codifications.

Even the funeral groupings deviate from the traditional planimetry used by the Shang. In fact, the tombs confirm the existence of numerous local typologies and differ from reign to reign and from period to period. For example, the tombs excavated from 1966 onwards in the Hupei province near Ying (the capital of the Ch'u reign) by the Hupei Cultural Office, although having the usual quadrangular graves with the sides aligned according to the cardinal points and funerary chambers constructed of wood, nevertheless have access ramps to the east and other lateral chambers arranged in an asymmetrical fashion.

More complete studies on the depictions of buildings on bronzes, although being limited by the summariness of the representations, perhaps could contribute to the analysis of these "regional variations" in the architectural language. An example would be the constructions engraved on a bowl taken from a Hui-hsien tomb in the Honan province, from which one could infer that the typical trussing system had not yet appeared; its forerunner was a single block resembling a wooden capital. A representation of buildings on a bronze receptacle in the Historical Museum in Shanghai, dating from the Springs and Falls period, shows a greater projection of the roof eaves, leading one to believe that perhaps already in this period the major local differentiations were delineated between a northern architecture having a more sober and less projecting roof and a more bizarre and animated southern architecture. It is necessary to examine other examples to support this hypothesis.

It is rather difficult to establish several local styles in the Eastern Chou production of bronze objects, whose examples are continually being added to by the excavations of Chinese archaeologists. The private collection of these furnishings, the provincial obstructions, and the presence of elements derived from the northern and central Asian cultures are factors which generate substantial disagreement among sinologists in regard to the solutions proposed. It has been quite some time since Karlgreen and Yetts proposed their order of a time sequence. Although using a different nomenclature, they established a "middle Chou," or a "second phase" of the Chou, in which the motifs and the forms differ and are simplified, assuming a particular monumentality. Then follows the "late Chou" or "Huai style" period, in which one notices, along with a revival of several Shang motifs rendered in a baroque and lively manner, the presence of hunting and "genre" scenes which replace the symmetrical-geometric rendering of the ancient designs with their rhythmic spatial organization. This is a distinct reflection of the rational philosophic attitude that was affirmed in this period, manifesting in a tendency toward realism in the artistic production. On the basis of this evidence M. Sullivan (1973) proposed an interesting parallel between this period and that of classical Greece.

On the subject of the contributions and the typical currents of other zones, W. Watson (1975) specified the style of Li-yu, a foundry in the province of Shansi, which assumes a position of great importance in the production from the VI to V century B.C. Its particular interpretations of the Shang t'ao-t'ieh and kuei in a low, flat relief with spiral band decorations influenced many of the prototypes of the period. This style represented one of the antecedents of the so-called Huai style, which had its following in the Ch'u state. The successive findings and excavations of this reign's funerary complexes, in which more than a hundred sepulchers have been identified near the capital, have contributed to our knowledge of the civilization of this period and the role that this southern state played in many fields of the late Chou artistic development.

This appears to confirm the hypothesis of A. Waley, who several decades ago proposed the idea of the important influence that the figurative art of the Ch'u reign had on the genesis of the Han painting. The decorations on the bronzes and, above all, the lacquers clearly give evidence of several lexical elements, such as the prevalence of the contour line and the profile. The internal details have been reduced to a minimum and present a vivid sense of rhythm and vital energy. These later become fundamental constants of the reproduction of the human figure in the Han period. In fact, one could agree with C. D. Weber (1968) that the same bronze vases with scenes of life and "genre" have not changed the decoration from "the art of the steppes," as had been hypothesized. Although sometimes they used modules of stylization, "they represent a reflex of the initial system of Chinese pictorial art that was developing during this time to satisfy the needs of the dynamic culture of the late Chou period.

A high technical level as well as a high artistic level had been attained in the Ch'u state (which had its center in the Hopei province). This has been documented also by the tombs of the V century B.C. opened in 1971 near Ch'ang-sha, of which Hsiang Po (1973) has provided us with an account. Among the nearly 300 funerary objects, including ceramics, bronzes, jades, lacquers, and silk, there appear various interesting types of weapons. These include ko (axes and daggers), mao (spikes), chi (halberds), and arrowheads, that demonstrate a wide assortment and an exceptional degree of technical skill that had been reached by the Ch'u weapons craftsmen, augmented during this period of conflict and continuous wars.

Under the Eastern Chou, and especially during the period of the Warring States, the bronze funerary supellectile begins to be gradually replaced by glazed ceramics. As Mino Yutaka (1975) observes, this use had far-reaching effects on the ceramic production, which, starting in this period, slowly began a progressive disengagement from the forms and the decorations of the bronzes, although many examples closely related to the ancient ritual typology continued to exist.

Going outside the limits of the subject of late Chou civilization, it is interesting to note that several remarkable remains of the megalithic cultures, uncovered for the most part in the areas near the upper course of the Yang-tze River in the Szechwan province, date back to this era.

Other examples that can be added are the dolmens, discovered at Wang-mu-shan in the Shantung

province, in the Liaoning province, and in Korea. The presence of megalithic manufactures in zones so distant from each other leads Hentze to presume a greater extension of these cultures, traces of which have by now disappeared. However, these discoveries considerably broaden the area of diffusion of the megalithic cultures, creating a certain continuity with analogous cultures of the Indian sub-continent, Tibet, and Indochina, going beyond the consistent differences of dating.

Lastly, one could also consider the elongated rocks that are widely seen in the gardens and parks of the Far East as vestiges of the megalithic cultures. This is an apparent transposition, in a purely aesthetic and symbolic sense, of an ancient psychic attitude of religious respect toward rocks as divine images, an attitude that still persists within the collective unconscious.

Ch'in and Han dynasties (221 B.C. - 220 A.D.). – As D. Bodde correctly states, 221 B.C. must be considered the most important date in Chinese history before 1912 A.D. In fact, it represents the abolition of the feudal reigns and the transition to an empire. The colossal effort exerted by Ch'in Shih Huang-ti to unite under his dominion the entire national territory obviously had significant repercussions in the artistic field. The new Ch'in dynasty (221 - 206 B.C.) demanded the affirmation of its supremacy over the aristocrats of the various provinces, and it needed to unify as much as possible the diverse regional traditions in order to create a common artistic language. Thus, we find the construction of colossal architectural works (the Great Wall and the A-fang Palace), and, with the deportation of the feudal nobles and their families to the capital Hsien-yang in the Shensi province, this center took on considerable interregional characteristics which lead to a consequent progression beyond the various local styles, ending with their fusion. The First Emperor ordered that every palace of a conquered reign be reconstructed in his capital, Hsien-yang, for magical-religious and political reasons. This circumstance provided the artisans of the capital with a vast knowledge of different styles and the opportunity to seek a unitary artistic language. The notorious burning of the ancient texts, ordered by Shih Huang-ti to break the dependence on the Confucian past, unquestionably helped cut off some of the ties with the late Chou art, allowing the creation of new artistic modules which were subsequently developed by the Han.

In 1974 an important discovery cast new light on the Ch'in artistic production. A subterranean chamber was being excavated that almost surely made up part of the enormous funerary complex of Shih Huang-ti near Lintung (Sian). The crypt was 210 meters long from east to west, 60 meters wide from north to south, and about 5 to 6 meters deep. On the inside were discovered bronze weapons, iron agricultural tools, gold, jade and bone objects, jute and silk fabrics, tanned hides, and, most predominately, hundreds of life-size clay soldiers together with carts drawn by four horses. It has been calculated that an entire army of several thousand statues is contained in the crypt, and the Chinese historians have recognized in the disposition of these clay statues the military formation typical of Shih Huang-ti's troops as suggested by the texts.

This finding was an assemblage of spirit objects, or ming-ch'i, which replaced the human victims used in preceding periods. Their great number reflects the monumental taste typical of the grandeur of the First Emperor; perhaps this can also be explained by the recent memory of the men actually buried together with their lords. The Ch'in realism was evident not only in the natural size of these figures, but also in the fully characterized face, demeanor, and clothing of each soldier. One notices a pronounced taste for portraiture, for the expression of a state of mind (fierceness, rashness, martialism) along with a strong sense of the body mass and the three-dimensionality of the sculptural work.

The rendering of the horses is also extremely realistic. Although they are in a static position, they demonstrate a pronounced vitality in the upright ears and in the tension of the muscles of the muzzles and legs. As one Chinese archaeologist has stated, these animals seem "to gaze attentively in the distance as if they were ready to neigh and break into a gallop on the signal of their driver, should something suddenly appear."

The great abundance of evidence in this hypogean chamber, which is located to the east, outside of the double walls located around the gigantic tomb of the emperor, gives us the measure of that which can effectively be accepted as a funerary chamber. The monumental hill on top of it was the first one having these proportions that had ever been encountered in China (a square base with 300-meter sides, 150 meters tall). Indeed, tombs of the Chou period have been found, but they have been of much smaller dimensions. One of the surrounding walls almost forms a square, while the other is larger and rectangular, and they are concentrically positioned according to the cardinal points. In our opinion, the entire complex, including the walls, is an expression of a clear intent to reconstruct the capital complex in the excessive residence of the First Emperor (with the external surrounding wall of the entire urban complex and the inner wall which delimits the imperial city in which the funerary tomb occupies the position of the Imperial Palace). Thus, taken as a whole, as in the city's example, it symbolized the entire macrocosm in which the imperial abode, either as a habitation or tomb, together with the emperor, constitute the center or axis mundi.

In today's China there is a manifest interest in the Ch'in period, especially in regard to its legalistic and Confucian features and in its application to the modern day political struggle directed against tradition and Confucianism. This interest has also led to an increased number of studies conducted on the artistic activity of this period. In 1976 an extensive report of the excavations conducted at Palace #1 of Hsien-yang was published, showing very interesting planimetry and reconstructions that present us with an essential picture of the Ch'in architecture. One finds two lateral blocks composed of various "tien," connected at the center by a covered passage. Although the complex, traditionally orientated with the facade to the south, exhibits an absolute axiality and symmetry, one can notice that the "tien" are assembled in an organic manner. This feature, together with the diversity of heights, volumes, and types of roofs, create several pleasing variations in the skyline. It is an extensive, monumental, formal, and classically-measured architectural work. In several large columns one notices the truss in the shape of a small boat. The use of a type of squared capital, which we have seen represented in the Chou bronzes, appears to be much more widespread.

As to the figurative arts, a splendid female figure in terra cotta recently discovered at Lintung displays a great sensitivity for the idealized portrait and a taste for pure volume depicted in a three-dimensional and realistic manner, even though the human form disappears under the heavy facing material which covers solid geometric figures.

In 1967 17 bronze vases with dedicatory inscriptions of the First and Second Ch'in Emperors were uncovered near Chin-an in the Kansu province. Together with other receptacles recently discovered near the capital Hsien-yang, they show a uniformity with the typical decorative motifs of the Warring States. Several characteristic notations are evident, such as the birds with elongated bodies that prelude the so-called "cloud spirals" which are later developed in the Han bronzes. Furthermore, prescribed weights and measures, ordered by Shih Huang-ti to unify the various systems used throughout China, were discovered in diverse regions such as the Kansu and Shantung provinces, proving the "capillarity" of the penetration of the imperial power. In an interesting 1973 article, Wang Shih-min examined the archaeological evidence of this unification (which was brought about also through the written word), giving us an idea of the tremendous effort employed by Shih Huang-ti to create a cultural homogeneity.

The Ch'in left to the following Han dynasty an artistic inheritance that was rich with ferment and the possibilities for further development. This circumstance was totally unknown until a few years ago. One certainly could say that the Han acquired the Ch'in tendency toward realism, but they diluted its monumental power with a more subtle taste for line, detail, and rhythm, together with a component of the southern influence. By now one could consider the Han artistic production, which has always been judged as the most "classical" Chinese art, not as the result of an "in vitro" evolution within a nearly total isolation, but instead as the result of exchanges and contacts with the external world. The Han envoys explored all of Asia, from Japan to Mesopotamia, from Mongolia to India; the Silk Road connected the Far East with the Roman West; Chinese colonies were founded in Korea and Indochina. Thus, it is not unthinkable that elements of the figurative codes of these distant countries had been transported into the heart of the Chinese Empire. But the steadfast ties with the past, with Confucianism and the Chou traditions, together with the awareness of their own supremacy, were so strong that the foreign elements were readily assimilated and reproduced in an original and autonomous fashion. In other words, they were used to enrich, but not to radically change, the Han artistic language.

The indestructible ties between the microcosm and the macrocosm, continuously sought in China since the most ancient periods, became systematized and rationalized (down to the smallest detail) in this period on the basis of past traditions. A system of correspondences was created, based on the principles of the masculine yang and the feminine yin, which are reflected in the organization of space and time, in the principal components of matter, and in colors. It is a system expressed in a precise code of symbolic elements that appear in widely different works of art, such as mirrors, lacquered objects, murals, and architectural complexes. This profoundly-felt and lived speculation actually enriched the artistic language with more meaning, rendering it ever more alive and viable, as a mirror and part of the whole.

In the field of urban planning, the capital of the Western Han (206 B.C. - 8 A.D.), Ch'ang-an, built by the general Hsiao Ho by the order of the emperor Kao-tsu (202 - 195 B.C.), presents a highly irregular surrounding wall that is 20 kilometers long. Undoubtedly, the previous Ch'in temples and palaces, along with the irregularity of the terrain, must have forced a deviation from a canonic arrangement of the entire urban complex, although an effort was made to adhere as much as possible to the plan of a checkered street system and a 12-door wall. Wheatley (1971) observes that this urban complex "has inspired the hypothesis that the city was founded on a spatial model of the two constellations Ursa Major and Ursa Minor combined, with the Imperial palace occupying the position of Polaris." Considering that the Ch'in capital, Hsien-yang, also seems to have incorporated analogous elements of astral symbolism, according to the historian Ssu-ma Ch'ien, it is possible that this hypothesis could be true. If this were so, then these elements would represent even more evidence of the symbolic ties with the macrocosm and constitute some of the most relevant features of the Han speculation continuing on in successive periods. The Han interest in astronomy is also documented by the depictions of constellations sculpted in stone recently discovered at Nanyang (Honan) and examined by Chou Tao (1975) and in the representations of the "vault of heaven" frequently found inside the funerary chambers.

Within the monumental type of Han architectural language (whether associated with astral conceptions or not), there remains a certain independence from the exact geometrical axiality of the planimetry, especially in the urban fabric. In the single complex, the module, or tien, is often aggregated in an organic fashion, but it continues to conserve its quadrangular and symmetric structure.

In this period there is also evidence of diversification in the altimetry of the complexes. Technical innovations and a generalized adoption of the trussing system (tou-k'ung) permitted a better distribution of the static forces and, thus, a higher elevation of the multifloor buildings, which in the Ch'in period were still being built by elevating an internal podium to construct the upper floors. Ch'ueh (towers that flank the doors), t'ai (detached, wooden towers), and lou (pavilions with several floors) gave a great diversity to the skyline of the complex and of the entire urban profile. The tendency toward a functional aggregation of the architectural elements was even more evident in the architecture of the homes of communal habitation, as has been documented by the numerous ming-ch'i found in the tombs and by graffiti, reliefs, and mural paintings. These small ceramic models show evidence of "L" and "H"-shaped edifices, at times with openings located in an asymmetrical fashion, with external stairs that lead to the upper floors, and imaginative altimetric variations of single structures, often with several floors. It is possible to identify several more evident variations of regional types of houses. Palafitte construction (pile-built dwellings) was already present in southern China (Archaeological Museum of Canton), and examples from the Eastern Han period show a round structure, often with highly projected ridge lines and sharp, protruding

acroteriums. The palafittes undoubtedly had their origin in the Indochinese area, and they were also used as granaries.

Even more interesting, from the standpoint of determining another regional style of the Han period, is the archaeological evidence, primarily in bronze, of the culture of the Tien reign in the Yunnan province. This evidence has been largely reexamined by the brilliant sociological analysis of M. Pirazzoli t'Serstevens (1974), who defined it as "an astounding richness, on a level of both technique and form, of decoration and the possibilities of expression." The constructions depicted on bronze cylinders demonstrate column-supported structures having a boat-shaped roof, with axes that intersect on the ridge line forming a scissor motif, and walls composed of logs laid one upon another. M. Pirazzoli differentiates three types of these structures, comparing some of their characteristics with those of several types of habitations in southern China and Indochina. It is interesting to note the close structural relation that links this representation with the Japanese Shinto constructions, which implies that this type of structure had spread across great distances.

New contributions to our knowledge of the Han metropolitan architecture have been made by the excavations conducted by the Sinic Academy at Lo-yang on the site of the Eastern Han capital (25 - 220 A.D.). The external surrounding wall definitely demonstrates more regularity than the wall of Ch'ang-an. It is oriented according to the cardinal points, but the north wall, composed of a broken line, does not completely exclude the possibility of the presence of astral symbolism. The monumental north-south axis is clearly identifiable, and it leads to the southern side of the internal surrounding wall, which has a rectangular shape (imperial city) and encloses the administrative center and the emperor's palace. But the traditional axial and symmetrical system is not followed here in the smaller details. For example, the south entrance of the inner wall is not centered. Similarly, the representative buildings are also in a position eccentric to the western side of the imperial city, and although they follow the classical courtyard design, they do not seem to be aligned in a regular manner. Planimetric and volumetric differences also appear in these monumental complexes, which give a very pleasing aspect and a variety to the habitation models.

The great flexibility and richness of the Han architectural lexicon is also evident in the funerary constructions. The hypogean chambers, solidly constructed in stone and brick, with ogival, domed, and barrel vaults and pointed and arched passageways, definitely demonstrate the presence of elements suggested by the Western world, but synthesized with the addition of the traditional bearing structures in sculpted wood and paintings on the walls. Even the complexes are strongly varied and differentiated, ranging from traditionally axial and symmetrical forms to more liberal forms in which the annexes are arranged less geometrically around the central chamber. A great variety of typology exists which is associated with the various social classes and with the regional and ethnic differentiations, ranging from simple graves containing wood coffins to tombs carved out of the rocky slopes in the Honan and Szechwan provinces.

Chinese archaeologists have recently excavated numerous Western Han tombs, including the double

tomb of Hou ho at Hai-chou (Kiangsu) and the San-li-tun tomb in the Kiangsu province, in which has been found a splendid tripod decorated with a "ring of animals" and crouching quadrupeds. The tomb of Ki nan-cheng in the Hupeh province was an extremely rich find, as it included 500 funerary objects and a perfectly preserved cadaver of a functionary inside its three biers. The Tsinan tomb in the Shantung province has provided a group of ceramic figures composed of acrobats and musicians that are full of movement and vivacity.

The excavation that has unquestionably provided the most varied findings of the Western Han is the tomb of the wife of the first marquis of T'ai, Li Tsang, excavated, along with many others, in the Ma-wang zone near Ch'ang-sha in the Hunan province. Since its opening in 1972, it has constituted one of the most important archaeological discoveries of modern China. Structurally very simple, it is composed of a very deep grave, with wood construction and insulating material (coal and white clay) which acted as a seal to permit the perfect preservation of the findings. More than a thousand objects have been uncovered (fabrics, dresses, paintings on silk, lacquered crockery, funerary statuettes, and ceramics), all listed in an inventory (ch'ien-ts'e) on 312 bamboo slats. This inventory is still legible, and it has permitted Ch'iu Hsi-kuei (1974) to resolve several questions concerning the li-shu (official writing).

The most interesting finding is the painting on silk on the inside of the bier. It is unquestionably the most ancient and complex finding ever uncovered in modern China, and it has overturned the great majority of the theories associated with the Han pictorial art. The scene is divided into three sections, arranged one upon another, typical of the cosmologic-religious speculation of the Han, representing the subterranean, terrestrial, and celestial worlds with complex symbolic figurations that refer to ancient traditional myths. It is an interesting document of the funerary practices, beliefs, and type of life and culture of the early Han period. Also, this composite is the most ancient prototype of the vertical roll painting (shou), which previously was thought to have been introduced into China, together with Buddhism, from the Central Asian and Indian regions. Fong Chow (1973) correctly observes that until now it had been a generally accepted postulate that the expression of a third dimension and of complex spatial effects (not to mention luminism and the corporeal quality of the figures), obtained with chiaroscuro, had been introduced into China along with Buddhism in the first centuries after Christ. Instead, in this painting the flat colors and the prevalence of the contour line, which were considered peculiar characteristics of the Han painting, were used with a technique of modelling the bodies with light and shade in human figures, mythical animals, and clouds. In this work, Chinese painting appears to liberate itself from the "colored design" schemes associated with the archaic ages, and it begins to assume characteristics that are fully pictorial, spatial, and coloristic. In fact, the pursuit of perspective is evident in the ramp which leads to the platform, on which the deceased is probably depicted, and in the three servants that accompany him.

The presence of spatial and perspective notations in the Han figurations had already been known, especially in the funerary tiles with bas-reliefs (of which two splendid examples with "genre" scenes of the second

Han period have been recently discovered in the Szechwan province near Yang-tzu shan), but until this time they had never been so clearly documented in the painting. The tendency toward realism, typical of this period, was expressed in an evident manner in the profile portrait of the deceased, with a few number of strokes fully defining the individual characteristics. In 1963 M. Loher proposed the late Han period as the beginning of portrait painting in China, but the pronounced realism that we have already encountered in the Ch'in funerary statues would incline one to shift the starting date of portraiture to the Ch'in period, given that we presently do not have sufficient documentation. The quality of the Ma-wang-tui painting, however, is such that one would suggest a preceding tradition. W. Watson (1974) states that at least six portrait painters are mentioned by the later writers as active in the first Han period, and in the second Han period a distinct and common artistic language had been formed, which spread from the southern regions to the extreme north (basket discovered in a tomb of the Korean colony of Lo-yang). It used a simple but greatly effective code, with profiles of three-quarter size figures realistically rendered with very few strokes.

The discoveries of mural paintings (tombs at Ch'eng-chou and Lo-yang) are also helpful in delineating the vivid characteristics of perspective spatiality, colorism and realism in the Han depictions. It is difficult to determine the extent of the contribution of the Western world on the total pictorial expression in China, since it was precisely in these centuries that another great pictorial tradition was developing, namely, the Greek-Hellenistic tradition. By now, however, it is certain that, more or less in the same period in the West and in the Far East, there was an affirmation of pictorial expression in a full sense. This expression was no longer merely "colored design," but, as R. Bianchi Bandinelli (1976) states, an expression "in its essential poetic value of a chromatic and tonal relation, and of an imaginative reality." Even if the prominent archaeologist asserts that this objective was reached in China only at the end of the fifth century A.D., which was the commonly accepted opinion until recently, the painting uncovered at Ma-wang-tui, at least in part, demonstrates that it dates back to the first Han period.

The rich figurative patrimony that this tomb has preserved for us has been the subject of study of many Chinese and Western archaeologists. An Chih-min (1973), Sun Tso-yun, Ma Yung (1973), and C. Larre (1976) have studied it primarily from an iconographic point of view. Sun Tso-yun (1973) skillfully interpreted the numerous lacquered mythological depictions on the most external coffin, which, although evidently symbolic and stylized, conserves a definite realism in the parts that compose them and a strong sense of movement, often captured at a climatic moment. But, it is above all in the quality of the pictorial and perspective rendering that one can recognize the "emergent" element of the painting of the first Han period. This element later becomes enriched and perfected in the Eastern Han period.

In 1971 an Eastern Han monumental tomb was excavated at Ho-lin-ko erh (Inner Mongolia), composed of various quadrangular hypogean chambers united by corridors and arranged according to an east-west axis and with lateral annexes arranged in an asymmetric form. This is a clear demonstration of the typological dissimilarites existing in the funerary architecture in this period. But the abundance and the richness of the artistic lexicon of the second Han period is documented especially by the mural paintings, and some very significant examples are found in this tomb.

Isolated figures, sometimes lacking perspective notations, are found alongside more complex representations. The most magnificent example is composed of a large architectural complex as viewed from above, in whose central courtyard a performance is taking place. The perfectly realized spatial structure and the liveliness of the characters, who are captured in the poses of various everyday activities, make this painting a prototype of the later "genre painting." It is also the starting point for the later depictions of Buddhist nirvanas that, until recently, were considered the first complete examples of painting having spatial and perspective organization. W. Watson attributes the tendency to represent "genre" scenes to the formation of a middle class of civilian and military bureaucrats. This tendency appears under different characteristics during the first and the second century A.D. and virtually ceases with the end of the Han empire, to reappear only much later. According to Watson, these "everyday dramas" came to be considered as hardly ceremonial (and in a certain sense vulgar) by the emperor and by the highest bureaucracy, who preferred, instead (as also described in the texts), more edifying depictions of a Confucian type depicting noble and mythological personages.

Unfortunately, in the well-known funerary complex discovered in 1968 at Man-ch'eng in the Hopei province, the last residence of the prince Liu Sheng and his wife (belonging to the Han imperial house), no trace was found of the expected mural paintings. Hsia Nai (1972) states that the two tombs, deeply excavated in rock, were "literally subterranean palaces with wood structures and tiled roofs" constructed inside the huge artificial caverns, but now completely collapsed. Liu Sheng's tomb, measuring 52 by 37 by 7 meters and formed by a central chamber and two auxiliary chambers at the north and south sides, once more demonstrates the extreme structural and planimetric variety of the Han funerary architecture. The rich supellectile discovered here — about 2,800 pieces comprised of bronze, gold and silver vases, and objects made of iron, glass, jade, ceramic, and silk — is a further proof of the richness and diversification of the artistic language of the first Han. The well-known "jade sudariums" of the prince and the princess were a highlight of the Western exhibit sponsored by the People's Republic of China, due to the preciousness of the material, the subtle blades bound by gold threads, and the perfection of their construction.

But the ability with which the Han artisans drew from their extremely rich figurative code is everywhere present - in the exquisite bronze lamp-holding figure, which presents an almost geometric rendering of the drapery and an interesting placement of an arm that leads to a vent at the top of the lamp, nothing detracts from the realism of the work as a whole. The greatly decorated bronze censer presents elegant "cloud spiral" motifs encrusted in gold below the sharp peaks of the Taoist "mountain of the blessed." To these works one could add the well-known bronze horse discovered at Wu-wei in the Kansu province, in which a strong real-

ism, expressed by the attention to the anatomic details, is diluted by a nervous and energetic elegance rendered by the movement of the body in space. The horse rears-up in a forced and artificial manner (this movement probably originated in Western art). In these bronzes nothing is reminiscent of the ancient tradition of the first dynasties. They present a wholly different conception in which man, though still immersed in the cosmologic and mythical world, has nevertheless coordinated it, become aware of it, and pigeon-holed it. He has consciously placed himself in the center of it, making himself the measure of everything.

Period of the Three Reigns: the Ch'in and the North and South Dynasties (220 - 589 A.D.). — Many analogies have been made between the period succeeding the fall of the Han empire and the period following the fall of the Roman empire. Both periods were characterized by ferment, political instability, continuous struggle, and invasions by barbarian peoples, all taking place at the centers of these empires. However, in the marginal zones - Byzantium for Rome, and for China, the southern region with Nanjing at its center - the ancient cultures and the imperial traditions remained intact. The peoples that were oppressed and divided by the continual wars and raids took refuge in two foreign religions that promised peace in a heavenly world and a means of salvation: Christianity and Buddhism.

In fact, with the fall of the empire in China, Confucian humanism lost favor, and the anthropocentric conception of the Han "classicism" became tempered into a more comprehensive religious and spiritual vision. In addition to Buddhism, the neo-Taoist mysticism (that was especially popular in the southern regions) contributed significantly to this vision.

As we have already mentioned elsewhere, the artistic field can suggest a parallel between the production of the early Western Middle Ages and that of China in the third to sixth centuries, solely from a point of view of correspondence between similar historical-cultural events and codes of artistic language to which they are correlated.

The strict iconographic and symbolic rules of Buddhism, at least in the beginning, seemed to have almost "frozen" the vitality and realism of the Han, especially in the most important depictions, which were rendered in a rigid and static frontal position.

As Watson proposes, one can notice the birth of an "analytic style" in which the figure appears to be divisible into geometric blocks. This style lasted until the middle of the sixth century. The study of plasticism and the third dimension was almost abandoned in the first Buddhist sculptures, being replaced by, especially under the northern Wei (386 - 535 A.D.), a tendency toward hieratic schematicism. This can readily be seen in the lengthening of the figures and halos, in the sharp folds of the drapery, and in the depiction of faces. But the strong regional, ethnic, and cultural differentiations, which had always been present but were even more pronounced in this period, make it almost impossible to delineate in a sylistically unitary manner the entire artistic production. To this we can also attribute the irregular and discontinuous documentation. However, for the northern regions, the grotto temples established by the Buddhist inspiration (such as Tun-huang, Yun-kang, T'ien-lung Shan, and Lung-men) provide an ample documentation of the artistic production of the northern, western, and eastern Wei (386 - 554); the northern Chou (557 - 581); and the northern Ch'i (550 - 577). The evidence is much less evident in regard to the southern regions. Only recently has there been a clarification of the importance of the role played by the Six Dynasties of the South, both in the genesis of the art of this period, and in the diffusion of the Chinese artistic language in Korea and Japan.

A. Soper has pointed out, with sufficient evidence, the importance of the Buddhist sculptures discovered near the Wan-fo ssu at Ch'eng-tu in the Szechwan province in the reconstruction of the southern sculptural code. Several of these statues appear to be associated with the so-called Shaka triad conserved in the Kondo of Horyuji and to other examples of the Paekche region in Korea. Furthermore, they demonstrate characteristics considerably different from the sacred figurations of the northern dynasties, appearing to be closer to the Indian production of the gupta period. The greater three-dimensional and spatial tendency, along with the synthetic capacity, of the southern sculptures is also confirmed by the funerary plastic art. The splendid stone lions discovered near the tomb of Hsiao Hsui at Nanjing and recently near a tomb at Hu-ch'iao, both in the Kiangsu province, demonstrate how some of the vital force of the Han lions, rendered with a powerful stylization, has been fully conserved, even if somewhat compressed.

It still remains a mystery how the series of over 200 grotto temples of Mai-chi Shan (Kansu), which date from the fifth century to the T'ang, with later reconstruction added, could remain unknown to the scholars until 1952. The rich harvest of sacred figurations, for the most part statues, reliefs, and parietal paintings, has been examined by M. Sullivan and D. Darbois in 1969 (as well as others). The exceptional quality of this discovery is also due to the use of clay in the statuary, a use not common in the grotto temples in the other localities, but certainly widespread in all of China.

This technique infused the work (especially the later figures) with traits of a softer and warmer plasticism, less angular and schematic than stone sculpture. Several minor figures (Bodhisattva, praying figures) express an exceptional grace and elegance, similar to the figures of several depictions in the Asuka and Nara periods in Japan, of which perhaps they constitute the prototypes.

Indeed, W. Watson states that "starting from the fall of the Wei (middle of the sixth century), the Buddhist sculpture of the north presents a series of styles that are little defined. The flat and frontal effect of the 'analytical style' . . . gradually makes way for a greater roundness . . . however, this change still remains within the limits of the analytic concepts and never achieves natural and plastic effects." Under the Northern Ch'i, in the northwest, there then appeared a new sculptural style with straight figures resembling columns with wide linear drapings and a Bodhisattva loaded with jewels. This was the operation of a new influence from India, the late gupta, which "eventually breaks up the analytic style" as a prelude to the new T'ang realism.

But realism had not completely disappeared with the fall of the empire. In the funerary furnishings we often see the plastic vitality and the decorative imagination of the Han maintained intact. A Western Chin (265

- 316 A.D.) sepulcher was recently excavated at Ma-t'ou in the Kiangsi province, in which were discovered bronze receptacles covered with a rich encrusted decoration typical of the Han. These decorations are full of imagination and movement, confirming the contiguity of the two periods. Also, in a northern Wei sepulcher belonging to Ssu-ma Chin-lung (died 484), a high official, which was excavated at Ta-t'ung (Shensi) in 1965-1966, the large number of figurines (several glazed), indicates the taste for "genre" detail, and several reveal a taste for the realistic portrait typical of the Han. Even though the figures of the ladies are already colder and more stereotyped, and the horses lack part of the Han dynamism, there still remains a strong tension manifested in the taut, spread-apart legs. In the equally numerous ceramic statuettes discovered in the tomb of Fan Tsui (the governor of Liang-chow who died in 575 under the northern Ch'i dynasty), we notice a rebirth of interest in realistic detail, though it is more potent and with more body mass, which becomes a characteristic of the figurative language of the Sui and T'ang. Also the marble lion of the northern Chou (557 - 581 A.D.), recently discovered near Hsi-an, shows a new interest in the living tension of the figure and in three-dimensionality, even though the leg muscles and the curls of the mane are still treated in a rather cold and decorative manner, typical of the early religious sculpture.

Buddhist sculpture definitely arrived in China before Buddhist architecture and was introduced by monks and pilgrims. We find iconographic traces of a Buddha in relief on late Han mirrors. Insofar as the texts record in the Han period, the presence of religious cult buildings in the Chinese territory and the widespread diffusion of constructive, planimetric, and spatial models closely related to Buddhism occurred only after the fall of the empire.

W. Eberhardt (1954) has provided a broad picture of the relevant building activity realized in the field of religious architecture in this period. In regard to the grotto temples, which perhaps appear for the first time in China in this age (the first cavern appears to have been excavated at Tun-huang in 376 A.D.), the work of T. Akiyama and S. Matsubara (1969) remains fundamental.

There has been much writing and discussion on the genesis of the other typically Buddhist building, the pagoda (t'a). As we have noted elsewhere on the brick and stone type (P. Mortari Vergara Caffarelli, 1973), the links with its prototype, the stupa, seem to be very close in this period. In fact, up till now, except for some sacrificial chambers, fortifications, and terracings, buildings with exposed bearing walls were not widespread in the Chinese monumental architecture. Thus, it is clear that the imitation of various types of stupa must have been almost total. In the prototype having a wooden structure, of which we have documentation in the bas-reliefs and the pictorial depictions, the connections with the towered buildings of the Han period seem to be very close. Probably only later do the brick pagodas arise from the inspiration of the wood constructions, imitating these characteristic structures in more durable materials of brick and stone.

We should also point out that it is above all the spatial conception of the stupa, as a non-feasible building (symbol of the cosmos, the axis mundi, and, analogously, of the body of Buddha and man) lacking internal space and religiously exploited with the ritual of pradaksina (circumambulation), that came to be clearly understood and utilized in the Chinese architectural language. Indeed, the pagoda, although sometimes permitting passage to the top floors, would always remain a building conceived not as a generator of internal functional space, but as a creator of omnicomprehensive external spaces. This concept was completely unknown to the traditional architectural language of this time and was assimilable only in part, above all for the cosmologic and sacral values, into the ancient sepulchral tomb or into the so-called tamped earth ritual altars.

Even in the traditional architecture of wooden structures (keep in mind that since its inception the Buddhist temple complex greatly changed its plano-volumetric arrangement from the typically Chinese ceremonial and palace modules) we notice innovations, especially structural in nature. The boat-shaped trusses of the Han increase the bearing surface with a third central arm. The adoption of roofs having a concave tendency in the eaves, which appears to have been defined in this period through the contribution of the southern styles, led to a search for new static solutions (the inclined beam or truss arm, called "ang"). Acroteriums having the classic "owl tail" form were later adopted by the T'ang buildings, while the wooden columns begin to present a slight entasis, perhaps of a distant classical quality. Nothing remains today of the wooden structures of this period, but the sculpted and painted depictions, which include those of the Mokao grottos studied by the Archaeological Section of the Tun-huang Institute (1976), permit us to reconstruct, at least partially, several of the plano-volumetric constants, as well as the structural characteristics. It appears that there was still present in the Han architecture the tendency to a development in height, accomplished primarily by means of tall podiums, along with several asymmetric solutions of a rhythmic type in the design of the complexes.

The tradition ascribed to the central-southern regions, the center of the most important pictorial schools of this period, in which many of the Han aristocrats had taken refuge, has been reconfirmed by recent discoveries. Under the influence of neo-Taoism, the pictorial art tends to lose almost completely its didactic and moralizing characteristics of a Confucian type, acquiring a purely aesthetic and spiritual quality. This was expounded upon by the numerous treatise writers (Hsieh Ho, Tsung Ping, Wang Wei) that were active under the southern dynasties.

A greater clarification of the pictorial language of the southern dynasties has resulted from the discovery around 1960 in a tomb in the vicinity of Hsi-shan ch'iao, near Nanjing, of a mural decoration depicting the "Seven Sages of the Bamboo Woods." The representation of this famous literary theme, associated with neo-Taoism (one of the principal sources of inspiration of the art of this period, as we have previously mentioned), has been examined by A. Soper (1961) and more recently by E. Johnston Laing (1974).

But, beyond the iconographic significance, the scene evidently demonstrates characteristics of plasticism, of clear spatial vision, of three-dimensionality, as well as the subtle rhythmic elegance of the line, the inseparable relation between the tree, or nature, and

man, who constitutes the fundamental motif of the successive paintings.

A similar sense of movement of the line and of the subtle rhythmic and spatial relations is evident in a relief on tile depicting a dignitary on a horse, recently discovered in a sepulcher near Hu-ch'iao in the Kansu province.

Although until now we have not had any further documentation, it appears to be commonly accepted by the scholars (Sullivan, Watson) that the birth of Chinese landscape painting took place during this period. The evidence of the critical texts, such as the brief writings of Tsung Ping, the scarcity of the remains (nymph from the Lo River, of Ku K'ai-chih), and, above all, the cultural and historical moment, fully confirms this assertion. Man no longer is the measure of the universe: Buddhism and neo-Taoism has redimensioned his position in regard to nature. Consequently, in this period, a tree, a rock, or a mountain begin to have the same importance, from a pictorial standpoint, as the human figure, opening the door to extraordinary developments in the successive periods. It is a landscape painting that Watson defines as "realistic," and, in fact, the naturalistic details create an environment that is very close to reality, even though these landscapes are often imaginary. It is doubtful that the Han realism was completely abandoned in this period, since in several artistic categories, such as portraiture, there was a development of a sense of introspection and psychological study. According to M. Loher, Ku K'ai-chih was one of the greatest portrait painters. In the few examples that remain today, it is clearly evident that his characterization of persons is much beyond the scope of a copyist.

Even the "barbarians" of the north underwent changes related to the new pictorial language that was forming under the dynasties of the south. Besides the rich figurative patrimony from the grotto temples such as Yun-huang (whose characteristics of landscape painting were examined by A. De Silva in 1964, identifying the sense of "open space" that is typically Chinese), we are presented with the testimony of a lacquer painting on wood discovered in 1966 at Ta-t'ung (Shensi) in the above-mentioned tomb of the high official of the northern Wei. This rare testimony of the secular painting of the northern dynasties shows scenes of family compassion, such as the stories of the emperor Ch'eng and Mrs. Pan. The contact with the manner of Ku K'ai-chih is evident, and it has been proposed that this is a copy, although, when compared to the other copies of his works the execution here is dry and mannered; the scarves fluttered around the figures in a rigid, scarcely realistic manner, and the spatial notations (seat, chest, palanquin) are more summary. On the other hand, the treatment of the clothing and the drapery is very interesting, with its use of chiaroscuro effects. These had always been considered as contributions made by the later copyists of Ku K'ai-chih, while this work demonstrates that they were already an integral part of the pictorial language of the period.

Often in the course of this treatment we have established how recent discoveries have been able to antedate the incorporation of new stylistic, formal, typological, and perspective codes in the Chinese artistic language. This is also the case in regard to the ceramic production. An example of this is the flat flask with eyelets at the sides of the neck, called the "pilgrim's bottle," clearly derived from the Mediterranean world and thought to have appeared in China at the time of the cosmopolitanism of the early T'ang period. The discovery in 1971 at An-yang (Honan), in a tomb dated to 575 A.D. and belonging to the northern Ch'i, of a flask very similar to the one in use under the T'ang demonstrates that the classical Western models, even though not closely linked to the religious iconography, had arrived in China alongside Buddhism.

On the pilgrim's bottle, a stoneware piece covered by a gilded brown glazing, there are representations in relief of a female dancer and some musicians. The scene, which recalls those of several Tun-huang paradises and several paintings of the T'ang period (Berenson roll attributed to Yuh-chih I-seng), is even more closely related to the decorative motifs of the sasanide gold-work. From the same tomb comes another vase of the "celadon" type, which, according to Sullivan, demonstrates "a technique that was thought to have been unknown in China before the T'ang dynasty," as evidenced by the slender neck with an ivory "craquele" lid and a glazing with green striping.

Sui and T'ang Dynasties (581 - 907 A.D.). — The creation in preceding periods of several technical, formal, and perspective codes, which until recently were considered to have been typical of the T'ang, certainly does not detract from the value of the great revolution of the artistic language that occurred in this period in China, leaving its mark on all the successive ages. Elsewhere we have mentioned the correspondence of this new era of imperial splendor with the European Renaissance. The attention placed by the T'ang on the artistic expressions of the "classical period," namely, that of the Han phase, along with a typical sense of measure, beauty, and harmony largely associated with the new affirmation of Confucianism, in our opinion, confirms this proposal.

D. Bodde expressed an identical opinion in regard to the political-social situation. In his opinion, the development of urbanization, commerce, and industrial activity; the formation of a new bourgeois type of mercantile class (but with reduced political opportunity) in the cities that had become commercial as well as administrative centers; and the use of printing generated an environment vaguely "similar to that of the Renaissance in Europe." Furthermore, the spread of Buddhism had already created in a large part of Asia, the premises for an "Asiatic humanism that profoundly modified the value of man. The Japanese scholars are not mistaken when they speak of an "Oriental panasiatic" style, referring to the diffusion of the T'ang artistic language in the neighboring territories such as Japan and Korea.

In 583, after the unification of the empire, the most significant achievement attained by the Sui dynasty (581 - 618 A.D.) was the new complex and the initiation of the construction of the capital Ch'ang-an, which must have been the symbol of the imperial power, even for the successive T'ang dynasty (618 - 907 A.D.). With its ordered planimetry and its monumental buildings, it constituted the model for the Japanese capitals Nara and Heian, along with numerous other Chinese cities such as Lo-yang, K'ai-feng and Nanjing.

The displacement of the directional complexes toward the north side of the surrounding wall, which has already been noticed in the Han urban complexes, is

very evident in the Ch'ang-an of the T'ang. The administrative city and the palace-city, situated along the north-south axis, are adjacent to the northern side of the surrounding wall. The Ta-ming palace, which is actually outside the northern wall, does not precisely follow the axial principle, but is displaced toward the east representing a curious anomaly that can be justified only in part by the qualification of "summer palace." This anomaly, coupled with the interrupted course of several portions of the wall, could cause one to associate the urban complex with astrological elements, as in the Han case.

Also the street plan varies from the single, preferred monumental north-south axis, since it appears to have three parallels of this axis. One leads to the central door of the administrative city and the palace-city, and the other two run along the side of these cities. Also, the major east-west thoroughfare is displaced toward the north, reaching and skirting the external wall of the administrative and palace areas. However, the position of the various fangs (districts), the east and west markets, and the entire surrounding wall is canonic. The wall is rigidly quadrangular and closely oriented according to the cardinal points, and the fangs are rigidly geometric blocks separated by the grid arrangement of the streets.

It appears that the entire city was conceived to create a barrier and a wall of protection around the imperial residence and to emphasize the ritual path of approaching the living political-religious symbol of the cosmos, the sacred royalty, the emperor. Recently Fu Hsi-nien (1973) has published an ample reconstruction of the Han-yuan room of the Ta-ming Kung which, adding to the previous reconstruction of the Lin-te room of the same palace, provides us with a rather complete picture of the monumental architecture of the T'ang. Until recently this architecture could be reconstructed primarily through painted or sculpted representations and a comparison with the remaining complexes in Japan. The buildings are of vast proportions - the traditional development in width (with structures having only one, or at most two, floors) becomes tempered by the tall masonry podiums with impressive multiple access stairways.

The "classical characteristics" — axiality, symmetry, and a heirarchy of single elements — are evident. However, it is not a case of a classical rigidity and fixity, but a powerful mass tension of the dynamic concave tendency. This is evidenced by the two covered galleries, which connect the central block of the Han-yuan tien with the two lateral towers.

In the Han-yuan tien, one is reminded of the twin towers that were often located at the entrance of buildings in the Han period. But here they are interpreted with a strong sense of rhythm and harmony, and a rational attention is given to the gradual passage from volumes having a horizontal development to volumes having a vertical development. A similar attention was devoted to the gradual progression of passages for the various heights and widths. This is found in the Lin-te tien, in which the three major "tien" that compose it and the other minor connecting tiens are organically aggregated at the center of the courtyard on the high terracings. The static "courtyard complex" is given a pleasing and varied aspect by the different types of roofs, which vary in height and volume.

As M. Sullivan correctly observes, this compound demonstrates how the T'ang architecture rationally pursued functional as well as ceremonial objectives. In fact, this complex is closely associated with the ancient architectural tradition, recently brought to light by the excavations of the Ch'in palace at Hsien-yang. It is much more "inhabitable" spatially than the vast "tien" separated by ample courtyards of the late Ming, which seem to follow an exclusive finality of representation and dynastic ritual. It has not yet been possible to determine the planimetry of the most important imperial palace, which is located on the north-south axis inside the surrounding wall. Unlike the depictions that have been brought to light (especially the Tin-huang grotto paintings, in which tall terracings support slender pavilions) in the Han-yuan tien, the balance between the "full" (podiums, part of the towers in masonry, roofs) and the "empty" (colonnades and wooden structures) is perfectly calibrated. The continuous walls were broken up and animated by appropriate recesses and mirrorings, thus graduating the contrast with the openings of the mighty wooden colonnades.

The door of the southern surrounding wall of the capital Ming-te, excavated in 1973, shows the perfect balance attained by the T'ang between the typically defensive and functional characteristics and the rhythmic play of the precisely calibrated volumes. A strict rationality was also applied to the wooden structures. The trussing system is developed in height, increasing the orders and conserving a solid compactness. The use of the inclined arm "ang" becomes more consistent; the upside-down "V" joint is still used, although relegated to internal or less visible parts; and the columns gradually lose entasis.

The T'ang "measure" is even encountered in the roofs, which demonstrate a preference toward a simplified angular type having a gradual slope and slightly-curving eaves, animated only by the linear "owl tail" acroteriums.

A further innovation is encountered in the interiors. With the progressive adoption of the chair, which M. Pirazzoli t'Serstevens (1977) dates to between the seventh and ninth centuries, and with the consequent elevation of the "work floor," there appear new types of furniture, though small in number, that never constrict or encumber the usable space. As to the Buddhist architecture, the great persecutions of 845, as well as those of the tenth century, nearly destroyed the splendid temples of Ch'ang-an and Lo-yang, which have been described in detail by Tuan Ch'ang-shih and Chang Yen-yuan.

The small main room of the Nan-ch'an-ssu on the Wu-t'ai-shan in the Shansi (782) has been recently recognized as the most ancient T'ang temple building in wood still existent. The recently initiated excavations of the Blue Dragon monastery at Sian will perhaps provide us with a more complete picture of a substantially differentiated temple complex.

Further discoveries have been made by the excavation carried out by Chinese archaeologists in the necropolis near Ch'ien hsien in the vicinity of the capital Ch'ang-an. On the walls of the "ling" (type of mausoleum used only by the members of the royal family) of the Chang-huai and I-te princes (circa eighth century) frescoes of buildings, doors, architectural elements, and guard towers have been discovered. These depictions are very different from those rendered in a more sum-

mary manner in the already cited Tun-huang grottos, both in the perfection of the single architectural details and in the perfection of the perspective arrangement. Furthermore, as Li Ch'iu-shih (1972) has noted, the "ling" tends to repeat the planimetry of the imperial city in its complex. In fact, this Chinese scholar claims to recognize in the long subterranean ramp leading to the tomb the axial avenue that leads from the southern door of the imperial city to the imperial palace. In the sepulchral crypt and in the hypogean annexes (symmetrically arranged around the crypt) he recognizes the various "tien," the rooms of representation of the imperial palace. The depiction of two chueh (guard towers), located on the walls near the entrance, confirm the symbolic presence of the surrounding walls.

But above all, the rich mural paintings discovered inside the hypogean chambers make the findings of these two tombs, along with those of the tomb of the princess Yung-t'ai (excavated in 1960 - 1962, in the same cemetery), one of the most important discoveries in recent years. It has always been a commonly-shared opinion that the T'ang period represents the culmination of the great flourishing of the religious and celebrative mural paintings. But, excepting the paintings of the grotto temples (that should be partially considered a "provincial fact") and some stupendous frescoes of the Kondo of Horyuji at Nara in Japan (closely linked to the T'ang pictorial language, but partially modified by the local code), we have not had any direct documentation of the great metropolitan painting of the capital, which has been enthusiastically described to us by numerous sources. The findings of this imperial necropolis have now at least partially bridged this significant gap.

The depiction of three Chinese courtiers and three foreign delegates in the tomb of Prince Changhuai evidently attests to the evolution of figure painting in the T'ang period. The position of the men in space and the shapes of the bodies are perfectly defined and well-proportioned. Besides the customary use of the line in defining both the forms and the structures, we also encounter the use of a typical chiaroscuro, especially in the clothing, which tends to give a precise, corporeal, and three-dimensional relevance to the images. M. H. Fong indicates (1973) that these details are "a probable influence of the khotanese painter Wei-ch'ih I-seng," a proposal which we cannot disagree with. In fact, in a preceding article (1972) we have proposed the reevaluation of the work of I-seng, or more correctly Yu-ch'ih I-seng, since, as we have demonstrated, the Wei-ch'ih transcription resulted from the erroneous reading of a character.

The importance that this Central Asian painter and his school had in the formation of the pictorial language of Eastern Asia in the T'ang period appears to be strengthened by the presence of typical elements of his style also in the mural paintings of the Kondo of the Horyuji at Nara. However, we are tempted to attribute to him a much greater "responsibility" than that which the ancient Chinese critics and the modern sinologists have identified in the formation of the eclectic and, at the same time, original style of the early T'ang. Thus, the presence of typical characteristics of the pictorial language of Yu-ch'ih I-seng in the figure paintings of these eighth century tombs only confirms our hypothesis, since we have proposed the dating of his activity to

be the last decades of the seventh century and the beginning of the eighth century.

Furthermore, Li Ch'iu-shih suggests, on the basis of the correspondence on the surroundings of the tombs with those of the imperial city, an analogous subdivision of the attendants and courtiers present in the single complexes and depicted life-size on the walls of the sepulchral chambers. The women with round fans of the I-te tombs must have been the attendants employed for fanning and holding parasols in the residential districts, while the men with braziers are the supervisors of coal and wood. This hypothesis is supported by the fact that the personages found in the frontal crypt of the I-te sepulcher are similar to those depicted in the same surroundings of the "ling" of the princess Yung-t'ai. Thus, there definitely is an order associated with the symbolic correspondences between the royal palace and the tomb (which we have already noticed in the Chinese architecture of the very ancient periods). This tomb has also provided us with a perfectly preserved group of ladies-in-waiting, which, in our opinion, represents one of the highest exemplifications of figure painting in China.

M. Sullivan proposes to recognize the work of a pupil of the famous Yen Li-pen in the slender young girls that gracefully go forward, speaking among themselves, in a long procession. It is certain that here we come into direct contact with the "court" painting of the T'ang without the mediation of a later copyist, and it is possible to notice the realism of the portrait and the liveliness of the three-dimensional pursuit in the figure that almost turns her back to speak with two other women. Although chiaroscuro is present in the treatment of these lovely figures, there is a partial prevalence of the contour line, which defines the faces and the clothing. This is a further proof of the variety of the T'ang pictorial language, which adopted diverse codes according to the subjects. These codes range from the more strictly traditional, which represents the court figures in light, faint colors, in which a rose-beige prevails with light touches of orange, to one having a Western, Central Asian, or Indian inspiration, in which the liveliness of the polychromy combines with a more nervous movement of the contour line and a more distinct pursuit of plastic construction of the corporeal mass through chiaroscuro, while still maintaining its unitary characteristic of classicism, of measure, and of a strong compositional and coloristic rhythm. The rendering of the landscape that we encounter in the polo-playing scenes of the tomb of Prince Chang-huai is also extremely interesting. Up to now this subject has been relatively unknown in the T'ang paintings, even though in the funerary "coroplastic" there appear numerous figures of polo players.

It is possible to verify that already in the early T'ang period there were mountains and trees present in their essentiality and in the most expressive framework, which we will later see in the successive landscape painting. The typical "aerial perspective" already encountered in the Tun-huang paintings, is here recreated with great vividness, organizing the elements of the composition in a determining manner on the right side, and leaving an ample empty space, occupied only by galloping horsemen, on the left. The disproportion of the landscape details (trees and mountains) and human and animal figures, already present at Tun-huang, is plainly evident, but the whole is rendered with more

elegant lines and more delicate passages. The forest landscape, crossed by a caravan of camels and horsemen, is more realistic, with the trees in the foreground assuming an almost real dimension. In the frescoes of these tombs, sometimes a tree is one of the protagonists of the composition. The size of the trees varies from large ones, under which delightful female figures move (the theme of women underneath a tree is typical of the T'ang), to the very small "bonsai" (miniaturized) trees carried in the hands of attendants and ladies. The latter are an interesting testimony of the development in China of this gardening art in an age preceding its diffusion in Japan.

In regard to the Buddhist artistic production in China, the scholars are in the process of reexamining the relationships between iconography, stylistic characteristics, and the three most important branches of Buddhism (Hinayana, Mahayana, and Vajrayana). Watson (1972) speaks of the important influence of the early Mahayana on that which he calls the "classical T'ang style," and an influence of the Vajrayana in the figurative art that he defines as belonging to the "Westernizing T'ang Style," which is more closely associated with the West. Going beyond these interesting correspondences, it is well to note how, despite large spans of time and space, the Buddhist art will subsequently conserve close ties with the initial religious schools and with the successive reelaborations of the doctrine. Even the T'ang pursuit of realism, stemming from the great "Confucian revival" (keep in mind that the term "ch'en," or truth, enters into the vocabulary of art criticism in this period), becomes "exasperated" and is modified in several pictorial works inspired by the Buddhist and Taoist speculation, with the result of a further distancing from the real, preceding the "expressionist" pursuit of the period of the Five Dynasties.

On this subject, P. Glum (1975) identifies the "illusionist" tendency of several T'ang paintings, noticeable in some frescoes of landscapes, especially those having the subject of the "meditation of the sun" of Tun-huang. In effect, the pursuit of luminism and colorism, accentuated (from a religious point of view) by the "meditation on the water" or "on the light," and the desire to achieve the "ultimate essence," for which the depiction of rocks seems to reveal the inside of their crystal structure, lead these works to a transcendence of the naked reality, presenting it as a more hidden and essential "truth" reached through an intense mental effort.

The calligraphic art is certainly not extraneous to this phenomenon. This art required an internal visualization process prior to its execution, written with a maximum spontaneity and rapidity. It is certain that under the T'ang calligraphy was regarded as the means through which the personality and the sensitivity of an artist was most directly expressed. Names such as Yu Shih-nan, Ou-yang Hsun, and Ch'u Sui-liang became famous, and their works were highly sought after, like the paintings, even though, as the critical writer Chang Yen-yuan (ninth century A.D.) stated, "there is, however, a difference - a calligraphic essay is executed in a few minutes, while a painting may require months of work. For this reason the calligraphic works are found - and have always been found - in greater quantity."

Associated with calligraphy is the type of painting executed by rapid and rhythmic brush strokes, which was highly developed in the successive periods and used by Chang Tsao around 750 A.D. To this we can add the innovation of Wang Hsia (died circa 800) in the use of inkspots, which were sometimes painted with the fingers. This was a technique also used by later painters such as Kao Ch'i-p'ei. Monochrome painting was greatly inspired by calligraphic art. Its creator has always been considered Wang Wei, who, according to the critical writer Tung Ch'i-ch'ang (1555 - 1636), "at first used ink water-colors, and changed the method of tracing the contour lines."

Unfortunately, the works of the great T'ang painters (Wu Tao-tzu, Yen Li-pen, Li Ssu-hsun and Wang Wei), from which the traditional and contemporary critical writings have derived the basis for their principal pictorial currents, are very scarce today, with the exception of later copies. The remains of T'ang paintings on silk, primarily discovered in 1963 - 1965 at Astana near Turfan, have aroused great interest, despite the "provincial" zone from which they originated. The various subjects of everyday life, such as horses and men in a landscape, show the spatial relationship between the figures and the surroundings in a well-defined manner. Exquisite figures of women with a corporeal vividness well-emphasized by chiaroscuro, recall the painting attributed to Chou Fang at the Freer Gallery of Art in Washington; plump children, including one who holds a puppy, reconfirm the realistic taste for the "genre scene" and constitute the prototypes of the "paintings of infantile subjects" so widespread in the Sung period.

Another exceptional finding was confirmed in 1970 near the palace of the Pin prince at Sian. This was a treasure of about 1,000 pieces that was hidden in two large jars, which included silver and gold vases, jade objects, precious stones, jewels, and Chinese and foreign coins. This treasure was probably buried when An Lu-shan attacked Ch'ang-an in 756 A.D.

The nearly 200 silver and gold vases alone constitute an unprecedented documentation for the T'ang period. The forms and the decorations often recall those of the Persian sasanide gold work, but, as Hsia Nai (1973) asserts, "the T'ang artisans of iron and gold assimilated the essence from them and instilled them with a Chinese quality."

One might make the same observation about several types of the T'ang ceramic production, which are closely associated with the types and the decorations of the metalwork. The rich grave furnishings recently discovered have added to the knowledge of several typologies, decorations, techniques, and probable production locations. A valid contribution to the definition of the T'ang porcelain production has been made by the examples uncovered by the Fustat excavations described by Bo Gyllensvard (1973, 1975). They constitute one of the essential components of the T'ang artistic production and are a further proof of the exchange and the contact between the East and the West.

The Five Dynasties (907 - 960 A.D.) and the Liao Dynasty (916 - 1125 A.D.). – As has already been stated, it is almost an axiom that the periods of the greatest artistic innovations in China have coincided with political instability and that the men in these periods have often dedicated the best of their creative energies to their art. One could add that the occurrences of separation, ferment, and struggle generated a break with

the past and, thus, also with the traditional artistic language. This facilitated an extension beyond the limits of the strong "conservative" tendencies and the formation of the major "variations" of the traditional codes that were the starting points for successive developments. That which has been verified in the late Chou period (an affirmation of the realistic depictions), and which was repeated in the period of the northern and southern dynasties (the spread of Western canons introduced by Buddhism), also occurred in this period, in which, under the various ephemeral reigns (latter Liang, 907 - 922; latter T'ang, 923 - 935; latter Ch'in, 936 - 946; latter Han, 947 - 950; latter Chou, 951 - 959; early Shu, 907 - 925; latter Shu, 934 - 965; southern T'ang, 937 - 975), an original pictorial art flourished. This art had a lasting influence on all of the successive productions, and it was subsequently amply described by numerous treatises.

Many have commented on the extreme difficulty of grouping the Chinese painters into homogenous artistic currents. The eclecticism of some and the originality of others render the most noted subdivisions by the ancient and modern critics hardly acceptable.

As W. Willetts has stated, the traditional division into Northern and Southern schools, codified by Tung Ch'i-ch'ang, is partially arbitrary. One need only consider that the Northern School, the one less esteemed by the Ming critics, groups together painters with very different styles and techniques who largely worked in southern China. Furthermore, the same artist often used different stylistic codes for different works. These codes defy any temporal, univocal classification because of the richness and diversification of the philosophical, mystical, religious, and aesthetic bases by which the artists, almost always belonging to the aristocratic elite, would inspire themselves from time to time. Undoubtedly, one can easily identify the two great branches of Chinese painting as proposed by V. Elisseeff (1966): one being rationalist, realist, conservative, of a Confucian mold, which produces representations of an analytic type, gradual, associated with the Northern School; the other being mystical, idealistic, and tied to Taoism and the various branches of Buddhism, advocating a synthetic style, global, and ascribed to the Southern School and to the so-called "literate painting."

Among a number of other proposals, the synthesis proposed by the Chinese scholar Yu Chien-hua (1962) appears slightly rigid in its classifications, but is nevertheless significant. On the basis of the most evident stylistic characters and the relationships of an artist's followers (one should keep in mind that these relationships do not have to be direct and are effected primarily through the practice of copying), he subdivided the principal Chinese painters from the end of the Han to the end of the Ch'ing period into four main artistic currents: the expressionists, the tonalists, the realists, and the impressionists. Undoubtedly, these definitions should not be taken as law in the Western sense, but only as denominations indicative of a particular type of code (often an artist could belong to more than one school), and they adequately define several characteristics common to a group of painters or to their work, depending on the choice of a particular language that would preserve intact the fundamental constants through the centuries of evolution.

The paintings inspired by Ch'an (meditative branch of Buddhism) present an "expressionism" which began to develop in the period of the Five Dynasties, even though it reached its apex in the Sung period and in Japan.

The image of the Buddhist patriarch with a tiger, by Shih K'o, is definitely related to the painting that P. Glumm has defined as "illusionist," already exemplified in several T'ang figurations of Tun-huang; but the rapid and abbreviated rendering of the subject with a few glazings of ink and broken brush strokes presents the immediacy of a vision of "identity and unity" of the Ch'an meditation and undoubtedly represents a particular form of expressionism.

The qualification of "impressionism," attributed by Yu Chien-hua to the most important landscape painters of this period, such as Li Ch'eng, Ching Hao, Kuan T'ung, Tung Yuan, and Chu Jan, appears less appropriate. It is more fitting to apply this definition to the later "literate school," which developed an impressionistic technique with clear lines "of fracture." These lines were compared by Lin Yutang (1967) to the bold and persistent lines in Cezanne's "Les Roches de Fontainebleau." However, it is certain that with Ching Hao we can recognize a transition from the type of "horizontal perspective" preferred by the T'ang to a new kind of "perspective with a vertical development," in which the foreground trees become monumental and the human figures appear overwhelmed by the tall perpendicular rocks.

Further clarifications on the important acquisitions realized by the landscape painting of this period are provided by the two writings of R. Barnhart (1970 - 1971) on works respectively attributed to Chu Jan and Tung Yuan. These two painters represent the transition between the production of the Five Dynasties and that of the Sung academy, since they lent their work to the court of the latter T'ang under the great patron Li Houchu and they also worked at the Sung court. It can be affirmed that a role identical to the one played by the painting of the Five Dynasties in regard to the pictorial language of the Sung was assumed by the Liao dynasty in regard to several aspects of the artistic production of the successive Mongolian dynasty of the Yuan. In our opinion, one cannot state that the advent of the Yuan led to sudden changes in many fields of art, as several scholars have asserted. Considerable variations of the artistic language have certainly been confirmed, but they were prepared by the preceding impact of the other "barbarian" dynasties, especially that of the Mongolian Liao.

In fact, preceding the Yuan, the Liao, on the basis of the T'ang "realism," had assumed the position antithetical to the subtle, romantic intellectualism of the Sung. This Kitan population tended to absorb the most evident and spectacular characteristics of the T'ang artistic language, such as the love of colorism, the heroic sense of the monumental, and the preference for celebrative and genre painting, and imbued them with Chinese qualities. Under the Five Dynasties and the Sung, another great branch of T'ang art was further developed. This was more intimate, intellectual, and speculative and was created by the poets, the calligraphers, and such great landscape artists as Wang Wei.

It is a logical consequence that the rough barbarian warriors could comprehend the solid, corporeal

quality of the sculpture and the figure-painting better than they could the subtle introspective scenes of the landscape masters.

The recent excavations carried out by the People's Republic of China in the necropoli of this dynasty are very important for the complete evaluation of the Liao artistic language. Significant evidence of the figure-painting has been discovered in a tomb near Hsuan-hua (Hopei).

The main subject is a dance scene in which the powerful corporeal quality of the images (of a T'ang derivation) assumes a heroic, almost exasperated, stasis. The loss of vital dynamism is compensated, especially in several symbolic-religious (bird) and female figurations, by a rich variety of coloristic and chiaroscuro effects on the surface (plumage, drapery), while a strong spatial definition is maintained (three-quarter figures).

Equally interesting, as a prelude to the Yuan "baroque," are the frescoes uncovered in the province of Kirim (Kulun, Tomb no.1), whose iconographic and historical meaning has been interpreted recently by Wang Tse-ch'ing (1973). In registers of scenes that are placed one on top of the other, there are depictions of a landscape with birds, a series of dignitaries (wearing the characteristic Mongolian boots) that move beneath trees, numerous women, and long processions with palanquins that wind along the walls of the monumental complex (three domed hypogean surroundings of a polygonal design, connected by corridors and axially arranged in a cross complex, preceded by a broad vestibule). Abounding with notations of space, movement, and chromatic vivacity, these frescoes constitute the maximum expression of the representations of aristocratic life, often with recollections of the ancient nomadic world, for which artists such as Khitan Ku Huai (circa 930) have remained famous.

Even the T'ang architectural language was often reinterpreted by the Liao in a "barbaric" code. The palaces sometimes have the entrance side oriented to the east instead of to the south, a probably survival of the ancient solar cult. This "variation" is also verified in the Buddhist complex of Hua-yen-ssu at Ta-t'ung and in many sepulchers such as the one recently discovered at Han Hsiang (Ch'ien-an).

Also in the tomb area we find a distinct reference to nomadic life antecedent to the acquisition of Chinese qualities. In fact, round, square, and polygonal designs came to be preferred, with domed or ogive coverings that, despite a fully Chinese use of decoration with structural elements in wood (trusses, corbels) and canonic axiality and symmetry in the planimetry, recall the ambient space of the primitive tent. As to the architecture of wooden structures, the sutra shelf in the Hua-yen-ssu library at Ta-t'ung-fu documents the Liao interpretation of the more animated and varied spatial aspect of the T'ang architecture (the few remaining complexes have not provided a significant documentation). Foreparts, different types of roofs located near one another, and a light, aerial catwalk at the center of the main facade enliven the symmetry of the whole, while the clusters of trusses, present also in the intercolumniation, animate the eave line.

We also find this tendency toward a greater modulation of the surfaces in the brick pagodas, of which there remain numerous examples. The preference for the octagonal complex, generally having from seven to thirteen floors, gives a greater movement to the outer shell, augmented by the use of pilasters, trusses, niches, and reliefs of animals and divinities, which, in a relentless pursuit of variety, succeed in transforming at least some of the remaining pagodas into sculptural jewels, like the eastern pagoda of Pri-chen at Chin-hsien (Manchuria).

Instead, the pagodas nearer to the southern borders of the reign appear to be less "baroque," and thus more sensitive to the linear clarity of the northern Sung, like those of the Yun-chu-ssu on the Fang mountain near Peking, of 1117. There was a successive evolution of the two distinct and fundamental typologies assumed by the T'ang pagodas; one adopted quadrangular complexes, developing in height with harmonious, sloping landings, decorated with subtle pilaster strips or imitations of the wooden structures, whose prototype was the Ta-yen-t'a of Ch'ang-a; the other, often with a polygonal complex, is volumetrically more varied, with floors of different measures and heights, augmented and animated by a rich sculptural decoration or by imitations of the often three-dimensional wooden structures, like the sepulchral pagoda of the master Liang at Shen-t'ung-ssu (Shantung) or the sepulchral pagoda of Ching-ts'ang on the Sung mountain. It is clear that the characteristic taste "for contrast," together with the preference for sculptural plasticism, led the Liao to adopt the latter type of construction.

In fact, in sculpture, the "barbaric" reigns of the north can be considered the true continuers of the Buddhist works of the T'ang and the creators of a type of wooden sculpture that later was greatly developed in China. The "Lohan" figures at the time of the Liao were derived from the "realistic" branch of the T'ang language, attaining profoundly realistic effects of portraiture. Together with several statues of Buddha and Bodhisattva, in which one can notice the pursuit of a rich pictorial effect translated in a three-dimensional form (especially in the drapery), they constitute the prototypes of the successive plastic art work, even in Japan.

The excavations carried out in China in recent years have confirmed the cultural and artistic model that these "Chinese-imbued" proto-Mongolians had in regard to the Yuan. Thanks to the excavation of the funerary complexes, in which have been found numerous supellectiles, there is an increased interest among the scholars in the ceramic production of this dynasty. Mino Yutaka staged an exhibition in 1973 in an unusual manner after having examined several aspects of the development and evolutionary history of these ceramics (1971).

It is certain that the ceramics best represent the "choices" made and the innovations created by the Liao to express their own artistic language. The preference for the "three color" ceramics (whose decorations were enriched by engravings and relief ornamentations) and for more animated forms, lobed vases, ribbed necks, flared mouths, clearly demonstrates a precise choice made within the environment of the rich code of the T'ang ceramic production, even though typically original examples were not lacking, such as the pouch-shaped container, which was the transposition in ceramic of the flask carried by the nomads.

There was little interest in the most characteristic pieces of the contemporary production of the Sung; the very refined and slender monochrome porcelains with

soft colors, furrowed by a subtle thread of craquele, were too far removed from the pursuit of the variety of color and by the animated plasticism of forms typical of the Liao, although they were imitated in some cases. Among the Sung ceramics, the one that stirred more interest among the Liao potters seems to have been the Tz'u-chou and the type that presents a rich floral decoration, both engraved and painted. A vase of this type was recently discovered in a Liao tomb at Yehmaotai (Liao-ning) and documented by Feng Yung-ch'ien (1975), along with the rest of the rich terra cotta and porcelain supellectile. The lobed goblet with the winged animal is equally interesting. But the ultimate proof of the imagination and variety of the "barbaric" and, in a certain sense, "baroque" ornamentation of the Liao is provided by the sculpted sepulcher with floral motifs discovered in the same tomb. This constitutes a further documentation of that dynamic and animated sculptural relief which we have indicated as an integral element of several architectural structures.

Sung Dynasty (960 - 1279 A.D.). – Due to the interest that has developed in the field of critical studies on the periods in which the most revolutionary variations of the artistic language were experimented with, the attention placed on the Sung period, which had been very strong until a few years ago, has noticeably diminished. Nevertheless, the phenomenon does not devalue one of the most fecund eras of Chinese art, that of the reflection and organization, though many times in a "traditional" or "national" sense, of the acquisitions and the innovations of the period of the Five Dynasties. However, it appears to us that the artistic expression in several cases became more static, almost mannered, by the excessive intellectual pursuit of an extreme formal elegance, especially beginning with the southern Sung.

Elsewhere we have proposed a parallel between European mannerism and that of the late Sung, obviously giving the broadest sense to the definition, without attaching any contingent value. This parallel is only an analogy between two attitudes applied to a following (though with different means) of a more sensitive, imaginative, and aristocratically intellectual ideal of beauty, which in some cases becomes pure academism.

The ideal of the Sung artist is best represented in the Wen-jen hua (literate painting) and in the painting of the imperial academy (yuan-hua), while the numerous treatises flourishing in this period only confirm the literary and intellectual interest cloaking the pictorial works, which are often treated in a "scientific" manner, with announcements of rules, schemes, and classifications. Painters and sculptors such as Kuo Hsi, Kuo Jo-hsu, Su Tung-p'o, and Mi Fei have left to us not only ample precepts on how to organize the entire spatial arrangement, the perspective rendering, the single compositional elements, and the various types of brush strokes, but also aesthetic affirmations and critical judgments on former artists, occasionally enlightened by extraordinary intuition.

Kuo Hsi (circa 1020 - 1090), or perhaps his son, Kuo Ssi, as others have claimed, described in the Lin-ch'uan kao-chih the different types of perspectives used to attain verisimilitude:

> mountains lack delicacy without clouds, they lack fascination without streams or cascades; without roads they lack a sense of life; without trees they seem dead. Without a perspective of

depth (shen-yuan) they become flat; without horizontal perspective (p'ing-yuan) they seem too close; without perspective of height (kao-yuan) they appear low. These are the three perspectives of mountains . . . the perspective of height is perceived by looking from low to high; the perspective of depth is perceived by looking from an elevated point to the interior of the mountain; the horizontal perspective is perceived by looking into the distance.

The three axes of vision (based on the perspective system uniformly studied in the West) are suggested to prevent the composition from becoming "cooped up" in rigid convergent or parallel lines and enable the viewer to feel as if he is within the landscape, not viewing it through a window. These spatial solutions were already present in preceding paintings, but now they become systematized and explained in a clear and coherent manner.

Much has been written on the prevalence of the paintings of landscapes, bamboo, flowers and birds, which gradually almost completely replaced human figure painting as the main object of interest among the Chinese painters. The major cause of the adoption of these subjects is related to the artists' religious-philosophical approach associated with Taoism and Buddhism, but it is certain that, more than all the others, the Sung treatise writers provided the technical means and the theoretical background to realize the works. As the critic Kuo Jo-hsu states in his T'u-hua Chien-wen Chih (Paintings That I Have Seen), "As to the Buddhist and Taoist figures, portraits and depictions of buffalo and horses, the modern ones are greatly inferior to the ancient ones; but as regards the landscape, the flowers, the insects and fish, the opposite is true."

There was also much debate over the issues of belonging to schools and currents and of the stylistic affinities of the various Sung artists. The treatise writers of the period sought to establish the derivations of the styles of the principal masters. It is certain that the latter subdivision, codified by Tung Ch'i-ch'ang, between the Northern and Southern schools, is in most cases insufficient. As Yu Chien-hua correctly states, the Northern School was, and is still, undervalued for the simple reason that its principal exponents, such as Ma Yuan and Hsia Kuei, hardly ever wrote anything, while the representatives of the Southern school were prolific writers.

Today, one must always work within the field of conjecture on the subject of Sung painting since the greater part of the work of these artists has disappeared, leaving only the copies to work with. The subdivision into the main currents of realism, impressionism, tonalism, and expressionism proposed by Yu Chien-hua as well as others merits some attention. One should not presume that the use of these and other Western terms that we have mentioned represents an attempt to assimilate the Chinese art with the European art. But, if one considers the artistic act as a means of communication that is executed following precise codes, then it is possible to establish several analogies between these codes, even if it is not a matter of a total coincidence, but only a resemblance of several lexical elements. The advantage of this is that these elements can then be immediately catalogued and identified by their adopted qualifications.

Neither should one be surprised to encounter the coexistence in the same period of denominations that redevelop styles that are so very different and chronologically distant from the European world. In fact, this is the measure of the profound difference that exists between the evolutionary courses of culture and art in the East and the West. Several precocious perceptions concerning certain scientific and philosophical concepts, such as the interrelation between space and time, have permitted a plural development of the Chinese artistic language associated with a range of philosophical questions, attained only much later in the Western world. The "realistic" school was applied to the academic paintings of Chang Tse-tuan, Li T'ang, Chao Po-chu, Liu Sung-nien, and Li Kung-lin, and it circumscribed the pursuit of the most faithful portrayal of reality, without arbitrary idealizations, based on the main branch of T'ang realism. Despite their common pursuit, each of these artists demonstrates his own personality.

Chang Tse-tuan was a member of the bureaucratic class and was active under the northern Sung. His roll describing the "Ch'ing-ming feast on the river," recently reexamined by Chiang Fu-tsung (1970 - 1971), represents the apex of the realistic description. In fact, it is often cited as evidence of the architecture of the K'ai-feng of the Sung, because of its exhaustive, almost photographic, description of places. The strong dominance of the typically Sung spatial arrangement is combined with a strong interest in everyday life (the bow store, the open-air barber shop, the innkeeper who decorates the inn), and this enlivens the densely populated streets, squares, and riverbank. In a 1975 article, E. Johnston Laing points out the same interest for the genre scene and the characteristic detail in several works by Li Sung and other southern Sung artists.

In the "Street Vendor" and in the "Village Doctor" of the National Palace Museum at T'ai-pei, the spatial arrangement is much more intricate and animated than the layout of Chang Tse-tuan. The figures are composed according to trapezoidal or triangular lines, while, as the scholar states, "the laborious brush work demonstrates a mannerism in which curved lines are accentuated."

The realism of Chao Po-chu is a different matter, as it sometimes presents a sense of restriction with a reconstruction of a fantasy world, such as the tondo depicting a feast in a Han palace in the National Palace Museum of T'ai-pei or the roll conserved at the Museum of Fine Arts in Boston. These M. Bussagli (1966) likens to a particular work of Simone Martini.

The work of Liu Sung-nien and Li Kung-lin presents a mixture of realism with mythical detail, though in several paintings the fantasy world prevails over the realistic world. In fact, one often can ascribe only several works of one painter to these principal stylistic currents, because often the same artist, depending on the subject and his momentary preferences and state of mind, could have used one or the other of the principal pictorial codes, and sometimes superimpose them.

This is also the case of the so-called "impressionist" current. It is evident that in several works by Kuo Hsi, Hsu Tao-ning, and Fan K'uan there is a use of pictorial effects as a means to establish an impression from the real, but the results are different for each one of these artists. For example, "Fishing in a Mountain Stream" by Hsu Tao-ning presents chiaroscuro effects and a treatment that borders on "expressionism." Speaking about this artist, Kuo Jo-hsu says: "In the beginning he took great pains to be precise and meticulous, but when he was older he was concerned only with the simplicity and the rapidity of the design."

A typical "expressionism" is, in fact, the best result of the confluence of the literate school with the Ch'an Buddhist painting. It is characterized by a singular economy of the stroke, by the rapidity of the execution, and by the simplicity of the composition. This leads to an intense expressive distortion, rendering the interior sentiments with greater immediacy. Su T'ung-p'o was, in a certain sense, its theorician, and in one of his poems he wrote: "To judge a painting by its life-like quality / reveals the mental capacity of an infant." The best effects were to be reached by two Ch'an monks, Mu-ch'i and Liang K'ai, even though the latter formerly belonged to the academic world. Although they were disregarded and inserted into the little-esteemed Northern School, these artists were instead well-followed and appreciated in Japan, where their style was further developed in the Zen paintings (the Japanese variation of the Ch'an) that H. Brinker reexamined in 1973. The expressionist contribution, despite the hostility of the academics, did not completely die out in China, as it later had a strong renewal in the Ming and Ch'ing periods.

The renowned Mi Fei was another exponent of the literate school, and Nicole Vandier-Nicolas devoted some studies to this artist. He is considered the creator of the so-called "tonal" painting, which was subsequently carried on by Li Ti and also, in a certain sense, by Ma Yuan and Hsia Kuei. In fact, the adoption of several revolutionary technical innovations has been attributed to Mi Fei. These include the abandonment of the "testura" brush-strokes (ts'un) used for shadings and the use of ink painting without contours. The charm of this artist's paintings lies in the subtle "tonal" atmosphere that pervades everything and provides extremely simple compositions with a unitary fusion of forms through a harmonious gradation of the chiaroscuro and coloristic combinations.

These delicate tonal effects were to be amply exploited by the later painting. The same "expressionist" Mu Ch'i made considerable use of it in his "Night Lights in a Fishing Village" in the Nezu Museum of Tokyo. However, we cannot completely agree with Yu Chien-hua when he proposes that Hsia Kuei and Ma Yuan were "tonalists" in the strict sense of the word, because the clear and decided contours of the foreground figures diminish the tonal significance of their paintings. This is so even if the ample empty spaces left in the composition are colored with subtle tonal gradations that are integrated into an atmosphere that enwraps everything, making the distant mountains seem barely visible. The intellectualistic and exasperated pursuit of the essence of the represented figures attains a sort of "mannerism" in the works of Ma. This is seen in several details, above all in the bare, contorted trees, while in some human figures, rendered with a few insistent strokes, one notices the use of typical modules of the "expressionist" current.

In the broad sense of the "realistic" current, one could also include several examples of Buddhist painting of the Yunnan, which, despite the symbolic values

of the Tantric type and the contributions of the Tibetan and Nepalese iconography, maintain intact several characteristics of the realistic current of the "Westernizing" T'ang type.

Li Lin-ts'an, in his 1967 study on the artistic production of the Nan-chao and Ta-li reigns, underlines the important contribution that the recognition of the art of these reigns has made to the evaluation of the Buddhist iconography of the Yunnan in the Sung period.

According to A.C. Soper (1970), the well-known roll depiction attributed to Chang Sheng-weng (12th century) of the Ta-li reign, in the collection of the National Palace Museum at T'ai-pei, perfectly illustrates the Chinese artistic ideal of "a thousand changes and myriad transformations."

A considerable part of the realism of the analogous T'ang figurations can be seen in the strong corporeal quality of the figures, in the almost heroic emphasis given to the human and divine creatures, and in the movement and dynamism of several terrifying beings and mythical animals. In several subjects this realism is transfigured by a whirling movement of the drapery; by the agitation of the clouds, drapes, and auras of smoke; and by the insistent nervousness of a "manneristic" type of contour line which prelude, in a certain sense, the Yuan figurations.

This painting is also evidence of the fervent pursuit, especially in the more marginal provinces far from the "academic" centers and the Sung power, of new pictorial expressions, often of an eclectic character. In several cases these new expressions will later converge in the Yuan production.

As M. Sullivan correctly emphasizes (1973), "it is in character with the intellectualizing orientation of the period, that the first major manual of architectural practice, the "Ying-tsao fa-shih" (presented to the emperor in 1100) was written under the Sung dynasty." In fact, in this period we notice a systematization of the architectural fact. However, this did not lead to a withering of the traditional structures; on the contrary, it enriched them with new solutions.

The "ang" arm, balanced on the many-stepped trussing system, creates a dynamic tension of forces, accentuated by the slenderness of the columns, while the architrave assumes a T-shaped section. Only infrequently does the pursuit of a purely formal elegance break up the constructive values. This mostly occurs in several wooden buildings, such as the sutra shelf of the Lung-hsing ssu at Cheng-ting-hsien (Hopei), in which the trussing structure is reduced to a simple exercise of the ability of the craftsmen. A type of flattened truss appears that visually gives the impression of a capital. This was used to compensate for the exaggerated slenderness of the columns and is present also in the second floor loggia of the library of the same temple. This element was later frequently used in the Ming and Ch'ing constructions. From a planimetric and volumetric point of view, the buildings show a tendency toward elegant variations, though always remaining within the sphere of rhythmic symmetry and restrained elegance.

The Mo-ni tien of the Lung-hsing ssu has an entrance vestibule with its own roof, which enriches the facade of an elegant pediment. In the above-mentioned library building, the use of several floors, each one having a different structure and altimetry, gives a pleasing

movement to the whole. The buildings belonging to the two architectural currents are, in our opinion, more static. These currents were defined in the southern Sung period and called in Japanese "karayo" (Chinese style) and "tenjikuyo" (Indian style), but perhaps the almost total loss of Chinese examples and the exclusive presence of Japanese buildings figure heavily in this judgment.

Elsewhere, we have written (1973) about the contribution made by the southern regions to the formulation of the Sung artistic language. Yu Hao, the famous architect who designed the reconstruction of the first capital K'ai-feng, was from the south. It is undeniable that the preference for chiaroscuro and volumetric contrasts, for coloristic effects, produced also through the use of glazed tile and accentuated by the movement of the pronounced curves of the roofs and by the fantastic acroteriums, is a contribution from the southern regions. Obviously, this perference was augmented by the moving of the capital from K'ai-feng to Hang-chou.

Little remains of the splendid buildings that ornamented the K'ai-feng of the northern Sung, which was destroyed by the Jurcin invasion. The urban planimetry, with the circles of concentric walls which respectively separated the external, internal, and imperial cities, demonstrates a strict adherence to the canonic rules, even though the street network is less regular, especially in the external city. In the already-cited roll of Chang Tse-kuan we have a description of the "popular" architecture of K'ai-feng. This is a series of one floor modules, with large roof tiles that often present a picturesque asymmetry in the variety of their aggregation. The courtyard complex appears less rigid and schematic, and the frequent openings to the outside are striking. These change the typically "introvertive" architecture of the aristocratic residence, harshly surrounded by a high wall, into a more "extrovertive" habitation open to the community life of the district.

The moving of the capital to Hang-chou (1138) resulted in the assimilation of interesting variations into the monumental architecture. However, the scarcity of documentation makes it difficult to evaluate them. This Chinese Venice, the Quinsai of Marco Polo (who has left us with an enthusiastic description of it), did not readily lend itself to a rigid application of the ancient urban-planning code. The streets were often flanked by canals, and the nature of the terrain forced the city to follow a very irregular, oblong contour. The north-south axis could not be laid out in a perfectly rectilinear manner, and the imperial palace was located in the totally anomalous southern zone, due to the suitability of the terrain there. The excessive population, resulting from the upgrading of the city to the level of capital, forced the construction of multifloor habitations (according to some sources 8 or 10 floors, though the texts appear more credible when they speak of 3 or 5), and resulted in the adoption of more complex constructive systems and new spatial and formal criteria. The preference for vertical development of the Sung architectural language has already been documented. Besides the traditional pagodas, ornamental towers, and doors, we encounter several multifloor monumental buildings, of which the library of the Lung-hsing-ssu is an example.

Another interesting contribution to the study of the Sung ceramics has been made by the already-cited Fustat excavations examined by Bo Gyllensvard. Thus,

it has been possible to better recognize and date several forms and types of pastes and coverings of the Ying ch'ing and of the Lung-ch'uan celadons. The mineralogical studies on the chemical composition of the glazes and bodies have helped to shed light on the very diverse techniques in use under the Sung, which sometimes have been poorly identified on the basis of the texts (which have left us names of kilns and descriptions of types, but in a very ambiguous way). These studies include those that were recently published (1973) by Chou Jen, Chang Fu-k'ang, and Cheng Yung-fu on the Lung-ch'uan celadons.

With this information, it is possible to state that a certain type of glaze with alkaline lime did not appear previous to the Sung. Also, the numerous recent findings in China, such as a boat (near the gulf of Chuanchou in the Fukien province, 1974) and the many kilns, along with the other examples in porcelain and stoneware, have broadened the picture of the Sung production, and have provided a tangible demonstration of the maritime commerce that was carried on between the southern Sung and foreign Asian and African ports.

The many questions posed by the Sung ceramics could perhaps be further clarified by this information, as well as by the new excavations of kilns now in progress (such as the kiln of Chi Chou Yao excavated in the Kiangsi province and published by Ch'en Po-ch'uan in 1975). Perhaps we may be able to understand why the Chinese failed to include a new type of white ceramic with azure reflections in one of the classifications listed by the traditional texts, called simply Ying-ch'ing (blue shadow).

An interesting example of this kind has been uncovered in the Anhwei province at Sasung. Its compound and refined shape (lobed basin in a lotus shape that contains a jug for heating wine) clearly demonstrates a "manneristic" type of accent placed exclusively on the vivacity of the profile and on the plastic variety of the combination of diverse forms, though detracting from its functionality. This is the same phenomenon that W. Willettes has already suggested for the widespread bowl shape that is flared with a wide mouth under the T'ang, but becomes almost a semisphere under the Sung. The wide, solid foot is replaced by a smaller one, making the entire vase much more elegant and animated, but certainly less functional and easily prone to overturning. As happened with the painting, in several cases the ceramics lose their "realism." In this case, the T'ang functionality is lost in favor of the pure and essential form, preferably expressed with only one color or with slight gradations, a clear "pendant" (even though the distance between the potter and the literate was immeasurable) of the monochrome ink painting. Thus, one can determine which predominating artistic codes were manifested in the "intellectualistic," and in a certain sense "manneristic," culture of the period.

Yuan Dynasty (1279 - 1368 A.D.). – For the first time, the entire Chinese territory was governed by foreign conquerors, and this event also was reflected in the artistic field.

The Mongolian ruling class generally did not win the favor of the Chinese bureaucratic and intellectual elite. This resulted in a rift between the "collaborators," who participated and assisted the Mongolians in the management of the government, and the "isolationists," who completely withdrew from the political sphere. The greatest consequence of this fracture was manifested in the field of painting, which had always been, especially under the Sung and with the academy, the figurative art most closely tied to the bureaucratic and aristocratic class.

Meanwhile, the Mongolian empire was spreading from Korea to Poland, stimulating commercial and cultural exchange. Arabs, Italians, Russians, Nepalese, and Tibetans served at the Yuan imperial court. Artists and artisans of many nationalities, attracted by the patronage of the Mongolian sovereigns, presented their work in the capital Ta-tu (Peking), enriching the Chinese artistic language with lexical elements and sometimes even new codes. There is no doubt that the Mongolians largely adopted the artistic expressions of the peoples they conquered, especially those that were more consonant to their own culture. Some of these had already been formulated by other foreign populations, such as the Khitan and the Jurcin during the long period of their domination of northern China. The Mongolians enriched them with new contributions that were produced through the contacts and exchange with very diverse populations. Within this cosmopolitan framework, we must not underestimate the role played by the figurative currents of Lamaism in the formulation of several codes of the Yuan artistic language. The very close relations of veneration and discipleship that tied Kubilai to the abbot Saskya 'Pags-pa (1235 - 1280 A.D.), the adoption of Lamaism as the official religion of the reigning house, and the bonds of political dependence which tied Tibet to China undoubtedly favored the affirmation in China of artists belonging to the Tibetan-Nepalese school, such as Aniko. Also, one cannot deny that several characteristics of the Yuan "baroque," other than the Liao and Chin legacies and the "Westernizing" current of the T'ang, can be deduced from the dynamism and vivacity of movement of the masses and the line in the Lamaist art.

Certainly, these characteristics seemed consonant to the national culture of the "barbarian" warriors of the steppes, a culture full of vitality that had endured much human struggle and the harshness of the natural environment, with a religious outlook still associated with the ancient animist and shamanist credos. The Mongolians gleaned solutions from civilizations that were more similar to theirs, instead of the sophisticated elegance, the worn out refinement, and the pronounced intellectualism that distinguished the Sung.

Of course, we do not suggest that the Mongolians rejected "in toto" the Sung artistic production, since artists belonging to the reigning house of the Sung, such as Chao Meng-fu (1254 - 1322), took part in the Yuan imperial academy and in many other such institutions. The Sung artistic and cultural "variations" came to be adopted by them. We only intend to state that often the most appreciated works of art in this period - if one excludes the paintings of the great landscape artists that were more a strictly "Chinese" phenomenon than a "Sino-Mongolian" one - are those that promote the "Westernizing" artistic "discourses" of the T'ang (mediated by the Liao and the Chin) or the ones of Tibet, which are much more consonant to the Mongolian "animus."

Ta-Tu, the Great Capital, was also planimetrically oriented according to the canonic rules (a rectangle with sides turned to the four cardinal points), but the

imperial city and, within this, the palace city, located on a central north-south axis, were almost contiguous to the southern side of the surrounding wall, a non-canonic position. This was probably due to the topography of the terrain and the nearness to the water, along with a different valuation of the traditional Chinese rules on the part of the Mongolian sovereign. In fact, as we have already mentioned, in the last capital of the Sung dynasty, Hang-chou, the imperial palace was situated in the southern zone of the city.

It is certain that the nomadic warriors constructed their capital largely in imitation of the architectural structures of the adjacent Liao and Chin cities, but adding elements belonging to their own traditional tastes to the numerous foreign elements. In place of the pavilion having a regular form, they often preferred a composite complex, which we have already seen used by the T'ang and the Sung, with porticos, annexes, and galleries which connect the single bodies. From a constructive standpoint we notice the affirmation of a preference for animated surfaces, for the dynamic tension of building structures ("ang" that are greatly inclined and projecting), and variously differentiated roofs that approach each other, as in the Sheng-ku-miao of An-p'ing-hsien (Hopei) of 1309. There is also documentation of circular pavilions, probably reminiscent of the yurt (Mongolian tent), and irregular pavilions, perhaps due to the presence of Arabic master builders who had travelled to the court of the Mongolian emperors.

The traditional pagodas, having symmetry (often polygonal) and regular sloping of the floors, often assume an exaggeratedly animated profile provided by the projections and indentations of the masses that are almost "baroque," as in the pagoda of the Kyong-ch'on-sa in Seoul, Korea. This profile is varied by symmetrical foreparts and by the movement of the numerous eaves that are different for every floor.

There is also documentation of the presence of the Tibetan Lamaist stupa, the mc'od-rten, with the typical "bottle" shape, from the monumental White Pagoda in Peking, whose design is attributed to the Nepalese Aniko, and from the three stupa (of which there is no trace today) that towered over the famous gate of Chu-yung near Peking, which, according to the studies by Murata and Fujieda, was completed in the years 1343 - 1345.

The impressive White Pagoda, which was erected in the eastern zone of the Tartar city (the northern part) of Peking, is amazing because of its extraneousness to its surroundings (inserted in a small temple, between one-floor habitations in masonry with courtyards, separated by continuous walls), and it is possible that at the time of its constuction there was open space around it, since it was located inside a monastery constructed by Tibetan monks. The measure of the contributions made by the Tibetan architecture to the Chinese architectural language of the Yuan period has not yet been fully evaluated. Elsewhere, we have mentioned (P. Mortari Vergara Caffarelli, 1976) the strong differences between the two architectural codes. The first, that of the Chinese monumental constructions, is the "classical" type, with symmetrical and axial planimetry, openings, and specular decorations; the other, that of the Tibetan palace architecture, is predominantly an "anticlassical" type, with asymmetry, dissonant foreparts and decorations, and often organic planimetry. Undoubtedly, a conflu-

ence of these two opposite planimetric and spatial conceptions would be extremely difficult to realize.

The constructive systems of Tibet and China were strongly divergent: one had a multifloor module based on the bearing function of solid brick or stone walling, with flat roofs; the other was expressed in the tien, often one-floor, with a wooden structure and plugged walls and a preponderance of the podium and the roof in the spatial economy of the building. The concept of the monumental, which in Tibet is developed in height (and which Tucci states is an architecture "obsessed by the idea of the mountain"), manifests itself in width in China. Paraphrasing Tucci's statement, we could say that the latter is an expression of the monumental "obsessed by the idea of the plain" of the great Yellow River, which constituted the cradle of the Chinese civilization. This concept led to the widening of courtyards and an ever greater distance between the principal tiens as the palaces and temples gradually assumed a greater importance. However, it must be added that the affirmation of Buddhism in Tibet had already, since the monarchic period (seventh to ninth centuries), systematized the Tibetan architectural module in the sacred buildings, with liberal possibilities of aggregation of the module in a mandalic, geometric, and symmetric complex of a "classical" type. Both in Tibet and in China during the Ch'ing period, there was a convergence of these two opposite architectural concepts, mediated by Lamaism.

It would be permissible to assume that also in the Yuan period, besides the mc'od-rten, there were other constructions present that repeated several elements of the Tibetan architectural language. In the recent excavations of aristocratic Mongolian residences, carried out by Chinese archaeologists near the Hou Ying Fang and the Yung Ho Kung at Peking, Ku Yen-wen (1973) identified brick foundations of the principal buildings. In our opinion, this corroborates the hypothesis of the use of typically Tibetan constructive techniques in several residences of aristocratic Mongolians. In regard also to the sculptural language, in several cases the code of Tibet, or, better yet, Lamaism, seems to have had a stimulating function. Already in 1968 S. E. Lee and Wai-kam Ho had pointed out the importance assumed by the Lamaistic models in several figurations of the Yuan period, especially in the bronze statuettes. These were important not only as iconography, but also because of their typical animated profile and the plastic evidence full of energy and movement.

The well-known artist Aniko (1243 - 1306) was a descendent of the Nepalese ruling family. As the leader of a group of 24 artisans dispatched by the 'Phags-pa to Peking, he made a great impression on Kubilai because of his ability and versatility. It has been said that he also took part in the designing of architectural complexes. Although Aniko created many works of sculpture, we unfortunately have not been left with any trace of them. It has also been suggested that he had a famous Chinese pupil, Liu Yuan, and that he created some paintings, also commissioned by Kubilai. H. Karmay (1975) attributes to his school a small Bodhisattva image in dried lacquer, which seems to follow the Tibetan-Nepalese stylistic traditions.

But the most conspicuous remains of Sino-Tibetan sculpture are in the mc'od-rten-porta of Chu-yung, northwest of Peking, which shows the achieve-

ment of the splendid fusion between sculpture and architecture that had already been proposed by several Liao pagodas. According to the evidence of the inscription discovered there, the rich sculptural reliefs that embellish the lower part were designed and supervised by the Tibetan Lama Nam-mkha'seng-ge, and the work was completed in the years 1343 - 1345.

The Japanese scholars Murata and Fujieda believe that these reliefs are definitely associated with the Tibetan-Nepalese school initiated by Aniko. The numerous Indian, Nepalese, and Tibetan divinities which ornament the extrados and the intrados of the arch and the entire podium are part of the Lamaistic iconography. Also, the decorative and architectural motifs which separate the various compositions (trilobed arches and columns with lotus flower capitals) are of an Indian origin, while the typical mandalas of the five Buddhas embellish the arch of the vault. In this work, the dynamism of the line, the liveliness of the movement, and the Tibetan "horror vacui" blend well with the Yuan baroque; so much so (inasmuch as the Lamaist matrix is so well-defined, iconographically speaking) that in these lively figurations it is difficult to separate the Yuan from the Tibetan-Nepalese contribution. Thus, an extraordinarily homogeneous language was created. In fact, the few remaining examples of Yuan sculpture document a profound vitality and dynamism which certainly had been influenced by the Tibetan contribution.

The variety of the lion figures of the Lu Kou Ch'iao (the so-called Marco Polo Bridge) at Peking, probably of the Chin period, with their tense aspect and a richness of anatomic detail (mane, coat of hair, musculature), attest to the presence of the typical dynamism of line and form which often resulted in an almost "baroque" expression. However, one must not think that this sculpture completely breaks with the Chinese past. We have already pointed out this vitality and richness of detail in the Liao sculpture and in the T'ang code of realism, especially seen in the "Westernizing" works. These qualities continued to have a presence after their respective periods, although they were changed by significant variations closely related to historical and religious circumstances. Nor should the Sung influence be completely ruled out. Several Kuanyin in a serene and regal resting pose (maharajalila), such as the one in porcelain that was recently found at Peking, although enriched by a more animated drapery and a more lively plasticism, maintain intact the unperturbed elegance, the supreme harmony of the gestures, and the smoothness of the flesh of the Sung representations.

As was mentioned, there was a clean break in the pictorial field, with the painters separating into two distinct, often highly differentiated currents. One was that of the artists in the service of the foreigners; these were the "Yuan academics," who used themes taken from the Sung (flowers, birds, bamboo) or created dynamic, highly ornamented pictures of figures with scenes of horses and hunting, which were closer to the Mongolian taste. The other current, that of the literates or the Wenjen, shirked the dominion of the "barbarians," and in the solitude of their voluntary exile they carried forward their diverse tonal and impressionistic "discourses," attaining, according to J. Cahill (1976), "the total overthrow of Sung standards and ideals." Chao Meng-fu

belonged to the Yuan Academy and was very skillful in figure painting. He was also a superlative landscape painter, representing a rare exception among the academic painters of this period. Although remaining faithful to the theories of the Yuan Academy, his work undoubtedly shows a great debt to the Sung school and above all to the creator of "tonalism," Mi Fei. He stated: "The Sung painters are much more inferior to the T'ang painters. For this reason I have taken the T'ang masters as my instructors, and I would almost like to liberate myself from the ink brushwork of the Sung artists." This affirmation is perfectly in line with the revival of T'ang realism that occurred in the Yuan court, but it was largely a theoretical stand that was taken. One need only view his painting "Autumn Colors on the Ch'iao and Hua' Mountains" of the National Palace Museum in T'ai-pei to be convinced that the Sung lesson had not been forgotten.

However, Chao Meng-fu has the merit of looking beyond the late Sung "mannerisms" to rediscover, as M. Sullivan proposes, "the poetry and the brushwork of the long-neglected art of Tung Yuan and Chu-Jan." His work came to be highly regarded among the works of the great landscape artists of this period.

Ni Tsan was one of the foremost exponents of that which B. Smith defines as the "counterculture" of the literate artists, which had its roots in Taoism, in the Ch'an, in neo-Confucianism, and in the latest Sung era. He proudly affirmed:

> among the landscape artists of the present dynasty, Kao K'o-kung is distinguished for the atmosphere of calm detachment which pervades his paintings, Chao Meng-fu for the expression of his bold brush strokes, Huang Kung-wang for his originality and Wang Meng for his freshness and elegance. Among them there are differences in quality, but I have only praise for these four. I know nothing of the others.

A.W.E. Dolby (1973) has pointed out the unconventionality and, in a certain sense, the "modernness" of Meng-fu, who admirably fused the tonalism of Mi Fei with the expressionism of the Ch'an (above all that of Mu Ch'i) and the lessons of the masters of the Five Dynasties. As a rule, all of the contemporary critics, from Seiroku Noma (1969) to S. E. Lee, Wai-Kam Ho, and J. Cahill (1976), have focused great attention on this "bohemian" artist. Cahill has emphasized the extremely relevant and "revolutionary" characteristics of his art, in which "few concessions were made to common pictorial, decorative or descriptive values." Actually, one cannot say that these four painters, described by the latter critic as belonging to the group of the "Four Greats of the Yuan Period," had been completely outside of the official culture of the time. The contained force and the nervous vitality present in many of their paintings closely associated them to the aesthetic attitude which pervaded the artistic language of the entire period.

Another conspicuous branch is that which includes the figurations of the Lamaist Buddhism, although it is difficult to set it completely apart from the rest of the Yuan painting. As has been observed, already in the southern Sung period (roll by Chang Shen-wen of the Palace Museum of T'ai-pei) there were figurations

present in China of a distinct Tibetan character. Thus, it is not surprising that Han-chou had been an active center of Lamaist art around 1300.

H. Karmay (1975) has recently studied numerous prints originating from this city, which were often used to illustrate Buddhist texts. They demonstrate a vivacity of the nervous and dynamic line, the "horror vacui" which fill the entire space of ornamental details. This is often matched with a static hieratic quality of the central figures, which is typical of several tanka of the same period. Lexical elements that go beyond the iconographic solutions constitute the most vivid contribution that Tibet made to the Yuan artistic language.

The Mongolian court was fond of ostentation, wealth, and color and consequently must have provided a great stimulation to the artisan production. The arts of lacquering, goldwork, and ceramics flourished during this period. The transposition of subjects of the academic painting onto supellectiles and ornamental objects became a widespread phenomenon. Although J. Wirgin (1976) claims that this phenomenon was widely present under the Sung, it was surely less diffuse than in this period. In several engraved lacquer objects (studied by J. Wirgin, 1972) we see depictions of genre scenes, while on a goblet published by Bo Gyllensvard (1971) there is a representation of a grotto with animals and trees, displaying a very animated profile. It is logical that at this time of breaking with the traditional past there was a more facile exchange of stylistic codes between the various arts, which became institutionalized and continued on through the Ming and Ch'ing periods.

Like the Liao, the Yuan also failed to fully comprehend the intellectualistic elegance of the Sung monochrome ceramic production. Their taste for polychromy, rich decoration, and contrast led them to often prefer the most vivaciously decorated and colored of the Sung ceramics. In 1970 in the streets of the Drum Tower at Peking, a hiding place was discovered among the ruins of an aristocratic residence containing 16 porcelains. Among these at least nine were of the white and blue type, representing one of the most important finds of this category of ceramics. In fact, these vases, with cobalt-blue decoration on a white background, constitute one of the most valid discoveries of the Yuan potters, and, according to Ku Yen-Wen (1973), they are "an important milestone in the history of Chinese porcelain." Until recently a large part of the remaining blue and white ceramics belonged to the Ming period. Therefore, the significance of this finding is obvious, providing us with pieces of a high artistic level in the modeling, the lustre and the decoration confirming that already the "white and blue" of the Yuan had reached that technical perfection and superior sense of harmony between form and decoration that was frequently ascribed primarily to the Ming.

Ming Dynasty (1368 - 1644) – We have already proposed a parallel between several aspects of the artistic language of the Ming and that of the European "neoclassicism." With the restoration of the imperial power under one national reigning house, there arose a spontaneous desire to be associated with the great classical ages of the past, with the Han and, above all, with the T'ang. But the Sung intellectualism had not been forgotten, and the ancient artists were brought back to life with the minute precision of the exegete and the literate, although in several cases they were deprived of their vitality. The antipathy toward the Mongolian experience, combined with a love of form and the clear and precise line, lead to a withering of the dynamism of the Yuan "baroque."

Even Peking, the capital of the Yuan "foreigners," underwent changes of a more traditional character. In our opinion, these changes were intended to render it as close as possible to the ancient canonic complex of Ch'an-an. But the preexisting urban structures did not permit a total adaptation to the ancient model. Nevertheless, the "anomalous" position of the administrative and imperial palace center (toward the south) was "corrected" through the incorporation of the southern, or Chinese, city and with the displacement of the northern surrounding wall, leaving a large part of the northern districts of the Yuan city outside. Thus, the Ming emperors reconstructed the long processional route, the north-south street axis, which was fundamental for a correct ritual approach to his majesty, the emperor. This is the "sacred path" which crossed a large part of the city of Ch'ang-an before reaching the doors of the administrative city, and then the doors of the palace city.

But because this had been strongly "willed" and historically reconstructed, the results, taken as a whole, were a little too cold and monumental. This was especially true inside the Forbidden City, whose central part (the three large ceremonial rooms, San-ta-tien, reconstructed in 1700 following the style of buildings of the early 1600s) was the result of a rigid "philologic" reconstruction of the traditional courtyard complex, already cited by the Chou texts which prescribed how the son of Heaven must dwell in the "three courts."

Because of this, the width of the courtyard was extended to extreme proportions, and it completely lost its strong organic quality of the aggregation of the modules, which we have alluded to in several T'ang and Sung complexes. This is not to say that the Ming architecture was devoid of value in comparison with the past architecture, as many scholars have suggested up to this day. The Ming constructions were linear in their design and avoided the exaggeratedly curved roofs, the overly-projecting acroteriums, and the irregular complexes. As we have stated elsewhere, "instead they embody a very pleasing and measured fusion between the simplicity of the ancient traditional complexes, the monumentality of the complexes inherited from the T'ang, and the coloristic and chiaroscural richness of the architectural decoration typical of the Sung, the Liao and the Yuan."

Even the "foreign" elements, which had been incorporated into the Yuan artistic language and were primarily associated with Lamaism, were not forgotten. Rather, as D. Kidd warns in regard to several paintings (1975), it is necessary "to pay more attention to the great patronage accorded to Tibetan Buddhism by many Ming emperors." In fact, until recently, the Ming period had been considered as an era of a temporary eclipse of Lamaism in China, later to be revived under the Ch'ing. Remaining in the field of figurative art, the work of H. Karmay (1975), J. Lowry (1975), H. E. Richardson (1975), and D. Kidd has permitted an evaluation of the presence and the survival of this "foreign" current in the period of the Ming "traditionalists."

Consequently, even the architecture did not escape the Tibetan-Nepalese influence. Many scholars

have noted the Ming interest in brick and stone constructions. Although they were executed using traditional typologies (remaking of the large wall, monumental doors, bell and drum towers, pagodas), the Yuan constructive technology definitely could have contributed to these constructions. Nor was there an absence of mc'od-rten replicas, such as the Sarira-stupa of the Ching-ming-ssu near T'ai-yuan (1385), even though they were less monumental than the preceding ones. The Wu-t'a ssu at Peking, an arbitrary replica of the Indian temple of the Mahabodhi of Bodhi-Gaya, with its parallelepiped-shaped wall mass surmounted by five masonry pagodas, easily fits into this architectural current.

By examining a bronze model dating from the Yung Lo period, one can notice the interesting manner in which the Ming architects interpreted this Indian construction (which they were well-versed in). The vertical tendency of the Sikharas of Bodhi-Gaya are toned-down, diminishing the volume and the height while basically increasing the dimensions of the structure. In observance of the Chinese tradition, each floor is marked by a roof eave, and there is a transformation of the cornices and the mouldings of the ancient temple.

In fact, it is unthinkable that a Ming architect would have constructed a multifloor building without employing the method of stacking "tien." This ancient module was so rooted in the Chinese architectural language that it could never have been completely forgotten, although variations in stone or brick could have been possible.

Despite the traditionalism intended by the Ming, it can be noted that the "colonial" expansion and the commercial and cultural exchange, by both land and sea (explorative expeditions of the admiral Cheng Ho), with southern Asia, Africa, and Europe led to a subsequent enrichment also of the artistic language. It was in this period that numerous buildings of a "European" type were constructed, such as the constructions of the colonial settlements of Macao and Canton, and the Catholic churches built by Father Matteo Ricci. Perhaps the two brick temples, with masonry bearing walls and barrel vaults, located at T'ai-yuan fu and Su-chou, owe part of their structures to the contribution of the new foreign suggestions, though they were grafted onto the ancient, traditional techniques which were employed especially in the funerary constructions.

The ambitious architectural activity of the Ming was intended to affirm the supremacy of the dynasty, above all through the use of the Chinese language, which was "unfurled" from the walls of the cities (the new wall of Hsi-an was built during this period, leading to the decline of the ancient capital Ch'ang-an to a much smaller city that almost exclusively utilized the zone of the imperial city) to the canals and to the Great Wall, culminating in the already-mentioned re-ordering of Peking.

The architecture of wooden structures shows a new symmetrical and rhythmic balance. The intercolumniation in the central part of the "tien" was widened, and on the outside the trussing system was reduced to a series of clusters, which formed a continuous chiaroscural mass (as in some Sung and Liao buildings) that was, however, hidden by the eave line. Plugged walls were frequently adopted, which, except for several rigidly symmetrical central openings, give a continuity to the outside surfaces. This continuity is modulated by classical mirrorings, geometric figurations, and the colonnade, which barely projects from the wall line and gives the impression of an elegant pilaster strip. The height of the arcades is contained by trabeations, often double, that are decorated by rich and colorful geometric motifs and by flat corbels mortised into the sides of the columns (already appearing under the Sung). Tall podiums with rich white marble stairs and sculpted balusters accentuate the monumentality of the most important tien, isolating them from the context and providing the viewer with a static and scenographic impression of great majesty.

An entire chapter could be written on the splendid residences scattered in the gardens of the principal cities, especially those of Su-chou and Hang-chou. They were an expression not of the imperial power, but of the wealthiest class of the literate artists, the aesthetes, the wen-jen. Here we encounter a free expression of the concept of blending-in with nature, which gives the impression of great spontaneity in the architectural manufacture (although it is "constructed" and willed), which had its roots in the ancient Taoist world and in several branches of Buddhism. Like the imperial monumental architecture, which demonstrates a sense of hierarchical order and symmetry, this expression is a direct consequence of the Confucian theories. These luxuriant gardens are the exact "pendant" in the architectural field of the suggestive pictorial language called Wen-jen-hua. The pavilions scattered throughout the gardens have fanciful openings and quite varied forms in picturesque, harmonious, and rhythmic disorder, which give an effect of lively immediacy (though studied in the finest details). There is an identical romanticism together with a pure, serene beauty, achieved through attentive research and long study, though this study is unnoticeable in the most successful works.

It was no accident that Su-chou and Hang-chou were the seats of the two most important unofficial pictorial schools of the Ming period, the Wu and the Che, which were differently inspired by the great masters of the Yuan period. Naturally the Summer Palaces of the emperors followed analogous architectural schemes, but the necessity of safeguarding the imperial majesty, and, thus, of expressing the maximum amount of monumentality, in a certain way altered the harmony of these complexes, which emphasized subtle nuances and the relations between water, vegetation, rocks, and buildings.

In the necropoli the monumental sense, conceived as spaciousness and the distance between buildings, was carried to extreme limits, to the extent that the structural unity of the planimetry was broken up, excessively diluting it in space and in the time necessary to cover this distance by foot. The great p'ai-lou in marble at the entrance of the Ming tombs near Peking functions as a marker for the beginning of the sacred area, as in many other analogous constructions. But the visitor must traverse a long course on the Shen tao (road of the spirit) before reaching the first great door, then the pavilion of the stele, and finally the road flanked by colossal statues. An even greater space separates the pavilion from the other cult buildings and from the various tombs with their annexes. The axial connection and the planimetric arrangement are spaced out in such

a way that each building becomes almost a complex in itself.

In this cemetery in 1957 the Ling (royal hypogean tomb) of the emperor Wan Li was excavated. It actually is a subterranean palace, having a continuation of rooms with barrel vaults arranged along an axis and lateral annexes, terminating with the large room of the sarcophagi, perpendicular to the complex. This discovery perfectly documents the order, symmetry, and axiality typical of the Ming, along with their great constructive ability.

Another sepulcher opened in 1970 - 1971 in the Shantung province and belonging to Chu Tan (prince of Lu, died in 1389) is less monumental. There are only two hypogean chambers, though of vast proportions, constructed with large bricks. This discovery is not only important from an architectural standpoint, since a rich funerary supellectile was found inside. This contained roughly a thousand pieces, such as vases of gold, jade, bronze, and porcelain; silks; lacquers; statuettes; and, above all, paintings, calligraphy, and prints in a well-preserved state. There are original paintings from the Sung and Yuan periods, including a splendid Sung depiction of flowers and butterflies that Lu Wen-kao (1973) defines as "characterized by exquisite and precise brushwork."

From Chu Tan's tomb we can also deduce the great admiration that the Ming art scholars had for the Sung and Yuan paintings, manifested in their writings and in their collections. In fact, this was the period of the great theoricians and collectors, and only in the last decades has it been possible to define the significance of the influence that the Ming aesthetic criticism had on the successive evaluations of the ancient artists.

In effect, for many centuries the most ancient Chinese painting, especially beginning with the T'ang, was seen through the eyes of these great theoricians (the foremost being Tung Ch'i-ch'ang). One certainly cannot consider them as "impartial," given their habit of placing all the painters that were not to their liking in the "Northern School." A further systematization of the theory of the Shih-ch'i (spirit of the literate) of the Wen-jen is also attributed to Tung Ch'i-ch'ang. A Wen-jen was an independent scholar-painter, not tied to the imperial Academy or the court (which were considered in a negative light), who painted following his own impulse, often imitating the Ch'i-yun (vital spirit) of the ancient masters. However, this judgment also involves periods in which the Academy still maintained all of its vitality, as under the Sung.

The pronounced fracture in the Yuan period between the court artists and the exponents of the so-called "counterculture," the scholar-painters or the Wen-jen (who had some of their roots in the meditative and religious Taoist isolationism of the first Ch'an painters), was not "resoldered" in the Ming period. Rather, it was systematized and theorized. On the one side were the painters following the emperor, experts in the more or less "realistic" themes; on the other side were the Wen-jen, whose code of conduct became institutionalized and ordered down to the most minute details. It is precisely this conduct that dries up the great vivacity of the "impressionistic" and "tonal" currents of the Sung and the Yuan, which were created as a "revolutionary" form. The works belonging to these currents were then dissected, and every brush stroke was examined in the ch'i-yun, to be reconstructed "in vitro" with a constant philologic attention similar to that applied by the Western neo-classicism.

Of course, not all the Ming theoricians and artists followed the precepts of Tung Ch'i-ch'ang to the letter. In this period there were also great artistic personalities who were able to liberate themselves from the prevailing conformism to create their own language. V. Elisseeff (1967) correctly establishes the 15th century as the beginning of a period "domin e jusqu' nos jours par la rivalit des lettres-novateurs et des lettres-conservateurs." Actually, Tung Ch'i-ch'ang was not as rigid in his suggestions of strictly imitating the ancients as his followers had interpreted him. In fact, he warned the landscape artists to "look at the true mountains." However, there were critics, such as Kao Lien (1521 - 1593), Ku Ning-yuan (end of the 16th century), and Yuan Hung-tao (beginning of the 17th century), who were well aware of the dangers awaiting the excessive systematization and the cold and stereotyped imitation of the past masters. Kao Lien stated in his "Chun Sheng Pa Chan," on the subject of the most orthodox Wen-jen, that "these artists talk of 'writing' and not 'painting' their works, because they do not want to have anything to do with the art of the painters of the Academy. This type of design is useful as a means of capturing the pleasing inspiration of a moment, but one certainly cannot consider it as art comparable to that of the masters." Thus, it was made clear that the exaggerated pursuit of spontaneity loses most of its lively characteristics of immediacy when it is excessively forced. Ku Ning-yuan, in his "Hua Yin," further clarified this concept, describing how women and children and people without pretension, who draw for their own delight, "have something that is not found in the works of the accomplished artists; they have sheng and chuo (freshness and ingenuousness)." He thus advised painters to reconquer the qualities of the ancient masters, rather than study their composition or their type of brush stroke.

Even Tung Ch'i-ch'ang placed some limits on the imitation of the ancients in his paraphrasing of Yuan Hun-tao: "The much-acclaimed modern artists do not make a single brush stroke in which they do not imitate the ancients. But imitating the ancients does not mean being like them. It is not even painting."

But because of the Confucian cult of the past, even the most anticonformist critics never doubted that the ancient artists had had some indefinable talents superior to those of the artists of their own time. Naturally, this substantially impeded innovations in the pictorial language, despite the affirmation of Yuan Hung-tao, the innovator who was a precursor of the "individualist" current of the Ch'ing, which emphasized that "ignoring the rules is sometimes the best way to follow the past masters."

However, one should not think of the pictorial world of the Ming as a statically fixed whole, totally applied to a neoclassical purity. The pictorial discourse of this period, as we have verified also in the theoretic field (keep in mind that the writers were almost always excellent painters), was rich with diversifications and contrasts. For this reason, a great interest has recently been developed in the Ming pictorial production, encouraged by the exhibitions staged both in the West and in the Orient and by new publications, primarily executed by the National Palace Museum of T'aipei,

which houses many masterpieces of the ancient imperial collection. Three of the so-called four great masters of the Ming period, Shen Chou, T'ang Yin, and Wen Cheng-ming, have been researched in exhaustive monographs by R. Edwards (1962), T. C. Lai (1971), and A. De Coursey Clapp (1975). Even artists considered as minor and anonymous works have attracted the attention of scholars such as V. Contag (1969), J. Cahill (1971), and Chu-tsing Li (1974).

Six tanka dating from the end of the 15th century to the beginning of the 16th century, have posed an interesting problem regarding the survival of the Lamaist pictorial language in China after the fall of the Yuan. As has been already mentioned for the architectural constructions, the prevailing opinion considers that the acquisitions of "foreign" forms by the Yuan were not completely rejected in the Ming period. Rather, especially as concerns the Sino-Tibetan art, the discourse was continued until it reached a new and larger diffusion under the Ch'ing. Despite several doubts expressed by J. Lowry (1973), we fully concur with D. Kidd (1975), who states that "China, and more specifically Peking, is the place of origin of these six tanka." This ascertainment will lead to further developments regarding the dating of other, similar tanka, and a better framing of this marginal production at the sides of the "traditional" Ming art.

In the sculpture there are some Sino-Tibetan bronzes present that H. Karmay (1975) fully justifies with his exhausting examination of the close relationship between the Ming emperors, in this case Yung-lo, and the uppermost ecclesiastical hierarchies of Tibet. In these elegant bronzes, the dynamic vitality, typical of the Lamaist iconography, is contained by the "neoclassical measure" of the Ming statuary, resulting in an amazing compromise between volumes in movement and static, monumental serenity. Indeed, little interest has been shown in the Ming statuary, which in our opinion represents one of the most significant and characteristic aspects of their typical artistic language. The same frontal pursuit is present that was expressed in the heroic power of the imperial portraits painted by the academics. This is evident also in the statues of dignitaries located along the Shen tao of the necropolis near Peking. They are majestic and powerful figures, almost geometric volumes, which are lodged in space, rejecting every affectation in the recapitulatory drapery and in the linear decorations, expressing a virile sense of contained dignity, serene composure, and classical harmony.

Despite the fact that paintings and sculptures are among the most protected of the cultural patrimony in modern day China (the exportation of works of art dated earlier than the 18th century is forbidden), the interest of the scholars of the People's Republic of China is focused, as regards the latest periods, on that which is commonly defined as the artisan production. In fact, in modern China, a painting ceases to attract widespread interest when it ceases to have interest in an archaeological or documentary sense and becomes only an expression of a dominating elite and almost completely out of the reach of the masses. The productions created by the class of simple laborers, such as ceramics, lacquers, and jades, are more preferred. Even in the West many studies on the Ming ceramics have been published (J. Ayers, 1968 - 1972; A. M. Joseph, 1971; M. Medley, 1973) dealing with the relations with the Arab and the Persian regions and the types and models used for exportation (M. Beurdeley, 1969, D. S. Howard, 1975). They are especially useful in explaining the ancient techniques and the authentic impasto, determined by means of X-ray examination, such as those executed by H. Shire (1974).

Regarding the decoration, as has been mentioned, the Yuan had in a certain sense knocked down the barricades which separated the pictorial subjects from the artisan works. Under the Ming there was a continued use of the iconographies and compositions of the paintings in the decoration of ceramics, such as the type of polychrome plate with human figures under arbors and trees found in Peking in the 1970s. Among the splendid lacquer objects of the royal collection, Bo Gyllensvard (1972) has identified several works of the Ming period bearing landscapes, architecture, and figures expressed in a strong compositional harmony and in a sharp spatial framing, modelled on the best pictorial tradition.

Ch'ing Dynasty (1644 - 1912). – The Manchu, or Ch'ing, dynasty, like all the foreign dynasties (although it was already strongly "Sinized"), represented a break with the past, and it renewed the occasionally repetitive artistic language of the late Ming on many levels. There was a reappearance of the taste for a richer decoration emphasizing the volume of bodies, typical of the "barbarian" peoples. However, instead of an affirmation of a preference for broad and dynamic compositions like those of the Yuan, there was a fractioning of the elegant compositional liberty and the vivacity of the detail. This resulted in the transformation in the late Ch'ing to attitudes that are often mannered and picturesque and that could be defined as almost rococo.

The Ch'ing artistic language is commonly evaluated as closed, traditionalist, and monostylistic. In the first centuries of the dynasty the splendors of the "cosmopolitism" of the T'ang and the Yuan were relived. It was only in the 19th century, when the Western colonialism began to bear down upon China, that the Manchu dynasty retired into itself as a stronghold of the ancient Chinese tradition and of its own conservatism, seeking to stem the tide of innovation in any way possible. This useless attempt to isolate the country partially dried up artisic invention. The modern Chinese scholars place the end of the feudal period — that is, the period of the traditional empire — at 1840, which signals the start of the transition phase that leads to contemporary China. In the beginning of the period, the colonial wars of conquest and expansion brought the Manchu from T'aiwan to Lhasa and from Turkestan to Annam. Western missionaries, scientists, and artists, such as Castiglione and Attiret, came to their court. The latter artist's production was encouraged and followed by the openhanded patronage of the emperor. There is no doubt that the codes of Ch'ing artistic expression were largely derived from those of the Chinese tradition, which were well-represented by the Ming. But because of their foreign qualities, the Manchu were able to introduce considerable variation, deriving from not only their own tradition, but also from the continuous contacts with very diverse peoples and populations.

In the same urban planimetry we notice a more precise differentiation and specialization of the centers

according to the activities that were carried on there, as has been pointed out by G. Rozman (1973). But after conquering Peking in 1644 and making it their capital, the Ch'ing did not considerably vary the urban complex intended by the Ming. One need only examine the Palace city to recognize the great difference between the part "of representation," situated on a north-south axis (above all the famous San-ta tien), which conserves intact the complex and the structures of the Ming, and the residential zones that are located in the western and eastern wings.

Wide, isolated tien with simple volumes are located in the central part. They are tall, rhythmically measured, and symmetrical, with white marble terracings. The decorative effect is achieved primarily from the lively chromatic contrast of the single parts (yellow roofs, reddish walls, pure white marble) and by the linear and polychrome geometric motifs of the structures. There is no garden - nature is absent here, where the apotheosis of human power occurs, representing symbolically the center of the cosmos. In the lateral courtyards, instead, there is less monumentality, and everything becomes more intimate, decorative, and romantic. The pavilions are of small proportions, varied in their openings and forms, and rich with decorations and carvings. They are arranged around small courtyard gardens with fountains, plants, and rocks. Even the surrounding walls, which often separate one complex from another, no longer present the severe mirrorings of the Ming, but are enriched by polychrome ceramic medallions in relief, of the most fanciful forms.

In the interiors, instead of the rich, but measured, furnishing of the Ming, we encounter a conglomeration of small, finely-decorated furniture and precious objects in lacquer, jade, gold, and silver, while on the wooden structures the geometric, linear motifs are replaced by flowers, birds, and landscapes. There are a large number of carvings and sculptures and a variation of colors and forms. This is the triumph of rococo, which sometimes comes close to bad taste, but often is only an expression of pure dynamism, of a constant pursuit of variety, litheness, and compositional freedom. This pursuit reaches its apex in the summer palaces, in which a more liberal expression of the monumental, not bound by the rigid traditional rules, permitted the Ch'ing emperors to fully manifest their eclecticism and experiment with newer solutions and more diverse architectural languages. One of these manifestations is the Yuan-ming-yuan, one of the summer palaces built for the emperor Ch'ien-lung (1736 - 1795) near Peking. It is a singular complex designed by two Western artists, the Jesuit G. Castiglione and J. D. Attiret, who were commissioned by the sovereign to "build in the European fashion."

The modules of the late Western baroque are well-united with several Chinese architectural elements, already transfigured in a decorative sense by the Ch'ing, creating a rather unitary and pleasing whole. In a letter written by Attiret (1743) to M. D'Assaut, examined by M. G. Loehr, he describes the summer palace, affirming that, contrary to Peking, here everything is in "a beautiful disorder, in an antisymmetry." This corroborates the intimate agreement between the way of conceiving the aesthetic fact by an exponent of a type of European baroque and the architectural language expressed by the Ch'ing (which was in a certain way similar in the type of formal expression and compositional conception). This agreement was more obviously demonstrated by the chinoiserie phenomenon, which was not limited to the assumption or imitation of objects (porcelains, lacquers, furniture, silks), but distanced itself more from the field of the art of the gardens to move nearer to the decoration of the interiors, as demonstrated by M. G. Loehr at the International Congress of Sinology at Chantilly in 1974. At this same Congress M. Dev ze pointed out that there was such a tremendous interest among Europeans for viewing and obtaining artistic works of the Ch'ing that for the first time, Europe, which had always exported its culture and manufactures, found itself at a disadvantage in its balance of payments with China in the 18th century. As J. Dehergne stated at the conclusion of the Congress, in the 17th to 18th centuries "China's influence on contemporary Europe was greater than Europe's influence on China."

The Tibetan artistic language seems to have had a much greater presence and was more vital than the "European" current under the Ch'ing, and this is easily explained by the acceptance of Lamaism by the Manchu dynasty. Mc'od-rten, buildings, and towers arose in the summer palaces and inside the walls of Peking that were reminiscent of several "constants" of Tibetan architecture, such as the massive wall structures and the trapezoidal openings. But an even clearer manifestation of the eclectic taste of the Ch'ing is at Jehol, where great palatial complexes (summer retreats from the heat), temples, and monasteries were constructed.

As Wei Chin and Li Kung (1974) have noted, the monuments of Jehol (Ch'eng-teh) are the architectural expression of a China considered as "a country unified by many nationalities." In fact, in the same complex, and often in the same building, constructive typologies, constructive systems, and architectural decorations corresponding to the two distinct architectural lexicons (Tibetan and Chinese) are superimposed and combined.

The great vitality and formal and compositional freedom of the Ch'ing architectural language is clearly expressed in the variety of solutions and in the imaginativeness of these fusions. The differentiation with the Ming architecture is also evident in the funerary complexes. A good example of this is the tomb (Pei-ling) of the founder of the dynasty, built in 1651 near Mukden.

Undoubtedly the builders availed themselves of the traditional model offered by the great Ming cemetery near Peking. The placement of the various monumental buildings on the Shen tao is similar, but the decorative tendency of the Ch'ing is evident in the lobed medallion ornamentations, with richly colored reliefs on the walls. The building modules are of smaller proportions and are more loaded with polychrome decorations, both externally and internally, while the wide, open spaces of the Ming are reduced and compressed. This results in closer distances between the various elements of the complex, "made to the dimensions of man."

The traditional, rigidly-squared profile of the entrance arch is mitigated by dense reliefs and decorations, while the imitation of the trussing system is transformed into a chiaroscural step motif. The sculptures and the bas relief are an integrating part of the architectural manufacture, animating and enriching the surfaces, deriving from the pictorial motifs and the traditional and mythical figurations of the ancient Bud-

dhist and celebrative patrimony. Often foreign elements (Indian, Tibetan, Indonesian, and sometimes Western) amplify and enliven the sculptural language. This is the case for the sculptures discovered on the site of the Tsung Sheng k'u (the seat of the T'ai-p'ing) at Nanjing and published in 1976. The typical symbolism of this sect is present here, especially in the stone bas reliefs. This is a grouping of local and Christian religious elements, which often achieve exquisitely decorative effects.

Instead, one can often detect the vivid presence of the Lamaist iconography and artistic modules in the Buddhist sculptures. H. Karmay notices in the bronze statuettes of the Ch'ing a continuation of the Ming production of the Yung-lo era. But the continuous contact with the Tibetan world and the Ch'ing "decorativism" enrich them with a greater vivacity and movement, although often the original tense dynamism is diminished by an excessive attention to detail, which is typically rococo and occasionally redundant, especially in the later eras. In the round bronze and stone sculptures which ornament the imperial residences, one frequently encounters an evident transposition of the terrifying animals which surround the figures of several Buddhist divinities and are also placed in defense of the Son of Heaven. But the agitated violence of the composition and the exaggerated definition of their monstrous attributes often take away their demonic aspect and render them as mere exercises in fantasy.

Proof of the Ch'ing eclecticism can also be had in the painting, which is the most closed and traditional of the arts due to its formulation by an elite group. In this period we see the acceptance of foreign elements, like the interesting production of G. Castiglione, which was highly admired by the court. This demonstrates the measure of the comprehension and the interest that the Manchu had for such diverse pictorial languages, although Castiglione's works were more comprehensible to the Chinese viewer because of his wide use of Far-Eastern lexical elements in creating an original artistic language. This phenomenon is analogous to that which occurred in the T'ang period with the Indian and Central Asian painters, especially the two belonging to the Yu-chih family. In fact, Giuseppe Castiglione had a Chinese name, Lang Shih-ning, and he was commissioned as a painter by the court. The subsequent treatises gave a precise evaluation of his work, treating the subject as if the artist was a Chinese painter. Because of the interesting mixture of such diverse artistic languages, along with his significance as a mediator between China and Europe, his work has aroused much interest among the contemporary scholars. The fullest demonstration of this is the exhaustive biography by C. and M. Beurdeley (1971), which examines all the diverse aspects of his multiform activities in China.

Besides the creation of "academic" works following in the wake of the Four Wang and strongly tied to the theories of Tung Ch'i-ch'ang, there was also a minor production of works with a Western influence, such as those by Ch'iao Ping-tseng and Leng Men (active around 1720). Keep in mind that the Italian painters Cristoforo Fiore and Giovanni Gherardini, the Frenchman Charles de Belleville, and the Armenian Michele Arailza had all worked at the court before Castiglione. The painting of the literate-artists, the anticonformists, the anti-academics, and the eccentrics also underwent a

renewal. The "tonal," "impressionist," and "expressionist" code of the past periods became enriched by new elements that achieved incredible results of "modernness."

This phenomenon paralleled that which was realized under the Yuan; in fact, many painters preferred to be detached from the life of the court and the affairs of a government run by "foreigners," taking refuge in solitude, and often becoming monks. Despite the original individualism of these artists, the later scholars, instilled with the "Confucian" tendency toward cataloguing, grouped them in schools and currents that were sometimes homogeneous and often convenient. The most noted of these were the Four Masters of Hsi-an (Anhwei), the Eight Masters of Ching-ling (Nanjing), the group of the Great Individualists, and the Eight Eccentrics of Yang-chou. These artists and writers, who worked in isolation or in restricted coteries, and whose activities were almost completely unknown to the Manchu court, also wrote the newest and most interesting works of aesthetic criticism. These written works greatly contrasted with the vast encyclopedias that were uninspiringly compiled under the imperial patronage, such as the P'ei-wen-chai shu-hua-p'u of Wang Yuan-ch'i.

Shih-t'ao (Tao-chi) (1641 - 1717), Chu ta (Pa-ta-shan-jen) (1626 - 1705), Kao Ch'i-p'ei (1672 - 1732), Cheng Hsieh (1693 - 1765), and Ching Nung (1687 - 1764) were foremost in bringing forward an incredible modernness, the vivid expressionism of the Ch'an masters Su Tung-p'o and Wen T'ung, whose contribution had been almost forgotten for many centuries in China. Shih-t'ao was the theoretician of this new artistic language.

As Lin Yutang (1967) correctly affirms, the essay of this monk painter, the K'u-kua Ho-shang Yu-lu (Sayings of Brother Bitter Melon), "is the best and most profound essay on art that has ever been written by a revolutionary artist . . . and it could be considered as an expressionist credo." The extent of the anticonformism of Shih-t'ao is clearly rendered by the following excerpts: "A man should be able to show the universe in a single brush stroke, executed to perfection." "Why should I seek to imitate the ancients and not attempt to progress and develop my self?" "If I were to be asked, 'Do you belong to the School of the South or the North?' or 'Which school do you belong to?', I would laugh and say: 'I have my own style.'" His works are alive, immediate, and overpoweringly expressive and make use of the ancient techniques, but in a new and impartial manner. The gray and light blue ink glazings, repudiated by the orthodox artists of his time because they were considered "of the northern school," were transformed into a greater expressionist sense and accompanied by essential "testura brush strokes." These works demonstrate that the ancient Ch'an contribution, which was strongly imbued with Taoism, had not passed in vain.

Like Shih-t'ao, Chu Ta also belonged to the Ming reigning family and detached himself from the political life, becoming a monk. His "expressionism" was similar, but perhaps less dynamic and vital, though more emotionally sensitive, than the work of Shih-t'ao.

Kung-hsien (Kung Pen-ch'ien, died 1689), one of the so-called "Eight Masters of Ch'in-ling," achieved extreme results in an "expressionist" sense, carrying forward Mi Fei's sweet and soft tonalism. His often very

dark tones contrasted with the white of the paper, and with only ink he succeeded in formulating tonal modules of an extreme richness and diversification. As L. Sickman states, "he created a vision of the dreadful landscape that was unprecedented in Chinese painting." Another great expressionist is Kao Ch'ih-pei (circa 1672 - 1734), who is similar in a way to Kung-hsien because of the terrible, almost lunar, solitude and harshness of several of his landscapes, with sharp and towering mountain peaks. But his technique, which included lines scratched by fingers and fingernails, produced very different results. The tonal passages are absent, leaving only the uneven and sensitive line, which assumes a nervous tendency similar to the cursive calligraphy of the type called "crazy," the K'uang-ts'ao-shu.

The exceptional modernness of these artists and the richness of this great creative moment of Chinese painting have attracted the interest of even the Western critics for many years. Critics such as J. Cahill (1967), V. Contag (1969), V. Elisseeff (1967, 1971), Li Chu-tsing (1973), and Fu Shin (1975) have contributed to the understanding of this "avant-garde" production, whose artistic codes are so rich and diversified in techniques and types of composition, but yet so unitary in the constant pursuit of the "individual expression" of the whole.

There were also currents of great interest centered around the court and the Academy, such as the official portraiture in which, as pointed out by D. Kidd (1973) and by R. J. Maeda (1973), there was a certain continuity between the Ming and the first Ch'ing. This was probably due to the same artists working at the end of the Ming continuing their work under the new rulers. However, gradually a new "realism" was gaining ground in the monumental, but static, frontal approach of the Ming, and this continued even under the foreign influences, represented primarily by the portraits executed by Giuseppe Castiglione. The landscape and flower and bird painting flourished in the Academy, though it was often excessively associated with the "classicism" of the imitators of the T'ung Ch'i-ch'ang. The writings of J. Longridge (1967), G. R. Loehr (1973), and Kuo Chi-sheng (1974), together with numerous exhibitions (primarily by the National Palace Museum in T'ai-pei), have contributed to the recognition of this production that was highly esteemed by contemporaries, but until recently not well-followed by modern critics. New studies have also led to an appreciation in the West of artistic personalities that had been ignored until now, such as Chang T'ing-lu (1675 - 1745), author of "Six Poems on a Painting of Peonies," studied by G. Malmqvist (1972), in which a supreme harmony was realized between the calligraphic and poetic work and the two tufts of peonies.

The artist Lo-p'ing (1732 - 1799) has been fully reevaluated in recent years by the Western critics. He was one of the Eight Eccentrics of Yang-chou and, according to M. Bussagli (1966), he had "the ability to transform the experience of the ancient masters into calculated deformations. His impossible rocks, almost reduced to informal sculptural projects, reproduce the sponge-like perforations of Wang Meng and other painters, but this effect is exploited in an imaginative sense."

The fall of the Ming, the taking of power on the part of the "foreigners," and the political disputes and economic struggles which followed and played such an important part in the great development of the painting, all had an unfavorable effect on the artisan production of the first Ch'ing period.

The great ceramic center of Ching-te-chen suffered a grave setback - between 1673 and 1675 it was largely destroyed. But during the 18th century it achieved a new splendor, even with the monochrome porcelains, recently studied by M. Medley (1973), which relived the magnificence of the Sung, though they were transfigured in a more purely decorative sense. But it is above all the polychrome porcelains which drew the interest and attention of the Western connoisseurs and scholars. They were produced using very fine techniques and were later grouped in various "families" according to their predominant color. Recently they have been reexamined and catalogued by S. Jennyns (1971), D. S. Howard (1973), and J. Ayers (1974).

The great vogue of the chinoiserie and the great demand in the West were such that "ceramics for exportation" came to be produced. This phenomenon was recently studied by scholars such as M. Beurdeley (1969 - 1974), L. Crossman (1972), and D. F. L. Scheurler (1974), regarding the Chinese production, and by M. Sullivan (1973) and M. G. Loehr (1974), regarding the influence and interference that this taste had on the Western artistic language. The Chinese artisans and industries were in fact coerced into an overproduction and a differentiation of quality of the various art objects, according to whether they were destined for exportation or for the imperial court.

By 1680 K'ang-hsi had established workshops within the Forbidden City in which were produced enamels, lacquers, jades, glass, and porcelains for the use of the court. Meanwhile, in Peking and in such other cities as Su-chou and Canton, industries arose that dedicated a part of their production exclusively for exportation.

The institution in the imperial court of artisan manufacturing easily explains the progressive bridging of the gap between the subjects, the spatial definitions and the compositions of the paintings, and the depictions on decorative and commonly-used objects in lacquer, porcelain, and enamel.

The delicate porcelain creations of the "pink family," recently studied by G. C. Williamson (1970), or those of the "green family," examined by J. Wargin (1974), with romantic, miniaturized landscapes, are the best demonstration of the derivation from the academic paintings of the period. Also, in the jades, lacquers, and enamels the depictions of landscapes and architectures, genre scenes, flowers, and birds are reproduced from the painting, although they are expressed in a more strongly decorative, almost "rococo," sense. As H. Moss has stated in a recent article, sometimes scenes of a Western character appear, especially in the objects that were destined for exportation. These scenes are often religious, of a type such as those of the two plates in the collection of the Metropolitan Museum of Art. Several directors of the imperial kilns of Ching-te-chen, such as the well-known T'ang Yin, were inspired not only by past works, but also by Western and Oriental techniques (Italian glass, enamels of Limoges, ceramics of Dreft, "Imari" porcelains from Japan), facilitated by the direct acquaintance of the European artists present at the court. This is further evidence of the eclecticism and of the receptiveness of the Ch'ing artists to "exotic"

themes. These factors, together with the taste for heavily-detailed decoration and rich colorism, result in an artistically valid and vital quality, even in several works of the later eras, which are incorrectly considered by art historians as a "period of decadence."

Contemporary Period. – The encounter, or, better yet, the collision, with the Western artistic languages, which were often very different, largely began at the end of the 19th century. This encounter had already been primed by the eclectic works of the Ch'ing period and by the European and American "colonial" settlements.

However, the attitudes behind this phenomenon were restricted to a group of aristocrats centered around the court and to coteries of "innovators," who were located primarily in the southern coastal cities. In the political, economic, and cultural fields, China was fruitfully searching, with much difficulty, for an identity of its own that would conserve the best of the past without damaging its progress. Thus, also, in the artistic field there was an attempt to maintain the acquisitions of the rich figurative language of antiquity, while accepting that which was considered the most interesting and new of the Western world. This pursuit and evolution was not devoid of mistakes, second thoughts, and self-criticism.

In the architectural field there was a formulation of distinctly Western currents and a contrasting monumental current. But the typical organic quality and functionality of these currents were altered to safeguard the national patrimony. In the figurative field there was an affirmation of an expression of exaggerated "realism" which led to almost photographic creations. This was an arduous and complex path that, however, permitted, especially later, the realization of true and original artistic solutions. Initially, the painters were facilitated by the certainty of the validity of the language that they used, and also by the extraordinary modernism of several masters of the Ch'ing period. They were aware that an autonomous artistic expression could be achieved only by carrying forward the national styles, although these were enriched by Western lexical elements.

Several artists were even well-known in the West, such as the famous painter of horses Hsu Pei-hung (Jupeon), or Ch'i Pai-shih (1863-1957), who, although profoundly embracing the influence of Pa-ta-shan-jen, was able to instill in his works a robust simplicity. Chan Ta-ch'ien (born 1899) carried forward the language of Shih-t'ao, producing paintings having much in common with abstract expressionism. Actually, the abstract current was one of the styles most congenial to the Far-Eastern painters, considering the correspondences with the calligraphic art.

Painters such as Chuang Che, who founded the group of the Five Moons at T'ai-pei in 1956, drew from the ancient traditional repertoire of the T'ang "expressionists" to achieve purely abstract effects. In the People's Republic of China, however, the tendency toward art that is comprehensible to everyone completely excluded abstractism and a great majority of the Western intellectualistic currents. Following the teachings of Chairman Mao, particularly expressed in his famous "Discourses at the Yunan conference on literature and art," there was a focus toward mass realism, including also the use of Western "techniques."

With the advent of the Cultural Revolution, there was an increased propensity toward the popularization of culture. There was an attempt to prevent the restriction of pictorial activity to only an elite group of professionals and to encourage popular spontaneity and the collaboration of the amateur painter with the other members of his group (community, factory, neighborhood). Examples of this are the original works that recall in part the naif art of the famous farmer-painters of Hu-hsien, which were recently exhibited at the Palace of the Fine Arts in Peking.

One of these artists, Li Feng-lan, stated (1974) that in his "Spring Scarification," in which the realism of the numerous squatting female figures blends well with the fog and tender green of the countryside, "the original version has undergone many retouches, thanks to the criticism provided by the masses." The sense of political relevance and class struggle in the cultural field is very vivid in this farmer-artist. This sense serves to prevent "the reactionary class from exercising its dominance over us in this field." This painting has great vividness and interpretive imagination, and it differs from the celebrative current of the so-called "socialist realism," although it conserves a trace in several figurations. It undoubtedly has its roots in the traditional humus, extracting the most spontaneous and immediate juices, rich with an extraordinary vitality.

The matter of architecture is very different; in an initial phase, the Chinese architects were struck by the technical, constructive, volumetric, and spatial characteristics of the Western currents. This occurred at the end of the last century, and they then imitated, without restriction, the contemporary European and American constructions.

The eagerness to adopt large sections of the Western life, which was manifested by the first reformers led by K'ang Yu-wei (1858-1927), was also reflected in the architectural field. Thus, buildings arose in an eclectic style that was strictly derived from the constructions of the foreign "concessions." Some of the most disturbing examples of this, which still stand today, are the ex-colonial residential districts of Shanghai. Absurd gothic buildings are united with neoclassic and Victorian villas, Swiss chalets, and medieval castles, while here and there one notices a Chinese type of roof, creating an incredible urban vision that is somewhat picturesque.

Starting in 1920 there appeared a tendency toward the reevaluation of the traditional values, paralleling the socio-political developments (the spread of nationalism which followed the first struggles of the Kuo-min-tang); this was the movement of the "Chinese Rebirth," which, however, led to an exclusive pursuit of the monumental that was often rhetorical and realized through the reintroduction of several formal elements of the Ch'ing into a Western type of building. At the very least, it had the merit of leading the architects toward their own historical perspective. A tendency similar to international "rationalism" (Hotel of Peace in Peking by Yang Ting-pao, 1952) began to be affirmed after the liberation of 1949. But, starting in 1952, it came to be supplanted in the most representative buildings by the ancient and monumental currents inspired both by Soviet Russia and by the architecture of the palaces and temples of the Ch'ing and Ming (buildings of the T'ien-an Men square). Already in 1956, the critic Chai Lin-lin, in a polemic with Liang Ssu-ch'eng, one of the expo-

nents of the aulic currents and a monumentalist, stated: "In each authentic architectural result, the contents and the function are fundamental."

Beginning in 1960, the deterioration of the Sino-Soviet relations accelerated the promotion of an organic type of evolution of Chinese architecture. Along with the Maoist campaign of the "100 flowers," this attempt proposed a greater liberalization, with the acceptance of a plurality of the architectural languages. In this way, a study of the recovery and application of the various habitative solutions of the "national minorities" was initiated (from the Tibetan to those of the T'ai in the Yunnan province and the Chekian rural habitations).

The cultural revolution undoubtedly had significant repercussions in the architectural field, especially on the urban level, as the recent works of E. Collotti Pischel (1971), A. Turco (1975), and C. Gavinelli and M. C. Gibelli (1976) have pointed out.

The struggle with the "three differences" (between city and country, industry and agriculture, intellectual work and manual labor) led to an intense pursuit of solutions of de-urbanization and a collective planning among the future inhabitants, the architects, and the politicians. Several complexes, such as the municipal building of the Tachai people (Shansi, 1969), were built by the people themselves, according to the modern necessities of housing and collectivism. Ancient techniques and traditional typologies were employed, in which the thickening of the linear building module of a parallelepiped shape with pitched roofs assumes an organic and varied aspect. This would lead one to believe that the considerable theoretic effort undertaken in recent years in China will surely lead to new and interesting architectural solutions.

The so-called minor arts are given much attention in modern China; there is a strong encouragement to produce and perfect the ancient manufactures following the traditional techniques, since, as Mao affirmed, "the farmers and the craftsmen are the ones that create the wealth and the civilization of society."

The artisan creations, the fruit of a great plurality of workers, tend to assume stereotyped aspects, because the need to innovate is usually absent. Although they undeniably conserve the original technical and formal characteristics, they are still a mere imitation of the past. But these are cultural and aesthetic attitudes that cannot escape the continual critical dialectic operating in China, which has started to bear fruit most conspicuously in the pictorial field - that millinary "feudal" stronghold of the aristocratic culture of the literates, bureaucrats, and artists - by means of original, spontaneous, and alive works, a fruit of the activity of the farmer-painters.

BIBLIOGRAPHY - H. A. Vanderstappen, Bibliography of Western Writings on Chinese Art, 1920-1965, London, 1975.

a) *Other bibliographies*: Revue Bibliographique de Sinologie, Paris, 1955; Books and Articles on Oriental Subjects Published in Japan during 1959 and ff., vol. 6 and ff., Tokyo, 1960 and ff.; E.J. Laing, Chinese Paintings in Chinese Publications, 1956-1968: An Annotated Bibliography and an Index to the Paintings, Ann Arbor, Michigan, 1969; Bibliography of Asian Studies, Pittsburg, 1970 ff.; (see also Bibliography in The Journal of Asian Studies); F. Aubin, La Mongolie intérieure et les Mongols de Chine: éléments de bibliographie I,

Études Mongoles, 3, 1972; C.M. Chen and R.B. Stamps, An Index to Chinese Archaeological Works Published in the People's Republic of China, 1949-65, Ann Arbor, Michigan, 1973; Hin Cheung Lovell, An annoted bibliography of Chinese painting catalogues and related texts, Ann Arbor, Michigan, 1973; Cinquante ans d'orientalisme en France, 1927-1972; Journal Asiatique, CCLXI, 1973; Chan Kam-po, Chinese Art and Archaeology, A Classified Index to Articles Published in Mainland China Periodicals 1949-1966, Hong Kong, 1974.

b) *General works*: J. Needham, Science and Civilization in China, 4 vols., Cambridge, 1954-1971; Ch'in Ling-yün, Chung-kuo pi-hua i-shu (the art of painting murals in China), Peking, 1960; Mizuno Seichi, Nagahiro Toshio, Bronze and Stone Sculpture of China: From the Yin to the T'ang Dynasty, Tōkyō, 1960; Tun-huang Ts'ai-su (Sculpturing in stucco—Tun-huang), Peking 1960; Tung Tso-pin, Chronological tables of Chinese History, Hong Kong, 1960; Hsia Nai, Archaeology in New China, Peking, 1961; Hsia Nai, Studies in Chinese Archaeology, Peking, 1961; S. Matsubara, Chinese Buddhist Sculpture, 2 vols., Tōkyō, 1961-1966; National Palace Museum, Treasures of Chinese Art, Taichung, Taiwan, 1961-1962; W. Watson, China before the Han Dynasty, London, 1961; A. Boyd, Chinese Architecture and Town Planning 1500 B.C. - A.D. 1911, London, 1962; Chan Hui-chuan, Ancient Relics of China, Peking, 1962; N. Egami, Sekai Bijutsu zenshū (a complete series on the art of the world), vol. XII-XVII, Tōkyō, 1962-1966; T'an Tan-chung, Chinese Arts, Taipei, 1962; Yü Chien-hua, Chung-kuo Hui-hua Shih (History of Chinese painting), Hong Kong, 1962; M. Bussagli, Painting of Central Asia, Genève, 1963; Chang Kwang-chih, The Archaeology of Ancient China, London-New Haven, 1968, II rev. ed. 1968, III rev. ed. 1971; P. Swann, Art of China, Korea and Japan, New York, 1963; Tsêng Yu-ho, Some Contemporary Elements in Classical Chinese Art, Honolulu, 1963; N. Wu, Chinese and Indian Architecture, New York, 1963; Directors of the National Palace Museum and the National Central Museum, Chinese Painting, Signatures and Seals, 4 vols., Taiwan, 1964-1975; Gin-dijh Su, Chinese Architecture, Past and Contemporary, Hong Kong, 1964; S.E. Lee, A History of Far Eastern Art, New York, 1964; Tung Tso-pin, Fifty Years of Studies in Oracle Inscriptions, Tōkyō, 1964; A. Bulling, Studies and Excavations made in China in Recent Years, Oriental Art, XI, 4, 1965; G. Ecke, Chinese Painting in Hawaii: in the Honolulu Academy of Arts and in Private Collections, 3 vols., Honolulu, 1965; M. Bussagli, Bronzi Cinesi, Milano, 1966; Ch'en Chih-mai, Chinese Calligraphers and Their Art, London and New York, 1966; V. Elisséeff, Dix Siècles de Peinture chinoise, Paris, 1966; The Joint Directors of the Palace Museum and the Central Museum, Taiwan National Palace Museum Porcelain, 14 vols., Taiwan, 1966-1969; A.C. Soper, La collezione Auriti, bronzi cinesi, coreani, giapponesi, Roma, 1966; W. Watson, Early Civilization in China, London, 1966; Yuzo Sugimura, Chinese Sculpture, Bronze, and Jades in Japanese Collections, Honolulu, 1966; Chang Kwang-chih, Rethinking Archaeology, New York, 1967; C. Hetze, Funde in Alt China, Göttingen, 1967; Lin Yutang, Teoria cinese dell'arte, Milano, 1967; H. Münsterberg, Chinese Buddhist Bronzes, Rutland-Tōkyō, 1967; Nara National Museum, Shōrai bijutsu, The Buddhist Art from China from 6th Century to 10th Century, Tōkyō, 1967; J. Pope, R. Gettens, J. Cahill, N. Barnard, The Freer Chinese Bronzes, vol. I, Catalogue, Washington, 1967; M. Sullivan, A Short History of Chinese Art, Berkeley and Los Angeles, 1967; Symposium on historical, archaeological and linguistic studies on southern China, South-east Asia and the Hong Kong region, Hong Kong, 1967; T. Akiyama, S. Matsubara, Arts of China, 2 vols.,

Tōkyō, Palo Alto, 1968-1969; J. Fontein, R. Hempel, China, Korea, Japan, Berlin, 1968; S.H. Hansford, Chinese Carved Jades, London, 1968; M. Loehr, Ritual Vessels of Bronze Age China, New York, 1968; M. Loewe, Everyday Life in Early Imperial China, London, 1968; P. Mortari Vergara Caffarelli, Cina, Dizionario di Architettura ed Urbanistica, I, Roma, 1968; H. Münsterberg, L'arte nell'Estremo Oriente, Milano, 1968; Mizuno Seiichi, Tōyōbijutsu (Asiatic Art in Japanese Collections), Tōkyō, Osaka, 1968; R.J. Gettens, The Freer Chinese Bronzes, vol. II, Technical Studies, Washington, 1969; A.C. Soper, Some Late Chinese Bronze Images (Eighth to Fourteenth Centuries) in Avery Brundage Collection, M.H. De Young Museum, San Francisco, Artibus Asiae, XXXI, 1, 1969; M. Sullivan, The Cave Temples of Maichishan, London, 1969; Tsugio Mikami, Toji no Michi (Via della ceramica), Tōkyō, 1969; W. Watson, Inner Asia and China in pre-Han period, London, 1969; Choy Kung Heng, A Complete Guidance to flower and bird Painting, Hong-Kong, 1970; H. Garner, Chinese and Japanese Cloisonné Enamels, London, 1970; E. Grinstead, Guide to the Chinese Decorative Script, Lund, 1970; Proceedings of International Symposium on Chinese Painting, Taipei, 1970; Taipei National Palace Museum, Masterpieces of Chinese Art Treasures in the National Palace Museum, 25 vols., Taipei, 1970-74; Yonezawa Yoshiho, Kawakita Michiaki, Arts of China: Paintings in Chinese Museums, New Collections, Tōkyō and Palo Alto, 1970; A.G. Bulling, I. Drew, The Dating of Chinese Bronze Mirrors, Archives of Asian Art, XXV, 1971-72; S. Bush, The Chinese Literati on Painting: Su Shih (1037-1101) to Tung Ch'i-ch'ang (1555-1636), Cambridge, 1971; V. Elisseeff, Peinture Chinoises et Calligraphies Anciennes VIII-XIX Siècles de la collection Chiang Er-shih, Paris, 1971; M. Pirazzoli-t'Serstevens, China Living Architecture, London 1971; J. Soame, Later Chinese porcelain, London, 1971; W. Watson, Cultural Frontiers in Ancient East Asia, Edinburgh, 1971; P. Wheatley, The Pivot of the four quartiers, Edinburg, 1971; N. Barnard, Early Chinese Art and Its Possible Influence in the Pacific Basin, 3 vols., New York, 1972; A. Bulling, Archaeological Excavations in China, 1949-1966, Expedition, 14, 4, 1972; J.O. Caswell, The Translation of Texts on Chinese Painting, Oriental Art, XVIII, 3, 1972; Chinese Cultural Art Treasures, National Palace Museum, Taiwan, 1972; W. Fairbank, Adventures in Retrieval Han Murals and Shang Bronze Molds, Cambridge, Mass., 1972; R. Friend, New Archaeological Work in China, East and West, XXII, Sept.-Dec. 1972; G. Gabbert, Buddhistische Plastik aus Japan und China: Bestandskatalog des Museums fuer Östasiatiche Kunst der Stadt Koeln, Weisbaden, 1972; J. Gernet, Le Monde Chinois, Paris, 1972; Historical Relics Unearthed in New China, Peking, 1972; Hsia Nai, Ku Yen-wen, Lan Hsin-wen, Hsiang Po and others, New Archaeological Finds in China, Peking, 1972, rev. ed. 1973; E. Kodansha, Chinese Art in Western Collections, Tōkyō, 1972; Lee Yu-kuan, Oriental Lacquer Art, New York-Tōkyō, 1972; H.A. Lorentz, A View of Chinese Rugs from the Seventeenth to the Twentieth Century, London-Boston, 1972; M. Medley, The Ceramic Art of China, London, 1972; Ssê-tiao chih-lu Han T'ang chih wu (La via della seta, tes-suti Han, T'ang), Peking, 1972; L.F. Sullivan, Traditional Chinese Regional Architecture: Chinese Houses, Journal of the Hong Kong Branch of the Royal Asiatic Society, 12, 1972; W. Watson, Mahayanist art after A.D. 900, London, 1972; Archaeological Treasures Excavated in the People's Republic of China, Tōkyō-Kyōto 1973; Catalogue of the Exhibition of Archaeological finds of the People's Republic of China, Peking, 1973; E.U. Erdberg-Consten, Die Architekture Tai-wans, Bonn, 1973; J. Fontein, T. Wu, Unearthing China's Past, Boston,

1973; F. Fu, C.Y. Fu, Studies in Connoisseurship, Chinese Paintings from the Arthur M. Sackler Collections, New York, 1973; A. Giuganino, Estetica della scrittura cinese, Roma, 1973; J. Hay, Ancient China, London, 1973; M. Ishida, Studies in Cultural History of Eastern Asia, Tōkyō, 1973; T.G. Lai, Chinese Calligraphy. Its Mystic Beauty, Hong Kong, 1973; H.A. Lorentz, A view of Chinese Rugs, London & Boston 1973; Y. Mino, P. Wison, An Index to Chinese Ceramic Kiln sites from the six dynasties to the present, Toronto, 1973; M. Medley, A Handbook of Chinese Art, London, 1973; P. Mortari Vergara Caffarelli, Cina, in M. Bussagli, Architettura Orientale, Venezia, 1973; National Palace Museum, Taiwan, Chinese Album Painting, Taipei, 1973; National Palace Museum, Taiwan, Chinese Enamelware, Taipei, 1973; National Palace Museum, Taiwan, Chinese Miniature Craft, Taipei, 1973; National Palace Museum, Taiwan, Chinese Writing Materials, Taipei, 1973; B. Smith, Weng Wan-go, China, A History in Art, New York, 1973; M. Sullivan, The Arts of China (rev. ed. of Short History of Chinese Art), London, 1973; M. Sullivan, Chinese Art, Recent Discoveries, London-New York, 1973; M. Sullivan, The Meeting of Eastern and Western art, London-New York, 1973; W. Watson, The Westward Influence of the Chinese Arts, London, 1973; Yonezawa Yoshiho, Representation of Grouped Figures in East Asia, Kokka 963, 1973; J. Ayers, The Baur Collection, Chinese ceramics, vols. I-IV, Genève, 1968-1974; N. Barnard, Early Chinese Art and its possible Influence in the Pacific Basin, Taiwan, 1974; J. Fontein, Tung Wu, Unearthing China's Past, Boston, 1974; Han T'ang Bi hua (Pitture murali delle dinastie Han e T'ang), Peking, 1974; C. Hentze, Chinese Tomb Figures: A Study in the beliefs and folklore of Ancient China, London, 1974; Lawton T., Chinese Figure Painting, London, 1974; The Colors of Ink: Chinese Paintings and Related ceramics from the Cleveland Museum of Art, New York, 1974; Li Chu-tsing, A Thousand Peaks and Myriad Ravines Chinese Painting in the Charles A. Drenowatz Collection, Ascona, 1974; Ku kung Po-wu-yüan tsao kung-i p'in hsüan (The selected handicrafts from the collections of the Palace Museum), Peking, 1974; D.F. Lunsingh Scheurleer, Chinese Export Porcelain, London, 1974; Y. Mino, Pre Sung Dynasty Chinese Stoneware, Toronto, 1974; W. Watson, Style in the Arts of China, Harmondsworth, 1974; W. Blazer, Chinese Pavilion Architecture, Zürich, 1975; H. Karmay, Early Sino-Tibetan Art, Warminster, 1975; C.F. Murck, Artists and Traditions, Uses of the Past in Chinese Culture, Princeton, 1975; Museum of Sinkiang Uigur Autonomous Region, Sinkiang Cultural Relics, Peking, 1975; Y. Yap, A. Cotterel, The Early Civilization of China, London, 1975; N. Barnard, Sato Tamotso, Metallurgical Remains of Ancient China, 1976; H. Brinker, Bronzen aus dem Alten China, Museum Rietberg, Zürich, 1976; M.H. Fong, The Technique of "Chiaroscuro" in Chinese Painting, A.A., XXXVIII, 2/3, 1976; M. Medley, Chinese Painting and the decorative style, London, 1976; P. Mortari Vergara Caffarelli, Il linguaggio architettonico del Tibet e la sua diffusione in Asia Orientale, Rivista degli Studi Orientali, L, I-II, 1976. A Selection of Archaeological Finds of the People's Republic of China, Peking, 1976; E. Capon, Art and Archaeology in China, London, 1977; Y. Yap, A. Cotterell, Chinese Civilization from the Ming Revival to Chairman Mao, London, 1977.

c) Prehistory and Protohistory: Chia Lan-po and others, Palaeoliths of Shansi, Peking, 1961; Chia Lan-po and others, Kêhê, Peking, 1962; Institute of Archaeology, Archaeology in New China, Peking, 1962; Institute of Archaeology, Excavations of Fêng-hsi, Peking, 1962; Institute of Archaeology, Scan Pan P'o, Peking, 1963; Chang Kwang-chih, Chronologies in

old world archaeology, Chicago, 1965; Chêng Tê-k'un, New Light on Prehistoric China, Cambridge, 1966; J.L. Treistman, The Prehistory of China, New York, 1972; N. Barnard, The First Radiocarbon Dates from China, Canberra, 1973, II ed. 1975; Lan Hsin-wen, Finds from Kansu, in New Archaeological Finds in China, Peking, 1973; Chêng Tê-k'un, The Prehistory of China, T'oung Pao, LIX, 1-3, 1974; The Archaeological Team of Ling-yi County Excavation of the neolithic Tombs at Ta-fan-chuang in Ling-yi County, Shantung Province, K'ao ku 1, 1975; Chia Lan-p'o, The Cave Home of Peking Man, Peking 1975; The Helung kiang Provincial Museum, Excavation of a Neolithic Site at Tung k'ang, 1975, 3, K'ao ku; The Kansu Archaeological Team, Institute of Archaeology, Academia Sinica, Excavations of the Neolithic Site at Ma-chia-wan in Yungching County, Kansu Province, K'ao ku, 2, 1975; Wu Jü-tso, The Division of Labor and the Origin of Private Property Viewed in the Light of the Neolithic Remains, at Ch'ien-shan-yang, K'ao ku, 5, 1975; Yang Hung-hsün, A Preliminary Study of the House Development in Yang-shao Culture, K'ao ku Rsüeh pao, 1, 1975; Chekiang Provincial Museum, Reconnaissance of the Neolithic Site at Ho-mu-tu in Yüyao County, Cekiang Province, Wen wu, 8, 1976; Chia Lan-p'o, Wei Ch'i, A Paleolithic Site at Hsü-chia-yao in Yang-kao County, Shansi Province, K'ao-ku Hsüeh-pao, 2, 1976.

d) Shang: Chêng Tê-k'un, Shang China, Cambridge, 1960; An Chin-huai, The Capital Ao, Wen wu, 4-5, 1961; N. Barnard, Bronze Casting and Bronze Alloys in Ancient China, Canberra, Tōkyō, 1961; W. Fairbank, Piece mold craftmanship and Shang bronze design, Archives of the Chinese Art Society of America, 16, 1962; W. Watson, Ancient Chinese Bronzes, London, 1962; Ch'i T'ai-ting, An-yang Ch'u-t'u ti chi ko Shang tai ch'ing t'ung ch'i (A few Shang dynasty bronzes excavated at An-yang), K'ao ku, 11, 1964; Shanghai po-wu-kuan ts'ang ch'ing-t'ung-ch'i (Bronzi del Museo di Shanghai), 2 vols., Shanghai, 1964; S. Umehara, Yin Hsü Ancient capital of the Shang-dynasty at An-yang, Tōkyō, 1964; Fang Yu-sheng, Erh-li t'ou, Yen-shih, Honan, K'ao ku, 5, 1965; Shirakawa Shizuka, Kimbun shū (Collezione di iscrizioni in bronzo), Tōkyō, 1965; Yü Hsiao-hsing, Chen Li-hsin, The two Shang dynasty tombs excavated on the west side of Ming King-lu road, Cheng-chou, K'ao ku, 10, 1965; Li Chi, Yin-hsü ch'u-t'u ch'ing-t'ung chüeh-hsing ch'i chih yen-chiu (Studi sui vasi Chüeh scavati a Yin-hsü), Taiwan, 1966; A.C. Soper, Early, middle and late Shang, a Note, Artibus Asiae, XXVIII, 1, 1966; A.C. Soper, A Problematical Chinese Bronze Vessel. The Ku, that was «too good to be true», Artibus Asiae, XXXII, 2-3, 1970; Jen-chün Kao, The Contribution of Ancient Bronzes to Chinese Culture, National Palace Museum Bulletin, VII, 4, Sept.-Oct., 1972; The Hopei Museum and C.P.A.M. Hopei Province, Investigations of the Shang Dynasty Dwelling Site and Tombs at Kao-Ch'êng County, Hopei Province, K'ao ku, 1, 1973; V.C. Kane, The Chronological Significance of the Inscribed Ancestor Dedication in the Periodization of Shang Dynasty Bronze Vessels, Artibus Asiae, XXXV, 4, 1973; Chang Kuang-yüan, Shang and Chou Bronze Inscriptions, A General View, National Palace Museum Bulletin, VIII, 6; Chêng Tê-k'un, Metallurgy in Shang China, T'oung Pao, LX, 4-5, 1974; V.C. Kane, The Independent Bronze Industrie in the South of China Contemporary with the Shang and Western Chou Dynasties, Archives of Asian Art, XXVIII, 1974-75; Y. Mino, Brief Survey of Early Chinese Glazed Wares, Artibus Asiae, XXXVII, 1-2, 1975; The Ancient P'anlung City Archaeological Team, The Provincial Museum of Hupei and Peking University, A Brief report on the 1974 Excavation of Shang Dynasty Palace Site at the

Ancient City of P'anlung in Huang p'i County, Hupei Province, Wen wu, 1976, 2; Higuchi Takayasu, Shang (Ying) Style Bronzes Excavated in the Southern Part of China, Museum, 301, 1976; Li Tsung, Studies on the Iron Blade of Shang Dynasty Bronze Yüeh axe Unearthed at Kao-ch'eng, K'ao-ku Hsüeh-pao, 1976, 2; The Hupei Provincial Museum, Report on the 1973 Excavation of Shang Dynasty Site at the Ancient City of P'anlung in Huang p'i, Wen wu, 1976, 1; Yang Hung-hsün, Some Questions Concerning the Development of Chinese Imperial Architecture as Seen from the Palace Site at the Ancient City of P'anlung, Wen wu, 1976, 2; Li Chi, Anyang, 1977.

e) Chou: S. Umehara, Nihon Shucho, Shina Kodo seikwa (selected relics of ancient Chinese bronzes from collections in Japan), 6 vols., Osaka, 1959-64; Chou Jen, Li Chia-chih, Cheng Yung-p'u, Research on the sherd from The Western Chou dwelling site in Chang-chia-p'o, K'ao ku, 9, 1960; Chang Han, Hou-ma Tung Chou i-chih Chu-t'ung t'ao-fan hua-wên so-chien (On the design of the molds for bronze casting discovered at Hou-ma in Eastern Chou sites), Wen wu, 10, 1961; T. Mikami, The dolmen and stonecist in Manchuria and Korea, Tōkyō, 1961; Chang Wan-chung, Hou-ma Tung Chou t'ao-fan ti tsao-hsing kung-i (The plastic art of the Eastern Chou clay molds discovered at Hou-ma, Shan-hsi) Wen wu, 4-5, 1962; Feng-hsi Fa-chüeh Pao-kao (Scavi a Feng-hsi), Peking, 1962; Chêng Tê-k'un, Chou China, Cambridge, 1963; Kuo Pao-chün, Excavation of Chün-hsien Hsin-ts'un, Honan, Peking, 1964; A.C. Soper, The Tomb of the marquis of Ts'ai, Oriental Art, V, 3, 1964; Institute of Archaeology, Academia Sinica, Western Chou Bronzes unearthed at Chang chia p'o, Ch'ang-an, Peking, 1965; Stanford University, Arts of the Chou dynasty, Palo Alto, 1968; C.D. Weber, Chinese Pictorial Bronze Vessels of the Late Chou Period, Ascona, 1968; Lo-Yang Museum, Report on the five western Chou tombs at P'ang-chia-kou Lo-yang, Wen wu, 10, 1972; Hsiang Po, Ch'u Tomb and Weapons from Changsha, in New Archaeological Finds in China, Peking, 1973; W. Watson, On some Categories of Archaism in Chinese Bronze, Ars Orientalis, IX, 1973; G.W. Weber, The Ornaments of Late Chou Bronzes, New Brunswick, 1973; L. Lanciotti, Ancora sulle spade cinesi, Gururājamñjarikā, II, parte III, Napoli, 1974; The Liuliho Archaeological Team of IAAS, CPAM of The City of Peking and the Bureau of Culture, Fangshan County, Excavation of the Western Chou Tombs of Immolated Slaves at Liuliho in Fangshan County, K'ao ku, 5, 1974; The Southeastern Shansi Archaeological Team, Excavation of the Eastern Chou Tombs n. 269 and 270 at Fên-Shui-Ling in Ch'ang-chih City, Shansi Province, K'ao ku hsüeh pao, 3, 1974; J. Rawson, The Surface Decoration Jades of the Chou and Han Dynasties, Oriental Art, XXI, 1, 1975; Ye Wan, The Bronzes Unearthed at Peking and K'ê-tso, Liaoning Province, in Recent Years and the Yen State of Early Chou, K'ao ku, 5, 1975; The Archaeological Team for the Excavation of the Western Chou Tomb at Ju-chia-chuang, Excavations of the Western Chou Tomb at Ju-chia-chuang in Pao chi, Shensi Province, Wen wu, 4, 1976; The Hupei Provincial Museum, Excavations of the Warring States and Han Tombs at Ch'ien-p'ing in Yi-ch'ang, K'ao-ku Hsüeh-pao, 1976, 2; The Provincial Museum of Hunan, Excavation of the Eastern Chou Tombs at Hsinghsiang County, Hunan province, Wen wu, 1977, 3; T'ang Lan, A Study of Western Chou History Through the Inscriptions on Bronzes - The Great Value of the Bronzes Discovered in Recent Years at Pao chi, Wen wu, 6, 1976.

f) Ch'in and Han: A. Bulling, A Landscape Representation of the Western Han Period, Artibus Asiae, XXV, 1962, 4; M. Loehr, The beginnings of Portrait Painting in China,

Trudy XXV Mezhdunaradnogo Kongressa Vostokovedov Moskva, Moscow, 1963; Li Ching-Hua, Lo-yang Hsi Han pi-hua mu-fa chüeh pao-kao (Rapporto sullo scavo di una tomba degli Han occidentali con pitture murali a Lo-yang), K'ao ku hsüeh pao, 1964, 2; T. Nagahiro, The representational Art of the Han Dynasty, Tōkyō, 1965; K. Finsterbusch, Verzeichnis und Motivindex der Han-Darstellungen, 2 vols., Wiesbaden, 1966 - 71; J. Chaves, A Han Painted Tomb at Loyang, Artibus Asiae, XXX, 1, 1968; M.T. Fedi Lucidi, A proposito di una Iastra tombale Han, Rivista degli Studi Orientali, XLIV, 1969; A.L. Juliano, Three Large Ch'u Graves Recently Excavated in the Chiangling District of Hupei Province, Artibus Asiae, XXXIV, I, 1972; Wen Pien, Discovery of a 2,000 Year-Old Tomb, Chinese Literature, 10, 1972; K. Riboud, Some Remarks on Strikingly Similar Han Figured Silks found in Recent Years in Diverse Sites, Archives of Asian Art, XXVI, 1972-73; An Chih-min, A Tentative Interpretation of the Western Han Silk Painting Recently Discovered at Chang-sha, K'ao ku, 1, 1973; E. Capon, W. Mac Quitty, Princes of Jade, London, 1973; Excavation of the Remains of Building n. 1 at Han-Wei City of Loyang, K'ao ku, 4, 1973; Fong Chow, Ma-wang-tui, A Treasuretrove from the Western Han Dynasty, Artibus Asiae, XXXV, 12, 1973; Fong Chow, Cheng Yeh, A Brief Report on the Excavation of Han Tomb N. 1 at Ma-wang-tui Ch'ang-sha, Artibus Asiae, XXXV, 1-2, 1973; R. Friend, Una tomba del primo periodo della dinastia Han, Cina, 10, 1973; Hunan Provincial Museum and Institute of Archaeology, Academia Sinica, Changsha Excavations (West Han Tomb Excavations at Ma-wang-tui in Changsha), 2 vol., Peking, 1973; The Hupei Provincial Museum Excavations of the Ch'u Tombs at T'ai Hui Kuan in Chiangling County, Hupei, K'ao ku, 6, 1973; The Kiangsi Institute of Timber The Identification of the Timber Used in the Making of Coffins and Wooden Chamber of the Han Tomb VI at Ma-wang-tui, Changsha, K'ao ku, 2, 1973; Kuo Mo-jo, Poem written for the Silk Painting from Ch'u Tomb at Changsha, Wen wu, 7, 1973; Ma Yung, A Discussion on the Name and Function of the Silk Painting Unearthed from the Han Tomb N. 1 at Ma-wang-tui Changsha, K'ao ku, 2, 1973; The Museum of the City of Hsienyang, Recent Finds of the Ch'in and Han Dynasties at the City of Hsien-yang, K'ao ku, 3, 1973; The Nanking Museum Excavations of the Western Han Tomb at San-li-tun, Lien-shui County, Kiangsu province, K'ao ku, 2, 1973; J. Rawson, A Group of Han Dynasty Bronzes, Oriental Art, XIX, 4, 1973; Sun Tso-yun, The Mitological Paintings on the Lacquer Coffin of the Han Tomb n. 1 at Ma-wang-tui, Chang-sha, K'ao ku, 4, 1973; Sun Tso-yun, Studies on the Silk Painting Unearthed from the Han Tomb n. 1 at Ma-wang-tui, Changsha, K'ao ku, 1, 1973; Wang Shih-min, An Archaeological Study of the Ch'in Dynasty Unification of the Written, Language, Weighing and Measuring System and Currencies, K'ao ku, 6, 1973; Yu Hsing-Wu, An Interpretation of the Decorations on the Inner Coffin of the Han Tomb, n. 1 at Ma-wang-tui Changsha, K'ao ku, 2, 1973; The Archaeological Team of Inner Mongolia and Museum of the Inner Mongolia Autonomous Region, An Important Eastern Han Tomb with Wall Paintings Found at Ho-lin-ko-êrh, Inner Mongolia, Wen wu, 1, 1974; A.C. Bulling, The Guide of the Soul, Picture in the Western Han Tomb in Ma Wang Tui, Chang Sha, Oriental Art, XX, 2, 1974; Ch'iu Hsi-kuei, Some Problems of the Arcaic li shu (Clerical Script) in the Light of the Ch'ien ts'ê (Inventory of Tomb Furniture) of the Han Tomb n. 1 at Ma-wang-tui, K'ao ku, 1, 1974; Huang Shêng-chang, The Wall Paintings of the Eastern Han Tomb at Ho-lin ko-êrh, Inner Mongolia, and Some Historical Geographical Problems, Wen wu, 1, 1974; The Kansu-Provincial Museum, The Han Tomb at Lei-t'ai in Wuwei County, Kansu Province, K'ao ku hsüeh pao, 2, 1974; Kao Ch'ung-wên and others, The Economic Causes of the Landlord Class Historical Transition from "Worshipping the Legalist School" to "Worshipping the Confucian School" as Seen from the Changes in the Burial Rites of the Western Han Dynasty, Wen wu, 7, 1974; The Nanking Museum and the Museum of Lien-yun-kang City, Excavation of the Tomb of Huo Ho of the Western Han at Hai-chou, Kiangsu Province, K'ao ku, 3, 1974; M. Pirazzoli-t'Serstevens, La Civilisation du Royaume de Dian à l'Époque Han d'après le Matériel exhumé à Shizhai Shan (Yunnan), Paris, 1974; The Shensi Provincial Museum and CPAM, Shensi Province, The Kiln Remains and Bronzes Found at the Site of the Ch'in Capital Hsienyang, K'ao ku, 1, 1974; Wu Yung-ts'êng, Life in the Eastern Han Society as Reflected in the Wall Paintings of the Han Tomb at Ho-lin-ko-êrh, Inner Mongolia, Wen wu, 1, 1974; The Archaeological Team of Han Tomb n. 168, Excavation of the Han Tomb n. 168 at Fêng-huang-shan, Chiangling County, Hupei Province, Wen wu, 9, 1975; Chiang Ying-chu, A critique of Confucianist Ideology in the Stone Reliefs of the Han Dynasty, K'ao ku, 1, 1975; Ch'in Chung-hsing, The Sculptural Arts of the Ch'in Dynasty Pottery Figures, Wen wu, 11, 1975; Ch'in Ming, Notes on the Arrangement of the Ch'in Dynasty Pottery Figures of Warriors and Horses from Lin-tung, Wen wu, 11, 1975; Chou Tao Constellations on the Han Dynasty Stone Reliefs of Nanyang, Honan Province, K'ao ku, 1, 1975; Institute of Archaeology Academia Sinica, Hunan Provincial Museum, Significance of Excavation of Han Tombs Nos 2 and 3 at Ma-wang-tui in Changsha, K'ao Ku, 1, 1975; Liu Chih-yüan, Life in the Eastern Han Society as Reflected in the Decorated Tomb Bricks of the Han Tomb in Szechuan, Wen wu, 4, 1975; Shantung Provincial Museum and Lin-yi Archaeological Team, Excavation of Four Western Han Tombs at Yin-ch'üeh-shen in Lin-yi County, K'ao ku, 6, 1975; Cultural Center of Fêng-hsiang County and the Shensi Provincial Museum, Trial Diggings at the Ch'in State Palace Remains Fêng-hsiang and Some Bronze Architectural Accessories, K'ao ku, 1976; The Hupei Provincial Museum, The Western Han Tombs at Wu-tso-fên in Kuang-hua County, Kao-ku Hsüeh-pao, 1976; The Kiangsi Provincial Museum, The Western Han Cemetery in the Eastern Suburbs of Nan-ch'ang, K'ao-ku Hsüeh-pao, 2, 1976; Cl. Larre, La bannière funéraire de Tch'ang-na, Actes du Colloque International de Sinologie, Paris, 1976; Su Chih-mei, The Legalist Political Line of Early Han as indicated by the Finds from Tomb n. 168 at Fêng huang-shan in Chiang-ling County, K'ao ku, 1, 1976; T'ao Fu, Notes on the Restoration of the Palace N. 1 at the Ch'in Capital Hsienyang, Wen wu, 11, 1976; Wang Chi-chieh, Important Relics unearthed in the Vicinity of Mou Ling (Mausoleum of Emperor Han Wu Ti) and Its Satellite Tombs of the Western Han Dynasty, Wen Wu, 1976, 7; Wang H. Wu Chên-fêng, The Painted Pottery Tomb Figures Unearthed from the Burial Pits of a Han Mausoleum at Jên-chia-p'o, Sian, K'ao ku, 2, 1976; Archaeological Team of Chungking Museum and Cultural Centre of Hochwan County, The Eastern Han Stone Relief Tomb at Hochwan, Szechwan, Wen wu, 1977, 2.

g) Dynasties of the South and North: A. Soper, South China Influence on the Buddhist Art of the Six Dynasties period, Bulletin of Museum of Far Eastern Antiquities, 1960; A.C. Soper, A New Chinese Tomb Discovery: The Earliest representation of Famous Literary Theme, Artibus Asiae, XXXIV, 1961; M. Sullivan, The Birth of Landscape Painting in China, London, 1962; A.C. Soper, Imperial Cave Chapels of the Northern Dynasties, Donor, Beneficiaries, Dates, Arts Asiatiques, XVIII, 1, 1966; K. Ono, The Buddhist Art from

China from 6th century to 10th century, Nara, 1967; A.C. Soper, Textual evidence for the Secular Arts of China in the Period from Liu Sung through Sui (A.D. 420-618), Ascona, 1967; A. Akiyama, S. Matsubara, Arts of China, Buddhist Cave Temples, New Researches, Tōkyō - Palo Alto, 1969; T. Nagahiro, Rikuchō jidai bijutsuzo no Kenkyū (L'arte figurativa del periodo delle Sei dinastie), Tōkyō, 1969; M. Sullivan, O. Darbois, The Cave Temples of Maichishan, London-Berkeley-Los Angeles, 1969; L. Hurvitz, Tsung Ping's Comments on Landscape Painting, Artibus Asiae, XXXII, 2-3, 1970; J. Shek, A Study of Kuk'ai-chih's "Hua Yün T'ai Shan Chi," Oriental Art, XVIII, 4, 1972; The Loyang Museum, The Northern Wei Tomb of Yuan Shao at Loyang, K'ao ku, 4, 1973; E. Johnston Laing, Neo-Taoism and the Seven Sages of the Banboo grove in Chinese Painting, Artibus Asiae, XXXVI, 1-2, 1974; The Kiangsi Provincial Museum, the Western Tsin Tomb at Ma-t'ou in Jui-ch'ang County, Kiangsi Province, K'ao ku, 1, 1974; The Loyang Museum, Excavation of the Northern Wei Tomb of Yüan Yi in Loyang, Honan Province, Wen wu, 12, 1974; The Nanking Museum, Excavation of a Large Southern Dynasty Tomb with Decorated Tomb Bricks at Hu-Ch'iao in Tan-yang County, Kiangsu Province, Wen wu, 2, 1974; The Purple Mountain Observatory and Peking Planetarium, The Star Map Found in the Northern Wei Tomb in Loyang, 12, 1974; China House Gallery, Art of the Six Dynasties: centuries of change and innovation, New York, 1975; K. Finsterbusch, Zur Archaeologie der Pei-Ch'i (550-577) und ui Zeit (581-618), München, 1975; Hin-cheung Lovell, Some Northern Chinese Ceramic Wares of Sixth and Seventh Centuries, Oriental Art, 1975; The Shantung Provincial Museum and the Hall of Culture, Ts'ang-shan County, The Stone Relief Tomb of the First Year of the Reign of Yüan Chia (A.D. 424) at Ts'ang-shan, Shantung Province, K'ao ku, 2, 1975; The Archaeological Team of the Tunhuang Institute Excavation of Architectural Remains in front of Grotto n. 53 at Mokao Caves, Tunhuang, K'ao ku, 1, 1976; Archaeology Section of the Tunhuang Institute, Ancient Architecture Depicted in the Wall Paintings of the Northern Wei Caves at the Mokao Grottoes in Tunhuang, K'ao ku, 1976; Art of the Six Dynasties Periods, Oriental Art, XXII, 1, 1976.

h) Sui and T'ang: A.C. Soper, A Vocation Glimpse of the T'ang Temples of Ch'ang-an, the Ssu-t'a chi by Tuan Ch'eng-shih, Artibus Asiae, XXIII, 1960; Chu Chang-ch'ao, T'ang Yung-'ai kung-chu mu pi-hua chi (una collezione di pitture murali dalla tomba della principessa Yung-t'ai dei T'ang), Peking, 1963; M. Kitagawa, Sitai kōshu no haka (tomba della principessa Yung-t'ai), Kobijutsu, 0, 1965; A.F. Wright, Symbolism and function, reflections on Changan and other Great Cities, Journal of Asiatic Studies, XXIV, 1965; M.M. Rhie, Aspects of Sui K'ai-huang and T'ang T'ein-pao, Buddhist Images, East and West N.S., 17, 1-2, 1967; H. D. Scott, The golden Age of Chinese Art, the Lively T'ang Dinasty, Rutland, 1967; Shōsō-in no kaiga (pitture nello Shōsō-in), Tōkyō, 1968; M.M. Rhie, Quattro sculture da T'ien-lung-shan, Roma, 1969; Y. Harada, Tōdai no fukushoku (vestiti cinesi e ornamenti personali nella dinastia T'ang), rev. ed., Tōkyō, 1970; W. Watson, Pottery and Metalwork in T'ang China: their chronology and external relations, London, 1970; P. Mortari Vergara Caffarelli, Proposte per una nuova cronologia e per un ulteriore esame critico dell'opera di Yü-ch'ih I-sêng, Rivista degli Studi Orientali, XLVI, 1-2, 1971; Li Ch'iu-shih, T'an Chang-huai, I-te liang mu ti hsing-chih teng wen t'i (una discussione sulle strutture delle tombe di Chang-huai e I-te), Wen wu 7, 1972; E.E. Schafer, Notes on T'ang culture III, Monumenta Serica, XXX, 1972-1973; Bo Gyllensvärd, Recent finds of Chinese

Ceramics at Fostat I, Bulletin of the Museum of Far Eastern Antiquities, 45, 1973; M.H. Fong, Four Chinese Royal Tombs of the Early Eighth Century, Artibus Asiae, XXXV, 4, 1973; Fu Hsi-nien, T'ang Ch'ang-an Ta-ming-kung, Han-yüan-tien yüan-ch'uang ti t'an-t'ao (una ricerca per la forma originale della sala Han-yüan del palazzo Ta-ming nella dinastia T'ang a Ch'ang-an), Wen wu, 7, 1973; Indianapolis Museum of Art, Arts of the T'ang Dynasty, Indianapolis, 1973; The Museum of Ch'ao-yang Region, the tomb of Han Chên of the T'ang Dynasty at Ch'ao-yang, Liaoning province, K'ao ku, 6, 1973; T'ang Heng-liang, Ancient Coins of the T'ang and Sung Dynasties Discovered at Wu-Ch'iu, The National Palace Museum Quarterly, VIII, 2, 1973; Wang Jên-p'o, A Study of the Themes Depicted in the Wall Painting of the tomb of the Crown Prince Yi Têh, K'ao ku, 6, 1973; W.R.B. Acker, Some T'ang and pre-T'ang Texts on Chinese Painting, vol. II: Chinese Painters from Earliest Times till T'ang, Leiden, 1974; The Archaeological Team of Sian, Excavation of the Remains of the Ming-tê Gate of the T'ang Capital Ch'ang-an, K'ao ku, 1974; R. Goepper, Shu-p'u, der Traktat zur Schriftkunst des Sun Kuoting, Wiesbaden, 1974; The Nanking Museum, the T'ang Dynasty Junk Unearthed at Ju-kao, Kiangsu Province, Wen wu, 5, 1974; The Sian Archaeological Team, Excavation of the Remains of the Ch'ing Lung (Blue Dragon) Monastery of the T'ang Dynasty, K'ao ku, 5, 1974; The Shensi Provincial Museum and CPAM Shensi Province, Excavation of the T'ang Dynasty Tomb of Li Shou at San-yüan County, Shensi province, Wen wu, 9, 1974; Chin Wei-no, Wei Pien, the T'ang Silk Paintings Unearthed from the Tombs at Astana Turfan Sinkiang, Wen wu, 10, 1975; P. Glum, Meditations on Black Sun. Speculations on Illusionist Tendencies in T'ang Painting, Based on Chemical Changes in Pigments, Artibus Asiae, XXXVII, 1-2, 1975; Bo Gyllensvärd, Recent Find of Chinese ceramics at Fostat, Bulletin of the Museum of Far Eastern Antiquities, 47, 1975; Wei Chiang, Suiye was an Important Military Center of the T'ang Dynasty in Western China, Wen wu, 8, 1975; Li Tso-chih, Reconnaissance of the Site of the Sui-T'ang City of Shengchow at Yülin County, Shensi Province, Wen wu, 2, 1976; Shensi Provincial Museum, Murals T'ang Dynasty, Peking, 1976; The Honan Provincial Museum, Trial Diggings of the Sui Dynasty Porcelain Kiln at Anyang, Honan province, Wen wu, 2, 1977; M. Pirazzoli-t'Serstevens, De la natte à la chaise, Critique, Fevrier, 1977, 357.

i) Five Dynasties and Liao: R. Barnhart, Marriage of the Lord of the River: a Lost Landscape by Tung Yüan, Ascona, 1970; R. Bernhart, The snowscape attributed to Chü-jan, Archives of Asian Art, XXIV, 1970-71; Y. Mino, Some Aspects of the Development of Liao Dynasty Ceramics, Oriental Art, XVII, 3, 1971; S. Edgren, The Printed Dhārani-sūtra of A.D. 956, Bulletin of the Museum of Far Eastern Antiquities, 44, 1972; Rei Sasaguchi, A Dated Painting from Tun-Huang in the Fogg Museum, Archives of Asian Art, XXVI, 1972-73; W. Watson, Styles of mahāyānist iconography in China, in Mahayanist Art after A.D. 900, London, 1972; Bureau of Culture, Jerim League and Kirin Provincial Museum, Excavation of the Liao Dynasty Tomb n. 1 at Kulun Banner, Jerim League, Kirin Province, Wen wu, 8, 1973; The Hopei Museum and CPAM Hopei Province, The Tomb of Han Hsiang of the Liao Dynasty at Shang-lu ts'un, Ch'ien-an County, Hopei Province, K'ao ku, 5, 1973; Mino Yutaka, Ceramics in the Liao Dynasty: North and South of the Great Wall, Tōkyō, 1973; Wang Tsê-ch'ing, A Tentative Interpretation of the Wall Paintings of the Liao Tomb n. 1 at Kulun Banner, Kirin Province, Wen wu, 8, 1973; K. Munakata, Ching Hao's Pi-fa-chi: A Note on the Art of Brush, Ascona,

1974; The Archaeologycal Team of the Liaoning Provincial Museum, Excavation of the Liao Dynasty Tomb of Yehmaotai in Faku County Liaoning Province, Wen wu, 12, 1975; CPAM Chekiang Province, The Sky Maps and Mi Se (Secret Glaze - Colour) Porcelains Found in the Five Dynasties Tombs at Lin-an and Hangchow, Chekiang Province, K'ao ku, 3, 1975; Feng Yung-ch'ien, Notes on the Pottery and Porcelain Object, Unearthed from the Liao Tomb at Yahmaotai, Wen wu, 12, 1975.

j) Sung: Tōkyō National Museum, Chūgoku Sō-Gen bijutsuten mokuroku (Arti cinesi dei periodi Sung e Yüan), Tōkyō, 1961; Tōkyō National Museum, Sō-Gen no Kaiga (Pittura Sung e Yüan), Kyōto, 1962; N. Vandier-Nicolas, Art et Sagesse en Chine, Mi Fou (1051-1107) peintre et connoisseur d'art dans la perspective de l'esthétique des lettres, Paris, 1963; Li Lin-ts'an. A Study of the Nan-chao and Ta-li Kingdoms in the Light of Art Materials Found in Various Museum, Tai-pei, 1967; R. Barnhart, Marriage of the Lord of the River: A Lost Landscape by Tung Yuan, Ascona, 1970; R. Barnhart, The "Snow-scape" Attributed to Chü-Jan, Archives of Asian Art, XXIV, 1970-71; B. Chapin, A Long Roll of Buddhist Image, ristampa, Artibus Asiae, XXXII, 1970; Chiang Fu-tsung, A City of Cathay, Monumenta Serica, XXIX, 1970-71; Takuichi Takeshima, Eizō hō shiki no Kenkyū (Studio del Ying Tsao Fa Shih) 3 vols., 1970-72; J. Wirgin, Sung Ceramic Designs, Stockholm, 1970; S. Bush, The Chinese Literati on Painting: Su Shih (1037-1101) to Tung Ch'i-ch'ang (1555-1636), Cambridge, 1971; H. Brinker, Some secular aspects of Ch'an Buddhist painting during the Sung and Yüan Dynasties, in W. Watson, Mahayanist Art After A.D. 900, London, 1972; S. Riddell, The Kuan-yin image in post T'ang China, in W. Watson, Mahayanist Art After A.D. 900, London, 1972; Illustrated Catalogue of Sung Dynasty Porcelain in the National Palace Museum, Taipei, 1972; H. Brinker, Shussan shaka in Sung and Yüan Painting, Ars Orientalis, IX, 1973; Chou Jen, Chang Fu-k'ang, Chêng Yung-fu, Technical Studies on the Lungchuan Celadons of Successive Dynasties, K'ao ku hsüeh pao, 1, 1973; Fong Wen, M. Fu, Sung and Yüan Paintings, New York, 1973; Lovell Hin Cheung, Sung and Yüan Monochrome Lacquers in the Freer Gallery, Ars Orientalis, IX, 1973; Liu Hsin-yüan, The Sung and Yüan Porcelain from Chingtechen and their Technological Studies, K'ao ku, 6, 1974; Ch'ên Po-ch'uan, Some Sung Dynasty Porcelains of the Chi Chou Yao Kilns Unearthed in Kiangsi, Wen wu, 3, 1975; E. Glahn, On the transmission of the Ying-tsao-fa-shih, T'oung Pao, LXI, 4-5, 1975; E. Johnston Laing, Li Sung and Some Aspects of Southern Sung Figure Painting, Artibus Asiae, XXXVII, 1-2, 1975; Sung Dynasty Painting in the Imperial Collection in the National Palace Museum, 6 vols., Taipei, 1975-76; Sung Dynasty Porcelain, National Palace Museum, 4 vols., Taipei, 1975; The Study Group for the Sung Dynasty Wooden Sea Vessel, Excavation of the Sung Dynasty Wooden Sea Vessel in Ch'üanchow Bay, Fukien Province, Wen wu, 10, 1975.

k) Yüan: Cheng Cho-lu, Ni Tsan, Shanghai, 1961; Commission for the Preservation of the Yün-kang caves, Shansi Province, Excavations of the Yüan Dynasty Tombs of Feng Tao-chen and Wang Ch'ing at Ta-t'ung, Shansi, Wen wu, 10, 1962; Wen Chao-t'ung, Huang Kung-wang shih-liao (Historical Date on Huang Kung-wang), Shanghai, 1963; Yang Ch'en-pin, Yüan-tai Jen Jen-fa Erh-ma t'u'chüan (I due cavalli, rotolo di Jen Jen-fa della dinastia Yüan), Wen wu, 8, 1965; M.S. Ipsiroglu, Painting and Culture of the Mongols, New York, 1966; Wang Chi-ch'ien, The Life and writings of Ni Yün-lin, National Palace Museum Quarterly, 1, 2, 1966; Li Lin-ts'an, A New Look at the Paintings of the Yüan Dynasty,

National Palace Museum Bulletin, II, 5, 1967; M. Pirazzoli-t'Serstevens, Note sur un plateau de Lacque attribué à l'époque Yüan, Arts Asiatiques, XV, 1967; Wang Chi-ch'ien, The Paintings of Ni Yün-lin, National Palace Museum Quarterly I, 3, 1967; Chen Tsu Lung, La vie et les oeuvres des Wou Tchen, Paris, 1968; Li Chu-tsing, The Freer Sheep and Goat and Chao Meng-fu's Horse Paintings, Artibus Asiae, XXX, 4, 1968; S. Lee, Ho Wai-kam, Chinese Art Under the Mongols: The Yüan Dynasty, Cleveland, 1968; Suzuki Kei, A Few Observations concerning the Li Kuo School of Landscape Art in the Yüan Dynasty, Acta Asiatica, 15, 1968; Li Chu-tsing, The Uses of the Past in Yüan Landscape Painting, Artists and Traditions: A Colloquium on Chinese Art, Princeton, 1969; Li Chu-tsing, Stages of Development in Yüan Landscape Painting Parts 1 and 2, National Palace Museum Bulletin, IV, 1969; S. Noma, Chinese Painting of the Sung and Yüan Dynasties, Tōkyō, National Museum, Tōkyō, 1969; H. Garner, Oriental Bleu and White, London, 1970; Li Chu-tsing, The Development of Painting in Soochow During the Yüan Dynasty, Proceedings of the International Symposium on Chinese Painting, Taipei, 1970; T. Toda, Figure Painting and Ch'an-Priest Painters in the Late Yüan, ibid.; H.M. Garner, The Export of Chinese Lacquer to Japan in the Yüan and Early Ming Dynasties, Archives of Asian Art, XXV, 1971-72; B. Gyllensvärd, Two Yüan Silver Cups and their Importance for Dating of some Carvings in Wood and Rhinoceros Horn, Bulletin of the Museum of Far Eastern Antiquities, 43, 1971; J. Wirgin, Some Chinese Carved Lacquer of the Yüan and Ming Periods, Bulletin of the Museum of Far Eastern Antiquities, 44, 1972; L. Caterina, The Phoenix vase in the "Duca di Martina" Museum at Naples, East and West, 23, 3-4, 1973; A.W.E. Dolby, Ni Tsan, Unconventional Artist of the Yüan Dynasty, Oriental Art, XIX, 4, 1973; Kao Mu-shen, The Life and Art of T'ang Ti, The National Palace Museum Quarterly, VIII, 2, 1973; Ku Hsiang, Ch'ên Po-ch'üan, Some Blue and White Porcelains of the Yüan and Ming Dynasties, Wen wu, 12, 1973; Hsü Pang-ta, Investigation of the Authenticity of Four Versions of Huang Kung-wang's River and Hills Before Rain, Wen wu, 5, 1973; Ku Yen-wen, Tatu, The Yüan Capital, Archaeological Work During the Cultural Revolution, Peking, 1973; Li lin-ts'an, Huang Kung-wang's "Chiu-chu feng-ts'ui" and "T'ieh-yai t'u," National Palace Museum Bulletin, VII, 6, 1973; M. Medley, A Fourteenth Century Blue and White Chinese Box, Oriental Art, XIX, 4, 1973; M. Medley, The Yüan-Ming Transformation in the Blue and Red Decorated Porcelains of China, Ars Orientalis, IX, 1973; C. Carrington, Tung Ch'i-ch'ang's Ownership of Huang Kung-wang's Dwelling in the Fu-ch'un mountains, Archives of Asian Art, XXVIII, 1974-75; E.J. Laing, Six Late Yüan Dynasty Figure Paintings, Oriental Art, XX, 3, 1974; M. Medley, Yüan Porcelain and Stoneware, London, 1974; Provincial Museum of Kwangtung, Some Yüan and Ming Porcelains Unearthed at Chu hai and Swatow, Kwangtung Province, Wen wu, 10, 1974; Chang Kuang-pin, The Four Great Masters of the Yüan, Taipei, 1975; Chiang I-han, Record of Miao-yen Temple a Calligraphic Handscroll by Chao Meng-fu, National Palace Museum Bulletin, X, 3, 1975; Toshio Ebine, Gen-dai dōshaku jimbutsu-ga (Pitture cinesi della dinastia Yüan di soggetti taoisti e buddhisti), Tōkyō, 1975; J. Cahill, Hills Beyond a River, Chinese Painting of the Yüan Dynasty, 1279-1368, New York, Tōkyō, Kuei Liang, The Dragon Motif in Blue and White Porcelain, National Palace Museum Bulletin, XI, 2, 1976.

l) Ming: R. Edwards, The Field of Stones, A Study of the Art of Shên Chou, 1427-1509, Washington, 1962; V. Elisseeff, Quelques peintures de Lettrés de la collection Ling su-hua,

Paris, 1963; J. Cahill, Fantastics and Eccentrics in Chinese Paintings, New York, 1967; V. Elisseeff, Peintures Chinoises Ming et Ts'ing, De la Collection Mu-fei, Paris, 1967; M. Beurdeley, Chinese Trade Porcelain, Fribourg, 1969; G.A. Rowley, A Chinese Scroll of the Ming Dinasty "Ming Huang and Yang Kuei-Fei listening to Music," Artibus Asiae, XXXI, 1, 1969; J. Cahill, The Restless Landscape: Chinese Painting of the Late Ming Period, Berkeley, 1971; T. G. Lai, T'ang Yin: poet painter 1470-1524, Hong Kong, 1971; Chiang Chao-shen, The Life of Wen Cheng-ming and the Suchou School of Painting in the Middle and Late Ming, National Palace Museum Quarterly, VI, 3, 1972; J. P. Dubosc, Plum Blossoms in Moonlight, A Round Fan Painting Signed Yen Hui, Archives of Asian Art, XXVI, 73, 1972; B. Gyllensvärd, Lo Tien, and Laque Burgantée, Bulletin of the Museum of Far Eastern Antiquities, 44, 1972; Chên Chüan-chüan, Some Ming and Ch'ing Dynasties Brocades, Wen wu, 11, 1973; Chiang Chao-shen, Yang Chi-ching and the Wu School of Painters, The National Palace Museum Quarterly, VIII, 1, 1973; H.M. Garner, Two Chinese Carved Lacquer Boxes of the fifteenth Century in the Freer Gallery of Art, Ars Orientalis, IX, 1973; J. Lowry, Tibet, Nepal, or China?, Oriental Art, XIX, 3, 1973; Lu Wen-kao, Tomb of the Ming Prince of Lu, in New Archaeological Finds in China, Peking, 1973; M. Medley, Ming and Ch'ing Monochrome, London, 1973; M. Medley, Ming Polychrome Wares, London, 1973; W. Watson, The Westward Influence of the Chinese Arts from the 14th to the 18th Century, London, 1973; Arab and Persian Influences in Ming Dynasty Blue and White Porcelains, National Palace Museum Newsletter, VI, 6, 1974; C. Carrington Riely, Tung Ch'i-ch'ang's Ownership of Huang Keng-wang's Dwelling in the Fu'ch'un Mountains, Archives of Asian Art, XXVIII, 1974-75; National Palace Museum, Ninety Years of Wu School Painting: Part Three, Taiwan, Taipei, 1975; H. Shire, X-Ray Observation on Ming and Ch'ing Porcelain Cups, Oriental Art, XX, 1, 1974; A. De Coursey Clapp, Wen Cheng-ming, The Ming Artist and Antiquity, Ascona, 1975; D. Kidd, Tibetan Painting in China, Oriental Art, XXI, 1, 1975, D. Kidd, Tibetan Painting in China, Author's Postscript, Oriental Art, XXI, 2, 1975; P'an Nai, Two Ancient Astronomical Instruments Collected by the Nanking Museum. Ming Dynasty Armillary Sphere and Simple Sphere, Wen wu, 7, 1975; H.E. Richardson, Tibetan painting in China, A Postscript, Oriental Art, XXI, 2, 1975; S. Wilkinson, The Role of Sung in the Development of Ming Painting, Oriental Art, XXI, 2, 1975; R. Edwards, The Art of Wen Cheng-ming (1470-1559), Michigan, 1976; Museum of the City of Pengpu, Excavation of the Ming Dynasty Tomb of T'ang Ho, Wen wu, 2, 1977.

m) Ch'ing: A.Y.C. Lui, The Hanlin Academy in the Early Ch'ing Period (1644-1795), Journal of the Hong Kong Branch of the Royal Asiatic Society, VI, 1966; C.B. Malone, History of the Peking Summer Palaces under the Ch'ing Dynasty, II ed., New York, 1966; J. Longridge, Bird paintings of the Ch'ien Lung period (1736-1796), New York, 1967; Select Chinese Painting in the National Palace Museum, Ching Dynasty, Taipei, 1968; V. Contag, Chinese Masters of the 17th Century, London, 1969; G. Debong, Chou Chün-shan, Lob der Naturtreue: das Hsiao-shan hua-p'u des Tsou I-Kuei (1686-1772), Wiesbaden, 1969; T. Lawton, Notes on Five Paintings From a Ch'ing Dynasty Collection, Ars Orientalis, VII, 1970; H. Lovell, Wang Hui's "Dwelling in the Fu-ch'un Mountains: A classical Theme, Its Origin and Variations, Ars Orientalis, VIII, 1970; P. Ryckmans, Les "Propos sur la peinture" de Shitao, traduction et commentaire pour servir à l'étude terminologique et esthêtique des Théories chinoises de la peinture,

Bruxelles, 1970; G.C. Williamson, Book of the famille rose, London, 1970; C. Beurdeley, M. Beurdeley, G. Castiglione, Fribourg, 1971; S. Jenyns, Later Chinese Porcelain, rev. ed., London, 1971; G. Malmqvist, Six Poems on a Painting of Peonies, Bulletin of the Museum of Far Eastern Antiquities, 44, 1972; J. Rohnström, Manchu Printed Books in the Royal Library in Stockholm, Bulletin of the Museum of Far Eastern Antiquities, 44, 1972; C. Le Corbeiller, China Trade Porcelain; Patterns of Exchange, New York, 1973; D.S. Howard, Chinese Armorial Porcelain, export 1695-1820, 1973; D. Kidd, Ritual and Realism in Palace Portraiture, Oriental Art, XIX, 4, 1973; Li Chu-tsing, The Bamboo Paintings of Chin Nung, Archives of Asian Art, XXVII, 1973-74, G.R. Loehr, Giuseppe Castiglione, Painter of Flower at the Chinese Court, Art and Archaeology Research Papers, June 1973; R. J. Maeda, The Portrait of a Women of the Late Ming - Early Ch'ing Period: Madame Ho-tung, Archives of Asian Art, XXVII, 1973-74; Museum für Ostasiatische Kunst, Kunst der Ch'ing-Zeit, 1644-1911, Cologne, 1973; G. Rozman, Urban Networks in Ch'ing China and Tokugawa Japan, Princeton, 1973; M. Sullivan, The Meeting of Eastern and Western Art, From Sixteenth Century to the Present Day, New York, 1973; Kuo Chi-sheng, The Landscape Style of Wang Yüan-ch'i, The National Palace Museum Quarterly, VIII, 4, 1974; D.F.L. Scheurleerr, Chinese Export Porcelain, London, 1974; Special Exhibition of Paintings by Catholic Artists during the Ch'ing Dynasty, National Palace Museum Newsletter, VI, 7, 1974; Wei Chin, Li Kung, Historical evidence of the Consolidation and Development of China as a Multinational Unified Country - A Summer Resort and Eight Temples in Ch'angteh, Wen wu, 12, 1974; J. Wirgin, K'ang-hsi Porcelain, Bulletin of the Museum of Far Eastern Antiquities, 46, 1974; Fu Shen, An Example of Connoisseurship understanding a Forgery as Reflection of the Original, National Palace Museum Bulletin, X, 1, 1975; V. Giacalone, Chu Ta (1626 - c. 1705), Oriental Art, XXI, 2, 1975; H. Moss, European Influence on the Ch'ing Imperial Workshop, The Connoisseur, January, 1975; M. Destombes, Les Originaux chinois des plans de ville publiés par J.B. du Halde S.J. en 1735, Actes du colloque international de Sinologie, La Mission Française de Pékin aux XVII-XVIII siècles, Paris, 1976; G. Lohr, L'artisiste Jean-Denis Attiret et l'influence exercée par sa description des jardins impériaux, Actes du colloque international de Sinologie, La Mission Francaise de Pékin aux XVII-XVIII siècles, Paris, 1976; Museum of the T'aiping Revolution, CPAM and the Museum of the City of Nanking, Reconaissance at the Site of Tsung Shêng of the T'aiping Heavenly Kingdom in Nanking, Wen wu, 1, 1976; G.W. Skinner ed., The City in Late Imperial China, Stanford, 1976; Sung Yu, A comparison of Two versions of the Chü Jui T'u by Giuseppe Castiglione, National Palace Museum Bulletin, XI, 3, 1976.

n) Contemporary Period: Mao Tse Tung, On Art and Literature, Peking, 1960; Shi Ch'eng-chi, Urban Commune Experiments in Communist China, Hong Kong, 1962; A.C. Scott, Literature and the Arts in Twentieth Century China, New York, 1963; Studying Talks at Yenan Forum on Literature and Art, China Reconstructs, 9, 1966; J. Salaff, The Urban Communes and Anti-City Experiment in Communist China, China Quarterly, 29, 1967; A New Form of Proletarian Art, China Reconstructs, 10, 1968; E. Collotti Pischel, Città e campagna nella Cina contemporanea, Controspazio, 1, gennaio-febbraio 1971; Desarollo de la Arquitectura de Viviende de la Republica Popular China, VII Convegno UIA, La Habana trad. it., Controspazio, 12, 1971; C. Gavinelli, V. Vercelloni, Cina Architettura e Urbanistica 1949-1970, Controspazio, 12, 1971; Chien Sung-yen, Creating New Paintings

in China, Stanford, 1971; Chien Sung-yen, Creating New Paintings in the Traditional Style, Chinese Literature, 11, 1972; E.O. Clubb, Twentieth Century China, 2d ed., New York and London, 1972; Hwang Yan-tai, Innovations in Traditional Painting, Chinese Literature, 11, 1972; S.M. Carson, Dialogue on the Peasant Art of Huhsien, Eastern Horizon, XIII, 5, 1974; M. Elvin, G.W. Skinner, Chinese city between two worlds, California, 1974; Jen Min, Paintings by One of Today's Peasants, Chinese Literature, 8, 1974; Les peintres paysans de Houhsien, La Chine en Construction, I, 1974; B. Mututantri, The Peasant Painters of Huhsien County, Eastern Horizon, XIII, 6, 1974; Peasant Paintings from Huhsien Country, Peking, 1974; Visite à une manufacture de taille de jades en République populaire de Chine, Collections Bauer, 18, 1974; E. Capon, Archaeological Techniques in China today, The Connoisseur, January, 1975; F.R. Scheck, Chinesische Malerei Seit der Kulturrevolution. Eine Dokumentation, 1975; C. Gavineli, M.C. Gibelli, Città e territorio in Cina, Bari, 1976; Lyo Museum, 10 of the best living Chinese Artists, Cumberland, 1976; E. Mingione, L'uso del territorio in Cina, Milano, 1977.

PAOLA VERGARA CAFFARELLI MORTARI

TIBET (PLATE 72)

The growing interest in the tantric doctrine, especially in the area of psycho-physical introspection and cosmological interpretation, has brought about a more widespread study of Tibetan Buddhism. Consequently, there has been more careful examination of the art of Tibet, which has always been closely linked to lamaism. Furthermore, current attention is focusing on the mingling and interchange of diverse artistic styles and on the locations and periods in which these took place. This intermingling brought Tibetan art to be considered a meeting point of the most significant of Asian cultures, including Iranian, Indian, central-Asian, and Chinese, and resulted in the emergence of new and original forms of art.

Prehistory and Protohistory. – There have not yet been sufficient excavations of pre-protohistory sites (megalithic complexes, habitation in caves, tombs) to make even partial conclusions on this subject possible. It has not yet been possible, in fact, to define the boundaries between prehistory and protohistory, despite, for example, the interesting discovery of objects of the neolithic period in the tomb of Nyelem (Ne-lam) Tai Erchchien (1972) and in the excavation of a neolithic site of Lin-Chih by Wang Hengchieh (1975). A recent interpretation of the megalithic monuments was made by G. Tucci (1973), who reported the presence of "doring" (dor-rin). These pillars of stone are positioned and aligned in ways that suggest a ritual significance as they are found in the center of quandrangles and rotund structures. This does not exclude the possibility that the same "doring" arrangement may be a "sema," or sign indicating the position of a tomb for funeral sacrifices. These "semata" have been found in the prehistoric and protohistoric necropolis of Swat. Tucci also hypothesizes that there were two paths through which megalithic culture spread: one across the corridor of Euroasiatic flatlands, from the region of Kokonor to Tibet, and the other from Kashmir to Spiti.

More difficult is the chronological documentation of the spread of the use of metals, including weapons such as the thodkde (t'og-rdeu, fallen rocks from heaven) or thoding (mt'o-ldin, 'high-flying'), and objects in bronze and sometimes in wood such as animal figures, plaques, rings, hoops, and pendants often found during field work and considered by the Tibetans as powerful amulets. In 1960, S. Hummel took up the original thesis of W. Ruben concerning the arrival of iron forging techniques in Tibet and linked magical and religious factors with the so-called "pontic migration" hypothesis of Heine-Geldern. Until today, however, there has been only a stylistic analysis of the magical or religious value of various objects, and for the most part these excavated discoveries have been ignored. In cases where it has been possible to conduct technical examinations similar to those of R. J. Gettens for the Chinese bronzes, one can hypothesize on some fundamental points of contact and exchange with other protohistorical and historical cultures of Asia. These relations of protohistorical and historical as discussed by Tucci (1935), M. Bussagli (1949), and Goldman (1961) were reexamined by Tucci (1973) in connection with objects from the Bonardi collection. Notable among these are two pendants, probably from late in the period, identifiable because of crosses of Nestor; some rounded objects possibly used for ritual formulas (probably prototypes of the widespread gau or gautama); some amulets with figures of animals showing a clear relationship with similar objects originating in Luristan; and figures of Khyung, a mythic bird connected with Garuda the Indian.

Architecture. – There has been less scholarly interest in Tibetan architecture than in other art forms; in fact, there has been only a scratching of the surface. Actually architecture is one of the most complete and interesting manifestations of Tibetan culture, as well as one of the most ancient forms of artistic expression. Its history evolved from premonarchical origins, in the primitive religions of animism and shamanism prevalent in Bon. In the Han era which spanned the first to third century A.D., the Chinese, or more properly the inhabitants of the Chinese-Tibetan area, had already demonstrated the ability to "construct houses of piled stone reaching about 10 cheng (or 25 meters) in height."

One of the most ancient of buildings of the monarchical era (seventh to ninth century A.D.), the Castle of Yarlung (Yum-blu bla-mk'ar) seems, from a structural point of view (massive walls and doors in brick and crude stones combined with columns, capitals, and networks of wooden beams), similar to structures of the Near East or of Central Asia. However, this similarity, as demonstrated by S. Hummel (1963 - 1964; 1973 - 1974) and P. Denwood (1975), does not preclude the independent origins of this type of structure in this region.

The single enclosed squares of different dimension, narrowing toward the top, come together in an organic way without any attention to the axis of symmetry. The openings are situated asymmetrically on the outside and are of various sizes and dimensions to provide the necessary light. It is a construction of the kind defined recently as "anti-classic" and one that, as eminent scholars (Hummel) have confirmed, did not arise from Indian Buddhism, which first spread to Tibet in this era.

Closely tied to the rules of geometry and cosmology and the axis of symmetry of the Indian mandala are the numerous Buddhist cultural buildings erected in this era from the mc'od-rten to the monument complex of bSamyas (end of eighth century A.D.) But this great dynastic sanctuary, while adapting the rules of space and volume typical of the Indian Buddhists, is also a reprise of an earlier and particularly Tibetan style of architecture. In fact, previous researchers considered that each floor of a building may represent a different style: Tibetan, Khotanese, Chinese, and Indian. This represents the Tibetan's precise way of thinking and their particular and well defined architectural style.

One hesitates to affirm that the architecture of Tibet was impervious to foreign influence. On the contrary, during this period there were close religious and political alliances among countries in this same area, particularly the Chinese Empire and the western regions of India; some of their form and structure were adopted along with their special solutions, although not to a great an extent.

In an article by P. Vergara Caffarelli Mortari (1975) the author tried to recollect the evolutive history of Tibetan architecture, at least in its fundamental stages and principal regional differences. One of the events recognized as a cause for noteworthy "variances" in Tibetan architectural style occurred in the 11th century when the monastery allied itself to the aristocratic residence as center of power. They adopted, therefore, a large part of the architectural lexicon of the monarchical epoch. One example is the monastic city of Saskya, founded in 1073, in which the free use of building blocks was adopted according to the typical dissonance which we have already noted in Yarlung. Here one notices an attempt at symmetry that is only achieved block by block, especially in major buildings in which the openings were aligned in long rows in which the projections were specular. These religious complexes reflect, without a doubt, concepts of order and geometrism originating in Indian culture.

In Sa-skya an element appeared which was wholly Chinese; it was a slanted roof (called rgya-p'ibs or rgya-p'ubs) that had already been used in the monarchical period. It does not involve the basic structure of the building, but is a slanted roof laid upon a flat cover, frequently pushed back by twine from the rainpipes (or gutters) to cover the courtyard.

Another historical occurrence of fundamental importance to the architectural field was the founding in the 15th century of the Yellow Society of the dGe-lugs-pa. If one examines the buildings and monuments of Ganden (dGa-'ldan), the first monastery of the dGe-lugs-pa, one sees the new formal elements combined. The openings of various floors ordered in parallel rows are closer together and thicker, giving more life and light to the environs. These are probably modeled after Chinese buildings called "tien," which were the precursors of the type of building with continuous rows of openings. Also, the monumental staircases with graded balustrades slanting toward the facade reflect, without a doubt, the influence of the high staircases used as access to the more important "tien."

Chinese architectural concepts were more evident still in the Potala in Lhasa, which was begun in 1645. Here the tendency toward order of the hierarchical system of the Yellow Society and the Dalai Lama was clearly apparent in the city planning of the all new architectural style of Tibet. The external city wall is oriented to the typically Chinese fashion; north-south axis, and the position of the Dalai Lama's palace is similar to that of the Imperial Palace in Chinese planning. Also the emphasis given the southern facade of the complex by means of the monumental stairway attests to the political and cultural influence exercised by the Ch'ing emperor on the theocracy of Lhasa.

At the same time, however, the rejection of the precise north-south directional artery typical of Chinese cities that resulted in a chessboard pattern of multiple blocks and the erection of buildings with dense walls and doors and flat roofs in the Indo-Tibetan style demonstrates the failure of Chinese influence in this era on the architectural style of Tibet. Tibetan architecture, in fact, endured centuries of religious, political, social, and economic influences without undergoing substantial change, retaining until today its original and principal characteristics.

Painting. – One of the problems, only minimally resolved, in studying the pictorial art of Tibet is that of precise punctualization of its stylistic development. The contributions of pictorial style by nearby civilizations — Indo-Nepalese, Kashmir, Central-Asian, and Chinese — vary according to the geographic, political, religious, and social factors of a given era. For the most part, even in the most definable and perfectly recognizable of cases, they are insufficient to determine the characteristics of a particular period or school.

The valuation is complicated, as Tucci pointed out in 1968, by the fact that artistic production by various monasteries frequently depended upon the "cultural contacts that each had with one country or another even though far away." The rigid iconographic rules of complex and precise codes, adopted from more ancient times, binds all pictorial production by its strictly religious character in predetermined form, dimension, size, mystic attitudes, symbols, and colors. Often the original models were then carried from one place to another and copied in minute detail; it thus became more and more difficult, as time went on, to determine the style of any given period. Moreover the same painters were such frequent travellers that it became almost impossible to connect a distinct area with a particular school. Particularly in later works we see in the same scene elements belonging to different styles, frequently making for unusual composition. A possible solution to the problem, and one that has been accepted for quite some time, is that of P. Pal (1969) and Tucci. Their solution was to reconstruct the fundamental phases of stylistic development through painted murals that, more than tanka (religious paintings on tapestry; often anonymous), are easily referenced to a given period by the inscriptions which frequently accompanied them. Unfortunately, this research, and even the reproduction of the painted murals, are inadequate.

M. N. Despande (1973) has published some reproductions, along with an interesting commentary, of the painted murals of Tabo in Spiti, already photographed and studied by G. Tucci. The oldest of these is attributed to the 11th century masterpiece of Guge Rein, in ideal parallel detail to the classical mural painting of Ajanta'.

The surveys and studies of some of the most important complexes built in the Peoples Republic of

China have been published for the most part in the periodical "Wen Wu." "Wen Wu" articles seem interested primarily in architecture but may subsequently bring new light to the problem of stylistic development with the publication of reproductions of painted murals that have up to now not been studied. In later periods, there are useful critical examinations of various printed matter, such as those by Y. Imaeda (1977) in the Chinese editions on Kanjur (Bka'gyur). Comparatively, the study of ancient Tibetan texts that had to do with diverse painting styles, such as the Kong-sprul translated by E. Gene Smith (1970), may serve to shed more light on schools and trends that have not previously been recognized. Also, the possibility of establishing a period for some groups of "tanka," for example in the 15th and 16th centuries for those studied by scholars such as J. Lowry (1973), serve undoubtedly to make a point on the production of the period. Lowry, in fact, thoroughly defines some of the characteristics of the painting styles of one of the most interesting movements in the history of Tibet, that of the formation of the Yellow Society.

The examination of pictorial art from well defined locations, such as Guge Rein, done by J. C. Huntington (1972) for the period of the 11th to the 16th century is extremely useful for reconstructing ancient schools and trends that often survived and flourished in areas east of Tibet.

Numerous exhibitions since the 1960s, especially in the West, also allowed a much wider comparison of work along with the acknowledgment of some styles. One style pertaining to some bronzes from the beginning of the 16th century and referred to by A. Neven (1979) as "style des socles a' gordrons" presents autonomous characteristics and makes one think of strictly Tibetan origins. The type of painting that G. Beguin (1977) defines as "plebeian and provincial" seems authentically nationalistic. It shows rigid figures, rotund faces immersed in a landscape free of all influences of Chinese "literary painting," and is expressed with a simple and elementary lexicon that is, however, full of life.

Unfortunately, the almost complete lack of original Tibetan paintings, or in other words of works from the pre-monarchical and monarchical periods, makes it most difficult to determine the primitive stylistic characteristics of that era. We concur, however, with H. Karmay (1975) on the fact that, as verified for architecture, a precise Tibetan language certainly existed for sculpture and possibly painting in the monarchical era. Upon examination of the oldest painted tapestries known to us (eighth to ninth century), those discovered at Tun-huang (now at the Guimet Museum, the British Museum, and the National Museum of Delhi) often demonstrate a pictorial art already matured, in which the influences of Indo-Nepalese, Central-Asiatic, and Chinese styles become fused together, and thereby permit some works to be considered typically Tibetan.

We have elsewhere (P. Mortari Vergara Caffarelli, 1972) searched for the traces, even if fleeting, in available works of the presence of art forms from the Reign of Khotan. Without a doubt these had considerable importance in the formation of the pictorial style of the period during the Reign of Khotan, and later on during the second diffusion of Buddhism. One can verify during the period of supremacy of the Sa-skya-pa that they had a certain predominance over Nepalese form. By contrast, beginning from the reign of the dGe-lugs-pa (16th century) another style emerged ("sinizzante") that subsequently assumed the characteristics of "lamaistic international art" with its strong eclectic tendencies that later spread primarily to the Far East. Regardless of the external influences and fusion of such influences, the research and punctualization of the elements of the pictorial code recognizable as the product of national culture are the true starting points for establishing the most important characteristics of the pictorial product of any given period and of the artistic trends that can be identified.

It is possible to point out some of the elements of this code which remain inalterable across time, such as the style for vivid, luminous colors, matched next to the other without shading; the tendency toward the ornate, almost Baroque; the dynamic tension in lines, as already noted by S. Hummel; and the free movement of masses in space as demonstrated by Tucci, especially in the designs of terrifying and monstrous figures and of the couples yab-yum (mother and father). These constants, recognizable in many "tanka" and pictorial murals of a religious character, are also present in some delicate landscape scenes with vaguely *naif* taste that form the background of sacred representations that are, from our point of view, one of the most direct expressions of Tibetan pictorial style. One sees, for example, the frescoes discovered by A. Gansser in Tinkar on the Tibetan Nepalese border that show the Buddhist holy grounds. The gracious white homes that express the discordant Tibetan architectural lexicon are scattered along the banks of the river, between the sinuous mountain range with a particular leaning towards colors that show the great joy of living and the Tibetan love of nature.

It should not go unnoticed that the above mentioned symbolic-religious value creeps in and becomes integrated into the pictorial representation, thus following precise codice already masterfully and skillfully described by Tucci in his "Tibetan Painted Scrolls." Tucci's research was also based on the studies of L. Chandra and was more recently refined by J. van Goidsenhoven (1970), by M. T. DeMallman (1975), and by B. C. Olschak and G. T. Wangyal (1973). This research brought further light to the innumerable manifestations of divine apparitions belonging to the lamaistic pantheon with numerous attributes of each God listed through the symbolism of their gestures and their surroundings. A rich repetoire of gestures was employed by the Tibetan artist to indicate to the initiated view the principal elements of his own faith.

One of the most significant of images in Tibetan symbolic expression is the portrayal of the "mandala." The mandala was clearly of Indian inspiration even if Camman (1948 - 1950) and Tucci (1969) mentioned a relation with the Han charts. The mandala paintings attained in Tibet had a notable expressive capacity. Such pictorial works are to be considered as an instrument of meditation that communicates visually to the initiated the complex cosmological and psychophysical theories of lamaism. They may also communicate to the novice a message of fascinating forms and colors similar to that of modern abstract painting. For example, the fresco that represents the cosmic mandala in the main temple of the Dzong fortress in Paro (Bhutan) is meticulously described in its symbolic components by C.

Olschack (1973). In it the movement of circular lines and colors become more and more vortical coming closer to the center in a dynamic movement of expansion and of contraction of one to all and all to one, perfectly understandable and extraordinarily fascinating.

Sculpture. – The indisputable connections made by Roerich in 1930 and later by Tucci in 1973 between the already noted objects in bronze in protohistory and the animalistic art forms of the plains give strength, as stated by H. Karmay (1975), to the hypothesis that pre-Buddhist sculptured arts from the first part of the monarchical period consisted mostly of representations of animals in stone, silver, gold, or stucco. Also, T'ang-shu while describing the city of the King of Tibet in the seventh century, recounted decorations of lions, camels, horses, rams, and men on horseback. The same Chinese sources remind us that the Tibetan kings, as tribute to the T'ang emperors, sculptured animals in gold and silver. It should be noted that there were also statues of famous individuals, such as the two portrayals of King Sron-btsan-sgam po (609 - 649) placed in his tomb at Phyon-rgyas, one in stone on the outside and the other in earthenware, silk, and paper mache on the inside. While they have not yet been dated precisely, some of the portrayals of this king and his two wives, a Nepalese wife, and a Chinese wife, are now preserved in Lhasa. They show in the singular plasticity of contours, a far echo from the Gandharich styles, which probably crossed Central Asia indirectly. It is not possible to say, therefore, if in this period the Tibetan propensity for physiognomic detail and human expression had already begun to manifest themselves. As indicated by A. Neven (1975), these propensities reached a high form of expression in later statuary, and particularly in models of evil divinities.

On the other hand the stone lion, as reported by G. Tucci and reexamined by Richardson in 1963, together with the sculptured pillars of the same period on the necropolis of Phyonrgyas, clearly show the mastery reached by Tibetan sculpturers during this period.

With respect to early Buddhist statuary, the ancient Tibetan texts tried to establish an evolutional developing line by dividing monarchical sculpture production into three periods: that of the ancient reign, of mid-reign, and of the last reign, and by connecting it especially with the styles of India. As Tucci rightfully states, these definitions are, from a stylistic point of view, somewhat generic and may become a starting point for a more profound study of early Buddhist art.

The work of the Chinese scholar Liu I (1957) draws attention to two statues found in Eastern Tibet, dating from 751 A.D. If the date can be confirmed without a doubt these may be the most ancient examples of ancient Tibetan Buddhist art. In this sculpture the relationship between the iconographic and the stylistic within the Central Asian statuary appears to our eyes more evident than the influence of the Indian world. Only a direct examination can establish, however, their exact artistic and historical origin.

With the second wave of Buddhism in the 11th century one might say that sculpture production, save for a few common use objects, was centered around lamaistic subjects, and with a distinct preference for bronze as a material of choice (or, more exactly, metal derived from a variety of alloys, formed by an ancient technique already known in the Near East and from the Indians by the so-called "cire perdue" technique).

As P. Pal rightfully states, when the artistic contacts with production of another country come into play, as in Kashmir and as seen in the sculptures of Tabo and of Toling, the Tibetan characteristics are clearly evident. Tibetan emphasis on detail and the ornate dominate naturalist intentions. Artistic production in Kashmir concentrated less on detail and was more ladden with tension and sensuality.

The relationships between Tibetan sculpture and that of the Chinese have been widely examined by H. Karmay in reference to the Sino-Tibetan works of the Yuan, Ming, and Ch'ing dynasties. This careful examination, in addition to giving a partial glimpse of the stylistic evolution of Tibet, also emphasizes the influence which lamaistic sculpture exercised on the Chinese world. We may be able to directly verify the expressive originality and vitality of an art that succeeds in imposing its own lexicon on all forms of art - a lexicon which recalls culture and tradition reminiscent of those of China. Tibetan writers painstakingly identified the use of particular materials for each school. They masterfully explain the way divine beings placed energy in solid form by placing figures in diagonal and in dynamic torsion. Within this language is a profound analysis of the subconscious with the cosmic and natural forces in continual transformation, represented by the great vitality of the monstrous and terrific beings and to the couple yab-yum.

This inexhaustable and vital force manifests itself regardless of any rigid, symbolic-religious code, even more detailed than the pictorial code which binds each image to typical gestures, attitudes, and attributes. In fact, one might say paradoxically that the meticulous attention the artist is normally forced to pay in order to follow all the complex iconographic rules, is almost abandoned in the most successful representations through dynamism -- be it contained or in motion. A highly regarded attempt to identify various regional differences in bronze and relative chronological classifications was made by A. Neven -- who, based on an analysis of various seals placed at the base of sculptured works, ascertained the existence of certain styles linked or aligned with the principal zones of western Tibet (Ngari, Guge, Purang, Ladakh) and to those of south (Tsang), central (U), and Eastern Tibet (Kham, Amdo) — and more recently by G. Beguin (1977).

The most extensive examination of the monasteries in caves with sculptured interiors, such as those indicated by A. Gansser in the valley of Sib-chu in Western Tibet during the Sa-Skya epoch, may shed light on certain stylistic characteristics. The search for such monasteries - abandoned and often completely unknown - could, together with the study of wall sculptures often encountered on the walls of the rocky mountain roads on camel drivers' principal routes, open yet another chapter in the developing history of Tibetan sculpture.

Handicrafts. – The manufacture of Tibetan rugs in India after 1959, primarily by refugees, brought to light the interesting characteristics of this kind of traditional artistic production. Tibetologists for the most part ignored rug making in favor of the great variety of other handicrafts which attracted their attention, including vessels in metal, foreign metals, damascene,

embossed work, tea trays, liturgical objects, and reliquaries.

Rugs (gdan) have always been typical furnishing of Tibet. Rugs were used as seats, beds, saddles, and decorations for pillars, windows, and doors. An immense tapestry was even displayed during holidays on the impressive walls of Potala.

As P. Denwood (1974) correctly stated, the use of rugs and tapestries may have spread from Tibet around the ninth century. The occupation of the oasis in the Tarim basin placed the Tibetans in contact with the rich textile production of Central Asia. But one may not exclude the possibility that the spread of this form of craftsmanship may have occurred prior to this. It is certain that the weaving technique used in Tibetan manufacturing is ancient and may be linked to the Iranian region and to the Near East. The so-called "Senna type" knot still in use today in Tibet had vanished for centuries in almost all warps and was documented in Egypt in the second millennium B.C. and then in Central Asia.

Other more ancient decorative motifs, such as geometrical figures, pomegranates, labyrinths, and stylized animals, are also linked to the Iranian and Central-Asian area. At the beginning of the 18th century, the presence of Chinese ornamentation can clearly be documented. The Tibetans named some tapestries with decorations, mostly of floral designs, and medallions the "Gyarum" (rgya-rum, tapestry of the Chinese style).

According to H. A. Lorentz (1973), one should not forget Tibetan influence on the commercial production of Chinese tapestries found mostly in the northwestern region of Kansu. The influence of Indian culture can be discovered more by looking to the presence of Buddhist symbols in the lamaistic psycho-cosmogramas in meditation rugs than merely looking to the decorative motifs and techniques which had been popular in the Mogul era in India. In these meditation rugs decorations develop from within brightly colored, concentric squares or circles that ultimately lead to the center of the mandala.

The Tibetan love of chromatism and almost baroque ornamentation is a clear demonstration of the peoples' intense vitality and their dynamic concept of being – even as expressed in common everyday tools and instruments. As P. Pal (1969) correctly stated, the Tibetan "designs and decorates everyday items like beer mugs, the base of tea cups and saddles with the same enthusiasm and sensitivity for beauty as lavished on his Tanka."

In Tibet both sexes show an unrestrained love for the colored jewelry enriched by turquoise, opals, tiger eye, and jade. But the highly expressive drawings decorating simple utilitarian articles demonstrate better than anything else continuity in the Tibetan tradition from pre-Buddhist times to the present.

BIBLIOGRAPHY - L. Chandra, A new Tibeto-Mongol Pantheon, 20 vols., New Delhi, 1962-1969; R.A. Stein, La civilisation Tibétaine, Paris, 1962; A. Getty, The Gods of Northern Buddhism, Rutland, 1963; M.H. Duncan, Customs and Superstitions of Tibetans, London, 1964; A.B. Griswold, C. Kim, P.H. Pott, The Art of Burma, Corea and Tibet, London, 1964; S. Hummel, Kosmiche Strukturpläne der Tibeter, Geographica Helvetica, I, 1964; S. Hummel, Tibetische Architektur, Bulletin der Schweizerischen Gesellschaft für Anthropologie und Ethnologie, 40, 1963-64; M.T. De Mallmann, Etude Iconographique sur Mañjuśri, Publication de l'Ecole Française d'Extrême-Orient, LV, Paris, 1964; J.M. Perrin, Recent Russian studies in Tibetology, Bulletin of Tibetology, I, 2, October 1964; S. Hummel, Die Kathedrale von Lhasa, Imago Mundi und Heilsburg, Antaios, VII, 3, 1965; S. Hummel, Lotusstab und Lotusstab Träger in der Ikonographie des Lamaismus, Asiatische Studien/Etudes Asiatiques, 19-20, 1965; S. Hummel, sMan-Gyi-bLa, Bulletin of Tibetology, II, 2, 1965; S. Hummel, Die Steinreichen des Tibetischen Megalithikums und die Gesar-Sage, Anthropos, 60, 1965; B.C. Olschak, Arcaic Tibeto-indian Relations, The Indio-Asian Studies, II, 1965; T. Schmid, Masters of Healing, Bulletin of Tibetology, II, 3, November 1965; D. Seckel, The Art of Buddhism, London, 1965; T. Wylie, Mortuary Customs at Sa-skya, Tibet, Harvard Journal of Asiatic Studies, 25, 1965; H.U. Guenther, Tibetan Buddhism without Mystification, Leiden, 1966; P.H. Pott, Yoga and Yantra, The Hague, 1966; J.R. Rivière, On the iconographical Origin of 1Camshing, The God of War, Bulletin of Tibetology, III, 3, 1966; F. Sierksma, Tibet's Terrifying Deities, Paris, 1966; W. Forman, B. Rintschen, Lamaistische Tanzmasken der Erlik Tsam in der Mongolei, Leipzig, 1967; A.K. Gordon, The Iconography of Tibetan Lamaism, New York, 1967; J. Kolmaš, Tibet and Imperial China, Canberra, 1967; Li Lin-tsan, A Study of the Nan-chao and Ta-li Kingdoms in the light of art materials found in various museum, Taiwan, 1967; R.O. Meisezahl, Die Göttin Vajavarahi, Oriens, 18-19, 1967; A. Mookerjee, Tantra Art: Its Philosophy and Physics in Search of Life and Divine, New York, New Delhi, Paris, 1967; B.C. Olschak, Tibetan carpets, Palette, 27, 1967; D. Snellgrove, The nine ways of Bon, London, 1967; P. Banerjee, Painted covers of two Gilgit manuscripts, Oriental Art, N.S., XIV, 2, 1968; Rimpoche Dhongthong, Important Events in Tibetan History, Delhi, 1968; S.E. Lee, Ho Wai-kam, Chinese Art under the Mongols, The Yüan Dynasty (1279-1368), Cleveland, 1968; J. Lowry, Three Seventeenth Century Tibetan T'an kas, Victoria and Albert Museum Bulletin, 1968, IV, 3; B.C. Olschak, Die Fusspuren und Handzeichen Buddhas, Image, 27, Basel, 1968; B. C. Olschak, Die Neunzig Mahasiddhas, Image, 27, Basel, 1968; I. Rácz, Kunst in Tibet, Bern, Stuttgart, 1968; Madanjeet Singh, Himalayan Art, London, 1968; D. Snellgrove, H.E. Richardson, A Cultural History of Tibet, London, 1968; G. Tucci, Tibet Paese delle nevi, Novara, 1968; J. Weir Hardy, Tibetan Carpets Method of Weaving Design Symbology, New Delhi, c. 1968; N. Barbe, From the Land of Last Content, Boston, 1969; K. Chattopadhyaya, Carpets and Floor Covering of India, Bombay, 1969; R. Christinger, Tibet: Un art serein et déchiré, Journal de Genève, 124, 31 Mai-1 Juni 1969; H. Goetz, Studies in the History and Art of Kashmir and the Indian Himalaya, Wiesbaden, 1969; M. Hermans, dPal-ldan IHa-mo, die Schutzgöttin von Lhasa, Die Kapsel, Sept. 1969; S. Hummel, Die Jacobinermütze im Parivāra des Yama, Asiatische Studien/Etudes Asiatiques, XXIII 1969, 1-2; S. Hummel, Die Maske in Tibet, Antaios, XI, 2, July 1969; J.C. Huntington, The Style and Stylistic Sources of Tibetan Painting, Los Angeles, 1969; M.T. Mallman, Notes d'iconographie Tântrique, Arts Asiatiques, 1969, XX; B. C. Olschak, A. Gansser, Bhutan, Berne, 1969; P. Pal, H. Tseng, Lamaist Art, the Aesthetics of Harmony, Boston, 1969; P.H. Pott, The Mandala of Heruka, Ciba Journal, 50, 1969; G. Smith, Autobiography of the first Panchen Lama Blo-bzanchos-kyirgyal-mtshan, New Delhi, 1969; A. Todo, Some notes, Acta Asiatica, XVI, 1969; G. Tucci, Theory and Practice of the Mandala, London, 1969; E. Bunker, C.B. Chatwin, A.R.

Farkas, Animal Style, Art from East to West, Asia Society, 1970; Bureau du Tibet, Genève, Artisanat Tibétan, Genève, 1970; J. van Goidsenhoven, Art Lamaïque-Art des Dieux, Bruxelles, 1970; A. Govinda, The Historical and Symbolical Origin of Chorten, Bulletin of Tibetology, VII, 3, 1970; J.C. Huntington, The Iconography and structure of the mountings of Tibetan paintings, Studies in Conservation, 15, 3, August 1970; J.C. Huntington, The Technique of Tibetan paintings, Studies in Conservation, 15, 2, May 1970; Kuo-yi Pao, The Lama Temple and Lamaism in Bayin Mang (Manciuria), Monumenta Serica, XXIX, 1970-71; V.R. Mehra, Note on the technique and conservation of some Thang'ka paintings, Studies in Conservation, 15, 3, August 1970; D. Odier, Sculptures tântriques du Nèpal, Monaco, 1970; B.C. Olschak, Mandalas Von der kosmichen Spirale zum Rad der Zeit; Color Image, 35, 1970; M.J. Ridley, Oriental Art of India, Nepal and Tibet, London, 1970; N.C. Sinha, Wat is Vajra?, Bulletin of Tibetology, VII, 2, 1970; E.G. Smith, Introduction to Kong trul's Encyclopedia of Indo Tibetan Culture, Shes-bya Kun-Khyab-śata-Pitaka, 80, New Delhi, 1970; G. Tucci, W. Heissig, Die Religionen Tibets und der Mongolei, Stuttgart, 1970; Ahmad Zahiruddin, Sino-Tibetan Relations in the Seventeenth Century, Rome, 1970; S. Chaudhuri, Bibliography of Tibetan Studies, Calcutta, 1971; P. Denwood, Forts and Castles, An Aspect of Tibetan Architecture, Shambhala, 1, 1971; D.J. Dwyer, Asian Urbanization, Hong Kong, 1971; Études Tibétaines, Dediées à la mémoire de Marcelle Lalou, Paris, 1971; K.M. Gerasimova, Relics of Aesthetic Thought of East - The Tibetan Canon of Proportions, Ulan-Ude, 1971; D.I. Lauf, Zur Geschichte und Kunst lamaistischer Klöster im Westhimalaya, Asiatische Studien, XXV, 1971, 1-2; M. Lerner, An "International Style" of Wooden mandala, Bulletin of the Cleveland Museum of Art, Nov. 1971; C. Melvyn Goldstein, Taxation and the Structure of a Tibetan Village, Central Asiatic Journal, XV, 1, 1971; A. Mookerjee, Tantra Asana: Ein Weg zur Selbstverwirklichung, New York, Basel, 1971; B.C. Olschak, Masks and Legends of Eastern Bhutan, Image, 42, 1971; M. Bell, The Unparalleled Poster Coloring Book of Tibetan Art, New York, 1972; E. Burckhardt, Das Yin-Yang Symbol, Image Roche, 51, 1972; P. Denwood, The Tibetan temple-art in its architectural setting, in W. Watson, Mahayanist Art after A.D. 900, London, 1972; J. Huntington, Gu-ge bris, A Stylistic Amalgam, Aspects of Indian Art, 1972; D.I. Lauf, Das Erben Tibets, Bern, 1972; D.I. Lauf, Preliminary report on the history and art of some important Buddhist monasteries in Bhutan, Part I, Ethnologische Zeitschrift, Zürich, 1972, 2; P. Mortari Vergara Caffarelli, Proposte per una nuova cronologia e per un ulteriore esame critico dell'opera di Yü-ch'ih I-sêng, Rivista degli Studi Orientali, XLVI, 1972; D.I. Lauf, Tshe-ring-ma die Bergöttin des langen Lebens und ihr Gefolge, Ethnologische Zeitschrift, Zürich, 1972, 1; B.C. Olschak, Das Leben Buddhas, Das Schweizerin Rote Kreuz, Heft 5, July 1972; Pasang, Great Changes in Tibet, Peking, 1972; H.E. Richardson, Phallic symbols in Tibet, Bulletin of Tibetology, IX, 2, July 1972; J. Schulmann, Mystères et Symboles du Tibet, ABC Décor-L'Amateur suisse, Jan, 1972; E. Stoll, Szenen aus dem Leben des Tibetischen Sänger-Yogin Mi la ras pa, Ethnologische Zeitschrift Zürich, I, 1, 1972; Tai Erhchien, K'ao ku, 1, 1972; I. Alsop, J. Charlton, Image Casting in Oku Bahal, Contributions to Nepalese Studies, I, I, Dec. 1973; P. Denwood, A Greek Bowl from Tibet, Iran XI, 1973; M.N. Despande, Buddhist art of Ajanta and Tabo, Bulletin of Tibetology, 1973, 3; S. Hummel, Zentral Asien und die Etrusker Frage Anmerkungen, Rivista di studi orientali, XLVIII, I-IV, 1973-74; T. Hursch; p.Lindegger, Katalog der Sekundäliteratur am Tibet Institut Rikon, Zürich,

1973; D.J. Lauf, Das Bild als Symbol im Tantrismus, München, 1973; H.A. Lorentz, A View of Chinese Rugs, London, Boston, 1973; J. Lowry, Tibet, Nepal or China? An early group of dated Tangkas (sec. 16), Oriental Art, Autumn 1973; B.C. Olschak, G.T. Wangyal, Mistic Art of Ancient Tibet, New York, St. Louis, San Francisco, 1973; P. Rawson, The Art of Tantra, London, New York, 1973; H.E. Richardson, Growth of a Tibetan Legend, Tibetan Review, VIII, 11-12, Dec. 1973; R. Rinpoche, Phallic Symbols, Bulletin of Tibetology, X, 1, March, 1973; G. Béguin, Bronzes himâlayens, La Revue du Louvre, Paris, 1974, 4-5; E. Olson, A Tibetan Buddhist Altar, The Newark Museum, Newark, 1974; G. Tucci, The Ancient civilization of Transhimalaya, London, 1973; P. Denwood, The Tibetan Carpet, Warminster, 1974; M.S. Randhawa, Travels in the Western Himalayas in Search of Paintings, Delhi, 1974; N. Vandier-Nicolas, Bannières et peintures de Touen-houang, Paris, 1974; P.E. Fisher, Tibetan Art and Chinese Tradition, Arts of Asia, 1975, V, 6; J.C. Huntington, The Phur-pa, Tibetan Ritual Daggers, Artibus Asiae Supplementum, XXXIII, 1975; H. Karmay, Early Sino-tibetan art, Warminster, 1975; D. Kidd, Tibetan Painting in China, Oriental Art, 1975, XXI, 1-2; R. Khosla, Architecture and Symbolism in Tibetan monasteres in P. Oliver Shelter, Sign & Symbol, London, 1975; M.T. De Malmann, Introduction à l'iconographie du Tântrisme bouddique, Paris, 1975; P. Pal, Bronzes of Tibet, Arts of Asia, 1975, V. 6; C. Trugpa, Visual Dharma. The Buddhist Art of Tibet, Berkeley, 1975; Wang Hêng-chieh, A Neolithic Site found at Lin-chih county in the Tibet Autonomous Region, K'ao-ku 1975, 5; M. Seth, Wall Paintings of the Western Himalayas, Delhi, 1976; P. Mortari Vergara Caffarelli, Il linguaggio architettonico del Tibet e la sua diffusione in Asia Orientale, Rivista di Studi Orientali, 1976; A. Silvestri, Una t'anka tibetana al Museo Naz. d'Arte Orientale di Roma, Arte Orientale in Italia, IV, 1976; Chogyam Trungpa, The Tibetan Heritage of Buddhist Art, The Tibet Journal, 1, 2, 1976; D.L. Snellgrove, The cultural Heritage of Ladakh, London, 1977; A. Macdonald, Y. Imaeda et al., Essais sur l'Art du Tibet, Paris, 1977; Tarthang Tulku, Sacred Art of Tibet, Dharma Publishing, Emeryville, 1977.

Catalogues: E. Olson, Catalogue of the Tibetan collection in the Newark Museum, New Jersey, 5 vols., Newark 1950-1973; University of Texas, Art Museum, Himalaya: An Exhibition of the Art and Craft of Tibet and Nepal, Austin, 1964; Tibet House Museum Catalogue: Inaugural Exhibition, New Delhi, 1965; O. Monod, Le Musée Guimet, Paris, 1966; H.P. Roth, Collection R. Lenzburg, Lenzburg, 1966; S. Semadeni, Tibeter Teppiche, Zürich, 1966; Tibet House Museum-Second Exhibition of Tibetan Art, New Delhi, 1966; S. Hummel, Die Lamaistischen Malerei und Bilddrucke im Linden Museum, Tribus, 16, July 1967; M. Brauen, Tibetische Kunst, Winterthur, 1968; D.I. Lauf, Tibetica, vols. 1-33, Stuttgart, 1968-1976; G.M.D. Ondei, Tibet Religieuse Kunst, Tongeren, 1968; E. Stoll, Orientalia Helvetica, Bern, 1968; Toyo Bisutsu Ten, Exhibition of Eastern Art celebrating the Opening of the Gallery of Eastern Antiquities National Museum, Tokyo, 1968; D.L. Snellgrove, C.R. Bawden, A Catalogue of the Tibetan collection and Mongolian collection, Dublin, 1969; P. Pal, E. Olson, The Art of Tibet, New York, 1969; E. Stoll, D.I. Lauf, H. Zimmermann, Tibetische Kunst, Zürich, 1969; C. Burrows, Tibetan Lamaist Art, New York, 1970; J. Eracle, L'art des Thankas et le Bouddhisme tantrique (Musée d'Ethnographie), Genève, 1970; F. Chow, Arts from the Rooftop of Asia, The Metropolitan Museum of Art, New York, 1971; A. Lommel, Buddhistische Kunst, Munchen, 1971; Masterpieces of Chinese Tibetan Buddhist Altar Fittings in

the National Palace Museum, National Palace Museum, Taipei, 1971; P. Pal, Indo Asian Art from the John Gilmore Ford Collection (exhibition catalogue), Baltimore, 1971; P.S. Rawson, Tantra, London, 1971; Christies Catalogue, The Ducas Collection of Tibetan, Nepalese and Chinese Bronzes, London, 31 Oct. 1972; N.De Craiova, Tibetische Kultbronzen Staatl Museen, Berlin, 1972; The Sacred Art of Tibet, Exhibition, San Francisco, December 1972, Berkeley, 1972; J.H. Schriever, Lamaistische Kunst in Tibet, s.1. 1972; E. Stoll, Kunstschätze aus Tibetischen Klöstern, Zürich, 1972; Christies Catalogue, Important Indian, Tibetan, Nepalese and Chinese Works of Art, London, December 1973; J. Lowry, Victoria and Albert Museum London, Tibetan Art, London, 1973; R. Goepper, T.T. Thingo, Buddhistische Kunst aus dem Himalaya, Köln, 1974; A. Neven, Le Tantrisme dans l'Art et la Pensée, Bruxelles, 1974; E. Olson, Tantric Buddhist Art, Exhibition Catalogue, China House Gallery, New York, 1974; A. Neven, L'art lamaïque, Bruxelles, 1975; Buddhistische Kunst aus dem Himalaya, Berlin, 1976; La Route de la Soie, Grand Palais, Paris, 1976; Dieux et démons de l'Himâlaya, Grand Palais, Paris, 1977.

PAOLA VERGARA CAFFARELLI MORTARI

JAPAN (PLATE 73)

Introduction. – Among the theories put forth in recent years regarding the broad and varied problems of Japan's historical artistic works, the contribution of Japanese studies themselves has always been a determinant factor. Archaeological excavations undertaken in many areas of the country, often utilizing highly specialized techniques, have permitted the reconstruction not only of prehistoric or protohistoric sites, but also of long forgotten ancient capitals such as Naniwa as well as residential villages from the medieval age, which have been studied in various phases of construction, with precise definition down to details of layout. (The studies by Ooka Minoru, 1971, and Naito Akura, 1976, come to mind.)

Ancient murals (such as Kofun Takamatsuzuka's extraordinary discovery), scrolls, pages from albums, screens, and prints by various masters (Sesson, the Kano, Shokaku) have been brought to light or acknowledged. These discoveries have still more enriched the study of Japanese painting codes, a complex and not easily resolved task owing to the subject's eclectic nature and the innumerable stylistic nuances represented in a given school and often in a given artist.

Indeed, in the expressive language of sculpture, the renovation of ancient statues, often located in "provincial" (and thus relatively unknown) areas, along with proposals for new, little known schemes for dating well-known and previously studied masterpieces, have contributed a great deal in recent years to the understanding of this art which has become peculiarly "Japanese." It has also caused greater importance and official recognition to be attributed to it down to the most ancient times, unlike the rest of the Far-Eastern world. Various expositions, conferences, studies, museum catalogues and collections, and series that have been translated into Western languages (one is reminded of expansive Heibonsha and Shibundo series of volumes edited together with Weatherhill) have all made valid contributions to the dissemination and understanding of Japanese artistic output outside the national boundaries.

Of perhaps more interest at the sociological level, the Western scholars (among them Pearson, Kidder, Munsterberg, Sullivan, Swann, and, in a more synthetic but nonetheless chronologically broader sense, Brandley Smith) have tried to define, insofar as possible, the social, political, economic, and religious forces that have determined and at the same time conditioned Japanese artistic expression.

Above all, interest in the history of art, be it Oriental or Western, impinges on the definition of the relationships that have tied Japanese artistic output to that of the Asian continent in past epochs, and subsequently to that of the European and American worlds. In ancient times the always important contribution of Southeast Asia seems to be even more decisive, and, in light of recent archaeological discoveries (the Ban Chiang civilization in Thailand) has come to occupy an even more important role in the genesis of Japanese culture. One sees in these, for example, the various types of regional habitations that Pezeu Massabuau (1966) identified as closely related, from the typographic and structural point of view, to the insular and peninsular styles found in the tropics. These are, in fact, more suited to protecting inhabitants from hot humid weather than from the extreme winters that are particularly cold in some parts of the country. In addition, this type of habitation occurs even more often in the same range of Chinese civilization.

Interest is naturally acute in those artistic manifestations considered peculiarly Japanese, as well as those which are autonomous developments of codes imported from the continent. The studies of Yamato-e (Saburo Tenaga, 1973); Shinto art (Haruki Kageyama, 1973); esoteric Buddhist art (Hamada Takashi, 1971; Sawa Takaki, 1972); and Zen art (J. Fontein, M. L. Hickman, 1970; H. Munsterbert, 1970; Takeuchi Naoji, 1973), together with studies of the art forms connected to the tea ceremony (S. E. Lee, 1963; Ryoichi Fujioka, 1973); the art of Japanese gardens (Loraine Kick, 1968; Shigemori Kanto, 1971; Ito Tuji, 1972, 1973); Yukiyo-e prints (Narazaki Muneshige, 1966; H. P. Stern, 1969, 1973; R. S. Keyes, 1973) to cite just a few, have all contributed to shedding new light on the genesis of such works, on the autonomous ancient substratum, and on the cultural and religious developments which determined their evolution.

In a related vein, a great deal of active interest has also been manifested in the study of ancient regional traditions, formerly little studied and primarily examined only in conjunction with metropolitan cultures. Today little by little, these regional traditions have come into their own and are being more carefully defined.

Interesting research undertaken in the field of calligraphy has helped to better define not only the esthetic value of this art form, but also its evolution throughout the course of various historic periods. That has permitted, for example, Matsubara Shigeru (Museum, 1974) to precisely date painted figures accompanying a text, thanks to these calligraphic characteristics. A further clarification of Japanese esthetic phenomenology comes from an ongoing examination of numerous ancient art texts, biographic dictionaries, and catalogues of collections which T. Tsuruta (1970) has recently sought to arrange chronologically.

In the attempt to pin down more precisely the evolutionary path of Japanese artistic expression — each period's inherent rigidity notwithstanding — it seems to us that the scheme proposed by V. Elisseeff (1974), among others, outlining four major phases of civilization, each divided into subphases, certainly illustrates the great cultural "models," periods of innovation in the religious field, and social policies which naturally have a precise effect on artistic expression. One can thus pinpoint a prehistoric and protohistoric period (Jomon, Yayoi, Kofun) in which Japanese artistic individuality evolved with a vast fusion of Siberian, Southeast Asian, Chinese, and Korean elements. It is a question of the formulation of a series of primitive codes — broad, differentiated, and perfectly characterizable — that constitute a long, yet constant, point of reference for that historic era in which other, completely independent, Japanese artistic forms of expression were realized, even if they were nurtured by continental contributions.

The second phase, using Elisseeff's schema, can be defined as a "formative" one in which Sino-Korean — especially Buddhist — elements of esthetic expression were in large part absorbed and soon reelaborated in a national form, by the time of the Asuka, Nara, and above all, Heian epochs, which constitute the "classic" moment of Japanese art. Thus the existence of a feudal society rich in the warrior traditions, often tied to the ancient period of Japanese autonomy, which manifests itself artistically through a vivid taste for realism, chromatic contrasts, and the monumental, is affirmed. This, however, forms a counterpoint above all to the sense of faith in the Zen movement as expressed by its symbolism, its esthetic stylization, its all important monochromatic linearity, and a propensity for the simplicity of materials in their natural state.

The artistic output of the feudal epochs — Kamakura, Muromachi, Momoyama, and in part also that of Edo — vacillates between these two sets of characeristics and opposing modes of artistic expression; at the same time it manages to realize a synthesis both lively and measured. The rise of the bourgeoisie by the time of the Edo epoch, and especially the industrial revolution that had taken place by the beginning of the Meiji Renovation (1867), constitute the last fundamental stage in the development of Japanese art and culture: the encounter with the Western world. Revolutionary new elements were introduced into the national esthetic lexicon which, after the brief period of acquisition, were forever integrated into the traditional Japanese artistic patterns.

Prehistory and Protohistory. – Japan's tremendous economic development since the 1950s has brought with it the construction of new residential districts and roads. This has often resulted in the unexpected discovery of many pre- and protohistoric sites. Acquisition of improved excavating techniques and the adoption of extremely accurate and highly specialized methods of scientific analysis have contributed to a considerable broadening of the Japanese prehistoric panorama. However, in the opinion of R. Pearson (1976), even though Japanese techniques are similar, and in some cases even superior, to those of Western archaeologists, the "conceptual framework" of the former is very different from our own.

In Japan, archaeology is in fact regarded more as national or cultural history than as a science with a social character. It must be added, however, that in recent years there have been several studies in the field of sociology as well, such as that carried out by M. Watanabe concerning the Jomon period. Archaeological interest has particularly centered around the ceramic period (Sendoki Jidai), which roughly corresponds to the paleolithic or mesolithic eras.

More than 500 sites dated as pleistocene era have been discovered. The analyses carried out by Japanese archaeologists, among others, of artifacts gathered at various stations on the Sagamino high plain in the prefecture of Kanagawa, have helped to clarify exchanges between the sites and provided interesting chronological notations.

Japanese relations with continental cultures have generally been considered only in regard to the Siberian, Chinese, or Korean zones. Recently T. Sato has documented those with the Southeast Asian region by way of examining certain knives (Ko), the prototypes of which are traceable only to that area.

R. Pearson (1976) has proposed that a relationship existed with the Siberian centers of Ushki and Mal'ta, based on the structures and typology of the recently discovered paleolithic dwellings found at the Uwaba and Kagoshima sites.

Still more interesting are the small stone statues in human form found, for example, at Kamikurowa, which seem to represent one of the rings of conjunction with that of the successive Jomon period, thereby attesting to, as F. Ikawa (1964) has noted, a certain continuity between the non-ceramic and ceramic period in Japan.

The problems of the origins and development of the period called Jomon (from the rope-like impressions found on the ceramics), which could very well correspond to Mesolithlic and Neolithic terms, still have not been resolved. The notion of two diversified cultural areas — Eastern and Western — has been proposed, and it is recognized that the Tohoku region represents a zone with a higher concentration of settlements. The Fukui site (Nagasaki prefecture), discovered in 1960 - 1964, has made an important contribution to the determination of the sequence of stratification that leads from the late Paleolithic (where the microliths no longer appear) to a clearly defined Neolithic period rich in ceramic artifacts.

At the same time, however, this excavation had considerably complicated archaeological inquiry by turning up artifacts that, in the judgment of the excavators, seemed much older (12,700 ± 500 and 12,400 ± 350 years ago). Some, like Pearson, have deemed that these primitive ceramics do not belong to the Jomon category and have given them the designation "Mesolithic." Other archaeologists (T. Sato and S. Yamanouchi) do not accept the dates proposed for the first ceramics found in sites such as the above mentioned Fukui or Kamikurowa (10,125 B.C.), suggesting an error in interpretation of the stratigraphic position of the artifacts. Through a comparison with the typology and decoration of the neighboring Chinese, Korean, and Siberian artwork, they pushed back the dates so far as to propose that the third or fourth millenium B.C. be fixed as the beginning of the Jomun period. But the majority of the protohistorians continue to pinpoint the begin-

ning of the Jomon era at 8000 or 7000 B.C., on the basis of results obtained by carbon-14 dating.

The many newly discovered settlements of that epoch seem to confirm the hypothesis of a certain differentiation in patterns of building based on the professions and specializations of the inhabitants. For example, the recently excavated site of Ohatano (1974), if the interpretation is precisely adhered to, would represent a ritual center, as a series of megaliths found by archaeologists would seem to support. By extension, this hypothesis would purport to pinpoint the very complex and different "variations" of Jomon ceramics not only in a diachronic sense (the famous five periods of development) but also in a synchronic sense, as a manifestation of various sociologically differentiated local or regional groups. In addition, the relationship with handmade continental products contributed to the clarification of several evolutionary phases of the Japanese Jomon period, such as the probable derivation from the Koreans of various types of Goryo and Yuso (Kyushu) ceramics noted by R. Pearson.

In discussing the subsequent transition to the Bronze age (Yayoi period; 300 B.C. - 300 A.D.), the tendency today is away from emphasizing the break with the preceding Jomun period. P. Bleed (1972) and Chester Chard (1974) have demonstrated that although this epoch produced some exceptional innovations (new types of ceramic, new forms of construction and burial practices, specialized agriculture, use of bronze and iron) which in part had resulted from a heavy Korean migration, there are elements of continuity from the Jomon period to the Yayoi.

Some examples of funerary urns that were already in use during the Jomun period in the Tohoku zone, and even more of the Yuso (Kyushu) type of ceramic of the late Jomon, are very similar to those of the Yayoi. This indicates, as stated above, undeniable contact with the contemporaneous ceramics of the Pusan region of Korea. One can thus state authoritatively that by the end of the Jomun period there had already been Japanese contact and exchange with the Korean peninsula, which later intensified. This was a prelude to the flourishing of the new, more complex and stratified Yayoi civilization.

Profound social differentiations can now be affirmed, as evidenced by funeral and burial practices, and especially in the diversity and richness of funeral ornamentation. As Elisseeff (1974) acutely observed, "for the first time in Japan the strange phenomenon of the importation of foreign objects clearly began to manifest itself." Mirrors, tripods, spears, spearheads, and Korean and Chinese knives came to be included in the furnishings of burial chambers. This phenomenon simultaneously stimulated Japanese artisans to perfect their technical and artistic skills.

Thus, in a nutshell, the Yayori epoch was already characterized by changes in social organization which are reflected in the great tombs and burial mounds of the Kofun period (fourth to sixth centuries A.D.). The discoveries at Kanto, in Fukui, in Shimane, and in other prefectures of the so-called square tombs (Hokei-shuko-bo) along with smaller burial mounds also belonging to the Yayoi epoch have led to the supposition made in some Japanese studies that the great burial mound tombs developed directly from the Yayoi tombs. An even more nontraditional and controversial hypothesis holds that the Kofun prototypes were closely connected with the Yamato clan's ascent to power and limited to the Kinai plain.

Certainly the process through which Yayoi agricultural society evolved into a warfaring civilization with widespread use of horses, armor, and iron weapons strong enough to make conquests even in Korean territory is still unclear. New discoveries and new interest in the study of the Haniwa, small handmade clay statues posted outside burial mounds, have enabled E. Kidder (1968) and Fumio Miki (1973), among others, to create an interesting reconstruction of this world where kings and warriors alike devoted themselves to both the martial arts and to religious contemplation, indicated by figures depicting hand-to-hand combat and those representing religious rites and symbols. One can reconstruct this evolutionary process in the unique stylization of such sculptures, the variation in their own forms and order according to time period (ancient, middle, or late Kofun), and especially in the diversity of regional traditions which center around two principal areas: western Japan (Kinai) and eastern Japan (Kanto).

The Asuka and Nara Periods (552 - 794 A.D.) – Exceptional new studies and findings regarding this fundamental period in Japanese artistic evolution, such as moments of acculturation and acquisition of foreign styles and models which make up the basis of all subsequent developments, have been realized in the past few years.

Excavations of imperial residences and peripheral villages alike have brought about a better understanding of palatial architecture and offered as well an interesting contrast with the persistence of protohistoric architectonic models to areas well beyond the highly Sino-influenced urban centers. In fact, with the foundation of Nara (710 A.D.) we witness the planning of a real and true fixed capital (formerly, the locations changed at the time of the death a king or emperor, for magical or religious reasons), and hence a real process of urbanization already highly differentiated by the adoption of the multisecular Chinese model which, however, seems not to have been applied outside of metropolitan zones.

With the reconstruction of eighth-century settlement of Nara published by M. Ooka in his ample 1973 study of that city's architecture, one clearly notes the repetition of the Chinese model of Ch'ang-an: designed to include a central north-south axis with the imperial palace always on the extreme north end of that axis. However, inside the walls of the palace the single room used for public assemblies is situated on the principal axis; the other runs off toward the east and the imperial residences are lined up along it. There are similarities in the delimitation of the fang, or zones. But while the Ch'ang-an model displays a predilection, especially with the southern zones, for rectangular delimitation, at Nara we can observe a preference for square forms. The very outline of the city does not have a quadrangular aspect, though, as it introduces the addition of rectangles of smaller dimensions on its eastern side, which includes some of the principal temples, such as Todaiji and Kofukuji. Even in this first example, there is already the question of a Japanese reinterpretation of the Chinese urban model.

The examination of the first complex Buddhist temples, such as those of Sairin in Furuchi (province of Kawachi), completed by S. Tanaka in his study of

ancient documents that he tracked down at the site, has permitted some evaluations of religious architecture. It can thus be verified that the typical asymmetric plan of the Horyuji temple, with its pagoda and prayer chamber not situated on the north-south axis, is repeated in the Sairinji temple, whose foundation is dated at 679 A.D. by Japanese studies. In fact, as V. Elisseeff (1973) affirms, the Japanese notion of architectonic space was born in this epoch, and certainly, in our considered opinion, was unlike other Buddhist temples of the same period, the majority of which are ordered according to the rigid symmetry and axis-based rules of planning typical of Chinese complexes. Hortyuji and Sairinji represent one of the most interesting constants: the quest for plano-volumetric harmony achieved through a rhythmic equilibrium of volumes — fullness and emptiness, horizontal and vertical lines — equivalent but not entirely symmetric.

We find the same rhythm and harmony of composition in the field of painting in one of the most important archaeological discoveries in recent years: the series of painted murals found inside the underground tomb of Takamatsuzuka, near the village of Asuka. The discovery, which occurred in 1972 and had incalculable repercussions in defining the evolutionary history of Japanese painting, has been studied both by numerous Japanese scholars (M. Suenaga, 1972; Kawano Keisuka, 1972; S. Matsumoto, 1972) and Western ones (E. Kidder, 1972; F. Berthier, 1973; D. Sadun, 1975). Not only is the location of this series of painting exceptional — no other paintings of this kind have been found within the Kofun period — but the very subject and style differ substantially from those of other formerly known examples of seventh- and eighth-century Japanese painting.

The walls of the burial chamber are in fact decorated with scenes which probably represent rituals in which groups of members of the court are interspersed with the four Shijin — the mythical symbolic animals representing simultaneously the four cardinal points, the four seasons, the principal elements, and colors, thereby synthesized in time and space. Without a doubt, we see in these pictures, repeated here, the cosmological model and symbols from Chinese tombs which were also adopted in Korea; the ceiling decorated with the constellations and the deceased's sarcophogus placed in the center of the room, thus fulfilling the representation of the macrocosm according to the oldest and most traditional symbolic Chinese patterns perfected by the time of the Han period. However, in our opinion, there is in the rendering of the human figure, beyond its ritual and symbolic meaning, a more interesting element than these representations. Besides the undeniable stylistic contact with the contemporaneous T'ang and Koguryo tomb figurations, we find, in a nutshell, some lexical elements that will constitute an integral part of the typical paintings of court scenes or of the types from subsequent epochs. The synthetic rendering of the human face with few espressive features and the heavy and voluminous presence of clothing that completely obliterates the lines of the body already appear in these delicate Takamatsuzuka figurines, almost a distant prelude to those of the Yamato-e.

The contrast is strong between such wall paintings, dated by the majority of archaeologists as between the end of the seventh century and the beginning of the eighth, and the nearly contemporaneous *kondo* of Hory-uji and Nara. These latter exhibit fully the Buddhist *koine* common in the Far East of this time, which have been defined in some Japanese studies as "Eastern pan-Asiatic style." We have already attempted to demonstrate (P. Vergara Caffarelli Mortari, 1972) the apparent incidence of the painting codes of the Khotanese school of Yu-ch'ih (better known by the incorrect transcription Wei-ch-ih) on the splendid frescoes of Kondo. This school developed in the T'ang capitals and went as far, according to some sources, as the Korean peninsula, where it had a certain impact.

The clear use of iconographic schemes and Khotanese iconography, more specifically that of Yu-ch'ih I-seng in the Horyuji figures, seems to us to confirm this hypothesis. On the other hand, this does not rule out a mediating function as well on the part of the Khotanese school of the typical Indian models recognized by many scholars (J. Kidder, 1970, among them) in these paintings. It is a question of verifying, after the discovery of Takamatsuzuka, the presence of two very distinct painting patterns in the same epoch. The first, that of the Horyuji Kondo, together with other Buddhist paintings, while strictly tied to the Sino-Korean religious world, in the final analysis is derived from Central Asia and India. Like that of the Kofun Takamatsuzuka, also assumed to originate from continental, but exclusively Far Eastern, models, the other pattern includes paintings of court scenes or rituals which, given a subject matter that is less tied to prefixed iconographic or iconologic schemes, allows for a more ready skirting of the original models and a more spontaneous adherence to a local "way of life," and thus the creation of a more typically Japanese form of artistic expression.

There have also been important new acquisitions recently in the field of early Buddhist sculpture: the discovery of ancient works together with a closer examination of those which were already known has led to a new assessment of the evolution of indigenous styles and their relationship with those of the continent.

K. Machida's 1972, 1973, and 1976 studies of Asuka sculpture have not as yet been proved as far as they concern the origins of the Tori style, which Japanese scholars agree derives from that of the Wei. This is the antithesis to the Soper's work, which finds its prototype in the southern Liang statuary that constitutes an extremely interesting acquisition for the definition of the final phase of this style.

Machida Koichi indicates the presence of some elements leading to the development of the non-Tori style in the Guze Kannon of the Yumedono and in the Shitenno of the Horyuji Kondo. An even more evident source of a new pattern of sculpture can be found in the Kannon bronze statuettes, dated at 651 A.D., now housed in the National Museum in Tokyo. The abundance of hand carvings on the surface along the base, the decorative treatment of the locks of hair, faces with round cheeks, and the way the eyes are represented all differentiate them greatly from the early Tori style. K. Yabuta's chronological study of the halo inscription on the famous Joryuji Sakyamuni triad, which altered its dating from 628 to 688, was not without consequences in the interpretation of the Asuka style.

It is certain that, especially when compared with the continental artistic modes of expression with which Japanese statuary is closely linked, greater clarification is called for. A noteworthy contribution to the under-

standing of the artistic rapport that existed between China and Japan in the Nara epoch was made in an article by S. Matsubara. Based on T'ang artifacts, the Japanese scholar drew a sharp distinction between statuary from the beginning of the period, which was subject to influences of the early T'ang style, and that of the later period in which there are elements of a more mature T'ang style sculptural expression. He has also succeeded in pinpointing, as well, the various Chinese regions from which some models originated. In addition, studies by S. Mizoguchi (1973) and R. Hayashi (1976) of decorative motifs and the multiform typology of artistic objects preserved in the famous Shosoin have contributed to illustrating, from another point of view, Japan's innumerable relationships and exchanges with continental cultures, from western Persia to China, in that epoch. As Mizoguchi correctly affirms, "the cultura of Nara which produced the Shosoin can well be considered as the final station on the international Silk Road.

Heian Period (794 - 1185 A.D.). – This epoch represents the most mature moment in the period of acquisitions from Chinese civilization. Having superceded the phase of mere acculturation, Japan reached the point not only of putting forth its own autonomous form of artistic expression, but actually that of forming a counter-expression, especially in the second phase of the period, to that of the Chinese. The so-called "Eastern pan-Asian style" in fact broke down into various national currents, a situation that was facilitated by the dissolution of the imperial T'ang power in China and by that nation's consequent of hegemony. This does not mean that in the course of her history Japan no longer turned to the art of the continent for inspiration and models. Rather, it was in the main a question of a relationship "among peers," in which Japan recognized that she was in a position not only to imitate, but also to transform all Chinese or Korean notions to fit her own artistic patterns.

We also observe in the monumental construction of the Heian period the reappearance of ancient traditional elements. Such original variations as pile dwellings and straw or inoki bark roofs have enriched the "tien" Chinese architectonic lexicon and undoubtedly constitute one of the most consistent impetuses for the subsequent development of a Japanese national architecture.

In the same imperial palace (Dai Dairi), built at Heian (the new capital from which the entire period takes its name) and partially excavated in the 1960s, we see that the general layout follows that of the imperial palace in the Chinese capital. But inside the rectangular outline there is no strict hierarchical distribution of the major representative buildings, in a line that follows the preferential south-north axis, as in almost all imperial residences of previous ages, some of them recently excavated.

In fact, though the audience room (chō doin) follows the axis in accordance with Chinese principles, the reception room (Burakuin) and the imperial residence (Dairi) are respectively located west and north-east of the south-north line. Also, the majority of the numerous structures (offices, barracks, libraries, warehouses, stables) situated within the enclosure (town wall) seem to follow, within their geometric arrangements, a more organic and functional order rather than strictly symmetric criteria in line with ancient traditional architecture.

Certainly, as J. W. Hall (1974) observes, such arrangements also reflect changes in the political situation, the progressive loss of imperial supremacy, and therefore the subsequent diminution of the buildings' representative function. It is also worth mentioning that as some upper-class families increased their power status there was a return to certain lexical themes belonging to the period when family clans held power.

The same contrast can be found again in Buddhist architecture when new sects, particularly the Mikkyō or those belonging to esoteric Buddhism, took a stand against the luxury and pomp exhibited by the great urban monasteries. A new architectural code was adopted whereby the order, symmetry, and hierachy of individual elements, derived from ancient Chinese models, was counterpoised to the places of worship built on top of mountains, whose shape followed the pattern of the terrain and whose building materials were left to the maximum extent possible in their natural state. Conversely, Shintoist temples, having acquired a more important political role, had the tendency to imitate in the plan and in the distribution of volumes, and often even in their building techniques, the urban Buddhist structures. A similar phenomenon took place later on, even in temples belonging to the esoteric sects, when, having abandoned the mountain areas, they moved their cultural centers to the cities and their rites became official ceremonies.

Another source that without any doubt inspired Japanese architecture a bit later belongs to the wide and varied architectural lexicon of regional traditions. These traditions have retained and developed ancient protohistorical elements, integrating them with continental traditions. Their impact on architecture has been reviewed by K. Asano (1964) and Teiji Ito (1972) in an evolutionary perspective and by J. Pezue Massabuan (1966), mainly in relation to environmental and climatic factors.

In fact, in the last few years there has been an attempt to define these regional traditions, which evolved under the influence of metropolitan cultures and not only in the architectural sector. The study by Taguchi Eiichi (1973) on the murals of the Fuki-no Odo (the great room of the Fukiji, Kyushus' oldest building, built between 1063 and 1128) has shown how provincial culture was also able to generate works of exceptional value, thus contributing to the heritage of Japanese Buddhist painting. The images of Amitabha's paradise and of other subjects belonging to the Amidist cycle adorning the walls of the Fuki-no Odo do not constitute, as Kudo Toshiaki (1973) confirms, a real Amida-do (hall of Amida) but an environment in which Jodo practices were taught and where meditation was held. The comparative and iconographic study by Taguki Eiichi attributes these images to a real expression of Rikugo culture (local Buddhist beliefs). In sculpture, Kunio Takeshi's study (1973) on Buddhist statues of the Heian and Kamakura period, discovered in the Kamusaki peninsula, has led to the conclusion that "in certain cases such artistic production is not inferior to urban works."

The gradual separation from the strict Confucian moral code in favor of a more nationalistic religious movement further removed the Japanese from the

nationalism and realism of the T'ang. Subsequently, a romantic and sentimental conception of life and nature prevailed. This feeling manifested itself more vividly in the arts through the delicate, stylized, yet lively paintings of the movement known as Yamato-e. This artistic school, physically tied to the elegant and pompous Fujiwara court, has always been considered the first, more complete manifestation of typical nationalistic painting. Obviously, many scholars have focused their attention on the historic precedents and on the expressive variants of Yamato-e. S. Jenaga (1973) has traced Yamato-e's entire history from its origins, recognizing its presence through the ages, sometimes evident and at other times sporadic. S. Jenaga reaffirms Yamato-e's vital permanence, even in modern painting. A similar interest has also been shown in regard to monochrome works (Sumi-e). The study of the various techniques, which led to such surprising results, represents a great contribution in this field. S. Yamada (1976) classified these techniques.

The reconstruction of a scroll of the Ise Monogatari (a likely copy of an original that can be traced to the Heian period), whose segments are owned by various museums, has been analyzed by numerous Japanese scholars (Takuya, Tamagami, Shunsho, Manabe, and others, 1970) under its technical, calligraphic, and stylistic aspects, thus widening our understanding of the vast and varied pictorial language of the period.

Equally interesting is the research on Heian sculpture in the region of Thoku led by K. Kuno (1971). The study has brought to light the existence of a unique regional style whose importance has never before been emphasized. On the other hand, new studies, discoveries, and proposals for changing the dates of certain works have led to a more accurate evaluation of various styles, including the urban. In regard to the famous statue of the Amida Nyorai of Koru-ji, the scholar K. Asai (1974) has proposed the date 840 instead of the traditional date ascribing the sculpture to the Tencho period (824-833). As for the image of the Yakushi Nyorai of Yakkushiji (Buddhist sandalwood sculpture), he presumes that it was imported from China in the middle of the eighth century. Two engraved stones with Buddha figures, discovered in the Kyoto area, show how the round and elegant forms of the Heian period later acquired a certain stiffness of contours as a consequence of the poor quality of unpolished stone and of a certain stylistic uncertainty.

The precise reevaluation of Shinto religion, as an indigenous element, falls within the framework of Japanese nationalistic assertion. The study by K. Saito (1975) on ten statues representing the Shinto divinity in the Keisokuji shows the pursuit of Shintoist sculpture of an individual figurative expression. While the first images imitated the plastic forms of Buddhist statues, those belonging to the late Heian period show a tendency toward smaller dimensions, a simplification of detail, and a particular stylization of the whole. Consequently, one can identify the intention of the artist to distinguish, through a different artistic code, Shinto from Buddhist divinities.

Kamakura (1185 - 1333 A.D.) and Muromachi (1333 - 1573) Periods. – In recent historical essays the term Chusei (medieval) includes not only the Kamakura and Muromachi periods but is also extended to the 11th century — that is, the middle of the Heian period.

However, in the historic and artistic perspective, the end of supremacy of the Fujiwara aristocracy and the transfer of power from the aristocrats to the military brought about considerable changes. Even works of art that were profoundly decorative and refined continued to evolve as imitations of Heian art. The scholar Saburo Mizoguchi rightly affirms: "the manner of expression gradually came to reflect the personality of the new military art patrons." The sentimentalism, the elegant style of the Heian were replaced by more realistic images, full of energy and vitality reflecting, during the Kamakura period, a certain mannerism reminiscent of Chinese Sung works and, for the Muromachi period, belonging to the typical Ming decorativeness.

In fact, during these periods contacts with China were resumed, but, as previously mentioned, the relationship became one of a more equal and autonomous nature. Japanese artists drew often from the figurative Chinese language those elements which, in their view, were more suitable to the codes that they were elaborating, an example being the adoption of Ch'an painting (Zen in Japan), whose essence was appreciated and carried forward by the Japanese in spite of the criticism and dislike expressed by Chinese critics, especially during the Ming Dynasty. Japanese independence manifested itself also in architecture. The adoption of the Tenjikuyo styles (Indian style, but in reality typical of the Southern Sung) and Karayo, or Chinese style connected to the Ch'an (Zen), did not interfere with the spread of architectural styles which remained totally autonomous and Japanese, such as the Buke-Zukuri (warrior style), which introduced an "organic" agglomeration of various buildings for strictly functional and defensive purposes.

Also, in the planning of the imperial capital, the destruction and abandonment of the ancient Heian imperial palace brought about a more natural redistribution of ceremonial, political, and residential structures without any regard to symmetry and centrality, a clear indication of the political polycentrism of the feudal period.

Sculpture remains, without any reservation, one of the most independent manifestations of feudal culture. In fact, the attention of critics, particularly of Japanese critics, has in recent years focused on the rich and varied Kamakura and Muromachi sculpture. In 1975 the magazine "Museum" dedicated a special edition to Kamakura sculpture. Several scholars, such as Sato Akio and Mizuno Keijaburo, contributed articles which analyzed the works of the sculptor Unkei (1148 - 1223 A.D.) and the activities of the Nara School, remarking on its similarity to the "shops" of medieval Europe. And if, in our opinion, a certain "Baroque" tendency, together with Siao and then Yuan, seems to be present in the works of the Kei school, especially when the dramatic expression is exaggerated, the feeling of vivid realism, masculinity, and soldierliness are typically Japanese. Scholars who consider Ukei the father of the Renaissance of Japanese sculpture have valid reasons, though other artists of the Kyoto schools of the Kamakura period, especially the In school, have recently drawn the attention of critics.

Nakano Genzo (1972), referring to Buddhist images of the Jakusho-in in the Otokuni district, states that these In school sculptures are not only tied to the late Heian period (as it has often been said of sculpture

in the Kyoto area) but also to the Kei school in view of their vivid and realistic expressiveness. The use of prominent "variants" in the sculpture of Kyoto artists belonging to the Nara school may be further justified by the fact that Buddhist art in Japan has always considered this center as a model.

The article by Shimuzu Mazumi (1974) has contributed to the reevaluation of the In schools, no longer seen as sterile, though refined, repetitions of Heian models. Mazumi, by reviewing the works of the sculptor Inko, who worked at the Ashikaya court, can prove that the In school had been active in the urban area until the Muromachi period. Yet realism in the feudal period manifests itself not only in sculpture but naturally in the other aspects of artistic expression. The new style of the naturalistic portrait (nise-e), which appeared first in the Kamakura period, was reviewed by Mori Toru (1971) in all of its most relevant stylistic and thematic variations, including the representations of the great masters of esoteric Buddhism. The portrayal of the female image, in the real sense of the word, began instead in the middle of the Muromachi period, even though in the Kamakura period a few images of female poets had already appeared. A special issue of Yamato Bunka (n.56, 1972) was dedicated to the analysis of this particular production, used to a greater extent for ritual purposes and for funeral rites. However, many other aspects of this vast and varied pictorial collection have been reviewed in recent years. This is especially true of the Sumi-e, the monochromatic painting so inseparably tied to Ch'an painting and to the China of the Sung and of the Yuan, but also rich in typically local original cues.

In addition to the general review by T. Matsushita (1974), the works of the most important painters of this period have been examined by Y. Shimizu and C. Wheelwright (1976), including the entire ink production, recently exhibited and belonging to American collections. In regard to Sesshu (1441-1507), one of the best known painters of the Muromachi period, the multi-stylistic features of his works (which gather elements of the so-called expressionist and impressionist movements of the China of the Sung) have not only been defined, but their relationship to other painters, such as Shubun and Sesson, has been proven by I. Tanaka (1972).

In addition, I. Tanaka, together with Y. Yonezawa, published (1974) an article on Sesshu works on the subject "flowers and birds," trying to establish among various "attributes" those that may be more reliably authenticated. I. Tanaka (1969) and G. Poncini (1972) have reviewed the works of Josetsu, founder of the so-called "new style" and teacher of Shubun, acknowledged by Sesshu himself as a guide. The reviews on his main works have identified the fundamental function of his art as introducing to Japan not only the stylistic Chinese models but also as creating a typically Japanese theme and a new Zen style as compared to Ch'an. The subsequent interesting discovery of other copies of the famous Hsiao and Hsiang landscapes by Sesson (born in 1504), published by T. Nakamura (1973), has widened our understanding of this artist whose works, closely related to the Southern Sung, are nevertheless so autonomous, so "Japanese," in their interpretation of landscape.

The artistic language of these painters, and above all of Sesshu, has been a decisive factor in the evolution of Japanese pictorial styles. Their works, enlarged to fit in the wide surfaces of the "Fusuma," lost in intensity but gained in charm and decorativeness. Interesting is the connection made by V. Elisseeff (1973) between the Kano shogunal school, displaying lively colors and frivolous themes, and the sober works of the Sumi-e. In fact, states Elisseeff: "the Kano's genius consists of having been able to unite Chinese abstraction to the colorful poetry of ancient Japanese tradition: painting Japanese style (Yamato-e)."

J. Umezu (1972) has dedicated a series of essays to the Emakimono of the Kamakura and Muromachi periods, publishing also the texts which constitute, among other things, an interesting collection of sources. T. Akiyama's study (1975) on the Emaki Amawakahiko Soshi (discovered in 1931 by his father), displayed at the Berlin Museum and traced to the 15th century, further defines the typical Muromachi spatial composition (figures in small scale, rich in animation, and interspaced by wide blank spaces).

As previously mentioned, during the Kamakura period many Japanese artist-monks left for China to complete their religious studies. However, this phenomenon was limited to the elite, or basically to the clergy, the aristocracy, and the court. Only later, during the Muromachi period, with the expansion of trade, did Chinese techniques and style enter Japanese handicraft.

As S. Mizoguchi (1973) properly observes: "This development is above all evident toward the middle of the sixteenth century, when Yoshimasa encouraged the imitation of Chinese art by Japanese artisans. Especially in the lacquers, one can detect the techniques and the decorative motifs of the Ming, though often combined with typically Japanese subjects and ornamentations."

In addition, excavations of numerous ceramic ovens, even outside the Seto area, carried out in recent years by Japanese archaeologists, have in a certain sense completed the picture of the various elements connecting Chinese and Japanese handicraft during this period. A review on the style called Temmoku has been prepared by J. Marshall Plummer (1972) and published posthumously.

Momoyama Period (1573 - 1614 A.D*)*. – This brief period has been recognized in recent years as one of the finest moments in Japanese art. The advent of political disunity and social instability that led to economic, political, and social changes broke away from the traditional elements of the past but also led an innovative thrust toward the search for new artistic expressions. Without any doubt this was an age of grandeur, as stated by J. Meech-Pekank (1976) in his recent study on Momoyama art. The brief occupation of Korea and the relations with the West enriched the artistic language of Japan through the introduction of new and extremely important expressive forms, such as the Yi ceramics transplanted to Arita and the European-inspired art known as Namban, belonging to the barbarians from the south.

Simultaneously, ancient traditional motifs, particularly those pertaining to the classic Heian period, were revived and reinterpreted with an almost neo-classic touch, were this term not too cold for describing the lively and richly decorative essence of the Momoyama period. Barriers separating various arts disappeared in richness and in the variety of forms and colors. Architectural space was also determined by the integration of

Fusuma paintings, carvings, and sculptures. The costumes worn in the No theater were at times real pictorial works of art in which naturalist, realistic, and abstract images alternate with perfect equilibrium and symmetry. One of the most innovative creations of the Momoyama art expression is definitely architecture as exemplified by the huge and complex building and planimetric code of the typical shogun and daimyo (feudal lord) castle. Scholars such as S. Hirai (1965) and M. Fujioka (1971) have provided monographies on this type of architecture emphasizing its structural and functional characteristics and disavowing previous accounts labelling it redundant and gaudy.

The great variety of structures, which often followed the natural contours of the terrain, the dissonancy of the volumetric masses (the modular element, the ancient Chinese "tien" superimposed and juxtaposed according to functional requirements), the rich variety of roofs, the openings, the color contrast with white walls, the living rock of the counterforts, and finally the tiles of the roofs made the castle one of the finest and most suggestive creations of Japanese art.

As stated by V. Elisseeff (1974): "Castles brought forth the secularization of Japanese architecture which up to the Momoyama period had remained essentially religious under any aspect. In fact, China taught Japan not to separate, in a distinct manner, religious from lay architecture." However, that secularization was not an immediate process is demonstrated by a study by Naito Akura (1976) on the Azuchi castle in the Shigo prefecture. This castle (built starting in 1576 by Oda Nobunaga) was presumably the first well-defined example of this building style in Japanese architecture. On the basis of historical data and of recently discovered works shedding light on the historical significance of the Azuchi structure, Elisseeff shows that the Donjon (the central edifice) displayed quite different features than later castles (Matsumoto, Himaji, Matsue) built for military purposes only. The castle served also as a political and religious center, a fact well-emphasized by the stupa raised in the middle of the building, which for Nobunaga was also a symbol of national unification.

Castles also became centers from which city planning radiated (the famous fortress-cities). However, the verticality of castles, noticeable in the framework of an architecture that was mainly horizontal, guaranteed their predominance in the urban context. The strict Chinese centrality and axiality were no longer necessary, and though the layout of dwellings was regulated by strict hierarchical laws (closer to the castle were the dwellings of the samurai, according to rank; further away dwelled artisans, merchants, and peasants, separated by profession in individual districts), one did not witness, generally speaking, a predisposed geometric and symmetric urban planning. The same capital of Kyoto is an example. Almost completely destroyed, it was rebuilt at various times within an irregular and broken perimeter enclosing only its eastern districts. The administrative and government buildings, including the imperial residence (Hideyoshi castle), held an eccentric position. In fact, the same socio-political feudal structure which set a relationship of direct dependence between master and subject had no need to expose itself in the urban plan through a precise axiality and symmetry; a phenomenon that is encountered also in Western medieval villages.

In the framework of the reevaluation of the Momoyama period as a time of innovation in Japanese art, numerous studies on paintings have appeared. The rich decorative gusto, surprisingly blended to a vivid realism, has been examined by Takeda Tsuneo (1971) and by T. Doi (1976) with special emphasis on the "birds and flowers" themes. Even genre painting, one of the favorites of the period for its vitality and inventiveness, has been studied, particularly by Yuzo Yamane (1973).

The recent discovery of a painting portraying a kabuki of Okuni (published by M. Narazaki, 1976), made around 1605, has added another superb specimen to that typical view of men and architecture and to that vivid attention to detail and everyday contemporary life, through synthetic stylization, of which the Japanese are masters. However, no drawings have been found representing vertical sections of buildings, a definite indication that a realistic depth remains at the base of Momoyama style and decoration.

The Momoyama interest in the exotic world — that is, for the West — conveyed through Namban art, has been extensively studied by both Western and Oriental scholars (Okamoto Yoshinomo, 1972; A. Tamburello). Full of realism, these images often reached surprising caricature effects in the exaggeration of personal traits. The tendency toward caricature is always present in Japanese art; for example, certain Zen paintings or Buddhist scrolls with animal scenes. Caricature manifested itself in these works through a variety of features. Of great interest for the understanding of Namban art is the study of works created for export. In our opinion, these works represent a further step in research on the fusion of Japanese and Western art. J. Okada (1974), for example, has analyzed an icon with a crucifix traceable to the Keiko period (1569-1614).

As J. Okada rightly observes, the fantastic work in lacquer on the case, combining Japanese hira-makie techniques and the motifs inspired by Chinese and Korean lacquer of the Yi dynasty with Western style decorations, stands out even more than the image of Christ itself.

The remarkable enrichment of techniques, typologies and decorational motifs of the Momoyama ceramics can be attributed also to the willingness of the artistic language to assimilate foreign ideas, particularly Chinese and Korean ideas, and to re-elaborate them in a Japanese way. Recent excavations of ceramic ovens, particularly in Kutani and Arita, have set certain premises for the solution of the many questions arising from this varied production, especially those concerning the origin of the first Japanese ceramics.

Edo Period (1615 - 1868 A.D.). – This is the period of the progressive affirmation of the bourgeoisie in Japanese society. As S. Mizoguchi (1973) admits: ". . . for the first time in the history of Japan, the urban commoners (particularly the wealthy inhabitants of the cities not holding an official position) imposed themselves as a dominant cultural force on society." A continuing debate thus began between the aristocrats and the military (shogun, daimyo, and samurai) who held political power and the merchant class (chonin) which was slowly coming into possession of the greater portion of economic power. It was this struggle between a traditionalist world tied to the past and the innovative thrust of a social class full of vitality and energy which natu-

rally led to the formation of different and often contrasting artistic styles. One witnessed therefore a contrast between pro-Chinese artists (kogaku, ancient school) and the followers of the Kokugaku or the national school. In literature as well as in painting, the former re-elaborated the Ming and Ch'ing patterns while the latter revived, under new aspects, the great autocton trends, especially the Yamato-e. The pro-Chinese artists were more often tied to the aristocratic and military classes. The Kokugaku artists conformed more to the rich merchant class that longed to see itself in pictorial works, for which the art of printing offered an enormous potential for diffusion, thus constituting a challenge to the more elitist and aristocratic phenomenon that was painting.

Feudal power receded even in architecture. The castles, for the greater part, were no longer built high and monumental, but became more symmetrical and uniform structures, an example being the star-shaped Goryokaku castle of Hakodate (1860). In order to outdistance surrounding structures, castles were encircled by gardens, patterned partially after the classic Shoin style (Nijo and Edo castles). Only the high surrounding walls, the ramparts, and the moats clearly reflected their ancient defensive purpose.

Yet the rise to power of the merchant class (starting in the 18th century) can be better seen in the tremendous growth of urban centers and in the city planning and architectural solutions that were proposed. In a collection edited by A. Turco (1975) and G. Rozman (1973), the spread of urban centers and their relationship to the countryside is analyzed, the best example being Edo (Tokyo), built around the castle of the Tokugawa shoguns, whose population in 1700 had already reached one million. This abnormal growth (attributed partly to a law that forced the feudatories - daimyo - and their followers to reside in the capital for part of the year) called for new structural solutions (use of multifloors, masonry, and tiles as an anti-fire measure) and brought forth the so-called "sukija" style. While from the urban standpoint this type of development was in sharp contrast to the development of the primitive imperial capitals, well-defined districts still grouped the various classes according to occupational status. To enforce and better control this type of segregation the authorities had even forbidden the printing of city maps.

The connection between Edo architecture and the garden has been recently reviewed by N. Okawa (1975) in relation to the Katsura and Nikko structures. Nothing was left to chance, everything was analyzed and accomplished with the subtle style of a landscape painter to the most minute detail in accordance with complex symbolic procedures closely related to Zen. Yet the final result was surprising simplicity and harmony. This constituted the prototype of all Japanese garden-making, which has had a profound influence even in the Western world.

Paradoxically, it was the West which gave exact and full value, in the eyes of the Japanese, to one of the most typical artistic forms of expression of this period: printing (Changa), known as Ukiyo-e. In fact, in the Japan of the 18th and 19th centuries, prints, which had become widely diffused among the bourgeoisie as a replacement for the too rare and expensive paintings, were not really considered by official culture as real artistic expressions, but were rather appreciated for their documentary and vaguely decorative aspect. It was the interest and also imitation by impressionistic painters such as Degas, Manet, Monet, and Van Gogh that made the Japanese recognize the originality, vitality, and style of their prints.

The Ukiyo-e school still continues to attract the attention of art historians and of the artists themselves. Numerous reprints of ancient masterpieces, exhibits, extensive monographies, and critiques (H. P. Stern, 1969, 1973; R. S. Keyes and K. Mizushima, 1973; G. C. Calza, 1976) have documented its traditional autocton roots and the Yamato-e connection. Also documented were ties with the late Kano and Tosa schools, Chinese traditions, and the impact of the bourgeoisie over the formulation of aesthetic codes (G. C. Calza, 1973, 1976). Its complete autonomy from pictorial techniques, starting from the middle of the 18th century with the practice of the beni-suri-e, which later utilized Chinese wood-block prints and promoted new chromatic and stylistic solutions, has also been more precisely defined.

Above all, the most important artistic personalities of the time have been examined, such as Hishikawa Monorobu (1618 - 1694), who was the first artist to reproduce in prints scenes of life in the capital. (M. Gentles, 1964); Kitagawa Utamaro (1753 - 1806), a great master of figure design (J. Hillier 1961); and Thoshusai Sharaku (active in 1794 - 1795), who employed Utamaro's techniques in his caricatures of actors' portraits. In regard to Sharaku, of whom we have sketchy biographical information, two polychrome prints (mentioned by Kakka n. 964, 1973) representing actors were discovered in 1970 in the Art and History Museum of Belgium. These prints belong to the less documented production of his later years, and they certainly constitute useful reference material for future studies.

Hokusai (1760 - 1849) and Hiroshige (1797 - 1858), the two great landscapists who renewed the Ukiyo-e repertory, which had become by then standardized and monotonous, have been cited, among others, by E. Ripley (1968) and B. W. Robinson (1964) for their connection to tradition, but particularly for their innovative solutions.

The interest in recent years in the varied and multi-form pictorial expressions of the Edo period has obviously not neglected the famous Bunjin-ga (School of the Letterati) or the Nanga (painting of the South) which adopted as a model the so-called southern painting of the Ming and Ch'ing (as an example, the long monographies of S. Cahil (1972), C. H. Mitchell (1972), and S. Addiss (1976).

Yet, a more complete analysis of the main schools brings forth, in our opinion, the impossibility of finding, especially in that period so full of unrest and contrasts, a clear demarcation line separating the works of individual artists according to different codes. Even within the Nango school, for example, Yosa Buson (1716 - 1783), as Sasaki Johei observes, does not hesitate to use Kano patterns of the Muromachi and Monoyama periods and cues drawn from the otsu-e. The ancient "classic" Japanese style reemerges even in the aristocratic painting of the Tosa and of the Kano through the work of such masters as Sotatsu. The term "neo-Yamato" is indeed quite accurate when applied to

some Sotatsu paintings, recently analyzed by Yamane Yuzo (1975) just because of their relationship to the Emaki. Neo-Yamato may well be easily applied also to certain works by Kano Naonobu (1607 - 1650). His "Artisans at Work," described by Shirahata Yoshi (1975), displays techniques and features with close connections to the Yamato-e.

But certainly, the typical eclecticism of this period, rich in social contrasts and unrest, triumphs in the Western style painting known also as Komo-ga. This style, widely acclaimed also by the bourgeoisie, is characterized by a blend of European realism, perspective, and colors and special Japanese techniques and styles. Artists such as Shiba Kokan (1738 - 1818) are still viewed today with great interest, even under the profile of "avant-garde" of the later Meiji period painting. This painter, to whose works a great exhibit was dedicated in the city of Nara in 1969, is, according to Funo Naruse (1979, 1975), a champion of the eclecticism typical of the 18th and 19th centuries, whose style spans from the Western to the Ganga and from the Ukiyo-e to the Yamato-e.

Even the rich and varied artisan creations in which the style and techniques of the Ming, the Ch'ing, Yi, and Western add themselves to the traditional Japanese have the focus of interesting studies covering the textile art (an entire issue of Yamato Bunka, n. 55, 1972, has been dedicated to the kimonos of Ieyasu) and ceramics (Sato Masahito, 1973; Hayashya Seiso, 1972).

Two contrasting poles are present in artisan works: Kyoto, the imperial capital guardian of taste and traditional culture; and Tokyo, seat of the Tokugawa shogunate and of the bourgeoisie to which other mercantile centers (open to any type of innovation and unrest) such as Osaka can be added. In addition, certain regional works of art created by common people are being evaluated today. This well-defined art was encouraged by various local leaders (daimyo) and is described by the term "Mingei" or popular art. Its subjects represent everyday life, and, as H. Munsterberg (1968) affirms: "are highly appreciated for their simplicity and beauty" Mingei influence can be particularly felt in various art works of modern day Japan.

Modern and Contemporary Period. – The massive westernization of Japan (which began in the Meiji-Taisho period, after 1926) and the revolutionary philosophies that were introduced into the traditional artistic language have long since been the object of detailed studies by both Oriental and Western scholars. In the last few years particular interest has been focused on the great influence that ancient Japanese arts have had on the evolution of European and American art. We have already mentioned the great impact that the discovery of the Ukiyo-e had on French impressionists (the round table discussions held in 1968 in Tokyo on the relationship between Japanese and Western art).

Above all in architecture, the respect of nature, the modularity, the structuralism, and the prefabrication that defines the Far Eastern, and particularly the Japanese, living space has, as W. Blazer (1975) emphasized, been frequently a constant reference point for distinguished Western architects such as F. L. Wright, O. Wagner, G. Rietveld, and L. Mies van der Rohe. It is therefore natural that after a period of mere imitation of the models of the eclectic 19th-century Western trends, Japanese architecture created new and well-defined styles, accomplished without losing their connection to the evolution of contemporary foreign architecture. Examples are the creations of Kenzo Tange and Kunyo Maekava which still inspire contemporary architects and critics (E. Tempel, 1969; R. Boyd, 1969).

The avant-garde groups which emerge today, such as the so-called "Metabolism Group," have in fact been recognized at the international level. Osaka's Sony tower by Noriaki Kurokawa is an example. The tower is above all a fusion of the ancient Japanese theater (abstract effects based on black and white and on the geometrization of volumes) and the most lively features of the modern anticlassic expression (asymmetry, dissonance, fulfilling structures) achieved through the use of the most advanced technology.

Likewise, as V. Elisseeff states: "the various schools of Japanese sculpture, established both in Japan and abroad, point out that even in sculpture Japan did not become the docile apprentice of foreign schools." Sensitive to matter and to form, the Japanese artist uses by tradition the realistic and expressionistic forms of Buddhist sculpture and painting as well as the symbolic and abstract expression of Raku ceramics, of Chintoist symbols, of Ikabana, and of the garden arrangement of rocks, plants, and sand. Not by chance, one of the most valid modern Japanese examples is the permanent Museum of Nino Daira (1969). The museum has been dedicated to sculpture "en plein air," and it is mainly nature — that is, the park — which superbly united with sculpture recreates the ancient tie between man and nature, between the microcosm and macrocosm.

The volumes of Tashigahara Sofu bury their roots in the deep past. These works inspire themselves to the elegant and subtle floral composition and to the fantastic vitality of Jomon ceramics. Nagano Ryuyyo's works and Ueki Shiyeru's abstractions and, after 1950, the works of the entire Niko-kai group are only a few examples of a creativity in full swing.

The debate which evolved during the Meiji period between the promoters of traditional artistic expression and national values and the followers of Western models is present in every aspect of art and culture. This is even more evident in painting, where artists devoted to "Nihon'ya" (Japanese painting), the promoters of ancient traditional values, aligned themselves against "Yoga" (Western painting, which during the first years of the Meiji period had become very popular). In 1888 the supporters of the Nihon-ya were even able to close the Fine Arts School (Kobu Bijutsu) where mostly Italian artists (A. Fontanesi, G. V. Cappelletti, and V. Ragusa) worked. Yet the real overcoming of these conflicts, more so than in the ideological struggles and aesthetic critique, took place in successive paintings wherein current Western trends blended and integrated themselves with artistic traditional styles, such as those pertaining to Zen painting, the calligraphic arts, Yamato-e, and Ukiyo-e.

In fact, in spite of the spread of Fauvism and Surrealism, it was pure abstraction, the closest art form to ancient traditions, which triumphed in the post-war years. Accordingly, it is in such avant-garde trends that Japanese painting shows a clear preference for the informal, though a preference united to the freedom of stroke typical of the painting of the bunjin-ga and of the taste for characteristic color of the ancient traditional schools such as the Yamato-e and the Tosa.

Similarly, even the great wealth of styles, decorative motifs, techniques, and traditional craftmanship (lacquers, furniture, ceramics) merges to a great extent into modern design. This constitutes an additional proof of the great willingness of Japanese artists to welcome and accept new artistic expressions and to readily reelaborate them in a manner which is uniquely and typically Japanese.

BIBLIOGRAPHY - *a) Bibliographies*: Annual Bibliography of Oriental Studies, Kyōto University; Kokusai Bunka Shinkokai, Bibliography of Standard Reference Books for Japanese Studies with descriptive notes, Tōkyō, 1959; Books and Articles on Oriental Subjects Published in Japan during 1959, vol. 6, Tōkyō, 1960; B.S. Silberman, Japan and Korea: A Critical Bibliography, Tucson, 1962; Centre for East Asian Cultural Studies, A survey of Japanese bibliographies concerning Asian studies, Tōkyō, 1963; Centre for East Asian Cultural Studies, A survey of bibliographies in Western languages concerning East and South-East Asian studies, Tōkyō, 1966; Bibliography of Asian Studies, Pittsburg 1970 (for the preceding period see the bibliography volume in the "Journal of Asian Studies"); F.J. Shulman, Japan and Korea, An Annotated Bibliography of Doctoral Dissertations in Western Language, 1877-1969, Chicago, 1970; Books on Japan, An Assorted Bibliography, Kyōto, 1974; The Japan Foundation, An Introductory bibliography for Japanese Studies, vol. I, part. 2, Tōkyō, 1975.

b) General Works: Emakimono Zenshū (Collezione completa di emakimono), Tōkyō, 1958-69; N. Egami, Sekai bijutsu zenshū (una collezione completa di Arte del Mondo), vol. I-XI, Tōkyō, 1960; T. Hasumi, Japanische Plastik, Friburg, 1960; R.A. Miller, Japanese Ceramics, Tōkyō, 1960; S. Rokkaku, Tōyō shikko shi (Storia della lacca in Estremo Oriente), Tōkyō, 1960; G. Sansom, Einführung in die kunst Ostasiens, München, 1960; E.D. Saunders, Mudrā, A Study of Symbolic Gestures in Japanese Buddhist Sculpture, New York, 1960; C. Yamada, Decorative Arts of Japan, Tōkyō, 1960; T. Akiyama, La Peinture Japanaise, Genève, 1961; A. Barbanson, Fables in Ivory. Japanese netsuke and their Legendes, Rutland, Tōkyō, 1961; S. Lee. Japanese Decorative Style, New York, 1961; B.W. Robinson, The Arts of the Japanese Sword, London, 1961; H. Okudaira, Emaki, Japanese Picture Scrolls, Rutland, Tōkyō, 1962; Gakuyo Shobo, Japanese interiors, Tōkyō, 1962; W. Alex, Japanese Architecture, New York, 1963; T. Kuno, A Guide to Japanese Sculpture, Tōkyō, 1963; S.E. Lee, Tea Taste in Japanese Art, New York, 1963; P. Swann, The Arts of China, Corea and Japan, London, 1963; T. Iwamiya, Schönheit Japanischer Formen, Fribourg, 1964; Shibusawa Keizō Emakimono ni yom Nippon Shomin Seikatsu Ebiki (La vita del popolo giapponese come è illustrata dagli emakimono), Tōkyō, 1964; S. Lee, A History of Far Eastern Art, New York, 1964; H. Münsterberg, The Ceramic Art of Japan, Rutland, 1964; S. Noma, The Art of Clay, Tōkyō, 1964; C.F. Yamada, Decorative Arts of Japan, Tōkyō, 1964; S. Jenyns, Japanese Porcelain, London, 1965; S. Noma, The Arts of Japan, Tōkyō, 1965-1967; R. Saito, Suiboku, Studies in Japanese Ink Painting, Tōkyō, 1965; B. Smith, Japan Geschichte and Kunst, München, 1965; M. Sullivan, Chinese and Japanese Art, New York, 1965; P. Swann, Japan, Baden-Baden, 1965; N. Egami, Nihon bjutsu no tanjo (La nascita dell'arte giapponese), Tōkyō, 1966; J.E. Kidder, Japanese Buddhist Temples, Tōkyō, 1966; H. Ota, Japanese Architecture and Gardens, Tokyo, 1966; W. Speiser, Die Lackkunst Ostensiens, Baden-Baden, 1966; P. Swann, Die Kunst Japans, Baden-Baden, 1966; H.L. Joly, Legends in Japanese Art, Rutland, 1967; B. von Rague, Geschichte der Japanischen Lackkunst, Berlin, 1967; T. Akiyama, Emakimono, Tōkyō, 1968; L. Kuck, The World of the Japanese Garden: From Chinese Origins to Modern Landscape Art, New York, 1968; H. Münsterberg, Der Ferne Osten, Baden-Baden, 1968; H.H. Sanders, Kenkichi Tomimoto, The World of Japanese Ceramics, Tōkyō, 1968; Kokuhō (Tesori nazionali) 12 vols. Tōkyō, 1968-69; L. Frédéric, Japan, Art et Civilisation, Paris, 1969; Nihon Kaiga-kan (Completa Storia della pittura giapponese), 12 vols., Tōkyō, 1969-71; D. Sadun, Emakimono: Struttura tecnica e storia, Il Giappone, IX, 1969; J. Fontein, L. Hickman, Zen Painting and Calligraphy, Boston, 1970; H. Münsterberg, Dyāna in Japanese Art, India's Contribution to World Thought and Culture, Bombay, 1970; J.M. Rosenfield, Shimada Shujirō, Traditions of Japanese Art, Harvard, 1970; T. Tsuruta, A Chronology of Japanese Essays on Art, Bunka 33, n. 4, 1970; R.L. Andrews, Japan: A Social and Economic Geography, Hong Kong, 1971; J.W. Dower, The Elements of Japanese Design, New York-Tōkyō, 1971; T. Hamada, Mandara no sekai - Mikkyō kaiga no tenkai (The evolution of esoteric Buddista paintings), Tōkyō, 1971; S, Kanto, Japanese Gardens: Islands of Serenity, Tōkyō, 1971; G. Kato, Chawan jiten (Dizionario di tazze per il the), Osaka, 1971; D. Keen, Landscape & Portraits, Appreciations of Japanese Culture, Tōkyō, 1971; M. Ooka, Nihon Kenchiku no ishō to gihō (Disegni e tecniche dell'architettura giapponese), Tōkyō, 1971; A. Tamburello, I grandi Monumenti del Giappone, Milano, 1971; T. Itō, The Classical Tradition in Japanese Architecture, Tōkyō-New York, 1972; T. Itō, The Japanese Garden, An Approach to Nature, Yale, 1972; T. Mikami, The Art of Japanese Ceramics, New York, Tōkyō, 1972; M. Ridley, Far Eastern Antiquities, London, 1972; T. Sawa, Art in Japanese Esoteric Buddhism, Tōkyō-New York, 1972; Shōheki-ga zenshu (Collezione completa di pitture murali) vol. 12, Tōkyō, 1972; R. Fujioka, Tea Ceremony utensils, New York-Tōkyō, 1973; M. Ishida, Studies in Cultural History of Eastern Asia, Tokyo, 1973; T. Itō, Space and Illusion in the Japanese Garden, New York, Tōkyō & Kyoto, 1973; H. Kageyama, The Arts of Shinto, New York-Tōkyō, 1973; S. Mizoguchi, Design motifs, New York-Tōkyō, 1973; K. Muraoka, K. Okamura, Folk Arts and Crafts of Japan, New York-Tōkyō, 1973; H. Okudaira, Narrative Picture Scrolls, New York-Tōkyō, 1973; M. Ooka, Temples of Nara and Their Art, New York-Tōkyō, 1973; N. Takeuchi, Researchers on the History of Zen Art: The Art of the Sōtō Order at Eihei-ji Temple, Museum, 1973, 264; A. Tamburello, Giappone, in M. Bussagli, Architettura Orientale, Venezia, 1973; D. et V. Elisséeff, La civilisåtion Japonaise, Paris, 1974; K. Machida, Nihon Kodai Chōkokushi gaisetsu (Cenni di storia dell'antica cultura giapponese), Tōkyō, 1974; Matsubara Shigeru, The Date of the Murasaki Shikibu Nikki Ekotoba from the view point of the calligraphic style of this text, Museum, 1974, 276; S. Noma, Japanese Costume and Textile Arts, Tōkyō, 1975; S. Uehara, On Objects Installed in the Cavities Inside Buddhist Statues, Museum, 1975, 280; N. Gutschow, Die Japanische Burg-stadt, Paderborn, 1976; L.P. Roberts, A Dictionary of Japanese Artists, Painting, Sculpture, Ceramics, Prints, Lacquer, New York, 1976; F. Maraini, Tōkyō, Amsterdam, 1976; M. Medley, Artistic Personality and Decorative Style in Japanese Art, London, 1976.

c) Prehistory and Protohistory: T. Esaka, Clay Figurines, Tōkyō, 1960; S. Hosaka, Studies on Recent Accessions, Haniwa Figures of Armored Men, Museum, 111, 1960; Y. Kōndo, Bronze Mirror with Design of Houses Excavated at the Takarazuka Burial Mound, Samida, Yamato Province,

Museum, 114, 1960; N. Matsubara, Haniwa, Tokyo, 1960; F. Miki, Haniwa: The Clay Sculpture of Protohistoric Japan, Tōkyō, 1960; I. Murai, Pottery and Haniwa, Tōkyō, 1960; Y. Noguchi, The Development of the so-called 'Goggled Figurines', Museum, 109, 1960; S. Otsuka, S. Suzuki, I. Sano, Sammaizuka Tomb, Tōkyō, 1960; S. Serizawa, The Stone Age of Japan, Tōkyō, 1960; M. Date, On the Haniwa Cylinder Coffins Excavated at Narayama in Nara City, Kodaigaku Kenkyū, 27, 1961; T. Esaka, A Clay Figurine in Sitting Position, Yamato Bunka, 37, 1961; T. Higuchi, Report on the Investigation of Shichikan Tomb of Izumi Province, Kodaigaku Kenkyū, 27, 1961; M. Ishibe, Haniwa Cylindrical Coffins, Kodaigaku Kenkyū, 27, 1961; Y. Noguchi, The Two Prehistoric figurines from the Yoyama Shellmound, Museum, 121, 1961; K. Mori, A Reexamination of the Excavated Condition of Haniwa Figures, Kodaigaku Kenkyu, 29, 1961; M. Svenaga, Tombs of Japan, Tōkyō, 1961; M. Homma, The Treatment of Space in Japanese Primitive Sculpture, Museum, 133, 1962; J. Komatsu, The Japanese People, Origins of the People and the Language, Tōkyō, 1962; H. Kanaseki, Recent Discovered Materials of Archaeological Research: Two Bronze Ring-shape Pommels from the Tumulus of Todaiji-yama, Yamato, Kōkogaku Zasshi, XLVII, 1962; K. Tange, N. Nawazoe, Y. Watanabe, Ise-Nihon Kenchiku no Genkei (Ise - Le origini dell'architettura giapponese), Tōkyō, 1962; P.J. Ucko, The Interpretation of Prehistoric Anthropomorphic Figurines, The Journal of the Royal Anthropological Institute, 92, I, 1962; F. Miki, Haniwa Shields, Museum, 153, 1963; M. Suenaga, Haniwa Hawkei, Yamato Bunka, 37, 1963; I. Yawata, Jōmon Pottery and Clay Figurines, Tōkyō, 1963; N. Egami, The Formation of the People and Origins of the State in Japan, Memoir of the Research Department of Tōkyō, Bunko 23, 1964; F. Ikawa, The Continuity of Nonceramic to Ceramic Cultures in Japan, Arctic Anthropology, vol. 2, 2, 1964; J.E. Kidder, Early Japanese Art, The Great Tombs and Treasures, London, 1964; Primitive Art of Japan, 6 vols., Tōkyō, 65, 1964; T. Shiraishi, On the Description of the Mausoleums in the Kojiki, the Nihonshoki and the Engishiki, Kodaigaku, XVI, 1, 1967; F. Iwaka, Some Aspect of Paleolithic Cultures in Japan, Paris, 1968; J.E. Kidder, Prehistoric Japanese Arts, Jōmon Pottery, Tōkyō, 1968; T. Kondō, A Study on the Relationship between the Flatype Bronze Found in Japan, Kodaigaku, XVII, 3, 1968; R. Pearson, The Archaeology of the Ryukyu Islands, Honolulu, 1969; K. Suzuki, Design System in Later Jōmon Pottery, Zinruigaku Zasshi, 78, 1, 1970; W. Watson, Cultural Frontiers of Ancient East Asia, Edinburgh, 1971; P. Bleed, Yayoi Cultures of Japan: An Interpretative Summary, Arctic Anthropology 9, 1, 1972; R. Pearson, The Ryukyus, Asian Perspectives, 15, 1973; M. Suzuki, Chronology of Prehistoric Human Activity in Kantō, Japan, Journal of the Faculty of Science, University of Tōkyō, vol. III, V, 1973, vol. IV, IV, 1974; C. Chard, Northeast Asia in Prehistory, Madison, 1974; V. Elisseeff, Archéologie Japonaise, Genève, Paris-Munich, 1974; F. Miki, Haniwa, New York-Tōkyō, 1974; M. Watanabe, The Basic Study of Jōmon Jar Burials, Kōkogaku Ronsō, 2, 1974; M. Watanabe, Various Patterns of Man's Adaption to the Natural Environments in the Jōmon Age, The Quaternary Research, vol. B., 3, 1974; T. Satō, Comments in the Neolithic Culture of Korea, in R. Pearson, The Traditional Culture and Society of Korea: Prehistory, Honolulu, 1975; R. Pearson, The Contribution of Archaeology to Japanese Studies, the Journal of Japanese Studies, vol. 2, n. 2, 1976.

d) Asuka and Nara: L. Warner, Japanese Sculpture of the Tempyō Period, Harvard, 1964; Shosoinran Mokuroku (Mostra speciale dei tesori dello Shosoin), Nara, 1965; S. Tanaka, History of the Sairin-ji Temple of Furuchi, Kawachi province, Kodaigaku, XIV, 1965, n. 1; K. Yabuta, Notes on the inscription on Nimbus of Sakya Buddha and its attendant, dated year of bo-shi, in possession of Hōryuji Temple in Nara, Kodaigaku, XV, 1966, n. 1; J.E. Kidder, Ajantā and Hōryūji, India's Contribution to World Thought and Culture, Bombay, 1970; Masashi Sawamura, Kojiro Naoki et al.; The Reports of the Historical Investigation of the Forbidden City of Naniwa, Osaka, 1970; E. Kidder, The Newly Discovered Takamatsuzuka Tomb, Monumenta Nipponica, XXVII, 3, 1972; Kawano Keisuke, Mugino Hiroshi, Takamatsuzuka Kofun, Tōkyō, 1972; K. Machida, The Statue of Yakushi in Hōryū-ji Kondō is an Imitative Antique Style Work, Kokka 951, 1972; Masaaki Iseki, Il tumulo di Takamatsu, Rapporto su un recente scavo in Giappone, Il Giappone, XII, 1972; S. Matsumoto, Takamatsuzuka hekigza no nendai suisetsu, Sekai, 319, 1972; P. Mortari Vergara Caffarelli, Proposte per una nuova cronologia e per un ulteriore esame critico dell'opera di Yü-ch'ih I-sêng, Rivista degli Studi Orientali, XLVI, 1972; S. Noma, Early Japanese Bronze Sculpture, Tōkyō, 1972; Shibata Maryse, La «Grande Sépolture» Takamatsu-zuka, Archeologia, 53, 1972; M. Suenaga, M. Inoue, Takamatsuzuka Kofun to Asuka, Tōkyō, 1972; F. Berthier, La Sepolture du Takamatsuzuka, Arts Asiatiques, XXVIII, 1973; H. Ishida, A Speculation on the Murals in the Takamatsuzuka Tomb, Museum, 264, 1973; K. Machida, The Gilt Bronze Buddhist Statuettes Originally Preserved at the Hōryūji and the Statue of Kannon Bosatsu Dated the Year Shin-gai, Kokka, 964, 1973; S. Matsubara, Tempyō period Buddhist Sculpture and the T'ang Style, Kokka, 967, 1974; S. Mizuno, Asuka Buddhist Art; Hōryū-ji, Tōkyō, 1974; T. Kobayashi, Nara Buddhist Art, Todai-ji, Tōkyō, 1975; D. Sadun, Il Kofun Takamatsuzuka. Una tomba a tumulo con dipinti murali nel Kinai, Rivista degli Studi Orientali, LIX, 1975, III, IV; R. Hayashi, Silk Road and Shoso-In, Tōkyō, 1976; K. Machida, The Guze Kannon in the Yumedoro and the Shi Tennō in the Main Hall of the Hōryū-ji, Kokka, 1976.

e) Heian: K. Asano, La Maison japonaise du VIII siècle à nos jours, Memoirs of the Faculty of Engineering, Osaka City University, vol. VI, 1964; J. Pezeu-Massabuao, La Maison japonaise et la neige. Études géographiques sur l'habitation du Hokuriku, Paris, 1966; J. Pezeu-Massabuao, Problèmes géographiques de la maison Japonaise, Annales de Géographie, 1966; S. Omi, A Study on the Round Eaves Roof Tiles Bearing the Hōtō Design Excavated from the Tsūhōji Temple, Kodaigaku, XVII, 1968, n. 1; Special Number Devoted to the monocrome picture scroll of the Ise-Monogatari, Yamato Bunka, 53, 1970; K. Kuno, Tōhoku Kodai chōkoku-shi no Kenkyū (Ricerche nella antica scultura della regione di Tōhoku), Tōkyō, 1971; T. Itō, Traditional Domestic Architecture of Japan, New York-Tōkyō, 1972; T. Kunio, On the Sculptural Image of Yakushi-Nyorai (Bhaisajyaguru vaidūrya) ensconced within the Hon-dō of Shin-Yakushi-ji Temple, Kokka, 948, 1972; S. Ienaga, Painting in the Yamato Style, New York-Tōkyō, 1973; T. Kudo, On the Fuki-no Odo, Kokka, 957, 1973; T. Kunio, Buddhist Statues in Kunisaki Peninsula, Kokka, 954, 1973; T. Kunio, Early Heian Statues at the Kanshin-ji Temple, Kokka, 961, 1973; Taguchi Eiichi, Studies on the Mural Paintings preserved within the Fuki-no Odo, Kokka, 957, 1973; K. Asai, About the Date of the Statue of Seated Amida Nyorai in the Lecture Hall of Kōryū-ji Temple, Kokka, 974, 1974; J.W. Hall, Medieval Japan, London, 1974; M. Mushakoji, The Old Buddhist Statues at the Kōzaki Jingū-ji, Shimōsa Province, Kokka, 965, 1974; N. Takeuchi, Portrait Paintings in Jodo Buddhism, Museum, 1974, 278; G. Nakano, Rock with line-engraved Buddha figures, Kokka,

979, 1975; K. Saito, The Honji-buhsu Statues at the Keisoku-ji, Kokka, 985, 1975; T. Fukuyama, Heian Temples: Byodo-in and Chuson-ji, Tōkyō, 1976; S. Yamada, Complete Sumi-e Techniques, Tōkyō, 1976.

f) Kamakura and Muromachi: R. Hempel, Zenga, Malerei des Zen Buddhismus, München, 1960; K. Brasch, Zenga, Tokyo, 1961; Kyōto National Museum, Muromachi jidai shoga (Pittura e Calligrafia del Periodo Muromachi) Kyōto, 1961; I. Tanaka, Josetsu, Shūbun to Akademi no Kreisei, Genshoku Nihon no Bijutsu II, Tōkyō, 1969; S. Hisamatsu, Zen and the Fine Arts, Tōkyō, 1971; Mizuo Shūichi, Composition in the Paintings of Sesshū, Japan Quarterly, XVIII, 3, 1971; T. Mori, Kamakura jidai no Shōzō-ga (Pitture di ritratto del periodo Kamakura), Tōkyō, 1971; J. Marshall Plumer, Temmoku, A Study of the Wares of Chien, Tōkyō, 1972; G. Nakano, The Buddhist Images in the Jakushō-in Temple, Kokka, 974, 1972; G. Poncini, Note sull'opera e la biografia di Josetsu, Annali dell'Istituto orientale di Napoli, 32 (N.S. XXII), 1972; Special Number Devoted to the Japanese Portrait paintings of ladies of the 16th and 17th centuries, Yamato Bunka, 56, 1972; I. Tanaka, Japanese Ink Painting: Shūbun to Sesshū, Tōkyō, New York, 1972; J. Umezu, Emakimono Sōshi (Saggi sul-l'Emakimono), Tōkyō, 1972; T. Matsushita, Ink Painting, New York, Tōkyō, 1974; A. Nakamura, The Newly Discovered Sesson's copy of the Scroll of Eight Sight of Hsiao and Hsiang, Museum, 270, 1973; M. Shimizu, The Buddhist Sculptor Inkō and His Works, Kokka, 973, 1974; I. Tanaka, Y. Yonezawa, About flower-and-bird Paintings by Sesshū (1420-1506), Kokka, 970, 1974; Y. Shimizu, C. Wheelwright, Japanese Ink Paintings from Armenian Collections: the Muromachi Period - An exhibition, Princeton, 1976; Tsuji Nobuo, Notes on Kanō Hideyori, Kokka, 986, 1976; T. Akiyama, Several Problems Concerning the Amawakahiko Sōshi Emaki on the occasion of the discovery of a complete version, Kokka, 985, 1975; K. Mizuno, The Sculptor Unkei and Sculptural Work on Atelier System, Museum, 294, 1975; A. Sato, Problems in the History of Sculpture of the Kamakura Period, Museum, 295, 1975; G. Poncini, I due Jūō-zu del Museo Nazionale d'Arte Orientale di Roma, Arte Orientale in Italia, IV; Roma, 1976.

g) Momoyama: J.B. Kirby Jr., From Castle to Teahouse, Tōkyō, 1962; S. Hirai, Shiro to Shoin (Castelli e shoin), Tōkyō, 1965; Murase Miyeko, Japanese screen paintings of the Hōgen and Heiji insurrections, Artibus Asiae, XXIX, 2-3, 1967; M. Fujioka, Kinsei no kenchiku (Architecture of the Modern period), Tōkyō, 1971; T. Takeda, Momoyama no kachō to fūzoku-shōhei-ga no sekai (Pitture di uccelli, di fiori e di genere del periodo Momoyama, Il mondo della pittura murale e su rotolo), Tōkyō, 1971; Y. Okamoto, The Namban Art of Japan, New York-Tōkyō, 1972; Hirai Kiyoshi, Feudal Architecture of Japan, New York, Tōkyō, 1973; Y. Yamane, Momoyama Genre Painting, New York, Tōkyō, 1973; J. Okada, The Crucifix Shrine Decorated in Maki-e and Japanese Export Lacquerware, Kokka, 966, 1974; T. Doi, Momoyama Decorative Painting, Tōkyō, 1976; J. Meech-Pekarik, Momoyama: Japanese Art in the Age of Grandeur, New York, 1976; A. Naito, Study of the Azuchi Castle, I, Kokka, 987, 1976; II, Kokka, 988, 1976; M. Narazaki, The Newly Discovered Okuni Kabuki Screen, Kokka, 989, 1976.

h) Edo: L. Binyon, J.J. O'Brien Sexton, Japanese Colour prints, London, 1960; J. Hillier, The Japanese Print - A New Approach, London, 1960; J. Hillier, Utamaro, London, 1961; R. Lane, Masters of the Japanese Print, London, 1962; M. Gentles, Masters of the Japanese Print: Moronobu to Utamaro, New York, 1964; B.W. Robinson, Hiroshige, New York, 1964; D.B. Waterhouse, Haronobu and his Age, London, 1964; Masaaki Iseki, La scultura di En Kū, Giappone, V, 1965; H. Münsterberg, Mingei, The Traditional Crafts of Japan, New York, 1965; Nihon no Bunjingaran Mokuroku (Mostra della "pittura dei letterati" giapponese), Tōkyō, 1965; T. Tamba, Hiroshige ichidai, Tōkyō, 1965; T. Yoshida, Ukiyo-e jiten, Tōkyō, 1965-71; M. Narazaki, Japanese Print: Its Evolution and Essence, Tōkyō, 1966; Y. Yonezawa, T. Yoshizawa, Bunjinga (Pitture dei letterati), Tōkyō, 1966; Istituto Giapponese di Cultura - Pitture giapponesi Ukiyo-e, Roma, 1968; E. Ripley, Hokusai: A Biography, London, 1968; Y. Yamane, Ogata Kōrin and the Genroku era, Acta Asiatica, 15, 1968; H.P. Stern, Master Prints of Japan: Ukiyo-e Hanga, Washington, 1969; Naruse Fujio, List of Books written or illustrated by Shiba Kōkan, Yamato Bunka, 52, 1970; Tadashi Sugase, Man and Thought of Shiba Kōkan, Yamato Bunka, 52, 1970; J. Suzuki, Utagawa Hiroshige, Tōkyō, 1970; J. Cahill, Scholar Painters of Japan, the Nanga School, New York, 1972; S. Hayashya, The Ceramic Art of Kōetsu and Kenzan, Museum, 26, 1972; S. Komatsu, Kōetsu, and Non Kōetsu, Museum, 259, 1972; T. Minamoto, The Style of Sōtatsu, Museum, 259, 1972; C.H. Mitchell, The Illustrated Books of the Nanga, Maruyama, Shijo and other Related Schools of Japan, Los Angeles, 1972; N. Tsuji, Soga Shōhaku's Paintings Existing in Ise Province, mainly on the works found in Matsuzaka City and Neighborhood, Kokka, 952, 1972; G.C. Calza, Il gusto borghese delle vedute celebri di Edo, Il Giappone, XIII, 1973; R. Goepper, Meisterwerke des Japanischen Farbenholzschnitts, Köln, 1973; R.S. Keyes and K. Mizushima, The Theatrical world of Osaka Prints. A Collection of Eighteenth and Nineteenth Japanese Woodblock Prints in the Philadelphia Museum of Arts, Philadelphia, 1973; Kitamura Tetsuro, The Early Edo Period in Japanese Textile Art, Museum, 271, 1973; Satō Masahiko, Kyoto Ceramics, New York - Tōkyō, 1973; H. Mizuo, Edo Painting Sotatsu and Kōrin, Tōkyō, New York, 1973; G. Rozman, Urban Networks in Ch'ing China and Tokugawa Japan, Princeton, N.J., 1973; H.P. Stern, Ukiyo-e painting, Freer Gallery of Art, Washington, 1973; K. Adachi, About Paintings of Inu-ou-mono, Kokka, 972, 1974; J. Sasaki, Paintings by Yosa Buson During his Sojourn in Tango Province, Kokka, 971, 1974; C. Yoshizawa, Preliminary sketch for a portrait of Kimura Kenkadō by Tani Bunchō, Kokka, 973, 1974; T. Doi, Fusuma Paintings by Takada Keiho, Kokka, 983, 1975; Kagesato Tetsurō, Western-Style Pictures of the Edo Period and European Prints Shiba Kōkan Western Style works, Museum, 286, 1975; Fujio Naruse, On the "Craftsman Mending the Sail" by Shiba Kōkan, Kokka, 976, 1975; N. Okawa, Edo Architecture: Katsura and Nikko, New York, Tōkyō, 1975; Y. Shirahata, Craftsmen at their work by Kanō Naonobu (1607-1650), Kokka, 984, 1975; A. Turco, Città e territorio in Giappone e in Cina, Bologna, 1975; Yamane Yūzō, Tawaraya Sōtatsu and Illustrated Scroll of Ise Monogotari and Shukongō-shin Engi, Kokka, 77, 1975; S. Addiss, Nanga Paintings, London, 1976; G.C. Calza, Le stampe del mondo fluttuante, Milano, 1976; G.C. Calza, Vedute celebri di Tokyo, Milano, 1977; F. Whitford, Japanese Prints and Western Painters, London, 1977.

i) Modern Period: J. Cary, Imperial Hotel, F.L. Wright, The Architecture of Unity, Rutland, 1968; N. Kawazoe, Contemporary Japanese Architecture, rev. ed., Tōkyō, 1968; R. Boyd, Orientamenti nuovi nel-l'architettura giapponese, Milano, 1969; International Round Table on the Relations between Japanese and Western Arts, Unesco, Tōkyō, 1969; E. Tempel, Nuova architettura giapponese, Milano, 1969; Brindgestone Museum of Art, Aoki Shigeru, Tōkyō, 1972; Museum of Modern Art, Kamakura, Takahashi Yūichi ga-shū

(Le pitture di Takahashi Yüichi), Kamakura, 1972; S. Takashina, Nihon Kindai bjiutsu shi ron (Saggi sull'arte moderna Giapponese), Tōkyō, 1972; K. Noboru, L'architecture japonaise d'aujourd'hui, Tōkyō, 1973; M. Harada, Meiji Western Painting, New York, Tōkyō, 1974; M. Kawakita, Modern currents in Japanese Art, New York, Tōkyō, 1974; W. Blazer, Chinese Pavillon Architecture, London, 1975; H. Munsterberg, Modern Japanese Art from the Meiji Restoration to the present, New York, 1976.

PAOLA VERGARA CAFFARELLI MORTARI

SOUTHEAST ASIA (PLATE 74)

The term "greater India," common up until a few years ago and previously used in the Encyclopaedia of World Art, and the more classical term "Magna India" are used less today in favor of a more simple geographical-cultural description: Southeast Asia. The war in Vietnam, which troubled a part of this area before the terrified eyes of the entire human community, contributed to the demise of the use of the former terms, which were inspired by peaceful and fertile acculturation phenomena. As such, those events created a preference for a term that — even though it is less committal — indicates, if rather vaguely, the geographic dimensions of a territory where different cultures and conflicting interests clashed for centuries, right up to the bloody confrontations between the present superpowers.

In spite of the richness of the monuments, the fascination evoked by these regions, the remarkable richness of human values and poetic harmonies, it should be pointed out immediately that anyone who imagines the centuries-old history of this area as idyllic is greatly mistaken. Apart from the recurring violent, fierce threats from outsiders and the desperate will of the local populations who struggled to maintain an autonomy often identifying itself with the right to survive, it should not be forgotten that the history of Southeast Asian countries has also been an eternal challenge, passed from generation to generation, to survive the violence and capriciousness of nature, which, like a cruel stepmother, manifests itself ruthlessly in continual catastrophes and destruction. Nevertheless, the people of these regions have never lost their faith in the future, not even in the roughest storms. And it is commendable that many researchers have had the calm courage to pursue their studies, which often have to do with a very distant past, when foreign powers have threatened to send the Vietnamese back to the Stone Age. To these researchers we are in debt for unexpected discoveries that have pushed the historical horizon of the human presence in the area of Vietnam beyond the past half a million years.

Actually, discoveries of great interest, focusing on the chronological and interpretive exactness of other criticism, were made one after another in the entire area of Southeast Asia as impressive works of restoration and conservation were undertaken following the long international debates on Barabudur, the Buddhist mountain-temple of Java. On the other hand, the series of unsolved mysteries and the difficulty of interpreting the unlimited volume of available data make one doubt the accuracy even of many of the most widely accepted deductions and interpretations. As a result, even if the 1960s and 1970s brought about considerable changes, the Southeast Asian area is still the subject of doubts and hypothetical interpretations. Thus, a predominantly analytical methodology remains, while iconographic studies (those identifying images and symbolic interpretations) are also extensively developed. Some of the most astute and perceptive scholars hold, moreover, that, in spite of the new critical approach, a secret and almost unconscious trace of Eurocentrism remains in researchers. Precisely because it is hidden, this Eurocentrism ends up being applied to a discipline that is based on historical and cultural premises quite different from Western ones, leading to misinterpretations and partially erroneous judgments.

With respect to this fact, the French school offers an important group of specialists from the regions in question who are perfectly knowledgeable about the methodology and research tools developed by their own school. All the same, the problem of Eurocentrism persists. Perhaps this problem can be solved only if we consider, almost conventionally, that even the European approach (or, if you wish, the Western approach) is and remains valid since it uses the adaptation model and takes advantage of its own methodological richness and its own experience to obtain an ever narrower approximation and an ever clearer focus on the data and the problems, putting together and exposing the characteristics of the local figurative tradition as much as possible. Nevertheless, the complete understanding of any one of the civilizations we are concerned with is excluded from any foreigner if complete understanding means passing certain limitations of extraneousness in an attempt to experience a way of seeing and feeling that cannot be grasped except by natives. Naturally, the emotional factors that determined the worldwide renown of Angkor Vat, Bayon, Barabudur, and other monuments remains. At the same time, the great communicative capacity of the work of art itself is strengthened because, in spite of the infinite varieties of figurative vocabulary, that capacity forms the only bridge of immediate communication among people separated by language and culture.

Also, bear in mind that no problem emerging from figurative work and archaeological discoveries in the area examined will ever be resolved if autonomous characteristics as well as the interrelationships characterizing the Southeast Asian civilizations are not given enough consideration. In other words, the entire area, including the Indochinese peninsula, Melaka, and the Indonesian islands, is subject to continual, wide-spread interference, even if the area shows great variety in cultural manifestations. Precisely for this reason, the area is inseparably united, especially from the point of view of figurative manifestations, which are forever linked with diverse and variable intensity to the Chinese and Indian cultures, the two greatest cultures of Asia. This does not exclude in any way their exceptional capacity for reinterpretation and autonomy, which can hardly be overemphasized, even if many of the observations previously expressed by G. Coedés (Les états hindouisés d'Indochine et d'Indonésie, Paris, 1948), who will always be, without a doubt, a truly distinguished scholar in this field of research, are extremely valid and well-balanced.

A summary panorama of the more well-known issues set forth by groups or by single researchers must

be added to these general considerations. The Buddhist and non-Buddhist iconography of the Indochinese world has ardently attracted French researchers and scholars, many of whom are also interested in architecture in general as well as in its technical aspects. The chronological and interpretive definitions of A. B. Griswold opened new horizons for Thai art, while the series of monographs (among which are the various volumes of *Manuel d'archéologie d'extrême-orient*, in the part devoted to Southeast Asia), with different objectives, becomes increasingly extensive (from popularized versions to compilatory ones in search of interpretive syntheses). Even the most recent ages (the 19th and 20th centuries) are beginning to interest scholars, especially since the symptoms of a cultural crisis because of the impact with the West are studied in those centuries.

The Pre- and Protohistoric Phases. – As far as South Vietnam is concerned, significant ruins in the Tân văn zone prove the human presence, at least as far as beings qualified as *arcantropi* are concerned, during the Middle Pleistocene Age. Bones of *homo sapiens* have been found in at least three rather far apart locations. These remains are part of the Late Paleolithic Age, and their culture is called the Thung lang culture after the name of the place where they were discovered. This location is characterized by cave-dwellings, the probable use of clothing made of unusual materials (leaves and bark of trees as well as animal skins), and the burial of the dead, which obviously reveals a certain level of emotional sensitivity. The estimated date of this site is conservatively 40,000 years ago. Nguyên Phuc Long wonders if it were not this civilization that gave birth to the archaic "community." For now, the question is destined to remain unanswered, assuming that the question itself is a valid one. What is certain, however, is the specialization of the people of this phase: they were hunters who used traps (and perhaps small nets as well), slings, and spears, which were also used for fishing. The tools of Thung lang are of smaller dimensions if compared to those of the preceding Stone Age. They are refined: a prelude, in a sense, to the Mesolithic Age, which was much later.

Apart from the recent placement of the human presence in time, the coming of the proto-historical phase (and later the historic one) coincides with the progressive establishment of human movements along a line that remains constant. This means that the humans of the area of interest to us were continuously moving from the north to the south in search of land. The minority ethnic groups limited themselves from the beginning to the higher areas, and the supremacy is always found in the populations of the plain (Viêt or Kinh). The mixture among the various groups came about only in the later and still pre-historic phases: for obvious necessities (the appropriation and exploitation of the territory), apart from other reasons that are less evident and yet equally important (if not more so) that came about with the evolution of the economy and the development of agriculture (the necessity of adequate water systems and of the settlement of the land).

The collective defense effort against foreign invasions has long played a major part. Naturally, this condition does not concern the Paleolithic Age nor the phases immediately following it. These latter ones, rather, are linked to similar manifestations of human existence revealed in Burma, Thailand, Malaysia, and even in Java. This confirms the validity of the expression "Southeast Asian," even in ages past, and in light of the corresponding ethnicities (or, better said, given the epoch, corresponding physical traits), among the human types and the humanoid Javanese and those of South Laos. The presence of Vedda-of-Ceylon-type Australoids, in later ages, is added to these relationships.

A characteristic not to be neglected is that the passage from one culture to its successor always comes about with a more notable persistence of characteristics already conventionalized in the environment of the new context. This is particularly clear in the Vietnamese area. It is seen most often and always with the same clarity up until the full affirmation of the Iron Age. The oldest cultures (the archaic one of Hòa binh and the other, somewhat later, one of Bac Sön) are, however, ancient and appear to have developed in areas not really suitable for human existence — that is, far from the plains. During the epoch of their diffusion (the Bacsönian stratum of Bó lúm is dated earliest by Carbon - 14 at 8040 (plus or minus 200 years) B.C., while the culture of Hòa binh is around 12,000 years ago), the geographic configuration of the plain was very different from its present one.

The general characteristics of the culture are as follows: still rather rough stone-working, which nevertheless may have created amulets with geometric representations; wall etchings on caves that are strongly characterized but do not always have a clear meaning; and the presence of *litofoni*, early percussive musical instruments of which one having eleven blades is noted for its dimensions, given that the blades range from 65.5 cm to 101.7 cm in length. Pottery is still made with vegetable fiber plaiting for strength and decorated by the impression of the fiber on the soft clay. During the evolution of the Neolithic Age (from Early to Late) the same type of pottery became progressively more refined, and the latest and finest examples show the design of etching and painting in addition to the ornamental design of the impression. It is probably in this phase (as L. Bezacier and Nguyên Phuc Long reveal) that the culture begins to form, extending from the Japanese archipelago to Madagascar and characterized by the contraposition of the mountains to the sea, of mountain people to those of the shores of the sea and rivers. This confirms the intuitions of the unforgotten Jean Przyluski. This phase is partially confused with that of the mythical or semi-historic reigns of Xích guỷ and Vanlang (perhaps connected, by name, with a local wading bird called Vlang or Blang).

In the Vanlang phase, which is rather conventionally given the date 258 B.C., the development of abundant marine possibilities, favored by the spreading of the pirogue and the development of the culture called Dông-so'n, which coincides with the last Vanlang phase, comes about. This latter epoch is characterized by a metallurgical industry noted for its works, diffusion, and technique and appears linked, in various ways, with other areas, not excluding Indonesia, with which it has in common certain burial practices. Dông-so'n uses the strong, short sword (actually a dagger) of southern origins (South China). Also of Chinese inspiration are the halberds with a slightly curved point and straight "hook." The axe typology, which progressively takes on the "Dutch clog" form, can be followed in numerous transformations that lead to the most elaborate, final

form, which, though not lacking elegance, is not very functional because of the molded curve of the blade (more or less crescent-shaped) and the flanged bars, which are exclusively for ornamentation.

The origin of Vietnamese metallurgy began around the beginning of the second millennium B.C., while around 1500 B.C. great progress was made in agriculture due to the use of bronze plows. Perhaps in relation to increased wealth, this signals the end of the apparently original "commune," which was broken apart more than by anything else by military necessities (made predominant by the search for efficiency). This happened, according to local scholars, at the beginning of the first millennium. The culminating point of bronze follows a couple of centuries later, while the Dông-so'n culture, the last splendor of Vanlang, radiates its prestige across a doubtlessly vast area, its limits yet to be determined. The phase that experiences this diffusion is characterized by contacts with China (Warring States), besides having to prepare itself for and then to face the conflict between the Âu Viêt and the Lac Viêt, two groups that had become rivals. The end of the Vanlang was brought about by that conflict.

It should be noted that one important production of the Vanlang phase metallurgy (and therefore, of the Dông-so'n phase) is that of bronze drums, grouped today in five typological series varying above all in proportions, confusingly scaled down in time, but with incredible persistence, considering that these instruments are still used in some festivals of the Mu'o'ng (in western Vietnam), populations closely related to the Viêt that modern local terminology distinguishes curtly from the Vietnamese (the minority ethnic that contributed forcefully to the rise of the Democratic Republic). The research carried out on the ornate etchings on the percussive plane and on the full relief of the borders of the drums is still far from having reached definitive interpretations. Think of the elegant geometry of the etched figures and of the variety of subjects represented in full relief (animals, each extraordinarily different from the others; human figures with great feathers; houses; boats). It is possible that each of the numerous explanatory theories expressed to date is partially true and that the theories do not contradict each other in the least. There could be both a representation of group life and a ceremonial, mythical, cultic, magical (the evocation of rain, for example), shamanistic aspect (see Nguyên Phuc Long, 1975). It is nevertheless rather difficult to overvalue the extreme importance of drums in the daily life of these populations and of other connected ones, since an interpretive analysis that is not extremely knowledgeable is destined to fail; disintegrating in apparent derivations and generic analogies that extend to an area including the Melaka peninsula, the confines of southern Mongolia, Indonesia, and beyond toward the Pacific.

Similar research is also conducted on the so-called elliptical bells, while a considerable resistance is being established towards the hypothesis advanced by R. von Heine-Geldern (supported by V. Goloubew) on the presence of an influence from Hallstatt in the bronzes of Dông-so'n. In general, today, the analogies and the writings on the geometric motifs are explained as an effect of an analogous capacity for abstraction and of ornamental reduction with regard to the forms existing in nature. In addition to the controversial nature of the two ideas, they do not bear in mind the reasons that led Heine-Geldern to confront the problem of the expansion of the Hallstattian motif: this means that it could have been the enigamtic presence of Western Indo-European groups (the "kentum" branch) in the regions of Sinkiang Chinese and the reconstruction of the historic phenomenology that determined their presence in those areas.

On the other hand, it is important to remember that among the monumental ruins of the phase after the Vanlang, the little city of Cô-loa, near Hanoi, was built by King Thuc Phan of the Âu Viêt towards the end of the III century B.C. The city is the major monument of the archaic Vietnamese periods. It is surrounded by a triple enclosure of bastions arranged in a spiral, of which the outer enclosure has a circumference of eight kilometers. The bastions are ten to twelve meters high and are never less than twelve meters thick on a base 25 meters wide. Defended by moats fed by the Hoàng River, they were further strengthened by watch towers and other defense towers. The result was a formidable military structure, very complex and imposing as a work, given that just the foundation required the moving of at least two million cubic meters of earth. The junction of the moats with the river made the tactical collaboration of the river and land forces possible. Large deposits of arrowheads were found in the area. With regard to the reconstruction of the dwellings of the culture of Dông-so'n, it must be remembered that, other than the traces of pile dwellings, well-known for some time, the study is undertaken on the basis of the images found on the drums or, indeed, on representations that are not patterns. Inversely, the research completed on the water systems of the ancients rests on aerial views and on excavations — even accidental ones — that brought to light the existence of a man-made canal system both for the reclamation of particular zones and for the irrigation of others.

During the Dông-so'n phase, simultaneous with the apex of Dôngsonian metallurgy, an entirely different culture flowered throughout the Indochinese peninsula: the megalithic one. At the same time three linguistic groups (Thai-Vietnamese, Cham, and Môn-Khmer) are formed. The exact origin of the three groups is practically unknown. In so far as megalithic culture is concerned, the archaeological date most evident and incontestable by nature is that it occupies a rather vast geographic area that goes from the Indochinese peninsula to India and Sumatra.

One of the strong points of this culture is the Mekong Valley, proven by the numerous findings of dolmens and menhirs (large stone slabs placed vertically in the ground or arranged in a circle) that are monuments characteristic of megalithic cultures. The presence of large urns with lids, positioned inside the encircled area (whether dolmens or menhirs), often containing the ashes of human bones, is a characteristic element in this specific case. Obviously, the cultic (and commemorative) apparatus for the dead (or at least for some of them) is important: in some cases, it is of utmost importance. We do not know if the circular constructions, furnished with encircling walls and moats (like the little city of Cô-loa, much farther north, which has, nevertheless, some differences), discovered in the Mekong Valley belong to the epoch and range of the local megalithic culture or not. If there were a connec-

tion, the local *facies* of this most peculiar culture would emerge as rather complex. At any rate, it seems that the area of greater diffusion of megalithic monuments coincides, more or less, with the area of establishment of the Môn-Khmer.

It is rather likely that an important part of the religious symbolism adopted by the Khmer was drawn from religious and symbolic concepts already in existence ("*in nuce*") during the megalithic period. In fact, according to R. von Heine-Geldern and other experts who support the same positions, the megalithic funereal monuments are not limited to the commemoration of the dead, but also materialize - defining and visualizing - the link that unites the living to the world of the dead, forming a way through which the magic power of the deceased can be transferred, at least in part, to whoever built or commissioned the monument. The research of Heine-Geldern can be integrated with the hypothesis of Quaritch Wales, revealing a reflection of Chinese thought of the Shang age in the Indochinese area. In this case the megalith would be transformed into the throne of the god of the soil, while the deceased, entombed within it, would become the mediators between the living and the divine. An interpretive analogy between the assumptions of the megalithic cultures of Indochina and the religious presuppositions of Shang China are certainly possible. In any case, the deceased, his ashen remains entombed inside megalithic circles, is pre-eminently joined to his ancestors. The interesting thing about this hypothesis, which is well based but still to be confirmed, resides in the fact that, in historic times, the king could have taken the place of the "dead mediator," with clear implications of the religious aspect of royalty. Similarly, the megalithic structures could have suggested, with relatively logical transformations, the symbolic basis of the "temple-mountain" and of the man-made (architectonic) pyramids.

A large part of the symbolism complex inherent to the Khmer monuments might have its roots in the local megalithic culture, which seems contemporary to the *facies* of Dông-so'n but distinct from it. Add to this that Paul Mus, as Chiara Silvi Antonini (1975) reveals, gives proof of the probability that for the Champas (rather, for those we would call proto-Champas), the dolmens and menhirs were erected at the center of the area of the settlement of a specific group. Consequently, the god of the soil accepted the settlement of the group, conferring upon it a type of ownership of the land in question. This coincides with the use of the Shiva phallic symbols that the Khmer sovereigns placed as a sign of ownership in conquered, or at any rate, acquired, territories.

The historical phases. – At the beginning of the Christian era, the phenomenon of "Indianization" developed, taking on an uninterrupted nature very different from the chance and sporadic preceding contacts. The Chinese contribution, up until then the only one, was joined and counterbalanced by the Indian cultural influence on the basis of a convergence of different factors that determined its prevalence and crushing affirmation. Among other things, the Indian culture expanded via sea routes, which were undoubtedly easier than the insurmountable land routes towards the north (along which the echoes of the Chinese culture reached). Not without reason, various Chinese sources, even late ones, hint at the great effort put forth by the inhabitants of the banks of the Gulf of Tonkin to start sea trade towards Southern China as an alternative to the land routes that were at best difficult and hardly practical.

The expansive nature of the Indian culture is inherent above all in its religion, but also in the culture's medical, technological, and organizational aspects. The expansive nature is essentially revealed to be more acceptable by the populations of the entire Southeast Asian area, notwithstanding geography and the obstacles imposed by nature on communications, which were almost inevitable, given the technical means and capabilities available in these ages. The conveyors of this diffusion can be found in the commercial thrust that radiated from India towards the east with a particular variant of the thrust; i.e., the flow of Indian gold seekers attracted by the mythical fame of the Indochinese peninsula, which was considered the "Land of Gold" (Suvarnabhumi). The commercial thrust and the search for gold depend, to a great extent, on the contacts India maintained with Rome and on the increase of trade with the western Mediterranean, while the spread of Buddhism facilitates the possibility of exchanges and contracts with other peoples, breaking up the Brahman prejudices on ethnic impurity as well as those of the caste system.

The oldest "Indianized" kingdom is the one called Fu-nan, of which Chinese sources chronicle various embassies and give detailed descriptions that allude also to more diffuse cults and to images of a clearly Indian type. Except for the reminiscence of local traditions (the cult of the "masters of the heavens"), the principal divinity was a certain Maheśvar. It is still uncertain if Maheśvar was a Bohisattva or the Buddha, or if, on the other hand, more probably, he represented Shiva. The archaeological data acquired in recent years have to do in particular with the city of Oc-èo, which was a rectangular plan of 3 by 1.5 kilometers and fortified with moats and defense ramparts. The city was urbanistically divided into ten neighborhoods or sectors by means of a canal system that served as the transit system as well as for the disposal of waste. It should be noted that most of the dwellings were made of wood, constructed on piles along the banks of the canals, except for some monuments conventionally marked by archaeologists with letters. One of these, named K, could be the adaptation of a *mandapa*-type Indian construction to a different environment. It is assumed to date from the fifth century.

A great deal of rather heterogeneous and, in part, imported, material was found at Oc-èo and elsewhere in the Mekong delta. A great quantity of etchings in stone and medallions or coins, especially of Marcus Aurelius and of Antoninus Pius, attests to the breadth of contacts with the West for a period of time that runs more or less from the second to the fourth century. Obviously, a greater breadth is encountered in the commercial contacts with India, and traces of trade with China and Iran also exist. Hence the impulse for a local production that has to bear in mind, among other things, the scarcity of stone suitable for sculpture is born.

At any rate, beginning with the reign of Rudravarman (515 - 550 A.D.), who usurped the throne, there is a local production of sculpture of sizeable dimensions attested by Angkor Borei and in the sanctuaries of Phnom Da. Dupont divided the same works into two groups, of which the first (called Style A of

Phnom Da) coincides more or less with the reign of Rudravarman, while the second (Style B) coincides with the second half of the sixth century and spills over briefly into the seventh century. These two stylistic varieties differentiate themselves from Indian works in that they are in full relief (while high relief characteristic of the stele is preferred in India) and also by the presence of certain harshnesses and uncertainties (supporting arches and listels which are superfluous in a more advanced technique). These confirm the autonomy of the artists, who are still not very technically developed.

Characteristics common to the two styles are the treatment of the hair; the shape of the tiara (which is a sign of royalty); large, flat faces; thin, elongated eyes; and the lack of jewels. The difference between the two local phases is marked, in particular, by the way the sampot (the short dress that winds around the loins) is tied and by the type of drapery. Furthermore, while in Style A the eyes are more open and the pupils often appear marked with the iris, in the later style the eyes are carved with more sinuous lines (as they are in India) and have no further anatomical details.

With regard to the Buddhist images, for which numerous unsolved problems remain, there was an Indian influence (of Amarāvatī, of the Gupta, and of the post-Gupta phase), not to mention the Ceylonese reminiscences. Just pursuing the research can give us a clearer picture of the relationship to the Indian schools in this area.

At any rate, a separate discussion is also necessary for Buddhist statuary, especially as far as the long series of chronological problems is concerned. It is uncertain, in fact, if the wood images of Oc-èo, Buddha of Romlok, and those of Angkor Borei can be dated from the fifth century, or if, indeed, they all belong to the more advanced sixth century. In any case, the traditional iconography, whether standing or seated, and the copious garment of Buddha (which, touching the base, eliminates the necessity of the so-called supporting arches) allude to a certainly strict, likely Indian, derivation (from Amarāvatī) that seems to imply a Hellenistic component, according to J. Boisselier. On the other hand, the absence of the ūrnā and the light relief of the usnīsa (the cranial prominence of Buddha) appear to be rather curious facts from the iconographic point of view, just as a different identification of the image does as far as the schemes of characterization used in the areas of origin are concerned.

A fragment of the head of Gandhāra and a collection of minor data attest to the precise relationships to the northwest Indian as well, even if it is impossible to establish the intensity and the frequency of these relationships except through hypotheses. And, speaking of precise, even if very enigmatic, relationships, it should be remembered that an important fact concerning the area of Oc-èo has to do with the widespread use of the pool, brought to light by L. Malleret. The pool was widely used in ages before the end of the fifth century. (Among other things, a figure of a humped ox in full relief, 17.2 centimeters long, was found in a pool.) This is significant since this metal was completely unavailable in the area and therefore came from far away, although its precise origin is not known.

After the Fu-nan, the Chên-la appears. This name, whose meaning is unknown, was chronicled in the history of the Sui, who gave it the name for the first time. The appearance of the Chên-la indicates a new state, Cambodia, that will be one of the determining factors of the disappearance of the Fu-nan. With Chên-la, the Khmer language is used for the first time in epigraphs, even though it is subordinate to Sanskrit, which remained reserved, in the same epigraphs, to more important passages, such as an invocation to the divinity or the exaltation of the sovereign. From the figurative point of view, the characterization and the extent of the images of the Bodhisattva Avalokiteśvara and Maitreya allude to a wider diffusion of Buddhism. This came about simultaneously with the affirmation of Chên-la, while Prei Kmeng, a new style following the so-called Sambor style, spreads over all the land occupied by the new state, culminating in an intense productivity that reaches its apex in the five years between 640 and 645.

The aim of the specialists is addressed to establishing the presence of a continuous concatenation among the different styles that follow. Often the link is revealed by a very significant detail that serves as a reference point and confirms the connections between one phase and another in a much clearer and more productive way than scattered research, since this is generally carried out through a formal analysis of the various monuments. In the totality of the creations, which continued unceasingly, and in the diversity of the solutions adopted by the artists, this method appears singularly fruitful. For the period we have examined thus far, and for the phase that followed immediately thereafter, the study of the form, decoration, and architrave in works might be and no doubt is a very clear indication of an evolutionary continuity that otherwise would not be perceptible because of the fragmentation of the territory, among other reasons. (The study includes the analysis of the forms that are used by what we would call the "allusion to the arch," which is constantly present in the sculpted decoration on the architrave and serves as a recurring module expressed in a very different way.) The stories of T'ang speak, in fact, of the "land Chên-la" and of the "water Chên-la" as the outcome of a divisive process long before established. However, in the eighth century, the Indochinese peninsula was a territory divided into various principalities of modest importance. At the end of the century, according to posthumous testimonies, a Javanese chief extolling parental ties to the Fu-nan dynasty reaches Cambodia, thinking he would return to dominate the territory of his grandfathers. He disembarks at the mouth of the Mekong, conquers a large territory, and, after various movements that lead him to found a series of different capitals, establishes himself at Mahendrapura in 802, claims he is the universal sovereign (but breaks the ties that connected him to Java), and establishes the cult of the divine sovereign.

Mahendrapura ("the city [on the mount] of Great India") is located on the Phnom Kulên plateau about 40 kilometers from Angkor, which is further southwest. The style of this phase, called Kulên because it was born on the plateau of the same name, is articulated in very differentiated forms. All the same, the characteristic vocabulary of the sanctuaries of this style is easily recognizable, now that it has been identified. The identification itself was not easy, given the fact that the first buildings, constructed in brick, had practically been reduced to piles of ruins. It is to the merit of Ph. Stern

that the characteristics of the Kulên style were reconstructed and that the enormous wealth of documents dealing with this subject and its relationship to the mountain cult (or, better said, to the cult of the mountain-temple) and to the lingam, the phallic symbol that indicates ownership and dominion, was collected and put in order.

Indravarman I, reigning at the threshold of the ninth century (877 to 889), carried out a great program that constituted a profound technical innovation with a vast economic impact when compared to the works of Fu-nan, which were themselves rather imposing. It began with the excavation of a water basin (Indrakatāka, or Lolei) that gathered the waters of Roluos, which were then distributed across a great expanse, flowing back, finally, to the natural lakes south of Angkor. The excavation technique appears greatly modified (compared to that of the Funanese, which was also highly regarded by the Khmer), more to adapt to the diversity of the environment than for any other reason. In fact, the problem at hand was that of uniformly irrigating the flatland. This brought about an incredible series of problems related to the retaining basin, the gathering system, the free-flowing canal system, the calculation of the slopes, and, naturally, the maintenance of the entire system.

The anticipated result was rather rewarding from the economic point of view: a greater agricultural yield, the additional use of the canals as routes of communication, the increased well-being of the population, and the consequent demographic increase. Thus, a real city, Roluos, was born with its characteristic Prah kô style and its monumental Bakong. Roluos is the prelude to the birth of the first Angkor, which will have the name Yaśodharapura, in honor of its builder, King Yaśovarman I (889 to 900). Yaśovarman I represented a change of more than a little consequence concerning the order personified and expressed by Indravarman. This order established great responsibilities for the sovereign towards the subjects, grandparents, royalty, and above all, towards the divinity. Yaśovarman, in fact, built a temple to ancestors on the island that rose from the center of the man-made basin of Roluos, thus moving the center of sacredness. The urbanistics of Yaśodharapura (which was given the honored name of Śri) developed around the enclosing and defensive canals. The urbanistics followed modules and numeric rhythms having a symbolic-magical value. Furthermore, Yaśovarman built another water retaining basin (Mébon) in the area, farther north and four times larger than Lolei.

H. Stierlin (1970) noted that with a minimum amount of excavation (meaning with a minimum effort and cost) a water reserve (Lolei and Mébon) totaling six million cubic meters of water was formed, situated so that it could be distributed simply by gravity to the entire plain below, which was irrigated by a rigidly geometric network of small canals and dams. As such, a unified system was created, its parts connected like links of a chain requiring the maximum of care and an organized and collective maintenance in order to function properly. Every part, in fact, had a direct influence on the working of the whole. It is probable that this complex system facilitated and strengthened the transformation of the sovereign into the sole owner of the land (in fact, he is defined as the "master of the low-lands"). In any case, the divine sovereign was assimilated to the god Shiva, but in an indirect form: the sovereign himself was required to build in every one of his capitals a temple to host a lingam, the symbol of god, because the "subtle and invisible io" of the sovereign was transferred to the lingam. The symbol, therefore, was the expression and the seat of the power of God as well as that of the king, who had by now assimilated to the divinity. The cult, translated to the temple and the symbol, unified the two values, but it seems clear that for the king this value was limited and conditioned by a partial psychic transfer. This makes the sociology, and consequently the economy, of the Khmer world extremely complex. Modern research tends, in fact, to define the Khmer civilization in terms of the "Asian way of production," beginning with L. Sedov (1967). There is no doubt, as Donatella Mazzeo revealed (1972), that the characteristics Marx indicated as essentials for the "Asian way of production" are found in an "exemplary" way in the Khmer organization. Nevertheless, it is not as simple as it seems, because the assimilation of the Khñum (in Sanskrit, dāsa) to the slaves is wide open for discussion, even if it most assuredly involves men for whom freedom is partially limited, at least in some cases.

On the other hand, in the appropriation of the surplus of products, the so-called nobility reacted not as individual owners of the land, but collectively; that is, they reacted as a state. Neither is the sovereign free or the absolute judge, in spite of his peculiar assimilation to the divinity. As a consequence, not only does no private property exist for anyone, but a unified collectivization seems to develop, involving even the sovereign, who reinvests the collective surplus both in the essential irrigation structures and in public and prestigious works. As Mazzeo reveals, supporting herself with Chesneaux, these are not all the expression of a 'grandeur mania" of the rulers, but rather a concrete expression of the "supreme unity." The temple-mountain and Khmer city are the expressions of a precise ideology that Chesneaux defines as a "feeling for an unchangeable order of the world," but which, we add, can be perhaps even more complex. What is certain is that a concept is born of this ideology, as D. Mazzeo points out, and from that ideology an ideal community that searches to conserve and elevate the essential conditions of human life through the stability of certain (collective) values is derived.

If we assume an interpretation of this nature, the moving of the capital to Koh Ker, its return to Angkor, and the construction of the third large water basin, hospitals, and numerous other public works all take on a different value, just as many of the values that contrapose the figurative production are clarified and made obvious. The basis of the figurative production, as Madeleine Hallade sensed for quite some time from the wealth of the research of the French school, is "order and logic, the sense of symmetry and 'grandeur,' the search for the effects of the whole (the effects, I would say, are almost like scene-painting) and the same richness of architectonic decoration." Not without reason the taste for order is essentially revealed, much more than in the Indian prototypes, "in the clarity of the plans, grouping of the buildings, concentric placement of the quadrilaterals of the tunnels, enclosure walls, and canals." The same rhythms and the same iconographic

solutions adopted in the decorative sculpture are linked to this strange reality of a social structure, which appears monarchistic but is actually communistic, having class distinction while unitarian. At times the rhythms and iconography are incorporated with exceptionally efficient effects (as in the four-faced towers, which are a massive expression, in my opinion, of the basic ideology). In such a social structure, the sense of the state crosses into the realm of metaphysics.

The battle against the Chams, their destruction of Angkor (1177), and the reconstruction of the city (1181 to 1219) by Jayavarman VII, who was a Buddhist ruler, are not extremely relevant in the topic under consideration. The last traces of the cult dedicated to the sovereign in the form we have described (the cult of devaraja) resurface in 1052 (inscription of Sdok Kak Thom). However, it is more likely that it stayed in power, almost unchanged, at least in theory (in spite of the Buddhist King Suryavarman I, in power from 1011 to 1050), through a period of movements and battles until Jayavarman VII took the place of Devaraja the Buddharaja. As far as the present discussion is concerned, this is not so relevant as one would think: the Buddha in question, identified with the essence of the universe, has characteristics very similar to those of the supreme Shiva (that is, of the cosmogonic aspect). It is necessary to emphasize, however, the relevance of the compassionate aspect (the Karunā, or compassion) of the divinity, and, through reflection, of the sovereign. Hence, the four-faced towers mentioned previously represent Lokeśvara, the Bodhisattva of compassion, assimilated to the sovereign. In clearer terms, these gigantic faces, animated by a sweetly meditative expression and mysteriously smile, represent the ideology at the basis of the entire community. The consciousness of the precariousness of life and of the uselessness of conflicts is the basis of the Karunā, which is also derived from a political and social idea.

Not without reason is the consecrating inscription of the temple of Ta Prohm (dated 1186) dedicated to the mother of Jayavarman. During the reign of Jayavarman VII, the works of public usefulness (with compassionate implications) had increased. In just the five years that elapsed between his ascension to the throne and the inscription, 102 hospitals, disseminated throughout the various provinces, and 121 "houses with fire" (that is, inns for travellers) constructed in wood along the major roads were put into use. Of the latter, only the chapel annexes constructed in stone a little later are left. The hospitals as well as the inns were directed by two centers organized by the large temples, indicating a tendency toward systematic centralization. Note that the hospitals were directed by the temple of Ta Prohm dedicated to Prajñāpāramitā (a female god of perfect knowledge), to whom the mother of Jayavarman had assimilated. The inns, on the other hand, were directed by the temple of Prah Khan, consecrated in 1191 and dedicated to Lokeśvara the Compassionate, to whom the father of the ruler was assimilated. In conclusion (keeping in mind the particular assimilations of the ruler's parents to the divinities that personify abstract concepts), there is an efficient organization promoted by a human being who feels and believes that he is acting on the basis of a transcendental will diffused throughout the land, as its instrument and with the power to assimilate himself to it. In theory, at least, the result of this is a power of collective de-personalization directed to goals that coincide, for the most part, with the "common good" of the social structures of our Middle Ages. At the same time, a more accentuated reduction of individual values, including those of the sovereign, exists. The figurative production of the Khmer world can take on new values if this very particular visual angle is investigated.

Further northwest, the Thai area is characterized from the seventh century by the presence of a kingdom called Dvāravatī, a Sanskrit placename whose equivalence to the Chinese T'o-lo-po-ti, mentioned in various sources, was confirmed by two silver medals discovered in a ruined building at Nak'on Pathom relatively recently. The art of Dvāravatī, inspired by Buddhism and the work of the Môn groups, flowered after the crumbling of Fu-nan. A more precise notion of this had its beginning in 1925. The excavations completed in successive years led to the discovery of important monuments (at P'ong Tük in 1927, at Nak'on Pathom from 1939 to 1940, and at Vat P'ra Pat'on) representing particular forms that remain more or less unchanged in similar works much later. The discovery of terracotta and stucco of the highest quality in 1961 at Kû Bua (Râtburî) was of vital importance: these works, close to the art of Śrīvijaya geographically as well as chronologically, seem to be the prelude to the taste of Sukhodaya and to a much later phase (13th to 15th century). This means that it demonstrates itself to be a constant of taste, not easily definable and at any rate not easily substantiated by history, given its evidence. Both the phase of Śrīvijaya (eighth to 13th century), witnessed above all in the Malaysian peninsula, and the semi-contemporary phase of Lop'buri (11th to 14th century) have less unified physiognomies, at any rate. The similarities here are strong enough that it is almost possible to consider them common denominators.

The name Śrīvijaya, which refers to the great seafaring empire concentrated around Palembang on the island of Sumatra, groups all the works having to do with southern Thailand. These works now appear vigorously differentiated one from another depending on whether the artists were inspired by the Javanese production, by that of Sumatra, or otherwise worked independently. This difference has as much to do with the Buddhist production as it does with the Hindu one. For the latter, centers like Vieng Sra and Ch'aiyâ present forms that deviate substantially from the iconographic point of view. The Buddhist production, which is more unified, is of Mahayanic inspiration and therefore different from the Dvāravatī one. In particular cases, as in certain series of "holy impressions" executed in raw clay and in rendered images of Buddha or of Bodhisattva, the derivation of Indonesian types is not only very clear, it is also extraordinary. In the architectonic field, it is easy to perceive today that some buildings of the Śrīvijaya phase, among which is Vat P'ra Th'at di Ch'aiyâ, which has undergone extensive restorations, bring to mind Indonesian works, despite their autonomy. At the same time, the Vat Keo, also of Ch'aiyâ, shows strong relationships and an affinity to the works of the Champa, even though the relationship is limited to decoration. The problem of chronology — as length of time and as internal order — is still a controversy. As far as Lop'buri is concerned, the problem includes the Khmer style and consequently is connected to the

evolution of Cambodia. The Kukhot'ai current, better known and more precisely dated than Śrīvijaya, rarely shows signs of a Khmer component. Intuitive reasons, even if they are not verifiable, lead us to say that it tends to contrast — perhaps not deliberately — with the Khmer style, especially when it turns more directly to an Indian inspiration. The artists of Sukhot'ai "perhaps unknowingly chose (for their creations) the physiognomic features furthest away from the Khmer aesthetic," George Coedés and Jean Boisselier concluded together. This phase is characterized by a large production in ceramics — of Chinese derivation, but autonomous in substance — which reaches such high quality in Celadon that it is now beginning to be fully appreciated even in the world of antiques.

Without taking a position on the complex problem of the so-called "school of Ch'ieng Sên" and its presumed contrast to the significantly more recent "school of Ch'ieng Mai," which some other scholars would lump together, we will use the Northern School, which is characterized above all by the very attentively studied supernatural anatomy that it attributes to the Buddhas. The most characteristic figures, persisting through time, can reveal foreign influences of significant consistency (derived, for example, from Ceylon or from the current India of the Pālas), but they appear at any rate autonomous for the *usnīsa* that carries a lotus bud at the top. (Buddha becomes a mixture of vegetal and human elements, a type of "anthrosandros.") In any case, the Ch'ieng Mai phase of the Northern School today appears characterized by goldsmithing of top quality, outstanding (even if they are not entirely original) ceramics, and a lapidary art of probably Chinese influence.

Insofar as the Indonesian area is concerned, there were remarkable determinations affecting the symbolic value of the monuments of the pre-Islamic era, the iconography, the evolution of ornamental design, and the symbolism of images or cycles of images. Of particular importance is the study of the symbolic fascia of the base (destined to remain underground and, as such, invisible) of Barabuḍur accomplished by A. Le Bonheur to the completion and integration of the classic works of Sylvain Lévi concerning the relationship between Karmavibhaṅga and this particular cycle of sculpture and on the Nepalese Sanskrit wordings and the other wordings (even Chinese, Kuceane, and Tibetan) of the Mahākarmavilhaṅga and of the Karmavibhaṅgopadeśa. At any rate, the primary problem posed by this monument, which is famous and the only one of its type in the world, was that of conservation and restoration. In fact, because of earthquakes (the volcanic one after the very violent eruption of Merapi in May of 1961 severely damaged not only the *candī Mendut*, but also the Barabuḍur), the erosion brought on by rain, not to mention the damage produced by root erosion and by other concomitant causes, the Barabuḍur found itself in such a critical condition that its continued existence was at risk.

With the contributions of various countries (especially Japan), together with the intervention of UNESCO, a series of works proceeded. The pre-planned work slowly should bring about the consolidation of the colossal work (in that it is an entire hill transformed into a temple-mountain) and bring about the progressive recovery of the disintegrating stone. The microor-ganisms that have attached themselves to the stone have become particularly destructive, provoking something similar to "wall leprosy," due to the acidity of the water they retain inside.

Lastly, as far as the area of Ceylon, a key point in the remarkable complex of Southeast Asia, is concerned, the scar of the pictures of Sīgirīya in red paint by a deranged and unstable protester and the damage that they suffered in spite of the attempts to restore them should be remembered. At the critical level, the value of the pictures in question - above all having to do with their meaning (divine or human) - remains unvaried and puzzling even if their worth and their quality are undisputed and unquestionable. The idea of S. Paranavitana, which involved the god of lightning and clouds, is still the most reliable. On the other hand, the type of dependent relationship of the works of Sīgirīya on those of Ajantā, or, better said, on the dominant pictorial currents on the continent, is still very much under discussion. Apart from a generic dependence, the diversity of the spatial conception is, in any case, too profound because the connection is remarkably able to overcome the limitation of a simple technical analogy and iconographic data dependent on a common base to all that was Indian in that age. M. Taddei (1972) excellently summarized the historical-political scene in which the construction of the rock of Sīgirīya is tied to the tragic destiny of the usurper Kassapa (Kāśyapa) and to the probable intervention of the samgha (the monastic Buddhist community) in an effort to break up Kassapa's attempt to install an absolute despotism on the island. His assimilation with the Kuvera god, tempted by Kassapa, is defined today much more clearly through the particularized examination of the architectonic structures of the rock and of the symbolisms connected, above all, thanks to the research of S. Paranavitana and his pupils.

BIBLIOGRAPHY - Reference works, written in the local languages, are important, but almost impossible to use; they are reserved to experts and easily found through the vast sector bibliographies of works listed that cover the ten years between 1965 and 1975. Another great source of material is found in professional journals. At any rate, it should be noted that a good series of articles by different authors and of various natures, above all concerning iconography, dating, techniques, and the relationships of Southeast Asian art to the contemporary Indian art and to that of other countries is found in "Arts Asiatiques," especially beginning in 1960. The French magazine has become an indispensable tool for research in this field, just as the Bulletin de l'Ecole Française d'Extrème Orient and the Bulletin de la Société des Etudes Indochinoises and many others have always been. G. Coedès, Inscriptions du Cambodge, Hanoi-Paris, 1937-1966, 8 volumes; J. F. Cady, Southeast Asia: Its Historical Development, New York, 1964; P. Dupont, La statuaire pré-angkorienne, Ascona, 1965; Ph. Stern, Les monuments khmers du style du Bàyon et Jayavarman VII, Paris, 1965; Arte Thailandese, Catalogue of the exhibition held in the Palazzo Vecchio in Florence from December 15, 1964, to January 31, 1965, with a vast, up-to-date bibliography; J. Boisselier, Le Combodge: Manuel d'Archéologie d'Extrème Orient, Asie du Sud-Est, vol. I, Paris, 1966; O. W. Wolters, Early Indonesian Commerce, Ithica, New York, 1967; J. Dumarçay, Le Bayon: Histoire architecturale du temple,

Paris, 1967; Soekmono, "Il faut sauver Borobudur," Arts Asiatiques, 1968; J. Gonda, Ancient Indian Kingship from the Religious Point of View, Leiden, 1969; H. Stierlin, Angkor, Freiburg, 1970; Mireille Benisti, Rapports entre le premier art khmer et l'art indien, published by E.F.E.O., Paris, 1970, 2 volumes; L. Bezacier, Le Viêtnam, Number 1, Paris, 1972; Tibor Bodrogi, L'art de l'Indonesie, Budapest, 1972; M. Bussagli et. al., Architettura Orientale, Milan-Venice, 1973; Nguyen Phuc Long, "Les nouvelles recherches archéologiques au Viêtnam," Arts Asiatiques, special edition XXXI, 1975; D. Mazzeo, Chiara Silvi Antonini, L'arte khmer, Milan, 1975.

RENATA LOMBARDO ARIOTI AND MARIO BUSSAGLI

NATIVE CIVILIZATIONS OF AMERICA

The surviving contemporary production of the native Americans has by now become mere folklore, rather than ethnography; thus the recent advances in the knowledge and appreciation of their figurative arts are due almost entirely to progress in archaeological research. Nevertheless the amount of work accomplished in the two American continents in the last 20 years (theoretical, art critique, excavations) by a growing number of better prepared specialists has been immense. New methods of research have been used, new methodological perspectives have been achieved.

Very significant results were obtained through the use of new dating techniques, a field of great experimentation in America. Carbon-14 techniques have been improved to reduce the variations in results to a very narrow margin, not only due to the sophisticated laboratory procedures used, but also because of the corrections made through dendrochronology (growth rings in trees), supported by the results obtained with the observation of the effects of the thermoluminescence of pottery and of the hydration of obsidian.

Nevertheless the task of interpreting the description of the data and the problems that the increased studies have raised, even if in a most summary way, appears very difficult. Therefore we will examine only the most important results and discoveries, without attempting to cover every area of the two continents.

NORTH AMERICA

There have been significant gains in the study of the pre-Columbian cultures of North America in recent years. In the United States, the contribution comes, in large measure, from the kind of archaeological research known as "salvage projects," intended to quickly provide information about areas in danger of being lost to research due to construction of plants, dams, and so on. These excavations become more important because in many cases the modern interests have been centered in areas with concentrations of pre-historic people for economic purposes - especially on those sites where dams were to be built, due to the presence of rivers and their easy accessibility. In this way archaeological sites have been discovered that were of great utility in completing the overall picture of the cultural development of the northern continent; otherwise they would have remained unknown for a long time. Inevitably, however, the thoroughness of the research has suffered due to the need for quick action.

On the whole, we can say that the broad lines of North American cultural development now seem clear; however, we can certainly expect many discoveries of primarily local importance and some areas and periods will have need of increasing studies. In fact, the subarctic, the whole western strip from the north-western coast to the Mexican border, and the Texan coast remain relatively little known.

However, there have not been any discoveries so sensational as to overturn the store of knowledge acquired in the past, either through various chronological perspectives or by discoveries of new cultures of important artistic patrimony. The lack of "high cultures" of great and multiform artistic tradition in North America, as in Middle America and the Andes, has not even allowed us individual findings of exceptional aesthetic value. The results achieved are of a different nature, confirming and enlarging our knowledge in the different areas.

For convenience in description, this summary of the status of the research will be arranged according to the subdivision into periods of the history of North American cultures proposed by Phillips and Willey (1958).

As far as the initial period of human presence in North America is concerned, it is one of the most obscure moments in the entire history of the continent. The earliest testimonies refer to the island of Santa Rosa, off the Southern California coast, and to the locality of Lewisville in Texas, where remains of fires and nearby rough hand-manufactured stone goods and bones of Pleistocene animals have been respectively dated by carbon-14 to 37,000 and 38,000 years. The validity of these dates, which seem to indicate a penetration into America of groups of hunters in a period preceding 40,000 B.C., has been challenged based on the re-examination of mineral deposits. The very same occurred for a dating of 28,000 years referring to Tule Springs (Nevada); this has been lowered to only 13,000 years by new C-14 data. However, the existence of different undated sites with a similar matching of the remains of Pleistocene fauna and of choppers, totally lacking the presence of pointed flintstones that characterize instead the later Paleo-Indian period, gave rise to the expression of "pre-point period" (A. D. Krieger, 1964), whose precise chronological position is yet to be determined. Also, its phyletic origin is uncertain, but it may be linked to the "choppers industries" of Eastern Asia.

The Paleo-Indian period begins around 15,000 B.C. when a second, different populating wave started moving from Asia to America. This date is presumed on the basis of the radium-carbon dating obtained from organic material associated with the lithic industry of the cultural complex of Sandia, the oldest found to date, located in the Sandia mountain chain of New Mexico. Sandia - with the well known cultures of Clovis, Folsom, and Plano, which followed one another up to the beginning of the Archean period - is set in the tradition of the "Great Hunt" - one of the two, Paleo-Indian traditions into which the cultures of the period are subdivided today. Its cultural imprint covers the part of North America that is south of the ice lines, which in this period are receding progressively toward the north, except for the north-western part of the continent in which, instead, the tradition of the "Old Cordillera" is

affirmed. The two traditions are distinguished on the basis of the different types of pointed flintstones. In the second tradition, they are shaped as willow leaves, pointed at each end. The first tradition shows, on the contrary, a wider variety, depending on the areas and on the period: from large, rough points with only one "shoulder" (Sandia) to others with partial grooving (Clovis) or total grooving (Folsom) or without grooving and of small dimensions (Plano).

Among the sites of major interest is the Levi site in Texas (10,000 B.C.), a Paleo-Indian camp where hand-manufactured goods (burins, scrapers) previously unknown have been found (H. L. Alexander, 1963).

The extinction of the great Pleistocene mammals, with the changes that such an event caused in the economic sector, and consequently in the material and social sectors as well, marks the passage to the Archean Period, around 8000 - 7000 B.C. (with some delay in the northernmost regions). For this period also, extensive and fruitful research has been carried out. The repertoire of hand-manufactured items - no longer limited to pointed flintstones but also, in the eastern area, including items made from other materials (bone, shell, cold-worked copper), especially in the final stage of the period - has led to a remarkable increase in our knowledge about the life of the people in those times. Also, pottery appears for the first time; the earliest examples, coming from Georgia and Florida, have been dated to 2500 B.C. (Stoltmann, 1966). In the western area, in which the Desert culture with its regional variations replaced the Paleo-Indian culture, the Archean didn't die out at the beginning of the first millennium B.C., as in the East, but continued in its way of life, based on small game hunting and on the harvest, up to the first millennium A.D. in the southwest and even up to modern times in the Great Basin.

In the middle area of the prairies, which were strongly influenced by eastern cultures, the Archean was replaced by cultural traditions of the Formative, also of eastern origin, in the first millennium A.D. (R. W. Neumann, 1967).

The Formative, because of its great achievements and its expansion over such large areas, has received a lot of attention from researchers during the last 20 years. G. Willey and P. H. Phillips (1958) proposed the term Formative for the period in which cultural advances were achieved that were based on the appearance of a series of new elements (agriculture, pottery, weaving, honing with stone); these achievements, in the archaeology of the Old World, marked the beginning of the Neolithic. This new cultural "state," characterized by permanent settlements following improvement of the techniques of farming, is not achieved everywhere. It is known that there are only three areas in North America in which agriculture became predominant and that can therefore be considered "Formative": the southeast, the southwest, and the area of the lowlands and prairies. In the latter area this took place at the beginning of the Christian era, while in the first two the transition to new forms of life occurred in the first millennium B.C., with the area of the Eastern Forests earlier than this by a few centuries. The end of the "Formative" will occur with the destruction of the native cultures in these three areas by the white people.

In the rest of the sub-continent the economic activities of subsistance, based on hunting, fishing, and harvesting, remained unchanged from the Archean until modern times, either because of a cultural idleness or real mesologic obstacles. Still, the problem remains as to whether the origin of agriculture in North America was independent or otherwise; even so, factors such as the proximity of the southeastern and southwestern areas to Middle America and the many cultural influences found in the level, the styles, and the motifs of their artistic production decidedly favor the theory of outside influences. As far as the area of the prairies is concerned, this is insignificant in relation to the problem: it acted as an appendage of the Eastern Forests until the arrival of the Europeans, even if in the final period (after 1000 A.D.) an independent cultural tradition was established (Plains-Village Tradition) — the result, though, of a mixture of eastern and southeastern elements.

Great progress has been achieved in the study of the Eastern Forests, not only through energetic research, which benefitted from substantial funding and from the research personnel from foundations and universities in the United States and Canada, but also through the widening of the research to previously neglected zones. The extreme north of the area of the forests, regarded as a marginal zone and therefore studied very little in the past, has benefited from this zealous research. Thus today the cultural sequences of southern Canada and the northern United States are very clear and have in fact been brought before the general public through widely distributed publications such as "The Archaeology of the New York State" by W. S. Ritchie or "Ontario Prehistory" by J. W. Wright. The latter shows how in this region of Canada the "Formative" emerges from the "culture shield" of the Archean, where the first handmade goods of cold-worked copper appear, around 1000 B.C.; it would eventually prosper under the influence of the culture of Hopewell, which introduced pottery and its most typical artistic manifestations (stone pipes, metal works, construction of effigy mounds). The exploration led by R. B. Johnson (1968) in the interior of the Serpent Mound (Rice Lake, Ontario) - a construction about 60 meters long, similar to the ones further south, dated between 100 B.C. and 300 A.D. - has brought to light tombs with rich funerary material consisting of flintstone implements and lithic pipes from Ohio, shells from the Gulf Coast, and objects made of quartzite mined in Labrador and of silver from Ontario. This shows that the region was not isolated, but, on the contrary, maintained intense trading relations with the rest of eastern North America and was completely included in the tradition of Hopewell, as we can infer also by the technical and artistic qualities of the handmade goods. The southern influences will continue on later, but after 1000 A.D., in that period of the "Formative" that is called the "Final Forests," the local styles will tend to diversify from the southern sub-areas, setting the basis of that artistic tradition that still lives in the sculpture of the Iroquois (see "North American Cultures," *Encyclopaedia of World Art*, vol. X).

The programs of excavation and research carried out in the southwest have been equally fruitful and substantial. D. Schwartz was able to identify as many as 48 new archaeological sites in one single survey of the Naukoweap Canyon, all included in the short space of one century (1050 - 1150 A.D.).

Works of great importance have been undertaken in 1964 - 1965 in Snaketown, near Phoenix (Arizona), to further the knowledge of the culture of Hohokam. The three great stylistic traditions of the area - Anasazi and Mogollón are the other two - seem to represent an intrusive extension of Middle American styles and techniques in the area. An undoubted impression of "high culture" is given by the great works of irrigation that included a canal system, up to 10 meters wide and 3 meters deep, altogether covering about 200 kilometers. However, due to the lack of precise data, the excavations haven't yet completely solved the absolute chronology of the various stages of the culture of Hohokam, especially for the earlier period. In any case, on the basis of the first dating by carbon-14 of Snaketown, it seems possible to affirm that the Hohokam culture began at the end of the first millennium B.C.

The culture of Trincheras appears to have close connections with the culture of Hohokam in its most recent stages. At the site of La Playa - excavated by A. E. Johnson (1963), near Santa Ana in the Mexican state of Sonora, 75 miles south of the United States border - the ancient inhabitants worked fields terraced on the sides of the hills and made "corrals" of rock and produced beautiful crockery both in polychrome and in bichrome of purple on red. A chronological reference for the Trincheras culture is obtained from some of its pottery that was found outside the base area in Arizona, which was dated to 800 - 1100 A.D.

The site of Dry Prong, located 16 miles northeast of Point of Pines, Arizona, discovered by A. P. Olson, appears, instead, to be associated with the production of Mogollón, although strongly influenced by the Anasazi culture. Dated between 1000 and 1150, it consists of a large "kiva" with five connected rooms, a "pueblo" in the form of a U, scattered storehouses, a reservoir, and terraced agricultural fields.

Much more prominence has been given the studies of the local "border" cultures of the southwest, such as the Pataya (lower Colorado River), Sinagua (northern Arizona), and the Cohonina (northwestern Arizona); between 800 and 1000 A.D., these cultures absorbed and adapted as their own the stylistic and cultural influences of the three great traditions mentioned above, thus coming out of their state of subjection and isolation. Such influences played a part in the formation of the Sinagua culture, for example: at first the Mogollón influence, later on the Hohokam, and finally the Anasazi, responsible for the greater architectural achievements (stone constructions at ground level) and the beautiful white painted pottery.

BIBLIOGRAPHY - W.W. Crook, R.K. Harris, A Pleistocene Campsite near Lewisville, Texas, AmAnt, XXIII, 1958, 3; R.S. MacNeish, An Introduction to the Archaeology of Southeast Manitoba, National Museum of Canada Bulletin, 157, 1958; G. Willey, Ph. Phillips, Method and Theory in American Archaeology, Chicago, 1958; R.S. MacNeish, A Speculative Framework of Northern North American Prehistory as of April, 1959, Anthropologica, I, 1959; C.W. Meighan, California Cultures and the Concept of an Archaic Stage, AmAnt, XXIV, 1959; W.R. Wedel, An Introduction to Kansas Archaeology, BAEB, 174, 1959; A.P. Olson, The Dry Prong Site, East Central Arizona, AmAnt, 26, 2, 1960; G. Quimby, Indian Life in the Upper Great Lakes, 11000 B.C. to A.D. 1800, Chicago, 1960; G. Vivian, P. Reiter, The Great Kivas of Chaco Canyon and their Relationships, School of American Research Monographs, 22, Santa Fe, 1960; R.B. Butler, The Old Cordilleran Culture in the Pacific Northwest, Idaho State University Museum, Occasional Papers, 5, 1961; M.R. Harrington, R.D. Simpson, Tule Springs, Nevada, Southwest Mus. Papers, 18, Los Angeles, 1961; W.R. Wedel, Prehistoric Man on the Great Plains, Norman, 1961; R.J. Braidwood, G.R. Willey (eds.), Courses Toward Urban Life, VFPA, 32, 1962; A.L. Krieger, The Earliest Cultures in the Western United States, AmAnt, 28, 2, 1962; R.J. Mason, The Paleo-Indian Tradition in Eastern North America, Current Anthropology, 3, 1962; E.H. Swanson, The Emergence of Plateau Culture, Idaho State College Museum, Occasional Papers, 8, 1962; H.L. Alexander, The Levi Site: A Paleoindian Campsite in Central Texas, AmAnt, 28, 4, 1963; D.W. Dragoo, Mounds for the Dead: An Analysis of the Adena Culture, Carnegie Museum, Annals, 37, 1963; B.P. Dutton, Sun Father's Way: The Kiva Murals of Kuaua, Albuquerque, 1963; A.E. Johnson, The Trincheras Culture of Northern Sonora, AmAnt, 29, 2, 1963; A.V. Kidder, An Introduction to the Study of Southwestern Archaeology with «A Summary of Southwestern Archaeology Today» by I. Rouse, New Haven and London, 1963; O.H. Prufer, Der Hopewell-Komplex der Östlichen Vereinigten Staaten, Paideuma, 9, 1963; C.V. Haynes, Fluted Projectile Points: Their Age and Dispersion, Science, 143; D.W. Schwartz, An Archaeological Survey of Naukoweap Canyon, Grand Canyon National Park, AmAnt, 28, 3, 1963; J.V. Wright, An Archaeological Survey along the North Shore of Lake Superior, Nat. Mus. of Canada, Anthropology Papers, 3, 1963; E. Finch, Recent Archaeological Work in New Hampshire, Eastern States Archaeological Federation Bull., 24, 1964; J. Jennings, E. Norbeck (eds.), Prehistoric Man in the New World, Chicago, 1964; N.M. Judd, The Architecture of Pueblo Bonito, Smithsonian Miscellaneous Collections, 147, pt. 1, 1964; W. Lindig, Die Cohonina-Kultur, Neue Forschungen zur Vorgeschichte des Nordamerikanischen Südwestens, Baessler-Archiv, NF XII, 1964; R. Stuckenrath, The Debert Site: Early Man in the Northeast, Expedition, 7, 1, 1964; H.S. Gladwin et al., Excavations at Snaketown. Material Culture, Tucson, 1965 (I ed., 1937); E.W. Haury, Snaketown: 1964-65, The Kiva, 31, 1965; W.A. Ritchie, The Archaeology of New York State, New York, 1965; A.H. Schroeder, Unregulated Diffusion from Mexico into the Southwest Prior to A.D. 700, AmAnt, 30, 3, 1965; F.W. Eddy, Prehistory in the Navajo Reservoir District, Northwestern New Mexico, Museum of New Mexico, Publications in Anthropology, 15, 1966; H. Müller-Beck, Paleohunters in America: Origins and Diffusion, Science, 152, 1966; J.B. Stoltman, New Radiocarbon Dates for Southeastern Fiber-Tempered Pottery, AmAnt, 31, 6, 1966; G.R. Willey, An Introduction to American Archaeology, vol. I: North and Middle America, Englewood Cliffs, 1966; J.B. Griffin, Eastern North American Archaeology: A Summary, Science, 156, 1967; R.W. Neuman, Radiocarbon-dated Archaeological Remains on the Northern and Central Great Plains, AmAnt, 32, 4, 1967; R. Schutler, Tule Springs; Its Implications to Early Man Studies in North America, in Irwin Williams (ed.), Early Man in Western North America, Eastern New Mexico University, Contributions in Anthropology, 1, 4, 1968; J.V. Wright, The Laurel Tradition and the Middle Woodland Period, National Museum of Canada, Bulletin 217, 1967; R.B. Johnston, The Archaeology of the Serpent Mound Site, Royal Ontario Mus., Art and Archaeology Occasional Paper, 10, 1968; A.J. Waring, The Southeastern Ceremonial Complex, in S. Williams (ed.), The Waring Papers, Peabody Museum Papers in American Archaeology and Ethnology, 58,

1968; J.A. Ford, A comparison of Formative Cultures in the Americas, Smithsonian Contribution to Anthropology, vol. II, 1969; J.J. Brody, The Kiva Murals of Pottery Mound, Verh. des XXXVIII Int. Amerikanistenkongresses, II, Stuttgart, 1970; J.E. Fitting, The Archaeology of Michigan: A Guide to the Prehistory of the Great Lakes Region, Garden City, 1970; W. Lindig, Die Präkolumbischen Kulturen Nordamerikas. Ein Überblick über den neuesten Stand der Forschung, Paideuma, 16, 1970; B.C. Kent, I.F. Smith, C. McCann (eds.), Foundations of Pennsylvania Prehistory, Anthropological Series of the Pennsylvania Historical and Museum Commission, 1971; B.K. Swartz (ed.), Adena: The Seeking of an Identity: A Symposium Held at the Kitselman Conference Center, Ball State University, March 5-7, 1970, Muncie, 1971; G.J. Gumerman, D. Westfall, C.S. Weed, Black Mesa: Archaeological Investigations on Black Mesa, the 1969-1970 Seasons, Prescott College Studies in Anthropology, 4, Prescott, 1972; W. Lindig, Die Kulturen der Eskimo und Indianer Nordamerikas, Frankfurt, 1972; W. Smith, Prehistoric Kivas of Antelope Mesa, Northeastern Arizona: Reports of the Awatovi Expedition, n. 9, Papers of the Peabody Museum of Archaeology and Ethnology, 39, 1, 1972; J.V. Wright, Ontario Prehistory. An Eleven-Thousand-year Archaeological Outline, Ottawa, 1972; J.V. Wright, The Shield Archaic, Nat. Mus. of Canada Publications in Archaeology, 3, Ottawa, 1972; Aa. Vv., Late Woodland Site Archaeology in Illinois: Investigations in South Central Illinois, Illinois Archaeological Survey Bulletin Series, 9, 1973; B.O. Simonsen, Archaeological Investigations in the Hecate Strait-Milbank Sound Area of British Columbia, Nat. Mus. of Man, Archaeological Survey of Canada, n. 13, 1973.

ITALO SIGNORINI

THE ARCTIC

Various experts – among them W. Lindig (1970) – in their general treatises of America place the entire development of the Arctic cultures from the beginnings to present times in the Archean period. Such a classification was necessary as they could not be considered to have been part of that process of evolution that was hastened by the introduction of an agricultural economy, as was the case in the southern regions. The same scholars, though, also recognize that the environmental conditions accentuated their "specialization" in order to differentiate them from all the other hunting cultures of the continent, so that a separate treatise is justified. Sophistication and high technological level, in fact, are its characteristics, proved by the quality of the artistic production (see Eskimo Cultures, *Encyclopedia of World Art*, Volume V).

Recent studies, benefiting by a greater number of datings by carbon-14, have furthered our knowledge of the Arctic cultural sequence and the connections and mutual influences between cultures. The framework of their development is presented in this manner today.

Around 6000 B.C., a cultural trend of Asiatic origin, tied to the third great population movement, joined the Paleo-Indian cultures as they entered into the southern Arctic at the retreat of the ice cover; this culture introduced a microlithic industry of the La Gravette type, constituting what H. G. Bandi (1965) calls the American Epi-Gravettian. This is divided really into two traditions: the earliest, the "Northwest Microlithic," which began around 6500 B.C., and the

"Arctic Microlithic," which undermined it and progressively replaced it, starting in 3500 B.C. The latter, which from 3000 B.C. spread also to the central and eastern Arctic areas up to the northern part of Greenland, has among its characteristic hand-manufactured goods small pressure-chipped points and crescent shaped blades, sharpened on both sides, that were used as knives. The "proto-Eskimo" traditions will derive from this, when between 2000 and 1000 B.C. new, Neolithic, cultural elements from Siberia are added through a final wave of population, this time of the Mongolians, extending over a period of about 3000 years; through superimposition, mixing, and substitution - the "horizon culture" of Thule (900 - 1300 A.D.) will ultimately be created, the immediate antecedent of the historical Eskimo culture and the one responsible for its remarkable homogeneity.

The theory that the proto-Eskimo traditions are of American Indian derivation seems now to be definitely discarded (Jenness 1922, 1928). In his study on the pre-history of the Copper Eskimos, McGhee (1972) has convincingly proved that the culture of this central group - which because of certain particularities seemed to prove better than any other the above mentioned theory - was also derived from the culture of Thule, coming from Alaska, of which it represents an adaptation in a different geographic setting. This adaptation used the local supplies of wood, copper, and soapstone for the manufacture of objects of daily use and for ornamention and gave up open sea hunting of the big sea mammals in favor of hunting and fishing on ice-packs and dry land.

The numerous datings we have by carbon-14 allow us to speak of absolute chronologies for the various proto-Eskimo traditions, their phase and cultures: Okvik (1000-100 B.C.), Choris (1000 - 500 B.C.), Old Bering Sea (300 B.C. to 500 A.D.), Near Ipiutak (500 B.C. to 100 A.D.), Ipiutak (100 B.C. to 500 A.D.), Norton (500 B.C. to 400 A.D.), Punuk (600 - 1100 A.D.), Birnirk (500 to 900 A.D.), Dorset (700 B.C. - 1300 A.D., Thule (900 - 1300 A.D.).

Finally, the excavations in Kodiak Island (southern Alaska) by D. W. Clark deserve mention; they add valuable new data on this southern Arctic area to what has been provided by A. Hrdlicka (1944). Within the southwest of Alaska, it constitutes a distinct cultural province - distinct from the Aleutian and the other Eskimo cultures - with a maritime culture in existence since the fourth millenium B.C. (Ocean Bay 1 Site 438, 3553 +/- 78 B.C).

BIBLIOGRAPHY - R.S. MacNeish, Men Out of Asia; as Seen from the Northwest Yukon, Univ. of Alaska, Anthropological Papers, 7, 2, 1959; F. Rainey, E. Ralph, Radiocarbon Dating in the Arctic, AmAnt, 24, 4, 1959; M.S. Maxwell, The Movement of Cultures in the Canadian High Arctic, Anthropologica, 2, 2, Ottawa, 1960; J. Meldgaard, Eskimo Sculpture, London, 1960; J.L. Giddings, Cultural Continuities of Eskimos, AmAnt, 27, 2, 1961; H. Larsen, Archaeology in the Arctic, 1935-1960, ivi, 27, 1, 1961; D.J. Ray, Artists of the Tundra and the Sea, Seattle, 1961; S.I. Rudenko, The Ancient Culture of the Bering Sea and the Eskimo Problem (trans. from Russian), Arctic Institute of North America, Anthropology of the North: Translations from Russian Sources 1, Toronto, 1961; J.M. Campbell (ed.), Prehistoric Cultural

Relations between the Arctic and Temperate Zones of North America, Arctic Institute of North America, Technical Papers, 11, Montreal, 1962; W.E. Taylor, The Prehistory of the Labrador Peninsula, Études Économiques et Humaines au Nouveau Quebec, Bibliothèque Arctique et Antarctique, II, Paris, 1962; W.E. Taylor, Hypotheses on the Origin of Canadian Thule Culture, AmAnt, 28, 4, 1963; R. Collins, The Arctic and Subarctic, in E. Norbeck, J.D. Jennings (eds.), Prehistoric Man in the New World, 1964; J.L. Giddings, The Archaeology of Cape Denbigh, Providence, 1964; R.S. MacNeish, Investigations in the Southwest Yukon: Part II: Archaeology Excavation, Comparisons and Speculations, R.S. Peabody Foundation for Archaeology Papers, 6, 1, Andover, 1964; Ch.A. Martijn, Canadian Eskimo Carving in Historical Perspective, Anthropos, 59; H.G. Bandi, Urgeschichte der Eskimo, Stuttgart, 1965; D.W. Clark, Perspectives in the Prehistory of Kodiak Island, Alaska, AmAnt, 31, 3, 1966, part 1; H.B. Collins, Composite Masks: Chinese and Eskimo, Anthropologica, n.s. 13; J.L. Giddings, Ancient Men of the Arctic, New York, 1967; W.E. Taylor, Summary of Archaeological Fieldwork on Banks and Victoria Islands, Arctic Canada, 1965, Arctic Anthropology, 4, 1, 1967; W.E. Taylor, G. Swinton, The Silent Echoes: Prehistoric Canadian Eskimo Art, The Beaver, Outfit 298; W.N. Irving, Prehistory of Hudson Bay. The Barren Grounds, in C.S. Beals, D.A. Shenstone (eds.), Science, History and Hudson Bay, I, Ottawa, 1968; W.E. Taylor, The Arnapik and Tyara Sites. An Archaeological Study of Dorset Culture Origines, Soc. for American Archaeology, Memoirs, 22, 1968; R. McGhee, Copper Eskimo Prehistory, National Mus. of Man, Publ. in Archaeology, 2, 1972; R. McGhee, Copper Eskimo Prehistory, National Museum of Canada, Publications in Archaeology, 2, 1972; E. Carpenter, Eskimo Realities, New York, 1973.

ITALO SIGNORINI

MIDDLE AMERICA (PLATES 75-78)

Middle America, with the central Andes, is the area (chiefly, Mexico) where most of the work has taken place and where the most important results in different areas have been obtained, such as the stratigraphs, the emphasis on monuments, and the restoration of great ceremonial centers.

The excavations in the Tehuacan valley, conducted by the Peabody Foundation for Archaeology between 1960 and 1965 under the direction of R. MacNeish, are of primary importance, not only for the data furnished to us on a previously little-known period, but also, and mainly, for the knowledge acquired about the history of the cultural evolution of that area. This evolution led, in the first millennium B.C., to the formation of a complex of cultural elements that were the basis for the development of the Middle American "high cultures" of the following periods. In this valley, which is about 100 kilometers long and 30 kilometers wide and is located in the southeastern part of the state of Puebla, the excavations have, in fact, furnished data for a cultural sequence that includes a period of up to 12,000 years from pre-history to the present.

This supports, integrating and perfecting the knowledge, the sequence that MacNeish himself had derived from the excavations he performed in Tamaulipas between 1946 and 1956.

Between 10000 and 4900 B.C., the valley was at first occupied by groups of hunters of big game, before the climatic changes at the end of the last Ice Age came to an end, and afterward by small game hunters, whose diet was drawn from the vegetables found growing naturally. In the periods known as Coxcatlan (4900 - 3400 B.C.) and Abejas (3400 - 2300 B.C.), agriculture first appeared, progressively becoming more important as a means of subsistence when new crops were added; the first attempts were made with beans, squash, and peppers.

An analysis on the food remains of a site of the Abejas period indicates that the hunting and the harvesting of wild plants continued to provide about 70 percent of their sustenance. Pottery is still absent, but there was a remarkable development of stone work — for example, bowls, jars, and oval metates — and also of work done with obsidian such as blades and other objects. According to MacNeish, we can already speak of "village life," even if it were probably limited to certain periods of the year.

The first examples of clay production are found in the Purrón period (2300 - 1500 B.C.): pottery fragments of a coarse and crumbly mixture that repeat the shapes of the lithic crockery of the preceding period. In the following Ajalpal period (1500 - 900 B.C.), different shapes and kinds of pottery were added: well-formed vases, lacking any pictorial ornamentation, and anthropomorphic clay statuettes, mostly representing women, of the type that will be characteristic of the whole Middle American Preclassic period. The settlements, meanwhile, can more and more be classified as villages. However, it is not until the preclassic period of Santa Maria (900 - 200 B.C.) that there is a significant increase in quality, foreshadowing the great achievements in architecture and town planning of the following eras. The dwellings are already grouped around a central space, either on the same level or raised, and on which some kind of ceremonial building in perishable material was probably erected.

By now the settlements had become permanent, as a result of the agriculture, which was based on a considerable number of products, among them new hybrids of corn of a higher yield. The pottery is monochrome, of white or gray color, but there are also bichrome examples and others decorated with pictures done in negative or with incisions. The crockery consists of bottles, bowls with flattened bottoms, and vases of elaborate shapes.

From 200 B.C. on, phases of the Tehuacan Valley will be expressed in a totally Middle American way, becoming a part, as a local variant, of the high cultures in the area.

The Olmec culture was the most famous of the Preclassic age, favored by the attraction it exercises because of its extraordinary aesthetic qualities, as well as the "mystery" of its appearance in such an early period. The intensive research carried out on this culture has enabled more precise and articulate dating for it and has also clarified many of the problems of its origin and diffusion.

The theory that the Olmec culture originated outside what is defined as the Metropolitan area, the forested and marshy territory covering an area in the states of Vera Cruz and Tabasco - regarded in the past as a shelter area by certain researchers - must be definitively

discarded. Therefore, the origin was not in the Guerrero (Covarrubias, 1956), on the plateau of Mexico (Piña Chan, 1958), or in the Mixteca (Wicke, 1965), or even, as still lately maintained by Girard (1968), on the stretch of coastline between Mexico and Guatemala on the Pacific side. According to Bernal (1968), much of this confusion was due to the scarcity of C-14 dating and also to the fact that, since 1200 B.C., an era preceding the great achievements of the Metropolitan area, the Olmec style also appears in sites in other areas — for example, in Tlatilco. Now, in reality, the C-14 datings obtained show a remarkable antiquity for La Venta, considered to be the capital of the area, where the artistic production is entirely of Olmec style and not mixed with different styles as it is in the other areas. By subdividing, as Bernal does, the history of the Olmec culture into phases, the diffusion of cultural elements into quite distant regions, perhaps driven by a religious ideology of great attraction, would have already taken place in the Olmec I period (1200 - 800 B.C.); this was really the first Middle American period, according to Bernal — a period of formation and experimentation preceding that of greatest splendor.

Examples of the Olmec I period have been found "in situ" in La Venta and in Tres Zapotes: it is pottery material that from its stratigraphic position can definitely be classified as prior to the construction of the great monuments of both ceremonial centers, started after 800 B.C. and proved by various dating by C-14. There is evidence of simpler buildings, of earth, built in the Olmec I period. In fact, clay from previous buildings was used for the earliest monuments of the Olmec II period. Without benefit of C-14 datings, Girard attributes lithic sculptures representing obese individuals with child-like features, found on the Pacific coast of Guatemala (he himself found several of remarkable importance in 1968), to the Olmec I period, which he calls "Pre-Olmec." Their greater roughness and their small dimensions, compared to the superb models of the Olmec II age of La Venta and other smaller centers, suggested to him that they could be antecedents of these, the product of an experimentation that would, later in time and in a different area, yield its fruits. Now, if it is acceptable, until proved otherwise, that they belong to Olmec I, then his hypothesis of a spreading of the Olmec style from the Pacific coast to the Gulf Coast is not. Rather, they seem to represent the precursors of those regional styles (for example, those of Tonala and Izapa, which, nourished by the Metropolitan area, flourished in this area during Olmec II and III.

The Olmec II era (800 - 400 B.C.), is subdivided by Bernal, for La Venta, into four sub-phases of about one century each, for a total period of 400 years.

Each sub-phase corresponds to a rebuilding or to an enlargement of the monuments, as well as to substantial ritual offerings. The sub-phases do not represent different cultural and stylistic times: the period, in fact, has a substantial unity. Nevertheless, we can point out that they mark a progressive enrichment of artistic manifestations: for example, in sub-phase I, rock crystal is not worked yet and floors are not yet built of white clay mixed with sand of the same color; in sub-phases III and IV, jade working reaches its highest perfection and the great monolithic sculptures are produced. In this period the Olmec culture has its highest diffusion, its effects being felt in virtually every area of Middle America, from Huasteca to Salvador.

In the last few years, thanks to the increase in excavations and to several fortunate findings, the documentation on this subject has grown remarkably rich. The findings at Pijijiapan, near the small town of the same name on the Chiapas coast, are among the most remarkable - a series of bas-reliefs sculptured on three large rocks. On the first of these are three standing persons, two of them seeming to speak to each other. They are dressed with loin-cloth, capes, and tall headgear. The central figure has his left hand inserted in some kind of iron first; this figures serves as a time marker, as it also appears in the works of the classical Olmec period. The second rock shows a series of scenes: a group of three figures - one wearing a mask - near a tree whose roots and lower trunk are shown; a face covered by a helmet shaped as the head of a jaguar; a man whose upper body is shown; and another man who is seated. The third rock shows the figure of an iguana. The stylistic similarities of the reliefs with the famous Olmec rock paintings of Chalcatzingo, in Morelos, described by Pina Chan (1955), and with the splendid one of Xoc, in Chiapas, studied (1973) by S. Ekholm Miller, are evident.

In 400 B.C., the city of La Venta was abandoned and its reoccupation, by a foreign and iconoclastic group, took place only after a period of time sufficient to allow the city to be overgrown with vegetation. On the other hand, it appears that the Olmec II period in Tres Zapotes lasted one or two centuries longer than in La Venta. Anyway, the evidence shows that the Olmec style declined everywhere, though without disappearing, and that various external influences, depending on the areas, penetrated it quite massively. It is clear that in this era the Olmecs are no longer the culturally and politically dominating people. This last era is called Olmec III (400 - 100 B.C.) by Bernal. In the general decline, the Olmec culture, nevertheless, succeeds in expressing a further creation, later assimilated and perfected by the Mayas, which will constitute one of the major intellectual achievements of these people. This is the Long Count, the arithmetic system that counted by twenties and included the zero and which enabled Middle America to work out one of the most perfected calendars. The oldest dated stelae, marked by the baktun 7, such as that of Chiapa de Corzo, found in 1961, belong to Olmec III. If the reconstruction of the dating, unfortunately incomplete, is accurate, this stele would be the earliest (7.16.3.2.13 = 7 December, 35 B.C., according to the correlation B system; 19 June 295 B.C., according to the correlation A system). It would precede by four years, therefore, the famous stele C of Tres Zapote (7.16.6.16.18).

We have already mentioned the Izapa center, where the Olmec influences from the Metropolitan area permitted the development of a regional style, extremely interesting and important for the development of the southern Middle American cultures. The style, in fact, constitutes a bridge between the classic Olmec horizon and the Mayan one; thus it links the classical culture with the preclassical. Chronologically it can be dated between 300 B.C. and 250 A.D. The artistic manifestations essentially consist of bas-relief sculptures on stelae, often found with altars; such a combination is later found in the classical Mayan art.

The subjects of the representations are religious and cosmological and in many cases may have a commemorative function. Often plants and animals are pictured together with the anthropomorphic figures.

The Izapa sculptures caught the attention of the researchers only since the 1960s, when they realized that the diffusion of their style was much wider than it had appeared at first. It can be found, in fact, in monuments in several locations of the Guatemalan coast (El Baul, Bilbao, Colomba), of the Vera Cruz coast (Tres Zapates, Cerro de Las Mesas), of Chiapas (Chinkultic, Chiapa de Corzo, Tonala), and of the Guatamalan plateau (Kaminaljuyu). The Izapa style, furthermore, eventually influenced the later sculptural production of several Middle American places of the classical age.

In the interests of conciseness, we may use the knowledge gained from the excavations in Tikal, in Peten (Guatemala), as a reference for the preclassical period of the Maya area. Several United States foundations and the Guatemalan government joined in the "Tikal project," undoubtedly the most ambitious archaeological operation ever undertaken in Middle America. For more that 10 years (1956 - 1969), this project employed dozens of specialists (archaeologists, topographers, architects, restorers, and photographers), with an exceptional display of technical and financial means.

Systematic excavations have allowed the development of this great center to be followed from the origins to the post-classical era. Tunnels and trenches enabled the archaeologists to penetrate and explore the inside of the larger complexes and to identify the successive phases of construction. Architectural treasures, tombs, sculptures, dated stelae, and pottery, buried under new buildings by the ancient Mayas in their periodical eagerness to rebuild (a characteristic of the Middle American cultures), have thus come to light, at least in part: artistic patrimony and scientific instruments of incalculable value for the reconstruction of the history of the Maya settlement in the forested lowlands. Furthermore, Tikal has become a tourist center of primary importance, with thousands of visitors each year, who can now enter and remain on the site, heretofore closed by an almost impenetrable jungle. The preclassical levels have provided many surprises, as we could have expected. The center appears to have been inhabited since 600 B.C.; the remains of their simple pottery have been found in refuse pits dug into the rock-bed on which the city lay. The beginning of a proper architectural activity, with stone buildings covered with plaster, can be placed between 300 and 200 B.C., in relation with a kind of pottery, called Chuen, producing the beautiful anthropomorphic clay statuettes. Furthermore, the cyclical destruction of the monuments, whether total or partial, and their reconstruction, incorporating the previous structures, has already been established.

Around 50 B.C. there was a great increase in building activity. The most important construction of this era is the structure 5D - sub/1-1°, one of the most remarkable examples of Preclassical architecture. The pyramidal body is arranged on a bi-level platform, on which is placed a small building of two rooms, divided by two staircases. On the front, a flight of steps leads to the entrance to the rooms, flanked in the lower part by big blocks of masonry, in the higher part by large masks representing jaguars, badly damaged. Two smaller stairways are arranged on the outer side of the blocks. The sides and the back of the construction are ornamented with wide moldings in the form of an "apron".

Of the upper facade, which was certainly decorated, only fragments remain from demolition due to the construction of a new group of buildings on the same site. The structure 5D - sub/10-1° is almost contemporary, which is of interest not for its architecture, but its paintings. The small building (3 meters by 3.30 meters), also buried under new buildings, is on a two-level platform and consists of only one room, decorated on the outside by a series of polychrome frescoes of figures with elaborate hairstyles and grotesque faces, which, in spite of being damaged, are impressive due to their fine workmanship. The figures are across the corners of the building, therefore vertically divided, and are connected to each other by an ornamental frieze, also painted. These findings are very important because no pictorial displays were heretofore known of the Preclassic period. A hieroglyphic sign that appears on one of the figures shows that writing was already used in this phase of the Preclassic. Around 50 A.D., most of the buildings on the northern acropolis, the part of Tikal that provided the greatest amount of information about the Preclassic era, were demolished and buried in order to create an immense platform of around 8,000 square meters where new buildings, temples, and platforms could be built. The latter were recurrently demolished, rebuilt, or modified during the remainder of the Preclassic era, that is up to 250 A.D. (see Design, *Encyclopaedia of World Art*, vol. IV).

The examination of the conclusions from the findings, which show that the Maya Preclassic art had reached remarkable heights of refinement and was the product of an already "complex" society, raised the problem of how much is due to internal evolutionary processes and how much to contributions from outside. Independently from the stimuli that the Olmec culture undoubtedly provided, those coming from the Mayans of the southeastern plateau appear no less important, even to the point of considering them as active participants in the populating of the lowlands. The excavations under the direction of, initially, Coe (1954), and later Sharer (1966 - 1967), in Chalchuapa in El Salvador seem to confirm this last hypothesis. Here the group of mounds of El Trapiche appears as a complex ceremonial center built and occupied in the late Preclassic era (200 B.C. - 200 A.D.). Consisting of six aligned platforms of earth covered with "adobe," supporting temple structures built with non-permanent material, it was, with mound no. 1, 23 meters high, one of the biggest constructions of the Mayan Preclassic period. The pottery articles are of exquisite workmanship, and stratigraphic wells permitted tracing its evolution from the Tok complex (1100 - 800 B.C.) to the Caynac, the final one, when the city was abandoned after the disastrous eruptions of the Ilopango volcano. The stylistic analogies with the lowlands (Tikal, Uaxactún) are evident, and the fact that the first stylistic connection takes place between 800 and 500 B.C., the period corresponding to the first occupation of the lowlands, appears very significant. The comparisons also are reinforced by the ruins of a stele sculptured in clear Maya style, with a seated human figure and a complicated hieroglyphic inscription.

The work accomplished in the last 20 years on the classical and preclassical eras is imposing, and the task of synthesizing the results is difficult. However, this work has not resulted in substantial changes in the knowledge in general, or in the chronology in particular, as it did for the Preclassic Olmec culture. The work of investigation has been supported by a huge number of studies that have examined the structure of the ancient societies, their economies, and their ideas, insofar as they can be inferred from the results of the excavations, in order to understand the foundations of the civilizations created and of the extraodinary achievements in the artistic field.

Growing interest and appreciation for Middle American art, patriotism, and economic demands connected with tourism are also added elements that encourage every initiative emphasizing the national archaeological patrimony. In fact, these elements contributed to the impetus given by various governments to the defense, the maintenance, and the rebuilding of the monuments. Furthermore, huge works that are beyond comparison in America have been undertaken for this purpose, also by foreign institutions, in the countries into which the ancient Middle America is subdivided today.

The Mayan area has been, from this point of view, a privileged area because of the very high aesthetic value of its production. From the plateau to the forested lowlands, from Mexico to Honduras, the efforts of studies and rescue operations have greatly increased. The efforts of survey and documentation accomplished in Quintana Roo, for example, a region almost completely neglected in the past, have been remarkable; here as well as in many other areas they led to the rediscovery of sites that were known only by name and whose exact location was unknown. This is the case of Tzibanche, found during the survey conducted in Quintana Roo by the Royal Ontario Museum.

This city, which developed in classical Mayan times, appears rather large and complex, even if its size didn't equal that of several coastal cities of the territory that were active in the Preclassic age, for example San Gervasio, on the island of Cozumel, which covered an area of 100 hectares.

Tzibanche has a large central square (80 meters by 85 meters), and other smaller ones; facing onto these squares are temples of considerable size. In temple no. 6, architraves are still found in place - as was indicated by Gann in 1927 - with a series of numbers tentatively interpreted by Morley in 1928 as the date 9.15.2.0.0 = 733 A.D. and by T. Proskuriakoff, on the basis of better photographic material, as 9.6.0.0.0 = 554 A.D.

Also in the Quintana Roo, between Chetumal and Escarcega (Campeche), another group of researchers succeeded in saving a very valuable monument, both from the wear and tear of time and especially from the destroying action of looters. This was the pyramid of Kohunlhich, which measured 21 meters at the base and 9.50 meters in height, although it may measure an additional 5 meters below ground.

Freed from vegetation and fallen material, it revealed a staircase 8.50 meters wide, whose sides are flanked by a series of grotesque stucco masks of splendid workmanship portraying human faces (adorned, according to the Mayan fashion, with labial buttons and with teeth mutilated in the shape of a T),

framed by stylized snakes. By stylistic comparisons it appears to belong to the end of the previous Classical age and to have been strongly influenced by Uaxactún.

In the rest of the Mayan area, significant works were carried forward in large and famous cities such as Copán, Palenque, Uxmal. In the last, all the major monuments were restored: these were the Palacio del Gobernador, the Templo de las Tortugas, the Cuadrilatero de las Monjas, and the Piramide del Adivino. In this city a sixth stage of construction was discovered, in addition to the five already known, as well as a C-14 dating was made (569 ± 50 B.C) that considerably moves back the beginning of the life in this center. Not too far from Uxmal, near Sayil, one of the most beautiful monuments of Yucatan of the puuc style, the Xlabpak palace, has been restored.

The work of Guillemin in Iximché, the ancient capital of the Maya Kakchiquel of the Guatemalan plateau, whose construction dates back to the end of the XV century A.D., deserves to be mentioned. Temples, palaces, and residential structures were grouped around four large squares and two small ones, forming separate nuclei. Two of them also have a ball court. The main square, for example, consists of a playing field, two temples, and ten platforms supporting palaces. The so-called Great Temple consists of three constructions built one on top of another, cut by a steep entrance stairway at whose top is a sacrificial altar. Traces of polychrome frescoes decorate the walls; remarkable is the figure of a man, painted in various positions, who is sacrificing himself.

In conclusion, in any study of the classical era the "Tikal project" must be mentioned. Besides the work of surveying, excavating, and uncovering the structures hidden by debris and thick vegetation, the titanic task of preserving and rebuilding most of the monuments was also accomplished.

For the latter consideration the greatest difficulties have been the choice of the objectives: splendid buildings of later ages revealed, for example, equally splendid buildings below them from the earlier eras that restoration work would have hidden. Sometimes, instead, the structures of the late classical era were so badly damaged that they couldn't be repaired, while preceding buildings from the earlier classical era were found to be in a perfect state.

This is what has been done in the case of the 5 D - 33-1° structure, a temple of the late classical age that was demolished due to the impossibility of strengthening its outer surfaces; as a result, it was possible to study the building techniques of this large Mayan building and also to bring to light the temple below 5 D - 33-2°, belonging to the prior classical age.

In spite of the fact that objections and perplexities concerning too "daring" works of restoration can be raised in this area, especially by the European archaeologists, we must admit that the final result is undoubtedly great.

The archaeologist had to cope with another difficulty, especially concerning the previous classical age: this is the intentional demolition of the sculptural monuments for ritual reasons (for example, stelae and altars). This was a distinctive feature of the classical Mayas, and, according to Coe (1965), involved at least half of the production of Tikal of the previous classical age. Independent of the loss of works of priceless value

to us, this has caused considerable complications in the connection between monuments, in many cases not allowing us, for example, to exploit the connection with calendrical stelae for the purpose of dating.

The chronology could be determined also, and Tikal has confirmed the moving back of the beginning of the classical age compared to what was formerly believed. The first half of the third century A.D. indeed marks the transition from the pre-classical to the classical age, subdividable into two stages: the early classical age (250 - 550 A.D.) and the late classical age (550 - 900 A.D).

An element of great importance that resulted from the study of the early classical age is the remarkable influence of Teotihuacan on the pottery typology - cylindrical tripods with a covering of stucco, painted in polychrome - and in the style of lithic and vascular representations; this has convinced several researchers to speak of Tikal as "the Teotihuacan commercial colony."

Supporting this advanced theory were the large trenches protecting the city on the north side for a distance of 9.5 kilometers; they were eliminated in the late classical age, as if - after the fall of Teotihuacan - alienations and hostilities previously existing had been overcome during this period. At any rate, there is the confirmation that the influence of Teotihuacan extended not only to the plateau, but to the lowlands of Guatemala. Tikal, also, has revealed much about the mysterious end of the classical Mayan culture and the abandonment of the cities of the lowlands. The final collapse appears to have taken place in Tikal after 869, the date of the last stele erected (but in the nearby city of Jimbal there is one from 20 years later). Nevertheless the city went on with its life for the whole tenth century, and most likely the same happened in many other cities, even if the number of people was much less. The creative abilities, however, disappeared. The monuments weren't being built anymore, and there was no sculpturing, but the social and religious significance of these activities wasn't forgotten. The post-classical Mayas of Tikal, in fact, didn't stop building stelae and altars; however, they used what had been produced by their ancestors. The result is a further upsetting of the archaeological material, which is often found in different places and levels from where they were originally placed. The same is true for the burials as well; the deceased often being buried with crockery and objects of a former era.

Outside the Mayan area, imposing works have been accomplished in each of the great cities of the plateau, as well as on the coast (Teotihuacan, Tajin, Monte Albán); the smaller cities and the isolated structures were not neglected either, of course, in relation to the comparative extension of the territory and the importance of the monuments. This is also true for the marginal regions of Middle America, as in Ixtlán del Rio (Nayarit), where many new buildings have been found and the circular pyramid of Quetzalcoatl was restored, or for areas outside Middle America, as in Casas Grandes (Chihuahua). Here, after three years of profitable excavations by the Amerind Foundation of Arizona, extensive works of reconstruction were started. The entire unit — 11,4000 square meters wide in the southeast of the city — has been restored; it appears as a complex surrounded by a wall with only one entrance

door and consisting of three great squares, a patio, and 38 rooms, two of which are underground. The buildings, served by underground aqueducts and drainage ducts, are made of adobe, while the massive external wall is made with the "tapia" technique. The communication between rooms, squares, and patio is completely internal through doorways that are oval, oblong, or shaped as truncated darts, with the openings somewhat above ground level.

In the far northwest part of Mexico, in the center of the peninsula of Lower California - an uninhabitable region where only small tribes of hunters and pickers lived until the arrival of Spanish people - artistic displays of its primitive inhabitants were found that drew the interest of the organizations responsible for protecting the national patrimony. These are nine cave shelters, discovered in 1962, with walls decorated with paintings. The figures, most of them anthropomorphic and zoomorphic, with the rest geometric, are painted in polychrome: red and black prevail, used with white and, less frequently, with yellow. The figures are often superimposed, and the difference between the stylization of the human figures and the naturalism marking those of the animals may be noted. An analysis by C-14 dated the works to 530 ± 80 A.D. The findings are certainly not unique, and further explorations of this inaccessible territory will add to the findings of this type of art.

BIBLIOGRAPHY - Ph. Drucker, R. Heizer, R.J. Squier, Excavations at La Venta, BAE, 170, 1955; R. Pîna Chan, Chalcatzingo, Morelos, México, 1955; M. Covarrubias, Mezcala. Ancient Mexican Sculpture, New York, 1956; R. MacNeish, Preliminary Archaeological Investigations in the Sierra de Tamaulipas, México, Transactions of the American Philosophical Soc., 48, 6, 1958; R. Piña Chan, Tlatilco, 2 vols., México, 1958; R.F. Heizer, Agriculture and the Theocratic State in Lowland Southeastern Mexico, AmAnt, 26, 2, 1960; R. Millon, The Beginnings of Teotihuacan, ivi, 26, 1, 1960; R. Millon, B. Drewitt, Earlier Structures within the Pyramid of the Sun at Teotihuacan, ivi, 26, 2, 1961; 371-80; Ph. Drucker, The la Venta Olmec Support Area, Kroeber Anthropological Soc. Papers, 25, 1961; J. Lorenzo, La Revolución Neolítica en Mesoamérica, I.N.A.H., Publ. 17, México, 1961; W.R. Coe, A Summary of Excavation and Research at Tikal, Guatemala: 1956-61, AmAnt, 27, 4, 1962; D.M. Pendergast, Metal Artifacts in Prehispanic Mesoamerica, ivi, 27, 4, 1962; M.D. Coe, Cultural Development in Southeastern Mesoamerica, Smithsonian Misc. Coll., 146, 1, 1963; R. MacNeish, El Origen de la Civilización Mesoamericana visto desde Tehuacán, Boletin I.N.A.H., 16, México, 1964; R.E.W. Adams, J.L. Gatling, Noreste del Petén: un nuevo sitio y un mapa arqueológico regional, Antropología y Historia de Guatemala, 17, 1, 1965; P. Armillas, Northern Mesoamerica, in J.D. Jennings, E. Norbeck (eds.), Prehistoric Man in the New World, Chicago, 1965; W.R. Coe, Tikal: Ten Years of Study of a Maya Ruin in the Lowlands of Guatemala, Expedition, 8, 1, 1965; M.D. Coe, The Olmec Style and its Distributions, in Handbook of Middle American Indians, vol. III, Austin, 1965; W.A. Haviland, Prehistoric Settlement at Tikal, Guatemala, Expedition, 7, 3, 1965; S.W. Miles, Sculpture of the Guatemala - Chiapas Highlands and Pacific Slopes, and Associated Hieroglyphs, in Handbook of Middle American Indians, vol. II, 1965; L.A. Parsons, P.S. Jenson, Boulder Sculpture on the Pacific Coast of Guatemala, Archaeology, 18, 2, 1965; Ch. Wicke, Olmec - An Early Art style in Precolumbian Mexico,

Doctorial Dissertation, s.l., 1965; C.W. Meighan, Prehistoric Rock-Paintings in Baja California, AmAnt, 31, 3, 1966, part I; J. Paddock, Ancient Oaxaca: Discoveries in Mexican Archaeology and History, Stanford, 1966; G.R. Willey, An Introduction to American Archaeology, vol. I: North America and Middle America, Englewood Cliffs, 1966; R. Berger, J.A. Graham, R.F. Heizer, A Reconsideration of the Age of the la Venta Site, Studies in Olmec archaeology, Contributions of the Univ. of California Archaeological Research Facility n. 3, Berkeley, 1967; E. Contreras, Trabajos en la Zona Arqueológica de Ixtlán del Río. Temporada 1967, Boletin I.N.A.H., 29, 1967; A. Caso, I. Bernal, J.R. Acosta, La cerámica de Monte Albán, Memorias del Instituto Nac. de Antropología y Historia, 13, México, 1967; G.F. Guillemin, The Ancient Cakchiquel Capital of Iximché, Expedition, 9, 2, 1967; G. Kubler, Pintura Mural Precolombina, Estudios de Cultura Maya, vol. 6, Seminario de Cultura Maya, México, 1967; L.A. Parsons, Bilbao, Guatemala: an Archaeological Study of the Pacific Coast Cotzumalhuapa Region, vols. I & II, Publications in Anthropology Nos. 11 & 12, Milwaukee Public Mus., 1967-69; D.E. Puleston, D.W. Callender, Defensive Earth Works at Tikal, Expedition, 9, 3, 1967; C.A. Sáenz, Nuevas Exploraciones y Hallazgos en Xochicalco, 1965-66, I.N.A.H., Publ. 17, México, 1967; G.R. Willey, T.P. Culbert, R.E.W. Adams (eds.), Maya Lowland Ceramics: A Report from the 1965 Guatemala City Conference, AmAnt, 32, 3, 1967; R. Millon, Teotihuacán, Scientific American, CCXVI, 1967; J.R. Acosta, Exploraciones en Palenque, 1968, Boletin I.N.A.H., 34, 1968; J.L. Alsberg, R. Petschek, Ancient Sculpture from Western Mexico: The Evolution of Artistic Form, Berkeley, 1968; I. Bernal, El Mundo Olmeca, México, 1968; R. Garcia Moll, Un Adoratorio a Tlaloc en la Cuenca de México, Boletin I.N.A.H., 34, 1968; D.C. Grove, Murales Olmecas en Guerrero, ivi, 34, 1968; R.F. Heizer; P. Drucker, J.A. Graham, Investigaciones de 1967 y 1968 en la Venta, ivi, 33, 1968; A. Kidder, II, The Conservation Program at Tikal, Expedition, 11, 1, 1968; A. Medellín Zenil, El Dios Jaguar de San Martín, Boletin I.N.A.H., 33, 1968; R. Piña Chan, Exploración del Cenote de Chichen Itzá: 1967-1968, ivi, 32, 1968; C. Sáenz, Exploraciones y Restauraciones en Yucatán, ivi, 31, 1968; D.L. Brockington, Investigaciones Arqueológicas en las Costa de Oaxaca, ivi, 38, 1969; W. Sanders, Mesoamerica, The Evolution of a Civilization, New York, 1968; R. Girard, Descubrimiento Reciente de Esculturas «Pre-olmecas» en Guatemala, Verh. des XXXVIII Int. Amerikanistenkongresses, I, Stuttgart, 1969; B. de la Fuente, Un Relieve de Palenque, Boletin I.N.A.H., 37, 1969; D. Heyden, Comentarios sobre la Coatlicue recuperada durante las excavaciones realizadas para la construcción del metro, Anales del Inst. Nacional de Antropología e Historia, II, 1969; G. Kubler, Studies in Classic Maya Iconography, Memoirs of the Connecticut Academy of Arts and Sciences, 28, 1969; L.A. Parsons, The Pacific Coast Cotzumalhuapa Region and Middle American Culture History, Verh. des XXXVIII Int. Amerikanistenkongresses, I, Stuttgart, 1969; C. Sáenz, Exploraciones y Restauraciones en Uxmal, Yucatán, Boletin I.N.A.H., 36, 1969; R. Sharer, Chalchuapa. Investigations at a Highland Maya Ceremonial Center, Expedition, 11, 2, 1969; J. Brüggemann, M.A. Hers, Exploraciones arqueológicas en San Lorenzo Tenochtitlan, Boletin I.N.A.H., 39, 1970; E. Contreras, Restauraciones en Casas Grandes, 1969-1970, ivi, 40, 1970; J. Gussinyer, Un adoratorio azteca decorado con pinturas, ivi, 40, 1970; T.H. Charlton, El Valle de Teotihuacan: Cerámica y Patrones de Asentamiento, 1520-1969, ivi, 41, 1970; W.R. Bullard (ed.), Monographs and Papers in Maya Archaeology, Papers of the Peabody Museum of Archaeology and Ethnology, 61, 1970; T.A. Joyce, Mexican Archaeology. An Introduction to the Archaeology of the Mexican and Mayan Civilization of the Pre-Spanish America, New York, 1970; I. Marquina (ed.), Proyecto Cholula, México, 1970; D. Pendergast, Vie et Mort d'un Site Maya: Altun Ha, Archeología, 34, 1970; R.J. Sharer, J.C. Gifford, Preclassic Ceramics from Chalchuapa, El Salvador, and their Relationships with the Maya Lowlands, AmAnt, 35, 4, 1970; P. Tolstoy, L. Paradis, Early and Middle Preclassic Cultures in the Basin of Mexico, Science, 167, 1970; D.C. Grove, L. Paradis, An Olmec Stela from San Miguel Amuco, Guerrero, AmAnt, 36, 1, 1971; P.D. Joralemon, A Study of Olmec Iconography, Studies in Precolumbian Art & Archaeology, 7, Dumbarton Oaks, 1971; C. Navarrete, Algunas Piezas Olmecas de Chiapas y Guatemala, Anales de Antropología, VIII, 1971; E. Noguera, Nuevas Exploraciones en «El Opeño», Michoacán, ivi, VIII, 1971; R.E. Smith, The Pottery of Mayapan: Including Studies of Ceramic Material from Uxmal, Kabah, and Chichen Itza. Volume 1, Volume 2, Papers of the Peabody Museum of Archaeology and Ethnology, 66, 1971; M. Greene, R.L. Rands, J.A. Graham, Maya Sculpture from the Southern Lowlands, the Highlands and Pacific Piedmont, Guatemala, Mexico, Honduras, Berkeley, 1972; G. Weber, Unos Nuevos Problemas Arqueológicos de la Región de las Palmas, Chiapas, Atti del XL Congresso Internazionale degli Americanisti, Roma-Genova, 1972, I, Genova, 1973; P.D. Harrison, The lintels of Tzibanche, Quintana Roo, ivi; A.P. Andrews, A Preliminary Study of the Ruins of Xcaret and a Reconnaissance of Other Archaeological Sites on the Central Coast of Quintana Roo, Mexico, ivi, Genova, 1973; S. Ekholm Miller, The Olmec Rock Carving at Xoc, Chiapas, Mexico, Papers of the New World Archaeological Foundation, 32, Provo, 1973; P.D. Harrison, Precolumbian Settlement Distributions and External Relationships in Southern Quintana Roo. Part I: Architecture, Atti del XL Congresso Internazionale degli Americanisti, Roma-Genova, 1972, I, Genova, 1973; F.W. Nelson, Archaeological Investigations at Dzibilnocac, Campeche, Mexico, Papers of the New World Foundation, 33, 1973; V.G. Norman, Izapa Sculpture, Part I: Album Papers of the New World Archaeological Foundation, 30, Provo, 1973; J. Quirarte, Izapan-Style Art: A Study of its Form and Meaning, Studies in Pre-Columbian Art and Archaeology, 10, 1973; J.A. Sabloff, W.L. Rathje, A Study of Changing Precolumbian Commercial Patterns on the Island of Cozumel, Mexico, Atti del XL Congresso Internazionale degli Americanisti, Roma-Genova, 1972, I, Genova, 1973; F. Robicsek, Copan: Home of the Magan Gods, New York, 1973; W. Tomasi de Magrelli, La Nueva Zona Arqueológica de Teotenango y su Cerámica, ivi, Genova, 1973; J.W. Ball, A Teotihuacan-style Cache from the Maya Lowlands, Archaeology, 27, 1, 1974; R.A. Diehl, R. Lomas, J.T. Wynn, Toltec Trade with Central America. New Light and Evidence, ivi, 27, 3, 1974; Ch. C. Di Peso, Casas Grandes: A Fallen Trading Center of the Gran Chichimeca, 3 vols., Amerind Foundation Inc. Series, 9, Flagstaff, 1974; N. Hammond, Mesoamerican Archaeology: New Approaches, Austin, 1974; Th. A. Lee, Mound 4 Excavations at San Isidro, Chiapas, Mexico, Papers of the New World Archaeological Foundation, 34, Provo, 1974; C. Navarrete, The Olmec Rock Carvings at Pijijiapan Chiapas, Mexico and Other Olmec Pieces from Chiapas and Guatemala, ivi, 35, Provo, 1974.

ITALO SIGNORINI

CENTRAL AMERICA

This area acted as a bridge between Middle America, largely Mexico, and the Andean cultures of South America; it still needs further study to clarify its chronology, and the intermediary role it played in the flow of cultural influences that passed through it in both directions.

Among the most valuable scientific contributions are several works of synthesis: Baudez (1963, 1970), Haberland (1969), Willey (1971), and Stone (1972). In them, particular attention is given to the initial Ceramic period and to the Formative period, as is by now the normal practice for research in the different areas. For the former, the earliest C-14 datings are of Monagrillo (2140 B.C.), whose findings show this local culture to be still deeply linked to a world of hunters and gatherers, in spite of the appearance of ceramics. This, as well as the stonework products, is very close to the findings of the earlier South American ceramic cultures and with them forms a single cultural horizon. For the Formative period, the effort required has been to connect a series of local cultures having a substantial homogeneity, thus establishing connecting stylistic horizons, through a process of reduction and simplification. Thus, the "Zoned Bichrome Period" of Coe and Baudez (1961), on the northern part of the Pacific Coast of the area, came to be joined to the "Scarified Ceramics Period" of the more southerly areas. They have in common a kind of pottery that combines engraving or striping in the decoration with alternating zones of color, red and black on a natural background or black on red. However, there are only a few sites that are datable to between 1500 and 500 B.C. The ceramics complexes found are, without doubt, connected with the Pre-classical or Formative period of Middle America (many are Olmec-like findings), but in the wider Central American area the datings are almost all around the beginning of the Christian era. It now seems certain that many Middle American cultural traits, among them the cultivation of corn and a complex of elements connected with it, passed directly into South America by sea in an early age, bypassing Central America. Only at the beginning of the Christian era did such elements reach the zone of the isthmus, but at the same time there was also a spreading from south to north, from Colombia to Middle America, of what G. Willey calls "the idea of the polychrome decoration of pottery"; likewise at the beginning of the Postclassic period - as revealed to us by the excavations carried out in northern Honduras - pottery with appliqué will reach the periphery of Middle America, a form whose origins are to be sought in the regions of Choco and of the lower Sinu in Colombia.

BIBLIOGRAPHY - M. D. Coe, C. F. Baudez, The Zoned Bichrome Period in Northwestern Costa Rica, AmAnt, 26, 4, 1961; C. gulo Valdés, Evidence of the Barrancoid Series in Northern Colombia, in A. C. Wilgus (ed.), The Carribean: Contemporary Colombia, Gainesville, 1962; M. D. Coe, C. F. Baudez, Archaeological Sequences in Northwestern Costa Rica, Akten des XXIV Int. Amerikanistenkongresses, Wien, 1962; I. Rouse, The Intermediate Area, Amazzonia, and the Caribbean Area, R. Briaidwood, G. R. Willey, VFPA, 32, New York; C. F. Baudez, Cultural Development in Lower Central America, in B. J. Meggers, C. Evans (eds.), Aboriginal Cultural Development in Latin America: An Interpretative Review, Smithsonian Misc. Coll., 46, 1, Washington, 1963; S. K. Lothrop, Archaeology of the Diquís Delta, Costa Rica, Papers of the Peabody Museum, 51, Cambridge, 1963; L.P. Biese, The Prehistory of Panamá Viejo, Anthropological Papers, 68, 1964; J. Ladd, Archaeological investigations in the Parita and Santa Maria Zones of Panama, BAE, 93, Washington, 1964; I. Rouse, The Caribbean Area, in J. D. Jennings, E. Norbeck (eds.), Prehistoric Man in the New World, Chicago, 1964; J. B. Glass, Archaeological Survey of Western Honduras, in Handbook of Middle American Indians, IV, Austin, 1966; O. Linares de Sapir, La cronología arqueológica del Golfo de Chiriquí, Panamá, Actas del XXXVI Congreso Int. de Americanistas, I, Sevilla, 1966; J. M. Longyear, Archaeological Survey of El Salvador, in Handbook of Middle American Indians, IV, Austin, 1966; S. K. Lothrop, Archaeology of Lower Central America, ivi, IV, Austin, 1966; E. E. Tabio, E. Rey, Prehistoria de Cuba, Habana, 1966; R. Torres de Araúz, Arte precolombino de Panamá, Panama, 1966; C. F. Baudez, Recherches archéologiques dans la vallée du Tempisque, Guanacaste, Costa Rica, Travaux et Mémoires de l'Institut des Hautes Études de l'Amérique Latine, 18, Paris, 1967; O. Linares de Sapir, Ceramic phases for Chiriquí, Panama, and their relationship to neighboring sequences, AmAnt, 33, 2, 1968; C. F. Baudez, P. Becquelin, La séquence céramique de los Naranjos, Honduras, Verh. des XXXVIII Int. Amerikanistenkongresses, I, Stuttgart, 1969; W. Haberland, Die Kulturen Meso-und Zentral-Amerika, in W. Haberland, H. Trimborn, Die Kulturen Alt-Amerikas, Handbuch der Kulturgeschichte, Frankfurt a. M., 1969; W. Haberland, Early Phases and their Relationship in Southern Central America, Verh. des XXXVIII Int. Amerikanistenkongresses, I, Stuttgart, 1969; C. F. Baudez, Central America, London, 1970; D. Stone, An Interpretation of Ulua Polychrome Ware, Verh. des XXXVIII Int. Amerikanistenkongresses, II, Stuttgart, 1970; G. R. Willey, An Introduction to American Archaeology, vol. II: South America, Englewood Cliffs, 1971; D. Stone, Pre-Columbian Man Finds Central America. The Archaeological Bridge, Cambridge, Mass., 1972; E. Kennedy Easby, Seafarers and Sculptors of the Caribbean, Expedition, 14, 3, 1972.

ITALO SIGNORINI

SOUTH AMERICA (PLATES 79-80)

Colombia - Ecuador. - Colombia and Ecuador represent an area that has promoted numerous studies and projects at archaeological sites for different zones and eras, but is dominated by the question of the first appearance of ceramics in South America, which was in fact in this area. At Puerto Hormiga, on the northern Colombian coast, and at Valdivia on the southern Ecuadorian coast, the lowest level ceramics have given C-14 datings that are the earliest on the continent.

At Valdivia, along with an isolated reading of 5150 +/- 150 - which, with dendrochronological corrections, is equal to 4320 to 3760 B.C. - the dates of the earliest ceramic levels are all around 3300 to 2900 B.C. The datings of Puerto Hormiga are more consistent, all in a range between 3800 and 3500 B.C., thus preceding by 400 to 600 years most of the datings of Valdivia. The acceptance, or rejection, of the oldest isolated date of the latter location - which could even be the absolute oldest date - thus becomes of the greatest importance for the ontological problem of the South American

ceramics. On it Meggers (1965, 1966, 1972) and her various other researchers have worked out a theory based on noted similarities in the techniques and the decoration of the trans-Pacific derivation of the Valdivia A, from the Jomon culture of the island of Kyushu in Japan. But more recent studies seem to decisively contradict this hypothesis. On the one hand the criticism of the validity of the above-mentioned dating, which establishes the chronological priority of Puerto Hormiga, and on the other hand the recent discovery of a pre-Valdivian ceramic lacking any similarity with the Jomon affiliation postulate the "American" origin of the pottery.

Differences can be perceived nonetheless between the clay productions of the different sites. At Puerto Hormiga there is one type of ceramics - mostly of dishes or cups - of a mixture of clay and grass or leaves, this technique being unique to South America. It lacks decoration and gives the impression of being really a first attempt. Together with this type of earthenware another type is found, more evolved - of a mixture made with sand, decorated with incised geometric motifs and with crudely modeled anthropomorphic and zoomorphic figures - which presupposes an earlier, unknown stage of preparation. For Valdivia, whose stages of evolution can now be followed, the excavations have brought to light dishes and jars from phase A (3300 - 2300 B.C.). At times they have small feet and a wavy rim, or are even raised on four equidistant points, decorated in ways that are very different among themselves, ranging from engraving by a sharp tool, to the use of fingernails, to the pseudo-corrugation, to the comblike decoration, to the creation of forms for marking the internal surface by pressure. In period B (2300 - 2000 B.C.), a transitional period with respect to the successive one and of short duration, the impressions by lines, by pointing, and by engraving dominate. Period C (2000 - 1500 B.C.) sees a change in the ceramic forms: no longer earthenware of rounded forms, but dishes with more pronounced angles and jars with convex necks. The decoration is often applique or with wide incisions. Of period D (beginning in 1500 B.C.), the decoration by engraving is typical, at times forming fields of finely drawn lines enclosed by thicker lines. The vases are in general smaller and not as smooth as in the preceding periods, while the sides tend to be thinner.

In periods B and C, anthropomorphic statuettes appear with the earthenware, portraying nude women in full round with elaborate hairstyles. In those of period B, in which this production reaches the best results, hair and arms are added by applique. At times women are portrayed holding a baby in their arms, and fairly frequent are bicipital. The predecessors to such seem to be, in period A, the lithic anthropomorphic statuettes that range from most elementary examples, in which the human figure is recognized only from an incision of the lower part, showing the legs, to others in which a human face is beautifully engraved with short lines on the upper extremities.

In addition to the trans-Pacific connections, another question concerning problems of diffusion has been widely debated on the basis of both early and recent archaeological data. This is the contribution that Middle America may have made to the development of the local Colombian and Ecuadorian cultures and,

through them, to the development of the high cultures of the central Andes. Reichel-Dolmatoff (1965) speaks of an earlier phase of contacts, around 1200 B.C., involving both the Atlantic and Pacific coasts of Colombia. At Momil, he found a series of ceramic elements in common with Middle America of the same era; among these are the bowls with flared bases, the tripods, the tubular necks, the breast-shaped supports, the anthropomorphic statuettes, the zoomorphic whistles, the vase ornamentations of engraved lines filled with color, the ornate rims with the Z profile. The same researcher also maintains that immigrants from Middle America introduced corn, the cult of the jaguar, the funerary mounds, the sarcophagi, and the mirrors of obsidian. A similar theory referring to Ecuador is held for the same prehistoric period by Meggers, who sees a direct connection between the culture of Chorrera and that of Ocos in Guatemala.

Reichel-Dolmatoff speaks further of a second and more substantial phase of contacts, beginning in 500 B.C. and lasting until the start of the Christian era, this time involving only the Western coast and the valleys leading from there into the interior. The culture of Tumaco, in the extreme south, shows the importance of such imports, which appear to have had different points of origin in different periods: for example, Oaxaca, cultures of the West, Vera Cruz, the Mayan area, and the central Mexican plateau. Thus elements appear such as the deep-welled tombs with lateral rooms, vases with stirrup handles and ones with breast-shaped supports, elaborate whorls, and biomorphic whistles. The findings in the adjoining Ecuadorian area, in particular in La Tolita, seem to fully confirm the presence of Middle American elements through the presence of terra-cotta masks, stamped figurines with feathered costumes, portrayals of human heads with zoomorphic head coverings, and vases painted in yellow, black, white, and green after the firing.

Among the projects carried out in Ecuador, we should mention the study of the pyramids of Cochasqui (70 kilometers north of Quito), one of the main cities of the Caranqui, the people who inhabited the region at the moment of the Inca occupation. The excavation is important both because investigations of the architectural structures have been rather overlooked in the past and for the information that it gives us about an important culture of the period of Integration. There are 15 pyramids, truncated at the top; nine of them have an access ramp. Oberem, the German archaeologist who conducted the excavations, gives the dimensions of the great pyramid G, which has a platform of 80 by 90 meters, a height of 20 meters, and a ramp 200 meters long. The smallest pyramid E has a platform of 50 by 30 meters, a height of 11 meters, and a ramp of 67 meters. The pyramids are completely artificial, made of hard earth, mud, and sand. Internal walls act as the framework that supports the mounds, with walls at a very steep angle. A new architectural feature characterizes these constructions: on the platforms of the pyramids there are circles in which the clay covering was baked in place by an open fire, giving it the consistency of brick. That this constituted the floor for buildings of perishable material (for cult purposes?) can be inferred from the openings to accommodate poles, as well as from the information passed on by chroniclers that the dwellings of the region were of a circular plan.

Venezuela. – After the arrangement of the phases and the cultural periods into series, from the origins to the conquest and to the colonial period, done by I. Rouse and J. Cruxant in 1963 (see VENEZUELA, ENCYCLOPEDIA OF WORLD ART, vol. XIV), the more recent works have been directed toward the precise definition of problems such as the relationships between series and a furthering of the knowledge of the less-studied areas of the territory. As in the Venezuelen Andes, the excavations of Wagner have permitted C-14 datings previously unavailable and a definition of two main cultural models of development, both intimately tied to the geographical ambient. One of these, "sub-Andean," in the temperate zone, is based on the cultivation of corn and characterized by the lack of construction in stone and by pottery of complex forms, of which the ceremonial forms have painted ornamentation or are sculptured, or combine both techniques. The second model is found above an altitude of 2000 meters, the "Andean," characterized by cultivation of "cold earth" plants, crudely decorated pottery, stone constructions, burials with rich funerary material, including, among others, statuettes - anthropomorphic and zoomorphic - and the famous pendants in the form of bat's wings.

Another area that has drawn the attention of the researchers is that of the Western "llanos," neglected in the past. According to Zucchi (1972), who had made recent excavations, vast migratory movements involved this territory in pre-Colombian times, with contributions from forestal groups of Amazon culture, some important.

At Cano Caoni, one of the localities studied, dating from after 500 A.D., the pottery presents vague resemblances both with the valley of Rio Magdalena in Colombia - in the decoration of the pottery, here engraved and not painted - and with the area of Valencia in the north - in the funerary urns, pear-shaped with convex neck. This indicates the possibility that peoples and elements from Colombia had contributed to the formation of the culture of the "llanos," while they in turn had influenced to a certain degree the center and the east of the country.

Culture of the Andes. – The central Andean area has continued to exercise a strong attraction for the archaeologists of many nationalities, not only for the pioneering work of classification of styles and sub-styles of the phases of ceramics, but also for the furthering of knowledge of various periods of evolutionary development of the Andean civilizations, mainly in relation to economic and ambiental factors. Much work has thus been accomplished on the earlier phases, from the Preceramic to the Formative. It is here that the most important results have been obtained, mainly with the definition of the different phases of the initial development. Lanning (1967) presents a chronological outline, which we will use here, that includes both the coast and the plateau, from the appearance of man in the area until the Spanish conquest; it is divided into 12 periods, six Preceramic and six Ceramic. The Preceramic periods range from 9500 B.C. to 1800 B.C., but of particular interest is the sixth (2500 - 1800 B.C.), in which the first settlements of substantial size appear, in connection with the increase in population made possible by the introduction of the cultivation of corn; this period is a prelude to the urbanistic center, characteristic of the area in the following periods, and to the presence of

"public" buildings. For example, the well known archaeological site of Huaca Prieta in the Chicama Valley (north coast of Peru) belongs to the Preceramic VI; excavations conducted here by J. Bird in the 1940s show the structure of a village lived in by a few hundred people and composed of permanent dwellings of one or two rooms partly sunken below ground level. Much more accentuated is the architectural character of the settlements of the Central Coast, brought to light thanks to the untiring excavation work carried out since the mid 1950s by F. Engel. Three of these settlements, located not far from Lima, are particularly interesting for the indications that they have given. Rio Seco, 85 kilometers north of the capital, shows the foundations of a series of constructions of several rooms; contrary to what is found in the northern regions, the rooms are not subterranean but at ground level. Public buildings are not lacking: two pyramids have been discovered. They were constructed beginning with a dwelling whose rooms were filled with adobe and on which was constructed another, in turn so filled. The operation was repeated over and over until the last construction was covered by a layer of sand. On the top of the artificial mound was finally placed a series of blocks and stone columns.

In the valley of Rio Omas, in the area of Canete, visitors can now see the structures of the great village of Asia. Engel (1966) places it in the final Preceramic phase, as it was already abandoned in 1300 B.C. It is composed of two sections: a central ceremonial one and a peripheral residential one arranged in a circle around the ceremonial one. The people lived in circular huts of reed matting supported by willow poles. In the central nucleus was a complex structure, 25 meters by 25 meters, in stone and adobe cemented with earth, subdivided into rooms and patios. In one of these can be seen a series of circular wells, open at ground level, which served as convenient storage for food in this very dry region of the Peruvian coast, as evidence of the agricultural economic activities of this period (the system will be widely used also in later periods). Characteristic are the external walls of the complex, doubled to contain the poles that supported the roof.

But the most imposing architectural site of all of the coastal Preceramic period is El Paraiso or Chiquitanta, about 40 kilometers north of Lima, in the valley of Chillon. It consists of eight platforms, arranged haphazardly in independent units and distributed over a very wide area (900 by 700 meters). The materials used for the construction are blocks of stone cemented with mud. On one of the units, number 1, Engel, after the excavations, proceded to a work of restoration that shows the configuration of the structure completely. Fifty meters long, in its final form it consisted of five or six superpositions obtained each time by using the rooms of the preceding construction, filled with earth or crushed stone, as a platform for the new one. The last stage is in the form of a truncated pyramid, which includes no less than 25 rooms on different staggered levels. Its purpose is not clear; it may have been a residential building or a ceremonial and religious complex. Another unit appears to be of this latter type; it was described by Lanning (1965) as consisting of three platforms enclosing a courtyard. On one of these a temple was probably erected, with the entrance turned in the direction of the open end of the courtyard itself.

The artistic manifestations of the coastal Preceramic, outside of the architecture, are not of great interest. The extreme dryness of the area has allowed the preservation of wood and cloth goods in an excellent state of preservation. The dead were buried with quite elegant clothing: in Asia the bodies were found wrapped in large cotton cloaks of a brilliant cream color, adorned with feathers, under which they wore cloth garments with decorated edges. The purses were characteristic, some decorated with stylized zoomorphic motifs or having multicolored edges.

One of the more interesting findings made at Asia is an instrument of bone, whose use is not clear, decorated on one face with dotted stellar motifs, on the other with figures of monkeys blowing into what appears to be a long trumpet or, more probably, a blowgun.

On the whole, the archaeological research intensively conducted in the last 20 years has demonstrated how the central coastal region was, for this period, an area in which a series of cultural elements was elaborated that were characteristic of the central Andean cultures of the successive periods. Among these are the "fardos," the trophy heads, the pyramids, the temples, and the multiple tombs in which in addition to the important person were others who were sacrificed in order to accompany him to the other world.

Important discoveries have also been made in the mountains. The most sensational is certainly that of Kotosh, in which a Japanese archaeological expedition worked for three seasons after 1960. The importance of the site had been recognized since 1942 (Acts of the Congress of Lima) by Tello, who had not, however, carried out any excavations. Kotosh is situated on the banks of Rio Higueras, a tributary of Rio Huallaga, a short distance from the city of Huanuco. The altitude above sea level (1,950 meters), relatively low with respect to the average of the other cities of the plateau, gives a milder climate, of sub-tropical type. The site has two large artificial mounds, surrounded by other smaller constructions. The excavations of 1960, the only one of which we possess complete data on, were directed to Mound KT, the larger of the two principle ones; in its final form, it is the result of no less than 10 constructions, built one over the other, for a height of 13 meters and a width of 100 meters. A small well allowed penetration into the ninth and tenth levels, revealing a ceremonial structure of extraordinary importance in the latter. This is the so-called "Templo de las Manos Cruzadas," which constitutes the oldest level of construction. It is in an excellent state of preservation, contrary to what has happened with other levels, which were torn down completely and served as a base for a successive construction; in this case, fortunately, the rooms of the temples were filled with pebbles. The internal space is not great (9.4 by 9.2 meters); the construction surmounted a supporting base 8 meters in height. The absence of pottery places the temple in the Preceramic and dates it at the beginning of the second millennium B.C., based on the results of the analysis by C-14 of the earliest ceramic level (1850 +/- 110 B.C.). Considering the age, the refinement of the complex cannot fail to amaze. The perimetral walls are thick, of fluvial pebbles held together by mud and plastered with a layer of fine clay, as is also the floor of the building. Inside, the central space is in the form of a quadrangle sunken into the ground. One of the walls contains a series of niches, under one of which is a splendid clay sculpture in high relief, portraying two arms with the hands crossed, which gives the name to the temple. Also noteworthy is another temple above the Templo de las Manos Cruzadas, also of the Preceramic, called the Templo de los Nichitos, for the small niches that open under a bench at the base of the walls.

For the Initial Period - which Gordon Willey (1971) includes between 1800 and 900 B.C., when ceramics and weaving appear - it is Kotosh that has given the most brilliant results with the uncovering of the structures above levels nine and ten, although they are not in good condition. The clay style initially connected with this period has been called Waira-jirca, distinguished by pottery of a dark brown color, well polished, whose most characteristic forms are the cups and the jars with no neck. The decoration is for the most part in geometric straight-lined motifs; it seems to show the influence of the contemporary ceramic style of Tutishcainyo of the upper Amazon River. Gordon Willey (1971) sees in them a strong resemblance to the clay production of Valdivia in Ecuador (v.) and at the same time notes that the Waira-jirca style, whatever its affiliations, cannot be considered an original style, as it was already perfectly developed. It is followed by the Kotosh phase, dated by C-14 to around 1000 - 900 B.C., whose ceramics differ from the preceding because of new forms (bottles with long necks, or as effigies) with geometric engraved decorations and paintings of black graphite on a polished red base.

Resemblance can be seen in some decorations to the Chavin style, which is fully affirmed in the following phase. Chavin had in fact already worked out its characteristic style in an epoch that goes back to the Initial Period. New C-14 datings have set back the time to the beginnings of this culture. In the Rocas gallery of Castillo di Chavin, which has given its name to the substyle, considered the initial one, a bone associated with Rocas earthenware has a dating of 3050 +/- 100 years, equal to 1200 - 1000 B.C., earlier therefore than the dates of 900 B.C. still indicated by Gordon Willey in 1971 as the beginning of the Chavin style and than the much more recent datings sustained by the major specialists of the Andean area before the invention of the C-14 system. The Rocas pottery is massive, quite heavy, and has the appearance of stone. The color is grey-black, and the most common forms are the globular bottles, short and large, and the bowls with vertical sides and swollen rims. The decoration is engraved or modeled, often rustic or resembling an orange peel, in such a way as to create contrast with the smooth areas. Red pottery also appears, mostly bowls having wide engraved designs with grooves that are covered with black paint.

Regarding the coast, 1800 B.C. seems by now to be confirmed as the date of the beginnings of the ceramics, based on many C-14 datings obtained in the last few years, in spite of some small variations in different areas. The only exception is the extreme southern coastline (together with the southern plateaus) where the ceramics appear to have begun much later, around the beginning of the Christian era. Both for the coast and for the plateau, it seems now to be an accepted fact that ceramics were not a local invention but were introduced into the central Andes from the northWestern regions of South America; this is shown by the era of its introduc-

tion, much later than in Ecuador and Colombia, and by its level of technical and artistic advancement.

Something else learned from the recent excavations: in the Initial Period, besides a further increase in the number and the dimensions of the villages, there was also the first creation of totally specialized ceremonial centers. An example is La Florida, an immense pyramidal structure that rises inside the city of Lima. The excavations conducted on it in 1962 by the specialists of the National Museum of Anthropology and Archaeology show that it was composed of a central pyramidal nucleus with platforms and rooms, constructed with angular stones cemented with mud. The peculiarity is that there is no trace of its use as a residence.

The following period, called the Archaic Horizon by Lanning inasmuch as it was distinguished by the first Andean horizon culture (that of Chavin), is dominated by problems connected to it: its origin, its affiliations, its diffusion. Many problems have been resolved, others instead in a sense have become more complicated. It has already been mentioned how the excavations conducted in the location of Chavin itself resulted in earlier datings of its oldest manifestations. It should be added that they have also cleared up a lack of knowledge of this site on both the architecture and the ceramic seriation. Curiously, in fact, in spite of the horizon culture of Chavin taking its name from the locality, very little work had been done on the ceramic production of this site of the plateau with respect to other localities (for example, those on the coast), thus leading to the theory of its coastal origin. The pottery of Cupisnique, originating in the valley of Chicama on the northern coast, was seen thus as the progenitor of all of the other clay expressions of the Chavin style. We now can affirm that the Cupisnique is only a coastal substyle, datable in part to the stylistic period of Las Ofrendas (after the Rocas), in part to that of transition between the two (Lumbreras, 1970).

The theory of Middle American origin of the Chavin culture, more specifically from the Olmec, can also now be definitely discarded; the new chronological information on the Chavin culture takes it too far back in time for the connection to be possible.

Concerning the possible derivation from the Tropical Forests, as maintained by Tello and again recently by Lathrap (1970), it is unlikely, as no Chavin archaeological sites have been found in forestal areas and because at Kotosh, which is the locality closest to the forests having a Chavin phase, this style appears to have been introduced from the outside.

The most plausible hypothesis seems to be that the Chavin culture originated somewhere in the northern Peruvian mountains. A final element to consider is that to the best of our knowledge the diffusion of the Chavin style did not occur all at once, but over a long period of time, with different stylistic phases that occurred in distinctly different periods of time. Furthermore, geographically it does not seem to have gone beyond the border of Ecuador to the north or the region of Ayacucho to the south.

For the following period, the Early Intermediate, the most interesting discoveries are in regard to the urbanistic studies, a phenomenon that first appeared in the final Preceramic, but that is now affirmed in a decisive way. Thus the first cities appear, those agglomerates that G. Willey (1971) distinguishes from the "towns" by the number of inhabitants (more than 5,000), and whose model he defines as "synchoritic" (from the Greek "choron," region) because a number of minor centers depend on them, on the political as well as religious, commercial, and intellectual planes.

Studies have been carried out on the centers of the coast as well as those of the plateau. But while for the former it was the case of furthering and completing the large amount of work already done there in the past, for the latter, on which much less had been done, the work has been in many cases of "implanting" the knowledge. Among the results obtained is the clarification of the reciprocal positions between the three major centers of the southern plateau: Pucara, Huari, and Tiahuanaco. The first is the oldest, contrary to what was thought in the past: it dates back to the initial phase of the period and its end seems to coincide with the beginnings of Huari. Studies have been made on its beautiful pottery, black and yellow on red, whose designs portray heads of humans or of cats, llamas, and other animals, at times in relief. To Rowe and Brandel (1960) we owe the analysis of the fragmentary material conserved in the National Museum of Lima, which has allowed an evaluation of the importance of the ceramics of Pucara. This permits a connection of the chronology of a good part of southern Peru with that of northern Bolivia, and at the same time shows, from an iconographic point of view, that it was at the origin of the later styles of Huari and Tiahuanaco.

Also very interesting are the new findings of monoliths, some over 4 meters high, made by Chavez, husband and wife (1970), in the area of dominion of the center of Pucara, corresponding to the modern department of Puno. Most of them, dated to the I century B.C., present anthropomorphic and zoomorphic reliefs. The motif of the serpent dominates in the final part of the culture, while in the classic Pucara feline figures predominated. In some cases the decoration is absent, but the form as a letter I suggests a severely stylized human figure. Probably they acted as a border marker, but one, the number 2 of Asiruni, sealed a ditch in which were gold rings, grains of turquoise, and pottery.

Regarding Huari and Tiahuanaco, the datings by C-14 indicate that the two cities were both founded and grew in the Intermediate Antique period, but had their period of greatest splendor in the subsequent Middle Horizon. The chronology of the development of the culture of Huari has a solid base in the studies of D. Menzel (1966, 1968). For Tiahuanaco the studies of the Bolivian S. Ponce Sangines (1969, 1970) are quite important; they show that the first phase of the culture belonged to the Intermediate Antique period, and to them are to be attributed constructions such as the Qalasasaya, the large ceremonial square surrounded by monoliths onto which the famous Gate of the Sun faces. The same researcher also is to be credited with the restoration of the small half-sunken temple inside the Qalasasaya.

A ceramic style that came to light thanks to clandestine excavators is the Vicus, of the department of Piura in the extreme north, which had an immediate success on the antiquarian market, both for its novelty and for its aesthetic values. The C-14 datings indicate that it had a long period of life: they range in fact from the III century B.C. to the seventh century A.D. There are

those who see an expression of the mother culture which gave rise to the coastal cultures of the Intermediate Antique, as does Larco Hoyle, and those (O. Klein, 1967) who instead consider it contemporary with the Mochica, or at the least later than the earliest Mochica phase. The stylistic affinities that it presents seem in fact to confirm its long duration; the ceramic (all funerary) at times shows analogies with the Cupisnique, at times with the Salinar, the Mochica, or, more often than any, with the Gallinazo, which it resembles in the anthropomorphic and zoomorphic representations in relief, decorated with pictures in the negative.

For the Recent Intermediate period and for the Final Horizon - the latter corresponding to the period of diffusion of the Inca style in the central Andes - the results have been in general less important that those accomplished for the other periods. In any case, even here there are brilliant and sometimes spectacular results. Examples are the discoveries, in some cases better defined as re-discoveries, of new sites along the eastern slopes of the Andes, in contrast with the formerly dominating theory of the "ceja de selva" (that is, the dense and low forest characteristic between 600 and 2,000 meters of altitude), considered to be an unpopulated natural barrier between the peoples of the Andean culture and those of the Tropical Forests culture. It appears rather to have been densely populated, at least in the late pre-Colombian era, with "urban" centers built in stone and supported by an agricultural economy that used to advantage, with great ability, the techniques of terracing; furthermore, a ceramic tradition of undecorated earthenware is found here. Lathrap, the leading specialist of the cultures of the eastern Andes, reveals (1970) how this type of pottery is normally associated with fortified settlements placed in dominating positions, controlling vast terraced agricultural areas. The carriers of these cultural elements were, according to him, the Quechua, whose potent expansion would have been favored by the development of a system of cultivation that permitted taking advantage of the steep mountainsides that characterized the geographic environment of the area. This expansion would have begun in the south, moving along the eastern slopes of the Andes. In the culture of Chullpa Pampa, which flourished in the basin of Cochabamba in Bolivia, the excavations (S. Ryden, 1961) have yielded undecorated pottery of the same type as that of the Eastern Peruvian Andes. The fact, however, that it was dated to the first or second century A.D. indicates that from here it was diffused northward, in connection with the other elements already mentioned.

We find thus a long series of fortified urban centers along the eastern slopes of the Andes. The peoples who lived there were incorporated into the Inca empire in the years immediately preceding the Spanish conquest. In the colonial epoch practically all of them were abandoned, especially because of the program of "reduccion" that had its moment of maximum incidence around 1570 with the viceroy Francisco de Toledo. In the extreme south, W. H. Isbell has determined the site of Trenchera, in the area of Sandia; in the center, D. Bonavia (1968) has identified the distribution of similar ruins in the zone of Ayacucho. But it is in the north that the exploration has obtained the most important results.

B. Flornoy, toward the end of the 1950s, and D. E. Thompson in 1971 identified and partially studied numerous centers in the region across the border between the departments of Ancash and of Huanuco, around the modern cities of Lamellin and of Tantamayo on the upper Rio Maranon; some of these were in a good state of preservation, positioned at rather high altitudes but dominating the lower valleys and of subtropical climate. Rapayan is the most spectacular of all, taking to their maximum development the multiple-storied buildings that are an architectural characteristic of this area. Here were erected, in fact, houses of up to six stories, with many windows and balconies, whose walls are constructed, however, with a rather crude technique, using stone slabs of irregular form, separated by smaller stones to form a sort of mosaic. Similar structures are also to be found at Yarcan, Takshamarca, and Tinyash. This method of handling stone is similar to that used in areas further north, on the other side of the watershed, in the valleys of the Huayabamba, the Jelache, and the Pajaten, tributaries of the Huallaga.

In this area, repeated stories that were heard over long periods of time about many important ruins buried in the forest have led to missions of exploration since the mid-1960s that have had a vast echo for the results obtained. The most important discovery was certainly that of Gran Pajaten, known also as Abiseo, made in 1965 by the Peruvian Rojas Ponce. The center, located on the upper Rio Pajaten, in the department of San Martin, consists of a series of circular buildings, mostly of two floors, whose external walls are decorated with stylized anthropomorphic and avimorphic representations and with geometric motifs shaped as zig-zags, triangles, and meanders. The figures are designed with slabs of stones inserted into the walls in such a way as to protrude about five centimeters. The heads of human figures are, however, of authentic protomes deeply stuck into the walls, surrounded by what seems to be a large crown of feathers opening into a fan. The bird-like portrayals are of rows of condors, all the same (as for the human figures), and arranged in a frieze. All around the site, on the lower parts of the hill on which it rises, are the ruins of vast agricultural terracing.

Regarding the Final Horizon, in any listing of the exploration activities the discovery by G. Savoy of the Inca city of Vilcabamba must be included; after the Spanish conquest, it was, for a few years, the seat of the Inca Manco and the last center of resistance against the invader. Savoy succeeded in locating its ruins in the area of the forestal village of Espiritu Pampa in the valley of the Urubamba, on the other side of Machu Pichu. The buildings composing it are of two types: one circular, similar to those described above, for the northernmost zones on the eastern side of the Andes; another, rectangular, of quite substantial dimensions. One of the constructions reaches 89 meters on a side and is made up of internal passages, stairways, and no less than 18 independent rooms. Another measures 30 by 25 meters and is composed of two large rooms with 20 windows and 3 large doors. Canals guaranteed the water supply to the center.

Tropical forests. - In the area of the tropical forests the difficulties presented by the climate have continued to be a great obstacle to archaeological research. Nonetheless in some zones most noteworthy results

have been obtained, confirming the existence in pre-Colombian times of forest cultures possessing artistic and technical qualities of high level - besides those already well-known of Santarem, Marajo, and Napo. The most significant results have been obtained by an American, Lathrap, who carried out excavations on the upper and middle Ucayil, tributary of the right side of the Amazon River, in eastern Peru. Here the researcher succeeded in reconstructing the complete series of the cultures that followed one another up to the present time; in part he determined their chronological position with datings by radiocarbon, in part by deductions from the dated cultures of the high plateau with which there are evident cultural and stylistic similarities. The series is today the basic reference for studies of the cultural sequences of the Amazon basin.

In the site of Yarinacocha, near Pucallpa, where most of the excavations were done, the earliest phase of occupation, known as the ancient Tutishcainyo, has similarities with the Waira-jirca of Kotosh (see entry in World Encyclopedia of Art) and can be dated to 2000 - 1600 B.C. Among the ceramic forms, along with very wide bowls with flanged edges and concave sides, representing the most common type of earthenware, there are also small vases with tapered sides and, interestingly, vases with stirrup handles. The decoration, when it is present, consists of parallel lines or a crosshatching or rows of dots, but the spiral motif is also quite common. Figurative representations are certainly quite rare; only one has been found, a feline head engraved on an oval cup. In the late Tutishcainyo, separated from the preceding subphase by a gap of 450 years, there is a change in the ceramic forms and in the decoration that makes wide use of the techniques of modeling and of applique. Furthermore, there is an abundant presence of imported earthenware, thus indicating active commerce and extensive relations with areas that may be even far away, as shown by the stylistic similarities with the contemporary ceramic production of the Ecuadorian culture of Machalilla (1200 - 1000 B.C.).

The Shakimu phase follows, dated by C-14 to 650 B.C.; in this era Chavin-like influences are clearly evident in the decorative motifs, created with complex engraved designs and covered by a brilliant red patina applied before the firing. While for the Tutishcainyo the cultural influences follow the forest-plateau direction, according to Lathrap, with the Shakimu phase the sense is inverted and the forest becomes the donor. With the end of the Shakimu every interdependence between forest and plateau ceases.

All of the following phases by then tie the basin of the Ucayali to the area of the Tropical Forests, and the excellent sequence that we have for that is of fundamental help in determining the succession of the historic events that involve the forest. The Hupa-iya phase, immediately successive to the Shakimu, is valuable for this aspect: its affinity with the ceramic of the Barrancoide series of eastern Venezuela - hemispheric or uniformly convex cups, engraved spiral decorations, flat handles adorned with engravings or applique of dots - testify to a diffusion over a wide area of the bearers of this stylized tradition, which in the course of the first millennium B.C. reached to the Bolivian lowlands and possibly the region of the upper Xingu to the south and into the Antilles to the north. Lathrap believes that the diffusion was the work of people of the Aruaca language

and that their movements covered the area of the middle Amazon River, or from the area between the upper Rio Negro and the upper Orinoco.

Of the succeeding phases - Yarinacocha, Cumancaya, Caimito - the latter (11th - 16th century A.D.) is certainly that of greatest aesthetic value, combining different decorative techniques, such as the applique, the engraving, the excisione, the champleve, painting. The motifs are curvilinear, and the colors used are red and black on white and white on red. The earthenware presents a great richness of form; its outstanding characteristic is the tendency to have rectangular sections rather than rounded. The Caimito phase reenters the Amazonian stylistic tradition that is defined as Polychrome Horizon. It expresses itself in almost total identity in a vast tropical area that ranges from the basin of the Ucayali to the Brazilian coast; testifying to this, besides the Caimito phase, are the Napo phase, brought to light by Evans and Meggers (1968) on the river of the same name; the various phases of the central Amazon basin (Guarita, Teffe, Sao Joaquim, Miracanguera) studied by Hilbert (1968); and the Marajoara phase of the island of Marajo on the Amazon delta. The dispute between those who maintain the derivation of the style of the Polychrome Horizon from migrations from the Andean mountains (Meggers and Evans, Hilbert) and those who consider them strictly "Amazonian" (Lathrap) is still unresolved. Regarding the modern clay production of the area of the upper Amazon, it is interesting to note how many of the indigenous groups that live there still produce splendid pottery. Elegant decorative, curvilinear, and polychrome motifs, seen also on the fabric, recreate those of the last pre-Colombian phases, and thus may in a certain sense be considered as survivors of that time.

BIBLIOGRAPHY - *Colombia-Ecuador.* C. Evans, B. J. Meggers, Formative Period Cultures in the Guayas Basin, Coastal Ecuador, AmAnt, 22, 3, 1957; E. Estrada, Las Culturas Pre-clásicas, Formativas, o Arcáicas del Ecuador, Guayaquil, 1958; G. Reichel-Dolmatoff, A. Dussan, Investigaciones arqueológicas en la Costa Pacífica de Colombia. I: El sitio de Cupica, Revista Colombiana de Antropología, 10, 1961; G. Reichel-Dolmatoff, Puerto Hormiga: Un complejo prehistórico marginal de Colombia, ivi, 10, 1961; E. Estrada, Arqueología de Manabí Central, Guayaquil, 1962; B. J. Meggers, C. Evans, The Machalilla Culture: An Early Formative Complex on the Ecuadorian Coast, AmAnt, 28, 2, 1962; G. Reichel-Dolmatoff, A. Dussan, Investigaciones arqueológicas en la Costa Pacífica de Colombia. II: Una secuencia cultural del Bajo Río San Juan, Revista Colombiana de Antropología, 11, 1962; L. Duque Gomez, Reseña Arqueológica de San Agustín, Bogotá, 1963; E. Estrada, B. J. Meggers, C. Evans, The Jambelí Culture of South Coastal Ecuador, Proc. of U.S. National Museum, CXV, Washington, 1964; R. E. Bell, Archaeological Investigations at the Site of El Inga, Ecuador (bound together with Spanish version), Quito, 1965; S. M. Broadbent, Investigaciones arqueológicas en el territorio Chibcha, Antropología, Estudios de la Univ. de los Andes, 1, Bogotá, 1965; B. J. Meggers, C. Evans, E. Estrada, Early Formative Period of Coastal Ecuador: The Valdivia and Machalilla Phases, Smithsonian Contributions to Anthropology, vol. 1, Washington, 1965; T.C. Patterson, Ceramic Sequences at Tierradentro and San Agustín, Colombia, AmAnt, 31, 1, 1965; G. Reichel-Dolmatoff, Colombia, New

York, 1965; G. Reichel-Dolmatoff, Excavaciones arqueológicas en Puerto Hormiga (Departamento de Bolivar), Antropología, 2, Bogotá, 1965; Pérez de Barradas, Orfebrería Prehispánica de Colombia. Estilos Quimbaya y Otros, 2 vols., Bogotá, 1965-66; H. Bischof, Canapote, an Early Ceramic Site in Northern Colombia, Preliminary Report, XXXVI Congreso Int. de Americanistas, I, Sevilla, 1966; M. A. Carluci de Santiana, Recientes investigaciones arqueológicas en la Isla de la Plata (Ecuador), "Humanitas," Boletín Ecuadoriano de Antropología, 6, 1, 1966; C. Evans, B. J. Meggers, Mesoamerica and Ecuador, in Handbook of Middle American Indians, IV, Austin, 1966; B. J. Meggers, Ecuador, New York, 1966; G. Reichel-Dolmatoff, Recientes investigaciones arqueológicas en San Agustín, Razon y Fabula, Revista de la Univ. de los Andes, 2, 1977; W. M. Bray, J. W. L. Robinson, A. R. Bridgman, The Cauca Valley Expedition 1964, Explorer's Journal, 46, 1, 1968; H. Bischof, Contribuciones a la cronología de la Cultura Tairona (Sierra Nevada de Santa Marta, Colombia), Verh. des XXXVIII Int. Amerikanistenkongresses, I, Stuttgart, 1969; H. Bischoff, La Cultura Tairona en el Área Intermedio, ivi, I, Stuttgart, 1969; S. M. Broadbent, Prehistoric Chronology in the Sabana de Bogotá, Kroeber Anthropological Soc. Papers, 40, 1969; V. Oberem, Informe provisional sobre algunas características arquitectónicas de las pirámides de Cochasquí/Ecuador, Verh. des XXXVIII Int. Amerikanistenkongresses, I, Stuttgart, 1969; B. J. Meggers, Prehistoric America, Chicago, New York, 1972; H. Bischof, The Origins of Pottery in South America - Recent Radiocarbon Dates from Southwest Ecuador, Atti del XL Congresso Int. delgi Americanisti, Roma-Genova, 1972, I, Genova, 1973; H. Bischof, J. Viteri Gamboa, Pre-Valdivia Occupations on the Southwest Coast of Ecuador, AmAnt, 37, 4, 1973.

Venezuela: J. M. Cruxent, I. Rouse, An Archaeological Chronology of Venezuela, 2 vols., Pan American Union, Social Science Monographs, 6, 1958-59; I. Rouse, J.M. Cruxent, Venezuelan Archaeology, New Haven, 1963; E. Wagner, The Prehistory and Etnohistory of the Carache Area in Western Venezuela, Yale Univ. Publ. in Anthrop., 71, 1967; E. Wagner, Problemas de Arqueología y Etnohistoria de los Andes Venezolanos, Verh. des XXXVIII Int. Amerikanistenkongresses, I, Stuttgart, 1969; M. Sanoja, I. Vargas, Arqueología del Occidente de Venezuela, 2nd Informe General, 1968, Revista de Economía y Ciencias Sociales, Univ. Central de Venezuela, 12, 3, 1970; A. Zucchi, New Data on the Antiquity of Polychrome Painting from Venezuela, AmAnt, 37, 3, 1972; M. Sanoja Obediente, Proyecto 72, Atti del XL Congresso Int. degli Americanisti, Roma-Genova, 1972, Genova, 1973; E. Wagner, Nueva evidencia arqueológica de Venezuela Oriental: el yacimiento de Campoma, ivi; A. Zucchi, Tropical forest groups of the Venezuelan Savannas: Archaeological Evidence, ivi; A. Zucchi, Prehistoric Human Occupations of the Western Venezuelan Llanos, AmAnt, 38, 2, 1973.

Culture of the Andes: J. C. Tello, Orígen y desarrollo de las civilizaciones prehistóricas andinas, Actas y Trabájos Científicos, XXVII Congreso Int. de Americanistas, Lima, 1939, Lima, 1942; J. B. Bird, Preceramic Cultures in Chicama and Virú, in W. C. Bennett, A Reappraisal of Peruvian Archaeology, Society for American Archaeology, 1948, 4; G. R. Willey, The "Intermediate Area" of Nuclear America: Its Prehistoric Relationships to Middle America and Peru, Actas del XXXIII Congreso Int. de Americanistas, I, San José de Costa Rica, 1959; O. F. A. Menghin, Estudios de prehistória araucana, Acta Prehistórica, 3-4, 1959-60; A. Cardich, Investigaciones prehistóricas en los Andes Peruanos, in Antiguo Peru: Tiempo y Espacio, Lima, 1960; H. D. Disselhoff, S. Linné, The Art of Ancient America. Civilizations of Central

and South America, New York, 1960; E. Ishida, Andes I: University of Tokyo Scientific Expedition to the Andes, Tokyo, 1960; L. G. Lumbreras, La cultura de Wari, Ayacucho, Etnología y Arqueología, I, 1, 1960; L. G. Lumbreras, Esquema arqueológico de la Sierra central del Peru, Revista del Museo Nacional, 28, 1960; J. H. Rowe, C. T. Brandel, Pucara Style Pottery Designs, Ñawpa Pacha, 7-8, 1960; L. Barfield, Recent Discoveries in the Atacama Desert and the Bolivian Altiplano, AmAnt, 27, 1, 1961; J. H. Rowe, The Chronology of Inca Wooden Cups, in S.K. Lothrop, Essays in Pre-Colombian Art and Archaeology, Cambridge, 1961; S. Ryden, Complementary notes on pre-Tiahuanaco site Chullpa Pampa in Cochabamba area, and notes on one Tiahuanaco site in La Paz, Bolivia, Ethnos, 26, 1961; D. Collier, The Central Andes, in R. J. Braidwood, G. R. Willey (eds.), Courses Toward Urban Life, VFPA, 32, New York, 1962; J. H. Rowe, Chavin Art, An Inquiry into Its Form and Meaning, New York, 1962; G. R. Willey, The Early Great Styles and the Rise of the Pre-Colombian Civilizations, AA, 64, 1, 1962; J. B. Bird, Pre-Ceramic Art from Huaca Prieta, Chicama Valley, Ñawpa Pacha, 1, 1963; F. Engel, A Preceramic Settlement on the Central Coast of Peru: Asia, Unit I, Transactions of the American Philosophical Society, 53, part 3, 1963; S. Izumi, T. Sono, Andes II: Excavations at Kotosh, Peru, 1960, Tokyo, 1963; A. Kidder, L. G. Lumbreras, D. B. Smith, Cultural Development in the Central Andes - Peru and Bolivia, in J. B. Meggers, C. Evans, Aboriginal Cultural Development in Latin America: An Interpretative Review, Smithsonian Miscellaneous Coll., 146, 1, Washington, 1963; E. P. Lanning, A Preagricultural Occupation on the Central Coast of Peru, AmAnt, 28, 3, 1963; G. Plafker, Observations on Archaeological Remains in Northeastern Bolivia, AmAnt, 28, 3, 1963; J. H. Rowe, Urban Settlements in Ancient Peru, Ñawpa Pacha, I, 1, 1963; W. C. Bennett, J. B. Bird, Andean Culture History, Garden City, 1964; B. Berdichewsky, Arqueología de la desembocadura del Aconcagua y zonas vecinas de la costa central de Chile, in Arqueología de Chile Central y Areas vecinas, Publ. de los Trabajo presentados al Tercer Congreso Internacional de Arqueología Chilena, Santiago, 1964; A. Cardich, Lauricocha, Fundamentos para una Prehistória de los Andes Centrales, Studia Praehistorica III, Centro Argentino de Estudios Prehistóricos, 1964; A. Kidder II, South American High Cultures, in J. D. Jennings, E. Norbeck (eds.), Prehistoric Man in the New World, Chicago, 1964; G. Iribarren Charlin, Decoración con pintura negativa y la cultura de El Molle, in Arqueología de Chile Central y Areas vecinas, Publ. de los Trabajos presentados al tercer Congreso Internacional de Arqueología Chilena, Santiago, 1964; D. Menzel, Style and Time in the Middle Horizon, Ñawpa Pacha, 1964, 2; D. Menzel, J. H. Rowe, E. Dawson, The Paracas Pottery of Ica. A Study in Style and Time, University of California Publ. in American Archaeology and Ethnology, 50, Berkeley, 1964; T. C. Patterson, E. P. Lanning, Changing Settlement Patterns on the Central Peruvian Coast, Ñawpa Pacha, 1964, 2; D. E. Thompson, Postclassic Innovations in Architecture and Settlement Patterns in the Casma Valley, Peru, SouthWestern Journal of Anthropology, 20, 1, 1964; D. E. Thompson, Formative Period Architecture in the Casma Valley, Peru, Actas y Memorias, XXXV International Congress of Americanists, I, Mexico, 1964; B. Berdichewsky, Exploración arquelógica en la costa de la provincia de Antofagasta, Antropología, 3, 1, 1965; J. B. Bird, The Concept of a "Pre-Projectile Point" Cultural Stage in Chile and Peru, AmAnt, 31, 2, 1965; H. Horkheimer, Vicús, Lima, 1965; E. P. Lanning, Early Man in Peru, Scientific American, 213, 4, 1965; R. Larco Hoyle, La Cerámica de Vicús y sus Nexos con las Demás Culturas, Lima, 1965; E. E.

Berberian, A. H. Calandra, P. Sacchero, Primeras Secuencias Estratigráficas para San Juan (Rep. Argentina), La Cueva de el Peñoncino, Dto. Jáchal mimeogr. and distr., XXXVII Congreso Int. de Americanistas. Mar del Plata, 1966; D. Bonavia, Excavations of Early Sites in South Peru, Current Anthropology, 7, 1966; F. Engel, Le complexe précéramique de El Paraíso (Pérou), JSAm, LV, 1, 1966; F. Engel, Geografía Humana Prehistorica y Agricultura Precolombina de la Quebrada de Chilca, Tomo I, Informe Preliminar, Lima, 1966; F. Engel, Paracas, Cien Siglos de Cultura Peruana, Lima, 1966; S. Izumi, K. Terada, Andes 3: Excavations at Pechiche and Garbanzal, Tumbes Valley, Peru, Tokyo, 1966; R. Larco Hoyle, Vicús 2, Lima, 1966; D. W. Lathrap, Relationships between Mesoamerica and the Andean Areas, in Handbook of Middle American Indians, IV, Austin, 1966; D. Menzel, The Pottery of Chincha, Ñawpa Pacha, 4, 1966; T. C. Patterson, Early Cultural Remains on the Central Coast of Peru, ivi, 4, 1966; T. C. Patterson, Pattern and Process in the Early Intermediate Period Pottery of the Central Coast of Peru, University of California Publ. in Anthropology, III, Berkeley, 1966; H. Scheele, T. C. Patterson, A Preliminary Seriation of the Chimu Pottery Style, Ñawpa Pacha, 4, 1966; O. Klein, La cerámica Mochica, Valparaíso, 1967; E. P. Lanning, Peru Before the Incas, Englewood Cliffs, 1967; P. Rojas Ponce, The Ruins of Pajatén, Archaeology, 20, 1, 1967; D. Bonavia, Investigationes en la Ceja de Selva de Ayacucho, Arquelógicas, 6, Pueblo Libre, 1968; D. Bonavia, Las Ruinas del Abiseo, Lima, 1968; W. H. Isbell, New Discoveries in the Montaña of Southeastern Peru, Archaeology, 21, 2, 1968; D. Menzel, New Data on the Huari Empire in Middle Horizon Epoch 2 A, Ñawpa Pacha, 6, 1968; J. R. Parsons, The Archaeological Significance of Mahamaes Cultivation on the Coast of Peru, AmAnt, 33, 1, 1968; H. D. Disselhoff, Seis Fechas Radiocarbónicas de Vicús, Verhandlungen des XXXVIII Amerikanistenkongresses, I, Stuttgart-München, 1969; G. Mostny, Estado Actúal de los Estudios Prehistóricos en Chile, ivi, I, Stuttgart-München, 1969; C. Ponce Sangines, Descripción Sumaria del Templete Semisubterráneo de Tiwanaku, Publicación n. 2, Tiahuanaco, 1969; J. S. Chávez, L. Mohr Chávez, Newly Discovered Monoliths from the Highlands of Puno, Peru, Expedition, 12, 4, 1970; D. W. Lathrap, The Upper Amazon, London, 1970; L.G. Lumbreras, Para una Revaluación de Chavín, in R. Ravines (ed.), 100 Años de Arquelogía en el Peru, Lima, 1970; G. Savoy, Antisuyo. The Search of the Lost Cities of the Amazon, New York, 1970; P. C. Sestieri, The Necropolis on the Huaca Tello, Archaeology, 24, 2, 1971; G. R. Willey, An Introduction to American Archaeology. Volume Two: South America, Englewood Cliffs, 1971; R. Ravines, D. Bonavia (eds.), Pueblos y Culturas de la Sierra Central del Peru, Lima, 1972; D. E. Thompson, Archaeological Investigations in the Eastern Andes of Northern Peru, Atti del XL Congresso Internaz. degli Americanisti, Roma-Genova, 1972, I, Genova, 1973; D. A. Proulx, Archaeological Investigations in the Nepeña Valley, Peru, Amherst, 1973; L. G. Lumbreras, The Peoples and Cultures of Ancient Peru, Washington, 1974.

Tropical forests: B. J. Meggers, C. Evans, The Reconstruction of Settlement Pattern in the South American Tropical Forest, in G. R. Willey (ed.), Prehistoric Settlement Patterns in the New World, VFPA, 23, New York, 1956; B. J. Meggers, C. Evans, Archaeological Investigations at the Mouth of the Amazon, BAE, Bull. 167, Washington, 1957; C. Evans, B. J. Meggers, Archaeological Investigations in British Guiana, ivi, Bull. 177, 1960; H. C. Palmatary, The Archaeology of the Lower Tapajós Valley, Brazil, Transactions of the American Philosophical Society, n.s., 50, 3, Philadelphia, 1960; B. J. Meggers, C. Evans, An Experimental Formulation of Horizon Styles in the Tropical Area of South America, in S. K. Lothrop et al., Essays in Precolumbian Art and Archaeology, Salt Lake City, 1961; W. R. Hurt, New and Revised Radiocarbon Dates from Brazil, Museum News, 23, 11-12, 1962; D. W. Lathrap, Yarinacocha: Stratigraphic Excavations in the Peruvian Montaña, Ph. D. thesis, Harvard University, Cambridge, 1962; I. Rouse, The Intermediate Area, Amazonia, and the Caribbean Area, in R. J. Braidwood, G.R. Willey (eds.), Courses toward Urban Life, VFPA, New York, 32, 1962; O. Blasi, Cronologia absoluta e relativa do Sambaquí do Macedo-Alexandra, 52.13 - Paraná - Brasil, Arquivos do Mus. Paranaense, Arqueología, 1, 1963; S. Izumi, T. Sono, Andes 2: Excavations at Kotosh, Peru, 1960, Tokyo, 1963; D. W. Lathrap, R. Lawrence, The Archaeology of the Cave of the Owls in the Upper Montaña of Peru, AmAnt, 29, 1, 1963; S. Ryden, Tripod Ceramics and Grater Bowls from Mojos, Bolivia, Völkerkundliche Abhandlungen, I, 1964; W. Hanke, Archäologische Funde im oberen Amazonasgebiet, Archiv für Völkerkunde, XIV, Wien, 1966; W. R. Hurt, Additional Radiocarbon Dates from the Sambaquís of Brazil, AmAnt, 31, 3, 1966; D. W. Lathrap, The Mabaruma Phase: A Return to the More Probable Interpretation, ivi, 31, 4, 1966; E. P. Lanning, Peru before the Incas, New Jersey, 1967; P. Myers, Reconocimiento arqueológico en el Ucayali Central, Boletín del Mus. Nacional de Antropología y Arqueología, 6, Pueblo Libre, 1967; M. F. Simoes, Considerações preliminares sobre a arqueología do Alto Xingú (Mato Grosso), Programa Nacional de Pesquisas Arqueológicas, Resultados preliminares do primeiro ano 1965-66, Mus. Paraense E. Goeldi, Publicaçoes Avulsas, 6, Belém, 1967; L. Allen, A Ceramic Sequence from the Alto Pachitea, Peru, M.S. doctoral dissertation, University of Illinois, Urbana, 1968; C. Evans, B. J. Meggers, Archaeological Investigations on the Rio Napo, Eastern Ecuador, Smithsonian Contributions to Anthropology, VI, Washington, D.C., 1968; P. P. Hilbert, Archäologische Untersuchungen am mittleren Amazonas, Marburger Studien zur Völkerkunde, 1, Berlin, 1968; D. W. Lathrap, The Tropical Forest and the Cultural Context of Chavín, in E. P. Benson, Dumbarton Oaks Conference on Chavín, October 26-27, 1968, s.l., 1970; R. Vossen, Archäologische Interpretation und ethnographischer Befund: Eine Analyse anhand rezenter Keramik des westlichen Amazonasbeckens 1 & 2, München, 1969; D.W. Lathrap, The Upper Amazon, London, 1970.

ITALO SIGNORINI

AFRICA AND OCEANIA

SIGNIFICANCE OF PRIMITIVE ART

Consideration of the definition. – The term "primitive" continues to be used to define the art of peoples that are the subject of ethnological disciplines; it has the evolutionary significance of "first in time." Consequently, it presumes different phases of development, or recurrent cycles, in the art of a single culture, and of all humanity, from the "primitive" to the "classic," to the "mannerist," etc.

There is, however, a negative connotation in the word "primitive," a heritage of the ethnocentric vision of the authors of the 18th and 19th centuries. If we agree that each art form supposes a subjective and deliberate elaboration of what is given by nature, this connotation can no longer be accepted. As a completed and coherent elaboration, defined within the limits of the cultural context in which it is born, the art of those peoples that were considered primitive has, rather, the form and content of classic art.

Beyond such a qualitative evaluation, given by William Fagg (1958), other definitions have been proposed in the last few years. Fagg himself suggests adopting the definition of "tribal art" for Africa, intending the tribal culture independent of external influences, relating only to itself, and beyond any reference to values of other cultures. According to Fagg, the artistic expression would thus have developed its classic "canons" with reference to and in the environment of the tribal culture.

However, in the most recent texts, the theory of tribal borders is no longer accepted, as a result of the progress made in research carried out on location, within limited areas.

The importance of the individual contribution of the artist in the setting of the classic tribal canons, already brought out by Fagg, opens the way to subsequent observations on the evolution and the mobility of the cultural contents.

William Bascom (1969) emphasizes how individual creativity, always present in artistic production, is the basis of every innovation, diffusion, or assimilation of cultural elements. René V. Bravmann (1973) rejects the concept of the closure of the tribal cultural world, demonstrating, with concrete examples based on direct observation, how there are free cultural exchanges between different ethnic groups in Africa. It is noted further how secret societies often extended beyond the tribal and political borders, using artistic forms as a vehicle of religious and social content.

On his part, Frank Willett (1971), widening his vision beyond the field of Negro art, proposes replacing the term "primitive art" with "traditional art" with a geographic description, such as: traditional African art (or Oceanic, or American), comparing, in each of these zones, the ancient forms of the art with those that are now changing in form and content.

In his proposal, Willett thus agrees, in a way, with the definition of classic art given by Fagg. But after having gone beyond the term "tribal art," it seems to us that what is proposed by Willett has the advantage of eliminating the negative implications contained in the term "primitive," while "traditional" evokes quite well the characteristics of a slow cultural evolution and pre-industrial phase commonly recognized in the ethnological cultures. The term preferred by Willett, furthermore, constitutes a further step towards the surpassing of the ethnocentric vision, which still survives here and there in the contemporary Western conscience.

For that matter, a similar complaint would not have any meaning if a sense of guilt were not still alive today, a consequence of our past as ethnocentrists. If this were not so, we could comfortably continue the use of the term "primitive," if for nothing else than as a conventional definition whose original meaning had been surpassed by the evolution of time, and thus forgotten.

Significance and interpretations. – Some considerations on the significance of the discovery of primitive art as a contribution of the Western aesthetic conscience seem to us to be necessary.

The enthusiasm provoked at the beginning of the 20th century by primitive art began with the assumption that such art was a free interpretation of nature, not conditioned by the canons of realism. In reality, there is a complete coherence, but with different canons from those postulated until then by Western art. Such an error, however, had a liberating effect on Western art, indicating new forms and a breaking loose from the old canons.

Besides enriching the Western artistic production with new formal themes, the "discovery" of primitive art has liberated the Western aesthetics from the shackles of ethnocentric cultural patterns; it has shown the existence of an aesthetic component of the human character, of an absolute value, placed above any cultural contingency. It is known, in fact, how much the Impressionists were ignorant or heedless of the cultural significance of the forms of the exotic art that they admired so much, neglecting to investigate the context from which these came. But it is just this fact that makes us reflect on the value of an eclectic appreciation, coming from what is universal in the aesthetics of every culture, whether more or less complex.

Such an evaluation, however, must remain a gratuitous aesthetic intuition, beyond cultural frontiers. In the name of a poorly understood intercultural sympathy, the error of going too far is often committed in an involuntary invasion of the territory; this has resulted in distortions in interpretation, based on subjective aesthetic experiences. The fact that this can come about demonstrates how a pure aesthetic evaluation is not enough, and how much is felt, in the reality of the facts, the need to interpret and to give an explanation of the signs and symbologies that are obscure to us. Also for

Western art, for that matter, the judgment and the evaluation do not exclude symbological and historical notions, which serve to increase the aesthetic enjoyment of the knowledge of contingent conditions under which the work is born. Nevertheless, because the cultural context of Western art has been almost always known, one forgets that such knowledge is a vital part of the appreciation of every work of art.

The limits of the eclectic evaluation are fixed by the "gusto" that is native to an individual culture. The first phase of recognition of a universal aesthetic value is therefore immediately followed by the need of a deeper comprehension; and such a comprehension is often reached beginning with particular cultural patterns.

Since Franz Boas (1927) showed how the same symbolic forms can assume different meanings in different societies, a new method was indicated for similar studies on the primitive arts. The ethnological direction, based on the supposition that the content of a work of art is essential for its comprehension, gradually overcame the purely aesthetic direction, which judged such an element superfluous, if not even prejudicial, for aesthetic enjoyment. Thus the primitive arts were studied jointly under the profiles of the form and the content; the stylistic analysis thus could no longer ignore the study of the content within the specific cultural context.

In the search for a comprehension that would be as intercultural as possible, it seemed clear that with the peoples of an ethnological level, art had a function and a meaning profoundly different from what it had in the Western context. Maintaining the principle of the universality of the existence of "beauty," it is recognized that art for art's sake does not exist with the peoples studied; for them the aesthetic quality of an object has essentially a functional value within the group, serving to strengthen the religious and social role of the object itself. The function of art in the tribal world is explained, in fact, in terms of community religion: art does not "portray" - rather, it "means." Such "meaning" uses symbolism, but it does not identify with it, nor does it end there; masks and sculpture have a life of their own, not to communicate a message, but rather to catalyze and redistribute the vital energy present in each being, animate or inanimate, which is indispensable to the well-being of the group.

ART OF BLACK AFRICA (PLATES 81-89)

Recent studies of Negro art: a) Growth in interest. - There has been a surge of interest in Negro art in the years since decolonization. The Western public has gradually become more conscious of the formal contents of Negro art and of the influence exercised by it on the evolution of modern art in the West.

In Europe and America, there has been an ever increasing number of exhibitions, from comprehensive reviews to exhibitions of different themes presenting a single region or a single ethnic group. The already important existing collections in both large and small museums have been enriched by new acquisitions; these have often been valorized according to the most modern museological criteria, following thorough studies carried out on location. The number of important private collections has also increased, resulting in a corresponding increase of the market at the international level. The important auctions have registered record quotations for objects from famous collections.

Specialized centers of study have sprung up in several American universities (Berkeley, UCLA), while those already existing at the museums in Europe have been further developed. African art has entered into the university curricula in the United States, in Canada, in France, and in England. Specialized periodicals have also appeared, while the number of studies specifically dedicated to art in the anthropological and ethnological periodicals has increased.

In parallel with these developments, but not without a certain delay, some exponents of the African elite became aware of the value of their traditional culture, treating it as a standard of identity to flaunt before the ex-dominators. "Négritude," created as a term by Aimé Césaire in 1932 - 1934, had its most passionate paladin in Léopold Sédar Senghor, who was also the co-creator; he defined it as "the whole of the values of civilization - cultural, economic, social and political - that characterized the black peoples," making of it a faith, a system of thought, a political program, and a cultural vocation in the contemporary world. The "World Festival of the Negro Arts" held at Dakar in 1966, made a worldwide impression.

The incipient cultural politics of the new independent states were inspired by "négritude," although by the mid 1970s the term was already contested by the new generation. Some African governments promoted and sponsored archaeological campaigns and study conventions that show how much the need to safeguard traditional values is felt; they also contribute to drawing the outlines of a history of the African civilizations. At Kinshasa, in the line of the "authenticité" promoted by President Mobutu, a convention was held in 1973 by the International Association of Art Critics, followed in 1974 in Lubumbashi by an Interafrican Symposium on the "authenticité." The Federal Department of Antiquities of Lagos is today directed by a Nigerian researcher, while at the university of Ibadan a center for the formation of specialists of the preservation of the African antiquities was founded in 1973.

Finally, in some countries — for example, Guinea, Nigeria, and Zaire — the exportation of objects of traditional art has been forbidden.

b) New orientations and techniques of study. - The growing interest in the Negro arts has been accompanied by an inevitable change in the orientation of the studies on African art. The all-encompassing exhibitions are no longer being given, with their need for arranging in an orderly way material that was difficult to adapt to systematic cataloging, due to the stylistic variety. There is now a need to put the different styles to the test, through more thorough analysis and by limiting them to ever more restricted geographic zones. The multiplying of research on location has therefore produced a great number of specialized studies based on systematic analyses by regions, subject, material, and other factors; new attention has been given to architecture and to the so-called "minor arts." Such works often reflect an interest of the researchers in new techniques and methodologies of inquiry and expand the limits of the traditional Western aesthetic vision, with its subdivisions of the artistic reality into categories (sculpture,

graphics, music). Attempts are therefore made to sharpen the instruments of criticism through an investigation of the presuppositions of the African aesthetic, within the coherence of the cultural context of the single areas. The ethnologists become ever more conscious of the importance of art, while art historians turn more and more to the Negro art, at times undertaking studies on location.

One of the pioneers of the interdisciplinary encounter between ethnology and art history is William Bascom, who in certain works (1969 and 1973), centered essentially on the Yoruba area, attempted to apply the methods of analysis of art history to the study of the manifestations of those peoples, to whom tradition has attributed only an ethnographic present.

Furthermore, the progress that is being made in the archaeological fields in some areas furnishes material for a more specifically historic orientation in the analysis of the stylistic characters and of their interrelation. Sociologists and anthropologists, finally, search for correlations and relationships between art and social phenomena.

c) *Characteristics of Negro esthetics.* - At the beginning of the century, the "discovery" of Negro art was judged mainly for what new things it could bring to the European art; the artists found there the new sculptural solutions that were being searched for in that precise historical moment. Parallel to the analysis of the aesthetics, the classic ethnology continued with its work to identify and classify the styles and the functional categories of the single objects, solidly anchored to a technical-scientific definition that was suspicious of the indefinable quality of the aesthetic intuition.

In an article published in 1961, V. L. Grottanelli, explaining the historical and cultural reasons for what he calls "the problem of the aesthetes" and the "pragmatism of the ethnologists," called for a new discipline, one that will unite the two orders of knowledge, the general historical-artistic and the ethnological. Such a new discipline should be intercultural. Since aesthetic appreciation is a "faculty determined by culture," it is no longer possible to use only the aesthetic criteria of the Western world; rather, one must reach a "double conscience," a combination of the African and the Western.

Since the mid 1960s, in spite of the delay (in some cases recoverable), and in spite of the lack of a valid African contribution, it is possible to see the development of a new orientation of the studies toward an investigation of the assumptions of the African aesthetic. The Western studies, initially centered on the study of the social role of the artist and on the technique of the creative process, turned gradually toward the identification of the individual creator and toward the analysis of the aesthetic criteria of the tribal communities.

Studies from the point of view of the creative technique and of the artists in general were completed as long ago as 1939, the year in which H. Himmelheber published a study of the sculptures of Kuba, Tshokwe, and Yaka of the Congo. In the same year M. Olbrechts, P. J. L. Vandenhoute, and A. Maesen became interested in the personalities of the artists of the Ivory Coast. In 1946 Olbrechts published "Arts Plastiques du Congo Belge," in which he dedicated a chapter to the need of identifying the anonymous artists and of investigating

the assumptions of the Negro aesthetics. Since 1953, the studies of William Fagg turned to analysis of the creative contribution of the single artist, allowing us, for the Yoruba area, to distinguish different schools and different "hands," thus dispelling the myth of the anonymity of the Negro artist.

But it is not until 1961 that we have, from Paul Bohannan, the first attempts to investigate the Negro aesthetics that overcame the problem of the technique and the analysis of the creative process. In his report at the Symposium of London on the artist in the tribal society, Bohannan goes beyond the sphere of the artist to widen his outlook to the field of the critic. From the information gathered from the Tiv of Nigeria, he deduces that with that group the skill used in the creation evoked greater interest than the person of the artist. With the Tiv, the artist is not considered as a separate being, neither is his work considered as isolated within a sacred aura (as happens for the craftsmen of the Sudanese societies); the work of the artist is a creative process open to all the members of the community; everyone can take part, with critical reflections or even with manual contributions.

In 1967 Michel Leiris dedicated an entire chapter of his book, written in collaboration with Jacqueline Delange, to analyze the aesthetic sense among the Africans, especially through a linguistic examination. He concluded that while the existence of a concept of "beauty" is documented in almost all groups, assimilated to that of "good" and functional, it is not equally certain that there exists an idea of "art," whether pure or functional.

This is confirmed in an interesting article by Robert Farris Thompson (1968). Turning from interrogation of the Yoruba artists to the group to whom the work is destined, Thompson succeeded in identifying as many as 19 criteria destined to define the aesthetic quality and categories that a sculpture requires. Some of these criteria are: "moderate similarity" (a midpoint between the portrait and the abstract), "visibility," "luminosity," "emotional proportion" (relation between the proportions of the work and the effective intuition of the observer), "precision of the positions," "composition," "delicacy," "roundness," "moderation of the relief," "harmonious angularity," "symmetry," and "ephebism." The last criterion takes on the quality of the beauty of youth requested for the portrayal of an ancestor, as old age is idealized and identified with the eternal beauty of wisdom. Finally, Thompson gives particular emphasis to the category that he calls "coolness," translating the Yoruba term "tutu." This is a quality that is appreciated also in social behavior, understood as the composure and the impenetrability of the personal emotions; in the sculpture it is indicated as the absence of violence in the expression of the face and in the gestures.

Some of the criteria announced by Thompson coincide with aesthetic judgments given by non-African observers of the sculpture of the Yoruba. This should not, however, induce one to believe that such a coincidence can occur for each work of African art. The studies of Biebuyck (1969 and 1973) with the Leagues of the Congo, for example, demonstrate that in that group "a critique of the physical appearance is inconceivable"; the traditional sculptures, used in the rites of the

"Bwami" society, are in fact judged "good" in the measure in which they fulfill their functions.

Similar observations result from the study of Fernandez (1966) on the aesthetics of the Fang. In the case of the Fang relics, in fact, the aesthetic value is always secondary with respect to the functional one, the Fangs not being able to isolate a judgment of aesthetic value in the general cultural context in which the object participates. The content and the function of the object seem to have a greater weight than its form, as that which is worth more in a sculpture is its function of catalyst of the vital energy; from here the importance given to the symmetry that, united with the frontality, seems to constitute the vitality of a sculpture. In this case there is, therefore, a contrast between the Western judgment, which considers the frontality as a static element, and the African, which rather indicates it as support for the vitality of the object.

The studies cited up to now are oriented toward the search for criteria for the aesthetic evaluation of the works of the Negro peoples, in an attempt to compare them with our own. But other studies, more recent, have been completed in an attempt to understand the genesis of the stylistic typology, the more widely cultural significance of the style, and the symbology of the different themes. Among these works are to be cited the numerous articles by P. S. Wingert that appeared in "African Arts" between 1972 and 1973. Wingert limited himself to a refined and knowledgeable stylistic analysis, intended to determine the formal constants of the production of each single group, as a premise for a further comparison and a study of similarities between the different groups. The contribution of J. D. Flam (1970, 1972) goes rather beyond the stylistic evidence to analyze the symbolic structure of the object, penetrating, thus, through an iconological analysis, the cultural context that produced it.

It should be noted that the numerous efforts completed so far by the Western researchers are still insufficient and remain, in a way, a monologue, since the African counterpart in the potential dialogue is either silent, only letting himself be seen, or is not able yet to translate his values for us. We will, nevertheless, cite two articles of African researchers who are trying to open a glimmer of hope for us in what appears to be an inevitable incommunicability of two cultural worlds.

The Cameroonian J. B. Obama (1963) explains the Negro art in terms of communion, rather than of dialectic comprehension: "in Africa," he says, "art is not only aesthetic, it is mystic." Judgments of this type reflect the imposition of the "negritude" of Césaire and Senghor. The latter wrote, in fact, in 1967, that to communicate with the Negro art it is necessary to "overcome the incommensurable space that spiritually separates the contemporary civilized man, nourished in logical reasoning, from his remote ancestor, who lived his art rather than simply fabricating it" and to recover what the Western civilization has lost in distancing itself from the "primitive." Reason, both classical and Cartesian, is for Senghor a screen for the pure expression of the spirit: Negro art does not portray, rather, it expresses, the essence of the object (the sculptures of ancestors are, in fact, both a symbol and a dwelling place at the same time). Furthermore, each element of an African sculpture is arranged according to a hierarchy of spiritual values, expressed by that stylistic Negro characteristic of rhythm; it is due to rhythm, which acts on the less intellectual part in us, that we may penetrate into the spirituality of the object.

In the writings of Senghor we can seen the difficulty in expressing the essence of one's own culture in a language that comes from a totally different culture; to translate, that is, into Cartesian language that which is not Cartesian. And here we are once again outside the door, waiting for other interpreters to give us the key.

d) *The artist and style.* - As more and more examples of the production of a single ethnic group became known in Europe, it appeared evident that Negro art had well defined styles, with limitations within each particular group. The pretended "liberty" of the African artist is thus reappraised and limited by the stylistic tribal canons. The artist came to be considered as a mere instrument of the community, a passive executor, obedient to the norms established by tradition; art seemed to be conditioned, at the level of the artist, by the traditional stylistic rules and, at the level of the group, by a cultural identity that put it in opposition with other groups.

Such conditioning, however, lost much of its importance in the light of successive studies; they demonstrated, on the one hand, the inevitable personal contribution of the artist within the ambient of the traditional stylistic patterns, and, on the other, the dynamic aspect of what had been considered rigidly fixed by an immobile tradition. The single object is enriched by the interpretation and the innovations of the individual creator, while the style of the group becomes more complex, due to the assimilation of new formal themes contributed by exchanges with surrounding groups.

First of all, we must consider how the tribal stylistic canons are only relatively restrictive, as the artist at his work does not have a model in front of him to copy; rather, having received from the client only some indications of the theme and the purpose of the object, he works according to the image that he has formed of that object, based on his exposure to similar works and on his personal technical experience. Such a combination becomes a set of rules, predetermined according to the dictates of tradition, within which the artist completes the selection most congenial to him.

It seems important for us to emphasize how the aesthetic quality of the product depends on the artist not limiting himself to merely copying a particular model; that would be more faithful to the original, but also so much more imprinted with the coldness of an imitation. The personal effort given to solving the different plastic and technical problems that gradually come up in the course of the work is what determines the originality and the authenticity of the creation.

It is necessary, nonetheless, to note that the autonomy and the liberty of invention that an artist can enjoy vary, quantitatively, in relation to the social and political institutions of the group.

In societies with central power, where a court art exists, the sovereign reserves for himself the exclusive right to determine the types of production, grouping the artists into corporations; this has the effect of levelling the production from the stylistic point of view. In such conditions, furthermore, the instructions of the client are more restrictive; art thus evolves more slowly,

degenerating, as in the case of Benin, into the "manner."

In the tribal art and with the societies of federal type, the situation is different; the sculptor is more isolated, with fewer models available, and there are a great number of stylistic variants from village to village, testifying to a greater dynamism.

The influence the work of the sculptor has in determining a personal style within the tribal style has permitted the discerning of the imprint of different schools in many groups and the identification of the "hand," as well as the dating of the production of a single artist, according to the grade of artistic maturity along the passing of the years. Works in that sense have been completed, in the last few years, mainly among the Yoruba (W. Fagg), but also among the Dogon and others.

e) *Stylistic classifications.* - Because of the scarcity of historic documents, a diachronic study of the Negro arts is impossible in the present state of knowledge; the variety in the styles identified to date does not allow a synchronous study. In any case, the complexity of this subject does not permit a precise classification of tribal styles, nor of the influence they had with each other. The same criterion of tribal style is still uncertain, in that no constants exist, specific or definite, that are limited to a single group; some objects, in fact, are not only related to a tribal culture but more often to common institutions of many tribes.

From a general cultural point of view, the African societies have been grouped according to different spatial and temporal criteria. Baumann accentuated the importance of the historical dimension, distinguishing between the fundamental civilizations and the derived groups, while researchers such as Daryll Forde preferred a classification on prevalently anthropological and geographic bases. Herskovits, emphasizing the preeminence of the social and cultural bases on the spatial and temporal in the identification of a cultural group, introduced into African studies the concept of the "cultural area," in which the geographic dimension is still quite important, but subordinate to the cultural. This notion has inspired many of the successive works, among which are those of Denise Paulme and J. Maquet, although with a different accentuation of the historic aspect.

From a point of view that is more strictly stylistic, the areas of richest artistic production have been, in turn, classified according to more general criteria, valid mainly for their convenience. An attempt has been made to establish certain correlations between style and the natural ambient; the theory of Hardy, comparing the naturalism of the arts of the forest to geometric symbolism of the art of the savanna, was very popular. The distinction proposed by Lavachery between the "concave style" and "convex style," however, had little following. Finally, an attempt was made to find a relationship between the social structures and some themes or forms of art.

The validity of the category of the "cultural areas," in the stylistic field, is denied by R. A. Bravmann (1970), who notes that with groups of peoples having similar traits there are differences contrary to the homogeneity required by the definition; degrees of stylistic integrity, although presenting similarities, do not stand up to a closer examination.

Categories established a priori cannot therefore serve the complexity of the African cultural situation, in which the unmistakable Negro character, common to all styles, suggests a derivation in space and time from a single cultural archetype. The traces of this archetype prevent discerning where the stylistic analogies are due to a multiple invention or to a transmigration of themes. The explanation of such analogies can be obtained by further progress in the study of linguistics, of the material culture, and of the oral tradition and also from advances in archaeological research.

Archaeological research: a) The impetus of archaeological research. - A certain static nature in the African cultures has long been accepted; this may be attributed to the weight of tradition and the type of social structure. Similarly, the possibility of a stylistic evolution because of the contribution of individual creativity and the circulation of the cultural contents has not been given enough consideration in terms of Negro art.

In reality, Negro art has continued to evolve, although the speed of such evolution has been different according to the time and place. Thus we can speak of a history of African art, even though based on our current level of knowledge this may be barely documentable.

Factors such as the perishability of wood, the precarious conditions in which the objects are conserved, and the nature of the climate have prevented our inheritance of works that could have attested to the stages of stylistic evolution. Consequently, the available documentation is limited to objects done in durable materials such as stone, terra-cotta, bronze, ivory, and iron. Such evidence is already fragmentary and is doubly insufficient if it is understood that such materials, which are thought to be valuable, are used less frequently than wood, at least in the contemporary cultures. Furthermore, the nature of these materials often requires that they be utilized for different categories of objects. Thus evidence that would show the solutions of stylistic continuity may have been irretrievably lost.

Archaeological research has had a notable impetus in the last 20 years and has been able to supply us with some basic points of reference; unfortunately there are still many chronological periods for which no documentation is available.

b) *Saharan rock art: paintings and graffiti of the Tassili-n-Ajjer and of the Tadrart Acacus.* - The rock paintings and engravings found in the mountainous regions of the Sahara belong chronologically to the prehistoric period. However, the problems connected with the interpretation of such artistic expressions are interesting ethnologically as well, inasmuch as they document cultures whose technological and economic levels are charateristic of "primitive" cultures. Furthermore, although the ethnic groups of the authors of such works have not been determined, and there are no significant stylistic connections with the art of the more recent African civilizations, the fact remains that the Saharan rock art constitutes the earliest proven artistic production on the African continent.

Rock art was discovered in Africa even before it was in Europe; in fact, paintings were found in Mozambique and in South Africa in the 18th century. In North Africa, rock art was discovered in 1847; since then, there has been a series of findings, and it has been

the object of systematic research. Findings were made almost everywhere there are mountains: in the Ennedi, in the Gehel Owen (where in 1969 more than 2,000 works were discovered, including graffiti and paintings), in the Fezzan, in Tibesti, in Tassili, and in the Hoggar. The important findings occurring in the 1970s stimulated the progress, as well as the iconographic analysis, of archaeological research for the purpose of chronological classification.

The chronology of the prehistoric Saharan art is still uncertain and, for the moment, is based on relative dates; it is not yet possible to obtain absolute dates for the artistic findings, as the modern methods of dating require organic remains. Only a small number of dates are obtained from stratigraphy because of the scarcity of the studies and reliefs as well as for the climatic happenings that have upset the stratigraphic order of the deposits over the centuries. The classifications published to date as provisional findings have been retouched several times on the basis of new discoveries; they are still awaiting a definitive and coherent formulation. The classification generally accepted today is based on the succession of subjects portrayed - which would reflect the phases of an evolution of the economic activities and of the climatic changes - as well as on the stylistic characters of the portrayals themselves. Works that reflect the way of life of the hunters and portray examples of fauna which, in the Sahara, were the first to be extinct have to be the earliest.

A chronological succession has been built on evolution from a recurrence of an early style that later leads to an even leaner stylization; the latter terminates in a period whose decisively geometric style preludes the appearance of signs of an ideographic writing. In reality, such a classification has a value of stylistic distinction, rather than convincing evidence of an effective chronological succession. In more than one site we find a superimposing of different styles, without it being possible to establish if there is an order of succession and what it is.

The four principal periods into which the Saharan art is divided are:

— *period of the "bubalus antiquus"* (ancient buffalo, formerly called the period of the hunter) that includes all those scenes of hunting in which, in addition to many other wild animals such as the elephant, the hippopotamus, the rhinoceros, the giraffe, the ostrich, and the great antelopes, the effigy of the "bubalus antiquus" is always present. The style of that period is of the archaic type;

— *period of the cattle herdsmen*, in which the bubalus is no longer portrayed, while the representations of the cattle and the pastoral scenes prevail over those of the hunting fauna. The classic naturalistic style that has excited the enthusiasm of the Western public is of this period;

— *period of the horse*, subdivided into three further phases - the cart, the horseman, and the horse and camel - begins the period of stylistic decadence; the representations are of ever smaller dimensions and rendered with greater simplification, although with great efficacy and incisiveness;

— *period of the camel*, in which, besides the camel, animals are represented that survive to today on the margins of the area - antelope, mouflon, oryx, gazelle, ostrich, zebu, and goat. The style of this period is strongly schematic and the human figures, rather small, are often rendered by means of two triangles joined at the vertex. The stylistic decadence is completed and the geometrism gradually comes near to the characters of an ideographic writing.

Such a schematic classification, initially established by the graffiti (that in North Africa has a wider diffusion than the paintings), is revealed by more recent discoveries to be an only generally indicative guide to the paintings subsequently found, in conspicuous number and various stylistic tipologies, in the shelters of Tassili-n-Ajjer and of Tadrart Acacus.

The rock paintings of Tassili-n-Ajjer (southern Algeria) were discovered before World War II and publicized in 1954 by the Abbot Breuil in the form of drawings copied from the stock of preceding reliefs; they were better known after 1958 from the reports of the trips made by the Frenchman Henry Lhote. Lhote's numerous missions revealed the existence in the Tassili of thousands of paintings, corresponding to about 30 different substyles, grouped principally within the periods "of the cattle," "of the horse," and "of the camel." He presented a rich documentation to the public consisting of pictorial representations, fruit of the decade-long work of a team of copiers directed by him on the site. Only in 1962 was the first photographic documentation obtained, through the work of D. Lajoux, that permitted putting into relief, for the use of the reader, some details that had inevitably been lost or overlooked in the work of the copiers.

The earliest paintings of the Tassili belong to a period between that of "bubalus antiquus" and that of the herdsmen, defined as the "archaic period." The dating of such pictures is still uncertain, but it seems to be a little after the first occupation of the area, established by C-14 as about the sixth millennium B.C. To the archaic period belongs the style called "of the round heads" and of the white figures, as well as numerous masks and masked figures that have suggested a Negro origin of the authors. The naturalistic paintings of the period of the cattle herdsmen appear to go back, for the Tassili, to about 4000 B.C. This period lasted until 1200 B.C., date of the appearance of the horse in the Sahara; the portrayals of the carts pulled by horses, ascribed in fact to the period "of the horse," have evoked a series of conjectures about the source of such vehicles: the most probable hypothesis is that which sees in such portrayals pure mythological images, rather than portrayals of carts driven by dominators coming from the north.

Finally, the decorations of a schematic character of the period "of the camel" are dated to the end of the first millennium B.C.

A more precise chronology of the paintings of the Tassili can be established when archaeological research is able to furnish stratigraphic datings that can be related to them. It is difficult, in fact, to connect the sporadic surface findings, which by their nature are mobile and superimposable, with the style of the paintings. The task of archaeology will be to further investigate the numerous mounds and the funerary constructions noted from the more recent explorations.

The artistic documentation in itself supplies us only with the data obtainable through a formal and thematic analysis. Such an analysis is not yet able to establish if the paintings of the Tassili are the work of one or more peoples or to what race they may belong.

Lhote suggests that the graffiti - which in the Sahara seem to belong exclusively to the period "of the bubalus" - were made by peoples of the white race. According to Lhote, painting, introduced only later in the period "of the cattle herdsmen," is attributable to a population of Negro race superimposed on a group of hunters. Many thematic elements could show that the authors of the pastoral scenes were of the Fulbe, a people of Ethiopian origin, according to some, who came to western Africa in successive migrations from the east from 4000 B.C. up to the eighth century A.D.

This hypothesis is obtained from Amadou Hampaté Ba on the basis of his personal experience as one initiated into the traditional religion of his people; he has examined the paintings in the light of the beliefs and knowledge of the pre-Islamic Fulbe shepherds. The interpretation of the subjects represented, of the gestures and the costumes of the personages, and of the different objects portrayed on the walls of the shelters induce Ba to suppose that the paintings of the pastoral epoch can be attributed to a race slightly different from the present-day Fulbe, who spread out from Senegal to the area immediately south of the Sahara.

Conjectures of this type appear, however, to be tenuous arguments if we consider the inherent difficulty in identifying certain motifs and if we note that the themes represented do not always objectively reflect the contents of the culture of the executing artist. The fact remains, however, that some osteological documents attest to the presence of Negroes in the Sahara in eras preceding the desertification.

Parallel to the work of Lhote on the Tassili was that of Fabrizio Mori on the Tadrart Acacus (south-Western Libya). His publication of the results of numerous expeditions beginning in 1956 has revealed the existence, in the Fezzan, of numerous examples of rock painting, whose stylistic classification traces that established for the Tassili with elements of lesser chronological approximation. In the Acacus the stylistic phase between the "bubalus antiquus" and the pastoral period is delineated more clearly. This period was given the name "of the rounded heads" by Breuil, because of the style of some paintings of the Tassili ascribed by him to the archaic period.

The research by Mori was not limited, however, to the analysis and stylistic classification of the iconographic material; interesting stratigraphic findings have permitted carrying on the research of an absolute chronology, as well as a better focusing of the hypotheses of the ethnic and anthropological type. The material furnished by important Neozoic deposits have permitted dating by C-14 of the different levels of sediment, furnishing values of absolute chronology, which in some cases have served for the dating "before" or "after" the paintings themselves. The finding of levels with superimposed painting have permitted the confirmation of the chronological sequence based on the parabola of the stylistic evolution (and successive involutions).

We are thus in a position to set out the major lines of an absolute chronology that inscribes the artistic production of the pastoral period of the Tadrart Acacus within a range of time that goes from 5000/6000 B.C. to 2800 B.C., while the production of the period "of the horse" can be placed at around 1500 B.C. Further, an infantile Negroid mummy of Somatic character brought to light by the excavations of Mori supports the hypoth-esis, already formulated for the Tassili, about the attribution of determined styles to peoples of the Negro race.

c) The Sao culture: recent datings. - With regard to the culture of the sub-Saharian area, some of the most important and significant archaeological centers for research in historic prospective are today distributed along the basin of the Niger River: from Mali along the upper course (Djenné, Gao), to the strong concentration of sites in northern Nigeria (Nok), western Nigeria (Ife), and southern Nigeria (Igbo-Ukwu). Further to the east there is the phenomenon of the Sao cultures of Lake Chad, which seem to have developed on their own.

The excavations carried out by J. P. Lebeuf and A. Masson-Detourbet about 1945 brought to light the ruins of a culture south of Lake Chad, today vanished, attributed to the Sao (see SUDANESE CULTURES, *Encyclopedia of World Art*, vol. XIII). In sanctuaries, tombs, and surrounding walls, numerous objects of terra-cotta and of bronze were found, belonging to different archaeological levels and apparently without any connection to other known cultures.

The morphological aspect of the sites and the information deduced from the Arab manuscripts had resulted in a preliminary chronological division into three periods included between the end of the tenth century and the end of the 18th: Sao I, Sao II, and Sao III. To the first period are ascribed those documents that reveal a precarious type of settlement, populated largely by hunters; the second period, more recent and richer in clay and bronze findings, in addition to the surrounding walls, documents a subsequent populating by fishermen of a more complex culture, who developed the art of ceramics and the fusion of the lost wax.

As a result of datings by C-14, J. P. Lebeuf (1969) has shown a rather more extended chronology for the culture of Chad, permitting us to go back to the epoch of the Nok culture; however, the Sao culture did not seem to have any elements in common with this culture.

Other research on the origins of the cultural traits of the pre-Islamic populations of the lower Chari, completed in 1969 by P. Huard, tends to demonstrate that certain elements are connectable to eastern areas of diffusion, some of which have their origin on the Nile.

d) Hypotheses of a relation between the art of Nok and that of other cultures. - The earliest and most significant African sculptural tradition outside of Egypt seems to have originated in Nigeria, where it has been possible to identify two important traditions (Nok and Ife) that furnish us today with evidence for the study of the development of sculpture over a range of 2,500 years.

We owe the study of the culture of Nok, named after the village where the first findings were made, to the work of Bernard Fagg. That culture can be placed by stratigraphy to a period between the V and the II century B.C. (and according to C-14 from 300 B.C. on); it appears to be the earliest of the Negro cultures to have had sculpture. The first casual findings, and the subsequent excavations carried out in a vast area in Northern Nigeria, have brought to light different small sculptures in terra-cotta, as well as fragments of terra-cotta sculptures of almost natural dimensions. They portray human and animal subjects. In the human portrayals, the head is generally cylindrical - or even spherical or conical - often adorned with elaborate hair dressings; pupils, nostrils, mouth, and ears usually are pierced,

while the lines that describe the face, in particular for the eyes, are made with neat and precise incisions; the mouth and the beard, finally, often project in sharp relief with respect to the rest of the face.

Such stylistic elements, more suited to the technique of wood sculpture than to modeling in terra-cotta, suggest to some (F. Willett, 1971) that the terra-cotta of Nok derives from a tradition of wood sculpture unknown to us, since no wooden objects of that age have survived. According to Willett, it is probable that the Nok culture extended beyond the area where the findings were made; it is not impossible that it lasted to beyond the second century A.D.

The study of the more recent artistic styles in western Africa suggest that many of these are, in part, descended from the Nok culture or, at least, from an artistic tradition of which Nok would be the only one known. Although the elements to prove such a relation of derivation are missing, we can note how some stylistic traits, such as for example the cylindrical head placed at an angle on a tubular neck, recur in the undated stone sculptures of the Esie and of the "nomoli" of Sierra Leone. The proportions of the body - preeminence of the dimensions of the head over those of the body - are also visible in the very few statuettes of Nok that have survived almost intact to us.

e) The naturalism of Ife. - There have been no archaeological discoveries in the long interval of time between the flourishing of Nok and the examples of art of the 19th and 20th centuries. But there is a style of sculpture chronologically close to the central period of this interval which seems to have many traits in common with the style of Nok: this is the art of the civilization of Ife.

The art of Ife was discovered by Leo Frobenius in 1910, when the Nok culture was still unknown. At first the Western critics formulated a series of hypotheses of a Greek or Egyptian influence as an explanation of the phenomenon of a refined naturalistic art without parallel in the typology of the Negro art known until then. The subsequent discoveries made by Bernard Fagg in 1953 and Frank Willett in 1957 - 1958, however, demonstrated the typically African character of such art. William Fagg was the first to note that the dimensions of the head were clearly exaggerated with respect to the rest of the body; such observation was confirmed by the finding of a bronze sculpture, found whole in 1957 by Willett at Ita Yemoo, in the Ife area.

A more accurate observation of the stylistic characters demonstrated how far the naturalism of Ife was from the Greek-European tradition; the art of Ife was in fact an idealized naturalism, fused with elements of extreme stylization. The apogee of the art of Ife is placed between the 13th and the 14th centuries. We do not know how much that production goes back in time, but we have datings by C-14 (Willett, 1967) that prove that Ife was already occupied between the sixth and the ninth century, an epoch that could, according to Willett, come very close to that of the culture of Nok, even though it does not appear that sculpture was practiced in Ife in that phase.

The hypothesis of a cultural connection between Nok and Ife is based on some observations that are interesting, but not wholly convincing. Most important, Nok and Ife are the only artistic traditions in all of Black Africa that represent the human figure in almost natural dimensions. In both cases the sculptures are often supported by a spheroidal base; they are further adorned by hair dressings and chest ornaments composed of pearls and arranged in a similar manner. In addition, the style of the terra-cotta of Ife is seen to be a more refined version of the style of Nok, with a greater naturalistic accentuation.

Finally, in the region of Ife there is a tradition of an ancient people who inhabited the zone in the times of a legendary hero, named Odudua, to whom is attributed the merits of having created the world. According to Willett (1967), this people, the Igbo, would be descended from the people of the culture of Nok.

f) Parallel derivation of the Yoruba style and that of Benin from the art of Ife. - Among the many hypotheses formulated by Willett (1967) in his analysis of an artistic evolution in Nigeria, the one that seems to be the most easily verified is the possibility of a stylistic derivation of the art of Benis and of that of Yoruba from the art of Ife. Such derivation could have had two lines of parallel development which would explain the affinity between the later style of Benin and the modern Yoruba art.

In the style of Ife can be seen how the rigorous naturalism of the classic period slowly evolved toward forms that are even more stylized, preluding decisively to the Yoruba sculpture in the post-classic period. A terra-cotta, found next to works of a more naturalistic style at Ita Yemoo in 1957, portrays a head, gagged - probably a victim of a sacrifice - and shows stylistic characteristics that recall those of the present-day Yoruba: protruding eyes, prominent lips, and a volume that evokes that of the "gelede" masks. Similar characteristics can be observed in a group of heads excavated in the area of the palace of Ilesha (30 kilometers from Ife) in 1959, also in terra-cotta, dated by Willett to the middle of the 19th century; in these sculptures what is most prominent is the globular form of the eyes, which preludes a more stylized Yoruba version.

Regarding an influence of Ife on the art of Benin, we know from the report of d'Aveiro, who visited the city of Benin in 1485, that during that time bronze objects were made at Ife and sent to Benin. Furthermore, there is a local tradition that Oba Obuola, who reigned at Benin toward the end of the 14th century, requested of Oni of Ife that he send a craftsman to teach the fusion of bronze to his people. On the other hand, recent studies have shown that the city of Owo, situated geographically between Ife and Benin, must have played the role of cultural intermediary. Archaeological excavations carried out at Owo suggest that the origins of this city were in Ife; the style and the technique of Ife therefore migrated to Benin by way of Owo. The style of Owo shows characteristics between the two, but is closer to the culture of the Bini than to the Yoruba.

Some of the earlier bronzes found at Benin seem to have been done at Ife, however. But whether the technique was passed on directly, or through Owo, the bronzes of Benin show that the technique may have come from Ife, but not the spirit. The development of the art of Benin, which style begins with a naturalism similar to that of Ife, shows changes in form that tend toward ever more conventional expressions and "of the manner," accompanied by a typological evolution. The purity of the primitive anatomical sensibilities is lost, the heads gradually become physically heavier, techni-

cally more elaborate and spiritually more inert; there is no longer the volumetric synthesis, but lengthy descriptions of decorative details whose intrusiveness hides the lack of fullness in the volumes. The relationship between the art of Ife and that of the Yoruba seems to be that of a natural stylistic evolution around a single cultural tradition; however, for the bronzes of the court art of Benin we see a stylistic degeneration resulting from a progressive weakening in the impact made by the inspiration derived from a foreign culture.

g) New evidence for the study of the cultures of the lower Niger: the excavations of Igbo-Ukwu. - The results of the excavations completed between 1960 and 1964 by Thurstan Shaw at Igbo-Ukwu, on the lower course of the Niger, were published in 1970; they have brought information to the public of a culture which existed, according to the data of the findings, in the ninth century and which represents a tradition distinct from that of Ife and Benin. The bronze objects found in tombs and sanctuaries show a particular style of fusion, besides being of a form that does not seem to have a counterpart in other zones of Nigeria. Containers shaped like snail's shells or squash are decorated with motifs of knotted cords in relief; the peculiar decoration is obtained with thin strings of wax, braided and applied in the modeling phase to the surface to be decorated.

If the particular disposition of the layers on the face of some small heads in bronze is excepted - which recall that of some terra-cottas discovered by Frobenius and of some sculptures in stone of Esie - the stylistic characters of the objects of Igbo-Ukwu do not seem to have significant ties with the art of other cultures of Western Africa. Shaw himself, in reporting the results of his work, does not draw any conclusions, leaving to others the interpretation of the data. However, Willett (1967 and 1971) notes that the existence of a civilization in the ninth century offering such refinement and technical ability in the working of metals can suggest that also at Ife, little more than 300 kilometers from Igbo-Ukwu, an artistic production that has not yet come to our attention could exist at the same time.

In addition to the excavations at Igbo-Ukwu, numerous small bronze objects were found in different locations along the lower course of the Niger, from the confluence with the Benue up to the delta; they prove the existence of cultures that were certainly older than Ife, although difficult to date.

h) Pre-Islamic cultures of the upper Niger: the terra-cottas of Djenne. - The upper basin of the Niger, in the regions where the Mandingo Empire of Mali flourished, has traces of ancient river cultures. In many zones of the present-day Republic of Mali, terra-cottas of small dimensions (30 - 40 centimeters) have been found, mostly fragmented, representing animals and human figures; they are attributable to vanished pre-Islamic cultures and approximately datable between the 12th and 14th centuries. A quite diversified typology exists, distributed among the regions of Segu on the Niger and at Djenne, the ancient commercial capital of Mali on the Bani and Mopti tributaries.

The terra-cottas of Djenne, of which we have an example at the I.F.A.N. Museum at Dakar, is distinguished for the elongated form of the head and for the scars around the eyes and the temples; the eyes are protruding, the nose and the mouth projecting from the plane of the face. Here also, as for the other ancient African terra-cottas (Nok and Sao), we have a fusion of models and intaglio, but, outside of that characteristic, there are no stylistic traits that can prove a connection with other styles, whether ancient or contemporary.

These findings have not yet been studied systematically, and it does not seem that official excavations have as yet been undertaken. It is probable, in any case, that there is yet much to find in a region such as that of present-day Mali, where great empires were close by, mainly along the Niger, that great artery of commercial and cultural exchanges.

i) State of archaeological research in central and southern Africa. - African archaeological research is still in its beginning stages and is unequally distributed across the continent. While in Nigeria one has reached the phase of searching for missing parts in the overall picture, which is by now laid out in its general lines, in other areas research is barely at the onset of investigation or it has yet to start.

The excavations promoted by the government of Zaire in the zone of Sanga, on the west bank of Lake Kisale, were begun in the early 1970s. These excavations have produced evidence of three cultures, of which the principal one, known as the "kisalian" culture, is datable to the eighth and ninth century. The findings made to date consist of numerous vases of terra-cotta, decorated with anthropomorphic subjects in relief, in addition to ornaments in brass and objects of iron, for various usage; no similarities have been seen between these objects and those of any other cultures, ancient or contemporary.

In Rhodesia, new excavations at Zimbabwe in 1958, together with previous excavations, were intended to shed light on what the romantic literature had popularized as the "mystery of Zimbabwe." The history of the high surrounding walls in stone, without mortar, made from the ruins of numerous constructions of ritual use ("dzimbahwe" - stone house), has been reconstructed with the help of stratigraphy, noting comparisons to the oral tradition. The C-14 dating permits us today to distinguish different periods of occupation, the oldest of which goes back to the fourth century A.D. From an artistic point of view, the meagre sculptural production, already despoiled and scattered at the beginning of the century before archaeological research had begun, does not show any stylistic affinity with the other known cultures.

Stylistic research and analysis: a) Influence of Islam on Sudanese art. - The penetration of Islam into the Sudanese area began at the end of the eighth century, coming from the Maghreb through the trans-Saharan trails. The great Islamic empires south of the Sahara used the religious wars as a pretext for expansion. The Islamic religion thus became an instrument of political cohesion; it spread mainly among the populations of the important commercial centers and, in a general manner, in the administrative areas, while the rural peoples continued to practice their traditional cults, which were tied to the land and the sources of vital energy.

The traditional Negro art, tied to the animist religion, therefore had its strength mainly in the areas not reached by Islam, or at least in the rural level of the peoples subjected to the great Moslem political complexes.

However, this assertion loses much of its rigidity in the light of a more thorough observation, since, in reality, numerous examples of reciprocal tolerance existed between Islam and the traditional religions.

It must be noted, first of all, that it is not precise to continue to consider Islam as an intrusion into the purity of the Negro culture, holding the culture of the rural areas to be more "African" than that of the urban populations. In reality, the Islamic elements, integrated centuries ago into the Negro cultures, constitute by now an authentic part of those cultures, fruit of an inevitable religious syncretism.

On the other hand, this religious assimilation created a Negro-African Islam, with characteristics quite different from those of the Arab-Mediterranean matrix, which has taken a multiform aspect according to the cultures with which it came into contact.

In Western Africa, in fact, we find a mosaic of Islamic communities with characteristics that show a compromise between the original Islam and the needs of adaptation required by the cultural contact. According to René A. Bravmann (1974), this occurred due to the syncretist nature of Islam, to its fundamental tolerance which has permitted an approach of a pragmatic type.

The discussion of the influence of Islam on the Sudanese art is thus rather complex. If it is true that Islam is, by definition, "iconoclastic" and that it therefore only favors the development of the decorative arts to the detriment of the human or animal portrayals, it is not yet possible to fully evaluate the contribution of such an influence on the fortunes of the Negro arts. For example, it is not known if the lack of figurative art with the Fulbe, and in general with the peoples dedicated to the raising of cattle, is due to the type of religion or to nomadism. Thus, for Sudanese architecture, it has not yet been established whether it was invented - or imported - by the Arab architect es-Saheli, as is reported, or whether it has rather an essentially local origin, strengthened and developed by the use made of it by the Mandingo empire for the construction of the great mosques. The noteworthy similarity of design between some Sudanese buildings and the design of the Dogon masks, which present a geometric portrayal of the human face, has often been emphasized .

William Fagg (1967) has suggested that the Moslem religion was able to influence Sudanese art to the point of containing its expression within rigorously geometric forms, stripped of all naturalism. In reality there is no evidence to prove that the abstract tendency of the Sudanese art derives from the Islamic culture, rather than from preexisting stylistic traditions. One might ask if the stylistic characteristics of the Mande type found throughout the Sudanese area, differently developed and integrated, do not owe their diffusion to the communications established by the Islamic empires.

The analysis carried out by Bravmann of peoples who are located across the boundary between Ghana and the Ivory Coast furnishes us with numerous examples of coexistence and interrelation between Islam and the traditional religion — examples in which the figurative art and the use of the masks survived in the populations that were strongly Moslemized. An interesting example of syncretism is found with the Nupe of northern Nigeria, where, next to the masked dances, performed today only during the feast celebrating the birth of Mohammed, we find sculpted doors in which the human and animal portrayals, strongly stylized and reduced to the essential forms, are covered with minute designs of typically Islamic crosshatching. The studies of Bravmann start with the indispensable preamble of a reexamination of that part of the Islamic dogma that regards figurative art, in addition to a revision of modes and of circumstances in which the Moslemization of Western Africa occurred. Such a work has no precedents and can lead to similar research in other regions.

In conclusion, while it is difficult to assert categorically that Islam has always had a negative influence on traditional art, it is not yet possible to say if it has had some weight in a stylistic evolution, as it is impossible to trace the lines of such an evolution or to document an assimilation of Islamic characters on the part of the traditional Negro art.

b) Similar stylistics in the area of Mandingo influence. - The empire of Mali, beginning in the 12th century, brought together a great number of cultural and artistic traditions, which were later redistributed and dispersed with the expansion and the migration of the peoples of the Mandingo language.

"Mandingo" - a name derived from Manden, or Mande, a place where the expansion of the peoples who founded the Mali empire had its origin - is a generic term that includes those peoples of west Africa who speak languages of common Mande origin, as the Malinka or Mandinka, the Bambara or Bamana, the Diula, and the Vai. As a cultural term it has rather wider borders and can be applied to a great number of cultures, even of non-Mandingo language.

The peoples of Mandingo culture are: the Bambara, the Maline, the Bozo, and the Marka, whose art had the strongest stylistic affinity. Following these are the Dogon, who come from Mande, although not speaking a Mandingo language, and the peoples of the west of Upper Volta (Kurumba, Nioniossi, Mossi, Gurunsi, Bwa, Bobo, and Samo), whose art, little known until only a few years ago, offers a notable variety of stylistic forms. Particular characteristics, more peripheral, are found in the art of some Senufo peoples, in the north of the Ivory Coast, and of some "Senufized" cultures in the west of the Upper Volta, besides certain Vai and Baga masks of Sierra Leone and Guinea.

In the art of all of these peoples, there are recurring common stylistic elements, differently developed and integrated according to the group. Thus, for example, the stylistic affinities between the Bambara and the Dogon art are not evident at first glance, but there is a stylistic passage from the Bambara and the Gurunsi art to the Kurumba-Nioniossi-Mossi style, also reflected in the Gurunsi art.

Affinities on the religious and mythological planes often correspond to the stylistic analogies. The social order and the initiation are regulated by a series of associations, hierarchically arranged, that correspond to the different ages of the individual. The traditional religion of the peoples of Mandingo culture places the accent on the introduction of agricultural techniques, suggesting the transition from a hunting and gathering economy of stationary type along the Niger River. The theme of the antelope, represented emblematically in the agrarian rites of "tyi-wara," reflects just this stage in which the antelope becomes, rather than a prize of the hunter, the guide of the cultivator.

The antelope is found as the protagonist of religious rituals and is represented more or less clearly in all of the art of the people originally of Mande and of those who were in some way culturally similar. With the Bambara of Mali, we have three different types of stylizations of the head coverings for the dance of the "tyi-wara": the most noted is the "minianka-segu" type, of the Western zone, around Degu and San, with vertical development and moderate stylization, in which the large curve of the neck stands out, marked with Minianka and Marka stylistic characteristics; in the Bamako region we find the horizontal antelope, whose horns extend parallel to the ground; finally, around Buguni, we find the type called "suguni," in which the stylization becomes freer and bolder, while the composition, more complex, often includes a human portrayal.

With the Kurumba and the Ko subgroup of the Gurunsi, we have a type of head covering known as the "Adoné," in which the antelope is portrayed with a more naturalistic plasticism.

Authentic masks, sculpted in the form of an antelope head, are found with the Bobo, the Bwa, and the Gurunsi of the Upper Volta - strongly naturalistic with the former and decisively geometric with the latter group. In the masks of the Mossi, the portrayal of the antelope is less pronounced, often consisting of little more than the symbolic presence of two very small horns placed at the sides of the mask. With the Mossi of Kongusi, a type of head covering is found for the dance, called "zazaigo," unknown until now, whose conception recalls the "tyi-wara" of the Bambara; only 20 centimeters high, it portrays the antelope in a flat profile of essential stylization.

Another element found mainly with the peoples of the Upper Volta is that of the pole masks; they seem to have their origin in the "Sirigi" mask (or "many storied house") of the Dogon. Characteristic of this type of mask is an effect of bidimensional geometrization conferred by the long pole surmounting the facial part of the mask; this is divided vertically into two symmetrical areas, thus increasing the effect of the linear thrust of the whole. Besides the "Sirigi" of the Dogon, which reaches a height of several meters, there are pole masks of notably lesser dimensions belonging to the Kurumba, the Mossi, the Gurunsi, the Bwa, and, with some variations, also to the Bobo. In these, the form of the facial part of the mask assumes changeable stylistic characteristics, while the theme of the pole varies in proportion and in decoration. The pole masks attributed to the Mossi and the Kurumba show a greater formal affinity with those of the Dogon: the pattern is analogous, even if the pole is rather shorter and the facial part passes gradually from the rectangular form of the Dogon to a form that is more decisively oval.

The pole masks of the Bwa and the Gurunsi (both called "doyo"), are difficult to distinguish from one other, as they were all made, it seems, by the Gurunsi; in them the proportions change, the plane of the pole assumes a wider form, and the facial mask flattens into a disc, lining up with the plane of the pole. In the version of the Bobo, finally, the pole loses much of its development, and its general proportions show the plastic character of the lower part, made up of a type of helmet.

The symbology of the pole mask is still somewhat obscure. An analogy has been seen between the pole masks in the Dogon, Kurumba, and Mossi versions, and the "Kata," symbol used by the dancer of the "Kore" society of the Bambara, consisting of a pole that is flattened, in the upper part, in a decorative tablet. A. M. Schweeger-Hefel (1966) suggests that the pole constitutes the symbolic representation of the human figure. But the use to which the different versions were destined vary, from the funerary of the Mossi and the Kurumba to a generally more social function in the cult of the "do" of the Bwa and the Bobo.

The studies of Schweeger-Hefel (1962-1966-1973) have brought a notable contribution to the stylistic relations between the art of the Dogon and of the Bambara with that of some peoples of the Upper Volta.

The art of the Kurumba, of which only the "adoné" antelope was known, thus comes to be an intermediary between the Dogon art and that of the Mossi. The art of the vast Mossi region shows, in fact, characteristics of Nionioga origin that can be explained by the history of the formation of the Mossi states. The Mossi, nomad and warrior people, originated in Dogomba (present-day Ghana) and had a culture that left little room for the development of artistic creations. Assimilating the indigenous group of the Nionioga, in the northWestern region of the Upper Volta, a bi-party society was created in which political power was the prerogative of the Mossi, but the religious power remained in the hands of the Nionioga rulers of the land ("teng-soba"). Thus it is possible to observe how the stylistic characteristics of the Mossi art had a very strong Nionioga imprint, gradually becoming weaker as it moved from the northwest region (Yatenga) toward the east and the south until meeting the area of Gurunsi stylistic influence.

The art of the Gurunsi (or Grunsi, or Grunshi), a name of uncertain origin attributed to a series of small groups until now little or inadequately known, presents a stylistic variety that is still waiting to be analyzed in all of its expressions. The fact that the Gurunsi culture is located geographically right between the Mossi and the Bwa has resulted in Gurunsi objects being attributed to one or the other of these groups; in reality the range of the Gurunsi stylistic variations seems to provide a continuity between these two cultures.

The Bwa (better known with the name of Bobo-Ulé, according to the Diulli informers at the time of the colonizations) are now distinguished from the neighboring Bobo (Bobo-Fing), at least regarding the artistic production, while it is not yet known with certainty if they come from a single stock or not. Bwa and Bobo in fact speak different languages, although they have notable cultural similarities. This distinction has permitted us to separate the artistic production of the Bwa from that of the Bobo, making it rather nearer to that of the Gurunsi. The hypothesis that the masks of the Bwa, stylistically very similar to those of the Gurunsi, were made by the latter has already been mentioned. While this hypothesis is still to be confirmed, one can in any case note how a type of Bwa mask, created of extremely ephemeral material (leaves and stalks of grains), differs totally from the wooden masks, and how it is used in particular rites. This type of mask may belong to an earlier cultural nucleus, similar to the culture of the Bobo; the wooden masks of the "doyo" type that one encounters, with very few differences, with the Bwa and the Gurunsi, in fact present greater analogies with the

art of some peoples of Ghana and the northern Ivory Coast than with those peoples of the original Mande nucleus, to which the art of the Bobo is very close.

That the Bobo belong to the Mande ethnic group is revealed, in fact, in the stylistic affinity with the art of some peoples of the same group (Bambara, Marka, Bozo, Bolon, Samo), expressed in an original synthesis that includes also the Volta elements. The element distinguishing the Bobo masks is the concept of full round of the mask, in the form of a heavy helmet, entirely surrounding the head of the dancer; the joining of the planes is sculpted in a naturalistic way.

c) The problem of the stylistic origin of the "Afro-Portuguese" ivories. - The so-called Afro-Portuguese ivories, sculped by the Bini and Bullom artisans on commission from the Portuguese in the 16th century, were long considered an example of hybrid art, as they were done by Africans with a European design; however, recent studies tend to minimize the Portuguese contribution.

More than one hundred pieces are known, distributed in different museums and collections in Europe and America; these are functional objects such as elaborate salt-cellars, hunting horns, spoons, and forks. Until a few years ago information about the area of production, the dating, and the stylistic paternity was quite approximate. The sculpted African ivories, classified as "Turkish" or "oriental" among the exotic curiosities of the European courts until the 16th century, were attributed in block to the production of Benin, after its discovery at the time of the English expedition of 1897. In 1912 these were the object of a first systematic and comparative study on the part of the Italian researcher R. Pettazzoni.

The German Wilhelm Foy (1900-1901) hypothesized that the ivories had been worked in Portugal by Negro artists transplanted there. This is refuted by Texeira da Mota (1974, manuscript cited by Grottanelli, 1975) on the basis of some lines of a Portuguese writer of the 16th century and by A. F. C. Ryder (1964), who produced documents from the registers of the Portuguese customs of the same era, in which it is shown that the ivories came from Sierra Leone.

Once the Guinean origin had been determined, the exact location of the centers of production remained to be established. In a book of 1959, William Fagg was undecided between three principal centers; it was only in 1970, in part due to the further studies (Ryder and others) stimulated by the first publication, that data emerged on the basis of which Fagg was able to distinguish two styles, corresponding to two distinct regions: the "Sherbro-Portuguese" style, found in roughly three quarters of the ivories known today, and the "Bini-Portuguese" style found in the remainder.

In the first group the stylistic characteristics of the human portrayal recall closely that of the "nomoli" (small sculptures in soapstone attributable to the Bullom of the island of Sherbro and of the nearby mainland, in Sierra Leone). The analysis of this stylistic correspondence has been conducted by Dittmer (1967) and by Allison (1968), showing how the volume of the head, the details of the stylization of the lines of the face, and the method of rendering the beard (with a thin cord that goes from the chin to the ears, where it joins a strip running over the forehead) are elements of undoubted common origin. The decoration of the objects belonging to this group, rendered in part in relief and in part in full round, alternate with wide spaces that confer to the whole an effect of great lightness, permitting the appreciating of the lines of design of the object.

In the ivories of the "Bini-Portuguese" style, a form of "horror vacui," in which the portrayals of the Portuguese horsemen (with all the details of the arms and of the dress of the era), closed within the block of ivory, does not allow seeing the form of the object, suggests the impression of a low-relief sculpture instead of a decorated object. In this second style, Hagg (1970) believes he perceives the imprint of the "Igbesamwan," the corporation of sculptors of ivory and wood that works, at Benin, both for the Oba and for the common people.

There is no information about a modern use or production of objects similar to those now in the possession of the Western museums. The possibility that objects of this type were produced before the arrival of the Portuguese cannot be excluded, even if, after that date, the iconography was enriched with the introduction of additional motifs requested by the European clients. This hypothesis appears legitimate from the observation of the style that, on closer examination, reveals itself decisively African; thus the opinion that these objects were created exclusively on European design, accepted until now, is in doubt. The Portuguese contribution seems to be limited to the suggestion of some themes, inscriptions, and heraldic motifs, re-interpreted by the executor at the pleasure of the client.

Although we are lacking data on the origin of an indigenous production, some dates are available. Thus we can approximate the dating of the objects that are known today. D. Pacheco Pereira, who wrote between 1506 and 1508, described the Temme and the Bullom of Sierra Leone as skillful in the fabrication of ivory spoons and matting of palm fiber. Around the same era, Valentim Fernandes refers to the skill of the people of Sierra Leone in the fabrication of ivory objects, even in very diverse designs. Alan Ryder (1964) reports some receipts for payments, taken from the registers of the Portuguese customs of 1504 and 1505, in which spoons and salt cellars of ivory from the coast of Guinea are mentioned. From the hands of travelers and of the first private buyers, the ivories quickly passed to curiosity cabinets and to princely collections, testifying to the precocious artistic appreciation encountered by them and to their evaluation as museum rarities.

The few dates of acquisition deduced from the European collections are attributed to the end of the 16th century and suggest that production had already ceased at the beginning of the 17th. According to Dittmer (1967), the end of the production could be fixed at 1560, the year in which, as a result of local events, the relations with Portugal were broken off.

In 1974, the Museo Preistorico ed Etnografico L. Pigorini, in Rome, acquired a beautiful specimen of a salt cellar of the Sherbro-Portuguese style, adding to the collection of other objects of the same era and production already in the possession of the museum since the first nucleus of the Museum Kircheriano of the 1600s. The existence of this object was unknown until the day of its casual discovery by V. Grottanelli. Notable for its dimensions and quality of execution, it corresponds, for its structure, proportions, and decorations, to other salt cellars already known, with the exception of the small

group in full round crowning the cover and portraying an executioner in the act of decapitating a victim. This detail is to be considered unique in the entire production of the ivory of the same origin.

Presenting the finding, Grottanelli (1975) observes that the salt cellars of the European Renaissance that, according to the current opinion, confirmed also by Fagg (1959), served as a model for the Guinean ones, differ almost totally from these for structure, material, and decoration. The form and the structure of the Guinean salt cellars recall, rather, those of different objects from other areas of Africa, in which a cup, a drum, or a chair are supported by persons or animals, who are represented in relief or in full round.

Based on these and other considerations of stylistic order, Grottanelli adopts the hypothesis of Dittmer (1967), according to which the ivory cups would have already been produced by the Bullom before the arrival of the white men; he concludes that the objects from Sierra Leone cannot be considered "hybrid" art, nor can they continue to be considered as "Afro-Portuguese," but rather as "Bullom art of the XVI century."

BIBLIOGRAPHY - D. Pacheco Pereira, Esmeraldo de Situ Orbis, Lisboa, 1892; W. Foy, Zur Frage der Herkunft einiger alter Jagdhörner: Portugal oder Benin?, Abh. und Berichte des Königl. zoologischen und anthropologischen-ethnographischen Museums zu Dresden, IX, 1900; R. Pettazzoni, Avori scolpiti africani in collezioni italiane, Roma, 1912; A. Gerbrands, Art as an element of culture, especially in Negro Africa, Leiden, 1957; H. Lhote, A la découverte des fresques du Tassili, Paris, 1958; B. Fagg, The Nock culture in prehistory, Journal of the Historical Society of Nigeria, I, 1959; W. Fagg, Afro-Portuguese Ivories, London, n.d., 1959; H. Himmelheber, Negerkunst und Negerkünstler, Braunschweig, 1960; E. Leuzinger, Africa Nera, Milano, 1960; M. L. Bastin, L'art décoratif Tschokwe, Lisboa, 1961; P. Bohannan, Artist and critic in Tribal Society, The Artist in Tribal Society, Royal Anthropological Inst., London, 1961; V. L. Grottanelli, A study in Akan art and religion, Africa, XXX, Londra, 1961, 1; V. L. Grottanelli, Sul significato della scultura africana, ivi, XXXI, Londra, 1961, 4; Y. Person, Les Kissi et leurs statuettes en pierre dans le cadre de l'histoire Ouest-Africaine, BIFAN, XXIII, 1961, 1-2; R. F. H. Summers, K. R. Robinson, Zimbabwe Excavation 1958, Johannesburg, 1961; J. Delange, Les arts anciens de la plaine du Tchad, Objets et Mondes, II, 1962, 3; D. Lajoux, Merveilles du Tassili n'Ajjer, Paris, 1962; P. Lebeuf, Archéologie tchadienne: les Sao du Cameroun et du Tchad, Paris, 1962; A. M. Schweeger-Hefel, Die Kunst der Kurumba, Arch. für Völkerkunde, XVII/VIII, 1962-63; W. Fagg, Nigerian images, London, 1963; J. B. Obama, Les arts nègres, in M. Huet, Afrique africaine, Lausanne, 1963; J. Laude, La statuaire du pays Dogon, Revue d'Esthétique, XVII, 1964, 1; A. Ryder, A note on the Afro-Portuguese Ivories, Journal of African History, 1964, 5; W. Fagg, Sculptures africaines, Paris, 1965; F. Mori, Tadrart Acacus: arte rupestre e culture del Sahara preistorico, Torino, 1965; H. A. Ba, G. Dieterlen, Les fresques d'époque bovidienne du Tassili n'Ajjer et les traditions des Peul: hypothèses d'interprétation, JSA, XXXVI, 1966, 1; W. Fagg, The Dakar Festival: colloquium on Negro Art, Africa, XXXVI, 1966, 4; W. Fagg, Sculptures africaines: le bassin du Niger, Paris, 1966; B. Holas, Arts de la Côte d'Ivoire, Paris, 1966; J. Laude, Les arts de l'Afrique Noire, Paris, 1966; F. Monti, Le maschere africane, Milano, 1966; A. M. Schweeger-Hefel, L'art nioniosi, JSA, XXXVI, 1966, 2; J. Delange, M. Leiris, Africa Nera, la creazione plastica, Milano, 1967; K. Dittmer, Bedeutung, Datierung und kulturhistorische Zusammenhänge der "prähistorichen" Steinfiguren aus Sierra Leone und Guinée, Baessler-Archiv, N.F., XV, 1967; W. Fagg, L'art de l'Afrique Centrale: sculptures et masques tribaux, Milano, 1967; A. Gerbrands, Afrika, Kunst aus dem Schwarzen Erdteils, Recklighausen, 1967; P. Mauzé, L'art nègre: sculpture, Paris, 1967; L. S. Senghor, Standards critiques de l'art africain, African Arts/Arts d'Afrique, I, 1967, 1; F. Willett, Ife in the History of West African Sculpture, London, 1967; Ph. Allison, African Stone Sculpture, London, 1968; J. Laude, La peinture française et l' "Art Nègre." Contribution à l'étude des sources du fauvisme et du cubisme, Paris, 1968; B. Menzel, Goldegewichte aus Ghana, Mus. für Völkerkunde, Berlin, 1969; R. F. Thompson, Aesthetics in traditional Africa, AN, 1968; W. Bascom, The Yoruba of Southern Nigeria, New York, 1969; D. P. Biebuyck, Tradition and Creativity in Tribal Art, Berkeley, 1969; K. Dittmer, Kunst und Handwerk in West Africa, Hamburg, 1969; B. Fagan, Zimbabwe: a century of discovery, African Arts, II, 1969, 3; W. Fagg, Recent work in West Africa: new light on the Nok culture, World Archaeology, I, 1969, 1; H. Haselberger, Bemerkungen zum Kunsthandwerk in der Republik Haute-Volta: Gurunsi und Altvölker des äussersten Südwestens, ZfE, XCIV, 1969, 2; H. Haselberger, Kunstethnologie - Grundbegriffe-Methoden-Darstellung, Wien, 1969; P. Lebeuf, Essai de chronologie Sao, Actes du premier Colloque Internat. d'Archéologie Africaine, Fort-Lamy, 1969; R. A. Bravmann, West African Sculpture, London, 1970; W. Fagg, African Sculpture, cat. di una mostra alla Nat. Gallery of Art, Washington D.C., 1970; J. D. Flam, Some aspects of style symbolism in Sudanese sculpture, JSA, XL, 1970, 2; Ph. Fry, Essai sur la statuaire mumuye, Objets et Mondes, X, 1970, 2; H. L. Hugot, L'Afrique préhistorique, Paris, 1970; H. Lhote, Le peuplement du Sahara néolithique d'après l'interprétation des gravures et des peintures rupestres, JSA, XL, 1970, 2; L. Prussin, The architecture of Islam in West Africa, African Arts, III, 1970, 4; T. Shaw, Igbo-Ukwu: an account of archaeological discoveries in Eastern Nigeria, London, 1970; J. Fernandez, Opposition and vitality in Fang Aesthetics, in C. F. Jopling, Art and Aesthetics in Primitive Societies, New York, 1971; J. D. Flam, The symbolic structure of Baluba caryatid stool, African Arts, IV, 1971, 2; F. Galhano, Esculturas e objectos decorados da Guiné Portuguesa no Museo de Etnologia do Ultramar, Lisboa, 1971; H. Himmelheber, The concave face in African Art, African Arts, IV, 1971, 3; R. Mauny, Les siècles obscurs de l'Afrique Noire; Histoire et archéologie, Paris, 1971; F. Willett, African Art, London, 1971; G. Atkins, Manding Art and Civilization, London, 1972; J. Cornet, Art de l'Afrique Noire au pays du fleuve Zäire, Bruxelles, 1972; E. Leuzinger, L'arte dell'Africa Nera, Milano, 1972; L. Perrois, La statuaire Fang, Mémoires de l'ORSTOM, Paris, 1972; P.S. Wingert, Style analysis in African Sculpture, African Arts, V, 1972, 4, and VI, 1972, 1; W. Bascom, African art in cultural perspective, an introduction, New York, 1973; R. A. Bravmann, Open Frontiers: the mobility of Art in West Africa, London, 1973; Ph. Y. C. Dark, An introduction to Benin Art and Technology, New York, 1973; R. F. Thompson, An aesthetics of the Cool, African Arts, VII, 1973, 1; P. S. Wingert, African Masks, Structure, Expression, Style, African Arts, VI, 1973, 2; R. A. Bravmann, Islam and Tribal Art in West Africa, New York, 1974; G. Connah, The Archaeology of Benin. Excavations and other researches in and around Benin-city, Nigeria, London, 1974; A. Texeira da Mota, Os Marfins africanos na documentação portuguesa dos séculos XV a XVIII, ms., 1974; R. F. Thompson, African Art in

motion, Los Angeles, 1974; V. L. Grottanelli, Discovery of a masterpiece: a Sixteenth-Century Ivory Bowl from Sierra Leone, African Arts, VIII, 1975, 4; H. Breuil, H. Lhote, Les roches peintes du Tassili n'Ajjer, Paris, s.d.; T. Spini, S. Spini, "Togu na" - Casa della parola - struttura di socializzazione della Comunitá Dogon, Milano, 1976.

ALESSANDRA ANTINORI CARDELLI

ART OF OCEANIA (PLATES 90-91)

Historic research as the foundation for the study of the stylistic-differences. - The problem of the art of Oceania has been much enriched in the last few years, mainly by new comparative analyses. Although there are still areas that are unexplored, the new information to be noted in the field of the art of Oceania consists not so much of the acquisition of new stylistic findings as of the different attempts at classification, intended to regroup and to confront a material already known in its formal elements.

These works shift the emphasis to the research of the cultural characteristics that furnish documents for the reconstruction of the historic happenings that contributed to the determination of the local cultures.

The evolutionary approach to the studies of the primitive art had as its principal objective the study of the laws of development that subtend the formation of a style. Thus researchers such as F. Speiser, who held that the artistic styles spread exclusively through the migrations of entire cultural complexes, wished to find in Oceania itself the stylistic roots of the individual Oceanic cultures.

In recent times, a more particularly historic and cultural approach has been affirmed, which takes into consideration the stylistic components and their reciprocal relationships in comparisons between different cultures, going back to historic reconstructions. The relationship between the stylistic characteristics of a single culture and the historical occurrences that it had gone through to produce it is seen today, for Oceania, from different perspectives.

R. Heine-Geldern (1966) searched for the origin of the stylistic forms of Oceania in the ancient cultures of Europe and eastern and southeastern Asia, reconstructing a system of influences that would have attested to the spreading of stylistic characteristics and successive local diversifications going back to a remote common origin. More precisely, he is trying to demonstrate the presence of pre-Shang cultural traits in what he calls the "Old Pacific Style," which would have spread to Sumatra, Borneo, and Oceania (New Ireland and the basin of the Sepik), besides the northwestern coast of America.

The theory of a proto-Chinese influence in some forms of art of Oceania is supported today by the finding of bronze objects in northWestern New Guinea (Vogelkop and Lake Sentani), attributed to the culture of Dongso'n (culture of the late Bronze age, of proto-Chinese origin, diffused in Indochina in the first half of the last millennium B.C.).

The complex cultural composition of the islands of the South Seas is in reality the result of the superimposing and mixing together of various cultures that had reached Oceania through successive migratory move-

ments occurring over a period of time ranging from the Paleolithic to the beginning of the Christian era. To understand the origin of the stylistic differentiation within Oceania, it is necessary to recall what is today known of the modes and times of the populating of the diverse zones.

By now everyone accepts the origin of the Oceanic peoples in southeastern Asia, from where they departed, on different routes, in various migrations. The migration that carried the Tasmanians and the Australians to their present homes, through New Guinea, did not leave any appreciable traces in the area of their presumed transition.

The earliest culture whose imprint is still visible in New Guinea is the "Papuan" culture, on whose origins the ethnologists do not agree. It made its appearance in the Neolithic era. Also in the Neolithic era was a migration that started in China or from the islands of Japan; went through Formosa, the Philippines, Celebes, and the Moluccas; and brought to Oceania the culture of the "two-faced knife" (stone blade with lenticular section). The Papuan culture and the culture of the two-faced knife was, in Melanesia, the basis of the cultures known as "pre-Austronesian," whose influence was determinant in the formation of the stylistic characteristics in Melanesia and Polynesia.

Two great migrations of peoles of light skin, the Austronesian, came in two principal currents from eastern and southeastern Asia. The movements of the first current, called the "southern Austronesian," reached the northern coasts of New Guinea and the other islands of Melanesia from Indochina. The second current, occurring later, reached Micronesia and Polynesia by a more northern route, from which came the name of "northern Austronesian."

The fusion of the pre-Austronesian cultures with those of the southern Austronesian along the northern coast of New Guinea resulted in the mixed culture "Austromelanoid" that spread throughout Polynesia, mixing successively with the northern Austronesian culture. Thus if we accept the last Austronesian migration that touched Micronesia and Polynesia exclusively, all of the other movements of populating interested mainly New Guinea and the other Melanesian islands. These regions, which constituted the area of contact and mixing of different cultures, are those where a greater variety of styles and of expressive forms are encountered.

The attempt to search for elements that are common to all the areas of Oceania, both from the stylistic point of view and the cultural, demonstrated how much the stylistic tendencies are connected to historic realities. The object of the more recent studies is, therefore, to isolate determined artistic styles and to follow their diffusion, where this is possible.

Mythological contents and stylistic typologies. - The methodological hypothesis of C. A. Schmitz is of particular interest, explaining some fundamental stylistic constants by means of the mythological content that is typical of the economic structure of some societies. The research completed by Schmitz (1960) in some regions of northWestern New Guinea have shown how the ceremonies of the cult and the sacred images - representation of the divine force - respect the forms of the myth. The myth would therefore explain not only the social and economic organization, but also the choice of the artistic themes and the forming of the style.

In his studies of the peninsula of Huon, Schmitz has demonstrated the existence of stylistic and formal elements of three cultures: the Papuan culture, the culture of the two-faced knife, and the southern Austronesian culture. Each of these cultures has its religion with well defined myths, which, when analyzed in their structure with particular reference to the cosmogonic part, present a fundamental difference between the pre-Austronesian and the Austronesian. According to the relative importance of one or the other sex in the economic and social life, the masculine or feminine principle prevails in the myth.

In the cosmogonic myths one often finds the protagonists of the mythical actions subdivided into two groups, referable, respectively, to a maternal figure on earth or to a paternal figure in heaven. The way in which the dialectic of the two principles - masculine and feminine - is articulated and the actions completed by the divinities for the creation of the world, of man and of the means of sustenance, give origin to the differences between the different myths.

The masculine principle prevails in the myths of the Papuan culture, with the economy based on hunting and gathering, and in those of the Austronesians, dedicated primarily to fishing (which is another form of hunting). The prevalence of the feminine principle, on the other hand, accompanies an agricultural economy, such as that of the culture of the two-faced knife, which exalts the feminine values, connected to the land of origin. In the mythology of the two-sided knife there is a motif of battle between the feminine and masculine elements, a battle that is concluded with the victory of the woman, "Magna Mater," and of the chthonic forces. A primitive giant, who devours men, is killed and his members eaten by two twin brothers, sons of the primigenial mother, in a first mythical meal that is renewed in ritual cannibalism. From a thematic point of view, this myth is found in the portrayals of the giant recognized in the masculine figures with the terrifying face (round eyes, curved nose with wide nostrils, mouth wide open with the tongue hanging out) or also in the portrayals of wild boar (northWestern New Ireland) and of the eagle and the crocodile (zone of the Korewori River, in the middle Sepik). The myth also explains the recurrent theme of the coupled figures, representations of the mythical twins, which are encountered with the Sulka of New Britain and of the Solomon Islands. From the stylistic point of view the myths of the culture of the two-faced knife would correspond to curvilinear and rounded forms, with generous use of color, general characteristics of the Melanesian art; in the human portrayals the figure appears extracted from a block of circular section, their arms are stretched upward or flexed and resting on the stomach, and the composition of the whole attests to a particular imaginative vivacity.

The southern Austronesian mythology is instead characterized by a relationship of collaboration between heaven and earth; the masculine principle reigns, and there is no trace of a battle; it is the mythical hero who draws the earth out of the sea, molds it and fecundates it to give life to the human beings and to the plants. The stylistic elements referable to that myth show an accentuation of straight-lined approach, found also in the geometric ornamentation; the sculptures are carved from a block of rectangular section, the trunk, the head, and the limbs, all written in the same volume, become rigid; the arms are extended downwards, while the feet blend into a single block that forms the base; the face, which is elongated downwards on the chest, covering the neck, presents a characteristic triangular outline within which the features are rendered with little plastic relief.

The stylistic characteristics that Schmitz connects to southern Austronesia are well visible in the sculptures of the bay of Astrolabio, of the island of Tami, and of the gulf of Huon. In the other regions it is often rather difficult to recognize the origin of a stylistic element.

Stylistic comparisons: relationships and concordances on the basis of common cultural elements. - The results of the studies of the history of populating, which we have mentioned, and the examination of the cultural characteristics - which agrees with these results - have permitted the identification of relationships and concordances between the larger areas in which one divides Oceania and, within it, between the styles of the single regions. At present, exhaustive comparative studies do not exist; the most accurate analyses regard, for the moment, only selected zones.

In an exposition of the stylistic typologies, J. Guiart (1962) regroups some stylistic provinces, at times geographically very distant from one another, on the basis of formal analogies that are not always historically explained.

More prudently, A. Bühler (1961), in the course of an analytical treatment, gradually signals cultural relationships and stylistic agreements, putting into relief, wherever possible, the historical factors that contributed to the characterization of the stylistic details.

With the exception of the "Tami style," typical of the island of that name and of the region of the gulf of Huon, strongly marked by the southern Austronesian culture, no other examples are known of a style of typical characteristics and incontrovertible completeness that has influenced the art of other areas. Many analogies nonetheless exist, born of the diverse mix of some fundamental stylistic elements that have resulted in local styles in some way related to each other. These fundamental elements, where they can be clearly seen, can be related back to the cultures that were superimposed in various ways on the three major geographic areas.

In Melanesia, the Papuan imprint can be seen in the art of the southern part of New Guinea, where one encounters the authentic Papuan cultures, which express themselves artistically in a typical archaic form, characterized by the total absence of items made of wood, by bidimensional style, and by the curvilinear ornamentation, as well as by a copious use of color. Papuan characteristics are also seen in the composition of the style of some zones of the upper Sepik and of that of Baining and of the Sulka of New Britain.

The culture of the two-faced knife is always present, as a characterizing element, in the styles of the northern part of New Guinea and of the other Melanesian islands; in these regions it is often difficult to discern the contribution of the pre-Austronesian cultures (Papua and two-faced knife) from those of the successive southern Austronesian migrations; nevertheless, in the resulting single local styles, the agricultural culture of the two-faced knife has the greater expressive impulse: to it one owes the richness and variety of the

forms, the prevalence of rounded forms and of curvilinear ornamentation, and the exuberance of color.

In Polynesia, the varied stylistic typology is the result of the meeting of the Austro-Melanoid cultures with the migrations of the northern Austronesian current. The contribution of the latter in Polynesia and in Micronesia determines a rarefaction of the expressive pre-Austronesian drive, with a prevalence of the straight-lined ornamentation and a lessening in the iconographic plastic and in the color.

Along with a higher grade of development of the social, political, and religious organization, in the Polynesian cultures a certain technical impoverishment and a prevalently profane character of the artistic production can be seen. Human portrayals, nonetheless, are present almost everywhere, and in particular in the outlying islands where elements referable to the duplex fundamental typology are encountered: hands resting on the stomach (Austro-Melanoid) and arms stretched towards the ground (southern Austronesian).

The characteristics of the northern Austronesian culture are more clearly visible in Micronesia, where, though few in number, they make the Melanesian influence felt; this seems to be the area that is the poorest in artistic manifestations of a plastic and expressive character, even if qualitatively the production is imprinted with a supreme elegance and ornamental refinement.

If one looks more closely at the detail of the thousands of local styles, rather than the general picture, there is the impression that an explanation considering the local cultures exclusively as the result of the superimposing and fusion of the cultural levels would not take into account the importance of the capillary exchanges; these exchanges, through a flow and counterflow, resulted in the passing of single cultural traits, or simply of stylistic modules, through the trade of manufactured items. Naturally the stylistic characteristics due to more recent influences are those whose origin is better identifiable, inasmuch as they are less integrated into the local stylistic syntheses.

An example of clear stylistic influence due to trade is in the style of Tami Island, which spread from the coastal zone of the Huon to the nearby islands of Sassi and Humboi, and then to New Britain, central New Ireland, the Admiralty Islands, the San Mateo Islands, and part of the Solomons. In each of the single zones with which it has come into contact, the Tami style becomes a part of the local style; thus on the island of Manus (Admiralty), where one has a moderate stylistic homogeneity, it can be seen how a marked Asiatic influence is united with the southern-Austronesian imprint of the Tami style. However, in the areas reached by the Tami influence one cannot easily say whether the characteristics of a straight-lined type are due to the local southern Austronesian component or to the migration of the already completed Tami style.

The discussion is analogous for those local styles in which one observes the presence of elements of an Oriental type. In some areas, such as northWestern New Guinea (Korwar style), Micronesia, and Paramicronesia, where recent influences are documentable, these characteristics are explained by a direct contact with Indonesia. In regions such as the Massim and New Zealand, however, one tends to see much older elements of origin, present in the cultures of the first immigrants. These general considerations, however much they are widely accepted, have not changed the current museological arrangement and classification by ethno-geographic criteria, regional or insular.

The problem of the stylistic origin in New Zealand. - The Maori style presents characteristics quite different from those of the other areas of Oceania and of Polynesia itself, to which New Zealand belongs culturally. The distinct domination of the low-relief over the sculpture in full; the extensive rhythmic development of the decoration, consisting of scrolls and intersecting spirals; and the recurring motif of the doubled portrayal constitute the essential components of a completed style that seems to have analogies only outside of the Oceanic area.

Different hypotheses have been formulated to explain the origin of these analogies. The debate is still open, inasmuch as incontrovertible proofs needed to sustain any single theory do not exist. The first analogies that have been emphasized - those, that is, with the art of the Indians of the northwest coast of America - concerned mainly some stylistic themes and motifs such as that of the tongue sticking out and of the doubled figure (development of two profiles side by side on the same plane, facing each other).

As there are no proofs of trans-Pacific contacts having occurred between New Zealand and the northwest coast of America, an attempt has been made to find the explanation of the stylistic analogy in a remote common origin in ancient China. Supporters of this hypothesis are the followers of the diffusion current such as J. Golson, D. Fraser, R. Heine-Geldern, and M. Badner. Fraser (1962, 1968) and Badner (1966) see in the Maori art and in that of the Indians of America strong Chinese influences of the late Chou dynasty; Heine-Geldern (1966) favors instead an earlier era, the pre-Shang period, suggesting the origin in that period of the diffusion of fundamental cultural elements and stylistic principles in the direction of Sumatra, Borneo, and Melanesia, on the one hand, and toward the northWestern coast of America, on the other.

The diffusion hypothesis is rejected, not only by Archey (1965) and others, but also by New Zealand researchers such as T. Barrow (1969) and S. M. Mead (1967, 1975), who up to the present are busy demonstrating that the development of the Maori art was accomplished inside New Zealand, beginning with a Polynesian sculptural tradition that arrived in New Zealand in the tenth century with the first migrations from the Society Islands. S. M. Mead (1975) sees the origin of the Maori curvilinear style in an evolution from the original Polynesian straight-lined style, an evolution that would have already begun in the era of the "hunters of moa" and continued in conditions of isolation, since after the first migrations there have not been other exchanges between New Zealand and central Polynesia; a local development of such significance would have required, nonetheless, important cultural changes - of which the artistic evolution would be an expression - that have not yet been documented, inasmuch as the archaeological research and the study of the oral tradition are not yet capable of furnishing complete chronological sequences.

From one point of view, the contrast between the diffusion hypothesis and that of local development is only apparent, since it is not demonstrable that the Pol-

ynesian migrations of the tenth century have not brought with it elements of Asiatic heredity.

At the current state of knowledge it therefore appears difficult to demonstrate either the diffusion or the local development, while the studies that follow the direction indicated by Lévi-Strauss have an open field; he explains the apparent similarities between cultures widely separated in space and time as "an expression of a precise type of civilization . . . of a hierarchical society and founded on prestige" (Lévi-Strauss, 1958).

BIBLIOGRAPHY - C. Lévi-Strauss, Anthropologie Structurale, Paris, 1958; A. Bühler, Kunststile am Sepik, Basel, 1960; C. A. Schmitz, Historische Probleme in Nordost-Neuguinea, Huon Halbinsel, Studien zur Kulturkunde, XVI, Wiesbaden, 1960; T. Bodrogi, Art in North East New Guinea, Budapest, 1961; A. Bühler, T. Barrow, C. P. Mountford, Oceania, Milano, 1961; H. C. van Resenlaar, Asmat: Art from South West New Guinea, Amsterdam, 1961; D. Fraser, Arte Primitiva, Milano, 1962; J. Guiart, Les religions de l'Océanie, Paris, 1962; A. Bühler, Kultur und Kunst, in C. A. Schmitz, Kultur, Frankfurt a.M., 1963; J. Guiart, Oceania, Milano, 1963; C. A. Schmitz, Kultur, Frankfurt a.M., 1963; C. A. Schmitz, Wantoat, Art and Religion of the Northeast New Guinea Papuans, Paris, 1963; G. Archey, The Art Form of Polynesia, Bulletin of the Auckland Institute and Museum, 1965, 4; H. Tischner, Das Kultkrokodil vom Korewori, Hamburg, 1965; A. C. Ambesi, Arte oceanica, Milano, 1966; M. Badner, The Protruding Tongue and Related Motifs of the Art Styles of the American Northwest Coast, New Zealand and China, Wiener Beiträge zur Kulturgeschichte und Linguistik, XV, 1966; D. Fraser, The many faces of primitive art: a critical anthology, New York, 1966; R. Heine-Geldern, A Note on Relations between the Art Styles of the Maori and of Ancient China, Wiener Beiträge zur Kulturgeschichte und Linguistik, XV, 1966; A. Gerbrands, Wow-Ipitis: eight Asmat woodcarvers of New Guinea, Paris, 1967; S. M. Mead, The Art of Maori Carving, Wellington, Auckland, Sydney, 1967; D. Fraser et al., Early Chinese Art and the Pacific Basin, New York, 1968; H. Kelm, Kunstgegenstände aus dem Sepik-Gebiet, Neuguinea, BA, XVII, 1968, 2; H. Nevermann, L'arte dell'Oceania, in Trowell, H. Nevermann, L'Arte in Africa e Oceania, Milano, 1968; T. Barrow, Maori Wood Sculpture of New Zealand, Wellington, 1969; A. Bühler, Kunst der Südsee, Zürich, 1969; U. Beier, A. M. Kiki, Hohao: the uneasy survival of an art form in the Papuan Gulf, Melbourne, 1970; P. S. Wingert, An outline of Oceanic Art, Cambridge, 1970; D. Fraser, The art of Melanesia, Hong Kong, 1971; C. Rocchi, Arte dell'Oceania, catalogo di una mostra al Mus. Preistorico ed Etn. L. Pigorini, Roma, 1971; C. A. Schmitz, Oceanic art: Myth, man and image in the South Seas, New York, 1971; N. Barnard, D. Fraser, Early Chinese Art and its Possible Influence in the Pacific Basin, New York, 1972; G. R. Ellis, The art of Oceania, African Arts, V, 1972, 4; S. M. Mead, The origins of Maori Art; Polynesian or Chinese?, Oceania, XLV, 1975, 3.

ALESSANDRA ANTINORI CARDELLI

PART III

THE MIDDLE AGES AND THE MODERN ERA

SUMMARY

THE MIDDLE AGES IN THE WEST

INTRODUCTION

It is relatively easy to discover certain recurring features in the whole picture of the history of Medieval art which are continuously clarifying themselves. As an example, the emergence of purely nominalist interest could be cited in connection with the repeated analyses and, in general, with the rejection of the traditional definitions of styles - and sometimes even of the concept of "style" itself - and the insistence of a return to certain themes and problems, the foremost of which is perhaps that of the validity and scope of cultural traditions (starting from "classical" culture) in comparison with the variations brought about by great historical events and by new linguistic graftings. An associated problem is that regarding the relationships between "traditions" and "variations" in culture and the corresponding argument of social, religious, political, and economic mutations and confrontations which appear from time to time to afford support or foundation. Again, one could and ought to remember the sometimes macroscopic and always clearly positive phenomenon of the enormous proliferation of new data made available during this period, both archaeological and documental or monumental. Some of these are of crucial importance, completely upsetting the whole picture in certain sectors and generally such as to bring about, both qualitatively and quantitatively, far reaching overall changes.

These phenomena, furthermore, always seem to concern only the arguments and conditions of research, At this point, it seems worth giving attention to the examination of their perhaps less obvious aspects, which nevertheless appear to affect directly the very essence of research and consequently its origins and aims.

I am referring on the one hand to the emergence of an historic dimension. This dimension, connected with the roots of Medieval art, tends nowadays, to assume at least preponderance, even if not to the exclusion of all else. On the other hand, there is a tendency to shift interest from the stylistic, formal, or iconological characteristics to the more strictly "material" factors of Medieval works of art. This naturally calls for a new methodology with problems which, while not new, are receiving more attention.

The variations in both cases are of particular importance if only because they seem to proclaim a reduction of interest in what, after all, constitutes the specificity, and hence the raison d'être, of all historico-artistic disciplines, namely the very existence of works of art identifiable as such.

It is to be observed that the phenomena seems to extend, although with different specific variants, over the whole field of Medieval studies. Two factual cases in the 1960s and early 1970s seem to be particularly novel. On the one hand the rapid advance of Medieval archaeology towards being recognized as a mature and autonomous discipline in its own right; and on the other hand the first steps taken in the same direction as regards Medieval town planning. In both cases, the novelty is all the greater because the "new" disciplines imply and constitute the opening door to the direct entrance into Medieval studies. The new disciplines are primary researches and not collateral or supporting ones of a whole series of relatively new scientific and humanistic disciplines. They are also really scientific techniques, similar to those of architecture and excavation.

It has been asserted that all this aims at discovering new historical "documents" (or this kind of "new historical subject," as Toubert defines it, which results from the dialectic between archaeological and urbanistic research and textual criticism). If this is true, then it follows that "the historian must absolutely refuse to be regarded as a specialist on written texts in a sort of constellation of specialists . . . but must feel himself obliged to integrate the results of others into a global vision." (P. Toubert, "General considerations on the theme of the relationships between documentation and archaeological data," in "Round Table on Medieval Archaeology," Rome, 1976.)

At first sight, the history of Medieval art seems to touch only marginally on this problem which, on the contrary, cuts to the very heart of its composition. In a certain sense, it can be said to show the greatest changes which have been brought about in direction, and which are inevitably carrying it towards magnitudes and requirements and, above all, towards appreciably altered or even inverted objectives, all in the space of a few years.

Consider the parallel, but distinct, characters of substantial novelty informing the two disciplines already mentioned. The first has its origins and, at least as compared with historico-artistic disciplines, still keeps its exclusively historical roots in the same sense and for the same reasons that a work of art is regarded as an artifact and a manufactured object is regarded as a document. It is thus to the same degree and for the same reasons that Medieval architecture is seen preferentially to coincide with, and to identify itself with, the so-called archaeology of "material culture." In such considerations of Medieval town planning, a work of art not only has no interest for its "artistic" qualities but neither does it hold attention as an individual reality, but rather only in relationship to the total physiognomy of an urban phenomenon and thus only as an instrument for an instantaneous identification of the structure of that phenomenon and its changes with time.

Careful examination makes it clear that the discussion involves the radical evisceration on a large scale of tensions and dialectics. In ultimate analysis, a real crisis in fact exists within and at the roots of present day studies in the history of art - and not only of Medieval art.

Works of art are regarded therefore as moments in a linguistic process and thus, at their limit, as simply phases in what is primarily a sociological phenomenon.

Or alternatively, and contrarywise, as "exposures" which, in spite of inevitable horizontal ties and obligatory ties of material origin, manage to detach themselves from the phenomenon and take on a separate and timeless existence, graced with their own internal logic and hence their own laws and dimensions of development, valuation, and value.

The question, which by its nature is generalized but which here is taken to its extremes for clarification, certainly becomes particularly urgent when referring to the Middle Ages. In this connection, the "material" contingencies mentioned above (which tie the work of art horizontally into the texture of history and which therefore precede any hypothetical moment of assumption of timeless autonomy) remain still largely unknown because of the actual scarcity of documentary and archaeological facts in our possession, though also because of our still insufficient capacity of understanding them. Now these insufficiencies ought to be enough to force the historian of Medieval art into a practical dependence on a whole series of other disciplines, first among which (though certainly not alone) would be Medieval archaeology and town planning. And then one thinks of some of the more celebrated "critical questions" and the battle fields resounding with the "clamour of arms," as one of the most illustrious protagonists of the 1960s described them, from Cividale to Brescia to Poitiers to Castelseprio and to Jouarre. (G. de Francovich, "Il problema cronologico degli stucchi di S. Maria in Valle a Cividale," in "Acts of the VIII Congress on Studies of the Art of the High Middle Ages," I, Milan, 1962.)

This does not mean that limiting cases of this kind are the prime cause of the present tendency to discuss the credibility or in other ways to throw doubts on the specificity of the discipline or at least of some of its most traditional working methods, such as the philological analysis of forms and cadences, both individual and of "schools," or, in other words, of investigations of form. The aim appears to be to make it difficult to accept the figure of the historian of Medieval art as one who reads and understands a specific language or message which belongs to and is part and parcel of a work of Medieval art.

Now, while this kind of tendency and crisis must be contained, and at least partly contested, it must also be greeted as being extremely beneficial, and in any case as evidence of a "changing reality" which as such requires new and appropriate critical forms (P. Toubert). Obviously, these new forms (be they Medieval archaeology or the material culture of the Middle Ages, or the sociology, or the town layout) must not be considered as a possible confirmation or means of comparison nor as elements which are complementary to the more traditional forms of stylistic or historical investigation. They must rather be considered as elements in a common need to reach a global vision which cannot be given by the sum of parallel specific data but by the new dimension which the confrontation brings to each kind of research.

In other words, one must not consider the history of art as an "illustration" of the history of written texts, nor archaeology as its setting. But neither, on the contrary, should the written text be considered as an "introduction" or "frame" of figurative or archaeological documents. Every piece of "data" must be treated as a document for a global history, or more exactly the history of an event which in fact happened involving and involved in each of the individual phenomenologies which single investigations adopt as their specific field of interest. In other terms, each discipline must be firmly reconstructed within its own original integrity and understood as an individual and distinct way of penetration within the essence of a multiform and complex phenomenological reality which is nevertheless in ultimate analysis a unity, or at least reducible to a whole. The point of linkage, after all, seems to consist in a reciprocal perception and comprehension which requires, at one and the same time, maximum specificity (and hence the most authentic and absolute scientific rigor in investigations) and maximum frankness in listening and communicating so that data can be reciprocally exchanged to form fresh material and new sources of knowledge.

It seems almost obligatory to mention at this point one of the limiting cases in which novel and traditional types of investigation seem already to be combining to create new dimensions of understanding in visual flashes of a dynamic nature. I refer to the history of Medieval architecture understood as the study of a "territory." This term covers an organic entity which coincides with the relationship between the natural ambience and human settlement. Therefore it includes a prior possibility of research limited to the traditional forms of classification of remains and objects and documentary data according to the "corpus," as it does also every other type of cataloguing of a more strictly inventory character. By regarding the territory as an evolving reality, involving and involved in the evolution of the structures (that is, the particular form which the settlement has realized and which has its effect on the ambience, modifying it into a new reality), new instruments for criticism are created, even while remaining within the history of architecture and, more widely, the history of Medieval art. These new instruments have been provoked by and are coherent with a point of view from which art is synonymous and monuments are documents, although this clearly does not exclude those documents, and indeed obliges one to read them according to their own internal and formal logic, which is the only way they can in fact be deciphered and thus transformed from objects into working elements.

Obviously the above is merely an example chosen as an indication of the new approaches which are, in fact, apparently opening to our studies new and valid means of penetration into the indeterminate vastness, still far too rarely investigated, of the art and, in general, the history of the Middle Ages in the West.

ANGIOLA MARIA ROMANINI

HIGH MIDDLE AGES (SEVENTH TO TENTH CENTURY) (PLATES 92-94)

The mere statement that in the publication "Il Mondo della Figura," edited by A. Malraux and A. Parrot, the five volumes covering the first thousand years of the West go, in chronological order of publication, from the monographs by A. Grabar on Paleo-Christian art and the golden age of Justinian to the triple collaboration of such specialists as J. Hubert, J. Porcher, and

W. F. Volback in two volumes on pre-Carolingian and Carolingian periods and finally arrives at a team of four co-authors for the times of Otto I shows what an increase and what specialization the studies of High Medieval Art have undergone since the 1950s. This indicates also how difficult it is today to attempt even a provisory synthesis of the recent achievements of critical studies.

Numerous exhibitions have been held all over Europe with exceptional frequency, from the fundamental one for the Carolingian period "Karl der Grosse" held at Aachen in 1965, to another one held at Corvey in 1966 on "Kunst und Kultur in Weserraum" or yet another on "Suevia Sacra" held at Augsburg in 1973, to mention only the most important ones regarding the High Middle Ages. These and other shows, some particularly opportune, attempt to offer pictures of the regional development of the figurative language of the High Middle Ages in certain cultural areas to as wide a public of non-specialists as possible.

Other undertakings, such as the "Corpus" of Italian sculpture in the High Middle Ages by the Italian Center of Study of the High Middle Ages or the "Colloquia" of the University of Heidelberg on High Medieval Sculpture, help to fill in serious gaps in our knowledge of the figurative inheritance of the West. They offer very trustworthy touch-stones for testing the instruments of criticism which are usually used in this field of investigation.

One of the most junior branches of the disciplines of Medieval history — that is to say, the archaeology of the material culture — continues to give solid results full of meaning also for the High Middle Ages period. While in Italy, in spite of some sporadic attempts, a satisfactory chronological basis is still far from being scientifically and systematically adopted, in the rest of Europe, and especially in Germany, Scandinavia, and the Eastern bloc, this kind of research has in the meantime succeeded in supplying an extremely convincing picture of city development during the period between Antiquity and the High Middle Ages, and from this to the Medieval city — that is, to the Independent City with laws, statutes, and its own administrative and territorial organizations. These are in fact called studies of the "material culture," because, quite apart from the artistic value of the artifacts, they consider the comparison of all the data which the stratigraphic method makes available, from those referring to various economic and environmental factors to those regarding social and productive organization. They try to provide, with the help of historical sources, a picture of the life of the inhabitants of a circumscribed area and its evolution during a given period of time. It is evident that discipline's contributions are essential also for the history of art, above all whenever one wants a concrete and meaningful basis for the many studies of the topography and town planning of the High Middle Ages which are now attempted.

Because of this it seems important to us to mention, although briefly, one of the problems which best show the type of contribution which Medieval archaeology can give to the history of the art of the High Middle Ages. This is the nodal problem of the origins and early development of the European city in the Medieval period. A symposium held at Heinhausen near Gottingen in 1972 produced a picture which, although not thoroughly exhaustive, was very representative of the present state of research in this field.

On that occasion it was possible to observe, at least for the regions of Central and Northern Europe, the change from the classical "vicus" in its meaning of a village with commercial and craft occupations to the Merovingian or Carolingian "vicus," which had the essentially different character of an agricultural settlement and habitation of peasant families. This is contrasted with the Medieval city ("oppidum," "urbs," or "castellum") which was not necessarily based on a pre-existing, late-classical city with administrative autonomy and its own "Curator" or "Defensor." In fact, when the Germans occupied Tréves and Cologne those towns no longer possessed any autonomous administration, but that did not prevent them from becoming extremely important cities of the Middle Ages without there being any apparent breaks in grape growing, in the city walls, or in those numerous functions in relationship with the territory. The same perhaps could have been the case also in Italy when the Lombards took over Benevento about the beginning of the seventh century, as can be deduced from the recent restorations of part of the walls and ancient gates of the town and from other clues.

The recent debate has also clarified the nature of a third type of center in the High Middle Ages - a traders' and artisans' settlement - which in the eighth and ninth centuries, that is, in its most archaic form, is neither a village nor yet a town. Although the same name is used as for the agricultural "vicus," the chief of the administration and defense is called a "comes" or a "praefectus vici." This distinction came about through the original (second or third century A.D.) territorial differentiation among the Germanic peoples between groups of farmers and groups of traders.

From the fifth century on, this type of settlement became widely diffused in Central and Northern Europe, as at Dorestadt, Hamburg, Haithabu, Helgo, and Birka. The first three in particular had already evolved by the ninth century to the point of possessing a regular street layout and houses of a very different type from those of the peasants of the agricultural "vici" and highly evolved systems of communications and defense.

In this case, a big acquisition for Medieval archaeology was the discovery and study of the Moravian cities of the eighth and ninth centuries in which this kind of urban settlement was greatly developed and politically coincided with the flourishing of the Moravian kingdom between the eighth and ninth century, encouraged by the improved relationship with the Frankish kingdom and under the strong cultural influence of the Salzburg missionaries. Furthermore, it is highly significant that, specifically for that type of research, another investigation was carried out, as reported by J. Cibulka, on the typing of Czechoslovak religious architecture of the ninth century. This has revealed the penetration, also due to the presence of Bavarian monks, of particular isolated architectonic forms - a single long nave ending in a square presbytery - along with other forms from Aquileia and from Noricum.

In fact, it has thus been possible to trace a fairly coherent development in Central and Northern Europe, and also in the Slav regions, which led the small settlements of traders and artisans to become, in the ninth and tenth century, towns of the High Middle Ages, still

different, however, from the Free Cities of the later Middle Ages (from the 11th century onwards) whose formation and birth followed the stimulus of precise Western models.

Under this aspect, it is furthermore possible, in retrospect, to examine the social and economic implications related to the extremely fertile debate which divided and still divides experts in Merovingian goldsmithery. We can summarise these into two opposing views: that of Werner, who, starting from the finding among grave goods of some sets of tools and from an analysis of sources, gives us a picture of the Merovingian goldsmith as a free and mobile artisan, able to satisfy both the exceptional demands of the powerful and the more modest requirements of less wealthy patrons (silver brooches, etc.); and that of J. Driehaus, who, mainly on the basis of a careful technical analysis of the tools and the geographical distribution of gold works found in the Merovingian area, came out against that view, affirming that the Merovingian goldsmith must be clearly distinguished from the simple melter and was closely tied, both socially and economically, to his patrons and hence not free to move about as he wished - and, naturally, his work was conditioned and regulated by the severe rules of craft tradition. His mobility would have been connected exclusively to the possibility that he might be lent, given, or bought from his lord. The few free goldsmiths of Merovingian times had only limited possibilities of movement - St. Eligius himself came to the Court of Clothair II under recommendation and in the last years of his life took as associate a certain Thille, of Anglo Saxon origin, who probably came from the important gold working school which flourished in Kent.

These and other considerations led the German scholar to make a sharp distinction between two areas of Merovingian goldsmithing. In the western zone (including Alemannia, the area of the eastern Franks, South East England, and almost certainly also Burgundia and the area of the western Franks) there were active goldsmiths' shops, while elsewhere gold work was imported. Also, in Lombard Italy, the heterogeneity of the finds appears to demonstrate that the so-called Lombard "court workshops" were dependent on outside influences at least as regards objects in worked gold. An interesting observation is that the richness of the hoards of Byzantine gold coins in the treasures of the Lombard princes might have attracted both Mediterranean and German artists, coming monthly from Alemannia, to those workshops. Thus they created the conditions for a slow and difficult, but extremely significant, fusion between some of the different cultural streams giving origin to the language of Western art.

This immediately seems to call to mind, in another field, a consideration of the very courageous dating given by A. M. Romanini (and steadily becoming more convincing) to the so-called honeycomb capitals reused in the recently restored Romanesque crypt at St. Eusebius Church at Pavia, the capital of the Lombard kingdom. She dates them to the end of the sixth century, thus making them almost a relic of the origins of Western idiom, strictly correlating them to an imitation of "honeycomb" gold work. Furthermore, the possibility of finding surprisingly similar pieces among Hispano-Visigothic objects (and these in turn can be compared - as T. Ulbert has also shown - with sculptures

from the North African area) has led her to outline an extremely complex and articulated picture of European sculpture in pre-Carolingian times. The other dialectical pole in this same picture is the persistence of techniques and craft workshops operating in the manner of the late classical tradition.

In many cases, these phenomena of the parallel co-existence of different traditions within the ambit of sixth and seventh century carving is easily checked. In the Iberian peninsula small local establishments were working from the fifth century. Schlunk, who has carefully studied their output, has in addition detected Eastern influences translated into a still coarse idiom which only later tends to crystallize (as for example in the Alcaudete sarcophagus) and, in some ways, to set itself up in opposition to those workshops producing in an idiom which is generically defined as Byzantine (even if not a single imported Byzantine sculpture has been found in the Iberian peninsula). Later, however (that is to say after the sixth century), the decorations in Visigothic churches (the architectonic study of which has been the subject of numerous monographs, comprehensive studies, and new discoveries, such as the interesting building of St. Giaus near Nazaré in Portugal) show an enrichment of the decorative repertory and a mature amalgamation of influences (from which one certainly cannot exclude Sassanid and Islamic elements). This was expressed in a felicitous and original synthesis between the severe, austere, square architecture of such buildings and their fantastic decoration, both interior and exterior.

The most recent studies underline the contribution given by illumination to the figurative sculpture present in Visigothic churches. It is certain that they appear effectively to be the translation into sculpture of the linear and two-dimensional idiom of illumination (examples are the famous capitals of San Petro de la Nave and the slabs at Quintanilla de las Viñas). But given the rarity of direct testimony from the Visigothic period, and notwithstanding recent attempts to separate the components of a local figurative tradition by an analysis of mozarabic codices, this argument is destined to remain only a theory.

In Gaul, the workshops of Aquitaine supplied sarcophagi and capitals in the classical style until the beginning of the eighth century with an amazing continuity of tradition. Among many examples we can mention are the architectonic sculptures of the Baptistery at Poitiers, whose date remains uncertain between the late seventh century, as proposed by Hubert, and the early sixth century of F. Eygun, who conducted the excavations there; the Memoria of Mellebaude of the Hypogeum of Dune, which shows different, perhaps Coptic, components in its architecture; and the cross base representing the two thieves beside a column with a capital strangely similar typologically to the other capitals reused in the crypt of St. Eusebius at Pavia. The cross base has been dated by Elbern to the eighth century, as also by Grabar, who compares it to the altar of Duke Ratchis at Cividale. Romanini, while preferring the seventh century dating proposed by Hubert, believes that also this case is an early manifestation of a new idiom which gives line an emergency value as the definer of a two dimensional space. It is the naked simplicity with which this new idiom is expressed here that persuades her to a "high" dating of the carving.

Just this kind of controversy, highly relevant methodologically, has come up as regards the other Gaulish complex on which there has been a great increase of research and critical effort - the crypts and sarcophagi of St. Paul's at Jouarre. The volume of the Marquise de Maillé has established with an unimpeachable documentation that, contrary to the views of Elbern and of Dom J. Coquet, the crypts were entirely rebuilt in late Merovingian times, to which would therefore belong both the so much discussed "west wall" executed, in the best Roman building tradition, with such care that it was left visible and the sarcophagi of Agilberta and Theodechilde. The sarcophagus of Bishop Agilbert, on the other hand, is noticeably older (c. 673 A.D.). Its sculptures (a Universal Judgment whose iconography is still not entirely clear and a Christ in Majesty) have been compared by Grabar (as other students have done previously) to the Scottish and Irish crosses of the seventh and eighth centuries, to which, it must be admitted, a great deal of research has been directed simply because in that cultural area, more than in any other, men continued to carve the human figure in forms which, although much indebted to local late Roman sculpture, show already a new figurative synthesis. And this is sufficient reason for not accepting Grabar's view that they represent a Byzantine influence.

Among the studies we must particularly mention are those of J. Beckwith on the Reculver, Ruthwell, and Bewcastle Crosses; of Aked on the Bewcastle Cross; of G. Walcha on the use, in these stone crosses, of compositions in "Flechtwerk," and of J. R. Pattison on the Nunburnholme Cross and the later Anglo-Danish sculpture.

Investigations in the British area have been particularly fruitful also as concerns illumination in the seventh and eighth centuries. The activities of the main scriptoria of the islands have been better defined.

Above all those of Northumbria (Wearmouth and Jarrow) which, starting from the Celtic decorative repertory and the use of Irish script (as in the Book of Durrow - c. 670) and accepting a transfusion of Roman culture (voyage of Benedict Biscop and Ceolfrid), managed, between the end of the seventh and the beginning of the eighth century, with the Codex Amiatinus to write in uncials and to absorb the classical influence, probably through the Codex Grandior of the Vivarium of Cassiodorus (which, as we shall see, left traces also at Corbie). The Northumbrian school has, however, recently lost one of the most famous of the products which had been attributed to it. The Frank ivory casket formerly assigned to Northumbria is now assigned to a date around 1000 A.D. by Vandersall in J. Beckwith's new catalogue of the ivories in the British Museum. Neither must we forget O. K. Werckmeister's attempt to supply a symbolic interpretation of the insular illuminated manuscripts of the early eighth century in relation to the monastic spirituality of the time, though this view has been seriously criticized by Grabar.

The other school was that of the Monastery of Lindisfarne, where at the end of the seventh century there was produced the famous Lindisfarne Gospel of which D. H. Wright, in analyzing its models, was able to emphasize the degree of emancipation shown in its energetic and abstract linearism in a style similar to the casket of St. Cuthbert.

The third school was that of Canterbury, with an eclectic style between Northumbrian elements and Oriental motifs (in the Vespasian Psalter, c.720). Meanwhile what has been defined as "Lindisfarne style" spread at the beginning of the eighth century to Germany (in the Monastery of Echternach). From here, according to Wright, came the Genoels-Elderen ivory while other scholars prefer a North Italian provenance for it. These are differences of attribution which certainly ought not to surprise one when one thinks that in the epoch to which the ivory is dated (the middle of the eighth century) the two cultural areas in question had probably reached, via different routes, a similar degree of radical re-elaboration of the classical idiom.

It now appears undeniable that, in any case Rome played a principal part in stimulating not only the insular culture but, more generally, Western culture, especially and consciously from the time of Gregory the Great.

As always, however, there remains the problem of defining sufficiently clearly the scale and components of Roman culture from the end of the sixth to the seventh century.

In this context we now have a base in recent very well documented repertories such as the works of G. Mathiae on Roman mosaics and painting and also on the well advanced Roman section of the "Corpus" of sculpture in the High Middle Ages. The studies of C. Bertelli on the icons of Rome are particularly interesting because it has been possible to improve our knowledge of the extremely delicate, ever-lasting problem of the relationships between Rome and Byzantium with the inevitable implications which this question has for the paintings in Santa Maria Antiqua. The following succession now seems ascertained for the famous palimpsest: first, the Madonna Queen of Heaven attributed to the reign of Justin II (565-578); second, the Beautiful Angel of the last quarter of the sixth century; and third, the Holy Fathers of 649. As regards Roman icons, the dates proposed by Bertelli range from the Madonna of the Pantheon of 649, certainly Roman even if it is clearly modelled on Byzantine examples; to the Madonna of the "Tempulo," perhaps of the first years of the eighth century; and the icon of the Seven Sleepers, near the frescoes of St. Mary in Via Lata, which Bertelli himself has recently restored and studied. As to the icon of St. Mary in Trastevere, the traditional dating to the time of John VII seems to remain for the present the most convincing in spite of attempts to place it earlier.

Our knowledge of Merovingian religious architecture remains problematical. The fact that no really important churches have been preserved, even in elevation, hinders us from having a clearer idea of a building activity which, according to our sources, must have been very intense.

However, we must notice the archaeological researches in the Merovingian Abbey of Nivelles, which has been found to have consisted of three separate religious buildings irregularly placed since the abbey was laid out inside a Merovingian "villa." Only the most important of these three buildings, the church, dedicated to the Virgin, has a nave with side aisles ending in apses - the other two are simple rectangular halls with a square ending to the presbytery.

As to the irregular arrangement of the buildings, a phenomenon which Hubert has observed in many different cases, it is worthwhile mentioning at this point a factor regarding the layout of monastery complexes before the rational planning order given them in Carolingian times and studied by W. Horn. That is to say, in Ireland the monasteries founded following the example of St. Patrick in the fifth century are circular fences enclosing more or less large circular huts of timber and straw where the monks lived. These are exactly similar to the settlements of the Celts who invaded Britain around the fifth century B.C. The only form of building for worship which is documented for these monasteries in the islands is a simple rectangular hall, quite unknown in local habitations. In the other example examined by Horn — i.e., Jumiéges, founded in 655 — the abbey enclosure contains four churches irregularly placed, with a common dormitory on two floors with a refectory and cellarium. The buildings were connected by pentises, though it does not seem that they formed a cloister. There were therefore considerable differences between insular and continental habits in Merovingian times and between both of them and the future layout of the Carolingian abbeys (first of all, obviously, St. Gallen).

The excavations and restorations at the Abbey of Ligugé near Poitiers are exceptionally interesting because if, as seems likely, Dom J. Coquet's hypothesis can be demonstrated, we shall have here a unique example (even if fragmentary) of an imposing presbytery, with a crypt beneath, erected in the Merovingian period. The church appears to have been reconstructed around 690 by Ursinus the Abbot near the ancient Memoria of Saint Martin and partly on the site of an older basilica dated in the sixth century, which in turn would be the result of a lengthening of an original cruciform martyrium. The presbytery was composed of a large rectangular choir, flanked by two lateral aisles, of which only the southern one remains, and was separated from the central crossing by an imposing screen wall with an arch with two twin windows above in well dressed masonry. On the north side, there remains in addition to the perimeter the splendid pavement in enamelled china clay tiles in various patterns (imbrication, interlaced circles, etc.) with a classical and geometrical elegance. The whole presbytery measured 26 meters wide and was 18 meters long.

Lastly, in order to round out a whole picture closer to the manners and customs of the time, we must mention the important study made by H. Kruger, principally working direct from sources, on "Konigsgrabkirchen," that is to say churches which served for or were connected with burial of Frankish, Anglo-Saxon and Lombard kings and princes. The discussion of the funerary practices of the Lombard kings is particularly interesting. Little by little there emerges an extremely evocative picture of the texture of urban life. One remembers that the inscription to King Cunicpertus (680 - 700) — "Aureo ex fonte quiescunt in ordine reges/Avus Pater hic filius heiulandus tenetur" — referred to the Church of Saint Saviour at Pavia, or perhaps better to a mausoleum which was "juxta basilican." In this way, even Bullogh's historico-topographical studies enter into this interesting kind of investigation.

The early emergence in Italy of artistic expressions before the Carolingian Renaissance is a problem which is closely connected to that of the continuity of the classical tradition in the seventh and eighth centuries and of the forms in which that tradition continued to ripen its own culture in different ambiental situations. This remains, on the other hand, inseparable from the evaluation of the exchanges taking place in that period between Byzantium and the Near East.

Some scholars have, therefore, emphasized the importance of certain phenomena which witness an uninterrupted and always lively reference to that tradition in the Lombard area, as in the case of the now-lost Santa Maria delle Pertiche at Pavia, on a circular plan with an inner ring of columns which supported the high drum of the cupola constructed by the "philo-Bavarian" and Catholic Queen Rodelinda. The age of Liutprand, which has even been given the significant epithet of "renaissance," gave origin to many examples of Pavian sculpture. Foremost among these, naturally, are the slabs of the so-called sarcophagus of Theodote (the church and tower of the Monastery of Posterula have been carefully excavated, restored, and studied by A. Peroni), and also the famous sculptor's slabs in Modena Cathedral and numerous Friulian sculptures such as the urn of Saint Anastasia in the crypt of the Church of Sixtus at Réghena. Certainly the possibility of identifying and excavating the remains of the Palace of Corte Olona, announced by Cagiano de Azevedo, would offer an extremely valuable field of studies for these aspects of that period.

It is probably in this chronological and cultural context that many attempts have been made, even recently, to refer to what is perhaps the most important and significant monument of the western High Middle Ages, namely the frescoes at Castelseprio. Weitzman's dating to the tenth century is now rejected by the majority (although naturally he retains the merit for having first posed the question of these frescoes as examples alternatively either of the continuity or of a renaissance of classical art). A dating to the seventh century has been corroborated by further arguments by the Byzantinists, who have in fact therein recognized the work of a wandering master from Constantinople. But other scholars, such as Fillitz, Bologna, and Gioseffi, prefer to suggest a date between the seventh and the eighth century. This puts them rather in the position of a necessary prelude to those protocarolingian aspects of art in Italy from the first half of the eighth century, as previously mentioned. Decisive weight in this sense must be given to the comparison between the sinopia with the ass in the frescoes in San Salvatore in Brescia and the other ass, which could almost have been traced from it, in the Flight into Egypt in Castelseprio. For these scholars, the comparison is so close that on the one hand it would justify dating to the time of Desiderius the complex of the upper basilica at Brescia and on the other it would not allow the Castelseprio cycle to be dated very far away from the beginning of the eighth century. However, it must be pointed out, that a sinopia can show, on account of its cursive character, stylistic characteristics somewhat different from the completed work which, by the use of color, can depart from the preparatory outline. Certainly, the ass at Brescia still remains a meaningful documentation of the continuity, in Lombard territory, of a very clear cultural tradition. However, I

do not think that it can be inferred from that that there is any similarly precise consonance between the frescoes at Castelseprio and those at Brescia.

Anyhow, the results of the excavations and restorations in San Salvatore at Brescia, carried out between 1956 and 1961 by G. Panazza, are undoubtedly one of the most important events of the period 1960 to 1975 in the field of the artistic historiography of the High Middle Ages. The works have brought to light the image of a splendid basilica with a nave and two side aisles divided by columns and corbelled capitals which support classically intervalled double springing arches. The ratio between the nave and the secondary aisles is less than 1 : 2. The building is closed at the east end by an apse with a raised arch five meters in diameter. Naturally the exterior, in which the ample windows which light the central nave are subtended to robust arches in the succeeding order of masonry, can be compared with the most select examples of Paleo-christian Lombard art, and above all with the Ambrosian Basilica of St. Simplicianus in Milan. Under the arches of the central nave were found considerable remains of the stucco decoration of vines and roundels, immediately related by the majority of experts to those in the Tempietto at Cividale. The walls of the central nave were then entirely covered by frescoes which, still preserved over wide areas, bear witness to the vitality of the Lombard schools in the High Middle Ages in constant but always original relationships with the Classical (as shown, for example, in the perspective frames of the frescoes). However, the discovery underneath this basilica of another, more modest, place of worship has raised the problem of the reciprocal relationships in the time of the two structures. While Panazza dates the underground building to the seventh or eighth century, and the basilica built over it to a later epoch, most probably under Louis the Pious, other scholars date the latter to a foundation by Desiderius and consider that the remains of the lower belong to a pre-existing Paleo-christian building.

The lively color sense, the vigorous plasticity, the tight rhythm, and the dramatic sense of the narrative immediately relate the Brescia pictorial cycle to the most important manifestations of Carolingian painting in the Italo-Alpine region, from the frescoes at Mustair (for which Y. Christe has suggested a retardation of about 30 years in respect to the traditional date of about 800) to those of St. Benedict at Malles which they resemble above all for their strong classical content. Another important acquisition which has added itself to the limited heritage of pictorial cycles of the Carolingian age and which has contributed to the agitation of the problem of the "fruhitalienische Tradition" is that of the frescoes of St. Sophia at Benevento. Discovered by A. Rusconi during his courageous, but highly criticized, restorations in the church which was the ancient Chapel of the Palace of the Lombard Dukes begun by Arechi II in 760, they still decorate, in a fragmentary state, two of the building's three apses, one with the story of Zaccharia and the other with episodes from the life of the Virgin. Unfortunately the decorations in the central apse were lost in a reconstruction in the Baroque period. The contrasting datings offered by experts (760 for the Italian scholars Rusconi, Rotili, and Bologna; and the fourth decade of the ninth century for Belting) emphasize that by dating frescoes in this quasi-classical - one could almost say Greek - manner still to the eighth century suggests a hegemonic or at any rate exceedingly important role for the figurative culture of Italy in relation to the Carolingian Renaissance. Alternatively, one has to accept a more hazy but structured conception of that renaissance as springing from the fertile terrain of a very much alive tradition of the antique, as it had been modified and matured — that is to say, combining itself with the autonomous idiom of the peninsula - also and especially in the regions belonging to the Lombards, which were never cut off from successive waves of Byzantine influences.

And here we come again not only to the already mentioned problem of the controversial dating of the frescoes at Castelseprio, but also to the really bothersome problem of the decoration, in fresco and in stucco, of the Tempietto at Cividale. Torp's revolutionary researches suggest these are original and coeval with the Lombard architecture of the building and therefore also to be attributed to about the middle of the eighth century.

In this context the clarification of the complex nature of the cultural exchanges and artistic objectives of the eighth century in Italy is absolutely crucial. Certainly this clarification is necessary if due weight is to be given to other different components which flow into this authentic crucible of civilization. These include Ommayad influences, seen in the stuccoes at Cividale and at Brescia and brought out by Hamilton's exhaustive publication on Khirbat-Al-Mafjar, and Sassanid ones introduced above all through the intermediation of textile art and seen in the iconographic repertory of Northern Italian sculpture of the eighth century. Clearly, however, a similarly complex interweaving of cultural contributions would never have been able to give rise to an antonomous and original culture if it had not been able to establish itself in a land already rich with an uninterrupted and evergreen tradition fed by a conscious and politically orientated commitment. In the case of Northern Lombardy, this can be clearly distinguished from a little after the middle of the fifth century in the victory of the Catholic-Bavarian Party and in the intense political, religious, and cultural activity of the Dukes of Cividale, the country of that Paul Diaconus who, on the fall of the Lombard kingdom, took refuge at the Court of Charlemagne. Nor equally certainly would it have found outlet into a larger, European ambit to bring about a radical transformation if, as a result of its long travail, it had not passed through the catalyzing filter of the organic and precise political plan of Charlemagne and his team of wise counsellors.

Among the idealogues who Charlemagne took care to select were Paul Diaconus himself, Alcuin of York, Angelbert, and Theodulf of Orleans, whom P. Block has identified in an acute study as the inspiring mind of the political and iconoclastic program in the mosaic representing the Arc of the Covenant in the apse of Germigny-des-Près.

The mere citation of these complex personalities is enough to give a measure of the convulsions of the Carolingian age. This brought to maturation, following the thread of an ideal but multivalent route, cultural streams which were already living and working in the preceding epoch. In this sense, the Carolingian Books remain, from the point of view of the theoretical elaboration of that route, the fundamental document, at a

highly elitist level of thought, for understanding the ideological foundations of Carolingian figurative civilization between the eighth and the ninth centuries. This makes us regret the delayed publication of the critical edition of the "Books" announced by L. Wallach, who credits Alcuin with their preparation. The more recent researches of A. Freemann point to Theodulf of Orleans and the study of the important Tironian Notes.

On the basis of this kind of methodological objective — that is to say, aiming at separating out the political and religious contents underlying the most significant expressions of Carolingian art — a whole critical current has been developed that has proved very proficient within the ambit of the study of the art of the High Middle Ages. In effect, this advances from the well-known classic studies by P. H. Schramm on the "Herrschaftszeichen" (or symbols of power) and extends the same concept to fields of study not immediately connected with the study of the symbols of imperial and religious power in the strict sense of the terms — that is to say, to architecture and manuscript illumination seen as expressions of an "ideology through images" of the greatest interest for a correct interpretation of the Medieval mentality.

Thus, for example, the extremely useful Repertory of lists of treasures from the epoch of Charlemagne to the middle of the 13th century produced by B. Bischoff and F. Mütherich and the publication edited by Schramm himself with Mütherich of the principal objects, mainly goldsmithery and sumptuary articles, express the concept of Power as seen by German kings and emperors and in which religious ideology always makes cross reference to political ideology and vice versa. There are also many studies of great interest not only of objects and works of art, which best lend themselves to this kind of discussion, but also on architectural works founded by the emperors. Among the studies of non-architectural works referred to above is that of Belting on the base of the Cross of Eginardus, in which the ancient world (in its most immediately striking expression, the triumphal arch, used as a pedestal for the cross) with all its imperial iconographic imagery is transmitted into a religious iconography; yet, in a way, that is not different from a conceptual point of view from what had already evolved, but with a new forceful cultural leap which confidently appropriated the past and remodelled it to its own ends.

In this context, the excavations and studies conducted on Charlemagne's palaces and those of his successors are significant. These excavations were in part started in the past, but were reopened with vigor and rigorous scientific methodology in the 1960s. The palace at Paderborn, site of the meeting between Charlemagne and Leo III in 779, excavated by Winkelmann from 1963, and that at Ingelheim, excavated from 1960 and later studied by W. Lammers, are both "palatia operis egregii" as Eginardus defined them. Particular attention has been given to identifying the royal hall and the so-called chapel of the palace. Comparison with the hall at Aachen is significant for Ingelheim, although that was on a reduced scale. It is important to learn that what was first taken to be the hall revealed itself on stratigraphical evidence to be a chapel, and part of the palace complex, but of the second half of the tenth century. Also important is the discovery on the south side of the hall of the palace of

Paderborn of a throne base with six steps, perhaps the base of a baldaquin. The obligatory comparison with the throne of Charlemagne at Aachen, and thus with the throne of King Solomon, is naturally of great significance.

Also the study, from basic sources, of the iconographic programs of the frescoes with which the walls of the royal halls — as compared with the walls of the palace chapel — were decorated has been found extremely interesting.

Among other contributions, within the ambit of this investigative direction, we must also mention the careful study by H. Schnitzler of the mosaics of the dome of the chapel at Aachen; and that by Vieillard-Troïekouroff on the chapel of the palace of Charles the Bald at Compiègne.

A propos of architecture in France under Charles the Bald, we must also mention the synoptic picture which Vieillard-Troïekouroff herself has produced as part of the study of the history of art, included in the third volume of the monumental publication "Karl der Grosse, Werk und Wirkung." That was in many ways, and not only in France, a period of final maturation and simultaneously of crisis of the values laid down in the preceding age. In the western regions of the empire an autonomous and vigorous development of architectonic forms was beginning to manifest itself as a direct precursor of the proto-Romanesque forms of the Burgundian school of Willaim of Volpiano and of the first masters who worked on Saint Bénigne's Cathedral at Dijon. The extremely articulate forms of the crypt of St. Germain at Auxerre fit into this perspective (as also the false architecture in part of the paintings, especially if compared with those in the Torhalle at Lorsch, about 70 years older), and also, to those of the crypt of Saint-Pierre at Flavigny, excavated, studied, and published by Jouven.

The building experience gained in these constructions by the masons working under Charles the Bald led to the free interpretation, in forms which we feel ought to be called "Baroque" (the radiating pointed chapels round the wide ambulatory in the crypt of Saint-Germain), as compared with the substantially conservative and retrospective tone of the architecture in France under Charlemagne and his immediate successors. The same current of substantial dependence on the constructional techniques and forms of the late classical age, with a live sense of imitation not only of the shapes of the Roman basilicas but also for the Vitruvian tradition, always making itself felt, runs from the Abbey of St. Denis with its semi-annular crypt of Roman type and its narrow transept (of which excavations by Vieillard-Troïekouroff and Hubert's studies have been able to correct the erroneous Merovingian dating of the crypt by Formigé and the equally erroneous reconstruction of the basilica suggested by Crosby) to the Church of Germigny des Près with a dome built of tile supported by conoids, to the lively plan of the Baptistery at Nevers and to the imposing crypt of Saint-Médard at Soissons (which has also been studied by Hubert).

The influence and imitation of Rome, which assumed the value of a symbol of the Carolingian renaissance have been amply underlined, particularly in relationship with the planned layout of the abbey of Centula-St. Riquier. The abbey was arranged in a triangle in honor of the Trinity to which it was dedicated,

with a set of seven appurtenances arranged along the liturgical way like the seven stations at Rome. H. Bernard excavated the three sanctuaries which constituted the vertices of the triangle and rediscovered the Round Church dedicated to the Virgin. This discovery confirmed Hubert's intuition that this had been a dodecagonal building with 13 altars, 12 dedicated to the Apostles and one to the Virgin, in the center. The innermost ring of foundations, which presumably supported the central covering, was, on the other hand, hexagonal.

It is undoubtedly necessary to assume that all the buildings of the Carolingian period constructed on a central plan were recalling the late classical period. This is so even if one momentarily forgets the fundamental Byzantine component (the most noted models of which are St. Vitale at Ravenna, St. Sergius, and St. Bacchus and the Crysotriclinium of the Imperial Palace at Constantinople) and also, above all, the Palace Chapel at Aachen, as is underlined in an ample paper on the prototypes of the chapel by G. Bandmann. These might be, more generically, prototypes directly derived from late Antiquity within the limits of the Frankish kingdom, such as St. Gereone in Cologne or the Daurade in Toulouse, or introduced through Lombard culture. Here, beyond renewing the reference to Santa Maria delle Pertiche at Pavia, one must again mention St. Sophia's at Benevento with its exceedingly original steller plan. St. Sophia's raised many doubts when it was discovered — not so much as to compare it with the Chapel of Aachen, from which it is radically different, but rather to point out the variety of the relationships which the Lombard builders, and after them those in the service of Charlemagne, knew how to extract from within the matrix of the late classical. Certainly, the unusual perspective points of view furnished by the angled walls of the church in Benevento show a continuity of late classical ideals. They also show an extremely strong originality in their emphatic play with the fixed space of the domed central hexagon.

Furthermore, it must not be forgotten that the problem of St. Sophia's at Benevento is surrounded by concentric circles of other larger problems, which go from the question of the so-called Beneventon Art (a very stimulating concept for critics, not universally accepted, put forward by H. Belting), to those of the relations between the same and Rome. The unavoidable question is of the Byzantine component (found, according to recent papers, principally in the hypothesis of Grabar about Greek scriptoria working in Rome) and the relationship between this cultural area and those of Lombardy and beyond the Alps. Finally all this must be contained within the total problem of the "frühitalienische Tradition," which remains a complicated meeting point for the origins of Western figurative idiom.

However, this moves mainly on the lines of illumination which offers a sufficiently vast subject for study and to which paleography has given not indifferent support and contribution. Belting's idea, in fact, is based on the work of Lowe on Beneventan calligraphy and takes off from this to retrace the cultural or figurative elements which allow an area of Beneventan culture to be defined in southern Italy. Furthermore, examination of the manuscripts proceeds *pari passu* with that of the frescoes of the High Middle Ages in Campania. These are carefully studied both from the point of view

of iconography and for idiom, thus recovering, for historico-artistic investigation, among other things, a considerable amount of valuable material which has never been re-examined as a whole since the old publication by Bertaux on southern Italian art. (The whole work of Bertaux will shortly be republished and critically brought up to date under the direction of A. Prandi under the aegis of the Ecole Française at Rome.)

These go from the frescoes in the caves of St. Biagius at Castellamare di Stabia (in which a head of the saint dated to the eighth century shows a free Hellenistic manner comparable with the older paintings in St. Saba's at Rome) to those in the crypt of St. Vincent's at Volturno (c. 830). The latter are seen not as an isolated work of very high quality, but in the vaster context of Beneventan art, and in particular to the miniatures on astronomical subjects in ms. 3 at Montecassino and those in Cod. LXXII, 41 of the Laurenziana in Florence.

Then there are those already mentioned at the Church of St. Sophia in Benevento, held by Belting to be coeval with the crypt at Volturno or preferably slightly later on account of a certain slackness or heaviness of forms; those in the crypt of the Cathedral of Benevento, those in the apse of the church at Prato near Avellino, and those in Saints Rufus and Carponius Church at Capua, which can all be dated to the last few years of the ninth century. Within the tenth century, on the other hand, must be placed the frescoes in the crypt of St. Michael's and those under the arches in St. Salvatore at Capua (but it must be pointed out that often for the Capuan churches Belting relies on the documentation of a local 18th century erudite, a notorious forger and "creator" of Medieval documents). According to Belting, the Pontificale and the Rotulo with the "Benedictio fontis" of the Casanatense fall within the same period (but F. de Maffei has recently raised serious doubts about this dating for the Pontificale, tending to bring its construction earlier and to detach it from the Beneventan "scriptoria").

On the one hand, the German scholar tends to distinguish Roman production of the ninth century, especially the later output (frescoes of Santa Maria Egiziaca and the fresco of the Ascension in the lower church of St. Clement) from the "Beneventan," emphasizing the undoubted vigor not only of the miniatures in the Codices of the Casanatense but also of the important frescoes at Cimitile as compared with the tired manner of the Roman products. On the other hand, Grabar in his publication on Greek manuscripts of the ninth and tenth centuries coming from Italy and imagining the laborious high quality work of Greek illuminators in scriptoria in Rome during the ninth century (with particular reference to Codex Vat. Gr 923 and Gr 749) also makes new proposals about the matrices of artistic culture in Rome at the time of Pope Paschal and thus in relationship with the Roman mosaic cycles of the epoch. On the other hand, he tries to erect bridges to the Beneventan area suggesting at least a reciprocal exchange of experience.

We must also observe that the already mentioned study by Maffei has added new arguments to this theory. She is strongly in favor of the view that the Roman scriptoria of the ninth century enjoyed a cultural hegemony even as compared with northern Italian illuminating (particularly the miniatures of the Home-

larium and of the texts of canonical law in the Chapter Library at Vercelli) and of northern European illuminating (proposing a Roman provenance for the prototype of the Stuttgart Psalter, which is held to be Lombard and between the eighth and ninth centuries by Mütherich and Bischoff, co-authors of the critique which accompanied the recent beautiful facsimile edition of the codex, and by others including Schapiro, Belting, and Kitzinger). Neither must one undervalue the very significant points of contact which can be met with between those Greek codices (especially Vat. Gr. 749) and the immediately post-iconoclastic output of the hermit caves in Cappadocia. These have previously been mentioned by Grabar and have been taken up again recently by Belting. Belting, however, insisted that this was not possible in the case of the production of Benevento. Even so, it does not seem to be by pure chance that certain similarities can be seen between the frescoes in the Chapel of Olevano on the Tusciano, of the second half of the tenth century and those at Ayvali Kilise at Gülüdere in Cappadocia.

The massive interchanges between the Byzantine world and the West as a necessary happening within the Roman cultural orbit is a burning point which critics are only recently attempting to approach. The possible range of this discussion can be judged by the fact that Grabar in his work (which has already been mentioned) suggests, on the basis of just those medallions portraying the Prophets in Vat. Gr. 923, a provenance from Roman circles of the illuminators of the group of the Evangelists of the Coronation. This reinvigorates not only the arguments of Tselos about the Italo-Greek schools in Rome during the eighth century but also, obviously, his own Carolingian dating of the Castelseprio frescoes.

And this is the way in which scholars at present explain "die Sunde," the famous "sin," as Koehler jokingly defined the upsurge of Greek as Greek, of the Evangelists of the Coronation, thus underlining the complete break with preceding productions and its value as a paradigm of change for Carolingian miniaturists. But it must, on the other hand, be stated that, in the sense that criticism has attempted to define, the "sin" turns out to be quite other than a sin. If, without trying to explain too many things with one "recipe," the Lombard ambit, so often called into the discussion (and there must here be remembered, among other things, the inevitable comparison between St. Vincent at Volterra and the Egino Codex), was an active center of exchange from the eighth century onwards of various components which came together in the "früitalienische Tradition," it must follow that Charlemagne's political action was enough to precipitate a situation already full of potential future developments. Precisely in this dimension, a determinant function is acquired, not only by the above-mentioned discoveries in St. Salvatore at Brescia and the eternal problem of the decoration of the Tempietto at Cividale, but also the relationships which had been continuing since the third quarter of the eighth century between Corbie and northern Italy.

Relationships between that center and Italy must have a still stronger tradition if Nordenfalk's attribution of an isolated page rebound in a late Merovingian codex produced at Corbie to the Vivarium of Cassiodorus is correct, as it seems to be (Paris, Bibliothèque Nationale Lat. 12190, fol. Av.). There were also relationships with the Scriptorium of St. Gallen. It further follows that the role of many Lombard scriptoria such as Vercelli, Nonantola, Ivrea, and Verona must also be clarified still more than has already been done, as also even that of Milan. The Lombard ambit is in fact now regarded by the most acute critics not as a province of ultramontane art, but as a leading protagonist of High Medieval Art.

With reference to the so-called Schools of Carolingian, illuminators we believe state that the researches conducted regarding the School of Tours are particularly important. The so-called Bible of St. Maximinus at Trier, discovered, in a fragmentary state, by Nordenfalk in 1933 and stylistically and iconographically resembling the Bible of Vivianus, has been enlarged by the discovery of other fragments at Trier in the Lilly Library of Indiana University, in London, in Berlin, in Coblenz, and at Ithaca (New York). Mütherich's latest observations - including the publication of another fragment discovered in a private collection at Trier - allow one to conclude that it was probably executed, like the Bamberg Bible, in the Monastery of Marmoutier. It has been possible to identify two other editions from the same source. One earlier, and with few decorations and certainly without miniatures, datable to about 810 (fragments at Berlin, Preuss, Kulturbesitz, Staatbibliothek, Theol. Lat. fol. 360); and another, commissioned by Lothar I at Tours, also similar to the Bible of Vivianus and conserved at Metz, a suffragan bishopric of Trier. This not only contributes to the better appreciation of the book production activity controlled by Tours, but also to the identification of the models which inspired the illuminators at Trier under the Saxon emperors. The Metz Bible in turn inspired the "Christ in Majesty with the Apostles" in Sainte-Chapelle, a masterly and mature work by the master of the Registrum Gregorii, as also the decorative apparatus (capitals and initial pages), even if, alongside the preponderant influence of Tours, it is possible to detect that of the so-called School of Ada (the Codex of Ada was in fact to be found at Trier) and that of the School at the Court of Charles the Bald.

The chronology of the master of the Registrum Gregorii has also been clarified (Nordenfalk has published a paper on this). Coming probably from court circles, like his great patron Archbishop Egbert of Trier, he produced illuminated codices also for Lorsch and Echternach. The portraits of the Evangelists in the Monastery of Strahove, near Prague, belong to the early years of his activity and were added to an older Carolingian codex of the beginning of the ninth century. A little later, he inserted a portrait of St. Mark in a pre-Carolingian Gospel at Echternach, now in the library of the Seminary of the Monastery of St. Peter in the Black Forest. The Evangelists at Sainte-Chapelle belong to about 980, while the separate pages at Chantilly and Trier are definitely dated to 983. The enthroned emperor in the first of these seems now certainly to be Otto II. To this same period also belong the seven miniatures added to the Codex Egberti of the Municipal Library of Trier with scenes from Christ's childhood and life. The last work of the master before 996 is the Gospels, of the John Rylands Library in Manchester, which were early transferred to Cologne where they became a major factor in the development of the flourishing illumination school there.

Furthermore, the originality of the master's invention of form has also been shown by a comparison

with the few illuminated manuscripts (and those only with initials) from the Scriptorium of Trier, before he started working, such as the "Morals from Job" (ms 2209/2328 of the Municipal Library of Trier), dating from about 960 in which fundamental cultural currents of the school combine. These were the "classical" influences from Tours and the "alemannic" influences, which were also felt in the beginning of Saxon imperial illumination at St. Gallen and at Echternach. The same originality can also be seen in the energetic drive to renovate the then already old contents of the ancient monastic library of St. Massiminus, certainly the site of the Scriptorium of Trier.

This habit of the master of the Registrum Gregorii to restore older manuscripts with the insertion of new pages which he had illuminated illustrates one of the principal characteristics of the art under the Hohenstaufen, which was to attach itself firmly to the preceding Carolingian tradition and rework it in the light of new forms derived from Byzantine influence.

This also explains why we shall attempt to give here a brief updating summary of both Carolingian and Hohenstaufen, illuminating them together. The cultural ties between the two can then be made evident. This is in fact one of the most substantial results of recent research.

We also want to mention here the studies made of the goldsmiths' work produced at Trier while Egbert was Archbishop (977 - 993), and particularly the very recent ones by H. Westermann-Angerhausen. Firm attribution to this workshop includes the portable altar of St. Andrew (also called Egbert's Treasure-chest); the Reliquary of the Sceptre of St. Peter, kept in the Treasury of Limburg Cathedral and datable to 980, which in its imagery (Peter and his disciples, apostles, popes, and bishops of Trier) displays the power the archbishop had acquired in that historic moment; and Cover of the Gospel of the Codex Aureus of Echternach (kept in the German National Museum at Nuremburg), dated between 983/85 and 991. All these goldsmith products clearly show the influence of the master of the Registrum Gregorii, especially of the Gospel of Sainte-Chapelle and that of Strahove.

The ornamental enamels can be divided into two groups using two different techniques: one with sunken enamel based on the decorations of the Codex of Ada; and the other with level enamelling based on the initials of the Trier School and of the master of the Registrum Gregorii. But the enamels on the Nuremburg cover also show the influence of the School of Charles the Bald in their use of almandine. The interstitial work on the two short sides of the Reliquary of St. Andrew is derived from the initials of Tours, which re-introduces and confirms the existence of the problem of the Bible of St. Massiminus at Trier.

Dodwell and Turner's book on the art of Reichenau considerably confused the picture of Hohenstaufen illumination. Starting from the assumptions that the codices certainly executed at Riechenau Monastery are few and not very significant and that the principal ones attributed to it often show surprising antinomic characteristics and could therefore have been executed elsewhere, such as Trier, the authors attempt to dismantle, piece by piece, the hypothesis of a "Reichenau-Malerschule." In effect, especially at the beginning, the manuscripts show anything but a uniform tendency. A unified style was reached only after 980 following on the favor shown the monastery by Otto III.

A necessary reference point for this period is obviously the recently cleaned and restored frescoes in St. George's at Oberzell, about which the publication by K. Martin can now be consulted.

However, the greatest gap in this sense is the lack of references on the activity at Reichenau in Carolingian times. The excavations carried out by Erdmann in the Church of St. Peter and St. Paul at Niederzell at least permit some light to be thrown on some aspects of architecture and sculpture at that monastic center at the time of Eginus (about 799), who, coming from the see of the Bishopric of Verona, passed his last years there. But in spite of the fact that many fragments of painted plaster were found during the excavations (explicit demonstration that the walls must have been entirely decorated) we have nothing at all which allows us to verify the existence of a Scriptorium operating at Reichenau during the time of Charlemagne. Of course, though, we are free to suppose it.

The geographical position of the abbey suggests that it would fall under Lombard influence. It is cogent that the first groups of illustrated codices which indicate the beginning of the activity of the Augsburg Scriptorium, and in particular the so-called Ruodprecht group (Cividale Psalter-Poussay Gospels), show plenty of contacts with Lombard ninth century codices while the illustrations of the Warmund Codices at Ivrea also come from the same Italian sources. The situation is no different at St. Gallen, which, at the beginning of the tenth century, supplied the models for the ornamental forms in the Homiliary of Karlsruhe (Landesbibliothek, Aug. XVI), nor at Einsideln, whose beginnings (under Abbot Gregory 964 - 994) have been recently studied by Fillitz precisely in relationship to the St. Gallen manuscripts, from which there are surprising reminders of the Egbert Psalter and the Vercelli Homiliary.

In general, it does not seem that new critical orientations will be revealed regarding the subdivision into Schools of ivory articles produced in Carolingian times (we mention here only Schnitzler's study of the ivories in the von Hüpsch Collection, belonging to the Ada Group, and A. Feigel's paper on the Lorsch Group). We must emphasize the importance of the publication supervised by the Pontifical Roman Academy of Christian Archaeology at St. Peter's and including ivories (an altarback with the figure of an emperor within a roundel supported by flying angels and plaques with episodes about Hercules and symbols of the constellations). These have touched off a violent argument among specialists, who, while all agreeing with De Rossi's previous identification of the emperor as a portrait of Charles the Bald, disagree about the dating of the plaques. M. Guarducci holds them to be Alexandrine works of the third century used in the throne of Maximinianus Hercules and then given by Constantine to Pope Sylvester, who kept them at the Lateran. Weitzmann believes them to be part of the whole work dated to the time of Charles the Bald and ascribable to the circle of the so-called School of Liutard, also because of the technique used, which is engravure, and by the use, as background, of thin sheets of gold - (it is furthermore significant that stylistically, or at least at the level of prototypes, P. Romanelli and O. Pächt have noticed

comparisons with the designs of the Utrecht Psalter). Although the dendrochronological analyses of the wooden backing of the plaques and the recent deeper study by N. Gussone and N. Staubach tend to exclude the dating and historical story suggested by Guarducci, the problem which is so frequently met with in considering high quality works such as those at Castelseprio from the High Middle Ages remains open: namely, whether they must be regarded as products of a continuity or of a revival. The former hypothesis is preferred by, for example, Fillitz, who places the plaques in a late Coptic ambit (perhaps of the end of the seventh century) which, although under Muslim domination (and this is a fact already demonstrable in many aspects), still continued to produce these refined luxury articles in a traditional style which show an astonishing continuity with late Antiquity.

Two Gospel covers conserved at the Metropolitan Museum of New York, with the Handing Down of the Law and the image of the Theotokon, studied by Vandersall, are thought to have been executed under Incmar, Archbishop of Rheims (835 - 882). They show, in their unusual iconography, a descent from the pentapartite Paleochristian ivories and belong stylistically to a limited group of metal and ivory objects executed within the ambit of the court school. They also show interesting possibilities of connections with the Stuttgart Psalter, made in the Scriptorium of Saint-Germigny-des-Prés. Furthermore, Incmar himself spent his formative years at Saint-Germigny-des-Pres before he went to the court of Charles the Bald.

Considerable importance must be given to the picture which it has so far been possible to draw of illuminating and ivory working in the Saxon ambit on the basis of studies by Usener and by Buddenseig and of the exhibition held at Corvey in 1966. In particular, as regards the small group of codices whose decoration consists only in pen and ink drawings of powerful beauty (strictly correlated with contemporary Anglo Saxon illumination), such as manuscripts New York Astor, 1, Wolfenbuttel 16.1 Aug. 2nd, Leipzig CXC, there has been recognized, beyond a root in Fulda and others derived from the court school of Charlemagne, a more determinant derivation from Rheims, especially in the spacing of the Gospel scenes and, more generally, in the connections with western Frankish cultural circles - connections which are further confirmed by the very close relationships, from half way through the ninth century, between Corbie and Corvey.

The flourishing of Corvey corresponds with the coming to power of the Saxon dynasty. Usener's hypothesis that the Astor I Codex at New York can be attributed to an order from Otto I is based on both the extraordinarily high artistic level and the elegance of the manuscript and on its programmatic reference to Carolingian manuscripts. Furthermore, a derivation from models from Rheims is already accepted for the manuscripts from the Hildesheim Scriptorium. Also, a small series of ivories (the Gospel cover of Ms 44 of the Treasure of Halberstadt Cathedral, the comb with St. Peter and the two Saints in the Treasure of Osnabrück Cathedral) have been brought by Buddenseig within the Saxon ambit and dated to about 1000 A.D. In any case they predate the style of the Master of the Registrum Gregorii, as previously stated by Nordenfalk.

In the ambit of Cologne studies, P. Bloch and H. Schnitzler have permitted a reconstruction of the whole picture of the "Kölnermalerschule" and the phases of its development. In particular, the importance which Byzantine artistic influences had on this school under the aegis of the Empress Theophano must be emphasized. The influences came especially from the manuscripts of the Macedonian revival and are to be seen particularly after the Sacramentary of St. Gereon. These influences have been detailed and defined from another point of view by H. Wentzels' studies of the precious objects (ivories, textiles, goldsmith work) which might have been part of the "marriage treasure" of the Empress Theophano, but which certainly constitute a massive reference point for the contribution of Byzantine culture from Otto II's time, or rather in the 30 years 972 - 1002. In architecture, the activities of "operarii graeci" can be directly observed in neighboring Westphalia in the Chapel of St. Bartholomew, fully restored and studied by H. Bunsen in 1963, and in the Busdorfkirche at Paderborn.

An important contribution to the understanding of artistic activity in Lombard circles in the tenth century has been made by Peroni, who has courageously moved the date of the metal Crucifix of St. Michael the Greater at Pavia (and of the one at Casale Monferrato which is closely connected with it) to the third quarter of the tenth century. This is in contrast with the traditional dating to the 12th century.

This new attribution, beyond giving us an evocative picture of the activity of Lombard goldsmiths workshops under the Saxon dynasty, has the undeniable merit of suggesting more subtle critical distinctions between works of art in which, as with goldsmith's work, the strength of technical and formal tradition is often such as to hinder an historically correct focussing of the different evolutionary phases of the artistic idiom.

To have carried back to the Lombard High Middle Ages a "mobile" object which had been attributed to the 12th century and to the Rhineland with a strong carry over of late Saxon dynasty traditions can, after all, be considered a fine result which has come from the better knowledge which, in spite of some persisting shady patches, we now possess of the artistic happenings of the High Middle Ages.

BIBLIOGRAPHY - *Works and papers of a general character, Exhibitions and Expositions, Reports of Congresses*: IX Week of Studies of the C.I.S.A.M., The Passage from Antiquity to the Middle Ages in the West (6-12 Apr. 1961), Spoleto, 1962; F. Henry, Irish Art in the Early Christian Period (to 800 A.D.), London, 1965; D. Bullough, The Age of Charlemagne, London, 1965; M. Hirmer, Spanien Kunst des Frühen Mittelalters vom Westgotenreich bis zum Ende der Romanik, München, 1965; Karl der Grosse, Lebenswerk und Nachleben, III, Karolingische Kunst, Dusseldorf, 1965 (cf. and rev. by A. Peroni and C. Bertelli, in Studi Medievali, VII, 2, 1966); M. Pallottini, Dalle Città alle Comunità. Vicende urbanistiche dell'Alto Medioevo Roma, 1966; Kunst und Kultur in Weserraum 800-1600, Ausstellung des Landes Nordrhein-Westfalen, Corvey, 1966 (1967); A. Bonnet Correa, Arte Prerromanico Asturiano, Balmes-Barcelona, 1967; H. Belting, Probleme der Kunstgeschichte Italiens im Frühmittelalter, in Frühmittelalterliche Studien, I, 1967; Rotterdam Papers: A contribution

to Medieval Archaeology. Symposium voor "Middellenswe archeologie in onde binnesteden," 1966, Rotterdam, 1968; Pavia Capitale di regno, Reports on the IV Congresso internazionale di Studi sull' Alto Medioevo, Pavia (10-14 Sept. 1967), C.I.S.A.M., Spoleto, 1969; P. De Palol, Arte hispànico de la época visigada, Balmes-Barcelona, 1968; "Kulturbruch oder Kulturkontinuität" im ubergang von der Antike zum Mittelalter, Wege Forschungen, 201, Darmstadt, 1968; Tardo Antico e alto Medioevo. La forma artistica nel passaggio dall'Antichità al Medioevo, Roma, Accademia Nazionale dei Lincei, Roma, 1968; W. Braunfels, Die Welt der Karolinger und ihre Kunst, München, 1968; Sources archéologiques de la civilisation européenne. Actes du colloque international organisé par l'Association internationale d'études du sudest européen. Mamaia (Romania), 1968, Bucarest, 1970; H. Fillitz, Das Mettelalter, 1, Propyläen Kunstgeschichte, Berlin, 1969; H. Hollander, Kunst des frühen Mittelalters, München, 1969; Varangian Problems. Report on the first international Symposium on the theme "The Eastern Connections of the Nordic Peoples in the Viking Period and the Early Middle Ages," Scundo-slavica, suppl. 1, Copenhagen, 1970; XVIII Settimana di studi del C.I.S.A.M., Artigianato e tecnica della società dell'Alto Medioevo occidentale (2-8 Apr. 1970), Spoleto, 1971; La Persia nel Medioevo. Atti del Convegno internazionale (31 Mar-5 Apr. 1970), Roma, Accademia Nazionale dei Lincei, quad. n° 160; C.R. Dodwell, Painting in Europe, 800 - 1200, Pelikan History of Art, London, 1971; M. Backes-R. Dolling, Art of the Dark Ages, New York, 1971; Atti del Convegno di Studi Longobardi (Udine-Cividale, 15-18 May 1969), Dep. di Studia Patria per i Friuli, 1970; C. Davis Weyer, Early Medieval Art, 300-1150, Sources and Documents, Englewood Cliffs, 1971; A. Corboz, Frühes Mittelalter, München, 1971 (1st ed franc); J. F. Uranga Galdiano, Iniguez Almech, Arte Medieval Navarro, vol. 1: Arte Prerromanico Pamplona, 1971; Atti del V Congresso Internazionale di Studi sull'Alto Medioevo, Lucca, 1971, C.I.S.A.M., Spoleto, 1973; Rhein und Maas, Kunst and Kultur, 800-1400, Köln, 1972; Grabar, Le tiers monde de l'antiquité à l'école de l'art classique et son rôle dans la formation de l'art du moyen âge, in Revue de l'art, 18, 1972; XX Week of Studies of the C.I.S.A.M., 1 problemi dell'Occidente nel sec. VIII (6-12 Apr. 1972) Spoleto, 1973; AA.VV., Vor- und frühge-schicht-liche Archäologie in Bayern, Bayerische Schulbuchverlag, München, 1972; Suevia Sacra, Frühe Kunst in Schwaben, Augsburg, 1973; H. Jankuhn, Umrisse einer Archäologie des Mittelalters, in Zeitschrift für Archaologie des Mittelalters, 1973; F. Salin, La civilisation Mérovingienne d'aprés les sepultures, les textes et le laboratoire, 1, Les sépultures, Paris, 1973; O. Renner, Die Durchbrochen Zierscheiben Merowingerzeit, Mainz, 1970; Vor- und frühformen der europäischen Stadt in Mittelalter. Bericht über ein Symposium in Reinhausen bei Göttingen in der Zeit vom 18 bis 24 April 1972, hrsg. von H. Jankuhn, Abhandlungen der Akademie der Wissenschaften in Göttingen, Phil- Hist. Klasse, 3, F. 83, Göttingen, 1973; T. E. Kendrick, Late Saxon and Viking Art, London, 1974; XXI Week of Studies of the C.I.S.A.M., Urban topography and town life in the High Middle Ages in the West (26 Apr. - 1 May 1973), Spoleto, 1974; H. P. L'Orange, Likeness and Icon. Selected Studies in Classical and Early Medieval Art, Odense, 1973; J. Beckwith, Early Medieval Art, 3rd rist., 1974; A. M. Romanini, Traditions and "Mutations" in pre-Carolingian figurative culture, in XXII Week of Study of the C.I.S.A.M., Spoleto, 1975; Roma e l'età carolingia, Reports on the Week of Study at the University of Rome, Istituto di Storia dell'arte, May 1976; J. Hubert, J. Porcher, F.W. Volback, L'Europa delle Invasioni Barbariche, coll. Il Mondo della Figura, Rizzoli, 1970; J. Hubert, J. Porcher, F.W. Volbach, L'Impero Carolingio, coll. Il Mondo della Figura, Rizzoli, 1970; L. Grodecki, F. Mütherich, J. Taralon, W. Wormald, Il Secolo dell'anno Mille, coll. Il Mondo della Figura, Rizzoli, 1974.

Architecture: G. Jouven, Fouilles des cryptes et de l'abbatiale Saint-Pierre de Flavigny in Les Monuments historiques de la France, 1960; A. France-Lanord, M. Fleury, Das Grab der Arnegundis in Saint-Denis in Germany, 40, 1962; F. Eygun, Le Baptistére Saint Jean de Poitiers, in Gallia, XXII, 1964; J. Mertens, Recherches archéologiques dans l'abbaye mérovingienne de Nivelles, in Archaeologia Belgica, LXI, 1962 (cf and the rev. of A. Erlande-Brandeburg, in Bulletin Monumental, 1965); C. Heitz, Recherches sur les rapports entre architecture et liturgie à l'epoque carolingienne, S.E.V.P.E.N., Bibl. générale de l'École Pratique des Hautes Etudes, II sect. Paris, 1963; H. Busen, Die Bartholomäuskapelle in Paderborn, in Westfalen Hefte, 41, 1963; E. Ewig, Résidence et capitale pendant le haut moyen âge, in Revue Historique, 230, 1963; S. Lehmann, Kaiserturm und Reform als Bauherren in Hochkarolingischen Zeit, in Festschrift P. Mätz, Berlin, 1965; H. Bernard, Prelières fouilles à Saint-Requier, in Karl der Grosse, op. cit., III; G. Bandmann, Die Vorbilder der Aachener Pfalzkapelle, in Karl der Grosse, op. cit., III, 1965; H.M.-J. Taylor, Anglo-Saxon Architecture, Cambridge, 1965; J. Fleckenstein, Die Hofkapelle der deutschen Könige. II. Die Hofkapelle im Rahmen der Ottonisch-Salischen Reichskirche, Stuttgart, 1966; A. Deiana, Saggi di Scavo a Castelseprio, in Rassegna Gallaratese di storia e d'arte, dal 1965 al 1968; U. Milojčic, Bericht uber die Ausgrabungen und Bauuntersuchungen in der Abrei Frauennorth auf der Fraueninsel in Chiemsee, Bayer. Akad. der Wiss. - Phil. Hist. KI. - Abh. Nf., Hf. 65, München, 1966; S. W. Winkelmann, Der Schauplatz, in "Karolus Magnus et Leo Papa," Paderborn, 1966; Reports on the excavations at the Palace of Paderborn, in Westfälische Forschungen, 19, 1965; S. W. Winkelmann, in Kunst und Kultur in Weserraum, op. cit., 4 Aufl., 2. B.; F. Soliani Raschini, Note sul Battistero di Lomello. Architettura del Battistero, in Bollettino della Società Pavese di Storia Patria, LXVII, 1967; F. Möbius, Zur deutung des Karolinischen Westwerkes, in Acta Historiae Artium, 14, 3-4, 1968; H. Christ, Die Kapelle des pippinischen Königshofes in Aachen, Aachen, 1965; F. Oswald, L. Schaefer, H.R. Sennhauser, Vorromanische Kirchenbauten. Katalog der Denkmaler bis zum Ausgang der Ottonen (Veroffentlichungen des Zentral-instituts für Kunstgeschichte in München, III), 1966-71; H. Schlunk Die Kirche von S. Giao bei Nazaré (Portugal). Ein Beitrag zur Bedeutung der Liturgie für die Gestaltung des Kirchengebäudes, in Madrider Mitteilungen, 12, 1970; H. Ament, W. Sage, W. Weimann, Die Ausgrabungen in der Pfalz zu Ingelheim am Rhein, in Germany, 46, 1968; K.H. Krüger, Königsgrabkirchen der Franken, Angelsachsen und Langobarden bis zur Mitte des, 8, Jahrh. Ein Historischer Katalog. München, 1971; M. Vieillard-Troïekouroff, La Charelle du Palais de Charles le Chauve à Compiègne, in Cahiers archéologiques, XXI, 1971; W. Weyres, Die Domgrabung XVIII. Der Ostteil des Spätromischen Atriums und der fränkischen Kirche unter dem Hochchor, in Kölner Domblätter, 1971; F. de las Heras Hernandez, La Iglesia de San Vicente de Avila. Memorias de un templo cristiano, Avila, 1971; Marquise de Maillé, Les cryptes de Jouarre, Paris, 1971; Dom Jean Coquet, L'intérêt des fouilles de Ligu0é, Liguoé, 1968; J. Cibulka, Grossmährische Architektur des 9. Jahrhunderts, in Stil und Uberlieferung in der Kunst des Abendlandes, Akten des 21, Internationalen Kongresses für Kunstgeschichte in Bonn (1954), Berlin, 1957; Führer zu vor- und frühgeschichtlichen Denkmalern, 21, Hochtaunus,

Bad Homburg, Usingen, 1972; M. A. Martin Bueno, Nuevos restos visigodos en Catalayud (Zaragoza), in Estudios de edad media de la corona de Aragón, 9, 1973; W. Horn, Two Early Monasteries: one insular, the other continental. A visual reconstruction based on literary texts, in Intuition und Kunstwissenschaft: Festschrift H. Swarzenski zum 70, Geburtstag, Berlin, 1973; W. Erdmann, Die ehemalige Stiftskirche St. Peter und Paul, Reichenau-Niederzell, in Römische Quartalschrift, 68, 1973; H. Schlunk, Estudios iconográficos en la iglesias de San Pedro de la Nave, Consejo superior de investigaciones cientìficas, Instituto Diego Velazquez, Madrid, no date.

Sculpture: I. Belli Barsali, La Diocesi di Lucca. Corpus della Scultura altomedioevale, 1, C.I.S.A.M., Spoleto, 1959; Gèza de Francovich, Osservazioni sull'altare di Ratchis a Cividale e sui rapporti tra occidente e oriente nei secoli VII e VIII A.D., in Scritti di Storia dell'Arte in onore di Mario Salmi, 1, 1961; J. Raspi Serra, La Diocesi di Spoleto, Corpus della Scultura Altomedioevale, 2, C.I.S.A.M., Spoleto, 1961. E. Doberer, Zur Herkunft der Sigualdplatte, in Oesterreichischer Zeitschrift für Kunst und Denkmalpflege, 4, 1963; R. Meyer, Karolingische Kapitalle in Westfalen und ihr Verhältnis zur Spätantike, in Westfalen Hefte für Geschichte, Kunst und Volkskunde, 41, 1963; P.L. Zovatto, II Ciborio di S. Giorgio de Valpolicella nell'ambito della cultura figurativa altomedieovale e longobarda, in Problemi della civiltà e dell'economia longobarda, Papers written in memory of G.P. Bognetti, Milano, 1964; G. Panazza, Gli scavi, l'architettura e gli affreschi della chiesa di San Salvatore in Brescia, Reports of the VIII International Congress on High Medieval Studies, op. cit., vol. II; G. Panazza, La Diocesi di Brescia, Corpus della Scultura Altomedioevale, 3, C.I.S.A.M., Spoleto, 1966; O. Pächt, The pre-Carolingian Roots of Early Romanesque Art, in Romanesque and Gothic Art. Studies in Western Art. Acts of XX International Congress of the History of Art, I, Princeton, N.Y., 1963; A.M. Romanini, La scultura Pavese nel quadro dell'arte preromanica di Lombardia, Acts of the IV International Congress on High Medieval Studies, op. cit.; B. Pavon Maldonado, Influjos occidentales en el arte del califato de Cordoba, in Al-Andalus, 33, 1968; C. Dufour-Bozze, La Diocesi di Genova, Corpus della Scultura Altomedioevale, 4, C.I.S.A.M., Spoleto, 1968; M. Rotili, La Diocesi di Benevento, Corpus della Scultura Altomedioevale, 5, C.I.S.A.M., Spoleto, 1968; H.M. Taylor, Reculver reconsidered, in Archaeological Journal, CXXV, 1968; F. Kreush, Im Louvre weidergefunden Kapitelle und Bronzebasen aus der Pfalzkirche Karls des Grossen zu Aachen, in Cahiers archéologiques, 18, 1968; H. Schlunk, Sarcófagos paleocristianos labrados en Hispania, in Acts of the eighth International Congress on Christian Archaeology, Barcelona (5-11 Oct. 1969), 1972; G. Walcha, Mittelalterliche Flechtwerk. Kompositionen auf Kreuzplatten und Steinkreuzen in Schottland, in Kinstegerschichtliche Aufsatze, Mélanges H. Ladendorf. Kunsthist. Inst. der Univ. Köln, 1969; B. Marusič, Istrien in Frühmittelalter, Pula, 1969; C. Gaberscek, L'eredita Sasanide nella scultura altomedievale in Friuli, in Memorie storiche forogiuliesi, 51, 1971; G. Casarelli Novelli, La Diocesi di Torino, Corpus della scultura altomedieovale, VI, Spoleta, 1974; L. Pani Ermini, La diocesi di Roma, Corpus della scultura altomedieovale, VII, 1, Spoleto, 1974; La diocesi di Roma, VII, 2, Spoleto, 1974; A. Melucco Vaccaro, La diocesi di Roma, Corpus della scultura medieovale, VII, 3, Spoleto, 1974; M. Cecchelli, La diocesi di Roma. Corpus della scultura medieovale, VII, 4, Rome, 1976; G. Gaberscek, L'urna di S. Anastasia di Sesto al Reghena e la rinascenza liutprandea, in Historical papers in memory of P.L. Zovatta, Milan, 1972; L.

Stone, Sculpture in Britain - The Middle Ages, Penguin Books History of Art, 1972; C.K. Aked, Bewcastle Cross, in Antiquaries Horology, 8, 1973, n° 5; A. Thierry, Provincial sculpture in Africa and in the Danube area, in Aquileia and Africa, Acts of the IV Week of Aquilean Studies (28 Apr.-4 May, 1973), Antichità altoadriatiche V, Udine, 1974; I. R. Pattison, The Nunburholme Cross and Anglo-Danish Sculpture in York, in Archaeologia, 104, 1973; A. Grabar, Recherches sur les sculptures de l'Hypogée des Dunes à Poitiers et de la crypte Saint Paul à Jouarre, in Journal des Savants, 1, 1974; A. M. Romanini, Problemi di Scultura e Plastica Altomedieovale, in XVIII Week of Study of the C.I.S.A.M., II, Spoleto, 1971; Important Discussions were held at Heidelberg University between specialists in Paleochristian and High Medieval sculptures, published under the title: Kolloquium über spätantike und frühmittelalterliche Skulptur, Universität Heidelberg-Institut für Ur- und Frühgeschichte, for the years 1968-1970-1972.

Painting: G. Panazza, Gli scavi, l'Architettura, ecc., op. cit.; H. Schnitzler, Das Kuppel Mosaik der Aachener Pfalzkapelle, in Aachener Kunstblatter, XXIX, 1964; P.J. Nordhagen, The Mosaics of John seventh (705-707 A.D.), in Acta ad Archeologiam et artium historiam pertinentia, 1965; A. Freeman, Further Studies on the "Libri Carolini," in Speculum, XLV, 1971; L. Wallach, The Libri Carolini and Patristics, Latin and Greek, Prolegomena to a critical edition, in The Classical Tradition. Literary and Historical Studies in Honour of H. Caplan, Itaka, N.Y., 1966; P. Bloch, Das Apsismosaik von Germigny des Près. Karl und der alte Bund, in Karl der Grosse, op. cit.; S. Langé, Preliminari al complesso monumentale della Torba, in Castellum, 5, I sem., 1967; H. Belting, Die Basilica dei SS. Martiri in Cimitile und ihe frühmittelalterlicher Freskenzyklus, Weisbaden, 1962; H. Belting, Studien zur beneventanischen Malerei, Weisbaden, 1968 (cf. rev. by A. Peroni in Studi Medievali, s. 3, XI, dasc.1, 1970); W. Lammers, Ein karolingisches Bildprogramm in der Aula Regia von Ingelheim, in Festschrift H. Heimpel, 3, Göttingèn, 1972; Y. Christe, Le jugement dernier des Carmina Sangallensia, in Zeischrift für Schweizerische Archaologie und Kunstgeschichte, 29, 1, 1972; C. Bertelli, Icone di Roma, in Stil und Uberlieferung, op. cit.; D. Gioseffi, Cividale e Castelseprio, in Aquileia e Milano, Acts of the III Week of Studies on Aquileia (29 Apr.-5 March 1972), Udine, 1973; W. Ueffing, Beitrag zum ikonologischen Programm der Michaelskirche in Hildesheim, in Das Munster, 26, 1973; C. Davis-Weyer, Das Apsismosaik Leos III in S. Susanna. Rekonstruktion und Datierung, in Zeitschrift für Kunstgeschichte, 28, 1965; Die Mosaiken Leos III, und die Anfange der karolingischen Renaissance in Rom, in Zeitschrift für Kunstgeschifte, 29, 1966; Karolingisches und nicht karolingisches in Zwei Mosaikfragmenten der Vatikanischen Bibliothek, in Zeitschrift für Kunstgeschichte, 37, 1974; D. Oakeshott, The Mosaics of Rome, London, 1967; G. Matthiae, I Mosaici medieovali delle chiese di Roma, 1st. Pol. dello Stato, (2 vols.), 1967; D. Gioseffi, Le componenti Islamiche dell'arte altomedieovale in Occidente, in Aquileia e l'Africa, op. cit.; M. T. Gusset, La représentation de la Jérusalemme céleste à l'époque carolingienne, in Cahiers archéologiques, 23, 1974; C. Bertelli, G. Galassi, S. Maria in Via Lata, Roma, 1971; Acts of the day of revision on Castelseprio, 1972, Castelseprio (4 May 1972), in Rassegna Gallaratese di History of Art, XXXII, 119, 1973; G. Macchiarella, Gli affreschi di Saint-Pierre-les-Èglises, in Annuario of the Institute of the History of Art, academic year 1973-74, University of Rome.

Miniatures, illuminated manuscripts, ivories, gold and jewelry, ceramics: W. Koehler, Die Karolingischen Minia-

turen, II: Die Hofschule Karls des Grossen, 2 vols., Berlin, 1958 (cf. rev. by E. Kitzinger, in A. B., 44, 1962); H. Schade, Studien zu der karolingischen Bilderbibel aus St. Paul von den Muern in Rom, in Wallraf-Richartz Jahrbuch, XXI, 1959, XXII, 1960; A. Boeckler, Das Perikopenbuch Heinrichs II, Stuttgart, 1960; Th. Hoving, The sources of the ivories of the Ada School, Princeton University, Ph.D., 1960, Fine Arts; V.H. Elbern, Neue Studien zum Goldaltar von St. Ambrogio, in Christliche Kunstblattern 4, 1961, Altar und Altarraum; J.E. Gaehde, The Painters and the Carolingian Bible Manuscript of San Paolo fuori le Mura in Rome, New York Univ., Ph.D., 1963; D. Fossard, Décors mérovingiens des bijoux et des sarcophages de plâtre, in Art de France, 1963; F. Mütherich, Ottonian Art: Changing aspects, in Romanesque and Gothic Art, op. cit.; H.L. Kessler, The sources and the construction of the Genesis, Exodus, Majestas and Apocalypse Frontispiece Illustrations in the ninth century Touronians Bibles, Princeton Univ., Ph. D., 1965; B. Bischoff, F. Mütherich, Der Stuttgarter Bilderpsalter, facs. and text, Stuttgart, 1965-1968 (cf. rev. by E. Kitzinger, in A.B., 51, 1969, and by C. Nordenfalk, in Zeitschr f. Kstg., 32, 1969); D. H. Wright, The Italian stimulus on English Art around 700, in Stil und Uberlieferung, op. cit.; O.K. Werckmeister, Irish-northumbrische Buchmalerei des 8. Jahrhunderts und monastische Spiritualität, Berlin, 1967; T. Buddensieg, Zur Ottonischen Buchmalerei und Ekfenbeibskulptur in Sachsen, in Festschrift Usener, 1967; D. Tselos, Defensiva Addenda to the Problem of the Utrecht Psalter, in A.B., XLIX, 4, 1967; J. Engelbregt, Het Ultrechts Psalterium, een Eeuw Wetenschaffschijke Bestudering (1860-1960), Utrecht, 1965; A. Peroni, Oreficerie e metalli lavorati tardo antichi e altomedioevali del territorio di Pavia. Catalogo, C.I.S.A.M., Spoleto, 1967; P. Bloch, H. Schnitzler, Die Ottonische Kolner Malerschule, Dusseldorf, 1967; B. Bischoff, Mittelalterliche Schatzverzeichnisse. 1. Von des Zeit Karls des Grossen bis zur Mitte des 13. Jahrhunderts, München, 1967; C. Bertelli, Stato degli Studi sulla Miniatura in Italia, in Studi Medievali, s. 3, 9, 1968, 1; S. Bruce-Mitford, The Sutton Hoo Ship Burial, London, 1968; O. von Essen, Die Langobardische Keramic aus Italien, Weisbaden, 1968; P. Hoegger, Ottonische Apokalypsen, "Unsere Denkmäler," 20, 1969, Mél. A. Knoepfli; R. L.S. Bruce-Mitford, The Art of the Codex Amiatinus, in the Journal of the British Arch. Association, XLII, 1969; J. Werner, Zur Verbreitung frügeschichlicher Metallarbeiten (Werkstatt-Wanderhandwerk-Handel-Familverbindung), in Antikvarist Arkiv, 38, 1970; R. Moosbrugger-Leu, Die Schzeiz zur Merowingerzeit, 2 vols., Bern, 1971; H. Kessler, "Hie homo formatur": The Genesis Frontispieces of the Carolingian Bibles, in A. B., 53, 1971; A. Gauert, Der Ring, Der Ring der Königin Arnegundis aus Saint Denis, in Festschrift H. Heimpel, 3, Göttingèn, 1972; S. Rosenthal, The Illuminations of the Vergilius Romanus (Cod. Vat. Lat. 3867). A stylistic and iconographical analysis, Zürich; J. Beckwith, Ivory carvings in early Medieval England, London, 1972; M. Werner, The Madonna and Child Miniature in the Book of Kells. Part I, in A.B., LIV, 1, 1972; H. Wentzel, Das byzantinische Erbe der ottonischen Kaiser. Hypothesen über dem Brautschatz der Theophano, in Aachener Kunstblätter des Museumsvereins, 43, 1972; P. Riché, Trésors et Collections d'aristocrates laïques carolingiens; J. Driehaus, Zum Problem merowingerzeitlichen Goldschmiede, in Nachrichten der Akademie der Wissenschaften in Göttingen. Phil-hist. Kl., 7, 1972; A. Grabar, Les manuscrits grecs enluminés de provenance italienne (IX-XI cent.), Bibli. des arch. VIII, Paris, 1972; A. V. Vandersall, Two Carolingian Ivories from the Morgan Collection in the Metropolitan Museum of Art, in the Metropolitan Museum Journal, 6, 1972; T.J. Brown, North-

umbria and the Book of Kells, in Anglo-Saxon England, I, Cambridge, 1972; P. Iso Müller, Disentiser Initialkunst des 9. Jahrhunderts, in Zeitschr. f. Schweiz. Arch. und Kstg., 30, 1973, 2; H. Belting, Der Einhardsbogen, in Zeitschr. f. Kstg., 36, 1973; J. J. G. Alexander, C.M. Kaufmann, English Illuminated Manuscripts 700-1500. Catalogue, Bibli. Royale Albert I, Bruxelles, 1973; H. Westermann-Angerhausen, Die Goldschmiedearbeiten der Trierer Egbert-Wekstatt, Trier, 1973; B. de Montesquiou-Fezensac, D. Gaborit-Chopin, Le trésor de Saint Denis. Inventaire de 1634, Paris, 1973; A. L. Vandersall, The date and provenance of the Franks Casket, in Gesta, 11, 2, 1973; V. Saxer, Le Manuscrit 1275 de la Biblioteca Governativa di Lucques, Sacramentaire grégorien du groupe de Fulda (X cent.), in Rivista di Archeologia Cristiana, 44, 1973; H. Fillitz, Die Cathedra Petri. Zur gegenwartige Forschungslage, in Archivum historiae Pontificiae, 11, 1973 (with the preceding bibliography on the argument); O. Pächt, J.J. Alexander, Illuminated Manuscripts in the Bodleian Library, Oxford, 1973; C. Nordenfalk, The Chronology of the Registrum Master, in Festschrift O.Pächt, op. cit.; H. Fillitz, Der Beginn der Buchmalerei in Einsiedeln, in Festschrift O. Pächt, op. cit.; B. Iso Müller, Disentiser Initialkunst des 9. Jahs., in Zeischrist f. schweiz. Arch. und Kstg., 30, 1973; P. Bloch, Gab es eine Reichenauer Malerschule? in 13. Deutscher Kunsthistorikertag in Konstanz, 1972; K. Hoffmann, Das Herrscherbild im "Evangeliar Ottos III" (Clm 4453), in Frühmittelalterliche Studien, 7, 1973; J. M. Plotzek, Zur Initialmalerei des 10. Jh. in Tier und Köln, in Aachener Kunstblätter, 44, 1973; C. Nordenfalk, The draped lectern. A motif in Anglo-Saxon evangelist portraits, in Festschrift Swarzenski, op. cit.; F. Mütherich, Die Touronische Bibel von St. Maximin in Trier, in Festschrift O. Pächt, op. cit.; F. Mütherich, Ein karolingische Evangelistenreihe. Kopie und original, in Festschrift H. Swarzenski, op. cit.; M. Schapiro, The Miniatures and the Florence Diatessaron (Laurentiana, Ms 81): Their place in late Medieval art and supposed connection with early Christian and insular Art, in Art Bull., 55, 1973; C. Nordenfalk, The Diatessaron miniatures once more, in A.B., 55, 1973, C. Nordenfalk, Die Zierbuchstaben, München, 1973; R.B.K. Stevenson, The Hunterston Brooch and its significance in Medieval Archaeology, XVIII, 1974; G. Haseloff, Salin's Style I, in Medieval Archaeology, XVIII, 1974; A. Melucco Vaccaro, Un bronzo con scene di battaglia da una tomba Longobarda, in Atti dell'Accademia Nazionale dei Lincei, CCCLXXI, 1974. Memorie. Classe di Scienze morali, storiche e filologiche, s. VIII, vol. XVII, fasc. 5; C. Nordenfalk, Corbie and Cassiodorus, in Pantheon, III, Sept. 1974; N. Gussone, N. Staubach, Zu Motivkreis und Sinngehalt der Cathedra Petri, in Frühmittelalterliche Studien, 9, 1975; Das Einhardkreuz, Vortrage und Studien der Münsterfaner Diskussion zum Arcus Einhardi. Hrsg. von K.Hauck (Abh. der Ak. der Wissensch. in Göttingen, Phil.-Hist. Kl., III, 87) Göttingen, 1974 (cf. rev. by K. Hoffmann in Götting. Gelehrte Anzeiger, 228, 1-2, 1976).

<div align="right">GIANCLAUDIO MACCHIARELLA</div>

ROMANESQUE (PLATES 95-97)

After the publication in 1968 of the final volume of Conant's investigations on Cluny, one can say that the themes stemming from the study of the great abbey are more than ever at the center of research. In spite of the attempt at finality, the differences of opinion as to

methods and times of construction, almost classical in the history of Romanesque art, have not been silenced.

Conant carefully followed the entire history of the abbey, collecting all notices about it from its first foundation and matching them with the results of the excavations. As regards Cluny II, built under Abbot Mayeul between 948 and 981, he insists on the analogy with the ideal building described with dimensions in the Consuetudinary of Farfa. It was a church with a nave and two aisles, probably barrel-vaulted with three graduated apses, transept with a tower at the crossing, with an atrium at the west end, transformed into a Galilee under Abbot Odilon (993 or 994 - 1048). Conant's chronology for Cluny III, the great building founded by Abbot Hugues (1049 - 1109) rests on a basic hypothesis that when, on October 25, 1095, Urban II was present at the consecration of the two altars in the Sanctuary and three in the Ambulatory the apse was already finished and construction of the surrounding parts well advanced. Thus, the minor transept could have been concluded inside that year, perhaps without the vaulting. According to this scheme, the preliminary plans for the great undertaking would have been carried out in 1077 - 1081. The foundation ceremony on September 30, 1088, would have taken place when the foundations for the eastern part had already been laid, perhaps from 1084 onwards, and the building was beginning to rise above ground level.

Thus, it is clear that for Conant, the work started at the east end with the apse, in agreement with the early dating (before 1095) of the famous capitals in the ambulatory already put forward by Porter and by Oursel. The building of the greater transept, with one or two bays of the nave, would date from the year of the consecration. At the same time, the vault of the smaller transept would have been completed, after which the vaulting of the larger one would have been undertaken. Conant has noted a reference point in the consecration, about 1100 - 1103, of the Chapel of St. Gabriel. The bearing portions of the five eastern bays of the nave ought to have been very well advanced towards 1105 - 1106 – our scholar thinks, in fact, shortly after the base for the great porch in whose remains he sees the presence of the artists working on the capitals of the apse area. Thus, he considers that the sculptures were readied between 1106 and 1109 and finished and set between 1108 and 1112. By 1113, the main body could have been finished at least to the level of the upper windows. This is taking into account that, for him, the nave of Cluny II was demolished in that year and that shortly after the construction of the great cloister was begun on the north side under Abbot Ponce, who succeeded Hugues on his deathbed in 1109. Inside 1120 the vaulting ought to have been finished in view of the fact that an accident which caused a collapse is recorded as happening in 1125. A rebuilding thus would have to have been carried out before the general dedication of the church in 1130 by Innocent II. This marked the final completion of the works.

Salet is decisively opposed to this chronological arrangement. He prefers, at least in part, the traditional scheme of the French archaeological school. His arguments are firstly based on a different interpretation of the sources relating to the early phases of construction. He emphasizes that the letter of Alphonso VI of Castile, with which that sovereign donated money to the Abbey of Cluny for the construction of the church, can certainly be placed after the dating of Toledo in 1085, but could even be later than 1088. This is the latest year acceptable to Conant, who deduces that the foundations had already been begun. Salet thinks that to imagine that the building was above ground level at the time of the foundation ceremony is to force the texts. The ceremony would, if anything, celebrate the effective beginning of the work, which in any case, in view of the lateness of the season, would not go ahead rapidly until the spring of 1089. A second point upheld by Salet is that Conant has made a confusion between the consecration of the alter and the dedication of the church as regards the ceremony which took place in 1095. At that time, the liturgical characters of the two ceremonies were totally distinct: for the dedication it was necessary that at least a part of the building should have been constructed, whereas that had no importance for the consecration of an altar. If at the time of the consecration by Urban II the choir had been completed, Salet fails to understand why Abbot Hugues did not take advantage of the Pope's presence to proceed to the dedication of the edifice. This ceremony, according to our sources, the Pope himself said would have to be held on another 25th of October, when the construction was far enough advanced, as in fact it was in 1130. Salet deduced from this that in the choir area at that time there existed neither columns nor walls, which are elements essential for a dedication. Neither were there radial chapels to connect with the consecration of the minor altars.

Salet is uncertain about the evidence of the fragmentary inscription recording the consecration of the Oratory of St. Gabriel which Conant used as a term of reference for the conclusion of the work on the southern branch of the greater transept. The break across the date, the type of lettering, and the name of the prelate remembered (Peter, Bishop of Pamplona) leave room for doubt. In his view, it would be possible to identify the personage with greater precision to discover whether the reference is really, as Conant thinks, to Peter of Roda, who died in 1114 or 1115. As for the construction program, Salet contests the theory that work began with the apse. He submits for evidence the southern arm of the great transept. The only surviving part of the building has been given a rigorous constructional analysis and shows evidence of a gradual increase in elaboration taking place in at least three places; according to Salet, this would correspond to different projects. An initial plan shows that without vaulting the builders advanced to considering one with vaulting at a lower level than that which was ultimately decided on in the third plan. This scholar further points to the southern arm of the transept, narrower than the central nave and hence creating an anomalous rectangular crossing, as being the oldest part of the building, at least as regards its lower courses.

In Salet's view, the masonry has been successively adapted to the variations of the plan. The capitals, integral with the upper parts of the columns which belong to the latest plan, cannot belong to the end of the 11th century. This hypothesis, which excludes the idea of a regular progression of the work from east to west, finds support in the fact, already noted by Conant, of a divergence of the axis of the minor transept in the sense of an advancing of its east wall with respect to that

of the ambulatory. In any case, for Salet, the area of the choir also shows the effects of a gradual variation of plan. Salet feels that while the ambulatory was set out from the beginning in accordance with the first project, the apse was built later, at the time when the greater height of the roofing in the second plan had been decided on. The right hand side of the choir shows the adoption of the elevation on three levels introduced by the first project. These vertical changes lead Salet to conclude that the work proceeded by horizontal sections, which evidently would place all the sculptured parts in the concluding phase.

According to this scholar, the times for the work which can be deduced from the sources would be longer than those which Conant arrives at. The connection between the burial of Abbot Hugues and the finishing of the apse is not reliable enough for him, since the first certain reference comes only from 1221 when Honorius III gave permission for the translation of the corpse there. The life of St. Hugues of Gilon, which declares that the abbot built the church in 20 years, is not a reliable document because it was written after the events. The document was written later than 1120. The demolition of the nave and transept of Cluny II, which could have taken place only after the completion of the sanctuary, should, he considers, be put around 1121 - 1122 following the creation of the cloister, which in turn could have been started only after 1118, in which year the abbot's chapel, which supports the north walk of the cloister, was dedicated.

Finally, for Salet, the work would have been completed under Peter the Venerable, partly because of donations received from King Henry I of England, and towards 1132, in which year a General Chapter was convened. Even the information about a collapse in 1125 does not seem conclusive for him. The exact part of the church in which it took place is not stated, so it might have involved the transept and not the nave. Salet also finds confirmation, in the results of the excavation of the portico, of his theory that the building proceeded by horizontal layers, since the masonry shows this kind of homogeneity. In this case, also, the differences of form between the two eastern bays and the others, deducible from the design of the surviving remains and from this arrangement of the three levels into which the wall is divided, would be due to different projects, originally with a barrel vault like that of the nave and successively with crossed ribbing. The portico would have been started, according to Salet, under Peter the Venerable around 1132 - 1135, but only a first setting out of the surrounding wall, while most of the work would have been done about the turn of the century, to be completed under Roland of Hainault (1220 - 1228).

This radical contrapositioning of hypotheses has not so far found any solution. It reflects in substance an interpretative duplicity which, as we shall see, rebounds also into other areas involving phenomena which are geographically distant from Burgundian culture, such as the Romanesque of Emilia. If at certain points, Salet's arguments seem to be forced polemics, as in the idea of erecting the building on its whole plan simultaneously associated with that of the impossibility of a dedication in 1095 because nothing had been finished (about which Crozet is justified in observing that, precisely in this case, we should have had listed at least approximately all the parts of the building necessary for carrying out the ceremony), it does not follow that they can be discarded, especially those concerning the archaeological analysis of the masonry. However, Conant, in a later paper, is right to object that the historical documents, such as the life of St. Hugues of Gilon, even if they were written towards 1120, always present material which is contemporaneous with the events. The Saint's funeral must have taken place in Cluny III and not Cluny II as sustained by the French scholar. Therefore, the apse must certainly have been terminated by 1109. This date is also deducible stylistically from the designs and the fragments of the sarcophagus in which the abbot was buried.

Above all, the American convincingly disagrees with the hypothesis of constructing in horizontal layers. He takes into account the different sizes and shapes of the column bases found during the excavations. He does not appear to be on such good ground in combatting the consequences following the changes in the project and the slow evolution of forms noticed by Salet. Very apposite and incisive is Crozet's invitation addressed to both contendants to observe more historical caution and above all to be more flexible in their limits, since it is evident that in judging a building as complex as Cluny III, and furthermore on the basis of very scarce evidence, a certain conciliatory prudence appears to be an unavoidable compromise.

A careful contribution to the architectural problems connected with the Cluniac Order has been made by the final publication of the results of the archaeological investigation carried out over many years by Read Sutherland on the remains of the abbey of St. Fortunat at Charlieu. This abbey came under Cluny in 932. Rebuilding started immediately on the Carolingian single-naved church with crypt, ambulatory, and timber roof, which was founded in 872. The internal space of the old church was divided by a double row of columns with which was associated a barrel vault over the central nave and two half-barrel vaults over the side aisles.

The greatest surprise, however, comes from the transformation of the apse with the recomposition of an ambulatory. Sutherland proposes that the six pairs of columns have been reused in the chapter house and cannot come from the 11th century building, which had no ambulatory. The fact that such layout is not found elsewhere in the Cluniac world suggests that the reconstruction at Charlieu took place in its first phase earlier than that of Cluny II. Therefore, this abbey church bears witness to the existence of a fully vaulted Cluniac church before 948. It must, however, be added that Read Sutherland historically justifies the presence of the columned ambulatory on the basis of the fact that Abbot Odon came from Tours, where already in the tenth century, according to a certain interpretative current, the erection of the ambulatory in St. Martin's had involved the creation of arcades on columns attached to the apse walls.

At this point, we must refer to the investigations subsequently carried out by Lelong, who demonstrated that the hypothesis of the existence of an ambulatory at St. Martin's in Tours before the foundations laid by Abbot Hervé between 1013 and 1014 had no basis in fact. He also showed that the ambulatory with five radial chapels, including a wider and deeper one on the central axis (traces of which were found in a 19th-century excavation) cannot, for archaeological reasons, be

referred to that epoch, but must be postdated to the reconstruction following a fire in 1096. The entire edifice was rebuilt on a nave and four aisles plan based, even for the dimensions, on St. Sernin at Toulouse and Santiago at Campostella.

A complete reconstruction was commenced at Charlieu under Abbot Odilon, who ruled from 994 to 1049. This is shown by the different orientation of the remains with reference to the oldest foundations. This was a building with a nave and two aisles of only four bays, with a slightly wider transept and a very large choir, and having five graduated apses, of the type conventionally known as "Benedictine." A characteristic element of this particular building was the presence of a small additional apse at the end of the main apse. The same type appears also at Anzy-le-Duc. The larger column foundations at the crossing demonstrate the existence of a tower, while the pillars of the nave, in view of the dedication date of 1094 which marks the end of the works, are among the very earliest examples of attached columns. The most important element from the whole study by Read Sutherland is the demonstration of the existence of a means of direct lighting of the central nave. This fact has always been rejected and is now finally vindicated by the discovery of a print which shows the last part of the building to survive during its demolition. This shows the presence of a long window flanked by two blind arches, in effect lighting, by means of windows cut into the barrel vault, according to a type which evidently existed before the improved solutions of Cluny III.

The variety of cultural impulses present in Cluniac buildings, and the difficulty of relating them all to the principal building of the order regarded as a reference point, come to the fore in a careful analysis of La Charité-sur-Loire. Starting from the monograph by Raeber, who first detected two separate phases in the building, Vallery-Radot has laid down the basic elements of its complex history, which shows a good five campaigns of work. The ground on which the abbey stands was given to the Cluniacs between 1056 and 1059. The founder, Abbot Gerard, died in 1087 and was buried in the choir. The first constructional campaign took place between these two dates and included the choir, the transept, and outer walls of the double aisles as far as the four eastern bays. Choir and transept were on two levels, with a central apse and six small side apses. In the whole of this building there remain both levels of the transept, including the columns of the crossing and the six little apses. Of these, the outer ones and the intermediate ones are still in their original state while the inner ones have been transformed into the side aisles of the new choir. The second and third periods of building involved the eight eastern bays of the nave and took place between 1087 and 1110 - 1115. In the meantime the building was consecrated by Paschal II. The nave, at present, is flanked by two side aisles with pillars similar to those at the crossing (cruciform with four attached semi-columns) and with the walls above showing three levels in elevation. Inside the perimeter set out in that way, the two oldest bays were realized: the one nearest the transept with large circular arches and a blind triforium at the middle level of the walls. This shows that they were planned from the beginning for a three level elevation in contrast to the two levels in the choir and transept. This gave rise to the reconstruction of the rest of the building according to a new formal and decorative pattern, with the work carried out in horizontal sections. The fourth and fifth campaigns, datable between 1110 - 1115 and 1135 were, in fact, dedicated to the transformation of the choir and transept and to the construction of the two remaining western bays of the nave and the northern tower of the façade. The old choir was substituted by a deeper one, of three bays, flanked by aisles created by breaking down the little apses immediately flanking the apse, and terminated by an ambulatory with five radial chapels. The three-level elevation, with an intermediate blind triforium and windows in the upper part, was extended to the whole of the area. An octagonal cupola was erected at the crossing, standing on conoids enclosed in a massive square drum. The whole area was characterised by wide segmented arches with double courses connected to a segmented barrel vault. The change of plan which took place in 1087 was very important because it is not possible to make reference to Cluny III (which was begun the following year) as regards the introduction of the tripartite division of the elevation of the walls and the blind triforium, but rather if at all to St. Etienne a Nevers in whose choir the blind triforium was already begun in 1068.

This means an independence of and a precedence over the ways of the mother house which must be underlined above all for the extraordinary parallelism it offers with what Salet has been saying about Cluny. The slow evolution through which La Charité-sur-Loire passed, with a subsequent raising of a monumental order, corresponds substantially to the idea that at Cluny there had been a change of plan involving a modification of the height of the vaulting and, consequently, a division of the walls. The tangible value of that parallelism can be felt in the different relationship between choir and apse. At La Charité-sur-Loire, which was the result of a unified operation, in the final phase these two are on the same level and are not divided by a filler wall as at Cluny. This is according to a formula which, for Salet, was determined by the fact that the apse belonged to the second project, while the vault of the choir was part of the third. It seems evident from these considerations that many problems remain to be cleared up as regards cultural currents which are seen to be much richer and more complex as a result of deeper investigation.

The problems of the "Benedictine" plan and its diffusion have found a new reference point in the excavations carried out in St. Etienne at Caen. They have shown the remains of the first abbey, built between 1063 and 1073 by William the Conqueror. The remains consist of a choir flanked by narrow aisles and closed by three graduated apses connected to those opening from the eastern wall of the transept. This announcement is important because this type appears only twice previously in Normandy - at Notre Dame at Bernay, perhaps about 1040, and at La Trinité at Caen, towards 1060. It is precisely its appearance at St. Etienne at a certain date that seems now to be determinant in explaining its immediately subsequent diffusion both in Normandy and in England.

St. Foy-le-Conques has been the object of studies by Lesneur and by Deyres as an example of a Pilgrimage Church. This theme is particularly interesting because, once it was established that the works under Abbot

Odolric were definitely started between 1041 and 1050, the exact determination of the course of events, and the time required for the building to reach the present form of the edifice, it would be possible to clarify whether or not the building served as a prototype for other great Pilgrimage churches such as St. Martial at Limoges, St. Sernin at Toulouse, and St. James at Campostella. The investigations have shown that the building was really the result of a complex series of operations and modifications of such magnitude as to exclude the idea that it can have been any kind of prototype. It has, in fact, been demonstrated that the original foundation (which is defined as Conques II to distinguish it from the primitive Carolingian church) was intended for a plan with a nave with alternate pillars for an exposed timber roof. In this arrangement, the nave would have been directly lit by means of very widely spaced windows at the height of the arcade connecting the pillars in such a way as to allow this wall to act as abutement for the cross-vaulted roofing of the aisles. This first project was, however, modified with the introduction of a vault over the central nave at a point lower than the present roof and without allowing for matrons' galleries over the side aisles. This is particularly noticeable in the choir area where the ambulatory with three radial chapels, although it appears as raised above the small apses, has windows at the same height and of the same size as theirs. This is an arrangement which is quite unusual and which makes it clear that the ambulatory has been raised to make connection with the tribunes above the aisles flanking the choir, with the transept, and, to a lesser degree, with the nave.

This observation, beyond confirming that the area of choir has been modified from the first design only as regards the elevation and not in plan, proves also that the women's galleries were introduced only at the beginning of the 12th century with the creation of the present edifice, Conques III. The key factor in the transformation was the appearance of a transept with three aisles and women's galleries (sharply distinguished from the previous church, which had only a single body towards the east end from which two graduated small apses opened on either side) realized by externally revealing the inner ones and closing the outer ones in line with the wall. The characteristic element of the original project for Conques II lies in the peculiar attempt to achieve a fusion of the ambulatory with the "Benedictine" plan, rather than in its worth, which is lacking, as a prototype for the great pilgrimage churches which the building came to resemble only in the later phases of the transformation. This fusion, at the same time, reversed the traditional disposition which at Cluny II, at St. Nicholas at Caen, at Morienval, and elsewhere has the same apses arranged in line with the wall in an internal position, beside the principal apse. This can be explained by the desire to cover both the choir aisles and the eastern aisle of the transept with a single roof.

Equally innovative proposals are advanced by Lyman for that crucial edifice which is St. Sernin at Toulouse. This edifice is an absolutely fundamental example. Starting from the four capitals of Miégeville Portal, which is situated in a zone which certainly belongs to a late stage in the building, he notes that they show an irregularity of insertion that indicated that they were originally situated elsewhere. The stylistic plan of the capitals shows evident affinities with the reliefs from the workshop of Bernardus Gilduinus, who "signed" the table of the High Altar, and, in particular, with the sculptor who executed the well-known reliefs in the ambulatory. This means that they can certainly be assigned to some period before 1096, the date of the consecration of the High Altar and of the finished parts of the basilica by Pope Urban II. This is in contrast with the date of the portal, which is undoubtedly later than that event. The second observation made by Lyman is that, in the interior, the Gilduinus lodge's output can be easily distinguished from the substantial number of capitals by the previous team and erected along the choir and the new Portal of the Counts and in somewhat lesser numbers in the transept and in the nave.

Analyzing the topographical disposition of the two groups of capitals thus separated, Lyman notes that the older ones are built into the lower parts of the basilica, from the eastern end of the choir down to the second bay on the south side and the third bay on the north side of the side aisles. On the level of the women's galleries they appear near the crossing, while they disappear at the second bay of the triforium of the nave and begin to be missing from the same point in correspondence with the second opening of the triforium in both transepts. And on the contrary, the capitals which can be directly referred to the masons under Bernardus Gilduinus are to be found in the third and fourth bays of the triforium (the lates ones) and all in connection with structures supporting the principal vaulting. The relationship between these two lodges is displayed, according to Lyman, in a capital in the upper range of the north transept in which he sees, as in at least one other case, work started by the one and finished off by Bernardus Gilduinus' masons.

According to the traditional view, that succession would be interpreted as due to an urge to complete the galleries and transept as soon as possible after the consecration in 1096 using Gilduinus' men who had previously been employed in working on the altar and for an incompleted decoration of the interior from which come not only the reliefs in the ambulatory but also the capitals of the Miégeville Portal. In the opinion of the the American scholar, however, the certainty of the date of 1096 has led everyone, with its fixed anchorage, to concentrate into the next three or four years happenings, such as the interruption of the first building campaign, the completion of the transepts, and the beginning of the nave, which could very well have been spread out over a different and longer period of years. The masonry indicates two decided interruptions, the first at the height of the portals and half way up the west wall of the transept, and the second at the connection of the transepts with the secondary apses. From observations of the positioning of the various styles of sculpture it appears that the architectural work was interrupted earlier than the decorative datings would suggest, in the sense that numerous capitals from the original workshop were utilized for the completion of the transept at the end of the intermediate constructional period.

If the works can be supposed to have been started between 1072 and 1077, when the Canons accepted the rule of St. Augustine, that phase can be placed as immediately following 1083 when they recovered possession of the already partly constructed building from which they had been forcibly ejected by the Benedictines of

Moissac in 1082, the date which would apply to the first interruption. Lyman finds confirmation for this early chronology in a comparison with the carvings in the cloisters of Moissac and in the supposition that in 1082, at the moment of the interruption of the works in Toulouse, part of Gilduinus' lodge, which had by then already completed the slab of the altar, went to work in the cloister, where the capitals show in many cases a fusion of motives used by both lodges separately at St. Sernin. In this scheme, assuming that the masons transferred from Toulouse to Moissac in 1083, it would become more logical to conclude that work on the cloister was finished in 1100, according to the well-known inscription there, rather than to coordinate this chronological element with the consecration of St. Sernin in 1096. This would lead one to suppose that the date on the cloister indicates rather its beginning.

Lyman's hypotheses have not yet been confirmed by other scholars. In fact, Cabanot and Durliat have repeatedly supported the validity of the traditional terms of the question, both for Moissac and for Toulouse. Particularly in the case of this last building, Durliat, while accepting 1080 as the date of the beginning of the work, has pointed out the presence in the initial phase of the construction (that of the choir and the transept) of three successive workshops, bringing forward the appearance of that of Bernardus Gilduinus to some time around 1096. This is the year when, in his opinion, the choir, the ambulatory, and the lower level of the transept must have been finished, while the work still in progress on the upper level was completed around 1100. It is not precisely known at what moment Canon Raymond Gayrard became "operarius," but work then began on the nave, which on his death in 1118 was probably finished, with the roof on the first three parts and over the parts corresponding to the aisles, while the rest can only have consisted of outer walls and the portals. With the sudden end of the canon's enthusiastic drive, the work dragged on for a long time halfheartedly and inefficiently, as can easily be seen from the analysis of the building.

On the other hand, Lyman's hypotheses about the spreading around outside Toulouse of the carvers from Bernardus Gilduinus' lodge have found some confirmation in the publication of a bracket reused in the apse of the Cathedral of Jaca, which was remade in 1790 with some use of ancient material. The Cathedral is closely allied stylistically with the products of the Toulouse Master. However, it must be added, that this does not provide a definite confirmation chronologically speaking of the American's theories. The construction of the Spanish cathedral has recently been put forward, for well-founded reasons which we shall mention later, from the traditional 1063, which had previously been considered as the consecration date. Moralejo Alvarez, in publishing this sculpture, mentions that it can be argued that work was still going on at Jaca until 1096 - 1098 and that this dating strangely coincides with the consecration of St. Sernin's. However, this still does not, as to general lines, contrast with Lyman's belief in a diffusion of Bernardus Gilduinus' methods towards 1083. He is taking into account that at the date the works at Jaca had already been started and also, in fact, that opportunely Moralejo Alvarez associates the Jaca bracket with other carvings in the area also in the Toulouse style, such as those on the porch of the

Castle of Loarre near Huesca dated before 1096, or the ivories of St. Felix' Chest at St. Millan de la Cogolla dated later than 1090, which is the date of the translation of the relics but perhaps executed before 1094. This evidently supposes a diaspora from Toulouse near the latest dating from the St. Sernin sculptures, which can be ascribed to the Bernardus Gilduinus lodge, even if it was before the consecration in 1096.

Among the problems which have been faced as regards sculpture in the Langue d'Oc, and beyond Sauerlander's study of the splendid wooden crucifix at Moissac, rightly compared with the abbey's celebrated portal, we must remember the attempt by Seidel to demonstrate that the well-known complexes preserved in the museum of the Augustinians at Toulouse — that is to say, the doorways to the chapter houses in St. Stephen's and La Daurade — are no more than improper recompositions at the limits of the ethical carried out between 1823 and 1835 by an amateur "archéologue," Alexandre Du Mège. However, Durliat has advanced full and well-motivated reserves about the way Seidel has quoted and interpreted his sources. He has shown how, in fact, a more careful and informed study could show the insufficiency of the bases of his arguments, even if the problems he raises are certainly not totally without foundation.

Recent interventions have also shown how, in many cases, a radical revision of beliefs enjoying long and continual acceptance is necessary. These regard particularly some monumental Spanish Romanesque capitals for which there have been proposed, and above all proved incontestable, chronological variations which considerably modify the position in a global critical appreciation. For St. Isadore at Léon, the date of 1063, the time of the consecration of the church founded by Ferdinand I and rebuilt in the 12th century, has been extended also to the Pantheon de los Reyes which stands in front of the later building like a porch. William, re-examining the question archaeologically, has shown how there still remains, along the north and west sides, pieces of Ferdinand I's church, an Asturian type edifice with three aisles covered by a barrel vault and having three rectangular apses. The relationship between these remains, the pantheon, and the northern gallery which flanks both of them and which shows, by the type of its capitals, that it was constructed at the same time as the pantheon proves that the church is certainly earlier than the pantheon. The latter cannot be dated to 1063, but must be thought of rather as belonging to the end of the 11th century. At the same time, other archaeological reasons prove that the well-known cycle of frescoes which decorates the pantheon was executed before the demolition of the church of Ferdinand I. So, although it is generally regarded as belonging to the third quarter of the 12th century, it ought to be brought forward to before 1124 when the work of renovating the church probably began.

Equally striking is the case of St. Mary of Besalù, an edifice with a nave and two aisles and three apses, a transept only slightly wider, and barrel vaulting in the choir area. Gaillard dated these, on the basis of the report of a consecration in 1055, to the 11th century. He interpreted it, in view of the fine quality of the stone carving, as proof of the survival in the Catalan area of a refined executive visigothic and Mozarabian tradition. Library research has, however, demonstrated that there

were two churches dedicated to St. Mary in the 11th century at Besalù. One was outside the castle, in which towards the end of the century there was installed a community of canons previously resident at the Church of St. Genesius and St. Michael; the other, inside the castle, is in fact the Palatine Chapel, which was consecrated in 1055. It was only after 1137 that the canons transferred themselves into the castle and carried out a reconstruction of what was defined as the "new" church in a document of 1179. So the edifice which has come down to us partially destroyed certainly goes well back to the 12th century, as in fact has already been suggested on stylistic grounds by Puig y Cadafalch.

A similar review of the data relating to early periods of Jaca Cathedral has shown that all the documents which testify to its consecration in 1063 are fake. This confirms the stylistic conclusions reached in the past by Gaillard in direct opposition to the historical dating. An essential element for deciding the effective date of starting the building is supplied instead by a deed by which Sancho Ramirez, King of Aragon and Pamplona, grants the city the increase of legal status from being a "villa" to being a "civitas" which it had to be to allow it to be chosen as the see of a bishopric. The deed is not dated; however, on the basis of a series of considerations the time of its preparation can be placed as around 1077, a date before which it would not have been possible to found a cathedral at Jaca. Work on the building would not in any case have had to be finished in 1096 when it was decided to transfer the see to Huesca, only just reconquered from the Muslims, so that the work was suddenly stopped. This explains why some capitals were used without ever being finished and why the vaulting of the central nave was never constructed.

The relationship between the masons' lodges of France and Spain between the 11th and the 12th centuries is also connected with the studies dedicated by Moralejo Alvarez and by Durliat to a porch which once existed at the northern end of the transept of Santiago at Campostela. This is the so-called French Gate, which was destroyed in a rebuilding in the second half of the 16th century. The surviving pieces, some inserted in the wall of the opposite Porta de las Platerìas and some preserved in the cathedral museum, are enough to permit the reconstruction of doors with two ordered openings, each decorated with six columns, three on the right and three on the left, plus a 13th column in the middle. The portal was also ornamented with a cycle of Stories from Genesis and with a Christ in Majesty surrounded by the symbols of the Evangelists. Stylistic analysis of the surviving pieces allows it to be said that the work is predominantly by the same Maestro de las Platerìas, with some of the same throw back to the flavor of late antiquity as can be seen at the same time at Jaca and at Toulouse.

There also appear two minor artists connected with the lodges at Jaca and at Leòn. The first, whose style is also to be found in the portal of the Lamb at Leòn, was the carver of the Christ in Majesty, of the symbol of the Evangelist St. Matthew, and of the Reproval of Adam and Eve. This artist is distinguished by a marked taste for smooth and geometrical forms channelled by stiff folds and by a certain vagueness in the faces. The second is the sculptor already indicated by Porter as the Master of the Betrayal, since his touch can be recognized in the scene of Christ's Arrest on the

Portal of the Platerías, while he also sculpted the Pardon Portal at St. Isidore's in Léon. Thanks to his freely narrative style, the Ejection from Paradise, and perhaps Abram's Sacrifice in the French Gate, can be assigned to him. The three artists appear to have worked simultaneously on the portal, going on then to that of Las Platerías only to leave Campostela before the end of the works. All this happened, according to Moralejo Alvarez, around 1100, but Durliat thinks this is too early a date.

The architectural, and hence sculptural, problems of Provence, which is an area usually held to be retarded relative to the great centers of the development of Romanesque (even if not less important in view of the influences which it had on sculpture in the Po Plain and South Italy), has been the object of a review by Borg who, basing himself on the study of decorative forms, has proposed a general revision of the chronological terms traditionally associated with Labande's hypothesis of lateness in favor of a development substantially parallel with the Romanesque of Burgundy and the Langue d'Oc. Observing an early relationship with the classical world, Borg dates all the following works to the end of the 11th century and the beginning of the 12th: the capitals of St. Peter's at Montmajour, in the so-called Baptistery of Venasque, and in the Church of Bourg-Saint-Andeol, as well as the reliefs on the Funerary Tower of St.-Restitut, and in the south transept of St. Paul-Trois Châteaux.

With an anticipation of about 50 years in respect of the traditional view, he holds that Notre-Dame-des-Domes at Avignon and the Church of Corpus Domini at Aix-en-Provence were largely constructed in the early years of the 12th century, while for him the capitals in the nave of St.-Trophime at Arles would also be early 12th century and much earlier than the façade and the cloister. The Cathedral of Notre Dame at Lavaillon, the Parish Church of St. Restitut, and the Church of Notre Dame de Nazareth at Pernes-les-Fontaines would be placed between 1115 and 1140, revealing decorative styles which last as late as 1170 - 1180 in St.-Siffrein and St. Audré-de-Rosans.

The unifying factor which gives continuity to this evolution is, according to Borg, a lodge active at Vaison between 1150 and 1170, that tended towards the adoption of a gradual concentration of decorative elements according to criteria which were already present in works of the late 11th century. The climax of this interweaving of contributions was reached at St. Paul-Trois-Châteaux, in which he recognizes four constructional stages, of which the third is the one involving the decorative phase which he dates as towards 1180.

Recognizing the work of two different hands in the decorative complex, he argues that the first of the two sculptors had worked previously in the northern wing of the cloisters of St. Trophime at Arles, at Les-Saintes-Maries-de-la-Mer, and at Nîmes while the second, who had also worked in the wing of the Cloister at Arles, would have been previously also at the Chapel of St. Gabriel near Tarascon. St. Paul-Trois-Châteaux thus becomes crucial for the chronology of St. Trophime at Arles, one of the two masterpieces of Provençal Romanesque, the other being St. Gilles. Borg believes that the façade was not begun earlier than the translation of the reliquaries of the Saint in 1152, but that in all probability the decoration was started not before 1160

in the northern wing of the cloisters by a small lodge composed of the two sculptors from St. Paul-Trois-Châteaux and two assistants. When the two principal masters left the site, one of the assistants continued to work on the façade, which was followed by the east wing of the cloister; the whole being done by a group of workers whose activity is thus placed in the main between 1160 and 1180.

With regard to St. Gilles, Borg argues, without taking his analysis to a conclusion, that since the façade rests on the eastern wall of the crypt, the epigraphic indications, which are usually invoked in favor of an early date, really refer to the lower part of the church and are therefore not strictly connected with the façade. He considers that the question will have to be reexamined, starting first from a careful reconsideration of the architecture of the church, which, among other things, has an apse with ambulatory of a type which is quite extraneous to the Provençal ambit. Borg holds that, in any case, most of the structure of the façade cannot have been started before about 1150. Quoting an idea of Hamann, he recognizes influences from Langue d'Oc and from Burgundy. On the other hand, he is turning St. Gilles into a kind of crucial cultural meeting point for the expressive forms of the areas to the south and southeast of the Royal Domain and especially of Bourges, since the later style of those regions would have been derived from a fusion of Provençal styles with the sum of their own experiences and with motifs coming from the building sites in the Ile de France and especially from Chartres.

Stoddard has taken up a different position as regards this particular problem, in a monograph dedicated to the façade of St. Gilles. Beyond attenuating the Burgundian presence in the Provençal style, he denies that the latter played a determinant role in other regions. In particular, he has identified the products of five workers among the sculptures on the façade. One of the two principals, the Master of the Thomas, would be from Angoulême, while Brunus, the only one whose name is known, had local training largely associated with classical reminders. The others produced only variants on the manners of the previous two. He dates the working period between 1130 and late 1170 based on those same elements which Borg had previously defined as uncertain.

In localizing the façade to between 1140 and 1150, he has introduced a comparative criterion in the sense of identifying the limits within which the direct influence of this work can be traced in other places. Among the most important of these are Notre-Dame-des-Pommiers at Beaucaire, which he dates, in contrast with all previous tradition, as not earlier than 1060; the work by the Campioni's on Modena Cathedral, for which he accepts De Francovich's dating of between 1165 and 1175; St. Barnard's at Roman; and St. Guilhelm-le-Désert, which he dates as near 1160 and in which he sees the presence of artists active at St. Gilles. As to St. Trophime at Arles, Stoddard, although he agrees with Borg on the idea of a succession of stages during a relatively short period, he disagrees with him in holding that the northern wing of the cloister was started towards 1150 and the eastern one towards 1160, although work continued up to 1170 and even later. He places the façade as between 1160 and 1170 or, in effect, in between the two wings of the cloister. He derives this consideration from the connection with the Deposition by Antelami in Parma Cathedral, dated 1178, and the capital with the same subject in the east wing of the cloister which he believes would have been already finished, or nearly so, by that date.

Passing now to the Lombard area, one of the most interesting papers is that dedicated by Peroni to the solution of the external roofing of the vaults. It shows that we are still very short of having sufficient knowledge to be able to clarify, in depth, the systems used in primitive building precisely on this point about the vaulting, which was always a very important and central characteristic of Lombard architecture. Starting from Sanpaolesi's suggestion, based on the finding, in the attics, of traces of a different and older system of covering than the present 15th century cross gabling, that the principal nave of St. Michael's at Pavia was originally covered by hemispherical domes, Peroni has shown that it is more probable, both historically and in fact, that they were false gables or, rather, of a mixed shape with a base like the cross gable type but rising like a dome. The roofing of the side aisles and women's galleries is still of this type, in which in some cases the caps rise above the top of the vaults. This flooring demonstrates that little importance was given to free passage there, so that the space served only for access to the roof. In this type of vault, the ribs have a decorative rather than a structural purpose, as is clearly seen in St. Savino at Piacenza where there are two domed pseudo-cross gables with ribs while the vault of the first bay has no ribs. This fact, which follows from an inconsistency in the original ground plan, shows the kind of empirical adaptation to which the builders could lend themselves and the plastic ductility of the "baldachin" shapes, as compared for example with the rigid structure which characterizes St. Ambrose at Milan, where the presence of the ribs conditions a spatial distribution which allows light to enter only through the façade, contrary to what happened at least originally in the two previously mentioned buildings.

Starting then from a second objection of Sanpaolesi that an hypothetical ribbed gable covering of St. Michael's at Pavia would have reached on the outside such a height as to interfere seriously with the roofing of the dome, Peroni analyses the solutions of the problem of external covering, basing himself also on the testimony provided by a rediscovered drawing which allows one to have a better knowledge of the interior of the demolished Romanesque Church of St. John in Borgo at Pavia. This drawing clearly shows cross-ribbed vaulting and the emergence of the aisle vaults above the floor of the women's galleries, as at St. Michael's. The most novel element is, however, provided by the presence of a low vault supported across the top of the principal vaulting, associated with a kind of transverse tunnel arranged to compensate for the dislevel between the top of one rib and another. This vaulted framework, immediately above the main vaulting, had the function of carrying the external roofing, which was arranged to rest directly on it. This also happened in St. Savino at Piacenza by means of a substantially similar walled framework which was destroyed in the restorations at the beginning of this century, while traces of a similar solution can be found above the vaults of the women's galleries in St. Michael's.

In this way, the views already expressed by Porter regarding the adherence of the roofs to the vaulting because of further complications in constructing the latter receive confirmation. This is taking into account the fact that, as the drawing of San Giovanni in Borgo testifies, a similar system was extended to the covering of the women's galleries. Obviously, this created problems of coordination of the abutments. Above all, though, it required the greatest possible lightening of the structure by reducing the inert filling. It followed that the domed shape of the vaulting showed outside since it had a considerable thickness or, alternatively, a framework bonded into the brickwork in places not ideally placed as regards the springing of the ribs. Traces of a similar solution in the relationships between vault and roof can also be seen at St. Ambrose's in Milan and also in Speyer Cathedral (which is a building that is central to any theme of the ties between the Lombard world and the Rhineland), for which the fundamental monograph of Kubach and Haas has become a conclusive document.

On the historical level, this analysis to identify the form of the roofing through a demonstrated use of domed vaultings with or without ribs as an alternative to other types or even timber coverings allows one to show how, in Lombard ambients, the presence of an alternating system of pillars is not strictly conditioned by the existence of vaults, in view of the formal and structural independence which the latter have as regards the clustering of the piers which is justified only by the existence of transverse arches. A building like St. Mary's at Lomello is exemplary in this respect, where an unvaulted central nave having transverse arches, which explain the complex section of the piers, is associated with vaulted side aisles. The barrenness of the clerestory was mitigated and absorbed by plenty of plaster decoration, which has been substantially recovered by Romanini.

In other words, the cross-ribbed vault did not represent the driving purpose of Lombard architecture. This fact seems evident also from a comparison with contemporary constructions in Norman territories where a more rigid and orthodox method of vaulting was accompanied by an equally careful study of the timber framing of the roof. This phenomenon must be admitted, however, to have had secondary importance in the initial phase of empirical adaptation. It is precisely for this experimental phase that it seems evident that it is not possible to erect as a counterfoil to the Lombard world an "Emilian" school embodied in Lanfranc, the builder of Modena Cathedral, on the basis of a planned choice of a timber roof, since in Lombard circles the use of a vault was always a simple integration of a spatial system which remained substantially identical in the two ambits.

The research carried out by Arturo Carlo Quintavalle on some of the great buildings in Emilia and, in general, the center of the Po basin seem to contrast with an interpretative position which tends largely to unify the Lombard world and that of the Po Plain in a common cultural area. Starting from the Cathedral of Modena, (for which he has incidentally proposed a short chronological period between 1099 and 1110 - 1115 which does not find adequate support in the stylistic evolution of the sculptures connected with it), he has set out to identify within Po Valley Romanesque what

might be defined as the "Lanfranc" School, to be understood as differentiated from the Lombard School which was almost wholly directed towards problems of vaulting. The stages of this contrast do not, however, always seem to be convincing. In particular, as regards Nonantola Abbey, the present writer has shown the rarity of cultural ties with the architecture of Modena and its probable derivation from general characteristics common to monastic architecture in the Po Plain. Above all the writer has demonstrated, in the face of the evidence of inscriptions, the lack of reliability of predating the present building to previous to the earthquake in 1117, as suggested by Quintavalle.

As for Piacenza, Quintavalle's attempt to identify a "Lanfranc" cathedral already in building before the traditional date of 1122 derived from historical and epigraphic sources has had a quick rebuttal from Romanini. Romanini has repeated that it is not possible to refer any part of the present building to any period earlier than that date. It is also stated that the plan for the first phase of the construction, which was prolonged until about 1150 - 1155, completely separates the edifice from any contemporary Emilian Romanesque building to tie it in with the typical themes of Anglo-Norman architecture of the early part of the 12th century. Quintavalle's examination of Cremona Cathedral is more convincing. Differing from the slightly earlier studies by Puerari, he recognizes as surviving in the present edifice many parts of the one that is known to have been founded in 1107, damaged in the earthquake of 1117, and restored from 1129 onwards. In this case, it appears justifiable to talk of a "Lanfranc" theme, for there is an alternation of supports connected with an original timber covering with transverse arches and a planked side gallery overlooking the central nave through a series of mullioned openings with a clerestory window above. These elements appear to be an evident elaboration of themes typical of Modena. The Cathedral of Borgo St. Donninus also contains these same themes, which Quintavalle associates with the early 12th century building, limiting Antelami's work to the areas of the front and the apse.

Finally, Quintavalle has published a long monograph on a novel interpretation of the architectural and decorative history of Parma Cathedral. In contrast to the two traditional views, one archaizing, which believes that the present building largely copies the one founded in 1056 and finished in 1106 (when there is notice of a consecration by Pope Paschal II), and the other, which prefers a late date proposed by Porter who considers it a reconstruction started perhaps in 1130 after the earthquake of 1117 and finished towards 1170, in view of the consideration that the building was originally planned with hexapartite vaulting. Quintavalle proposed a different interpretation, including a building begun in 1090, consecrated in 1106 when only the crypt and choir had been completed, and finished at the latest around 1130. The arguments he adduces in favor of this scheme are of various kinds, principally documentary.

The statement in the Chronicon Parmense that the cathedral was damaged in the earthquake appears in a contradictory context full of lacunae, immediately after a reference to a similar event in 1104. This is evidently in contrast both with the notice of the consecration in 1106 and with the internal evidence of a document of 1105 which states that it was sealed in the

choir of the church. It is probable, therefore, that the mention of the destruction was inserted in the 14th Chronical by analogy with the reports in other texts about the damage sustained in other cities, without any concrete evidence. On the other hand, the presence of hexapartite vaults in the original plan does not seem acceptable to Quintavalle because the particular irregular distribution of them would have left the vault nearest the presbytery only half developed, while the idea of late execution would be in contrast with the style of the sculptured decorations, which is strangely retarded for a building begun towards 1130 since on the whole it resembles the fashion of "Lombard" sculpture of the end of the 11th century and the beginning of the next. He, therefore, believes he can find a terminus ante quem for the start of the construction in a document of 1092 which mentions the existence of the Church of St. Mary "extra moenia."

The original plan should not differ from the present one except for the presence of a timber covering to the central nave and aisle galleries, transverse arches connected both to the larger piers and to the smaller, and a square dome over the crossing instead of the present cupola. The aisles would have been vaulted from the beginning, but the cross vaulting over the nave would have replaced the wooden roof only in a second constructional period around 1170. This chronology is supported by a stylistic analysis of the sculptures which seem to Quintavalle to be produced by two different teams working one after the other, so closely that the second has actually reused pieces worked by the first. The sculptures from the first lodge, which he thinks can be dated between 1090 and 1100, are to be found in the areas of the crypt, the presbytery, and the first bays of the nave. These sculptures have as a leit motif variations on the Corinthian theme, while figurative capitals are absent. These latter appear with the second team's work, which was culturally more varied and in which Quintavalle notes, along with a widespread constant adoption of Lombard models, Aragonese and Burgundian influences in at least one sculptor, the Master of the Months, suggesting that he had experience similar to that of the Master of the Porch of the Princes at Modena, which evidently ties in with a general dating to before 1117.

Sculpture production in Emilia has received most attention in consequence of the lively critical debate which followed Quintavalle's studies. In substance, the arguments in discussion are on two themes — reconstructive and chronological. Through an analysis of these points he arrives at a completely new outlook on the problems for which the researches of De Francovich and of Salvini have long provided the traditional explanation. As regards the proposed reconstructions, the most surprising (though perhaps not the most fortunate) one is the idea that the Wiligelmus slabs with Stories from Genesis on the facade of Modena Cathedral were originally intended to be part of a side altar piece. Although the motive behind the proposal is the apparent incongruous relationship of the slabs to the external architectural features which now enclose them, the hypothesis has not so far found decisive confirmatory arguments. This is partly due to the criticisms put forward by Salvini and by Fernie, who have demonstrated that the incongruencies are justified by internal reasons, so that it is not possible to argue from their existence that the slabs were intended for elsewhere.

A second theory, which Quintavalle himself subsequently abandoned, or, rather, corrected to adopt a different placing on the side of the building, was that about the recomposition of Antelami's sculptures for the baptistery of Parma into a porch for the front of the cathedral, based on a previous similar attempt by Masetti which he himself had justly criticized. If this second hypothesis still awaits confirmation, there has been a recrudescence of debate about the original placing of Antelami's slab with the Deposition (now in the right hand transept of the cathedral) and of the other fragmentary piece with Christ in Glory, now in the Archaeological Museum at Parma. It has been accepted for some time that both of these came originally from a single composition. Reopening a question which seemed already solved after the study by De Francovich, who proposed a side altar piece as the whole of which the pieces were originally part, Quintavalle repeatedly sustains the theory of a pulpit. Finally offering, in his monograph on the cathedral, the support of an archaeological and technical analysis of the 16th century chamber beneath the stairs has undoubtedly produced new elements of extreme interest in the lengthy debate about the problem. Even if the new data still have not resolved the question in favor of one or the other thesis, they have allowed research to be directed positively so that subsequent investigations may be able to reach a definite conclusion.

Quintavalle has also put forward a radical revision of the traditional views about the stylistic and chronological position of the vast output of sculpture in Emilia. Together with putting the first workshop back in time, the scholar has proposed a similar scheme for the modelling. More especially he has turned his attention to those artists commonly defined as pupils of Wiligelmus. These pupils had their greatest moments, apart from the different masters who completed the Cathedral of Modena, in the shops working at Cremona, Nonantola, and Piacenza, whose different composition and styles had already been identified and carefully described by Salvini.

The fundamental basis of Quintavalle's proposals is still the classical one of relationships with Burgundy, but approached in quite a different way. If, in precedence, the references have always been to the so-called phase of Burgundian sculpture — that is to say, the latest parts of complexes like Vézelay and Autun — he now passes completely over this intermediate phase and sustains a direct descent from the first matrix of Burgundian sculpture — that is to say, from Cluny III and more particularly from the famous capitals in the ambulatory and the remains of the porch, which he sees as already culturally related with the first expressions of Wiligelmus himself. On the basis of this framework for the stylistic problem, and accepting Conant's early dating for the building operations at Cluny, he reaches an interpretation of the formal course of Romanesque sculpture in Emilia. The interpretation gives grounds for believing that towards 1110 - 1115 there would already have been completed all those phases of contribution and interchange which according to traditional interpretations were concluded only towards 1130 - 1135 with the achievement of preponderance by the School of Niccolò.

Without considering here the individual problems of attribution, and remembering how complex the chronological problem of Cluny is, it must be mentioned that Quintavalle's basic hypothesis has been substantially and unanimously rejected by all who have treated of the question. Both Salvini and the present writer, as also more recently Cochetti Pratesi, have on several occasions repeated the greater reliability of the old interpretative scheme. Beyond certain divergences of dating or of stylistic typing in relation to a more or less demonstrable presence of Burgundian elements of one or other master, one can say that these successive contributions agree in recognizing that the wholesale moving forward proposed by Quintavalle is impossible, above all for the untrustworthiness of the inductions he draws from historical sources to arrive at the global anticipation in time of the lodges producing the plastic forms. Furthermore, remaining consistent with the position he has taken up, Quintavalle has, one could say, filled the vacuum created by the pulling back of the activities of the workers in the Wiligelmian tradition before Niccolò became famous, thus literally atomizing that group of homogeneous works which a long series of investigations had grouped under the name of the Piacenza School. According to him, the most important pieces should in fact be placed substantially earlier — the porch of St. Antoninus at Piacenza to 1110 - 1115, the sculptures on the porch of Lodi Cathedral to 1150 - 1160, and the porch and reliefs at Castellarquato to 1122 - 1130. In this scheme, what was formerly a culturally homogeneous set is divided on the one hand into a group of Wiligelmus' sculptures still associated with Burgundian themes and works connected with Niccolò's first efforts on the other, while the latest should be considered as related to the Île de France.

Re-examining the question of the Piacenza School, and starting from Quintavalle's own arguments, Cochetti Pratesi has, however, reconstituted the old catalogue, again placing the porch of St. Antoninus at its usual date of 1171, bringing the Castellarquato reliefs into the field of the figurative culture of Piacenza between 1170 and 1190, and emphasizing the ties between each of them and the Lodi reliefs, which are rightly brought back to the traditional late date, towards the seventh or eighth decade of the century. At the same time, she has further defined the cultural texture of the Piacenza School, noticing its ties at the beginning with Wiligelmus' circle and the later dialectus with Niccolò's lodge. For the central period and for the successive outcome she has confirmed the connections with the proto-Gothic sculpture of the Île de France, as already pointed out by Porter and De Francovich.

The excavations in Florence Cathedral, which have brought to light the entire ground plan of the ancient Cathedral of St. Reparato, which was finally demolished in 1374 to enable the building designed by Arnolfo di Cambio in 1295 to be completed, have turned out to be very important for the history of Romanesque architecture in central Italy. The plan of the final phase of St. Reparata's, belonging to the middle of the 12th century, is unusually complicated, mainly because of the clear superimposition of various building phases which will need further research to clarify in view of the fact that the excavation has not yet been fully published.

Several stages of transformation have so far been proposed. The ancient Paleochristian basilica was modified in Carolingian times with the substitution of the colonnade which had pillars and pilaster strips towards the aisles along the sides by an arcade with rounded lintels while two external chapels were opened through the external wall in the presbytery area to form a kind of bastard transept. Subsequently, in the tenth century, two towers were added at the sides of the apse. These can be seen in the 1342 fresco of Our Lady of Mercy in the Hall of the Captains of the Bigallo. A further considerable transformation took place between the 11th and 12th centuries with the creation of a second non-projecting transept and of an enormous crypt with several aisles extending to the line connecting the two lateral chapels, the opening of the two minor apses partly carved out of the solid foundation blocks of the two towers, and transformation of the brick semi-columns butting on the pillars in the presbytery into semi-pilasters.

It is obvious that all decorative motifs recovered are simultaneously sources of interest and of problems within any discourse on the formation of the Romanesque architectural idiom. If in fact the pilasters with strips recall the complex problem of the old parish churches of the Ravenna area, and consequently the interchanges of idiomatic notions between the Po Valley and Tuscany in the proto Romanesque period, the two lateral chapels, undoubtedly a Carolingian feature, await verification, above all, in respect of their internal decoration with semi-columns. The type of the two towers flanking the apse, however, implies a closer contact with early Lombard style, after the examples of Ivrea, Aosta, and Como, and, from there, possible connections from beyond the Alps. Lastly, the presence in the presbytery area of brick pillars with semi-columns certainly predating the last working phase (that connected with the crypt) poses on the one hand the problem of their place in the interior chronology of the edifice, since they seem to suggest a different date from that of the pillars of the nave, and on the other again the connections with the Po Valley ambient in which such supports were developed in the first half of the 11th century. Return must certainly be made to this whole series of themes of extreme complexity to clarify, with fuller knowledge, many of the typical motifs of Florentine (and more generally, Tuscan) Romanesque.

The excavations carried out in several campaigns at Montecassino and ultimately published by Pantoni were not so fortunate as regards finds, but are, however, important for a fuller picture. Few elements were found remaining from Desiderius' church consecrated by Pope Alexander II on October 1, 1071. However, there were enough to establish the reliability of historical sources at least on two points: its size and the fact that it was rebuilt completely, since it was oriented differently from the still more ancient structures connected with the foundations of the preceding abbey. In substance, the reconstructions previously proposed by Conant and by Willard were confirmed. One novelty which has great importance is the recovery of the jambs of the original doorway, which show a free light classicism which will have to be the subject of careful attention in the future, also as regards its relationship with plasticity in Campania, to which we shall refer below.

The exhibition at Bari dedicated to the 11th century in Apulia was particularly vital for the renewal of the study of the formation and development of Romanesque art in southern Italy. The results of that critical effort can be summed up as a complete overturning of traditional historiographic perspectives which regarded the birth of southern Romanesque only in connection with Norman influence, and their replacement by a hypothesis of local formation derived from autonomous cultural themes. The investigation which caused this change of outlook was an historical, and especially an archaeological, analysis of a number of buildings which, although founded before the date of the definitive establishment of Norman domination, have usually been considered as owing their present form to later works and modifications. Through a more careful reading of the available elements and an investigation of the constructional events it has been possible to demonstrate that a great part of the present masonry can be assigned to the earliest constructional phases. The starting point was the dating of the fabric of the Cathedral of Bovino to the end of the tenth century instead of the usual date a hundred years later. This was a small building with a nave divided from the aisles by four columns each side, with a flush transept and a dome at the crossing supported on angular pendentives, a feature which, although rare, can be matched in local Paleochristian and early Medieval buildings. This decidedly local typology, furthermore, shows a concrete vitality, for it reappears again at Bovino in the Church of St. Peter, although with the variant of a barrel vault covering the square crossing, in a church for which there is evidence of a building operation about 1100 which must have been the remaking of an older building which was perhaps demolished in 1045 but partly influenced the new one.

The same type reappears in St. Basil's at Troia, certainly erected during the 11th century and before the cathedral, characterized by a jutting transept and by a cupola which was originally a baldaquin without pendentives supported in a very rudimental way on four semi-circular arches. Even if the present vaulting of the nave of that building is certainly later, the same cannot be said of the transverse barrel vault of the right hand branch of the transept or for the space, marked out by four arches attached to the surrounding wall and covered by a right-angled cross of low columns inserted at the angles, which occupies part of the left hand branch and seems to be even earlier than the construction of the church.

The disencrustation of the 19th century piers of Vieste Cathedral has permitted the finding, inside them, of the columns and capitals of the original building which, on account of the stylistic characteristics of the rediscovered elements, has been placed in the first decades of the 11th century. It is distinguished for its almost basilica-like form with three aisles divided by colonnades in spite of the total loss of the crossing which prevents the discovery of eventual similarities with the types previously described.

The Cathedral of Siponto is at the core of the investigation of that group of buildings to which a late date is traditionally assigned. In this specific case, the usual reference point is a notice of a consecration of the building in 1117. The fact that there are preserved in the church fragments of articles dated to 1039 and connected with Bishop Leo, in office from 1023 to 1050, leaves open the question whether any part of the present church (and if so, which) can be dated to that time, since obviously there must have been a cathedral then. The building has an unusual plan, square with an apse on the east and another on the south and door to the west. Excluding the north wall, which was rebuilt later, the other three sides are decorated both inside and out with blind arcades. Underneath, there is a crypt extending the full width of the building and divided into five aisles, where four great cylindrical columns support the pillars which, in the church above, carry the dome and the half barrel vaults supported by the external walls (a covering which is the result of 17th century work).

The hypothesis was that if there was anything left of Leo's church, the surviving parts must be found in the crypt. The recent excavations have, however, demonstrated that the crypt is later than the superstructure and that the upper walls are the remains of Leo's church, which had a north-south orientation, so that the southern apse alone out of the two present apses belongs to it. The eastern one is part of a later transformation connected with the opening of the present entrance in the west wall.

A similar movement backwards in time has been suggested for Canosa Cathedral, usually referred, on the grounds of a dedication date of 1101, to the last decades of the 11th century, and thus to the supposed rebirth brought about by the Norman intervention. The plan of this building, which is constructed with alternating courses of stone and brick according to the Byzantine taste, is still recognizable in spite of numerous modifications. The three aisles are separate constructional entities since the communicating archways are openings cut out of effective party walls. This allowed the covering a complete independence for each part, and thus the two side aisles have barrel vaults while the central nave is closed by two baldachin-type domes in tandem, each standing on four arches which are supported on six reused columns backed against the walls. The independence from the roofing of the side aisles permits a higher elevation and hence the opening of paired windows beneath the arcades. The two branches of the transept and the crossing are covered by domes similarly standing on four columns each, but in this case they do not have an arcade in common as do those in the nave, and instead they are separated by low heavy arches. This is effectively a plan which finds its justification in local culture, still definable as Byzantine, and leads to an early dating of within the first decades of the 11th century in view of the fact that this type, certainly connected with preceding experience in the zone, had no subsequent development.

In the Cathedral of Bari, with the freeing of the lower church which extends for two-thirds of the way under the central nave and the identification of previous floor levels, excavations have permitted the extraction of much more and better founded information about the ground plan of the edifice founded by Archbishop Byzantius in 1034 and about how much of it survives in the present building. The fact that it has been discovered that the edifice has three aisles, a nonprojecting transept, and only one apse is extremely important from an historical point of view since this is a type of plan usually regarded as a Norman importation

into Apulia through the influence of Desiderius' construction at Montecassino.

The Cluniac motive as an interpretative key has been discovered to be unfounded as regards the Cathedral of Taranto. A recent investigation had, in fact, assumed that the building's unique crossing, composed of three barrel vaulted arms which form a square on which there is erected a cupola on pendentives, was part of the reconstruction carried out by the Norman Archbishop Drogo before 1072, the year of his death. This early constructional nucleus, following a scheme found in Normandy in the Abbey of Bernay and based on a nave and two aisles with three apses with a choir projecting beyond the square of the crossing by two bays, would have had the subsequent addition of the present nave before the original building had been completed. The latest investigation, connected with restoration of the building, has demonstrated, on the contrary, that the unique crossing ought to have a single naved fourth branch, probably also barrel vaulted, completing a plan of a full cross with dome, clearly belonging to an area under Byzantine cultural influence and probably the cathedral rebuilt after the destruction of Taranto by the Saracens in 927. Archbishop Drogo worked on the older building, adding at the crossing the present aisles divided by columns, thus realizing the unusual plan by an aggregation of heterogeneous elements. We have a definite date for Otranto Cathedral, that of the consecration in 1088. The date usually refers to the crypt since the arcades contain capitals assigned to the late 12th century. Previous attempts have been made to identify how much of the upper church belongs to the time of the consecration. In doing so, the Cluniac hypothesis had again been invoked, above all with reference to the particular structure of the flush transept with three apses divided by two great round low arches so that only the central part of the crossing reaches the height of the central nave. The recent investigation has, however, led to the conclusion that the great arches which divide the transept into three parts are a later insertion. They were inserted not much later since they were already allowed for in the mosaic pavement of 1164. The original plan, which included the shape of the crypt, contained an open undivided transept according to a Campanian pattern and a main body divided by arcades on much lower piers than the existing ones.

Last, but not least, among the many contributions which deserve to be remembered from the Bari Exhibition, because it bears witness to the richness and variety of the architectural idiom of the region during the 11th century, is an adequate appreciation of the Abbey of St. Mary and St. James on the island of St. Nicola in the Tremiti Islands, consecrated in 1045. The restorations have brought out the elegance of the building's unique plan. The plan is composed of a great quadrangular central chamber surrounded by a peribolus, with clustered piers appearing very early. The piers form a kind of side aisle along the flanks, doubled at the front and by the addition of a two-storied vestibule and characterized by three recesses at the apse end. This is a very singular plan, which needs further investigation to clear up its historical connections after the original completion, above all as regards the finding and the covering of the central chamber, which has been most affected by subsequent modifications. It has already been opportunely indicated as possibly entering into the matrix of architecture under the three Emperors Otto.

The theme of the Norman contribution to local architectural culture in view of a formal modification open to the possibility of acquisitions from the Cluniacs is still at the center of the analysis of architecture in Calabria in the 11th and 12th centuries conducted by Bozzoni. As a demonstration of an already clearly necessary reconsideration of the whole of southern Italian Romanesque, his conclusions substantially coincide with the proposals of the Bari Exhibition. Through a careful revision of the documentary and architectonic dates, he has reached the conclusion that there are no proofs, apart from the documented presence in Calabria of monks coming from Normandy, on which to base a supposition of the use of plans of types definitely connected with European Romanesque before the last two decades of the 11th century. The presence of Western characters (and, more particularly, the solution of the choir with graduated apses, projecting transept, and dome at the crossing) in a union of Cluniac formulae with motives connected with the local Byzantine tradition in buildings like Old St. John's in Stilo or St. Mary of the Rocella at Squillace is the argument of greatest weight to justify an early dating and consequently a similarly early Norman influence. On the other hand, the early dating is also justified by the fact that those buildings are not earlier than the 12th century, any more than is St. Mary of Tridetti.

This last building, which contains no evidence of Cluniac influence, is also significant of the moment of the cultural step taking place in Byzantine circles. With its short three-aisled body and three apsed unprojecting transept, it is a concrete example of a fusion of Western and Eastern ideas. Above all, the dome, as in Old St. John's at Stilo, shows a decided move from the traditional Byzantine form supported on four free-standing piers and spherical pendentives to introduce graduated corner niches and a double order of windows, of which the lower ones open into the square drum.

Decidedly Romanesque features are also to be met with in St. Mary of the Rocella. They are in any case justified by the new dating of the second quarter of the 12th century, proposed on account of the mixing of elements referable both to late Comnenian constructions at Constaninople and to Sicilian Islamic architecture with others certainly originating north of the Alps; such as the plan with a single nave joined to a three apsed presbytery by a central arch with two lesser passages at the sides - a "wide-naved" type which can be met with in the Loire Valley. These northern elements are so strong as to lead to the supposition that the building was erected by monks coming from beyond the Alps. The late dating of these buildings also makes improbable the existence of Norman-Cluniac elements already in the Benedictine abbeys founded around 1060 by Robert Guiscard, such as St. Euphemia near Nicastro and St. Mary of the Morning, or in the Trinity at Mileto founded by Count Roger before 1070 - buildings in which, in spite of the certainty that Norman monks were present (from St. Evroul-sur-Ouche, which, however, was a Benedictine Abbey and not Cluniac), either the total disappearance or a partial destruction makes a safe judgment impossible. But, on the other hand, neither does any documentary evidence seem to confirm the hypotheses of Schwartz and Bottari about a

direct influence stemming from the Cluniac plan of Bernay, so much so that nothing of that type remains in the only one of the Guiscard monastic foundations to survive, namely, the Trinity at Venosa.

The cathedrals founded by the Normans in Calabria between 1080 - 1085 and 1120 - 1122, such as those of Reggio Calabria, Mileto, Gerace, Nicastro, and Catanzaro, were probably modelled on Desiderius' reconstruction of Montecassino without going to the length of an unimaginative repetitiveness. This situation is certainly recognizable in the only still surviving building of the group, the Cathedral of Gerace, for which the date of 1045 for its consecration has long been opposed. Today it is suggested that the works were completed towards 1120. The design of the long basilical type nave divided by columns is the element which most recalls the tradition of Campania-Cassino, contrasted, however, by the area of the presbytery which for the jutting transept divided by powerful arcades, the form of the crossing repeated in the arms of the transept, the choir covered with barrel vaulting, and the actual shape of the crypt all suggest Lombard and Germanic examples.

All are centered on a dome on stepped pendentives which bears testimony to the lively persistence of Byzantine methods. The old-style plan of the nave is considerably modified, furthermore, by the introduction, half way along its length, of a pair of columns connected in the aisles to transverse arches. The arches interrupt the continuity and give a clear view of the double square on which the arrangement of the space is organized with a ratio between central nave and aisles of 1 to the square root of 2, which is the same as that between the total width of the building and the width of the nave plus one of the aisles, bearing witness to the uniqueness of conception of the area with respect to what has been said even recently to the contrary.

If the special emphasis given to the side aisles with respect to the nave again recalls the buildings in Campania, there still are too many elements in the edifice which are unusual and without any similarity to other cultural areas, particularly in the harmonizing combination of vastly different components, for it to be reasonable to speak of themes of Norman influence, particularly in view of the fact that no trace can be found in the contemporary or late Sicilian constructions. They do appear, however, to be connected, especially in the form of the presbytery area, to discoveries typical of the beginning of the Romanesque architectural culture, in which the Cathedral of Speyer might be the point of meeting with and departure from the Saxon culture. Since it is not possible to put the introduction of these elements down to the intervention of workers from another area, the latest idea tends to see them as the result of a conscious decision to modify the local architectural culture towards the generically defined "Western influence" which was already making itself felt in the first half of the 11th century.

Traces of the existence of this process can be found, to a lesser extent, in the Old Cathedral of St. Severina, dated at 1036. Alongside the obvious suggestions of Byzantine style lent by the chromatic effect given by the materials used, the basilical layout on pillars of this cathedral seems to suggest a similarity to Western models. This same type was seen in the destroyed basilica-style Abbey of St. Mary of Terreti,

where it also had a dome, and in San Donato of Umbriatico. The complex constructional history of the latter, which continued until the 12th century, does, however, point to the existence, before the Norman conquest, of a floor plan with a non-protruding transept, a rather square crossing edged with four square arches of equal height and perhaps surmounted by a tower covered by a roof, a barrel-vaulted choir, and one single apse: a structure decidedly tied to Saxon influence which demonstrates that architectural ideas from central Europe had already penetrated the Byzantine world of southern Italy well before the rise of the Normans.

Still searching for a sign of a valid recovery of the local style, also with regard to sculpture, the Bari exhibition succeeded finally in fitting into the picture Archdeacon Accetto and his lodge, whose very existence has been denied even in recent investigations. Thanks to the fortunate discovery at Siponto of some new fragments of epigraphs and also to a careful study of those at Monte Santangelo, it has been possible to give some substance to the sculptor who, with assistants, as is proved by the existence of a signature in a magister David at Siponto, was active in the two places respectively in 1039 and 1041 and also at a time not yet precisely known, but certainly not much different, at Canosa. The fact is historically important because, once established that the lodge later working on Bari Cathedral was also trained in the methods of Accetto, it becomes clear how all the Romanesque sculpture in Apulia received its initial impetus from the work of this lodge on the basis of a culture able to translate the careful linear elegance of the Byzantine tradition into more solid and articulated plastic lines. In this same context, although perhaps with a different significance, considerable interest is attached to the other noteworthy interventions carried out with regard to Romanesque sculpture in Apulia by Belli. The later dating of the execution of that throne by Elia which, usually dated before 1105 and compared with Wiligelmo, was seen as clear proof that the Romanesque style of Apulia followed that of northern Italy.

A more careful consideration of the historical data relative to the Basilica of St. Nicola of Bari brought the scholar to the conclusion that the throne must have been executed between 1166 and 1170. This dating, which can, after all, be confirmed on a stylistic plane by other sculptures of the late 12th century in Apulia, removes the piece, so unexpectedly dated in the early years of the same century, so that the sculpture of Accetto, and that derived from his lodge, is seen as the real beginning of Apulian Romanesque.

In the case of Sicily, it is necessary to remember the wide panorama on building activity in the Norman epoch provided by Kroenig with the monograph on the Cathedral of Monreale. In the monograph, he clarified analogies and differences with respect to the Anglo-Norman world. Héliot, on the other hand, in an article on Cefalù, finds a summarized reference point of all the complex questions proposed by the construction, and particularly a clarification of the cultural matrix on the individual components of this complex problem. More particularly, it seems to the scholar that elements introduced in the second phase of the work corresponding to the supraelevations of the transept and the presbytery, such as the gallery with small arches at the top of the walls, the initial persistence of a wooden covering modi-

fied in a ribbed vault during the same phase of the execution, and the idea of a tower at the crossing, are of decidedly English derivation, and perhaps the plans of the fronts of the transept, in which, however, there is a considerable French influence. Elements which, on the other hand, refer generally to a northern culture appear to Héliot to carry the stamp of other regions. Thus, the scholar sees as Lombard Romanesque the projections and the arches of the central apse, while the towers of the façade suggest, for the different arrangement with respect to the northern models, a reference to the towers flanking Roman city gates.

A subject of lively critical debate is that of the sculpture of southern Italy, and, in particular, the problem of the internal relationships between the different zones of Campania and between those of Sicily. In the case of Sicily, the apple of discord – or rather the beginning of a contrasting interpretation of the sculptural events of the region – is the sarcophagus of Frederick II. This sarcophagus had already, in the past, been the subject of different points of view according to whether it was identified as one of the two which Roger II donated in 1145 to the Cathedral of Cefalù, which we know was transferred to that of Palermo by order of Frederick II in 1215, or was claimed to have been made after the emperor's death and consequently in the sixth decade of the 13th century. Accepting the earlier date for the sarcophagus and seeing it, along with that of Roger II, as the founding masterpiece of a well-defined school of sculpture, Salvini, in a monumental study of the plastic decoration of the cloister of Monreale, places the artistic events of the region in a position of direct Provençal derivation. This would also include, in addition to the monuments mentioned above, the capitals of the cathedral and the cloister of Cefalù. This scholar examined contemporaneously all the sculptural production of Campania, drawing the conclusion that it is substantially a derivation from the methods and the working of the Sicilian one. The scholar Cochetti Pratesi opposes the position of the critics in a series of articles in which she reviews the complex and intricate problem. The point of departure of her case is the dating of the sarcophagus of Frederick II in the second quarter of the 1200s, and assignment of it to an Apulian artist. She has since insisted on her thesis regarding the presence of elements derived from the School of Piacenza in the work of the artist who carved the eight Telamons of the sarcophagus of Roger II, of which she puts the dating in a period shortly after the death of the sovereign, which took place in 1154.

All this is in view of a valuation of the stylistic origins of the school different from the Provençal one indicated by Salvini and designed to emphasize the links with the proto-Gothic productions of the Ile-de-France. On the basis of this, Cochetti Pratesi consequently also contests Salvini's thesis in which, seeing in the Telamons a derivation from Provençal, he claims that these had penetrated into Sicily much earlier than into Campania, where there is evidence only towards 1180 in the figures of the Two Deacons in the rectangular ambo of Salerno. The interpretative dichotomy is applied also, of course, to the other groups of works. Thus for the capitals in the nave at Cefalù, while the two experts agree in recognizing the affinity with the Telemons in Palermo, Salvini proposes references not so much to the Provençal area as to Dauphine works

which can be inserted in an area of direct Provençal culture and ascribed to the middle of the 12th century. Cochetti Pratesi considers them to be works by an artist who moved in the same cultural climate as that of Palermo, even if he did not identify with it, but seemed to acquire, second hand, the ways of the Emilian culture through the mediations of the former. Salvini sees in the capitals of the cloister of the same cathedral sufficient suggestions of Provençal sculpture to guarantee the homogeneity of the tendency in the region and above all to prove the chronological precedence of the group with respect to the sculptural works of Monreale. Cochetti Pratesi, on the other hand, notes reminders of a well-defined group of capitals of Monreale which she assigned to western France; this obviously calls for a different valuation of the reciprocal relations.

Unchanged opinions emerge with regard to the intricate problem of the Easter Candelabrum in the Palatine Chapel. Even though both scholars agree in refusing to accept the traditional hypothesis of two different times for the execution of the stem and of the candleholder, which is usually advanced as an explanation of the stylistic differences between the two, they have come to completely different conclusions. For Salvini, in fact, the candelabrum, in which he still finds certain Provençal elements, is the work of Sicilian sculptors active not long after 1160; while for Cochetti Pratesi the Provençal elements are limited to the intermediate part of the stem and originate furthermore from the intervention of Campanian work, while the rest of the sculpture, except for the candle-holder, shows the direct influence of western France, which gives the object a dating in the first decades of the 13th century, whereas the candle-holder, which recalls the culture of Frederick's time, moves toward the middle of the same century.

The cloister of Monreale with its rich carved decoration is the culminating point of the complex interpretative struggle. Salvini has recognized it as a substantially unitary complex, the work of a single lodge of Provençal formation and culturally tied to the preceding sculptural experience in the region. He has individuated the presence of five masters within this lodge, who, with the collaboration of a vast number of assistants, would appear to have begun their operation at the time of the foundation of the cathedral or soon afterwards. They concluded the work in a relatively short time, certainly before 1189 when William II, who had commissioned the undertaking, died.

The panorama, in Cochetti Pratesi's interpretation appears more complex. She believes, from the subject of the quadruplicate capital at the southwest corner, that he who Salvini calls the "Master of the Mission," hails from the culture of the Portal of the Kings at Chartres. Then, in a series of small capitals and slender columns which Salvini assigns to the ambit of this artist, she sees remembrances of the School of Piacenza and in others, such as the capital of Mithras, clear classicist elements that link them to the works of Campania, and more especially to the ambones of Salerno. The Provençal tendencies of those who for Salvini are Master of the Dedication and Master of the Putti become, in the other interpretation, Byzantine tendencies evidenced by similarities to the mosaic decorations of the same cathedral and with images in ivory or in illuminated manuscripts of Constantinopolitan provenance which justify the

refined classicism — not free, however, from possible direct references to ancient art. This latter is an element which leads to a recognition in the group of a first concrete association with the production of Campania, while the Provençal elements which are present to a certain extent in some of the monuments in this zone appear from an interpretative point of view as precluding a Sicilian origin. This, which for Salvini was the outstanding group of works which could be assigned to the Master of the Putti, thus becomes split into two different groups: the first tied to the plastic culture of western France of the high 12th century and the work of artists coming directly from those regions; the second derived from that moment of Lombard Romanesque sculpture which can be individuated in the sculpture of the monuments of Pavia, perhaps through the mediation of older artists from central Italy, such as those responsible for the decoration of the portal of the Cathedral of Assisi.

It is logical, in this respect, that Cochetti Pratesi should contest Salvini's interpretation, according to which the ambones of Salerno are derived from Sicilian work and particularly from that of Monreale, with the conditional of direct Provençal experience for the artists of the Ajello pulpit. This alters the substance of the report by assuming the presence at Monreale, to work on the columns of the cloister and other pieces more substantially connected to Byzantine and neo-Classical experience, of artists of Campania, or at least connected with the culture of Campania. In this culture, even earlier than in Sicily, an opening occurred to the study of the lesser productions of the Constantinopolitan world. The plastic culture of Campania was to continue, also later, to maintain a substantial autonomy looking directly to Provençal texts. Only in the sculptures of the Cathedral of Sessa Aurunca and in the slabs of St. Restituta at Naples would it be possible to find ties with the group of reliefs of Byzantine influence in the cloister stylistically tied to the mozaic decoration.

In order to overcome the divergence of critical opinion, Glass has recently suggested that a more accurate valuation of the homogeneity of the two ambients should be made by emphasizing the common elements derived from late Antiquity and from the Paleochristian world. In this way, the variants with respect to the constant of the relationship with Antiquity would tend rather to be seen as exceptional elements with regard to the true stylistic and cultural substance in such a way that the problem of the precedence of one or another region in being responsible for certain facts loses its interpretative intensity.

The study of Romanesque painting has been condensed primarily to a number of determinate basic themes. A contribution toward giving this direction to the course of research undoubtedly comes from the publication of the monumental work of Demus on Romanesque frescoes, destined to remain for a long time as an important reference point. This volume, in fact, in addition to representing the history of the art of fresco painting in the Romanesque period seen in all its most complex components, presents itself as a practically exhaustive reperatory of the facts and the knowledge at the present time. Very few gaps can be found. One can see the need, in view of Nordenfalk's accurate review, of adding to the imposing catalogue some discoveries made known since its publication, such as the fragments of frescoes from St. Gereon of Cologne and later in the Schnütgen Museum, shown at the Rhein und Maas Exhibition in 1922, or, for the Italian ambit, the frescoes of St. Antonino's in Piacenza; those of Filacciano discovered by llaria Toesco, and those of S. Andrea al Celio in Rome, published by the same scholar and assigned to the 11th century; and lastly the important cycle at St. Angelo di Lauro. Also, as regards, the dating, one can remember how it was not possible for Demus to quote the new chronology proposed then for archaeological reasons, as had been seen before, by William, in the case of the Pantheon de los Reyes at St. Isidore's at Léon, or as, on the other hand, he had maintained the date around 1140 for the frescoes of the Frauenchiemsee, while Nordenfalk claims that the dating in the middle of the 12th century, proposed by Demus for the Tavant frescoes, is too advanced.

In view of the co-ordinating function filled by the work of Demus, there are few investigations of single monuments that are worth recording. Among these figure the study of that outstanding masterpiece of Romanesque painting on panels which is the ceiling of the Church of St. Martin at Zillis. This study was carried out by Murbach and Heman. Another, on the same subject, is the work of recomposition of the original arrangement of the panels carried out by Jenny on the basis of the individuation of the iconographic thematics. We should mention among the discoveries also the remains of a cycle of frescoes found near Tours – Charlemagne at St. Martin of Tours – and published by Vieillard-Troiekouroff. This cycle is to be placed chronologically shortly after the construction of the tower, towards 1060 - 1080, which proves, along with the poorly preserved and somewhat similar frescoes of St. Julien's, how around this date Tours was one of the most flourishing centers in the development of painting in the regions of western France.

Also worthy of mention is the conclusive study by Wibiral of the restored frescoes of the west choir of the Stiftkirche of Lambach, consecrated in 1089. In these the scholar discovered some considerable evidence of Byzantine influence, connected in a particular way with provincial monastic painting, along with a certain persistence of Saxon tradition in the second half of the 11th century, typical of the Salzburg area and with contacts within northern Italy, and more especially with the frescoes in the Baptistery of Concordia, recently assigned to a more or less contemporary moment. According to Wibiral, this relationship with the Byzantine world originated, as well as through northern Italy, from direct contacts with Constantinople through the Salzburg Archbishop Gebhard (1060 - 1088). Under the archbishop the illumination of the "Custos Bertold," the Perikopenbuch of the Pierpont Morgan Library of New York, which came from the Convent of St. Peter at Salzburg, and the Gospel of the Convent of Admont in Styria, which presents characteristics similar to those of the frescoes of Lambach and those of Concordia, were executed. A number of ivories linked with the name of the Bishop Adelbert, the consecrator of Lambach, also contain some decidedly Byzantine elements.

The frescoes of Lambach and the cultural problematics connected to them introduce what has certainly been the favorite theme of recent studies on Romanesque painting; that is, its relationship with the

Byzantine world. It is not that the theme is new — after all, it has received lively criticism in the volume by Schapiro on the Ms 1650 in the Palatine Library at Parma containing a treatise on the Virginity of Mary by Bishop Hildefonse of Toledo, who lived in the seventh century. The basic facts obtained from the analysis of the manuscript are that it cannot have been later than the beginning of the 12th century and that it was executed at Cluny under Abbot Hugues, the builder of Cluny III. On the stylistic plane of the 35 miniatures which decorate it, 33 appear to be the work of a provincial artist still close to the Saxon culture, perhaps from Bavaria. Two present that which Schapiro defines with an expression which clearly introduces the conclusions of a cultural relationship subsequently individuated as Italo-Byzantine in style or a fusion of Carolingian, Byzantine, and Saxon elements in a combination. Because of the unusual outcome, the combination created an autonomous style frankly Romanesque or rather Burgundian. Also, because of the ties, it presents with the contemporary sculpture of Charlieu and Anzy-le-Duc at Vézelay.

As the scholar points out, the phenomenon is not isolated in the Western ambit, because Italo-Byzantine elements are found in dissimilar monuments around 1100, such as the Bible of Stavelot of 1097, the manuscripts connected with the scriptoria of Angers, Limoges, Dijon, and the previously mentioned German centers. In this disagreement regarding the diffusion, Cluny, even if inserted into a substantially unitary movement which, as historical data suggest, had already been formed at the moment in which it was raised to a great abbey, is individuated as a center of considerable importance because it is possible to recognize there at least three, if not four, masters associated with the Italo-Byzantine methods. The illuminator of the Book of Lessons of Cluny is not in fact the same artist who painted the frescoes at Berzé-la-Ville, a small priory near Cluny and depending from it where, according to Conant, the decoration in the apse contains a direct record of the apsidal decoration in the great mother church. The illuminator, Hildeforne of Parma, while moving in the same cultural climate, appears in his turn to be distinct from both the preceding artists. Only the author of the Book of Lessons of Montreal could be the same person as the illuminator of Cluny, or at least an artist closely associated with him. The origins of this style, which for that matter can be deduced from its definition, are to be found, according to Schapiro, at least regarding what concerns the components extraneous from the Burgundian world and Cluny in particular, mostly in the Campania area, at Montecassino with the allied problem of the Byzantine artists brought in by Abbot Desiderius to decorate the new basilica, together, however, with a certain Roman contingent, justified by the fact that the connections with Montecassino at the present state of our knowledge are so few as not to allow the formation of the hypothesis of a direct relationship of the Burgundian with the Campania center.

As an alternative hypothesis to that which sees Rome or Cassino as intermediary elements in the diffusion of the Byzantine style, another route which might be defined as "Saxon" has been suggested by Cames and Wettstein. These two scholars do not substantially deny the presence of Byzantine elements in illumination and pictorial cycles astride the 11th and 12th centuries, but tend to attribute them to a process of transmigration already taking place in Western culture from both an iconographic and a stylistic point of view. Nordenfalk, however, reviewing Wettstein's book, noticed how it is in fact the illuminations done by Hildefonce of Parma that refute this thesis. He sees the absolute stylistic contrast which exists between the two entirely Romanesque, tied to the frescoes of Berzé-la-Ville, and the others due to a still truly Saxon artist. In his opinion they are Rhenish, and not Bavarian as Schapiro believes. As for the former, Nordenfalk thinks they are the work of an Italian artist, perhaps educated at Montecassino. If it is not the same person it is certainly an illuminator with a similar story to that of Opizus, who is known to have collaborated with a certain Albert of Trier on a now lost Bible of Cluny intended for Abbot Hugues, a Bible of which an isolated picture of St. Luke preserved at Cleveland may be a fragment.

Approaching the problem in a volume dedicated to the intercurrent relationships between East and West, Demus has re-examined the frescoes at Berzé-la-Ville, discovering there a complex and refined cultural stratification. In his view, some components of Byzantinism go back to Carolingian times. The Christ Enthroned, with the asymmetrical proportions dictated by the contrasting arrangement of parts with unequal dimensions and with the drapery in a violently disturbing zig zag, is tied to the Palatine School of Charlemagne. On the other hand, Byzantine influence was to emerge later in the disturbed drapery in the two scenes of the Martyrdom in the apse, connected to perhaps provincial decorations of the 11th century, such as those of St. Sophie of Ochrida, while certain ways of drawing the faces go back to Byzantine prototypes of the tenth century. In all this complex whole, there can easily be, as Demus says, elements such as the tendency towards repetition of the lines transmitted to Cluny from Rome and others from Campania and Montecassino, such as the technique of "cloisonné" which appears in the figure of the beheaded St. Blaise and which recalls St. Angelo in Formis. However, such details as these are indications of a cultural path and take on secondary values with respect to the direct contribution that one can imagine Cluny received from Byzantium after the ascent to the throne in 1081 of Alexis Comnenus inaugurated a new epoch of political and cultural expansion. This brings a further new hypothesis to the intricate and certainly not resolved problem.

An element of clarification of the whole complex question could perhaps come from a greater knowledge of the pictorial facts of Campania and substantially of Cassino; beyond that contributed by Belting's book on what he called Beneventan painting, which has only marginally attacked the problems and particularly the monuments in question. The publication of the volume on the frescoes of the Grotto of the Fornelle at Calvi Vecchia, the first of a series which promises to illustrate the various Medieval cycles of Campania, can therefore be welcomed with hopes that in the not too distant future the still large gaps in our knowledge of the pictorial facts and consequences directly connected with the phenomenon of Desiderius will be filled. Then one can perhaps attempt a more accurate analysis of the effective content of the question and avoid the return every so often of theses which are already out of date on publishing, like that on the existence of a "Benedictine"

School connected with Montecassino. This problem, in which Thierry has intervened, demonstrates once again the historical and artistic inconsistency and at the same time offers a useful panorama of the situation regarding the Medieval painting of Campania. Also, some new studies of illumination would contribute to a better understanding of the phenomena. The volume by Cavallo and Bertelli on the Exultet of South Italy (incidentally the exposition by the two scholars at Bari Exhibition on Apulian Romanesque should not be overlooked) comes out as a first revision of a subject substantially stopped at the always fundamental but still old work by Avery.

The Byzantine contributions, and those of Cassino on the other hand, are more apparent in the study dedicated by Toubert to the little-known Breviary of Oderisius, the Ms. 364 of the Mazarine Library in Paris. The manuscript was illuminated not very much later than 1099 for Abbot Oderisius, the successor of Desiderius at the head of the Abbey of Montecassino. A study of the initials has shown that there are two types. The first is characterized by gilded interlacing of Saxon type, an element typical of the scriptorium and due to the imitation of the Gospel given to the monastery by Henry II around 1023. The second, more numerous, has the letters set in panels alternately gilded and filled with interlacings and populated with small figures of greyhounds, green and pink in color; this also had been characteristic of the scriptorium for some time.

The two types of initial also existed in the Book of Lessons Vat. Lat. 1202, from which the Breviary appears to derive, even though its author has taken liberties which lead one to imagine a direct inspiration from the Saxon Gospel. For this reason, it appears to be more closely associated with the methods in use in the scriptorium at the time of Desiderius, with respect to the matter found in manuscripts such as the Urb. Lat. 585, which already showed an early modification of the initials which was to be continued in the 12th century. The Breviary is decorated with eight miniatures which, with the frescoes at St. Angelo's in Formis, represent the only cycle from the Cassino sphere to present a complete and coherent series of pictures of the Passion. Iconographically the scenes belong to the Byzantine tradition, but with connections with Germanic models which can not be justified by the idea of a common influence, since formulae of evidently different provenances are mixed together in the same scene. This is a declaration of particular importance in view of the complex problem of the relationships between the West and Byzantium, because it does seem to attenuate, at least as regards this specific case, the possible function of the passage of the Cassino style and induce one to see a sequence of connections very much more complex than certain linearistic simplifications lead one to believe.

On a stylistic plane the Breviary does not present any motives typical of the scriptorium which are also derived from the Byzantine culture, such as the superimposition of colors or the "cloisonne" stylization of the drapery, but rather an emphasis on the design over color which is left fluid, so much so that the faces are left almost without any further underlining, while it is the almost transparent lines which convey the folds in the drapes and the volumes of the bodies. For this reason, the Breviary is a testimony to a return to different Byzantine sources from those of the Book of Lessons

Vat. Lat. 1202, influenced by the "cloisonne" style and close to those of the Exultet in the British Museum. It appears with this to absorb, in a design sense, elements of the evolution of Byzantine illumination of the second half of the 11th century, at the time of Alexis Comnenus. This is another hypothesis which, if verified by future studies and by a wider margin of knowledge, would contrast with that which sees in Alexis Comnenus' ties with Byzantium one of the moments of diffusion of formulae — in this particular case, in the sphere of Cluny, which in reality had been present previously in that of Cassino which, at the time and in its turn, derived different and contrasting elements from Byzantium — confirming yet again the thick and inextricable network of relationships and, consequently, of unresolved problems.

A different kind of question, which seems particularly stimulating for the interpretation of other cultural areas, is brought out by Ayres' investigation of what he calls the "Angevin style." This is a pictorial method which seems to have had its center of diffusion in the regions which, in the 12th century, made up the possessions of the English crown in French territory. The frescoes of St. Savin-sur-Gartemp show the typical treatment of this style, dominated by violent agitation of line and emphasis of parts of the design to give the figures a rather mannered roundness. This method differentiates itself from the Italo-Byzantine novelties introduced at Cluny around 1100 and presents itself instead as the direct conclusion of experiments typical of the 11th century, but entirely unconnected with the Mediterranean world. The principal witnesses to this style, the frescoes of St. Savin, are to be seen in the decorations remaining in three churches in Poitiers — Notre-Dame-la-Grande St. Hilaire-le-Grand, and the Baptistery of St. Jean — as well as in a group of miniatures including the Life of St. Radegonda (Ms.250 in the Municipal Library of Poitiers), some miniatures from the Second Bible of St. Martial at Limoges (Ms. Lat. 8 in the National Library in Paris), and five designs which decorate the Life of St. Martin coming from St. Martin's Abbey at Tours (Ms. 1018 of the Municipal Library of Tours).

In the second half of the 12th century, the Angevin style still showed its vitality in one of the artists who took part in illuminating the Winchester Bible. The artist was the so-called Master of the Apocrypha, who also did part of the illustrations to the manuscript of Terence's comedies coming from St. Albans and now in the Bodleian Library at Oxford (Ms. Auct. F.2. 13).

The most striking element of the work of the Master of the Apocrypha is again the absence of any links with Byzantine or Italo-Byzantine fashions of the early part of the 12th century which resulted in a more plastic form in Western pictorial culture, fashions which are best seen in English circles in the Bury Bible (Ms. at Corpus Christi College, Cambridge), and the wall paintings of the Chapel of St. Anselm in Canterbury Cathedral. Its culture is perhaps linked, rather, with an ancient tradition, giving a flavor which must be called archaic, bearing in mind the direct contacts with the Byzantine world which English artists could have had in the second half of the 12th century through Norman Sicily. But this fact is not a censure, since the Angevin style, above all, flourished continuously on French soil as is shown in the area north of the Loire for the second

quarter of the 12th century by the frescoes in St. Gilles at Montoire and in the third quarter of the same century by the oldest works in the crypt of St. Aignan-sur-Cher near Tours. This flourishing is also shown, as regards illumination, by a collection of Lives of the Saints (Ms. Lat. 5323 of the National Library in Paris) datable to the middle of the century and coming from western or central-western France, in which some initials show close affinity with the work of the Master of the Apocrypha.

On the other hand, the only miniature which decorates a Gospel in the Bodleian Library (Ms. Auct. D. 2. 15) with the Annunciation to Zacharias shows a contemporary reintegration of the correct Angevin style in an English ambit. This makes it possible to identify the scriptorium of St. Albans as the place where this took place, owing to the links which it shows with the illuminated initial of Psalm 105 in the St. Albans Psalter. This, the so-called miniature of Christina since it is a portrait of the one-time proprietor of the manuscript (now preserved in the Church of St. Godehard at Hildersheim), shows a commemorative scene which must have been added after 1155, when there is a notice of the personage portrayed, and long after 1123.

In that year the principal artist, the Master of Alexis, was working on the codex in his own personal style, only rarely influenced by Angevin modes. So the Miniature of Christina represents a moment of union between the two styles. The Master of the Apocrypha came from this studio, as is shown by the illustrations by his hand in the Terence at Oxford, which was executed at St. Albans by a team which included, among others, the so-called Master of Jumping Figures.

These two masters then went together to Winchester, a passage previously thought to have taken place in the opposite direction, but which the recent paper clarifies. A characteristic element of these two artists' collaboration is that while the former seems tied to the Angevin style, the latter uses the plasticity of the "wet draping" style typical of derivatives from the Byzantine or Italo-Byzantine world. In addition, both extract some elements of their personal styles for methods previously adopted in the St. Albans scriptorium. The Master of Jumping Figures seems to be linked, through certain forms of initials in the Winchester Bible, with the Gospel in the Bodleian Library and hence with the ambit of St. Albans towards the middle of the 12th century. The fact that the two miniaturists had previously worked on the illumination of the Comedies of Terence further helps to explain the Angevin culture of the Master of the Apocrypha. The model on which the decoration was redone, was actually a manuscript executed at Reims in the ninth century and now in the National Library at Paris. However, this manuscript should not constitute the only point of reference. The key factor is that it was partly copied towards 1100 in some part of western France according to the current local style, that is, the Angevin style. In fact, Morey has been able to suggest that the copy (Ms. Vat. Lat. 3305) has close comparisons with the Life of St. Martin of Tours and with the Second Bible of St. Martial at Limoges. Evidently, it is not possible to close the gap which separates the copying of the Carolingian manuscript in western France near 1100 and its appearance at St. Albans towards 1170. However, as Ayres proposes, it is not improbable that the Master of the Apocrypha was himself the vector, having transferred to the scriptorium not only the model, but the associated characteristics of the Angevin style in which it had been copied. Thus he made himself an intermediator between English art and the "Angevin School."

Berg's investigation of 12th century Tuscan illuminating has a special value as summarizing the state of research in another area. Garrison has previously made fundamental contributions in this field. The Norwegian scholar first proceeds to analyze the development of initials from the second half of the 11th century, this being a method which has already given good results. In that starting period, fashion dictated a type of geometrical composition with a structure divided into compartments whose extremities ended in finials formed of plaits or in a palmette. Berg derives the special development of Tuscan initials directly from this type, which recalls its far off Carolingian origins and which appears in the Roman area at just that time, but using an earlier chronology than that suggested by Garrison.

Berg distinguishes four phases in this development, the oldest of which he defines as the "first geometrical style," which remained still tied to Roman models and existed around the turn of the 11th century. During the first quarter of the 12th century, there came into existence a "transitional geometrical style," which, in addition to far better quality, has very clear compositional characteristics — colored backgrounds with naturalistically foliated spirals. In this group, which seems to have had its powerhouse in Florence, zoomorphic initials begin to be used alongside the geometrical styles. The "intermediate geometrical style" appeared towards 1125 in the Rhineland and seems to have been little followed in Tuscany except for sporadic examples from the Arezzo locality. The last stage is called the "late geometrical style" and seems to have been imposed on the transitional style since it uses most of the same elements in more elaborate form. The backgrounds become more complex and the spirals are carefully and delicately shaped into symmetrical and neatly arranged volutes. Initials of this type, which appear in the oldest form in the Carolinus Bible (Biblioteca Laurenziana Conv. Soppr. 30) dated about 1140, show a notable uniformity all over Tuscany and a greater stability as is shown by a comparison of the Calci Bible (Certosa di Calci Ms. 1) dated 1169 with the other Bible. The diffusion of this gave Tuscany a pre-eminence in central Italy and led to it having a certain influence in the Roman region.

A similar process of progressive unification can also be seen with the illustrations. The knowledge which can be gathered about the style of Tuscan miniaturists in the second half of the 11th century and the beginning of the following century is, however, limited owing to the lack of a corpus of manuscripts of proven provenance. The two most important texts are a Passion from the Abbey of Arezzo (Florence, National Library F.N. ll. l. 412) and a Bible from Florence Cathedral (Biblioteca Laurenziana Edili 125/126) which show (particularly the second) links with Roman pictorial art. It is only nearly half way through the 12th century that the previously mentioned Carolinus Bible shows the presence of a new style, characterized by a technique using thicker colors and stylistically by a more marked use of Byzantine fashion as part of a generalized movement in Europe at the time. The most significant works of this

period are the Mugellano Bible in the Laurenziana, a Book of Homilies in the British Museum and another in the Casanatense (Ms. 717), the Psalter of St. Michael's at Marturi (Biblioteca Laurenziana Conv. Soppr. 302/303), and a Bible in the Laurenziana (Plut. 15, 13). A related, but different, style appears in the Sacramentary in the Pierpoint Morgan Library in New York (Ms. 737) and can be approached by other texts, among which is a Sacramentary in the Laurenziana (Conv. Soppr. 292). Berg refers other important texts to the last quarter of the century, among them part of a Bible in the Casanatense (Ms. 732) and a Gospel concordance in the Vatican (Ross. 587).

Berg has also investigated the strength and ways of expression of the individual schools, as well as the social status of the miniaturists. They, contrary to what was still true of the rest of Europe, were still strictly tied to the monastic life, sometimes giving evidence of an already lay professional career. The School of Pisa seems to have been the richest center, besides Florence. The manuscripts in the Abbey of St. Vitus and in the Abbey of St. Mary and St. Gorgonius, kept in the Charterhouse of Calci, have proved to be a useful research tool in this field. The most notable are a Sacramentary (Ms. 2) and the previously mentioned Bible begun in 1169 by a cleric called Girardus. Approaching these are a Gospel in the Laurenziana (Acq. e Doni 91) which shows evidence of the use of a prototype from the Reichman School of the time of the Saxon emperors and a Bible kept in Madrid (National Library, Ms. 7/8). Except for the Laurenzian Gospel, all these works show ever increasing use of Byzantine formulae with the result that the artistic style is entirely directed toward the pictorial, which reaches full expression in one of the latest products of the Pisan School, the Psalter of St. Paul's at Ripa d'Arno (Bibl. Laurenziana Acq. e Doni 181), with which Berg compares the Bible in the Guarnacci Library of Volterra (Cod. LXI.8.7.).

As regards goldsmithing, in addition to the results of the "Rhein und Maas" Exhibition, Gauthier's volume on Western enamels, and the more detailed studies by Souchal on the Grandmont enamels, we must mention the publication by Cecchi of a small bronze dog curled up on a triangular base preserved in the store rooms of the Galleria Estense at Modena. This piece, beyond its intrinsic quality, has particular historical importance since it is signed on the bottom by a certain Gregorius aurifex when Patella, although not reproducing the piece, had already identified by epigraphic analysis as the artist who signed the silver Reliquary of the True Cross and the portable altar preserved in the Roman Church of St. Mary in Capitelli and which is remembered for having participated in 1117 in the dedication of the Cathedral of Palestrina by Pope Paschal II.

In spite of the fact that the two Roman pieces were exhibited at the recent "Treasures of Sacred Art in Rome and Latium from the Middle Ages to the Nineteenth Century" the failure to connect them with the little dog in Modena has left our knowledge of the artist's personality rather gappy. In fact, Cecchi's hypotheses do not appear to be thoroughly convincing as, although she places the Modena piece as a product of Roman workshops, she gives the artist a place in Countess Mathilda's Tuscany, inevitably putting his activity back to the 11th century - so much so as to suppose him to be a man from Campania or Latium (perhaps educated at Montecassino, or in any case in an ambient stemming from Desiderius) who emigrated to Rome and came into contact with Nordic culture, especially that of Lotharingia and Lower Saxony, thanks to the numerous political connections which had been established in the course of the 11th century between those regions and Tuscany. This would be a cultural progress which is also in contrast with the characters of the two Roman pieces of which the exhibition emphasized the uncertain elements of their recomposition in their original condition and of their date. There was also a disclaimer of recognition of only one artist named Gregorius who appears in both. This is therefore still an open problem, though it is very important as it offers, open to investigation, the inviting possibility of recomposing the personality of a Medieval Roman goldsmith. His eventual definitive identification as the maker of all the pieces cited would be a unique case, on the documentary level, for a Medieval artist. Therefore, it is a not unimportant reference point for the interpretation of central Italian culture of the first half of the 12th century.

BIBLIOGRAPHY - *Architecture: a) France*: R. Raeber, La Charité-sur-Loire, Bern, 1964; M. Deyres, La construction de l'abbatiale Sainte-Foy de Conques, B. mon., 123, 1965; F. Lesueur, Conques ll, B. mon., 124, 1966; J. Vallery-Radot, La Charité-sur-Loire. Á propos d'une thèse récente, Cah. de civilisation médiévale, 9, 1966; T. W. Lyman, Notes on the Porte Miègeville Capitals and the Construction of Saint-Sernin de Toulouse, AB, 49, 1967; J. Vallery-Radot, L'ancienne prieurale Notre-Dame à la Charité-sur-Loire. L'Architecture, CAF, 125, 1967; M. Deyres, La nef de Sainte-Foy de Conques, B. mon., 126, 1968; K. J. Conant, Cluny, Les églises et la maison du chef d'Ordre, Cambridge, Mass., 1968; F. Salet, Cluny III, B. mon., 126, 1968; M. Deyres, Le premier project de Conques II, B. mon., 127, 1968-1969; R. Crozet, Á propos de Cluny, Cah. de civilisation médiévale, 13, 1970; K. J. Conant, Medieval Academy Excavations at Cluny, 10, Speculum, 45, 1970; E. Read Sunderland, Charlieu à l'époque médiévale, Lyon, 1971; M. Deyres, L'interversion du thème bénédictin à Saint-Foy de Conques, B. mon., 129, 1971; E. G. Carlson, Excavations at Sainte-Étienne, Caen (1969), Gesta, 10, 1971; M. Durliat, La construction de Saint-Sernin de Toulouse, étude historique et archéologique, La construction au Moyen Âge. Histoire et archéologie. Actes du congrès de la Société des Historiens Médiévistes de l'Enseignement Supérieur Public, Paris, 1973; Ch. Lelong, La date du déambulatoire de Saint-Martin de Tours, B. mon., 131, 1973; Ch. Lelong, Le transept de Saint-Martin de Tours, B. mon., 133.

b) Spain: A. Ubicto Arteta, El románico de la catedral jaquesa y su cronologia, principe de Viana, 25, 1964; M. Durliat, Histoire et archéologie: l'exemple de Sainte Marie de Besalù, B. mon., 130, 1972; J. Williams, San Isidoro in Léon: Evidence for a New History, AB, 55, 1973.

c) Italy: A. C. Quintavalle, La Cattedrale di Modena, Modena 1964-1965, P. Héliot, La Cathédrale de Cefalù, sa chronologie, sa filiation et les galeries murales dans les églises romanes du midi, Arte Lombarda, 10, 1965; P. Salvini, Il Duomo di Modena e il romanico nel modenese, Modena, 1966; W. Krönig, Il duomo di Monreale e l'architettura normanna in Sicilia, Palermo, 1966; A. C. Quintavalle, Romanico padano, civiltà di Occidente, Florence, 1969; A. Puerari, Contributi alla storia architettonica del Duomo de

Cremona, B. stor. Cremonese, 24, 1969; A. Peroni, La struttura del S. Giovanni in Borgo di Pavia e il problema delle coperture nell' architettura romanica Lombarda, Arte Lombarda, 14, 1969; A. Puerari, La cattedrale di Cremona, Milano, 1971; G. Gandolfo, Problemi della Cattedrale di Modena, I, Comm., XXII, 1971; A. C. Quintavalle, Piacenza Cathedral, Lanfranco and the School of Wiligelmo, AB, 55, 1972; A. Pantoni, Le vicende della basilica di Montecassino attraverso la documentazione archeologica, Montecassino, 1973; A. C. Quintavalle, La Cattedrale di Cremona, Cluny, la scuola di Lanfranco e di Wiligelmo, Stor. dell'Arte, 18, 1973; F. Gandolfo, precisazioni sull'architettura monastica di Nonantola in epoca romanica, Comm., XXIV, 1973; J. Raspi Serra, Lo schema basilicale in Puglia in relazione alle cattedrali di Otranto e di Taranto, Cenacolo, III, 1973; A. C. Quintavalle, La Cattedrale di Parma e il romanico Europeo, parma, 1974; G. Morozzi, F. Toker, J. Herrmann, S. Reparata. L'antica Cattedrale Fiorentina, Florence, 1974; C. Bozzoni, Calabria Normanna, Rome, 1974; Alle sorgenti del Romanico. Puglia XI century, cat. prod. by P. Belli D'Elia, Bari, 1975; A. M. Romanini, per una "interpretazione" della Cattedrale di Piacenza, Acts of the studies conv. for the 850th anniversary of the found. of the Cathedral of Piacenza s. I. né d.

d) Germany: H. E. Hubach, W. Haas, Der Dom zu Speyer, Munich-Berlin, 1972.

Sculpture: a) France: L. Seidel, A Romantic Forgery: the Romanesque "Portal" of Saint-Etienne in Toulouse, AB, 50, 1968; A. Borg, Architectural Sculpture in Romanesque Provence, Oxford, 1972; W. S. Goddard, The Façade of Saint-Gilles-du-Gard, Middletown, 1973; W. Sauerlander, Zu dem romanischen Kruzifix von Moissac, Intuition u Kw., Festschrift f. H. Swarzenski, Berlin, 1973; L. Seidel, The Façade of the Chapterhouse at La Daurade in Toulouse, AB, 55, 1973; J. Cabanot, Le décor sculpté de la basilique Saint-Sernin de Toulouse, B. mon., 132, 1974; M. Durliat, Le portail de la salle capitulaire de la Daurade à Toulouse, B. mon., 132, 1974.

b) Spain: S. Moralejo Alvarez, La primitive fachada norte de la catedral de Santiago, Compostellum, 14, 1969; M. Durliat, La parte de France à la Cathédrale de Compostelle, B. mon., 130, 1972; S. Moralejo Alvarez, Une sculpture du type de Bernard Gilduin à Jaca, B. mon., 131, 1973.

c) Italy: R. Salvini, II chiostro di Monreale e la scultura romanica, Palermo, 1962; L. Cochetti Pratesi, In margine ad alcuni recenti studi sulla scultura medioevale nell'Italia meridionale, Comm., XVI, 1965; XVIII, 1967; XIX, 1968; XXI, 1970; A.R. Masetti, II portale dei Mesi di Bendetto Antelami, Cr. Arte, XIV, 1967, 86 and 87; A. M. Romanini, Stucchi inediti di Santa Maria Maggiore a Lomello, Comm., XIX, 1968; E. Fernie, Notes on the Sculpture of Modena Cathedral, Arte Lombarda, 14, 1969, 2; L. Cochetti Pratesi, II frammento romanico di San Benedetto Po e precisazioni sulla maestranza di Nonantola e di Piacenza, Comm., XXIII, 1972; L. Cochetti Pratesi, La scuola di Piacenza, Roma, 1973; L. Cochetti Pratesi, Postille Piacentine e Cremonesi, Comm., XXV, 1974; P. Belli D'Elia, La Cattedra dell'Abate dell'Elia - Precisazioni sul romanico pugliese, B Arte, LIX, 1974; D. Glass, Romanesque Sculpture in Campania and Sicily: A Problem of Method, AB, 56, 1974.

Painting, Miniatures, and Minor Arts: a) General Works: O. Demus, Romanische Wandmalerei München, 1968; O. Demus, Byzantine Art and the West, London, 1970; J. Wettstein, La fresque romane, Italy, France, Spain, Geneva, 1971; M.M. Gautier, Émaux du moyen âge occidental, Fribourg, 1972; C. Nordenfalk, recens. Demus, Romanesque Mural Painting - Wettstein, La fresque romane, AB, 55, 1973.

b) France: G. François-Souchal, Les émaux de Grandmont au XII siécle, B. mon., 120, 1962, and 121, 1963; M. Schapiro, The Parma Ildefonsus, a Romanesque Illuminated Manuscript from Cluny and Related Works, New York, 1964; G. François-Souchal, Autour des plaques de Grandmont: une famille d'émaux limousins champlevés de la fin du XIIᵉ siécle, B. mon., 125, 1967; M. Vieillard-Troïekouroff, Fresques récemment découvertes à Saint-Martin de Tours, Les Mon. historiques de la Fr., 13, 1967, 2; J. Wettstein, Les fresques bourguignonnes de Berzé-la-Ville et la question byzantine, 38, 1968.

c) Italy: H. Belting, Studien zur beneventanischen Malerei, Weisbaden, 1968; K. Berg, Studies in Tuscan 12th Century Illumination, Oslo-Bergen-Tromsö, 1968; I. Toesca, Affreschi a Filacciano, Paragone, 221, 1968; A. M. Damigella, Pittura Veneta dell'XI-XII secolo. Aquileia-Concordia-Summaga, Roma, 1969; A. Thiery, Per una nuova lettura degli affreschi medievali campani, Comm., XX, 1969; A. Segagni, Affreschi inediti della chiesa di S. Antonino a Piacenza, Arte Lombarda, 15, 1970, 1; C. Bertelli, A. Grelle-Iusco, St. Angelo di Lauro, Paragone, 225, 1971; H. Toubert, Le Bréviaire d'Oderisius (Paris, Bibl. Mazarine, Ms. 364) et les influences byzantines au Mont-Cassin, Mél, 83, 1971; I. Toesca, Antichi affreschi a Sant'Andrea al Celio, Paragone, 263, 1972; G. Cavallo, C. Bertelli, Rotoli di Exultet dell'Italia meridionale, Bari, 1973; E. Cecchi, Un bronzetto siglato "Gregorius Aurifex" e alcune ipotesi sull'oreficeria centro-italica e padana, Antichità viva, 12, 1973, 2; A. Carotti, Gli affreschi della Grotta delle Fornelle a Calvi Vecchia, Roma, 1974; Tesori di arte sacra di Roma e del Lazio dal Medioevo all'Ottocento, Roma, 1975.

d) Germany: G. Games, Byzance et la peinture romane de Germanie, Paris, 1966; Rhein und Mass, Kunst und Kultur 800-1400, 1. Eine Ausstellung des Schnütgen-Museums der Stadt Köln und der belgischen Ministerien für französische und niederlandische Kultur, Köln, 1972; 2, Berichte, Beitrage und Forschungen zum Themenkreis der Austellung und des Katalogs, Köln, 1973; H. Sedlmayr, Kriterien zur Chronologie der Wandmalereien auf der Fraueninsel im Chimsee, Z. f. bayerische Landesgeschichte, 34, 1972.

e) England: L. M. Ayres, The Role of the Angevin Style in English Romanesque Painting, ZfKg, 37, 1974.

f) Switzerland: E. Murback, P. Heman, Zillis. Die romanische Bilderdecke der Kirche St. Martin, Zurich u. Frieburg, i. Br., 1967; M. Jenny, Zur Anordnung der romanischen Deckenbilder von Zillis, ZS AKg, 27, 1970.

g) Austria: N. Wibiral, Die Wandmalereien des 11 Jh. in ehemaligen Westchor der Stiftkirche von Lambach, Alte u. moderne K., 13, 1968, 99.

FRANCESCO GANDOLFO

GOTHIC (PLATES 98-99)

In spite of the many studies of Gothic Art that characterized the period 1960 to 1975, no particularly radical changes in the general historical interpretation of the period have been noted. On the other hand, an infinitely detailed critical work over an ever wider front of research, divided up among an ever growing number of scholars, is being carried out with the object of recreating the whole series of still ascertainable facts, with an exhaustive examination of the works and — this is a novelty at least as regards the first transalpine Gothic period and particularly the architecture — the recon-

struction of individual artistic personalities, even though many are destined to remain anonymous.

On the other hand, because the period between the middle of the 12th century and the end of the 15th, which, for different lengths of time according to the particular branches of art, included the whole complex of phenomena collected under the name Gothic, has involved all of Europe in a constant general artistic "presence." This has largely been conserved locally and today, in fact, is still dominant. The picture is still far from completion. It refers to a phase of the studies which is now more than ever in full evolution and without accentuation in any particular direction; if not that, it is basically contrary to synthesis.

In this situation, the debate on the actual term "Gothic," as a brief recapitulation critically significant of a unique period in the history of art in Western Europe has been sacrificed to concentrate attention on individual facts. Where history has not left it out altogether, it has, however, even further reduced the traditionally scarce area of application. The search for new proofs has concentrated the attention on homogeneous facts and phenomena and is thus somewhat limited. It is not unusual for one of the results to be refused the word "Gothic" or to have doubts raised against its validity; while on the broader problem of the "period," a widespread attitude of waiting or indecision is noticeable. In the ample and compelling synthesis on European art of the 12th to 15th centuries provided within the ambit of the program of the Propyläen Kunstgeschichte (1972), it was preferred to divide the epoch into two main periods (Vol. VI, "Das hohe Mittelalter," edited by O. V. Simson; vol. VII, "Spätmittelalter und beginnende Neuzeit," edited by J. Bialostocki). In the proposed reconstruction, the physiognomy of two moments complete in themselves and different from each other is assumed. The second one is closely tied to the growth of the Renaissance. The renouncement of the term "Gothic" in favor of "Medieval" corresponded to a breaking up of the middle century and heart of the Gothic period - the 14th century - which ends up drastically cut and unrecognizable. It is not by chance that similar criteria for the fixing of periods had already been followed in the two panoramic exhibitions on European Gothic under the patronage of UNESCO: "Europaische Kunst um 1400" (Vienna, 1962) and "L'Europe Gothique XII-XIV siécle" (Paris, 1968), which in spite of the excellence of the critical contributions, at least in the first case, rather than opening to a new perspective were reflections of the situation and often also of the difficulties encountered in the studies.

Possible definitions of synthesis emerge from those studies. In view of the subsequent inevitable partiality, it is well to concentrate some attention on them.

Historiography has always identified the birth of the Gothic style in the cathedrals founded in the Île de France and in Champagne between the second half of the 12th century and the first two decades of the 13th century. But if as such this birth is unquestionable, the only clear breakaway from the preceding and surrounding European Romanesque civilization, the relative problematics have always been founded in the sense of a more or less strongly needed evolution in Romanesque architecture, often ending up by losing the sense and the moment of the breakaway.

In the case of sculpture and painting, the birth of new types appropriate to the cathedral (monumental statuary and glasswork) constituted a precise reference point on which to base the studies. The criteria used for distinguishing type and style continue to occupy much of the relative literature which, except for the high degree of specialization that has been reached and the consequent quality of the results, gives no indication of any change of direction. The most stimulating novelties are noted at the moment of the connection with architecture — that is to say, in the individuation of the particular "workshop" — and even more in the iconographic investigation.

It is principally on the analysis of the specific architectonic fact that scholars have gone back to examining the origins and the consistency of the Gothic style with new theoretical and methodical approaches. In fact, much has been lost of that interest in the history of the single elements and typologies that had arrived at the cathedral in the course of a continuous evolution from preceding architectural phases and that had led one to see the Gothic cathedral as the logical and necessary result of static and formal experiments carried out within the ambit of Romanesque architecture and begun even earlier. Although there is no shortage of contributions, even recent ones, in that respect, there is now a widespread conviction that the cathedral can not be understood by investigating the origins and the preceding diffusion of the ogive arch, the ribs, cross-vaulting, or external buttress systems. Looked at today, the highly colorful "chauvinist" discussions on the priority of this or that region in the use of ribbed cross vaulting, are simply amusing.

The sense of continuity between the formulation of the cathedral and the preceding phases of architecture going back to the Carolingian age can be recognized, if at all, in a progressive articulation in the thickness of the walls, in their being perforated with continuous tunnels and passages which identifies in the "plastique murale" (P. Héliot) the specific evolutionary moment until the introduction into the architectonic context of the ribbed cross vault and buttresses.

The actual concept of transition has been submitted to criticism (J. Bony) in the introduction of a group of papers read at the XX International Congress on the History of Art (Princeton, 1961), all of which dealt with episodes of Europe's conversion to Gothic. It was proposed to substitute the idea, borrowed from biology, of "changer," which, when it occurred, determined the death of that which was changed. Thus, four types of solution evolved: anticipation, change, evolution following the change, and compromise after the fact. Compromise, yes, but with infinite possibilities of intermediate solutions and with the ability to absorb the historical reality of the formation and propagation as an always active and current process of a new movement or artistic style in dialectic rapport with the pre-existing ones.

In substance, the refusal to insert the birth of the French Gothic cathedral, and therefore Gothic style, into an evolutionary perspective becomes more decisive when the attention moves from the structurally static moment and the cathedral comes to be considered from different points of view. Focillon had already, and brilliantly, closed the diatribe begun by Viollet-le-Duc on the supporting value of buttresses when he, seeing the

impossibility of an univocal response in either sense, had substantially denied any value in the question. He recognized in the buttress not only, and not even principally, a static construction element but, and in equal measure, a plastic form presented to the eye when looking at the spatial concept.

This opened the way to the triumph following the interpretation of the first examples of French Gothic architecture as the art of spatial illusion "architectural illusion," according to the formula that Pol Abraham had immediately countered to the "Medieval rationalism" of Viollet-le-Duc. In reality, the little fortune that the "illusionistic" interpretation enjoyed on its first appearance could not be explained only by the positivist turn that the study of the history of art had taken at the beginning of the 1900s. The myth of Medieval rationalism and the volume of Viollet-le-Duc's studies undoubtedly exercised a function of stimulation and theoretical guide incomparably wider and deeper than that of the late Romantic type of evaluation of Gothic architecture that Pol Abraham proposed.

But above all, there existed a problem of meanings. If the cathedral no longer represented even the figuratively proposed meanings - a moment of affirmation of the triumph of reason over matter; if the architectonic idiom inaugurated by it was not a purely formal function of a perfectly logical and coherent structure - visual exaltation of the victory over gravity, but instead, the artificial creation of an impression of that sort, then did the interpretation of the first Gothic architecture go back to the Vasarian evolution of imaginary architecture - just a mass of forms, the incongruous witnesses of themselves alone - architecture so delicate as to seem made of paper? Was it an interpretation that the contemporary taste, having once overcome any reference to classical canons, could at most remove the sense and the value of the condemnation?

The two replies already given to the question some time ago ("diaphanus structure," Jantzen; "baldachino structure," Sedlmayr) had indicated in the space taken from the gravitational and optical condition of real space, substantially in the illusionistic potential of the cathedral, the wish to create an unworldly space, full of religious and liturgical significance. Sedlmayr, in particular, had already indicated in "civitas Dei" the model to which the builders of the cathedral turned, like Soloman in the Temple of Jerusalem.

Yet a third reading is added to those which O. V. Simson has proposed by systematically developing ideas from Panofsky and combining them with the exegetic term of Jantzen's structural transparency. One clear breakaway of Gothic architecture is represented by the Abbey of St. Denis near Paris. This structure was begun by Abbot Suger with the building of the choir and façade with the atrium. The cathedrals found in the Île de France up to the end of the 12th century, in the so-called proto-Gothic style, do not correspond to a transitional phase from Romanesque to Gothic. They show clear signs of a sudden adaptation of the Romanesque organism of the basilica and the women's galleries to the new architectural principles inaugurated at St. Denis. The alteration is shown mainly by the adoption of the choir with radial chapels and the harmonious façade with triple horizontal and vertical partitioning.

Thus the causes of the birth of Gothic architecture do not exist primarily in the gradual technical and static perfecting of a complex of structural elements that entirely assumes the definition of the spatial image and of every formal value. They are indicated rather in motivations of a theological and political order with reference to the situation of the region in which the Gothic architecture is born when modelled on the new basilical form of cathedral which was entirely realized for the first time at Chartres. All the proto-Gothic cathedrals are, in fact, the episcopal sees of crown lands and, as such, have royal cathedral status. St. Denis is, in its turn, a royal abbey. Suger, ambassador and chancellor of Louis VI and for a time Regent of France, began its reconstruction to revive not only its role as mausoleum for the royal family, but that of custodian of the divine investiture of the French monarchy.

The architectonic idea of Suger's St. Denis is derived from the theology of beauty, developed on Platonic and Augustinian motives by theologians and philosophers of the 12th century. They, seeing in the beauty of things created the reflection of divine beauty true and absolute, preached the need to raise oneself to the contemplation of true beauty through the senses. The architecture of the cathedral provokes the process of elevation through two fundamental aspects: the vertical movement (which has no end, but is an overwhelming force) and light, source of the purest beauty. The two aspects combine architectonically in a double spatial covering. The internal one consists of polarized linear elements in height; the external is represented by the windows, which substitute the walls as an abstract projection of purified light "sanctified' by the color. An important theology of light is found in the writings of the so-called pseudo-Areopagita, a siriac mystic of the fifth century who, through a double error, was identified with both Dionysius the Areopagita, a disciple of Paul, and with Dionysius, apostle and patron of France, whose bones were laid to rest at St. Denis. The theologico-moral motives behind the architecture of St. Denis thus conferred upon the church the authority of an "exemplum" which had been the precursor of Gothic architecture and the Gothic style in absolute. Meanwhile in France sacred architecture became the "theology of the monarchy" (R. Fawtier) and flourished for another century.

From another point of view, the cathedral is seen as a re-creation in process - "Nachbildung" (Simson) - and not as a fixed and definite image - "Abildung" (Sedlmayr) - of the universal harmony of the "civitas Dei" according to a still Platonic and Augustinian cosmology developed by the School of Chartres. I refer to the methods of calculating the proportions and geometrical dimensions which, starting from Dehio, have been the subject of a vast amount of literature of which P. Frankl has offered an excellent synthesis. In coming back to the question of the birth of the cathedral, according to a clear historical scheme - beyond aesthetic-anthropological or simply fantastic interpretations, which had thrown doubt on the credibility of this type of study - we note the only inconsistency in Simson's exposition. In fact, he underlines the value that the metric relationships corresponding to those of the perfect musical agreement of Plato and Augustine would have for the architecture of cathedrals. Studies of documents and metric analyses, on the other hand, have long since individuated measurements of both spaces and structures obtained principally by geometrical

means and consequently for constructions based more on angular openings than on the numerically fixed metric quantity. Thus they have no aesthetic value, but seem rather to consist of a sort of non-experimental equivalent of modern building science (P. Booz, M. Velte). Metric proportions not only remain unnoticed in cathedrals (unlike, for example, Cistercian churches) but, as generators of fixed images, they are in flagrant contrast with the principle of verticality "ad infinitum" and also with the principle of "diaphanous structure."

The series of studies by R. Branner is dedicated to a complementary, but more extensive and articulated, description of French Gothic architecture up to the initial stage of the "flamboyant" style. Worthy of particular mention is this scholar's method which, within a serious, but precise and functional framework of social and political history, is based essentially on what he calls archaeology. It consists of an analytical reading of the monument in principally stylistic key on the lines of which the architectural events outside the order of ideas of a uniform and continuous evolution have occurred. On the contrary, he searches for a complex interweaving of relationships, and especially of the new factors that every monument proposes, until reaching a sort of science of attribution which, on being applied to French Gothic architecture, is a practically unknown method. Architectural masterpieces such as Chartres, Bourges, and Reims, or the entire regional variant of Burgundy, assume, in Branner's pages, a vivid characterization of autonomy. They become stages in a history of architecture created and lived by the masters who, even though most of them are anonymous, emerge as clear and evocative personalities, in an active and dialectic relationship with a global interpretative background also founded on the "leitmotif" of architectonic illusionism.

The finest fruits of a similar scheme are provided by the study dedicated to the Franco-Parisian phase of architecture of the time of St. Louis. The reconstruction of a court style of which it has been possible to trace the origins and the maturation up to the explosion of the "flamboyant" fashion while combining with the effective homogeneity and consistency of the court was resolved, on the other hand, in the individuation of various types of stylistic polarity. This process flowed from the conservative Cistercian style of Royaumont, to the rich fantasy of Libergier in St. Nicaise at Reims, seen in counterposition to the logical and rigorous attitude of the "Master of St. Denis," up to the time of the artist who, working in Notre-Dame of Paris, seemed almost to normalize the style in lines and within rules which determined its fortune throughout Europe. A passage certainly essential in the redimensioning, or rather the historical dimensioning, of this junction of late Medieval architectural civilization is the sacrosanct demolition of the personality of Pierre de Montreuil. This personality was unreasonably exaggerated by the preceding historiography to the point of including practically everything that remained anonymous of the architectural production promoted by the saint king. In indicating in the "style of the court of St. Louis" a moment of close connection between the theological, moral, and political meanings and the form and architectural structure, the paper by I. Hacker Suck on the iconography of Saint Chapelle, its precedents and its derivations are to be added to results obtained by Branner.

It was only at a later date, starting from the transepts of Notre-Dame in Paris, that this style became a taste, an architectural fashion, whose particular characteristics, such as the rose window set in an openwork square and glazed or the gable-shaped tympanum, were to find European recognition and give consistency to the "flamboyant" phase of Gothic architecture.

Again, it was Branner who pointed out some of the ways in which French Gothic architecture spread through Europe, constantly as an alternative to the idea of absorption by means of the separation and reconjunction of various components. In the contact of new components with the various local substrates of the host region, these particular traditions were equal to a bastardization of the principles of the region of origin. Cologne Cathedral became the "principal heir of Amiens," changed, however, by the court style — that is to say, with some forms from Sainte-Chapelle and from St. Denis. To the observation that Cologne was the only case of the unreserved adherence of German architecture to the cathedral system, there corresponds the confirmation of the fact that Cologne Cathedral, metropolitan see of German Catholicism, was rebuilt on the lines of the French model as an alternative to the configuration of sacred architecture in the Hohenstaufen ambit, particularly at Bamberg, sponsored by the deposed emperor.

The same considerations — a certain rivalry with the French monarch, but expressed here as emulation — explained Westminster Abbey, once again the first and only "cathedral" of England. The Abbey was transformed, however, in objectives and form according to a plan to use it as a national shrine like Sainte-Chapelle. Branner's arguments have been convalidated by a truly exceptional series of accounts for architecture commissioned by Henry III, published recently by H. M. Colvin. Particularly in the case of Westminster Abbey, with a degree of detail never before known for a 13th century monumental structure and methods of building organization, those accounts give proof of the direct royal patronage of the undertaking and of how the French taste was connected with it. This last point was confirmed also by the use of French chisels and materials.

However, the notion that there were certain national constants with ethnic roots or at least of stylistic definition if not of historical certainty held at the beginning of this century is now considered uncertain. If, for example, a unitary panorama had been possible for England only during the decorated style (H. Block), the architectural picture up to the end of the 13th century (T.R.S. Boase) looks much more disorganized in a well consolidated situation of "compromise after the fact."

W. Gross has repeatedly underlined the dishomogeneity of the architecture that appeared in German-speaking countries between 1180 and 1380, denouncing the impracticability of the Gerstenberg proposal. Even on late Gothic some of the dogmas on which the definition of the "deutsche Sondergotik" was based are more or less violently contrasted today (H.J. Kunst, F.W. Fischer). An attempt has been made (W. Gotz) to find constant values in a particularly vigorous, centralized tendency in Germany by relaunching the old thesis of the interference of a regional tradition of

ancient and proto-Medieval descent in the lower Rhine Valley; focusing on a renewed contact with Antiquity through Byzantine architecture at the time of the crusades; and finally emphasizing iconographic motives and derivations.

But, in spite of the political and social consolidation between the 11th and the 15th centuries of organisms of a national character, Gothic architecture and art could never be defined within the geographical and theoretical confines of the nation. There existed, on the other hand, political, religious, and social incentives which provoked unitary phenomena in Europe and allowed the occurrence of unforeseen facts unrelated to each other.

Using the idea that Gothic architecture was transmitted by a gradual diffusion from Northern France to the confines of Europe, acquiring on the way new characterstics and deviants imposed by the adaptation to local architectural traditions, has contributed to a decisive extent to the new impostation of the Cistercian question that has been formulated around the studies by Hann. In the initial phase of Cistercian architecture, corresponding to the generalship of St. Bernard and contemporary with the birth of the cathedral, it has been found necessary to recognize a substantial fidelity to the idiomatic elements of Burgundian Romanesque. This fact has raised some doubts about the existence of a Cistercian architecture as such (E. Kubach). But where it occurred with clearer autonomous and, at the same time, Gothic characteristics — that is "in the abstract or mathematical conception of space: A conception which constitutes the only effective revolutionary aspect and is in fact the great inspiratory "theme" . . . of primitive Cistercian architecture" (A. M. Romanini) — it applied to the proportional reorganization according to the Augustinian musical harmony properly of the Cistercian architecture of all Europe, of Eberbach or Chiaravalle Milanese no less than Fontenay.

The international dimension that all the central moments of Gothic architecture assume in Europe, therefore, gives the methodological reason for the failure a priori of the history of Gothic architecture for nations and, to a certain extent, for chronological divisions or types.

Similar difficulties have been met with, particularly in the definition of Italian Gothic architecture and Italian Gothic in general. It is not very long since Italy was refused the right to any Gothic citizenship with the exception, for a short period, of a few regions. It is enough to leaf through Keller's interesting volume on Italian artistic regions and compare it with the analogous one on France to realize how little and for which relatively "little Gothic" examples the ponderous contribution of the 13th and 14th centuries appears even today to the critical conscience in defining the artistic panorama of the peninsula. The synthesis of the history of art in Italy 1250-1400 offered by J. White never exceeds the limits of a more or less attentive and balanced classification of the results obtained on single arguments. Consequently, the synthesis does not even attempt to deal with the problem of Italian Gothic. From a panoramic view, only Wagner Rieger poses with any clarity the problem regarding the architecture of the 12th and 13th centuries and of Italian participation in Gothic. Although his treatise is still irreplaceable today

for the vastness of the investigation and the richness of the partial results, it is necessary to underline, even in this case, the anchorage to a theme of fundamentally foreign derivation that can no longer be sustained today as an historiographical record. So it seems useless to search in Italy for formal examples of transalpine influence (H. Klotz).

The fact is that before the prestigious nucleus of artists who worked in Tuscany between the end of the 13th and beginning of the 14th century, the artistic fortunes of Italy and, in particular, those most closely tied to the problem of the Gothic style represented the heads and tails of an equal number of international questions. Considering the Cistercian question first, if that, even for Italy, is inserted into the wider European problematics mentioned above (A. M. Romanini), finally abandoning the confines conferred upon it by Enlart, others remain in the anonymous limbo of regional treatments or of monographs on single monuments. In the case of friary architecture, in the impossibility of recognizing typological or idiomatic constants in Italy, even to a limited extent (R. Wagner Rieger), sectorial studies on regional variants, often within the ambit of wider architectural histories, have been carried out; and sometimes (H. Dellwig, W. Kronig, P. Heliot) actually centered on friary problems. Or they have continued to consider the major problems: for them the Basilica of Assisi (W. Schöne, E. Hertlein) and the St. Anthony of Padua (H. Dellwig) are extraneous, within certain limits, to the creation of friary architecture:

With the abandonment, except for an occasional revivification (M. L. Cristiani Testi, M. Lorandi) of the unrewarding lands of Arabian and Eastern connections, the area still considered as that of Frederician art has been drastically reduced (F. Bologna). The result is that one goes hunting the gnat while failing to see the elephant in the shape of Swabian art in Germany. The problem there does not consist of an umpteenth search for imaginary transalpine influences in Italy, but of the individuation of a Europeo-Swabian area of which Castel del Monte or Porta di Capua are equal protagonists with the choir of Naumburg and the Cavalier of Bamberg.

The absence of solutions to questions of this kind weighs negatively on problems which are directly derived from them. The greatest of these — that is, that of the origins of Nicolo Pisano — still remains open even after the most recent contributions (S. Bottari, Ch. Seymour, O. Morisani). This lack of information goes a long way to deprive the greatest period of Italian art, which began in Tuscany in the second half of the 13th century, of every antecedent fact and to eliminate it entirely from the problematics of Gothic style.

As the phoenix which rises again from its own ashes, it is still the preserve of Vasari to bring back the controversial anti-Gothic subject even in a paradoxical reversing of values. In fact, the historiography of Italian art in the passage from the 13th to the 14th century continues to evolve in specific monographs centered on artists and monuments. Thus, while the last decade has seen a colossal revival of interest in Giotto, this is still channelled in a honeycomb of traditional questions still, however, unsolved, regarding Assisi, the relationship with the Roman School, Maestro d'Isacco, and so on, with, if anything, a renewed attention to the iconography. Because of the irrelevance that all this has to the

present context, even when it is a case of excellent contributions, it is not necessary to go into details. The most interesting novelties refer to the architectural activity of the Master, both with regard to the Campanile (M. Trachtenberg) and the possibility of his intervention in the design of the Chapel of the Scrovegni, and generally to the architectural dimensions of his frescoes (D. Gioseffi). These are in addition to the hypothesis of some Milanese architectural activity (A. M. Romanini). The interest is not motivated only by a catalogue of Giotto's architectural works, but also by the artist's net insertion into a Gothic context as a result.

The destiny of Nicola and Giovanni Pisano is more unusual. Along with contributions of an iconographic character (H. von Einel, G. Jaszai), the commitment to clarify, beyond any attributive questions, the key moments of the building yards of Pisa and Siena has been discharged excellently, if not finally (M. Seidel, A. Kosegarten). But then, while Nicola seems to be hidden by a curtain of embarrassed silence, the sculptural activity of Giovanni has been examined in studies aimed at an immediate aesthetico-semantic recovery (M. Ayrton, G. L. Mellini). Although they may touch on evocative moments they do little to unravel the tangle of Italian figurative culture. The artist remains floating on the indefinite foam of an heroic dimension of the genious of Vasarian descent.

In the period 1965 to 1975, only Arnolfo de Cambio enjoyed a happy critical season. This renewed interest in the artist provoked primarily the proliferation of new additions to the catalogue of culture. Among the many proposals, the recovery of a second scribe of the fountain of Perugia (F. Santi) and the attribution of a virile statue, perhaps destined for the façade of Santa Maria del Fiore (M. Salini), should be remembered as particularly convincing. The Roman activity was reconsidered as regards both the architecture (P. Cellini) and the sculpture, with a study of the origin of the tomb with figures (K. Bauch) which, if it does too readily accept attributions which have already been disproved, still examines the iconography of this monumental type and its suppositions, thus supplying an essential datum for the interpretation of the art of Arnolfo. On a philological plane, on the other hand, there is a series of clarifications which should be mentioned regarding the Roman ambient tied to Arnolfo (J. Gardner). It was left to A. M. Romanini to deal in block with the work of Arnolfo, to draw up a credible catalogue, not as a complete "corpus" of the master's works, but as a secure basis for interpretation, principally connecting the artist with the "flamboyant" Gothic phase. But the stylistic comparisons with the Parisian ambient are valid only as evidence of the fundamentally Gothic mentality of Arnolfo the sculptor. Above all, the architect expresses himself in the abstract, but clear, immediate value of the geometrical figure with which the spatial image can immediately be resolved, just as every sign of plastic representation becomes upset in an acute bidimensional synthesis. If the reconstruction starts from the certain sculptural works, it eventually clarifies, above all else, the master's architectural activity, definitely assigning to him Santa Croce and the Florentine Abbey and concluding, with an accurate demonstration in terms of stylistic analysis, the Arnolfian pertinence of

a first design for Santa Maria del Fiore which remained as the basis of the constructive work of the monument.

The critical and methodological bases of a similar operation, which aimed at bringing the term "Gothic" back to a type of judicial summary of a phase of the history of Western art, had already been experimented by Romanini in opening to the history of art that sector of Lombard Gothic architecture which until then had been practically unexplored. In the panorama which embraces the 12th to 15th centuries, many of the points touched on are mentioned here in other respects. Cistercian architecture, suggestively flanked by communal architecture in giving origin to a Lombard Gothic idiom, was taken up again with a new expressive individuality by the Friary Orders, which in their turn were to have a determinant effect on the architecture of the region and constitute a central chapter of its history. The penetration of transalpine, principally German, elements, but also the introduction of typologies, church-to-hall and pseudohall, like the North German were to become constants of Lombard Gothic architecture. The critical unifying term, also, where figures of architects at first unsuspected or noted by little more than name have emerged with sharp individuality, has been the recognition of the fundamental means of expression represented by the wall, with its lucid geometry and consequently bidimensional drafting.

Having examined the principal problems connected with the definition of a first Gothic period, without making any claim to have made a complete summary of all studies but remaining based on the indications from the architecture, we must now pass on to the consideration of the second period, usually called Late Gothic. Also, for this period, which starts around 1370, the field to be examined is constituted principally by a very large volume of research including a quantity of recoveries and re-examinations which would be impossible to list. They are covered by the still debatable basic historico cultural systemization under the denominations of "International Gothic" or "Courtly Art" proposed by the founding fathers of the Late Gothic historiography, or perhaps by the term "Cosmopolitan Gothic" which has been put forward again in the pages of the Encyclopedia of World Art.

In this sense we also immediately mention the seventh volume of the Propyläen Kunstgeschichte, which makes a decisive step forward in the difficult osmosis between studies on Western Europe and studies on Eastern Europe. Only the Bohemia of the first Luxemburg rulers was considered, on account of their Western forebears. The exceptional quality and volume of the artistic production was always considered one of the two or three most important protagonists in the formation and development of the international idiom which belongs to the first phase of European Late Gothic. The idea of confronting Westerners of undeniable renown with a squadron of scholars, presumably of Eastern, or even American, extraction and education has given solid advantages hard to come by otherwise, although suffering from the defect of a totally insufficient information in the relative texts (the documentary part) about the main structure of traditional 15th century historiography. They even include some gross blunders.

One of the benefits from this confrontation is the revelation of artists whose names still sound unfamiliar to us when compared with Donatello and Sluter,

Stethaimer and Brunelleschi, Masaccio and Jan van Eyck. Even more important is the revelation of works which confer a totally unsuspected richness and vitality on the Gothic world of that period. In addition, there is the advantage of having a unified presentation in which no particular ambit, either new or inferred or even merely accreditted by an age-old historiography, receives preferential treatment or undue emphasis. Finally, there is an effective refusal to divide the material into blocks corresponding to national entities (which, if transferred to the reality of those times, would in any case be stupidly presumptious) rather than classifying the type.

Transferring oneself from quantity to quality — which is to say, exercising historical judgment — the vision of Late Gothic as a cultural world as an alternative to the Renaissance is reinforced. It is, thus, clearly not given over to decadence, nor yet subordinated vis a vis the Renaissance, by the famous ultimate inertia of the medievalism in splendid decline. The autumnal vision of the last of the Middle Ages tends to fade, and the historian who wants to support it still is rather forced to adopt Hegel's quills from Minerva's owl.

The expressions used for stylistic qualification seem to be more readily acceptable. The definition of "Dolce Stile" (Smooth Style) for the first sub-period of Late Gothic seems to be gaining favor. This term was for a long time applied to a division of German sculpture, the "weicher Stil" (the softer style). Then it was transferred, first to painting and then to the architecture in the German region, and often used as a distinction from the "spiky style" ("eckiger Stil") in a Wolfflinian opposition of concepts (E. Petrasch). It can now legitimately be used for a whole stylistic class in the Late Gothic in general. "Nobody doubts any more now that 'smooth style' is a different term for the sociological denomination of 'courtly style' and of that 'international style' derived from its geographical extension." (J. Bialostocki).

Just because it is strictly tied to stylistic values, to the calligraphy of the decorative detail, or of the draping, and, in painting, to the precious quality of the color which is not mortified by the chiaroscuro effects of lighting but emphasized by dappling, the name of "stile dolce" can be used all over Europe. But the name "stile dolce" should never be applied later than the last quarter of the 15th century (excluding eventual stylistically divergent episodes, of which there were plenty everywhere between the 14th and 15th centuries). However, it does not involve certain fundamental facts which were present at the birth of Late Gothic and remained among its essential components. In a European panorama whose Gothic and unitary nature has never been denied (in spite of the difficulty of an all-embracing definition), the style is first seen in Italy, which thus jumps immediately to the center of discussions on Late Gothic. The decisive proving ground is no longer architecture, but painting and illuminating. Naturally, to speak of Italy is purely a convention based on the present national unity. In reality, the area in the foothills of the Alps and in the Po Valley was made up of lordships and dukedoms connected by trade and by dynastic relationships more with the principalities north of the Alps or with the South than with the free cities beyond the Appennines. The web of relationships and interchanges was never static any more than were political or social

life. From the second half of the 1300s, there is a continuous ferment of international perspectives which, at a certain point, became focussed in the hegemonic aims of Gian Galeazzo Visconti's Milan. This produces problems concerning the Lombard contribution to the earliest Late Gothic and to that naturalism which never, even in its moments of maximum expression, with Giovannino de Grassi, can be properly defined in terms of sweetness of style.

But even before this, criticism has considered its assumptions and cultural matrices. After the effective discovery of a Lombard art, which at the beginning of this century was associated with Late Gothic by Schlosser and Toesca as pioneers, it is well known that Late Gothic Lombard naturalism was examined by Pächt. Pächt traced its geneology, as one might say, from the South, from its beginning in the Angevin Naples of Frederick, with "secondary buds in the French area" (but in reality these were the frescoes of the Garde Robe Tower at Avignon).

Pächt's study has remained the only one in that direction. Others have preferred to seek out the stylistic origins in Giotto's Tuscany or have occupied themselves with the difficult question of Lombard or Venetian precedence. For instance, there have been debates on the Tuscan influence on the origins of the Lombard art of fresco painting, with difficult distinctions between personalities among Giotto's followers not very clear in themselves. These debates have seen Arslan, starting from the situation in Lombardy, rebut the thesis of Longhi or the Maso-Stefano-Giottino triangle; or exclude Giusto from the Viboldone painters, again in opposition to Longhi and also Bettini, whose conclusions have however been reproposed by M. Gregori. Critics have, on the other hand, been very cautious on the problem of the Lombard participation (and let us not talk of formation) of Giovanni da Milano. Later contributions on that painter (M. Gregori, M. Boscovits) have set out to perfect our knowledge of his Florentine activities.

Beginning with the "From Altichiero to Pisanello" exhibition, in counterpoint and in some ways in contrast with that on "Lombard Art from the Visconti to the Sforza" in the summer of 1958, there have been attempts to re-evaluate the position of the centers of the Venetian hinterland, beginning with Altichiero and Avanzo, who, it has been found, left many influences in late 14th century illuminating (L. Magagnato, G. L. Mellini, G. Fiocco). There has been a re-evaluation by means of monographs and shows (F. Flores d'Arcais) of a personality like Guariento, who, at the beginning of the period in question, travelled all the Venetian hinterland and arrived at Venice. The ample review (R. Pallucchini) of Venetian painting has not been able to do other than confirm its splendid isolation, tied to Byzantinesque models, which not even the internationalism of Jacobelli or Lorenzo Veneziano succeed in penetrating.

The recovery of Late Gothic pictorial art in Piedmont and Savoy has been even more widespread and profound. We have seen the reconstruction of the story of an intense and characteristic activity, often independent of a contemporary Lombard art and, based as it was on commissions for Amadeus eighth or the Antipope Felix V, linked rather with Burgundy or Switzerland. Among the numerous contributors (L. Mallé, R.

pick out the monograph on Jacquerius by A. Griseri, which is really a wide ranging excursus through Piedmontese Late Gothic painting, which is characterized, in its greatest exponent, as sharp expressionistic realism polemically contrasted with the joyous naturalism of Lombardy. It is, however, surprising that the underlining of certain 14th century Piedmontese priorities - and I refer above all to Montiglio's frescoes - should be left almost entirely to the evidence of illustrative work. Neither should one overlook the prolific series of studies by Gardet culminating in the recovery of the Apocalypse of the Escorial.

Contributions were sometimes massive, or not lacking, on painting in Florence and Siena (M. Meiss, E. Carli, M. Boskovitz) and on painting and miniatures in Naples (F. Bologna, M. Rotili, A. Schmitt, F. Avril). A mastodontic performance to the benefit of Gothic and Late Gothic art in central-southern Italy has been the appearance of the first four volumes of the "Corpus der italienischen Zeichnungen 1300-1450" by two such specialists as B. Degenhart and A. Schmitt.

But it is right at the end of these ample notices that one returns to recognize the Lombard pre-eminence in the moment of the ripening of Late Gothic — somewhat apart, therefore, from the cultural matrices mentioned above — not only, or not so much, as a center of radiation of influences to the rest of Italy as in the role of active member in debates with the major centers of Late Gothic beyond the Alps. This was a season in which Lombard art, tied as it was to commissions by, and to the fortunes of, Gian Galeazzo Visconti and his two capitals of Milan and Pavia, traced with Burgundy and Berry on one side and on the other Prague, with which it was linked with direct bonds along the ways opened by dynastic, diplomatic, and commercial relationships, formed a triangle of central European and specifically international and courtly Late Gothic art. This has been restated by ample collections of Lombard painting: those on 14th century frescoes (F. Matalon) and 15th century frescoes (F. Mazzini) can be said to be really complete and full of unpublished material; and that on miniatures (M. L. Gengaro - L. Cogliati Arano) forcibly limited to a selection, although it is vast and has remained interrupted at the end of the 14th century.

The best results have come from the crowd of analytic studies. The wide panorama of Lombard pictorial and illuminatory output in the second half of the 14th century which E. Arslan has published in a series of papers is outstanding. Some of the texts included have already been mentioned at the beginning, but even more interesting is the analysis of late 14th-century illuminating into distinct types which emphasize its nascent naturalism (although the investigation is always directed mainly towards the style) and the intensity of the exchanges with the Nordic area, so much so that the author has raised insistent doubts about the effective Lombard pertinence of some of its milestones.

There are more contributions about the most stimulating artist of the moment - Giovannino de Grassi. An edition of the two fragments of the Visconti Breviary has been produced in fascimile (M. Meiss - E. Kirsch) on the occasion of its felicitous return to the National Library at Florence and will be invaluable for wide econographical researches and codicological comparisons. There is no lack of attempts to attribute works to him. The most serious is that of part of the "Tacuinum" at Liéges, at last made known (L. Cogliati Arano - M. Righetti) though still insufficiently owing to publishing difficulties. It is true that the direct area of influence of Giovannino within Lombard illuminating has still to be defined, but it is equally true that each proposed attribution which does not take account of the links between schools or studies remains a useless superfluity detracting from an exact evaluation of the stylistic interpretation which the artist gave of Lombard naturalism. The present writer has proposed drastic cuts regarding the most accredited works of Giovannini - the Bergamo Notebook and the Visconti Breviary.

There is an insistence, somewhat to excess, on the Italian, and particularly the Lombard, situation in the second half of the 14th century because it is exemplary of the critical itinerary on the first phase of Late Gothic and the problematic nodes connected with it - from the need to check the 14th century sources to the plurality of lodes running through the same region, to the intense and complex international interchange, and to the identification of the patrons — but also because the feeling for this Lombard contribution to the flowering of Late Gothic has been rather lost. And on the other hand, it is there that one must look for the identification of a phase which rejuvenated the figurative contents, adapting them to the stylistic tenor — the unification of idiom, which coincides with the "dolce stile," did not find in Lombardy its principal home, but that was already a second phase of Late Gothic.

The degree of consciousness with which, in strict connection with the ducal court, style was developed in Viscontean Lombardy into that more splendid variant which was headed by Giovannino de Grassi can be measured better in an architectural work. Clearly, this means Milan Cathedral, "omnes aras omnesque ecclesias mundi praecellens," in Galeazzo's intentions and in fact the most gigantic (if I may be permitted the improper superlative) Gothic building in Europe. After the historical and documentary ascertainments of the end of the 19th century, a wall of incomprehension and silence had closed around this monument, interrupted only by H. Siebenhuner's generous attempt and by the proportional studies of P. Frankl and J. S. Ackerman. Although the 1968 Congress and the full chapter on the culture (R. Bossaglia) in a monumental miscellaneous monograph of 1973 offered, for the period which interests us, accurate philological clarifications, it has been above all the studies by A. M. Romanini from the chapter in the already mentioned volume on Lombard architecture to that on architecture in the monograph cited above which have reached a critical definition. This has happened by recognizing in the cathedral a monumental dilation of the Lombard pseudo-hall type or graduated hall of an open Late Gothic structure. A figurative conception of space — "ad triangulum ad quadratum" — accepted by the North, but also the closed rhythm of Lombard walling, were dissolved in variable and emotive spatial images by means of a decorative attitude which resolves every structural connection. This is, therefore, not a watered down version of orthodox northern Gothic (which was difficult to distinguish even north of the Alps at the time when the cathedral was built), but is a surpassing of the most advanced position reached in architectural development in the North. If we must recognize the Duke's choice as the first reason

for reference to northern architecture, the Milanese townspeople, who identified themselves immediately with the building operations and which perhaps they had themselves autonomously begun in a thoroughly Lombard fashion, as recent soundings of the oldest parts lead one to suppose (C. Ferrari da Passano), also immediately absorbed the cultural lead in spirit in ways which came out as an affirmation of perfect "Sondergotik," or rather perhaps of Pinder's "Kunst der Bürgerzeit." Thus reappears the problem of Art of the Court/Middle Class Art which applies throughout the early phase of European Late Gothic.

There is, thus, a precise reason for the failure of any research aimed at explaining in substantially Lombard terms or, respectively, transalpine terms, the birth of Milan Cathedral. And if perhaps the moment has arrived to test the possibility that the ideas and forms of the Milanese building crossed the Alps, we do seem to have gained another aspect of the monument, namely its value as an indicator in that hotly debated subject of Late Gothic architecture.

Strangely, it is precisely with reference to architecture and sculpture that there have been proposed, both by Gerstenberg and by Pinder, the most decisive theories on the origins and character of Late Gothic. The latest attempt brings the terms of the question on to the plane of stylistic reading postulating (W. Paatz, F. W. Fischer) a meeting of two opposite stylistic currents — one directed from east to west which originated in the Swabian and Bohemian Parlers, and the other from west to east, deeply rooted in French architecture. The spark between the two poles flashed during the passage from the 14th to the 15th century, announcing the beginning of Late Gothic. In support of the emphasis on Western influences, put forward above all by Fischer, there has been a search (G. Schmidt) to trace the Rhenish roots of the Parler's sculpture, also on the track of documentary evidence of the French origin of the Parler family and their arrival in Bohemia after a slow migration through Germany, which has recently been reconstructed (V. Kotrbá). Putting the origin of Late Gothic architecture in phase with "Art towards 1400" would be supported by the fact, underlined by W. Gross, that "construction by spaces and volumes," already initiated by the German Parlers at Friburg, Nuremberg, and Gmünd and followed up by Peter of Prague, "remains still arranged in a series of formal respondences and therefore wholly tied to the spatial division by succession which is fundamental to classical Gothic."

An anti-French view would be expressed differently. Peter Parler's knowledge of English architecture has been documented, both stylistically (H. Bock) and in the iconography of the busts in the lower triforium in Prague Cathedral (R. Hausherr). But it is, above all, in the re-evaluation of the new spatial and static solutions and, more generally, of a new concept of a unitary, wide, luminous space that the Parlers' renewal is now made to coincide with the start of Late Gothic in architecture (V. Mencl, G. Brautigam) and the beginning in sculpture of the process which led to the "smooth style" (A. Kutal). This is also the fundamental direction of the liveliest argumentative cue in relation with the "West-Ost Gefälle," which suggests that late 14th century French architecture does not belong to Late Gothic and places it, also in its "flamboyant" manifestation, in a spatial synthesis fundamentally derived from "rayonnant" (G. Ringshausen).

It must be admitted that the late period of French architecture, known as flamboyant, is still very little known, and attempts at systemization are very recent (R. Sanfaçon). But for France there is totally lacking what was probably the most fertile ambit for the elaboration of a Late Gothic style in architecture. I refer to the great building activity in the last decades of the century by the king, but even more by the Dukes of Burgundy and Berry, which was expressed in religious buildings (Champmol), but even more in residences and chateaux. A building like the Palace of Jacques Coeur at Bourges, at the middle of the 15th century, cannot do else but witness to the last flashes of a extraordinary civil building activity whose preceding phases can only be guessed at from the Limbourg miniatures which show the Duke of Berry's residences, from the remains of the Palace of Justice at Poitiers, and from those recently made known (A. Erlande Brandenburg) remains of edifices at Vincennes going back to the patronage of Charles V of France. And that this architecture supplied stimulus and ideas to sacred architecture or even to the communal burgher architecture of Flanders is shown by the "beau pilier" and respectively, for example, by the Lagrange Chapel in Amiens Cathedral and by Bruges Town Hall.

That similar architecture served as a model on a European scale seems to me to be demonstrated by the relationship I have already pointed out between the decorative array of the exterior of Milan Cathedral and that of the Lagrange Chapel later repeated at Bruges — an array which now seems to have had a previous manifestation in a fragment of decoration from the great tower of Vincennes.

The example of Milan Cathedral, both in its aspect as a substantially new monument and protagonist of Late Gothic architecture and as a mirror of the principal northern styles, seems to devitalize any assertian of absolute priority. Late Gothic reimposes itself as a close network, never merely a single voice in a conversation involving all Europe, and thus in an international dimension. To follow its traces means practically to pass again over the paths of economic, political, and dynastic relationships between the principal actors in contemporary history. Events in the world of painting and illuminating are a valid confirmation.

The importance of Siena and of Avignon as direct progenitors of Late Gothic painting having also been devalued by the most recent studies (E. Castelnuovo, M. Laclotte) following Panofsky and Meiss, the Lombard contribution emphasized above stands out even in comparison with the French production, in particular that connected with the Court of Paris, of which recent studies have widened our knowledge (F. Avril, R. Thomas, P. Deschamps, M. Thibout). However, it is equally true that at the beginning of the 15th century, in coincidence with the rise of the genuine "stile dolce," leadership in painting, and above all in miniatures, belonged to that French-Flemish area which centered around the splendid Courts of Burgundy and Berry. We must be grateful to Meiss and Troetscher for a delineation of its physiognomy. By comparison, the production depending on the Court of Prague, already in the descending part of its parabola by the time of Wenceslas, as it has been reconstructed by J. Krása, appears as

only second rank, while for example, the activity of Meister Francke was outstanding in the free city of Hamburg and has been the subject of much recent work (O. Pacht, O. V. Simson, P. Hirschfeld).

Nor is it surprising that after nearly 25 years silence, contemporaneous with the crisis in the Dukedom following the death of Gian Galeazzo Visconti, Lombardy offers a fragmentary panorama very difficult to systematize. The difficulties affected even the greatest and most prolific artists from Michelino to Belbello, from the "Master of the Lives of the Emperors" to the Zavattaris. High quality works remain, not so much without a sure paternity as without a satisfactory critical historical insertion in a Lombard panorama, which is in any case only vaguely outlined and full of lacunae. This is the case, for example, with the frescoes of games in the Borromeo Palace in Milan to which, after an ad hoc attribution of a stylistic feel of Giovanni Zenoni da Vaprio (R. Cipriani), a subsequent attribution to Pisanello is perhaps a little derogatory (G. Consoli).

Some important steps have been made in the publication of new material; from the recovery of a splendid triptych (unfortunately lost to the dealer's market), which remains, however, uncertainly dated between the third (M. Meiss) and the fifth decade (G. Panazza) of the 15th century; to the reconstruction of a notable production of miniatures between Lombardy and the Venice region, substantially centered on Balbello at Pavia, which lasted nearly until 1470 (G. Mariani Canova). This last artist, isolated until now in the Lombard panorama of the middle decades of the 15th century, has been the subject of an attempted reconstruction by the present writer of his whole active life seeking in relation to him to clarify some circumstantial problems in Lombard illuminating — from the definition of the 14th century precedent of Giovannino de Grassi and his studio to the identification, furthermore on the basis of known works, of new artists working for Philip Maria Visconti, who were responsible for the Lombard dimension of Belbello's art and also for its international developments.

In the period in question, the Italian Plain was projected into Europe by merit above all of Pisanello. Studies on this artist have their central point in the discovery of a knightly cycle of frescoes at Mantua. These were duly illustrated by a show and a monograph when they were presented (G. Paccagnini) and were then examined by B. Degenhart. This scholar has also attributed to Pisanello a detached miniature. A new cataloguing of the designs of the Master (M. Fossi Todorow) has given rise to some perplexity owing to the excessively rigorous criteria for ascertainment of the autography.

The growth which Late Gothic in northern Italy has had with the recovery of these frescoes by Pisanello is not only quantitative, but indicates also a jump in quality, again showing the vitality of a world and a culture which all too easily can be considered as on the way to extinction without that drive which it is believed must be attributed to the Renaissance. To claim that the end of Late Gothic was a violent suppression would undoubtedly be a senseless trial of history, but this is also the moment to refuse also the vision of a Late Gothic in slow but inarrestable euthanasia. This is an old problem, treating the relationship between Gothic, as the last stage of the Middle Ages, and the Renaissance. Possible solutions naturally depend on the opinions held about the respective periods.

The picture becomes that much more complex if the observer's horizon is raised beyond the Alps. There it must be accepted that, with the exception of Hungary and sporadic and limited cases elsewhere, there was no Renaissance phase corresponding to the Italian Quattrocento. Late Gothic, or similar phenomena which precede it, brusquely give way to the Roman Grand Manner, or even jump to a kind of proto Baroque. The proving ground, even in terms of concrete geographical extension, is thus immense, and partly, at least, unploughed, so much so that it is worth while now summarizing as examples some individual questions where proposed solutions have been put forward as of general validity.

The assertion of the substantial novelty of the Renaissance is a constant theme of Panofsky's criticism, at least after his paper on perspective. But, from that first study on "the Renaissance and the Rebirth of Western Art," which is what interests us here, we can perhaps detect an appreciable deviation of terms. Also, in his analysis of Renaissance classicism, Panofsky recognizes the radical difference in the way of referring to Antiquity from that in various Medieval mentions. Antiquity was recognized as a closed and finished historical epoch only by the Humanists, who separated it from their contemporary world by a "media aetas" according to a concept then taking form. However, renaissance naturalism, which implies a reference to Antiquity, did not assert itself contemporaneously but was born earlier, with Giotto. And while in architecture and sculpture the term Classic was valid from the first generation of the "reborn," from Brunelleschi and Donatello, this happened much later for painting. For Masaccio, it was still Giotto's naturalism re-expressed according to the rules of perspective. And at this point the distinction between Late Gothic and Renaissance, detached as it is from any effective stylistic investigation, seems to fade and lose itself. In reconstructing the influence in Europe of Italian 14th century painting, Panofsky goes so far as to demonstrate that the formation of the most markedly "courtly" pole of Late Gothic painting corresponds with the complete assimilation on the part of a transmontane artistic region (France) of prehumanistic naturalism in a secular process begun by Pucelle and brought to its conclusion by Broederlam, by the Master of Marshal Boucicaut and by the Limbourgs.

A recent book by P. Philippot on Flemish painting is, however, dedicated to the definition of a northern way to naturalism independent of the Renaissance. This scholar proposes that the basis of Late Gothic French-Flemish naturalism and then of the spatial intuition of Flemish painting remains the Gothic principle of the figure — that is to say, the coloring of the visible world by the "minimum of elements necessary for the materialization of the symbol." Therefore Flemish space, contrary to the Renaissance structure founded on perspective, remains a representation, never becoming a "new way of thinking about the visible."

What would inevitably be a radical internal dichotomy in the 15th century is, on the other hand, rejected by Bialostocki, who has underlined precisely the common problems of the representation of an infinite space, but also the concrete affinity of some results

and the common departure of the international style from 1400. Having erected this bridge between the Middle Ages and the Renaissance, the scholar is however compelled to admit an internal fracture in Late Gothic, between painting on one hand and architecture and sculpture on the other.

In reality it is possible to demonstrate that the discovery of space is not extraneous even to the Late Gothic sculpture after the "weicher Stil." If Michael Pacher, who worked both chronologically and geographically astride the two epochs and whose contacts with Mantegna's art are well known (lately mentioned by N. Rasmo), might appear a captious example, help can be obtained from the works of another artist whose training is placed in the French-Flemish world. I refer to Hans Multscher, whose period of activity at Ulm has been the subject of a monograph (M. Tripps) which may be debatable from a number of points of view but is absolutely unapproachable on the reconstruction of the original state of the three altars with doors — the Karg niche in Ulm Cathedral and the altars of Wurzach (or, as is proposed, of Landsberg) and of Vipiteno.

An essential figurative theme underlying the three works is the desire to suggest an infinite space. The pyx of the altars remains largely void, and the figures which peer through the pretence windows in the back wall seem to imply that the space continues indefinitely beyond the limits of the representation. At Vipiteno, statues of saints stand under small baldaquins at the sides of the altar and emphasize the connection between the space portrayed and real space in a way that strongly reminds one of what Donatello had done less than a decade earlier with the altar of the Saint at Padua. But, in the impossibility of tracing even the slightest point of concrete contact between the two works, although tantalizingly near to one another, it becomes necessary to remember that, once more, one is dealing with parallel problems, not with analogous solutions. Donatello's work has a basis of a precise structure of perspective and an objective knowledge of space which is totally absent from that of Multscher in which the space is linked with the monumental plastic existence of figures and architectural elements, not constituting a condition for their existence but a limit of physical presentation.

If, in the field of architecture, Schmarsow or Gurlitt originally saw in Late Gothic a northern metamorphosis of the Renaissance, before claiming for it an effective autonomy, there is now a tendency to assimilate the first Florentine Renaissance architecture to the final phase of Late Gothic. This assumption has not so far been enunciated very clearly, but it is implicit in the shaping given to certain questions. The first phase of Brunelleschi's architecture has recently been the subject of an attempt at explanation in terms of a substantially Late Gothic heritage (H. Klotz), and a more complex and subtle operation is still going on with the object of supplying a more solid background to this theory. It turns principally on the problem of the planning and construction of Santa Maria del Fiore in Florence, for which there has been a complete reversal of the situation. On the basis of discussions on the documents, (A. Grote, H. Saalman), the possibility of reconstructing a design by Arnolfo is excluded a priori. Alternatively combining with that possibility an examination of the marble encrustations and external molded decorations

(G. Kiesow, G. Kreytenberg), reconstructions are made of Arnolfo's designs which are totally different from the actual building, the planning of which would have all its important stages within the period from the commencement of the works in 1355 and their prosecution until the setting of the dome. It is clear that in giving oneself in this way serious limitations on the stylistic responsibility for the dome itself one creates the hypothesis of a late 14th century and very early 15th century Florentine architectural phase, which would be Late Gothic, with unadmitted Renaissance characteristics; corresponding to what was originally divided between Arnolfo and Brunelleschi.

Avoiding here, obviously, any discussion of its merits, one can still make the observation that this demonstration also is developed almost wholly without reference to the true and real problems of style. It thus constitutes a significant indication of the lack of precise parameters on which to base the critical segregation of Gothic, for while some moments have been clearly defined, too many phases continue to slip away from any general proposition towards individual solutions.

The question of whether it is possible to detach a unified period of Western European art between the 12th and the 15th century with distinctive characters which can be summarised as "Gothic" continues to remain, at the present stage of research, largely unanswered.

BIBLIOGRAPHY - M.G. Agghàzy, Lasse d'Ungheria e i rapporti tra Buda e Milano nel 1391, Acts of the International Congress "Il Duomo di Milano," 1, Milan, 1969; E. Arslan, Appunti sulla pittura lombarda del primo Trecento in Lombardia, Bollettino d'Arte, 3, 1963; E. Arslan, Riflessioni sulla pittura Gotica "internazionale" in Lombardia nel tardo Trecento, Arte Lombarda, VIII, 2, 1963; E. Arslan, Aspetti della pittura lombarda nella seconda metà del Trecento, Critica d'Arte, 61 and 64, 1964; Art (L') européen vers 1400, Catalogue of the Exhibition, Vienna, 1962; Arte Lombarda dai Visconti agli Sforza, Catalogue of the Exhibition, Milan, 1958; F. Avril, Trois manuscrits napolitains des collections de Charles V et Jean de Berry, Bibliothéque de l'Ecole des Chartres, 127, 1969; F. Avril, Trois manuscrits de l'entourage de Jean Pucelle, Revue da l'Art, 9, 1970; F. Avril, Une bible moralisée de Charles V, Jahrbuch der Hamburger Kunstsammlungen, 14-15, 1970; M. Ayrton, Giovanni Pisano Bildhauer, Frankfurt, 1970; K. Bauch, Anfange des figurlichen Grabmals in Italien, Mitteilungen des Kunsthistorischen Institutes in Florence, XV, 1971; S. Bettini, Giusto dei Menabuoi nel Battistero di Padova, Venice, 1961; J. Bialostocki, Late Gothic, Disagreements about the Concept, The Journal of the British Archaeological Association, s. 3, 29, 1966; J. Bialostocki, editor propyläen Kunstgeschichte 7 - Spätmittelalter und beginnende Neuzeit, with contributions by F. Anzelewsky, D. Bayón, H. Bock, C. Gilbert, L. Grodecki, H.W. Janson, A. Milobedzki, H. Saalman, P. Skubiszewski, Sh. Stark, E. Steingraber, Ch. Sterling, Berlin, 1972; H. Bock, Der Beginn der spatgotischen Architektur in Prag (Peter Parler) und die Beziehungen zu England, Wallraf Richartz Jahrbuch, 23, 1961; H. Bock, Der Decorated Style, Heidelberg, 1962; F. Bologna, l pittori alla corte angioina di Napoli (1266-1414) a un riesame dell'arte nell'età federiciana, Rome, 1970; J. Bony, Transition from Romanesque to Gothic - Introduction, Romanesque and Gothic Art, Studies in Western Art, Princeton, 1963, P. Booz, Der Baumeister der Gotik, Berlin-

Munich, 1956; M. Boscovits, Notes sur Giovanni da Milano, Revue de l'Art, 11, 1971; M. Boscovits, La pittura fiorentina tra Medioevo e Rinascimento, Florence, 1975; R. Bossaglia, La Scultura in Il Duomo di Milano, II, Milan, 1973; S. Bottari, Saggi su Nicola Pisano, Bologna, 1969; R. Branner, Burgundian Gothic Atchitecture, London, 1960; R. Branner, Gothic Architecture, New York, 1961; R. Branner, La Cathédrale de Bourges et sa place dans l'architecture gothique, Paris-Bourges, 1962; R. Branner, Paris and the Origins of rayannant Gothic architecture down to 1240, The Art Bulletin, 44, 1962; R. Branner, Gothic Architecture 1160-1180 and its Romanesque Sources, Romanesque and Gothic Art, Studies in Western Art, Princeton, 1963; R. Branner, Westminster Abbey and the French Court Style, Journal of the Society of Architectural Historians, 23, 1964; R. Branner, St. Louis and the Court Style in Gothic Architecture, London, 1965; R. Branner, Reims West and Tradition, Festschrift für Werner Gross, Münich, 1968; R. Branner, Chartres Cathedral, New York, 1969; R. Branner, La place du "style de cour" de Saint Louis dans l'architecture du XIII siécle, Le siécle de Saint Louis, Paris, 1970; R. Branner, Die Architektur der Kathedrale von Reims im 13. Jahrunderts, Architectura, 1, 1971; R. Branner, The Sainte Chapelle and the Capella Regis in 13th century France, Gesta, 10, 1971; G. Bräutigam, Gmünd, prag, Nürnberg, Die nürnberger Frauenkirche und der Prager Parlerstil vor 1360, Jahrbuch der Berliner Museen, 3, 1961; G. Bräutigam, Die nürnberger Frauenkirche, Idee und Herkunft ihrer Architectur, Festschrift Peter Metz, Berlin, 1965; A. Cadei, Giovannino de Grassi nel taccuino di Bergamo, Critica d'Arte, 109, 1969; A. Cadei, I capitelli più antichi del duomo di Milano, Acts of the International Congress "II Duomo di Milano," 1, Milan, 1969; A. Cadei, Belbello miniatore lombardo - Artisti del libro alla corte dei Visconti, Rome, 1976; R. Carità, La pittura del ducato di Amedeo VIII, revision by Giacomo Jaquerio, Bolletini d'Arte, 41, 1956; E. Carli, I mesi di Folgore da San Gimignano illustrati da Sano di Pietro, Rome 1969; E. Carli, A. Cairoli, I pittori senesi, Milan, 1971; E. Castelnuovo, École d'Avignon, Art de France, 1, 1961; E. Castelnuovo, Un pittore italiano alla corte di Avignon - Matteo Giovannetti e la pittura di Provenza nel secolo XIV, Turin, 1962, P. Cellini, L'opera di Arnolfo all'Aracoeli, Bollettino d'Arte, XLVII, 1962; M. Cinotti, II maestro del S. Paolo eremita, Acts of the International Congress "II Duomo di Milano," Milan, 1969; R. Cipriani, Giovanni da Vaprio, Paragone, 87, 1957; L. Cogliati Arano, M.L. Gengaro, Miniature lombarde - Codici miniati dall eighth al XIV secolo, Milan, 1970; L. Cogliati Arano, M. Righetti, Tacuinum Sanitatis, Milan, 1975; H.M. Colvin (ed.), Building Accounts of King Henry III, London, 1971; G. Consoli, I giuochi Borromeo e il Pisanello, Milan, 1966; M. L. Cristiani Testi, Cultura Federiciana, Critica d'Arte, 85 and 87, 1967; B. Degenhart, A. Schmitt, Corpus der Italienischen Zeichnungen, 1300-1450, 1-IV, Berlin, 1968; B. Degenhart, Ludovico II Gonzaga in einen Miniatur Pisanellos Pantheon, XXX, 3, 1972; B. Degenhart, Pisanellos mantuaner Wandbild, Kunstchtonik, 26, 3, 1973; H. Dellwig, Studien zur Baukunst der Bettelorden im Veneto - Die Gotik der Monumentalen Gewolbebauten, Munich-Berlin, 1970; H. Dellwig, Der Santo in Padua, - Eine baugeschichtliche Untersuchung, Mitteilungen des Kunsthistorischen Institutes in Florenz, XIX, 2, 1975, P. Deschamps, M. Thibout, La peinture murale en France au debut de l'epoque gotique de Philippe Auguste à la fin du régne de Charles V, 1180-1380, Paris, 1963; Sh. Edmunds, The Missal of Felix V and early Savoyard Illumination, The Art Bulletin, 46, 1964; H. v. Einem, Das Stutzgeschoss der Pisaner Domkanzel, Colonia Opladen, 1962; A.

Erlande Bradenburg, Aspects du Mécénat de Charles V - La sculpture décorative, Bulletin Monumental, IV, 130, 1972; Europe (L') Gothique 12th e XIV siécles, Catalogue of the Exhibition, Paris, 1968; C. Ferrari da Passano, Le origini lombarde del duomo, Milan, 1973; G. Fiocco, Una miniatura di Altichiero, Studi in onore di Mario Salmi, 1 Rome, 1962; G. Fiocco, La rivincita di Altichiero, II Santo, 1963; F. W. Fischer, Die Spätgotische Kirchenbaukunst am Mittelhein 1410-1520, Heidelberg, 1962; F. W. Fischer, Unser Bild der deutschen spätgotischen Architektur des XV. Jahrhunderts (mit Ausnahrne der nord- und ostdeutschen Backsteingotik), Heidelberg, 1964; F. W. Fischer, J.J.M. Timmers, Spätgotik zwischen Mystik und Reformation, Baden-Baden, 1971; F. Flores D'Arcais, Guariento, Venice, 1965; Flores D'Arcais (ed.), Da Giotto al Mantegna, Catalogue of the Exhibition (Padua, 1974), Milan, 1974; G. Folena, G. L. Mellini, Una Bibbia istoriata padovana della fine del Trecento, Venice, 1962; M. Fossi Todorow, I disegni di Pisanello e della sua cerchia, Florence, 1966, P. Frankl, The Gothic - Literary sources and interpretations through eight centuries, princeton, N.J., 1960; C. Gardet, Le livres d'heures du Duc Louise de Savoye, Annecy, 1960; C. Gardet, De la peinture du Moyen Age en Savoye, I, Annecy, 1965; C. Gardet, De la peinture du Moyen Age en Savoye - L'Apocalipse du duc de Savoye, Annecy, 1969; J. Gardner, A relief in the Walter Art Gallery and the thirteenth Italian tomb design, The Liverpool Bulletin, XIII, 1968-70; J. Gardner, The Capocci tabernacle in S. Maria Maggiore, papers of the British School of Rome, XXXVIII N.S., XXV, 1970; J. Gardner, The tomb of Cardinal Annibaldi by Arnolfo di Cambio, The Burlington Magazine, CXIV, 828, 1972; J. Gardner, Nicholas III's oratory of the Sancta Sanctorum and its decoration, The Burlington Magazine, CXV, 842, 1973; J. Gardner, Pope Nicholas V and the decoration of Santa Maria Maggiore, Zeitschrift für Kunstgeschichte, XXXVI, 91, 1973; J. Gardner, Arnolfo da Cambio and the Roman tomb design, The Burlington Magazine, CXV, 844, 1973; D. Gioseffi, Giotto architetto, Milan, 1973; J. Gitlin Berstein, The Three Statues in the Cathedral of Milan attributed to Jocomello and Pier Paolo dalle Masegne; Acts of the International Congress "II Duomo di Milano," 1, Milan, 1969; W. Götz, Zentralbau und Zentralbautendenz in der rotischen Architektur, Berlin, 1968; M. Gregori, Giovanni da Milano alla Cappella Rinuccini, Milan, 1965; M. Gregori, Presenza di Giusto dei Menabuoi a Viboldone, Paragone, 293, 1974; A. Griseri, Jaquerio e il realismo gotico in Piemonte, Turin s.d. (1964); W. Gross, Gotik und Spätgotik, Frankfurt, 1969; A Grote, Das Dombauamt in Florenz 1285-1370 - Studien zür Geschichte der Opera de Santa Reparata, Münich, 1959; I. Hacker Sück, La Sainte Chapelle de Paris et les Chapellas Palatines du Moyen Age en France, Cahiers Archéologiques, 13, 1962; H. Hahn, Die fruhe Kirchenbaukunst der Zistenzierser - Untersuchungen zur Baugeschichte von Kloster Eberbach im Rheingau und ihre europaischen Analogien im 12. Jahrhunders, Berlin, 1957; R. Hausherr, Zur Auftrag, Programm und Busterzyklus des prager Domchores, Zeitschrift für Kunstgeschichte, 34, 11, 1971; P. Héliot, Du Carolingien au Gothique - L'évolution de la plastique murale dans l'architecture religieuse du Nord-Quest de L'Europe, Paris, 1971, P. Héliot, La filiation de l'église haute à Saint Francois d'Assise, Bulletin Monumental, 126, 1968; P. Héliot, Les coursières et les passages muraux dans les églises du Midi de la France, d'Espagne et du Portugal au 13 et 14 siécles, Annuario de Estudios Medievales, 6, 1969; P. Héliot, Coursiéres et passages muraux dans les églises gothiques de l'Europe centrale, Zeitschrift für Kunstgeschichte, 33, 1970; P. Héliot, passages muraux et coursiéres dans les églises gothiques du

Nord-Quest de la France Médiévale, de la Lorraine et du Pays du Rhône moyen, Zeitschrift für Schweizerischen und Kunstgeschichte, 27, 1970; P. Héliot, Sur les Eglises gothiques des ordres mendiants en Italie centrale, Bulletin Monumental, 130, 1972; H. Hertlein, Die Basilika San Francesco in Assisi, Florence, 1964; P. Hirschfeld, Hat Meister Francke für Jean sans Peur von Burgund gearbeitet?, Zeitschrift für Kunstgeschifte, 33, 1970; H.W. Janson, The meaning of the gigantic, Acts of the International Congress "II Duomo di Milano, 1, Milan, 1968; G. Jaszai, Die pisaner Domkanzel, Munich, 1968; M. Laclotte, L'école d'Avignon, la peinture en Provence au XIV et XV siécles Paris, 1960; M. Laclotte, Peinture en Provence au XIV et au XV siécles, Art de France, I, 1961; H. Keller, Die Kunstlandschaften Italiens, Munich, 1960; H. Keller, Die Kunstlandschaften Frankreichs, Wiesbaden, 1963; H. Klotz, Deutsche und Italienische Baukunst im Trecento, Mitteilungen des Kunsthistorischen Institutes in Florenz, 1966; H. Klotz, Die Fruhwerke Brunelleschis und die mittelalteriche Tradition, Berlin, 1970; G. Kiesow, Zu Baugeschichte des florentiner Domes, Mitteilungen des Kunstistorischen Institutes in Florenz, X 1, 1961; V. Kotrba, Kdy prisel Petr Parléř do Prahy (When did Peter Parler come to Prague? Contribution to the history of the beginning of Gothic of the Parlérs in Europe Central), Uméní, 19, 1971; J. Krasa, Deux dessins du Louvre et la peinture de manuscrits en Bohème vers 1400, Scriptorium, 23, 1969; J. Krasa, Die Handschriften Konigs Wenzel IV; Prague, 1971; G. Kreytenberg, Der Dom zu Florenz, Berlin, 1974; W. Krönig, Caratteri dell'architettura degli ordini mendicanti in Umbria, Papers of the Congress on Umbrian States, IV, 1968; H.E. Kubach Ordensbaukunst Kunstlandschaft und Schule, "Die Klosterbaukunst," Special number of the Bulletin des Relations artistiques France-Ammemagne, Mayence, 1958; H.J. Kunst, Zur ideologie der deutschen Hallen kirche als Einheitsraum, Architecture, I, 1971; A. Kutal, Les problèmes limitrophes de la sculpture tchèque au tournant de 1400, Sborník prací filosofické fakulty Brnénské Univ., 18, F 13, 1969; A. Kutal, Zur Genesis der spätgotischen Plastik Mitteleuropas, Sborník prací filosofické fakulty Brnénské Univ., 19/20, F 14/15, 1970-1971; M. Lorandi, I modelli orientali dei castelli federiciani - I qasr Omàyadi e la loro influenza nella genesi dell'architettura sveva, Bollettino d'Arte, 58, I, 1973; G. Fiocco, L. Magagnato (ed.), Da Altichiero a Pisanello, catalogo della mostra (Verona, 1958), Venice 1958; L. Magagnato, Arte e civiltà del medioevo veronese, Turin, 1962; L. Mallé Elementi di cultura francese nella pittura gotica tarda in Piemonte, Scritti di Storia dell'Arte in onore di Lionello Venturi, I, 1956; G. Mariani Canova, II recupero di un complesso librario dimenticato: i corali quattrocenteschi di S. Giorgio Maggiore a Venezia, Arte Veneta, 1973; S. Matalon, Affreschi Lombardi del Trecento, Milano, 1963; F. Mazzini, Affreschi lombardi del Quattrocento, Milan, 1964; M. Meiss, An early Lombard altarpiece, Arte Antica e Moderna, 1961; M. Meiss, painting in Florence and Siena after the Black Death, New York, 1964; M. Meiss, French painting in the time of Jean de Berry - The Late 14th century and the patronage of the Duke, London, 1967; M. Meiss, French painting in the time of Jean de Berry - The Boucicaut Master, London, 1968; M. Meiss, E. W. Kirsch, The Visconti Hours, London, 1972; G. L. Mellini, La Sala "Grande" di Altichiero e Jacopo d'Avanzo e i palazzi scaligeri di Verona, Critica d'Arte, 35, 1959; G. L. Mellini, Disegni di Altichiero e della sua scuola, Critica d'Arte, 51, 53, 1962; 57-58, 1963; G. L. Mellini Altichiero e Jacopo Avanzi, Milan, 1965; G. L. Mellini, Miniature di Martino da Verona, Arte Illustrata, 19-20, 1969; G.L. Mellini, Giovanni Pisano, Milan, 1971; V. Mencl, poklasická gotika jizní Francie a Švábska a jeji vztah ke česke (Late Gothic, French and Swabian, and its relationships with Bohemian Gothic), Uméní, 19, 1971; A. Middeldorf Kosegarten, Die Skulturen der Pisani am Baptisterium von Pisa, Jahrbuch der Berliner Museen, X, 1968; A. Middeldorf Kosegarten, Nicola und Giovanni Pisano 1268-1278, Jahrbuch der Berliner museen, XI, 1969; O. Morisani, Commentari capuani per Nicola Pisano, Cronache di Archeologia e Storia dell'Arte, Catania, 1963; W. Paatz, Verflechtungen in der Kunst der Spätgotik zwischen 1360 und 1530. Einwerkungen aus den westlichen Nachbarlandern auf Westdeutschland langs der Rheinlinie und deutschrheinische Einwirkungen auf diese Länder, Heidelberg, 1967; G. Paccagnini, II Pisanello e il ciclo pittorico cavalleresco di Mantova, Milan, 1972; G. Paccagnini, M. Figlioli (ed.), Pisanello alla corte dei Gonzaga, Catalogue of the Exhibition, Mantua 1972, Milan, 1972; O. Pacht, Meister Francke Probleme, Jahrbuch der Hamburger Kunstsammlungen, 14-15, 1970; R. Pallucchini, La pittura veneziana del Trecento, Rome, 1964; G. Panazza, La pittura nella prima metà del Quattrocento, Storia di Brescia, II, Milan, 1963; E. Panofsky, Renaissance and renascences in Western Art, Stockholm, 1960; E. Petrasch, "Weicher" und "Eckiger" Stil in der deutschen spätgotischen, Architektur, Zeitschrift fur Kunstgeschichte, 14, 1951; P. Philippot, Pittura fiamminga a rinascimento italiano, Turin, 1970; N. Rasmo, Michael Pacher, Milan, 1969; G. Ringhausen, Die spätgotische Architektur in Deutschland unter besonderer Berücksichtingung ihrer Beziehungen zu Burgund im Anfang des 15, Jahrunderts, Zeitschrift des deutschen Vereins für Kunstwissenschaft, XXIII, 1973; A.M. Romanini, Le chiese-a-sala nell'architettura gotica lombarda, Arte Lombarda, Milan, 1957; A. M. Romanini, L'architettura gotica in Lombardia, Milan, 1964; A. M. Romanini, Giotto e l'architettura gotica in Alta Italia, Bollettino d'Arte, III-IV, 1965; A. M. Romanini, Giotto a Padova e il Trecento architettonico padano e Veneto, Bulletin of the Centro internazionale di Studi Andrea Palladio, 1965; A. M. Romanini, "II Dolce Stil Novo" di Arnolfo di Cambio, Palladio, I-IV, 1965; A. M. Romanini, Arnolfo e l'architettura del Duomo di Orvieto, Papers of the Sixth Congress on Umbrian Studies, Gubbio, 1968; A.M. Romanini, Povertà e razionalità nell'architettura cistercense del XII secolo, Povertà e ricchezza nella spiritualità dei secoli XI and XII, Todi, 1968; A. M. Romanini, Le arti figurativi nell'età dei Comuni Aevum, XLII, 1968; A. M. Romanini, Arnolfo di Cambio e lo "stil novo" del gotica Italiano, Milan, 1969; A. M. Romanini; Nuove tracce per il rapporto Giotto-Arnolfo in S. Gottardo a Milano, Studies in honour of Roberto Pane, Naples, 1969-1971; A. M. Romanini, L'architettura, II Duomo di Milano, I, Milan, 1973; A. M. Romanini, Le abbazie fondate da San Bernardo in Italia e l'architettura cistercense "primitiva," Studi su San Bernardo di Chiaravalle, Rome, 1975; M. Rotili, Miniatura Francese a Napoli, Rome, 1968; M. Rotili, La miniatura gotica in Italia, Napoli, 1968; H. Saalman, Santa Maria del Fiore, 1294-1418, The Art Bulletin, XLVI, I, 1964; M. Salmi, Una Statua di Arnolfo, Commentarii, 1-11, 1965; R. Sanfaçon, L'architecture flamboyante en France, Quebec, 1971; F. Santi, Un altro "scriba" di Arnolfo per la fontana perugina del 1281, Paragone, 225, 1968; G. Schmidt, Peter Parler und Heinrich IV Parler als Bildhauer, Weiner Jahrbuch fur Kunstgeschichte, 23, 1970; A. Schmidt, Die Apokalypse des Robert von Anjou, Pantheon, 28, 1970; W. Schöne, Studien zur Oberkirche von Assisi, Festschrift Kurth Bauch, Berlin, s.d. (1975); M. Seidel, Die Ranken-saulen der sieneser Domfassade, con appe dice di A. Middeldorf Kosegarten, Jahrbuch der Berliner Museen, 11, 1969; M. Seidel, Die Rankensaulen der Sieneser Domfassade, Jahrbuch der Ber-

liner Museen, XI, 1969; M. Seidel, Die Verkündigungsgruppe der sieneser Damkanzel, Münchner Jahrbuch der bildenden Kunst, 3, 21, 1970; Ch. Seymour, Invention and revival in Nicola Pisano's heroic style, Romanesque and Gothic Art - Studies in Western Art, Princeton, 1963; O. v. Simson, Die Gotische Kathedrale, Darmstadt, 1962; O. v. Simson, Meister Francke und Jacquemart de Hesdin, Jahrbuch der Hamburger Kunstammlungen, 14-15, 1970; O. v. Simson (ed.) Propyläen Kunstgeschichte 6 - Das Mittelalter II, das hohe Mittelalter, with contributions by T.S.R. Boase, F. Deuchler, M. Durliat, J. M. Fritz, C. Gnudi, W. Gross, J. Ch. Klamt, P. Kurman, A. C. Quintavalle, W. Sauerländer, Z. Swiechowski, M. Trachtenberg, Berlin, 1972; N. Thomas, F. Avril, La librairie de Charles V, Paris, 1968; M. Trachtenberg, The Campanile of Florence Cathedral; "Giotto's Tower," New York, 1971; M. Tripps, Hans Multscher - Seine ulmer Schaffenszeit 1427-1467, Weissenhorn, 1969; M. Velte, Die Anwendung der Quadratur und der Triangulatur bei der Grund- und Aufrissgestaltung der gotischen Kirchenkörpers, Basel, 1951; R. Wagner Rieger, Die italienische Baukunst zu Beginn der Gotik, Graz-Colonia, 1956-1957; R. Wagner Reiger, Zur Typologie Italienischer Bettelordensbaukunst, Romische Historische Mitteilungen, 2, 1957-1958; R. Wagner Rieger, Italienische Hallenkirchen (Zur Forschungsanlage), Mitteilungen der Gesellschaft für vergleichende Kunstforschung, 12, 1960; J. White, Art and Architecture in Italy 1250-1400, London, 1966.

ANTONIO CADEI

RECENT DISCOVERIES AND RESTORATIONS
(PLATES 100-102)

As has been recently emphasized with reference to the new researches on the art of the Gothic age (see the editorial "A New Approach to the Trecento," BM, CXVII, 1975), but as would also be valid for almost all studies of the artistic culture of the Middle Ages, there has ultimately been an attitude of careful re-examination of the works as functional phenomena and as regards their technical aspects not less than in their styles and imagery. It is precisely from that attitude that the most interesting and sometimes absolutely novel results have been obtained.

This same attitude, which is systematically explorative, has been both cause and effect of restoration operations, which are becoming more frequent on Medieval monuments. They have been carried out aiming at radical objectives with the purpose of recovering the most from the original works - be they architectural, pictorial, or decorative. Often, these operations have a kind of anxiety to free the originals not only from superfluous incongruencies, but also from modifications which none-the-less had their own historical and aesthetic value.

This method of proceeding is clearly rooted in the residues of positivist conception of restoration. Thus attempts at meagre recoveries has, instead, led to disastrous losses (at the expense of entire sections of Mannerist, Baroque, or Neo Classical Art, irremediably erased). Also, sometimes the sought for original version has been more imagined or simply deduced from too exiguous clues instead of being identified with proper logic. The factual impossibility of being able to recover it have laid bare attempts to "reconstruct" it arbitrarily.

This is the sad story of recent years, punctuated by scandalous manipulations or universally deplored ruinations (but still carried to their conclusion), such as those of Collemaggio Church at L'Aquila, Lodi Cathedral, and many churches in and around Pistoia and in Apulia.

Rightly the noted "Charter of Restoration" has come out with the most severe warnings against such procedure and its flagrant anti-historical sense. But, always under the drive for a renewal of practical investigation, some operations have been guided, not by gross radicalism, but by extreme scrupulosity. At the same time this has given rise to manifold problems of historical criticism.

One excellent example is the Baptistery of Novara, whose octagonal plan has been revealed as a very important building of the fifth century with the inner walls and arches which open on radial niches which are alternately rectangular and semicircular. The original structure, which rises to a little above the round-arched windows, was greatly modified towards the end of the tenth century, somewhat raising the drum on which was then erected the present segmented dome. In this early Medieval part, added to the Paleochristian, there have been discovered the fantastic remains of a great cycle of frescoes, very fragmentary, in the top of the cupola (where there was probably a "Christ in Majesty") and in the lower order between the windows (there remain only a few figures, perhaps Prophets), but substantial and newly rendered very visible in the intermediate part round the drum, where there are eight scenes from the Apocalypse — that of the "Angel Offering Incense" introducing, according to the biblical sequence, those of the "Seven Angels Sounding Trumpets to Announce the Plagues" (there remain only six because one was covered in the 15th century by another fresco which it has been decided not to remove).

This cycle is already exceptional on account of the complete illustration of the Apocalyptic chapter of the "Seven Trumpets," which is found otherwise only in the illuminated "Apocalypse" of Bamberg. But even more important is its stylistic timbre which, while recalling in many aspects the pictorial cycles of Gallianus, of Civate, and of St. George's at Oberzell, also has individual inflexions, expressive tones, and ideas of form which proclaim it as representing a key moment in the original elaborations of figurative civilization at the time of the Emperors Otto. Also, special links were established in Italy with the Byzantine world (see G. Chierici, "The Master of the Apocalypse of Novara" in Paragone, 201, 1966; Id., "Il Battistero del Duomo di Novara," Novara, 1967).

There have been important discoveries of wall paintings in the Piacenza area (see A. Segagni, "Affreschi inediti della Chiesa di St. Antonino a Piacenza," in Arte Lombarda, I, 1970); Id., "Affreschi inediti della chiesa di S. Giovanni a Vigolo Marchese," in Studi storici in onore di Emilio Nasalli Rocca, Piacenza; 1971) and around Pavia (see A. Peroni, "Contributo all'architettura e alla pittura lombarda dal secolo XI al secolo XII: alcuni inediti monumenti pavesi," in "Atti del IV Congresso internazionale di Studi sull'Alto Medioevo," Spoleto, 1969). Some notable contributions have been given to this same cultural node, notoriously depending on only a few surviving relics, by the discovery, in the course of a preservation

operation, of a complex of frescoes in the space under the roof of the Church of St. Andrea al Celio in Rome. The frescoes were previously hidden by a coffered ceiling installed at the beginning of the 17th century as part of a far reaching transformation of the building.

This cycle was formerly attributed by Salerno, who discovered it, to the 12th or 13th century (L. Salerno, "Affreschi ritrovati nella cappella del Triclinio a S. Gregorio Magno al Celio," in *Palatino*, 1968 — what is properly the Church of St. Andrew being wrongly called the Triclinium Chapel through a "lapsus"). It has been re-examined by I. Toesca who, in spite of its defective state, has been able to identify prevalent consonances of style with miniatures of the time of the Saxon Emperors, especially the Gospels of Otto III. Therefore Toesca proposes dating them to the beginning of the 11th century, implicitly considering them a last stage on that bridge between West and East whose creation was of cardinal importance to the whole artistic civilization of the Europe of those times (I. Toesca, "Affreschi a S. Andrea al Celio," in *Paragone*, 263, 1972).

Obviously, the additions to our knowledge of Romanesque and Gothic painting have been much greater particularly where preservations operations have been wider spread and more systematic. This has happened above all in Latium thanks to the extensive restoration campaigns undertaken by G. Matthiae during his time at the Roman "Soprintendenza" (Department of Ancient Monuments). The most noteworthy rediscovery is that of the "Madonna with Child" in the Church of St. Angelo in Pescheria in Rome. The Madonna, freed from gloomy overpainting, revealed itself as a stupendous, although still incomplete, piece from between the 11th and 12th centuries and signed "Petrus de Belizo. Pictor. Pbr. Bellushomo Pictor" and the hinge of a group including the famous triptych of the Saviour at Tivoli and the Madonna in St. Mary's in Via Lata in Rome, and which is associated with the frescoes in the lower Church of St. Clement and the other Madonna in the Church of the Name of Mary in Trajan's Forum (see I. Toesca, "Un monumento della pittura medioevale romana," in *Paragone*, 153, 1971). This discovery contributes to the confirmation of the terms of reference for redrawing the profile of those two artistic personages - Pietro di Belizo and Belluomo - who have only just emerged from that anonymity which surrounds so much of Romanesque art in Latium.

The detaching of the frescoes under the roof of the Church of the Holy Cross of Jerusalem in Rome and their presentation in a special exhibition (see G. Matthiae, "Gli affreschi medioevali di S. Croce in Gerusalemme," Rome, 1968) has rekindled the problem of their various components, distinguishing one, of markedly Byzantine tendency, although, as suggested by Bertelli (see C. Bertelli, "Un problema medioevale romano," in *Paragone*, 231, 1969), worked up a Tuscan ambit. The other, executed later but with an archaic tendency, was tied to the St. Clement tradition and executed by Romano.

Already in the threshold of Gothic art, towards 1250, are the frescoes of a cycle discovered in the hidden and now ruinous little Church of St. Egidius at Filacciano in which the portrait of St. Francis of Assisi already appears and which recall the frescoes of the so-called "Master Ornamenter" of the crypt of Anagni Cathedral - hence their importance as witnesses of a period of rapid growth in figurative art in Latium (see I. Toesca, "Affreschi a Filacciano," in *Paragone*, 221, 1968); Id. "Gli Affreschi della Chiesa di S. Egidio a Filacciano," in *Bollettino d'Arte*, LIII, 1968 [but really 1972].

Other discoveries in the southern Italian area have been plenty and fruitful and have served to bring out again various very far reaching problems on levels different from the usual. A considerable part of these interests has been directed towards the methodical re-examination of vestiges from the High Middle Ages. An example is the thick summary of these investigations given by M. Rotili in "I monumenti della Longobardia meridionale attraverso gli ultimi studi" (in "La civiltà dei Longobardi in Europa," Atti del Congresso internaz., Accad. Naz. dei Lincei, Roma-Cividale, 1971, published in 1974), where there is an account of the results following particularly from the restorations of St. Sophia's and St. Hilarius at the Golden Gate at Benevento; of the Venosa Trinity; of the church of the Monastery of St. Benedict at Teano and that of St. Rufus and St. Carponius at Capua. Following the developments of this restoration campaign, which in general has been carried out with a sense of responsibility regarding the successive appearances assumed by the buildings, there has come the discovery, in the Church of St. Peter at Court in Salerno, of the remains of architectural structures which may have belonged to the Palace of Prince Arechi. This discovery widens our knowledge of Lombard architecture up to the end of his time, between the eighth and ninth centuries.

This same restoration has also produced another discovery of great importance - some frescoes on the faces of a heavy quadrangular pilaster in a wide underground chamber, or cellar, under the church itself. One of these paintings, in which the "Madonna Enthroned with the Child" is shown according to a Byzantine iconographic canon already common in the Venetian-Dalmation area, is signed "Daimore ping." This painting marks one of the expansions of the stylistic modules radiating from the cycle of St. Angelus in Formis, as also of its translation into a latinised form. The complexity of this diffusion has already been revealed by the frescoes discovered in St. Angelus at Lauro near Sessa Aurunca, which in fact offer many clues for a reconsideration of the age-old "Benedictine question," not only in the sense of contacts with the Byzantine matrices but also — for imagery rather than style — with the liveliest Western ferments sprouting vigorously with the 11th century decline in Cluniac circles (see C. Bertelli - A. Grelle Iusco, "Sant' Angelo di Lauro" in *Paragone*, 255, 1971).

In Sicily, a recovery which will certainly be a pivot for further investigations of pictorial happenings in the 13th century is that of the splendid "Cross" in the Cathedral of Mazara. First thought to be of Pisan manufacture but then, thanks to the excellent restoration, seen to be specifically contiguous with local examples such as the mosaics of the so-called Hall of Roger II in the Royal Palace at Palermo, it was inserted as a link in that Islamic-Byzantine-Norman complex which shaped Sicilian culture in the 13th century (see V. Scuderi, in "VIII mostre di opere d'arte restaurate," Palermo, 1972). A mixture whose later outcome is made better known by other interesting recoveries - from that of the

"Odigitria" in the Church of St. Nicholas at Albercheria (freed from no less than two layers of overpainting, one 16th and the other 18th century), to that of the fresco with the "Panthocrator" discovered in the transept of Mazara Cathedral (see M. Andaloro and B. Patera, in "IX mostra di opere d'arte restaurate," Palermo, 1974-75).

Also in Apulia, numerous restorations (here carried out, as already mentioned, in a somewhat short-sighted way) and rediscoveries, and above all an extensive rereading of the documentation, have led to a global reconsideration of the artistic culture and especially of the plastic and architectonic aspects of the 11th century, which is to say, before the foundation of St. Nicholas of Bari. This has led in turn to an evaluation of a monument which, while certainly not autocthonous, is in any case very individual, full of fervid drive and the flower of local production and of decidedly original and creative people. This has been well clarified, in lively contrast with recent and already traditional historiography, by the exhibition "To the Springs of Romanesque - 11th century Apulia," produced for the year 1975 by P. Belli d'Elia.

The extensive campaigns of conservation operations carried out over the years in the Franciscan Basilica of Assisi by the Central Institute for Restorations have obviously been an opportunity for very detailed reconsideration, in privileged conditions of legibility of the leading chapters in Italian Trecento painting. All the more, one might say because of the contemporaneous confluence on the same themes of investigations with completely different methodologies, among which perhaps the most important was the identification, still not unanimously accepted, of the chronological moment of Cimabue's Apocalypse cycle which A. Monferini ("The Apocalypse of Cimabue" in Commentari, XVII, 1966) has been able to fix between 1280 and 1283, seeing in the imagery a heterodox line, tied specifically to the religious movement headed by Gioacchino da Fiore, which was followed by the spiritual wing of the Franciscan Order so that it coincided with a momentary and particular anti-papal policy in the history of the order itself.

The Giotto problem has also reached deeper conclusions thanks to textual recognition of the principal Assisi cycle (see L. Tintori - M. Meiss, "The Painting of the Life of St. Francis in Assisi," New York, 1962). These have gone beyond the mere examination of the technical data and have aligned themselves with the whole wider discussion which, from the exemplary monograph on the artist by Gnudi ("Giotto," Milan, 1958) to the more detailed work by M. Meiss ("Giotto and Assisi," New York, 1966, II edit., ibid., 1967), has then been stimulated by particular opportunities (the Conference for the 7th Centenary of the birth of the Master, held in 1967 and which cross reference the Acts, "Giotto and his Time," Rome, 1971). This is certainly not the place for a detailed report of such a vast mass of research, which has enormously increased the bibliography on Giotto. (However, consider the outstanding nature of the new treatment by G. Previtali, "Giotto and his School," Milan, 1966, which far exceeds the limits of a monograph and covers wide sectors on the figurative art of the early Trecento.) Nevertheless, we must emphasize the more evident innovative points of this great critical work.

Before anything else come the close arguments which establish once and for all 1276 as the date of Giotto's birth, as against the tradition attributed to Vasari who fixed it as 1277 (see P. Murray, in "Giotto and his Time").

As to the early training of the artist, absolutely new clues have been supplied by the discovery of the "Crucifix" in the Church of St. Thomas in Cenci in Rome, but coming from the Aracoeli, and by the restoration of the "Madonna with the Child and Angels" in the Prepositura dell'Assunta at Stia.

Toesca, who discovered and published the "Crucifix" in St. Thomas in Cenci ("A Painted Roman Cross" in Bollettino d'Arte, LI, 1966), has precisely identified the tracts with proto Giottoesque connotations, an undoubted imaginative tour de force, carried to such completion as to impose itself as an indicator of uninterrupted continuous relationships with the Assisi frescoes. From this, although with great caution, there has been outlined an identikit which has been immediately accepted, by C. Brandi, though with similar caution in "Giotto and his Time," expressing so far only a suggestion of an Umbro-Roman artist who was Giotto's immediate precursor, but in any case convalidating the theory of Roman training for the Master. More explicit, on the other hand, are R. Salvini's considerations (in "Giotto and his Time,") in favor of the acceptance of the "Crucifix" in Rome into the "Corpus" of Giotto's works, as immediately preceding the Cross in St. Maria Novella, which he places in about 1290.

A re-examination of the Madonna of Stia, already well-known and previously attributed to the so-called Master of Varlungo, but whose quality has become obvious after the exceptionally complete and so far unpublished restoration, has led A. M. Maeztke (in Art in the Arezzo Area, Catalogue for the Exhibition, Arezzo, 1974-75) to a convincing revelation of formal and structural characters. Above all, Maeztke reveals expressive meanings of such innovative subtlety as to introduce a renewed credibility that identifies the work with the Master himself, although only hypothetically and as an alternative to the admission of an unknown personality capable of anticipating instead of reflecting the art of Giotto around the turn of the century. Previtali had already raised doubts about this in his above mentioned monograph, extracting from that in any case further support for the belief that Giotto's training was Florentine.

The Crucifix of St. Thomas in Cenci and the Madonna of Stia therefore reintroduce in fresh terms and with sharpened polarization, the complex vintage problem of the training and first activities of Giotto. This is a problem which, among other things, interests cultural horizons even more extended than those which can be inferred from the closest comparisons, as C. Gnudi has demonstrated in his paper on "Giotto's Origins and his Relations with the Gothic World" (in "Giotto and his Time").

Another new result in the problem of Giotto's activity is the chronological clarification of the period of his activity at Rimini, which Salvini (in "Giotto and his Time") puts after the work in Assisi and Rome and before that at Pavia, and thus before 1302, on stylistic grounds as well as an examination of the reflections from Giotto's work revealed in works by Rimini painters. In particular, the "Crucifix" by Giovanni da Rimini

in the Church of St. Francis at Mercatello, with a signature recently dated as 1309 instead of, as previously believed, 1349, constitutes an irrefutable "terminus and quem" for the Cross by Giotto in Malatesta's Temple.

On the documentary front, there has been the exceptional rediscovery, among the papers in the historical archives of the Commune of Bevagna, of a notary's file in which, under the date 4th January 1309, there is mentioned the restitution of the sum of 50 Cortona pounds made by Palermino di Guido, presumably a painter, on his own account and that of Giotto, in discharge of a debt which there is good reason to believe was contracted during the year 1308 or perhaps 1307. With this, the presence of Giotto in Assisi during that period having been ascertained, two equally important hypotheses come to have some weight, as pointed out by V. Martinelli ("A Document for Giotto at Assisi," in *Storia dell'Arte*, 19, 1973, but really 1975). One is that the debt was contracted to resolve the obligations still due on account of the works in the Upper Basilica, while waiting for the full settlement of account by the patrons; and the other (preferable) is that it was to be able to undertake fresh obligations regarding other more recent jobs, such as possibly the decoration of St. Nicola's Chapel or of the Magdalen in the Lower Basilica.

A final Giotto "novelty" was the proposal put forward by F. Bologna at the 1967 Congress and then more widely discussed in a specific volume (in "Giotto and his Time," then in *News on Giotto*. Giotto at the time of the Peruzzi Chapel, Turin, 1969). Hereby, a panel portraying "St. John the Baptist in prison, sends two messengers to Christ," now in the Gemaldegalerie in Dresden, is attributed to the Master, although admitting some intervention by one of his collaborators. For Bologna this panel, and another showing "The Baptism of Christ" which was already with it during the last century in the Woodburn Collection in London, and which has not been located since is obviously for reasons of style part of the so-called Peruzzi Polyptych which would have been completed so that the five panels of the front face, now at Raleigh, North Carolina, Museum of Art, would have had a correspondence on the back of another five stories of the two Saints John, seen as an integration of the iconographical program of the Peruzzi Chapel in Santa Croce.

Still staying within the Tuscan Trecento ambit, an exemplary demonstration of how much a good restoration can widen the horizons of our critical knowledge has been given by the operation on a panel with an "Annunciation," now in Arezzo Museum and perhaps originally part of a polyptych and unusual for the iconographic treatment which here associates the main theme with the Incarnation. Already at the center of a voluminous technical examination intended to define the outline of the so-called "Master of the Bishop's Palace" - so-called on account of the Crucifix in the Tarlati Chapel in Arezzo Cathedral—the work has revealed after cleaning the signature of its author, one "Andrea" undoubtedly identifiable as that Andrea di Nerio whom various documents mention as active from 1331 until 1369, and who appears to have died before 1387. In addition to the discovery of a concrete artistic personality we have also the improved "legibility" of the work, which produces innovative effects in the sense of a different idea about the figures as compared with those proposed in previous studies (Bellosi, Donati, Zeri, Boskovits), or at least their division into two distinct groups - namely that of Andrea di Nerio and that which prefers the reference to the "Master of the Bishop's Palace," perhaps identifiable with Balduccio di Cecco. But, above all, there has been produced a general clarification of Arezzo painting in the generation preceding Spinello Aretino (see also for the critical history, A. M. Maetzke, in *Arte nell'Aretino*).

It is at this period that we must refer to the enormous labor of restoration which the curators of the Florentine Galleries have had to face owing to the exceptional situation produced by the floods in November 1966. Among the works of every kind and every age struck by the disaster, the old panels and frescoes were in fact particularly numerous and suffered the worst damage. One example is the almost total loss of Cimabue's "Crucifix" in Santa Croce. Often in combatting this immense catastrophy, problems of very special nature have had to be handled technically (to mention just one, think of the gradual drying out of wood and plaster soaked in water, sewage, and creosote) as well as organizationally. But, we cannot do better than to refer to the very detailed treatment in the catalogue of the *Florence Restored* exhibition, prepared by U. Baldini and P. Dal Poggetto (Florence, 1972).

Studies on Italian Medieval sculpture are in a phase of renewed fervor (we have already remembered the investigation of P. Belli D'Elia in Apulia, and we must also mention those by A. C. Quintavalle in Emilia and those for the "Corpus of Sculpture of the High Middle Ages" sponsored by the Spoleto Study Centre, as well as important finds in Lombardy - see A. M. Romanini, "Unpublished Stuccoes in St. Mary the Great at Lomello" in *Commentari*, 1, 1968); A. Ebani, "The Capitals in the Crypt of St. Michael's at Cremona," in *Commentari*, 1, 1971) and have benefitted from two particularly important rediscoveries.

One is the figure of a "Scribe," part of the fountain which Arnolfo di Cambio executed at Perugia in 1281 and which, already dismembered by 1301, has only now been able to be put together again in its imposing monumentality. Neither must one neglect the very circumstantial valuation of Arnolfo's originality of style based on this practically intact sculpture - unlike the other "Scribe" which was refound in 1938 - and which can be related to an intentional recovery of Romanesque, and even of Late Classical, tradition which permeates that Perugian fountain (see F. Santi, "Another of Arnolfo's 'Scribes' for the Perugian Fountain of 1281," in *Paragone*, 225, 1968).

The other rediscovery is that of the "Madonna," which unfortunately has reached us headless, belonging to the tomb of Margaret of Brabant by Giovanni Pisano, formerly in St. Francis Castelletto in Genoa. Although Valentiner had already recognized the paternity of this statue in 1939, it was subsequently lost during World War II and only the exploration of a mass of stone fragments near the St. Agostino tunnel enabled it to be saved from being irrevocably lost. Added to the already noted refinding, shortly before (1960), of the figure of "Justice," this defines the motival interpretation of the whole famous tomb and confirms its chronological collocation at the end of Giovanni's activity (see C. Marcenaro, "The Madonna from the Tomb of Margaret of Brabant," in *Paragone*, 167, 1963).

Still on problems relative to the art of Giovanni Pisano the restoration of the wooden Crucifix in St. Nicholas' at Pisa has been of great interest, even if any direct reference to the Master remains a matter of opinion, cautiously put forward by Caleca. It is also a fact that the recovery of so powerful a piece of sculpture throws new light on a cultural situation in Pisa which has still largely to be investigated (see A. Caleca, in "Exhibition of the Restoration," Pisa, 1972, Catalogue).

A new contribution, similar to that concerning the diffusion of Tuscan (or more properly Sienese) sculpture to Rome in the first half of the 14th century, has been given by the restoration of the wooden Crucifix in the Church of St. Mary in Monticello, which is one of the few 14th century sculptures which remain in Rome (see I. Toesca in "Attività della Soprintendenza alle Gallerie del Lazio," Rome, 1967).

ORESTE FERRARI

EASTERN CHRISTENDOM

Constantinople. – The excavations conducted by
W. Kleiss, of the Deutsches Archaeologisches Institut in
Istanbul, of the remains of the famous Basilica of
Chalkoprateia have made possible a precise reconstruc-
tion of its plan. Situated 150 meters behind the ancient
and grandiose Theodosian Propylaeum of Saint
Sophia – a sanctuary of primary importance for the
cult of the Virgin (the sacred relic of the girdle is pre-
served there) – it was begun by Pulcheria shortly
before 450. Finished and dedicated by Verina, the wife
of Leo I, little more than ten years later, it was restored
after an earthquake under Justinian II. It was covered
with a dome under Basil I (867 - 886). It originally had a
nave and two aisles for a total width of 31 meters,
ending with a polygonal apse towards the exterior, semi-
circular inside, similar to that of the Church of the
Studios Convent, and preceded by a narthex and
atrium. However, no trace can be found of the atrium.
On its north side, the remains of an octagonal building
have been discovered. This building had a square plan
and has been interpreted as a baptistery, possibly
because of its similarity in form and location to the
baptistery of the Church of the Virgin at Ephesus.

The analogies with other pre-Justinian construc-
tions in Constantinople (in addition to the Studios
Church, the basilica discovered in the area of the II
courtyard of the Topkapi Sarayi) can most easily be
identified by the existence (also in the case of
Chalkoprateia) of secondary entrances at the end of the
small aisles. In this case, they must have been preceded
by porticoed passages, as was proven by the sources and
by vague suggestions by Mamboury, which served as
connecting passages to the Propylaeum of Saint Sophia.
Regarding the latter, the pre-Justinian phases would
appear to be more correctly identified by dating also the
west side of the Propylaeum leading to the large The-
odosian atrium in the fourth century, and consequently
at the time of the Emperor Constance's original build-
ing (about 360). This possibility, cautiously advanced
by Mathews, also assigns to this period – because of
the similarity in the walling technique of bricks with
thick layers of mortar – the construction of Skeuophy-
lakion on the northeast corner of Saint Sophia. This was
probably not far from the ancient baptistery to which
Palladio, in the Life of St. John Chrysostomos, gave the
name of "Olympos." In any case, the studies and
research of the Dirimtekin already permit one to
exclude a late date for the Skeuophylakion – an origi-
nal construction in 12-sided polygonal form with alter-
nating niches and the same number of windows on the
upper floor destined to contain liturgical vessels. Thus,

it is at least of the Theodosian age. It has been suggested
that it escaped the fire of 404, along with the west side
of the Propylaeum, and that it could have been part of
the first building of Saint Sophia.

Passing to the buildings of Justinian age in Con-
stantinople, our attention must linger on two with a
central plan. Their importance has been underlined in
recent studies. One of them is the Church of the Baptist
in Ebdomon, the residential quarter of the Byzantine
emperors, not far from the Palaces of Magnaura and
Iucundianae. This is the church where John the Bap-
tist's head was preserved and where many of the emper-
ors were crowned. Very few remains were excavated by
Demangel, but Procopius' descriptions are sufficiently
detailed to fix the consecration at a few years before 560
a.d. On this basis, Mathews composed a reconstructive
hypothesis which appears more convincing than that of
Demangel himself. It suggests an octagonal building sur-
rounded by porticoes on all except the east side, from
which emerged the apse. This consisted of an internal
circle of supports alternating with niches that spread the
weight of the galleries – and galleries certainly
existed – and of the dome, which had a diameter of
about 18 meters, to the external circle of pilasters. A
wide crypt was underneath the bema on the east side.
Possible analogies with San Vitale in Ravenna are obvi-
ous. In spite of the fact that this is no more than a
reconstructive hypothesis, it does confirm the Constan-
tinopolitan origin of the plan of the Ravenna Basilica.

Another Paleo-Byzantine construction on a cen-
tral plan is St. Euphemia, which was built inside the
boundary of the triclinium of the lost Palace of Antioch
("praepositus" under Theodosius II). It has been the
subject of serious study by H. Belting. Although discov-
ered in 1939, it was not studied at length at that time
from an archaeological point of view or in view of the
valuable, but much later, series of frescoes. It has now
revealed its original complex structure, situated on the
central axes of a "sigma" colonnade, on an hexagonal
plan with deep, wide semicircular niches on all sides
except that of the entrance, complicated by a number of
small circular porticoes between the niches which gave
oblique access from the outside. The entrance wall was
flanked by two deep semicircular niches from which the
towers could be reached via spiral staircases, analogous,
once again in many ways, to San Vitale in Ravenna.

It is in fact these apparent similarities that have
led those who believe in the "typological" method to
consider the existence of a common typology; that of
the Palace Triclinia for both Antiquity and Late Anti-
quity, on which the Paleo-Christian churches on a cen-
tral plan depend. The most noted supporter of this the-
sis was Lavin, who wrote an article in *Art Bulletin* in
1962. Against that, many well-founded objections have

been raised, particularly for its excessive vagueness—as for example regarding the architectonic context of the Mediterranean Basin during the passage from Late Antiquity to the High Medieval period. Actually, in the case of Saint Euphemia of Constantinople, there is no controversy regarding the dating of its transformation into a building for the Christian cult. If it is true that it was originally the triclinium of the Palace of Antioch, built at the beginning of the fifth century (416 - 418 or 413 - 433), it is also true that the whole complex suffered the disastrous consequences of the fall of Antioch in the latter part of its existence which, as far as is known, led to the destruction of its palaces. Accepting for true the date "ante quem" (615 or 626 a.d., when the relics of the martyr were taken there), the question still arises as to how the Triclinium of Antioch could have remained standing for a period of almost two centuries. Could it possibly, after so much time, have been chosen because "in antiquity" it had been a palace triclinium? Or was it because of the already consolidated preference for architecture on a central plan?

Added to these problems there is the one regarding its function as a martyrium. For Grabar, Saint Euphemia is the most significant example, even in Constantinople, of the "formula" of the martyrium. Having rejected the possibility that it was transformed into a building of the cult during the fifth century, after a more careful archaeological analysis it appeared to be a rather unusual type of martyrium in the picture of the Byzantium of the early centuries. The relics, unlike those at Studios or Chalkoprateia or even St. John's in Ebdomon, were not deposited in a subterranean crypt. Rather, they were contained in a reliquary casket in an altar with an opening to allow the faithful to touch them. While not archaeologically proven, Grabar supposed that the relics were kept in the altar facing the entrance.

The Basilica of Saint Euphemia has also provided material of primary importance for the reconstruction and the layout of the bema in the early centuries of Byzantine art. Many traces of the original bema, situated in the southeast niche, are still "in situ." There also are considerable sculptural remains belonging to it, including small columns encrusted with glass frit, similar to those found at Ebdomon and in the Aghios Polyeuktos. These comparisons allow one to suppose that sculptures from a more ancient complex, probably from the first half of the sixth century, had been used in Saint Euphemia. It must be remembered, in order to emphasize the uncertainty with which the study of Byzantine sculpture is still pursued regarding the early centuries, that Grabar claims these columns to be ninth century works, along with other more or less similar ones from Constantinople. They should thus be included in the sphere of the revived taste for colored goldwork that was established during the post-iconoclastic period.

Grabar made a valuable contribution in the field of sculpture with the collection of fourth century Constantinopolitan sculptures from the iconoclast period. Equally valuable contributions have been made in this field by E. Kitzinger and Ch. Delvoye. However, a consistent and precious enrichment of the documentation at our disposal has come from excavations, yet to be completed, in the area of the Basilica of Aghios Polyeuktos and of the complex of the Palace of Anicia

Juliana, situated to the south of the Valente aqueduct, between the new entrance to the city and the Column of Marcianus. For this important complex, C. Mango and I. Sevčenko propose the date of 524 - 526. This would appear to be confirmed by the cruciform marks on the bricks bearing the third year of an indiction (in this case September 1,524). It is by no means easy to reconstruct the religious building as not a single wall of any elevation is still standing; consequently, any hypothetical reconstruction can only be based on an analysis of the foundations and on stratographs of the excavations. If one excludes the narthex and the apse, the church appears as a large square of 52 meters on each side. Inside, two enormous longitudinal foundation walls that are quite deep lead one to believe it was a structure on a basilican plan. But the square shape of the perimeter, the presence of open exedrae, the particular characteristics of the foundations (in addition to a passage in the "Antologia Palatina": I, 10, 57) suggest that the building was covered by a central dome. There follows, for Aghios Polyeuktos, the belief that it is a forerunner of Saint Sophia itself, to the point that it might be thought of as a preceding work by the two celebrated architects Antemius and Isidore. Other longitudinal foundation walls are found at the center of the church, and above them it is possible to recognize elliptical foundations for the ambo. According to Mathews, the central foundation walls between the narthex and the crypt presuppose a long "solea," but Peschlow believes the opposite is true.

One important discovery, among many from this long archaeological excavation (conducted since 1960 by a Dumbarton Oaks team), is that of the fragments of a pillar and of its capitals. These are similar to the noted pair of pillars known as the "acritani" located in Piazzetta San Marco in Venice - so-named because they are believed to have come from Acri (Tolemaide). The strictly metropolitan and courtly matrix of this sculptural technique with flat, linear engraving, almost an embroidery of phytogeometrical motives, around the architectural element of a structure is thus unequivocably confirmed. M. R. Harrison, who has made an indepth study of the sculptural material from Saraçhane (this is the present name of the site of the excavations) describes the manner as "luxuriant, plastic and underdrilled," that is to say, closer to the Late Antiquity micro-Asiatic sculptural traditions. Numerous pieces belong to them, including fragments of niches (probably appertaining to the internal exedrae of Aghios Polyeuktos) in shell shape with peacocks and an inscription. It has been possible to reconstruct this inscription through the Palatine Anthology, which quotes it in full. It was distributed in metric verse over the architectural cornices inside the building, according to a common custom of the time — e.g., the inscriptions in praise of Justinian and Theodora in the interior of Saints Sergius and Bacchus. This inscription had to respond to a luxurious and sumptuous taste, especially if one considers that the sculptures and architectural elements in question were covered in fine colors, large traces of which have been found.

The "honeycomb" pillars previously mentioned present a geometrical design of squares of amethyst surrounded by triangles and trapezoids of green glass frit which together form a series of hexagons. Traces of gilded glass adhering to the diagonal channels were also

found in one fragment. Archaeological evidence has confirmed what was already known about the considerable financial outlay provided by the Princess Anicia Juliana for the erection of this sumptuous complex. Furthermore, it is believed that the narthex of Aghios Polyeuktos was raised above a flight of steps to allow direct communication with the princess' palace. This linkage between Christian tradition and court patronage originated at the beginning of the sixth century and attained vast dimensions, first with Anicia Juliana, and then with Justinian and Theodora.

A specific point of interest is raised in the controversy surrounding the interpretation of the structural work of Saints Sergius and Bacchus. This controversy focuses on the original function of the part of the Imperial palace of Costantinople that slopes toward the sea and, consequently, on the goals of its reconstruction. There are two opposing theses: that of R. Krautheimer – who claims it to have been the "palace chapel" of Theodora and Justinian, a type which later became the prototype for most octagonal palace chapels in the West; and that of C. Mango who, on the basis of analysis of various sources, claims it was the "martyrium" of a large Monophysite convent, built between 527 and 536. Furthermore, Mango denies the existence of a "tradition" of octagonal palace chapels. The only chapel that can be considered such is the Palatine Chapel at Aquisgrana, but one monument does not constitute "tradition." Along with these contrasting opinions, there are several purely architectonic studies of this monument. Mathews, in his most recent chapter on the subject, suggests that the twin Church of Saints Peter and Paul (reserved for the Western clergy) stood at the south side of Saints Sergius and Bacchus, and that on the north side Saints Sergius and Bacchus was in communication with the palace (an opinion that has not received much consensus, e.g., that of U. Peschlow). These investigations, however, have pointed out the unusual structure of the building. The axis of the internal tetraconch on which the dome rests is different from the square of the external perimeter, with a considerable rotation of one in relation to the other, which demonstrates the need to adapt it to the pre-existing structure.

On the other hand, after the discovery of the remains of Aghios Polyeuktos, somewhat diminished, the importance of Saints Sergius and Bacchus as an "architectural experiment" preceding Saint Sophia seems to lead one to place the two buildings in separate architectural traditions, of which that of Saint Sophia and — if the interpretation of the archaeological remains is correct — Aghios Polyeuktos are absolutely original and limited to the Justinian age.

As regards the architecture of Justinian Saint Sophia, the investigations carried out by R. J. Mainstone and R. L. van Nice on the tympana confirm the belief that they have been reconstructed, probably after the earthquake of 869 under Basil I. It is possible, however, that this reconstruction had already been planned and begun before that date in order to alter the space between the principal supporting pillars and relieve the strain on the arch. As for the tympana, it can be imagined that they were almost identical to the present ones, except for the niches in the lower order that contained the mosaic effigies of the Saints Fathers of the Church. In place of the present windows (in groups of three in the upper order) there must have been large, single apertures, as on the west side.

The other large and important Justinian construction, St. Irene, has not received any organic treatment relative to the present system which has modified the results of the old, but still valid, study by George. (Attempts by Mathews to attribute to the sixth century parts of the building, which are obviously later, represents a glaring misinterpretation.) Some extensive archaeological investigations have been carried out around the Basilica (west of the narthex and on the south side in the area between Saint Sophia and St. Irene) in order to study that complex of ancient buildings to which the two large constructions were co-ordinated. Other investigations have been started up recently on the north side and behind the apses. These excavations already had begun and made considerable progress between 1946 and 1947 by the then director of the Museum of Saint Sophia, Marmud Akok. Unfortunately, they were left without the necessary archaeological documentation. The present director, F. Dirimtekin, has entirely reconsidered his predecessor's excavations and has attempted to supply an exhaustive explanation. A further campaign of excavations was carried out between 1958 and 1960. Nevertheless, it will be possible to obtain a clear idea of the entire complex only when the archaeological investigation is extended to the surrounding zone. Meanwhile, it has been possible to ascertain that beyond the south wall of the atrium of Saint Irene there existed a complex of buildings that surrounded a large porticoed courtyard that contained water cisterns. As previously mentioned, we understand from information obtained that in the zone between Saint Irene and Saint Sophia there had been a series of xenodochia, all of which were destroyed during the Nika revolt (532). Only that of Samson was rebuilt and enlarged by Justinian after that date, although the roofless rooms around the courtyard probably belonged to this type of building. However, there is archaeological proof of a direct connection between these rooms and Saint Irene. This lies in the fact that along the south wall of the atrium a vaulted corridor (corresponding to the narthex) was replaced by a covered passage to allow access to the apse of St. Irene.

The reconstruction of the original Justinian atrium, based on such old walls as still remain, appears extremely complex. It has been attempted by Grossmann, who imagined the existence of an arcade of columns supporting arches on the four sides, with a vaulted roof and preceded by a kind of anti-atrium running obliqëly to the east side of the atrium, for the necessary alignment with the Northwest/Southeast passage in front of the complex, to which access was given by a triple opening probably on pillars. The fire in 563 must not have caused major damage to the atrium, except for the ceiling and roof. Consequently, it can be confirmed that the atrium and the narthex represent the most completely Justinian part of Saint Irene (that is to say, the part of the building erected between 532 and 563).

As has already been mentioned, in recent years the general picture of sculpture in Constantinople between and the fourth and the seventh centuries has been considerably enriched by the publication of systematic collections of existing material and by an occasional discovery of unpublished material. The overall

picture seems somewhat varied, and it oscillates between products of high quality craftsmanship (mainly from the Justinian period) carried out on a large scale; more elaborate products of Iranian influence; and decidedly inferior artifacts for which it is difficult to attribute a chronological or historicocritical collocation. This could be the case of the slabs from St. John of Studios, two of which (clearly made by the same hand) represent the "Entrance into Jerusalem" and a group of Apostles in front of a triangular tympanum which it is difficult to believe could have been produced by the same workshop that executed the beautiful capitals in the nave. Because of their abnormal proportions, their unnatural drapery stiffly carved in limestone, the dilated eyes of the figures, and their untidy hair, these slabs could be dated much later than the fifth century. It is also conceivable that other workshops were producing sculptures during the fifth and sixth centuries in Constantinople. The busts of the Apostles and of Christ from the Sarachane excavations, of uncertain date but certainly before the Iconoclasts and the Turkish occupation, were mentioned by Grabar as having been produced in a coarse and tired manner. Because of their stereotyped expressions and treatment of drapery, Graber places them at the end of the sixth century.

However, one can point out that there also might have been other workshops working in the true classical tradition and expressing an aulic, extremely refined, taste. (A valuable example of this hypothesis is represented by the capitals with animal decorations that were recently found in Istanbul and published by Firatli. These might have been executed by the same workshop as the celebrated pillar drum with animal and vegetable decoration and Christian subjects, now in the Archaeological Museum.) Also, there might have been other workshops sensitive to the profound changes of technique and taste that the sculpture of the eastern Mediterranean basin was undergoing during the sixth century. T. Ulbert has recently attempted to provide an overall picture of these, though limited to decorative sculpture alone. The material relative to the finest of these ranges of styles demonstrates a constant and substantial ambiguity between profane and religious repertories with reciprocal exchange between the two sectors. This ambiguity can be considered quite logical if one looks at the cultural environment of Byzantium between the fifth and sixth century (as explained by P. Lemerle in his volume on Byzantine humanism in the early centuries). The tenaciousness of the tradition in which stoneworkers working for these workshops had been educated can also explain this overlapping repertory.

This truly semantic ambiguity has recently inspired a number of scholars who have attempted to trace a subtle merging of profane and religious cultures in the subjects represented in the famous mosaics on the peristyle of the Imperial Palace of Constantinople (the date of which has already been agreed upon as around the reign of Justin II). S. Hiller and K. Weitzmann cover the same route that the emperor presumably followed when he went from the Imperial Chrysotriclinium to one of the churches near the Pharos. The peristyle was the point of discrimination between the area of civilian affairs and the one of affairs of the Christian cult of the imperial palace.

Scholarly research has been oriented in this direction in an effort to decipher the iconographic and iconological meaning of other noted products of Constantinople from the sixth and seventh centuries, such as, in the case of silverware, the celebrated Cyprus plates with stories of David, which are divided between the Metropolitan Museum of New York and the Nicosia Museum. According to Weitzmann and, more recently, to H. Wander and M. van Grunsven Eygenraam, these plates illustrate the entire battle between David and Goliath, following the biblical text of the First Book of Samuel. The scenes have been taken from various sources and, because the subjects belong to the beginning of the seventh century, the story narrated must be considered as referring, for analogy, to the commemoration of some specific historical event in the reign of Heracles (610 - 641).

The studies by E. Cruikshank Dodd on this silverware, already considered in some ways classics, begun on the basis of the preceding work by Rosenberg and on the indications contained in the well-known essay by E. Kitzinger on pre-Iconoclastic art of 1958, proposed the attribution to Constantinople of all the silver plates stamped with the mark of the imperial seals. Among these plates are also the plates from Stûma (in the Istanbul Archaeological Museum) and Rika (in the Dumbarton Oaks Collection). The objections to this attribution have been few (the most recent of which was from Francovich). The assay marks, one of which was always reserved for the "comes sacrarum largitionum" — a kind of Ministry for the Treasury of the time — were applied by embossing the metal. They served as a guarantee of the quality and purity of the silver used. In practically all the silver objects bearing this stamp the emperor's monogram is accompanied by that of the "comes" and other functionaries; it is believed that these objects could not be made other than in the court laboratories which, at the time of Justinian, enjoyed privileged treatment and worked only on commissions from the court.

However, it has been observed that such stamps could also have been applied outside Constantinople (it is conceivable that there might have been the rights to guarantee metals where there already were coinage rights). What is more important to note is that some of these objects found their way into the sphere of artistic production in Constantinople. It would otherwise be difficult to reconcile these objects from a linguistic point of view with the cultural picture of the metropolis in the sixth and seventh centuries, a picture essentially of highly classical, conservative, and traditional culture. This fact is particularly significant because, for a long period of time, the studies of Byzantine art have proceeded on this basis towards an "agglomeration" around the culture of an often radically differentiated artistic production. This was without taking into account the possibility that in Constantinople there may have coexisted different artistic trends from different cultural substrata, in which it is opportune to distinguish a court trend. The studies did not take into account the presence in the capital of an abstract trend (Kitzinger cited the mosaic panel with the donors of S. Demetrio of Salonnika) next to a fully conservative trend in the purest Hellenistic tradition. This dichotomy surely indicates a latent cultural antagonism which has since been found to be at the basis of the history of Byzantine art,

but can not involve the original manifestations of different cultural and artistic spheres.

Thus, it has been possible to repudiate the attribution of the celebrated, if problematic, codex of the Ambrosian Iliad to Constantinople on the basis of paleographic considerations and of a careful evaluation of the artistic and cultural environment of Alexandria of Egypt at the beginning of the sixth century. Following a comparison with papiri of Alexandrine provenance, G. Cavallo demonstrated that the small rotunda that characterizes the text of the codex constitutes the expression of an intentional archaism on the part of a conservative pagan culture absolutely contrary to the new trends of Christian Byzantine book production. On the other hand, Bianchi Bandinelli observed that the miniatures of the Alexandrine group probably go back not to miniature prototypes but to the contemporary monumental painting of profane subjects. This is not surprising, as the historical sources mention the existence of pagan manifestations at the beginning of the sixth century in Egypt and in Syria, on both a literary and a properly artistic level.

If one combines the critical acquisitions of the early 1970s with the re-evaluation of the role played by Egypt and by Syria in the first centuries of Byzantium, and particularly during the Iconoclast period, one can confirm that the global picture has become more specific, in directions which call for careful meditation and serious probing. The study of the icons in the Monastery of St. Catherine on Sinai (a formidable collection which includes the whole range of Byzantine artistic experience) has with good reason led Weitzmann to suppose that many of them are from Constantinople or the work "in loco" of artists of Constantinopolitan provenance or training. (There is proof that artists and architects were sent from Constantinople to Sinai in the time of Justinian.) This could be the case of some of the most beautiful icons of the early centuries, such as the one of the Virgin enthroned with Saints and Angels, the icon of St. Peter, or the one of Christ. The last is admirable for the pure humanity that Christ's expression conveys. They are works of the finest quality in which Christian spirituality appears harmoniously fused with the ancient pagan form, and they indicate the expression of a mature and conscious civilization. The continuity between the legacies of pagan culture and the first manifestations of Byzantine culture on Egyptian soil and the connection between Egyptian and Syrio-Palestinian contexts, particularly with the environment of Jerusalem and Antioch, should be researched more extensively.

More than the expression of a Constantinople workshop transplanted to Sinai (and therefore adapted to new specific iconographic needs), the splendid apsidal mosaic of the Church of St. Catherine seems to be the work of a Syrio-Palestinian workshop. This is particularly seen in the stringent comparison that is possible between a few of the heads in the mosaic (like that of Elijah) and those of the Ascension in the Codex Plut. 1, 56 at the Laurentian Library in Florence, the well-known Syrian Codex of Rabula, of 587 a.d. It should not be forgotten that G. H. Forsyth recognized in the architecture of the church on Mount Sinai not so much a reflection of the Justinian architecture of Constantinople, but characteristics in accord with the Syrio-Pales-tinian tradition; that is to say, the ancient and Constantinian basilican tradition.

The picture described above of the Constantinian buildings in the sixth century is not absolutely indicative of the prevalence of architecture on a central plan. Next to Saints Sergius and Bacchus and to Saint Sophia, grandiose buildings on basilican plans were still erected. A too rigid schematization of the evolution of architecture depending exclusively on studies of typologies runs the risk of completely distorting a more complex and articulated reality.

A significant discovery has recently confirmed the date of the conservative tendency in painting in Constantinople as immediately following the first iconoclastic crisis. This discovery, made during the Kalender Cami restorations, is that of a mosaic panel of "The Presentation at the Temple" in the iconographic formulation of Hypapante, appertaining to a remote phase of that religious building between the second half of the sixth century and the beginning of the eighth (before 730). The discoverers, C. L. Striker and Y. Doğan Kuban, compared the style of the panel (with magnificent colors obtained by using glass tesserae and intense flashes of light and shade) to the Greek style of the frescoes and Roman mosaics from the time of John VII. The unusual texture of the mosaics and their chromatic break-up clearly recall that sphere of culture and unequivocally confirms the Constantinopolitan matrix. The spacial sensitivity that emerges from this psychologically intense scene, suspended on an emotional thread of brilliantly orchestrated glances, is of an altogether special quality. This quality is confirmed, at least in the present state of our knowledge, only in the frescoes of Santa Maria "foris portas" at Castelseprio and in some Roman paintings of the time of Martin I. The figures – the single personages and their gestures – have a definite unconstrained sense of space.

Important elements, such as the singularity of the background, the precious frame, and the fact that the action takes place rigorously in the foreground, suspend the occurrence in a substantially timeless dimension of intense contemplative spirituality. In this splendid mosaic panel one can already notice the process of elevated spiritualization of classical models that will, over the centuries, become a dominant characteristic of the highest expressions of figurative Constantinopolitan language.

Syria. – Of the great urban complexes of Paleo-Byzantine Syria (fifth and sixth centuries), Dārā is still awaiting an excavation and a systematic study, while Resafa (Sergiopolis) has partly been brought to light by the excavations by the mission of the University of Freiburg, which unfortunately halted after the campaign of 1966. These excavations (the results of which have been published by J. Kollwitz) led to a general revision of the little that was already known. Of the three basilicas brought to light, Basilica A, the most modest, is dated at the middle of the fifth century and is believed to be the renovated pilgrimage basilica of St. Sergius. (It was at the time of the Emperor Anastasius that the name of the city was changed.) This attribution is based on the discovery of the foundations of a chapel to the north of the main apse (with a pavement in sectile work, remnants of wall paintings, and mosaic tesserae undoubtedly belonging to the decoration of the apses) corresponding, probably, to the martyrium of San Sergius.

Finally, after Kollwitz' excavations, the famous tetraconch can no longer be identified with the martyrium of San Sergius, because there is no element to suggest it. The same building plan, with the addition of a baptistery – it is the only baptistery found in the city – reasonably suggests, also to Kleinbauer, the identification of the remains of this monumental church as the Cathedral of Resafa. As Kollwitz has proposed, the remains of buildings along the sides of the roads could belong to the episcopal complex associated with this cathedral which, on the basis of its splendid sculptural decorations, could be dated around the third decade of the sixth century. After the interruption of the German mission's excavations, the studies and researches concentrated on the imposing walls – reinforced in the Justinian age – which surround the city with a circuit of a little under two kilometers. Karnapp has demonstrated that each of the four sides is provided with an entrance gate, not all of which are on the same axis nor of the same type of architecture. The semicircular tympanum of the west gate may have been decorated with a mosaic. The towers on the corners of the rectangle are circular and the ones on the sides rectangular, pentagonal, and rounded, for a total of 46 in all. There are two wall walks reached by steps, the lower one with niches open towards the interior of the city, the upper one uncovered but protected by parapets at the sides; in addition, the walls must have been entirely surrounded by a moat.

Deichmann has recently returned to the other fortified Justinian city, Zenobia-Halebija, to re-affirm (contrary to the thesis of Krautheimer) the technical and cultural independence, as compared with Byzantium, of Mesopotamian builders of this and the other fortified cities of Dārā and Circesium. If the general plans for the new Justinian urban layout drawn up by John of Byzantium, the individual buildings — particularly the religious ones — were executed in the characteristic Mesopotamian walling techniques and were decorated by extremely skillful local stoneworkers. However, the introduction of brick for arches and vaults (especially in the baths) indicates the impact of the Constantinopolitan custom.

Besides the above mentioned cities, the most noted fortified urban settlements of the Byzantine times, is the recently discovered citadel of Dibsi-Faraj (published by R. P. Harper), identified with Neocesarea (probably the Roman Athis) in the Euphrates Valley on the road from Aleppo to Sura. It is surrounded by a long circuit of walls with towers (part of the Diocletian fortification), which was restored in the Justinian era. Great importance is attached to the discovery inside the citadel of a basilica with nave and two aisles and of paved corridors on the north and south sides, datable around the middle of the fourth century. Also discovered inside the citadel is a martyrium with a nave and two aisles, with pilasters and pseudonarthex of north-Syrian type, and reliquary apses. The nave and aisles are dated by a mosaic floor inscription at 429 a.d. The floors of both religious buildings were covered by a large mosaic, of which some consistent traces remain.

In a brief article on the churches of the Tūr 'Abdin region, J. Leroy has indicated an undoubtedly important road to follow to acquire knowledge of the monophysite Christian culture of the northeast sector of Ancient Syria on the Persian border. This territory, as Leroy writes, "since the earliest times of the organization of the Jacobite church, has been a Christian reserve. A large group of monks, favoured by the limestone geology of the terrain which allowed them the possibility of living in caves, gave the region its name, because Tūr 'Abdin means mountain of the servitors." Despite the abundance of important archaeological material in the region (one thinks of the splendid architectonic sculptures in the Church of Hah or of Deir Zapharan, which may be considered in the light of the discoveries of Aghios Polyeuktos of Constantinople), the studies are limited to the research made by Gertrude Bell and to the more generic ones of U. Monneret de Villard. Worthy of note is the study conducted by E. J. Hawkins and M. C. Mundell on the convent and mosaics of Qartamīn, datable around 512 a.d., previously studied in 1956 in a rather cursory way by Grabar. The ceiling is decorated with bunches of grapes protruding from amphorae, standing on the diagonal axes at each of the four corners, while a medallion in the center carries a radiate Greek cross. The lunettes contain "edicules" supported by four thin columns with stylized Corinthian capitals from which emerge branched arms on which two lamps are hung. Each edicule contains an altar, on which three chalices are standing, framed at the sides by two trees on a gold background. The colors and lighting suggest a central source of light that corresponds to the edicule itself. One is struck by the obvious impossibility of duplicating the effect, by the absence of any animal creature in the representation, and by the absolutely simplified style, concentrating on a refined play on color. The cultural connection of these mosaics with the monophysite regulations and with the figure of Philoxenus of Mabbūg (a great supporter of Severus, Bishop of Antioch) has been suitably emphasized by the two above-mentioned scholars.

The region of North Syria saw the continuation of the investigation carried out by Tchalenko into the limestone massif in the northwest. In the course of his campaigns, numerous churches were discovered, including the Church of Kimâr. As so often in the noted scholar's research, the cultural material of the time was inserted into an agricultural context. Also worthy of note in this same context is the newly re-opened study of the important Basilica of Qalb-loze, of which Tchalenko has recently pointed out the originality with respect to the Basilica of St. Simeon Stylite the Older, considered until now to be its undisputed prototype. Tchalenko has suggested an earlier dating, around the middle of the fifth century, for this building, established in relation to another church clearly modelled on it which it is possible to date with certainty at 469 a.d. Tchalenko has also supplied a series of notes accompanied by useful observations on the construction techniques and on the statics of the monument.

It is certain that the most interesting discoveries in the field of Syrian art in the Paleo-Byzantine period have come since 1965 from the excavations conducted by the Belgian archaeological mission under the direction of J. Ch. Balty. Facing the Cardo, southeast of the tetrapylon, is the tetraconch or "Rotonda of Apamea," a building certainly of Late Antiquity which has since been altered, according to Balty, around the second quarter of the sixth century or, according to Kleinbauer, around 460. Apparently certain, however, is its function as a cathedral because of the presence of a synthronon,

episcopal chair, and baptistery. Its original dedication to the Holy Cross, the precious relic of which is worshipped at Apamea, is also quite certain, as is the evident stringent relationship to the tetraconch of Santa Tecla at Seleucia di Pieria and to the Sanctuary of the Virgin at Diyarbakir-Amida.

The "ad atrio" church, parallel with the Cardo and southeast of the tetrapylon, was built around 420 on the site of a synogogue that had previously been burnt and pillaged. The building underwent various restorations and alterations in the sixth and seventh centuries. At that time, the basilica must have been finished with a large polygonal apse on the outside and with reliquary apses formed as a result of the enlargement of the preceding rooms. Its wide U-shaped nave ended at the east end in apses, large paved atrium, and baptistery opposite the entrance. Also on the Apamene, at El-Mezraa-cl'Vlia, a chance discovery brought to light an impressive series of mosaics belonging to a church with a nave and two aisles, in which some magnificent and still intact reliquaries have been found at the end of the small aisles. The floor of the nave is decorated with a procession of fierce wild animals and birds, facing an unusual direction with respect to the axes of the basilica. This mosaic, which in many ways resembles that of the Amazons at Apamea, is now in the Damascus Museum.

As regards southern Syria, the definitive liberation of the tetraconch of Bosra is worthy of note; it resulted in the transformation (at a time yet unknown) of the building on a central plan into a church with a nave and aisles using an east-west colonnade.

An entire monasterial complex has emerged from the excavations of M. Amer at Qānata. In the fifth century the temple was transformed into a basilica which, along with two other churches, houses, and other buildings, must have represented a monastic and economically autonomous center.

From this quickly sketched picture of research in the territory of Ancient Syria one can see that the prevalent trend is that of a study of the monastic phenomenon in its complex integration into the economy and the culture of the territory. On the other hand, through the excavations the role of the large urban centers in the Paleo-Byzantine period is more deeply probed in the search into the progressive forms of organization of the episcopal power in relation to the changed economic and social needs of the population.

In this sense, yet in a different sector from that treated above, a fundamental contribution is provided by the publication by J. Leroy of the Syrian illuminated manuscripts in the libraries of Europe and the East. It is clear that monasticism has played a central role in the cultural history of Syria. There is no more direct proof of the artistic trend in the different sectors in which monasticism was divided than that of the manuscripts. If one considers the overall picture offered by Leroy's publication, one can see with a sufficient degree of clarity not only the relative artistic isolation of Syrian culture, but also the need to seek elsewhere that specific aspect of Syrian art which is still so problematical today that it is frequently questioned in the field of Paleo-Byzantine art. In this respect two critical problems emerge: one is that of the definition of Syrio-Palestinian art in the sixth through the eighth centuries on the basis of the Jerusalem-Sinai cultural axes; the other is that of the purple codices, and in particular the Rossanense, the Sinopense, and the Genesis of Vienna.

A widespread tendency is noted on the part of some scholars (Beckwith, Grabar, Delvoye, Talbot-Rice, and, to a lesser degree, Gough) to assign the above mentioned codices to the Constantinople workshops (as has happened with many pieces of silverware previously mentioned). In opposition to this tendency there are, among others, Weitzmann and Loerke. The former suggests a possible connection with the Jerusalem ambience; the latter has emphasized the relationship between the miniatures of the Rossanense codex and their possible monumental prototypes on Palestinian soil. In the 1960s, the interest of the critics was directed mainly towards the Genesis of Vienna, to the complex question of the origin of Christian manuscript art, and to the problem of its derivation from Judaic illustration (but this point must also be deferred to the controversy regarding the floor mosaics of Misis-Mopsuestia).

Furthermore, Weitzmann also assigns to the scriptorium of Jerusalem some ninth-century codices of dubious provenance, such as the "Sacra Parallela" of Giovanni Damasceno (Cod. gr. 926) of the National Library of Paris. (Grabar, in his recent publication of Greek manuscripts of Italian provenance, claims that the "Sacra Parallela" was produced in Rome.) If one connects this problem with those regarding the ivories of the Chair of Grado and with the flowering of the arts in the Omayyadi courts, as well as with the most ancient icons of the Sinai collection, one can deduce – according to Weitzmann – the existence of a continuity in Palestine from the age of Justinian to the tenth century. This hypothesis goes against the conviction of many other Western scholars that a true and proper "caesura," caused by the iconoclastic movement and by Christian emigration before the Arabian advance, had interrupted the artistic tradition of the Christian Near East in the seventh century.

Asia Minor. – In view of the progress made in the study of Byzantine art in Asia Minor, one should note that discoveries and excavations still in progress give an extremely articulated overall picture (by epoch and by region) of metropolitan art from the tenth century onwards. For the period that precedes that date, one should distinguish three areas of what is now the Turkish peninsula. The first is the west coast, where the Hellenistic and Late Roman cultures flourished and conditioned the artistic trends of the first Byzantine period. The second is the southern/southeastern region, which was rich (especially in the fifth, sixth, and seventh centuries) in intense and lively cultural relations with the metropolis and with the culture of the East Mediterranean basin. The third is the Central Anatolian region which, in the early centuries and particularly in the field of architecture, developed an original product connected with the North Syrian, Mesopotamian, and primitive Christian Armenian architecture. These connections became even more evident in the High Medieval architecture which flourished in the northeastern regions of Turkey.

At Ephesus, in the north side of the Basilica of St. John, one has to note the discovery of a large octagonal baptistery, with four niches on the diagonal axes and columns inset in the corners whose date is still uncertain. A Seal Room and a series of other rooms from this complex have not yet been fully excavated, but it is

conceivable that they were part of the ancient Bishop's Palace. The discovery of basilica on the terrace under the Doric arcade has been recorded at Cnido (Muğla). The basilica has three apses with Synthronus at the center and a mosaic floor which in many respects relates to that of the synogogue in Sardi.

The continuing excavations at Hieropolis by the Polytechnic of Turin, under the direction of P. Verzone, have brought to light the celebrated octagon in the Christian part of the digs. At Mileto, Kleiner has investigated the remains of the Great Church (with a nave, two aisles, a narthex, and an atrium), dating it in the sixth century. Fragments of the floor mosaic and some architectonic sculpture have been published. Peschlow has published the sculpture pertaining to the different phases of the construction of the basilica erected in the adytum of the Temple of Didyma. These included the remains of an ambo which tie in with the remains published by Verzone relative to the Cathedral of Priene and with those of Paros published by Orlandos, forming a complex which is substantially homogenous in technique of execution and iconographic repertory. This complex pertains to the activity of micro-Asiatic coastal workshops, which are still inserted into the best Hellenic traditions. (In this respect, we are also reminded of the study carried out by Yegül on the Paleo-Byzantine capitals in Sardi.)

In recent years, on the Acropolis of Xantos in Lycia, H. Metzger has discovered a large basilica with a nave and two aisles, narthex, and atrium, decorated in an extremely original iconography with pavement mosaics of geometrical and phytomorphic character. Another church with baptistery and atrium, probably part of a convent, has been discovered near Letoon. In both cases, by means of archaeological stratification, the continuity of the building activity from the Hellenistic age to the first Byzantine era was clearly proven. Evidence of this kind represents an important "in vitro" sample, even from the urban point of view, because it expresses the progressive transmutation of life and of culture in the most important Anatolian centers.

R. M. Harrison has conducted a series of studies on the churches and chapels of Central Lycia. The archaeologist claims that in Paleo-Byzantine times this region – a "bridge" over the trade road from the Aegean to the Middle East – was closely associated, in spite of its ecclesiastical dependence on Byzantium, with Antioch and Alexandria of Egypt. This would explain the frequency of a type of architecture of Egyptian and Palestinian provenance, such as the basilica ending in an apse in the form of a trifoil crowned with a dome. Harrison cited the cases of the triconches of Alcahisar, of Dikmen, of Alakilise, and of Karabel (perhaps the oldest, before 442) in which one notes the use of pendentives in the passage from the square base to the circular domed roof, a precious and timid anticipation – if the date of the fifth century is correct – of the grandiose architectural solution of Saint Sophia at Constantinople. After the Arabian occupation, Lycia – by now a primary strategic outpost — entered into the orbit of the capital. In this context it is possible to explain the subsequent relative cultural isolation of the region and the contradictory, and sudden, flowering of exceptional architectural works such as the complex at Dere Aši and the Basilica of San Nicola at Myra (Demre).

The greatest surprise in the field of Paleo-Byzantine art came from the discovery and publication by L. Budde in 1969, of the mosaics of Misis-Mopsuestia in Cylicia. It is already evident that this publication has given rise to opposing interpretative hypotheses. These mosaics made a sumptuous floor for the nave and aisle of the building (which is outside of the city walls) and their liturgical function – whether for a Christian or Hebrew cult – remains the subject of controversy. Noah's Ark is depicted in the nave; the stories of Samson are depicted in the aisle, in a series of scenes interupted and accompanied by inscriptions, which are transcriptions and paraphrases from a version of the Septuagint. Budde believes these mosaics pertain to the martyrium of Saints Probus, Taraco, and Andronicus, erected by Bishop Aussentius around the middle of the fourth century. Kitzinger thinks they belong to a synagogue of about the middle of the fifth century. For Buschhausen they could belong to a later Christian building (from the beginning of the sixth century – ca. 519 a.d. – at the time of Bishop Aussenius II) principally on the basis of a stylistic comparison with the later mosaics of Antioch.

These mosaics assumed a particular significance with respect to the relationship between Misis and Antioch, especially at the time of Bishop Theodoric. In the eyes of Kitzinger, they can help clarify the problem of the illustration of the Old Testament in the Jewish sphere, as well as that of the origins of the illustrations on "scroll" and on codex. In the codex hypothesis, Kitzinger has suggested a reconsideration of Weitzmann's theory, which claims that the production on scroll with continuous scenes would be a Macedonian age reproduction "in the old style." In reality, the Cylician mosaics appear to show that, already in the pre-iconoclastic period, scrolls were illustrated with continuous scenes to the point that they could have been imitated, on a much larger scale, on the pavements of religious buildings.

The complex and sometimes contradictory aspects of a composite culture emerge within the sphere of Central Anatolia. The research M. Gough has been conducting since the early 1960s on the Alahan complex is fundamental for establishing that area's chronology. As a result of his studies, the chronological succession of the three principal edifices has been clarified: the Church of the Evangelists, c. 425; Church of the Monastery, middle of the fifth century; and, Portico and principal church, third quarter of the fifth century. The entire layout of this sanctuary-monastery (which enjoyed considerable fame and the attention of highly skilled workers during the fifth century) was also brought to light by Gough's research.

The iconography of the sculptures from the principal doorway of the Church of the Evangelists becomes much clearer when related to the antagonism between pagan culture and traditions and the triumph of Christianity. (The sculptures of the later Eastern Church were associated with a more mature phase of the same process.) Next to the principal church, a baptistery has been found in the form of a bi-apsidal hall with a cross-shaped fountain. Since 1966, Gough has investigated the remains of the primitive basilica of Alahan Manastir. This grandiose basilican structure with galleries similar to the Acheiropoietos of Salonika has come to light with a large quantity of high quality sculptural material.

This material was destined for the liturgical boundary walls and was decorated with luxuriant foliage in high relief. A colonnade joined the basilica to the Eastern Church (Koça Kalesi).

In a vastly different, though not geographically distant, sphere we can follow the still incomplete research by the team of S. Eyice on the imposing group of buildings in the region of Kara Dág. Eyice's mission focuses on three different sectors which had already been partly explored by G. Bell more than half a century ago, when a far greater number of buildings were still standing. These are the group at Ma'den Šehir, the ruins of the upper region of the Yukari Ören, and the ruins of Degle. A church and a Christian settlement have been found at Yesildere. The churches of the village of Der-eköy and those of Dağpazari have also been studied. The Church of Tomarza in Cappadocia (from the first half of the sixth century) was published again recently by S. Hill on the basis of old but extremely clear photographs taken by G. Bell. This church can also be associated with others in the Kayseri region, as it is representative of the Central-Anatolian type of church in cross form.

Greece and the Balkans. – The general picture of Paleo-Byzantine art in Greece is constantly being enriched by numerous and important examples through new excavations. The complex of basilicas at Nea Anchialos near Phthiotis Thebes, excavated by P. Lazaridis, are significant to any study of the fourth and fifth centuries. Basilica alpha or Saint Demetrius, has revealed the remains of a baptistery and of an episcopal palace; the basilica beta, of Bishop Elpidius, is notable for its quadruple entrance; the basilica delta of Archbishop Peter, with narthex and exonarthex, has provided valuable floor mosaics and a few remains of sculptures; and the basilica gamma is noted for the remains of a fountain in the atrium built against the wall of the narthex on the longitudinal axes of the building. A later dating must be given to the Basilica of Saint Sophia at Mityka, excavated by Vokotopoulos, with nave and two aisles, a narthex, a single apse, and the pastophorium bordered by a baluster built against the north wall. Little is known of this basilica, except that it must have been destroyed between 989 and 1028 a.d.

Stikas has continued the excavation at Amphipolis of three basilicas (one with a nave, two aisles with narthex, and large atrium), and has discovered noteworthy pavement mosaics. The remains of a beautiful ambo and pavement mosaics have been recovered in Basilica gamma. It has been possible to partially reconstruct the ambo, which can now be associated with those in Paros.

The continued excavations at Philippi have led to the discovery of ruins relating to the Episcopal Palace. This has clarified the topographic context in which the celebrated octagon was situated, limited on the north side by a tract of the Via Egnatia (discovered in 1971), on the west and on the east by transverse roads, and on the southeast side by porticoes. There also is extreme interest in the excavations (conducted by D. Pallas) at the Basilica of San Leonidas at Lechaion (Port of Corinth), which has a nave and two aisles with narthex and atrium, and also the Basilica of Kranion, which has a nave, two aisles, a baptistery, and other rooms on the north side. This complex cannot be dated earlier than about 500.

The restorations carried out by A. K. Orlandos at the Basilica of Katapoliana of Paros have led to the individuation of the phase preceding that of Justinian which should – according to tradition – be Constantinian. This had the same horizontal layout (with apse), but it must have been covered with a dome-less roof. The present baptistery, which is situated on a level 72 centimeters lower than that of the Justinian basilica, belongs to the Constantinian phase. Furthermore, the connections of the original atrium, which preceded the imposing Constantinian basilica, have been found in front of the facade (now restored to its primitive condition).

In this context, one should also remember other interesting discoveries made in the Balkans, such as those by B. Alexova and C. Mango during the excavation of the episcopal complex of Bargala, Macedonia. This complex is surrounded by a wall of the fourth or fifth century. Inside, a basilican building with nave and two aisles with endo- and exo-narthex was found, the former with five enhances, the latter with three, and probably also a women's gallery. A. Boyadžev has excavated and studied the celebrated Red Church of Peruš-tica in Rumania, connecting it to the more general problem of the Paleo-Christian churches on a central plan. What seems most surprising is that the dome itself was covered by a kind of terrace, as is apparent from the presence of four small rooms fitted into the space between the walls enclosing the dome. This brought the scholar to compare the Rumanian edifice with the Armenian Church at Soradir, near Lake Van, for the characteristic projection of the arms of the cross above the upper structure of the dome on the sloping roof. The Church of Peruštica is closely related to the quadriconch of Ochrida, identified by I. Nikolajevic as the ancient palace of Lorenzo, Bishop of Lychnidus (492 - 598). The palace is the first resulting from the transformation of a pagan building into a building of the cult. It is conceivable that its northern annex, with the mosaic floor representing the four rivers, could have fulfilled the function of funerary chapel of the bishops of Lychnidus.

A tangible change in current opinion has resulted from a series of studies on the mosaics of Salonika. In 1969 R. S. Cormack published a study on the mosaic decoration of San Demetrius, which broadly re-examined the question of its dating in light of W. S. George's watercolor referring to the destroyed mosaics in the small north aisle. On this basis, the archaeologist states that, on the one hand, the intervention conducted after the terrible fire at the beginning of the seventh century must have been either an entirely new work, like the lower panels of the bema, or works of restoration, as in the major part of the north side internal aisle; and, on the other, that the mosaics of the first phase should be assigned to the last quarter of the fifth century. This thesis has been accepted by Kleinbauer, who has extended it, as has Vickers, to the problem of the dating of the other Thessalonian mosaics. Thus the mosaics of the subarches of the Acheiropoietos, and those of the apse of Hosios David and of the Rotunda have been dated in the last quarter of the fifth century.

The mosaics of Hosios David and of the Rotunda, which had been dated by a large number of experts at the end of the fourth century, have had their date advanced by almost a century. This has been prin-

cipally justified by arguments of an archaeological nature. Vickers maintained that it is not possible to date the transformation of the Rotunda into a place of the Christian cult before about 475. He thus excludes, on the basis of archaeological reasons, Dyggve's hypothesis that it could have been a "palace church." The date of 475 a.d. is confirmed by the presence of tiles bearing the stamp of the prefect Ormisda, who also directed the reconstruction of the city walls. Now, if it is true that the mosaics of the first phase of St. Demetrius and those of the Rotunda find stylistic confirmation in the two busts between clipei from the basilica Δ of Nicopolis (dated provisionally at the time of Bishop Alkison, who died in 516), it is also true that considerable stylistic and iconographic differences can be seen in the Thessalonian mosaics assigned cumulatively to the last quarter of the fifth century. There are differences which are not found in the same epoch either in Rome or in Ravenna. Consequently, independent from the more or less pronounced provincial character of the Thessalonian mosaics, the problem arises of the possible affirmation of an artistic current tending toward an accentuated linear stylization and to a different chromatic sensitivity. These characteristics can be attributed to the influence of previous experiences matured in the metropolitan area in a phase not earlier than the fifth century. The parallel co-existence of different trends, pointed out by Kitzinger in his 1958 essay on pre-Iconoclastic art, would thus begin at least 50 years earlier and therefore should be given more consideration in the evaluation of the artistic trends in the crucial passage from Antiquity to the Middle Ages.

FROM THE ICONOCLAST CRISIS TO THE TWELFTH CENTURY
(PLATES 105-107)

Constantinople. – The picture thus far traced of the discoveries and the critical trends of Paleo-Byzantine art in Constantinople and in the provinces offers a view of the dynamic interior of the Byzantine figurative civilization at the threshold of the iconoclast crisis. This crisis seems to give an original explanation of the tensions of the period that immediately followed it, of the nature of the theological debate around images, and of the role of art and artists in Byzantine society and in the religious conscience of the time. On the one hand it clarifies the complex and sometimes contradictory cultural texture and the politico-religious contrasts which are at the root of this artistic civilization. On the other, it tends to subordinate the production of the sacred images to the authority of the Church, with the cogency of subtle theological argumentation hiding deep political motives. The church is therefore a "tradition" which explicates its unifying function no differently from any central political power, for the purpose of creating a unique codex, though variously articulated and diversified within.

Thus, if W. E. Kaegi has been able to confute the widespread opinion that the Themata of Anatolia were responsible for the early spread of iconoclasm, it is not possible to accept the simplistic, though richly documented, opinion of S. Gero that iconoclasm was a personal imposition on the part of Leo III. The origin of iconoclasm is probably extremely complex and stemmed from the conflict of various motivations which were at the same time historical, political, and religious (the Arab advance into the territories of Syria, Palestine, and Egypt, still profoundly permeated with monophysite heresy; the position taken by the bishops of Anatolia; and the rise to power of Leo III). On the political/religious plane, the result of iconoclasm was to push to the extremes the autocratic concept of imperial power as a power derived directly from God. This is a concept that, having survived the tempest of the iconoclast, remained at the heart of the Byzantine mentality. In iconography, this manifested itself in the frequent joining of the figure of Christ or of the Virgin with that of the emperor. Examples of this are the Berlin ivory (already believed to be of the time of Leo VI, then later attributed by Weitzmann to Leo the Armenian 813 - 820 that is to say, to the iconoclastic revival at the beginning of the ninth century), and the famous miniature of the menology of Basil II, in which the emperor celebrates his triumph over the Bulgarians. In the first example the emperor was crowned by the Virgin; in the second, by Christ himself.

Recent accurate collection of texts of iconoclastic age and a more careful reading of the sources of the time make it possible to observe today an altogether more complex and articulated reality in the figurative arts. Attention is therefore drawn to the careful reading by F. de Maffei of the texts of the Nicene II Acta del Concilio. De Maffei, among other things, focuses on the specific role of the "techne" defined as "Nicene Platonism" and compares it with the "mimesis of the prototype" and the role of hierarchy in the fixation of orthodox iconography. The artist's aim is therefore to reproduce the prototype by means of his own technique and of the indications furnished by tradition. The truly faithful will be in the right when, captured by the contemplative power of the icon (which consists principally in the power of concentration through color), he or she succeeds in making contact with the divinity beyond the physical world and the materiality of the work.

The premises of spiritualization of Byzantine art and of it fixation with the subtle discrimination between the legacy of the past and a new spirituality are therefore established. Around these two poles, and with varying success, the artistic production of Byzantium always rotates. An essential contribution has been made to it by monachism with its complex cultural roots, its elaborative strength, the tenacity of its tradition, and its energy in affecting the reality of the time. The role of monachism in Syria and in Constantinople during the iconoclast period and immediately afterwards is seen today as the central problem for the individuation of the origins of mid-Byzantine art. There is no doubt that the four principal components of Macedonian culture contributed to mid-Byzantine art. The four components are: a) The liturgical, which dominated the narrative component in both book illustration and internal distribution of the space in religious buildings; b) the classicist, which assumed the aspect of a true and proper "revival," especially under Leo VI, whose aim was to cause the more pure cultural tradition of the empire to re-emerge as "new"; c) the monastic, in the glorification of the values of asceticism and of religious concentration; and d) the humanistic, under which it is intended to draw attention to every day life. The humanist component is one of the constants of Byzantine art, especially in later periods. It can only be understood as the

immediate identification or, rather, overturning of heavenly life into earthly life, almost as if the one were the mold which shapes the still incandescent metal of the other in its own image (whence the value of the "prototype" mentioned above).

The monastic nature of the internal space of the Byzantine church in Greek cross form with a dome has been invoked by some scholars, principally C. Mango – not to mention other far-fetched hypotheses of derivation from Iranian fire temples or from ancient Mesopotamian architecture – to explain the origin of the plan that has become a canon of Byzantine art. This particular space is not divisible, as is a basilican plan; furthermore, it can not contain a great number of the faithful. According to Mango, the system of resting a dome on free standing columns was the most natural in the Byzantine tradition. This system called for antique pillars and capitals, not easily findable in a period of crisis of building materials. Exactly for this reason, Mango thinks of Bitinia and the region around the ancient Cizico on the south coast of the Marmara Sea, and so not far from the capital, as the original "home" of the church on a Greek cross plan with a dome supported on free standing pillars. A monachism grew and flourished there during the eighth century, in particular during the reign of Empress Irene, with personages of high intellectual rank such as Theodorus Studita, his uncle Plato, Theophanes the Confessor, Metodicus, Nicetus the Patrician, all members of the bureaucratic class, with landed property in Bitinia on which they had built their own monastries.

It has been possible to identify a few of them, such as the Church of the Archangels at Sige near Mudanya, studied by H. Buchwald, dated by the 19th-century inscription at 780; the Monastry of Pelekete, destroyed by the iconoclasts in about 764, rebuilt before the end of the eighth century; and that of Megas Agros, built by Theodorus Studita in about 785, both at Tirilye. More recent research, conducted by Mango and by I. Sevcenko, has helped in obtaining greater knowledge of Fatih Cami, also at Tirilye, yet without being able to identify it with the name of a monastery. All that is known is that it already existed in 815. It is, however, the church of a monastery of the end of the eighth century or the beginning of the ninth century. This can be determined by its archaic characteristics; in addition to having a dome supported by four columns (from a previous site), the narthex is covered by a single barrel vault (instead of a triple) and the prothesis projects beyond the northern wall. If one bears in mind that the first known church of this type is the Nea Ekklesia of Basil the Macedonian (in the description by Photius) of 886, and the first still in existence is the Theotokos of Lips (Fener Isa Cami) of 987, one understands the importance of the Tirilye buildings. This is, of course, as long as a more detailed archaeological research can definitely demonstrate that they are, in fact, archaic.

The connections of the Byzantine cruciform plan with Byzantine liturgy have been emphasized by P. G. Ehser who, if death had not prevented him, would have attempted to extend this research method to a true and proper "Soziologie der Byzantinischen Kreuzkuppelkirchen." The radical differences between western and eastern liturgy (the latter codified in forms that have remained almost unaltered since the eighth century) essentially depend on two factors. The first is the absence of any dialogic rapport between celebrant and congregation in the eastern liturgy. The second is the prevalence, also in the eastern liturgy, of a more contemplative and mystic rapport between heaven and earth and earth and heaven, coherent to the strongly concentrated cruciform space in which, through "apatheia," man can reach "theiosis."

The restoration of the Fener Isa Cami complex brought a better understanding of the northern church which is, today, still the finest Constantinopolitan church with a mid-Byzantine dome. It consists of a nucleus in the form of a Greek cross, including side chapels, crenelated reliquary chapels, large side windows that light the nave, and a stepped tower antiguous to the narthex, that gives access to the floor above, where four more chapels with domes are arranged – two on the narthex and two above the reliquary chapels. The external appearance of the church with its five domes, the large number of chapels, the richness of the internal decorations (mosaics, inlay work, tiles, and enamels) among which the beautiful decorative sculptures are outstanding — many came from the Roman cemetery of Cizico — leads one to believe that the northern Church of Fener Isa Cami might in many ways reflect the appearance of the Nea of Basil I.

The use of enamelled tiles as borders or frames, and of tiles decorated with Sasanid motives and cuphic characters reflect the Arabian taste of the time of Theophilus. This emperor had sponsored the construction of the most elegant rooms in the Grand Palace, perhaps in a spirit of emulation of Hārūn-al-Rašīd.

On the basis of the studies and the findings of C. L. Striker, it is today possible to believe in the dating (920 a.d.) of another Constantinopolitan monument, the Mirelaion (Bodrum Cami). Once again, it must have been a monastic church, built near the residence of the Grand Admiral Romano Lecapeno and transformed by him into a monastery after his elevation to the imperial throne. His wife Theodora was buried there in 922. It actually consists of two superimposed churches with the same design, so that the complex must have looked rather like a high, articulated tower with a wall walk on corbels all around it. The outside is particularly elaborate: the side walls of the narthex are slightly curved outwards, while six semicircular pilaster strips on each of the long sides respond to the spatial articulation of the interior. Curved bricks are used in the pilaster strip, so that the same material is used throughout the entire building. This plastic modelling of the exterior seems, in effect, to imitate the modelling of the contemporary churches in Georgian and Armenian stone. It could be an indication of the spread of a "Caucasian" taste at the very moment in which the Armenian architect was called to Byzantium to solve the serious stability problems of the dome of Saint Sophia (after the earthquake in 989). In effect, if it is possible to agree with the line of development of 11th–century Byzantine architecture (in the sense of a taste that is ever more accentuated and aware of its own means towards the pictorial and plastic animation of the spaces, as traced by C. Delvoye), other observations submitted by Mango demand the attention of anyone seeking to enquire deeply into the sense of the origins of mid-Byzantine architecture.

As is well known, the "fashion" of the trilobate and the quadrilobate plan had been affirmed with increasing vigor since the beginning of the 11th century.

In Greece, the Catholicon of the Grand Lavra (trilobate, about 1000); Veljuša, near Strumica in the Balkans (quadrilobate, 1080); and the catholicons of Ivivo and Vatopedi on Athos demonstrate the use of the trilobate plan in the Atonite tradition. It probably was derived from Georgia; Mango cites the Church of Osk Vank (ca. 960) as an example of this formulation with four free pillars in the interior, later strictly observed at Mount Athos. Constantinople must have played a crucial role of "bridge" for this tradition. Sufficient proof of this can be found in the fact that not only was the Church of Christ of the Chalké a tetraconch (enlarged by G. Tzimisces, of Armenian origin) – as C. Mango has demonstrated – but that even a church of considerable dimensions, such as St. George of the Mangani (ca. 1042 - 1045), has a naos in the form of an inscribed cross with four large pillars with rounded inner corners (a sign that the dome could not have been supported on normal corbels as in the Cathedral of Aghtamer). Therefore, according to Mango, the origins of mid-Byzantine architecture are to be found principally in the affirmation of the monastic movement to the disadvantage of the secular clergy (in this respect Mango cites the exemplary case of Saint Sophia of Ochrida, still modelled on basilican lines) and in the "Caucasion" influence — that is to say, only in those regions where, during the tenth century, there is evidence of intense building activity. This hypothesis does not seem to be refuted by that of H. Hallensleben regarding the internal evolution of Byzantine architecture toward the type of a cross inscribed with apses, which will be referred to later.

The above–mentioned Church of Christ of Chalké was, therefore, probably a tetraconch; but it can not be claimed – as pointed out by Janin in his review of the book by S. Miranda on the Palace of the Byzantine Emperors – that it was a building distinct from the Chalké itself. We know, in fact, that it was built as a chapel above the vault of the Chalké by Romano Lecapeno and that it could not contain more than 15 people; it was later enlarged by Giovanni Tzimisches, who had his tomb built in it. But where did the Chalké fit into the topography of the Imperial Palace? Mango and Miranda locate it more in line with the imperial itinerary, in the southeast. Labarte, Ebersolt, and Vogt place it in the north, not at the corner of the Mesé, on the tract that led from the Forum of Constantine to the entrance to Saint Sophia, but much farther away, because of the excessive amount of space allotted to the Noumera.

One has to admire the attempt at the reconstruction of the Imperial Palace made by Miranda, who in 1965 republished, with a preface by Mango, a book published in Mexico ten years before. In it, he conjectured the arrangement of the plans of the many buildings listed in the sources, extending his research also to the Palace of Blacherne and to the other imperial residences in the capital and in the surrounding districts. More meditated and systematic studies of the Grand Palace, the Hippodrome of Byzantium, and the itineraries of the Book of Ceremonies were made by R. Guilland in a series of papers that represent a sound contribution to the reconstruction of the Byzantine capital around the tenth century. The volume, published by Guilland in 1969 in Berlin, contains all his previous papers up to 1959 on the topography of Byzantine Constantinople. We would like to mention the studies on the Hippodrome of Byzantium (inside the city — the Tzykanisterion, the Amastrianos demolished by Irene, the covered Hippodrome, the Stadium, and the Palace Hippodrome; in the outskirts — the Hippodrome of San Mamas, important because it can be considered the private hippodrome of the emperors; the Philopation, near the Blacherne; and the Wooden Hippodrome). We would also like to mention the Achilleus, often cited in the sources as the meeting place of the intellectuals during the Macedonian era. This was a statue erected at the north end of the eastern façade of the Zensippus Springs, in front of the Meletios Gate, near the Mesé, which gave access to the Augustium. It formed a kind of statium with arcades which continued southwards in the direction of the previously mentioned Noumera and of the Hippodrome.

Also of particular importance are the studies conducted by R. Janin on the Patriarchal Palace of Constantinople. This must have been situated on the southwest side of the courtyard facing Saint Sophia and must have communicated with it. One part of the building extended along the west side of the Augustium. On the east side, beginning from Saint Sophia, was the Thomaean and the Synod building, connected to the Patriarchate by the south gallery of Saint Sophia. The various administrative bodies were spread around in different places, also outside of what was properly called the Patriarchate and the Thomaean building.

The minutely detailed examinations conducted in 1964 by Hawkins and Mango have demonstrated the perfect integrity of the mosaics in the apse of Saint Sophia. It is not a question, as it has been supposed, of a late restoration, but of one of the works of the highest quality of the post-iconoclast period. On this basis, it is not possible to accept the hypothesis of Galavaris that the present image of the Madonna enthroned with the Child has taken the place of a preceding Hodigitria (a supposition based on the interpretation of a debatable passage in the homily by Photius), nor that advanced by Francovich that it had been preceded in the Justinian age by a cross, because the technical examination has proved that the gold background was executed after the image of the Virgin. Therefore, the date ascertained is that of the co-emperors Michael III and Basil I, and more precisely ante-867 (date of Photius' homily). J. Beckwith, Talbot-Rice, and G. de Francovich note differences of style between the Virgin and Child and the Archangel of the subarch, while C. Mango and V. Lazareff emphasize the substantial homogeneity characterized by the original fusion of sensuality and spirituality.

Also subject to widespread debate is the attribution of the mosaic in the narthex of Saint Sophia. Some scholars favor the identification of the kneeling emperor as Leo VI (886 - 912) and others as Basil I (867 - 886). More recently, Veglery and Maffei, with different arguments, have again proposed the second, and perhaps more reliable, identification. Also dated in the last two decades of the ninth century is the Fathers of the Church, a mosaic on the north tympanum, carefully studied from a technical point of view by Mango and Hawkins. The scholars identified two different phases of the mosaic: the first, of which remain slight traces along the cornice of the arch, shows the use of glass tesserae; the second largely used tesserae made of other materials, such as marble and terracotta. The first phase

belongs to the Justinian construction (532 - 537) or to the reconstruction of 558 - 563; the second has a post-quem date of 877, because St. Ignatius, who is represented in the mosaic, was canonized under the Patriarch Photius, who had been his enemy all his life, between 877 and 886.

In 1960 P. Underwood discovered a mosaic on the northwest pillar of the north gallery of Saint Sophia depicting an emperor whom the monogramatic inscription indicates as Alexander (912 - 913). The emperor is depicted in a rigidly frontal pose, wrapped in heavy clothes with a loros encrusted with precious gems, wearing an imperial crown, and holding the akakia or anexikakia in his left and the globe in his right hand. The mosaic, with its obvious date, adds an element of certainty to the picture of the monumental painting of the Macedonian age. It also emphasizes how, at the turn of the century, the mellow classicism of the last years of the ninth century were progressively giving way to an incipient linearism of the image and to a strong flattening of colors. This stylistic picture also includes the mosaic above the entrance door to the south vestibule of the narthex, with the Virgin enthroned and the Child between Constantine and Justinian, dated according to Whittemore, Lazareff, and Mango in the tenth century. Galassi, and more recently Francovich, would date it instead as late as the 12th century, on the strength of the fragments of mosaic in the apse of the Basilica of Ursis in Ravenna for the characteristic stylization and linear segmentation of the faces (noted also by Lazareff who, however, does not consider this to postdate the Constantinopolitan mosaic). More recently, Maffei has suggested the retrodating also of the first resumption of the cult of images to the time immediately after the second Nicene Council (787) on the basis of historical, iconographic, and stylistic argumentation. This shows how limited our knowledge of Byzantine painting in the post-iconoclastic period really is.

Perhaps greater clarity could be achieved in this field by a study of miniatures. Almost all the mosaics in Saint Sophia referred to above find, some more and some less, probative stylistic comparisons in the miniatures of the Codex gr. 510 in the Paris National Library. A careful study of this well-known manuscript was made in 1962 by S. Der Nersessian. More recently, Spatharakis has been able to pinpoint the date to 879 and thus make it coincide with the vast campaign of mosaic decoration undertaken by the first Macedonian emperors, in particular by Basil 1. Galavaris assigns the illustrated prototype of the liturgical homilies of Gregorius of Nazianthius to the beginning of the tenth century. This means that the process of "reconversion in the liturgical sense" of Byzantine painting and illumination of manuscripts (which was to become a main characteristic of the later age) began in this period.

In Gregorius' homilies was already present that complexity of components which was later to be followed in all codices modelled on them. In particular those were the classical component, found mainly in scenes of bucolic character; the monastic found in the ascetecism of certain images, such as that of Gregorius in monastic habit talking to monks; and the vein of that which, perhaps improperly, is defined as "the humanism of the Macedonian Renaissance," noticed in the figurative field, in the search for anecdotal detail, or taken from everyday life, which carries the imprint and

spark of heavenly life. It therefore appears from more recent discoveries that the tenth century was an extremely complex and problematic age, as has already been noted with different characteristics in the case of architecture. The scriptorium of the Palace of Constantine Porphirogenitus had to be particularly active in the production of manuscripts of high librarian quality, but also destined to various other needs and uses. From this scriptorium we know the "Scroll of Joshua," which was certainly derived from an octateuch. It is hoped that the experts will soon go beyond the not recent study by Weitzmann and dedicate themselves in a more organic way to the later, but not for this reason less important, illustration of this type of manuscript, exemplified by very old prototypes with detailed narrative, such as Vat. gr. 746), a Psalter (the well-known Gr. 139 of Paris) and a Book of Gospels (the atonal Stauronikita Cod. 43.)

As Weitzmann has proven, there must have also been a Book of Lessons, an essential instrument for liturgical use. This can be reconstructed through the ivories of the "Malerische Gruppe," of the middle of the tenth century, through contemporary provincial miniatures, such as those in the Public Library of Leningrad (Cod. 21.), through the Books of Lessons after the Macedonian Renaissance, and through "migrated" miniatures of the Books of Lessons and other texts (such as the Vatican Menology, whose miniatures are direct copies of a Book of Lessons of the Renaissance.)

A useful addition to the patrimony of Byzantine works of the late Macedonian age is the publication of the bronze doors of the Monastery of Lavra on Mount Athos, still in a perfect state of preservation and dated by C. Bouras in the first five years of the ninth century. The decorative motives carried out in "repoussé" and other techniques include clear references to Antiquity and to illuminated models of the tenth century. The leafed cross, which is repeated several times on the panels of the door, has a close analogy with the reliquary of Limburg an der Lahn. This door, undoubtedly executed in Constantinople, and that of the south vestibule of Saint Sophia – carefully restored by the Central Institute of Restoration – can thus be placed at the time of Michael III, among the most ancient works in bronzes of which Byzantium was a large exporter during the tenth century. (An accurate synthesis of this production has been offered by M. E. Fraser.)

It is certain, however, that it is in the production of ivories that the most exquisite works of art of the Macedonian age are to be found. Weitzmann's studies in this field offered a solid base on which to build a more detailed research into the individual problems of this area. This is the case of H. Wentzel, who, in studying the lesser Byzantine works of art which flowed into Ottoman Court circles at the time of the marriage of Princess Theophanes with Otto II, has been able to isolate a series of ivories of refined Constantinopolitan execution. Weitzmann has produced an interesting hypothesis regarding the constitution of an ancient ivory templon which probably decorated the iconostasis of the imperial chapel of the Palace of Theophanes. This templon, or at least two parts of it, were later used to make the cover of the prayer book of Henry II and Cunegonda, now at the Staatsbibliothek in Bamberg (Lat. Cod. 8). It is significant that, from this hypothesis, Weitzmann drew his interesting conclusions regarding

the ivories' probable influence on the artist of the stuc- coes of Santa Maria in Valle at Cividale.

The publication of the ivories in the Dumbarton Oaks Collection – of which, among others, the splendid Hodigitria from the Niceforum is particularly striking – was the occasion of a timely revision of the entire production of ivories of Byzantine age, in partic- ular of those preceding the Macedonian production. However, K. Wessel has been able to refute the wide- spread opinion that ivory was never again worked in the Byzantine sphere after the 11th century. He has in fact changed the dating of the ivory casket at the Landesmuseum of Stuttgart from the Macedonian age to the Paleologus age on the basis of its manifest affinity with that period. A more subtle stylistic investigation would probably allow the reconsideration of what some scholars (among them C. Walters) have called the "panmacedonianism" of Weitzmann. Weitzmann has also emphasized the relationship between ivory and statuary art during the Macedonian Renaissance and in the 11th century. That was the time when, in the Byzan- tine sphere, marble icons flourished, mostly inspired by the ivories of the Romano group.

In the Constantinopolitan production of illumi- nated manuscripts between the tenth and 11th century, a progressive degree of spiritualization has been noticed in the forms. These forms tend, through the use of clear and refined colors, toward a more sober and less aca- demic style, showing that it is from this period that the Byzantinian style of illumination of the second half of the 11th century evolved. Not to be forgotten is the study by C. Paschou on the Four Gospels paintings in the Paris National Library (Cod. gr. 115), dated at the end of the tenth century. Originally this manuscript must have had an illuminated miniature on every page; it was strictly inspired by the magnificent ancient mod- els (here the scholar recalls the Rossanense and the Sinopense). Its range of watercolors, clearly distinct from the later codices of the 11th and 12th centuries; the austere sobriety and the limited use of gold and silver in the decoration; and the absence of the ostenta- tious architectural backgrounds of the first Macedonian age, substituted here by delicate blue or green back- ground shades, make the miniatures of this codex a typical example of the work done in the tenth century by the Constantinopolitan scriptoria (among which the scriptorium of the Palace of Constantine Porfirogenito must have played an essential role).

Weitzmann has recently published the minia- tures of an important illuminated manuscript, previ- ously known only to Kondakov, who, however, had only been able to admire its 15th–century Walachian bind- ing. It is preserved in the Monastery of Dionysus on Mount Athos; together with many other unknown and little known Atonite manuscripts, it was represented in the long-awaited collective publication (1973) of the manuscripts in the monasteries of Protaton, Dionysus, Kutlumisios, Xeropotamos, and Gregorius. The manu- script in question is a Book of Lessons which – accord- ing to the evocative reconstruction by Weitzmann – was probably executed at the court atelier for the Monastery of St. John of Studios and was commis- sioned by the Emperor Isaac Comnenus I around 1059, when he decided to abdicate in order to embrace the claustral life in that same monastery of Studios. The resemblance to the Psalter (Vat. gr. 752) confirms the

date proposed by Weitzmann. This date also received further confirmation by the fact that the scenes of the martyrdom are derived from the menology of Basil II. The importance of these illuminated manuscripts rests in the fact that they represent a precise reference point in the passage from the Macedonian age to the flowering of manuscript illumination in the Comnenus age in the third quarter of the century.

The stylistic trend of Byzantinian illuminated manuscripts and paintings on board in the 11th century was lucidly traced by Weitzmann in the Oxford Con- gress in 1966 and again in the chapter dedicated to it by Lazareff in his "History." Thus we can claim to be suffi- ciently well-informed in this field, even though the iden- tification of various scriptoria still escapes us. That is the case of the provincial ones (a term behind which a real gap in Byzantine studies still hides); certainly this is because of the strong centralizing role that Constanti- nople played immediately after the post-iconoclast age.

As has previously been mentioned, a special place is to be given to the study of the Octateuchs between the 11th and 12th centuries. The importance of an investigation in this field is underlined by Lassus and by his paper dedicated to the Byzantine illustration of the Book of Kings. (This is a paper which, like others previously mentioned, responds to the methodological need to group the illuminated manuscripts by subject. This is in order to be able to trace a useful diagram of the variations that the text has undergone in different times and places, similarly to the paleographic method.) It is in fact clear from the French scholar's paper that the octateuchs and the psalters were of great importance also for the type of illustration of the Book of Kings (second half of the 11th century), especially for the "romanticized" episodes where the "diminutive style" of the octateuchs plays a decisive role.

The central role played by Studios from the 11th to the 12th century has also emerged from more recent studies. The work of Eleopoulos can be considered among the first courageous attempts to detail more ana- lytically (i.e., by scriptoria) the Constantinopolitan pro- duction of illuminated manuscripts in the mid- Byzantine age. The study of Der Nersessian – which followed, in the series of the Bibliothèque des Cahiers Archéologiques on the illustration of Greek medieval psalters, the study of Dufrenne dedicated to post-icono- clast Psalters with illustrated margins – has demon- strated that the London Psalter Add. 19352 constitutes "an important example of the general and not only monastic trends of the period . . . since it is a work in which the politico-mystical ideas of the Christian Empire and those dear to the monks of Studios were reflefed."

Useful clarifications have come from recent find- ings, and from various studies of paintings at the end of the 12th century — that is to say of the late Comnensus phase. One should in particular remember Weitzmann's publication of a Sinaiatic icon of the "Annunciation" for which, because of its high quality and its refined elaboration of a mannered style, the scholar has pro- posed a Constantinople matrix.

The connections with the famous frescoes of Kurbinovo – on which a very recent and exhaustive monograph has been produced – and others in the Cypriot area, are the confirmation of the substantial

stylistic homogeneity of Byzantine painting at the threshold of the Latin conquest.

Syria and Palestine. – It is a valuable sign of progress that most recent papers have been able to refer to the arts in Syria-Palestine during and after the iconoclastic age. The merit is due mainly to K. Weitzmann, who has again proposed the old, but never clarified, problem of Palestinian art on new and more certain foundations. These foundations are, on the one land, the icons of the Sinaiaticus Collection, many of which are definitely pertinent, for iconographical and stylistic reasons, to the Palestinian ambient from the sixth to the ninth century. We cite here, among the more important ones, the "Ascension" icon (sixth century), the "Chairete" icon (seventh century), the "Crucifixion" icon (ca. eighth century), the "Saints Paul, Peter, Nicholas, and John Chrisostom" icon and the one that represents Saints Chariton and Theodorus (datable between the eighth and ninth centuries).

On the other hand, the study of the ivories in the Cathedral of Grado (until now so difficult to place in the usual scholastic picture of Byzantine art) has proven their connection with the figurative culture of the Christian Near East, and in particular with Syria and Palestine between the seventh and eighth centuries. It was generally believed that artistic production had, in this period, been suddenly interrupted by the innumerable political and religious events which marked the decisive passage into the Medieval world. In view of all the contrasting opinions on the monumental prototypes that inspired the iconography of the Ampullae of the Holy Land, it is no longer possible today to believe that there was one single source for them nor that, as Grabar had suggested, they were executed in Constantinople. Rather, it will be necessary to refer them to a number of sources and to a variety of "media," such as painting on board, ivories, illuminated manuscripts, and monumental art. This would explain both the diversities within the iconography, and the vastness of the influences that this culture exercised through the cult of the "Loca Sancta Palestinae" and through Syrio-Palestinian monachism throughout the whole Eastern and western Mediterranean area. In this same sense, it is possible to understand the attribution of the "Sacred Parallel" of John of Damascus (Cod. 923 in the National Library of Paris) to the scriptorium of Jerusalem at the beginning of the ninth century. It is actually the affinity with the Sinaiatic icons mentioned that makes it possible to verify what Weitzmann calls a dominant characteristic of Eastern art. This characteristic is the "inner glance" which, in the contemporary Western sphere (for example, in the frescoes of Santa Maria Egiziaca in Rome), corresponds to a more descriptive and narrative "exterior movement." This "exterior movement" may seem similar to the Eastern "inner glance," specifically for the influences that the Palestinian "language" has exercised on Carolingian and post-Carolingian Europe.

According to this hypothesis the Arabian invasion would not have caused a massive exodus of Christian artists. The flowering of the cultural life at the courts of the Omayyadi Caliphs, the series of icons of the Sinai, and the ivories of the Cathedral of Grado represent the most eloquent testimony of this fact. The objects fashioned at the Omayyadi courts culturally oscillate from the most conservative classicism to a marked tendency toward stylized linear tension in the drapery and in the faces. This diversity would demonstrate the fecundity and the intrinsic vitality of a culture in rapid and sure evolution. Schematically speaking, this phenomenon, is similar to that of the complex eighth-century Longobard culture of Northern Italy, which so intensely nourished the Carolingian culture that it was entirely absorbed by it. Whether one accepts the sometimes excessively schematic hypothesis of Lazarev (of separation between courtly and monastic art) or the newer thesis of Weitzmann, it would still be difficult to explain the extremely eccentric nature, with respect to the revived Macedonian classicism in Constantinople of, for example, the splendid mosaics of Saint Sophia in Salonica.

Asia Minor. – In the last decade a decisive impulse has been given to the study of Byzantine art in Asia Minor and especially that of Cappadocia. This impulse was given by the explorations conducted by N. and M. Thierry in the Peristreme Valley at the foot of Hasan Daği, by Lafontaine-Dosogne's mission into the north and west of the territory already investigated by Jerphanion, and by Gough, who published the Church in the Rock at Eski Gümüs. An extremely useful contribution has been added by the ponderous synthesis by M. Restle, who has collected in three volumes a large part of the material known to date, documenting it with graphic diagrams of the painting and architectonic reliefs, in addition to a careful technical analysis of the frescoes. Without being able to consider them as totally exhausting the argument nor replacing the still fundamental work of Jephanion, these syntheses supply a richly documented instrument for consultation and an invaluable assistance towards the development of further investigations. Nevertheless, there still remains the problem of the dating of the oldest Cappadocia series. In this sense, an emblematic case is represented by the "mixed" (aniconic and iconic) decoration of the Church of Aghios Basilios at Sinassos. There one reads an inscription (with the opposite interpretation) of iconoclast character, interpreted by most as appertaining to the iconoclast age and more exactly, by the Thierrys, to the first iconoclast crisis. D.S. Pallas, however, has referred more to a post-iconoclast tendency, of archaic flavor, in protest against the insertion of new trends in Cappadocia, tending to cover the internal walls of buildings of the cult with vast iconographic programs. This thesis of Pallas is, in effect, based on the supposition that the iconoclast conflict had been an exclusive affair of the capital (see also the analogous conclusions on the historical plane by W. E. Kaegi) and that the provinces, particularly Greece and Cappadocia, remained substantially unaffected by those controversies. These provinces had an ancient tradition of their own in the decoration of the interiors of religious buildings which was very old and was well documented by Pallas with the decorations of the chapel on the Island of Ikaria. The tradition has its roots in an anthropologically different context.

With so much doubt thrown upon it, the use of an iconoclast inscription to support the dating of one of the oldest of the Cappadocia cycles, and others – St. Stephen at Cemil, St. Niceta near Ortahisar, Saints Peter and Paul at Meşkendir, of Saints Joachim and Anna at Kizil Cukur, and above all, the N° 3 of Mavrucan, recently dated by M. Thierry in the seventh century – risk collapse under a too precarious dating

which R. Cormack also made an attempt to erect in 1967.

From here, consequently, we come to the problematics of the other important question posed by the high Medieval pictorial arts of Cappadocia concerning their dependence or otherwise on the art of the Metropolis, or, rather, their insertion into the picture of a rooted and conservative persistence of Syrian, or, more generically, Near Eastern, traditions. There is no doubt that the new thesis on Syrio-Palestinian art suggested by Weitzmann could provide useful indications for the solution of this problem, as well as in relation to the recognized extraordinary affinity of language between many of the Cappadocia cycles and many artistic products of the Western High Middle Ages (in both the pre-Carolingian and Ottoman spheres) and not only High Medieval (one thinks of the comparisons between the Cappadocia cycles of the first half of the 11th century and the Iberian frescoes of the Pedret group). Also, the post dating to the tenth century has been widely accepted for the cycles in the three churches of Ihlara which had been assigned previously by the Thierrys to between the seventh and the ninth centuries. The relationship with the mosaics of the dome of Saint Sophia of Salonica on the one hand, and with Western art on the other (this latter also noted by Demus) has been emphasized recently by Thierry with reference to some Cappadocia cycles of the tenth century. The cycles belong to the same stylistic trend seen in the decoration of the two twin chapels of St. John in Gullu Dere (913 - 920 a.d.) in the vault of the Saints Apostles' at Sinassos and in the nave at the ancient Church of Tokali at Göreme.

The still too little known frescoes discovered in a chapel on the north side of St. John of Ephesus (two strata) and those found in 1974 in a room, perhaps the narthex, of a church of the High Medieval period, connected to the basilica of the acropolis in Xanthos, are to be carefully inserted into the picture of Anatolian monumental pictorial art.

Passing to the south coastal region of the Anatolian peninsula, some notice is due the in-depth investigations conducted by J. Morganstern at the Church of Dere Aši. The investigations are condensed into a series of reports published in the Dumbarton Oaks papers and in other periodicals and finally, more exhaustively, in the doctoral dissertation published in 1973. The imposing cross-shaped construction, domed and flanked to the north and the south by subsidiary octagonal buildings, has been assigned by the scholar to the period of Basil 1. Consequently, it is considered as a monument of exceptional importance in the context of the architectonic style of formation of a church of mid-Byzantine age becoming a true and proper "unicum" in the extrametropolitan field.

It is opportune here to mention also the discovery of a church in Phrygia, to be exact in Sebaste, of which Firatli carried out the excavation and the publication of the important sculptural fragments which came to light. Two phases can be distinguished there, the first datable in the sixth century, the other in the tenth to 12th century. It is to this phase that the numerous marble remains of the iconostasis belong. They are composed of an architrave, almost complete, with inscriptions mentioning Bishop Eustace as a munificent re-founder of the cathedral, in which are represented the "deesis" and four archangels, the apostles, and St. Eutychius, according to an iconograph that Weitzmann dates from the Macedonian age. There are also numerous remains of plutei and small pillars, all produced with a highly original and precious technique in the field of Byzantine sculpture of which until now little has been known. The technique must have been of ancient tradition, if one looks back on the "honeycomb" finds in the excavation of Aghios Polyeuktos; marblework, that is, which, resembling the technique of Champleré enamel, is cut out to receive the glass frit.

N. Thierry, in a paper on the characteristics of monumental Byzantine art in Asia Minor from the 11th to the 14th century, distinguishes four stylistic trends in the 11th century. The first is a classical kind of style, characteristic of the tenth century monumental art, of which in fact the best examples are found in the figure of St. John the Evangelist painted on the tenth-century picture in the apse of the above-mentioned chapel on the north side of St. John of Ephesus in Cappadocia; in the portraits in the decoration of Sümbüllü kilise (tenth to 11th-century church), and in the "deesis" of Tagar (11th century) in which the intense plasticity of the face is achieved by using deep shadows, a method similar to that used in the mosaics of Osios Lukas. The second is a "precious" style, to connect essentially to the cycles in the pillared churches at Göreme: – Carikli kilise, Elmali kilise, and Karanlik kilise, the work of different artists that belonged to the same atelier, operating, according to Jerphanion and the Thierrys, around the middle of the 11th century (while for J. Lafontaine-Dosogne, V. Lazarev, and M. Restle they are later works, of the end of the 12th century, beginning of the 13th). They are characterized by fine workmanship, with a decorative function and accurately drawn lines which recall the contemporary Constantinopolitan illuminated manuscripts. Third is a realistic and expressionist style that exists in the "search for an individuation of the figures and of an impression of movement and inner life." The images, characterized by a vigorous modelling, from the splashes of juxtaposed color and the violent lighting on the drapery recall the cycle in Karabaş kilise, dated with certainty at 1060 - 1061. The style is very close to that which was adopted in the mosaics of the Nea Moni of Chios and by the fresco artists of Saint Sophia at Ochrida. According to Thierry, they also were adopted at the metropolitan level, in the mosaic panel of Zoe and Constantine Monomachus at Saint Sophia. Finally, a linear style, more schematic and summary in the delineation of the plastic bulk, to be found in the decorations of St. Michael of Ihlara (1025 - 1028 or 1055 - 1056) and in the apsidal pictures at Eski Gümüs and Ayvali Köy. This trend is similar to the c.d. monastic style and particularly to the frescoes in the Protaton at Osios Lukas.

Greece and the Balkans. – A considerable rethinking of ideas can be seen, also, in the field of the problem of the evolution of architectonic typology up to the threshold of the 11th century. The old opposing ideas of Millet between the truly Greek basilican type and the type on a cross with a dome on pillars (of the metropolis) must be reviewed in the light of a continuity of the basilican type on Hellenic soil. This seems to be independent of any suggested revival due to the influence of the expansion of the Babylonian Empire. This is supported, furthermore, even recently, by Korač and by

Stričevič. In particular, C. Bouras' studies on the little Church of Zourtsa in the Peloponnese (dated about 1000), that by M. P. Mylonas on the architecture of the Monastery of Protaton and Rabduchos on Mount Athos, and the excavations by D. Pallas of the Basilica of Glykis (with one Theodosian and two High Medieval phases), to cite only a few of the more important cases, lead one to see as the closest to the historical reality the hypothesis of a continuity and an internal evolution of basilican type, parallel to the formation, in a more correctly monastic and not strictly metropolitan sphere, of the type in the shape of a cross with a dome supported on pillars.

Furthermore, the excavations conducted since 1965 by N.C. Mutsopoulos at the Church of St. Achilles on Lake Prespa have demonstrated the pertinence of this important building to the well known group of churches with a nave and two aisles covered by a roof, built in Greater Bulgaria from the second half of the ninth century to the end of the tenth. But the type of architecture chosen – with reliquary apses, in the shape of a Greek cross covered by small domes – does not belong, as Krautheimer believes, to a "revivalist" theme aimed at legitimizing, architectonically, the new Balkan state as compared with the Byzantine, but more simply to the metropolitan type churches of Macedonia and Thessaly, such as Kalambaka, Salonika, and Larissa. In fact, having conquered this last city in 986, Tsar Samuel took the relics of St. Achilles from it to Lake Prespa and had the sanctuary built there between 986 and 990. Even the technique used for the building of the dome of the prothesis, with its reticular facing, agrees with a whole series of Greco-Byzantine churches of the same type, erected between 850 and 1000, to which Megaw has dedicated a very detailed study. Next to the basilica dedicated to the saint, the tsar also had his own palace built, according to a widely consolidated tradition in the Bulgarian sphere, as recent excavations have demonstrated. K. Mijatev has reported this in his last synthesis on Medieval Bulgarian architecture. In this sense, also, the study by S. Bojadzev on the church of the village of Vinica has proved particularly useful, both in establishing the original appearance of the building with great precision and in individuating the similarities between this and other High Medieval Bulgarian churches, such as the Church of Čupkata with a nave and four aisles and the No. 1 Church of Avradaka.

A violent disagreement between E. G. Stikas and M. Chatzidakis has invested the problem of the dating of Osios Lukas in Phocis. The date proposed by Chatzidakis — that is, 1011 – assumes that the founder of the convent would have been the Hegumen Philotheos represented without a halo in the funerary chapel of St. Luke. Stikas proposes 1042 - 1055, in the reign of Constantine Monomachus, when the great catholicon was erected on the site of a chapel in the form of a cross, the lower part of which would appear to have been transformed into a crypt to receive the remains of the saint. In consideration of the crucial importance that attaches not only to the architecture, but particularly to the mosaics and the frescoes, of this complex, the difference between these dates is of special note because of the rapid evolution that the artistic form underwent in Byzantium during the first half of the 11th century and in relation to the specific problem of the intervention of metropolitan workmanship in the decoration of the complex.

Meanwhile, work proceeded on the restoration of the frescoes, which has made it easier to read the painting in the crypt, claimed by Lazarev to be works of a provincial school. Frescoes in the chapels in the corners of the church were also restored, particularly in the chapels on the west side studied by Chatzidakis for the somewhat rare iconography (the meeting between John the Baptist and Christ on two contiguous walls), the similarity to the mosaics of Osios Lukas becomes increasingly accentuated – which for Lazarev would seem to be "outside the line of development of Constantinopolitan aulic art" – and with some trends of micro-Asiatic art (see above) and with other pictorial cycles in the Byzantine sphere. In this respect, we mention here the frescoes discovered recently on Corfù in the Chapel of San Mercurio, definitely dated by an inscription at 1074 - 1075. These were published by Vocotopoulos, who sees stylistic contacts there also with works in South Italy, such as the Exultet of Bari, but there is a greater similarity to the mosaics and frescoes of Saint Sophia at Kiev. The restoration, begun in 1952, was not finished until around 1971. Lazarev has dedicated a lot of work there, emphasizing the possibility of fixing a precise "ante quem" date of 1045. He studied the orthodox program of the mosaic and fresco decoration for the realization of which Constantinopolitan craftsmen, must have worked with local craftsmen who quickly learned the technique sufficiently to be employed on other series and not only the Russian Kiev works. The existence of the austere classicism of the mosaics of Osios Lukas and of Saint Sophia at Kiev, next to the vigorous expressionism and the accentuated chromatism of the mosaics of the Nea Monì of Chios and the noble classicism of the mosaics at Daphne, can not be justified except with the co-existence in the same metropolis of different trends. Also, as is well known, the sources show the more or less direct intervention of the emperor.

There are numerous recent finds of frescoes in Greece, Macedonia, and the Greek Islands which demonstrate the rise of Byzantine art in the 11th and the 12th centuries. Noteworthy among these are the frescoes of the Monastery of St. Neophyte on the Island of Cyprus, restored by the Dumbarton Oaks Institute in collaboration with the Cyprus Department of Antiquity. The frescoes were previously little known except through the few photographs published by Sotiriou and Stilyanou. The date of 1183 can be assigned to the decoration of the burial chamber, signed – and this is claimed to be the first we have heard of a Byzantine painter signing his work – by a certain Theodorus Apsuedes, who must have been of Constantinopolitan provenance, judging by the fine Deesis and the Crucifixion, which show a considerable degree of stylistic elaboration and approach to the metropolitan models. These frescoes relate to the better known ones of Lagudera — to which Megaw has dedicated an interesting study — as do the paintings in the Church of Samarnia in Messenia, with the 16 feast days of the Orthodox Church, published by H. Grigoridu–Cabagnols, and are substantially pertinent to the late-Comnenus stylistic phase seen in the frescoes of one chapel and of the refectory of the Monastery of St. John the Theologian on the Island of Patmos, published by Orlandos, who dates them at

the beginning of the 12th century. However, Lazarev thinks they could be earlier, around the end of the 13th century.

Note here also the attribution by Weitzmann of a group of icons of Sinai of the beginning of the 12th century, in which one again finds the same characteristics as in the frescoes of Asinu. They, however, are attributed, along with a restricted group of miniatures, to the work of Cypriot artists working on the island at that time.

Russia. – The studies carried out in these last 20 years on pre-Mongolian Russian art, which have been accompanied by thorough works of restoration of the monuments and series of pictures, are worthy of a separate discussion. We shall begin in a chronological sense from the studies conducted on the remains of the Desjatina at Kiev by Schäffer relative to the Constantinopolitan construction technique between the tenth and 11th centuries, which he calls "verdeckte Schichttechnik", evidence of the participation of craftsmen sent by Byzantium to lay the foundations of the first buildings in masonry of Prince Vladimir. Around the Church of the Decima N. Kholostenko has discovered the remains of princely residences built of stone (at least the foundations), perhaps large halls or towers, whose purpose is not yet clear.

The architect I. Aséev has led, among other things, the restoration of the Cathedral of the Transfiguration at Černigov, built between 1031 and 1036, in the form of a cross, with three apses, five domes, narthex, and a large gallery covering the side aisles, to which access is gained via a stairway in a cylindrical tower at the northwest corner of the building. The technique "ad opus mixtum" and the ornamental arrangement of flat bricks lead one to believe that the same workmen who first worked here were then used on the building of Saint Sophia in Kiev, where the large cruciform pillars and open external gallery again suggest a precise expression of local preference. A noticeable modification in relation to the local needs and to probable influences of Western Romanesque architecture – claimed by P. Maximov and confirmed by V. Lazarev – conditioned Kiev architecture in the buildings in Novgorod and primarily in the Cathedral of Saint Sophia, restored by G. Stender. It has, in fact, been stated that the external galleries had to be closed off during the construction, while the drum of the central dome was considerably raised, giving the internal pillars a more compact and elongated structure, and the adoption of decorative motives in brick in the external parameter was abandoned. All of this gave the complex a more severe and austere appearance, distinctly different from the more open and spacious churches of Kiev and Černigov. It is believed that builders who were brought from Constantinople and Kiev for this work found they had to compromise with local traditions and needs.

An accentuated influence of western Romanesque has been noted in the architecture of the principalities of Galič, Volynsk, and Smolensky. A typical example is Saint Sophia of Polock (1044 - 1066), which has three apses on the west side, rhythmically designed with arches on delicate columns. The excavations carried out in 1958 by M. Karger have led to the discovery, at Vladimir-Volynsk, of the remains of a rotonda with three apses and a colonnade under the dome, to compare with the rotonda discovered in the country around Galič, not far from the city of Esupol on the Dniestr and at Smolensk (near the Church of St. John the Theologian). Bognosevič imagines this architectonic typology to be of Slav origin (Bohemia, Moravia, Slovakia, Poland). It is certain, however, that the western influence was more accentuated in the constructions of the early 13th century, from the Cathedral of the Archangel Michael at Smolensk (ante 1159) to the Church of Saint Parasceve-Piatnitza at Černigov. This Church was recently restored by Aséev to its original form in all its concentrated and intense dynamism.

As regards the art at Vladimir-Suzdal', there is no doubt that a fundamental contribution has been made by N. Voronin with his work on the architecture of North East Russia from the 11th to the 15th century. He has studied, among others, the sculptural decorations of the Cathedral of the Dormition of Andrej Bogoljubskij at Vladimir (1158 - 1161), recognizing the work of a western atelier, probably Rhenish – according to Lazarev – along with local work. The same atelier must have worked on the fortified castle of Andrej Bogoljubskij (1158 - 1165) 10 kilometers from Vladimir, of which Voronin has made an excellent reconstruction. With this reconstruction it is possible to compare it, in the opinion of Lazarev, with the mid-Rhenish castle of the Staufen family. In the decorative sculpture of the outside of the cathedrals, with the point of greatest excellence in the Church of the Dormition of Vsevolod (1176 - 1212), the reference to the influence of the sculptures in wood of the ancient Slav people operating and, in fact, prevailing over the earliest western influence has been accentuated in the most recent studies.

Lazarev has made an important contribution to the understanding of the origins of the painting of the School of Novgorod. Lazarev individuated works of certain Novgorod provenance and circumscribed the distinctive characteristics which are those of a far from literal imitation of the Constantinopolitan models in the search for a constant plastic strength in the image and a more frank and luminous chromatism. Among the works of the 12th century we mention the Holy Visage at Tretjakov, the Annunciation at Ustiug (with original iconographic characteristics), the Archangel at the Russian Museum, the icon of St. George at the Tretjakov. All these works were probably from the Monastery of Jur'ev and by the studio of the Greek painter Petrovic, under the protection of the Grand Prince of Novgorod.

Furthermore, Lazarev has demonstrated the parallel existence alongside this more aulic current of a second current which he defines as "more democratic, tied to the reinforcement of the 'republican' regime and of the craftsmen of the city." It is characterized, stylistically, by the employment of a free and frank technique reminiscent of that of fresco painting, from the miraculous icon of the Virgin, who defended the city against the Suzdal' attack (about the middle of the 12th century) to the icon of St. John Climacus at the Russian museum in Leningrad, which recalls the frescoes of Neredica, and the icon of the Saviour in the second half of the 13th century that already directly foreshadowed the art of the painters of icons in Novgorod in the 15th century. Worthy of mention in this field is a study by Lazarev on a group of icons appertaining to the Christo-

logical cycle of the Calendar of the Church of Saint Sophia of Novgorod. The icons have scenes from the life of the Virgin, St. John the Baptist, and the Saints, in which the double influence of the tradition of the School of Novgorod and that of the Muscovite School with the participation of a group of artists including, perhaps, Andrej Lakent'yev and Ivan Derma Yartsey, between the end of the 15th and the beginning of the 16th century, can be recognized.

FROM THE 13TH TO THE 15TH CENTURY (PLATES 108-109)

Constantinople. – An important and valuable element of the passage from the "mannered" phase of the Angeli period to the statuesque style of the middle of the 13th century, which Weitzmann has associated with Constantinopolitan manuscript illumination during the Latin domination, has been studied by R. Hamann–MacLean in the Berlin Codex Gr. Quarto 66 and other similar documents (Dionisiu 4 and Cod. Harley 1810 in the British Museum). This manuscript, which was written and illuminated before January 5, 1219, presented in the illustrations some close affinity with the frescoes of Studenica (1206-1207). However, it is already distinctly different from the stylistic phase represented by the Mileševo cycle and has nothing to do with such "antique style" manuscripts as the Par. Gr. 51 and the Iviron David, N° 5; in fact, the pictures of the Evangelists show the influence of a late-Comnenus model.

Research into the art of the Palaeologus era has made considerable progress, reaching – on articulated and problematic methodological lines that have given the best results when associated with the in-depth examination of the spiritual trends of society at the time – a point where it was possible to define, with the essential contributions of Belting, Buchthal, and Weitzmann, the essential lines of development of monumental art, particularly in the last quarter of the 13th and the first of the 14th century. It should be mentioned, furthermore, that the change in the dating of the frescoes of the martyrium of Saint Euphemia near the Hippodrome in Constantinople to the last quarter of the 13th century – and most probably in the 1280s – has allowed Belting to recognize and evaluate the true nature of the, certainly not Macedonian, classicism which is demonstrated there in monumental and simplified, but no longer organic, form. As in the Sopočani phase, it is associated with some of the frescoes in the narthex of Fethiye Cami. The mosaics in the narthex of the Čamí Kilise have been assigned to the same trend and consequently to the same dating at the end of the 13th century. The mosaics represent a homogeneous group between the Sopočani phase and that, at the beginning of the 14th century, of St. Clement at Ochrida.

There is no doubt, however, that, as regards the art of the Palaeologus era, the best results were obtained in the field of illuminated manuscripts. H. Belting's paper on the "Illuminated Book in Late Byzantine Society" undoubtedly represents an obligatory reference point for later studies. In it, he emphasizes a number of fundamental characteristics of Palaeological illuminations, such as the progressive tendency toward the imitation of iconic painting, which involves an accentuated distinction between the work of the scribe and that of the miniaturist in the scriptorium; the prevalence of commissions by private persons of high rank, mostly moving within the orbit of the imperial family, who usually ordered valuable productions of prayer books which meant using a particular, but not unknown, type of iconography, such as that of the Months in books on the monthly liturgy; the more 'juridical' than strictly religious character of the dedications (one thinks of that of Cod. Iviron 5, in which the commissioner is represented by Mary in front of the throne of Christ); and the birth of the Horologion, a kind of Book of Hours, but distinguishable from this for its own particular characteristics. Belting also succeeded in individuating, in the manuscripts he had studied, a group called "of the Palaiologina" from the name of the commissioner of Cod. Vat. Gr. 1158, dated at 1285, with which are associated also the Gr. 1208 of the Vatican, Cod. Gr. Plut. VI, 28 of the Laurenziana and others similar, all localized in Constantinople, but no longer in one palace scriptorium, long since dissolved, but in various metropolitan scriptoria operating for a clientele, as has been said, of court dignitaries and also of monks and intellectuals.

In the numerous Evangelistaries of Palaeologus age which have come down to us the decoration is limited principally to the use of a broad ornamental repertory and pictures of the four Evangelists. Narrative scenes rarely appear. Buchthal attempted in a rapid synthesis to delineate a picture of the stylistic development of Palaeologus illumination. As a result of the Latin occupation, one sees from 1261 the introduction of Western iconographic elements. These elements are then overborne by the great aristocratic tradition, recalling Macedonian models, although not without originality. In fact, new subjects, inspired by the liturgy appear (the hymns of Acatisto and Anapeson). Thus the tradition established at the turn of the century and confirmed by the parallel trend of monumental painting was carried on to the next generation, gradually passing to a more solemn style, perhaps, as we have seen, under the influence of iconic painting. The central decade is the fourth (1330) which marked a renewed fervor of creativity in Constantinople. The only two manuscripts with narrative cycles, the Gregorius 543 in Paris and the John Climacus of the Monastery of Stamonikita, also belong to this period. The first is associated with the Parision Book of Lessons of 1336 (Cod. Gr. 311), even if they were written by different scribes in different scriptoria, and with an Evangelistary of Pistoia (Fabroniana Libr. Cod. 307). There the Evangelists are represented in a mixtilinear frame decorated with elegant racemes. In the same decade this group was confronted with the other narrative cycle, much more homogeneous, consisting of the four Evangelists of Patmos Cod. 81, Lavra Cod. A46, Grottaferrata Cod. A11, and Athens, Byzantine Museum, Cod. 157. Among these, particularly that of Patmos is of exceptional splendor.

In the second half of the century the scriptorium of the Monastery of Odegon became celebrated for the works of the monk Joasaph, whose work is dated between 1360 and 1405 († 1406). Among the manuscripts which came out of this scriptorium there seems to be neither uniformity nor homogeneity of direction. This signifies a multiplicity of models. Only one is illuminated, the Cantacuzenus of Paris, dated 1371 - 1375,

which is similar to the Vat. Gr. 1160 and the Atonite manuscript of Kutlumusi, Cod. 62. This master's style appears, according to Buchthal, in a somewhat more developed manner in the illuminated manuscripts of Theophanes the Greek and his followers. The affinity between these miniatures and the frescoes of the Periblemtos of Mistrà (flaccid figures in curiously rounded backgrounds) would find some confirmation in the political bond between the metropolis and Morea, at that time (1349 — 1380) occupied by Manuel Cantacuzenus, second son of the deposed emperor.

Palestine. – We feel it a duty here to mention also the progress of the studies of the art which flowered in the Holy Land at the time of the Crusades. In this field, the publication of the icons of the Sinai has brought in new material which has contributed to a better clarification of phases and ateliers operating in the Holy Land in the 13th century, under Latin domination. A significant case is that of a group of Sinaiatic icons published by Weitzmann (Deesis and Apostles, Moses and the Twelve Apostles, Majestas Domini and Birth of Christ) which relate to a group of miniatures, among which that of Cod. 6 of the Biblioteca Capitolare of Perugia is noteworthy. Undoubtedly, various Western artists who worked on these icons, perhaps at Acri, were united by an original synchronization of different traditions. These traditions find extraordinary confirmation in the frescoes with scenes from the life of St. Francis, discovered at Constantinople, in the Kalender Cami during recent restorations. Thus confirming the vastness of the diffusion of the art which flourished in the Holy Land during the Latin domination.

Asia Minor. – The picture of Byzantine art in Asia Minor can certainly not be considered complete without a brief reference to the restorations conducted by D. Talbot Rice and D. Winfield at the Church of Saint Sophia at Trebisonda between 1958 and 1962. These results were published in a monograph in 1968. It is evident from them that, among other things, the "vaulted" porticoes which precede the three entrances are original and can be compared with those of the nearby churches of Georgia; that the present church, like the preceding one of which the plans have been found, rests on enormous foundations; and that there are many contacts – through the culture of the Crusades – with contemporary Western Gothic art, shown particularly in some architectonic details (quadrilobate windows) and in the sculptures which decorate the intrados in the arch of the façade. But above all, the frescoes have emerged in all their splendor, restored and studied by Winfield. In them there is particularly clear evidence of the search for an intense and often mannered dramaticity. The frescoes have been dated by the two authors at the middle of the 13th century. However, Grabar, not without some doubt, claims that they can be compared with the frescoes of the Pantanassa of Mistrà and, therefore, he suggests a post dating to about 1400.

Greece and the Balkans. – Some recent publications have mentioned an intense revival of studies regarding the art which flourished in the Peloponnese in the 13th and 14th century. These studies range from Bon's topographical of the "Mistratypus," studies on autonomous Morea to the work of S. Dufrenne on the iconographic programs of the churches of Mistrà, (which has provided an excellent reference manual), to the studies by Musiki on a number of problems of iconography, to the investigations by H. Hallensleben on the architectonic typology of the "Mistratypus," (the church with the ground floor in basilican style and the floor of the gallery in the shape of a cross on pillars), which seemed so "strange" to Millet, and has been found only at Mistrà. The origins of the "Mistratypus," which have been studied by Hallensleben, show how it derives, organically, from the solutions previously adopted in the iconoclast period, in Saint Irene in Constantinople and later, in the following century, in an imposing construction such as Dere Aši, and consequently in the Transfiguration at Černigov, until it reached the Aphentikó of Mistrà, according to the criterion of building galleries on the narthex and over the aisles of a lower church. So the "Mistratypus" is strictly correlated to the Byzantine construction technique called by the Germans "gebundenes System." The system is typical of a church in the form of a cross and with a dome.

The symposium on Byzantine art of the 13th century, held at Sopočani in 1965, called together the foremost specialists in this field of study to debate, particularly, the crucial problems of the role of the formation of the Serbian National School in the field as much of architecture as of pictorial art. Already ascertained, also, from the more recent studies by V. Korač and S. Dufrenne, the original and individual character of the architecture in Rascia since the beginning of the century – not unlike the national character of the School of Architecture of the 12th century in Vladimir Suzdal' – became established with a typology of a single nave with a dome (which, according to Korač, has antecedants on the Italian Adriatic coast), later enriched with chapels beside the naos and the wide narthex. St. George of Djurdjevi Stupovi near Novi Pazar, built by Stephen Nemanja shortly before 1168, and the complex of Studenica and the Monastery of Žiča are examples of this type of architecture. This typology seems also to have been conditioned since the beginning by the need to allow space for the congregation to follow the special rites of the Serbian Church. On the outside, the pictorial decorations of Byzantine buildings were dispensed with in favor of the solidity and the finish of Romanesque geometrical blocks with pilaster strip and delicate suspended arches.

The national character deeply rooted in the specific traditions of a people and the character of Serbian art of the 13th century, are insisted upon particularly by Lazarev and P. Miljković-Pepek. However, the latter has emphasized the different artistic trends, some of which are retardatory, as can be seen from the frescoes in the Church of St. Nicola in the village of Manastir, dated 1271; in St. John the Theologian – Kaneo at Ochrida – in the Monastery of the Archangel near Prilep, which still has figures of Apostles which demonstrate a robust plasticity of Comnenus descent without graphic additions; and in the Monastery of St. Constantine in the village of Svečani, which follows in the wake of Nerezi and Manastir. For another thing, this archaism is shown more as a "codex" widely diffused in a society in rapid and articulated expansion than as a merely provincial echo. This seems to be the most sensitive result of the investigation carried out by A. Cutler into the "Greek manner" in Italy and in Serbia, observ-

ing the internal dialectics between art and society in two different spheres under Byzantine influence.

In this perhaps contradictory context, decidedly new artistic facts represent an important return into circulation of an aulic area deeply rooted in the official authentic Byzantine tradition, no longer developed at a national, but at an international level. Thus S. Radojčić has pointed out how the frescoes of Sopočani are not in fact isolated cases in the area of Byzantine artistic culture. Not only do the frescoes follow the Macedonian models of the tenth century and relate to such precedents as paintings of Morača (1252), and particularly with the Atonite Codex N° 46 of Stamonikita, but that type of artistic experience has an immediate echo at the European level (see the carnet of drawings by Wolfenbuttel which Weitzmann claims was taken from the preceding collection of miniatures, sometime around 1230 - 1240, while Radojčić observes that it is exemplified in contemporary Byzantine monumental painting). Consequently, compared with the serious gaps concerning metropolitan art of the first half of the century, one is perforce constrained to suppose there was a rapid evolution of the art, perhaps in the Nicene sphere, in the direction of the Palaeologus Renaissance. Therefore, in this respect, it is certainly not to be seen as the unexpected and nostalgic resurgence of the "old fashioned" culture of Byzantium.

The discovery of new icons of Serbian and Macedonian provenance has directly confirmed this view of the dynamic interior of the figurative civilization in the western Balkans in the course of the 13th century. These include the icon of St. George of Struga (1266 - 1267), considered as proto-Palaeologus by Miljkovic-Pepek; to the Christ enthroned of the 13th century; the Virgin and Child from the village of Banjani (of the beginning of the 14th century), appertaining to the Macedonian sphere; and the portable mosaic icon of Aghiosoritissa before 1261, perhaps of metropolitan provenance, published by B. Dab Kalinowska.

A real change of direction, however, can be seen in the development during the century in Serbia and in Macedonia. This change is marked by a number of names of painters which today, after new discoveries, put us in a position to follow more closely the movements of the fresco workshops from the Thessalonian sphere to that of the Court of King Milutin. Michael Astrapa and his pupils Michael and Eutychius worked on the decoration of the present St. Clement's at Ochrida (1295). Frescoes were signed by Michael at San Niceta of Skoplje (1307 - 1320, with inscriptions by Eutychius and Michael, according to Xyngopoulos brothers; according to Mirkovic, from Salonica or Constantinople) and in the Church of St. George at Staro Nagoricino (toward 1317; frescoes signed by Eutychius, who, according to Millet and Diehl, met Milutin at the court of the latter's father-in-law, Andronicus II Palaeologus, in Constantinople, while Xyngopoulos has more recently refuted this hypothesis, sustaining instead Macedonian provenance). The name of Astrapa appears also in the inscription of the frescoes studied recently by S. Djordjević in the narthex of the Virgin Ljeviška at Prizren (1307). These frescoes, although dated later, would seem to have a close affinity, as demonstrated by the splendid frescoes discovered in the lower part of the demolished calotte of the narthex of Saint Sophia of Ochrida, with the illustration of the canon of the Virgin by John of Damascus, published by G. Grozdanov.

The cleaning and restoration of the frescoes of St. Nicola Orphanos of Salonica helped Xyngopoulos to recognize the strong resemblance they have to the work of Staro Nagoricino and so assumed them to be from the same workshop. However, his tendency to attribute to them the greater part of the cycles frescoed between the end of the 13th and the beginning of the 14th century is opposed by numerous critics, including Lazarev, who dates the Thessalonian work in the second quarter of the 14th century. T. Velmans also puts it as late as the middle of the century. M. Chatzidakis associates the frescoes of St. Nicola with those of the Saints Apostles of Salonica (1312 - 1315). Chatzidakis sees them as the expression of a common trend toward the monumental, realized via the order of the composition in a geometrically conceived arabesque, with accents of a rhythmic order and "impressionist" treatment of the modelled and vital contrasts of light and shade.

Contemporaneously, a different trend manifested itself in the sphere of Salonica around the first decade of the 14th century with the works of the celebrated Manuel Panselinos. His work, like an unreachable model, still gave inspiration very much later to Dionysis of Furnă in his famous "Ermeneutica of painting" (of which the long awaited critical edition by P. Heatherington has been published). He is certainly the author of the frescoes in the Protaton on Mount Athos (1303). Chadzidakis also associates with him the frescoes in the Chapel of St. Eutimios in San Demetrius in Salonica, because of their emphatically dramatic style, with realistic accents and inner spirituality.

Another outstanding figure at the beginning of the second decade of the century is George Calliergis, who considered himself and signed his work as "the best painter in Thessaly." This inscription is seen on the frescoes of Christos at Verria (1315), of definite Thessalonian provenance and with close Atonite relations. Chatzidakis dedicated a long monographical paper to this artist.

Thus, it was around this personality that the ambient of Salonica and Macedonia revolved in the first decades of the 14th century, demonstrating an extraordinary cultural vigor certainly not independent of the intense association with the Constantinopolitan sphere.

THEOPHANES THE GREEK, ANDREJ RUBLEV: THE
SCHOOL OF MOSCOW AND THE CRETAN SCHOOL

The artistic activity of Theophanes the Greek has been made the subject of a monographic report on the part of Lazarev. Lazarev has accurately separated the work definitely attributed to the master from that of his numerous followers. Above all, he has given prominence to the Constantinopolitan formation under the influence of hesychastic philosophy in the last quarter of the 14th century and has also hypothesized some relationships with the Genoese world, through the Galata quarter. However, other scholars are not in agreement. Then Lazarev also cancels the attribution to Theophanes of the painting of Volotovo and the icon of Our Lady of the Don, assigned to a pupil. He studied the painter's impact on the Moscow School of illumi-

nated manuscript work at the end of the 14th century. The renewed energy that the master brought to the school conditioned its later development. Also, among the icons of the iconostasis in the Annunciation in Moscow, dated 1405, the scholar distinguishes between the master's own works and those of his school. G. V. Popov has dedicated a recent work to the Muscovite School dealing with painting and illumination from the middle of the 15th century to the beginning of the 16th. Numerous monographs on A. Rublev succeeded one another (I. Lebedeva, M. Alpatoff, N. Diomyna, V. Lazarev), but the most important, especially for the purpose of a more precise description of the master's work, is that of Victor Lazarev in which, as in the case of Theophanes the Greek, particular attention has been paid to the School of Rublev in which the "spirit" and the emotional "tonality" of the work of the head of the school does not appear.

For the controversial icons of Svenigorod, Lazarev suggests a date around the second decade of the 15th century. This is the same period as the celebrated icon of the Trinity, recently carefully restored and studied in every technical detail. The cycle of paintings in the Monastery of Stavrinos Svorozevski, generally considered to have been executed in the master's youth, is in fact a late work. Nevertheless, in the collective work published by M. V. Alpatoff in 1971 on A. Rublev and his era there emerge a number of important points regarding the most recent Soviet historico-artistic criticism. It is important, above all, to stress the refusal, which has been further emphasized recently by, among others, V. Lazarev, to admit that A. Rublev was influenced by the Italian art of Duccio and of Giotto or, even worse, that he was the Beato Angelico or the Paolo Uccello of 15th–century Russia and in this way, to establish parallel between the Italian proto-Renaissance and a supposed Russian Renaissance at the beginning of the 15th century, for which, in reality, there existed neither cultural nor historico-social conditions. (There was certainly no Russian middle class comparable with that of Florence at that time.) Emphasis is given, on the contrary, to the influences which connect A. Rublev to the preceding Russian Byzantine tradition. The disciple-master relationship more with Daniel Chervei than with Theophanes the Greek is also pointed out.

M. Chatzidakis has dedicated a monographic paper to Theophanes the Cretan, an important moment of that insular school. Theophanes was undoubtedly the versatile master to whom the major decorative works of the Greek Orthodox world in the second quarter of the 16th century were entrusted. His 30–year activity shows an interior evolution which tended more and more toward the recovery of the noble Palaeologus classicism. In 1527, as an easel painter, he introduced into Greece the pictorial traditions of his native island, with limited Venetian influence. In 1535, he worked at the Monastery of Lavra on Mount Athos as a traditionalist and orthodox fresco painter. In 1546, he moved on to the Monastery of Stauronikita and his colors became ever more brilliant and were applied in isolated splashes. Then he concluded at Meteoron, with a return to an accented traditionalism.

BIBLIOGRAPHY - *General works, exhibition catalogues, conference reports*: E. Cruikshank Dodd, Byzantine silver stamps, Washington, 1961; K. Weitzmann, Geistige Grundlagen und Wesen der Makedonischen Renaissance, Koln, 1963; E. Kitzinger, The Hellenistic Heritage in Byzantine Art, Dumbarton Oaks Papers 17 (1963); Idem, Some reflections on portraiture in Byzantine art, Recueil des travaux de l'lstitut d'études byzantines, VIII (1963), Mélanges G. Ostrogorskij, I; Actes du XII Congrés International d'études byzantines, Beograd, 1964; M. C. Ross, Byzantine and early Mediaeval antiquities in the Dumbarton Oaks Collection, Washington, 1962-1965; A. Grabar, Byzantium – from the death of Theodosius to the Rise of Islam, London, 1966; B. Brenk, Tradition und Neuerung in der christlichen Kunst des ersten Jahrausends, Wein, 1966; L'art byzantin du XIII siècle, Symposium de Sopočani, Beograd, 1967; Proceedings of the XIII International Congress of Byzantine Studies, Oxford, 1967; J. Lassus, The early Christian and Byzantine World, London, 1967; Ch. Delvoye, L'art byzantin, Paris, 1967 (cf. rev. of K. Wessel in Oriens Christianus, 17, 53, (1969); R. Krautheimer, Early Christian and Byzantine Architecture, London, 1968 (cf. rev. by F. W. Deichmann, in Byzantinische Zeitschrift, 65, 1972; E. Cruikshank Dodd, Byzantine silver stamps, Supp. II, Dumbarton Oaks Papers, 1968; W. Fr. Volbach-J. Lafontaine-Dosogne, Byzanz und der christliche Osten, Propyläen Kunstgeschichte, Berlin, 1968; A. Grabar, Christian iconography. A study of its origins, Princeton, 1968; Year 1200, Acts of the Congress, New York, 1970; J. Lassus, Oldchristen og byzantinsk Kunst, Kobenhavn, 1970; J. Beckwith, Early Christian and Byzantine Art, London, 1970; F. W. Deichmann, Zur frage der Gesamtschau der frühchristlichen und frühbyzantinischen Kunst, Byzantinische Zeitschrift, 63, 1, (1970); G. Matthiae, Studi Bizantini, L'Aquila, 1970; C. Walter, Iconographie des conciles dans la tradition byzantine, Paris, 1970; M. R. E. Gough, bibliography of, in Mediaeval Studies, XXXVI, 1971; P. Lemerle, Le Premier Humanisme Byzantin, Paris, 1971; O. Demus, Byzantine art and the West (cf. rev. by C. Nordenfalk, in Konsthist. Tidskr. 40, 1971; Société et vie intellectuelle au 14e siècle. 14e Congrès des Etudes Byzantines, Bucaresti, 1971; R. Stichel, Studien zum Verhältnis von Text und Bild spätund nachbyzantinischer Vergänglichkeitdarstellungen (Byzantino Vindobonensia, V), Wien, 1971; H. Buchthal, Historia troiana. Studies in the history of Mediaeval secular Illustration, Warburg Institute Studies, 32, London, 1971; D. Talbot Rice, The Appreciation of Byzantine Art, London, 1972; Dumbarton Oaks Bibliographies, ed. Jelisaveta S. Allen, London, 1973; S. Der Nersessian, Etudes byzantines et arméniennes, Louvain, 1973; Y. Christe, La Vision de Matthieu (Matth. XXIV-XXV). Origine et développement d'une image de la Seconde Parousie, Paris, 1973; K. Weitzmann, Studies in Classical and Byzantine manuscript illumination, Chicago, 1971 (cf. rev. by O. Demus, in Speculum, 48, 1973; and by I. Sevčenko in Slavic Review, 32, (1973); R. Cormack, Recent studies in early Christian and Byzantine art, Burlington Magazine, 166, 1974, 856; F. De Maffei, Icona e pittore al concilio niceno II, Roma, 1974; Venezia e Bisanzio, Catalogue of the Exhibition, Venice, 1974; A. Cutler, Transfigurations: Studies in the dynamics of the Byzantine Iconography, London, 1975; S. Geno: Byzantine Iconoclasm and Monochomachy, The Journal of Eccliastical History, 28, 3, July 1977.

Constantinople: a) *Architecture*: R. Guilland, Sur les itinéraires du livre des Cérémonies, Jahrbuch der Osterreichischen Byzantinischen Gesellschafts, X, 1961; F. Dirimtekin, Les fouilles faites en 1946-47 et en 1958-60 entre Sainte Sophie et Sainte Irène à Istanbul, Cahiers archéologiques, 13, 1962; R. Janin, Le Palais patriarcal de Constantinople, Revue des Etudes Byzantines, 20, 1962; Y. Christern,

Zum Verhältnis von Palasttriklinium und Kirche, Instanbuler Mitteilungen, 13-14, 1963-1964; S. Miranda, Les Palais des Empereurs byzantins, Mexico, 1965; P. Grossmann, Zum atrium der Irenenkirche in Istanbul, Instanbuler Mitteilungen, 15, 1965; Idem, Grabungen im Bereich der Chalkopraten kirche in Istanbul, 1965, Istanbuler Mitteilungen, 16, 1966; H. Kähler-C. Mango, Hagia Sophia, London, 1967; G. H. Forsyth, The Monastery of St. Catherine at Mount Sinai. The Church and Fortress of Justinian, Dumbarton Oaks Papers, 22, 1968; P. G. Ehser, Zur Soziologie der byzantinische Kreuzkuppelkirchen, Zeitschrift für Aesthetik, 13, 1968; C. L. Striker, The Myrelaion (Bodrum Camii) in Istanbul, New York University microfilms, Ph. D., 1968, Fine Arts; R. Guilland, Études sur la topographie de Constantinople byzantine, Berlin-Amsterdam, 1969; R. J. Mainstone, Original forms of the tympana and arcades, Dumbarton Oaks Papers, 23-24, 1969-1970; C. Mango, Notes on Byzantine monuments, Dumbarton Oaks Papers 23-24, (1969-1970); D. Kuban-C. Striker, Kalenderhane Camii, 1969, Anatolian Studies, 20, 1970; R. Guilland, Etudes sur le Grand Palais de Constantinople. Les Passages d'Achille, Jahrbuch der Osterreichischen Byzantinistik, 19, 1970. T. F. Mathews, The early churches of Constantinople. Architecture and Liturgy, London, 1971; C. Mango, The Church of Saints Sergius and Bacchus at Constantinople and the alleged tradition of octagonal palatine churches, Jahrbuch der Osterreichischen Byzantinistik, 21, 1972; C. Mango-I. Sevčenko, Some churches and monasteries on the southern shore of the Sea of Marmara, Dumbarton Oaks Papers, 27, 1973; C. Strube, Die westliche Eingangseite der kirchen von Konstantinopel in justinianischer Zeit, Wiesbaden, 1973; U. Peschlow, Neue Beobachtungen zur Architektur und Ausstattung der Koimesis Kirche in Iznik, Instanbuler Mitteilungen, 22, 1974; C. Mango, Architettura bizantina, Milano, 1974; C. Mango, Les monuments de l'architecture du XIe siècle et leur signification historique et sociale. Travaux et mémoires. Center de Recherche d'histoire et civilisation de Byzance, 6, Recherches sur le XIe siécle, Paris, 1976.

b) Frescos, painting on board, mosaics, illuminations: K. Weitzmann, The Mandylion and Constantine Porphirogenetos, Cahiers archéologiques, XI, 1960; O. Demus, Studien zur byzantinischen Buchmalerei des 13. Jahrhunderts, Jahrbuch der Osterreichischen Byzantinischen Gesellschaft, IX, 1960; S. Der Nersessian, The Illustrations of the Homilies of Gregory of Nazianzus, Paris. Gr. 510, Dumbarton Oaks Papers, 16, 1962; K. Weitzmann, Aus den Bibliotheken des Athos, Illustrierte Handschriften, Augsburg, 1963; K. Weitzmann, The Jephtah Panel in the Bema of the Church of St. Catherine's Monastery on Mount Sinai, Dumbarton Oaks Papers, 18, 1964; Idem, An Encaustic icon with the prophet Elijah at Mount Sinai, Mélange K. Michalowski, Warzawa, 1966; Idem, The mosaic in St. Catherine's Monastery on Mount Sinai, Proceedings of the American Philosophical Society, CX, 1966; P. Miljkovic-Pepek, La formation d'un nouveau style monumental au XIIIe siécle, Actes du XIIe Congrès international d'études byzantines, T. III, Beograd, 1964; C. Mango-J. W. Hawkins, The apse mosaic of St. Sophia at Istanbul. Report on work carried out in 1964, Dumbarton Oaks Papers, 19, 1965; S. Der Nersessian, A Psalter and New Testament Manuscript at Dumbarton Oaks Papers, Dumb. Oaks Pap., 19, 1965; K. Weitzmann, Eine spätkomnenische Verkundigungsikone des Sinai und die zweite Welle des 12. Jahrhunderts, Festschrift H. von Einem, Berlin, 1965; K. Weitzmann, Eine vorikonoklastische Ikone des Sinai mit der Darstellung des Chairete. Tortulae (Festschrift J. Kollwitz), Roma, 1966. M. Chatzidakis, An encaustic icon of Christ at Sinai, Art Bulletin, XLIX, 1967; S. Defrenne, Deux chefs-d'oeuvre de la miniature du XIe siécle, Cahiers archéologiques, XVII, 1967; R. Hamann-Mac Lean, Der Berliner Cod. gr. quarto 66 und seine nachsten Verwandten als Beispiele des Stilwandes im frühen 13. Jahrhundert. Studien zur Buchmalerei und Goldschmiedekunst des Mittelalters (Festschrift K. H. Usener), Marburg a.d. Lahn, 1967; G. Babič, Les discussions christologiques et le décor églises byzantines au XIIe siécle, Frühmittelalterliche Studien, 2, 1968; G. Galavaris, The illustration of the liturgical homilies of Gregory Nazianzenus (Studies in manuscript illumination n° 6), Princeton, 1969; S. Hiller, Divino Sensu agnoscere. Zur Deutung des Mosaikbodens im Peristyl des Grossen Palastes zur Konstantinopel, Kairos, II, 1969; S. Der Nersessian, L'Illustration des Psautiers grecs du moyen âge, II, Londres Add. 19352, Paris, 1970; H. Belting, Das illuminierte Buch in der spätbyzantinischen Gesellschaft, Heidelberg, 1970; V. H. Elbern, Ikonen, Berlin, 1970; K. Shoju, The formation of the Byzantine world, Orient, VI, 1970; C. L. Striker-V. Doğan Kuban, Work at Kalenderhane Camii in Istanbul, Third and fourth preliminary Reports, Dumbarton Oaks Papers, 25, 1971; T. Velmans, Le tétraévangile de la Laurentienne, Fl. Laur. VI 73, Paris, 1971; Art et société à Byzance sous les Paléologues. Actes du colloque organisé par l'association internationale des études byzantines à Venise, 1971; D. Talbot Rice, Byzantinische Malerei: die letzte Phase, Frankfurt a. M., 1972; A. Grabar, Les manuscrits grecs enluminés de provenance italienne (IX-XI cen.), Paris, 1972; C. Paschou, Les peintures dans un tétraévangile de la Bibliothéque nationale de Paris; le Grec 115 (X siécle), Cahiers archéologiques, 22, 1972; H. Buchthal, Illuminations from an early Paleologan scriptorium, Jahrbuch fur osterreichischen Byzantinistik, 21, 1972; (Festschrift O. Demus); K. Weitzmann, Three painted crosses at Sinai, Festschrift O. Pächt, Salzburg, 1972; I. Sevčenko, On Pantaleon the Painter, Jahrbuch der Osterreichischen Byzantinistik, 21, 1972; I. Hutter, Paläologischen Übermalungen in Oktateuch Vat. Gr. 747, Jahrbuch der Oaterreichischen Byzantinistik, 21, 1972; C. Mango-E. J. W. Hawkins, The mosaics of St. Sophia at Istanbul. The Church Fathers in the North Tympanum, Dumbarton Oaks Papers, 26, 1972; C. Walter, Un commentaire enluminé des Homélies de Gregoire de Nazianze, Cahirs archéologiques, 22, 1972; J. Lafontaine-Dosogne, Manuscrits byzantins à miniatures, Scriptorium, 26, 1972; Illuminated Greek Manuscripts from American Collections: an exhibition in honour of K. Weitzmann, Princeton, 1973; K. Weitzmann, Illustrated manuscripts at St. Catherine's Monastery on Mount Sinai, Collegeville, 1973; J. D. Breckenridge, The Iconoclast's image of Christ, Gesta, 11-2, 1973; G. Vikan, Illuminated Greek manuscripts from American collections. The Art Museum Princeton, Princeton, 1973; P. Huber, Bild und Botschaft, Byzantinische Miniaturen zum Alten und Neuen Testament, Zürich-Freiburg, 1973; D. Dab Kalinowska, Die Krakauer Mosaikikone, Jahrbuch fur Osterreichischen Byzantinistik, 1973; W. Grape, Zum Stil der Mosaiken in der Kilise Camii in Istanbul, Pantheon XXXIII, 1, 1974; H. Buchthal, The Exaltation of David, Journal of the Warburg and Courtauld Institutes, 37, 1974; T. Velmans, Le dessin à Byzance, Monuments et Mémoires. Académie des Inscriptions et Belles Lettres, 59, 1974; J. Lassus, L'illustration byzantine du Livre des Rois. Vaticanus graecus 333. Bibliothèque des Cahiers archéologiques, 9, Paris, 1973 (cf. rev. by O. Demus in Jahrbuch fur Osterreichischen Byzantinistik, 24, 1975; P. Huber, Image et message. Miniatures byzantines de l'ancien et du Nouveau Testament, Zürich, 1975; The place of book illumination in Byzantine art, Princeton, 1975; P. A. Underwood, The Kariye Djami, vol. 4; Studies in the art of the Kariye Djami and its

intellectual background, London, 1975; K. Weitzmann, The Monastery of St. Catherine on Mount Sinai. The Icons, Princeton, 1976; J.C. Anderson, An examination of two twelfth century centers of Byzantine manuscript production. Dissertation Abstract, A., 37 (1976-1977) N° 7, 4524 A.

c) *Sculpture*: H. Buchwald, The carved stone ornament of the high Middle Ages in San Marco, Venice, Jahrbuch der Osterreichischen Byzantinischen Gesellschaft, 13, 1964; R. Lange, Die Byzantinische Reliefikone, Recklinghausen, 1964; B. Forlati, Le porte bizantine di San Marco, Venezia, 1969; C. Mango, A newly discovered Byzantine imperial sarcophagus, Instanbul Arkeologi Müzeleri Ylligi, 15-16, 1969; C. Sheppard, Byzantine carved marble slabs, Art Bulletin, 51, 1969; T. Ulbert, Untersuchungen zu den byzantin ischen Reliefplatten des. 6, bis. 8, Jahrhunderts, Instanbuler Mitteilungen, 19-20, 1969-1970; A. Grabar, La sculpture byzantine au moyen-âge (introduction à une étude en cours), Académie des Inscriptions et Belles Lettres. Comptes Rendus, 1971; M. E. Fraser, Church Doors and the Gates of Paradise: Byzantine bronze doors in Italy, Dumbarton Oaks Papers, 27, 1973; R. M. Harrison, A Constantinopolitan capital in Barcelona, Dumbarton Oaks Papers, 27, 1973; C. Bouras, The Byzantine Bronze Doors of the Great Lavra Monastery on Mount Athos, Jahrbuch der Osterreichischen Byzantinistik, 24, 1975; A. Grabar, Sculptures Byzantines de Constantinople, 2 °, Paris, 1976.

d) *Ivories, cloth, enamels, gold work, and jewellery*: A. Frolow, Les Reliquiaires de la vraie Croix, Paris, 1966; J. Déer, Die Heilige Krone Ungarns, Wien, 1966; K. Wessel, Die byzantinische Emailkunst, Recklinghausen, 1967; J. Déer, Die Pala d'Oro in neuer Sieht, Byzantinische Zeitschrift, 62, 1969, 2; C. Aik, Wer ist die Kaiserin auf der Elfenbeintafel in Bargello? Deltion, 1969; K. Weitzmann, Ivory sculpture of the Macedonian Renaissance, Kolloquium über frühmittelalterliche Skulptur, Heidelberg, 2 (26/29-6-1970), Heidelberg, 1971; Idem, Diptih slonovoj kosti iz Ermitaza otnospascijsia k konger imperatora Romana, Vizantijsky Vremenik, 32, 1971; H. Buschhausen, Die spätrömischen metallscrinia und frühchristlichen Reliquiäre, Wien, 1971; K. Weitzmann, Ivories of the so-called Grado Chair, Dumbarton Oaks Papers, 26, 1972; Idem, Catalogue of the Byzantine and early Mediaeval antiquities in the Dumbarton Oaks Collection, 3, 1972; S. H. Wander, The Cyprus Plates: The Story of David and Goliath. Metropolitan Museum Journal, 18, 1973; M. Van Grunsven Eygenraam, Heraclius and the David plates, B. ant Besch, 48, 1973; J. L. Schrader, An ivory Koimesisplaque of the Macedonian Renaissance, Museum of Fine Arts bulletin (Houston, Texas), 1972-1973; H. Wentzel, Byzantinische Kleinkunstwerke aus dem Umkreis der Kaiserin Theophano, Aachener Kunstblätter, 44, 1973; K. Wessel, Das Byzantinische Elfenbeinkästchen in Stuttgart, Jahrbuch der staatlichen Kunstsammlungen in Baden-Württemberg, 11, 1974; S. H. Wander, The Cyprus Plates and the Chronicle of Fredegar, Dumbarton Oaks Papers, 29, 1975; A. Grabar, Les Revêtements en or et en argent des icones byzantines du moyen-âge, Venezia, 1975; P. Johnstone, The Byzantine 'Pallio' in the Palazzo Bianco at Genoa, Gazette des Beaux Arts, 118, 1976.

Syria: – M. Chéhab, Mosaïques du Liban, Paris, 1957-1959; J. Kollwitz, Die Grabungen in Resafa, Berlin, 1959; J. Kollwitz, Resoconti degli scavi a Resafa in Arch. Anz., 1963, and in Ann. Arch. de Syrie, 14, 1964; J. Leroy, Les manuscrits syriaques à peintures conservés dans les Bibliothèques d'Europe et d'Orient, Paris, 1964; Idem, Un portrait du Christ à Palmyre au VI Siécle, Cahiers archéologiques, 15, 1965; W. Karnapp, Die Stadtmauer von Resafa, Bonner Jahrbucher, CLXVI, 1966, and in Arch. Anz. LXXXIII, 1968; C. Durliere,

La mosaïque des Amazones, Bruxelles. Centre Belge de recherches archéologiques à Apamée de Syrie, 1968; J. Ch. Balty-K. Chéhadé-W. Van Rengen, Mosaïques de l'église de Herbet Müga, Bruxelles, 1969; J. Balty, La grande mosaïque de Chasse du Triclinos, Bruxelles, Centre Belge de recherches archéologiques à Apamée de Syrie, 1969; J. Napoleone-Lemaire-J. Ch. Balty, L'église a atrium de la grande Colonnade, Fouilles d'Apamée de Syrie, I, 1. Centre Belge de recherches archéologiques a Apamée de Syrie, 1969; P. Canivet-M. Fortuna, Recherches sur le site de Nikertai, Annales archéologiques Arabes-Syrien, XVIII, 1968; Idem, in Archaeology, XXIII, 1970; J. Leroy, Le couvent des Syriens au Ouadi Natroun, Cahiers archéologiques, XXIII, 1971; G. Machiarella, Ricerche sulla miniatura siriaca del VI secolo: 1) II Codice c.d. di Rabula, Commentari, XXII, 1971; P. H. E. Voûte, Chronique des fouilles et prospections en Syrie de 1965 a 1970, Anatolica, n° IV, (1971-1972); J. Nasrallah, Couvents de la Syrie du Nord portant le nom de Siméon, Syria XLIX, 1972; Actes du Colloque Apamée de Syrie, Bruxelles, 1972; J. Ch. Balty, Nouvelle mosaïques païennes et groupe episcopal dit Cathédral de l'Est à Apamée de Syrie, Académie des Inscriptions et Belles Lettres. Comptes rendus, Janv.-Nov. 1972; H. Stern, Notes sur les mosaïques du dôme du Rocher et de la Mosquée de Dams, Cahiers Archéologiques, 1972; J. Lassus, Eglises d' Apaméne, B. ét Orient, 25 (1972); E. J. W. Hawkins-M. C. Mundell, The mosaics of the Monastery of Mar Samuel, Mar Simeon and Mar Gabriel near Kartamin, Dumbarton Oaks Papers, 27, 1973; A. Perkins, The Art of Doura-Europos, Oxford, 1973; W. B. Kleinbauer, The origins and functions of the aisled tetraconch churches in Syria and Northern Mesopotamia, Dumbarton Oaks Papers, 27, 1973; J. Engemann, Palästinensische Pilgerampullen im F. J. Dölger-Institut in Bonn, Jahrbuch für Antike und Christentum, 16, 1973; P. Maser, Das Kreuzigungsbild des Rabula Kodex, Byzantinoslavica, XXXV, 1, 1974; G. Tchalenko, La Basilique de Qalb-Lozé, Les Annales archéologiques arabes-syriens, XXIV, 1974; P. Cuneo, La basilica di Qalb-Lozé, Corsi di cultura sull'arte ravennate e bizantina, 1974; R. P. Harper, Excavations at Dibsj Faraj, Northern Syria, 1972-74: a preliminary note on the site and its monuments, Dumbarton Oaks Papers, 29, 1975; M. T. Canivet-P. Canivet, La mosaïque d'Adam dans l'église syrienne de Hüarte (5 siècle), Cahiers archéologiques, 24, 1975.

Asia Minor. – J. Lafontaine-Dosogne, L'église aux trois croix de Gülü Dere en Cappadoce et le problème du passage du décor iconoclast au décor figuré, Bysantion, XXXV, 1965; P. Verzone, Hierapolis Christiana, Corsi di cultura sull'arte Ravennate e Bizantina, 1965; R. Cormack, Byzantine Cappadocia: the archaic group of wall paintings, Journal of the British Archaeological Association, XXX, 1967; D. Talbot Rice, The Church of Hagia Sophia at Trebisond, Edinburgh, 1968; N. Firatli, Découverte d'une église byzantine à Sebaste de Phrygie. Rapport préliminaire, Cahiers archéologiques, 19, 1969; H. Buchwald, The Church of the Archangels in Sige near Mudania, Wien-Koln-Graz, 1969; M. Restle, Die byzantinische Wandmalerei in Kleinasien, Recklinghausen, 1967 (cf. also the rev. of St. Kostof, in Art Bulletin, 52, 1970; N. Thierry, Les peintures murales-de six églises du Haut moyen âge en Cappadoce, Comptes rendus de l'Académie des inscriptions et Belles Lettres, juillet-oct. 1970; P. Verzone, La Cattedrale di Priene e le sue sculture, Felix Ravenna, n.s. 1, 1970; S. Eyice-M.me Thierry, Le monastére et la source sainte de Midye en Thrace turque, Cahiers archéologiques, 1971; N. Thierry, Un atelier de peintures du début du 10e siècle en Cappadoce: l'atelier del l'ancienne église de Tokali, Bull. de la Société nationale des Antiquaires de France, 1971; W. and D.

Gutschow, Kirchen in Taoklardjethien in der nord östlichen Turkei, Archaeol. Mitt. Iran, n.F., 4, 1971; M.E. Weawer, A Tower House at Yeni Foçca Izmir, Balkan Studies, 12, 1971; S. Eyice, Les monuments byzantins de la Thrace Turque, Cultural courses on Ravennate and Byzantine art, 18, 1971; H. Alkim, Explorations and excavations in Turkey, 1965-1966; Anatolica, 2, 1968; 3, 1969-1970; 4, 1971-1972; N. Thierry, Art byzantin du haut moyen âge en Cappadoce: l'Eglise no. 3 de Mavrucan, Journal des Savants, oct-déc. 1972; H. Buschhausen, Die Deutung des Archemosaiks in der justinianischer Kirche von Mopsuestia, Jahrbuch der osterreichischen Byzantinistik, 21, 1972; L. Budde, Antike Mosaiken in Kilikien, Recklinghausen, 1969 (cf. rev. by E. Kitzinger, in Art Bulletin, 55, 1973; E. Kitzinger, Observations on the Samson Floor at Mopsuestia, Dumbarton Oaks Papers, 47, 1973; J. Morganstern, The Byzantine Church at Dereagzi, Diss. Fine Arts, New York University, 1973; M. Restle, Zwei höhlenkirchen im Haçi Izmail Dere bei Ayvali, Jahrbuch der osterreichischen Byzantinistik, 22, 1973; G. Kleiner, Milet, 1972, Instanbuler Mitteilungen, 23-24, 1973-1974; U. Peschlow, Fragment eines Heiligensarkophags in Myra, Instanbuler Mitteilungen, 23-24, 1973-1974; S. Yegül, Early Byzantine Capitals from Sardis. A study on the Ionic import type, Dumbarton Oaks Papers, 1974; O. Feld, Christliche Denkmäler aus Milet und seiner Umgebung, Instanbuler Mitteilungen, 25, 1975; U. Peschlow, Byzantinische Plastik in Didyma, Instanbuler Mitteilungen, 25, 1975; S. Hill, The Early Christian Church at Tomarza, Cappadocia. A study based on photographs taken in 1909 by G. Bell, Dumbarton Oaks Papers, 29, 1975; W. Epstein, Rock cut chapels in Göreme Valley, The Yilanli Group and the column churches, Cahiers archéologiques, 24, 1975; N. Thierry, L'art monumental byzantin en Asie Mineure du XI siècle au XIV, Dumbarton Oaks Papers, 24, 1976; N. Thierry, Mentalité et formulation iconoclastes en Anatolie, Journal des Savants, avr.-juin, 1976.

Greece and the Balkans: A. Grabar-M. Chatzidakis, Greece-Byzantine Mosaics, New York, 1960; A. K. Orlandos, La forme primitive de la cathédrale de Paros, Reports on the sixth International Congress on Christian Archaeology, Ravenna, 1962; S. Procopiou, La question macédonienne dans la peinture byzantine, Athénes, 1962; A. Stylianou-A. H. S. Megaw, Cyprus. Byzantine Mosaics and Frescoes, New York, 1963; A. Cutler, The Maniera Greca in Italy and Serbia. Art and Society in two Byzantine spheres of influence, 1204-1355, Emory Univ., Ph. Diss., 1963, Fine Arts; R. Hamann-Mac Lean-H. Hallensleben, Die monumentalmalerei in Serbien und Makedonien, Giessen, 1963; St. Bojadzev, L'église du village Vinica à la lumière de nouvelle données, Byzantinobulgarica, III, 1966; R. Miljkovic-Pepek, L'oeuvre des peintres Michel at Eutych, Skopie, 1967; C. Mango-E. J. W. Hawkins, The Hermitage of St. Neophytos and its Wall Paintings, Dumbarton Oaks Papers, 20, 1968; A. Papageorgiou, Ikonen aus Zypern, München-Genf, Paris, 1969; H. Hallensleben, Untersuchungen zur Genesis und Typologie des 'Mistratypus,' Marburger Jahrbuch für Kunstwissenschaft, 18, 1969; G. Millet, La peinture du moyen âge en Yougoslavie (Serbie, Macédoine, Montenegro), fasc. 4°. Texte et présentation par T. Velmans, préf. par A. Grabar, Paris, 1969; R.S. Cormack, The mosaic decoration of St. Demetrios, Thessaloniki, The annual of the British School at Athens, n° 64, 1969; A. Xyngopoulos, The mosaics of the Church of St. Demetrios at Thessaloniki, Thessaloniki, 1969; M. Chatzidakis, A propos de la date et du fondateur de Saint Luc, Cahiers archéologiques, 19, 1969; A. Bon, La Morée franque. Recherches historiques topographiques et archéologiques sur la Principauté d'Achaïe (1205-1430), Paris, 1969; M. Chatzidakis, Recherches sur le peintre Téophane le Crétois, Dumbarton Oaks Papers, 24, 1970; W. E. Kleinbauer, Some observations on the dating of St. Demetrios in Thessaloniki, Bysantion, XL, 1970; Nt. Moupikh, Ai Biblikai proekoniseis tes Panaghias eis ton troullon tes Peribletou tou Mistra, 'Archaiologhikon Deltion,' 25, 1970; V. Mutsopoulo, Byzantinische and nachbyzantinische Baudenkmäler aus Klein-Prespa und aus HI. German, Byzantinisch-Neugriechische Jahrbucher, 22B, 1970; M. Vickers, The Date of the Mosaics of the Rotunda at Thessaloniki, Papers of the British School at Rome, 38, 1970; Ch. Delvoye, Sur le passage des Voûtes et des coupoles en brique de l'Anatolie à la peninsula Balcanique, Bull. de Corr. Héll., 100, 1970; S. Dufrenne, Les programmes iconographiques de Mistra, Paris, 1970 (cf. rev. by N. Mouriki, in 'Byzantinische Zeitschrift' 64, 1971; A. Frantz, The Church of the Holy Apostles, Princeton, 1971; B. Aleksova-C. Mango, Bargala: a Preliminary Report, Dumbarton Oaks Papers, 25, 1971; I. Nikolajevic, Le tétraconque d'Ohrid, Bulletin de la Société Nationale des Antiquaires de France, 1971; H. Grigoridou-Cabagnols, Le décor peint de l'église de Samarnia en Méssenie, Cahiers archéologiques, 21, 1971; E. Vovotopoulos, Fresques du XI siècle à Corfou, Cahiers archéologiques, 21, 1971; H. Bojadžev, L'église rouge de Perustica et le probléme des églises paléocrétiennes à plan centrique, XIV Congrès des études byzantines, Bucarest, 1971; Ch. Bouras, L'église de Zourtsa, Cahiers archéologiques, 21, 1971; A. H. S. Megaw, Background architecture in the Lagoudera frescoes, Jahrbuch der osterreichischen Byzantinistik, 1972; P. Miljkovic-Pepek, Deux icones nouvellement découvertes en Macédoine, Jahrbuch der osterreichischen, 21, 1972; M. Chatzidakis, Précisions sur le fondateur de saint Luc, Cahiers archéologiques, 22, 1972; W. C. Moutsopoulos, Anaskafe tes Basilikes tou Haghiou Achilleiou, Thessaloniki, 1972; K. Kalokyris, The Byzantine Wall Paintings of Crete, New York, 1973; K. Mijatev, Die mittelalterliche Baukunst in Bulgarien, Sofia, 1974; M. Panayotidi, L'église rupestre de la nativité dans l'île de Naxos. Ses peintures primitives, Cahiers archéologiques, XXIII, 1974; D. S. Pallas, Eine anikonische lineare Wanddekoration auf der Insel Ikaria. Zur Tradition der bilderlosen Kirchenaustattung, Jahrbuch der osterreichischen Byzantinistik, 23, 1974; K. Weitzmann, A group of early twelfth century Sinai icons attributed to Cyprus, Studies in memory of D. Talbot Rice, London, 1975.

Pre-Mongolian Russia. – V.H. Lazarev, Old Russian murals and mosaics, from the XI to the XII century, London, 1966; V.H. Lazarev, Teophan grec 'i ego Schola, Moskva, 1961 (cf. rev. in Byz. Zeit., 64, 1971; and in Bull. Mon., 111, 1969; G. Wagner, Old Russian Sculpture, XII century: Vladimir, Bologliubovo; Moscow, 1969 (in Russian); N. Voronin, The Architecture in North East Russia in the XI-XV century, I: the XII century, Moscow (in Russian); V.H. Lazarev, Moscow School of Icon-painting, Moscow, 1971; M. Alpatov, Andrej Rublev, Moscow, 1972 (in Russian); H. Schäfer, Architekturhistorische Beziehungen zwisch. Byzanz und der Kiever Rus im 10 und 11 Jahrhundert, Instanbuler Mitteilungen, 23-24, 1973-74; V. H. Lazarev, Récentes études sur l'art russe prémongole, Cahiers de civilisation médiéval, 17, 1974; N. Demijna, Andrej Rublev, Moscow, 1972 (rev. in Deutsche Literaturzeitung, 96, 1975; n° 2); G.V. Popov, Zivopis 'i miniatijura Moskov Serediny 15-Nacala 16 Veka, Moskva, 1975; V.H. Lazarev, The bipartite tablets of St. Sophia in Novgorod, Studies in memory of D. Talbot Rice, London, 1975.

GIANCLAUDIO MACCHIARELLA

ARMENIA

The geographical position of Armenia, divided today between Iran, the U.S.S.R., and Turkey, has conditioned the historico-artistic events connected with it. Thus, in view of the multiplicity of the components, it becomes extremely difficult to isolate and define what external influences have been brought to bear on the picture of the origins and the formation of this complex art. Connected historically with the formulation of an autochthonous, polyvalent artistic language is the problem of the birth of the Armenian language, which includes words of various extractions (Persian, Hebrew, Greek, Syrian and others) and which was created by Mesrop at the beginning of the fifth century. The difficult conversion to the Christian religion is tied to the figure of King Tiridates III (250 - 330) and to Gregory Lousaworich (The Illuminator). However, the region seems already to have been evangelized in the first century by the Apostles Thaddeus, Bartholomew, and Judas.

Architecture. – In addition to the greatly varied iconography, the most uniting and descriptive element of Armenian architecture is represented by the structure of the masonry, which consisted of large, perfectly squared blocks which act as stable outer casing for the internal conglomerate composed of tufaceous material and mortar. If the adoption of this building method has led, on the one hand, to specific and circumscribed formal solutions, on the other, it has had a conditioning effect. Particular interest is attached to the problem of the origin of this technique, somewhat similar to that of late Antiquity and to that of Syria. However, while claiming local autonomy for these methods, de'Maffei has recently demonstrated their close connection with those already in existence there and appertaining to Urartean architecture. Worthy of mention, furthermore, is the topicality of these questions, which have recently been reopened, particularly in regard to the scientific contributions made by the Universities of Rome and Milan, on the pattern of the Strzygowski discourse but disagreeing with it because the typological evaluation has been substituted by an historico-evolutive criterion.

Specific examples of early Armenian architecture are the funerary monuments, datable from the fourth to the seventh centuries: these are groups divided into three entities — chapel, hypogeum, and stele — according to a formula which is common in Armenia. Among these, the most noted complex is the mausoleum of Aghtz. This mausoleum probably consisted originally of a small church with only a nave (which has now disappeared), one stele, and an hypogeum. From his examination of the decorative and iconographic motives, Khatchatrian has dated the complex in question in the second half of the fourth century. This date has also been confirmed by other sources. However, the origin of such complexes, for which the prototypes have been found in Syria, is problematical. But if the stele-hypogeum combination effectively originated in Syria after the second century A.D., it must also be pointed out that solutions arrived at in Armenia are particularly typical and very different from the prototypes.

In a recent publication, Gandolfo has dealt broadly with the basilican form with a single nave which is common to a vast number of Armenian churches. Gandolfo points out some of the architectural elements and their liturgical functions and also the problem of the dating. This is a series of chapels and churches with a single nave and semi-circular apse. Some of these present a rectangular ambient sometimes apsed, to the right of the main apse. One often finds that these ambients have been inserted at a later date, as in the case of the church in the village of Garni, fourth century, to which the apsed ambient and the south door were probably added in the sixth century.

While considering churches with a nave and no side aisles, mention must be made of the discovery of a Paleochristian chapel in the village of Lowsakert (in the Aštarak region), which was located by Hasrat'yan. He claims that the construction was carried out in two parts; to be precise, the lower building in the fourth century, and the upper in the fifth century. However, following a careful analysis of the masonry, Gandolfo has thoroughly upset the chronology proposed by Hasrat'yan, claiming that the lower part, roughly walled, is probably a later work of the 13th century. This would appear also from a comparison with walling of the period in question. The most interesting element resulting from Gandolfo's studies is the function as a martyrium common to these small chapels without aisles, in which the priest celebrated the liturgy only in the "dies natalis" of the saint to whom each of the chapels was dedicated. Following these conclusions, the fascinating theory of Grabor, who sees the buildings as being of a funerary nature conforming to a central typology, has had doubt thrown upon it in recent years by new discoveries and new approaches, but has also become much weakened. While on the subject of the new discoveries, notice is certainly due to a whole series of basilicas, published by Hasrat'yan, situated in the zone bordering on Georgia, which show undoubted contamination by Georgian art, dated around the sixth century.

There still remains the problem, within the field of Paleo-Christian architecture, of recognition of the remains brought to light under the Cathedral of St. Etchmiadzin at Vagaršapat, on the planimetry of which a number of contrasting hypotheses have been advanced. The present building, with four apses jutting out from the principal axes, is dated in the fifth century. A smaller apse and some remains of walling were found under the east apse. Before the discovery of these remains, Thoromanian had been of the opinion that the present building had been erected above the preceding structure, also on a quadrilobate plan in square form; an ichnography subsequently maintained in the fifth century building. Conversely, Sahinian, who directed the excavations under the present building, suggests a reconstruction on a basilican plan, a nave and two aisles, with a jutting polygonal apse on the lines of that of Qassakh. Khatchatrian interprets the remains as part of a square building with a crossing, an apse at the east end, and a dome in the center, supported on four pillars, an ichnography derived from the analogous audience chambers. In reality, in view of the exiguousness of the remains, it is extremely difficult, on that basis alone and without the assistance of specific historical sources, to offer any proposals whatever with regard to the reconstruction of the original planimetry of the Church of St. Etchmiadzin. Even though the proposals advanced may seem probable, at the present state of affairs it would be impossible to verify each one, even if the most likely, on

the basis of the archaeological evidence, is that of a church with a nave and two side aisles.

A series of new contributions in the sphere of early Armenian architecture have been published by D'Onofrio on the churches of Dvin. Dvin was the capital of Armenia from the fourth century to the ninth century.

Through a searching review of the sources, and on the basis of the archaeological findings on the Church of St. Gregory, the original phase of which is dated in the fifth century, it has been possible to define the constructive phases, and in particular the first and second moment of the Church of Vahan Manikonyan and of the Church of Smbat Bagratuni. For the originality of the design and the presence of certain structural elements, such as the probable introduction of pendentives at Dvin (and at Zwartnots), a series of comparisons with the Byzantine-Palestinian architecture of the Justinian era, especially with the Basilica of the Nativity of Bethlehem was also suggested. The Church of St. Yisbuzit of the sixth century, of which D'Onofrio has offered a reconstructed plan, has facilitated a long excursus on the single nave building with a square side room. Of particular interest among the new discoveries is the Church of St. Ejmiacin at Soradir, situated in the historical region of Valpurakan, east of Lake Van.

This is a building on a central floor plan; with four apses on the principal axes, covered at present by an enormous dome supported by four monumental pillars. The presence of the pillar, an element peculiar to Armenian architecture, is connected to the construction technique. In fact, even the roofs in Armenia, unlike those in use in Syria and in the Byzantine world, are built entirely in masonry, so the constant use of pillars is dictated for purely static reasons. Inserted at the top of these great arches are the four inverted conical domes still at an early stage, another constant of Armenian architecture up to the second half of the second century. This element marks the passage from the square base to the circular base of the dome itself (the Armenian dome is always mounted on a square floor plan; cf. in this respect the article by dé Maffei). The outer wall of the dome is enclosed in a cylindrical drum rounded at the corners. Breccia-Fratadocchi dates the church in the seventh century (the dome, as proved by an inscription, was rebuilt in 1681). However, as dé Maffei suggests, the date can probably be brought forward to the first half of the sixth century in view of the archaic type of structure of the inverted conical domes, the decorative motifs, and the method used for cutting the stone.

The seventh century marks the acme of Armenian artistic production. At this moment the local artistic code, which was to create the basis for the Medieval artistic manifestations, was evolved.

This picture must certainly include the Church of St. Thaddeus at Dedmachéne, recently published by Hasrat'yan, who dates it in the very early years of the seventh century. The church has a domed hall with semicircular apse enclosed in a polygonal wall. The dome, partly rebuilt in wood in some recent age, is covered outside by a pseudodrum decorated with a series of alternately open and closed windows connected and framed by the intricate design of the cornice and delicate pillars. The window-niche motif represents a solution for the purpose of statics. In particular, the structural organization and composition of the drum anticipates a monumental prototype, the Church of Zwartnots, whose walls were decorated all over with a series of blind arcades (see Khatchatrian's article on the external niches motif). The interpretation of the motif in question, limited here to the zone of the drum, led to this specific plastic and chiaroscuro solution. The date proposed by Hasrat'yan, the earliest years of the seventh-century, is confirmed by both the analysis of the monument and a whole series of comparisons with seventh-century buildings, particularly the Churches of Ptghavank and Aroutch, and also, the Cathedral of Talin.

The Church of Zwartnots, erected under the Armenian Catholic Nersēs III (641 - 661); "The Builder" is a symbol of this happy historico-artistic period. The church is described in the form of a tetraconch with an ambulatory. The exedrae are opened by columns (a rare sight in Armenia), except for that on the east side which, for liturgical reasons, consists of a solid continuous wall. The use of columns shows that this ichnography had been imported (the pillar was always used in Armenia for static reasons). In fact, at a later date, when the column was found to be inadequate to support the roof, the intercolumniation was filled with masonry. In the case of this particular church, believed to have been a burial martyrium already at the time of the Catholic, John (beginning of the tenth century), Kleinbauer has recently pointed out evidence of a liturgical function. It was, in fact, a Congregational church dedicated to the Watch Forces (the Zvart' noc' in Armenian), the angels who appeared to St. Gregory. Consequently it was a Theophanic martyrium and not sepulchral. There have, as yet, been very few publications on the architectural sculptures of Zwartnots that are particularly connected with the artistic manifestations of the nearby Iranian world, to which the history of Armenia has often been allied. One still unresolved problem is that of the presence of two baptismal fonts in the building, a portable one behind one of the large W-shaped pillars, the other in the middle of the building, which probably dates from a period later than that of the foundation of the church. Also attributed to the same Nersēs III The Builder is the Church of St. Sergius at Dvin. Regarding this, D'Onofrio has reproposed the thesis of Haroutiunian. This thesis suggests an hypothetical relationship between the "phantom" building of Dvin and the Church of Zwartnots, both commissioned by Nersēs, mainly on the basis of a structural and stylistic analysis of the two "basket weave" capitals which have come down to us.

In the eighth and ninth centuries, the Armenian territory under the Arabs was the theater of Arab-Byzantine conflicts. It was only in the ninth century that Abbasids and Byzantines declared Armenia independent. Ani was chosen as the capital city, and a period of true and proper artistic and cultural renaissance began for the country.

The most noted monuments of this period are undoubtedly the Church of St. Gregory at Ani, designed as a true copy of the plan of Zwartnots, and the Church of the Holy Cross at Achtamer, both of the tenth century. The sculpture and the pictorial decoration of the Church of Achtamar, in particular, represent an example of perfect symbiosis.

As for the Medieval period, the artistic manifestations most indicative of the status quo of Armenian

architecture are without doubt the convent complexes, on which a few brief papers have recently been published. Among the oldest and most important figure that of Sanahin which, between the tenth and the 13th century, became one of the principal cultural centers of Armenia, beginning when Sanahan was raised to a bishopric in the tenth century. The convent, erected on the foundations of a Paleo-Christian church, consists of a small church dedicated to the Virgin, preceded by a gavit; the large church dedicated to the Saviour, it also with a gavit; the Academy; the round chapel of St. Gregory; the library; and the bell tower. Still in the field of monastic architecture, important contributions by M. Thierry on the monasteries of Vaspurakan must be mentioned. Another still open field of research is that relative to civilian architecture. We know from the sources of the existence of numerous palaces, noteworthy among which is that of the Armenian Catholics, near the Church of Zwartnots. However, there are no publications on it.

Before concluding this brief excursus on Armenian architecture, it is opportune to mention the gavit, a structure peculiar to the architectural culture of Medieval Armenia. This is an ambient situated in front of the façade of the church. It is generally in the shape of a quadrangle with a dome, divided inside by pillars and arches, which appeared in Armenia not before the tenth century. Its function is problematical, and there are a number of contrasting opinions on it. As regards the gavit in Sanahan, Alpago Novello claims that the origin of this structure might be connected with two traditions, the one popular (from Armenian peasant houses), the other aulic (which sees in the gavit a contraction of the hypostyle room of the palace with several aisles on columns). As regards the function of such a structure, it seems that the gavit may have lent itself to both liturgical and civil functions.

The influence of Armenian architecture is practically nonexistent outside the confines of the region (apart, of course, from the Silician parenthesis). There is an Armenian church in the Armenian quarter of Jerusalem, situated in the southwest zone of the city. There was a considerable Armenian quarter here already in the fourth century and the existence of a church is recorded in the fifth century. Furthermore, we know from the sources that in the seventh century, a good 70 Armenian convents existed in Jerusalem. The Armenian cathedral dedicated to St. James is dated in the 12th century. It consists of a nave and two aisles with three apses and a two-apsed chapel which is believed to have made part of the more ancient nucleus along the north side. The church in question faithfully follows the contemporary Armenian models. At the present time, the ancient structure, of which the 12th century apses hung with large tapestries of 1798 are visible, is partly hidden behind a late facing.

The situation is different in the case of the Armenian settlements in New Djulfa in Persia where, from 1587, Šāh 'Abbās, the Great, transferred a great part of the Armenian population. Unlike that of Jerusalem, this community adopted Persian architectural designs for both civilian and religious buildings which were completely uninfluenced by Armenian architecture.

In conclusion, analysis of the architectonic documents that have survived offers a sufficiently clear and homogeneous picture of the evolution of Armenian architecture. The fourth century constructions present a single nave with apse enclosed within a rectilinear wall or, as in the basilicas of Qassakh, Everuk, and probably the primitive Church of E. Ejmiacin at Vagaršapat with nave, two aisles with jutting apses semicircular inside, polygonal outside (it should be mentioned here that in the Armenian architectonic conception, the side aisles were intended for static rather than liturgical functions). In the sixth century both organisms on a longitudinal and those on a central floor plan were built with a dome on a square base, a structure peculier to Armenian architecture whose origins are to be found, as de'Maffei has shown, in the Sassanid world. Until the middle of the seventh century, the construction element between the square of the base and the dome consisted of pendentives in the shape of a segment of a cone and not of a quarter sphere as in the monuments of late Antiquity. The so-called Armenian pendentive appeared in the seventh century. It fulfilled not only the function of allowing direct passage from the square base to the bottom of the dome, but also that of concentrating the weight of the roof on four clearly defined points. In this century, next to the buildings on a basilican plan there appeared a group of buildings on a central floor plan derived from the noted Church of Zwartnots (641 - 661). With the political revival of the tenth century, Armenian architecture deliberately aimed at improving on the seventh century models, redesigning them. This is when the gavit, the structure peculiar to Medieval Armenia, appeared. There was a great increase in the number of monastic foundations, complexes often fortified and comprising a number of buildings, cultural centers of notable interest. Also, with regard to this particular period, mention must be made of a number of close relationships with Georgian architecture which were favored by the particular historical situation in the country.

Sculpture. - There are few publications on the plastic production strictly connected with architecture. The particular aspects of Medieval Armenian culture include the khatchkar. These are richly decorated slabs of stone in the form of a cross set into a foundation which, in the Paleo-Christian period, was probably made of wood. In 1973, Azarian published an exhaustive paper accompanied by a lengthy list of Armenian khatchkar, of which he analyzed the principal evolutive stages and their meaning in Armenian traditions. While in the early centuries there was still a classical flavor to the choice of plastic decorations (cf. for example the Basilica of Ereruk), in the seventh century a particular linear and geometrical style was established, with additions of both Sassanid and Byzantine origin, as can be seen in the remaining decorations in the Church of Zwartnots. The most noted Armenian sculptures in the following period are those in the Church of Achtamar (915 - 921) for which Otto-Dorn has proposed a whole series of comparisons with the Abbasid sculptures of Sāmarrā, Işiroğlu with Islamic culture; for Der Neressian, these sculptures are clearly in line with the evolution of the properly Armenian sculpture. One particular aspect of Armenian sculpture is represented by a vast series of models of sculptured churches, although only a few people regard them effectively as models (see, for example, the small model of the Church of St. Gregory at Ani). In the series listed by Cuneo, one group of

models can be considered rather as elements of a decorative character.

Painting, Illuminations, and Mosaics. – The bibliography of Armenian painting, which is somewhat fragmentary, does appear to be characterized by a series of informative articles. In addition there are some as yet unpublished series. The most ancient pictures, although again extremely fragmentary, are dated in the seventh century: at Talich, Talin, and Goch, of the original decoration there is still preserved in the apse a figure of Christ and some other fragments difficult to read. The decoration of the absidal conch at Lmbat, inspired by the visions seen by Isaiah and Ezekiel, allow a stylistic reading which, while approximate, does indicate something of the contemporary Armenian figurative and stylistic trend. According to N. and M. Thierry, the schematic process is parallel to that of the plastic decorations. The frescoes in the Church of Achtamar, of the first half of the tenth century, representing stories of Genesis and the childhood and the public life of Christ, represent a document of extreme interest for the lively style connected stylistically with the external sculptures. The cycle of frescoes of the Church of Abugamrenč, of the same period, is still practically unpublished. A particular aspect of this fragmentary picture is constituted by the frescoes in the Church of Saints Peter and Paul at Tatev (beginning of the tenth century) executed according to tradition (cf. Stephen Obelian, Archbishop of Tatev in 1285) by Frankish artists and that, in the opinion of N. and M. Thierry, would seem to relate to the figurative tradition of the post-Carolingian world. Practically no pictorial testimony of the following centuries has survived, but the vast production of illuminated codices of high quality offer a wide field for research.

The Evangelistary of Etchmiadzin (Mat. 229, copied in 989) contains the oldest Armenian illuminations, two pages of pictures of the Annunciation to Zachariah, The Annunciation, The Adoration of the Magi, and The Baptism, claimed by Strzygowski to be Syrian work of the sixth century. This attribution has since remained more or less constant. But recently, the examination of the seventh century Armenian frescoes, and particularly those at Lmbat, have led Der Nersessian to reconsider the problem of the dating of the stylistic origin of these miniatures, which are very similar to the frescoes. If the prototypes of the miniatures of Etchmiadzin were probably done in Syria, according to Der Nersessian, the latter should be considered, instead, an Armenian product of the seventh century.

The end of the ninth century is the date of the Evangelistary of Queen Mlke, wife of King Gagik, which, according to Thierry, was influenced by the impressionist painting of the Alexandrine style. A codex tied stylistically to the contemporary Armenian figurative culture is dated by Der Nersessian at 966.

The Medieval production marks the acme of Armenian illumination. Particular interest is attached to the School of Cilicia which, particularly in the 13th century, produced artists of a very high calibre. One student of this school was the noted Toros Roslyn, who was active in the second half of the 13th century. The personality of Toros Roslyn, originally associated with the illuminations of the Hromkla School, is complex. His mastery of painting techniques and the vast thematics of his work can not be over emphasized. The rich production associated with the name of T. Roslyn is connected historically with the ancient Armenian miniatures, while the iconographic origins of his painting touch in a particular way on the Byzantine traditions. There are numerous codices signed by and attributed to T. Roslyn. Among them, of very high quality, is a codex published recently by Der Nersessian and kept in Baltimore.

An exponent of the Cilician School of the 14th century, Sarkis Pidzak, is a less noted personality than T. Roslyn, whose work responds with considerable interest to both an historical and an artistic examination.

The mosaics preserved at Garni, stylistically similar to the Iranian (cf. Bishāpur) bear witness to the existence of a local school back in the most ancient times. From the Paleo-Christian period Strzyowski has indicated a number of minute remains of mosaic pavements. One interesting fragment from the primitive Church of St. Gregory at Dvin, kept in the museum at Dvin, has been published by D'Onofrio. There is no evidence of the use of pavement mosaic in Armenia during the Medieval period.

As regards mosaics outside the region or Armenia, particular importance attaches to the so-called Armenian mosaics in Jerusalem, preserved in the Oratory of St. Polyeucto (the present Students' Hostel almost opposite the Damascus Gate) and at the Mount of Olives. In the first case, the well-preserved mosaic exhibits some writing in the Armenian language in praise of the Unknown Soldier. This writing is inserted into the mosaic pavement with racemes and figures of animals, of clear Palestinian stylistic tradition. The mosaic is dated in the seventh century. The fragments preserved in a number of small churches which belong to a convent of nuns on the Mount of Olives are more interesting. Some pieces are preserved in the Chapel of St. John the Baptist. However, since I have been able to see it recently, for me the most interesting mosaic is that preserved in what is at present an antiquarium. The floor is related, stylistically, to the taste of late Antiquity and can probably be dated before the end of the fourth century. In my opinion, the writing in Armenian, which refers to Susanna, mother of Artabano, was probably added at a later time because the tesserae are arranged in a different and disorderly manner with respect to the rest of the pavement. Furthermore, the date attributed to the writing (sixth century) appears incompatible with the stylistic characteristics noted in the work.

BIBLIOGRAPHY – *Architecture and Sculpture*: K. Hovhannessian, S. Azadian, J. Tamanian, Monuments of Armenian Architecture, Yerevan, 1960; H.K. Ghalpakhdjian, L'architecture de la Cilicie Armenienne, Moscou, 1961 (in Russian); N.M. Tokarsky, The Armenian Architecture from fourth century to the 14th century, Yerevan, 1961 (in Russian); A. Sahinian, The Architecture of Etchmiadzin Cathedral, Etchmiadzin, 1961 (in Armenian); K. Otto-Dorn, Türkisch-Islamisches Bildgut in dem Figuren Reliefs von Achtamar, Anatolia, 6, 1961; M.S. Ipsiroglu, Die Kirche von Achtamar, Berlin, 1963; V. Haroutiounian, The City of Ani, Yerevan, 1964 (in Russian); M. and N. Thierry, Notes sur des monuments arméniens en Turquie, REArm NS, 2, 1965; S. Der Nersessian, Achtamar, Church of the Holy Cross, Cambridge Mass., 1965; A. Khatchatrian, Quelques observations à propos des fouilles sous la cathédrale d'Etchmiadzine, Akten

des VII Int. Kongress für christliche Archäologie, Trier, 1965; A. Khatchatrian, RBK, I, Stuttgart, 1966, s.v. "Armenien", A. Sahinian, Recherches Scientifiques sous les voûtes de la cathédrale dÉtchmiadzin, REArm NS, 3, 1966; A. Khatchatrian, Les Monuments funeraires arméniens des IV-VII s. et leur analogies syriennes, Polychordia, I, 1966; W. Kleiss, Das Kloster des heiligen Thaddäus in Iranisch Azerbeidjan, Inst. Mitt., 17, 1967; A. Khatchatrian, Les église cruciformes du Tayq, CahArch, 17, 1967; E. Utudjian, Les monuments arméniens du IV au XVIII s., Paris, 1967; M. Thierry, Monastères arméniens du Vaspurakan, REArm NS, 4, 1967; V. Haroutiounian, L'aménagement urbain en Arménie médiévale REArm NS, 4, 1967; A. Sahinian, Nouveau materiaux concernant l'architecture arménienne du Haut Moyen Age, REArm NS, 4, 1967; P. Cuneo, La basilica di Cicernavank', REArm NS, 4, 1967; H.K. Ghalpakhdjian, L'architecture de l'Armenie médiévale, Moscou, 1967 (in Russian); G. Čubinašvili, Recherches sur l'architecture arménienne, Tbilisi, 1967; T. Maroutyian, Zvart'noç, Yerevan, 1967 (in Armenian, Russian, and German); Aa. Vv., Architettura medioevale Armena, Roma, 1968; S. Mnazaganian, A. Alpago Novello, Il complesso monastico di Hakhpat, Milano, 1968; W. Kleiss, Das Armenische Kloster des Heiligen Stephanos in Iranisch Azerbaidjan, 1st Mitt., 18, 1968; A. Khatchatrian, A propos de niches extérieures dans l'architecture arménienne, Synthronon, II, 1968; V. Haroutounian, L'urbanisme en Arménie du Moyen Age, REArm NS, 5, 1968; M. Thierry, Monastères arménien du Vaspurakan, REArm NS, 5, 1968; P. Cuneo, L'église de St. Etchmiadzine à Soradir, REArm NS, 5, 1968; J. Carswell, New Julfa (The Armenian Churches and Other Buildings), Oxford, 1968; A. Manoukian, Documenti di architettura armena, Milano, 1968; F. de'Maffei, Armenien, Propyläen Kunstgeschichte, Berlin, 1968; S. Der Nersessian, The Armenians, London, 1969; H. Koepf, Armenische Architektur, Wien, 1969; A. Sahinian, Nouveaux materiaux concernant l'architecture des constructions antiques de Garni, REArm NS, 6, 1969; M. Thierry, Monastères arméniens du Vaspurakan, REArm NS, 6, 1969; P. Cuneo, Les modèles en pierre de l'architecture arménienne, REArm NS, 6, 1969; A. Alpago Novello, La fortezza di Amberd sul monte Aragadz, Castellum, 9, 1969; M. Thierry, Monastères Arméniens du Vaspourakan, REArm NS, 7, 1970; O. K. Ghappakhtchian, A. Alpago Novello, Sanahin, Milano, 1970; P. Cuneo, Les ruines de la Ville d'Ani ..., Monumentum, V, 1970; E. Neubauer, Armenische Baukunst, Dresden, 1970; Aa. Vv., Armenian Churches Holy See of Etchmiadzin, Lisbon, 1970; M. Hovhannessian, Les forteresses d'Arménie, Venice, 1970 (in Armenian); L. Azarian, Khatchkar, Milano, 1970; T. Maroutyian, Les monuments arméniens du Tayq, Yerevan, 1970 (in Russian); T. Breccia-Fratadocchi, La chiesa di S. Ešmiacin a Soradir, Roma, 1971; A. Khatchatrian, L'architecture arménienne du IV au VI s., Paris, 1971; M. Thierry, Les monastères arménien du Vaspourakan, REArm NS, 8, 1971; A.L. Jacobson, Les rapports et les correlations des architectures arméniennes et géorgiennes au Moyen Age, REArm NS, 8, 1971; S. Mnazaganian, Zvart'noç', Moscou, 1971 (in Russian); W. Kleiss, H. Seihoun, Il convento di Sourb Thadé, Milano, 1971; N. Stepanian, A. Tchakmaktchian, L'art decoratif de l'Arménie Médiévale, Leningrad, 1971; D. M. Lang, Armenia, Cradle of Civilisation, London, 1971; S. Mnatsakanian, N. Stepanian, Architectural monuments in the Soviet Republic of Armenia, Leningrad, 1971; N.M. Tokarskij, A. Alpago Novello, A. Zarian, La fortezza e la chiesa di Amberd, Milano, 1972; A. Khatchatrian, H. Dasnabidian, Monuments of Armenian Architecture, Beirout, 1972; W. E.

Kleinbauer, Zvartnitz and the origins of Christian Architecture in Armenia, DOP, 26, 1972; P. Cuneo, Le basiliche di T'ux,Xngorgin, Pasvack, Hageačvank, Roma, 1973; M. D'Onofrio, Le chiese di Dvin, Roma, 1973; F. Gandolfo, Chiese e cappelle armene a navata semplice dal IV al VII secolo, Roma, 1973; T. Breccia-Fratadocchi, Le basiliche armene a tre navate e cupola, Corsi CARB, XX, 1973; T. Breccia-Fratadocchi, La Cattedrale di S. Giovanni a Mastâra, ibid.; P. Cuneo, Le basiliche paleocristiane armene, ibid.; P. Cuneo, Le chiese paleocristiane armene a pianta centrale, ibid.; F. de'Maffei, Rapporti tra l'architettura armena e l'architettura urartea, ibid.; F. de'Maffei, L'origine della cupola armena, ibid.; T. Scalesse, La cattedrale di Mren in Armenia, ibid.; A. Zarian,, Formazione e sviluppo della "Sala a cupola", ibid.; A Zarian, Gošavank, ibid.; A. Sahinian, A. T. Aslamian, A. Manoukian, Il complesso monastico di Gheghard, Milano, 1973; A. Haghnazarian, Das Armenische Taddäuskloster in der Provinz West Azerbaidjian in Iran, Aachen, 1973 (in Armenian, French, and English); M. Hasratyan, La salle à coupole du VII s. de Dedmachéne et les monuments similaires du Haut Moyen Age en Arménie, REArm NS, 10, 1973-1974; M. Thierry, Monastères arméniens du Vaspourakan, REArm NS, 10, 1973-1974; A. Zarian, H. Vahramian, Il complesso monastico di Gosh, Milano, 1974; S. Der Nersessian, H. Vahramian, Aght'amar, Milano, 1974; C. Mango, Architettura Bizantina, Milano, 1974; F. Gandolfo, Un martyrium sepolcrale armeno: Ia capella degli Apostoli a Karenis, Annuario dell'Istituto di Storia dell'Arte dell'Università di Roma, 1, 1975; R. Krautheimer, Early Christian and Byzantine Architecture, Baltimore, 1975; A. L. Jacobson, Armenis i Sirija Architecturnye sopostavlenjia, Vizantiiskij Vremennik, 37, 1976.

Paintings and Illuminations: S. Der Nersessian, The Chester Beatty Library: A Catalogue of the Armenians Mss., 2 vols., Dublin, 1958; A. L. Durnovo, La Miniatura Armena, Milano, 1961; J. Assfalg, J. Molitor, Armenische handschriften, Weisbaden, 1962; B. Bagatti, L'archeologia cristiana in Palestina, Florence, 1962; S. Der Nersessian, Armenian Mss in the Freer Gallery of Art, Washington, 1963; S. Der Nersessian, La peinture arménienne au VII s. et les miniatures de l'Evangile d'Etchmiadzin, Actes du XII Congrés Intern. d'Etudes byzantines, III, Belgrade, 1964; T. Izmailova, L'iconographie du ms. du Mat. n° 2877, REArm NS, 1; L. R. Azarian, La miniature cilicienne du XII et XIII s. Erevan, 1964 (in Armenian); T. Izmailova, Tables de Canon de deux mss. arméniens d'Asie Mineure du XI s., REArm NS, 3, 1966; V. Lazarev, Storia della pittura bizantina, Torino, 1967; S. Der Nersessian, Un évangile cilicien du XIII s., REArm NS, 4, 1967; T. Izmailova, L'iconographie du cicle des Fêtes d'un group de Codex arméniens d'Asie Mineure, REArm, 4, 1967; T. Izmailova, Le style: resemblance et divergence dans le group de codex arméniens d'Asie Mineure, REArm, 5, 1968; N. and M. Thierry, Peintures murales de caractère occidentale en Arménie: église de ss. Pierre et Paul de Tatev, Byz., 38, 1968; T. Izmailova, Le cicle des Fêtes du tétraévangile de Mougna (Mat. 7736), REArm, 6, 1969; S. Der Nersessian, Miniatures ciliciennes, l'Oeil, 179, 1969; A. Mekhitarian, Catalogue du trésor du Patriarcat Arménien de Jerusalem, Jerusalem, 1969; T. Izmailova, Le tétraévangile illustré arménien du 1308 (Mat. 6201), REArm, 7, 1970; S. Ter Avetissian, Catalogue des mss. arméniens du Monastère du Saint Sauveur de Djoulfa (Iran), Vienna, 1970 (in Armenian); S. Der Nersessian, Deux exemples arméniens de la Vierge de Miséricorde, REArm, 7, 1970; P. M. Gianascian, Armenian Miniatures, Venice, 1970; T. Izmailova, Le ms. enluminé d'Ani de 1298, REArm, 8, 1971; N. and M. Thierry, La Cathédrale de Mren

et la décoration, Cah. Arch., 21, 1971; N. Thierry, La Peinture médiévale arménienne, Corsi CARB, XX, 1973; S. Der Nersessian, Armenian mss. in the Walters Art Gallery, Baltimore, 1973; J. Carswell, Kütahya tiles and pottery from the Armenian Cathedral of St. James, Jerusalem, Oxford, 1972; M. Stone, C. Safrai, Further Armenian mss. in the National and University Library of Jerusalem, REArm, 10, 1973-1974; H. L. Nickel, Kirchen, Burgen, Miniaturen (Armenien und Georgien Während des Mittelalters), Berlin, 1974.

<div align="center">Grazia Marina Falla Castelfranchi</div>

GEORGIA

The geographical position of Georgia, situated between Asia and Europe, a territory crossed by great commercial highways, represents an important element for the historico-cultural development of the region. In the period preceding the Christian era, the country gravitated between the Hittites and the Achaemenids. This fact is confirmed also by the splendid bronze work which has come down to us, such as the small bronzes of the seventh century B.C., and silver objects decorated with pairs of horses, of clear Achaemenean influence. Also of great artistic interest are the silver plates with a smooth surface from which emerge human busts, creating a very striking effect. These pieces, which have been published by Amiranachivili, are dated in the time of Hadrian.

Christianity became the official religion of Georgia between 325 and 337, in the reign of King Miriam, when Saint Ninus, from Cappadocia, Patron Saint of Georgia, evangelized the country. Georgia became autonomous in the fifth century. The residence of the Catholicos was established at Mtskhet, the ancient capital and pre-eminent religious center. It was in this period that the Georgian alphabet was constituted, and a number of epigraphs in the Georgian language are known to be dated before the end of that century. Until the Sassanid invasion in 614, the region was related culturally to Jerusalem. After the invasion, it moved into the Byzantine sphere of influence, although with the iconoclast conflict the Georgian position remained iconodulous. The region was subjected later to Arab and Seljukian domination. Eventually, it gravitated culturally towards Persia.

Architecture. - The plans of Georgian churches of the fourth century have been published only recently. These chapels are of modest dimensions (according to the liturgy only the celebrant entered the church). In reality, judging from the artistic documents which have come down to us, it is only from the fifth century that a properly Georgian architectonic language has been formed. The building materials used were primarily stone and wood. The walling technique has very ancient origins: from the cyclopic work cited by Beridzé, to the splendid court composed of solid blocks of perfectly squared stone, and mortar had probably been used ever since the earliest times.

Noteworthy among the constructions assigned by Beridzé to the fourth century (second half) is the church of the Monastery of Nekresi, erected above a crypt, it consists of a single nave with a small apse set within a rectilinear wall. In the first half of the fifth century buildings of somewhat reduced dimensions still pre-

vailed (as, for example, the small church of the Monastery of Dzveli-Chouamta, or that of the Forty Martyrs at Nokalakévi). It was only at the end of the century that the first large Georgian basilicas appeared. The most noted among these is that of Sion of Bolnisi, begun, as can be deduced from an inscription (one of the oldest in the Georgian language), in 478 - 479 and finished in 493. The denomination of Sion is very common in Georgia and is linked with the Sion of Jerusalem, the Basilica of the Dormition of the Virgin. In Georgia the term Sion thus became synonymous with basilica, particularly one dedicated to the Virgin. The basilica of Bolnisi has a nave and two aisles with semi-circular apse jutting outwards and a baptistery in the southern zone. This element, according to Beridzé, can be found only at Bolnisi, with two facing apses. Along the north wall is a gallery, at present in a poor state, which is believed to have acted as a narthex. Amiranachvili has published an up-to-date plan of the basilica in question, reviewed by Beridzé and by Alpago Novello, in which a new element appears with respect to the preceding planimetry: a small apsed room in the north of the apse which, according to Amiranachvili, would be a later addition. The beginning of the sixth century is the date assigned to the Church of Ourbnisi, with a nave and two aisles and a horseshoe-shaped apse enclosed within a rectilinear wall.

Amiranachvili has published an hypothetical reconstruction of the façade of the church, in which the most noticeable element is the manner in which the nave juts out over the side aisles. As in the Sion of Bolnisi, also at Ourbnisi, we find the cruciform pillar arch acting as a support for the masonry vault (all the Georgian basilicas are covered with vaults; the staticity of the building is always ensured by the use of pillars because the column is not considered suitable to carry the weight, neither is the architrave, and the arcades are always supported on pillars). The sixth century saw the appearance of the "three church" basilicas according to Čubinasvili's definition. These are a series of basilicas, in which the nave is completely separated from the aisles with solid walls, in order to create what are almost three independent churches. An example of this style is the church of Zegani, dated by Beridzé in the sixth century. This typology continued until the tenth century.

Churches often had a central floor plan. Ever since the fifth century Georgia has had, in addition to the basilican form, a whole series of buildings on a central floor plan, in the form of a Greek cross, and polylobate. The origin is ascribed symbolically to the famous Cross of Saint Ninus. In the place where the Cross originally stood, in the sixth century, the Cathedral of Ninocminda was built on a polylobate plan with the two principal axes accentuated. The Church of the Cross at Mtsket Djvari, built between 586 and 604 to the order of Prince Stephanos, is a tetraconch, with four rooms in the corners, reliquary apses, a women's room, and a room for the donors.

The building is at the center of a continuing controversy with regard to the presence of the foundation stone inscribed in the Armenian language and broken, on which is written, "This Cross of Mtsket has been decorated to pray the patrician Stephanos, Demetrios Hypatos, Adnerse Hypatos for their souls and bodies and for the protection of all the House." On the basis of

a letter contained in the inscription, Mouradian has composed the name 'T'odosak and consequently has attributed also the church of Djvari to the famous builder of the Sion of Ateni. Abouladzé has contested this somewhat forced interpretation of the epigraph which, on historical grounds, he considers to be later than the date of the foundation of the church. Čubinašvili has stressed the importance of this building as the prototype of a series of Georgian churches such as Tsromi, the Sion of Ateni, and the Cathedral of Martvili. These examples represent a particular typology of that region with respect to the picture of Byzantine architecture. According to Beridzé, these edifices also represent a number of analogies with tetraconch buildings in Syria, and in particular with the Church of Saints Sergius, Bacchus and Leonzios at Bosra, of about 512.

We find many churches on a central floor plan in Georgia, particularly from the first half of the seventh century. Among these are the churches of Ateni near Gori and of Dzveli Chouamta and the Cathedrals of Tsromi and Martvili. All these constructions are without free standing supports, and the domes rest on the walls. A new discourse in this sense has been opened by the church of Tsromi (626 - 634) in which, for the first time in Georgia, the dome is supported on four free-standing pillars, as was pointed out by Čubinašvili, who wrote a monograph on Tsromi, and by Beridzé. This building, which is located in the province of Kartli, a Georgian cultural center, is in the form of a cross in which the dome, above a square space, rests on four free cruciform pillars, and the passage from the base square to the circle is obtained by the adoption of four inverted conoids. The apse, enclosed within a rectilinear wall, is flanked by two rectangular rooms, probably the reliquary apses. An inscription allows the church to be dated between 623 and 624. Thus, it is one of the first domed churches in Georgia.

Extreme interest is attached to the Church of Bana, now in the Turkish zone, on a plan very similar to that of the Armenian Church of Zwartnots. Built in the local tufa, the church has a circular structure, or, to be more precise, a polygonal one with 28 sides. With respect to the Church of Zwartnots, Bana presents a variant in the adoption of base supports — four square pillars opened by narrow corridors which lead to small rooms, while at Zwartnots there are four large pillars in the shape of a "W." It has long been claimed that the church in question had been built at the time of King Adarnase IV (888 - 923) and of Bagratide Curopalate, King of Iberia. Recently, Maroutyian and other scholars have attributed it to the first half of the seventh century because of its close similarity to the Church of Zwartnots. Maroutyian attributes the foundation of Bana to Nersēs lll The Builder (641 - 661). However, Thierry dates it at the beginning of the tenth, century and identifies it with the royal tomb of Adarnase IV, but without supporting the hypothesis with any other data. Kleinbauer sustains the date of the seventh century and, furthermore, has defined the liturgical function of the church which probably, in his opinion, was a cathedral (Bana has been a bishop's see since the 18th century).

The masonry technique is again the common element in seventh century constructions. The proportions of the buildings are well balanced without excessive vertical emphasis and are dominated by octagonal drums with pyramidal coverings. From the second half of the seventh century until the end of the tenth the region was the scene of great struggles for political and territorial unity. In this period, the monasteries undertook the duty of passing on Georgian cultural traditions. Religious buildings are preserved, particularly in those regions where independent principalities were created between the eighth and ninth centuries. The Church of Gurğaani (eighth century) has an elongated basilican plan, of the "three churches" pattern on which are imposed (the only example in Georgia) two domes in line. Because of the shape of the ground, the horseshoe apse, standing within a rectilinear wall, is on two levels, a fact noticed by Alpago Novello. Peculiar to this transitional period, are the churches on a central plan with domes and attached spaces, similar to Armazi Church from the ninth century. For the tenth century, the church at Gogouba, with six apses, is worth mentioning.

A unified state was constituted in Georgia around the end of the tenth century and beginning of the 11th century. This unity gave a great impulse to art. The particular characteristic of the architecture of the period is its typological variety, dominated however by the basilica with a dome standing on four pillars, with the apse constructed inside a straight wall and the adoption of pendentives instead of inverted conoids. In addition, all the most important churches were provided with a portico on the west or, more often, on the south. The process of unification of the country was consolidated toward the beginning of the 11th century. Bagrat lll, the first king of united Georgia, built the cathedral at Kutaisi as a concrete symbol of this new situation. The patriarchal Church of Sveti-Choveli at Mtskhet, erected by the architect Arsukisdze between 1010 and 1029, is one of the most important buildings of this period. Connected by legend with an early foundation by St. Ninus, the building presents a series of stratifications not yet entirely clarified. The Cathedral of St. George at Alaverdi, from the first quarter of the 11th century with later alterations, is considered the highest Medieval one in Georgia. It has a very complex plan, similar to that of Kutaisi Cathedral, and is a synthesis between the triple-conch type and the so-called "three basilicas" type. The construction of the Church of Samtavisi on a basilican plan (tending to be square) with dome is assigned to 1030. This construction introduced a decorative style much used in the following centuries. Alpago Novello says that the great Georgian buildings of the 11th century should be considered as within the framework of European Medieval church architecture.

In the 12th and 13th centuries, the political peak of the country, the function of religious architecture began to evolve. In fact, the patrons of new buildings were principally Georgian feudatory nobles, for whom the social character of the church was modified to become private. This situation was also reflected in the choice of site for the construction. The site was usually far from populous centers, and the size of the building itself was smaller than those. of the 11th century. The constructional method, with well squared ashlars, remained traditional, and the kinds of building did not differ substantially from those of the preceding centuries. The dominant form in religious architecture was the church on a basilican plan with a high dome on pillars, with the external decorative style growing richer.

The complex of Betania, with two churches and a clock tower situated in a mountainous region, is attributed to the 12th or 13th century. The principal church (basilican with dome) was built to the order of Queen Tamara, who is portrayed with King George in frescoes in the interior. Typologically linked with the church at Betania is that of the Monastery of Kimotesubani, of the same period, with an inscribed cross with a dome on two free supports. The massiveness of the brick cupola is lightened by enamelled ceramic decorations.

N. and M. Thierry have described a small double church of Georgian style in Turkey. On the basis of a stylistic examination of the architectural sculptures, as compared with contemporaneous Georgian sculptures, the church has been dated to the first half of the 11th century. In the Kara Dag area, Djobadzé has described a Georgian inscribed cross church with dome. Djobadzé dated the complex between 1025 and 1042 on a comparison between some inscriptions in the Georgian language found there and inscriptions preserved in the cathedrals of Sveti-choveli, Manglisi, and elsewhere, and an analysis of the style of surviving sculptures. There are numerous Georgian monasteries in Egypt and Palestine. Monneret de Villard had already identified a church near Thebes as of Georgian style, with a nave and two aisles, composed of three oriented churches, and which he dated as between the ninth and tenth century. This same building is tentatively ascribed by Tarknichvili, on the other hand, to the Prince Archbishop Peter of Georgia, who died in 488 and who, it is known, had a monastery with a church attached constructed in Egypt. A large number of Georgian monasteries mentioned by T'sareli have also been found in Syria. Corbo has discovered, not far from Bethlehem in Palestine, Hirbet al Ghanam, a monastic complex with a small church in which there remain the most ancient inscriptions in the Georgian tongue, in mosaic with black letters on a white ground. The main center among the numerous Georgian convents was the Monastery of the Holy Cross at Jerusalem. The church was built by order of King Bagrat IV on the foundations of a yet older building.

Sculpture. - There is practically no literature on this subject, in spite of the fact that still existing documents offer vast scope for investigation. It is mostly architectonic sculpture, of which the character is particularly evident in the capitals of the Sion of Bolnisi (fifth century) decorated with extremely stylized figures of animals and plants. Čubinašvili dates in the sixth century some steles in which the figures are rendered schematically in extremely low relief and which are preserved in the museum of Tbilisi. According to Beridzé an originally Hellenistic plastic taste evolves until the forms are completely flattened. A similar evolution can also be seen in goldworking. In the feudal period (tenth to 13th centuries) there is to be seen a further evolution in sculpture which developed naturalistic plastic forms. An example of this is found in the reliefs on the Brili processional cross and on the 11th century iconostases. The decorative element prevails in the 12th and 13th centuries, characterized by the richness of the motives used. A vast number of richly carved wooden doors fall into the same class and are found particularly in Svanezia.

Painting and Illumination. – Although the Georgian Church did not accept iconoclasty, only rare fragments remain from the period before the tenth century flowering. But among them must be mentioned the mosaic pavements at Pitzounda (fifth century) and those in the apse at Tsromi (seventh century), of which some fragments – Christ between two angels – remain. The dominant iconographic theme in Georgian churches is the cross, which at Ischran (tenth century) is painted on the dome, supported by four angels. In southern Georgia the more refined painting can show, according to Thierry, some affinities with Cappadocian painting, while the picture cycles in the regions bounding on Iran show the influence of the Eastern world. The most interesting 11th century cycle is that in the church at Ateni, but the dating is controversial. Amiranachvili dated it between 904 and 906, but on the evidence of certain stylistic evidence a later date would be acceptable. There remain fragments of a Universal Judgment in the western apse and of Marian episodes in the southern one. The artists were Georgian (the scrolls are written in the Georgian language) and the style monumental. Stylistically associated with Ateni are the recently cleaned frescoes in the narthex and the southern chapel of Gelati, in which the seven Ecumenical Councils are shown in chronological order. The most appreciable Byzantine influences, according to Lazarev, are to be seen in the well-known mosaic at Gelati (12th century) but, notwithstanding the scrolls in Greek, stylistically and iconographically their execution can well be attributed to Georgian artists.

A separate stylistic group is composed of the frescoes recently discovered in several small churches in northern Svanezia. This mountain region was spared in many invasions and preserved some documentation of Medieval art. In treating these little churches, a common decorative scheme was preferred, with the "Deesis" and the Fathers of the Church in the apses. The style is monumental and archaic. This fact is explained by the isolated position of the region.

Medieval Georgian painting frequently includes portraits of the donators inserted into the decorative context (cf. e.g. the portrait of Queen Tamara at Varzia (1184 - 1186)). Certain relationships with Iranian culture, as shown in decorative elements and costumes, can, according to Thierry, be dated to the 12th and 13th centuries, while in the 14th century, particularly in the cycles at Martvili and at Lychni, there can clearly be seen evidence of relationships with paleologus art. But there is no detailed study of Georgian painting. So far, it has been illustrated only in short articles which offer a very fragmentary picture of the situation.

The fifth and sixth century manuscripts preserved in Georgia are without ornamentation. The writing, as some ancient caligraphic experts state, is of such high quality that any decoration of the text is unnecessary. Only in the ninth century do illuminated manuscripts appear, as for example the Four Gospels of Adiši (c. 897) executed with a lively style and brilliant colors. In the 11th century, the decoration became predominant. Certain iconographic rules were laid down. One of the most interesting works of the period is the Sinassarius of Zachariah of Valochkert (first quarter of 11th century.), recently published by Alibegachvili, with fully 74 miniatures in the text, probably executed by Greek artists, and compared with the miniatures in the Menology of Basil II.

In the 12th century, the decoration became more solemn and academic. This can be seen in the Triodion, done by Georgian artists with a classical education and preserved without the text. The manuscripts of the 11th and 12th centuries were mostly illuminated by Georgian monks, who probably had Byzantine models available. However, in some cases the illuminated manuscripts were ordered from Constantinople. In the 13th century, more complex decorative systems were created and great importance was given to illuminated initials, for whose decoration stylized elements from the vegetable kingdom were preferred. The 13 miniatures from the Collected Homilies of St. Gregory Nazianzenus, actually dated in the 13th century, were executed by Georgian artists with Byzantine training. Their special stylistic character shows in the monumental imposition of the composition. This characterization is a factor which runs through Medieval Georgian art.

Enamels. – In the nexus of Byzantine art, Georgian enamels constitute a chapter in themselves, although they remain within the stylistic orbit of the capital. It was a local school which differentiated itself from that of Byzantium, both for some stylistic aspects and in technique. Chemical analysis of the components of these enamels has in fact revealed the cause of the substantial technical difference from those of Byzantium. In Georgia, local raw materials, particularly manganese, were used. This element, not found in Byzantine enamels, led to the introduction of certain color ranges. The cloisonné technique was usually used, fusing the enamel into a metal network with rather wider spacing than the Byzantines used. Among the oldest pieces, mention must be made of the Martvili triptych (which represents a Trinity of which the central figure has been lost) and the Martvili Pectoral Cross coming from the same monastery and datable to the last iconoclastic period (end of eighth, beginning of ninth century). There are numerous enamels dating from the tenth century, like the Cross and Virgin of Martvili and the Gold Cross of Clmochmedi, dated by an inscription to the time of Emperor Georgius (died 957). The most interesting pieces often come from the 12th century. Among these is the Martvili Icon, a Virgin and Child set in a silver–gilt 17th–century frame decorated with 11 enamelled medallions. This piece is dated by Amiranachvili in the eighth century, some iconographic details of which later reappear in miniatures of the same period. The masterpiece of the 12th century is the Khakhouli Triptych (2 x 1.47 meters) a reliquary which holds the Icon of the Mother of God whose central core is dated in the tenth century. The present version is due mainly to Dimitri I (1125-1146). This work, according to Amiranachvili, is in the Georgian artistic tradition of which the pictorial taste shows a predilection for vegetable decorative forms linking enamels of various provenance, some of them Byzantine, although it is the Georgian enamels that make up the decorative basis of the triptych.

BIBLIOGRAPHY - *Architecture and Sculpture:* Tarknichvili, Un vestige de l'art géorgien en Egypte, BK, VI-VII, 1959; B. Bagatti, L'archeologia cristiana in Palestina, Firenze, 1962; G. Čubinašvili, La sculpture artistique géorgienne sur bois en Moyen Age, BK, XV-XVI, 1963; C. Amiranachvili, Storia dell'Arte georgiana, Moscow, 1963 (in Russian); C. Amiranachvili, Georgian cloisonnés enamels, BK, XVII-XVIII, 1964; Aa. Vv., Gelati, Tbilisi, 1965 (in Russian and Georgian); R. Mepissachvili, L'esemble architectural de Guelathi, Tbilisi, 1966; D. M. Lang, The Georgians, London, 1966; W. Beridzé, L'architecture géorgienne, Tbilisi, 1967 (in Russian); G. Čubinašvili, Georgien, in Propilaen Kunstgeschichte, III, Berlin, 1968; W. Beridzé, L'architecture géorgienne, BK, XXV, 1968; P. Mouradian, L'inscription arménienne de l'église de Djvari, REArm, 5, 1968; I. Abouladzé, Quelques remarques à propos de l'article de P. Mouradian: l'inscription arménienne de l'église de Djvari, REArm, 6, 1969; M. and N. Thierry, L'eglise géorgienne de Petreskin, BK, XXVI, 1969; P. Mouradian, Encore au sujet de l'inscription arménienne de l'église de Djvari, REArm, 6, 1969; K. Salia, Some remarks on the subject of two articles by P. Mouradian, BK, XXVI, 1969; G. Čubinašvili, Tsromi, BK, XXVII, 1970; W. Ponomarew, Georgien, RBK, II, Stuttgart, 1971; W. E. Kleinbauer, Zvart'notz and the Origins of Christian Architecture in Armenia, DOP, 26, 1972; W. Beridzé; L'art de la Géorgie, BK, XXIX-XXX, 1972; W. Beridzé, Architecture géorgienne paleochretienne, Corsi CARB, XX, 1973; P. Verzone, L'architettura géorgiana e l'architettura Romanica, ibid.; G. Čubinašvili, I monumenti del tipo Gvari, Milano, 1974; H. L. Nickel, Kirchen, Burgen, Miniaturen: Armenien und Georgien Während des Mittelalters, Berlin, 1974; A. Alpago Novello, Architettura georgiana, Bergamo, 1974; R. Krautheimer, Early Christian and Byzantine Architecture, Baltimore, 1975; E. Tompos, Georgien, Hanau/Main, 1975; W. Beridzé, L'architecture géorgienne à coupole de la moitié du X s. à la fin du XIII s.; BK, XXXIII, 1975.

Paintings, Illuminations, and Enamels: G. Nosadzé, Apercu sur l'ancienne peinture réligieuse géorgienne, BK, VIII-IX, 1960; G. Tseretheli, The Most Ancient Georgian Inscription in Palestine, BK, XI-XII, 1961; C. Amiranachvili, Georgian Illumination, Moscow, 1966 (in Russian); K. Wessel, Die Byzantinische Emailkunst vom 5, bis 13. Jahrhundert, Recklinghausen, 1967; V. Lazarev, Storia della pittura bizantina, Torino, 1972; G. Garitte, Un fragment de l'évangélaire géorgienà la Bodleienne, Le Muséon, 85, 1972; G. Alibegachvili, Miniatures de mss. géorgiens de XI debut XIII s., Tbilisi, 1973; T. B. Virsaladze, Frescoes of the Monastery of the Holy Cross at Jerusalem and the portrait of Chota Roustaveli, Tbilisi, 1973 (in Russian); D. Barret, Catalogue of the Wardrop Collection and of other Georgian books and mss. in the Bodleian Library, Oxford, 1973; N. Thierry, La peinture médiévale géorgienne, Corsi CARB, XX, 1973; P. Verzone, Smalti medioevali in Georgia, ibid.; G. Alibegachvili, L'art de la miniature géorgienne de XI, debut XIII s., BK, XXXIII, 1975; L. Kouskivadzé, Monuments géorgiens de peinture encaustique, ibid.

GRAZIA MARINA FALLA CASTELFRANCHI

COPTIC ART (PLATE 110)

Introduction. – Coptic Art is the Egyptian art of the first centuries of the present era. Its widest chronological limits were the third to 12th centuries. All the inhabitants of Egypt were called Copts by the Arab invaders, and it was only later that the use of the term became restricted to its present-day meaning of Christian Community in Egypt. The historical profile of Coptic Art (as generally recognized) includes an initial formative phase, in which the local traditions, strongly influenced by Hellenistic culture, develop the character-

istics of Coptic Art. This is followed by a second phase, historically definable as that of Byzantine domination, during which Coptic Art finds its fullest and most coherent expression. A third phase starts with the Moslem conquest (641 a.d.) and corresponds to a progressive Islamization of the artistic tradition, which at the same time becomes a heritage of values from which Egyptian Islamic art derived a large part of its own idioms.

Connoisseurs' opinions of these generalized schemes are various and frequently contrasting. All agree that the best period is that between the fourth and sixth centuries. Many uncertainties, however, remain as regards the earliest period in which the foundations of this artistic language were laid down and for the first centuries of Moslem domination when some of its peculiar aspects began to be felt.

As to its relationships with the art of ancient Egyptmost scholars hold that the linking elements are sporadic and do not amount to much. However, this view seems likely to change with a more general consideration of recent studies and discoveries. This is very important for clarifying the origin of some iconographic schemes in the oldest Christian art, which were in fact formed in Egypt on the basis of a very ancient cultural foundation. From there they became diffused throughout the Christian world. This is the case with some symbols (e.g., the frog) and the modulus of the Virgin suckling the Babe, of which there is already admitted (H. W. Muller, 1963) the descent from the famous scheme of the Goddess Isis suckling Horus. Then, again, we have the theme of the Saint Conducting the Dead and, in our opinion, also that of the Devotee at Prayer, is common in Egypt and has which been the subject of lengthy debate. Opinions about the later period, that immediately following the Moslem occupation, are also controversial.

There is general acceptance now of the idea of a continuity in Coptic Art, at least for the first centuries of Moslem domination. Some want to prolong its activities until the full Fatimid period (12th century). Others maintain that already around the year 1000 the Christian art of Egypt (and only then, in our opinion, does it make sense to distinguish between Christian and non-Christian in Egypt from the point of view of artistic expression) had been absorbed in the context of a vaster cultural complex in which Byzantine characteristics were predominant. A large number of the problems mentioned here are still open, partly because there is no accurate chronology of Coptic Art available so that it often happens that datings varying by some centuries may be given to the same work of art (H. Torp, 1965). This fact imposes limits on the various attempts which have been made in recent years to unravel the intricacies of a subject which even now lacks a satisfactory systemization. However, we may expect better results from the reworking of the latest researches and from others still in course. In fact, an exhibition of Coptic Art was held at Essen in 1963 in connection with a symposium which took into consideration various aspects of the matter.

This exhibition at Essen was an important milestone in Coptic studies. Coptology was clearly seen to be becoming a discipline in its own right. The exhibition was followed by a renewal of interest for the whole cultural ambit. From then on there has been growing attention and a regular output of studies, an increase of archaeological researches in loco, and finally, in December 1976, the formation of an International Association for Coptic Studies (which published a news letter under the auspices of T. Orlandi starting March 1977). Certainly many problems remain unsolved, while others have not yet even been correctly stated. However, justice has been done to certain propositions which cannot any longer be sustained, such as the equation Copt = Egyptian Christian (P. Du Bourguet, 1975) and the hypothesis of Christian reinterpretation of works inspired by Hellenistic mythology (A. Torp, 1969). Moreover, many previously unpublished pieces have been made known. Groups of works and monuments have been re-examined. More attention has been given to identification of sources and ambitious programs have been prepared (and partially launched) for bibliographies, indexing, and collection of data regarding areas and monuments. In brief, there is a much clearer appreciation of the work which still has to be done. One significant result of this burgeoning of activities related to the study of Coptic culture is that the most recent works on Christian and Medieval archaeology in the Western world give ever-increasing space to consideration of Egyptian material.

Architecture. Little is known of the public buildings and residential houses of the better-off citizens. As regards the Ptolemeic period, the material analyzed in a study by M. Nowicka (1969) can also furnish useful indications for the Coptic period. The town houses of the wealthy must have been decorated with valuable materials, sculptures, and more rarely with mosaics. A mosaic pavement with polychrome hard stone and glass paste tesserae displaying representations of the seasons and probably datable to the fifth century has been found in the urban center of Antinoupolis (G. Uggeri, in "Antinoe," 1974). The study of military architecture received an important contribution with the publication of the fort of Qasr-Qârûn/Dionysias (J. Schwartz, A. Badawy, 1969). J. M. Carrié (1974) fitted this fort into the picture of the Roman architecture of the Low Empire, identifying the principia, throwing doubt on the hypothesis that the central building with a double row of columns can be accepted as being a basilican scheme, and finding clues suggesting at least two construction periods. The hypothesis that the first of these can be ascribed to the brief period of Palmyran occupation remains, in our opinion, still to be demonstrated. It would be useful to put the fort into closer relationships with the numerous others extant all over Europe (an interesting notice was given in 1901 by V. De Bock about one controlling the road from the oasis of el-Khârga to the Nile Valley).

Much more is known about the religious architecture which started, at least officially, from the Edict of Tolerance by Gallienus (311). The model which was greatly prevalent in cult buildings was the basilica, with some particularities which define an Egyptian type. Many sprang up in the surroundings of pharaonic temples, as at Luxor (where five have been identified – P. Grossman, 1974), at Philae, and at Dendera, where a basilica of considerable importance was constructed, toward the fifth century, between the "mammisis" of Nectanebo and the Roman one. The original project intended the construction to be placed in the courtyard, in front of the Roman "mammisis" as can be seen from the outline of the tricuspid apse cut into the paving

stones, following building practices belonging to the previous period (and to be seen, for example, at the Kalâbsha). It is noteworthy to see these practices still in use then. Building components taken from the pharaonic temples were frequently used, especially in the most exposed places, in accordance with a habit which had developed as soon as the ancient religion died out and its buildings became available for demolition.

Another interesting basilica is that excavated within the town boundaries of Antinoupolis (G. Uggeri, in "Antinoe," 1974) near the eastern gate of the city. This is a building in limestone and baked brick, provided with a crypt, and flanked on the north side by a paved area with porticoes on the two longer sides which it has been suggested was a cloister (but in our opinion this identification is doubtful). It is datable on the basis of the finding of a coin of Leo the Thracian (457 - 474). These were two different constructional periods, and it presumably remained in use up till the time of the Persian occupation (619 - 628).

In the field of monastic architecture, excavations have again been started in already noted monumental areas, as at Saqqara and in the St. Mena complex in the Maryût (excavation reports in MDAIK). The results profoundly modify the previous picture, for various monuments have been uncovered, cleaned, and studied and are collected in universal work which analyzes their architecture, decoration, and fittings (C. C. Walters, 1974). First of all, it must be remembered that monastic foundations showed different configurations according to whether they belonged to Anthonian or Pacomian communities. The Anthonian ones began to develop from the time, approximately 305, that St. Anthony (251 - 356?), the founder of monasticism, dedicated himself to organizing monastic life and have the characteristic of spontaneous aggregations grown up around the cells of certain hermits of great fame, or around their tombs, when other monks came to hear their teachings or to venerate their memory. The plans always respect the double intention of conducting a solitary life and of observing certain phases of collective life, at first the daily services and the weekly "agape." An evolution can be observed in the different emphasis placed on these two almost opposing needs.

The Pacomian foundations originate from the time of St. Pacomius, toward 320. The Saint organized the first cenobitic community at Tabennisi according to a precise rule inspired on poverty, obedience, and penitence (St. Pacomius is, in fact, the founder of cenobitism, or institutional monasticism in the Western sense of the term). The foundations reveal their character as planned for organized community life. The monks, therefore, preserve certain constant characteristics at all periods in their history. Among these Pacomian foundations, there was excavated in 1968 at Fâw Qiblî (F. Debono, 1971) the biggest cenobitic center, founded by St. Pacomius in 323. There have been identified, in three occupation levels, various buildings. There was a large 5-aisled basilica of which the great smooth pink granite columns remain and which was probably remodelled on the same foundations as the original basilica constructed by the Saint. Other monastic buildings have been identified and studied, including the Laura of Deir ed-Dîk in the Antinoupolis area (M. Martin, 1971), and the Monastery of Phoebammon, situated in the Thebes region at the end of a narrow valley at the foot of a cliff (Ch. Bachatly, 1961 and 1965). The study of this building has not yet been completed. However, the contributions to the two published volumes include a very interesting analysis of the botanical finds (V. Tackholm, III, 1961). This analysis has given results which are extremely significant also in the study of ancient flora in general.

Among the oldest monastic associations of Anthonian type are the Kellia, erected about 335 not far from Wâdi en-Natrûn. Because of the size and fame of the community many authorities cite the area (a masterly study was made by A. Guillamont, 1969). The zone is very extensive (20 by 8 kilometers maximum, covering a total of 100 square kilometers). It goes from Qusûr er-Rubâ'iyât, where a French archaeological expedition (F. Daumas-A. Guillamont, 1969) has worked, to Qusûr'lsâ, where Swiss archaeologists (R. Kasser, 1967, 1972) have dug. In this area there are spread around, without any traceable organized arrangement or planned road system, monastic institutions. Some are isolated, others are grouped into larger complexes. The recurrent module is that of rooms, cells for habitation, oratories, and larger chambers for communal prayers or meals. These are collected around a courtyard which is open to the sky and often partly under cultivation. The installations include services, storerooms, kitchens, latrines, and wells, tanks, and water pipes and are enclosed within a curtain wall, usually quadrilateral (and sometimes with watch towers). However, given the general layout, the wall does not seem to have been more than a boundary. The walls with towers and bastions which now surround some monasteries, as that of Amba Hadra (also called St. Simeon's) at Aswan and that of Wâdi en-Natrûn, are in fact later additions, probably not earlier than the eighth to ninth centuries.

The building material is unbaked brick with baked brick reinforcement and sometimes includes stamped earth. Some chambers are paved with cement. These have white plastered walls which often have rather simple painted decoration (floral and geometrical motifs, animal and human figures, crosses), especially inside the numerous niches which have been cut into the walls. The Swiss team, which surveyed the area, has uncovered at Qusûr el-Abyad a compact complex of rooms hypothetically destined for habitation or as a hostel for pilgrims. At Qusûr 'Isâ, a monastery called the House of the Boats from the recurrent theme in the wall decorations has three nuclei of rooms surrounding a large courtyard. On the basis of ceramic finds the complex has been dated between the second half of the sixth and the seventh century.

At Qusûr er-Rubâ'iyât the French mission worked at Kôm 219, almost in the center of the area. Here they found an important monastery with chambers decorated with paintings and inscriptions executed at various times between the fifth and the eighth centuries. There are indications of reconstruction, some of them perhaps followed the Berber incursions which devastated the area in the last years of Patriarch Damianus (604 - 605). A rebuilding carried out as a result of intercession by Patriarch Benjamin (622) has been noticed. The latest date on an inscription in the monastery is 739. According to 'Obeid el-Bakrî, the place had already been abandoned in the ninth century.

The three groups of hermitages excavated by a French archaeological expedition (S. Sauneron et al., 1972) in the desert west of Esna between the Deir el-Fâkhûrî and the Deir esh-Shuhadâ, near Nag' Buwayl and near 'Adâyma are also very significant finds in the study of the life of the monastic communities. A characteristic which seems so far to be unique in Egypt is that the hermitages are underground. That is to say, they are dug vertically into the ground and are reached by a moveable ladder or by steps dug out of the rock. At Nág, Buwayl there was only one chamber. The others consisted of more than one room connected with an open space, covered by a removeable roof of reeds. This courtyard usually leads to the oratory, the best looked-after chamber of the complex from which open the storerooms. Other chambers, the dormitory, and the kitchen (often provided with a larder and a cellar) open off the courtyard. These hermitages are dug out of the local conglomerate and are completed by unbaked or baked brickwork. The walls are plastered and often carry painting. The pavements are in cement or cobbles. In one of these hermitages at 'Adâyma a sealed cupboard which contained items of crockery and other objects of great interest was found. These finds illustrate aspects of the daily life of these hermits. These places were presumably inhabited between 550 and 630.

Sculpture. – Coptic sculpture shows, besides a substantial homogeneity of theme, differences of style which make it difficult to trace a coherent story. The work of J. Beckwith (1963) is a useful collection of material put in the setting of a brief introduction. A critical re-edition of this work could, in our opinion, lead to a framework of analysis for funerary steles of which there exists a proposed classification (DACL, 43-44, 1921) which needs to be re-examined in view of the large number of items which have been brought to light in recent years. This vast output naturally shows different stylistic configurations. The most useful fact from which useful data could be extracted is that often the area of provenance is known, and the inscription sometimes indicates the date of death of the person commemorated, which is bound to be highly relevant. It is material of which little is known. A corpus giving an exhaustive picture is very desirable. Already a preliminary examination allows different groups to be distinguished.

Among the oldest group is that composed of these steles from Kôm Abû Billû, the cemetery of ancient Terenuthis. The steles are of great interest in the study of the relationships between the culture of ancient Egypt and that of Graeco Roman Egypt (A. Hermann, 1963; L.V. Zabkar, 1969; K. Parlasca, 1970). The excavations, now carried out by the Service des Antiquités, have been very productive. In the 1974-1975 campaign other burials came to light, some with steles. About 6,000 tombs have been uncovered so far, restoring 450 steles bearing figures (J. Leclant, 1976). The recurrent themes are of the deceased, alone or with his family, with an arm raised in the attitude of prayer or taking part in the funerary feast; more rarely he is shown on horseback or holding a horse by the bridle. This was the case with a notable stele brought to light in the 1969 - 1970 diggings (ASAE, LXI, 1973). Also, among the oldest groups are those steles, often with no inscription, showing a young man standing or reclining with a bunch of grapes or a wreath in his hand and a small animal (or more often a bird). The steles are shown almost entirely in the round inside a niche. This category is commonly believed to come from Antinoupolis, but on grounds which now seem uncertain (doubts were advanced by M. Krause, 1971, and by S. Donadoni, 1974).

The only example with related stylistic characteristics (these are figures with accentuated volumes and clothing stiffly draped with almost parallel fluting) which has been excavated comes from Ossirinco. The interpretation proposed by H. W. Muller (1960), and frequently accepted, is that the representation of the young man means that the deceased was a follower of the cult of Isis. This interpretation remains. in our opinion, largely hypothetical. In fact, this same iconography is to be found in some Palmyran funerary steles. Here, the infant dead have a lateral plait. In dynastic Egypt this expresses the basic connotation of childhood and shows that this theme, which was Egyptian in origin, later spread to the neighboring areas which were in contact with Egypt. Its presence at Palmyra is a chronological element valid for placing these products at least as early as the beginning of the third century.

According to an interesting hypothesis by H. Torp (1969), the reliefs on mythological subjects from Ahnâs could have been part of the decoration of funerary chapels. It seems possible, in fact, that the necropolis in this center contained some funerary chapels (those to which these reliefs belonged) which were erected during the Coptic period above similar buildings of the Greek and Roman period and which retained the old decorative schemes. They would have been chapels commissioned by people of Greek culture. This work makes an extremely important contribution to the evaluation of Coptic art in general. Coptic art has in fact long been considered the Christian art of Egypt by many. For this reason, it is important to accept a reinterpretation from the Christian point of view, even though based perhaps on forced paradoxical concepts of the numerous representations inspired by the wealth of subjects from Greek mythology. Now Torp's work does justice to this ambiguous situation. If one accepts his hypothesis, it is necessary to admit that a production claimed to be typical Coptic art, such as that of the reliefs at Ahnâs, has no real Christian significance.

On the other hand, this is not so surprising when one considers that the Greek element remained present in the country to a very late age. This has been extensively documented. The Ahnâs production has also been examined by L. Torok (1970), who divided it into groups on the basis of the evolution of the motif of the broken pediment. The scholar offered a new dating period, placing it between the end of the third and the last decades of the fourth century—that is to say, in an earlier period and with a chronological range shorter than that of the traditional chronology. With regard to the sixth-century sculpture which has been documented principally in the monumental complexes at Saqqara and of Bâwît, two contributions made by H. Torp illustrate that eclectic classicism with a neo-Theodosian inclination was popular in Byzantium in the first decades of the sixth century. First (1965), two reliefs from Bâwît with unusual scenes from the life of Daniel and of David and, second (1962), the architectural decoration of Saqqara and of Bâwît where the unusual presence in church decoration of classical style human

figures is studied in relation to a particular stylistic moment of Byzantine art.

This same period at the beginning of the neo-Theodosian style would appear to be that also of the stele of Copenhagen (dated around 520). In the same volume, O. Grabar examined it from an iconographic point of view and with his sharp eye recognized in it the figure of a deceased person with the archangel conductor of the dead.

Painting. – The Coptic pictorial production developed from that vast complex of paintings on wood and on textile for funerary purposes with pictures of the deceased that go under the name of Fayûm and from the wall paintings in catacombs and funerary chapels, of which some outstanding examples have recently come to light in the environs of Alexandria and in the oasis of ed-Dâkhla during researches conducted by A. Fakhry in the acropolis of Qâret el-Muzawwaqa (J. Leclant, 1973, 1974). Looking at these works from a thematic and stylistic point of view, it is possible to recognize a language combining a mixture of ancient Egyptian and Hellenistic elements, cultural timing to which even works of uncertain provenance can be assigned, such as that pointed out by P. Du Bourguet ("Une peinture charnière entre l'art pharaonique a l'art copte," MDAIK, 15, 1957). Further examination (J. Schwartz, 1962; M. L. Thérel, 1969) has also been given to the complex of paintings in the Chapel of Exodus at el-Bâgawât in the oasis of el-Khârga. In this necropolis (in use between the middle of the fourth and the middle of the fifth century) A. Fakhry has identified 263 tombs in various shapes made of unbaked bricks, distributed along the sides of a main road and laid out in several rows that were joined by small secondary roads. The Chapel of the Exodus, a domed 5 by 5 m chamber, has the cupola decorated with glue tempera paintings. These paintings are somewhat out of the main stream of contemporary Egyptian painting as we now know it, both for style and for the choice and matter of the subjects represented.

These paintings include both Old and New Testament scenes that belong to the repertory of Judeo-Christian configurations of the third and the fourth centuries. The principal subject that occupies the entire calotte of the dome is the Flight of the Jews before the Pharaoh's army. Credit is due to recent studies for the clarification of the interpretation of the scenes and the order of their arrangement in a pattern of salvation, depicted in the threefold scheme of past, present, and future and fixing their relationship with the evangelical texts. A local cult of Saint Thecla seems definitely confirmed, perhaps in correspondence with the circulation of the apocryphal text of the Acts of Paul and Thecla. We are interested in the interpretation of the figure below Thecla as the deceased owner of the chapel. Furthermore, there is the fact that the figure is portrayed at prayer. The choice of themes alluding to the salvation and perhaps also the particular accentuation given to that of the Exodus has instigated an evocative hypothesis which connects them with the presence at el-Bâgawât between the fourth and fifth centuries of a community of Christian deportees among whom were members of the cultured classes of Alexandria, exiled here to prevent them from causing embarrassment to the regime. Fragments of paintings in the other chapels of the necropolis appear to indicate other similar themes: Paul and Thecla and the Sacrifice of Isaac.

Also, the pictures brought to light by the Italian archaeological teams in the necropoli of Antinoupolis are funerary paintings. The Chapel of Theodosius (sixth century) in the northern acropolis, brought to light during the excavations of 1936 - 1937, presents a style of painting which has been re-examined from an iconographical point of view by O. Grabar (1968). The deceased is represented between St. Collutus, a figure particularly venerated at Antinoupolis, and the Virgin Mary. The Saint, with one hand on Theodosius' shoulder, is taking him to the Virgin, who shows him the crown with a cross. Thus, he is playing the role of psychopomp saint, according to a scheme based on the ancient Egyptian iconography of the deceased accompanied by Anubis, often in a similar manner, to the tribunal of Osiris.

Paintings brought to light during the 1969 campaign (Donadoni, 1974) came from the southern necropolis: mirrors reproducing marble inlay work, peacocks, vegetable elements, two nude figures holding a spiral shell (one of them portrayed on a pedestal, like a statue), two figures in tunic and cloak. Monastic painting also enjoyed its greatest flowering between the fifth and the sixth centuries. A rather rare (dated no later than the fifth century) picture of Christ is in Room XII of the Monastery of Kôm 219 at the Kellia. He is in front of a cross (not crucified), his right hand with three fingers raised in the sign of a benediction, the left holding a closed Bible. The head, with a crossed halo, is in front of the center of the cross; the body rests on the lower arm of the cross itself. Also in the same monastery, in Room XXXIV, there is a painting of St. Mena in the usual iconography; the face and the body have been intentionally mutilated. Another room of the same group leads to an inscription which alludes to the Patriarch Dioscorus, 4 September (454) which, if it is contemporary, as is possible, or even probable, would exactly date the complex.

Reconsideration has been given, on more than one occasion, to the paintings at Bâwît. P. Du Bourguet, when tracing a profile of Coptic painting (1970), recognized three styles in Bâwît painting which fall between the sixth and the tenth centuries. The first, picturesque and lively, can be documented in the scene of the Baptism of Christ and is seen again at the Deir Abû Hinnis. The second, somewhat more severe, includes the group of Christ and the Apostles in the south church and other configurations of monks, while they are comparable also with the painting of the wall tomb in the Chapel of Theodosius at Antinoupolis and the group of three Jews with the angel at Deir Abû Sarga. The second group could be dated in the eighth century. (As can be seen, Du Bourguet favors a later chronology than that currently adopted.) The third style, rather heavier, includes numerous groups of monks and can be ascribed to the eighth to ninth centuries. The three styles are in accordance with the progressive accentuation of the decorative element. With regard to the meaning of one of the most noted paintings at Bâwît, which portrays the Virgin reclining and, facing her, Salome pointing a finger, we have offered the hypothesis (L. del Francia, "Le thème de la Nativité ..." that it is not a nativity scene, as is commonly believed, but rather an allusive representation of the dogma of the Virginity of Mary, a question enthusiastically received in Egypt at the time of the Council of Ephesus. The paintings in the convent of el-

'Adra al Deir es-Sûryânî in the Wâdi en-Natrûn, which belong to the ninth century, show a net differentiation from the language of the preceding centuries. Here, Du Bourguet notes, the characteristics are those of an official language permeated by Byzantine customs. The painting of the 12th and 13th centuries is documented in the convents of Esna, in the Convent of St. Anthony, in the Red Sea desert, and in the painting of Deir el-Abyad. This last painting is credited to the Armenian Theodoros (inscription of 1124).

All these paintings, and also those of Coptic churches of Old Cairo, have been discovered and studied by J. Leroy within a program carried out by the IFAO. Some complexes have been published (Monastery of St. Anthony). Publication of the others is expected to follow.

The Minor Arts: a. Illustrated Codices. – The Egyptian production of illustrated codices is not particularly large. Egypt is not like its neighboring areas which have major traditions in this art. Some 40 examples have been preserved and have been studied in an extensive and exhaustive work by J. Leroy (1974). Regarding the relationship with Coptic mural painting he notices an analogy of themes — Christ enthroned and Teaching; the Virgin, also enthroned, praying (Galaktotrophousa) — of the iconography and of style with the illustrated codices up to the latter part of the year 1000. Subsequently there is a difference which can clearly be seen in the Copto-Arabic codices. It was only then that the true and proper illustrated evangelistaries appeared. These found their highest expression in the Parisinus Coptus 13 and in the Copto mss. 1 of the Institut Catholique. The Copto 13 written, illuminated, and bound between 1178 and 1180 by Michael of Damietta (but the possibility of others having assisted can not be excluded) has 74 plates which accompany, in different proportions, Matthew, Mark, Luke, and John. We are in the presence here of traditional iconography produced in an Islamic style which also affects the details of the representations. It adopts a lively polychromy and large areas of gold. The N° 1 of the Institut Catholique was produced about 70 years later, in 1249 - 1250, by Gabriel (who became the Patriarch in 1268). It includes extra-text plates on ten large pages divided into six panels. This is a profoundly original work, realized on iconographical lines that are different from those traditionally ascribed to the Byzantine and Eastern worlds.

In the choice of themes one notices also the presence of scenes not found in the Copto 13, such as the Flight into Egypt, the parable of the wise virgins and the foolish virgins, the Schism in two pictures of Palm Sunday, and the nocturnal conversation of Christ and Nicodemus. Marked evidence of Islamization can be seen in the stylizations. The polychromy is brilliant and presents unusual rose tones. The bindings, of which a recent study has been made of a noteworthy example of the eighth century, are comparable to the bindings by Hâmûlî and are frequently of great interest. The oldest examples of books bound in Egypt are of the fifth and sixth centuries and come from the Library of Naǵ Hammâdî. The oldest decorated binding seems to be that of a volume of the Acts of the Apostles of the Glazier Collection on deposit at the Pierpont Morgan Library, attributable to the fourth or fifth century, in leather glued to wooden plates with a stamped decoration of small discs.

b. *Ceramics.* In Egypt, a global, systematic study of ceramics is something too recent to have obtained concrete results yet. (Announcement has been made of a general project of classification and study of Egyptian ceramics from the predynastic age to the Islamic, and a "Liaison Bulletin" is published periodically.) As regards the general lines, reference is made to the important work of classification of Nubian pottery carried out by W. Y. Adams (1962) and later modified by him. Also, the work of H. Jacquet-Gordon on the ceramics discovered in the hermitages at Esna (1972) is helpful. A profile of Coptic ceramics, preserved at the Louvre, has been prepared by Cl. Neyret (1968). Neyret is in process of classifying the ceramics brought to light in the excavations at the small Deir of Qûrnet el-Mura and datable to the sixth or seventh centuries (S. Sauneron, 1974).

The terracotta figurines in attitudes of prayer kept in the National Museum of Warsaw (31 pieces from the Edfu diggings) have been studied by K. Polaczek-Zdanowicz (1974), who associates them with the clay figures of Aphrodite and claims that they were connected to a fertility cult and that they were placed in the houses, churches, and tombs in an invocation for numerous progeny or the cure of sterility. For many reasons this interpretation does not seem very convincing.

The frog-shaped oil lamps found at Karanis in habitations datable between the second century and the beginning of the fourth century have been examined by L. A. Shier (1972). The motif of the frog, derived from dynastic Egypt, where it is found in the writing of the name of Heket, goddess of birth and of fertility, in Christian times came to mean rebirth and resurrection. In an example mentioned, of a later type, not confirmed by Karanis, there appears an inscription "I am the resurrection." The Coptic oil lamps in the Archaeological Museum of Florence, for which the provenance is indicated as Antinoupolis, have also been published (M. Michelucci, 1975).

c. *Textiles.* – A study has been made of the range of Egyptian, Greek, and Roman textile production (E. Wipszycka, 1965) starting from an examination of the documentary sources. The accent is put, above all, on the organization of the work of weaving, both domestic and in workshops. One can never insist enough on the importance of a continuous reference to the sources as a necessary preliminary to every historical research. The work quoted shows the kind of results that can be obtained. Research has also been begun relative to weaving (principally by the CIETA of Lyon, Abegg Stiftung of Berne, and the Textile Museum in Washington), analysis of the instruments and the materials used (yarns, mordants, dyes), and the problems relative to the preservation and exposition of this material. Some particularly interesting pieces have been made the subject of a monographic study (M. Th. Picard-Schmitter, 1962; E. Simon, 1970; and others). Interest has also been shown in the examination of a number of iconographies (S. Lewis, 1973; L. Del Francia, "Le thème de la Nativité. . ." We feel that for a schedule of iconographs on the art of the Nile Valley (a project which has been considered) (M. and J. Debergh-Rassart, 1975) the documentation offered by textiles could be of primary importance.

The chronology remains the most thorny problem. There are two trends, one toward an earlier chro-

nology, the other toward a late dating which puts the greater part of the production right into the Islamic era. But if the supporters of this last method are credited with having emphasized the continuity of Coptic manufacture in the Islamic period, it seems nevertheless that this position must be revised in the light of the latest researches and some recently published documents. to which a definite date has been assigned (W. Kosack, 1974). Furthermore, in a work now being printed ("Tissus coptes d'Antinooupolis. . .") we have inserted the contribution of a documentation, that of a group of Coptic textiles discovered in the northern necropolis of Antinoupolis during the Italian excavations of 1936 - 1937. This information is very valuable from many points of view. These are textiles which, thanks to the discovery of papyri in the same site, can be dated between the fifth and the beginning of the seventh centuries. This period is in fact before the Moslem occupation. This discovery shows unequivocably how certain techniques (embroidery, for example) and certain stylistic configurations (minute figurines thickly filling the entire surface), believed by many to be peculier to the Islamic age, can be assigned to an earlier period with confidence. The data we have available are already sufficient to allow a global study of Coptic textiles and to take account of the technical characteristics of the work and of the contribution that textiles offer to the knowledge of the culture of Coptic and proto-Islamic Egypt. This is what we are proposing to do within the scope of a program of work, announced and discussed ("Projet pour une étude générale sur les tissus coptes") during the 1st International Congress on Coptic Studies held in Cairo from 8 to 16 December 1976.

BIBLIOGRAPHY - For complete bibliographical information see the bibliographic catalogue cited. The selection of the works listed has been made fundamentally with the object of integrating the above-mentioned lists, to give a picture of the principal works, and to provide references to the arguments treated.

Bibliographies, News Letters: Annual Egyptological Bibliography, Leiden, from 1948; A. Biedenkopf-Zeihner, Koptologische Literaturubersikt, I, 1967-68, Ench., II, 1972 (annual); Bollettino d'Informazione. Sez. Archol. 1st. It. di Cultura per la R.A.E. a cura di C. M. Burri (three monthly); J. Dummer, Zusammenstellung koptische Bibliographie, Orpheus, 19, 1972; J. Leclant, Fouilles et travaux en Egypte et au Soudan, 1960-61, Or., 31, 1962 (annual); J. Simon, Bibliographie copte. 13 (1960), Or. 30, 1961 (annual until 1967; from 1971 continued by P. Du Bourguet).

General Works: E.J. Grube, Studies in the Survival and Continuity of Pre-Islamic Traditions in Egyptian Islamic Art. JARCE, I, 1962; G. de Francovich, L'Egitto, La Siria e Costantinopoli: problemi di metodo, RIASA, 11-12, 1963; H.W. Müller, Die stillende Gottesmutter in Aegypten, Materia Medica Nordmark, 2, 1963; Koptische Kunst. Christentum am Nil, Essen, 1963; M. Krause, Ägypten, RBK, 1, 1963; K. Wessel, Koptische Kunst, Recklinghausen, 1963; P. Du Bourguet, L'art copte, Paris, 1964; K. Wessel (Hrsg), Christentum am Nil, Recklinghausen, 1965; H. Torp, Book Reviews, AB, 47, 1965; J. Shapley, Coptic Art: A Review Article, Archaeology, 20, 1967; E. Dinkler (Hrsg), Kunst und Geschichte Nubiens in christlicher Zeit, Recklinghausen, 1970; M. Krause, Zur Localisierung und Datierung koptischer Denkmäler, ZAS, 97, 1971; W. Kosack, Alltag im alten

Ägypten. Aus der Ägyptensammlung des Museums, Freiburg, 1974; S. Sauneron, Travaux de l'Institut Francais d'Archéologie Orientale 1969-1974, Paris, 1974; H. Zaloscer, Die Kunst im christlichen Ägypten, Wien, 1974; M. and J. Debergh-Rassart, Pour un répertoire iconographique de l'art chrétien dans la Vallée du Nil, Hommages à Cl. Préaux, Bruxelles, 1975; P. du Bourguet, Une assimilation abusive "copte = chrétien (d'Egypte), Actes du XXIX Congrès Internationale des Orientalistes, Orient chrétien, 1975; A. Effenberger, Koptische Kunst, Wien, 1975.

Architecture: Ch. Bachatly and others, Le monastère de Phoebammon dans la Thébaïde, Le Caire, II, 1965, III, 1961; H. Torp, Murs d'enceinte des monastères coptes primitifs et couvents-forteresses, MEFRA LXXVI, 1964; H. Torp, La date de la fondation du monastère d'Apa Apollo de Baouit et de son abandon, MEFRA, LXXVII, 1965; A. Badawy, A Coptic Model of Shrine, OA, 5, 1966; R. Kasser, Kellia 1965, Genève, 1967; Id. and others, Kellia, Topographie, Genève, 1972; F. Daumas-A. Guillaumont, Kellia I, Kom 219, Le Caire, 1969 (rev. : R.G. Coquin, BSAC, XXI, 1971-1973; M. Nowicka, La maison privée dans l'Egypte ptolémaïque, Wrocaw, 1969; F. Debono, La basilique et le monastère de St. Pachôme à Faou-el-Qibli, BIFAO, 70, 1971; M. Martin, La laure de Dêr al-Dîk à Antinoé, Le Caire, 1971; S. Sauneron and others, Les ermitages chrétiens du désert d'Esna, 4 vols., Le Caire, 1972; P. Grossmann, Eine vergessene früchristliche Kirche beim Luxor-Tempel, MDAIK, 29, 1973; S. Donadoni and others, Antinoe (1965-1968), Roma, 1974; J.M. Carrié, Les castra Dionysiados et l'evolution de l'architecture militaire romaine tardive, MEFRA, 86, 1974; C.C. Walters, Monastic Archaelogy in Egypt, Warminster, 1974.

Sculpture: H.W. Müller, Grabstele eines Isismysten aus Antinoe/Mittelägypten, JbAC, 6, 1963; H. Torp, Two sixth-Century Coptic Stone Reliefs with Old Testament Scenes, AIRN, 2, 1965; A. Hermann, Das erste Bad des Heilands und des Helden in spätantiker Kunst und Legende, JbAC, 10, 1967; H. Torp, Byzance et la sculpture copte du VI e siècle à Baouit et sakkara, Synthronon, Bibl. CahA, II, 1968; H. Torp, Leda Christiana, AIRN, 4, 1969; L.V. Žabkar, A Graeco-Egyptian Funerary Stela, Studies in honor of J.A. Wilson, Chicago, 1969; K. Parlasca, Zur Stellung der Terenuthis Stelen, MDAIK, 26, 1970; L Török, On the Chronology of the Ahnâs Sculpture, ActHung, 22, 1970; S. Trauzeddel, Ursprung und Entwicklung des Orantenmotivs in der koptischen Sepulkralkunst, BBA, 43, 1972.

Painting: J. Schwartz, Nouvelles études sur des fresques d'El-Bagawat, CahA, Synthronon, cit.; J. Leroy, Peinture copte et peinture romane, VIII Congreso Int. de Arqueologia Cristiana, Barcelona, 1969; M.L. Thérel, La composition et le symbolisme de l'iconographie du Mausolée de l'Exode à El-Bagawat, RAC, 45, 1969; P. du Bourguet, La peinture murale copte: "quelques problèmes devant la peinture murale nubienne, Kunst und Geschichte Nübiens, cit.; O.F.A. Meinardus, The Martyria of Saints: the Wall Paintings of the Church of St. Anthony in the Eastern Desert, Studies in Honor of A.S. Atiya, Leiden, 1972; J.D. Deckers, Die Wandmalerei des tetrarchischen Lagerheiligtums im Ammon-Tempel von Luxor, RQ, 68, 1973.

Minor Arts: a) Illuminated Codices: M. Cramer, Koptische Buchmalerei, Recklinghausen, 1964; J. Leroy, Les manuscrits coptes et coptes-arabes Illustrés, Paris, 1974.

b) Ceramics: W.Y. Adams, An Introductory Classification of Christian Nubian Pottery, Kush, 10, 1962; CL. Neyret, Panorama et évolution de la céramique copte d'après la collection du Musée du Louvre, BAEO, 4, 1968; L.A. Shier, The Frog on Lamps from Karanis, Studies A.S. Atiya, cit;, G.

Beate, Menaslegenden und Pilgerindustrie, BMed, 9, 1974; K. Polaczek-Zdanowicz, Figurki Orantek Kopyjskch Pochdzce z Polsko-Francuskich Wykopalisk w Edfu, Roczik Muzeum Narodowego w Warszawie, 18, 1974 (French sum.); M. Michelucci, La collezione di lucerne del Museo Egizio di Firenze, Firenze, 1975.

c) Textiles: A.M. Franzen, En koptisk tunika, Rig, 1961 (English sum.); M.—TH. Picard-Schmitter, Une tepisserie hellénistique d'Antinoé au Musée du Louvre, monPiot, LII, 2, 1962; P. Du Bourguet, Musée National du Louvre. Catalogue des étoffes coptes, I, Paris, 1964; E. Wipszycka, L'industrie textile dans l'Égypte romaine, Wrocaw, 1965; G. Bröker, Koptische Stoffe, Leipzig, 1967; G. Egger, Koptische Textilien, Wien, 1967; R. Shurinova, Coptic Textiles, Leningrad, 1967; E. Simon, Meleager und Atalante, Bern, 1970; D. Thompson, Coptic Textiles in the Brooklyn Museum, Brooklyn, 1971; G. Weinholz, Koptische Stoffe, DK, 1972; S. Lewis, The Iconography of the Coptic Horseman in Byzantine Egypt, JARCE, X, 1973; D. Renner, Die koptischen Stoffe im Martin-von-Wagner Museum der Universität Würzburg, Wiesbaden, 1974; T. Svarstad Flo Undersokelser av koptiscke veveteknikker, Kunstindustrimuseet i Oslo, Arbok, 1972-1975 (English sum.); I. Peter, Textilien aus Ägypten in Museum Rietberg Zürich, Zürich, 1976; L. del Francia, Le théme de la Nativité dans les tissus coptes, à propos d'un exemplaire inédit, paper delivered at the 1° International Congres of Egyptology, Il Cairo, 1976; L. del Francia, Projet pour une étude générale sur les tissus coptes e Id., Tissus coptes d'Antinooupolis à Florence, paper delivered at the 1° International Congress of Coptic Studies, Il Cairo, 1976.

LORETTA DEL FRANCIA

THE MODERN ERA

FIGURATIVE ARTS IN THE RENAISSANCE
(PLATES 111-114)

Introduction. – A broad glance at recent studies of work produced during the Renaissance shows the vast increase in production that is evident both in the findings of new texts (or the critical re-examination of some already known through their restoration) and in the identification of a wider problem which weaves through the very fabric of traditional history. But it also appears that the methods of research, its means, and the legitimacy of its historical position are today the subject of passionate discussion, denounced in theory, and implied in the procedure of individual studies.

A sign of the importance and difficulty in choosing among the various proposed methods is given, in Italy, by the translation and consequent diffusion in recent years of what can be considered as its proof. Thus in the work of Panofsky, *The Meaning in Visual Arts* (1955), we see a new autonomous discipline, namely iconology, or the interpretation of symbols. This not only gives the purely formal circumstances for interpretation of works of art, but also the contents which would determine them. From iconology comes research that goes beyond the pure artistic facts (design, color, light) to the motivations behind their use in all fields of the culture of a particular era and the message brought across by the image supplied in art. The proof of this method is the particular part of the Renaissance in which art becomes, as never before, the converging point of innumerable cultural factors.

The institute formed by A. Warburg and E. Gombrich was founded by this method to reach art by means of a vast network of knowledge. The works of the two men aim especially at investigating how, in the Renaissance, opinions on art, either theoretically formulated or traceable only in testimonies of varying types, could establish a precise "norm" for the artistic production, which in some cases has continued into our times. From these suggestions comes, among other things, the danger of a very decisive interpretation of works of art on the part of outside agents. The agents today can become motivated by economic and political interests in the identification of a non-sociological society. The sophism invalidates the *Social History of Art* by A. Hauser (1956), where all the art work appears to be a result of an economic Marxist concept of history. In fact, the Renaissance appears to be more subordinate to the economic power of the classes of the patrons than to openness to new ideas. The most active period of the Renaissance is taken to be that in which the authorities of the Western world were in crises. The crisis reawakened the personal opposition of the artists to rules or mannerisms which were becoming void. It is true that Hauser himself, in his investigative study of *Art Theories* (1958), limits his own statement by assigning to art sociology a function not of a definite solution to problems, but rather of "declaration of the possibilities of rationally penetrating the problems of life, and battling against prejudices."

There is also the danger of avoiding instead of investigating the true artistic value and attributing it to other purposes. And P. Frascatel reacts to this in his 1970 studies, while accepting the possibility of the existence of an art sociology, which, however, he only sees at its beginnings. He admits that "the artist belongs to the society in which he lives," but he states, nonetheless, that "only when he can realise with his technique, harmonious and original works can he proclaim himself to be the mouthpiece of his environment." A true art sociology "cannot be developed without first becoming aware of the specific character of the figurative idea," different from all other forms of thought (verbal, conceptual, or mathematical). Its basic element is the "dialectic of space and time," understanding time as the fact which differentiates the constituents "from occasions, events, problems," and space as the fact which unifies, bringing the whole process into the present without hindering it. On this basis, he sees in the Renaissance not the new announcing of, but the persistence of, a problem which the Middle Ages had already posed, and which can only be given a new value. Italy is particularly active in this, not in the name of a supposed identification of artistic space with that of reality but, at the same time, developing "an imaginary space-time problem" which, in principle, is not different from the previous one.

Francastel's observations have helped also in the maturing of the problem of the sociological method. Hauser himself, in a more recent and comprehensive study of "The Sociology of Art" (1974), approaches similar propositions to a more detailed and diffused identification of cultural moments against the arrangements of tendencies to consider historic phenomena in the general categories of "Zeitstil" (and that of the Renaissance is now among the most compact and conditioning). Hauser emphasizes, in fact, the differences in synchronization, in reference also to developments of disciplines, and within these, of the technical phenomena and the cultural situations; thus he derives a type of approach, also on the sociological side, less axiomatic and encompassing, which more concretely adheres to the specifications of the historical phenomena.

The development of Hauser's ideas, and those of Gombrich (see his "Art History and the Social Sciences," 1975), stimulated E. Castelnuovo (in "Paragone," No. 313, 1976, and No. 323, 1977) to a broad scrutiny of the whole problem of the sociological

method, a positive reconsideration of some of his investigative means, and the proposition of particularized research themes which, in the field of studies on the Renaissance, have already shown themselves to have importance. An example is that of M. Baxandell's "Painting and Experience in Fifteenth Century Italy. A primer in the social history of pictorial style," 1974.

The problem, no longer so much that of a social history of art, has not only been shown as a hypothesis of elementary redemption of subordinate cultures, of applied arts, of the so-called "material culture" (as happened, for example, in the field of archaeological studies), but also suggests a re-examination of the criteria behind periodification and proposes a different determination, relevant also to social circumstances, with true adherence to historical circumstances. In a particularly significant manner, G Kubler, in his book on "The shape of time" (1962), speaks of the "history of things" and insists on pointing out the historian's specific roles of recognition and individualization of what he calls "values of position" which artistic manifestations have in relation to the conditions of their specific chronological sequence.

G. Previtali, therefore, in an examination of "Prospettiva," No. 5 (1976) and in the preface to the Italian edition of Kubler's book, sees in that methodological hypothesis the beginning of a new practice of global investigation of creative works and a radical critical revision of the moments of most intense dialectic of historical phenomena that was the Renaissance itself.

A clear but dismaying picture of the ambiguity which today undermines the same concept of history is given to us by the work of C. Brandi, "Teoria generale della critica" (1974). This work – *The General Theory of Criticism* – denounces in a narrow analysis the refusal – which was the basis of the structuralistic method – of any causal or temporal co-ordination of single phenomena linked only by similarities of "structure" raisable one at a time in a choice not always exempt from judgment in the multiplicity of the events of which any historical judgment thus becomes impossible. Argan, on the other hand, in the true declaration of method stated at the beginning of the issue of the journal "Storia dell'Arte," recognizes the shortage and sometimes empyreanism of the methods of traditional historiography. But Argan resolutely reaffirms, also for art, the legitimacy of an historical construction as an idea expressed through "signs." This necessitates the ability to read the signs, not in their external peculiarities, but in their internal genetic formulation and in their actual interrelations. For this reason, we can accept, but in a subordinate manner, as a method of analysis the proposals of structuralism, as those of psychology, sociology, and iconology provided they all concur with the establishment of a "history" in which the artistic factor, although illuminated in depth in every manner, maintains full autonomy.

The interest, which has intensified in recent years, particularly in these methodological proposals, denounces the growing recognition of the need to deepen awareness of art, to place it in the flow of history as an autonomous factor, irreplaceable, in line with and often in front of all other spiritual activity. If it is compared with the reality of operating in the art-historical field, we will see how it brings about a substantial and lively renewal. One of the most obvious testimonies to this is the studies of the Renaissance.

The Fifteenth Century. – The deepening of the investigation, promoted by new indications of method, has not yet altered the established periodification within the Renaissance in the two phases of the 15th century, as enunciation and first application of the new humanist and rational principles, and of the 16th century as their full explanation in "classic" fullness of expression, and therefore as their crisis (mannerism). However, it proceeded to a deeper historification of these phenomena, in the dialectic of their initial evolution, which brought the beginning of a new problem: the recovery of texts and their concatenation in time and space. The critical work was vast, and it is not possible to show it in detail. We must look at the main reviews, which collect the activities of individual groups working in each country and which often give lucid overall information. Touching only on the most vividly debated problems, and not on the particular procedures of the debates, we will look first at the fundamental principle of perspective. This was no longer considered, as in the historiography by Vasari, to have been a sudden invention by Brunelleschi and Alberti, but rather the end of a long elaboration of ideas on the illumination of their renewed thought.

If an implied, but not expressed, intention to demolish the mythical superiority of the Italian Renaissance appears occasionally in the decisive importance attributed to the culture of Northern Italy for the renovation of concepts of space, proportion, and size, the historical judgment of Klein, and particularly of Parronchi, who dedicated much time to perspective, seems much more composed.

The problem of spacial organic unity is seen even in the medieval view, particularly Arab intuitions and proposals which continue their course even alongside the Brunelleschi statement on "artificial perspective." Klein insists on the originality of the Paduan studies. In this manner, throughout the 15th century, there would be not one but several perspective systems. This suggests new angles for the interpretation of Ghiberti and Paolo Uccello, who were not incapable of understanding the Brunelleschi perspective, but were truly followers of different theories. Even if Brunelleschi were to reduce to the rational principles of mathematics the enormous confusion of previous visual notions, he still opens the way to a representation of space, the place of human activity in its "historical" explanation, which would have revolutionary consequences for all figurative art.

One must also consider that this catalytic and totalizing operation was carried out by Brunelleschi with an unheard-of ability for real intellectual invention. Nowadays, this is seen in the light of cultural incidences more complex than are traditionally maintained, or than even recently sustained by E. Battista and C. L. Ragghianti in their monographs on the artist (respectively 1976 and 1977). This is the result of studies which are still in progress. The studies, however, have been seen in advance on the occasion of the 600th anniversary of the death of Brunelleschi (1977). The work aims to outline the profile of a "non-classical" Brunelleschi, deviating in his creative pursuits from the rigors of an ideal normality, and open instead, as a result of his mathematical experience, to an experimental fervor

which continually proposes and verifies the same notion of perspective.

It is, nevertheless, along the lines of the general appraisal of the innovation of perspective that the most conspicuous nucleus of recent studies on the early Renaissance developed: the Brunelleschi indication of an attemptible definition of space. Parronchi concludes: "And it will be Donatello along with Masaccio who senses the possibilities within this space which is finally open to the certainty of light and the tricks of the atmosphere around bodies."

A lively discussion has opened in the last few years around these two very artists and their work within these new principles. There is now the question of establishing not only their relationship with Brunelleschi, but their reciprocal relationship with respect to the artistic activities of painting and sculpture. Was Masaccio the first to produce a "perspective painting"? Did Donatello suggest to him how the homogenous space of Brunelleschi could be filled with the vitality of real light, as Parronchi had clearly seen? Ragghianti had already asserted in Donatello the origin of pictorial facts which carried as far as Titian. Romanini had examined, in depth, the question of "Donatello and perspective." She returned to it in the course of the conference held in Florence in 1966 on the occasion of Donatello's centenary. Romanini noted how, "alongside the requirements of measuring and having the volume-space relationship with total and rational certainty of a number, one can detect [in Donatello] the opposite need to penetrate the very life of a space . . . of dynamic substance, determined not so much by the three-dimensionality of the bodies as by the live reality . . . of their free movement." On the one side, the determining action of Donatello on Masaccio himself sustained on the same occasion by the writer ("Donatello and painting"). L. Puppi placed the scenic novelty of Donatello's reliefs in Padua as a basis for paintings by Mantegna and the whole of Northern Italy, Foppa in Lombardy, Tura and Cossa in Ferrara, and even the Venetian Giovanni Bellini in the Pala of Pesaro.

The figure of Donatello was outlined at the conference, at which many aspects of him were explored. However, many of these aspects, unfortunately, have to be neglected here. His critical review, already begun during previous decades and continually removing him from the constrictions of a narrow "realism," to make him the protagonist of the rediscovery of the "reality" to which Brunelleschi had given the new method, was advanced. The reconstruction of his activities contributed to the rediscovery (by Parronchi) of one of his masterpieces, the linear crucifix in the convent at Bosco ai Frati (even though Parronchi's proposal of seeing the object of the famous dispute with Brunelleschi told by Vasari in this and not in the crucifix of S. Croce is not convincing). It was also contributed to by the attributive proposal of the head of one of the "Virtues" in the Loggia dell'Orcagna in Florence (Brunetti), the documented specifications of Sartori for the original appearance of the Altare del Santo in Padua, and the rediscovery and acquisition by the Victoria and Albert Museum of the bronze plate showing on both sides the "Madonna with Child" and identified as that given in 1456 to the physicist Giovanni Chellini by Donatello.

Also recovered, by means of critically knowledgeable restorations, was the stupendous original poly-chromy of the crucifix of S. Croce, the Maddalena in S. Giovanni in Florence, and of S. Giovanni Battista ai Frari in Venice, on which was uncovered the unthinkably precocious date of 1438, causing a revision of Donatello's chronology. Donatello's position of absolute pre-eminence is convincingly asserted by Pope Hennessy, who in his great study of Italian sculpture (1963 - 1966) places him at the top of the group considered in his volume on the Renaissance. Ghiberti and Jacopo della Quercia are placed in a splendid conclusion to the "Gothic" period. The great contemporary (1966) volume by Seymour on the same subject assumes on the other hand as a fulcrum not so much the perspective principle as the "classicism" shown in the work of Alberti and Ghiberti. Although, it gives a thorough investigation and distinguishes between the phases of "definition," "consolidation," and "elaboration" as coinciding with a true succession of operative phases until 1465, he then has to return for the ensuing phases to the uncertain "titles" of "regionalism and eclecticism." For Tuscany, "activism and realism" is used when the word "classicist" is insufficient to define the flow of the Renaissance.

It was also an arduous task to try and trace general plans while there still remained individual episodes in Italian sculpture on which today there is in progress a close critical exercise, of which we can only give an insufficient and empty review. There are innumerable contributions, be they monographical, like that of Cardellini (Desiderio da Settignano), Passavant (Verrocchio), Seymour himself (Jacopo della Quercia), Kuhlenthal (Agostino di Duccio); specifically attributive like those of Marchini (Ghiberti), Sciolla and Hersey (for the Arco di Castl Nuovo in Naples), Kruft (D. Gagini); or constituting recovered works such as the marvellous "harmonious works" by Benedetto da Maiano, now reunited with other parts of the unfinished Coronation of Ferdinand of Aragon in Naples. These are surrounded by the vast general studies by Del Bravo on "Sienese sculpture" (1970) and by Wolters (1976) on Venetian sculpture. The latter is a truly erudite corpus, but also of great enlightening critical openness, particularly in the reconstruction of the work of Bartolomeo Buon, recognized author of the much disputed "Judgment of Solomon" on the Doges Palace, and the true interpretor of the contributions of sculptors from Florence as a renewal and not a rejection of local Gothic work.

If one considers the personalities of the Renaissance "creators," the reception of their statements in a "Gothic" language, we see that they are not in the least bit decadent, but rather vital and capable of development. In its European diffusion, we see the problem enriching and becoming more complex, stimulated by the new relationships established methodically between art and culture. The rediscovery (1967) in the Palazzo Ducale in Mantua, of a great mural pictorial cycle, immediately recognized as the work of Pisanello, was the great occasion of a new identification of his art by both Paccagnini and Degenhart. Paccagnini discovered it, directed its restoration, and established its dates within the last phase of the master's work which was interrupted by his death in 1455. Degenhart, exploring the relationships of the artist with the chivalrous culture of the Gonzaga court circle, saw how the same fairytale subject of the mural cycle, inspired by the story of King

Arthur, was tainted by an ethical/satirical feeling on a purely human basis. The attention Pisanello paid to the Florentine news, confirmed by his drawings which reproduced works of Donatello and Luca della Robbia, prompted Chiarelli to the hypothesis of his stays in Florence, already overshadowed by the proposal of his collaboration with Gentile da Fabriano in the Adoration of the Magi of S. Trinità (1423).

The opinion which seems to be confirmed in the movement of studies occasioned by the centenary of Jacopo della Quercia is that the Gothic style, in Italy, could insert itself into the exemplary ways of the Renaissance renewal, bringing to life its own structures. Brandi, in his brilliant preface to the catalogue of the instructive exhibition held in Siena in 1976, maintained that from the same complexity of the Gothic rhythm, Jacopo took the idea for an "Internal circulation of the image." This regenerated the idea in an unparallelled plastic tension, which even rejects the spacial suggestions of the quashed Donatello. Therefore the idea will have no consequence in painting, but in the great sculpture of Michelangelo. For this evolution, albeit with its individuality, during the new Florentine culture, the convention of Siena which accompanied the exhibition (proceedings edited in 1977 by G. Chelazzi Dini) was favorable to the idea of accepting the hypothesis formulated by Brunetti. It was greatly discussed until now, on the first formation of Jacopo in the Florentine workshop of the Porta della Mandorla, where today one can see the convergence in a new humanistic inspiration of a multitude of tendencies that originate not only locally, but also from Siena, and even from over the Alps. The problematical research into the origins of Jacopo in Siena, Lucca and Bologna in the Dalle Masegne, which so exhausts critics, would thus be simplified with recent, not altogether persuasive, proposals (Seymour, Kusenberg). Positive contributions, founded on new documentary bases, were obtained from Matteucci and Beck for his mature work: the portal of San Petronio.

André Chastel, in his fundamental work on "Art et Humanisme à Florence au temps de Laurent le Magnifique," published in 1955, had singled out the dialectic tension noticeable in the 16th century between the theoretical research of the intellectuals and the "culture des ateliers," the thought which is borne and elaborated on in the reality of the operative experience. The investigation of this culture increasingly affects critical work of today. A symptom of this is the growing importance of the study of design, interpreted not as material preparation for specific works, but as an investigation into the genetic process of the very reality of the operative procedure. We have had not only the publication (1961) of Berenson's Florentine drawings, but also the integration of this first basic collection with the corpus of Degenhart and Schmitt, whose first volume appeared in 1968. Public and private collections articulated in every country the investigation of their very contents by means of general catalogues and special exhibitions which were periodically and critically illustrated. From drawing, the investigation turns to all collateral incisory work, in which the circulation of the ideas in all Western countries comes especially to light.

In the boundless literature which gives origin to this feverish critical activity, we can only touch on the work "Disegni dal Modello" by C. L. Ragghianti and G. Dalli Regoli (1975) (preceded by partial studies published annually in "Critica d'Arte" and by the monograph of Dalli Regoli on Lorenzo di Credi of 1967). The basic enlightening which came from these works to the study of the late 15th century in Florence was the regrouping of drawings, dispersed by early criticism from various artistic personalities, into one group of studies from life, so it seems, in that work organization which critics saw as the so-called "workshop of Verrocchio" (Ragghianti seems more inclined to move the directive center towards Sandro Botticelli in the years following 1470).

To reconstruct factually the incessant experiences with which the Renaissance artists fuelled their art, the greatly intensified interest also aims at those which were once called "minor arts." Today these seem more like the field of exploration of materials and techniques. For questions inherent to embroidery, tapestry, and goldsmithery, dominated by the great figures of Pollaiolo, Verrocchio, Benedetto da Maiano, one should refer to the recent catalogue of the "Museo dell 'Opera del Duomo' in Florence (Becherucci – Brunetti, 1967-1968). A greater understanding of Botticelli, who is increasingly described as an inexhaustible experimentor, will be found here, and also in the volume which Garzelli (1973) dedicated to her embroidery. However, we cannot move any further forward from the field now open to research and in which innumerable single contributions still await some sort of organization.

In present opinion, the Renaissance is presented as a feverish dialectic of problems and not as a calm procedure in the security of tradition. New angles continuously appear for the interpretation of individual artists. The monograph by Marchini on Filippo Lippi (1976) reconsiders in the light of their close inter-relationship the facts that the previous critic had listed as signs of discontinued eclecticism. Pollaiolo, in the margins of the excellent monograph by Busignani (1969), the examination of the Silver Cross in the "Opera del Duomo" (Becherucci, Catalogue 1968) stabilizes, in a renewed study around 1468 of the work of Donatello, the basis of his latest development. Busignani also proposes a reconstruction of the youth of Verrocchio who, although only one of his works has been accepted — S. Scolastica di S. Spirito — is not lacking in valid suggestions. Passavant, painstakingly analyzes the painting, which is still waiting to be fully extricated from the confusion with Ghirlandaio and Perugino.

Evident contact with Flemish art by these masters has been validly specified from documented certification (Hatfield Steens, 1968) of the date of the arrival in Florence in 1483 of the grandiose Trittico Portinari of Van der Goes. But these return to the broader picture of the relation between Italian Renaissance painting and work from over the Alps by the Flemish and German artists. On this subject, the acquisition by the Museo del Prado of an unpublished "Cristo Morto" attributed to Antonello da X. de Salas (1967) and accepted by R. Pallucchini (who has also published a new "Ritratto virile" by Thyssen of Lugano, 1967), has unquestionably enlarged the range of the Antonellian circle and its implications on Venetian culture.

Those who study perspective are troubled by the question of a Flemish priority compared with Brunelleschi's formations. Parronchi, in a proposal of recomposition of the "Polittico dell'Agnello" by the Van Eyck

brothers, sees in it an undefined spacial concept far removed from that of Brunelleschi. The Renaissance of the north had its own existence no less important, if its premises were completely independent of those imposed in Italy. This is the informative idea of the recent work of P. Philippot *Flemish painting and the Italian Renaissance* (1970), which follows the evolution of painting through its diversification in many local schools of the Netherlands, but always within the premise of a space which, "ignoring the internal order of the integral perspective which is pre-existant in bodies and shapes, reveals to the contrary the infinite unity of a reality which surrounds everything, including the onlooker." The representation of this "infinite unity" is based predominantly on light and color and will attain in this manner an insuperable pictorial coherence. In German painting, however, it was the expressionistic tension of the plastic block, derived from the sculpture of the late Gothic period, that discomposed this unity of the contrast and dissonance of tones which followed the clash of relief plains.

The contacts of this art with the Italian humanistic concept occurred through partial assumptions, but not for the identity of principles. The awareness of this diversity and the great effort to overcome it was to be the task of the great personality of Albrecht Dürer.

In 1971, the centenary of his birth was the occasion of a total critical revision and integration of the now classic biography by Panofsky (1943). In the great exhibition held in Nuremberg in 1971, the personality of Dürer was presented not only through his painting, drawing, and incisory activities, but also through every aspect of his thinking. Dürer's thinking was oriented to assume the great eloquent Italian discoveries, right at the moment of a passionate adhesion to and participation in the intense spiritual movement of the Reformation. As a new analysis of this idea with all its implications, a lovely catalogue with an introduction by H. Kauffman was prepared.

Working on this catalogue with Kauffman was a whole army of historians, not only of art, but also of humanism and religious movements. To each group was entrusted a chapter of the total review of activity, both theoretical and practical. In Dürer is embodied a "moment" from European thought; a basic attempt at synthesis. The direction of this drive for synthesis begins in the north of Italy, between the pictorial space of Flemish painting, the chromatic and formal expressionism of the German, and the Italian research into a law of mathematical certainty of the structure of the universe, man, and nature. The pure spirituality of the Reformation and the rational concreteness of the Italian Renaissance – directly investigated in travels across Flanders, Germany, and in Italy in Venice and perhaps in Lombardy and Rome and culturally addressed by the German humanist Pirkheimer, who was its great friend – became the terms of a stylistic tension which will have profound effects on the Italian 16th century. In the vast experience of Dürer, Winzinger discerns, through drawings, the proof of his attention to Leonardo. Finally, the iconological study of M. Calvesi on the meaning of the famous "Melancholia" proposes an interpretation in an alchemic key, Alchemy, taken not as a semimagic technique for transforming substances, but as a real system for reconducting — with other means than those of Italian speculation — according to

a unitary law the multiform structure of the universe. New critics will see Italian artists such as Parmigianini moving in this direction.

Limiting, through necessity, the present proof of the only statement of the principal problems proposed by the most recent criticism, it is impossible for us to exhibit particular parts of the great investigative work on the more specific problems of trying to reconstruct in detail the historic fabric of the Renaissance. The recent reprint of the "History of Art" by Adolfo Venturi and the publication of the whole of the works of Roberto Longhi, draw again to our notice the great models of an extensive investigation into all the Italian schools, equally active in the elaboration of that complex action within the new principles. In greater detail, the vast synthesis of R. Pane on the Renaissance in southern Italy (1975) constitutes a sure point of reference for a problematically complex view of the culture of one of the most fervent areas, which is still insufficiently explored, of the Renaissance world. It is said that a frequent contributor to the capillary research and reorganization of facts is the restoration conducted today, with the critical intentions not only of preserving, but also of restoring the integrity of the texts. The exhibitions held in all major Italian centers to publicize these results are continual reminders of a knowledge which is constantly spreading. We touch on those, determined by the great restoration campaign begun in Florence by the disastrous flood in 1966, which brought, among other things, a powerful updating of techniques. Among the most important recoveries we remember, for knowledge of the 15th century in Lombardy, was that of the frescoes on the facade of a house in Via Arena in Bergamo. The frescoes were restored by Mauro Pellicoli and attributed to Bramante. M. L. Ferrari (1964) brought to light the great importance of these for the diffusion of art in Lombardy, the mediation of the artist, and the principles of space of Piero della Francesca. We can consider the very accurate restoration led by A. Blunt (1975) of "Trionfi di Cesare" by Mantegna at Hampton Court to be a true critical recovery which today allows the reading of the original text.

The Sixteenth Century. – Recent reflections on the 16th century seem to assume a different attitude from those previously followed. In previous decades, critical attention was particularly polarized on abnormal phenomena, on crises rather than evolution of the Renaissance premises, from which there was a wish to identify the presumed autonomous tendency toward "mannerism." Today there is a return to the study of the initial movement of the 16th century. Instead of the Renaissance premises of rational coherence, "heroic" exaltation of the historic actions of man (Weise) seems to be confirmed in an ideal balance of images called "classic." Today, the investigation into this very classicism, in the work of its greatest advocates Michelangelo and Raphael, to discover how, also, in that grandiose balance there persisted the profound tensions, the ambiguities and contrasts which Chastel had seen circulating throughout the Renaissance, is being carried out.

Although isolating these tensions, Battisti (1962) managed to configure the persistent opposition of an "antiRenaissance." There is no doubt that from their presence was integrated a dialectic of the most complex artistic movement that had ever existed. The result is

not a decrease, but rather a much deeper knowledge of its historic value.

The study of Leonardo holds the primary position in this new historicization because the whole difficult problem of the 15th century of a new interpretation of the universe was fired by the superior intelligence of this artist. From the studies of Leonardo since the mid 1950s, Anna Maria Brizio in 1968 gave a lucid detailed report. She concluded it with a most important fact: in 1967, two stupendous manuscripts by Leonardo, which today are given the names Madrid I and Madrid II, were rediscovered in the library of Madrid. The happy circumstances of the rediscovery, fortuitous, but preceded by research conducted by A. Corbeau and L. Reti, are exhibited by Brizio. Brizio also gives the description of two codes and makes us aware of the first studies on these. The criticism during the ensuing years was mainly directed toward the new illumination brought by them to the interpretation not only of art, but also of Leonardo's way of thinking.

The subject of the two codes was, in fact, mainly scientific, although it did also contain some notes regarding painting. The tendency of modern day criticism is, in the opinion expressed by Brizio, to not dissociate the figure of Leonardo as a scientist from that of Leonardo as an artist. Furthermore, as A. Marinoni made very clear in 1974 — at the Lettura Vinciana which was held, as it is every ten years, in the town of Vinci - the limitations found in Leonardo as a scientist, his discontinuity, his cultural gaps which he tried so hard to fill, become somehow live stimuli for the imagination of the artist. The motion is not, and cannot be, due to Leonardo's scarce mathematical knowledge, the object of a systematically scientific investigation, but it attracts him for its dynamic aspects. It is the artist and not the scientist who "even in the movements of insensible things wants to reveal the 'virtues' or secret forces which move the earthly machine." The sharp exegesis by Marinoni shows the awakening in Leonardo of "the meeting, which is also a clash between the world of work, which wants to have a scientific discipline . . . and the world of traditional academic culture, which, to stay close to the absolute subtlety of the ideal forms, has ignored the contacts with the varied activities of the world of experimentors."

Brizio, in the "Presentazione dei Codici di Madrid," held in Vinci also in 1974 (Florence, 1975), maintains that the vast clarification of scientific interest happened particularly in Milan when the artist passed from the culture of the workshops, from his special practice as a painter of "ingeniarius ducalis," which gave him greater operating responsibilities which required a more systematic knowledge. It was in Milan that the meeting took place with Luca Pacioli. The geometric studies which began then increasingly held his attention. Ragghianti, furthermore (Disegni dal Modello, 1975), examining the group of youthful drapery designs, chronologically corresponding to the stay of Leonardo in the workshop of Verrocchio, sees in these the overcoming of the accepted principles of Alberti in the dynamic tension impressed on the movement of bodies, the dialectic of light and shade, and the very regularity of perspective. Finding a correspondence with some of his statements, later united in the treatise on painting, Ragghianti deduces from this that the origins of all of Leonardo's thoughts are traceable right to his juvenile participation in the experiments which he did with the artists of Florence during the decade from 1470 to 1480. This was also the intuition of Castelfranco in his "Studi Vinciani" collected in a book in 1966.

The problems of the paintings on which Leonardo collaborated, along with other frequentors of Verrocchio's workshop, have had explanations from Ragghianti himself limiting his part in the Baptism of Christ and by Passavant for the Annunciation in the Uffizi Gallery, work which was begun by Ghirlandaio. For the beginning of the Battaglia d'Anghiari he gives us the precise date of June 6, 1505, in the manuscript II of Madrid, investigated with exhausting acumen by Pedretti (1968). Pedretti, who also traced in the so-called "Tavola Doria" (which passed from the possession of the Duca Doria d'Angri to Col. Hoffmann of Munich) one copy of the only part carried out (the fight of the horsemen) closer to the methods of Leonardo than all others that have been discovered so far. This particular work is of such high quality as to suggest that it could be the hand of Raphael.

The other dated indication, contained in manuscript number II on the phenomenon of "green shadows" noted by Leonardo on the wall of a house in Piombino which he visited in November 1504, gave occasion to Parronchi, and therefore with deeper investigation to Pedretti, to sharply interpret the gradual maturing of the thought of Leonardo on painting as knowledge of the universe.

Freedberg, placing Leonardo at the top of his investigation into the "classic style," places the accent on the unitary harmony of his composition of shapes, but in this ideal harmony he sees the convergence of a deep knowledge of reality "which the intellect can discover beyond the face of visible experience." Thus conceived, classicism is not an exterior formula, but rather, a method of interpreting reality. It may have an evolution consequent to the evolution of this interpretation. In this picture of problems there is a special place for the influence which Leonardo exerted on the painting of Raphael and Michelangelo, not to mention on the first "mannerism" in Florence and Rome, until almost halfway through the century. K Weil-Garris dedicated a series of studies to this theme (1974). The research into a superior "truth" of form, interpreted as beauty, and a bitter sense of reality are placed in dramatic and unsolved opposition. This is continuously recognized in the investigation on Michelangelo to which the occasion of two centenaries gave the incentive - that of his death (1964) and that of his birth (1975). The celebration of these had results which were not rhetorically memorable, but were aimed at deepening critical knowledge. In 1964, the Istituto di Studi Michelangioleschi of Florence was created which, guided by C. Tolnay, undertook the publication of the correspondence of the artist. Meanwhile, Paola Barocchi, in the republication of Vasari's life of Michelangelo in the two versions of 1550 and 1568 (1962 and following), in an erudite but also deeply critical manner, presented a milestone for all present and future studies. Furthermore, the very corpus of Michelangelo's work has been increased by significant works, the discussion of which leads to a completely new direction of studies.

Alessandro Parronchi has stated ("La Nazione," March 6, 1975) that, rather than seeing Michelangelo as

a superhuman apparition, beyond which any possible historicization may need to "follow him to the center of reality . . . allowing oneself to be led into the most intimate grains of existence . . . research Michelangelo in his human dimension, freeing him from the commonplace critical formulary." This does not, however, mean fine desecration in itself, but research into a human effort to heighten "the sense of beauty beyond a purely personal concept." In this wish, into which is translated the suffering and the effort of a very high personality, the very effort of the whole Renaissance, appears today the modernness of the artist. The critics attempt to return to the period of the artist's formation, to the time when Michelangelo was able to individualize into tireless experience that which was later to be the dramatic directive of his maturity.

Object of a still unfinished discussion is the rediscovery by Lisner (1964) of the wooden crucifix which Michelangelo had carried out as a young man for Santo Spirito. The powerful originality of interpretation which is manifest in this, from the circulating facts in coeval sculpture, speak in favor of Michelangelo. Lisner has, in fact, maintained her attribution by trying to reconstruct this previously obscure formative period of Michelangelo during which the artist's attention turned fully to Italian sculpture as far as Arnolfo and Jacopo della Quercia in Bologna. She tried, also, to establish the collaboration of Baccio da Montelupo in the little statues on the Piccolomini altar in Siena and hypothesized a strong connection with the workshop of Benedetto da Maiano in the possible participation in one of the putti on the altar of S. Anna dei Lombardi in Naples, and finally reconducted to the knowledge of drawings by Leonardo the complex problems of movement which he posed himself in the Bacco (Bargello). This research culminates in the studies of Parronchi. Parronchi tries to convalidate, with temerarious attributions which are sometimes difficult to accept, the origin of the titanic drama of shape in which all the experiences finally converge.

According to Parronchi, the great Roman experience which revives classicity "in the order of spirituality even more than shape" will be fundamental. To clarify this we are shown the proposal of identifying the "Cupido dormiente" (Sleeping Cupid), declared a classical re-elaboration, with a sculpture in a private collection in Bologna or in another statue also privately owned in Florence, the Hercules for the Palazzo Strozzi (later passed on to France and lost), on whose base it is supposed that the "Zuffa dei Centauri" was destined. Whatever opinion one may have on this and other proposals contained in the two volumes (1968 and 1975) on the "Opere giovanili (Youthful work) di Michelangelo," the critical design is the valid manifestation. Its validity is superior to what has been done in the last few years for the understanding of the unique position of Michelangelo throughout the course of art. "The ideal of speed, grace, and accomplished subtlety" was a fruit of his stay in Rome. The young artist had already discovered the "need to not completely extinguish the shapelessness from which shape was born," the germination of the "unfinished" future.

Placing Michelangelo resolutely in this evolutive direction, one must reconsider his youthful painting, choosing between the two antithetical positions: that of Salvini (1966), who decidedly refutes the so-called "Madonna di Manchester" (London) and the works reunited with it by Fiocco (apart from the Deposition, also in London), and that of Mariani, who recognizes the entirely Michelangeloan high quality of the most important of these works, on which we are completely in agreement with Mariani, at least for the two paintings in London.

In the activity of the artist's mature years, we notice a specific uncertainty which we cannot even begin to summarize. There is an outline, instead, of fundamental importance in the very recent rediscovery (1976), effected and illustrated by P. dal Poggetto, of a series of large figures in charcoal on the walls of a semi-subterranean room at the New Sacristy of San Lorenzo. Dal Poggetto believes this to be the refuge of the artist during the persecution following the siege. The consensus of most critics is not obviously without opposition. It seems to us that only a mature Michelangelo could have drawn with such a certain hand those enormous nudes, some of which anticipate those of the Judgement. They would appear to demonstrate how the artist already had his future masterpiece in mind before the Papal commision. No less important is also the rediscovery by Mantura (1973), in a private collection in Rome, of the first draft of the head of Christ for the Pietà Rondanini. This brings interesting clarification to the event.

In the general synthesis of previous studies, in two great volumes published in 1966 by Mario Salmi (to which we refer for bibliography), one notes particularly that of G. de Angelis d'Ossat's work on Michelangelo's architecture. It attracted the attention of the most recent critic (Ackermann, 1961), who tends to see in it, projected into construction, and in opposition to Bramante's classicism, the strong tensions of mass in the very sculpture. But the event of architecture and town-planning is not followed in this study for the detail of his questions of a technical type, which only specialists would be able to understand.

The subject of this more intimate historicization of great figures, with a secular investigation which has not subtracted from the danger of an hagiographical crystallization, appears otherwise evident in the more recent consideration of Raphael. Reference was made to the artist with particular emphasis by the English critic who, in the last century, participated in the unmitigating campaign of the "Pre-Raphaelites" the later reprinting of the monograph of Oppe, who already in 1909 represented its first opposition, is symptomatic. The studies of Pope Hennessy and the part relative to Raphael contained in the History of Italian Art by Freedberg, have become associated with the studies of Hirst, Shearman, and, in German criticism, of Oberhüber. The authors were particularly intent on intrepreting the illuminating event of works which were previously uninvestigated — works such as the Cappella Chigi Chapel in Santa Maria del Popolo and in the Santa Maria della Pace in Roman churches.

A broad glance over the corpus of the work of Raphael, and his configuration in modern criticism, are permitted today by the vast catalogue of L. Dussler. The catalogue was republished in an English translation in 1971. Studies on every aspect of the activities of the artist known by 1968 were published in a two-volume work accomplished on the initiative of M. Salmi.

Longhi's 1955 attribution to Raphael of the altar-step at the Pala di Fano presented valid suggestions for Raphael's placement beside Perugino, but with strong Florentine components. We are even induced (by Becherucci) to suppose that the very young Raphael was with the master (before he was in Perugia) in Florence where Michelangelo had moved in 1493. Here it was possible for him to gain the experience of the figurative problems which later determined the "critical" attitude recognized in him regarding the master. Wittkower reconstructed, on a new basis, the first autonomous activity of Raphael since the Vatican Coronation. There is also the detailed investigation by Shearman (1972) on the sketches for the tapestries in the Sistine Chapel. In the convinced integral application of the iconological method, he asserts, on the basis of innumerable texts investigated for the first time, that the later evolution of Raphael occurred in the faithful figurative rendering of the great political-religious plan of Julius II. In this declared crisis with the esthetic criticism, the individual artistic will of Raphael is sometimes overshadowed. The intention to subtract Raphael from the olympic myth in which he has been placed for centuries, to place him within the active course of history, is no less appreciable.

This course appears to be the common aim of all modern criticism in the investigation into the 16th century event of the Renaissance. The concept of "mannerism" is still accepted for the crises which cross it. Weise (1971) gave an exhausting critical balance of the whole problem. There is no longer an effort to compare this active phenomenon with the static hesitancy of a "classic" norm taken as definitive so much as to see it only as an episode of the vital evolutive tension which is discerned within "classicism" itself. Thus, the most recent research no longer concentrates on the punctual verification of opposing and rigidly preconceived stylistic systems, but rather on following the inter-relation in the subtle differences which the 16th-century language suffered during its great expansion in Italy and the whole of Europe.

Shearman postulates, along with the two currents of classicism and mannerism, an introductory address to the 17th-century renewed "naturalism" which informed Venetian painting. Florence also had an exponent of this in Andrea del Sarto. Faced with the definition given, by Shearman (1965), Monti based his view on the disagreement between the two contrasting tendencies, but Freedberg (1963) had reconducted it to an active and knowing action for an intimate evolution of the "classic style." This style never renounced, even while wanting an ideal "norm," toward a deep incessant experience of reality.

Today, we recognize how pure naturalism is not enough to explain even the exclusively painting procedure of Venetian art.

The recent recovery, with the restoration of the frescoes on an outside wall of the Fondaco dei Tedeschi in Venice (1967) by a young Titian, shows him to have a deep knowledge of Renaissance classicism. His splendid color is always maintained by a full awareness of shape. This style is followed from one to another of his works, which are now gathered in a grandiose corpus by Wethey (1975). In Venice, the statements of the Renaissance were not an external assumption, but a hard-earned conquest, since the 15th century is testified to by

the long experiences of the major masters. These are outlined for Giovanni Bellini by Robertson (1968) and Huse and for Giorgione by Pignatti (1969). It is the beginning of a long and intricate period which found a new apex in the ready reception of formal Tusco-Roman elements, already in balance on "mannerism," in the young Tintoretto and in Jacopo Bassano. On the subject of the latter, he again demonstrated the new reading allowed by an exemplary restoration of the frescoes with bible scenes on the front of the Michieli-Bonato house in Bassano, which is dated to approximately 1540.

Maturity is gained in the new methodological approaches. The present investigation shows the monographic studies which appear also around cultural areas which were previously considered to be marginal and inert. We perceive in the studies of these areas the active contribution of artists who were previously relegated to an opaque "second level" and continually suggesting new historical perspectives from which emerges the vast contribution of figurative art to the evolution of civilization. The continuous progression of photography and typographic art, guided by a more secure critical judgment, contributes to the growing expectancy of the analysis. Exhibitions and the discussions which they cause, reflected in catalogues and conferences (see bibliography), give a maximum incentive to this detailed recovery. The premises of a new and more concrete historical synthesis are developed in this context.

One tries to penetrate the thoughts of the artists by means of contemporary writings. The publication by Barocchi (1973) completed the preceding one (1962) of the Treaties. One finds that there has been added between 1961 and 1974 work by Ciardi regarding G. Paolo Lomazzo. Lomazzo gathered with his encyclopedic ambitions all the theoretical-practical knowledge relative to figurative arts. The author also touched on an esoteric, mysterious, and astrological culture very different from the great rationalism of the early Renaissance. The author, from Lombardy, supplies us with interpretative openings specifically tuned for the artistic activity of his region, which Ciardi, himself, followed with his study (1967) of his Milanese disciple, Giovan Ambrogio Figino.

The restoration of the works by Correggio and Parmigianino, promoted by Augusta Ghidiglia Quintavalle during the 1960s, provided fundamental contributions to the knowledge of the 16th century in Northern Italy. In 1965, the frescoes by Correggio in the Church of San Giovanni Evangelista in Parma, with ever important chronological and interpretative specifications, were recovered. Parmigianino and his passionate alchemic experiences supplied the critics with new viewpoints for understanding.

The evasions in the obscure domain of the irrational do not, however, only characterize the culture of Northern Italy. Berti (1967) sharply identifies these evasions, and follows them within the complex picture of Florentine culture after the middle of the century, which he centers on the ambiguous figure of the "Principe dello Studiolo," the Grand Duke Francesco I. This is the most valid interpretative comment relevant to that episode of almost disconcerting singularity which was the painted decoration of the Studiolo in the Palazzo Vecchio.

The high intellectuality of Florence seems to fold into an exasperated intellectualism. This intellectualism later became an active critical force in the picture which the Renaissance gives of itself in the great historic work of Vasari. The Vasari Congress in Florence in 1974 reconfirmed the high value of the "Vite" for framing an enormous conglomeration of sharp and pertinent single judgments in the superior evolutive designs of the two centuries of the Renaissance. The Book of Drawings by Vasari, skilfully reconstructed by L. Collobi Ragghianti (1975), does not always appear inspired by qualifying criteria. He only wanted to assemble the documents, be they masterpieces or not, of the many characters of his dramatic narrative of a now closed great epoch.

The artistic situation in Rome during the first half of the 16th century has also become a rich field of investigation. The exemplary volume by Dacos on the discovery of the grotesque paintings in the Domus Aurea (1969) finally clarifies the attitude of the Renaissance artists with regard to the antique text and the suggestions which they selectively wanted to take from it. The studies by Frommel on B. Peruzzi the painter (1967 - 1968), by Dumont on Fr. Salviati (1975), and by Keller on the Oratory of S. Giovanni Decollato in Rome (1976) elucidate - in consideration also of the varied relationship with the patronage - the cultural conditions that led to a formal language already on the brink of "mannerism," already definitely inclined toward the transfer of the ideologically formalized decorative apparatus, and nonetheless aware of its intact imaginative vitality.

New interest also sparked the study of the Renaissance in Southern Italy. We have already noted the general essay by R. Pane, to which we must add that of Rotili (1972) and, for painting, that of F. Abbate and G. Previtali (1972).

The artists were no longer working on a centralized idea, but rather on the varied impressions which radiated from it. And on these, the modern critic notes, rests the true research, until that final moment on the brink of the 17th century, which is the expression of emotions and affections individually exalted in the spiritualism of the Anti-reformation. It was the end of a high figurative intellectualism, now that the interpretative function of the universe had passed to science. A new culture was outlined which the exhibition in Bologna (1975) set alight in Federico Barocci. His investigations, published in the true general monograph which is his catalogue (Emiliani), with an imposing bibliographic review, leads us to the brink of the 17th century, the most chronologically advanced limit of the cultural studies on the Renaissance.

BIBLIOGRAPHY - Although this bibliography is more extensive than that mentioned in the text, it represents only one choice in the enormous quantity of works published since 1960. For reasons of space we have omitted monographic texts which are part of special series, such as those published by Fratelli Fabbri (The Masters of color), by the Case Rizzoli (Bibliography of Art), and Sansoni (Shape and color - The treasures of Art). For special bibliographical reviews one must refer to the journals *L'Arte* (1968-1971), *Commentari, Storia dell'Arte*, and Zeitschrift für Kunstgeschichte. In addition, refer to the specific bibliographies contained in the books listed.

General and theoretical works: A. Hauser, A Social History of Art (1956), Turin, 1957; A. Chastel, Art et Humanisme à Florence, Paris, 1961; G. Weise, The Heroic Ideal of the Renaissance, Naples, 1961; G. Weise. The Renaissance and its inheritance, Naples, 1961; E. Battisti, The AntiRenaissance, Milan, 1962; E. Panofsky, The Meaning in Visual Arts, Turin, 1962; M. Salmi, Civiltà fiorentina del primo Rinascimento, Florence, 1967; R. and M. Wittkower, Born under Saturn (1963), Turin, 1968; G. C. Argan, The History of Art, History of Art, 1-2, 1969; A. Hauser, The Theories of Art (1958), Turin, 1969; P. Barocchi, Scritti d'Arte del Cinquecento, Milan-Naples, 1973; E. Gombrich, Riding a Broom-handle (1963), Turin, 1971; E. Gombrich, Norm and Form (1966), Turin, 1973; R. P. Ciardi, G. P. Lomazzo, Scritti sulle Arti, 2 vols., Florence, 1972-1974; C. Brandi, Teoria Generale della Critica, Turin, 1974; C. L. Ragghianti, Arte fare e Vedere, Florence, 1974; R. Pane, Il Rinascimento nell'Italia meridionale, I, Milan, 1975.

Fifteenth century (perspective): R. Klein, Pomponius Gauricus on perspective, The Art Bulletin, XLIII, 3 (Sept 1961); R. Klein, Etudes sur la perspective à la Renaissance, Bibl. d'Umanisme et Renaissance, XXV, 1963; R. Oertel, Perspective and Imagination, The Renaissance and Mannerism, Princeton, 1963; A. Parronchi, Studi su la Dolce Prospettiva, Milan, 1964; M. Emiliani Dalai, La Questione della prospettiva (1960-1968), L'Arte, 2, 1968; C. L. Ragghianti, Prospettiva 1401, Studi in Onore di R. Pane, Napoli, 1969-1971.

Sculpture: P. A. Sartori, Documenti riguardanti Donatello e il suo altare a Padova, Il Santo, I, 1961; J. Pope Hennessy, Italian Sculpture, 3 vols, Milan, 1963-1966; F. Hartt, G. Corti, and C. Kennedy, The Chapel of the Cardinal of Portugal, Philadelphia, 1964; P. Belli D'Elia, Niccolò dell'Arca: additions and details, Commentari, XV, 1964; A. Coffin Hanson, J. della Quercia's Fonte Gaia, Oxford, 1965; M. Wundram, Die Sienese Annunciata in Berlin etc, Jahrb. d. Berl. Mus. 6, 1964; G. Marchini, Ghiberti ante litteram, Boll. d'A. d Ministero P. I., L, 1965; G. Brunetti, Ghiberti, Florence, 1966; C. Seymour Jr., Sculpture in Italy 1400-1500, Penguin Books, 1966; L. Becherucci, G. Brunetti, Catalogo del Museo dell'Opera del Duomo Florence, 1967-1968; H. Klotz, Jac d Q Zyklus der "Vier Tempreamente" am Dom zu Siena, Jarhb d Berl Museum, 1967; A. Bertini, Calchi della Fonte Gaia etc, Critica d'Arte, 97, 1968; A. Kosegarten, Das Grabrelief des San Aniello Abbate im Dom von Lucca, Mitt d Kunsthist Inst in Florenz, XIII, 1968; Donatello e il suo tempo, Records of the VIII International Congress of Studies on the Renaissance (1966), Florence, 1968; A. Romanini, Donatello e la prospettiva, Commentari, XVIII, 1966; G. Brunetti, Una Testa di Donatello, L'Arte, 5, 1969; G. L. Hersey, Alfonso II and The artistic renewal of Naples, 1485-1495, New Haven, 1969; M. Wundram, Donatello und Nanni di Banco, Berlin, 1969; C. Del Bravo, Scultura senese del Quattrocento, Florence, 1970; J. H. Beck, Jacopo della Quercia e il portale di San Petronio a Bologna, 1970; C. Seymour, The Sculpture of Verrocchio, London, 1971; H. W. Kruft, Domenico Gagini und seine Werkstatt, München, 1972; G. C. Sciolla, Fucina aragonese a Castelnuovo, Critica d'A, 123, 1972; V. Herzner, Die Kanzeln Donatellos in San Lorenzo, Münchner Jahrbuch der bildenden Kunst, band XXIII, 1972; G. L. Hersey, the Aragonese Arch at Naples, 1443-1475, New Haven, 1973; Notiziario Veneto (San Giovanni di Donatello ai Frari), Arte Veneta, XXVII, 1973; C. Seymour, Jacopo della Quercia, New Haven-London, 1973; C. Gnudi, Nuove ricerche su Niccolò dell'Arca, Rome, 1973; X. de Salas, The St. John of Niccolò dell'Arca, Essays in the History of Art presented to R. Wittkower, London, 1967; F. Hartt, Donatello - Prophet of

Modern Vision, London, 1974; A. Paolucci, I Musici di Benedetto da Maiano e il Monumento di Ferdinando d'Aragona, Paragone, 303, 1975; Catalogue of the exhibition "Jacopo della Quercia nell'Arte del suo tempo" (with bibl.), Florence, 1975; W. Wolters, Gothic Venetian Sculpture (1300-1460), Venice, 1976; Jacopo della Quercia fra Gotico e Rinascimento, Records of the study conference (Siena, 1975), Florence, 1977; Brunelleschi scultore, cat. a cura di E. Micheletti e A. Paolucci, Florence, 1977; C. L. Ragghianti, Filippo Brunelleschi, un uomo un universo, Florence, 1977; A. Radcliffe and Ch. Avery, The 'Chellini Madonna,' by Donatello, Burlington Magazine, 1976.

Painting: M. Salmi, Lombardy, Veneto and Tuscany in Castiglione Olona, St. Lombardi, II, 1963; J. Lauts, Carpaccio (1962), II publ. Venice, 1963; G. Perocco, Carpaccio nella Scuola di S. Giorgio, Venice, 1964; O. Matthiesen, Bramante in Bergamo alta, Apollo, Sept. 1963; M. L. Ferrari, L'ampio raggio degli affreschi di Bramante in Bergamo, Paragone, 117, 1964; G. Perocco, Carpaccio nella scuola di S. Giorgio, Venice, 1964; P. Stefano Orlandi O. P., Beato Angelico, Florence 1964; G. Robertson, Giovanni Bellini, Oxford, 1965; R. Chiarelli, Due Questioni Pisanelliane. Pisanello in Florence and the "lost" frescoes of the Pellegrini Chapel, Records of Accademia di Agricoltura, Scienze e Lettere di Verona, VI, XVIII; R. del Pisanello nel Palazzo Ducale di Mantova, Boll. d'A. del Minist. P. I., V, LII, 1967; L. Berti, Masaccio, Milan, 1964; A. M. Matteucci, La Porta Magna di San Petronio in Bologna, Bologna, 1966; X. de Salas, Un tableau d'Antonello da Messina au Musée du Prado, Gazette des Beaux-Arts, 1967; R. Pallucchini, Due Nuovi Antonello, Arte Veneta, XXI, 1967; C. Varese, Lorenzo Costa, Ferrara, 1967; F. Casalini, Corrispondenze fra teoria e pratica nell'opera di Piero della Francesca, L'Arte, 2, 1968; G. Passavant, Verrocchio, London, 1969; A. Busignani, Pollaiolo, Florence, 1969; E. Rigoni, L'Arte rinascimentale in Padova - Studi e doc., Padua, 1970; E. Panofsky, The Life and Works of Albrecht Dürer (1955), Milan, 1967; M. Calvesi, A noir (Melancholia I), History of Art, 1-2, 1969; Catalogue of the Ausstell. des German. Nationalmuseums Nürnberg, Munich, 1971; F. Winzinger, Dürer und Leonardo, Pantheon, XXIX, 1, 1971; Catalogue of the exhibition of prints and designs "Homage to Dürer" by A. M. Petrioli Tofani, Florence, 1971; M. Dalai Emiliani, Per la prospettiva "padana": Foppa rivisitato, Arte Lombarda, XVI, 1971; E. Battisti, Piero della Francesca, Milan, 1971; M. Bacci, Piero do Cosimo, Milan, 1966; R. Dubos, Giovanni Santi, Bordeaux, 1971; E. Sindona, Introduzione alla poetica di Paolo Uccello, etc, L'Arte, 17, 1972; C. L. Ragghianti, Stefano da Ferrara, Florence, 1972; G. Paccagnini, Pisanello e il ciclo cavalleresco di Mantova, Milan, 1972; B. Degenhart, Pisanello in Mantua, Pantheon, XXXI, IV, 1973; A. Padoa Rizzo, Benozzo Gozzoli, Florence, 1972; A. Garzelli, Il ricamo nell'attività artistica del Pollaiolo, Botticelli, Bart. di Giovanni, Florence, 1973; E. Borsook, Fra Filippo Lippi and the murals for Prato Cathedral, Mitteil d. Kunsthist. Inst. in Florenz, XIX, 1, 1975; G. Marchini, Filippo Lippi, Milan, 1975; J. Pope Hennessy, Fra Angelico, London, 1975; A. Blunt, Andrea Mantegna: the Triumph of Caesar, London, 1975; C. L. Ragghianti, G. delli Regoli, Disegni dal modello, Pisa, 1975; M. Calvesi, Sistema degli equivalenti ed equivalenza del Sistema in Piero della Francesca, Storia dell'Arte, 24/25, 1975-76.

Sixteenth century. - general works: N. Dacos, La découverte de la Domus Aurea et la fonction des grotesques à la Renaissance, London, 1969; S. J. Freedberg, Painting in Italy 1500-1600, Pelican History of Art, Penguin Books, 1971; A. Hauser, Mannerism (1964), Turin, 1965; J. Shearman,

Mannerism, Harsmondsworth, 1967; G. Nicco Fasola, Aspetti del Manierismo, L'Arte, 3-4, 1968; G. Weise, Mannerism. Critical balance of the stylistic and cultural problem, Florence, 1971; G. Weise, Mannerism and literature, Florence, 1976.

Leonardo, Michelangelo, and Raphael: G. Castelfranco, Studi Vinciani, Rome, 1966; A. M. Brizio, Rassegna degli studi Vinciani dal 1952 al 1965, L'Arte, 1, 1968; C. Pedretti, Leonardo da Vinci inedito, Florence, 1968; A. Marinoni, I codici di Madrid (8937 and 8936), Florence, 1974; A M. Brizio, Presentazione dei codici di Madrid (1974), Florence, 1975; F. de'Maffei, Michelangelo's Lost St. John, New York, 1962; V. Mariani, Michelangelo, Naples, 1964; M. Lisner, Das Quattrocento nu M-A, Records of the congress Stil. u. Ueberlieferung in d. Kunst d. Abendlandes, Bonn, 1964; M. Lisner, M-A's Kruzifixus aus S. Spirito in Florenz, Munich, Jahrb d. bild. Kunst, 3, XV, 1964; F. Hartt, Michelangelo, Milan, 1964; C. A. Isermeyer, Das M-A Jahr 1964 und die Forschungen zu M-A als Maler und Bildhauer von 1959 bis 1965, Zeitschr. f. Kunstgesch, XXVIII, 1965; Michelangelo, 2 vols. (preface by M. Salmi and introductory study by Ch. de Tolnay: Historical and artistic personality of Michelangelo), Novara, 1965; A. Parronchi, Opere giovanili di Michelangelo, 2 vols., Florence, 1968 and 1975; B. Mantura, Il primo Cristo della Pietà Rondanini, Bollett. d'A. del Minist. P. I. s. V., LVIII, 1973; R. Kuhn, Michelangelo: Die Sixtinische Decke, Berlin, 1975; P. dal Poggetto, I disegni murali di Michelangelo scoperti sotto la Sagrestia Nuova, Prospettiva, 5, 1976; O. Fischel, Raphael (1948), translated into English, London, 1962; R. Wittkower, The Young Raphael, Allen Memorial Art Museum Bulletin, XX, 3, 1963; Raffaello, 2 vols., with introduction by M. Salmi, Novara, 1968; J. Pope Hennessy, Raphael, London (1968); A. P. Oppè, Raphael (1969), reprint, London, 1970; L. Dussler, Raphael – A critical Catalogue, London, 1971; J. Shearman, Raphael's Cartoons in the collection of H. M. the Queen, New York, 1972; Annual readings in Vinci collected in a book, Florence, 1972-1976; K. Weil-Garris, Leonardo and Central Italian Art: 1515-1550, New York, 1974.

Special studies: S. J. Freedberg, Andrea del Sarto, London, 1963; J. Shearman, Andrea del Sarto, Oxford, 1965; R. Monti, Andrea del Sarto, Milan, 1965; Catalogue of the exhibition of Romanino, Brescia, 1965; A. Mezzetti, Il Dosso e Battista ferraresi, Ferrara, 1965; D. Sanminiatelli, Beccafumi, Milan, 1967; L. Berti, Il Principe dello Studiolo, Florence, 1967; Gibbons, Dosso, Princeton, 1968; F. Valcanover, Tiziano al Fondaco dei Tedeschi, Arte Veneta, 1967; A. Marabottini, Polidoro da Caravaggio, Rome, 1969; T. Pignatti, Giorgione, Venice, 1969; M. Fagiolo dell'Arco, Il Parmigianino, un saggio sull'ermetismo nel Cinquecento, Rome, 1970; Catalogue of the exhibition of Niccolò dell'Abbate, Bologna, 1969; N. T. De Grummond, Giorgione's Tempesta: The Legend of St. Theodore, L'Arte, 18-20, 1972; S. Regan McKillop, Franciabigio, California Press, 1974; L. Ragghianti Collobi, Il libro de' disegni del Vasari, Florence, 1974; H. E. Wethey, The paintings of Titian, 3 vols., London, 1969-1975; Catalogue of the exhibition of Federico Barocci (A. Emiliani), Bologna, 1975; Ch. L. Frommel, Baldassarre Peruzzi als Maler und Zeichner, Römische Jahrbuch für kunstgeschichte, 1967-68; C. Dumont, Francesco Salviati au Palais Sacchetti de Rome et la décoration murale italienne (1520-1550), Rome, 1975; R. E. Keller, Das Oratorium von S. Giovanni Decollato in Rom, Rome, 1976.

Graphics and miniatures: B. Berenson, Florentine Drawings, last edition, Milan, 1961; P. H. Pouncey and J. Gere, Italian Drawings ... in the British Museum, London, 1962; U. Middeldorf, Les dessins italiens dans les collections hollandaises (Catalogue of the exhibition), Paris, Rotterdam, Haar-

lem, 1962; M. Salmi, C. Tolnay, P. Barocchi, I Disegni di Michelangelo, Milan 1964; K. T. Parker, Catalogue of the Collection of Drawings in the Ashmolean Museum, Oxford, 1965; B. Degenhart, A. Scmitt, Corpus dei disegni italiani I-Süd und Mittelitalien, Berlin, 1968 (recens Salvini, Commentari, 1972: Il Disegno – aspetti e problemi); R. Scheller, Dessins Italiens du Musée de Lille, Exhibition Amsterdam, Brussels, Lille, 1968; K. Clark, Leonardo da Vinci Drawings at Windsor Castle, London, 1969; Ch. de Tolnay, Drawings of Michelangelo's Youth, Records of the Accad. dei Lincei, CCCLXXI, 193, 1974; M. Levi D'Ancona, Miniature e Miniatori a Firenze dal XIV al XVI secolo, Florence, 1962; A. E. Popham, Catalogue of the Drawings of Parmigianino, New Haven, 1975; F. Abbate – G. Previtali, La Pittura Napoletana del '500, in Storia di Napoli, V, Naples, 1972; M. Rotili, L'Arte del Cinquecento nel Regno di Napoli, Naples, 1972.

The Renaissance and Europe: Catalogue of the exhibition Le Siècle de Bruegel, Brussels, 1963; N. Dacos, Les peintres belges à Rome au XV siècle, Brussels-Rome, 1964; O. Benesch, The Art of the Renaissance in Northern Europe, Oxford, 1965; Catalogue of the exhibition Malerei der Donauschule 1490-1540 (A. Stange), Linz, 1965; A. De Bosque, Artistes italiens en Espagne du XIV siècle aux Roix catholiques, Paris, 1965; N. Dacos, Spranger e i pittori rudolfini, Milan, 1966; A. Crivelli, Artisti ticinesi in Russia, Locarno, 1966; M. Gukovski, The Italian Renaissance and Russia, European Renaissance and Venetian Renaissance, Florence, 1967; G. T. Faggin, La Pittura ad Anversa nel Cinquecento, Florence, 1968; G. von der Osten and H. Vey, Paintings and Sculptures in Germany and the Netherlands, Pelikan History of Art, 1969; P. Philippot, Flemish Painting and the Italian Renaissance (with a broad bibliography), Turin, 1970; C. L. Ragghianti, Pertinenze francesi nel Cinquecento, Critica d'Arte, n. S. 122, 1972; Catalogue of the exhibition Vasari et son temps, Paris, 1972; Catalogue of the exhibition L'école de Fontainebleau (H. Chastel and S. Béguin), Paris, 1972-1973; Actes du colloque international sur l'Art de Fontainebleau (1972), Paris, 1975.

LUISA BECHERUCCI AND ORESTE FERRARI

ARCHITECTURE AND TOWN-PLANNING OF THE RENAISSANCE IN RECENT HISTORIOGRAPHY
(PLATES 115-118)

Methodological introduction. – The term Renaissance is conventionally used to indicate the period between the end of the 14th century and the beginning of the 17th century. During this period, the role of the city in the organization of territory maintained an important position, steady in its functional character (mercantile). The rhythm of its demographic increase was intense (with the exception of a decline for political reasons during the first decades of the 16th century, mainly in Rome, Florence, and Milan). This situation continued to change half way through the 16th century. The movement of commercial interests from the Mediterranean to the Atlantic and the economic compensation sought in the agricultural sector (refeudalization of the countryside) precipitated the economic weakening of the city and its functional changes.

Lewis Mumford denies that one can speak of a "city of the Renaissance." This author considers the city which developed during the 15th and 16th centuries in two ways: on the one hand, as the survival or result of the dissolution of the medieval city; and on the other, as

an introduction to the development of the Baroque city. Mumford's idea is explainable if one bears in mind that he refers above all to non-Italian social realities. The realities which effect the change from medieval to Baroque. Personally, I maintain that one must make a distinction. There is no city of the Renaissance; the social and institutional changes of the first decades of the 16th century prevented it from becoming a reality.

During the period in which Astengo, under the heading of "Town Planning" in the *Encyclopedia of World Art*, wrote an essay on the city of the Renaissance, a radical transformation in the history of town planning was taking place. The dominant tendency until then had been that of dividing research into sectors; developing separately the discussions regarding the new foundations, the restructuralizations, the fortifications, the habitat typologies, the concepts of essayists, and so on. The work which most fully and clearly expresses this concept is *L'histoire de l'urbanisme. Renaissance et temps modernes*, by Pierre Lavedan (1959). Moreover, the city of the Renaissance was considered, with few exceptions, only with regard to the most disciplinary, formal, and technical aspects. The interest for political, economic, and cultural aspects of the investigation was irrelevant. Within this picture, one tended to consider irrelevant the very history of the city, which was generally considered to be an articulation of the history of the buildings.

Already during those years there was no lack of some important exceptions. In Lewis Mumford's works *The culture of cities* (New York, 1938) and *Cities in History* (New York, 1961), the period in question and the Italian environment are only lightly treated. The author declares his incomprehension of the type of culture expressed in that period in this area. The work presents reasons of validity for the method proposed, based on the evaluation of the economic and political aspects of the urban question. One concept of this type is equally at the center of the work of Bruno Zevi on Ferrara ("Biagio Rossetti, Architetto ferrarese," 1960). This is also the first work in which the subject of the Renaissance is developed with regard to the case of a specific city and in which the city is considered as a whole and not by sectors. Successively, in Italy, there was a strong increase in the interest in the Renaissance town. Among the reasons for this increase, one can see the importance assumed by the discussion on the recovery of historic centers.

At present, studies on the Renaissance town, and above all those of a general character, no longer present a purely descriptive statement. They tend to overcome the disciplinary urban concept. Not by chance did this statement develop during the same period in which the ancient city became the subject of study not only for art and architecture historians, but also for historians of different cultural formations. As regards the Renaissance, the recall to the recurring city in the studies of Eugenio Garin can be considered fundamental to the stimuli exercised in the specific field of urban history.

The first work which speaks in detail on the relationship between the city and society is "La storia dell'Architettura nel Rinascimento" by Leonardo Benevolo (1968). In this work, the social reference is mainly centered on the political aspect. Particular attention is paid to the role assumed by political patronage in the definition of urbanistic work. The evaluation of this

role leads to the passage from the subject of society to that of the city. The truly urbanistic discussion has developed on an ever more particular scale that leads toward the settlement of the research on the city and that of buildings.

Giulio Carlo Argan treats the city of the Renaissance in two essays: "The Renaissance city" (1969) and "Introduction to Italian Art" (1972). The role of connective tissue with regard to all possible discussions on figurative culture seems to be attributed to the reflection on the city. The Renaissance city, in the second study, is not evaluated for itself, but emerges through the continued comparison with the city of different periods. This city does not exist in actual fact, but only in a moment of transition. The social reference is mainly centered on the definition of planned orientations which are the basis of the works. Indications of specific cases are introduced purely in an exemplary role. The center of the discussion is not the city, but the act of planning, the moment of mediation "between the theory or the idea, and the practice, or the concrete," and, therefore, between social instances and urban choices. This conceptual statement supposes and carries out a rigorous articulation of the discussion by problems and overcomes all chronological or topographical distribution of the subject.

An urban history must have a different definition according to the period examined. The method is not autonomous with regard to the choice of subject. Moreover, within it, one must bear in mind the study experiences and the stimuli deriving from requirements of "actual use" of the material in question (operations in historical centers). In line with such choices, as regards the Renaissance, it appears necessary to deepen the relationship between the spacial position and the urban social position. By social position we mean the overall picture of the economic, political, and cultural facts, which constitute the organization of the town. The method proposed and tried by the writer is that of first outlining the urbanistic situation and then comparing it, point by point, with the social situation. In the practice of historical work, this method seems to allow a much closer relationship between the two situations. Whoever writes the history of a town covers again in an inverse sense the planned "iter" followed by whoever built the town.

The center of the discussion is not the authors or the urban cases, but the criteria according to which the authors have acted and the works have been illustrated. In other words, it is that which in real terms can be defined as the "politics of planning": the unity of the political, economic, and cultural choices which have influenced the organization of the town. The reference to social motivation here is only barely (and sometimes not at all) touched upon. This means that a chronicle and not a history of the urbanistics of the Renaissance has been made. In reality, the objective of this study has been considered not that of writing a history, but that of offering information "orientated" toward the sense of history.

The Conception and Planning of the Renaissance City. – During the 15th century, a novel concept and planning method which was not in contrast with the type of medieval city was worked out. It's main aim, as a result of the proposals of scholars and of experiments completed, was not that of transforming the medieval city, but of rationalizing it. The problem was not to realize a different town, but rather, a town which was "better than all others"; these are the words of Alberti. Referring to Leonardo Bruni (but this reference can be generalized), Eugenio Garin wrote, "His ideal city, so full of platonic echoes, is not a fantasy born outside reality, but seems to identify with an existing city whose characteristics he improves and corrects according to a greater rationality."

This urbanistic concept terminates during the first decades of the 16th century. Progressively, it became the opinion that the ideal city was no longer a real fact, dependent on the requirements of those who live and work in it, but rather an abstract, absolutely dependent on the requirements of those who govern it. At this point the link with the ancient city is broken. The new city develops on the basis of a model elaborated "from the outside" and is rigidly carried out. A city which anticipates the ideas of later centuries is outlined in this climate. The break between the two centuries is expressed, also, in the fact that the 15th-century town is still an Italian city, whereas that of the 16th century is already a European city.

There is also a difference between the two centuries as regards the type of operations accomplished. In the 15th century, given the continuity of the medieval city, restructural operations prevail. New foundations are rare; the small fortified town of Cortemaggiore (1470 - 1481) is an exception. Among the restructuring operations the local ones prevail; each operation was carried out in relation to the immediate surroundings. Only in the second half of the century in Urbino (1477 onwards), Pienza (1459 - 1464), Rome (the time of Niccolò V, 1447 - 1455, and Sisto IV, 1471 - 1484), in Naples (planned by Alfonso II, 1485 - 1495) do we see the first attempts to co-ordinate local operations; and only in Ferrara (Addizione Erculea, 1492 - 1494) did they reach the elaboration of a true "urbanistic plan." We are on the brink of a new century.

In the 16th century the city inherited from the past is considered to be disjointed, and all operations are trying to unite it. Local operations, when carried out, tend to involve the whole of the urban fabric, as in Naples (Via Toledo, 1536 - 1543), in Palermo (Via Toledo e Maqueda, 1567 - 1600), and in Venice (Quartière di Rialto, 1536 onwards). There were also direct interventions with unitary plans: the Roman plan of Sisto V (by Domenico Fontana, 1585 - 1590) represents the most interesting case.

The tendency to unify the urban fabric is valid not only on a fictional level, but also, and sometimes only, on a figurative level. In Venice, the work of Palladio aims at realizing a coherent system of reference points (coherent also with regard to previous work, such as Piazza San Marco and the Quartiere di Rialto), governed by composite and constant laws, and able to guarantee the figurative unification of the urban panorama. The interest in total rebuilding has its natural bulk in the newly founded cities, whose number increased beginning halfway through the century, particularly in Central Europe.

The numerous town changes realized in Italy during the 16th century seem to contrast with the crisis situation which is seen in the economy of the country in this century. But the contradiction is obvious: it was, in fact, this very situation, for the movement of the activ-

ity from the entrepreneurial sector to the profitable sector, and for the inflation which occurred, to direct the available capital toward investment in urban real estate.

Among the urban changes with sections during the 14th and 15th centuries, those regarding the construction or reconstruction of fortified belts were particularly frequent. Beginning in the second half of the 15th century, this type of building became less frequent. The initiative in this sector remained, however, in Italy until almost halfway through the 17th century as regards practical aspects and toward the end of the same century for the theoretical aspects. Successively, the initiative moved to Central European countries, particularly France and Germany.

During the 15th century, fortifications were intended to protect the whole of the population and, therefore, concerned all towns independently of their political and economic functions. During the 16th century, however, the fortifications were destined to protect the political and economic power of the prince, and therefore concerned almost exclusively those cities in which there was such a power: the cities which held courts and the fortress-cities located in strategic positions in the territory. On a parallel with a different destination, one notices within the two centuries a different relationship between the design of the city walls and the design of the buildings. In the 15th century, the city walls followed the contours of the establishment, adapting to the existing natural and urban factors. This choice is very clear. Alberti mentions it: it is necessary to vary "the circuit of this town . . . according to the varying positions." Beginning in the early decades of the 16th century there was a progressive functional and figurative dissociation between the two elements. The fortified perimeter assumed a more and more precise and abstract design, while the response to the town fabric minimizes and then disappears. Overthrowing the prevailing planning method of the 15th century, the design of the city is elaborated from the outside toward the inside; first the fortified perimeter must be individualized, and then the town fabric. Pietro Cataneo, who was the first of the military scholars, and Daniele Barbaro are perhaps the last theorists interested in the research of a connection between the two elements. After their period opens a period of urban specialization: Maggi, Bellucci, and others deepened the city theme with regard to the requirements of defense, and therefore the type of fortified perimeter. Bartolomeo Ammannati and Giorgio Vasari il Giovane deepened this theme with regard to the requirements of representation and the type of urban fabric.

The dissociation shown on a planning level corresponds to the dissociation shown, during the same period, on a professional level between engineer and architect and on a disciplinary level between town-planning and architecture and takes its place in the general tendency toward functional, social, and spacial dissociation which characterizes the 16th - century city.

The 15th-century city was functionally integrated. Government, defense, and market activities were present in all cities, however small and unimportant. The 16th-century city, however, is functionally dissociated, at all levels. At a territorial level, the dissociation transfers to its specialization of the role of the city. There is the court-town where government activities are concentrated, fortress cities, and mercantile cities. On an urban scale the dissociation is translated into the zone division of the city. On the one hand the activities of representation (political, religious, and economic) and on the other the activities of service and production. The Roman pontiff, the prince, or the oligarchy in power see their residence as a small city opposed to the real city. The royal palace of the Gonzaga family in Mantua is a perfect example. The 16th century translates into terms of space the reflection of Plato: "Every city . . . is divided into two parts: one is the city of the rich, the other is the city of the poor." The possibility of clearly and immediately individualizing this dissociation inside the town fabric, represents perhaps the main characteristic of the 16th-century city.

Between the 15th and 16th centuries, we see also the passage from a polycentric urban concept to a monocentric one. Polycentrism, although it had already been overcome in the proposals of scholars, survived in practice throughout the 15th century. The last great urbanistic operation of the century, the Addizione Erculea in Ferrara, maintained this characteristic. The piazza onto which the expansion gravitated was not placed on the intersection of main roads, but to one side, decentralized within the building fabric.

Polycentrism leant itself to diffusive types of road networks. Florence of the 14th and 15th centuries was organized on the basis of a ring road, along which grew the representative buildings of the various urban functions: the Bargello, the Palazzo della Signoria, and the main religious buildings, among which was the Duomo. In the case of small towns, such as Urbino and Pienza, polycentrism leant itself to a main road. Along this main road grew the most important buildings and the main piazzas.

In most cases, the polycentric organization was connected to a netlike road system. At the base of this choice, one can suppose the prevalent reasons were cultural (link with the type of newly built medieval city and reference to the Roman "castramentatio" and the Greek city) and technical reasons. These are clearly a result of Leonardo's studies on urban restructuralization (water drainage and traffic problems).

If in the medieval city the road network was configured indifferently, in the 15th century, beginning halfway through the century, a difference between main and secondary roads appeared. Main roads were those around which the most important buildings were placed. These were planned to connect the center with the city gates (a fact which offered the possibility of a radial or orthogonal plan) and had a military and commercial function. The ideal model of this was a straight wide road, lined with gates and uniform aligned buildings, and centralized on an important building. These characteristics, with the exception of the last, were already present, if only potentially, in the medieval city. Not for nothing does Alberti refer, on this subject, to the ancient city of Padua. Of these characteristics, only the first was often seen. The straight configuration is most obvious in the ex-novo urban foundations. The main roads of Ferrara are between 1.5 and 2.0 kilometers long and between 16 and 18 meters wide. In the most ancient cases of road rebuilding, the straight road becomes a broken one. The criteria of adaptation to existing circumstances prevails. Important public or private buildings were often built on the bends of the road. The Florentine Palazzo Medici was built on a bend in

the ancient Via Larga. The main road of Cortemaggiore is lined by gateways. However, solutions of this kind, frequent in the images of painters, were rare in practice. The use of figurative signs is evident particularly in Florence; many roads frame in the distance, perhaps above a building, the cupola of the Duomo. This cannot be pure coincidence.

The secondary roads were those around which were placed minor buildings. Alberti states that these roads must be winding both for security reasons and for esthetic reasons. In this way, he noted, "as well as looking longer, its greatness will grow in the opinion of that city." Consider the arrangement of Pienza. In this case, the winding derives from the need to adapt to existing factors.

In line with medieval tradition, the 15th-century city was endowed with piazzas for different functions (government, economy, and culture). Sometimes there was an association between government and culture. Only in theory, with Filarete and Martini, does one speak of one main piazza.

As regards the spacial organization of the piazzas, there appear to have been two tendencies. The first is homogenous to the type of town described above: the new piazza represents the perfection of the medieval piazza. The connection with the existing town environment is maintained and evaluated; the object of the operation is that of regularization and not transformation of the environment. In the case of articulated piazzas of a medieval origin, the individuality of each articulation is accentuated. The Piazza Maggiore in Bologna, the Piazza Ducale in Urbino (1447 - 1468), the piazza Soprammuro in Perugia (1475 - 1488), and the first version of the Piazza and Piazzetta San Marco in Venice (1442 onwards) all express this concept.

The second tendency anticipates the ways of the 16th-century town. The design of the piazza derives from an idea of figurative contrapposition compared with the existing environment. The piazza suggests as an ideal model the concept of the Roman forum. Perfect examples are Brunelleschi's Piazza dell'Annunziata in Florence (1421 onwards) and Bramante's Piazza Ducale in Vigevano (1492). This type of piazza is not thought of in parts and realized through time, but is planned as a whole and realized in one go, like a building. This concept of the piazza-building refers us to the type of city-palace mentioned above. On a planning level, it is not the design of the buildings which qualifies the organization of the piazza, but it is the design of the piazza which qualifies the type and position of the buildings.

There are also some affinities between the two types of 15th-century piazza. The most important one is the absence of spacial centralization. Eventual celebrational elements (statues) or functional elements (fountains) are not placed in the center of the piazza but to one side. The traditional use of the piazza as a meeting place may also have influenced this choice. The 15th-century piazza is not even centered on a dominant building. If there is a figurative emergence, another is created. Uniformity of the walls surrounding the piazza was sought. The continuous gateway may be considered as a factor of spacial unification.

In any case, both in different ways and on different levels, the piazza of this century presents a certain figurative autonomy with regard to the surrounding urban fabric. Functional autonomy corresponded to figurative autonomy. The piazza had a true function which was the above mentioned meeting function. City autonomies were still active in the 15th century.

The organization of urban space. – With the passage from rule to princedom one notices in the 16th century a different organization of town space. For reasons of control, representation, and security, the headquarters of political, economic, and religious power were concentrated in one point in the city. This fact provoked, in time, a radial organization of urban space. The introduction of the radial scheme was motivated on the basis of predominant political reasons. Brinckmann placed this scheme alongside the spirit of absolutism, Lavedan with the hierarchial system of power outlined beginning from this period.

A city based on the radial scheme, as an exception, had already been suggested during the second half of the 15th century. This was Sforzinda, the ideal city of Filarete (1461 - 1464). During the first half of the 16th century the radial scheme was fully expressed only on a theoretical level and in the cases of civil takeovers (studies by Peruzzi, Fra Giocondo, et cetera). On a practical level this scheme was expressed, in an allusive way and on a local scale, in the invention of the road trident. The one on Ponte S. Angelo was completed (perhaps taken from an idea by Alberti) and so was that on Piazza del Popolo. The latter assumed the role of prototype and inspired many urban restructuralizations in successive centuries. In most cases, the orthogonal scheme predominated on a theoretical and practical level, but not because of this did the idea of the monocentric city lessen. In theory, this scheme still characterizes the installations where the problem of defense assumed a growing value. The reference to this is frequent in the work of Machiavelli (1521), Dürer (1527), and Cataneo (1554).

The situation began to change in the middle of the century. The preference for the urban radial scheme was clear in theory, now characterized by prevalent military requirements. In practice, the use of the radial scheme was expressed in the realization of some fortress towns and more generally in the rebuilding operations. In most of the new foundations the use of the orthogonal scheme was prevalent.

A military scholar named Maggi in 1564 justified the choice of the radial scheme with a basis of technical reasons. A radial organization would allow control from one central point (seat of command) of the whole city and the realization of rapid connections between its various parts. This choice was largely shared by other Italian and later also foreign writers. The production of foreign military theorists began toward the end of the century – for instance, Daniel Specke in Germany (1589) and Jacques Perret in France (1604). The first fortified cities on a radial plan appeared in Central Europe. Note the cases of Villefranche sur Meuse by Gerolamo Marini (1545) and Philippeville by Sebastien van Noyen (1555). The first Italian realization was Palmanova by Giulio Savorgnan (1593-1600). In any case, the realization of new foundations was practically limited to the second half of the 16th century. Later this represents an exception. Among the operations of total urban rebuilding, note the cases of Milan and Rome. In Milan (1548) the expansion bears radial witness to the ancient medieval nucleus. This system was later to have the greatest diffusion in the whole of Europe. One

remembers, among the most important cases, the expansion of Amsterdam effected during the 17th century. In Rome (Plan of Sisto V by Domenico Fontana, 1585 - 1590) the radial system is converted to a star-shaped organization of the town space. This was the first case of adaptation of the radial scheme to a polycentric rather than a monocentric spacial organization. This plan later represents a frequent reference pointing to the rebuilding of major European cities, beginning with London (planned by Christopher Wren, 1666). The monocentric radial scheme was still in the logic of the Renaissance. The polycentric or stellar radial scheme was already in the Baroque logic.

The greatest diffusion of the radial scheme did not, however, happen with regard to cases of total rebuilding, but in cases of local restructuralization. The realization or evaluation of diagonal roads within the road network is similar to a radial organization of town space. This choice expresses the Baroque preference conceded to oblique, rather than frontal, vision.

The preference for the orthogonal scheme remains clear in practice with regard to cases of new foundations. Among the civil cities one could mention: Le Havre (1524), Leghorn by Bernardo Buontalenti (1575), Nancy by Gerolamo Citoni (1588), Charleville (1600 - 1608), and others built to accommodate refugees from the religious wars which raged following the Reformation. Among the military cities one could mention: Vitry-le-François by Gerolamo Marini (1545), Portoferraio by Gian Battista Bellucci (1548 - 1549), Hesdin by Sebastien van Noyen (1554), Sabbioneta (1560 - 1584), La Valletta by Bartolomeo Genga, Francesco Luparelli, and others (1566 - 1571), and Zamość, in Poland, by Bernardo Morando (1578).

With regard to the 15th century, the orthogonal scheme presented a substantial difference. It was associated with a monocentric and no longer polycentric spacial organization. The centralization of the urban establishment is underlined in various ways: simple geometric perimeter shape, central piazza with strong functional and figurative importance, and orthogonal main roads. In the cases of new foundations, these characteristics appear together. In the cases of rebuilding, the tendency to strengthen or build orthogonal roads prevails, as in Guastalla (1568) and Palermo (1567 - 1600).

During the 16th century one tended to see roads not only with reference to military, commercial, and traffic requirements, but also representational requirements. The important buildings of the 15th century were located preferably in a piazza. If there was no piazza, one was built, breaking the line of the building or the road opposite. During the 16th century, however, important buildings were often located along the main road. Palladio states that roads should be decorated by "magnificent and superb buildings . . . the most worthy temples, palaces, gateways and other public buildings." As examples of the Palladian theory, we can quote the previously realized cases of the Via Giulia in Rome (1503 - 1513), the Via Toledo in Naples (1536 - 1543) and the Strada Nuova in Genova (1548 onwards).

The 16th-century road is also the centerpiece for an emergence of a celebrative type (statues) or a decorative type (fountains, obelisks, as in the Plan of Sisto V in Rome) or a monumental type (buildings). This is a concept outlined in the theory of Alberti, which became common practice beginning halfway through the century and acquired a determining value in the rebuilding of existing centers. Centralized main roads are rigidly superimposed on the existing road network. The solution effected in Caprarola is among the most significant.

The 16th-century town, in its turn, was centralized on a main piazza where the most important urban functions were integrated; specialization was only for secondary piazzas. The integration of functions into the main piazza had already been suggested by Vitruvio. This piazza, according to Palladio, "should contain the princes palace; . . . the mint and the treasury where treasure was kept, and public money and prisons."

The piazza of this century represented (with few exceptions) a monocentric type of organization, exactly the same as that of a monocentric town, and tended to be built on the basis of a simple geometric shape, ideally a central shape. During this century, the polycentric piazza was an exception. The most organic cases were those built in the Venice area: Piazza San Marco in Venice and Piazza dei Signori in Vicenza. Veneto is an area where, during the second half of the century, specific figurative experiences developed, and not only within the architecture and town-planning fields. In this area we pass directly from medieval to Baroque spacial polycentrism. Giulio Romano, consulted before Palladio because of the arrangement of the Vicenza piazza, wanted to transform the originally medieval space, heterogenous and figuratively articulated, into a unitary, regular, arcaded space dominated by the Palazzo della Ragione in an isolated central position. This proposal was turned down, and Palladio's solution was then executed. This reorganized the piazza while maintaining the existing polycentric layout.

The 16th-century piazza is, as a rule, centered on a building, as a celebrational or decorative element. Space is configured in relation to this element. Contrary to the piazza of the 15th century, it was not important for its own specific function as a meeting place, but, rather, in regards to the function expressed by the element which it serves. Once again, there is the exception, constituting the Venetian piazza. Palladio is once again interpretor of this exception: " . . . cities are divided more according to their size, and they need piazzas in which to meet people to bargain for necessities . . . to walk, to linger, and to do business." The presence of a few "beautiful buildings and even a Temple" is not so much important in relation to its express function as in relation to the "ornamental" value.

The element around which the piazza is built is preferably placed in the center (with the usual exception of Palladio's piazza, which has the center free, coherent with the meeting-place function of the piazza). In the ideal case, this element is represented by a building exactly in the center. This style of piazza appears often in paintings, as in the anonymous tables in the Palazzo Ducale of Urbino (circa 1490) and in works by Carpaccio, Raphael, and others. Urbanistic solutions inspired by this model were proposed by Bramante for the temple of San Pietro in Montorio of Rome, also by Bramante, and perhaps by Michelangelo for the Basilica of San Pietro in the Vatican, and by Giulio Romano in the above-mentioned case of Vicenza; but they remained incomplete and unaccomplished. Sometimes they were given token representation. The stellar design at the center of the Piazza del Campidoglio (1561 - 1568) or

the great fountain at the center of the Piazza Pretoria in Palermo (1575) refer in an obvious way to this ideal model. Echoes of this concept were also seen outside Italy: consider the plan of Du Cerceau for the Pont-Neuf in Paris (1578 - 1579).

In practice, the type of closed piazza ends up centered not on a building but on a celebrational element. It is the purpose of the Florentine Piazza dell'Annunciata that is taken, completed and transformed into a prototype. The prototype is expressed already in a mature manner in the main piazza in Charleville. Numerous "places royales" were replanned and realized on this basis during the 17th century, beginning with the Place des Vosges in Paris.

In the case of the open piazza, the tendency was to center the space on an element placed to one side and not in the center. This element, as a rule, was a building. The centralization was emphasized by contrasting dimensional and figurative effects between the wall occupied by the building and the others; the latter were generally treated uniformly. The placing of the principal buildings in the 16th-century piazza followed a precise logic. Civil, public, or private buildings were placed on the long side of the piazza; the religious ones on the short side. This logic was true of both mixed function piazzas and specialized function piazzas. This is similar to the arrangements in Roman forums. Note, among others, the cases of Ascoli Piceno, Carpi, and Faenza.

BIBLIOGRAPHY - G. Giovannoni, Sangallo Urbanista, Antonio da Sangallo il Giovane, Rome, 1959; P. Lavedan, Histoire de l'urbanisme, Renaissance et temps modernes, Paris, 1959; L. Quaroni, Una città eterna, Urbanistica, 27, Turin, June 1959; H. De La Croix, Military architecture and the Radial City Planning in Sixteenth Century Italy, Art Bulletin, December 1960; B. Zevi, Biagio Rossetti architetto ferrarese, Turin, 1960; P. Lavedan, Les villes françaises, Paris, 1960; F. Santi, Appunti per la storia urbanistica di Perugia, Urbanistica, 30, 1960; R. Lefevre, La "gloriosa piazza de Colonna" a metà del 500, Archivio della Soc. romana di Storia Patria, LXXXIII, I-II, 1960; M. Zocca, Sommario di Storia urbanistica delle città italiane, Naples, 1961; L. Mumford, The city in history, New York, 1961; E. R. Dickinson, The West European city, London, 1961; W. Lotz, The library of S. Marco and Renaissance town-planning, Bulletin of the International Center for Studies of the Architecture of Andrea Palladio, III, 1961; S. Bettini, Palladio urbanista, Bulletin of the International Center for Studies of the Architecture of Andrea Palladio, III, 1961; F. Basile, La palazzata di Messina e l'architetto Giacomo Minutoli, Quaderni dell'Istituto di Storia dell'architettura, s. VI-VII-VIII, 1961; C. Pedretti, Leonardo's plan for the Enlargement of the city of Milan, Raccolta Vinciana, XIX, 1962; C. Savonuzzi, Catalogue for the exhibition of the urbanistic development of Ferrar through the times, Ferrara, 1962; C. Buttafava, Visioni di città nelle opere d'arte del Medioevo e del Rinascimento, Milan, 1963; L. Firpo, Leonardo architetto e urbanista, Turin, 1963; M. Morini, Atlante di Storia dell'urbanistica, Milan, 1963; Aa. Vv. University Institute of the history of the architecture of Venice, Michelangelo the Architect, Turin, 1964; A. Berghoef, Les Origines de la Place Ducale de Vigevano, Palladio, IV, 1964; G. Bellafiore, Architettura e forme urbane nella storia dell'edilizia in Palermo, Quaderni dell'Istituto di Elementi di Architettura, 2-3, 1964; R. Del Duca, Vicende topografiche del centro storico di Palermo, Quaderni dell'Istituto di Ele-

menti d'architettura, 2-3, 1964; E. Garin, Science and civil life in the Italian Renaissance, Bari, 1965; H. Rosenau, The Ideal City in Its Architectural Evolution, New York, 1965; E. Trincanato, Residenze collettive a Venezia, Urbanistica, 42-43, 1965; T. Zarebska, The collective dwelling in the Italian urbanistic theory of the XV and XVI centuries, Urbanistica, 42-43, 1965; P. Hamberg, Vitruvius, Fra Giocondo and the city plan of Naples, Acta archaeologica, 36, 1965; P. Portoghesi, Saggio di Introduzione al "De re aedificatoria," di Leon Battista Alberti, Milan, 1966; M. Tafuri, L'architettura del Manierismo cap. IV; Fra lo sperimentalismo e l'utopia: dai riformatori sociali alle "invenzioni" del Montano, Rome, 1966; A. Tenenti, L'utopia del Rinascimento, Studi Storici, 4, 1966; W. Lotz, Reflections on the theme of Palladio as a town planner, Bulletin of the International A. Palladio Center, VIII, II, 1966; W. Lotz, Sansovino's transformation of Piazza San Marco and town-planning of the sixteenth century, Bulletin of the International A. Palladio Center, VIII, 1966; E. Bacon, Design of Cities, New York, 1967; P. M. Lugli, Storia e cultura della città italiana, Bari, 1967; L. Quaroni, The Tower of Babel, Padua, 1967; E. Carli, Pienza, Rome, 1967; L. Vagnetti and others, Genoa, Strada Nuova, Genoa, 1967; L. Benevolo, Storia dell'architettura del Rinascimento, 2 vols., Bari, 1968; P. Marconi, La cittadella come microcosmo, Quaderni dell'Istituto di Storia dell'Architettura, Rome, 1968; E. Trincanato, Venezia nella storia urbana and Sintesi strutturale di Venezia Storica, Urbanistica, 52, 1968; A. Poleggi, Una lottizzazione del '500 a Genova, Genoa, 1968; G. C. Argan, The Renaissance city, New York, 1969; D. Bayon, Un précurseur de l'urbanisme romaine, 1550-1650 env, in: Aa. Vv. L'urbanisme de Paris et l'Europe, Paris, 1969; L. Benevolo, La città italiana nel Rinascimento, Rome, 1969; M. Guiffre, The myths and realities of Sicilian town-planning, Palermo, 1969; G. Labrot, Aspects de l'urbanisme romain, 1500-1650 env, in: Aa. Vv. L'urbanisme . . . ; M. Muraro, Palladio et l'urbanisme vénitien, in: Aa Vv, L'urbanisme . . . ; S. Muratori, Studi per una operante storia urbana di Venezia, Libreria dello Stato, 1969; L. Quaroni, Immagine di Roma, Bari, 1969; M. Tafuri, Jacopo Sansovino, Vicenza, 1969; F. Thiriet, Espáce urbain et groupes sociaux à Venise au XVII siècle, in: Aa. Vv., L'urbanisme . . . ; L. G. Hersey, Alfonso II and the artistic Renewal of Naples (1485-1495), New Haven, London, 1969; P. Marconi, Un progetto di città militare, Controspazio, June 1969; M. Zocca, La concezione urbanistica del Palladio, Palladio, I-II, 1969; W. K. Forster, From Rocca to Civitas; urban planning at Sabbioneta, L'Arte, 5 March 1969; C. de Seta, Cartografia della Città di Napoli, lineamento dell'evoluzione urbana, 3 vols., Naples, 1969; G. Severini, Architetture militari di Giuliano da Sangallo, Istituto di Architettura e Urbanistica, Pisa, 1970; P. Sica, L'immagine della città da Sparta e Las Vegas, Bari, 1970; P. Zucker, Town and Square, Cambridge, 1970; G. Samonà e altri, Piazza San Marco, Padua, 1970; J. Q. Hughes, The planned city of Valletta, Records of the XV National Congress of the history of architecture, Rome, 1970; E. Trincanato, U. Franzoni, Venise au fil du temps, Boulogne-Billancourt, 1971; B. Zevi, Saper vedere l'urbanistica, Turin, 1971; A. Morris, History of urban form, Prehistory to the Renaissance, London, 1972; G. C. Argan, M. Fagiolo, Premessa dell'arte italiana, Storia d'Italia, Turin, 1972; F. Farneti, G. L. Ricci, S. Van Riel, Terra del Sole Città fortezza rinascimentale, Firenze, 1973; G. Fanelli, Firenze, architettura e città, San Casciano, 1973; G. Simoncini, Città e Società nel Rinascimento, vol. 2, Turin, 1974.

GIORGIO SIMONCINI

MANNERISM (PLATES 119-122)

Progress in Research. – During the last 15 years the rythym of studies on Mannerism has enjoyed sharp growth. Increasingly numerous wide range studies on the critical concept of Mannerism have been added to by specific research and the recognition of recurring moments and themes and the rise and fall of schools and protagonists.

The previous critical panorama does not appear too put out by this extraordinary historiographical reflection. However, the previous panorama is profoundly changed. From the archives, new data emerged, a mixture of notices and testimonies which have enriched our knowledge of the historical event of Mannerism. The growing practice of competitive investigation into artistic phenomena and other cultural manifestations, the analysis of the 16th-century theoretical debate also permitted a more subject-divided definition of the period. Certainly there are still many shadowy periods, and no unanimous conclusions have been reached. The most serious contradictions are still thickening in the very heart of the historiographical problem: the conceptual outlining of the critical notion of Mannerism. There are still many differences of tone and accent even in the most recent bibliography, but now the insane antitheses which contradict themselves concerning the pioneering studies of the decades between the two world wars seem remote.

Only in recent years has the systematic demolition of the suffocating superstructures surrounding mannerism been undertaken, and by the very historians who contributed most to its clamorous "rediscovery." Freed from the heavy hypotheses impressed by uninhibited and rather ingenuous interpretations in the world of "new," the historical image of Mannerism became clearer. The shadows projected onto protagonists by a criticism suggested by the "isms" of the avant-garde of this century — by Cubism, by Expressionism, by Surrealism, and even by Dada — were dissolved.

The main duty is still to re-open the debate on Mannerism in the historic context and researching a Mannerism which is "iuxta propria principia" which is all but exhausted. The history of art, however, can count on a large number of firm points, or at least of satisfying approximations.

Anti-Renaissance or Late Renaissance? – The field of Mannerism has broadened in regard to traditional analysis: the poeticism of Mannerism is borne in the very heart of the Renaissance city. Its characters are not dominated people ruminating the formulas of the great masters of the Renaissance, as in the ancient condemnation of Bellori. But neither are they angels rebelling against the tyranny of inaccessible leaders. They are more likely to dwell on continuing problems.

The height of the Renaissance, the "golden age," is an exiguous peak, a subtle watershed based on precarious and illusory certainties. Its lack of problems is only illusory. Its serenity – this sharp observation is by Panofsky – was achieved at the price of reducing to harmony the most strident contradictions.

Anthropocentric vision, nature-reason equality, universal dogmatism, the myth of the "renovatio" and the Ancient — in other words the nucleus of humanistic thought — was eroded from the center by pangs of doubt and was cracked by the testimonies fired by its own premises. The analysis and comparison with reality, philological criticism, the blows which the dialectics of history inflict on universalistic utopias – from the Florence of Bruni and Salutati to the Rome of Sisto IV, Giulio II, and Leo X – denude the internal contradictions on which leaned the castle of humanistic certainties. The brusque laceration of the Reformation and the suddenly revealing authentic historic trauma which was the episode, militarily insignificant, of the Sack of Rome reflect a process of disintegration and loss.

Presentiments, anticipations, and unsolved boundaries bloomed everywhere in the previous century. A witness to this, in the theoretical field, is the Alberti trilogy, ambitious "summa" of humanistic art. Reasonably encouraged by this are the creative itinerary of Michelangelo, the late work of Raphael, and even the programmatic universalism of Bramante in Rome.

The risk of a narrow identification between Mannerism and Anti-Renaissance grew. Mannerism advanced within humanistic thought. Its problematic horizon, its cultural models, its linguistic structures were substantially circumscribed by those of the Renaissance. However, where humanistic ideology indicated certainties, Mannerism insinuated doubt. Alongside dogmatism was placed criticism and experimentalism; alongside the rule was the exception; alongside rationality the irrationality of nature and history; alongside obsequiousness, the intolerance for masters; and alongside classicism an irreverent anticlassicism.

Separating into dialectic polarities that which Humanism had forcefully reduced to a unity; pointing at and presenting the contradictions and antitheses it was unusual that Mannerism should reach the univocal anticlassicism which many past studies indicate. This interior dualism is dissolved in the sceptical irony in which theses and antitheses cancel each another out, leaving a wider and disenchanted canonism. At other times, the same crisis of values lived in a more burning and direct way, woven into religious disquiet, assailed by doubt, and wavering between a clear, ruthless rationalism and an exalting impulse for transcendency. Underneath the veil of Mannerist ambiguity one can guess the double face of the sophisticated game. This game is mundane, sometimes accommodating, anxious, and wanting to live.

Mannerism: etymology of a category of criticism. – Having reached its peak with Raphael, painting "was seen to decline and become humble and vulgar . . . The craftsmen, abandoning the study of nature, influenced art with mannerism, or rather fantastic Ideas, leaning towards practice and not imitation." With this phrase Giovan Pietro Bellori traced a synthetic outline of the 16th century and emitted a condemnation without appeal that lasted three centuries. At the beginning of the 20th century there was an interest in seeing that that judgment was not overturned. A positive sign was preferred rather than a negative one. Little was done to return to the origins of the term Mannerism and establish its cultural etymon. This is research which has been carried forward to more recent times by Treves, Coletti, Weise, Battisti, Shearman.

When a 16th-century author uses the term mannerism, he wants to indicate that which in our modern language is defined wih the word "style." Vasari, who makes wide use of the word, pairs it often with adjectives (dry, strong, crude, soft, united, simple, tiled,

pasty, delicate "Mannerism") to characterize the style, the particular stylistic title of individual artists. Vasari himself, like any other writer of the time, uses the term with no coloring of any kind, in an absolute sense, as today we say "to have style." The author implies the adjective "beautiful," "Beautiful Mannerism." Everyone can see the example of the famous letter of Raphael (or rather of Castiglione) to Leo X, in which the medieval buildings "from the times of the Goths" are described as "lacking in grace, and with no style whatsoever." But what does the 16th century mean by "style"?

One must investigate the etymological study, return to the literature and note the etiquette of the good civilian life from which the art of the 16th century coined the word "Mannerism."

In the "literature of Mannerism" the term has the meaning of graceful and careful behavior. In the "Courtesan," an incunabulum of this literary type, the precise word is even better in its surroundings: the "beautiful style" exudes elegance, self-control, dissimulation of the craftsman, or better artificialness of methods cloaked in apparent naturalness. For Bladassarre Castiglione, "beautiful Mannerism" coincides with the scornful behavior. The scornfulness, not by chance, is paced in relation, by a Mantuan scholar, to visual arts: it is the universal rule, opposed to affectation, from which "grace" is born, a difficult weaving of research and spontenaity, lifestyle and art. It demonstrates "that which does not appear to be art is true art."

The apparent philological digression allows the individuation, in a first approximation, of some of the main cultural models of the age of Mannerism. The Mannerist language is cultured, sophisticated, idealized, esoteric. Its rules are the continuous overcoming of "difficulties," the reduction of these to simplicity, research into the capricious, the bizarre, the concise, and the fantastic. A happy term, Shearman described it as "stylish style" in a century of an intellectual society practically inflated with culture.

Vasari's "Third Age." – After careful reading and clarification of obscure terms, Vasari's introduction to the lives of 16th-century artists – the so-called "third age" — reveals itself for what it is: an interpretation in a subtly Mannerist tone of the whole figurative culture of that century. This view is certainly a challenge. Mannerism was the dominant but not the exclusive current of the height of the 16th century. The artistic panorama registered isolated areas hostile to Mannerism and several countertendencies, but as such particularly illuminating, precisely because, rather than a historical analysis, it appears as a poetic declaration.

Vasari begins with a synthesis of "progresses" introduced in the art of the masters of the 15th century, indicating five principal veins: "rule," "order," "measure," "design," and "style." The first two aspects are essentially linked to architecture and derive from the study and the rediscovery of the Ancient. The "rule" is the "method of measuring ancient objects, observing ancient buildings in modern work." "Order" concerns correctness of usage of architectural orders, the absence of lexical contamination between elements belonging to different orders. "Measure," on the contrary, is common to the three arts — in fact, it guarantees universality. Vasari expressed the concept: "do the bodies of figures upright, straight and with members similarly organized."

Progress in 15th-century "design" is also noted. The biographer refers to the inevitable classic anecdote of Zeus and the maidens of Crotone. His theme centers on the "choice" of the most beautiful parts of nature. Finally, he emphasizes how "beautiful mannerism" is recognized only when the selection of the beauty is applied to "all figures" and in "all works."

We have seen the "increases" introduced by the masters of the 15th century. In the "Third Age," the "Modern Age" had to bring these "increases" "to within perfection." Thus, to the "rule" was added "an exception which, not being the rule, was organized in the rule and could remain without confusion or breakage of the rule." The latter made use of "an invention of all things, and a certain beauty continued in every small thing, which shows the rule with most ornament." The "measure" acquired "a rigid judgment, which without the figures being measured, would have in their sizes a grace exceeding their size." "Design" had a "graceful and sweet simplicity which appears between the visible and the invisible." This simplicity was unknown in the previous century. The new "style" opposes the "effort of diligence" and in any manner "dry and crude and cutting . . . for excessive study."

When he wrote his "lives" Vasari lived in a declining and unheroic period of Mannerism. His vision reflects a certain involution dictated by moderatism and conformism introduced in Florence by the Medici restoration by Cosimo I. However, in his phrases and in his very adjectivity, one cannot see one of the deepest motivations of the Mannerist crisis: the cracking of the relationship between art and nature, between the subject (the artist) and his object.

Panofsky confirms that in humanistic hypotheses, the subject and object were "as if placed under good fixed rules a priori although empirically based." Mannerism, on the contrary, while maintaining nature as a scale of values (orders, rules, and measures), insinuates a dialectic tension between the two poles. The Vasari artist has a wide margin for contradicting the aprioristic normalcy of nature, perhaps with the exception which confirms the rule. He can "exceed the measure" and alter the natural truth in the name of "grace," even while being guided by a "rigid judgment." This latter, certainly, is a brake on the judgment of the subject, but fragile and imaginable, unwilling to be placed in a stable and safe norm.

It is natural, therefore, that in the age of Mannerism art was often praised in its function of "overcoming" and "perfecting" nature. This theme was already present contradictorally, in the humanistic theory (the "choice" of Zeus) alongside the calls of a passive faith in natural reality. The new fact – again we are enlightened by Panofsky – is not so much in the presence of these two theoretical postulates, as in its recognition as a contradiction, to the point where the *tam quam* of once upon a time became an *aut aut*.

The Manneristic alteration of the subject-object relationship becomes explicit in the theory of geniality as a "digression from the norm." This theory has a paradigmatic comparison in the Vasari "life" of Michelangelo. The work of Buonarroti is seen as a culmination of art, an unattainable apogee because of the overcoming of the norm and because of its victory over nature. It is interesting to note how, even in this case, the partially involutive character and the restorer of the Vasari ideol-

ogy is facing us from between the lines of the story. The accent is placed on the need to found a new if broadened dogmatism. The anticanonic heresy of Michelangelo is denied at the root for being placed at the origin of a new if unbiased orthodoxy.

Form and metamorphosis: the world as a labyrinth. – The title which G. R. Hocke gave to his study of European Mannerism, "Die Welt als Labirinth," summarizes the evidence of an image the disorientation injected into the culture of Mannerism from the crisis of humanistic ideals. Once the traditional concept of nature and history is cracked, the whole hierarchy of values wavers, and with it, the linked system in concentric circles on which leans cosmology and even social order. The myth of the "Rebirth" assumes alternately the caustic nature of irony or the evanescent and evasive nature of utopia. This is the same norm as that of Ancient times which is placed in doubt. Philology is given the duty of dismissing the doubts. The divarication between classical theory – from Pliny to Vitruvius – and the reality of archaeological repertories are confirmed. These are surveyed and studied with an obstinacy which wavers between aspiration and revision and between polemic or sceptical criticism. Medieval nostalgia, sometimes stimulated by political events (think, for example, of the neo-feudal climate installed in Rome by the Farnesian domination) take over from the traditional classical code, giving way to a dissonant concert in which the taste of contradiction, ambiguity, and contamination prevails over that of coherence and synthesis. Similarly, on the central trunk of the classical lexicon, new hybridizations were introduced with the grafting of exotic speeches from Germany and Flanders.

The proportional-perspective system and its pretext of reflecting the homogeneity of the subject, the rationality and the knowledgeability of natural space is continually put to trial and is often intentionally disproved. The brusque dimensional rejections, the "horror vacui," the proportional forcings, and the spacial polycentrism appear sometimes timidly and sometimes peremptory between the folds of classical periodification.

After Certosa's exercises on Dürer, Pontormo seems to bore the hypothesis of convexity of optical space and invents the extraordinary composition of the stake of Santa Felicita. Rosso, Parmigianino, Blocklandt, and El Greco violate the "aurea" policletan proportion lengthening and "forcing" nature in the name of an ideal superior to grace and transcendency. In the "Self-portrait of a convex mirror," which can be judged one of the examples of poeticism of Mannerism, Parmigianino shows with an exhibitionistic tour de force the illusiveness and arbitration of a universal concept of space, sealing emblematically, with the substitution of the deformity to "form," the change from an art understood as a representation of an order which is in reality an art as anxious research of an autonomous identity, ready to unveil or to accept the contradictions of reality possibly aspiring their transcension to a superior order.

In nature, as in art, the universal attributes are understated, while the exceptional cases are avidly researched, with deviations, strangenesses, and monstrosities. Natural reality appears sometimes to be an enigma governed by chance, by fate, or by inscrutable laws, animated by an interesting panpsychistic metamorphosis.

In the secret of the Scholars and the "Wunderkammern" Mannerist principles even in the art of government like Francesco I dei Medici and Rudolph II of Hapsburg cultivate an introvert collectionism. Alongside natural rarities and the "marvels" brought from distant countries, the products of an art surrected from the resources of a dangerous technique, assailed by the continuous challenge to the "laws" of nature from the research into the stupendous and the improbable, are observed.

Thus are born the triumphs of shells and corals, porcelain, the inlaid work on hard stone, vases in lapiz lazuli or rock crystal, puppet theaters, mechanical models. With Francis I, the "principe dello studiolo," Manneristic technology seemed to actually oscillate between the mundane game of an esoteric court and the fancies of transformation into a state industry.

The Mannerist garden, made of labyrinths and water games, of geometric hedges and wild gorges, populated with puppets and giants, with its cosmological allusions which mix with a joke or the moralizing precepts, is one of the privileged places where the other race without winners of nature and art takes place; a challenge where the contestants are entertained by exchanging roles, playing hide-and-seek among themselves, always on a balance between the pride of superiority and the presentiment of the square.

In the grotto, "topos" as a result of the Mannerist park, the "bricolage" of rocks, stalactites, and shells are confused with paintings and architecture, camouflaged with a reciprocal simulation which alludes, as in a mirror game, to the exchange between truth and fiction. At Bobli, Buontalenti manages to interpret even the "unfinished" of the "Prisons" of Michelangelo as metamorphic "artificial nature" and decides to use them as telamons on the four sides of his fairytale grotto.

In that extraordinary "Wunderkammer" in the open which is the Sacro Bosco of Bomarzo, Vicino Orsini spreads the "stations" of a labyrinthic initiation. Senses and reason are continually put to the test, deceived and undeceived in an uninterrupted alternation of devilish epiphanies and consulatory pauses, incubuses, and dreams. "Leave all thoughts o ye who enter" admonishes the writing at the opened mouth of the monster, whose inside reveals a banquetting hall. In the fallen down cottage, where the walls and the floors slope and straighten optically to make the visitor lose his balance and sense of reality, the inscription mockingly asks, "Tell me then if so many marvels are made for deception or for art." Is this a spell or an artifice?

The organic world of Bomarzo, monstrous and disquieting, even breaks the architecture of buildings. There is biomorphic stylization in Ammannati and Buontalenti, producing monsters which face out from the walls of the Zuccari house. Serlio codifies a "bestial order." With the "grotesques" from Italy, with the Nordic "Rollwerk" and "Beschlagwerk," with the Spanish "estilo monstruoso," a fantastic and metamorphic decorative style emerges. In architects such as Wendel Dietterlin and Meyer the imaginative technique of the grotesque breaks the preordained channels of the whole of architecture.

To the humanistic concept of "form," as an imminent sign of reality, Mannerism opposes that of

metamorphosis, which insinuates doubt of the very reality of things.

The Mannerist artist, writes Tafuri,

> no longer owns a stable territory of universal mirroring, feels sliding from beneath him all faith and certainty, and he has no choice but to jump the obstacle, gain the actual rules of that eternal fermentation of material, lean towards disenchanted experimentation while trying complex operations which confine with magic and exorcism. The eruption of nature, in its most singular forms, in the narrative themes of decoration, and the apparition of heretic spatial devices which antiperspectively multiply the co-ordinates of literature of space itself, can be conducted together to an exorcistic attitude. When something is feared as a constant danger, the most immediate impulse is to absorb that which is frightening, showing it in a defiant manner.

It is not surprising, therefore, that magic and alchemic practice do not only appear among the biographical data of many artists of the Mannerist era or are shown in their painting, but appear, looking closely, as the real operative model of their art, the way, difficult and esoteric, to meet the challenge of a threatening and enigmatic reality. If one cannot objectify the reality, one need only try to identify with it, to introduce it, following the philosophical stone of a ritual and initiative fusion of the object into the subject.

Escape to the ephemeral. – The taste of metamorphosis, of deception, and of experimentation find a privileged application point in the theater and the carnival. The scene is the place deputed to the exchange between reality and fiction. The Mannerist artist engineers this joining of an uninterrupted dialectic to the insignia of the surprise and technical prodigy. The Mannerist scenographer breaks the fixedness of the stable scenario and invents a changing scene; he spreads with intermissions the spectacle in the pit, involving the spectators in a space and time different from reality; he feigns every natural phenomenon, from the rising of the sun to the twilight of the evening, from thunder to snow, from birdsong to the rustling of leaves, from fire to flooding. Beyond the stage, in the attics, behind the scenes, a complex instrumentation made of mechanical giants and stage tricks transforms the theater into a visual field where one continually sees marvellous optical and sound illusions and effects. The new prodigious scenotechnicians cause the memory of the medieval "mirabilia" to pale, and they prevail over all other components, literary or musical, becoming the very protagonists of the show.

The city and court celebrations, princely courts, and public ceremonies offer continuing occasions for celebration. Through the theater and urban setting we see this triumph of the provisory and the ephemeral. Their importance in the Mannerist age is not only a quantitative detail, widely documented by sources, but it is also a qualitative fact, a reflection of a cultural centralization. Even the most "stable" of languages, that of permanent architecture, registers this phenomenon, delighting in words or whole phrases taken from the most superstructural and uninhibited festive repertory. The villa, the park, even large operations in the urban fabric are due to scenographic experiences. Important is

an episode on an urban scale such as Vasari's Uffizi, conceived as a bifocal optical perspective tube facing onto changing scenes of the Piazza della Signoria on the one side and of the loggia on the Arno River on the other.

In "The Antirenaissance," Battisti observed that the artist:

> on one hand is automatically dissolved from the social link of buying and selling, the reality of life; on the other hand, from the links of "decorum," in other words classicism. The apparatus creates – Like Carnevale – an area of freedom, where the naughty, the absurd and the impossible are licit; and where inventions, deemed to be indecorous in the sacred art or in the monumental headquarters, become legitimate and generally accepted.

One cannot deny this "flight" into the ephemeral and the proviso of celebration of the symptom of a consolatory evasion. Artificial arches, festoons, obelisks, and allegorical carts engage artists intent on realizing the convergence and the involvement of all visual techniques. Among other things, this is the reflection of the deep cracking suffered in this period, by the autonomous environment of any single artistic system of communication, the effect of the greatest crisis of values. The phenomenon, which is not only manifested in exhibitions or the theater, is translated into the taste for intersection and contamination of techniques. The exchanges with philosophical themes and with literary language give origin then to conceptism and symbolism, the use and abuse of metaphor. Here the artistic lexicon loses its own original denotation to communicate and have more meaning. The same investigation promoted by Benedetto Varchi to establish a scale of priorities between painting and sculpture hides, behind the frontage of an elegant and sometimes pungent academic dispute, the doubt on the "singularity" of all arts and the impulse for a superior synthesis of order. They do not demonstrate either the opposite specifications on singular technical areas supplied by some protagonists of the enquiry: in fact, they seem to be dictated by an assertive scruple which betrays an identity crisis. At the same time, the literary and erudite complacency of the artistic environment in Florence bore the first academy.

It is interesting to note how the first collective proofs of the Florentine Academy of Design, a late recognition on an institutional level of all that had matured in the social role of the artist with the humanistic "renovatio," will be precisely the realization of imposing and costly festive shows in honor of the Medici household.

The definitive sealing of the subordinate artisan condition and the fully rightful entry into the category of the intellectuals seem to come paid with a tighter and institutionalized subordination to constituted power. In the advanced station of late Mannerism, the academic honors hide the ideological enslavement of a corporation dedicated to the "State courtesanship," protected and even spoiled, insofar as available to the realization of wide celebratory programs.

Counter-reformation and the decline of Mannerism. – Pevsner identified Mannerism as the figurative expression of the Counter-reformation, while in his turn Weisbach could see the reflection of the lay and antireligious spirit opposing the Baroque-Counter-reforma-

tion equation. Since then modern historiography has taken some steps forward, but has still not overcome the logic of opposed schemes. In recent decades, the picture of a Baroque dominated, and animated by the ideology of the Catholic "re-conquest" has become clearer. The relationship between the Church and Mannerism remains, however, nebulous and is often described in elusive or contradictory terms.

An initial indication was advanced by Shearman, who leans on the thesis of Weisbach noting a "certain natural antipathy" between Mannerism and Counter-reformation and even sees in the confirmation of the cultural debate stimulated by the Tridentine and Post-Tridentine Church one of the basic causes of the ending, sometimes gradual and sometimes sudden, of Mannerism in Italy.

The confirmation of Shearman is a useful reference point. This point can be strengthened by some new evidence: one need only remember how Mannerism had a prolongation, if not a true revival, at the end of the century, under the reign of Francis I de' Medici in Florence and of Rudolph II in Prague, two "alchemists" whose cultural and non-cultural policy was counter-signed by a jealous "State esotericism," strange and hostile to Counter-reformist interferences.

However, to overcome the limits of genericity still present in the position of Shearman one needs to take a step backwards and take the impetus from the studies which have spaced out the equivocals and the implicit schematism in the very historic concept of "counter-reformation." One must, in particular, return to where Jedin, also on the inside of a mystifying integral concept of the history of the Church, has synthesized in his famous pamphlet "Catholic reformation or Counter-reformation?" Jedin itemizes two lines, different but not necessarily divergent, which intersect in the 16th-century Church: the line of the Catholic Reformation, "a reflection on itself activated by the Church in accordance with the ideals of Catholic life, attainable through internal renewal," and the line of the Counter-reformation, "self-confirmation of the Church in the fight against Protestantism."

If one thinks of religious anxiety, of spiritual crisis, of the rarely obvious travail of the "low Church" or of the cultured, aristocratic evangelism of the major exponents of the Catholic Reformation, one has to admit that Mannerism was often touched upon and was sometimes totally involved. Michelangelo lived as a protagonist through that cultural and religious experience, but Rosso and Pontormo were full participators, with their "heretic" predisposition to interpret the sacred iconography and with their documented contacts with the crypto-reformed groups in Catholic territory. In Rome, there was a climate similar to that of the clique of artists of the Farnesian circle, where the young Greco was formed.

Very different, of open and irreducible hostility, is the relationship between Mannerism and the counter-reformed Church determined by the Tridentine restoration, which absorbs the self-reformatory pushes to make a block around the new dogmatic body of the conciliary decrees.

It could not have been otherwise. The Mannerist language, in its very essence, is an "èlite" language destined for an "èlite" people. Hermetic philosophy, contradiction, and individualism are integral parts. The classical world and its cultural horizons are ever present, although denied or contradicted. The Church, coming out of the conciliation of Trento, requested something completely different. Gilio, with his "Degli errori e degli abusi de' pittori" (1564), and, above all, Gabriele Paleotti with the "Discussion around sacred and prophane images" (1582) took on the duty of translating the purely inhibitory and censory preceptive of the conciliary decrees into positive proposals for artists. First of all, they were used to fight the abuse in pictures. They wanted to make art a weapon of faith against heretics. For this, they defended a sacred illustrative and perspicaceous art, instructive and popular, which knows when to turn to the motion of the affected and to the "common sense." Paleotti reminds us of Gregorio Magno and his concept of painting as an "idiot's book" (for illiterates). The classical "ut pictura poesis" is compared to an implicit "ut pictura rhetorica." Gilio attacks pictures which "to truly understand we would need a Sphynx or an interpretor or a commentary." Paleotti stigmatizes "obscure and difficult to understand paintings" and declares war on the pagan world, setting himself against the "monstrosity" of the Grotesques. Together with the artists, even the patrons are called to the crusade against the "abuse." It was hoped that they could be co-responsible in a mission which had a much wider range than the circulation of a social sector restricted and privileged of some cultural content and which had as referee the great masses and as objective the divulgation of the truths of faith, the organization of the ideological consensus, mass edification.

A greater indulgence is conceded by the post-Tridentine studies to the "prophane images," and Mannerism found a chameleonic refuge in the folds of the new theory of the "double truth." Thus, solely superficially contradictory attitudes, those which Zeri attributed to the so-called "bi-fronted painters," in which "the devoted face is castigated, sometimes even ardently by the most red-hot mystical flames, sign on a thermometer of the religiousness the same grading which, on the second face, the lay one, indicates the measure of the courtesan, araldic, feaudalistic spirit." Typical, in this sense, of the late Roman Mannerism, or that of certain areas of Cosimo I's Tuscany, where even "the dream of God's Bourgeois city of Savonarola, all burning still in Joachim's apocalypse, will discolor slowly until it returns to the ranks of the official orthodoxy and the mercy of the Counter-reformation, as veneration of a non-canonized saint of the Church" (Spini).

However, the true interpretors of the rigorous Tridentine turnaround are elsewhere. They are the lucid Ludovico Carracci of the Annuciation of Bologna, with his calculated and demure neo-15th-century intimacy and the compulsory eclecticism of the sacred pictures of Scipione Pulzone.

On the other hand, the rigorous phase of the Counter-reformation is not univocal or homogenous. Even after Trento, Catholic Reformation and Counter-Reformation, more than any other two historical periods one after the other, are the two moments of an internal dialectic of the Church. Jedin writes:

" . . . in concrete reality, in men and events, the phenomenon are parallel. The Trento Council and the Jesuit Order belong to the history of the Catholic Reformation as much as to that of the Counter-reformation. We would be

embarassed if we were to decide whether determined individuals could be placed in one or other line of development. If we talk of Ghiberti, Seripando, Filippo Neri, Giovanni and Teresa d'Avila, we can include them also in the Catholic Reformation: consider instead Ignazio di Loyola, Carlo Borromeo, and Francesco di Sales as counter-reformers; it is absolutely impossible, since they have in them the elements of both the phenomena.

It is actually in the Milan of Carlo Borromeo, traced with a religious disquiet to the limits of millenarism, in which Mannerism lives its last season, deep and ardent. These are the same years in which the solitary Barocci, freeing himself on the wings of the imagination and tiring himself in his "vigilant study," conjugated Mannerism and benevolent Catholic Reformism, throwing a bridge towards Baroque.

BIBLIOGRAPHY - *The debate over Mannerism (books, exhibitions, and essays of a general character)*: G. Briganti, La Maniera italiana, Roma-Erfurt, 1961; Manierismo, Barocco, Rococò: Concetti e termini, Convegno Internaz., Roma (1960); Relazioni e Discussioni, Roma, 1962; E. Battisti, L'Antirinascimento, Milano, 1962; M. Chiarini, Michelangelo e la Maniera, Cultura e Scuola, I, 3, 1962; A.R. Gutiérrez De Ceballos, La arquitectura del manierismo, Revista de ideas esteticas t. XX, 77, 1962; G. Weise, Le Maniérisme: histoire d'un terme, L'Information d'histoire de l'art, VII, 1962; F. Würtenberger, Der Manierismus. Der Europäische Stil des Sechzehnten Jahrhunderts, Wien-München, 1962; Acts of the 20th International Congress of the History of Art (1961), The Renaissance and Mannerism – Studies in Western Art, New York, 1963; E.H.J. Gombrich, Recent Concepts of Mannerism. Introduction: The Historiographic background, II; C.H. Smith, Mannerism and Maniera, II; J. Shearman, Maniera as an aesthetic Ideal, II; F. Hartt, Power and the individual in Mannerist Art, II; W. Lotz, Mannerism in Architecture: Changing Aspects, II; F. Baumgart, Renaissance und Kunst des Manierismus, Köln, 1963; J.F. Revel, Une invention du XX siècle, le Maniérisme, L'Oeil, 131, novembre 1963; L. Salerno, Arte scienza e collezioni nel manierismo, Scritti di Storia dell'arte in onore di M. Salmi, III, Roma, 1963; R. e M. Wittkower, Born under Saturn, London, 1963 (ed. it., Nati sotto Saturno, Torino, 1968); F. Barbieri, Palladio e il Manierismo, Boll. del Centro Intern. di Studi di Architett. A. Palladio, VI; 1964; P. Barocchi, Michelangelo e il manierismo, Arte antica e moderna, 27, 1964; J. Bousquet, La peinture manièriste, Neuchâtel, 1964; D. Frey, Manierismus als europäische Stilerscheinung, Stuttgart, 1964; A. Hauser, Der Manierismus, München, 1964 (ed. it., Il Manierismo. La crisi del Rinascimento e l'origine dell'arte moderna, Torino, 1965); D. Heikamp, L'architecture de la métamorphose, L'Oeil, 114, 1964; P. Preiss, Zum anthropomorphismus in der manieristischen Kunst, Sbornik praci Filosof Fakulty Bruěnsk Univ., XIII, 8, 1964; P. Prodi, Il Concilio di Trento e la riforma dell'arte sacra, Chiesa e quartiere, 32, 1964; P. Prodi, Riforma cattolica e Controriforma, Nuove Questioni di Storia moderna, I, 1964; Between Renaissance and Baroque. European Art 1520-1600 Mostra della Manchester City Art Gallery, Catalogo a cura di G.L. Conran e F.G. Grossman, Manchester, 1965; Le seizième siècle européen. Peintures et dessins dans les collections publiques francaises, Paris, Petit Palais, Cataloghi con scritti di A. Chastel, M. Laclotte, M. Serullaz, R. Bacou, Paris, 1965; J. Biaostocki, Der Manieris-mus zwischen Triumph und Dämmerung, Michelangelo heute . . . , Berlin, 1965; J. Bousquet, Manierismo in Europa, Milano, 1965; S.J. Freedberg, Observations in the painting of the Maniera, The Art Bulletin, XVLII, 2, 1965; G. Grzimak, Manierismus als Kunstperiod, Weltkunst, XXXV, 19, 1965; G.C. Argan, Il Michelangiolismo, Atti del Convegno di studi michelangioleschi (1964), Roma, 1966; J. Biaostocki, Stil und Ikonographie Studien zur Kunstwissenschaft, Dresden, 1966; C. Dumont, Le Maniérisme (Etat de la question), Bibliothèque d'Humanisme et Renaissance, XXVIII, 2, 1966; M. Tafuri, L'architettura del Manierismo nel Cinquecento europeo, Roma, 1966; E. Battisti, Storia del concetto di Manierismo in architettura, Boll. del CISA A. Palladio, IX, 1967; A.M. Brizio, Manierismo: Rinascimento, Boll. del CISA A. Palladio, IX, 1967; A. Chastel, Le Maniérisme et l'art du Cinquecento, Boll. del CISA A. Palladio, IX, 1967; W. Hager, Strutture spaziali del Manierismo nell'architettura italiana, Boll. del CISA A. Palladio, IX, 1967; A. Hauser, L'ambiente spirituale del Manierismo, Boll. del CISA A. Palladio, IX, 1967; N. Pevsner, Palladio e il Manierismo, Boll. del CISA A. Palladio, IX, 1967; M. Tafuri, L'idea di architettura nella letteratura teorica del Manierismo, Boll. del CISA A. Palladio, IX, 1967; H. Jedin, Katholische Reform und Gegenreformation, Handbuch der Kirchengeschichte, IV, Freiburg-Basel-Wien, 1967; L. Murray, The Late Renaissance and Mannerism, London, 1967; J. Shearman, Mannerism, Harmondsworth, 1967; C. Singleton, Art, Science and History in the Renaissance, Baltimore, 1967; W. Tatarkiewicz, Wer waren die theorethiker des Manierismus?, Zeitschrift für Ästhetik und Allgemeine Kunst, XII, I, 1967; G.C. Argan, Storia dell'arte italiana, III, Firenze, 1968 (Il Cinquecento); L. Benevolo, Storia dell'architettura del Rinascimento, Bari, 1968 (II ed. riveduta, Bari, 1973); A. Chastel, La crise de la Renaissance (1520-1600), Genève, 1968; G. Nicco Fasola, Aspetti del Manierismo, L'Arte, 3-4, 1968; S. Sebastian, El manierismo y la arquitectura manierista italiana, Revista de Ideas Esteticas, XXVI, 103, 1967; M. Tafuri, Il mito naturalistico nell'architettura del '500, L'Arte, I, 1968; A. Pinelli, Il Manierismo, Storia dell'arte, 1-2, 1968; A.M. Göransson, Studies in Mannerism, Konsthistorisk Tidskrift, XXXVIII, 3-4, 1969; G. Pochat, On Mannerism, Konsthistorisk Tidskrift, XXXVIII, 1-2, 1969; M. Tafuri, L'architettura dell'Umanesimo, Bari, 1969; The Age of Vasari, mostra alla Art Gallery University of Notre-Dame, Indiana, March 1970; A. Hauser, Le basi spirituali del Manierismo, Rappresentazione artistica e rappresentazione scientifica nel secolo dei lumi, Firenze, 1970; G. Kauffmann, Die Kunst des 16. Jahrhunderts, Berlin, 1970; P. Philippot, Pittura fiamminga e Rinascimento italiano, Torino, 1970; P. Portoghesi, La lingua universale. Cultura e architettura tra il 1503 e il 1527, Controspazio, November-December 1970; G. Weise, Il Rinascimento e la sua eredità, Napoli, 1970; S.J. Freedberg, Painting in Italy (1500-1600), Harmondsworth, 1971; G. Weise, Il Manierismo. Bilancio critico del problema stilistico e culturale, Firenze, 1971; F. Bologna, Dalle arti minori all'industrial design. Storia di un'ideologia, Bari, 1972; E. Chojecka, Die Kunsttheorie der Renaissance und das Wissenschaftliche Werk des Kopernikus, Zeitschrift für Kunstgeschichte, 4, 1972; G. De Angelis D'Ossat, La vicenda architettonica del Manierismo, Atti del XIV Congresso di Storia dell'Architettura (1965), Roma, 1972; A. Smart, The Renaissance and Mannerism outside Italy, London, 1972; D. Summers, Maniera and movement: the Figura serpentinata, The Art Quarterly, 3, 1972; N. Badaloni, Cultura e vita civile tra Riforma e Controriforma, Bari, 1973; L. H. Heydenreich, W. Lotz, Architecture in Italy – 1400 to 1600, Harmond-

sworth, 1974; P. Lavedan, Contreréforme, Baroque, Maniérisme, Gazette des Beaux-Arts, February 1974.

The center of style - Tuscany and Rome: S.J. Freedberg, Painting of the High Renaissance in Rome and Florence, Cambridge (Mass.), 1961; G. Labrot, Conservatisme plastique et expression rhétorique. Réflexions sur le développement de l'académisme en Italie centrale (Rome et Florence), Mélanges d'arch. et d'hist., LXXVI, 2, 1964; A.M. Nagler, Theatre Festivals of the Medici, New Haven and London, 1964; L. Berti, Il Principe dello Studiolo. Francesco I de' Medici e la fine del Rinascimento fiorentino, Firenze, 1967; L. Berti, L'architettura manieristica a Firenze e in Toscana, Boll. del CISA A. Palladio, IX, 1967; M. Tafuri, J. Barozzi da Vignola e la crisi del Manierismo a Roma, Boll. del CISA A. Palladio, IX, 1967; P. Portoghesi, Roma del Rinascimento, Milano, s.d.; J.A. Gere, Il Manierismo a Roma (I disegni dei maestri), Milano, 1970; C. Monbeig-Goguel, Il Manierismo fiorentino (I disegni dei maestri), Milano, 1971; C.L. Frommel, Der Römische Palastbau der HochRenaissance, Tübingen, 1973; F. Borsi, Firenze del Cinquecento, Roma, 1975.

Of special importance to the Tuscan-Roman area was the exhibition of designers and printers in the Uffizi in Florence: Jacopo Ligozzi (Firenze, 1961); Michelangelo e la sua scuola (1961); Michelangelo (1962); I Fondatori dell'Accademia delle arti del Disegno (1963); Vasari e la sua cerchia (1964); Perin del Vaga e la sua cerchia (1966); Carri trionfali e costumi per la Genealogia degli dei di Vasari (1966); gli Zuccari (Taddeo e Federico Zuccari e Raffaellino da Reggio) (1966); Bernardo Buontalenti (1968); Feste e apparati medicei da Cosimo I a Cosimo II (1969); Alessandro Allori (1970).

Piedmont and Lombardy: G. Testori, Manieristi piemontesi e lombardi del '600, Milano, 1966; G. Romano, Casalesi del Cinquecento. L'avvento del manierismo in una città padana, Torino, 1970; G. Bora, Disegni di manieristi lombardi, Vicenza, 1971; A. Scotti, Architettura e riforma cattolica nella Milano di Carlo Borromeo, L'Arte, 18-19-20, 1973; Il Seicento lombardo, Cataloghi della mostra con scritti di G.A. Dell'Acqua, M. Gregori, M. Rosci, G. Testori, F.M. Ferro, Milano, 1973.

Venice: M. Rosci, Sebastiano Serlio e il manierismo nel Veneto, Boll. del CISA A. Palladio, IX, 1967; R. Pallucchini, Per la storia del Manierismo nel Veneto, Bulletin du Musée National de Varsovie, 3-4, 1968.

Emilia: G. Frabetti, Manieristi a Ferrara, Ferrara, 1972.

Sicily: G. Bellafiore, La Maniera italiana in Sicilia. Profilo dell'urbanistica e dell'architettura, Palermo, 1963; M. De Simone, Manierismo architettonico nel Cinquecento palermitano, Palermo, 1968.

Spain: G. Weise, La sculpture espagnole du temps de la Renaissance et le problème du Maniérisme, L'Information d'histoire de l'art, 1964; G. Weise, Der Monstruöse Stil der Spanischen Renaissance - Ornamentik als Kunstgeschichtliches und Geistesgechichtliches Problem, Festschrift Ulrich Middeldorf, Berlin, 1968.

France: H. Zerner, Die Schule von Fontainebleau. Das graphische Werk, Wien, 1969; L'Ecole de Fontainebleau, mostra a Parigi, Catalogo con scritti di A. Chastel e S. Beguin, Paris, 1972.

Flanders: Le siècle de Brueghel. La peinture en Belgique au XVIe siècle, mostra a Bruxelles, Catalogo con scritti di L. van Puyvelde e K.G. Boon, Bruxelles, 1963; G.T. Faggin, La pittura ad Anversa nel Cinquecento, Firenze, 1969; P. Philippot, Pittura fiamminga e Rinascimento italiano, Torino, 1970.

England: N. Pevsner, L'Inghilterra e il Manierismo, Boll. del CISA A. Palladio, IX, 1967.

Austria: L. Zoege von Manteuffel, Die Kunst am Hof Rudolfs II, Kunstchronik, 1969, XXII, 8.

The Principal Figures of the Style (Monographs and Exhibitions). - *Alessi:* Mostra di Galeazzo Alessi, Genova, 1974; Galeazzo Alessi e l'architettura del Cinquecento, Atti del Congresso internaz. (1974), Genova, 1975. *Ammannati:* M. Fossi, Bartolomeo Ammannati architetto, Firenze, 1966. - *Barocci:* H. Olsen, Federico Barocci, Copenhagen, 1962; Mostra di Federico Barocci, Bologna, Catalogo a cura di A. Emiliani, Bologna, 1975. - *Barozzi:* Mostra di Jacopo Barozzi detto il Vignola, Catalogo con scritti di M. Walcher Casotti, W. Lotz, J. Coolidge, ecc., Vignola, 1973. - *Beccafumi:* D. Sanminiatelli, Domenico Beccafumi, Milano, 1967. - *Bertoja:* A. Ghidiglia Quintavalle, Il Bertoja, Parma, 1963. - *Bordone:* G. Canova, Paris Bordone, Venezia, 1964. - *Bramante:* A. Bruschi, Bramante architetto, Bari, 1969; Bramante tra Umanesimo e Manierismo, Catalogo della mostra con scritti di R. Bonelli, C. Tiberi, S. Benedetti, G. Miarelli Mariani, G. Spagnesi, A. Bruschi, Roma, 1970; Studi bramanteschi, Atti del Congresso Internaz. (Milano-Roma-Urbino, 1970), Roma, 1974. - *Bronzino:* C.H. Smith, Bronzino as draughtsman. An Introduction, New York, 1972. - *Cellini:* Benvenuto Cellini. Artista e scultore, Convegno internaz. (1971), Roma, 1972. - *Cerano:* M. Gregori, Il Cerano, Milano, 1964; Mostra del Cerano, Catalogo a cura di M. Rosci, Novara, 1964. - *Cesari (Cavaliere D'Arpino):* Mostra de Il Cavaliere D'Arpino, Catalogo a cura di H. Röttgen, Roma, 1973. - *Del Duca:* S. Benedetti, Giacomo Del Duca e l'architettura del Cinquecento, Roma, 1973. - *Della Porta:* V. Tiberia, Giacomo. Della Porta, un architetto tra manierismo e barocco, Roma, 1974. - *Dosso:* A. Mezzetti, Il Dosso e Battista ferraresi, Ferrara, 1965; F. Gibbons, Dosso and Battista Dossi court painters et Ferrara, Princeton (N.J.), 1968. - *Genga.* A. Pinelli, O. Rossi, Genga architetto. Aspetti della cultura urbinate del primo '500, Roma, 1971. - *Greco:* H.E. Wethey, El Greco and his School, Princeton (N.J.), 1962. - *Michelangelo:* J.S. Ackerman, The Architecture of Michelangelo, London, 1961 (ed. it., L'architettura di Michelangelo, Torino, 1968); C. De Tolnay, The Art and Thought of Michelangelo, New York, 1964; Michelangelo architetto, a cura di B. Zevi e P. Portoghesi, Torino, 1964; Michelangelo. Artista, pensatore, scrittore, scritti di M. Salmi, C. De Tolnay, U. Baldini, R. Salvini, G. De Angelis D'Ossat, L. Berti, E. Garin, ecc., Novara, 1965; R.J. Clements, The poetry of Michelangelo, New York, 1965; Atti del Convegno di Studi michelangioleschi (1964), Roma, 1966; X. De Salas, Miguel Angel y el Greco, Madrid, 1967; C. De Tolnay, Michelangelo, the final Period, Princeton (N.J.), 1971. - *Morazzone:* Mostra del Morazzone, Catalogo a cura di M. Gregori, Milano, 1962. - *Nicolò dell'Abate:* Mostra di Nicolò dell'Abate, Catalogo a cura di S. Béguin, Bologna, 1969; Per Nicolò dell'Abate. Mostra di affreschi restaurati, Catalogo a cura di A. Mezzetti, Modena, 1970. - *Paladini:* Mostra di Filippo Paladini, Catalogo a cura di M.G. Paolini, e D. Bernini, Palermo, 1967. - *Palladio:* R. Pane, Andrea Palladio, Torino, 1961; G. Zorzi, Le opere pubbliche e i palazzi privati di Andrea Palladio, Vicenza, 1964; J.S. Ackerman, Palladio, Harmondsworth, 1966; G. Zorzi, Le chiese e i ponti di A. Palladio, Vicenza, 1966; J.S. Ackerman, Palladio's villas, New York, 1967; N. Ivanoff, Palladio, Milano, 1967; G. Zorzi, Le ville e i teatri di A. Palladio, Vicenza, 1968; L. Puppi, Andrea Palladio, Milano, 1973; Mostra del Palladio, Catalogo a cura di R. Cevese, Venezia, 1973. - *Parmigianino:* A. Ghidiglia Quintavalle, Gli affreschi giovanili del Parmigianino, Parma, 1968; M. Fagiolo, Il Parmigianino. Un saggio sull'ermetismo nel '500, Roma, 1970; A. Ghidiglia Quintavalle, Gli ultimi

affreschi del Parmigianino, Parma, 1970; A. Ghidiglia Quintavalle, Parmigianino, Disegni scelti, Firenze, 1971; A.E. Popham, Parmigianino. Catalogue of the Drawings, New Haven and London, 1971. – *Peruzzi*: C.L. Frommel, Die Farnesina und Peruzzi Architektonisches Früihwerk, Berlin, 1961; C.L. Frommel, Baldassare Peruzzi als Maler und Zeichner, Wien-München, 1967-68. – *Polidoro*: A. Marabottini, Polidoro da Caravaggio, Roma, 1969. – *Pontormo*: J. Cox Rearick, The Drawings of Pontormo, Cambridge (Mass.), 1964; L. Berti, Pontormo. Disegni scelti. Firenze, 1965; L. Berti, Pontormo, Firenze, 1966; K.W. Forster, Pontormo, München, 1966; L. Berti, L'opera completa del Pontormo, Milano, 1973. – *Pordenone*: I. Furlan, Giovanni Antonio Pordenone, Pordenone, 1966. – *Raffaello*: S. Ray, Raffaello architetto. Linguaggio artistico e ideologia del Rinascimento romano, Bari, 1974. – *Romanino*: Mostra di Girolamo Romanino, Catalogo a cura di G. Panazza, Brescia, 1965; G. Panazza, Affreschi di Girolamo Romanino, Brescia, 1965. – *Sanmicheli*: L. Puppi, Michele Sanmicheli, architetto di Verona, Verona, 1971. – *Sansovino*: M. Tafuri. Jacopo Sansovino e l'architettura del '500 a Venezia, Padova, 1969. – *Sarto*: S.J. Freedberg, Andrea del Sarto, Cambridge (Mass.), 1963; J. Shearman, Andrea del Sarto, Oxford, 1965. – *Tintoretto*: Pierluigi De Vecchi, L'opera completa del Tintoretto, Milano, 1970. – *Vasari*: P. Barocchi, Vasari pittore, Milano, 1964; P. Barocchi, Complementi al Vasari pittore, Firenze, 1964; Il Vasari storiografo e artista, Atti del Congresso internaz. (1974). – *Vitozzi*: N. Carboneri, Ascanio Vitozzi, un architetto tra Manierismo e Barocco, Roma, 1966. – *Zuccaro*: J.A. Gere, Taddeo Zuccaro. His development studied in his drawings, London, 1969.

The Literature of the theory of the style (modern reprints, unpublished material, and interpretive essays): Trattati d'arte del Cinquecento fra Manierismo e Controriforma, a cura di Paola Barocchi, I, Bari, 1960 (Varchi, Pino, Dolce Danti, Sorte), II, Bari, 1961 (Gilio, Paleotti, Aldrovandi) III, Bari, 1962 (C. Borromeo, Ammannati, Bocchi, R. Alberti, Comanini); Robert J. Clements, Michelangelo's theory of art, New York, 1961; F. Zuccaro, Scritti d'arte a cura di D. Heikamp, Firenze, 1961; P. Prodi, Ricerche sulla teoria delle arti figurative nella Riforma cattolica, Archivio Italiano per la Storia della Pietà, Roma, IV, 1962; The Divine Michelangelo. The Florentine Academy's Homage on his death in 1564, ed. in facsimile, a cura di R.E.M. Wittkower, London, 1964; Il carteggio di Michelangelo, ed. postuma di G. Poggi, a cura di P. Barocchi e R. Ristori, Firenze, I, 1965; II, 1967; I Ricordi, a cura di L. Bardeschi Ciulich e P. Barocchi, Firenze, 1970; R. Klein, H. Zerner, Italian Art, 1500-1600. Sources and Documents, Englewood Cliffs (N.J.), 1966; E. Spina Barelli, Teorici e scrittori d'arte tra manierismo e barocco, Milano, 1966; R. Borghini, Il Riposo (Firenze, 1588), ed. anast. a cura di M. Rosci, Milano, 1967; Il trattato di architettura di Sebastiano Serlio, ried. a cura di M. Rosci, Milano, s.d.; P. Marconi, Un progetto di cittá militare. L'VIII libro inedito di Sebastiano Serlio, Controspazio, 1969; Karel van Mander, Het Schilder boeck (Haarlem, 1604), ediz. anastat., Utrecht, 1969); B. Ammannati, La città. Appunti per un trattato, a cura di M. Fossi, Roma, 1970; G. Vasari il Giovane, La città ideale. Piante di chiese (palazzi e ville) di Toscana e d'Italia, a cura di V. Stefanelli, introd. di F. Borsi, Roma, 1970; P. Roberto Ciardi, Le regole del disegno di Alessandro Allori e la nascita del dilettantismo pittorico, in "Storia dell'arte,"12, 1971; C. Ossola, Autunno del rinascimento, "Idea del Tempio" nell'arte dell'ultimo Cinquecento, Firenze, 1971; A.M. Pupillo Ferrari Bravo, "Il Figino ovvero del fine della pittura" di Gregorio Comanini, Storia dell'arte, 13, 1972; C.M. Strinati, Studio sulla teoria d'arte primoseicentensca tra manierismo e barocco, Storia dell'arte, 13, 1972; S. Rossi, "Il trattato delle perfette proporzioni" di Vincenzo Danti e l'incidenza della "Poetica" sulle teorie artistiche del secondo Cinquecento, Storia dell'arte, 14, 1972; G.P. Lomazzo, Scritti sulle arti, a cura di P. R. Ciardi, Firenze, 1973; S. Rossi, Idea e accademia. Studio sulla teoria artistica di Federico Zuccaro. I – Disegno interno e disegno esterno, Storia dell'Arte, 20, 1974; A.M. Pupillo Ferrari Bravo, "Il Figino" del Comanini. Teoria della pittura di fine '500, Roma, 1975.

ANTONIO PINELLI

FIGURATIVE ARTS IN THE 17th CENTURY (PLATES 123-126)

Italy. – The Caravaggesque theme, in its largest meaning (including Caravaggio's art and its immediate implications, as well as the "Caravaggismo" in any and every indicative ramification), is the one which most magnetized many interests and varieties of methodological approaches. This is proved by a bibliography of more than a hundred titles, including volumes and essays published from 1960 onwards, and also by the great interpretative debate which, according to documentary and philological researches, is still a prolific field for surveys of iconological, historical-cultural, and sociological-psychological character.

Concerning Caravaggio's personality, the recent researches, and mainly the documentary one, produced innovative results. For example, the date of birth of the artist, usually considered on September 28, 1573 (resulting from the back calculation made on the known epitaphs written in 1610 by Marzio Milesi), is on the contrary about two years earlier. It has to be fixed at the end of October 1571, and probably took place in Milan and not in the place of origin of the Merisi family, namely Caravaggio, as proved by the detailed verification of the archives promoted by Cinotti (see M. Cinotti, in *Immagine del Caravaggio*, catalogue of the exhibition, Milano-Bergamo, 1973, and also "La giovinezza del Caravaggio, Ricerche e scoperte," in *Novità sul Caravaggio*, 1974, Milan, 1975).

Besides the chronological specification, the recent verifications give a new light to the whole formative moment of the artist, to the relations he had with the Lombard cultural ambience (longer than previously supposed), and also to the period after his transfer to Rome. Significant in this regard, the signs of a long gravitation in the spiritual area and in the society entourage of Cardinal Federico Borromeo are noticed by Calvesi, "Letture iconologiche del Caravaggio" (1974), in *Novità sul Caravaggio*.

From the same documentary researches coordinated by Cinotti, it appears that the painter was still in Caravaggio on May 11, 1592, for the final division of his parents" inheritance with his brothers: thus stating a steady "post quem" for the journey to Rome, which therefore was really made at about the age of 20, as declared some time before by the first biographer Giulio Mancini. The journey was made with no dangers if, as already proved, the artist met in Rome his uncle priest Lodovico, who was in a fairly good position.

As to the artistic activity in Rome, a major chronological reconsideration has been caused by the documents published by Röttgen in 1965 concerning the paintings for Contarelli chapel in St. Luigi de Francesi: the commission for the altar-piece ("S. Matteo e l'angelo"), the first version of which - the one rejected, already in Berlin - had to be made in a few months time, since the final version was delivered on September 22, of the same year 1602 (see H. Röttgen, "Giuseppe Cesari, Die Contraelli-Kapelle und Caravaggio," in "Zeitschrift für Kunstgeschichte," XXVII, 1964, and "Die Stellung der Contarelli-Kapelle in Caravaggios Werk," in "Zeitschrift für Kunstgeschichte," XXVIII, 1965).

Other documents give a more detailed knowledge of the vicissitudes concerning the "Madonna dei Palafrenieri," particularly about the first placing, for two days only on April 14-15, 1606, in St. Pietro basilica, and about its purchase by Cardinal Scipione Borghese, followed almost immediately by the ecclesiastic authorities' refusal (see L. Spezzaferro, "La pala dei Palafrenieri," in "Caravaggio e i caravaggeschi," Records of the conference organized by the National Lincei Academy (1973), Rome, 1974).

The discovery of the inventories of Cardinal Del Monte's inheritance (died on August 27, 1626), dated February 21 and May 18, 1627, and of the records concerning the subsequent sale of that collection, by June 3, 1628, has confirmed several historical landmarks for some of the most important works of Caravaggio's youth. But it has also caused new interpretative waves, suggesting connections between those works and the literary-hedonistic ambience and the hermetic-scientific one which surrounded the cardinal's personality, as well as other connections with a sharper and captious counter-reformistic spirituality (see L. Frommel, "Caravaggio's Frühwerk und der Kardinal Francesco Maria Del Monte," in "Storia dell'Arte," 9-10, 1971; Ch. Kirwin, "Addendum to Cardinal Francesco Maria Del Monte's Inventory: the date of the Sale of various Notable Paintings," ibid.; L. Spezzaferro, "La cultura del Cardinal Del Monte e il primo tempo del Caravaggio," ibid.; M. Calvesi, "Caravaggio o la ricerca della salvazione," ibid.; and, of the same "Lettere iconologiche . . . ," ibid.).

To these, which are among the most important documentary verifications, have to be added the discoveries of works for which, besides the quotations of sources or of inventory papers, philological research was often helped by the better conditions of the paintings, obtained with proper restorations, as in the autograph confirmation of the "Flagellazione" of Rouen Museum (see P. Rosenberg, "Tableaux Français du XVIIᵉ Siècle et Italiens des XVIIᵉ et XVIIIᵉ Siècles, Rouen, 1966, n. 194).

Based on an absolute certainty, it is, first of all, the final identification of the original version of the "Marta e Maddalena," entered into the collection of the Detroit Institute of Arts (see F. Cummings, "The Meaning of Caravaggio's 'Conversation of the Magdalen,'" in "Burlington Magazine," CXVI, 1974) and then recognized as the one previously in the collection of the banker Ottavio Costa, who also owned the "S. Francesco in estasi," now in Hartford; the "Giuditta," now in the National Gallery of Ancient Art in Rome, the "S. Giovannino," now in Kansas City; and another "S. Francesco" (see L. Spezzaferro, "Ottavio Costa e Caravaggio: certezze e problemi" in "Novità sul Caravaggio," ibid.).

Just with reference to "S. Francesco" in meditation, it must be considered sure that another original version - besides the one of the Cappucini Church in Rome - is the painting of St. Peter Church in Carpineto Romano, published by M.V. Brugnoli ("Un S. Francesco da attribuire al Caravaggio e la sua copia," in "Bollettino d'Arte," LIII, 1968 [but 1970]).

Another important recovery is the "Ritratto di Alof de Wignacourt" kept in Pitti Palace in Florence. This work wasn't unknown, but for the first time at the moment of its reproposal at the Florentine exhibition of 1970, and then more incisively thanks to M. Gregori's argumentations ("A new Painting and some Observa-

tions on Caravaggio's Journey to Malta," in "Burlington Magazine," CXVI, 1974, 859; id., "Significato delle mostre caravaggesche dal 1951 ad oggi," 1973/1974, in "Novità sul Caravaggio," ibid.), showed itself completely suitable to the creative temperament of the Master.

Several reservations have, on the other hand, greeted another recovery. The unique "mural" painting of Caravaggio that is the ceiling of the small room where Cardinal Del Monte used to make alchemistic experiments, representing "Giove, Nettuno e Plutone" (see G. Zandri, "Un probabile dipinto murale del Caravaggio per il Cardinal Del Monte," in "Storia dell'Arte," 3, 1969), is an example of an unfounded reservation, in our opinion. Even considering the deterioration of the work due to the building vicissitudes after passage of the property to the Boncompagni Ludovisi family and the silence concerning its sources, it is unacceptable to exclude it from the Caravaggesque corpus.

Not yet completely solved are some attributive questions concerning the "Martirio di una santa" belonging to the Banca Commerciale Italiana in Naples and the remarkable "Negazione di S. Pietro," clandestinely exported from Italy in the early 1970s (see M. Marini, "Caravaggio 1607: la 'Negazione di S. Pietro,'" in "Napoli Nobilissima," XII, 1973, 5; the opinion about this work remains pending, just because it has been taken away from verifying examinations of students). However, the attribution of the "Cavadenti" of Florentine Galleries, now in Rome in Montecitorio Palace, is absolutely unacceptable. (For all these works see also M. Gregori, "Significato . . . ," ibid., with the relevant bibliography.)

The list of the more acceptable, even if sometimes uncertain, additions to the catalogue of Caravaggesque works, cannot neglect the high reduction for stealing which took place in 1969, of the great piece of the "Natività" from the Oratory of St. Lawrence Congregation in Palermo.

The survey of "Caravaggismo" was developed on two opposite lines. The efforts to enlarge the concepts terms, therefore also the chronological ones of the phenomenon, had their greatest supporter in A. Moir, "The Italian Followers of Caravaggio" (Cambridge, Mass., 1967), but also helped - even if in a controlled measure and without the vagueness of the American studies - the planning of the exhibition "Caravaggio e Caravaggeschi nelle Gallerie di Firenze," attended in 1970 by E. Borea (see catalogue of the exhibition, Florence, 1970).

On the other hand, the wish to define in detail the nature and the moments of the same phenomenon (already recalled by the reviews of Moir's book made by A. Paolucci in "Paragone," 213, 1967, and by B. Nicolson in "Burlington Magazine," CX, 1968) became the rigorous examination, certainly convincing but sometimes too reductive, of R. Spear (see the introducing essay to the catalogue of the exhibition "Caravaggio and His Followers," Cleveland, 1971); later the same wish has been reproposed, but moderated by a more sensitive feeling of the different cultural phenomena interfering among themselves, in the exhibition "Caravaggio y el Naturalismo Español (catalogue prepared by A. Pérez Sanchez, Siviglia, 1973) and in the one "I Caravaggeschi francesi" (catalogue prepared by A. Brejon de Lavergnée and J. P. Cuzin, with introducing essay by J. Thuillier, Rome, 1974).

However, it seems strange that (as already noted by M. Gregori, "Significato . . . ," ibid.) both researches of enlarging trend and the ones of reducing trend in respect to "Caravaggismo" moved on different levels, even following contemporary research which produced new standards of interpretation of Caravaggio's own art. In other words, these studies referred "Caravaggismo" phenomena to just one point - that is, the interpretation of Caravaggio's art in a naturalistic key, a key which in fact was of more immediate perception and of easier example to contemporaries (artists as well as writers), but which never was exclusive.

The acquired knowledge about other cultural implications, and especially the expressive ones belonging to Caravaggio's paintings, keep open to further considerations and to verifications not only of documentary or morphological character the problem of the artist's influence on figurative arts of the 17th century.

Anyway, recent research on "Caravaggismo," also owing to the specific occasions which promoted them, involved wide operations of philological sifting among the vast quantity of works which often were hypothetically referred to this or that real or supposed follower of the Lombard master. It was a detailed rebuilding of history, a resettlement of biographies, which would be too long to mention here in detail. Therefore we recommend bibliographic sources mentioned above, adding also: R. Spear, "Unknown Pictures by the Caravaggisti (with notes on 'Caravaggio and His Followers')," in "Storia dell'Arte," 14, 1972, and B. Nicolson, "Caravaggio and the Caravaggesques: Some Recent Researches," in Burlington Magazine," CXVI, 1974.

It will be helpful anyway to review here recent knowledge concerning Ribera and his first years in Rome after the surveying of new documents (V. J. Chenault, "Ribera in Roman Archives," in "Burlington Magazine," CX, 1969) and the restoring of the early series of the "Sensi" allegories, already started by R. Longhi ("I Cinque Sensi del Ribera," in "Paragone," 193, 1966) and continued by E. Schleier, C. Felton, and R. Spear (see, by the last one, the treatment of the question in "Unknown Pictures . . . ," ibid.).

The presence in Florence of the Neapolitan Battistello Caracciolo from 1617 to beginning 1619 was ascertained with the documentary reference to 1618 of the "Riposo nella fuga in Egitto" (see Borea, ibid. n. 5), particularly when the studies around the first part of the Neapolitan 17th century freed them from the usual historical clichés connected only to naturalistic presuppositions (see O. Ferrari, "Le arti figurative," in "Storia di Napoli," vol. VI, Napoli, 1971; R. Causa, "La pittura del Seicento a Napoli dal naturalismo al barocco," ibid., vol. V, 1972; W. Prohaska, "Carlo Sellitto," in "Burlington Magazine," CXVII, 1975, 862).

The Florentine exhibition of 1970 itself (see Borea, ibid.) promoted a better definition of the corpus of Bartolomeo Manfredi's works, thanks to convincing attributive proposals; a short time before B. Nicolson had already given the essential features about him ("Bartolomeo Manfredi," in "Studies in Renaissance and Baroque Art presented to Anthony Blunt," London, 1967).

Other personalities which took advantage of the new archive researches for their critical definition are the ones of Orazio and Artemisia Gentileschi (see A.M.

Crino, "More Letters from Orazio and Artemisia Gentileschi," in "Burlington Magazine," CII, 1960; A. M. Crinò - B. Nicolson, "Further Documents Relating to Orazio Gentileschi," in "Burlington Magazine," CIII, 1961; R. Ward Bissel, "Artemisia Gentileschi: A new documented Chronology," in "Art Bulletin," 1968; and E. Borea, ibid.).

Also, the recovery of the previously completely ignored artistic figure of the Neapolitan Giov. Battista Spinelli (see R. Longhi, "G. B. Spinelli e i naturalisti napoletani del Seicento," in "Paragone," 227, 1969), even considering that this is a personality which has been included by force among the followers of Caravaggio, is full of eccentric and no more up to date late-manneristic humors.

With respect to the French Caravaggesques, new research has been noted in the catalogue concerning the exhibition held in Rome and in Paris in 1974 ("I Caravaggeschi francesi," ibid.). The more consistent critical reconsiderations have been made by Vouet (see also W. R. Crelly, "The paintings of Simon Vouet," New Haven - London, 1962, and G. Dargent - J. Thuiller, "Simon Vouet en Italie, Essai de catalogue critique," in "Saggi e Memorie di Storia dell'Arte," 4, 1965), by Valentin (see J. P. Cuzin, "Pour Valentin," in "Revue de l'Art," 28, 1975), and by the problematic Trophime Bigot (see B. Nicolson, "The Candelight Master; a follower of Honthorst in Rome," in "Nederlands KunsthistorischJaarboek," II, 1960; B. Nicolson, "Un caravagiste aixois: Le Maître à la chandelle," in "Art de France," IV, 1964; B. Nicolson, "The Rehabilitation of Trophime Bigot," in "Art and Literatur," 4, 1965).

A separate mention has to be made on studies concerning Georges de la Tour, which culminated with the great monographic exhibition of Paris (see Catalogue prepared by J. Thuillier, Paris, 1972), which led to serious discussion of two courses, both with valid arguments: to tighten the criteria for identification with the Caravaggesque example, even if mediated (see A. Ottani Cavina, "La Tour all'orangerie e il suo primo tempo caravaggesco," in "Paragone," 273, 1972), and to propose a different cultural connaturation (see A. Blunt, "Georges de la Tour et 'Orangerie," in "Burlington Magazine," CXIV, 1972, where the painter's presence in Rome during his youth before 1616 is put under discussion). The La Tour case is excepted even from the ambit of the "Caravaggesque" phenomenon, to involve other and different problems of French painting during the first half of the 17th century, as clearly explained in the monograph concerning the artist by B. Nicolson and C. Wright, "Georges de La Tour" (Oxford, 1976).

Among the interesting discoveries regarding 17th-century art (also because it proves how the most famous monumental complexes are still subject to unexpected explorations) is the one of the hall and of the "grotta" - or internal "ninfeo" - which Pietro da Cortona made in the left side of Pitti Palace in Florence, shortly after 1644, for Cardinal Giancarlo de' Medici, which has a singular relief. These rooms, the entrance of which had been closed in 1847 from the stentorian great staircase made by P. Poccianti, preserves the very noble architectonic division, partially ruined, and the stucco and fresco decorations: the last ones partly of Pietro da Cortona. The lunette with biblical episodes placed in airy landscapes, referable to Salvator Rosa, provide the unique known proof of fresco painting by him (cf. M. M. Chiarini - K. Noehles, "Pietro da Cortona a Palazzo Pitti, un episodio ritrovato," in "Bollettino d'Arte," LII, 1967).

The studies concerning sculpture - which usually have fewer occasions of new contributions following restorations - had at least the chance of some important discoveries, which enlarged the corpus of the greatest exponent of Baroque plastic. As a matter of fact, in the fervent studies on G.L. Bernini - caused by the re-edition of Wittkower monography (1966) and by the published one of Marcello and Maurizio Fagiolo (1967) the proposals (largely discussed, that's true, but very stimulating) of I. Lavin have been introduced, based mainly on the discovery, in the basements of S. Giovanni dei Fiorentini in Rome, of the busts of "Antonio Coppola" (died 1612) and of "Antonio Cepparelli" (died 1622), about which there are also archive documents elliptically interpretable, and on the reference, always documentary, of the "Fanciullo con il drago," now in a private collection in New York. To these proposals has also been added the one, less acceptable, about the attribution to G. L. Bernini of the two putti on the fastigium of the arc on the right side of Barberini Chapel in S. Andrea della Valle; while for the other two putti on the frontal arc he suggests a reference to Mochi (cf. I. Lavin, "Five New Youthful Sculptures by Gianlorenzo Bernini and a Revised Chronology of his Early Works," in "Art Bulletin," L, 1969).

Absolutely undiscussed has been the discovery of a bust of Urbano VIII, already in a private collection and then exported to the National Gallery of Ottawa, Canada, which Wittkower reports, as a first version, the well known bust of Principe Barberini. In the meanwhile the bust was bought by the National Gallery in Rome. From this discovery came (also owing to the fact that documentary sources concerning directly the now published book were missing) the problem of the date of the Rome exemplar, between the second and the third decennium of the century (cf. R. Wittkower, "A New Bust of Pope Urbano VIII by Bernini," in "Burlington Magazine," CXI, 1969).

ORESTE FERRARI

Apart from the Caravaggesque phenomenon, which saw the studies concerning Caravaggio going on following a proper line in historical-artistic research (see above), in Italy a revival of interest in the field corresponding more or less to "baroque" conceit and identifying itself in a European style deeply different from "Caravaggismo" must be noted. The baroque tendency, opposite to the Caravaggesque current, presents itself as monumental art intimately connected in its three greatest expressions - architecture, sculpture, painting - and mainly decorative, affirming in works destined not to private use but to a public one. It is at its best in the painting of frescoes.

The baroque phenomenon has been studied and abstracted both in publications and in exhibitions involving the most important Italian artistic currents, from Piemonte to Southern Italy. A complete and up to date (about 1970) bibliography is the one offered by the third edition, of the classic book of R. Wittkower, "Art and Architecture in Italy: 1600 to 1750." The wide literature of the early 1970s had an important contribution

from the exhibitions catalogues, which are often the most up-to-date abstractions. We will give you an outline of them, without pretending completeness.

Starting from Piemonte, in 1963 the great "Mostra del Barocco Piemontese," exhibition made a fundamental contribution to the knowledge of 17th-century art in that region. The exhibition underlined the composite character of the Piedmontese art for the different contributions due to its geographical position, all with a strong French accent. From that exhibition, it was evident that continuous exchanges between "major" and "minor" arts, were integrated in a common language well joined and coherent. The exhibition showed also the importance in this moment of scenography, mainly in respect to architecture.

Painting and decorative art in Liguria always offered, thanks to the very reach and complex local production of a well-characterized school, the start for numerous studies and exhibitions up to very recent times. Major and minor personalities always interested students of the 17th century for the connections with the Nordic culture, especially Flemish, due to the presence in Genoa of such artistic personalities as Rubens and Van Dyck. Therefore, we find several recent studies, including monographic studies, specifying different currents of taste, and analyzing the decorative aspect of Ligurian production in this century, which will see some of the most brilliant solutions concerning baroque decoration. Such major personalities as Baciccio, Bernardo Strozzi, Giovanni Benedetto Castiglione, and Valerio Castello found their place in monographic studies, without forgetting such minor ones as Travi, Scorza, Tavella, and Niccolò Cassana (see bibliography). Decorative painting also remains important. The monographic studies point to that direction ("La pittura a Genova . . . dal Seicento al primo Novecento," Genova, 1971; E. Gavazza, 1974). For movable paintings there has been a further search in the "Mostra dei pittori genovesi a Genova nel '600 e nel '700," held in 1969, which documented, with works in great part unedited, that there was important Ligurian artistic production in all the different branches. Also, the drawings of this time has attracted the interest of students. The relevant studies have been synthetized in an exhibition of 1972 in the United States (Genoese Baroque Drawings," prepared by M. Newcome). An important contribution to research concerning landscape and "seascape" paintings, particularly favored in Genoa, has been given by the book dedicated to "Cavalier Tempesta e al suo tempo" by M. Roethlisberger, with a particular mention of Tavella. Minor aspects have been treated also in local exhibitions ("Dipinti e disegni genovesi . . . ," prepared by G. Godi, 1973). Genoese collections have been studied especially by Pietro Torriti, who published in different editions some artistic works belonging to old Genoese families ("I tesori di Strada Nuova . . . ," Genoa, 1970).

As far as Lombardy is concerned, after the exhibition dedicated to three protagonists of local painting between mannerism and baroque (Morazzone, Cerano, and Tanzio) and after the parts concerning figurative arts in "Storia di Milano," later studies and critical improvements have been analyzed and synthecized in the exhibition "Seicento lombardo" (Milano, 1973). In the three catalogues of this exhibition there is extensive and current documentation on the figurative arts of this period. In the introduction essay, it is noted that it is necessary to connect figurative art to historical events, including the predominant role of Carlo and Federico Borromeo, as well as the famous plague of 1630 (see F. M. Ferro, "La peste nella cultura lombarda," Milano, 1973). Besides the figures largely documented in the above-mentioned monographic exhibitions, there emerged in the exhibition the less studied Camillo and Giulio Cesare Procaccini Daniele Crespi, Francesco del Cairo, and Genovesino. The section regarding drawings offered the largest choice available today, after the first research was started in 1959, thanks to Ambrosiana ("Disegni di maestri lombardi del primo Seicento," prepared by E. Spina Barelli).

Many are the contributions to the Venetian art of the 17th century. For a complete bibliography, we suggest the year-book "Arte veneta," which contains the bibliographic "voices" of each year following systematic and capillary selections. Up until 1959, anyway, research and studies regarding this sector are all in the catalogue of the exhibition "Pittura del Seicento a Venezia," which can be up-dated by later research reported in exhibitions and special studies which, even if not at the level of the ones regarding the 18th century, were numerous between 1960 and 1975. Very important for the knowledge of this culture is the inventory of Donzelli and Pilo dedicated to "Pittori del Seicento veneto" (1968), which will have to be integrated with the catalogues of two exhibitions which pointed out local problems, i.e. the "Pittura veneta del Seicento in Friuli" (Udine, 1968) and the larger one "Cinquant'anni di pittura veronese, 1580-1630" (Verona, 1974). The latter one, starting from the late-manneristic painting of the 16th century (Felice Brusasorzi, Bernardino India, Paolo Farinati), which had a part also in the exhibition "Disegni veronesi del Cinquecento" (Venezia, 1971), focussed on the three more interesting figures: Alessandro Turchi, Marcantonio Bassetti, and Pasquale Ottino, already studied by Roberto Longhi for their connection with Caravaggesque painting. With references to that ambit, and for the problems connected with transalpine and lagoon cultures, we must be reminded also of the monography concerning the Venetian Carlo Saraceni made by A. Ottani Cavina (1968).

As to the Emilian art, once again the exhibitions have offered the most up-to-date research material and the concrete start to the "discovery" of a sector of Italian painting which had been disregarded and limited by the critics as "eclecticism." The series of exhibitions held mainly in Bologna has reproposed, for monographic themes or for periods, the reconsideration of what today is called one of the most important moments not only of Bolognese painting, but also of Italian and the European painting, for the start towards the baroque opening in the interpretation of classic ideals of the 16th century. Monographic exhibitions - from Reni to Carracci, from Guercino to Barocci - reproposed the study of important culture points concerning the protagonists. The exhibitions, dedicated to one theme, stated the European value of Bolognese culture of the 17th century. These were the theoretical components of the exhibition dedicated to "Ideale classico del Seicento in Italia e la pittura di paesaggio" (1962), which together with the Bolognese - Carracci, Domenichino, Lanfranco, Albani - included the French Poussin, Claude Lorrain, and Dughet, who will have great importance in the formula-

tion of the classic language in European painting. The exhibition prepared by Francesco Arcangeli in 1970 had a different trend, but similar originality in the statement. "Pittura ed espressione nell'arte bolognese-emiliana," wanted to find a common and continuous line in the Emilian figurative tradition of the 14th century (Vitale da Bologna, Jacopino dei Bavosi) to the 16th century (Aspertini), to the 17th century of Ludovico Carracci, to the 18th century of Giuseppe Maria Crespi, and to the contemporary world of Giorgio Morandi.

The last revaluation concerning these studies and affecting a larger ambit was the one of Federico Barocci (1975), not Emilian of birth but bound to a culture mediated by Bologna and Rome. The Bolognese exhibitions provided a lot of research material and gave rise to interest in the major personalties (see, for example, A. Emiliani, "Guido Reni," Milano, 1964; D. Posner, "Annibale Carracci," London, 1971; C. Garboli - E. Baccheschi, "L'opera completa di Guido Reni," Milano, 1971), as well as the historical-social problems referred to (A.W.A. Boschloo, "Annibale Carracci in Bologna. Visible Reality in Art after the Council of Trent," S. Gravenhage, 1974), and the ones more specifically of drawing (C. Johnston, "l disegni dei maestri. ll Seicento e il Settecento a Bologna," Milano, 1971; C. Johnston, "Gabinetto disegni e stampe degli Uffizi. Disegni bolognesi dal XVI al XVIII secolo," Firenze, 1973). The research about collections had also been very useful, as the exhibition of London in 1973 ("England and the Seicento. A Loan Exhibition of Bolognese Paintings from British Collections," Thos. Agnew and Sons Ltd., catalogue prepared by C. Whitfield) and the one of Florence Uffizi in 1975, "Pittori bolognesi del Seicento nelle Gallerie fiorentine," catalogue prepared by E. Borea). Also, more peculiar areas have been recently subject to an accurate research (E. Riccomini, "Il Seicento ferrarese," Milano, 1969).

Painting, sculpture, and architecture in Tuscany until a few years ago had been considered a phenomenon dependent on Roman baroque in a style without proper characteristics. Studies and exhibitions of these last ten years sought a verification of this position and search for an original language - even if opened, of course, to different experiences - which, still sharing the manneristic taste so deeply rooted in Tuscan culture up to the 18th century, will open to Roman baroque following proper meanings and characteristics which distinguish it from a servile imitation. Mannerism, being a fundamental experience in Tuscan art, appears with evidence up to the arrival in Florence of Pietro da Cortona, about at the middle of the century, followed 30 years later by Luca Giordano. The facts connected to these experiences have been surveled mainly by Mina Gregori in an exhibition of 1965 ("Settanta pitture e sculture del '600 e '700 fiorentino," Florence, Strozzi Palace), which represents a first synthesis of the problems concerning the figurative Florentine baroque art. Some researchers then started on problems of reading Florentine painting in a new key (Avant-propos sulla pittura fiorentina del Seicento," 1964). In the meanwhile also outside Italy an interest developed in the Tuscan artistic ambience (Florentine Baroque Art from American Collections, New York, 1969) and in court patronage (M. Campbell, "Medici Patronage and the Baroque . . . ," 1966;

"Artisti alla corte granducale," Catalogue of the exhibition, Florence, 1969).

Different artistic personalities have been studied in detail. They have been reconsidered in the light of new research and new discoveries, most of all referring to the first half of the century (C. del Bravo, "Per Jacopo Vignali," 1961; A.R. Masetti, "Cecco Bravo," 1962; F. Sricchia, "Lorenzo Lippi . . . ," 1963; C. Del Bravo, "Carlo Dolci," 1963), while a few attempts have been made trying to interpret some phenomenon in a Caravaggesque key ("Caravaggio e caravaggeschi nelle Gallerie di Firenze," Catalogue prepared by E. Borea, Florence, 1971). The second half of the century, as regards to architecture and sculpture, had a fundamental sifting in the study made on "Florentinische Barokplastik" (1962) by K. Lankheit. All this period, including the so-called "minor arts" and scenography, have been synthetized in the exhibition "Gli ultimi medici. Il tardo barocco a Firenze, 1670-1743" (Detroit-Firenze, 1974) the catalogue of which, together with the "Records" of the meeting in Florence about the same argument (Kunst des Barock in der Toskana. Studien zur Kunst unter den letzten Medici," 1976), offer the most up-to-date documentation about it. The aspects of graphic arts have been recently studied, even if only referred to by the most important personalities (Cristofano Allori, Cecco Bravo, Francesco Furini, il Volterrano, Stefano della Bella) in monographic exhibitions or in catalogues of collections.

As far as the Roman 17th Century is concerned, undoubtedly the "caravaggismo" phenomenon with all its implications receives the greatest interests, thanks to the last surveyes which brought to light discoveries of the highest interest and new verifications and interpretations (see above). The "baraque" phenomenon, on the contrary now systematically studied and set in specific works, dedicated both to single artists and to periods and "kinds," has been summarized in the classic book of R. Wittkower, "Art and Architecture in Italy, 1600 to 1750," now at its fourth edition (Baltimore, 1973). As a matter of fact it is possible to say that the critical process has been directed, more than to new surveyes and "discoveries," to baroque placement in the European culture following a settlement which gave rise to various exhibitions, as the one in Detroit in 1965 ("Art In Italy, 1600-1700"), the one dedicated to "Caravaggio e la pittura italiana del '600 in Paris (1965), to "Barocco romano" (Tokyo, 1971) and at last the one about the "themes" of figurative arts of the United States in 1974 ("Roman Baroque Festival"). While in the painting field, the contributions to trends or to single personalities seem reduced one must remember at least the contribution (1964) of A. Sutherland Harris to the decorative cycle of S. Martino ai Monti, of Enggass for the monography about Baciccio (1964), and of Cocke for the one about P.F. Mola (1972). It has to be recalled that the flourishing of studies in the drawing field, has just slightly been surveyed up to now. The general volumes by Roli (1969) and by Vitzthum (1971) and the exhibitions as the one dedicated to Roman baroque drawing (Berlin, 1969, and London-Edinburgh, 1973) started the survey of single personalities (Pietro da Cortona, Maratta, Sacchi).

The only place in Southern Italy which had an autonomy and some importance in respect to other Italian regions was Naples. The studies have always been

addressed in that way, even if particular research has been dedicated to the manifestation of local phenomenon in different places (Puglia, Sicilia). About Naples, there is the recent synthesis dedicated by R. Causa to painting both figurative and still-life (the two fundamental aspects of that figurative culture) in "Storia di Napoli" (1972), completed as to the second half of the century with a similar text by O. Ferrari. Both of them form the indispensable base to the global knowledge of that period in the light of the last studies. Exhaustive studies have been dedicated recently to the two best known personalities of the Neapolitan 17th century: Salvator Rosa (L. Salerno, 1963 and 1975), who was the subject of a monographic exhibition (London, 1973), and Luca Giordano (Ferrari - Scavizzi, 1966), whose really numerous works have been studied also in particular periods and aspects (Meloni Trkulja, 1972, Büttner, 1972). Once more, the research field which gave the best results was the one about drawing, almost completely recovered by W. Vitzthum. In books (1971), but mainly in catalogues of exhibitions (Naples, 1966, Florence and Paris, 1967), Witzthum rebuilt unexplored facts and still little known personalities which previously did not have a historical character.

Low Countries. - In the Low Countries, the trend is to survey protagonists and to complete the study about them in the exhaustive form of the "corpus," both concerning painting and graphic works. Nevertheless, while in Holland, major personalities of the 17th century are studied also in their connection with the minor ones. The interests about Belgian art of these last years have pointed nearly completely on the three major personalities of the century: Rubens, Van Dyck, Jordaens. Rubens continues to cause inexhaustive studies - due also to the large quantity of his production, extended in different ambits - which see him right in the middle of the attention as painter, as draftsman, graphic artist and decorator. Studies ended also in exhibitions in which this protagonist of European baroque is supported by his followers and contemporaries such as the big exhibition in Brussels (1965) dedicated just to the "Secolo di Rubens," where appeared also sections dedicated to sculpture and graphic art. Recently (1971) the exhibition held in the painter's house in Anversa, also dedicated to his works referred to his time ("Rubens en rijn tijd"). The influences created by his works have recently been studied in another exhibition in Providence (USA) in 1975 ("Rubenism"). While Rubens drawing works found an exhaustive catalogue in the recent "corpus" (Burchard-d'Hulst, 1962), the large painting production of the artist created the problem of assistance and of the followers. It is still waiting for an up-to-date study resuming in a reasoned catalogue the enormous quantity of studies that have appeared recently about the artist. Particular studies have also been dedicated to the interpretation of the world made by Rubens (Stechow, 1968) and to one of his best followers, Caspar de Crayer (Vliege, 1972).

Jordaens received recently a lot of attention and was the subject of two important exhibitions which popularized the knowledge about him; one dedicated to drawings (Anversa - Rotterdam, 1966-67) and the other one to the whole activity of the artist, including his work as creator of cards for tapestry and as a rare engraver (Ottawa, 1968-69). This last exhibition gave his attendant, M. Jaffé, the impetus to return afterward

on some points of the artist's production in a special issue of the "Bollettino della Galleria Nazionale del Canada (n. 13, 1969). More recently appeared also the "corpus" of the artist's drawings (d'Hulst, 1974). Compared to it Van Dyck's works have received less attention, even in the "corpus" of the drawings (Vey, 1962). The Flemish "Caravaggesques" have been studied quite deeply during general research in that current (see above). The contributions to knowledge of the baroque painting of the Southern Low Countries are recent and reach interesting personalities (Bodart, 1970; Hendrick, 1973; Exhibition, 1975). The graphic production of this period has been studied under the monographic aspect concerning main personalities, and in exhibitions designed to enlarge knowledge about the minor ones (Geneva 1969-70; London-Paris, 1972; Paris, 1974), and in recent studies (Zwollo, 1973).

The figurative painting culture in Holland is certainly one of the most important aspects in the European art of the 17th century, both for quality and for the future developments of other European artistic currents. The discussion and the critical surveyes took place in parallel, to try to individualize and to point out the origins of the "national" language, to discover and rebuild personalities, and to take out from general outline the characteristics of a school and of a trend often connected with the contemporary European movements. Rembrandt represents, of course, the inexhaustible pole of attraction both of studies and exhibitions, the last ones dedicated to painting and graphic works often separately. The centenary of the death (1699), has renewed the possibility of celebrating the artist trying to illuminate the many aspects of his personality. The Exhibition in Amsterdam ("Rembrandt 1669-1969") to the one in Chicago ("Rembrandt after Three Hundred Years," 1969) and in Montreal-Ontario ("Rembrandt and His Pupils," 1969), in Tokyo-Kyoto ("The Age of Rembrandt," 1968), in Paris ("Le siècle de Rembrandt," 1970-71) and in Brussels ("Rembrandt et son temps," 1971) were limited, for evident reasons, to paintings of easy access. More complete and complex are the ones about drawings and graphic art: Vienna, 1969-70 ("Die Rembrandt Zeichnungen der Albertina"); Paris, 1969-70 ("Les plus belles eaux-fortes de Rembrandt . . . ," "Rembrandt et son temps. Dessins des collections publiques et privées . . . en France"); Vienna, 1970-71 ("Rembrandt. Radierungen . . . der Albertina"); Berlin, 1970 ("Rembrandt legt die Bibel aus"); Boston-New York, 1969 ("Rembrandt: Experimental Etcher"); Dresden, 1969 ("Rembrandt. Die Radierungen im Dresdner Kupferstichkabinett"); London, 1969 ("The Late Etching of Rembrandt. A Study in the Development of a Print"); Milan, 1970 ("Rembrandt, trentotto disegni").

Rembrandt's personality caused until recently "expansive" and "contractive" trends. This is shown in two works by H. Gerson oriented towards the last address: the monography including what the critic considers the true works of the artist (Amsterdam, 1968) and the new edition of the fundamental catalogue, published in 1935, by Bredins (London, 1969). In both publications, the trend is to eliminate from Rembrandt's catalogue any work leaving still a minimum doubt about his autography, even in case of famous works as "Saul of Mauritshuis in Aja," "Ritratto della signora Six" and "Sacra Famiglia a lume di candela" in Amster-

dam. In the graphic field two fundamental works appeared recently: the volume dedicated to Rembrandt in the "corpus" by Hollstein, "Dutch and Flemish Etchings . . . " prepared by K. G. Boon and C. White (Amsterdam, 1969) and the one by C. White "Rembrandt as an Etcher" (1969). An introduction to the artist's figure seen by a personal point of view is the one offered by Vitale Bloch in "Rembrandt Today" (1970).

Among the major artists, contemporary or preceeding Rembrandt, who recently received a particular attention have to be mentioned: Hercules Seghers (Havercamp-Begeman, 1973), Frans Hals (Slive, 1970-74), Jan van Goyen (Beck, 1973). To Ter Borch has been dedicated a monographic exhibition (Münster-L'Aja, 1974) to Saenredam his drawings (Paris, 1970) and to Willem Buytewech (Rotterdam-Paris, 1975). Monographies or particular studies appeared on Gabriel Metsu (Robinson, 1974). Govaert Flink (von Moltke, 1965), Frans Post (Larsen, 1962), Emanuel de Witte (Manke, 1963), Ostade (Gerson, 1969), Jan van der Heyden (Wagner, 1971), P. van Laer (Janeck, 1968). Besides the adhesion to "caravaggismo" by some personalities recently studied, as Bor (Gudlaugsson, 1969), Bijlert (Hoogewerff, 1965), Honthorst (Rezniceck, 1969), and Sweerts (Bloch, 1968), about whom see the text by Ferrari. Other artists belonging to European currents have recently attracted attention, as the group of "pre-rembrandtists" following the German Elsheimer's culture (see below). The studies dedicated to major personalities of this trend, as M. van Uyttenbroeck (Weisner, 1964), C. C. Moeyaert (Tömpel, 1974), Jacob Pynas (Waddingham, 1963), have been synthetized in the catalogue of the exhibition dedicated to them in Sacramento, 1974 ("The pre-Rembrandtists"). Another theme examined during the last ten years, was the one concerning Dutch landscape painters working in Italy in the 17th and 18th centuries and the individualization of the origin of realistic landscape and the "vedutismo" which gave rise to an Exhibition held in Utrecht, 1965 ("Nederlandse 17e Eeuwse Italianiserende Landshapschilders") and to studies about more restrictive periods (Zwollo, 1973) or to monographies (Briganti, 1966, on van Wittel; Roethlisberger, 1969, on Breenborgh; and Steland-Stief, 1971, on Asselyn).

France. - As to French painting, the central theme of research, besides the more recent one of "caravaggisme," was "the classicism": the protagonist of this theme is Nicolas Poussin. After the great monographic exhibition about him held in Paris in 1960, the various studies concerning his personality have been condensed in the essays and in the critical catalogue by A. Blunt (1966). However, the debate about some attributions remained, as proved by the concise monography by Thuillier (1975), taking off some Poussin works considered as autographs up to now, such as the "Madonna delle scale" of the National Gallery in Washington. The substance of the historical interpretation of Poussin's figure, which is the big "genius loci" of 17th-century French painting, has major implications for European art. The values of French classic culture and their expansion into other cultural fields have been recognized in exhibitions such as the one dedicated in Bologna in 1962 to the "Ideale classico del Seicento in Italia e la pittura di paesaggio," where, the exchanges with the European figurative language were evident.

On that occasion, two more personalities found their right position: Claude Lorrain and Gaspard Dughet, two French painters who lived in Italy, both of them strictly in touch with Poussin and among the major landscape painters of the century. Claude Lorrain only recently received the deserved attention, both in the catalogue of his "corpus" concerning pictures and drawings, by M. Roethlisberger (1961, 1968, and 1975), and in the monographic exhibition of 1969 in London ("The art of Claude Lorrain"), which largely confirmed the artist's importance in the development of European landscape painting. On the contrary, Gaspard Dughet, brother-in-law of Poussin and the creator of a kind of landscape painting which, even if coming from the classic base of the two French painters, turns towards an "ante-litteram" Romanticism which will have a great importance for some aspects of 19th-century painting, is still waiting for a systematic study besides the partial contributions only recently dedicated to him.

Charles Lebrun received particular acknowledgement with the big monographic exhibition of 1963 in Versailles. Considerable interest has been shown in the graphic works of French artists, especially Jacques Callot, who was the subject not only of a monumental monograph with a reasoned catalogue of his works by D. Ternois (1962), but also of various European and American exhibitions which underlined his exceptional personality and creativity both for the Italian and the French periods. Recent surveys in the field of drawing have been largely extended, tending to revalue an activity not adequately studied up to recent times: particular mention should be made of the research in European and American collections (Paris, 1964; Florence, 1968; Ottawa-New York, 1972-1973) and of the synthesis of Rosenberg (1971) which greatly increased our knowledge in this field.

Central Europe. - The knowledge of Baroque art in the Central Europe, mostly in the German area, increased in the 1960s and early 1970s. Important critical acquisitions from single personalities and periods also brought a recovery of drawing in this period (London Exhibition, 1975). Often the exhibitions had the rôle of promoting and popularizing knowledge previously limited to specialists. In this regard, a culmination was the exhibition dedicated to painting and drawing of the 17th century in Germany (Berlino, 1966). The catalogue of this exhibition, with the relevant bibliography, summarizes all the previous studies in the painting field. There followed a series of monographic exhibitions (Elsheimer, 1967; Schoenfeld, 1967; Liss, 1975) or ones concerning limited themes (the Augsburghese Baroque; Rhenish goldsmith's art in Renaissance and in Baroque) which brought further results also in the minor arts field in Austria (the ancient treasure of Salzburg). As to the major personalities of German painting in this century, while for Schoenfeld and Liss the relevant monographic exhibitions reinforced their critical aspect, the one dedicated to Adam Elsheimer opened new prospects and solutions, including the possibility of taking away from his catalogue many wrong attributions and better distinguishing this figure from his followers; anyway, the complex personality of this artist is still being recovered, as proved by the literature which followed the exhibition and the discoveries of important works and new documents. The most typical and known Baroque

current of Central Europe, with its logical outlet in the 18th century and the Rococo, was the object of general and summarizing treatments (Hempel, 1965) and of exhibitions and studies of particular kinds (Borocco Boemo; Barocco al Bodensee; II paradiso barocco; La natura morta barocca in Svizzera).

Spain. - In Spain, the present trend is to deepen the connections among local painting and other European schools; Italy and the Caravaggesque phenomenon were of most interest in studies and exhibitions in the 1960s and early 1970s. At the same time, research continued along traditional and autochthonous lines, mainly concerning the great personalities of the century, starting from Velàzquez, who remains right in the center of attention after the 1960 exhibition dedicated to the artist and his followers (Camòn Aznar, 1964). Zubaràn too, subject of an exhibition on the third centenary of his death (Madrid, 1964-1965), had many contributions dedicated to his works, summarized in a recent monograph published in Italy (Gregori-Frati, 1973). For the whole period see the exhibition held in London ("The Golden Age of Spanish Painting," 1976), summarizing all research of the preceding years. The great flourishing of studies concerning Spanish drawing has led to a revaluation of A. Pérez Sanchez, who popularized the art through exhibitions (Florence, 1972), catalogues of collections (Madrid, 1967, 1969, and 1972), and summaries for the public (Milano, 1970), up to the "corpus" in cooperation with D. Angulo intending to catalogue all existing drawings (1975).

MARCO CHIARINI

BIBLIOGRAPHY - *General works*: For an up-to-date bibliography to 1973 and concerning main works see: R. Wittkower, Art and Architecture in Italy, 1600 to 1750, Baltimore, 1973. See also: La natura morta italiana, Catalogue of the exhibition (Naples-Rotterdam-Zurigo, 1964-65), Milano, 1964; Actes des journées internationales d'étude du Baroque (Montauban, 1963), Toulouse, 1965; A. Pérez Sanchez, Pintura italiana del siglo XVII en Espana, Madrid, 1965 (see by the same author the catalogue of the exhibition with the same title held in Madrid in 1970); J. Bean, F. Stampfle, Drawings from New York Collections, II, The 17th Century in Italy, New York, 1967; Natura in posa, Catalogue of the exhibition, Galleria Lorenzelli, Bergamo, 1968; R. Roli, I disegni italiani del Seicento, Treviso, 1969; Barocco europeo, Barocco italiano, Barocco salentino, Reports and communications presented at the international congress on Baroque (1969), Lecce, 1970; M. Chiarini, I disegni italiani di paesaggio dal 1600 al 1750, Treviso, 1972; Actes du XXIIé Congrès International d'Histoire de l'Art (1969), vol. II, Les diverses aspects de l'art baroque, Budapest, 1972; Drawings by 17th Century Italian Masters from the Collection of Janos Scholz, University of California, 1974; C. del Bravo, Lettera sulla natura morta, Annali della Scuola Normale Superiore di Pisa, vol. IV, n. 4, 1974; A. Pigler, Barockthemen, Budapest, 1974, M. Aronberg Latin, 17th Century Barberini Documents and Inventories of Art, New York, 1975.

Northern Italy: Mostra del Barocco piemontese, Catalogue, Torino, 1963; R. Enggass, The Painting of Baciccio, Philadelphia, 1964; M. Bonzi, Sinibaldo Scorza and Antonio Travi, Genova, 1964; M. Bonzi, Dal Cambiaso al Guidobono, Genova, 1965; L. Mortari, Bernardo Strozzi, Roma, 1966; C. Donzelli, G. M. Pilo, I pittori veneti del Seicento, Firenze,

1968; Mostra della pitura veneta del Seicento in Friuli, Catalogue prepared by A. Rizzi, Udine, 1968; A. Ottani Cavina, Carlo Saraceni, Milano, 1968; Mostra del Guercino, vol. I, I dipinti, vol. II, I disegni, Catalogue prepared by D. Mahon, Bologna, 1968; Mostra dei pittori genovesi a Genova nel '600 e nel '700, Catalogue prepared by C. Marcenaro, Genova, 1969; E. Riccomini, Il Seicento ferrarese, Milano, 1969; V. Belloni, Pittura genovese del Seicento dal Manierismo al Barocco, Genova, 1969; A. Rizzi, Storia dell'arte in Friuli, Il Seicento, Udine, 1969; Natura ed espressione nell'arte bolognese-emiliana, Catalogue of the exhibition prepared by P. Arcangeli, Bologna, 1970; M. Roethlisberger, Cavalier Tempesta and His Time, University of Delaware Press, 1970; La pittura a Genova e in Liguria dal Seicento al primo Novecento, Genova, 1971; D. Posner, Annibale Carracci, London, 1971; A. Percy, Giovanni Benedetto Castiglione, Philadelphia, 1971; C. Johnston, I disegni dei maestri, Il Seicento e Il Settecento a Bologna, Milano, 1971; M. Newcome, Genoese Baroque Drawings, State University of N.Y. at Binghamton/Worcester Museum of Art, 1972; C. Manzitti, Valerio Castello, Genova, 1972; C. Johnston, Mostra di disegni bolognesi dal XVI al XVIII secolo, Catalogue of the exhibition, Firenze, 1973; Il Seicento lombardo, Catalogue of the exhibition, Milano, 1973; England and the Seicento, Bolognese Paintings from English Collections, Catalogue of the exhibition prepared by C. Whitfield, London, 1973; E. Gavazza, La grande decorazione a Genova, Genova, 1974; Cinquant" anni di pittura veronese, 1580-1630, Verona, 1974; A. Boschloo, Annibale Carracci in Bologna, Visible Reality in Art after the Council of Trent, s"-Gravenhage, 1974; Maestri della pittura genovese, prepared by P. P. Brugnoli, Verona, 1974; M. Chiarini, Niccolò Cassana Portraitist of the Florentine Court, Apollo, September, 1974; F. Arisi, Felice Boselli, Piacenza, 1974; Pittori bolognesi del Seicento nelle Gallerie di Firenze, Catalogue of the exhibition prepared by E. Borea, Firenze, 1975; Federico Barocci, Catalogue of the exhibition prepared by A. Emiliani, Bologna, 1975; Disegni di Federico Barocci, Catalogue of the exhibition prepared by G. Gaeta Bertelà, Firenze, 1975; R. Arisi, II Brescianino delle battaglie, Piacenza, 1975; L. Mallè, Le arti figurative in Piemonte, vol. II: dal sec. XVII al sec. XIX, Torino, w. d. (year 1975), with bibl. up to 1974.

Central Italy: C. Del Bravo, Per Jacopo Vignali, Paragone, XII, n. 135, 1961; M. Gregori, Avant-propos sulla pittura fiorentina del Seicento, ibid., XIII, n. 145, 1962; A. R. Masetti, Cecco Bravo, Venezia 1962; M. Bacci, Jacopo Ligozzi e la sua posizione nella pittura fiorentina, Proporzioni, IV, 1963; F. Stricchia, Lorenzo Lippi nello svolgimento della pittura Fiorentina della prima metà del Seicento, ibid.; G. Ewald, Opere sconosciute di Jacopo Vignali, Antichità viva, III, n. 7-8, 1964; G. Ewald, Simone Pignoni, A Little Known Florentine Seicento Painter, The Burlington Magazine, VIII, 1964; C. Del Bravo, Carlo Dolci devoto del naturale, Paragone, XIV, n. 163; Art in Italy 1600-1700, Catalogue of the exhibition prepared by F. Cummings, Detroit, 1965; Caravaggio e la pittura italiana del Seicento, Catalogue of the exhibition, Paris, 1965; Mostra dei disegni di Pietro Berrettini da Cortona per gli affreschi di palazzo Pitti, Catalogue of the exhibition prepared by M. Campbell, Firenze, 1965; G. Ewald, Studien zur Florentiner Barockmalerei, Pantheon, XXIII, 1965; M. Gregori, Settanta pittura e sculture del '600 e '700 fiorentino, Firenze, 1965; M. Campbell, Medici Patronage and the Baroque: A. Reappraisal, The Art Bulletin, XLVIII, 1966; G. Di Domenico Cortese, Percorso di Giacinto Gimignani, Commentaries, XVIII, 1967; C. Del Bravo, Su Cristofano Allori, Paragone, XVIII, n. 205, 1967; A. Suther-

land Harris, Notes on the chronology and death of Pietro Testa, Paragone, XVIII, n. 313, 1967; A. Sutherland Harris, E. Schaar, Die Handzeichnungen von Andrea Sacchi und Carlo Maratta, Düsseldorf, 1967; G. Di Domenico Cortese, La vicenda artistica di Andrea Camassei, Commentari, XIX, 1968; A. Sutherland Harris, Andrea Sacchi and Emilio Savonanzi at the Collegio Romano, The Burlington Magazine, CX, 1968; P. Bigongiari, G. Cantelli, Disegni di Francesco Furini, Firenze, 1969; J. Nissman, Florentine Baroque Art from American Collections, Catalogue of the exhibition, New York, 1969; Artisti alla corte granducale, Catalogue of the exhibition prepared by M. Chiarini, Firenze, 1969; P. Bigongiari, G. Cantelli, Disegni di Cecco Bravo, Firenze, 1970; C. Thiem, Gregorio Pagani, Stuttgart, 1970; I. Faldi, Pittori viterbesi di cinque secoli, Roma, 1970; E. Schleier, Aggiunte a Guglielmo Cortese detto il Borgognone, Antichità Viva, n. 1, 1970; 11 Barocco romano, Catalogue of the exhibition, Tokyo, 1971; G. Cantelli, Precisazioni sulla pittura fiorentina del Seicento: i furiniani, Antichità Viva, n. 4, 1971; G. Cantelli, Disegni di Francesco Furini e del suo ambiente, Firenze, 1972; R. Cocke, Pier Francesco Mola, Oxford, 1972; M. Chiarini, Pandolfo Reschi in Toscana, Pantheon, XXXI, n. 2; Cavalier d'arpino, Catalogue of the exhibition prepared by E. Roettgen, Roma, 1973; Disegni italiani di paesaggio del Seicento e del Settecento, Catalogue of the exhibition prepared by M. Chiarini, Firenze, 1973; G. Ewald, Unknown Works by Baldassare Franceschini, called II Volterrano, The Burlington Magazine, CXV, 1973; Master Drawings of the Roman Baroque from the Kunstmuseum Düsseldorf, Catalogue of the exhibition prepared by D. Graf, London, 1973; A. Forlani Tempesti, Stefano della Bella. Incisioni, Firenze, 1972; Mostra di incisioni di Stefano della Bella, Catalogue prepared by A. Forlani Tempesti, Firenze, 1973; Disegni e bozzetti di Cristofano Allori, Catalogue of the exhibition prepared by P. Bigongiari, G. Cantelli, Firenze, 1974; Gli Ultimi Medici. II tardo Barocco a Firenze, Catalogue of the exhibition, Detroit-Firenze, 1974; F. Viatte, Musée du Louvre. Dessins de Stefano della Bella, Paris, 1974; Ch. McCorquodale, Aspects of Florentine Baroque Painting, Apollo, September 1974; Disegni di Stefano della Bella dalle collezioni del Gabinetto Naz. delle Stampe, Catalogue prepared by M. Catelli Isola, Roma, 1976; Kunst des Barock in der Toskana. Studien zur Kunst unter den letzten Medici, Records of the meeting (Firenze 1974), München 1976; A. Moir, Caravaggio and his Copyists, New York, 1976; A. Sutherland Harris, Andrēa Sacchi, London, 1977.

Southern Italy: For a general treatment and the relevant bibliography, see R. Causa, La pittura del Seicento a Napoli dal naturalismo al barocco. La natura morta a Napoli nel Sei e nel Settecento, Storia di Napoli, vol. V, Napoli, 1972; O. Ferrari, ibid., vol. VI, 2, Le arti figurative. See also: Mostra dell'arte in Puglia dal tardo Antico al Rococò, Catalogue of the exhibition prepared by M. D'elia, Bari, 1964; O. Ferrari, G. Scavizzi, Luca Giordano, Napoli, 1966; Disegni napoletani del Sei e del Settecento, Catalogue of the exhibition prepared by W. Vitzthum, Napoli, 1966; Cento disegni napoletani, Catalogue of the exhibition prepared by W. Vitzthum, Firenze, 1967; Le dessin à Naples du XVIe au XVIIIe siècle, Catalogue of the exhibition prepared by W. Vitzthum, Paris, 1967; R. Longhi, Giovanbattista Spinelli e i naturalisti napoletani del Seicento, Paragone, n. 227, 1969; O. Ferrari, Pittura napoletana del Seicento e del Settecento, Storia dell'arte, 1969; In the Shadow of Vesuvius, Catalogue of the exhibition, New York, 1969; The Two Sicilies. Drawings from the Cooper-Hewitt Museum, Finch College Museum of Art, 1970; Disegni napoletani del Seicento e del Settecento, Catalogue of

the exhibition prepared by W. Vitzthum and R. Causa, Roma, 1970; S. Meloni Tekulja, Luca Giordano a Firenze, Paragone, n. 267, 1972; Salvator Rosa, Catalogue of the exhibition prepared by M. Kitson, London, 1973; M. Chiarini, Una corrente giordanesca a Pistoia, Festschrift Klaus Lankheit, Köln, 1973; L'opera completa di Salvator Rosa, prepared by L. Salerno, Milano, 1975; Pittura napoletana del Seicento, Catalogue of the exhibition prepared by R. Causa, N. Spinosa, 1975-1976; Various Authors, Carlo Sellitto, Catalogue of the exhibition, Napoli, Capodimonte Museum, 1977.

Belgium: H. Gerson, E. H. Ter Kuile, Art and Architecture in Belgium 1600-1800, Harmondsworth, 1960; L. Burchard, R. H. d"Hulst, Rubens Drawings, Bruxelles, 1962; H. van Hall, Portretten van Nederlandse Beeldende Kunstenaars, Repertorium, Amsterdam, 1963; H. Vey, Die Zeichnungen A. Van Dyck, Anvers, 1962; Le siècle de Rubens, Catalogue of the exhibition, Bruxelles, 1965; G. T. Faggin, Per Paolo Bril, Paragone, n. 185, 1965; Tekeningen van Jacob Jordaens, Catalogue of the exhibition, Anversa-Rotterdam, 1966-67; W. Stecow, Rubens and the Classical Tradition, Cambridge (Mass.), 1968; Jordaens, Catalogue of the exhibition, Ottawa, 1968-69; Dessins flamands et hollandais du XVIIe au XVIIIe siècle . . . , Catalogue of the exhibition, Ginevra, 1969-70; D. Snope, Gerard Lairesse als plafond-en kamerschilder, Bull. van het Rijksmuseum, 1970; Rubens en zijn tijd, Catalogue of the exhibition, Anversa, 1971; D. Bodart, Les Peintres des Pays-Bas Méridionaux et de la principauté de Liège à Rome au XVIIe siècle, Bruxelles-Roma, 1970; Dessins Flamands du Dix-Septième siècle. Collection Frits Lugt, Catalogue of the exhibition, Parigi, 1972; H. Vliege, Caspar de Crayer, Bruxelles, 1972; J. Hendrick, La peinture liègeoise au XVIIe siècle, Gembloux, 1973; A. Zwollo, Hollandse en Vlamse Veduteschilders te Rome. 1675-1725, Assen, 1973; R. A. d"Hulst, Jordaens Drawings, Bruxelles, 1974; Rubenism, Catalogue of the exhibition, Providence, 1975; A. Busiri-Vici, Jan Frans van Bloemen "Orizzonte," Roma, 1975; Le siècle de Louis XIV au Pays de Liége, Catalogue of the exhibition, Liegi, 1975.

Holland: For a bibliography up to 1966 see: J. Rosenberg, S. Slive, E. H. Ter Kuile, Dutch Art and Architecture, 1600-1800, Harmondsworth, 1966 (11 up-to-date ed., Baltimore, 1974). And also: H. Van Hall, Portretten van Nederlandse Beeldende Kunstenaars. Repertorium, Amsterdam, 1963; M. Waddingham, Bologna in retrospect. Some Northern Aspects, Paragone, n. 159, 1963; l. van Regteren Altena, "Vereeuwigde Stad Rome door Nederlanders Getekena," s. 1, 1964; G. Ungaretti, P. Bianconi, L'opera completa di Vermeer, Milano, 1967; A. Wassenbergh, De Portretkunst in Friesland in de 17e Eeuw, Lochem, 1967; A. Janeck, Untersuchung über der Holländischen Maler Pieter van Laer, Würzburg, 1968; Nederlandse 17e Eeuwse Italianiserende Landschapschilders, Catalogue of the exhibition, Utrecht, 1965; G. Briganti, Gaspar Van Wittel, Roma, 1966; V. Bloch, Vermeer, Paris, 1966; P. Descargues, Vermeer, Genève, 1966; W. Stechow, Dutch Landscape Painting of the XVIIth Century, London, 1966; K. Clark, Rembrandt and the Italian Renaissance, Glückstadt, 1966; Artisti olandesi e fiamminghi in Italia, Catalogue of the exhibition, Firenze, 1966; V. Bloch, Michael Sweerts, La Haye, 1968; L. J. Bol, Holländische Maler des 17. Jahrhunderts nahe den grossen Meistern, Brunswig, 1969; Rembrandt and His Pupils, Catalogue of the exhibition, Montreal-Ontario, 1969; The Age of Rembrandt. Dutch Painting and Drawings of the Seventeenth Century, Catalogue of the exhibition, Tokyo-Kyoto, 1968-69; La vie en Hollande au XVIIe siècle, Catalogue of the exhibition, Parigi, 1967; Dessins de paysagistes hollandais du XVIIe siècle, Catalogue of

the exhibition, Parigi, 1968-69; B. Haak, Rembrandt. Sein Leben, Sein Werk, Köln, 1969; Rembrandt 1669-1969, Catalogue of the exhibition, Amsterdam, 1969; Rembrandt after Three Hundred Years, Catalogue of the exhibition, Chicago, 1969; J. Held, Rembrandt's Aristotle and Other Studies, Princeton, 1969; H. Gerson, Rembrandt Paintings, Amsterdam, 1968; Rembrandt. The Complete Edition of the Paintings by A. Bredius revised by H. Gerson, London, 1969; Rembrandt Experimental Etcher, Catalogue of the exhibition, Boston-New York, 1969; Rembrandt. Die Radierungen im Dresdner Kupferstichkabinett, Catalogue of the exhibition, Dresda, 1969; The Late Etching of Rembrandt. A Study in the Development of a Print, Catalogue of the exhibition, Londra, 1969; Die Rembrandt Zeichungen der Albertina, Catalogue of the exhibition, Vienna, 1969-70; Les plus belles eaux-fortes de Rembrandt . . . , Catalogue of the exhibition, Parigi, 1969-70; Rembrandt et son temps. Dessins des collections publiques et privées . . . en France. Catalogue of the exhibition, Parigi, 1969-70; Rembrandt, trentotto disegni, Catalogue of the exhibition, Milano, 1969; Rembrandt legt die Bibel aus, Catalogue of the exhibition, Berlino, 1970; Rembrandt, Radierungen . . . der Albertina, Catalogue of the exhibition, Vienna, 1970-71; Rembrandt et son temps, Catalogue of the exhibition, Bruxelles, 1971; F. W. H. Hollstein, Dutch and Flemish Etchings . . . Rembrandt, prepared by R. G. Boon, O. White, Amsterdam, 1969; C. White, Rembrandt as en Etcher, London, 1969; Dessins flamands et hollandais du XVIIe au XVIIIe siècle, Genève, 1969-70; V. Bloch, Rembrandt Today, Amsterdam-New York, 1970; Saenredam pointre des églises, Catalogue of the exhibition, Parigi, 1970; E. Havercamp-Begemann, Hercules Seghers, Amsterdam, 1968; Le siècle de Rembrandt . . . , Catalogue of the exhibition, Parigi-Amsterdam, 1970-71; M. Roethlisberger, Cavalier Tempesta and His Time, Delaware, 1970; M. Roethlisberger, Bartholomaeus Breenbergh. Handzeichnungen, Berlin, 1969; A. C. Steland-Stief, Jan Asselyn, Amsterdam, 1971; J. Kustnesov, I maestri del disegno. Capolavori fiamminghi e olandesi, Milano, 1971; J. G. van Gelder, Jan de Bisschop, Oud Holland, LXXXVI, n. 4, 1971; H. Wagner, Jan van der Heyden, Amsterdam-Haarlem, 1971; Dessins Flamands et Hollandais du XVIIe siècle du Musée de l'ermitage et Pouchkine, Catalogue of the exhibition, Bruxelles-Rotterdam-Parigi, 1972-73; Dutch Genre Drawings of the Seventeenth Century, Catalogue of the exhibition, New York-Boston-Chicago, 1972-73; H. U. Beck, Jan van Goyen. Leben und Werk, Amsterdam, 1973; L. J. Bol, Die Holländische marinemalerei des 17. Jahrhunderts, Braunschweig, 1973; E. Havercamp-Begemann, Hercules Seghers. The Complete Etchings, Amsterdam-Den Haag, 1973; A. Zwollo, Hollandse en Vlaamse Veduteschilders te Rome 1675-1725, Assen, 1973; The Pre-Rembrandtists, Catalogue of the exhibition, Sacramento, 1974; S. Slive, Frans Hals, London-New York, 1970-74; Ter Borch, Catalogue of the exhibition, Münster-L'aja, 1974; F. W. Robinson, Gabriel Matsu . . . , New York, 1974; Dessins Flamands et Hollandais du Dix-Septième siècle, Catalogue of the exhibition, Parigi, 1974; Willem Buytewech, Catalogue of the exhibition, Rotterdam-Parigi, 1975; Kunst als regeringszaak in Amsterdam in de 17e eeuw. Rondom schilderijen van Ferdinand Bol, Catalogue of the exhibition, Amsterdam, 1975.

France: For a general bibliography up-to-date to 1973, sce: A. Blunt, Art and Architecture in France 1500-1700, Baltimore, 1973. And also: G. Wildenstein, Le goût pour la peinture dans le cercle de la bourgeoisie parisienne autour de 1700, Gaz. des Beaux-Arts, n. 1052, 1956; The splendid Century. French Art 1600-1715, Catalogue of the exhibition,

Washington-Toledo-New York, 1960-1961; Poussin et son temps, Catalogue of the exhibition, Rouen, 1961; Ch. Sterling, Les Peintres Jean et Jacques Blanchard, Art de France, 1, 1961; M. Rocthlisberger, Claude Lorrain. The Paintings, New Haven, 1961; II ritratto francese da Clouet a Degas, Catalogue of the exhibition, Roma, 1962; D. Sutton, Gaspard Dughet, Gaz. des Beaux-Arts, II, 1962; D. Ternois, L'art de Jacques Callot, Paris, 1962; D. Ternois, Jacques Callot. Catalogue complet de son oeuvre dessiné, Paris, 1962; W. Friedlaender, A. Blunt, The Drawings of Nicolas Poussin, IV, Leiden, 1963; N. Whitman, The Drawings of Raymond de La Fage, The Hague, 1963; Le Brun, Catalogue of the exhibition, Parigi, 1963; M. Waddingham, The Dughet Problem, Paragone, n. 161, 1963; Claude Lorrain und die Meister der Römischen Landschaft, Catalogue of the exhibition prepared by E. Knab, Vienna, 1964-65; M. Stuffman, Charles de la Fosse et sa position dans la peinture française à la fin du XVIIe siècle, Gaz. des Beaux-Arts, n. 1146, 1964; J. Thuillier, La peinture française, II, De la Nain à Fragonard, Genève, 1964; Le dessin français dans les collections hollandaises, Catalogue of the exhibition, Parigi-Amsterdam, 1964; A. Blunt, The Paintings of Nicolas Poussin. A Critical Catalogue, London, 1966; B. Teyssèdre, L'art au siècle de Louis XIV, s. I, 1967; M. Roethlisberger, Claude Lorrain. The Drawings, Berkeley-Los Angeles, 1968; Jean Jouvenet, Catalogue of the exhibition, Rouen, 1966; Au temps de Louis XIV: les peintres du roi Soleil, Lille, 1968; A. Blunt, Nicolas Poussin, New York-London, 1967; Disegni francesi da Callot a Ingres, Catalogue of the exhibition prepared by P. Rosenberg, Firenze, 1968; M. Chiarini, Gaspard Dighet. Some Drawings connected with Paintings, The Burlington Mag., n. 801, 1969; K. Badt, Die Kinst des Nicolas Poussin, Köln, 1969; The Art of Claude Lorrain, Catalogue of the exhibition prepared by M. Kitson, Londra, 1969; Jacques Callot und Sein Kreis, Catalogue of the exhibition, Vienna, 1969; T. Schröder, Jacques Callot. Das Gesambe Werk, 1971; French Master Drawings of the 17th and 18th Centuries. Catalogue of the exhibition prepared by P. Rosenberg, Ontario-Ottawa-San Francisco-New York, 1972-73; P. Rosenberg, F. Maré de Lépinay, Georges de la Tour, Berlin, 1974; M. Roethlisberger, Gaspard Dighet, New York-London, 1975; Various Authors, Nicolas Poussin 1594-1665, Catalogue of the exhibition, Roma, Accademia di Francia, 1977-78.

Central Europe: H. Jedding, Der Tiermaler Johann Heinrich Roos, Strasbourg, 1955; Barockmalerei in Böhmen, Catalogue of the exhibition, Colonia-Monaco-Norimberga, 1961; Barock in Nürnberg, Catalogue of the exhibition, Nuremberg, 1962; H. Voss, Johann Heinrich Schoenfeld . . . , Biberach, 1964; Barock am Bodensee, Catalogue of the exhibition, Stoccarda, 1964; G. Ewald, Johann Carl Loth, Amsterdam, 1965; E. Hempel, Baroque Art and Architecture in Central Europe, Harmondsworth, 1965; Deutsche Maler und Zeichner des 17. Jahrhundert, Catalogue of the exhibition, Berlino, 1966; L'arte del barocco in Boemia, Catalogue of the exhibition, Milano, 1966; Adam Elsheimer, Catalogue of the exhibition, Francoforte, 1966-67; H. Möhle, Die Zeichnungen Adam Elsheimers, Berlin, 1966; Johann Heinrich Schoenfeld, Catalogue of the exhibition, Ulm, 1967; Augsburger Barock, Catalogue of the exhibition, Augsburg, 1968; Baroque in Bohemia, Catalogue of the exhibition. Londra-Birmingham, 1969; R. Biedermann, Die Zeichnungen des Johann Heinrich Schoenfeld, Jahrb. der Staal. Kunstsamml. in Baden-Württemberg, 8, 1971; K. Andrews, Adam Elsheimer, II contento, Edinburgh, 1971; H. Pée, Johann Heinrich Schoenfeld: Die Gemälde, Berlin, 1971; Schweitzer Stilleben im Barock, Catalogue of the exhibition, Zurigo, 1973; Central Europe 1600-1800, Catalogue of the exhibition,

Sarasota, 1972; J. Glaesemer, Joseph Werner, München, 1974; Deutsche Handzeichnungen des 17. Jahrhundert, Catalogue of the exhibition, Darmstadt, 1974; Deutsche Kunst des Barock, Catalogue of the exhibition, Brunswick, 1975; Rheinische Goldschmiedekunst der Renaissance uns Barockzeit, Catalogue of the exhibition, Bonn, 1975; German Baroque Drawings, Catalogue of the exhibition, Londra-Birmingham-Cambridge-Glasgow, 1975-76;

Spain: E. Trapier, Valdès Léal, New York, 1960; J. Camòn Aznar, Velàzquez, Madrid, 1964; P. Muller. The drawings of Antonio des Castillo, Ann Arbor, 1964; Zubaràn, Catalogue of the exhibition, Madrid, 1964; H. Vey, X. De Salas, German and Spanish Art to 1900, New York, 1965; P. Muller, Antonio del Castillo and the Rustic Style, Apollo, 1966; J. Brown, Francisco de Herrera the Younger, Apollo, 1966; J. R. Buendia Muñoz, Mateo Cerezo en su tercer centenario, Goya, n. 71, 1966; Exposiciòn del Centenario de Alonso Cano, Catalogue of the exhibition, Granada, 1967; Spanische Zeichnungen von El Greco bis Goya, Catalogue of the exhibition, Hamburg, 1966; A. Pérez-Sanchez, Catalogo de los dibujos de la Real Academia de San Fernando, Madrid, 1967; D. Angulo Iñiguez, A. Pérez-Sanchez, Pintura madrilena del premier tercio del siglo XVII, Madrid, 1969; A. Pérez-Sanchez, Catalogo de la colecciòn de dibujos del Instituto Jovellanos de Gijòn, Madrid, 1969; A. Pérez-Sanchez, I disegni dei maestri. Gli spagnoli dal Greco a Goya, Milano, 1970; A. Pérez-Sanchez, Disegni spagnoli, Catalogue of the exhibition, Firenze, 1972; San José en el Arte español, Madrid, 1972; A. Pérez-Sanchez, Museo del Prado. Catalogo de dibujos, I, Dibujos Espanoles de los siglos XV-XVI-XVII, Madrid, 1972; M. Gregori, T. Frati, L'opera completa di Zubaràn, Milano, 1973; J. Brown, Jusepe de Ribera. Prints and Drawings, Princeton, 1973; D. Angelo, A. Pérez-Sanchez, A Corpus of Spanish Drawings . . . , London, 1975; C. Felton, More early paintings by J. de Ribera, Storia dell'arte, 26, 1976.

ORESTE FERRARI AND MARCO CHIARINI

ARCHITECTURE IN THE 17TH CENTURY
(PLATES 127-130)

After the first generation (1887-1914) of pioneers such as Gurlitt and Wölfflin and the second generation (1920-1940) of a general revaluation of Baroque art (think about Brinckmann's, Sedlmayr's, and Weisbach's studies), it was the third generation of studies (1940-1958) that brought together the first monographs and first critical interpretations of Baroque architecture (Argan, Tapié, Wittkover). The big settlement of Italian Baroque made by Wittkower (1958) closes this period and opens the fourth generation of studies, characterized by many generical histories, by several complete monographs about architects, and mostly by systematic research concerning monuments, ambiences, and key works for comprehension of Baroque phenomenon. The discussion about art and architecture of the 17th century developed also owing to several international meetings, which in the 1960s placed such problems in a central position.

Historicity and historical methods. – a) Baroque characteristics: Peculiar characteristics of 17th-century architecture have been placed with authority inside a classification of themes, classes, methods, and behaviors following a project. Particularly, the most specifically "Baroque" poetics may be summarized in the following terms (see "Dizionario di architettura e urbanistica," 1968): 1) antidogmatic use of classic architectonic language; 2) new composite methods in aggregating basic elements of the classic code; 3) new connections between architecture and ambience (town or nature) and interaction between architecture and ambience (architecture which may transform or modify the surrounding space and vice versa); 4) persuasion and rhetoric; 5) illusionism; 6) elaboration of new models suitable to rite, to structures of political power, and to new social exigences.

The matter is, of course, susceptible to change and integration according to different points of view and to prejudicial hypothesis (we will see more particularly the results of some of the indicated problems). It must be mentioned that the overcoming of the equation "Baroque-art of the Counter Reformation": Wittkower (1958) points out that the joyful and sensual architecture of Roman Baroque is opposite to the gloomy severity supposed by the Council of Trent.

The discussion about "Baroque" as style has its most interesting moments in the attempts of making the phenomenon historical. For example, it has to be mentioned that the analysis of the Baroque-Classic bipolarity is in a key of economic history and of "model of civilizations" (polemic between Tapié and Francastel, 1957-1959).

b) Classicism in the 17th century: If the classic model in Renaissance culture has the character of monolithic unit, vice versa in the Baroque one "the classic model is represented by the tree: a central nucleus, a trunk of certitudes, from which depart some branches, i.e. of many single experiences, far one from the other and tending to diverge, and at the same time to give vitality to the center experience" (Portoghesi, 1971). More generally, the classic model is interpreted as "the authority of history. In Classicism's name we are opposed to Mannerism of the late Sixteenth Century, which is fought in its two opposite and complementary aspects, the 'rule' and the 'caprice.' They propose Classicism as an order principle, not a rigid heirarchic order but a 'natural' order" (Argan, 1964).

Classicism may be internal to poetics of "Baroque" current, putting even itself as a didactic start. The roots of the Baroque classicism of an artist such as Bernini have been individualized in the juvenile Hellenism of the lover of ancient sculpture. "After that there is a double moment, a subtle dialectics, and Bernini seems hesitating between an unconscious or subconscious classicism (the 'Classicism as filigree') and an ostentate classicism invoked at his justification (the 'classicism as mark'). Classicism may be an outside imposition (and then it will be a 'classicism as fashion,' avoided by Berini nearly always) or more consciously it may be a personal research, a self-imposition (the one defined 'classicism as balance'). At the end, in the last and more significant moment, Classicism is elevated and ostentated as a flag polemically opposed to contemporaries or prophetically showed to the future. It is classicism as warning which we could also define 'classicism as polemics'" (Fagiolo, 1966).

Completely opposite is the "classicism of the exception" of Borromini, as an instance of heretical empiricism, having its roots in the Mannerism culture.

Classicism is also the current, parallel to Baroque, dominant in France and in Protestant coun-

tries: in France a symbol of absolutism, in England and Holland an expression of a laic and empiric architecture.

c) *Revivals, survivals, historicism, exoticism:* Bazin (1968) outlined correctly historicism in the 16th century: "revivals" and "survivals" of Gothic and Mannerism go together with various exoticisms, regressions, medieval results, or revivals of popular tradition (but the "retrospective" outline is balanced by the prefiguration of realism, Romanticism, or even Art Nouveau).

Gothic is the most studied component. Gothic as linguistic infiltration and also as ethical behavior is demonstrated in Borromini's works: "Borromini is a workman at a sublime level. His restless, feverish drawings are not projects but the tormented beginnings of making. Unconsciously he tends to remake the medieval yard, an operating community working for an end: Bernini will reprove him also this, his being a "gothic" (Argan, 1964).

Gothic appears itself more exactly as an inventory of constructive ways and of engineering resources in Guarini's theory and practice. Gothic may also be a landmark, as in case of continuously interrupted cathedrals: see the 17th-century chronicles concerning the yards of Duomo of Milan or San Petronia of Bologna and the several plans for "gothic" fronts.

More general is the gothic "survival" in France or in England, including also the open-minded position of a Wren "talking" in Gothic.

Interest in exotic models before the 18th-century explosion is, on the contrary, minor, helped by the colonial enterprises of Iberians and Dutchmen and also by missionary mediation of Propaganda Fide. (This could explain some images reminiscent of Islamic, Indian, and Chinese archetypes in Borromini's and Guarini's architecture could be explained.)

Theory, technique, rôle, and perspectives of architecture: As in the Renaissance, the trend of intellectual architect, is opposed to the qualification of the architect-technician. But the scientific-structural technique is not always opposite to the technique of representation. It has been observed that Bernini's or Pietro da Cortona's architecture, perfect as image technique, is often faulty as to constructive technique; viceversa in Borromini and even more in Guerrini is the principle of operative technique (not at random Borromini entitles 'Opus architectonicum' the presentation of his works) corresponds to self-edification, with the architectonic 'esprit' moving towards the sublime and the perfection. Guarini thought "about the problem of technique as image generatrix. His structures are a constructive acrobatics; and the value comes just from the developing rhythm, over the balanced limit, from that perfect but dangerous intersection of forces in tension. It is true that the technique is the product of a rationality; but human rationality, wanted by God, is itself; a miracle and produces miracles: therefore it always overcomes itself through its creativity it realizes its progress" (Argan, 1964). Of course Guarinil had all scientific papers in order, having also the possibility to count on Desargues and Derand experience.

Prefiguration of descriptive geometry and its representation methods opened unknown ways offering inexhaustive ideas to spatial imagination. "Intersections of planes and volumes showed that shapes may be com-

plicated in an almost unlimited way" (Charpentrat, 1964).

It is not easy to synthetize the architect's strategy and rôle in the 1600s. They become more rare, in respect to the preceding century, demiurge-architects. Bernini is one of the few exceptions, and not casually has he been called a second Michellangelo. It overcomes the "technic" aspect. As with other artists, the architect "is now a bourgeois professional-man as the doctor and the lawyer; as such he disposes a specific technique. This technique is also a culture, because it refers not only to material execution of works, but also to formulation and elaboration of images" (Argan, 1964). If integrated in absolute monarchies or in Protestant countries, the architect becomes more and more an official, entering in a precise hierachic system. His work has an entirely pragmatic and worldly value: architecture belongs to a logic 'Realpolitik.' "After having destroyed the metaphistic Absolute" writes Tafury about Wren (1971), "it appears a new Absolute, all worldly and concrete, but not less binding. The divine law was replaced by "social law": architect is the scientist of social conventions, but as a technician, not as a critic." In comparison with this open-minded empiricism, it stands out even more as a contradiction dear to Italian architects. "The exploration of ethical microcosm, of human psycology, of subjective value of emotions, is not casually pursued by Italian research mostly with the attitudes of a pathetic "rear-guard" than the typical ones of a "vanguard". This is showed by Borromini's and Bernini's choices, which brought them to build their opposite *Summae,* especially when compared with the facts feeding the researches of leading European countries towards a new political ethos" (Tafuri).

Perspective discourse connects actions to their results and developments, thereby making them actual. It is interesting to say that ellipses and triangles "are the equivalent of Gropius' and Mies' parallel-epipeds," or that Bernini's altars anticipate years the "light jets" of Le Corbusier (Charpentrat, 1964). Borromini, perhaps more than the other architects, has been passed through the "unvarying" of modern architecture testifying to the vitality of his message.

It is also interesting to see how in the 17th century contradictions started among artists, purchasers, and public. "New leading classes (sovereigns with their courts and their bureaucratic apparatus, merchants and noblemen obtaining new big patrimonies, new religious orders and new clergy) lost in great part the competence and the confidence of cultural production, and they were no more valid artists' interlocutors; at the same time subordinate classes start to lose their solidarity conscience with leading classes and their cultural symbols" (Benevolo, 1968).

The typological problem. - The survey about different typologies is perhaps the main aspect of studies on 17th-century architecture. It is sufficient to say that two among the most important total syntheses (Charpentrat, 1964; Norberg Schulz, 1971) are based on a typological aspect. Apart from several valid studies about towns and urban centers, the most interesting conclusions are the ones vertically cutting the typological study to institute new typologies and supertypologies. We refer, for example, to the idea or ideological type of "monument" (Argan, 1964) which includes a series of phenomena from San Pietro to Bernini's Lou-

vre, from urban gates to the complete plan of a town as monumental structure. "Monument has always ideological contents and meaning and since it represents the stability of some ideal values, it always expresses a principle of authority and of its historical foundation." Again, quoting Argan "If Michelangelo's purpose was to build a large cupola to cover all Christian people, then Bernini's was to enlarge the Church embrace to contain all humanity." Monument is everywhere. "In the monument form there are, presently, the history-authority, given in the memory and in the experience of the past, and the future-possibility, given in the imagination. The arbitrary act of prefiguration may be corrected imagining the future as anticipated history or memory: but in this way also the past is more imagined than remembered, because it is only the anticipated form of future events."

In the hierarchic scale of architecture as a social class sign, beneath aristocratic or ecclesiastic monumental art, there is the private building, qualifying most of all the aspect of big bourgeois towns (see in Paris the continuous foundations of "hôtels particuliers"); farther below is the renting building, and at last, the place where workmen and countrymen are housed, which are the emerging aspect as to quantity in the hundreds of new districts and new centers built during the 17th Century. The principle of mass-production and normalization seems to unify at least the two last categories, putting together under urbanistic homogeneous parameters, the aseptic classicism of so many Northern bourgeois districts and the vernacular functionality of new countrymen foundations.

Historical studies seem still hesitant about differences among types destined for the leading class. Some interesting statistics emerge: for example, it has been noticed (Norberg Schulz, 1971) the trend to build larger churches with longitudinal plan but with centralizing cupola ("longitudinal centralized churches"), and smaller churches with central plan but with longitudinal axis ("extended central plan churches"). It is then the nomenclature of major types of aristocratic or bourgeois building: on one side, city palaces (palace; hôtel), on the other side, country residences (villa, château). As a proportional medium, the type "palace with garden" or "suburban villa," has "three fundamental ambiences put in relation: the private world of habitation, the public world of cities, and the "natural" world of garden and of landscape. The palace gives to man his place in social context, the villa connects him to nature, and in the suburban villa all the three elements are synthetized" (Norberg Schulz).

In social and political scale, the most important type produced and even invented in the 17th century is the palace-park. The park has its prototype in Versailles, the new capital of Louis XIV posed between nature and history, and nearly between heaven and earth. The Sun-King of Versailles may be defined as a "privileged nature which a mysterious connection binds to God. His court is an elect society and his worldly Olimpo is an Arcadian organized, educated nature, obedient to wise man's government. The garden or the park is the space of the man who, placed at the top of social hierarchy, roves behind it and is connected with the whole creation" (Argan, 1964).

Sign and space in Baroque art: (a) Architecture and idiom. The Baroque linguistic system is obviously conditioned by the classic code of architecture. We see, for example, that Borromini's architecture compared with the classic system (a universal and monolithic system based on static proportions and connections) "tends to distinguish itself - as poetic speech differs from the prose one - through the generalized use of "figures" having remarkable analogies with the literary ones. The column of classic tradition, which is the support or instrument of subdivision, tends to grow rich in variable features: becoming buttress, angular blunting, and tie-beam or axis of a rotating movement; the frame which is the linguistic sublimation of beam and of covering structures, becomes a connecting structure supported by an internal tension which opposes itself to disgregation of structure" (Portoghesi, 1967). Rhetoric or grammatical figures condensed in Baroque language may be indicated in a list: metaphor, antithesis, irony, personification, allegory, gradation, anastrophe, ellipse, hyperbole.

It is a system which risks collapse for exuberance of elements and for too many logical reasons, and surely not for illogicality. If synthesis remains always precarious, analysis is impossible for a linear consequentiality. Reaction to Baroque will be caused just in name of a cultural reduction to a few fundamental elements.

(b) Geometry. - Mathematics and geometry were not considered for themselves, but as a system of principles and relations observable in nature. To follow such principles, in the 1500s as well as in the 1600s it meant to conform to a superior order. During the 1600s there is a progressive growing of interest in geometry, verifiable both in works and in architectonic treatises, which parallels the enormous development of that science. Geometrical processes may be extremely elementary (modules or empiric geometry in Bernini), or elaborated but rigorous (Borrominian constructions), or intricated up to the limit of the irrational.

The highest degree of complication seems reached by Guarini, who obtains results nearly non-Euclidean although using Euclidean geometry, as well as rational techniques and matters. "Easiness of Guarini in using superior geometry explains his facility in elaborating simple geometrical schemes. But it would be excessive to pretend that it was mainly his knowledge of projective geometry that make his plans so complex. Complexity of his plans seems to be caused by his will to accentuate contrasts and antithesis between formal and technical values" (Millon, 1968). Also Zevi (1967) points out risks: "It is obvious that project genesis is not in geometry, and it is acknowledged on a theorethic level. But instead of researching the meaning of the genetic act, they indulge on geometric methods of verification. So that, for example, San Carlino will not rise from an incredible collision of space situations, of interpenetrations of empty masses charging extraordinarily its inside. It will rise from the rational erection of two triangles, one rectangle, one ellipse, and so on. Giving an abnormal importance to geometrical verification and censoring creative, terrible, terrifying, heretical everting genesis, it results that Borromini, after all, develops the methods of Renaissance projects, of course going onwards, drawing fluted surfaces, making more abstruse interlacings, but without departing from traditional way of working."

If in Borromini and in Guarini geometry maintains a naturalistic or divine meaning, on the contrary

Wren goes on with an abstract and laic process. "Geometry substitutes Nature. This is of some importance: whatever mathematical-geometrical laws are metaphysically justified, the "natural" and "positive" foundation of architecture is now based on an arbitrary intellectual construction. Wren accepts the specific "emptiness" of Geometry, its absence of specific meanings: his use of elementary models is to this regard symptomatic" (Tafury, 1971).

(c) Space and infinity. - The "existential space," according to Norberg Schulz' definition, is an entity measurable and definable both as to quantity and as to psychological meaning.

The spatial image of Baroque architecture is an image characterized by continuity (i.e., intercommunication between inside and outside space) and by progression (i.e., the importance given to courses).

"Architectonic space tends always to be a limit of real space and an opening to imaginary space" (Argan, 1964). The limit loss gives an infinite sensation, which often is an illusion of infinite, researched artificially. "There is this sensation," wrote Sypher (1955), "every time we seem to violate or to go beyond well defined limits, i.e. every time a "denial" of space is immediately followed by an "affirmation" of space. Real Baroque space comes from a contradiction: at first it fixes monumental limits, then, immediately, denies them, opening melodramatically an horizon beyond them, giving in this way the sensation of an heroic triumph of liberation.

(d) Space and matter. - Space is made by "full," besides and more than by "emptiness." Columns, as hinges or wings, may have as much capacity as big basements. Spatial intuition may become a space sentiment. San Carlino clothes itself "with the church flesh itself, with all the deepness of its folds and cavities, and translates its pang. Surfaces were suppressed and everything became expression. Also columns, out of proportion among themselves, became similar to statues expressing the crushing weight of the mass or the weakness. Capitals vegetation is tormented, the architrave of the central niche is trembling with angel feathers" (Charpentrat, 1964).

Architecture, as it has been noticed, gains real tactile, physical values, impresses hands and heart besides the eyes. Transcendence is secularized and released into flesh. For Milton the spirit was flesh, and Bruno asserted there was matter of corporeal things and of uncorporeal ones. This process is compared with transsubstantiation dogma: the Council of Trent declared that "the real body of Christ and the blood are consummated; when there is the transformation the spirit becomes flesh, and the matter of bread and wine becomes spiritual nourishment. Therefore during this sacrifice the spiritual experience may be represented and consummate at a flesh level. Devotion and Baroque art modified and defiled the transsubstantiation doctrine; flesh did not become spiritual - spirit became physical" (Sypher, 1955).

(e) Space and movement. - "Baroque art seems to catch a key connection as rythm inside the origins, the sources of life. It affects inert matter and gains an organic value. They arrive at visualizing an intuition as a survey in living matter, experimenting with it in figuration. A new dimension is created where matter emerges in abstract way as a vital element" (Griseri,

1967). If matter seems provided with proper life and energy (think about "fluxion" theory of "indivisibles" in Bonaventura Cavalieri), space curvature seems to contain a priori an idea of movement. We will see later some scientific premises justifying this idea: it is sufficient here to analyze at a level of psychology of vision some of the movements implicit in architectonic images. Borromini's works, for example, visualize movement principles aspiring to a condition of dynamic balance. "Movement is recalled through a series of composite operations which can be reconstructed in the final image and thus give the impression, everytime, of a movement in process, of an imminent movement, of a passed movement" (Portoghesi, 1967). Operations of such an organic process may be synthetized as follows: increase, rotation, translation, curvature, torsion, overturning, extroflexion, dilatation.

Form becomes an exercise field: formalism principle may lead also to deformation. One of the most exasperated level of Baroque metamorphoses will be, not casually, anamorphosis.

(f) Space, representation, and illusion. - The perspective - identified by Francastel as a "theatrical space," therefore as an artificial and dramatic situation - becomes complicated by the illusion outlines. "It could be said that built architecture would like to conform to painted architecture: as a matter of fact its structure is not one of a tectonic space, but of a purely visual space. The interest in the structure of the vision prevails on the interest in the structure of the thing: therefore, optical and psychological visions, at both the conscious and unconscious level, gain an absolute value of reality as components of the vision" (Argan, 1964).

The quadrature technique, the visual drawing to the ephemeral, the abnormal use of dimensions - differences and exchanges among opposite outlines of the infinitely small and of the infinitely big - produce also "diabolic deceits" (Panofsky's expression painted the perspective deceit of Berninian Scala Regia).

Inside walls, presbyteries, fronts, streets, and squares qualify themselves as elements of an open space to representation or to scenotechnique craftinesses. The Baroque cradle - i.e., Rome - became more and more a "representative town, a kind of gigantic historical stage where a heterogeneous population played its everyday comedy, without having the cohesion and the political force of a community" (Portoghesi, 1966). The great producer of this scene was Bernini: with him "art joins life, and life reveals itself as a fiction, a scarcely covert form of "theater in theater." And if theater is life and life is dream (therefore once more theater, fiction of reality) world order is upset from doubt wind" (Fagiolo, 1966). Each Bernini's works is interpreted as one part of a big performance, so that we see the most part of his sculptures pass under the symbol either of the tragic play or of the farce or of the ballet, and then the scenery of Baldacchino, the "theater in theater" of Raimondi and Cornaro chapels, the "machine" of the Cattedra, the total scene of Sant'andrea at Quirinale, the backstage of the Assunta at Ariccia, the scenic arch of Porta del Popolo, and the curtain of the Sala Ducale.

(g) Space and light. - Light is an essential element, "inside" the architectonic space. If in Caravaggio, light is an instrument of mediation and of salvation in a Manichean conception of the world, in Baroque architecture light may also become a deceit instrument:

often, in unperceivable continuity, from true light irradiates a false light, materialized in bronze or stucco rays.

But let's try to make a map of different characterizations of light following different uses. "Searchlight": violent and exclusive illumination of central episodes through the opening of appropriate windows. "Light from above": golden illumination from the presbytery of Sant'andrea at Quirinale; musical staircase of light and shadows in the second arm of Scala Regia or in the Borrominian columnade of Palazzo Spada. "Side light, of wing": in the Berninian prototype of Cappella Raimondi two windows are opened, with the effect of grazing illumination (it will be called "Berninian light"). "Frontal lightback lighting": the characteristic radiant effect which finds its apogee in the Cattedra of San Pietro. "Half-light, twilight": voluntary darkening through the reduction of sources of light or the use of dark materials may characterize ambiences with funeral symbols, as the Pantheon of Kings at Escorial or the Guarinian Chapel of Sindone. "Rooms of light": frequent most of all in Borromini, destined to store and filter the light. "Cryptographic light": the technique of solar watches and the knowledge of ancient Egypt documents induce a re-proposal of the theme of the light-ray which every year on a given day reaches a privileged point. "Light-sound": light-space may identify itself in sound-space where places are conceived as "theaters of light and sound" (inflexions and extroflexions, echos and filterings, waves and reflections refer themselves to a unitary conception of the space, which utilizes also scientific knowledge about optics and acoustics).

(h) Music and harmony. - The arguments about analogy of composing method between architecture and music, scientifically introduced by Ghyka and Wittkower, have not been really deeply studied as to Baroque architecture, apart from some significant exceptions. Therefore, starting from Sedlmayr's exegesis (1930), which evidenced the process of "variation on the theme," Borrominian works were the object of reading in musical key. Apart from the decoding of metrical rhythms (Wittkover, 1958; Portoghesi, 1967), San Carlino front has been compared with a "fugue" (Wittkower) and the inside of Santa Maria dei Sette Dolori to monodic treatment (Marconi); in Propaganda Fide front, entirely committed to sound memories, "under-unities are highly characterized and unified by the continuous re-emergence of diagonal directrices, besides the continuous bass of the wonderful frame" (Portoghesi).

The most exalting work conceived in musical sign may be the Cappella of Santa Cecilia at San Carlo ai Catinari of Antonio Gherardi. From the colored and sensual space of the chapel, the patron saint of music librates in ascension in the vault of a white "room of light." The scene takes place in a rarefield atmosphere, among concerts and angelic choirs: it is as if time would stop at the supreme music moment, as the angel's hand stops its writing on a paper "Cantantibus organis Caecilia Virgo Dom"

Perhaps the musical key, together with scientific instruments of acoustic surveying, will offer new explanations as to the dynamics of many spaces which seem to open and then close and then open again with wrapping movements. As an epigraph of these new, desirable readings, we could put two verses of a great Mexican poetess of the end of 1600, sor Juana Ines de la Cruz: "Es una linea espiral,/no un circulo, la armonia." Harmony is a spiral, not a circle.

Image and meaning: (a) Architecture and rhetoric. - In a memorable essay of 1955 Argan proved that the two great sources of aesthetic thought of the 17th century are the Poetics and the Rhetoric of Aristotle, with the relevant Latin derivations. In clarifying (1964) that the 17th century "is the first century of what was later called "image civilization," which is just the modern civilization," Argan threw a bridge between complementary problems of sign and of meaning. The image, being a propagandistic image, has the tactical aim of the persuasion more than the strategy of the demonstration. Architecture, as well as the other arts, becomes "a technique of persuasion and persuasion implies an open, bilateral connection. The persuading wish must correspond with the attitude of being persuaded: art is not only the product of people endowed with a great imagination, therefore it gains the value of an essential mental process." The imaginative art of persuasion becomes science, nearly social psychology, analyzing the soul forces, the feelings, the memory mechanisms: but always with feet anchored to historical reality. "Aristotle says that to poet is opened the domination of the possible, but adds that only what has already happened is believable or possible (Poetica, IX). Therefore, serious imagination has a foundation in memory and its premise in the historical experience; this prevents imagination from wandering without a direction." The prolific watch of imagination produces figurative and peremptory images to reach levels of self-sufficiency and of explanations in themselves. "It is true," Argan continues, "that the Seventeenth is the Century of allegories, but allegories are not images reduced to conceits, but conceits reduced to images. They do not want to conceptualize the image, but to give to conceit, made image, the force no more demonstrative but of practical solicitation which is proper of the image" It does not seem to me, really, that image always prevails on conceit, absorbing it with conceitism tentacles. Of course, if we analyze the position of a Bernini, the principle meets many points of credibility. We see that on other parts (Borromini and Guarini, for example) completely different principles of semantics lead to polysemantics or to ambiguity: the crucial trouble between image and conceit continues some Humanism and Mannerism experiences. "Rhetoric points its attention on meanings demonstration, on argumentation, on the communicative value of dialogue: for Bernini or Guarini the dialogue with the observer is founded on an "articulation of contents," on conceits institutes, on the associative power of allegory or of symbol" (Tafuri, 1971).

(b) Socio-political interpretation. - Studies on economic structure, made previously in the methodologic ambit of "Annales" (Tapié, Mandrou, Mauro), proved that Baroque overstructure coincides sufficiently with particular economic conditions: Baroque, as well as late Gothic or Romanticism, should be an art of crisis and depression. The economic trend (in the 17th century a negative trend exists between the two positive cycles of 1500 and 1700) should have made free conspicuous capitals, then largely invested in buildings and generally in patronage; at the same time the mercantile capitalism emphasis on agriculture should have brought the revival

of a rural civilization. As a consequence, Baroque would be connected to rural economy of the Mediterranean and central and eastern Europe, in opposition to the capitalist classicism of north-western Europe. Undoubtedly, there are opposite results in the two different economic groups, but language differences have to be verified in more restricted surveying scales, according to socio-cultural situations in addition to the productive and political one.

If sometimes the power center coincides with the diffusion center of an artistic current ("Style Versailles," for example, contaminated with Roman Baroque, soon becomes the language of European courts), vice versa in other cases the center seems to move towards extremely representative oases, but deprived of authority. We must not be surprised if during the Thirty Years War the Baroque cradle is out of the whirl. The first Baroque architecture "is the art of a peaceful Rome in the middle of an upset Europe, of a Rome consciously connected to its history, isolated among those peoples which little by little became inferior with respect to their past and those which still look for themselves in distress and violence" (Charpentrat, 1964). Likewise in the last part of the century, the empire - even if reduced to a symbol - will see its two traditional capitals, Praga and Vienna, rise to the rank of capitals of late-Baroque Europe. "To the Holy Roman Empire, 1648 brought an empty form, and Baroque civilization gave back to it something like a content" (Charpentrat).

(c) Philosophy and science. - Wölfflin already in 1888 noticed the correspondence between Bruno's thought and Baroque architecture, since the latter simulates the infinite inside a finished space. Assunto (1970) poses Bruno at the beginning and Vico and Leibniz at the end of the Baroque period. Most of all, it seems that three Brunian assertions must be isolated: the first one refers to persuasion, or sensorial demonstration (senses would be necessary "to excite the reason only"); the second one refers to a conceit of harmony or of unity in multiplicity ("the highest perfection consists in the unity which complicates the whole. We are delighted in colours . . . mostly in one which complicates all colours. We are delighted in voice, not in a single one, but in a complicated one resulting from the harmony of many of them. We are delighted in a sensitiveness, but mostly in the one including in itself all the senses"); and the third one might offer a philosophic justification to Baroque polycentricity and to spaces in succession behind spaces as an image of infinity ("One then is the sky, the immense space There innumerable stars, planets, globes, suns and earths may be notably seen, and infinities are reasonably argued. The eye of our sense, without seeing an end, is won by the immense space presenting itself in a way leaving the sense indeterminated and obliges the reason to always add space to space, reason to reason, world to world").

Even more surprising is the "summa" of Leibniz's thought considered from the point of view of spatial philosophy. Assunto (1969) evidenced the following points: aesthetic harmony and metaphysical foundation; glorious harmony and triumphal grace; sensitization of the infinite; the town as theater and joyful life; metaphysical monadism and plurality of urban perspectives; the natural pleasure; natural grace and graceful nature; and metaphysical grace as aesthetic grace. Just to limit us to one aspect only, "in "Teodicea" we

find again that image of unequal lines and different among themselves . . . with explicit reference to the difference of layout. Leibniz is an apologist of the curved line, restored to its mathematic rationality. This mathematical justification, rigorously rational, of curved or broken line, provides a community of interests, and also of cultural meetings, between Leibniz and Guarini."

The influence of new scientific thought on the new spatial vision of Baroque architecture has been underlined many times. "Conceits of dynamic force, of inertness, of weight, of mass," indicated Sypher (1955), "were introduced in physics by Galileo, who measured the speed of balls running up and down inclined planes. When he died in 1642 (the birth year of Newton) he had discovered that matter contains energy, that bodies do not need to be kept in constant movement by the immobile Supreme Mover of Aristotle, but once put in motion they behave following stated laws of force. Newton gave to these Baroque laws of force a definition consisting of three elements distinguishing between mass and weight and formulating the dynamics of action and reaction, of direction, and of speed. Rhythmic movement - i.e., the motion speed - in Baroque style is similar to the play of forces in Baroque physics, since matter consists of "mass" as well as of "weight" and it follows a principle of "compound motion.""

In architecture, these principles find stimulating analogies in the "rotation of undulating walls, from Borromini to Guarini, or in the complex dynamics of the fronts of Roman Baroque Churches. In the Berninian "Colonnato" of San Pietro, the fusion in circle and ellipse plan has been interpreted as an arrangement between the two maximum cosmological theories: between the circular universe of Tolomeo and the elliptic universe revealed from Copernico's, Galileo's, Keplero's observations" (Fagiolo, 1966).

The theory of Cartesian vortices and curved geometry offer further supports to Baroque and late-Baroque projecting. As to Guarini's architecture, it is possible to find also internal references, if compared with the astronomic theorizing itself of the Theatine. The planimetry of Cappella della Sindone has been compared with the Guarinian representations of an eclipse of the sun (also with an iconological reference to the death of Christ-Son); circles penetration, sinusoid and spiral, have to be literally compared with schemes of celestial orbit courses (Fagiolo, 1968).

At a level of method more than application, the behavior of another architect scientist is also interesting. Wren put together or substituted to sacrality the "mathesis" as the universal science of measure and of order. Wren seems in fact to assert "the primacy of exact sciences as the propulsive motor of global development of the ambience and of new survey instruments With Bacon, Cartesio, and Hobbes, Wren found a sure and rational method of reality exploration and of invention of new means for its transformation." (Tafuri, 1971).

(d) Architecture and nature. - The connection between architecture and nature is in a series of moments of method, as organic unity, anthropomorphism, and naturalism, but also in a concrete will of nature transformation as antidote to world transformation: European countries and forests will be in a good part remodelled into gardens and colossal parks for

kings, courts, and aristocrats, while hill skylines will start at the end of 1600 to change into the "sacred landscape" of sanctuaries and convents, heirs of medieval castles.

"Organic unity" is a universal and programmatic principle, following which architecture is guided by laws similar to the natural ones. From here the "anthropomorphism" (see the "embrace" of Bernini's Colonnato or the front of the Oratorio dei Filippini, articulate as a human body, following Borromini's own exegesis) "ideal proportion" identifies itself with human proportions, and even it is defined as "an aspect of the divine since it has its origin from Adam's body, not only modelled by God's hands, but also made in his image and likeness" (from Bernini's diary).

"Naturalism" is a particular principle which intervenes in an advanced level of projection, but which may be included in iconological premises. In false rocks used for the Fontana dei Fiumi or in the basement of the Louvre, Bernini is not drawn only to the coeval taste of ruins: "he does not want to create an artificial ruin, he does not want to cry or to astonish in front of the signs of a lost civilization, he does not want to put the death and time trace on presumed eternity of an ancient monument. He wants, on the contrary, to release the contingency of the monument, he wants to substitute weak and frail architectonic material with a more fluid and evergreen material (an "actificial rock" will always be a rock, and even it will become more and more a "real rock"); he wants to put life and eternal phases of nature on architecture" (Fagiolo, 1966). Naturalism may show itself, from time to time, as a joke, as metamorphosis, as allegory, as warning, and even as desperate fiction.

e) Nature's transformation. - Naturalistic motive progressively developed with the use of more complicated forms: "it came to prevail in the decoration, but also in disarticulation of traditional planimetries, in the ever more free movement of masses, in surface curves, in the connection of building with the ambience through ramps, terraces, exedrae, protruding and receding parts, in the use of parks or gardens for surroundings. Towards the end of the 17th century nature, as a live contest of water, trees, and the sky becomes an essential urbanistic component" (Argan, 1964).

A symbolic form of nature transformation is made by the "cortonesque" allegory of Monte Athos transformed in simulacre of Alessandro Magno (the sovereign is represented in the clothes of Alessandro VII): nature becomes imagination, water course regularizes into rhythmic fall, rock condenses into town, and above the mountain a star, the Pope's emblem, twinkles.

Versailles must surely be considered the supreme sign of the transformation of nature as a powerful statement. It is almost like a war campaign by the general staff of Louis XIV in the name of solar order against natural chaos: in that operation an army (the biggest one from the end of ancient world) of 30 or 40,000 soldiers and workmen was mobilized, and a strategist as important as Vauban was called in to design the aqueduct. Nature, at last, became image and "representation": and it is not hard to see, near the several solar symbols constellating the palace and the park, also a general image of "radiant sun," with its epicenter in the Palace of the Sun King and with its diffusion in the

historical world (radiate streets making the structure of the town) and in the natural world (radiate avenues in the park). The "town of Sun" of Versailles seems to represent the expansionist politics of Louis XIV beside human resistances or chaotic irrationality (but the order proposed and imposed during the "Grand Siècle" was a hard order, a permanent war règime).

f) Emblem, symbol, allegory. - "Emblem" may be the representation of a simple heraldic datum (in the Sant 'Ivo alla Sapienza plan, contemporaries saw the Berberini bee), but it may also be a profession of faith (the same plan has been read, by Portoghesi, as schematic "chismon"). Emblem is often an erudite reconstruction, with a transfer from a literary-figurative language to an apparently abstract representation.

"Symbol" is the main material which can be used either as itself or as a lexicon for a general construction: in the Sant 'Ivo project the star with six points has to be read as Solomon's star and, therefore, as a masonic-corporative symbol and at the same time as a sapiential sign (Fagiolo, 1967; De la Ruffinière Du Prey, 1968). The symbol may be structural - and not only overstructural - identifying itself with processes of projectual genesis and of work formation.

"Allegory" is a demonstrative moment, nearly theatrical: symbols enter into dialogue, perhaps in dialectics, identifying themselves with the course of vision and with the spatial representation (Sant 'Ivo was conceived in its first Borrominian project as "Domus Sapientiae," with an allegoric itinerary culminating in exedrae at columns, which had to contain a simulacre of Divina Sapienza). In ecclesiastic thought, allegory is the maid of the truth. Allegoric architecture becomes the visual image of the "Truth," while the "Probable" is rejected in a limbo adjacent with the "Mistake." And then, allegoric art must be dogmatically taken back to orthodoxy: from this obliged way, it is possible to come out only through the theatrical escape, or with the introspection in the enigma, through concealed meanings, dialectic if not contradictory, with the dogma at the base.

We have selected, not casually, as an example the most complex and also polysemantic work, as it has been revealed by critics in the early 1970s. Borromini's Sant 'Ivo, considered up to 1965 as a work of mere will, if not of mad caprice, is now being laboriously discovered, through different interpretations trying to throw flashes of light in the dark, as one like Giorgione's "Tempesta."

Sant 'Ivo is real "talking architecture," even if it remained silent for three centuries. The projectual genesis sees a continuous evolution or a change of the fundamental meaning: for example, the abstract allegory of "Domus Sapientiae" puts into concrete form the most important revelation of Divine Wisdom in Church history: Pentecost. The seven columns of the project must be identified as the seven gifts of the Holy Ghost; Sant 'Ivo becomes the house of Pentecost: the Holy Ghost the little flames in the middle of the lantern, which had to ideally descend over the 12 niches, empty simulacres of the apostles (Ost, 1967). The recourse to number seven, as well as the other symbolic elements, is also a clear reference to the Apocalypse, under the sign of the Lamb opening the seven seals and revealing the secrets of the Book of Wisdom; also the stars of the Cupola, emblem of Alessandro VII, belong to the wisdom cycle

(stars - Doctors of the Church - theological wisdom) and also to the apocalyptic contest (Fagiolo, 1967).

The outside cusp was interpreted at first as "Torre della Grammatica," above the 12 preliminary steps, corresponding to the doctrines taught by the Roman University (Battisti, 1967). More precisely, the spiral crowning is referred to the Tower of Babel and interpreted as Anti-Babel: the tower of pagan confusion becomes a monument to Wisdom overcoming language confusion through Pentecostal revelation (Ost); the symbol concretizes even more exactly if compared with Ripa's figurations: "Philosophy," a matron wearing a zikkurat mantle (cf.: the basement of the cupola) or like a spiral gradin (cf.: Sant 'Ivo spiral), and "Intellect," an old man wearing on his head a blazing crown, quite similar to the terminal crowning of the cupola (Fagiolo). More recently, a further archetype has been indicated: the Light of Alessandria; the Borrominian cusp is interpreted as "pharos," light metaphorically guiding men to eternal salvation, to "Lex divina" (Hauptman, 1974). In any case, the gradin, the spiral, and the blazing crown express the ascetic or philosophic itinerary of human thought to God, the itinerary of which the starting point is known but the arrival point - beyond the intellectual possibilities - enigmatic as a mystery of faith.

BIBLIOGRAPHY - *General works*: R. Huighe, L'art et l'homme, Paris, 1958; F. A. Van Scheltema, Die Kunst des Barock, Stuttgart, 1958; B. Allsopp, A History of Renaissance Architecture, London, 1959; P. Francastel, Les Architects célèbres, Paris, 1959; E. Lundberg, Arkitekturens Formspråk, vol. VIII, Stockholm, 1959; K. Gerstenberg, E. M. Wagner, Baukunst des Barock in Europa, Frankfurt a.M., 1961; N. Powel, From Baroque to Rococo, London, 1959; S. Sitwell, Great Houses of Europe, London, 1961; V. L. Tapié, Le Baroque, Paris, 1961; Aa.V.v., Manierismo, Barocco, Rococò: concetti e termini, Atti del Conv. Intern. dell'Acc. dei Lincei (Roma, 1960), Roma, 1962; Aa.Vv., Barocco europeo e barocco veneziano, l Corso Intern. Fondaz. Cini (Venezia, 1959), Firenze, 1962; G. Cattaui, L'architettura barocca, Roma, 1962; H. Millon, L'architettura barocca e rococò, New York - Milano, 1963; Aa. Vv., Stil und Ueberlieferung in der Kunst des Abendlandes, Atti del XXI Congr. Intern. di St. dell'arte, Bonn, 1964; G. C. Argan, L'Europa delle Capitali, Ginevra-Losanna, 1964; G. Bazin, Baroque and Rococo, New York, 1964; P. Charpentrat, Architettura barocca, Fribourg-Milano, 1964; M. Wackernagel, Renaissance, Barock und Rococo, Berlin-Paris, 1964; F. G. Pariset, L'art classique, Paris, 1965; J. Vanuxem, L'art baroque, Enc. de la Pléiade, Histoire de l'art, vol. III, Paris, 1965; M. Von Platen, Queen Christina of Sweden. Documents and Studies, Stockholm, 1966 (studies of G. Axel Nilsson, A. Braham, S. Karling, S. Vänie); Aa.Vv., Essays in the History of Architecture presented to R. Wittkower, New York, 1967; P. Charpentrat, L'art baroque, Paris, 1967; A. Griseri, Le metamorfosi del Barocco, Torino, 1967; M. Kitson, The Age of Baroque, AQ, summer 1967; S. Sitwell, Southern Baroque revisited, London, 1967; M. A. Ashley, Das Zeitalter des Barock. Europa zwischen 1598 und 1715, München, 1968; G. Bazin, The Baroque. Principles, Styles, Modes, Themes, New York, 1968; L. Benevolo, Storia dell'architettura del Rinascimento, Bari, 1968; W. Hager, Barockarchitektur, Baden-Baden, 1968; E. Hubala, Renaissance und Barock, Frankfurt a.M., 1968; P. Portoghesi, Dizionario enciclopedico di architettura e urbanistica, Roma 1968-69 ('Barocco' by S. Bordini;

monographs on architects, etc.); Aa.Vv., Studi sul Borromini, Atti del Convegno (Acc. Naz. di San Luca, Roma, 1967), 2 vols., Roma, 1970, 1972; Aa.Vv., Guarino Guarini e l'internazionalità del Barocco, Atti del Convegno (Acc. delle Scienze, Torino, 1968), 2 vols., Torino, 1970; E. Hubala, Die Kunst des 17. Jahrhunderts (Propiläen Kunstgeschichte, Band 9), Berlin, 1970; Aa.Vv., Barocco europeo, barocco italiano, barocco salantino, Atti del 1°Conv. Salentino (Lecce, 1969), Lecce, 1971; C. Norberg Schulz, Architettura barocca, Milano, 1971; Aa.Vv., Renaissance, Maniérisme, Baroque, Atti del Convegno (XIe Stage International d'etudes Humanistes, Tours, 1968), Paris, 1972 (studies of V. L. Tapié, T. Klaniczay, R. E. Wolf); J. S. Held, D. Posner, 17th and 18th Century Art, New York, 1972; A. C. Sewter, Baroque and Rococo Art, London, 1972; G. Cattaui, Baroque et Rococo, Paris, 1973; P. Lavedan, Contre-Réforme, Baroque, Maniérisme, GBA, 1974; C. Norberg Schulz, Il significato nell'architettura occidentale, Milano, 1974; L. Benevolo, Storia della città, Bari, 1975.

Italy: G. C. Argan, L'architettura barocca in Italia, Milano, 1957; G. Agnello, l Vermexio, Firenze, 1959; K. L. Franck, Die Barockvillen in Frascati, München, 1959; E. Lavagnino, G. R. Ansaldi, L. Salerno, Altari barocchi in Roma, Roma, 1959; J. Lees Milne, Baroque in Italy, London, 1959; J. S. Pierce, Visual and Auditory Space in Baroque, Roma, Journal of Aesthetics and Art Criticism, Sept. 1959; A. Rossi, L'architettura religiosa barocca a Genova, Genova, 1959; D. Formaggio, ll barocco in Italia, Milano, 1960; Aa.Vv., Via del Corso, Roma, 1961; N. Carboneri, Andrea Pozzo architetto, Trento, 1961; F. Fasolo, L'opera di Hieronimo e Carlo Rainaldi, Roma, 1961; V. Golzio, Seicento e Settecento, Torino, 1961; K. Noehles, Die Louvre-Projekte von Pietro da Cortona und Carlo Rainaldi, ZfKg, 1961; P. Portoghesi, Gli architetti italiani per il Louvre, Q. 1st. Stor. d. archit., 1961; M. Anderegg Tille, Die Schule Guarinis, Winterthur, 1962; E. Bassi, Architettura del Sei e Settecento a Venezia, Napoli, 1962; D. R. Coffin, Some architectural Drawings of G. B. Aleotti, J. of Soc. of Arch. Historians, 1962; H. Hibbard, The Architecture of the Palazzo Borghese, Roma, 1962; G. Lo Jacono, Studi e rilievi di palazzi palermitani dell'età barocca, Palermo, 1962; R. Wittkower, Il barocco in Italia, Manierismo, Barocco, Rococo, ibid., meeting, 1962; M. Bernardi, N. Carboneri, V. Viale, M. Viale Ferrero, Mostra del Barocco piemontese, Architettura - Scenografia, Torino, 1963; C. Brayda, L. Coli, D. Sesia, Ingegneri e architetti del Sei e Settecento a Torino, Atto Soc. Ing. e Archit. in Torino, 1963; R. Causa, Il Seicento (Capolavori nei secoli, vol. VII), Milano, 1963; V. Mariani, Le chiese di Roma dal XVII al XVIII sec., Bologna, 1963; G. L. Marini, L'architettura barocca in Piemonte, Torino, 1963; P. Portoghesi, SS. Luca e Martina di Pietro da Cortona, L'architettura, 1963, n. 92; C. Thoenes, Studien zue Geschichte des Peters-platzes, ZfKg, 1963; R. Wittkower, Santa Maria della Salute, Saggi e memorie di Storia dell'Arte, 1963; M. Accascina, Profilo dell'architettura a Messina dal 1600 al 1800, Roma, 1964; N. Carboneri, Ascanio Vitozzi, Roma, 1964; G. Gangi, Il Barocco nella Sicilia orientale, Roma, 1964; F. Mancini, Scenografia napoletanadell'età barocca, Napoli, 1964; P. Portoghesi, Borromini nella cultura europea, Roma, 1964; G. Spagnesi, Giovanni Antonio De Rossi, archit. romano, Roma, 1964; D. De Bernardi Ferrero, Il conte I. Caramuel di Lobkowitz vescovo di Vigevano archit. e teorico dell'architettura, Palladio, 1965; C. D'Onofrio, Gli obelischi di Roma, Roma, 1965; H. Hibbard, Bernini, Harmondsworth, 1965; E. Hubala, Roma sotterranea barocca, Das Münster, 1965; A. Pedrini, Ville dei secoli XVII e XVIII in Piemonte, Torino, 1965; G. Brino, L'opera di Carlo e Amedeo di Castellamonte, Torino, 1966;

N. Carboneri, A. Griseri, G. Morra, Giovenale Boetto, Fossano, 1966; D. De Bernardi Ferrero, I' Disegni di archit. civile ed ecclesiastica'di G. Guarini e l'arte del maestro, Torino, 1966; M. e M. Fagiolo dell'Arco, Bernini, Roma, 1966; L. Grassi, Province del Barocco e del Rococò, Milano, 1966; P. Portoghesi, Roma Barocca, Storia di una civiltà archit., Roma, 1966 (3rd ed., Bari, 1974); J. Wassermann, Ottaviano Mascherino, Roma, 1966; P. Bianconi, F. Borromini, Vita, opere, fortuna, Bellinzona, 1967; E. De Negri, C. Fera, L. Grossi Bianchi, E. Poleggi, Le ville genovesi, Genova, 1967; C. D'Onofrio, Roma vista da Roma, Roma, 1967; M. L. Gatti Perer, Nuovi documenti per l'archit. barocca milanese, Arte Lombarda, 2, 1967; P. Portoghesi, Borromini. Architettura come linguaggio, Milano, 1967; M. Tafuri, Inediti borrominiani, Palatino, 1967; H. Thelen, F. Borromini, Die Handzeichnungen, Graz, 1967; H. Thelen, Zur Entstehungsgeschichte der Hochhaltar-Architektur von St. Peter in Rom, Berlin, 1967; A. Alpago Novello, Ville della provincia di Belluno, Milano, 1968; G. C. Argan, Storia dell'arte italiana, vol. III, Firenze, 1968; C. Baroni, Documenti per la storia dell'architettura a Milano nel Rinascimento e nel Barocco, Roma, 1968; A. Blunt, Barocco siciliano, Milano, 1968 (rec. D. M. Smith, BM, 1969); A. Cavallari Murat et al. Forma urbana e architettura nella Torino barocca, Torino, 1968; M. Del Piazzo, Ragguagli borrominiani, Roma, 1968; G. Gangi, il Barocco nella Sicilia occidentale, Roma, 1968; H. Hager, Zur Plannungs- und Baugeschichte der Zwillingskirchen auf der Piazza del Popolo, Römisches Jhb. f. Kg., 1967-68; M. Laurain Portemer, Mazarin, Benedetti et l'escalier de la Trinité sign of Saint Peter's, New York, 1968; P. Marconi, La Roma del Borromini, Roma, 1968; F. Mancini, Feste e apparati civili e religiosi in Napoli, Napoli, 1968; R. Mormone, Dionisio Lazzari e l'archit. napoletana del tardo Seicento, Napoli Nobilissima, 1968; L. Natoli Di Cristina, Aspetti e momenti dell'esperienza architettonica dell'età barocca in Sicilia, Palladio, 1968; G. Panofsky-Soergel, Zur Geschichte des Palazzo Mattei di Giove, Römisches Jhb. f. Kg., 1967-68; L. Profumo Müller, B. Bianco architetto e il barocco genovese, Boll. Centro Studi per la Storia dell'Architettura, 22, 1968; F. Strazzullo, Edilizia e urbanistica a Napoli dal 1500 al 1700, Napoli, 1968; L. Tamburini, Le chiese di Torino dal Rinascimento al Barocco, Torino, 1968; P. e C. Cannon -Brookes, Baroque Churches, London-New York-Sydney-Toronto, 1969; C. D'Onofrio, Roma nel Seicento, Firenze, 1969; M. Fagiolo dell'Arco, F. Borromini, Storia dell'arte, 1969; K. Noehles, Architekturprojekte Cortonas, Münchner Jhb. der bild.K., 1969; K. Noehles, La chiesa dei SS. Luca e Martina nell'opera di Pietro da Cortona, Roma, 1969; W. Oechslin, Bemerkungen zu Guarini und Caramuel, Raggi, 1969; L. Quaroni, Immagine di Roma, Bari, 1969; F. Strazzullo, Architetti e ingegneri napoletani dal 1500 al 1700, Napoli, 1969; Aa.Vv., Piazza Navona, isola dei Pamphilj, Roma, 1970; I. Belli Barsali, Ville di Roma, Milano, 1970; C. Brandi, La prima architettura barocca a Roma, Bari, 1970; M. Calvesi, M. Manieri Elia, Architettura barocca a Lecce e in terra di Puglia, Milano-Roma, 1970; G. Colmuto, Chiese barocche liguri a colonne binate, Quad. n. 3 dell'Univ. di Genova, 1970; S. Colombo, Profilo dell'archit. religiosa del Seicento. Varese e il suo territorio, Milano, 1970; G. Eimer, La fabbrica di S. Agnese in Agone, Stockholm, 1970; R. Mormone, Architettura a Napoli 1650-1734, Storia di Napoli, VI, 2, 1970; A. Scotti, Ascanio Vitozzi, Firenze, 1970; B. Wallace, The World of Bernini, New York, 1970; A. Blunt, Roman Baroque Architecture, BM, 1971; M. Heimbürger, Alessandro Algardi architetto?, Analecta Romana Instituti Danici, 1971; M. Heimbürger, L'architetto

militare Marcantonio De Rossi, Roma, 1971; H. Hibbard, Carlo Maderno and Roman Architecture 1580-1630, London, 1971; B. Kerber, Andrea Pozzo, Berlin, New York, 1971; J. L. Varriano, The Architecture of Martino Longhi the Younger (1602-1660), J. of the Soc. of Archit. Historians, 1971; C. Bocciarelli, Disegni richiniani alla Bibl. Ambrosiana, Arte Lombarda, 37, 1972; F. Borsi, M. Del Piazzo, Montecitorio. Ricerche di storia urbana, Roma, 1972; S. Langé, Ville della provincia di Milano, Milano, 1972; P. Pietrini, L'opera di G. Di Conforto, architetto napoletano del 1600, Napoli, 1972; A. Pugliese, S. Rigano, P. Vivarelli, E. Rasy, Architettura barocca a Roma. Studi su Martino Lunghi il giovane e Pietro da Cortona, Roma, 1972; R. Wittkower, Arte e architettura in Italia 1600-1750, Torino, 1972; E. Bentivoglio, S. Valtieri, San Martino al Cimino, Viterbo, 1973; F. Borsi, M. Del Piazzo, Il Palazzo del Quirinale, Roma, 1973; G. Cristinelli, B. Longhena, Padova, 1973; V. De Feo, La piazza del Quirinale, Roma, 1973; C. De Seta, Storia della città di Napoli dalle origini al Settecento, Bari, 1973; C. D'Onofrio, Scalinate di Roma, Roma, 1973; G. Fanelli, Firenze. Architettura e città, Firenze, 1973; A. Gambuti, Ludovico Cigoli Archit., Studi e Doc. d'Archit., 2, 1973; H. Hager, Carlo Fontana's Project for a Church in Honour of the 'Ecclesia Triumphans' in the Colosseum, Warburg, 1973; H. Hibbard, Recent Books in earlier Baroque Architecture in Rome, AB, March 1973; C. Perogalli, M. G. Sandri, Ville delle province di Cremona e Mantova, Milano, 1973; V. Scuderi, Architettura e architetti barocchi del trapanese, Trapani, 1973; B. Adroni, L'architettura farnesiana a Parma, 1545-1630, Parma, 1974; A. Barigozzi Brini, Disegni scenografici ed archit. del 1600 e 1700 alla Bibl. Ambrosiana, Arte Lombarda, 41, 1974; G. Cantone, Guglie e fontane di Cosimo Fanzago, Napoli Nobilissima, March-April 1974; G. Ciucci, La piazza del Popolo, Roma, 1974; G. Cuppini, 1 palazzi senatorii a Bologna, Bologna, 1974; H. Hager, Carlo Fontana and the Jesuit Sanctuary at Loyola, Warburg, 1974; P. Marconi, A. Cipriani, E. Valeriani, 1 disegni di architettura dell'archivio storico dell'acc. Naz. di San Luca, Roma, 1974; L. Zangheri, Ferdinando Tacca archit. e scenografo, Antichità viva, 1974; A. Blunt, Neapolitan Baroque and Rococo Architecture, London, 1975; R. Wittkower, Studies in the Italian Baroque, London, 1975; L. Zeppegno, Guida all'Italia nel Manierismo e Barocco, introd. by E. Battisti, Milano, 1975.

Spain, Portugal, Latin America: G. Faber, Koloniales Barock, Das Kunstwerk, Nov. 1969; G. Kubler, M. Soria, Art and Architecture in Spain and their American Dominions, 1500 to 1800, Harmondsworth, 1959; C. Arthaud, F. Hébert-Stevens, F. Cali, L'art des Conquistadeurs, Paris, 1960; J. Cornejo Bouroncle, Derroteros de arte cuzqueño, Cuzco, 1960; J. Lees Milne, Baroque in Spain and Portugal, London, 1960; R. Perez, Philippine Architecture: Baroque J. of Am. Inst. of Architects, Oct. 1960; F. A. Plattner, Deutsche Meister des Barock in Südamerika in 17° und 18° Jahrh., Basel, Freiburg, Wien, 1960; H. Wethey, Arquitectura virreinal en Bolivia, La Paz, 1960; A. Bonet Correa, Iglesias madrileñas del siglo XVII, Madrid, 1961; A. Benavides Rodriquez, La arquitectura en el virreinato del Perù y en la Capitanìa General de Chile, Santiago de Chile, 1961; M. J. Buschiazzo, Historia de la architectura colonial en Iberoamérica, Buenos Aires, 1961; J. A. Baird, The Churches of Mexico, 1530-1810, Berkeley, 1962; M. Toussaint, L'art colonial en Mexico, Mexico, 1962; Aa.Vv., Acts of the twentieth Intern. Congr. of the History of Art (New York, 1961), Princeton, 1963 (vol. III, Latin American Art and the Baroque Period in Europe; studies by G. Kubler, M. J. Buschiazzo, J. A. Baird Jr.); P. Rpjas, Historia del arte mexicano, vol. V, Epoca Colonial, Mexico,

1963; V. Marc, Ouro Preto: le lyrisme et le Baroque au Brésil, Architecture d'aujourd"hui, July 1964; J. Vargas, El arte ecuatoriano, Quito, 1964; A. Bonet Correa, Las iglesias barrocas, en Guatemala, Anuario de Estudios Am., Sevilla, 1965; G. Gasparini, La arquitectura colonial en Venezuela, Caracas, 1965; E. Pereira Salas, Historia de arte en el reino de Chile, Santiago de Chile, 1965; A. Bonet Correa, La arquitectura en Galicia durante el siglo XVII, Madrid, 1966; Y. Bruand, Baroque et Rococo dans l'architecture de Minas Gerais, GBA, May 1966; J. De Meja, T. Gisbert, Contribuciones al estudio de la arquitectura andina, La Paz, 1966; G. Kubler, Missionary Arquitecture of Antigua Guatemala, Philadelphia, 1966; C. Arbelàez Camacho, S. Sebastiàn, Las artes en Colombia, vol. 4, La arquitectura colonial, Bogotà, 1967; A. Bonet Correa, V. Villegas, El Barocco en España y en Mexico, Mexico, 1967; G. Gasparini, Anàlisis crìtico de la historiographìa arquitectònica del barocco en América, Boletìn del Centro del Investigaciones Històricas y Estèticas, 7, Caracas, 1967: V. Annis, La arquitectura de la Antigua Guatemala 1543-1773, Guatemala, 1968; Y. Bottineau, Architecture éphémère et baroque espagnol, GBA, 6, 1968; F. Chueca Goitia, El método de los invariantes, Boletìn, 9, Caracas, 1968; L. Lujan Muñoz, Sintesis de la arquitectura en Guatemala, Guatemala, 1968; E. W. Palm, Perspectivas de una historia de la arquitectura coloniale hispano-americana, Boletìn, 9, Caracas, 1968; R. C. Smith, The Art of Portugal, 1500-1800, London, 1968; F. Chueca Goitia, Et protobarroco andaluz, AEA, 42, 1969; J. Vilardebo, Azores Baroque, Archit. Review, Feb. 1969; Y. Bottineau, Baroque ibérique: Espagne, Portugal, Amérique Latine, Fribourg, 1971; G. Kubler, Portuguese Plain Architecture 1521-1706, Middletown, Connecticut, 1972; E. M. Dorta, Arte en America y Filipinas, Ars Hispaniae, vol. 21, Madrid, 1973.

France, Belgium, Holland: F. Bourget, C. Cattaui, Jules Hardouin-Mansart, Paris, 1960; A. Laprade, Francois d'orbay, Paris, 1960; R. A. Weigert, Louis XIV, Faste et décor, cat. of the exhibition, Paris, 1960; H. Gerson, E. H. Ter Kuile, Art and Architecture in Belgium 1600 to 1800, Harmondsworth, 1960; P. T. A. Swillens, Jacob van Campen, Assen, 1961; P. Verlet, Versailles, Paris, 1961; G. C. Argan, Il Barocco in Francia, in Inghilterra, nei Paesi Bassi, Manierismo, Barocco, Rococò, ibid., meeting, 1962; A. Boinet, Les églises parisiennes, Paris, 1962; M. Fox, André Le Nostre 1603-1700, Paris, 1962; S. Bettini, Barocco francese, Firenze, 1963; W. D'Ormesson, Merveilles des châteaux de l'Ile de France, Lausanne, 1963; F. Simone, V. L. Tapié, Trois conférences sur le baroque français, Torino, 1964; M. Whiteley, A. Braham, Louis Le Vau's Projects for the Louvre and the Colonnade, GBA, Nov. 1964; Aa.Vv., Le siècle de Rubens, catalogue of the exhibition, Bruxelles, 1965; J. P. Babelon, Demeures parisiennes sous Henry IV et Louis XIII, Paris, 1965; J. Langner, Das Schloss von Versailles, Meilensteine europäischer Kunst (attended by E. Steingräber), München, 1965; P. Reuterswärd, The two Churches of the Hotel des Invalides, Stockholm, 1965; A. Cassi Ramelli, Sebastiano Le Prestre marchese di Vauban, Roma, 1966; J. Rosenberg, S. Slive, E. H. Ter Kuile, Dutch Art and Architecture 1600 to 1800, Harmondsworth, 1968; B. Teyssèdre, L'art français au siècle de Louis XIV, Paris, 1967; C. Tooth, The early Town Houses of Louis Le Vau, BM, 1967; R. W. Berger, Antoine Le Pautre, New York, 1969; A. Blunt, Art and Architecture in France 1500-1700, London, 1970; R. W. Berger, The Church of St. Didier, Asfeld-la-Ville, Architectura, 1973; R. Coope, Salomon de Brosse and the Development of the Classical Style in French Architecture, from 1565 to 1630, London, 1972; A.

Brabham, P. Smith, François Mansart, London, 1973; W. Herrmann, The Teory of Claude Perrault, London, 1973.

Central and Eastern Europe: N. Powell, From Baroque to Rococo: an Introduction to Austrian and German Architecture from 1580 to 1790, London, 1959; N. Lieb, F. Dieth, Die Voralberger Barockbaumeister, München, 1960 (2nd ed., Zürich, 1967); N. Sumi, Ljubljanska baročna architektura, Ljubljana, 1961; A. Angyal, Slavische Barockwelt, Leipzig, 1961; H. G. Franz, Bauten und Baumeister der Barockzeit in Böhmen, Leipzig, 1962; O. Sandner, Barock am Bodensee. Architektur, catalogue of the exhibition, Bregenz, 1962; V. L. Tapié, Baroque slave et d'Europe centrale, Manierismo, Barocco, Rococo, ibid. meeting; Barock in Oberschwaben, catalogue of the exhibition, Weingarten, 1963; D. Hennebo, Geschichte der deutschen Gartenkunst, vol. 2, Der architektonische Garten, Renaissance und Barock, Hamburg, 1964; K. M. Swoboda, Barock in Böhmen (Architektur, prepared by E. Bachmann), München, 1964; E. Hempel, Baroque Art and Architecture in Central Europe, Harmondsworth, 1965; R. Wagner-Rieger, Die Baukunst des 16. und 17. Jahrh. in Oesterreich, Wiener Jahrb. f. Kg., Wien, 1965; T. Dobrowolski, Geschichte der polnischen Kunst, Krakau, 1965; E. Berckenhagen, Barock in Deutschland, Residenzen, catalogue of the exhibition, Berlin, 1966; F. Mielke, Die Geschichte der Deutschen Treppen, Berlin, 1966; W. Tatarkiewicz, Ueber die polnische Kunst des 17. und 18. Jahrh., Warschau, 1966; J. Zachwatowicz, Polnische Architektur, Warschau, 1966; O. J. Blažiček, Barockkunst in Böhmen, Prag, 1967; G. Passaŭant, Studien über Egidio Rossi und seine baukünstlerische Tätigkeit innerhalb des süddeutschen und österreischen Barock, Karlsruhe, 1967; E. Von Knorre, Die Augsburger Baukunst des Barock, catalogue of the exhibition, Augsburg, 1968; A. Miobedzki, Abriss der Architekturgeschichte in Polen, Warschau, 1968; C. Norberg Schulz, K. I. Dientzenhofer e il Barocco boemo, Roma, 1968; E. Weber-Zeithammer, Studien über das Verhältnis von Architektur und Plastik in der Barockzeit. Untersuchungen an Wiener Palais des 17. und 18. Jahrh., Wiener Jahrb. f. Kg., 1968; K. L. Lippert, G. A. Viscardi, 1645-1713, München, 1969; J. Neumann, Česki Barok, Praha, 1969; H. Reuther, Barock in Berlin, Berlin, 1969; N. Šumi, Ars Sloveniae. Baročna arhitektura, Liubljana, 1969; V. L. Tapié, Monarchie et peuples du Danube, Paris, 1969; W. Oechslin, Die Voralberger Barockbaumeister, catalogue of the exhibition, Einsiedeln, 1963; J. Blazicek, Contributi lombardi al barocco boemo, Arte Lombarda, 40, 1974; P. Charpentrat, L'architecture religieuse en Allemagne du Sud de la guerre de Trente ans à l'Aufklärung, Paris, 1974.

England and Scandinavian countries: N. Pevsner, The Planning of the Elizabethan Country House, London, 1960; P. Kidson, P. Murray, P. Thompson, A History of English Architecture, Harmondsworth, 1965; K. Downes, English Baroque Architecture, London, 1966; Christina, Queen of Sweden, ibid. cat., 1966; G. Eimer, Romerska centraliseringsidéer i Sveriges barocker Kyrkobyggnadskonst (Roman influences on Baroque churches with central plan in Sweden, Studies on Art History for S. Karling), Stockholm, 1966; J. Summerson, Inigo Jones, Harmondsworth, 1966; J. P. Bonta, Clasicismo y Barroco en la arquitectura inglesa, Buenos Aires, 1968; K. Downes, Hawksmoor, London, 1969; J. Lees Milne, English Country Houses: Baroque 1685-1715, London, 1971; K. Downes, C. Wren, London 1971; M. Whinney, Wren, London, 1971; J. Harris, S. Orgel, R. Strong, The King's Arcadia: Inigo Jones and the Stuart Court, catalogue of the exhibition, London, 1973; B. R. Kommer, N. Tessin der Jüngere und das Stockholmer Schloss, Heidelberg, 1974.

Historicity and historical methods: P. Francastel, Baroque et classique, une civilisation, Annales, 1957; P. Francastel, Baroque et Classicisme: histoire ou typologie des civilisations, ibid. 1959; V. L. Tapië, Baroque et classicisme, ibid.; D. Cantimori, L'età barocca, Manierismo, Barocco, Rococò, ibid. meeting, 1962; E. Forssman, Dorisch, Jonisch, Korintisch . . . in der Architektur des 16.-18. Jahrh., Stockholm, 1961; J. Bialostocki, Le 'Baroque': stile, ëpoque, attitude, L'information d'histoire de l'Art, 1962; A. Maśliński, Architektura antyku w interpretacij baroku, Lublin, 1962; A. Blunt, Barocco e antichità, in Acts of the twentieth Internat. Congr., ibid., 1963; J. Summerson, The Classical Language of Architecture, London, 1963; M. L. Gatti Perer, Le 'Istruzioni' di san Carlo e l'ispirazione classica nell'architettura religiosa del 1600 in Lombardia, in II mito del classicismo nel Seicento, Messina-Firenze, 1964; B. Champignuelle, Baroque et classique, La revue des Deux Mondes, 1966; Studi sul Borromini, ibid. meeting, 1967 (M. Fagiolo, Appunti per una ricostruz. della cultura di B.; Tavola rotonda sul rapporto tra B. e la tradizione); S. Bordini, Bernini e il Pantheon. Note sul classicismo berniniano, Q. dell'Ist. di Storia dell'Archit., 1967; Guarini e l'internazionalità del Barocco, ibid. meeting, 1968 (P. Marconi, G. e il gotico; A. Florensa, G. e il mondo islamico; M. Tafuri, Retorica e sperimentalismo: G. e la tradizione manierista); R. Huyghe, Introduction au Baroque, Jardin des Arts, 164-165, 1968; M. Tafuri, Teorie e storia dell'architettura, Bari, 1968; P. Portoghesi, Concetto di Barocco, Arte illustrata, 45, 1971; G. Germann, Gothic Revival in Europe and Britain. Sources, Influence and Ideas, London, 1972; A. Blunt, Some Uses and Misuses of the Terms Baroque and Rococo as applied to Architecture, London, 1973; R. Wittkower, Palladio and Palladianism, New York, 1974; R. Wittkover, Gothic v/s Classic. Architectural Projects in 17th Century Italy, London, 1974.

Theory, technique, role, and perspectives of architecture: H. Rosenau, Zum Sozialproblem in der Architekturtheorie des 15. bis 19. Jahrh., Festschrift M. Wackernagel, Köln, 1958; P. Portoghesi, Metodi di progettazione nella storia dell'architettura, Roma, 1960; F. Jenkins, Architect and Patron, London, 1961; P. Portoghesi, Introduzione a F. Borromini, Opus architectonicum, reprinting, Rome, 1964; Guarini e l'internazionalità del Barocco, ibid. meeting, 1968 (G. C. Argan, La tecnica del G.; P. Verzone, Struttura delle cupole del G.; L. Vagnetti, La teoria del rilevamento archit. in G.; W. Müller, G. e la stereotomia; C. Maltese, G. e la prospettiva); M. Tafuri, Teorie e storia dell'architettura, Bari, 1968; W. Tatarkiewicz, L'esthëtique du Grand Siècle, XVIIe Siècle, 1968; T. Thieme, Disegni di cantiere per i campanili del Pantheon graffiti sui marmi della copertura, Palladio, 1970; P. Di Paolo, L'architettura civile del Guarini e la trattatistica archit. del XVII secolo, Ann. della Scuola Normale Superiore di Pisa, vol. II, series 3, 1972; W. Herrmann, The Theory of Claude Perrault, London, 1973; L. Vagnetti, L'architetto nella storia di occidente, Firenze, 1974 (1st temporary ed., Genova, 1971); B. Zevi, Architecture and historiography, Le matrici antiche del linguaggio moderno, Torino, 1974.

Spatial, linguistic, structuralistic studies: B. Zevi, Architectura in Nuce, Torino, 1960; M. Passanti, Nel mondo magico di Guarino Guarini, Torino, 1963; C. Norberg Schulz, Intentions in Architecture, London, 1964; O. Schubert, Optik in Architektur und Städtebau, Berlin, 1965; T. K. Kitao, Bernini's Church Facades: Method of Design and the Contrapposti, J. of the Soc. of Architectural Historians, 1965; L. Moretti, M. Tapié, Le Baroque généralisé. Manifeste du Baroque ensembliste, Torino, 1965; Studi sul Borromini, ibid. meeting, Roma, 1967 (C. Brandi, Codice e struttura nel B.; L.

Moretti, Le serie di strutture generalizzate di B.); F. Borsi, la chiesa di S. Andrea al Quirinale, Roma, 1967; Guarini e l'internazionalitá del Barocco, ibid. meeting, 1968 (F. Borsi, G. a Messina; M. Passanti, Disegni integrativi della Architettura civile; A. Cavallari Murat, Struttura e forma nel trattato archit. del G.; P. Portoghesi, II linguaggio di G.; H. Millon, La geometria nel linguaggio archit. del G.; M. Passanti, La poetica di G.; C. Norberg Schulz, Lo spazio nell'archit. postguariniana); G. Torretta, Un'analisi della cappella di S. Lorenzo di G. Guarini, Torino, 1968; G. Roisecco, Spazio. Evoluzione del concetto in architettura, Roma, 1970; C. Verga, Del progetto borrominiano per una villa pseudofortificata a S. Pancrazio in Roma, Palladio, 1970; B. Zevi, Cronache di architettura, 8 vols., Bari, 1970-73; T. Thieme, La geometria di piazza San Pietro, Palladio, 1973; R. De Fusco, Segni, storia e progetto dell'architettura, Bari, 1973; R. De Fusco, L'architettura segnica di Inigo Junes (introd. to J. Summerson, Inigo Jones, Ital. trans.), Milano, 1973; T. K. Kitao, Circle and Oval in the Square of Saint Peter, New York, 1974.

Socio-political, philosophic, scientific, iconologic interpretations: R. Mandrou, Le Baroque européen: mentalité pathétique et révolution sociale, Annales, 1960; E. Rosenthal, The Cathedral of Granada, Princeton, 1961; E. Guillou, Versailles, le palais du Soleil, Paris, 1963; H. Hibbard, I. Jaffé, Bernini's Barcaccia, BM, 1964; Actes des Journées Internat. d'etude du Baroque (Montauban, 1963), Toulouse, 1965 (V. L. Tapié, Expériences histor. du baroque; F. Mauro, Y a-t-il une économie du baroque?; J. Krynen, Aperçus sur le Baroque et la Theologie spirituelle); M. Fagiolo, Villa Aldobrandina Tusculana. Percorso, allegoria, capricci, Quad. dell'Ist. di Storia dell'Archit., 1964 (1965); M. e M. Fagiolo, Bernini e Borromini: un dialogo, La botte e il violino, March 1965; H. G. Evers, Zur Scala Regia des Vaticans, Atti Pontif. Acc. Romana di Archeol., 1966-1967; Studi sul Borromini, ibid. meeting, 1967 (M. Fagiolo, L'attività di B. da Paolo V a Urbano VIII; E. Battisti, II simbolismo in B.; G. C. Argan, B. e Bernini; H. Ost, L'iconologia di S. Ivo alla Sapienza; M. Fagiolo, Sant 'Ivo, Domus Sapientiae; M. Fagiolo, Appunti per una ricostruzione della cultura di B.); W. Herrmann, Unknown Drawings for the 'Temple of Jerusalem' by C. Perrault, Essays . . . presented to R. Wittkower, ibid., New York, 1967; N. Huse, G. Bernini's Vierströmebrunnen, diss., München, 1967; H. Ost, Borrominis römische Universitätskirche S. Ivo alla Sapienza, ZfKg, 1967; Guarini e l'internazionalità del Barocco, ibid. meeting, Torino, 1968 (E. Battisti, Schemata nel G.; M. Fagiolo, La "geosofia" del G.; E. Guidoni, Modelli guariniani); P. De la Ruffinière du Prey, Solomonic Symbolism in Borromini's Church of S. Ivo alla Sapienza, ZfKg, 1968; M. Tafuri, Borromini in Palazzo Carpegna, Quad. 1st. Storia dell'Archit., 1967 (1968); B. Tavassi La Greca, La posizione del Guarini in rapporto alla cultura filosofica del tempo, appendice a G. Guarini, Architettura civile, ristampa, Milano, 1968; R. Assunto, Un filosofo nelle capitali d'Europa. La filosofia di Leibniz tra Barocco e Rococo, Storia dell'arte, 1969, n. 3; W. Lotz, Die Spanische Treppe. Architektur als Mittel der Diplomatie, Röm. Jahrb. f. Kg, 1969; A. Scotti, Giardini fiorentini e torinesi fra 1500 e 1600. Loro struttura e significato, L'arte, 1969, n. 6; F. A. Yates, Theatre of the World, London, 1969; R. Assunto, Introduz. alla storia della filosofia come storia dell'architettura, L'arte, 1970, n. 9; N. Huse, La Fontaine des Fleuves du Bernin, Revue de l'Art, 1970; M. Fagiolo, Borromini in Laterano. II "Nuovo Tempio" per il Concilio Universale, L'arte, 1971, n. 13; H. Ost, Studien zu Pietro da Cortonas Umbau von S. Maria della Pace, Röm. Jahrb. f. Kg., 1971; G. Wilkinson, The Iconography of Bernini's Tomb of

Urban VIII, L'arte, 1971, n. 14; A. Blunt, The Temple of Salomon with special Reference to South Italian Baroque Art, Kh. Forsch. O. Pächt zu Ehren, Salzburg, 1972; M. Fagiolo, La "religiosa trasmutatione" della Piramide di Caio Cestio, Arte illustrata, 1972; R. Wittkower, J. B. Jaffe, Baroque Art, The Jesuit Contribution, New York, 1972; A. Guidoni Marino, Il colonnato di piazza San Pietro, Palladio, 1973; M. Muraro, Il tempio votivo di S. Maria della Salute in un poema del Seicento, Ateneo Veneto, 1973; W. Hauptman, "Luceat Lux Vestra coram Hominibus": a New Source for the Spire of Borromini's S. Ivo, J. of the Soc. of Architectural Historians, 1974; R. Pacciani, Heliaca. Simbologia del Sole nella politica culturale di Luigi XIV, Psicon, 1974, n. 1; R. Porro, Cinq aspects du contenu en architecture, Psicon, 2-3, 1975.

MARCELLO FAGIOLO

FIGURATIVE ARTS IN THE 18TH CENTURY

(PLATES 131-134)

Italy. - Among the studies concerning Italian art history of the 18th century, it is the Venetian art which has mostly interested students. Therefore, there has been a relevant bibliographic increment, mainly concerning the most important Venetian painter of the century, Giambattista Tiepolo, and his sons, who were largely discussed during the exhibitions held for the artist's centenary (Udine, 1970 and Passariano, 1971).

Among the several general and specific studies which, during the period 1965 to 1975, allowed a large and critical revision of the wide Tiepolesque activity, the most interesting aspect is surely the one concerning graphic production of the master, nearly unknown up to now and emerged at present with all its importance from the various shows held in Venezia and Udine in 1965, 1970, and 1971; in Stoccarda and in Cambridge (Mass.) in 1970, and at the exhibition of Italian drawings held in New York in 1971, where 96 of Tiepolo's drawings were showed (see relevant catalogues). A more deepened control and the possibility of direct comparison allowed a quite definitive clarification about one of the most important attributive, critical, and philologic problems, the distinction of Giambattista's drawings from the ones of his son Domenico, based on their creative or reproductive characteristics.

Still problematic remains the settlement of Giandomenico's graphic production, whose artistic personality has at last gained its place and a more exact critical placement in art history (see also A. Mariuz, 1971).

The examination of this production, including both drawings and etchings, led not only to the discovery of many unedited works, but also to the chronological revision of known works. Among the others are important new dates proposed by Rizzi concerning some drawings and the consequent theory stating that all Tiepolo's engravings have to be anticipated to 1735-1743 and that "Scherzi" precede "Capricci," as previously asserted by Knox, who does not agree with the dates (see Rizzi, Venezia, 1970 and Passariano, 1971). Rizzi's proposal has been rejected by almost all the critics.

The valid contributions given in this regard have to be mentioned also: the up-to-date and enlarged republication by G. Vigni of the catalogue concerning drawings of Sartorio's collection in civic Triestini Museums, accompanied by an acute critical outline of Tiepolesque graphics; Tiepolo's drawings anthologies by A. Pallucchini (1971), who compared the development of the artist's graphics to the critical history of his paintings, and by T. Pignatti (1974), who critically summarizes all studies in this regard.

Following the same line of Tiepolesque exhibitions, later surveyings moved on to Sebastiano Ricci's art, culminating in the 1976 exhibition which was dedicated to him in Passariano. Previous analysis and revision of Ricci's works led to the drawings exhibition (Udine, 1975) and to the publication of the acts of the international conference dedicated to the artist (1976). In the meantime, an extensive catalogue of drawings prepared by J. Daniels (1976) concluded long studies of the author, and from the systematic analysis of all Ricci's paintings emerges the validity of the new positive judgment of modern critics about this Venetian master of 1700s.

Accurate monographs, with complete catalogues of works, have also been dedicated for the first time to G. Diziani and G.B. Pittoni, respectively by A.P. Zugni Tauro (1971) and by A. Zava Boccazzi (1977).

It has been possible to rebuild the rich corpus of Pietro Longhi's paintings and drawings (T. Pignatti, 1968; 1969; 1971; 1974). Pignatti offered, also, an acute critical interpretation of the artist's language surveyed in the stylistic process from the preparatory drawing to finished painting (T. Pignatti, 1975). Longhi's figure, reincluded in the European illuminist world, gained in this way an adequate critical valuation. Also, with respect to the last phase of his stylistic course, the artist points the attention on psychological portraits more than on social ambience, in a new way defined as "bourgeois" by Pignatti.

An undiscussed merit of the most recent critics is the fact of having clarified another old problem concerning the two brothers Giovanni Antonio and Francesco Guardi (A. Morassi, 1973). In this regard they were fundamental in the big Venetian exhibition concerning Grandi, prepared by Zampetti in 1965, allowing the comparative examination of works and the relevant meeting of studies about Guardesque problems (1967), allowing a total recovery of Gianantonio's personality and clarifying also many aspects of the problem.

Besides major figures, many other artist's personalities of that time have been critically revisioned by students of Venetian art, either on the occasion of panoramic exhibitions as "Dal Ricci al Tiepolo" (1969) and "I maestri della pittura veneta del Settecento" (1973), or in studies concerning single artists. G.B. Piazzetta's personality and his rôle in Venetian art of the 18th century has been, for example, acutely analyzed in settling the scientific catalogue of the two albums of the artist's drawings kept in the Biblioteca Reale in Torino, and mostly destined to illustrate "Gerusalemme Liberata" and Bossuet's work (D. Maxwell Wlaita and A.C. Sewter, 1969). Together with the master's activity has been studied, also, that of one of his pupils, Giulia Lama, whose personality had not yet been sufficiently valued, and who merits a better place in Venetian painting of the 18th century (R. Pallucchini, 1970; U. Ruggeri, 1973).

In Venetian art, an important studies revival concerned sculpture, which in 1700, even if not at the

level of paintings, reached the same rich and remarkable quality production. C. Semenzato systematically rebuilt a numerous series of sculptors" personalities, some of them of the highest level. Semenzato critically analyzed the connection among sculpture and other arts and culture of that period, pointing out the prevalence in this art of a standard of subordination to decorative exigences of architecture, often with a simple spatial function, and only towards the end of the century with celebrating aims. In these works, a preference for mythological and allegoric subjects is also stylistically similar to the coeval production of ceramics and china (C. Semenzato, 1966).

Important contributions concern the cultural ambience of that time, with interesting studies on first rank characters connected to the artistic and literary world, such as the merchant and collectionist Smith, consul of England in Venezia from 1741 to 1760 (F. Vivian, 1971), and the Veronese Scipione Maffei, literate and erudite of European fame (G. Silvestri, 1968).

One of the most important facts of recent historiography was the great interest for the other important aspect of Venetian art of the 18th century, the "Vedutisme," as proved by the wide bibliography included in a monograph dedicated to Luca Carlevarijs (A. Rizzi, 1967) and the several exhibitions held in these last years, among which the one of Bellotto in Varsavia, Dresda, and Vienna (1964-1965), and the one of Venetian "Vedutists" in Venice (1967). Exemplary in this regard are the studies of G. Briganti, the first dedicated to the beginner of this style in the 18th century conceit - i.e. the Italianized Dutch Gaspar Van Wittel - the second more generally to "Vedutism" (G. Briganti, 1966; G. Briganti, without date). Both studies offer the author the chance to deal with the themes of the "Veduta" origin and the differences among various kinds of nature representation. The student tries to define the voice "veduta," studies the relevant operative methods (he thinks, moreover, that the use of the optical room was limited to the summary sketch of the whole), then offers a trace of surveying about the history of this style, which owes its luck also to the demand of foreign tourists, mostly English, and has its highest development in Venice where the major representatives of this style, Canaletto and Bellotto, became popular. On the latter one, the critics of these last times have tried to recognize totally the artistic autonomy and validity of the master and to define exhaustively and settle his works. Such results may be considered reached in S. Korakiewicz's monograph (1972) and in the studies on minor masters who operated in the cultural ambit of Bellotto, as his brother Pietro.

Disregarded until a short time ago were the 18th-century pictorial schools of the other Italian regions. They have been brought to light since 1965, offering a proof of the brightness of the Italian painting, also in smaller centers, for the entire 18th century.

In Genova an exhibition (1969) and general organic studies on the 17th and 18th centuries brought to light the wealth of this figurative culture and gave start to the more specific survey which is being developed in these times. Among the single artists, the main attention continues to concern Magnasco, who had dedicated the monographs by V. Magnoni (1965) and H. Durst (1966).

As far as Emilia is concerned, it has been evident in the less known aspect of local art, i.e. sculpture, for years studied by E. Riccomini, who organized the exhibition about Bolognese sculpture in the 18th century (1966). Even if at a lower level, sculpture had a determinant part in Bolognese artistic civilization owing to its strict connections with painting and especially with architecture. The student found the stylistic connections with other cultures and the ways that made this art develop and critically outlined its major representatives, starting from Mazza, whose figure was deeply defined at the end of Riccomini's book "Ordine e Vaghezza" (1972) up to the strange Piò and to other minor ones, offering an essential view of the whole to comprehension of the entire period in its artistic performances unity.

There was interest also in "theatrical" activity of Bibienas, trying to reach a distinction among the various members of this prolific family (exhibition of Bibienas" theatrical drawings, Venice, 1970; exhibition "l Bibiena - disegni e incisioni del museo teatrale della Scala," Mantova, 1975).

In Ferrara, there has been a significant and original contribution to knowledge of the most disregarded period of local painting, including systematic research by E. Riccomini (1970 and 1971). The survey recovered works and artistic personalities of high level belonging to an historical situation which, after the economic standstill of the preceding century, came up in a bright way with the consequent cultural reflorescence.

Firenze of the 18th century, seeing the end of the Medicean dynasty, seems still an alive center of artistic creation absorbing the past tradition. Just for this artistic moment between the end of the 17th and the first half of the 18th century, disregarded for a long time, critics showed recently an increasing interest from which arose a big exhibition destined to evidence climate and various aspects of local artistic production (exhibition "Gli ultimi Medici. ll tardo barocco a Firenze, 1670-1743," Firenze, 1974). Divided in various sections: sculpture, painting, decorative arts, architecture, entertainment, and theater, the exhibition seemed polarized on Cosimo Ill's personality (1642-1723), who with his taste and his particular interests determined a real style, supported by his patronage and that of such rich collectionists as Ferroni, Magliabechi, and Gaburri (see also S. Rudolf, in "Arte illustra," 1972; 1973).

Taste and interest partially conditioned his successors, but the son Ferdinando distinguished himself from them. The son had a sharper and more refined critical sense, which oriented his preferences on Venice more than on Rome, as had his father. Research on the works of such little known and little studied artists as sculptors Foggini, Soldani, and other minor ones whose vitality was demonstrated and the finest objects of applied art (tapestries, china, hard stones), often reaching a masterpiece level, allowed an organic and unitary settlement of all late-Baroque Florentine performances to be put together. These performance are still full of fascination.

In the artistic culture of 18th-century Tuscany, the personality of one of the major artists of this period, Giovan Domenico Ferretti, emerged with all its value. A. Maser (1968) in a monographic outline about Ferretti, based on archive research and on stylistic analysis,

rebuilt his life and the work chronologically, partly using studies started earlier by Marangoni.

To study 18th-century Roman painting, A. Clark dedicated several years to obtaining clarifying contributions tending to outline various personalities of local major and minor artists, from Agostino Masucci (1967) to Placido Costanzi (1968), from Sebastiano Conca (1967) to Marco Benefial (1966), who operated in Roman artistic ambience, stating the passage from Baroque tradition to Neoclassicism. Pompeo Batoni, perhaps the most famous of Roman painters of the 18th century, was particularly studied by the critics, especially after the exhibition held in Lucca, his town of birth, in 1967. The monographic aspect of the exhibition and the bright essays of the catalogue (A.M. Clark, A. Marabottini, F. Haskell, I. Belli Barsali) helped clarify many problems between tradition and classicism still open concerning Batonian painting. As far as the study and the way of approaching the ancient time of an artist immediately preceding Winckelmann, it is interesting to note the book by Guerrini on drawings of ancient marbles of Ghezzi (1971), even if the authoress sees the graphic work of the Roman master from a merely archaeological point of view. Other students examined several foreign artists who lived and worked mainly in academies, and it was possible to rebuild the activity and the connections with contemporary artists of many of them through documents.

Concerning Roman painting, the ponderous work of Busini Vici on Frans von Bloemen, called the "Horizon," and the origin of Roman landscapes of the 18th century (1974) has to be mentioned. The artist's figure is rebuilt in biographic data, in stylistic evolution, and in septennial cooperation with his brother Pieter and with the artists who painted the figures of his landscapes (Lauri, Passeri, Batoni, Costanzi). But the interest in this work is greater than the interest in the painter's figure and is, in the Busini Vici's survey, tending to explain the presence and the development of landscape painting in Rome of the 18th century and the rôle played by the artist in it (landscapes in Italian drawing of 17th and 18th centuries studed by M. Chiarini, 1972).

To complete Roman artistic civilization, Busiri Vici studied a famous family, Poniatowski. The Poniatowski family was very important for its connections to artists of the capital. Vici succeeded in rebuilding their collections (1971). Some important articles by D. Sutton and B. Ford (in "Apollo," 1974) have been dedicated to English collectionists of 1700s connected to the Roman ambience. Since 1965 there has been also a wide revival of Piranesian studies (exhibition in Amburg, 1970; exhibitions in Rome, 1976), from which derived a more precise vision of the master's art, by now considered "the interpreter of illuministic ferments preparing European culture for revolution" (Calvesi), and no longer generically connected to that fantastic and psychological interpretation which is the subject of the brilliant essay by Praz (1975). Praz considered Monsà Desideó's art a precedent of visionary ruinism. The recovery of Piranesi's figure, which had been abandoned to the myth of isolated genius, owes much to the specification of the artist's connections with the reality of his time and of minor figures connected to him by affinity, exchanges, and influences. Following this line, the exhibition "Piranèse et les français" (Catalogue with

texts by A. Chastel and B. Brunel, 1976) was held at Villa Medici, in Rome. Sculpture in the first half of the 18th century in Rome, at last, was precious for its rich archive documentation, the contribution of R. Enggass (1976).

The problem of 18th-century painting in Southern Italy, which had in Napoli its most active and creative moment, has been studied in its complexity, it his may be said for the first time, by N. Spinosa, who traced the principal lines of a painting history, showing at first the persistent Solymanesque influence on artists such as Filippo Falciatore, Lorenzo de Caro, Francesco De Mura, and Giuseppe Bonito, and later, from the middle of the century, the evolution operated on one hand with Gaspare Traversi and on the other with such big decorators as Giacinto Diano and Fedele Fischetti. The general view ends with a sight on landscape artists and on portraitists (N. Spinosa, in "Storia di Napoli," 1971). Various particular essays followed this study, always by Spinosa, in order to philologically rebuild personalities of some of these painters and their connections with the court and with the major architect of the reign, Luigi Vanvitelli. Interesting contributions have been given also to the knowledge of Giaquinto's work, during the symposium about the artist held in Molfetta (1969), which ended with the publication of the studies (1971). The studies, especially the ones by P. Amato and M. Carmen Garcia Saseta, brought to the enrichment of the artist's catalogue many unedited works, both drawings and paintings, and specifications and documentary rebuildings. However, as Ferrari pointed out (in "Bollettino d'arte," 1973), a "critical set-up at wide range of the artistic physiognomy" of the master was missing.

As to Sicilia, we must mention Carandente's work on Serpotta (G. Carandente, 1966), now recognized as among the major European sculptors of the 1700s. The student, examining the artist's work, tried to clarify the fundamental problem concerning the complexity of his formal genesis, giving also a bright critical judgment on his production. The study of M. Blanco of Pietro Vasta's frescos in ancient churches of Acireale (Palermo, without date) must also be mentioned.

France and England. – In the other European countries, and most of all in France and England, the historical period which mainly interests students is the 18th century.

French 18th-century art, after a long period of generic estimation instead of a real critical consideration, has been recovered in all its value with a series of important studies and such big exhibitions (not always to say the truth without critics) as "L'art français au XVIII siècle" (1965), "France in the 18th Century in the Royal Academy" (1968), and the other ones held for the centenary of the death of Louis XV: "Louis XV. Un moment de perfection de l'art français" (1975) and "The age of Louis XV: French painting 1710-1774" (1975-1976). Of these two last exhibitions, the first one, relying on an easy grip on the public, aimed too illustrate all the aspects of artistic production in France at that time, resulting in a too generic and scientifically unstimulating show. The second one, on the contrary, clarified how the 18th century in France was not only the frivolous century of gallant entertainments and amorous scenes, but also the one of a pictorial tradition of sacred and historical subjects which also triumphed

in the Academies, revaluing this lesser known aspect of the artistic production of the reign of Louis XV.

An important synthesis work, missing until now, concerning the artistic activity in France from the last years of Louis XIV's reign to the empire proclamation, was prepared by W. Graf Kalnein and M. Levey (London, 1972). Thanks to the most recent studies in this regard and to a new point of view of critical analysis concerning artistic facts of that period, they obtained fully original results changing substantially the traditional judgment, also, on qualitative value, especially regarding great painting and sculpture.

Several other contributions enriched the knowledge of works of major French artists of the 18th century. Particularly, Antoine Watteau had an exhibition in Paris in 1968 ("Watteau et sa generation," prepared by J. Cailleux and R. Michel) dedicated to him and several studies were done for the 250th death anniversary (1971) and for the acquisition, from the Louvre, of the portrait called "Jean de Jullienne" (1973). Further results have been reached concerning philological research and formal survey, while the critical definition of the master's art, in spite of the new contributions, remains difficult. Also, Russian students showed their interest in Watteau with an exhibition at Ermitage where, to clarify the artist's rôle and importance in the historical and social context of his time, they presented not only painting works, but also sculptures and decorative arts of precedents, contemporaries, and followers (Leningrad, 1972). At the same time, the compiling of the scientific catalogue of paintings and drawings of the artist, at Ermitage Museum, gave the opportunity to outline also the history of his several works belonging to other Russian collections, to study his favorite themes, and to prepare a stylistic and technical analysis of his paintings (Y. Zolotov et al. Leningrad, 1972). Recently, a sumptuous and pretentious monograph, prepared by a group of researchers new to art history, guided by Saint-Paulien and by Ferré (Madrid, 1972), proposed original examination methods for Watteau's work, a new catalogue, and astonishing theses, such as the suggested non-authenticity of "Gilles." Negatively received by critics, the work, despite the enormous quantity of documentation, does not answer in fact to standards of scientific exactness. For a definitive catalogue on the pictorial production of the artist it will be necessary to wait for the comparative study between drawings and paintings being prepared for the exhibition at the Louvre in 1984.

Interesting results have been given also in the studies on François Boucher, particularly concerning his graphic work. The 1966 catalogue by Ananoff (Paris, 1966) followed the presentation of drawings and engravings of Cabinet des dessins and of E. de Rothschild's Collection at the Louvre. This was prepared by P. Jean-Richard (1971) and included the exhibition of drawings of North-American collections at Washington and Chicago (1973-1974). To conclude the bicentenary of the artist, moreover, a rich exhibition at Ermitage (1970) testified not only to the variety of pictorial work, but also to the rich production of applied arts (tapestry, china, engravings) derived by the French master.

Also Fragonard's graphic work has been deeply examined through studies by P. Mazars (Paris, 1971) and by Ananoff, who, at the end of a job lasting 25 years, offered with her ponderous reasoned catalogue a view, the most complete up until now, of the drawing activity of the artist (A. Ananoff, Paris, 1961-1971). An exhibition dedicated to Fragonard and his followers celebrated the purchase of four of his paintings by the Louvre (1974).

A revival of studies on J. B. Grenze began with the new biography by A. Brookner (London, 1972), which tried to clarify problems concerning the interpretation of the artist's style and personality, based on the meaning of "sensibility" conceit so important in that period. In the light of such phenomenon, the author studied Grenze as man and as artist, found his sources of inspiration, and pointed out his influence on J. L. David and on developments of French painting at the end of the century.

Neither have we disregarded less famous personalities such as Tremolière, a pleasant artist whose pictorial and graphic work has been studied, thanks to an exhibition at Musée Cholet prepared by P. Rosenberg and J. F. Méjanés (Catalogue of the engravings by J. Vilain), and Adelaide Labille-Guiard, a still little known portraitist who was overshadowed by the more famous rival Vigée-Lebrun (A. M. Passez, Paris, 1973).

As to landscape painting, the study by H. Burda on Hubert Robert was useful in clarifying the history of ruins in graphic and pictorial art, from the introduction of that genre to the different aspects of the theme, through evocations in various periods and by various artists (H. Burda, Münich, 1967).

As to sculpture, an interpretative essay on Falconet, one of the main sculptors of the century, was prepared by G. Levitine (London, 1972). The restricted analysis of the most significant of the artist's works and the recent research have caused Falconet to emerge as an artist more profound than thought previously. A book by F. Souchal (Paris, 1967) has been dedicated to Slodtzs and to all the period of about 80 years, among the most prolific of French art. During this periods the family serving the French kings Louis XIV and Louis XV carried on a sculptural activity extremely various. Slodtzs" art is presented by the student in different aspects, characterizing the production of the different family's members. The work is permeated with classicism in Sébastien, fully involved in roçaille in the brothers Sébastien-Antoine and Paul-Ambroise, and at last with more complex forms, at the same time neoclassic and neo-Baroque ones, in Michel-Ange.

In English art, historical studies are enriched with an extremely erudite and important work, due to J. Dobai, concerning artistic literature of Classicism and of Rococo and limited to the first half of the century (J. Dobai, Berna, 1975). Another study has been dedicated to landscape painting, in which England had, during the 18th century, absolute prevalence. L. Herrmann outlined the history of that genre from its start in the classic tradition revival, under the Italian influence, to the reception of the Netherlands' tradition, and to its picturesque revival. This is the moment in which Gainsborough prevails and, even if more known as portraitist, leads the genre, towards 1740, to one of its highest levels (L. Herrmann, London, 1973). Another substantial contribution to knowledge and to full reconsideration of Gainsborough's landscape activity has been given by the monumental work by J. Hayez about the graphic production of the master (J. Hayez, London, 1971). Besides the catalogue, the volumes are important for the activity of assistants, pupils, and imitators of the

artist, who was one of the most prolific draftsman of his time. Closely connected and complementary to the drawings catalogue is the engravings catalogue, also prepared by Hayez. In it the exceptional skill and the technical precision of Gainsborough are evident. Hayez afterwards turned his studies towards the portraitist activity of the master (J. Hayez, London, 1975).

Another painter, among the major ones of the English 18th century and an object of a particular interest, was Hogarth, the monograph of whom was published by R. Paulson (London, 1971). Paulson prepared the first monographic exhibition dedicated to the English painter (London, Tate Gallery, 1972), but here his portraitist activity was emphasized.

To the already wide literature on Reynolds has been added an anthological work uncluding various unedited pieces, prepared by E. Waterhouse (London, 1973). Its introducing essay offers an acute analysis of the painter's work, especially regarding the psychological interpretation of his portraits, which are considered certainly superior to the Gainsborough ones. The whole Waterhouse essay, with the exhibition "Sir Joshua Reynolds at Plymouth," held in 1973 for the 250th anniversary of his birth, contributed significantly to the revaluation of this artist, who has to be considered one of the great masters of the European 18th century.

Among the artists who were still without a critical settlement, Stubbs has to be mentioned. Two books, by C. A. Parker and by B. Taylor, recognize the master and judged not only the virtuous technique but assigned him a primary rôle in the English 18th-century painting.

An important monograph on George Rommey, prepared by G. C. Rump (Hildesheim and New York, 1974), brought up-to-date the one by G. Pastou of 1903. Rump interprets Rommey's art as a pictorial expression of the English middle class in neoclassicism, but already with precursory signs of Romanticism.

Among the studies on minor personalities of the English 18th century we mention also M. Webster's work. Webster addressed his attention to London painter and engraver Francis Wheately (London, 1970), a portraitist not original but pleasant who specialized in domestic and genre scenes.

Moreover, some exhibitions have reproposed to students' interest some artists disregarded for a long time, such as Francis Cotes and Samuel Scott. The inventive capacity and the sensibility, mainly for the portraits of intimate tone, not idealized, of the first one has been realized through a good choice of portraits exemplifying the different periods of his stylistic course. Cotes was the most remarkable English Pastellist of the 18th century. To counteract a negative judgment owing to several works passed under his name, an attempt has been made to deepen the knowledge of Scott, a topographic painter, by presenting a selection of paintings surely made by him. However, it was missing a critical settlement allowing solution of some intricated problems, such as the one about connections with Canaletto.

Other European countries. – As far as Spanish art is concerned, there has been an increasing interest in Goya. This is proved by the several exhibitions and voluminous studies on different aspects of his art, some of which offered new interpretations of the figure and of the work of the Spanish master. Two fundamental works are by serious students of Goyesque work: J. Gudiol (Barcellona, 1970), and P. Gassier and J. Wilson (Paris, 1970). The highest merit of these essays is to have studied Goya's paintings, finding and assembling connections for series belonging to different periods. This methodology (recovering suggestions by X. de Salas in "Archivio español de arte," 1968, n. 1-6) was applied also to drawings and engravings analysis and led to a better comprehension of the operative processes of the master.

A well known artist in his time, but nearly forgotten since then, Frey José de S.to Antonio, has been recently revived with a monumental work by R. C. Smith. Following the biographic part to a catalogue we see several wooden sculptures and furnishings left by the friar in monasteries of his order in Southern Portugal. Here worked as engraver, draftsman of "retablos," and decorative sculptor from 1754 to 1798.

There have also been many studies about the art in Central Europe of the 18th century. In Germany, for example, the Rococo importance has been recovered, not as much in the works of single artists" personalities, as in the whole decoration complex, which flourished not only in religious buildings or in noble residences, but also in the houses of the rich middle class. A flourishing school of decorative painters guided by Jsaac de Loucheron, Jacob de Wite, and, later, by Jurrian Andriessen gave life to a new style appealing to a classicism of domestic type ("Apollo," XCVI, 1972, 129). A view of German pictorial and graphic art through its major representatives has been given by an important American exhibition, offering a critical catalogue by E. R. Mandle and J. W. Niemeijer (Minneapolis, Toledo, Philadelphia, 1971-1972).

About the Baroque art in Bohemia, one of the most important centers of this artistic moment, a wide synthesis work summarized present knowledge (Various authors, München, 1964), analyzing, in connection with its various results in the sculpture, painting, and architecture fields, the stylistic evolution of an art which must be interpreted in the totality of its expression, not only through major figures but also through less known ones.

Studied also, for the first time, has been the plastic art in Slovenia. S. Vriser (Wien, 1974) offered a general view, pointing out mainly the Italian influence together with that of the Asburgic provinces of Stiria and Carinzia. In this essentially religious art stand out the personalities of Francesco Robba and Joseph Straub.

Among the more studied German artists there is the enchanting master of Austrian Rococo, Franz Anton Maulbertsch, whose catalogue has been enriched with several paintings and drawings identified by K. Garas, who brought up to date his monograph on the painter (Salzburg, 1974), and with critical specifications obtained through the exhibitions held in 1974 for the 250th anniversary of the artist's birth in Vienna, Halbturn, Heiligenkreuz-Gutenbrunn, and Budapest.

To K. L. Dasser (Weissenhorn, 1970) is due the rebuilding of the catalogue on J. B. Enderle's works. An artist who specialized in church decoration, he carried on nearly all his activity in his native country.

The systematic inventory of Swiss monuments offered the recovery, in the German Baroque sculpture ambit, of Johann Baptist Babel's personality. Babel was an artist with a capricious temper considered at Feuchtmayer's and Günther's level. To this sculptor,

more valid in general effect than in composition details, are due the imposing decorative complexes of Einsiedeln Abbey, the Hotel Zum Rechberg gardens in Zurigo, and the Sain-Ours church in Soleure.

Some interest has also been shown to Schwanthalers, a family of Baroque and classic sculptors, to whom an exhibition was dedicated (1974) in Reichersberg at Inn Abbey. On that occasion, there was also a series of studies by W. Oberwalder, M. Koller, and A. Hannl, tending to define and to distinguish the activity of each member of the family (in "Alte und Moderne Kunst," n. 136-137, 1975).

In Denmark, among the artists whose personalities have been revalued recently, there is the protraitist and landscaper Chr. August Lorentzen, whose life and works have been studied thanks to an exhibition at Thorwaldsen Museum for his 250th anniversary (H. D. Schepelern, Copenhagen, 1971).

There has also been a recovery of 18th-century art in countries such as Poland, the art of which has been studied in its connections with other countries, mostly France and England (A. Ryszkiewicz, Varsovie, 1967; and "Bull. Historii Sztuki," n. 3-4, 1970) and Russia. In a monumental work with contributions by 13 authors, they have treated different artistic branches of this country in the first quarter of the 18th century, a particularly interesting moment especially for Western contributions, which were introduced and then blended, following Peter the Great's reforms, with the Russian artistic tradition (various authors, Moscou, 1974).

International level studies have tended to develop particularly towards the neoclassic movement, to which was dedicated a glamorous exhibition by the European Council in 1972 in London. The London exhibition stimulated various performances also in other countries. Most of all, it attracted the attention of students all over the world to this period, the problems of which are still being discussed (cf. "Apollo," whole October issue, 1973, and "Burlington Magazine," November 1973).

A review of studies concerning 18th-century art cannot be completed without a special mention of M. Praz's volume on "conversation pieces" (Rome-London-University Park, Pa., 1971). These were pictorial representations of groups of real people - mostly "family portraits" - placed in a domestic inside setting, in the studio, or outside in a villa or in a landscape background. The genre, which has his origins in Dutch painting of the second half of the 17th century, developed mainly in England (where it was treated by such artists as Hogarth, Gainsborough, Zoffany, Wheatley, and Stubbs) and also in Germany (in the works of J. Zick, J. H. Tischbein, and F. G. Waldmüller) and in other Northern Europe countries. Even if almost always the represented people belong to aristocracy, or anyway to elevated classes, the "conversation piece" stays at the opposite side of aulic and idealizing portraitists, privileging working attitudes at the most sometimes just veined by a light Arcadian intonation.

BIBLIOGRAPHY - *Italy*: V. Magnoni, Alessandro Magnasco, Roma, 1965; R. Pallucchini, Francesco Guardi, Milano, 1965; T. Pignatti, Eighteenth-Century Venetian Drawings from the Correr Museum (Catalogue), London, 1965; P. Zampetti, Catalogue of the Exhibition of Guardi, Venezia, 1965; G. Briganti, Gaspar Van Wittel e l'origine della veduta settecentesca, Roma, 1966; A. Busiri Vici, Giovanni Battista Busiri, vedutista romano del Settecento, Roma, 1966; A. M. Clark, Manners and methods of Benefial, Paragone, XVII, 19, 1966; G. Carandente, Giacomo Serpotta, Torino, 1966; H. Durst, Alessandro Magnasco, Zürich, 1966; F. Haskell, Mecenati e pittori (Italian ed.), Firenze, 1966; M. Milkovich, Sebastiano e Marco Ricci in America, Cat. of the Exhibition, Memphis, Lexington, 1966; G. Perocco, I Guardi, Padova, 1966; T. Pignatti, I disegni veneziani del Settecento, Treviso, 1966; E. Riccomini, Scultura bolognese del Settecento, Catalogue of the Exhibition, Bologna, 1966; A. Rizzi, Mostra della pittura veneta del Settecento in Friuli, Catalogue, Udine, 1966; C. Semenzato, La scultura veneta del '600 e del '700, Venezia, 1966; F. Valcanover, I vedutisti veneziani, Milano, 1966; Various Authors, Problemi guardeschi, Venezia, 1967; Vv.Aa., Sensibilità e rezionalità nel Settecento, prepared by V. Branca, t. 1-2, Firenze, 1967; I. Belli Barsali, and Vv.Aa., Mostra di Pompeo Batoni, Catalogue, Lucca, 1967; A.M. Clark, Sebastiano Conca and the Roman Rococò, Apollo, 86 (1967), 63; A. M. Clark, Agostino Masucci: a conclusion and a reformation of the Roman Baroque, Essays presented to Rodolf Wittkower, II, London, 1967; H. Focillon, Giovanni Battista Piranesi, prepared by M. Calvesi and A. Monferini, Bologna, 1967; L. Mallè, G. Testori, Giacomo Ceruti e la ritrattistica del suo tempo, nell'Italia settentrionale, Torino, 1967; T. Pignatti, Disegni dei Guardi, Firenze, 1967; A. Rizzi, Luca Carlevarijs, Introd. R. Pallucchini, Venezia, 1967; P. Zampetti, I vedutisti venezian del Settecento, Catalogue of the Exhibition, Venezia, 1967; Exhibition of drawings by the Bibiena family, Catalogue, Philadelphia, 1968; Mostra di Giovanni Battista e Francesco Piranesi alla Calcografia nazionale di Roma, pres. L. Salerno, introd. M. Calvesi, Roma, 1968; A. M. Clark, An introduction to Placido Costanzi, Paragòne, XIX, 219, 1968; K. Garas, La peinture vénitienne du XVIII siècle, Budapest, 1968; E. A. Maser, Gian Domenico Ferretti, Firenze, 1968; T. Pignatti, Pietro Longhi, Venezia, 1968; M. Precerutti-Garbieri, Affreschi settecenteschi nelle ville venete, Milano, 1968; L. Puppi, L'opera completa del Canaletto (pres. G. Berto), Milano, 1968; G. Silvestri, Scipione Maffei, europeo del Settecento, II ed., Vicenza, 1968; D. Maxwell Wlaita, e A. C. Sewter, I disegni di G. B. Piazzetta nella Biblioteca reale di Torino, Roma, 1969; C. Mercenaro and Vv.Aa., Mostra dei pittori genovesi a Genova nel '600 e nel '700, Genova (ed. Milano), 1969; T. Pignatti, Paintings and drawings, London, 1969; M. Valsecchi, Venezia '700, Catalogue of the Exhibition, Venezia, 1969; P. Zampetti, Dal Ricci al Tiepolo, Catalogue of the Exhibition, Venezia, 1969; Vv.Aa., Paintings in Italy in the 18th Century: Rococò to Romanticism, Chicago, 1970; G. Knox, Tiepolo: a bicentenary exhibition 1770-1970, Cambridge (Mass.), 1970; G. Knox and G. Thiem, Tiepolo, Catalogue of the Exhibition, Stoccarda, 1970; O. Michel, Lambert-Francois Cammas et l'académie romaine de Saint Luc, Mélanges d'archéologie et d'histoire, t. 8é, 1, 1970; M. Muraro, Ricerche su Tiepolo giovane, Udine, 1970; M. T. Muraro and E. Povoledo, Mostra dei disegni teatrali dei Bibiena, Catalogue of the Exhibition, pres. G. Folena, Venezia, 1970; R. Pallucchini, Per la conoscenza di Giulia Lama, Arte Veneta, XXIV, 1970; E. Riccomini, Settecento ferrarese, Milano, 1970; A. Rizzi, Le acqueforti del Tiepolo, Catalogue of the Exhibition, Udine, 1970; E. Schaar, Mostra delle acqueforti di Piranesi alla Kunsthalle di Amburgo, Catalogue, introd. W. Hofmann, 1970; Vv.Aa., La pittura a Genova e in Liguria dal Seicento al primo Novecento, Genova, 1971; Vv.Aa., Acts of the Meeting of studies on Corrado Giaquinto,

Molfetta, 1971; J. Bean, F. Stampfle, Drawings from New York Collections. The 18th Century in Italy, New York, 1971; C. and M. Beurdeley, Giuseppe Castiglione, peintre jésuite á la cour de Chine, Paris, 1971; A. Busiri Vici, I Poniatowski e Roma, Firenze, 1971; L. C. Frerichs, Mariette et les Eaux-Fortes des Tiepolo, Gazette des Beaux Arts, 1971, Oct.; K. Garas, Antonio Galli Bibiena et Franz (Xaver) Karl Palko, Bulletin du Musée des Beaux Arts, 37, 1971; K. Garas, Giovanni Antonio Pellegrini in Deutschland, Storia dell'arte studies in honour of A. Morassi, Venezia, 1971; G. Gatto, Per la conoscenza di Rosalba Carriera, Arte veneta, XXV, 1971; G. Gatto, Due pastelli inediti di Rosalba Carriera, Arte Veneta, XXVI, 1972; L. Guerrini, Marmi antichi nei disegni Pier Leone Ghezzi, Documents and reproductions, 1, Città del Vaticano, 1971; M. Levey, The 17th and 18th Century Italian Schools, Catalogue, London, 1971; A. Mariuz, Giandomenico Tiepolo, Venezia, 1971; O. Michel, Peintres autrichiens á Rome dans la seconde moitié du XVIII siècle, Römische historische Mitteilungen, XIII, 1971, and XIV, 1972; A. Pallucchini, Giambattista Tiepolo (Disegnatori italiani), Milano, 1971; T. Pignatti, Aggiunte per Pietro Longhi; Arte illustrata, 1971; T. Pignatti, Francesco Guardi, Brescia, 1971; E. Riccomini, Il Settecento a Ferrara, Catàlogue of the Exhibition, Ferrara, 1971; A. Rizzi, Mostra del Tiepolo. Catalogue of the paintings. Catalogue of the drawings and the etchings, Milano, 1971; H. Salamon, Il Canaletto, Milano, 1971; N. Spinosa, La pittura napoletana da Carlo a Ferdinando IV di Borbone, Storia di Napoli, XVIII, Napoli, 1971; F. Vivian, Il Console Smith mercante e collezionista, introd. A. Bettagno, Vicenza, 1971; E. K. Waterhouse, Painting in Rome in the eighteenth century, Museum Studies, 1971; A. P. Zugni Tauro, Gaspare Diziani, Venezia, 1971; Vv.Aa., Acts of the international Meeting of studies on Tiepolo, with an appendix about the Exhibition, Milano, 1972; A. Bettagno, Venetian Drawings of the 18th Century, Catalogue of the Exhibition, London, 1972; M. Chiarini, Il disegno nel paesaggio italiano, Treviso, 1972; S. Kozakiewicz, Bernardo Bellotto, vol. 2, Milano, 1972; J. C. Links, Townscape Painting and drawing, London, 1972; E. Riccomini, Ordine e vaghezza. La scultura in Emilia nell'età barocca, Bologna, 1972; S. Rudolf, Mecenati a Firenze tra Sei e Settecento. 1. I committenti privati; 2. Aspetti dello stile Cosimo III; 3. Le opere, Arte illustrata, 5, 1972, and 6, 1973, and 7, 1974; H. D. Russel, Rare Etching by Giovanni Battista and Giovanni Domenico Tiepolo, Washington, 1972: J. Stolz, Artisti austriaci a Roma, dal Barocco alla Secessione, Roma, 1972; G. Vigni, Disegni del Tiepolo (II edition revised and enlarged by the author), Trieste, 1972; A. Barigozzi Brini and R. Bossaglia, Disegni del Settecento lombardo, Vicenza, 1973; O. Ferrari, Review to Acts of the Meeting of studies on G. Giaquinto, Bollettino d'arte, 2-3, April-September 1973; A. Morassi, Antonio e Francesco Guardi, vol. 2, Venezia, 1973; A. Rizzi, I maestri della pittura veneta del '700, Catalogue, Gorizia, 1973-74; U. Ruggeri, Giulia Lama, Dipinti e disegni. Study and Catalogues, Bergamo, 1973; Vv.Aa., Gli ultimi Medici. Il tardo barocco a Firenze, 1670-1743, Catalogue of the Exhibition, Firenze, 1974; R. Bacou, Piranése (Choix de) gravures et dessins, Paris, 1974; A. Busiri Vici, Franz von Bloemen detto l'orizzonte e l'origine del paesaggio romano settecentesco, Roma, 1974; E. Claye, A group of Portrait Drawings by Jacopo Amigoni, Master Drawings, XII, 1, 1974; B. Ford, William Constable. An enlightened Yorkshire patron; Thomas Jenkins. Banker, dealer and unofficial English agent; The Earl-Bishop. An Eccentric and capricious of the arts; Sir Watkin. William-Wynn. A Welsh Maecenas; Sir John Coxe Hippisley. An unofficial English envoy to the Vatican; James Byres. Principal antiquarian for the English visitors to Rome

Apollo, 99, 1974, 148; T. Pignatti, L'opera completa di Pietro Longhi, Milano, 1974; T. Pignatti, Tiepolo. Disegni, scelti e annotati, Firenze, 1974; L. Rossi Bertolatto, Francesco Guardi, Milano, 1974; L. Stainton, British artists in Rome, 1700-1800, London, 1974; S. Susinno, La veduta nella pittura italiana, Firenze, 1974; B. Hercenberg, Nicholas Vleughels (1668-1737), peintre et directeur de l'Académie de France á Rome, Paris, 1975 (1976); M. Monteverdi, I Bibiena, Disegni e incisioni nelle collezioni del Museo Teatrale della Scala. Catalogue of the Exhibition with contribution by E. Marani, Milano, 1975; T. Pignatti, Pietro Longhi, dal disegno alla pittura, Venezia, 1975; M. Praz, Giovanni Battista Piranesi: Le carceri, Milano, 1975; A. Rizzi, Sebastiano Ricci disegnatore, Catalogue of the Exhibition, Udine (ed. Milano), 1975; Mostra di Giovanni Battista Piranesi alla Calcografia nazionale di Roma, Catalogue, Roma, 1976; Vv.Aa., Acts of the international Congress of studies on Sebastiano Ricci and his time, Milano, 1976; A. Chastel and G. Brunel, Piranèse et les français (1740-90), Catalogue of the Exhibition, Rome, 1976; J. Daniels, Sebastiano Ricci, Wailand, 1976; R. Enggass, Early eighteenth-century Sculpture in Rome, Pennsylvania State University Press, 1976; E. Riccomini, I fasti, i numi, le grazie. Pittori del Settecento paramense, Parma, 1977; A. Zava Boccazzi, Giambattista Pittoni, Milano, 1977; M. Blanco, Gli affreschi di Pietro Paolo Vasta nelle antiche chiese di Acireale, Palermo, without date; G. Briganti, I vedutisti, Milano w. d.

Outside Italy: A. Ananoff, L'oeuvre dessiné de Jean-Honoré Fragonard (1723-1806), Catalogue raisonné, t. 1-4, Paris, 1961-1971; Vv.Aa., Barock in Boehmen, München, 1964; L'art français au XVIII siècle, Catalogue of the Exhibition, Paris, 1965; K. Rosacher, Visionen des Barock, Darmstadt, 1965; La pittura inglese da Hogarth a Turner (1730-1850), Catalogue of the Exhibition, Roma, 1966; Barock in Deutschland, Catalogue of the Exhibition, Berlin, 1966; Masters of the Loaded Brush, Catalogue of the Exhibition, Knoedler's 1967; A. Ananoff, L'oeuvre dessiné de François Boucher, Paris, 1968; Amis et contemporains de Mariette, Catalogue of the Exhibitions, Paris, 1967; Le cabinet d"un grand amateur, Pierre-Jean Mariette, Catalogue of the Exhibition, Paris, 1967; H. Burda, Die ruine in den Bildern Hubert Robert, Monaco, 1967; B. Bushart, Deutsche Malerei des Rokoko, Königstein, 1967; G. Mandel, L'opera completa di Hogarth pittore, pres. G. Baldini, Milano, 1967; R. Rosenblum, Transformations in Late Eighteenth Century Art, Princeton, 1967; A. Ryszkiewicz, Francusko-Polskie swiaski artys" tyczne w kregu Dawida, Varsovie, 1967; F. Souchal, Les Slodtz sculpteurs et décorateurs du Roi (1685-1784), Paris, 1967; J. Thuillier, Fragonard. Etude biographique et critique. Le goût de notre temps, 46, Genève, 1967; France in the 18th Century in R. A., Catalogue of the Exhibition, London, 1968; Romantic art in Britain: Paintings and Drawings, 1760-1860, Catalogue of the Exhibition, Detroit and Philadelphia, 1968; J. Cailleux et R. Michel, Watteau et sa generation, Catalogue of the Exhibition, Paris, 1968; E. Camesasca, Tutta l'opera dipinta di Watteau, Milano, 1968; Paris, 1970, with introd. by P. Rosenberg; P. Gaxotte, Paris au XVIII siècle, Paris, 1968; H. Honour, Neo-Classicism, Harmondsworth, 1968; E. C. Montagni, L'opera completa di Watteau, pres. G. Macchia, Milano, 1968; B. Nicolson, Joseph Wright of Derby, London, 1958; British Neo-Classical Art, Ickworth, 1969; Sir George Beaumont, Artist and Patron, Catalogue of the Exhibition at Manning Galleries, 1969; Goya, Exposition. Orangerie des Tuileries, Paris, 1970; Grafiek van Goya. Tentoonstelling. Rijksmuseum, Amsterdam, 1970; Thomas Jones 1742-1803, Catalogue of the Exhibition, Marble Hill, 1970; K. L. Dasser, Johann Baptiste Anderle. Ein Schwäbischer Maler des

Rokoko, Weissenhorn, 1970; L. Eitner, Neoclassicism and romanticism 1750-1850: Sources and documents, Prentice-Hall, 1970; P. Felder, Johann Baptist Babel. Ein meister der Schweiserischen Barockplastick, Basel, 1970; P. Gassier and J. Wilson, Vie et oeuvre de Francisco Goya, with introd. by E. Lafuente Ferrari, Paris, 1970; G. Gerkens, J. Schultze, A. Winther, Francisco Josè de Goya y Lucientes. Radierungen aus dem Besitz der Austellung Kunsthalle Bremen, Bremen, 1970; J. Gudiol, Goya. 1746-1828. Biografia, estudio analitico, y catàlogo de sus pinturas, Barcelona, 1970; J. Harris, Sir William Chambers, 1970; V. N. Prokofev, Kapricos Goyi, Moscou, 1970; Francis Cotes, Catalogue of the Exhibition, Nottingham, 1971; Watercolours by John Robert Cozens, Cat. of the Exhibition, Witworth, 1971; Y. Bottineau, Iberian, American Baroque, London, 1971; W. Gaunt, The great century of British painting: Hogarth to Turner, London-New York, 1971; J. Hayes, The drawings of Thomas Gainsborough, vol. 2, London, 1971; P. Jean-Richard, François Boucher, gravures et dessins provenant du Cabinet des Dessins et de la Collection Edmond de Rothschild au Musée du Louvre, Paris, 1971; G. Lemurier, L'art baroque et classique en Wallonie, s.1., 1971; E. R. Mandle, J. W. Niemeijer, Dutch masterpieces of the eighteenth century: paintings and drawings, 1700-1800, Cat. of the Exhibition, Minneapolis-Toledo-Philadelphia, 1971-1972; P. Mazars, L'univers de Fragonard. Les Carnets de dessins, 8, Paris, 1971; R. Paulson, Hogarth: his life, art and times, 2 vol., New-Haven, London, 1971; M. Praz, Conversation pieces, Roma-London, University Park Penn., 1971; X. de Salas, El Arte de Goya, Catalogue of the Exhibition, 1971-1972; H. D. Schepelern, C. A. Lorentzen, Udstilling i 225-aret for malerens fodsel, Cat. Exhib., Copenhagen, 1971; S. Vrišer, Barockplastik in Slovenien, Wien, 1971; Winckelmann: writings on arts, prepared by D. Irwing, London, 1972; Goya Druckgraphik des Oldenburger Stadtmuseums. Katalog, Oldenburg, 1972; Vatto i ego vremja, Zivopis', grafika, skulptura, prikladnoe iskusstvo, Katalog vystavkj, Leningrad, 1972; Vv. Aa., The age of neo-classicism. Cat. Exhibit., London, 1972; A. Brookner, Greuze: The rise and fall of an 18th Century phenomenon, London, 1972; P. Jaffé, Lady Hamilton in relation to the art of her time, Cat. Exhib., London, 1972; M. Levey and W. Graf Kalnein, Art and architecture of the 18th Century in France, London, 1972; G. Levitine, The sculpture of Falconet, New York, 1972; G. Mandel, L'opera completa di Fragonard, pres. D. Wildestein, Milano, 1972; R. Paulson, Hogarth, Cat. Exhibition, Tate Gallery, London, 1972; P. Quennell, L'Angleterre romantique, écrivains et peintres (1717-1851), s. 1., 1972; P. Rosenberg, French Master drawings of the 17th and 18th Centuries in North American Collections, Catalogue of the Exhibitions, Toronto, Ottawa, San Francisco, New York, 1972-1973; Saint-Paulien, J. Ferrè and Vv.Aa., Watteau, Madrid, 1972; Y. Zolotov, Antoine Watteau, with texts by S. Nemilova, I. Kuznetsova, T. Kamenskaya, V. Alexeyeva, Leningrad, 1972; English Watercolours of the 18th and 19th centuries from Withworth Art Gallery, Cat. Exhib., Manchester, Bruxelles, 1973; H. Berriman, Sir Joshua Reynolds at Plymouth, introd. E. Waterhouse, Catalogue of the Exhibition, 1973; D. Eckardt, Antoine Watteau, Berlin, 1973; P. Gerlach, Antikenstudien in Zeichnungen Klassizistischer Bildhauer, München, 1973; L. Herrmann, British Landscape Paintings of the 18th Century, London, 1973; L. Parris, Landscape in Britain, c. 1750-1850, introd. C. Shields, Cat. Exhib., London, 1973-74; A. M. Passez, Adelaide Labille Guiard, biographie et catalogue raisonné de son oeuvre, Paris, 1973; T. A. Selinova, Ivan Argunov, Moskva, 1973; R. Shoolman Slatkin, François Boucher in North American collections: 100 drawings, Cat. Exhib., Washington, Chicago, 1973-74; E.

Waterhouse, Reynolds, London, 1973; Y. Zolotov and Vv.Aa., Antoine Watteau. Grans série, Leningrad, 1973; L'art du Dix-huitième siècle, introd. J. Cailleux, Cat. Exhib., Paris, 1974; The Changing Image: Prints by Francisco Goya, Boston-Ottawa, 1974; Vv.Aa., Franz Anton Maulbertsch, Cat. Exhib., Wien, Halbturn, Heiligenkreuz-Gutenbrunn, 1974; Vv.Aa. guided by T. Alkseeva, Rousskoïe iskousstvo pervoï tchetverti XVIII vieka. Materialy i issledovania, Moscow, 1974; E. Croft-Murray, Decorative painting in England 1537-1837, vol. II: The Eighteenth and Early Nineteenth Centuries, London, 1974; E. Eriksen, Early Neo-Classicism in France, London, 1974; K. Garas, Franz Anton Maulbertsch. Leben und werke, Salzburg, 1974; K. Garas, Franz Anton Maulbertsch és kora, Cat. Exhib., Budapest, 1974; K. Garas, Franz Anton Maulbertsch, 1724-1796, Alte une moderne Kunst, 135, 1974; A. Hahnl, Die Bekehrung des Paulus und des Hubertus. Werke von Johann Georg Schwanthaler in Salzburger Sammlungen, Alte und Moderne Kunst, 136-37, 1974; M. Koller, Zur Ausstellung der Schwanthaler-Familie in Reichersberg-Barocksculptur aus der Sicht des Restaurators, Alte und Moderne Kunst, 136-137, 1974; W. Oberwalder, Zur Ausstellung Die bildhauerfamilie Schwanthaler (1633-1848), Alte und Moderne Kunst, 136-137, 1974; G. C. Rump, George Rommey, Hildesheim, New York, 1974; Vv.Aa., Louis XV: un moment de perfection de l'art français, Cat. Exhib., Paris, 1975; J. Dobai, Die Kunstliteratur des Klassizismus und der Romantik in England, t.I, 1700-1750, Berne, 1975; R. Paulson, Emblem and expression. Meaning in English art of the 18th Century, London, 1975; P. Rosenberg, The Age of Louis XV: French Painting 1710-1774, Cat. Exhib., Toledo, Ottawa, Chicago, 1975-1976; Vv.Aa., Charles-Joseph Natoire, Catalogue of the Exhibition, Troyes, Nîmes, Rome, 1977.

SERENITA PAPALDO

ARCHITECTURE IN THE 18TH CENTURY
(PLATES 135-136)

Historiography. - For a chronological outline of architecture in the 18th century, the lists of the principal personalities, and the cataloguing of what are considered the most important monuments, see the relative parts of the *Encyclopedia of World Art* ("Baroque," 1958; "Rococo," 1963; and "Neo-classic," 1963). This reference work gives a first fundamental, complete, and accurate approach to the sequence of European and extra-European events - except for some lacunae such as town planning and the "Utopia" of S. Leucio. Another slightly earlier and certainly more easily readable description is given in the well-known volumes by Golzio (1950 and 1955). On the other hand, it is difficult, if not actually over-whelming, to attempt a synthesis of the vast amount of material available. Artistic historiography as accepted from the 1950s, both on the level of the headings and texts mentioned above and at the not less important "general reader" level, apart from the purely didactic function which the more diffuse manuals may be expected to fulfil, is limited to a more or less articulated sequence of names and events during the whole extent of the century, at best divided on a topographical basis (for example, the very well informed Salmi, 1977, on Italy) or made to revolve around some central figure whose name is already well known (such as the "profiles" of Juvara and Vanvitelli,

traced by Bottari (1957) with, it must be admitted, a very fine pen, but boldly excluding a whole epoch. On this plane the peak is reached in the famous Penguin Books dedicated to a careful and detailed review of artistic activity and securely backed by an extremely extensive bibliography. However, even the volume which may be considered the best of the series - *Art and Architecture in Italy 1600 - 1750* by Wittkower (1958, 1966, 1972) - and which is unquestionably a fundamental instrument for analytical reference does not have an easily followed main thread, at least as regards architecture.

In reality, even when the complex results of the research have been organized, use has been made all too often of a classification by categories, hoping that the essential complexity of the phenomena could be explained away by a definition. Discussions in the sector which interests us here reached a crucial result in 1960 on the occasion of the International Convention at the Roman Academy of the Lincei dedicated to "Mannerism, Baroque, and Rococo. Concepts and Terminology" (Proceedings, Rome, 1962). It would be superfluous - and in any case would not be cogent here - to insist on the real profundity of the papers and the validity, at least in theory, of the conclusions, but it is not possible to escape mentioning some immediately resounding consequences. Starting from what are fundamental considerations internal to the formal structures, within the inspirational climate of the convention, the various authors of articles on Baroque in the E.W.A. include treatment of architects such as the Venetian Massari, who died in 1776, or the Piedmontese Bernardo Vittone, who went on till 1770, after having discussed the Place de la Concorde in Paris (which was designed about 1763) and Neumann's prodigious "Vierzenheiligen" (1743) and then connect the activity at St. Petersburg of the last Rastrelli with the brusque arrival of Quarenghi. Sedlmayr and Bauer (1963), on their part, although they proclaim Rococo as a generating style, demonstrating its influences on particular constructive types and thus excluding "part of official buildings and most of the ecclesiastical ones" which "only show it secondarily in their ornamentation," end up by interesting themselves in all that was architecturally best in 18th-century Europe.

Ansaldi (1963), based on the observation that "from the Papacy of Benedict XV interest in the classical world spread beyond a restricted circle of antiquarians" extending its influence on taste in combination with the arrival in Rome of the Venetian Piranesi in 1740, sees this date as the origin of a "new movement" already, after all, "manifest in Rome during the first half of the century, and called Neo Classicism." Thus welding the remaining traces of Baroque - or, better, the development of Late Baroque according to Norberg Schulz's recent postulation (1972, repeated in 1974) - with the great expansion of Rococo and the early arrival of the Neo Classic, he fills up the rest of the century.

It is significant that the article on Illuminism by Battisti (1958) has been reduced to only two half columns in the E.W.A., and that no better fate will be meted out on the other hand to Vercelloni (1969) in the *Encyclopedic Dictionary of Architecture and Town Planning*. The ambiguity remains and is confirmed in current usage - and the consultation of any manual will be enough to demonstrate the fact, from Paribeni-Mariani-

Serra (1953) to Salvini (1954) from Rotondi (1955) to Pittaluga, and from the above mentioned Bottari (1957) to Borgese-Cevese (1963) - that often the architecture of the 17th and 18th centuries is treated as if it were a single body, in the absence of any reliable criterion for analysis within the superficial observation of the continuity of formal development. The few attempts to latch on to the reality of 18th-century history and culture are reduced to associations which are external to the discourse purposely anticipated and separated even typologically (see the re-edition of D'ancona-Wittgens-Gengaro, 1954, or the final volume of Castelfranchi-Vegas, 1960). More deeply involved, Mazzariol and Pignatti (1959) close the sixth decade attempting an exposition tied to the usual themes of personalities and the imposition of categories and of professional differentiations intended to emphasize the overall characterization of the different artistic circles. However, this remains, for that date, a practically isolated case and is, in any case, limited to the Italian scene.

The escape from the insidious quagmires of this renewed, though all the more limited objectively, "dispute on universals" is destined in the end to exhaust itself in a barren "nominalism." (See, on this point, the clarifying paper by Salerno, 1969, and, in a related field, the exhortations of Rosenblum, 1967.) It was necessary to awaken a consciousness of the "historicity of Art" worthy of investigation in conjunction with the outcome (although not on parallel lines) of the work at the Warburg and of scholars with a sociological bent from Cassirer to Wittkower, from Antal to Hauser, and through the determinant incisiveness on the practical level of the subtle but continuous work of an Argan or a Francastel.

Specifically in the field of architecture this means Zevi, and, above all, Tafuri (1968). What must be accepted is, therefore, totally and simply (Argan, 1977) that "history is the only discipline which explains artistic phenomena;" yet still allowance must be made for the peculiar "specificity" of the history of art (Argan, 1977; Francastel, 1970 and 1976) as compared with mere history - a correction of the integralism of the sociologists (Hauser, 1953 and 1964, without forgetting the opportune reservations he made in 1958, at least in the introductory pages of *Aims and Limits of Sociology of Art*), for whom art seems to be almost a subordinate activity suitable for the reflection, through patrons" commissions, of the ideological values and customs of the dominant classes, rather than a contribution at least as equally as valid as those of philosophers, men of letters, and scientists to the construction of a culture. It must be remembered that the 18th century can be, retrospectively, regarded as a passage from Locke's Empiricism ("An Essay Concerning Human Understanding," 1690), through Berkeley's (*Treatise Concerning the Principles of Human Knowledge*, 1710) and Hume's (*A Treatise on Human Nature*, 1738), to Kant's Idealism (*Critique of Pure Realism*, 1781; *Critique of Practical Reason*, 1788; *Critique of Judgment*, 1790) along the main road of Enlightenment universally expanding almost unopposed from its privileged French origins, more forcefully in England and Germany.

A serviceable overall vision, therefore, requires the support of the rapid but exhaustive panoramas delineated by Corban (1968) and by Stark (1969) within the fine mesh of cultural phenomena, as well as of the

abstracts of contributions on the subject collected by Geymonat (1971) or, with a wider orbit, the masterly *The Eighteenth Century Reform* by Venturi (1969) and the specific sector in the *History of Political Economic, and Social Ideas* edited by Luigi Firpo (Vol. IV, 1975). The balanced syntheses of Gay (1967) and Hampson (1968) and the acute investigation by Horkheimer and Adorno (1966) get nearer the roots of 18th-century thought, while the studies Ulivi (1957) and Walter Binni (1963) are more precisely sensitive to the relationship between poetic taste and figurative taste.

The penetrating papers by Assunto (1969, 1970), which decisively set out to show "the reciprocity connecting architectural concepts and the theoretical ideas of philosophers particularly between the seventeenth and eighteenth centuries," still up to date and exhaustive, are uninhibitedly directed at becoming "an introduction to the history of philosophy as history of architecture." This investigation clearly shows the triumphant progress decade after decade throughout the century of the "priority of reason," victorious even when combatting "sentiment," in an adventurous journey marked by memorable moments, among which, in the crucial 30 years 1751 - 1780, are the regular publication of the 35 volumes of the celebrated *Encyclopédiè* managed by Diderot and D'alembert; so that the end of the century can be identified (Corban 1968) as the Age of Science. At the same time, the myth of absolute power pales, fades, cracks, and is finally destroyed and the successive generations advance running, according to Starobinski's happy phrase (1964), to the "discovery of liberty," without hesitating when faced with the blood of revolution.

Current studies. In such a context, the first "present day" studies of the architecture of the 18th century are undoubtedly those carried out by Kaufmann in the far-off 1920s, rethought and integrated in his masterly "Architecture in the Age of Reason," published posthumously in 1955. Justly, in introducing the first Italian edition (1966) Castelnuovo noted the working "on the one hand of the analyses and interpretative schemes of the Viennese school, enriched by Wölfflin's classifications, and on the other of a vague Marxism or at least of a lively desire to tie architectural phenomena to the cultural and social history of their times." For Kaufmann, the architectural 18th century started off from renaissance and baroque ideals - a long Baroque covering all the 17th century and the beginning of the 18th - of the harmonious organization of composition by means of gerarchical concatenation, integration, and graduation of spaces, analogous with the centralized system of fully developed monarchies and ended by progressively destroying that concept in an evident parallelism with the corresponding shift from absolutism to republican hopes.

In spite of the obvious gaps, largely justified by the special limits voluntarily imposed to shorten the work (Neogothic and the still incipient Architectural Romanticism are only just touched on, covering even Quarenghi in little more than three lines), the conclusions are exemplary. Kaufmann admires the results obtained from the polemical ardor of debate, by the committed and aggressive "1760 generation" - the "Architects of the Revolution" such as Boulleé, Ledoux, and Lequeu - at the end of a process which sees architecture go from a fusion of parts to a contrast of elements and from a compenetration of nature to isolation from it, if not actually to opposition or at least to indifference to it.

The extreme rationalism of the outcome is, for Kaufmann, loaded with an unsuspected vitality, which operates to prolong its life in various ways until it comes to the surface again, near our own times, as a definite and glorious aspect of the architectural experiments of the 20th century of Loos and Le Corbusier. Argan, after some 15 years of broadening and deepening Kaufmann's interpretation with the same methodological outlook (imbued with the same idea of the "immanence of history" and, later, freed from Wöfflin's influence), restating "Science . . . the perfect form of Reason . . . foundation of illuminant thought" and the vehicle for the "invention of Liberty," proceeds (1970 and 1970, I) to examine with a more subtle critical rigor the relationships between this guiding activity and artistic production, identifying three possibilities: first, the separation of art from science by an exaltation of its techniques," second, the assimilation by art of the methods of science, and third, the constitution of art as a science in its own right, the "Science of Beauty." These three possibilities become in turn the basis for a plausible time scale in which the terms Rococo and Neoclassical can again be used and applied to the beginning and final phases, but full of a new meaning which is derived from adherence to history. The central core is established as the "Philosophy of the Enlightened," which was translated in different countries into spatial rhythms and the development of ambience and of town planning solutions.

The various historical and critical contributions made from 1950 till now can be comfortably fitted into the wide frame-work of reciprocal correlation between the two positions of Kaufmann and of Argan, including both the generalized and the particular and not forgetting in certain cases some detailed refinements. Hitchcock (1958 and 1971) insists, for the period 1750-1790, on the concept of Romantic Classicism put forward in the past by Giedion and accepted by Kimbale. This movement (for the eventual American effects of which see Levis, 1971) would have ripened in Paris from roots in Roman circles (Winckelmann, Gavin Hamilton, Piranesi) showing as exemplary buildings, after 1755, the Parisian Sainte-Geneviève by Soufflot (Petzet, 1961), which became better known as the Panthéon, and the Doric Temple in Hagley Park (Worcestershire) by James Stuart. The great masters of this particular stream, Boullée and Ledoux, flourished around 1780. In spite of the attraction of its name the term remains ambiguous. Artists such as Boullée (and, although to a different degree, Ledoux, who was linked to the former by "the same ideology and, within certain limits and with certain differences, the corresponding methodology of design" - Argan, 1970 II) can be much more profitably attached to the poetic ideal of the "Sublime," formulated by Kant (Pareyson, 1968). The essence of "form" available to architects continued to be geometrical form dictated by Reason, but the latter, involved in a continual struggle with the rebellious senses, is no longer merely a means for understanding but a duty and a moral force. From this point, it is a short step to that architecture morality acutely described by Chastel (1967). Mention has already been made of Starobinski's important work (1964) in which he sees the 18th cen-

tury as the "Century of Liberty," reached through science and action.

The Schonberger Soehners, on the other hand, under the deprecatory and misleading title of Rococo, in giving an analytical review of the cultural components of the 18th century up to the "threshold of the technological era," might perhaps be accused of deliberately exaggerating the difference between the examination of these components and a treatment of artistic development as such. The valuable contributions collected by Vittore Branca after the Venetian conference (1967) on "Sensibility and Rationality in the 18th Century" are on the same plane of research. Particularly worth mentioning is Wittkower's paper on "The Classical Theory and the New Sensibility." The same interests again came out in an even more marked way in "An Updating of Critical Discipline and a New Focus on 18th Century Culture" (Dezzi Bardeschi, 1976) on the occasion of the following conference (1970, Proceedings, 1972) on Vittone and the debate between Classicism and Baroque, organized by the Turin Academy of Science. The specifically architectural contributions were by Rossi, by Verselloni, and by Tafuri, who had earlier also produced a lucid paper on the dialectic between symbols and ideology in the architecture of Enlightenment (1964). The excellent chapter by Maltese (1960) on the architecture of Neoclassicism is on a wider historiographic plane and remains always firmly attached to the ferments of an age of violent struggle, after the fine opening pages on "Taste and Revolution." It is even possible to enjoy an intelligent application for the general reader of the new aims of criticism and recent achievements of science in the able perspective view of European art by Ciotti Marzi-Kienerk (1973) in a very complete context of interdisciplinary references which have become an essential and integrative part of the development of their discourse.

Development of theory. As regards theories of architecture, the century which worshipped Reason was very productive, and, always bearing in mind, at least for the sources, the basic updatings by Otto Kurz of the re-editions of Schlosser's classical "Artistic Literature" (1964 and 1967), one can start from the well-informed relative paragraph of the bibliographic supplement by Castelnuovo to the Italian edition of Kaufmann (1966), which gives exhaustive data. A slight gap can be filled by including Wittkower (1952 and 1964), who dedicated some pages to the systematic progressive breaking down of the laws of harmonious proportions - which were upheld particularly by the Italians Bertotti Scamozzi, Temanza, Preti, Riccati, and Vittone himself and by the Frenchman Briseux - on the part of 18th-century Englishmen, who can be defined as fundamental subverters of the "whole structure of classical aesthetics," from Hume with his "A Treatise of Human Nature" (1738) to Burke's search for the origin of the Sublime and the Beautiful (1751) and from the criticism of Kames (1761) to the studies on the principles of taste by Payne Knight (1805). Numerous studies have followed along the road opened by Kaufmann, who had renewed interest in the "Architects of Revolution" and their theoretical and practical operations. Among these are the first Italian edition (1967) of "Architecture, Essai sur l'art" by Boullée with an illustrative introduction by Rossi; the publication of an important corpus of unedited designs also by Boullée (Lankheit, 1968); and,

still by the same man, in an excellent book by Vogt (1969) the exact reproduction of the design for a cenotaph of Newton (1784), an authentic ideal monument of illuministic culture where the architectonic form, identified as absolute geometrical form, "presents itself simultaneously as subject and as concept, as art and as philosophy" (Argan, 1970, ll). Pérouse de Montclos (1969 and 1974) returns to Boullée, while Ledoux is the subject of various contributions to a specific Parisian essay of 1971. Reference is naturally made to both of them in the catalogue of the London exhibition (1971) on the "Art of the Revolution," which has an introduction by Rosenau (1966) on the oscillation between the functional and the ideal in the late 18th century in France. Useful comments are made by Forssman (1971) on the relationships with the "antique" in Laugier, Ledoux, and Boullée, while Summerson (1964 and 1970) makes much of Langier, considering that after his "Essai sur l'Architecture" (1753), which had, as Hitchcock says (1971) "a certain weight as a profound criticism of the dying Baroque," almost all the original and innovative works either reflect or reject his theories, whose principles were then incarnated in the most spectacular way by Sufflot in his Sainte-Geneviève.

Werner Oechslin, in some very brilliant pages (1970), studies the bases, the collateral influences, and the consequences of "revolutionary architecture" which was promoted by the Italian "Jacobins" (cf. Investigation by Cerrutti, 1969, in the literary area) Cagnola, Canonica, Antolini, some of Selva's output (but some work by Pistocchi should be added), and so on right down even to Otto Wagner and Schöntal, Olbrich, and Sant'Elia. In this climate, even if the negative judgment formulated by an old style academic like Hautecoeur (1953) is no surprise, the strong reserves put forward by Benevolo (1960) and repeated by Zevi (1975) regarding Boullée and Ledoux are puzzling, for they are considered in no uncertain terms as "very slightly revolutionary . . . remote and equivocal precursors . . . of the modern movement" (Zevi), victims, especially the former, of "formal abstractions . . . in the ambit of a wormeaten stylistic research for allegorical meanings, even if returning a pervasive metaphysical fascination." It is odd that, on the contrary, even such a personality as Ragghianti, whose formation favors pure vision, produced in 1954 an editorial on these two late 18th-century protagonists plus Lequeu in "sele arte" with a decidedly favorable slant, emphasizing the "openness" of these artists, and especially the third, as compared with subsequent European experience.

Certainly, in the heat of "cultural imagination" or, as it might be almost said, the "kaleidoscopic phantasmagoria" of Lequeu ("sele arte," 1954) we see another aspect of 18th-century culture, namely the anxiety for historical experience. The criticism by Griseri-Gabetti (1973) clarified that there is at most only an apparent contrast between this thirst for experimentalism and the cult of Reason. This last, in fact, from its unchallenged supremacy requires "the re-examination of every style, and therefore also of the Classical," the strongest inheritance of tradition "in the light of the present," for the purpose of an "ad hoc" appreciation. But this operation, naturally, dethrones antiquity and classicism as unique models - and the "repertory of forms" is consequently enriched by "new possibilities" and ends by absorbing "with equal curiosity and enthu-

siasm many styles, manipulating them extremely freely and associating them with the most diversified typologies."

In a more or less active way there were also simultaneously and constantly present empiricist ferments, which were never entirely suppressed by the illuminists and which became vital motives in the dramatic alternative of the century through the dynamic argument. Out of all this was born an heretical current which "through the revaluation of the sensations and of sentiment [led] art criticism and aesthetic pleasure to base themselves on empirical psychologism and on imagination" (Patetta, 1975). For Patetta, the relative products - a whole series of architectural 18th-century neologisms, from the oddest Neo-Greek or Neo-Roman to Neo-Renaissance, with frequent exotic contaminations aimed at connection with vague "Oriental" motives even from far off China - already fit into a wider concept of "electicism," bringing forward its origin to about 1750. And it cannot be denied that these foundations were the basis (Griseri-Gabetti, 1973) for Neo-Gothic followed by Eclecticism properly so-called in their typical forms, which lasted the whole of the 19th century. In this attempt to clarify some aspects of the question, one must not overlook a mention of the modern meaning of the phenomenon of "revivals," especially after what was argued on the subject in the fundamental volume of 1974. There Pinelli emphasizes the bivalent attitude of a revival - namely the negation of the present and a recurring appeal to the past. On the one hand, the values of the past become an "idea force" in polemical contrast with the present, while on the other we use those values "as a shield to enclose us and exorcise reality."

Now if in the vital impulse which pervades the 18th century, namely the search for exoticism and the experiencing of the antique such as Gothic, undoubtedly reveals bounding enthusiasm in the approach to life, pushing in any admissible direction under the drive of a basic empiricist continuity - think of Canova's travel notebook with sketches ranging from the Lorenzettis to Innsbruck Cathedral and from the postillions" cloaks to the corpses of the hanged - it must be admitted that the ease with which such mixtures are made sometimes shows an undoubtedly revivalistic tinge. And this in both senses, both as a recovery of an "idea force" to oppose to the meanness and deficiencies of the present - in architecture the majesty and monumentality of the "antique" were exaggerated to titanic gigantism, or, in the opposite direction, its grace and exquisite refinement were proclaimed - and as the fictitious creation of an alibi, the evocation of a magic place of forgetfulness and irresponsibility - and, again in architecture, the profound significance which can be sometimes discovered beneath the "false purpose" of all that grand show of Chinese pavilions, Indian pagodas, or mock peasant villages like the cynical and tragic game with the "hameaux de la reine" in the park at Versailles.

While on the theme of revivals, the biggest mistake of the usual critical historical treatment has been to consider Neo-Classicism, the movement which underlies the whole of the second half of the century and at the end goes over into the 18th century, as merely a super-revival of the deliberate "repêchage" of the antique exaggerated in the imitation under the pressure of a whole series of what are considered as determining factors although they are apparently extraneous and random. It is true that, in this specific case, the succession of concommitant events is such as to constitute an impressive escalation, from the fascinating discovery and excavation of Pompei, Stabia, and Herculaneum around and immediately after 1748 to the publication of extremely varied Italian and Roman (Cochin, 1754; the "Antiquities of Herculaneum," 1757 - 1792) as well as Etruscan and Egyptian (Caylus, 1752 - 1767) archaeological material, to the rapid diffusion of Winckelmann's exhortations ("Gedanken uber die Nachahmung der griechischen Werke," 1755; "Geschichte der Kunst des Altertums," 1764), immediately followed by the popularizing actions of Piranesi and of Mengs. Nevertheless, the massive archaeological component must not make one lose sight of the essential fact, which is, according to the sense of the famous passage by Marx, that under "this old and venerable disguise" the men of the later generations of the century represented "the new historical scene" of their own times. Therefore, the simplistic thesis of a passage from "the picturesque genre" to the "goût grec" is discarded. Instead (Griseri, 1971), in its illuminist roots the origin of Neoclassical architecture is identified so that Neoclassicism (Honour, 1968) is recognized as "the culminating and revolutionary phase" of Illuministic culture, with its precise re-proposal of the antique model not - or not only - as science but rather as the ideal to be followed with a "personal" itinerary in the difficult course of evolution from "sentiment" to "concept" and from "sensibility" to the "sublime."

But this is not the place to insist on the analysis of a phenomenon which, if according to the timing put forward by Vogt (1971), originated from the debate following the first edition of Laugier's "Essai sur l'Architecture," 1753 (which showed a radicalism not unlike that of Lodoli) between the asserters of "geometrical purism" and the traditionalists, and was protracted with its protagonists well into the initial decades of the 19th century. It will be discussed in the appropriate period. It will be sufficient here to mention the outcome of the Venice Conference of 1957, including the essential exemplary methodological overview by Argan (1970, II), the stimulating and exhaustive papers by Assunti and by Puppi (1971) respectively on the theoreticians and the historiography of the movement, and the very wide anthology of material and bibliography offered, in 1972, by the catalogue of the London Exhibition on the Neoclassical Age (see, for architecture, the substantial pages by von Kalnein).

It is more pertinent to concern ourselves with two problems within whose ample boundaries we can observe, during the 18th century, a coherent debate between the requirements of "rationalism," taken as far as the purity of Neoclassicism and the persistence of practical and "sentimental" components - those of the theater and of Palladianism. As for the theater, many reviews of undoubted value, at least for the historiography, have been offered, for example by Baur-Heinold (1971) and by Ricci (1971, limited to Italy), as well as in the Italian edition (1971) of the classic manual (1927) by Nicoll. All are full of illustrative material and give essential bibliography. The most important recent work is by Matteucci and Lenzi (1977) who, while correcting the picture of Cosimo Morelli (who has been too long

neglected), give a worthwhile description of various aspects of 18th-century experimentalism in the scenic and theatrical fields. In effect, the inexorable sifting by Illuminist critics subjected the architectural structure of the buildings used for show presentations "to a lucid and pressing review" (Pinelli, 1973), suggesting the need for "a radical reshaping in the light of new principles of utility . . . or morality and of rationality." The guiding principles were still those handed down from the late 16th-century traditions of court theaters designed by Vasari and Buontalenti and codified by 17th-century experience into the canonical type of U-shaped hall - with slight variants of mixed shape, eliptical, ovoid, or campanular - surrounded by a honeycomb of boxes and opening through massive prosceniums to enormous stages. After an accommodating suggestion by Arnaldi (1762) of a compromise between halls and boxes, the arrangement of the space according to the canonical cadence of the classical orders, the much more acid and aggressive Milizia took up the struggle in "Del Teatro" (1771, reprinted 1794). He proposed drastic reform in the included plan by the architect Vincenzo Ferrarese: inside the simple but "perfect" generative idea of a circumference there are to be arranged the hemicycle for the spectators - with stepped loggias - and that for the performance, the whole perfused by periodicities on a gigantic scale in various modulations. All around were to be numerous rooms, not only for services but to be used for different cultural and social purposes with a functional polyvalence by which the theater would become the high spot and reference point of the social life of the citizenry.

The acute conclusions of Marotti (1974) are that on the whole the proposal was of the idea of the theater "as a theorem regulated by the rigid laws of optics." The most notable outcome in this field was the investigations and publications of Francesco Riccati (1790), who dedicated the organization of theatrical space to the "esprit de Géométrie," thus removing it decisively from the changeable flow of sensations offered by acoustics, which cannot be easily or simply codified in spite of Algarotti's attempt ("Saggio sopra l'opera in musica," Livorno, 1763). At the end of the violent argument, in spite of the fact that optics were defended by artists of the stature of Ledoux, with the spherical theater proposed for Besançon victory went to the upholders of the "reasons of acoustics," as can be easily confirmed by remembering the theaters of the Bibienas, by Juvara, by Vanvitelli, by Benedetto Alfieri, and by Morelli.

One single attempt at reconciliation between the opposing theories can perhaps be found realized in the Academic Theater of Castelfranco by Mattia Preti (1754). Furthermore, everywhere scenographic illusions were exaggeratedly multiplied, encouraged by the introduction of "angled scenes" and "multiple foci" by the Bibienas. After the synthesis of this subject offered by Fagiolo (1963) the contributions to the Venetian Exhibition (1975) should be consulted, for it was expressly aimed at an "understanding of scenic space" in the 17th and 18th centuries. The motives for the resounding defeat of Reason have been identified by Pinelli (1973) and further analyzed by Tafuri in an acute paper (1976): Melodrama, which at heart covers all 18th-century theatrical life, is suited to the tried type based on acoustics and the maximum use of the available space to squeeze in the maximum possible number of spectators, but it is to be noted that this situation discloses the profound elitist sense of the most rigid illuministic ideals and the prevalence of the compromise between the sense of the "heroic" and the "sublime."

Palladianism. – As regards Palladianism, few artistic movements have had as much attention since the 1940s, as a result principally of the work of the International Architectural Study Center at Vicenza. And yet, although the literature on this subject is vast and seemingly capable of following in extreme detail any presumed traces in Europe or America (see the bibliography for a division by region) there remain some not indifferent problems of program and methodology. This could even raise the disquieting question of the very essence of what is being examined, or at least of its extent, neither of which are self-evident. A check carried out by Barbieri in 1972 at the epicenter of the phenomenon, which was "undoubtedly provincial as compared with the radiation of that architectural gospel which was certainly not negligible if one remembers that Palladio was a local genius belonging to Vicenza" (Argan, 1972), of the "founder-masters" of the generation of the "Twenty" (Cerato, Arnaldi, Bertotti, Scamozzi) revealed the creation of a "body of common doctrine" formed around the surviving works of Palladio and the analysis of his treatise ("l quattro libri dell'Architettura," Venice, 1570), which is considered, with a risky but perhaps justifiable equivocation, the sole valid witness of the architect's objectives in planning, in the total absence of any real innate pattern both as regards those signed drawings which have survived or the effective chronological development of the buildings as it actually occurred. This common fund is drawn upon for different purposes, facilitated by the work of Bertotti (an "illuminated" mediator (Olivato, 1975) in close contact with Venetian circles and with British culture, between the opposite poles of the built and the "planned") for a publishable "quid medium" ("Le Fabbriche e i disegni di Andrea Palladio raccolti ed illustrati," Vols. 1-IV, Vicenza, 1776-1783) "qui n'est exactement ni celui de traité, ni celui des oeuvres, mai qu'il estime le vrai" (Corboz, 1970).

Through a kind of catechistic dogmatism in which the unrestrained "sentiment" of admiration prevails over the "rational" vigilance of the critics we can use this "quid medium" as an unexceptionable repertory of grammar and syntax which is applicable without difficulty and with tolerance of the wider view in any kind of different situation, since it is to be understood as abstractly "metahistorical" (Askermann, 1966). In this case, after Pane's reflections (1962) in which he speaks openly of "pastiches," and at least the better fruit of combined works of Zador (1963) and of Forsmann (1970), one must agree with Murray (1973) that the word Palladianism ends up lacking all meaning, having descended to becoming an ambiguous qualification "applied to all sorts of types of villa or palace of Italian inspiration erected in Europe between 1600 and 1900" - an empty academic eulogy rather than the definition of a style.

One can use the same repertory "in a critical non-academic spirit," the direct descendent of "illuminist Rationalism," and this is the case in the English-speaking world - England (Wittkower, 1974) and America (Azzi Visentini, 1976). Palladian influence followed various channels in Great Britain, from the astringent

direct contacts of Inigo Jones at Vicenza (Tafuri, 1971; Summerson, 1973) to Lord Burlington's Venetian visits (1714, 1715, and 1719), the purchase of the master's drawings now in the R.I.B.A. collection in London, and the numerous English editions of the "Four Books" (Wittkower, 1965 and 1970). There were also many reasons, examined with great acumen by Puppi (1970) and by Murray (1973, 1), for which, after the Glorious Revolution of 1688 and above all the succession of the House of Hanover (1714, George I), people wished to reject the Frenchifying influences which had grown up in the preceding cultural situation - in this case the Baroque tendencies of Wren and others, which spread after the death of Inigo Jones (1653) - and to return, with a renewed austerity, to the severely rational principles derived from Palladio's teaching. Without ever building it up into a myth or making an institution of Palladio himself as all too often happened elsewhere (Argan, 1970, III; Hager, 1970) one can denounce without hesitation his inconsistencies in the light of "modern" criteria and needs. This would start with the strong criticisms by some of the major exponents of the "new style" (Matthew Brettingham the Elder, William Chambers, Robert and James Adam, and Christopher Wren Jr.) of Palladio's buildings, even the most admired, during visits to Vicenza (Whiffen, 1953). Murray considers this English and American style, with a few Irish offshoots (Craig, 1961), as the only one which "can be defined in a meaningful way as Palladianism" (1973, I). Not being easily contradicted, it takes one back to the original question of the practical use of this new category considering the enormous differences which, in spite of everything, exist between the real Palladio "on site" and the results of this, the only "Palladianism" which can be defined as authentic.

Contributions to town planning. - In town planning, after the pungent comments which one can appreciate in a re-reading of Mumford's old book ("The Culture of Cities," 1938), partly revised in 1967, and the ideas offered in the still up-to-date work of Giedion (1975), the main argument runs on the lines laid down by Argan (1964) in his long treatise on "The Europe of the Capitals, 1600-1700." The "Baroque" capital was regarded as a "monumental representation" of the "idea of power," and consequently established its precedence over all other cities in the state, degrading them to the rank of provincial capitals at best. Supreme examples of conurbations where ideology and power are displayed in the urban structure are the Rome of the triumphant papacy and Paris, the capital of the strongest and most centralized European monarchy.

Starting from Paris and studying in it "the evolution of the function of squares" in the 18th century, Chastel (1967) immediately arrives at some interesting deductions which are widely applicable to the whole development of the city during the 18th century. The scenographic ideas of the 17th century, probably derived from settings for festivals and capable of organizing enormous spaces - which were, however, always closed in and perspectively defined (like the Parisian Place Royale - now Place des Vosges) or at least with clear perspectives imposed (St Peter's Square in Rome) - became associated with, and sometimes came into conflict with, a new "panoramic" concept, born together with the growing attention given to the treatment of parks as an expression of the love of and the

search for Nature. Thus the squares and even more the long avenues of the streets tended to open more and more towards the green of enormous gardens, leaving undefined the boundary facing the open horizon. In this sense one can agree that the London of the 18th century which grew (Benevolo, 1975) "as an open city, not . . . subjected to any military threat" and expanded into "a gigantic indefinite periphery which continued in all directions and mixed itself with the country" was truly an emblematic city.

Benevolo himself (1975) and, in a more organic way, Sica (1976) analytically review the urban achievements of the century in Europe and America (Sica) with richly illustrative material and modern bibliographies. Among particular studies, in addition to the one by Chastel (1967, I) on Paris, we must mention three by Sambricio, Pracchi, and Teyssot (1974) respectively on Madrid, Lisbon, and the London area (and especially the personality of George Dancie Jr.). The recent observations by Brizio (1977) on Milan and the position of Piermarini should also be noted. Bordoni (1971) and Battisti (1974) prefer more specialized aspects - the plan for the reconstruction of a rural center (San Lorenzo Nuovo) by the Papal State or the really unique "worker's" village of San Leucio near Caserta dating from about 1773. Franceschetto concerns herself with the urban structure of Cittadella at the end of the century.

These references call for a last consideration: that pioneering attention is now being given to a fascinating aspect of the architecture of the 18th century, namely that connected with the first developments of the Industrial Revolution continued from the middle of the century. The first Italian translation of Klingender's classic investigation ("Art and the Industrial Revolution," 1947) appeared only in 1972, with additions by Arthur Elton and an important introduction by Enrico Castelnuovo. It is enough here to suggest some meditation on the fact that the fundamental 18th-century concepts of "the picturesque" and "the sublime," the tremendous antagonists of the century, can now be seen applied not only in the parks of English country houses (preferably "Palladian") or in Boullée's heroic "Utopias," but, under the guidance of the reproductive ability of some contemporary landscape artists or even the verse of poets (The Botanic Garden, by Erasmus Darwin), in showing the "terrifying and demoniac" spectacle of the first steam engines or of a mining town in full blast, such a Coalbrookdale in Shropshire; and on the further fact that the century of Lodoli, Ledoux, and Soane is also (Castelnuovo, 1972) "the period of canal revolution . . . of Adam Smith and the first iron bridge . . . and of Thomas Telford's great undertakings."

BIBLIOGRAPHY - *General Works*: V. Golzio, Il Seicento e il Settecento, Torino, 1950; R. Wittkower, Architectural Principles in the Age of Humanism, London, 1952; A. Hauser, Sozialgeschichte der Kunst und Literatur, München, 1953; L. Mumford, The Culture of Cities, New York, 1938; V. Golzio, Il Seicento e il Settecento, Vols. I-II, Torino, 1955; E. Kaufmann, Architecture in the Age of Reason, Baroque and Post-Baroque in England, Italy and France, Cambridge (Mass.), 1955; S. Bottari, Storia dell'Arte italiana, Vol. III, Milano-Messina, 1957; M. Salmi, L'Arte italiana, Vol. III (IV ed.), Firenze, 1957; F. Ulivi, Settecento neoclassico, Pisa, 1957; Aa.

Vv., Barocco, in Encyclopedia of World Art (d'ora in avanti E.W.A.), III, 1958; E. Battisti, Illuminismo e razionalismo dal Settecento ad oggi, E.W.A., III, 1958; A. Hauser, Philosophie der Kunstgeschichte, München, 1958; H. R. Hitchcock, Architecture: Nineteenth and Twentieth Century, Harmondsworth, 1958; G. Mazzariol, T. Pignatti, Storia dell'Arte italiana, Vol. III, Verona, 1958; R. Pane, La storiografia palladiana dell'età neoclassica da Bertotti Scamozzi a Magrini, Bolletino del Centro Internazionale di Studi di Architettura Andrea Palladio (d'ora in avanti Bollettino C.I.S.A.), I, 1959; L. Benevolo, Storia dell'architettura moderna, Vol. I, Bari, 1960; C. Brandi, Perché Palladio non è neoclassico, Bollettina C.I.S.A., II, 1960; A. Schönberger, H. Soehner, II Rococò, Milano, 1960; Manierismo, Barocco, Rococò. Concetti e termini (Proceedings of the Roman International Convention, 21-24 April 1960); Quaderno 25 dell'Acc. Naz. dei Lincei, CCCLIX, Rome, 1962; R. Pane, Palladio e la critica, Bollettino C.I.S.A., IV, 1962; G. R. Ansaldi, Neoclassico, E.W.A., IX, 1963; W. Binni, Classicismo e Neoclassicismo nella Letteratura del Settecento, Firenze, 1963; H. Sedlmayr, H. Bauer, Rococò, E.W.A., XI, 1963; Aa. Vv., Arte neoclassica (Proceedings of the Venetian Conf. 12-14 October 1957), Venice-Rome, 1964; J. Schlosser Magnino, La letteratura artistica, Florence, 1964; J. Starobinski, La scoperta della libertà (1700-1789), Ginevra, 1964; J. Summerson The Classical Language of Architecture, London, 1964; M. Tafuri, Simbolo ed ideologia nell'architettura dell'Illuminismo, Comunità, 124-125, 1964; E. Castelnuove, Nota introduttiva, in E. Kaufmann, L'architettura dell'Illuminismo, Torino, 1966; J. Ackermann, Palladio, Harmondsworth, 1966; M. Horkeimer, T. W. Adorno, Dialettica dell'Illuminismo, Torino, 1966; N. Pevsner, Storia dell'architettura europea, Milano, 1966; P. Scurati Manzoni, II Razionalismo. L'architettura dell'Illuminismo alla reazione neoespressionista (XVIII-XIX-XX secolo), Milano, 1966; Aa. Vv., Sensibilità e Razionalità nel Settecento (by V. Branca), Vols. I-II, Florence, 1967; J. S. Ackermann, Palladio's Villas, New York, 1967; A. Chastel, L'Architecture moralisée, Sensibilità e razionalità nel Settecento, Vol. II, Firenze, 1967; P. Gay, The Enlightenment: an Interpretation. The rise of modern paganism, London, 1967; L. Mumford, La Città nella Storia (third Italian edition), Milano, 1967; R. Rosenblum, Transformations in Late Eighteenth Century Art, Princeton University Press, 1967; R. Wittkower, La teoria classica e la nuova sensibilità, Sensibilità e razionalità nel Settecento, Firenze, 1967; G. C. Argan, Storia dell'Arte Italiana, Vol. III, Firenze, 1968; A. Corban, The New Cambridge Modern History, Vol. VII: The Old Regime, Milano, 1968; N. Hampson, The Enlightenment, London, 1968; H. Honour, Neoclassicism, Harmondsworth, 1968; L. Pareyson, L'estetica di Kant, Milano, 1968; M. Tafuri, Teorie e storia dell'architettura, Bari, 1968; Dizionario Enciclopedico di Architettura e Urbanistica (directed by P. Portoghesi), Roma, 1968-1969; G. C. Argan, La Storia dell'Arte, Storia dell'Arte, 1-2, 1969; R. Assunto, Un filosofo nelle capitali d'europa. La Filosofia di Leibniz tra Barocco e Rococò, Storia dell'Arte, 3, 1969; M. Cerruti, Neoclassici e Giocabini, Milano, 1969; L. Salerno, Dal Rococò al Neoclassicismo, Storia dell'Arte, 1-2, 1969; The New Cambridge Modern History, Vol. VIII: The American and French Revolutions (1763-1793), Milan, 1969: essays by W. Stark (Literature and thought) and by P. Murray (Art and Architecture); F. Venturi, Settecento riformatore. From Muratori to Beccaria, Torino, 1969; V. Vercelloni, Illuminismo, Dizionario Enciclopedico di Architettura e Urbanistica, Vol. III, Rome, 1969; G. C. Argan, Studi sul Neo-classico, Storia dell'Arte, 7-8, 1969; G. C. Argan, L'Arte moderna 1770-1970, Firenze, 1970, I; G. C. Argan, La fortuna del Palladio, Bolletino C.I.S.A., XII, 1970; R. Assunto, Introduzione alla Storia della Filosofia come Storia dell'Architettura, L'Arte, III, 9, 1970; A. Cornoz, Palladio: enter center et absence, Bollettino C.I.S.A., XII, 1970; P. Francastel, Etudes des sociologie de l'Arte, Paris, 1970; Bollettino C.I.S.A., XII, 1970, essays by: W. Hager, Palladio: essai d'un profil artistique/C. A. Isermeyer, Palladio come stimolo al Neoclassicismo europeo/N. Ivanoff, La fortuna critica del Palladio nel periodo neoclassico/L. Puppi, II Trattato del Palladio e la sua fortuna in Italia e all'Estero; M. Baur-Heinold, Teatro Barocco, Milano, 1971; Bollettino C.I.S.A. XIII, 1971; Essays by R. Assunto, I teorici del Neoclassicismo; E. Forssman, L'antico come fonte dell'architettura neoclassica; A. Griseri, L'Illuminismo e l'avvio dell'architettura neoclassica; L. Puppi, La storiografia del Neoclassicismo; A. M. Vogt, Le fasi storiche dell'architettura neoclassica; L. Geymonat, Storia del pensiero filosofico e scientifico, Vol. III, Il Settecento (with contributions by various authors), Milano, 1971; A. Nicoll, Lo spazio scenico. Storia dell'arte teatrale, Roma, 1971; G. Ricci, Teatri d'Italia dalla Magna Grecia all'Ottocento, Milano, 1971; M. Tafuri, Alle origini del palladianesimo. Alessandro Farnese, Jacques Androuet Du Cerceau, Inigo Jones, Storia dell'Arte, II, 1971; Various Artists; Bernardo Vittone e la disputa fra classicismo e barocco nel Settecento, Proceedings of the Turin Convention, 21-24 September, 1970, Vols. I-II, Torino, 1972; Var. artists, The Age of Neo-classicism (Catalogue of the London Exhibition 9 September-19 November 1972), London, 1972: W. von Kalnein, Architecture in the Age of Neoclassicism; G. C. Argan, Prefazione, in F. Barbieri, Illuministi e Neoclassici a Vicenza, 1972; F. D. Klingender, Art and the Industrial Revolution, Curwen Press, 1974: introduction by E. Castelnuovo, Arte e rivoluzione industriale; C. Norberg Schulz, Architettura tardobarocca, Milano, 1972; P. Ciotti Marzi, V. Kienerk, Storia dell'Arte in prospettiva europea con riferimenti inter-disciplinari, Firenze, 1973; M. Fagiolo, La scenografia, Firenze, 1973; A. Griseri, R. Gabetti, Architettura dell'Eclettismo, Torino, 1973; J. Summerson, Inigo Jones, Milano, 1973; Var. authors, Mostra del Palladio (catalogue of the Palladian Exhibition at Vicenza, Summer 1973), Milan, 1973: essays by P. Murray, II Palladianesimo, and L. Puppi, Bibliografia e letteratura palladiana; A. Pinelli, I teatri. Lo spazio dello spettacolo dal teatro umanistico al teatro dell'opera, Firenze, 1973; L. Puppi, La storiografia Palladiana dal Vasari allo Zanella, Bollettino C.I.S.A., XV; L. Vagnetti, L'architetto nella storia dell' Occidente, Firenze, 1973; Var. authors, II Revival (by G. C. Argan): essays by L. Patetta, I Revivals in architettura, and by A. Pinelli, Dialettica del Revival nel dibattito classico-romantico; F. Marotti, Lo spazio scenico. Teorie e tecniche scenografiche in Italia dall'età barocca al Settecento, Roma, 1974; C. Norberg-Schulz, Significato nel l'architettura occidentale, Milano, 1974; Var. authors, illusione e pratica teatrale. Proposte per una lettura dello spazio scenico dagli Intermedi fiorentini all'Opera comica veneziana (Catalogue of the Venetian Exhibition, Summer, 1975), Venezia, 1975; Various authors, Storia delle idee politiche economiche e sociali (directed by L. Firpo), Vol. IV: l'Età moderna, Torino, 1975; Architettura e cultura dell'illuminismo, Psicon, 4 (monographic number); L. Benevolo, Storia della città, Bari, 1975; H. Gardner, Art through the Ages (sixth edition), New York, 1975; S. Giedion, Spazio, tempo ed architettura. Lo sviluppo di una nuova tradizione (second Italian ed. edit. by E. & M. Labò), Milano, 1975; L. Patetta, L'architettura dell'Eclettismo. Fonti, teorie, modelli 1750-1900, Milano, 1975; B. Zevi, Storia dell'architettura moderna (fifth ed.), Torino, 1975; P. Sica, Storia dell'Urbanistica. II Settecento,

Bari, 1976; M. Tafuri, Il luogo teatrale dall'Umanesimo a oggi, Italia meravigliosa. Teatri e scenografie, Milano, 1976; Var. authors, Nuove idee e nuove arte nel '700 italiano (Proceedings of the Roman Convention promoted by the Academy of the Lincei, 19-23 May 1975), Rome, 1977.

Specialized Works: – An excellent basis can be found in the highly informative Penguin Books of London - the Pelican History of Art (A. Blunt, 1953, Art and Architecture in France 1500-1700; J. Summerson, Architecture in Britain, 1530-1830, 1953, R. Wittkower, 1958, Art and Architecture in Italy 1600 to 1750, second ed., 1966; G. H. Hamilton, The Art and Architecture of Russia, 1954; G. Kubler, M. Soria, Art and Architecture in Spain and Portugal and their America Dominions, 1959; H. Gerson, E. H. Ter Kuile, Art and Architecture in Belgium 1600 to 1800, 1960; J. Summerson, Architecture in Britain 1530-1830 (fourth ed.), 1963; E. Hempel, Baroque Art and Architecture in Central Europe; 1935; J. Rosenberg, S. Slive, E. H. Ter Kuile, Dutch Art and Architecture 1600 to 1800, 1966; in addition to the bibliographical supplement presented by Castelnuovo to Kaufmann's Italian edition (1966).

Italy: C. Maltese, Storia dell'Arte in Italia 1785-1943, Torino, 1960; C.L.V. Meeks, Italian Architecture 1750-1914, New Haven and London, 1966; the series Ville Italiane (Milano, SISAR: C. Perogalli; P. Favole, Ville dei Navigli Lombardi, 1967; A. Alpago Novello, Ville della provincia di Belluno, 1968; S. Langé, Ville delle Provincie di Como, Sondrio e Varese, 1968; G. Perogalli, M. G. Sandri, Ville della Provincia di Bergamo e Brescia, 1969; I. Belli Barsali; Ville di Roma, 1970; R. Cevese, Ville della provincia di Vicenza, Vols. I-II, 1971; S. Langè, Ville della provincia di Milano, 1972; C. Perogalli, M. G. Sandri, Ville delle Provincie di Cremona e Mantova, 1973; I. Belli Barsali, M. G. Branchetti, Ville della campagna Romana, 1975; and I. Belli Barsali, La Villa a Lucca dal XV al XIX secolo, Roma, 1964; G. P. Cuppini, A. M. Matteucci, Ville del Bolognese, Bologna, 1967; Various authors, La Villa nel Veronese, Verona, 1975. However, for man's work in relation to the ambience, see the bibliography collected in M. Olivieri, for a method of historical analysis of the territory, Ricerche di Storia dell'arte, 4, 1977.

(a) Rome: L. Bianchi, Disegni di Ferdinando Fuga e di altri architetti del Settecento (Catalogue of the Roman Exhibition), Roma, 1985; Var. authors, Il Settecento a Roma (Catalogue of the Roman Exhibition), Roma, 1959; P. Marconi, Giuseppe Valadier, Roma, 1964; W. Oechslin, Premesse all'architettura rivoluzionaria, Controspazio, 1-2, 1970; S. Benedetti, Per un'architettura dell'Arcadia. Roma, 1730, in Controspazio, 7-8, 1971; W. Oechslin, Bildungsgut und Antikenrezeption des frühen Settecento in Rom, Zürich, 1972; R. D'Amico, Scena e città nel '700 a Roma, Storia dell'Arte, 17, 1973; M. G. Gargano, Carlo De Dominicis, Storia dell'arte, 17, 1973; P. Marconi, A. Cipriani, E. Valeriani, 1 disegni di architettura dell'Archivio Storico dell'Accademia di S. Luca, Roma, 1974; G. Muratori, G. C. Argan, L. Quaroni, Scuola, Accademia, Architettura. Some considerations on the publication of the designs for architecture in the history archives of the Accademia di S. Luca, Controspazio, 3, 1975; B. Molajoli, L'architettura neoclassica a Roma e nell'Italia centrale, Bollettino C.I.S.A., XIII, 1971; S. Bordini, Il piano urbanistico di un centro rurale dello Stato Pontificio. La construzione settecentesca di San Lorenzo Nuovo e l'attività di A. Dori e F. Navone, Storia dell'Arte, 11, 1971. As regards the Piranesi phenomenon: B. Molajoli, Piranesi architetto, Bollettino C.I.S.A., V, 1963; H. Volkmann, Giovanni Battista Piranesi, Architekt und Graphiker, Berlin, 1965; H. Facillon, Giovanni Battista Piranesi, Bologna, 1967

(Italian ed. of the volume of 1928, with introductory essay by M. Calvesi); J. Harris, Le Geay, Piranesi and International Neoclassicism, Rome, 1740-1750, Essays in the History of Architecture presented to Rudolf Wittkower, London 1967; Var. Authors, Sensibility and rationality of Eighteenth Century, Vol. II, Firenze, 1967, essays by: G. Poulet, Piranèse et les Poètes romantiques français, and by R. Wittkower, Piranesi e il gusto egiziano; G. Messina, Teoria dell'Architettura in Giovan Battista Piranesi, Controspazio, 8-9, 1970, and 6, 1971; plus the intervention by M. Tafuri, Atti del Congresso su Bernardo Vittone (1972).

(b) Piedmont: Various Authors, Exhibition of the Baroque of Piedmont (Turin, June-September, 1963), Architettura e scenografia, Torino, 1963: with all the preceding bibliography up-dated; P. Portoghesi, Bernardo Vittone. Un architetto tra Illuminismo e Rococò, Roma, 1966; V. Viale, Filippo Juvara Exhibition, Messina, 1966; A. Griseri, Le Metamorfosi del barocco, Torino, 1967; N. Carboneri, Il palladianesimo in Piemonte, Bollettino C.I.S.A., XI, 1969; M. Viale Ferrero, Filippo Juvara scenografo e architetto teatrale, Torino, 1970; P. Portoghesi, Vittone nella cultura europea, Controspazio, 10, 1972.

(c) Lombardy: A. Rossi, Il concetto di tradizione nell'architettura neoclassica Milanese, Società, XII, 1956, 3. Torino; L. Grassi, Razionalismo settecentesco e architettura neoclassica milanese, Milano, 1957; A. Ottino della Chiesa, L'età neoclassica in Lombardia (Catalogue of the Exhibition at Villa Olmo), Como, 1959; P. Mezzanotte, L'architettura a Milano nel Settecento e l'architettura dal 1769 alla caduta del Regno Italico, Storia di Milano, Vol. XII, Milano, 1959; and XIII, Milano, 1959; G. Mezzanotte, Architettura neoclassica in Lombardia, Napoli, 1966; C. Perogalli, L'architettura Neoclassica in Lombardia, Bollettino C.I.S.A., XIII, 1971; R. Fregna, E. Godoli, Una raccolta inedita dei disegni del Foro Bonaparte, Parametro, 27, 1974; O. Rossi Pinelli, Il Foro Bonaparte: progetto e fallimento di una città degli eguali, in Ricerche di Storia dell'Arte, 3 (La Città Immagini e documenti); A. M. Brizio, Il rinnovamento urbanistico di Milano nella seconda metà del Settecento, in Nuove idee e nuove arte nel '700 Italiano (Proceedings of the Roman Convention), Roma, 1977.

(d) Venice: the bibliography is up-dated to 1971 in F. Barbieri, Illuministi e Neoclassici a Vicenza, 1972: to be added: M. Brusatin, La Cupola di S. Pietro che crolla. For an intervention-investigation, 18th century: Giovanni Poleni e Luigi Vanvitelli, Controspazio 3, 1971; L. Olivato, Les Monuments de Palladio . . . font grande impression: J. A. Raymond to Tomaso Temanza, in Arte Veneta, XXIX, 1975. As regards the individual centers, still starting from the Barbieri bibliography, 1972, these are integrated with: *Venice*: E. Bassi, Episodi dell'edilizia veneziana nei secoli XVII e XVIII. Palazzo Pesaro, Critica s'Arte, VI, 1959, 34; E. Bassi, L'architettura della prima metà del Settecento a Venezia, Bollettino C.I.S.A., IV, 1962; E. Bassi, Episodi di architettura Veneta nell'opera di Antonio Gaspari, Saggi e memorie di Storia dell'Arte, Venezia, 1963; E. Bassi, Considerazioni su alcuni disegni di Antonio Visentini, Bollettino C.I.S.A., VI, 1964; C. Semenzato, L'Architettura neoclassica a Venezia e a Padova, Bollettino C.I.S.A., XIII, 1971; L. Olivato, Antonio Visentini su Palazzo Trevisan a Murano, Bollettino CISA., XIV, 1972; A. Palluchini, Un personaggio della cultura europea del Settecento: Il console Smith, Arte Veneta, XXVI, 1972; E. Bassi, Palazzo di Venezia, Venezia, 1976.

Vicenza, Padua, Treviso, Bassano, Castelfranco: C. Semenzato, L'evoluzione urbanistica di Padova durante il Settecento, Bollettina C.I.S.A., III, 1961; G. M. Pilo, Qualche

appunto sull'architettura barocca e rococò a Padova e a Treviso, Bollettino C.I.S.A., IV, 1962; G. M. Pilo, Notizie sull'architetto somasco Francesco Vecellio, Bollettino C.I.S.A., VI, 1964; B. Prijateli, Francesco Melchiori architetto vicentino a Spalato (Jugoslavia), Bollettino C.I.S.A., VI, 1964; P. Moscato, Chiaramenti sull'apporto di Giordano Riccati e Gian Antonio Selva nella rico-struzione del Duomo del Treviso, Bollettino C.I.S.A., VIII, 1966; B. Prijateli, Additions to Francesco Melchiori architetto operoso in Dalmazia, Bollettino C.I.S.A., X; G. Franceschetto, La struttura urbana di Cittadella alla fine del Settecento, Bollettino C.I.S.A., XIII 1971; C. Semenzato, l'archettura neoclassica a Vicenza, Arte Veneta, XXVI, 1972; B. Zevi, Palladio e l'architettura vicentina, L'Espresso, XVIII, 1972, 22; J. Ackerman, Illuministi e Neoclassici a Vicenza, Journal of the Society of Architectural Historians, XXXII, 1973; F. Barbieri, Una villa dei Leoni-Montanari alla "Madonnetta" di Arzignano. Two documents on the Borella, Valle del Chiampo. Antologia 1973, Chiampo, 1973; B. Mazza, Un episodio della ricostruzione settecentesca di una fabbrica romana. Il progetto Miazza per la Cattedrale di Treviso, Bollettino C.I.S.A., XV, 1973; R. Bossaglia, illuministi e Neoclassici a Vicenza, Arte Lombarda, XIX, 1974; L. Olivato, Ottavio Bertotti Scamozzi studioso di Andrea Palladio, Vicenza, 1975.

Verona: P. Gazzola, Il Barocco a Verona, Bollettino C.I.S.A., IV, 1962; P. Gazzola, II Neoclassicismo a Verona, Bollettino C.I.S.A., V, 1963; L. Magagnato, Letteratura critica e tradizione sanmicheliana nel periodo neoclassico a Verona, Bollettino C.I.S.A., XIII, 1971; P. Carpeggiani, Paolo Pozzo, un profilo dell'architetto e la vicenda degli ospedali di Mantova alla fine del Settecento, Bollettino C.I.S.A., XIV, 1972.

Trento and Friuli: A. Benussi Giaiotto, Domenico Schiavi, Bollettino C.I.S.A., VI; R. Togni, Antonio Rosmini architetto e pittore, Trento, 1969. *Trieste*: P. Montesi, L'architettura neoclassica a Trieste, Bollettino C.I.S.A., V, 1963; C. Semenzato, L'architettura neoclassica a Trieste, Bollettino C.I.S.A., XIII, 1971.

e) Emilia: A. M. Matteucci, Carlo Francesco Dotti e l'architettura bolognese del Settecento, Bologna, 1968; W. Oechslin, Carlo Francesco Dotti Architect des Frühen Settecento in Bologna, Zeitschrift fur Kunstgeschichte, 1971; Various Authors, Giuseppe Pistocchi (1744-1814) architetto giacobino (Catalogue of the Faenza Exhibition, ed. by E. Godoli), Faenza, 1974; N. Pirazzoli; p. Fabbri, Camillo Morigia (1743-1795), Architettura e riformismo nelle Legazioni, Bologna, 1976; M. Dezzi Bardeschi, Itinerario 1770-1790. "Logica degli addottrinamenti," e mandato sociale di un architetto: un'interpretazione; premesso un saggio di A. M. Matteucci, D. Lenzi, Cosimo Morelli e l'architettura delle Legazioni ponteficie, Bologna, 1977.

f) Marches: note above all the essay by B. Malajoli, L'architettura neoclassica a Roma e nell'italia centrale (cit. under Rome), with a wide bibliography up-dated to 1971; to be added, the monograph on Vanvitelli (1973: cited under Naples) and again: A. Montironi, Andrea Vici d'arcevia e la libraria Marefoschi a Macerata, Antichità viva, 4, 1975; A. Montironi, II Valadier nelle Marche, Annals of the Faculty of Letters and Philosophy of the University of Macerata, VIII, 1975; P. Carreras, Studi su Luigi Vanvitelli. Supplement to N° 23-25 of Storia dell'Arte, 1977.

g) Naples: R. Pane, Ferdinando Fuga, Napoli, 1956; A. Venditti, Architettura neoclassica a Napoli, Napoli, 1961; M. Dezzi Bardeschi, Riesame del Neoclassico, Comunità, 99, 1962; R. De Fusco, L'architettura della seconda metà del secolo (XVIII), Storia di Napoli, VIII, 1971; A. Venditti, Urbanistica e architettura neoclassica a Napoli e nell'italia

meridionale, Bollettino C.I.S.A., XIII, 1971; Var. Authors, Luigi Vanvitelli, Napoli, 1973; F. Strazzullo, Lettere a Luigi Vanvitelli, in Arte Cristiana, LIX, 1973, 606; Var. Authors, Recupero di una utopia. S. Leucio presso Caserta (by E. E. Battisti), Controspazio, VI, 1974; C. De Seta, I disegni in Luigi Vanvitelli per la Reggia di Caserta ed i progetti di Carlo Fontana per il palazzo del principe di Liechtenstein, Storia dell'Arte, 22; Disegni di Luigi Vanvitelli nelle collezioni pubbliche di Napoli e di Caserta (Catalogue of the Exhibition by J. Garms), Napoli, 1974; G. Alisio, Siti reali dei Borboni, Roma, 1976; F. Strazzullo, the letters of Luigi Vanvitelli in the Palatine Library in Caserta, Galatina, 1976.

Austria: R. Wagner-Rieger, Palladianism in Austria, Bollettino C.I.S.A., VII, 1965; P. Morachiello, Schönbrunn: a series of projects not carried out, Storia dell'Arte, 22, 1974.

Czechoslovakia: J. Kreálova`, Palladianism in Czechoslovakia and the influence of the Veneto Region on Czech. architecture, Bollettino C.I.S.A., VI, 1964.

France: L. Hautecoeur, L'architecture classique en France, Vol. V (1792-1815), Paris, 1953; Gli architetti della Rivoluzione, Sele Arte, II, 1954, 10. A. Blunt, Palladio e l'architettura francese, Bollettino C.I.S.A., II, 1960; M. Petzet, Soufflot's Sainte-Geneviève und der Franzosische Kirchenbau des 18. Jahrhunderts, Berlin, 1961; H. Rosenau, The Functional and the Ideal in Late 18th Century French Architecture, The Architectural Review, 1966 (October); E. L. Boullée, Architettura, saggio sull'Arte (by Also Rossi), Padova, 1967; A. Chastel, Problèmes d'urbanisme à Paris au XVIII siècle in Var. Authors, Sensibilità e razionalità del Settecento, Vol. II, Firenze 1967; A. Blunt, Palladio in Francia, Bollettino C.I.S.A., X, 1968; K. Lankheit, Der Tempel der Vernunft. Unveröffentlichte Zeichnungen von Boullée, 1728-1799, de l'architecture classique à l'architecture révolutionnaire, Paris, 1969 (and English, New York, 1974); A. M. Vogt, Boullée Newton Denkmal Sakralbau und Kugelidee, Basel & Stuttgart, 1969; Bollettino C.I.S.A., XII, 1970, essays by: J. Pérouse de Montclos, Palladio et la théorie classique dans l'architecture francaise du XVII siècle; D. Rabreau, L'architecture neoclassique en France et la caution de Palladio; Var. Authors, L'oeuvre et les rèves de Claude Nicolas Ledoux, Paris, 1971; Art in Revolution, Catalogue of Exhibition, London, 1971.

Germany: B. Rupprecht, Die Bayerische Rokokokirche, Kalmünz, 1959; E. Hubala, Palladio und die Baukunst in Berlin und München, 1740-1820, Bollettino C.I.S.A., III; F. Mielke, L'architecture palladienne à Potsdam e Frédéric II de Prussie et l'oeuvre de Palladio, Bollettino C.I.S.A., X; G. Schweikhart, German edition of the Palladian Treatise, Bollettino C.I.S.A., XII, 1970; E. Forssman, L'architettura neoclassica nei paesi tedeschi, Bollettino C.I.S.A., XIII, 1971.

England and Ireland: M. Whiffen, Visitors to Vicenza, Architectural Review, 114, 1953; G. G. Zorzi, I disegni palladiani delle antichità pubblicati da Lord Burlington e le loro deficienze e arbitrarietà, Bollettino C.I.S.A., VII, 1965; R. Wittkower, Diffusioni dei modi palladiani in Inghilterra, Bollettino C.I.S.A., I, 1959; R. Wittkower, Il prepalladianesimo in Inghilterra, I principi informativi del nuovo movimento e Lord Burlington (1694-1753) e il suo ambiente, Bollettino C.I.S.A., II, 1960; P. Murray, L'architecture de Burlington et de Kent, in Utopie et Institutions au XVIII siècle. Le Pragmatisme des Lumiéres, Paris; R. Wittkower, La letteratura palladiana in Inghilterra, Bollettino C.I.S.A., VII, 1965; R. Wittkower, English Neo-Palladianismus, the Landscape Garden, China and Enlightenment, l'arte, II, 1969, 6; L. Harris, Fonti dell'influenza in Inghilterra, Bollettino C.I.S.A. XII, 1970; J. Harris, Sir William Chambers, London, 1970; D. Hill, A Hundred Years of Georgian London from the acces-

sion of George I to the heyday of the Regency, London, 1970; R. Wittkower, Le edizioni inglesi del Palladio, Bollettino C.I.S.A., XII, 1970; M. Azzi Visentini, La fortuna del neopalladianesimo inglese e la letteratura neopalladiana minore, Comunità, 1973, October; P. Murray, Il palladianesimo inglese, Bollettino C.I.S.A., XV, 1973; I. Harris, Palladio and the English, Apollo, 1974; G. Teyssot, Città e utopia nell'illuminismo inglese: George Dance il giovane, Controspazio, VI, 1974, 4; R. Wittkower, Palladio and English Palladianism, London, 1974; M. Craig, L'architettura di ispirazione palladiana in Irlanda, Bollettino C.I.S.A., III, 1961; P. Scurati-Manzoni, Dublino nell'epoca georgiana, Milano, 1968.

Holland and Belgium: M. D. Ozinga, Le palladianisme d'empreinte hollandaise en Allemagne du Nord et surtout aux Pays Scandinaves; les influences italiennes en Holland pendant la domination des Styles décoratifs français, Bollettino C.I.S.A., I; R. M. Lemaire, L'influence de Palladio et l'architecture du XVI siécle aux Pays-Bas, Bollettino, C.I.S.A., VI.

Poland: S. Kosakiewicz, Le varie correnti dell'architettura polacca dal 1600 al 1750 come sfondo dello sviluppo dell'influsso palladiano e L'influsso palladiano in Polonia dalla fine del XVII secolo fino all'età neoclassica, Bollettino C.I.S.A., II, 1960; P. Bieganski, Reflections of the Palladian theory in the works of the theoreticians of architecture in Poland and the Inspiration of the Rotonda in the designs for the villas of Krolikárnia and Lubostrón, Bollettino C.I.S.A., III, 1961; T. Jaroszewschi, Polish villas and palaces with porticoes and exedras and some attempts to imitate the Rotonda built in the XVIII century, Bollettino, C.I.S.A., IX, 1967; J. Zachwatowicz, Le palladianisme en Pologne sous les aspects des Bâtiments de type "villa," Bolletino C.I.S.A., XI, 1969; T. Jaroszewschi, The Neoclassical interpretation of Palladio in Poland, Bollettino C.I.S.A., XII, 1970; A. Milobedzki, L'architecture néo-classique en Pologne, Bollettino C.I.S.A., XIII, 1971; T. Jaroszewski, Neoclassical architecture in Poland and the Veneto, in Italy, Venice, and Poland between Enlightenment and Romanticism (Proceedings of the third Convention of Italo-Polish studies), Firenze, 1973.

Spain and Portugal: G. Kubler, Palladio and Juan de Villanueva, in Bollettino C.I.S.A., V, 1963; C. Sambricio, Urbanistica e Illuminismo a Madrid, Controspazio, VI, 1974, 4; C. de Azevedo, Andrea Palladio e l'influenza italiana nell'architettura portoghese, Bollettino C.I.S.A., VI, 1964, A. Pracchi, Una città dell'Illuminismo, la Lisbona del marchese di Pombal, Controspazio, VI, 1974, 4.

Sweden, Denmark, and Norway: E. Forssman, Palladianism in Sweden, Bollettino C.I.S.A., IV, 1962; E. Forssman, The Interpretation of Palladio in the countries of North Europe, Bollettino C.I.S.A., XII, 1970.

Hungary: A. Zador, Palladianism in Hungary: i Pollak, Bollettino C.I.S.A., V, 1963; A. Zado, Penetration of the Palladian Form in Hungary, Bollettino C.I.S.A., VIII, 1966.

Russia: M. Ilijn, Giacomo Quarenghi, Bollettino C.I.S.A., V, 1963; G. M. Pilo, Disegni di Giacomo Quarenghi e dei Gaidon (Catalogue of the Bassano Exhibition, April 1964), Bassano 1964; V. Piliavskij, Palladianism in Russian Architecture and particular characteristics of the architecture of Russian Classicism, Bollettino C.I.S.A., IX, 1967; V. Piliavskij, L'attività artistica di Giacomo Quarenghi in Russia, Rota d'Imagna, 1967, (I); C. Ceschi, Il periodo romano di Giacomo Quarenghi, Essays and Memories of History of Art, VI, 1968; M. Il'in, The Russian Villa of the XVIII century, Bollettino C.I.S.A., XI, 1969; J. A. Egorov, Architectural planning of St. Petersburg, Athens (Ohio), 1969; M. Il'in, Russian classicism

and Palladianism, Bollettino C.I.S.A., XII, 1970; A. Corboz, Neoclassical architecture in Russia, Bollettino C.I.S.A., XIII, 1971; M. F. Korsunova, Novye materialy o Dz Kvarenghi (New material on Giacomo Quarenghi), Trudy gos Ermitage, 1973; V. Zanella, disegni di Giacomo Quarenghi nelle raccolte lombarde, Arte Lombarda, 42/43, 1975.

United States: J. S. Ackerman, President Jefferson and American Palladianism and Palladio and Architecture of '700 in the United States, Bollettino C.I.S.A., VI, 1964, D. Lewis, The problem of the villa and the American "plantations" (1760-1860), Bollettino C.I.S.A., XII, 1970; D. Lewis, Romantic Classicism in America: the temple in its complete form, Bollettino C.I.S.A., XIII, 1971; M. Azzi Visentini, Il Palladianesimo in America e l'archtettura della Villa, Milano, 1976; F. Doveton Nichols, Palladio in America, Palladio in America (Catalogue of the Palladian Exhibition in America, 1976), Milano, 1976; L. Olivato, Il palladianesimo in America, Arte Veneta, XXX, 1976.

FRANCO BARBIERI

NINETEENTH CENTURY ART (PLATES 137-141)

Neoclassicism and Romanticism. - The complete articulation of European figurative culture in response to the profound changes which took place in the economic and political structure of various countries as a consequence of the industrial revolution and of the reversal of values brought about by the progressive affirmation of the middle classes has constituted since about 1960 the connecting thread of many studies. These studies, from different ideological positions and sometimes taking origin from only slightly philological arguments, have been dedicated both to the entire period considered here and to the individual artistic personalities, regarded no longer in the framework of a periodization (the oversimplified academic one of Pre-Romantic, Neoclassic, and Romantic which has been discredited for some time) but as complementary expressions. The expressions may be dialectically opposed to one another, of a single historical matrix, and of a profoundly unitarian basis, such as the culture of Enlightenment was between the end of the 18th and the beginning of the 19th centuries.

This connecting thread is present in Rosenblum's study, as in the exhibitions, respectively at London and Paris: "The Age of Neoclassicism" and "De David à Delacroix."

The refusal of the traditional division into periods is, in fact, the start point for Rosenblum's discourse. He then carries out a mainly iconographical investigation of the vast amount of material he has collected and sees the opening up of various research paths, all, however, within the same matrix of Neoclassical culture. These include the erudite philological interest in the past ("Archaeological Neoclassicism"); the search for ideal forms connected with a sensibility for the "graceful" of Rococo inspiration ("Erotic Neoclassicism"); the search within the poetics of the sublime in Burke's sense, with preference for subjects drawn from Homer, Ossian, Milton, and Shakespeare ("Horrific Neoclassicism"); and, lastly, the illustration of history understood as "exemplum virtutis," an exaltation of the political and civil virtues of antiquity (Stoic Neoclassicism).

In this last part, Rosemblum studies the persistence of certain historical subjects interpreted as "exemplum virtutis" (true examples) between half way through the 18th century and the first decades of the 19th. He emphasizes that the same subject may have different ideological and political meanings under the monarchy, the republic, and the empire. Some of the most interesting things in his study are those researches defined as "clean sheets," which in architecture reject any reference to the past and are based on the use of pure volumes in juxtaposition (as with Boullée and Ledoux) and which in painting and sculpture (Carstens, Blake Flaxman), although for different reasons, reduce the expressive medium to the essentiality of elementary shapes to pure linear outline. Within this aesthetic ambit, in which there is also a lively interest in the primitive, Rosenblum detects the formation, around 1800, of an innovation with particular importance for the future, in the possibility of linear abstraction and the negation of perspective illusory systems.

Although the analysis thus offers material for further research, even on less known artists, it sometimes lacks a precise historical articulation. Such an articulation of the various components of the period can, on the other hand, be found more profoundly pursued in Honour's paper, which examines the various manifestations in artistic practice of the dialectical counterpoint between platonic idealism, sensism, and empiricism, the poetry of Sturm und Drang and of the Sublime, and the formation of a middle class ethic. He identifies in the affirmation of the independence of art and of its rationale and criticism, from which follows the necessity for theoretical verification, the fundamental conquest of the culture of Enlightenment. Thus, Neoclassical art is seen to be the culminating phase of the profound historical change of the "Age of Enlightenment," interpreting its clear civic conscience, its aspiration for a new social order, not only as the expression of the affirmation of revolutionary ideals but also as their apex; even if at the same time (as the author is careful to emphasize) there exists a danger of evaluating Neoclassical works on the basis of their adherence to those revolutionary ideals. Honour, too, restates the real continuity between Neoclassicism and Romanticism, of which an example might be the particular change in sensibility which, with the decay of the revolutionary drive, operated in the group of David's pupils.

There is thus a general feeling that the terms of the relationship between the Neoclassical and Romantic periods must be reviewed. One investigation from a theoretical/philosophical angle (Assunto) shows how Winkelmann's conjecture contributes, particurlarly through Schiller's help, to the formation of romantic sensibility - the ideal of the Beautiful followed in Grecian art through a happy conjunction of natural and political conditions. This becomes the ideal for the recovery of human wholeness, the untrammelled balancing of Reason and Feeling which modern man might imagine with "sehnsucht," and aims at recreating a society in which the aesthetic groups controlled politics. The presence of such Utopian objectives in Neoclassic culture, already identified by Zeither (1954), shows up the contradictions between the ideal and the real experienced in a society undergoing profound changes and the beginning of the crisis and transformation of artistic activity itself as a result of the introduction of industrial techniques.

It is in just this sense and in relation to the development of the industrial society that Argan proposes the elimination of the traditional concept of "periods" for artistic production between 1750 and 1850 and the consideration of Neoclassicism as a "phase of the romantic idea of art" which permeates the whole of the above period. The author prefers the term Neoclassic to Neoclassicism since it was at precisely this time that "classicism was combatted and permanently destroyed as a model, which, since by its very nature it was absolute and immutable, could not be handed down through time." Thus the artist no longer had to keep to a model, but could get back, by means of a rational and selective operation, to the "archtype" or original scheme of unchangeable nature behind any phenomenistic appearances. One of the conquests of Neoclassic art is the projectual and the typological experimentation, which opened the way to the possibility of suiting artistic procedures to industrial reproduction.

The work of individual artists is studied in the light of the freer perspectives of this criticism and reconstructed - as in the case of Canova and of Thorwaldsen - through careful library research. Thus in re-examining (Honour, Argan) the relationships between Canova's sketches and his finished works, the latter previously judged disappointing as compared with the former, a fundamental node in understanding the Venetian sculptor's art (and, in general, a great part of the output of those times) was discovered, namely that two inseparable phases of the process of Neoclassical idealization occur between the first inspiration and the final execution. This involves the passage from the individual to the universal of the nature and the process of selection and sublimation which follows the initial sensorial approach. Unlike Thorwaldsen, Canova cannot avoid the sensorial approach, and his classicism, like Foscoli's, tends to a "classico-Christian syncretism" (Argan). Among the papers which enrich the artist's catalogue and offer new ideas, there is one which clarifies the last phase of Canova's activity, in which Ost notes the birth of a religious sensibility in a Nazarene-Purist direction (see the analysis of the "Pity" altar piece, 1799-1821).

The increasing interest given by numerous scholars in deepening our knowledge of personalities such as Piranesi, Boullée, Ledoux, Füssli, and Blake is significant, for these artists do not fit well into the earlier "periodical" schemes.

Piranesi has been for some time the subject of many investigations aiming at clarifying the dialectic between his various cultural components and the historical significance of his personality. Lodolian rationalism, the influence of the aesthetics of empiricism, the poetics of the sublime in its different meanings from grandiose to terrific (as which it later gave a new understanding of space to many English and French architects), the anticlassical and neomannerist ferments introduced into Roman circles by Le Geay - all these elements are taken into consideration by the critics and show the artist's connection with some of the most vital concepts of his time. The exaltation of the "magnificence" of the Romans as a Utopian projection into the past of a modern civilized ideal puts Piranesi near to the David of "the Horatii and the Curiatii." The discov-

ery in "Prisons" of a masonic symbolism of hermetic-alchemical derivation links the engraver to the Jacobin circles of the end of the century. The concept of history and the relationship with antiquity is also demonstrated, contrary to Winkelmann, and near to the Vichian philosophy of "repetition" (Calvesi).

A recent analysis by Tafuri poses the problem of the dramatic historical significance which the architect-engraver's activity had as a "negative Utopia," as the only outlet for an intellectual work which refuses to give up its urge towards "prefiguration." The "revolutionary" architects (Boullée, Ledoux, Lequeu) according to the now accepted definition of Kauffmann, who first studied them, are also of great interest to current criticism which tends to historicize their search, mostly directed to design not so much as a hind sight on rationalism as in its cultural context. The foreshadowings of "revolutionary" architecture can be found, as was observed by Oechslin and Marconi, in the Roman architectonic culture of the French Academy (between 1730 and 1750), closely connected with Piranesi, and of the Academy of St. Luke. Boullée then appears as the destination point of that tradition, and also as a point where many different tendencies of the Enlightenment tend to converge - beside Platonic idealism, Sensist thought remains fundamental as the basis on which the architect's preference for "regular bodies" characterized by the qualities of symmetry and variety, immediately perceivable by the senses, rests, so that the sphere, uniting symmetry and variety, must be considered the most beautiful of natural bodies (P. de Montclos).

Theories of the Sublime are fundamental for understanding the illustrations of "Architecture. Essay on Art" by Boullée - the regular geometrical figures with their repeatability suggest the image of the infinite and of immutability, and so also does the concept of architecture, as an architecture of shadows on a gigantic scale isolating the architectural object from Nature (Lankheit). But above all with Boullée, architectonic forms are no longer representations of a space, but objects with an intrinsic value and symbols of rational structures (Argan). The revolutionary ideological commitment and the acceptance of masonic thought, the cult of the hero, and the search for a new social order link Boullée to the other architects moving along the same lines. Ledoux in particular, aiming at a system which will bring happiness to mankind on principles derived from Rousseau's thought, planned the ideal city of Chaux, which can be interpreted according to masonic symbology (Bardeschi) anticipating in it Fourier's phalansteries. Lequeu's "imaginary folios," for which Guillèrme has recently suggested a psychoanalytical interpretation, are to be thought of as an expression of that split between practice and theory, of that dilemma of professional architects which Piranesi was among the first to point out. The exaltation of the genius of Diderot and the theory of the enthusiasm of Shaftesbury guide the free inventiveness of his designs while at the same time emphasizing a criticism of the "esprit de raison" (Bardeschi). Other architects working around the turn of the century, such as Soane, Durand, Schinkel, Gilly, and, in Italy, Selva and Valadier, sought a simplification of forms and a juxtaposition of pure values, although they had less revolutionary drive.

Füssli clearly shows knowledge of the separation between artist and society which was created in the ambit of Sturm und Drang culture. The poetics of the Sublime, of which he is considered one of the major exponents along with Blake, is revealed in an existential mode of tragic opposition more with the World than with Nature, to whose very foundations he wishes to cling, beyond any inevitably corrupt civilization. His formal choices, the sharp cutting outlines, the closed shapes under tension undeniably indicate his personal isolation, while space is a place outside time, which can be tragically weighed against human actions. Psychoanalytical explanations have been proposed for some recurrent motives of imagery, among which is the fetish for hair and the dominating "femme fatale," the antagonism between the sexes, and the fear of castration (Gert-Schiff). However, the interpretations introduced by Antal remain valid all the same on the socio-political level, according to which Füssli, having progressed from revolutionary ideals to a conservative position, can be considered as an expression of the uncertainties and contradictions in a middle class which, in the political climate then ruling in Switzerland and Germany, felt itself impotent in the struggle to obtain the reforms already brought about by the progressive French middle class.

Blake, whose position in relation to the English political situation was not dissimilar from Füssli's, first followed the line of English Radicalism and shared its revolutionary enthusiasms, and then, as a reaction from the results of the revolution, went on to reject the ideals of the Illuminists, confuting Empiric culture, especially Locke. Blake held that knowledge obtained through experience was misleading and found the basis for a revaluation of the imagination in the Neoplatonism of the Cambridge school, in Berkeley's theory of vision, and in an interest in the Hermetic-Symbolic culture of Böhme and Swedenborg (Raine). Knowledge of the universe can be obtained not through the positive science of Newton but through the imagination, since phenomena are "signs" requiring interpretation. History is not to be understood, according to what the artist himself came to avert, as a set of "facts" connected by the law of cause and effect but as a set of "actions" to be identified on the same level as natural phenomena. He thus makes a radical criticism of the Illuminist concept of the historical frame, and therefore remains in this sense one of the fundamental reference points for European Romanticism.

GIANNA PIANTONI

Romanticism in Germany. The Theory of art and the effective artistic output developed in Germany during the Romantic period have recently been subjected to a critical review which has produced Rosenblum's monograph, the cycle of exhibitions in the Kunsthalle at Hamburg, and rationalized catalogues of the works of Runge and of Friedrich.

The analysis and evaluation of the real artistic situation is complex because of its close connections with the literature, literary criticism, and philosophy of the period, but the essential trends or polarities to which studies on this subject refer are only two. The "Nazarene" group of painters experimented with the approach to art postulated by Wackenroder and by Tieck as divine language interpreted by the artist and on

the whole recall the theories of F. Schlegel as regards a substantial conservatism in the choice of subject (themes from the history of the German nation) and the formal repetition of the models of the 15th-century Rhenish school and Durer's circle. But their stay at Rome (Andrews, 1966) in the climate of Catholic revival through strict dogmatic observance, typical of the Restoration, which deprived the Nazarenes of their previous motivation and turned them into illustrators of orthodox religious themes. The Nazarenes and lesser successors in their following of Pre-Raphaelite taste belonged to that current of German artists who, from the middle of the 18th century, had always looked on Rome as possessing an unquestionable spiritual and formal authority, first derived from Antiquity but later from Christianity.

The outlook of Runge and Friedrich is very different and is structurally consistent with the effective *Weltanschauung* of German literary and philosophical romanticism. O. Runge (Traeger, 1975), exactly like Novalis, assimilated Christian spirituality in a more fruitful way, transposing it into the knowledge of a basic naturalness as a condition of the existence of the whole creation and an integration and reciprocal communication between all things. Therefore the philosophy and practice of art must fulfil. the needs of the new individual man who, released from the religious and social conventions of the 18th century seeks a direct relationship with God and with the force of Nature which can no longer be expressed by the prevalently narrative and allegorical formulae of the past.

Runge did not accept the validity of paintings of history and worked out a primary conscious interpretation of landscape painting in terms of symbolic correspondences. In his concrete artistic activity, he followed Carstens' lead (Berefelt, 1961), investigating the possibilities of abstraction of the means of expression, reduced to a linear mark, and renewing the affirmation of creative independence of the conditions imposed by academic teaching. Friedrich's work confirmed the theses which Runge had not been able to demonstrate owing to his premature death, namely that the breakdown and renunciation of the usual process of the appropriation of the specific nature of the landscape is shown by the introduction of negative or archaizing elements according to the classical rules such as uniformity, repetition, and the emptiness created by the distance at which the subject is concentrated, which lead to a correspondence between the degree of abstraction which controls the formal invention and the symbolism of the affirmation of the content.

MARIA GRAZIA MESSINA

Architecture: eclecticism and new experimentation. - Studies of the development of artistic phenomena during the course of the 19th century cannot omit the historical analysis of the relationship of artistic activity to the irreversible transformation of industrial technology, which with its progressive affirmation disclosed its contradictions.

The function of art in the new industrial society, and even its survival, were at the center of the theoretical debate and of artistic innovation in the 18th century. Therefore, the recent historiography of greatest interest is that which in considering that problem investigates events and judges their outcome. In this light even some aspects of the artistic culture of the period which might seem marginal compared with the main development of Impressionism have had to be re-examined and have been found to be of interest for the historical reconstruction of the phenomena as a whole.

Following the pioneering studies of English-speaking criticism (Clark, Pevsner, Hitchcock), there has been a deeper historico-sociological analysis of the complex phenomenon of revivals in architecture (and in the production of useful objects), whether introduced separately or mixed in a single building. This is interwoven throughout the period with experimentation with new materials and new types of public and private buildings. The term "Eclecticism" is preferred by Italian critics (Portoghesi, Gabetti, Patetta) to "Historicism" or "Historismus," as used by others. For Gabetti Eclecticism covers architectural production from 1815 to 1890, and he considers it substantially correlated with Romantic culture and terminating with the experimentation of the "new style" of Art Nouveau.

The undiscriminating absorption of different styles - which in the philosophic field finds correspondence with the theories of V. Cousin, as Collins has observed - was founded on scientific positivist thought, linked with 19th-century naturalism. It was held to be possible to repeat the "features" of the past isolated from their original historical context, trusting in their perfectability, namely in the choice and recreation of the best of them and their eventual "correction" on the basis of the new methods of industrial production. The division between architecture and engineering, which hindered architects experimenting with the technical and expressive potentialities of new materials, does not seem, according to critical reviews of eclecticism, to have been very sharp in practice. Patetta re-examines the phenomenon of the crisis of classicism until 1900, reconstructing it from the special viewpoint of the analysis of the theoretical sources and of the vast amount of published material connected with the phenomenon (magazines, manuals, bibliographies) both in Europe and in the United States.

The roots of the phenomenon are to be sought in the culture of Enlightenment and in the psychological theories formulated from the aesthetics of empiricism which founded the evaluation of examples from the past not so much on whether or not the work of art corresponded to any predetermined scheme of rules as on the psychological effect it produced in terms of its capacity to excite the imagination and associations.

Patetta's study examines the various components - the criticisms of Vitruvius by rationalist theories; the archaeological excavations which uncovered the production of civilizations different from the Classical; the formation of such collections in the Eclectic taste as, for example, those of Sloane and T. Hope; the craze for the antique at the end of the 18th century (Piranesi, Adam, Clerissean); suggestions drawn from literary culture; the theatrical taste for scenography; and, finally, the parameters for the interpretation of styles deduced from the poesy of the Sublime and the Picturesque (the value of mass, the dialectic between light and shade, pure volumes, in the Sublime; while the other displayed irregularity, asymmetry, variety, and the relationship between architecture and landscape) and from the

importance which national ideals developed during the 19th century. But above all the phenomenon is considered as related to the formation of a middle class of patrons and to the definition of new characteristics in the profession of architect which in the course of the century had to satisfy the growing demands, both political and private, of an industrial society in transformation. These changes resulted in an indiscriminate tendency to use the distinctive features of past styles as if they were freely interchangeable.

The extremely wide field investigated by Patetta and his chosen point of view, while on the one hand offering numerous elements for further analysis, do not lead to a clear identification of the different historico-social components which distinguished the various revivals during the period.

As regards Victorian and late Victorian Gothic, mention must be made of the analyses, on an interdisciplinary basis, by Hersey, Muthesis, and Thompson, both for a critical interpretation of the innovations achieved without bothering about functionalism (according to the opinions of Pevsner, Summerson and Hitchcock) and for their reconstructions of the social context and the growth of the Victorian town and the serious problems of urban congestion in British industrial towns. Hersey's paper is particularly interesting, since it identifies precise relationships between the Victorian and late Victorian architect's formal solutions and the associative theories of late British empiricism. From a detailed analysis of London's output, for instance, and the theories of A. Alison, according to which the Beautiful is to be judged on the basis of "Common Sense," Hersey extracts numerous elements for the understanding of those prefunctionalist investigations of solutions aiming at fitness of purpose of forms which was a subject for debate in architectural circles at the time.

Such solutions strike the eye of the user with an immediate perception of the organization of the internal masses, of the correspondence between exterior and interior, and of the clear distribution of the openings and the distinguishing of spaces according to their function. The priority given to these characteristics of "truth" of the forms and their satisfaction of "comfort," especially when dealing with private residences, pushes into the background any reference to styles and explains their indiscriminate use, for they become accessories to the tastes of a middle class which could not resist "ennobling" architectural forms with the authority of the past and ostentatiously displaying its recently gained social prestige. The study by Muthesius sets out to identify the various achievements of the period by considering social and political motives and investigating the characteristics of patrons.

The phenomenon of revivals not only in architecture but as a basic attitude of 19th-century culture originating from the change of values brought about by the industrial revolution and by the consequent crisis in artistic activity is the subject of "Il Revival." In this study various authors have collaborated to clarify the concept, both philosophically (Assunto) and historio-artistically (Argan, Pinelli, et al.). This study identifies the various ideological motivations which judge the return to the past either as an escape from and neutralization of the contrasts of the present or as a stimulus for its transformation, of which an example might be the revaluing of the Middle Ages through the religious movements which promoted Neogothic and through the thinking of Ruskin and Morris.

The Pre-Raphaelites. - The recent reconstruction of the activity of the major exponents of the Pre-Raphaelite Brotherhood, such as Rossetti and Burne-Jones, and a general re-examination of the movement, including its historical roots and its ideological motives within Victorian society, offer new elements for the evaluation of its program of artistic renewal. The Illustration of edifying and sentimental anecdotes, which the movement opposed, avoided and mystified the serious social problems of life in Britain. The diverse personalities of Rossetti, Millais, Collins, Hunt, and Madox Brown found a common ideological aim in combatting false morality and the pragmatic mentality of the liberal middle class which, basing itself on the principles of utilitarianism and "laissez faire," had brought about the tremendous industrial and economic development of Britain at the price of deep social unrest. Careful historical research (Grieve, Duncan Macmillan, Morris) on the themes of some of the most representative works of the group's early period - for example "Christ in the Home of His Parents" by Millais or "Convent Thoughts" by Collins - show close connections (and even commissioning) with the High Church. On the other hand, Hunt, Madox Brown, and others were involved with Christian Socialism, another of those movements of Catholic revival (probably supported by the landed aristocracy) which were sometimes in violent contrast with the growth of the power of the industrial middle class and strongly criticized the British paleo-Capitalist system.

It is precisely this profound moral and religious drive which flavors pre-Raphaelite verse and explains the movement's reference to the art of the Primitives more as a moral than a formal model (Argan), to be directed to a spiritualization and an allegorical view of Nature, with a minute and detailed observation of each single element in order to capture the process of the divine design. The evolution of Rossetti and his younger contemporary Burne-Jones - which showed, however, an ever more evident tendency towards a decadent and aestheticizing sensibility - interests critics, who investigate its origins and the effects of the literary culture of Swinburne, Wilde, and Pater and also the adoption of subjects taken from occult texts, thus revealing by their research an anticipation of a symbolist climate in Europe.

William Morris and the "Arts and Crafts" movement. - Morris' complex cultural formation, from his early syntonic literary and figurative experiences with Rossetti and the pre-Raphaelites to the crucial influence of Ruskin's thought and to his participation in socialism, has been the subject of a complete critical revision. The sources of Marxist opinions and Morris" political theories and activity have been profoundly researched by Meyer, on the basis of an extremely extensive documentation, with the object of focusing the position of the English artist and theoretician in the development of socialist thought in the 19th century. It is the historico-critical study by Manieri Elia of the political theory and actions of Morris that is of most interest. This author sets out to test the effective historical reality of the thesis that considers Morris the originator, together with Ruskin, of the Modern Movement. This argument

is somewhat weakened by a close analysis of Morris" position within the Victorian artistic debate. The undoubted importance that Morris has on the ideological plane as regards the introduction of modern architectural experimentation is recognized by the author, who, however, at the same time shows that linguistic innovations which were more fruitful of future results have been intentionally obscured. These include the research on industrial design by H. Cole and his group and the precocious structural innovations in Godwin's architecture, resulting from a fresh interpretation of Japanese art in the lively cultural circle of Whistler, Wilde, and Beardsley which, unlike Ruskin and Morris" group, was open to French culture.

The analysis of the Arts and Crafts movement by Naylor also emphasizes the fecundity of the solutions of Cole's group. The theoretical program is carefully reconstructed along with the different developments of artistic experimentation by Macmurdo, Ashbee, Voysey, Lethaby, and others who, although they shared the ideological position of Ruskin and Morris as regards the rejuvenation of the so-called applied arts, did not follow them in their criticism of the industrial system of production and proposed instead a line of action which took into consideration a relationship of art to industry according to Cole's outlook.

GIANNA PIANTONI

Impressionism. - Study of the Impressionist period and of the roles of its protagonists has usually followed the path already opened by Rewald and by Leymarie through an exhaustive historical analysis of the documentation and attempts to discover presently applicable factors for insertion in sociological problems. A typical example is the monograph by M. and G. Blunden (1970) in which pictorial experimentation is considered in the context of the social unrest which led to the *Comune* of 1871 and the Third Republic and interpreted as pungent manifestations of the period, thanks also to the collection of numerous pertinent pieces of evidence. Analysis defined in that way is self-limiting and without any critical investigation in depth of ideologies, the structure of the operations carried out, and their importance regarding the development of the next experiment. R. Huyghe, in the introduction to the Catalogue of the Centenary Exhibition (1974), is partly guilty of a similar sociology which aims at weaving the most complex network with the phenomena of contemporary culture but lacks any real historical perspective. The results obtained in painting are there shown as parallelled by those in science, as confirmation of a shared intellectual outlook. The theme of the death of the old view of matter as a static mass is compared with the exclusive role of the impalpability of luminous vibrations. The fact of painting as an immediate reaction of consciousness and the anticipation in figurative fluidity of the temporal dimension foreshadow Bergson's concept of duration and modern relativity.

It is not only with these circumstantiated references that Impressionism is seen as a revelation of the structure of perception and the representation of the real world. One must also consider the outcome and results so that, for example, Monet's "Séries" becomes understandable in terms of an already acquired symbol-

ist climate. A worthwhile criticism must do more than turn over the news, it must make history out of the facts, as Venturi has already shown. In this connection Francastel's work (1961) is apposite, for it distinguishes two categories of phenomena (fashions and styles) and implies that the latter's influence is not limited to tastes and appearances, but spreads also to the values which decide the artist's relation to society and even to the relationships between the individual and the exterior world. In this sense Impressionism, since it introduced a novel order of imagination for transferring figurative evidence from the universal field to consciousness, had its real development after 1885 when it ceased being an avant garde problem, although experimentally defined, and became the typical form of Western art. Studies aimed at a really detailed and profound analysis of Impressionism must therefore research along those lines. F. Novotny (1961) developed the previously formulated concept of a polarity between an already highly developed and therefore independent pictorial form and a drive towards an equally extreme Illusory effect relying only on what was visible.

The reaction to Impressionism and also its appropriation as a basic perceptive idea consists in renouncing the second pole and intensifying the formal analysis of the two opposites of the micro-organization of surfaces and their broad representation. A. M. Hammacher (1961) considers that the transit to post-Impressionist culture does not imply any discontinuity, but instead is marked by the prevalence of an architectonic consciousness in the sense of a purely mental perception of space and a more spiritual and symbolic idea of light. Impressionism, which was not merely a limited exemplary breakthrough episode, was a preliminary to all 20th-century experimentation, including the most recent, and this is demonstrated by the fact that the qualitatively less appreciated works are often the more influential. W. Seitz (1969) outlines its connections with the New York School, through the intermediation of Mondrian, and the less obvious connections with visual, Op, and Minimal Art. This was the first formulation of perceptive modes later distinguished as: open or fragmentary form, motion as physiological data, rejection of tactile perception, independence of light as a formal and expressive medium, and touch or technique as an insertion of ambiental dynamism.

F. Schmalenbach's 1966 study remains the one that best follows the argument and which focalizes the nucleus of impressionist research, paradoxically defined as naturalist if referred to the surface. A first radical "desubjectivation" of the data of representation resulted in the expression of chromatic values as if separate from the subject and in emphasizing the specific nature of the pigments in the sense of a materialization. This subjective attitude is also shown in choices such as the reduction of the format and the preference for landscapes rather than still life or portraits. This is the kind of painting that shows the maximum degree of chance or irrelevance, partly because of the contemporaneousness of the references. Also, characteristics which have been considered crucial, such as fragmentary cutting, fluid instability of vision, and the abolition of shadows in the prevalence of pale colors are rather the consequence of such an abolition of the subject which, under a patina of vitalistic variety, discloses how effectively the role, although unintentional, of the impressionists

was that of reducing to the essentials the motives and the means for pictorial experimentation, and in that sense a step towards abstraction. Oriented in that way, interpretations of the analysis of formal specificity avoid the ambiguity of others which may be provided with wider references and methods. A paper by P. H. Feist (1964) is an example, retracing similarities of trend between Rococo painting and Impressionism and revealing its sociological background to arrive at the conclusion that it is a secession - more similar to Garnier's Opera than to the Halles - in as much as it is an escape into the sphere of art and the incapacity of facing up to the emerging reality of the industrial proletariat.

As regards the study of the individual personalities, we must mention an increase in library research producing organized general catalogues on the works of Sisley (1959), of Morisot (1961), of Cassat (1970), of Guillaumin and Renoir (1971), and of Boudin (1973). Particular problems (data on format, themes, techniques, patrons, and dealers) have, on the other hand, been handled by such specialists as Rewald, Huyghe, Daulte, Perrouchot, and Reff (who in various contributions on Degas and Cézanne bases new methods for the analysis of the structure and ultimate meaning of the works on a rigorous documentation). This orientation, which was foreshadowed by K. Badt on Cézanne, is also followed by G. Hopp in his study on Manet (1968) aimed at giving back to the monograph a scientific dimension beyond the persistent myths, even if the aim is hidden by the show of documentary backing and connected references and linked with the proliferation of series for the general reader. Hopp analyzes Manet's pictures only as regards their structural data, in the reciprocity of ratios and developments, and especially as regards chromatic values, disproving that these are themselves offered as unique objects with the result making the representation into a "pure painting"; and instead draws out the relationships with content and meanings, re-establishing a positive attitude regarding the tried measures of interpretation.

As regards post-Impressionist output, in view of the deep-rooted tendency to concentrate interest on the personalities - the major contributions turn on Seurat, Van Gogh (Roskill), and Gauguin (Bodelsen) - the paper by W. Jaworska (1971) must be mentioned. This aims at rediscovering the personalities and roles of the painters associated with Pont-Aven, considering their reciprocal interferences and their sharp differentiation beyond the usual preferential relationship established with Gauguin. He bases a profound investigation of the aesthetics of the group on an interpretation of the exhaustive material he has collected and sees them in an antipositivist mode as foreshadowing their own motivations towards abstract experimentation.

MARIA GRAZIA MESSINA

Symbolism and Art Nouveau. The complex cultural *lingua franca* of symbolism has been the subject of numerous general studies (Jullian, Barilli, Russoli) and of exhibitions which have introduced both a deeper knowledge of the reconstruction of the intricate philosophical and literary pattern woven on the figurative symbolist theme (in which it is possible to recognize frequent iconographic motives connected with esoteric hermetic traditions as, for example, in the group of Rosicrucian artists) and a widening of the knowledge of other circles less known than the French, such as the German, Belgian, or Dutch. Legrand has produced a study of Belgian symbolist culture dissecting out its main literary inspirational track, which favored hermetic esoteric subjects (as in Knopff); another aiming at the expressive values of line leading to Art Nouveau productions; and a third founded on mystico lyrical interpretations of Nature and on ideas drawn from popular art and folklore (Spillaert, Degouve).

The Dutch coterie, profoundly influenced by English, French, and Belgian symbolist culture, produced an original idiom particularly in Toorop and Thorn Prikker, with whom the valency of the symbol spreads into refined hieroglyphs (Joosten). What comes out of this diffuse critical interest is, on the one hand, a wish to clarify aspects of 19th-century culture beyond analyses of the idealistic basis which leads to metahistorical valuations, and, on the other hand, an appreciation of the difficulty of giving a satisfactory historical pattern to the different results of symbolist figurative culture. Together these two make clear the danger of an indiscriminate and generical recovery. If, in fact, it were easy to identify the common philosophical and literary matrices (such as the general criticism of positivist thought, the mistrust of any objective knowledge of reality, the interest in the mystical and magical tendencies of German romanticism, the fundamental importance of the aesthetics of Schopenhauer and Wagner and Nietzsche's thought) and their circulation between the various European symbolist groups and coteries, it would be all the more difficult to analyze the way in which these common matrices separated themselves and recombined with others in the individual historico-sociological situations and in different linguistic formulations.

The plurality of formal solutions is the foundation of symbolic poetry itself, both literary and figurative - the constant experimentation with new means of expression is maintained by confidence in the magical evocative power of the word and of symbolic synthesis. This recreates a primordial mentality which manages to draw on the archetypes of a different world, beyond the signs and phenomenalistic appearances, and to travel in the new dimensions of the dream world and the subconcious. The new scientific studies worked over by Impressionist and neo-Impressionist culture; Hildebrand's investigations of form, line, and rhythm; and research into natural processes were assimilated and re-elaborated to formulate - according to Mallarmé - "un mot total, neuf, étranger à la langue et comme incantatoire." Now it is precisely in the identification of the "alchemies" of form and motifs and their collocation in an historical perspective that many difficulties remain to be unravelled.

Similarly it remains necessary to make a careful verification of those socio-political motives which assist in understanding the history of symbolist culture and which are to be identified in the accentuation of division between the artist and society (which has already been pointed out in Rewald's paper on post-Impressionism, which other scholars recognize as important) in the acceptance by many artists, all too tragically in some cases, of the end of their function, and in that "perte d'auréole" (loss of halo) of which Baudelaire wrote. This

fracture began in France in 1848 and worsened after 1871. It also existed contemporaneously in England, to become a European reality with the installation of a mass society.

The multiform ideological and political orientations in an anarchical socialist direction were the result of positions of rejection, hostility, and provocation by the middle class artist against his own class, and the proposals to construct a culture in opposition to the system reveal the contradictions and ambiguities of the historical situation itself. Alongside a genuine heartfelt consciousness of isolation and of the vanity of intellectual work in a society which rejects it and a recovery and transformation of the most vital aspects of romantic culture on account of their corrosive and capsizing forces against worn-out middle class values, we find a "bad conscience" which lends itself to providing Illusory myths and mystifying flights from reality which support conservative attitudes and the restoration of the dominant class.

Knowledge of the Art Nouveau period, as compared with the fundamental studies of Schmutzler and Madsen, has been extended into new cultural areas and to new personages. The study of Bohigas on the important cultural moment of Catalan Modernism reveals unpublished material still only partly assessed. The author explains the historical background of the formation of a modernist movement in Catalonia, both because of the region's economic potentiality in which industrial progress was keeping pace with the rest of Europe and for the ideals and political drive which carried the Renaissance ahead and on which was grafted the search for a new style that would express both its own national identity (which explains the Catalan movement's interest in the Middle Ages) and the wish to accept contemporary culture, European in origin, by adapting it to new purposes. The particular activity by Gaudì no longer has to be considered as an isolated phenomenon disconnected from foreign innovations, but as belonging to an extensive rejuvenation in which architects and craftsmen take part, with a very wide diffusion made possible by the closeness of the contacts of craftsmen, encouraged by the ethical and social tenets of the Arts and Crafts Movement, with architectural practice and new technological experimentation. Bohigas identifies, out of the various developments of architectural research alongside the "expressionist" line of Gaudì, another early and more "rationalist" line followed by Doménéch i Montaner.

The other critical tendency in overcoming the historical outlook which tended to separate and read the period's output exclusively as an evolution towards the apex of the Modern Movement now more freely checks the intersection of various cultural currents. These are clarified through the analysis of the theoretical reflections which accompany artistic achievements. In this sense, a deeper analysis was made of the initial processes of the communication of forms and of the psychology of perception by Art Nouveau, as is clarified by the accent placed on the romantic and idealist-positivist theories of Einfühlung and of pure visibility.

Originating in the last decades of the century as an opposition, these theories offer a common reference basis for the importance given to the physiologico-psychological correspondence between the subject and Nature, between the beholder and the work of art (De Fusco, Portoghesi, Baculo). The special relationship Art/ Nature which permeates pictorial experimentation at the end of the century, tending to communicate not so much the form as the dynamic structure, the organization of natural elements, the different processes of abstraction and simplification which are developed from the original data, and the novel spatial values thus obtained by the best of Art Nouveau design, as also the fundamentally hedonist and elitist nature of the production of the period, can be clarified according to an empathy existing between man and Nature as was first identified by the theoreticians of the Einfühlung such as Volkelt and Lipps, not as a simple association but as a perception and emotional representation of reality, a psychophysiological adhesion and intensification of things, by which aesthetical pleasure and the qualitative value of a work of art are considered on the basis of the beholder's response to visual stimuli.

A parallelism, though not a cause and effect relationship, can thus be drawn between the artistic production even of different circles and similar theoretical ideas, as for instance in the output of Endell, Guimard, Van de Velde, and Horta. This last has been the subject of a study (Borsi and Portoghesi) as a typical personality of the period. The various components of his formation have been identified - from the theories of Viollet-Le-Duc to the implications of symbolist literary culture (Verhaeren, Maeterlinck), emphasizing the musical, symbolic, and evocative significance of the idioms used. Furthermore, in reconstructing the relationship of architect to his patron, Solvay the industrialist, further light has been shed, within the particular historical situation in Belgium, on the links between Art Nouveau and the developments in industry and the interest of the industrial and banking middle class which was open to the idea of a cultural advance and progressive ideals and which included most of the patrons of the greatest architects of the period (Gaudì, Guimard, Van de Velde; and in Italy there is an example in the relationship between Basile and Florio).

De Fusco uses a psychological matrix and the Einfühlung and Sichtbarkeit theories to explain both the organic and abstract-geometrical motives sustained mainly by that purification and correction of natural phenomena upheld by the Sichtbarkeit theoreticians and particularly characteristic of Viennese work.

Viennese circles offer some of the most interesting solutions to the problems of Art Nouveau, showing a progressive independence of natural forms leading up to the enunciation of an early Sachlichkeit research in a particular interpretation by Loos. Among the cultural components which have contributed to the innovative drive, the crucial ones are those of Semperian positivism in designing the research into the relationship of form to function and the technical and expressive possibilities of new materials and the "pure vision" thinking in promoting an investigation of the possibilities of learning about reality through the sense of sight. A free re-reading of the historicism worked out by Wagner in architecture, his ability to combine in a visual whole different elements, and his proto-rationalist output (and not only Wagner's; there were also Hoffmann and Loos) are all aspects and seem to be the interpretation of an axiom by Fiedler that an "absolute clarity" must coincide with an "absolute necessity" (Baculo). Recent historiography (Hoffmann, Nebebay) produces new

elements on the events and meaning of the program of Secession which was published in the periodical "Ver Sacrum." The ideal of the "Integration of Art" and the rejuvenation of the applied arts originated with the thoughts of Ruskin and Morris and developed through knowledge of the Arts and Crafts productions and of the second phase of Jugendstil, which was characterized by the abstract constructive style of Van de Velde (Messino). There was a continuous connection between graphic art and architecture in the search for common denominators through an extremely refined purification of forms, an exact and balanced individuation of the spaces according to the fundamental axes of the straight line and the combinatory possibilities of the square or of the curve and of the elipses, according to the preference of, respectively, Hoffmann and Olbrich. The program of Secession, considered in relationship to the particular alienating Austrian political situation, appears as an extreme romantic claim to the priestly function of the artist, to his right to create while tending to avoid the effective problems of reality, and who finds support in the taste of the aristocracy and the upper middle class.

Liberty and Pointillism. Among the numerous studies on Art Nouveau in Italy, that by Bossaglia presents an enormous wealth of material and a preliminary general analysis of the subject.

Between 1895 and 1902, the date of the Turin Exhibition, Liberty's output reached a level of great originality which was, however, quickly suffocated by academic rhetoric and a neo-Renaissance taste. The phenomenon has been evaluated in respect of the specific Italian historical situation (Nicoletti, Rosci) and in relation to the type of industrial development which took place particularly in northern Italy with state support but developed by a middle class that was somewhat unenterprising economically and with moderately progressive ideas. The majority of Italian artists in the 1890s were imbued with the ideals of a reforming socialism, and in the argument on the social function of art the thoughts of Tolstoi, Ruskin, and Morris had great weight. Although knowledge of Liberty culture in Italy has been enlarged by specific studies of the Sicilian and Emilian ambits (and we can add the names of Fenoglio, Rigotti Premoli, Velati, and Bellini to those of already accreditted critics in this field) its episodic nature must be admitted along with the lack of originality regarding the concept of space in architecture - experimentation, in fact, seems not to turn on the structure but rather on the decorative improvement of the building.

The cultural primacies of Liberty were various, successful, and interwoven with each other. The first pre-Raphaelite influence was followed by a Franco-Belgian period, then at the turn of the century the objective turned on to Mackintosh, Ashbee, and Voysey, the influence probably coming through Austrian culture (Bossaglia). In fact, the relationship with the Viennese Secession must be regarded as fundamental (Bossaglia, Pevsner, Nicoletti) for it was the European area closest to Italy for political and cultural aspects. The appeal to Classical-Renaissance-Baroque traditions found a ready response here in the nationalistic spirit that more and more permeated Italian culture and conditioned its renewel.

The careful reconstruction of the activity of Pointillist painters and the detailed collection of their writings (see Belloni and Quinsac), together with a further analysis of the various cultural and social motivations (Rosci, De Grada) result in a clarification of the significance of the experimentation on the relationship between light and color in the Italian ambience.

The driving ideal behind the group, and especially Previati, Segantini, and Pellizza da Volpeda, was the claim, of romantic origin, to the function that the artist ought to grasp of guide towards the discovery of a universal truth beyond the contradictions of the present. These artists, therefore, moving from a culture with an idealistic spiritualizing background where the late romantic motives of the "Scapigliatura" mingled with the knowledge of the pre-Raphaelite ambit and the literary and philosophical influences of European symbolism (see Bellonzi), finally, for the purpose of a symbolic interpretation of Nature, developed the new technique of the division of color (Pointillism).

The assumption of Impressionist and neo-Impressionist painting, although known from direct or indirect sources, remained virtually extraneous. A study by Quinsac has shown the importance as cultural mediator of V. Grubicy (not only through his knowledge of French art but also that of the pre-Raphaelites and the Belgian symbolism of the Twenty group) and the idealistic literary slant of his theories, aimed at promoting "significant and ideist" painting - theories which had considerable influence on Previati and on young Segantini

The novel idiom of Previati and Segantini found acceptance in contemporary symbolist circles where the former was a member of the Rosicrucian group and the latter was known among the Secessionists of Munich. Pellizza da Volpedo was distinguished by a different attitude to naturalism and to the researches on optics and light, for his precise geometrical mensuration of the space filled with the spots, for his study of the correspondence between form and feeling, and for investigating the new possibilities of pointillist technique for the symbolic expression of moral deeds and social ideals (see the study by A. Scotti for the iconographic and structural origins of one of his most significant works, "The Fourth State").

GIANNA PIANTONI

BIBLIOGRAPHY - *General Works*: A. F. D. Klingender, Arte e rivoluzione industriale (1947), Torino, 1972, introductory essay by N. Castelnuovo; W. Hofmann, Arte nel XIX secolo (1960), Milan, 1962; R. Williams, Culture and Society, 1780-1950 (1961), Turin, 1968; E. De Keyser, L'occident romantique (1789-1850), Genève, 1965; N. Ponente, Le strutture del mondo moderno, Ginevra, 1965; Bibliographie zur Kunstgeschichte des 19. Jahrhunderts Publikationen der Jahre 1940-66, München 1966 and the other publications of the series Materialen zur Kunst des 19. Jahrhunderts e Studien zur Kunst des 19. Jahrhunderts, München; R. Barletta, M. Carrà, D. Durbè, R. Negri, F. Russoli, Realtà e forma del post-impressionismo, Milan, 1967 (L'Arte Moderna, Vol. I); R. De Fusco, L'idea di architettura, Storia della critica da Viollet Le Duc a Persico (1965), Milan, 1968; M. Praz, Mnemosyne, The Parallel between Literature and the Visual Arts (1967), Princeton, 1970; G. C. Argan, L'Arte moderna, 1770-1970,

Firenze, 1970; Var. Authors, Bietrage zur theorie der Kunste im 19. Jahrhundert, Frankfurt, 1971, 2 vols.; N. Pevsner, Some architectural writers of the 19th Century, Oxford, 1972; F. Bologna, Dalle arti minori all'industrial design, Napoli, 1974; Var. Authors, Il Revival, by G. C. Argan, Milan, 1974; Var. Auth., Beitrage zur Rezeption der Kunst des 19. und 20. Jahrhunderts, München, 1975; H. Haskell, Rediscoveries in Art: some aspects of taste, Fashion and collecting in England and France, London, 1976.

Neoclassicism and Romanticism: a) General Works: Var. Auth., Aspects of neoclassicism, Apollo, Nov. 1963 (special number); G. Hubert, Le sculpteurs italiens en France 1790-1830, Paris, 1964; G. C. Argan, La pittura dell'Illuminismo in Inghilterra, Roma, 1965; K. Lankheit, Revolution und Restauration, Baden, 1965; E. R. Wassermann (ed), Aspects of the 18th Century, Baltimore-London, 1965; F. Antal, Classicism and Romanticism (1939), London, 1966; D. Irwin, English Neoclassicism. Art-studies in inspiration and taste, London, 1966; M. Levey, Rococo to Revolution, London, 1966; Var. Auth., Sensibilità e razionalità nel Settecento, Venezia, 1967; R. Rosenblum, Transformations in late 18th Century Art, Princeton, 1967; G. C. Argan, Il neoclassisismo, Roma, 1968; H. Honour, Neoclassicism, Harmondsworth, 1968; Illuminismo e architettura del 700 Veneto, Cat. dell'esposizione, Castelfranco Veneto (by M. Brusatin, with introductory essay by A. Rossi), 1969; G. C. Argan, Studi sul neoclassico in Storia dell'Arte, 7/8, 1970; Var. Auth., The Age of Neoclassicism, cat. of the exposition, London, 1972 (with introductory papers by H. Honour, L. D. Etlinger, H. von Einem, C. Pietrangeli, W. von Kalnein, M. Laclotte, R. Herbert, G. Hubert, D. Helsted, M. Praz, M. Monteverdi and an extensive bibliography); Var. Auth., Cultura neoclassica e romantica nella Toscana granducale, Cat. of the Exposition, Firenze, 1972 (with introductory essay by S. Pinto); Proceedings of the Convention "Napoleone e l'Italia," Milano, 1973; R. Assunto, Antichità e futuro, Milano, 1974; S. Eriksen, Early neoclassicism in France, London, 1974; P. Marconi, A. Cipriani, E. Valeriani, I disegni d'architettura dell'archivio Storico di S. Luca, Roma, 1974, 2 vols.; Var. Auth., Ossian, Cat. of the Exposition, Paris, 1974 (with introductory papers by D. Ternois and W. Hofmann); Var. Auth., Quaderni di Storia dell'Arte, 3, Miscellanea, Roma, 1975; Var. Auth., From Watteau to David, Cat. of the exposition, Bruxelles, 1975; Var. Auth., De David à Delacroix, La peinture française de 1774 à 1830, Cat. dell'esposizione, Paris, 1975 (with bibliography and introductory essays by P. Rosenblum, F. Cummings, A. Schnapper); Architettura e cultura dell'Illuminismo, Psicon 4, 1975 (monographic number).

b) Individual Artists: In addition to the works mentioned below, see also the catalogues The Age of Neoclassicism in London, 1972, and De David à Velacroix, Paris, 1975. *W. Blake*: A. Blunt, The Art of W. Blake, New York, 1959; S. F. Damon, A Blake Dictionary, the ideas and symbols of W. Blake, Providence, Rhode Island, 1965; K. Raine, W. Blake, London, 1970; Var. Auth., W. Blake, Cat. of the exposition, Hamburg, 1975 (with introductory paper by W. Hofmann). *A. Canova*: G. C. Argan, Canova, Roma, 1969 (lecture notes); H. Ost, Ein Skizzenbuch A. Canovas, Tübingen, 1970; H. Honour, Canova's Studio Practice, Burlington Magazine, 828 and 829, 1972; E. Salling, Canova and Thorwaldson, a study in contrast, Apollo, 127, 1972; A. Gonzales-Palacios, Sei fogli di A. Canova, Arte Illustrata, 48, 1972; Var. Auth., Studi Canoviani, Rome, 1973; H. Honour, Canova's Napoleon, Apollo, 139, 1973. *J. L. David*: R. Herbert, David, Voltaire and the French Revolution, London, 1972: *J. H. Füssli*: G. C. Argan, Füssli, Shakespeare's painter (1960), Studi e Note dal

Bramante a Canova, Roma, 1970; P. Tomory, The Life and Art of H. Füssli, London, 1972; G. Schiff, 1741-1825, Oeuvre-katalog, Zürich-München, 1973; Var. Auth., J. H. Füssli, Cat. of the exposition, Hamburg, 1974-75 (with introductory papers by G. Schiff and W. Hofmann). *F. Gérard*: R. Kauffmann, F. Gérard's Entry of Henry IV into Paris, the iconography of Constitutional Monarchy, Burlington Magazine, 871, 1975. *A. L. Girodet*: G. Bernier, A. L. Girodet, Paris-Bruxelles, 1975. *M. Grigoletti*: Var. Auth., M. Grigoletti e il suo tempo, Cat. of the esposition, Pordenone, 1970. *J. Mortimer*: J. Sunderland, Mortimer, Pine and some political aspects of English history painting, Burlington Magazine, 855, 1974. *P. Palagi*, Cat. of the exposition in Bologna, 1976. *G. B. Piranesi*: J. Harris, Le Geay, Piranesi and International Neoclassicism in Rome 1740-50, Essays on Architecture presented to R. Wittkower, London, 1967; H. Focillon, G. B. Piranesi, Bologna, 1967 (with introductory paper by M. Calvesi); M. G. Messina, Teoria dell'architettura in G. B. Piranesi, Controspazio, 8-9, 1970, and 6, 1971; M. Tafuri, G. B. Piranesi, L'architettura come utopia negativa, Angelus Novus, 20, 1971; Var. Auth., Piranése et les Français (1740-1790), Cat. of the exposition, Rome, 1976; *J. T. Sergel*: Var. Auth. J. T. Sergel, Cat. of the Exposition, Hamburg, 1975. *J. Soane*: G. Teyssot, Città e utopia nell'illuminismo inglese (J. Soane), Roma, 1974. *B. Thorwaldsen*: J. B. Hartmann, B. Thorwaldsen, Roma, 1971; Var. Auth, B. Thorwaldsen, Cat. of the Exposition, Köln, 1977 (2 vol.). G. Valadier: P. Marconi, *G. Valadier*, Roma, 1964. *F. Xavier-Fabre*: D. Ph. Bordes, *F. Xavier-Fabre*, pientre d' Histoire, Burlington Magazine, 863-864, 1975.

Romanticism in Germany: a) General Works: G. Berefelt, The Regeneration Problem in German Neoclassicism and Romanticism, The Journal of Aesthetics and Art Criticism, XVIII (1960), 4; K. Andrews, The Nazarenes, Oxford, 1964; Var. Auth., Deutsche Romantik, Gemalde und Zeichnungen, Cat. of the Exposition, Berlin, 1865; L. Pesch, Das Utopia der Romantischen Kunsttheorie und die Moderne, Wandlungen des paradisiasischen und utopischen, Berlin, 1966; Var. Auth., Klassizismus und Romantik in Deutschland, Cat. dell'esposizione, Nürnberg, 1966 (with introductive paper by K. Lankheit); L. Grote, ed., Beitrage zur Motivkunde des 19, Jahrhunderts, Münich, 1970; L. D. Ettlinger, Nazeriner und Preraffaelliten in Festschrift fur G. der Osten, Köln, 1970; R. Rosenblum, Correlations between German and non-German Art in the 19th century, Yale University Art Museum Bulletin, 33, 3, 1972; Deutsche Romantik Handzeichnung, München, 1974, 2 vols.; R. Rosenblum, Modern Painting and the Northern Romantic Tradition, Friedrich to Rothko, London, 1975; Var. Auth., La peinture allemande à l'epoque du Romantisme, Cat. of the Exposition, Parigi, 1976-77 (with introductive papers by W. Hofmann, H. J. Neidhardt, and V. Kouznetsov); Var. Auth., Die Nazarener, Cat. of the exposition, Frankfurt am Main, 1977.

b) Individual Artists: C. D. Friedrich: G. Eimer, C. D. Friedrich und die Gothik, Analysen und Deutungsversuche, Hamburg, 1963; W. Sumowsky, C. D. Friedrich Studien, Wiesbaden, 1970; H. Borsch Supan, K. W. Jahnig, C. D. Friedrich, Gemalde, Druckgraphik und bildmassige Zeichnungen, München, 1973; Var. Auth., C. D. Friedrich 1774-1840, Cat. dell'esposizione, Hamburg, 1974 (with introductive paper by W. Hofmann); Var. Auth., C. D. Friedrich und sein kreis, Cat. of the exposition, Dresden, 1974. *P. O. Runge*: G. Berefelt, P. O. Runge zwischen Aufbruch und Opposition, 1777-1802, in Stockolm Studies of the History of Art, VII, Uppsala, 1961; C. Grützmacher, Novalis und Runge, die Zentralmotive und ihre Bedeutungssphäre, Münich, 1964;

H. Matile, Die Farbenlehre P. O. Runges, Bern, 1973; C. Franke, P. O. Runge und die Kunstansichten Wackenroders und Tieck, Marburg, 1974; J. Traeger, P. O. Runge und sein Werk, monographie und kritischer Katalog, München, 1975.

Landscape painting and realism in France: a) General Works: D. Durbè, A. M. Damigella, La Scuola di Barbizon, Milano, 1967; J. Burè, L'école de Barbizon et le paysage français au XIX siècle, Neuchâtel, 1972. *b) Individual Artists: J. B. Corot*: Var. auth., J. B. Corot, Cat. of the exposition, Paris, 1975. *G. Courbet*, Somerset, 1973. *F. Millet*: L. Lepoittevin, F. Millet, 3 vol., Paris, 1971; R. Bacou, F. Millet, dessins, Paris, 1975; R. L. Herbert, F. Millet, Cat. of the Exposition, Paris, 1975-1976.

Revolutionary Architecture: W. Oechslin, Introduction to revolutionary architecture, Controspazio, 1-2, 1970; W. Oechslin, Pyramide et Sphère: notes sur l'architecture révolutionnaire du XVIII siècle et ses sources italiennes, Gazette des Beaux-Arts, LXXVII, 1971; M. Dezzi Bardeschi, Eccesso e ragione nell'architettura "rivoluzionaria," Psicon, 4, 1975; H. Rosenau, Boullée and Ledoux as town-planners. A Re-Assessment, Gazette des Beaux-Arts, LXIII, 1964; D. Le Comte, Boullée, Ledoux, Lequeu, Les architectes révolutionnaires, Paris, 1969; L. Khan, D. De Menil, J. C. Lemagny, Visionary Architects: Boullée, Ledoux, Lequeu, Cat. of the Exposition, U.S.A., 1968, Berlin, 1970; E. L. Boullée, Architecture, Essai sur l'art, ed. A. Rossi, 1967; K. Lankeit, Der Tempel der Vernunft. Unveroffentlichte Zeichnungen von Boullée (1728-1799), De l'Architecture Classique à l'architecture Révolutionnaire, Paris, 1969; A. M. Vogt, Boullée Newton denkmal, Sakralbau und Kugelidee, Bâle, 1969; A. Chastel, The Grand Eccentrics, The moralizing Architecture of J. J. Lequeu, Art News Annual, XXXII, 1966; J. Guillerme, Lequeu, entre l'irrégulier et l'electique, Paris, 1974; J. Guillerme, Lequeu et l'invention du mauvais-goût, Gazette de Beaux Arts, LXVI, 1975.

Eclecticism and revivals: a) General works: P. Portoghesi, L'Eclettismo a Roma 1870-1922, Roma, 1960; J. Gloag, Victorian taste and some social aspects of architecture, London, 1962; P. Collins, Changing ideals in modern architecture, London, 1965; W. O. Robson, The literary background of the Gothic Revival in Germany, Oxford, 1965; F. Borsi, L'Architettura dell'Unità d'italia, Firenze, 1966; C. Meeks, Italian Architecture 1750-1914, Yale, 1966; E. Schild, Dal palazzo di Cristallo al Palais des Illusions (1976), Firenze, 1971; R. Gabetti, Eclettismo, Dizionario Enciclopedico di Architettura, Roma, 1968; Var. Auth., Historismus und Baustile des 19, Jahrhunderts, di H. Lietzmann, München, 1968; P. B. Stanton, Gothic Revival and American Church Architecture, An episode in taste, Baltimore, 1968; M. Leva Pistoi, Torino, mezzo secolo di architettura, 1865-1915, Torino, 1969; R. Macleod, Style and Society (1835-1914), London, 1971; G. German, Gothic Revival in Europe and Britain. Sources, Influence and Ideas, London, 1972; G. L. Hersey, High Victorian Gothic: A study in Associationism, Baltimore, 1972; S. Muthesius, The High Victorian Movement in Architecture, London, 1972; J. Summerson, Victorian Architecture, Four studies in evaluation, New York, London, 1972; Var. Auth., The Victorian City, ed. H. J. Dyos and M. Wolff, 2 vol., London, 1973. H. Habel-K. Mesten, M. Petzet, S. von Quast, Münchener Fassaden, 1850-1914, München, 1974; S. Muthesius, Das Englische Vorbild, München, 1974; L. Patetta, L'Architettura dell'Eclettismo, Milano, 1975 (with a large bibliography); R. Wagner-Rieger-W. Krause ed., Historismus und Schlossbau, München, 1975; E. Borsch-Supan, Berliner Baukunst nach Schinkel, 1840-70. München, 1976.

b) Individual artists: A. Antonelli: F. Rosso, A. Antonelli, Torino, 1976. *W. Butterfield*: P. Thompson, W. Butterfield, Victorian architect, Cambridge, 1972. *G. Semper*: M. Fröhlich, G. Semper, 1975.

Impressionism and Post-Impressionism: For Impressionism see the fully up-dated bibliography, in J. Rewald, History of Impressionism, London, 1973, and for Post-impressionism in Var. auth., L'Arte Moderna, Milano, I, 1967, and XIV, 1970. Studies either omitted there or more recent are mentioned below.

a) General Works: P. Francastel, La fin de l'impressionnisme: esthétique et casualté, in Problems of the XIX and XX Century, IV, New York, 1961; A. M. Hammacher, The changing values of light-space-form between 1876 and 1890; F. Novotny, The reaction against impressionism from the artistic point of view, c.s.; P. H. Feist, Franzosische Impressionismus und neorokoko, in Anschauung und Deutung, Berlin, 1964; F. Schmalenbach, Impressionismus, Versuch einer Systematisierung, Wallraf-Richartz-Jahrbuch, XXXVIII (1966); A. M. Damigella, L'impressionismo fuori de Francia, Milano, 1967; J. Sutter, Les Impressionnistes, Paris, 1970; Var. Auth., Gli impressionisti (series of monographs on Degas, Manet, Pissarro, Renoir, Sisley, Seurat, Gauguin), Milano, 1971-72; The Painters" analogies and their theories 1845-1880, Symposium on French XIX Century Painting and Literature, Manchester, 1972; Swiler Champa, Studies in early Impressionism, New Haven-London, 1973; H, Adhemar, A. Dayez, Musée du Louvre, Musée de l'Impressionnisme, Jeu de Paume, Cat., Paris, 1973; Var. Auth., Centenaire de l'Impressionnisme (introduction by R. Huyghe), Cat., of the Exposition, Paris, 1974. For a "counter history" see A. Boime, The Academy and French Painting in the XIX Century, London, 1974.

b) Individual Artists: E. Boudin: R. Schmit, E. Boudin, catalogue raisonnè, Paris, 1973. *P. Cézanne*: G. Berthold, Die Kunst Cézannes als Seminar, in Festschrift fur K. Badt, Köln, 1970; S. Lichtenstein, Cézanne's copies and variants after Delacroix, Apollo, CI (1975), 156; J. Rewald, Some entries for a new catalogue raisonné of Cézanne's paintings, Gazette des Beaux Arts, LXXXVI, 1975, 117; Var. Auth., The late Cézanne, Cat. of the exposition, New York, 1977; *J. B. Jongkind*: V. Hefting, Jongkind, sa vie, son oeuvre, son époque, Paris, 1975. *C. Monet*: L'opera completa di Monet 1870-1889, Milano, 1972. *P. Renoir*: Renoir, l'opera completa del periodo impressionista 1869-1883, Milano 1972. *A. Sisley*; A. Scharf, Sisley, London, 1966. *G. Seurat*: J. H. Rubin, Seurat and theory: the near identical drawings of the "Café Concert," Gazette des Beaux Arts, LXXVI, 1970, 1221; L'opera completa di Seurat, Milano, 1972 (presentation by A. Chastel); F. Menna, Quella Domenica alla Grande Jatte, Qui Arte Contemporanea, 1974, 13. *P. Gauguin*: M. Bodelsen, The Dating of Gauguin's Early Paintings, The Burlington Magazine, CVII, 1965, 747; W. Jaworska, Gauguin et l'école de Pont-Aven, Neuchâtel, 1971; L'Opera Completa di Gauguin, Milano, 1972. *V. van Gogh*: A. Styles Wylie, An investigation of the vocabulary of line in Van Gogh's expression of Space, Oud Holland, LXXXV, 1970, 4; L'opera completa di Van Gogh, I: from Etten to Paris, Milano, 1971; M. Roskill, Van Gogh's exchanges of work with Bernard in 1888, Oud Holland, LXXXVI, 1971, 2-3; C. Mettra, L'univers de Van Gogh, Paris, 1972; P. A. Heelan, Toward a new analysis of the pictorial space of Van Gogh, the Art Bulletin LIV, 1972, 4.

The Pre-Raphaelites: a) General Works: W. E. Fredeman, Preraphaelitism, a Bibliocritical Study, Cambridge, 1965; W. Gaunt, The Pre-Raphaelite Dream, New York, 1966; R. Barilli, I preraffaelliti, Milano, 1967; Q. Bell, Victorian Art-

ists, London, 1967; C. H. Fleming, Rossetti and the Pre-Raphaelite Brotherhood, London, 1967; M. Hardie, Watercolour Painting in Britain, 3 vol., London, 1968; J. Dixon Hunt, The Pre-Raphaelite imagination (1848-1900), London, 1968; A. Grieve, The Pre-Raphaelites and the Anglican High Church, The Burlington Magazine, Vol. CXI, 1969; J. Maas, Victorian Painters, London, 1969; T. Hilton, The Pre-Raphaelites, London, 1970; J. Nicole, The Pre-Raphaelites, London, 1970; P. Quennel, Romantic England, London, 1970; G. Schiff, Zeitkritik und Zeitgluck in der Malerei der Preraffaeliten, in Beitage Zur Motivkunst des 19. Jahrhunderts, München, 1970; J. Steegman, Victorian Taste, Cambridge, 1970; R. Watkinson, Pre-Raphaelite Art and Design, London, 1970; Var. Auth., La peinture romantique anglaise et les préraphaélites, Cat. of the exposition, Paris, 1972; A. Staley, The Preraphaelite landscape, Oxford, 1973; Var. Auth., Preraffaeliten, Cat. of the Exposition, Baden Baden, Nov. 1973-Feb. 1974; J. Murdock, English realism, G. Elliot and the Pre-Raphaelites, Journal of Warburg and Courtauld Institutes, 37, 1974.

b) Individual artists: F. Madox Brown: M. Bennet, Ford Madox Brown at Southend in 1846: some lost paintings, The Burlington Magazine, 839, 1973. *E. B. Burne-Jones*: B. Waters-M. Harrison, Burne-Jones, London, 1975. *W. Crane*: L. Spenser, W. Crane, London, 1975. *H. Hunt*: Var. Auth., H. Hunt, Cat. of the Exposition, Liverpool-London, 1969; J. Duncan Macmillan, H. Hunt's Hireling Shepard: some reflections on a Victorian Pastoral, The Art Bulletin, 2, 1972. *F. Leighton*: L. & R. Ormond, F. Leighton, New Haven, 1975. *J. E. Millais*: Var. Auth., P. R. B.-J. E. Millais, Cat. of the Exposition, London, 1967; E. Morris, The Subject of Millais's Christ, Journal of Warburg and Courtauld Institute, XXXIII, 1970. *W. de Morgan*: W. Gaunt-M. D. E. Clayton-Stamm, W. de Morgan, London, 1971. *W. Morris*: P. Thompson, W. Morris, London-New York, 1967; P. Meier, La pensée utopique de W. Morris, Paris, 1972; A. Ch. Sewter, Catalogue des vitraux de W. Morris et de son cercle, London, 1975; M. Manieri Elia, W. Morris e l'ideologia dell' architettura moderna, Bari, 1976. *D. G. Rossetti*: V. Surtees, The paintings and drawings of D. G. Rossetti, Oxford, 1970, 2 vol.; A. Grieve, The applied art of D. G. Rossetti, The Burlington Magazine, 838 and 839, 1975; P.H. Walton, D. G. Rossetti, Cat. of the Exposition, London, 1973. *J. Ruskin*; G. P. Landow, The aesthetic and critical theories of John Ruskin, Princeton, New Jersey, 1971; J. Clark-Sherburne, J. Ruskin or the ambiguities of Abundance, a study in social and economic criticism, Cambridge, Massachusetts, 1972.

Symbolism: a) General works: E. W. Herbert, The artist and social reform, France and Belgium 1885-1898, New Haven, 1961; R. Barilli, Internazionalità del Simbolismo, L'arte Moderna, Vol. 2, Milano, 1967; G. Briganti, Pittura fantastica e visionaria dell'ottocento, Milano 1969; F. C. Legrand, Il Simbolismo in Belgio - E. Joosten, II Simbolismo in Olanda, Arte Illustrata, July-August-September 1968; Var. auth., Il sacro e il profano nell'arte dei simbolisti, Cat. of the exposition, Torino, 1969; Ph. Jullian, Dreamers of Decadence, London, 1971; F. C. Legrand, Le Symbolisme en Belgique, Bruxelles, 1971; T. Milner, Symbolists and Decadents, London, 1971; E. Lucie-Smith, Symbolist Art, London, 1972; R. Spenser, The aesthetic Movement: Theory and Practice, London, 1972; Var. Auth., French Symbolist Painters, Cat. of the exposition, London-Liverpool, 1972; Ph. Jullian, Les Symbolistes, Paris, 1973; H. H. Hoffstatter, Symbolismus und die Kunst der Jahrhundertwende, Köln, 1973; L. Carluccio, Du Symbole à l'expression XIX et XX siécle, Genève, 1974; A. Mackintòsh, Symbolism and Art Nouveau, London, 1975; R. Pincus-Witten, Occult Symbolism in France, s.l., 1975; Var. auth., Le Symbolisme in Europe, Cat. of the exposition, Rotterdam, Bruxelles, Baden-Baden, Paris, 1976 (with introductory essays by F. Russoli, H. H. Hoffstäter, G. Lacambre); J. E. Bowlt, The Blue Rose: Russian Symbolism in Art, B. M., 881, 1976.

b) Individual artists: A. Beardsley: B. Reade, A. Beardsley, London, 1967. *A. Bocklin*: Var. Auth., A. Bocklin, Cat. of the exposition, Basel, 1977. *R. Bresdin*: D. van Gelder, R. Bresdin, La Haye, 1976, 2 vol. *P. Puvis de Chavanne*: Var. Auth., Puvis de Chavannes, Cat. of the exposition, Paris, 1976-77. *M. Denis*: Var. Auth., M. Denis, Cat. of the exposition, Zürich, 1972. *J. Ensor*: H. Haesaerts, J. Ensor, Tielzeitgenossischen Kritik, Lausanne, 1970. *F. Khnopff*: Ph. Mertens, F. Khnopff, Vlandaaren, 1968. *G. Klimt*: M. Eisler, G. Klimt und die Wiener Jahrhundertwende, Salzburg, 1970. *M. Klinger*: Var. Auth., M. Klinger, Cat. of the Exposition, Göttingen, Tübingen, Wiesbaden, 1977. *A. Kubin*: Var. Auth., A. Kubin, das zeichnerische Fruhwerk nis 1904, Cat. of the exposition, Baden-Baden, 1977 (with introduction by H. A. Peters). *L. Levy-Dhurmer*: G. Lacambre, L. Levy-Dhurmer, in La revue du Louvre et des Musées de France, 1, 1973. *C. Meunier and G. Minne*: Var. Auth., C. Meunier et G. Minne, Cat. of the exposition, Brussels, 1969. *G. Moreau*: J. Kaplan, G. Moreau, Los Angeles-New York, 1974; P. L. Mathieu, G. Moreau, Friburg, 1976. *E. Munch*: J. P. Hodin, E. Munch, London, 1972. *O. Redon*: J. Selz, O. Redon, Paris, 1971. *F. Rops*: Ch. Brison, An Introduction to the life and work of F. Rops, London, 1969. *D. F. Vallotton*: G. Guisan et Jakuben, D. F. Vallotton - Lettres et Documents, Paris-Lausanne, 1973. *J. McNeil Whistler*: D. Sutton, J. McNeil Whistler, London, 1966. *The group-Rose-Croix*: J. Lethève, Les Salons de la Rose-Croix, Gazette des Beaux-Arts, December 1960; M. Fagiolo, 1 grandi iniziati, Il Revival Rose-Croix nel periodo simbolista, Il Revival, Milano, 1974; M. G. Bernardini, Les Salons de la Rose-Croix, Storia dell'Arte, 26, 1976.

Art Nouveau: a) General works: J. Cassou, E. Langui, N. Pevsner, Les sources du vingtiéme siécle, Paris, 1961; R. Schmutzler, Art Nouveau Jugandstil, Stuttgart, 1962; H. Hoffstatter, Geschichte der europäischen Jugendstilmalerei, Köln; l. Cremona, ll tempo del Art Nouveau, Firenze, 1964; M. Rheims, L'art 1900 ou le style J. Verne, Paris, 1965; M. Spielmann, Der Jugendstil in Hamburg, Hamburg, 1965; S. Tschudi Madsen, Art Nouveau, London, 1967; W. Meazek, Die Wiener Werkstätte, Cat. of the exposition, Wien, 1967; Var. Auth., Kunst in Wien um 1900, Cat. of the exposition, Darmstadt, 1967; O. Bohigas, Architettura Modernista, Torino, 1968; H. H. Hoffstätter, Jugendstil Druck Kunst, Baden-Baden, 1968; N. Pevsner, Studies in Art, Archittcture and Design, London, 1968; E. Aslin, The aesthetic movement: Prelude to Art Nouveau, London, 1969; N. Pevsner, L'architettura moderna e il design, Torino, 1969; Var. Auth., El Modernismo en España, Cat. of the exposition, Madrid, 1969; N. Gray, Lettering as Drawing: Contour and silhouette, London, 1970; L. Spagnoli, Architettura e Societa) in Germania (1880-1914), Controspazio, 4-5, 1970; F. Borsi-H. Wieser, Bruxelles, Capitale del Art Nouveau, Bruxelles-Roma, 1971; Var. Auth., Jugenstil, by I. Hernand, Darmstadt, 1971; R. Wassenberger, Die Wiener secession, Wien-München, 1971; G. Naylor, The Art and Crafts Movement, London, 1971; Var. Auth., The Antirationalists, ed. by N. Pevsner-J. M. Richards, London, 1973; M. Cacciari, Metropolis: essays on the great city of Sombart, Endell, Scheffer, and Simmel, Rome, 1973; R. Judson Clark, The Arts and Crafts Movement in America (1876-1916), Princeton, 1973; Ph. Jullian, The Triumph of Art Nouveau, Paris Exhibition, 1900, London, 1974; F. Amendolagine-M. Cacciari, Oikos da Loos a Wittgen-

stein, Roma, 1975; Ch. M. Nebebay, Ver Sacrum 1898-1903, Wien, 1975; M. Massobrio-P. Portoghesi, L'album del Liberty, Bari, 1975; P. Vergo, Art in Vienna 1898-1918, London, 1975.

b) Individual artists: *H. P. Berlage*: P. Singelberg, H. P. Berlage, Utrecht, 1972. *S. Bing*: G. Weisberg, S. Bing, International Dealer of Art Nouveau, The Connoisseur, 709, 710, 711, 1971. *A. Gaudi*: J. Pernecho-L. Pomes, Gaudi, Barcellona, 1968; L. V. Masina, Gaudi, Firenze, 1969. *H. Guimard*: G. K. Koenig-E. Colbo, H. Guimard, Casabella, 329, 1968; Var. Auth., H. Guimard, Cat. of the Exposition, New York, 1970. *J. Hoffmann*: E. F. Sekler, The Stoclet House by J. Hoffmann, Essays in the History of Architecture presented to R. Wittkower, London, 1967; F. Windisch-Graetz, Das Jagdhaus Hochreith, zur Stylanalyse der Raume von J. Hoffmann, Alte und moderne Kunst, 92, 1967; Var. Auth., J. Hoffmann, A. Loos und die Weiner Kunst der Jahrhundertwende, Alte und Moderne Kunst, 113, 1970; M. G. Messina, Hoffmann, l "mobili semplici," 1900-1910, Cat. of the Exposition, Roma, 1977. *V. Horta*: F. Borsi-P. Portoghesi, V. Horta, Roma, 1969; F. Loyer, L'espace d"Horta et H. van de Velde et son foyer, Oeil, February, 1971. *A. Loos*: M. G. Messina, L'opera teorica di A. Loos, Annali della Scuola Normale de Pisa, serie III, vol. III, 1973; A. Loos, Parole nel Vuoto, Milano, 1973. *Ch. R. Mackintosh*: R. Macleod, Ch. R. Mackintosh, London, 1968. *A. Mucha*: B. Reade, Art Nouveau and A. Mucha, London, 1967. *J. M. Olbrich*: K. H. Schreyl-D. Neumeister, J. M. Olbrich, Cat. of the exposition, Darmstadt, 1967; K. H. Schreyl, J. M. Olbrich, die Zeichnungen in der Kunst Bibliothek Berlin, Katalog, Berlin, 1972. *H. van de Velde*: A. M. Hammacher, Le monde de H. van de Velde, Paris, 1967; Var. Auth., H. van de Velde, special number of Casabella, 1967. *O. Wagner*: A. Giusto Baculo, O. Wagner, Napoli, 1970.

Liberty and Pointillism: a) General works. R. de Fusco, Il floreale a Napoli, Napoli, 1959; G. E. Meeks, The Real Liberty in Italy, Art Bulletin, XLIII (1961); V. Brosio, Lo stile Liberty in Italia, Milano, 1967; R. Bossaglia, Il Liberty in Italia, Milano, 1968; F. Bellonzi-T. Fiori, Archivi del divisionismo, Roma, 1968, 2 vols.; R. Barilli, Aspetti di simbolismo italiano, Arte Illustrata, 22, 23, 29, 1969; Var. Auth., Torino, 1902, Polemiche in Italia sull'arte nuovo, ed. by F. R. Fratini, Torino, 1970; F. Bellonzi, A. M. Brizio, R. De Grada, P. L. De Vecchi, M. Rosci, Mostra del divisionismo italiano, Cat. of the exposition, Milano, 1970; G. Pirrone, Palermo Liberty, Caltenissetta-Roma, 1971; Var. Auth., Aspetti dell'arte a Roma (1870-1914), Cat. of the exposition, Roma, 1972, ed. by D. Durbè (with introductory essays by P. Frandini, G. Piantoni, A. M. Damigella); A. P. Quinsac, Le pienture divisionniste italienne (1880-1895), Paris, 1972; E. Bairati, R. Bossaglia, M. Rosci, L'Italia Liberty, Milano, 1973; Var. Auth., Liberty a Palermo, Cat. del exposition, Palermo, 1973 (with papers on the Bilancio di Studi sul Liberty and essays by A. Alfano, A. M. Damigella, M. Leva Pistoi); M. Nicoletti, Art Nouveau in Italy, in The Antirationalists, op. cit; Var. Auth., Mostra del Liberty, Cat. of the exposition, Milan, 1974; Var. Auth., Situazione degli studi sul Liberty, by R. Bossaglia, C. Cresti e V. Savi, Firenze, 1977; Var. Auth., Il Liberty a Bologna e nell'Emilia Romagna, Cat. of the exposition, Bologna, 1977; Var. Auth., Archivi del Liberty, by R. Bossaglia, Roma.

b) Individual artists: E. Basile: G. Pirrone, E. Basile designer, Comunnità, 1965, 128. *D. Cambellotti*: A. M. Damigella, Idealismo e socialismo nella cultura figurativa Romana del primo '900: D. Cambellotti, in Cronache di Archeologia e Storia dell'Arte, 1969, 8; M. Fagiolo, D. Cambellotti, Roma, 1976. *G. Pellizza da Volpedo*: A. Scotti, Il quarto stato, Milano, 1976. *G. Previati*: Var. Auth., G. Previati, Cat. of the exposition, Ferrara, 1969. *G. Segantini*: L'opera completa di Segantini, Milano, 1973 (presentation by F. Arcangeli).

GIANNA PIANTONI AND MARIA GRAZIA MESSINA

PART IV

THE 20th CENTURY
AND
PROBLEMS OF CONTEMPORARY CRITICISM

SUMMARY

ARTISTIC TRENDS AND EXPERIENCES

SYMBOLISM AND RUSSIAN AVANT-GARDE (PLATES 141-142)

INFORMAL ERA/ABSTRACTION (PLATES 143-146)

THE NEW REALISM (PLATES 147-150)

Prehistory: The new awareness of a modern nature. — The New Realist group: theory and facts. — The diffusion of the theory.

POP ART AND NEO-DADAISM (PLATES 151-152)

SUPERREALISM/HYPERREALISM (PLATES 153-154)

BEHAVIORAL ART (PLATES 155-156)

Definition of the area. — Historical models. — The "situation" and the "drift." — Fluxus and happenings. — The actions.

MINIMAL AND CONCEPTUAL ART (PLATES 157-158)

VISUAL POETRY (PLATES 159-160)

The alphabet and poetry. — Pre-literary visual poetry. — From symbolism to concrete poetry. — From concrete poetry to "spatialism." — Asemantic concrete poetry. — Visional writings. Visional poetry. — Visual poetry. — Later developments.

NEW ARTISTIC TECHNIQUES

PHOTOGRAPHY

Optical and chemical research. — The inventors. — Artistic use of the calotype. — Diffusion of the negative on paper. — The wet collodion process and the first war reportages. — The daguerreotype and photographic portraiture. — Motion photography. — Photographic aesthetics. — Alfred Stieglitz and "pure photography." — Documentary photography. — Avant-garde photography. — Photojournalism. — Later developments.

CINEMA

Trends and theories. — Color and environment. — The avant-garde film. — Cartoons. — Art films. — Festivals, exhibitions, and museums.

ILLUSTRATION (PLATES 161-163)

COMICS (164-165)

ADVERTISING AND THE URBAN SCENE (166-170)

Advertising communication. — The city as a communication tool.

KITSCH

Definitions. — Kitsch and social aesthetics. — The characteristics of Kitsch. — Brief history of Kitsch. — The rise of neo-Kitsch. — Several Kitsch phenomena: a) Tourism; b) Souvenirs; c) Religious Kitsch; d) Religion as Kitsch; e) Scientific Kitsch. — Anti-Kitsch. — Kitsch and the artistic movements.

NEW METHODOLOGIES AND CRITICAL ISSUES

AESTHETICS AND THEORIES OF ART

Introduction. — Psychoanalysis of art. — Jung's analytical psychology. — The set-back of psychoanalysis as a theory of art.

INFORMATIONAL AESTHETICS AND STRUCTURALIST THEORY OF PERCEPTION

Introduction. — Content of the doctrine. — Conceptual evaluation. — Extension of informational attitude. — Limits of the receiver's capacity. — The role of measure in aesthetics. — Criticisms and obstacles. — Experimental works. — The development of informational aesthetics. — Applications and orientation. — Socio-aesthetics under society's cultural patrimony. — Perspectives on an aesthetic sociology in the computer age.

SEMIOTICS

Introduction. — 17th and 18th centuries: Locke and Lambert. — Logic and semiotics: Frege, Peirce. — Linguistics and semiotics: Saussure and Hjelmslev. — Semiotics today: problems, limits, application.

POPULAR ART IN A CONTEMPORARY PERSPECTIVE

First definition of popular art. — The Italian tradition of studies on popular art. — Tradition and renewal. — Debates and orientations: a) The discussion of aesthetics; b) Mukarovsky and the detail as semantic unit; c) Two interventions on Mukarovsky. — Popular art in the framework of research on popular culture: a) Folklore and the "popular;" b) Folklore between city and country; c) Linguistics and semiology; d) Production, circulations, use; e) Objects of use, techniques, craftsmanship, minor arts. — Research on particular aspects of popular art. — Some further issues: mass communications, Kitsch, cultural patrimonies, market, museums. — Conclusions.

CONTRIBUTIONS TO THE STUDY OF URBAN SHAPE

URBAN SHAPE

Introduction. — Studies in the first half of the century. — Studies in the decade 1950-1960. — Studies after 1960.

URBAN DECOR

THE GREAT EXPOSITIONS (PLATES 171-172)

The competitive conception of the 1800s. — The exhibition as propaganda in the early 1900s. — The Post-World War I renewal of the expository structures. — Post-World War II: the balance of conflict and the nationalistic revivals. — The affirmation of technological ideology.

OUR ARTISTIC AND CULTURAL HERITAGE

PRESERVATION AND MANAGEMENT OF CULTURAL GOODS (PLATES 173-176)

Introduction. — Legal tools and operative structures. — Knowledge as a presupposition for protection. — Preservation as research program and system.

MUSEOLOGY

The museum debate. — Museum design and its problems.

ARTISTIC TRENDS AND EXPERIENCES

SYMBOLISM AND RUSSIAN AVANT-GARDE (PLATES 141-142)

Studies of Soviet and Russian avant-garde movements of the 1920s and 1930s have evolved considerably in recent years. Camilla Gray's book, *The Great Experiments: Russian Art 1863-1922* (London, Thames & Hudson, 1962) represents the first serious effort at providing a coherent overview not only of the Suprematist, Constructivist, and Productivist movements, but also of the linear continuity of Russian art. This continuity, starting from 1863, justified the persistence of certain concepts and of certain poetic elements in a time when a most dramatic break occurred with traditional forms of expression. This break was brought about by extreme modernist artists such as Malevich, Tatlin, Chagall, and Kandinski. Gray's book may seem incomplete due to the real difficulties encountered by the author in finding reference data. Nevertheless, her work is interesting and essential for starting any discussion on this art. One must add also the work by Troels Andersen (*Moderne Russisk Kuknst* - Modern Russian Art - *1910-1925*, Copenhagen, 1967) and such theoretical and documentary material as the collection of writings by Kazimir Malevich, translated into English by Troels Andersen himself, and the French edition revised by Andrei B. Nakov (Paris, Editions Champ Libre, 1975). One should also include numerous articles and documents that have appeared in Italy in the "Rassegna Sovietica" - Soviet Review - in January - March 1965 (texts by N. Punin, I. Puni, A. Rodchenko, K. Malevich, El Lisitskij, I. Ehrenburg, D. Arkin, O. Brik).

All of the above works, particularly Gray's book, have shed light on lesser-known or neglected artists such as Filonov, Popova, and Rojanova. Most important, through these works it has been possible to better define the cultural elements that characterized the avant-garde movement (from various essays by A.M. Ripelino to the publication of the volume by V. Markov, *Russian Futurism: a History,* 1968) and the parallel development of figurative, musical, and literary expressive forms. This unit of which applies to European avant-garde from post-impressionism to surrealism, unfolds itself clearly in Russian and Soviet movements especially in its relationship to political action and organization. The artists of the time held this action as essential and predominant in that particular historical period preceding and following the October Revolution.

In fact, reflections of such poetics and concepts still appear to this date, notwithstanding the long interruption in research on the avant-garde period. One can still find a strong mysticism expressed by such painters as Malevich. This mysticism was not born with Malevich but was derived from a cultural tradition of Russian symbolism, and it can be found in certain works of writers known as dissenters or, even more, at higher level, in the works of such great movie directors as Tarkowskij (an example being the World Conception inspired by films such as "Solaris" or "Rublev"). Indeed, it was the attention on Malevich, encouraged by the publication of his theoretical literary works and of his fundamental work, "Suprematismus - Die gegenstandslose Welt," 1927 (republished by Du Mont Schauberg, Cologne, 1962), and above all by a series of exhibits that led to a better understanding of these implications and of their relationship with spiritualistic trends and Bely's and Berdiaev's philosophies. This applied also to iconography, which preserved extremely powerful symbolic traits even after 1913, when it was led toward total abstraction. Such symbolic traits were often rooted in the traditional symbolism of popular Russian art. (This applies also to Chagall and El Lisitskij's iconographies. In fact, it should be noted that these artists, together with Ivan Puni, worked in Vitebsk between 1917 and 1919 at the Fine Arts school under Chagall).

An additional contribution to our understanding of Malevich has been made by the exhibits of his works, especially by exhibits organized by Amsterdam's Stedelijk Museum, the Western museum which holds the greatest number of Malevich's works. This museum published a catalog also on the paintings exhibited by Malevich in 1927 in Berlin. Altogether important has been the exhibit of Malevich's graphic arts which began its tour at Israel's Museum of Jerusalem (1975) and was later shown in various European cities including Venice (Querini Stampalia Foundation) in 1976. This exhibit emphasized further the search for cultural unity and harmony among the art of the Novis group, to which Malevich belonged, the theory of the transmental expression "Zaum" of Krucenych, and poets such as Chlebnikov and musicians such as Matjusin. Furthermore, now that there is no evidence of Marinetti's visit to Russia in 1910 or 1911 (though the influence of Italian futurism is still undoubtedly present) it seems clearer that Malevich's persistent reference to "surrealism" as an element of his own "futurism" applies also to cubism as proved by Malevich's interpretation of Cezanne's art. In fact, wrote Malevich: "With a clear, incisive individuality, Cezanne has become aware of the cause of geometrization and he has conscientiously explained how the cone, the cube, and the sphere are the elements on whose principles it was necessary to build nature, reducing therefore the object to a simple geometric expression."

Cezanne, therefore, laid down the basis of cubist art which evolved in France under Braque, Picasso, Leger, Metzinger, and Gleizes and which grew in Russia through new trends toward alogism (surrealism). Fur-

thermore, Cezanne gave new impetus to a new pictorial style by inspiring himself to impressionism. He was able to portray a sensation of movement in expressionist forms toward contrast. One can observe this phenomenon in his works wherein all straight horizontal lines reach almost toward the center of a vertical line or to the center of the painting, while all irregular curves join together in contrast to the surface and to the volume, and the volume places itself in contrast to the surface ("O Novykh Sistiemakh v i Iskousstvie, Vitebsk, 1919). Apollinaire, for example, wrote that Cezanne "had been able to raise impressionism to an art of reason and culture" (G. Apollinaire, "Figures de Cezanne chez Vollard," "L'Intransigeant," Paris, September 27, 1910). Malevich considered Cezanne the forerunner of "alogism." By underlining certain aspects of Cezanne's compositions, the vertical and horizontal lines, the curves, the contrasts, he interprets them as clearly symbolistic works.

Through this interpretation and through other similar critiques, El Lisitskij agreed that

> Suprematism enclosed dynamics, which is in itself a form of energy. Suprematism did not represent a movement like impressionism nor did it represent futurism. Suprematism established a relationship between colors and surfaces and gave shape to dynamic tensions. As a result of Suprematism, a style rose that conveyed inner vigor. This style was pure in its colors and precise and clear in all of its aspects. Each structured surface was a sign and not a mystic symbol, but a complete outline. A sign is a form in which a phenomenon is expressed. A sign can be conceived in two ways. First there must be an agreement on the meaning of signs. Therefore an outline is drawn, for example of a city on a flat piece of paper; an example being a city map. This drawing can be interpreted because the meaning of the signs has been established a priori. In the same fashion, the globe is represented by two circles in a map and the immensity of the starry sky by dots on an atlas. Yet through these signs we are expressing something which already exists and that has already been built. These signs have been created by us and have become clear to us as our intellect evolved to the present state from its most primitive origins. A sign is created, yet much later does it acquire a name and even later a clear meaning. For the same reasons we do not understand the signs and the outlines created by artists, because man's brain has yet to evolve to a more sophisticated stage. Suprematism held new criteria for appreciating all that falls within plastic creation. If on the one hand Suprematism was the consequence of the entire pictorial heritage, on the other its chromatic intensity and its world view were rooted in the Russian village.

(From a 1922 conference on "New Russian Art" whose typescript is preserved in Moscow's Central State Archive for Art and Literature. Published in "El Lisitskij, Maler, Architekt, Typograf, Fotograf" by Sophie Lisitskij-Kuppers, Verlag der Kunst, Dresden, 1967). Notwithstanding the obvious distinction between "mystic symbol" and sign, it would be impossible not to notice that the sign fills itself with clear symbolic meanings (one should not forget that Roman Jakobson could be found next to the artists of the Soviet avant-garde).

We have previously mentioned the iconographic similarities existing between Chagall and El Lisitskij. El Lisitskij's reference to the "Russian Village" confirms such similarities and sets forth, under a different perspective, the influence exercised by Chagall on the other artists that worked with him in Vitebsk, Malevich included. Marc Chagall had returned to Russia from Paris in 1914. During the revolution Lunacarskij, whom Chagall had met in France, nominated him commissar for the fine arts of the Vitebsk governorship. It was Chagall who brought to the art school El Lisitskij, Ivan Puni, and Kazimir Malevich. Differences between Malevich and Chagall were great; nevertheless, the influence exercised by Chagall on his colleagues is clear and particularly the influence exercised over El Lisitskij's figurative art and especially on his illustrations for the "Popular Ukrainian Fables" made in 1919. In fact, it seems that Chagall's influence went even further, for it not only affected the figurative works but also other non-figurative works of El Lisitskij and Malevich himself. For example, a "Cubist Landscape" (Bern - private collection) painted by Chagall in Vitebsk in 1918 assumes a particular meaning as expressed by Lionello Venturi, who wrote: "Chagall's work conveys the impression of an animated cubism, somewhat futuristic, slightly and suspiciously ironic" (L. Venturi, *Chagall,* Geneva, Skira, 1956). This may be the starting point for understanding the innovative function (which to this day has not received due recognition) that Chagall exercised in the Soviet Union around 1918. Certain rhythms and certain fantastic shapes of that period (self-portrait of 1917; the famous Goat Composition, 1920, belonging to a private collection in Paris; the 1917 "Forward Painting") seem to have had a direct influence on El Lisitskij, even on his famous 1920 Manifesto "Strike the Whites with the Red Wedge" as far as dynamism and style are concerned. There are further similarities between certain scenes that Chagall made in 1919 for Moscow's Jewish Theater and the sketches drawn by Majakoskij for his "Amusing Mystery."

However, an analysis of the strong symbolic components that characterized the art of that period cannot be complete without considering the influence exercised by Majakovskij on the entire Soviet culture immediately after the Russian Revolution. For this purpose, it is extremely important to cite the documentation that Majakovskij, the poet, gathered in 1929 in setting up an exhibit that would display the "Twenty Years of Work" carried out by himself and by other exponents of the avant-garde. The exhibit, inaugurated in Moscow's Writer's Union Building in February 1930, was subsequently entrusted to the State Museum for Literature where it is still kept as Majakovskij had originally planned. The documentation is impressive, representing the cultural period which it intended to portray with a spirit of cultural unity.

The works acquired a special significance due to their connections to the unique social situation and to revolutionary aspirations of the period preceding and following the 1917 revolution. It was an experience not shared by other movements of the European avant-garde; it was in fact a dialectical connection, not lacking contradictions, yet determined by the firm conviction

that renewal would coincide with the conquest of freedom (as it was made clear by El Lisitskij's view on Suprematism). The conquest of freedom would then be followed by the defeat of all hierarchies, by the academic separation of various disciplines, and by the certain overcoming of a culture that belonged definitely to the past. At the end of the 1920s, the movie director Mejerchol'd wrote to Lunacarskij: "It does not appear to me that the truly revolutionary art of the counter-reliefs [his reference to Tatlin was evident - the art of volumes and surfaces, which replaced many ugly paintings-] has come to a standstill. Instead, due to its strength it moves forward with its fencing cap exposed to all blows. In directing its arrows against the enemies the Commissar of the People has injured me also. Nonetheless, I am still willing to fight, I seize my banner and, surrounded by the army of my followers, I shall never lay down my arms until the final victory. Three times long life to our Great Revolution! Charge dear comrades, and may Lunacarskij be with us." The reply, published by Vsevolod Mejerchol'd in "Vestnik Teatra" of December 14, 1920, was addressed to the People's Commissar, that is, Lunacarskij, who sometime before had criticized both Mejerchol'd as well as Majakovskij in an article entitled "To my Opponents."

By observing and taking into consideration the material gathered by Majakovskij for the exhibit "Twenty Years of Work" (placards, drawings, photographs, books, projects, and reconstructions of scene-paintings) one has a clear idea of what Mejerchol'd intended to accomplish through art: that is, march forward with an impetuous and unison step without any class distinction, unequivocally, so as not to factiously exclude any linguistic expression. Majakovskij appears certainly like a demiurge of every experience, but what Mejerchol'd affirmed was intended to underline the common origin of all avant-garde painters, poets, and movie directors. For them art could not have been a private matter; on the contrary, it had to project itself toward the exterior by becoming an efficient communication channel.

Undoubtedly, the Russian and Soviet avant-garde had gathered and developed themes of Western avant-garde taking into careful account the cubist and futurist innovations. In 1915 Larionov, together with Diaghilev, visited the studios of Balla and Depero. In 1917, in Rome, at the Teatro Costanzi, Diaghilev's choreographer, Leonide Massine, exhibited certain works from his collection including paintings by Carra, Balla, Depero, Larionov himself, Leger, Picasso, Goncharova, Juran, Gris, and Gleizes). Notwithstanding the differences that emerged in linguistic solutions, there were other substantial differences. One should keep in mind, however, that the strong symbolic and secessionist elements found at the origins of Italian futurism apply also to Soviet avant-garde. Aleksandr Blok and Vladimir Markov traced the origins of Russian avant-garde to an impressionism which in reality was a form of symbolism.

Keeping this in mind, one must admit that just as Italian futurism began to lose its momentum (after 1916, following the death of Boccioni and when Carra undertook his metaphysic adventure) the Russian avant-garde movement started to define and criticize itself. Even Lunacarskij, who in 1913 had expressed a very negative opinion on cubism and futurism, later modified his views. Nevertheless, he had been right to a certain extent in criticizing the futuristic subjectivism and what he perceived as a crisis in creativity which could have been resolved only through an "adequate emancipation of society." Speaking at the International Congress, Antonio Gramsci stated on January 5, 1921,

The futurists are revolutionaries in their field, that is in the field of culture. Within culture, it is probable that the working class will not be able, for a long time, to accomplish more than what the futurists have accomplished. When workers supported the futurists they showed no fear of the "destruction" and felt confident of being able to master writing, poetry, drama, and painting just like the futurists. These workers supported the historicity and the possibility of a proletarian culture, established by the workers themselves.

In reality, Gramsci's opinion seems to apply more to the Soviet avant-garde movement than to Italian futurism, plagued by so many ideological contradictions. The actions of the Soviet avant-garde movement, though at times contradictory, encompassed Suprematism, Constructivism, Productivism, and so forth. Going back to Italian futurism, Gramsci himself was compelled to admit a year later that "after the peace conference the futurist movement lost entirely its character and faded out into different currents that evolved in the post-war years. The young intellectuals were generally very reactionary. The workers, who saw in futurism the elements of a struggle against the old, and alien, Italian academic culture, had to struggle for their freedom and displayed little interest for old disputes" (Letter to Leon Trotsky of September 8, 1922).

The situation of Soviet artists was quite different. It was their diversity which distinguished Malevich, Tatlin, Majakovskij, and others from the Western avant-garde movements. For these authors, art was no longer divided into air tight compartments nor distinguishable among traditional genres. Instead, it encompassed literature, painting, sculpture, theater, and the new mass communication means. This new movement set forth a new art devised in accordance to the needs of the new society. It was intended to underline and vindicate a new historicity of art unrelated to the historicity having idealistic and positivistic origins. Certainly for these artists art was a super-structure which expressed, represented, and interfered with structure and expressed the reality of a social condition.

For this reason Majakovskij was not only a poet or a painter or a theoretic. According to Trotsky, Majakovskij

has a great and powerful talent. He is capable of using things that had been seen many times before in a manner to make them seem new. He dominates words and expressions like an audacious maestro who performs according to his rules, whether his performance is appreciated or not. Many of his images and expressions have entered literature and will stay there forever, or at least for a very long time. He displays his own structure, rhythm, and rhymes. The artistic trait of Majakovskij is almost always expressive and at times majestic. The poet places under his jurisdiction war and

revolution, heaven and hell. Majakovskij displays hostility toward mystics and bigots and toward man's exploitation of fellow man. He sympathizes totally with the fighting proletariat. Art as a vocation is alien to him. Instead, he is always ready to put his creativity at the complete service of the revolution.

(Leon Trotsky, "Futurism and Majakovskij," Literature and Revolution, 1923).

During the period when Majakovskij was involved in propaganda activities, on his own and in collaboration with Ceremnych and other painters, he was able to fully complete the objectization of a reality and of a condition. The moment of critical reflection was indeed an essential component of all Soviet avant-garde. For this reason, Majakovskij was a key and central character. The manifestation of Malevich's Suprematism was already born, perhaps not through direct collaboration with Majakovskij, but certainly through his theoretical influence. The critic Aleksei Aleksandrovic Gvodioz wrote in a booklet (published in Leningrad in 1927) dedicated to the Mejerchol'd Theater, that the producer "in organizing the theater and the spectacle displays his own ideological views. Following his path, the theater penetrates the art of a certain period and fulfills a specific social duty as a power instrument that organizes class conscience." However, added Gvodioz, "The ultimate blow to the old theater, to those old anti-historical theatrical traditions, came from Majakovskij himself through his "Amusing Mystery," whose theatrical version Mejerchol'd had produced. This play "reflected the period of the revolution by taking sides with the revolution and attacking its enemies . . . such as the Menscheviks. Workers appeared on stage set to demolish heaven. Heaven with its white clad winged characters was mocked without respect." In addition, there was a fortunate meeting of ideas and programs of the great representatives of the avant-garde, movement such as Stanislavskij, Mejerchol'd, Malevich, Talin, and El Lisitskij, not to mention the producer Sergei M. Eizenstein and his use of the Suprematist and Constructivist expression. This unity pointed to a common desire to achieve choral creativity in its institutional form, perhaps by transcending art itself. This creativity stemmed from participation without any distinction of linguistic schemes, a participation originating from a critical conscience which was fundamental to all contemporary art, starting from the 19th century. This critical conscience was particularly emphasized by the Soviet avant-garde which was able to overcome the influence of European symbolism and decadence by defining the same art, not through a generic vitality but through a definite revolutionary flavor.

BIBLIOGRAPHY - For a more detailed bibliography, especially for material in the Russian language, see Camilla Gray, The Great Experiments, Russian Art 1863-1922, London, 1962, Milan, 1964; For Malevich, see 'Scritti', Andrei B. Nakov, G. Habasque, Documents inédits sur les débuts du Suprématisme, Aujourd'hui, n. 4, 1955; M. Aschenbrenner, Farben und Formen im Werk von K. Malevich, Quadrum, n. 4, 1956; M. Larionov, Souvenirs de Malevich, Aujourd'hui, n. 15, 1957; A. Pevsner, Rencontre avec Malevich dans la Russie d'après 1917, Aujourd'hui, n. 15, 1957; P. Mansurov, Les débuts de l'art abstrait en Russie, Aujourd'hui, n. 15, 1957; W. Sandberg, Malevitch et P. Mondrian, Aujourd'hui, n. 15, 1957; M. Calvesi, Il Futurismo russo, L'Arte Moderna, vol. 5, Milano, 1961; C. Belloli, Il contributo russo alle avanguardie plastiche, Galleria del Levante, Milano, 1964; N. Chardžiev, Appunti sull'avanguardia russa, Paragone, n. 183, 1965; Rassegna Sovietica, n. 3, 1967; by El Lisitskij, V. Quilici, J. A. Tugendchol'd, E. Semenova; Cimaise, n. 85-86, 1968; Michel Hoog, Jean-Jacques Levêque, Roger van Gindertael, Miroslav Lamac, Michel Ragon, Julien Alvard, Marc-Albert Levin, J. C. Marcadé, John Franklin Koenig; A. Del Guercio, Le avanguardie russe e sovietiche, Milano 1970; M. Volpi-Orlandini, Note sull'avanguardia russa e K. Malevich, Annali della Facoltà di Lettere, Filosofia e Magistero dell'Università di Cagliari, vol. XXXIII, 1970; A. Del Guercio, Pour une histoire qui reste á écrire: l'avant-garde russe, Opus, n. 24-25, 1971; V. Quilici, Futurismo e costruttivismo, Controspazio, n. 4-5, 1971; N. Chardžiev, Russkie Kubo-futurusty, Rossya-Russia, n. 1, 1974; 'L'avanguardia dopo la rivoluzione. Le riviste degli anni Venti nell'URSS,' edited by L. Mangarotto, Roma, 1976; K. D. Muratova, 'Ešeegodnik Rukopisnogo otdela Puškinskogo doma na 1974,' Leningrad, 1976, with contributions by B.N. Kopeljuš, A.E. Kručěnych, K. Malevich; J.E. Bowlt, Russian art of the avant-garde: Theory and criticism, 1902-1934, New York, 1976.

NELLO PONENTE

INFORMAL ERA/ABSTRACTION (PLATES 143-146)

The art critic N. Ponente has examined the phenomena that had developed as "informal experiments" in various cultural circles throughout the 1950s. The quest for novelty and for an accelerated revival of the art market during the early 1960s, with the huge influx of American art onto the European market, brought about the new movements of New Dada and Pop Art, which virtually decreed the death of the Informal Era in a way which appeared sudden and complete. In reality, though, some of the more significant protagonists of the Informal Era (for example, Burri, Dubuffet, and Vedova) were to continue and further their work during the next decade, but the ideological push which had supported the era had been superceded by new historical situations and by new urgent problems, so much so that the Informal Era, as a basic cultural attitude, remains essentially tied to the more general development of the 1950s. Although a discussion about the facts of the Informal Era can only be a repetition of Ponente's analysis there is room to discuss the general, sometimes uneven, development of the history of criticism of the Informal Era, which took place mainly in the 1960s. We should also examine modalities and critical methods used, as well as the extent to which we can adopt the concept of "historical" as relating to this era.

The early critics appeared, for example, in a 1961 edition of "Verri," which was totally dedicated to the Informal Era and open to contributions from art and literature historians, from linguists and philosophers. This initial debate was characterized by radicalizing and interpreting the era's key elements and by the consequent judgment of the Informal Era as an absolute and unwavering irrationalization and, therefore, as an abandonment of art to meaningless expressions or to subjects which had no significance except in their basic

physicality. It was seen as the art of negation - a complete stylistic and especially ideological break from any previous art tradition. In this kind of radicalization, various different idealistic hypotheses are presented, but they all give a literal interpretation to the refusal of the Informal artist to control his expression on canvas or to control his subject-matter, and they all see in this refusal an explicit attack on the persistence of exemplary "values" which art was supposed to support and endorse. On the other hand, the fact that these interpretations were basically aesthetic in character means that they are probably inadequate to understand a phenomenon such as the Informal Era: they were on the wrong track for a figurative movement which ignored any systematic aestheticism. This can be seen by looking at a few Informal artists, where we notice the affirmation and persistence of beauty and poetry - not by putting this "poetry" into a dialectic context, but by opposing it to the general negativity of the tide.

These "condemnations" of the Informal Era could be seen throughout a whole range of critical standpoints. In his "Verri" article, Brandi goes back to the argument of his 1960 essay and speaks of the "Informel" as an alteration of the traditional distinction between symbol and image, which alone can provide the symbolic communicability of artistic expression. Such a distortion is a "symptom of a serious change which threatens or blocks the cogs of civilization" and causes the Informal Era to swing inevitably between two poles: "on the one hand the decorative offering, and on the other the meaningless symbolic offering." And the allusiveness of an Informal symbol lending itself to free interpretation can only be read on a psychoanalytical level, in which, in a schematically rationalistic vision, "the claim of the Informal Era to have established a direct line from the psyche to the hand without passing through the filter of the conscience brings the conscience down to the level of an animal psyche."

From the explicit condemnations of the critics who saw only "monotony and stereotype, radical inarticulacy of a kind of exclamatory, undeveloped expression" (Cecchi), with moments of "quality" - not denied by the critic in aesthetic terms - which are noticeable by their "preciousness of competing subject-matters with the multi-colored shine of the fused-glass collages, and with the flowered cabbalistics of oriental rugs," we move on to condemnations based on the more articulate reasoning of ethics and philosophy. All critics, however, were in basic agreement about the need to try to save the image of the creator-artist, who should either "express" values of freedom which are negated by the "quest for denial" and by the fatal self-destruction of the Informal "express" artist (Devoto), or express hidden values of recomposition in aesthetically reassuring units. Real inconsistencies should be perceived phenomenalogically, but the Informal artist, by not emerging from these, alienates himself radically from perceptive and material feelings (Paci). The irrelevant, Informal discomposition, therefore, becomes a "projection of abstract and gratuitous reasoning onto perception . . . falser and more dogmatic than the old naturalism, testimony to laziness, documentation (not expression) of the loss of meaning of life" (Paci).

At the base of these interpretations of the early 1960's was a form of time-consolidated idealism - that same idealism which prevented Italian culture from understanding avant-garde movements which had, in more or less contradictory ways, attacked the institution of "art" as a separate and privileged realm. However, even in more recent criticisms an occasional similarly generalized interpretation of the Informal Era has reappeared - even in criticisms which are more up-to-date and which have developed from an intense re-examination of those same avant-garde movements. Once again, all American Action Painting is seen only as an interest in irrational and unconscious manifestations, as a phase of absolute subjectivity given over to chance and instinctive impulse, as a desire to re-establish the primal activity of painting as a mythical and mystical identification of the self with the work (Celant). It is significant that this reappearance of the use of generalized and, as such, deviant categories of total irrationality and subjectivity does not just have the instrumental purpose of dialectic contraposition; it does not just have the purpose of illuminating by contrast those contemporary currents (from minimal to new abstraction and to certain aspects of concepual art) in which one could discern the move from Informal painting as a register of expression to the "art as art" form of painting as a redaction and analysis of ideas. The more fundamental reason for the use of these categories lies rather within the critical viewpoint from which the analyses of both Action Painting and "art as art" stem: in the face of an aesthetic experience in knowledge which becomes more and more reflected onto itself, this viewpoint runs the continual risk of seeing the experience become increasingly rare and change from "knowledge" to just "consciousness," lying beyond history as the sole reality able to qualify history.

No less abstract than these negations - and just as radical - is the acceptance "in toto" of Informal Art, seen in the light of the affirmation of a new, unconditioned freedom of expression, or in the light of a proposition of new linguistic methods, of new ways of communicating and of bringing about the artistic object. In this explanation one can trace the key interpretation of continuity from the experiments of the early 20th century. The whole Informal Era - "a response provoked by disquietening visions of reality and of modern science in the subconscious of contemporary man" - is a development from surrealistic automation (Haftmann). One can also trace the heroically-based exaltations of the Informal Era as a radical renewal of the same concept of creating art directly from historical avant-garde movements. The neo-romantic, rebellious characteristic of the era has been seen, along with the integral involvement of the artist with his work (Hunter), and to this characteristic has been added, as corollary, the Informal discovery of disrupted expressive forms which, in themselves, would witness the full exploration of original and germinating moments of thought and of the phenomenon of life (Paulhan) or of emotional life in its fullness and truth (Haftmann). And again, with a distinguished cultural imperialism there has been an emphasis on the influence of Action Painting on the defining of a new attitude towards artistic creation and on the beginning of a unifying force which was to give birth to a New York School, opposed to an exhausted European culture, but heir to the universality and to the irradiation strength of a symbolic Ecole de Paris, the coming together of the great currents of the early 20th century (Geldzahler).

In this same idea of "total recovery," the most complex interpretations are those which move their attention from the key approach of sensitivity, emotion, and beauty, to one which tends to present itself as "scientific" to guarantee an objective (not a poetic or aesthetic) analysis of the Informal phenomenon, "as a true and real culture or, rather, counter-culture, characterized by a coherent style to solve problems of art, literature, knowledge, and life - in short, a bringer of a complete world vision" (Barilli). These are the most significant theses in the history of Italian criticism of those years - witnesses to the field of figurative investigation into a vast technical, scientific, mostly intellectual vocation, attentive during the economic boom to the problem of two cultures and to the search for possible integration of the old humanistic standpoint with modern scientific knowledge.

We can trace a platform, a common gnosiological basis of the Informal Era, which, along with phenomenology, existentialism, and pragmatism, supercedes the opposing positions of "realism" and "idealism" and preaches "the relationship, the close binomial link between subject and object, their co-operation and joining within a single structure, in which it appears theoretically impossible to distinguish where one finishes and the other begins" (Barilli). And from here spring the characteristics of the Informal "expression": no pure existential act deprived of recourse or openings which would exhaust itself of its testimonial value, but a path towards knowledge which refuses contemplation, implies practice, leaps from and reconquers the world, violently broadening the linguistic techniques, instruments and methods traditionally assigned to art.

Or, starting from a re-examination of the changes in the concept of Form which have appeared in the artistic language of the 20th century, we can recognize in the Informal Era - the culminating moment in this sense of the development of modern art - not the abandonment of Form as a basic condition of communication, but a negation solely of the unity of direction towards a privileged meaning of the classical Form and the replacement of such unity and restriction with an open concept of Form as a "field of possibilities" (Eco). An analysis of this kind clearly touches one of the focal points of Informal Art, which has been both object of and reason for the most bitter condemnations: if we think of Levi Strauss' "Il crudo e il cotto" and his interpretation of the Informal Era as a "serious illusion" - common to all abstract art - in its ability to organize form and color "by following the rules of a code independent of sensitive experience." Far from constituting a language, the forms of non-figurative art would be more like "creatures of caprice, thanks to which we can abandon ourselves to a combined parody" of meaningless units.

Where the Informal refusal of reasoned linguistic convention - a refusal pushed to the limit by breaking every single rule - had been interpreted as the enclosure of "symbol" or "expression" into a sphere of such radical self-significance so as to present itself as incommunicable, Eco finds a semantic and communicative richness - multi-directional in its messages and available at many levels of achievement. This richness places conscious aesthetic activity alongside the most general vision of the world as seen by contemporary scientific methodology. "We are talking about [artistic] structures which appear as epistemological metaphors, structural solutions to a diffused theoretical knowledge: the reconfirmation in art of those categories of indetermination, of statistical distribution, which regulate the interpretation of natural facts . . . This is the function of open art: in a world in which the discontinuity of phenomena has ruined the possibility of a unified and defined image, open art totally confronts the task of presenting us with an image of discontinuity: not the telling, but 'the is'" (Eco).

Both types of analysis examined above have doubtless enriched the investigation of the Informal Era with new interpretative categories, as well as with wide, sweeping explanations such as the "open art" of Eco. But their abstraction is revealed in their attempt to provide a global, all-embracing picture of the Informal Era and to define it by means of a methodological grid totally from within the contemporary philosophical, semeiological and psychological debate, from which they take their formats and categories - formats which then become value criteria for artistry. The linguistic grid, the notion of the "field of possibilities," ends up by being too bare, as it individualizes from the general trend of contemporary culture as a whole - a "Kunstwollen" (Eco) - and it therefore risks turning itself into an atemporal judgmental category. On the other hand, the idea of the "worldly vocation" of the Informal Era is too restricted, ignoring all these moments in which mutual relationships in themselves appear insufficient - and thus Barilli falls into the "aberration" of abstraction, as in the case of Fontana and Burri.

Beyond this implied but fundamental ahistoricity of the two methods, the needs of both types of art critic for proof similar to that used by contemporary science (in which we can accept the positive value of overcoming a metaphysical vision of reality) hit internal contradictions within their own analyses. If, on a general level, we can defend the extreme innovation of Informal works, precisely because of their assimilation of modern scientific principles, the moment we pinpoint the characteristics of this new external artist-world relationship it does not really appear to have changed, and we see the reappearance of traditional categories of "art as imitation," "art as objective representation" (Barilli), "art as an integration of reality with subjective sensitivity" (Eco).

The same affirmation and exaltation of the achievement of the Informal Era in its idealistic division between subjectivity and objectivity, between the ideal of the image and its material being, become almost incidentally redimensioned not by a real elimination of the divide, but only by a moving together of the two levels, which "tend to merge at the extremes" while maintaining the presupposition that the "identity of the two levels, or rather the limit itself, if reached, would constitute a result which would be theoretically unjustifiable" (Barilli). In practice what is reconfirmed is a primary intellectual function which presents itself as taking control of the indistinct flow of continuum and reality in which it would otherwise risk sinking. It is important to emphasize that, although this safeguarding of its own role is an aspect which truly characterizes certain Informal artists, this aspect is not just given in the above-examined interpretations as belonging to the general Informal Era, but is presented as a "necessary" position, in order for it to be possible to continue dis-

cussing art. The variegated contradictions of the Informal Era can be explained by the idea of it being an imitation of the world - an imitation of a less monolithic reality, completely crossed by a dynamism which goes from one extreme of existence to the other; but the imitation of this reality still remains "detached" - its purpose is that of "seeing what we live in and, by seeing it, accepting it" (Eco).

All the solutions to the problem of analyzing the Informal Era, with their emphatic need to give a place to either negative or positive value judgments, clearly lean on a more or less openly-declared ideological concept. In the first case, starting out from a restricted, humanistic approach, there is the clear wish to preserve an intellectual guiding role, which is seen as degraded or denied by the Informal rejection of the possibility of offering meaningful examples in an historically alienated situation. The conclusion is therefore one of clear denial, which sees the Informal Era as the true and painful mirror of a more general crisis of truths. In the second case, the danger of this degradation is noted and immediately rejected by pointing out the social and cultural crisis of this neocapitalistic phase onto which the Informal Era is attached. The crisis is resolved in a process of adaptation of logical structures to scientific expansion and indetermination of reality, and even if this expansion provokes shock and trauma, these are all treated and overcome in the self-sufficient cultural field, which vehemently denies the "systems" of vision in the world, but does not dispute the possibility of "one" knowledge, as long as it is pliable and flexible; thus the Informal Era can be seen as a form of art which moves closer to the broadening or potential of a reality which cannot be immobilized in predefined rules.

This is no fundamental move away from the first-analyzed approach, despite a few interpretations which would appear to draw attention to a non-linearity of the elements constituting the Informal image or its meanings. Wedewer talks of an ill-defined, disturbed connection between arbitrary expression and objective effect of color; Dorfles sees the Informal Era as being able to portray "the most genuine face of man today . . . torn to pieces, discomposed, disintegrated and schizoid . . . yet looking forwards in the search for a 'new order' which occasionally blossoms and shines through." The conclusions, however, have a clear idealistic tone; efficient aesthetics can only truly be obtained when the need for "the formative" is imposed where "the dissolution of traditional forms allows a new representation to see the light" (Dorfles) or when the subjectivity of expression is brightened by the "formal value of colour, so that it becomes a form of artistic expression" (Wedewer). Along the same lines, Brandi, in a 1964 revision of his earlier thesis, recognizes the Informal Era as "the response to an irreversible moment in contemporary conscience" but, despite the intense involvement of the creator in the creation, precise formal values are discovered to be "wisely" present, if unpredictable, and they recover the contemplative dimension of "pure reality" and of the "moment of absolute freedom."

In order to overcome the ideological nature of these interpretations, it was necessary to stop passing judgment and to pay attention to the "concrete" analysis of the different elements of Informal poetry and works. This same historical concreteness had brought about the revision of ideas against two opposing and incommunicable flows of historical avant-garde movements - irrational and rational idealism - and turned them into a universal symbol of opposites. On the basis of this historical concrete analysis, the two sides of the Informal Era are shown to be two elements with the unifying presence of the same intellectual condition and form; tendencies toward either extreme - negation or affirmation of values - will always have to compromise and will never be an effective synthesis of these two elements.

In this argument, it would be "futile" to discuss whether the problem is concerned with "a crisis in art or an art depicting crisis" (Argan); nor would it be possible to give a precise answer (warns Argan) to the question of "whether the images of Informal art are of the right type to bring the condition of individual existence to that of mass existence, or whether they are an exception to and in some way the opposite of psychic action." There is a basic ambiguity recognized in the Informal phenomenon: it makes its declaration about the failures of history and of ideology - which, historically, should have given it its main push - and it therefore claims a diminished sphere of external reality in which an ordered and regulated intellectual action is possible: this sphere becomes reduced to a confused magma which is simply the existential limit of self. On the basis, however, of this disillusionment, which hit Western consciousness after the war years and which provoked the immediate response of a subjective withdrawal, of an attempt to escape from reality - on the basis of this moral trauma and of this anguish we can see the emergence of various attempts to find the space and maximum potential within one's own self in order to attack and go beyond the limit of an uncontrollable reality; to find the whole inside the individual, denied by the breakdown of external conditions.

Condensing these known ambiguities of the Informal Era displaces general critical complacency and naturally lets loose the field of interpretations of the Informal Era as a pure reflex of the dehumanization of society in general, as well as the field of interpretations which remain silent about the ideological nature of the values proposed by the Informal Era - i.e., about its birth under the alienated and traumatic conditions of "fact." But the idea of "ambiguity" still leaves vagaries not irrelevant to the evaluation of its meaning. Rosenberg's essays, for example, rather than being detached critical works, appeared as clear and impassioned radiographies from the inside of the American Informal period: he links the growth of Action Painting to the "anxious" conscience of the contemporary artist "cut in two" and to his dramatic identity crisis as he sees the objective narrowing of the known horizon of cultural forms. While starting out from this clear analysis, Rosenberg goes on to see an undeniable revolutionary content within the contradictory debates about the Informal Era - in their obstinate affirmations of artistry as the only outlet for free action and in the blind alley of an era in which "doing" had been depersonalized by the machine. One of his sentences is particularly meaningful here: "Action Painting has never placed any doubt about the revolutionary qualities of its own intentions or of its own substance." This would seem to replace moments of doubt and uncertainty with totally unconditional faith, shown by the works and declarations of

some artists: "Painting seems to be impossible, with only one occasional sign from the same light" (Philips Guston); "The fact of being free [in art] lies precisely in its uselessness"; "We all melt our work into pictures when we no longer believe in the ideas," said Willem De Kooning. Or, to find a parallel with the European situation: "The laws of semantics have now been overturned . . . the work of art has become a geometrical place for doubting and questioning Conscience no longer exists to any degree . . . in this format which precedes the birth the symbols are still to be made, but how?" (Georges Mathieu).

The strong ethical motivations with which Rosenberg credits painters - motivations which have been seen more recently in Arcangeli - are seen as an almost categorical "obligation" to save the moment of individual creation from social distortions, so that ambiguity is not shown as an internal fact or as an intrinsic part of the Informal Era strongly acknowledged by the artist. Instead, it is pushed to the conclusive phase of the work itself, when the objectivity of a product which "is hung on the wall" contradicts, by its final inertia, the tension and vigor which created it. "Its existence as a work of art contradicts its existence as an active creation." The creative phase maintains faith in the possibility of the free externalization of the self: "In fervor of subtraction, art was dismembered element by element, and the pieces were thrown away. Each phase of the dismemberment widened the confines between which the artist could put into motion his critical-creative processes: the patrimony which remains intact when all the superstructures waver" (Rosenberg).

More analytically, Calvesi sees constitutional reality in the ambiguity of the Informal era, along with the era's own language - a continual dialectic between form and non-form, unidentified by enthusiasm for the unformed as an anti-value par excellence. He also sees the psychological and expressive roots which are at the base of this language: "the content of the Informal Era is not exhausted by anguish . . . it is something that can be built upon, but which of necessity meets with instinctive, as well as ideological resistance, which is pushed to the attack." He talks, however, of a joining and merging of psychological attitudes and of linguistic solutions "whose contradiction can only be valued at another level - i.e. translated into terms of an ideological report." On this level, the sense of ambiguity is at last clarified and shows its final meaning: the most significant exponents of the Informal Era - those who can provide a knowledgeable, articulate response to the crisis of their own position - show the era to be not just evidence of, but a radical declaration of, the importance of art - to the limits of survival - in an age of advanced industrialization; they show it to be a result of exasperation with the use of art as a therapy and catharsis by a society void of values, which destroys it in its efforts to consume it totally in individual moments. The history of art as a unique and final place in which individual values can be confirmed is being ambushed, says Hess, by the initial, middle, and final expression or action of the Informal Era. From this "ambush," Pollock expands into pure mythical dramatization and, in his panic, brings up the "natura naturans" discussed by Argan; from here he talks about Fautrier's "beautiful painting"; and from here he sees in Burri the painful coexistence of

an ugly and offensive subject and of an irrepressible need for order.

In the mid-1960s, a fundamental contribution was made towards the recognition of this internal contradiction as a connecting link binding Informal activities together: this was an analytical reconstruction of both individual artistic methods and of the development of fairly homogeneous groups. It was the philological approach - not finite in itself - which managed to make sense of the chaos of infinite labelling: action painting, "art autre," "art brut," "informel," "tachisme," "abstraction lyrique," "nuagisme," material painting, symbolic painting, expressionist painting, informal naturalism, abstract expressionism, abstract impressionism - all varied and complex cultural realities. This approach brought to light the direction and importance of the influence of historical avant-garde language on the different artists. Finally, it broadened the analytical data-base available by turning its attention not just to the results, but also to the explicit or implicit declaration of poetry. The approach was generally developed by monographic studies, by exhibitions such as the one in Livorno in 1963, by anthologies by men such as Claus, and by histories such as those by Ashton, Volpi Orlandini, and Crispolti.

Arguments have also taken place about the proclaimed international character of the Informal phenomenon: it has been emphasized - especially in more recent articles which show a growing discomfort with all-inclusive definitions - that the simple spread of the phenomenon does not constitute proof of an international character. The expansion of this art form, especially around 1960, was judged to be so widespread as to include all forms of pictorial and sculptural expression which did not distinguish between figure, subject, and form. "Within these broad and confused guidelines it became very difficult, although necessary, to make distinctions" (Russoli). We can talk of a moving together of different Informal languages, but these are certainly not all alike or interchangeable, despite a certain fluidity of information and of exchange between different countries. Differences are especially seen in individual and historical origins - war, East/West politics, the specter of the atomic bomb, the alienation and anonymity of mass civilization: these origins are basically common to the West, or to societies which conform to the models of Western development (e.g., the development of Japanese Informal Art).

Elements found developing among all the Informal artists are: the more and more radical intellectual dissasociation from society; the feeling of not fitting in - even the feeling of antithesis as in historical avant-garde movements; the inexplicable uprooting of oneself as an absolute fact of the Western condition. But these elements vary a great deal and are dependent on different historical and cultural situations - not just on the method of expressing this crisis condition, but also on the methods used in "reflecting" it. The investigation, therefore, cannot be exhausted by describing the fundamental dialectic "contemporary threat" of the different protagonists "to art as its extreme defense" or by laying a final emphasis on either of the two components. It is more important to discover the level of critical knowledge used by the Informal artist for these negations and affirmations within the intellectual history of America, or Italy, or France, etc. - within the political history of

post-war society. If we notice substantial differences between U.S. and European experiences, and if we can see a wide range of Informal works within each continent, we can see that the general emphasis is on the diversity of the "results" of the crisis among the different artists rather than on the ideological meaning behind these different solutions to historical conditions - conditions which are already varied in themselves.

If we outline these historical pre-conditions in two countries such as Italy and the United States they will be seen to have their own distinct characteristics.

In post-liberation and post-reconstruction Italy: the emergence of a new history (economic, social, and political) and, at the same time, the establishment of governments which reflected the contradictions of a period of restoration; fiery debate and the need to use the intellect to cope with the changed political situation, along with objective difficulties in critically overcoming the tradition of hegemony and its supportive structure in favor of separation and autonomy of conscience, as opposed to the social conscience; the revival of contact with and updating of European figurative trends, after shunning the avant-garde movements during the dictatorship; a division - seen as a violent rupture - between abstract and neo-realist proponents. In the U.S.A.: a cultural tradition, developing from the early 20th century, with a diffidence for ideology and for any humanistic wavering between ethics and politics and, on reflection, between art and reality; in the 1930s and 1940s the emigration of European avant-garde artists attracted by hope for and images of freedom promoted outside the United States, along with the recognition, on the part of the American artists, of the failure of the progressive Roosevelt Works Projects Administration program; after the war, feverish activity for rearmament and expansion of economic strength with a plan to help Europe, so as to attain leadership on a world scale; at this time, then, a violent distortion of the constant American anti-ideology in the face of fierce anti-intellectualism, which was expressed in the most showy of forms in artistic "egg-heads."

This summarizes just a few of the details which should be taken into consideration for a deep study - not so much of the products of post-war international art, but of the ideological motivations behind its development. For example, it was not by chance that the intellectualism of post-war Italian culture, which was continually discussed but never resolved, left its traces in the characteristic which can be defined as "mental." It responded to needs arising before or after an expression which bore witness to a "deed": Burri's "sewing up," Fontana's holes, Capogrossi's repetitive symbols. These three artists, especially Capogrossi and Fontana, and not forgetting the programmed and violent efforts of Vedova, start out from the then widespread need for a positive suggestion for new artistic behavior and instruments (note, for example, the goals of Spacialism or the "Origin" group). It is true that these artists were working with a choice of "models" from outside the more immediate debate of the times: not the cubism and abstractism of the "New Art Front" and the "Group of Eight," but futurism, Prampolini, the same metaphysics recognized in Colla by Calvesi.

If this initial faith in a conscious awareness of one's own rigorous working is mixed with elements which tend to contradict this positivity, one is nevertheless generally aware of the contradiction - with Burri as the most critical - but this does not make for a total lack of validity in art. In the American situation, the departure point appears to be the opposite: partly because of the failure of public commitment in the 1930's, we can truly talk of a radicalization of crisis, project, and utopia of historical avant-garde movements among U.S. artists. It is in this cultural climate, reinforced by objectivity, that we see the advance of individualistic segregation of contemporary American society, which developed into attention being paid once again to German "negative thought," filtered - according to Motherwell - by the existential interests of the magazine *Possibilities*. The "negativity" of the West is sometimes compared with the "absence" of Eastern philosophy, or Kierkegaard is taken out of the context of the German 19th century and seen as a key for the ethical Absolute. Subjectivity is then added to these ethics, which become an individual commitment - the only possible "act" in historical reality. From here develop two possible complementary sides to the initial crisis: mythical ecstasy and/or ecstasy vigorously charged with individual action. These new value-proposals, however, are based on an intense negativity, and are therefore continually wavering and end up in an extreme position, such as the "nullity" of Ad Reinhardt.

If these general indications can only help to point out how different the origins of the Informal Era in the two countries were, the generality itself of this analysis confirms the need for investigations which must concentrate on specific cultures and artists. Back in 1963, Calvesi spoke about the "ethnic and cultural roots" of the Informal Era, to be uncovered in the "patrimonies of tradition that the era has managed to bring to fruition" in individual nations. The reconstruction of these different stories would not mean losing sight of the common denominator of existential and social problems or of thematics and solutions, nor would it negate the possibility of using the term "Informal" as a critical category. But, by overcoming the commonly accepted dangers of broadening this category, it would mean the recovery of individual historical pictures for different areas. When we find these precise cultural situations, not only can we reach the real roots of the different levels of dialectic tendencies in the "grand" Informal conscience, but it will also be possible to retrace the basic motivations behind many episodes of simple acquisition of the Informal language, as well as to trace the reasoning behind the multiple critical and deviant solutions which have been offered in the debate about the Informal heredity.

Bibliography - *a) General*: C. Brandi, Segno e immagine, Milano, 1960; cat. Abstract Expressionism in 1960, 60 American Painters 1960: Abstract Expressionist Painting in the Fifties (intr. by H.H. Arnason), Minneapolis, 1960; R.V. Gindertael, Permanence et actualité de la peinture, Paris, 1960; J. Guichard-Meili, La peinture d'aujourd'hui, Paris, 1960; W. Haftmann, Enciclopedia della pittura moderna, Milano, 1960 (ed. ted. 1955); P. Restany, Lyrisme et abstraction, Milano, 1960; L'Informale, n. speciale Il Verri, 1961, 3; cat. American Abstract Expressionist and Imaginist (intr. by H.H. Arnason), New York, 1961; G. Dorfles, Ultime tendenze nell'arte d'oggi, Milano, 1961; C. Greenberg, Art and Culture, Boston, 1961; R. Wedewer, Gesto e figurazione, La

Biennale, n. 43; D. Ashton, The Unknown Shore. A View of Contemporary Art, Boston-Toronto, 1962; E. Crispolti, La poetica dell'Informale, Milano, 1962; G. Dorfles, Il divenire delle arti, Torino, 1962; U. Eco, Opera aperta, Milano, 1962; W. Hofmann, La scultura del XX secolo (intr. by E. Crispolti), Bologna, 1962 (ed. ted. 1958); K. Kuh, The artist's voice. Talks with 17 Artists, New York, 1962; J. Paulhan, L'art informel, Paris, 1962; M. Seuphor, La peinture abstraite, sa genèse, son expansion, Paris, 1962; cat. Il dopoguerra. La pittura in Italia dal 1945 al 1955 (testi by Aa. Vv.), Ferrara, 1962-63; cat. L'Informale in Italia fino al 1957 (intr. by M. Calvesi and D. Durbè), Livorno, 1963; J. Claus, Theorien zeitgenössischer Malerei, Hamburg, 1963; E. Protter, Painters on paintings, New York, 1963; R. Wedewer, Bildbegriffe, Stuttgart, 1963; G.C. Argan, Salvezza and caduta nell'arte moderna, Milano, 1964; G. Ballo, La linea dell'arte italiana dal simbolismo alle opere moltiplicate, Roma, 1964, vol. II; R. Barilli, L'Informale e altri studi di arte contemporanea, Milano, 1964; C. Brandi, Significato dell'Informale, in Arte e cultura contemporanee (Quaderni by S. Giorgio), Firenze, 1964; H. Read, A concise history of modern sculpture, London, 1964; H. Rosenberg, The Anxious Object. Art today and its audience, New York, 1964; cat. American Painting of the Twentieth Century (intr. by H. Geldzahler), New York, 1965; cat. New York School. The First Generation (intr. by M. Tuchman), Los Angeles, 1965; cat. The decisive years 1943-53, Philadelphia, 1965; D. Sylvester, From Fauvism to Abstract Expressionism, New York, 1965; G. Battcock, The New Art. A critical anthology, New York, 1966; M. Calvesi, Le due avanguardie, Milano, 1966; cat. Cobra 1948-51, Rotterdam, 1966; cat. Systematic Painting (intr. by L. Alloway), New York, 1966; M. Fagiolo, Rapporto 60, Roma, 1966; N. Ponente, La peinture américaine, Genève, 1966; D. Ashton, Scultura americana moderna, Milano s.d.; P. Bucarelli, Scultori italiani contemporanei, Milano, 1967; C. Greenberg, The artist in America, New York, 1967; W. Grohman, Kunst unserer Zeit. Malerei und Plastik, Köln, 1967; A.M. Hammacher, Modern English Sculpture, New York s.d.; U. Kultermann, Neue Dimensionen der Plastik, Tübingen, 1967; L'Arte Moderna, Milano, 1967, vols. 34-37, 39 (scritti by J. Lassaigne, F. Meyer, N. Ponente, F. Russoli, D. Ashton, S. Hunter); B. Rose, American Art since 1900. A critical history, New York, 1967; A. Solomon, U. Mulas, New York Art. Arte and persone, Milano [1967]; H.H. Arnason, History of Modern Art, New York, 1968; cat. Cinque del Cobra, Firenze, 1968; cat. Italienische Kunst des 20. Jahrhunderts, Berlin, 1968; B. Rose, Readings in American Art since 1900, New York, 1968; Aa. Vv., Depuis 45. L'art de notre temps, Bruxelles, 1969, vol. I; cat. New York Painting and Sculpture: 1940-1970 (scritti by Aa. Vv.), New York, 1969; U. Kultermann, Neue Formen des Bildes, Tübingen, 1969; M. Volpi Orlandini, Arte dopo il 1945. USA, Bologna, 1969; V. Aguilera-Cerni, Arte dopo il 1945. Spagna, Bologna, 1970; cat. Bildnerische Ausdrucksformen 1960-1970, Darmstadt, 1970; I. Sandler, The Triumph of American Painting. A History of Abstract Expressionism, New York-Washington, 1970; cat. Aspetti dell'Informale (scritti by G. Ballo, P. Marino, F. Russoli), Bari, 1971; E. Crispolti, L'Informale. Storia e poetica, Assisi-Roma, 1971, vols., I, IV; T. Spiteris, Arte dopo il 1945. Grecia, Bologna [1971]; I. Tomassoni, Arte dopo il 1945. Italia, Bologna, 1971; H. Rosenberg, The De-definition of Art. Action art to Pop to Earthworks, New York, 1972; M. Rowell, La peinture, le geste, l'action, l'existentialisme en peinture, Paris, 1972; P. Vogt, Geschichte der deutschen Malerei im 20. Jahrhundert, Köln, 1972; cat. Arte come arte (intr. by G. Celant), Milano, 1973; M. Volpi Orlandini, La retina e

l'inconscio [Palermo, 1973]; cat. Surrealität - Bildrealität 1924-1974 (compiled by J. Harten, Schuldt, B. Kerber), Düsseldorf-Baden-Baden, 1974-75; cat. Acquisition priorities. Aspects of postwar painting in America, New York, 1976; cat. Painting and Sculpture in California: The Modern Era, San Francisco-Washington, 1976-77; F. Arcangeli, Dal romanticismo all'Informale, Torino, 1977.

b) Monographs and catalogues of exhibitions (essential bibliographies are listed in alphabetical order by artist): cat. Afro (scritti by B. Mantura, G. De Feo, V. Gramiccia), Roma, 1978; J. Putman, Alechinsky, Milano, 1967; A. Bosquet, Alechinsky, Paris, 1971; cat. Pierre Alechinsky (intr. by R. Wehrli), Zürich, 1975; P. Bellew, Karel Appel, Milano, 1968; R.V. Gindertael, Bryen, Paris, 1960; C. Brandi, Burri, Roma, 1963; cat. Alberto Burri (intr. by B. Mantura), Roma, 1976; M. Tapié, Capogrossi, Venezia, 1962; G. Dorfles, Capogrossi, Roma, 1964; G.C. Argan, Capogrossi, Roma, 1967; cat. Giuseppe Capogrossi, Baden-Baden, 1967; cat. Capogrossi (intr. by P. Bucarelli), Roma, 1974-75; G. De Marchis, S. Pinto, Colla, Roma, 1972; F.T. Gribling, Corneille, Amsterdam, 1972; H. Janis, R. Blesh, Willem De Kooning, New York, 1960; cat. Willem De Kooning (intr. by T.B. Hess), New York, 1968; G. Drudi, De Kooning, Milano, 1972; cat. Jean Dubuffet 1942-1960 (with a contribution from the artist), Paris, 1960; R. Barilli, Dubuffet materiologo, Bologna, 1962; cat. The work of Jean Dubuffet (intr. by P. Selz), New York, 1962; L. Trucchi, Jean Dubuffet, Roma, 1965; M. Loreau, Dubuffet et le voyage au centre de la perception, Paris, 1966; J. Dubuffet, Prospectus et tous écrits suivants, Paris, 1967; cat. Jean Dubuffet, Paris, 1973; G.C. Argan, Fautrier. Matière et mémoire, Milano, 1960; P. Bucarelli, Jean Fautrier, Milano, 1960; M. Tapié, Lucio Fontana, New York, 1961; L. Fontana, Concetto spaziale, Venezia, 1966; cat. Lucio Fontana, Amsterdam, 1967; A. Mauri, U. Mulas, Lucio Fontana, Milano, 1968; cat. Lucio Fontana (intr. by L. Mallè and A. Passoni), Torino, 1970; J. Van der Marck, E. Crispolti, Lucio Fontana, Bruxelles, 1974; cat. Sam Francis (intr. by F. Meyer), Berna, 1960; cat. Sam Francis (intr. by J.J. Sweeney), Houston, 1967; cat. Sam Francis (intr. by P. Schneider), Paris, 1968-69; H. Rosenberg, Arshile Gorky, New York, 1962; cat. Gorky (intr. by W.C. Seitz), New York, 1963; cat. Arshile Gorky: drawings to paintings (scritti di Aa. Vv.), 1975-76; cat. Adolph Gottlieb (intr. by R. Doty and D. Waldman), New York, 1968; R. V. Gindertael, Hans Hartung, Paris, 1960; U. Apollonio, Hans Hartung, Milano, 1966; cat. Hans Hartung (intr. by G. Marchiori and L. Mallè), Torino, 1966; cat. Hans Hartung, Paris, 1969; cat. Gerhardt Hoeme, Mannheim, 1964; C. Greenberg, Hofman, Paris, 1961; cat. Hans Hofman (intr. by W.C. Seitz), New York, 1963; S. Hunter, Hans Hofman (con un saggio di M. Tapié), Torino, 1964; cat. Hans Hofman (intr. by W.C. Seitz), Torino, 1965; G. Atkins, Jorn in Scandinavia 1930-1953, London, 1968; cat. Asger Jorn, Berlin, 1973; cat. Kline (intr. by E. De Kooning), Washington, 1962; cat. Franz Kline (intr. by F. O'Hara), Torino, 1963; cat. Franz Kline 1910-1962 (intr. by C. Gordon), New York, 1968; G.C. Argan, M. Calvesi, Leoncillo, Roma, s.d.; cat. Leoncillo, Spoleto, 1969; G. Mathieu, Au-delà du Tachisme, Paris, 1963; F. Mathieu, Georges Mathieu, Milano, 1969; A. Jouffroy, Michaux, Paris, 1961; cat. Henry Michaux (intr. by R. Bertelé), Amsterdam, 1964; cat. H. Michaux, Paris, 1965; cat. Michaux a Venezia, Venezia, 1967; cat. Robert Motherwell (intr. by L. Mallè, R. Motherwell and F. O'Hara), Torino, 1966; cat. The collages of Robert Motherwell (intr. by E.A. Carmean), Houston, 1973; T.B. Hess, Barnett Newman, New York, 1969; cat. B. Newman, Paris, 1972; B. Robertson, Jackson Pollock, New York, 1960; cat. Jackson Pollock (intr. by

F.V. O'Connor), New York, 1967; I. Tomassoni, Pollock, Firenze, 1968; G. Ballo, Giò and Arnaldo Pomodoro, Milano, 1962; cat. Ad Reinhardt (intr. by L. Lippard and S. Hunter), New York, 1966-67; cat. A. Reinhardt, Wien, 1973; cat. Ad Reinhardt (scritti by Aa. Vv.), Düsseldorf-Zürich, 1972-73; cat. Mark Rothko (intr. by P. Selz), New York, 1961; cat. Mark Rothko (intr. by P. Bucarelli), Roma, 1962; cat. Mark Rothko (intr. by W. Haftmann and D. McKinney), Berlin, 1971; E. Crispolti, Saura, Roma, 1962; cat. Bernard Schultze (intr. by E. Roters), Rotterdam, 1974; W. Schmalenbach, Emil Schumacher, Hannover, 1961; cat. Schumacher, Hambourg, 1962; cat. Emil Schumacher (intr. by W. Schmalenbach), VII Bienal de Sao Paulo, 1963; M. Ragon, Pierre Soulages, Paris, 1962; J.J. Sweeney, Soulages, Neuchâtel, 1972; M. Ragon, Gérald Schneider, Amriswil, 1961; R.V. Gindertael, M. Brion, Gérard Schneider. Pitture, Venezia [1967]; cat. Gérard Schneider (intr. by E. Jonesco, L. Mallè and G. Marchiori), Torino, 1970; cat. Clyfford Still, San Francisco, 1976; J. Cirlot, Signification de la pintura de Tàpies, Barcelona, 1962; G. Gatt, Antoni Tàpies (contr. by G.C. Argan, M. Calvesi, F. Menna, N. Ponente, I. Tomassoni), Bologna, 1967; F. Vicens, Antonio Tàpies o l'escarnidor de Diademas, Barcelona, 1967; M. Tapie, Antoni Tàpies, Milano, 1969; cat. Antoni Tàpies (intr. by W. Haftmann, W. Schmalenbach), Berlin, 1974; cat. Mark Tobey (intr. by W.C. Seitz), New York, 1962; W. Schmied, Tobey. Reihe «Kunst heute», Stuttgart, 1966; J. Russel, Tobey, Basel, 1971; cat. Mark Tobey, Krefeld, 1975; cat. Cy Twombly. Paintings and drawings, Milwaukee, 1968; G. Marchiori, W. Haftmann, E. Vedova: ieri and oggi, Venezia, 1961; E. Vedova, Scontro di situazioni. Libertà dell'espressione, Milano, 1963; cat. Vedova. Presenze 1935-1968 (intr. by G. Montana), Ferrara, 1968; cat. Vedova (intr. by W. Haftmann), Baden-Baden, 1964-65; W. Haftmann, Wols. Aufzeichnungen Aquerellen Aphorismen Zeichnungen, Köln, 1963; cat. Wols. Peinture Aquarellas Dessins, Paris, 1974.

PIA VIVARELLI

NEW REALISM (PLATES 147-150)

We now see 1960 as the pivotal year of the post war period, an effervescent and explosive year. The crucial events which then came to light were in fact the result of artistic research which had been going on unnoticed for some time. At the very moment that abstract art seemed to reign supreme everywhere, the younger generation of artists (those between 30 and 40 years old) cast doubt once again, but in a radical new way, on the preeminence of non-figurative art. In 1960 Paris discovered Kandinsky at the National Museum of Modern Art, Mathieu at the Paris municipal museum, and Vasarely at the Musée des Arts Decoratifs, while the high point of the season was Soulages's exhibit at the Galerie de France.

But this was a triumph only in appearance. The young avant-garde artists did not identify with this artistic establishment which had no other suggestions to offer them beyond escape into an imaginary universe, so they had already turned their attention elsewhere. Far from rejecting the world in which they lived they wanted to submerge themselves in it. Their vision of things found its inspiration in a "modern nature" - that of the factories and cities, advertising and mass media, science and technology. This avant-garde had thus found its subjects as well as the underlying philosophy of its vision. For these artists the underground years were over. The outcasts were about to join forces. On October 20, 1960, in Yves Klein's house and in the presence of Arman, Dufrêne, Hains, Yves Klein, Martial Raysse, Spoerri, Tinguely, and Villeglé, I (Pierre Restany) founded the New Realists group. César and Rotella, invited but not present, participated in the subsequent activities of the group, as did Niki de Saint Phalle (1961) and Christo and Deschamps (1962).

Prehistory: The new awareness of a "modern nature." – The creation of the group was no more than the reaffirmation by the participants of what they felt was an already existing fact — the existence, that is, of a certain similarity in their theoretical and practical aspirations and the existence of the need to make certain positive and negative choices together.

At the historical level this collective action was the logical conclusion of a series of extremist expressions presented as programmatic statements, basic esthetic beliefs, which of course caused an uproar. The years 1958 to 1960 constitute the immediate prehistory of New Realism, a period in which events followed thickly one upon the other.

On April 28, 1958, Yves Klein set in motion this series of events with his exhibit on "The Void" at the Iris Clert Gallery. The Parisians were asked to paint the walls of the gallery, which were completely bare but sensitized by the presence of the artist. The event represented a fundamental stage in Klein's artistic evolution, a stage which illustrated the transition from monochrome to immaterial art. Since the void is the empty space in which cosmic energy can radiate, it is the premise of all communication among perceptive individuals. In order to be in full control of his language the monochrome painter captures the ultimate reality, the immaterial reality. Already a year earlier Yves Klein had aroused the public's irritation by showing the monochrome creations of his blue period - several panels of the same color and format joined together. Now, in order to capture the energy which was freely radiating in space, he no longer needed the tangible support of pure color. Such a notion was interpreted as a deliberate provocation. The official critics decided not to take it seriously, and the one to set the tone was George Ravon with his review in the "Figaro." However, a well-known Parisian doctor (whom I shall do the favor of not naming), enraged after reading my preface, offered me a room at the St. Anne insane asylum.

For Jean Tinguely the exhibit of "The Void" came as a revelation. The Swiss sculptor grasped instinctively the wide implications of this act of appropriating reality. At that time he had just reached the end of a long period of research on motion which had led him to develop a systematic language consisting of geometric forms in motion mounted on panels designed to conceal their propelling devices, and he found himself at an artistic standstill. The revelation of the Void prompted a collaboration between Klein and Tinguely which in October 1958 resulted in a show at the Iris Clert Gallery entitled "Pure Speed, and Monochrome Stability." Klein's monochrome disks, mostly blue, were set in motion at different speeds of rotation by Tinguely's propelling devices. "The Space Excavator," a jack-hammer mounted on a wooden stand and with a central axle capped by a moving white disk, became the

center of attraction of the show, and, for Tinguely, also the first page of a new chapter. It led him to devote himself to the mechanical universe, to the engine as an artistic expression in itself by virtue of its structural properties.

This second event in the prehistory of New Realism rekindled in Tinguely an extraordinary burst of artistic creativity; 1959 was the year of the "Metamatics," the famous abstract painting and drawing machines: a motor propelled a mobile structure to which was attached a drafting arm which rested on a piece of paper fastened to a drawing board. The interchangeable tip of the arm was capable of alternatively accommodating a pencil, or a pen, brush, charcoal crayon, etc. A token would set the machine going for about a minute and this could be repeated at will. The "respectable" critics saw in these automatic Hartungs and ready-made Mathieus an obscene satire of that abstract art to which they had just barely begun accustoming themselves. Despite their opinion Tinguely, having discovered the fantastic poetry of the machine, was living his most glorious hour.

Tinguely's adventure was to reach its apotheosis in New York on March 17, 1960, with his "Homage to New York" shown at the Museum of Modern Art. His "Homage" was a gigantic monument made with an assortment of iron scraps into which he had incorporated the most disparate objects: bicycles, carts, radios, a rotary printer, and even a piano. This ephemeral architecture, crowned by a smelly cloud of smoke, was destined to be destroyed by remote control. The "Homage to New York" was a wild success: America recognized itself in this apocalyptic cult of the machine. In fact, at this very moment New York was rallying around Rauschenberg, Jasper Johns, Stankiewicz, and Chamberlain - that is, around a Neo-Dadaist current which, inspired by the pioneering intuitions of Duchamp and Schwitters, became directly interested in the discovery of industrial and urban folklore.

Thus Tinguely suddenly attained a special status in the artistic life of New York. Indeed, he became one of the determining forces in the second generation of postwar avant-gardes, both European and American. When the antagonism of the contemporary art dealers had developed into a true cold war among styles and schools, between Paris and New York, and Informal art and Action Painting, the Neo-Dadaists (who were the immediate precursors of Pop Art) took advantage of the breach. Unlike the Abstract Impressionists, they actually established close ties with the new European Realists whose artistic vision, despite some differences, was fairly akin to theirs. One cannot stress enough the importance of this reversal of direction in the cultural winds blowing between Paris and New York. After Tinguely's initiative, Niki de Saint Phalle. Spoerri, and a bit later Arman and Christo all contributed greatly to normalizing the relationship. Beginning in 1961, thanks to the new contacts between France and America, Jean Lacarde and I were able to organize at the Galerie Rive Droite an "encounter" exhibition entitled "New Realism in Paris and New York." This exhibition brought together Jasper Johns, Chryssa, Stankiewicz, and Chamberlain on the one hand, and, on the other, Yves Klein, César, Arman, Hains, Tinguely, and Niki de Saint Phalle.

The third event was "The Fence Reserved for Commercial Advertising" shown by Raymond Hains in 1959 at the first Paris Biennale. In a special hall he had erected an entire fence covered with the layered shreds of original advertisement posters. Since 1949 Raymond Hains and Jacques de la Villeglé had been systematically collecting from the walls of Paris the posters which anonymous hands had "poetized" by tearing them. In these they found their finished canvasses: the street was for them a "ready-made" Museum of Modern Art. Raymond Hains, the muse of this treasure hunt conducted on the "skin" of the edifices of Paris, had only once before shown this art – in 1957 at the Collette Allendy Gallery where he had exhibited a few specimens under the title "The Law of July 29, 1881." Thus the fence was really his first important public pronouncement.

By exhibiting his "Side Dishes Off the Fence," the chance transformations of torn posters, Hains allowed us to see the indescribable beauty of the city's walls in a completely new and fresh way; an unstable and ephemeral beauty which up till that moment had escaped our everyday perception dulled by monotonous habit. Hains' background was that of photographer, and within him spoke the voice of the photographer of the unusual.

Moreover, the first Biennale also presented, besides Raymond Hains' Fence, one of Tinguely's giant metamatics and a monochrome work by Yves Klein. It was certainly not by chance that these three outstanding artists, with whom I had long been close, had come together. It was then that I understood the common denominator of their very different artistic explorations which had evolved independently one from another: an act of impregnation by means of pure color for Yves Klein; animation by mechanical means for Tinguely; and for Hains the selection of a torn poster. Each individual's adventure had developed its inner logic by starting from an extreme position which exemplified the very essence of language, the mainspring of communication. This absolute act is an ultimatum given to the spectator, who is therefore expected to participate. And thus, at the height of their lyrical abstraction, in the full transport of their introspective introversion, Yves Klein, Tinguely, and Hains elaborated a methodology of perception, a new vision based on the awareness of an *objective* modern nature, on the appropriation of this contemporary reality. This was a far cry indeed from the paroxysm of informal subjectivity, gestural painting, and instinctive calligraphy. After 15 years of "systematic abstractionism" they were returning to earth by shaping the ends and the means of a sensitivity in tune with contemporary scientific and technical developments.

These ideas prompted me to write the New Realists' Manifesto, which I published in Milan on April 16, 1960, in preparation for a collective show which took place the following month at the Galerie Apollinaire. To the works of Klein, Tinguely, and Hains I added the "affichistes" ("poster specialists") Villeglé and Dufrêne, who had shared Hains' visionary research, as well as Arman, one of Yves Klein's closest friends, who after a phase of prints and impressions of objects ("cachets" and "allures") was producing his first series of refuse-accumulations.

The fourth event: after Milan I launched the term New Realism. It had an immediate crystallizing effect.

This effect intensified as things gathered momentum and came to a head between April and October of 1960, making clear to me first one and then the other of the two basic premises for founding the group.

At the Salon de Mai, César, just when everyone expected him to display once again his mastery of soldered metal, instead presented his new sculptures: automobiles compressed into one ton blocks. At the age of 40 even at the risk of compromising a brilliant career half-way between Gonzalez and Germaine Richter, César was following the voice of his instinct. The discovery of the most up-to-date American automobile crusher in a junkyard on the outskirts of Paris had shown him the possibility of gaining a more complete and absolute mastery over metal, arriving in effect at a new phase of the material. The compressed automobiles, just as they came out of the crusher, had seemed supremely beautiful to him. He had made them his own and wanted to assume the esthetic responsibility for them by presenting them as works of art. This time too a great uproar ensued. The high-priests of the Salon de Mai could not allow such an act of high treason against art, such an attack on the dignity of metal sculpture by one of the greatest specialists in that medium. On my advice César stuck to his guns. I must add, however, that in the context of that period his stand was also particularly instrumental in crystallizing my ideas. When César joined the movement of New Realism at the very moment that collective action was being organized, his act had wide repercussions and represented a fundamental contribution. In fact, for many his participation constituted a validation of the movement. Up until then the greater part of public opinion had considered Hains and his friends whimsical practical jokers and Yves Klein a provocateur. The young critics of the time, with the exception of Jacques Jouffroy, were the most ferociously hostile. However, César was not an upstart; he had already amply demonstrated his ability. With his presence, the challenge to established values acquired a new degree of credibility.

Finally, in October of 1960 at the Galerie Iris Clert, Arman performed the last important act in the series of opening moves with an artistic event in answer, two years after the fact, to Yves Klein: after the "Void" now the "Mass." The Iris Clert Gallery was stuffed all along the walls from floor to ceiling with junk of all descriptions. The haphazard piling up of material was ennobled with architectonic status. By then the situation was ripe and the official consolidation of the group, which was also prompted by the imminence of the second Avant-garde Festival, was a mere formality. The festival, organized by Jacques Polieri and Michel Ragon at the Palais des Expositions at the Porte de Versailles, allowed the New Realists to exhibit under this aegis.

The New Realist group: Theory and facts. – Once created, the group needed a formula to which they could all subscribe. The group's declaration of purpose, signed by the founders present on October 20, 1960, was merely an acknowledgement of the uniqueness of the New Realists: "What is New Realism? It is a new perceptive approach to reality." This was clearly only a general principle to which each subscribed for individual reasons. These avant-garde artists, who were under increasing pressure from their society to conform, had a very strong awareness of their common sensitivity to modern nature and of the need for immediate action.

But beyond this basic springboard, many personal divergences soon came to the fore. It was at this point that I stepped in. It was imperative that we find the common denominator of the three points of departure – those of Yves Klein, Tinguely, and Hains – so as to derive from it the framework of a common vision, a method of perception, the syntactic premise of a polyvalent artistic language.

At first their personalities seemed indeed very different. Yves Klein's cosmic dimension led him naturally towards a mystic concept of energy, to an internalization of the world through a complete feeling for it, and to a theory of communication by "impregnation." Tinguely, engaged in more precise and exactly circumscribed problems, saw in his appropriation of the mechanical universe the realization of a continual and multiple metamorphosis. Finally, for Hains his harvest of torn posters was the discoverer's highest reward; he was the poet voyeur, the alchemist who had been able, in the mental laboratory of his vision, to transform lead into gold, a simple sociological reality into a poetic form.

We started out with three basic premises:

1. a method which employs perception and communication to achieve a cosmic understanding;
2. a determination to make industrial technology a part of art's transformation of daily reality; and
3. the intent to poetically legitimize the most current forms of organized visual languages and their explosive proliferation: posters, advertisements, and mass media.

These three directions make up the three branches of New Realism. They were embodied in the three main founders together with those artists who, because of profound affinities, joined them. Around Klein gathered the members of the Nice School – Arman and Martial Raysse. And this was not simply due to geographical proximity. Arman, through the rigorous logic of his quantitative language, and Martial Raysse through his sophistication of nature, both tried – in imitation of Yves but using their own vocabulary – to define a general methodology of communication, a syntax of expression, or, in Raysse's words, a "visual cleansing." It is with this spiritual "family" that the César of the automobile crushers as well as Christo, the consummate wrapper, identify.

Tinguely attracted the technicians of metamorphosis, the reorganizers of our industrial world: Spoerri with his "trapdoor paintings," which were veritable still-lifes produced by the hand of chance; and Niki de Saint Phalle with her target-reliefs "painted" with a rifle. The technological metamorphosis was thus a continuous spectacle.

Around Hains flocked the "poet-voyeurs," for whom the world of the street was an everchanging painting, a public poetic resource whose hidden treasures needed to be revealed: Villeglé, who in 1949 had been his companion in the first exploratory forays and his intimate partner in all the adventures related to the modern explosion of visual languages; Dufrêne, the "ultralettriste," explorer of the backs of posters and of the semiotic value of letters; and, finally, Deschamp, master of chiffon patchwork and inventor of large canvas curtains and armored foil.

In Rome, Rotella had followed the same path, but on his own and with no contact whatsoever with his Parisian colleagues. His shreds of posters, skin peeled off the walls of Rome, which he had exhibited in 1954 in a gallery of the Italian capital, had provoked general derision. I was one of the few who could testify to the originality of his discoveries. Therefore it was only appropriate that when I founded the group I invited him to join his spiritual family.

The various manifestos which I wrote during the period of the group's collective activity reflect in a significant way the evolution of my thought and my effort to develop a theoretical synthesis which would encompass a plurality of languages.

The Milan manifesto emphasizes the central concept of the appropriation of reality and its consequences: the sociological "constat" becomes language and even the poetry of language. This first phase reflects both the euphoria of the first discussions and the "irradiating" influence of Yves Klein and his theory of communication by means of an energizing impregnation (pure color, blue, immateriality).

Yves Klein had sent his checkbook to Milan. With this checkbook he relinquished, for their weight in gold, the zones of immaterial pictorial sensitivity: at the founding of the group, which took place at his house, seven of the nine original manuscripts of the declaration of foundation had been written on monochrome blue paper, one on a gold sheet (monogold), and one on a monochrome pink sheet (monopink). Here we recognize Yves Klein's cosmogonic trilogy, the three energetic components of the universe - blue, pink, and gold, - whose synthesis is manifested in a burning flame. On that same occasion Yves Klein performed an historical anthropometry, a collective shroud, uniting along with his and my blue imprints also those of the bodies of Arman, Hains, Raysse, and Tinguely. Raymond Hains used to say that Yves lived in the marvelous. Indeed, during that period of great intellectual ferment, the marvelous was contagious. Yves Klein lived it as a painter who considered himself "classical"; Tinguely as a mechanic-sculptor of technological metamorphosis; and Hains as an inspired photographer who focused on posters. From César to Deschamp and from Arman to Dufrêne or Rotella, all the discoveries and "inventions" of the New Realists exalt the sense of the marvelous in modern nature - that is, the latent poetic dimension in the reality to be found in our surroundings.

To appropriate this or that fragment of the real for poetic purposes is equivalent to stating the problem of the expressive autonomy of the object and to go back to the Dadaist referent, to Marcel Duchamp's ready-made. The common object rechristened as sculpture is truly a work of art to the degree in which the artist takes moral responsibility for it. Today this problem no longer exists. But in those days the New Realists had some psychological problems with Duchamp. The reference to the notion of ready-made provoked some lively opposition from Yves Klein who not until shortly before his death, in the spring of 1962, understood that his profound affinity for Duchamp's philosophy was a moral one. In Klein, as in Duchamp, art completely merged with morality, esthetics with ethics. Hains rejected Duchamp's irony for fear that it would contaminate his own sense of humor. Tinguely, Spoerri, and Arman, on the other hand, suddenly considered Marcel

Duchamp the inventor of modern nature and closely identified with him.

Nevertheless one must take into account the context of that period and say in defense of Yves Klein and Hains that Dada had by then been used and abused. Dada had long been considered as part of the school of surrealist art, the anti-art posture par excellence. In the hands of Michel Tapié, who had proceeded to make the necessary clean slate in order, esthetically, to bail out "Art-Autre" informal art, Dada had gone from a posture of "no" to that of "zero." In 1960 it was difficult for those artists who were completely dedicated to their artistic vision to accept the positive implications of the third phase of the Dada experiment. To us, blessed with the perspective of time, it appears obvious that to this third phase is due the credit for the discovery of contemporary industrial folklore and its expressive possibilities as they are linked to the perception of modern nature. The title of the second manifesto on New Realism, which I wrote in Paris on the occasion of the collective show of May 1961 at the Galerie J, underlines precisely this positive aspect and its consequences: "Forty Degrees Celsius Above Dada." The fever which assailed the New Realists was the fever of poetic discovery: it propelled the Dadaists of the ready-made into the dimension of the marvelous modern.

The third New Realist Manifesto, published on the occasion of the Munich Festival (February 1963), already assumed the guise of a retrospective while clearing the way for the various new expressive possibilities, beginning with the basic appropriative options: the esthetic of the object, assemblage art, kinetic art, environment, etc. New Realism anticipated a renaissance of the art of assemblage; it heralded, besides the explosion of traditional genres, an esthetics of the object observed in its particular spatial context.

After all, the Munich Festival marked the end, or almost the end, of the group's collective action. The group's active period, which lasted from 1960 to 1963, had been brief but intense. Besides the private gallery shows and participation in the Paris salons, these activities gained their real dimension of originality through two types of events: the festivals and the Europe-USA "encounter" exhibitions.

The first Festival of New Realism took place in Nice in July 1961. It was made up of two parts: (1) An exhibit at the Muratore Gallery, where the main attraction was a beach window-display environment by Martial Raysse. The gallery also displayed an anthropometry by Yves Klein, a refuse accumulation by Arman, a compressed composition by César, some peeled and torn posters by Hains, Rotella, Dufrêne, and Villeglé, a structure in motion by Tinguely, a trap-door painting by Spoerri, and a bas-relief by Niki de Saint Phalle. (2) A series of what were in effect true "happenings" *ante litteram*, which took place in the gardens of the Roseland Abbey on the evening of July 13: "Anger" by Arman (the destruction of a chair and table and the glueing of their fragments onto a panel in the exact place where they had fallen); the lowering into water of a rotating metallic fountain by Tinguely; a surprise-effect shooting by Niki de Saint Phalle (rifle shooting at a target panel containing glass objects, sacks of paint, and smoke bombs); the consumption of a ritual cake, "the side-dishes from a fence," organized by Hains; and the recital of phonetic poems by Rotella.

The second festival, which took place in Munich in February 1963 at the Neue Galerie of the Künstler Haus, had been organized along the same guide lines, exhibit plus action, but emphasized even more the spectacle aspect. The festival, which I inaugurated with a press conference, was filmed from beginning to end by Belgian TV and included, besides Arman's "burst of anger" and Niki de Saint Phalle's target shooting, a demonstration-recreation of poster tearing by Mimmo Rotella and the erection of an ephemeral monument (a pile of beer kegs) by Christo.

This ephemeral monument was a reminiscence of the wall of barrels that Christo had raised seven months earlier right in the middle of Saint-Germain-des-Prés, a replica of which had been shown at the Galerie J in July 1962. This manifesto-like act can be seen as belonging to the series of events by individual artists which characterized the prehistory of New Realism. After all, all the New Realists had an innate sense of spectacle, of communicative extroversion, of the "happening." This is particularly true of Yves Klein (the Void, the Fire, the Imprints), but it is almost equally true of César, Arman, Hains, Rotella, Tinguely, Niki, Spoerri, and others. During the entire first week of March 1953 Spoerri turned the Galerie J into a restaurant. Each evening the kitchen concocted new gastronomic specialties, "with chef Daniel minding the stove and the art critics taking care of the service." The fragments of menus were glued to the place where they had been left behind by the customers, thus providing material for as many ready-made trap-door paintings.

Nevertheless, such actions were never gratuitous. They were always executed according to the rigorous language of each provocation. It needed to wait until the made-in-USA formula of the happening was introduced to France in 1963 in order to reappraise the whole question of the spectacle-action. The Parisians did then reappraise this genre as it had been practiced by the "affichistes" with their harvesting forays (which had taken place since 1949), or as Yves Klein had codified it in his public performances since 1955, and finally as had been adapted by Tinguely starting in 1958. It is useful to remember that Allen Kaprow's first "environment-happenings" go back to 1959-1960 and that their direct precursors had been the open-air spectacles organized at Osaka by the Gutaï group in 1955. Actually we ought not to speak of a direct filiation, since Hains, Rotella, Klein, and Tinguely were completely oblivious of Kaprow's activities and he of theirs; the same is true for Jokira's Japanese group.

The diffusion of the theory. – These ideas were in the air in the United States as well as in Europe. The New Realists again took up their dialogue with the 1960 New York protagonist. Even when the results were self-destructive, as in the case of Tinguely's "happenings" from 1960 to 1963 or some of César's "expansions," these actions preserved the quality of a technical verification, a testing out, or a fine-tuning. The spectacle-actions were demonstrations designed to elicit spontaneous and direct participation on the part of the public, drawing it into the whole process of communication. The action itself is the "labor," while its result is the "artifact." Unlike the happening, the action of New Realism does not exhaust its meaning as it unfolds. At the end of the spectacle we are left with its tangible trace. Thus the collective endeavor has performed an act of creation.

New Realism without doubt not only appealed to intuition but made concrete this dimension of human action and collective participation strictly integrated into the creative process. And this is hardly the least of its contributions. At the crucial turning point of 1960 the Parisian public had been incapable of reacting positively to what it perceived as an act of continuous generation, overcoming the cultural obstacles unnecessarily created by dealers on both sides of the Atlantic. The New Realists contributed to the reestablishment of an "open" atmosphere between Paris and New York, receiving, it must be said, an immediate reward. America recognized Tinguely, Arman, Raysse, and Christo long before Paris did, and this serves to explain how they achieved world recognition so quickly. The American reticence towards a Klein or a César can be ascribed to inverse homothetic reasons — that is, to the much more profoundly "Europeanized" aspect of their careers.

The chronology of New Realism includes two Europe-USA encounter exhibits which I organized on the spur of the moment, so to speak. The first, which I have already mentioned, took place in Paris in July 1961 at the Galerie Rive Droite. The second took place a year later in October of 1962 at the Sidney Janis Gallery in New York under the title "The New Realists." Given the evolution of the situation which had taken place between these two dates, the terms of the encounter turned out to be somewhat skewed. The European New Realists were no longer measured against the American Neo-Dadaists, but rather against the late-comers of Pop art who in this way found their official consecration. The "New Realist" label had served to promote a new movement; it had in effect helped Pop art take its first steps.

The term Pop art spread with dazzling speed. Employed for the first time in 1955 by the English critic Lawrence Alloway in connection with the experiments of a group of London artists united around Richard Hamilton at the Institute of Contemporary Art, the word "pop" is the onomatopeic abbreviation of popular (art). This chance use of the word would not have spread worldwide had it not been taken up again in New York between 1962 and 1963. This reutilization of the term was such that it has been used to define some very different realities — that is, the entire spectrum of industrial and urban Realism, including Neo-Dadaism. The authentic leaders of Pop art, the visual reporters of the American way of life, are Claes Oldenburg, Jim Dine, Roy Lichtenstein, Andy Warhol, George Segal, Tom Wesselman, and James Rosenquist. To compare them to the European New Realists would be to change the terms of the equation. The New Realists, in fact, are the exact contemporaries of the Neo-Dadaists, both on the historical as well as the conceptual level. The Neo-Dadaists Rauschenberg, Johns, Stankiewicz, and Chamberlain are the immediate precursors of Pop art. The Pop artists exploited the fundamental elements of a folklore which the Neo-Dadaists had pointed out to them and, with the exception of Claes Oldenburg and Andy Warhol, dealt with this folklore in a traditional Realist way. Theirs was a modernistic painting tied to a specific trend of the moment. When transferred to

Europe it flopped because its element of "narrative" figuratism was in effect a lead balloon.

On the positive side, the New Realists and the Neo-Dadaists share the Dada element — that is, Duchamp's ready-made and Schwitter's collage. Rauschenberg has been able to integrate the common object within an abstract expressionist context, thus using the sociological energy of the ready-made to compensate for action painting's worn out quality: the New York followers of Pollock and Kline had turned out to be as weak as the followers of Mathieu and Soulages.

But Rauschenberg's "combine paintings" made it possible for American art to pull itself out of the dead end of non-figurative expressionism. At the same time, his "borrowings," inspired by today's technological folklore, opened the way for Pop art. Rauschenberg's historical role has been without doubt a determining one, and he was given deserved recognition with the "Gran Premio" at the 1964 Venice Biennale. But when compared to Klein's cosmic extremism, or, more directly, to Arman and Hains who truly plumbed the depths of appropriative logic vis à vis the treatment of objects, Rauschenberg shows his debt to a post-Cubist art and he remains this side of Schwitters: he remains anchored to a traditional language, to a lyrical or expressionistic synthesis of Cubism, as his attachment to certain problems of composition or as the persistence of pictorial elements shows. The same analysis applies to Jasper Johns as well as to Chamberlain and Stankiewicz if we compare the latter to César or Tinguely. In reality the Neo-Dadaists, unlike the New Realists, did not draw the full logical conclusions inherent in the ready-made. They did not go beyond the Dada concept, limiting themselves instead to integrating the found object in structurally formal esthetic compositions which still use the expressionist and cubist languages.

The New Realists, on the other hand, considered the artistic rechristening of the object to be a fundamental event, deriving from it a transcendental lesson. Each fragment of the concrete world which they made their own was thus invested with an absolute and general expressive potential, becoming the ends and means of all objective language. That is why the influence of the group goes far beyond its brief existence. The brilliant success of the group's members, the poetic renaissance of an entire sector of general expressivity, the passage from industrial folklore to an esthetics of the object, and the advent of a modern sense of "nature" are all facts which by now are self-evident and must be credited to this group. Born of a reaction against non-figurative conformism and sustained by a clear method of action and a specific concept of sensitivity, New Realism ended by embodying in the space of ten years the concrete beginnings of the technological humanism which represents the only reasoned and reasonable guaranty of a second Renaissance.

The influence of the New Realists is directly related to the stature of its protagonists. And it depends above all on the stature of the most fascinating of them all, Yves Klein. He was able to raise the consciousness of New Realism to a very high level, that of the void, of total space, of a tangible yet incommensurable reality. The collective action was for all of them the catalyst for energy which up till then had remained dispersed in individual quests. For some it was also the key to a new world view, the crystallizing agent of a more suitable formula for the appropriation of reality. The protagonists who came together for that short lapse of time by now have their own stories and destinies which each follows in his own way.

However, what links them forever, I believe, is the consciousness of having together pursued a truth, a common perception or programmatic vision, to its very limits. At times encounters come about which are deserved and which for this very reason cannot help but take place. Within a certain context and given certain premises, these encounters have to happen, and do happen at the precise moment in which they are supposed to. It is this which explains the extraordinary force of the New Realists' collective action, and by the same token its brief duration. The artistic atmosphere changed swiftly, opening up new perspectives, as if a cloudy sky had suddenly given way to sunlight. From the end of 1963 the conditions which had justified this encounter no longer existed. Yves Klein, who died on June 6, 1962, at the age of 36, belongs now to future legend. César, after his crushed cars, underwent a moment of crisis. However, he finally discovered his polyurethane expansions, and, by probing the expressive potentials of these materials, he ended up by producing lasting monumental reinforced castings which he ground down, polished, and varnished. His plastic creations triumphed at the CNAC (Centre National d'Art Contemporain in Paris) in June of 1970 and reaffirmed his status - as if there were any need - as the greatest sculptor of his generation.

For Tinguely, Niki de Saint Phalle, Arman, and Raysse, America - especially New York - and the rest of the world now took the place of a Paris which had not yet recovered from the blows which they had inflicted. It was no longer a question of overcoming obtuse critics and hostile public opinion. It was no longer a case of a voice crying in the desert. The time of polemic gestures, of testimonials and manifestos, had passed. The obstacles had vanished; the times called for positive action and building, and America offered the New Realists an occasion, an opening, for doing something. Some knew how to grasp the opportunity on the wing, and thus more easily proceeded to achieve world renown. Arman and Christo especially illustrate this success. Arman is enjoying a meteoric career on both sides of the Atlantic. As for Christo, his has been a boundless ascent. Ever since his 1964 demonstration in the United States, his "wrapping" has known no limits. The small packages of his Paris days are a thing of the past. After the collossal air packaging of the Documenta in Kassel (1968), we witnessed in Australia the wrapping of an entire beach, rocks and boulders included. All his on-going or already completed projects are on an ever increasing scale: Valley Curtain in 1972-1973, Running Fence in 1976.

As for the other artists, their adventure, or to be more precise, its poetic quality. has remained tied to their particular lives and human dimensions. They are open spirits who never cease to observe the world. Niki, with his "Nanas," remains open, as does Spoerri with his restaurants. Hains, in a perpetual mystic rapture, remains open, as do the "regardeur" friends Villeglé, Dufrêne, and Deschamp. Mimmo Rotella, who since 1963 has gone from the tearing of posters to their photographic reportage, thus inaugurating an *ante litteram* "mec-art," also remains open. And it is in this availability, in this openness, that in the last analysis the key to

their style and the secret of their artistic durability can be found.

Four of these New Realists, because of the vigor of their vision which is tightly bound to a rigorous methodology of the appropriation of reality, dominate their time. Therefore it is not surprising if those present-day artists who are investigating the raw materials contained in the environment, whether those materials are technological, ecological, or conceptual, recognize their historical debt to Yves Klein or Christo. Through the mediation of Beuys, Tinguely and Spoerri now appear as the undeniable precursors of "Art Pauvre." The present-day "organizers of space" cannot disregard the "architecture of the air" nor the conditioning, by means of wrapping, of large geographical spaces. The spirit and the sensitivity which emanated from New Realism now condition their method of analyzing the structural data of visual language. The mythology of modern nature is now generating theorems of action and investigation. The appropriation of reality remains inherent, beyond the ephemeral fetishism of the ready-made, in all the psychosensorial problems of communication.

The great journey which started with the object has resulted in the appropriation of space.

BIBLIOGRAPHY - P. Restany, Die Beseelung des Objektes, Das Kunstwerk, XV, 1-2, 1961; S. Janis, The New Realists, Catalogo, New York, Oct.-Nov. 1962; P. Restany, Les Nouveaux Réalistes, Paris, 1968; P. Cabanne and P. Restany, L'Avant Garde au XXe Siècle, Paris, 1969; P. Restany, Il Libro Bianco dell'Arte Totale, Milano, 1969; L. Lippard, Pop Art, Paris, 1969; G. C. Argan, L'Arte Moderna 1770-1970, Firenze, 1970; P. Restany, Le Baptême de l'Objet, Ring des Arts 2, 1971; P. Restany, Nouveau Réalisme 1960-1970, Catalogo, Milano, Dec. 1970-Jan. 1971; P. Restany, Yves Klein le Monochrome, Paris, 1974; P. Restany, Il Nuovo Realismo, Milano, 1974; L. Vergine, Dall'Informale alla Body Art, Torino, 1976.

PIERRE RESTANY

POP ART AND NEO-DADAISM (PLATES 151-152)

Pop art, like its immediate predecessor, neo-Dadaism, is also a phenomenon of a large scope, a meeting point rather than a tendency dependent on posters or some programmed declarations. We can in fact also include in neo-Dadaism the French nouveau realism and in Pop art all the results of the depiction of objects of the European artists. In its different variations in expression it makes up one of the most representative manifestations of the second avant-garde or the neo-avant-garde, that spans the period 1955-1975 and like any other phenomena of the second avant-garde, is seen in two different aspects: of resumption - of poetics and technique - and of renewal, primarily in completion and extension of a study whose basis lies in the experiences of historic avant-garde.

The common point of convergence, the basis for the artistic work, is in the objects of everyday use, which in its predominant manifestation is the world of industry and the means of mass communications: objects done in series and of common use and images produced and retransmitted by the mass media (cinema, TV, advertisement, photography, comics), basically the whole of technological languages.

If this is the common denominator, it is appropriate to distinguish between neo-Dadaism and Pop art in a manner that will be explanatory. It should be noted that the former (neo-Dadaism) occurs before the latter (Pop art). If 1955 is the beginning of neo-Dadism, then 1960 can be considered the time this new trend - that is, Pop art - surfaced, and 1968 was the time of its crisis or demise, precisely when urban civilization was being questioned, when it was contested from within and there was a search for new models of reality and attitude.

Neo-Dadaism, in addition to displaying since its conception its ties with historic Dadaism (particularly with Duchamp and Schwitters), assumes this name as it made use of already existing objects and images taken from the average person's everyday environment. Furthermore, behind the informal stage Neo-Dadaism supports mainly the subjective and psychological atmosphere of the actual informality, even through an introverted attitude as it was in the exponents of the informal it shifts to an extroverted attitude such that it projects itself into the outside world with the intention of receiving it and appropriating it. The already existing information is recovered in a context that is so subjective, psychological, and vital that there is an attempt to have the link be offered by life itself.

In contrast, Pop art does not so much assume images and objects already existing as it does recreate them with literal fidelity. Pop art's use of the object consists not of a manipulation, as occurs in neo-Dadaism, but rather of a textual re-creation. In going through the constitutive process of the actual data, it involves not a matter of use, but of creation, which originates in technical problems. Its potentially colder and less existential atmosphere seems more linked to the problems of sight. In time, which is dominated by sight, it has been discovered, or rather rediscovered, that even perception is a technique, a creation; thus the mechanical perception of the modern means of communication is preferred to the perception of the eye. In this way, the mass media, which includes a series of specific languages and techniques, supplies the materials, objects, and images, particularly to Pop artists, and together the "equipment," that is to say, the way of seeing and evaluating the world. This is a primarily visual sensitivity, fragmentary and quantitative, formed upon a reality that tends to enlarge figures and objects. Thus new formal conceptions, elaborated within the framework of mass media and of the consumer society, are applied to the aesthetic sector.

The two different basic approaches influence the technique that is chosen: as it is tied to a moment in life, neo-Dadaism is potentially omnivorous, all-encompassing. It has chosen the way that contaminates language and techniques. Pop art instead has chosen the specificity of the techniques, and even if these are used over a wide range, they are each used distinctly and separately from one another. The attitude of Pop art is more specific and analytical, preferring the use of techniques according to their independence and in fact choosing the technical and linguistic.

The tendency towards specialization, typical of an industrial society, now extends even to the area of

artistic research. The artist attempts to assume the role of the common man or, especially in Pop art, of a specialist in the problems of sight perspective and of the creation of images rather than that of the exceptional and eccentric person.

The characteristics of the two movements, neo-Dadaism and Pop art, seem perfectly clear only in historical and critical analyses. They are useful for a general approach, while in practice the two movements often intersect. Thus, their characteristics should be more thoroughly compared case by case, according to the personalities of the individual artists.

An important point is in the correct way of interpreting the term "popular" (abbreviated to "Pop"), which appears in the identifying name of one of the two tendencies, the Pop art. Despite everything that has been said, "popular" should not be taken as such, but rather as the opposite. Today's mass culture is anything but popular in origin, which it would be if it were authentically popular - spontaneous, from the lower levels, as are all depictions of folklore (which always has an agricultural and artisan connotation) - but rather popular only because of expansion, reaching the entire mass of consumers through the capillary circuits of the mass media.

At its origin is a group of specialists who, in a competitive system, manipulate an imaginary image of today's world for the benefit of a well defined power. All this supplies the basic linguistic and factual material; the individual artist then builds on this. The artist, working within the prevalently cold atmosphere of Pop art, tends to hide his or her own individuality, becoming more like a technician of a well-defined language of images (photography, comics, traffic signs, advertisement). The intention of the neo-Dadaism artist instead remains subjective, to the point of acquiring the characteristics of an open autobiography.

This reveals to what degree the subjectivity of the artist intervenes in the climate of dominating objectivity, which is an aspect of the fundamental problem the "I" has with relations with the world.

With the exception of the neo-Dadaist and the Oldenburg areas, the subjectivity of U.S. artists as compared with European artists is the most questioned. In this direction the analytical approach of a Lichtenstein or a Worhol is exemplary of the entire movement, in which the "I" of the artist is transposed, that "I" which indeed has a dramatic aspect in Warhol. In the Europeans, on the contrary, it is the objective material drawn from the technological universe that transposed itself in the subjective life of the artist. In short, the contribution of the "I" seems more important inasmuch as it is still a subject, a peculiarity, an idiosyncrasy, and also an historical and formal conscience. For this reason, instead of the harsh isolation of images, the solution preferred by American Pop artists, European artists introduce juxtaposition and adhesion, from which can emerge a comment, an explicit personal meaning.

Its origin, not at all spontaneous or coming from the roots of depiction of Pop art, can also be confirmed by going back to the origin of this term. The term represents a transposition of a term from one discipline to another. Already used by the sociologists as the means of mass communication and urban folklore to indicate the new "popular" art produced and fueled by the mass media, it was subsequently used by visual art critics in the area of refined art to indicate an entire group of professional and very sophisticated artists. This draws its contents and its language from the mass culture, while remaining always in contact with it.

As all movements of the neo-avant-garde, neo-Dadaism and Pop art, for their unquestionable aspects of renewal, are considered in various ways to be the heirs of all historical avant-garde tendencies that have undertaken a direct relationship with the urban world. There is evidence of a relationship with cubism, in its collage episode - that is, the first utilization within the framework of daily reality, such as newspapers, packs of cigarettes, publicity logos. This relationship exists also with futurism, above all for its wide ranged approach towards the new urban panoramas, and with Dadaism in particular, in its capital manifestations, a sort of archetype of "ready-mades" by Duchamp and of "merz" and "merzbau" by Schwitters, and, finally, with the popular iconography by Leger and with surrealism, for its pleasure aimed at the "wonderful" citizen, which is also an artificial "wonderful." This interest, urban and of primarily visual relations, has deep-seated roots in modern art: it dates back to the time of the impressionists and Baudelairian poetics of the "peintres de la vie moderne" (painters of modern life).

The difference between the first avant-garde, interested in the urban world, and the new one, in addition to being of a linguistic and poetic nature, is also ideological. The first avant-garde, especially in futurism, in Dadaism, and in surrealism, displays some highly ideological characteristics, which move among the opposites of the apologia of the new industrial reality and of the violent negation, of the demystification of all values: the opening towards the future or the challenge of the future. Futurists and Dadaists tend towards the extremes, while surrealists strive for integration and positive experimentation. In contrast, the second avant-garde, and especially neo-Dadaism and Pop art, between the paths of apology and negation, chooses a third path: that of ascertainment, the exploration of the world, in the sense of the expansion of the "I" as well as in critical and cognitive senses. The artist, lowering his ambitions, ceases to place himself at the center of the world with the objective of changing or transforming it, or integrating it, even negatively, with the "I." He now places himself in a collateral sector, which in Pop art becomes a clearly specialized sector.

In the first position, the survey of the world in relation to the expansion of the "I," the subjective heredity of action painting and of American literature (in the background) all converge. In the second position, colder and more detached, it is possible to register a synchronic convergence with the "ecole du regard," and with linguistics and structural analysis.

Nevertheless, the wide cultural context, a direct or indirect reference point for the historian and the critic, is offered by sociology for the consumer society and mass media culture (particularly from Theodora Adorno and, more recently, from the analysis of Marshall McLuhan) and, for the new position of works of art, with technical reproduceability, from the reflections of Walter Benjamin.

Up to end of the 1800s, we can maintain that the artist is the only creator of images within society - or at least the most important and privileged - and the means used are still those of the artisan tradition. A first break

is marked by Art Nouveau, during which the artist appropriates and makes use of the means made available by the new techniques and also of the new channels of diffusion. A very important new technique is lithography, and a new channel of diffusion is the street vendors. Here, the direct art admirer, and possible buyer - also of magazines and serigraphic series - is represented by the crowd of passers-by. From this point of view, Toulouse-Lautrec is a key figure.

The second definite break occurs when the artist, by means of the new artistic techniques - papier colle, collage, the selection and the displacement of the everyday object - utilizes the objective materials of the outside world. At this point one can revive the concepts of manipulation, of bricolage, and of recycling. Acknowledging not being the only producers of images (of the imaginary) in the new society of image, the artist ends up renouncing a production of his own. The world, or, more precisely, the visual field of the artist, which is equal to that of the average man, is already rich in images, as his very existence is influenced by the presence and the use of everyday objects. Thus the artist, rejecting a direct production, concentrates on a use and a manipulation of already existing images and objects. In this manner, contiguous grounds are established between empirical and artistic spheres. Through a precise comparison between the basic materials of the mass and consumer societies, the artist and the man on the street find themselves working on common grounds.

Because of these complicated issues, the geographic extension of the two movements (neo-Dadaism and Pop art) ends up including the entire Western community; the emerging areas stand out, which are, of course, the capitals: New York, London, Rome, and then Paris. It is precisely at this time that New York can sum up its contributions to modern art and can be included as one of the capitals of Western art.

Immediately following this is the season of informality, which in Europe, as in America, had secured the art of the 1950s, dominating theme and attitude. However, there were different declinations within: action painting in America, painting of matter and signs in France, in Italy, and in Germany - declinations which will not fail to have direct or indirect influence on new artistic manifestations. The informal invariably ends up acting as a filter between the first avant-garde and the new.

At this new encounter with reality, art in fact progresses in a non-linear development of its language. It is here that the deepening and the depletion of the informal is seen. The informal artists had pursued a relationship with the world on an existential basis, thus affirming the surpassing of that completed dimension of objects and images, which instead will solicit the works of new artists. Abandoning the surface of reality strewn with its unauthentic history and technology, the informal artist looks back on the material substratum and to the structures of strength of reality itself. Concerning subjectivity, from the level of consciousness one returns to an unconsciousness, trying to be freed of any rational security as well as the over-elaborate mythology that surrealism had given it. This informal is a poetics that in the entire West had arrived at the creation of exceptional works, but which soon after had nurtured in its numerous followers a facile taste for the subject matter, an empty attitude, a rhetorical exhibitionism of chaos

and anxiety. Instead of assuring a meeting with reality, it obstructed it. No longer helping to see the world, it erases it in an attempt to see it through different eyes.

In effect, this tendency of trusting adhesion to the artificial level of the world is preceded by an act of cancellation, and not only metaphorically, almost setting the sensory perceptions at zero so as to start a new forward count. Such a cancellation can be seen in the various times and declinations of Rauschenberg as well as Klein, of Manzoni as of Schifano, of those artists, that is, who in their respective cultural areas act as an intermediary between the past and the new present. This cancellation, which affects the rhetoric of ideology as well as the facile complacencies of the subject, what emerges are the operative instruments, the techniques, the language, which in the general crisis of values represent the only professional certainty held by the artist. It is, furthermore, a certainty that again puts him in touch with the daily news and the completed surface of the world.

The first manifestations occurred almost simultaneously in British and American circles in the second half of the 1950s. In London, this phenomenon displays a primarily sociological and didactic background, a group effort involving painters and sculptors, but also architects and scholars of sociology and art as well. From the discussions held within the "Independent Group," affiliated with the Institute of Contemporary Art, the term "popular art" is introduced. This term will later become widely diffused. All of this work, with its sociological, cultural, and linguistic observations directed towards the urban environment in which modern man is immersed, prepares the sensitivity through which a new figurative language can begin to be created.

In New York, the new orientation is more clearly the work of individuals, still linked, however, to a common cultural climate. These young artists, through the filter of action painting, still relate to the work and teachings of the Dada master Duchamp and to the earlier, but parallel, research by the musician John Cage. It should be remembered that the pre-Dadaist manifestations promoted during World War I by two European artists, Marcel Duchamp and Francis Pacabia, joined by the American Man Ray, are at the origin of all American art. Therefore, the origins of American art are the industrial techniques, the machine, the ready-mades (notably Duchamp's), and a spirit of radicalism.

For the New York artists who are the spokesmen of the new Dadaism, Robert Rauschenberg and Jasper Johns - who were directly at the origin of Pop art - the starting point is action painting. Now the attitude of action painting, instead of falling back into the circle of subjectivity after having missed its hold over the totality of the world, projects itself especially on the objective world made up of those daily objects and contemporary images that surround and influence the artist's existence as they do that of any other contemporary. This shift from internal to external, from the totalizing metaphor of the world to just one aspect of it, sectorial and concrete, produces a deep change in the conception of the attitude as well as the work itself. The attitude is no longer an absolute projection of the psyche of the artist in its entirety, loaded with the subject's physical energy, but becomes a specific and limited attitude. In Rauschenberg, it is aimed toward the appropriation, the taking and the reproduction on can-

vas. In Johns, it produces an ambiguous presence linked to the separation of the image from the object. In this way, the canvas itself is no longer the absolute metaphor of the existential relationship linking the "I" (the painter) to the world, the field or the arena of their clashes. Rather, it is conceived as an objective field, and therefore capable of being limited or augmented by material additions and superpositions.

The canvas is a material object on which one can create works that are also material - and these works comprise all the activity of the artist, who can no longer be guided through the canonical categories of painting and sculpture. The attitude, or, more precisely, the flowing brushstrokes, of action painting is now transformed into a connective substance that amalgamates, links, and combines within itself the added material. This is why, in search of a term that would indicate the novelty of his work, Rauschenberg called his works "combine-painting." In Johns, the brushstroke ends up conferring a dual existence of object and image. In contrast, Cy Twombly, whose work crosses neo-Dadaism, has an attitude that is reproduced by tracing, writing, graffiti, diary notes. In substance, and on a metaphoric or significant level, the brushstroke alludes to the life of the painter, who exists in relation to things of the world. Considering the canvas as an object, it follows that the canvas-object is aligned with other material objects of any kind, to the point of surpassing the traditional dimensions of the paintings, of entering existential space, reaching out into daily reality. Naturally, the metamorphosis knows no boundaries: the canvas-object is but a cornerstone on which is built the life and expansion of the artist. As Rauschenberg states, it (the canvas) occupies that fluid space, that no-man's land that is "between art and life," continuously moving between the two limits - first it is art, then it is life. A movement of expansion of the canvas-object begins, reaching the point of including and strategically influencing the entire environment, as though transforming the entire artistic experience into new forms of theatrical experiences.

In the first direction, we encounter the phenomenon of "environment." In the second, the very real experiences of "happenings," which have in Allan Kaprow their primary theorist and experimenter and which can be seen as environments to which the action of man is added. In this movement of crossing previously existing borders, and in this art-life link, we find one of the major contributions of neo-Dadaism, rich in novelty and developments, even comparable to concurrent experiences such as the international group "Fluxus" or with subsequent experiences such as the "art of behavior."

If this is one of the ramifications of neo-Dadaism that is based on Rauschenberg's personality, another ramification is based on the work of Johns. The attitude-painting, used for that degree of fluidity to which action painting had led him, now encounters a trivial image, of geometric structure, as a flag, a target, a chart with numbers and letters: all images capable of guiding, of disciplining attitudes. Johns uses the brushstroke precisely for appropriating these anonymous and impersonal images, for redoing them literally and absolutely faithfully to the original. The result of this work is one of ambiguity, since it - whether the U.S. flag or a bullseye, for example - vacillates between its existence of the image created on the canvas and its existence as an object. The work completed by the artist moves between these two limits. The textual reference to the image precedes Pop art, the prevailing of the visual element of the image itself has certain links with the American "new abstraction" by a Kenneth Molandor or a Frank Stella - and in general with the study of Op art, which is, for that matter, concurrent with the entire development of Pop art.

Moreover, through the work of Johns the sense of the whole work of neo-Dadaism and, thereafter, of Pop art is becoming established. This sense consists of a rediscovery and a reevaluation of the ordinary, of all that whose influence we are unable to evaluate due to its familiarity. However, there exists the idea of modernism as a loss of experience on the part of modern man (this could even be the prominent characteristic of modernism) due to the increasingly massive modernizing processes of technology and standardization. Similar processes, making experience automatic, and thus preventing direct contact (Benjamin), led to a major fall in experience itself. One of the first acknowledgements of this new condition is found in a story by a writer who is, in a significant way, American. We are referring to "The Purloined Letter" by Poe, where it was just because the missing letter was placed in the most obvious place that it remained hidden, escaping the notice of those searching for it, including the police.

Faced with this condition, modern art and literature, although turning to differently organized sensory structures - where visual perception prevails as figurative art - have taken on, among other tasks, that of unmasking similar realities, revealing them, bringing them to light. To carry out this objective one of the basic techniques of modernality was developed, that of a breaking of all connections with the country of origin. Developed by Duchamp in the visual arts, in the same years it found an immediate literary counterpart in the theories of the Russian formalists, and it is to be considered as the fundamental technique of neo-Dadaism and of Pop art. What is the purpose of this separation, if not to decontextualize an object or an image, so as to take it from a familiar context where it is unnoticed to one in which it will come to our attention?

We have so far described the foundations and main characters of American neo-Dadaism. In addition to Rauschenberg and Johns, there are also a series of different contributions not attributable exclusively to neo-Dadaism. Using a constructive approach with the use of ordinary objects, Richard Stankiewicz, with his montage of pieces of machinery, and Chamberlain, with his very colorful montages of automobile body parts, have renewed sculpture. Another direction is marked by the work of Louise Nevelson, where the realistic and urban vision, a "low" level, takes several steps upward, to be transformed into a solemn and noble vision. The attitude does not so much appropriate an object or an image; rather, it tends to create. It seems to openly reconnect with the more unorthodox areas of constructionism, intended more as an orientation than as a specific tendency or an individual master. The objects used in the constructive approach of Nevelson also have a long history behind them, a sedimentation of the memory. They belong to furnishings from the old mansions of the colonial aristocracy of the American South. To this neo-classic current, rich in sepulchral elements, are

added contributions of Mexican, pre-Columbian, and Baroque art. The objects are assembled according to syntactic links of a geometric nature, separated mainly in a vertical direction, and undergo an additional transformation: a unifying color - gold, white, black - is used to cover and make them even, to raise them to a level of ambiguous sacredness. We, therefore, find ourselves before a theca, a wall, even a sacred wall.

While the relationship between the painting and the object in Rauschenberg is connected, and it is up to the painting to act as a linking element, in other problematic directions it instead changes into a relationship of tension and composition. In Johns, the object is placed on the border of the canvas and the artists look for the means to assimilate the trivial object with the painting, so as to include it in a context where priority is given to this traditional and noble presence that, indeed, is painting. This research is the starting point for the complex survey by Jim Dine. The common object undergoes a probing - alone or in series or in a realistic context familiar to the actual object, such as the selection of the wall of a bedroom or of a bathroom. It is tested in connection with its psychological resonance within the artist, and with his or her linguistic or conceptual problem, in the relationship the object has with its image, the part with the whole, the single object with its series.

At one point in the neo-Dadaist itinerary, which marks a significant turn and which can be dated to the late 1950s or the early 1960s, the object as the main theme becomes of secondary importance. The focus is now on the image, already present in the concrete "objectuality" of Rauschenberg's paintings and already inspiring Johns' research. After reproducing the image on canvas and reconstructing it in varying combinations of its visual surface and its objective substance, new means of incorporation of the image itself are researched. One of these media is offered by tracing: the image is pressed on the canvas by means of direct, elementary procedures of printing. The adoption of this technique comes from the consciousness of literality, from the adherence to a faithful reproduction, a literality that finally, in Pop art, will reach the level of actual tautology.

Linked to tracing are two other techniques. The first is by projection of the image directly on the canvas by means of photographic equipment and the fixing of this image on the material surface. The second is the technique of silk-screening, which has had much development; this is the photographic reproduction of the image on the canvas, which has been especially prepared. Tracing, initially used by Rauschenberg and by Johns, is carried on with important variations by Dine. And the photographic reproduction used by Rauschenberg, of connection of uneven fragments of images with the constant intervention of the brushstroke - although still within his syntactic language - is used by Warhol in an entirely different linguistic context: the isolation of the individual image or its monotonous serial repetition.

Pop art focuses its attention on the image, or, rather, ends up abolishing all canonical distinctions between object and image, since in the mass-media civilization, with the visual prevailing over all other aspects of reality, everything is image or is reduced to image. The same artistic operation experiences - a sort of renaissance: from a maximum opening, as is neo-Dadaism, whose highest point is touched by the convergence of artistic object, environment, happening, and dance, there is passage to the focusing of a single problem, a definite technique, and a specific language. Following the syntactic system prevailing with the neo-Dadaists is a system that is potentially paradigmatic. The montage is followed by the isolation of the image or its serial repetition, the extraction of a sample from a homogeneous whole - series or sequence - for the purpose of its display as a sample or an enlargement. Similar focusing is exemplified in the fact that there is within Pop art a reproposal of the painting, with a subsequent canonical closing of the canvas.

When further techniques are used, they are not used concurrently, mixed or superimposed, as occurs in neo-Dadaism, but rather individually, in successive times or moments, with an interest towards retracing and revealing their specific autonomy. There is passage from photograph to cinema. This is one of the most common transitions (particularly in Warhol, but also in Schifano, for example), for linguistic similarity and contiguity rather than improvement or for a movement to expansion. At the beginning of such a process of distinguishing, and almost of separation, is the fact that the action element, which the neo-Dadaists had inherited from action-painting and had succeeded in transforming in an original fashion, is less frequent. The relationship with the urban world ceases to be linked with action, which is potentially multisensorial. Touch plays a major role, changing to a mainly visual relationship. Sight, thus, becomes the most important sense, acted on by strictly visual tendencies - from Op art to programmed art - with the support of the psychology of form (Gestaltpsychologie), whose fundamental texts were widely circulated during this period.

This emphasized objectivity in the relationship between artist and the world acts as an introduction to the specialized selection carried out by all artists of Pop art. Each artist attempts to become a specialist in a specified technical-linguistic sector, ranging from comics to photography and advertising. The form of the picture becomes firmer, it is true, but only after the picture has been given a new meaning. As an example, the panel of a comic strip, a photogram, an urban sign, or a publicity billboard is accorded to the particular sector in which the individual artist has specialized.

The sample taken by Roy Lichtenstein from the sequence of comic strips in the individual frame, with a progressive narrowing of the field and a consequent broadening in the detail, determines a transition from the iconic element, still present in the artist's early works, to an emphasis on the linguistic components of the actual comic. This operation presents a cognitive interest concentrating on the language of the comics, together with a commitment to an aesthetic release from the "popular" triviality of the comics themselves. Completely indifferent to the story narrated by the comic strips, to the myth of heroism, adventure, and sex, the subject Lichtenstein deals with is presenting the linguistic structure of the comic - the tone of the color, the curved lines that descend from Art Nouveau, and finally the typical dotted surface of the printing screen. Once these structures are displayed, the artist intends to use this as a starting point and a foundation, to give it a linguistic and formal coherence or beauty. These are all

qualities that the comic does not have. What may seem paradoxical, but isn't, is the statement that Lichtenstein set forth with respect to the language and printing techniques, in the same way that Seurat had confronted the impressionist vision: as the French master had used a scientific order within the "naturalistic" vision of the impressionists, so did the Pop artist introduce a rigorous formal discipline within a popular and modern language, as that exaggerated one of the comic strips.

While Lichtenstein is on the "classic" pole of Pop art, Andy Warhol was on the cynical pole and as such bordering on the pathetic. He too saw himself as a specialist of a specific language, that of photography, and he examined the ambient of its diffusion as well as its component parts. Proceeding to the first study, we should first isolate the single photogram, which acquires a paradigmatic value as an example for the entire series to which it belongs. With such a procedure, Warhol showed the artificiality of photographic language, the reduction of an image of real information to a neutral relationship of spots in black and white, or, in color, to a dosage of light and dark. Examining the method of using the individual photograms, a serial repetition of the same image on the surface of the canvas is used. The photogram, which has a limited duration in time, ceases to flow and rather repeats itself evenly, inflated, as the diffusion of images in the mass media is in fact repetitive. We can say that the observation point from which Warhol developed his exploration of the image is that of the consumer.

While Lichtenstein, by taking it out of the series, frees the image of the comic in a time-out taken from the duration - which is consumption and erosion - Warhol uniquely revealed the image as made up only to pass beyond it; at the end of its path what is awaiting is a disappearance, a nothingness. From this lucid and forcedly negative observation came Warhol's reverse; the path that takes him from cynicism, the acknowledged acceptance without illusion of reality, also takes him towards the pathetic. This is a hidden note, emphasized if anything only by the iconographic content of certain symbolic images of his entire world: flowers, the series dedicated to "American death," the electric chair, and especially the movie stars, as the summary image of an "American Dream": Marilyn Monroe. The technique he used was photographic copying on canvas, an impersonal technique which, according to the American artists can be effectively used by anyone: Warhol intended to depersonalize himself to the point of the automatism of a machine.

Claes Oldenburg, who used common tools of daily use, a tube of toothpaste, the typewriter, and the ice cream cone, can be assigned, after the "classic" pole of Lichtenstein and the cynical one of Warhol, the oneiric (dream-like) pole in the rather articulated panorama of American Pop art. His objects appear created on a large scale, in accordance with a tendency for "gigantism" which is present throughout Pop art. Dilated in this manner, although reproduced with the exactness of a technician, the result is out of place. This seems further reinforced by the changes made in the color of the objects as well as the nature of their substance. Oldenburg particularly emphasized substance. His oneiric vein, which is the greedy and acidic one of the passive consumer, ends up eroding and attacking the material of which the objects are made. The tools and machines turned out in series by industry are hard and functional, while those produced by Oldenburg are soft and yielding to the touch, created to satisfy the laziness and the desire of infantile regression of the average man of the consumer society - that is to say, of all of us.

An oneiric element also exists in James Rosenquist, whose sector of specialization is the poster: enlarged fragments of trivial images are put together according to subconscious associations. In contrast, Tom Wesselmann's poster art, in which erotic context prevails, appears cold, hard, and impersonal. The purism of landscapes and highways by Allan D'Arcangelo is of an ascetic precision, organized on canvases similar to large signs. This style is also seen in the numbers and symbols of Robert Indiana, while other artists such as Mel Ramos and John Wesley do not go beyond the temptation of the subject, of the pure iconographic fact. At this point, obviously, at the folkloristic fringes of Pop art, at its many misunderstandings that, to many observers, make it appear as a vulgar emphasis on content, whereby its working in operation is essentially perceptive, the emphasis on a new way in which to form images and to see the world is accompanied by a constant commitment to the aesthetic release from triviality.

In American neo-Dadaism the object is recovered through the procedures of action painting. In the concurrent European manifestation, united around the Nouveau Realism group, the appropriation of the object is not through the direct intervention of painting. The dynamism of attitude painting opposes the staticity of informal materialism the background of which should be considered. An expressiveness intrinsic to the urban universe and to the daily reality is assumed, and it shows how the appropriative attitude for a fragment of the urban universe and its simple presentation is sufficient on the part of the artists to free its expressive potential. This is what can be deduced on the level of poetics from an elaboration done by the critic Pierre Restany.

Nevertheless, by examining the work of the most typical Nouveau Realists, it is pointed out that the intervention of each artist consists not so much in the simple act of choice and of appropriation, as it does in an attitude; it is through very specific behavior that one can intervene in reality, modifying it and manipulating it. The undertaking is not neutral, but specific, and it is specifically an accumulation in Arman, a construction in Tinguely, a laceration in Hains and Rotella, a compression in César, a wrap-up in Christo. Since the objective world is mediated through an attitude, a strong dose of imagination (while there are still surrealist tendencies, for that matter inevitable in a French cultural group) can emerge, but only in objective forms.

Beyond its unquestionable mythological currents, all of Yves Klein's work can also be considered the zeroing of all aesthetic instruments on a realistic scale. There is the reality of color simply spread on the canvas (with a preference for blue); there is the reality in one of its infinite aspects (leaving an imprint on the surface of woman's bodies covered with color and then imprinted onto the canvas in a 1960 demonstration); there is the reality of natural elements (air, wind, rain, fire). A realistic and total conception of a universe now makes the moon and any other planet readily available to man.

The concrete presence of space cannot be missing. This is proposed to us by Klein's 1956 "monochromatic propositions," which are pure rectangles covered by a single color. "I am a painter of space. I am not an abstract painter: I represent, I am a realist artist." This is a fundamental statement by Klein, a key artist for the entire span of French and European experiences of these years.

Arman (Armand Fernandez) is tied by an obsessive relationship to the object and the form. Since his procedure is clearly formal, it aims at neutralizing the quantitative over-abundance of objects that are nothing more than Kitsch and presumptuous poor taste; he almost aims at exorcising their quantitative profusion and at the same time his own internal obsession.

For the purpose of making an ordinary object lose its grey identity, and to have it acquire a precise formal identity, Arman systematically resorts to two opposite procedures. The first consists of repeating the same object over and over, regrouping or reordering a large number of its samples or its fragments; this is the procedure that originates his "accumulations." By inflating, the objects show their formal similarities, the lines, the volume, the density of the color matter. The quantitative repetition ends up raising the objects to an aesthetic dimension which is neither distant nor offensive. Next to the "Accumulations," Arman perfects another procedure, the destruction of the object, by cutting the actual object and mounting it on a surface of the parts obtained ("cutting of objects"), as well as by combustion, directed by the artist himself, particularly of musical instruments, violins and pianos (Collere). In the second direction as well, the loss of the object's identity and its function allows room for the suggestive beauty of the combusted substance, which the artist then permanently attaches in a covering of transparent plastic.

If accumulation and destruction represent Arman's appropriative forms, the appropriation of Christo (Christo Javacheff) is called packaging. It too is an objective attitude, so much so that Christo, by openly theatricalizing, can even display it in public or capture on film the different phases of his procedure. For the packaging there is a choice of the object - for instance a motorcycle, a woman, or a statue - in accordance with a equalization of things that presupposes a sort of secret, unifying animism; and then the following moments, the covering by transparent cellophane and the tying by multiple and exaggerated looping of rope. The wrapped object represents only the final act of a procedure, the various phases of which the observer must repeatedly run through mentally so as to exactly grasp the significance of Christo's work. This is not so much a destruction of identity, as in Arman, but a concealment of identity that ends up giving the object an enigmatic appearance, with the exterior, the covering, becoming a work of denial of the interior.

"The only stable thing is movement" or "The permanent is temporary" are among the rare statements of poetics by Jean Tinguely, who is, with Arman, among the most important of the French group. The sculptor carried his interest for machinery in motion to a fantastic level, using it as an index of reality and as a recapitulatory metaphor of the contemporary universe. If life and man, undergoing the influence of technique, have embarked on rigid and automatic paths, human existence and machine meet on a plane of reciprocal alterations: machine becomes anthropomorphous to the same degree as man is transformed into machine. Tinguely's "metamatic," above and beyond the machine, in fact displays this emblematic region of modern life where nature and artificial reality merge. Tinguely captures reality in a moment of frenzied motion, or, more specifically, in a waste of energy, which consumes the object. The sculptor coherently builds this dispersion of energy to the point where it attacks and destroys the object. The uselessness of this, and the inevitable destruction awaiting every display of energy, elicit in Tinguely a reaction intolerant of parody and sarcasm, which assaults man from the machine. With his "metamatic," the sculptor directed major shows that were "happenings" where he went from "the kinetics of disorder" to the explosion of the kinetics machine. Superficially, the obvious theme of the display is the end, the destruction of the world, so that by anticipating the end in make-believe there is hope of avoiding it through an act of exorcism. Exorcism appears to be the fundamental function given to art by the Nouveau Realism.

The sculptor César also shifted to Nouveau Realism during his "Compression" phase. These compressions of old cars by a compactor constitute a sort of monumental and formal homage to industrial refuse, obtained by intensifying the concentration of volume of the scrap material. In mountings of objects by Daniel Spoerri can be seen the division that is at the foundation of Nouveau Realism. On the one hand is the brute inertia of the found object, on the other is the artist's significant, expressive desire which intervention, as a direct and simple approach, is not always able to weld together. This is so in Spoerri's "trap pictures." Here one notices the presence of only one side of the split, the inertia of trivial objects - a set of bowls, bottles, and every other utensil belonging to any meal - that the artist did no more than glue on a board and hang on the wall as one would hang any other composition. Despite his intentions, there is no alteration in the ordinary vision of things; the object remains in its naturalistic insignificance.

In connection with the work on the objects that link Arman and Tinguely and César and Christo, an entirely different sector of Nouveaux Realists placed the poster at the center of their study. Political or publicity posters, or posters that were simply informative, contributed so greatly to the creation of urban decor and appeared to several artists to be the powerful imaginative and irrational essence of modern man. From this surfaced an immediate technique of using already affixed posters, consisting in the selection of the subject, in the actions necessary to remove the poster from the wall, to reproduce it on canvas, and finally to use it according to the different personalities of the artists. Along with Jacques de la Villeglé and Francois Dufrêne, the major affichistes are Raymond Hains and Mimmo Rotella.

Hains systematically explored this sector of urban folklore, being careful above all to enclose in a unitary and organic syntax the fragments of these objective images. In fact, Hains viewed the poster as a typographic composition for its constructive and dynamic qualities. Shortly thereafter, however, he was attracted also by the political poster, collecting an explosive series entitled "France in torment." Hains always considered

the act of tearing down posters as an appropriative act of an expressive sector of sociological reality. He furnished this expressive sector with an exemplary demonstration when he transferred within the space of an exhibit an entire palisade covered with posters, the "palisade with reserved seats" of 1959, closing the visual and imaginary horizon of common man.

The poster accompanies Rotell from the start of his work, marking the different phases of a timely and original evolution. At the beginning, during the phase of his very personal informal, the poster is regarded as an objective material, a film of external appearances, in accordance with the poetics of the wall, typical of European informal. The poster that Rotella tears directly from the wall and applies to the canvas then undergoes further intervention and manipulation by the artist for the purpose of identifying and structuring its composition. This can be called "double decollage." Subsequently, the attention shifts from the material to the image, to the incisive and popular iconography. Then, the poster is seen as an objective image of the city, intended almost as a prototypical image of the collective subconscious of its inhabitants. Rotella's attention dwells in fact on themes of eroticism, of the movie star, and of violence. One of his most evocative series is meaningfully entitled "Cinecitta." Finally, always disconcertingly experimental, the Italian artist has begun to reproduce directly onto the impressed screen images taken from posters, or superimposing different proofs of print.

Martial Raysse makes systematic use of all materials and technological instruments, from the image to the standard object, from neon to actual motion, to implement his artificial and strident "mises en scene." Alain Jacquet also proposes new photographic images obtained by the accentuation of the dots of the typographic plate. The result is a sort of mechanical "pointillism," tending towards disassociation of its components. All these experiments on photographic reproduction on an impressed canvas have been included in the principle of Mec' Art (Mechanic Art). Its adherents are Jacquet, Bertini, Nikos, Béguier, Pol Bury, Neiman, and Patella. Bernard Rancillac and Hervé Télémaque, on their part, pictorially rework images obtained from the mass-media; but while Télémaque displays a highly fantastic streak in his work, Rancillac captures the image more coldly in his works.

Along with these studies on image, another group of artists is pursuing studies of the object, with the intent of organizing a specific environment through the placement and multiplication of objects. As an example we see Jean-Pierre Raynaud and Daniel Pommerville. French precedents for this environmental approach can be found in some works by Klein, Armen, Christo, Raysse, and Tinguely.

In England, the first overtures toward popular culture of the modern metropolis appear during the second half of the 1950s. The very first examples of this tendency go back to two important, but opposite, personalities: Francis Bacon and Eduardo Paolozzi. Between 1949 and 1951 Bacon had used famous photograms of the "Cruiser Potemkin" and photos of Eadweard Muybridge to give a touch of up-to-dateness to his greatly disturbed human figures. For his part, Paolozzi had taken and incorporated in the volume of his sculptures, still of an informal nature, images taken from daily techniques and daily life, which the use of aluminum, often painted with industrial paint, took steps to unify. Obviously Bacon and also Paolozzi only enter marginally in our discussion: they open up a new direction, but it will be up to the others to follow it to the end. Furthermore, Paolozzi's direction, submitting the popular image to a metamorphosis, integrating it with a homogenous syntax that would modify the formal structure and the significance, will have a definite influence on the younger English artists.

Some notable examples are the collaborative relationship of Paolozzi with Richard Hamilton, an artist usually associated with the beginnings of English Pop art. Since 1956, Hamilton has experimented with many techniques, where the assembly of fragments of commercial images is joined with the reworking of materials from the same source, and thus the collage is married to the pictorial refiguration. The organization space passes from an initial imitation of conventional three-dimensional space to a more greatly autonomous and invented structure. While these early works recreate the enclosed space of a stockroom with all the makings of popular mythology, the later works organize space starting with the bidimensionality of the canvas. In the transition, the style becomes more lively and eliptical, a simple profile is used as a reference, as a sign of the total corresponding figure. Hamilton's attitude proves to be intellectual and detached, and with this detachment he explores a framed urban scene through and within man, in this way linking a series of connections - between man and domestic machinery, between woman and the automobile - with imaginative psychological ties capable of alienating, but also of giving a vitalistic acceleration to the existence of man himself. In Hamilton, as in Paolozzi, there is an availability of attitudes towards the stimulus of the urban universe; within English Pop art, this will favor the development of many variations.

A comparison is immediately possible for the concurrent but extremely different works by Peter Blake and by Richard Smith. As Blake is vernacular, exaggerated and wittily figurative, Smith is subtle, lyrical, and potentially abstract. Moreover, Blake helps us to better understand the popular nature of this English art. It exists in an environment much more extended than American Pop art, and substantially different. Such an environment includes, it is true, the images of the means of mass communication, but also includes the truly popular and spontaneous images of urban folklore, the picturesque figures of music halls, all-in wrestling, and amusement parks. In other words, the environment of the origin of the images is presented as major historic wedges and an accumulation of time, presupposing a technological civilization which, although it did not push itself towards the threshold of the post-industrial era as did the United States nevertheless has behind it a more rich tradition, giving deeper, and in a sense familiar, roots to that civilization.

The current discussion is especially applicable to Blake, who in fact proposes to reveal the human side of urban folklore, transforming each stereotyped image into a personalized image rich in human substance. Blake reanimates the subjects - wrestling heroes, light rock singers, and musicians - through pictorial means and photographic collages and through a series of objects that reevoke the environment and the atmos-

phere, then giving the entire depiction the non-conventional support of a door, a table, a fence. To personalize, to give harmony, means to tie to each image the feeling of time, of its stratification. For this reason Blake preferred, during one phase of his work, to evoke themes and personalities of the mythical 1920s, as well as undertaking "historical" compositions.

Diametrically opposed is Smith. In his work an analytical approach is joined to the attention for the communicative effectiveness of the image. The artist appears less interested in iconography and more interested in the visual deformation and novelty introduced by means of mass communication. An image he has focused on many times is the box, the packaging that covers each product of mass consumption, and his study is directed towards determining how, with a two-dimensioned canvas, can there be a three-dimensioned object, with plastic and illusionistic relief of the advertising image. From the initial mimicry of the package there is a transition to its subsequent reconstruction, restoring to it direct material projection; the object presented by the artist represents the physical tangibility of the path followed by the image of the package for the purpose of striking the visual perception of the observer. All of Smith's work maintains a fresh and sensitive color which, through the tones of the new American abstraction, recalls the tones of Matisse.

In the subsequent developments of English Pop art, the essential points are found in the studies by Kitaj, Hockney, Tilson, and Jones. There is underlying influence by Bacon, which is seen, as already in Blake, in his commitment to give back human, existential importance to current images. Ronald B. Kitaj is the most acknowledged representative of this. He unfolds a cultured and sophisticated narration, where he employs a multitude of instruments and materials: from the mark of illustrious lineage (Bacon) or a popular one (comics), to the photographic insert and the spreading of color. The materials are introduced as a quotation extracted from literature and history or from the violent accounts of the modern city.

Whereby in Kitaj the play of multiple metamorphosis of the images has an intellectual twist, In Allan Jones, the same play follows a clearly diverted and formal order and the intervention of provocation does not go beyond the level of malicious eroticism. David Hockney focused on the events of ordinary man in the reduced skit of a puppet theater, a depiction that was obviously false. An emphasis with a hardy and popular freshness emerges in Peter Phillips' phantasmagoria. In the assembly of this, different sources vigorously confront each other and hit against each other, creating an overall conflicting and syncopated syntax.

From the group of Baconian ascendance, Joe Tilson stands out through his independent sense of play. At first, this artist gave us a very brilliant series of wood reliefs. In its simplification of profiles, in its joyful happiness of colors, in the incisive and fragmentary clearness of his images - an eye, a question mark, a clock - there shines through a humoristic and joyous vision of urban reality. These reliefs appear as festive publicity or amusement park signs, made with an artisanal know-how sensitive to the transfer and exchange between work and figure, between full and empty, between the surface of the image and its surroundings. He subsequently simplified his constructions, basing them on the serial reproduction of an element - repeating the design step by step or by zikkurat, a simplification which allowed him to adopt an industrial technique and to abandon wood for plastic.

In central and northern Europe the objective current of the 1970s encounters many difficulties, the full expansion, the tendency towards the fantastic and the symbolic typical of this culture interposes tenacious resistance to objective poetics, down-played and realistic, as are those of Pop art. In Germany, an interesting use of photographic material was developed by Lueg and Richter. While Lueg sequentially repeats the same image, which varies only by the stylization of negative and positive, Gerd Richter reworks the photographic sources, attempting, through the instability of the haziness and the obsession with repetition, to bewilder, in the sense of anxiety and mystery, a backward world in its usual tired aspects. Peter Klasen encloses mechanical particulars and feminine details in a tense but lucid assembly, hinting by fragments at a narration interwoven with technological cruelty and erotic violence. Finally, Winfred Gaul's painting is a synthesis of objective observation of urban signs and of pure visuality.

A unique position in the European view is taken by the Swede Öyvind Fahlström, who opportunely took an interest in popular depictions: comics, magazine illustrations, publicity images. Fahlstrom's calling is as narrator of the fantastic, and as such time becomes the only protagonist of his crowded compositions. Along the coordinates are conceived the discords, the abstractions or conflicts, still within time that fatality and chance influence, as well as the freedom of man. Moreover, Fahlström's assembly, in which the value is not only from the single element, but from the relationships between elements, presents itself as a variable combination. A position of importance is given to the observer who, concretely intervening, is free to move the figures, to change the relationship - in short, to alter the order and the rhythm of narration.

Rotelle is not the only artist to initiate the new Italian situation, to the point of becoming one of its major representatives. Openly or indirectly, it is the attention that Alberto Burri has always given to the material and the subject that orients the work of Italian artists. His work has also had an influence on the approach of a central artist such as Rauschenburg, who spent several of his most formative years in Europe.

One of the connecting points between the past and the new studies is named Piero Manzoni. The artist proceeds to a preliminary reduction of artistic creativity and to the simplicity of an idea and the subsequent linguistic translation acts as an immediate demonstration of the same idea. Because of the didactic value given to art and the unquestionable preference of the intellectual aspect of the aesthetic work, Manzoni returns to Dadaism. Manzoni's multiple experiences have an internal coherence. They are directed towards pointing out the role that society assigns to art. Once society ends up identifying art with activity and with the artist's person, Manzoni develops each idea starting from himself and from the relationships that unite him, as an artist, with society. First of all, the body is a means of expression, and, utilizing the products of one's own body, breath and feces, in an unscrupulous levelling, Manzoni creates a series of artistic products, from "Bodies of Air" to "Merde d'Artiste," whose contents

do not textually deny the honest truth of the label. The works that make his relationship with the world concrete are intellectual relationships which have close connections between idea and act, clearly demonstrable for both distinctness and verification at one time. The time-space relationship takes form in the idea of a "travelling": a line drawn by the artist on a long role of paper. In his relationship with the public, Manzoni impresses his thumb on a number of hard-boiled eggs and then invites the public to swallow the "works of art." Manzoni identifies the nodal point of artistic problems and he exaggerates it in an ironic and elementary dialectic verging on reduction. A proposition of cancellation, as if to return perception to the starting point, is noticeable in the "achromes," which mark his entry into the experimental field between 1956 and 1957.

Manzoni's experimentalism, his logic, both gratuitous and motivated, does not find an immediate counterpart in subsequent Italian studies. His presence works in secretive ways and does not emerge until seen with later artists. If at all, a neo-Dadaist current can be noticed in Gianfranco Baruchello's (as in Gianni Emilio Simonetti) experimentation, especially in his assembly of objects. The objects are assembled in the order of the meaning given them in tight parallelism with his pictographic panels. The graphic sign and the figurative fragments coexist in the verbal discussion.

The new starting point, not neo-Dadaism, but more broadly Pop, through the initial attempts of Kounellis and Schifano, seems less intellectual and more highly visual, of abandoned participation in the appearances of the world or the elaboration of the first signs of a new vocabulary. What predominates in Mario Schifano's painting is in fact the visual aspect - not the descriptive representation of the image, but its immediate perception. This is restored on canvas through a clear and first vision, since painting essentially consists of a technique of sight. In his initial compositions, covered with an single coat of very smooth paint, Schifano cancels the pictorial congestion of the informal, and prepares the visual implementation so as to be able to see the world in a different light. Moreover, his fresh perception is not at all natural, but indirect, having been influenced by the mechanical perception of photography and film.

It is as if Schifano were always looking at reality through an artificial screen, whether it be the frame of the television screen or the car window in his initial period or the material screen of plexiglass covering the underlying image, as in his following works. Behind this screen, the artist encloses fragments of images within the visual field, which have a casualness and a surprise of the unfocused field. Initially these were details of publicity writings, then they became sections of landscapes. The image is directly transferred to the canvas by means of several techniques of transfer and impression, both traceable to two different basic procedures, remaking and retracing. Schifano dematerialized the image, reducing it to a visual negative. The same pictorial tradition, from the futurists to Picabia and the Russian supremacy, is receivable through the intermediation of photographic documents which bear witness to not only works, but also the human figures of the protagonists.

The reduction of the canvas to the essentials of the screen emerges also in the experimentation of Fabio Mauri. Giosetta Fioroni, with her preference for silver tones, furthermore reduces the film-like aspects of the images. Gino Marotta instead displays a safe constructive attitude, producing in transparent plastic a false nature.

James Kounellis, of Greek origin but working in Rome, begins his complex itinerary with vast surfaces on which are impressed letters, typographic and mathematical signs, almost always in black. The void creates tension in the full. The act is blocked in the sign of clear monumental foundation, between the lyrical and the contemplative. The empty spaces show the vast area of the possible, on which, after the letters, there are inscribed the stars, the moons in their changing phases, the waves of the sea, always in simple depictions blocked by an essential writing. The figures are equivalent to other signs, and, overall, they make up the personal vocabulary of an introverted and meditative artist.

Alongside Schifano's photographic essay and Kounellis' vocabulary, another group of Roman artists, among them Angeli and Festa, opens an area which has been defined, among other things, as "neo-metaphysical." Franco Angeli introduces symbols of history and of power, the swastika, the hammer and sickle, the eagle, and the American star, as well as typically Roman symbols such as the she-wolf and the Capitoline eagle. On the canvas, a covering of paint tones down the visual, and thus significant, obviousness of the image. The screen filters the violence of the symbol, it exorcises it, making it hazy in an indistinct dimension of inertia. Conversely from Angeli, Tano Festa tends to empty the historical image, dividing it into harsh and lifeless spaces (the successive positioning of an armoire or mirrors with no reflection). Similar serialization interrupts the exemplary act of a historical character, whether he or she be historical or religious - of Adam and the Eternal Father or of Michelangelo, for example - in an ironic and mental immobility.

Play and irony are also used by Lucio del Pezzo to exorcise and desecrate historical heredity, relived as a burdensome memory. This heredity includes the sacred and profane folklore of a popular city such as Naples, as well as the decorative frieze of a middle-class dwelling, such as De Chirico's metaphysical repertoire. History, deprived of all haughtiness, is shown here with its uneven inventory of now common objects, and the artist moves in the direction of a parodistic current with which to untangle the intricate muddle.

We are led into a completely different area by the works of Baj and of Valerio Adami, with which we can include the painting of Concetto Pozzati and of Emilio Tadini, a narrative direction that borders the objective study of Pop art without ever really entering into it.

The actual scene where the existence of man unfolds makes up the constant objective of Michelangelo Pistoletto, and to this end the artist makes use of large surfaces of reflecting metal as simple catalysts to capture life, space, and the things surrounding it. The elementary experience upon which it is based is the duplication of the mirror. The reality reflected by Pistoletto's surface received a further bewilderment due to the slight optical alterations it undergoes and because the artist has a new element of tension and disturbance intervene: some photographic enlargements of people in unusual positions or ordinary objects glued onto the

surface of the mirror. There is an intricate dialogue with many voices between real life and its mirror image, between reality and illusion, between life and the different deceitfulness of photography and the reflected image. Together with space, time is questioned in this work, divided between the rigidity of the large photographic figures, which witness an instant of life lived, and the mobility of present life that unfolds inside-outside the mirror.

Within this animated branching out of the research, there is the beginning of a tendency which, intolerant of the boundaries of the picture and of the wall, attempts to widen the material presence of the work, creating a relationship between it and the real space in which the observer moves. It is primarily Pistaletto who, with his reflecting surfaces, offers us the most conscious example of a desire to encompass within a work the space-environment and the observers themselves. Now the act of building the object becomes of primary importance, compared to the set of "refiguring" an image, and the photographic technique is replaced by various artisan techniques.

An artist such as Cesare Tacchi still seems to limit himself to the simple surface. By using an upholsterer's technique, not an artist's, he is able to modulate the surface by variation of the padding. By developing the constructive, manual aspect of his work, Sergio Lombardo went from geometric designs of news personalities on the surface of the canvas to the structuring in space of exact and anonymous volumes; Renato Mambor, from the isolation on canvas of figures and objects, to the construction of tele-characters and tele-objects. Luca Patella, who along with Rotella and Bertini uses photographs on impressed canvases, projects a series of slides to animate an entire environmental space.

It is, however, Ceroli and Pascali to whom can be compared the artificial nature of Piero Gilandi, who confront with greater awareness and inventiveness the task of broadening the work, to the point of giving it an environmental dimension, which essentially means confronting the problem of reality of space. The human silhouette cut against the two-dimensionality of the rough outline of wood - its basic material - represents the basic form, already spatial, of the constructions of Mario Ceroli. By means of this silhouette, the sculptor can animate and invade a certain space, representing the spatial construction of Ceroli, the domestic or urban localities, the historic or the current, making possible the existence of its dynamic and stylized characters. Each spatial locality closely unites architecture and figuration. It acts as a link with a defined sense of rhythm, still trapped in the steps of a stairway and in sections of building, but dynamic in the profiles of men and women who travel there.

Ceroli has a fervid dialectic creativity. He does not conceive the singular, but rather the multiple, the straight or backwards of a silhouette, the positive or negative of the cutting, the opposite faces of the same construction, proceeding only by quantity. So begins an invading group of works: a Piper with a crowd of dancers, the squares in various versions, the obsessive flow of Chinese marching in compact groups.

The plan of invading and occupying space is perfected in Pino Pascali in the project of recreating the world, and for this means he develops many techniques and materials that are rarely used by other artists. Essentially, according to Pascali, recreating the world means recreating nature. The artist undertakes the task of reconstructing nature with artificial materials as well as with authentic primordial elements such as water and earth. With his refabricated nature, large sections of white animals, feminine idols, silkworm caterpillars, plowed fields, stretches of water to represent the sea, he occupies and concretely furnishes a portion of space, transforming it into a fantastic place where dream, childhood, and nostalgia of Paradise lost all meet within a dense physical dimension. If within this range of American and European experiences, it is the iconography of the outside world that presents itself to the artist, in Pascoli, it takes on an opposite direction; and it is the artist himself who elaborates and presents his own personal iconography.

The world recreated by Pascali with formal exactness, spectacular fantasy, and tactile and visual sensitivity displays a precise movement, a return to the human subject and to nature, bearing witness to a diffused need of compensation, of physical and fantastic compensation to our overly mechanized and repressive civilization.

Starting from the city and from a public and objective iconography, the object-oriented current finally reaches a changed horizon, where nature reflourishes. Since nature always ends up being the cause of both historical and technological man, such an horizon leads to human nature and basic needs. There is in progress a regression which, departing from the world of material objects, goes back to the world of the subject, recovered in binding totality of mind and body; a freeing from the public sphere of conformity and of the commonplace, so as to again find a place which can be a potential terrain for a meeting place and for the formation of a new community. At this point, the prospective of the 1960s is abandoned, turned resolutely towards the new prospective of the 1970s, where an introduction to its proposals and its failures has been made by the "total" crisis of that watershed year that was 1968.

BIBLIOGRAPHY - *General works:* H. Rosemberg, The Tradition of the New, New York, 1959 (Roma, 1964); B. Friedman, School of New York: Some Younger Artists, New York, 1959; A. Kaprow, Paintings, Environments and Happenings, New York, 1960; G. Dorfles, Ultime tendenze nell'arte d'oggi, Milano, 1961; H. Rosemberg, The Anxious Object, New York, 1964; A. Jouffroy, Une Révolution du Regard, Paris, 1964; M. Amaya, Pop as Art. A Survey of the New Super Realism, London, 1965; J. Rublowsky-K. Heyman, Pop Art, New York, 1965; M. Kirby, Happenings, New York, 1965; M. Calvesi, Le due avanguardie, Milano, 1966 (Bari, 1971); M. Fagiolo, Rapporto '60, Roma, 1966; L.R. Lippard, Pop Art, London, 1966; A. Boatto, Pop Art in USA, Milano, 1967; A. Boatto, Poetiche europee dell'oggettualità, L'Arte Moderna, n. 38, Milano, 1967; B. Rose, American Art since 1900. A critical History, New York, 1967; E. Crispolti, La Pop Art, Milano, 1967; S. Hunter, Neorealismo, Pop Art in America, Milano, 1967; A.R. Solomon-U. Mulas, New York, Arte e Persone, Milano, 1968; P. Restany, Nouveau réalisme, Paris, 1968; J. Russel-S. Gablik, Pop Art, London, 1969; M. Volpi, Arte dopo il 1945, U.S.A., Bologna, 1969; M. Compton, Pop Art, London, New York, Sidney, Toronto, 1970; I. Tomassoni, Arte dopo il

1945: Italia, Bologna, 1971; L. Alloway, American Pop Art, New York, 1974.

Catalogues of collective exhibitions: L. Alloway, This is Tomorrow, Whitechapel Art Gallery, London, 1956; M. Schapiro, Artists of the New York School: Second Generation, The Jewish Museum, New York, 1957; R. Coleman, Place, Institute of Contemporary Art, London, 1961; W.C. Seitz, The Art of Assemblage, Museum of Modern Art, New York, 1962; F. Menna, Vecchio e Nuovo Dada, Alternative Attuali, L'Aquila, 1962; New York, New Dada, and Pop Art, Gallery of Modern Art, Washington, 1963; XXXII Biennale by Venezia, Venezia, 1964; P. Restany, Nouveau Réalisme: que faut-il penser?, Palais des Beaux Art, Bruxelles, 1965; Lo Spazio dell'Immagine, Foligno, 1967; L. Mallé, New Dada e Pop Art Newyorkesi, Galleria Civica d'Arte Moderna, Torino, 1969.

ALBERTO BOATTO

SUPERREALISM/HYPERREALISM (PLATES 153-154)

The term "superrealism" refers to the artistic tendency manifest in the United States and Europe after 1960 that employs the original cast and the photographic image as the bases for statuary forms and pictorial images. Statuary forms are constructed following natural proportions and by covering, when necessary, the original cast with clothing and other real objects. Special attention is also given with respect to obligatorily plastic parts to the meticulous chromatic reproduction of visible aspects of the model (for example, the color of the skin, the color and brightness of the eyes). The pictorial image has the exclusive function of reproducing photographic images and simulating their models, but at the same time of enlarging (only rarely reducing) it, occasionally in massive proportions.

Characteristic in superrealism, therefore, is the "perceptive beguilement" (also perceptive provocation) attained by superrealist works: sculptures placed among museum visitors, such as "The Woman Who Takes Notes" by Duane Hanson (at the Louisiana Museum in Copenhagen), shock even the most expert eye; paintings astonish the viewer for their technical perfection in the simulation of photographic textures as well as for the exceptional dimensions (for example, "The Pioneer's Old Cabin" by Paul Sarkision, a painting in 4.06 by 8.26 meters on exhibit in Kassel in 1972). From this point of view superrealist work can be related to the earlier school of "trompe l'oeil." However, the genetic foundation of superrealism, as well as its cultural significance and thematic predilections, differ. The same can be said for its formal collocation, which makes the superrealist structure of the "sign" an unmistakable novelty for its rigid semantic neutrality - apparently lacking any value judgment with respect to its content.

The origin of the term "superrealism" and of the movement itself are still disputed. A painter whose work is most representative of the movement is Charles Close. In a 1972 interview he denied any descendance whatsoever from Pop art but also denied his own membership in the superrealist school. By contrast, sculptor John De Andrea (interviewed in 1972) not only admitted the influence of Pop Art but also acknowledged at least an initial dependance on it in George Segal's work. If one considers the extreme characteristics of the work of Close (exorbitant dimensions, relentless optical defi-

nitions of detail, extremely close perspectives), the distance between superrealism and the greater part of Pop art increases; meanwhile, the bonds between Close and other superrealists (such as Ester, Salt, and Cottingham) become tighter.

On the other hand Segal always excluded integral iconism (with true to life skin coloring and clothing) in three-dimensional statuary, but preceded the superrealists in giving his works expressions resembling persons encountered in real life. In the end, if one excludes certain purely abstract compositive and stylistic variations which were created by Lichtenstein especially in his later works, the enlarged pieces of comic strips appearing in many of his better known paintings resemble the exorbitant enlargements of Close.

Therefore, the Pop art roots of superrealism are morphologically undeniable in sculpture and painting. By contrast this is confirmed by a quick comparison with the works of other exponents of Pop art: "The Stone" by Oldenburg (1962) corresponds in its naturalism to "Woman in the Supermarket" by D. Hanson, save for the ostentatious preciousness (naif and therefore "popular") of everyday objects, intentionally bright and unrefined coloring; "Spaghetti" by Rosenquist, his details of automobiles and other common objects painted in photo-realism since 1961, preceded by ten years (save for the meticulous definition of details) the automobiles of Salt; and Warhol's "Cambell's Soup can" (1962), so enlarged and isolated, correspond to the "Crown Jewel" canvas by H. Kanowitz (1970). The reemergence of the terms "realism" and "new realism" after the long predominance of abstract expressionism can be documented since at least 1961. In this year the Guggenheim Museum in New York exhibited a show entitled "American Abstract Expressionists and Imagists" (Rauschenberg was among the latter) and the Galerie Rive Droite in Paris presented the "Le Nouveau Realisme" exhibition, also with Pop art works. Finally, in 1964 the exhibit entitled "The Painter and the Photograph" was presented in Albuquerque at the University of New Mexico and in Vienna at the Museum des 20sten Jahrhunderts an exhibition opened that was entitled "New Realism and Pop Art." The photographic trend in evidence was linked with popular imagery but was also distinct and apart from it. The following year the critic Mario Amaya wrote the essay "Pop As Art - A Survey of the New Super Realism" (Vista Studio, London 1965), in which the term "superrealism" was utilized and closely connected with Pop art.

If American superrealism is indisputably descendant from Pop art, its primary links consist not only of the visual similarities and photographic techniques already discussed (note the previous discussions of Rauschenberg and Warhol) but also and especially consist of the popular structure (or naif); postcards, pictures, and images are considered valid subjects simply because they appear to reflect some aspect of the surrounding world (in other words, copying for copying's sake). These are all aspects of a naive and subordinate culture - typical of a consumerist age which has been reevaluated and simulated by Pop artists and at the same time dilated and repeated almost to the point of obsession.

By contrast, it is more difficult to trace in Pop art the roots of European superrealism. This consequently explains the fact that the term superrealism is associ-

ated exclusively with U.S. artists. In general one might say that the few European superrealists did not emerge concurrently or with any connection with Pop Art. Instead, they emerged on their own or in different contexts, and therefore it is best to speak of their movement simply as "realism." Nevertheless, this term is out of place or generic given the fact that some superrealist features have emerged independently from the Pop Art matrix. In particular one should note that Gerhard Richter, who seems to have "painted the first photography," after having moved from Dresden to Düsseldorf between 1962 and 1963 immediately adopted the perspective typical of art photographers. In fact, in the well known "Scenes from Berlin" Richter attempted to achieve two different tasks: first, for viewing at close range, revelation of a mingling of dense colors; second, when viewed at a distance, an ordering of the painting according to rigid photographic values. Richter, like Sarkisian, was diligent in his use and attention to the scale of grays. However, Richter almost always discarded sharp details and preferred instead the "out of focus," moving images, or images distorted like a malfunctioning television.

Other Europeans such as the Frenchman J. O. Hucleaux, the Swiss Franz Gertsch, and the Italian A. Caminati (who joined the superrealist trend in 1972) were all scrupulously attentive to the photographic but usually avoided the naif or kitsch, particularly prevalent in the United States. This probably contributed to greater emphasis of the photographic model, not as much for its iconographic content, but for the new type of pictorial "sign" that it implied, characteristically structures produced by retouching techniques (smooth supports, colors without body, spray pens, abrasives, air brushes). If superrealism had its productive humus in the United States, in Europe it achieved theoretical legitimization which gradually shed light on the value of analytic intervention (in a semiologic sense) in the experimentation of plastic, pictorial, and graphic art.

The heterogeneous nature of the superrealist group has given rise to a constant reluctance to use the term "superrealism." In fact, the group was considered sufficiently organic and mature during the preparations for an exhibition in New York in 1970; still, the exhibition was entitled "Twenty Two Realists." Likewise, an exhibition at the Museum of Contemporary Art in Chicago in 1971 was entitled "Radical Realism." The exhibition in Stoccarda from 1972 to 1973 was entitled "Amerikanischer Fotorealismus" adopting the same term used in the magazine "Art in America" in 1972 (Nov.-Dec. issue).

In the same year, at the Sidney Janis Gallery in New York, the title "Sharp Focus Realism" was adopted for a brief anthological exhibition (which was attended, notably, by M. Pistoletto of Turin). The exhibition presented works by artists of which only three were Europeans. The titles proposed in the catalogue for the artists displayed at this exhibition include "ultrarealists," "realists from New York," "Precisionists," and post-Pop realists," in addition to those previously mentioned. Jann Haworth was also represented by his "Domesticity" (1965), a work closer to Segal than those of the "photo-realists." Pistoletto's work, "Man with Yellow Pants" (1964) developed the theme of double reflection, consisting, on the one hand, of indirect reflections of the photographic figures, cut and reapplied on to the reflecting surface, and, on the other hand, the direct reflection of the view and his environment. Theme and development were, however, foreign to superrealists. These considerations leave us to infer that it was not yet possible to give a uniform definition for the movement. On the other hand, the most important celebration of superrealism, which took place in Dassel in 1972 at the exhibition Dokumenta 5 and was prepared by C. Amman, was simply entitled "Realism," thus reflecting notable caution in the denomination of the movement. Nevertheless, after the Kassel exhibition the term superrealism was fully accepted and at the same time expanded beyond its original bounds. More refined and critical interpretation and definition began. The relationships between painting and photography were the subject of a very challenging exhibition in Turin in the spring of 1973 entitled "Battle for an Image, Photographers and Painters." The show was used as a forum to present contemporary painters previously unknown and not classifiable as superrealists (for example, Guy Johnson from the United States and, among the Europeans, Antonio Lopez Garcia).

Shortly thereafter, there developed a systematic confrontation between the new forms of "Realism" and analogous European forms of a different and more complicated nature: at the Centre National d'Art Contemporain in Paris sharp contrasts were presented in the February-March 1974 exhibition entitled "American Superrealists, European Realists." The show was quickly transferred to Milan with the exact same title. Within the critical approach, a search for the American precursors of superrealism took place, reaching back to E. Hopper, G. O'Keefe, A. Colville, G. Tooker, and even to George Bingham of the mid 1800s. They also searched with little reason for European precursors in Dalí, Magritte, and others. Moreover, a tendency already prevailing in the writings of Amman for "Dokumenta 5," in which he proposed as the origin of superrealism the work of Jasper Johns, R. Aschwager, and M. Morley and to a lesser extent the designer W. Thiebaud and others, was followed. In this search, artists such as the Frenchmen Titus-Carmel or B. Moninot, the Germans H. Gafgen or Eve Gramatski, the Italian D. Gnoli (1933-1970) and the Spaniards F. Lopez and I. Quintanilla emerged. Yet these artists are not only to be distinguished from the European Pop artists; their "realism" cannot be assimilated with superrealism since the French proposed mixed iconic, super-iconic and analytic forms and the Spanish proposed a very subtle pictorialism, only legible from a photographic point of view. The others can be assimilated, however, with variations of partly surrealist supericonism.

With this series of analogous contrasts culminating in 1974, interest in superrealism as an autonomous and well-defined phenomenon seems to decrease.

Based on these observations it is necessary to render a more conclusive definition of the superrealist contribution to art. The necessity of "photographic" imagery in superrealism is clear - not just any image but an image obtained with optics that "overcome normal physiological vision" (for example, optics valid for extremely close distances or for wide angular openings mediated by an electronic apparatus). It is, in short, a radical iconism and at the same time not a direct iconism, like the old pictorial tradition of "trompe l'oeil." It is an iconism mediated by contemporary technology

that is super-iconism based on second generation images. The same can be said for statuary in which coloring materials, glues, and synthetic resins are the equivalent to photographic optics which produce highly objective results.

In the extremely vast field presented by recent art forms based on super-iconic images, in which second generation images appear manipulated and variously mixed with traditional plastic, pictorial, and graphic forms, superrealism is distinguished for having isolated forms that are impersonal, integral, and super-iconic iconism. Therefore, works by R. Goings, Estes, Cottingham, McLean, and others can also appear assimilable to a sort of new, magic realism - only, however, if one notices the absence from the picture of things, persons, or animals considered spurious or disturbing. Meanwhile, the works of D. Hanson, F. Gertsch, and G. Richter appear closer to the tradition of European naturalism and realism - if one considers the strong interest for the human figure. Nevertheless, these distinctions are superficial if one takes into account that all of these orientations have in common an explicit interest in a clear and integral super-iconism, not attenuated by intrusions or any personalized manipulation. What remains is an apparent neutrality of the image to which it is possible to attribute subtle values in any given case of indifference, participation, irony, or support.

BIBLIOGRAPHY - W. Seitz and others, Photo-realism, Art in America, Nov.-Dec. 1972; (interviews with 14 artists); U. Kultermann, Hyperréalisme, Ed. Du Chène, Paris, 1972; La révolte des réalistes, Connaissance des arts, n. 244, 1972; G. Lista, Iperrealisti americani, NAC, n. 12, 1972; I. Mussa, L'iperrealismo, Nuova Antologia, a. 107 (1972), fasc. 2064; C. Baldwin, Le penchant des peintres américains pour le réalisme, Connaissance des Arts, 254, 1973; C. Maltese, J.v.d. Marck and others, Scritti vari nel fascicolo speciale by Qui Arte Contemporanea, n. 10, Roma, 1973; C. Maltese, L'iperrealismo, conferenza del 10 giugno 1973, Galleria Nazionale d'Arte Moderna, Roma, Arte e Società, Roma, 1973; L. Marziano, Iperrealismo, la coagulazione dell'effimero, Il Margutta, VI, n. 3-4, 1973; E. L. Smith, Superrealism from America, The Illustrated London News, vol. 261, n. 6896, 1973; P. Restany, Sharp Focus, La continuité réaliste d'une vision américaine, Domus, n. 525, 1973; P. Sager, Neue Formen des Realismus. Kunst zwischen Illusion und Wirklichkeit, Du Mont Dokumente, Köln, 1973; Filippachi, L'Hiperréalisme Américain, Le monde des grandes Musées, Paris, 1973; Aa. Vv., Hyperréalisme, Isy Brachot Éditeur, Bruxelles, 1973; Realisti Iperrealisti, La Medusa, Nov.-Dec., 1973; Aa. Vv. (a cura del CNAC, Parigi), Kunst nach Wirklichkeit. Ein neuer Realismus in Amerika und Europa, Kunstverein, Hannover, Dec. 1973-Jan. 1974; Aa. Vv., Hyperréalistes américains, réalistes européens, CNAC/Archives, n. 11-12, 15 Feb.-25 Mar. 1974; Aa. Vv., Iperrealisti americani, realisti europei, Rotonda della Besana, Milano, 1974; G. Di Genova, Il Mondo in posa, Capitolium, 2-3, 1975.

CORRADO MALTESE

BEHAVIORAL ART (PLATES 155-156)

Definition of the area. - The term "Behavioral Art" is used to describe those artistic manifestations which, since the 1950s have taken the human being as the means of expression and aesthetic communication and discarded the traditional means of art - whether paintings, sculpture, or objects removed from their context and presented in an art context. With "Behavioral Art," the limits of traditional linguistics are exceeded and replaced by the deeds and actions of the body taken in its totality. The work of art - as autonomous, self-contained object - is thus substituted by an event or by an action (performance) which the artist executes in a specific environment.

A performance can be of variable duration. Its length is often determined by the unprogrammed participation of the spectators and presents itself as an ephemeral event. The locus of a performance can be a place traditionally delegated to art, such as a gallery or a museum or, more often than not, an improvised environment provided by an urban or rural context. "Behavioral Art" originates from the artist and tends to expand into and modify the surrounding environment, involving the spectator and placing him outside his traditional role as passive observer. Instead, the spectator becomes co-artist and actor. "Behavioral Art" is thus related to another tendency of contemporary art, Environmental Art, a form that goes beyond the realization of object/works to create a new environmental structure.

This double trend covers a large range of contemporary artistic experimentation. It has taken a precise theoretical and operative definition since the second half of the 1950s. This phenomenon involves problems of different nature, from more strictly linguistic to widely sociological ones. The latter represent a significant term of reference in the interpretation of the phenomenon. The abandonment of the object/work is to be placed in relation with the growing process of merchandization of aesthetic products and with the attempt at delivering artistic activity from this uncomfortable situation of marketing. Socio-ideological motivations are closely connected to linguistic problems. From this angle, the questioning of painting and sculpture - of artistic objects in general - represents a crucial point in contemporary artistic research and marks a decisive stage in the long course of destruction of illusionistic space in "traditional" art and of gradual approach toward an aesthetic and vital space.

In "Behavioral Art," artistic operations tend to leave behind specialistic limitations in the attempt to place themselves at the center of life. Aesthetic behavior in performances takes on the meaning and value of a whole model of behavior which is free from external motivations. As such, it is presented as the alternative model to the merchandized, constructive, fragmentary, and divided work offered by modern industrial society. Gratuitous action, apparently lacking in meaning, regains value in that it represents the polarity opposed to the pure functional efficiency dictated by the "principle of performance." Art is transformed in general aesthetics: as Artaud stated, art becomes "a refined means for understanding and living life."

Historical models. - The need to go beyond the physical limits of a work of art was strongly felt by the Futurists, who introduced the element of artists' behav-

ior vis-a-vis spectators. The technique of futurist soirées can be considered as the "mise-en-scene" of a collective action, the plot of which was provided only in the general outlines. A significant part of the soirée depended on two variables: the response of the public and the counter-responses that the artists had to provide on the spot. A third variable was the likely arrival of the police, often called to restore order in the room. The Futurists had a taste for theater and easily tended to dramatize anything they did. Moreover, their theatrical theories and practice, as shown by Marinetti's posters and backdrops from "Teatro della Sorpresa" and "Teatro Sintetico," explicitly aim at creating a series of occurrences that involve the public. At the time of their exhibitions, the Futurists often organized real performances, like the one held at the Permanente Futurista in Rome in 1914 and described in the columns of "Lacerba."

In Zurich, Dadaist soirées at the Cabaret Voltaire were closely linked to futurist inventions, even though Dada provocations took on even greater violence and were targeted at art itself. "The new artist protests: he no longer paints . . . any painted or plastic work is useless" is the copy of a 1918 poster by Tristan Tzara. Reality, " . . . belonging in its infinite variations to the spectator," escapes the work. The viewer is provoked and directly involved in the Dada event. This event overcomes the concept of art as object, enclosed within definite limits, to give life to an art that is capable of accepting the aleatory and contradictory nature of everyday existence. For this reason, in 1920, at the opening of Max Ernst's first personal exhibition in Cologne, an axe was available so that visitors could destroy works they did not like.

In "ready-mades," works that Duchamp removed from reality and placed in the context of art, the qualifying factor is not appearance, but rather their choice and de-contextualization. Duchamp pinpointed this aspect of the operation, stating that a "ready-made" should be designed for a "future moment (such a day, such a date, such a minute) The important thing is this clockwork precision, this instantaneousness, like a speech made on no matter what occasion, but at *such and such a time*. It is a date. Naturally one ought to make a note of this date on the ready-made itself as *information*." It is thus a matter of action, or rather of a plan for action. In a "Ready-made" the physicality of the object counts less than the unpredictable research operation and still less than the planning intention and idea. Behavior, in its broadest sense, does not even consist of the action, as it is already comprised in the mind of the artist. Its most faithful representation is given by Duchamp himself in the 1919 photograph by Man Ray "Tonsure," in which Duchamp presents the back of his head shaven in the shape of a star to indicate that everything *happens* in the process of thought. An artist can thus stop working, as Duchamp had done, and still remain within the domain of art. To do so, it is sufficient to plan one's own existence in the sense of art, whether as a professional chess player or as anything else. This direction will be taken up later by Salvator Dali, in his construing a *surrealist life* for himself. After World War II, Andy Warhol will do the same, challenging the laws of artistic merchandization by accepting them provokingly.

The exercise of art - not as production of works but as exercise of life, and therefore behavior - is explicitly found in Surrealism, both at the theoretical and at the operative level. The Surrealists, for example Breton, made a series of public political gestures, such as membership in the Communist Party, anti-Stalinist polemics, Bretonian confraternity with Trotsky, and opposition to Spanish Francoism. On an individual and group level, the Surrealists systematically practiced a series of behaviors aimed at clarifying the creative process and at establishing closer links between artistic creativity and the creative use of one's life. The *game* is one of these behaviors. It was pursued by the group as everyday exercise of the imaginative and associative faculties of the mind. Streets, and the city as a whole, were favored for carrying out behaviors supported by the imagination and given over to chance. The urban peregrinations of Breton and the Surrealists represent a way of being and indicate an everyday common, banal, even *idiotic,* use of one's time and of the environment: " . . . certaines salles de cinema du dixieme arrondissement me paraissent etre des endroits particulierement indiques pour que je m'y tienne, comme au temps ou, avec Jaques Vache, a l'orchestre de l'ancienne salle des "Folies-Dramatiques," nous nous installions pour diner, ouvrions des boites, taillions du pain, debouchions des bouteilles et parlions haut comme a table, a la grand stupefaction des spectateurs."

"Situation" and "drift." – The heritage of historical avant-gardes, especially that of Surrealism, was subject to close scrutiny and relaunched with a specifically ideological and political aim into the area known as "Internazionale Situazionista." This was done with particular attention to the problems of art/life and art/politics relationships. A specific focus of the debate was the opportunity art has of transforming itself into a behavior which can be experienced concretely, a so-called "situazione," *situation*.

The "Internazionale Situazionista" was formed in July 1957 at the "Conferenza (conference) by Cosio d'Arroscia" in the province of Imperia, on the basis of the alliance and confluence of various groups operating in the early 1950s: "Movimento Internazionale per una Bauhaus Immaginista," formed in 1957 by Pinot Gallizio, Asger Jorn, Piero Simonda, Elena Verrone, and Walter Olmo, in opposition to the "Hochschule für Gestaltung" of Ulm, the school of industrial design directed by Max Bill; "The Internazionale Lettrista," founded in 1952 by Guy Debord, Michel Bernstein, Gil J. Wolman, and Mohamed Dahou; and the "Psychogeographic Committee of London" represented by Ralph Rumney.

The "Conferenza" had been preceded by a document by Guy Debord, published in Paris in May of the same year: "Rapport sur la Construction des Situations et sur les Conditions de l'Organization et de l'Action de la Tendance Situationiste Internationale." In this document, the fundamental password of the avant-garde - which assigns art the task of transforming society - was relaunched with its own specific means: "Above all we think that we must change the world. We want to achieve the most liberatory change of the society and life in which we are trapped. We know this change is possible by means of appropriate actions." It is a question of *actions* promoted not in the area of culture and art, but "in the perspective of an interaction of all revolutionary changes." Thus attention is drawn to the artistic avant-garde and, in particular, to the movements such as Futurism, Dadaism, and Surrealism, that had stated the primary need of bringing closer the links

between art and life and that had seen artistic action as an instrument for the destruction of the old society, and the construction of a new individual and/or collective life.

In the face of these movements, the "Rapport . . . " assumes a critical position, clearly identifying their positive contributions and historical limitations:

> The notion itself of collective avant-garde, with the militant aspect that it implies, is a recent product of the historical conditions which carry the necessity for a coherent revolutionary program in the area of culture, and at the same time struggle against the forms which impede its development. Some of these groups tend to transfer organizational methods created by revolutionary politics into their activity. Their action can no longer be conceived without a link with a criticism of politics. From this point of view, the progression between Futurism, Dadaism, Surrealism and the movements formed after 1945 is remarkable. Therefore, in each of these movements the same universal desire for change can be discovered along with the same rapid crumbling, when the inability to change the world profoundly leads to defensive retreat.

The principal theses of the "Rapport . . . " are taken up by Debord in the first number of the central bulletin of the "Internazionale Situazionista," of June 1958. In an article significantly titled "Theses on the Cultural Revolution," Debord explicitly states the need for surpassing art in favor of behaviors and actions that are directly experienced. "Art should cease being a summary of sensations to become the direct organization of higher sensations. It is a question of producing ourselves and not things that serve us." An artist's work should no longer culminate in an object, in which everyday existence escapes its contradictions and confusions to rise to a plane of absolute perfection. Situationism, instead, aims to revalue everyday life and everything ephemeral that belongs to time and to the present. This is not to irrationally abandon oneself to the flow of life and be drawn in a sort of ecstatic participation, but for the "immediate participation in the passionate fullness of life through the changing of deliberately ordered ephemeral moments." The programmatic moment is thus decisive in the situationist poetics of behavior, whose main aim consists in perfecting an "experimental method of constructing daily life." The Situationists insist on the concept of construction by defining in a precise manner their area of behavioral theory, in relation to other and different proposals advanced in the same years in the field of "happening" and as part of the "Fluxus" program. The term "situationism" itself refers to the notion of "situation" this is defined as "a moment of life, concretely and deliberately constructed through the collective organization of a unitary environment and of a game of occurrences." That which happens in time - the "evenement" - is at the center of the situation and forms its basis; yet, the *situation* in its ephemeral duration, is different from the *event*, which celebrates that other representation of daily life, the "happening." What counts in the *situation* is the specific and constructed moment of life; this brings a different evaluation of the formative, organizing, and definitive activity

of a work. This experimental feature is at the basis of the Situationists' notion and practice of "drift" in the footsteps of the urban shifts theorized by the Surrealists. Like all *situations*, the *drift* is a collective experience (even though the ideal group is of few people) and consists of "experimental behavior connected to the conditions of urban society" which occurs in passing through different environments. The "drift" is therefore a behavioral experience not very different from another situationist urban practice, *psychogeography*, the study of the geographic environment and its effects on the affective behavior of individuals. One example is the study carried out by the Englishman Ralph Rumney in Venice in 1957 and 1958 (when the artist disappeared mysteriously), and another is the study of the psychogeography of the Halles quarter in Paris.

The behaviors which establish the *situations* suggest a distancing from any type of constrictive activity and presuppose a re-evaluation of the concept of game as free activity, self-determined and supported by desire. For this reason, the game is a model of behavior which opposes alienated work, functional to the "necessity for the present organization of production." As it is for art, which must be pushed beyond the line that separates it from daily life, the game should infringe onto the whole range of individual and collective life. "The central distinction which must be overcome - we read in the "Contributo a una Definizione Situazionista del Gioco" - is that which is placed between the game and daily life, the game being considered an isolated and temporary exception." At this point, situationist ideology takes on a marked utopian component. The *situation* represents a model alternative to the "oppressive reality of work." This is not because the *situation* refutes work, but because it aims at achieving equilibrium between game and work, at reaching an activity which struggles for a life determined by desire and an art that is a concrete prefiguration of such a life.

"Fluxus" and happenings. – Around 1955-1960 the "Fluxus" group was formed. Fluxus artists were motivated by the necessity to overcome the separation of the arts and to transfer the conditions enclosed in the work/object to the more general level of daily existence. Fluxus included artists, musicians, American poets, and Europeans. Members included George Brecht, George Maciunas, Dick Higgins, Alison Knowles, Benjamin Patterson, Joe Jones, Rag Johnson, Robert Filliou, Ben Vautier, Daniel Spoerri, Joseph Beuys, Wolf Vostell, Giuseppe Chiari, G. E. Simonetti, and the Korean Naum June Paik. Like Situationalism, Fluxus was an international movement. It resisted being labelled as an artistic current, school, or homogeneous group. However, they gave as their common denominator the desire to provoke individual and collective creativity. Their objective was the revelation of the potential creativity in every act and gesture within daily life. The re-evaluation of the daily and the transient is thus the foundation for both international movements. Both were political in their aesthetic ideology and engaged with the ethics of art. Destroying the confines limiting the work of art was, for both, a fundamental aim. Fluxus, however, did not have the strong ties with constructivism which the Situationists exhibited. The practice of drift comes closest to Fluxus concepts in its constant connection with all aspects of daily experience. For the Situationist, no particular moment is privileged. The constructive and

collective intention supporting this differentiates it from Fluxus. The Fluxus artists based their theories and practice of the *journey* on spontaneity and chance.

For their re-evaluation of the aleatory and their openness to the limitless unpredictability of the real, Fluxus found its mentor, as did happenings, in the poetics of John Cage. Cage had systematically applied the principle of chance to the creation of the work of art in order to re-establish the art experience on the level of life experience. Fluxus and the happenings authors adopted his teachings, making them central elements in their work. Brecht explicitly recognized Cage's paternity: "Through his life and his life-style he was, for us, the grand liberator." In fact, the origins of Fluxus and happenings can be located in the courses given by Cage in 1956-1958 on "The Composition of Experimental Music" at the New School for Social Research in New York. Among the students were George Brecht, Dick Higgins, and Allan Kaprow. Fluxus and happenings were thus born simultaneously, in the same cultural context. Additionally, both "movements" had ties to the same galleries: The Reuben Gallery, The Judson Gallery, and the AG Gallery, directed by George Maciunas.

It was Maciunas who moved from America to Europe. In Germany he met the groups "Action Music" and "Décollage," which was founded in 1959 by Naum June Paik and Wolf Vostell who initiated "Fluxus Fluxorum," a series of presentation/concerts. In America, George Brecht and Robert Watts organized similar demonstrations, among which the "Yam Festival" was of particular importance. It lasted the entire month of May in 1963 and signaled an important moment in the history of Fluxus. Also in New York, in the same year, the composer La Monte Young and Mac Low published a booklet entitled *An Anthology*. The actual title was much longer and analytical, specifying that it dealt with an anthology of "Chance-Operations, Concept Art, Anti-Art, Indeterminacy, Improvisation, Meaningless Work, Natural Disasters, Plan of Actions," etc. The book includes the names of Cage and his pupils; artists such as de Maria and Robert Morris, Ray Johnson, Yoko Ono, and Naum June Paik; composers such as Earle Browne, Christian Wolff, Richard Maxfield, and, of course, La Monte Young.

George Brecht theorized about "chance-imagery," making it the focal point in his performances. The kind of withdrawal of objects from life practiced by Brecht assumes a transitory character quite different from the Duchampian withdrawal of the ready-made. The use of the real object no longer posed radical questions about the nature of art. Objects are presented as normal appropriations from everyday life - from reality. Brecht proposed the idea of the "container" which makes all of nature a supply, or repository of forms, at the disposal of the artistic operation. In October of 1959, at the Reuben Gallery, Brecht's "Toward Events" consisted of a box on a table. The action depended on the intervention of the public, which was invited to open the box, take out the objects it contained, and use them as they pleased. The event, which lasted between 10 and 30 minutes, included all the possible incidents occurring between the time the box was opened and its closing, after the objects had been replaced. The same chance principle presided over "Composition 5" (1960), by La Monte Young. One or more butterflies were freed in the performance space. The event ended when a but-terfly flew out of the gallery through a window or a door.

Through Cage's procedures and his poetics of chance, Fluxus revived not a few of Dada's ideas. Among these was the use of objects and instruments deprived of their functions. Thus, Maciunas, in his "Piano Piece N. 13," played on a piano with the keys nailed down. Ben Patterson did his "Piano-piece" in which a piano was whitewashed on the stage. In his "Music and Distance," Giuseppe Chiara seated himself on a stool, far away from the piano. Dick Higgins traced the outlines of a few randomly placed forks onto the ground or on black sheets of polyethylene, making a kind of map. Along the lines of the map he wrote words, all taken from the same book and all beginning with the same letter. The actors followed the lines of the map, responding to the words they met along their path. The evocation of Dada is obvious, extending from the legendary casual selection of the term "Dada" itself to the chance poems of Tristan Tzara.

The spirit with which the Fluxus artists advanced their ideas was profoundly different from that of original Dada. The difference is clear in Fluxus performances from the first period of 1958-1964 and even more so in American Fluxus. Fluxus did not have the same destructive or nihilistic intent, nor did it seek to create a "Theatre of the Absurd." Instead, the artists showed a total openness to life. They happily accepted the confused and contradictory flow of life. This culminated in an appreciation for that which others considered banal and senseless. Robert Filliou clearly explains this fundamental aspect of the movement in a letter to Allan Kaprow: "Life must be (become) essentially poetic. The most important thing to teach our children is how to use their free time creatively. Artists can participate in this project. As promoters of the creative spirit, they can gain more control over their surroundings and thus escape the *ghetto* in which society constricts them - considering artists as simple providers of useful entertainment appealing to the snobbish values of the leisure class" (1968).

The themes of the ephemeral, the recovery of the quotidian, in its most common and banal aspect, and the celebration of the present already existed in American "New Dada," especially in Robert Rauschenberg's work. His combined paintings are arrays of images and elements drawn directly from reality. His paintings incorporate such items as: bottles of Coca Cola, photographs of female movie stars, pictures of anonymous people, clippings from the newspaper about short-lived, famous events, or contemporary reproductions of old masterpieces. He chose things which are part of our daily existence but which stand in danger of disappearing from our consciousness. He chose them just at the moments they were about to disappear from the scene, giving them new life imbued with all the weight and richness of the memories and meanings they excite in us.

The use of the object and fragments of objects within the work of art once again recalls Dada, but as Dada identified itself with the principle of chance and nonsense, the end result was considerably different. Dada's use of the object had a predominantly, if not exclusively, destructive and subversive objective. The object was employed within their conceptual investigation into the worth of the language of art and its very

nature. From this point of view, Dada can be considered a *gesture* in the sense used by Hugo Ball in his discussion of the Cabaret Voltaire: "Our cabaret is a gesture. Every word pronounced and sung here explains at least one thing: this demoralizing era has not succeeded in gaining our respect." Duchamp, by sending a urinal entitled "Fountain," to the exhibition of Independents in New York, made a gesture similar to Rimbaud's (who had the Dadaist Huelsenbeck in mind) when, at a "Parnassian Recital," he ended every line with the words "Oh, shit." A subtly ironic gesture, but no less aggressive, was made by Man Ray when he attached nails to the smooth, functional plane of a clothes iron and offered this innocuous "present" to the spectator.

In Rauschenberg's combines, as in chance-imagery and the meaningless works of George Brecht and Fluxus, the old spirit of Dada is replaced by a decidedly more positive intention. There was also more of a poetic accent, in Fillou's sense of the word. Rauschenberg himself explicitly stressed the difference: "Dada wanted to exclude, censure the past, cancel it out. For us, today, we try to include the past in the present, into the totality of the moment." The employment of objects has to complete this recovery of wholeness, to reinsert the past into the present, but also to live and celebrate that which belongs to the present. Rauschenberg also stated, "I am in the present, I try to celebrate it." Thus, he wanted an art of the daily and ephemeral. This put him in close rapport with other tendencies, such as Fluxus and happenings, which saw art as a production of behavior rather than objects. These events occurred on the New York art scene, appearing in the work of numerous artists. Particularly important were: Allan Kaprow, Robert Whitman, Rauschenberg, Jim Dine, Claes Oldenburg, Meredith Monk, and Red Grooms.

The gesturality of Action Painting, especially that of Jackson Pollock, was an important influence. The performances of the Japanese group Gutai (1955-1957), whose members included Akira Kanayama, Sadamsa Motonaga, Shuso Mukai, Saburo Mirakami, Kazuo Shiraga, Atsuko Tanaka, and Shozo Shinamoto, gained much attention. John Cage was a decisive reference point for happenings artists as well. His concert/actions in which he combined pictures, dance, films, slides, radio, tapes, and piano had a major impact. In 1951-1952, Cage presented a concert/action event at the Black Mountain College. Merce Cunningham, Charles Olson, Robert Rauschenberg, M. C. Richards, and David Tudor all collaborated on the project. Cage stood at the top of a stair, reading a text with intervals of silence. Olson and Richards recited poetry from another stair. Tudor played the piano, while Rauschenberg carried around a gramophone. Cunningham and other dancers moved around the space. Some white-on-white pictures by Rauschenberg hung from the ceiling. On every seat an empty glass was placed, which was filled with coffee at the end of the piece. Cage's enterprise was a college of different linguistic methods. This medley of various elements was the foundation for "happenings." Similar activities relate to the American artistic experience of the first half of the 1950s, which involved surpassing art's limits in a progression toward theater. At first, this process of trespass consisted in putting objects and fragments of objects taken from the surroundings

into the work of art. Through this process, painting cast off its traditional two-dimensional definition to protrude into space. At this point, there was an interchange between painting and sculpture; each one lost its usual connotation. The work of art extended beyond the walls, to a place within environment. It was transformed into a kind of tool used to demonstrate a slice of life. But the object within actual space was not complete. It also incorporated and controlled a portion of space within itself. The work of art overcame the inconsistent limits of the object and enclosed the spectators themselves into its space. Theater, architecture, and a new conception of space are at issue in this process, which began with the combination of diverse linguistic "media."

Dick Higgins used the term "intermedia," reviving (perhaps without knowing it) the term employed by Mejerchol'd in 1910 for his "Intermedia House." There he presented theatrical pieces including pantomime, dance, circus performances, etc., all of which involved the spectators. Yet again, the benefits of Dada were referred to, in particular the work done by Kurt Schwitters. Schwitters' "Merzbild" overcame the two-dimensional definition of painting. His "Merzbau" was an assembly of things taken from life which he incorporated into the structure of his studio. He renounced the limits of the walls to make use of the total space. It was truly an "environment" in which to live. Schwitters was also interested in theater. The definition he gives for his "Merz Theatre" anticipated, in more than one way, the theory and practice of "happenings."

> In contrast to drama and the opera, all the parts of the Merz Theatrical work are inseparably united: the Merz Theatre cannot be written, read or listened to, but only realized visually. . . . The Merz Theatre only knows the fusion of all the elements of the work into one total composition. The materials for the scene are solid bodies, liquids, gasses People can also be used. They can be tied to the wings and appear as they are while doing their everyday job.

The first happening was created by Allan Kaprow. In October of 1959, at the Reuben Gallery, Kaprow performed his "18 Happenings in Six Parts." Like other "happenings" artists, Kaprow himself participated. He spoke and played a musical instrument. Other participants were Rosalyn Montague, Shirley Predergast, Lucas Samaras, Janet Weinberger, Robert Whitman, Sam Francis, Red Grooms, Dick Higgins, Lester Johnson, Alfred Leslie, Jay Milder, George Segal, and Robert Thompson. The "actors" moved around, talking, playing music, joking, and painting on stage. The visitors were seated on randomly placed chairs facing in different directions. They were asked not to leave their seats at intermission. Prior to the performance, Kaprow had published a kind of script in the magazine "Anthologist" with the title "Something Which Must Happen: an Event."

Kaprow was also the theorist for happenings. In one of his clarifications, he traced the progress of his own work in order to define the new artistic manifestation. He points out his starting point within the scope of Action painting and the importance it held for him, particularly the work of Jackson Pollock. Significantly, Kaprow speaks of a "multidimensional attitude towards

painting" and "action-collage" referring to the first break with painting in two-dimensions in the attempt to occupy surrounding space. "My action-collage is extensive and I incorporate intermittent lights and huge pieces of different materials. The conglomerations kept extending farther away from the walls to the very center of the setting and grew aurally richer. At the end, they contained almost all the sensory elements with which I worked in the following years." After this came the gallery invasion and the creation of environments involving the visitors. Kaprow goes on to say,

> It came to me immediately that every visitor to the environment became a part of it (this was something which, in truth, I had not foreseen), therefore I gave some small task to those who came, like moving something or turning the switches, etc. Around 1957 and 1958 this necessity seemed more important and suggested to me that I give more a "marked" responsibility to the visitor. I gave them more and more tasks. This was the birth of the Happening.

The artistic event thus moved away from the object (the painting or sculpture) toward actions, always bringing the experience of art closer to that of theater. Another step was made by taking the event into places not traditionally dedicated to art such as rooftops, stores, garages, school rooms, gymnasia, as well as the street.

The happening is essentially a sequence of events with a general plot set out beforehand. A more or less broad margin is left for spectator participation and possible interpretive variations by the actors. The actors are generally not professional. Almost all of them were part of the same circle of New York artists, musicians and poets who made the city one of the most important cultural centers during those years. According to Kaprow, professional actors were inappropriate in a happening because they tended to "recite" and "talk as much as possible." They are too caught up in themselves to appear natural. Simplicity, naturalness, and spontaneity are, apparently, the qualities necessary for the happening. Kaprow lists the four fundamental points around which his actions revolve and which represent the most typical characteristics of the happening.

> First: the immediate *quiddity* of every action, simple or complex, deprived of any meaning beyond the simple immediacy of what happens. This "being of the action" - physical, felt, tangible - is very important for me. Second: the actions are fantasies. They do not exactly follow any example from life, even if they are derived from it. Third: the actions constitute an organized structure of events. And fourth: their "meaning" is legible in an allusive and symbolic sense.

This last aspect of the happening seems to contradict the immediate affirmation and the pure physicality of the action, but instead, this quality is at the base of happenings. It is particularly evident in Kaprow's 1962 happening entitled "The Courtyard," which was held in the New York in the courtyard of the Greenwich Hotel. Kaprow used certain symbolic structures which he defined as "archetypal" such as a mountain which was to be understood as "self-eruption" and the "revelation" of Mother Nature. A girl enters the scene, listening to a transistor radio. She climbs the mountain and ends up being swallowed by the earth. She is simultaneously the Goddess of Nature, Aphrodite, and Miss America. The endowment of the actions and participants with symbolic meanings was an unusual aspect of happenings, especially the American brand. However, symbolism was an important aspect of 1960s performance, especially those done by European artists.

Robert Whitman was another artist who insisted on the programmed, yet unpredictable, character of the happening. His instructions for the progress of the action are much less detailed than Kaprow's. Whitman did not prepare a script in the strict sense, but outlined for himself a series of notes, sketches, drawings, watercolors, and stage directions. His central theme was time and its "occurrences." In his pieces ("The American Moon," 1960; "Mouth," 1961; "Flower," 1963; "Water," 1963; "The Night Time Sky," 1961; and "Cinema Piece,"1968), he worked on a more abstract level than Kaprow, Dine, or Oldenburg. The physicality of the objects and humans were less important to Whitman than making time solid, which he understood as the abstract thread which tied together past and present into a "history." For him, "Time is something concrete," and he "likes to use it in the same way as color, paint or any other material." Time supports the description of the events, of the experiences of people. Fantasy also "becomes an object of the physical world, no different from a street or rain. It becomes a product of physical events, a part of nature that one can describe." Thus, what counts in Whitman's happenings is not so much the physical presence of objects or people as their "flow." In "The American Moon" the actors traversed the space in all directions. They could be seen only from the waist down because they were suspended along a network of ropes which extended across the entire space of the action. As Whitman stated, " . . . the actors travel very fast and the space is full of disappearing bodies, to the right and to the left."

The *actions* of Jim Dine and Claes Oldenburg display a notable change in relation to Kaprow and Whitman. The relationship with the quotidian is still the center of the act, but the sense of this relationship is changed, just as the attitude toward reality was altered, (by such Pop artists as Dine, Segal, Lichtenstein, Oldenburg, Warhol, and Rosenquist.) More than any participation or adhesion to daily life, one must see these artist in relation to their fundamental interest in contradictions. The real is seen more definitively in terms of violence and aggression.

"The Car Crash," an *action* performed by Jim Dine in November 1960 at the Reuben Gallery, is the description of an auto accident (like Oldenburg's "Autobody's"). Dine created a disturbing situation through a violent play of lights which were attached to the bodies of the protagonists. The noise level rose as recorded sounds of traffic were played, the actors enunciated fragments of words, and Dine operated the "Machine That Asks For Help." There was an emblematic presence of a girl, with a white face, who appeared to be two and a half meters tall. She was actually perched on an overturned stair which was invisible beneath her enormous tunic of white muslin. She remained immobile for the duration of the action.

Aggression and violence were already part of his previous works, "The Smiling Workman" and "The Vaudeville Show," in which Dine played recordings in different languages and assumed the repertoire of the circus. He had wild make-up on his face which transformed it into a mask somewhere between the comic and the tragic. The end result was somewhat grotesque staging. Claes Oldenburg moved further away from the direct appropriation of the real in his happenings. ("The Store," 1961; "Injun," 1962; "World's Fair II," 1962; "Gayety," 1962; "Autobody's," 1963; and "The Home," 1964). As in his plastic works, Oldenburg depended on the manipulation and deformation of daily objects (typewriters, ping-pong tables, articles of clothing, furniture, ice cream cones, hamburgers, pastries). In Oldenburg's actions the role of the imagination was an important element. He created situations in which the realistic and the fantastic are mixed, without differentiating between the two.

The participation of the spectator and the incorporation of chance did not play as major a role for either Dine or Oldenburg as it did for Kaprow and Whitman. In fact, Dine disagreed with the very definition of a happening, declaring: " . . . the word was Kaprow's, and has no relationship with my work." While Oldenburg, speaking of his work said, " . . . the term "Happening," in its ambiguity, provokes an expectation quite far away from the effect I seek which has nothing to do with spontaneity or improvisation." The "Happenings" of Dine and Oldenburg should really be understood as "pieces" which resulted from strictly organized structures, producing works which were, in a sense, closed. This kind of work anticipated the more formalized basis for "Behavioral Art" beginning in the second half of the 1960s.

Toward the end of the 1950s in America a large and well-defined movement developed which attempted the same abandonment of the production of art *objects* in favor of the creating ephemeral events and actions. Jean Tinguely's "Hommage to New York," presented in 1960 at the Museum of Modern Art, is a significant event in this development. It was purely an event, during which the work of art (the sculpture) created by Tinguely was also destroyed by Tinguely. Happenings and Fluxus events are forms of the theatricalization of everyday life, although different methods were used. There are many analogies between them and new forms of theater concurrently under development, in particular the new "Living Theater" which exhibited the same urge to join together the relationships between theater and daily life.

There were analogous events in Europe. When George Maciunas returned from America to bring to the Continent his new American experiences, he found that a similar discourse had already been launched, especially in Germany with the activity of Wolf Vostell and Joseph Beuys and in France with that of Ben Vautier, 1962; signals the moment of maximal convergence between the European experience and that on the other side of the ocean. This was the occasion of the "Fluxus Internationale Festspiele neuester Musik," which was organized by Maciunas in Wiesbaden. Nineteen Sixty-two was the year of Fluxus, which officially existed by then. In the same year, in Düsseldorf, Fluxus publicly acknowledged its debt to Dada with a concert entitled "Neo-Dada in Music." Maciunas, Paik, Brecht, Higgins, La Monte Young, Cage, and Vostell were all involved.

In 1956, Wolf Vostell had initiated a series of exercises quite similar to those occurring at the same time in United States. In a street in Vanves, Vostell carried out an "event" which directly involved the public, who became the protagonists of the action. In "The Theater is in the Street," the artist urged passers-by to tear down the manifestos attached to the walls of the street and read the message in a loud voice. The second part of the event was the construction of a short-lived sculpture. Vostell prompted the spectators to gather the junk left by a ruined vehicle and pile it up until traffic was totally blocked.

The appropriation of real objects and fragments of objects again recalls Dada, particularly the work of Duchamp. But Vostell's action in the creation of the "sculpture" (and that of asking the passers-by/spectators/actors to participate), did not remove the object from its context. He left it where he found it, in the street, i.e., in the context of its everyday existence.

Ben Vautier acted within the Duchampian idea of removing manufactured objects from their own environments. But Vautier's removal was itself profoundly different from the Duchampian one. The Duchampian act of removal seized on a given thing, isolated it, and inserted it into the context of art. This is the basis for a penetrating inquiry into the problem of art, its relations between reality and representation, and its actual value. Ben Vautier does not isolate the objects or emphasize them. But, like Robert Filliou, Robert Whitman, Daniel Spoerri, and Arman, he accumulates objects without thinking of making them into a composition, as Rauschenberg did in the combine-paintings. Like George Brecht, Vautier often makes use of "refusee," that is, the things that the spectators of his "exhibition" had thrown away. He does not attempt to bring everyday life to the level of art. On the contrary, he tries to break down the language of "high" art and put it back at the "zero degree" of the contemporary and common status of the everyday. Thus, he created a circularity somewhere between the experience of art and the experience of life. As he explains, "Art is like space, space is like environment, the environment is like an event, the event is like art, art is like life, life is like a work of art" (1964). The gesture of appropriation is, thus, extended to everything, not limited to a definite object. In the end, objects are placed in a privileged position - the privilege of art.

When Vautier wrote "I sign everything," he extended the Duchampian gesture. He transforms the sense of art not only on the level of quantity, but also on that of quality. All of daily existence can be substituted for the work of art. Thus, when the artist was invited to the Venice Biennale, it was not even necessary that he move from his own city, his own house, or even that he send a work of art. In 1966, Vautier decided to participate by sending the following note: "650 kilometers from Venice, in Nice, in the Marrittime Alps - 32 rue Tendutti de l'Escarene - beginning on the 18th of June, 1966 - and while the Biennale lasts, Ben will live as he usually does."

Ben Vautier can be considered, along with Vostell, as one of the most reliable interpreters of Fluxus. He separates himself from the "happening" movement, the American NeoDadaists (Rauschenberg) as well as

French "Nouveau Réalisme" (Arman, Spoerri, etc., with Pierre Restany as their theoretician). Vautier also makes a distinction between his work and the ideas advanced in France near the end of the 1950s by Yves Klein. In a 1966 essay, with the significant title "Ben's Happening," Vautier offers a lucid theoretical clarification of behavioral trends. Using his own personal experiences as a source, he analyzes the affinities and the differences between happenings and Fluxus. He distinguishes between two interpretations of the happening. The first is its definition as "an extra-pictorial manifestation" whose principal characteristic resides in transformation of reality through the use of different objects. It is a sequence of events with specific actions improvised within a prearranged plot. There is some type of public involvement and the frequent presence of a leitmotif of political or sexual symbolism. The second interpretation defines the *event*, " . . . as the representation of reality with reality. It is the communication of the viewpoint that all details of life are theater." It is not the extra-pictorial transformation of life as in a Happening, " . . . but the representation and communication of life through simple and real expressions such as drinking a glass of water or buying a hat. It is a mental attitude that can be summed up by saying: 'all is art and art is life'."

The actions. – Along with the two forms of artistic exercises described by Vautier and reconfirmed by happenings and Fluxus events, there is another variation on "Behavioral Art" which occurred, especially in Europe, which can be defined as *performance*. The performance is understood by artists as a strictly structured event with pre-established contents. Each of its elements are introduced in a moment which is precisely defined by the space and time of the performance. Consequently, the entire effect of the action is calculated and obtained through a mise-en-scene which tends to eradicate chance and indetermination. One of the most important "performers" in the 1960s is Joseph Beuys, who participated in Fluxus but also opposed them with actions inverting some of the movement's ideals. Beuys worked and taught in Düsseldorf during the 1950s. Around 1960 he began to make his presence felt and to exercise a strong influence in the city's artistic circle and German culture at large. At this time, Düsseldorf was one of the most important cities of the international avant-garde. In addition to Beuys' activity, there was an active group called "Zero." Zero was founded by Otto Piene and Heinz Mack, who published the magazine "Omonima" beginning in 1958. The group and the magazine became a point of reference for many foreign artists such as Yves Klein and Piero Manzoni. The group organized a series of exhibitions with artists such as Daniel Spoerri, Francesco Lo Savio, Günter Uecker, Dieter Rot, Paul Bury, and Oscar Holweck. Zero attracted Fluxus artists, who were still energetically working in Düsseldorf. Those artists gathering around Zero included George Maciunas, George Brecht, Robert Filliou, the composers Maurizio Kagel and Henning Christiansen, and the young students of Beuys, Palermo, and Reiner Ruthenbeck.

Although many of Beuys' performances were created as part of Fluxus, ("Fluxus Konzert," 1963; "Fluxus Sibirisch Symphonie 3," 1963; and "Der Chef," 1964), his behavioralistic attitudes put him on a different plane of experience, one defined in the area of *actions*, if not that of the *event*. The difference lay in the clear philosophical intentions he displayed and his language, rich with metaphoric reductions and symbolic distillations. In "Der Chef" the artist wrapped himself in a mantle of felt, with two dead hares attached to the ends. A rope emerged from beneath the felt with a loudspeaker attached to it. From the loudspeaker came sounds of Beuys making intermittent guttural noises. These are some of the elements which often recur in his other performances. He often employed animals and felt, later adding fat or grease to his repertoire. These elements have a symbolic significance within his complex and philosophical discourse. Beuys' poetics show an affinity with traditional German Romanticism, especially in the idea of man as a being ceaselessly affected by the forces of nature, animals ("Iphigenie," 1969), and matter, whether organic or inorganic. The animation of matter can be sensed like a mysterious pulse. It is the mechanism which drives matter from the condition of chaos to that of form. The two polarities - chaos and form - are symbolically represented for Beuys by fat and felt. The fat, whose plastic potentials are practically infinite, awaits formal organization. The felt has already arrived at its state of structure. Space also contributes to the affirmation of his metaphoric and symbolic discourse. A corner is the result of straight lines meeting. It is thus a privileged place. Beuys frequently puts the materials he uses in his performances in a corner, especially the fat and the felt. The symbolic system of his performances is always imbued with the concreteness of a *personality* which is an extraordinarily powerful physical presence. He is thin, almost emaciated, with wild and restless eyes.

Wearing a felt hat, an open shirt, and an apple-green colored jacket, Beuys is above all a consummate performer. He has an imposing face which recalls those of the silent screen actors; it is an impassioned mask, mysteriously pathetic, like Buster Keaton's. Beuys has a powerful need to enter into discourse with others, to relate to them. But he is also an evangelist, with a passion to preach and convert others to his vision of the world and his political ideas. In the 1970s, Beuys' performances had a more marked political content: freedom, democracy, and socialism are the themes which engaged him. Beuys rejects representative democracy, bureaucratic socialism, and anarchy. He proposes, instead, an organized community based on consensus and self-determination, in short, life founded on individual freedom. This must be rooted in all of existence. It will coincide with the creativity of individuals. Art possesses the requirements for this transformation because its function is specifically a creative one. It is, thus, an ideological and political model for living.

Yves Klein also had the nature of a preacher and philosopher, setting him apart from the French "Nouveau Réalisme." Stimulated by Oriental culture, an international black belt in judo, a frequent attendant of Bachelard's lectures on Jungian symbolism at the Sorbonne, he was also an indefatigable scholar of the hermetic and alchemistic traditions and Rosicrucian esotericism. Yves Klein made his work, his actions, his very existence into one unitary act of contemplation and dynamic growth. Like the ancient alchemists, he considered matter as a condition of psychic projection. Thus, the changes he undergoes entail the transformation of the ego. Water, earth, fire, and air were the

primary elements Klein used in a series of works and projects ranging from "Fire," 1960-1962, to a project for an aerial magnetic sculpture, 1962, to "An Architecture of Air" and the "Fountains of Water and Fire," 1959. He used monochromatic colors, especially blue. These colors assumed symbolic meanings, becoming the focal point for cosmic meditation and the means to spiritual sublimation. In his monochrome blue period, the first examples of which were shown in 1957, he produced canvases with dense, physically impenetrable color. At the same time, however, the canvases seemed receptive to an intangible infinitude. Klein has written, regarding this art, "The authentic quality of a picture, in its very being, once it is created, is revealed beyond the pictorial effect. This is what made me decide to present 'The Immaterial Blue' at the Iris Clert Gallery."

At the same gallery, in Paris, in 1958, Klein proposed a show on the theme of "The Void." The visitors stood in a completely empty gallery which Klein had painted white. The white was substituted for blue, the two colors representing the polarities of the void and the whole, absence and presence. The positive pole was not neglected. On opening night, outside the gallery, beams of blue light were supposed to illuminate the obelisk in the Place de la Concorde.

Klein reestablished the human body as one of his materials. It, too, had a primary value. Klein let it do the work of painting directly, transforming the bodies of his models into "human paintbrushes" in his "Anthropometrics" of 1959-1960. Klein writes, " . . . I threw a large white canvas on the floor and poured twenty kilos of blue in the middle. The girls moved into the paint and literally painted my picture by rolling on the surface of the canvas, in all senses." The body is a primary material, like color. It is also an alchemic material that must be transformed through art to its most perfect state. From this point of view, Klein's involvement with judo becomes a somber rite. As he employs the human body in his aesthetic creations, judo is an experience which pushes the body to the limit of its physical potential. An example of this maximum use of the body is his "performance" of the "Jump into the Void" of 1962.

Around 1958, while the production of art as objects was being questioned in America, Germany, France, and Italy, in Milan there was an analogous tendency developing. The Azimuth Gallery opened in that year through the efforts of Piero Manzoni and Enrico Castellani. In the following year the magazine "Omonima" was published. Although only two editions were published between 1958 and 1959, it was an important reference point internationally. Already, by the beginning of the 1950s in Milan, a group calling themselves "Nuclear Artists" had been established, including the artists Baj and D'Angelo. In 1954 they had belonged to The International Movement for an Imaginist Bauhaus. The influence of Lucio Fontana was another important factor. In the exhibition "Miriorama," the young artists Boriani, Colombo, Anceschi, and Devecchi presented work/events such as "Picture of Fire" and "Large Inflatable Object." These were immediately followed with objects containing within them a series of real events which continually modified the structure.

The questioning of the picture/object and the move towards "Behavioral Art" was at the center of artistic activity. This is seen especially in the work of Piero Manzoni, author of the series of "Achromes" in which painting is returned to the pure materiality of the canvas and its preparation. Following this series was another based on the gesture and the direct employment of the body. Manzoni thus made the point explicit that one must have faith in total corporeality to transmit the aesthetic message. It must possess within itself, and its productions, those attributes traditionally displayed in the artistic object. Between 1960 and 1961, Manzoni engaged in a series of efforts such as tracing a line 7,200 meters long on a roll of paper; signing or eating eggs; and offering his own breath and excrement as art. The trespass beyond painting's boundaries was also actualized by appropriating the real, something which Manzoni did increasingly as a method of infringement on art's limits. He autographed a person, transforming them into a "living" sculpture. He created a "Magic Pedestal," which made whoever stood on it into sculpture. His "Base of the World" in Herning announced the paradox of the appropriation of all reality.

During the 1960s, Behavioral Art was one of the most visible trends on the international art scene. There are so many variations of it that it is difficult, if not impossible, to make an adequate summary. On the one hand, Behavioral Art calls attention to the physicality of the body as a whole as well as in its parts (hands, feet, gestures, walking, speech reduced to primary sounds). On the other hand, the body, whether that of the artist or another person's, is used to prompt an awareness of the artificial or man-made environment. The first alternative is "Body Art"; the second, "Land Art."

Body Art in its "coolest" form is an investigation of the body used as a means of aesthetic expression. This maneuver emphasizes the functions of the body and its parts. Body art also employs mechanical reproduction techniques of photography, video, and film. This is done not so much for the permanence of documentation as it is to conduct a more searching inquiry, because it allows the action to be arrested. Body Art performances almost always presuppose long preparation and analysis. Bruce Naumann was interested in facial movement, exploring the face as a whole, and in its details. Klaus Rinke analyzed the movements of walking. Ketty La Rocca was involved with the study of the "body language" of different parts of the body, particularly the hands. Arnulf Rainer explored the distortions of gestures and the face using photography which underlined their mutability. Lucas Samaras did a series of photographs using himself as the subject. The common analytical approach of these different tendencies within Body Art can be considered as kinetic proposals—that is, a semiotic approach to the use of the body in the field of aesthetics.

At the opposite pole is a sado-masochistic attitude toward the body which is seen as the subject/object of violence and aggression. Artists of this temperament include Vito Acconci, Gina Pane, Pier Paolo Calzolari, and Gilberto Zorio. Violence often occurs within ritual acts, as was the case with the Body Art of Hermann Nitsch, Otto Muhel, Günter Bruss, Oswald Wiener, and Rudolph Schwarzkogler. Nitsch and the artists in his circle advanced the idea of a kind of theater of cruelty which reveals our "unconscious desire to kill." The result is an "orgiastic abreaction" which uncovers our profound impulse to violence, bringing it to the consciousness of both the individual and the collective. The

bodies of humans and animals become objects of displaced aggression. The gallery is transformed into a ritual site; the performance becomes an initiation process. Rudolph Schwarzkogler was the artist exhibiting the most extreme sense of violence. He offered an interpretation of his ideas in his 1965 "Panoramic Manifesto" dedicated to "total nudity." He asserted that "artistic nudity" had supplanted painting made by hand. The "liberating quality" of this operation affirms that " . . . 'artistic nudity' shakes off traditional constrictions and, similar to a wreck, is finally liberated from mechanical reproduction. At last, artistic nudity and exhibition are one, unified thing."

The ritual aids in transferring the "action" from the quotidian level to one of liturgical operation. The work is willingly enclosed within a privileged space and time in opposition to everyday space and time. Even the spectators are asked to make a passage, to cross the threshold beyond which it becomes possible to participate in the ceremony. Behavioral Art reverses the situation proposed by Fluxus and happenings just a few years earlier. Behavioral Art does not attempt any extension into the entire field of experience, but conceptually accepts its own segregation. Instead, it makes itself into a place of concentration and mediation for small groups. The ritual "actions" of Janis Kounellis move within this sphere. In his "Event With Signals" (1960), he dressed in sacred vestments to draw on a canvas. His other works range from "Senza Titolo" (1970), to his more recent performance pieces which concentrate on the theme of music and dance.

Not a few artists engaged in actual transvestitism in order to direct the "action" away from a quotidian level. Klein appeared dressed as a Knight of the Order of San Sebastian, pushing the "action" to the "high" level of historical transvestitism. Pino Pascali, in a manifestation dedicated to Corradino di Svevia at Torre Astura (1966) created an environment rich with evocative implications by placing himself in near darkness while wearing the "clothes" of an emperor. Urs Lüthi brought the technique of transvestitism to a "literal" level. He dressed as a woman and put on make-up in the presence of the spectators. The poses he struck, which he had photographed, were rich in cultural references. In doing this, he was returning to the Surrealist technique of displacement, in evoking memories of the great silent movie stars. The transvestitism of Lüthi fuses the feminine and the masculine. He proposed that the body contains within itself a repetition of the myth of androgyny. He questions the possibility of union and joining that which is and remains divided.

The performances of Gilbert & George recall a different ritual – that of the music hall. In one performance they wore out-of-date, shabby clothes with their faces covered with gold. They accompanied tape recorded songs with silent movements of their mouths and stereotypical gestures. Pistoletto also played with exhibitionism and transvestitism. He sometimes performed in the closed space of the gallery ("Cinecittá," 1966); at other times he went to the street or the wide, older areas of the city. He brought his "Zoo" to such a place, putting himself in the role of the showman by associating himself with the low-class tradition of the strolling player or balled singer. The concept of violence and its theatricalization are the foundation for other types of Behavioral Art which arose with a more ernest

and articulated ideological intention. Such activities include the recent performances of Vostell, the theatrical events arranged by Fabbio Mauri ("What is Fascism?" 1971; "The Jew," 1972); and the activities of Vettore Pisani ("Gliding," 1970; "Masculine, Feminine and Androgenous, Incest and Cannibalism in Marcel Duchamp," 1970; "The Hero in his Room. All Words, From Duchamp's Silence to Beuys' Noise," 1973).

The use of the body as a form of free and self-determined activity represents the common denominator in Behavioral Art. Ideological content is implicit. Methods of expansion and extroversion are employed. The artist trusts to the body the duty of reestablishing a more direct contact with nature through series of numerous events. For example, Jan Dibbets unwound a ten meter white line under a stream of water (1968). From above it looked like a trail on the sea. In 1969, he made a continous line in the forest by painting the tree trunks white. Dennis Oppenheim dug a deep, dark trench in the white blanket of snow on the land's surface. Robert Smithson used a truck to dump a huge amount of dirt down an embankment (1969). Carl André made a path in the forest with pieces of wood prepared in advance (Log Piece, 1968). Walter de Maria traced two lines on the surface of the desert, interrupting them with the outline of his own body stretched out on the ground, ("Two Lines Three Circles The Desert, 1967). Christo took part with his technique of "wrapping" on the grand scale of nature ("Little Bay," New South Wales, Australia, 1969).

Actions still understood as an intervention in the natural landscape were also realized by Hamish Fulton, Michael Heizer, Richard Long, Giuseppe Penone, Giovanni Anselmo, and Eliseo Mattiacci. The term "Land Art" can be used to describe these works, even with the inevitable imprecision that comes in trying to label a movement embracing so many different experiences. The common denominator is in the will to go beyond urban limits, to undo the artificial universe, resolutely characterized as technological. They attempt to escape the modern metropolis to recover anew the natural dimension. The processes used by these artists no longer include appropriation, but involve the direct manipulation of nature. They use simple gestures in which the traces of the manual gesture - by then neglected and forgotten - are obvious. As if put between parentheses, the process of manipulation by hand is displayed, emphasizing its value and restoring to it its lost sense. That which these manual gestures restore differs from the past. They no longer produce representations or illusionistic images. They are concrete things which one can manipulate and construct. Thus, manual gestures attain the solidity of real and familiar surroundings.

BIBLIOGRAPHY - G. E. Debord, Rapport sur la construction des situations et sur les conditions de l'organisation et de l'action de la tendance situationiste internationale, Paris, 1957; B. Vautier, Manifesto del Laboratoire 32, Nizza, 1958; Miriorama, primo manifesto del gruppo omonimo firmato da Anceschi, Boriani, Colombo, De Vecchi, Bellinzona, 1969; P. Manzoni, Libera dimensione, Azimuth, n. 2, Jan. 1960; Les Nouveaux Réalistes, primo manifesto del Nouveau Réalisme redatto da Pierre Restany, Milano, 1960; A. Kaprow, Happening on the New York Scene, Art News, Mar. 1961; Environments, Situations, Spaces, New York, Martha Jackson

Gallery, Catalogo con testi degli artisti partecipanti (Oldenburg, Dine, Kaprow, Brecht); «ccV Tre», primo numero della rivista del gruppo Fluxus diretta da G. Brecht e G. Maciunas, New York, 1964; M. Calvesi, Le due avanguardie, Milano, 1966; Lo spazio dell'immagine, Catalogo della mostra omonima, Foligno, July-October 1967; Arte povera, Catalogo a cura di G. Celant della mostra omonima, Galleria La Bertesca, Genova, Sept. 1967; P. Gilardi, Microemotive Art, Flash Art, Milano, Jan. 1968; Il Teatro delle mostre, Catalogo a cura by M. Calvesi della Rassegna omonima, Galleria La Tartaruga, Roma, May 1968; Arte povera + azioni povere, Catalogo curato da G. Celant con interventi di vari autori della Rassegna omonima, Amalfi, Oct. 1968; R. Smithson, A sedimentation of the mind: earth projects, Artforum, Oct. 1968; F. Menna, Profezia di una società estetica, Roma, 1968; M. Kirby, Happening, tr. it. De Donato, Bari, 1968; T. Trini, Nuovo alfabeto per corpo e materia, Domus, n. 470, Milano, Jan. 1969; Live in your head. When Attitudes Become Form. Form. Works. Concepts. Processes. Situations. Information, Catalogo della mostra omonima a cura by H. Szeeman, testi by Beeren, Burton, Gilardi, Müller, Szeeman, Trini, Kunsthalle, Berna, Mar.-Apr. 1969; G. Celant, Arte povera, Mazzotta-Praeger-Studio Vista-Wasmuth, Milano-New York-London-Köln, 1969; Comportamenti. Progetti. Mediazioni. Catalogo della rassegna omonima con testi by R. Barrili, M. Calvesi, A. Emiliani, T. Trini, Museo Civico, Bologna, Jan. 1970; Happening & Fluxus. Materialien, Koelnischer Kunstvrein, Koeln, 1970; R. Barrili, Dall'oggetto al comportamento, Roma, 1971; Opera e comportamento, sezione italiana della 36 Biennale Internazionale d'Arte a cura by F. Arcangeli and R. Barilli; A. Bonito Oliva, Il territorio magico, Centro DI, Firenze, 1972; La ricerca estetica dal 1960 al 1970, Catalogo della mostra omonima curata da F. Menna con la collaborazione di numerosi critici e artisti nell'ambito della X Quadriennale Nazionale d'Arte, Roma, May-June 1973; Contemporanea, Catalogo della mostra omonima curata by A. Bonito Oliva, Parcheggio by Villa Borghese, Roma, Nov. 1973-Feb. 1974; L. Vergine, Il corpo come linguaggio (La «Body-art» e altre storie simili), Milano, 1974; G. Celant, Precronistoria 1966-69, Centro DI, Firenze, 1976; Situazioni dell'arte contemporanea, testi delle conferenze tenute alla Galleria Nazionale d'Arte Moderna di Roma nel 1973, Roma, 1976 (G.C. Argan, L'artistico e l'estetico; R. Barilli, Il «Comportamento»; G. Celant, Conceptual art, Arte povera, Land art, Body-art); Arte in Italia 1960-1977, Catalogo della mostra omonima a cura by R. Barilli, A. Del Guercio and F. Menna, Galleria Civica d'Arte Moderna, Torino, May-Sept. 1977; M. Bandini, L'estetico il politico. Da Cobra all'Internazionale Situazionista, Roma, 1977.

FILIBERTO MENNA

MINIMAL AND CONCEPTUAL ART (PLATES 157-158)

The character of recent and chancy developments in minimal and conceptual movements and the debated and debatable links of single personalities to the same movements brings about a continuous problem and calls for extreme caution in tracing a credible historical path. Some protagonists will deserve a passing reference, others will be discussed in a wider fashion not just on the basis of their intrinsic value, but because of their importance in shaping groups and defining movements.

Minimal art, one can say, begins with Malevich and his theoretical work in reducing expressive means within the framework of a contingency which encompassed the artistic vanguard toward Marxism in the first years of the Soviet revolution. On the other hand, one could say that conceptual art was born with the invention in 1913 of the ready-made in a bicycle wheel by Duchamp, an axiomatic statement on the quality of art inasmuch as the artist chooses it to be art. Nevertheless, the crucial years for the historically limited theories of the two movements are 1965 and 1966 in the United States, in England, and throughout Europe.

Once the historical dating is done, for the sake of clarity, it is necessary to limit the range of developments that shall be examined. Even if we consider that in the 1950s and 1960s, from the Zero Group of Dusseldorf to the Azimuth Group of Milan, to the Fluxus of Wiesbaden, up to the happenings in the United States, ideas and data are being processed that will lead to minimal and conceptual art - suffice it to mention Uecker, Castellani, Manzoni, and, outside such groups, Lo Savio and Yves Klein - it must be said that among these artists ideas and forms of behavior are maturing and will bring about new developments as well, outside the range of minimal and conceptual art. I am referring to the so-called "Poor" Art, Body Art, to Land Art, to Narrative Art, and so forth, that do not pertain directly to the subject.

A definition by Carl Andre of the United States is particularly effective as it synthetizes the nature of minimal art and restricts its import to an experiment that is open to even opposite developments: "A hole is one thing in something that is not a hole." The skeleton-like articulation of that phrase derives from the reductive tendency of Abstract Expressionism (from Malevich to Albers), but the message seems to play upon the traumatizing character of Duchamp's gesture. Most of all, Andre sees eye to eye with Magritte, who writes: "The visible outlines of things touch each other as if they were part of a mosaic." Minimal is a definition that has been applied to a provisional group of American artists, whose work is fed by the experience of techniques based upon the perception and articulation of the visual language, the heritage of Abstract Expressionism, but in post-Dada situation. The participation of single artists is altogether different and susceptible to vociferous modifications. Judd is a critic of the abstract tradition and of avant-garde as a tradition that verifies the last opportunities for movement within itself. Smith is an architect who derives from the informal his dramatic monumentality. Morris is an experimenter who is closer than others to the aesthetics of materials — i.e., to the identification of a unitary physical perception as a possibility of sensitive surprise. Sol LeWitt, Flavin, and once again Judd have resurrected the model and the sequence as a means to cause forms to spring from each other to create the widest context, with reference in part to experiences that were known in Europe between 1916 and 1930, within the framework of rationalism deriving from expressionism; and in part to the analytic philosophy of Wittgenstein's origin and to structuralism.

The "Primary Structures" exhibition at New York Jewish Museum in 1966 brought about a first differentiation: Americans, who for the most part are committed to the serial or modular repetition, were at variance with the English, who are careful to illuminate

the allusive elements of a plastic-architectonic fantasy (i.e., King and Tucker) or to penetrate and modulate space in a lyric or formal way (Caro).

The iconographic aspect of minimals is rather common to all, without a doubt: cubes, trapezoidal solids, irregular tetrahedrons and octahedrons — a repertory of solid geometry, for the most part angular, has developed in opposition to Pop images and those of the post-informal Abstract Expressionism, vaguely similar to the pre-war Abstract Expressionism. Previously, such images drew the attention of the critics and the public both in Europe and in the United States. Tony Smith's architectonic monumentality, that is still giving life to space for the heroic conception of the individual, has no relationship whatsoever to the paradoxical idea of planned chance that is implied in the work by Andre and Le Witt: the series, the pattern, set to challenge the vacuum and nothingness by way of their emptiness of subjective thought and their lack of emotion. Flavin's spectacular rigorism (among other things, he uses neon lamps and differs morphologically as well from other artists) has nothing to do with the theoretical problems raised by Robert Morris.

The fear of losing the force of an experience that had acquired typically American characteristics in Pollock and other artists of the 1950s had pushed an artist such as Judd to search, with a certain pedantry, for a deductive synthesis of traits that were foretold by the American Abstract Expressionism and that Judd saw as essential: a) a tendency to a non-hierarchical entirety of the composition, indeed the composition as a whole, devoid of details and subordinate elements; b) a tendency to exit the inevitable illusion of the painting as a rectangle of light opening to a background and forms framed therein, creating the necessity, as expressed 50 years before by Vladimir Tatlin, for "real material in real space." Work as an art critic of many years led Judd to pick up certain trends of American artistic research toward the destruction of all supports: canvas and stretcher are warped in the "shaped-canvas," color is casually rimmed in the large canvas by Pollock and Louis, the dialectics of simple, angular repetition within Stella's canvas aim at escaping from the play of painted space.

Judd intentionally kept this process in mind, but only for what concerns Abstract Expressionism and its derivations up to Stella. First of all, it must be stated that the "destruction" of the supports went from Pollock all the way to certain sectors of Pop Art, having as an extreme consequence the "happenings" which according to Allan Kaprow can duly claim a true relationship of derivation from Pollock's art: that is, action + materials. The minimalist leap thus is a negative one and springs from the need for closer adherence to function (in this case structural function) while investigating its essence and refusing any substitute elements. This occurs because the actions of some of the minimalists is in direct relationship to their materials, their structures, rather than to hypostatic form, as in the case of abstract classicism. With Morris, the so-called architectural-urban evaluation of the object's environment is connected to a sensitivity for the materials and their intrinsic expressiveness, which derives from both "Dada" experiences and Abstract Expressionist ones.

While Judd was able to elaborate a theoretical scheme for this rigid and paradigmatic invasion of space, Morris invented a didactical method to perceive this phenomenon and to investigate the modifications that volume, color, materials, and forms have on our sensitivity to space. His work, in fact, is a kind of take-over of "a space which is as undistinguished as possible, with the most neutral elements possible regarding previous meanings." By always insisting on the more perceptive aspects of his research, he concentrated on the gravitational features of his volumes and on their essence, their inertia, and their consistency, while focusing attention on the contrast between constructive intervention and the intrinsic properties of the materials themselves. In order to more clearly underline the sensations belonging to these properties, he chose soft materials or even uncoagulated ones: first felt, then dirt, industrial oils, etc. The structural themes (sequences, modular characteristics) used by Judd, Sol LeWitt, Flavin, and others with a forced and aggressive ostentation were used by Morris in his experiments with hard materials and stationary, heavy, soft, and opaque ones. It is for this reason that geometry was a problem for him, while for the others it was a convention that was accepted, whether despite or because of the knowledge of its expressive emptiness. On the other hand, for Morris the realized object was more important than the project, and his work is the farthest from possible conceptual consequences.

As for Morris, Andre, and many other artists of the so-called minimal art, space is a place, an itinerary, an experience to be invented. The environment and the happenings had pointed out this need to exorcise the void, having inherited it from Pollock's drippings. Bourdon writes that Andre transformed a room in a gallery, where he was being shown, into a "golden rectangle - into an archipelago of Euclidean islands." But the aggressiveness and the ambiguity of Andre's work immediately suggest a programmatic development of that kind of dark aphasia which characterizes his Duchampian inventions, in which the element of mathematical sequences is a pure mental exercise. For example, his "Lever" exhibited in Kassel in 1968 at a pavillion entrance, in the form of a series of varied tiles indicating a path, seemed to suggest that out of all possibilities the best one is that of nonexistence whether as form or tactility or even meaning. His constructions of regular modules in different materials, placed on the floor, develop relationships which each time invented create certain tensions and thus make the space a dynamic environment which at times could even be an allusive one. Andre's inventions operate subliminally using the clarity of the matrix ideas of his language, even though he himself paradoxically stated that his "true sculpture is the street."

In this way the investigation could be considered similar to that of such artists as Sandback, De Maria, and Serra, as well as Sarret and Heizer who have underlined the aspect of negation of art as a finished product, to be hung on a wall, and have realized works and situations comparable to those previously created by such European artists as Klein, Manzoni, Pascali, Kounellis, and Beuys.

An important element is the lack of manual labor, the transference of interest in the moment of conceptualization - but not necessarily of intellectualizing or of rationalization - to the one of realization.

The work of such minimalists as Margritte or Duchamp and the other European artists mentioned makes one concentrate on the idea that caused its creation — rather than on the manual aspect and its characteristics or the visual perception — whether it be a mathematical, philosphical, linguistic, or poetic one (should one want to make an approximate categorization of the phenomenon). The merits of "sculptors" such as Flavin, LeWitt, Judd, Morris, Sandback, and De Maria thus do not depend so much on the results and their geometrical aspect, but on their having heavily focused on areas not yet categorized by research and which, since 1968, many young artists have explored, even going in apparently opposite directions. These are areas in which the intense focus of the conceptual experience - not always verbalized or capable of being verbalized - reveals the possibility for play, reversion, scientific analysis, and troubling questions regarding language, while at the same time ensuring that a hermetic work may become more meaningful via one or more mental passages to be traced back before its realization.

Aspects of minimalist art are close to those of conceptual art and its extreme ambiguity in results. (Already in 1967 LeWitt was writing that "I will call the kind of art I am interested in conceptual art. In conceptual art, the idea and the concepts are the most important elements of the work. When an artist uses a conceptual form of art it means that all the projects and decisions have been developed at the beginning and the execution is a secondary element. The idea becomes a machine to produce art. Generally it doesn't depend on the artist, as author. . . . Conceptual art is not necessarily logical. The logic of a piece or a series of pieces is an expedient that at times is used only for the purpose of being destroyed. Logic can also be a mask behind which the artist's real intent is hidden or can be used to draw the observer into believing he understands the work, or to conclude a paradoxical situation, whether it be logical or illogical.") This is another aspect which, mainly in Europe, is connected with abstract and constructivistic tradition and above all develops the methodology and the possibility of creating a norm within the composition. (This is the extremist methodology on which Thomas Mann in "Doctor Faustus" wrote decisive pages, considering the paradoxical effects of this reduction of the musical composition to the material and the productivity of variation.)

In this manner many have operated and still operate in the visual arts – for example, such artists as the Italian N. Carrino; the Dutchmen J. Schoonhoven, E. Hilgemann, A. Dekkers, and C. Visser; the Germans E. Heerich, W. Nestler, and J. Meyer-Rogge; the Czechs R. Kratina and J. Hilmor; the Englishman A. Hill; the Americans K. Snelson and B. Pepper; and the Pole R. Opalka. But it is difficult to draw a true line of demarcation. In fact, if one reads the writings of Sol LeWitt, of Nicola Carrino, of Dorothea Rockburne, and of Mel Bochner, one finds a great similarity in syllogistic, didactic, and analytical character which goes beyond tried and true constructivistic tradition and in which the didactic element is never considered by itself, but is posed in the function of a work of art to be realized (thus becoming one of those esthetic characteristics typical of art in general).

For a majority of the artists mentioned above, the influence of real conceptualism, and thus of philosophy of logical positivism, starts to be of importance (see for example Darboven and Tuttle). Reflected in their work one sees the negation of the characteristics of decorative manufacture and of the esthetic quality of the object, favoring instead an impersonalization which is not fortuitous, but rather caused by a mathematical or geometric variation.

The only painter who may be mistakenly placed among them is Ad Reinhardt. He (like A. Martin, F. Lo Savio, V. Gastini, and others), while belonging to the reductionism of this tendency, excludes any theorization which may eliminate the object or diminish its importance with regard to the project. Reinhardt's theoretical compulsions are often due to a polemical tension similar to Malevich's.

The Italian G. Uncini, despite his constructivistic point of departure, can be seen as significant within the field of objectivity. Only on the surface can he be described as using minimalist forms since he is a recipient of a typically Italian and European tradition of craftsmanship. We are thus excluding from the field all European and American groups which have worked in a Gestaltic, kinetic, or manual manner. Their very important work has an objective character which is not strictly pertinent to the aspect of project theory, being researched by minimalist art. As a consequence, also outside of our realm of analysis will be all relevant research episodes for a glossary of pictorial means which are today being conducted within the field of the so-called "cold painting" to achieve results of great interest in technical and intellectual depth.

The tendency to go beyond the objectivity of art, clearly characterized by G. Dorfles' book "From Meaning to Choices" includes artists ranging from H. Fulton to E. Isgró, J. Beuys, D. Graham, V. Agnetti, L. Weiner, D. Huebler, and R. Barry to beyond the Art and Language group to J. Kosuth. Nevertheless, one must remember those personalities which Kosuth himself understands as being conceptual in the second half of the essay: "Art after philosophy" (Studio, Nov. 1969): On Kawara, Beinbridge, Hurrel, Christine Kozlov, Jean Baxter, Hanne Darboven, Frederic Barthelme, Edward Ruscha, some of Bruce Nauman's works, Barry Flanagan, Richard Long, Steven Kaltenbach, Jan Wilson, Franz Walter. Out of order, he continues by mentioning Bochner, Dibbets, and Oppenheim, and naturally also others from the Art-Language group. He has some reservations regarding John Baldessarri and says he has been influenced more by Duchamp (via Johns and Morris) and by Reinhardt and Judd than by LeWitt. Naturally, he gives priority to Smithson, Flavin, and Andre as well as Manzoni and Klein.

In order to focus on conceptual art we will limit ourselves to examining in detail the area concentrated on by C. Millet and E. Migliorini underlining, correctly, their direct relationship with the English philosophy of A. J. Ayer and G. Moore. We could also add that Borges' paradoxes and certain thoughts of Wittgenstein were circulating, however approximately, in the writings of the leaders of the minimalist group in America, among them Smithson, as mentioned by Kosuth. We will not, however, since he later dedicated himself primarily to spectacular forms of Land-art.

Conceptual art derives from the flowing together of two different situations: on one side the reductive process operating on art as an esthetic-decorative factor, as seen in minimalist art in general and as previously evidenced by "functionalism" and abstractionism (see, for example, Mies Van der Rohe's formula "Less is more" and Barilli's citing Carlo Belli's 1935 "Tra Presenza e assenza" - Between Presence and absence), with its consequently ever more rigid and programmed lack of communicating contextualism.

On the other hand, the work of Magritte, Duchamp's analysis, and the Surrealist and Dadaist tradition demonstrate the relationships among reality/representation/language.

A precursor and at the same time - as we shall see - in a certain sense a silent but tenacious opponent of conceptualism, is the Italian Giulio Paolini, who around 1960 was exhibiting canvases, millimetered papers, frames, sketches, tubes of paint, etc., and radicalizing experiences undertaken by J. Johns and J. Dine on the elementary intellectual and material components of art and art history. Already in 1928-1929 Magritte had painted an illusionistically perfect pipe and had written on the painting "Ceci n'est pas une pipe," thus axiomatically pointing out the total conventionality of the representation and in this way attacking artistic tradition with regard to meaning, just as Duchamp had attacked it from the point of view of esthetic manipulation. But already in 1910 with Braque's "Violon et cruche" (we could even say starting from Velasquez' "Las meninas" and other examples of Baroque art), the theme of the work of art which adds itself to the world but does not reflect it has been of great interest to artists. The orbit of representation and meaning escaped art, and the artists, just like the philosophers, tried to investigate the essence of that representation and those meanings.

Paolini tried to trace certain etymologies in the plastic arts. Having noticed the static and defined aspect of the imagery characteristic of the more rarified areas of pictorial culture, he subtly satirized his (and our) propensity for the "sovereign appearance of things" as well as the Apollonian view of the vision, making us feel the original strength of the shadow which escapes any optical determination. The eye of the mirror which watches the spectator in Paolini's "Elegia" belongs to the same kind of thoughts as those of Magritte and Valesquez, in the play between the drawing of the eye and the perfect reflection of the mirror's pupil. It is like an epigram on the illusion of the world's art-mirror. For Paolini classical art may be a closed cycle, but his whole repertory is seen as the symptom of an ideal beauty. In the work of this Italian artist beauty lives within the dispersion of the "solitude of signs" of which De Chirico spoke with regard to metaphysical painting.

But to investigate the essence of art also meant to investigate the essence of things and to transport out of the work that element of epiphany that characterized so many discoveries of the past. To take art out of art — that is, out of the specific field of objects of art — is a tendency common to many artists with "philosophical" intentions. Besides Paolini and the already mentioned minimalist-conceptuals, one should list L. Fabro, M. Snow, G. Anselmo, On Kawara, A. Trotta, H. Nagasawa, Gilbert, and George. The case of Gilbert and George (like the very interesting one of On Kawara) is

significant, in that it reveals how hard it is to limit the work of these artists with definitions. Their irony regarding the expansion of art beyond the art object can be synthesized by the daily recital to which they seem to expose themselves as living sculptor-sculptures. And yet one cannot link them to Body Art except for the fact that they use their own bodies. The total complex of their work is mental. They model themselves on the dandy artists of the 1800s and on the theme of life as art. And what happens if we live art from morning to night? This is the problem they have posed themselves. And, in genre, this also belongs to the conceptual field.

The work of Michael Snow (like that of Dan Graham), whose range would seem to more appropriately include photography, video, and film, also seems closely linked to the conceptual, even if the point of reference this time seems to be more Husserl than logical positivism. If we cannot limit ourselves to a minimal common demoninator of morphology, then we also cannot use technique to discriminate. Snow began working with film in 1966. Michelson defined his work as being an acute "recurring metaphor on the nature of conscience," at least concerning contemporary artistic discourse as it is illusion based on time. The film "Wavelength" (1966) as well as his photographs shown in 1970 at the Venice Biennale are a visual analysis of the phenomenology of time and space. They are elements upon which his vision of art is based, both as structure and meaning.

I would, however, exclude from conceptualism many artists of great importance who use a variety of different methods, such as J. Beuys, H. Haacke, J. Baldessarri, G. Zorio, M. Merz, and B. Vautier. These artists are all involved in "political" situations and their work is more tied to an ideology than to philosophical-esthetic speculation. (In the case of Beuys we see a liberterian humanism with obvious appeals, even in his performances, to the meaningfulness of freedom in the depths of psychic life. As for Vautier, we have there a constant auto-criticism of himself as an artist.)

In any event, before dealing directly with such artists as Kosuth, Burgin, and the Art-language group in general, all of whom were most decisive and eloquent exponents of conceptual art, one must remember that all artistic trends of this kind have felt, directly or indirectly, consciously or not, the influence of L. J. Wittgenstein's thought within the English tradition of mathematical logic according to Russell and of empiricism. This includes minimal art and art which could today be called "repertory analysis," such as that of Sol LeWitt, Paolini, Dine, Weiner, Kosuth, Barry, Morris, Burgin, Carrino, Huebler, Andre, and Agnetti and so forth.

The conclusion of Wittgenstein's 1922 "Tractatus logicus philosophicus," "One must be silent about that of which one cannot speak," is the point of departure for Kosuth's 1969 article "Art after philosophy." It is well known that Wittgenstein was investigating the nature of language and its capacity to reflect reality. Thus for him the purpose of philosophy is reduced to an exploration of the logic of what is stated. Even during the second phase of his research, undertaken while teaching at Cambridge in 1939, he considered philosophical methods a therapy to be used to settle philosophical problems (which would have originated only from confusion derived from the use of common language). Beyond critical work on the use we make of

language, which for a philosopher is the correspondence between elementary empirical propositions (the basis of science) and facts, one can only demonstrate and not explain. On the other hand mathematics and formal logic are only tautologies, pseudo-propositions, deriving from transformations of linguistic signals.

I thought it best to briefly mention some of Wittgenstein's cornerstones, because many "works," even when not strictly conceptual, are derived from them - whether consciously or not - in the field of deductive tautology (Bochner, LeWitt, Prini, Craig-Martin, Agnetti, Burgin, Kosuth), as well as in that of the pertinent linguistic analysis (Hafif, Marden, Mangold, Ryman). We could say that the so-called "wild" aspect of the historical avant-garde that permeated the artistic culture of the 1950s with pathos vanished completely thanks to this new epigrammatic knowledge of the main structure of Western artistic culture. This knowledge did not assume any dramatic overtones but rather took on ironic and/or interlocutory ones. To this the mass media lent excessive viability, thus often burdening the field with approximations.

Another point of reference for "conceptual art" is of course Jorge Luis Borges. The Argentine writer's taste for paradoxical philosophy is well known. But it is well worth remembering that it is always based on a refutation of taxonomic culture and of the faith that it has given to the sequential quality of language (and in general to the rationality of its systems). His work seems to be a continuous verification of the double layer of language/experience, of its being irreducible, and of the enormous task of cataloguing-allegorizing in the infinite labyrinth of the library (and with it alphabetical culture too). The perfect functioning of computers is seen as the other side of the division of reason, when the (irrational) faith in being able to progressively reach the universe's infinity disappears from Western culture. All one has to do is remember the analysis of the "regressus in infinitum" of the "Metamorphosis of the turtle" or the wildly anomalous cataloguing of the "Analytical idioms of John Wilkins" or the paradoxical questions on the history of language in "Pierre Menard, author of Chisciotte," and so on. The important ideas of many shows of conceptual art can be traced back to the bottomless pit of Borges' erudite conjuring; all of it may be seen as metaphysical paradoxes, often weakly recalled by the "artists." To be considered as having been influenced by the great Argentine writer are all the undertakings of apparent codification, paradoxical enumeration, and incongruous linkings of language to non-pertinent objects and experiences, typical of Huebler, Weiner, Barry, and Burgin, and others.

Within the opposite field of English analysis derived from philosophy one must take into consideration the contesting propositions of evaluating assertions in general as well as the critical/historical framework of art: this includes the Frenchman Buren; the American Kosuth; the Englishmen Atkinson, Burn, and Ramsden; and, in general, the artists of the Art-language group. Kosuth started in 1965 by following J. Dine's formula of "Shoes." To be noted as being of particular importance are "Three color sentences," where on the black background the three words of the title are written out in neon red, blue, and sea green; also, "One and three chairs" with the photographic image of the chair, the chair and a series of words, besides "chair" written on a sheet. Kosuth's work is seen as a cold investigation of language. He has inherited the lack of representative and expressive function of minimal art and therefore, as Millet writes, he no longer needs a representative code, nor an esthetic code, having exasperated all autoanalytical characteristics of abstract tradition.

Another important stage is the 1969 article already cited, in which he takes from Wittgenstein his conclusions on the purpose of philosophy and from Duchamp the idea of the purpose of art as an esthetic artifact. The article continues by mentioning a debate which took place in New York during the 1960s in which Greenberg supported post-informal abstract painting and sculpture (Louis, Olitsky, Caro) while the minimalists were considered by the supporters of the abstract tradition to be a kind of "novelty art", that is just one of many fashionable trends. Kosuth strongly supported the minimalists against Greenberg's formalism and the lack of theory in the artists he supported and wrote: "to be an artist today means to investigate the nature of art." The problematic nature of art, according to Kosuth, was pointed out by Duchamp - although he sees some first critical mentions in Manet and Cezanne. (Unlike Buren, he still sees timidity and ambiguity in impressionist art.) At this point Kosuth denies the value of art as an object and considers the work of art only a "physical residual" of the ideas of the artist. The interesting part of a work would only be of a documentary nature (for example, only the ideas and not the works of the Cubists would be of any interest). However, by denying meaning to the formal and manual elaboration of the work of art, by denying it the value of experience, he establishes, through an arbitrary logical leap, that art, like mathematics, analytical geometry, and logics, is a tautology — that is, a definition of itself. In this way he thinks he has saved the theoretical characteristics of art without falling back on an explicit philosophical thought. It is in this way that the link with LeWitt and Judd is obvious.

Kosuth in fact has in mind the deductive quality of their work, and in order to clarify their "artisticality" he adds only that, despite the similarities, logic, mathematics, and science are useful, but art is not and that is its reason for being. It is clear that interest in art and its survival being due to the delicate dialectic equilibrium between language and meaning, the incapacity to realize that the techniques and forms of past art are inventions alive in themselves; all of this will lead inevitably to the idea of the purpose of art.

Starting in 1967 Kosuth began making photographic enlargements with only dictionary definitions in the middle of a square panel, reproduced in negative. In 1968 the influences of Weiner and Huebler cause him to want to capture something more than pure analytical propositions and to try to focus on the enigmatic and provocative nature of the search. He started to dedicate himself to puzzles, classifications, and lists of terms linked by mysterious associations. But Kosuth's most vivid dialectic is that of the Art-language group. One can already see it in the second and third parts of that same article "Art after philosophy," where the most important work (besides that of Kosuth) is "Map to not indicate" of T. Atkinson and M. Baldwin (1967). The Art and Language Press was founded in Coventry, England, in May 1968 by Terry Atkinson, David Bainbridge, Michael Baldwin, and Harold Hurrell. In 1969

they published the first issue of the magazine "Art-Language." In 1969 Kosuth joined the staff, and in 1971 Jan Burn and Mel Ramsden collaborated as editors and Charles Harrison assumed the position of chief editor for all publications. The clamorous active character of a certain Dada tradition, derived from Duchamp and on to Manzoni, was totally abandoned by the English in apparently similar undertakings such as the Air Conditioning Show or the Air Show of 1967 and its place was taken by an analytical attitude towards these undertakings which in itself was also the object of shows and publications. Starting in 1969 they documented in print, both organically and continuatively, discussions, collective and individual interventions, statements on the function of art and its meaning in relation to such undertakings. Various personalities who had started a "search for language as a maximum point of artistic abstraction" in 1966 joined the magazine. We have mentioned Ramsden and we cite his 1967 "Black Book"; of Atkinson and Baldwin we make note of their 1967 "Measurements drawings" and "Time drawings." We should also mention, besides Kosuth, On Kawara and his "One Hundred Year Calendar" (1966), also Kozlov and Baxter, as well as H. Flynt, whose 1961 essay "Conceptual Art" postulates a kind of art in which operational material is written language (see G. Celant "Data," September 1971, "Book As Artwork").

The first issue of Art-Language came out in May 1969, with participation by LeWitt, Graham, Weiner, Bainbridge, Baldwin, and Atkinson. The second, of February 1970, included S. McKenna, M. Thompson, I. Burn, and R. Barthelme, as well as other editors. Having published four issues, the magazine in 1972 began publishing three issues a year reporting on what the editors believed to be interesting in the field of conceptual art. In the first issue Atkinson stated programmatically that: "Many probably think this tendency would be better described by the following categories: theory of art or art-criticism; and there is no doubt that works of conceptual art can include peripheral aspects of art-criticism and theory of art" According to Atkinson, however, the question to be asked was not: "Are works of art theory part and parcel of the baggage of conceptual artists?" but rather "Should the previous works of art theory be considered as works of conceptual art?" His answer was no, since he felt that the first exact formulations of conceptual art did not appear until 1966. This syllogistic necessity and archival taste (see for example in the Kassel "Documenta" of 1972) made Agnetti observe that the spectator feels betrayed in his search for an immediate experience and the consequent derived provocation signals the existence of other magnetic fields for art. It is, of course, based on the desire to attribute to art the eminent function of provocation true of Dadaism, to which Agnetti returns, despite analytical appearances. One of the basic motivations for the spreading and success of this syllogistic and analytical attitude lies in the resistance that much of contemporary art has raised to any form of theory and in the devaluation of theoretical interpretations of art.

All this occurred mainly after the explosion of the crisis of traditional theories caused by the historical avant-garde. While ready-made Duchampians are considered obligatory reference points for the conceptualists who see in them a forecasting of their positions (see Atkinson, "Art-Language," 1970, as well as Kosuth,

"Art after Philosophy," 1969) as an offshoot; this position gave rise to an interesting debate. In an article published in 1971 in Germany, the Frenchman Daniel Buren examined the undertakings of the Cubists and Duchamp and found them to be regressive and restorative when compared to Cezanne. He stated that:" . . . one of the questions posed by Cezanne's art was: it is possible to eliminate any painting's subject and show only the painted picture - or that one is painting - that is, to show a painting without any other history than its own, without illusions, without any representation of a beyond, without perspective, without any other frame than the one where such a painting imprints itself, as its framework?"

According to Buren when Duchamp placed a urinal in a museum one had a total rehabilitation of art history since it restored to the institution all the prestige and entirety once attributed to technique and artistic form. The object (the Cezanne still life) debated by Cezanne thus once again finds its "artistic" place. He wrote: "Duchamp's work is not only a censuring of Cezanne's, but rather a backwards shift that ends up in the formal problems raised by the Renaissance! The "break" that took place was really a "regression" when compared to Cezanne." For Buren the real and permanent break can only occur when art is practiced as a problem. But in 1969 in "Art-Press" R. Cutforth had sharply underlined the value of the undertaking as announced by Duchamp, according to which the Empire State Building should be considered a work of art. He pointed out that the status of any object as art or art object is proportional and not active; thus trying to reintroduce Duchamp's proposition. He wanted to do this not as an element of rupture or conservation, but rather as an example of experimentation of the valued capacity of language and of the validity of an evaluating proposition. It is in this sense that Duchamp remains emblematic. Duchamp is an artist who investigates in each work the nature of art itself.

While artists such as Barry, Huebler, Lamelas, Pistoletto, Prini, Boetti, and Mochetti were more or less directly involved in conceptualism (the latter two in a particularly significant way), we can pinpoint two basic attitudes over and above the large quantity of other echoings. One is mainly concerned with the Anglo-Saxon field where-in the essential character is a real and true persecution of art as an esthetic revelation. In it the element of vital suspension and intensified perception caused by form (painting or music, image or language, space or time) is centered by an arbitrary undertaking within the orbit of pure but not pertinent rationality. It is placed in vitro with an almost infantile pleasure for vivisection. The other is a tendency which, while participating in the same order or problems, yet opposes it; this consists of mainly Italian artists, some from Southern Europe and a few South Americans. The contrast is found in a knowledge of the linguistic problems raised by the conceptualists and in the capacity to maintain, in this reducing and analytical tension, the characteristic of surprise, enigma, and suspense caused by the friction belonging to all art in the metaphysical-surreal tradition from Magritte to De Chirico and Man Ray, as well as Borges and Buñuel. It derives from the instantaneous contact of the incongruous with the routine, of the finished concept with the infinite, of the arbitrariness of language with the incontrovertible truth of fact. They

casually use images and form to uncover, it is true, the cards of tradition and art history while maintaining their magnetic and interrogative form.

In any event the conceptual art of Kosuth and Art-Language remains a footnote to the theme of "purpose of philosophy" of Wittgenstein as well as that of "purpose of art" declared by Tzara and continuously restated by the many artists and critics who continue to exercise their respective professions with all the seriousness of those who would like to see it buried. They practice, with a sharpness and logical tension that almost reaches parody, the highest levels of auto-analytical reflection while inheriting the total (if not totalitarian) contextualization of minimal art. From this point of view one should remember that art in all Western and Eastern civilizations, be they archaic or decadent, is not the idea of art, but is rather the equivalent of artistic technique, capable of producing an object which is esthetically meaningful. Only the crisis in our culture is what for over 200 years has been pushing the simple and elementary nature of this experience, shared by all of humanity, to become a cause for confusing philosophical problems.

A lack of faith in the synthetic elaboration of experience on the part of the individual as an artist and the echo of structuralism and analytical philosophy is at the basis of many of the lists of words, of the repetitious/varied photographs, of the games of verbal displacement, of geometrical/mathematical exercises, of communications of an informational nature (and also persistently interactive), which have inundated art galleries, the specialized press, and museums. In 1975 in "The Fox" #1, Kosuth published an essay full of erudite citations: "The artist as anthropologist," in which, after having examined the condition of art today from an abstract point of view that he defines as autoparodist as well as that of a hyper-realism of a "bureaucratic" nature, he considered the problem of utopia and integrated societies. He confirms the importance of contact with nature as a continuous verification of the terms of language and judges our system of civilization to be out of control to an alienating degree of abstraction. These statements are not new and allow one to foresee a decision to abandon "artistic" activity for politics.

In any event, the problem of how much the fine arts are really an invention of middle class society had already been examined with historical objectivity in an interview in "Art-Language" with C. Millet ("Art Vivant, 25, 1971), while Atkinson and Baldwin with originality and bibliographic richness had already torn apart the theme of the relationship of subject-content-form in an article entitled "La Pensée avec Images" ("Art-Language, Nov. 1971). In 1970 Ramsden had examined the conditioning which gives birth to the "art object" in history and theory, in technique, galleries, market, and critics, trying to reduce the phenomenon to such conditioning. We should say that from the point of view of theoretical criticism some interventions are cause for greater interest than the so-called "artistic" activity or the "syllogistic reasoning" which tend to give rise to paradoxical identifications. One must also mention the fact that despite Seth Siegelaub's efforts to organize diffusion, the galleries and merchants that have grabbed onto the latest wave have done little to clarify and deepen understanding of these contributions.

So we must conclude that the work of the conceptualists should be placed in a situation similar to that of the authors, philosophers, and scholars we have mentioned, within the limits of a "recasting" *ex novo* of those specific activities which go beyond the given contexts, and that this apparent no man's land is instead the heir of all requirements of the historical avant-garde: to break all distinctions between life and art, to break away from past technique and formal tradition, to ignore all meaning other than the contextual one. But this idealistic deductivity has forced the minimalists and the conceptualists closest to them, such as Judd, Andre, Kosuth, and the Art-Language group, into a dead end full of contradictions and inevitable self-destruction.

BIBLIOGRAPHY - D. Judd, Specific Objects, Arts Yearbook, 1965; B. Rose, ABC Art, Arts in America, October-November, 1965; M. Bochner, Art in Process, Arts Magazine, September-October, 1966; L.R. Lippard, Rejective Art, Art International, October 1966; D. Flavin, Some Remarks . . . , Artforum, December, 1966; D. Bourdon, The razed sites of Carl Andre: a sculptor laid low by the Brancusi Syndrome, Artforum, October 1966; D. Bannard, Present-day art and ready-made styles, Artforum, December 1966; K. Mc. Shine, Primary Structures, Jewish Museum, New York, 1966; R. Krauss, Allusion and illusion in D. Judd, Artforum, May 1966; J. Perrault, A minimal future? union made: report on a phenomenon, Arts Magazine, March 1967; D. Graham, A minimal future? models and monuments: the plaque of architecture, Arts Magazine, March 1967; R. Morris, Notes on sculpture I-II-III, Artforum, 1966 and Summer 1967; M. Fried, Art and Objecthood, Artforum, June 1967; R. Smithson, Toward the development of an air terminal site, Artforum, June 1967; L. R. Lippard, Sol LeWitt, Artforum, March 1967; L. R. Lippard, The silent art, Art in America, January-February 1967; L. R. Lippard, Hommage to the square, Art in America, July-August 1967; M. Bochner, The serial attitude, Artforum, December 1967; R. Smithson, The monuments of Passaic, Artforum, December 1967; C. Cintoli, Tony Smith: Geometria dell'inevitabile, Qui Arte Contemporanea, Nov. 1967; T. Atkinson, Hot-cold book, Art and Language Press, Coventry, 1967; J. Perreault, A minimal future?, Arts Magazine, March 1967; S. LeWitt, Paragraph on Conceptual Art, Artforum, Summer 1967; L. R. Lippard and J. Chandler, Visual Art and the Invisible World, Art International, May 1967; L. R. Lippard, Sol LeWitt: non visual structures, Artforum, April 1967; D. Graham, Carl Andre, Arts Magazine, December 1967-January 1968; M. Fried, Art and Objecthood, Artforum, Summer 1967; C. Andre, New in New York: Line Work, Arts Magazine, May 1967; S. S. Prokopoff, A Romantic Minimalism, Inst. of Contemporary Art, University of Pennsylvania, Philadelphia, 1967; I. Burn, Xerox Book 1, New York 1968; J. Burnham, Systems esthetics, Artforum, September 1968; E. Develing, Ideologische Kunst: Minimal Art, Museumjournaal, January 1968; M. Pleynet, Peinture et Structuralisme, Art International, November 1968; M. Calvesi, Topologia e ontologia, oggetto e comportamento, forma e strutture: rilievi provvisori, Carta Bianca, Roma, May 1968; C. Cintoli, Un atteggiamento riduttivo: LeWitt and Humphrey, Carta Bianca, Roma, May 1968; T. Atkinson, A notion of 350 years old spectator, Art and Language Press, Coventry, 1968; C. Blok, Minimal Art at the Hague, Art International, May 1968; L. R. Lippard and J. Chandler, De-materialization of art, TIME magazine, 1968; G. Brown, The-

dematerialization of the object, Arts Magazine, September-October 1968; N. Calas and E. Calas, Icon and Images, ed. Dutton, New York, 1968; M. Ramsden, Abstract relation 8, New York, 1968; Xerox-Book, Andre, Barry, Huebler, Kosuth, LeWitt, Morris, Weiner, ed. Siegelaub - Wendler, New York, December 1968; J. Kosuth, Four titled abstracts, New York, 1968; R. Morris, Antiform, Artforum, April 1968; G. Battcock, Minimal Art: a critical anthology, ed. Dutton, New York, 1968, contributions by G. Battcock, M. Benedikt, M. Bochner, D. Bourdon, M. Fried, E. C. Goosen, C. Greenberg, J. Perrault, B. Rose; L. Weiner, Statements, ed. Siegelaub, New York, 1968; Down with art, New York, 1968; contributions by Flynt, Riley, Morris, De Maria, Vautier; S. Siegelaub and J. W. Wendler, Untitled Book, New York, 1968, contributors: C. Andre, R. Barry, D. Huebler, J. Kosuth, S. LeWitt, R. Morris, L. Weiner; T. Atkinson Introduction, Art Language, n. 1, vol. I, 1969; B. Reise, Untitled 1969: a footnote on art and minimal-stylehood, Studio International, April 1969; H. Reuther, Minimal Art, Das Kunstwerk, Feb.-Mar. 1969; J. Perreault, Para-visual, Village Voice, 5, 6, 1969; L. Alloway, The expanding and disappearing work of art, Auction III - 2, 1969; U. Meyer, De-objectification of the object, Arts Magazine, Summer 1969; R. Morris, Note on sculpture, part 4: beyond objects, Artforum, April, 1969; S. Kaltembach, Art works, Artforum, January-December 1969; A. Rose, Four interviews with Barry, Huebler, Kosuth, Weimer, Arts Magazine 43 - 4, 1969; R. Cutforth, the ESB - a reference book, Art Press, 1969; T. Atkinson, Sunnybanck 1-3, Art Language Press, Coventry, 1969; S. LeWitt, Sentences on Conceptual Art, Art Language, May 1969; C. Andre, 7 Books of Notes and Poetry, ed. Dwan-Siegelaub, New York, 1969; G. Celant, Arte Povera, ed. Mazzotta, Milano, 1969; R. Wedewer and K. Fischer, Konzeption-Conception, Köln, 1969; T. Trini (editor) Quando le attitudini diventano forma. Opere-concetti-processi-situazioni-informazioni, ed. Kunsthalle, Bern 1969; J. Burnham, Reat Time Systems, Artforum, September 1969; W. Sharp, Place and Process, Artforum, November 1969; I. Burn, Read Premise, Conceptual Art and Conceptual Aspects, New York, 1970; G. Celant (editor) Conceptual Art - Arte Povera - Land Art, ed. Galleria Civica d'Arte Moderna, Torino, 1970; D. Buren, Limites Critique, ed. Lambert, Paris, 1970; D. Huebler, Duration Durata, ed. Sperone, Torino, 1970; D. Lamelas, Publication, Greenwood, London, 1970; L. Weiner, Tracce-Traces, ed. Sperone, Torino, 1970; D. Shapiro, Mr. Processionary at the conceptacle, T. Trini, Arte Povera - Land Art - Conceptual Art, Arte Illustrata, Torino, Oct.-Dec. 1970; J. Kosuth, Function - Funzione - Funcion - Funtkion, ed. Sperone, Torino, 1970; K. Groh, Concept Art, International Edition, N.Y.C,. 1970; U. Meyer and A. Brunelle, Art-Anti Art, ed. Dutton Paperback, N.Y.C., 1970; H. Jürgen, Maxi-Konseption, Mini-Concept, Kunstjahrbuch Fackelträger, Hannover, 1970; H. Rosenberg, The art world: de-aestheticization, The New Yorker, 24, Jan. 1970; M. Ramsden, Art Enquiry, Art-Language 1-3, 1970; H. Hurrell, Notes on Atkinson's "Concerning Interpretation of the Bainbridge-Hurrel Models," Art Language, 1-2, 1970; Bainbridge, Untitled, Art Language 1-2, 1970; I. Burn, R. Cutforth, M. Ramsden, The Society for Theorical Art and Analyses, Art Language 1-3, 1970; J. Burnham, Alice's head, reflections on Conceptual Art, Artforum, February, 1970; P. Tuchman, An interview with Carl Andre, Artforum, June 1970; M. Snow, A Survey, Art Gallery of Ontario & Isaacs Gallery, Toronto, 1970; Exhibition Book, Photos, drawings, documents from 37 artists, including Baldessari, Serra, Sonnier, Buren, Kosuth, Karawa, Darboven, Studio International with S. Siegelaub, London, July-August 1970; A. Atkinson, Concerning Interpre-

tation of the Bainbridge-Hurrel Models Duchamp's Concepts Transubstantiation, Art Language I, 1970; G. Battcock, Documentation in Conceptual Art, Arts Magazine, April 1970; A. Goldin and R. Kunshner, Conceptual Art as Opera, Art News, April 1970; K. Groh, If I had a mind, Köln, 1971; Situation concept, Galerie im Taxispalais, Innsbruck, 1971; J. M. Poinsot, Mail Art - Communication à distance - Concept, CEDIC, Paris, 1971; T. Atkinson and M. Baldwin, De legibus Naturae, Studio International, May 1971; A. Pacquement, Art conceptuel, Connaissance des Arts, Oct. 1971; G. Celant, Book as artwork 1960-70, Data, Sept. 1971; A. Michelson, Toward snow, Artforum, June 1971; R. Morris, The art of Existence: three Extra Visual Artists, Artforum, January 1971; M. Bochner, 11 Excerpts 1967-70, Paris, 1971; F. Menna, Sol LeWitt: un sistema della pittura, Data, May 1972; S. Siegelaub, pp + nn, Data, May 1972; L. Borden, Three Modes of Conceptual Art, Artforum, June 1972; I. Tommassoni, Dall'oggetto al concetto. Elogio della Tautologia, Flash Art, Dec. 1971-Jan. 1972; R. Friedman, Fluxus and Conceptual Art, Art and Artist, October 1972; Documenta V, Museum Fridericianum, Kassel, 1972; K. Honnef, Concept Art, Köln, 1972; U. Meyer, Conceptual Art, ed. Dutton, New York, 1972; E. Migliorini, Conceptual Art, ed. Fiorino, Firenze, 1972; C. Millet, Textes sur l'art conceptuel, ed. Templon, Paris, 1972; G.C. Argan, L'artistico e l'estetico, ed. Gall. d'Arte Moderna, Roma, 1972; Art & Language, Texte zum Phänomen - Kunst und Sprache, contributions by Atkinson, Bainbridge, Baldwin, Hurrell, Kosuth, ed. Du Mont International, 1972; Rosalind Krauss, Sens and Sensibility, Artforum, Nov. 1973; R. Pincus-Witten, Mel Bochner: The Constant as Variable, Artforum, December 1972; C. Millet, Donald Judd, Sol LeWitt à propos du Minimal Art, Art Press, Feb. 1973; C. Millet, Ad Reinhart par Ad Reinhardt, Art Press, May-June 1973; M. Volpi Orlandini, Strutture Primarie And Minimal Art, Ed. Gall. d'Arte Moderna, Roma, 1973; R. Morris, Some splashes in the ebbe Tide, Artforum, Jan. 1973; A. Michelson and S. Sadruy, Robert Morris, Art-Press, July-Aug. 1973; J. De Sanna, Vincenzo Agnetti, Art Press, Mar.-Apr. 1973; D. Buren, Five Texts, New York-London, 1973; J. Kosuth, Joseph Kosuth: Art Investigations and Problematics since 1965, Luzern, Torino, 1973; G. Celan and D. Crimp, Arte come Arte, Centro Comunitario by Brera, 1973; L. R. Lippard, Six Years: The dematerialization of the object, ed. Praeger, 1973; G. Dorfles, Dal significato alle scelte, ed. Einaudi, Torino, 1973; R. Pincus-Witten, Theater of the Conceptual: Autobiography and Myth, Artforum, October 1973; L. R. Lippard, Hanne Darboven: Deep in Numbers, Artforum, October 1973; M. Roth, Robert Smithson on Duchamp, An Interview, Artforum, October 1973; J. Kosuth and C. Beret, Art Conceptuel Joseph Kosuth, Art Press, Mar.-Apr. 1974; J. Gilbert-Rolfe, Robert Morris, The Complication of Exhaustion, Artforum, September 1974; J. M. Poinsot, Bruce Nauman le problematique du non sens, Art Press, Mar.-Apr. 1974; R. Barilli, Tra presenza e assenza, ed. Bompiani, Milano, 1974; D. Vallier, Malévitch et le modelé linguistique en peinture, "Critique," ed. De Minuit, Paris, 1974; On art artists' writings on the changed notion of art after 1965 - Uber Kunstt Künstlertexte zum verandorten Kunstreständnis nach 1965, testi di: Andre, Art Language, Buren, Burn-Ramsden, Huebler, Judd, Kosuth, LeWitt, Morris, Roehr, Weiner, edited by Ger de Vries, 1974; V. Agnetti, Image of an Exhibition, Milano, 1974; S. LeWitt, Incomplete Open Cubes, New York, 1974; J. Coplans, Mel Bochner on Malevich, Artforum, June 1974; T. Smith, Art and Art and Language, Artforum, February 1974; G. Paolini, Idem, a cura di I. Calvino, ed. Einaudi, Torino, 1975; L. Alloway, Sol LeWitt: modules,

walls, books, Artforum, April 1975; J. Kosuth, The artist as anthropologist, The Fox, vol. 1, n. 1, 1975; M. Baldwin and P. Pilkington, For Thomas Hobbes, The Fox, vol. 1, n. 1, 1975; I. Burn, Pricing works of art, The Fox, vol. 1, n. 1, 1975; M. Ramsden, On practice, The Fox, vol. 1, n. 1, 1975; T. Atkinson, Looking back going on, The Fox, vol. 1, n. 1, 1975.

MARISA VOLPI ORLANDINI

VISUAL POETRY (PLATES 159-160)

The movement which has been given the controversial definition of "visual poetry" is just one part of that great adventure of the crossing of poetic and visual spheres. Nevertheless, its widely-publicized title amongst a non-specialist public has resulted in including under its umbrella many of the logoiconic exhibitions of the second half of the 20th century, despite their many different original appellations. Whether we want to study the self-proclaimed "visual" Italian group with its elevations and affiliates, or whether we want to accept the widest sense of the name, there is room to verify historically the anti-literary tension which led to the re-examination of the works in order to revitalize poetry through the new element of space.

The alphabet and poetry. – The gradual development of the alphabet obeyed a "technological" push towards the abbreviation of reporting. The resulting creation was one of symbols corresponding to individual sounds which, when organized into a system, became the vehicle for linguistic communication. This creation combined vocal and visual concepts, which had previously been separated by ideo-pictorial languages, but it also provoked a new division between symbol and reference. The ideogram is a "symbol" a substitute, an agreed indication; the alphabet as a whole in its final form is the visual symbol of the phonic element in verbal expression.

Both collective and individual poetic expression (which finds its roots in that same social context that continually creates language), has relied on phonetic vocalizations which have at last been recognized. Thanks to the invention of the alphabet, these vocalizations have been sub-divided and labelled by the written letter, so that with the correlation of sound their original basic information can be retrieved and thus reversely penetrate the double symbolic division. In this way, poetry becomes enriched with new combined possibilities for an energetic concentration of meanings. It therefore comes to create a new system - prosody - which, in the absence of expressive impetus and thanks to the way its mechanisms work, can generate innumerable specialist pseudocommunications and, with the superimposition of further automatism, actually deprives language of praxis.

The history of poetry, and now of visualized poetry, lies in the continual head-on clash between instrumental progress and cultural acquisition: reappropriation of the instruments by culture: reappropriation of the culturalized instruments by the institution (by the "system").

Pre-literary visual poetry. – A few sporadic logoiconic examples found in Western poetic works of the past could be considered as pre-literary visual poetry. These overflows of ideographic origin mainly appear in periods of cultural saturation, when automatism tends to prevail. The calligrams of the Alessandrini and those from the literature of the late Latin, Medieval, Renaissance, and Baroque eras (from Theocrites "La Zampogna" [The Bagpipe] to Simmia Tebano's "La Scure" [The Axe]; from Porfirio's "L'Uovo di Rondine" [The Swallow's Egg] to Rabelais' "La Bottiglia" [The Bottle]) were not explorations into new or reconquered expressive territories, but documentations disconnected from any compensatory process. In the effort to represent objects by means of conclusive, tautologically-descriptive, poetic transcription, the calligrams of every era tend to eliminate the separation of the literary instrument from the sensitive world. In an uncoordinated way - or, at least, by the use of addition rather than interaction - these suggestive compositions generally include the two separate semantic levels of the phono-verbal and the ideo-iconic. In due course, the abstract-geometric interlacings of acrostics (such as those of Porfirio, Josephus Scottus, and Milone by Saint Armand) were to free the cabbalistic imagination within ecclesiastical learning by means of a split character which remained inside the language and therefore pointed at transcendence through the enigma of the alphabet. But the poetry of the past is constantly renewed on its own terms of verse, and its visual, sometimes blossoming, vein does nothing but transplant the irrational onto the mechanical, thus obtaining the artificial-magic fruit of the hypersymbol.

On a parallel path, we should look at the semantic deviation from the phonic elements of language in the traditions of poetry, theater, and story-telling (syllable repetition in Aristophanes, letter alienation in Dante, nonsense in Rabelais, permutation in Lewis Carroll). This appears to be a phenomenon close to the social structure, flowing from anonymous creation (dirges, nursery-rhymes, jokes): not technistic redemption from extraneousnesses, such as figural verses, but a sign of substantial distrust of the verbal institution - a spontaneous exercise in the physical properties of meanings. We should also look along this wide and informed path, which had Freud as one of its first investigators, for the seeds of visual poetry.

From symbolism to concrete poetry. – We can attribute to early Romanticism that oneiric flow of images which was to balance the different languages (whether verbal or not: think, for example, of Blake) and which, in more recent times, was to lead to Freudian discoveries. Towards the end of the 19th century, with the consolidation of industrial civilization, French symbolists were recording the symptoms of a change in the methods and timing of sensorial perception and were pointing to the autonomy which these instruments were achieving in "espacement de la lecture": for example, the elimination of punctuation, the white of the page being called away from its neutral function of frame, "silence alentour."

In a parallel progression, pictorial movements since Impressionism have directed attention to the surface of the canvas and the materials used to achieve color: materials and background of the poetic work are both symbol and page. One of the first to experiment with these complements was Stéphane Mallarmé, with his "Coup de dés" (1897). In the 20th century, while the linguistic crisis was being brought into focus by

semeiologists and structuralists, few poets after Guillaume Apollinaire ("Calligrammes," 1916-1918) proved themselves to be knowledgeable about the visual interference of the reading medium or of its espressive adaptability. Among those who did was Ezra Pound, who in the giddy plurilinguistics of his "Cantos" (from 1925) united thematic sections with the "gestual" immediacy of the Chinese ideogram - which was, in its archaic version, effectively derived from the representation of gestures. But the anti-literary movement found its main thrust in avant-garde movements devoted to sculptural research, their global revision cannot exclude the central problem of communication - language. This increased openness toward neighboring specialities can be eplained by the contact which the "manual" operators maintain with primacy of the materials. It can also be explained by the links that visual works - for a long time considered artisanship - kept with the community ("schools" and "shops", whereas in the history of literary disciplines the thread between top and bottom had already been entangled and cut off.

In Italy, on the other hand, in a particularly reactionary moment for the destiny of poetry, the destructive vitality of futuristic writings emerged (1912) almost suddenly, but prepared underground by a widepsread Art-Nouveau taste for alphabet graphics. Syntax was dismantled; "words in liberty" (Marinetti, Buzzi, and Cangiullo, for example) assumed new spatial connections; characters, not subject to external figuration, were selected according to their sound effects. It was the discovery of a visible onomatopoeia. In futurism, vocabularies took on an optically-maneuvered volume-sound within the page-space, like space in perspective fiction.

Dadaism (1916) does not acknowledge this Mediterranean movement, this "tridimensional," simultaneously phono-visual-semantic pagination. Its linguistic experiments, which are more subtly intellectual, tend to analyze, to separate the phonic from the visual agent (the earliest research carried out in phonetic poetry was by Francis Picabia, Tristan Tzara Hugo Ball, and Raoul Hausmann, among others. They tended to structure the illogical, the preconscious, and the prealphabetic, excommunicating civil mechanisms and thus approaching the target in a different way. We no longer see the thematic-iconographic deposits of the futurists who were bound to the poetic tradition of a happy situation capable of action in a codified and passive reality: counter-poetry, a fundamental part of contemporary visional poetry, was to appear within the Dada prophecy.

Nor should the influence of minor contributors be undervalued: for example, that of the surrealist digressions of the second and third decades of the century, with their automatic writings and sculpture poems (Andre, Breton); also, somewhat earlier (from 1912), that of synthetic cubism, with its typographical inserts which did not usually limit themselves to formal suggestion, since they did not develop from a thematic relationship between collagistic verbalization and pictorial context.

The first irreversible detachment from literature and from historical avant-garde movements, with an autonomous, programmatically-interdisciplined language, bore the signature of the late-futurist Carlo Belloli and the date of 1943. Thus the destiny of the cyclical emergence of verboiconic facts was confirmed

and concluded. With his "mural poem-texts" and his later "street poems" Belloli developed a dialectic of space - not just in the spreading tension of his verbographic iterations, but also in the unedited relationship that he established between poetry and town planning. Despite his hypersymbolic" bittterness in placing the concept of existence alongside that of subjective fruition, he presented the still-burning problem of placement and, even if only on a formal level, he moved the poetic symbol from a private to a public reality.

But in the sphere of relationship between reference and content the definitive contribution is given by Eugen Gomringer, the Bolivian-Swiss collaborator of Max Bill. Bauhaus' radical lesson stimulated Gomringer to examine the relationships between form and function, between alphabetic materials, medium, and meaning. In his famous "Konstellationen" (from 1953) he loaded his instruments with their mutual semanticity and, with extremely reduced means, he prearranged the deflagration of a stratified energy, which the receiver would take on both as a whole and also in different optical moments and movements. For example, the vigorous multi-linear transcription of the word "silenzio" (silence) contains in the middle a brief empty interval, of the same length as the vocable: almost an upside-down reference to the symbolist "silence alentour." Here is connotation by absence, a chain negation of the phonic, visual, and semantic elements. For echo and rebound, the contradicted verbality formulates the depth of incommunicability, which can only be explored subjectively. Slower poetry, the word "vento" (wind), asymmetrically disconnected into multi-diagonal directions, can be reassembled from any point - even at an angle or at a rhombus - objectifying when read multi-directionally the inherent mobility of its meaning.

The function of the new language is to visualize the abstract in particular onto a transparent magnetic field of pure relationships, and to include the observer in the text as its only possible content. In this there is a conscious reference to the technological nature of the alphabetic symbol which, if it has allowed the enunciation of abstract concepts, has also complicated the mechanisms for its reception in an abstract way. After Gomringer, visualized poetry was to be the stimulus for the linguistic mirror which separates us from objects, for the desire to put them back together again in their double, poetic-objective realities (visual-phonic) of symbolic reflections.

The name "concrete poetry," borrowed from the sculptural arts but already in existence in Oyvind Fahlström's 1953 Manifest, defines compositions which do not in themselves refer to anything: "Poetry becomes an object and not the interpreter of an object." A parallel movement occurred in the sculptural arts with the move away from figuration. With the fundamental contribution of Latin America to the history of avant-garde movements, concrete poetry was born, with full approval of the 1956 exhibition in San Paolo, Brazil, in the magazine *Noigandres* (an esoteric name from Provence, used in Pound's "Cantos"). It referred to the works of Haroldo and Augusto De Campos and of Decio Pignatari, with the list later including Manuel Bandeira, Ronaldo Azeredo, Oswald De Andrade, José Lino Grünewald, and others who, with a knowledge of

European avant-garde movements and contact with the author of "Konstellationen," had merged previous, deep-rooted working experiences with a common interest in multi-racial, Afro-Iberian, and anti-heroic local culture.

Satirical humor extraneous to Gomringer's protoconcretism is based on a Latin enjoyment of vocalization, visualized by asymmetrical, rhomboidal zones and drumming, bi-syllabic magnetizations. Such humor as the double, mirroring litany of the words "fome" (hunger) and "come" (eats) placed in respective triangles widely separated by a phono-visual pregnant pause; the game between the aerodynamic form of the initial utterance of the long word "velocidade" (speed) and the gradual acceleration of its reading; the imperative "beba coca cola" (drink coca cola), anagrammed with exchanges of silences and sounds, almost to the point of an alphabetic abacus, and ending with the anti-colonial "cloaca," influenced poetry on all levels.

In practice as well as in theory, the *Noigandres* activated a program of social commitment. Musicians, painters, and poets got together in teams and experimented verbally with the phonic value of color; the merging of concrete poetry with popular music revealed the interdisciplinary push behind the anti-specialist challenge.

From concrete poetry to "spatialism." – At the beginning of the 1960s the poeticized alphabet, almost in opposition to the linguistic Babel, revealed its cohesive capacity and "expatriated itself from language," adapting itself to the communicative rapidity of a supernational era. The extreme decrease in verbalization and the loosening of syntactic restrictions allowed for immediate polyglot versions, while discrimination by channels of the cultural industry guaranteed the semi-secret rigor of a form of research which basically developed by contagion and by spontaneous germination in all industrialized countries.

Initially ignorant of each other's existence, the experimenters later gathered together across the borders of Middle Europe, Scandinavia, Britain, the Slavic countries, South America, and Iberia and recognized their theorist in Max Bense, who promoted the first international exhibitions in Germany. As early as 1960 the words of the Brazilians reached Japan, where Kitasono Katué of the Vou group had been experimenting for some time with "sculptured poetry." With a natural relativist tendency towards the optical measurement of space and an intrinsic refusal of sensorial and conceptual divisions, the Japanese proved themselves to be particularly receptive to the new Western language whose ideogram they adopted. The ideas were especially well-received by the Asa group. In 1962 tentative multilinguistics such as the Franco-Japanese poems of Pierre Garnier and Seiichi Niikuni showed that in the new poetic era there was already the same dissatisfaction that was behind the uneasy Esperanto of Pound's "Cantos." In the meantime, in the iconoclastic oneiricism of Prague, Jiry Kolar (along with Ladislav Novák, Josef Hirsal, Bohumila Grögerova, and others, each orientated along different graphic-poetic investigations) developed symbolic equivalents, adapting typewritten names of known abstract artists (such as Mondrian and Brancusi) into syntheses which were obtained from their composite outlines. This was a symptom of the irreversible slide of the alphabet symbol toward a final

optical support and of culture toward the attempt at a separate dialogue with oneself, in the strenuous search for non-worn-out rules.

Mary Ellen Solt, in her anthology (which is recommended as a source of information about the numerous protagonists from Gappmayr to Ernst Jandl, from Emmet Williams to Diter Rot), refused any unifying definition of concrete poetry because of the lack of a common denominator. Even the heterogeneous census (250 inclusively) at Amsterdam's Stedeljik Museum was to puzzle over its own title with the prudent question: "Konkrete Poezie?" Until the beginning of the 1960s a common nucleus can be identified: a non-univocal and non-tautological relationship between significance and meaning; a liturgy of combined iteration; the geometric-sculptured retrieval of repetitive values of alliteration and rhyme and of the rhythmic values of accents; multi-directionality; substitution of verse with word; and substitution of the verse's protagonist - the word - with the new parameter, the alphabetic letter. Nevertheless, the microstructure of the concretist page was soon to give way to styles which could be measured with expositive spaces. In any case, the constructive-poetic rigor could do nothing else but clash with the documented truth of the history of sculpted art in each of its stages from the moment in which these art forms had lost the function of representation. In particular, as with every combined-module operation, the danger - and, in a certain sense, the goal - of concrete objectivization lies in its own capacity for self-function. In the heart of the 1960s dissemination, multiplication, accumulation, and superimposition of alphabetic symbols risked exhausting not so much the resources of the diminished keyboard but the stimulus of the imagination. "The literary utopia" (Roland Barthes) against which the alphabet had rebelled, risked, in turn, becoming an alphabetic utopia.

In 1963 Ilse and Pierre Garnier from France, who for some time had carried out nouveau-poetic experiments along with Henri Chopin, decided to present the visual poets throughout the world in their exhibition, but they were not aware of the homonymy of their "spatialism" with Lucio Fontana's movement. But choices of language are not casual. The Garniers almost prolonged the 1945 Parisian "letterism" of Isabelle Isou, Robert Altmann, and Roland Sabatier, who encouraged the use of notes, numbers, and algebraic symbols to create a total script, and they proposed the inclusion in the linguistic category of any "classified and non-classified" symbol. This breach of alphabetic dikes was like the slash of a razor on canvas. If, as Arrigo Lora Totino asserts, the limits on concrete poetry are the same as those on language, the compactness of concretism and "spatialism," converging on the linguistic universe, dissolves, not because of the inclusion of other classified symbols, but because of the admission of the existence of non-repertory symbols causing the possible subjectivization of decodifying instruments and the resulting collapse of social rule, of agreement or convention, which allow inter-human communication. If the symbol refers to nothing else, it refers to the transitive potentials implicit within its own structure, as in every abstract image.

Thus visualized poetry can be interpreted as a semeiological revolution, since it implicitly declares the adaptability of any tangible phenomenon to a letter in a

linguistic key (or it refers to another), and it presupposes - apart from institutionalized rules - a metacodification of the cultures of race. Poetry, therefore, is not defeated by sculptured arts, but the fabric of language is split to confront the universality of poetic symbolism.

Asemantic concrete poetry. – From the isolated word which privileges the letter, the metrical unit moves to the alphabetic symbol itself, subtracted from its verbal connection. This process constitutes the first overcoming of national borders in order to reach a planetary linguistic area by means of an operation which elects the morphological components of the "letter" (present in the same etymological root as "literary" fact) as protagonists: pressure, measurement, structure, everything that the concretist beginnings taught us to place in the visual-semantic sphere. This presupposes the sacred nature as well as the technological substance of the alphabetic symbol; behind its origins are not only hidden the commercial expansionism of the Phoenicians but also the compactness of Semitic monotheism. Filled with the knowledge of Western tension, this symbol has acquired the stateliness of the ideogram and the ritualism of the utensil: gestures have accumulated geologically along its thought-folds. In a society where every meaning is diverted and utilized by large numbers of mechanisms, the asemanticity of the late concretists witnesses their distrust of institutionalized rules. It witnesses the most complete recovery of the collective store of communication; the poetic "ostranenje" (Victor Sklovskij) of the alphabetic "objet trouvé" (found object); the decontextualizing manipulation, and a return to mechanistic dynamics which recharge symbolism.

Lee Whorf has stated that the human mind organizes a kaleidoscopic flow of impressions according to the linguistic system: the organization of space handed over to the letter could therefore correspond to the fleshing of the integratable product - the recognition of the elementary forces of cogitation as expressed by their symbols. Franz Mon, Hansjörg Mayer, Mira Schendel, De Vries, Flarsheim, Mathias Goeritz, Edgardo Vigo, Clemente Padin, Luigi Ferro, Jashuo Fujitomi, Emilio Villa (one of the most involved Italian forerunners), Adriano Spatola ("Zeroglifici," invalidation by falsity), and Giovanna Sandri (alphabetic galaxies and lettered use of phonetic symbols): these are just some of the working protagonists who widely cover the period of the last decade. Even if in part they reattach themselves to the neo-Dada collage, they come from literary apprentices and glottological reflection, from the noticeable muteness of verbal mechanics, and from participating in the problems analyzed by Jakobson, Cassirer, Hjemslev, and Pierce; they come separately from mercantile mechanisms and are faithful to an absolute idea of poetry.

Visional writings. – The final step in the sense of logical rather than chronological development is the promotion of the written element in poetic works: the protagonist will be the deed. Forerunners are the Russian Dadaist Iliazd, with his nonexistent alphabets, and Klee, with his memorized larval proto-writings. The first programmatic documents were Jiry Kolar's "Cvokograms" - illegible writings of 1961-1962 - and the coeval "Denklandschaften" (mental landscapes) by the German poet Carlfriedrich Claus, who, so as not to subordinate gestual movement to mechanical conditioning, trusted his asemantic, modulated writing to his uninstructed left hand.

Moving away from the letter - or at least from the loose representation of sounds - we see a concentration on the recording of vital-vitalizing movements. Poetry, which had become more and more reduced, was thus reconnected to the graphic-pictorial world of Zen-Oriental descent: from the White Writing of the Pacific School, through Tobey to Twombley, and to the final conceptual rings in the reducing chain, which had begun with the rejection of the rule of representation. The new amanuenses objected to the common denominator of the representative or synthetic-abstract image, into which Man - from the time of the Cro-Magnon caves until yesterday - has been able to place his own monitors. They also objected to the linguistic codes in which Man was looking for an intersubjective, articulated breach. The "informative" purpose, in the most exact sense of the term, was achieved by identifying every aesthetic work with no critical-historical subdivision of disciplines.

There remains the importance of verbal language, raised to a "non-classified symbol," or, by division, the importance of the Grafia metacode: the "bodily habit" (Bertrand Russell) of writing which has the result (again in the words of the English philosopher) "of a series of pieces of matter put into a spatial order." These existential suprematist communications are changed by the ritual action of writing, or by the norm, consecrated by common notion, of transmitting impulses to the hand that supports an instrument which, in turn, leaves a visible trace on a base, which can be of any material, even human skin. Note "Deiscrizione," the written scribe, Claudio Parmiggiani's living man covered with symbols, who illustrates the passivity of the operator when conditioned by a meaningless language. The "trace" can also be of any material: Carlo Sitta, in his book "Magnetodrome" marks out the phonetic slavery and the expressive freedom of handwriting with the linear tangles of a magnetic tape. Fashion - the recycling of obsolescence - is also exhausting asemantic writing, which has fallen far down in the market and is now epigonic in nouveau-poetic circles. In Italy it was practiced as a priority, with the structured connections of whoever wished to find them, by Martino Oberto, the founder, along with Anna Oberto, of the first magazine for interlinguistic research (*Ana etcetera*, 1958).

Code-rejection can be the same as crossing codes to create a relationship which breaks the rules of the game by working through the mesh of the mechanisms: thus written poetry also embraces verbalized works without contradiction (the forerunner being Picasso, with his textual writings of 1930-1935). To escape monoglossic conditioning, handwriting was to rely on pluri-alphabetism (Luciano Caruso); on meta-alphabetism (Franco Vaccari and his para-pointillistic transcription of the cricket's song); on multi-direction (Vincenzo Accame with his linear geometrics and intersections); on the accompaniment of handwriting and chromaticisms (Magdalo Mussio and Ana Hatherly's "memory maps"); on emptying iteration (Pacheco and Chaves: the quotient of semanticity is reduced because the letter is placed over the meaning); and on the significance of the base (Klophaus: carved-written cement and Amelia Etlinger: fabric poetry, which is knotted, fringed, and

veiled until it becomes desemanticized). These procedures, because of the associated rejection of the peculiarities and functions of the base materials, are already part of the next cycle, where space is the parameter and base the protagonist.

Visional poetry. – The late 1960s saw a movement toward a more radical concept of space in many nouveau-poetic areas. The first tri-dimensional poems (Villa, Belloli, Furnival, and Carrega, for example), luminous letter projection (Ferdinand Kriwet), and object-volumes with the new kinetic dimension of modular page-composition (Agentzia, Geiger, and Schwarz editions) are all products of the spatial phase, which presumes the theoretical opening of "spatialism" and is generally designated by a fluid "visional" predicate.

Visional poetry does not describe specific groups, nor does it issue placards — rather exists in the conscience of its participants. In Italy, where the language allows for a distinction between visual (visivo) and visional (visuale), the word "visional," widely promoted by Belloli with polemical intent, has ended up being attributed to all the nouveau-poetic phenomena of the intermediate phase. "Visional" is the product which is no longer "Concretist" and not yet "Visual": the strictly visional aspects of the elements of linguistic communication increased, but without resulting in the division (which was to occur in "visual" poetry) between iconic code and writing. This ever more inclusive figural, logographical vocation results in a transformation of the base with reference to space, and thus a linguisticization of the base materials.

Poetry makes an effort to deny the bi-dimensionality of its medium. For example, in Ugo Carrega's xerography "Genesis" the sheet of paper represents a gesture, simulating the crumpling and rejection of a used page, while the Biblical title used in the text describes the idea of the crumpling as the shutting down of development. In visional poetry, the ubiquity between opposite semantic poles sets the wheels of poetic rebound into motion, thanks to the interactive inclusion of the suggestions of space.

In this transitional phase, iconic contamination is in progress. The linguistic symbol seems to recognize its own nature of "a sealed image": when the verbal seals are broken away from the different interventions of avant-garde poetry, the "image" which stands behind and in front of the alphabet aims at undermining it. Early, non-representative texts admit to iconographic connections (for example, the halo-orbit, the supreme verbal "layer" in a typewritten page by the Garniers). And concretists, initially alienated from plastic allusions, also give in to the new calling: Arrigo Lora Totino, for example, records the gradual perspective miniaturization of the word "space" onto a black background to achieve the semeiological rejection of the concept of page.

"Image" makes progress under the sign of ambivalence. It also appears from the iconic analogies of the linguistic symbol itself in relation to context: repetitive quotation marks on the paravitreous transparency of a "Window-page" signify ambiguous raindrops (Bentivoglio); the empty space in the center of a graphic grid of Japanese ideograms meaning "Spring" outlines, of its own accord, a leaf (Yutaka Ishii).

Thus Gomringer's muteness leads to the sculptural alternative: language, which has been penetrated by nouveau-poetic probing for years, reveals itself as a deposit for the conscience. It is no longer a mask of subjective powerlessness, but an impression of the human psyche. The linguistic symbol subordinates its own phonic instrument to the less-used language of ideovisual memorization. The artifice of the old representative versifier - the forerunner of visional poetry - is desubjectivized, and the magic of the calligram of the past is exorcised by the joining of intuition with reason. The visional poet associates the tracing with the idea, like a hunter following tracks, in agreement with anthropologists and psychoanalysts who discuss that the peculiarity of the "homo sapiens" lies in their ability to produce symbols.

This regressive maturity leads to the division of phonic creativity. As with writings (which are also "visional" because of their pictorial descent), the phonic agent loses its expressive role. The iconic properties of the written language are analyzed more than its connections to the spoken language: articulate vocalization, a slow instrumental conquest in the history of Man, proves to be incompatible with the primary-synthetic tendency of visionalism. But at this point the phonetic poetry started by the Dadaists reaches its full possibilities with the use of magnetic tape (Bob Cobbing, Paula Claire, Henri Chopin, Bohumila Grögerova, Arrigo Lora Totino, and Patrizia Vicinelli, for example), and the major collections of visible poetry (Ca' Giustinian, Stedelijk Museum) also contain listening sections. Thus, thanks to the technical evolution which allows the reconquest and free structurization of the genetic physicality of language, poetry has managed to separate sound and image: which the invention of the alphabet over thousands of years had instrumentally united.

At the same time as this spatial phase, in several chronological cases musical experimentors along the lines of John Cage (Earle Brown, Sylvano Bussotti, Schnebel, and Giuseppe Chiari, for example) also include in their exhibitions the same perceptive sphere stimulated by the nouveau-poetic experiments. They used graphic, verbal, and sometimes chromatic notations in their poem-scores, presupposing expressive, multi-dimensional synchronisms which drive critical methodology crazy and confuse creative passivity. Some poets connect their own verbal research to the parallel phonic experiments of the Fluxus group (in Italy, Caruso, Diacono, and Martini). Others, with more or less pregnant semantic short-circuitry, mix pentagram and monogram, reported images and words. In this way, developing from spatial simulation to the simultaneous and joint use of diversified languages ("singloxis," as termed by Rossana Apicella), and with a logoiconic table, poetry steps over the real "visual" threshold.

Visual poetry. – Towards the beginning of the 1960s Nanni Balestrini and Alfredo Giuliani of the 63 literary group and a few isolated experimentors such as Corrado D'Ottavi had built the first poetic messages with scraps of printed paper: strips of different lengths with characters of different shapes and sizes, depending on their origin. One of the forerunners of this was the Slovenic constructivist Svecko Kosovel, with his poetry-collages of 1926. This manual and anonymous operation amounted to the declaration of compulsory silence by the poet and to the formulation of his desire to smuggle his own presence through the screen of the

mass media. There was a return to grammatical rules, which had been destroyed since the time of the futurist. The language itself now came to be considered as an object, and so its mechanisms were allowed - in the same way that the form of existing objects is accepted in an assemblage. Later, the poetic offensive also resorted to including representative inserts from published sources: with super-national language par excellence, image thus became equal to language under the symbol of objectivation.

The members of the 70 Group (which included Eugenio Miccini, Luciano Ori, Lucia Marcucci, Michele Perfetti, and Lamberto Pignotti, among others) developed the first experiments in logoiconic assemblages, which were baptized "visual poetry" by a collection directed by Pignotti in 1965 for the Sampietro editor, documenting the different post-literary Italian works. In this way a refined, alternative term was monopolized. Other poets joined the group and, towards the end of the decade and beyond, they gave way to museographic initiatives (Denza Archive), editorial mergers, potentiation (Techne, Amodulo, Sarmic), and even attracted foreigners of concretist descent, such as Paul De Vree. The distinct classification of the visuals occurred in Italy in articles and presentations during the first half of the 1970s. A new collection, directed by Ori in 1975 for the Carucci editor, documents this kind of experimentation on an international level, while confirming the historical precedence and the numeric domination of the Italian "visual" nucleus.

While commercial centers are making use of the cultural patrimony of symbols in order to trademark them in the market - while, in order to stimulate consumption, they are imposing on unrealistic, hyper-symbolic urban background with reactions based only on negation - at the same time, the poets are making this simple and astute discovery: only a language which has already been exploited cannot in turn be exploited. To avoid the devastation of its instruments, it is necessary to remove them from the iconosphere of the mass media, consider their significance, and return them to poetry as a vitalized filter of falsification.

In the 1964 "Biennial," Pop Art had established the aesthetic promotion of mass iconography, giving preference to the neo-capitalistic side of the history of expression with the inclusion of individuality under the sign of subjective gesture. Visual poetry, coming later, placed itself on the anti-capitalistic side. The new poet, alienated from the use of primary elements such as color and subject (which he considered contradictory in the context of his partition), recognized only active opposition to structural thought. Lacking any pictorial redemption, his messages — indiscriminately verbal and iconic — became charged with unedited, second-hand connections which rebound against their creator. The merit of the visuals is one of keeping language at its basic level: the new texts do not need any preconceived ideas, since these would break the mechanism which starts from the level of mass information.

While the first, strictly verbal, collages (such as those by Balestrini,) achieved strange effects of tension chilled by pseudo-automation, the new logoiconic language seems to be missing the target. The abundance of counter-messages, which maintain a temporal, literary course, make for complicated reading and can rarely compete with the original communicative speed of the

same publicized materials left in context. But, in time, the operation was refined: there was a reduction of the sparse reporting verbalization and of the mocking transplanting of advertising Kitsch, which risked a semantic upset in its vulgarity. In this phase, visual poetry ceded predominance to imagination, generally by means of printed matter on photographic bases. The materials also use photo-reproductions of past works of art, as in the Pop revisitation principle, and their desecration is aimed at making the code difficult (for example, the addition of cartoons and writings by Sarenco and Marcucci). But the visuals achieve their strength of impact on a world in transformation with photographs of the present day. De Vree suggests coincidentally fixing the date of the new poetic movement at May 1968 in France: protest boards, wall graffiti, spontaneous demonstration - logoiconic products of a culture uncontrolled by persuasion, but fixed by report - are the direct matrixes of the new unsubjectivized vulgarity. According to Walter Benjamin, photographs, which are "documentary proof of the historical process, . . . move the ritual foundation from art to politics"; Benjamin states that the person who is ignorant of photography, not of the alphabet, will be the uneducated person of the future. The parity of the languages is thus recognized outside the literary relationship between caption and image: a relationship which poetry can make circularly creative.

In Sarenco's gigantic "Poetic license" the formal carelessness of the felt-tip writing is a significant element (poverty and availability of materials being the basis of a coherent desubjectivization), and the newspaper reproduction is provided with an elementary communicativeness. As can be seen, the return of articulate language re-established the use of the metaphor, which had been ignored by the concretists and only partly intrinsic to the ideogrammatical ambivalence of the visionals. "With the metaphor, the poet loosens a concept from its previous semantic series and transfers it to another series. Thus we see it as something new. Its label has been removed" (Sklovskij). Visual poetry encourages metaphor with reciprocally iconic terms and non-invertible words, until form interacts with linguistic content and is not limited to illustrating it (which would make it superfluous and would sterilize or privatize the public image, as sometimes happens). The various sense levels, included not just for harmony, are released in mutual geometric progression so that the message becomes "a source of messages" (Umberto Eco), as in every form of poetry. In the above-mentioned work, every element converges towards metaphorical collision, thereby achieving a multiple purpose: poetic license is the expression of the young girl, it is the intervention of the poet, the logoiconic metaphor, poetry which recognizes itself as the continual exception.

According to Rudolf Arnheim, photography introduces the element of chance to the product and "implies critical selection of an unconsciously-elaborated space" which is brought out by poetry. In the collage "Black flower" (Mirella Bentivoglio), the journalistic caption has the double purpose of sculpture and reference: for the funeral of a murdered Negro, the coffin, horses, clothes, and even the flowers are black. The artifice of the protagonists brings out the semeiological common denominator of the blackness of the skin and

the blackness of mourning and, by blackening the vegetable elements, denounces the insult that racism makes against nature. But the clipping shows the outlines of a flower in the photograph of the funeral itself: thus it discovers and offers up the reconstituted naturalness of poetic challenge.

Several poets make use of the verbalized photograph, including Julien Blaine, Hans Clavin, Dencker, Dias Pino, Jean François Bory, Shahakiro Takahashi, and Françoise Janicot. Alain Arias-Misson achieves the levelling of symbol and figure by means of composed gigantographs and miniaturizations (the large word "olio" [oil], proportioned by the author, refers to the traditional pictorial medium and visual communication reconquered by linguistics). While the debate about "visual" content against the formal rigor of the concretists reflects the secular dispute between romanticism and classicism, the debt of logoiconic poetry to concretism is clear from the frequent verbal games (double meanings and assonances) introduced into the captions. In these cases the integration of sound has once again been achieved after the interval of the visionals (for example, Betty Radin's photo-assemblies, with the crossing of sculpture and sound on unedited semantic paths).

Sometimes the process of visualization activates a parallel series of codes and establishes predictable connections (for example, Herman Damen's deflagration of the chemical formula of dynamite in the reproduction of the Nobel Peace Prize medal). This does not make a revelation, but illustrates previous knowledge: the chain of association, which can run inside the same semantic series, is thus abbreviated. This type of interlinguistic communication, not founded on the autonomy of meanings and therefore closer to prose, is, at the moment, also listed among the products of visual poetry. These products are still awaiting some form of specific critical organization which goes beyond monographic apologias.

Given the difficulty of a synchronous, converging sculptured-structural and poetic-inventive control, a large number of balanced works are to be found in the less-investigated logoiconic area, which contains cryptic linguistic orimage intervention. Emilio Isgrò applied the interrupted symbol of Man Ray's Lautgedicht to the concept of obliteration, enucleating brief self-ironic enumerations. On the printed page, asemantic handwriting assumes the sculptured irregularities of covered words, highlighting the physicality of breathing rhythms which become translated into hand seismography. The participation of this operator in the iconic sphere comes from the secretly graphic suggestion of illustration. Thanks to the same merging of manual production and mass medium, the obscure technique is practiced by Pignotti by partially inking journalistic images. In this sphere we can also include Miccini's and Grögerova's political rebuses - logoiconic enigmatizations tending toward the formal and semantic redemption of a polished process.

Later developments. - While the authors of verses, bound to edition seriality, were unaware of the most problematic side of the market relationship, wall and object poetry both participated in the contradiction of marketed demarketing. This makes use of gallery circuits to reach its audience, in the knowledge that "on a linguistic level, private property does not exist" (Jakobson). Through catalogue reproduction, works made up of technological elements, or which are already of second-hand origin, will be reinstated with the infinite seriality which already exists in their own nature as public messages.

Dialectizing the relationship with the market and preventing this from blocking the transformation process, several protagonists of visual poetry in the late 1960s demonstrated tendencies toward body art and behavioralism. The word "air" written by Jiry Valoch on a female breast, with its double meaning of anatomic and symbolic container and of provider of vital life; the mimic behavior of the same author in pronouncing the letters which compose the word "poem" - conscious enigmatization of the duplicity of meaning; Maurizio Nannucci's finger writing on water - pulsing elimination of words in a primary element; the punch card tape in which Todorovic wraps and immobilizes himself; the foam-rubber letters that Arias-Misson mixes with the foam from waves; the macro-parentheses which he erects in narrow underground railway passages; Bory's writings, poeticized by the connection between meaning and context, in sand, and those of Valoch in snow - these are all translated into photographic sequences which foresee the unspectacular involvement of the author in a symbolic action. There has also been the more recent emergence of the symptoms of poetic action broadening into pluralistics and of the absorption of the visual-poetic border into ideo-sculptural working areas.

The deep-seated fluidity of every form of visual poetry - that recovery of semeiological freedom - prevents us from making any predictions, except for one of further merging, about how automation can gradually be overcome. Poetry in its visual sense, as the first codified interdisciplinary language in the history of aesthetic activity and moving in a confluent moment towards new social hypotheses, implies the recognition of culture as multi-directional dynamism and unifying conscience, and thus the recognition of the decrease of roles and boundaries - even of the roles and boundaries of the already imprecise specification of "visible poetry."

BIBLIOGRAPHY - Works of criticism: M. Bense, Poesia concreta, Invençao 3, 1963; P. Garnier, Spatialisme et Poésie Concrète, Paris, 1968; R. Dohl, E. Gomringer, Poesia sperimental, Madrid, 1968; L. Pignotti, Istruzioni per l'uso degli ultimi modelli by poesia, Roma, 1968; A. Spatola, Verso la poesia totale, Salerno, 1969; A. H. De Campos, D. Pignatari, Teoria de Poesia concreta, San Paolo, 1975; M. D'Ambrosio, Bibliografia della poesia italiana d'avanguardia, Roma, 1977; V. Accame, Il segno poetico, Samedan, 1977. See also the volumes in the series of visual poetry, Sampictro, Bologna, Carucci, Roma; in the series Marcalibri, Roma; Geiger Sperimentale, Torino; and in the edition Agentzia, Paris, Techne, Firenze, ElleCi, Roma.

Anthologies: Antologia do verso a poesia concreta 1946-1962, Noigandres, 4, 1962; Kleine Anthologie Konkreter Poesie, Spirale, 8, Frauenfeld, 1962; Antologia della poesia visiva edited by L. Pignotti, Bologna, 1965; Poesia concreta edited by A. Lora Totino, Modulo, 1, 1966; An Anthology of concrete poetry, edited by E. Williams, New York, 1967; Concrete Poetry, edited by S. Bann, London, 1967; Situazione della poesia concreta, edited by A. Lora Totino and A. Spatola, La Battana, 12, 1967; Experimental Poezie, edited by

J. Hirsal and B. Grögerova, Praga, 1967; Poezie in fusie, edited by P. de Vree, De Bladen voor de poezie, Lier, 1968; AH 0105, Utrecht, 1968; A world look at concrete poetry, edited by M. E. Solt, Bloomington (Indiana), 1968; Il gesto poetico, edited by L. Caruso and C. Piancastelli, Uomini e Idee, 18, 1969; The book as object, edited by Simon and Schuster, New York, 1969; Textbilder. Von der Antiken zur Gegenwart, edited by K. P. Dencker, Köln, 1972; Poesia e/o poesia, edited by E. Miccini, Brescia-Firenze, 1972; Poesia visiva, edited by E. Miccini Brescia-Firenze, 1972; Notes sur une possible fin des livres, L'art vivant, 1974; La escritura en libertad, edited by F. Millan and J. Garcia Sanchez, Madrid, 1975; Poesia al femminile, edited by V. Accame and A. Oberto, Le Arti 10-11-12, 1975; Historische Anthologie de visuele poezie, edited by G. J. De Rook, Rjikscentrum Hoger Kunstonderwjis, Brussels, 1976.

See also various review publications: *Marcatré* (Lerici, Roma), *Ana Etcetera* (Genova), *Amodulo* (Brescia), *Lotta Poetica* (Brescia), *Linea Sud* (Napoli), *Quaderni di scrittura simbiotica e Bollettino Tool* (Genova and Milano), *Tam Tam* (Geiger, Torino), *Diagonal Cero* (La Plata), *Hexagono* (La Plata), *Ovum* 10 (Montevideo), le antologie annuali *Geiger* (Torino), i calendari del *Kumm Verlag* (Offeñbach a.M.) le schede *Linguaggio & Poesia* (Savona).

Catalogues. Schrift und Bild, Stedeljik Museum, Amsterdam, 1963; Visuelle poesie, Westfalischer Kunstverein, Munster, 1968; Poesia concreta, indirizzi concreti, visuali, fonetici, La Biennale di Venezia, 1969; La poesia degli anni 70, Museo del Castello, Brescia, 1970; Konkrete Poezie?, Stedeljik Museum, Amsterdam, 1971; I denti del drago. Transformazioni della pagina e del libro, L'Uomo e l'Arte, Milano, 1972; Il libro come luogo di ricerca, XXXVI Biennale di Venezia, 1972; Italian Visual Poetry 1912-1972, Finch College Museum, New York, 1973; Scrittura visuale in Italia 1912-1972, Galleria Civica d'Arte Moderna, Torino, 1973; Hors Langage, Centre National Dramatique, Théâtre de Nice, Nizza, 1973; Poesia visiva arti visive, Artivisive, Roma, 1974; La visione fluttuante, Unimedia, Genova, 1975; Parola immagine oggetto, Istituto Italiano di Cultura, Tokyo, 1976; Tra linguaggio e immagine, Il Canale, Venezia, 1976; La scrittura, Seconda Scala, Roma; Studio Santandrea, Milano; Unimedia, Genova, 1976-1977; La forma della scrittura, Galleria Civica d'Arte Moderna, Bologna, 1977; Poesia visiva, catalogue, Studio Santandrea, Milano,1977. - See also the exhibition catalogue of visual poetry, Galleria Schwarz, Milano; al Mercato del Sale, Milano; Artivisive, Roma; Centro di Documentazione Estetica, Torino; Il Brandale, Savona; Visual Art Center, Naples; Other Books and So, Amsterdam; Klingspor Museum Der Buch-und Schriftkunst, Offenbach a. M. and the references to visual poetry in the catalogue Artistas Italianos de Hoje, Biennale di Venezia per il Musco di San Paolo, 1972; and in the catalogue Arte in Italia 1960-1977, Galleria Civica d'arte Moderna, Torino.

MIRELLA BENTIVOGLIO

NEW ARTISTIC TECHNIQUES

The history of techniques in art of the 1900s takes its shape as the history of methods, procedures, and distinctly anti-arts materials that some artists, supporters of the avant-garde movements, begin to use in their works as early as the beginning of the century. This apparently unexpected fact actually has rather distant causes if it is looked at in the scope of an environment much larger than the crisis of the production of art. As Argan pointed out, the birth of the industrial era and the consequent transition from an economy based on hand-made production to one based on mechanical production is not without consequences for the artist. The artist, if he is able to use only traditional techniques in a society that has begun to realize its aesthetic necessities through the assembly line process, very quickly becomes superfluous; that is, society could get along without the artist but does not really want to relinquish him any more than it wants to relinquish a useless but precious object. Slowly the artist abandons his own professional role, transforming himself into a dilettante to whom everything is permissible; the artist does not have to subordinate himself to the laws of economics. This is how the stereotyped figure of the romantic artist, poor and talented by definition, intolerant of every bond and uprooted from the social context, is born. From the point of view of production, this allows him an absolute independence from the preceding tradition as far as the formal scope is concerned, and, more importantly for the purposes of the present article, as far as the technical scope is concerned.

While all the preparatory elements related to the moment of conceptualization, like drawings and sketches, were being thrown out, the actual technique of making the work was also undergoing considerable transformations. This is especially apparent in the work of the impressionists, who painted directly on the canvas without first preparing a sketch. The quick, imprecise brushstrokes of the impressionists move to Van Gogh's globs of paint and then to Cezanne's exposed preparation of the canvas, which contributes to the value of the image. It is now simple to understand how the radicalization of the artistic vocabulary after Cezanne pushed artists to experiment with new and more suitable expressive techniques. The first of these attempts is in debt to cubism and futurism and can be dated at 1912. In that year, Picasso and Braque almost contemporaneously created the first collage and the first papier collé; in Italy, Boccioni produced the first multimedia sculpture. In one of his paintings entitled *Still Life with Straw-Bottomed Chair*, Picasso had incorporated a varnished piece of straw-printed fabric, while Braque had glued pieces of wallpaper imitating wood-grained panelling to his painting *Compotier et verre*. Boccioni, finally, in his *Fusion of a Head and a Window* (no longer extant), had put together rather dissimilar materials such as iron, porcelain, and a woman's hair, according to Marinetti's description of it. It should be remembered, moveover, that Boccioni, in his manifesto *Futurist Sculpture* of the same year, proposed not only introducing new materials in works of art, as he actually did, but also suggested the possibility of putting these plastic combinations into motion with mechanical force. This idea was then adopted by Balla and Depero, who integrated mechanical dynamism with the addition of tones, sounds, lights, and smells.

The reasons that pushed the cubists as well as the futurists to utilize such radically new procedures are deep within in their respective poetics. Both Picasso and Braque had inherited from Cezanne a new concept of the painting: it was no longer a canvas on which reality was projected, but rather was a plastic plane on which reality, broken down in the cubist method, was organized (Argan). This idea and the thought that the

real space of the work could accept elements from the outside were not far apart. They were even closer together if one recalls that the material element had taken on a specific role in cubist work even before collage. Picasso and Braque, in fact, added sand to paint to give more body to the pictorial texture: for reasons explained above, they were interested in the way the object itself looked in addition to its image. It is possible, therefore, to think of the collage as no more than the concrete solution to a problem on which the cubists had not been able to focus previously.

However, it is more difficult to identify the reasons that explain the adoption of multi-media by the futurists, because each of them practiced the technique with rather different applications. Prampolini, for example, who later became the theoretician of multimedia, gave it a rather personal interpretation in his writings. His interpretation is evident in the particular compositional criterion of his works, which, unlike the sculptures of Boccioni, were actual collages on a support plane, and, unlike those of the cubists, entailed a greater variety of applied objects. Boccioni's multi-media, which was, among other things, the first, requires a more lengthy discussion. In the manifesto of futurist sculpture mentioned above, the Reggio artist declared that he wanted to abolish the finite line of the closed statue; the statue should instead be opened to incorporate whatever surrounded it, including the air of the atmosphere, in a true sculptural representation of the environment. The goal Boccioni was proposing, in short, was that of realizing an anti-traditional sculpture that would present, in a true futuristic break, the reciprocal physical and psychological relationships that tied the subject to the environment. The reason for Boccionian multi-media emerges clearly from this: to realize this universal synthesis immediately, it was easier to build a sculpture with materials that were heterogeneous but directly related to the content of the work than to resort to their representation through traditional bronze or marble.

The new cubist and futurist techniques had a vast impact on all 20th-century art. Many other movements and currents, beginning with the contemporary futurism, borrowed from cubist collage, giving themselves different interpretations. Dada artists and surrealists inherited from futurism an extreme ability to use very different materials in their works, and, as one gets closer to the present, it is possible to note that the multi-media of certain currents, such as New-Dada, reveal clear futurist roots. It is evident, then, that all 20th-century kinetic experiments in art find their precedent in the mechanical dynamism anticipated by Boccioni and accomplished by Balla and Depero. It is necessary to remember, moreover, the influence another characteristic of futurism - action - had on some of the successive avant-garde movements. While action had a predominantly propagandistic goal for futurism, it was slowly transformed, first in dada and then in other later currents which put the inability to repeat gesture and action, and, eventually, the artistic work itself, at the center of their poetics. Thus, while a futurist evening was no more than an occasion to spread futuristic ideas, in the "happening," for example, the work was defined in its performance, and new artistic techniques had to be perceived, even if indirectly, in the methods used to accomplish the work.

Let us now continue our examination of new techniques in chronological order. If, for the cubists and futurists, the issue was to choose the procedures that responded to the new poetic demands, for the dada artists it was instead that of abolishing the technique and rejecting any traditional reworking of the piece. Among these, Duchamp, who was particularly sensitive to the historical problem of the role of art in society, realized that every work of art (even the most revolutionary one), even if it had used both mental and material processes to achieve an aesthetic result, would always be a product to which a value could be assigned; thus, being transformed into goods, it would lose it own innovative value as art. To do something artistically revolutionary, it was necessary to create works that had only "status" and not value in the art world. Thus, in 1913, "ready-made" was born. This term refers to objects that have already been realized and accomplished in themselves, such as a bicycle wheel or a bottle opener, which Duchamp exhibited as real art, making minor changes to them from time to time ("corrected ready-made"). The great ideological range of ready-made will not have an immediate influence in the successive years, except in some artists who were particularly close to Duchamp, like Man Ray. Its influence will be felt, on the other hand, in those currents generically definable as conceptual (especially beginning in the 1960s): those which attribute primary value to the abstract mental dimension and to the speculation on art, refusing the traditional concept of improving art by reworking it.

Before continuing the examination of dada, it is advisable to briefly address the topic of industrial design, which offers the opposite solution to the problem Duchamp resolved with ready-made. In doing so, the direct comparison of the two is illuminating for both. A particular type of projection of objects that bring an aesthetic content to other industrial products in their final form is termed "industrial design." Contrary to what happened in the past century, however, when conserving artistic characteristics in assembly-line products was attempted, with "design" a specific industrial aesthetic is sought. It is practically impossible to establish a precise date for the beginning of this concept, but it is certain that it existed by the time of Gropius' teaching at the Bauhaus. Like Duchamp, he was convinced that it was impossible for traditional art to survive in a society defined by industrial production, but strongly believed in the social function of the artist in the most classic sense as the craftsman of aesthetic objects. The solution he proposes is, at least theoretically, rather simple: artists must work within society, with the means it tangibly offers, rather than, as Duchamp maintained, against it. From the point of view of the present discussion of technique, this choice allowed the artist to permanently reject his art media and to adopt the systems of industrial production based on a design of a prototype and its subsequent mass production. Accepting industrial technology as his working medium, the artist, like any other technician who designs consumer goods, began to limit his involvement to the conceptual part, leaving the actual realization of the product to the machine.

We can now return to the examination of the dada techniques. Their panorama presents itself in a rather inorganic way, since the substantial anarchy and

the intolerance for any tie that characterize this movement cause the artists to utilize any means of expression without discrimination. Next to ready-made we find collage, assemblage, and photo-montage. Assemblage differs from collage in that the conglomeration of objects does not occur on a support plane. The "Merzbau," a type of architecture constructed of various materials, including discarded materials, fits into this category. (Schwitters began to build this type of architecture as early as 1920 in his house in Hannover.) The photo-montage, utilized expecially by the Berlin dada artists, consists of combining various cuts of photographs in such a way as to make the resulting image credible and absurd at the same time (Argan). In the field of photography, there is an important new technique: in 1922, Man Ray discovered that it was possible to photograph without a camera simply by putting the object in contact with the negative, a procedure he later called "rayography."

An identical sense of freedom in the choice of techniques also characterizes surrealism, which, indeed, can be considered a direct descendant of dada. Breton himself puts it in writing when, in the Manifest of 1924, he affirms that "no means is designated *a priori*" to bring to the surface the forces that are concealed in the "depths of our spirit." But even in these words the diversity of attitudes between the two movements suddenly becomes evident: while the dada freedom is derived from the programmatic absence of any choice criterion, the surrealistic one has the precise goal of defending the expressive autonomy of the unconscious. For different reasons the traditional techniques as well as the newer ones are thought to be able to achieve this goal with equal efficiency: the former would not have impeded the free flow of the unconscious towards the external, since their extensive familiarity was by now almost second nature to the artist; the others, like the collage, the assemblage, and the photo-montage (in which Ernst's *roman-collages*, composed of cuts of late 19th-century serial novels, can be included), would have equally allowed the barrier of the conscience to be broken, being based on irrational and chance processes, at least according to the interpretation given to them by the dada artists.

Next to these, more specifically surrealistic techniques are developed, above all by Masson and Ernst. To the former we are in debt for the "scrittura automatica" (rising again in 1924), which, even though it used the classic media of painting and design, can be considered the most revolutionary discovery in the field of the transcription of the data of the unconscious because of the particular situation of the suspension of the rational faculties in which those media are used. The same French artist also produced the so-called sand paintings, a technique he began to utilize in 1927. With these works, whose composition consisted of covering with sand a canvas that had been prepared with an irregular layer of glue (so that the sand would not adhere in places where the glue had not been applied), Masson seems to want to concede a greater space to the role of chance and to the autonomy of the material, thus forming perhaps the most direct premise of the informal painting. We are also in debt to Max Ernst for the discovery of some typically chance techniques, like that of "frottage," whose use can be dated as early as 1925. This is derived from typical child's play, in which a pencil or piece of charcoal is rubbed over a piece of paper placed on a rough surface. As the artist draws, the small rough spots under the paper cause unexpected forms to appear in turn; these, one at a time, stimulate the imagination of the artist in a reciprocal game of repartee. A few years later, Ernst will adopt a technique similar to that of "frottage" in the field of painting. This technique consists of squeezing paint between two canvasses or between a canvas and a piece of paper in such a way that the "successive pull leaves a revealing impression on both" (Tadini).

In the field of sculpture, two new technical turns of substantially opposite movements can be discerned next to the traditional ones of great prevalence. On the one hand is the primitivistic movement. Here artists of most disparate currents, like Brancusi, Gonzales, and Moore, can be included. These artists, who followed the example of Negro, or, at any rate, primitive sculpture, prefer to resort to the techniques whose natures do not entail pre-planning and then reworking, such as carving on wood with a hatchet, or, in the case of Gonzales, the soldering together of iron parts of his sculptures. On the other hand is the turn of constructivist impression, represented by the brothers Anton Pevsner and Naum Gabo, who introduced industrial manufacturing materials (glass, plexiglass, perspex, etc.), into their sculptures under the influence of the upcoming design of the time. The American artist Calder appears in a position isolated from both of these movements. Calder, after his first "stabiles," created some moving sculptures at the beginning of the 1930s (put in motion at first by motors and then simply by air currents or a touch of the hand) using metal plates, thin metal blades, and other products of industry, without regard, however, to the criteria of economy and utility that their industrial nature would have recommended. The influence of Calder and his "useless" mobiles will be particularly important for the kinetic sculpture of the following ten years.

It is now necessary to examine the issue of informal techniques. To attempt just one explanation is almost impossible because, while generically speaking, almost all these techniques could be defined as pictorial techniques due to their constant presence of color and of the support on which it is distributed, they present great differences from the point of view of operative procedures and materials. Moreover, as if to complicate the understanding of these techniques, they only rarely coincide with the division into "action paintings," semiotic art, art of gesture, and art of material. generally accepted by the critics While some artists resort generally to oil paints that they spread in a traditional way (Capogrossi), with wide paintbrushes normally used to paint walls (De Kooning, Kline, Soulages), or with their hands or even directly from the tube (Wols, Mathieu), Pollack instead prefers industrial paints (duco, aluminum paints), which he drips directly from the container onto the canvas placed on the ground without a frame, using the dripping technique experimented with since 1940 by the German painter Hans Hoffmann. The diverse techniques among the so-called materials artists are no less important. Fautrier habitually works with a paste of tempera and glue that he spreads on pieces of paper which are only later applied to the canvas; Tapiés uses a mixed technique in which cement, wood, fabrics, and so on are used; Burri, finally, whose works could be rigorously, logically defined as real collages of different

materials against a support plane, uses bags, wood, metal plates, and sheets of plastic to which he sometimes adds scraps, stitches, and burnings in chronologically successive moments.

These procedures, even though very different, nevertheless share a common characteristic: the absence of any pre-planning of the application. It can be stated, in fact, even with the great difference shown on one hand by the semi-craftsmanship-like work of Burri and Fautrier and on the other hand by the improvisation of Mathieu and Pollock, that normally the informal artist trusts the extemporaneousness and the immediateness of the unmeditated act, rejecting any pre-planning, for the realization of the work. This sort of suspended consciousness, if it has certain similarities with the surrealistic one, nevertheless differentiates itself because it tends to translate into the material the much greater indistinctness of the conscious more than revealing the complexity of the unconscious in the shape of an image. This refusal to pre-plan the work should not, then, be understood only in the surrealistic sense as an attempt on the part of the artist not to contaminate those instinctive and irrational faculties that are deemed to be of the highest creative potential, but also to guarantee the analogous "freedom of expression" of the material, recognized as the essential dignity, and of the object, both of which are equal. With respect to this autonomy, that desired sense of "imperfection" of informal painting, which, in the most finished works, is seen in the apparent incompleteness of the work, and in the "most free," like the canvasses of Pollock, in the chaotic disposition of colors in strings, spots, and globs, is explained.

A subsequent reflection of this attitude concerning material can also be contrasted with that of artists far from informal, such as Helen Frankenthaler and Morris Louis, who adopted a procedure that could be defined as the spontaneous absorption of paint. This consists of placing a certain amount of rather diluted paint on a horizontally-positioned canvas and guiding its absorption by turning the canvas in various ways. The predictability of the result is partially impeded by the unpredictability of the behavior of the paint.

It can be stated that the problem of technique becomes confused with that of the absolute freedom of expression in the period following informalism, since the aesthetic conceptions that subordinated the use of the means and specific materials had faded. This fact can be explained by reasons of varying importance: on one hand, by the sense of extreme freedom and independence from the traditions inherited from the preceding avant-garde movements; on the other, by the diffuse knowledge that artistry does not depend on the use of particular, specialized techniques, but rather (and here a renewed dada influence can be perceived) by the intentional quality of the act, whatever it is. As one can easily imagine, this allowed artists who worked in the last 20 years a nearly unlimited expressive autonomy that has been translated into an uncontrolled proliferation of creative media, especially in more recent times. For these reasons, and also because of the difficulty in "historicizing" such recent facts, it will be impossible to give a complete picture of the situation, at least from this perspective.

While the current "opticals," in accordance with their rationalistic roots, are characterized by the use of procedures and above all by industrial materials, Pop Art (in which New-Dada and Nouveau Réalisme are included for convenience) frequently resorts to the typical dada object techniques. This ranges from the most simple works of objects to the multi-object experiences of the "combine-paintings" of Robert Rauschenberg, in which the objects (with the addition of paint) are placed according to certain compositional relationships, according to the old technique of "assemblage." When, as in the case of the neo-realist Arman, it is the accumulative criterion that guides the whole, the term "bricolage" is used instead: this term, in anthropology, defines the collecting characteristics of primitive cultures. In other cases, the object is roughly modified and sometimes partially destroyed. This is the case of Chamberlain, who puts parts of damaged cars together, of César, who shows blocks of crushed scraps from mechanical presses, and of Rotella, who slashes posters and billboards according to a procedure (*décollage*) that tends to place different superimposed layers of paper in an iconic relationship. A particular technique used by some artists of the Pop movement, like Oldenburg, Dine, and Segan, and later, by some hyper-realists, is that of the environment, which consists of a real environmental composition of sculptures and objects put in a reciprocal relationship. Some conceptual works that are placed in structural and spatial relationships with the defining environments for which they were created, like the luminous compositions of neon light tubes by Dan Flavin, can also be defined as environment.

The 1970s saw the ever more intense application of the so-called "intermedia" in the field of visual arts (which, due to the current process of aesthetic osmosis between the different arts, are losing the traditional characteristics that differentiated each from the other). "Intermedia" refers to the media of other art forms such as cinema, television, theater, photography, writing, printmaking, books, etc. The theater, for example, and more specifically, the "Living Theatre" of Julian Beck, together with the "happenings" of Allan Kaprow, can be considered the direct origins of the recent phenomenon that goes by the name of "body art." (The indirect predecessors can be found, as noted, in the action of the futurists and the dada artist.) Body art includes that of artists who consider their own body or the bodies of others as a medium and object of artistic nature (Günther Bruss, Urs Lüthi). Similar to body art is the behavioral tendency in which the interest of the artist moves from the body to the action, sometimes simply as movement through words, and sometimes expressed in a more complex manner (Ben Vautier, Joseph Beuys). Writing, whether by hand or through typography, has also developed a rather important role in recent years. It has had a vast application in the various movements of visual poetry and conceptual art (Joseph Kosuth, Art-Language), in which, however, the instrumental function of support to mental elaboration is involved. As noted, writing was seen in many cubist and futurist works with a primarily iconic objective and in other surrealist works as a patent contradiction to the meaning of the image. (Here one recalls Magritte's *Ceci n'est pas une pipe.*)

Before concluding, a brief acknowledgement of the ambiguous problem of techniques that are destined to document the conceptual works (other than writing, object art and photographs or videotapes) is necessary. Too often, perhaps because of the pressures of the art

market, this problem tends to identify *tout court* with the work, failing to remember the more modest function of materializing mental concepts.

BIBLIOGRAPHY - Nothing specifically or globally exists on this topic. For the theoretical foundation of the issue, see G. C. Argan, "L'arte del XX secolo," *Enciclopedia del Novecento*, Rome, 1976. See also numerous references to the topic in G. C. Argan, *L'arte moderna, 1770-1970*, Florence, 1970.

MASSIMO BONELLI

PHOTOGRAPHY

The verb "to photograph" comes from Greek and means to draw with light. In 1839, Sir John Herschel first used this word in an attempt to define the process of chemically reproducing the images of objects on to surfaces sensitive to light. This linguistic baptism unified the research of many who had been developing a technique for the non-manual reproduction and, more specifically, the miniaturization, of the visible.

Optical and chemical research prior to the invention of photography. – Photography represents the results of two combined disciplines, one physical and the other optical in nature. Even before the actual invention of photographic methods, scientists and artists were pooling their experiences and theories in the field.

Initially, chemical research in photography began with the discovery of sensitive surfaces and the fixing of images on these surfaces. The Arabs in particular noted that certain metallic salts, especially silver salt, turned dark when exposed to sunlight. Until 1727, this phenomenon had been attributed to heat. At that time the experiments of the German physicist Johann Heinrich Schulze (1687-1744) finally proved the reaction was, in fact, due to light. In one of these experiments he glued paper letters on a bottle which had been previously filled with a mixture of chalk and silver-based compounds. When exposed to light the mixture darkened, except in those areas behind the letters. The same experiment was attempted without the same result by exposing the bottle to fire and heat. It was thus concluded that silver salt was sensitive only to light. Schulze's experiment was replicated by an English scientist, William Lewis, who described it in his notebooks. Josiah Wedgewood, a famous ceramicist, hired one of Lewis' assistants, a man named Davy, to be his son's tutor. He and Wedgewood continued experimenting and were reportedly the first persons ever to use a darkroom (Journal of the Royal Institution, 1802). No tangible record of their experiments survived, however, as they could not find a way to fix their images.

The concept on which use of the "darkroom" is based was recognized in ancient times. In the *Problemata*, Aristotle talks of an image appearing on the inner wall of a dark room after light had been filtered through a small opening. Medieval scientists used this idea to study solar eclipses. Likewise, from the Renaissance on, many artists frequently used such devices to accurately and quickly ascertain the silhouettes and contours of objects. In his notebooks, Leonardo da Vinci was the first artist to describe use of a darkroom, though it appears he never used it for painting purposes. Many other artists, however, did resort to its use in drawing. These include Canaletto, Bellotto, Giuseppe Maria Crespi, Guardi, Claude Vernet, John Crowe, John Ruskin, and many more. Expanding use of the darkroom, not only among professional painters, but also among amateurs desiring to capture and bring home images from their travels, contributed to the perfecting of both the optics and manageability of the darkroom. Ultimately, lenses were placed on the opening to improve the clarity and precision of the images. The first recorded use of darkroom with lens is by the venetian Daniele Barbaro in 1568. Eventually, the darkrooms or "cameras" were reduced to tents that could be disassembled, and later evolved into smaller, portable devices. Innumerable variations on the camera were produced by the ingenuity of 19th century experimenters: from the glossy camera to the graphic telescope, the graphic mirror to the solar magascope. These were all eclipsed, however, by the invention of photography.

The inventors. – Within photography, the title of inventor belongs to Nicéphore Niepce (1765-1833), who is appreciated for his intuition, the comprehensive experiments he performed, and his surprising, if sometimes fragmentary, results. A typical representative of the French gentry, Niepce was fond of inventions and began his photographic research in 1813. At that time lithography was very popular in France. Not being very talented in sketching, however, Niepce began to search for a way to automatically reproduce images. In 1816 he managed to partially fix an image with the use of silver chloride, but was dissatisfied because of his inability to reverse the contrast of tones. His goal was to directly record positive images and, to this end, instead of using darkening compounds (for example, the silver salt which darkened in areas exposed to light but remained unaffected in the unexposed areas) he employed bitumen, a compound that hardens when exposed to light. In 1822, by using this compound he produced a reproduction on glass of an engraving. In the following years he continued his experiments, developing what can be considered the first photomechanical procedure in history. He reproduced many prints by juxtaposing images on to metal sheets (zinc or pewter) which had been covered with a layer of bitumen, and made transparent after being dipped in wax. The best of these attempts consisted of portraits of Cardinal d'Amboise, and were printed by Lemaître between 1826 and 1827.

Meanwhile, Niepce had also been experimenting with a small portable darkroom. Using this device, in 1826 he produced the first photograph: a view from the window of his studio in Gras, near Chalon-sur-Saône. The darkroom, together with a pewter sheet which had been covered with bitumen, was exposed for an entire day. The image was actually obtained after washing the sheet with a mixture of lavendar oil and turpentine. This melted the bitumen in the areas not exposed to light, leaving a permanent positive in which the illuminated features were represented by the bitumen and the shadows by the metal. The length of the exposure time, about eight hours, explains the incongruity in the distribution of sunlight in the picture. Light appeared on both sides of the reproduced images with no real shadows recorded. Niepce used the term "heliographs" to describe both the silhouette prints described above

and the pictures taken with his optical camera. At the same time he used the term to indicate that the images captured by this process had been directly impressed by sunlight.

In December 1829, Niepce signed a partnership contract with Jacques Louis Mandé Daguerre (1787-1851) with the goal of improving the heliographic process. Daguerre had a background in stage design and had acquired fame for his work with the Paris Opera, and especially the opera Diorama. Spectacular views were painted on both sides of a semi-transparent cloth, and by projecting light from either the front or back of the cloth the scene changed. Daguerre, who was already using the darkroom for his job as a stage designer, continued Niepce's experiments after his death. In 1835 Daguerre discovered that an almost invisible, latent image could be developed with mercury vapors, thereby reducing the exposure time from eight hours to twenty or thirty minutes. Not until 1837, however, did he discover a way to use a solution of common salt to fix the latent image. The first daguerreotype, as the inventor called it, currently occupies a corner of Daguerre's former studio. In an attempt to promote public awareness, he sent some samples of daguerreotype to various European princes. Finally, Daguerre found an ally in France in the scientist and politician François Arago (1786-1853). In discussions at the Academy of Sciences and Fine Arts over the future of the invention Arago interestingly asserted the importance of the invention as one which "does not require knowledge of design and does not depend on manual skills. Everyone has a reasonable chance of success in obtaining as good results as those of the author." He further declared that photography was the most extraordinary invention for public education since the encyclopedia. Scientist Gay-Lussac supported the idea of placing the invention in the public domain, thinking that by remaining in private hands, it would not be improved on for a long time. On the other hand, if publicized, it would be quickly perfected with the help of other people's ideas. Thus, on August 19, 1839, the French government assigned Daguerre and Niepce's son a life pension and made public the invention of daguerreotype without patenting it. Success was immediate. The booklet written by Daguerre to explain the procedure, *Historique et Description des Procédés du Daguerréotype et du Diorama*, was published in at least twenty six editions and translations in the five months between August and December 1839. The success obtained by Daguerre shadowed the results of Hyppolite Bayard (1801-1887) who, on June 24, 1839 (i.e., before publication of Daguerre's process) prepared the first photographic exhibition of positives obtained directly, without negatives, on paper treated with silver nitrate.

For Niepce, Daguerre, and Bayard, photographic research was based on the production of a positive developed from a latent image. The diffusion of daguerreotype prevented for a long time the development of another photographic procedure based on the production of a negative on paper. This was to be the direction ultimately taken by photography; for while the daguerreotype positive yielded a single image, production of a negative made it possible to obtain an unlimited number of positives. The inventor of the calotype process was a country gentleman, William Henry Fox Talbot (1800-1877), who delighted in drawing with the help of a portable camera. It was his limited skill in drawing that induced him to search for a method of obtaining the automatic transcription of shapes appearing on his camera glass. He began his experiments with "photogenic drawings," the image formed by simple juxtaposition of the object - leaves, flowers, lace - on to photo sensitive paper and exposed to light. Then, inside a small dark room he processed this sensitive paper, which he had invented, with two consecutive baths; the first of sea salt, and the second of silver nitrate. The first picture processed, in 1835, was a negative of a window from his country house in Lacock Abbey, near Bath, England. Early in 1839 the idea came to him of using his photogenic drawings to print some positive samples. In this way one of the problems of Talbot's photography was solved: the reversal of light and shadow images and the placement of the images so as to reflect the right side on the left and vice versa. Previously, with positive copies the sides and lights were reversed. While Talbot was still experimenting with these problems as well as ways to fix the images, he heard of the stir being provoked by Daguerre's invention in France. In order to affirm his priority, Talbot on January 31, 1839, read to the Royal Society of London a "Report on Photogenic Design Art." Immediately afterward (on February 1) he visited Sir John Herschel (1792-1871), a famous astronomist and scientist, who recommended to him the use of sodium hyposulphit to fix the pictures. He also suggested the terms "positive" and "negative" to indicate the two phases of the photographic process. Twenty years later Herschel would likewise be the first to use the term "snap shot." Herschel also perfected his own photographic procedure. However, the first one to produce a convenient method for photography on glass was Abel Niepce de Saint-Victor (1805-1870) (a cousin of Niepce) in 1848. The glass was covered by egg white, (albumine), sensitized with potassium iodide, washed in a mixture of silver nitrate and fixed as usual. The exposure time lasted from five to fifteen minutes, thus excluding the opportunity of producing portraits. The greatest advantage to this procedure, however, was the high precision of detail it offered.

Artistic use of the calotype. The coarse grain of negative paper limited the delineation of early photographic images. For a while the calotype, also called in accordance with the name of its inventor (William Talbot) "talbotype," imprinted a particular aura onto the pictures. The soft contours and diffused light which resulted from the material were exploited by the first calotypists, most of whom had backgrounds in painting.

After patenting his procedure in 1841 Talbot was concerned about propagating its use and, to this end, suggested some potential applications of the new art (particularly in his work "The Pencil of Nature," published in 1844). He predicted the great popularity of his invention among amateur photographers, writing, "There is certainly a more superior road to drawing and soon, when it becomes better known and explored, it will also become more frequented. Many amateurs have already abandoned the pencil to take up chemical solutions and darkrooms, especially those people, not a small number, who find it difficult to apply the rules of perspective . . ." Nevertheless, Talbot's predictions of a large increase in the number of amateur photographers had to wait a long time before becoming a reality.

For by applying excessively restrictive conditions in the use of his patent, Talbot actually impeded its diffusion.

The Scottish painter David Octavius Hill (1802-1870), working together with the chemist, Robert Adamson (1821-1848), was the first to use the calotype for artistic purposes. In 1843 he was assigned to paint a group portrait commemorating the Foundation of the Church of Scotland; instead of gathering the almost 450 members of the church to pose for a painting, Hill photographed them with Adamson's help. While the commissioned painting. "The Signing of the Deed of Demission" turned out to be a group of faces in an improbable setting, Hill and Adamson's photogenic portraits had a very expressive and realistic quality. The picture was taken outdoors, although the deliberately ordered scenery makes the picture appear as if it were taken indoors. The eyes of the subjects were often closed to allow the models to endure the sunlight during the time required for posing.

These beginnings of photographic portraiture differ greatly from those of daguerreotype; while the latter enhanced the detail and the precision of the image, Hill and Adamson created images with contrasts of light and shadow so striking as to bestow on them the title of "The Rembrandts of photography." The faces stand out on the dark background in the three-quarters profile so common of 18th and 19th century English and Scottish portraiture. The naturalness of the pose and psychological penetration of these portraits spread their fame and encouraged others to inquire into their work. Up until Adamson's death, they had taken about 1,500 pictures, some of which included architectural and landscape views of nearby fishing villages. The partnership between Hill and Adamson was ideal to the point that it is hard to distinguish their individual contributions. After Adamson's death, Hill almost completely abandoned photography in order to take up painting. The calotype was often used by other English photographers for the purpose of recording architecture and landscapes. For example, Thomas Keith (1827-1895) photographed Edinburgh, Scotland between 1854 and 1856. John Shaw Smith brought back many calotypes from his travels in the Mediterranean between 1850 and 1852.

Diffusion of the negative on paper. – In France the invention of daguerreotype retarded the development of calotype for many years. To the French, the advantages of being able to make infinite multiplications of an image did not compensate for the extreme precision and detail offered by the daguerreotype. In 1850, however, an entrepreneur from Lille, named Louis Désiré Blanquart-Evrard (1802-1872), who had begun to use the calotype in 1847, invented a new type of sensitive paper, called "albumine paper," with which it was possible to obtain excellent prints. He opened a factory in Lille that employed thirty to forty people and produced thousands of prints a year until it closed in 1855. He printed not only the negatives of amateurs, but also produced positives for the illustration of books. The first of these was a book of 125 photographs taken by Maxime Du Camp (1822-1894) and edited by Blanquart-Evrard, entitled "Egypte, Nubie, Palestine et Syrie." His production popularized the calotype in France. Many people adopted it, improved the process and produced remarkable works. In 1851, Gustave Le Gray (1820-1862) made public his procedure utilizing waxed paper, which by making the negative transparent

on paper, resulted in a precision of details almost equal to that obtained from negatives on glass. Le Grey, who had a background in painting, took seascapes and other images from the Crimean War which demonstrated an extraordinarily pure, simple and formal approach. Henry Le Secq (1818-1882), calotypist of still lifes and architecture, had once explained in a review of architecture, "it appears that the holy, medieval artists foresaw the existence of photography." The widespread success of these photographs familiarized the public with obscure aspects of famous monuments. Also sharing in this success were calotypist and portrait artist Charles Nègres (1820-1880), Edouard Baldus and Charles Marville.

Apart from in France the calotype was rarely practiced in the rest of Europe. In Italy, Count Flachéron founded a small photographer's club in Rome to which Eugène Constant and Giacomo Caneva belonged. In Milan, an unusual artistic personality, Luigi Sacchi, practiced photography in addition to his activities as painter, xylographer, musician and critic.

The wet collodion process and the first war reportages. – At the beginning of photography, technical improvements were often related to the evolution of photographic language. The definition and stability of the picture, as well as the range of subjects it was possible to record, depended in fact on technique, more specifically, on the exposure times, and the size and portability of the photographic apparatus. The wet collodion process, introduced in 1851 by Frederick Scott Archer (1813-1857), emphasized preparation of the negative with the positives transferred on to albuminide paper immediately after exposure. The process thus inconvenienced the photographer by requiring him to have a dark room immediately available for developing the negatives. This disadvantage was, however, compensated for by the high sensitivity of the emulsion and by the limpidity and precision of the picture. Consequently, some photographers outfitted themselves with custom-made carts and wagons. This was the case with the Englishman Roger Fenton (1819-1869) and the American Matthew B. Brady (1823-1896), already known in their times as two of the most modern daguerreotypists.

Roger Fenton left to photograph the Crimean War in 1855, with a wagon converted into a darkroom. He left with five cameras, 700 glass sheets, chemical materials and other instruments and supplies. The wagon was pulled by four horses. During the Mexican War, daguerreotypes of officers and troops had been made, but nobody had ever photographed the battlefield action, and neither could Fenton since the required exposure time varied between ten and fifteen seconds. However, Fenton did skillfully photograph the fortifications, officers and troops in the war, thereby successfully conveying the impression of a snapshot. Still, the photographer could not yet compete with the reporter who, armed with only pencil and notepad, could go anywhere. Nonetheless, when some of Fenton's photographs were printed in "The Illustrated London News" the "Times" commented, "His portraits of the battlefield must be real," and adding, "private soldiers are portrayed with the same likeness of generals." James Robertson was another photographer who filmed the siege of Sebastople during the Crimean War. Fenton was sent as a correspondent photographer to bring back

marketable pictures from the war which were intended to demonstrate the good living conditions of English soldiers, avoiding all of the saddest and most cruel scenes. Robertson, as head engraver for the Imperial Mint of Constantinople, photographed English and French trenches, the destroyed Russian fortifications, and the ruins of the bombed city. Two years later he photographed an interesting documentary on the Indian revolt, together with his partner A. Beato who, in 1860, went to China as a reporter to cover the Opium War. The first to photograph the horrors of war, including dead and wounded soldiers, were the photographers covering the second Italian war of independence, 1859. These included Bérardy, Ferrier, and Luigi Sacchi.

In 1861, when the Civil War broke out in the United States, Matthew Brady, convinced that "the camera is the eye of history," abandoned his studio to photographically document the protagonists and events of the war. During this period he supervised a group of nineteen photographers, including Timothy O'Sullivan (1840-1882), George Barnard (1819-1902), and Alexander Gardner (1821-1882), who had previously authored many pictures in Brady's studio.

Gardner, however, eventually grew discontented at seeing his name ignored in favor of Brady's and, in association with other assistants, produced a two-volume album entitled "Photographic Sketch Book of the War." The pictures of the Civil War were enthusiastically received by the public. When compared with the documentation of the war that Winslow Homer had been producing with his drawings in Harper's Weekly, it is impossible to disagree with Brady's statement that his pictures "portrayed the serious side of the war, exactly as it appeared."

After the war, these reporters were employed in the U.S. to document the construction of the railways; others explored little known American frontiers, bringing back photographic documentation which eventually aided in the organization of the American national parks system. Timothy O'Sullivan photographed the Colorado River canyons and William Henry Jackson (1843-1942), the Yellowstone region. Enlargements were impossible at the time so to obtain prints of effective dimensions, the two dragged large cameras up to the mountain tops with heavy equipment. Other difficulties stemming from the limited convenience in photographic technology taught them to be selective in their subjects, and restricted them to photographing only majestic scenes. In this way, they communicated in their pictures the sense of the untouched and wild beauty of these natural locations.

In Europe as well, the wet collodion process gave rise to the popularization of photography, not only among amateurs but also among the general public, who were eager to collect pictures of various types of subjects, now that photographic prints promised greater longevity than the previous talbotypes. Between 1856 and 1860 Francis Frith (1822-1899) traveled in Egypt, Palestine and Syria, photographing the Nile in unexplored areas and returning with pictures more beautiful than those taken earlier by Du Camp. Meanwhile, William England took thousands of stereoscopic pictures, a type of photography very successful up to 1900.

The Alps naturally attracted many photographers. In 1849, John Ruskin had already photographed Mount Matterhorn. Photographs were also taken by Claude Ferrier (1819-1889) and Adolphe Braun (1811-1877), whose great sensitivity to nature was also expressed in pictures of flowers photographed in actual size, the brothers Louis and August Bisson (1814-? and 1826-? respectively) however, became especially famous for their views of the mountains. In 1860, they followed Napoleon III in an expedition to the Savoy Alps; the following year they were the first to take pictures from the top of Mount Blanc, thus overcoming the technical difficulties involved in utilizing the collodion process at low temperatures. In 1864, Samuel Bourne, an English photographer whose pictures made known to the Europeans the beauties of India, carried out a photographic expedition to the Himalayas.

This kind of photography, between art and photojournalism, gave rise to a new genre. The romantic and fantastic aura surrounding these wonders of nature was swept away by the realism of photographic analysis. The availability of contact prints as large as 60 centimeters resulted in more careful attention to print details and increased public sensitivity to the aesthetic qualities such as contrast, consistency (as dictated by the chemical purity of the emulsion) and the sense of being transported in place and time.

In the 1880s Vittorio Sella (1859-1943) demonstrated a rare combination of both photographic and alpine skills, despite the fact that he did not have to deal with the difficult wet collodion process. He explored the Alps, the Caucasus, Alaska (1897), equatorial Africa (1906) and the Himalayas (1909); often as official photographer in the expeditions of the Duke of Abruzzi. Despite his great mastery of technique, (he published the first general handbook on photography in Italy) he had no problem communicating the grandiosity of untouched landscapes and stressing the contrasts of colors and light in the snow-covered mountains.

With the discovery of wet and dry collodion processes photography almost completely replaced the traditional techniques for documenting works of art, architecture, and monuments. These pictures, especially those of architectural subjects, were not always simple to photograph, but often communicated a poetic sense of discovery of detail which was normally hidden from the human eye. After 1851, Robert Macpherson (1811-1872) photographed the Roman antiquities, emphasizing their grandiosity. Another Englishman, James Anderson (1813-1877) who came to Rome in 1853, photographed a wide range of art works; for the most part, those requested by tourists. After the war his negatives, together with Brogi's and those of the Alinari brothers were purchased by Count Cini and placed in an archive in Florence. Many Italians photographed Rome, sometimes with rare sensitivity: Tommaso Cuccioni, Ludovico Tuminello and the extraordinary Altobelli, who animated his pictures of Roman antiquities with skillfully posed groups of characters. Giorgio Sommer photographed Rome, Naples and the Amalfi coast, while Carlo Ponti, together with Naya and Perini, photographed the touristic Mecca of the 1800s - Venice. Ponti's pictures convey a strong sense of volume, influenced by his use of light; famous monuments are often depicted as part of the social environment of the city. Many of the early photographers developed a taste for real life scenes and for the rich detail of human interaction and social customs. The best known name in this kind of photography is that of the Alinari brothers, Leo-

poldo (1832-1865) and Giuseppe (1836-1891). They began to photograph in approximately 1854, and produced wonderfully printed large-size pictures of the architecture in Florence and Tuscany.

Photographs and stereographs of monuments, cities, and famous landscapes were produced and sold by the millions from 1850 onward. To produce a stereophotograph, the scene to be portrayed was photographed twice, each time from slightly different perspectives which corresponded to the distance between the photographer's eyes. The stereoscopic effect was obtained by looking at the pictures through a special viewer. The two pictures juxtaposed in the retina, giving the impression of depth and adding a further touch of realism.

The daguerreotype and photographic portraiture. Despite its inconveniences, the daguerreotype enjoyed more popularity than photography on paper. In fact, few other inventions caught the public's imagination so rapidly and unanimously. In 1840, Samuel Morse (1791-1872) and John W. Draper (1811-1882) began to experiment with portrait photography, utilizing daguerreotype in their work and also giving lessons to others interested in the art. But before imposing itself on the portrait genre, the daguerreotype method was used to photograph monuments and landscapes, particularly for photography books. Between 1840 and 1844 in Paris, Lerebours published a series of volumes called "Excursions Daguerriens" from daguerreotypes taken in Europe, Africa and America. These first photographers included names such as Goupil-Fesquet, who travelled in the Middle East, and the Englishman H. L. Pattison, who took the first picture of Niagara Falls. In Italy the first photo-illustrated book to include daguerreotype was by Giacomo Pirola, whose work was published in 1844 in Milan. It contained aquatinted daguerreotypes of anonymous authorship and was entitled "Milano e il suo territorio." The French diplomat, Baron Jean Louis Gros (1793-1870) photographed Colombia in 1842, and Joseph Girault de Prangey (1804-1892) made approximately one thousand daguerreotypes in the Middle East between 1842 and 1844.

Towards the end of 1840, three technical improvements made possible the application of daguerreotype to portraiture. A lens, designed by Joseph Petzval, increased the definition of the picture, and Joseph Goddard invented a procedure to increase the light sensitivity of the glass paned film. With these improvements, exposure times could be reduced, and poses limited to thirty seconds, thus making portraits more feasible. From then on, preserving one's appearance became accessible to everyone for a modest price and studios opened everywhere. In England, names to remember include Richard Beard, John Mayall and Antoine Claudet (1797-1867), who used to take portraits with painted backgrounds; in Germany, portrait painter J. C. Schall precociously opened a photographic studio. In France the daguerreotype craze became the target of Honoré Daumier's caricatures; and in the U.S. Matthew Brady opened three studios to satisfy insatiable customers and prepared portable studios for travelling in the countryside. In Italy, the first to import Daguerre's instrument was Alessandro Duroni (1807-1870), a dealer in glass and optical instruments in Milan.

With the invention of the wet collodion negative, it was possible to accelerate the production of portraits and to make them more accessible to the public. The ambrotype was a wet collodion negative on glass, underexposed and bleached. By reintegrating the tones of the shadows and lights with a black background, it appeared as a positive. Like the daguerreotype - which it resembled when set in gilded frames - it was unique and could not be copied from a negative. The tintype and ferrotype are variations on the metals used in the ambrotype which were particularly successful in the United States. In Europe, however, the *carte-de-visite* was more popular and was patented by Adolphe Eugène Disderi (1819-1890) in 1854. With this method, eight small pictures could be made from a single sheet. Cut and glued on paper similar to calling cards, the *carte-de-visite* was popular until 1870. The poses were conventional and the characters were photographed from a distance, so that the smaller faces of the subjects would not require any touch up.

The great school of French portrait photographers opposed mass portraiture, preferring a psychological approach. Their work was collected in the seven volumes titled "Galerie Contemporaine," which included works by Etienne Carjat (1828-1906), Pierre Petit (1832-?), Adam Salomon (1811-1881) and Nadar (pseudonym of Gaspard Felix Tournachon, 1820-1910). The choice of the pose, the concentrated light, the lack of any background setting and the use of large film plates helped to emphasize the faces of the models who were the protagonists in French artistic, literary and political life. Besides his qualities as portrait photographer, Nadar was also known as a pioneer in many other photographic fields. He took the first aerial picture (1858), financed the construction of a gigantic aerostatic balloon entitled "The Giant" (1863), and used the first battery-operated Bunsen lamp to photograph the catacombs in Paris. In 1878, Nadar hosted in his studio, which by then was a habitual meeting place for the Parisian intelligentsia, the first exhibition of the Impressionists.

Also, Julia Margaret Cameron (1815-1879) took up photography to record "the inner greatness beyond the individual's appearance." She had a personal style which relied on the use of sharp lighting, and intense poses and expressions, but above all, on blurring images to cancel out details. Her portraits of Tennyson, Darwin, and Herschel attest to a great dramatic power.

Another British photographer, Lewis Carroll (pseudonym of Charles L. Dodgson, 1832-1898, and author of "Alice in Wonderland") left some enigmatic and ambiguous portraits of his favorite subjects, which were, in his words, "children, except boys." Among these are some unforgettable portraits of Alice Liddell, the central figure of his famous novel.

Motion photography. The development of motion photography is linked to technical improvements in photographic emulsions. In the first motion pictures, the streets actually appeared deserted, as passers-by did not stop long enough to allow an impression to be made on the film. With the invention of wet collodion, some photographers (including Ferrier and Braun) filmed several pictures in motion, though far enough away to hide certain details. Edward Muybridge (1830-1904) began his photographic investigations on animal locomotion in 1872, following a controversy about the movements

of horses' legs while trotting. Five years later, with the perfecting of the new dry gelatine plates, he repeated the experiment using a battery of cameras, the shutters of which were released mechanically. The sequence of these pictures showed, for the first time, movements too rapid to be perceived by the human eye. They made an enormous impression in America as well as in Europe. Etienne Jules Marey (1830-1904), who until then had studied animal locomotion through chronometry abandoned this approach in favor of chronophotography. He used a single camera that shot twenty consecutive exposures on one plate, in order to simulate the impression of an observer following the animal's movements. Muybridge, however, used a battery of cameras (up to 36) to complete his monumental work, "Animal Locomotion." Published in 1887 by the University of Pennsylvania, it consisted of 781 plates on human and animal locomotion. The painter, Thomas Eakins, (1844-1916) based his art on scientific principles and adopted Marey's method to record the motion and anatomy of animals and naked athletes. These investigations paved the way toward the development of cinema and uncovered a source of aesthetic inspiration in photography, as well as providing a tool for scientific research.

Photographic aesthetics. – Cameron and Carroll, together with other photographers in the Victorian Age, shot "genre scenes." Cameron took inspiration from the pre-Raffaelites in pictures such as "The Peace Kiss," "Beatrice Cenci," and "The Angel by the Grave;" others took inspiration from the Bible, from popular legends or literary sources. The yearly exhibitions of the Photographic Society of London stimulated photographers to strive for "the elevation of photography to the level of the fine arts." Academic painters with their allegorical, literary and anecdotal subjects became models for these photographers, who in a similar way touched up images by manipulating mechanical means and combining various negatives. Such was the case, in particular, with Oscar G. Rejlander (1813-1875), who reached a certain peak with the allegorical composition, "The Two Ways of Life" (1857). Henry Peach Robinson (1830-1901) conceptualized his work by starting from a preliminary drawing and separately realizing the different parts of the composition and finally gathering them together in a unique picture. This style, called "photographic pictorialism," was exemplified by Robinson in works like "Fading Away" (1858), and "Dawn and Sunset," and described in a very successful book entitled "Pictorial Effects in Photography" (1869) that adapted Brunet's treatise on painting to the photographer's needs.

Running counter to Robinson's pictorial taste, which dominated the photographic scene in England for many years, H. P. Emerson (1856-1936) proclaimed the necessity of a return to nature as a source of inspiration. In his book "Naturalistic Photography" (1889), he invited photographers to abandon artificial manipulation of images and to practice greater control over their instruments, particularly in focusing and developing. With regard to subjects and themes there were no fixed rules; rather, there was great flexibility as demonstrated by the landscape scenes of Emerson, Frank M. Sutcliff (1853-1941) and George Davison.

The influence of Impressionism induced some photographers to produce a less contrasted kind of printing, with dark tones and grainy textures. This new type of photographic impressionism became a general-ized style in Europe until 1914. In England, with Davison, France with Robert Demachy and Puyo, Belgium with Leonard Misonne, Spain with Ortiz Echague, Germany with Hugo Erfurth and Dürkoop, and in Italy with Guido Rey, Rho Guerriero and Emilio Sommariva.

Alfred Stieglitz and "pure photography." – Alfred Stieglitz (1864-1946) strongly supported the dignity and artistic autonomy of photography by switching from a pictorial aesthetic to a purely photographic one. As a photographer and promoter of photographic language he at first adhered to the visual canons fixed by traditional painting. In his editorial work in "Camera Notes," the press review of the American amateur photographers' group called the Camera Club, and in the group he later founded called Photo-Session, Stieglitz presented many pictorial works, including portraits by Edward Steichen (1879-1974), with their strong and dramatic contrasts in rubber print; the delicate platinum prints of architecture by Frederick Evans (1853-1943); the luminous and whitened prints of Clarence White (1871-1925); and the romantic prints by Gertrude Käsebier (1852-1934). The review "Camera Work" and the public photo gallery called Gallery 291 (291 signifying the address on Fifth Avenue where it was located) were the two means used by the Photographic Session group to disseminate ideas and photographic results. At the beginning the gallery exhibited only the group's photographic works, but eventually it became an important cultural center for European avant-garde art, which it presented for the first time in the United States. Among the artists exhibited were Matisse, Picasso, Brancusi, Picabia, and the American painters John Marin, Arthur Dove, Marsden Hartley and Georgia O'Keeffe.

Between 1902 and 1917 "Camera Work" published fifty issues combining theoretical essay accompanied by photographic works printed in photoincision. Over time the review oriented itself more and more toward photographic aesthetics that incorporated functional aspects of technique with regard to its potential as well as its limits. In the last two issues of the magazine, Stieglitz published pictures by Paul Strand (1890-1976, one of the first to discover the beauty in the mechanical precision of photography. The pictures were street scenes of passers-by, containing realistic and semi-abstract details, which were described by Stieglitz as "brutally direct, pure and without tricks." As a photographer, Stieglitz was a tireless experimenter. His desire to test the versatility of the medium induced him to photograph with portable cameras and in particularly difficult conditions. He photographed at night, made portraits by flash light and shot street scenes during winter snow storms. In his final years, the photographic ascetism that led him to prefer platinum plates, or Azo and Asturo (which were less effective than bromide papers and gum prints) also extended to his subjects. He took hundreds of pictures of clouds, as he stated, ". . . to show that my pictures do not depend on their subjects. Clouds are there for everybody." He called these images "Equivalents." Their form, independent from any illustrative meaning, becomes an equivalent for his thoughts, hopes and aspirations, or for what he called his "philosophy of life."

On the West Coast, in California, Edward Weston (1886-1958) tried to combine abstraction and pho-

tographic realism. In his landscapes, as well as in his still lifes and nudes every detail is perfectly focused so that the eye can gather each accessory. This capacity to obtain, through the camera, the exact definition of specifics denied to the eye, combined with an extraordinary geniality in the shooting of the subject, gave the picture not only a feeling of realism but also a sense of the photographer's style. In 1932, under the influence of Weston, some young photographers founded the "Group of 64" - whose name refers to the technical term for the aperture of the lens used to increase the definition of the picture. The group included Imogen Cunningham and Ansel Adams, both gifted with an intense sensitivity for nature. Adams developed Weston's aesthetic theory of the necessity to visualize the picture before the lens in a system called the Zone System. In Europe, the theme of love of nature was developed by Albert Renger-Patzsch (1897-1966), as revealed in his book *Die Welt ist Schön* (The World is Beautiful).

Documentary photography. – The spreading of "pure photography" led many to reevaluate portfolios of numerous photographers - some of whom were often amateurs. The American photographer Bernice Abbott reevaluated Eugene Atget's archive (1856-1927), which consisted of thousands of plates of Paris. This archive is the visual memory of the city that has disappeared: its streets, gardens, shops, modes of transportation and windows; valued in the same way as the photo album was, in the family of the 1900s. In Italy, Count Giuseppe Primoli (1851-1927) dedicated himself to photographing the social life in Rome and Paris, including the races, living room reunions, and high society; also the street shows; beggars, lower class women, and the worker's milieu. Jacques Henri Lartigue, "enfant gâté" of the French borgeoise, began at an early age to collect photo albums of the "belle époque" life: the first automobile "raids," the strolls at the "Bois," and the first dangerous experiments in aviation.

The documentary approach was not employed to record events only, but also to persuade and convince. The first sociological study to include pictures was "London Labour and London Poor" (1851-1864), followed by "Street Life in London" (1877) which contained 36 pictures of poor landowners by John Thompson (1837-1921). The American Lewis Hine (1874-1940) used photography since 1905 to investigate burning issues of social importance: the exploitation of juvenile workers, and the conditions of immigrants. Hine, who was a sociologist, always linked the image with the political and economic structures generating the given exploitation. He called his works "photointerpretations." Before him, Jacob Rijs (1849-1914) had arrived as an immigrant in the United States and became a reporter for the police. He also used photography to document the unhealthy conditions of immigrants, and subsequently to ask for repairs of old homes and the construction of new homes - that are still standing today. Books, such as Rijs' "How the Other Half Live" (1880) and Hine's photographic stories employed photographic images to serve as evidence and as a powerful instrument for persuasion and social change, which ultimately contributed to the passage of housing reform laws and laws against the exploitation of children.

Realism and the documentary approach were revived again in the years preceding the Great Depression. After a previous stay in Paris, Walker Evans (1903-1975), returned to America in the 1930s and began photographing American rural life with a sense of abstraction which appeared to be of European origin. In 1935 the federal government employed some photographers to document conditions in agriculturally depressed areas. The Farm Security Administration boasted among its members Arthur Rothstein, Walker Evans, Dorothea Lange (who worked earlier for the state of California in conjunction with economist Paul Taylor, documenting the economic consequences of the Depression); the painters Ben Shan, Russell Lee, Hohn Vachon and others. Through the camera the needs of the American lower classes were exposed in a convincing and graphic manner. Meanwhile, in Europe, the interpreter for the New Objectivity school of photography was August Sander (1876-1964).

Avant-garde photography. – The linguistic revolution carried on by the avant-garde manifested itself in photography through the adoption of new techniques. While they did not pursue goals to increase creativity through experiments in optics and photographic chemistry, they often stirred controversies with regard to the history of photography. They were "anti-photographers." Alvin Langdon Coburn (1882-1966), for example, interpreted Vorticism - an English movement combining cubism and futurism - with his work entitled "Vortographs," which consisted of portraits and objects photographed through prisms. Anton Giulio Bragaglia (1889-1963) realized the futuristic photodynamic by recording the trajectory of motion (1911-1913). Russian constructivism often employed the montage techniques of El Lissitzky (1890-1941) and Rodchenko, as a vehicle for the cultural development of the masses. The dadas with Christian Schad produced pictures without the use of a camera (schadographies). Man Ray (1890-1976) called his photographs "rayographs." From the 1920s on he practiced photography not only to produce surrealist art but also portraits and fashion photography, and with great originality. Laszlo Moholy Nagy (1895-1946) of the Bauhaus school, theorized on the means of recording images in his book "Malerei Photographie Film" (1925). Within creative photography he distinguished between the *photogram*: abstract pictures created without a camera by exposing light directly on to photosensitive paper; the *montage* and *collage*: pictures obtained by combining various negatives printed together, or by glueing together photographic materials of a differing nature; and real *pictures*, where creativity is the result of the image structure, of the choice of new perspectives, etc. Photographic collage was produced with controversial political aims by Raoul Haussmann (1886-1971), Hanna Höch, and John Heartfield (1891-1969); André Kertesz and Herbert Bayer practiced forms of photographic surrealism as well.

Photojournalism. – Since its origin, photography had been used to visually supplement the printed page. Earlier on, however, since photos could not technologically be printed with the text, they were first transformed into drawings. Only after 1880, with the invention of the halftone cliché (printing plate) could the actual pictures be reproduced in newspapers and books. The photojournalists, through their relation with newspapers, soon specialized in searching out spectacular scoops which would increase newspaper circulation.

Wars, homicides and executions proved to be the most photogenic of such events.

Erich Salomon (1886-1944) was the first to penetrate the world of high politics by using small, portable cameras. His work thus familiarized the public with the people who had previously determined historical events behind the scenes. Photo interviews and photographic essays became the alternatives to the sensational snapshot and contributed to the popularization of photographic works. Nadar, a forerunner in this field, obtained his results through cooperation with the talented editor Stefano Lorant, and with another photographer, Felix Man. In the "Illustrierte Zeitung" they presented pictures organized in narrative sequences which affected the whole structure of the printed page.

In November 1936, the first issue of the magazine *LIFE* was published with a cover photographed by Margaret Bourke-White; *Look* was first published in January 1937. Both were based on largely pictorial stories. The style of these magazines resulted from collaboration among editors, graphic artists and photographers. Camera work was planned after choosing the best way to present an issue or theme, but with an understanding of the unforseen possibilities for improvisation offered in the instantaneous photographing of events. Beside Bourke-White, among the founders of *LIFE* who were particularly sensitive to social problems was Alfred Eisenstaedt, who specialized in political portraiture. An article entitled "Spanish Village" (1951) by Eugene Smith and another concerning the Spanish Civil War by Robert Capa (1913-1954) are among the most appreciated depictions ever published in the magazine. Within 18 years Capa had photographed five wars and was among the many reporters who ultimately lost their lives for their profession. The attitude of these photojournalists can definitely be described as antiheroic and antispectacular. They do not praise the actions of war, but merely show its human aspects.

In works about cities, villages and human events the photographer takes up different points of view revealing a human and social panorama. Before World War II Brassaï gave a portrait of an underground Paris bistro and the night streets of the city. Margaret Bourke-White documented conditions in the southern states of America, in particular the situation of blacks. Photo magazines similar to those in America, for example, *Stern* in Germany, *Paris Match* in France, and *Epoca* in Italy also developed in Europe, but only after the war. Photoreportage was recognized as capturing cultural expressions in an age of memorable images, combining the documentary and expressive qualities of the photographer in works such as "Images à la sauvette" by Henry Cartier-Bresson; the reports on starvation and hunger in India and Japan by Werner Bischof (1916-1954); the Korean War by David D. Duncan; and pictures of the Budapest uprising by Mario De Biasi. The first example of an encounter between a photographer and an event was the reportage on the San Francisco fire (1910) by Arnold Genthe (1869-1942). Despite the fact that the public often tends to identify the photographer with the exceptionality of the event, it is the photographer's style and interpretation that determine the historical memory we may have of it.

Later developments. – In the 1960s photography developed by virtue of the mass media. When the press was later brought into crisis by the growing popularity of television, however, photography started looking for new means of diffusion and for a redefiniton of its own nature. But in the immediate post-war period, photographers already had been trying to maintain their own identity in relation to newspapers by founding independent agencies like "Magnum," which was created in 1947 by Robert Capa, David Seymour (1911-1956), and Cartier-Bresson. Moreover, with time the book has become a more likely vehicle for photographic essays. For with books the photographer becomes more aware of his work by virtue of the longer preparation period required for its publication. Regardless of the amount of preparation time available, however, photography universally involves a spontaneous contact between the photographer and his subject. Cartier-Bresson exactly described the nature of this contact as taking place in a "decisive moment" dictated by the optical subconscious and mediated by the cultural and expressive controls of the photographer himself. In the moment of release there is no room for rational analysis; instead it is the overall character of the individual, reacting through the instrument to the external environment.

Starting with Robert Frank, the new American school maintains a global and uninhibited relation with the environment. Frank, of Swiss origin, sees America as a foreigner and his book "Les Americains" (1958) looks beyond surface impressions with irony and sarcasm. Diane Arbus (1923-1971) gathered in a series of realistic portraits the hideous face of America with its rituals and customs. A group of young photographers, including Ray Metzger, Joel Mayerhovitz, Lee Friedlander and Garry Winogrand, have opened the lens to the new and degraded urbane environment of the suburbs and supermarkets, accepting of their desperate banality. These photographers and the generations of photographers who will follow them will not be able to rely anymore on media such as newspapers for diffusion of their work. The book, the exhibition and other alternative channels - including those yet to be invented - have and will impose a total revision in the contents and structure of the documentary picture.

Three British photographers - Larry Burrows (1926-1971), Philip J. Griffiths (born 1936) and Donald McCullin (born 1935) - end the age of war reportage by revealing the extremes of violence which are innate in the genre. Meanwhile photojournalists have looked for new subjects, and have continually altered the structure of the photographic essay, the ideal vehicle for which remains the book. Some of these new subjects include visual portraits of foreign countries; for example Russia (Cartier Bresson, William Klein), Japan (Klein, Werner Bischof), China (Bresson, Marc Riboud), Mexico (Fulvio Roiter). Some projects depict a country from a particular point of view or by isolating peculiar subjects, for example the work of Italians Mario Giacomelli and Paolo Monti. The photographer's interests become more focused by combining a love for the instrument with more careful social and artistic preparation. Such was the case with Josef Koudelka who recorded the destiny of the gipsies; with Ugo Mulas (1928-1973), who penetrated the customs of the contemporary art world; with Lisetta Carmi in her book about "transvestites;" with Mario Cresci with "Matera," a photographic essay about an early settlement devasted by building speculation.

In the same way these books developed from models such as books like "Un Paese" by Strand-Zavattini or "East 100th Street" by Bruce Davidson, other fields of photography have also developed the present styles by adapting traditional models to contemporary needs. In the landscape photography of Wynn Bullock and Minor White the themes developed by the Californian school continue to evolve with an ecologic and almost pantheistic sense of nature. In portrait photography Josuf Karsh and Arnold Newman conjure old styles of iconography which include psychological as well as abstract formal imagery. In fashion photography Baron de Meyer and Cecil Beaton have found their heirs in Irving Penn and Richard Avedon who, after having been the stars of "Vogue" and "Harper's Bazaar" for more than ten years, are now exploring a new vein in pictorial and spectacular forms of presenting their work.

In the field of creative photography, the post-war period was dominated by the "subjective photography" movement led by Otto Steinart. It emphasized the creative contribution of the individual and sanctioned the use of experimental techniques which were capable of producing new visual experiences in photography. Variations on the movement spread all over Europe in a manner similar to that in informal and gestural painting. In Belgium, Pierre Cordier perfected his "chimigrams;" in France Jean Pierre Sudre is the inspiration for the school that combined a love of nature with refined techniques for coloring and printing drawn from Denis Brihat, John Stewart and others. In Italy the group "La Bussola" with Giuseppe Cavalli and Luigi Veronesi also found its niche in this movement, though with more evident accents derived from the avant garde. In England the extraordinarily talented photographer Bill Brandt, author of a particularly incisive reportage on London, has identified himself in the group on the basis of his nudes (c. 1947), the inspiration for which takes from both surrealism and organicism. Before him André Kertesz drew on the surrealist themes of the 1930s in a historical series of "distortions" of nudes. In the United States creative photography developed through the successors to the "pure photography" of Stieglitz and Strand, through the abstract pictures of walls and posters of Aarond Siskind, to the new generation represented by Duane Michals, who manipulates images with poetic concept and intent.

At present the themes and techniques in creative photography and painting have been coming closer together, leading both to redefine their functions and disciplines, most likely towards a more interdisciplinary approach.

BIBLIOGRAPHY - L. Moholy, A hundred years of photography, London, 1939; B. Newhall, The history of photography, New York, 1949; H. and A. Gernsheim, Storia della fotografia, s.1. 1966; A. Scharf, Art and Photography, London, 1968; W. Settimelli, Storia avventurosa della fotografia, Roma, 1969; Life Library of Photography, ed. Time-Life Books, U.S.A., 1971; V. Kahmen, Fotografia come arte, Milano, 1974; I. Zannier, Breve storia della fotografia, Milano, 1974; A. Gilardi, Storia sociale della fotografia, Milano, 1977; D. Palazzoli, Fotografia, cinema, videotape, Milano, 1977.

DANIELA PALAZZOLI

CINEMA

Cinema, a graphic expression of images in motion recorded on a film, is a dynamic "continuum," visual or audio-visual, limited by the borders of the camera lens and united by montage. It reflects the reality of nature and living forms as well as the composed reality invented by man and reduced before the camera.

By reflecting reality, cinema can be naturalistic or realistic. This depends on whether it imitates, synthetizes or exaggerates reality. It thereby creates completely new realities, or at least realities different from that which we currently experience.

Cinematic works can be of "imitation" or of "invention." An additional type, really a subcategory of invention, is based on "animation" procedures (drawings, puppets, animated objects). "Imitation" cinema can be dated to 1891 and the invention of kinetoscope or "cinema for a single spectator" (the show taking place inside a box and viewed through lenses) by T. A. Edison and to Louis Lumière who, on December 28, 1895, gave the first cinematographic show before an audience in which the images were projected on a screen via mechanical traction of perforated film.

A pioneer of "invention" cinema was Georges Méliès (1861-1938), a magician, caricaturist, painter and stage set designer. "Animation" cinema actually pre-dated "kinetoscope" and "cinematography" with the work of Emile Reynau (1844-1918) with hand painted films including the "Pantomimes lumineuses" in 1892. Animation confirmed itself in 1908 with the work "Fantasmagorie" by Emile Cohl (Emile Courtet, 1857-1938).

Films of "spectacle" are not documentaries, but creations of imagination. Documentaries have the unique purpose of informing and documenting, or of fixing reality in a poetic form. Such films are shot in the desired location with local people. The director intervenes upon the documentary material by selecting and compiling it in creative forms. The documentary is thus a movie that records and creatively reflects the existing world, thereby making it a subjective view, but without changing it. Robert Flaherty said: "the object of the documentary is to represent life in the form it is lived."

"Didactic" movies are aimed at a specialized audience. Their goal is to teach by utilizing the means of cinema. The goal of the producer of a "spectacular" film, by contrast, is most especially to attain commercial success. By further comparison, "creative" movies (e.g. abstract movies) are concerned mainly with aesthetic and linguistic issues, while "research" movies utilize the cinematographic instrument as a means of investigation (for instance movies about art or art-criticism).

Trends and theories. – In less than a century, cinema has developed a rather dense history. Born as a means of recording reality, it developed a language of its own, thereby realizing artistic values in concrete forms of fantasy. Cinema progressed steadily in almost every continent, but differed in its development according to the country and the cultural environment, as well as by the individual artists attracted by the new art form.

Within the Italian cinema of the World War I era, it is possible to distinguish three trends: "historical" (actually pseudo-historic films, having been inspired by historical events and characters), "realistic" and "dan-

nunziano-floreale." French cinema produced avant-garde films in the 1920s, and realistic and populist films in the 1930s. German cinema during the Weimar republic produced expressionist movies, the "Kammer-spielfilm" and monies connected with the "Neue Sachlichkeit" (new objectivity). Swedish cinema is known for its important discovery of the role of the landscape as actor. Revolutionary Russian cinema had strong ideological motivations which led to the emergence of socialist realism. In American cinema, during the silent-film era, three phenomena are identifiable: the comic school of Mack Sennet, the original "western" and the rise of stardom. In the post-World War II period, Italian Realism emerged, while elsewhere other trends developed: e.g. the French "nouvelle vague," the American "underground" and political cinema.

Through the development of cinematographic productions, new doctrines were being formulated as reflected in published essays on the aesthetic and social value of cinema and on the nature of cinematographic language. Ricciotto Canudo considers cinema as a "seventh art," a *total art*, which derives on one hand from the music that generated poetry and dance, and on the other, from the architecture that produced sculpture and painting ("The moving circle of arts creates the seventh art").

Soviet theoreticians consider montage as unique to cinema, as the foundation for the "poetic scissors" in the theory of Béla Balázs. Rudolf Arnheim regards the "differentiating factors" of cinema (silence, black and white, limitation of the visual field, etc.) as creative variables of movie art. Dziga Vertov and Eisenstein believe in the movie without subject or actor; while Pudovkin prefers collaborative movies in which the actor participates more creatively while the screenplay establishes the montage.

In Italy, Luigi Chiarini and Umberto Barbaro founded a school of criticism which gave rise to the movie magazine "Bianco e Nero." In it they published some of the most significant text in cinematography, taking positions consistent with those of Béla Balázs and the soviets. Meanwhile C. L. Ragghianti originated the theory "Cinema arte figurativa," which combined cinematography with other visual arts. But the development of sound in the cinema stimulated even newer developments, such as the "Asyncronism manifesto" by Eisenstein, Pudovkin and Aleksandrov, in which the authors theorized on the non-coincidence of sound and image, resulting in an estrangement of the image in the mind of the viewer.

Color and environment. – Color movies, presaged by the hand painted films by E. Reynaud and G. Melies, and later in the "toning process," has its baptism in the age of sound with the film "Becky Sharp" by Rouben Mamoulian (1935). Except for a few isolated attempts, cinematographic productions before and after "Becky Sharp" aimed primarily to achieve a naturalistic reproduction of color. To the present, the movies with perfect manipulation of available chromatic means have been rare. Among these rare attempts are "Deserto Rosso" (Red Desert) by Michelangelo Antonioni, "Macbeth" by Lawrence Olivier and "Cries and Whispers" by Ingmar Bergman. In "Deserto Rosso" Antonioni uses color as a functional aspect in the scenes. He paints houses and plants, burns the grass and takes advantage of the fog to create an atmosphere of red to emphasize a

moment of madness. In "Le Socrate" painter-cineaste Robert Lapoujade changes the landscape by painting the ground. In the film "White Negro" the Romanian Ion Popescu-Gopo, also a fine animation artist, plants small trees in landscape images that were inspired by medieval fantasy painting.

German expressionism in cinema - before the arrival of color - employed the collaboration of graphic designers and architects like Hermann Warm (for "The Cabinet of Doctor Caligari" by Robert Wiene, 1919), and Ludwig Meidner (for Karl Grüne's "Die Strasse"-The Road, 1922). The set designer had a fundamental role in expressionist movies. Fritz Lang, Paul Leni, K. H. Martin, Friederich Murnan, Josef von Stenberg and Lotte Reininger were, in fact, painters and architects before becoming directors. Among the other scene designers who contributed expressionist distortions to their films were: Robert Neppach ("From Dawn to Midnight," 1922), Cesar Klein ("Genuine," 1922), Walter Rohrig, Walter Reimann, Albin Grau ("Nosferatu," "Schatten"), Hans Pölzig ("Golem," 1920), Rochus Gliese, Robert Hertl, and Ernst Stern.

Many movie directors took inspiration for their settings from the masterpieces of paintings. In "Heroic Kermesse" Jacques Feyder created figurations in the style of Franz Hals; for "Via delle cinque lune," set in 1800 Rome, Luigi Chiarini drew from the etchings of Pinelli and Thomas. P. P. Pasolini studied the masterpieces of religious painting for the film "Vangelo secondo Matteo" (The Gospel According to Matthew), and Antonioni's movies display a lively sensitivity for modern painting. In "A Bigger Splash" the painter David Hockney not only inspired the images in the film but also acted a role portraying himself, thereby creating a satire of the British artistic environment of the 1960s. Accurate and thorough film biographies of "Andreij Roubliov" (by Andreij Tarkosvkij) and of "Pirosmani" (by Georgy Shengelaya) have similarly been produced in the U.S.S.R.

The avant-garde. – Avant-garde cinema was born during a period when historical vanguards flourished. At the time of the first Futurist Manifesto, the brothers Arnaldo and Bruno Ginanni-Corradini (nicknamed by Balla as Arnaldo Ginna and Bruno Corra) were distant from the pseudo-historical pantomime and the tragedies typical of the period, and were already thinking of abstract animation cinema as a means of obtaining a "real chromatic symphony."

A significant book on the early avant-garde experience was "Musica Cromatica" (1912) by Bruno Corra. Movies mentioned in the book, but now lost, include: "Accordo cromatico," "Studio di effetti per quattro colori," "L'arcobaleno" and "La Danza." Also produced were "Canto di Primavera," based on Mendelssohn's work, another based on a Chopin waltz, and a film based on a poem by Stéphane Mallarmé entitled "Les Fleurs." Anton Giulio Bragaglia was experimenting in "futuristic photodynamics," which was based on Etienne-Jules Marey's pictures of motion. He also utilized prisms, and concave and convex lenses in the filming of his 1916, movies entitled "Thais," "Perfido incanto" and "Il mio cadavere" (Enrico Prampolini also collaborated in set designing for these works). In 1916, Ginna filmed "Vita Futurista" with the help of Marinetti, Balla, Settimelli, Corra, Chiti, Venna and Nannetti. In particular, Balla collaborated in the filming of the

sequence called "Danza dello splendore geometrico." His contribution was based on prior works called "iridescences," which attempted new effects using the reflection of beams of light in motion.

Encouraged by Apollinaire and Blaise Cendrars, Léopold Survage (Leopold Sturzwage) in 1914 wanted to translate his painting "Rythme colore" into an animated movie. He imagined colors in motion and produced a series of drawings that were to be filmed. The occurrence of World War I, however, did not permit the experiment to be carried out.

In 1916 the "Manifesto della Cinematografia Futurista" was published. In it appeared the following theory on abstract cinema:

a) In Futurist cinema the most diverse elements can constitute the means of expression: from the slice of real life to the blotch of color, from the sentence to the collection of unrelated words, from chromatic music to the music of objects. The movie will then at once be a work of painting, architecture, free words, music in colors, lines and shapes, medleys of objects and chaotic reality. We will provide new inspiration to the painters who have explored the limits of their art" (from the "Introduction"). It is impossible not to see here an anticipation of kinetic and video art.
b) Research into cinematographic music (dissonances, chords, symphonies of gestures, facts, colors, lines, etc.).
c) Linear, chromatic and plastic equivalences of men, women, events, thoughts, music, feelings, weights, odors and noises. We will give, with white lines on a black background, the internal and physical rhythm of a husband discovering his adulterous wife and running after her lover - rhythm of the spirit and the legs.

The theories of Marinetti and his followers did not gain acceptance in Italy. Among futurist painters only Depero (see "Depero Futurista" [1927] for his thoughts on the Magic Theatre), Fillia and Pippo Oriani - who, with Martina and Cordero, produced the movie "Vitesse" in France showed interest in cinema. Instead, Marinetti and his followers were appreciated in other European countries, such as Germany and Switzerland. Viking Eggeling aimed to create the "Kinetic painting" and experimented with "rolls," beginning in 1917 with the "Horizontal Symphony," and finally in films with the "Diagonal Symphony," shown for the first time in Berlin in 1925, only a few days before his death. The "rolls" were large sheets of paper on which appeared a sort of stately calligraphy that Jean Arp considered "of rare beauty": "These figures grow, split, multiply, move and penetrate from one group to another, then disappear and return again in constructions that evoke the design of vegetable forms." He called them "Symphonies" and adapted the invention to cinema in his work with Hans Richter.

At times Hans Richter utilized the UFA studies to create his short works. "Rythmus 21, 23, 25," "Filmstudio" and "Inflation," were based on abstract, mobile graphics. The German Walter Ruttmann produced similar cartoons, like "Opus I, II, III, IV, V" that may have been less inventive than those of Eggeling and Richter, but were certainly no less interesting from a cinemato-graphic point of view. In 1932, Oskar Fischinger filmed "Composition in Blue," in which the abstraction consists of shapes and colors in motion, linked by a musical rhythm recorded before filming. The achievements of Richter, Ruttmann and Fischinger ultimately permitted the realization of such famous sequences in Walt Disney movies as "Fantasia," inspired specifically by Fischinger before his departure from Disney's studios.

Herbert Seggelke expanded on the tradition of German abstract movies with "Abstract Ballet" and "Love Poem." In France, Man Ray, with "Emak Bahia" and "Retour à la Raison," and Marcel Duchamp with "Cinéma Anemic" (using the *rotoliefs*) introduced abstract sequences. In 1924-1925 Henri Chomette (René Clair's brother) filmed "Cinq Minutes de Cinéma Pur" and "Jeux et Reflets de la Lumière et de la Vitesse."

Czechoslovakia also had a movement of cinematographic avant-garde at the end of the 1920s. Scene designers Alexander Hackenschmied (who emigrated to the United States where, under the name Hammid, he and Maya Deren became part of the American avantgarde with their film "Meshes of the Afternoon" [1946] Otakar Vavra and François Pilat were this movement's most famous exponents. Hackenschmied produced the abstract movie "A Pointless Walk" in 1933 and Vavra and Pilat were the authors of "Svetlo Pronika Tmon" (1930-1931). It was an "absolute" movie, that tended not to be representative nor objective, by employing the structures and sculptures that Zdenek Pesanek had created for a power plant in Prague. Symbolic electrical wires seemed to wrap around the globe. The idea of the film can be traced to "The Bridge" by Joris Ivens and to "La Tour" by René Clair, where the architectonic structures served as visual music for an abstract ballet.

In Italy the most important abstract developments came from Luigi Veronesi, who was a painter, a photographer and a follower of L. Moholy Nagy and the Bauhaus. He hand-painted several films, including: "Film n.4" (with the music from "Histoire du Soldat" by Stravinskij), "Film n.5," "Film n.6," "Film n.8," "Film n.9," the first of these concerning jazz music, the last one being a silent film. Most of these films were destroyed in 1943 bombings. Other abstract forms drawing on contacts with the industrial world, and in particular on the relationship between metal and light, appeared in experiments by Bruno Munari at Monte Olimpino, such as "I colori della luce" and "Inox."

Experiments in North America that are worthy of attention include those of the New-Zealander Len Lye who, first in Great Britain and later in Canada (under the influence of John Grierson), produced such films as "Color Box," "Trade Tattoo" and other works that ultimately influenced Norman Mac Laren. Lye produced animation movies using the "scratch" technique, consisting of razor blade marks on celluloid. In Canada, Norman Mac Laren later expanded on this technique by engraving films with a pen, dyeing them and then perfecting them with a paintbrush. His finished works included "Fiddle-de-Dee," "Begone Dull Care," "Around is Around," "Blinkity Blank" and "Hen Hop." He explained his technique as follows: "first, I apply colors on virgin film, often on both sides, to obtain various textures. Then I apply dottings, brush strokes and scrapings. I have also pressed certain textiles on the fresh paint and used an air brush or utilized two chemi-

cally different paints. This creates effects similar to those obtained by a painter who mixes tones of oils and watercolors on the palette."

Among the American innovators in abstract film making, Dwinell Grant is to be remembered for works like "Themis," "Contrathemis," "Abstract Experiments," "Scratch Composition," "Three Themes in Variation," "Composition" and "Color Sequence." These films, composed during the World War II period, were similar to those of Veronesi. Grant also wrote the "Theory of Composition of Animated Films."

In Russia the activity of painters in cinema goes back to the period of the historic avant-garde, when Mikhail Larionov and Nina Goncharova appeared in the movie "Drama in the Futurist Cabaret n.13" with the "Donkey Tail" ensemble, and when the painters Simov and Rabinovitch designed the sets, and Aleksandra Exter the costumes, for "Aelita" by Protozanov. The true presence of futurist cinema - apart from the set designs of Vladimir Majakovskij - existed only in Dziga Vertov's "Kino-Pravda" and "The Man and the Camera" where, at times, the characteristic elements of Futurism, such as simultaneity, dynamism, synthesis and interpenetration are visible. Dziga Vertov took inspiration also from the photographic and constructivist works of El Lissitzky, who - like Kazimir Malevič - had considered working with cinema as a medium, though never actually did. This is evidenced in the "Story of the two Squares," which Lissitzky declared to have created for the screen. In creating subtitles Vertov collaborated with Rodčenko, who worked also in the cinema poster industry for the movies of Dziga, Vertov and Eisenstein.

In the magazine "LEF", as in all European avant-garde magazines, the interest in cinema was always present; from "L'Italia Futurista" to "SIC," from "391" to "La Révolution surréaliste" and from the dada publications in every country to the Hungarian magazine "Ma" (Today) edited by Lajos Kassak. "Ma" gave space to Viking Eggeling and his theories on the "cinematic picture," and to Laszlo Moholy-Nagy, publishing his set design "Dynamics of the City." Some of Moholy-Nagy designs can be seen in the book "Painting, Photography, Film" (which includes "Dynamics of the City") "Light Display, Black and White and Grey" and "Do not Disturb" and in "Vision in Motion," published in America where he founded the New Bauhaus (later known as the Institute of Design) in Chicago. "Vision in Motion" summarizes the research of this "total experimentor," analyzing his works in the following areas: painting, photography, sculpture, architecture, cinema and literature. The movies by Moholy-Nagy are: "Still Life," "Marseille Vieux Port" (1929), "Light Display, Black and White and Grey" (in which only the sixth part of his design was actually utilized, 1930), "Sound ABC" (1932), "Gypsies" (1932), "Architecture Congress" (Athens, 1933), "Lobster" (1935), "New Architecture at the London Zoo" (1936), "Design Workshops" (1942), "Do not Disturb" (1945). "Vision in Motion" also contains documents evidencing Moholy-Nagy's studies for an abstract set design in 1922.

Like Moholy-Nagy, Hans Richter had a great impact in America, particularly influencing the underground cinema movement with "Dreams that Money Can Buy" (1946) - for which he collaborated with Marcel Duchamp, Alexander Calder, Max Ernst and Fer-

nand Léger - and with "8 x 8" (1952) for which certain sequences (variations on a chess game) were shot in collaboration with Max Ernst, Yves Tanguy, Nicolas Calas, Hans Arp, Marcel Duchamp and Jean Cocteau. In these movies Richter developed from abstract and dadaist work into surrealism.

A quick inventory of surrealist films requires mention of "La Coquille et le Clergyman" (The Shell and the Clergyman, 1927) which was directed by Germaine Dulac on an idea by Antonin Artaud (and then criticized by the latter), "Le Sang d'un Poète" by Jean Cocteau (1932) and "Le Mystère du Château des Dés" (The Mystery of the Castle of the Dice) by Man Ray (1929). ("Retour à la raison" and "Emak Bahia," also by Ray, actually stem from his dada period [1923]. Salvador Dalì and Louis Buñuel with "Chien Andalous" (1928) and "L'Age d'Or" (1930) were among the leaders in surrealist cinema. Buñuel brought surrealist elements to all his movies, including those for the larger audience, and Salvador Dalì collaborated with Alfred Hitchcock for a surrealist sequence in the movie "Spellbound" (1945).

American surrealism, to which Hans Richter and Man Ray certainly offered inspiration, is represented by Jan Hugo (engraver and etcher) who realized the operetta "Ai-yé" (Mankind) and "Bells of Atlantic," based on the book "The House of Incest" by Anaïs Nin (1949); and also by Maya Deren, James Broughton and Curtis Harrington. It found supporters and heirs in underground cinema, which was inspired by beat literature and the paranoic visions of Artaud and Dalì. In relation to ordinary cinema it aimed to be a cinema of transgression, of visions, of free images.

Among the exponents of the underground cinema are: Kenneth Anger (Eaux d'Artifice," 1953, filmed to reflect a state of trance), Gregory Markopoulos (whose work harkens back to Greek myths and to Cocteau), Stan Brackage ("The Art of Vision," based on an idea by Ezra Pound; a visual symphony, blending music and images) and John Mekas (director of the magazine "Film Culture" and theoretician of a cinema inspired by Baudelaire, who stated: "the universe is nothing but a warehouse of images"). Underground cinema tended to sway toward social protest, advocated improvisation ("the highest" form of condensation"), and was dominated by a high degree of autobiographic romanticism. The work of Brackage is rhythmic, Mekas and Markopoulos are lyric or romantic, while Andy Warhol was both static and anti-romantic, at least in his voyeurist films "Sleep," "Couch," "Beauty n.2," "Eat" and "Chelsea Girl" (produced from 1963 to 1966). Warhol shot with a fixed camera, rejecting all technical procedures, theories and myths. He aestheticized objects with games, as did Duchamp. He was an exponent of what P. Adams Sitney defines as "structural cinema," to which can be assigned the following characteristics: mobile camera, stroboscopic effects, exact repetition of the same shot or a series of shots, and the filming of images projected onto a screen.

Underground cinema has its share of abstract and animated movies (Harry Smith, "Dance Chromatic" by Ed Emshwiller; "Form Phases I, II, III, IV" by Robert Breer) which manifest experimentation at every turn, but most especially on the margins of abstractism. Breer also directed "Pat's Birthday (1963) for which he took inspiration from Pop art and collabo-

rated with Claes Oldenburg. Stan Vanderbeeck created "Collages," filming from life and employing, mixed graphic techniques. With "Three-Screen-Scenes" he operated in the multi-screen cinema. Carmen D'Avino takes up abstract and dada experiences with "Pianissimo" (1963), "Tarantella" (1966) and "Background" (1973).

At first "underground" cinema could be considered a typically American product. It did not remain as such, as it was also international and nomadic, like Pop music, the "Living Theater," "pop art" and the "happening." Although they all began in America, such manifestations diffused universally. Accordingly, among the Italians, it is necessary to remember Mario Schifano, who made his directing debut in the United States with "Round Film" (1964), and in Italy made "Satellite," "Umano non umano" and "Trapianto Consunzione e Morte by Franco Brocani," Gianfranco Baruchello and Alberto Grifi ("La Verifica Incerta," favorably reviewed by M. Duchamp); Nato Frascá ("Kappa"); Umberto Bignardi (utilizing the cylindrical screen in "Motion Vision"); Alfredo Leonardi; Sylvano Bussotti (with his diary-styled movies), and Luca Patella ("Tre e Basta," "Paesaggio Misto," "Terra Animata," "Piove"). Patella, also a painter, brought his pictorial technique both to the cinematic screen and to the "photographic canvas." "SKMPr" is a collective work by Jannis and Efi Kounellis, Eliseo Mattiacci, Pino Pascali, Fabio Sargentini, and Luca and Rosa Patella in a series of ironically played interactions based on a free examination of perceptible dynamism. Also by Patella are the "Sfere per amare," in which a projector is placed between two plexiglas hemispheres that dilate the image of slides, while a movie is projected onto a third hemisphere suspended above the other spheres.

With the work of Taka Iimura, Japan also gave a noticeable contribution to "underground" cinema. John Mekas described Iimura's "Love" as "a poetic and sensual exploration of the body," his "Iro" as a metamorphic game of colors and "I Saw a Shadow" as a movie of shadow - of people and things. From "Film Strips" Iimura switched to video-tape programs like "Self-identity" and "Field works," in which the "underground" moves toward video-art. From the video-tapes by the Korean Nam Paik June (a pioneer in this area), by Boltanski, Iimura, Kaprow, Baruchello and Alberto Grifi, video-art appears to have strong connections and common interests not only with the underground cinema and cinetic art, but also with scientific and animation cinema, and even with "body-art." In video-art, the use of mass-media is considered an extension of both conceptual and physical forms of art. Video-art is, however, by nature, the negation of "underground," since it goes outdoors. By expanding it eliminates the segregation (also seen as self-segregation) that is typical of the "underground" culture.

Video-art is realized by means of a camera, a recorder and a TV screen. It transforms reality through tricks and uses the screen for the purpose of documenting conceptual or physical expressions. It is realistic but also abstract, and utilizes electronic distortions. New types of reactions between the producers of images and the audience can be realized, along with a new concept of painting - and without the "static" encountered by Agam, creator of moving pictures.

Cartoons. – Abstract, futuristic and cubist images (with a sketch of Charlie Chaplin's Tramp over the sound of words) greet the viewer in "Ballet Mécanique" by Fernand Léger (1924). It was probably Léger's example that pushed other painters towards cinema; among these were Aleksandr Alekseev (or Aleksandre Alexeieff) who invented the "pin screen" with numerous holes that allowed pins to slide in, and the shooting of an "in motion etching." One evocative result of this technique was "A Night on Bald Mountain" (1933), a visual interpretation of a symphonic poem by Mussorgsky. Alexeieff said: "After seeing "Le Ballet Mécanique" by Léger and "L'Idée" by Bartosch, I wanted to create motion illustrations of music, and images different from the linear drawings typical of traditional cartoons. I wanted to animate the chiaroscuros, the soft contours, the indistinguishable shapes, in the spirit of my etchings."

Berthold Bartosch, who collaborated with Lotte Reiniger in "Avventure del Principe Ahmed" and in "Die Jagd nach dem Glück," produced "L'Idée" (1929) with the expressionist painter and graphic artist Frans Masereel. The latter illustrated also Romain Rolland's cinematographic scenario "The Revolt of Machines," which was not made into a film, and a series of etchings inspired by the movie "Grotesk-Film" (1920). The film studies and drawings by Richard Teschner, for "Die Krieg" (The War), "Ameise und Grille," and "Die Orchidee", most of which are now lost, also belong to the Jugendstil and expressionist schools. In Vienna, Teschner, of Bohemian origin, a painter, graphic artist and sculptor of stone and wax, became the "Max Reinhardt of puppets." Born in Karlsbad (today Karlovy Vary) he belongs to the great tradition of Czechoslovakian puppeteers, whose most important exponents are Josef Skupa, teacher to Jiry Trnka, Karel Zeman, Hermina Tyrlova and Bretislav Pojar.

Since the "Pantomimes Lumineuses," animation has accumulated a history full of names and events. Lo Duca, Gianni Rondolino and other specialists have dedicated much of their work to this history, identifying often very important groups, schools and personalities. Names which did not receive individual treatment above include: The American Fleisher Brothers, John Hubley, George Dunning, Richard Williams and Peter Foldes (of Hungarian origin); Jiry Brdecka and Edouard Hoffman from Czechoslovakia; Dusan Vukotic and Vatroslav Mimica from Jugoslavia; the Russian Ivan Ivanov-Vano; Constantin Popesuc (father of Ion Popescu-Gopo) from Romania, Gyorgy Pal, teacher of a substantial group of cartoonists and caricaturists from Hungary, Holland and America; the East German Bruno J. Böttge, follower of Lotte Reiniger; the Bulgarian Todor Dinov; Paul Grimault, Jean Image and Jean Effel of France; Jan Lenica and Walerian Borowczyk from Poland; the Hungarian John Halas; Joy Batchelor of Great Britain; Wan Ku-cian of China, and Noboro Ofujii, Yojii Kuri, Taku Furukawa and Tanadori Yokoo from Japan. The most recent research in the field of animation cinema involves the use of computers. Computer animation attained remarkable results, both technically and artistically, with Lillian Schwartz in the abstract cartoons "Pixillation" and "Ufo's" (1971 and 1972).

Among Italian cartoonists it is necessary to mention: Pagot, Domenighini, Rubino, Zac, Gavioli, Luzzati, Gianini and Bozzetto. "La Lunga Calza Verde"

(The Long Green Stocking) by Roberto and Gino Gavioli, was written by Cesare Zavattini and dedicated to the history of the Italian Risorgimento. It was created for the centennial of the Unification of Italy.

Art films. – Beside fantasy cinema, which drew inspiration from painters and their work, it is necessary to consider the cross between cinema and plastic arts within the documentary genre. The subjects of these films are the artist's works, examined through the proper means of cinematography.

Art documentaries developed particularly in Italy, France, Belgium, Germany, the United State and in certain Eastern European countries. They are mainly short- and medium-length movies, but there are also some full-length features, including "Le Mystère Picasso" by Henry Geores Clouzot (capturing the painter in the middle of his pictorial activity), "Michelangelo" by Carlo Ludovico Ragghianti and "Borromini" by Stefano Roncoroni. In Italy, in the years around World War II, Luciano Emmer began a series of movies that dealt with art, but were conceived as dramatic-narratives. These included "Dramma di Cristo," "Racconto di un Affresco" and "I Fratelli Miracolosi." Soon the need for a more informative and instructive approach was felt, and numerous documentaries of didactic value were produced. Finally the true critique film, or "critofilm" as defined by C. L. Ragghianti, was realized. Such works included "Stile di Piero della Francesca," "Cenacolo by Andrea del Castagno "Comunità Millenarie," "Terre Alte di Toscana," "Lucca," "Pompei" and "L'Arte della Moneta del Basso Impero." Umberto Barbaro and Roberto Longhi collaborated in the creation of "Caravaggio" and "Carpaccio."

Valuable films based on artists' lives and works have also been produced in Belgium. First, Henry Storck and Paul Haesaerts filmed "Rubens;" then André Cauvin with "The Mystical Lamb;" and again Storck with his film "The Open Window," about European landscape painting. Later came various documentaries by Haesaerts: "From Renoir to Picasso," "Visit to Picasso" (showing Picasso painting on glass), "Regina Coeli" (about Beato Angelico), "The Golden Century" (about Flemish painting), "Urbanism," "African Sculpture," "Humanism," and others.

In France, art documentaries have focused on social and cultural issues. Such films include "L'Affaire Manet" by Jean Aurel, "The Spice Road" by William Novik, "L'Architect Maudit" by Pierre Kast, "L'Enchantement de l'Existence" by Jean Grémillon, "Balzac" and "Zola" by Jean Vidal, "Guernica" and "Van Gogh" by Alain Resnais, "Maillol" by Jean Lods, "Matisse" by Campaux and "Toulouse Lautrec" by Robert Hessens. Arcady is a well-known specialist in art film and also the discoverer of many technical innovations.

In Germany, art documentary specialists include; Kurt Oertel ("Michelangelo," re-edited by Robert Flaherty), Hans Curlis, Carl Lamb ("Bustelli,"and "Kubin") and Herbert Seggelke, whose style came closer to avant-garde in his documentaries on Cocteau and Mirò. In Denmark the famed director Carl Theodore Dreyer realized "Thorwaldsen" and the architectural documentary "Danish Churches."

In the United States art documentaries are abundant. They include films showing the painters Tobey, Pollock, and Grandma Moses at work. In the U.S.S.R.

and Eastern Europe feature-length documentaries on museums have been produced such as the Hermitage of Leningrad, the Tretjakov Gallery of Moscow and the National Gallery of Budapest.

Surveys on avant-garde Soviet art have been filmed by directors from Western Europe, including Axlain Moreau ("Architecture Sovietique des Années Vingt") and Lutz Becker ("Art in Revolution"). In Great Britain the primary specialist in art documentaries in which artists themselves appear is John Read, who filmed, among others, Henry Moore and Graham Sutherland.

Festivals, exhibitions, and museums. – The International Exhibition of Cinematographic Art, in Venice, has dedicated special attention to movies about art, either as a side event within the Biennial or, since 1948, under the International Exhibition of Documentaries and Short Films. Since 1973, the International Festival of Art Movies and of Artist Biographies has been organized in Asolo under the auspices of Unesco and the Maeght Foundation. Among the documentaries shown there have been those by the Belgian Luc de Heusch ("Alechinsky d'Après Nature," "Magritte ou la Leçon des Choses" and "Dotrémont-Les Logogrammes"); by the Britains David Pearce ("Portrait of David Hockney") and Stephen Cross ("The Secret World of Odilon Redon"); the Japanese Takeo Yanagawa ("The World of Shiko Munakata"); the Jugoslavian Borislav Benazic ("Unknown Motika") and "The Glass of Anton Motika"); the American Peter Gill ("Christo Wraps the Grand Canyon"); the Italian Mario Carbone ("Emilio Scanavino," "Realismo in Arte a Berlino," "Wilfredo Lam") and Luca Verdone ("Paolo Uccello. Genesi e Sviluppo di un Linguaggio Pittorico," "La Scuola Ferrarese del '400," "Giorgio Celiberti. I Fossili della memoria," "Fantasie e Capricci del Manierismo Romano"); and the French Jean Louis Fournier ("Klimt et l'Art Nouveau"), Charles Chaboud ("Calder: un portrait"), Jean Christophe Averty ("Vasarely"), Jack Clemente ("Balla et le Futurisme"), Yves Kovacs ("Richard Lindner") and Michel Pamart ("Boltanski").

Other short documentary films on art presented during the festival include "Renato Guttuso: Autobiografia" and "Galileo Galilei semper" (about Sergio Vacchi), which were directed by Riccardo Tortora and Marisa Malfatti and filmed with the help of the critics Mario Micacchi and Enrico Crispolti; "Manzù," "Omiccioli a Scilla" and "Arte in Vaticano" by Glauco Pellegrini; "Assassino Speranza delle Donne" (a tribute to Kokoschka) by Giuseppe Gatt; "Immagini Popolari Siciliane," "Macchiaioli," "Rinascita dell'Arazzo," "Uno Svizzero in Italia (A. Jean Louis R. Du Cros)," "Madonne Senesi," "Sano di Pietro," "Viole di Santa Fina," "Stracittà" (Album by Mino Maccari) and "Bodoni-Arte della Stampa" by Mario Verdone; "Udine città di Tiepolo" by Mario Volpi; "Il Futurismo" by Vittorio Armentano; "La terra dei Naïfs Jugoslavi" by Luciano Emmer; "Mani alla Ribalta" by Fulvio Tului (about the puppets of Maria Signorelli); "Roma dei Misteri" by Vittorio Di Giacomo, and documentaries about Mexican painters and German expressionists by Giovanni Angella.

In every country TV stations broadcast many programs dedicated to the major artists and to the understanding and criticism of art. Italian programs

often include biographies, interviews, presentations of masterpieces (by critics like Cesare Brandi) and shows centering on museums, such as the series "Musei d'Italia" produced by the Italian national network (RAI) and which aired approximately sixty episodes between 1954 and 1960.

Cultural programs address issues concerning art conservation and preservation of artistic heritage. In "L'Approdo," a program which specialized in artistic and cultural affairs, the painter Nato Frascà - for example - between 1969-1971, dealt with the following themes: "Futurism," "Debates on Futurism," "Edward Munch," "Piet Mondrian," "Marcel Duchamp" and "Art as Research. The Experimental Pavillion of the Venice Biennial."

Beneficial collaboration is developing between mass-media and museums. On the one hand, films are made which describe museums, some providing elaborate and informative presentations with a certain artistic value; on the other hand, museums use films for archival purposes. Museums that do not own works of great artists can show films of such works to their visitors. And through film it is possible to preserve not only pictures of works of art but also images of artists at work. Film screening in museums, as well as permanent displays and symposia are not to be underestimated for their didactic value. Finally, through cinema, the museums can carry out a documentation and research function, no less important than that performed by an archive. Movies themselves become an archive and a museum. In this way museums can extend their activities beyond their walls and into life itself.

BIBLIOGRAPHY - A.G. Bragaglia, Fotodinamismo futurista, Roma, 1912; M. Bessy and G. Lo Duca, Georges Méliès mage, Paris, 1945; G. Lo Duca, Le dessin animé, Paris, 1948; Aa. Vv., Le belle arti e il film, 1950, Il costume nel film, 1950, La scenografia nel film, Roma, 1956; B. Balázs, Il film - Evoluzione ed essenza di un'arte nuova, Torino, 1952; M. Verdone, Gli intellettuali e il cinema, Roma, 1952; A. Kyrou, Surréalisme au cinéma, Paris, 1953; L.H. Eisner, Lo schermo demoniaco, Roma, 1955; L. Moholy-Nagy, Vision in motion, New York, 1956; C.L. Ragghianti, Cinema arte figurativa, Torino, 1957; U. Barbaro, Il film e il risarcimento marxista dell'arte, Roma, 1960; V. Pudovkin, La settima arte, Roma, 1961; M. Verdone, L. Moholy-Nagy nella Bauhaus, and L. Moholy-Nagy, Dinamica della città, Roma, 1962; N. Abramov, Dziga Vertov, Roma, 1963; M. Ray, Self Portrait, London, 1963; P. Rocchetti and C. Molinari, Le film sur l'art, Vicenza, 1963; S.M. Eisenstein, Forma e teoria del film e lezioni di regia, Torino, 1964; L. Chiarini, Arte e tecnica del film, Bari, 1965; R. Canudo, L'officina delle immagini, Roma, 1966; H. Richter, Dada arte e antiarte, Milano, 1966; M. Verdone, R. Teschner e il "figurenspiegel," Bianco e Nero, 5, 1966; Dix ans de films sur l'art (1952-1962), Catalogo Unesco, Parigi, 1966; M. Verdone, Cinema e letteratura del futurismo, Roma, 1968; A Schwartz, Duchamp, Milano, 1968; M. Verdone, Il ritmo colorato by Léopold Survage, Carte Segrete, 6, 1968; C. Mayer e l'espressionismo a cura by M. Verdone, Roma, 1969; L. Barsacq, Le décor de film, Parisi, 1970; M. Verdone, Sommario di dottrine del film, Parma, 1971; J. Mitry, Storia del cinema sperimentale, Milano, 1971; J.P. Matthews, Surrealism and film, Michigan, 1971; P. Tyler, Underground film, London, 1971; V. Eggeling, Principi di un'arte cinetica, Qui arte contemporanea, 8, 1972; L'occhio tagliato, a cura by G. Rondolino, Torino, 1972; M. Verdone, Le "surrealtà" del cinema, Qui arte contemporanea, 13, 1974; S. Koch, Andy Warhol. Son monde et ses films, Paris, 1974; G. Rondolino, Storia del cinema di animazione, Torino, 1974; A. Aprà and E. Ungari, Il cinema by A. Warhol, Roma, 1974; P. Adams Sitney, Visionary film, New York, 1974; C.L. Ragghianti, Arti della visione. I. Cinema, Torino, 1975; Standish D. Lawder, The Cubist Cinema, New York, 1975; M. Verdone, Poemi e scenari cinematografici d'avanguardia, Roma, 1975; L. Moholy-Nagy, Pittura fotografia film, Torino, 1975; M. Verdone, Dal cinema underground alla video-art, Qui arte contemporanea, 14, 1975, e Le avanguardie storiche del cinema, Torino, 1977.

MARIO VERDONE

ILLUSTRATION (PLATES 161-163)

Contemporary illustration, which developed with the evolution of reproduction and print techniques, has employed all the instruments of technology, gathering the elements which characterize contemporary artistic movements, to become a creative, autonomous movement and a method of direct confrontation with the issues of our age.

Today, its centers of development are still specialized schools, like the Royal College of Art in London; the editorial offices of illustrated magazines, such as that of the *New York Times* or *Avant-Garde*; publishing houses like Nord-Sud in Zurich, Delpire or Harlin-Quist in Paris, Annette-Betz in Munich, Emme in Milan, and Shiko-Sha in Tokyo. Development has also originated from collaborative work by artists in places like the Push Pin Studios, founded by Seymour Chwast and Milton Glaser in New York which, in the late 1950s, produced the most noteworthy American illustrations. Lastly, development has been inspired by the political will of governments that are aware of the cultural value of illustration. In Poland, for example, a member of the Artists Society is introduced in every publishing house through the offering of prizes and the organization of specialized exhibitions by the Ministry of Home Affairs. Likewise, from the early 1970s in Iran, the Institute for the Intellectual Development of Children and Young Adults has created an internationally known publishing trade, already competitive because of the high quality of its illustrations.

The conditions in which illustrators operate today vary considerably. While cultural emargination and discrimination of the artists grow in those countries that, because of a lack of specific traditions, have become territories of conquest by the foreign publishing industry, which saturates their markets and suffocates their local production, as in the Disney "colonization." In countries that have advanced capitalism the illustrators are organized in unions, capable of sustaining the costs for modernization, increasingly refined technical instruments, and the ability to operate in a climate which encourages them to affect society. At the same time, criticism has evolved so that it is more aware of the aspects of illustration that allow it to be incorporated into a broader cultural and historical sphere. Developing concurrently as these changes is the greater interest in illustration of an increasingly sensitive audience, which, although dealing with diverse tastes - from

the educated graphic to the most irrelevant "imagerie" - has understood, in addition to inferior aspects, the importance of the diffusion and circulation of documents and evidence. Such interest is confirmed by the foundation in Europe and America of archives and museums dedicated exclusively to illustration, and by the increasing number of Prizes and international exhibitions. Among prizes awarded after the "Randolph Caldicott Medal" of 1937, were the "Kate Greenway Medal" instituted in 1955 and the "H.C. Andersen Prize for Children's Literature" opened to illustrators in 1966. Exhibitions include those held at the seventeenth annual meeting of "American Illustrators;" the "Biennial for Children's Literature Illustration," held in Bratislava since 1967; the "Exhibition of Illustrators" held at the Children's Book Fair for the last ten years, in Bologna; and the fourth edition of the "European Illustration" in London. To these must be added the numerous critical and monographic studies recently published.

If in the first half of this century the illustration's size did not exceed the pages of the book or review, today recent technology allows for visual communication through audio-visual equipment and computers. These produce images creating new formal issues, the former being linked primarily to concentration and the moment of fruition, the latter to programming.

By limiting our study to editorial illustration, we will discover how it has evolved from being constrained by the logic of production and the limitations of strict rules, to its present absorption by the market. Among the sub-divisions of illustration, the main category is determined by the buying public: either the traditional publishing market, or a market which has been mediated by advertising. The latter designates a certain part of the work each time to various artists, for the purpose of including it in the finished product, be it a poster, a record cover, or a book cover. This process requires the execution of highly specialized illustrations, both technically (through the use of modern instruments, spray-pens, projectors, screens, adhesive films already graded in blended colors, and every kind of photographic and photomechanic processing available) and in content. (We identify here the two basic categories of illustration: scientific and fantastic.) If the latter has found an excellent substitute in photography, especially in the fields of documentary and description, the former, in addition to being the only means of visualing certain messages and phenomena, demands constant updating accompanying scientific evolution. Science and technology have in fact always encouraged contributions from art, thus introducing many illustrators to various disciplines. For example, Walter Linsemmaier, whose research in materials has reached the perfect representation of colors and organic structures in "Insects of the World;" Paul Peck, interpreter of internal medicine with his "Poetry of the Body;" Arthur Lidov, who expresses human physiologic rhythms with audacious cosmogeny, Will Burtin (+ 1972), who illustrated the latest biological discoveries by photographing models of molecular structures that he built; the zoology experts Ilona Richter, Cornelia Hesse-Honegger, and Eva Hulsmann; and the student team from the special class in scientific design created by Karl Schmid at the School of Fine Arts in Zurich. Those who collaborated on the "Livre de la Santé" are also important: Peter

Schneider, Michel Simeon, Peter Wyss, Elisa Patergnani, H. V. Osterwalder, Gustave Falk and Urs Lanis. This twenty volume collective work is one of the best examples of the integration of art and science. Finally, to be remembered for didactic functionality, aesthetic quality, and the tradition of place, are: Allen Beeghel, Jim Egleson, Tom Prentiss, Lorelle A. Raboni, Bunji Tagowa and Dan Todd, all members of the illustration staff of *Scientific American.*

Equally broad is the field of parascientific illustration, which is both informative and didactic. Producing this type of illustration requires the use of many techniques, with particular attention to album-games which use only images to stimulate a child's creative imagination beyond reading; "Piccolo Giallo e Piccolo Blu" by Leo Lionni is an example. Linked to the issue of perception is the organic series of album-games by Veronika Zacharias, the abstract adventures of the "Histories Pliantes" by Warja Honegger-Lavateur and the book "How the Mouse Was Hit on the Head by a Stone and so Discovered the World," an allegory of the infantile cognitive process, created by Etienne Delessert in cooperation with the psychologist Piaget. Among contributors to methodological analysis and to didactic application of visualization techniques are: Giulio Mezzetti, Luciano Vignali and the illustrators of the project, "Education Development Center Inc." - U.S.A.

The United States, whose large production makes it sensitive to a wide range of tastes, and which is open to cooperating with foreign artists, is an attractive territory for every kind of creative activity, including the broadest spectrum of schools in the field of illustration. In addition to Seymour Chwast and Milton Glaser, whom we have already mentioned, those who are versatile and largely representative of a restless vanguard in current research in the United States are: Tomi Ungerer, graphic artist and illustrator, noted for his work on the pathology of the child in American society, analyzed in his book "America;" Roy Carruthers, notable for his smooth, symbolic giants; Paul Davis, formally studying folk patrimony. The Polish origin of Maurice Sendak is betrayed by the graphic simplicity of his illustrations which resemble ancient carvings, and by his incredible insight into the psychology of the child. Richard Hess' oil illustrations recall popular American painting of the 19th century, lending more violence to the social contradictions on which they focus. Brad Holland provokes the readers of the "Op-Ed" section of the, *New York Times* with his surreal allegories. Saul Steinberg is the most intellectual of humorists. Also worth noting are the caricaturists: Davide Levine, John Alcorn, Eugene Mihaesco, Jiri Salamoun, Domenico Gnoli, Emil Antonucci, Beni Montresor, Anita Siegel, Charles Saxon, Anita Lobel, Edward Sorel, R. O. Blechman, Edward Gorey, Eleonore Schmid, Don I. Punschatz, Roger Hane, Alan E. Cober, Richard Scarry, M. B. Goffstein, Robert Grossmann and, last only in order of citation, Norman P. Rockwell. West Coast illustrators Wes Wilson and Victor Moscoso are to be noted as prophets of "underground" culture and authors of works that, by blending the most revolutionary elements of pop and folk culture in free, neo-liberty works, marked one of the happiest creative moments of the 1960s.

Great Britain, father of modern illustration, through artists such as Crane, Caldecott, Greenaway,

Tenniell, Bearsdlay, Rackham, and Potter, is generally close to its classic models, leaning toward traditional illustrations and frequent reprints, such as watercolors by Quentin Blake, and sketches by Edward Ardizzone, Paul Hoghart and John Birmingham. More advanced in their formal conception are the works by Michel Foreman and Charles Keeping, whose "Through the Window" should be mentioned. The revolutionary influence of Alan Aldridge, pioneer of British pop graphics, explodes in "The Beatles Illustrated Lyrics." Also to be noted are those works by: Ronald Searle (better known as a caricaturist), the more caustic Ralph Steadman, Victor Ambrus, Brian Wildsmith, Gerald Rose, Pat Hutchins, Marie Angel, Raymond Briggs, Violet Drummond, Walter C. Hodges, William Stobbs, Anthony Maitland and Wood Owen.

The most significant French illustrations include those created by Nicole Claveloux in cooperation with Bernard Bonhomme for a reprint of "Alice in Wonderland;" those by Alain le Foll for "C'est le Bouquet!;"the prints by Claude Lapointe for "Pollicino" and those works by Maurice Garnier. Also to be mentioned are: Jean Alessandrini, Laurent de Brunhoff, Christine Cagnoux, Alain Gautier, Ileane Roels, Daniele Bour and Colette Portall. Most important is the restless and emblematic Roland Topor, inexhaustible visionary whose pen and ink drawings suggest the tangles and tremors of a grotesque humanity.

In the Low Countries we want to stress the work of the Belgians Jean Michel Folon, whose geometric language has subtly entered international visual communication, and Josse Goffin, for his everyday objects endowed with beaks, wings, and tails; Max Velthuijs, Friso Henstra and Dick Bruno from Holland, illustrators for children's literature.

Of note in West Germany are Heinz Edelmann who has illustrated a great number of books, but who is better known for the cartoon "Yellow Submarine;" Lieselotte Schwartz for "Der Traummacher," built on big transparent masses; Lilo Fromm for his contribution as a narrator; the great engraver Hap Griesaber; Binette Schroeder, who leavens neurotic precision in her poetry; Gunther Stiller, who switched from erotic illustration to illustration for children with an exceptional number of different techniques. Others include: Jurghen Spohn, Janosch, Eric Carle, Holgher Mattheis, Jochen Bartsch, Reiner Zimnik, Hans Hillimann, Klaus Winter, and Helmut Bischoff.

The Swiss publishing industry has recently shown that international co-production plays a necessary role in the evolution of illustration. Its artists illustrate books published in eight different languages simultaneously, and they are stimulated, from the start, to the rationalization of, and experimentation in, advertising graphics. Better known as commercial artists are Hans Erni and Celestino Piatti; the hyper-realism of the former, and the unmistakable graphic ability of the latter, are evident in their many works for children. Also not to be omitted are Walter Cizieder, extroverted humorist; the previously mentioned E. Delessert, whose international experiences have further refined his fairy works (see the "Histoire n°s 1 et 2" by Jonesco); and Ruth Hurlimann, Monika Laimgruber, Carieget Alois, Fred Bauer, Horst Lemke, and Beatrix Scharen.

Among Austrian artists worth mentioning are: Erich Brauer, and the fantastic bestiaries engraved by Angelika Kaufmann and Olga Prosenc.

Italy is one of the countries with a minor tradition in illustration, due to the fact that the country's artists have always been forced into an artisan's status. This is borne out by Aleardo Terzi, Filiberto Scarpelli, Ugo Finozzi, Yambo (Guilio Enrico Novelli), Attilio Mussino, Umberto Brunelleschi, Antonio Rubino, Golia (Eugenio Colmo), Sto (Sergio Tofano), Bruno Angoletta, Filiberto Mateldi, Carlo Bisi, Piero Bernardini, Mario Pompei and Ennio Zedda, who, in the first half of this century, although part of the major European figurative movement, were the major figures in the most important elements of Italian illustration, without de-provincializing its condition. Artists known internationally today are: Emanuele Luzzati, who alternates children's books and cartoons; Flavio Constantini (the "Art of Anarchy"); Maria Enrica Agostinelli, Stĕpán Zavrel, the previously mentioned Leo Lionni, Ielo Mari, Dino Battaglia, Ugo Fontana and Alberto Longoni. Bruno Munari is an isolated phenomenon because his experience and imagination make the illustrator indistinguishable from the graphic artist, and the professor inseparable from the art critic.

In Spain, where the situation is similar to that of Italy's, Gervasio Gallardo seems to be the artist whose technical eclecticism most nearly compares with each aspect of illustration. Also to be mentioned are: José Pla-Narbona, Caledonio Perellon, Fernando Olmos, Ulises Wensel, Luis de Horna, Sanchez Prieto, Francisco Vilaplana Esteve, Javier Carvajal Bañof and Carmen Solè Vendrell.

In the Scandinavian countries the concrete presence of illustration is found in the restless mark of the Dane Lars Bo, or in Ib Spang Olsen, author of "Gamla Mor Lundgren," and in the humor of the Swedes Lasse Sandberg and Ulf Löfgren. In addition to the Norwegian Kaare Espolin Johnson, we cite Haraldur Gudbergsson, Per Beckman, Virginia Allen Jensen, Ilon Wikland, Ivan Andersen Kjell, Egon Mathiesen, Elsa Beskow and Barbro Werkmaester.

Yugoslavia's evidence of the influence of naive painting is apparent in the work of Marlenko Stupika, who uses it to investigate the popular and fantastic world. (See "How the Tailor Hlacec Managed to Hide Himself"), in Cujeta Job, who illustrates national legends in miniature, and in the *ex voto* images by Ive Seljac-Copoc, and also in the work of Jose Ciuha, Roza Piscanec, and Tunic Mladen.

In East Germany, as in all socialist countries, the distinction between pure art and commercial art does not seem to have affected the illustrators. To be noted is Werner Klenke, for the scathing social satire in his work; and Manfred Butzmann whose "Die Kuckuckspfeife" is worthy of citation; Hans Beltzer, Rolf Felix Müller and Klaus Ensikat.

Hungarian figurative tradition is expressed through illustration in the primarily decorative works of László Réber, János Kass and with those works which derive from popular iconography by Emma Heinzelmann. Also worthy of citation are Adam Wurtz, Endré Balint, Hinz Gyula and Szanto Piroska.

In Bulgarian illustration, generally influenced by medieval figurative tradition, one finds artists such as Borislav Stoev, Rumen Scorčev and Nicholaj Stoianov.

In Romania we shall note the xylographist Val Muntaneo and the work of Stan Done, Emilia Boboia and Gheorghe Marinescu.

To complete what has been said earlier about Poland, we must mention "The Copper Lamp" by Antoni Boratynski, whose fluorescent "pastose campiture" recalls Chagall's magic; Andrzej Strumillo, whose "The Fiancée who Came from the Sea" expressively condensed national underground symbolism; Olga Siemaszowa for her work in children's literature; the satirists Szimon Kobylinski, Andrzej Dudzinskj and Jerzy Czerniawski; Jan Lenica, who, with Bronislaw Linke dedicates his treacherous, witty pencil to cartoons. We shall also note Boris Butenko, Elzbieta and Marion Murawski, Józef Wilkoň, Maria Usaszka, Janusz Stanny, Zbigniew Rychlicki and Adam Kilianex.

Czechoslovakian Jiri Truka's (died 1969) style had completely evolved to a synthesis which had matured in the all-important sphere of animation, whose influence is found in its didactic subject and in the transmission of the national artistic patrimony. Of his large legacy of illustrations, those for "The Fairy Tales of La Fontaine" and "Beetles" are the most noteworthy. His influence is evident in the work of Eva Bednàrova, whose "Chinese Legends" carefully penetrates oriental symbolism. Also to be noted are Ota Janecek, for his mellow objects and luminous colors; Adolf Born, caricaturist and illustrator for children's literature, Miroslav Cipar, creator of masks, and Jan Kudláček, Viera Bombová, Kallay Dusan, Dagmar Berkova, Kveta Pakovska, Ondrey Zimka, Stanislav Konibal and Karel Machalek.

Contemporary illustration in the U.S.S.R. has been established only recently, under the motivation provided by international contests. It continues, however, its traditional epic and poetic style. The use of color, never conventional, and always expressive, is present in "Varlè Karalienè" by Algirdas Steponavicius, in the work of Birutè Žilytè, who should be noted for his cubist illustrations of animals, and in "The Two Roosters" by Volodomir Golozubov, in monochrome plates, drawn with the functional precision of confectionery decorations, and revealing a careful analysis of Russian "imagerie." Also worth mentioning are: Šinedeg Galsongor, Mar Miturič, Nikita Čiaruščin, A.V. Kokorina, Y. Vasnetsov, Erik Banjamison, Boris Kystymov, Vitalij Galsiaev and Maria Ladigaite.

In Japan, as in all highly industrialized countries, illustration expresses in an extremely advanced language pessimistic ideas concerning the main issues of existence. The predisposition for the two dimensions of the page is still intact on a formal level, together with the traditional graphic refinement that, in perfect symbiosis with the Western World, is expressed through every possible technique. Two examples of this phenomenon are the drawings of fantastic objects by the graphic artist Shigeo Fukuda for an anti-pollution campaign, and the illustrations by Kota Taniuchi, poet of open spaces. The extenous graphic preciousness of Toshinobu Imai is worth noting, as in the chromatic harmony of Kioshi Awazu, exploding with the joyousness of the "papier peint." Also to be mentioned are Segowa Yasuo, Schinta Cho, Suekiki Akaba, and Shasike Fukuda, all more traditional illustrators; the humorists Maki Sasaki, Riki Nagata, Wakiko Satoh and Tadashi Ohashi, Yutaka Sugita, Yashio Okada, Yashio

Hayadama, Akida Uno and the "escherian" Mitsumasa Anno.

In China, the recent campaign in favor of comic-strips has led to a greater number of comics consisting of a "suite" of traditional illustrations, and characterized by great clarity and quality.

Among Iranians, we should mention Farshid Mesghali, Ardeshir Mohasses, Zarrin Kelk, Pulak Ranjan Biswas and Banham Dadkhah.

Two South American spirits that contrast the exuberant decorative tradition with popular macabre styles, are embodied in the Uruguayan Hermengildo Sabat and by the engraver Antonio Frasconi in one school, and by the Mexican Alberto Beltran and the melancholic José Luis Cuevas in the other. In Brazil the following artists should be noted: Darcy Penteado, Ziraldo Pinto and Gian Calvi; in Colombia, Davide Consugra Uribe; in Peru, Charo Nuñez Patrucco; in Argentina, Oski (Oscar Conte) and Guillermo Mordillo, caricaturists and illustrators for children's books.

Working today in Canada are Rolf Harder and Ernest Roch, graphic artists and illustrators; in Israel, Ora Ayal, Thalma Goldman and Gak Ullman; in India, Shandar Pillais.

Africa offers William Papas of Transvaal, the Nigerian, Bruce P. O. Onobrokpeya, the Algerian, Choukri Mesli and E. Addo Osafa from Ghana. Finally in Tunisia, we shall mention "L'ogresse," a collection of popular legends, whose violent, picturesque, illustrations are an exceptional document of the collective work of five adolescents, the Khemir sisters.

In this study, which has aimed for the most part to identify illustrators according to their school of origin, only artists of international fame and active since about 1960 have been cited. For this reason, other artists, better known as painters and engravers, and who have only occasionally worked in illustration, have been excluded, as well as those who, operating in related fields, will be more closely examined in the relevant sections.

BIBLIOGRAPHY - L. Hogben, Dalla pittura delle caverne ai fumetti, Milano, 1952; Gec (E. Gianeri), Storia del cartone animato, Milano, 1960; R. Benayoun, Le dessin animé après Walt Disney, J.J. Pauvert (Suisse), 1961; M. Rubin, American Illustrators, Graphis, 98, 1961; H.A. Halbey, La qualité artistique du livre d'images, Graphis, 111, 1964; W. Benjamin, L'opera d'arte nell'epoca della sua riproducibilità tecnica, Torino, 1966; Gec (E. Gianeri), Storia della caricatura europea, Firenze, 1967; Illustration de Livres d'Enfants (1), Num. speciale, Graphis, 133, 1967; L. Kingman e altri, Illustrators of children's books 1957-1966, Boston, 1968; B. Munari, Design e comunicazione visiva, Bari, 1968; K. Murgatroyd, Modern graphics, Londra, 1969; A. Wright, Designing for visual aids, Londra, 1970; F.A. Hurlburt, Editorial design in America, Graphis, 149, 1970; A.E. Hamilton, Graphic design for the computer age, New York, 1970; Illustration de Livres d'Enfants (2), Num. speciale, Graphis 155, 1971; B. Munari, Artista e designer, Bari, 1971; A. Giovannini, Ricordo by Nino Pagot, Comics 5, 1972; A. Faeti, Guardare le figure, Torino, 1972; (The) Illustrators of Alice, London, 1972; E. Quayle, Collector's book of children's books, New York, 1973; M. Glaser, Il mestiere del grafico, Milano, 1973; (The) Artist in the service of science, Zurigo, 1974; Record covers (The evolution of graphics reflected in

record packaging), Zurigo, 1974; G. Rondolino, Storia del cinema d'animazione, Torino, 1974; A.L. Guptil, Norman Rockwell illustrator, New York (8ª ed.), 1975; M.S. Hoffman, E.A. Samuels (a cura), Authors and illustrators of children's books, Epping-Bowker, 1975; Illustration de Livres d'Enfants (3), Num. speciale, Graphis, 177, 1975; T.K. Toeplitz, Le dessin d'humor dans la presse polonaise, Graphis, 178, 1975; L. Silverstein, *The New York Times* (The world's best illustrated newspaper), Graphis, 181, 1975; B. Ballantine, Gervaso Gaillardo, Peacock Press/Bantam Book, New York, 1976; H. Baumeister, Bilderbücher, Novum Gebrauchs - Graphik, 12, Müchen, 1976; Children's books in print 1975, Epping-Bowker, 1975-76; O. Eksell, Werbegraphik und illustration in Scwede - Graphis, 186, 1976; I. Tanaka, Illustration in Japan, Graphis, 183, 1976; C.H. Morris, Illustration of children's books, London, 1976; Illustrators da 10 a 17, Catalog. American Ill. Exib., New York, 1966-1976; F.H. Wills. East German graphic design, Graphis, 183, 1976; D. Birdsall, Michael Foreman, Graphis, 187, 1976-77; L. Lionni, Leo Lionni imaginary botany, Graphis, 188, 1976-77; Illustratori di libri per ragazzi, Cataloghi dal 1968 al 1977, Bologna; Biennale dell'illustrazione di Bratislava, Cataloghi, Bratislava, 1967, 1969, 1971, 1973, 1975 and 1977.

PAOLA PALLOTTINO

COMICS (PLATES 164-165)

The years since about 1965 have been marked, particularly in Italy, less by a promotion of the comic-strip itself considered as a cultural phenomenon, but more by the growth of a real critical methodology. This methodology, although somewhat imprecise, has studied this art and its different modes of expression in depth.

Critical research has indicated that at least one comic-strip has been a fully expressive work, a fact almost indisputable, even by the most factious exegetes. A case of visual poetry absolutely out of the ordinary, and so unrepeatable that, at its creator's death, it has remained suspended in time, like the time of comic-strips, characterized by its repetitive, insistent, serial nature, and compromised by industrialization.

This comic is the surreal "Krazy Kat" which emerged in July 1910, still unevolved from a strip of generically wider narration, and it lasted until the death of its creator, George Herriman, in 1944. Herriman was born in New Orleans in 1881, but was influenced by European graphics, as were all the greatest North American cartoonists. At the beginning of the phenomenon (comics were officially born with film in 1895), cartoonists felt, with their applied art, like the poor brothers of so-called "pure art." The first cartoonists, like Winsor McCay (1879-1934) in the beautiful "Little Nemo," felt compelled to imitate the artistic style of the time, Art Deco.

Krazy Kat was the name of male/female cat, in love with a mouse who returned this sentiment by heaving heavy bricks at the feline's head. The third character was a policeman accomplice of this hard-headed, derisable character. This officer was himself part of a scenario filled with the purest, most charming middle-American kitsch.

At about the same time as this development, between the 1930s and 1950s, many comics were born. These were legitimized by some as artistic, but they were mainly clever social documents and products of skillful craftsmanship. We shall cite "Terry and the Pirates" by Milton Canif and "Flash Gordon" by Alexander Raymond - Canif because of his use of chiaroscural optic to black and white cinema. Raymond because of his ability to synthesize various elements from the neo-classic to Pre-Raphaelite. The two gangster comics, with their extremely violent plots, found their nearest relative in Weimar's expressionism. These were "Red Barry" by Will Gould and "Dick Tracy" by Chester Gould.

After 1960, the shrewdest graphic language for comics emigrated from the United States to Europe, where the phenomenon appeared to be accepted even at the highest levels of culture; after widespread ostracism, which was supported by fascist dictatorships closed to, and leary of, a "medium" born in democratic nations.

In Europe, in addition to the French who, like Nicolas Devil in his semi-erotic "Saga de Xam," played intellectually with the past, as well as with the great Chinese vase paintings, we state that the Italians were those who supported both tolerance and new techniques: Guido Crepax. in the stories of "Valentina" evidenced a composite geniality and a sense of montage that revolutionized comics, and Hugo Pratt, whose "Ballad of the Salted Sea" began an extremely refined graphism of explosive popular communication, that stylistically involved image and "verbum," including the codification of the latter in "lettering."

Recent years have seen artists like Allen Jones or Bill Copley and Roy Lichtenstein, borrowing from the comics in order to give new life to their creativity. The comic has escaped the restraints of a promotional instrument to main art. From this moment it enters with every right into art history.

BIBLIOGRAPHY - L. Hogben, Dalla pittura delle caverne ai fumetti, Milano, 1952; C. Della Corte, I fumetti, Milano, 1961; F. Caradec, I primi eroi, Milano, 1962; Aa. Vv., Almanacco Bompiani 1963 (dedicato a La civiltà dell'immagine), Milano, 1962; U. Eco, Apocalittici e integrati, Milano, 1964; G. Forte, Gli eroi by carta, Napoli, 1965; Aa. Vv., Bande dessinée et figuration narrative, Musée des Arts Decoratifs, Paris, 1967; Aa. Vv., I fumetti, Ist. di Pedagogia dell'Università di Roma, Roma, 1967; J. Sternberg, M. Caen, J. Lob, Les chefs d'oeuvres de la bande dessinée, Paris, 1967; J. Sadoul, L'enfer des bulles, Paris, 1968; R. Traini and S. Trinchero, I fumetti, Padova, 1968; Aa. Vv., Az comics, Archivio Internazionale della Stampa a Fumetti, Roma, 1969; L. Becciu, Il fumetto in Italia, Firenze, 1971; G. Genovesi, La stampa periodica per ragazzi, Parma, 1972; Aa. Vv., Comics, Zurich, 1973; G. Strazzulla, Fumetti di ieri e di oggi, Bologna, 1977. - Numerose anche le riviste specializzate tra le quali citiamo Linus e Comics.

CARLO DELLA CORTE

ADVERTISING AND THE URBAN SCENE (PLATES 166-170)

Advertising communication. – Advertising, advertisement, and the public: these terms define a system of

communication, the message producers within this system and the receivers of the communications. A semiotic analysis of the relationship between these elements must obviously be discussed within the context of contemporary culture. To understand advertising is to understand questions of mass culture. Such an inquiry naturally leads to issues concerning the structure of mass marketing. Here, however, we shall try to identify relevant issues as raised in recent literature.

The world of advertising has produced a large amount of writings on the lawfulness of the advertising phenomenon, but without facing structural problems. This literature has slowly departed from sociological analysis and indirect economic evaluations of our culture. In fact, from one perspective, advertising appears to represent the "affluent" or "opulent" society, being at the same time a direct method of public persuasion created to increase consumption of goods beyond the so-called limits of human "necessity." Based on this functional hypothesis which is shared by Vance Packard and other North-American scholars, a Marxist evaluation of the whole system developed. Baran-Sweezy's analysis ("Il capitale monopolistico") considers advertising to have an actual influential function of its own within the system, a function implicitly absent in different societies without the advertising phenomenon. In fact the debate on advertising coincides, in many respects, with that over mass society. What scholars state about the latter automatically becomes an analytical discourse on communications and, consequently, advertising.

A problem within the system itself concerns the morality of advertising communication. Advertising can be sincere or insincere, true or false. The truth of advertising is taken for granted simply by the establishment of certain rules, some merely formal or symbolic (the so-called advertising codes in the U.S., now imported in Europe), which would provide various guarantees to the consumers. Viewing the debate in this way, however, distracts from a more correct interpretation of the phenomenon. The approach does not define advertising in itself, nor does it consider the phenomenon within a general societal context; the context is subsumed while the attempt is made to reconcile the existing social system with the one suggested by advertising. Reality, as distinct from myth, is constantly recast to integrate a newly realized hypothesis. Before further pursuing this analysis however, it is necessary to confront the issues previously posed by marxist commentators, issues which represent the most productive trend in this field.

An entire group of scholars, which elaborated exact parameters of analysis for studies on advertising, is not represented in the prior debate on the advertising issue. This group, of the "Frankfurt Institute fur Sozialforschung," disbanded after the arrival of nazism; it contributed, however, an alternative perspective to the debate over mass society. Research by Walter Benjamin, first of all, and then by Theodore W. Adorno, Max Horkheimer and Marcuse (the last including a psychoanalytical component that will be analyzed below) faced the issue of mass society, and therefore of advertising (i.e. of communication within society) in completely different terms. These cultural historians faced a German society between the two wars which was experiencing a boom of industrialization. They were concerned with the issues posed by mass production and at the same time by alienation as conceived in Marxist terms. The "Economic-Philosophic Manuscript of 1844," together with Hegelian concepts, were for them a starting point. The society in which they lived was an alienated society; its products were the instruments of this alienation, transforming men themselves into products. The problems arising from the analysis of society's acceptance and adoption of advertising communication into the social structure are eliminated *a priori* by tightly connected interpretations of structure and superstructure.

The subtle analyses conducted by Horkheimer and Adorno examined the mythical model of Western culture, in which man discovers reality, understands it without experimenting and is isolated by the universe of "practice." It presents a new Odisseus, tied to the tree in order not to be led into temptation by the mermaids. These analyses indirectly compel one to consider these mythic experiences in the real world. In contrast, Benjamin's essays on the reproduceability of art, photography and other topics, state that uniqueness is a myth within particular cultures, and that the aura surrounding so-called artistic objects is a way to separate them from the context, not as an experiment but merely as a way of excluding them. In short, we are facing an obvious contradiction where, on the one hand, an object is endlessly reproduced and, on the other, its uniqueness and individuality are mythified. The dilemma exists indirectly even today in the distinction between "artistic" and *tout-court* advertisements. An artistic advertisement does not exist except as a post hoc example of communication in a given society. It is we who establish, usually after the fact, the criteria for distinguishing, often on the basis of the literary content, whether an advertisement constitutes "art," or whether it stands on some inferior level. Within the advertising system two perspectives have taken shape, one of the marketers and the other of the "critic" with its numerous shadings.

According to the Frankfurt school, whose work was taken up and developed particularly by Hans Magnus Enzensberger, the problem presented by advertising requires its elimination as a system of alienated communication. An alternative way of dealing with this kind of communication is suggested by the counter-information hypothesis and the thesis characterizing an alienated system of consumption, as opposed to a system based on real necessities. In facing the problem in Marxist terms, Baudrillard's hypothesis appears to cast doubt on this optimistic interpretation. He states that the utilitarian value - the supposed "truth" the advertisers should aim for in their rhetorical operations - is a cultural convention. Turning to the utilitarian value of objects lends itself to a mythical conception of reality; it means to evoke concepts of the "return to nature" rooted in the Enlightenment Age, recalling Jean-Jacquesen Rousseau in the last period of his reflections. Consequently "objects" are not exchanged according to a hypothetical utilitarian value, for this value is distinguishable only in formal terms from the exchange value. According to this hypothesis then, what is the relation between the signifier and the signified with respect to the objects? It is necessary at this point to turn to Derrida's thesis ("De la grammatologie"): in analyzing "writing" he acknowledges the fracture between signifier and signified as typical of idealized cultures, from

Plato onwards, and recognizes that the depreciating materiality of "writing," as stated by Sollers ("On materialism"), is an operation internal to a precise and ever idealistic cultural model. Consequently, if the exchange value coincides, in a culture, with the signifier (Goux: "Marx and the inscription of labour") variations in the meanings of different objects will be the goods, while the exchange of such meanings and their variations will be the moment of trade. In Baudrillard's opinion ("Pour une critique de l'économie politique du signe"), the exchange value coincides with the signifier and has predominance over the utilitarian value, which corresponds with the signified. In short, for both Baudrillard and Goux the problem is not the relation between Exchange Value and Signifier or Signified (EV = Sier for Baudrillard; EV = Sied for Goux) but the substantial *a priori* negation of a "pure" utilitarian value, where the goods do not come into contact with the social dialectic but satisfy non-existent "primary needs."

It is important to consider that (Goux) the association of a word with a particular meaning operates as a real censor on the alienation of the sign materiality. Baudrillard's statements must be read with due consideration to his previous studies, and in particular, his volume "Le systeme des objects." If, however, the utilitarian value is defined as the signifier and the exchange value as the signified, Baudrillard's critique of the Marxist approach in both the "Manuscripts of 1844" and in "Das Capital" becomes clear. This hypothesis is indirectly confirmed by Sollers' historical analysis, beginning with Derrida, in "On Materialism," on the relation between signifier and signified, and therefore of the idealistic fracture between the two levels: sign materiality, on the one hand, as the signifier, and, on the other, the spirituality of the sign itself as the signified. The positions by Derrida, Sollers, Baudrillard and Goux, instead of being contradictory, as it might appear, all lead to the same unique conclusion: that the sign cannot be separated - except formally - as signifier and signified and that the utilitarian value is an abstract hypothesis that must be considered in the reality of constant exchange; that is, where signifiers undergo constant transformation.

From the foregoing it is understood that analyses of advertising cannot begin from a supposed connection to primary needs, nor can such analysis be built upon outside the social system that employs it. The problem of advertising as an information system characteristic of the capitalist world is thus eliminated. From the beginning, in distinguishing information theory between senders or the media and message receivers or the public, I indirectly posed the problem of the impossible overcoming the alternative: Either advertising is a separate branch of information, identified in our culture as "apart" due to historical and ideological reasons, or it is to be analyzed as an aspect of the capitalist system. Either we analyze communication on its own terms or we decide that communication exists only within the capitalist system, which is absurd.

Obviously, communication exists in every system, whether it be capitalist or Marxist. Likewise, public information is a generalized problem, and therefore generalizations can be made about it. It is thus nearly impossible to assert that information can only be utilized within a capitalist ideology. Accordingly, Marshall McLuhan's hypothesis, posed the problem in only apparently correct terms. From the receiver's point of view, it is certainly true that the message is conditioned by the medium, because the medium has its own iconology; that is, its own process of reception that predetermines the public's expectations. It is also true, however, that McLuhan places his analysis within the capitalist system and does not offer any alternative except for that of social-democratic rationalization, which has been suggested earlier by the sensitive advertizer, Vance Packard. The emphasis placed on the medium is correct but does not diminish at all the weight of Derrida, Sollers, Goux or Baudrillard in their theses which take into consideration the use and consumption, or transformation, of signifiers. This includes signifiers with particular meanings that later change their meaning, and fall into disuse like worn out goods awaiting a future cultural recycling.

A series of analyses dealing directly with advertizing, conducted by scholars like Roland Barthes, emphasize the mythologies within mass culture. Eco also dealt with these questions by expanding on the concept of signification, of the transformation of meanings in the context of consumptive cultures. According to Derrida and Baudrillard, myths are nothing but the use of the senses in our culture; in mass culture the myth is the only way to sell and bring about the exchange of goods. The duration of a myth is the duratin of the goods. "Today's Myths" by Barthes and the "Diario minimo" by Eco are two texts that face this issue and pose the problem in terms of fruition or production, and of rapport building with the public. It is clear at this point that the use of the mythical model in advertizing functions as a kind of lowest common denominator within one group or among many groups. Moreover, it promotes comprehension in terms of exchange; i.e., exchange of equivalents of "things" mainly known. When applied to advertising and to advertising rhetoric, however, this theory of information demands only limited attention to the transformational level within the system of communication and yet for constant reference to the common points of narrative structures.

Another issue posed by Roland Barthes in "Systeme de la Mode," (following his prior work, "Mythologies") was what Barthes termed analysis of the "written fashion," — of the rhetorical system underlying the icons of fashion. This refers not to clothing fashion, but to the "written" fashion, syntama, or the "topoi" of this narration. Barthes obviously responded to the prevalence in our culture of the literary word on the icon - of the necessary translation of the visual world into the world of the spoken and written word. Reflecting on what has been said about Sollers, however, presents an important problem; excluding clothing fashion and the photographic fashion in magazines is to separate the literary from the iconographic culture. It means eliminating communication problems of earlier media and using the new iconographic language as signifiers, the signifieds of which would normally have been literary expressions. Barthes' problem, then, was not only in choosing literary language but also - and importantly - in censoring unwanted iconographic language. Thus, it is understood that advertising cannot be read in terms of literary or iconographic language alone, but must be seen as a combined system. The critical debate on these themes, however, prompts deeper models of analysis.

Advertising is an interpretative system that consists not only of myths; it also links the myth to analyses which allow a syncronic or historical interpretation of the myth itself. I refer here to the Proppian methodology that has been applied in many cases in the study of mass communication. There is Propp of 1929 with his "Morphology of the Fairy Tale" and in 1946 with his "Historical Roots of Fairy Tale;" later the formalist Propp examining narrative "functions," and the anthropologist Propp who clarified the cultural matrices of fairy tales as historical transformation - that is, the transformation of their signified or their exchange value. This methodology has a limit, however. Having been analyzed within the literary universe, fairy tales do not tend to identify the iconographic moment, its syntama and systems of images in historical terms. In short, it does not examine the iconology within language or become a useful instrument for analyzing mass communication, including literature, tales, and systems of plots.

Other studies, including those by Marmori and Eco are particularly interesting. By posing the issue in terms of rhetoric of communication they escape from the contradiction mentioned before and better clarify the problem as it appears from an iconographic point of view. Mass cultural communication must be read according to a rhetoric or a model of rhetoric (communication is rhetoric, Tyteca-Perelman, Lansberg, Barthes) that cannot be confused with the one historically associated with the literary universe; it would be extremely dangerous, in fact, to transfer the rhetorical figures of the literary tradition to that of the iconographic tradition. When Eco in his "Trattato di Semiotica" places himself in the context of production and consumption in his analysis, he progresses from a qualitative point of view as compared to the *a priori* semiotic theories. In this way his work can be linked with the analyses offered by the French, from Derrida to Sollers.

There is, however, another critical perspective from which it is possible to interpret advertising rhetoric: a psychoanalytical one, usually reduced to a schematic Freudism.

Advertising cannot, in fact, be satisfactorily analyzed within a system of myths which is incidental to the superego and separated from the reality of the ego and the substratum of the emerging subconscious. Also unacceptable is an interpretation of the advertising icon as superficially related to the conscious system, but referring instead to the subconscious system, to repressions or to the mythical models of mass experience. The relation between advertising and psychoanalysis can be correctly posed only in terms of the Locanian hypothesis, which salvages the most significant of Freud's discoveries, his analysis of the language. Condensation, transfer and symbolization: these are the three elements characterizing every possible interpretation of the "analytical" process. These elements, themselves, undergird the structures of every hypothesis of language. Obviously symbolization comes before everything else, but condensation and transfer are necessary instruments for correct interpretation of messages, in both production and reception by the public. From this perspective, Locan's analysis (in "Scritti") offers interpretations that are not different from the theses expounded by Sollers, Derrida, Goux, and Baudrillard. In fact, transformation of the signifiers of a certain "event" as affected by the different influences on production, or by the different

producers themselves, proves once again that in a commodity-centered society meaning can become value. Many different perspectives are thus opened to an analysis of advertising messages within a psychoanalytical context. By comparison, in this context a more banal interpretation of the subject would focus, for example, on subliminal advertising, where messages are presented quickly but not long enough to reach the conscious level; it is considered an "unfair" practice and "forbidden" by official codes of advertising. The advertising system, however, suggests a lot more than these schematic systems of persuasion: it utilizes and manipulates variables and procedes to transform meanings or condense them in order to aggregate new significant syntagma. Small variations within an expected or expectable context are one of the main characteristics of advertising rhetoric operating on the language. It is here, in my opinion, that the real influence of psychoanalysis on advertising is to be found.

Thus far we have offered several possible interpretations of advertising. First the one that considers advertising as a characteristic element of a consumer society; then the one that presumes a different ideology from that of the consumer system, making an essentially Marxist interpretation of society. Within the latter we have seen different perspectives: the one developed by the Frankfurt school that considers the multiplications of objects as functional to the transformation of the system itself; and the one that pulled together the results of the most advanced research in different spheres. The interpretation of advertising in terms of the fairy tale and of its function - as done by Propp and the Russion formalists like Eichenbaum, Tirianov and Sklovskij - aims for an analysis of literary and narrative meanings; meanwhile, the analysis based on an interpretation of the advertising system as a primary model of communication in our time draws on modern semiotics, elaborating on the work of Jakobson and Hjebuslev. We then mentioned the interpretation of advertising according to the most recent Marxist perspectives, from Derrida and Sollers to Baudrillard and Goux, without forgetting the contributions of Eco and Roland Barthes - the former stressing the concept of production, the latter separating literary from iconographic language. We also addressed the most recent analytical critiques offered by modern semiotics, as well as the Lacanian contribution, which represents a real change in the interpretation of advertising originally presented by the Freudian school.

Returning again to the receivers issue, it is necessary to come to terms with a group of other hypotheses (based in sociological analysis, albeit an alternative sociology). These presume structures of information in different societies that are not narrowly directed from the producer of the message to the receiver, but multidirected, in which everyone can be considered producers on one side and receivers on the other. I am referring here to the so-called theory of counterinformation that, from 1968 on, has been elaborated primarily in Europe by the French with their "manifestos," and in 1969 and 1970 by the Italians. In addition, specific areas such as television have nurtured their own specialized analysts, including Faenza ("Senza chiedere permesso"). From this perspective, the problem is to interpret the messages as a system of meanings subject to transformations, revolutions and changes that can be foreseen and thereby permit analysis from either side of

the chain that links the producer, the channel and the receiver (Moles).

It is convenient, however, to reflect here on the historical fracture between iconographic and non-iconographic language in order to determine how advertising acts as an alternative to previous models. The heirarchy between literary and iconographic language, in fact, tends not only to be upended; it also transforms (and this is a transformation that dates Liberty way before Bauhaus) the signifier into the signified. Within advertising, writing thus becomes the icon. Hjemslev's analysis and his distinction between "form" and "substance" in content and expression overcome the idealistic fracture between content and form or, if preferable, between signifier and signified, and imposes between these two the same correlation that is, in the consumerist context, within the meaning itself. It is necessary to identify in the messages within advertising the prevalence of the "form of content" or the "substance of content." This is also true with posters, where the iconographic invention prevails. Where narration is emphasized, we do not establish sharp contrasts between the two worlds, nor do we affirm that the poster is necessarily within the realm of metaphor or methonimy. This is because even the rhetorical figures are historical facts and the use made of rhetorical figures in our culture wears out constantly, transforming itself and transforming meanings, as well as the distinctions between methonimy and metaphor. Jakobson notes that it is similar to when we face the concept of "realism," a strange word full of different meanings which have been absorbed at different times, a word that becomes functional within the already mentioned dialectic of use, and that must be clarified according to the context within which it is used.

From what we have said so far, it is clear that the issue of advertising cannot be considered in the simplistic terms of communicative models aimed at enlarging the market for consumer goods; it is also clear that notions of advertising as a restricted and restrictive sphere programmed by the system must be broadened to include an analysis of advertising as communication. In analyzing advertising it is not possible to speak only of posters and campaigns but of packaging, design and the urban system as a communicative system; it will be necessary to conduct a functional analysis of the context within which a certain advertising activity operates. Only by including one or more codes in such a context will it be possible to truly comprehend the whole of communication studies.

In the next section we shall attempt a contextual reading of the communication system in our culture. We operate on a dyacronic, historical axis, attempting to link the issue of mass communication and its different moments of development with the problems of the so-called Industrial Revolution. "Elite" communication is clearly a part of the required dialectic - as is "mass" communication - and can therefore not be excluded from discussion. Without elite communication, in fact, the expression "mass communication" could not, relatively speaking, exist. For this reason, within different cultures, the term "advertising" necessarily coincides with that of "communication."

The city as a communication tool. – Even though the earlier chapter points out that advertising is no more than a convention in our culture system, we use the term to refer to a particular kind of communication that is transmitted through certain channels. In the absolute sense, all advertising is communication, and *vice versa*, all communication is advertising, inasmuch as it conveys an ideology, whether that ideology is the dominant one or a contrasting one within the system.

Nevertheless, it is commonly held that advertising is communication only if it is connected to the different products of *loisir*, connected to what the consumeristic system advocates, creating, as Baudrillard suggests, not only value in exchange, but also value in the use of objects. In this same system, however, the hypothesis of an openness to different ideologies has posed issues that must be resolved: if a dominant ideology and its system of communication exist, does this ideology contradict other ideologies that use different or similar models to communicate? And which social scene is to be chosen as characteristic of the advertising system? Faced with these questions, several possible answers come to mind: on the one hand, insisting on the stability of the capitalistic system and on the need to analyze advertising within its own channel, and on the other, rejecting the system, and asserting, rather, that it is possible to use new and different means of communication.

The first answer is given by advertising in its theory of advertising, or better said, in its functional autoanalysis. This thesis, however, requires the consideration of certain changes at the roots of the theory of communication. The problem of the relation between the means and the message, if not grossly misunderstood, allows the entire advertising problem to be brought back to the general topic of communication, and, therefore of semiology. The use of a certain means of communication creates, in fact, predictable expectations in the receiver. The planning of advertising campaigns in Western mass culture implies a certain attitude, one aware of choice as far as the media and the functions they carry out are concerned. To isolate a medium, however, does not mean simply to identify a particular kind of audience; rather, it means to identify a process of reception and, therefore, a model of the function of advertising. Baudrillard's thesis, then, which overturns the Marxist hypothesis on the value of use and which contradicts the thesis of the Frankfurt school (especially that of Benjamin, but also that of Marcuse) is correct: "real" needs do not exist, except within terms of different cultures. Moreover, in a correct anthropological perspective, it is not possible to isolate advertising from the general communication system; on the contrary, advertising is itself the most important communication. In short, it is not possible to distinguish between real communication and advertising communication, and therefore, between reality and space of *loisir* or of advertising because, in our culture, they tend to be the same.

Consequently, the system uses different channels as they relate to different models of reception. First of all, there is the scene inside which the message exists, is built, and is received: it is the main urban scene, the one we cannot exclude. Within this scene we have to read the message, just as we cannot avoid, in due course, considering the other scenes from within, since it is within their context that the message must be interpreted.

Advertising space is consequently and principally the city: the city that has devoured the surrounding territory, covering it with its signs, the signs of urban settlement, the signs of advertising. Of course, in cultural terms, we have to distinguish different areas, since the relation between the city and the countryside is not exactly juxtaposable in the West and presents strong differences elsewhere. For a long time architects have theorized the notion of the "written" city; that is, they analyze the contrast between the city by day, for instance, and the city at night. (This exercise is characteristic of the North American culture.) A recent analysis of Las Vegas contrasts these two models, actually identifying a mythical city and a real city. Even these two polarities, however, do not exactly respond to the demands and functions in the system of the city, just as it is not sufficient to mention Piccadilly Circus in London, the Champs Elysées in Paris, or Broadway in New York to proceed in the study. The issue, in fact, is not the opposition between the city by day and the city at night; or at least, it is not only that, but rather the analysis of the city in its functions as they are visually represented today.

In short, the issue is that of the city as a communication tool. It is necessary to distinguish at this point several different areas; first of all, the American one, where the relationship of the city with the countryside is very different from what we see in the rest of the Western world, particularly in Europe. The directional axis system, which is the function of the highways in the United States, deeply differentiates the relationship between city and countryside from the rest of Western culture. More precisely stated, this antithesis, historical in the last century, was completely removed by the destruction and rebuilding of various massive structures and infrastructures. The fact that the highways have become the reference axis of the entire system, and the fact that often the vital functions of the city - the reference points and meeting points - have been located outside the urban confines, projects a completely different image of the city.

And that's not all: in the United States, for instance, a series of identical structures, easily recognized by the general public, is, in fact, an advertising signal-image. The skyscraper, within the urban context, is always the sign of a large corporation, a large insurance company, executive headquarters, a business center. A chain of restaurants, all organized exactly the same way and recognizable by their external appearance, indicates another, different set of functions in the areas outside the city, as do motels, supermarkets, and so on. By this I mean that the defunctionalization of the city as a pole has brought about the signs of the functions themselves on the whole territory. It has eliminated the stratifications, by now in the urban context only rare and half-demolished traces, to emphasize the symbolization of the new. Within such a context, the advertising system of billboards, signs, and lights is certainly secondary, because we read the city through common, unmistakable parameters: highways, focal points along the highways around the rest areas, gas stations, supermarkets, highway junctions. The city center is left with its new functions: department stores like glass houses or intentionally antiquated, the already mentioned insurance companies, banks, and major companies, a rundown area in transformation, a little older (30

to 40 years at most); at the periphery are the suburbs, which tend to be built of cookie-cutter houses, bedroom communities repeated in the name of a bourgeoise icon of existence.

In this territorial system, advertising plays the most important narrative function, both during the day with posters and billboards and during the night as well. There is no contradiction, however, between the day city and the night city because everything is in writing (Derrida), and there is perfect continuity between the two. Of course, at night the focal points of the functions are more evident: the skyscrapers are lit, the lights of the symbolic life of the massive structures are on, the suspended bridges are illuminated, the interstate rest areas and interchanges are identified by the lights. The sleeping city, the inhabited city that lives the function of *loisir*, the symbolic consumption of the system, is in the dark.

If we examine Western culture, we find that the issue of advertising, and therefore of the advertising image within the context of our urban scene, finds extremely different solutions. In Italy, France, Switzerland, and England there are completely integrated urban centers, complex and stratified architectural structures, inside which the system of the signs and symbols belonging to the modern consumeristic culture must find their places. Above all, however, in Western culture, the relationship between city and countryside does not find the solutions that characterize the civilization of the United States. There, the countryside has not been industrialized; the massive structures of the countryside have not been integrated with the city; the interstate highways have not imposed their systems on a preexisting one.

The so-called historical city, damaged by the industrialization process, has not, however, lost its own historical symbols, its image system as it is related to the revolution of the ever more complex icon that characterizes consumerism. At the same time, the countryside, regardless of highways, industrial areas, and all the signs of a different network of symbols, still offers an alternative rapport with the city; it is on the outside of the city. In this case, too, times are changing: the countryside is becoming a place devoid of signs, a place where "historical" signs have been partly destroyed or worn out, while the new signs do not take over so drastically as is characterically the case in the United States. (But we have to keep in mind that everything is actually history.) This brings to light a contradiction that becomes even more striking in the relationship between the day city and the night city. In fact, the night city, the city of signs, neon lights, offices, and shop windows, negates - in the Western world - the city that preceded it; that is, it denies all the urban stratifications existing up until the last century, including the entire urban system up until the "reconstruction" of the Post World War II period, in certain areas of Europe and in Italy, for example. On the other hand, this trend is not developing in a third area, that of Eastern Europe, where the ancient core of the city finds no inconsistency with the reconstructed city and the modern city in explicit symbolizations, with few exceptions.

This horizontal distinction among systems could suggest the existence of different models of urban communication and, consequently, qualitative differences in the structure of communication; but this is not the

case. The attrition of urban signs exists in the two environments, in Western as well as in Eastern Europe, but it is much more pronounced in the West than elsewhere. On the other hand, the problem is not so much to measure the attrition, this consumption, as it is to question the syntactic system within which the consumption takes place, and then to read the existing relationship between advertising and "design." In the history of the icon, the different spheres of advertising and "design" have a tight relationship in the split between form and content, and therefore, between the packaging and the tool. If the origins of "design" are those of industrialization (Klingender), "design" comes straight out of the process of the construction of manufacturing industries in England; but this "history" risks being a history built *a posteriori*, a projection of our modern ideas on "design" in the past, and contradicts our historical analysis of advertising. We have seen that we give a precise date to the history of advertising only as a literary convention (i.e., an analytical tradition). Inasmuch as the history of advertising is the history of communication, it cannot be verified except in terms of communication itself.

Then what is the relationship between advertising and "design"? If a nullifying term is not even that of the multiplication of objects/message, since such multiplication characterizes previous ages from the official histories of the two systems - and if neither the distinction between value of use and value of exchange is a distinctive element, since it characterizes our social life, from the symbolic "gift" ahead - then the choice of the starting point will be political, cultural, and connected to the relationship between the classes. This is why the issue of "design" and that of advertising can be made to coincide, because they are no more than two aspects, not even differing ones, of the packaging, or, shall we say, of the syntactic connection, and, therefore, functional connection, of "objects." The idea that a city is packaged in its own systems of writing, that the packaging is the same everywhere within a certain social and temporal context and therefore perfectly recognizable by anyone, coincides exactly with the construction of "design" operating on an urban scale.

In New York and elsewhere, Leo Vignelli, for instance, by planning a new vertical system of street and service signs, an organic and readable indication of subway stations, of fire extinguishers, etc., takes part directly in planning the urban scene, just as Franco Albini did in designing the entrances and structure of the subway system in Milan. But the issue is not limited to this sphere: the "design" of a bus or of a car is part of the planning and advertising exactly as is the planning of "interiors" that characterizes the historical system of "design." The fact is that design is actually functional to mass culture, and that it is, in the version widely accepted today, the ultimate product of the Bauhaus attempt to rationalize mass culture (Argan). This proves that the study of advertising should not be constrained by historical limitations characteristic of the system, but functional limitations to the problem of urban communication. In these terms, which are typical of Western culture, the structural organization of interiors becomes an advertising system itself, a sign system of extremely strict syntax, or, from time to time less rigid, depending on the classes and their social symbologies.

The hypothesis, once again, is that the general issue is that of the "packaging." The fashion system, not only the "written fashion" (Barthes), but also the fashion that is worn and, more importantly, of advertised fashion, fit within the scope of this term. On the other hand, the distinction between form and content, typical of idealism, characterizes the entire planning of urban facades, where the internal structure, the "machine," is covered by a modular grid often made of glass and metal. All this is still part of an urban semiology that has a structure projected *a priori*, inside of which the single variables are, in fact, marginal.

From 1968 on in France and Europe and beginning in the early 1960s on American campuses, spray-painted graffiti, activism expressed on walls, and "off" posters apparently built a different system of communication. This, too, is advertising, obviously not of "products" in technical terms, even if the ideologies themselves are certainly a product whose value of exchange is altered. Whatever the incidence of these signs, their duration in the urban context appears brief, limited by the medium itself, not comparable with the possibility of affecting mass culture. Their existence, however, together with other phenomena (independent radio and TV stations, and so on) proves that the system of information is reversible and not mono-directional, and opens critical areas in the system of communication. The most recent advertising has begun to use, ideologically neutralizing it, this form of semiology once again. If the city is the dominant scene of communication within the context of mass culture, both inside and out with its significant syntactic nexus of actual associations of objects, the message that increases the acceptance of these associations gets to the public through channels that characterize the message regardless of the content of the message communicated.

The city as a whole, it has been said, is the first message, the first system, the system of systems, the symbolic system of consumption; there are, nonetheless, sub-systems, different channels, all of which are functional to the culture of the city. The poster here is linked to two different kinds of impact on the reader. One assumes a quick reading from the car; the other assumes a slower reading, perhaps as the reader is walking. In the urban context, the poster plays a recall role, usually of an advertising campaign that finds its necessary point of reference in pages of magazines, where the written words, the explanation, increase rapidly in quantity and the "technical" information becomes a sign of a convergence of the two layers, literary and iconographic, which are the terms of the debate in the history of poster we will outline here. In this way, newspapers and magazines postulate a different length for advertising messages; they are abbreviated or more complex narrations of an event whose culminating experience (a fairy-tale experience) is found at every street corner.

However, the different advertising channels, i.e., channels of the system's syntax, imply a different public attitude: television spots, for instance, represent something completely different from what is represented by the slides projected in a movie theater. The latter are, in functional terms, on the same level as the street posters: recollections, references, allusions, while television shorts, different in every country, are "true," brief accounts. They are fairy tales to be interpreted as instruments of a familiar narration perceived not as a myth

(like the posters), but as a reality. The issue of how the public interprets the message, and therefore the function of the advertising message, is a problem in semantics, or, if you will, of the value of exchange given to the message itself that cannot be neglected. In this context, then, the advertising messages refer to a series of psychoanalytic models: billboards and posters generally move from the *superego* to the *ego*, while many television commercials move from the *ego* to the *es*, even if they seem linked to the *es*. The interpretation of the advertising message, apparently similar in all media, is, rather, very different. A poster is certainly less "true" than a magazine advertisement, even if the poster and the page are analogous (except for the more bold-faced print in magazines), since magazines are characterized by a different duration and therefore by slower consumption: proof of a "culture" more similar to the book than any other.

TV, however, casts more doubt on the urban system as a communication tool than does the radio. The radio is still the voice of literary culture, the persuasive voice that uses extremely schematic and direct advertising. On the contrary, TV offers advertising that is fable-like in its narrative structures (Propp). Above all, TV does away with the function of the urban context because it eliminates the belief that the urban structure is an organized, meaningful system. The advertising system had already managed to eliminate, visually, some of the referents of the city image, but today, beyond this and beyond the mythic function of the posters and the narrative one of the shop windows, we are facing an organization of existence in which TV is the dominant element and the objects are interpreted within a context of narrative which is television narrative. For this reason the shop windows of the city often reflect the minimal, focusing on a small screen, causing an immediate association with the TV screen, so that they can be accepted and perceived on the basis of the narrative suggested by TV.

The repetition of the name and the graphic inventiveness of the poster can be useful as points of reference, but as the contents page of magazines demonstrates, the story, the narrative, is most important. The internal dialogue, the fable of television advertising, read as reality, no longer serves to interpret the written city, but in fact prevents the city from becoming a readable city in its historical stratification. This, then, is another consequence of advertising: it reports everything in the present, building an all-present urban icon. Here, too, is a contradiction with the "historical" culture of the urban signs, an obvious contradiction between the symbolic model of the new city of advanced American capitalism, which we are imitating, and the traditional city.

One could speak of advertising *genres*, distinguishing them internally, not so much by the length of their message (as is also done), but by the type of socialization offered by the message itself, whether that socialization is collective, a group, a small group, or individuals, in order to expose different occurrences on a psychoanalytical level as well. The main contradiction of the advertising in our culture is that its all-present aspect tends to erase the urban collective memory, and does so in the context of the urban structure, forcing us to remove the structure itself, or, more reasonably, to replace the advertising itself. The fact that so much of its message is concentrated in the pages of newspapers, magazines, or on the TV screen, and, therefore, the fact that it is an individual, direct message so that the conditioning is given in terms of a type of self-analysis or of a relationship with the analyst, suggests what might become the trends of advertising in the future.

To lose sight of the fact that the core of the issue is not the difference between a city of paper and a city of light, a written city and an architectural city, "design" and architecture, but rather the idealistic opposition between the culture of packaging and the culture of contents - in fact, form and content - may prevent us from achieving a correct interpretation of the communication issue in our culture.

BIBLIOGRAPHY - Aa.Vv., Cultura e sottocultura, I problemi by Ulisse, XIV, VII, 1961; Aa.Vv., Les besoins des beins de consommation, Paris, 1963; Aa.Vv. (Fondazione Carlo Erba), Psicologia e pubblicità, Milano, 1966; Aa.Vv., Pubblicità e televisione, Roma, 1968; Aa.Vv. (Tel Quel), Théorie d'ensemble, Paris, 1968 (tr. it., parziale, Scrittura e rivoluzione, Milano, 1974); Aa.Vv., La tigre di carta. Viatico alla retorica pubblicitaria, Parma, 1970; Aa.Vv., Politica culturale?, Bologna, 1970; Aa.Vv., Pubblicità e communicazioni di massa, Milano, 1970; Aa.Vv., Contro l'industria culturale. Materiali per una strategia socialista, Bologna, 1971; Aa.Vv., Les mithes de la publicité, numero speciale di Communications, 17, 1971, Aa.Vv., L'art de masse n'existe pas, numero speciale della Revue d'Esthétique, Paris, 1974; Aa.Vv., Cultura, comunicazioni di massa, lotta di classe, Roma, 1976; T. W. Adorno, Minima moralia, Frankfurt am Main (tr. it. Minima moralia, Torino, 1954); T. W. Adorno, M. Horkheimer (a cura di), Soziologische Exkurse, Frankfurt am Main, 1956 (tr. it. Lezioni di sociologia, Torino, 1966); J.M. Agostini, M. Hugues, Les effets de la publicité dans la presse et à la télévision. Mesures et comparaisons, Paris, 1972; F. Alberoni, Alcune considerazioni critiche sulle ricerche motivazionali, Sociologia, ott.-dic. 1958; F. Alberoni, Le ricerche psicologiche sul consumatore, Studi di mercato, 3, 1963; L. Allegri, Le reazioni del pubblico ai contenuti, Relazione al Convegno su Immagine, pubblicità e communicazione globale, Firenze, 1972 (Atti pubblicati a cura della Federazione Relazioni Pubbliche Italiana, 1972); M.L. Altieri Biagi, Note sulla lingua della pubblicità, Lingua nostra, XXVI, fasc. 3, 1965; A. Anfossi, Consumi di massa, gusti di massa e fisionomia della società, Siprauno, 1, 1967; M. Anglaret, Tout l'emballage, Paris, 1967; U. Apollonio, Prefazione a Pubblicità in Italia 1969/70, Milano, 1970; G.C. Argan, Walter Gropius e la Bauhaus, Torino, 1951; G.C. Argan, Progetto e destino, Milano, 1965; G.C. Argan, Arte moderna 1770-1970, Firenze, 1970; G.C. Argan (a cura di), Il revival, Milano, 1974; F. Attanasio, La pubblicità, oggi. Metodi e tecniche, Milano, 1963; R. Audy, Stratégie publicitaire et marketing, Paris, 1971; P. Baldelli, Informazione e controinformazione, Milano, 1972; P. Baldelli (a cura di), Communicazioni di massa, Enciclopedia Feltrinelli-Fischer, Milano, 1974; F. Barbano, Pubblicità e società, Sipradue, agosto 1967; Barnicoat, A Concise History of Posters, London, 1972; Barthélémy, A travers le monde de la publicité, Paris, 1972; R. Barthes, Mythologies, Paris, 1957 (tr. it. Miti d'oggi, Milano, 1962); R. Barthes, Le message publicitaire, rêve et poésie, Cahiers de la Publicité, 7, 1963; R. Barthes, Eléments de semiologie, Communications, 4, 1964 (tr. it. Elementi di semiologia, Torino, 1966); R. Barthes, Rhétorique de l'image, Communications, 4, 1964; R. Barthes, Image publicitaire de l'automobile, Paris, 1966; R.

Barthes, Système de la Mode, Paris, 1967 (tr. it. Il sistema della moda, Torino, 1970); R. Barthes, L'ancienne rhétorique, Communications, 1970 (tr. it. La retorica antica, Milano, 1972); J. Baudrillard, Le système des objets, Paris, 1968 (tr. it. Il sistema degli oggetti, Milano, 1972); J. Baudrillard, Pour une critique de l'économie politique du signe, Paris, 1972 (tr. it. Per una critica dell'economia politica del segno, Milano, 1974); J. Baudrillard, La société de consommation. Ses mythes ses structures, Paris, 1974 (tr. it. La società dei consumi. I suoi miti e le sue strutture, Bologna, 1976); G. Baudry, R. Marange, Comment on imprime, Paris, 1960; G. Bechelloni, Pubblicità e politica culturale: il potere dell'informazione, Relazione al Convegno su Immagine, pubblicità e communicazione globale, Firenze, 1972 (Atti pubblicati a cura della Federazione Relazioni Pubbliche Italiana, 1972); W. Benjamin, Das Kunstwerk im Zeitalter seiner technischen Reproduzierbarkeit, Frankfurt am Main, 1955 (tr. it. L'opera d'arte nell'epoca della sua riproducibilità tecnica, Torino, 1966); M. Bleustein-Blanchet, La rage de convaincre, Paris, 1970; L. Bogart, Strategy in advertising, New York, 1967; S. Bojko, New graphic design in Revolutionary Russia, London, 1972; F. Bologna, Dalle arti minori all'industrial design. Storia di una ideologia, Bari, 1972; P. Bonaiuto, Prefazione a Pubblicità in Italia 1971/72, Milano, 1972; M.P. Bonanate, La pubblicità come fiaba, Sipra, 1, 1973; R. Bossaglia, Il déco italiano, Milano, 1975; P. Bourdieu, J.C. Passeron, Sociologues des mythologies et mythologies des sociologues, Les Temps Modernes, 211, 1963 (tr. it. Mitosociologia, Bologna, 1971); A.P. Braddock, Psychology and Advertising, Butterworth, 1932; F. Brambilla, Personalità e pubblicità, Genova, 1965; S.H. Britt, D.B. Lucas, La misura dell'efficacia della pubblicità, Milano, 1964; G. Braga, Struttura sociale e consumi, Siprauno, 1, 1964; A. Cadet, B. Cathelat, La publicité. De l'instrument économique à l'institution sociale, Paris, 1968; A. Calabresi, Pubblicità. Teoria e pratica, American Advertising Agency, 1925; M. Calvesi, Le due avanguardie, Milano, 1966; G. Campa (a cura di), Pubblicità e consumi in Italia, Milano, 1976; R. Cantoni, Appunti per una filosofia del consumo, Siprauno, 1, 1967; A. Carbonaro, Materiali per una sociologia del consumo, Passato e presente, 2, 1958; E. Carpenter, M. McLuhan (a cura di), Explorations in communication, Boston, 1960 (tr. it. La comunicazione di massa, Firenze, 1966); U. Castagnotto, Proposta per un'analisi semantica del linguaggio pubblicitario odierno, Sigma, 13, 1967; U. Castagnotto, Semantica della pubblicità, Roma, 1970; B. Cathelat, Mass Media et Mutations culturelles, Paris, 1974; G. Cattanei, Etica e pedagogia dei consumi, Roma, 1968; S. Ceccato, Prefazione a Pubblicità in Italia 1968/69, Milano, 1969; G.P. Cesarani, I persuasori disarmati, Bari, 1975; P.A. Cetica, La funzione sociale del design, Firenze, 1963; P.A. Cetica, Tre ipotesi sul design, Firenze, 1964; E. Cianetti, Problemi attuali della produzione e del consumo, Roma, 1960; G. Ciribini, Architettura e industria, Milano, 1958; R. Ciria, P. Favari (a cura di), L'arte grafica, Milano, 1973; R.H. Collery, La publicité se définit et se mesure, Paris, 1964; M. Corti, Il linguaggio della pubblicità, in G.L. Beccaria (a cura di), I linguaggi settoriali in Italia, Milano, 1973; J. Darracott, The first World War in posters, New York, 1974; J.C. Dastot, La publicité. Principes et méthodes, Verviers, 1973; M. David, Processo alla società dei consumi, L'impresa, 4, 1968; R. De Fusco, Architettura come mass-medium, Bari, 1967; T. De Mauro, Note sul linguaggio pubblicitario, Rinascita, 6, 1966; M. De Micheli, Manifesti della seconda guerra mondiale, Milano, 1972; M. De Micheli, Manifesti rivoluzionari, Milano, 1973; B. De Plas-Verdier, La publicité, Paris, 1966 (tr. it. La pubblicità, Messina-Firenze, 1974); J. Derrida, De la grammatologie, Paris, 1967 (tr. it. Della grammatologia, Milano, 1969); J. Derrida, L'écriture et la différence, Paris, 1967 (tr. it. La scrittura e la differenza, Torino, 1971); J. Derrida, Positions, Paris, 1972 (tr. it. Posizioni, Verona, 1975); A. Devoto, Contributo allo studio delle tecniche di persuasione e conversione, Atti dell'Accademia Nazionale dei Lincei, 360, s. XIII, XVIII, fasc. 5-6, 1963; E. Dichter, La strategia del desiderio, Milano, 1963; E. Dichter, Gli oggetti ci comprano, Milano, 1967; G. Dorfles, Le oscillazioni del gusto, Milano, 1958; G. Dorfles, Voce Design in Enciclopedia Universale dell'Arte, Venezia-Roma, 1958; G. Dorfles, Il divenire delle arti, Torino, 1959; G. Dorfles, Simbolo comunicazione consumo, Torino, 1962; G. Dorfles, Il disegno industriale e la sua estetica, Bologna, 1965; G. Dorfles, Artificio e natura, Torino, 1968; J. Dubois, Les cadres dans la société de consommation, Paris, 1969; M. Dubois, La publicité en question, Paris, 1972; J. Dumazedier, Vers une civilisation du loisir?, Paris, 1962; S. W. Dunn, Advertising. Its role in modern marketing, New York, 1961 (tr. it. Il libro della pubblicità, Milano, 1965); J. Durand, Rhétorique et image publicitaire, Communications, 15, 1970; U. Eco, Opera aperta, Milano, 1962; U. Eco, Diario minimo, Milano, 1963; U. Eco, Apocalittici e integrati, Milano, 1964; U. Eco, Prefazione a Pubblicità in Italia 1965/66, Milano, 1966; U. Eco, La struttura assente, Milano, 1968; U. Eco, Il costume di casa, Milano, 1973; U. Eco, Il superuomo di massa, Milano, 1976; U. Eco, Dalla periferia dell'Impero, Milano, 1977; G. Elgorzy, Les paradoxes de la publicité, Paris, 1969; O. Ellefsen, Campaign Planning, London (tr. it. Come programmare una campagna pubblicitaria, Milano, 1968[2]); J.F. Engel e altri, Consumer behavior, New York, 1968; F. Enel, L'affiche, Tours, 1971; H.M. Enzensberger, Einzelheiten, Frankfurt am Main, 1962 (tr. it. Questioni di dettaglio, Milano, 1965); H.M. Enzensberger, Palaver. Politische Überlegungen, Frankfurt am Main, 1974 (tr. it. Palaver. Considerazioni politiche, Torino, 1976); R. Escarpit, L'écrit et la communication, Paris, 1973 (tr. it. Scrittura e comunicazione, Milano, 1967); Etiembe, La langue de la publicité, Cahiers de la Publicité, 15, 1965; P. Fabbri, I processi pubblicitari: analisi semiotica, Sipra, 6, 1973; P. Fabbri, Le comunicazioni di massa in Italia: sguardo semiotico e malocchio della sociologia, VS, 5, 1973; P. Fabbri, Margini semiotici per il racconto pubblicitario, Strumenti critici, 23/24, 1974; G. Fabris, La comunicazione pubblicitaria, Milano, 1968; G. Fabris (a cura di), Sociologia dei consumi, Milano, 1971; F. Ferrarotti, Caratteristiche, problemi e prospettive della società opulenta, Siprauno, 1, 1967; G. Folena, Aspetti della lingua contemporanea. La lingua e la pubblicità, Cultura e scuola, III, 9, 1964; G. Folena, Analisi linguistica di contesti pubblicitari, Ulisse, XXI, fasc. LXIII, 1968; F. Fornari, Il potere decisionale al consumo è proprio una utopia?, Tempi Moderni, 3, 1970; P. Fossati, Il design in Italia 1945-1972, Torino, 1972; P. Fossati, Il design, Roma, 1973; K. Frampton, America 1960-1970. Notes on Urban Images and Theory, Casabella, 359/360, 1971, E. Fratelli, Design e civiltà della macchina, Roma, 1969; C. Frassinelli, Trattato di architettura tipografica, Roma, 1955; M. Friedman, A Theory of the Consumption Function, Princeton, 1947; N. Frye, The Modern Century, Oxford, 1967 (tr. it. Cultura e miti del nostro tempo, Milano, 1969); G. Galli, F. Rositi, Cultura di massa e comportamento collettivo, Bologna, 1966; M. Galliot, Essai sur la langue de la réclame contemporaine, Toulouse, 1954; M. Galliot, La publicité à travers les âges, Paris, 1955; M. Gallo, I manifesti nella storia e nel costume, Milano, 1972; C. Geffroy, Analyse économique du fait publicitaire, Paris, 1970; O.J. Gérin, C. Espinadel, La publicité suggestive, Paris, 1911; L.E. Gill, Advertising and pshychology, 1953 (tr. it. Psicologia

della pubblicità, Firenze, 1963); G. Giudici, Prefazione a Pubblicità in Italia 1961/62, Milano, 1962; J.J. Goux, Freud, Marx. Économie et symbolique, Paris, 1973 (tr. it. Freud, Marx. Economia e simbolico, Milano, 1976); R.C. Grass, W.H. Wallace, En publicité, l'imprimé contre la TV, Communication et langages, 26, 1975; C. Grassi, Il linguaggio pubblicitario vecchio e nuovo, Sipradue, 2, 1967; C. Grassi, Linguaggio pubblicitario e storia della lingua italiana, Ulisse, XXI, fasc. LXIII 1968; V. Gregotti, Orientamenti nuovi nell'architettura italiana, Milano, 1969; J. Gritti, M. Souchon, La sociologie face aux media, Tours, 1968; U. Groupe, Rhétorique générale, Paris, 1970; V. Gruen, The heart of our cities, London, 1965; R. Gubern, Mensajes icónicos en la cultura de masas, Barcelona, 1974 (tr. it. Immagine e messaggio nella cultura di massa, Napoli, 1976); C.R. Haas, Pratique de la publicité, Paris, 1970; J. Hampeel, W. Grulich, Politische Plakate der Welt, München, 1971; H. Henry, Motivation Research: its Practice and Uses for Advertising, Marketing and other business purposes, London (tr. it. La ricerca motivazionale, Milano, 1966); P. Herbin, La publicité en une leçon, Lagny; 1964; P. Herbin, Vocabulaire de la publicité, Lagny, 1964; P. Herbin, Exercises de publicité. Publicité et distribution, Lagny, 1968; W. Herdeg, Graphis Annual 60/61, Zürich, 1960; W. Herdeg, Graphis Annual 61/62, Zürich, 1961; W. Herdeg, Graphis Annual 62/63, Zürich, 1962; W. Herdeg, Graphis Annual 69/70, Zürich, 1969; W. Herdeg, C. Rosner, Graphis Annual 1954/55, Zürich, 1955; W. Herdeg, C. Rosner, Graphis Annual 1957/58, Zürich, 1957; A. Hohenegger, Graphic design, Roma, 1974; M. Horkheimer, T.W. Adorno, Dialektik der Aufklärung. Philosopische Fragmente, Amsterdam, 1947 (tr. it. Dialettica dell'illuminismo, Torino, 1966); F. Hourez, Traité de publicité directe, Bruxelles, 1952; C.I. Hovland e altri, Communications and Persuasion, New Haven, 1953; G. Iliprandi, Linguaggio grafico, Milano, 1964; M. Jacqmain, Il linguaggio della pubblicità, Firenze, 1973; H. Joannis, De l'étude de motivation à la création publicitaire et à la promotion des ventes, Paris, 1965; G. Katona, L'uomo consumatore, Milano, 1964; E. Katz, P. Lazarsfeld, L'influenza personale nelle comunicazioni di massa, Torino, 1968; J. Klanfer, Théorie de l'information et publicité, Revue française de recherche opérationelle, 22, 1962; F.D. Klingender, Art and the Industrial Revolution, 1968 (tr. it. Arte e rivoluzione industriale, Torino, 1972); J. Kobal, D. Robinson, 50 Years of Movie Posters, London, s.d.; G.K. Koenig, L'invecchiamento dell'architettura moderna, Firenze, 1967[2]; G.K. Koenig, La città come sistema di communicazioni, Casabella, 339/34, 1969; J. Kristeva, Semeiotiké. Recherches pour une sémanalyse, Paris, 1969; A.L. Kroeber, The nature of Culture, Chicago, 1952 (tr. it. La natura della cultura, Bologna, 1974); J. Lacan, Écrits, Paris, 1966 (tr. it. Scritti, Torino, 1974); J. Lacan, Télévision, Paris, 1974; G. Lagneau, Vers une sociologie de la publicité, Cahiers de la Publicité, 17, 1967; G. Lagneau, Le fairevaloir. Introduction à la sociologie des phénomènes publicitaires, Paris, 1969; H. Lausberg, Elemente der literarischen Rhetorik, München, 1949 (tr. it. Elementi di retorica, Bologna, 1969); M. Leach, Letter Design in the Graphic Arts, New York, 1960; F.R. Leavis, D. Thompson, Culture and environment, London, 1933; Le Corbusier, L'art décoratif d'aujourd'hui, Paris, 1925 (tr. it. Arte decorativa e design, Bari, 1972); R. Leduc, La publicité, une force au service de l'enterprise, Paris, 1971; R. Leduc, Le pouvoir pubblicitaire, Paris, 1974; J. Lewis Watkins, The 100 greatest advertisements, New York, 1949; M. Livolsi (a cura di), Comunicazioni e cultura di massa, Milano, 1969; Lo Duca, L'affiche, Paris, 1963; B. Lucas, S.H. Britt, La misura dell'efficacia della pubblicità, Milano, 1964; S. Lux,

Arte e industria, Firenze, 1973; K. Linck, L'immagine della città, Padova, 1964; D. McDonald, Against the American Grain, 1962 (tr. it. Controamerica, Milano, 1969); R. Maiocchi, F. Attanasio, Fondamenti by pubblicità, Milano, 1965; T. Maldonado, La speranza progettuale, Torino, 1970; T. Maldonado, Avanguardia e razionalità, Torino, 1974; T. Maldonado, Disegno industriale: un riesame, Milano, 1976; L. Manconi, Manuale di pubblicità, Milano, 1953; C. Mannucci, La società di massa, Milano, 1967; A. Marcolli, Topos, Khora e architettura, Genova, 1969; A. Marcolli, Teoria del campo, Firenze, 1971; H. Marcuse, One-Dimensional Man, Boston, 1964 (tr. it. L'uomo a una dimensione, Torino, 1967); H. Marcuse, Kultur und Gesellschaft, Frankfurt am Main, 1965 (tr. it. Cultura e società, Torino, 1969); E. Mari, Funzione della ricerca estetica, Milano, 1970; G. Marmori, Senso e anagramma, Milano, 1968; P. Martineau, Motivation in Advertising, New York, 1957 (tr. it. Motivazioni e pubblicità, Milano, 1964); P. Max, Poster Book, New York, 1970; S. McIlhany, Art As Design: Design As Art, New York, 1970; M. McLuhan, Understanding Media, New York, 1964 (tr. it. Gli strumenti del comunicare, Milano, 1967); M. McLuhan, Q. Fiore, Il Medium è il Messaggio, Milano, 1968; F. Menna, Inchiesta sull'Industrial Design, Roma, 1962; F. Menna, La regola e il caso, Roma, 1970; P. Michel, Le conditionnement et l'emballage dans la conception du nouveau produit, Paris, 1970; A. Miotto, Psicologia della propaganda, Firenze, 1953; A. Miotto, Prefazione a Pubblicità in Italia 1967-68, Milano, 1968; A. Moles, Théorie de l'information et perception esthétique, Paris, 1958 (tr. it. Teoria dell'informazione e percezione estetica, Roma, 1969); A. Moles, Sociodynamique de la culture, Paris, 1967 (tr. it. Sociodinamica della cultura, Bologna, 1971); A. Moles, Théorie de l'information et sémantique, Cahiers de la Pubblicité, 5, 1963; A. Moles, L'affiche dans la société urbaine, Paris, 1970; E. Morin, L'Esprit du temps, Paris, 1961 (tr. it. L'industria culturale, Bologna, 1962); V. Morin, Érotisme et publicité: un mécanisme d'autocensure, Communications, 9, 1967; B. Munari, Arte come mestiere, Bari, 1966; B. Munari, Design e comunicazione visiva, Bari, 1968; B. Munari, Artista e Designer, Bari, 1971; B. Munari, Fantasia, 1977; C. Munari, Prefazione a Pubblicità in Italia 1964-65, Milano, 1965; R. Musatti, Prefazione a Pubblicità in Italia 1963-64, Milano, 1964; D. Ogilvy, Confessioni di un pubblicitario, Milano, 1965; J. Ortega y Gasset, La rebelión de las masas, Madrid, 1930 (tr. it. La ribellione delle masse, Bologna, 1962); V. Packard, The hidden persuaders, New York (tr. it. I persuasori occulti, Torino, 1958); G. Pampaloni, Prefazione a Pubblicità in Italia 1960-61, Milano, 1961; V. Papanek, Design for the Real World, 1970 (tr. it. Progettare per il mondo reale, Milano, 1973); C. Perelman, L. Olbrechts-Tyteca, Traité de l'argumentation. La nouvelle rhétorique, Paris, 1958 (tr. it. Trattato dell'argomentazione. La nuova retorica, Torino, 1966); G. Peninou, Analyse sémiotique du manifeste publicitaire: anatomie des messages, Publicis, Bulletin des recherches, 5, 1968; G. Peninou, Physique et métaphysique de l'image pubblicitaire, Communications, 15, 1970; G. Peninou, Intelligence de la publicité. Étude sémiotique, Paris, 1972; A. Pellegrini, Analisi psicologica della pubblicità, Archivio Italiano di Psicologia, XIV, 1937; L. Pignotti, Fra parola e immagine, Padova, 1972; L. Pignotti, Il supernulla. Ideologia e linguaggio della pubblicità, Rimini-Firenze, 1974; A. Pillet, Les grandes marques, Paris, 1962; G. Ponti, Il disegno industriale, Milano, 1958; A.C. Quintavalle, Parola-Immagine. Manifesti dal Museum of Modern Art New York, Parma, 1971; A.C. Quintavalle e altri, Nero a strisce. La reazione a fumetti, Parma, 1971; A.C. Quintavalle e altri, La bella addormentata.

Morfologia e struttura del settimanale italiano, Parma, 1972; A.C. Quintavalle, Analisi critica, in Max Gallo, I manifesti nella storia e nel costume, Milano, 1972; A.C. Quintavalle e altri, La tana del lupo. Mostra critica del giocattolo/massa, Parma, 1973; A.C. Quintavalle, La figura e il ruolo, Libri Nuovi Einaudi, luglio 1973; A.C. Quintavalle, Il critico e i "media," Iterarte, 1, 1974; A.C. Quintavalle, Se il settimanale muore, Ulisse, XIII, fasc. LXXX, settembre 1974; A. C. Quintavalle, La morte di Sigfrido, in G. Vittori (a cura di), C'era una volta il Duce. Il regime in cartolina, Roma, 1975; A.C. Quintavalle, Via il regime della forchetta, Roma, 1976; A.C. Quintavalle, L. Allegri, Il manifesto politico italiano: 1972, Milano, 1974; C.L. Ragghianti Prefazione a Pubblicità in Italia 1962-63, Milano, 1963; G. Ragone, Modelli by consumo e struttura sociale, Napoli, 1968; G. Ragone (a cura di), Sociologia dei fenomeni di moda, Milano, 1976; R. Reeves, Le réalisme en publicité, Paris, 1963; R. Reeves, La communication, Paris, 1971; F. Richardeau, La lisibilité, langage, typographie, signes . . . lecture, Paris, 1969; D. Riesman, The Lonely Crowd. A Study of the Changing American Character, New Haven, 1950 (tr. it. La folla solitaria, Bologna, 1956); L. Rodwin (a cura di), La metropoli del futuro, Padova, 1964; E.N. Rogers, Editoriali di architettura, Torino, 1968; J. Rennert (a cura di), The Poster Art of Tomi Ungerer, New York, 1971; G. Romanelli, Lingua e "parole" nel messaggio pubblicitario urbano, La Biennale by Venezia, 66, 1970; G. Romanelli, Città-pubblicità: sul caso Las Vegas, Op. cit., 25, 1972; F. Rossi-Landi, Il linguaggio come lavoro e come mercato, Milano, 1968; F. Rossi-Landi, Semiotica e ideologia, Milano, 1972; J. Ruesch, K. Weldon, Non-Verbal Communication, Berkeley, 1956; F. Sabatini, Il messaggio pubblicitario da slogan a prosa-poesia, Il Ponte, agosto 1968; C.H. Sandage, V. Fryburger, Advertising, theory and pratics, Homewood, 1958; W. Schramm, The Process and Effects of Mass Communication, Urbana, 1954; P. Schuwer, Histoire de la publicité, Lousanne, 1965; Ph. Sollers, Sur le Matérialisme, Paris, 1973 (tr. it. Sul materialismo, Milano, 1973); C. Soucy, Un art de vivre unique au monde. Mythologie et réalité dans la publicité immobilière, Communications, 10, 1967; P. Spadolini, Progettazione artistica per l'industria, Firenze, 1960; P. Spadolini, Design e società, Firenze, 1969; L. Spitzer, American advertising explained as popular art, in A method of interpreting literature, Northampton, 1949; J. Sternberg, Kitsch, Paris, 1971; J. Sternberg, P. Chapelot, Les charmes de la publicité, Paris, 1971; J. Sutton, Signes in action, London-New York, 1965; W. Taplin, Advertising, London, 1960 (tr. it. La pubblicità, Milano, 1961); E. Tarroni, Pubblicità e psicologia, Siprauno, giugno 1962; P. Tedeschi, Disegno Industriale, Bologna, 1965; S. Tintori, Cultura del design, Milano, 1964; D. Toscan du Plantier, Donnez-nous notre quotidien, Paris, 1974; G. Toti, Il tempo libero, Roma, 1961; E.S. Turner, The shocking history of advertising, London, 1952; D. Victoroff, Psychologie de la publicité, Paris, 1970; M. Vidal, Introduction au control de la publicité, Paris, 1960; M. Vidal, Publicité et gestion, Paris, 1971; E. Vallini, Pubblicità e communicazione di massa, Milano, 1963; C. Vielfaure, Une monographie publicitaire: Nicolas, Communications et Langages, 6, 1970; C. Vielfaure, Spectographie de la publicité directe, Communications, 17, 1971; C. Vielfaure, La publicité du refus, Communications et Langages, 24 1974; C. Vielfaure (a cura di), La publicité de A à Z, Paris, 1973; D. Villani, Confessioni di un "persuasore," Milano, 1972; L. Vinca Masini, Prefazione a Pubblicità in Italia 1966-67, Milano, 1967; F. Viscidi, Pubblicità tra informazione e persuasione, CM, 1, 1971; S. Vitale, Consumismo e societá contemporanea, Firenze, 1975; H.M. Wingler, Das Bauhaus, Bramsche, 1962 (tr. it. Bauhaus, Milano, 1972); L. Wolff, Idéologie et production: le design, Paris, 1972 (tr. it. L'estetica del profitto, Rimini-Firenze, 1974); C.R. Wright, La comunicazione di massa, Roma, 1965; G. Yanker, Prop art. Over 1.000 contemporary political posters, London, 1972; M. Zanuso, R. Piano, R. Lucci, Elementi di tecnologia dei materiali come introduzione allo studio del design, Milano, 1967; B. Zevi, Michelangelo illuminato al neon. Architettura e pubblicità, L'Espresso, 16-8-1970; J. Zurfluh, Pour une psychanalyse de la publicité, Cahiers de la Publicité, 15, 1965.

CARLO ARTURO QUINTAVALLE

KITSCH

Definitions. – Kitsch is a social process of the expansion of the aesthetic activity into the society of mass-consumption which leads to a devaluation of art works by a multiplication of their copies, thus creating secondary forms of art, lacking authenticity but nevertheless satisfying a basic human need.

Kitsch is a Bavarian term which made its first appearance in Munich around 1860. At that time it signified a transformation of the old into the new, and touch-up and copying work which was mainly applied to furniture fabrication. Gradually it spread within the artistic environment as an adjective with a negative connotation, and towards 1920-1940 it became a commonly-used word in German critical writing. "Kitsch" is a cheap copy realized with second quality materials, an arrangement of a piece of classical music written to satisfy the taste of a greater number of people, as well as cheap printed literature, reproduced in thousands of copies, based on stereotyped characters and situations that offer an easy distraction without requiring any efforts of comprehension on the part of the reader.

The term "Kitsch" has equivalents in many languages; the meaning of "quétaine" in French-Canadian and that of "camp" in English are quite close to the idea of Kitsch, although they have other distinct connotations.

It has been clear for several years that the Kitsch phenomenon, made known by the many German critics, is linked to a sort of aesthetic pathology of the mass-consumption society, which seeks, through the market place, to satisfy the aesthetic needs of the greatest number of people at a minimum cost by means of the multiple copy, one of the essential characteristics that technology has given to our culture. Within this category are the "souvenirs" from religious pilgrimages. Usually made of plastic, and made attractive by the use of bright colors, they are sold everywhere at an accessible price, and are typical examples of the mass-production of an original work of art. The praying hands by Dürer, evoking mercy and made out of frosted glass, the shape of the Venetian gondola recalling Casanova, the 1920s covers of the Domenica del Corriere, the picture-story that summarily schematizes a story from Dostoevskij or the Bible displayed in an illustrated magazine, represent further examples common to our daily life. These artistic aspects of mass-society have acquired such a practical and quantitative significance that one could consider them as elements in the satisfaction of the artistic need of the average man, the "little man" considered by Eick as the measure of all things.

In an extreme way, Kitsch could be defined by transcribing the well-known commercial formula "higher quality is more expensive" into: "for a little less money, although perhaps less beautiful, but not ugly, it is nonetheless acceptable." It is thus within everybody's reach.

Kitsch and social aesthetics. – Is there such a thing as cheap art? This is the aesthetic question that poses the problem of Kitsch, at least if "cheap" is understood not only in the economic sense, but in a broader sense, accepted by psychologists, of the motivations implying the idea of a "generalized cost" from the aesthetic act, cost for which the individual accepts, in his own sensitivity, an external perception or an action. It is the price of a cultural effort of a material and temporal expenditure, of a will, of a minimal commitment that, taken together, constitutes the cost of access to art, which is considerably higher than the monetary cost. One is inclined to reply that art is valid only if sanctioned by an intellectual, sensorial or temporal effort that represents its perception.

Considered from this point of view, Kitsch appears as anti-art, since it negates the essential character of the work of art, the effort, the desire for originality on which its transcendence is based. It is then clear that the Kitsch phenomenon appears more as an "attitude of the spirit" than a group of works or a style common to all of them. There is Kitsch for everything, for all works and human actions, like a cheap substitute of the original. Kitsch, like art, is not a thing, but an attitude of man towards things. Certainly both art and Kitsch translate and become concrete in pieces of work, but they go beyond and merge all these works into "attitudes;" such as being compared with other things. The sunset over a sea shining with a thousand reflections can be a moment of great aesthetic thrill. The reproduction of this sunset by a skillful photographer (not involved in the procedure) on a thousand illustrated postcards, seen by who knows how many people, provokes an extension of the card's proposed perception, together with their devaluation; the aesthetic thrill melts away as it loses its preciousness, strength, importance and value.

Although the term Kitsch was conceived by a group of manufacturers of "stylized" furniture, it has spread to every field of human activity. There is a Kitsch of horror movies, a Kitsch of heroic deeds, a Kitsch of touristic emotion, a Kitsch of the pastry store as well as a Kitsch of literature.

If Kitsch were to be considered universal, it would depend on the conditions of perception or the action to which this perception is linked; Kitsch is never pure and, "if there is a drop of Kitsch in all art, there is a drop of art in all Kitsch" (Broch). Every art spawns its own Kitsch as soon as it becomes defined, thanks to its vulgarizers and diffusors. Every style of the past implies a neostyle. Kitsch is more a qualifying element than something having its own existence. Every transcendence has its own Kitsch; this tendency is inherent to the mass-society, to which it poses the problem of its acceptance. It is therefore hard to delineate the borders of the Kitsch universe since it parallels the artistic universe; "Kitsch is as permanent as sin, it is the devil of art" (Eggenter).

Nevertheless, recognizing Kitsch's importance in the sociology of art, and given that from now on, the art is determined and ruled by the infinite copy, and music is inseparable from the record like painting is inseparable from the imaginary museum and literature from "rewriting," it is possible and useful to define certain factors of the Kitsch process that, without exhausting its diversity, almost always appear as the most complete expression of the social degradation of what had been accepted as authentic.

The characteristics of Kitsch. – In order to illustrate the universality of Kitsch we propose a number of characteristic examples, each one linked to a definite artistic form or style.

One of the characteristics of Kitsch is associated with the bourgeois attitude of world conquest through commerce, acquisition and ostentation. The triumphant bourgeois at the end of the 19th century is characterized by the acquisition of property; it is, so to speak, coextensive to its possessions; the inclination to accumulate is one of the most constant components of the bourgeoise Kitsch. It greatly profits from the arts, which in turn speculated in its own way on profusion and abundance like the rococo style, from which Louis of Bavaria derived the aesthetic inspiration that made him the king of Kitsch. But the aesthetic philosophical problem persists: can the king of Kitsch be identified himself as Kitsch, or is it the excess that constitutes his transcendence?

Also characteristic of Kitsch is the complex play of mediocrity with excess or, more precisely, the excess within mediocrity, of the disproportion between the means and the end. The shoe maker's whimsical display in the store window of the world's largest shoe, measuring 1 1/2 meters, is the expression of this excess in the mediocrity of objectives, but certainly it would be difficult to distinctly separate the excess of a Gaudi (Sagrada Familia) from the redundant tendence of a Spanish Kitsch.

The accumulation of opulence (of form or of material), that an Oriental potentate would introduce into his furniture, the redundant decoration of a bed with ivory houri set in silver, also expresses this excess or this deficiency between the means and the end. The deliberate and total rejection of functionality, a bed too high to climb onto, a plate too decorated to be washed, a chandelier too fragile to withstand the candle flame, perfectly illustrates this tendency and the spread of Kitsch in both applied arts and in decoration.

Synaesthesia also constitutes one of the main elements of Kitsch in art. The tendency of the theater to stage the "Total Show," which lays eyes and ears, comprehension and sensation, color and shape, sets and actors, music and poetry and, if possible, also the nose, mouth, and the tactile sense in order to accentuate its omnipresence, represents another example of Kitsch. The spectacular comic opera, with its inconsistencies, its papier-maché sets and its bel canto, contains more than a trace of Kitsch.

Even within a sphere of a defined art like music, the simultaneous use of a vast range of procedures, discovered by great composers to make a musical work more popular and hypersensualize it, is an expression of these same tendencies. The accumulation within the same orchestral interpretation, of the repetitiveness of a linear theme with variations, like that in the fugue by Bach or in Ravel's Bolero, greatly amplified by a giant orchestra (101 violins in a string orchestra), the adding

of strong rythmic forms to an orchestra based mainly on percussion and voice, as illustrated by Stravinskij and Orff, the use of amplified plucking with an intense artificial reverberation as mastered by the sound technicians of the radio programs and the arrangers of popular music, can lead, from a straightforward symphony by Mozart, to a sensual prodigality, making it perfectly suitable as a "hit" in any juke-box.

The combination of materials, the deliberate change of the original material, usually for reasons of price, such as the substitution of silver with silver-plated copper, of stone with concrete, of wood with cement (the imitation "rocailles" or the imitation branches in public gardens), of ivory with plastic, of diamond with zircon, and of zircon with rhinestones, is one of the most constant tendencies of contemporary Kitsch.

Brief history of Kitsch. – Kitsch, being a universal attitude of the spirit, is thus not only permanent and indelible, but eternal; it is one of the great trends of the universal aesthetic attitude, correlated with the tendency to accumulate and the spread of Lebensraum. Obviously, every great artistic age is followed by an aftermath of Kitsch, and one should look for an "ante-litteram" Kitsch in the markets of the declining Roman Empire that collected the sun-dials brought back as booty by the legionnaries, and the Greek vases and black amulets, and re-worked them in artisan series, in the low-lying parts of Rome. Kitsch is linked to the same mechanisms of the spirit in both the citizen of the Roman Empire and in the bourgeois person of the 19th century.

Undoubtedly, there is a late Gothic Kitsch, dating to the end of the Renaissance and the late Mannerism, whose relations with rococo (see, for example, the analysis of the "trompe d'oeil") have not yet been clearly established. Only recently has a social-aesthetic analysis been started that deals with this. The concept, however, is significant and merits further development only when it assumes a sufficient quantitative importance to create an explicit mental category.

In fact, lacking a deeper analysis, it is possible to date the history of Kitsch to the beginning of Romanticism and to the inception of "manufacturing" in a series production (initially it was manual, employing artisans, later it became mechanical) for the department stores, the new temples of the bourgeois society. A perusal of the pages dedicated to interior decoration, furniture and "works of art" in the turn of the century catalogues of *Sears, Roebuck, Bon Marché, Karstadt* and *Rinascente*, would strikingly demonstrate this process. The great era of Kitsch coincides with the triumphant expansion of the bourgeois society; Kitsch is the art sold "Au Bonheur des Dames" (Zola) which later coincided with contemporary movements, sometime springing up in reaction to it. If the "Angelus" by Millet was considered a work of art (and still is for some connoisseurs or professionals in the sense of its authenticity and unique emotion) it has become, through its reproduction in the Postal Calendars, chromolithography and girls' embroideries, one of the mainstays of the Kitsch attitude of the European provincials.

In keeping with the spirit of the era, the Kitsch at the end of the century displays a redundant and floral style, with a tendency toward extreme decoration deriving from the basic factors mentioned above. It is diffi-cult to refrain from applying the "Kitsch" label to the profusion of Dolma Bahce in Istambul in 1900 (Palace of the Ottoman Empire), to the extravagance of the Bavarian Jugendstil and to the acrostics of the "nouille" style of Guimard. The history of Kitsch from 1860 to 1915 zigzags across the artistic movements of that period, always latching on to an idea of "neo-something," having specific qualities of excess, exaggeration, disproportion, pseudo-functionalism and mania. As a reaction against the bourgeois establishment and its Henry II furniture, its castles renovated by Viollet-le-Duc and the languid romanticism of the Viennese waltzes, Van Gogh, Cézanne, and Rouault created Impressionism: dynamic designs and vibrant contours in contrast to the affected painting of the Medusa Shipwreck; Kubin, Münch and the Blue Knight created Expressionism in Central Europe (conflicting with the Bidermeier style), while in Weimar the Bauhaus was founded through a theoretical research of functional authenticity.

This was a revolt of the children against the fathers, of the artists in the suburban meeting places against the salons where on Friday afternoons the lady hosts guests, offering tea in pseudo-Chinese cups, with saucers, napkins, trays and a table cloth on a little table; a revolt against the silverware for fish and tongs for sugar, the red fish and the electric gas lamp, was staged by the functionalists who abhorred decoration.

The "great age of Kitsch" ended in the West with the movements of dislodgement and aesthetic mystical exaltation, which, under the generic name of Bauhaus, dominated first Central Europe and later the rest of the world. Kitsch became aware of its guilt, while the bourgeoisie became apologetic. Obviously they had imposed an art of living, a complicated and strict model of life based on a variety of models born from the loins of aristocrats from Victorian customs and from the colonial conquests, through numerous required practices propagated by manuals on how to live, cheap novels, department stores and advertising. Every citizen, at every level of the social pyramid, builds a decalogue of these imposed practices corresponding to his particular resources.

In the period between the two wars, while the Western Kitsch was spreading throughout the United States and colonizing Brazil, Patagonia, and Siberia, at home it was losing ground. Kitsch was repenting: it was being progressively liquidated, filling up trash cans and junk stores. This trend was not exempt from the ambiguity on the part of those who relegated to the attic or the dump the Empire style tables heaped with Gallé vases. Some of the new mechanisms of social massification were the poster, the radio, film and systems of distribution. Starting with Woolworth, Prisunic, Kaufhaus and Standa, these systems supplied the chain stores with objects "bearing the shape," objects that were adapted to the public taste using certain principles of functional sobriety that were mysteriously inspired by the Bauhaus mistique through its offshoots. This influence was evident in the United States and England, but less so in France and Italy, where the true influence of the Bauhaus of Weimar, Dessan and Berlin erupted 30 years after its disappearance.

The rise of neo-Kitsch. – Cultural norms thus were overturned. Wealth, expansion, profusion, synaesthesia and ostentation were considered the dominant

elements or models to follow for the man of the 1900s (according to his means). This was replaced by another mode and accepted by the leaders of behavior: the model of soberty, of nudity, of the flat and ascetic surface, of functionality. The object was made to be useful and from its function derives its beauty: "beauty is a premium" (Gropius). The impressionist art in the West and the expressionist art in the East became the real "work of art," all the rest was nothing but passivity, weakness or conservatism. The Kitsch attitude became manifest in the Evil aesthetic portrayed by the door-keepers who subjected people to their cries: "Archer, beautiful plaster of Paris imitation of polished bronze, by such and such a person, limited series, reasonable price." In this way, the first dominant current became complicated. This happened only because mass-society is a society of well-being; the right to well-being implies everyone's right to beauty (beauty within everyone's reach), to the aesthetic pleasure whose rules are established by the consumer and not by the creator. It was the expression of socialist realism of the Zdanov Circular; it was the art of Upim and the design of the Galeries Lafayette which applied pressure to the essential creative ascetism of a Bauhaus, intended to satisfy man's needs, but did not want to render these needs, since the promotion of a consumer society implied an unlimited manufacturing fabrication, unless it also created the needs to be satisfied.

This mechanism began due to the influences of the department store chains, the invention of new synthetic materials, mass-production, generalized tourism and the concentration of the large cities; it is consistent with the main mechanisms of society. The department stores chains, with their limited and normalizing assortment, their furniture made in a factory and not by an artisan, their home furnishings and parade illuminations, their appeal to the social masses and access on the sidewalk, begun to recruit designers to realize expressions accessible to everyone, thus playing a didactic, vulgarizing and Kitsch role. They shifted the useless from the level of the object to the level of the function to create the "gadget," an expression of pseudo-functionality claiming to be useful although actually superfluous and redundant. In the field of furnishings, small everyday objects such as cuckoo clocks, office lamps, big clocks and paper weights, pen holders and ashtrays were becoming more and more widespread, expressing the level of the dominant social class, that which had been expressed by the department stores at the bourgeois level fifty years earlier. Their designers had no scruples when it came to creating what can be called neo-Kitsch; that is, the intake or grabbing a hold of a certain number of principles proposed by the functionalist school expressed by the Bauhaus, and later, after 1950, by the Hochschule für Gestaltung. They introduced flat surfaces, dull black colors, rounded corners, and brilliant and sober contrivances, into disposable lighters or washing machines sold by thousands that gave the consumer the illusion of making his contribution to the aesthetic morality of the time.

This subject is frequently associated with the Kitsch exaggeration of the American Western culture, in which the luxury of the means and materials used in the manufacturing of a "neo-antique" or in the "reconstruction" of a past "classic work" (the New York "cloisters," Paul Getty's Papyrus Villa [tr.] in Malibu)

exceeds the original work and the idea of a "low price" inherent in the original economic motivations of Kitsch. The absence, in a country like the United States and, more specifically, in the Western states, like California, of the historical sources of antique forms produces, given the availability of the material means, an enhanced copy embellished by the richness of the materials. Thus, Kitsch becomes an apparent state of mind, a component of aesthetic sensitivity and a source of national conscience in the stylistic melting pot of New England, of the Spanish-American palaces of Mexico, or in the prefabricated reconstruction of Port of Call in the Pacific Islands.

A neo-Kitsch style paves the way for the anti-ascetic pressure of a consumer society in which the idea of the extension of Lebernsraum to everyday functions replaces, in the limited sphere of the great complexes, the idea of coexistence of the bourgeoisie with its possessions, although introducing the same psychological factor.

Several Kitsch phenomena: a) *Tourism* - The above-mentioned phenomenon appears in other fields, accentuated by specific mechanisms such as tourism, which is gradually transforming all the cultural, religious, and historical places into a series of programs or "tours" which became merchandise sold and made available to everyone. The invasion by the pilgrims of culture or religion of once sacred locations implies the same devaluating mechanism already pointed out, regarding works of art. In the extreme case are the artificial tourist centers such as Disneyland, and the prehistoric Kitsch has risen to satisfy a thirst for "culture" that is confused with a thirst for "beauty" at every level of the cultural pyramid.

b) *Souvenirs* - The souvenir market has led to the growth of the industry. The idea of "souvenir" imported apparently from the early romanticism in the cultural life of society, has become generalized; if the stones of the Acropolis are limited in number, it is necessary to manufacture them. This process generates a series of products and a huge industry having its own international trade fairs, politics, experts and technicians. This industry is characterized by its diversity in its uniformity, in its efforts to give pseudo-meaning to each souvenir, resulting in Eiffel Tower thermometers, Paestum Temple vases for sauce, and other important contributions to universal Kitsch.

c) *Religious Kitsch* - Another important critical problem that should be dealt with is that of religious Kitsch. Within a social context, religions appeal to the greatest number of people, to the common man. They are considered to be instilled into one's daily life; the more fragile a society becomes, the more intensely a religion attempts to become an essential part of that society. Thus, some religions avail themselves of all the possible ways to appeal to the individual and to offer him an effort without effort, cult objects in place of cults, a vulgarization rather than a teaching, a justification rather than an obligation.

In this manner, mass religions become Kitsch first in their objects, and later in their attitude. They subtly convey - not always unconsciously - the essential adoration of the sacred to objects, statues, amulets or images that succeed in mysteriously conserving a trace of the sacred that they represent, and this conveyance facilitates the access to the divine for the majority of

people that they intend to keep faithful. Thus, there exists a collusion between religions of a social nature and Kitsch, whence the derivation of a profusion of a bona fide religious Kitsch (a fine example is the St. Suplice style in France at the end of the 19th century) which gradually becomes sought after and collected, as it is swept away from the churches. It is then replaced by a new style that shares the same attitudes of the previous era. In a more subtle way it is replaced by a "search for sobriety," guaranteed by Le Corbusier's aftermath and linked to a "return to the origins," which attributes to the nudity of the Romanesque style an axiomatic value superior to the late Gothic or the rococo splendor. Furthermore, one can imagine a religious neo-Kitsch, that recreates a sacred nakedness based on the neo-Gothic cathedrals in the expanding South American cities. This mechanism, tied to the description and to the material elements of a cult, will manifest itself on very different levels according to the philosophical positions taken by the various religions in relation to the material environment and the sacred fund of cult objects.

d) *Religion as Kitsch* - One can foresee the possibility of religions being based solely on Kitsch; a good example of this is "caodaism," which mixes gods and prophets in a dogmatic syncretism and reconciles the different divergent groups of followers and avoids the conflicts of moderation: Napoleon, Buddha and Confucius all agreed with Auguste Comte on how to attain the peace of the soul along with the mystic impulse, reason and action. Consequently, following religious Kitsch, the Kitsch religion is outlined and this problem, linked to the conflict between a slightly demagogic desire to appeal to the people and the inclination toward mystical exaltation that is found outside of everyday life and poses a fundamental dilemma to the teologicians who are aware of the clash between the religious and the social relationships.

e) *Scientific Kitsch* - Every field within the realm of human activity is subject to Kitsch, at whatever stage of its development. Although we are only at the beginning of its exploration, the scientific field, starting from its tendency toward bourgeois ways, suggests a Kitsch of science based on the deficiency between the end goal and the means, on the accumulation of technological procedure, on the refinement of useless precision (Sorokin's Quantofrenia). These are all made evident by the criticisms of numerous great scientific minds dealing with the development of contemporary science.

The expression "Kitsch of reason" is an appropriate term used to express the worship or awe of people for what has been "scientifically proven," in a form of reverence that is exactly the opposite of reason. Will the religion of science, served by a widely-circulated vulgarization, make up the framework of the scientific community? The easiest way to sell a facial cream is to announce its support from the work of a dozen researchers on 100,000 rabbits, validated, if necessary, by a lawyer. The consumer judges that the quality of the cream must somehow be related to the number of rabbits, the same way that a consumer is impressed by the learned phraseology of a scientific authority on the label of a bottle of mineral water; this represents the contribution of scientific Kitsch to the universe of consumers.

This universalization of a person's attitude, compared to an environment in which the term Kitsch starts to be accepted in the language, suggests that it is possible to recognize a kind of totalitarianism of everyday life, which imposes its rules on every object, while imposing its wide-reaching manner on everyone. There is an aspect of Kitsch in every man: no one can claim to be sheltered from this socio-aesthetic disease.

Anti-Kitsch – The student of logic might then ask if certain beings, phenomena or situations exist that are totally outside of this universal tendency.

We will examine some extreme cases, starting with an officer carrying out orders for a security mission on a nuclear submarine. The sum of the constrictions, regulations and tensions governing his role - as an element of carefully designed strategy - remove from his mind any aesthetic consideration that would otherwise distract him from his crucial activity, eliminating the accessibility of Kitsch in the rare moments of private life that do not fit into the definition of his existence.

In a parallel manner, Kitsch's recovery of the craftsmen, who had been recruited almost exclusively by the industrial society, is contrasted with the Indian who makes shoes in his primitive village, and being below the zero degree in art, without any concern for or against art, carries out his social role with an attitude so totally identified with a function, so indissoluble that it does not come to the surface as conscious expression. This is similar to the formula adopted by the Bauhaus "beauty is a premium." Beauty in this case is accidental or residual to the carrying out of a function, consciously perceived only from the outside by the ethnologist or by an artist passing through the area, whose intervention introduces the categories of Art and anti-Art: the beauty of the Chianti flask and the Kitsch of the plastic basket.

If any anti-Kitsch attitude exists in a nonetheless proper aesthetic universe, it would be the attitude of the surrealist, who, through his autonomous research governed by precise ethics, will be aware of the Kitsch elements in a show, situation or group of objects, in order to reorganize them through his thought. In a proper creative impulse he will be able to place a Mexican skull of pink sugar on a black piece of paper in a creative and subtle operation that is diametrically opposite to the Kitsch ideal.

Another example worth mentioning is the determined, circumspect and passionate research of the aesthetics scholar or of the antiquary who scours the countryside seeking "other people's Kitsch," the beautiful Kitsch object to collect or to promote. He begins with considerations or from studied values, which he does not share, and closeness to the phenomenon immunizes against the attacks.

Kitsch and the artistic movements. – The position of Kitsch is contradictory in its relation to the contemporary aesthetic movements.

On the one hand, Kitsch is basically a vulgarizer and diffusor: by diminishing transcendence, it increases accessibility; the Hymn to Joy is easier to learn in a version for guitar interpreted in English by a Spanish singer with all resources of the microphonic art, in the same way in which the artifices of composers of bona fide music are perfectly exploited independently from their music. Kitsch will vulgarize Xenakis and Pierre Henry through the subtle work of the arranger, in the same way that chrome or the manufacturers of printed fabrics will vulgarize geometric art.

Art, or what the cultural ministries intend with this term, now becomes available to everyone, realizing one of the main objectives put forth by certain cultural policies.

On the other hand, however, pop art will use a Coke bottle, the American flag, the comic or the design on food cans for an inspiration associated with a "parenthesizing" of their senses, in order to bring them, in an ironic way, the artistic micro-environment, framing the elements worthy of noting and proposing this exercise as an activity that has aesthetic value by itself, a new form of attention on the surrounding world as industry builds it. Surrealism, largely exploited by the poster in its basic artistic techniques, serves to construct still-lives, following the same techniques of Dali, properly placed within everyone's reach.

Thus, Kitsch and artistic movements are necessarily in symbiosis, with art supplying the source to feed the universal Kitsch, and in turn expecting the destruction of its transcendence, its very essence. An artistic cycle imposes itself as one of the fundamental mechanisms of contemporary society.

One of the basic mechanisms of the contemporary society of micro-environments is imposed on the relations between important art movements: on the one hand, surrealism, pop art and poor art, which use Kitsch as an "object to look at," frame it and emphasize it by directing the attention of the cultural micro-environment on this object as worthy of being seen. They thus prepare the inevitable diffusion of art, its degradation through vulgarization. At the extreme, one might wonder if the Coke pin-up belongs to the daily world of Kitsch or to a partial rehabilitation, as a reflex, of pop art into poor art. On the other hand, Kitsch will lay hold of Magritte and Salvador Dali's surrealism through the publicity channels to sell hand cream or mineral water, producing a harmless vulgarization and thus immunizing society against the explosive force of the diluted surrealism of paintings and Kitsch posters. Through its diminution of transcendence, its dissolution of effort, its vulgarization and reducing action, Kitsch prevails over all the sectors of art in society. The hut that shelters the heart shelters the poster-calendar; happiness in an everyday thing, and Kitsch is the art of happiness.

If Kitsch appears to be on trial - a trial attended by artists, art critics or sociologists of alienation - it is necessary to mention that preparing this case for trial is as easy and entertaining as it is sociologically important to defend the accused. Keep in mind what we have seen above - that Kitsch is a social product; that it is didactic that at the level of masses the road to good taste first passes through the purging of bad taste; that Kitsch is the form of art idealized and respected spontaneously by children; that an artistic education actually involves the progressive distancing from Kitsch art forms, from affected painting and from photographic exactness for the benefit of the imposition and projection of values on the world. Good taste is nothing but the limit of bad taste.

Kitsch is the art of happiness, and thus an anti-art because happiness has no tension or effort; it offers one of the broadest answers to the problem of social art, which up to now has caused the nonfulfillment of the best minds of social humanism.

Could it be that Kitsch is an example of totalitarism without violence, against which the only remedies are ascetism and creativity, which, in the social pyramid, are accessible only to the few?

BIBLIOGRAPHY - R. Hoggart, The uses of literacy, London, 1958; M. Rheims, Vie étrange des objects, Paris, 1959; W. Killy, Deutscher Kitsch, Göttingen, 1962; R. Eggenter, Kitsch und Christenleben, Arena-Taschenbuch, 1962; H.L. Zankl, Kunst Kitsch und Werbewirkung, Düsseldorf, 1966; G. Dorfles, Il Kitsch, Milano, 1968; A. Moles, Teoria dell'informazione e percezione estetica, Roma, 1969; P. Vogt, Was Sie liebten, Köln, 1969; Bertelsmann Lexicon Verlag, Kitsch-Lexicon von A bis Z, Gütersloh, 1970; A. Moles, Psychologie du Kitsch. L'art du Bonheur, Mame, 1971; L. Giesz, Phänomenologie des Kitsches, München, 1971; A. Moles, Sociodinamica della cultura, Guaraldi, 1971; N. Pevsner, Richards, The anti-rationalists, Harper and Row, 1973; Ch. Jencks, N. Silver, Adhocism, Anchor Books, 1973; W. Bruckner, Elfenreigen Hochzeitstraum, Köln, 1974; C.F. Brown, Star-Spangled Kitsch, New York, 1975; A. Celebanovic, Some call it Kitsch: Masterpieces of bourgeois realism, Abrams, 1975.

ABRÁHAM A. MOLES

NEW METHODOLOGIES AND CRITICAL ISSUES

AESTHETICS AND THEORIES OF ART

Introduction. – The secularization of art disputes the notion of art as ritual and cult, and its supposed magic-religious basis. However, as Benjamin points out, the absence of ritualism is compensated by the authenticity and non-reproducibility of the work. Only in the age of technical reproducibility does art become liberated from "its parasitic existence in the sphere of the ritual." The work of art becomes, more and more, the "reproduction of a work of art predisposed to reproducibility." With the abandonment of authenticity and non-reproducibility the very function of art changes radically: "its foundation in the ritual is replaced by its foundation on politics" (W. Benjamin, "L'opera d'arte nell'epoca della sua riproducibilità tecnica," Ital. transl., Torino, 1966).

This is not the place to analyze the current meaning of the hypothesis of art as "reproduction of a work of art predisposed to reproducibility," its transformation in mass societies, or the functional changes of the artistic experience. What should be questioned, instead, is the other foundation to which art refers, once the cultural and magic-religious dimensions are removed: its foundation in praxis, and in political and social contexts. Hence art, having abandoned the theological sphere, becomes work, an operation taking place within history in the realm of passion and melancholy.

In a 1934 work "The Author as Producer" (which precedes the essay on the reproducibility of art by two years), Benjamin offers a precise and indisputable key for deciphering the relation between art and politics and for understanding the meaning attributed to the foundation of artistic work in the praxis. "I would like to show them that the orientation of a poem can be politically correct only if the poem is also literally correct. That is, a politically correct orientation also implies a literary orientation. It is this literary orientation, contained implicitly or explicitly in every correct political orientation, that represents the quality of the work. The correct political tendency in a work implies its literary quality, since it implies its literary inclination" (W. Benjamin, "Avanguardia e Rivoluzione," Ital. transl., Torino, 1973).

Setting aside the issue of the political foundation of a work, the role of the writer and the artist, and the myth of "proletarization" (". . . 'the proletarization' of the intellectual almost never produces a proletarian"), it is relevant to point out that after the defeat of the theology of art and of the rituality of the work of art, it was possible to develop a critical theory of art.

Art, by regaining its historical foundation and an association to a level of wordly experience, became a tool for deciphering the discourse, and it came into contact with sciences and epistemology. It became science and epistemology itself, capable of reflecting on its constitution, foundation, its social duties, and historicity.

Psychology, psychoanalysis, sociology, semiotics, anthropology, and information theories are thus the territories that the theory of art, now rid of its rituality, crosses to enter into the space of history, to become a part of the intricate game of conflicts and contradictions.

Psychoanalysis of art . – The author, the work, the consumer, the socio-psychological connections and the linguistic articulation all became the problems that had to be faced and resolved. Starting with the psychoanalysis of art, we will try to demonstrate how this tangle of problems, dating back more than 50 years, has been drastically modified. We will also see how the psychoanalysis of art has been transformed, and how (and why) it has abandoned its traditional investigations of the author, the characters and the consumers, and finally, how it has addressed itself to the structure and the subconscious of the work.

"If . . . Freud reads Hamlet with an orientation to psychoanalyis, Jones instead reads the tragedy starting from an already constituted psychoanalysis" (J. Starobinski, "L'occhio vivente," Ital. Transl., Turin, 1975). This indication is extremely important because, beyond the specific analysis, it leads to more general issues, such as Freud's interest in Oedipus and Hamlet, and the psychoanalysis of art.

The tendency is clear: to refute the hypothesis that Freud practiced applied psychoanalysis (to use a poor expression). Oedipus and Hamlet are figures that mature with the advancement of Freudian reflection on important themes: Oedipus, indeed. Starobinski also states: "Initially Freud formulates the hypothesis: "the Ego is like Oedipus," but this concept is instantly overturned to become a universalized historical truth: "Oedipus was us." In self-analysis the awareness of the self is not possible except as the recognition of the myth, and the myth, thus interiorized, will be interpreted as the dramatization of an impulse. But the most audacious recognition that Freud made exceeds that: Hamlet is still Oedipus, but he is a masked and removed Oedipus, too active in the shadow, so that he who removed him can advance one step further. And here is the last recognition: Hamlet is neurotic and hysteric, and requires my constant care" (Starobinski).

Thus, Freud's interest in Oedipus and Hamlet is not so much linked to the analysis of exemplary texts of Western history or to the crossing of required cultural passages, but rather to the utilization of appropriate materials to organize a psychoanalytic system. Oedipus and Hamlet were present in Freud's conscience from 1897 on into his old age (letter to Fliess dated September 21), as proven by the addition to the "Abriss der

Psychoanalyse" of a 1938 journey where Oedipus and Hamlet, always together, are evaluated differently.

Referring to Starobinski's essay, we wish to point out the effort of the most recent and diligent storiography - a tension that refutes the long accepted idea of Freud as a critic and exegete of poets, painters and writers, such as Sophocles, Shakespeare, Goethe, Leonardo, Jensen, and Dostoevskij.

In this sense Leonardo is a sample of verification. The Freudian literature (1910) was for years an unsurpassed model for the deciphering of the author's subconscious. This cannot be denied, but there is a different question now. Freud in these years attempted to reconstruct Leonardo as a figure internal to the theoretical scheme, having accepted the idea that "it would be a mistake to seek in this study, something referring to painting or, above all, to the origin of Leonardo's talent" (O. Mannoni, "Freud," Ital. transl., Bari, 1970).

Freud's construction, it is now obvious, has collapsed. Mac Lagan ("Leonard in the Consulting Room," "Burlington Magazine," 1923) insisted that it was not a vulture but a modest kite who put its tail-feathers between Leonard's lips when he was born. Shapiro ("Leonard and Freud: an Art-Historical Study," "Journal of the History of Ideas," April 1956), from an iconological position, explains that a bird that visits a newborn is a literary topos that was present in the classical culture and revived in the Renaissance. It signifies only those kissed by glory. Recently, Leclaire ("Psicoanalizzare," Ital. transl., Rome, 1972), using a data from Lacan (Seminario by Santa Anna, 1954-63, unpublished) changed the question on the meaning which should be given to Freud's error: why, then, the vulture and not the kite?

"In German, kite is translated as Weihe or Gabelweihe to emphasize the forked characteristic of the long tail. As Lacan had observed, Freud translated kite with Geier, which in German indicates the vulture, a much larger bird that is also different in the shape of the tail and the length of the neck." According to Lacon-Leclaire "Freud's mistake can be considered as the combined effect, on one side, of the repression of the Weihe series (which means "kite" and also more prevalently "consacration" and "sacred") and on the other, as the effect of the appeal of the Geier series (vulture, eagle, which is close in its sonority to the Geil series, lustful, lewd)." In conclusion: "Eagle, sparrow, vulture or hawk, it seems that the presistent element of this representation is certainly the bird's beak (and perhaps in the dipthong "ai") that, for Freud, always indicated the enigma of desire, in its most trivial sense (vògeln, Geil) as well as its sacred character (Weihe)" (Leclaire).

With the re-assignment of the vulture to the kite, the implied symbology underlying the bird of prey drops away. "In the hierogliphic symbols of the ancient Egyptians, the mother is represented by the figure of a vulture." In fact, the "Egyptians venerated a maternal divinity which was represented by a vulture's head. The name of this goddess was pronounced Mut; could the phonetic affinity with our word 'Mutter' appear casual?", Freud wondered (S. Freud, "Saggi sull'arte, la letteratura e il linguaggio," Ital. transl., Torino, 1969).

Philological and iconological difficulties dissuade us from considering the Freudian text as an art-critique. For this reason we will try to identify in "Leonard" an "outline of the theory of the compulsions that will be fully dealt with in Pulsioni e il loro destino of 1915" (Mannoni).

In "Compulsions and Their Destiny," Freud deals with the theme of compulsions in an articulate way, starting from the very notion of compulsion (radically different from that of instinct). There is no doubt that the distinction, assumed as a simple working hypothesis, between ego-compulsions and sexual pulsions, and the attention to the destiny of compulsions (conversion into the opposite, reflection on the subject, repression, sublimation) represent, in reference to "Leonardo," a further expression of the Freudian theory. Nonetheless, in the "Ricordo d'infanzia di Leonardo da Vinci" we find, already broadly developed, the relation between sexual compulsions and sublimation.

The "desire to know" (the thread running through Leonardo's life) is linked to the period "of infantile sexual exploration;" this "desire" does not arise spontaneously in children, but is stimulated by the birth, real of feared, of a younger brother.

Another obligatory course taken by Freud in his analysis of Leonardo's life is homosexuality and, more generally, Leonardo's difficulty in initiating relationships with women. Freud's insistence on Leonardo's homosexuality is based on scarce biographical information and suspicion. But this is not the point. Considering the flimsy data and references, Freud's intervention on the subject of Leonardo is suspect: the absence of a "transfert" relation has thus conclusively cast a shadow on the question.

Homosexuality, self-eroticism, and double maternity are components of a composite used by Freud to represent his theory. Leonardo was the son of a notary named Pietro and his modest wife Caterina. Mr. Pietro soon after married a lady of his own social class, but did not have any children from her. Leonardo, taken back by his father, had to adapt to his stepmother Lady Albiera, in his new home. His homosexuality (at least latent if not overt) was supposedly prompted by the distance between Leonardo and his father, and by the mother's insistent presence. According to Freud: "it almost seems that the presence of a strong paternal personality would assure the male child of the right decision in on objective choice, that of the opposite sex" (Freud).

Freud goes on to generalize that the absence of the father and the presence of the mother (too doting and attentive) and a very strong erotic tie with the maternal figure, are conditions always underlying "all our male homosexuals." On the other hand, since "the love for the mother cannot play a part in the subsequent conscious development, it is subjected to removal. The boy removes the love for the mother by placing himself in her place, thus identifying himself with the mother and taking his own self as a model, resembling the way in which he chooses his new objects of love. He has become homosexual; actually he has slipped again into self-erotism. . . . "while it would appear that he runs after the boys, in reality he escapes from the other women who could make him unfaithful (Freud).

We now apply the analytical hypothesis to the work: the "Gioconda," "Saint Ann, the Virgin and the Child." The circle is closed. The enigmatic smile of the Gioconda is certainly not the representation of the model's smile: the model only stirs up another much deeper memory in Leonardo: his mother Caterina's

smile; "Saint Ann, the Virgin and the Child" is even interpreted as a synthesis of Leonardo's childhood.

The iconography of this work should be reexamined to help explain this story. In the new house Leonardo meets his stepmother, but also Monna Lucia, his grandmother, who was probably very nice to him (Freud suggests). Caterina, the real mother, Lady Albiera and Lady Lucia are then the origin inspiration of the triad of Saint Ann. "In Leonardo's painting, Mary, leaning forward, is sitting on her mother's knees and holds out her arms towards her son, who is playing with a lamb and mistreating it. The grandmother is the only figure with a visible arm, in a position along her side and looks at them both with a joyous smile. . . . The smile radiating from the lips of the two women, although it is the same smile of Mona Lisa, has lost its uneasy and enigmatic tone; it expresses tenderness and silent bliss" (Freud, cit., p. 124). Freud establishes a strict symmetry between this iconography and Leonardo's family situation. "The maternal figure further away from the child, representing the grandmother, corresponds, both in aspect and spatial relation to the child, to his real mother, Caterina. Under Saint Ann's blissful smile, the artist has hidden and belied the envy felt by his natural mother when she had to surrender to the more nobel rival, first her husband, and later her child" (Freud).

Freud's deciphering of the Gioconda's enigmatic smile and the analysis of the special setting and iconography of "Saint Ann, the Virgin and the Child" did not endure the historical-cultural critique and iconology. Shapiro pointed out that the Leonardian smile goes back to Verrocchio, that the theme of the "double-maternity" does not have much in common with Leonardo's Oedipal scene, since it represents a recurring theme in the history of images at the end of the 15th century. There is no doubt that when Freud tackles the problem of decoding Leonardo's work, he is very schematic and disappointing, inasmuch as the relation he establishes between text and biography is too narrow and symmetric.

If our hypothesis is correct, "A childhood memory of Leonardo da Vinci" must be considered as an analytic document, similar to the "Wolfman" or "President Schreber," and not as an art theory text. The set of analytic notions displayed by Freud is abundant and it occasionally includes outlines of propositions which will be developed at a later point (i.e., the compulsions, the religious issue). Freud knew, however, that it was not a critical text. His insistence that "Leonardo" is only a "psychoanalytic novel" is, thus, not a coincidence.

There is an important point, however, that should be made by using Leonardo as an object of investigation, Freud tried to prove, as already mentioned at the beginning of the essay, that "no one is so great that he would be ashamed to be submitted to the laws regulating, with equal rigour, normal and pathological behavior" (Freud, cit., p. 75). This is probably the deepest meaning of the Freudian interpretation of Leonardo: the insistence on the need for cancelling the ideological distinction between normality and illness. Leonardo was not a neurotic and Freud clearly states so.

It is well known that "A Childhood Memory" represents a good example of the author's psychoanalysis; in fact, the lives of many artists have been modelled on Leonardo's biography. It is known that Freud transformed modes and techniques of the biographical critique. The biographies practiced by Freud not only collect, piece by piece, the data and news concerning the artists and the events, but are involved with gathering the hidden deeds, motives and mechanisms. In short, the biography proposed by Freud is meticulous in gleaning the author's subconscious, or, as in "Gradiva," in identifying the subconscious mechanisms of the characters. It attentively deciphers the dreams and deliriums of Norbert Hanold, the archaeologist obsessed by a bas-relief seen in the Vatican Museum. The subconscious of the author and the characters are the poles along which the Freudian experience proceeds: a lesson that has been taken up and repeated too many times (often too naively and irrationally). Art-neurosis and art-illness are two very terrifying pairs.

It must be said, however, that the Gradiva-model (attention to the characters' subconscious) is less active than the other. The analytic approach in an artist's biography is certainly easier, and is part of everyday work. Ernst Jones (one of Freud's greatest students), approximately in the same period, offers a quite interesting "case," in "The Influence of the Wife in the Art of Andrea del Sarto," "Imago," 1913 (now in "Saggi di psicoanalisi applicata: estetica, sociologia, politica," Ital. transl., Bologna, 1971). The postponement of Freud's investigation of Leonardo's life was obligatory. In fact, Andrea is also the subject of a homosexual case. We should add that Jones' work does not possess the charm and penetration, nor the literary quality of the notable model. The possibility of a theoretic or critical contribution to the field of art must also be immediately excluded in the case of Andrea.

Jones wonders why Andrea del Sarto, "despite his incredible talent in every area of painting," has not reached a predominant position in the culture of the Renaissance period. Are lack of genius and the negative influence of his wife, Lucrezia, the reasons for the artist's "mediocrity?" Jones, obviously, excludes Andrea's artistic make-up and turns to the biography and the wife's influence. He collects some evidence on Andrea's homosexuality: some witnesses declare that before marrying, Andrea did not dislike the company of men. It is also known that Andrea loved to eat (doesn't Ferenczi relate the pleasure of eating with homosexuality?). Vasari defines Andrea as "torn by jelousy," and Jones adds without hesitation: "An obsessive jelousy is, in fact, an almost certain element of such a condition" (Jones, cit. p. 26). So, where does Lucrezia come in? "Andrea's attachment to his wife could partially be interpreted as an escape from his repressed homosexual tendencies. The wife becomes the security blanket to whom he must hang on at all costs. His love for her is so great because she represents for Andrea a defense against himself; but at the same time, Andrea's hatred for Lucrezia is just as extreme, since she prevents him from seeking the company of other men" (Jones). According to Jones the issue was even more complicated by the fact that "his (Andrea's) homosexual masochistic desire found partial satisfaction in the particular temperament of the wife; in other words, he loved her as a woman loves a man" (Jones).

Following the Freudian technique, Jones searches and finds this confirmation by analyzing one of Andrea's works, the "Madonna delle Arpie." This work

can be understood only if considered within the context of the artist's biography. "On the pedestal of the Madonna who represents his masterpiece, . . . appear several harpies, completely out of place in a religious subject. . . . The critics have been misguided by this element. But if my analysis of Andrea's attitude towards his wife is correct, this is not difficult to explain" (Jones). Once again, philology and iconology throw light on Jones' psychoanalytic dazzlement, as snobbishly insinuated by the Wittkowers ("Nati sotto Saturno," Ital. transl., Torino, 1968).

Rudolf and Margot Wittkower did not find it hard to be merciless. "Unfortunately for Jones's thesis, the harpies, clearly portrayed at the Virgin's feet, are not at all out of place in such a subject." The harpies, as well as the mermaids and the sphynxes in similar pose, are rather common in the religious iconography of the time" (Wittkower). To support this claim, Filippino Lippi's "Virgin and Saints" from Prato (1498), and "Saint Sebastian" from Genoa (1503), which present the same theme, are cited. "In the context in which those monsters are set, they can only symbolize the defeat of paganism by the Christian religion; more specifically, the enthroned Virgin elevated above them symbolizes the triumph of purity over sin" (Wittkower). Jones, just like Freud, takes a rhetorical topos as proof of homosexuality. The biography does not help us understand the work, nor, on the other hand, is the work helpful in throwing light on Andrea's life.

It is probable that Jones had a slight suspicion of this sort when re-evaluating Lucrezia's influence on the maturation of Andrea's art; he adds that "as to the development of Andrea's art, we can affirm that Lucrezia plays little more than the role of a fixed character: it is Andrea's character that assigns to her the meaning she presents for him" (Jones). From this standpoint (which has nothing to do with the artistic experience) Jones' analysis can be a good example: the example of a difficult interpersonal relationship, centered around the painful rhythm of love-hate and sado-masochism.

Neither does Abraham's essay on Giovanni Segantini ("Giovanni Segantini. Ein psychoanalytischer Versuch" in "Schriften zur angewandten Seelenkunde," 1911) appear any more significant. One would expect a deeper analysis of the relation art-dream-myth, but it is not to be found here. However, Abraham did conduct a relevant investigation on the dream-myth relation. The approach to Segantini, instead, occurs according to rather ordinary analytical formulas: firstly, the fixation for the maternal figure and the hostility towards the father; the marriage with Beatrice as analogous to the maternal, singular love: thus exaltation of the monogamous tendency. Finally, Segantini's symbolic art forms are given the attribute of isolation and the rejection of reality, a rejection that is linked with the hostility towards the paternal figure.

Jung's analytical psychology. – "If one assumes . . . that analysis also explains the essence of the art work, such an assumption must be categorically rejected since the mystery of creativity is . . . a trascendental problem that psychology cannot solve, but only describe" (cfr. C. G. Jung, "Psicologia e Poesia," in "La Dimensione Psichica," Ital. transl., Torino, 1972). Jung's statement is, actually, a recurrent motif (and concrete) also found in Freud. In the essay on "Dostoevsky and the Parricide" (1927) the warning already appears in the beginning. "We would like to distinguish, in Dostoevsky's rich personality, four aspects: the writer, the neurotic, the moralist and the sinner. . . . Unfortunately, when dealing with the problem of the writer, analysis must lay down its weapons (Freud). Another point is the great interest in the Jungian thought on art: the radical critique of the biographical method. "His (the poet's) biography . . . is always irrelevant from the stand point of art" (Jung).

In an essay written in 1922, Jung outlines his plan in a very clear and concise fashion. Essentially, the criticism of the Freudian biography is directly linked to one of the axes, if not the fundamental axis, of Jung's doctrine. "The exclusive orientation towards the personal factors required by the search for the personal causality is not acceptable for the work of art, since it is not a human being, but a production that goes beyond the individual" (C. G. Jung, "La psicologia analitica nei suoi rapporti con l'arte poetica," in "Il problema dell'inconscio nella psicologia moderna," trad. It., Torino, 1973). Therefore, the criticism of the contents, biographical approach, causality, and 'biologism' (". . . . A psychology whose orientation is exclusively biological, can be reasonably applied to man, but never to the work of art") has its own reasons in the theoretical necessity to skip over the "personal myth" and the individual, in order to draw from the contents of the collective subconscious. It is at this point that the fracture between Freud and Jung occurs.

Having outlined the project, Jung promptly warns that not every artistic production reaches such a goal. But it is obviously these (and these alone) that are the object of his research and commitment. The distinction lies, outside the splendor of the words, between intentional work and symbolic work (also considered deliberately symbolic). It is clear, however, that even the intentionality of the work cannot help but to defer to secret and hidden motives, to a subconscious stratigraphy. But in this case the subsoil is merely a "retroplane:" "In the first case it is an intentional production, accompanied and directed by the conscience that, through reflection, achieves the desired form and effect; in the other case it is quite the contrary: a phenomenon rising from the subconscious nature, forming without the intervention of the human conscience and at times, even rebelling against it, to conquer its own form and effect (C.G. Jung, "La psicologia analitica nei suoi rapporti con l'arte poetica").

Following Jung, I will simply refer to how this distinction brings us back to Schiller, to the naive attitude and to the sentimental attitude. It cannot be casual, however, that Shiller's theme has been considered by Jung as one of the significant moments in the history of the "Psychological types:" ". . . Through the observation of opposed mechanisms, Schiller eventually established the existence of two psychological types, which in essence correspond to the same meaning that I attribute to the introverted and extroverted" (C. G. Jung, cit.; p. 38-44). Within the same sphere of relationships, we could mention the Jungian ambivalence (also found in Freud) between classicism and Romanticism. This ambivalence is evidenced by the difference between intentional work and symbolic work, to such an extent that to the intentional work of conscience (guided and organized by clarity, however sterile) Jung entrusts the brightness of the "laws," the "beautiful

form of style" and even the "armonious vision of perfection (C. G. Jung, "La psicologia analitica"

It has been said that the idea of the symbolic work is located along the Jungian fracture. "We modern people are bound to relive the spirit, that is, to live the primordial experience. This is the only possibility with which we may break the magical circle of biological laws (C. G. Jung, "Freud e la psicoanalisi," Ital. transl., Torino, 1973). Jung, indicated these biological laws (representing, as we know, the extreme working of the Freudian theory) that, without a reason, cannot aim at becoming the unifying principle of the work of art. Consequently, the path is laid out: it is a path leading to the encounter with one's own Shadow. This encounter is a necessary encounter because the Shadow can open one up to the "world of water, in which every form of life is suspended, where the realm of the "sympathetic" starts, the soul of everything that lives, where I am inseparable from this and that, where I experience the other in myself and where the other experiences me as an Ego" (C. G. Jung, "Gli archetipi dell'inconscio collettivo" in "La dimensione psichica"). The Shadow, one's own source and the world of water are suggestive images (platonic-mystical) that allude to (rather than designate) the collective subconscious. This is an extremely problematic and controversial theory, however ambiguous and suggestive, that admittedly, is an attempt to interpret the foundation of our being.

The geography of possible citations will prove the difficult nature of the collective subconscious theory. "The collective subconscious does not even exist in itself, as it is nothing more than a possibility." But it is a possibility "that we inherited since the remote ages in determined forms of mnemonic images or, from an anatomic point of view, it is the possibility transmitted to us in the structure of our brain" (C. G. Jung, "La psicologia analitica nei suoi rapporti con l'arte poetica," in "Il problema dell'inconscio"). The thematic rendering of the collective subconscious as a possibility or a void is thus seriously attacked by the obstinate biological persistence, by the theory of historic or physiological heredity.

In spite of his refined approach, Jung could not avoid the trap of heredity, nor the issue of innatism: the two poles, according to Lévi-Strauss, imprison the theory of collective subconscious (G. C. Lévi-Strauss, "Introduzione di C.L.S. all'opera di Marcel Mauss," in M. Mauss, "Teoria Generale della magia," Ital. transl., Torino, 1965.) "There are no innate representations, but possibilities of innate representations . . . , there are categories of the activity of immagination, some type of "a priori" ideas whose exhistence cannot be proved without experience. They appear only in the formed matter as regulating principles governing its formation" (C. G. Jung).

Jung certainly tries to establish a relation among *a priori* ideas, categories and finished work, insisting that it is possible to reconstruct the "primitive model of the primordial image" only by starting from the "formed matter;" that is, the formation before our eyes. Nonetheless, Jung does not configurate these *a priori* ideas or the categories, except as "innate possibilities of representation," also coming up against the unavoidable "theologism" underlying the "innatism," as suggested by Lévi-Strauss. Jacobi's same interpretation, based on the formal character of the archetypes, clashes with this

dramatic reality. When Jacobi states that the archetype "can emerge in many studies and psychic levels, in the most varied constellations, and is adapted, in its appearence, to the situation of the moment, although always retaining its own structure and inherent meaning" (J. Jacobi "La psicologia di C. G. Jung," trad. It., nuova ed., Torino, 1973) she is obviously concerned with stressing only the formal aspect of the collective subconscious and the historical variations of the archetype. However acute and intelligent the interpretation, it fails to neutralize Lévi-Strauss' rigorous notes.

Thus the collective subconscious, theorized as a "possibility and a void," immediately acquires "innate possibilities of representation" - it becomes, like Freud's personal subconscious - a topos and a presence. From this point of view, according to Jung's interpretation of Freud's theory of the subconscious, the hypothesis of the collective subconscious retains all the problems which Jung identifies with Freud, while gaining, at the same time, the dangerous shortcomings of innatism-theologism and mysticism. The symbolic work defers to the collective subconscious and its contents, to the archetypes or primordial images, to the deep sources of life and to the extreme remoteness of the being. Thus, the work of art bursts out of the "realm of the mothers." The secret of creation and artistic action is "to go back and plunge into the original state of the 'participation mystique' since it is at this level of experience that "not only the single comes into play, but the collectivity as well (C. G. Jung "Psicologia e poesia"). Jung, thirty years or so before, proposed that "the creative process . . . consists of the subconscious animation of the archetype in its development and formation with the eventual realization of the perfect work. Shaping the primordial image is in a certain way equivalent to translating it into contemporary language. It is through this translation that each one can access to the deepest springs of life. . . . Here lays the social importance of art" (C. G. Jung, "La psicologia analitica nei suoi rapporti con l'arte poetica").

Therefore, Jung leaves to the artist, or rather to the "creative spirit," the task of shaping the original image and the contents of the collective subconscious. Jung even spoke of translating the archetypal image into contemporary language. The "creative spirit" animates, and in fact translates the archetypal symbol which, despite its variations, preserves its own structure and inherent meaning. It is true that the archetypal symbols are inexhaustible and that "the only thing that corresponds to their nature is their multi-meanings (C. G. Jung, "Gli archetipi dell'inconscio collettivo" in "La dimensione psichica"). Obviously, multi-meaning refers exclusively to its ductility and its capacity to adapt to the situation of the moment, along with its historical variations.

According to Jung, the work of art, once completed, becomes the mediation and the path for the deepest life, for the most remote sources of creative energy. The circle is now complete. The artist's "creative spirit" animates the archetypes for the construction of the work which, upon completion, becomes the vehicle and lens of transition for the primordial life.

Thus, the work plays a double role within Jung's theory: the role of mediation and regression toward the forgotten sources of energies and, at the same time, it is the figure of compensation and balance. "By turning its

back to the imperfection of the present, the artist's aspiration withdraws until it reaches, in his subconscious, the primordial image which can compensate most effectively the imperfection and partiality of contemporary spirit. It takes hold of this image, and from the deepest subconscious it draws it closer to the conscious, modifying its shape to render it acceptable to the contemporary person, according to his capacities" (C. G. Jung, "La psicologia analitica nei suoi rapporti con l'arte poetica"). On the other hand, the idea of art as a possibility to return to the "sources of pleasure, inaccessible to the users' subconscious" is thematically proposed by Freud in the "Introduction to Psychoanalysis" (S. Freud, "Introduzione alla psicoanalisi," trad. It.). From this point of view then (even if the perspective has changed), Freud does not make any new contribution.

Actually, this is not the real problem, since it concerns mostly the same possibility of the composition of the symbolic work. What is totally unclear (theoretically) is how the creative spirit of the artist can animate the archetype, translate the primordial symbolic image into contemporary language and give shape to these primitive figures.

The extreme difficulty rises from the fact that Jung totally devalues the function of language, that radicalize at most the "two forms of thinking," and reduces communication to a simple transmission of information. There are two "forms of thinking," Jung states in "Symbols of Transformation:" "applied thinking, and dreaming or fantasizing. The first, by operating with the elements of language, serves to communicate and is tiresome and exhausting. The second, instead, operates without effort, almost spontaneously, through already formulated concepts and is guided by subconscious reasons (C. G. Jung, "Simboli della transformazione, trad. It., 2a ed. rev., Torino, 1970). Science and technique side with "applied thinking," whereas dreams and myth (a "secular dream") and fantasies obviously side with "dreaming and fantasizing." This happens also, I believe, with intentional work and symbolic work, associated with these "two forms of thinking."

Thus, the symbolic work is a symbolic and not a linguistic-communicative formation. It is the breath of the archetypes in their historical variation (though immutable and universal in their substance) and at the same time the starting place from which it is possible, for each one of us, to descend into the real life.

This means that the symbolic work (the only form of art worthy of attention) is an epiphany, a revelation of "subjective tendencies" and of "ready contents," inexhaustible, universal and irrational. Repetition appears here as a theme. However, it is a repetition that it is not a rejection but a variation of, and on, the already known (and about the already known). One might say it is a work of citation, still reflecting the positivist mentality of the direct and immediate glimpsing of reality. It does not matter if the reality is the human world or the personal subconscious (Jung's great enemy) or the archetypal contents of the collective subconscious. The work is repetition of a model, and the critique that follows Jung is inevitably a formation of the third one. The platonic image of the cave which greatly affected Jung can be considered, at this point, as an emblem. The critique, through the work, should derive the primordial life, which risks falling into oblivion and solitude. It should become a psy-chological work. Jung attempted this in his book on the symbols of libido, "The Golden Branch," considered by Northrop Frye and Frazer as "true and important studies of literary criticism" (N. Frye "Favole d'identità, Studi di mitologia poetica," trad. It., Torino, 1973.) This reference is necessary since it broadens the discourse which would otherwise be limited to the meager theoretical scripts on the relations between analytical psychology and artistic experience, or to only two examples (the readings of Picasso and Joyce). It is, in fact, a comment which is rarely found in the scripts that Jung dedicated to the subject of art. The invitation to re-read the "Symbols of Transformation" as literary criticism and, more generally, as artistic criticism, together with the results that can be drawn from it, encourage us to add another book to this recent theoretical-critical cosmography, the "Psychological Types." The Goethe-Shiller axis and, above all, an attentive reexamination of the ties with Nietzsche, could be useful in considering Jung's theory of art and criticism especially after having read Nietzsche and after having clarified certain Junghian temptations.

This theory, although pushing the research to inaccessible limits, does not advance much further than the Freudian theory. The shift from personal subconscious to collective subconscious appears less definite than what it would appear. Jung's subconscious, like Freud's, is a topos and presence, a fullness. Thus, it is irrelevant, whether the contents are deletions and instinctive forces or archetypal symbols and primitive images. The work, in both cases, repeats a content, with the result that Jung, like Freud, is not concerned about analyzing the work. The work, instead of being related to the author's personal mythology, or to that of the characters or the users, is reapplied to the mythology of the collective subconscious, or, in other words, to the contents. After all, Jung was clear: "Only the part of art that includes the process of artistic foundation can be the object of such studies, and not the one representing the very essence of art. This second part, which attempts to understand what art itself consists of, cannot become the object of the psychological investigation, but solely the object of an aesthetic-critical examination (C. G. Jung, "La psicologia analitica nei suoi rapporti con l'arte poetica.") Therefore, there is no doubt that the unification is complete. Jung shifts to the same positions of Freud. Analysis must yield to the problem of the writer and artist. What Freud and Jung can indicate are the "processes of artistic formation" and the contents of the work. The essence of art is an investigation which they entrust instead to the critics and aestheticians. This halving of the artistic experience (into "processes of formation" and "essence") must be brought back to the *leit-motiv*, to the fact that both Freud and Jung forget the idea that art is a linguistic system and a communicative structure, and that a study of the essence and the mystery of art is an ascetic legend.

Between Feud and Jung we find Baudouin. "Most analysts who work in the study of art . . . have . . . insisted largely on the artist's obsession with the mother and the range of feelings deriving from the Oedipus complex" (C. Baudouin, "Psicanalisi dell'arte," trad. It., Ramini, 1972.) Around 1930, Baudouin becomes aware of the limits of art psychoanalysis as it was formed in Freud and Jung's work (and

in that of their students). In order to avoid difficulties, Baudouin suggests the reduction of the work of art into internal instruments of the analytical practice. "At that time, people made associations beginning with a work of art instead of a dream." He adds that they were "subjects analyzed in a different time" (C. Baudonin). The reduction of art to a psychological test is the dramatic symbol of a set-back: the impossibility of psychoanalysis to build a theory of art and a critique capable of operating on the work, on the semiotic levels that form it and on its globality.

The set-back of psychoanalysis as a theory of art. – This psychoanalytic impossibility is clearly recognized by Vygotskij in "Psicologia dell'arte" (Ital. transl., Roma, 1972), an interpretation developed emblematically on two levels: on the opposition between psychoanalysis and formalism. "This new orientation (formalism) intended the artistic form as the center of its attention. . . . Art is explained as a procedure that has an end in itself" (Vygotskij). Vygotskij clearly points out the contribution of formalism, which is the importance assumed by the rejection of sociological and psychological motivations as a foundation of the theory of art. He identifies the sense of abandonment of the form-content dicotomy and the different value of the form. Form is no longer decorum, cosmetics or *a priori* form legitimizing and ordinating the magma of experience and the chaos of matter." Formalists have been forced to repudiate the usual categories of form and content, and to replace them with two new concepts: form and materials. Everything the artist finds ready . . . forms the material of the work of art, along with those ideas included in the work." Now the relation is between form and materials. Form becomes the procedure, the artifice. "Any relation of materials, within the work of art, must be form and procedure. Consequently, the verse is not the sum of the sounds that form it, but the sequence or the alternation of their correlation" (Vygotskij).

Form, materials, art as procedure, all define another major notion: the structure as a system of relations, and consequently, art as a system of correlations. This structural notion was to be formulated in the sphere of research of the Linguistic Circle of Prague ("Le tesi del '29, Ital. transl., Milano, 1966). Nonetheless, Vygotskij underlines the limit of this theoretical experience along with the decisive contribution of formalism. " In formalism . . . regardless of its great merits . . . is the deep vice of every theory of art that tries to move exclusively from the objective data of the artistic form, and that does not base its constructions on any psychological theory of art" (Vygotskij). This important conclusion brings us back to the psychology and psychoanalysis of art. However, Vygotskij is very critical of the psychoanalysis of art. "The weakest side of the theory is evident in the definition of the artistic form: the way that form is intended. It is an issue to which psychoanalysts do not give any satisfactory answer, and their attempted solutions clearly demonstrate the insufficiency of the principles on which they are based." For psychoanalysis "form would serve . . . to attract the reader or spectator, and to deceive him, since he believes that everything is reduced to form and, thus deceived, he obtains the possibility to free himself from his rejected tendencies" (Vygotskij).

It is certain that psychoanalysis of art has little usefulness, unless it is considered from a different point of view. This is in fact what Vygotskij did, and his reflections shifted to "The motto of the spirit," thus avoiding the specific results that Freud applied to art. The attention to "Witz" is related to the fact that it is a linguistic construction, a strongly socialized artifice. "It is a work that can be considered a classic model of any analytical research. By moving from an accurate analysis of the motto technique, Freud shifts from the form to the impersonal psychology corresponding to the motto, thus noticing that regardless of any similarity between the motto and the dream, there is a radical difference for the psychologist" (Vygotskij, modified translation). This difference recalls a famous passage from "The motto of the spirit:" "The most important difference is in their social attitude. The dream is a psychic product, absolutely anti-social; it has nothing to communicate to others: it grows inside a person as a compromise of the psychic forces fighting against each other, and remains incomprehensible even to this person: therefore, it lacks any interest for others. . . . The motto is instead the most social of all psychic functions aiming at the profit of pleasure. It often requires three people and seeks fulfillment in another person's participation in the psychic process which it has started" (Freud, "Il motto di spirito e la sua relazione con l'inconscio," Opere, vol. V, Ital. transl., 1972). The linguistic construction and the sociality of the motto place it in a close relation with literature and art (in general), obviously considered as complex semiotic articulations. This is the route followed by Kris and Gombrich in the 1950s, and more recently by Francesco Orlando ("Per una teoria freudiana della letteratura," Torino, 1973), who re-examined the "Witz" within the perspective of structural linguistics.

This different suggestion of the psychoanalysis of art is part of a project that questions itself on the meaning of a return to Freud and, ultimately, the meaning of Freud. In fact, the idea of using the other Freud to refound the theory of art developed within this project. This theory is found in the following works: "The Interpretation of Dreams," and the "Psychopathology of Everyday Life," "Il Perturbante," "La Denegazione" ("Die Verneinung") and "The motto of the Spirit". The subject of these works, which do not talk openly about art, concerns the linguistic structures and rhetorical codes, the internal organization, the game of relations and functions and of the individual subconscious productions. Such is the hypothesis. This hypothesizes that the subconscious (and therefore its production) is structured like a linguistic system; it is a language set according to a specific logic and a strictly defined rhetorical code. The Lacanian interpretation of the subconscious (mediated by Jakobson) is thus the basis of this theory and its most prestigious and indispensable point of reference.

Its origin is Jakobsonian and concerns the metaphoric and the "methonimic" directive. "One or the other of these two processes is weakened and totally blocked in aphasia. . . . In the normal verbal behavior both operate without discontinuity." In fact, the "competition between the metaphoric and "methonimic" procedures is evident in any symbolic process, either intra-subjective or social. In a study about the structure of dreams, the main problem is that of knowing whether

the utilized symbols and time sequences are based on contiguity (Freud's "methonimic transfer" and "symedoctic condensation") or on similarity (Freud's "identification" and "symbolism") (R. Jakobson "Saggi di linguistica generale," Ital. transl., Milano, 1966.) Lacan, while radicalizing Jakobson's proposal, relates transfer to "methonim" and condensation to metaphor, hypothesizing that the same subconscious desire constitutes itself as "methonimy" (J. Lacan, "L'istanza della lettera dell'inconscio o la ragione dopo Freud," in "Scritti," vol. I, Ital. transl., Torino, 1974). The dream, like any other subconscious production, and like desire itself, is composed of a text and a scripture, a text ruled by specific laws, by the axes of condensation ("Verdichtung") and of transfer ("Verschiebung"). Paradoxically, this narration is at the same time ellitic and lacking, over-abundant and over-determined (Freud, "L'interpretazione dei sogni," Ital. transl., vol. III, Torino, 1969, chapter 6). The over-determination has been taken by Lacan as the tract characterizing feature of subconscious productions, to the extent that in the "Funzione e campo della parola e del linguaggio in psiconalisi" (1953), one reads that even the "symptom becomes an analysis of language; since it is structured as a language, it is a language whose words must be freed" (J. Lacan, "Scritti," vol. I).

The reading of "Traumdeutung" in the light of Jakobson's, Lancan's and Vygotskij's suggestions concerning the method of retrace, "The motto of the Spirit," illustrate how the "predominance of the letter" appears in subconscious mechanisms. Undoubtedly, this predominance belongs to the language of art. Under this light, psychoanalysis can decipher "art, not only as that which is equal to the artist but rather, that which is different from him, as work on something that resists (Th. W. Adorno, "Teoria estetica, Ital. transl., Torino, 1975). The emphasis on the linguistic and semiotic characteristics of the artistic production, the work on what is different and asymmetric, boosts the psychoanalysis of art even beyond the limits of idealism (the same way this was conducted outside of the positivistic area). "The psychoanalytic theory of art has the advantage (over the idealistic theory) of bringing to light the parts of art that are not necessarily artistic. It helps to free art from the domination of the absolute spirit." Paradoxically, however, the idea that art is a projection, a representation of the contents of the subconscious, enables to express a "domination similar to idealism, that of an absolutely subjective system of signs for instinctive subjective reactions" (Th. W. Adorno).

We must point out that inequality is not only asymmetry between the work and the author but, more radically, between the work and the subconscious (the subconscious of the work, obviously). It is then advisable not to insist too much on the homogeneity and on the substantial continuity between the language of the subconscious and the language of the work. In fact, if one makes the hypothesis of the substantial homogeneity (the language of subconscious and that of the work structured according to the metaphorical-methonimical directive) the work risks appearing again as a symmetric model of the other scene, or even as the identical model. The renewed attention to the "Motto of the spirit" has the following motivations: the "Witz," which is a complex linguistic construction in relation with the subconscious, is a strongly socialized experience. According to

Vygotskij, it is precisely this strong trace of sociality running through it (and composing it) that distinguishes it from any other subconscious production. It is sociality, then, that guarantees the inequality and asymmetry between the work and the subconscious and dialectically maintains the work, balanced between its semiotic level (or levels) and this radical distortion of the perpetual latency against the background of the scheme. But doesn't the subconscious as radical arrogance, as absence, as an endless game of the never ending parade of significants become the bottomless abyss of an "Ur-Codice," in a fascination very close to Heidegger's metaphisical vertigo? Art, then, sinks into theology and once again becomes a cypher of the inexplicable.

Is the notion of absence such a dangerous concept that it becomes useless, or can it be re-proposed in another theoretical context, such as the Althusserian one? Althusser states that "the structure that defines the concrete human existence, i.e., that informs the lived ideology of human relations with objects and men, can never, as structure, be represented in person, in positive, in relief, in presence, but only in absence, by proxy, negatively, through absence indexes, in void" (L. Althusser, "Cremonini pittore dell'astratto," Ital. transl., in "Nuovi Argomenti," 3-4, 1966). The structure as absence and void, without center, comes back in Althusser's theory, although differently calibrated. It comes back as determined absence, a determined reality and as ideology. Certainly it is a second theory, a non-representable difference, a diversity that is not, mystically, a trace of the inaccessible being. Along Althusser's itinerary, Macherey ("Per una teoria della produzione letteraria," Ital. transl., Bari, 1969) states that the work, like the linguistic system, is characterized by a double articulation. There is a level of the "determined reality" and of the ideology inside of which the work is created, and the level of the fable and the figure. It is for this reason that the work does not go flat or reduce the linguistic latitude (rhetorical and semiotic) to the historical-social dimension, as it happened in Lukacs and Goldmann's tradition, nor does it assimilate it to the rhetorical code of the other scene, as it occurs in Lacan. Thus, the inequality of the work radically becomes Adorno's "work on something that resists" and its perpetual denegation: to postulate the other scene (determined absence and ideology) as a concept breaking the claim to represent the work as an internal play of deferments and functions, as a rhetorical machine that places itself beyond desire.

BIBLIOGRAPHY - *The idea of aesthetics*: R. Ingarden, Das Literarische Kunstwek, Tübingen, 1931 [trad. it. = Italian edition], Milano, 1968); J. Dewey, Art as experience, New York, 1934 (trad. it. Firenze, 1951); S. Langer, Feeling and Form, New York, 1953 (trad. it., Milano, 1965); M. Dufrenne, Phénoménologie de l'expérience esthétique, 2 voll., Paris, 1953 (trad. it., Roma, 1969); D. Formaggio, Fenomenologia della tecnica artistica, Milano, 1953; W. Benjamin, Das Kunstwerk im Zeitalter seiner technischen Reproduzierbarkeit, Schriften, vol. 1, Frankfurt/Main, 1955 (trad. it., Torino 1966); G. Dorfles, Il divenire delle arti, Torino, 1959 (che riprende, riscrivendolo, il Discorso tecnico sulle arti, Padova, 1952); G. Della Volpe, La critica del gusto, Milano, 1960; G. Morpurgo Tagliabue, L'Esthétique contemporaine, Milano, 1960; A. Banfi, I problemi di un'estetica

filosofica, a cura di L. Anceschi, Milano-Firenze, 1961; G. Kubler, The Shape of Time, New Haven, Conn., 1962 (trad. it. Torino, 1976); L. Anceschi, Progetto di una sistematica dell'arte, Milano, 1962; A. Banfi, Filosofia dell'arte, a cura di D. Formaggio, Roma, 1962; U. Eco, Opera aperta, Milano, 1962; G. Lukács, Aesthetik 1. Die Eigenart des Aestetischen, Berlin-Spandau, 1963 (trad. it., 2 voll., Torino, 1970); G.C. Argan, La storia dell'arte, in Storia dell'arte, 1-1964; R. Barilli, Per un'estetica mondana, Bologna, 1965; M. Bense, Aestetica, Baden-Baden, 1965 (trad. it., Milano, 1974); Th. W. Adorno, Äestetische Theorie, Frankfurt am Main, 1970 (trad. it., Torino, 1970); D. Formaggio, Arte, Milano, 1973; C. Brandi, Teoria generale della critica, Torino, 1974; L. Pareyson, Estetica. Teoria della formatività, 3ª ed. riv., Firenze, 1974 (1ª ed., Torino, 1954); R. Wolheim, Art and its objects. An introduction to aesthetics, New York, s.d. (trad. it., Milano, 1974); L. Anceschi, Autonomia ed eteronomia dell'arte, Milano, 1976 (1ª ed., Firenze, 1936).

The theories of sociology, psychology, and psychoanalysis:
V. N. Volosinov, Frejdizm. Kritičeskij očerk, Leningrado-Mosca, 1927 (trad. it., Bari, 1977); F. Antal, Florentine painting its social background, London, 1947 (trad. it., Torino, 1960); P. Francastel, Peinture et société, Lyon, 1950 (trad. it., Torino, 1957); E. Kris, Psychoanalytic explorations in art, International University Press, 1952 (trad. it., Torino, 1967); R. Barthes, Le degré zéro de l'écriture, Paris, 1953 (trad. it., Milano, 1960); M. Blanchot, L'espace littéraire, Paris, 1955 (trad. it., Torino, 1967); P. Francastel, Art et tecnique, Paris, 1956 (trad. it., Milano, 1959); R. Arnheim, Art and visual perception, Berkeley, 1957 (trad. it., Milano, 1962); A. Hauser, Philosophie der Kunstgeschichte, München, 1958 (trad. it., Torino, 1969); E.H. Gombrich, Art and Illusion, Washington, 1959 (trad. it., Torino, 1965); J. Starobinski, L'Oeil vivant, Paris, 1961; R. Barthes, Essais critiques, Paris, 1963 (trad. it., Torino, 1966); E. Garroni, La crisi semantica delle arti, Roma, 1964; L. Goldmann, Pour une sociologie du roman, Paris, 1964 (trad. it., Milano, 1967); L. Althusser, Freud et Lacan, La Nouvelle critique, 161-162, 1964-65 (trad. it.,, Aut Aut, 141, maggio-giugno, 1974); C.G. Argan, Progetto e destino, Milano, 1965; P. Ricoeur, De l'interprétation. Essai sur Freud, Paris, 1965 (trad. it., Milano, 1965); F. Antal, Classicism and Romanticism, London, 1966 (trad. it., Torino, 1975); R. Arnheim, Toward a psychology of art, Berkeley, 1966 (trad. it., Torino, 1969); J. Lacan, Ecrits, Paris, 1966 (trad. it., 2 voll., Torino, 1974); J. Derrida, L'écriture et la différence, Paris, 1967 (trad. it., Torino, 1971); J. Duvignaud, Sociologie de l'art, Paris, 1967 (trad. it., Bologna, 1969); P. Francastel, La figure et le lieu, Paris, 1967; E.H. Gombrich, Freud e la psicologia dell'arte, trad. it., Torino, 1967; G. Poulet (sous la direction de), Les chemins actuels de la critique, Paris, 1967; G. Vattimo, Poesia e ontologia, Milano, 1967; U. Eco, La struttura assente, Milano, 1968; E. Garroni, Semiotica ed estetica, Bari, 1968; J. Kristeva, Semiotiké. Recherches pour une sémanalyse, Paris, 1968; M. Blanchot, L'Entretien infini, Paris, 1969 (trad. it., Torino, 1977); S. Freud, Saggi sull'arte, la letteratura e il linguaggio, 2 voll., Torino, 1969; L'edizione critica completa delle opere di Freud è The standard edition of the complete psychological works of Sigmund Freud, curata da J. Strachey, 24 voll., London, 1953-1974. L'edizione italiana delle Opere freudiane, a cura di C. Musatti, iniziata nel 1966, presso l'editore Boringhieri, si avvale appunto degli apparati critici di questa edizione. C.G. Jung, l'edizione critica italiana è quella curata da Luigi Aurigemma presso l'editore Boringhieri. (Sono previsti 17 voll. più alcuni volumi finali che comprendono scritti vari, bibliografia, indici); A. Green. Un oeil en trop. Le complexe d'Oedipe dans la tragédie, Paris, 1969; O. Mannoni, Clefs pour l'imaginaire ou l'autre scène, Paris, 1969; P. Francastel, Études de sociologie, Paris, 1970 (trad. it., Milano, 1976); L. Goldmann, Marxisme et sciences humaines, Paris, 1970 (trad. it., Roma, 1973); S. Kofman, L'enfance de l'art, Paris, 1970; J. Starobinski, La relation critique, Paris, 1970; R. Arnheim, Entropy and art. Essay on disorder and order, Berkeley, 1971 (trad. it., Torino, 1974); M. Foucault, Scritti letterari, trad. it., Milano, 1971; J. Baudrillard, Pour une critique de l'économie politique du signe, Paris, 1972 (trad. it., Milano, 1974); J. Derrida, La Dissémination, Paris, 1972; H. Damisch, Théorie du nuage. Pour une histoire de la peinture, Paris, 1972; R. Barthes, Le plaisir du texte, Paris, 1973 (trad. it., Torino, 1975); N. Hadijnicolau, Histoire de l'art et lutte des classes, Paris, 1973 (trad. it., Roma, 1975); J.-F. Lyotard, Dérive à partir de Marx et de Freud, Paris, 1973; J.-F. Lyotard, Des dispositifs pulsionnels, Paris, 1973; J.-F. Lyotard, La peinture comme dispositif libidinal, Università di Urbino, 1973; P. Macherey, Pour une théorie de la production littéraire, Paris, 1973 (trad. it., Bari, 1975); F. Orlando, Per una teoria freudiana della letteratura, Torino, 1973; R. Barilli, Tra presenza e assenza, Milano, 1974; B. Fornari-F. Fornari, Psicoanalisi e ricerca letteraria, Milano, 1974; J. Starobinski, Les trois futeurs, Paris, 1974; R. Bastide, Art et société, Paris, 1977 (nuova ed.); H. Damisch, Arti, ad vocem, Enciclopedia Einaudi, 1, Torino, 1977; F. Rella (a cura di), La critica freudiana, Milano, 1977; J. Starobinski, La critica letteraria, in La filologia e la critica letteraria, Milano, 1977.

ANGELO TRIMARCO

INFORMATIONAL AESTHETICS AND STRUCTURALIST THEORY OF PERCEPTION

Introduction. – What is presently called informational aesthetics is based on the observation that every work of art or artistic expression can be considered a message transmitted between an individual (or creative micro-group), the artist, also called transmitter, and a receiver, chosen in a given socio-cultural set, through a channel of transmission; a system of visual, acoustic sensations, etc. Informational aesthetics, starting from the "general theory of communication" founded on the mathematical plane by Shannon in 1948, attempts to isolate objectively the physical characteristics of the message and their statistical properties.

This approach is based on a formalization similar to that of the physical and psychological sciences; it tends to ignore initially all the transcendental values of the work of art in order to re-introduce them at a later stage of analysis, as properties, inherent to the issuers or receivers, statistically provable and susceptible to experimental control. In fact, according to a constant method of natural sciences, it compensates for the variability of the human being with a model which the psychologists call human operator. This model consists of a certain number of normative properties; then it enlarges this model by examining the variables according to the algorism that Stern and Pieron call *differantial psychology*.

Informational aesthetics appears as a branch of empirical psychology and includes:

a) A theoretical part: institution of schemes and doctrines through reasoning and, eventually, calculation.

b) An experimental part: the study of the properties of the message, the creator, the receiver.

c) A sociological part: the influence of the established doctrine on the artistic development in society.

Informational aesthetics originated in France (1952-1958), then found its way to Germany (1955-1962) and afterwards its ideas spread under different forms in the main countries. Under its founders' spirit (Moles, Bense) it acquired an essentially statistical and general character. It presents itself as a science; its limits of validity are the same as those of the statistical theory, and especially as those of the informational theory established by Shannon's and Weavers' works. Informational aesthetics then represents an attitude of the spirit contrasting the traditional philosophical aesthetics, an attitude that provoked categorical stands, either for or against it.

Since then it has emerged that the range of doctrines and experiences gathered in this field was directly linked to more general problems; the problems of the mechanisms of intellectual creation (Moles), which are apparently common - "in statu nascendi" - to the artistic and scientific fields, to the creation of computer art work, to the automatic scripture of meaningful texts, to the abolishing of ambiguity of automatic translation; in general, the problems of simulation of the creative processes. Informational aesthetics generally seems to offer ways of structuring the rules and techniques of programming and statistical numerical data to be introduced in the procedure.

These doctrines no longer have a purely academic character; they are practiced in the laboratory and in computer centers, at times under different names, and they require a noticeable scientific effort.

Content of the doctrine. – The essential element of the reasoning underlying the communication procedure is the amount of novelty or originality transmitted through the message from the creator's Umwelt to the receiver's Umwelt. This is measured mathematically - and this is Shannon's great contribution - with a quantity called "information, or negative entropy," linked by a simple formula to the individual probability of the recurrence of elementary signs accumulated in a previously existent repertoire.

This presumes that the message is objectively decomposable by an external observer who does not participate in the act of communicating - if necessary the scholar of aesthetics - in a series of elementary "signs" which are identifiable and proclaimable in a repertoire. This is directly linked to the structuralist hypothesis which postulates the existence of atoms of phenomena. This is evident particularly in linguistics (Jakobson, Cherry): the words, the letters of a text (poetry, prose), admissable in music where the conventional score reduces the musical message to a series of operating elements (notes derived from a repertoire, system of solfeggio), but a lot less evident in the case of the visual arts where the notion of Gestalt (or of Form) is evident *a priori* (Arnheim).

By permanently setting aside the notions of meaning and sense of the work of art, informational aesthetics has recently concentrated, on the one hand, on the ever more perfected adjustment between the basic theory and real situations (physics of the message,

institution of repertoires at the different levels of information, research of the recurrence probabilities, laws of grouping of the so-called codes of gathering etc.). On the other hand, it has concentrated on the assumption of the Gestalt notions which are original contributions to informatics, quite different from the original work on "discrete" messages, consisting of objectifiable signs and transmitted with the intention of economizing on the time of communication or on the cost of occupation on the channel (which was Shannan's initial concern.) In this way, it maintains the separation between the container and the content, the temporary refusal of interesting oneself in the content (the "sense," the aesthetic emotion) rather than the container (the context, the codification, the signals, the forms), in a purely objectifiable formulation.

The measure of information is then the amount of novelty, and it can be demonstrated (von Neumann, Moles, Simon) that the quantity of information is nothing but the expression of the complexity of a message, which appears to be a fundamental notion. A message is considered a sequence of "signs" or eventually as a collection of "parts," in the same way as an organism is a sum of parts. One of the fundamental statements of the theory is that the complexity (or the information) and numerical quantity tied to the message, is one of the essential objective measures of perception; this has been confirmed by Noll's factual study in the Bell Laboratories. The complexity or quantity of novelty, offered by an aesthetic message, would thus be one of the measures of perception.

Part of the basis of the adaptation of the art work to the individual will then be an optimization of this complexity or of this information, based on the fact that the human receiver is capable of receiving only a limited quantity of originality per unit of time; a concept proved at first empirically by industrial psychologists or laboratories (Hicks, Miller, Brunner, Attneave). This was then widely confirmed by the works of the physiologists of the cerebral structures and of the corresponding cibernetic models (Frank). The communication between "human operators" is based, in fact, not so much on the concern of economizing the cost of occupying a channel of transmission (the time when one speaks, a record's surface when listening to music, the number of printed signs read, etc.), but mostly on the realization of a message having the maximum impact on the receiving subject. It is the idea of intelligibility that appears as a dialectic phenomenon in contrast to the originality of the message: the greater "the information," the more novelty the receiver takes in; the greater the novelty, the less the receiver is capable of controlling perceptively, the sum of separate signs he receives, or of gathering them in a global "pattern" (Gestalt).

Thus, the intelligibility of a message varies in the opposite sense of information, and informational aesthetics affirms that most of the artist's work is based on a more or less elaborate and conscious dialectic play between originality and intelligibility.

If the message is totally "original," it is merely a collection of all the diverse signs of the repertoire, and the operator is overwhelmed - he does not know what to do with it, and gives up. However, if the message is totally intelligible, it is, at the extreme, completely trivial, totally expected and lacking interest, since the operator already knows everything it contains.

The real messages are experimentations, situated somewhere within this margin. Being based on subjective probability of elementary signs etched by the culture in the memory of the human operator, they play on the subtle dialectic of the expected and unexpected, of the known and unknown, thus proving one of the basic aspects of the work of art, considered as a particular case of transmission in which the act of communication is "free," in the philisophical sense of the term. It is necessary to point out that most of the attempts of contemporary visual or audio art are aimed at exploring almost systematically, regardless of the receiver, the whole field included between total order and total disorder; between the perfect foreseeability of a clear wall, of a blue square, of a continual whistle of an oscillator, and the perfectly unforeseeability of a group of aleatory stains or of a noise brought to the spectator's attention (Meyer-Eppler).

Conceptual evaluation. – Starting from a physical-mathematical theory of communications, which is founded on the spirit of a reduction of the telecommunication cost, informational aesthetics has progressively distanced itself from this while considering communication among human operators, which is characterized by some sort of saturation of these compared to the flux of originality they can absorb. The measure which is most significant is not so much the quantity of information (measured in binary digits, bits or binary matters), but rather the measure called redundance, which is actually the relative excess in the number of signs necessary to convey the same amount of originality with an unexpected collection, therefore "disordered" for the receiver. Redundance is linked to intellegibility since it expresses the receiver's attitude to project global forms (Gestalt) on the gathering of signs constituting the message.

Summed up in this way, the informational theory of aesthetic perception may appear a little simplistic. The refusal to consider the issues of meaning, and the atomic shattering in global elements of form repertoire (even if certain technical devices like the detailed exploration realized by movie cameras apply this attitude and the intervention of the cost concept (Zipf, Mandelbrot), although it is a generalized psychological cost) are obtuse forms of reasoning that lead to numerous criticisms.

Extension of informational attitude. – A first, although banal, observation: most messages are not a simple system of collected signs, drawn from a unique and well-defined repertoire, but involve a hierarchy of levels.

A musical work corresponds to a great number of communication systems that are objectively as well as subjectively separable by the observer, if he wants to pay attention to it. There is a microscopic structure of sound elements, a structure of gathered notes found in a solfeggio, a structure of sound object in the sense of musical phenomenology created by the experimentation of concrete and electronic music (Schaeffer), several gathering structures of culturally known patterns (melodic phrases, harmonic chords, etc.) and more. In each of these levels of expression it is possible to discover elementary, "proclaimable" signs, a repertoire with groups of subjective, "gathering laws" or code laws and, consequently, a quantity of information, at this level. From here it is possible to perceive a redundance

more or less close to the "optimum" that can be expected by the receiver according to his cultural background (signs expectancy). There then exist a hierarchy of experimentally separable levels, among which the receiver's attention can change according to a perceptive strategy still poorly developed.

In this regard, systematic works have been made in labs for visual research as well as in those for the treatment of images (Harmon, Götz), on the construction of messages whose levels of repertorie are well distinguished and where the interferences among them can be controlled by the same experimentator. In each of these levels certain super-signs are found (Moles, cfr. Ronge), consisting of a normalized and routine gathering of signs from the lower level, thus codified in an "under-routine," according to a term borrowed from the programming theory (Harmon). It seems that the idea of pleasure, which the informational theory links to the experimented dominance of a receiver in regard to an easily solvable problem of Gestaltung easy to solve, could be considered in a much more subtle way, if we accept the fact that many informational levels react upon each other.

A second observation generalizes the influence of reasoning on the theory of information. This is what Moles called the opposition between semantic and aesthetic information, based essentially on a dual way of learning the received message: it has been reworked more or less independently by all the authors who have explored the subject of message and semiology (Barthes' field of dispersion, Martinet's double articulation, Bojko's artistic level, Meyer-Eppler's ectosemantic message, opposition between denotative and descriptive of the analysts of content, etc.). This notion is based on the idea that the message transmitted between transmitter and receiver will always appear to an external operator as the juxtaposition of two distinct messages; the first is the semantic message formed by signs explicitly known and proclaimable, not only by the external observer (scholar of psycho-aesthetics or linguistics), but also by the creator and receiver of the message, who are susceptible to proclaiming the signs of the clearly perceived and gathered code.

An inherent property of this semantic message is the possibility, at least in principle, of changing the repertoires of departure and arrival, provided that they are common to the two communicants, and then translating the message in another "language" without losing anything of its substance. For example, a novel, a short story and a musical work, "tell a story" or propose certain invariable melodic patterns susceptible to being translated in any other language without any loss. But obviously the usual messages transmitted among human operators go beyond the semantic message in which every communication can be reduced to a system of sign recognition; for example, not everything is fixed in the form of the sound signal, once the score has been transcribed as carefully as possible, and even once the receiver is susceptible to recognize or throughly read such score. The real message goes beyond the semantic message; Moles proposed that the aesthetic message is superimposed over the semantic message. This aesthetic message consists of the sum of variables, fluctuations and deviations undergone by the Gestalt of the message without ceasing to be recognized as such. A musical note, without changing the composer's intentions, can

vary the height, duration or intensity, in a way perceivable by the transmitter as well as by the listener, without either one of them failing to recognize it as a particular note of the range. A phoneme can maintain the same "distinctive features" (Jakobson) although varying in a large number of numerical values that characterize it (Meyer-Eppler's ectosemantic elements). Thus, a typographic letter can undergo fluctuation of form perceivable and at the same time irrelevant to the identification of such letter.

The aesthetic message consists of the globality, or rather, the sequence of all these deviations (perceivable, i.e., superior to the differential thresholds of perception, that for the psychophysicists constitute the elementary granulation of the message) and these not explicitly decomposable by the receiver. The realization of a musical message in relation to a score learned or read by the conductor and by his musicians, and the painter's details in the creating of a figurative image remain generally unformulated even if they obey statistical characters that can be objectified by an external observer or at times by the scholar of aesthetics with his "metalanguage." They involve certain rules in many executions of a work or in various works, by the same author, or may be grouped under the global term of "style" or of a way of realization, and can be perfectly studied. There is, in other words, a more or less original way of using the field of freedom or of dispersion (Barthes) offered to the creator in relation to the basic semantic message. This is a quantity of aesthetic information that can be measured by the external observer who studies the sound or visual document, beginning with the identification of the elements of fluctuation and including the probability of their recurrence.

Limits of the receiver's capacity. – This method of reduction also implies the fact that if the human's capacity of receiving the information is somehow limited, the receiver would face a permanent choice with regard to the different aspects of the message. If the basic semantic message is too rich and complex and catches his attention, the receptor will necessarily forget the richness of the aesthetic message of fluctuation that was imposed on him. If this is not the case, he "will seek" or will desire to reduce this richness, by suggesting a rule of composition to the creator, who wants to be understood and fully accepted. The result will be a compensation between semantic and aesthetic message; justifications of this point of view are provided by the recent developments in contemporary music.

On the other hand, the extension of the theory of the message to a series of levels (each level having its own repertoire, code, amount of originality and measurable information) provides some sort of system of informational architecture that encloses it within a series of numerical characters. It implies a choice, at each moment, of the attention levels for the spectator, listener and reader alike. It is a question of the choice of the levels that confront him at each moment of the development or of the presentation; this problem can be seen objectively in some cases. The informational reasoning thus stimulates the experimenter to shed light on the process of perception of an image, of a sound or literary form (to systematically realize multiple structures whose levels are well characterized) and of amounts of diverse information, in order to study the average receiver's behavior. This is what has been done

in the pursuit of purely artistic goals, by Vasarely, or in Günther Sellung's pedagogical studies, or studies by researchers like Harmon and Julesz in the Bell Laboratories.

The role of measure in aesthetics. – Initially, the informational theory of aesthetic perception proposes an objectivist stand, leaving aside momentarily the notion of values, a quite complex terminology partially borrowed from the information, and realizing what Wertheimer calls a "recodification of the thought," a theoretical system of measures surrounding an architectonic network, that which was once called a work of art, though rejecting the measuring of beauty with a single figure, an old dream of the aesthetic scholars whose most concrete expression was given by Birkhoff around 1930. It seeks to pinpoint the nature of the aesthetic stimulus, or give it a structure, to capture the individuals' reactions to it, to predict their behavior. Like any theory of a structuralist base, it does not claim to present itself as the sole description of the work, but goes back to the philosophy of the "as if," builds a model and claims to obtain some results from the "functioning" of this model. It will then be judged according to operational criteria, on the quantity of new results that it brings to aesthetics, to contemporary art, and to other fields of the human sciences: linguistics, theory of creativity, etc.

Criticisms and obstacles. – Informational theory encounters a number of difficulties in principle. The concept of information is defined starting from a basis of probability of recurrence of the elementary signs constituting the message. Now these signs must form a whole large enough to give sense to the notion of "probability." The theory of information furnishes numerical values on the adjustment between the novelty proposed by the message offered to the receiver and the amount of novelty acceptable by the latter, but only if the messages involve a large number of elements. At the moment, it has no bearing on the information or on the novelty or pleasure "value" offered by a simple message formed by a small number of elements: the shape of a Greek vase or a very short melodic theme. In this case it is necessary to turn to other notions, like Birdoff's concepts of quantity of symmetry: $m = O/C$, the intrinsic characters of the Gestalt. Max Bense and his school of Stuttgard, in particular Gunzenhòuser, showed that when the number of elements involved in the message multiplied, Birkhoff's famous measure of the Beautiful (based on the number of rules of ordering related to the total number of elements in the field of perception) decreased to the expression of a quantity of redundance related to the variety of signs of the message as it is proposed by the informational theory. There would seem to be continuity between these two aspects.

A second objection to the informational theory is that the "set of probabilities" of the signs, and eventually of the transmittable combinations, must be stable in the message; this particular is proposed in relation to the sum of the preceding messages that could be transmitted on the same channel (Baltzmann's "ergodic" theorem). Actually, this is not true, since the transmission of an original message is added to the preceding message, modifying the distribution of the frequency of recurrence of the signs in the proposed human or social whole, and therefore modifying the probabilities for the following message. It can be generally admitted that

these variations are weak and continuous, and represent a cultural evolution.

A third objection, though more difficult, is the relation between objective probabilities of recurrence of a group of signs at a certain moment in a defined repertoire and the notion of the measure of information offered to a given individual, based on a subjective probability of waiting for a sign or for an element of perception, or for a group of these (set of expectations). This problem preoccupied all the theoreticians of the calculation of probability (Paul Lèvy). On the other hand, the subjective probabilities are functions of an individual culture and are different in the creator and in the receiver. This implies the necessity for the correction of the analysis, and of introducing in the situation of communications the concept of an independent observer who expresses himself in a metalanguage (scientific language compared to the studied language of communication).

Informational aesthetics also clashes with great experimental difficulties in the separation of the hierarchical levels of perception. We saw that most works or messages involve different levels among which the receiver's attention oscillates. However, in categorizing repertoires, it is often difficult to divide without risk the signs, supersigns, super-supersigns, etc., into well-separated levels; hence, the uncertainty on the extension and contents of the repertoires, and on the value of the numerical reasonings that could derive from them. Recent works exploiting the notion of self-correlation (Julesz, Moles, Matthews) in order to numerically determine the oppositions between close order and distant order, and especially the attempts of computer simulation of processes of perception, should permit clarification of this issue, probably in correlation with the synthesis of aesthetic stimuli to the computer. Presently, most researchers are satisfied with building or studying the stimuli found at a single level of signs, defined in the best possible way.

Ultimately, the notion of "value" of a work considered as absolute is totally eliminated by the informational theory. It is replaced by a notion of adjustment to an "objectifiable" optimum of informational flux or of redundance at multiple levels. This analysis appears to be strongly opposed to traditional aesthetics. It seems to demonstrate its operative value when the creator wishes to communicate with the greatest number of members of society (Aesthetics of men by Max Bense); this is the idea of applied aesthetics that offers to the creator certain rules with which to communicate in the best possible way with the greatest number of people in a given socio-cultural stratum (posters, decoration, etc.). It is, however, a lot less operative when the creator fails to consider that the greatest pleasure for the greatest number of people is the goal of an artistic work, and instead he is faced with the problem of creating new rules in an absolute way (Aesthetics of the Gods).

Experimental works. – A series of experimental works based on the principles of informational aesthetics has been developed. Many of these works led to literary and musical fields, since they contained a message that was concrete and objective, already registered in a testimony that can be freely studied: the magnetic band or the written text. In the Western World, musical art, among others, has been based for many years on the idea of a score; that is, of an operative "program" consisting of signs that can be isolated and realized in performance. The notions of semantic or aesthetic messages impose themselves as natural. For some time, however, particularly since the invasion of computers in the human sciences, the quantification of the signals and their memorization, the explorative analysis of an image in technical devices like movie-cameras and the basic reasonings proposed by the founders of the theory have gained more and more operative value and have been extended systematically.

A large part of the first studies led to the formation of repertoires attaining a branch of works created by statistics. The first authors, Yule, Zipf, and Herdan, studied the statistical economics of the signs in a repertoire (Zipf's law). Guirard reworked these problems in relation to a poetic vocabulary; a whole school of statistical linguistics was created, which resulted in the formation of critical studies on the "false" or "historical authenticity" of works beginning with the distribution of the probabilities in repertoires, and the analysis of entropy or information in a given message. These works later extended to other fields, particularly to music with Mol, Leida, Fucks and Aquisgrane. The latter pointed out the stylistic laws of evolution of the quantity of information through the ages of musical history. The results obtained, particularly as to the probability of gathering signs 2 by 2, 3 by 3, etc., Markoff's diagrams, which were triagrams expressed in the so-called matrixes of transition, have been directly utilized in the works of composition through machine music (Hiller, Barbaud) and of text composition ("The type-writer," Baudot, Montréal, Lutz, School of Stuttgard, Stickel, Bense).

Other works have been realized above all in the field of separation of the perceptive levels for purely artistic goals (Vasarely, Groupe d'Art visuel) as well as for scientific goals (emergence of forms built with supersigns totally independent of the signs of which they are formed: Noll, Harman, Knowlton, etc.). The measure and separation of the aesthetic and semantic quantity of information was researched at the experimental level by Moles, in the musical field, by utilizing different methods of perturbation or of distruction of the message that strikes in different ways, partly semantic and partly aesthetic (inversion, reduction, filtering, cut, mask, etc.). He was able to trace curves of distribution of aesthetic and semantic information associated with different parameters of the sound signal (frequency, level). These methods are now starting to be applied to the study of visual stimuli like pictures and posters, for which they have numerous industrial applications. Following Buswell's works, Molnar sought to derive laws of eye movement while viewing a picture and to build upon these hierarchies of signs and supersigns. Berlyne experimentally verified the growing stimuli of complexity proposed to certain subjects, and the law of optimization of the complexity at a given level, which was described qualitatively by Moles in 1958.

The development of informational aesthetics. – Informational aesthetics appears very unitary in its development. According to the principles of the Theory of Information and of Cybernetics, it focuses on whatever is common to phenomena that are dissimilar in their physical nature but which can all be brought back to a canonic scheme of communication. Audio, visual, literary or typographic messages, fixed photographic

images, moving images of cinema, graphic arts and painting, messages of the arts, perfumes and taste, are nothing but different physical sensorial channels, for which the same methodology is applied:

1.—description of the issuer's and receiver's channels, formal and structuralist description of the message;

2.—research of the separable and proclaimable elements at the level considered, at the most elementary level (psychophysical differential threshholds);

3.—division in repertoires of the signs, research of their probability of recurrence in the cultural environment where the communicative act is placed;

4.—research of the laws of constriction governing the gathering of these signs and whose sum forms the structure;

5.—reconstruction of a model (and of its functioning) and re-examination of the analysis, at another level of supersigns as well as from another standpoint that perfects the model. It is a sort of algorithm of thought, extremely useful and systematically utilized by a great number of researchers. The experimental works are easily divisible according to this progression.

Informational aesthetics, on the contrary, is not always perfectly situated when the communication mechanism of the system of combinable elements is not the essence of the artistic process. It has, for example, very little bearing on a great number of recent phenomena of contemporary art such as the surrealistic scandal, the "ad absurdum" reduction of the art work by the Pop artists or by the "Salone del Vuoto" (Klein), certain aspects of "tachisme" and of informal painting, easily approachable by the scholar of aesthetics from a sociological standpoint, or from Husserl's profile of eidetic reduction, etc.

Informational aesthetics is at ease especially in the very constructed systems of optic art, cinetics and of the new branches of computer art, all related, more or less, to the combinatory and to what can be called premutational art (Moles). It enjoys the favor of a great part of the arts linked to language since it renews, under a concrete and operational form, the old metaphor of art as language.

A great part of its most significant results (and closest to its applications; that is, the introduction of "works" in the consumer society and of their commercialization) matured in the musical field, which, because of its nature, was ready to manipulate operative signs according to the concept of score (music for movies, theater, ballet, etc.). However, it seems that the contributions in this field must be rapidly transposed to visual art, since the computers became the essential element of manipulation, together with interface organs convenient for the artist.

From its original atomistic character (i.e., Shannan's works on the discrete successions of signs, informational aesthetics) it evolved into an ever more satisfying adaptation of what can be called the "syntactic structures" of the art work. This work is significant under the generalized form of the copy belonging to the imaginary museum, of an element of a "multiple whole" rather than under the aspect of the transcendental uniqueness of the "masterpiece," of which the copies are the imperfect approximation, vulgarized, and non-authentic.

Applications and orientation. – In actuality, informational aesthetics prepares a branch of contemporary artistic development (everything linked to the use of computers in the creation of aesthetic works) by experimenting with the technical means, extracting syntactic structures, and by suggesting programming rules. Moreover, it proposes "Gedankenexperimente" of the creative act as the idea of the "imaginary machine" (Philippot): a sequence of simple actions carried out with an "obstinate rigour" (Leonardo da Vinci), without resorting to machines, necessitating the result of a structured whole. It is based largely on the utilization of large systems of manipulation of numerical data, codifying, for example, musical notes (Hiller, Tenney, Beauchamp's works at the University of Illinois on the simulation of the composition process for tests and errors; Barbaud's works on algorithmic serial music as a result of a combinatory, etc.). Similarly, it paved the way for the literary experimentation carried out by groups of experimental literature (Lescure's S + 7 method, modifying substantives of a text according to a given rule, although respecting Chornsky's syntactic structure; the experimentation on the programming of a literary synopsis beginning with the work of Propp, Levi-Strauss and Todorov, the direct construction of the sound of the musical signal, without score, utilizing the facility of a computer's graphic subprograms (Music IV and V by Matthews, Gutmann, Risset in the Bell Laboratories), the construction of cartoons on similar principles (Harman, Knowlton, Mezei's works), the systematic study of the variables of a computer program giving commands to a drawing machine (Nees, Francke, Nake's works in Stuttgart), and the creation by computer (Kawano in Tokyo), etc.

From a general aesthetics' standpoint, the majority of these works should be considered as explorations of the new means at the artist's disposal rather than works in the classic sense of the term, even though this latter concept of work loses some of its rigor in mass society.

Socio-aesthetics under society's cultural patrimony. – "The work of art" thus dissolves in the mass society where the characteristic of consumption prevails on the trascendental character. Its main mechanisms are the creation of the imaginary museum through the cheap multiple copy, the nihilization of the value of the original through this process when the copy resembles more and more the original, and through the free circulation of the beings and of the works. An awareness of these mechanisms leads to the establishment of new scales of values; this is the first of these new functions assumed by the scholar of aesthetics.

The mechanism of the imaginary museum establishes the existential authenticity of the copy (photographs, color reproductions, records, serial objects) to the detriment of the original, which is nothing but a matrix of its own copies addressed to the specialists and the creators, but seen, moreover, by millions of tourists. The copy suggests a new vision of the work and, above all, an asymtomatic ideal of the function of the art work in society; at the end of its evolution in every place, at any time, for everyone, every spatial or temporal form

can be made available. We are submerged in an omnipresent aesthetic universe which pervades each one of our actions, in the measure in which we can be sensitive to any given form of beauty. The problem is no longer between "The haves" (right to beauty), the rich ones, the princes, the indolents and "The have nots," the farmers, laborers and slaves. It is simply at the level of will: he who wants to perceive what is "beautiful" can go to the corner shop and purchase the aesthetic object that suits his means.

This notion of availability establishes a new fracture that replaces the one between the haves and have-nots with those who want and those who don't want; it gives a new importance to the aesthetic attitude, which is a particular sensitivity.

The introduction of the work into the original-reproduction dialectic gives it new types of values among which the value of fidelity seems essential. The fidelity (of the copy compared with the original) is a notion characterizing intrinsically the copy and which can be defined by the psychologist as the state of absence for the receiver, of infidelity discerned in relation to a prototype having a little of that platinum meter-champion/sample kept at the Institute of Metrical System of Paris, whose more or less perfect copies are sold all over the world. In fact, exactness varies with the receiver's level of artistic culture; it is a relative idea and not absolute; an illustrated postcard can be faithful for an individual and unfaithful for another; the problem is ultimately of an artistic nature.

Fidelity must then be completely separated from another essential, usually linked to the art work, namely, that of authenticity, for which a new definition emerges. Authenticity is no longer connected to the relation between the receiver and the object; it is an authenticity of situation. There are artistic situations that are authentic and not authentic; the illustrated postcard will be authentic to the amateur who looks at it with love, while the original work of art will not be authentic to the victim of "touristic alienation," who looks at it because it was in the guided tour of the city. The authenticity of situation which replaces the authenticity of the object is then a particular attitude of an individual encountering something characterized by its absence of cultural alienation.

Socio-aesthetics also underlines another essential concept derived from political economics; with the imaginary museum, there now exists a political economics of the work of art, whose laws must be determined. This is Pareto's idea of "ofelimità;" the adjustment of the multiple work to the structure of the sociocultural pyramid.

In a more precise way, beginning with the moment in which the work of art is multiple in its essence, within the universe of copies there is created a series of quality layers that gradually move away from the perfection of the original, being realized in more and more numerous copies. In a sociology of the work, more or less independent from the amateur's sociology, there will first be an establishment of a demography of the aesthetic object, and a tracing of a "quality pyramid" that expresses the number of existing copies, in the vast imaginary museum, as a function of their degree of quality. This will form a historiogram (upside-down according to the demographers' use) which we will call quality pyramid, assuming that it is possible to

define this "quality" on a nondimensional scale, whose construction is in itself a subject of research for the scholars of aesthetics. Alongside this quality pyramid the sociologist can define, at least theoretically, the pyramid of sociocultural needs.

The basic sociocultural problem is thus that of adjustment, of the more or less relevant similarity between the shape of the sociocultural pyramid and the shape of the quality pyramid. If this is the case, we must admit that Pareto's ideal of ofelinità has been attained; there is a total adjustment for social objectives in the measure in which the shape of the socio-cultural pyramid is correlated in a sufficiently strong way to the exercise of the aesthetical need.

Although the development of the imaginary museum is a precise function of this ideal of a more or less conscious "ofelimità," it is obvious that this is very far from being realized. A socioaesthetical study should identify this point, particularly considering the reproductions in the fields of easy access, such as the illustrated postcard and the record, and their comparison with the sociocultural statistics of which some rudiments are known (Fucks, Toffler, Zahn, Girard).

The sociocultural pyramid and the quality pyramid (also called pyramid of "value," in a strictly sociological sense) of the works on the market are thus significantly different; this difference, which will be translated into a unit to be agreed upon through the difference of surfaces between these two pyramids traced on the same graph, in effect constitutes a measure of a vague and important factor of contemporary society, the dissatisfaction of the need of beauty, assumed statistically to be shared by every citizen of the welfare state. One can consider that this global dissatisfaction, expressed here in a quantitative form, is one of the basic motivations of the social body; in other words, the quantity of dissatisfaction ends up being the reaction of the effects on the causes, the perception of the huge quantity of trash that conditions a further action in this field. Like the dissatisfaction in the standard of living which causes an individual or a social group to make an effort of ingenuity or a creative action, we can consider the dynamic of the artistic creation as being linked, to a certain extent, to a dissatisfaction of the more or less latent need for beauty in the population. This motivation, or latent need of the social body, concentrates on its restricted subsystems instead of dividing its action in the different layers that form such a need. Thus, the important role played by the rebelling children of a solid middle class is the result of the convergence in them of a basic minimum education, a spiritual availability and a sharper perception of social inequality (Kònig and Silbermann: der selbststäudige Künstler). It is well known that the most creative countries in the artistic field are generally those in which social inequalities are more easily perceived.

Socioaesthetics seek to accept or refuse such a hypothesis: and in a parallel manner work to establish the facts and to underline the artistic social layers in an intellectual city where the artist's everyday function has greatly changed. The artist, starting as creator of unique works charged with a great "potential of originality" that gradually diminishes through the copy, becomes essentially producer of artistic events, be they originals destined to be copied, or permutational; i.e., products in a field of possibilities chosen by the artist.

Another objective of socioaesthetics is the examination of the consequences of the multiplicity and of the ubiquity of the copy of the institutions of the artistic city. The museum becomes a deposit of matrixes or a gallery of models; it no longer has a reason to remain open for the consumers, except for the role it plays for the tourist agencies seeking something sensational that quickly wears out. The function of the museum is thus deeply criticized by the sociology of the consumption of beauty. Consider, for example, the replacement of the museum by the sequential aesthetic event, of which the research of conceptual art gives an idea or event placed in space and time that proposes to the individual a series of aesthetic situations and recalls the "ludic city" of certain theoreticians (Lefebvre, Schoeffer); the aleatory dispersion of copies and works in a labyrinth with more than one solution, sought by numerous contemporary artistic movements, is the translation of this search for a new contact between the work and the public.

This program emphasizes the broadness and aesthetic function of the new society. It is based on a sociology of art which is the first point we would like to focus on. However it is best, given the universality of the aesthetic function in the contemporary world, to stress another very different aspect, deriving not from the image of the global society, but from the problem of its individual progress; this is the euristic role of aesthetics. This is no longer the philosophy of what is beautiful, but an experimental science based on psychology, sociology and on the theory of creation. One of the basic problems is to establish the mechanisms of this creation beginning with the study of the art work and of the artist's work.

Perspectives on an aesthetic sociology in the computer age. – Art cannot be considered as something like the Venus of Milo or the Empire State Building; it is a relation that man has with things; an active relation for the creator who changes and reorders them at his own pleasure; a passive relation for the consumer - the beneficiary of forms and rearrangements. Whether a surplus of life, a programming of sensuality or an experience of sensualization of forms, it is always a matter of dominating one's own field or of being dominated by it.

Fascination is the quality of this relation between the being and the form that lastingly imposes it to the field of the glance. Its resources are innumerable; the simple "strength of the form" is merely one of them; the plot, the double meaning, the symmetry, the perspective vertigo, the perceptive integration, the color-shock, the imposed refinement of the detail and the mastery of complexity are, among the instruments of fascination, those which the artist exploits at his own pleasure, and are systematically explored by the innovators of visual art. Computer art, among others, makes use of new resources of fascination; this is a search for a broad project resulting from precise and endless variations that can be integrated in the blink of an eye.

Art thus appears as a programmed visualization of the environment; this is a close and almost passive environment of the visual field explored by the eye in a motion that is too inexpensive to be considered extravagant, the temporary environment of the sound or stage development, the spatial environment explored or discovered by man in its totality. Whether the arts are for viewing, for listening, or for pursuing, the artist is always the programmer who semi-determines micro-movements of the eyes or the ways of the urban wandering, the games of labyrinths and of gardens; it is he who conditions them by establishing as a rule of the game the acquisition of pleasure for those who practice it. The computer and its memories, sub-routines and algorithms, offers the artist the means of utilizing this programming of the sensorial process at a level that the artists of the past could not have imagined, excepting perhaps the Mannerists, whose obstinate rigor caught the dizziness of infinity in the field of permutations.

In a society transformed into a social system, art is necessarily based on the machines that manipulate the complexity. A Neo-Mannerism of the machine is forming, which is an operative style in which the manner/way is more important than the form, since a form is nothing but a "solution" out of a great number of other possible solutions that demonstrate existence. The process of realization is the real source of richness, invention and strength. It is the problem of the artistic patent, which is to say that through a particular realization it becomes a realizable idea granted by the social institution.

On the grounds of this structural theory of perception, of which we have traced the basis, there are three ways open to the dyad (paired) man/computer.

The first one is that of having the computer realize/produce, in a more and more autonomous way, testimonies and samples of everything that art has been capable of proposing to our imagination so far: figurative or abstract art, concrete or formal music, ballets, or movies. Electronic feat or a certificate of attitude is a necessary steppingstone; it is in any case the most spectacular because it proposes something we can understand, since we have already understood it.

The second way is that of using the computer to realize the innumerable variations of which every already existing form of art contains in itself. It is the variational art, the improvement of the existing work through aesthetic refinement, the personalization of suggested copies beginning with the analysis of an existing element, followed by a synthesis with variation. "Did Brahams write all the Brahams he could write? Could there be a better Brahams hidden in the machine?" This is the dreaded route for the sociologist scholar of aesthetics, since it multiplies the works and, if necessary, makes them available to anyone by introducing certain variations which make them more accessible. Therefore, if by now the little man is the measure of everything, it is desirable for the artist-demiurge-programmer to produce works that are scaled to man and through this, he consecrates himself to the "devil in art," to Kitsch.

The third way is the most difficult, unpopular, and also the longest one; if art is the programmed sensualization of the environment, it applies to many environments, many sensualizations and many types of programs, as well as many new promises of works to be realized. It is here that the trascendence and aspiration of the philosophers must be sought.

BIBLIOGRAPHY - K. Alsleben, Aesthetische Redundanz, Quickborn bei Hamburg, 1962; K. Alsleben, A. Moles, F. Molnar, Probleme der Informations-Aesthetik, München; R. Arnheim, Art and visual perception - University of California

Press, Berkeley and Los Angeles, 1966; W. R. Ashby, An introduction to Cybernetics, London, 1956; F. Attneave, Applications of Information Theory to Psychology, New York, 1959; P. Barbaud, La musique, discipline scientifique, Paris, 1968; P. Barbaud, Initiation à la composition musicale et automatique, Paris, 1966; J.A. Baudot, La machine à écrire, Montréal, 1964; M. Bense, Einführung in die Information theorische Aesthetik, Rowohlts Deutsche Enzyklopädie, Reinbeck bei Hamburg, Octobre 1969; M. Bense, Aesthetica, Baden-Baden, 1956 (trad. spagnola, Buenos Aires, 1957); M. Bense, Theorie der Texte, Köln, 1962; M. Bense, Bestandteile des Vorüber, Köln; Berlyne, The Influence of Complexity in visual figures or orienting responses, Exp. Psychol. 1958, 55; D. Campion, Computers in architectural design, Amsterdam, London and New York, 1968; C. Cherry, On human communication, New York, 1957; H. Davies, International Electronic Music Catalog, MIT Press, 1968; U. Eco, L'oeuvre ouverte, Paris, 1965; E. N. Ferentz, Computer Simulation of Human behaviour in Music Composition, Computational linguistic, Yearbook IV, 1965, Center of Hungary Academy of Science, Budapest; H. Frank, Grundlagen Probleme des Informationsästhetik und erste Anwendung auf die Mime pure, Waiblingen; W. Fucks, Nach allen Regeln der Kunst, Stuttgart, 1968; W. Fucks, Arbeitsgemeinschaft für Forschung des Landes Nordrhein-Westfalen, Hefte 124 und 34a, Köln, Opladen; R. Garnich, Konstruktion, Design, Aesthetik, Stuttgart; P. Guiraud, Problèmes et Méthodes de la Statistique Linguistique, Paris, 1960; R. Gunzenhauser, Aesthetisches Mass und aesthetische Information, Quickborn bei Hamburg, 1962; L.D. Harmon, K.C. Knowlton, Picture Processing by Computer Science, April 1969, N° 1163; A. et Al. Hill, Data - Direction in Art, Theory and Aesthetics, London, 1968; L.A. Hiller, L.M. Isaacson, Experimental music, New York, Toronto, London, 1959; M. Kiemle, Aesthetische Probleme der Architektur unter dem Aspekt der Informationsästhetik, Quickborn, 1957; H. Kupper, Computer und Musikwissenschaft, in IBM Nachrichten, n. 180, Décembre 1966, Verlag IBM Sindelfingen; M.V. Matthews, The technology of computer music, MIT Press, 1969; W. Meyer-Eppler, Grundlagen und Anwendung der Informationstheorie, Berlin, 1959; L. Mezei, A. Rockman, The Electronic Computer as an Artist, Canadian Art, vol. XXI, n. 6, 1964; A. Moles, Théorie de l'Information et Perception esthétique, Paris, 1958 e 1972; trad. tedesca: Informationstheorie und Aesthetische Wahrnehmung, Köln, 1970; trad. spagnola: Buenos Aires, 1969; trad. italiana: Roma, 1969; trad. inglese: Information Theory and Esthetic perception, University of Illinois Press, Urbana and London, 1966; trad. russa: Moscou, 1966; Les musiques Expérimentales, Paris, Zürich, 1960; Sociodynamique de la Culture, Mouton, 1967; L'Affiche dans la Société Urbaine, Dunod, 1969; Die Permutations Kunst, Rot n. 8, Stuttgart, 1962 (in italiano, cecoslovacco, tedesco); Structures du message poétique et niveaux de sa sensibilité, Paris, 1961; (trad. It. Il Verri, Milano, 1963; trad. Polacca, Poetika, Mouton, 1961); Cybernétique et OEuvre d'art, Revue d'Esthétique n. 2; 1965; (trad. It. Casabella 323, 1968); La nuova posizione dell'artista nell'ambiente di consumo, D'Ars Agency, n. 34, 1967; F. Molnar, Sur l'art abstrait, Galleria Groda, Zagreb, 1963; A.M. Noll, Computers and the Visual Arts, Design and Planning, n. Computers in Design, 1967, n. 2; J.R. Pierce, Symbols, Signals and Noise, New York, 1961; F.K. Prieberg, Musica ex Machina, Berlin, Frankfurt, 1960; M. Puzin, Simulation of cellular patterns by computer graphics, Technical Report, n. 10, Maggio 1969, University of Toronto; W. Reckziegel, R. Mix, Theorien zur Formalanalyse mehrstimmiger Musik, Köln und Opladen, 1967, n. 1768; H. Ronge, Moles, Nake, Bense, Otto et al., Kunst und Kyberne-tik, Köln, 1968; P. Schaeffer, A. Moles, A la recherche d'une musique concrète, Paris, 1952; Seminaire vor Musikgeschiedenis, Jearbook, Rijkuniversität, Gent, n. 2, 1967; C.E. Shannon, E. Weawer, The mathematic theory of communication, University of Illinois Press, Urbana, 1949; H.A. Simon, Pattern in Music, Complex Information Processing Paper, n. 104, Carnegie Institute of Technology, Pittsburgh, Giugno 1967; Von Neuman et al., The general and logical theory of Automata, Harvard; Y. Xenakis, Musiques formelles, Revue Musicale, Paris, 1969.

ABRÁHAM A. MOLES

SEMIOTICS

Introduction. – Only recently has semiology gained a true specialistic configuration, as a "theory and science of signs." This statement requres some specifications. First of all, the current dictionary definition, mentioned above, is merely approximative and temporary, and it has often been criticized by semiologists; whenever possible it will be clarified within context in the course of this article. Moreover, the specialistic configuration assumed by semiology is not presently univocal and consistent, and somehow we must still discuss various theorized semiologies practiced by various authors and associated with different trends. The name of this discipline shifts, at times, with certain differences of meaning, between the term "semiology" (which prevailed particularly in the 1960s having spread from Continental Europe under the influence of F. de Saussure who coined it "sémiologie") and the older term "semiotic" (present for some time, particularly in the German - "semiotik" and Anglo-American "semiotics" areas), together with other variations. "Semiotics" has recently been adopted as a universal term by the "International Association for Semiotic Studies," and has progressively become dominant without replacing completely the term of "semiology"; in this article both terms will be used, depending on the author cited and the requirements of context, with a preference for "semiotics" in optional cases.

The novelty of the discipline should be understood in a precise and somehow limited sense; it is here suggested that it is now in every sense, and from a theoric and applicative point of view; we simply propose that only recently has there been an attempt (successfully or not and to what extent are obviously other issues) to rigorously, systematically and scientifically determine its object and methods, thus acquiring (even in the case of a co-presence of different semiotic courses not compatible among them) a specific disciplinary relevance, its own terminology, though not always sufficiently unified and a largely autonomous statute that is epistemological, theoretical and applicative. It is also obvious that the often fundamental and productive ideas and problems forming the basis of modern semiotics, have notable traditions in the history of scientific-philosophic thought, though only in the sense of generalities or in a rich and determined way, but episodic and not systematic; inevitably, they are within the sphere of different issues that are not easily translatable into the language of semiotic in a modern sense. Certainly, at least, an "implicit semiotic" (Ducrot-Dodorov, 1972) in the intellectual cultures of ancient China and India; but

surely the epicureans and, above all, the stoics have the merit of having developed a true theory of signs as a logical process that enabled an inference from that which was immediately given, that which was not immediately observable (Sebeok, 1972), with particular attention given to the verbal language, but with definite semiologic resonances - at least in the sense of a metatheory specifiable also in a theory of language.

If it is true that nothing remains of the original work of the epicurean logicians and grammarians and of the first Stoa, and that their ideas are only indirectly known to us, particularly through the late Sesto Empirico and Diogene Laerzio, thus making it difficult to precisely evaluate the weight of their theories, in any case, it is certain that the very general conceptual bases of a semiotic science must be sought there. Often great significance has been attributed to the stoics (Hubschmann, Pohlens cf. Melazzo, 1975), and it has even been proposed that they affirm an antinomenclatorial conception of language. As we shall later see, this is the idea of the formativity of language and semiosis in general. This could very well be, although not only the novelty, but also the isolation of the stoic philosophers would appear too strong in respect to later thinking. To be safe, one should speak of very general bases and needs, which translate into an important terminological and conceptual framework. Within the overall context of ancient and medieval culture, the theory of signs does not issue from the generic and little-articulated notion of "representation," (in a nomenclatorial sense) which arose primarily from Aristotele, to whom "referentialism" has been attributed (strictly speaking); this has survived to modern times (De Mauro, 1965). This notion undoubtedly is still important for modern semiotics, but it also requires (and has obtained in its most important representatives: Peirce, Saussure, Hjehuslev, etc.) essential specifications representing the passage from a generic semiotic horizon to semiotics as a specialistic science (even with all its difficulties and persistent inequalities).

A modern semiologist, Ch. Morris, outlined in the appendix of "Signs, Language and Behavior" (1946) the history of semiotics from the ancient times to the present day (with generosity and broadness of interests), without going much beyond the notable generalities. It appears that what can be found, in a semiotic sense, in the earlier thinking, previous to the 17th century, about the nature and structure of signs and images should generally be ascribed to other disciplines (where the semiologist can have a non-marginal role), such as gnoseology, logic, rethoric, the theory of perception, the theories of art, etc.; that is, to different disciplines, not always strictly and necessarily correlated between themselves under a semiotic profile, and in which the study of the sign and its functions is often presented as accessorial or instrumental, at least in relation to the position it occupies within modern semiotics and in its nearest antecedents. As said before, this does not exclude the possibility of finding, especially in the sphere of rhetorical and grammatical studies from classic antiquity to the Renaissance and later, various elements not only of an implicit semiotics but also of a non-generic doctrine of signs, explicitly pointed out by the authors or inferable in an unequivocal way by similar studies and, most importantly, not exclusively linked to the consideration of verbal expression (see in the *Encyclopedia of World*

Art, ICONOGRAPHY AND ICONOLOGY—Vol. VII, and SYMBOLISM AND ALLEGORY—Vol. XIII).

Starting with the second half of the century, not only the most important, systematic and articulated developments occurred, but the most specific, and therefore the most specialistic developments of semiotics and disciplines strictly related and complementary to it (such as linguistics and logic). Also, the first explicit and decisive references to a true theory of signs as an autonomous and general science, in an organic framework of an epistemology, of a theory of communication or even of the culture, historically linked to modern developments, did not occur until the 17th century (Hobbes, Locke) and 18th century (Lambert). Clearly, Locke did not go much beyond ancient semiotics in the scanty allusions he makes to the question; but with him, and more generally through the intellectual environment to which he belonged and the culture of his time, there was an establishment of a different direction of thought, expressed not only in a renewed semiotic interest, but also in the emphasis (and in the discovery) of those objects of investigation that later became part of the future human sciences, together with a new way of conceiving these natural sciences. Within this perspective modern semiotics took its first steps and it developed a particular interest in a semiology of art.

Within this historical and problematic sphere (determined on the basis of theoretical, historical, and practical criteria) we will begin our examination with three objectives: a) to outline, through a few significant points, the profile of an essential vertical section of the development of semiotics, b) to establish its main theoretical and pertinent passages, c) to offer a general idea of its applicative possibilities and limits, referring in particular to what is usually called "semiology of art."

Seventeenth and Eighteenth centuries: Locke and Lambert. – Locke is usually considered to be the first person to speak explicitly of a semiotics; he also coined the corresponding term. It is advisable to keep in mind what has already been mentioned: Locke only incidentally addressed the doctrine of signs, in the last chapter of his "An Essay Concerning Human Understanding" (1690), and he did not delve further into the ideas that were already in circulation. However, it is true that some circumstances and observations can be considered as particularly significant regarding the new orientation mentioned above. The clarity of Locke's statements, together with a more specific scientific novelty, easily justifies the relevance attributed to these few pages. He intended to trace a general and thorough outline of everything that falls within the sphere of human knowledge, and in this regard he presented a general tripartition (subject to further divisions), within which semiotics occupies its relevant position. This tripartition includes, "a natural philosophy," a concern for our capacity to apply our actions toward the accomplishment of useful and good deeds and whose most salient part is constituted by the "ethical," and a third branch that can be called a doctrine of signs of which the most used ones are words and for this reason it is usually called "logic." A function of logic is the consideration of the nature of signs used by the mind for the comprehension of things, or for the communication to others of its knowledge. The criterium of division is an Aristotelian derivation, and as is also the notion of sign as representative of some other thing: "And, since the

group of ideas that constitutes man's thought - writes Locke - cannot be exposed to the immediate vision of another man, neither can it be kept anywhere else but in the memory, which is not a completely secure deposit; in order to communicate to each other our thoughts, as well as to record them for our use, some signs representing our ideas are necessary (other than the ideas as signs of things)."

No privilege, theoretically, is accorded to verbal communication; on the contrary, it is understood that the value of the sign is not in the matter in which it is realized, but in the representative capacity of "ideas" (in the broad sense of "representations," existing in the British language and culture). With this decisive and advanced reaffirmation of the rather old principle of arbitrariness of the sign, not only does one go beyond (in a theoretically explicit way) the verbal language horizon (supposedly important for a broadening of linguistics into semiology, as it later occurs with Saussure and his followers), but one reaches the syntactic - grammatical dimension, which is really of the traditional logical conception, a semantic dimension (an equally important presupposition for the extension or foundation in semiotics; this occurs with Peirce, and notable results are obtained in the fild of logic with Tarski and Carnop). All this is not naturally susceptible to a truly historical-theoretical demonstration, since there are so many mediations and innovations that connect Locke's thinking to the modern thinking. However, it seems certain that Locke proposed the specific requirement (shared also by others such as Bacon and Hobbes) of a specific consideration of the meaning and that the problem of the meaning tends to ideally precede the logical problem of the correct reasoning. The constitution of a discipline concerned with studying the "meaning" in its broadest sense is conceivable, since it involves the totality of cultural and artistic behaviors. This is exactly the route which allowed the organic placement of the artistic experience generally within the theoretical-practical sphere under the sign of signification.

In the following century, Johann Heinrich Lambert's thinking is particularly important (1728-1777). Having read Wolff and Locke, in addition to Aristotle, he arranged the sciences into four groups, the third of which was "Semiotics or doctrine of designation of thoughts and things;" it "must indicate how the language and other signs influence the knowledge of truth and how these influences can be made useful to the objective" ("Neues Organon," 1764). According to Lambert, the function of the sign is not only to "renew the concept [. . .] without repeating the sensation," but also to act as an "indispensable aid to thinking." However, we are still far from the idea of "formativity" of the sign (of arbitrariness, in the sense of Saussure and Hjelmslev), which will eventually allow linguistics and semiotics to obtain extraordinarily fecund results. Lambert, under the influence of Leibuiz's analogous aspirations conceived semiotics as a science of the possible institution of a "characteristic," that is, of a strictly scientific language in the same determination and articulation of its elements, or signs, or "characters."

With this, in a peculiar crossing of Aristotelic, Lockian and Leibnizian ideas, the properties of the enacted object are transitively transferred first to the thought, and then to the sign. The isomorphism between language and reality, in the case of the sup-

posed scientific language, was of such a degree in Lambert that he affirmed that "the signs of concepts and objects are scientific in the narrowest sense, since they not only generally represent the concepts and objects, but indicate also such relations that the theory of the object and the theory of its signs can be interchanged." It is a strong formulation of a widespread conception, of classical origin, later established and mediated by the Thomist thought, for which words are signs of the thought and the thought is structured similarly to the comprehensible things through the intellect and/or perceivable through the senses ("res non cognoscitur ab anima - Thomas writes in the comment to "De interpretatione" - misi per aliquam similitudinem existentem vel in sensu vel in intelectu"); this conception and formulation lasted for a long time and found a relevant expression also in contemporary thought with the early Wittgenstein ("Tractatus logico-philosophicus," 1922) and a true popularization with the gnoseological theory of the "reflecting," of the "Wiederspiegelung" (Engles, Lenin, Lukàs). It is a conception that often goes by the name of "referentialism" (however it is a naive referentialism, to be distinguished from the referentialism of modern epistemology, and of Ogden, Richards, Russell, and Morris), by now completely overcome and overturned by the same Wittgenstein in his posthumous work "Philosophische Untersuchungen" (1953). However, it should be noted that Lambert was completely aware that the ideal language, capable of realizing an absolute congruence between words and things, represents for the existing languages and systems of expression only some sort of asintotic limit, which can be approached through a graduality of systems at the apex of which would be found the algebraic language "the most perfect model of the characteristic." This is the part of Lambert's thinking that is relevant to us today; it merges very different cultural experiences to the extent of representing one of the first and most complete anticipations of that which will later become the sphere or the applicative field of modern semiotics. By pointing out limits and hypothesizing changes, he analyzed the most different communicative languages (artistic, musical, behavioral, etc.) examining, in relation to the criteria of established validity, the pentagrammatic musical language, the choreographic language, the heraldry, the verbal and non-verbal language (genealogic trees) used in the description of family relations.

The analyses proposed by Lambert, tending to establish categories and semantic distinctions in the complex semiotic sphere (one could say: the cultural world "tout court"), makes him somewhat of a "forerunner" of the semiologic investigations of verbal and non-verbal communication, or even of signification in general, typical of the mid-20th century (Lèvi-Strauss, E. T. Hall, D. Morris, L. Prieto, etc.). The category of the "forerunner" is only intended as a useful artifice; Lambert obtained a first concrete realization of what had been simply hypothesized, and not specified, by Locke.

In order to form a true scientific semiotics, a radical rethinking of the traditional theory of knowledge is necessary ("adaequatio rei et intellectus"); paradoxically, such a rethinking was taken up through an 18th century philosopher who never had explicit linguistic and semiotic interests: I. Kant. It is from him, and from

the subsequent epistemology of Kantian origin (born in the second half of the 19th century and developed in our century by the "Kritik der reiner Verunuft," and particularly by the "Kritik der Urteilskraft," where the notion of intellectual "spontaneity" is united and specified with the notion of "creativity" of the judgemental faculty, establishing the basis for the "formativity" of knowledge and semiosis; cf. Garroni, 1976) that a semiotic conception was affirmed, particularly in the scientific field and as a theory of science (Helmholtz, the neoKantians, Cassirer, etc.). In a modern sense, semiotics will have to come to terms with this tradition, of which it is a sort of condition of possibility. The statement is theoretically provable through the examination of the anti-empirical components of linguistics and semiotics of the 1900s, all clearly deriving, although at times mediated, by Kant: the canonic pair of "langue" and "parole" for example, the idea-guide of "system" or "structure" (in Saussure, in the linguists - semiologists of the School of Prague, in Hiemselv), and so on, in which the retracing in a Kantian way from the "conditioned" to the "condition" is central, both conceived under the sign of systematicity. However, it can be confirmed also by relevant factual indications; for example, by the explicit connection between neoKantism and structural linguistics in Cassier ("Structuralism in Modern Linguistics, 1946) and by the significant rediscovery of rationalism and of the "a priori" entreatly (in reference first to Descartes, and then to Kant) by Chomsky, by his followers and by the so-called post-Chomskiani.

Logic and semiotics: Frege, Peirce. – Between the second half of the 1800s and the first years of the 20th century, substantial and decisive contributions to the formation of a semiotic science were also attained by the development of two related and complementary disciplines: logic (Frege) and linguistics (Saussure, foremost). The new categories for a semiotic as science of the production and interpretation of signs begin forming, together with the basics for an extraordinary broadening (even eccessive, at times) of its applied field.

In many ways, logic and linguistics can be considered as real "mother sciences" of semiotics, even in the case of Peirce, whose logical roots are indisputable; Peirce spoke properly of a logic as semiotics, or of a semiotics as "regenerated logic." It is also worth mentioning that in both these sciences (considered in a strict sense), and particularly within semiotics itself, there soon appeared a phase-difference epistemologically significant to the progress of their internal branches, and this lasted until modern times. Thus, if on the one hand logic and linguistics perfect their own methodologies in the syntactic analysis, on the other it is also possible to identify the problematical limits and the unsatisfactory solutions clashing with the attempts of a formalized definition (in an algorithmic sense) of the semantic structures of the language and of the communicative systems in general.

Toward the end of the 1800s the semantic issue was dealt with and defined by the studies of a logician, according to a scheme almost unchanged up till now, although criticized in many ways. In his 1982 essay "Ueber Sinn und Bedentung," Gottlob Frege (1848-1925) outlined the relations that link a sign with its meaning and its denotation; such a scheme, although it is outlined in relation to the verbal languages, and in the cited essay the references are mainly to that specific class of verbal signs that are nouns, is correctly extensible in most cases to the other expressive forms. Frege's contribution originated the consequent formulations; with another terminology, we find a similar distinction between "Sinn" and "Bedeutung" in Ch. Morris, and from this there developed an even more refined distinction between "meaning" and "sense" of linguistics and of recent semiology of Saussurian tradition (Prieto, 1964; De Mauro, 1970). Frege believed that a given meaning always corresponds to a sign, while it is not definite that a denotation corresponds to it; and vice versa to a single denotation or denotatum more than one meaning that expresses it can exist. By "denotation" or "denotatum" Frege meant what in logic is defined as "extension" of a sign, that is, the object indicated and represented by the sign. However, the term is used by Frege in a narrow sense, whereby the object is the "thing," an observable entity belonging to the empirical world; for example, in the object denoted by the sign "Venus," given that we are talking about the planet Venus, the denotatum is the celestial body whose entity has been recognized through the observation of the sky. By "sense" or "connotation" he meant what in logic is defined as the intension of a sign, that is, the way the denotatum is designated. Referring to the same example, which is the same one used by Frege, we would say that the planet Venus would be represented by the expression "Evening star" or with that, denotatively equivalent of "Morning star."

The pair "Sinn" - "Bedeutung" is synthetized in logic with the following proclamation: a sign expresses its own meaning (or intension) and designates its denotation (or extension). According to Frege, signs having a sense but not a denotation can exist. Thus, when I pronounce the word "centaurus" and trace an iconographic representation of it, I am well aware of expressing something that for me, and for whomever perceives such a sign, has a meaning; but it is true that that sign does not have a denotatum in the above specified sense; the centaurus, in the sphere of our knowledge, is not in fact a real, observable entity of the empiric world. The associated representation should be kept distinct from the denotation and from the same meaning: "If the denotation of a sign - Frege writes - is a sensibly perceivable object, my representation of it is instead an internal image that formed on the basis of memories of sensible impressions [. . .]. This image is often full of feelings; the clarity of its parts is different and incostant [. . .]. The representation is subjective and changes from person to person. Therefore, the representations linked to the same sign are variously different." The purely subjective moment, in the semantic structuring of the sign, is not as it might first appear in the meaning with which the designated sign is described, a meaning that can be universally understood, rather in the individual representation, that is in the range of internal associations evoked by the perception of the meaning itself. This third element, the representation thus assumes a value of semantic pertinence in the poetic messages (or extensively, artistic); likewise, in the referential or scientific messages the value of truth (the denotation, the Bedeutung) of the judgement establishes itself as semantic pertinence. It is at the level of representations that Frege places "the colorings and shadings that poetic art or eloquence attempt to give to the sense of the discourse;" they are not objective and the beneficiary has

to procure them by himself from the indications and promptings that he manages to gather from the work. But the poetic-artistic message does not consist solely of the necessarily imprecise evocation of the subjective representations but also of the meaning, which has its own objective statute; likewise, the referential message always manifests itself through the meaning. In this case, however, the meaning turns, so to speak, to the denotatum, while in the other case it turns to the subjective representation.

It is important to note that despite the immediate appearances, and irrefutable traditional logical-gnoseological reasons, which lead it to affect the notion of denotation - Frege's referentialism, which is undoubtedly at the basis of the referentialism characteristic of logic, linguistics and modern semiotics is something very different from its naive version, going back at least to Aristotle, and even more from its strong version (Lambert and Wittgenstein's isomorphism). Not only the Bedeutung is objective, but also the Sinn, even in the case in which a Sinn does not correspond to Bedeutung; this opens a wide range of scientific studies on the meaning, since this is no longer simply the "thing," or a close equivalent of it, about which not much can be said under a semantic profile, but it is our own talking of the "thing" and of something else (for example, of centaurus). Therefore, the meaning becomes the center, the mediator of every expressive phenomenon, between denotation on the one hand and subjective representations on the other; hence, the premises for an attempt to create a semiotics not only as a specialistic science, but even as a discipline unifying many other disciplines. This universalistic vocation was to be verified by the further development of semiotics and semiology. Moreover, it is clear that the Bedeutung tends to present itself, in Frege, as a border notion, some sort of "transcendental object" in a Kantian sense, or as a principle regulating the construction of criteria intended to assign different meanings to the same class of equivalence. Frege did not come to this conclusion, although he affirms that in order to thoroughly know a given denotatum "it would be necessary to be able to decide, given whatever meaning, whether or not it applies to the previously mentioned denotatum," and he added significantly that such a decision "is never reached." The already-mentioned intrinsic difficulties for a complete scientific comprehension of the semantic dimension are immediately clear, and the rigorous basis are combined with this for a treatment of the "sense" and the "meaning" outside of the traditional gnoseologic sphere. This is the conclusion reached by the successive semiology, when it reinterpreted the "Sinn" as "sense of a single expression" (Frege's "unilateral sense"), and the "Bedeutung" as "meaning," as "class of all the equivalent meanings." Obviously, this does not mean that the real object, or the observable thing, disappears; the object, more than an hypothesis, as Frege (and Kant) well knew, is an unavoidable condition for any cognitive act and any referential expression to be possible.

Charles Sanders Peirce (1839-1914) in his studies on the fundamental logical concerns, conceived semiotics as "regenerated logic," in the sense of logic not simply formal or, in Kant's precise sense (which has an important role in the formation of his thought), a trascendental logic. His semiotic research (as well as all the other kinds of research) goes far beyond Frege's interests, and he rightfully can be considered the real founder of modern semiotics, though successive studies utilized only partially, especially in Europe, his contributions, and at times even ignored them altogether. While alive, the novelty and extraordinary variety of his research was not given the interest it deserved, even in the U.S., and this delayed the publication of a great part of his works. His semiotic model appears schematically organized in the inter-relation of three characteristic entities: the sign, its object, and its interpreter. The meaning of the first two notions is, at least approximately, clearly perceivable; they apparently trace only the old concept of "function of representation" of the sign in relation to its object, as "something that stands for some other thing;" but the third term not only adds an important specification to the classic referential scheme, but deeply transforms it. In order to understand fully the novelty and depth of the Peircian position, it is necessary to go back to the definition of "sign," already considered by others as one of the most complete and rigorous: "A sign, or representation, is a First whose relation with the Second (its object) is such a genuine triadic relation that it enables a Third (its interpreter) to assume the same triadic relation with the object that sign does." This means, as it has been written, that "in a correct description of the semiotic connection none of the three terms - not even the object - can be defined independently from its relations with the other two" (Salanitro, 1969). It is then clear that the object of the sign is not at all the "thing," the real observable object, Frege's denotatum, but what is determined by the "thing" within the semiotic relation; therefore, it is rather a semiotic object, belonging by right to the sphere of a semiotic consideration. This does not mean, again, that the real, extrasemiotic object does not exist and that we end up in some sort of idealism. Peirce clearly distinguishes between the "immediate object," as Second of a semiotic relation, the "dynamic object" - the real one existing independently from the signs - and believes that this object is really operative, although not immediately present. What is observable is, at its proper level, the semiotic object (and it is worth emphasizing here again, the strong Kantian ascendence of such a problematic "dynamic object" - "semiotic object"). The meaning of a sign, then, is not at all the "thing."

The meaning of a sign is instead represented by the Third element, which is the interpreter, which assumes itself as a triadic relation with the object, in order to function as sign and to therefore require a further interpreter. A famous example in the linguistic-verbal field is the meaning of the word "cheese;" it does not refer to the cheese we eat, smell or point to, but it is another sign or group of signs (an interpreter) that explains the meaning of the given word, for example the expression "food obtained by the fermentation of curdled milk" (Jakobson, 1963). In this sense, not only the naive referentialism is overcome, but the new conception of the formativity of sign advances, equivalent to the Saussurian notion of arbitrariness. We have no hope of anchoring signs and meanings to a nomenclature, on an immediate and already analyzed, ordered and classified reality. Language, and semiosis in general, represent rather (to use Cassirer's expression in the "Philosophie der symbolischen Formen," 1925-1929)

original levels of elaboration of experience, something "new" (forms, categories, organizational principles) compared to lower levels, to which they cannot be reduced, for example compared to purely "expressive" levels (in Cassirer's sense), or to those properly of an animal behavior. Language, as Cassirer stated, is mediation (which is a different way of expressing the same notion of "triadic relation"), not a nomenclature. On the contrary, every form of spiritual activity (Cassirer) or semiosis (Peirce) is mediation; as the reality of empirical objects remains well-grounded, the indication of one or more objects is already a part of the construction of the intellectual world of things or of their semiotization. The semiotic process never starts from the immediate, but from a semiotic relation, that is, its "leaving" is (in fact) an "already left;" nor does it ever reach a complete semiotization, a total explanation of the meaning that through it is conveyed, to a last interpreter. Also at higher levels of semiosis, where we deal with the full generalizing capacity of language, the meaning of a sign can be revealed only by another more explicit verbal sign; and, in case such a sign is not sufficiently clear, it will have to be referred to a further interpreter, and so on. The "so on" is essential; semiosis proceeds (at least under an ideal and defined profile, given the fact that things can be different) ad infinitum. This means that semiosis is by definition, in Peirce, "unlimited semiosis." However, it is not to be interpreted only in a cognitive sense, since for Peirce even interpreters of actions and emotional interpreters existed, the latter ones being particularly important, it seems, in the case of the work of art (Hocutt, 1962, Smith, 1972, Shapiro, 1974); and this hypothesis alone, original and fascinating, can give an idea of the broadness and impartiality of Pierce's semiotic conception.

Better known is Peirce's systematic-classifying activity of all types of signs (which, from a theoretical standpoint, not considering certain restrictions, seem to be 59,049!); perhaps, again, an authentic mine of small and large discoveries to be made, but also weighed down by a quantity of theoretical and descriptive frictions that not always allow one to see the meaning, the consistency and the applicability of this typology. Nonetheless, even considering the first elements (for example the triple distinction of "icon," "index" and "symbol," that had an important influence both conceptually and terminologically, in the following studies) it must be recognized that Peirce not always has been correctly interpreted and utilized: the case of the so-called "iconic sign," widely used in the semiology of visual arts, is exemplary, and that notion has understandably undergone criticism (Eco, 1975). The most common mistake was to take Peirce's description literally, as descriptions of concrete signic objects, without considering the underlying theoretical compactness and several basic metatheoretical presuppositions here illustrated. The very notion of "unlimited semiosis," which is the basis of the definition of sign, raised perplexity and polemics, thus revealing a specific difficulty of comprehension and a relative tendency to take Peirce's formal character of the discourse to the level of factual description. Typical is the case of Charles Morris, one of the most authoritative post-Peircian American semiologists, who observed that Peirce's definition seemed "to confuse the problem of the definition of "sign" with the empirical issue of knowing whether the signs always generate new signs," stating that consequently "a circularity in the definition is introduced, since a sign is defined as something generating a sign generating a sign etc., and that this form of definition of "sign" is certainly debatable." However, Morris position is important, even from the standpoint of an artistic semiology; the essay "Esthetics and the Theory of Signs" (1939) is particularly interesting.

Linguistics and semiotics: Saussure and Hjelmslev. – The methodology, the theoretical-systematic theories, the terminologic instrumentation, the same object and goals of semiology of this century are offered by the new linguistics rather than by the studies of the logicians. Its main innovative period is found in the thinking of the Genevan F. de Saussure (1857-1913), reconstructed from the notes of his university courses in the posthumous volume "Cours de linguistique générale" (1916). Saussure's prevalent interests were linguistic, and particularly those relating to the theory of language; although he clearly foresaw the possibility of a more general science of signs or "semiology:" "The language is a system of signs expressing ideas and, therefore, it is comparable to writing, sign-language, symbolic rituals, polite forms, military signals, etc. It is simply the most important of these systems. It is therefore possible to conceive of a science that studies the life of signs in the context of social life; it could be part of social psychology and, consequently, of general psychology; we will call it semiology (from the Greek word for "sign").

Saussure's linguistic theory is so general that it prefigures the theoretical outlines, or at least certain basic presuppositions, of future semiology. This is what Saussure himself affirmed when, having wondered why semiology had not been recognized yet as an autonomous science, he replied: "The fact is that we go around in circles: on one side nothing is more suitable than language for explaining the nature of the semiological problem; but, to put it conveniently, it would be necessary to study the language in itself; except that, so far, the language has been examined almost always as a function of some other thing, under different points of view." Saussure refers to physiological, psychological and sociological studies, but also to the consideration of language since it refers to something already constituted and analyzed; language as "nomenclature." The objective is to study exactly what is specifically linguistic, where segments of semiology are also found; in this perspective a series of basic and related ideas can be proposed; they were to be the basis not only of linguistics and semiology of the 1900s, but also in an emerging philosophical-cultural environment that favored it, of that method or methods of investigation known as "structuralism." The idea of language as "system" (as "structure," as affirmed by the linguistics of the Prague Circle) is one of these, to which the opposition "sincrony" - "diacrony," the idea of "form," of sign as "double faced psychical entity," and finally the new idea of "arbitrariness" are linked. A sincronic consideration, in relation of opposition (but not of exclusion) with a diacronic or evolutionary consideration, allow the study of language as a system of internal dependencies; this consideration will be formal (its object being the form of language, the *langue* as system of dependencies, in relation of opposition with the *parole* as a single linguistic manifestation), and only in this case are we able to

speak properly of an "object" of linguistics (in an epistemological sense) and not simply of a "matter" (admitting different, heterogeneous types of investigation about language, as something "irregular"). Within this framework, the sign as "double faced entity," as union between "meaningful" and "meaning" (one being unmotivated in relation to the other), stands out as something that can be studied in its objectivity and autonomy since it is organized essentially with a system of differences. They are not simply unmotivated (according to the old idea of conventionality), but are also arbitrary (in themselves), both as a meaningful and as a meaning, in the sense that they analyze arbitrarily and respectively, as a form, the substance of the meaningful (for example the phonic form) and the substance of the meaning (the conceptual substance, the ideas or, in general, the experience); two implicit analyses (possible in function of the above-mentioned "formativity") that can exist only in their union, in the sign and in the system of signs. (For the explanation of Saussure's modern concept of arbitrariness, cf. De Mauro, 1966 and 1967).

The idea of "system of language" is not only a useful epistemological device used to study the language under a more compact hypothesis, and therefore with greater rigour and homogeneity; in the large it also indicates the same condition of concrete linguistic production. This does not affect at all the fixity, singularity and unrepeatability of these productions as acts of "parole:" it would be incorrect to contrast Saussure, as a theorician of the language-system, with Croce's contemporary thought, as a theorician of linguistic creativity without rules; idealistic lingustics deals with primarily one side of the issue (the side of "creativity"), and in a purely speculative way; while in Saussure the peculiarity of the linguistic realizations (and, in general, of the semiotic ones) and of their possibility, as conditioned by the "potentiality" of the langue are contemporaneously affirmed. Creativity and regularity are included in a unique theoretical device: this is an important discovery (not always considered adequately) for the subsequent studies, especially in the sphere of aesthetics and of artistic-literary criticism, since it confirms, without omitting explanatory requirements, the unrepeatability and the limits of imitativeness of the realizations of the "natural" codes of expression and not the gestual or recitative codes from the ritualistic, musical and figurative, etc. codes even when the aesthetic function is dominant.

In the specific sphere of the figurative arts, we find traces of these methodic concerns in certain authors, however different, who were aware, directly or indirectly, of Saussure's thinking and of the later structuralism, and who, nonetheless, participated in the emerging cultural climate, which was progressively maturing, which makes Saussure's revolutionary positions possible, regardless of the dominant historicism. What characterizes esthetics and criticism, which we can define "structural" in a broad sense, is not so much the application of methods resorting to (often in a material and analogous way) the use of categories of linguistics and semiotics, but the operative conscience of the opposition between diacronic and historic study, on the one hand, and on the other, the sincronic study of the dependencies, or of the relations, between entities constituting the most different "signic systems." This is an example of sincrony which carries with it, almost inevitably, the entire constellation of Saussure's main ideas, which in the period of their spreading in the post-war years tended (not always legitimaly) to consolidate in the semiology prefigured by Saussure. In particular, what is known today as "semiology of art" is part of that trend of research, with all the consequences - positive and negative - related to it. What must be rediscussed, in the context of these questions, is the possibility, so far unrealizable, of building systems of signs appropriate and analogous to the linguistic *langue*, in relation to the so-called artistic languages.

Probably Saussure's influence has been decisively reinforced, not only in Europe, by the contribution of Louis Hjelmslev (1899-1965), the Danish linguist who is considered the most rigorous continuer and systematizer of Saussure's current. However, no semiologic contribution was made in the last two decades, especially in the sphere of the so-called non-verbal languages (cinema, architecture, figurative arts in general) which would not refer to Hjelmslev's thought, notions and terminology. From a general standpoint, there are probably two traits that distinguish Hjelmslev from Saussure: a very strong tendency toward a purely formal foundation ("axiomatic" or "hypothetical-deductive," in non-Hjelmslevian language) of the theory of language and toward a consequent formalization of the language of linguistics (a formalization more desired than realized, and in fact closer to a symbolization); secondarily, the effort to build a very powerful metatheory, which would serve in the formation of a very general semiotic theory. Whether or not these objectives have been reached the undisputably positive fact remains that Hjelmslev carried forward an interesting and extremely productive generalization of Saussure's thought, and that this generalization, surpassing the traditional terminology of a strictly linguistic origin, offers unusually fertile theories for a general semiotics (together with its possible specifications in particular semiotics), meant to affirm the most diverse expressive phenomena, particularly the languages related to aesthetics and artistic-literary criticism.

It is almost impossible, given the extreme complexity and specialistic difficulty of Hjelmslev's thought (expressed especially in "Omkring sprogteoriens grundlaeggelse," 1943, Engl. transl. authorized and edited by the author "Prolegomena to a Theory of Language, 1953, and in the "Essay Linguistique," 1959, particularly in his basic essay "La stratification du language," 1947), to attempt and give a quick and reliable description of it. It will suffice to recall here certain significant aspects in relation to our problem. First of all, the traditional notion of sign is destroyed (which remains as particular term) and replaced by that of "signic function." If the "sign" was required, according to the classic ("realistic") conception, to be a "sign of same other thing" and therefore an "external function," the "signic function" is instead conceived essentially as an "internal function" between (in Saussure's terminology) "meaninful" and "meaning," or between (in Hjelmslev's terminology) "expression" and "content." These are two notions that no longer refer intuitively to what is the substantial signifier and what is the substantial meaning of the concrete experience of verbal language; these can be identified only, according to Hjelmslev, in their opposition and reciprocal relation, formal and non-sub-

stantial. Expression and content are then conceived as two hierarchies of classes, not in a biunivical relation, formed by all those formal distinctions representing the conditions for the realization of a semiosis, that is to say (in Hjelmslev's language) they can be coordinated to something material, not immediately observable, to which they give a structure, so that the "matter" becomes observable as "substance" (= informed matter). Saussure's basic concepts are thus specified and systematized; we speak of "form," "substance" and "matter" respectively as formal organization (which is the object of semiotics and linguistics), as observable language or semiosis, as theoretical non eliminable presupposition that allows the justification of the material equivalency (for example in the order of the sense) between two substantially different texts, inasmuch as they are organized differently in function of different forms, and they refer to the same segment of the sense matter (for example, two texts, one Italian and one English, where one is the translation of the other and vice versa). The equivalency, or at least the strong analogy (unless certain obvious differences exist) between Frege's "denotation," Peirce's "dynamic object" and Hjelmslev's theoretical notion is easily observable, by putting aside the aporias of the traditional idea of "representation." No longer "representation" but "coordination" (of a form to a substance and therefore to a matter). The most serious difficulties seem to fall; up until then they had hindered the systematic use of semiotic instruments in the sphere of aesthetics and of artistic-literary criticism, and had consisted essentially of the opposition between the transitive character of semiosis ("something for some other thing") and the intransitive character of artistic expression (something having, except for obvious but not characterizing deferments to something else, its own meaning). We might say: between "absence" and "presence" (cf. the particularly significant analyses by Brandi, 1966 and 1967). The opposition seems to lose much of its dramatic character, without eliminating the real problem it designates; in fact (also in the obviously transitive communication), we come to terms with something which must be analyzed and explained no longer in terms of "representations," but in distinctive formal traits, which can be coordinated to something substantial. In other words, in semiosis, whether the aesthetic function is dominant or not, we must consider in the first place, according to Hjelmslev's perspective, the problems inherent in its formal organization. The semiotic approach even in non verbal arts, particularly the visual arts, where the representative function too is clearly subordinated if not absent, as in the typical case of architecture, would thus be fully justified.

However, it is necessary to specify that the definition of "semiotics" (as a formal system) is not, in Hjelmslev, so universal and universally applicable, as the previous description would suggest. He proposes, in fact, a precise restriction, which consists of a "biplanar" semiotic system by definition (the levels being "expression" and "content"). This biplanarity would be missing if the levels would remain in complete biunivocal correspondence (if to each element of one would correspond one and only one element of the other, and vice versa); in this case according to the "principle of semplicity," their own distinction would not be justified from a formal point of view. This does not occur for all the known languages, whose systems include a distinct analysis of expression and content in "figures," in minimal entities (for example phonemes and semantic components), without any correspondence on the other level. In an abstract way, the theory poses the question of the presumed existence of those other cases (of non-languages) in which the condition of biplanarity (analogous to Martinet's condition of "double articulation") is observed; Hjelmslev limits himself to suggest the examples of logistics, of mathematics and of musical language to the specialists. This condition would not be required by the symbols, considered by Hjelmslev as "non semiotic interpretable entities," which can appear as a semiosis under a substantial profile, of function and usage, as they are still interpretable, that is, they can be coordinated with something substantial, but they cannot be reconducted to a semiotic system because they are not formally biplanar; it is the case of "representations or emblems" like Thorwaldsen's Christ as a symbol of pity, the hammer and sickle as a symbol of communism, the scale as a symbol of justice, or onomatopoeia in the linguistic sphere."

But it is also true that Hjelmslev's semiology has generally neglected the distinction between "semiotic system" and "symbolic system." There was an attempt to uphold the idea that this distinction, although theoretically correct, is not completely supportable, considering the whole context of Hjelmslev (Garroni 1972); and in any event, various and more comprehensive semiotic theories have been proposed, which maintain it only subordinately (cf. especially Prieto, 1966 and 1975). Whether acceptable or not, these theoretical and interpretative trends have signaled the need for a further extension of a semiotic consideration, particularly in the domain of the figurative arts. In the same extensive sense, Hjelmslev's notion of "descriptive semiotics" has been used by many, with applications in the fields of literature, cinema and architecture. Hjelmslev's operative definition is the following: a connotative semiotics is a semiotics "whose level of expression is a semiotic." It is a complex and heterogeneous formal model, in which different systems intervene, in which the "stylistic forms" (verses, prose, their various combinations), "styles," different "values" (superior, fair, inferior and so on), "means" (word, writing, gesture, flag signals, etc.), "tones" and different "idioms" (vernaculars, national languages, regional languages, etc.) are considered. The extension of this model to various expressive forms, even and especially non-verbal forms, particularly to those considered traditionally as "combined" (dance, melodrama, cinema, etc.) is evident. But, beyond the aesthetic area, Hjelmslev's instrument proved to be particularly suitable to confirm the cultural experience of each type in its stratification, crossing and multiplication of the meanings (where we have a proliferation of "second functions:" cf. Eco, 1968 and 1972 and the important studies by Ivanov, Toprov, Lotman).

Semiotics today: problems, limits, applications. – The strongest stimuli for the formation of a generalization of semiology or semiotics have come especially, but not only, from Saussure and Hjelmslev's approach. A typical case, which has been much discussed between the late 1950s and 1960s, is that of Lévi-Strauss and of structural anthropology, which represented a big step from linguistics and semiotics to human and social sci-

ences in general. It is not easy to precisely evaluate this universalistic tendency and its practical applications. Usually perceived as a sign of vitality and productivity (Jakobson, 1973; Prieto, 1975; Eco, 1975), it nonetheless presents some initial difficulties (of which the cited authors and others are aware). Actually, it appears certain that a structural methodology has become prevalent (aimed at determining, according to Hjlmslev, the system of internal dependencies to which any sphere of cultural pheonomena is, or could be, referable), more than a semiology as a specific discipline. This methodology has often been specified as a systematic application of the logic of the classes. It is legitimate then to ask ourselves whether or not a semiology as a specific discipline, with its own defined object of investigation exists, and how it can be identified in the field of general knowledge (including also non-cultural territories, as in the case of zoosemiotics). It is also legitimate to ask - as it occurred to Chomsky in regard to structural linguistics, especially the American one - if a classifying-systematic method, always useful for the preparation and the inventorial control of the materials of investigation, besides being descriptive, is always explicative. Finally, it should be noted that the theory of information in the late 1940s, which developed even further in the following decade (Wiener, Shannon and Weaver) has contributed to the generalization of semiotics. One might also ask how this generalization could ever concur with the specificity of semiotics, given the existence, other than formal or purely mathematical definitions, of intuitive notions, whose congruence with the others has been given at times to simple homonymy (for example, in the case of the term "information").

These intuitive notions have had, and still have, an important place in the semiology since about 1930, even in the sense of a theoretical restriction of its object. On a more properly philosophical level, with the influence of the documentation from Husserl's phenomenology, we can recall the idea of "intentionality" (and finality) which sustained the theories expressed by the semiologists and linguists of Prague, at least since the well-known "Thesis" of 1929, which led to the opening of the important "Travaux du Cercle linguistique de Prague," with the collaboration of Jan Mukarovsky and Roman Jakobson among others. Mukarovsky is worth mentioning especially for his interest in the most diverse cultural phenomena, for his theorization of the so-called "aesthetic function" and for the foundation of a true "functional aesthetics" (no longer categorical) on semiologic bases. This was an important and original development of the poetical and technical formulations (operating between 1910-1920) of the so-called "Russian formalists," particularly J. Tynjanov and Jakobson. However, Mukarovsky subsequently went beyond the primitive "intentionalism" in his work dated in the 1930s and later.

A basic internationalism remains, nonetheless, in Jakobson's recent works, although in a more complex and articulated form. He has the merit of the noted schematization of the aspects, or necessary conditions, of communication, including even non-linguistic ones ("sender," "message," "receiver," "code," "context," "contact") on which a more rigorous and complete theory of the linguistic or semiotic functions is based ("emotional," "poetic," [or "artistic]," "metalinguistic," "referential" or "cognitive," "conotative"). This was uti-

lized and widely discussed in many later studies ("Linguistics and Poetics," 1958, in Jakobson, 1963). These functions were determined and identified in relation to the fact that, in communication, the "intention," the "attention" and the "interest" are centered around a particular aspect or condition, and that the phenomenon is noticeable through the observation of characteristic indexes. Clearly this intentionalistic and finalistic conception is certainly explanatory within certain limits, but it will no longer be so if we tangibly lose the possibility of verifying, if that which occurs at a communicative level is really the objective of an intention instead of the result of profound structures that are not necessarily conscious, or subconscious impulses. All this is identifiable in Jakobson, to the extent that the original intentionalism become specified as structural methodology. A stronger and more material intentionalism has instead been postulated by the Belgian semiologist of a predominantly Saussurian influence, E. Buyseseus. According to him, the "communicative act" is the "act through which an individual who knows a perceivable fact associated with a certain state of consciousness (a "sign," in short), realizes that fact because another individual understands the objective of this behavior, and forms in his own conscience that which takes place in the conscience of the first person" ("La communication et l'articulation linguistique," 1967, re-elaboration of a 1943 text). This leads to a clear distinction between "index" (non-communicative) and "semantic act" (communicative), and the limitation of the object of semiology to the latter. The definition is very strong; it is not a coincidence that artistic expression, in which the will to communicate (which undoubtedly exist) is not identifiable according to this definition, is placed among the non-communicative expressive facts. Prieto attempted to tone down this radical opposition by introducing the triple distinction between "spontaneous index," "falsely spontaneous index" and "intentional index," and by formulating the following classification of the semiologic disciplines: "linguistics," "semiology of communication" and "semiology of signification," according to an order of increasing generality ("Etudes de linguistique et de sémiologie générales," 1975). Thus, there remains a distinctive criterium of intentionality (semiology of communication, semiology of signification), next to a formal criterium (linguistic-semiology, distinguishable for the relations of "exclusion" between the meanings of non-linguistic systems, and for the relations of "exclusion"-"inclusion"-"intersection," which, instead, would characterize the meanings of linguistic systems), but always in the general, classificatory framework of a universalistic semiology.

The universalistic (or the "imperialistic") aspect of semiotics could be flawed due to its weak and inadequate explanation of everything. It is associated with a "theory of codes" (or of "systems"), which are not known to be realizable and to what extent. In fact, beyond the verbal language and the semiotic systems that are conditioned by it, this theory has been only imperfectly developed, and often only analogically (in material analogy with the method of linguistics). At the moment, we do not possess cognitive equivalents of the linguistic systems in reference to the so-called literary, pictorial, architectonic, cinematic languages, etc. A theory of systems is perhaps legitimate only as a regulative scientific ideal, in the sense that we should identify all

the possible regularities of the considered phenomena through the formulation of formal systems of invariables (or quasi-invariables); but at the same time it cannot prescribe that this construction is always necessarily possible and, if possible, adequate.

On the other hand, it has been suggested that this must be excluded in regard to the same verbal languages, for that which is properly semantic in them and which expresses itself opposite to that which is expressed by the conditions of the "lexical noema" ("Saggio di teoria formalizzata del noema lessicale," in De Mauro, 1970). Now, in the cases of non-constructibility, a semiotic theory of systems could be realized only in a descriptive form; it will provide an inventory of the "signs," empirically and not without the gross approximations in the identification of these signs, but it will not succeed in properly explaining their process of functioning, their legality and the internal principles that support them, and therefore, it will be forced to renounce something that is essential to the very idea of system, the rigor, the exhaustiveness and the cohesion. We will then have an inventory and not a system. This also happens with "cinesica," "prossemica," and "zoosemiotics" and to all those particular semiotics dealing with weakly structured languages, including also the so-called artistic languages. A reliable hypothesis useful in dealing with this kind of difficulty was proposed by Roland Barthes in 1964; it overturned the traditional ideas of Saussure through the affirmation that semiology must be considered as a science of the "second language," as a part of linguistics and not vice versa. Even this attempt has been shown to contain problems since the hypothesis that states that any non-verbal message always has a precise equivalent in terms of a verbal language, is still verified (this led Barthes to extreme and inadequate suppositions, as in the case of the postulated equivalence between photographs and their captions; cf. "Système de la mode," 1967). However, it is probable that verbal language is to be considered not simply as a language among the others, and perhaps only the most important of them for "power," "clarity," "explicitness," "ductility," "controllability" etc., but actually the base of every semiotic activity, such as the language that generates or radically restructures, in a semiotic sense, every other behavior. The examination of the presumed semiotic activity of non-human animals and children in a pre-verbal stage appears, despite the disparity of opinions on the subject, to legitimatize this hypothesis. This perspective could perhaps be usefully associated with the theory (left at an incomplete state in the 1930s, by L. Vygotsky), according to which one retraces from the structures of the "manifested language" to those of the "internal language," and from here to the various, possible, non-verbal semiosi, following an order of investigation which is inverse to the order of apprition from a genetic point of view. Even the attempt of the approach associated with Greimas (anchoring semiotics to the "meaning" as its primitive category) is in some ways analogous to Barthes' perspective; however, it has its own inconveniences; it could lead one to forget that the meaning is strictly correlated to the ways of identifying and conveying it, or to suppose that the critical-analytical discourse on painting can be considered as a "metalanguage" compared to painting itself as its "object language" (Greimas, 1966); thus there begins a sort of "ontologization" of the meaning (Greimas, 1970), an involuntary agreement with an antisemiotic and antistructuralist approach, which has produced interesting results in various cultural fields, although more speculative than scientific (Gadanner, Lacan, Derrida).

The cultural and applicative merits of semiology in the field of study of artistic languages are, however, unquestionable regardless of any difficulty, inadequacy or erroneousness of its current statute. Putting aside the studies dedicated to literature and poetry, and considering strictly artistic languages, we will mention that so far, for various reasons, only architecture (Koenig, Garroni, Eco, Jencks and Baird ed., 1969, De Fusco, Scalvini, Zevi, etc.) and film (Metz, Pasolini, Garroni, Bettettini, etc.) have particularly stimulated the semiologists; that musical semiology (Ruwet, Nattiez, Stefani, Pousseur, etc.) has provided many interesting results. The semiotic consideration of painting and of the figurative arts in general, although rudimental and heterogeneous, has made several relevant contributions, resulting from a cross between semiology, psychology of perception and iconology of a Warburghian inspiration, is the semiotic consideration of painting and of figurative arts (Gombrich, Francastel, Danmish, Schefer, Menna, etc.). However, aside from any applicative result, one must keep in mind that semiology, in as much as it is heterogeneous, has contributed in a decisive way to discredit the intuitionism, the historicism, the sociologism and the eclecticism that have heavily influenced the tradition of artistic-literary criticism since their inception (we do not mean intuition itself, historicity, the sociopolitical valences and the heterogeneity in art and in criticism). It also has promoted a more careful consideration of the sincronic conditions in the function for which any message is possible, a necessary basis for a better formulation of its comprehensive, historical placement. Even in the Marxist area, and in a clear opposition to Croce's aesthetical critical tradition, a semiotic-linguistic point of view (with explicit references to Saussure and Hjelmslev) characterized the notable contributions made by G. della Volpe in the 1950s and 1960s. The limits of semiotics can be summarized by schematization, in the recognition of the fact that the idea itself of system, associated with an often material and naive idea of sign, has made possible research that is not always well-calibrated, of the non-linguistic semiotic systems that are presumed to be underlying the artistic languages, in an excessively close analogy with the linguistic systems. Also, the aspects to be discarded in relation to this approach have been realized, in the sense of Barthes' "great significant unities," of Greimas' semiotics of signification, or of a simply and consciously descriptive semiotics. Instead, it is probable that, if the semiotics of the arts is a sincronic consideration of the invariables or quasi-invariables retraceable in the artistic languages, in their connection with culture in general, and with verbal culture in particular, as their semiotic foundation, then it is necessary to impartially seek those invariables, more than the "signs," since these invariables are the condition of "material codes," that is, of empirical artistic rules, and of the realization of messages as bearers of one of their peculiar significations, not codifiable in a strict sense. This also entails a reattachment to tradition, a reconsideration of the old theories of proportions as true organi-

zational principles (but then even Wittkower would belong to semiotics!), the projective systems (as in the case of the perspective studies by Panofsky), the basic formative categories (Woeffein), in short, the presuppositions of the way of visualizing and constructing - together with every other condition of a different order: iconographic, typologic, functional, etc. Within this perspective Brandi's severe criticism of artistic semiology (Brandi, 1974) is justified also from a semiotic point of view, and it is possible to integrate it within a more correct and articulated problematic horizon. But this work is still in progress.

BIBLIOGRAPHY - a) Reviews (the date given is that of the first year of publication): Communications, Paris, 1966; Langages, Paris, 1966; Lingua e stile, Bologna, 1966; Op. cit., Napoli, 1964; Semiotica, The Hague, 1969; Versus (VS), Milano, 1971. See also the issues dedicated to Semiotics in the reviews: Recherches Internationales, Paris, 81, 1974; Le Scienze, Milano, 61, 1973. - b) Collections of bibliographies: Communications, 4, 1964; O. Calabrese, E. Mucci, Guida a la semiotica, Firenze, 1975; T. De Mauro, Introduzione alla semantica, Bari, 1965 (ed. riveduta e integrata, Bari, 1970); U. Eco, Trattato di semiotica generale, Milano, 1975; V. Erlich, Russian Formalism, The Hague, 1954 (tr. it., Milano, 1966); G. C. Lepschy, La linguistica strutturale, Torino, 1966; G. Mounin, Clefs pour la sémantique, Paris, 1972 (tr. it., Milano 1975); Versus (VS), 8-9, 1974. c) Bibliographies by text sections - 1) Introduction: O. Ducrot, T. Todorov, Dictionnaire encyclopédique des sciences du langage, Paris, 1972 (tr. it., Milano, 1972); T. De Mauro, Introduzione . . . , cit., 1965; B. Malmberg, La linguistica contemporanea, Bologna, 1972 (tr. it. dalle versioni inglese e francese; ed. originale sved. 1962); L. Melazzo, La teoria del segno linguistico negli stoici, Lingua e stile, 2, 1975; G. Mounin, Introduction à sémiologie, Paris, 1970; Ch. Morris, Signs, Language and Behavior, New York, 1946 (tr. it., Milano, 1949); Th.A. Sebeok (a cura di), Current Trends in Linguistics, vol. 3, The Hague, 1966; Th.A. Sebeok, Semiotica e affini, Versus (VS), 3, 1975). 2) Seventeenth and eighteenth centuries: R. Bastide, Sens et usages du terme structure, The Hague, 1962 (tr. it., Milano, 1965); E. Cassirer, Structuralism in Modern Linguistics, Word, 11, 1946 (tr. it., Napoli, 1970; e in Nuova Corrente, 44, 1967). N. Chomsky, Language and Mind, New York, 1968 (tr. it., in Saggi linguistici 3 - Filosofia del linguaggio, Torino, 1969); E. T. Hall, The Silent Language, New York, 1959 (tr. it., Milano 1969); E. T. Hall, The Hidden Dimension, New York, 1966 (tr. it., Milano 1969); E. Garroni, Estetica ed epistemologia. Riflessioni sulla Critica del Giudizio, Roma, 1976; J. H. Lambert, Neues Organon, Leipzig, 1974 (tr. it. parziale delle parti III e IV in Lambert, semeiotica e fenomenologia, a cura di R. Ciafaredone, Bari, 1973); Cl. Lévi-Strauss, Anthropologie structurale, Paris, 1958 (tr. it. Milano 1966). 3) Logic and semiotics: E. Cassirer, Philosophie der symbolischen Formen, 3 voll., Berlin 1923-29 (rist. anastatica, Darmstadt, 1953-54; tr. it., con ampia bibl. di e su Cassirer a cura di R. Klibansky e W. Solmitz, Firenze, 1961; in rif. a Cassirer vedi anche: C. H. Hamburg, Symbol and Reality: Studies on the Philosophy of Ernst Cassirer, The Hague, 1956; S.K. Langer, Feeling and Form, New York, London, 1953; tr. it., Milano, 1965); T. De Mauro, Introduzione . . . , cit., 1965; U. Eco, Trattato . . . , cit., 1975; G. Frege, Über Sinn und Bedeutung, Zeitschriften für Philosophie und philosophische Kritik, 100, 1892 (rist. in Kleine Schriften. 1967, tr. it., in Aa. Vv., La struttura logica del linguaggio, a cura di A. Bonomi, Milano,

1973 e in Logica e aritmetica, a cura di C. Mangione, Torino, 1965); S. Ch. Pierce, Collected Papers, Cambridge, 1931-35 (in rif. a Peirce vedi pure: N. Bosco, La filosofia pragmatica di Ch.S. Peirce, Torino, 1959; M. O. Hocutt, The Logical Foundations of Peirce's Aesthetics, Journ. of Aesth. and Art Crit., 165, 1962; N. Salanitro, Peirce e i problemi dell'interpretazione, Roma, 1969; C. M. Smith, The Aesthetics of Charles S. Peirce, Journ. of Aesth. and Art Crit., 1, 1972); Ch. Morris, Foundations of the Theory of Signs, Chicago, 1938 (rist. in Chicago, 1959; tr. it., Torino, s.d.); Ch. Morris, Esthetics and the Theory of Signs, Journ. of Unif. Science, 8, 1939; Ch. Morris, Signs . . . , cit., 1946; Ch. Morris, Signification and Significance, Cambridge, 1964 (in rif. a Morris vedi anche: F. Rossi-Landi, Charles Morris, Roma, Milano, 1953, con ampia bibl. di e su Morris); L. Prieto, Principles de noologie, The Hague, 1964 (tr. it., Roma, 1967). 4) Linguistics and semiotics: F. De Saussure, Cours de linguistique générale, Paris, 1916 (tr. it., con ampia bibl., note e apparato critico a cura di T. De Mauro, Bari, 1967); T. De Mauro, Modelli semiologici: l'arbitrarietà semantica, Lingua e stile, 1, 1966; T. De Mauro, Senso e significato, Bari, 1970; L. Hjelmslev, Omkring sprogteoriens, grundlaeggelse, Copenhagen, 1943 (tr. it. dall'ed. inglese, 1953: I fondamenti della teoria del linguaggio, Torino, 1968); L. Hjelmslev, Essais linguistiques, Copenhagen, 1959 (rist. Paris, 1971; in rif. a Hjelmslev vedi pure: F. Antinucci, Note metodologiche in margine alla teoria hjelmsleviana, Lingua e stile, 2, 1969; E. Garroni, Progetto di semiotica, Bari, 1972; A. Martinet, Au sujet des fondaments de la thèorie linguistique de Louis Hjelmslev, Bull. Soc. Ling., 42, 1946; G. Graffi, Struttura, forma e sostanza in Hjelmslev, Bologna, 1974; R. Raggiuniti, Il problema del significato nella teoria di Louis Hjelmslev, Problemi di significato, Firenze, 1973); C. Brandi, Le due vie, Bari, 1966; L. Prieto, Messages et signaux, Paris, 1966 (tr. it., Elementi di semiologia - messaggi e segnali, Bari, 1971); L. Prieto, Pertinence et pratique, Paris, 1975; L. Prieto Études de linguistique et de sèmiologie gènèrales, Paris, 1975; R. Faccani, U. Eco (a cura di), I sistemi di segni e lo strutturalismo sovietico, Milano, 1969 (con saggi di aut. vari, tra cui V. V. Ivanov, V. N. Toporov, A. Zaliniak); J.M. Lotman, B.A. Uspenskij: in Aa. Vv., Ricerche semiotiche, Torino, 1973, J.M. Lotman, B.A. Uspenskij, Tipologia della cultura, Milano, 1975; J. Tynjanov, Il problema del linguagio poetico, Milano, 1968 (tr. it.); J. Tynjanov, Avanguardia e tradizone, Bari, 1968 (tr. it.); V Propp, Morfologia della fiaba, Torino, 1966 (tr. it.); J. Vachek (a cura di), A Prague School Reader in Linguistics, Bloomington, 1964 (saggi di aut. vari, tra cui V. Mathesius e A. Artimovyč); Il Circolo Linguistico di Praga, Thèses, in Travaux du Cercle Linguistique de Prague, 1 Praga, 1929 (tr. it., Le tesi del '29, Milano, 1966); U. Eco: La struttura assente, Milano, 1968. 5) Semiotics today: R. Barthes, Eléments de sémiologie, Communications, 4, 1964 (tr. it., Torino, 1966); R. Barthes, Système de la mode, Paris, 1967 (tr. it. Torino, 1970); M. Bense, Aesthetica, Baden-Baden, 1965 (tr. it., Milano, 1974). C. Brandi, Teoria generale della critica, Torino, 1974; E. Buyssens, Le langages et le discours, Bruxelles, 1943; E. Buyssens, La communication et l'articulation linguistique, Paris, 1967; G. Della Volpe, Critica del gusto, Milano, 1960; J. Derrida, L'ecriture et la différence, Paris, 1967 (tr. it., Torino, 1971); U. Eco, Trattato . . . , cit., 1975; R. Jakobson, Essais de linguistique générale II, Paris, 1963 (tr. it., Milano, 1966); R. Jakobson, Essais de linguistique générale II, Paris, 1973 (in rif. a Jakobson vedi pure: E. Holenstein, Jakobson, Paris, 1974); J. Mukařovský, Il significato dell'estetica, Torino, 1973 (in rif. a Mukařovský vedi pure: A De paz, Semiologia e sociologia nell'estetica strut-

turalista di Mukařowský, Lingua e stile, 3, 1975); A. Moles, Théorie de l'information et perception esthétique, Paris, 1958; L. Prieto, Pertinence . . . , cit., 1975; E. Garroni, La crisi semantica delle arti, Roma, 1964; E. Garroni, Semiotica ed estetica, Bari, 1968; E. Garroni, Progetto . . . , cit., 1972; T.A. Sebeok, Animal Communication, Bloomington, 1968 (tr. it., Milano, 1972); E.H. Lenneberg, Biological Foundation of Language, New York, 1967 (tr. it., Torino, 1971); R.H. Hinde (a cura di), Non-verbal Communication, Cambridge, 1972 (tr. it., Bari, 1972); A.J. Greimas, Sémantique Structurale, Paris, 1966 (tr. it., Milano, 1969); A.J. Greimas, Du sens, Paris, Paris, 1966 (tr. it., Milano, 1969); A.J. Greimas, Du sens, Paris, 1970 (tr. it., Milano, 1974); L.S. Vygotsky, Pensiero e linguaggio, Firenze, 1966 (tr. it.; pubbl. originale 1934).

Specific bibliographies. – 1) Semiotics of architecture: Aa. Vv., Architettura come semiotica, Milano, 1968; R. Barthes, Semiologia e urbanistica, Op. cit., 10, 1967; C. Brandi, Struttura e architettura, Torino, 1967; R. De Fusco, Architettura come mass medium. Note per una semiologia dell'architettura, Bari, 1967; R. De Fusco, Significanti e significati nella Rotonda palladiana, Op. cit., 16, 1969; R. De Fusco, Segni, storia e progetto dell'architettura, Bari, 1973; G. Dorfles, Valori iconologici e semiotici in architettura, Op, cit., 16, 1969; U. Eco, La struttura . . . , cit., 1968; E. Garroni, Progetto . . . , cit., 1972; C. Jenks, G. Baird edd., Meaning in Architecture, London, 1969 (tr. it., Bari, 1974); G.K. Koenig, Analisi del linguaggio architettonico, Firenze, 1964; N.L. Prak, The Language of Architecture, The Hague, 1968; M.L. Scalvini, Architettura come semiotica connotativa, Milano, 1975; M. Tafuri, Teoria e storia dell'architettura, Bari, 1968; M. Wallis, Semantic and Symbolic Elements in Architecture, Semiotica, VIII, 3, 1973; B. Zevi, Saper vedere l'architettura, Torino, 1949; B. Zevi, Alla ricera di un 'codice' per l'architettura, L'Architettura, 145, 1967; B. Zevi, Il linguaggio moderno dell'architettura, Torino, 1973. *2) Semiotics of art*: R. Arnheim, Art and Visual Perception, Berkeley, 1954 (tr. it., Milano, 1962); R. Arnheim, Toward a Psycology of Art, Univ. of California (tr. it. Milano, 1962); C. Brandi, Teoria . . . , cit., 1974; E. Cresti, Oppositions iconiques dans une image de bande dessinée reproduite par Lichtenstein, Versus (VS), 2, 1972; H. Damisch, Théorie du nuage, Paris, 1972; P. Francastel, Peinture et société, Naissance et destination d'un espace plastique, De la Renaissance au Cubisme, Lyon, 1951 (tr. it., Lo spazio figurativo dal Renascimento al Cubismo, Torino, 1960); P. Francastel, La figure et le lieu, Paris, 1967; P. Francastel, La réalité figurative, Paris, 1965; E. Garroni, Immagine e linguaggio, Documenti di Lavoro del Centro Inter. di Sem. e Ling., 28, Urbino, 1973; E. Gombrich, Meditations on a Hobby Horse, London, 1963 (tr. it., A cavallo di un manico di scopa, Torino, 1972); E. Gombrich, Art and Illusion, Washington, 1956 (tr. it., Torino, 1965); F. Menna, La linea analitica dell'arte moderna - Le figure e le icone, Torino, 1975; E. Panofsky, Meaning in the Visual Arts, New York, 1955 (tr. it., Torino, 1962); E. Panofsky, Die Perspektive als 'symbolische Form,' Leipzig - Berlin, 1927 (tr. it., con altri saggi, Milano, 1961); G. Shapiro, Intention and Interpretation in Art, Journ. of Aesth. and Art Crit., 1, 1974; M. Shapiro, On some Problems of the Semiotics of Visual Arts: Field and Vehicle Image-Signs, Semiotica, I, 3, 1969: J.L. Schefer, Scénographie d'un tableau, Paris, 1969 (tr. it., Roma, 1974); M. Wallis, La notion de champ sèmantique et son application à la théorie de l'art, Sciences de l'art, 1, 1966; M. Wallis, Inscriptions in Painting, Semiotica, 9, 1, 1973. *3) Semiotics of the cinema*: Aa. Vv., Teoria e prassi del cinema in Italia, Milano, 1969; R. Arnheim, Films as Art, Berkeley, 1959 (tr. it., Milano, 1963); Aa. Vv., Linguaggio e ideologia nel film, s.l., 1968 (con saggio di

G. Della Volpe sulla semantica musicale); G. Bettetini, Cinema: lingua e scrittura, Milano, 1968; G. Bettetini, L'indice del realismo, Milano, 1971; G. Kraiski (a cura di), I formalisti russi nel cinema, Milano, 1971 (saggi di aut. vari, tra cui: J. Tynjanov, B. Ejchenbaum, O. Brik, V. Sklovskij); U. Eco, La struttura . . . , cit., 1968; U. Eco, Le forme . . . , cit., 1971; E. Garroni, Progetto . . . , cit., 1972; E. Garroni, Esiste e che cos'è una 'avanguardia cinematografica'?, Film-critica, 241, 1974; Ch. Metz, Le cinéma: langue ou language, Communications, 4, 1964 (rist. e riveduto in Essais sur la signification au cinéma, Paris, 1968; tr. it., Semiologia del cinema, Milano, 1972). Ch. Metz, Langage et cinéma, Paris, 1970; P.P. Pasolini, La lingua scritta dell'azione, Nuovi argomenti, 2, 1966; S. Worth, The Development of a Semiotic of Film, Semiotica, I, 3, 1969. *4) Semiotics of music*: J.J. Nattiez, Trois modèles linguistiques pour l'analyse musicale, Musique en jeu, 10, 1973; J.J. Nattiez, Is a Descriptive Semiotics of Music Possible?, Language Sciences, 23, 1972; H. Pousseur, Musica, semantica e societa, Milano, 1972; N. Ruwet, Contraddizioni del linguaggio seriale, Incontri Musicali, III, 1959; N. Ruwet, Langage, musique, poésie, Paris, 1972; P. Schaeffer, Traité des objets musicaux, Paris, 1966; M. Schneider, Il significato della musica, Milano, 1970 (saggi vari in tr. it.); G. Stefani, Sémiotique en musicologie, Versus (VS), 5, 1973. *5) Semiotics of the theater*: R. H. Hinde, Non-verbal . . . , cit., 1972; G. Bettetini: Produzione del senso e messa in scena, Milano, 1975; E. Goffman, Where the actions is, London, 1970; M. Pagnini, Per una semiologia del teatro classico, Strumenti critici, 12, 1970; F. Ruffin, Semiotica del teatro: la stabilizzazione del senso, Biblioteca teatrale, 10-11, 1974.

EMILIO GARRONI AND MASSIMO PRAMPOLINI

POPULAR ART IN A CONTEMPORARY PERSPECTIVE

First definition of popular art. – In the encyclopedias and dictionaries published since 1970 the entry "Popular Art" does not seem to have found favorable mention. At most it has received a few subordinate and peripheral references. This is the case with two important works in the field of ethno-anthropologic studies: the "International Encyclopedia of the Social Sciences" (IESS, 1968) and the first two volumes of the "International Dictionary of Regional European Ethnology and Folklore" (IDREEF, 1965). In the first work the term "Primitive Art" is mentioned, lumping together "the indigenous art of Oceania, the Americas, and Africa" with the "prehistoric art of the population in the ages prior to civilization," (IESS, 1968, vol. 1). Among the possible subdivisions under the term "Folklore," it is referred to as "Folk Art," but no thematic or bibliographic indications are given. Instead, the notion of "Verbal Arts" is introduced, confirming the prevalence of interest in oral phenomena.

No specific mention is made in the otherwise relevant work published in Copenaghen (IDREEF). Even in the two most recent volumes of the Feltrinelli Fisher Encyclopedia, "Arte 2," (dedicated primarily to pictorial activities), only a few references are made to research orientations directed to folk material (under the term "Iconography"), while the trends and debates on exotic art and primitivism (that of the "pre-Raphaelites," and not of the indigenous civilizations) are mentioned under the term "Primitivism" and "Exotism."

Certainly this neglect derives from factors associated with the history of folkloric and historical-artistic research, but it is also related to difficulties of a conceptual nature.

The difficulties inherent in the application of the noun "art" with the adjective "popular," which were already evident in the previous tradition of research, have intensified in recent years. A cursory look at the matching of these terms, would suggest diverse combinatory possibilities; "Art" could be understood as a quality that distinguishes certain expressive facts from others, or a certain field of expressive phenomena (that could include all or part of the poetic, visual, plastic activities, etc.). And does the term "popular" define a social stratum, or, instead, a quality that could be attributed to phenomena variously classifiable from a social standpoint? All these possibilities, together with the sub-possibilities that can derive from them, define an extremely wide field of variables regarding at the same time the object, the methods and the theoretical and ideological hypotheses against which the notion of popular art makes a claim. We will call this the "problematic field" of popular art, since today we can speak of thematic nodes (more than of a definition), in a generally broad sense of a theoretical dimension. These nodes can usefully be brought together around the notion in order to attempt a balance. It is understood that this problematic field is not defined by the combinatory hypotheses in themselves, but by the framework of the standpoints assumed by the ethno-anthropological, historical-artistic and aesthetic research, and that these standpoints appear to effectively cover all the combinatory possibilities.

Switching from the hypotheses to the true orientations of research, I will present an exemplifying picture of how popular art has been, and still is, differently understood.

According to A. Hauser, popular art can be defined as "the poetic, musical, and figurative activity of uneducated and non-urbanized people" (Hauser, 1969). It is seen in the contraposition-distinction between "mass-art" and the "art of educated classes." An analogous preference, for such a broad object, seems to be shared by other European orientations, although with differences concerning the relation art-social strata. In the works of the First International Congress of Popular Arts (which took place in Prague in 1928 under the aegis of the Institut International de Coopération Intellectuelle, an organ of the United Nations) there already was a tendency to include under the denomination a very wide field of products like architecture, wooden, iron and other metallic works, ceramics, textiles, music, dance and theatre; however, the plural form (popular arts) was significantly used, while popular poetry was excluded. On that unique and fundamental occasion, the greatest inaccuracy concerned the concept of popularity, although in the majority of interventions it remained defined mostly in qualitative terms (naivitè, lack of technique, spontaneity) and, only subordinately, it was referred to social groups associated with the countryside (Art Populaire, 1931).

In a recent British work the notion is proposed with a broadness similar to Hauser's, but with different connotations: "folk art" (distinct form "popular arts") was defined as art that refers to "the collective products of a primitive or rural community" and also to the "anonymous culture created by the lower class after the industrial revolution when it was excluded from the official "upper culture" due to class barriers, economic or cultural inequality, literacy" (Hall-Whannel, 1970).

From this list of positions, noticeable differences in both terminology and content emerge in relation to such terms. A more selective use of the term seems to characterize the Italian tradition and other European approaches in general. For example, a recent work by H. J. Hausen excludes poetry, music, dance and theater from popular art, thus limiting the notion to "home, furniture, tools, ceramics, glass, textiles and costumes, painting and sculpture . . . " (Hausen, 1970). This choice is shared by P. Toschi, one of the few Italian scholars of popular art (Toschi, in Hausen, 1970). Also A. M. Cirese appears to propose, within the sphere of popular expressivity, the field of popular art as a "field of the figurative 'put into form' called popular" (Cirese, 1968), and G. C. Argan indicates a possible classification of popular art in "Strumentazione, ornamentazione, figurazione" (Argan, 1960). Although these definitions are not necessarily coincident in their object, they tend to identify the field of popular art not as a comprehensive whole of the popular expressive activities, but more as a part of them distinct from poetry, music, choral and dramatic activities. A range of phenomena is thus delimited within the field of expressiveness, characterized by a certain internal affinity, related to the modalities of the expressive "put into form."

Another point of view seems to be configured in other non-homogeneous positions, which tend to underline the technical capacities rather than the characteristics of the "put into form," that is, the language of the production rather than the language of the product. These accentuations are not always explicit and thus, should be kept distinct. In this perspective we should recall the space given by R. S. Boggs to popular art in "Types and classifcations of the folkloric patrimony." Under this entry, better specified as "Arts, professions, architecture," Boggs, while offering an indication of a field that largely coincides with Hansen's, underlines the aspect of the "materials and manufacturing methods," classifying products according to raw materials, productive activities and social use, with a strong tendency to interpret the term art not so much in the sense of aesthetic productions, but more as "artifacts," products of techniques (Boggs, 1950). Another definition prior to 1960, although little-known, found in the Volkundliche Bibliografie (started in the 1920s, see Cirese, 1973) seems to follow this same tendency, proposing a division according to "Techniques, arts and professions, industries" (different from: home, objects, signs, clothes . . .).

If we focus the analysis on the first term of the definition "Popular Art," that is on the "popular," we encounter an equal amount of difficulty and the differences of positions will be shown to intersect with those found in the analysis of the second term. In certain positions "popularity" appears as a sociological concept; it is referred to by Hauser as "non-urbanized and non-educated social strata," by Hall and Whannel as primitive and rural communities and also as industrial lower class, and by Cirese (following Gramsci's indications) as the instrumental and subordinate strata of every society. In other approaches an "essentialistic" criterium seems to be preferred, related to the intrinsic

quality of the products; examples are the naivitè (Hausen) and the psychological tone ("naivitè, simplicity, elementarity, ignorance, popular art shaped by itself, while the great art rises from the depth of thought, from broadness of ideas and cognitions and from the full mastery of the expressive means," Toschi, 1960) and "its having become traditional patrimony of a community . . . " (ibid.). Another variation of this criteria is associated with the lack of a specialized technique (Argan) or with the possession of a technical level not evolved to the industrial levels, remaining within the range of artisan and manual production and of limited production and circulation (Boggs).

Some of these points of view can be integrated, if one assumes a methodologic priority and the others are taken as secondary aspects.

Also, the terms proposed as distinctive or appositional to popular art are characterized by the same degree of difficulty; they are also distributed between the accentuation of a sociological methodology and the accentuation of methodology which we have defined as "essentialistic." The use of the expression "art of the educated classes" (Hauser) is an example of sociological apposition, and indeed the use of the term art, great art . . . is a "qualitative" apposition of popular art. In the already cited authors, further distinctions intervene, such as "mass art," "popular arts" (distinct from folk art and also from mass art), and in the demologic literature other distinctions are found (periferal and "popularizing" art). They indicate intermediate stratifications or particular characteristics of the expressive modes of the production-circulation-fruition circuits of culture.

The picture would be even more complex if terms like "minor arts," "applied arts," "primitive art" (the latter used to designate the art of "ethnologic" populations as well as certain trends of hegemonic art [from Giotto to Rousseau]) were included in this range; or if we had considered the notion of "popular art" to designate an educational art, of popular emancipation, addressed to the masses.

The composite picture which we have traced through several exemplifications is the result of a debate and of methodological options that do not refer solely to the notion of popular art, but also to the entire debate on folklore and art in general. In fact, the different interpretations of the term "popular art" refer to the concept itself of folklore and to the determination of the field of studies of this discipline. It is necessary then to be aware of this broader picture in order to avoid becoming limited by a sectorial point of view.

Before analyzing some of the questions presented thus far, a synthesis of the picture proposed appears useful:

1) Distinctions of broadness (art)
 a) art as a set of expressive activities (poetry, music, figuration . . .)
 b) art as a set of expressive activities excepting poetry.
 c) art as a set of the expressive activities different from poetry, music, dance, theater.
2) Distinctions of "sociological" broadness (popular)
 a) popular as a set of the non-urbanized strata.
 b) popular (folk) as a set of primitive, rural and lower class "communities"
 c) popular as a set of the instrumental and subordinate "classes" of society.
3) Characteristics inherent to the popular-artistic products
 a) technical characteristics: non-specialization, limited technical level, community character of the production-elaboration.
 b) qualitative characteristics: naivitè, simplicity, elementarity; popular psychological tone.
4) Distinctive and/or appositive levels in relation to "popular art"
 a) popular arts
 b) mass art
 c) art of the educated classes, "elite" art
 d) educated art
 e) major art, great art.

After an initial identification of the problematic aspects of the notion of "popular art," it is now necessary to focus on the theoretical tensions, the empirical research and the relevant attempts at clarification in the field of Italian studies, in the debates arising from foreign schools of thought and in the European research. It should be noted that it is difficult to speak of a literature of popular art within this perspective. Except for the few studies on particular aspects, and the very rare general studies, the theoretical research on popular art are largely tributaries of broader debates on the objects and methods of ethno-anthropological research, on aspects of aesthetic research, on the methodologies of the semiological research, and so on. The notion of popular art will then have to be examined within this much broader reality. This will be possible, hypothetically, if we choose from a range of phenomena; among the various possible solutions we have chosen the one proposed and practiced within the tradition of Italian studies. The reason for this choice lies not in the fact that it is not problematic, but rather because it has a minimum of tradition in our research which also corresponds to more general orientations and distinctions (popular poetry, popular theater). It is clear that the use of the concept of "culture," the tendency to read the expressive products within their social context or to read them as "texts" characterized by autonomous languages, leads to an instability of the autonomy and compactness of the grouping proposed in the Italian tradition, especially by Toschi. A practical and empirical use of the grouping proposed by the Italian tradition, if utilized without absolutes and with the awareness of limits, will allow the formulation of more solid points of reference and development.

Furthermore, all the successful systems of classification in the field of demologic research are actually debatable empirical frameworks of placement of materials, whether they are based on the "life-cycle and year-cycle," or propose groupings of activities-objects that are somehow related to them.

Not only the characteristics of the popular object, but also the systems of classification and "reportarialization" represent modern themes of debate in connection with the cultural history which has justified and gone beyond the old systems, proposing new systems, also including the methods of informatics and the use of

computers (Cirese, 1973). Thus, the true problems are sought using an existing hypothesis, and these problems and the development of the research led to new definitions and classifications.

The Italian tradition of studies on popular art. – In general, tradition would not seem to be a pertinent part of an updating. However, in our case, the reference to the tradition of studies has a particular importance, since on the one hand, it justifies the present state of studies, and on the other, because tradition has a continuity in recent orientations of research; furthermore, the greatest Italian scholar of popular art, Paolo Toschi, forms a part of this tradition. His work had been productive until his death, in 1974, representing a qualitatively relevant presence of "tradition" in the years that have passed between this updating and the Encyclopedia.

Paolo Toschi, in both old and new writings, had observed that the Italian studies on popular art had fallen behind; this topic had been studied also by A. Buttitta, who pointed out that in some countries, especially in Eastern Europe, the development of this field of study had been contemporary with the birth and the new interest in the 19th century for studies on folklore (Buttitta, 1959). In Italy, in fact, a significant interest in popular art had developed only in 1900, particularly in the 1920s. It is well known that in most parts of Europe, including Italy, the studies on folklore developed especially around the interest in "popular poetry" and that pretty much only writers and philologists were concerned with them. This prevalence has persisted to this day, although in different terms. According to Buttitta, in order to affirm an interest in research in the field of popular art, there had to be a critical movement in the field of aesthetics, taste, and artistic production. This duty was absolved by the intellectual movements (especially in Great Britain) that re-evaluated "preRaphaelite" art and revised the dominant artistic values. The stimulus must have arisen also in Italy, with the establishment of the first museums of tools, furnishings, and costumes (by Pitrè in Sicily) which led to the Congress of Ethnography in 1911 (Buttitta, 1959). From 1920 onward the research by Corso, Toschi, and Cocchiara was developed following the impulse. Although they did not invert the prevalent literary approach, they nonetheless began to fill the gaps in the research, verify methodologies and propose to scholars an interest in the popular artistic production. The schools of these scholars were characterized by different approaches, uniting in positivistic cultural formations with idealistic-historical orientations, influenced by Croce's work on Italian culture. The field of popular art remained in the hands of these scholars, even in the second post-war period.

To begin an historical-critical analysis in the field of the most recent developments, it seems proper to start with Toschi's work. He began his work on popular art in the 1930s with several essays (compiled later in "Saggi sull'arte popolare," 1945), then in 1960 he published his great work "Arte popolare italiana," to return on the same subject in 1962, with the new edition of the "Guida allo studio delle tradizioni popolari," with the introduction and with the Italian section of "Arte popolare europea e arte popolare americana d'influenza europea" (Aausen, 1970), and with the "Bibliografia degli ex voto italiani" (Toschi, 1970) together with a continuous work of university research and guidance for the magazine "Lares."

"Arte popolare italiana" is undoubtedly his most complete work of analysis and documentation on the topic available in Italy.

After noting the scarce interest of Italian culture (which prefers the "great art" and archeology) for popular art, Toschi criticized the notion of "Popular Arts" proposed by UNESCO that includes "the chants, music, dance, popular theatre, etc . . . thus covering almost completely the whole field of folklore" (Toschi, 1960), stating that "such extensive use creates confusion, since the issues and the aspects are different" (ibid.). He then organized the materials in nine groups: the art of sheperds' agricultural life; furniture, textiles, jewelry, embroidery, costumes ornaments, ceramics and glass, iron, copper works, insignias, maritime art, masks, theatre, popular celebrations, popular religion, popular prints. These groupings represent intense chapters of the work on the levels of both analithical study and photographic documentation.

The work is also introduced by important theoretical-methodological observations and by a rich history of studies. The bibliography is however very limited, both here and in other writings, though considered significant by Toschi. Toschi believes that "popular art differs from great art only through the psychological tone and the cultural antecedents from which it arises." He then distinguishes two levels, one of aesthetic evaluation and another of popularity. Regarding the latter he points out that "popular comes from "people," and in the concept of people, the idea of collectivity is inborn; an intrinsic character of popular art is then its becoming the traditional patrimony of a community . . ." and this is so since this art "satisfies the people's spiritual and practical needs, and for this vital function it is transmitted in time, preserving, modifying or formulating itself according to its own stylistic tradition, until a population adopts it as its own." As far as the artistic values go, he noted that "aesthetically, popular art can have, and actually has, the same absolute values of great art, reaching, although through more hidden paths, equally high peaks;" in popular art, as well as in great art, "art" and "non art" can be found. In the "Guida . . . " he summed up these themes as follows: "For popular art we intend the art that, born from a psychological tone of primitivity and simplicity, became the humble people's common expressive patrimony" (Toschi, 1962).

In this and other scripts, Toschi proposed further observations that represent important points of reference for a discourse on popular art:

a) the attempt of synthesis of the aesthetic qualities of the popular expressive field with the elements of
 - lyrical synthetism;
 - simplification of lines and colors;
 - exaggeration;
 - materialization of movements, sounds, ideas,
 - stylization (crossing between synthetism and simplification);
 - repetition of lines, shapes, relations of color (Toschi, 1960, Toschi, 1970).
 These are, obviously, important elements for the classification of the structural

modalities of the popular artistic product, although they are not always distinct elements of expressive logic and references to the psychological tone;

b) the analysis of the phenomena of "circulation" and of "ascent-descent" between popular level and cult level, seen in the assumption of popular elements in several artistic currents, as well as in the descent-re-elaboration of the cultivated products gathered in popular art. Popular art conserves ancient traces, on which there have been historical juxtapositions of taste " . . . undergoing, more than once, the influence of great art and of illustrious craftmanship, but simplifying and conforming everything to its practical needs and to the elementarity of its life and psychology" (Toschi, 1970);

c) the general acceptance of both the evolutionary and diffusionistic methods, to study popular art also as a testimony of archaic phenomena or of irradiation of shapes and objects on a geographic-historical level;

d) the inclusion of craftmanship within the artistic-popular sphere (also with the listing of still productive artisans, in the Appendix of Toschi, 1960), except that which is defined as "illustrious craftsmanship";

e) the affirmation of a connection between popular art and the issues of the ethnological "primitive," of infantile art and of pre-Raphaelite "primitivism" (in relation to which he states that Giotto would be an example of popular psychological tone);

f) the claim of the historical-artistic dignity of the study of popular art, tied also to the conviction that "popular art proves to us that, through the centuries and notable events, it has always had, as a basis of inspiration, the brotherhood among populations, reaching at times expressions of absolute aesthetic value." "By now, for a global vision of art history, the broad sector of popular art must be included" (Toschi, 1970).

In Toschi's works it is then possible to identify a wide range of concepts and proposals of classification that adequately define the popular-artistic field. This commitment should not be underestimated, since it is almost "unique" in the history of studies (on the topic); in fact his proposals can be used as a reference for a possible renewal of the methodology.

Tradition and renewal. – Toschi's work, presented in the previous section, largely reflects the European cultural tensions, where evolutionary and diffusionist methodologies meet with idealistic positions, and it also includes ideas aimed at identifying "regularity" and specific "norms" of popular art. However, it is not difficult to note that the bases of Toschi's ideas go back to a cultural formation developed in the 1930s, to which the scholar remained faithful. In relation to the studies of Eastern European functionalism (Circle of Prague), the Central European studies (Van Gennep, Marinus), and the Anglo-American anthropology, this consideration places the attention on the modalities of cultural dialectics in the folkloric research prevalent in Europe and particularly in the complex of Italian post-war culture. As a consequence of the fact that the debate on social sciences had almost no influence on the field of folklore, new positions and methodologies were spread with great delay. Particularly in the popular art, the elements of innovation developed much later than, for instance, the research on poetry and on popular song. These elements stress once again the relevance of Toschi's work, however, while urging its critical updating.

Seen in the light of the new cultural developments, Toschi's studies testify both to the value and the limits of the ideas developed in the years between the two wars. It is evident that Toschi attempts a mediation between Croce's aesthetics (the psychological tone) and the findings of the philological research on popular songs (Santoli's popularization as a phenomenon of popular and common elaboration). The result is a difficult balance between disputable aesthetic evaluations (art and non-art; popular art attains expressions of "absolute aesthetic value") and methods of inquiry that required a deeper "semiologic" or "sociological" commitment (popular needs, ascent-descent, popularization, characteristics of the expressive language). As a whole, the idea of a popular art characterized by psychological elementarity and by naivitè seems to persist, and there emerges the difficulty of thoroughly examining the characters of popular art as a specific expressive language. At times, the attempt to address the relevant problems is resolved through an eclectic methodology that gathers pictorial-aesthetic interests together with influences of a positivistic anthropology (specifically Frazer) and of "diffusionism."

Neither were these difficulties overcome by the studies of Corso and Cocchiara, who address issues of popular art, the first studying the fossils of archaism, and the second focusing on an artistic and historical-individualizing historiography.

The documentary and interpretative work developed around the magazines "Lares" and "Rivista di Etnografia" (Corso-Tucci) appears, in today's light, to have been conditioned by a complex cultural delay, and at the same time, to have been a cause of the delayed answers to the contemporary questions.

As of today, we have not entirely come to terms with tradition, and fundamental problems remain that have been posed by the artistic-popular research: the issues of popularity and of the expressive characters of popular artistic fact. Still unresolved are also the problems of interdisciplinary confrontation, particularly with aesthetic, artistic-historical, sociological and ethno-anthropological disciplines.

The picture that has been illustrated reveals a prevalent line that does not exclude the occurrences of important discussion (for instance Toschi's intervention in the debate on applied anthropology published in "La Lapa" between 1952 and 1955, together with the interventions by Tentori, De Martino, Cirese and works by American writers), neither should one undervalue E. De Martino's innovative contribution to the studies that he called ethnological. However, this did not lead to a significant reordering of methodologies and categories, which began to develop, although fragmentarily, only in

the 1960s. The renewal was stimulated by different contributions: the new opening toward European and American studies; the development of Gramsci's themes, already operating in the 1950s in the writings of De Martino and Cirese; the rising of a new interest in linguistics and its "structural" developments.

The most explicit appeals came from the Anglo-American cultural anthropology and from its affirmation of the concept of "culture;" this concept required a global consideration of the popular cultural products (thus contrasting the sectorial methodologies of a historical-comparative nature) as well as a relativistic consideration of the different cultural formations. This concept was extraneous to the consideration of absolute cultural values, and it recognized the presence of specific value systems for each cultural formation. On the other hand, Gramsci's analysis of folklore and popular literature indicated the necessity of redefining the concepts of people and popularity in terms that modified the dominant attitude aimed at understanding the popular as collective creativity, aesthetic quality and psychological tone.

Santoli played an important role in this direction. He brought Gramsci's theme closer to philological studies, and for a long time, he had proposed the concept of "popular elaboration," which derived from important European research, in particular from Menendez Pidal's Spanish school and from the school of Prague (Santoli, 1968).

Finally, linguistics, in its different fields of study, and particularly with the rediscovery of Saussure's "structural" linguistics, played a role in the renewal of studies that were beyond its own thematic field. This renewal was also based on the indications originating from the experience of the "Linguistic Circle of Prague," where the research in the field of folkore, aesthetics and in other fields had developed together with the renewal of the linguistic studies (see Angioni, 1971). In Italy, the interest in linguistics strengthened first of all the studies on popular poetry, but determined also some general rethinking on the globality of folkloric facts, especially as a result of the work (already mentioned in the 1930s by Vidassi and Santoli) "Il folklore come forma di creazione autonoma" translated in 1967 (Bogatyrev-Jakobson, 1971).

Buttitta's work "Cultura figurativa popolare in Sicilia" (Buttitta, 1961) represents the first sign of a presence of new ideas in the field of popular art. In the introduction the author attempts to rebalance the popular-artistic field in the encounter between anthropological, demologic and artistic-historical perspectives. Three elements are sufficient to formulate the wholeness of the investigations. They are the diacronic-historical level, the sincronic level (or the level of cultural totality) and the aesthetic or artistic-historical level. Developing Cocchiara's lesson, Buttitta stresses that "people's artistic productions offer figurative solutions that, although at times recalling past formal languages, have developed in time, have had and still have their own history. The reconstruction of this history will be the first duty that the scholar of popular art is called to assume" (Buttitta, 1961, n. 23). Next to this perspective Buttitta places a cultural-anthropological appeal, pointing out that the historical perspective would be incomplete if the figurative, popular-artistic components "are isolated from the cultural complex in which they are

determined. The studies aimed at discovering relations and similarities among the manifestations of popular art and the uses, beliefs, rituals, in a word the culture from which they rise, are, then, not only legitimate, but indeed necessary" (ibid.). A third element of the investigation comes from the conviction that "it is a mistake to believe that it is sufficient for their complete evolution. Art as such goes beyond the extra-artistic instances from which it develops . . . in order for the evaluation of the people's artistic productions to be complete, it is necessary that the scholar of popular art, though remaining an ethnologist, becomes an art critic" (ibid.).

In the case of the predominance of the first and third elements on the second one, this method seems to accentuate the historical level as opposed to the level of expressive forms, thus reflecting the influence that tradition has on it. This predominance seems confirmed by the way the distinction between artistic fact and artisan fact is traced: "the artistic fact . . . is always an unrepeatable unique piece, the artisan fact, instead, is the faithful reproduction of old formal schemes" (ibid.). However, the method allowed the individuation of several popular artistic schools (the Sicilian carriages, the puppets and the signs for the puppets opera . . .); these elements of analysis, together with the study of the realization techniques, allow the distinguishing of the popular-artistic facts (with phenomena of non-anonymous individual or collective creations) from the range of phenomena concerning popular poetry. They also indicate the importance of a study of the operational levels of popular creativity that tend to put aside categories such as naivitè, technical incompetence and spontaneity; that is, they indicate that the possession and the competence of certain expressive languages are characteristics of the popular artistic activity. With further research the same author came to be one of the protagonists of the development in the study of the Sicilian area. In 1972, he stressed the social character of the figurative modes of popular art, together with the clear distinction between popular expressivity and naif. The latter is characterized by individual forms as opposed to popular art, in which the elementarity is not psychological simplicity, but a result of the "realization of elementary means and techniques as an answer to primary needs, not implying that the results must necessarily be simple. Collectivity, functionality, dependency on the great art and elementarity are then the intrinsic characteristics of popular art" (Buttitta, 1972).

In the same work, a classification of the forms of ritual-popular art is developed in the sections on magic art, votive art and devout art; there is also a deeper analysis of the aspects of interrelation among the existential popular conditions, the conceptions of the world and the pictorial expressivity, in particular regarding glass painting.

The instances of methodological renewal attained greater precision with the research and development of other fields in an intervention by A.M. Cirese at the "XV International Convention of Artists, Critics and Scholars of art." On the subject of popular art, Cirese operated a rather complete transposition of methodologies which he had already outlined for other fields of demologic research, particularly for poetry. By questioning the notion of popular art in relation to the apposition popular art-educated art, he noticed how, in romantic popolarism as well as in idealistic aesthetics,

the relations between the two levels were placed on an *a priori* evaluative level, attributing art-quality to one term, and non-art to the other. "But is it possible to escape from this field of taste and bad taste? Are the affective and evaluative attitudes both essential to the distinction-apposition between "popular art" and "educated art," or are they instead accidents that can be removed? And what is left of the notion of "popular art" when the adjective does not mean exaltation nor disdain? This is the real problem, at least in the field in which I operate professionaly, which is the study of the cultural inequalities inside the so-called superior societies. I believe such a notion must absolutely be neutralized, thus reappraising the same psychological connotations that are considered proper to each one of the two terms" (Cirese, 1968).

Popular art then is not immediacy, naïvitè, or nature; like any human activity it is part of the "culture," it is "culture" in the same way that "élite" art and poetry are culture. As a consequence of the questioning of aesthetic values, a more autonomous and internal evaluation of the popular artistic facts seems to follow . . . If popular art is culture, it is "a concrete product - historically determined - of human activities, since men have their own horizon of knowledge and ideals, their own patrimony of techniques and their own tradition of styles." These phenomena must be studied with the awareness that "In every society qualified types of communication exist, that distinguish themselves from the current communication by special rules of "putting into form." It is not true however, that that kind of specific communication, the "putting into form" that is art to us, finds an exact correspondence in all the societies that have existed historically" (ibid.). The investigation requires an internal methodology of popular expressivity that verifies the possibilities of revealing "in the field of the figurative products that which has already been revealed in the field of poetic forms: that is, recognizable systems, logics or structures. Perhaps we should realize that since it is meaningless to apply to popular poetry the historiographic analysis focusing on the unrepeatable phenomena, which are significant in their individual uniqueness, an investigation in the field of popular art and into the repetition and the norms regulating this repeatibility in the study of significant facts, is just as meaningless" (ibid.).

Cultural analysis, however, does not limit itself to the artistic product considered as "text," instead it must investigate the whole popular condition as a context: "In the traditional popular art . . . there was a personal execution of the product . . . there was a direct tie between the executor and the buyer; even if a "rhetorical" intervention existed, consisting of the "putting into form" according to certain rules that the buyer might not have known, a belonging to a very homogeneous stylistic cultural horizon was evident" (ibid.).

In this intervention the aggression of the artistic-popular object from new methodological angles ("culture," "popularity" as social position, study of the rules of "putting into form," crisis of a "centric" concept of art) leads to the theoretical overcoming of several difficulties met by the traditional orientation, while bringing the concept of popular art to the forefront of the problems evidenced by the debate in European and Anglo-American cultures.

Debates and orientations: a) The discussion of aesthetics. – Although the notion of popular art does not seem to find any specific verification in the aesthetic debate, it cannot be denied that in the themes based on the results of ethno-anthropological research, new areas and categories are defined, which might lead to specific developments also in that field. Such are the considerations P. Francastel, by J. Duvignaud and C. Lévi-Strauss.

The latter had entered the field of primitive art research in 1944-45 with a work (published in Italy in 1966) entitled "Lo sdoppiarsi della rappresentazione nelle arti." Here he proposed a method of investigation that does not consider the historical method as fundamental, formulating instead a hypothesis through the connections and combinations of elements. The question deals with the symmetric graphic doubling present in some cultures and geographic areas. Through this analysis, Lévi-Strauss affirmed: "In the indigenous thought, the decoration is in the face, it creates it, it gives the face its social being, its human dignity, its spiritual meaning. The double representation of the face, considered as a graphic procedure, then expresses a deeper and more essential doubling: that of the biological "stupid" individual, and of the social character it must incarnate. We can assume that the doubling of the representation is the result of a sociological theory of personality doubling. The decoration is the graphic or plastic projection of a reality belonging to another order, just like the doubling of the representation that results from the projection of a three dimensional mask on a two dimensional surface, and like the biological individual who is also projected on the social scene by his own costume. Lévi-Strauss identifies among artistic elements common to distant civilizations the functional expressions of similar types of societies: "in the doubling process we have found not only the graphic representation of the mask, but also the functional expression of a precise type of society" (Lévi-Strauss, 1966). The relation facial painting-mask takes issue with the function of the mask and of the doubling function which distinguishes civilizations with characteristics inherent to a determined relation between social order and supernatural order. A broader dimension develops then around a symbolic element, and the capacity to interpret the signic element activates explanatory mechanisms and connections that traditional methodologies could not bring together.

In a more general and theoretical perspective, the issue of aesthetics is reproposed in "Il crudo e il cotto" (The raw and the cooked) in the attempt to realize an "inventory of the mental enclosures" capable of "reducing what appears as arbitrary data to an order, reaching a level in which an imminent necessity to the illusions of freedom is revealed" (Lévi-Strauss, 1966). Summarizing his theoretical itinerary, the French ethnologist arrives at the investigation of the myth with which he compares music, paintings and other arts, in an attempt to prove "the existence of a logic of the sensible qualities," of which the stage of the myth is an experience aimed at tracing the lines of development and manifesting the laws of that logic.

Relativistic convictions, the search for unitary laws of the functioning of the human spirit and the original use of semiology, which have all been proposed by Lévi-Strauss, have raised questions that stimulated

aesthetic research. For example, the aesthetic scholar Pierre Francastel contributes in this direction, with a work on "Esthétique et Ethnologie." He points out the critical value of ethnologic experience, stating that cultural relativism has led to the re-opening of the field of aesthetics and has proposed the role played by art within culture as the central issue. Aesthetics forms a science of its own provided that the concept of beauty as a "metahistorical" manifestation of the spirit is overcome. Actually, "the distinction established between the serie and the models, the work of art's ambivalence, the distinction between the human faculty that creates the possibility of the plastic institution and the group of works that places art in history, the refusal to consider this faculty as a mimetic faculty and its assimilation to the other faculties of the spirit, all form an important range of notions that have been reinforced after 50 years, following the development of ethnography, converging with the artistic movement of our time" (Francastel, 1968).

Francastel rejects the apposition between art and technique, while claiming that because art is an institutional act is should be relocated within social life and history. He then proposes a first consideration on the characteristics of thought and plastic language activities; in every work - he observes - there is a technical level (the product materiality), a functional level (which refers to social usage) and a significant level (whose code is relatively unknown). These levels are placed outside of any pre-existing value, as characteristic of the artistic fact in every socio-historical ladder. A project of research can be developed around them based on the hypothesis that " . . . the system of plastic signs is a system of elaboration aware of the knowledge of the verbal systems. There is no doubt that the notions of structure and symbol are found in the study of aesthetic mechanisms. That which changes is the relation between the main sign and meaning, the realism of the material, the relation of time and space, the different psychological attitude between the one who speaks this language and the one who interprets it, and finally, the more elaborated character of the sign considered in itself" (ibid).

J. Duvignaud proposed an hypothesis of sociology of art, whose conceptual premises are based on Kurkheim and Mauss, from Gurvitch's sociology and from the more recent positions of cultural anthropology and ethnology. Duvignaud critiques the "myth of the essence of art," the genius-scandal-artist, the myth of the beautiful and of the "enslavement to reality or nature" (Duvignaud, 1969). Thus, art is no longer "absolute mental function," extra-historical and immaterial essence, but is proposed as a significant moment of the infinite variety of human expression. The investigation is centered on creation, on the imaginary experience placed in a material and historical context. Sociology of art, in fact, must not be a reduction to the analysis of environmental and historical influences, since the authenticity of the artistic fact lies in its power of convincing, in its autonomy, which can not be reduced to simple external conditionings: art is essentially anticipatory. It is rather from the internal complexity of the historical fact that the whole historicity must be recuperated and of which "the artist is the momentary crystallizer." The operative category of "drama" proposed by Duvignaud indicates "the range

of behaviours, emotions, attitudes, ideologies, actions and creations which, at the level of the creative individual, crystallize the whole society and engage the genesis of the work in the scheme of the contraddictory forms that create the collective life" (ibid). More operative concepts arise from the notion of "encounter of the systems of cosmic classifications with the systems of social classifications," linked to Durkheim's legacy and applied to man's cognitive-social-imaginary horizon according to different relations, between material activities of production and reproduction of existence and artistic expressions. This is not the fault of those who carry forward their ideologies, but of those who neglect to pick upon the other approaches and incorporate them into more convincing cognitive dimensions.

b) Mukarovsky and the detail as semantic unit. – Although deriving from the 1930s and from a research oriented on the relation between aesthetic norm and social facts, the theory proposed by the Czechoslovakian Jan Mukarosky had a particular influence on our demologic studies, justified by the author's explicit interest for folkloric expressivity. The advanced level of this research is premised on the liveliness of the Czech folkloric school, of which some authors will be mentioned.

In the International Convention of Popular Arts, held in Prague in 1928, the Czechoslovakian research already appeared very advanced in Europe. In particular the contribution of Joseph Vydra on "Des principes constructifs et logiques du génie artistique populaire" raised an interesting range of issues. Vydra stated that in the aspects of "descent" of models, styles or educated or urban artistic examples, a process of assimilation and adaption takes place - at a folkloric level - according to peculiar forms of production-circulation-fruition, that remodel the source in an original manner. Vydra also pointed out the fundamental character of popular ornamentation, which is not "vain filling with useless ornamental motifs . . . On the contrary, it is the ornamental motif that gives the object all its value. The popular activity applies the ornament to the creation only when this responds to the objective to be realized, the place to occupy, the idea to represent . . . " (Vydra, 1931, Vol. I). Popular plastic art is oriented toward abstract and schematic models, substantially antinaturalistic, "it can be affirmed that formal expression and popular processes are, in general, ideographic, and nearly ever do they become - so to speak - physiographic . . . The people do not feel the need to worry about the resemblance when they draw inspiration from nature . . . ," therefore, "The popular plastic transposition is generally rhythmic or dramatic, never imitative; popular artists have different ways of dealing with their symbolic ideas when they wish to enrich their creations with novelties . . . Popular art rests on a purely symbolic substratum and on the specific intensity of the image, of intensity obtained through rhythm, the repetition and the broadening of the motif" (ibid.). With this logic, the operating through details (it is the "horror vacui" phenomenon) tends to resolve problems of the organization of space, a space on which the popular artist operates with different modes in comparison with the educated artist. The educated artist "has ideas." A sketched idea is largely configured in his brain. The educated artist studies and prepares his realization by analyzing that idea. The popular artist, on the contrary,

proceeds through details in order to attain the whole. By juxtaposing details and schemes, he gives a true logical construction of his composition . . . " (ibid).

Another of the Czecholovakian school is P. Bogatyrev, who is perhaps at a higher level of complexity in his research. His work on costumes in Moravia is a true example of ethnologic research on the phenomena of social and symbolic representation, of cultural functionality, which places the costume within the cultural mechanisms of a group (Bogatyrev, 1971). Equally interesting is his work on the "Semiotic of popular theater" (Bogatyrev, 1973).

Within this lively climate of research, particularly attentive to the formal characteristics of expressive facts, one finds the historical periods and types of society. From the analysis based on these concepts arises the plurality of the artistic functions in different social environments, together with the character of "second degree" of aesthetic experience in societies in which it is not affirmed as a fact autonomous from other collective social functions (for instance from a function of "generalized exchange, intensive circulation of social substance in the whole group").

So far it is evident that the discourse on popular art has a secondary position, however some considerations emerge which significantly relate to our discourse. Two of these are the rejection of aesthetic beauty as a universal concept and of art as an absolute function of the spirit. These elements allow the studies on popular art to be freed from the pressure to scrounge dignity from educated art. Thus, the discourse on popular art will not be an imitative decadence of the "great art," nor a spontaneous product of an elementary psychology, but a particular language, of a particular function of art that involves expertise and rules, whose code is in the organization of society and in the conceptions of the world in which the society expresses. Following from this is the legitimacy of conceptual instrumentations, which allow the interpretation of the popular-artistic product in its specificity and the examination of the mechanisms of creativity, repetition or variation. These are examined not as badly-realized copies of other models nor as border-cases of phenomena which have their apex in the field of "great art."

It is necessary to point out that the general perspectives of the cited authors, operating in a theoretical light (inspired by Durkheim) that is "mentalistic" or purely symbolic, or Kantian "without a transcendetal subject" (Lévi-Strauss, 1966), probably lead to a diminishing of the importance of certain historical core of Mukarovsky's studies: the design of an aesthetics and a sociology of artistic facts. The general theme of his work revolves around the concepts of function, norm and aesthetic value. He considers that "the aesthetic function is one of the relevant factors of human behavior; it can be coupled with any human act, anything can become its bearer." Gestural behaviours, cooking, handcrafts, are all examples of facts in which an aesthetic function can emerge. These facts are analyzed in order to establish the limit between aesthetic and extra-aesthetic levels, or the combination of the two. This aesthetics, intended not as science of the beautiful or of pleasure, "is not a simple and insignificant epiphenomenon of other functions, but it codetermines the behavior of man in relation to reality . . . " (Mukarovsky, 1973). Aesthetics does not coincide with art, which is

characterized by the prevalence of the aesthetic function; in other phenomena the aesthetic level can manifest itself in a secondary form (cerimoniality, magic, eating habits, furnishings . . .).

The aesthetic function is a social phenomenon and therefore historically and sociologically changeable. "The establishment of the aesthetic function is a matter concerning the collectivity, and the aesthetic function is a component of the relation between the collectivity and the world . . . the attitude of this social complex toward the aesthetic function determines the objective conformation of the things bound to act in an aesthetic sense and the subjective aesthetic attitude toward them" (ibid).

The aesthetic norm is the institutionalized aspect with which the aesthetic function presents itself historically. As a substratum it has "the fundamental anthropological presumptions" of the species that establish the subjective relation with aesthetics (e.g. "the complementarity of colors for painting, and a few other phenomena of contrast and intensity"). Such presumptions however, do not determine the norm; they are rather the common denominator, the base, of the historically and socially determined norms. In relation to them, the norm builds its dialectics of variability, institutionalization, violation and transformation. Art in particular, among the aesthetic facts, is characterized by a continuous dialectics of norm - transgression: "art history appears as the history of the revolts against the dominant norm/norms)." "The vital work of art always wavers between the past and the future state of the norm" (ibid).

Another category is that of the aesthetic value, pertinent especially to art; under this profile the work of art appears as "a closed whole, and it is an individualizing act." Even the aesthetic value is itself variable in its nature of being "in relation with the evolution of society." Within this group of concepts, which operate variably in the different social contexts, is placed the study on the modalities of incidence of the aesthetic categories in the folkloric area.

Mukarovsky distinguishes between folklore (and folk art) as a traditionalist activity tied especially to the countryside, and urban "periferal art" and "artistic handcraft." The latter, developed in the last few centuries, tends to integrate with superior art in a process of reciprocal enrichment, but "as soon as it entered the field of art and began to aim at the production of unique pieces, . . . it lost its practical function," and therefore its specificity. The periferal or "more modest arts," produced in that which Mukarovsky calls "non-folkloric popular environment," are characterized by greater freedom from the restrictions affecting the aesthetic norm in folklore. But while this freedom signifies that "the aesthetic norm very easily attains the predominance on the other norms for superior art" (e.g. l'art pour l'art), in urban periferic art, it usually signifies a prevalence of utilitarian or emotional norms.

Folkloric societies show instead, a level that in a certain historical or logical way precedes the phase of the differentiation-autonomy of the aesthetic function. In these areas, in fact, "a coherent division of functional spheres" does not exist, and the absolute predominance of a norm over others cannot occur. The aesthetic elements at this level are tributaries of the aesthetic norms historically affirmed in the superior strata, and they

show phenomena of rather ancient conservation of canons. However, the "aesthetic creativity of popular production" cannot be denied; in fact, the difference between folklore and "the industry of popular art" is in the variety and richness of the folkloric production, a phenomenon that does not occur at the other level - a variety that is not, however, a phenomenon of transgression of the norm.

A further element of analysis is derived from the examination of the semantic unit of the popular artistic product, in which the basic semantic element seems to be the detail. While in superior art the tendency is to move from the whole to the detail, "the situation is different in popular poetry. The series of meanings formed by the single motif which follow each other remains open; the comprehensive meaning . . . can change in the course of the work. There are, of course, cases in which the unity of meaning is attained, however, in such cases the semantic unity is not the presumption, the norm, but only the result, one of the possible results" (ibid).

The detail as semantic unit is found also in painting. In a painting on glass, " 'Escape to Egypt,' the landscape, the donkey, and St. Joseph, all disappear next to the dominant figure of Mary who hides the Son of God." The same holds true in sculpture: "St. Joseph Nepomuceno's two dimensional head (1:3) documents the same plastic principle. Here the semantically important details of the Saint's face are again two dimensional . . . , because for the popular artist they are the bearers of the expression and the comprehensive meaning of the statue" (ibid.). The detail maintains semantic autonomy, and thus popular elaboration is a continuous process of "grouping, an increase or decrease of the details." The "semantic gaps" created with this mosaic procedure are overcome by the viewer who interprets them. The way of creating popular art is so different from that of "superior" art, that it is unjust to approach popular works of art with the habits and attitudes that we employ for "superior" art, even though we consider them natural and necessary" (ibid).

From this synthesis, the importance of Mukarovsky's work in the field of popular art is evident, despite several theoretical and practical difficulties included in the analysis of the French approach. Some of these include the way of distinguishing folklore, urban popular art, crafts and the theory of detail, which seems to require broader verification. In fact, while its validity is undeniable in the field of popular poetry, it remains to be verified in regard to other fields (music, painting, theater).

Another matter requiring consideration arises from the subject of the aesthetic norm in the folkloric sphere. This is a reproposal of a classic node of the studies on popular art and folklore; whether the norm operating on the popular level is an "ancient" aesthetic norm of superior art (although subordinated to other norms and modified in its function), or a different norm operating in folklore. In the first case, the diversity of construction of the semantic unity between popular art and educated art is reduced to an adaptation of a dominant ancient aesthetic canon. In the second case, the different semantic structure is evaluated as a principle producing different norms, thus formulating the hypothesis of an autonomous aesthetic norm of folk-

lore. Mukarovsky vacillates in his thinking on this question.

c) Two interventions on Mukarovsky. - In the book "La controversia estetica nel marxismo" (1974), Prestipino took up Murkarovsky's theme. This work is useful as a starting point in observing that aesthetics has had rather significant moments of theoretical settlement, even in Italy, though it lacks explicit reflections on this question. A connection is instead encountered in the previously-cited work, not only in taking up Mukarovsky's theory, but also in pointing out, within Marxist aesthetics, the presence of a "praxiological perspective" intended as an inquiry into the "formal-material 'genesis' of the aesthetic modalities from the modalities of the material productive activity" (Prestipino, 1974): "Marx and Engels had not neglected the more original character of the artistic phenomena that links them to man's productive activity, as products of a manual-intellectual ability, with a capacity of original cognitive content, since it grafted onto the multiple practical exercise of man's work. In the Introduction, dated 1857, Marx had considered the artistic object as a "product" among the others, destined for a consumer whose needs are themselves products together with the objects destined to satisfy them" (ibid). Prestipino believes that this theme is the most fertile ground for the study of Marxist aesthetics, which should delve deeper in "analyzing the 'simplest form' of aesthetic behavior (specifically, not its "form of merchandise," but its form-work)." According to the author, signs of this tendency are also found in the analyses of "certain structuralism and cultural anthropology more or less related to Marxism."

In a chapter of this work, Prestipino compares Mukarovsky's theme of the aesthetic norm with Gramsci's opinions on folklore. The two authors share in an antiromantic attitude toward folkloric expressivity, in which a passive attitude toward the reception of the dominant aesthetic norms seems to prevail. Within this problematic perspective, a specific aspect of the relation hegemony-subalternity is examined "as a relation concerning more closely the aesthetic functions, i.e., educated art on one side and the "folkloric" cultural tradition on the other." Gramsci's work seems to confirm the hypothesis of a prevailing receptivity (or passivity) of the "non-artistic aesthetic forms . . . Their passivity, however, is in relation to the social-economical structures . . . they distinguish themselves for their "contentistic" tendencies, in the sense that they transmit and maintain extra-aesthetic contents (naturalistic, passional, ethico-social, etc.) in relation to which the aesthetic form is only complementary and auxiliary." While educated art "organizes and subordinates" the extra-aesthetic facts, popular art registers a subordination of the aesthetic level to different phenomena. This analysis seems to confirm a certain "coplanarity" between Mukarovsky and Gramsci's observations; a further confirmation comes from the analysis of the cultural systematicity and organicity, attributes that Gramsci perceives in the hegemonic culture, opposite the asystematicity and unorganicity of folkloric culture. Mukarovsky's verification of this thesis is identifiable in the phenomenon of the construction of the artistic product through "detail," as opposed to the unitary construction appropriate to the "educated" artist. The interpretation given by Prestipino of the theme of the

detail re-opens the issue of the norm in the "educated" sphere and in the educated and folkloric spheres. Is detail the example of an unorganic activity or of a different way to construct organicity? The same question of "contenutism" of popular art posed, since in some analyses (Cirese, Vydra and others) the decisive element of popular expressivity seems to be formalism. Mukarovsky's thesis, according to which the method of the detail is "a principle of semantic structuring of popular art," could also be interpreted in this perspective.

This range of issues also includes D. Carpitella's observation on Mukarovsky's aesthetics. He definitely assumes the hypothesis of an autonomous folkloric creativity and believes that the research on expressivity must - once the "differentiating elements typical of the folkloric sphere" are identified - question the emerging values in a critical comparison with the elements of the superior level. Also to be discussed is the value of the "Euroeducated" tradition, which "has always emphasized the 'parole' rather than the 'langue,' and whether the extent of the validity of a defunctionalization of expressivity is valid, in the "universal" pretext of aesthetic norms" (Carpitella, 1972). It is possible, then, that the differential apposition between "defunctionalized expressivity" (superior art) and "functional expressivity" (folkloric art) might be resolved in a choice of value that will give preference to the second aspect.

Popular art in the framework of research on popular culture: a) Folklore and "popular." – We have seen how the notion of art is redefined in the field of aesthetic research, while the notion of "popular" appears much less precise. The latter represents the focus of the demologic research and of the same definition of folklore, which will now be analyzed with particular attention to the expressive phenomena.

M. Maget proposed a broad approach to this question, presenting an almost complete range (except for Italy) of the tendencies between 1930 and 1960. Various definitions of "popular" emerged in this field, but most were based on orality, traditionalism, anonymity and non-integration or disorganization (also psychological). These elements are, in fact, according to Maget, universal categories of mental activity, and not distinctive features of folklore; in order to define "popular" it is necessary to use more objective parameters. On this level a criteria of social stratification is evident, but we must remember that "the 'popular' world is not a fully distinct cultural world" (Maget, 1968). Thus there exist a gap between social strata and cultural strata, which intensifies with the increase in unitary sources of influence on the cultural behaviors (mass-communication, scholarization, fashion . . .) and with the decrease of the difficulties of cultural participation of the lower classes. Also on the social level, as well as on the cultural one, there are difficulties of classification of the middle classes. Hence the need to study complex social groups, including the phenomenon of traditionalism as well as that of transformation. "All types of life will have to be studied in the name of folklore. This investigation will not be limited to the farmers, but will extend to all the groups belonging to the social category of popular class" (ibid.).

What Maget excludes is the possibility of a definition by "essence" or by "quality" of the folkloric fact. If these "essences" (orality, anonymity, etc.) always lead to a neglect of the real characters of folklore or to a transformation of its aspects into myths, it may be necessary to refer to more objective categories aimed at the "totality." In this way the phenomena will not be formulated according to predetermined forms. Here we encounter explicit the reference to the orientations of "human geography," with which folklore should build strong scientific ties.

The need to overcome the idea of a popularity as an intrinsic quality of folkloric objects developed also in Italy. Important contributions to this area are offered by the works inspired by Gramsci. In his "Osservazioni sul folklore," Gramsci (1971) pointed out the possibility of studying folklore seriously by considering it as "conception of the world," truly of the "subordinate and instrumental" social classes, in opposition to the official conceptions of the world. This indication hypothesized a folklore not characterized by its essence, but by its position, by its ties with certain social groups. Gramsci added that "in the framework of a nation and its culture, that which characterizes popular singing is not the artistic fact, nor the historic origin, but its way of conceiving the world and life, in contrast with the official society . . . From this other criterium of research on folklore the following derive: that people are not a homogeneous collectivity of culture, but present numerous cultural stratifications, variously combined" (Gramsci, 1971).

Folklore was then considered as a combination of cultural strata of popular connotation, characterized not by 'those' products with particular features of a psychological tone, but by all the cultural facts pertinent to the popular strata in opposition (mostly mechanical and implicit) to the dominant strata. In this field, E. De Martino underlined and developed the interest for a history of the "subordinate popular world" (no more a history of objects, but of subjects), and Cirese formulated the concept of "inequalities of culture" correspondent to socio-economic and power inequalities, followed by the motion of popular "connotation" of folklore and of socio-cultural representation (Cirese, 1973). Folklore was being defined as a sum of ideologies, behaviors, representative cognitions of an "unequal participation of the different social strata in the production and use of cultural goods," as well as of the means of production and of the power (Cirese, 1973). Within this framework, the oral phenomena of elaboration of texts, the variables, etc . . . could recuperate a non essentialistic function, although of effectively descriptive categories.

b) Folklore between city and country. – Although within a socio-cultural perspective in the studies, folklore continued, and still continues, to suggest a whole series of problems. First of these would be whether folklore refers to the sum of subordinate strata of the countryside. Gramsci's solution does not seem to present any distinction between city and countryside, at most cultural stratifications internal to folklore, more or less advanced levels of consciousness. Mukarowsky placed the category of periferal art (regarding the "popular, non folkloric" strata) between folkloric art (rural and traditional) and superior art. Similarly, A. Hauser attributes to the urban level the notion of mass-art, characterized by "an absolutely non-creative audience, completely passive in its behavior, and with a commercial production that strictly satisfies the demand" (Hauser, 1969); it is the art "of the readers and buyers of detective

stories and comics, serial novels and oliography" (ibid.). On a different level, as has already been shown, the level of the urban, lower-class culture, emerging from the working neighborhoods linked to industrial settlements is recognized as "folk-art" (Hall-Whannel, 1970). In Italy, an analytical theme in this regard is very recent, especially because the research has always been oriented toward the rural areas. However, certain indications of more precise categories are beginning to emerge, like the connection folklore-pre-capitalist, or non-dominant ways of production (Angioni 1974, Gallini 1974); or the reclaiming of the extension of folklore to all the cultural phenomena, even the most modern, concerning the subordinate social strata (Lombardi-Satriani, 1973).

c) Linguistics and semiology. – In the framework of the influence exercised on the demologic studies of linguistics, and thus of semiology, the delayed debate on an essay by Bogatyrev and Jakobson in 1929 has a particular significance. This essay is named "Folklore as a form of autonomous creation." In it the category of "collective censorship of the community" was formulated, the change of the function of the elements belonging to the "superior" culture (that were part of the folkloric horizon) were pointed out and the interest for the extrafolkloric sources was redimensioned. The concepts of 'langue' and 'parole' were applied to folklore, while the rules regarding the functioning of the folkloric facts were researched within the context of their specific process of production-circulation (e.g. the oral rhytmic style, the mnemotechnic function of the rhytmic schemes . . .) (Bogatyrev-Jakobson, 1971).

Linguistics and semiology offered the possibility of researching the rules underlying a series of concrete and individual messages conforming to such rules, and which manifested themselves only in reference to those rules. Therefore, they also offered the possibility to create interpretative models by increasing the cognitive power of the analysis of the texts in general (Eco, 1968).

R. Barthes, for instance, had studied the application of linguistics to the "history and sociology of clothing" (Barthes, 1957), while Jakobson had identified from linguistics certain distinctive features of the poetic and artistic fact. He considered such facts characterized by the phenomenon that "Ambiguity is an unchangeable intrinsic character of every message concentrated on itself; it is a corollary of poetry" (Jackobson, 1966), the "emphasis put on the message in itself constitutes the poetic function of the message" (ibid.). Jakobson derived many of the exemplified materials from popular poetry.

A. M. Cirese's research on the Sardinian "mutos and mutetos" (1964) and on proverbs (1968) followed in a parallel way. However, the possibility of identifying the underlying rules of folkloric facts was applied to aural tradition (with very productive results) rather than to popular art. In this direction a brief work by A. M. Cirese on the artistic popular patrimony in the Taranto area is worthy of attention: "Anatomic reproductions of the ex-voto . . . votive canvas and tablets . . . interwined Easter palms, reproductions of useful objects . . . sacred shrines are immediately interpretable as simulation and mimesis" (Cirese, 1971). Numerous suggestions are proposed for the semiologic research on the meanings whose signifier consists of facts regarding the sphere of popular cerimoniality.

In general: "Cerimoniality as passage from the event to its representation belongs to a sector of the signification universe which is very close to the sector of the arts in general, and particularly to the dramatic and visual arts." However, "to speak of art, certain unspecified aesthetic qualities are no longer required, only the presence of certain specific forms of language" (ibid.).

Furthermore, the influence of linguistics and semiology on the studies of folklore has not been unilateral. At times, in fact, it appears as an instance of interpretation of specific sociocultural facts; at other times, it tends to change from method to ideology. In certain trends semiology tended to reverse the relation between material level and symbolic level by applying itself to the identification of categories of the spirit, unifying principles of the knowledge of reality. In other trends, the application of the semiologic method to phenomena linked to the development of the "mass-media" seems to eliminate the contradictory physiognomy of the socio-cultural stratifications, while aiming to find the rules of a unified culture, i.e., the illusion of the myth of a uni-dimensional man (the consumer) distant from the reality studied by the investigation of folklore.

d) Production, circulation, use. – The stimulus provided by the linguistic research appears to have developed the "differentiating" study of the forms of production-circulation-use of the popular cultural products.

The premises can be found in a 1929 essay by Bogatyrev and Jakobson. The authors stress the fact that "the existence of a folkloric work necessarily presumes a social group that receives and sanctions it. In the folkloric research, the basic principle of the preventive censorship of the community should always be taken into consideration" (Bogatyrev and Jakobson, 1972). "The life of a folkloric theme begins only at the moment of its acceptance by a given community, and it only exists in the extent to which the community makes it its own." "A folkloric work represents a fact of the 'langue,' from the point of view of the interpreter. It is impersonal, and not dependent on the interpreter, although he can always deform it, and introduce new elements into it to render the work more poetic or to update it." "In the field of economics there is an equivalence of the relation between literature and consumers in the so-called "production for the market," while folklore is closed to the "production on commission."

The subsequent writings basically agree with this phenomenon, although with some significant differences. Hauser points out: "an innate characteristic of this art is the fact that its exponents do not participate in it only as receptive subjects, but mainly as creative subjects, although individually they do not appear as such and do not claim any personal paternity" (Hauser, 1969). Similarly, in relation to the study of mass communication, O. Handlin observed: "Popular culture, contrary to the official one, maintained a functional character, in the sense that it was strictly related with the needs felt and the familiar ways of expressing of the people it was directed at. . . . Popular culture, although chaotic and unstructured, represented a concrete world, realistically familiar to its own audience. . . . This relation was maintained through a direct relation between the creators and the consumers" (Handlin, 1969).

Starting from this presumption Hall and Whannel propose the category of "popular arts" (different from folk art and mass art). By "popular arts" they mean an artistic activity that is by now individualized and separated from the organic circuit of the community: "it is essentially a conventional art that strongly reaffirms previously known values and attitudes; it reassures and reconfirms this relation to its "cognitive emotion." It has the genuine contact between public and creator in common with folk art; but it differs from it by being an individualized art, the art of a known creator. The "public as a community" is presently dependent on the creator's skills, on the strength of a personal style, which can articulate its common values and interpret its experiences" (Hall-Whannel, 1970). The example refers mainly to the music-hall, to jazz music, to Chaplin and to Dickens. However, it is an hypothesis that could be usefully experimented in some strongly individualizing approaches or schools of thought within the popular-artistic field, and even in certain aspects of craftsmanship that do not seem to follow the phenomenon of collective censorship.

Gallin's input regarding the question of Sardinian singing is closer to the relation between material production and folkloric production: "In the dialect singing, the reciprocal conditioning between production and use appears much tighter and immediate (at times we observe . . . the alternation of the roles between singer and listener), according to types of relations whose form appears strictly affected by the limited presence, at an economic level, of complex forms of labor division (Gallini, 1973).

All these themes present a general difficulty in the fact that - once the existence of a proper "language" of popular art is established - it is impossible to avoid the fact that the dynamism of the socio-cultural reality is very strong. As a consequence, the phenomenon of "collective censorship" is a border-phenomenon, a valid model, but also used to analyze its transformations. In fact, at the intersection of industrialization and depopulation of the countryside (the mass media and the extension of the large unions and political organizations, the capillarity of basic education, of clubs, post-work activities), collective censorship (where detectable) has radically modified its operational "norms," by integrating itself with a change of models and mentalities no longer comparable to the influence and descent of elements of the dominating culture within the culture of the subordinate classes. Therefore, there is a need for a complex interpretative model which accounts for the fact that the sphere of popular-artistic production is involved in a rather rapid phenomenon of disappearance-misunderstanding.

e) Objects of use, techniques, craftsmanship, minor arts. – The technologic-ergomonic perspective, although remaining on the fringes of research on popular art, is nonetheless relevant. The "historical" division of labor in the ethno-anthropological area seems to have abandoned this field to the ethnologic investigation, well represented in Italy (Grottanelli, Cerulli, etc.), but substantially geared to the study of extra-European countries. To this lack of investigation in the demologic research, we can also add the difficult placement of craft activity within the studies on folklore. However, in the historical-artistic field and in the published works on "minor arts," this component does not seem to emerge with a large number of research and conceptual categories.

Sometimes the tendency has been to isolate the technical-artisan component from the aesthetic-expressive one, as it can be revealed from the apposition "art-crafts" proposed in the "International Encyclopedia of the Social Sciences," where "crafts" mean " . . . strength, practical ability, skill," in apposition to "art, which usually implies an intention to produce beauty or pleasantness" (IESS, 1972).

Certainly, on these grounds, it might be difficult to understand the range of manufacturers in which the functional utility is coupled with a communicative effect as well as those whose functions, capabilities and techniques are of a primarily communicative type. With reference to the objects of use and the techniques, the French studies offer a vast experience on the historical approach linked to the "Annales" (Bloch, Fèvre, Braudel), and in the research of human geography. These experiences, as well as the notion of "material culture," are also part of our historical and archeological studies, as well as some sectors of the human sciences. On the basis of what has been said so far, the relation of this issue with popular art should be clear. In fact, an art whose expressivity is functionalized, an art in which the "aesthetic norm" is interwined with the "extra-aesthetic" ones, thus has a wide range, not only of ritual and cerimonial objects, but also of objects of use. The pantry (madia), the chest, the decorated carriage, the container obtained from a carved pumpkin, etc. represent a small number of examples of connections between objects of use and signification. These are objects that sometimes belie M. Bloch's observation, according to which the objects of use do not have a style (Bloch, 1969).

The issue is more complex for the functional objects whose plastic conformation is subject to a certain margin of compositive arbitrariness; typical is the case of containers and particularly of vases where the problem of a style as socio-historical conditioning that goes further back in time is independent from the decoration or the choice of conscious plastic solutions. Archaeologists - we believe - must have largely exerted their ability to "read" the objects centering on the identifiability (or styles) of this sort. Recently, an archaeologist affirmed that among "tools, artisan products and applied art, there is no real solution of continuity . . . " and that one should not exclude the fact that "for the arts that imply a more evident manual aspect - like the figurative arts - a specific aspect of the structure exists that, together with the general aspect, serves as a base for the artistic superstructure: the material structure. Art then seems to have a "natural history" along with an "art history" (Carandini, 1975). And further: " . . . the anonymous productions of community traditions (cultural heritage of the masses) seem comprehensible only in the quantitative dimension, but quantity becomes quality with time . . . then it is possible to observe that the style of the works of art seems to correspond, in the objects of common use, not so much to the single type - that in itself is nothing but an iconography - but to the fundamental moments of the history of the type, in the stages of its morphological development, in the types created by the *artisan selection* within a main model, extraordinarily stable but also historically determined."

A wide range of manufactures and tools would then be part of the discourse on popular art, and their functional and plastic representation would be linked to a "long lasting" dimension. The need to repropose the technical component as an element that characterizes "communicative" manufacts re-emerges. Such category includes those manufactures that are "communicative" a posteriori, as a result of an historical interpretation of slow transformations (in which the refinement of instruments is more obvious in the relation man-production-nature than the symbolic horizon of the producers) as well as those manufacts that are part of the world theories and rules of symbolic behavior. The same issue, but with different characteristics, arises concerning the relation between popular art and craftmanship. Even though this problem appears as secondary within the demologic research, it still poses some questions for consideration.

P. Toschi, for example, includes craftmanship within popular art, although distinguishing an "illustrious craftsmanship," whose characteristics are not well defined within popular art. He also places the revitalization of the "typical" craftsmanship in a modern touristic perspective. Mukarovsky instead keeps the urban craftsmanship well-separated from folklore, while proposing a further category of artistic craftsmanship. Fabian, from the Czechoslovakian school, considers a clear distinction between city and country, and in referring to Czechoslovakia he points out that "thanks to the freedom and mobility of the artisans grouped in professional associations, the atmosphere of the cities was strongly influenced by the contemporary artistic movements. This is something totally unknown and extraneous to the suburbs" (Fabian, 1931). The history of the modifications of the rural artisan class is, according to Fabian, the history of the influence of the urban artisan class on the former. Maget notes that "every professional category has its own traditions and its own innovative dynamics: trade secrets, habits, ceremonies, social organization, language, ethics" (Maget, 1968). This observation, together with the broad and well-known history of associations and "gremi," gives a particular dimension of craftsmanship in the framework of popular activities.

The issue of craftsmanship mixes with that of "minor art" or "applied arts," which abound in the artistic historical research. F. Bologna observed the historic-ideological character of the apposition between applied arts and art, as an aspect of manual work-intellectual work. At the same time he noticed the close relation between the experience of the artisan workshop and the developments of the emerging artistic experiences. He also observed how the relation applied art-art has been proposed differently in different historical phases. In relation to this, F. Bologna identifies a phase of actual interchange (up to the age of the Counter Reformation), a very influential and lasting phase of ideological detachment and practical disdain, and various moments of recuperation of the relation artisan-art in the attempt to re-unite aesthetics and function, the spiritual and the material, craftsmanship and art. "Critical thought formulated or accentuated the hierarchy of the arts when it reflected the split of class solidarity within society, or at least the deepening of that split, which determined the taking over by a hegemonic aristocracy, and the social discrimination of the subordinate classes.

In the aesthetic conceptions, the separation between invention and realization has always corresponded, and to the priviledge of creation at the expense of to the first technical and functional factors" (Bologna, 1972). However, every photographic documentation proves that the craftsmanship to which F. Bologna refers is deeply tied to the expressive dialectics of the dominating culture, displaying the signs of the styles most appreciated at different times, and having an innovative character related to a work-shop in which expressive techniques are experimented on complex materials.

Actually, a large amount of "applied art" objects were produced for and commissioned by the clergy, the rulers and the noble families. Given their high technical level, and their association with the main trends in style, they came to be displayed in churches, private or public palaces and castles. This craftsmanship was located mainly in the urban centers, in contact with a lively economic and cultural activity. Our discourse regards particularly the period from 1800 to the present, and becomes more specific with the tendency to substitute the artisan object with industrial production. As a result, the problem does not involve the usual craftsmanship, organized in associations and jobs; instead it is pertinent to the events that, after the French Revolution, accompanied the struggle against technology and the corporations, for the creation of a free market of labor force. As mentioned in Marx's "Das Kapital" (book I, chapter XII), craftsmanship is grafted to manufacturing, and this in turn to the great industry; the powers of science are separated and juxtaposed to manual activity. While this phenomenon developed, the urban and rural artisan class was not dying, rather, it continued to play a role. In this perspective of functional survival of craftsmanship within a changing mode of production, it may be possible to attempt some distinctions. A first level could be indicated by the distinction, within popular art, between a manual-expressive activity internal to the productive rural family unit and an activity separated and complementary to the others (still in a rural environment). The first category includes family productions by women based on a division of labor internal to the family, as well as all those activities linked to the self-sufficiency cycle (the shepherd carving wood or horn, the farmer making a pantry or a ladle), or even to particular moments of cerimoniality (the cerimonial making of bread). The second category (which coexists primarily with the first) includes forms of craftsmanship related to the agricultural production or to other specific functions of rural life. In this case the buyers remain mostly within the so-called "preventive censorship of the community." This sector includes, for example, the makers of carts, the head masons and carpenters, certain ex-voto painters, etc. To this sector there can also be added the painters of the Sicilian carriages, or the makers of puppets (see Buttitta, 1961 and 1972: schools, training of students, division of labor. See also the use of cult models in the costumes and stage-designing of the Opera dei Pupi; A. Pasqualino, 1975).

Also to be considered is the artisan urban production oriented toward agriculture or the creation of manufacturers having spread-out functionality and clientele, and not aesthetically distinguished by a particular aesthetic request (churches, particular houses).

Despite the historical ambiguity, we should consider the phenomenon of artisan associations with a high level of tradition and technical specialization (furniture makers, potters, jewelers . . .), where the buyers are mostly tied to luxury and oriented toward expressive models, peculiar to the upper culture, seeking at the unique and unreproducible object.

A subordinate socio-cultural placement seems to prevail historically at least in the first three cases, even if the relation with the market and with the "preventive censorship of the community" is different. The fourth case, for example, falls into the field of the so-called minor arts. The technical level, productive apparatus, division of labor, ability to experiment on materials, all operate in different ways. In any case, a study of these themes will be helpful in articulating the socio-cultural strata, and therefore will lead to an enrichment of the cognitive processes, especially in the technological-ergologic field.

Presently, a further aspect of this question is ideological. As there exists not only the phenomenon of artistic trends, which see in craftsmanship the opportunity of recuperating the dignity of the job (considered as a unit of intelligence and work) there also exists the broader phenomenon of the ideological re-evaluation of the manufacture as an escape from the consumption society. M. Maget clearly affirmed that a form of "cosmologic evaluation" of the popular world exists and it corresponds to a new dimension of the idyllic, and moreover it is linked to a condition of crisis of the industrial-urban life. "The amateur is fascinated by the imperfections that make an artisan production more poetic, transgressing the rules of fabrication. The artisan, instead, is proud to have adequate equipment, to reduce the time of fabrication and the imperfections. . . . The earthenware pieces in which a stranger finds multiple qualities of form, color and taste, is considered by the maker or by those who ordinarily use it as being without beauty, or even as a scrap to be discarded" (Maget, 1968).

Within this phenomenon, contemporary craftsmanship falls between tradition and "revival;" it is a craftsmanship of regional products, often supported or reorganized by organizations dealing with tourism, and linked to new ways of production and selling, whose clients are mainly tourists or amateurs and whose modes of production fall between home labor and regular paid work. This craftsmanship is in some ways the symbol of the ambiguity in which popular art lives, or survives, today; popular art is a part of the market of the crisis in urban consciousness, and it becomes the object of a consumer or "elite" taste, while its real bases have disappeared or are disappearing. In order to guarantee the supply, they are replaced by the antique collectors or by mass-production, which Mukarovsky defined as the industry of craftsmanship.

Research on particular aspects of popular art. – After having provided a framework of several problematic nodes around which certain aspects of popular-artistic research can be defined, it is necessary to propose some examples of practically realized research, and to point out methodologies and orientations.

F. Bologna noted that "the problem of minor arts . . . is considered resolved in terms of strictly specialistic historiography" (Bologna, 1972); this discourse is extendable to a wide editorial production which, sector by sector, offers several historical tracts of the minor arts and a wide visual documentation. The service rendered by this consumer editorial function is not secondary, however it does not confront the terms of the problem nor does it enter the subject of the categories used. As a result, there are numerous publications on jewelry art, wrought iron, miniatures, ceramics, lacque art, art furniture, coral, etc., which enrich the visual contact of these productions, but not the circulation and the development of consciousness. Similar publications are not lacking in the classical artistic-popular field, although often they are historiographically more precise. We will mention here two of them.

The first publication deals with the ex-voto from the Sanctuary of the Madonna of the Mountain in Cesena (Novelli-Massaccesi, 1961); the publication constitutes an important service for the scholar because of its complete photographic reproduction of the 690 votive tablets, dating from 1500 to the present. The history of the phenomenon is presented within the history of the sanctuary and although this presentation does not merit a scientific study, several observations on the variations of the executive styles of the tablets are significant only in regard to research on particular objects (the bed or the crib through the centuries). The visual aggression of the 690 images is however a much more stimulation since elements that characterize a formal rule are evident. The second publication deals with artistic and popular crib scenes (Zeppegno, 1968). Here too, a historical analysis of the phenomenon is presented beginning from its legendary origin. The historiographic discourse usefully presents the evolution of the crib scenes and the stylistic variations. Although the work is based on a traditional method, it offers some interesting data, not only on the variations of technique (dimensions of the statuettes, use of the materials), but also on the subject of craftsmanship. It appears, in fact, that the craftsmanship of the crib scene is often characterized by well-known artistic schools (the Neapolitan sculptor Sammartino), and that a large proportion of the production was commissioned for prominent families. The predominant stylistic trends are well evident in these works. In the author's perspective however, the popular aspect of the crib scene is lacking on both the productive and the ceremonial levels; nor is the problem of the survival of the custom addressed, except to discuss the decadence related to plastic statuettes. The crib scene emerges as an unclear subject between the boundaries of dominant religion and popular religiosity, between dominant art and popular expressivity. The works by A. Uccello on the crib scene (using a primarily historiographic methodology), tend to document a purely popular artisan activity: "besides the so-called 'pasturare,' who used to make clay crib scenes, there were also modest artisans and farmers, often amateurs, who in their free time dedicated themselves to the making of the 'pasturi,' which were at times given as gifts to relatives and friends, some times sold, but more frequently produced for family use. Generally these are authentically popular crib scenes, and scarcely documented, which have been lost due to the little consideration that the owners had for them" (Uccello, 1972). The crib scene is also found in various strata of the popular production of cities, villages, and families with different expressive modules. In the village environment, however, schools and names of "pasturara" remain, but the

expressive modules seem to reflect the "agricultural community's conception of the world."

An extensive historiographic-documentary work by Hausen on European popular art presents a significant documentation of objects (furniture, tools, ceramics, glasses, textiles . . .), together with a presentation based on the "ethnicity" of the products and on popularity intended as immediacy and ingenuousness of the manufactures. His method attains the most interesting results in the analysis of the historical consistency of popular traditions in the different European areas, in relation to the presence of a more or less developed dominating culture. Particularly relevant is the notion that suggests that craftsmanship is "a second source of income" in the Scandinavian countryside, characterized, however, by the "technical secret," competency and well-developed skills (Hansen, 1970).

This research is limited by its avoidance of unresolved questions; the discourse remains generic on the level of the notions used, as well as on the level of the definition of the object, however, this does not detract from its documentary and historiographic value.

A new attempt of interpretation is offered by C. Scarpellini's short work on the ex-voto. The author makes use of categories of psychoanalysis within the field of experimental aesthetics and applied psychology for interpretative purposes. For example, Hauser, noticing some analogies between the method of the romantics (based on the convinction that "popular poetry . . . owes almost everything to an instinctive impulse and . . . draws its best part from a collective subconscious") and psychoanalysis, had already pointed out that "popular art becomes a particularly favorable object of psychoanalitical interpretation because the latter permits the observation of the process of sublimation, to which art is tied, at a less evolved level, and thus it makes evident the original instinctive impulses better than almost all the other cultural creations" (Hauser, 1969).

With a different and more complete treatment Gombrich underlined the importance of a psychological study on the symbology in art: "Everything that we intend by art was not created as an expression of the personality, but rather as a search for metaphors, to which all those who aspired to give sensitive form to the supersensitive, could concur. . . . I believe that the analysis and the interpretation of the experience derived from the immersion in the abysses of the symbol should be included among the tasks of a modern psychology of art" (Gombrich, 1965).

The thesis expressed by C. Scarpellini's work is that the ex-voto represents a primordial form of art deriving from a primordial form of psychological attitude. The theme of the ex-voto is salvation, and thus the relation between man and the threat of the negative. This relation is original: "The presence of anguish subtilizes the critical power of man and strengthens his imaginative, fantastic notions" (Scarpellini, 1969). Art assumes the role of transcending the historical-sensorial dimension in the expression of a typical-emotional dimension. The coordinates of space and time are thus cancelled in the ex-voto, and it becomes a "document of the typical functional mode of the anguished man." This occurs with simple expressive forms that are aesthetically naive: the essentiality, which selects figurative elements, underlining the dramatic immediacy; the vio-

lent colors without shadings or blendings, a "manifestation of the rational non-control;" the absence of technique and perspective, as a prelogical and fantastic dimension; the stressing of the personal relation with the saviour, mediator of the overcoming of the negative. The ex-voto is made "for the need to relive the drama in order to exteriorize it and, therefore, overcome it emotionally," like the dream, it is "dramatic, essentialist, regressive, centered around the subject" (ibid.).

It seems that this analysis, other than rehabilitating certain traditional categories, does not give the phenomenon its proper physiognomy. We believe that in order to be reliable, a perspective of psychoanalytic investigation should undergo more complex mediations. The iconographic structure of the ex-voto, seems to be based more on a figurative convention than on an original immediacy. In fact, there is a standardized compositive structure that consists of four basic elements:

1) the realistic figuration of the negative (eg. an encounter with bandits, an ill person in bed, a ship during a storm, etc.).

2) the presence, in the scene, of the person seeking the intercession of the divinity (not always the same person involved in the negative);

3) the portrayal, always on high, of the divinity or of any other person invoked (Madonna, Madonna and Child, Saints) often depicted in a pose of concession (hand gesture) towards the person who prays;

4) the realization of the saving intervention, represented by the votive tablet itself and that is not represented in the portrayal.

The relation of these elements attest to a consolidated tradition, from which the painter derives inspiration (although changing the styles and figurative techniques). On the other hand, the ex-voto presumes a relation of exchange, represented by the moment of restitution; actually, the cycle is: request of grace and vow - fulfillment of the request - taking of the vow. Since the vow can be portrayed in different plastic, figurative and penitential forms, the ritual aspect must be the most relevant significative element of which the plate is the materialized synthesis. This ritual exchange does not seem to correspond with the original immediacy or the psychological elementarity that emerge from the cited interpretation. Instead, certain ritual-expressive modules are evidenced which are consolidated in tradition and have a clearly formalistic component.

In the field of semiologic research, there is a treatment of ancient Russian icons, forming part of a volume intended as a documentation of Russian semiotic approaches. The essay does not deal strictly with the topic of popular, but the method fits in well with our discourse. The author, B.A. Uspenskij aimes, through the analysis of certain works by masters of the icon, to reconstruct the fundamental elements of a specific language, of which the meaning of the sign values are unknown. This language presents also relevant problems of "decipheration," in the field of medieval painting. The analysis demonstrates that the language of the icon has precise figurative conventions, such as, for example "in the icons that can be identified through the signs of various saints, which are communicated in a

very detailed manner in the manuals of iconic painting" (Uspenskij, 1973). For the reading of the iconic "texts" Uspenskij suggests three symbolic levels:

a) decontestualized elements whose symbolic character is "conditioned exclusively by their semantics . . . but never by the syntactic relations in which they are found;"
b) the second order signs in reference to the simply significative images (first order signs); these are signs whose composite can be used to designate another content (eg. the rooster to designate the morning, etc.);
c) the internal symbolism of the pictorial construction of the composite and of the use of the material (construction of the body beginning with the skeleton; representative colors of the vegetable, mineral and animal world).

These and other levels of interpretation of the icon can be contrasted with other levels of the language. These instruments demonstrate the original character of the organization of the space in the icon - a non-naturalistic space in which the direct optic perspective is excluded, being replaced by an "overturned perspective" in reference to a relation artist-image-viewer that is totally different from that of the Renaissance and post-Renaissance periods. The artist operates within the figurative field, proposing varied and dynamic perspectives. Among these is the characteristic "reduction of the image dimensions according to the nearness to the foreground," which presumes an "internal abstract observer that is thought to be placed in the background of the picture." In this way whoever looks is asked to enter the picture and "the dynamics of our look follow the laws of construction of this microworld." Some of the characteristics of this spatial organization are the effects of deformation related to the principle of the "sum of the visual impressions in space and time," which lead to a representation of motion with decomposition of figurative elements: three arms, 180° twisting of the neck, etc.; or with "cinematographic" effects such as the repetition of the figure in different areas of the picture. Furthermore, the semantics of the picture affect the processes of figuration by determining the relative sizes of the depicted images or their position (the face turned towards the viewer, even though in an unnatural position).

Although condensed, the Russian scholar's essay presents a rather precise attempt to determine, both from within and from outside the figurative fact, the coordinates of its language. In this sense the work appears to represent an example that can be used as a tool for verification in the popular-artistic field.

Just as interesting is the classifying work by E. Silvestrini and C. Peluso on horn objects from the Museum of the Popular Arts and Traditions in Rome. It consists of a documentation divided by regions. Its material is unitary and deals with a rather homogeneous social area. The analysis of the horn engraving-ornamentation proceeds through a classification of the iconographic elements while pointing out "stylistic recurrences." The observations that emerge show an affiliation with the writings of the Prague school; we will present here some of these observations that are germane to our study. The artisan activity is considered as external to the popular artistic facts; the criterium of exclusion is primarily based on the presence in these productions of an "educated or semi-educated taste" and of an "executive refinement," and a destination to a clientele that is not part of the community. In regard to the Alto Adige horns, we are dealing with "a production that, although belonging to a folkloric creative sphere (poor families from the suburbs) and made on commission, is placed in a reality quite different from those of the agricultural and pastoral cultures; in fact, from the time that works were first produced out of horn, it was possible to identify a tendency towards the formation of a touristic market, which later led to the development of an artisan activity." "The taste and technical complexity shown by these objects were not properly popular, tending instead towards an educated and semi-educated expressivity and towards the sterotyped repetition of several motifs, in contrast with the peculiar characteristics of folkloric creativity" (Silvestrini-Peluso, 1974).

The work also identifies two popular, iconographic currents: 1) "a distinct tie with an iconographic tradition, such as prints, religious paintings, and church statues," 2) "a traditional decorative repertoire, primarily constituted by geometric motifs, tending toward the geometrization of human and animal figures." In the first case there is a manifestation of an "openly communicative function of these objects at an alphabetized level of communication that is historicized and non-symbolic, as in the non-thematic geometric and naturalistic decorations." There is an autonomous re-elaboration and an adaptation to the popular "aesthetic norm," which appears as an autonomous configuration.

Inasmuch as several of these theses require further discussion, this work generally seems to represent a serious example of relevance to the characteristics of the field studied. We will conclude this survey by citing two more works in which semiologic research is tied to ergological research.

The first one is a broad attempt to define the "logic of the recipient," and combines ethnological observations (technology, functionality of the object) with semiological ones (Profeta, 1974). The structure of the mechanic use and the plastic structure of the recipient are analyzed, in an attempt to reconstruct the simple elements of functionality-plasticity of the object-container. The connection between artificial vase and natural vase is analyzed, and the problem of "structural" plastic figuration (requirements of functionality) and "extra-structural" plastic figuration (pictorial-plastic additions) are addressed. From these premises one passes to the emphasis of the "signic" aspect of the container, which relates to its "decorability" (support for graphic, pictorial and plastic expressions), its capacity to signify other than itself (inn signs, religious symbols . . .) and the indication of the social stratum of the user: "the container is not only a symbol of what it contains, of the ethnic and social groups who use it, or of the place in which it is used. But, with its shape, it presents itself for what it is, that is, a container, and it illustrates in a certain way its functional history through its components and its structures, rather than through articulated sounds" (Profeta, 1974). The analysis of the magical-religious use is also conducted on symbolic grounds, together with a range of possibilities of the reciprocal conditioning between aesthetic and functional levels.

The work directly addresses the issue of the useful object, and employs a wide range of interpretive

instruments. Thus, it is a useful contribution to this field of study, although the attempt to identify the logic of an homogeneous series of functional objects carries the risk of losing the contextual relevance, and of the formulation of non-secular logic of the intelligent activity of man.

The last work we will mention is presented as a group research in the very early stages, centered around traditional bread-making in Sardinia. The volume (Cirese, Delitala, Rapallo, Angioni, 1973) establishes the methodology of an inquiry, presents examples of analysis of ceremonial situations and indicates the lines of a semiological interpretation. The inquiry attempts to synthesize descriptions in relation to the following levels: the ergological level (raw materials, techniques and instruments), the zonal distribution and the lexicon, the ceremonial or daily occasions, the plastic forms. The application of the semiologic research on bread-making, defined as a modality of the "ephemeral plastic art," is carried out on the analogy between bread-making and popular singing. It is based on the familiarity of both procedures; "the matter on which and with which it operates (in bread-making) is familiar integrally and daily, and the techniques to master it, from the mixing to the baking, are a common and generalized patrimony since childhood . . . ," therefore there is not "a social separation between the producer and the user, between the artist and the consumer." Ceremonial bread-making and popular poetry deal with goods that are commonly available and widespread, characterized by non-durability and the production of an endless series of variations on the basis of a "durability of models, schemes and constructive procedures." That which radically differentiates them is the naturally communicative character of the language opposite to the exceptionally communicative character of the food product.

The issue becomes more general when we consider that "we are facing the fundamental problem of ceremoniality," intended as the procedure through which, in certain occasions, sectors or levels of the socio-cultural life, "things" must not only "serve" their primary use . . . but they must also "signify."

The works presented exemplify various research with various methods in the various sectors of popular art, and seem to demonstrate the necessity to reconsider a discourse on popular art through specific studies, along with the use of complex methodological instruments, articulated according to the needs of the various aspects of popular expressivity.

Some further issues: mass communications, Kitsch, cultural patrimonies, market, museums. – By inserting a chapter on popular prints in his volume on Italian popular art (in the framework of a previous interest in "imagerie populaire"), Toschi legitimated a very-up-to-date question. If the popular print, religious image, printed horoscope, and vignette are popular facts, how can this characteristic be denied to the almanac and the farmer's almanac? The first ones are in a certain way analogous to the advertising poster, while the second ones are the antecedents of the illustrated magazines; neither would it be difficult to find analogies between the posters of the story-tellers and comic books. Although produced in the small typographic workshop, popular printing is directed to an audience not tied to the "collective censorship;" often it issues

from the city and it is addressed to the urban as well as rural popular classes. In the same way, the printed texts of the Tuscan popular theater (maggi e bruscelli) or the better known "contrasti," the horoscopes and the ribal stories in rhyme, are sold in rural markets and are found at various levels of popular life. It is hard to deny a certain popularity, for example, in Salani's Florentine editions, aimed at satisfying a taste widespread among the lower urban and rural classes and also among the urban middle class (popular songs, amorous "stornelli," witticisms, rebus, riddles, charades, mottos, jeers jokes, recipes, anecdotes and prayers . . .).

Popular culture, at least in certain "semicultured" strata, circulated also through the press, thus grafting literature onto the oral tradition. The notion of folklore does not seem to easily fit in with these themes, following instead a production emerging from the popular strata. However, if we accept - together with Gramsci - that the criterium that characterizes popularity is the acceptance within the popular sphere, based on a correspondence with conceptions of the world and the life of that sphere, then the problem will not be avoided. The Santolian distinction between popular and popularizing could come in handy (the first is characterized by popular formulation, the second is not); however, it indicates a formal aspect, external to popular use and hence also to the phenomena following the grafting of writing to a traditionally oral circuit. Another distinction could be attempted between printed texts which carry on traditions ("contrasts," popular theater) on which it later intervenes in the execution of the variation and phenomena like the serial novel. Even in this case however, although the authors are far from popular life, contaminations and grafts may occur within the cultural circulation; Gramsci spoke of the debates in the government-sponsored housing concerning the episodes of the novels in the daily newspaper "La Stampa," and pointed out also the role of the narrator: " . . . for example, contaminations occur between different novels because the characters resemble each other; the popular narrator unites in one hero all the adventures of different heroes, and he is convinced that this must be done in order to be 'intelligent'" (Gramsci, 1971).

The distinction is obviously complex, especially if we start from socio-cultural criteria. What is certain is that the scholar of folklore, the art historian and the scholar of the image will not be able to evade the problem of the development of an editorial and publishing industry, an iconography and a film and television industry which carry on several functions of the popular press, popular theater or the story-teller's poster. Moreover, the domination of industrial production has at times uprooted, contaminated or juxtaposed new languages and visual stimulations to those that were previously dominant among popular classes. The topic merits discussion, since this theme deals with the notion of "mass art," which is often placed between the levels of distinction-apposition in which popular art is involved.

"Once the concept of culture is assumed in its anthropological sense, it is hard to understand the usefulness of the distinction between that which has been learned "by tradition" and that which has been acquired any other way . . . " This was written by Lombardi Satriani, asking himself the question "why is a song like 'Donna lombarda' considered folkloric, while the songs

sung by workers during the occupation of a factory are not? . . . why is a popular xylography considered folkloric while a pastoral or sea landscape executed by or for the lower classes are not?" (Lombardi Satriani, 1973). The problem exists, and although there is a need to distinguish between the levels indicated by Lombardi Satriani, one definitely cannot elude the question.

Proceeding in his analysis, Lombardi Satriani examined the phenomenon of the "advertising discourse that utilizes folkloric themes," in order to reach a "conservative" audience, as well as to satisfy the general needs of all consumers; he also pointed out the character of expropriation present within the touristic and commercial utilization of folklore. Although the deduced thesis of "ethnocide" appears as extreme and neglects many levels of mediation, the problem today involves the whole theme of folklore. The phenomenon of the folkloric object as urban consumption, of the undifferentiated fashion of the old and rustic, has already created a large market of popular objects. The ex-voto, the chest, the painting on glass, the crib scene, whether authentic or products of the touristic craftsmanship, all have their own vast "consumability," like folk-inspired songs and, in the case of the authentic, they have a significant market-value. It is almost as if the popular object has found some sort of historical vendetta in its being sold at an expensive price. But the phenomenon that interests us is much broader and it involves the juxtaposition of television and advertising images and their iconographic models onto tradition, even in the more isolated areas.

One of the themes emerging from these phenomena is, on the level of the image, the so-called "Kitsch." In this case the issue seems to be the inverse to that of the industrial appropriation of folkloric themes. From this there emerges a sort of barbarization of taste, as if the dimension of the mass of artistic facts caused their decadence. An important and well known work on this subject is G. Dorfles' anthological work "Kitsch, antologia del cattivo gusto:" "From the Christmas tree to the crib scene, from St. Nicholas to Halloween, to the "Befana," it is all a rosary of celebrations tied to a parade of images that rarely are saved from the jaws of kitsch . . . It is hard to elude kitsch: as soon as something becomes conformism and tradition, it rarely is able to save itself" (Dorfles, 1968).

" . . . People have always tended to accept what previously had been appanage of the aristocracy and the élite. It is well-known that popular customs are fashioned under the influence of aristocratic customs . . . (Today) even the farm home, once faithful to the tradition of massive shapes of ceramics and copper and stout implements, has passed to a collection of new and cheap furniture, the electric stove and junk from all over the world . . . " (Calebonovic Aleka, 1968). This "pan-Kitschist" perspective, which identifies tradition with the fall to vulgarity, tends toward an aristocratic position, to the élite model of art or to the "pureness" of the primitive. The lower classes no longer exist. They are now part of the large and spreading 'consumer society'" (Pawek, 1968).

Other studies attempt to examine more concretely the clash between traditional values and consumer models. This is the case of R. Hoggart, who, in certain sectors of the British working class, examined the conflict between the two levels. His hypothetical

resolution seems to favor the second one, without excluding, however, the third possibility of a new "independent" cultural dimension: "The influence of the environment and the powers of persuasion carry much weight but are not irresistible, and there are examples of the efficacy of the independent action" (Hoggart, 1970).

The already-mentioned Hall and Whannell attempted to define the characteristics of an artistic language which, although being channelled through the "mass-media," maintain the characteristics of popularity. The anthological work by M. Livolsi, published in "Comunicazioni e cultura di massa," appears particularly useful; here the discussion is carried forward through the most important interpretations. A classic thesis is that of the total cultural enslavement of the masses to a dominating class whose dominion is uncontested on the level of cultural models: " . . . As the dominated class has always accepted the morality given it by the aristocracy more seriously than the latter, so today the deceived classes are subjected even more than the fortunate ones, to the myth of success. They have what they want, and obstinately seek the ideology that serves them" (Horkheimer-Adorno, 1969). E. Morin's perspective seems analogous; it sees the cultural barriers among different social classes as modified but not abolished; however, they take part of the formation of a new gigantic, salaried social strata in the confluence between lower and middle classes. The unequal dialogue between production and consumption of culture, based on the fact that the "customer does not talk," causes the industrial culture to be "like alcoholism for the popular masses. First of all, it destroys more radically and widely than any political propaganda, the traditional values and hereditary models" (Morin, 1968).

Also O. Handling, analyzing the sociologically compact functional circuit of traditional culture, identifies within mass-communications the formation of the abyss between artist and public, the disappearance of the forms of collective control and finally, the "paradoxical diminution of the efficacy of communication with the improvement of communication techniques."

These "apocalyptic" evaluations, which illustrate a "unidimensional" humanity, are constrasted by W. Benjamin's classical analysis, which exalts, as a conquest, the desecration of uniqueness and "irreproducibility" (the "aura") of the work of art with its technical "reproducibility." "The freeing of the object from its sheath and the destruction of the aura are the countersigns of a perception whose sensitivity for that which is the same genre in the world, increased to such a point that, through reproduction, it derives the equality of genre even in that which is unique . . . The adjustment of reality to the masses and of the masses to reality is a process of unlimited capacity for both thought as well as intuition" (Benjamin, 1966).

Beyond the declarations of trust or distrust in the future, a concrete analysis of the phenomena of transformation, juxtaposition, superimposition and conflict on conceptions of the world remains, especially in Italy, like a practical horizon on which research should be applied. In this respect socio-anthropological research on the public consumption of art can be useful, as proven by G. Harrison's study on the occasion of a week of Museums (Harrison, 1966). Within this framework we can also place an evaluation of the neo-popularistic phenomena, of a "revival," of return to magical-ritualis-

tic horizons, together with the same didactic and scientific perspective of the museums of the popular world, presently placed within the heart of a society in which the "fetishism of goods" passes also through the industry of images.

Within today's ideological and social horizon we find phenomena of organization, preservation and diffusion of the popular patrimony. Among these are the associations that protect typical craftsmanship; through more relevant, especially for their cultural and scientific aspect, are the policies for "cultural patrimony" and the initiatives related to museums.

The concept of "cultural patrimony" seems to derive from the French studies on material culture, and is related to the preservation of village conditions, significant rural agglomerates, suburban churches, and minor art objects that have a strong value as historiographic documentation or as protection of the urbanistic and ecological features of the territory. The public character of this "patrimony" is not to be underestimated, not only as a testimony but also as an object of aesthetic and cognitive appreciation linked to tourism.

Nationally and regionally, the public associations seem to have started (even in Italy), to develop initiatives in these directions, utilizing guiding concepts that do not ignore the ethno-anthropological debate. It is worth noting that the imprecise value of the concept of "cultural patrimony," placed in a tradition in which the patrimony is that which has value and therefore, in our case, the art of the hegemonic classes, leads to the prevalence in these policies of a traditional concept of "artistic" extended to the phenomena of the so-called minor art. These conclusions appear to issue from several publications on the topic (Piraccini, 1974; Baccilieri-Lentini, 1974; Emiliani, 1974). This tendency seems to be opposed by the formation of museums, collections, exhibits of work objects, furnishings, supellectiles and popular rural expressive productions. The situation of the museums sketched by Buttitta in 1959 has been enlarged by numerous initiatives that are less institutional but at the same time stimulating in their character. They arise, at times, from the rustic claim of the dignity of its own past (Museo della civiltà contadina di S. Marino di Bentivoglio) or from the need to propose moments of popular cultural identity in scattered areas (House-museum of Palazzo Acreide). In any case, other than an ideological component linked to the crisis phenomena of our time, a scientific and didactic approach is identifiable, which sustains the operation of preservation of valuable testimonies that will later become objects of collective use. The two initiatives mentioned represent also two different choices of planning. The Museum of Bentivoglio, based essentially on the reconstruction of the cycles of agricultural work, sees the expressive work as a secondary aspect, visible in the wood-carving of carts, in the plastic characteristic of brass "stadure," or only in the aesthetic overconnotation that the modern visitor's eye attributes to objects of household use or agricultural work (Museum of farmer civilization, printing proofs, 1975). Actually, the House-museum, where the ergologic documentation is visible, tends to gather examples of the popular plastic-figurative experience (Uccello, 1968). Both museums document the production of the area in which they are located, thus underlying also the "territorial" function, that the modern decenteralized museum must support

the role of the centralized "museographic" institutions carrying out an operative function in the social fabric from which it derives its documentary existence.

Conclusions. – The issues presented define not a concept, but a problematic field of popular art within a range of wider issues raised by different disciplines. To speak of popular art today entails finding the strands of the discourse that justify its unity on true bases and on a new impulse for research. The term has rapidly become outdated and refers to a concept of art and of popularity substantially subordinate to romantic and idealistic questions. However, the one who recognized its obsolence did not indicate possibilities for substitution, perhaps because the field of objects that we continue to define as popular-artistic is so internally differentiated that it requires microcategories or dismemberments of sectors to place alongside of others.

Some of the most urgent problems are beginning to be answered, while some up-to-date methods are being applied. It is from these experiences that new terminologic proposals will arise, corresponding to new ways of thinking and classification of the technical, social and symbolic aspects of popular activities, together with their internal divisions. At the moment, popular art signifies that which it can: a tradition and some problems, which are not to be underestimated.

In conclusion, it is important to stress that a particularly complex aspect that is often misunderstood in popular art has been excluded from our discussion: architecture. However, this is a topic of investigation that has its own history, its own debate, its own particular complexity: it requires the approach to problems of planning and disposition of territory. It is a sector particularly inadequate for the classification of popular art. Therefore, we will only indicate here the bibliographical references most pertinent to the discourse we have addressed: the geographic work on the rural house by R. Biasutti and two contributions on popular architecture (Giordani, 1958; Zevi, 1968).

BIBLIOGRAPHY - Art populaire, travaux artistiques et scientifiques du 1er Congrés International des Arts Populaires, Prague, 1928, Paris, 1931; V. Fabian, Rélations entre l'art populaire et l'art classique, Art populaire, Paris, 1931; J. Vydra, Des principes contructifs et logiques du génie artistique populaire, Art populaire, Paris, 1931; R. Biasutti, La casa rurale nella Toscana, Bologna 1938; e direzione della collana 'Ricerche sulle dimore rurali in Italia,' per vari editori e per conto del Consiglio Nazionale per le Ricerche, e del Comitato Nazionale per la geografia; R. S. Boggs, Tipi e classificazione del materiale folklorico, in Standard Dictionary of Folklore, Mythology and Legend, II, New York, 1950; P. Giordani, I contadini e l'urbanistica, Bologna, 1958; A. Buttitta, Introduzione storico-bibliografica allo studio dell'arte popolare, Annali della Facoltà di Magistero, Palermo, 1959, 1; C. G. Argan, Arte popolare, in Enciclopedia Universale dell'Arte, Roma, 1960; P. Toschi, Arte popolare italiana, Roma, 1960; A. Buttitta, Cultura figurativa popolare in Sicilia, Palermo, 1961; Novelli-Massaccesi, Ex voto del santuario della Madonna del Monte di Cesena, Forlì, 1961; P. Toschi, Guida allo studio delle tradizioni popolari, Torino, 1962; A.M. Cirese, Struttura e origine morfologica dei mutos e dei mutetus sardi, Cagliari, 1964; W. Benjamin, L'opera d'arte nell'epoca della sua riproducibilità tecnica, Torino, 1966; G. Harrison, Studio pilota ad un approccio antropologico sul

consumo dell'arte, Roma, 1966; R. Jakobson, Saggi di linguistica generale, Milano, 1966; C. Lévi-Strauss, Lo sdoppiarsi della rappresentazione nelle arti dell'Asia e dell'America, in Antropologia strutturale, Milano, 1966; C. Lévi-Strauss, Il crudo e il cotto, Milano, 1966; E. H. Gombrich, Freud e la psicologia dell'arte, Torino, 1967; B. Zevi, Arte popolare come architettura moderna, D'Ars Agency, VII-VIII, 1966-67, 5; C. Aleka, Nota sul kitsch tradizionale, in G. Dorfles, Il kitsch, antologia del cattivo gusto, Milano, 1968; A. M. Cirese, Per una nozione scientifica di arte popolare, Arte popolare moderna, XV Convegno di Artisti, Critici e Studiosi d'arte, Verucchio, 1967, Bologna, 1968; A.M. Cirese, Prime annotazioni per un'analisi strutturale dei proverbi, Università di Cagliari, a.a., 1968-69; G. Dorfles, Il kitsch, antologia del cattivo gusto, Milano, 1968; U. Eco, La definizione dell'arte, Milano, 1968; P. Francastel, Esthétique et ethnologie, in Ethnologie générale, Encyclopédie de la Pléiade, Parigi, 1968; M. Maget, Ethnologie européenne, in Ethnologie générale, Encyclopédie de la Pléiade, Parigi, 1968; K. Pawek, Kitsch e religione, in G. Dorfles, Il kitsch, antologia del cattivo gusto, Milano, 1968; V. Santoli, I canti popolari italiani: ricerche e questioni, Firenze, 1968; L. Zeppegno, Presepi artistici e popolari, Novara, 1968; M. Bloch, Lavoro e tecnica nel Medioevo, Bari, 1969; J. Duvignaud, Sociologia dell'arte, Bologna, 1969; O. Handlin, Osservazioni sulla cultura popolare di massa, in M. Livolsi, Communicazioni e cultura di massa, Milano, 1969; A. Hauser, Le teorie dell'arte, Tendenze e metodi della critica moderna, Torino, 1969; M. Horkheimer, T. W. Adorno, L'industria culturale, in M. Livolsi, Comunicazioni e cultura di massa, Milano, 1969; C. Scarpellini, Una forma d'arte popolare: gli ex voto, in C. Genovese, G. F. Dasi, Estetica sperimentale, Bologna, 1969; S. Hall, P. Whannel, Arti per il popolo, Roma, 1970; J.H. Hansen, Arte popolare europea e arte popolare americana di influenza europea, Torino, 1970; R. Hoggart Proletariato e industria culturale, Roma, 1970; E. Morin, Il grande pubblico, in M. Livolsi, Comunicazioni e cultura di massa, Milano, 1969; P. Toschi, Introduzione, in H.J. Hansen, Arte popolare europea, Torino, 1970; A. Uccello, Motivi d'arte popolare in Sicilia, in Libro siciliano, Palermo, 1970; G. Angioni, Il "Circolo linguistico di Praga" e la considerazione funzionale del folklore, Lingua e stile, 1971, 3; P. Bogatyrev, The functions of folk costume in Moravian Slovakia, L'Aia-Parigi, 1971; A.M. Cirese, Aspetti della ritualità magica e religiosa nel Tarantino, Manduria, 1971; A. Gramsci, Letteratura e vita nazionale, Roma, 1971; P. Bogatyrev - R. Jakobson, Il folklore come forma di creazione autonoma, in Materiali per lo studio delle tradizioni popolari, Roma, 1972; F. Bologna, Dalle arti minori all' "industrial design." Storia di una ideologia, Bari, 1972; A. B. Buttitta, La pittura su vetro in Sicilia, Palermo, 1972; D. Carpitella, Lo studio del folklore come analisi differenziale di cultura, in Materiali per lo studio delle tradizioni popolari, Roma, 1972; A. Uccello, Casa-museo di Palazzolo Acreide, Siracusa, 1972; P. Bogatyrev, Semiotica del teatro popolare, in Ricerche semiotiche, Torino, 1973; A. M. Cirese, Cultura egemonica e culture subalterne, Palermo, 1973; A.M. Cirese, E. Delitala, C. Rapallo, G. Angioni, Plastica effimera in Sardegna, Cagliari, 1973; C. Gallini, Dinamiche di produzione, trasmissione, fruizione del canto sardo, Comunicazione al I Convegno di Etnomusicologia, Roma, 1973; M.L. Lombardi Satriani, Folklore e profitto, Rimini, 1973; J. Mukarowsky, Il significato dell'estetica, Torino, 1973; A. Uccello, Natale di cera nella Casa-museo di Palazzolo Acreide, Palazzolo Acreide, 1973; B.A. Uspenskij, Per l'analisi semiotica delle antiche icone russe, in J.M. Lotman, B.A. Uspenskij, Ricerche semiotiche, Torino, 1973; G. Angioni, Rapporti di produzione e cultura subalterna, contadini in Sardegna, Cagliari, 1974; A. Bacillieri, J. Bentini, Il patrimonio culturale della provincia di Bologna, Bologna, 1974; R. Barthes, Storia e sociologia del vestiario, in F. Braudel, La Storia e le altre scienze sociali, Bari, 1974; A. Emiliani, Dal museo al territorio, 1967-1974, Bologna, 1974; O. Piraccini, Il patrimonio culturale della provincia di Forlì, Bologna, 1974; G. Prestipino, La controversia estetica nel marxismo, Palermo, 1974; G. Previtali, Arte 2, Enciclopedia Feltrinelli Fischer, Milano, 1974; G. Profeta, La logica del recipiente, L'Aquila, 1974; E. Silvestrini, C. Peluso, Oggetti di corno inciso, Mus. delle Arti e Tradizioni Popolari, Roma, 1974; A. Carandini, Archeologia e cultura materiale, Bari, 1975; Museo civiltà contadina, Bozze di stampa della presentazione al Mus. di S. Marino di Bentivoglio, Bologna, 1975; A. Pasqualino, I pupi siciliani, Palermo, 1975.

PIETRO CLEMENTE

CONTRIBUTIONS TO THE STUDY OF URBAN SHAPE

URBAN SHAPE

Introduction. – Under the heading Town Planning in the *Encyclopedia of World Art*, Giovanni Astengo in his chapter on the 'Rediscovery, analysis and recomposition of urban space' wrote: "Further penetration of the deep, latent, psychological, magic-symbolic meanings behind urban space should enhance interpretation, and lead to a full re-evaluation of the importance of archaic, emotional reminiscence - individual or collective. It should lead to more systematic research into spatial perception, and look at its development along the long path of spatial-organizational experience. Thus, we can conclude that modern urban space is seen today as a multi-dimensional synthesis, whose geometric components form the simple basis for a complex and varied context of conceptual and emotional meanings, impregnated with any living beings that have survived historical and archaic experience, and with anything which is constantly being annexed by actual experience and by scientific speculation"

This conclusion was the result of a rapid, but penetrating review of recent literature covering the subject of urban space, from Sitte's studies to those of the Englishmen Unwin, Gibberd and Gordon Cullen, and up to the key applications in K. Lynch's "Gestaltpsychologie." He made a general review of the American School, including S. Giedion from Switzerland who, in his "Space, Time and Architecture" (Cambridge, 1941), announced the dichotomy between scientific and "mythical" thought. Giedion used an interpretive line borrowed from the last Cassirer, as could be seen in his later "The aeternal praesent" (S. Giedion, New York, 1962), where he was also influenced by ideas from the American Jung School.

Astengo's work, then, was determined by literature concerning the discipline of town planning - as imposed by the monographic formula of the Encyclopedia. His work, however, through the contribution of depth psychology, was also determined both by the psychology of form and of the complex world of cultural demand which came from his teaching of the philosophy of "symbolic forms," and by his students and followers - from Germany and America. His was a work which, in reality, consisted of an appeal to other disciplines with an interest in the problem of city form - an appeal to enrich the urban space by methodological means. These disciplines, although separate in themselves - such as archaeology, religious history, ethnography, structuralism, iconology - had all contributed to urban improvement during the first half of this century.

As will be seen, this appeal did not fall on deaf ears, and the basic layout of the *Encyclopedia of World Art*, with the space it allowed the above-mentioned disciplines, probably provoked a catalysis of cultural processes, which saw a significant number of contributions to the problem of urban space and its relationship to the land. Even if the sociological component was sometimes sacrificed - at least ostensibly, and out of methodological necessity - and even if the problems of the "forma urbis" or of "urban shape" were stressed, the results of these studies have made a real contribution to the definition of strictly interdependent relationships between form, internal arrangement, city orientation, and both global and local configuration of the social body and of its dominant ideology: this interdependence is obviously also linked to the political, economic and social situation.

These recent studies, which we will consider in detail below, were the ones which developed the expression: "figura urbana." This definition aims at avoiding the trend for inflating the meaning of the word "form," and at keeping closer to the English meaning of "shape" and to the German meaning of "Gestalt." "Figura," then, means "shape," without losing its etymological Latin meaning of "figura" (e.g. 'figura terrae'), and it therefore keeps its meaning of "image." In this way, it is susceptible to analysis in gestaltistic, structuralistic and iconological terms.

The loss of meaning compared to the expression "urban space" is clear, but it is justified in instrumental and methodological terms. The idea of urban space was meant to overcome planimetrical consideration of the city in favour of the irreducable space-temporality of urban enjoyment; the idea of urban space, on the other hand, is explicitly meant to describe the moment of structural and symbolic speculation on urban configuration. Urban shape does not wish to return to the schematism of Lavedan, but it recognizes that the basis of urban configuration has to have a "plan" - conscious or unconscious - and that it is the duty of the scholar to interpret this plan as a cultural product of a specific historical society. Thus, the moment of interpreting the city phenomenon is equated with the moment of the inherent judging of the plan. If this appears to be a regression from the concept of space-temporality of enjoyment, it is due to the fact that we are not talking about the enjoyment of urbanity, but about the enjoyment of cultural values, and thus of the historical-social values of the city plan which, for methodological reasons, is reduced to a bidimensional image, or rather to an interpretative model of that image, stressing the essential configurations of the city: to be exact, the "urban shape."

Studies in the first half of the century. – Even though the development of the concept of "urban shape" is recent - it can be dated at around the decade 1965-1975 - modern studies on the symbolic signifi-

cance of the city have been made in Germanic lands since the end of the 19th century, with the main investigators being historical and religious experts. Of course, interest in the city as a whole has been given over to the study of its evolutionary form. But interest in its contradictory literary traditions, as well as interest in the orientation of and morphological choices for temples and public buildings, is given over to the legacy of historical evidence, which alone permits the interpretation of artistic intentions with a methodological, positivist perspective. On the other hand, in the first half of this century, ethnography also contributed to the expansion of knowledge found in documentary sources about evolutionary and "primitive" settlement form. Archaeologists and Orientalists - expressing the guilty conscience of the European colonial nations of this period - also contributed to the documentation of the literary tradition and symbolic motivation which lay behind both town and temple planning in non-European civilizations - e.g. in Indian, Chinese, Muslim and pre-Columbus civilizations. Thus, by the middle of this century, a fund of important documentation had been built up, which was essential for the move to the comparison and synthesis studies which were to characterize the following decade.

It is interesting to note that, possibly due to historical and religious custom, no methodological difference was ever made between interpreting the symbolism of the city and interpreting the symbolism of the buildings within the city. This is interesting, despite the fact that neither ancient nor primitive man ever saw a qualitative difference between the magic-religious commitment needed to found a town or a village, and that needed to coin the symbolic project of a temple: often they entrusted both undertakings to the same priestly rank or to a person invested with specific powers. Fortunately the division of discipline and title between "town planning" and "architecture" had never been made until the over-specialization of recent times, and we therefore find ourselves dealing with literature which sometimes talks of buildings and sometimes of villages or towns with the same methodological plan. It is thanks to the return to this extended discipline that we can talk of studies during the fifty years in question which are propedeutic to our argument, and which even deal with the apparently heterodisciplinary fields of religious historiography, of art and ethnography, of Medieval and Oriental classical archaeology, and not forgetting the specific, illuminating contributions of R. Krautheimer and R. Wittkower to Medieval and Renaissance architectural symbolism.

Studies in the decade 1950 - 1960. – The decade 1950-1960 saw one phenomenon which is of definite interest: ethnographic studies of the first half of the century, such as those of the French School, were developed into the elaboration of documentary evidence, which determined the concept of a mutual relationship between the symbolic and ceremonial organization of urban space and the spatial arrangement of the relative social structure.

Thanks to the progress made in applying to anthropology the structural method developed in linguistics, scholars from the Paris School caught sight of the methodological possibility of: " . . . studying social and mental phenomena from their objective display, in an exteriorized and - one might say - crystallized

form . . . offered . . . by stable spatial configurations, such as village plans . . . " (C. Levi-Strauss, 'Structural anthropology,' Paris, 1958; Italian edition, Milan, 1966). Levi-Strauss had previously advanced this idea during the international conference "Le symbolisme cosmique des monuments religieux" ("The cosmic symbolism of religious monuments"), held in Rome in 1955 (Archives, 1957), which followed the exhibition "Symbolisme cosmique et monuments religieux" ("Cosmic symbolism and religious monuments"), which was held in the Guimet Museum in Paris in 1953 under A. Chastel. Levi-Strauss' paper addressed: "Le symbolisme cosmique dans la structure sociale et l'organisation cerimonielle des plusieurs populations nord et sud-Americaines" ("Cosmic symbolism in the social structure and ceremonial organisation of several North and South American populations"), and, amongst other matters, it discussed the urban establishment of ancient Cuzco in relation to the structural models of the villages of Zuni and Bororo. In his above-mentioned 'Structural anthropology,' the same author concluded with similar arguments, showing a structural similarity between the concentric, octagonal city of Hopewell in Powerty Point, Louisiana, and the Bororo village-type. He also referred to morphological similarities between ancient Bolivian and Peruvian cities. Although he did not develop his argument about the connection between social and spatial patterns, he did, nevertheless, provoke a lot of curiosity about the study of a sector which had never previously been the object of systematic treatment. We should emphasize the fact that the strictly sociological 'habitus' of the School of M. Mauss merged with the ideas of Levi-Strauss (probably after a suggestion by the work of another of Mauss' great students, Marcel Granet), towards the field of research into the symbolic meanings behind human behaviour. This was specifically in accordance with the wish of the last Cassirer (E. Cassirer, 'Essay on Mankind,' 1st. edition, New Haven, 1944, Italian edition, Rome, 1968; and, more especially, 'Structuralism in modern linguistics,' New York, 1946) to include every branch of human knowledge in a unique, methodological, structural perspective, with the purpose of penetrating the world of the meaning of mankind which, according to Cassirer, is a symbolic world.

During the above-mentioned conference, M. Eliade also gave an important paper on 'Centre du Monde, Temple, Maison' ['Centre of the World, Temple, House'] in which he summarized and updated the information laid out in the tenth chapter of "Traitè d'histoire des Religions" ("Treaty on the history of religions") (Paris, 1948). He also discussed themes taken from the same author's "Le mythe de l'eternel retour" ('The myth of the eternal return') (Paris, 1949) and from "Images et Symboles" ('Images and Symbols') (Paris, 1952). The same congress, not by chance held under the auspices of ISMEO, saw the contribution of G. Tucci on Tibetan architectural symbolism, which systematized his previous contributions (G. Tucci, 'The architectural symbolism of Western Tibetan temples' for Indo-Tibet, Rome, 1938, and 'Mandala theory and practice', Rome, 1949). The congress on the cosmic symbolism of religious monuments thus saw religious historians, anthropologists, archeologists and Orientalists all meeting in Rome in the effort to give systematic

coherence to some very rich materials. There was by now an impelling need to co-ordinate the different aspects of symbolic architectural meaning from the small scale - that of individual buildings - to the large scale - that of the city.

It seems clear, then, that the international climate in art research around 1960 was being directed towards the great subject of symbolism - sometimes in agreement and sometimes in disagreement with the School of C.G. Jung. Note Eliade's introduction to his 'The myth of the eternal return' (Italian edition, Turin 1968), in which he takes a methodologically autonomous position with respect to Jung, despite the use of the term "archetype," or see Tucci's explicit reference to Jung in his above-mentioned 'Mandala theory and practice.' To demonstrate the wave of interest in artistic symbolism, it will suffice to look at the international study conference on 'Humanism and Symbolism,' held in Venice in 1958 (Archives, Padua, 1958), with contributions, amongst others, from E. Castelli, H. Sedlmayr (who tried to establish an "othnic" symbolism), E. Garin, R. Klein, P. Rossi, K. Kereny, and A. Chastel. This conference was clearly contemporary with the return to neo-Warburg studies, which was seen in the activities of the same Warburg Institute which, in 1957, had re-edited F. Saxl's 'Lectures,' and which had seen Edgard Windt, collaborator in the Institute with Wittkower since 1937, as the brilliant expounder of 'Pagan mysteries in the Renaissance' (London, 1958). In the same period the American Cassirer School was contributing to revive the memory of its Maestro (NB 'The philosophy of E. Cassirer,' New York, 1958), with the important work by S.K. Langer, who had already translated 'Sprache und Mythos' ['Language and Myth'] (1st. edition, Leipzig, 1925), and who had already distinguished herself with her 'Feeling and Form' (New York, 1953). This new work was dedicated to the memory of E. Cassirer, and in it the author outlines a theory which criticizes application methods of the symbolic theory, as discussed in her 'Philosophy in a new Key' (Cambridge, 1942, 2nd. edition, 1951) - in likely contact with the world of Giedion.

Studies after 1960. - Interest in architectural symbolism became the essential concentration of work in an area which had so far been little discussed in art, and which, also due to a shortage of iconographic documentation, had basically been left undiscovered. This new interest was also seen in the 1950s writings of Eugenio Battisti. The year 1960, then, can schematically be assumed to be the first year to have a reasonable amount of literature on the subject - literature which was fed by new translations and re-editions of the fundamental texts by Panofsky, Saxl, Gombrich, Windt, Cassirer and Wittkower (see also Jan Bialostocki's Iconography and Iconology in the *Encyclopedia of World Art*). We are mainly dealing here with a literature which applies the Warburg method to works and historical periods which had been neglected or barely touched upon by Warburg's immediate successors. This literature appeared at the same time as the second generation of the Warburg Institute was studying the problems of cultural history rather than the problems of art history, as in the case of F. Yates' works ("Giordano Bruno and the Hermetic Tradition,' London, 1964, and "The Art of Memory," London, 1966); these works followed a line of enquiry which had already been initiated in Italy

by E. Garin, E. Castilli and by other key scholars of history and philosophy.

One of the first works which discussed the shape of the city was H. Rosenau's "The Ideal City' (London, 1959), which developed the fascinating argument of the so-called "Utopian" city - the city planned according to geometrical reasoning (implying social reasoning) and to ritualistic and religious themes, which reached a Medieval-type iconography - unusual for that time. This is essentially a fast book with the aim of illustrating a series of figuaral suggestions, which run from the hieroglyphics of Egyptian cities to models of Vitruvio orientation, to Filarete's city, up to nineteenth-century and contemporary Utopism; the book has the great quality of calling up images in a field which - it is worth repeating - is very poor in specific iconography. Another stimulating and, in a way, programmatic book, is that by Werner Muller, 'Die Heilige Stadt' ("The Holy City") (Stuttgart, 1961), which discusses the myth of the "square" city from the time of Romulus' Rome, up to the time of new Gothic establishments; it includes a substantial excursion into Hindu manual cities (Silpasastra), and manages to rediscover the "city centres" (blaue stein) of some present-day Germanic cities. It is a book which shows an admirable command of the subjects dealt with by the religious history of the preceding sixty years, as well as an understanding of previous research in the field of Orientalistics and Classical and Medieval archaeology; needless to say, the author is a religious historian, who concentrates his active research on the rites and religions of the American Indians. We can say that, after Muller's book, it appeared imperative for everyone to enrich the hermetics of urban shape with at least the contribution of religious history and anthropology. At this point the new approach of the 1960s was represented by the entrance into the historical-critical competition of architects, who were armed with a certain amount of disciplined and specialized culture, and who were therefore capable of contributing at a level of image collation and confrontation with some advantage over art-lovers with a literary background, who were armed with humanistic superiority, but who possessed inferior iconographic references to the form of the city. In this way, literature in the field of urban shape became full of works which were often disappointing or elusive on a methodological level, but rich with images and contrasts taken from town-planning manuals, from land registers, and from specialist histories of town-planning or of individual cities. These works were therefore unquestionably pertinent, and with the diffusion of those images, they were able to provoke later waves of interest in a subject which, until then, had been approached with a notable degree of generality and disinformation.

It is worth pointing out the fact that Italian studies devoted to the problem of the meaning of "urban shape" began in Rome. This can only be connected with the important influence in the early 1960s of the School of S. Muratori, backed by a decade of Venetian experimentation. With its systematic reference to the study of urban context, its purpose was to follow the development of the main contemporary philosophical currents and to formulate a concept of structural and urban "organicity," and, with its "operative" understanding, the history of architecture was seen as the most explicit and lasting image of civilized society (S. Muratori,

'Studies for a working urban history of Venice,' 1, in 'Palladio,' III-IV, 1959; S. Muratori, 'Architecture and Civilization in Crisis,' Rome, 1963; G. Caniggia, 'Reading a city: Como,' Rome, 1963). The concept of "organicity" had also been developed in America by the Cassirer School: it will suffice to remember the link between the above-mentioned S.K. Langer and K. Lynch. Langer's work 'Feeling and Form' (Italian translation, Milan, 1965) reads as follows: "Therefore every building capable of creating the illusion of an ethnic world, of a 'place' regulated by the print of human life, must appear to be as organic as a living form. 'Organization' is the significant word in architecture" There is a clear connection between this work and the organicism expressed by K. Lynch, student of Frank Lloyd Wright, in his 'The Image of the City' (Cambridge, 1960, Italian edition, Padua, 1964), in which he actually quotes Langer in a context infused with gestaltic method.

It cannot be a coincidence that E. Guidoni's first essay on methodological innovation, 'Organicity "in a new Key"' (in 'Marcatre,' 1965), consisted of an updating of building terminology through Langer's concept of "organicity" and Lynch's method of reading the city, in order to reach an extremely useful series of structural comparisons between images and organisms of different natures and origins. These comparisons led to the notion that the cadastral "pattern" of certain Medieval villages in the Lunigiana had gestaltic properties, and to the development from this notion to the interpretation in historical terms of the evolution of urban aggregates: " . . . The planimetrical pattern, which is nothing but a complex of iconic symbols representing the intersection with the world of urban organism, allows us to study the formation of this world over time, as it conserves within itself traces of its most ancient evolution" Guidoni also follows the course of phenomenology and gestaltism in his essay on the Campo of Siena ('The Campo of Siena,' in 'Notes of the Architectural History Institute,' Rome, 1965). This essay is strongly based on the comparison between the shape of the Campo and the stylized shape of a cloak as found in coeval pictorial evidence: Guidoni declares that he only heard about the popular legend of the Captain who determined the shape of the Campo by throwing his cerimonial cloak to the ground, at the end of his work, and that this did not influence his interpretation. But there is no doubt that the recent Italian translations of the masters of symbolic form (F. Saxl, 'The history of image,' Bari, 1965; E. Panofsky, 'Perspective as symbolic form,' Milan, 1961; E. Panofsky, 'The meaning behind visual arts,' Turin, 1962; R. Wittkower, 'Architectural principles of the Age of Humanism,' Turin, 1961; E. Gombrich, 'Art and Illusion,' Turin 1965) had influenced Guidoni on a methodological level. Some also influenced him on the matter of the relationship between philosophical-political programmes and symbolic and numerologic programmes (e.g. Panofsky, 'Gothic Architecture and Scolasticism,' Latrobe-Pennsylvania, 1951-6 [not yet translated]). On the other hand, both Panofsky, as mentioned above, and Wittkower's 'Principles' had been reviewed in 1964, and therefore published in the same year by P. Marconi and the Library of the Faculty of Architecture in Rome. This Library had shown a very lively interest in the translations, which certainly had something to do with

some of Wittkower's specific quotations on the subject of architecture taken from Galvano della Volpe in his 'Criticism of Taste' (Milan, 2nd. edition, 1964).

The general climate of the 1963-1964 Rome School was therefore favourable to the appearance of a decisive turning-point in the study of art history, and a move in a direction away from the late-Crotian method which was still being followed by some of its own scholars and by others from other influential Faculties (note Pane and his anti-Wittkower argument, which were developed within a successful consensus of opinion during the 18th Convention on the History of Architecture, held in Venice in 1956). The move can therefore be seen to have embraced the Hamburg School method, and extended its ideological limits, or to have embraced della Volpe's proposed method which, while inspired by historical materialism with a particular accent on the investigation of the semantic (linguistic) aspect of poetry and of art in general, did not oppose the Hamburg School method in the idea of a new respect for "scientific" research.

In this way a climate developed which found consonance with the world of art historians of literary background: note the appearance of the iconological method, thanks to the Fagiolo brothers, during the 1967 Borrominian Convention (held under the patronage of the pioneer E. Battisti); also note M. Calvesi's hermetic and masonic interpretations, and his general interpretations of Piranesi's cultural history (respectively in the Archives of the 'Convention on Borrominian Studies,' Rome, San Luca, 1967, and in the introduction to the reprint of H. Focillon, 'G.B. Piranesi,' Bologna, 1967). The 1968 Guarinian Convention was to see art historians and architects meet up to celebrate an incredibly learned and expressive architect. It was now that a methodological bond was formed between the two fields: a bond which was inspired by Panofsky's iconologism - or, at least, by the research carried out in the field of cultural history, which is the most distinguishing feature of the Hamburg School. It was a key to cultural history that E. Guidoni proposed his "Guarinian models," inspired by his recent study of Yates' above-mentioned books. Also memorable are the contributions of Battisti on the Guarinian "plans," and of Marcello Fagiolo on the St. Sindone Chapel.

A climate was developing which was to preside over the foundation of the "Histoy of Art" magazine (Florence, 1969). This magazine was inaugurated by G. C. Argan's methodological essay devoted "To the venerated memory of L. Venturi and of E. Panofsky," in which he states that: " . . . the great quality of E. Panofsky lies in his having understood that, despite confused appearances, the world of images is an ordered world, and that it is possible to uncover the history of art along with the history of images" However: "iconologism, much more than Woelfflin formalism, attacks the problem of art and that of linguistic structures: Panofsky, not Woelfflin, is the 'Saussure' of the history of art" The historical-critical essay in the first number of the magazine was by M. Calvesi, and discussed the refutation, after some dialectic lavishness, of the interpretations given by Panofsky, Klibanky and Saxl on the subject of Melancholy being astrologically connected to Saturn - an idea which was dear to Durer ('Saturn and Melancholy,' London, 1964). This essay referred to Jung, and is one of the most scrupulous

exegeses of sixteenth-century hermetic and cabalistic texts ('A noir [Melancolia I'] in 'History of Art,' nos. 1-2, Florence, 1969). Finally, the magazine made an "orientated" collection of the iconologistic contributions of recent years, and basically, for Italy, came to represent the meeting point between structuralist and iconological methods - the latter at last being recognized at an academic level thanks to Argan's wonderful introduction.

The time was ripe to face the subject of "urban shape" with methodological understanding. The year 1968 saw the appearance of P. Marconi's essay 'A key to interpreting Renaissance town planning: the citadel as microcosm' ('Notes of the Architectural History Institute,' Rome, 1968 [1969]), in which he used an impressive amount of largely unedited, iconographic documentation to understand the symbolic significance behind the design of Renaissance town walls between 1400 and 1500. By examining a specially-oriented structural grid, the statistical analysis of "urban shapes" proposed by Francesco di Giorgio determined the notable frequency of a basic anthropomorphic model. This is explained by the idea of cultural history emerging from the delightful pre-Renaissance Microcosm theory, which was also mentioned in the Vitruvio question - still open before Vitruvio's critical edition - and which was therefore particularly dear to 15th century architects, who ventured into interpreting manuscripts which had more or less been interpolated by that splendid writer. But even Medieval and Renaissance magic-alchemic culture had its role in magnifying the virtues of the five-point star which made up the geometrical support of the Martinian 'homo' - part of the city-type. The author did not hesitate, in his enthusiasm of the moment, to determine other five-point 'patterns' documented by ethnography and archeology; he was contemporaneously and explicitly indebted to Giedion and his 'The Aeternal Praesent' (Italian edition, Milan, 1965), to Cassirer and his 'Individual and Cosmos in Renaissance Philosophy' (1st. edition, Leipzig, 1927), as well as to the verve of E. Battisti's 'Anti-Renaissance' (Milan, 1962).

With a paper written in late 1967 and edited in late 1970, E. Guidoni made his most stimulating contribution to the study of urban shape which, in his introductory note, is defined with the lexical outline: " . . . Critical planning has partially followed the line of urban iconology, as shown in the special study of Siena Piazza del Campo (1966); the fundamental aspect of the problem appears to be that of perceiving urban planimetry as 'shape' . . . " (E. Guidoni, 'Art and town planning in Tuscany 1000-1315,' Rome, 1970). This book is a fundamental contribution to enhance the idea of "town planning," thanks to its interrelated linking of the history of art with the history of culture: the architecture of the Tuscan Medieval city is seen with continual reference to contemporary image culture - to both the symbolic and formal constants in painting, sculpture and decorative art, and to the development of poetic and musical techniques.

Another important contribution of Guidoni to the study of urban shape comes from his essay on 'The town planning significance of Rome between Ancient and Medieval times' (in 'Palladio', I-IV, 1972). In this essay he gives light to the concept of the "Church cross," and to the idea of the city center coinciding with the center of this cross, as demonstrated by Herzog in Medieval Germany and Italy (H. Herzog, 'Town planning problems of the 11th century in Germany and Italy,' in 'Art Criticism,' 13-14, 1956). Guidoni shows the Rome Colosseum to be the center of an ideal cross drawn between the four main Christian basilicas (San Giovanni, San Pietro, Santa M. Maggiore, San Paolo) and he also shows the "axis urbis" to be the "via Lateranensis." The same number of "Palladio" in 1972 also contained P. Marconi's essay, "The problem of city form in Renaissance architectural theory," in which the author stresses the Vitruvio aspect of architectural studies by so-called Italian Renaissance "Utopists," and points out that the octagonal "pattern" (which was the structural basis of Filarete's city, of Francesco di Giorgio's city, and of the graphic following of Vitruvio's plans by Fra' Giocondo, Cesariano and Barbaro) also existed during Medieval times. In fact, Vitruvio gave special importance to the moment of "orientation" of a city under construction, and determined an octagonal diagram which, when put into practice, became a characteristic "topos" of Vitruvio exegetics from the oldest known manuscripts. This "topos" was capable of facilitating the work of scholars of Renaissance architecture, from Alberti to Palladio, whenever they wished to find a shape on the perimeter of the city as described in that same book.

The year 1973 saw the book by P. Marconi, F.P. Fiore, G. Muratore, and E. Valeriani, *The city as symbolic form - Essays on the theory of Renaissance architecture*, which elaborated on and detailed the subject of symbolic meaning behind the urban models of Renaissance imagination, but which did not forget the tangencies of architectural theory with contemporary technical-scientific theory. Nor did it forget the subject of possible repetition or of indisputable assonance between some of the more "bizzarre" ideas (see Filarete's work) and the exotic handbook of architecture, which came especially from the Middle and Far East, and which was certainly known along the spice and silk routes from at least as early as the 14th century.

Guidoni furthered his research into the form of the Medieval city in his book 'City, countryside and fief in Medieval town planning' (Rome, 1974). He also recently made use of his editorial skills in the 'Encyclopedic Dictionary of Architecture and Town Planning' (Rome, 1968-9), when he edited 'Primitive Architecture' (Rome, 1975). Here, he offers the reader an updated collection of contemporary European ethnographical contributions to the form of "primitive" urban aggregations - i.e. to the form of urban areas developed by animist peoples (excluding, with exemplary methodological clarity, the products of "popular" cultures). Guidoni achieves the distinction of finally condensing into the space of one volume (albeit a large one) existing visual and ethnographic documentation of cultural complexes which are destined to become more and more quickly downgraded because of conflict with European "civilization."

A series of investigations on the subject of urban shape have recently appeared, and deserve to be mentioned, if only briefly, in order to demonstrate the interest with which the debate is followed, at least in Italy: "The Colosseum, symbolic, historical and urban purpose;" by M. Di Macco (Rome, 1972); "The walls of Rome - Military architecture in urban history;" by L. Cassanelli, G. Delfini and D. Fonti (Rome, 1974).

Another volume edited by Cappelli which discusses the problems of urban iconology is currently being printed: 'History as a project,' (Bologna, 1976), with essays by E. Battisti, Marcello Fagioli, P. Marconi, G. Monti, G. Muratore, I. Pineschi and A.M. Racheli.

P. Marconi's essay in particular discusses the recent history of the return to the iconological method by scholars of urban form, who had been disappointed by the semeiological approach to the same problem: " . . . The investigation of semeiological ideology shows that linguistic analysis of a work cannot lead beyond mere description, which could be obtained by the binary opposition process borrowed from computer logic. Experimentation on a large scale has led to the conclusion that it might be more useful to stop at the semantic aspect of architecture, since it does not appear tenable to further the theory of marking architectural messages, and the suspicion thus appears that these messages are moved by symbolism. On one hand, then, any interest that is more than just instrumental in the semeiological approach to architecture is excluded, as soon as the object of the investigation becomes the ideology behind the work; on the other hand, the object of the investigation can just as well be moved to the "contents" of the work, by revising in the final analysis and returning to updated iconological methodology - or, at least, by opening a structural semantic perspective to the investigation of the "deep structure" (Choay) of the architectural message. In both cases, then, we can see the revival of content examples, as against the exasperated formalism of some recent semeiology. But whichever method is adopted, what counts is understanding the reason for the work - its historical and cultural hinterland"

BIBLIOGRAPHY - J. Sauer, Symbolik des Kirchengebaudes in der Auffsung des Mittelalters, Freiburg i.B., 1902; E. Kornemann, Polis und Urbs, Klio, 1905; A. Nissen, Orientation, in Studien zur Geschichte der Religion, 1906; F. Cumont, La Théorie solaire dans le paganisme romain, Mémoires de l'Académie des Inscriptions, 1909; F. M. Lund, Ad Quadratum, London, 1921; E. Cassirer, Philosophie der symbolischen Formen, Berlin, 1923-29; B. B. Dutt, Town planning in Ancient India Calcutta & Simla, 1925; J. Pontew, Architektur, die nicht gebaut wurde, Stuttgart-Berlin, 1925; P. Lavedan, Histoire de l'Urbanisme, Paris, 1926; H. Liebensschutz, Kosmologische Motive in der Bildungswelt der Früscholastik, Leipzig und Berlin, 1926; A. H. Allcroft, The Circle and the Cross, London, 1927; G. Munter, Die Geschichte der Idealstadt, Stadtebau, 1929; P. Zucher, Entwicklung des Stadtbildes, München-Berlin, 1929; F. Bork, Die Geschichte des Weltbildes, Leipzig, 1930; G. Mengozzi, La città italiana nell'alto Medio Evo, Pavia, 1931; E. Kornemann, Heilige Städte, Die Antike, 1932; K.A.C. Creswell: Early Muslim Architecture, Oxford, 1932-1940; O. Wolff, Tempelmasze, Wien, 1932; L. Deubner, Mundus, Hermes, 1933; P. Mus, La boussole géomantique et les villes royales à l'axe du monde, Bulletin de l'École Française d'Extrème Orient, 1933; M. Granet, La pensèe chinoise, Paris, 1934; Puig I Cadafalch, Idees teoriques sobre Urbanisme en Segle XIV, Barcelona, 1936; J. Baltrusaitis, Roses de Vents et Roses de Personnages à l'époque Romane, GBA, 1938; A.K. Coomaraswamy, Symbolism of the Dome, The indian Historical Quarterly, 1938; G. Tucci, Il simbolismo architettonico dei Templi del Tibet occidentale, Indo-Tibetica, 1938; F. Dornseiff, Roma Quadrata, Rheinisches Museum für Philologie, 1939; L. Quaroni, L'architettura delle città, I, Roma, 1939; G. Vinaccia, Il problema dell'orientamento nell'urbanistica dell'antica Roma, Roma, 1939; S. Giedion, Space, Time and Architecture, Cambridge, 1941; R. Krautheimer, Introduction to an "Iconography of Mediaeval Architecture," JWCI, 1942; K. Lehmann, The dome of Heaven, Art Bulletin, 1945; A.C. Soper, The dome of Heaven in Asia, Art Bulletin 1947; M. Eliade, Traité d'histoire des religions, Paris, 1948; M. Griaule, Dieu d'eau, Paris, 1948; A. Sedlmayr, Architektur als Abbildende Kunst, Wien, 1948; G. Tucci, Teoria e pratica del Mandala, Roma, 1949; R. Wittkower, Architectural principles in the Age of Humanism, London, 1949; E. Baldwin Smith, The Dome, a study in the History of Ideas, Princeton, 1950; A. Stange, Das fruhchstliche Kirchengebaude als Bild des Himmels, Köln, 1950; H. Sedlmayr, Die Entstenung der Kathedrale, Zurich, 1950; G. Bandmann, Mittelalterliche Architektur als Bedeutungtrager, Berlin 1951; F. Castagnoli, Roma Quadrata, Studies presented to D.M. Robinson, Saint Louis, Missouri, 1951; K. Gruber, Die Gestalt der Deutschen Städte, München, 1952; S. Lang, The Ideal City from Plato to Howard, Arch. Rewiew, 1952; H.P. L'Orange, Studies in the Iconography of cosmic Kinship in the Ancient World, Oslo, 1953; Symbolisme cosmique et Monuments Religieux, Musée Guimet, 1953; L. Hautecoeur, Mystique et Architecture, Paris, 1954; P. Lavedan, Representation des Villes dans l'art du Moyen Âge, Paris, 1954; H. Rosenau, Historical aspects of the Vitruvian tradition in Town Planning, Journal of RIBA, 1955; E. Baldwin Smith, Architectural Symbolism of Imperial Rome and the Middle Ages, Princeton, 1956; H. Herzog, Problemi urbanistici dell'XI secolo in Germania e Italia, Critica d'Arte, 1956; P. MacKendrick, Roman Town Planning, Archaeology, 1956; M. Eliade, Centre du monde, Temple, Maison, Serie Orientale, Roma, 1957; G. Lesser, Gothic Cathedrals and Sacred Geometry, London, 1957; E. Panofsky, Gothic Architecture and Scholasticism, New York, 1957; F. Saxl, Lectures, London, 1957; R. Stein, L'habitat, le monde et le corps humain en Extrème Orient et en Haute Asie, J.A., 1957; Aa. Vv., Le Symbolisme cosmique des Monuments Religieux, Roma, 1955, Atti, 1957; K.A.C. Creswell, A short account of Early Muslim Architecture, Harmondsworth, 1958; C. Lévi-Strauss, Anthropologie Structurale, Paris, 1958; S. Muratori, Studi per una operante storia urbana di Venezia, I, Palladio, 1959; H. Rosenau, The Ideal City, London, 1959; K. Linch, The Image of the City, Cambridge, 1960; M. Eliade, Images et Symboles, New York, 1961; W. Müller, Die Heilige Stadt, Stuttgart, 1961; S. Giedion, The Aeternal Praesent, New York, 1962; E. Testa, Il simbolismo dei giudeo-cristiani, Gerusalemme, 1962; G.F. Caniggia, Lettura di una città: Como, Roma, 1963; M.M. David, Initiation à la symbolique romane, Paris, 1964; F. Choay, L'urbanisme. Utopie et réalités, Paris, 1965; E. Guidoni, Organicità "in a new key," Marcatré, 1965; E. Guidoni, Il Campo di Siena, Quaderni dell'Istituto di Storia dell'Architettura, Roma, 1965; A. Giuliano, Urbanistica delle città greche, Milano, 1966; M. Coppa, Storia dell'Urbanistica dalle origini all'Ellenismo, Torino, 1968; G.C. Argan, The Renaissance City, New York, 1969; K.W. Forster, From "rocca" to "civitas:" urban planning at Sabbioneta, L'Arte, 1969; P. Marconi, Una chiave per la interpretazione dell'urbanistica rinascimentale: la cittadella come microcosmo. Quaderni dell'Istituto di Storia dell'Architettura, Roma (1968-1969); E. Guidoni, Arte e Urbanistica in Toscana 1000-1315, Roma, 1970; P. Sica, L'immagine della città da Sparta a Las Vegas, Bari, 1970; M. Di Macco, Il Colosseo, funzione simbolica, storica, urbanistica, Roma, 1972; E. Guidoni, Il significato urbanistico di Roma tra Antichità e

Medio Evo, Palladio, 1972; P. Marconi, Il problema della forma della città nei teorici di architettura del Rinascimento, Palladio, 1972; C. Korvin Krasinsky, Microcosmo e Macrocosmo nella storia delle religioni, Milano, 1973; P. Marconi, F. P. Fiore, G. Muratore, E. Valeriani, La città come forma simbolica - Saggi sulla teoria dell'architettura nel Rinascimento, Roma, 1973; E. Guidoni, Città contado e feudi nell'urbanistica medievale, Roma, 1974; G. Simoncini, Città e società nel Rinascimento, Torino, 1974; L. Cassanelli, G. Delfini, D. Fonti, Le mura di Roma - L'architettura militare nella storia urbana, Roma, 1974; E. Guidoni, Architettura primitiva, Roma, 1975; E. Battisti, M. Fagiolo, G. Monti, P. Marconi, G. Muratore, I. Pineschi, A.M. Racheli, La storia come progetto, Bologna, 1976.

PAOLO MARCONI

URBAN DECOR

Urban decor, as a critical notion, is increasingly assuming a meaning which is analogous to urban ornamentation. At the same time, its usual definition, which is that it restricts the concept of decor to a generic listing of buildings devoid of internal space, appears decisively simplistic. This last definition may still hold true for identifying that series of urban features considered, more or less, decorative objects for squares or streets such as fountains, obelisks, columns, steps, wells, balconies, monuments, arches, ruins, facades, mosaic floors and in modern times, advertisements, signalling, and lighting. Today these interesting features assist us in discovering and defining the spatial, symbolic and mnemonic rapport that urban decor establishes with its surroundings. Naturally, decor elements do not always assume a prominent value within the urban context. In fact, their presence and symbolic value are historically conditioned by social, economic and cultural changes, so that during the slow evolution of the urban stratification, changes have occurred promoting certain features, at times rich in expressiveness, at other times displaying only a marginal or irrelevant significance. It is also true that cases of intensive decor or of total absence of decor may be attributed to esthetic choice or simply to a lack of adequate resources.

All this aside, it becomes necessary to specify that a tendentious analysis is by far more useful in defining urban decor than a falsely "objective" analysis which would inevitably miss the point. An analysis advancing a definite point of view should be able to concentrate on the salient aspects of the decor-city relationship and underline the instances in which decor assumes the role of "visual focus" or spatial knot, often capable of transforming the perception of a given environment, and requalifying and adapting (in terms of functionality or synthesis) wide areas of a city to changes of needs dictated by new social realities. A clear indication supporting the above statement is the use of decor in transforming Florence's sixteenth century Piazza della Signoria, a typical example being the placement of the Colleoni monument in Campo SS Giovanni e Paolo, in Venice. These arrangements have diverted the axis of the squares, thus promoting a decisively new perspective in respect to the original.

A description of the evolution of urban decor is undoubtedly tied to the rise and transformation of the city. Today for lack of data, it is almost impossible to trace the history of decor prior to the city-states era. Fragments of decor which survived the classic civilization, and that were subsequently reintroduced in medieval and modern cities, have lost their original meaning, in relation to the city, by having acquired new messages and having integrated themselves to a new reality. This is a very particular aspect of the problem that relates to the mixing of different elements in different periods from ancient to modern times. Let us consider the significance of decor from the time when cities began to acquire their own independent historical role. We can simply state that in this historical phase the most common form of decor (fountains, niches, mosaics) contributed to the definition of an environment planned for public activities, and exerted a relative influence on the structure of the environment itself. In fact, it is very difficult to trace a premeditated autonomous spatiality in decor elements, with the exception of certain examples of fountain-monuments (Perugia's Fontana Maggiore) where, in addition to the functional and symbolic element connected to the water theme, the surrounding environment is also clearly defined. A specific role for decor began to be defined only in light of the great urban changes envisioned by the architects of the fifteenth century, prevalently in the areas influenced by humanistic culture. Alberti, Francesco di Giorgio, Rossellini and Biagio Rossetti laid down the essential coordinates for "refounding" cities in accordance to perspective principles which enhanced both the symbiotic relationship between all parts of the city and their subordination to the politico-cultural center, an abstract order represented symbolically as unchangeable. If at the theoretical and design level this process intended to profoundly influence structures, the outcome of reality was almost always different. Consequently, it was often urban decor that assumed an essential role in adapting the old plans of the city states to a new configuration and image with a fixed focus perspective. Decor became the essential element of a perspective network that was layed over the key areas of the city in order to radically transform the optical discernment. The decor of Florence's Piazza della Signoria is extremely suggestive, a clear undertaking for adapting a medieval environment to a sixteenth century spatial conception. Yet in order to better understand the use and the value of Renaissance decor, one has to examine carefully Pienza di Rossellino's square.

Only through Michelangelo, and particularly through the realization of Piazza del Campidoglio, do decor and structure blend in a visual synthesis which tends to transform the square into an embracing monument wherein each element, whether structural or ornamental, relates to all the other elements on a level of absolute parity.

With that architectural experience a process began, sanctioned during the Baroque period, when urban decor became a predominating ideological element. At this time cities spread out dynamically toward multiple directional poles and the concept of subordination of all parts of the city to a single center was abandoned once and for all. The Renaissance perspective was subsequently used as a hyperbole, the streets as a background, or better yet, as axes escaping to the infinite, the squares as stages of an immense open air theater and the facades as ornaments of streets and squares.

Decor was no longer a reticular perspective serving as a unit of measurement. Decor encompassed everything that was contained between the open spaces of buildings. The city, or at least the capitals of the large or small European kingdoms tended to transform themselves along these two lines: the first consisting of new street structures shaped by the functionality, the practicality and expansion of urban centers; the second following a different concept, aimed at involving, pleasurably disorienting, but above all, communicating through tangible signs the stability of "power." The fountains, the obelisks, the commemorative or devotional monuments, the facades, the gates, the staircases and the corners were all created for the sake of decor, which in that historical time, perhaps unlike any other period, became synonymous with pomp.

The recurrence in the use of obelisks, spires, and devotional columns was a clear sign of new vistas; these slender vertical structures were not only the visual point of attraction of streets and squares, but also the "foci" of horizontal irradiation of different and intersecting paths.

Accordingly, a dichotomy was achieved between the rich iconographic reality of urban decor and the dynamic tendency of cities to transform themselves from monocentric, enclosed structures to polycentric structures expanding toward the surrounding countryside. An inverse process took place, that is to say: squares-streets-monuments became independent visual microstructures. This dichotomy may be synthesized through certain enlightening examples: on one hand by the great arteries unfolded in Rome by Domenico Fontana (notwithstanding the dates these undertakings belong to the Baroque era); on the other hand, always in Rome, by squares such as Santa Maria della Pace, St. Peter, and Navona, where circular or elliptical matrixes, surrounded or enhanced by superb examples of decor, invite a pause delaying any possible escape to other points of attraction. This fortunate coincidence of antithetical moments in a same culture was severed with the outset of the industrial civilization when the transformation of production and communication means, work, living and leisure concepts preserved and carried to extremes the structural innovations of the Baroque urban plan. At the same time, banished for morality and technology's sake, was the ostentatious image of urban centers characterized by a blend of the popular and the aristocratic.

The swift expansion of the city, promoted by forced and heavy urbanization, created inexorable fractures in the precarious equilibrium existing between old city centers and the new planning requirements, for which speculation became the deciding factor. The coupling between new cities and their historical centers was difficult to accomplish. In spite of some nostalgic, reactionary, formal reproposal of past urban models, the same ancient squares were left over as monuments, and together with more recent structures, as elements of pure decor. The architecture and the new city acquired features, structures, collors and decor which overturned in fact any residual image of the city as a closed space. The city expanded itself to the surrounding countryside erasing any reference to any privileged centers. In this framework "signs" often became elements of decor; signs such as advertisements, signalling, lighting for which the principle of quantity prevails in order to cover the frailty of the qualitative content. The signs, brought forward by a new science supporting mass communication, also became the essential basis for planning any type of decor. Profound psychological acquisitions and high technology converged into images covering as a spiderweb the urban structure, and directing, with a powerful impact, city life. The primary texture of this "spiderweb" is the total sum of graphic and bright elements which invite, seduce and reassure every single individual of "mass society."

The use of light has reached spectacular forms of the highest level. As in the case of graphic arts for advertising, light borrows ideas from the most advanced fields of design, technology, images and language. Signalling and advertisements cover every street, building and interstate highway. Today they have become irreplaceable elements of our urban landscape. The signboards of shops or "public places" have perhaps become the most "showy" element of decor. We are dealing with temporary, yet increasingly elaborate, imposive, aggressive structures designed to attract attention and force a pause along the great arteries. The sign-boards have been entrusted with carrying the messages of a consumer-capitalist society. Metallic structures and synthetic materials of great visual effect have been added to the use of colored, flashing, fluorescent lights. Their surfaces have the tendency to exaggerate and superimpose themselves over buildings. Consider Piazza Duomo in Milan, Las Vegas, Tokyo, especially at night: entire bright walls covering reinforced concrete and brick structures. Cities change, space changes and in contrast to the bright lighting, the supporting walls are engulfed in the dark; the messages impose themselves as totems. The presence of decor in modern cities is even more pervasive. It materilizes itself in a myriad of new sign-symbols: from newspaper kiosks (Paris' beautiful cylindrical kiosks) to subway terminals (Guimard and Otto Wagner's works), to service stations and vehicles of public transport (Milan's yellow buses, London's black cabs, Rome's green trolley-trams). These sign-symbols are permanent features of the city's image insofar as the quality and quantity of their presence creates a visual relationship inherent to forms of decor. To conclude with a hyperbolic statement, which however comes close to the truth, today, a few ancient ruins, the survivors of past devastations, have been reclaimed as pure signs of decor. Having lost any "contact" with history, modern cities have undermined the expressiveness of ancient ruins by isolating, preserving and utilizing them as dividing structures. There is no point in denying that Rome's Colisseum has become the most spectacular and unique traffic circle in the world.

BIBLIOGRAPHY - See "Structural types and methods" by Oreste Ferrari in *Encyclopedia of World Art*, XIII; Paolo Farole, Piazze d'Italia, Architettura e monumenti delle piazze d'Italia, Milano, 1972.

ORIETTA ROSSI PINELLI

THE GREAT EXPOSITIONS (PLATES 171-172)

The competitive conception of the 1800s. – Some of the fundamental circumstances of the great exposi-

tions were their solemn officialism and their wide-ranging publicity. These conditions help to illustrate, in addition to the trends of taste, some of the architectural forms and techniques, the evolution of urban structures, the sociopolitical doctrines and the historical situations occurring at that time.

In France, national expositions took place beginning in 1798, under the blessing of the Revolution; once the political and ideological difficulties were surpassed, the country shifted its attention toward economic prosperity. By 1849 eleven expositions were held in various European cities.

The idea of an international exposition, launched symptomatically in France during the second republic, was realized in England in 1851. In Great Britain, according to radical economic principles, it was believed that competition was the motivation behind progress, and any obstacle that stood in its path was not to be tolerated.

There was a movement to abolish the protective tariffs on merchandise produced in Great Britain as well as on goods produced in other countries. The prosperity of the Victorian age and the recent affirmation in England of the economic concept of free exchange, favored the success of a great exposition. The protagonists were Henry Cole and the prince consort Albert. An international competition was announced for the construction of the exposition building, and Henry Horeau won first prize for his large shed of iron and glass. Because these structural elements did not permit a practical cost recovery, it was advisable to establish another project, more economical and more simple to execute.

Joseph Paxton's crystal building, an architectural complex of exceptional scale and solemnity, was the logical expression, not only in a technological sense, but also in a formal sense, of the indisputable soundness of Victorian England. The building hosted the exhibits of all the nations. It had the appearance and the form of a greenhouse, and it sheltered trees along with the exhibited machines.

From the successful London experiment, and from a half century of tradition in the field of national industrial expositions there emerged the universal exposition of Paris of 1855. The establishment of the Second Empire, of which Napolean III was the chief proponent, was created through the same spirit that instigated the urbanistic transformation of Paris by the work of Haussmann.

The principal element of the exposition facility was the Industry Building, erected in the center of the Champs-Elysees. Between the building and the Seine there was a long gallery for the machines. Not far from there, between the avenue Montaigne and the rue Narbeuf, the building dedicated to the Beaux-Arts was constructed.

The Industry Building was conceived prior to the exhibition; its construction was decided in 1852, while the decision to hold the universal exposition was made only the following year. The commission was given to a private firm, which employed the engineer Barrault and the architect Viel for the project.

It was intended as the rival to the Crystal Building, measuring 250 meters long and 108 meters wide. Its central light was the largest that had ever been fabricated. This building represented a testimonial monument to the new faith, a cathedral to the economy.

Despite the inspired ideological references - or perhaps precisely because of this uncontrolled emphasis - the authors did not succeed in presenting all the facts of their radical idea. The construction's metallic structure was totally concealed by a sheath of masonry. Barrault, in his "Description du Palais de l'Industrie," admitted to having employed a compound technique from which a bastardized architecture resulted. He specified that it wasn't possible to connect the interior with the exterior and realize the structure and the facing contemporaneously. The facade buried the underbody of crystal and iron, making it impossible to appreciate it from the exterior. It was declared that the urban plan of the exposition facility corresponded to the great transformation of Paris already initiated by Haussmann. In effect, this transformation did not follow a precise definition of a general character. The exposition of 1855 marked the attainment of one of the first great realizations in metallic construction, along with the first research and the first products of reinforced concrete technology. A section was specifically devoted to the arts, thereby signifying an increasing awareness of the integration between technology and art. The technical and aesthetic propositions were necessarily juxtaposed rather than fused, but this offered the occasion for Baudelaire to make a remark at the exposition about "the inevitable relationship between form and function."

The first American international exposition was held in New York in 1853. The building constructed for the occasion was modelled on the idea of the crystal building, with the superimposing of a monumental cupola. This dome was probably inspired by the project that had also been executed by Paxton the year after the London exposition for the reconstruction of the Sydenham building. The New York exposition of 1853 found a favorable climate among the socio-political polemics that the northern and the southern states were engaged in at that time. While the South was almost entirely rural, the North was continuously advancing technologically, and all its industries were manufacturing every type of product on a large scale. For these reasons the North was already grappling with the tough problems of organized labor and worker's housing.

In the years immediately preceding the exposition, New York, Philadelphia, and Baltimore had been connected by railroad lines to the urban centers in the hinterland. The exposition attempted to manifest the efficiency of the Northern business world as contrasted with the agrarian, slave-holding oligarchy of the South, which had no intention of modifying its traditional economic system.

The Philadelphia exposition of 1876 represented the confirmation and the celebration of the economic, industrial and civic reconstruction of the country. It was the first example of an exposition divided among various pavillions, classified according to the different types of presentations.

Henry Hobson Richardson, who had completed his studies at the Ecole des Beaux-Arts in Paris, was chosen to direct this project, along with Richard Morris Hunt and Charles Falles Mckim. Having no precedent in his own country to which he could refer, he relied upon his own stylistic abilities while avoiding the facile reinterpretations and simplifications of the Roman-

esque, on which he had done research. For this he is considered the founder of American protorationalism.

In the meantime, in Europe, two great expositions were held - in London in 1862, and in Paris in 1867. The former could not boast of any particularly innovative characteristics, while the latter left the memory of a great festivity. However, it could not conceal the difficulties which were soon to plague Europe.

The leading figure behind the exposition was Federico Le Play, an engineer and an economist who conceived the fundamental idea of the organization and the rigid classification of its exhibited products. A large building was constructed according to Napolean III's plan for a circular structure to represent the earth's globe, but the situation of the building's site at the Champ-de-Mars forced a change from the original plan. The compromise resulted in an elliptic structure measuring 490 x 336 meters. A dual system of classification was applied to the building, in which a series of concentric galleries was devoted to analogous products of all the countries, while radial aisles were arranged into sectors that corresponded to the principal exhibiting nations.

This simple facility was pleasing because of its scientific physiognomy, and it was noted for its lack of aesthetic pretense. The construction was entrusted to the prominent engineer Krantz, who collaborated with Eiffel. Its general appearance was that of an enormous amphitheater, a type of modern Colosseum.

Despite the regulations that forbade the admittance of bellicose instruments, the French military industry was represented at the exposition, and the Krupp firm had sent a gigantic cannon of 50,000 kilograms. Its appearance seemed to represent a sinister foreboding, and it created much controversy. The earth's globe, upon which the show's exposition's facility was inspired, could not have been represented more objectively.

Vienna was the site of a new universal exposition in 1873. It was arranged at Prater within a complex of buildings erected specifically for the occasion on an area of more than 2 million square meters. The main building had a central gallery 950 meters in length, divided transversely by other galleries in the form of a comb. At the center of the building there arose a huge rotunda surmounted by a conical cupola of over 100 meters in diameter. The gallery devoted to machines was erected along the Danube. Occurring soon after the end of the war of 1870, an exposition of this type could not have avoided the exhibition of cannons. In fact they constituted the principal attraction in a competition contested by the steel-mills of St. Petersburg and those of Essen, which the Russian cannon won. In every section of the exposition, charts were posted presenting official statistics of single countries, showing the industrial progress that had been attained after the first universal exposition of 1851.

The Paris exposition of 1878 was not burdened by any abstract metaphysics, and it is considered the most moderate and discrete of the universal expositions. Occurring only seven years after the disaster of the Franco-Prussian War and the Commune, its promoters wished to illustrate the revival of the bourgeoisie in France. The United States participated with a large presentation, for the first time, along with the usual exhibitors. The Philadelphia exposition had marked the

U.S. entrance into the international circle of universal expositions. Those sympathetic to the progressive spirit had a high regard for this great Western democracy. The centennial of American independence had just been celebrated, and on that occasion a committee had decided to offer to the city of New York a type of sky-scraper statute, the Liberty, to place at the entrance of its port. The colossal head of the statute, which was exhibited at the show, permitted the entrance of the exhibition-goers, which led to the deprecatory popular proclamation that the Liberty was brainless.

Until this time, the exposition facilities were generally conceived as being temporary structures variously erected in the available public spaces. For this occasion the exposition had the availability of the Champ-de-Mars, and also the high ground of Chaillot on the other bank of the Seine, an under-urbanized zone which by then had been targeted for upcoming urban development.

Thus, it seemed to be a good opportunity to regulate and organize such a development - in effect, realizing a massive work of urbanization that was considered at that time, and for the future, the ultimate of all the expositions. And so the Champ-de-Mars hosted the international fair, and the new Palais des Arts was erected on the hill of Chaillot.

The competition announced for this building was won by the architects Bourdois and Davioud. The "pastiches" were then in fashion and the Trocadero architects offered more of an anthology than a true work of architecture, although there were those who were describing it as "functional" architecture.

However, the new building did not develop in this manner. It was conceived by the architect Hardy and its structural elements were studied by the engineer Krantz. Having affinities with the De Dion studies, it permitted the installation of a 35-meter light and had continuous trusses that obviated the use of tie-beams and enabled the ground to take all of the load of the building's shell.

The gigantic 706 x 350-meter rectangular pavilion was arranged according to the organizational scheme of the 1867 exposition, where one could walk the length of the building visiting all of the sections of the same group; or one could walk parallel to the width of the building to visit all the groups of the same country. The Galeries des machines, conceptualized by the De Dion studies, dominated the construction.

In the following decade another six expositions took place in these cities: Sidney, Melbourne, Amsterdam, Antwerp, Barcelona, and Brussels.

The Paris show of 1889 has to be the maximum official expression of these manifestations, which had continued to grow and spread beyond anyone's imagination. Everything that had preceded it constituted the progressive unfolding of an idea that found its full expression in the Eiffel Tower and in the enormous Galerie des Machines of Dutert, Contamin, Pierron and Charton. The exhibit was decided for the commenoration of the centennial of the French Revolution.

An enormous amount of preparatory work was done in the four years preceding the show. In only 17 months Eiffel erected the 300-meter tower that dominated the entire exposition and the city, while two polychrome buildings were constructed at its sides. These were destined for the Fine Arts and the Liberal Arts.

The industry building was constructed in only 7 months and had a cupola surmounted by the statute of France that measured 75 meters. The machine gallery was situated perpendicular to the axis of the exposition facility and extended for 420 meters. The transatlantic companies' presentation and the human habitation presentation were located on the other side of the exposition, along the Seine.

Gustave Eiffel was the great protagonist of this exposition, and his enterprise and initiative were responsible for the most important engineering works of the last century. According to S. Giedion, "19th century construction is the unconscious of architecture." Nevertheless, it now appears that the structural element had begun to vindicate the intrinsic aesthetic prerogatives.

The tower had aroused strong opposition rather than critical consideration due to its novelty and the intrinsic megalomania behind its conception. Likewise, the Galerie des Machines succeeded in provoking reactions of amazement for the structure's total overturning of the traditional and static architectural relationships.

Although they represented the most significant elements of the show, these two constructions were not the sole attraction. As the 19th century drew to a close the promise that accompanied the beginning of the century had to be maintained, and so the exposition represented the most complete assortment of the numerous new activities to which man had dedicated himself. The products and the machines exhibited began to take on specific forms, with their own distinct styles.

Between 1889 and 1900 the expositions had become so widespread that it is practically impossible and useless to make a complete survey of them. Many national expositions were held, being primarily of a specialized commercial nature.

The Columbus World Fair was organized in 1893 to commemorate the fourth centennial of the discovery of America. The city of Chicago had won the contest to host the exposition. A marvelous location was chosen on the shore of Lake Michigan for the intended dream city, the "white city by the lake." The work of planning was assigned preliminarily to the studio of Burnham & Roat, which later had the assistance of ten architects, half of whom had come from eastern states.

The proposed facility was based on two perpendicular axes, and the planning of the pavilions was entrusted to various architects, according to their preferences. In the end only two pieces of work distinguished themselves: Cobb's fishery pavilion, the last fruit of the Romanesque revival, and the Transportation Building of Sullivan and Adler, the most recent expression of the Chicago school in the official architecture of the United States. All of the other buildings expressed the forms of eclecticism and classicism of the European expositions.

It does not appear to be accidental that the official conversion of the representative American architecture toward classical eclecticism coincided with a wave of imperialism and ultrapatriotism that swept the United States, culminating in 1893.

Antwerp hosted an international exposition in 1894, and in 1896 one was held in Budapest for the celebration of the millenary of the founding of the city. Additional exhibitions were held in Dresden, Kiel, Stuttgart, Geneva, and Berlin.

In 1897 the universal exposition of Brussels took place along with the international exposition of Stockholm. The world exposition of Paris was held in 1900, and it was the last great exposition that had managed to conserve the spirit of the 19th century while also showing the signs of the new age.

The exhibition as propoganda in the early 1900s. – Due to the great ease in the exchange of products and news and information there were fewer instances comparison between the national presentations productions. This was replaced by a widespread desire for prestige, and the large expositions tended more and more to become enormous propagandistic complexes. However, the exposition of 1900 marked an innovative outburst that would result as the most fecund presentation of all the expositions. In order to develop a theme for the show a contest was announced.

One hundred and ten projects were presented. Aside from the numerous, atrocious masquerades of the Eiffel Tower that were offered, many of the proposals represented the bursting forth of futurism. After the magnificent structural experiments of 1889, there was a rush to attempt the most astounding utilizations of construction techniques.

As the show was being developed in every large space available in the city of Paris (Champ-de-Mars, Champs-Elysee, Esplanade des Invalides, Trocadero) it was imagined that the various sections would be connected by an elevated train system making use of tall bridges.

The real significance of the exposition of 1900 consisted of the attainment of integration between the plastic arts and industry, and of the generally good quality of the exhibited machines and products. Every country was undergoing changes in the field of industrial production, and quality was to become a determining factor in the public's choice in buying a product.

Beginning in 1861 Italy was also staging some significant expositions. From a report on the 1881 industrial exposition of Milan one can easily infer that practically every industry was making claims of a protectionist character. The exposition provided the perfect opportunity to attract attention to the products of Italian industry from a populace that had not yet had the opportunity to admire the wonders of 19th century technology.

As with the Paris expositions of 1855 and 1867, the Milan exhibition addressed social problems in a modest way. Workers' quarters were an issue of the day, and the Societa' Edificatrice di Abitazioni Operaie exhibited a project related to this that the society had been developing. The exposition newspaper carried a comment written with a paternalistic tone on the activities of the new welfare initiatives.

In 1902 in Turin one of the most interesting sectoral expositions was held - the international exposition of decorative art. The name of Raimondo D'Aronco is notoriously associated with this show. He won the contest proclaimed by the exposition agency with a project that was evidently influenced by the Viennese Secession. It was the result of the intense design activities that the creator had conducted outside of Italy with Joseph Maria Olbrich and Otto Wagner, and it was wholly transported to the exposition facility.

Important figures in the European movement for the revival of the arts were present at this exhibition,

including Victor Horta, Joseph Hoffman, William Morris, Walter Crane, Charles R. Mackintosh, and Hendrick P. Berlage. In Milan in 1906 an international exposition was held to celebrate the Sempione tunnel. It was arranged in two distinct sections; in the Piazza d'Armi and at the Sempione Park, in the part adjacent to the arena. The two sections were connected by an elevated electric train system. The facility in general was interesting, but there was no corresponding innovation in the architectural field. The contest-winning project for the park buildings, done by the architect Giuseppe Sebastiano Locati, proposed solutions highly infused with a Liberty style. The agriculture and road pavilions, by the architects Orsino Bonci and Lodovico Aceti respectively, were modelled upon the successful secessionist experiments of D'Aronco in Turin. The pavilion dedicated to the architecture exhibit went up in flames during the exposition, together with a large part of the material exhibited. After a rapid reconstruction, the architecture exhibit hosted, along with a model of the Victor Emanuele II monument, designs by Raimondo D'Aronco related to his work done in Turkey, the model of the Parliament building by Ernesto Basile together with photographs and plans of his minor works in Palermo. Cannons and armaments also figured prominently in this exposition.

The year 1911 marked a climax for Italy in the first part of the 20th century. An international exposition was organized in Turin with a significantly large participation. It was arranged with national pavilions located on both sides of the Po River in the Valentino Park. The two sections were connected by a wood bridge having two levels, and the lower level was equipped with a conveyer belt for pedestrian traffic. All of the national pavilions were constructed in the eclectic style that had become the recognized fashion of the expositions. Hungary was the only exception, with its construction of a building by the architect E. Tory. It was a conventional, planimetric building composed of simple volumetric elements with an almost complete absence of decoration.

With the passing of ten years after the exposition of 1902, the great success of D'Aronco's unitary architectural theme had been almost completely forgotten. In the meantime an international exposition was held in Brussels in 1910, and there were other shows in Milan in 1912, and Gand and Leipzig in 1913.

Practically on the eve of World War I, the Werkbund show was inaugurated in Cologne in 1914, with the participation of the leading figures of the European architectural avant-garde. The buildings by Van de Velde, Hoffmann, Behrens, Gropius, and Taut continue to display a panorama of rather different tendencies, but a definite sensitivity to reciprocal influences is evident in them.

The post-World War I renewal of the expository structures. – With the expositions of the first years after World War I, there was a substantial change in the nature of the opportunity afforded to the architects. The gamut of technical-architectural experiments had been run, and interest had spread in expository techniques that were related to the arrangement of the object and to the definition of the surroundings having the most efficiency. This led to the beginning of a series of more formal research and innnovations. Also, the problem of the relation between the subject and the object came to

be addressed, with the consequent formulation of several typical solutions that were to be widely adopted in the planning and preparations of the permanent expositions and museums.

At the same time there was a much more prevalent use of permanent fairground facilities that responded to commercial demands by permitting the staging of annual merchandise shows. Since 1903 the Humanitaian Society, whose original activity consisted of aiding the unemployed and émigrés, and of constructing workers' housing, had been publishing a report on the plans for the institution of trade school workshops in applied industrial arts "for the objective of a moral and artistic coordination of the nation's craftsmen." The activities of these workshops became a reality only after the war, in 1919, when the first Lombardy exposition of the decorative arts was opened. Home furnishing was the theme of this Milanese exhibition, concurring with the fact that the Lombard furniture craft industry was the most developed and open to possible evolution.

The second exposition promoted by the Humanitarian Society was the First National Biennial of Applied Art, opened in 1923 at Monza in the Villa Reale. It represented the first gathering of the various Italian regions in the field of the applied arts. However, on that occasion the problem of the applied arts and its technical-productive implications was not realistically put into perspective. In the subsequent biennials of 1925 and 1927 two important tendencies in architecture were noted, the current 20th Century, with neoclassic and nationalistic inspirations coming together with futurism, and that of the "Group of 7," which declared itself rationalist and sought to conform Italian architecture to the European rationalism.

A year later, in 1928, on the occasion of the 10th anniversary of victory, a show was organized in Turin under the directorship of Giuseppe Pagano. A more heterogenous architecture resulted, with evidence of more varied derivations of the extra-national tendencies of the architectural culture.

The following exhibition, which should have been called the 4th Triennial, witnessed the beginning of the political interference of the regime that used the exposition as a propaganda instrument, identifying artistic problems with those of national prestige and the testimony of the Italian civilization. From that moment on, the Triennial was to be always subjected to the danger of political aggression and coercion, even in the years immediately after the second world war.

In 1923 Paris was the site of the international exposition of decorative art, and it was on this occasion that the new Soviet architecture was officially recognized. Melnikov, a Soviet architect belonging to the ASNOVA group, won a prize for his pavilion, which housed the presentation of constructivist objects. It was particularly interesting for the disarticulation of its internal space, made possible by breaking-up the covering shell into a multiplicity of inclined planes. "The intent to transform the 'spatial stasis' into movement was perfectly carried out . . . The construction is proof, not only of the architect's ability, but also of a more general maturity, of a crystallization of the group's ideas, by now far from simplism and the original rhetorical schemes" (De Feo, 1917-36).

For this same occasion Le Corbusier and Pierre Jeanneret constructed the pavilion of the "Esprit Nouveau," with which was launched the first trustful and pathetic appeal to industry to address the housing problem.

In the exposition of 1930 Gropius, Beyer, Breuer and Moholy-Nagy were in charge of the preparations for the German section, in which they aimed at illustrating the organic relationship existing between architecture, furnishings, commonly-used objects and art in general. This uniquely clear and uniform undertaking could be noticed in the juxtaposition of objects arranged in a severely expositive manner that had never been seen before.

We have already pointed out the affirmation of new expositive forms of a specialistic character. This was not the reason for the cessation of the great universal expositions. Nevertheless, they became more infrequent and they once again became exceptional events. In 1929 the International Exposition of Barcellona was held, which completed Montjuich's urbanization.

Under the direction of Gunnar Asplund an exposition was held in Stockholm in 1930, and this event ushered in the definitive renewal of the practice of organizing expositions on a grand scale. Asplund had been involved with the publicity activities of the Swedish Arts and Crafts, and the movement had gained a considerable notoriety outside Sweden. The time was ripe for a national exposition and national recognition. The Stockholm exposition appeared to be the most natural place to engage the official architectural culture in battle, and Asplund proposed one of Sweden's youngest architects as its leading proponent.

An exposition's architecture might involve only the structure that protects, separates and exhibits the objects to be displayed, such being the case for several of the previous large expositions. But a tendency was becoming more and more evident to define an exposition's architecture as a separate element, without regard to the exposition's concept. For the Swedish exposition, however, its facility served to place the exhibited object at the center of attention, surrounding it with simple elements of a visual "resonance."

The resultant facility was extremely articulated, composed of a multiplicity of forms and new elements that were devised in a case by case manner. When the Chicago World Fair of 1933 was inaugurated to commemorate the centennial of the proclamation of the city, the economic depression, which had broken out in 1929, had sunken to its lowest level and the United States' economic system was on the verge of total collapse. If the exhibition was carried out nevertheless despite this situation, it was due to the launching of the New Deal by the newly elected President Roosevelt. In fact, government funds were used to subsidize the most disparate private enterprise in the hopes of stimulating private investment initiatives.

The site of the exposition was developed along Lake Michigan, with the addition of an island that was connected to land by a suspension bridge used by special vehicles, supported by two 200-meter piers that functioned as observation decks. The rest of the fair was a summary of the history of the city and the last 100 years of science. Aside from the federal government building, composed of 3 towers of a triangular prism form with concave sides, symbolizing the three branches of power and supporting an enormous cupola with monumental entrances, the other buildings were not without some interest, to the extent that they were defined in terms of an emphasized and futuristic rationalism.

In Europe, a new universal exposition was held in Brussels in 1935, and it was fortunately not dominated by the pompous rhetoric of European nationalism. In fact, the Italian Fascist pavilion, by Libera and De Renzi, presented the ambiguity of a cross between rationalism and fascism.

In 1937 Paris proposed a new exhibition, the International Exposition of Art and Technology, on the grounds of the exposition of 1900. The Trocadero building that had been erected in 1878 was razed to make way for a new structure, and the hills of Chaillot were covered with new buildings of a nerveless neoclassic style that had come into vogue during the advent of the dictatorial regimes. Everything was imbued with rhetoric. Even in Russia monumentalism had attained an unopposed favor, and the Soviet pavilion, which was surmounted by an enormous sculpture, was at best a compromise between classic and modern styles, executed by the VOPRA group.

Italy participated in this event, with a pavilion designed by Piacentini with the collaboration of Pagano, in a vain attempt to salvage what was usable of Italian rationalism, which by then had been in decline. The Spanish republican government decided to participate in the exposition just before its inauguration with a pavilion arranged on three levels. The iron-framed structure was faced with undulated asbestos cement and translucent material, and it hosted Picasso's "Guernica," a fountain by Calder and a fresco by Mirò. The result of this work was a perfect example of the integral collaboration between architects, painters and sculptors. Amid the general atmosphere of nationalistic celebrations, the abundance of scenographic effects such as lighted fountains and other nocturnal marvels, served to distract the visitor from the panorama of deplorable architecture that represented the imminence of conflict.

But the event also highlighted someone who publicly expressed hope by presenting a program and proposing an alternative to the arms race. Le Corbusier built the airplane "Pavillon des Temps Nouveaux" with materials and natural elements such as "steel, cloth, the wind and the rain." Among the widespread cynicism of the consciousness of the masses and of the European cultural elite, there was still a man who had the courage to proclaim a message for a better life, making use of the same "civilisation machiniste" that had already caused conflict.

Argan writes: "Le Corbusier is a man of good faith, and he seriously believes in a new type of social contract: the bourgeoisie will refrain from war if the proletariat renounces revolution." But at the moment that Le Corbusier brought out his message the bourgeoisie was already quarreling within itself, while the proletariat was nothing more than an instrument used to wage war, like the cannons.

In 1939 in Zurich at the Swiss National Exposition, Maillart presented his famous vault, which was a subtle structure of concrete. The public visited the exhibition in small boats that cruised a canal that followed the entire itinerary, even inside the pavilions.

On the 150th anniversary of George Washington's inauguration the New York world fair was held in 1939 under the title "Tomorrow's World." It was intended to illustrate the progress of human activities and their possible future development. For this occasion a 1,235-acre park was created with artificial lakes, and this was to be incorporated in the city development plans after the exposition. The general plan had a radial configuration that was imposed upon an axis of symmetry. An enormous sphere 65 meters in diameter and a 240-meter tall obelisk were the symbols of the exposition.

A mobile platform raised visitors from the ground to the inside of the sphere, where a large plastic representation of a hypothetical city of the future was located. The attentive sensitivity of Markelius was reflected in the Swedish pavilion, which was the most interesting expository structure at the exposition. Unlike the rhetorical solidity of the other pavilions, which also included the Belgian pavilion designed by Van de Velde and Saarinen, the Swedish structure revealed an ephemeral quality in the lightness of its construction. This feature was most manifest in its covering, which resembled the wing of an airplane, under which the public passed without being channeled by obligatory routes. Walter Gropius and Marcel Breuer executed the "Hall of Democracy," Pennsylvania's pavilion, which was intended to represent the evolution of history and prospects for development. The dominating element of the work was a suspended bridge 50 meters in length that connected the "traditional" section with the "progressive" section. The severe juxtaposition of objects and images of Werkbund's Paris exposition of 1930 had disappeared, leaving ample room for unrestrained innovation in the realization of the facility. Rationality had been disappointing not only as a system, but also as a method.

When the New York fair was concluded in 1940, war broke out in Europe, interrupting the tightly-woven sequence of expository manifestations and precluding the upcoming Roman exposition of 1942. This demonstration had been given the attention of all the whims and caprices of the Italian empire, and it was intended to represent its international splendor and direct Rome's urban development toward the sea. For this event work was begun on the first subway line, which connected the exposition to the Termini train station. This was later completed after the war ended. There is little reason to regret the aborted exposition, because the last battle that was to be waged by the most courageous figures of Italian rationalism over this event would have been most decidedly lost from the very beginning, resulting in the certain surrender of the front lines of the Italian architectural culture. Pagano's critical activism, along with the polemics that he had engaged in with Casabella, had all been in vain. But he, along with others like Piccinato, Libera, Quaroni, Pollini, Banfi, Belgioioso, Peressuti and Rogers, still hoped at that time for the possibility of at least an open polemic with the official architectural and urban monumentalism that would have dominated the entire exposition.

Post-World War II: the balance of conflict and the nationalistic revivals. – After the war, even considering the limited means available, there was a great number of small expositions dedicated to the documentation

and the themes of the recent disaster, such as the horrors of war, the atomic bomb, imprisonment, deportation, the Resistence and reconstruction.

In Turin, in 1947, a presentation was dedicated to the Resistance in the Piedmont region. In the following year the 8th edition of the Triennial was addressed to the more urgent needs of a country whose social and economic fabric had been drastically affected by the war. A series of studies was commissioned with a wide participation of collaborators resulting in an organic program that dealt with the problem of building reconstruction.

For once the Triennial was not associated with retrospective problems of furnishings and graphic arts. As a more tangible contribution, a new district called the QT8 was founded, in the hopes of creating a balanced and autonomous unit for urban-planning. However, the euphoric climate, which allowed little room for a critical analysis of the political situation, led to a failure to realize any practical possibilities. The experimental QT8 building program was not destined to disappear with the close of the 8th Triennial, and it was kept alive at subsequent editions of this exposition. A study center was created to assure the continuity between the program and its realization. The changing political tides later nullified this proposal for structural transformation, leaving a void to be filled by another intricacy. The 9th Triennial was to be newly imbued by an official formalism, dealing with scenography, cinematography, the graphic arts and advertising, and the history of the chair down through the centuries.

The first postwar exposition to be widely acclaimed internationally in the spirit of the past great expositions was the South Bank Exposition opened in London in 1951. This was intended as an innovation in respect to the almost exclusive use of a radical organization, by the previous expositions' facilities. For this project the organizers availed themselves of the rich tradition of the urban landscape study. The leading figures behind this school lived in England, and at that time the school had a large influence on the urban-planning of the New Towns. Until that time, an experiment of this type had never been actualized in the dense and stuffy urban fabric in the center of London.

The first postwar universal exposition was in Brussels in 1958, intended as a celebration of the marvels of the atomic age. "World balance for a more human world" was inscribed under the Atomium, which was more of a grotesque curiosity than a symbol or a work of architecture. Nationalism had not yet gone out of fashion, but it had been toned down considerably. The juxtaposition of the blocs was reflected in the dimensions of the buildings, while contrasting ideologies did not present any formal alternatives. Once again Le Corbusier presented the newest innovation of the day. His pavilion "The Marvels of the Electronic World" was the manifestation of his ceaseless dedication, even in his old age, to the pursuit of revolutionary renovation. Actually, the pavilion contradicted the tradition of this message, which had, by then, been indiscriminately applied to the sacred and the profane.

In 1961, an exposition was held in Turin celebrating the centennial of the Unification of Italy. It was located on the last available ground of the Valentino Park along the Po River.

Apparently 100 years of national unity had not served to even-out the great disparity between the northern and southern part of Italy. A series of distinct pavilions housed the corresponding presentations of the different regions, which had been organized according to themes coordinated by Mario Soldati, such as "Lombardy - model of civilization" or "Along the state roads."

Nervi's International Exposition of Work building inaugurated a new type of monumentalism into the Italian architectural culture, based on a pre-existing environmental and neo-liberty themes. Sixteen mushroom-shaped structures with sides measuring 36 meters and 20-meter reinforced concrete pillars were surmounted by a square-shaped steel covering. This facility boasted of 25,000 square meters of covered area, 45,000 square meters of useful area, and 650,000 cubic meters in total.

One of the fundamental conditions stipulated by the announcement of the competition was the convertibility of the building for a later use. But it was recognized that a utilization other than that of a generically expositive nature was practically impossible, since the facility represented merely a container totally devoid of any typological requisites.

An elevated monorail system ran longitudinally along the exposition's facility, bordering the corso Polonia and offering a complete panorama of the pavilions.

Another work of engineering, the Exhibit Building, illustrated more of the technological wonders of the exposition. It was a rather large structure composed of three united cross vaults topped by a single large having an hexagonal plan inscribed in a circle 150 meters in diameter. This was supported only at three points, which were separated from each other by a distance of 130 meters.

The Italian section of the International Exposition of Work was also subdivided by themes, each of which was handled "under the auspices of one or more large industrial companies" according to the system used at the New York world fair in 1939. All of the well-known private and public companies like Rizzoli, Pirelli, Olivetti, Montecatini, FIAT, ENI, IRI and RAI were represented, along with Ponti, Albini, Sottsass, Zanuso and Castiglioni, who designed the plans for the preparations. However, they were unable to rid the exposition of its provincialism, the attacks by the humorists and the resentment for all the billions of lira spent.

The Helvetic Confederation evaluated itself in terms of development and progress through the means of national expositions. The last took place in Lausanne in 1964, and preceeding ones were held in Bern in 1914 and Zurich in 1939, on municipal land adjacent to the lake.

The general themes that were treated were the history, self-portrait and the future of the Confederation, tied in with the sections dedicated to productive activities, way of life, communications, transportation, exchange of goods, the land and the forest.

It had been made clear that all the pavilions were to be temporary, so that the terrain that had been set aside for the expositions could be once again restored to its original condition. Even so, the diversity of the techniques and the architectural solutions that were adopted gave a definite unitary image to the whole, without the impression of an exaggerated propaganda or an absurd stylistic and technological monumentalism that was then customary for this type of exhibition.

Bourgeois manners and morals and professional skills were engendered by the effects of the reassuring quality of the exposition's environment, in which the Swiss citizen could contemplate the perfection of his work along with the economy of means, social order and the absence of contradictions. The exposition as a whole reinforced the expectations of the average visitor, whose characteristics had been ascertained beforehand.

One of the most interesting pavilions of this dignified panorama was designed by Max Bill, and it was dedicated to "The Art of Living." Although creating a structure of brief duration, he managed to confer an architectural "concreteness" to the pavilion, both in terms of the facility and the manufactured building. Generally speaking, it was composed of a plate with articulated margins that rose in height between the 3.5-meter walkways and the 7-meter exhibiting areas, measured on a 5 X 5 meter grill. This was applied to an inexpensive metallic structure which did not present particular difficulties in mounting. An uncovered space making up the perimeter of the pavilion was dubbed the "courtyard of the arts," and 20 works of art by various artists were placed here.

Technological refinement was not ostentatiously used. The external perimeter revealed a simple trabeated structure closed by light steel paneling or particleboard covered with PVC or translucent polyester. The covering had canals of self-bearing asbestos cement that were 5 meters in length. The wind-bracing, for the most part arranged above the covering, wisely contradicted the static obviousness of the bearing structure without overly interfering with it.

The Bauhaus program proposed by the Ulm school, of which Max Bill had been founder in the postwar years, was revised and transposed to a social program instead of a discipline in this country of neutrality and social peace. It seems superfluous to point out the ideological significance of the discourse that would claim to use art for the redemption of life from the degradation caused by capitalistic exploitation. The historical lesson of the political failure of the Modern Movement's program certainly does not help to develop a conscious self-criticism in respect to one's own committment, but it separately and persistently promotes the disciplinary committment in architecture and in the tools that it should provide for transforming reality.

That same year, 1964, the New York World Fair was held in the same area with the same street arrangement as the fair of 1939, notwithstanding the international conventions which regulated this type of event. In fact, the initiative was taken by the New York municipality to celebrate the 300th anniversary of the foundation of the city. Despite the pretensiousness of its theme, "Peace Through Comprehension," the exhibition was purely commercial in character. A large sphere provided by the United States Steel Corporation was erected as a symbol of the exposition, and it was surrounded not only by the modest pavilions of the various states, but also by the bizarre and gigantic pavilions of Du Pont, General Electric, Bell Telephone, IBM, General Motors, Ford, and other corporations.

The president of the fair's institution, Robert Moses, employed strictly commercial methods in organizing the event. Exposition space was granted to whoever could pay the most, and no stipulations were imposed on the exhibitors regarding the architecture of the pavilions. Within this secular and commercial panorama, various religious organizations, such as the Mormon Church, the Russian Orthodox Church, and Christian Science, were conspicuous with their own propaganda displays.

Not one commentator failed to note the absurdity of this exposition. In our opinion, it had at least one value in that it revealed the future trend that these exhibitions would follow in the postwar years, in contrast to the trend of the prewar exhibitions. From a nationalistic propaganda displayed and promoted by the various participating nations, there was a shift to a propaganda promoting the international capitals and the large cities. The rhetoric of the monument, which had predominately been applied to the prewar expositions, was substituted by the rhetoric of technological means, devoid of its already dubious objectivity and used solely as a publicity ploy.

The only instance in which irony had tempered the propagandistic invasion was represented by IBM's pavilion designed by Charles Eames. The structure was composed of a plastic covering of a large pentagonal shape, supported by a forest of skeleton-like steel trees and surmounted by a white ellipse that was covered by plastic IBM monograms printed in relief. Visitors gathered on a gallery platform that could accomadate 500 people, located between the branches of the steel trees. It would then be raised up into the large ellipse, where, in the midst of a succession of images, a commentator in a tuxedo explained the information theory.

According to the agreement regarding international exposition rules, signed by 31 countries in 1928 in Paris, the world was divided into three zones: Europe, America and the "other countries." No nation was authorized to hold a "first class" exposition more than once in 15 years, and the nations belonging to the same zone could only host one exposition of this type every six years. The worldwide limit was set at no more than one every two years.

On the basis of these conventions, in 1960 the International Exposition Commission examined the Soviet Union's request to commemorate the 50th anniversary of the October Revolution, along with Canada's request for a centennial celebration of the Canadian Confederation.

The affirmation of technological ideology. – Although the Soviet Union's request was favored by the Commission, the country abandoned its project two years later. At this time Canada was granted its renewed request, and Montreal was chosen as the location for Canada's world exposition of 1967.

The expository facility was located on two islands and a peninsula of the Saint Lawrence River, which were widened and otherwise altered by the addition of landfill taken from the subway work that was then in progress. The city had hoped to orient its development beyond the river by taking advantage of the opportunity to improve the transportation network linking the different parts. Along with recovering areas that presented utilization problems and orienting the ensuing development, this operation led to a compre-hensive restructuring of the city based on the transportation system.

The pavilion constructions were very diverse and eclectic, even though there was evidence of an attempt to exercise a certain type of formal control, as through the use of "ambientation," urban furnishings, flooring, street lighting and transportation services within the expository complex.

On this occasion Richard Buckminster Fuller revealed the results of his study experience in the field of geodesic domes with the United States' pavilion. The structure was three quarters of a 75-meter diameter sphere framed with steel rods that were joined together in a tetrahedral pattern and lined with a transparent acrylic material. On the inside were several platforms serving as exhibiting areas.

On the whole the show had a reassuring quality that was devoid of ostentatious monumentalism. New building technologies were experimented with, and a prototypic habitat resulted from this work. The German Federal Republic pioneered the use of tensile-structures in the building of its pavilion. This technology was later employed in the construction of the Olympic stadium in Munich.

The 1970 Japanese World Exposition, the most recent of the expositions of its kind (which date back to the London exposition of 1851), should be regarded more as a current event than as an historical event. It was dedicated to the pretentious and rhetorical theme "Progress and Harmony for Mankind," and offered a dazzling spectacle of an exclusively technological character.

Instead of an involvement in experimentation or re-application of techniques having a possible utilization in the urban services field (when combined with the most advanced technology), this show reflected a more rigid coordination of these applicable tools between the position of potential building transformations and the position of the necessary restructuring of the urban environment.

This exposition, designed by Kenzo Tange as a "living city," with facilities and services proportionate to a population of 400,000, was located on a smaller and less suggestive site than the one afforded to the Montreal fair. The main pavilion devoted to the show's theme was composed of a plaza over which an equipped platform functioned as a sort of switching station, connecting the various walkways of different levels.

A large totemic figure towered over the plaza, interrupting its covering and spreading a sinister aura over the muddle of devices and structures.

The latter pavilion was part of the "symbol area," a series of structures that included a tetrahedral mesh tower designed by Kiyonari Kikutake and others of the "Metabolism" group, the "Festival Plaza," a fine arts museum, a museum of applied arts by Japanese craftsmen, and a concert hall. These permanent constructions represented the core of the structures that were to be converted to other uses after the closing of the exposition.

Even this event had a decidedly propagandistic tone in regard to the technology used, but the propaganda was no longer associated only with a demonstration of technology's possible effects. Rather it was a confirmation of its actual performance capabilities, closely tied to and dependent upon the type of capitalis-

tic development that was the essence of the Japanese economy and industry. Only the Japanese industry, with its strict economic-productive discipline, could have obtained such perfect results in the demonstration of its political and economic hegemony at the first such world event to be held in Asia.

We now have reached the end of our itinerary, covering the principal expositions over a 100-year period of history. We have seen that a requisite feature of the facilities used in the events up till the last quarter of the 19th century was the construction of large, unitary pavilions employing experiments in new industrial building technologies and the application of new iron technologies.

With the Paris exposition of 1878 the expository facilities become articulated on an urban scale, and served to orient the development and expansion of certain urban sectors according to a determined street network. Sometimes they even served to restructure some non-periferal zones of the city. We thus pass from a building technology to a technology of an urban scale which experimented with new structures and traffic devices, and determined new functional relationships between the old and the new parts of the city. These events fostered an increased development of the prefiguration of the neotechnological city with a preliminary application of the material means of controlling its physical development and the effects of its increased territorial influence.

These occasions also gave rise to an attempt to represent comprehensively the economic system then in force, its monopolistic and international nature, and even, in the most recent phase, the excesses of the most superficial aspects of the political alignment between blocs. It is these exhibitions that made the greatest propagandistic display, alongside the manifestation of the contradictions raised by the struggles of the Third World, which experienced a different type of development, not subject to the economic and political domination of the so-called mature capitalistic nations.

Science and technology, which objectively represent fundamental factors in the development of the productive forces, were sublimated in their ideological content, and utilized through a reproductive function to validate and perpetuate the system.

This historical account was intended to be primarily illustrative. However, the tracing of this itinerary has served to demonstrate the actual significance of exhibitions of this type, which claim to offer an accounting of our "civilization." It appears that the global balance sheets are much more contradictory today than they were at the end of the last century. In regard to science, cultural cynicism has in fact been added to political cynicism. As a result of all the propagandistic efforts being made, the symbols of the space and atomic age bring to the minds of the masses more a prospect of progressive degeneration than a possible progression of the present system.

BIBLIOGRAPHY - C. Baudelaire, Curiosités Esthetiques. Exposition Universelle 1855, Paris, 1868; M. Besset, Gustave Eiffel 1832-1923, Paris s.d.; trad. it., Milano, 1957; C. Boito, Le industrie artistiche dell'esposizione di Milano (1881), Nuova Antologia, V, 1881; F. Buzzi Ceriani, V. Gregotti, Contributo alla storia delle Triennali, Casabella, 212, settembre-ottobre 1956 e 216, maggio-giugno 1957; A. Camenzind, Expo 1964, Werk, febbraio 1964; citato in Edilizia Moderna, 84; G.F. Chadwick, The work of Sir Joseph Paxton, 1803-1865, London, 1961; H. De Parville, L'Exposition Universelle, Paris, 1890; G. Holmdahl, S. I. Lind, K. Odeen, Gunnar Asplund Architect 1885-1940, Stockholm, 1950; R. Isay, Panorama des Expositions Universelles, Revue des Deux Mondes, tomi XXXVI, XXXVII e XXXVIII, 1936-1938; S. Muratori, L'esposizione Internazionale di Bruxelles, Architettura, 10, ottobre 1932; R. Pedio, La crisi del linguaggio moderno nella Esposizione Universale di Bruxelles 1958, Architettura, IV, 6, ottobre 1958; A. Perilli, Le Esposizioni Universali, Civiltà delle Macchine, 2, febbraio 1957; V. Pica, Arte decorativa all'Esposizione di Torino 1902, Bergamo, 1906; E. N. Rogers, All'Expo '58 il futuro (dell'architettura) non è cominciato, Casabella, 221, settembre-ottobre 1958; P. Berlyn, C. Fawler, The Crystal Palace, London, 1851; K. Wachsman, Una svolta nelle costruzioni, Milano, 1960; Ch. Beutler, Weltausstellungen in 19. Jahrundert, München, 1973; L'Esposizione Universale del 1867. Illustrata, Milano, 1867; A. Messel, Ausstellungsbauten, Handbuch der Architektur, IV, 6, 4, Darmstadt, 1893; L'Esposizione Universale del 1873. Illustrata, Milano, 1873; L'Exposition de Paris, 1900, Paris, 1900; Milano e l'esposizione italiana del 1881, Milano, 1881; L'esposizione illustrata di Milano del 1906, Milano, 1906; Guide de l'exposition internationale, Turin, 1911; Book of the Fair-Official Guide, Chicago, 1933; J.L. Sert, Architecture, city planning, urban design, London, 1967; Histori Sovectikoi Arkitecturi, Moskva, 1962; Esposizione Universale di Roma, 1942, Anno XX E. F., Roma, 1942; Edilizia Moderna, 84; Casabella, 221; L'architettura, IV, 6, ottobre 1958; L'architettura, VII, 70, agosto 1971; L'architecture d'aujourd'hui, 117, 1964; W. Clasen, Exhibitions, exhibits, industrial and trade fairs, London, 1968; J.A. The Japan Architect, 164, maggio-giugno 1970.

EMILIO BATTISTI

OUR ARTISTIC AND CULTURAL HERITAGE

PRESERVATION AND MANAGEMENT OF
CULTURAL GOODS (PLATES 173-176)

Introduction. – Two of the most qualifying factors of modern archeological and historical-artistic developments since about 1960 have been the renewal of the wide debate about new - and possibly more efficient - methodology, and, more importantly, the renewal of the debate about the establishment of responsible behaviour by society and by its institutions with regard to the creative evidence left from both ancient and recent civilizations.

This is a debate which is generally understood to have more or less moved away from the quite recent concept of protection of "monuments and of works of art," which was recalled in two articles in the *Encyclopedia of World Art*: "Preservation of Works of Art" (Vol. XI) and "Restoration and Conservation" (Vol. XII). The debate has now moved on to the concept - expressed in different ways - of understanding the word "protection" as a fundamental (and therefore not exhaustive) idea of a much more challenging and dynamic public "management" activity. This is not just restricted to the revered relics of the past (the so-called monuments and works of art), but covers the entire complex of our inheritance of creative civilization, better defined as "cultural goods."

In an unspecific way, a progressively collective conscience has contributed to the ideological and political side of this debate - a conscience which broke out in societies with a combination of ancient and modern cultural identity, such as Third World societies, and which was eventually to be found throughout the social classes. This conscience brought with it a decisive call for active participation by those same social classes in the practical "management" of protection and in the carrying out of its goals.

At times, it has to be admitted, this call for participation was only expressed in approximate terms, or it was consumed by forms of foolishly ambitious pragmatism; more than occasionally it also tended to see emotional pressure rather than clear ideological propositions. Nevertheless, in its many and various forms, it has become recognized as a positive sign of a willingness for general responsibility on a level which, not long ago, would have appeared imaginary and utopian.

A detailed and complete examination of the concrete results of such a huge cultural phenomenon does not appear to be possible at the moment, because the different social groups still translate the needs into practical action using different interpretations and planning levels.

We feel it would be fairer and more expedient to highlight the main tendencies that have so far stimulated the development of legislative and institutional structures. These correspond to the need: to determine clearly - at least in the basic essentials - the new, desired models of behaviour by a modern civilization with regard to the civilizations of the past. We will also try to determine the focal points of the establishment of new or renewed methodology, which are affected by the more specific requirements of the disciplines of history, archeology and art.

Legal tools and operative structures. – Recent years have seen particular emphasis on the need and desire to organize the work of protecting and evaluating our historical-artistic inheritance through effective international as well as national co-operation, and through the co-ordination of specific norms which now exist in almost all countries. "Cultural goods" are understood to be a network of evidence and expression from past civilizations: they are closely connected with the development of territorial order, and are especially felt to be an inheritance common to all peoples. This understanding has led to the formulation of agreements and decisions which have been promoted by the most important international organizations: UNESCO and the European Council.

At the London headquarters of the European Council on May 6th, 1969, the 'European convention for the protection of the archaeological inheritance' was signed. The purpose of this Convention was to protect sites of archaeological interest, to prevent clandestine excavations, and to oppose the circulation and commerce of objects from these digs. It regulated excavations by keeping a tight control over them and entrusting their supervision to scientifically-qualified personnel; it established archaeological "reserves," it circulated the results of excavation and study. In general, it helped to encourage knowledge about archeological goods through the establishment, amongst other things, of scientific catalogues, which were in accordance with the continually increasing circulation of documentation on cultural goods.

At the end of the Year of Architectural Inheritance, in October 1975, the same European Council met in Amsterdam to develop the 'European map of architectural inheritance,' with an importance which has been confirmed at all levels. It proposed "complete" preservation through the combined efforts of restoration and research technicians, and through research into the means of avoiding the dangers which were threatening the inheritance, because of the phenomena of urbanization, land transformation, new industrial installations, and so on.

UNESCO has, in turn, used conferences and successive recommendations to adopt two important 'Agreements' in recent years. The first of these was

signed in Paris on November 14th, 1970, and deals with ways of forbidding and preventing the exportation, importation and transfer of illicit ownership of cultural goods between member States, by outlining directives for the recovery and restitution of stolen works of art from one State to another.

The second 'Agreement,' again signed in Paris on November 16th, 1972 deals with the protection of the world's cultural and natural inheritance, and groups together several proposals which had already previously been put forward. This international agreement assigned the task of ensuring the identification, protection, preservation and evaluation of cultural and natural goods to the signatory States: it adopted a general policy of giving the goods a collective function, and established a system of international co-operation and assistance by instituting a special consultative Committee and by compiling an international inventory of goods of exceptional universal value, as well as a list of goods in serious danger: help in preserving these goods was to be funded by a financial foundation which was set up for that specific purpose.

These agreements clearly represent the crowning of a large movement of political demand from the better-informed cultural sectors of society and from an increasing general public awareness. They aimed at establishing principles of general validity, and at setting in motion systems of co-operation wherever particularly complex, and sometimes technical problems emerged (for example, in helping to give specialist assistance to developing countries), or where international agreement was essential in order to harmonize the respective legal norms (mainly the case with the measures taken to confront the huge problem of clandestine movements of archeological material, and of thefts of works of art and of other cultural goods).

These general agreements, then, did not aim at overriding or, in any way, at replacing the internal laws of each country - even if it is undeniable that they have, in effect, been seen as a term of reference for the development of these internal laws.

Such development has particularly been seen in Italy where, under pressure from knowledgeable levels of national public opinion and from the same important international organizations, the desire to confront the problem of protecting the inheritance of cultural and environmental goods in a positive way has finally been put into action, by radically revising and updating the relevant legislation.

To this end, 1963 saw the institution of a 'Mixed Parliamentary Committee for the protection and evaluation of the archeological, artistic and countryside inheritance,' led by the Hon. Francesco Franceschini. The Committee had the task of carrying out an in-depth inquiry into the state of public administration, and of formulating proposals for new relevant legislation which would both protect and restructure its work. The investigation, carried out over the course of more than two years, was summarized in three volumes with the title: 'On saving the cultural goods in Italy' (Rome, 1967). But the proposals made did not pave the way for any concrete changes, even though a law had been passed to activate administrative reorganization following the recommendations of the Committee. In 1968 a new Committee was formed, led by a magistrate - Antonino Papaldo - with the specific task of formulat-

ing the text of a new protection law. Then, in 1971, a second Papaldo Committee was formed to formulate a law to reform the administrative structure, in accordance with the protection law which had been developed by the work of the two previous years. But political and technical difficulties prevented this second Committee from even presenting a conclusive plan of action.

The attention given to the serious state of our artistic inheritance, the charges of wrongdoing and the legislative proposals of the solutions presented by the Franceschini and Papaldo Committees, had all set fire to a heated debate which also tried to encourage political commitment to the subject. A lively cultural and political battle broke out in associations such as the 'Our Italy' group, or during Conventions such as the ones at the Lincei Academy (1964 and 1969), and was presented in contributions, confrontations and debates in the daily press and in specialized Italian and foreign magazines. All this sustained the action of the groups which had been more directly invested with specific responsibilities and led to a greater sensitivity of and sense of responsibility towards public opinion, as it grasped the seriousness of the situation and the importance of these problems from a socio-economic as well as cultural point of view.

Even the Roman Catholic Church felt an obligation to take a decisive stance on the protection of an inheritance which, in Italy, is very largely made up of religious art - its importance had also been confirmed by the Vatican Council II. In this way there emerged the 'Norms for the protection and preservation of the historical-artistic inheritance of the Italian Church,' formulated by the 10th. General Assembly of the Italian Episcopal Conference, in accordance with the instructions of the Central Pontifical Committee for religious art in Italy. These norms clarified the legal questions about the relationship between State and Church, and recognized the respective spheres of competence which would lead to greater and more advantageous collaboration between the two. The norms were concerned not just with safeguarding historical-artistic values, but also with safeguarding values relating to the faith, in relationship to the particular situation which had occurred as a result of the liturgy reform. Their main objectives were cataloguing and maintenance - which can also be seen as preventive protection - and, where necessary, the establishment of diocese museums. The problems connected to the protection of ecclesiastical artistic inheritance were further developed during the 13th. National Convention for religious art, held in Pisa in September 1972 - an occasion for an effective meeting between representatives of the State and the Church.

On the other hand the need for a different method of managing the cultural inheritance, which had already grown up in more open cultural environments, was left to the Regional Governments. These, in accordance with constitutional law, had acquired complete autonomy and administrative power over town and country planning, and over museums and libraries belonging to local organizations or of local interest. The Regional Governments therefore set out a series of proposals - some of them concerning the rules for carrying out the specific tasks assigned to them, and others which, in the context of the global restructuring of the whole Administration, gave responsibility to the

Regions for work usually carried out by the State. Reserved for the State - through the creation of centralized Institutions - were the tasks of directing and co-ordinating the work on a national scale.

Amongst the most important regional projects in action or in the process of being activated are the creation of the Institute for Cultural and Natural Goods in Emilia Romagna, and the creation of Regional Committees with the task of programming the conservation and evaluation of the cultural goods placed under their direct management. With their early legislation, the Regions confronted the tasks which had been specifically assigned to them, especially in the sectors concerning local museums and libraries, with energetic commitment. But each Region faced its task in a different way, and in general tried to place the problem within the larger picture of programming the territorial order, of materially protecting the goods and of the participation of local citizens. The result was a temporary situation which was soon to lead to the promotion and participation of all the local authorities and institutions which were able to increase interest in museum activities and develop new relationships within the local community. It also led to the recognition of the existing inheritance and to the creation of offices capable of promoting and co-ordinating the work (Councils for Cultural Goods). And finally, it led to Regional tasks being assigned to the local City Governments, or to combined groups from several City Governments.

All this made a particularly stimulating impact on the national governmental authorities, and finally encouraged them to put into practice that broad legislative reform process which had already been begun in the 1960s. This, as far as the Central Administration was concerned, corresponded to the need for enough autonomy to guarantee the inherent possibility of intervention through special bodies - both in the true sense of protection and in the wider sense of directing and promoting joint responsibility over the inheritance of cultural goods.

Thus, thanks to an exceptionally broad collaboration between the different political powers, and to the special efforts of Minister Senator Giovanni Spadolini, a new Ministry for cultural and environmental goods was effectively developed, which merged the pre-existing Administrations of Antiquity and Fine Arts, of Libraries and of Archives.

The new Ministry later formulated the "delegate decree" which concerned the restructuring and re-organization of the Ministry itself. This decree replaced the existing Superior Councils as the major administrative body with a National Council for Cultural Goods. This Council guaranteed a wider representation from all the interested sectors, formed Group Committees from within the Council, and re-organized the Central Institutions (including the founding of the new Institution for cataloguing and documenting goods of archeological, historical-artistic and environmental interest, as well as the new Institution for cataloguing libraries and library information). The Council also founded the National Institute of Graphics and, on a peripheral level, it created Regional Committees; in general it increased the numbers of involved personnel on all levels.

Within the Ministry itself, we should also look at the updating of the old inadequate protective legislation, which had not been modified since 1939 - with the exception of changing the norms for the exportation of objects of artistic and archival interest which had been made necessary - despite some resistance and contrary opinion - by the agreements on free circulation of goods between the countries of the European Economic Community (judgement of the European Community Court of Justice no.7/68, December 10th, 1963).

Other laws have appeared in recent years which guarantee more control and easier intervention in certain sectors of cultural goods. There was, for example, the so-called "bridge-law" about town-planning which in particularly looks at the definition and perimiterization of historical town centres. A 1971 law establishes penalties to be imposed for counterfeiting and altering works of art, and it regulates the commerce of these works. Finally a 1975 law deals with administrative protective measures and safety regulations for the cultural inheritance. These distinct sectorial measures, often characterized as emergency procedures, did not make the need for a general legislative reform any less urgent: in fact it became all the more pressing in order to establish a clear relationship between the state administration and local offices.

A radical development of protection laws such as those found in Italy is not seen in other countries, despite great interest in the problem of cultural goods. Rather, in recent times, there have been a few general updatings - especially where new constitutional orders of the state have required more legislative consistency from the whole operative structure. This happened, for example, in Poland, where a 1962 law aimed at overcoming the incidental empiricism of the immediate post-war efforts, which had had the purpose of supporting the huge effort of repairing war damage. This law also had the advantage of being the first one to be based on the modern idea of the inheritance of "cultural goods," with the same comprehensive acceptance which later became widespread and which we have since seen in Italian legislation.

Hungary also developed a general legislative measure which created the Superintendency of Monuments, and which entrusted its museums with territorial tasks similar to those carried out by our Gallery Superintendents. The legal emphasis, however, was especially placed on the protection of the inheritance of the city and environment, and tended to establish decentralizing mechanisms which progressively handed responsibility over to municipal administrations and other local offices.

In the United States an important innovation was the appearance of the Historical Preservation Act (Public Law 89-665, October 15th, 1966), which was a Federal Law replacing the previous rulings of 1935, and which founded the National Park Service (with one special branch being the Office of Archeology and Historical Preservation). This is a specialized body, which collaborates with other national organizations such as the National Trust of Historic Preservation, and which also has an authoritative function over the Governments of the individual States.

In the vast majority of cases, however, the most recent legislative provisions have only integrated and reinforced the pre-existing rules (for example, the synthesis given in R. Di Stefano - G. Fiengo, 'Modern protection of the world's monuments,' E.S.I., Naples,

1972, with its large bibliography). Most interest has been focused on the ideas of protecting and renovating the monuments and historical centers of natural sites: in France, for example, a 1966 law outlined strict rules about the protection of real estate, and even provided private citizens with large grants of money to help them adopt these measures. A 1967 law again stated the need for and the advantage of an inventory of monuments and sites, the drawing up of which was entrusted to the departmental Committees. These same Committees and, more especially, the municipal authorities, promoted experimental Conventions from as early as 1964-1965 to stimulate widespread urban improvements in association with private bodies or with mixed organizations (of public bodies and private societies).

Similarly, in England, the Town and Country Planning Act (first appearing in 1962, and amended in 1968) aimed at protecting the countryside and city parks: this covered some of the traditional responsibilities of an associate, fundamentally private organization - the National Trust. For the urban centers, however, after the environmental planning experiences of post-war Great Britain, a new ruling was made by the Civic Amenities Act of 1967.

Another subject which has led to different legislative rulings was the importation and exportation of archaeological and artistic goods: a significant tightening of existing rules was seen in France and in many Third World and Latin American countries, while the United Kingdom saw the introduction of rules which had not even previously existed. All these provisions made more or less explicit reference to the general criteria which had inspired the International Paris Convention of November 14th, 1970.

Knowledge as a presupposition for protection. – This general development of a conscience which we have referred to, and which encouraged the participation of all social levels in the "management" of cultural goods, did not just coincide with an impressive extension of knowledge about the cultural goods themselves, but it was also both cause and effect of this knowledge in a process of close interaction.

Institutional instruments had encouraged the lifting of the level of knowledge: instruments such as the educational structure and the means of mass communication: it was made easier for people to come into direct contact with cultural goods, with exhibitions and other numerous shows of genuine cultural value; there was also a development (certainly not uniform, but often decisive) of the didactic function of museums.

We should not forget to include the important incentive role of the increase in specialist research, which is nowadays seen as the natural outcome of greatly improved research methods on a philosophical, documentary and interpretive level. This research should be placed at the top of the true "system" of historical-artistic disciplines.

As an important intermediate factor between specialist research and cultural appropriation by huge and different elements of society, other methods of dealing with cultural goods have recently been proposed - other channels of research which have often tried to define themselves as the real methodological institutions (or, at least, as incentives for other possible methodological institutions).

We would mention, in particular, those methods of approach which can be explained with reference to the activity of cataloguing the cultural goods: in general, this specific work is carried out in very close correlation with the activities of preserving, restoring and protecting these same goods; but nowadays it is more and more concerned with overcoming its original technical or "administrative" tasks, and with relating rather to society's great need for knowledge.

There is, in fact, a common idea about activities such as cataloguing, which assumes its goal to be a general knowledge about the various existing (or previously existing) cultural goods from any context (be it the context of the museum or of the collection, or be it that of the city, the land, or the cultural area in its most comprehensive historical dimension). For this reason a recognition process has begun which does not just value the specific phenomenon of the existence of these goods, nor does it just consider their so-called numerical totality, but, rather, it puts them into context.

And so, by working on successive levels of critical intensity, this cataloguing process mainly aims at placing the emphasis on the value - which must be the historical value - of the actual context. As we have already mentioned, this context overrides the mere procedure of inventory summaries, and it avoids prejudging the qualitative level of the single cultural object, in order to concentrate on discovering a more expansive and complete dimension of knowledge.

How all this can make the recognition process correspond better to its primary purpose, is clear: the emphasis placed on the value of historical context basically becomes, as a logical corollary, a clearer point of reference for the actual process of preserving and protecting cultural goods. If this context is kept separate, the objective of the preservation process will be nothing but that preservation - the ensuring that the work is not tampered with: if, however, all the relevant components are interwoven, (components from the so-called work of art right down to the everyday work tool) the objective becomes an interest in the components themselves, as well as in their reciprocal correlation.

Thus the objective of the work no longer corresponds to a static or selective preservation process (which happens when it is limited to simple restoration); instead, it corresponds to an active, dynamic and global concept of preservation. There is, then, a connection with the earlier objectives which, as we saw above when we discussed the recent legal provisions, were subject to the most coherent formulations of a "policy" for cultural goods.

We should also not forget the potential incentive that the recognition process of cataloguing gives to specialist research itself: if, in fact, it is true that cataloguing largely depends on the results of specialist research, it is just as true that the research is, in turn, fortified by the cataloguing - both being joined together by a natural osmosis. It is also true that the more innovative results, even in a philological or documentary sense, have often been those which have emerged from universally-recognized cataloguing investigations into specific cultural areas. Here we can see, for example, the knowledge, which implies intense activity in methodological planning with a decidedly interdisciplinary character, which has developed from the world-wide problem of preserving historical city centers and the environment.

It is known, then, that this attainable knowledge about cultural goods coincides with that cultural identity which society - with all its components, and breaking through every stratification - intends to make participate completely in a genuine "policy-making" sense: it is exactly this knowledge that has favoured the increasing number of initiatives in this field.

Extemporaneous efforts have often been made, with an imprecise operational orientation and organizational structure, by local groups or associations; these efforts have, however, made clear how widespread and compelling the growth of the desire of society to participate has become - especially where institutional structures (from public administration to specialized cultural bodies) have been late in initiating such efforts.

The debate on this subject has also had its heated moments: the Italian reader can find these in the opinion poll taken by 'Our Italy" in 1972 (nos. 99-105 in the Association's 'Bulletin'), as well as in the "Reports" of the surveys which the Gallery Superintendency of Bologna has conducted since 1969 with the collaboration of the local regional offices. Also, there is the study of the problem made by F. Negri Arnoldi (in 'Italian Museums and Galleries,' no. 43, 1971), our own study (in 'Art Bulletin,' no. 3-4, 1972) the study by A. Emiliani (in the above-mentioned Bologna 'Reports' and later in 'A policy for cultural goods,' Turin, 1974) and the one by R. Bianchi Bandinelli (in 'AA.BB.AA. and B.C.,' Bari, 1974). Finally, he can find them in the repeated declarations of the principles which are contained in the different regional laws as outlined above.

Among the practical results of all this, the most prominent are the creation of the 'Institute for artistic, cultural and natural goods in the Emilia-Romagna Region,' and the creation of the 'Regional centre for cataloguing the cultural inheritance' of the Friuli-Venezia Giulia region, with its offices at Passariano. At present, these are the only existing operative structures, which have been added to the large number of published works which are rather intermittent and of varied value. Examples of these can be taken from the good volumes of the series of catalogues in the Lombardy museums or in the Veneto archaeological museums (ed. Electa-Alfieri), or from the accurate 'Inventory of archaeological cultural goods in the province of Brindisi' drawn up by L. Quilici and S. Quilici Gigli, and edited in 1975 by the Provincial Administration. We can then look at other works which are just propagandist, such as the volume on 'Cultural goods in the Province of La Spezia, I - The Paintings,' edited at Genoa in 1975 by the La Spezia 'Cassa di Risparmio'.

The debates and resulting practical efforts which concerned not the universal complexity of cultural goods, but rather the specific subject of historical city centers or, in natural consequence, of the environmental context, have had a much more defined role. Knowing how pressing the need for town and country planning programmes is, these efforts have generally involved the need to find immediate answers, and therefore (as we have already mentioned) unrefined research procedures have often been used. This was the case with the investigations into the city of Bologna (note the exemplary study by P. L. Cervelleti and others, 'Bologna/Historical City Center,' Bologna, 1970), and into the Le Marche area (note C. Carozzi and R. Rozzi, 'Historical city centers, open question: the case of Le Marche,' research under the auspices of the Ancona Superintendency of Monuments, 1971); it was also true for the investigations into Southern Tuscany (note E. Guidoni and A. Marino, 'Land and city in the Valdichiana, Rome, 1972, and G. Di Pietro and G. Fanelli, 'The Tuscan Tiberian Valley,' under the auspices of the E.P.T. of Arezzo, 1973). More detailed studies have recently been added to these concerning the localities of Certaldo (note M. Dezzi-Bardeschi and G. Cruciani Fabozzi, 'Certaldoalto: studies and documents for safeguarding its cultural goods,' Florence, 1975) and Lombardy (note A. Mioni and R. Rozzi, "The historical city centers of Lombardy, an inheritance to be saved," under the auspices of the Lombardy Region, Milano, 1975).

The efforts made by local institutions thus aimed, on the one hand, at responding to distinct practical needs (which were still technical and "administrative"), but on the other hand they became interpreters of the more general cultural pressure of public opinion. It does, however, remain true that these efforts were made as sectoral, integrative phases, to be kept concurrent, but not competitive with those universal efforts, which were being sustained by strong interdisciplinary interweaving and which have been projected irrevocably onto today's wider range of purpose. It is exactly this move towards a universal effort that qualifies as a unifying moment of the different contributions (from the contributions of institutional organizations to those of local bodies or specialized institutions): at last an effort has been made by the State Administration which, through the Cataloguing Office of the General Direction of Antiquities and Fine Arts, has determined fundamental methodologies and given a new push to the activities of the Territorial Offices (over approximately the last five years, for example, more catalogue files have been compiled than had been compiled in the entire period from 1889 to 1969). And now the Ministry for Cultural and Environmental Goods has, for the first time, created a specialized operative body, the Central Institute for Cataloguing and Documentation. It has thus created something very different from a high, centralized structure: instead, it has created a virtual point of convergence, of comparison, of mediation, and therefore of fluidity, and sees many different purposes for the information which results from any activity carried out in connection with cataloguing.

This sort of organization finds quite significant connections with previous experiences of other countries. A good example in many ways is the creation of the 'Inventaire General des Monuments et des Richesses Artistiques de la France' ['General Inventory of the Monuments and Artistic Riches of France'] which was started in 1969. France does not have any territorial protection bodies similar to the Italian Superintendencies, yet it still managed to mobilize huge and disparate cultural resources (using university students to Museum curators, and municipal and departmental technicians to lovers of local history). This obviously meant a much bigger effort of methodology co-ordination and control, and the imposition of rather strict rules almost from scratch (note the 'Principles d'analyse scientifique' ['Principles of scientific analysis'] formulated for distinct categories of cultural goods). It also meant the preparation of even elementary research tools (note the 'Repertoires des Inventaires' ['Inventory List-

ings'], which are partially based on bibliographic materials).

The French 'Inventaire' ['Inventory'] has the great value of having planned and already edited several volumes of "Inventaire topographique" ('Topographical Inventory') which concentrate on individual territorial areas - limited in size and culturally homogeneous - and can therefore be used to illustrate any aspect in detail, placing it both in its entire historical context (from the very first human settlements to the most recent urban and rural developments) and in the context of objective evidence.

There is a need for a major revision of research methodology and of operative praxis, and most of all there is a need for a major revision of purpose: these needs have also been noticed in areas where the work of cataloguing the cultural inheritance has been carried out for decades, and where the researchers might be thought to be anchored in their traditional inventorial ways.

The work of the Vienna "Institut fur Oesterreichische Kunstforschung des Bundesdenkmalamtes" ('National Institute for Austrian Cultural Inheritance Research') deserves special attention because of its publication of the series of "Oesterreichische Kunsttopographie" ('Austrian Art Topography'). Later volumes of this series have abandoned the generally descriptive method, in favour of a stricter critical definition of the catalogued goods; and, with these stricter definitions, the field of research of every volume, which is devoted to a specific territorial environment, includes the entire historical-cultural complex, similar to what we have already seen in the volumes edited by the French "Inventaire" ('Inventory').

The Austrian Institute was also concerned with transmitting the knowledge gained from the cataloguing through faster information lines, which would be accessible to the general public, as in the booklets in the series "Dehio-Handbuch der Kunstdenkmäle Oesterreichs' ('Handbook of Austrian Cultural Inheritance').

We find this same idea of cataloguing as an integral and interdisciplinary investigation, transferred to common knowledge by publications both at the specialist level and at the generally informative level, in several lander of the Federal Republic of Germany: for example, in the Munich "Bayerisches Landesamt fur Denkmalpflege" ('Bavarian Institution for the Protection of the Cultural Inheritance'), which published both the detailed volumes of the series "Bayerische Kunstdenkmale" ('Bavarian Cultural Inheritance') and the volumes of the "Kurzinventar" ('Short Inventory'), which resemble illustrated guides.

Similarly, since 1880 in Switzerland, the "Gesellschaft fur Schweizerische Kunstgeschichte" ('Swiss History of Art Society') has, in agreement with the canton authorities, promoted its critical catalogue of the country's cultural inheritance. It has also edited territorial volumes of the series "Kunstdenkmaler derSchweiz" ('Cultural Inheritance of Switzerland'), monographic volumes on individual monuments, and succinct but specific guides such as the series "Kunstfuhrer durch die Schweiz" ('Art trips through Switzerland'). The volumes of the most important territorial series developed research criteria which included, within the same works, the results of technical research, of preservation research (restoration, reconditioning, etc.), of archival research (for a kind of census of lost monuments), and, sometimes, of evidence of popular culture.

Other work has recently seen a clear qualitative improvement in its documentary research, and this improved information has quickly been made available to the public. Here, we should include the work carried out by the Royal Commission on Historical Monuments, which has been promoting the census of monuments in the United Kingdom since 1908, and which now, since 1970, has taken a new look at its original criteria and inventory purpose, and has, with its new 'Inventory' volumes, moved on to methodologies with a sounder historical-critical base: these new methodologies had first been inspired in England by the monographic papers of the "Survey of London" and of "Country Life."

To conclude this summarization of the cataloguing activities of various nations, we should point out that united and centralized work has recently been carried out even in a country where the tradition of local autonomy is the strongest - in the United States. Following the legislative guidelines of the 1966 Historic Preservation Act (which included the 1935 Historic Sites Act), the Office of Archaeology and Historic Preservation - which is administered by the Federal National Parks Service - began a detailed census campaign, aimed at creating the "National Register." This Register is basically an inventory of goods placed under precautionary control, but it can also be seen as a real scientific catalogue of cultural and environmental goods. Because it has been raised in the most qualified cultural environments of so many nations, and because it finds itself pushed by the same interest of co-operation which has promoted other international agreements and conventions, the subject of cataloguing the common archaeological, historical-artistic and environmental inheritance could clearly not be excluded from the interest in, or from the proposal of a universal movement which has recently been made by various community bodies.

After a specific "recommendation" by UNESCO on December 11th, 1962, the European Council entrusted a committee of experts (F. Sorlin, G. Alomar and P. Gazzola) with the task of outlining a plan for the 'Inventory of the European Cultural Inheritance' (IECI), which would have the exclusive objective of listing constructions - from "monuments" to historical city centers and sites (note, G. Alomar, 'Criteria and methods of cataloguing: a basic report,' 1965).

This restriction on the objective of the study, the conciseness of its formula (census "forms" rather than real scientifically-catalogued documents) and, finally, its scantiness (as found in previous investigations), all greatly limited the practical usefulness of the work. This can be seen by the publication of the 'Inventario Resumido' ['Revised Inventory'], edited by the Madrid 'Comisaria General del Patrimonio Artistico Nacional' ['General Commission for the National Artistic Inheritance'] and, more recently, by the publication of the Brazilian 'Inventario de Protecao do Acervo Cultural' ['Inventory for the Protection of the Cultural Inheritance], which began with a volume on the locality of Salvador (Bahia, 1975).

We have already seen how the problem of historical city centers developed along a different course in Italy; the same thing happened in other European

nations - especially in France, in the Federal Republic of Germany, and in Poland, where environmental and urban research was always carried out in strict collaboration with research into all the other components of the cultural inheritance. Different needs and different systems of cognitive approach were clearly demonstrated during the international "symposium" on the 'Contribution a l'inventaire-standard des Monuments d'architecture' ['Contribution of Architectural Monuments to the standard Inventory'], held in Prague in 1969.

The suggestions of the European Council, however, were an important indication of a desire and need for co-operation between the various countries, even in the field of cataloguing cultural goods. This desire has recently been seen at the Helsinki Conference (November 1975), which proposed the creation of a network of documentary archives which would act as a focal point for the continuous exchange of information.

As the range of possible goals expands, this idea of co-operation within the diffusion of information found in the work of cataloguing, brings up other problems which appear technical, but which have some effect on methodological questions. For example, there is the problem of agreement on terminology and, more especially, there is the problem of a "minimum threshold" of information: work is of little use if it does not reach this threshold, as we saw with the IECI historical city center forms.

To be specific, we are dealing with a problem which has already been posed during the experimental use of automated systems (electronic calculators) for organizing the so-called catalogue "data-banks." The need to resort to highly-sophisticated technical instruments is so widespread nowadays, that there are currently about fifty projects in progress for organizing catalogue archives - each with its distinct purpose. The direction which such experiments are taking, however, can be seen by their two radical extremes: the first consists of selecting a restricted amount of data which is, to a certain extent, objective and which is essentially individualist (an example of this would be the Museum Computer Network system, which has already been run and improved by a consortium of about thirty of the biggest museums in the United States, and which has recently also been adopted in England: IRGMA, Information Retrieval Group of the Museums Association). The other extreme is the system of working from a much larger amount of data, which is compiled according to strict correlation logic and according to detailed analytical principles (for example, the system adopted by the French 'Inventaire' ['Inventory']: note J.C. Gardin, 'L'informatique et l'Inventaire General' ['Information and the General Inventory'], Paris, 1972; also, the very similar system from which the Archeology Institute of the University of Cologne requested the documentation of the 'Forschungarchiv fur Romische Plastik:' note H. Ochler, in 'Museum,' XXIII, 1970/71).

The continual growth of information places obvious and economic limits on the second method of working. In any case, some factors which cannot be disregarded - such as the unavoidable (even desirable) subjectivity in the formulation of much of the ostensibly "objective" data - mean that recourse to automated techniques is limited to organizing the documentary archives. Nevertheless, the problem cannot be limited to just the simple facilitation of access to archives, libraries and photo libraries: we should also consider the incentive that technical instrumentation can give to the practical field of documentary analysis, and to the field of exploring new sectors (note J. C. Gardin, 'Documentary analysis in the Inventory of artistic goods,' in 'Italian Museums and Galleries,' no. 53, 1974. Also see the 1970 Paris Archives of the Marseilles 'Colloques' ['Talks']: 'Archeologie et calculateurs' ['Archeology and calculators'], held in April 1969, and 'Les Banques des Donnees Archeologiques' ['Archeological Data-Banks'], June 1972, Archives Paris, 1974. For the application of electronic instruments with the special purpose of morphologically individualizing works of art, also see the articles by M. Libman and N. Gueckij in the 'Iskusstvo' issue no. 2, 1974, which is wholly devoted to the discussion of the problem of the proposed cataloguing of the museum collections in the Soviet Union, part of which have never even been inventoried).

Preservation as research program and system. – It is clear that the proposal for a "universal policy" for cultural goods, which we discussed earlier, would require a temporal as well as quantitative increase in preservation work. And, in fact, if the objective is one of safeguarding the entire context of cultural goods, the first result will be the abandonment of any selective privilege, the ignoring of any event - which might pave the way for perfect, unique opportunity - and the adoption of a strategy of wide plexus, based on detailed planning. The result, then, is that we can no longer consider the "repair" function of the work to be exhaustive ("repair," that is, in the traditional sense). Instead, the goal has to be a system of permanent controls and rulings, working as preventative action, to be applied to the entire context as well as to its single components.

So, in accordance with a plan which can be appropriately defined as "programmed preservation," the work which is still commonly known as restoration has been subject to a radical reconsideration of its basic criteria, of its technical methods and of its purpose: all in all, its whole identity has been reconsidered. This process of reconsideration has happened in different conceptual and methodological stages: the protection and the restoration of historical city centres and of the general environment to their original social purpose have been the most influential factors here, in the same way that they had had the strongest policy-making influence, as we saw above. In fact, we should remember that, during the debate about these factors, the cognitive moment was nearly always and uninterruptedly connected to the planning moment, which concentrated on concrete technical as well as legislative measures. And we should also emphasize that the debate about these same factors was not restricted to individual procedural principles and patterns, but it aimed instead at recognizing forms of behavior which were of common value for every category of the cultural goods. The most illuminating example in Italy of the complexities of this new code of behaviour has been the creation of the "1972 Restoration Paper," published in the 'Art Bulletin,' no. 2, 1972. We should notice how this document uses detailed technical norms and basically aims at limiting the guarantee threshold to the level of general knowledge: all work below this threshold is effectively seen as a transgression of both professional and cultural responsibility.

The '1972 Restoration Paper' replaced a similar document written in 1931: even though it acknowledges its inadequacy and its infraction of precautionary measures, it does allow for the measurement of the distinct level of knowledge about the preservation of cultural goods - a level of knowledge which had developed over the forty years, during which the need for strict preservation behaviour had been made all the more acute because of the dramatic historical events and various other factors.

We cannot forget that the root of this proposal for a "universal policy" for cultural goods lies in the problems (and the experiences that these problems have brought) which have developed from the recent conflicts in Europe, Asia and some parts of Northern Africa: conflicts which have directly hit and destroyed so many secular cities, and which were the beginning of the longer-term phenomena of overflowing urbanization and, at the same time, of the abandonment of other inhabited and country areas. And then, there have been still more problems coming from the huge and widespread phenomena of atmospheric pollution, of physical stress produced by heavy traffic inside th cities, of the change in the environmental equilibrium and in the course of the flow of underground water, and so on, with extremely serious consequences: as a symbolic example we should remember the disastrous floods in Florence and Venice on November 4th, 1966.

Solutions to these and to many other problems - some of which have hardly been discussed, and others which have been known for centuries - clearly do not come just from technological restoration progress. It has to be admitted that, despite their importance and sophistication, the contributions of scientific resources have not always left their experimental debate phases.

A good and important example is the problem of preserving stones and sculptures in the open air: under the combined action of many physical-chemical factors, even in areas not contaminated by industrial pollution (such as Avignon and York), these have suffered from extremely rapid deterioration over the course of two or three decades. The enormity of the problem is witnessed by the fact that there are currently dozens of specially-created research laboratories in the world: these have put forward different hypothetical solutions running from the simple removal of dirt and atmospheric pollution to the application of substances which would stop the processes of chemical transformation or which would provide structural consolidation. The results have often been very effective - for example, the work recently carried out in Venice on the 'Lunetta Corner' of Santa Maria dei Frari and on the Sansovino Loggetta; also the work done on the lower part of the San Petronio facade in Bologna. Nevertheless, it has to be admitted that no ideal method has been found to solve all the problems which stem from many different situations (note the Archives of International Conventions: 'The Preservation of Sculpture in the Open,' Bologna, 1971, and 'The Treatment of Stone, Bologna, 1971).

Another similar problem is that of frescoes and other wall paintings: in areas such as Asia, for example, which have a very different environment from Europe, and whose art is executed with very different techniques, this problem seems to have reached a critical phase over the last few decades. Clear preservation practices have been installed in these areas - some of them using strict, well-tested scientific methods (such as the sinopite "removal and recovery" techniques used in Italy, France and Spain), but others have often remained at the level of empirical observation.

Even the most traditional techniques have not always been enough to carry out the preservation process correctly: the uproar of the 1960s over the so-called "cleaning controversy" in England has still not died down - the arguments which exploded about the very debatable restoration (supported by a significant number of technicians) of several famous paintings from London's National Gallery, and from other English public collections. The extent of this debate symptomatically shows how wide the spread of direction is and how many working hypotheses can exist. (For more information about this debate, see J. Plesters' bibliography in the appendix of H. Ruhemann's 'The Cleaning of Painting, Problems and Potentialities,' London, 1968).

Despite all of this, however, we clearly do not wish to undervalue the contribution which science can give to the process of preserving cultural goods, this contribution is, in fact, significant, as is borne out by the excellent study of new resources and problems which can be found in H. Foramitti's book, 'Kulturguterschutz' ['Protection of Cultural Goods'], Vienna-Graz, 1970. (See also G. Thomson, 'Recent Advances in Conservation', London, 1963, and 'Problems of Conservation' by G. Urbani, Bologna, 1973). Nor should we completely exclude what can be defined as experimental boldness: in fact, without this real courage, we would never have been able to restore any damaged paintings such as Mantegna's famous 'The Triumph of Caesar' at Hampton Court, which John Brealey brilliantly restored (note A. Blunt, 'The Triumph of Caesar,' London, 1975).

We would like to emphasize further that, with such wide scope now available to the preservation efforts, the need for strictness and for qualitative development has become more important.

The need for monitored discipline can be seen in the structure of the technical organizations called in to carry out the work. For example, after the flood of 1966, it was especially important for the laboratories of the Florentine and Venetian superintendencies to be restructured with new organizational methods, to deal with the inventive technical research needed and face the unforseeable problems imposed by the circumstances; this new organizational structure had rightly been seen as ideal for dealing with this kind of situation. (For Florence, see the catalogue of the exhibition 'Florence Restored,' by U. Baldini and P. Dal Poggetto, Florence, 1972). The Rome Central Restoration Institute and the Brussels Royal Institute for Artistic Inheritance have also seen new developments in the direction of better-qualified experimentation, while the creation in France of a National Restoration Insitute is imminent.

The aspect of qualitative development is now seen to be most urgent in the field of professional preparation of technicians and scholars of archaeology and history of art, on these people falls the "critical" responsibility of the work and organization of preservation. There has also been a lot of progress made in this part of the problem, through the growth of the International Center for Conservation which is based in Rome and which works closely with the above-mentioned Central

Restoration Institute. A more widespread, detailed network of training centers is still needed though - centers which would also update technicians in modern methods of so-called cautious maintenance. In several countries a few such centers have already been developed at a local level alongside the major museums: in Italy, for example, there is the Spoleto Regional Course, which works as a co-operative (CooBec), and which offers interesting apprenticeship possibilities in the field of preservation of paintings and wooden objects.

A third area which is in the process of being developed is the area of exchange of information and experience, which is not always easy to find in the large amount of literature about restoration. Again at an international level (at the 1975 Helsinki Conference, but through the initiative of groups of small associations such as ICOM and ICOMOS) the idea of multiple documentation centres was once again proposed, with Rome's International Centre serving as a focal point.

Thus, the problem of preservation has come to take on new and bigger implications, with its determining factor lying in the programmed management of the environment and the land. Its basis and principal legitimization (and, we should add, its only chance of redemption from future technical decline) lies in the fact that it complements the whole field of archaeological and historical-artistic interest.

A simple critical summary of recent preservation work would only confirm that the verification of this work - its real test - depends on its connection with historical and philological research: and it would be right to see an important connection between the essential objectives of this research and those of preservation work.

Every so often this connection does not occur - the "technical" aims of preservation are infringed. But the principle of this idea, which by now should be universally accepted, has at times continued to be subjected to major derogation: it has even provoked heated arguments as well as demands for a return to the elementary observance of correct professional behaviour, as contained in the above-mentioned '1972 Restoration Paper.'

We have already mentioned the lively debate on the "cleaning controversy," and, while in the field of the preservation of paintings, we should also remember the imprudent cleanings which are still often carried out in many United States museums, in the Leningrad Hermitage, in the Vatican Pinacoteca (for example, the cleaning of the platform of Ercole de' Roberti's 'Pala Griffoni'), and on the Sant'Angelo frescoes in Formis. Even more devastating, because they are more easily subject to arbitrary decisions, are the so-called "cleaning" restorations which have forever altered the historical physiognomy of so many famous monuments in Tuscany, the Abruzzi, and Puglia. In fact, cases such as these were perfect examples of how the more clearly technical processes of restoration work, such as finding solutions to static problems, have been prejudiced because of some radically erroneous and arbitrary objectives of historical-philological research (to quote an example, the idea of finding and "freeing" original structures from any additions annexed in later historical periods - or at least presumed to have been annexed in different periods).

In other words, there are still some die-hard ideas about restoration, which are abstractly positivist in character, and which sometimes even appear in the naive methodologies of the followers of Viollet Le Duc. It is no surprise that these ill-fated methods have been used throughout France and the Germanic countries, without even provoking any of the public reaction which was at least seen in Italy.

Often, however, an obtuse, deliberate deaf ear is turned to the historical-artistic lesson. For example, there was the destruction of Baltard's pavillion in Les Halles and, again in Paris, of the internal furnishings of the Printemps store. Occuring at the same time as these devastations was the development of a critical and serious reconsideration of 19th century architecture and more generally of Art Nouveau, and a field of study in the so-called "industrial archeology" was also being expanded. The outcome of such behaviour is recorded in an impressive amount of documentation in issue no. 27 (1975) of 'La Revue de L'Art' ('The Art Review'), which serve as a sort of appendix - devoted to the changes made in just the last decade in Paris - to the even more dramatic collection of information made by L. Reau, "Les monuments detruits de l'Art francais" ('The destroyed monuments of French Art (History of Vandalism') Paris, 1959).

But wherever conservative practice has been maintained in close connection with historical-artistic research, and the objectives of both have coincided, some works have been excellent, and some have been exceptional in their contribution not just to better morphological legibility, but also in providing critical studies with real revelations. A signicant amount of new acquired knowledge, and of philological discovery and clarification (which are discussed in more detail in other chapters of this book), were by no means casual, and often intentional results of the improved work of preservation.

We have already mentioned the excellent restoration of Mantegna's 'Triumphs' in Hampton Court, and we should also remember the discovery of the series of Ottonian frescoes on the cupola of the Novara Baptistry (note, U. Chierici, in 'Paragone,' 201, 1966). Even more sensational was the discovery of the important Pisanello fresco decoration in the Mantua Ducal Palace, which happened thanks to the lucky intuition and accurate archivistic philological analysis by G. Paccagnini (see his 'Pisanello in the Gonzaga Courtyard,' Milan, 1972).

More often than not, medieval studies have benefited from the results of good preservation campaigns, which have discovered previously unknown artistic personalities, such as Pietro di Bellizio and Belluomo, creators of the San'Angelo in Pescheria 'Madonna' in Rome (see I. Toesca, in 'Paragone,' 227, 1969). Or the Andrea di Nerio of the 'Annunciation' in the Arezzo Museum, who has been revealed to be a key figure in the Tuscan 14th century (see A. M. Maetzke, in 'Art in the Aretino,' Florence, 1975). To give other examples, among the most important are the restorations of the Prepositura of Stia 'Madonna' (see A.M. Maetzke, op.cit.) and of the 'Crucifix' in San Tommaso in Cenci in Rome (see I. Toesca, in 'Art Bulletin,' 1966), which have both opened new questions on the dawning of this period of art.

Works of preservation have, however, also brought new acquisitions to other historical periods. We

will limit ourselves to mentioning the Bramante frescoes in a house in via Arena in Bergamo (see M.L. Ferrari, in 'Paragone,' 171, 1964), and the decorations by Pietro da Cortona and Salvator Rosa in a few areas discovered in the Florence Pitti Palace (see M. Chiarini and K. Noehles, in 'Art Bulletin,' 1967).

We should also add the acquisitions of the famous Raffaello 'Deposition') in the Borghese Gallery in Rome and of Caravaggio's 'Annunciation' in the Nancy Museum. Both works were really able to be rediscovered thanks to the extremely accurate work carried out by the Central Restoration Institute, respectively in 1973 and in 1969.

As well as the new museum systemization, some exhibitions have also provided excellent conditions for promoting joint efforts, in harmonious symbiosis, of conservative preservation and critical and philological research. It is a very positive fact that exhibition catalogues, which are not strictly technical in the provision of information, are beginning to make a habit of giving detailed accounts of restorations, and are pointing out the morphological and phenomenological peculiarities of the exhibited works. Here we can see M. Hours' explanations in the catalogue of the 'Nicolas Poussin' monographic exhibition (Paris, 1960), and those by A. Mezzetti in the catalogue of the 'Homage to Guercino' exhibition (Bologna, 1967) and by P. Dal Poggetto in the catalogue of the "Seventeenth Century Bolognese Painters in Florentine Galleries" (Florence, 1975).

Even some recent museum reorganizations, as we have already mentioned, have encouraged preservation campaigns which were guided by illuminated critical scruples. We can find many discussions of this in the 1971-1975 issues of the Amsterdam 'Bulletin van het Rijksmuseum' ['The Rijksmuseum Bulletin'], and, as a sign of a situation greatly changed from the not too distant past, in the National Gallery of London yearbooks.

BIBLIOGRAPHY - *a) Legal tools and operative structures*: K. Malinowski, Organisation de la protection des monuments en Pologne, Varsovie, 1964; Aa. Vv., Per la salvezza dei beni culturali in Italia. Atti e documenti della Commissione d'indagine per la tutela e la valorizzazione del patrimonio storico, archeologico, artistico e del paesaggio, 3 voll., Roma, 1967; Martinez-Mautino, Tutela del patrimonio storico, artistico, naturale e disciplina urbanistica, Firenze, 1967; A guide to Historic Building Law, Cambridge, 1967; A. Cantone, Difesa dei monumenti e delle bellezze naturali, Napoli, 1969; Ward (ed.), Conservation and Development in Historic Towns and Cities, Newcastle, 1968; Cenni legislativi e strumenti di rilevamento, in 3a Campagna di rilevamento dei beni artistici e culturali dell'Appennino, Appendice, Bologna, 1970 (stralci delle leggi di tutela del patrimonio artistico e culturale francesi e inglesi); H. Foramitti, Kulturgüterschutz, Wien-Graz, 1970, 3 voll. (anche per i problemi del restauro); C. Brandi, Commissione Franceschini-Commissione Papaldo: anno zero, Futuribili, V, 30-31, gennaio-febbraio 1971; A. Emiliani, La conservazione come pubblico servizio, Bologna 1971; M. S. Giannini, Uomini, leggi e beni culturali, Futuribili, V, 30-31, gennaio-febbraio 1971; M. S. Giannini, Difesa dell'ambiente e patrimonio naturale e culturale, Rivista trimestrale di Diritto pubblico, 1971; R. Di Stefano, La difesa dei beni culturali in Italia. Norme e orientamenti, Restauro I, 1, giugno-luglio 1972; R. Di Stefano, G. Fiengo,

La moderna tutela dei monumenti nel mondo, Napoli, 1972; F. Marenyi, La tutela dei monumenti in Ungheria, Restauro, I, 3, ottobre-novembre 1972; A. Paolucci, Il Convegno d'arte sacra di Pisa e il problema dei Musei diocesani, Bollettino d'arte, V, LVIII, 1973; Convenzione europea per la protezione del patrimonio archeologico, Bollettino d'arte, s. V, LVIII, 1973, 2-3; Dichiarazione delle Nazioni Unite sull'ambiente umano, Bollettino d'arte, s. V, LVIII, 1973, 2-3; Beni culturali e naturali. Proposta della Regione Toscana per un'iniziativa legislativa delle Regioni per la riforma dell'Amministrazione dei beni culturali, 9 ottobre 1973; A. Paolucci, Scuola e tutela del patrimonio artistico, Musci e Gallerie d'Italia, 51, 1973; Aa.Vv., Tutela e conservazione del patrimonio storico e artistico della chiesa in Italia, Bergamo, 1974; R. Bianchi Bandinelli, AA., BB., AA. e B.C. - L'Italia storica artistica allo sbaraglio, Bari, 1974; P. Dussaule, La loi et le service des Monuments Historiques, Paris, 1974; A. Emiliani, Una politica dei Beni culturali, Torino, 1974; K. Driessen, Systematischer Vergleich der Denkmalschutzgesetze in der Bundesrepublik, Deutsche Kunst und Denkmalpflege, XXXII/1, 1974; R. Di Stefano, A. Aveta, F. La Regina, Regioni; beni culturali e territorio, 1° e 2°, Restauro, III, 16, novembre-dicembre 1974 e IV, 17, gennaio-febbraio 1975; Aa. Vv., Da Antonio Canova alla Convenzione dell'Aja - La protezione delle opere d'arte in caso di confltto armato, in Quaderni di S. Giorgio, 35, Firenze, 1975; Una politica per i beni culturali - Stato e Regioni. Incontro col Ministro Giovanni Spadolini, Quaderni della Giunta regionale, 1, Bologna, 1975; Regione Lazio - Strumenti per una politica della cultura - La normativa regionale per i Musei, Biblioteche e Archivi Storici, Roma, 1975; M. Corsale, Un autobus per Utopia - Beni culturali - Cultura - Controcultura, Roma, 1975; I beni culturali dall'istituzione del Ministero ai decreti delegati (Introduzione di G. Spadolini), Roma, 1976; A. Torricelli, Legislazione regionale in materia di Musei locali, Amici dei musei, 4, gennaio 1976; G. Spadolini, Beni Culturali: diario, interventi, leggi (con uno scritto di G. C. Argan), Firenze, 1976; The protection of the artistic and archaeological heritage, a cura dell'UNSDRI, Roma, 1976.

b) Knowledge as a presupposition for protection: Aa. Vv., Il futuro dei centri storici e il P.R.G. di Urbino, Urbino, 1964; A. Giuliani, Monumenti, centri storici, ambienti, Milano, 1964; F. Oberbizer, Relazione sul progetto di legge per la tutela e il risanamento dei centri storico-artistici, Atti del Convegno nazionale di studio sui centri storici, Gubbio, 1964; Política de principios para la defensa de las antiguas ciudades españolas, Madrid, 1965; Política de principios para la salvaguardia de los parajes rurales en los aspectos histórico-artísticos, Madrid, 1965; G. Alomar, Criteria and methods of cataloguing, Consiglio d'Europa, 1965; V. G. Astengo, Studi esperienze e problemi attuali dei centri storici in Italia, Urbanistica 42, 43, 1965; Aa.Vv., International Symposium on Mathematical and Computational Methods in the Social Sciences. Journées internationales d'études sur les méthodes de calcul dans les sciences de l'homme, Roma, 1966; Inventario de protección del patrimonio cultural europeo. España. Conjuntos histórico-artísticos y sitios mixtos urbano-rurales. Inventario resumido, Madrid, 1967; R. Delogu, Il problema della catalogazione delle opere d'arte, Rapporto della Soprintendenza alle Gallerie di Bologna 1967-68, Bologna, 1968; Aa.Vv., Contribution à l'inventaire-standard des monuments d'architecture. Recueil de conférences du symposium international, Prague-Namesti, 10-17 settembre 1969, Prague, 1969; A. Samonà, Centri storici: urbanisti contro architetti, Il Mulino, 200, 1969; P. L. Cervellati e altri, Bologna/centro storico, Bologna, 1970; H. Ooehler, Mise sur

ordinateur d'une documentation photographique sur la sculpture romaine, Museum, XXIII, 1, 1970-71; Editoriale: Fautori o nemici del catalogo?, Bollettino di Italia Nostra, 84, 1971; C. Carozzi, R. Rozzi, Centri storici, questione aperta. Il caso delle Marche, a cura della Soprintendenza ai Monumenti delle Marche, Ancona, 1971 (con bibliografia precedente); A. Emiliani e altri, Ipotesi per un piano di tutela, intervento e riqualificazione dei beni artistici e culturali mobili delle province di Bologna, Ferrara, Forlì e Ravenna, 1971-1975. La conservazione come pubblico servizio, Bologna, 1971; F. Negri Arnoldi, La catalogazione del patrimonio artistico in Italia: storia e attualitá, Musei e Gallerie d'Italia, 43, gennaio-aprile 1971; A. Paolucci, Una proposta per il catalogo dei beni culturali, Paragone, 261, novembre 1971; Inchiesta di "Italia Nostra" sulla catalogazione del patrimonio storico-artistico in Italia, Bollettino d'Italia Nostra, 98-105, luglio 1972-febbraio 1973; Aa. Vv., Territorio e conservazione. Proposta di rilevamento dei beni culturali immobili nell'Appennino bolognese, Bologna, 1972; M. L. Casanova, Relazione sulla catalogazione nella provincia di Latina, Bollettino d'arte, 3-4, luglio-dicembre 1972; A. Emiliani, Relazione sulla catalogazione nelle province di Bologna, Ferrara, Forlì e Ravenna, Bollettino d'arte, 3-4, 1972; O. Ferrari, La catalogazione dei beni culturali, Bollettino d'arte, 3-4, 1972; J. C. Gardin, L'informatique et l'inventaire général, Paris, 1972; E. Guidoni, A. Marino, Territorio e città della Valdichiana, Roma, 1972; G. Di Pietro, G. Fanelli, La valle tiberina toscana, a cura dell'E.P.T. di Arezzo, 1973; A. Baccilieri, J. Bentini, Il patrimonio culturale della provincia di Bologna, Bologna, 1973; A. M. Chieco Bianchi, La catalogazione al Museo nazionale atesino, Bollettino d'arte, s. V, LVII, 1973, 1; G. Fogolari, Rapporto 1972 della Soprintendenza alle Antichità delle Venezie sulla catalogazione dei beni archeologici, Bollettino d'arte, s. V, LVIII, 1973, 1; P. Gazzola, Catalogazione del patrimonio immobiliare di interesse culturale. Esperienze del centro studi presso la Soprintendenza ai Monumenti di Verona, Bollettino d'arte, s. V, LVII, 1973, 1; P. Gazzola, L. A. Fontana, Analisi culturale del territorio, Padova, 1973; A. Paolucci, Il catalogo dei beni culturali di pertinenza ecclesiastica nelle province di Firenze e Pistoia: prospettive ed ipotesi di strutturazione museale del territorio, Bollettino d'arte, s. V, LVIII, 1973, 2-3; Aa.Vv., L'impiego dei mezzi di rilevazione ed elaborazione dei dati ai fini della gestione dell'anagrafe dei beni culturali, Seminario tenuto presso l'Accademia di Brera, Milano, 1974; D. Bernini, La Regione e la catalogazione dei beni culturali, Cronache parlamentari siciliane, XIV, 1974, fasc. 1-2; D. Bernini, Il Museo e la catalogazione dei beni culturali, Musei e Gallerie d'Italia, 54, 1974; J. C. Gardin, L'analisi documentaria nell'inventario dei beni artistici, Musei e Gallerie d'Italia, 53, maggio-agosto 1974; A. Paolucci, La catalogazione del patrimonio artistico territoriale delle province di Firenze e Pistoia nell'anno 1973, Bollettino d'arte, s. V, LIX, 1974, 1-2; O. Piraccini, Il patrimonio culturale della provincia di Forlì, Bologna, 1974; Inventario de proteção do acervo cultural, Bahia, 1975; Aa.Vv., L'automazione del catalogo del patrimonio storico-artistico. Atti del Convegno organizzato dall'Inforav, Roma, 1975; A. Cavallaro, A quando il catalogo come servizio pubblico?, Bollettino d'Italia Nostra, 128, 1975; M. Dezzi Bardeschi, G. Cruciani Fabozzi, Certaldoalto, studi e documenti per la salvaguardia dei beni culturali, Firenze, 1975; I. Eri, L. Nagy, P. Nagybakay, Electronic data processing of the sources relating to crafts and guilds in Hungary, Budapest, 1975; A. Mioni, R. Rozzi, I centri storici della Lombardia, un patrimonio da salvare, a cura della Regione Lombardia, Milano, 1975; V. Casale, G. Falcidia, F. Pansecchi, B. Tos-

cano, Pittura del '600 e '700. Ricerche in Umbria 1, Treviso, 1976; Repertorio dei beni culturali delle province di Firenze e Pistoia: 1, La montagna pistoiese, a cura di A. Paolucci e altri, Firenze, 1976; Valle di Susa/Arte e Storia dall'XI al XVIII secolo, Catalogo a cura di G. Romano e altri, Torino, 1977.

c) Preservation as research program and system: Bollettino d'arte del Ministero della Pubblica Istruzione, in Arte veneta, nella Revue des Arts, nella Gazette des Beaux-Arts e in Ochrona Zabytków. Bollettino dell'Istituto Centrale del Restauro, Roma, 1950 sgg.; Studies in Conservation, London, 1952 sgg.; Bulletin du Laboratoire du Musée du Louvre, Paris, 1956 sgg.; Bulletin de l'Institut Royal du Patrimoine Artistique, Bruxelles, 1958 sgg.; Maltechnische, München, 1955 sgg.; Quaderni di restauro dei monumenti e di urbanistica dei centri antichi, 1972 sgg.

1) General Treatment: G. Thompson, Recent advances in conservation, London, 1963; J. Guillerne, L'atelier du temps, essai sur l'altération des peintures, Paris, 1964; C.E. Peterson, Historic preservation U.S.A.: some significant dates, in Antiques, LXXXIX, 2, 1966; R. H. Marijnissen, Dégradation, conservation et restauration de l'oeuvre d'art, Bruxelles, 1967; H. Ruhemann, The cleaning of Paintings, problems and potentialities, London, 1968 (nel repertorio bibliografico, curato da J. Plesters, una diffusa disamina della 'cleaning controversy' che fu dibattuta in Inghilterra agli inizi degli anni Sessanta in conseguenza di alcuni discutibilissimi restauri effettuati nella National Gallery di Londra e in altri musei inglesi e statunitensi); P. Bieganski, Strategia del restauro. Note sulla conservazione e la tutela dei monumenti storici in Polonia, Casabella, XXXIII, 341, 1969; A. M. Corbo, Il restauro delle pitture a Roma dal 1814 al 1823, Commentari, 1969; R. Di Stefano, S. Casiello, Restauro dei monumenti, Notazioni tecniche, Napoli 1969; Sculture all'aperto. Degradazione dei materiali e problemi conservativi, a cura di E. Riccomini e G. Torraca, Bologna, 1969; C. Ceschi, Teoria e storia del restauro (con bibliografia precedente), Roma, 1970; C. Chierici, Il problema del restauro, Milano, 1971; M. Gregori, Per la tutela dei beni artistici e culturali, Paragone, 257, 1971; B. Nicolson, Restauro dei monumenti in Toscana, ibid.; A. M. Romanini, A proposito di restauro architettonico, ibid; H. J. Plenderleith, A. E. A. Werner, The Conservation of Antiquities and Works of Art. Treatment, repair and restauration, II ed., London, 1971; A. Tonolo, Sviluppi delle ricerche microbiologiche per la conservazione della carta, Roma, Gabinetto Nazionale delle Stampe, 1971; La conservazione delle sculture all'aperto, Atti del convegno internazionale di studi, a cura di R. Rossi Manaresi e E. Riccomini, Bologna, 1971; Aa.Vv., The treatment of stone, Bologna, 1972; A. Wind, Arte e anarchia, III ed., Milano 1972 (p. 105 sgg.: sulla 'cleaning controversy' e sulla deontologia del restauro in genere); Carta del restauro 1972, Bollettino d'arte, 2, aprile-giugno 1972; Art and landscape of Italy: too late to be saved?, Catalogo a cura di Aa.Vv., New York, Metropolitan Museum, 1972; A. Conti, Storia del restauro e della conservazione delle opere d'arte, con un saggio di R. Longhi, Milano, 1973; P. Sanpaolesi, Discorso sulla metodologia generale del restauro dei monumenti (con bibliografia precedente), Firenze, 1973; Problemi di conservazione, a cura di G. Urbani, Bologna, s.d., ma 1973. G. La Monica, Ideologie e prassi del restauro, Palermo, 1974; Teoria e cultura del restauro dei monumenti e dei centri antichi, a cura di F. Gurrieri e altri, Firenze, 1974; V. Dragut, La restauration des monuments historiques dans la perspective de trois décennies d'activité, Revue Roumaine d'Histoire de l'Art, XI, 1974; M. Dvorak, Denkmalpflege in Österreich, Österreichisches Zeitschrift für Kunst und Denkmalpflege, XXVIII/3, 1974; A. Knoepfli, Schweizerische

Denkmalpflege. Geschichte und Doktrinen, Zürich, 1972 (1974); M. Warnke, Bildersturm: die Zerstörung d. Kunstwerks, München, 1973; Aa.Vv., Restauro e Beni culturali, Bollettino d'Italia Nostra, 128, 1975; Inquinamento e patrimonio dei beni culturali, a cura di F. Capuano, G. Urbani e altri (documenti ISVET, n. 29), Roma, s.d.; E. Ferroni, D. Dini, Prospettive per la conservazione degli affreschi, Scritti di Storia dell'Arte in onore di Ugo Procacci, Milano, 1977; G. Morozzi, Appunti di restauro, ibid.

2) Exhibitions, reviews, and particular treatment: O. Matthiesen, Bramante in Bergamo Alto, Apollo, settembre 1963; Restauri d'arte in Italia, Catalogo a cura di Aa. Vv., Roma 1965; U. Chierici, Il Maestro dell'Apocalisse di Novara, Paragone, 201, 1966; Dipinti salvati dalla piena dell'Arno, Catalogo a cura di S. Meloni, Firenze, 1966; Opere d'arte restaurate, Galleria nazionale della Sicilia, Palermo, Catalogo a cura di D. Bernini, Palermo, 1966; Arte a Pavia, Salvataggi e restauri, Catalogo a cura di Aa.Vv., Pavia, 1966; Mostra dell'attività delle Soprintendenze, Catalogo a cura di Aa.Vv., Roma, 1966; Mostra di opere d'arte restaurate, Catalogo a cura di F.M. Aliberti, G. Marchini, A. Rossi, Roma, 1966; Restauri nel Veneto 1965, Catalogo a cura di Aa.Vv., Venezia, 1966; G. Chierici, Il Battistero del Duomo di Novara, Novara, 1967; Mostra di restauri a sculture e oggetti d'arte minore, Catalogo a cura di K. Piacenti Aschengren e altri, Firenze, 1967-68; F. Santi, Gli affreschi dell'abside di S. Francesco a Montone, Bollettino d'arte, s. V, 1967, 2; Attività della Soprintendenza alle Gallerie del Lazio, Catalogo a cura di Aa.Vv., Roma, 1967, Mostra di opere d'arte restaurate, Catalogo a cura di Aa.Vv., Urbino, 1967; Rapporto sull'attività di tutela, conservazione e restauro della Soprintendenza alle Gallerie per le province di Bologna, Ferrara, Forlì e Ravenna, 1967-1968, a cura di Aa.Vv., Bologna, 1968; Tesori nascosti della Galleria di Parma, Catalogo a cura di A. Ghidiglia Quintavalle, Parma, 1968; A. Ghidiglia Quintavalle, L'Incoronata del Correggio, Bollettino d'arte, s. V, 1968, 1; Dipinti restaurati della Diocesi di Pistoia, Catalogo a cura di M. Chiarini, Pistoia, 1968; Mostra di opere d'arte restaurate nel 1967, Catalogo a cura di M.V. Brugnoli, I. Faldi, L. Mortari, I. Toesca, Roma, 1968; Mostra di antichi dipinti restaurati delle raccolte accademiche, Accademia di San Luca, Catalogo a cura di I. Faldi, Roma, 1968; Mostra di opere d'arte restaurate, a cura di F. M. Aliberti, A. Cecchini, A. Rossi, Urbino 1968; M. V. Brugnoli, Recupero di un crocifisso trecentesco nel Museo di Palazzo Venezia, Bollettino d'arte, s. V, 1968, 2-3; G. Matthiae, Gli affreschi medioevali di S. Croce in Gerusalemme, Roma, 1968; I. Toesca, Gli affreschi della chiesa di E. Egidio a Filacciano, Bollettino d'arte, 53, 1968 (ma 1972); Dipinti restaurati delle Gallerie fiorentine, Catalogo a cura di Aa.Vv., Firenze, 1969; Frescoes from Florence, Arts Council of Great Britain, Catalogo a cura di U. Baldini e altri, con introduzione di U. Procacci, London, 1969; Mostra dei dipinti restaurati della chiesa di S. Giorgio dei Genovesi di Palermo, Catalogo a cura di D. Bernini, Palermo, 1969; Attività della Soprintendenza alle Gallerie del Lazio, Catalogo a cura di Aa.Vv., Roma, 1969; Mostra di opere d'arte restaurate e poco note del Palazzo reale di Torino, Catalogo a cura di U. Chierici E. R. Tardito Amerio, Torino, 1969; IV Mostra di opere restaurate, Museo nazionale Pepoli, Trapani, Catalogo a cura di F. Negri Arnoldi, s.1., 1969; Mostra di opere d'arte restaurate, Catalogo a cura di F. M. Aliberti, G. Mulazzani, A. Rossi, P. Torriti, Urbino, 1969; Arte in Valdichiana, Catalogo a cura di Aa.Vv., Cortona, 1970; Opere d'arte restaurate, Museo nazionale, Messina, Catalogo a cura di G. Consoli, Messina, 1970; Mostra dei restauri, 1969, Catalogo a cura di Aa.Vv., Roma, 1970; Galleria nazionale d'arte antica. Acquisti, doni, lasciti, restauri e recuperi, 1962-1970, Catalogo a cura di Aa.Vv., Roma, 1970; VII Mostra di opere d'arte restaurate, Galleria nazionale della Sicilia, Palermo e Museo nazionale Pepoli, Trapani, Catalogo a cura di M. Stella, Trapani, 1970; Mostra di opere d'arte restaurate, Catalogo a cura di Aa.Vv., Urbino, 1970; Pitture murali restaurate, Catalogo a cura di M. T. Cuppini, Verona, 1970; A. Ghidiglia Quintavalle, La pittura gotica padana negli affreschi di S. Lorenzo a Piacenza, Parma, 1970; F. Gurrieri, La chiesa di S. Antonio abate o del Tau (Pistoia), estratto dal Bollettino storico pistoiese, LXXII, 1970; Arte in emilia. 4 Capolavori ritrovati e artisti inediti dal '300 al '700, Catalogo a cura di A. Ghidiglia Quintavalle e L. Fornari, Parma, 1971-72; Mostra del restauro delle opere delle Province di Pisa e Livorno, Catalogo, Pisa, 1971; Rapporto n. 8. Ipotesi per un piano di tutela, intervento e riqualificazione dei beni artistici e culturali mobili delle province di Bologna, Ferrara, Forlì e Ravenna. 1971-75. La conservazione come pubblico servizio, a cura di Aa.Vv., Bologna 1971; Firenze restaura, Guida alla Mostra a cura di U. Baldini e P. Dal Poggetto, Firenze, 1972; Ritrovamenti e restauri, Catalogo a cura di G. Magnanini, L'Aquila, 1972; Opere d'arte restaurate del messinese, Catalogo a cura di F. Campagna Cicala e G. Consoli, s. 1., 1972; VIII Mostra di opere d'arte restaurate, Catalogo a cura di M. G. Paolini, V. Scuderi e M. Stella, Palermo, 1972; Mostra del restauro, Catalogo, Pisa, 1972; Restauri della Soprintendenza alle Gallerie e alle opere d'arte medioevali e moderne per il Lazio. 1970-1971, Catalogo a cura di Aa.Vv., Roma, 1972; G. Paccagnini, Pisanello alla corte dei Gonzaga, Catalogo della Mostra, Venezia, 1972 (con bibliografia precedente); Storia e restauro della Deposizione di Raffaello, Catalogo a cura di L. Ferrara, S. Staccioli, A. M. Tantillo, Roma, 1972-1973; A. Mignosi Tantillo, Restauri alla Farnesina, Bollettino d'arte, s. V, 1972, 1; Il cofanetto argenteo di Anagni, Restauro e ricerche, a cura di A. Monferini, Roma, 1972; Abbazia di San Zeno in Pisa, Relazione sui lavori di restauro e indagini storico-artistiche, a cura di U. Lumini, Pisa, 1972; Restauri nelle Marche. Ricerche, studi e interventi per la conservazione e la valorizzazione dell'ambiente storico, Catalogo a cura di Aa.Vv., Urbino, 1973; Restauri nelle Marche. Testimonianze acquisti e recuperi, Catalogo a cura di Aa.Vv., Urbino, 1973; A. Ghidiglia Quintavalle, Una singolare scoperta, Bollettino d'arte, s. V, 1973, 1; A. Ghidiglia Quintavalle, La "Deposizione" e il "Martirio" del Correggio dopo il restauro, Bollettino d'arte, s. V, 1973, 4; Arte nell'Aretino. Recuperi e restauri dal 1968 al 1974, Catalogo a cura di L. Boccia, C. Corsi, A.M. Maetzke e A. Secchi, Arezzo-Firenze, 1974-75; IX Mostra di opere d'arte restaurate, Catalogo a cura di Aa.Vv., Palermo, 1974-75; Restauri 1972-73, Associazione Amici di Spoleto, s.d. ma 1974; F. Gurrieri, Il restauro del palazzo di Giano, Firenze, 1974; Vystavka pamjatnikov, restavrirovannyh v Ermitaze, Catalogo a cura di N. Gerasimova e altri, Leningrado, 1974; A future for our past: the conservation of art, Catalogo a cura di Aa.Vv., Washington, Smithsonian Institution, 1974; P. Paolini, Consolidamento e restauro della chiesa di S. Francesco di Paola in Longobardi, Bollettino d'arte, 1974, 1-2; Due restauri e un'acquisizione, a cura di E. Micheletti e A. Paolucci, Firenze, Museo del Bargello, 1975; Restauri in Umbria, Catalogo a cura di V. Tiberio, Perugia, 1976; X Mostra di opere d'arte restaurate, Catalogo a cura di V. Scuderi e altri, Palermo, 1977.

Oreste Ferrari and Serenita Papaldo

MUSEOLOGY

Although most of this section focuses on Italy, the author discusses principles and problems that have widespread application.

The museum debate. – Over the years a significant debate has developed, not just about the "technical" history of the museum, but mostly about the cultural purposes of the museum itself, especially if these purposes are examined in their relationship to society. This debate has mostly taken place in Italy — i.e. in the country which, both naturally and historically (with France in a distant second place), contains the greatest number of museographic formations, the most widespread distribution over the national territory, and the most different legal system. It also contains the most archaic idea of service, and so the most frequent inability to offer itself to that generally social purpose which is spontaneously requested nowadays.

Other similar circumstances have also made a decisive contribution to the debate, which the museum has had to take some heed of: sometimes through an effective reconstruction, verified by a real cultural and application vocation. At other times it has had to adapt itself (at least in theory) to updating and modernization forces, which are not limited to simple architectural "styling," but which have developed a new and different way of envisaging the museum. And this is not always to the advantage of the museum itself.

These related circumstances took off around the dynamic period of the 1960s, when the cultural, political and even socio-economic worlds in Italy were being subjected to consistent demand and pressure. At this time, structural reform and modernization were not keeping pace with the progressive increase in demand: these are the only things which would have been able to compensate, at least in part, for the clear imbalance which was emerging between society and its most traditional services. We can attempt to enumerate the most important of these demands, but we should understand that the simultaneous demand from local bodies on the one hand and from schools on the other, constituted the most recognizable and immediate pressure, which was followed by demands from other directions.

Of course, there was no shortage of declarations concerning the total lack of confidence in the museum and in the type of service it provided, especially if we look at the large amount of literature produced in post-1968 Europe. To look at it another way, though, canonical literature, seeing museography as a constructive and architectural technique, replaced the idea of the museum seen only in relationship to projected programming and policy-making. The relationship which was often either developed, or at least encouraged, between city and museum and between museum and the land, belongs to this way of thinking. It is important to realize, though, that theories tended to appear in this way of thinking much more regularly than actual results. This, however, appears to be consistent with the entire horizon of public cultural services, in which we certainly have to recognize the signs of a growth crisis, along with a stall situation stemming from the major economic crisis. This economic crisis has had a significant effect on the museographic sector, as it seriously affects the local bodies - namely, those in charge of running a large proportion of the museums in Italy.

The beginning of the 1970s was literally dominated by the debate about administrative decentralization, which had been started (along the lines determined by the national constitution) immediately after the war, mainly by Article 117 which had created the regions: thus the decentralization began at the very same time as the new constitution was put into practice. There is no doubt that the work, the social and cultural aims, and the goals for preservation and education, in addition to the basic idea of the museum, were all widely, and sometimes acrimoniously debated at the time. Apart from the first concrete results - which, as we have already seen, were late in showing themselves - we must emphasize that the museum, and especially the "local" museum has, at least in image, departed from its old characteristic of silent conservatory, with the very aleatory purpose of the material survival of works. In a desire for a more homogeneous and global cultural policy, the museum has now acquired a more precise position, in placing both the specific place and purpose of its cultural service alongside other existing cultural services (libraries, archives, public readings, etc.). For example, technicians and town-planners, working on city plans, and detailed projects in historical city centers or (more recently) on complete districts, have more and more need for precise information about museographical presence, about details which do not just concern buildings (i.e. which do not just concern the "container"), but which are also a functional part of the museum itself. They require information about the working of the museum compared with and in relationship to other homogeneous institutions, and about how the museum is related to the town-planning order of either the residential quarter or of the whole city. In some cases, the museum has been seen as the most legible "element" of all in town-planning interpretation: it is argued that, if we look at the effective characteristics of the museum (and this is not just suggested by some oppressive "logomachia"), we can easily recapture the measure of importance and purpose which the debate has managed to give to museographic and preservation institutions in the space of just a few years.

Along the same lines, we can sum up by seeing that the idea of the museum has been extended beyond the boundaries of its home city, and faces the situation of having to develop a suitable purpose and service comparable with the territory: or, at least, with that part of the territory which, for reasons of gravitation, congruence, etc., is nowadays commonly recognized as a "district." In this more and more common situation, we can also see the development of a demand which encourages the formation of new or even previously unheard conservation and educational structures, which are directly connected to the historical, cultural and social characteristics of the land itself. And since the land in Italy has definitely evolved from a farming history, it would be useful to recognize this traditional image (which only began to fade a few years ago) as the matrix for most of the demands: i.e. the demands for anthropological and ethnographic documentation about farm work, about conditions of the mountains, or about paleo-industrial work (especially in the Po Valley).

The more traditional image of the museum, however, has made much less progress: this image is a basic and integral part of its fundamental purpose, which is bound to the problems of material preservation of

goods, and to determining methods for a specific and correct approach to works of art (placement, preparation, light, exhibitive clarity, etc.). This is the case, even though it is certain that the examination of the mainly social and cultural debate has to absorb differing views, which really ought to be resolved by newly-efficient organizational and preparation methods: but this efficiency cannot "overcome" the more traditional museographical ideas. As we will see, in fact, the same "styling" has too often been forced onto museums and exhibition sites - not to mention the many unrestrained restorations and modernizations - and this has led to museums facing serious distortions of their traditional historical and cultural image.

But the debate has effectively achieved a renewed purpose, at least methodologically speaking, in determining the privileged museum/society relationship which it has to build with education - with all its general and particular problems. In fact, we could say that a large part of the pressure on museography during its transition towards becoming a museological problem (if we are permitted to summarize the situation in such a way), has been an explicit force (despite the use of different methods in different areas of the country) which has clearly encouraged a new and different role for the museum - it has encouraged an image with an important didactic aspect, especially at the level of compulsory education. Even if not too many centers have yet confronted this need (Milan, Rome and Bologna are amongst the first), another fundamental conviction has developed from the idea of the museum as a public service: the conviction that the current image of the museum - as an establishment aimed at large numbers of tourist activities - has to be compensated for by a much more definite cultural proposal: the first of these has been this proposal concerning the school and its activities.

However, nobody can fail to appreciate that, under the current policies which encourage tourism, this image can only be subject to very little planning or control: instead, to a great extent, the museum has to take notice of very commercial, international "leisure" schedules, and its image is determined by the larger travel companies as it takes on the prevailing form of a fixed "landing-place," both in chronological terms and in its visiting methods. So-called "professional" tourism and artistic obsession combine spontaneously to transform entities of enormous cultural value (such as the Louvre, the Uffizi, the Prado, Villa Borghese), into products of effective servitude, which satisfy the most immediate and therefore most recognizable cultural desires. The difference between the place itself and obsession for the place, so clear in the famous case of the Louvre and the "Gioconda," has, of necessity, led to topographical changes which direct - or try to direct - public circulation, and which do not allow the public to stop in front of the favourite focal points of the museum. The same reason has to explain the unpleasant decision made by the Louvre about materials exhibited in this great museum: it had to transfer the Italian School - the "Gioconda" - to an area away from the traditional "Grande Galerie."

Since "professional" tourism follows a system of intensive exploitation, the offering of symbolic and closely-packed examples to this aspect of mass culture, and especially to international tourism - organized in

Transatlantic form as the "European Tour" - clearly provides the ideal map for Italian museography. Thus the very image of Italian art history tends to become a reduced interpretation - especially in Venice, Florence and Rome - and tends to destroy the extent, distribution, variety and balance found both in the artistic history of this country and in reality: factors which are so deeply and inherently a part of the Italian cultural inheritance. It is worth emphasizing that the above-mentioned concentrated obsession ends up - partly for economic reasons - by clearly increasing the number of people in transit, but by diminishing the number of percapita days spent in any one place: in other words, it substantially reduces the effective cultural and economic quality which any sensible tourist policy tries to promote. Similar problems also appear in the easier to control areas of incentivizing internal tourism.

Again, when looking at the Italian museographical problem and, in particular, at the aspect of its public cultural service, we must notice that recent years have decisively highlighted the precious relationship between museum and place: i.e. between the intrinsic qualities of the preserved inheritance and the general qualities of the city where this inheritance is museographically established in various ways. In a great many cases, it is important to appreciate and respect this relationship, in order to discover its clear historical, scientific and techno-scientific advantages which all lead to the inclusiveness of the cognitive method. But since the "outdoor" dimension of the historical and artistic cultural image and preservation aspects appears to be so huge and all-inclusive in Italy, it is very clear that most political concerns have recently been turned towards the main parts of this inheritance - in other words, towards the enormous spatial-temporal dimension of the territorial inheritance, which belongs almost exclusively to the Church. This legitimate concern developed from the clear need for intervention, and from the work of research and investigation which, in turn, developed from the current cataloguing and census programmes; this concern has certainly delayed some reviewing, verification and restoration work in museographical complexes. It does not take away the fact that the problem of museographic "renovation" has, in some cases (for example, in the most recent and symptomatic case of Brera in Milan), taken on an urgent need - both for reasons of physical deterioration, as well as from functional necessity.

Museum design and its problems. – As we pointed out above, the problem of museographic restoration and renovation has quite often been dealt with by concentrating much more on architectural and design considerations, rather than on considerations which are more completely and totally museological. It is not difficult to find examples of significant architectural and environmental work carried out in many Italian cities. The results of this work are all too often limited to "styling" the old, pre-existing structures into stand or exhibition types of structure: however an element that must be strongly emphasized about these projects, is the need for inclusion of an accurate master museological scheme to which the work can be referred, instead of the usual deviations from the architectural plans. We have to say that the extended era of art shows and exhibitions has had great influence on this concept of museum, with all its splendour of exhibition precariousness and con-

tingency; yet, at the same time, almost nothing has been taken from the more relevant planning of some shows - elements such as contrast and comparison, exhibitive clarity, and even an ordered placement of the exhibition contents, etc. All too often, in fact, renovated Italian museums seem to take on a style which responds badly, or negatively, to the great potential of the museum itself: the museum should be understood as not just a physical inheritance, but as an historically-created collection, relying on dynamics which should be indentified, so as not to provide the public with images which stray from this museological potential.

Although elementary, the first point to ascertain is the determination of circumstances regarding the museum's origin, the dynamics of its creation and the principle historical methods of its expression. It is obvious that there are substantial differences between a museum created from oppressive Napoleonic policies of interference in the cultural inheritance and in town-planning, and a museum created by patronage at the height of family or heraldic fortune (the commissioned galleries in Rome, for example). No museological design can even consider ignoring these very important differences, without losing the fundamental form and information intrinsic to the museum itself.

It does, however, become more difficult to follow these obvious guidelines to the point of carrying out effective verifications about the origin, development and historical aspect of the collections. This, unfortunately, is clear from the facts; it is extremely rare for cataloguers to have subjected any Italian collection to a detailed analytical examination of the methods and timing of its formation, even though the collections usually do have a reasonable, or even good historical and critical catalogue to offer the public. Yet this examination is indispensible for the often enormous collections, whose historical inventories of origin were destroyed - after the Unification of Italy - by exactly the same administrative-type cataloguers; these cataloguers produce lists which lose the original stigmata of the collections, and the materials become mixed with later additions and acquisitions as well as with the occasional piece or legacy from private patrimony. Even the information in public catalogues is often lacking, since every catalogue almost always coincides with the type of exhibition which the individual registrar had decided upon during his time in office. With the exception of a few cases, we cannot really say that Italian museographical organization has been setting an example - especially after 1860.

It would be right, however, to turn our thoughts about conscious museology towards the idea of constant verification of origin: this is because verification will make it very easy to discover the motivations which have led, by means of such complex paths, to a "particular" development of the museum. In order to make sense of the prevailing number of works present in the collection, the development must be allowed to promote its own cultural and didactic policy for extending information, in a simple organization of architecture and design; and, of course, it also has to indicate the direction to be followed in the purposeful search for the acquisition of new originals. Now one fact is clear: within the very broad generalization of the present condition of collections and design-work, it is very difficult to recognize the original movements of many Italian museographical nuclei. These nuclei, with some well-known older or commissioned exceptions, have nearly always started out from two matrices, both determined from a political and administrative as well as from a cultural basis. One of these matrices is recognizable in the Enlightenment or Napoleonic museum, with the focal points of the 'manu militari' ['military hand'] of an entire culture of encyclopedic tassonomy. The other can be seen in the Italian museum which tries to portray the idea of the mainly civic and legal structural situation, brought about by the so-called "destructive" Italian laws of 1866: these laws led to the abolition of other religious places (congregations and fraternities), and to the handing over of moveable goods into Municipal or Provincial possession. Belonging to this second, post-Unification matrix, is that difficult collection destined to become the civic archeological museum, which developed as much from deliberate excavation programmes as from casual, usually urban finds, made during demolition and speculation work in our cities, both large and small. And we must not forget that the museum which results from these unalterable actions, can and must be interpreted, and therefore managed, in the light of bad preservation conscience, instead of a center of edifying critical and historical narration. In addition, we often find belonging to this second, post-Unification situation an abundant and dangerously unknown quantity of mixed historical collections (often potential museums in themselves), which can be recognized in the innumerable patrimonies belonging to religious, assistential and hospital institutions, etc. In these cases, the problem of verification is actually a legal and administrative problem, as competent administrations, capable of producing just an accurate list of the works in their possession, are extremely rare. We should now realize that work in this direction would provide the most immediate and simple solution to the serious problem which stems from the disjointed shortage of information in local museums (which are nearly always built on the representative model either of larger museums, or - even more often - of major art galleries), and which also stems from the spontaneous growth of these local museums, an advantage of the development of local, cultural and public nuclei.

We have now ascertained the matrix of Italian museums - or, at least, of a large percentage of them - within this general typology of origin: French abolition or the result of the period of Enlightenment as the first matrix, and Italian abolition and civic accumulation as the second. At this point it would be opportune to develop some general ideas, in order to evaluate a valid method of finding - from within the matrix itself - the sense and vocation of the original purpose, or even the characteristics of the culture which led to the first development of exhibition. There is not the slightest doubt, for example, that the rich inheritance of the National Pinacoteca of Bologna represents the value of both the historical and critical culture already developed over time by Carlo Cesare Malvasia on the subject of the 'Felsina Pittrice.' During the Napoleonic interlude of 1797-1803 we can recognize biographical and urban aspects of this Malvasia culture - aspects which were transferred to grandiosity, mainly by means of altarpieces and large items; it was from this that the later 18th century culture developed its pantheon for the coming Romanticism (compare the basically parallel letters of Goethe and Stendhal). Finally, it has proved

very difficult to enter works of secular character or of room formation into this museographical compactness.

This typical example can be used to ascertain that correct museological behaviour cannot be separated from a constant recognition of the initial purpose; whether we are dealing with architectural renovation or expansion of the building (large spaces which can be reduced in size, a rhythm which constantly runs parallel to the chain of exhibitions, vertical lighting suitable for large format, etc.); or whether we are dealing with the critical-historical models of dissemination (which clearly do not depart too far from the museum-city equilibrium) and didactic activity; or, finally, whether we are dealing with the policy of museum acquisition, which tends to build further on this 'Malvasian' idea rather than generally promoting incentives for a theme or quality collection.

If we move away from Bolognese or Venetian compactness - which, for good reason, we have called Napoleonic - we can consider the exceptional case of the Milan 'Braidense;' this was the well-known result of an abandoned building well after Jacobean or Republican times, which was taken into Appiani's care, under the order of Eugenio of Beauharnais, and "restored" by means of a huge number of snatchings and raids carried out once again in the Marche, in the Romagna, in Veneto, and, of course, in Lombardy. Even though a good part of these paintings which (never returned to their original homes) were used to pacify parish demands and to decorate a great many churches in the Lombardy countryside, the construction of the Brera Pinacoteca had to take place on the basis of a selective buying spree, which, only at a very high cost, could represent the Italian Kingdom in the way that Beauharnais and Appiani had obviously strived for. And this is certainly comforting to the tight-knit museological opinion, which sees the Braidense reconstruction as capable of restoring value and presence to the regional and anthological character of Italian collections, and even to the obvious distortions of actually fulfilling this capacity.

Clearly it is more complex to develop a basic methodology for the second type of Italian museographic collection - i.e. the museum made up of natural and locally-found pieces, which is run by the local community; after national Unification, this type of museum was especially promoted by the devolution to the cities (Municipalities and Provinces) of the rich congregation and fraternity patrimonies, which had been taken away by the law of 1866. Here we are certainly talking about the most frequent type of museum in Italy, but we are also talking about the type of museum on which most management and economic uncertainties have weighed and continue to weight - uncertainties which the central power has continually handed over to the local bodies. Of course, because of the great variety which this generic typology covers, a discussion about possible methodology can only look at individual cases: yet this assertion itself is a basic part of a sensible methodological principle. Nevertheless, we can try to trace some distinctive lines, which are able to support the idea of a more homogeneous behavior. For example, as we have already mentioned, a perimeter almost always runs through the civic inheritance, and it is the chronological perimeter which can determine from within a collection the way it was created. Collections from

before 1860 showed culturally conscious agglutination characteristics, in a historical, artistic or even documentary sense: these collections, coming from repressed areas or from legacies, inheritances or acquisitions, deserved complementary museological treatment. They had regularly accumulated essential, if often delayed information from Enlightenment classification work, and the museum had to offer them space and interpretation which would salvage the original homogeneity of the nuclei, the cultural and biographical nature of the collectors, and the intentions expressed by inheritance and legacy laws. As far as the latter is concerned, we must not underestimate the huge and expressive literature of national history and civic pride, which saw the museum as a place "open to the public" and representative of the "education of citizens," and which provided the museum with an inheritance which was accumulated along the Renaissance political axis, and often appropriately used with the intention of giving shape to the new nation.

An almost completely different dynamic, however, tends to dominate museographical civic collections after Italian Unification. Here, in fact, run factors which are partially or completely new. For example, the civic museum becomes the reference point for an increasing quantity of archeological materials (Classical as well as late-Ancient or Medieval); these sometimes arrive directly from the more and more frequent, carefully-planned excavation campaigns. They also come from the first historical-artistic discipline - i.e. from archaeology itself, under the stimulus of analyses of the surviving rich cultural inheritance which, in some fortunate places, had been carried out from as early as the 18th and 19th centuries, but which at the end of this period were extended in an organized way until they provided precious information (and therefore materials) for historical knowledge. It is difficult, however, to pick out the moment when 19th century excavation and prospecting was joined by the very rich chance discoveries made during urban excavation. Sewerage, paving, civic lighting networks, the opening of new suburban streets - these are all some of the most common reasons behind the chance (and sometimes deliberate) discovery of materials of extraordinary consequence and importance. When the early appearance of a very rapid building speculation in Italian urban areas is added to this, mueseological patrimonial fortunes appear to increase in an irregular, but often plentiful way, thanks to this demolition and destruction. In this case, materials left over from a demolished building are directly added to the materials which have been studied in depth, and the museum thus collects an increasing number of objects - especially from Medieval and Renaissance periods: these enlarge the very idea of cultural goods, and broaden the very critical purpose of these museums - at least in theory (in practice, an appropriate use of this material has not been noticeable).

This line of demarcation which we have drawn, has a visible influence on the organizational and design behaviour of the museum, as well as on the actual purpose of its collection. For example, while the first patrimonial type can take on a behaviour which is more exclusively collectionist, it now seems inevitable that the second type is organized in constant relationship with the city and with the same occurrences which provoked its initial development. In fact, in this area, it is

impossible for that further museological specialization not to appear - that specialization which was vocationally present in many original affirmations, and which can now be summarized by the expression "city museum." With its concept thus explained, and not just in local terms, the museum can be seen as a sort of spatial-temporal intersection which maintains its metalinguistic prerogatives, while its collection and exhibition methods have take social, economic, political and administrative factors into consideration. The museum can also lend itself to a popularization which is not just based on a qualitative axis, but rather on an informative and documentary axis, without having to renounce that history of material culture and work, which seems able to be documented in urban areas much more accurately than in rural areas. In other words, it appears fairly obvious that a museographic formation of this type is legitimately connected to an active and current horizon which ends up with a public didactic exhibition of town-planning schemes of the city, of detailed plans, and of every other town-planning instrument: town-planning decisions being what society considers as the most important decisions.

Everything leads us to believe that it is exactly to this last type of museographical formation that much effort must and can be directed: this is in accordance with the community's demand for a better knowledge of the problems, and it is especially behind the pressure for a decentralized reorganization of culture. This pressure, due to the enormous size of the Italian cultural inheritance, has one of the most fervent followings.

For obvious reasons, we have left until last all consideration of the most famous historical typology of the museum: that of inheritance. Inherited cultural goods directly come (in part or completely) from the pre-Unification States, they are still located in their original sites, and more often than not they are managed by State authorities. From Modena to Naples, from Florence to Turin, there are many centers of governmental patronage - especially art galleries - which collect materials from family lines, and exhibit them in old residences. In these cases, it appears very clear that museological work ought to lend itself to a 'restitutio ad pristinum' of the value of the collections; this value depends on the cultural or political moments which inspired the creation and successive growth of the collections, and which determined choices of fashion and of museographical organization. In actual fact, however, at least in some cases, there has been the intervention of an often destructive architectural renovation, again inspired by the generic formula of design "styling." This runs alongside the lack of verification work carried out on the exhibited materials - work on their cultural and artistic association and purpose, as expressed in their formation phase, or even in the transition phase from the pre-Unification States to the new Italian State.

As has been mentioned, the debate of recent years has certainly lifted the museum from its dusty and basically useless image, into which it had fallen - partly because of pressure from misunderstood avant-garde assertations, but more especially because of the clear obsolescence of its original characteristics of purpose and function. While some apocalyptic views continue to ignore the museum, stronger and more widespread is the assent which is accorded to the museum by historicism (which also makes the most frequent proposal of

methodology - i.e. that of verifying the information). The most interesting thing is to notice that other cultural and social services are not required from just the existing changed and renovated museum, but there is also a constant demand made from the latent or even inexistent museum. This is the case, even when we consider the undeniable shortage of facts, revealed by any expressive and material typologies, and when we consider the innovative studies - especially in anthropology - which are initiating new sectors of historical culture. In this sense the persistent demands for the establishment of museums become understandable, when these become seen mainly as documentation centers, concentrating on farm work and the rural countryside, and also on aspects of more artistic work which have been neglected by the traditional museographical institution, such as cloth and embroidery, carving, urban furnishing, ceramics, folk traditions, environmental documents, etc. These are areas which have been touched rarely by Italian culture, and there seems to be a shortage of illustrative methodological models (unlike in England and even in France): this also explains the real difficulties which are met before the plans can be put into effect.

One of the most recurrent views found today is that which sees the museum not just as an institution detached from and impenetrable by the city and land (and the patrimony expressed by these), but as a much more vast and all-inclusive concept. For this reason, too, the repeated insistence with which we have tried to defend the static, rather than the inappropriately dynamic museological method (in the final analysis, every museum can be nothing but the history of itself), tends to emphasize that the museum complements the local historical fabric; we have to establish a constant link between museum and land, in order to make sure that on both the conceptual and functional level, the two sectors do not go back to being identified as discordant or even opposing ideas. All too often, in fact, the museum has ended up by absorbing all the values due to the land, for reasons of status symbol, but also because of the diminished effect of the idea of cultural inheritance; this can happen until the land is almost brought to the threshold of a cultural popularization which wavers between "loisir" and florilegium. In this sense, then, the repeated affirmations of museum vitality are based almost exclusively on architectural and design renovation, which takes place because of the absence of a real museological strategy. These affirmations have all too often led us to see the museum itself as a base for recording the general fashion movements of our age, rather than as a site of a decisively historical institution. As an historical institution, it should be based on strict historical verification, capable of building an accurate exhibitive order and of carrying out an efficiently modern cultural service in didacticism, instead of a loud modern cultural service in exhibition models. Since nowadays there is a lot of talk (and rightly so) about the museum being a laboratory, we should insist on the essential distinction which has to be made between work carried out within the limits of an historical model, thanks to efficient interpretive equipment, and an activity which aims at subverting the historical model with pretentious and short-lived modernizations, thus adapting the museum to needs which, because they

are typical of a laboratory, have all the characteristics of being experimental.

In Italy more than elsewhere, the museum of ancient art developed from a base of precise age and history characteristics, and is therefore (in a sense of patrimonial character and general behaviour) a closed work; it is a nucleus among the nuclei of a larger whole, in which the institution - far from assuming that predominant value which was gradually accorded to it - places itself next to other historical artistic and cultural institutions, such as the great churches and palaces - i.e. the most significant concentrations of aggregation and sedimentation. Of course, while making this statement, we also have to specify that a very clear chronological line divides the idea of the museum as an historical formation from the museum of contemporary art, and what we have so far discussed about the former is by no means valid for the latter. Nevertheless, we feel that all the considerations we have looked at do help to make decisions about the duties and methods of a museum of contemporary art; these museums are too unsure of themselves, and often waver between the need for exhibition and preservation (materials from between 1870-1890 and 1945), and the need for a more dynamic exhibitive undertaking, which is mainly made up of touring exhibitions, cultural organizations, the documentation and illustration of contemporary events. This last aspect is typical of every public institution, and its temporal dimension is, in most cases, commensurate with the interest which the celebrated events provoke in the current cultural mood. This is a subject which is of very great interest, from the moment that every modern art gallery decides to develop a promotional activity based on updated information about the same places and the same environments where works of art have accumulated for almost a century; these works of art are made interesting by similar promotions and then are gradually transferred to historical sedimentation. We would maintain that the only solution to this continually-growing problem will be attained through a clearer demarcation between the two types of museum, which currently seem to be contradicting each other. The pre-existing "art museum," even though it does not have the same characteristics as the museum of ancient art, must still be designed and organized according to cultural order and historical method (this is also true for its architectural base, which has to pay attention to the importance of natural light, of vantage points, of perspective observation, etc.). The contemporary art museum or gallery, however, has to be linked with characteristics which are typical of the present-day and its material and cultural methods; its continual "exhibitionism" (and commercialization stigmata). It also has to model itself on the demand which grows out of the need for cultural organization and management; the architectural environment has to make sure that it lends itself mainly to the new and very different demands for the products of contemporary art.

ANDREA EMILIANI

INDEX

THEMATIC INDEX

The first column below lists the subjects covered in this volume. The second column notes the page numbers and in parentheses the plate numbers in this volume. The third column indicates the corresponding subjects in the *Encyclopedia of World Art*.

INDEX OF AUTHORS

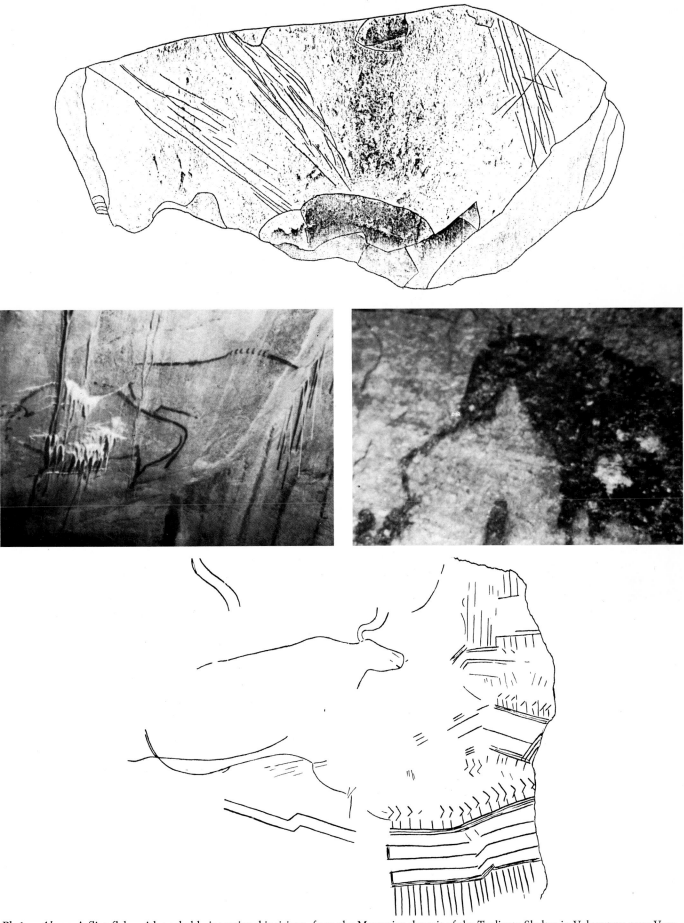

Pl. 1. – *Above:* A flint flake with probably intentional incisions, from the Musterian deposit of the Tagliente Shelter in Valpantena near Verona. – *Centre left:* Grotto of Niaux (Ariège), New Clastres Gallery, bison. Magdalenian. – *Right:* Villar del Humo (Cuenca), detail with figure of a horse. Art of the Spanish Levant. – *Below:* The Horse Grotto near Uluzzo (Lecce), bovids and geometrical figures. "Mediterranean Province" art.

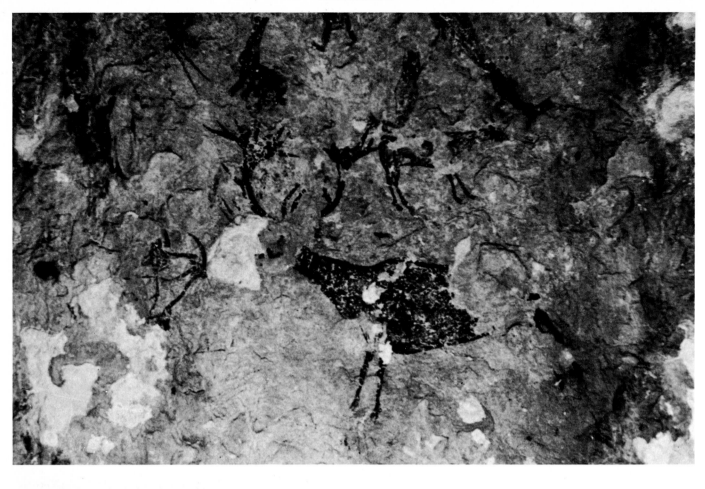

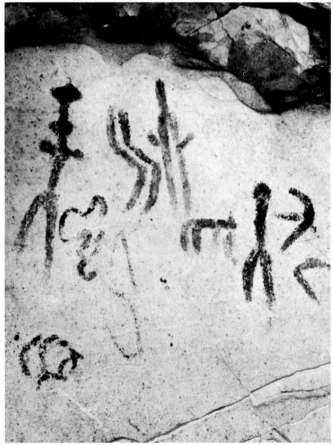 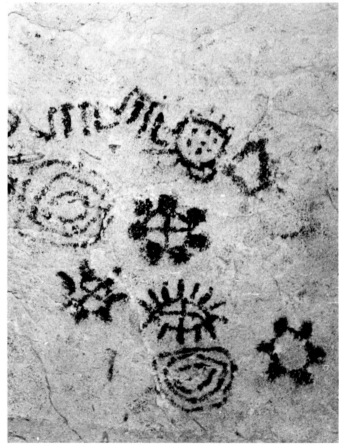

Pl. 2. –*Above:* Solana de las Covachas (Albacete), cervidae and other figures. Art of the Spanish Levant.– *Below left:* Cosma Grotto near S. Cesarea (Lecce), schematic anthropoid figures. – *Right:* Porto Badisco Grotto (Otranto, Lecce), schematic and abstract figures.

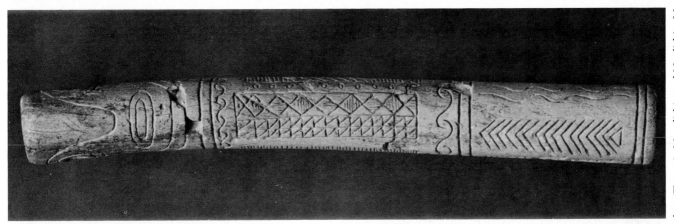

Pl. 3. – Figurative and decorative carving and intaglio, from the Gaban Shelter (Trento). Mesolithic and Neolithic. Museo Tridentino di Scienze Naturali, Trento. – *From left to right:* Small female figure made from a wild boar's molar. – Female figure on branch of deer horn. – Segment of human femur with face and geometrical patterns.

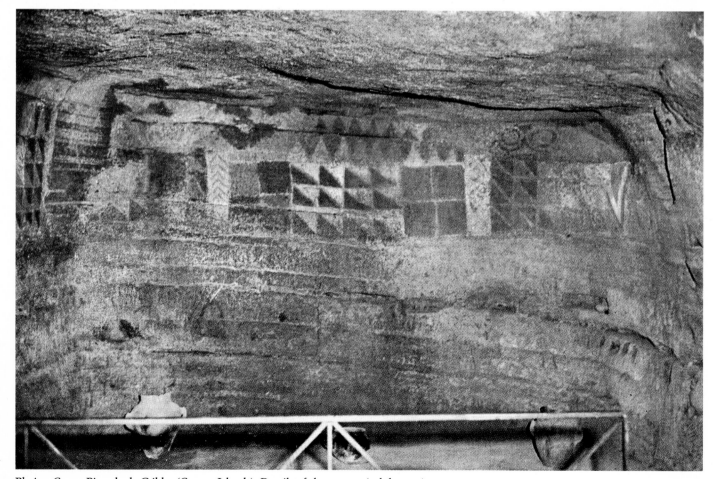

Pl. 4. – Cueva Pintada de Gáldar (Canary Islands). Details of the geometrical decoration.

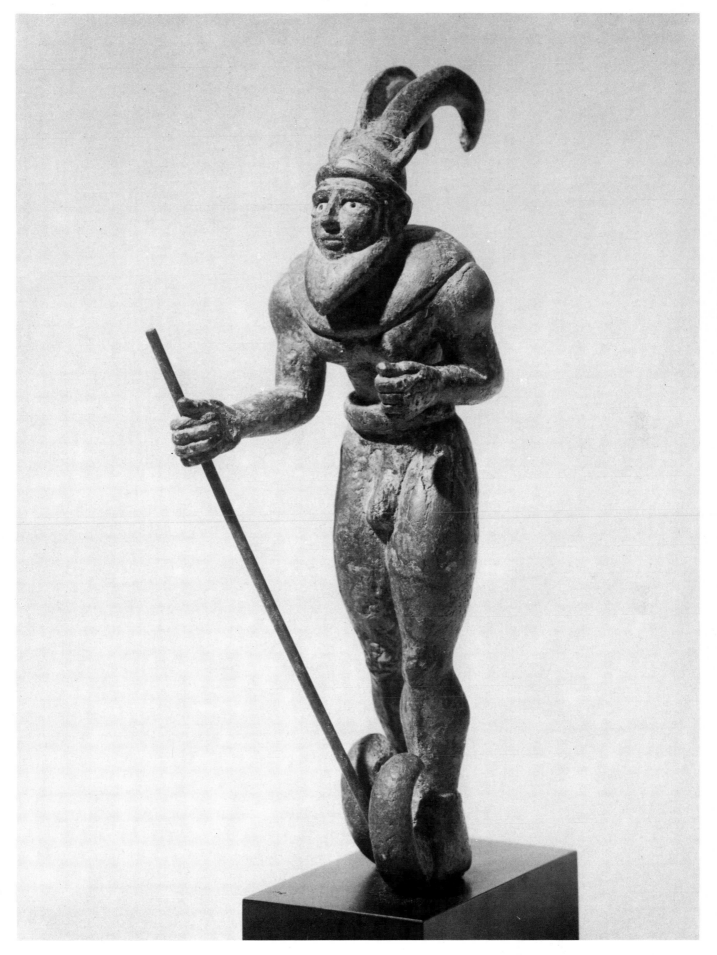

Pl. 5. –Male statuette, probably from Tellō. Copper (height 6 3/4 in.). Ca. 3000 B.C. New York, Brooklyn Museum, R. Martin Coll.

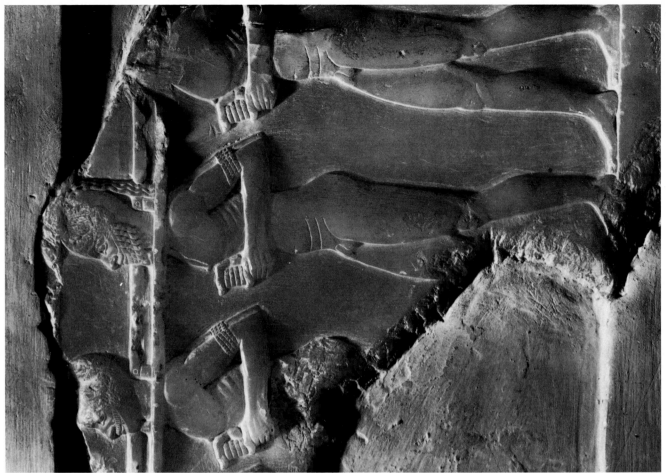

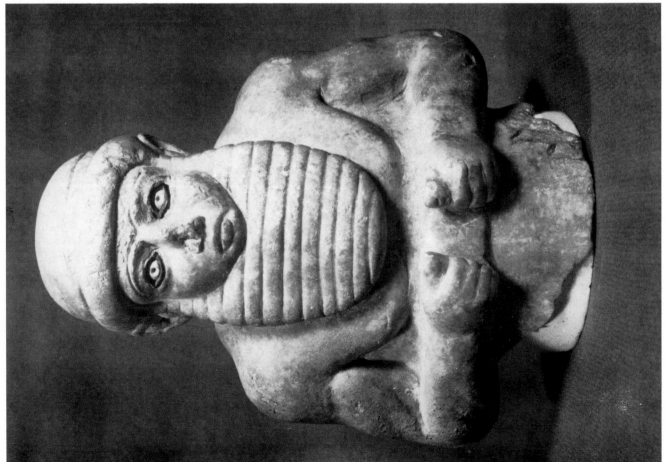

Pl. 6. – *Left*: Bust of prince, from Uruk. Alabaster (height 7 in.). Ca. 3000 B.C., Baghdad, Iraqi Museum. – *Right*: Fragment of stele with relief of prisoners, from near Nasiriyya (Iraq). Alabaster (height 8 1/4 in.). Ca. 2250 B.C. Baghdad, Iraqi Museum.

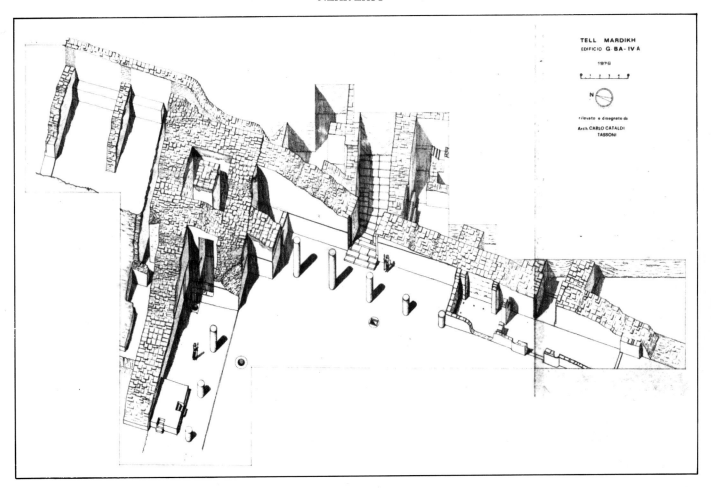

TELL MARDIKH
EDIFICIO G-BA-IV A

1976

N

rilevato e disegnato da
Arch. CARLO CATALDI
TASSONI

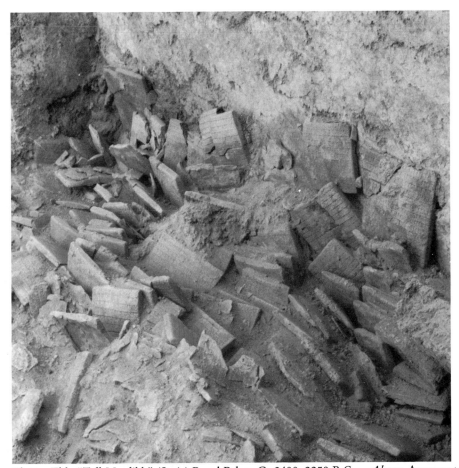

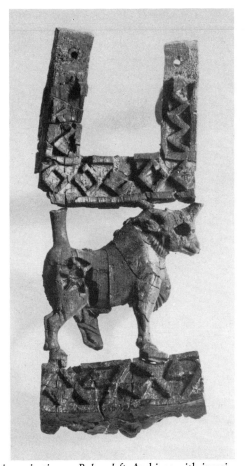

Pl. 7. – Ebla "Tell Mardikh" (Syria) Royal Palace G. 2400–2250 B.C.. – *Above*: Axonometric projection. – *Below left*: Archives with inscribed terracotta tablets. – *Right*: Fragment of a piece of furniture with a carving of a young bull. Wood.

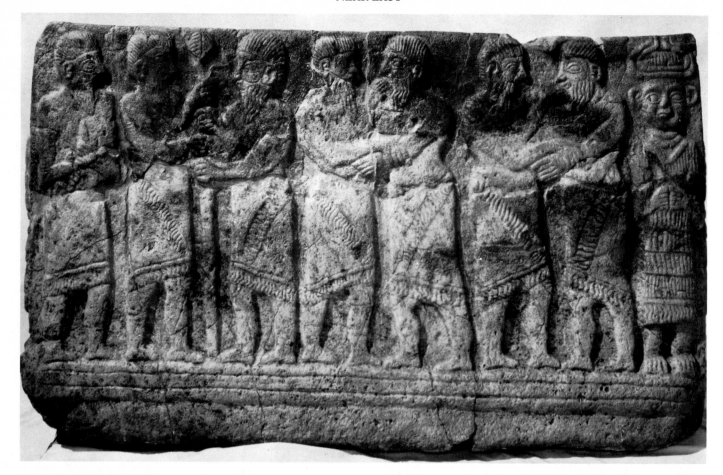

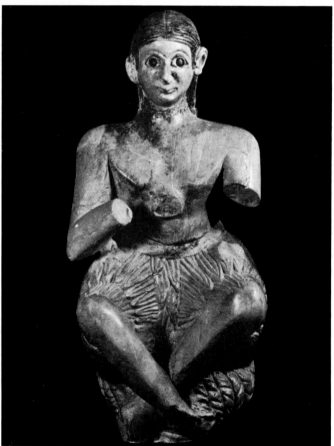

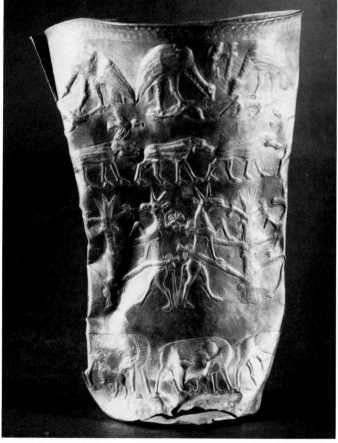

Pl. 8. – *Above*: Relief with ritual scenes on basin wall, from Ebla "Tell Mardikh". Limestone (height 29 1/2 in.). Ca. 1800 B.C. Aleppo, National Museum. – *Below left*: Female divinity from Ugarit (Rās Šhamra). Bronze (height 10 in.). Ca. 1650 B.C. Damascus, National Museum. – *Right*: Beaker embossed and engraved with scenes in the life of a caprid, from Marlik (Iran). Gold. Ca. 1100 B.C. Teheran, Bastan Museum.

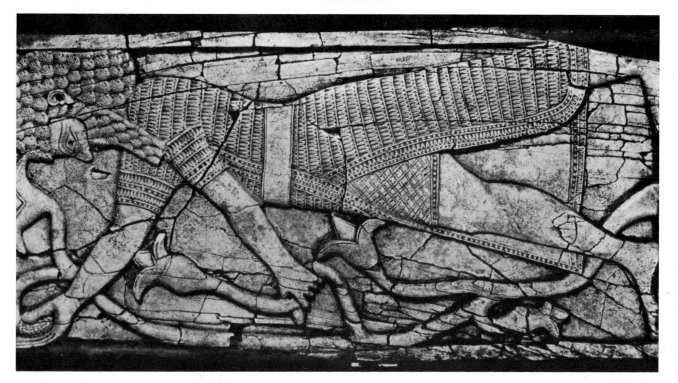

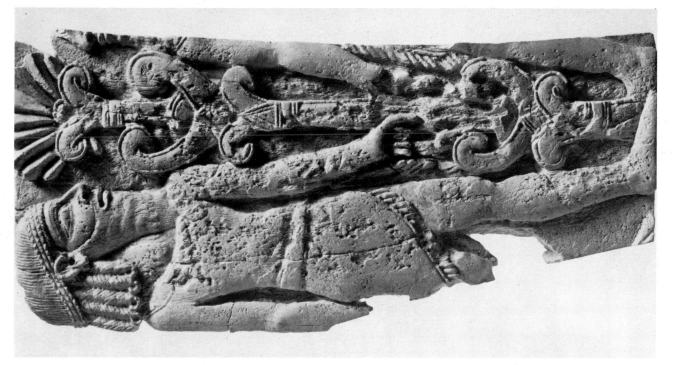

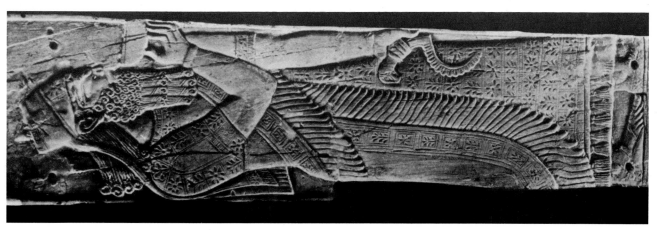

Pl. 9. – Reliefs on ivory plaques. – *From left to right*: Figure of King Assurnasirpal II, from Nimrūd. Height 10 1/2 in. Ca. 880 B.C. Baghdad, Iraqi Museum. – Figure beside a sacred plant (height 8 1/2 in.). Ca. 800 B.C. Karlsruhe, Badisches Landesmuseum. – Hero grasping a plant, from Nimrūd-Kalkhu, (height 10 in.). Ca. 725 B.C. Baghdad, Iraqi Museum.

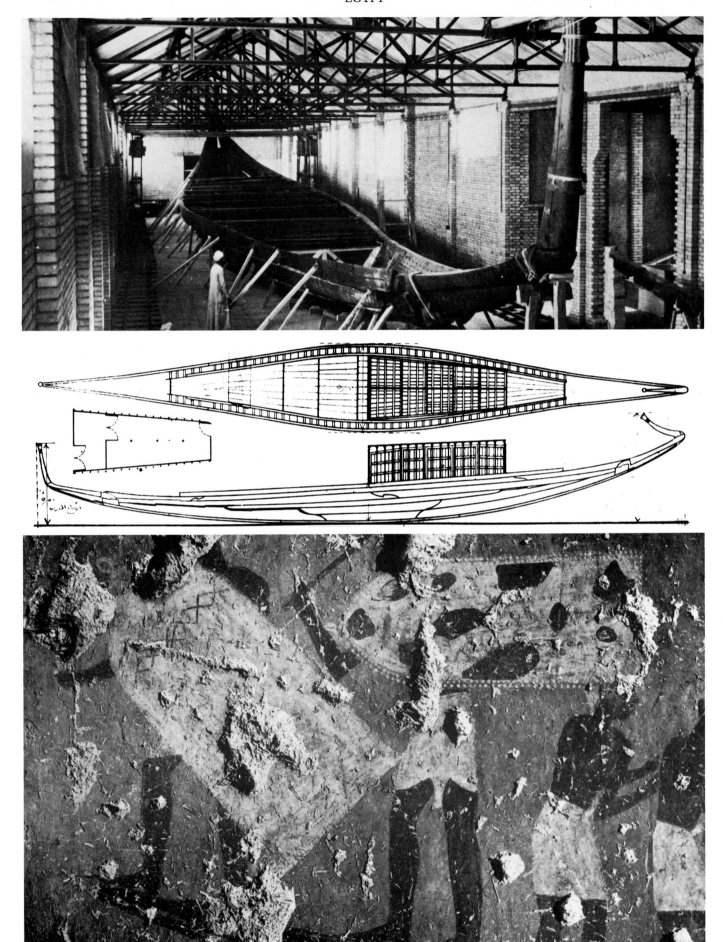

Pl. 10. – *Above and centre*: King Cheop's boat. Arrangement in the museum at the Great Pyramid of Ğīza, and a reconstructed drawing. IV Dynasty. – *Below*: Thebes. Detail of a funerary painting with figures of warriors. VI Dynasty.

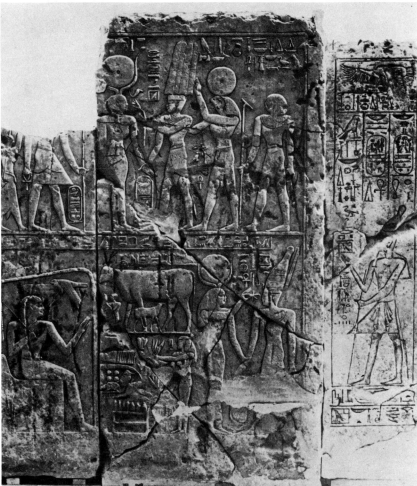

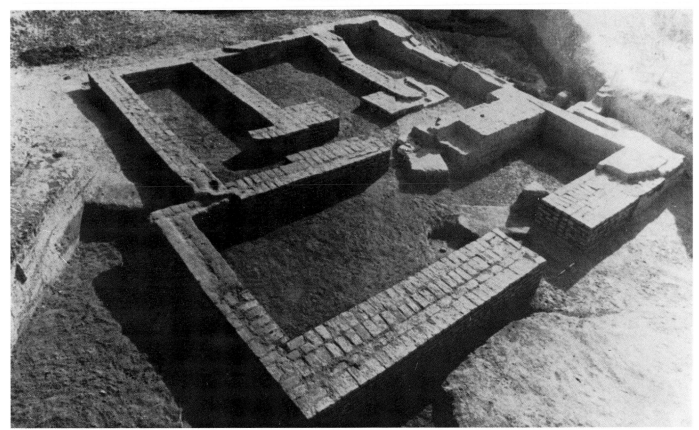

Pl. 11. –*Above left*: El–Tārif. Facade of the tomb of Anteph. XI Dynasty. – *Right*: Dendera. Reliefs of King Mentuḥopte. XI Dynasty. – *Below*: Qantir, the Temple of "Hyksos".

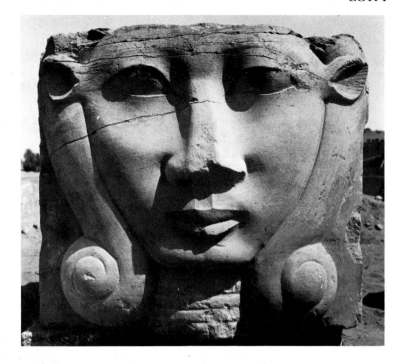

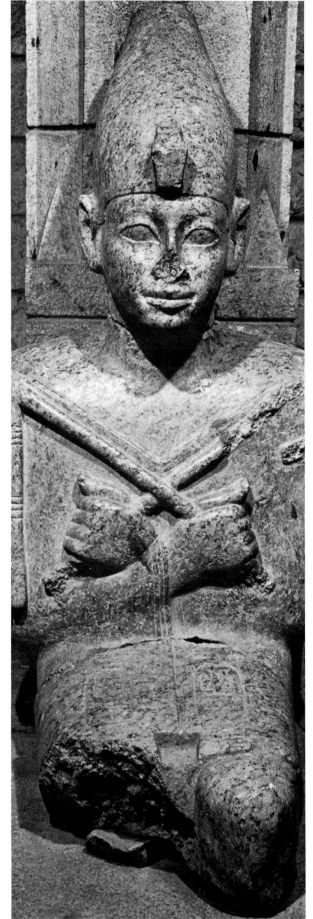

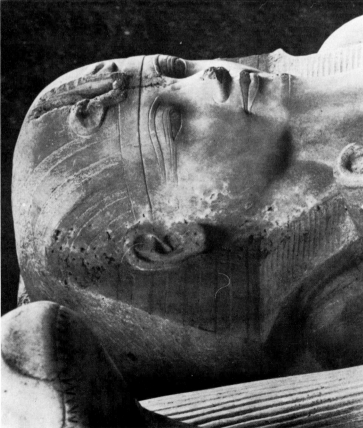

Pl. 12. – *Above left*: Elephantine, Temple of Satis. Hathoric capital. Time of Ḥašepsowe or of Tuthmosis III. Between 1500 and 1450 B.C. – *Below*: Detail from the Amenophis III group with the god Sobk, from Rizeiqat. Alabaster. Ca. 1400 B.C. – *Right*: Statue of Amenophis III, Elephantine.

Pl. 13 – *Above*: Reliefs of the Temple of Aton, Thebes. Time of Amenophis IV Eḫnaton. Ca. 1360–1350 B.C. Luxor, Museum. – *Below*: 'Aṣāṣif (Thebes). Tomb of Šošenq. IX century B.C.

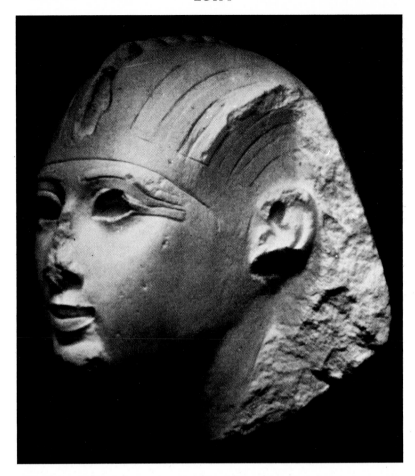

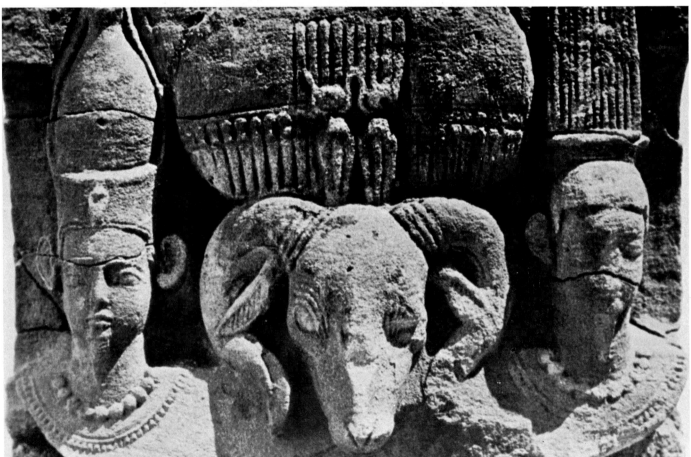

Pl. 14. –*Above*: Head of statue of Osorkon II. First half of the IX century B.C. Philadelphia, University of Pennsylvania, University Museum. (The body of the statue is in Cairo, Egyptian Museum). – *Below*: Detail of sculpture with Divine Triad, from the Temple of the Lion, Musawwarāt el-Ṣofra (Sudan). Meroitic art.

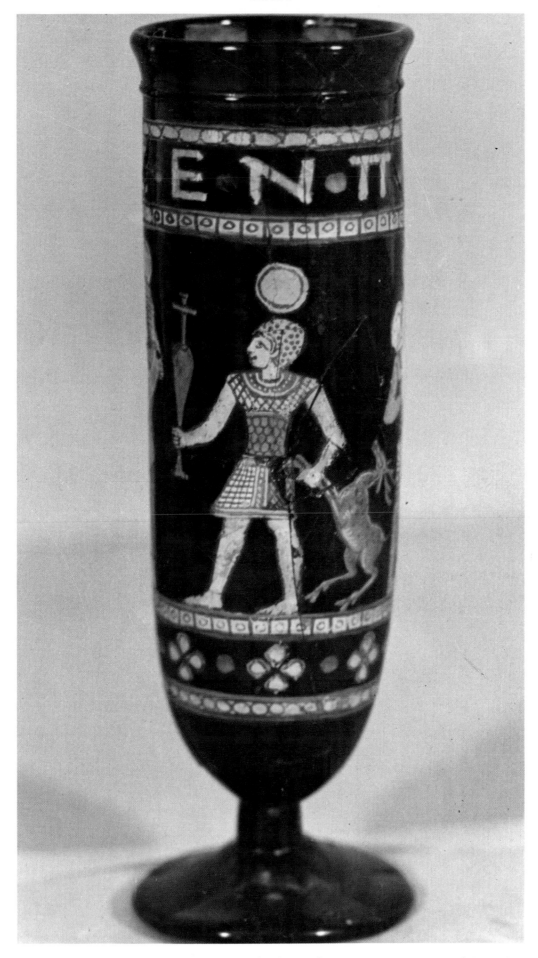

Pl. 15. – Goblet with figures from Sedeinga (Sudan). Glass painted with enamels. Meroitic art. Pisa, Istituto di Storia Antica dell'Università.

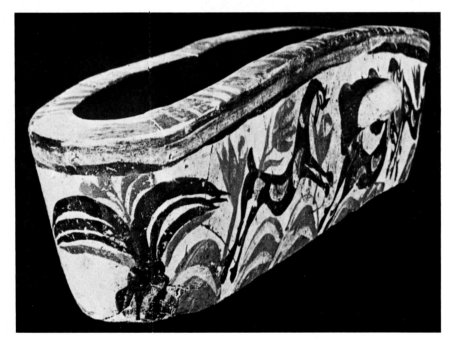

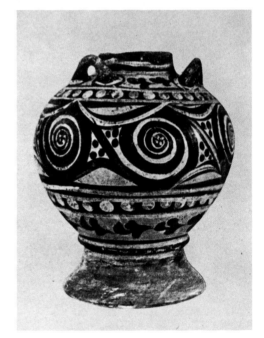

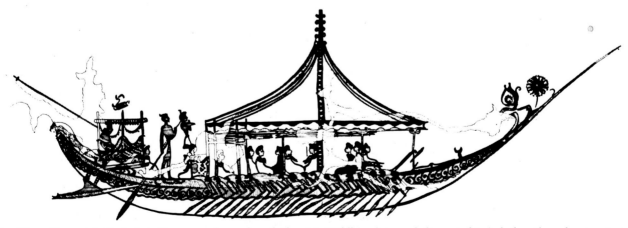

Pl. 16. – Thera (Santorini, Cyclades). Monumental complex of Akrotiri. Middle to late–cycladic period 1 A, before the volcanic catastrophe of ca. 1500 B.C. – *Above*: Plan and view of the excavations. – *Centre*: Polychrome vases. – *Below*: Ship from the painting in the Western House, room 5.

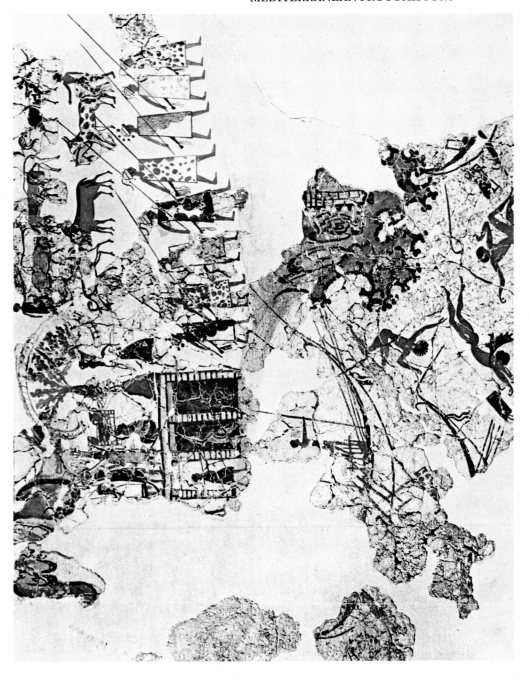

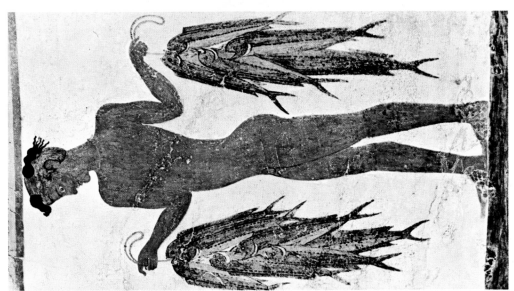

Pl. 17. – Paintings in the monumental complex of Akrotiri at Thera (Santorini, Cyclades). 1550–1500 B.C.. Western House, room 5. – *Left*: Fisherman. – *Right*: Detail from the miniaturistic frieze with battle scenes on the river bank.

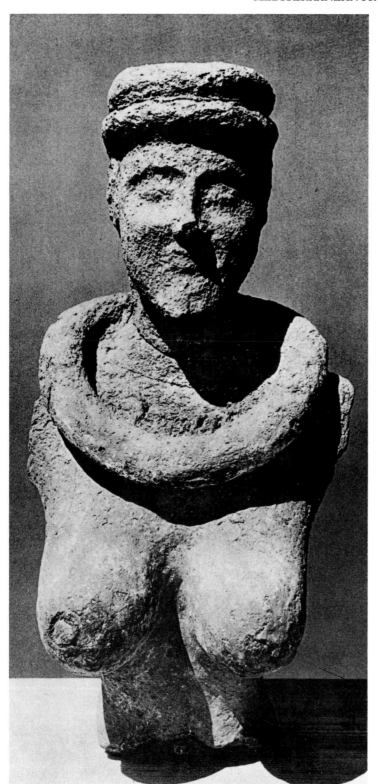

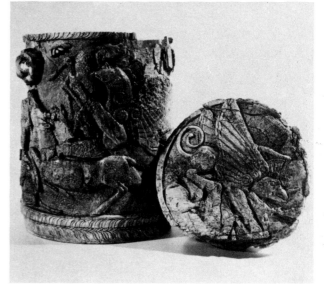

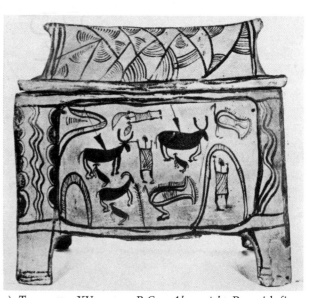

Pl. 18. – *Left*: Fragmentary statue of a female, from Hagia Irini (Keos, Cyclades). Terracotta. XV century B.C. – *Above right*: Pyx with figurative intagli, from the agora in Athens. Ivory. Mycenaean art. Late XV century B.C. Athens, Agora Museum. – *Centre*: Gem stone carved with a human profile, from the funerary circle B of Mycenae. Amethyst. Middle of the XVI century B.C. Athens, National Museum. – *Below*: Sarcophagus painted by Armenians (Rhethymnos, Crete). Late Minoan. Hanià, Museum.

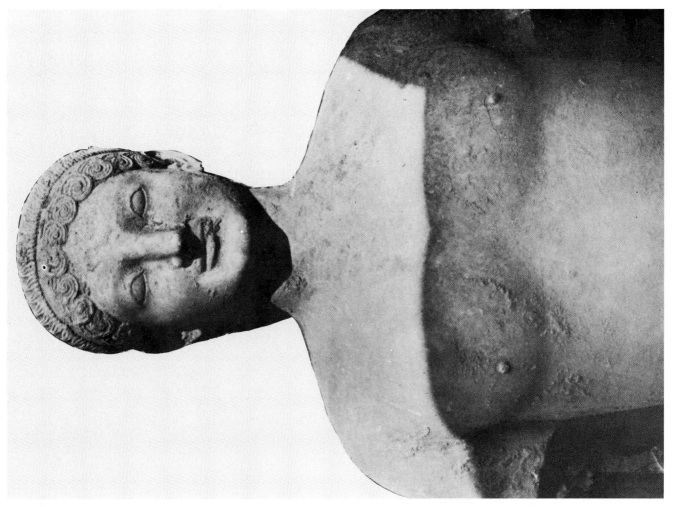

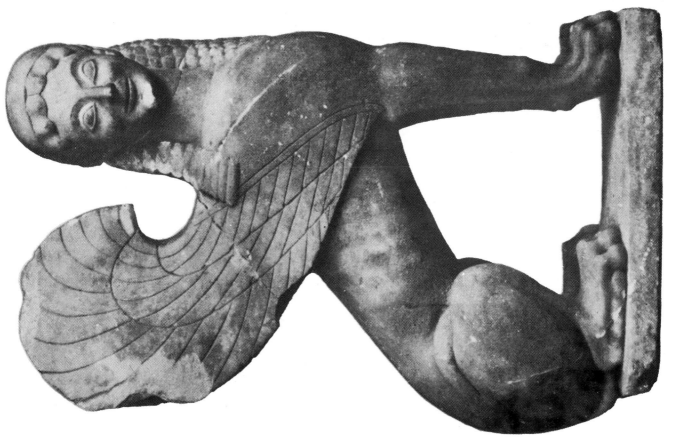

Pl. 19. – *Left*: Sphinx, Corinth. Marble. VI century B.C. Corinth, Museum. – *Right*: Kouros of Merenda (Attica). Detail. VI century B.C. Athens, National Museum.

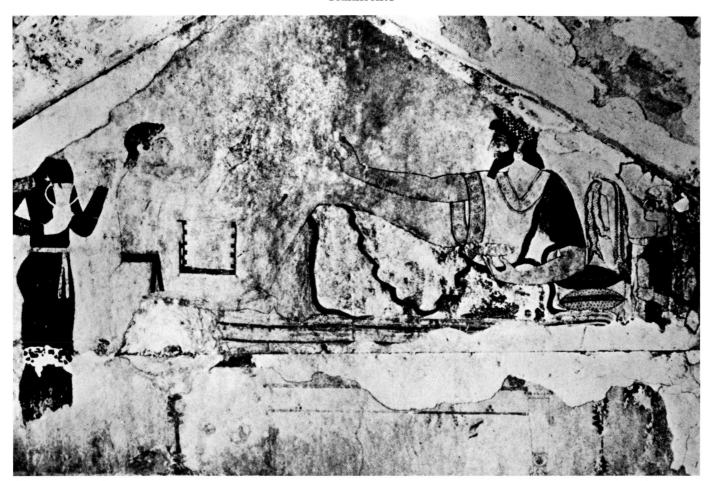

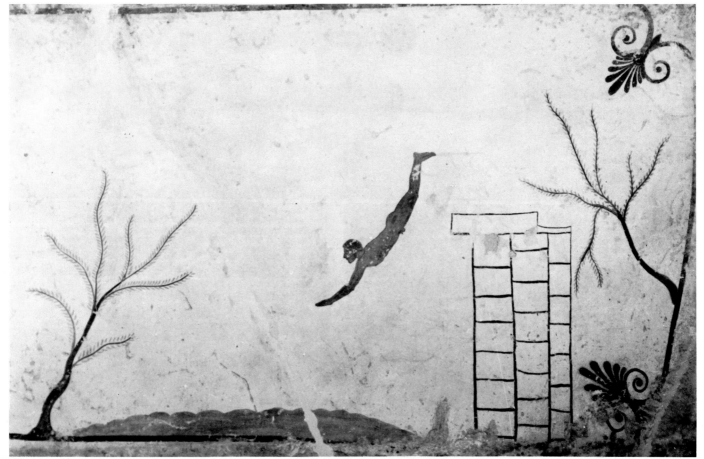

Pl. 20. –*Above*: Funerary painting with banquet scene, Elmali (Kizilbel, Lycia). Beginning of V century B.C. – *Below*: Detail of funerary painting in the Tomb of the Diver of Posidonia. Ca. 480 B.C. Paestum, Museo Nazionale.

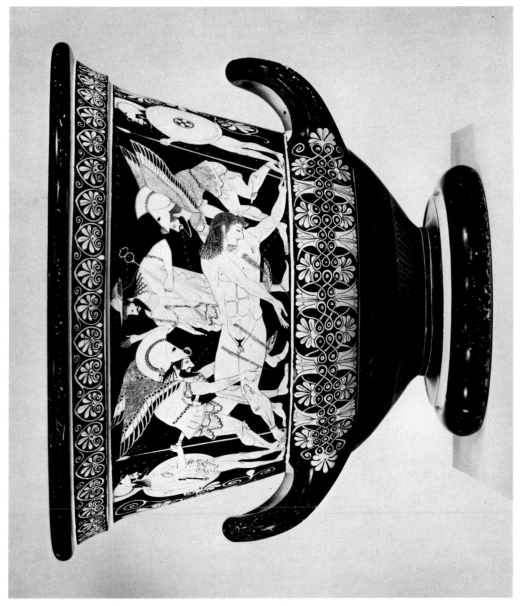

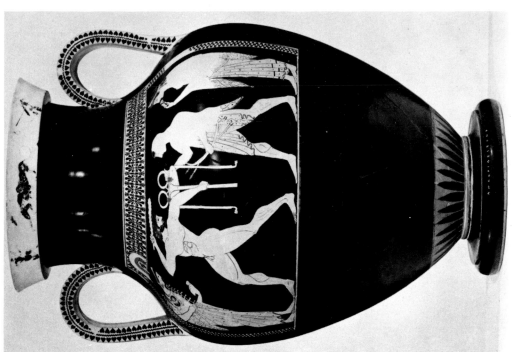

Pl. 21. – *Left*: Amphora by the painter of Andokydes. New York, Metropolitan Museum of Art. – *Right*: The Euphronios Krater. New York, Metropolitan Museum of Art.

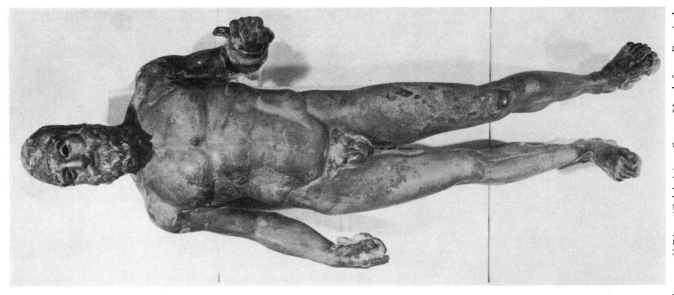

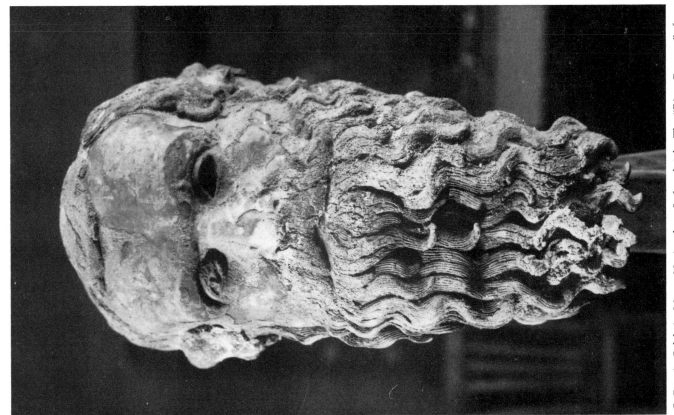

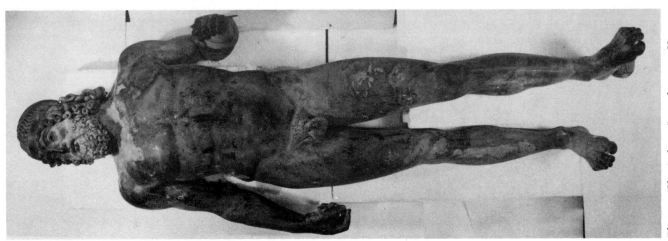

Pl. 22. – Classical art. Large bronzes. V century B.C. Reggio Calabria, Museo Nazionale. – *Left and right*: The "Riace Bronzes", from the sea off Riace (Calabria). – *Centre*: Head, from Ponticel-lo (Calabria).

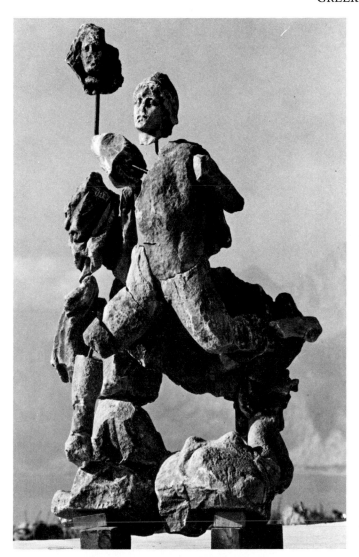

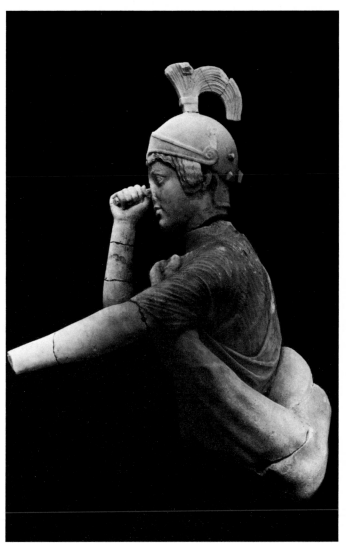

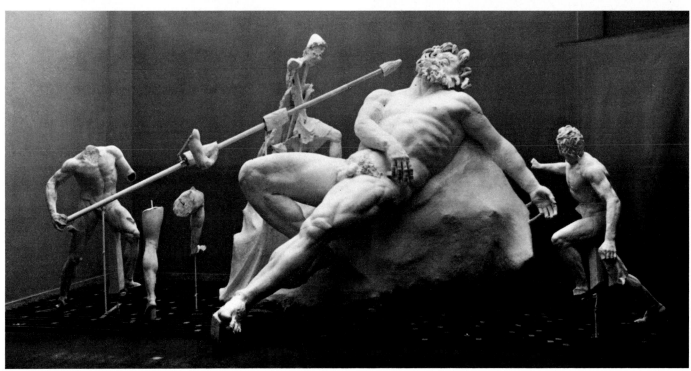

Pl. 23. –*Above left*: Acroterial group with Perseus, from a tomb in Lymira (Lycia). Marble. Hellenistic age. Antalya, Museum. – *Right*: Fragment of group of the Abduction of Palladium, from the Grotto of Tiberius, Sperlonga (South Latium). Marble, Hellenistic age. Sperlonga, Museum. – *Below*: Reconstruction of the group of the Blinding of Polyphemus. Sperlonga, Museum.

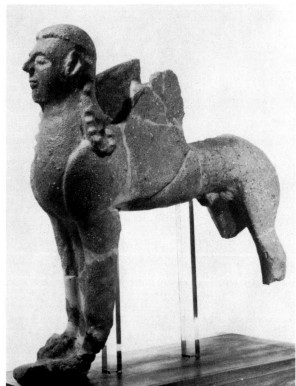

Pl. 24. – Terracottas from the decoration of the monumental Etruscan complex of Poggio Civitate near Murlo (Siena). VI century B.C. Siena, Museum. – *Left*: Acroterion with seated figure. – *Above right*: Head. – *Below*: Sphinx.

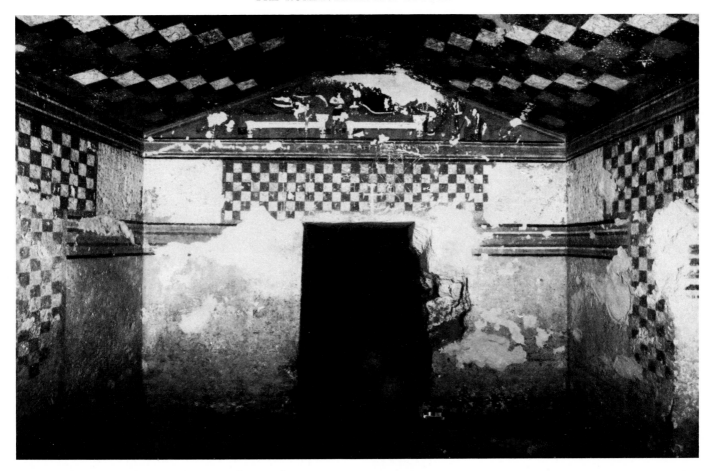

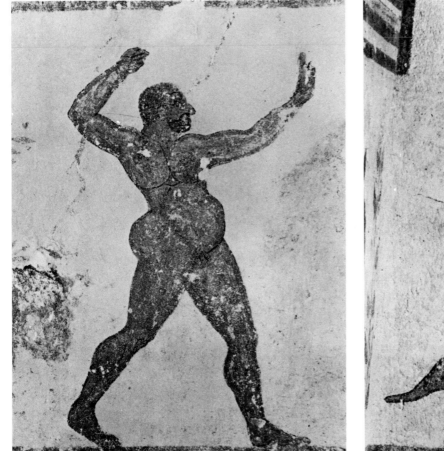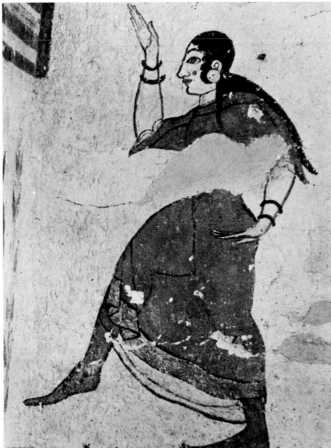

Pl. 25. –Tarquinia. Etruscan tomb painting. VI century B.C. – *Above*: Interior of the Bartoccini Tomb with geometrical decorations; banquet scene is in the pediment. – *Below left*: Wrestler, detail of the frieze of the Cardarelli Tomb. – *Right*: Dancer, detail from the frieze of the Tomb of the Jugglers.

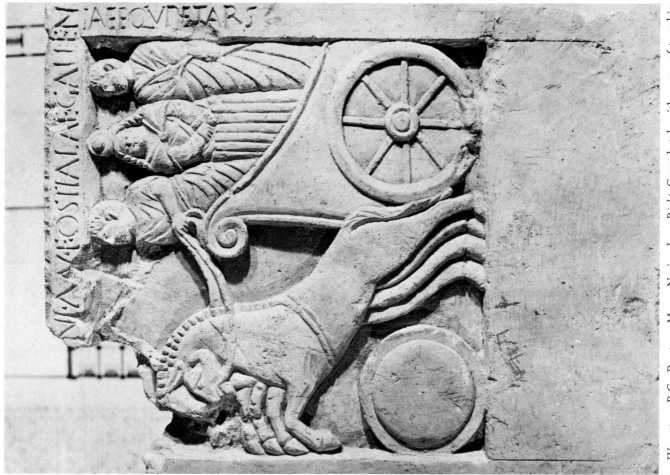

Pl. 26. – *Left:* Funerary painting with Italic warrior on horseback, from the necropolis in Paestum. IV century B.C., Paestum, Museo Nazionale. – *Right:* Carved stele with scenes of travel in the netherworld, from Padua. – Veneto–Roman art. I century B.C.. Padua, Musei Civici.

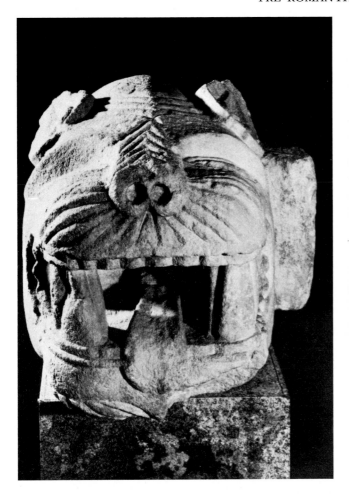

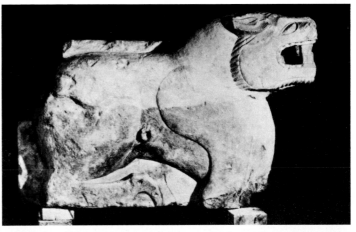

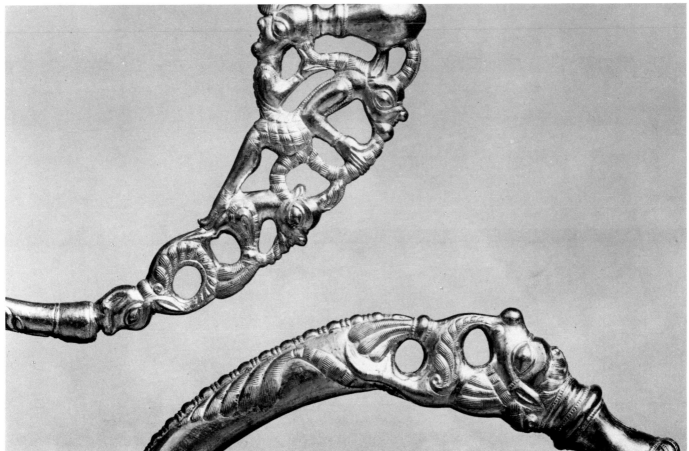

Pl. 27. –*Above*: Iberian sculptures from Pozo Moro (Albacete). VI century B.C. Madrid, Archaelogical Museum. – *Below*: Detail of Celtic torques, from the Erstfeld Treasure (Canton of Uri, Switzerland). Gold. Zürich, Schweizerisches Landesmuseum.

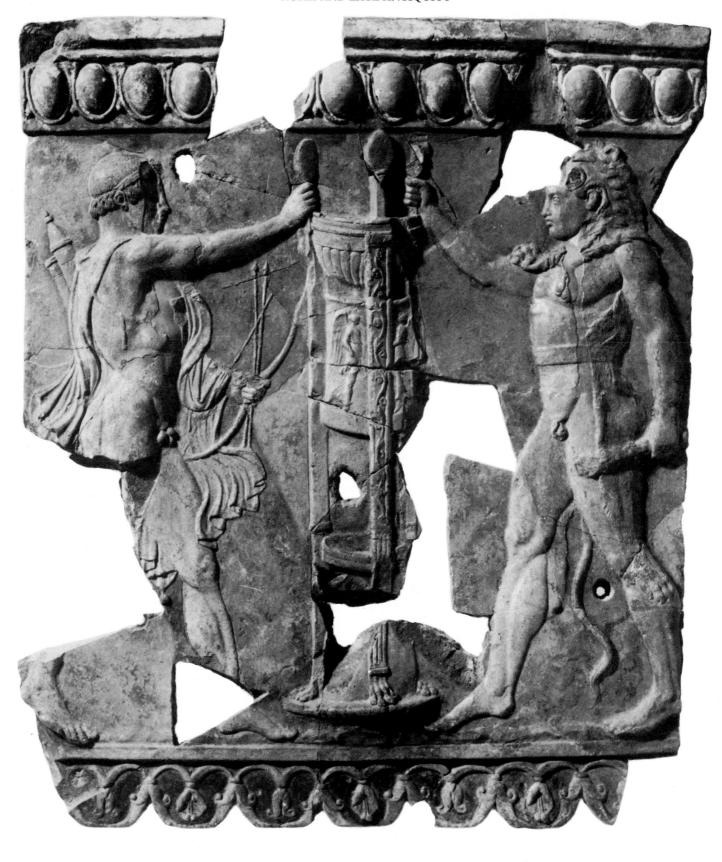

Pl. 28. –Architectural slab of the type known as "Campana", depicting the struggle between Apollo and Hercules for the Tripod of Delphi, Rome. Forum. Terracotta. Augustan Age. Rome, Antiquarium del Palatino.

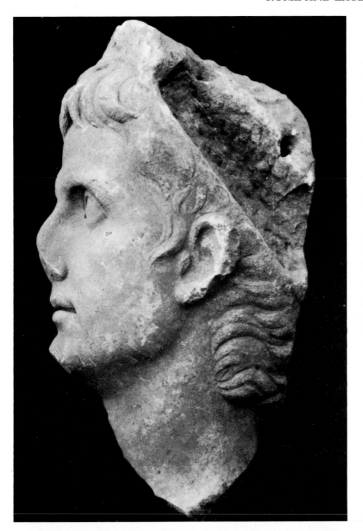

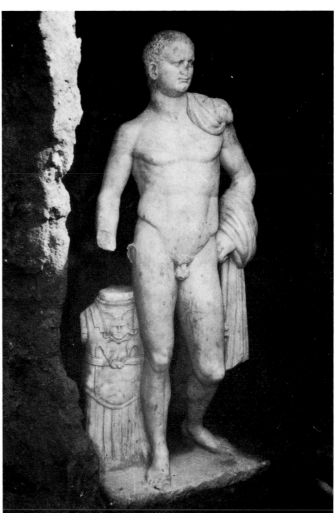

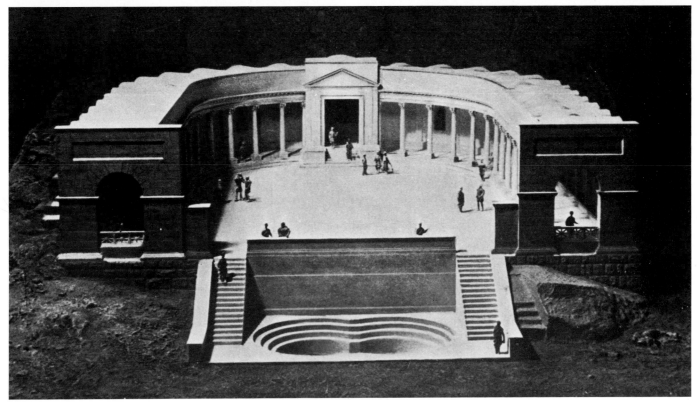

Pl. 29. – *Above left*: Fragment of relief with the portrait of Augustus, from Luni (Liguria). Marble. Luni, Museo Nazionale. – *Right*: Statue of the Emperor Titus, from the Augustali Sacellum of Miseno (Campania). Marble. Depository of the Castle of Baia. – *Below*: Reconstructed view of the Sanctuary of the Waters in Zàgwān (Tunisia). II century.

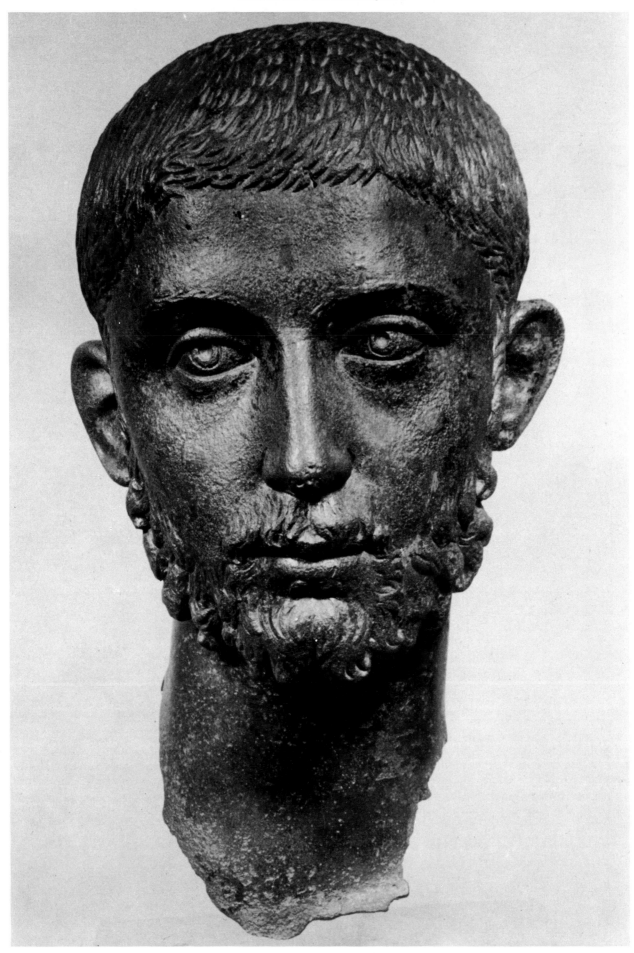

Pl. 30. –Portrait of Alexander Severus, from Salonika. Bronze. Salonika, Museum.

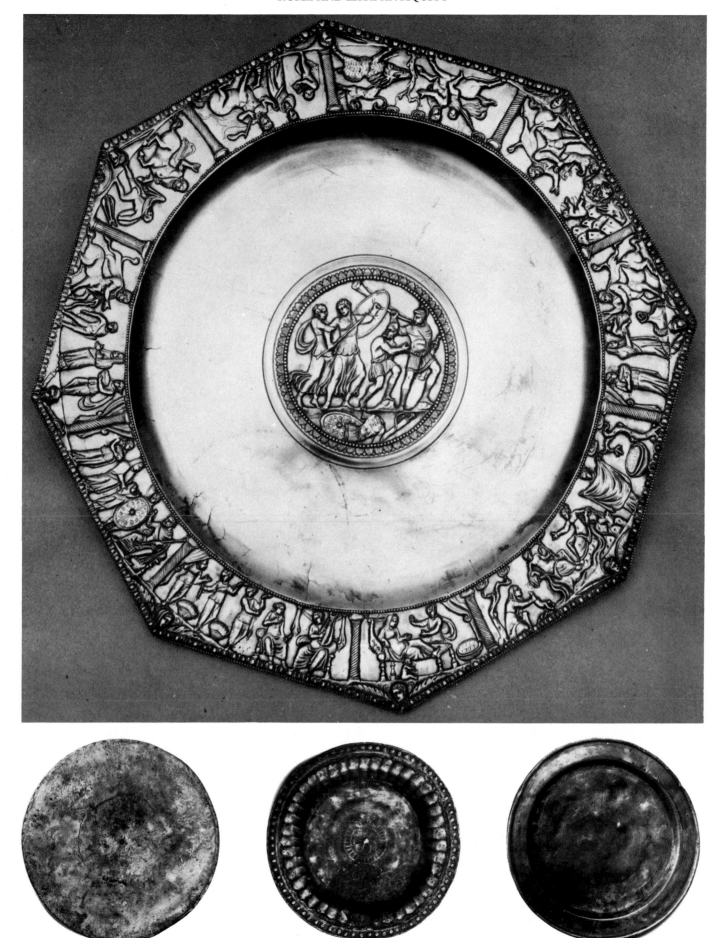

Pl. 31. – *Above*: Plate with embossed mythological figuration, from the Treasure of Augusta Raurica (Kaiseraugust, Switzerland). Silver. IV century. Augst, Römer Museum. – *Below*: Plates, from Appleford (Oxfordshire). Pewter. IV century. Oxford, Ashmolean Museum.

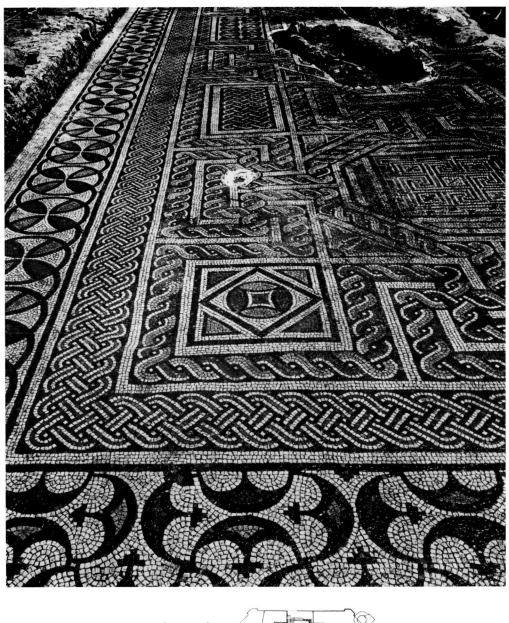

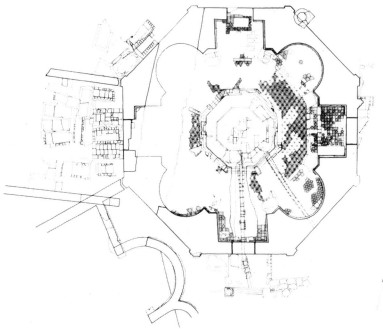

Pl. 32. – *Above*: Montmaurin (Haute Garonne), De la Hillère Sanctuary. Detail of mosaic floor. IV century. – *Below*: Milan, Plan of the Baptistery under Piazza del Duomo. IV century.

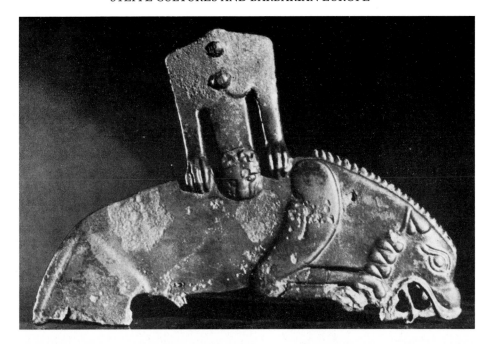

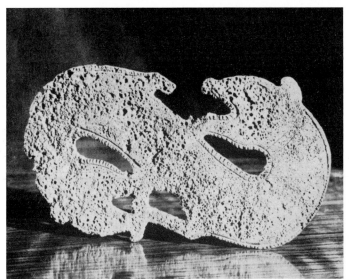

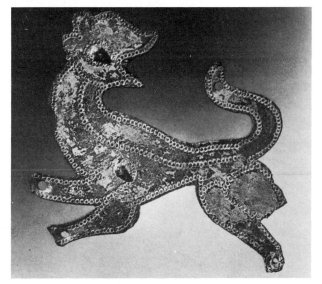

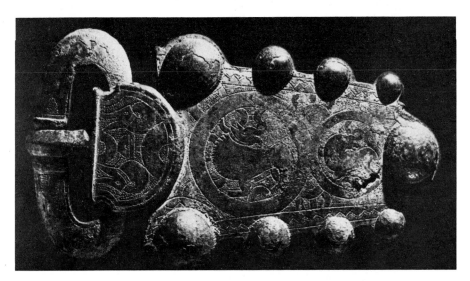

Pl. 33. – *Above*: Ornamental plaque for a bridle in the shape of a lion attacked by another carnivore, from Tumulus IV of the Seven Brothers (Region of Krasnodar–Kuban). Bronze (length 7 1/2 in.) Scythian art, Leningrad, Hermitage Museum. – *Centre and left*: Plaque in the shape of a two–headed animal, from Tumulus IV of the Seven Brothers (Region of Krasnodar–Kuban). Bronze (height 4 in.). Scythian art. Leningrad, Hermitage Museum. – *Right*: Helmet badge with feline figure. Bronze. Merovingian art. Bern, Historisches Landesmuseum. Bronze. Art of Merovingia–Aquitania. VII century. Troyes, Musée des Beaux–Arts.

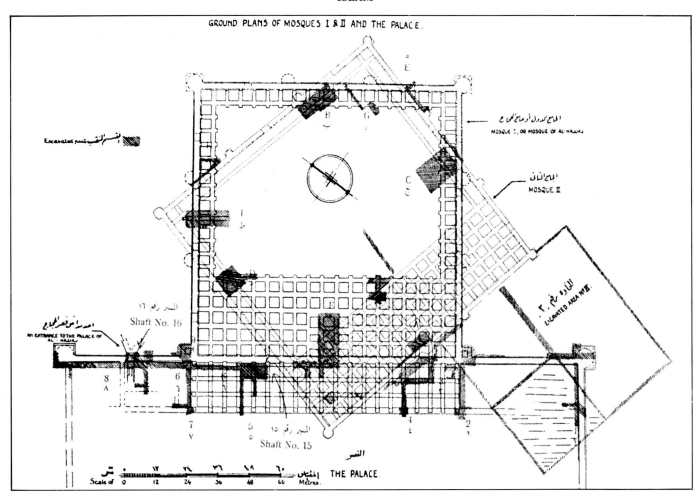

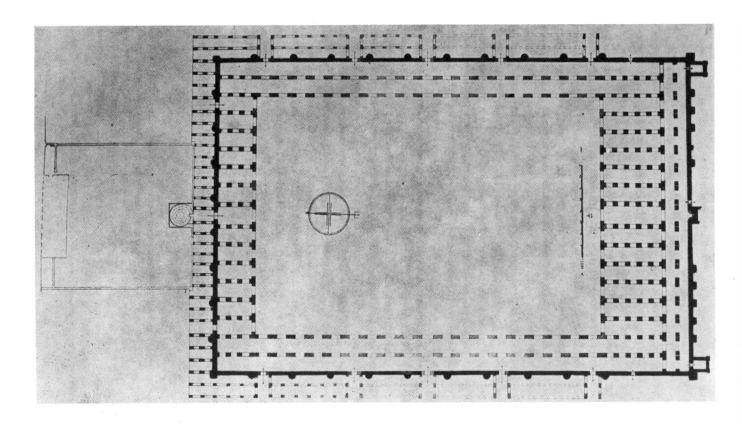

Pl. 34. – Plan of the Wāsiṭ Mosque (Mesopotamia). VIII–IX century. – *Below*: Plan of the Abū Dulaf Mosque (Mesopotamia). IX century.

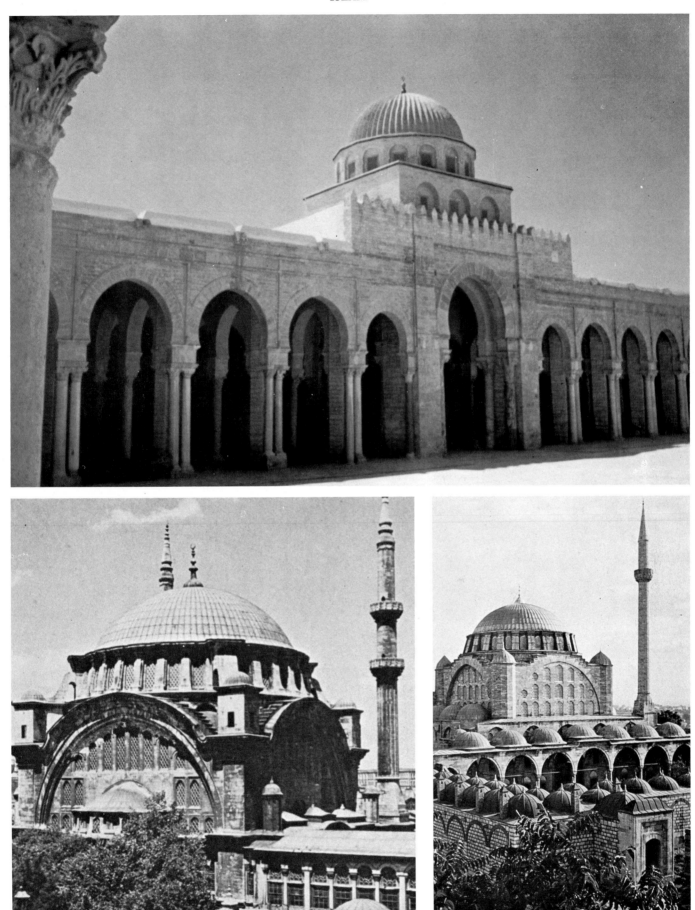

Pl. 35. – *Above*: Qairawān Mosque (Tunisia). IX century. – *Below left*: Nūr–u 'Osmāniye Mosque, Istanbul. XVIII century. – *Right*: Mihr–u–Māh Mosque, Istanbul. XVI century.

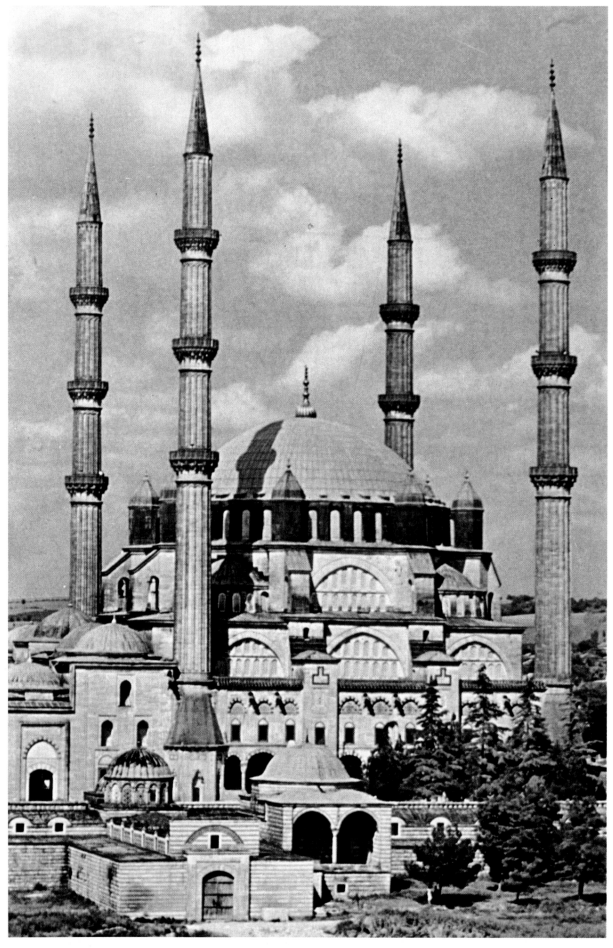

Pl. 36. – Selīmiye Mosque, Edirne (Jordan). XVI century.

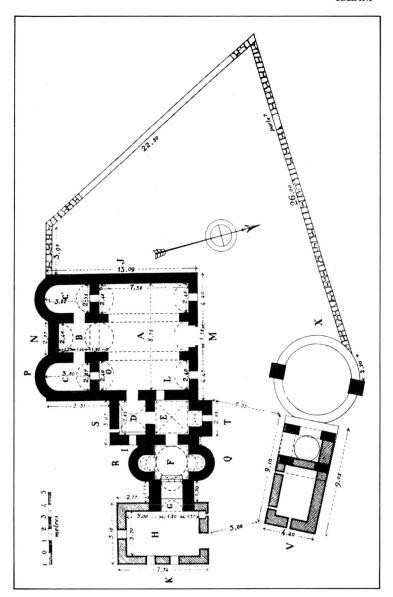

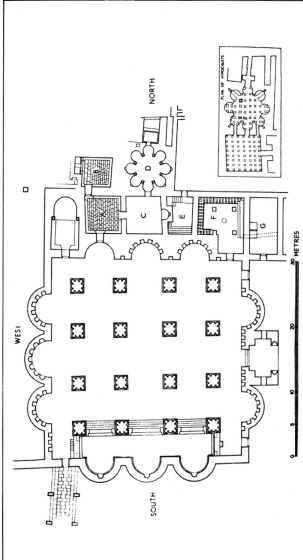

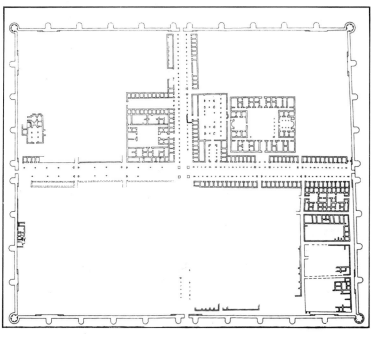

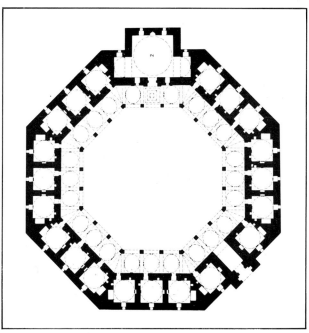

Pl. 37. – Plans of buildings. – *Above left*: Baths at Quṣayr 'Amra (Jordan). VIII century. – *Right*: Khirbet al–Mafǧar Baths (Jordan) VIII century. – *Below left*: Angar (Lebanon), VIII century. – *Right*: Madrasa Kapiaga. Amasya (Turkey) XV century.

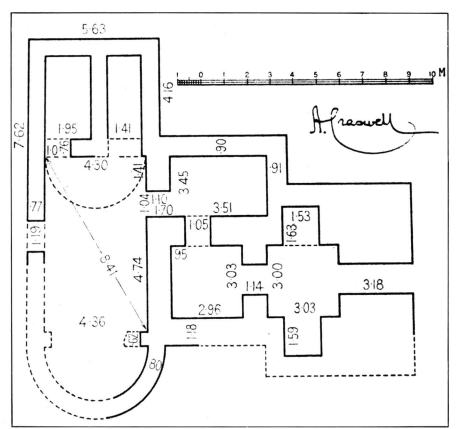

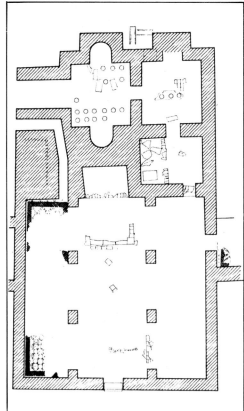

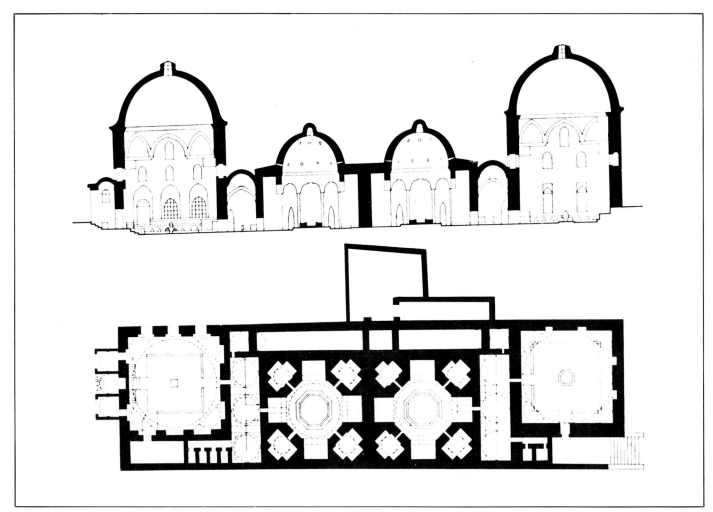

Pl. 38. –*Above left*: Gebel Seis Baths (Syria). Plan. VIII century. – *Below*: Haseki Hurrem Baths (Istanbul). Section and plan. XVI century. – *Above right*: Anğar Baths (Lebanon) Plan. VIII century.

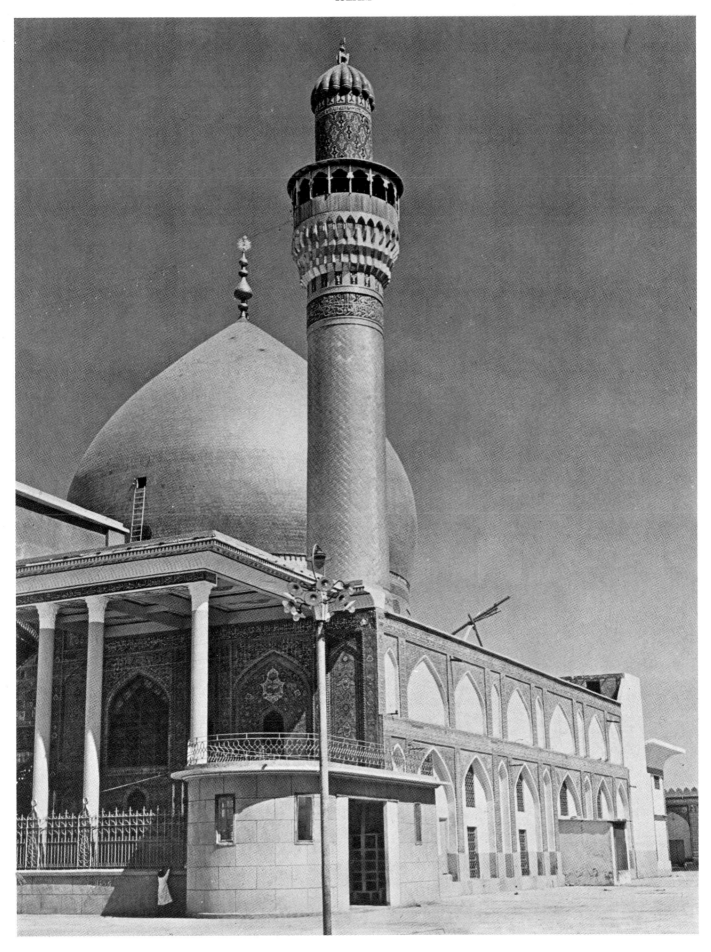

Pl. 39. – Sanctuary of al–Kāẓimayni (Persia). XVI century.

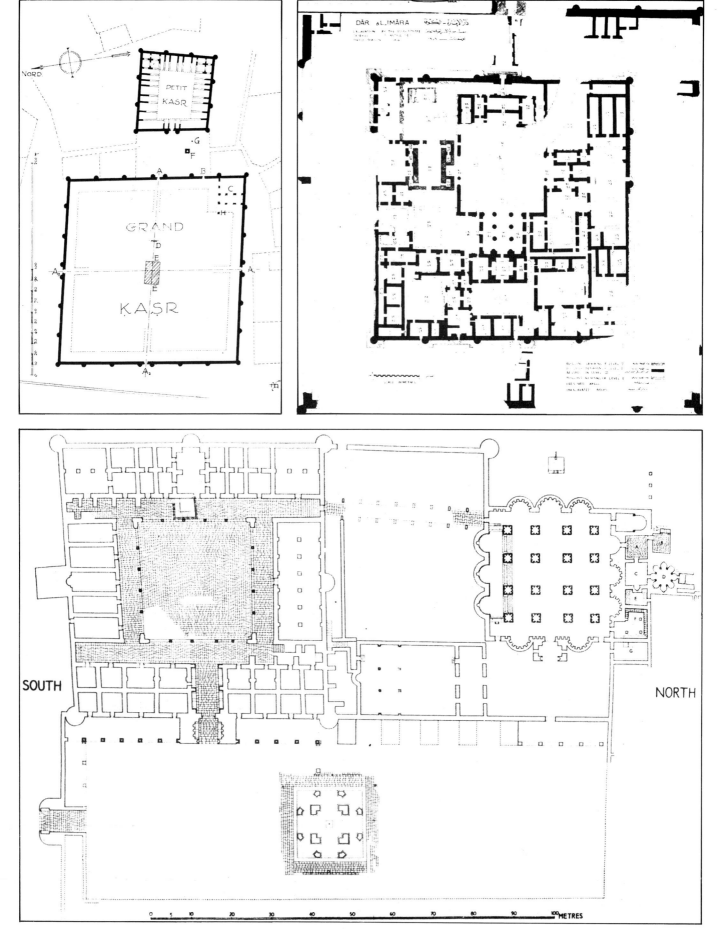

Pl. 40. –Plans of buildings. – *Above left*: Qaṣr al-Ḥayr al-Šharqī (Syria). VIII–X century. – *Right*: Dār al-imārah of al-Kūfa (Iraq). VIII–X century. – *Below*: Khirbet al-Mafğar complex (Jordan). VIII Century.

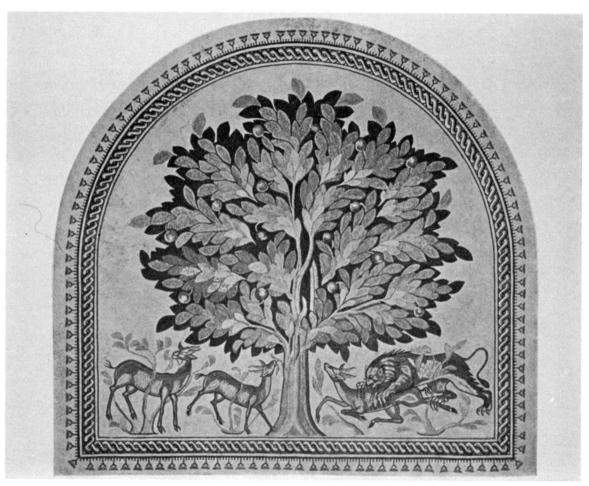

Pl. 41. – *Above*: Beylerbey Palace (Turkey). Interior. XIX century. – *Below*: Mosaic of the dīwān of Khirbet al–Mafğar (Jordan). VIII century.

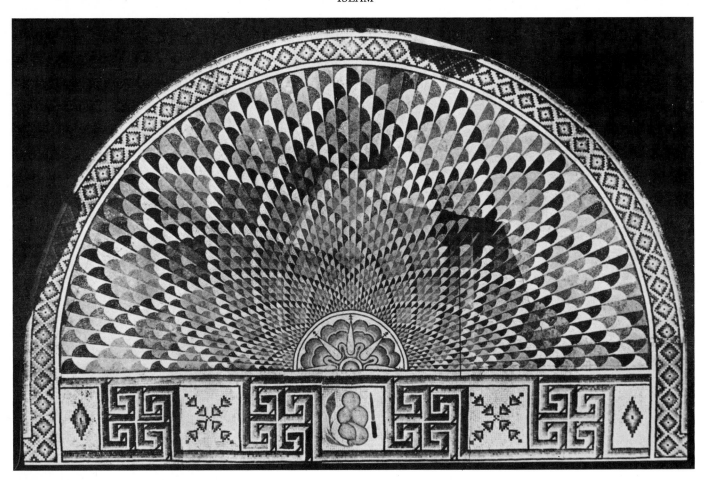

Pl. 42. –*Above*: Mosaic from the Hall of the Baths at Khirbet al–Mafğar (Jordan). VIII Century. – *Below left*: Female figure. Marble. Khirbet al–Mafğar. VIII century. – *Right*: Hellenistic sculptures. Qaṣr al–Ḥayr al–Ġarbī (Syria).

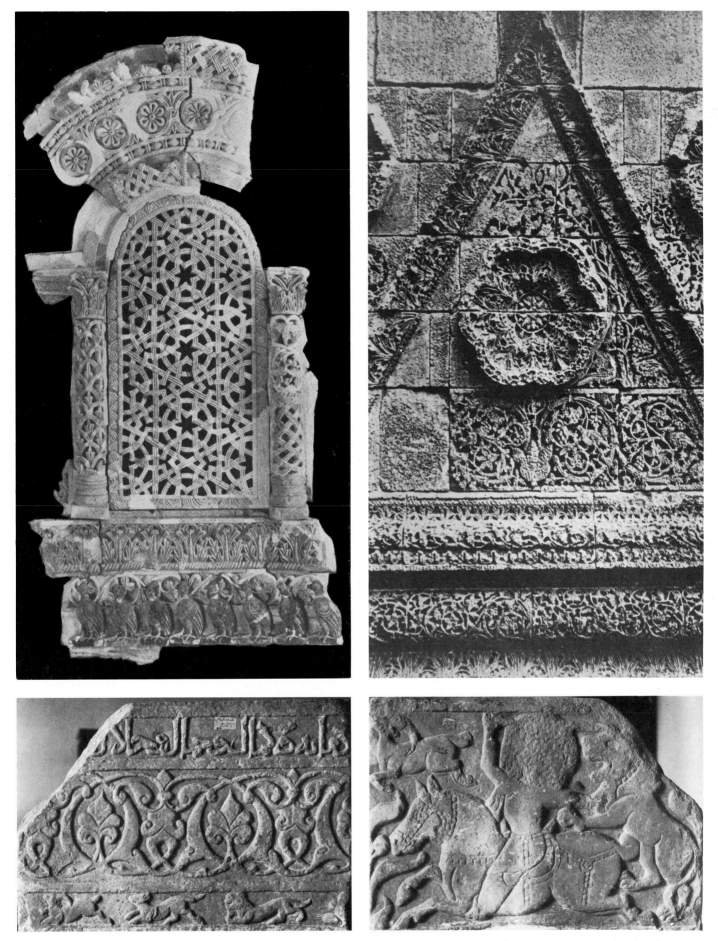

Pl. 43. – Architectural decoration. – *Above left*: Window. Khirbet al–Mafğar (Jordan). VIII century. – *Right*: Decorative detail with rosette inscribed in a triangle. Msattà Castle. VIII century. – *Below*: Details of screens, from Kabul. XI–XII century.

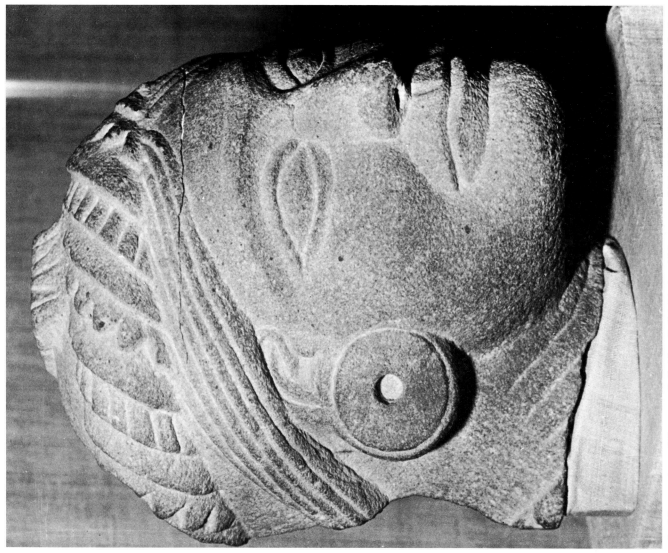

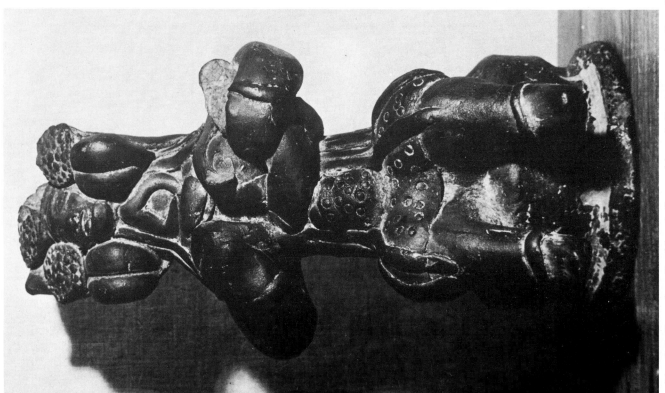

Pl. 44. – *Left*: Strongly stylized female figure with symbolic elements. Attributed to the Maurya phase. III century B.C. New Delhi, National Museum. – *Right*: Man's head, from Sarnath. Stone. Attributed to the late Maurya phase, and also to the I century A.D. New Delhi, National Museum.

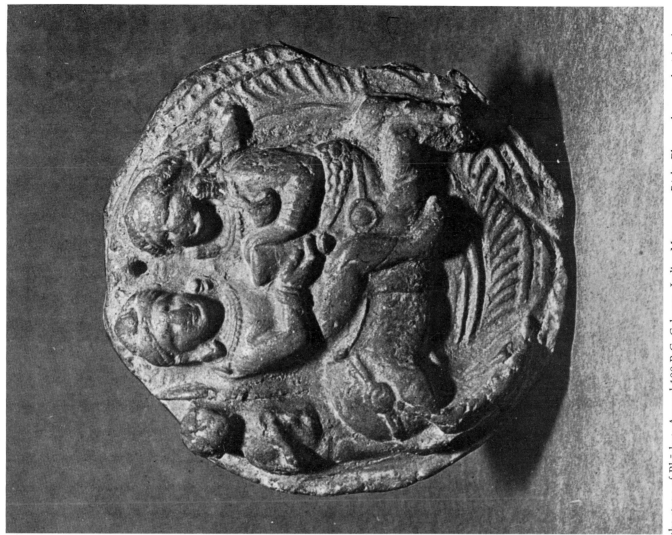

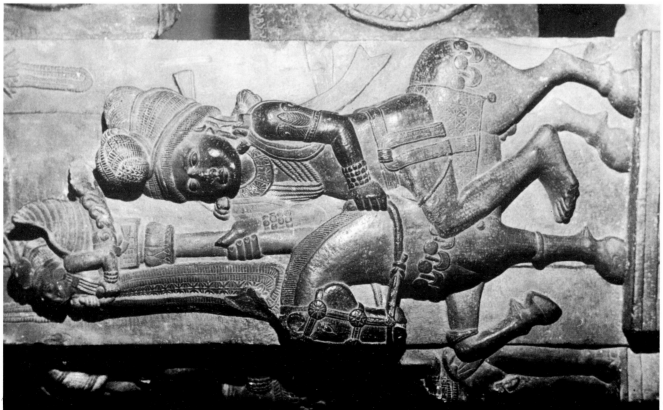

Pl. 45. – *Left*: Figure of King on horseback with banners. Decoration on a pilaster of the stupa of Bhārhut. Around 100 B.C. Calcutta, Indian Museum. – *Right*: Plaque decorated with a horse-man, a female centaur and a putto. Terracotta. End I century B.C. – beginning I century A.D. Rome, Museo Nazionale d'Arte Orientale.

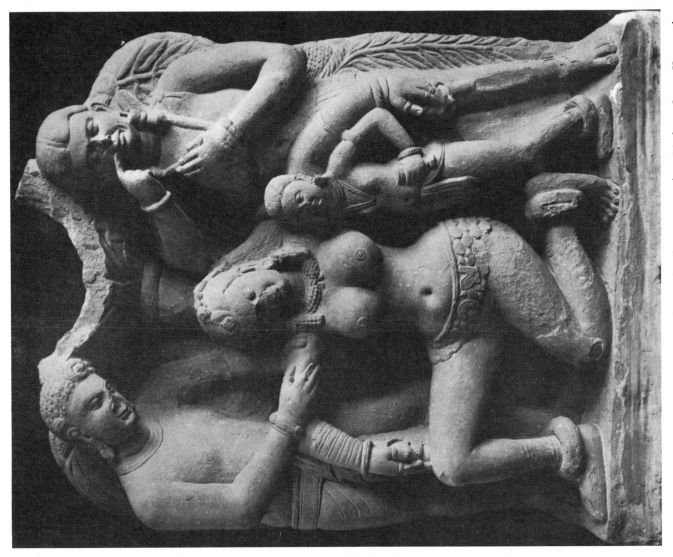

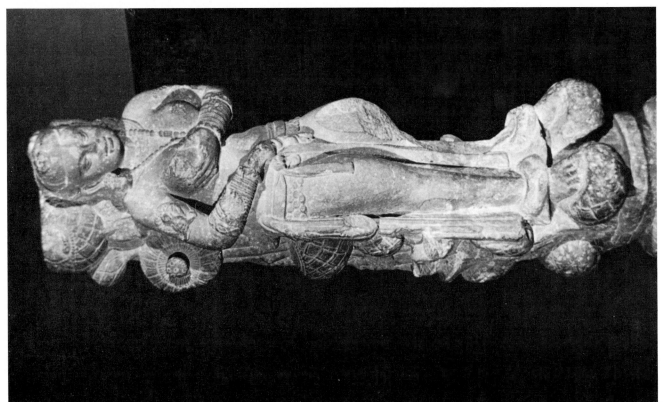

Pl. 46. – *Left*: Female figure (probably Srī Laksmī), Mathurā, Kuṣāna phase. II century A.D. New Delhi, National Museum. – *Right*: Panel with erotic scene from Mathurā. Stone. Kuṣāna phase. II century A.D. New Delhi, National Museum.

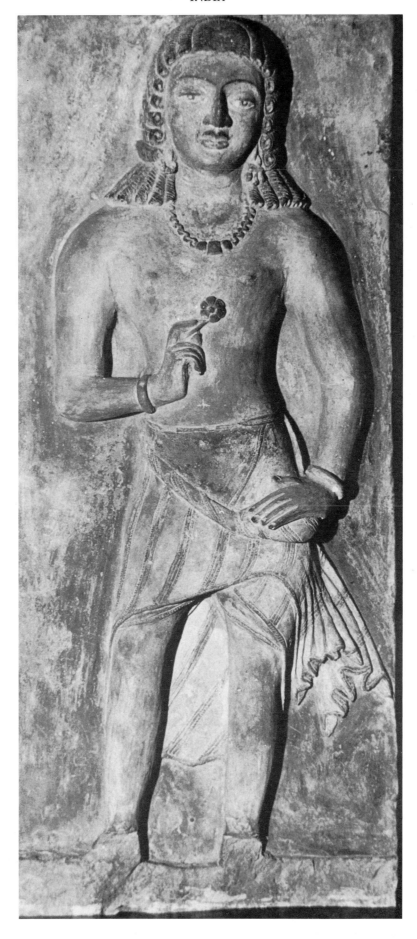

Pl. 47. –Panel with figure carrying a flower, Mirpukhas (Sind). Terracotta. Gupta art. V century A.D. Bombay, Prince of Wales Museum of
Western India.

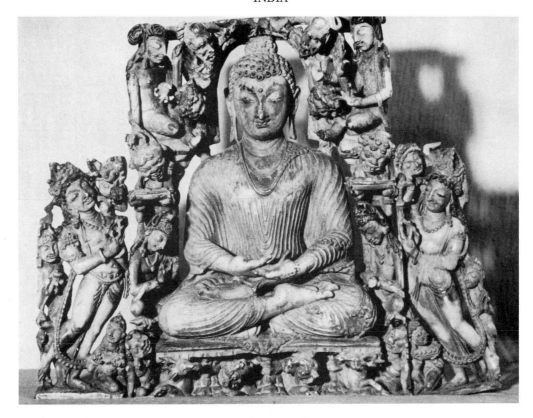

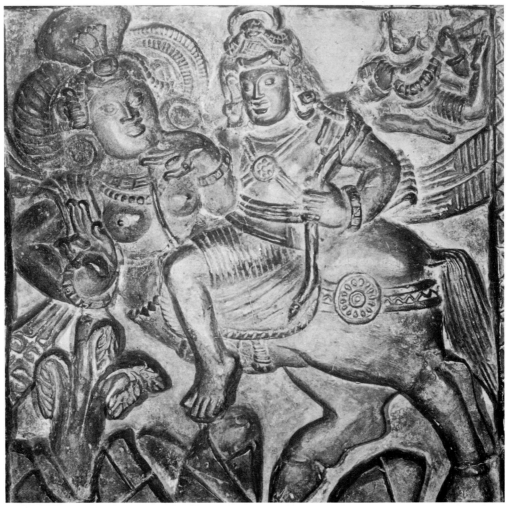

Pl. 48. – *Above*: Panel showing the Māra tempting the Buddha. Kashmir. Ivory. V century A.D. – *Below*: Panel with a female centaur carrying a man (The love between Vikrama and Urvaṣī?), Siva Temple, Ahichhatra. Terracotta. Gupta phase. V century A.D. New Delhi, National Museum.

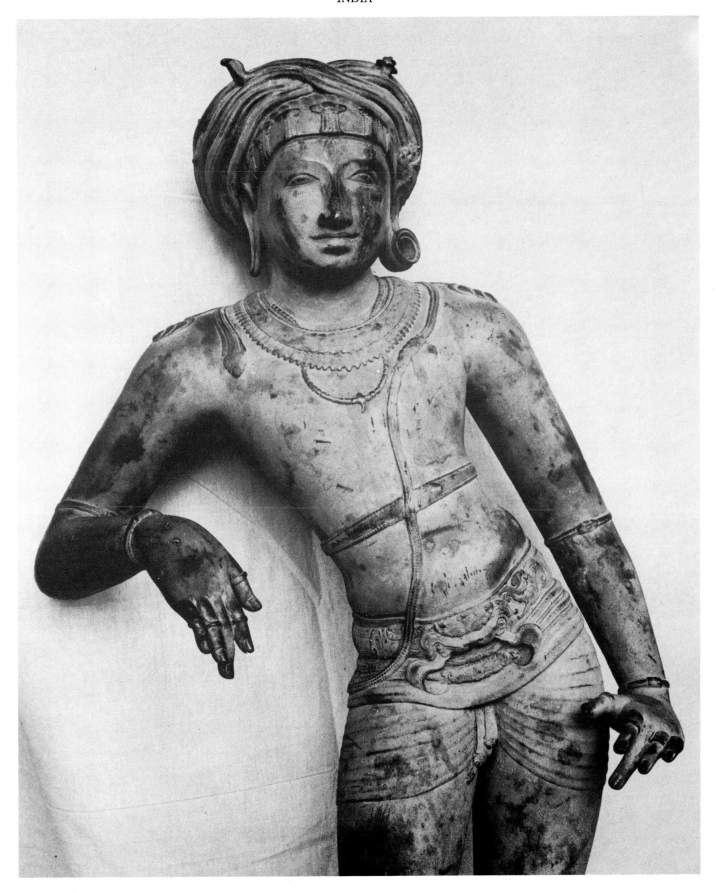

Pl. 49. –Statue of Vriṣabhavahanamurti. Bronze. First Cōḷa period. Dated 1011 A.D. Tanjore, Art Gallery.

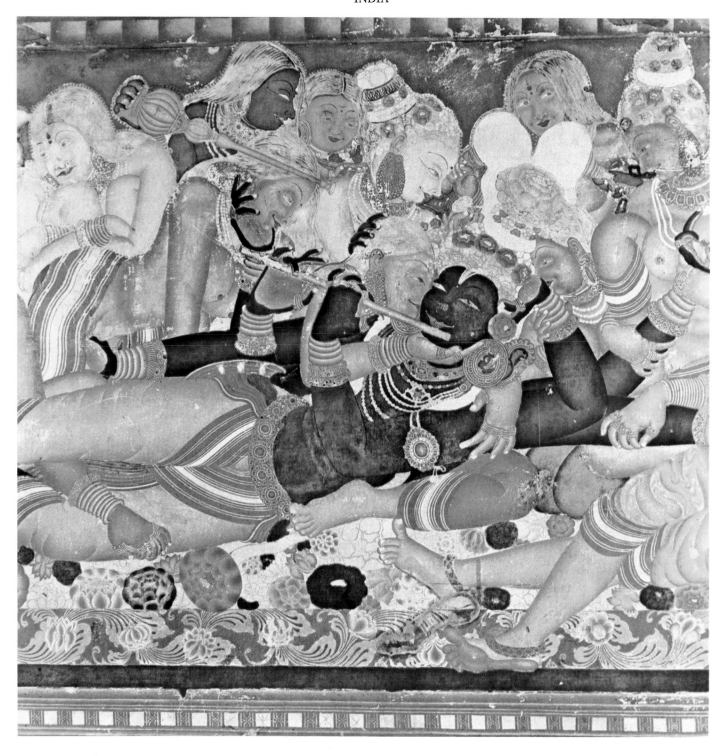

Pl. 50. –Kṛṣṇa playng the flute surrounded by shepherdesses (gopinī), from the Maṭṭancēri Palace in Cochin. Mural painting. Late Vijayanagar art. XVIII century.

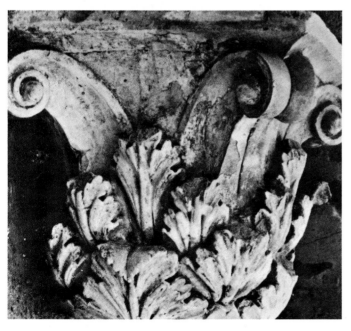

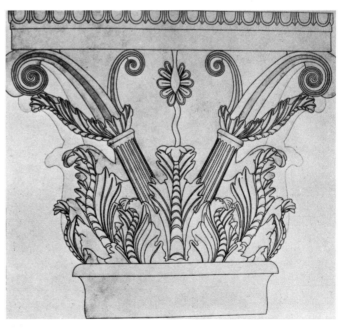

Pl. 51. –*Above left to right*: Hellenistic head and herma of a priest or high official, from Ai Khanum on the Amū–dāryā (Afghanistan). III century B.C. – *Below left*: Pseudo Corinthian capital in the inner vestibule of the Propylaeum. First quarter of the III century B.C. – *Right*: Drawing (by J. Bernard) of one of the capitals of the N° 2 vestibule. Around 200 B.C.

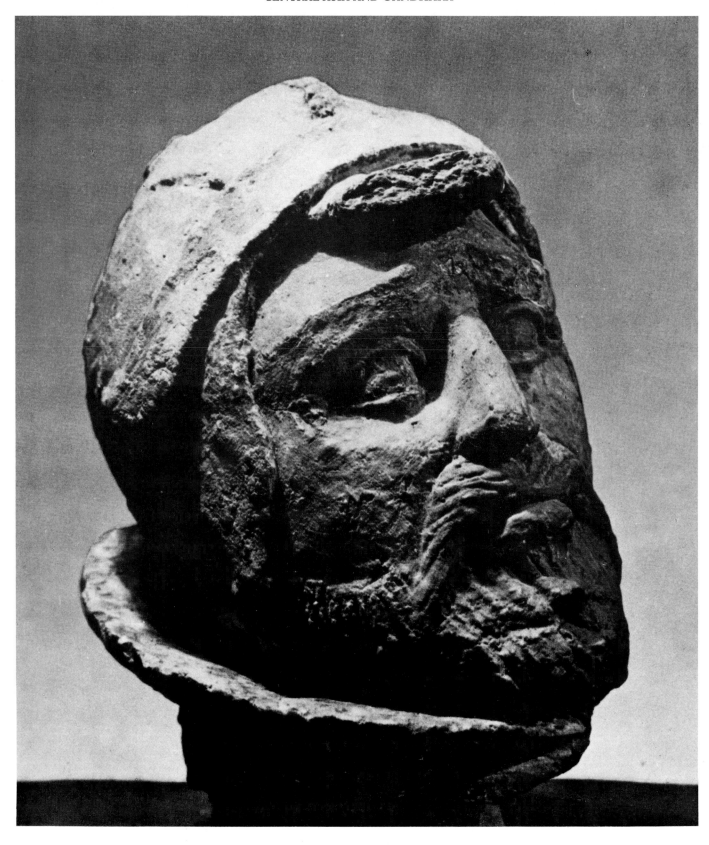

Pl. 52. – Warrior's head, from Khalchayan (South Uzbekistan), Raw clay. I century B.C. Tašhkent, Museum af Art.

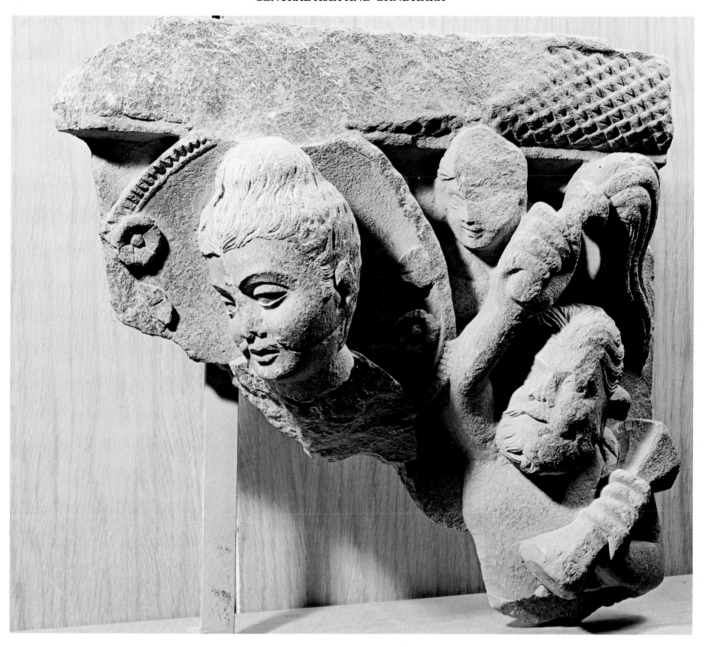

Pl. 53. – Fragment of a relief of a Buddha's head and Vajrapani waving a flabellum, from Butkara (Swat). Gandhāra art. III century A.D. Rome, Museo Nazionale d'Arte Orientale.

Pl. 54. – Sanctuary of Tepe-Shutur (Hadda, Afghanistan). IV century A.D. – *Above left:* Figure worshipping Buddha (perhaps a Bodhisattva). Stucco. – *Right:* Detail of the wall decoration with waves and aquatic flora and fauna. Stucco. – *Right:* Remains of a gigantic Buddha with a disciple. Stucco. North-west entrance to the cell with the aquatic scene. – *Below left:* general view of the main court of the Sanctuary.

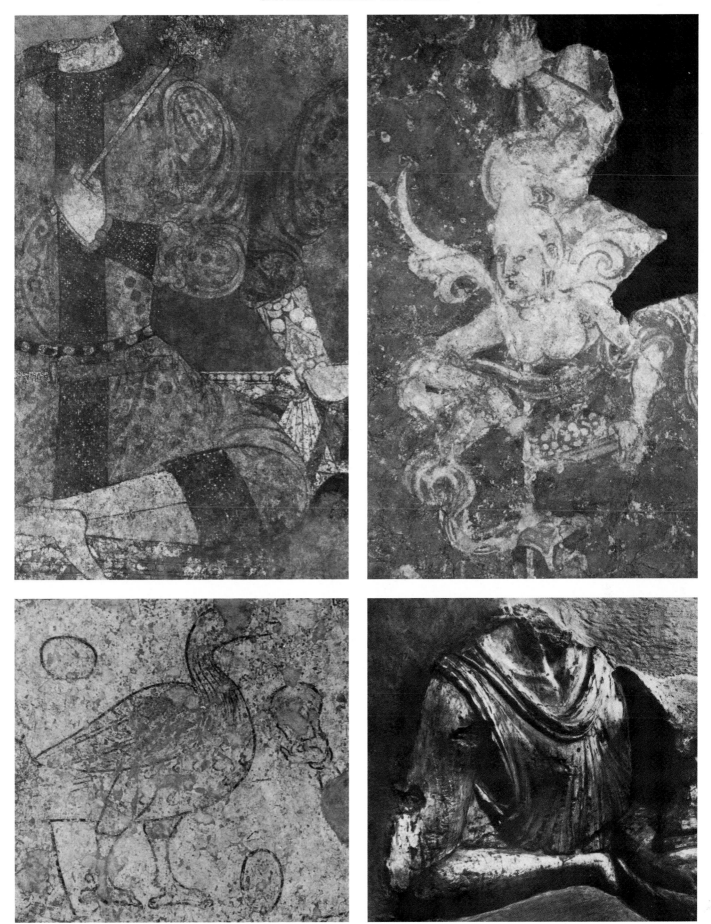

Pl. 55. – Pjandžikent (Tadzikistan). – *Above left*: figure with a flabellum. Detail of a mural painting representing a banquet or a festival. VII century A.D. – *Right*: Flying female figure. Detail of mural painting in the throne room. End VII century A.D. – *Below left*: Mural painting. Detail of the story of the goose that laid the golden egg. End VII century A.D. – *Right*: Fragment of stucco decoration showing a figure making an offering. Stucco.

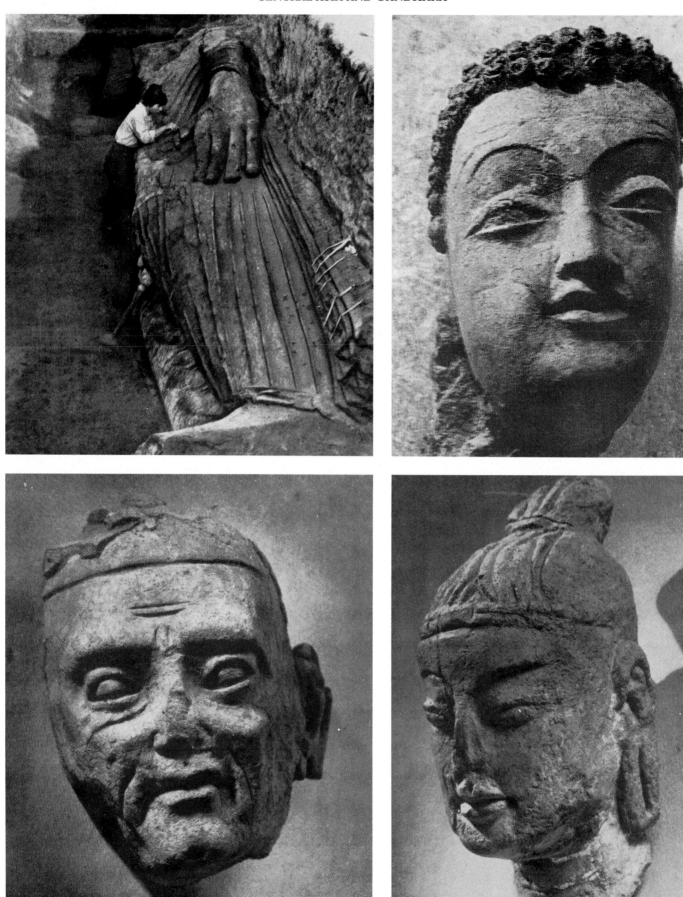

Pl. 56. –Adžina Tepe (Tadžikistan), Sculptures. Middle VII century A.D. – *Above left*: Gigantic figure of dying Buddha (Parinirvāna). Clay covered with plaster and with an internal polymateric reinforcement (width 6 feet without pedestal, lenght 34 feet). – *Right*: Head of Buddha. Raw clay. – *Below left*: Head of monk with strong local ethnic characteristics. – *Right*: Head of Bodhisattva (or of Buddha?) with strong Mongol characteristics. Raw clay.

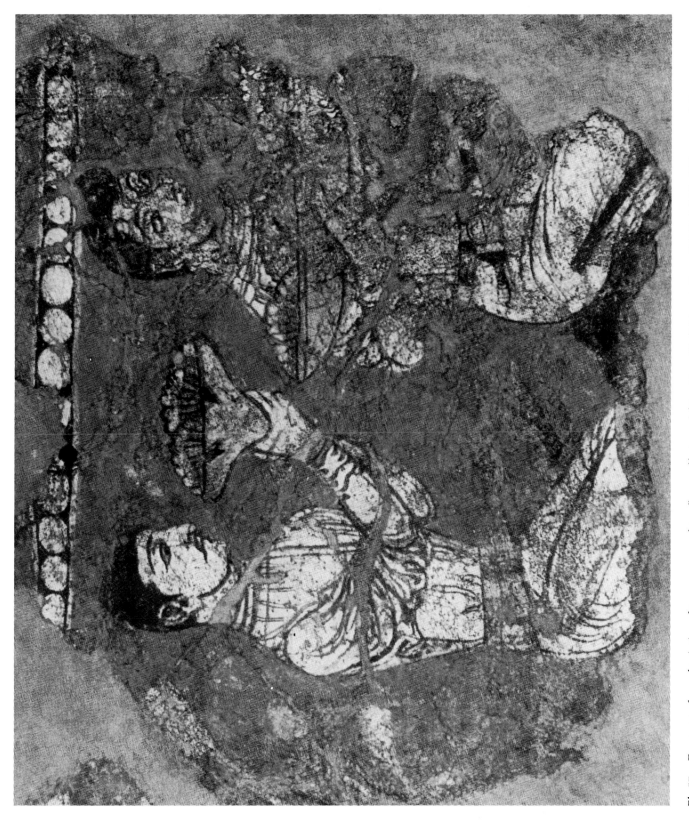

Pl. 57. – Fragment of mural painting of two persons making flower offerings. Adžina Tepe (Tadžikistan). Room XXXI. Middle VII century A.D.

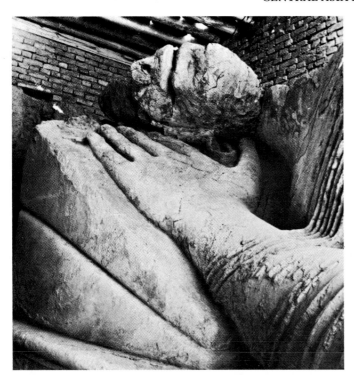

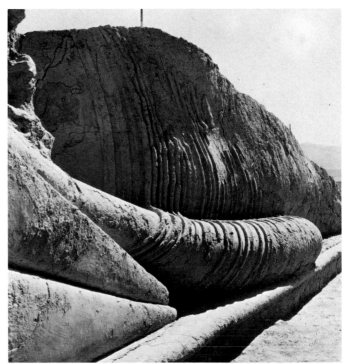

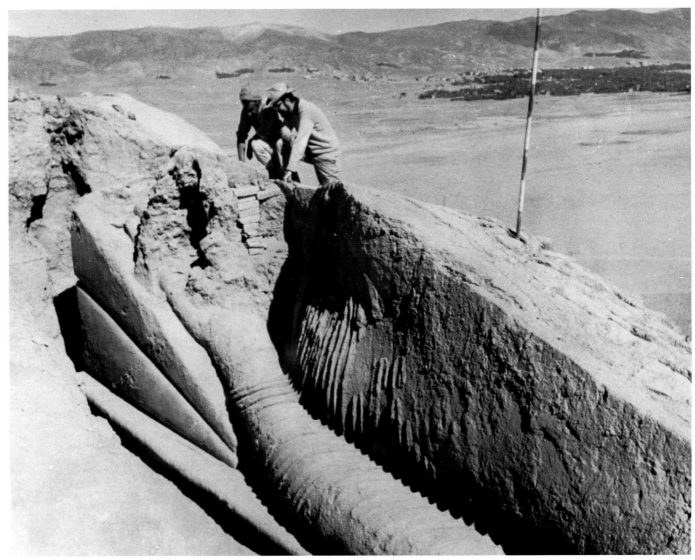

Pl. 58. – Gigantic dying Buddha (Parinirvāna) from Chapel 63 for Tepe Sardār (near Ghazni). Raw clay on a frame of whole and broken raw bricks (length ca. 39 feet). VII–VIII century A.D. – *Above left*: Head and hand. – *Right*: Detail of the body. – *Below*: The Buddha, at the beginning of the excavations (note the wedge-shaped cushions).

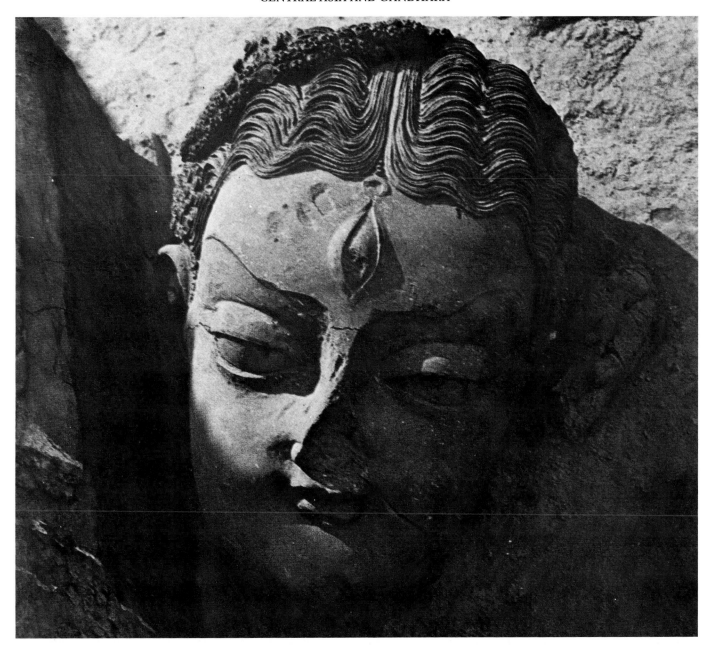

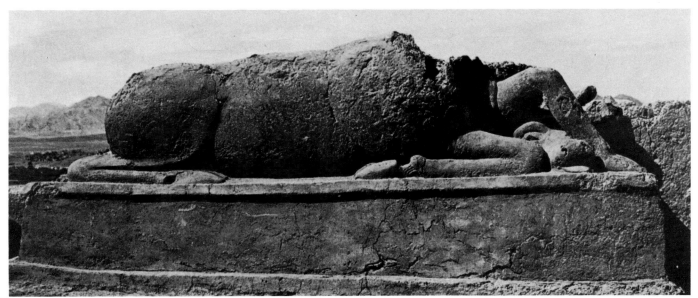

Pl. 59. –Sculptures at Tepe Sardār (near Ghazni). VIII century A.D. – *Above*: Head of Durgā Mahiṣāsuramardinī. Raw Clay (height ca. 3 feet). – *Below*: Body and pedestal of the demon–buffalo beheaded by Durga.

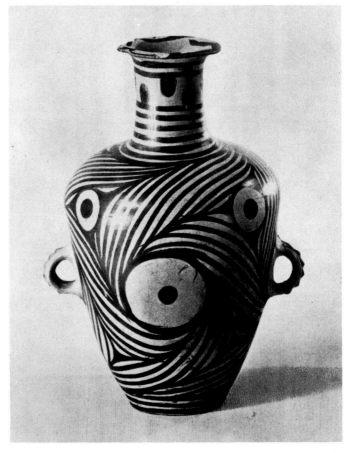

Pl. 60. – Red pottery with Neolithic painting. – *Above*: Bowl decorated with human masks and fishes (height 7 1/2 in., diameter 17 in.) ca. 4000 B.C. Yang-shao culture, from Chiang chai (Shensi). – *Below left*: Flask with mask and geometrical motives from Chiang chai (Shensi) (height 10 in., diameter of opening 1 1/2 in.). Ca. 4000 B.C. Yang-shao culture. – *Right*: Amphora with spiral design (height 10 in., diameter opening 2 3/4 inches). Ca. 2000 B.C. Kansu Yang-shao, Lanchow (Kansu).

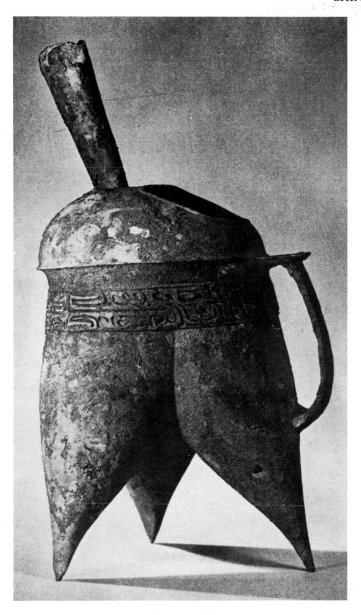
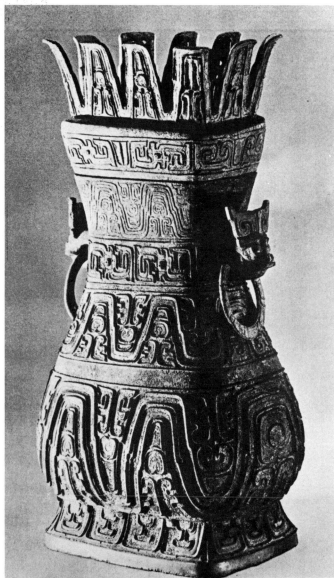
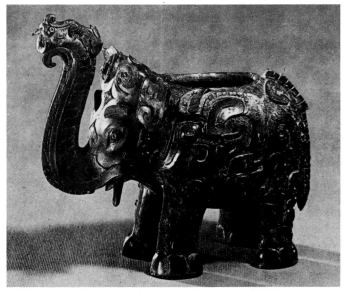
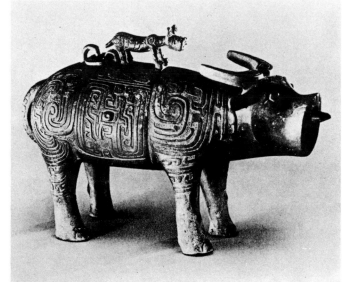

Pl. 61. –Ritual receptacles in bronze. – *Above left*: "Ho" type vase with dragon (Kuei) decoration (height 13 1/2 in.). Shang period. From Huangpi (Hupei). – *Right*: "Hu" type vase with lid in the form of a lotus flower (height 26 in., opening 9 × 6 1/2 in.). Spring and Autumn period. From Chingshan (Hupei). – *Below left*: Elephant–shaped receptacle of "tsun" type (height 9 in., length 10 1/2 in.). Shang period. From Liling (Hunan). – *Right*: Receptacle in the form of a bull – "tsun" type with a tiger on the lid (height 9 1/2 in., length 15 in.). Period of the Western Chou, Chishan (Shensi).

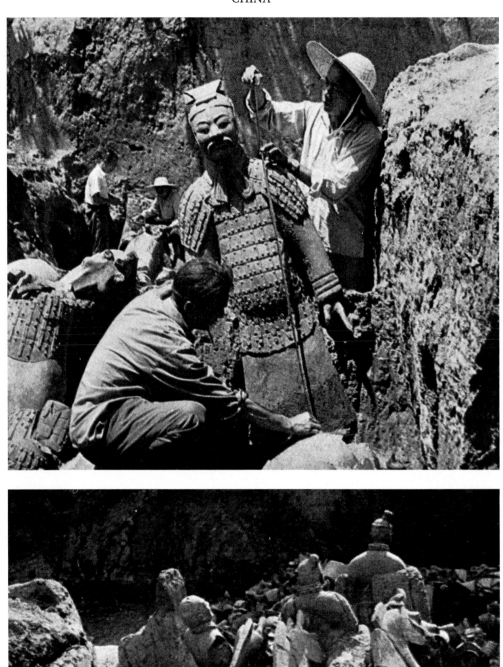

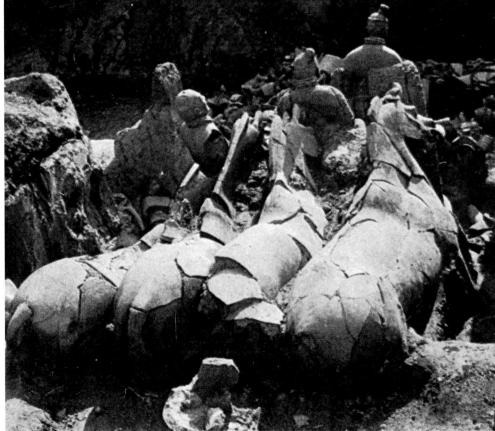

Pl. 62. – The excavation of the hypogeum area near the tomb of Shih Huang–ti, Ch'in period, Lintung (Sian). – *Above*: Measuring the clay statue of a warrior. – *Below*: Recovering the clay statues of horses and warriors.

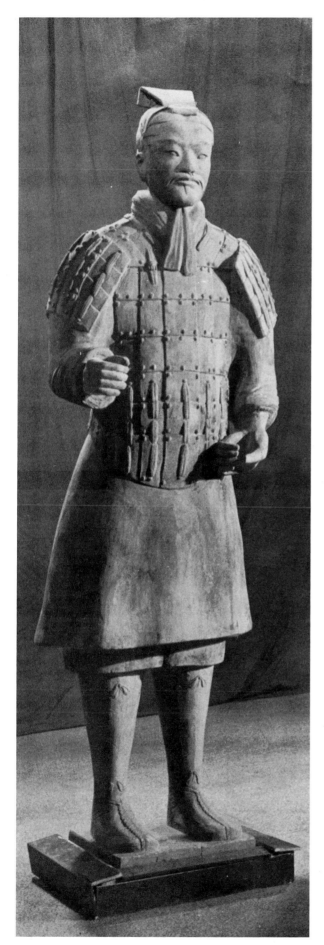

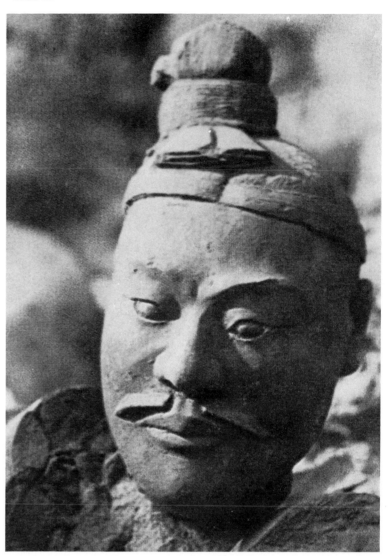

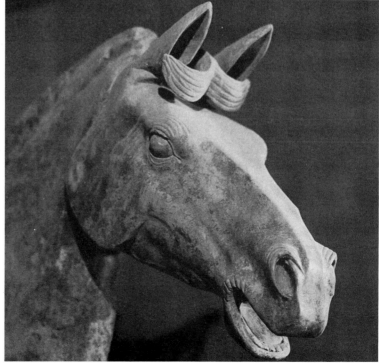

Pl. 63. –Clay statues from the hypogeum at the tomb of Shih Huang–ti, Ch'in period, Lintung (Sian). – *Left*: Warrior with plate armour (height 6 feet). – *Above right*: Detail of a warrior. – *Below*: Horse's head.

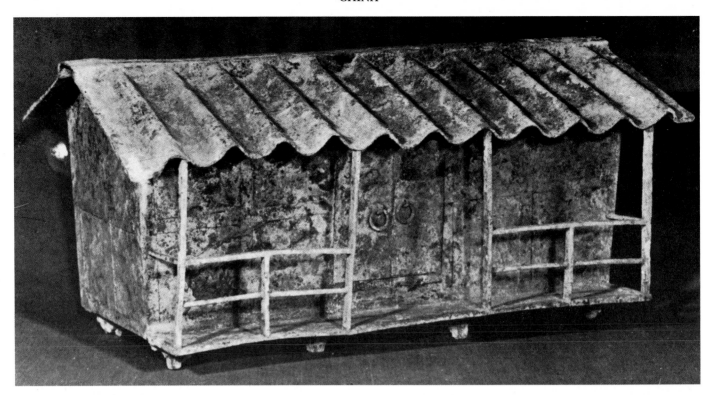

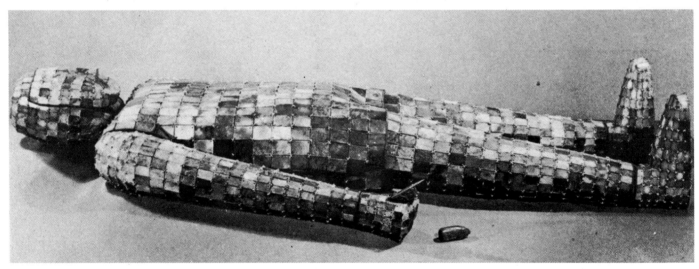

Pl. 64. – *Above*: Bronze model of a habitation (14 1/2 × 31 1/4 in.) from a tomb of the Western Han period. Second half of the 1 century B.C. Ho–p'u (Kwangsi). – *Below*: A nobleman's burial vestment, jade tiles joined by silver wire (lenght 5 1/2 feet, width 18 1/2 inches at the shoulders, sleeve 31 3/4 in.). From a tomb of the Eastern Han, mid II century A.D. Hsü–chou.

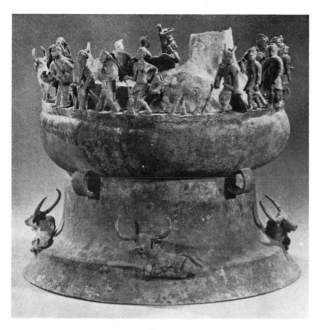

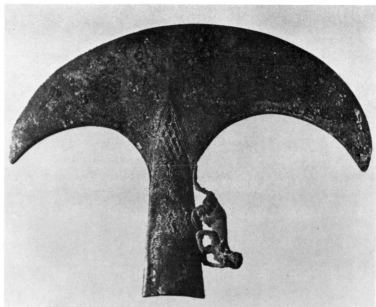

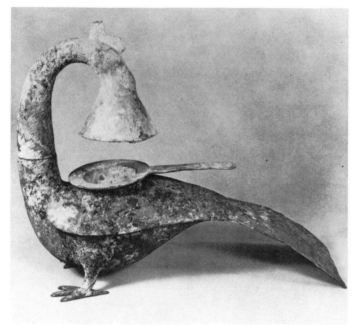

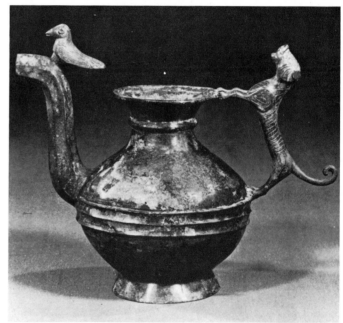

Pl. 65. – Bronze remains from the necropolis of Shih–chai–shan, Western Han period, I century B.C. Chin–ning–hsien (Yünnan). – *Above left*: Container for shell money with characters "Kung Na" inscribed. – *Right*: Axe blade ("yueh") with figurine of a monkey. – *Below left*: "Teng" type lamp in the form of a bird. – *Right*: "Ho" type vase with bird and quadruped, perhaps a dog.

Pl. 66. –Model of a grinding wheel with a statuette of a female holding a spade (ch'an) and another with a harvesting receptacle. Ceramic. Sui period. Tomb of Chang Sheng, Anyang (Honan).

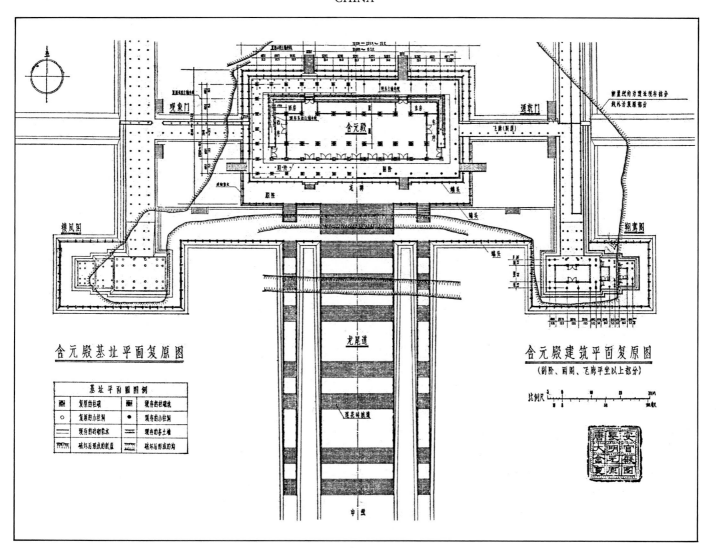

含元殿基址平面復原圖

含元殿建筑平面復原圖
（副阶、兩閣、飛廊平坐以上部分）

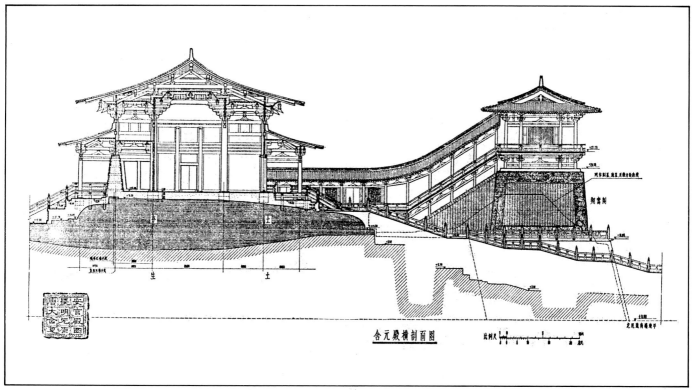

含元殿横剖面圖

Pl. 67. –Ch'ang-an (Sian), Ta-ming Kung, Han-yuan tien, T'ang Dynasty. – *Above*: Partially reconstructed plan. – *Below*: Detail of the reconstruction of a section.

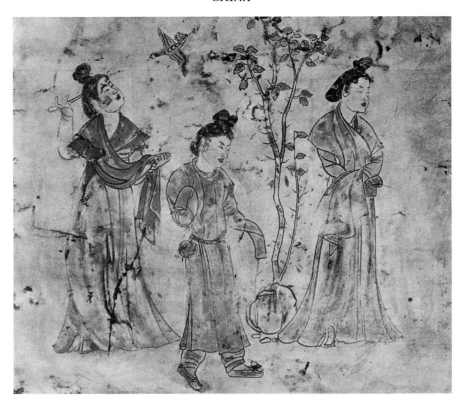

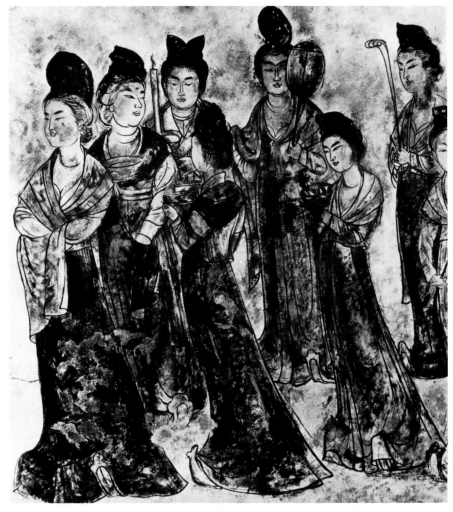

Pl. 68. – Mural paintings from the necropolis of the T'ang period in Chienhsien (Shensi). – *Above*: Ladies of the court watching birds. From the tomb of Prince Chang–huai. 706 A.D. – *Below*: Retinue of court ladies bearing candle, fan and vessels, copied from the mural painting of 706 A.D. From the tomb of Princess Yung–t'ai.

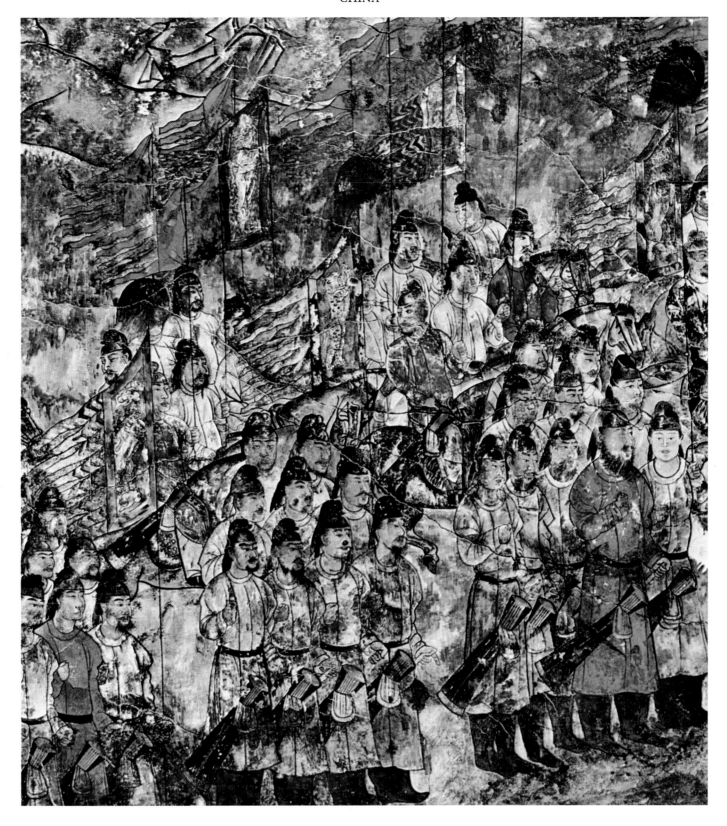

Pl. 69. –Ceremonial procession, copied from the mural painting (height 12 3/4 feet, width 7 3/4 feet), east wall of the entrance corridor. Tomb of Prince I–te. 706 A.D. Chienhsien (Shensi).

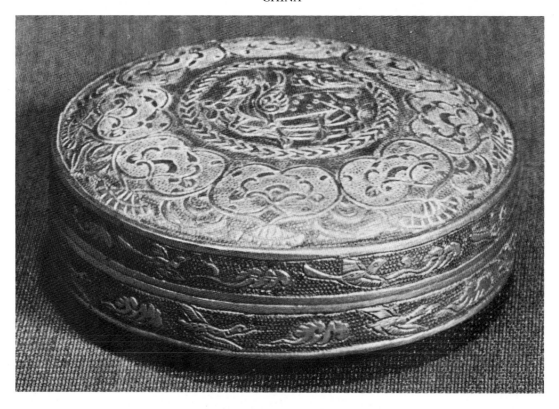

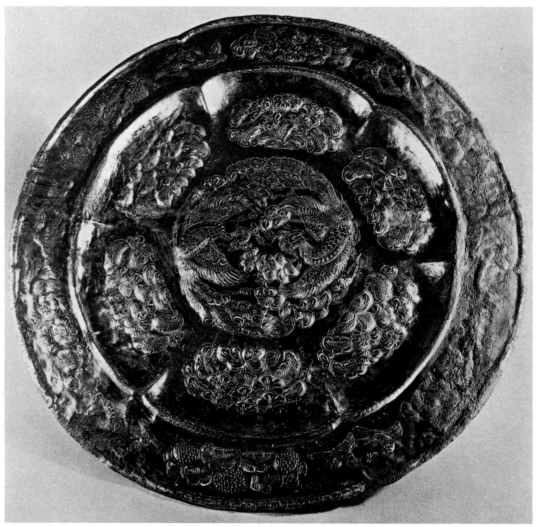

Pl. 70. –Silverware of the T'ang period. – *Above*: Box (ho) with figure of a winged caprid and floral motifs. From Ch'ang-an (Sian). – *Below*: Gilded plate with phoenix' head, floral motifs and birds, from Ta–ming Kung at Ch'áng-an (Sian).

Pl. 71. –Receptacle with lid and movable handle decorated with parrots and peonies, silver with gilded incrustations (height 9 1/2 in.). Treasure of the Prince of Pi. T'ang period. Ch'ang–an (Sian).

Pl. 72. – Scenes from the life of Buddha. Mural painting. Western Tibet. XV–XVI century. ISMEO Fund. Rome, Museo Nazionale d'Arte Orientale.

Pl. 73. – Mural painting of the Kôfun Takamatsuzka. End VII – beginning VIII century A.D. Asuka, Prefecture of Nara. – *Left*: Retinue of Ladies, west wall. – *Right*: Group of Dignitaries, east wall.

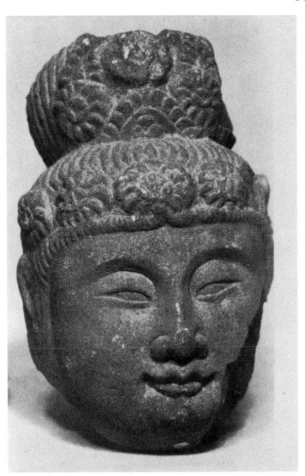

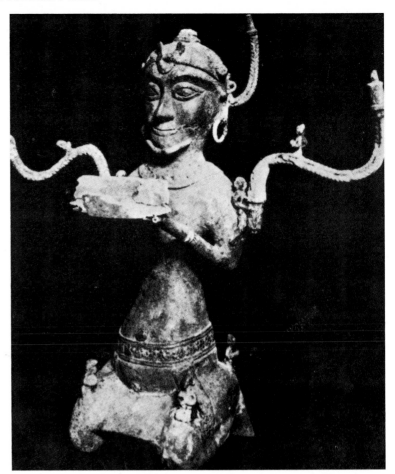

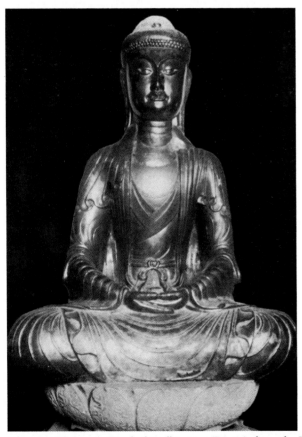

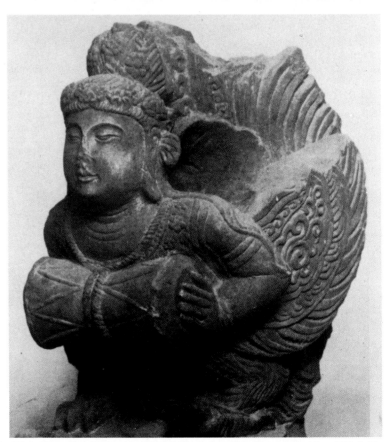

Pl. 74. –*Above left*: Head of Bodhisattva (Bô tât), from the Vạn Phúc Temple at Phật tích (Bắc ninh). Stone. Tiên lê period. After 980 A.D. – *Right*: Lamp in the form of a kneeling figure. Bronze. The so–called Âu Lạc period (257–207 B.C.). – *Below left*: Buddha Amitābha, from the Vạn Phúc Temple at Phật tích. Gilded Stone. Vạn Xuân period. 541–544 A.D. – Right: Winged Kinnari (Thân dieu) beating a double drum. Fragment of the decoration of the Vạn Phúc Temple at Phật tích after restoration. Stone. Tiên lê period. After 980 A.D.

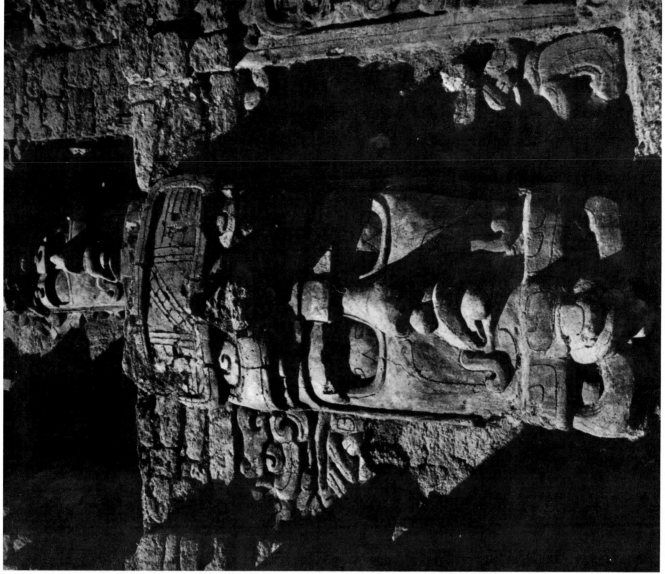

Pl. 75. – *Left*: Xoc (Chiapas, Mexico). Olmeco bas-relief of a man in a bird mask. Height 7 1/4 feet ca. Olmeco II phase (800–400 B.C.). – *Right*: Kohunlich (Quintana Roo, Mexico). Detail of the Temple of the Masks. Stucco. Classic Maya Period (250–550 A.D.).

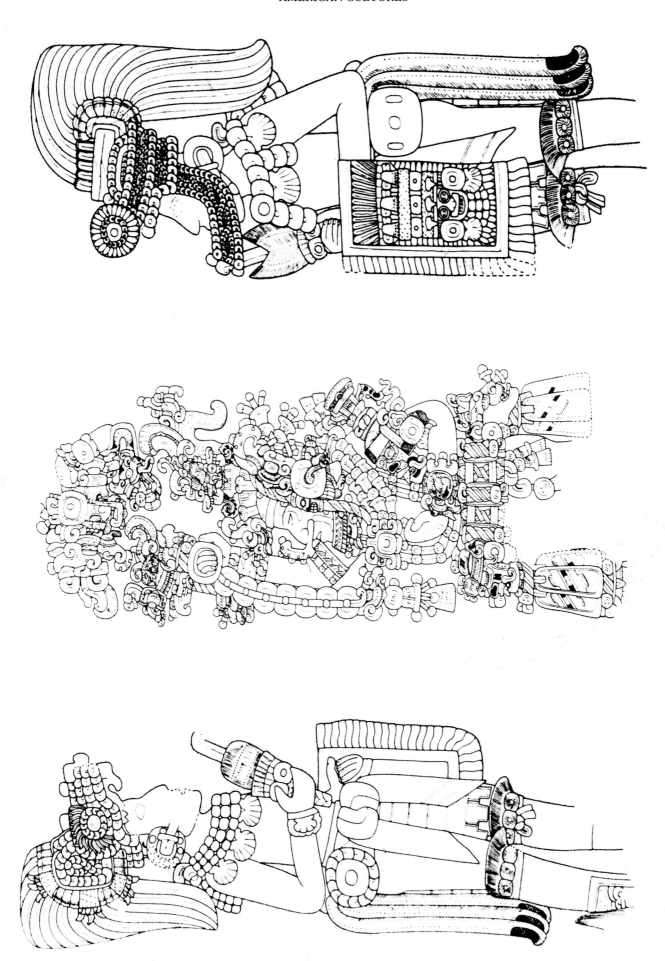

Pl. 76. – Drawings of stele 31 at Tikal (Petén, Guatemala). The figures of warriors at the sides clearly show the influence of the Teotihuacan culture. Classic Maya period (250–550 A.D.).

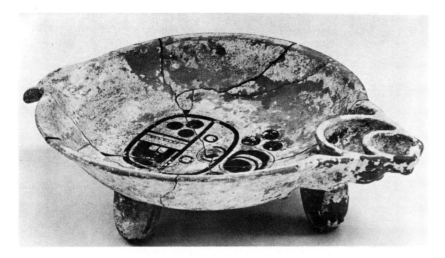

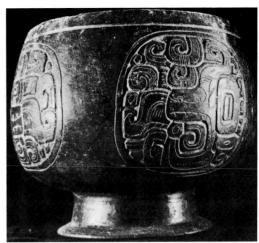

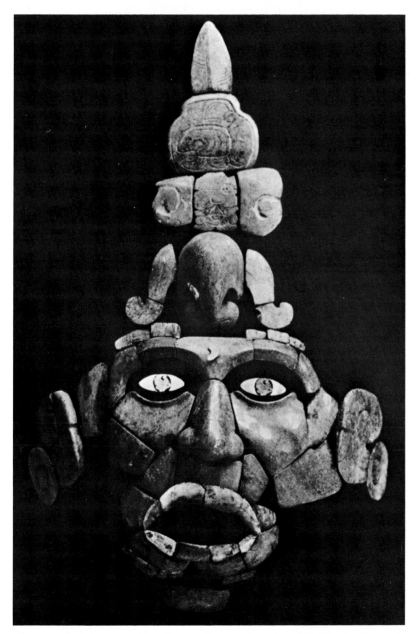

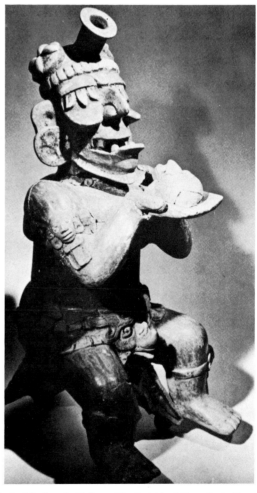

Pl. 77. – Tikal (Petén, Guatemala). – *Above left*: Bowl modelled in the shape of one half of a bivalve shell, from Tomb 116 of Temple 1. Decorated with a glyph painted on the bottom. The bottom of the shell presents a hole, possibly drilled in order to "kill it". Late Classic Maya period (550–900 A.D.). – *Right*: Black polychrome cup decorated with four panels of intricately curvilinear motives, from the Painted Tomb. Clay. Classic Maya period (250–550 A.D.). – *Below left*: Mosaic mask From Tomb 160. Jade and shell (height 14 3/4 in.). Classic Maya period (250–550 A.D.). – *Right*: Polychrome censer depicting an Ancient God seated on crossed human femurs: a severed human head is resting on the plate. From Tomb 10. Clay (height 13 3/4 in.). Classic Maya period (250–550 A.D.).

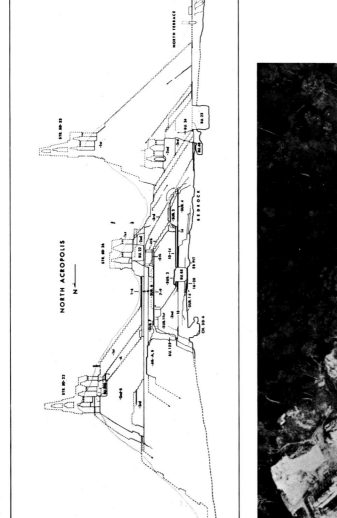

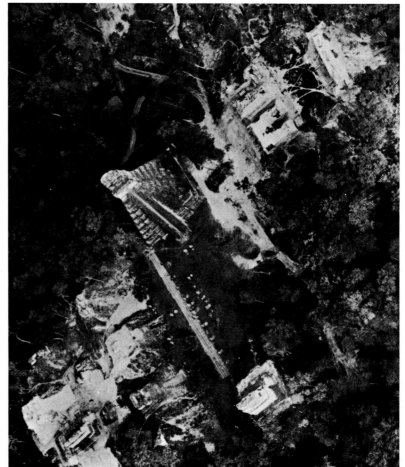

Pl. 78. – *Above left*: Tikal (Petén, Guatemala). Composite section of the northern Acropolis. Buildings of the Classic period correspond only to the four upper floors. The 5D–33 structure is Late Classic Period. The part below floor 5 belongs to the pre-classic period. – *Right*: Archaelogical zone of Casas Grandes (Chihuahua, Mexico). – *Below left*: Tikal (Petén, Guatemala). Aerial view of the central section. – *right*: Iximché (Guatemala). View of Temple N° 3 with the small platforms of Square A. XV century A.D.

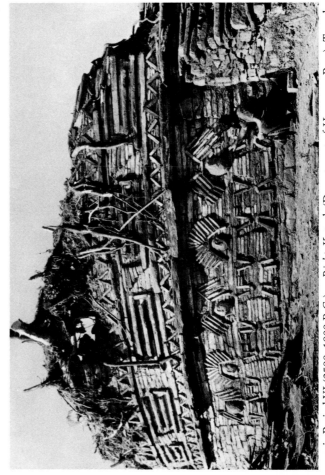

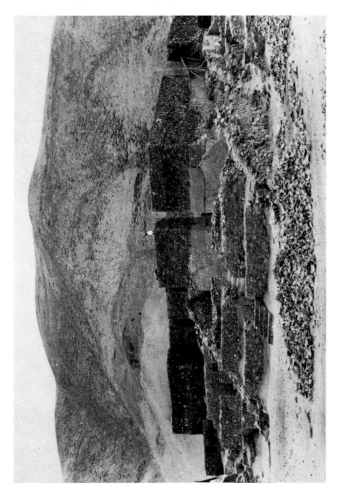

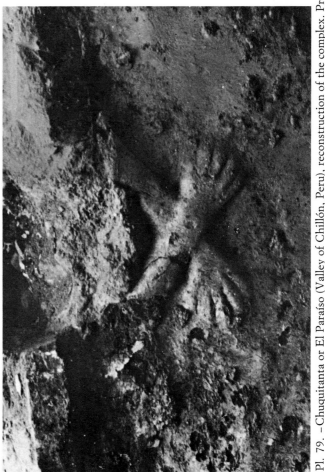

Pl. 79. – Chuquitanta or El Paraíso (Valley of Chillón, Peru), reconstruction of the complex. Pre-ceramic Period VI (2500–1800 B.C.). – *Right:* Kotosh (Department of Huanuco, Peru). Temple of the Crossed Hands. Late Pre-ceramic (end of the III millenium B.C.). – *Below left:* Kotosh (department of Huanuco, Peru), detail of the crossed hands of the temple of that name. Late Pre-ceramic (end of the III millenium B.C.). – *Right:* Pajatén (Department of San Martín, Peru), one of the circular buildings decorated with anthropo-avimorphous and geometrical motifs. Final horizon (XIV–XVI century A.D.).

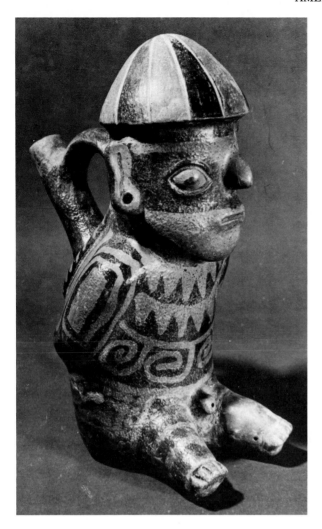

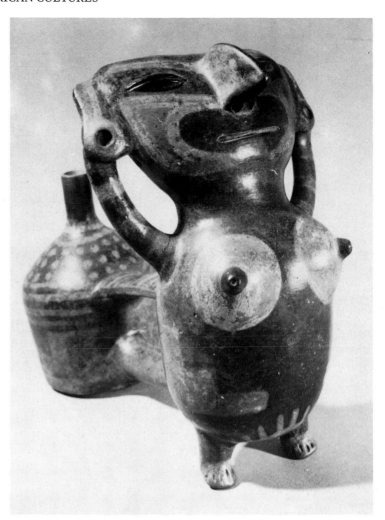

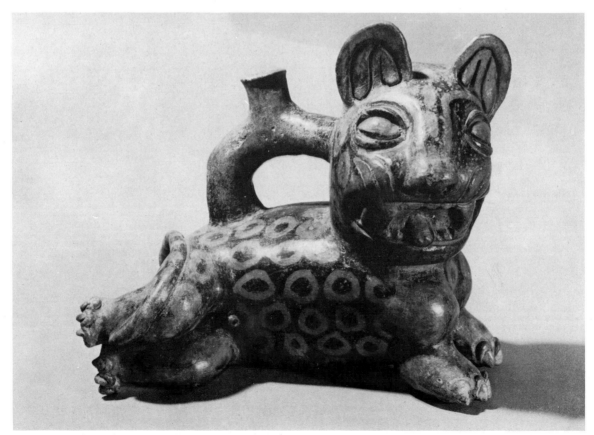

Pl. 80. – Vicús culture (department of Piura, Peru). Funerary vases with bracket handles. III century B.C. to VII century A.D.

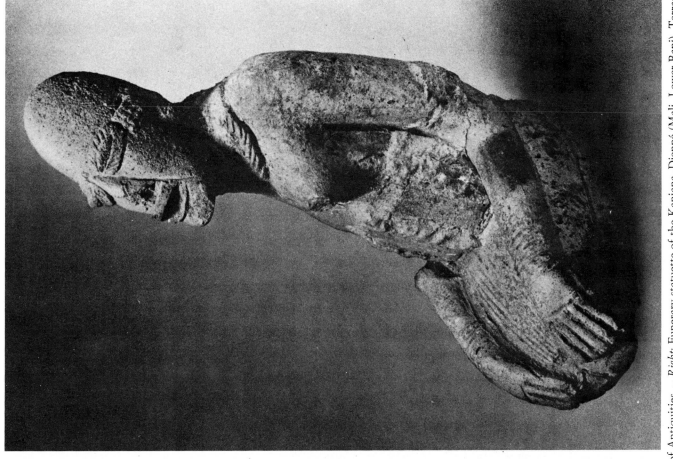

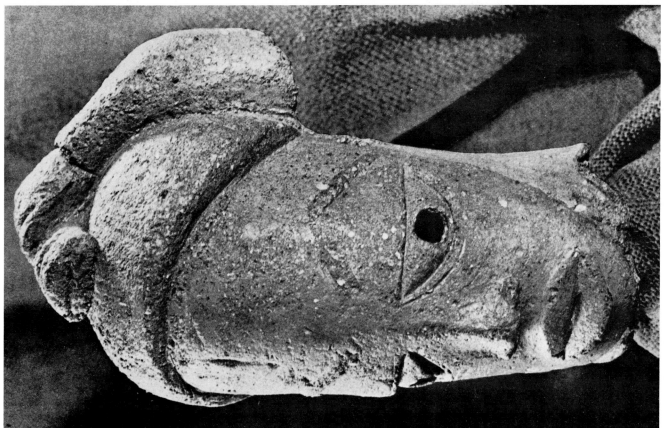

Pl. 81. – *Left*: Head, Nok Civilization (Nigeria). Terracotta. Lagos. Federal Department of Antiquities. – *Right*: Funerary statuette of the Kaniana–Djenné (Mali, Lower Bani), Terracotta. Dakar, Musée de l'I.F.A.N.

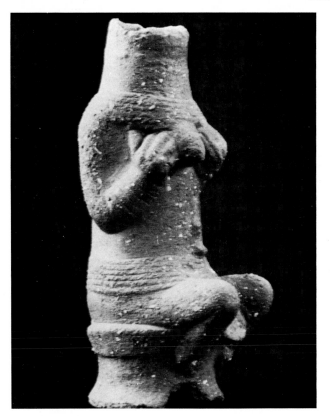
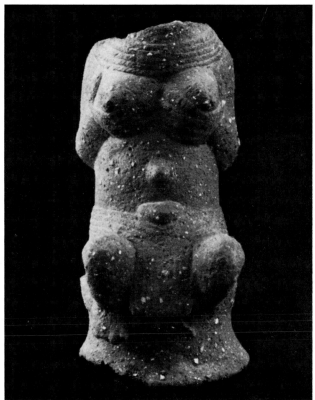

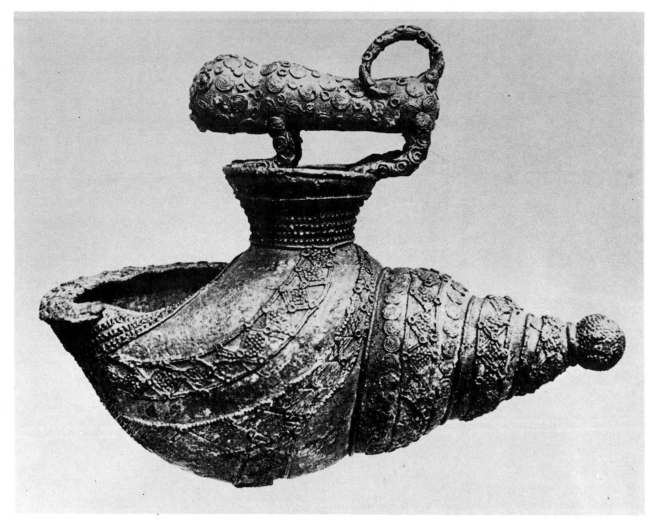

Pl. 82. – *Above*: Two statuettes representing a seated female, Nok Civilization (Nigeria). Terracotta. from the Taruga excavations. – *Below*: Gilded shell surmounted by a leopard. Art of Igbo–Ukwu (Nigeria). Bronze. Lagos, Federal Department of Antiquities.

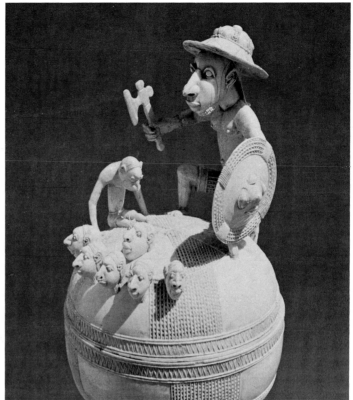

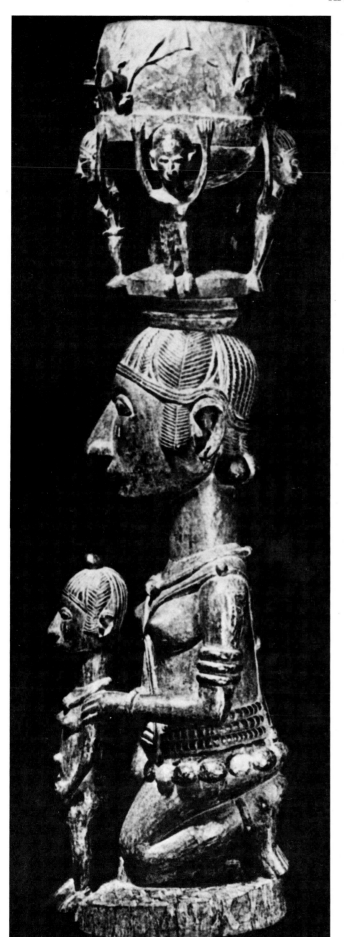

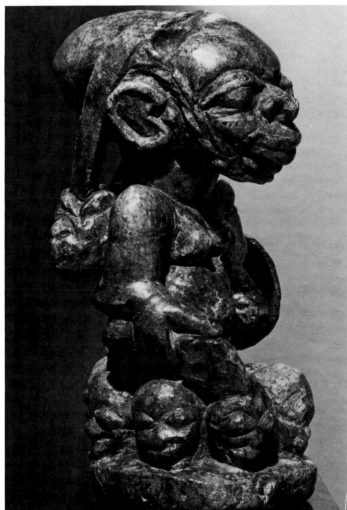

Pl. 83. –*Left*: Large drum with a kneeling mother, of the Baga (Guinea). Wood. Paris, Nicaud coll. – *Above right*: Cup with lid or salt cellar. Afro–Portuguese art. Ivory (part. of Plate 84). Rome, Museo Preistorico-Etnografico L. Pigorini. – *Below right*: *Nomoli* statuette of the Sherbro (Guinea). Steatite. Milan, Monti collection.

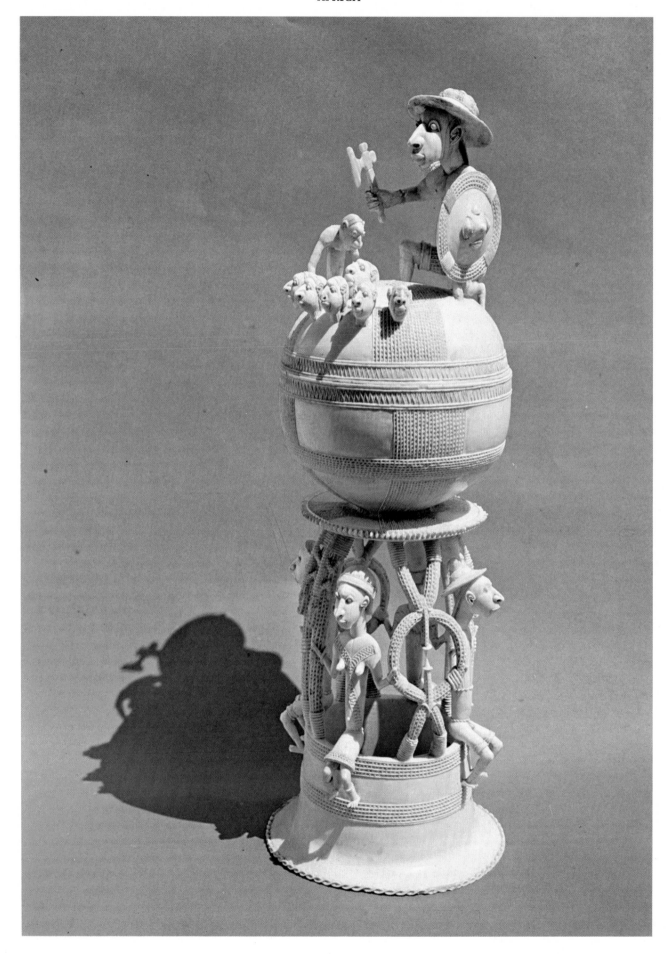

Pl. 84. – Cup with lid, or salt cellar. Afro–Portuguese art. Ivory. Rome, Museo Preistorico–Etnografico L. Pigorini.

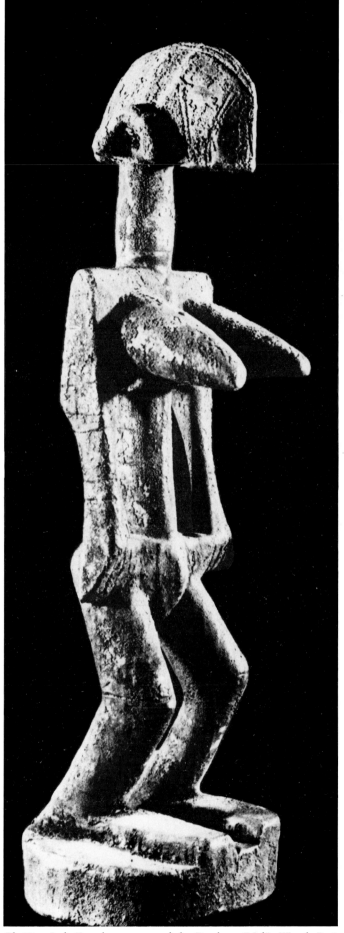
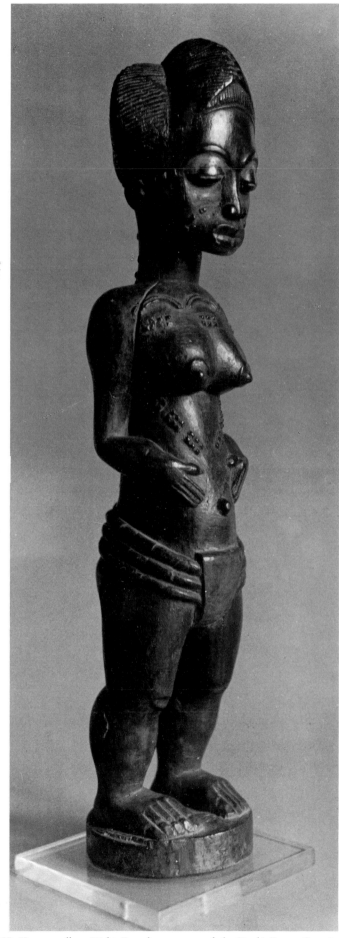

Pl. 85. –*Left*: Female statuette of the Bambara (Mali). Wood. Paris, H. Kamer coll. – *Right*: Female statuette of the Baulé (Ivory Coast). Wood. Rome, V.L. Grottanelli coll.

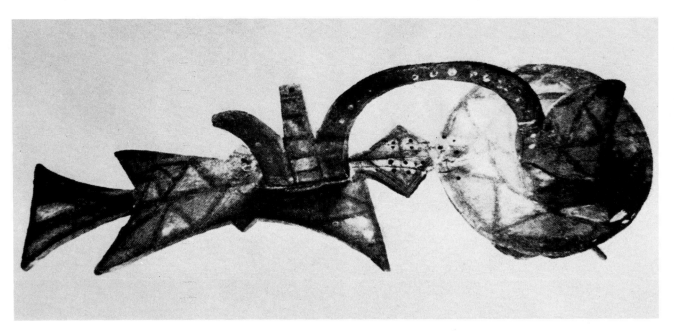

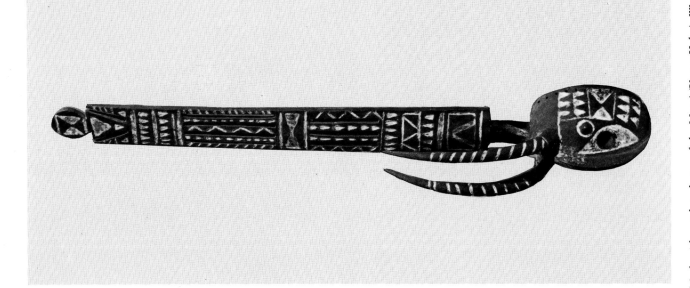

Pl. 86. – *Left*: Mask with antelope horn, of the Mossi (Upper Volta). Wood. Rome, Antinori Coll. – *Centre*: Mask of the Kurumba (Upper Volta). Paris, Musée des Arts Africains et Océaniens. – *Right*: Mask with a stylized bird, of the Gurunsi (Upper Volta). Wood. Wagadugu, Musée National de Haute Volta.

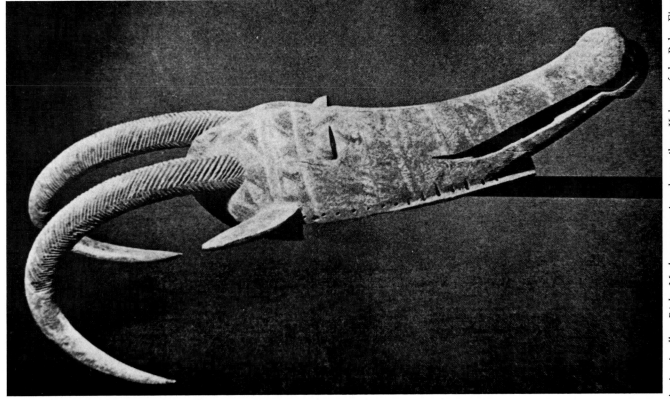

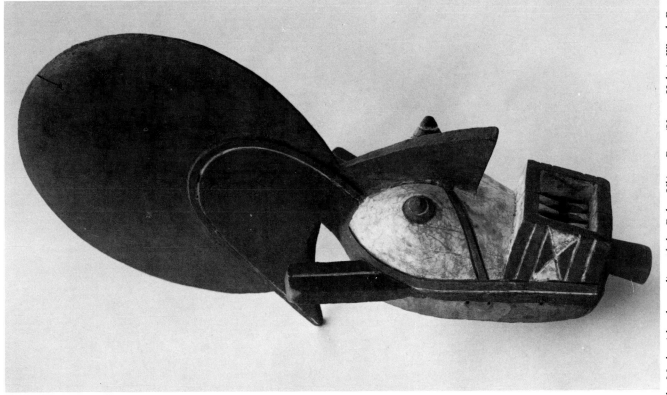

Pl. 87. – *Right*: Mask with a large disc, of the Bobo-Ulé or Bwa (Upper Volta). Wood. Paris, Nicaud coll. – *Right*: Mask representing the antilope Kobus, of the Bobo-Fing (Upper Volta). Wood. Rome, Antinori coll.

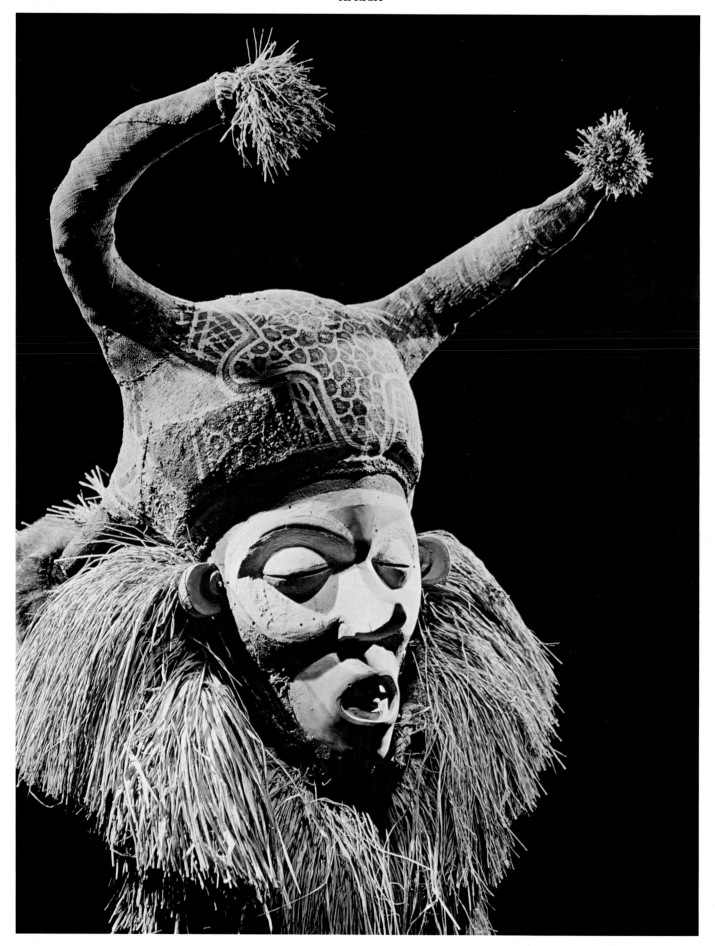

Pl. 88. – Anthropoid mask of the Kikongo (Angola). Polychrome wood. Lisbon, Museu de Etnologia.

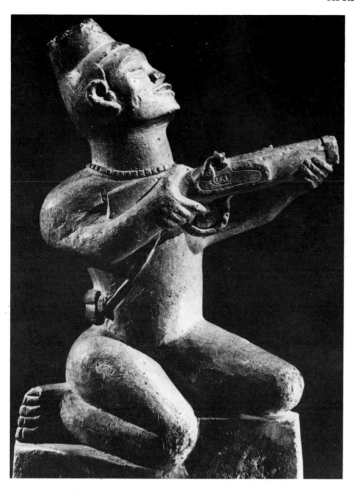

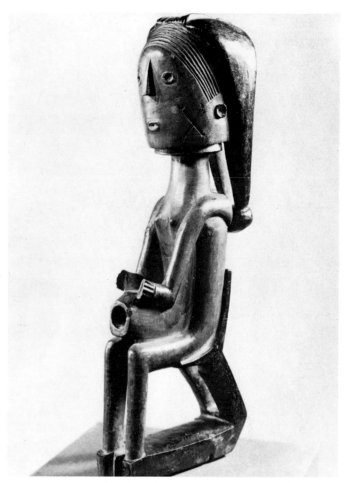

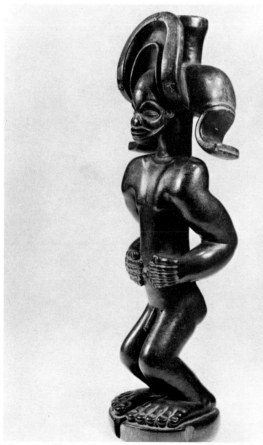

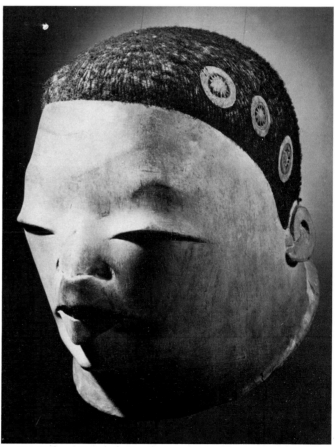

Pl. 89. – *Above left*: *Mintadi* funerary statuette of the Kongo (Angola). Steatite. Lisbon, Museu de Etnologia. – *Right*: Pipe bowl in the shape of a girl, of the Ovimbundu (Angola). Wood. Ibid. – *Below left*: Male statuette of the Tschokwe (Angola). Wood. Ibid. – *Right*: Helmet mask of the Makonde (Mozambique). Wood. Ibid.

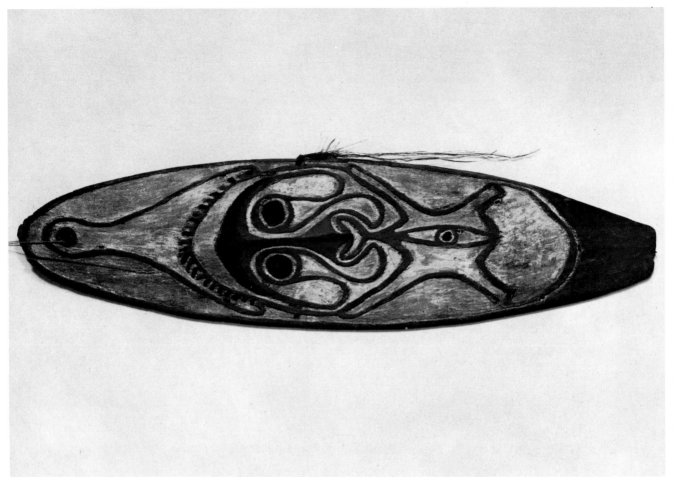

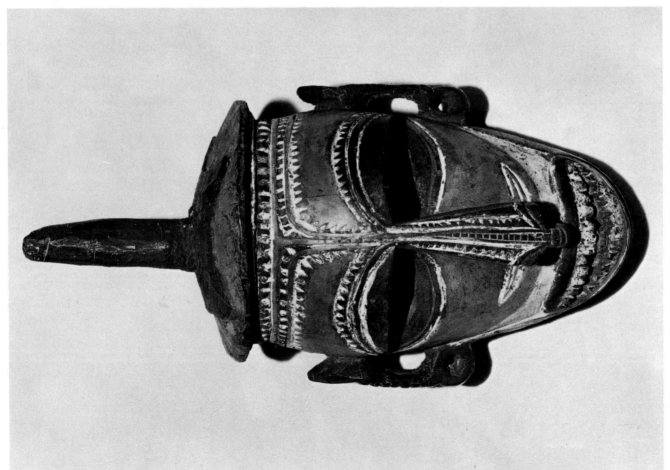

Pl. 90. – *Left*: Tami style mask, Umboi Island (New Guinea). Wood. Basel, Museum für Völkerkunde. – *Right*: Shield with stylized figure, from the Gulf of Papua (New Guinea). Polychrome wood. Ibid.

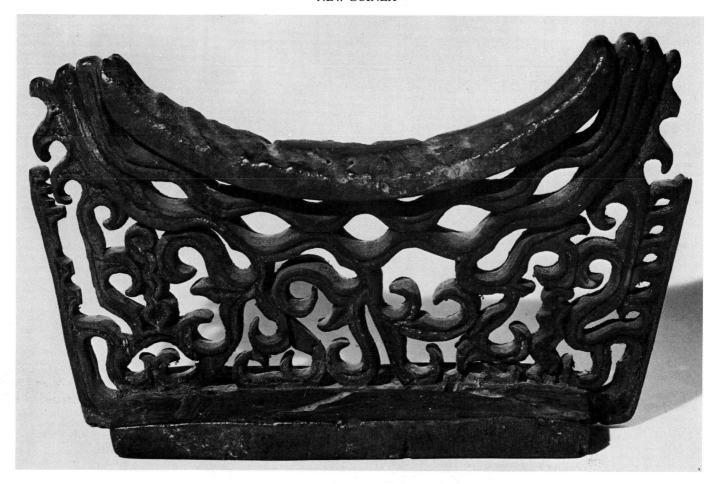

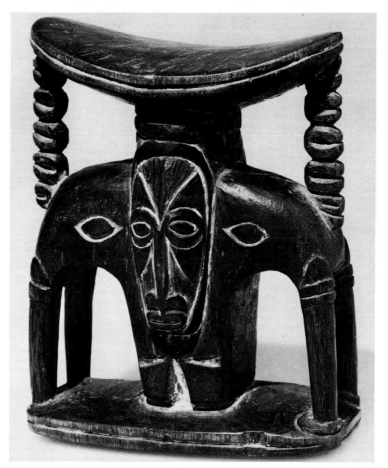

Pl. 91. –*Above*: Head rest, from the Bay of Geelvink (New Guinea). Wood. Basel, Museum für Völkerkunde. – *Below*: Headrest in Tami style (New Guinea). Ibid.

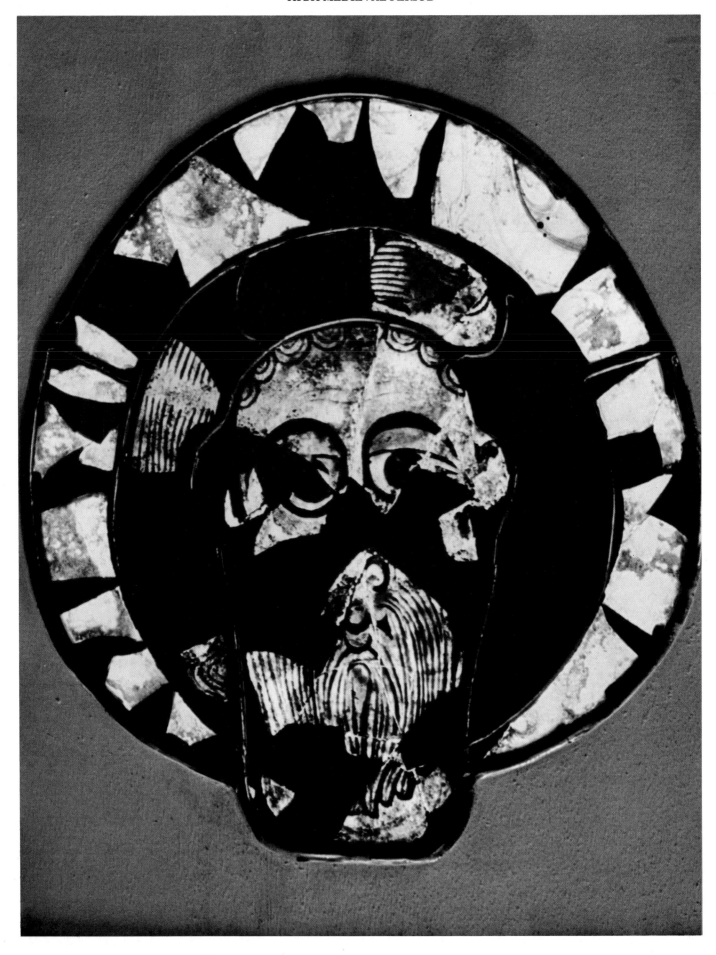

Pl. 92. –Head of Saint. Glass. Darmstadt, Hessisches Landesmuseum.

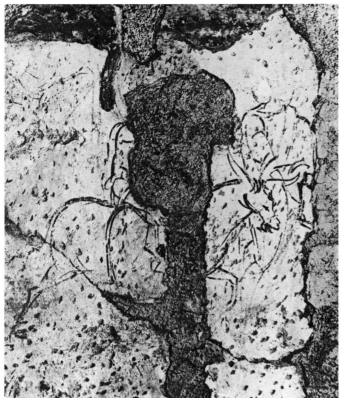

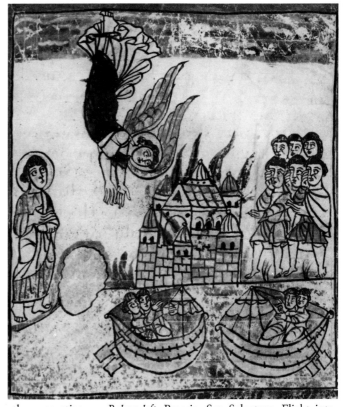

Pl. 93. –*Above*: Brescia. San Salvatore, interior. Photographed during the excavations. – *Below left*: Brescia, San Salvatore. Flight into Egypt. Sinopite. – *Right*: The Angel throws the Millstone into the Sea. Illumination. Trier, Stadbibliothek. ms. 31, fol. 59 v°.

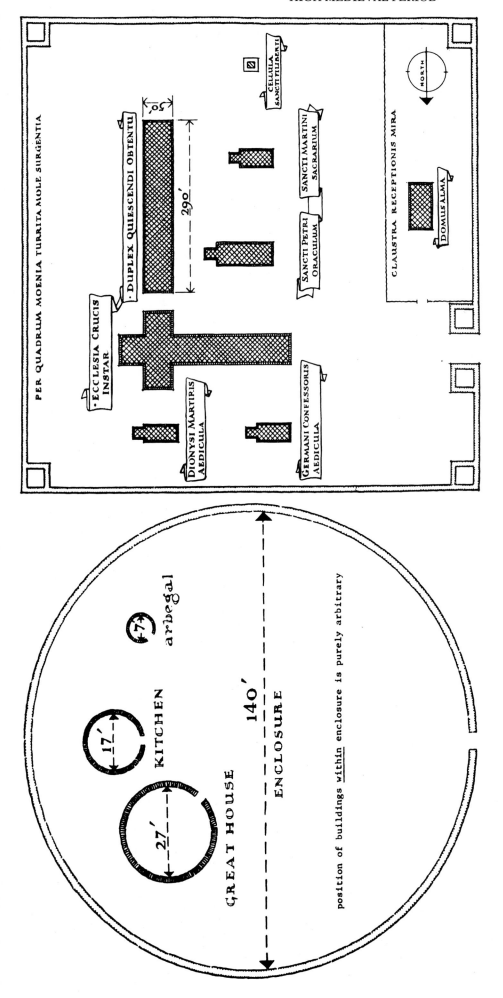

Pl. 94. – *Left*: Armagh (Ireland). Monastery. Reconstruction (*Drawing by C.B. Lund*) from W. Horn. – *Right*: Jumièges (France, Siene Maritime). Monastery. Reconstruction (*drawing by C.B. Lund*) from W. Horn.

Pl. 95. – Italy. *Left:* Piacenza, Cathedral, façade. Telamon. Ca. 1122. – *Right:* Nonantola. Abbey of S. Silvestro. Ca. 1121 and beginning XIII century.

Pl. 96. –Italy. – *Above*: Maestro Gregorio. Bronze Dog. Modena, Museo Estense. XII century. – *Below*: Cremona, Cathedral. Capital. About 1129.

HILDEFVNS

Pl. 97. –France. S. Ildephonse, De Virginitate Marie. Ildephonse writes a treaty. Illumination. End XI century. Parma, Biblioteca Palatina. ms. 1650, fol. 4 V°.

Pl. 98. – *Left*: France. Amiens, Cathedral, south side. Lagrange Chapel. Detail with St. John the Baptist. Claus Sluter? Ca. 1370. – *Right*: Italy. Giovannino de Grassi. Capital. Milan, Duomo, South side of the choir. 1391–1393.

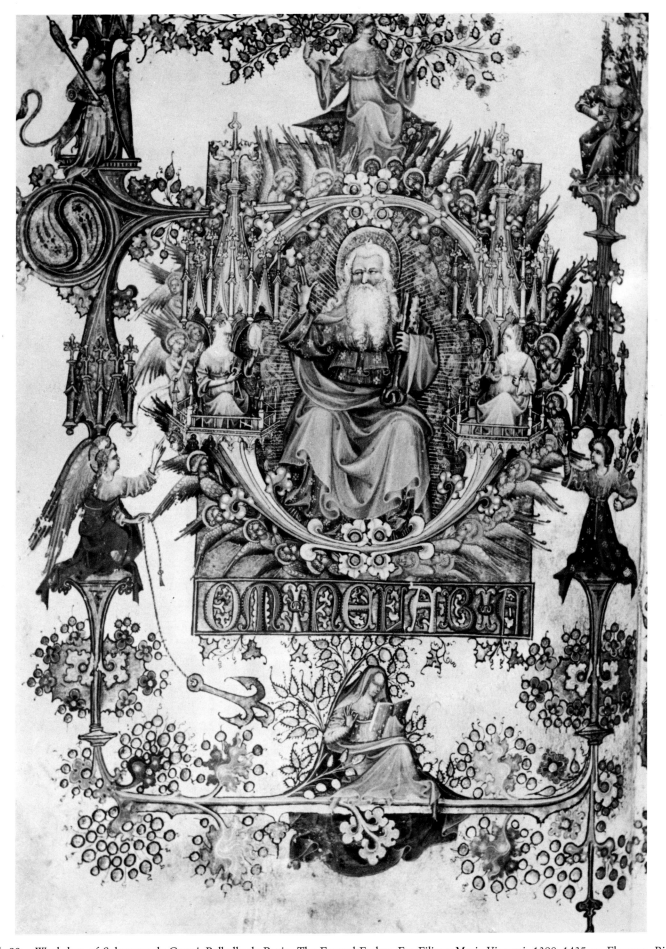

Pl. 99. –Workshop of Salomone de Grassi–Belbello da Pavia. The Eternal Father. For Filippo Maria Visconti. 1398–1435 ca. Florence, Biblioteca Nazionale, ms. LF 22, f. 10 r.

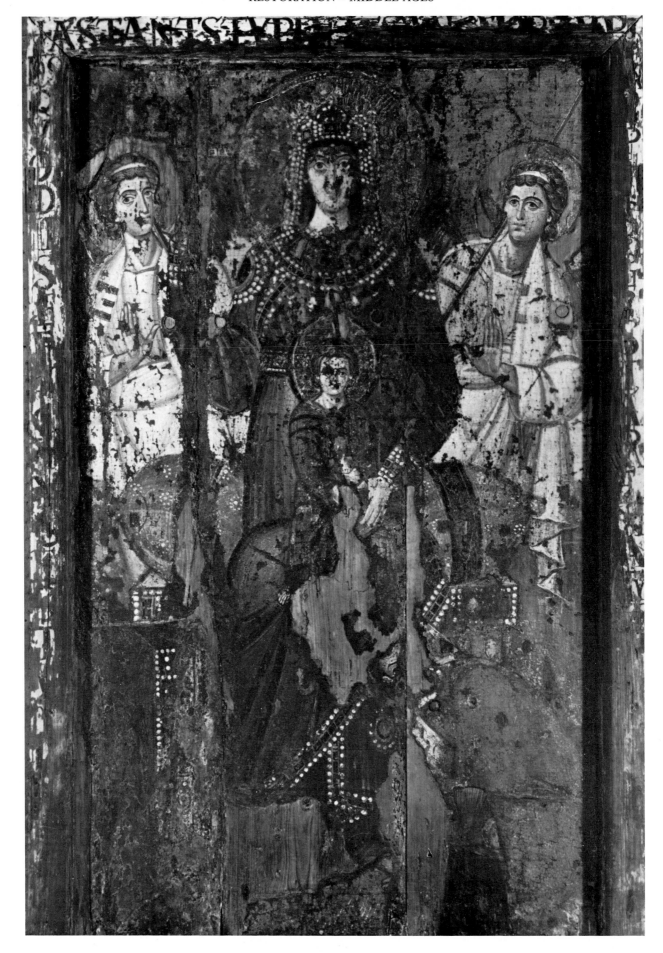

Pl. 100. – Icon of Mercy. Rome, S. Maria in Trastevere. After the restoration 1954–55.

Pl. 101. – *Left:* Painted Cross, detail with St. John the Evangelist. End XIII century. Maestro d'Isacco? Rome, S. Tommaso dei Cenci. After the 1966 restoration. – *Right:* Arnolfo di Cambio. Scribe. From the lost fountain of Perugia. 1281. Perugia, Galleria Nazionale dell'Umbria. Acquired in 1968.

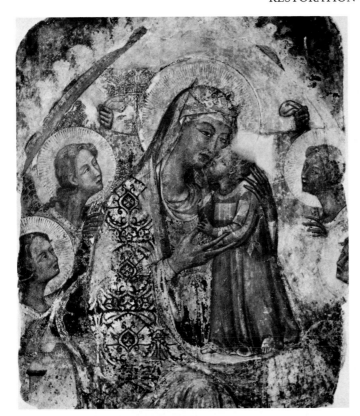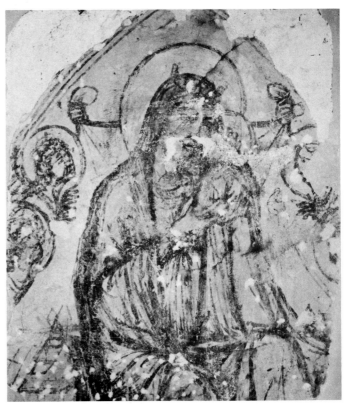

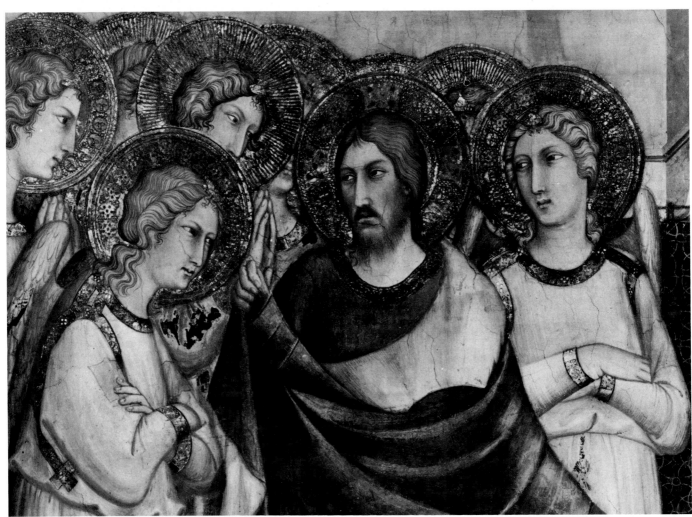

Pl. 102. – *Above left*: Maestà. First quarter of XIV century. Perugia, Oratorio delle Volte. After the removal and restoration of 1968. – *Right*: Maestà in the Oratorio delle Volte. Sinopite discovered upon removing the fresco. – *Below*: Simone Martini. Fresco in the Chapel of S. Martino. Detail after the restoration of 1971. Assisi, San Francesco, Lower Church.

Pl. 103. – Qartamin. Monastery. Main Church. Southeastern lunette. Mosaic.

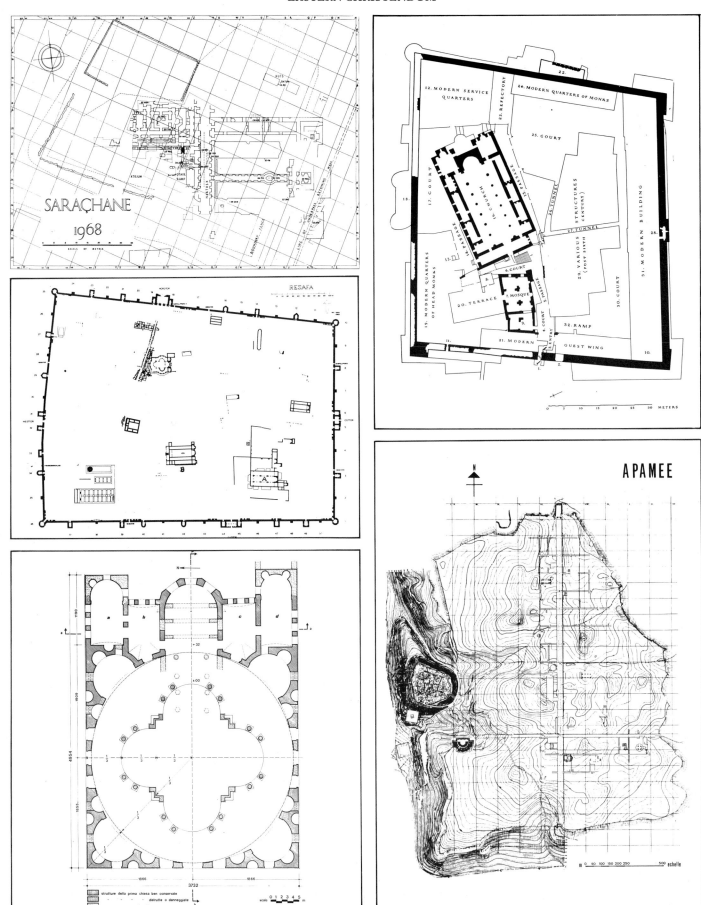

Pl. 104. – *From left to right and from top to bottom*: Istanbul. Saraçhane. The complex of Aghios Polyeuktos. Plan of the excavations (by R.M. Harrison – N. Firatli). – Sinai. St. Catherine's Monastery and plan of the complex (by G.H. Forsyth). – Reṣafa, Plan of the city. – Apamea (Syria). Plan of the entire complex. (By kind permission of Dr. J. Ch. Balty). – Boṣra. Plan of the Cathedral (relief by S. Cerulli; courtesy of the Istituto di Antichità Ravennati e Bizantine dell'Università di Bologna).

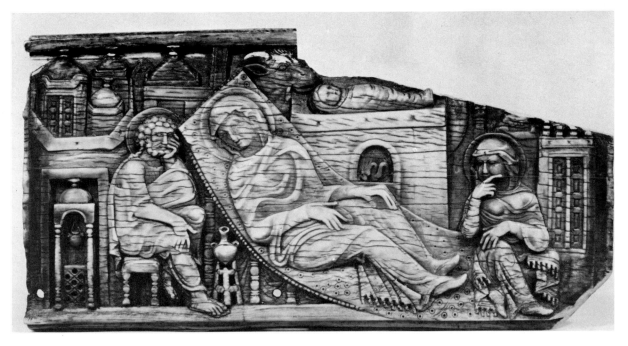

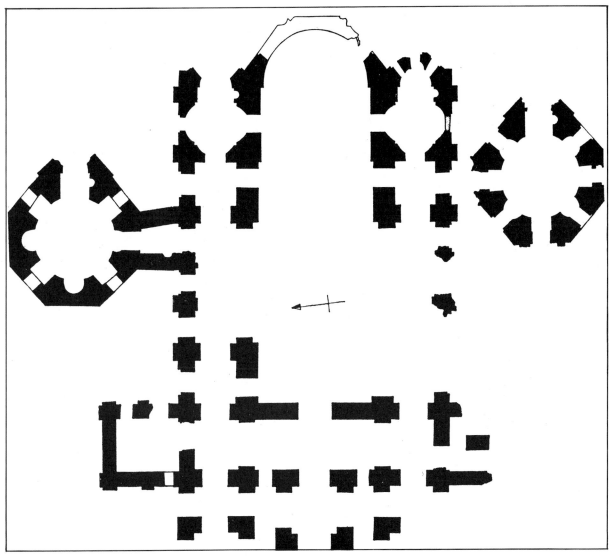

Pl. 105. – *Above*: Nativity. Ivory. Washington, Dumbarton Oaks Collection. – *Below*: Dere Ašï. Basilica. Plan (by Morganstern).

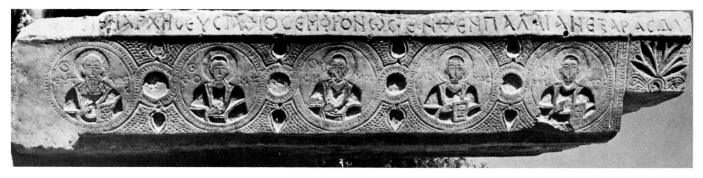

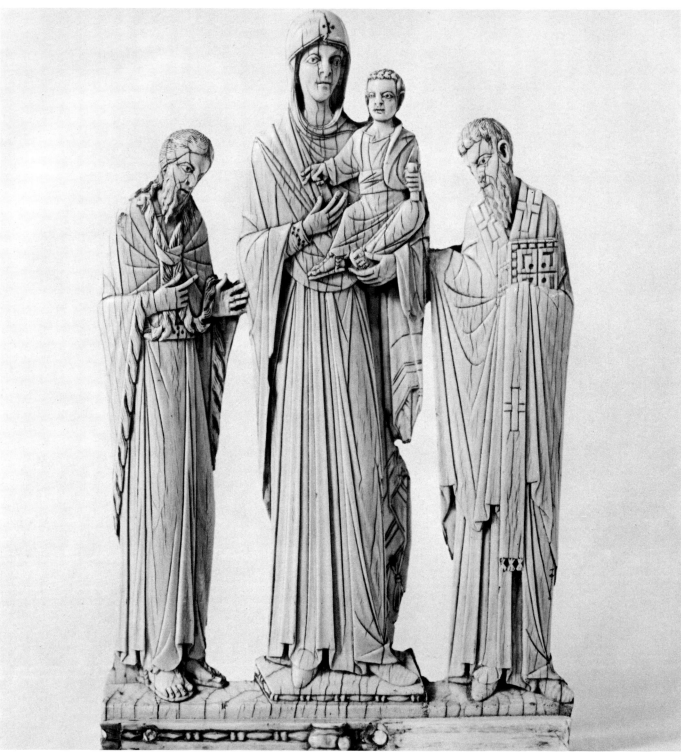

Pl. 106. – *Above*: Sebastian of Phrygia. Byzantine Church. Architrave of the Iconostasis. – *Below*: Hodigitria between John the Baptist and St. Basil. Ivory. Washington, Dumbarton Oaks Collection.

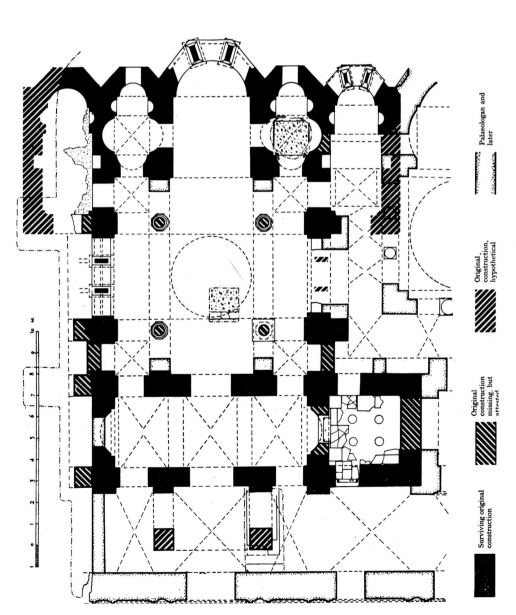

Surviving original
construction

Original
construction
missing, but
attested

Original,
construction,
hypothetical

Palaeologan and
later

Pl. 107. – *Left*: Istanbul. Church of the Theotokos by Costantine Lips (Fener Isa Cami). Plan (by Macridy, Megaw, Mango, Hawkins). – *Right*: The Prophet Elisha (detail). Fresco. Corfù. Saint Mercurius. North apse.

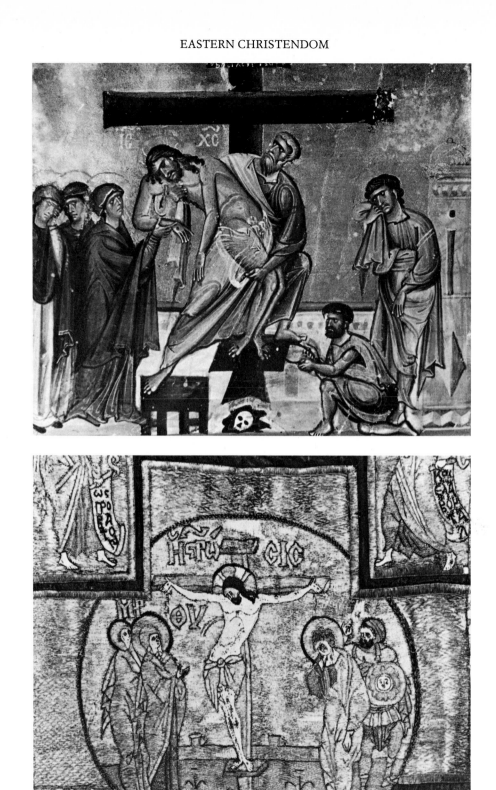

Pl. 108. –*Above*: Deposition from the Cross. Illumination. Berlin, Staatsbibliothek der Stiftung Preussischen Kulturbesitz. Cod graec. 4th 66, f. 256 V°. – *Below*: Crucifixion. Textile. Moscow. Kremlin. Detail of the Sakkos "Major" of the Metropolitan Photius.

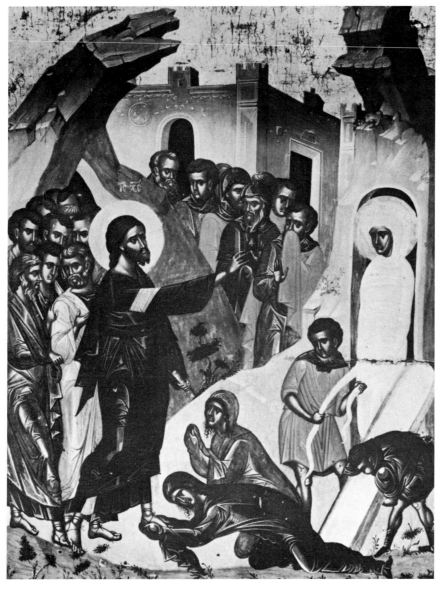

Pl. 109. –*Above*: Adam (detail). Fresco. Verria. Church of Anastasis. – *Below*: Theophanese the Cretan. Resurrection of Lazarus. Painted tablet. Dodecaorton Icon. Mount Athos, Monastery of Lavra (by kind permission of M. Hatzidakis).

Pl. 110. –Coptic textile with a Nativity scene. Rome, Museo di Palazzo Venezia.

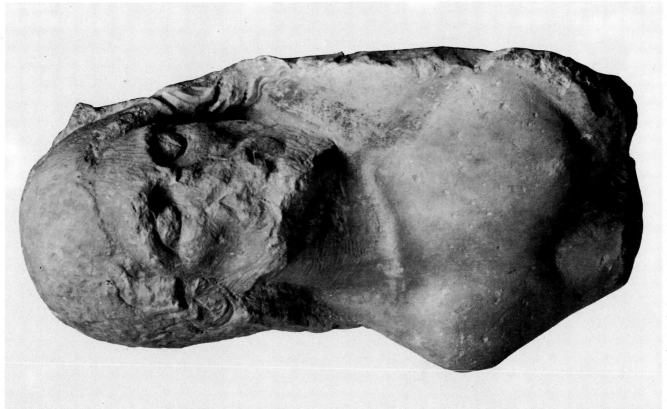

Pl. 111. – *Left*: Donatello. St. John the Baptist (1438). Venice. S. Maria Gloriosa dei Frari. Detail, during cleaning. – *Right*: Michelangelo. Head of Christ of the Pietà Rondanini. First version (1552–53).

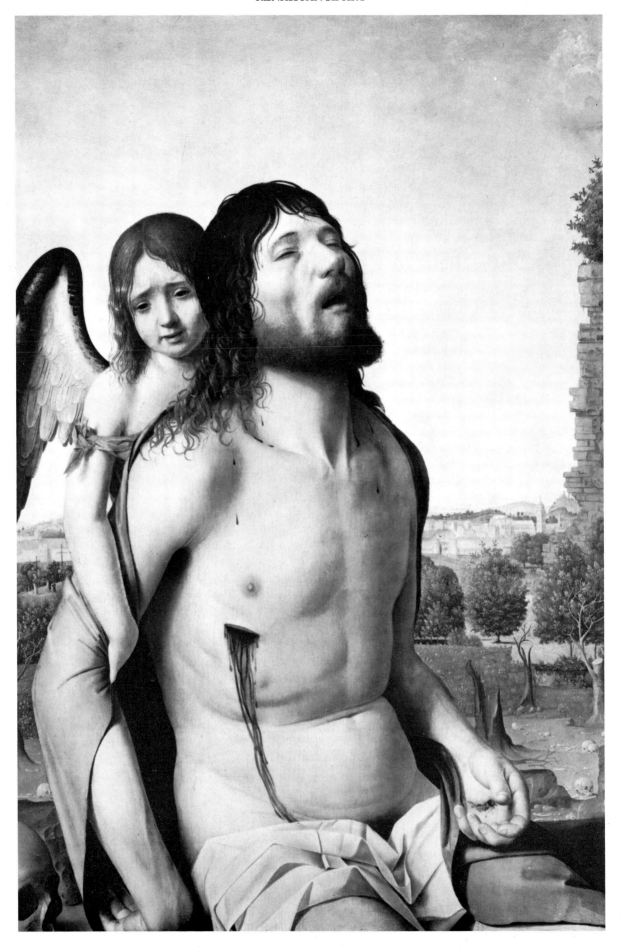

Pl. 112. –Antonello da Messina (attr.) The Dead Christ supported by an Angel (1474–75). Madrid, Museo del Prado.

Pl. 113. – *Above*: Justice (1509). Venice, Galleria dell'Accademia (from the Fondaco dei Tedeschi, after the restoration in 1967). – *Below*: Tintoretto. Mary Magdalen. (1583–87). Venice, Scuola di San Rocco, Lower Room, cleaning test.

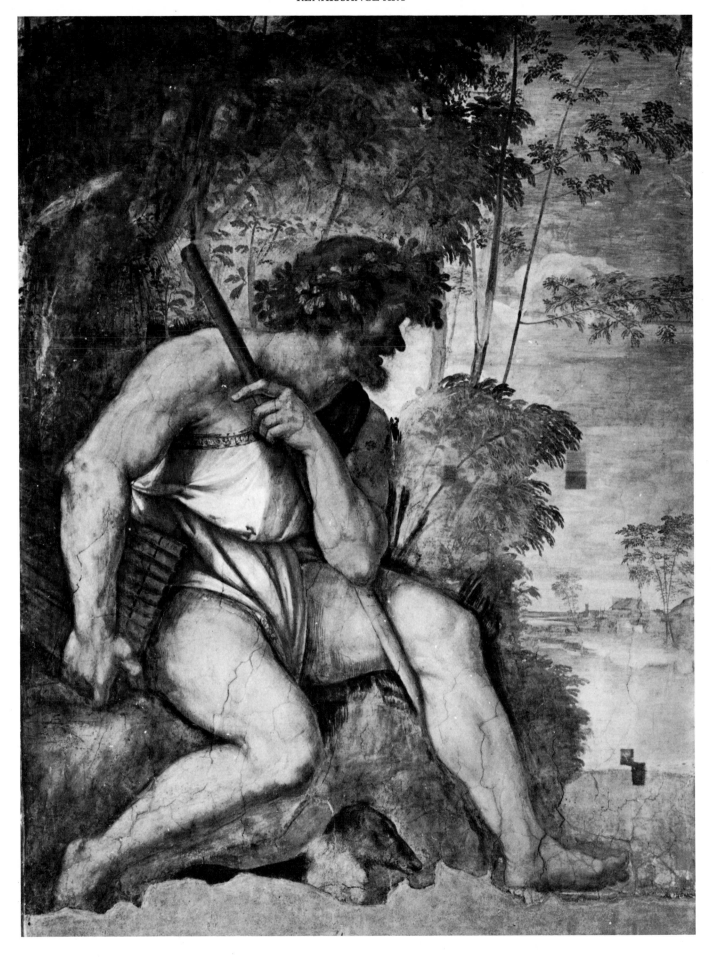

Pl. 114. –Sebastiano del Piombo. Polyphemus (1512). Rome, Farnesina, Sala di Galatea. After restoration.

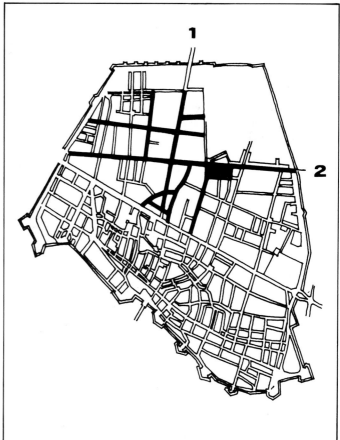

Pl. 115. –*a*: Urbino. Urban rebuilding and extension (1447–68). 1. Via Valbona. 2. Piazza Ducale. 3. Market Place. – *b*: Naples. Rebuilding plan of Alphonso II (1485–95). 1. Palace of the Tribunals. 2. Fortified boundary wall. – *c*: Ferrara. Adelarda and Borso d'Este addition. 1. Medieval nucleus. 2. Adelarda expansion. 3. Borso I, d'Este addition (1451 ca). – *d*: Ferrara. Erculea addition by B. Rossetti (1491). 1. Corso Ercole. 2. Corso Porta Mare.

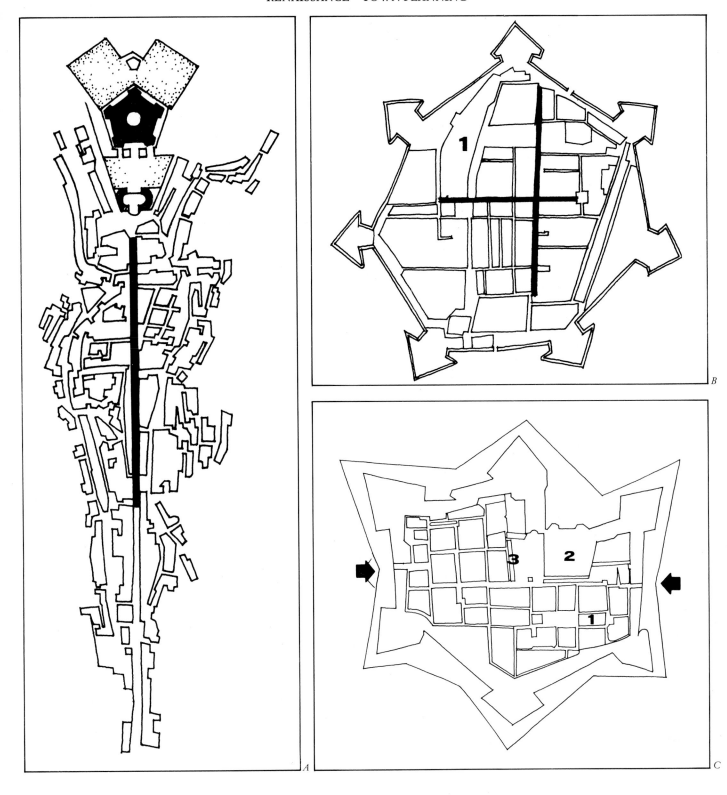

Pl. 116. –*a*: Caprarola. The sixteenth century urban restoration (1550 ca.). *b*: Guastalla. Urban rebuilding by D. Giunti (1565–68). 1. Communication axes and Medieval nucleus. – *c*: Sabbioneta. Town Planning (1560–84). 1. Ducal Palace. 2. Fort. 3. Gallery of Antiquities.

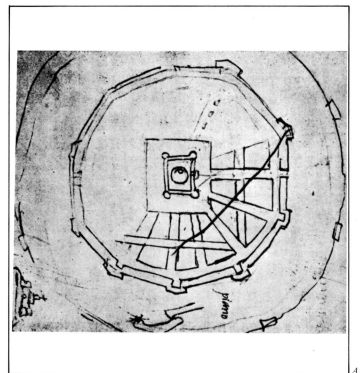

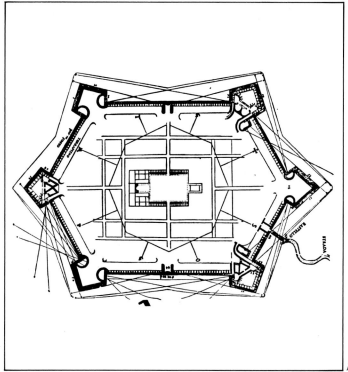

A

B

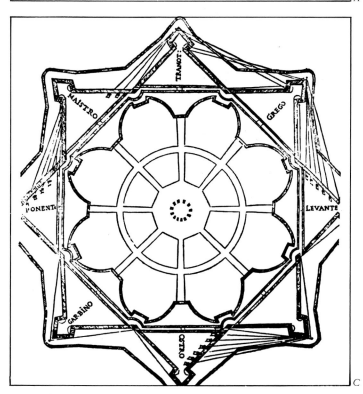

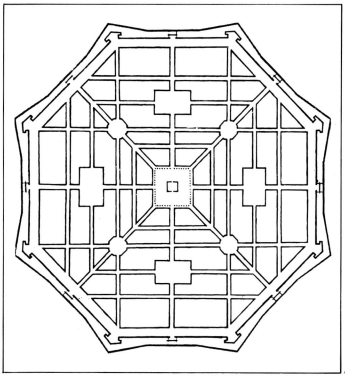

C

D

Pl. 117. –*a*: B. Peruzzi. Town study (1518–20). Florence, Uffizi. Arch. design. 557. – *b*: D. Barbaro. Drawing of a Vitruvian town (1556), from *The Ten Books on Architecture of Vitruvius*. – *c*: G. Maggi and J. Castriotto. Study of a fortified town (1564), from *On the fortification of towns*. – *d*: G. Vasari the Younger. Study of the Ideal City (1598), from *The Ideal City*.

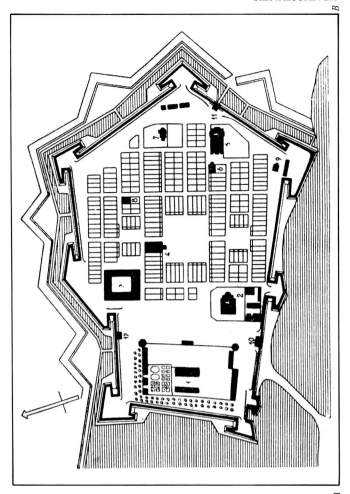

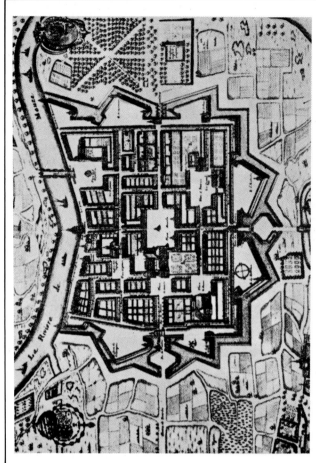

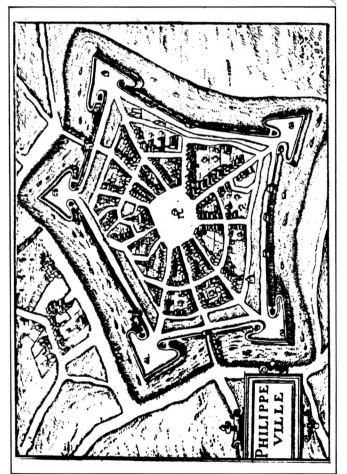

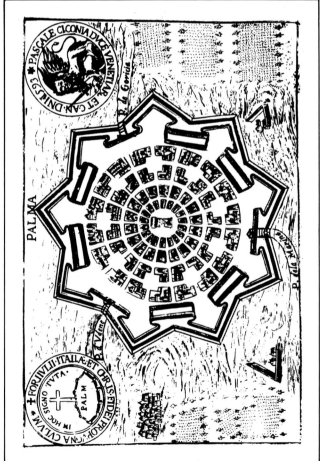

Pl. 118. – *a*: Philipville. Project by S. van Noyen (1555). – *b*: Zamosc. Project by B. Morando (1578) reconstruction by W. Kalinowsky. – *c*: Palmanova. Project by G. Savorgnan. (1593). – *d*: Charleville. Town rebuilding plan (1608–20).

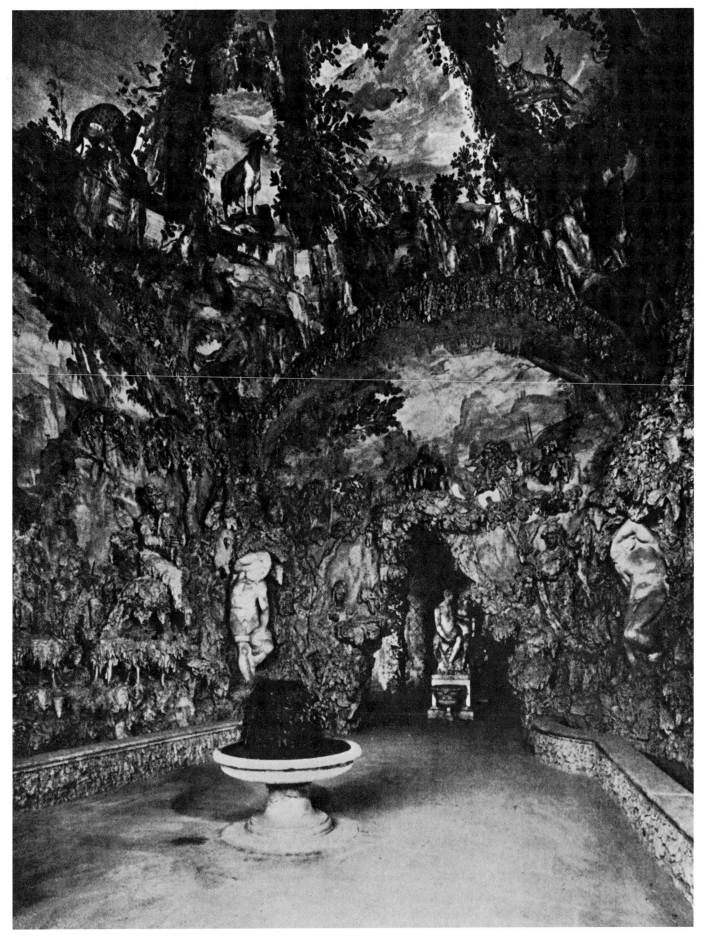

Pl. 119. –B. Buontalenti. First room of the large Boboli Grotto with the arrangement of Michelangelo's "Prisoners" (1585). Florence, Boboli Gardens.

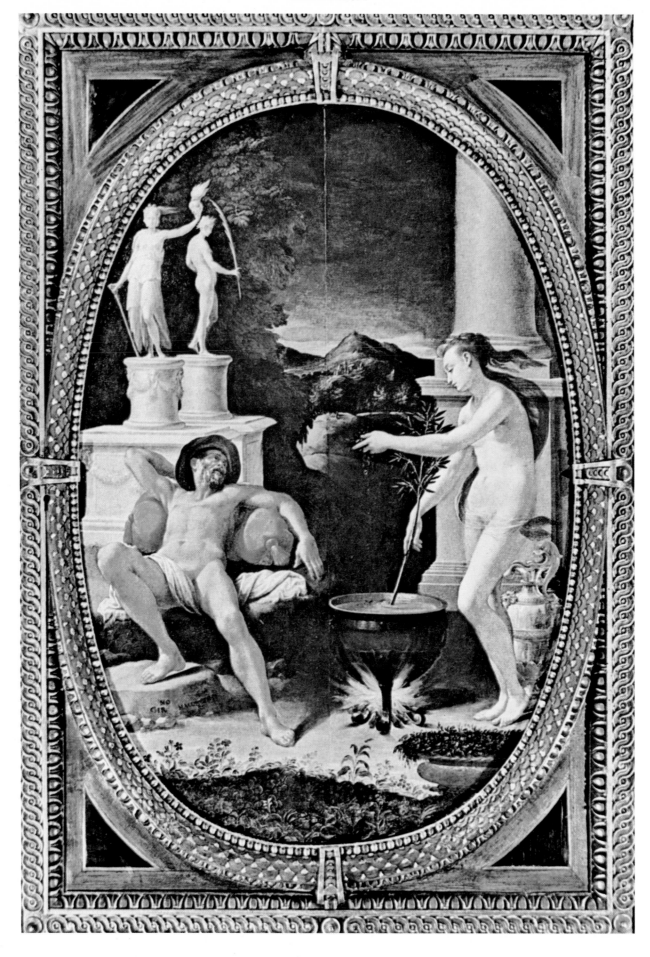

Pl. 120. –G. Macchietti. Medea rejuvenates Jason (1572). Florence, Palazzo Vecchio. Studio of Francesco I.

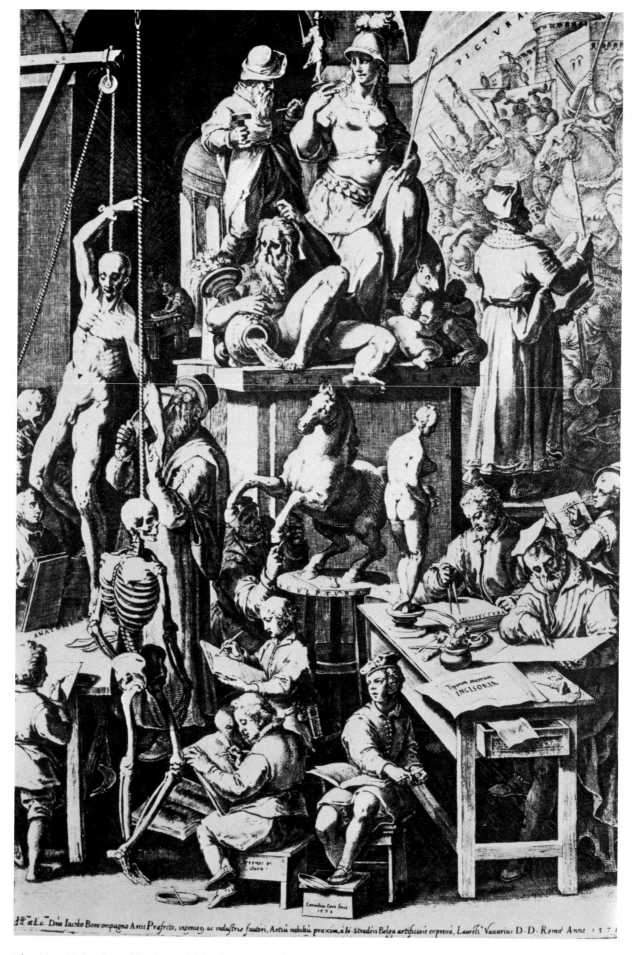

Pl. 121. –G. Stradano. The Artists' School. Engraving by Cornelis Cort (1578).

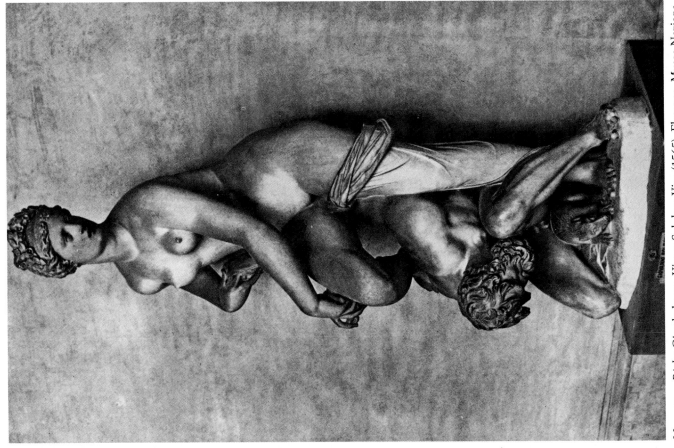

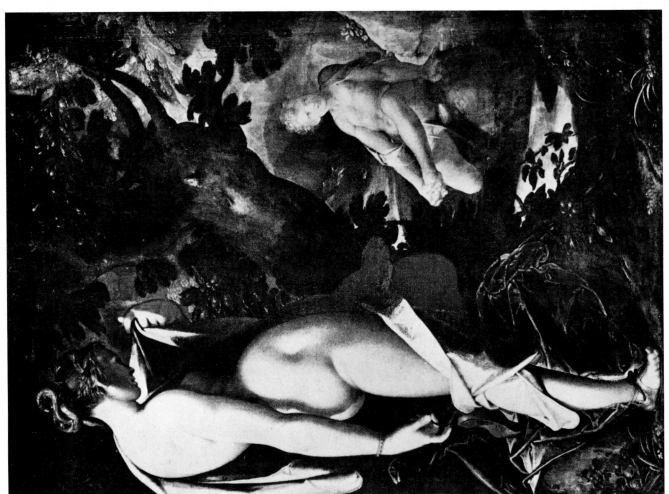

Pl. 122. – *Left*: B. Spranger. Hermaphrodite and the Nymph Salmaces (1582). Vienna, Kunshistoriches Museum. – *Right*: Giambologna. Virtue Subdues Vice (1565). Florence, Museo Naziona-le del Bargello.

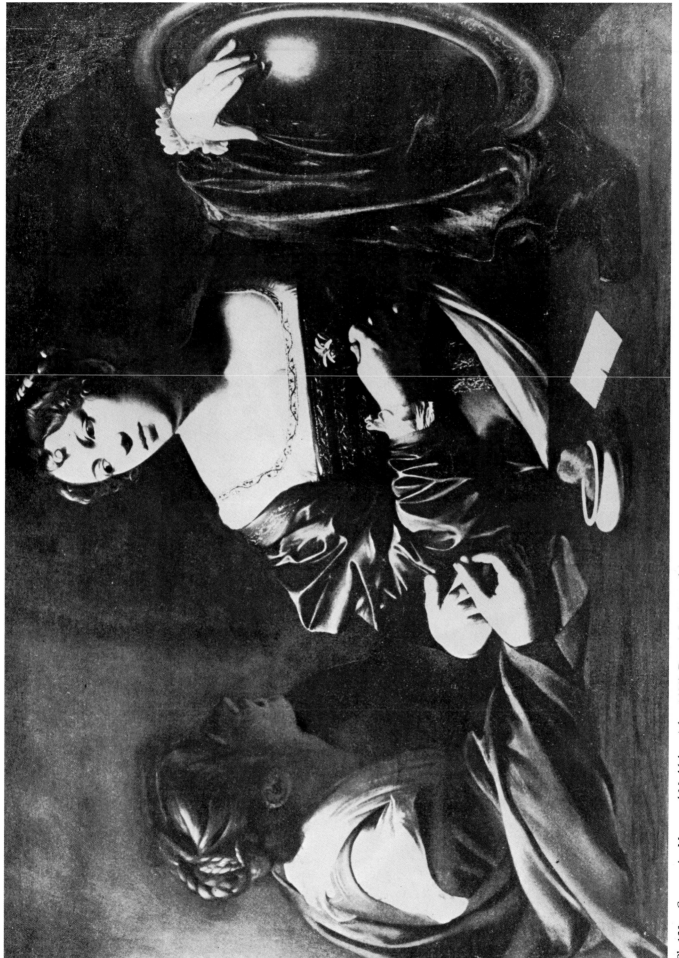

Pl. 123. – Caravaggio. Marta and Maddalena (after 1600). Detroit Institute of Art.

Pl. 124. – P. da Cortona and S. Rosa (?). Decoration of the Great Hall of the Mezzanine (1644–47). Florence, Pitti Palace.

Pl. 125. – *Left*: P.P. Rubens. Altarpiece of the Trinity (1604–05), detail. Mantua, Museo del Palazzo Ducale. – *Right*: X-ray of the angel's head.

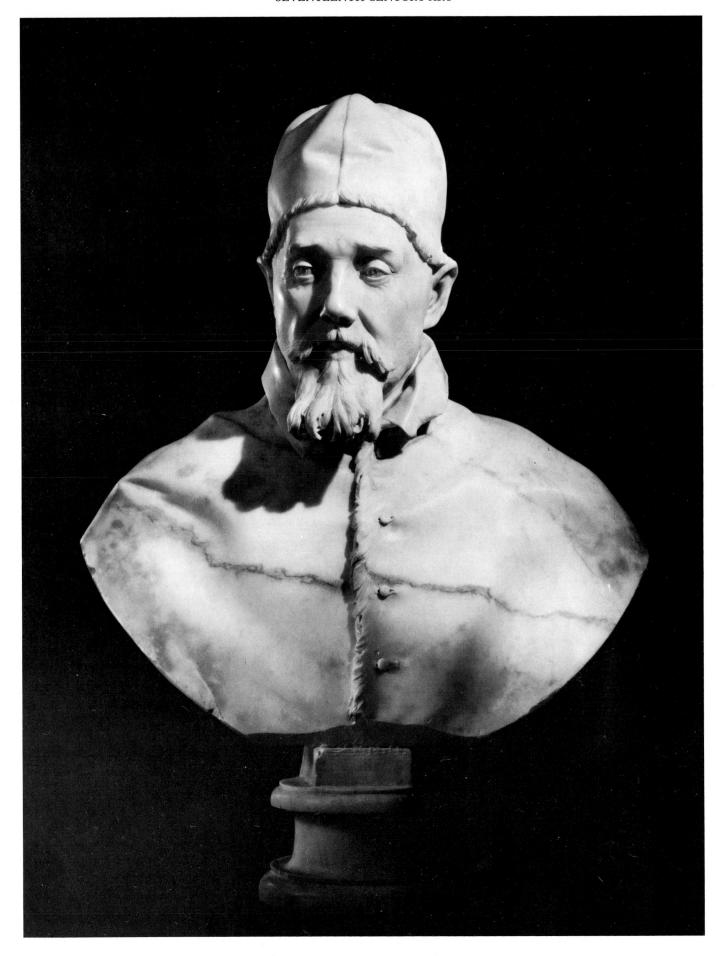

Pl. 126. –G. Bernini. Bust of Urbano VIII (1639). Ottawa, National Gallery.

Pl. 127. – Critical diagrams by Ch. Norberg Schulz (1971): *a*: Italian Baroque palace and French hotel. – *b*: Placement of the cours in the Italian and French palaces. – *c*: Castle of Vaux–le–Vicomte. – *d*: Palazzo Carignano. – *e*: Baroque churches: Central space lengthened and longitudinal space centralized. – *f*: Dutch Protestant churches. – *g*: Saints Luke and Martin. – *h*: Oval plan for Santa Maria in Campitelli.

Pl. 128. –*a*: Diagram of St. Peter's Square (by Ch. Norberg Schulz, 1971). – *b*: Guiding lines of the plan of Sant'Andrea al Quirinale (by F. Borsi, 1967). – *c*: F. Borromini. Church of San Carlino alle Quattro Fontane. Diagram of the ideal tensors of the internal space (by L. Moretti, 1970). – *d*: Spatial interpretation of the façade of San Carlino according to the "fields" theory (by P. Portoghesi, 1967).

Pl. 129. – *a*: Geometrical diagram of the Church of San Carlino alle Quattro Fontane (by P. Portoghesi, 1967). – *b*: Geometrical diagram of the plan for Sant'Ivo alla Sapienza (by P. Portoghesi, 1967). – *c*: Temple imitating a heraldic charge, on the lines of a planimetric scheme (by S. Benedetti, 1968). – *d*: Critical diagram of the Chapel of the Holy Shroud (by M. Fagiolo, 1968). – *e*: G. Guarini, Church of San Filippo in Casale, pulsation patterns (by Ch. Norberg Schulz, 1971). – *f*: Elevation of the Church of Saints Luke and Martin (by K. Noehles, 1969).

Pl. 130. – *a*: F. Borromini. Sant'Ivo. The Lantern. – *b*: M. Van Heemskerck. The Lighthouse of Alexandria (1572). – *c*: "Reason" according to a representation by Ripa (1613). – *d*: "Philosophy" as painted by Boethius in *De Consolatione Philosophiae* according to the representation of Ripa (1603). – *e*: "Philosophy" according to the representation in another edition of Ripa (1613).

Pl. 131. – *Left*: G.M. Mazza. Madonna (1687). Bologna, Pinacoteca Nazionale. – *Right*: G.M. Mazza. St. Joseph (1687). Bologna, Pinacoteca Nazionale.

Pl. 132. –F. Goya. Louis Bourbon and his Family Sit for the Painter (1783 ca). Magnani Coll. Bannone di Traversetolo (Parma).

Pl. 133. – B. Bellotto. View of Gazzada with the Villa Melzi d'Eril (1744). Milan, Pinecoteca di Brera.

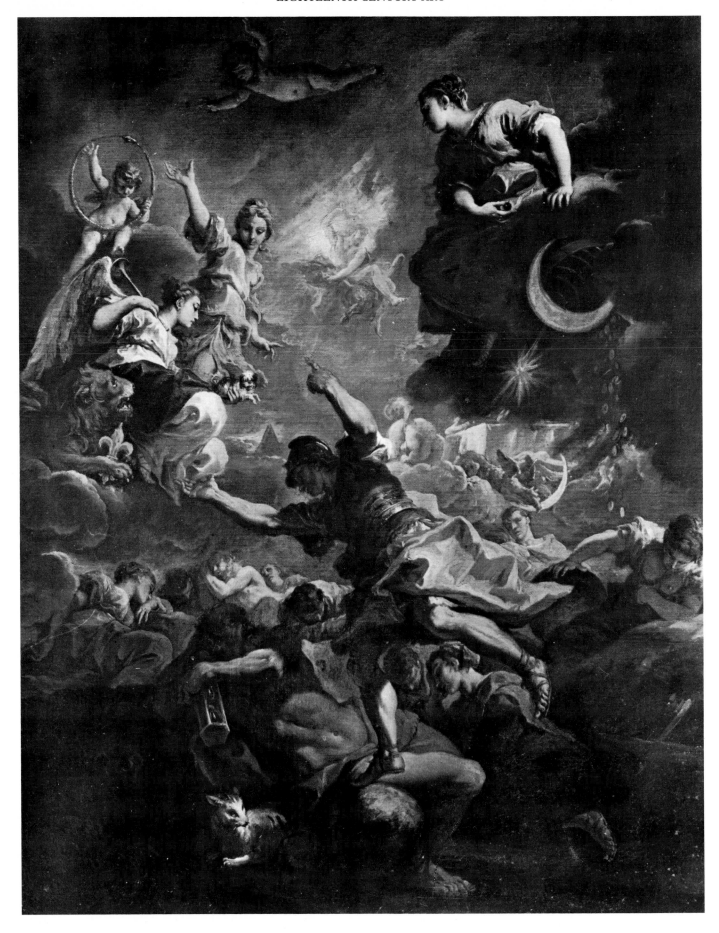

Pl. 134. – S. Ricci. Allergory of Tuscany (1706). Florence, Uffizi Gallery.

Pl. 135. – B. Vittone. Santa Caterina, previously Santa Croce (1755). Villanova di Mondovì. General view from the centre of the well between the nave and the choir (by P. Portoghesi, 1966).

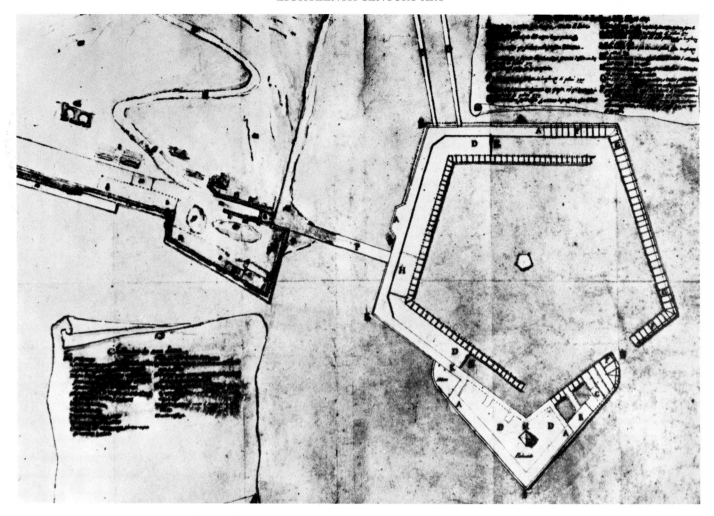

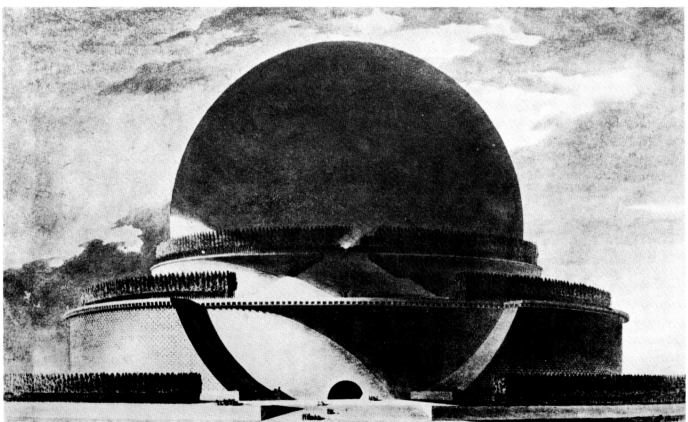

Pl. 136. –*Above*: L. Vanvitelli. Lazzaretto. Ancona. Signed drawing of the plan (1734). Rome, Gabinetto Nazionale delle Stampe. – *Below*: E.L. Boullée. Plan of the Newton Cenotaph (1784). Paris, Bibliothèque Nationale (by A.M. Vogt 1969).

Pl. 137. – C.D. Friedrich. Einsamer Baum. (1823). Berlin Staatliche Museen, Nationalgalerie Stiftung Preussischer Kulturbesitz.

Pl. 138. –*Above*: J. Toorop. Study for Die Drie Bruiden (1892 ca). – *Below*: J.M. Olbrich. Preparatory sketch for the building of the Vienna Secession (1897). Berlin, Staatliche Museen, Kunstbibliotek Preussischer Kulturbesitz.

Pl. 139. – E. Basile. Bedroom for the Ducrot firm. (1902).

Pl. 140. – *Left*: E.E. Viollet le Duc. *Maçonnerie* from the *Entretiens*. Engraving by G. Sauvageot from a drawing of 1865 by Viollet le Duc. – *Right*: P. Puvis de Chavannes. *Sainte-Geneviève* series, detail (1874–78). Paris, Panthéon.

Pl. 141. – Majakovskij. The Unchaste (1919). Sketches for *Comic Mystery*. Moscow, State Museum of Literature.

Pl. 142. –K.S. Malevič. Woman Next to a Placard (1914). Amsterdam, Stedelijk Museum.

Pl. 143. –M. Rothko. N° 2 (1954).

Pl. 144. –*Above*: G. Mathieu. Festivities and Procession for the Victory of Lepanto (1959). La Chaux–de–Fonds, Musée des Beaux–Arts. – *Below*: E. Vedova. Plurimo I, (1962). Rome, Galleria Nazionale d'Arte Moderna.

Pl. 145. –G. Capogrossi. Surface 564 (1965). Lausanne, Private Collection.

Pl. 146. –A. Burri. Erect Black G/4 (1975). Burri Collection.

Pl. 147. –Arman (A. Fernandez). La Fin du Zin–Zin (1962).

Pl. 148. –J. Tinguely. La Cloche (1960).

Pl. 149. – M. Rotella. Cinecittà (1961).

Pl. 150. –*Above*: N. de Saint–Phalle. Relief–cible (1962). – *Below*: D. Spoerri. Le Piège du Pain (1963).

Pl. 151. – *Left*: R. Rauschenberg. Canyon (1959). New York, Sonnabend Coll. – *Right*: M. Pistoletto. Man Seen from Behind (1963).

Pl. 152. – R. Lichtenstein. Standing Rib (1962). Milan, Private Collection.

Pl. 153. –*Above*: R. Goings. Sacramento Airport (1970). – *Below*: J. Salt. Vehicle with Decomposing Seats (1970).

Pl. 154. – F. Gertsch. Les Saintes–Maries de la Mer (1971).

Pl. 155. – P. Manzoni. Living Work of Art (1961)

Pl. 156. –*Above*: Christo (C. Javacheff). Little Bay, New South Wales, Australia (1969). – *Below*: J. Beuys. Iphigenie (1969).

Pl. 157. –*Above*: L. Fabro. Half Mirror and Half Transparent Rectangle (1965). – Below: S. Lewitt. Model for 46 Variations in 3 Parts (1968).

Pl. 158. – *Left*: W. De Maria. Bronze Column (1966–'67). – *Right*: K. Snelson. Needle Tower (1968).

Pl. 159. – *Left*: E. Gomringer. Wind (1957). Archivio Denza, Rezzato (Brescia). – *Right*: A. Lora Totino. Space (1966) Ibid.

Pl. 160. – *Left*: I. and P. Garnier. Strati (1969). Archivio Denza, Rezzato (Brescia). – *Right*: M. Bentivoglio. Black Flower (1971). Ibid.

Pl. 161. – *Left*: B. Holland. Harvest. Drawing (from "Graphis", N° 178). – *Right*: R. Topor. Love Crime. Drawing (from "Graphis", N° 179).

Pl. 162. −*a*: M. Sendak. The Fisherman and his Wife. − *b*: Hänsel and Gretel. − *c*: The Faithful Ferdinand and the Unfaithful Ferdinand. − *d*: The Lazy One. From the illustrations for a collection of 27 Grimm's Fairy Tales (from "Graphis", N° 177).

Pl. 163. –M. Glaser. Illustration for an article in "Signature", the Diner's Club periodical.

Pl. 164. –A. Raymond. Flash Gordon. Ming Counterattacks (1938–39), published under the title "Gordon, the Intrepid" in the weekly "Adventure", N° 1 to 8 (1944) and N° 1 to 11 (1945).

Pl. 165. –G. Crepax. Histoire d'O. (1973). Sketch N° 4, detail (courtesy Rondanini Gallery, Rome).

Pl. 166. – *Left.* J. Chéret. Poster for the Folies-Bergères (1881). – *Right.* H. Bayer. Poster for the European Exhibition of Applied Arts, Leipzig (1927).

Pl. 167. – *Left:* E. Lissitzky. Poster for the Russian Exhibition in Zürich (1929). – *Right:* Poster advertising dining cars (1932).

Pl. 168. – Series of election posters of the Italian Republican Party. 1972 elections.

Pl. 169. –Advertisement for San Pellegrino. Studio Testa.

Pl. 170. – Night view of Broadway, N.Y.

Pl. 171. – *Left*: Unity of Italy Centenary Exhibition, Turin 1961. Plan. – *Right*: National Swiss Exhibition of Lausanne, 1964. Plan.

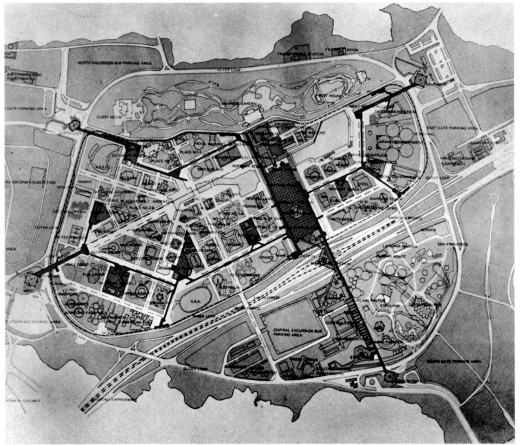

Pl. 172. – *Above*: National Exhibition of Montreal, 1967. Plan. – *Below*: Japanese World Exhibition at Osaka, 1970. Plan.

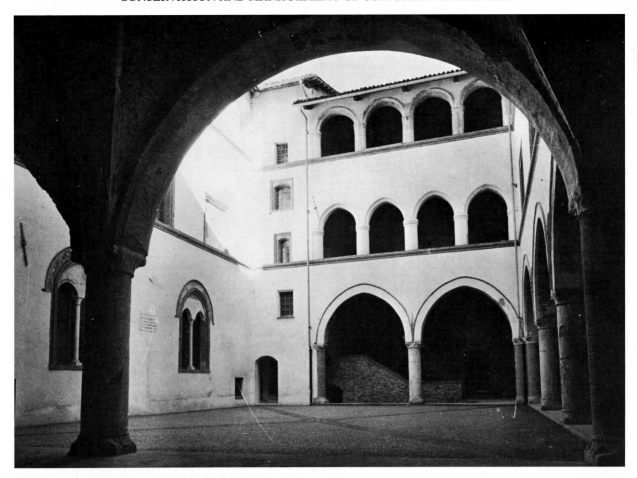

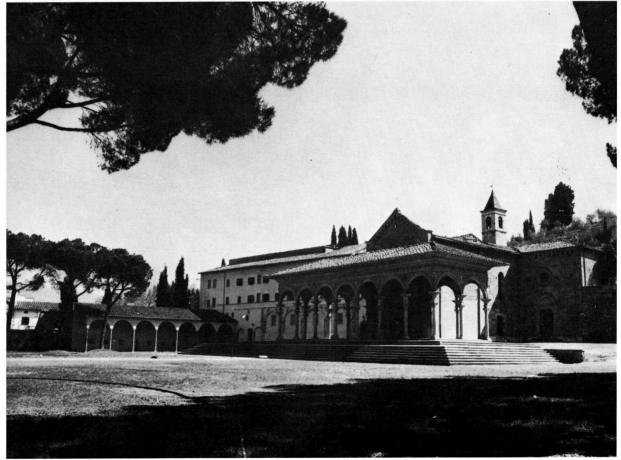

Pl. 173. – *Above*: Castello degli Acaja (XIV century). Fossano (Cuneo). The courtyard after the restoration. – *Below*: B. da Maiano. Loggia of Santa Maria delle Grazie (1490 ca.). Arezzo. After the restoration.

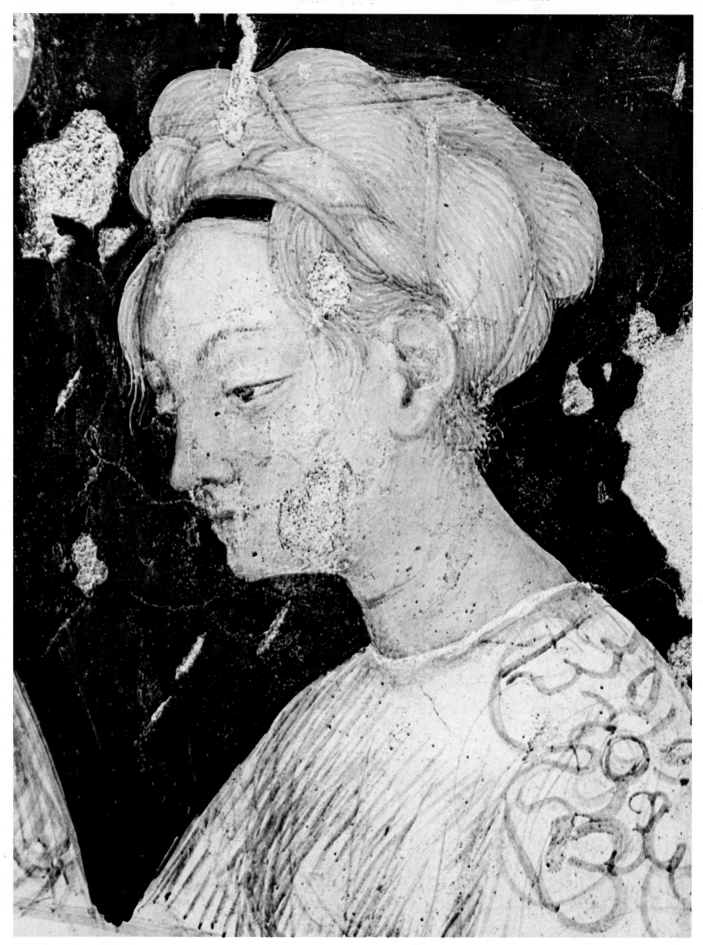

Pl. 174. –Pisanello. Chivalry cycle. Detail from the group of Ladies. 1447–'55. Mantua, Ducal Palace, Hall of the Princes (by G. Paccagnini, 1972).

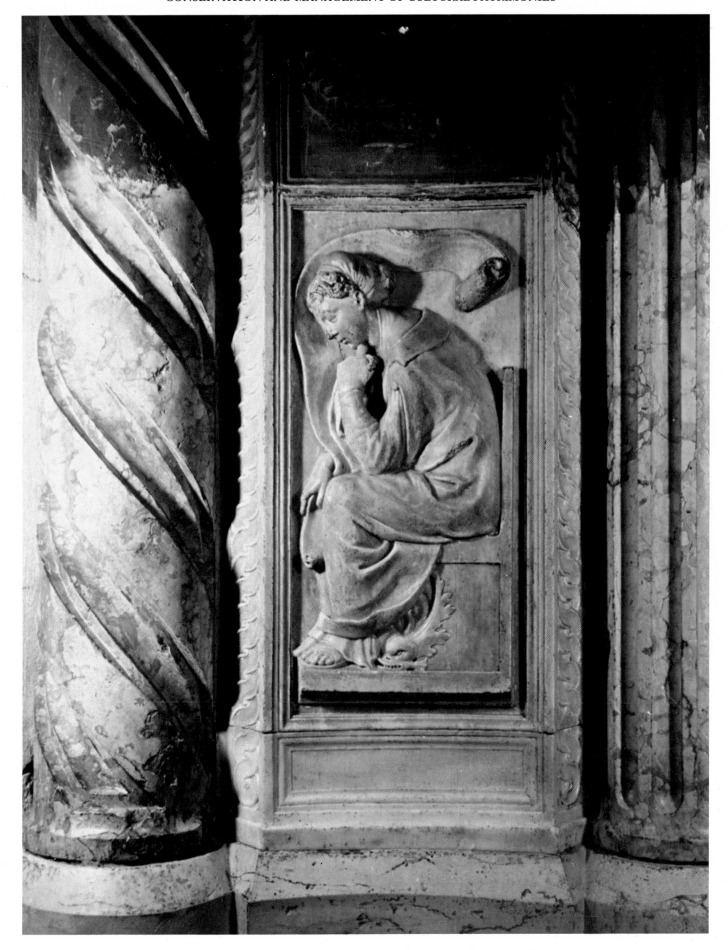

Pl. 175. –Bologna. Church of St. Petronius. Detail of the sculpture of the façade during the cleaning.

Pl. 176. – *Left*: Venice. S. Pantalon. Relocation, after its restoration, of a canvas by G.A. Fumiani depicting the Martyrdom and the Glory of the Saint (1680–1704). – *Right*: Anonymous Umbro-Marchigiano of the second half of the XVIII century. Decorative paintings in a hall of the Antinori-Gallenga Palace, in Perugia. After the restoration of 1971.